# THE
# OXFORD COMPANION
# TO ART

# THE
# OXFORD COMPANION
# TO ART

EDITED BY

HAROLD OSBORNE

OXFORD
AT THE CLARENDON PRESS

Oxford University Press, Walton Street, Oxford OX2 6DP

Oxford New York Toronto
Delhi Bombay Calcutta Madras Karachi
Petaling Jaya Singapore Hong Kong Tokyo
Nairobi Dar es Salaam Cape Town
Melbourne Auckland

and associated companies in
Beirut Berlin Ibadan Nicosia

Oxford is a trade mark of Oxford University Press

Published in the United States by
Oxford University Press, New York

ISBN 0 19 866107 x

First published 1970
Reprinted 1971, 1975, 1978, 1979, 1984, 1986, 1987

Printed in Great Britain
at the University Printing House, Oxford
by David Stanford
Printer to the University

# PREFACE

THE *Companion to Art* has been designed as a non-specialist introduction to the fine arts. In planning what to include in it the word 'art' has been given the narrower meaning in which it denotes the visual arts generally but excludes the arts of theatre and cinema and the arts of movement such as dance. Even so our scope, covering human artistic endeavour through all time and throughout the world, takes in a far greater volume of far more varied material than that of other Oxford Companions. In order to bring this material into manageable compass it was found necessary somewhat arbitrarily to exclude the practical arts and handicrafts such as metal-work, textiles, furniture, book design, etc., although the Editor was aware that over the greater part of human history no clear distinction has been made between arts and crafts and that the distinction between the useful or practical and the fine arts is both a recent and a fluctuating one. Yet even this arbitrary restriction has not been applied with entire consistency. For some of the practical arts, and in particular architecture and ceramics, bulk so importantly in our knowledge of the artistic development of certain peoples and cultures that their complete exclusion was out of the question. In early periods especially, conditions of survival have brought it about that ceramics often provide a major source of information about artistic achievement. Nor would it often make sense to attempt a summary of the artistic history of a people or a period without reference to architecture. In these cases, and in the case of some handicrafts (as, for example, the illumination of manuscripts) which verge or impinge on the field of fine art, a compromise has been struck in the interest of general usefulness.

While the scope of the book is more comprehensive than that of other similar volumes, individual articles are not intended to be more than introductory. The *Companion* is a handbook, not an encyclopedia, and the information given in particular articles is planned to provide both a preliminary conspectus for readers who are not already specialists in their field and a guide to further study. For example, in biographical articles no attempt is made to supply a complete list of the artist's *œuvre*, but bibliographical references will usually indicate sources where such information can be found. Historical articles on the art of various nations differ both in length and in the degree of detail into which they enter. This has depended upon the intrinsic importance of the artistic output in each case though consideration has also been given to the amount of the existing literature easily accessible to an ordinary reader. Articles on technical matters have been kept to a minimum but a few longer and more detailed technical articles have been included when their subject seemed to be of importance for understanding and appreciation over a wide field of art. Examples of such articles are those on Perspective by B. A. R. Carter, on Graphic Processes by Frank Martin, and on Colour by the Editor.

The articles have been prepared by experts for readers who are accustomed to tackling specialized reading in other fields. They are neither popular in tone nor do they assume specialized knowledge in their own field. The Editor has aimed at achieving uniformity of presentation without sacrificing the individuality and liveliness of contributions. Information has been brought reasonably up to date but no attempt has been made to include such up-to-the-last-minute facts and opinions about contemporary art movements or fashions in art history as would inevitably become out of date within a few years. As far as was possible the reader is given a central body of fairly well-established fact and opinion against which he can gauge the fluctuating diversities of taste and fashion. Furthermore, while few experts can or should set out to write on the arts from a position of strict neutrality, the Editor has not regarded it as consistent with the idea of the *Companion* to dictate on matters of aesthetic judgement. So far as he could do so without emasculating the material he has made it his object to provide information which may serve the reader as a preliminary orientation from which to form his own taste and base his own aesthetic valuations.

In the composition of the book as a whole a compromise has been attempted between making each article reasonably self-sufficient on the one hand and on the other hand avoiding excessive duplication. The reader is enabled to supplement information contained in each article by a system of cross-references. On the first occasion in any article when a subject or person is mentioned about whom there is a separate article in the *Companion* this is indicated by the use of small capitals. In this way the articles hang together and greater consistency is achieved than would be expected from an encyclopedia. References to art objects are frequent but they are intended to be illustrative rather than exhaustive, for complete lists of all relevant art objects would have required more space than could be available in a single volume. Where possible and useful the location of art objects has generally been given.

As an aid to further study a selective bibliography of over three thousand titles has been prepared. It has been compiled with the needs of the general reader in view rather than those of the specialist and it comprises both basic general reading and books which have a primary bearing on particular articles or groups of articles. In the selection of the latter attention has been paid to the inclusion of books which themselves provide guidance, bibliographical or otherwise, for further study. The bibliography is divided into five sections. The first four (unnumbered) sections are devoted to basic general works, as follows: (1) dictionaries, encyclopedias, general histories of art, and bibliographies; (2) general works on art theory and criticism; (3) general works on the arts in the nineteenth and twentieth centuries; (4) works on materials and techniques. The fifth and longest section contains those books which have a special bearing on individual articles or groups of articles. The entries in this section are numbered alphabetically and the numbers of the titles relevant to particular articles are printed at the end of the articles. This section of the bibliography is therefore not designed to be used independently but in conjunction with the articles in the *Companion*. The bibliographical references appended to indivi-

dual articles have been planned hierarchically. For example, appended to an article on an individual artist the reader will usually find numerical references leading him to monographs on that artist. From the article itself he will learn the nationality and dates of the artist, the movements to which he belonged, the style in which he worked, and so on. Below the articles on movements, styles, etc., he will be able to obtain bibliographical references to books of a wider scope and from information contained in these articles he can proceed to articles of still more general scope, which in turn will contain appropriate bibliographical references. In this way it will be possible to compile reading lists at successive levels of generality and at all stages lists can be supplemented by bibliographical information contained in the books listed in the bibliography.

Illustrations have been kept deliberately sparse. Any attempt at systematic illustration over so enormous a field was prohibited by the limitations of space and in any case would not have been consistent with the idea of the *Companion*, which is not designed to be a picture-book of the arts. The illustrations are not intended to be used as imperfect substitutes for the aesthetic impact of original art objects but are in the main designed to give visual clarification of some technical point of style, iconography, etc., dealt with in the text. Figures are used chiefly to illustrate architectural devices, modes of ornament, points of technique, and similar matters.

Finally, I am glad to be able to avail myself of the opportunity provided by this Preface to acknowledge my deep debt of gratitude to the many contributors, without whose unfailing courtesy, forbearance, and kindness the task of editing would have been not only formidable but impossible. Special recognition is due to Professors E. H. Gombrich and L. D. Ettlinger, who in addition to contributing articles were unstinting of their help and advice during the early, planning stages. My personal thanks are owed also to my predecessors on the project, especially Miss Lucy Hutchinson who bore the heavy burden of editorship until her untimely death in 1959, to the Publishers, whose helpfulness in all things has exceeded what even the most exacting editor could have expected, and to the meticulousness and perfectionism of the University Printer.

H. O.

*December 1969*

# ACKNOWLEDGEMENTS

ACKNOWLEDGEMENT is made to the following for photographs and permission to reproduce illustrations: Alinari (34, 61, 124*a*, 124*b*, 159, 172, 190, 221, 269, 302, 308, 316*a*, 316*b*, 317, 318, 358, 363, 380); Anderson (8, 17, 89, 171, 263, 270, 290, 291, 298, 303, 304, 319, 357, 365, 378); Antikensammlungen, Munich (155); Archives Photographiques (148); Arxiv Mas, Barcelona (5, 6, 22, 175, 213, 223, 224, 225, 355); Professor B. Ashmole (269); Ashmolean Museum, Oxford (7, 107, 244, 289); Axel Poignant (28, 29); Bayerische Staatsbibliothek, Munich (252); Bibliothèque Nationale, Paris (41, 88, 142, 192, 214, 257, 306, 368, 387); Bodleian Library, Oxford (3, 19, 23, 24, 72, 81, 95, 98, 101, 121, 122, 264, 285, 286, 343, 349, 350, 370, 391, 392); J. Bottin, Paris (140, 233); Trustees of the British Museum (25, 26, 30, 31, 32, 33, 38, 47, 51, 52, 62, 63, 64, 65, 66, 79, 80, 82, 85, 86, 91, 96, 106*a*, 106*b*, 114, 118, 119, 126, 127, 138, 146, 160, 161, 167, 170*b*, 170*c*, 174, 178, 179, 180, 193, 195, 196, 203, 210, 217, 226, 228, 236, 249, 275, 280*a*, 281, 297, 300, 301, 331, 341, 372, 374, 383); Museo Civico, Como (334, 335); Courtauld Institute of Art, London (2, 4, 13, 15*b*, 16, 18, 21, 35, 36, 37, 40, 43, 48, 49, 50, 53, 54, 57, 67, 73, 75, 83, 94, 100*a*, 100*b*, 102, 105, 110, 113, 115, 120, 132, 135, 136, 147, 152, 153, 163, 170*a*, 183, 186, 187, 188, 198, 199, 200, 204, 208, 209, 212, 219, 235, 245, 246, 260*a*, 260*b*, 262, 271, 279, 280*b*, 294*b*, 295, 305, 307, 310, 311, 312, 322, 323, 327, 332, 337, 375, 376, 377, 379, 384, 388, 389, 390, 393); Damascus Museum (177*a*, 177*b*); Librairie Ernest Flammarion, Paris (77, 92, 93, 261); Giraudon (137, 149, 207, 229, 314, 321); Graphische Sammlung Albertina, Vienna (55, 56, 111); Musée Guimet, Paris (164); Gulbenkian Museum of Oriental Art, Durham (58, 59, 60, 84, 373); State Hermitage Museum, Leningrad (10); Horniman Museum and Library, London (333); Jewish Museum, London (181, 182); Miss K. Kemper Collection, London (276); Klosterneuburg Abbey (1, 194, 382); Kunstbibliothek, Berlin (14, 176*a*, 176*b*); Kunsthaus, Zürich (324); Kunsthistorisches Museum, Vienna (20); Kunstmuseum, Basel (165); Raymond Laniepce, Paris (87); Laurentian Library, Florence (125, 166); Mansell Collection, London (11, 12, 27, 30, 76, 78, 99, 104, 112, 162, 168, 169, 206, 250, 287, 292, 296, 313, 315, 320, 329, 336, 338, 339, 342, 347, 360); Metropolitan Museum of Art, New York (154); National Gallery, London (131, 158, 259); National Portrait Gallery, London (9*a*, 9*b*, 325, 326, 328); Verlag Arthur Niggi, Switzerland (97*a*, 97*b*); Pierpont Morgan Library, New York (256); Paul Popper Ltd., London (222, 231, 248, 267, 268, 277*b*, 351, 356, 361); J. Powell, Paris (189); Radio Times Hulton Picture Library (230, 232, 240, 288, 354); Réunion des Musées Nationaux, Paris (205, 273); Royal Academy of Arts, London (15*b*, 117, 364); Sächsische Landesbibliothek, Dresden (109, 253, 255); Science Museum, London (71, 265, 284); D. A. Siqueiros (348); Sir John Soane's Museum, London (352, 353); Staatliche Museen, Berlin (14); Tate Gallery, London (211, 218, 220, 237); Uffizi Gallery, Florence (68); Unterlinden Museum, Colmar (90); Victoria and Albert Museum, London (39, 69*a*, 69*b*, 103, 116, 123, 128, 134, 139, 143, 145, 150, 156, 157, 173, 185, 201, 215, 227, 247, 266, 274, 293, 330, 336).

Illustration numbers 202, 211, 214, 327, and 368 are all © SPADEM 1970 and illustration numbers 49, 132, and 187 are all © ADAGP 1970.

# LIST OF CONTRIBUTORS

Ronald Alley
Keith K. Andrews
John Ayers
Mary Baldwin
R. D. Barnett
Eleanor Barton
Michael Baxandall
Quentin Bell
Roberta Bernstein
†T. S. R. Boase
P. J. Bohannan
†Stephan F. Borhegyi
Eve Borsook
Alan Bowness
Patience Bradford
Anita Brookner
D. A. Bullough
M. C. Burkitt
J. B. Bury
B. A. R. Carter
H. Carter
Stephen Chaplin
André Chastel
W. G. Constable
Edward Conze
R. M. Cook
F. R. Cowell
William Dale
Allan Ellenius
Robin Ellett
L. D. Ettlinger
†Joan Evans
William Fagg
Philipp Fehl
†C. J. Gadd
Kenneth Garlick
M. Girouard
E. H. Gombrich
J. R. Harris

J. P. Harthan
Francis Haskell
Helena Hayward
J. F. Hayward
Heidi Heimann
Ursula Hoff
Christopher Hohler
†Percy Horton
R. H. Hubbard
†Christopher Hussey
Lee Johnson
E. M. Jope
C. M. Kauffmann
Peter Kidson
Michael Kitson
O. Kurz
S. Lang
Edmund Leach
P. Lemerle
Janet Lynton
Norbert Lynton
E. H. McCormick
Heather Martienssen
Frank Martin
A. Gervase Mathew
Hamish Miles
Peter Mitchell
Sabrina Mitchell
Jennifer Montagu
Kathleen Morand
Peter Murray
Arnoldus Noach
Harold Osborne
Mary Parry
E. D. Phillips
R. W. Pickford
William H. Pierson, Jr.
Stuart Piggott
Ralph Pinder-Wilson

D. T. Piper
H. J. Plenderleith
M. I. Podro
†Phoebe Pool
†Bernard Rackham
Philip Rawson
Stephen Rees-Jones
Patrik Reuterswärd
J. M. Richards
C. H. Roberts
M. S. Robinson
L. R. Rogers
E. Rosenbaum
†Cecil Roth
A. Scharf
E. F. Sekler
A. F. Shore
K. D. Simon
Frank Simpson
Seymour Slive
Bernard Smith
Sheila Somers
John Steer
R. C. Strong
F. H. Stubbings
P. C. Swann
Rachel Toulmin
†Karel Vogel
John Walker
M. I. Webb
M. Webster
W. T. Wells
Margaret Whinney
Paul S. Wingert
Francis Wormald
P. M. Worsley
Manfred Wundram
A. McLaren Young
G. Zarnecki

# NOTE

The name of the artist or subject that forms the headword of each entry is printed in capitals in bold type, and variant spellings or alternative terms in ordinary type (e.g. **MONDRIAN** (MONDRIAAN), **BOUCHARDE** or BUSH HAMMER). Capitals are also used within an entry for the names of members of the same family who were practising artists (e.g. **OSTADE,** ADRIAEN VAN (1610-84) . . . ISAAK (1621-49)). Cross-references are shown by small capitals (e.g. See GRECO, El; . . . carved MOULDINGS). The numbers at the end of an entry refer to the main part of the bibliography (as explained in the Preface).

# ABBREVIATIONS

| | | | |
|---|---|---|---|
| Ass. | Association | Nat. Mus. | National Museum |
| b. | born | N.G. | National Gallery |
| Bib. | Bibliothèque | N.P.G. | National Portrait Gallery |
| Bib. nat. | Bibliothèque nationale | | |
| Bk. | Book | *O.E.D.* | *The Oxford English Dictionary* |
| B.M. | British Museum | | |
| Bodl. | Bodleian (Library) | pl. | plural |
| c. | century | Prof. | Professor |
| *c.* | *circa* | r. | reigned |
| ch. | chapter | R.I.B.A. | Royal Institute of British Architects |
| coll. | collection | | |
| d. | died | S. | Saint, San, Sant', Santo |
| ed. | edited, edition, editor | ser. | series |
| Eng. | English | *S.O.E.D.* | *The Shorter Oxford English Dictionary* |
| est. | established | | |
| *fl.* | *floruit* | SS. | Saints, Santissima, Santissimi |
| ft. | feet | | |
| Gal. | Gallery | St. | Saint |
| in. | inch(es) | Sta | Santa |
| Inst. | Institute | Staatl. Mus. | Staatliche Museen |
| Kunsthist. Mus. | Kunsthistorisches Museum | Staatsbib. | Staatsbibliothek |
| | | Stadtbib. | Stadtbibliothek |
| Lib. | Library | Ste | Sainte |
| Met. Mus. | Metropolitan Museum | trans. | translation, translated |
| MS., MSS. | Manuscript(s) | Univ. Lib. | University Library |
| Mus. | Museum, Museo, etc. | V. & A. Mus. | Victoria and Albert Museum |
| Mus. Naz. | Museo Nazionale | | |
| Nationalbib. | Nationalbibliothek | vol. | volume |

# A

**AALTO,** ALVAR (1898-1976). Finnish architect, a leading member of C.I.A.M. and one of those who have made the strongest impact on the direction in which architecture evolved since c. 1930. He has done much to bridge the gap between the geometrical purism of MODERN ARCHITECTURE in its early days and the later demand for a richer and more flexible idiom. His work approaches closer than that of many other European architects to the ORGANIC qualities demanded by Frank Lloyd WRIGHT. He is notable for his expressive and inventive use of timber (Finland's basic building material) for structure and decoration, taking full advantage of plywoods and laminated woods, as in his Finnish Pavilions for the Paris Exhibition of 1937 and the New York World Fair of 1939.

In 1925 he married Aino Marsio, who was his chief collaborator until her death in 1949, particularly with the *Artek* furniture (first designed for the Paimio Sanatorium in 1928), whose new methods of bending and jointing and revolutionary lines became internationally popular and had a lasting influence on furniture design.

Aalto first came to the fore at the Jubilee Exhibition of Turku in 1929, where he collaborated with Erik Bryggman (1891-1955) towards a structure of considerable originality as an expression of the Scandinavian version of modern FUNCTIONALISM. The first important building of his own, a reinforced concrete office block in Turku for the *Turun-Sanomat* newspaper (1928-30), made a bold use of mushroom construction. It was followed in 1929-33 by his Paimio tuberculosis sanatorium near Turku, a six-storey concrete building of great originality and a landmark in the evolution of modern architecture. Aalto's other important building of this period was the library at Viipuri (1927-34). It has been destroyed since being incorporated in Russian territory. Notable also is his enormous industrial and residential complex for the Sunila Cellulose Works, begun 1936-9 and completed 1951-4.

After the Second World War Aalto took a prominent part in the rebuilding of Finland and was responsible for much civic and industrial construction. The outstanding example of his first post-war period, when he was building in red brick, is the Town Hall at Säynätsalo (1950-2) with butterfly roof. He also made a dormitory building for the Massachusetts Institute of Technology, where he taught intermittently during the years 1948-50. During the 1950s his civic building schemes altered the face of Helsinki and his building included the Rautatalo office block

(1952-4), the Cultural Centre (1955-8), and the Engineering Institute (1952). From the latter part of the 1950s come his church at Vuoksenniska near Imatra, a block of flats for the Berlin Interbau, the Maison Carré near Paris, done in collaboration with Elissa Makkinheimo whom Aalto married in 1952, and projects for a museum at Aalborg, the Volkswagen Cultural Centre at Wolfsburg, the Enso-Gutzeit office block at Helsinki (1959-62), the Opera House at Essen, and a college building at Uppsala (1962-5). His subsequent work showed still more original constructive uses of complex space manipulation.

1, 1205, 1919.

**AALTONEN,** WÄINÖ (1894-1966). Finnish sculptor. His classically pure forms have a certain mellow heaviness and softness of surface. In his portraits, e.g. the statue of the Finnish runner Nurmi (1924-5, bronze) and busts of Sibelius (1928) and Queen Louise of Sweden (Nat. Mus., Stockholm, 1942), he skilfully combines the individual with the timeless.

1967.

**ABACUS.** Term in classical architecture for the flat square slab of masonry placed on the top of the CAPITAL of a COLUMN to bear the ARCHITRAVE or the ARCH or LINTEL which is supported by the column.

**ABBATE,** NICCOLÒ DELL'. See NICCOLÒ DELL'ABBATE.

**ABBOTT,** JOHN WHITE (1763-1851). English amateur landscape painter. He was a disciple of Francis TOWNE and exhibited oil paintings at the R.A. from 1793 to 1805, in 1810, and in 1822. These received high praise, but today his pen and monochrome drawings are prized more highly. There are references to him in FARINGTON'S Diary and an account by A. P. Oppé in *The Walpole Society*, volume xiii (1925).

**ABBOTT,** LEMUEL FRANCIS (c. 1760-1803). English portrait painter, chiefly known for his portrait *Nelson* (N.P.G., London), of which several versions exist.

**ABERCROMBIE,** SIR PATRICK (1879-1957). Leading English town-planner, responsible for many plans for rebuilding bomb-damaged and overcrowded cities after the Second World War, including London (County of London Plan, with J. H. Forshaw, 1943; Greater London Plan, 1944), Plymouth, Edinburgh, the Clyde Valley (with Robert H. Matthew),

Warwick, and Hull. He also prepared planning reports for many regions of the British Commonwealth and taught town-planning in Liverpool and London universities. A pupil of Sir Patrick GEDDES, he based his plans on exhaustive social and topographical surveys rather than on the visualization of architectural effects.

**ABRAHAM.** Of the many scenes of Abraham's life which are depicted in Christian art three, which were seen as 'types' of events in the New Testament (see TYPOLOGICAL BIBLICAL ILLUSTRATION), occur most frequently.

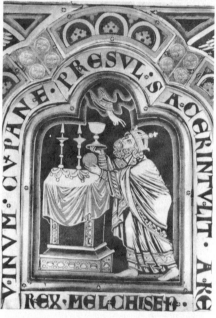

1. Detail from the *Klosterneuburg Altarpiece* (1181) by Nicolas of Verdun. Gold and enamel panel showing Melchizedek depicted as a priest at the altar. (Klosterneuburg Abbey)

1. ABRAHAM AND MELCHIZEDEK (Gen. xiv. 18–24; Ps. cx; Heb. vii). After his victory over Lot's captors, Abraham meets Melchizedek, King and High Priest of Salem, who offers him bread and wine. This was interpreted as a prefiguration of the Eucharist. In the earliest representation, a 5th-c. mosaic in Sta Maria Maggiore, Rome, Melchizedek offers the bread and wine to Abraham who approaches on horseback. The parallel with the Eucharist is made more explicit in the mosaics at Ravenna (S. Apollinare in Classe and S. Vitale, 6th c.) and in the 12th-c. enamel altar of NICOLAS OF VERDUN at Klosterneuburg, for in these Melchizedek is depicted as a priest at the altar. From the 15th c. Abraham frequently kneels or stands before Melchizedek as in Dirk BOUTS (Louvain Altar); School of RAPHAEL (Vatican Loggia); TINTORETTO (Scuola di S. Rocco, Venice); and RUBENS (Prado).

2. ABRAHAM AND THE THREE ANGELS (Gen. xviii. 1–16). Three men appear at Abraham's tent and he offers them hospitality. While they are at meat one of them foretells that Sarah, despite her advanced age, will bear a son. In EARLY CHRISTIAN, BYZANTINE, and RUSSIAN ART the three angels were taken as a symbol of the Trinity. In the West the story was at first taken to foreshadow the Annunciation; but later, in the period of the Counter-Reformation, it symbolized Hospitality, the third of the works of Mercy. In the early versions the angels sit at table and are waited upon by Abraham while Sarah stands to one side, e.g. in the mosaics of Sta Maria Maggiore, Rome, 5th c.; S. Vitale, Ravenna, 6th c.; and Monreale, Sicily, 12th c. In the West the scene is sometimes arranged like an Annunciation with the angels standing opposite Abraham, as in the enamel altar at Klosterneuburg and the bronze door of S. Zeno, Verona, both 12th c. Among many later versions are paintings by the School of Raphael (Vatican Loggia), REMBRANDT (Hermitage, etc.), MURILLO (N. G., Ottawa), and G. B. TIEPOLO (Prado).

3. SACRIFICE OF ISAAC (Gen. xxii). To test Abraham's faith the Lord commands him to sacrifice his son, but an angel stays his hand and a ram is substituted. The earliest version of this scene is a 3rd-c. fresco in the Synagogue at Dura Europos, Syria. It was popular throughout the Middle Ages and later because it was taken to prefigure the Sacrifice of Christ, the Crucifixion. The moment chosen is usually the climax—the angel intervening just as Abraham is about to plunge a knife into his son's body—and this scene, unlike the other two, is consistently represented in the same way from the 4th-c. sarcophagus of Junius Bassus (Vatican Grotto) to Rembrandt (Munich and Leningrad), Rubens (Louvre), and William BLAKE (Boston). It was chosen as the subject for the competition, held in 1401 and won by Lorenzo GHIBERTI, for the second bronze door of the Florentine Baptistery.

**ABSTRACT ART.** A term commonly applied to the more extreme 20th-c. styles in reaction against the traditional European conception of art as the imitation of nature. The unnecessarily loose and imprecise use of the term has caused considerable misunderstanding and argument at cross-purposes. It has in fact been pressed into service to cover two distinct and in some ways contrary tendencies, viz. (i) the reduction of natural appearances to simplified forms; and (ii) the construction of art objects from non-representational basic forms (sometimes inappropriately called 'geometric' forms).

The former tendency may itself lead in either of two directions. (i) The first is the depiction of the essential or generic forms of things by elimination of particular and accidental variations. This was foreshadowed by Schopenhauer (1788–1860) when he maintained that art imitates the Platonic ideas which underlie perceived things rather than their casual appearances. It is

well exemplified in some early ANIMAL art and it has been a powerful driving force among others with many modern artists of widely different schools (KLEE, CÉZANNE, COURBET, FORAIN, Thurber). (ii) The other mode of abstraction from the actual appearances of natural scenes and objects works away from the individual and particular with a view to creating an independent construct of shapes and colours which will have aesthetic appeal in its own right after the manner of music and architecture. This method may be exemplified by Roger BISSIÈRE. Although many of his later and most valued paintings have been compared to non-figurative tapestry designs and the like, they always retained a relation to natural scenes and Bissière himself refused to have them called 'abstracts'. The derivation from perceived nature is apparent too in the work of Ivon HITCHENS. In sculpture this method of abstraction from actual appearances in order to arrive at works of autonomous aesthetic importance is best illustrated by BRANCUSI.

The foregoing applications of the term 'abstract' have been frequently but none the less unfortunately confused with STYLIZATION and DISTORTION. 'Stylization' refers correctly to representation through a set of characteristic and recognizable schemata (neolithic art, modern fashion design, ROMANESQUE mural painting). It is often contrasted with NATURALISM. 'Distortion' denotes incorrect (or sometimes merely unusual) reproduction of the shapes of things or of the proportions among their parts. It may be a part of stylization (El GRECO, BURNE-JONES, MODIGLIANI, Wilfredo LAM) or it may be used for particular expressive ends (Henry MOORE, Francis BACON, Jacob EPSTEIN, Constant PERMEKE, Giorgio de CHIRICO). Stylization must be, and distortion may be, also abstract in the sense discussed. But abstract art need neither be stylized nor involve distortion.

The second tendency of abstraction in 20th-c. art leads to the construction of non-representational (or 'non-figurative') aesthetic objects not by abstraction from natural appearances but by building up with non-representational shapes and patterns. Although called 'abstract' art, and sometimes even 'pure abstract', this mode does not in fact involve a process of abstraction from appearances, but is rather in one way or another constructive. It divides into two types, the one ROMANTIC and organic and the other CLASSICAL and geometric as they have been not very appropriately called. There is no sharp line of demarcation between them and work done in the ABSTRACT EXPRESSIONIST style may involve the recognition of a third type. The so-called geometric type is exemplified by the SUPREMATIST paintings of MALEVICH and sculptures of MOHOLY-NAGY and Naum GABO, by the work of MONDRIAN in Holland and Ben NICHOLSON in England. To the more 'organic' style belong such diverse manners as those of KANDINSKY, MIRÓ (who often includes stylizations of SURREALIST dream objects), Soulages (reminiscent of Chinese calligraphy), ARP (whose 'biomorphic' sculptures do not represent any particular natural forms but suggest growth as such), and Franz KLINE. To this group also perhaps belong the works of such sculptors as Barbara HEPWORTH with great interest in subtleties of surface form and texture.

Kandinsky is usually credited with having made the first entirely non-representational picture within the ambit of German EXPRESSIONISM in 1910. The Czech painter Kupka and others passed from CUBISM to non-representational abstraction working in Paris about 1913 and from about the same time Malevich developed Suprematism. The De STIJL group was formed in Holland in 1917, its most prominent member being Mondrian. During the 1930s and after the Second World War abstractionism in one form or another and to varying degrees became the most general and the most characteristic feature of 20th-c. styles.

It is characteristic of most modes of abstraction in some degree or other that they abandon or subordinate the traditional function of art to portray perceptible reality and emphasize its function to create a new reality for perception. The 'geometrical' forms of a Ben Nicholson or a Mondrian (the whole point about them is that, they are *not* geometric) are not images of 'real' squares and circles and rectangles in the sense that a cow in a CONSTABLE painting is an image of a real cow: they are to be perceived exactly for what they are in themselves, not as images of anything other than themselves. And this mode of looking at works of art is also postulated by most of the characteristic modes of 20th-c. art.

402, 1281, 2168, 2462, 2463, 2937.

**ABSTRACT EXPRESSIONISM.** A term which came into common use from *c.* 1950 to describe the non-geometric abstract art which flourished mainly in America since the Second World War. It seems to have originated as a description of KANDINSKY's paintings of 1910–14, but first came into vogue in 1946 when applied to the work of the American painters Arshile Gorky (1904-48) and Jackson POLLOCK. It was soon extended to the work of other New York painters, even when it was neither abstract (DE KOONING, Gottlieb) nor expressionist (ROTHKO, KLINE, etc.). Because of its inexactness the poet-critic Harold Rosenberg in 1952 proposed an alternative: Action Painting, which emphasized the new importance attached to the physical act of painting and the dominant 'existential' attitude which held that the artist 'grasps authentic being' through the act of creating rather than by a finished product.

The core of the Abstract Expressionist movement was a small band of innovators, working mainly in New York, who began to come to the public notice during the Second World War and who since the end of the war dominated the American scene, creating what has been described as a new orthodoxy. So far as the school has a

unified outlook it is characterized by a spirit of revolt against affiliations with traditional styles or prescribed technical procedures, renunciation of the ideal of a finished art product subject to traditional aesthetic canons, an aggressive spirit of self-determination, and a strong demand for spontaneous freedom of expression. In their many diverse formulations the artists who have been brought together under this classification have preferred to lay emphasis on individuality and non-conformity, but agree broadly in looking upon their painting primarily as a way of life and an activity which expresses or solves their dilemmas in the complexities of contemporary civilization.

The movement has affinities with TACHISME and made a strong impact in several European countries during the late 1950s and 60s. Despite its experimental nature and the lack of a uniform style, it was there considered to have brought about a new aesthetic sensibility and to have modified our ways of seeing. Among the artists who made the strongest impression internationally are: Mark TOBEY, Jackson Pollock, Willem de Kooning, Franz Kline, Mark Rothko, Robert MOTHERWELL, Philip Guston. Though the diversity of the work of these artists makes it less susceptible than most schools to be confined within any general formula, the essence of Abstract Expressionism may perhaps be summed up as imageless and anti-formal painting, improvisatory, dynamic, energetic, and free in technique, tending to stimulate vision rather than gratify established conventions of good taste.

402, 1281.

**ACADEMIES.** The Academy was an olive grove outside Athens where Plato and his successors taught philosophy. His school of philosophy was therefore known as 'The Academy'. In the Italian RENAISSANCE the word began to be applied to almost any philosophical or literary circle. In the 16th c. academies became more formal, with established rules of procedure, and began to cover a greater range of activities. It was in this atmosphere that there appeared the first academies of art, with which alone this article will be concerned.

Before turning to such established institutions it will first be necessary to discuss a few precedents in which the words 'academy' and 'artist' were associated in a way that has caused much confusion. By a natural extension of current Renaissance terminology the word 'academy' was sometimes employed of groups of artists who discussed theoretical as well as practical problems—in this sense it was used somewhat ironically of BOTTICELLI's studio c. 1500. Similarly the famous Accademia of LEONARDO DA VINCI—the reference has come down to us in engravings of the first years of the 16th c.—almost certainly implied no more than a group of men who discussed scientific and artistic problems with Leonardo. Another premature 'academy' is the one attributed by VASARI to

Lorenzo de' MEDICI under the direction of the sculptor BERTOLDO. In fact Vasari is here finding a suitable ancestor for the one that he himself had promoted in 1561; all the evidence suggests that while Lorenzo allowed artists and others easy access to his collections, there was no organized body of any kind concerned with the arts in the Florence of his day. Finally there is an engraving of 1531 by Agostino Veneziano which shows the *Accademia di Baccio Bandin in Roma in luogo detto Belvedere.* Although this portrays sculptors drawing a small statue in BANDINELLI's studio, it probably represents no more than a group of friends discussing the theory and practice of art.

The first art academy proper was set up some 30 years later when Duke Cosimo de' Medici founded the Accademia del Disegno in Florence in 1562. The prime mover was Giorgio Vasari, whose aim was to emancipate artists from control by the guilds, and to confirm the rise in social standing they had achieved during the previous hundred years. MICHELANGELO, who more than any other embodied this change of status in his own person, was made one of the two heads and Duke Cosimo himself was the other. Thirty-six artist members were elected, and amateurs and theoreticians were also eligible for membership. Lectures in geometry and anatomy were planned, but there was no scheme of compulsory training to replace regular workshop practice. The Academy quickly won great international authority, but in Florence itself it soon degenerated into a sort of glorified artists' guild.

The next important step was taken in Rome, where in 1593 was founded the Accademia di S. Luca, of which Federigo ZUCCARO was elected president. Though more stress than at Florence was laid on practical instruction, theoretical lectures were also prominent in the Academy's plans, for once again the motives for its foundation had been largely ones of social prestige. As in Florence, these plans proved to be far too ambitious and nothing remotely approaching an 'academic doctrine' emerged in these early years. Nor was the Academy at all successful in its war against the guilds until the powerful support it received from Pope Urban VIII in 1627 and 1633. Thereafter it grew in wealth and prestige. All the leading Italian and many foreign artists in Rome were members; debates on artistic policy were held; some influence over important commissions was wielded; and everything was done to make the lives of those who were not members (such as many of the Flemish freelance artists in Rome) as unpleasant as possible.

The only other similar organization in Italy was the Academy established in Milan by Cardinal Federigo Borromeo in 1620. But meanwhile the word was very frequently used of private institutions where artists met either in a studio or in some patron's palace to draw from life. The most famous example of this kind was the Accademia degli Incamminati, which was organized by the CARRACCI in Bologna.

4

In France a group of painters, moved by the same reasons of prestige as had earlier inspired the Italians, persuaded the king to found the Academy of Painting and Sculpture in 1648. Here too the guilds put up a powerful opposition, and its supremacy was not assured until COLBERT was elected Vice-Protector in 1661 and found in the Académie an instrument for imposing the official standards and principles of taste. Colbert and LEBRUN, the Director, envisaged dictatorship of the arts, and for the first time in history the expression 'academic art' acquired a precise significance.. The Académie arrogated to itself a virtual monopoly of teaching and of exhibition and by applying rigidly its own standards of membership came to wield an important, if not decisive, economic influence on the profession of artist. For the first time an orthodoxy of artistic and aesthetic doctrine obtained official sanction. Implicit in the academic theory and teaching was the assumption that everything to do with the practice and appreciation of art, or the cultivation of taste, can be brought within the scope of rational understanding and reduced to logical precepts that can be taught and studied. The phenomenon of academicism in the arts, in so far as it fell within the Académie of Lebrun, was perhaps the most extraordinary manifestation of that ubiquitous rationalism which marked the Age of Enlightenment. Even a theory of EXPRESSION was elaborated for the rational and logical expression of emotions by visual means. Though much of the systematization of rule and precept was derived from handbooks of the late MANNERIST writers such as LOMAZZO and Zuccaro, academic theory adopted in principle the CLASSICISM of the Renaissance (see IDEAL) and in 1666 a branch of the Académie was set up in Rome in order to give prize students opportunity to study the ANTIQUE on the spot. The monolithic character of Académie doctrine was to some extent shattered in the last years of Louis XIV by a splinter group who attacked certain aspects of the official theory. There was, for example, the controversy associated with DE PILES about the relative importance of colour and design. None

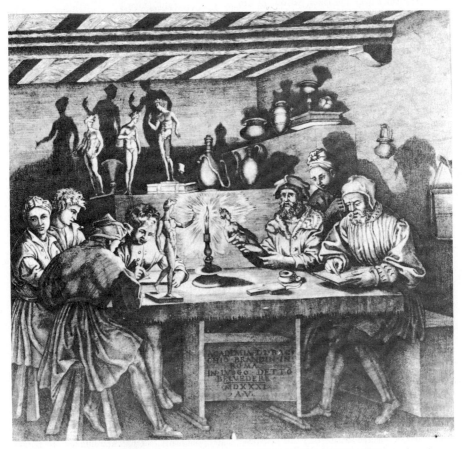

**2.** Engraving by Agostino Veneziano. *Academy of Baccio Bandinelli in Rome* (1531)

the less the Académie succeeded in creating and imposing an official orthodoxy for France which persisted through subsequent centuries with the result that from the date of its formation most of the creative movements in French art took place outside the ambit of the artistic establishment.

Other art academies were founded in Germany, Spain, and elsewhere between the middle and end of the 17th c., and it has been estimated that in 1720 there were 19 of them active in Europe. But though they differed fairly widely among themselves and were of varying importance for the art of the countries concerned, none calls for special comment. The great change did not occur until the middle of the 18th c.—a change indicated by the fact that by 1790 well over 100 art academies were flourishing throughout Europe. Among these was the ROYAL ACADEMY in London, which was founded in 1768. For the most part these academies were the product of a new awareness on the part of the State of the place that art might be expected to play in the life of society. The Church and the court were no longer the chief patrons of art. But with the growth of industry and commerce the economic importance attributed to good DESIGN led to official support for teaching academies. Inseparably linked to this motive was the promotion of NEO-CLASSICISM in opposition to the surviving styles of BAROQUE and ROCOCO. Everywhere the academies made themselves the champions of the new return to the antique. As far as instruction went the copying of casts and life drawing were paramount, and classical subjects were particularly encouraged.

There was some opposition to these bodies from the start. Towards the end of the 18th c. French Revolutionary sentiment was especially bitter about the exclusive privileges enjoyed by members of the Académie, and many artists, with DAVID in the lead, demanded its dissolution. This step was taken in 1793, but after various experiments had been tried and substitute bodies set up, the Académie was reinstated in 1816 as the *Académie des Beaux-Arts*.

In fact the real threat to academies came rather from the ROMANTIC notion of the artist as a genius who produces his MASTERPIECES by the light of inspiration which cannot be taught or subjected to rule. The concept of the artist-genius made headway first among English 18th-c. aesthetic writers. It was formalized by KANT and gained impetus from GOETHE and the German Romantics. Opposition to academies was accentuated by the widening breach between creative artists and the bourgeois public after aristocratic patronage declined. Virtually all the finest and most creative artists of the 19th c. stood outside the academies and sought alternative channels for exhibiting their works. When the revaluation of 19th-c. art took place with the final recognition of the IMPRESSIONISTS this contrast was too blatant to be ignored. Academies were condemned out of hand by the adventurous, though they still retained prestige among those who were too confused in the prevailing breakdown of taste to risk supporting what they did not understand. Gradually compromises were made on both sides, facilitated by the liberalization of the academies and the increasing number of art schools which have finally broken academic monopolies (see ART EDUCATION). Academies now generally hold the view that they should at least insist on certain standards of sheer craftsmanship which any artist, however personal his vision, is expected to display. During the 20th c. the pace has quickened. Most of the aesthetic movements, however revolutionary they seemed at the time, have rapidly produced their own 'academicism' as minor artists of no more than moderate endowment have aped the mannerisms of the few geniuses who have shaped each movement. Creative art becomes academic in the hands of its followers and an opposition between the original creative and the derivative academic has persisted.

22, 890, 2065, 2538.

**ACADEMY BOARD.** A pasteboard used for painting, especially in oils, since the early 19th c. It is made of sheets of paper sized and pressed together, and treated with a GROUND consisting usually of white lead, oil, and chalk. Sometimes it is embossed with indentations—a sort of mechanical 'grain'—in imitation of canvas weave. Academy board is used chiefly for sketches and studies and is a popular SUPPORT with amateur painters.

**ACADEMY FIGURE.** A careful study from the nude made as an exercise. There is a tradition of suitable poses and treatment of such figures which goes back to the CARRACCI.

**ACANTHUS.** A plant (in England called bear's breech) whose leaves were adopted as an architectural enrichment in classical decoration. It appears fully developed in the ERECHTHEUM in the late 5th c. B.C., and forms the distinctive foliage of the Corinthian and Composite capitals (see ORDERS OF ARCHITECTURE).

**ACCADEMIA DI BELLI ARTI,** Venice. The municipal picture gallery of Venice and one of the most important collections in Italy. It was founded by decree of Napoleon in 1807 and combined the collection of the old Academy, the Galleria dei Gessi founded in 1767, with works of art from suppressed churches and monasteries. The collection has continually been enriched by additions, in particular Venetian paintings returned after the fall of Napoleon and those ceded by Austria in 1918. It is the best single collection of paintings of the VENETIAN SCHOOL.

**ACCIDENTAL COLOURS.** See COLOUR.

**ACROPOLIS.** Greek cities generally had an acropolis, that is a fortified citadel. In MYCE-NAEAN times it served as a castle for the local king

and his entourage. Later it became a place of refuge in an emergency, but was normally the habitation of the gods. In the medieval period it might again become a castle. The acropolis of Athens, as the most famous, is often referred to simply as the Acropolis. Presumably the Mycenaean palace was there. During the HELLENIC age it received two important temples of Athena, other lesser religious buildings, and an increasing number of votive statues and inscribed public records. In 480 B.C. the Persians wrecked the Acropolis and afterwards many of the damaged remains were piously buried by the Athenians, so that we possess much archaic Attic statuary. The edifices that now survive—PARTHENON, ERECHTHEUM, PROPYLAEA, and temple of Athena Nike—belong to the great building programme of the second half of the 5th c. B.C. and, since Frankish and Turkish additions and alterations have mostly been cleared away, still give some impression of the classical Acropolis. The walls of the Acropolis, at first irregular in outline, were straightened about 460 B.C.; their existing masonry comes from all periods till the end of the Turkish occupation.

**ACROTERION** (pl. *-ia*). An ornamental block on the apex and at the lower angles of a PEDIMENT, bearing a statue or a carved FINIAL.

**ACTION PAINTING.** See ABSTRACT EXPRESSIONISM.

**ADAM,** FRANÇOIS GASPARD (1710-61); LAMBERT SIGISBERT (1700-59); NICOLAS SÉBASTIEN (1705-78). French sculptors from Lorraine, brothers. All three brothers adapted the Roman BAROQUE style to French ROCOCO taste. Lambert Sigisbert, called Adam the Elder, was in Rome 1723-33 and modelled his style on that of BERNINI. He was received into the Académie in 1737 for his group *Neptune Calming the Waves.* His masterpiece was the Neptune Fountain at VERSAILLES. Two large groups, *Hunting* and *Fishing,* were sent by Louis XV to Frederick II at Potsdam. Nicolas Sébastien, called Adam the Younger, worked on the Hôtel Soubise and on the monument of Queen Catherine Opalinska, Nancy (1749). François Gaspard did sculpture at Sans Souci and for Frederick the Great.

**ADAM,** ROBERT (1728-92). Scottish architect, the second of four sons of William Adam (1689-1748), Master Mason to the Ordnance in Scotland and author of *Vitruvius Scoticus* (1720-40). JOHN, the eldest son, succeeded to the family estate but like his younger brothers forwarded Robert's career. JAMES (1730-94) and WILLIAM (c. 1738-1822) worked for Robert, James as chief of staff and draughtsman (he also designed a few buildings independently) and William as business manager. Robert matriculated at Edinburgh University in 1743, but little is known about him before 1754, when he left for France and Italy. In France he

met C. L. Clérisseau (1722-1820), the architectural draughtsman, and in Rome he became friendly with PIRANESI; in 1757 he employed Clérisseau and others to accompany him to Spalato (Split), in Dalmatia, to study DIOCLETIAN'S PALACE. He returned to England in 1758 and in 1764 published *Ruins of the Palace of the Emperor Diocletian at Spalato,* which was an important element in the 'Adam Revolution'. It dealt with a building that was antique but situated outside Rome and its revolutionary aspect lay in the choice of a domestic building for study—PALLADIO's reconstructions of ancient domestic architecture were based on temples and public buildings and in this he had been blindly followed by later generations. The discoveries at Herculaneum and POMPEII began to reveal the truth, but it was Adam's fortune that so little was known that he had a very free hand. His tendency to equate antiquity with his own ideas was a chief cause of opposition led by his fellow-countryman CHAMBERS, who prevented his election to the Royal Academy.

Adam's theories are set out in the Preface to the *Ruins,* in an open letter to Lord KAMES (1763), and most fully in the Prefaces to *The Works in Architecture of R. and J. Adam* (i, 1778; ii, 1779; iii, posthumously, 1822). In the letter to Kames he says that he does not regard the Orders (sc. Antiquity) as sacrosanct: 'I have ventured to alter some parts of this Order. . . . These alterations most people have allowed to be much for the better.' In the Preface to the *Works* the authors pride themselves on having brought about 'a greater movement and variety in the outside composition and in the decoration of the inside an almost total change'. Movement—in itself a PICTURESQUE idea—is defined as 'the rise and fall, the advance and recess with other diversity of form, in the different parts of a building, so as to add greatly to the Picturesque of the composition . . .'. His own work at Kedleston (c. 1765-70) was an instance of movement, but unfortunately the curved wings and pavilions were never completed. At Osterley (1761-80) and Syon (1762-9), both near London, he was able to transform old houses, giving proof of his skill as a planner and interior decorator. In 1768 the brothers embarked on the ambitious Adelphi scheme in London, the idea of which was to reclaim part of the Thames foreshore by building wharves and warehouses at river level, with a splendid terrace above and streets of moderate-sized houses running back at right angles. The decorative treatment led Horace WALPOLE to describe the blocks as 'warehouses laced down the seams, like a soldier's trull in a regimental old coat', and such criticisms, coupled with financial difficulties, led to the comparative failure of the scheme. Although at the same time their reputation also began to be eclipsed by the rise of James WYATT, yet some of Robert's finest houses were built in these years—Chandos House (1771), Derby House (1774, now demolished), 20 St. James's Square (1774, now altered), and 20

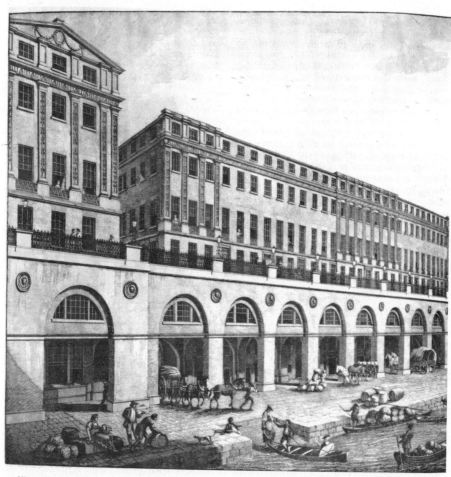

3. *View of the South Front of the New Buildings called Adelphi formerly Durham Yard.* Detail of engraving from *The Works in Architecture of Robert and James Adam*, Vol. III (1822)

Portman Square (1777, now the Courtauld Institute of Art). All of these were rare examples of the planning of a town house to afford maximum convenience with the finest sequence of grand rooms possible on a limited site. It is probable that his skill as a designer of moderate-sized houses, supervised by him down to the last detail of furnishing, is Robert Adam's chief claim to fame, although he longed to work on the grand scale. Towards the end of his life he was able to undertake this in the New Town of Edinburgh, especially at the Register House (1774–92) and the University (begun *c.* 1789, much altered 1815), as well as in the layout of Charlotte Square (1791), which, with Fitzroy Square, London (*c.* 1790), shows town-planning ideas anticipating NASH. From the beginning of his career in the 1760s his style was widely imitated, and more buildings have been attributed to him than to any other British architect.

9, 336, 882, 1472, 1612.

**ADAM AND EVE.** 1. CREATION OF ADAM (Gen. i. 26–30). (*a*) *Creation of Adam from clay.* In this scene, which may be derived from classical versions of the creation of Prometheus, God models with His hands the body of the first man (sarcophagus at Campli, 3rd c.; mosaic in St. Mark's, Venice, 13th c.). It is rarely depicted after the Middle Ages. (*b*) *Animation of Adam* (Gen. i. 28; ii. 7). This is a more common theme of artistic representation. It was occasionally depicted by showing a ray leading from the mouth of God to Adam's nostrils, as in the Cappella Palatina at Palermo, 12th c., but more often by a simple gesture of blessing (*Bible of Charles the Bald*, Bib. nat., Paris, 9th c.), which might be combined with a touch of the hand, as in GHIBERTI's bronze door of the Florentine Baptistery (1427–52). The scene was transformed by MICHELANGELO, whose *Adam* in the Sistine Chapel (1508–12) is brought to life by the power emanating from God's finger-tips.

2. CREATION OF EVE (Gen. ii. 18-24). This scene is rare in EARLY CHRISTIAN ART (sarcophagus, Lateran Museum, c. 400), but became very frequent from the 9th c. onwards. True to the biblical text, Adam is generally shown lying asleep and Eve as emerging, or having emerged, from his side. The Creation of Eve was taken as a 'symbol' (see TYPOLOGICAL BIBLICAL ILLUSTRATION) for the birth of the Church from the open side of Christ on the cross. This comparison, which was illustrated from the 13th c. onward (*Bible Moralisée*, Bodl., Oxford), explains why the Creation of Eve occurs even more frequently in Christian art than that of Adam.

3. THE TEMPTATION (Gen. iii. 1-8). Adam and Eve most commonly stand symmetrically on either side of the tree and the serpent coils round it. This basic composition is almost constant from the early Christian period onwards (Catacomb of S. Gennaro, Naples, early 3rd c.; sarcophagus of Junius Bassus, Vatican Grotto, 4th c.). It is probably derived from the theme of the sacred tree flanked by two persons, which is common in ancient Near Eastern art.

Following a theological tradition the serpent is sometimes shown with a woman's head (NICOLAS OF VERDUN, enamel altar at Klosterneuburg, 1181; Hugo van der GOES, Vienna).

4. THE EXPULSION (Gen. iii. 22-24). Adam and Eve are expelled from Paradise, generally by an angel or seraph with a flaming sword. This scene is common from the Early Christian period (sarcophagus, Lateran Mus., 5th c., *Vienna Genesis*, 6th c.) onwards through the whole course of Christian art.

**ADAMS,** HERBERT (1858-1945). American sculptor. After an apprenticeship in the U.S.A. Adams studied in Paris (1885-90). His work combines end-of-the-century sentimentality in subject matter with vigour of expression and vitality of finish. One of his most typical and lively portraits is of Adeline Pond (1887), who later became his wife. Among his best-known works are the McMillan Fountain, Washington, D.C.; the tympanum of St. Bartholomew's Church in New York (1902); and the statue of William Cullen Bryant in New York.

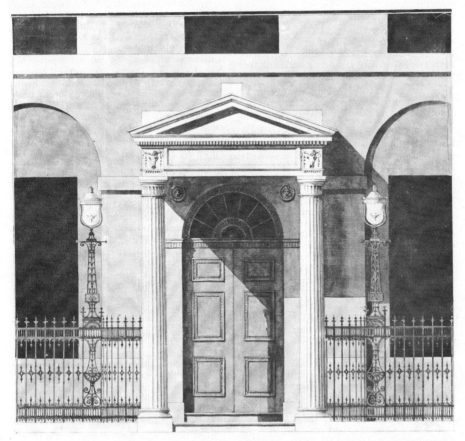

**4.** Design for doorway at 20 Portman Square, now The Courtauld Institute of Art. Detail from pen-and-ink drawing by Robert Adam. (Sir John Soane's Mus.)

**ADA SCHOOL.** A term which used to be applied by art historians to a group of ILLUMINATED MANUSCRIPTS and IVORY carvings of the time of Charlemagne executed partly at the Emperor's commission in the Middle Rhine region. (During the 1950s it has been argued that the name 'Ada School' is inappropriate and too restricted; that there was a more general movement in illumination and not one group of manuscripts.) The name is derived from a Gospel book in Trier made by order of Ada, reputedly a sister of Charlemagne. Style and iconography combine EARLY CHRISTIAN and BYZANTINE models. The manuscripts are written in gold, sometimes on purple vellum, and are sumptuously illuminated. The earliest is an *Evangelistary*, in the Bibliothèque nationale, Paris, written by the monk Godescalc (781-3). There is also a fine example from this school in the British Museum. The Victoria and Albert Museum has an ivory book-cover originally belonging to the *Lorsch Gospels*, one of the latest manuscripts of the School. (See also CAROLINGIAN ART.)

**ADDISON,** JOSEPH (1672–1719). English essayist and critic. His papers 'On the Pleasures of the Imagination' published in *The Spectator* in 1712 were regarded by 18th-c. writers on AESTHETICS as striking out new ground and formulating problems which became the basis of aesthetic discussion well into the 19th c. Thus Hugh BLAIR wrote in 1790: 'Mr. Addison was the first who attempted a regular inquiry in his Essay on the Pleasures of the Imagination. . . . He has reduced these Pleasures under three heads: Beauty, Grandeur and Novelty. His speculations on this subject, if not exceedingly profound, are, however, very beautiful and entertaining; and he has the merit of having opened a track, which was before unbeaten.' Addison himself spoke of his undertaking as 'entirely new'. By 'Pleasures of the Imagination' Addison meant 'such as arise from visible Objects, either when we have them actually in our View, or when we call up their Ideas into our Minds by Paintings, Statues, Descriptions, or any the like Occasion'. He laid the basis for the notion of 'sensibility' and for that of an 'inner sense' of beauty which was taken up by HUTCHESON and Hume.

**ADORATION OF THE MAGI** (Matt. ii. 1-11). The Gospels give few details of this, which acquired a special significance as the first act of homage paid to the Infant Christ by the pagan world. Even the number of Wise Men is not stated, and although three soon become the accepted figure because of the number of their gifts, only two are depicted on a 3rd-c. fresco in the Petrus and Marcellinus catacomb, while four appear in the Cemetery of Domitilla (4th c.).

In EARLY CHRISTIAN ART in the West two different versions occur. One shows the Magi following the star and arriving to worship the Infant in His cradle (sarcophagus, Lateran Mus., 4th c.). This combination of NATIVITY and Adoration is also found in BYZANTINE ART though in a different composition (mosaic in Cappella Palatina, Palermo, 12th c.). Much more frequent is the second type which depicts the VIRGIN enthroned but in profile or three-quarter view, holding the Child on her lap while the three Magi, wearing Phrygian caps and short tunics, approach in a row from one side (fresco in Cemetery of Priscilla, Rome, late 2nd c.; two sarcophagi, Lateran Mus., 4th c.). This composition is derived from classical reliefs of barbarians paying homage to the Roman Victory. In the early Christian East the figure of the Virgin was more hieratic in character and shown in a strictly frontal pose (three ampullae, Monza Cathedral; mosaic, S. Apollinare Nuovo, Ravenna, 6th c.). Later and throughout the Middle Ages eastern and western artists alike used both aspects, so that the Virgin appears in profile in a mosaic at Daphni (11th c.) and in frontal view in a tympanum at the church of Ste-Madeleine, Vézelay (12th c.).

By the 6th c. the Magi had acquired names and were often differentiated in art, Melchior being pictured as an old man with a white beard, Balthazar as middle-aged with a short dark beard (third ampulla at Monza, 6th c.), and Gaspar as a sallow youth. Later Gaspar was depicted as a Negro (Gerard DAVID, Pinakothek, Munich, MEMLING's early *Adoration of the Magi*, Prado, and the dated *Floreins triptych*, Hôpital de S. Jean, Bruges, 1479) or as a Moor (Hieronymus BOSCH, Prado). The tradition that they were kings (cf. Ps. lxxii. 10) is ancient but does not appear in art until the 10th c., when the Phrygian caps were gradually replaced by crowns, as in the *Benedictional of St. Aethelwold* (B.M.). From the 12th c. onwards they were almost invariably crowned. A charming motif appeared in the 13th c. when the first of the Magi was shown kneeling and kissing the Infant's feet, as in Nicola PISANO's pulpit in Siena Cathedral (1266-8) and GIOTTO's fresco in the Arena Chapel at Padua (1305). Later artists, including LEONARDO, added large numbers of attendants and followers, and Benozzo GOZZOLI (Palazzo Riccardi, Florence, 1459) managed to introduce most of the Medici family into the train of the Magi. Later still the processional and ceremonial character of the theme attracted both BAROQUE and ROCOCO artists (e.g. RUBENS and Sebastiano RICCI).

**ÆDICULA.** An ornamental architectural frame, having COLUMNS or PILASTERS at the sides and an ENTABLATURE or CANOPY at the top.

**AERIAL PERSPECTIVE.** A term invented by LEONARDO. Because the word 'perspective' was already in use for the linear method of creating the appearance of depth or receding picture space, he gave the name 'aerial perspective' to the means of producing pictorial depth through

a scaled variation of colour that imitated the effect of atmosphere on colours at different distances. Modern analysis shows that the presence in the atmosphere of dust and large moisture particles causes some scattering of light as it passes through it. The amount of scattering depends on the wavelength (hence colour) of the light. Short wavelength (blue) light is scattered most and long wavelength (red) is scattered least. This is the reason why the sky is blue and why distant dark objects appear to lie behind a veil of blue. Distant bright objects tend to appear redder than they would be if near because some blue is lost from the light by which we see them.

Aerial perspective as we may see it used in paintings from POMPEII and southern Campania (see ROMAN ART) was discussed by Ptolemy (2nd c. A.D.), who said (11, 24): 'When painters of architectural scenes wish to show colours of things seen at a distance they employ *veiling airs* (*aereos latentes*).' It is also treated at some length in the fragment of a papyrus roll of Alexandrian origin by an unknown writer on optics from the pre-Christian era, who explains how the air can change the perception not only of shape but also of colour: shape loses its distinctness and colour becomes dull (K. Wessely, *Wiener Studien*, xiii, 1891). Earlier still, the Aristotelian pamphlet *De Coloribus* (794) states that a colour may be changed by being seen through a transparent medium, such as air or water. In Chinese painting atmospheric perspective was recognized not later than the T'ANG period, as is shown by Wang Wei's Notes (8th c.) about the effect of distance on the perception of detail and again in Kuo Hsi's essay *Liu Ch'uan Kao Chih* (*Three Distances in Mountain Painting*, 10th c.), and it reached its highest development in the landscapes of the Sung period. In Europe it remained in abeyance for 1,000 years, to be rediscovered by the early 15th-c. FLEMISH painters. In the *Hours of Turin*, for example, it is employed with a subtlety hardly
, surpassed by the 'atmospheric' painting of the 19th c.

Leonardo relates aerial to linear perspective and in the *Trattato* (sect. 231) he wrote: 'The diminution or loss of colours is in proportion to their distance from the eye that sees them. But this happens only with colours that are at an equal elevation; those which are at unequal elevations do not observe the same rule because they are in airs of different densities which absorb these colours differently.' An attempt to systematize aerial perspective and relate it to linear perspective was made by A. BOSSE in his once important work *Manière universelle de M. Desargues pour pratiquer la perspective par petit-pied comme le géometral ensemble des places et proportions des fortes et faibles touches, teintes ou couleurs* (Paris, 1648). Aerial perspective helps to achieve the spaciousness and luminous harmony of the landscapes of CLAUDE or CUYP and plays a part in the powerfully planned landscapes of RUBENS. No one exploited it more thoroughly than TURNER,

who included it in his perspective lectures. In *Dido building Carthage* (N.G., London) he used it to give a sense of infinitely extended space, and in his late works, such as *Rain, Steam and Speed* (N.G., London) the 'haze' and the pictorial structure are as indivisible as in the most atmospheric paintings of MONET and the IMPRESSIONISTS. (See also PERSPECTIVE.)

**AERTSEN,** PIETER (1508/9–75). Dutch painter of Amsterdam who worked at Antwerp from 1535 to c. 1555. He is known chiefly for the monumental pictures set usually in the surroundings of a kitchen or a butcher's shop (Uppsala), which at first glance look like pure GENRE or STILL LIFE pieces; but some are connected with biblical subjects like *Jesus in the House of Martha*. Aertsen also painted ALTARPIECES, very few of which survive (fragment of an altarpiece, Amsterdam). Aertsen was the head of a long dynasty of painters, of whom the best known are his sons PIETER PIETERSZ and AERT PIETERSZ and his grandson Arent (or Cabel) ARENTZ.

2483.

**AESTHETICISM.** A term applied to various exaggerations of the doctrine that art is self-sufficient, autonomous, and autotelic; that it need serve no ulterior purpose and should not be judged *qua art* by non-aesthetic standards, whether moral, political, or religious. Both the doctrine and its exaggerations have found expression in the phrase 'art for art's sake'.

The autonomy of artistic standards was first expressly formulated by KANT, who distinguished aesthetic criteria from moral goodness, utility, and pleasure. In their several ways the doctrine was stressed by GOETHE, Schiller, and Schelling. It was introduced into England by Coleridge and Carlyle; into America by Emerson and Poe. Its poetic and literary aspect is exemplified in the lines from Emerson's *Rhodora*:

That if eyes were made for seeing
Then beauty is its own excuse for being.

In France it was popularized by Mme de Staël, the philosopher Victor Cousin and his disciple Théophile Jouffroy. Cousin is credited with having been the first to use the phrase 'l'art pour l'art' in his lectures on *Le Vrai, le Beau et le Bien* (1818, first published in 1836) at the Sorbonne.

An exaggerated form of the doctrine was voiced by Théophile Gautier in the Preface to *Mademoiselle Maupin* (1835), where he declared that art *may not* serve any other values than the aesthetic without damaging its aesthetic value. 'Il n'y a de vraiment beau que ce qui ne peut servir à rien.' Deliberate emphasis was set on the aesthetic values by the French Symbolist poets from Baudelaire to Mallarmé, although Baudelaire declared against 'the childish utopianism of the school of art for art's sake in ruling out morals'. The de GONCOURT brothers declared that painting exists to delight the eye and the senses 'and

not to aspire to much beyond the recreation of the optic nerve'. In England 'art for art's sake' became the catchword of an exaggerated Aestheticism which was satirized as early as 1827 by De Quincey in his essay *On Murder as one of the Fine Arts* and later parodied by W. S. Gilbert. In the 1870s and 1880s the hyper-sensibility cultivated by certain elements of the PRE-RAPHAELITE Brotherhood obtained an almost official sanction in Walter PATER, who in the conclusion to *The Renaissance* (1873) advocated a sensibility which finds the most precious moments of life in the pursuit of sensations raised to a pitch of 'poetic passion, the desire of beauty, the love of art for art's sake'. Oscar Wilde's *The Picture of Dorian Gray* (1891) expressed the same primacy for the aesthetic experience. Reaction from the tendency to regard the artist and CONNOISSEUR as specially endowed individuals whose role was to withdraw from everyday life and remain shut off in what Sainte-Beuve first (in 1829) called the 'Ivory Tower' came from the ARTS AND CRAFTS MOVEMENT of William MORRIS and LETHABY. RUSKIN, despite his enthusiastic worship of beauty, threw in his weight against an art which was out of touch with common life and his controversy with WHISTLER on the 'art for art's sake' doctrine has become famous. The would-be emancipation of fine art from moral standards and the common man was challenged by TOLSTOY in *What is Art?* (1898).

The exaggerated one-sidedness of the doctrine that art may have no ulterior motive, religious, political, social, or moral, hardly survived the turn of the century, though an echo of the implied emphasis may be seen in the extreme version of the 'formalist' doctrine advocated by Clive BELL, who maintained that the values of visual art reside solely in its formal qualities to the exclusion of subject or representation. But the more moderate form of the doctrine, in which it is held that aesthetic standards are autonomous and that the creation and appreciation of beautiful art are 'self-rewarding' activities, has become an integral part of 20th-c. aesthetic outlook.

**AESTHETICS** (Greek *aisthētika*: perceptibles). Term introduced into philosophical discourse about the middle of the 18th c. by Alexander Gottlieb Baumgarten (1714–62), who applied it to the theory of the liberal arts or the science of perceptible beauty. KANT criticized Baumgarten for restricting the word to the field of taste, but in his *Critique of Judgement* he adopted it in Baumgarten's sense. The neologism had a somewhat rough passage and in Gwilt's *Encyclopaedia of Architecture* (1842) it was still described as a 'silly pedantic term' and one of 'the useless additions to nomenclature in the arts' which had been introduced by the Germans. But writing in 1859 Sir William Hamilton could say: 'It is nearly a century since . . . Baumgarten applied the term Aesthetic to the doctrine which we vaguely and periphrastically denominate the

Philosophy of Taste, the theory of the Five Arts, the Science of the Beautiful, etc.—and this term is now in general acceptation, not only in Germany, but throughout the other countries of Europe.' During the second half of the 19th c. the word and its derivatives became associated with the affected dandyism and extravagant cult of the beautiful which was parodied by W. S. Gilbert and passed from philosophical jargon into the general language (see AESTHETICISM). Although it is no more closely defined today than when Hamilton wrote, it has become so general a semantic term that even in specialized writing its meaning is often assumed to be precisely enough known for older terms of criticism and appreciation to be defined by reference to it. Thus in *Art as Experience* (1934) John Dewey wrote: 'To be truly artistic, a work must also be aesthetic.' In *A Glossary of Art Terms* (1950) by J. O'Dwyer and Raymond Le Mage *fine art* is said to be 'that art which is principally concerned with the production of works of aesthetic significance as distinct from useful or applied art which is utilitarian in intention'. Even the word 'beautiful' itself has become subordinate to 'aesthetic', as in such statements as: '. . . the beautiful is merely one of many aesthetic categories' (*An Aesthetic Approach to Byzantine Art*, P. A. Michelis).

The *Oxford English Dictionary* defines aesthetics as 'the philosophy or theory of taste, or of the perception of the beautiful in nature and art'. This definition looks back to the English 18th-c. writers from Shaftesbury onwards, who wrote aesthetics before the word had been coined. In the 20th c. there is no general agreement about the scope of philosophical aesthetics, but it is understood to be wider than the theory of fine art and to include the theory of natural beauty and non-perceptible (e.g. moral or intellectual) beauty in so far as these are thought to be susceptible of philosophical or scientific study.

**AFRICAN PREHISTORIC ART** (compare STONE AGE ART in EUROPE). In Africa the prehistoric period (i.e. the time before there was written history) continued in many places until almost yesterday: in fact, over the sub-continent generally it ended only with the coming of the white man—although in North Africa, of course, in Egypt, Abyssinia, and in the Mediterranean and east-coast areas there were written records earlier. A survey of African prehistoric art must therefore cover greatly varying and sometimes immense stretches of time over a colossal expanse of space. The surprising thing is that the artistic manifestations throughout vary so little. The conditions for cave art were rarely present. But paintings and engravings in open rock shelters and engraved drawings on rocks and boulders are abundant and widely distributed, extending from very early times until recently. They correspond very roughly to a Stone Age culture. Africa had no Bronze Age and the cultural periods worked

out for Europe are relevant only in a rough-and-ready way to African civilization.

African prehistoric art will be discussed under two regional heads: (1) The Sahara and northern Africa (Morocco, Algeria, Tunisia); and (2) Africa south of the Sahara.

1. THE SAHARA AND NORTHERN AFRICA. Prehistoric rock art was discovered in the mountains south of Oran as early as 1847 and in the Sahara by Heinrich Barth in 1850. By 1900 it was known that rock engravings could be found in all the larger massifs over a very wide area, and by the middle of the 20th c. it had become apparent that no other known part of the world contains so important and varied an abundance of rock art as the Sahara. In 1956-7 new discoveries were made in the Tassili area which surpassed in number and magnificence anything hitherto known.

This rock art is assigned to four main periods:
(a) The early *Hunting* period of undomesticated animals (elephants, rhinoceroses, hippopotamuses, giraffes, large antelopes, and ostriches). The period is characterized by representations of the Cape buffalo or bubalus, a species which is now extinct and otherwise known only from fossils, and for this reason it is commonly called the *bubalus* period. Only engravings, no paintings, are known from this period. The style is naturalistic with close attention to detail and displays highly developed powers of observation. Human beings are shown armed with boomerangs, a neolithic form of axe, and occasionally with bows.

From evidence of Stone Age implements and the examination of kitchen refuse it is supposed that the Sahara area was densely populated during the lower Palaeolithic Age but that it became uninhabitable in the upper Palaeolithic (corresponding with the European Ice Age and the cave art of the Aurignacian-Magdalenian cycle). The whole region between the Atlas mountains and the Niger was repopulated in neolithic times. While dating is difficult, the engravings of the *bubalus* period—found mainly in southern Oran, the Tassili, and Fezzan—are tentatively assigned to this period, c. 7000-4000 B.C.

(b) The art of the *Pastoralist* period, dating c. 4000-1200 B.C., is very widely disseminated in shelters below overhanging ledges of rock. The style is less fully naturalistic, sometimes almost schematic, and the technique is inferior to the best engravings of the *bubalus* period. Paintings occur in the Tibesti, Tassili, and Hoggar massifs. Figures are usually combined in scenes which show a talent for composition and an attention to PERSPECTIVE such as is not found in European Ice Age art.

(c) The period of the *Horse* is divided into two phases, an earlier one characterized by the depiction of the chariot and a later one in which the chariot is superseded by the mounted horseman. The larger pachydermata are no longer depicted, domestic cattle still appear and moufflons and tame dogs are frequent. During the latter part of the period camels were depicted as well as horses. The horse and chariot were introduced into Africa by the Hyksos invaders of Egypt, but the rock paintings, with their horses

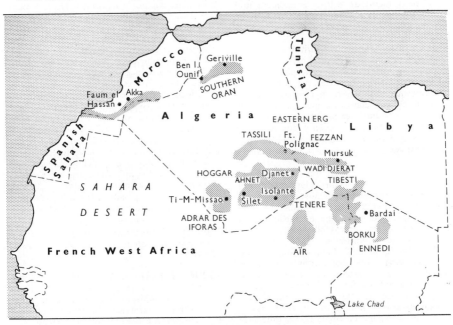

**Map 1.** ROCK ART IN NORTH AFRICA

extended at the gallop, seem to derive from the later invasion by the 'people of the sea' from Crete and Cyrenaica. Herodotus attests to the use of the chariot by peoples of the Sahara in the 5th c. B.C. and its use is known to have continued into Roman times. The chariots are often rendered schematically, animals and human figures although conventionalized are often vigorous and lively. It is sometimes known as the 'double triangle' style from the convention of representing the human body.

(d) The most recent period, where the *Camel* predominates, continues into the present day. The figures are usually small, execution inferior, and the schematic style is rarely distinguished.

The recent finds in the Tassili contain a distinctive 'round headed' style of human figure, which is assigned to a period intermediate between the *bubalus* and the Pastoralist. The paintings display a markedly symbolic and animistic character foreign to the *bubalus* and Pastoral art and they are sometimes thought to represent the earliest known origins of Negro art. The style lasted through several millennia. The figures were small at first but gradually increased in size and some are among the largest prehistoric paintings known. In the later phases the style becomes more elegant and decorative and traces of Egyptian influence are apparent (*White Lady* of Auanrhet; *Kneeling Woman* of Jabbaren).

Paintings have been found in Mauritania from the Pastoralist and later periods. In Abyssinia two groups of rock shelter paintings are known: the earlier and more naturalistic may date from neolithic times. Crudely executed rock paintings have been found in British Somaliland and engravings have been studied at sites between the Nile and the Red Sea, as well as near Onib in the Nubian desert.

2. SOUTHERN AFRICA. In South Africa a hunting and food-gathering mode of existence analogous to that attributed to the palaeolithic peoples of Ice Age Europe has been practised by the Bushmen up to the present day, and with it an art of painting and engraving in caves and rock shelters. Rock drawings and engravings are very widely distributed. Particularly fine examples occur in the large granite caves of Rhodesia and in sandstone galleries of the Union of South Africa.

The first person to study this art was G. W. Stow in the 1860s. He copied a large number of paintings at sites in what is now the Union of South Africa and these were published by Miss D. F. Bleek under the title *Rock-paintings in South Africa* (1930). It was followed by a further volume in 1940, written in conjunction with J. Riet. Owing to the fact that the hunting and food-gathering culture has continued in Africa without abrupt transitions into recent times, it has proved difficult for prehistorians to reach agreement about its antiquity. European scholars have in general been impressed by their palaeolithic character, and H. Breuil at one time suggested that some of the well-known polychromes

dated to more than 4000 years ago. Africans have seldom held for a date much earlier than the European Middle Ages. A number of different styles have been distinguished, however, and to some extent a chronological sequence has been determined.

Engravings occur commonly in the Kimberley district, where there are no caves or rock shelters. Several styles have been discriminated to form a chronological sequence, the latest examples being quite modern. The earliest are simple engravings; subsequently various 'pecking' techniques were used. In the earliest style elephants were depicted, but when elephants finally disappeared from this region is not known. In no case can any absolutely certain correlation between the paintings or engravings and any of the cultures present in the region be established.

Further north, in Zambia and the Katanga province of the Congo, a very geometrical style of art occurs, both paintings and engravings, and some of this has been associated in part at any rate with the local Nachikufan culture, the industries of which are sometimes found in the same rock shelters. Once again no great antiquity can be proved. At Kasma some of the paintings occur on flat surfaces of rock which are the result of recent exfoliations of the granite. In northern Tanganyika a large number of sites with paintings belonging to various periods has been studied. The most recent are probably fairly modern. Some of the others show signs of greater antiquity, though none is likely to be older than the art in Rhodesia. Along the southern fringes of the Sahara Desert, especially in French Equatorial Africa and in Nigeria, many rock shelters with paintings and engravings have been discovered. Most of these seem to be fairly recent and some of them are so modern that European objects are portrayed.

It is impossible to be certain why any of this rock art was produced or what social purpose it served. But as a result of field observation among the Bushmen by Erik Holm and others, it has been not implausibly suggested that part at any rate of the purpose may have been to set forth pictorially a traditional world-view and mythological cosmogony such as is embodied in the folk-tales and songs which have recently been studied by anthropologists. They may also and not inconsistently with the foregoing serve as decorations for sacred sites connected with initiation or other rituals of the tribe, and they may in some cases have had a propaedeutic significance in recording or expounding the symbolism of traditional mythology.

150, 186, 393, 846, 1141, 1142, 1711, 2566, 2888, 2910.

**AFRICAN TRIBAL ART.** The use of the word 'tribal' to designate what roughly corresponds to a protohistoric and early historic period of African art requires some explanation. It used to be customary to use the term 'primitive art' for this in common with the art forms of the Oceanic

peoples, the pre-Conquest peoples of America, and so on. The term had the disadvantages that it too readily acquired a derogatory sense, that it invited confusion with other uses of PRIMITIVE in art history, and that it suggested the naïve 'evolutionary' assumption that social patterns or art forms classified as primitive parallel stages through which the great world civilizations have progressed, whereas it is the general conclusion of more recent investigation that they are neither early formative nor late degenerative phases of development but mature and complex structures of beliefs, institutions, and technologies more static than and basically different from those through which the major civilizations evolved. Despite these disadvantages the expression 'primitive' is still used by some anthropologists and art historians (e.g. Paul S. Wingert, *Primitive Art*, 1962) on the ground chiefly that a tribal organization is not coextensive with the group of peoples desired to be classified as 'primitive'. In the case of the Negro peoples of Africa, however, during the period under consideration the tribal pattern has been the most characteristic feature of their social structure and the term 'tribal art' seems appropriate. Its use here does not imply any attitude to the 'tribalism' which has in the 20th c. been repudiated by some African régimes.

The African tribe, constructed on the basis of a complex family cell, was an exclusive 'in-group', conscious of being differentiated from other tribal groups by a traditional way of life and belief. Tribal art and ceremony were means among others by which the tribe expressed its internal solidarity, its sense of self-identity and difference from others. Tribal art embodied the values and beliefs of the tribe and was immediately comprehensible within the tribe, correspondingly alien to those outside. African art was therefore essentially an art of belief and commitment, part of a cultural pattern which was understood as an integral part of an inherited pattern of life. Art forms are one of the principal criteria for the identification and delimitation of tribes. The arts of a tribe are intimately associated with its way of life and change as this changes, or disappear with the decay of its institutions. It must, however, be remembered that the African tribe was not a static or completely self-contained unit. Tribes are dynamic, changing, and interacting social structures and in their artistic manifestations there was room for considerable local and individual variation within the art of a tribal group and also symbiosis and fusion between the art forms of different tribes. Influences from tribe to tribe occurred particularly in masks and cult objects connected with traditional ceremonial, dance, and recreational activities.

Scarification and body painting were common to many African tribes. Although religiously or socially prescribed by tradition and often connected with rites of status, they afforded a major outlet and motivation for the aesthetic impulse and at the same time served the interests of prestige and personal vanity. The patterns of bodily decoration are very frequently reproduced in sculptures. Apart from body painting and some rock painting, notably by the Bushmen (see AFRICAN PREHISTORIC ART), no significant art of painting has survived, although there are many areas in which painting was practised. The most important form of African tribal art has been sculpture and decorative carving. Through sculpture it has made its greatest impact on modern European and American art, bringing in a new vocabulary of form and helping Western artists in the early years of the 20th c. to free themselves from narrow formal preconceptions. The influence of African sculptural forms on PICASSO's *Les Demoiselles d'Avignon*, on CUBISM, and on other 20th-c. stylistic and aesthetic movements is a commonplace of art history. The most distinctive contribution of Africa to world art has often been considered to be its intuitive character and direct, non-literary apprehension of form, which acts as a foil to what many authorities regard as an imbalance between intellect and intuition in the traditions of Western art.

African sculptors have worked in stone, metal, wood, ivory, pottery, terracotta, raffia, and mud.

African wood sculpture is often dominated by the original shape of the trunk or branch from which a work has been cut. The wood was always worked green and for this reason African sculptures are inclined to crack as they dry. Oiling or smoking to prevent this cracking often produces lovely patinas. The sculpture was in most cases first roughed out with an axe; the sculptor would then squat in front of it and, holding it with one hand, would work on it with an adze or knife. It was sometimes finished with rough leaves or other abrasives. It is a mistake to regard the simplicity of the tools as a mark of a crude or bungling technique capable of embodying only partially the artist's feeling for forms. In this sense African tribal art is not 'primitive'. The tribal artist was, typically, superbly proficient in traditional techniques of craftsmanship. Technique and style went hand in hand without the hiatus of which one is so often conscious in the West.

African wood sculpture can be conveniently divided into three types: masks, small figures, and articles of everyday use. Masks were used primarily in traditional rites, dances, or religious ceremonies for representing ancestral or other spirits. The wearer of a mask abandoned, as it were, his own identity and loaned his vitality to the ancestor or spirit, who through the consecration rituals *became* the mask. Some masks covered only the face and were held in place by cloth or raffia head-coverings, which were usually a part of a costume. Others, the larger and heavier helmet-type masks, were made with hollowed wooden or wicker frameworks which rested either on the head or more often on the shoulders. A mask might combine several faces, or the 'face' of the mask might be an entire head

carved above the helmet. Thirdly, there was a type of flat mask which was worn not over the face but on top of the head. A fourth type, very rare, was attached to a handle and held in front of the face. There were in addition some miniature masks—notably those carved from ivory by the Bapende of the Congo—and small ivory masks were made at BENIN.

Wooden figures were widely used for religious or ritualistic purposes. Over much of Africa they represented ancestors. In some places they embodied spirits and in others they served as loci for the concentration of powerful non-personal forces. Figurines were also used for divination and other 'magical' purposes, such as healing or protection from evil. Among the Yoruba and some other tribes when a twin died the surviving twin had to keep a wooden figure by him until he became adult. In tribal society there was no sharp distinction between religious or magical and secular spheres, but figurines were also extensively carved for purposes which would be regarded in Western society as secular. In the kingdoms of the Guinea coast and the Congo they were a feature of palace art and they were extensively commissioned and kept for purely aesthetic or prestige motives.

Fine craftsmanship, aesthetic feeling, and often a keen humour went to the decoration of wooden objects of daily use such as bobbins, bowls, drums, and objects of personal adornment such as combs or hairpins. Stools and thrones had a particular significance over most of the continent and ranged from the intricately carved geometric and representational stools of the Guinea coast to those with attached standing human figures, sometimes life-size, from the Cameroons; from the beautifully made human and animal stools and head-rests of the Baluba and other Congo peoples to the beaded stools of the Gusii east of Lake Victoria. Indigenous African architecture (except in the northern Sudan areas, where mud was used, and in South Africa, where beehive huts of grass used to be common) usually consisted of a framework of wood or mud, or both, with a thatched roof. The posts which held up the framework were often beautifully carved and decorated and the house-posts of Yoruba or Dahomey in particular had fine artistic feeling. Indeed almost every article of common use in the tribe might be artistically decorated: mortars and pestles, handles of knives, adzes, and axes. Wooden bowls often bore incised designs or were carried by figures in relief, and cups, drums, and cooking and storage vessels were worked with love and care.

Stone is in short supply over most of the area. Soapstone figures called *nomoli* were made by the Sherbro of Sherbro Island and south-western Sierra Leone, and by the Temne of Sierra Leone. They appear to be relics of a past culture and may originally have been ancestral figures but are now used as 'rice gods' when dug up in the fields. Similar soapstone figures, called *pomtan*, were also used by the Kisi, whose territory straddles the Guinea–Sierra Leone frontier, both in connection with an ancestral cult and for purposes of divination. Stone sculpture has been found in southern Nigeria and stone was sometimes used by the Bakongo group of tribes around the mouth of the Congo river.

Ivory was one of the two products which led to the opening up of Africa by Arab and European travellers and merchants. African IVORIES were almost always worked with knives; the use of the drill has never been other than exceptional. The most celebrated ivories come from Benin in southern Nigeria. They are also fairly widely found in the Congo; Bapende pendant masks and Baluba head-rests are among the most interesting. There is today a flourishing tourist trade in ivory curios in many parts of Africa, but these have little in common with the ancestral tribal art.

In the excavation of tin mines at Nok in northern Nigeria there have been discovered relics of a terracotta sculpture which was flourishing when the Neolithic Age was giving place to an Iron Age, c. 250 B.C. The simplified stylization of forms is a characteristic of much later sculpture in the region and the exaggerated proportions of the head had affinities with the naturalistic terracotta figures from ancient IFE in central Yorubaland. Terracotta heads and figurines were also produced by the Sao culture which flourished near Lake Chad from the European Middle Ages until the 17th c. But the African peoples have not excelled in pottery and never developed the use of the potter's wheel. As with many peoples, domestic pottery was generally made by women. Pottery figures decorating such objects as pipes or pot lids and fetish figures were not uncommon but are of very irregular quality.

Metal sculpture was mostly in bronze, though the alloy was by no means constant. Casting by the *cire-perdue* method (SEE BRONZE) was used at Ife and may have been derived from there by the court art of Benin c. 14th c. There are interesting bronze masks from the Cameroons, and the Ashanti and Baule bronze or brass figures to be used as weights for measuring gold dust are well known in Europe. Larger brass sculpture was also practised and some interesting iron sculptures have been reported from the central Congo. Africans have worked little in gold, although the Ashanti and Baule both used a technique of covering wood sculptures with pounded gold leaf.

The artist in African tribal societies was generally a professional who worked on commission and his patrons were the heads of family units, village headmen, or tribal chiefs, who were responsible for providing the various art objects and other accessories needed for the rites and ceremonies, social and religious, at which they had to officiate. The professional artist was held in high esteem and in some areas had priestly or political status. Sometimes the right to become an artist, like the right to religious or medical rank, was hereditary in certain families. The artist's training embraced a long period of

apprenticeship during which he was grounded in traditional skills and techniques and even more importantly acquired a mastery of the traditional forms of representation and expression, the traditional designs, and the meaning and details of the social and religious rituals to which his products contributed. The apprenticeship system of artistic training maintained the conservatism which is fundamental to most primitive and tribal societies. Yet though the basic forms, patterns, and subjects were determined by tradition, inherent conservatism did not entirely inhibit the creative artist from bringing his personal interpretation to fruition and in tribal art as in the art of the great civilizations there is mediocre, derivative work and creative masterpieces by gifted individual artists. In the great religious centre of Ife and the great kingdoms such as Benin, where art ceased to be based on religion, artists were trained as individual craftsmen sometimes organized in guilds and worked almost exclusively for the court or hierarchy.

In so far as contact with Europe and the West led to a disruption of the tribal pattern and introduction of European or Moslem religious ideas, the ancient tribal art forms were emptied of meaning and function and largely disappeared. The art activity fostered for the tourist trade has not in general been considered to have equivalent intrinsic value. In some of the independent African regimes, however, there have been interesting movements to create an artistic renaissance based partly on a revival of the traditional art forms, sometimes on a fusion of native forms with contemporary Western aesthetic movements and sometimes on inspiration drawn from the African concept of 'negritude'. Closely though they may sometimes be linked with revival of the ancient art styles, these new movements cannot properly be regarded as manifestations of tribal art.

Although traits corresponding to Cubism and EXPRESSIONISM and other European aesthetic movements have been found in African art, it must be remembered that it is European eyes which have found them there. African art is an art with its own cultural and social background and its influence on 20th-c. Western art is an aspect of Western not of African art history. While the distinction between good and bad art, art and non-art, must no doubt ultimately imply universal standards, none the less there is much to be said on the side of those who protest against the application of purely Western aesthetic canons in the judgement of African art and who repudiate the attempt to appreciate African art objects as *objets trouvés* out of all relation to the background of culture and belief which alone gave them a purpose and *raison d'être*. The opposite mistake is to treat them primarily as ethnological data without due appreciation of their aesthetic qualities.

The major art-producing area of Africa is bounded on the north by the Sahara, on the east by the Great Lakes, and on the south by a line drawn westward from the Zambesi. Archaeology may expose a pre-Islamic art in the northern part of this area; papers have been written on the design of shields and body painting east of it; southern Bantu music and poetry are of very high order. But the plastic arts are, to all intents and purposes, limited within this area. It can reasonably be divided into four sectors (see Map 2): the western Sudan, the Guinea Coast, Middle Africa, and the Congo, the last extending to the Ogowe and into Angola on the west and as far as the east coast of southern Tanganyika. In each of these main areas there are many stylistic centres.

1. WESTERN SUDAN. (a) The *Dogon* group, inside the big Niger bend, were among the leading tribes of Africa in sculpture. Much of their art was produced by the caste of blacksmiths and techniques of iron-working may have influenced the linear stylization of the wood-carvings. The figures are easily identifiable, for the chin, breasts, and navel are pointed and the eyes and mouth are diamond-shaped and carved in high relief; they have an air of closed, esoteric intensity. Dogon masks are even more characteristic: one type represents animals, birds, snakes, and human beings; another is surmounted by a large 'Lorraine' cross. All were used by the men's religious societies. The underlying shape of all Dogon masks is the vertical rectangle; they are often painted black, white, or red. In use the masks were generally surrounded by fibre fringe costumes to hide the wearer. Carved human figures are sometimes to be found on the top of the masks. There is no clear evidence dating any of the known objects earlier than c. A.D. 1800.

(b) The *Bambara* tribe, further up the Niger, in western Sudan, are noted for their distinguished wooden ancestral figures, usually seated females, and their masks, which were connected with agricultural ceremonies. These were worn on top of the head, were made with an open fretwork, and might be as much as 2 ft. high. Their fine formalized rhythms suggest the forms of metal and no doubt derived from the fact that they were the prerogative of the blacksmith's guild. Other types of Bambara masks were used in rites of men's societies and boys' protective societies. Peculiar to this tribe are stylized antelope masks, called *chi wara*, used in ceremonies commemorating the mythical birth of agriculture.

(c) *Mossi* tribes of the upper trans-Volta have an urban population which is largely Moslem and a rural sector among whom the native cults survived until recently. The outstanding contributions from their tribal art were impressive masks of stylized horned animals, which could be as much as 7 ft. high. This style had variants westward to the *Bobo* and *Senufo* groups, both tribal clusters whose cultures were notable for their masks. From the Bobo come two very different types of masks used in agricultural rites, the one flat and geometrical, decorated with red, white, and black paint, and the other type ovoid helmet masks often surmounted by a human

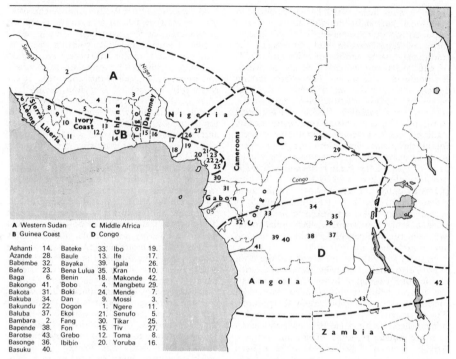

**Map 2.** DISTRIBUTION OF AFRICAN TRIBAL ART

| A Western Sudan | | C Middle Africa | |
| B Guinea Coast | | D Congo | |

| Ashanti | 14. | Bateke | 33. | Ibo | 19. |
| Azande | 28. | Baule | 13. | Ife | 17. |
| Babembe | 32. | Bayaka | 39. | Igala | 26. |
| Bafo | 23. | Bena Lulua | 35. | Kran | 10. |
| Baga | 6. | Benin | 18. | Makonde | 42. |
| Bakongo | 41. | Bobo | 4. | Mangbetu | 29. |
| Bakota | 31. | Boki | 24. | Mende | 7. |
| Bakuba | 34. | Dan | 9. | Mossi | 3. |
| Bakundu | 22. | Dogon | 1. | Ngere | 11. |
| Baluba | 37. | Ekoi | 21. | Senufo | 5. |
| Bambara | 2. | Fang | 30. | Tikar | 25. |
| Bapende | 38. | Fon | 15. | Tiv | 27. |
| Barotse | 43. | Grebo | 12. | Toma | 8. |
| Basonge | 36. | Ibibio | 20. | Yoruba | 16. |
| Basuku | 40. | | | | |

figure. The Senufo masks were often half-human, half-animal figures. Even finer than the masks were the Senufo dance figures, called *deble*, which achieved at their best remarkable dynamic tension in the vigorously rhythmic play of forms.

2. GUINEA COAST. (*a*) Akin to the Bambara is the vigorous carving of the small *Baga* tribe on the Guinea coast. Baga figures have a strangely disturbing quality with stylized, protruding and usually pointed faces, hands raised to the chin, and neck set far back. The same type of head was used on the famous *nimba* masks, the most massive masks of all tribal art. The head was set on an enormous hollowed bust, which the dancer carried over his head, seeing through holes drilled in the symbolic breasts, his body covered by a large hanging fibre dress.

(*b*) The *Mende*, the most important tribal group of Sierra Leone, were dominated in their social life and their art by powerful secret societies. Best known of their art products are the large black masks worn as helmets which were made for the *Bundu* women's initiation society. The *Poro* society for men extended among the so-called Dan-Ngere complex of tribes—including Dan, Ngere, Wobe, Toma, Mano, Geh, Gio, Kran, Gerze, Grebo, and Kru —over an area of eastern Liberia running into French Guinea and the western Ivory Coast. It spread the use of a face mask with a wide variety of local and tribal stylistic variants ranging from naturalistic but expressive faces of Dan to the horrendous monsters of Ngere with tubular eyes and jointed jaws and the more simplified abstractions of Kru and Toma. The Mende are also noted for beautiful carved wooden figures, called *minsereh*, which were used by the Yassi society in magical healing rites.

(*c*) The *Baule* tribe of the Ivory Coast split off from the Ashanti *c.* 1730. Their beautifully polished and finished masks have had the most ready appeal of all African art for Western taste. The face is oval, the forehead round and broad, the features fine, the mouth especially small and set rather low, the chin beneath it small and pointed. Masks and figures have the same careful finish, the same 'classical' face. The figures are thought to have served as loci for ancestral spirits, the masks for use in religious ceremonies. Baule sculpture aimed at charm rather than vigour. At its worst its sweetness degenerated into banality; at its best it reached a dignified solemnity which sets it in the front rank of African tribal art. The Baule decorated their everyday implements—looms, bobbins, spoons, and stools—with the same careful workmanship. They and the Ashanti seem to be unique in Africa in covering wooden stools and figures with pounded gold leaf (though the technique of metal-covered wood was practised elsewhere in Africa, notably among the Bakota).

18

(d) The *Ashanti* tribes occupy southern Ghana and owing to rich gold mines in their territory gold has played an increasing part in their culture over the last three centuries. Their sculpture was more mediocre than that of the Baule and mainly consisted of miniatures. Best known to the West are small figures for weighing gold dust which often have liveliness and charm. Of minor charm also are the fertility figures called *akua'ba*. Perhaps their most important sculptures were the funerary terracotta heads. Ashanti stool designs had a complex iconography, each design being related to at least one official position in the Ashanti state or else specifically to commoners. A cast gold mask, the only one known in Africa, has been found in Ashanti country.

(e) *Dahomey*. A powerful kingdom was established by the Fon of southern Dahomey about three centuries ago. Here, as in other kingdoms of the Guinea coast and the Congo, an unpretentious popular art was divorced from the secular court art which centred in the capital, Abomey, and furthered the prestige of the royal family. A wrought-iron figure of the war god (Musée de l'Homme, Paris) is accounted one of the masterpieces of African art. Dahomey was and is not so much an art centre as a point at which several styles, especially those of the Yoruba and the Ashanti, overlap.

(f) *Yoruba* tribes of western Nigeria and eastern Dahomey were one of the largest and most prolific groups of sculpture-producing tribes. Their wood-carvings are among the finest and most easily identifiable in Africa, though comprising several sub-styles. In their figures the centre of interest is the head and face. The eyes are large, the other features prominent but still naturalistic. Carvings of women are often combined with small figures of children. Figure sculptures were used in the cult of their numerous deities and figures were also carved on house-posts and the bowls used for divining. From Yoruba also come some of the best and most complex examples of groups: 10, 12, or even 20 figures in a single carving are not unusual. In these carvings the over-all cylindrical form dominates in the arrangement of the figure-groups instead of the individual figures. Yoruba masks were sometimes surmounted by such figure-groups, or by carved horsemen and the like. Many Yoruba wood-carvings were painted. Lamp-black, fixed with the sap of trees, served for black, clay for white, and ground camwood for red.

Yoruba masks were of two sorts: one was carved flat and was worn on the top of the head, the other was a large helmet type which was hollowed out and rested on the shoulders. They were used by the members of the various closed societies which were powerful forces in Yoruba political life.

Two important styles, both related to Yoruba, are treated separately: the royal art of Benin and the ancient religious art of Ife.

(g) Tribes east of the Yoruba between the Niger and Cross rivers. The *Ibo*, nearly as numerous as the Yoruba, formed the bulk of the population of eastern Nigeria. But unlike the Yoruba they were loosely organized and their art products display a very large diversity of local stylistic variants. Best known are the white-faced masks of beautiful female ghosts used in the *mmwo* or spirit cult. The most important society among the Ibo of the Awa and Kwa regions, through the greater part of the Ibibio country south and east of the Ibo and reaching as far as the Ekoi, was the Ekpo Njawhaw. Many authorities speak of the brutalities of this society but the Ekpo masks, built up of subtly curving planes and with movable lower jaw, have a certain calm and serene beauty to European eyes. The Oron, at the mouth of the Cross and Calabar rivers, were a branch of the Ibibio, but their tribal culture was distinct. Their sculpture was limited to ancestral figures called *ekpu* which were erected on the graves of the heads of families and which have been regarded as among the finest of all African art for their subtle composition of sculptural volumes. The Ekoi are the most important of a cluster of tribes, including the Boki, the Keaka, and the Anyang, with certain cultural affinities. Common to the group were naturalistic head-dress masks carved in wood over which animal skin might be stretched (except among the Boki) for increased realism. Two or more heads might be combined in a single mask. The Ekoi also used a non-naturalistic type of grotesque animal mask. There have been recorded from the Ekoi country some 300 stone figures carved from about the middle of the 17th c. to about 1900.

(h) Cameroons. Several smallish tribes of the grasslands of south-west Cameroons made small wooden figures, such as those of the Bakundu and Bafo. The masks were often cheerful and even humorous, although the Bafo had also an abstract and expressionistic mask style. The higher grasslands of the Cameroons were the home of tribal groups who were among the most accomplished in figure sculpture. From the Bikom and Bafum of the Tikar group of tribes come large figure sculptures with stools or thrones. The Bamileke cluster produced a vividly imaginative 'Cubistic' style of mask as at Bacham, a very large decorative type with inflated cheeks from Bamum, while the Bangwa group were outstanding for their skill in representing the human figure in the movement of dance. The Cameroons was one of the principal areas for ceramics and the carved pipe bowls have become famous, though they were often rather clumsily done when the clay was leather-hard.

3. MIDDLE AFRICA. (a) From the confluence of the Niger and Benue rivers the *Igala* were in antiquity supporters of a divine kingship with which are associated brass sculptures and ceremonial dance masks. At an early period their culture was related to that of the Yoruba, and later, some centuries ago, they themselves

exercised a strong artistic and cultural influence over the tribes of the lower Niger. With the Ibo, Ijo, etc., they shared a cult of the life-force dwelling in a man's right hand (the *ikenga*) and they had characteristic carvings of stylized horns supported by groups and tiers of human figures in connection with this cult. Their neighbours, the Idoma, whose wood sculptures give evidence of originality and invention, represent a transitional stage between the Ibo and the tribes of the upper Benue. The Jukun along the Benue and the Jompre on the borders between Nigeria and the Cameroons produced the most abstract of all tribal masks. The Tiv, on both sides of the middle Benue, were noted for their independence and practised carving without specialization. They produced interesting and classically simplified carvings in wood, brass, and bone. Higher up the Benue the Chamba combined the cult of ancestors with a worship of bush spirits. The ancestral or funerary figures, approximating to pole figures, had considerable sensitivity. In the dances in honour of the bush spirits they wore large, abstract masks based on the form of the bush-cow.

(b) The *Mangbetu* and the *Azande*, living at the juncture of the Central African Republic with Sudan and northern Congo, produced wooden figure sculpture, harps ornamented with human heads, carved stools, gaming boards, slit gongs, etc. The elongated heads of the Mangbetu (a deformation produced by binding them in infancy and thought by some to have been due to Egyptian influence) were reproduced in pottery, ivory, and wood figures.

(c) The *Fang*, who for the last two or three centuries have lived mainly in the Gaboon and south Cameroons, were a warlike and cannibalistic tribe. Yet the heads and figures they carved for the cult of ancestors have been described as 'classical examples of the serene beauty of which African art is capable'. The Bakota to the east of the Fang also carved apotropaic figures for protection from ancestral spirits. But they were two-dimensional, schematic, decorated with strips of copper and brass.

4. CONGO. This area has been the most artistically fertile of all tribal Africa.

(a) The *Ogowe* river peoples are famous for their fine-featured masks with whitened faces and elaborately carved hair-styles. They have sometimes been said to resemble Europeans.

(b) The tribes of the lower Congo coastal area, including the *Bakongo* around the mouth of the Congo, and the *Badindo* (often referred to as *Babwende*), the *Basundi*, *Babembe*, and *Bateke*, made principally two sorts of figures: naturalistically carved ancestral figures which were kept in memory of the dead or buried with them, and more roughly carved fetish figures, intended to act as concentration points ('lightning conductors' as it were) for spiritual forces of evil or disease. These fetishes often have a hollow dug into the belly, sometimes covered with a mirror or other substance, into which magical materials for 'medicines' could be introduced. One of the best known types of fetish has nails and bits of metal driven into it by the priest.

Fetish figures called *Sibiti* were also extensively used by the Babembe, who carved them in miniature with great attention to details of body scarification, etc., and the Bateke, a large tribe also in the region of Brazzaville. The art of the latter had affinities with that of the Bayanzi at the confluence of the Kwango and the Kasai. Also on the Kwango river the Basuku and Bayaka, living in close contact, had distinctive styles of fetish figures. The large tribe of the Bapende was divided into an eastern and a western group. The latter are known for initiation masks carved in the round and with what seems to European eyes a particularly peaceful expression. The eastern section had more abstract masks and also made wooden figures modelled in the round which were placed on the pinnacle of the chieftain's hut.

(c) Most famous in the central Congo area is the tribal federation of the *Bakuba* (formerly named *Bushongo* after the ruling tribe), whose traditions go back to the 16th c. A long series of royal portrait statues is said to have been initiated by the king Shamba Bolongongo (c. 1600), whose own statue is in the British Museum. The style is rigidly frontal, with large ponderous head and the expression has been described as 'that of the aloofness, omnipotence and oppression of divine African kingship'. The Bakuba had also a well developed decorative art of wood articles, raffia textiles, drums, embroideries, and so on. Particularly fine were their decorated palm wine cups, of which one category were covered with rich geometrical surface designs apparently taken from raffia-work and embroideries and the other, called effigy cups, formed in the shape of ovoid human heads with neck and base also geometrically patterned.

(d) To the south-west of the Bakuba the *Bena Lulua* tribes produced standing figures known as *lupfingu*, which are conjectured to have been either commemorative ancestral figures or protective amulets and which have been described as the epitome of the non-naturalistic tradition of expressive stylization in Negro Africa. Both the figures and the Bena Lulua masks achieved an unusually successful balance between sculptural form and surface decoration.

(e) The *Baluba* complex of tribes, in the eastern and south-eastern parts of the Congo, were responsible for one of the most important sculptural and aesthetic traditions of tribal Africa. Their products were given an over-all unity by a kind of idealized naturalism and a predilection for fluid curving masses. Their art work consists of characteristic groups of standing or kneeling figures supporting bowls, figures bearing stools or neck-rests, free-standing ceremonial figures, and masks with stylistic affinities to certain masks from the central Congo. The many variants and local sub-styles have been divided for convenience into two main types. (i) The

central or classical style is represented by stools, head-rests, crouching figures holding a bowl, carved in hard wood, sometimes in ivory, notable for the fine integration of organic forms. Some of the figures bearing head-rests convey an almost uncanny impression of supporting great weights. (ii) The long-faced Buli style of the eastern sector, perhaps the most notable of all Congo art, is best represented by the kneeling figures holding bowls which were called 'begging spirits', although their exact function is not certainly known. They are said to have been placed outside the homestead in order to receive gifts from passers-by and also to have been used in divination. The style is exceptionally expressive and the best of the examples seem to have been from the hand of two, or perhaps three, artists known as 'masters of Buli'.

(*f*) The *Basonge*, neighbours of the Baluba, produced the same sort of art objects but in a style which contrasts strongly with the Baluba. The most interesting are the anthropomorphic masks, which William Fagg has called: 'a combination of great cubic masses with flowing systems of parallel incised and painted lines, which comes to life with dramatic effect when seen in the motion of the dance'.

(*g*) The most accomplished sculpture of eastern Africa is that of the *Makonde* and their neighbours the Makua who lived on the boundary between Tanganyika and Portuguese East Africa. They produced masks, dolls, decorated household objects and dancing figures which combined a high degree of naturalism with a tendency to caricature.

8, 316, 693, 847, 848, 849, 850, 851, 1076, 1200, 1575, 1652, 1658, 1809, 2041, 2096, 2608, 2702, 2703, 2704, 2889, 2911.

**AGATHARCUS OF SAMOS.** Greek painter of the mid or later 5th c. B.C., noted for stage scenery and experimental PERSPECTIVE.

**AGORA.** See GREEK ART.

**AGORACRITUS.** Greek sculptor from Paros of the second half of the 5th c. B.C., pupil of PHIDIAS. His most celebrated work was a colossal marble statue of Nemesis at Rhamnus; a fragment of the head is in the British Museum.

**AGOSTINO DI DUCCIO** (1418-81). Italian sculptor. He was the most original if not the greatest sculptor of his time and the only 15th-c. sculptor born at Florence who owed little or nothing either to DONATELLO or to GHIBERTI. Unlike Nicola PISANO he owed little to ancient Rome but had affinities rather with the Neo-Attic art of Greece. Reliefs at Modena Cathedral executed by 1442 are accepted as his earliest work. Some have seen in them indications of a debt to Jacopo della QUERCIA, and others of possible training by Luca della ROBBIA. From *c.* 1450 to 1457 he worked on the sculptural reliefs for the Tempio Malatestiano at Rimini

(see MALATESTA), which include personifications of the Trivium and Quadrivium (see LIBERAL ARTS). The individuality and beauty of these figures inspired in modern times Adrian Stokes to write his *Stones of Rimini* (1934). His other memorable large work is the series of reliefs, partly in terracotta, on the façade of the Oratory of S. Bernadino at Perugia, on which he worked *c.* 1457-61. There is also a relief of a *Madonna and Child*, contemporary with the sculptures at Rimini, now in the Victoria and Albert Museum.

2108, 2125, 2560.

**AHMAD IBN BÂSO** (active 1160-85). Architect employed by the Almohad (Moroccan) rulers of southern Spain in the 12th c. He directed work on fortifications and public buildings at Gibraltar and Cordova and in 1172 began the famous minaret known as the Giralda which is now the bell tower of Seville Cathedral.

**AIR BRUSH.** An instrument, used chiefly by commercial artists, for spraying paint or varnish by means of compressed air. It can be controlled so as to give large areas of flat colour, gradations of colour, or a fairly fine line.

**AJIMEZ** (Arabic *ach-chimesa*: aperture admitting light). Term in ISLAMIC architecture for a characteristic form of window with twin arched lights separated by a column. Ajimeces were also characteristic of the MOZARABIC and MUDÉJAR styles of architecture of Spain and Portugal.

Fig. 1. AJIMEZ. Church of San Miguel de Escalada, León (913)

**ALABASTER.** A name which has been applied to two different kinds of stone. In antiquity it was used of onyx marble, a carbonate of lime now sometimes called 'Mexican onyx'. The stone was much used by the Egyptians for sculpture and for ART MOBILIER (*Head of Prince Shepsekaf*, 4th Dynasty, Mus. of Fine Arts,

Boston; *Sphinx of Thutmosis III*, 18th Dynasty, Cairo Mus.). It was also used in the ancient Middle East (cult vase of Uruk, Iraq Mus., Baghdad; statue of Ebih-il from Mari, Louvre) and it was much used by the Chinese.

Modern alabaster, which was used extensively in Europe during the later Middle Ages, is a sulphate of lime, a granular form of GYPSUM. It is a fine-grained stone, smooth and translucent, white or yellowish or pink and sometimes veined or cloudy from impurities. It will take a high polish but it is very soft, easily scratched and bruises easily. It is most suitable for small sculpture and for work which will remain protected from the weather. The fact that its surface will take paint without an underlying GROUND or GESSO contributed to its popularity in the 14th c. for RETABLES and TOMB effigies. It has been used by modern sculptors, although its rather precious effect has limited its popularity and the smooth, polished surface offers little scope for the subtleties of texture with which some modern sculptors have been particularly concerned.

In the 14th and 15th centuries alabaster was quarried and carved chiefly in the Meuse valley and in England. Quarries were opened in Derbyshire, Staffordshire, and Nottinghamshire and centres of carving sprang up also in Lincoln and York. About 1330 alabaster began to take the place of the harder stones or wood for tomb effigies and this became one of its most important uses until about the middle of the 15th c. The earliest surviving alabaster effigy is at Hanbury, near the quarry at Tutbury in Staffordshire. One of the finest tomb effigies is that of Edward II in Gloucester Cathedral (*c.* 1331); other fine examples are those at Westminster Abbey of John of Eltham (d. 1334), second son of Edward II, and of the two young sons of Edward III (d. 1340). The tomb of Henry IV (*c.* 1405) at Canterbury is one of the most important effigies. Some 14th-c. tomb sculptures had a Romantic character, as that of Sir Oliver de Ingham at Ingham, Norfolk, and those of the Duchess of Suffolk at Ewelme and Lady Eleanor Fitzalan de Percy (*c.* 1365) in Beverley Minster. Most effigies simply represented stock types since realism of portraiture in mortuary monuments was not expected in tombs until later.

Small alabaster statues of *weepers* (or mourners) became a feature of tombs of the nobility from *c.* 1290, an early instance being those on the tomb of John Eltham at Westminster Abbey. Alabaster was also used for making statuettes for placing on the altar, for relief retables, and for other church ornaments. A flourishing school of carvers or 'alabastermen' soon achieved a continental reputation and exported work widely, even as far as Italy, Spain, and Russia. Their small alabaster statues were conceived in the round but usually had flat backs to stand against the altar and were painted. Most of these were destroyed at the Reformation but a few remain in England, e.g. the three from Flawford church (now in the Nottingham Mus.) representing a *Virgin and*

*Child, St. Peter*, and a priestly donor, and there is a *Trinity* from the early 15th c. at Boston, Mass. Even more popular than free-standing figures were reliefs set in wooden frames and painted or gilded to be used as retables or REREDOSES. One of the earliest reredoses is an enormous set of panels ordered in 1372 for St. George's, Windsor; generally, however, the reliefs were small. The best collection of extant alabaster retables is in the Hildeburgh bequest at the Victoria and Albert Museum.

The production of religious images was cut off abruptly by the Reformation but some tombs continued to be carved in alabaster until the 18th c. The latest example is believed to be the tomb of Rachel, Lady Pole, in Baxted, Suffolk (1725).

**ALAN OF WALSINGHAM.** Appointed sacrist of Ely Cathedral in 1320, he was the monastic official in charge of the fabric of the church at the time when the central tower collapsed (1323). This, together with his known interest in the arts, has led to his being credited with the design of the famous octagon which replaced the fallen tower. The idea may well have been his, although the execution of the most important parts, i.e. the timber vaults and the LANTERN, is now recognized as the work of William Hurley, the King's Master Carpenter, who was called in from London.

**ÁLAVA, JUAN DE** (d. 1537). Spanish architect. He was one of the nine architects called together in 1512 to decide upon the plans for the new cathedral at Salamanca and was employed upon its construction from 1520 onwards. He himself designed the church of S. Esteban at Salamanca (begun 1524); and was largely responsible for the magnificent late Gothic chancel and crossing of Plasencia Cathedral where he was master of the works 1513-37.

**ALBA BIBLE.** Codex owned by the Duke of Alba containing the translation of the Old Testament, executed for the Master of Calatrava between 1422 and 1430 by a Jewish scholar, Moses Arragel. Some of the illuminations also seem to reflect a Jewish tradition. It is the subject of a Roxburghe Club monograph.

**ALBANI, CARDINAL ALESSANDRO** (1692-1779). Nephew of Pope Clement XI and regarded as the leading patron of the arts in his day. He was a friend of WINCKELMANN, with whose help he made a fine collection of ANTIQUE sculpture, much of which is now at Munich. It was housed in the villa he had built by Carlo Marchionni (1743-63) on the ceiling of which MENGS painted his at one time famous *Parnassus*.

**ALBANI (ALBANO), FRANCESCO** (1578-1660). Italian painter of the BOLOGNESE SCHOOL. After a period in the studio of Denis CALVAERT and subsequently in the CARRACCI academy

under Lodovico Carracci, he moved to Rome
(*c.* 1600), where he collaborated with Annibale
Carracci and DOMENICHINO on various decorative schemes, including the Farnese Palace. In
1616 he returned to Bologna and produced,
besides important ALTARPIECES, many allegorical
paintings and idyllic landscapes in a personal
style which proved very popular in England in
the late 18th c. He was known as the 'Anacreon
of Rome'.

**ALBERTI, LEON BAPTISTA** (1404-72).
Architect and humanist, born in Genoa, the
illegitimate son of an exiled Florentine merchant.
Educated at Padua under the famous teacher
Barsizza and at Bologna University, he proved
himself a precocious scholar and at the age of 20
wrote a Latin comedy *Philodoxeos* which passed
as an original Latin work. This was the age when
classical manuscripts were being recovered, and
the 'rediscovery' of VITRUVIUS's treatise on architecture inspired Alberti's own. He was able to go
to Florence *c.* 1428 and became a friend of the
most advanced artists—BRUNELLESCHI, DONATELLO, GHIBERTI, Luca della ROBBIA, and MASACCIO. To all these, jointly, he dedicated his first
theoretical work on the arts, *Della Pittura* (1436),
which contains the first description of PERSPECTIVE construction. Alberti held a secretarial
post at the papal court 1432-64. He practised
architecture from the 1440s and *c.* 1450 began
writing his treatise *De re aedificatoria* on which he
worked until his death. This emulates Vitruvius
and deals with architecture as a civic art, including town-planning, but it also gives a
theoretical exposition of the Orders and an
aesthetic. He also wrote *De Statua, c.* 1464.

Alberti worked as an architect in Florence,
Rimini—where he met PIERO DELLA FRANCESCA
—Rome, and Mantua. In Florence he built the
Rucellai Palace (begun 1446), the first RENAISSANCE building in which a system of classical
pilasters articulates the façade (based on the
Colosseum); he also designed the façade of Sta
Maria Novella (finished in 1470), a Renaissance
solution of the medieval problem of a church
façade with nave and aisle ends to be screened.
At Rimini, in the church of S. Francesco ('Tempio
Malatestiano', *c.* 1450), he had already used the
antique TRIUMPHAL ARCH motif for the façade, and
his last two churches, both in Mantua, also
adapted classical themes. S. Sebastiano, begun
1460, combines the temple front and triumphal
arch motifs, while its plan was a new type of
Latin cross with side-chapels, alternately large
and small, instead of aisles, and a classical barrel-
vault over the nave. This type was used by
VIGNOLA for Il Gesù, Rome, and has been
popular ever since.

Alberti was the most representative figure in
the change which took place at the Renaissance
from the medieval attitude to art as a symbolic
expression of theological truths to the humanistic
outlook, and the new ideas of scientific naturalism
found their fullest expression in his writings. In
the breadth of his knowledge and the rational and
scientific temper of his mind he was typical of
the early humanists. He thought of architecture
as a civic activity and broke new ground by dealing with it in the context of unified town-planning.
In accordance with the new status of the artist
as an exponent of LIBERAL ART and not a mere
manual worker, Alberti emphasized in all his
works the rational and scientific basis of the arts
and the necessity for the artist to have a thorough
grounding in such sciences as history, poetry,
and mathematics. His definitions of the various
arts were no longer in terms of religious function,
but entirely in human terms with a strong admiration for classical antiquity. In some contexts
he defines painting in language of unqualified
naturalism, but elsewhere he recognizes that the
artist is bound to seek an ideal of beauty which
cannot be achieved simply by accurate reproduction of nature but involves selection. At times he
identifies the beautiful with the typical in nature.
In the *De re aedificatoria* he evolves a theory of
beauty in terms of an ultimately mathematical
symmetry and PROPORTION of parts. He distinguished the rational appreciation of beauty
from the vagaries of individual taste, though at
times he held that beauty is what pleases the eye.
While many of Alberti's ideas were of Platonic
origin, often derived through Vitruvius, he was
not identified with the mystical Neo-Platonism
of Marsilio Ficino and Pico della Mirandola
encouraged by Lorenzo de' MEDICI.

25.

**ALBERTINA, Vienna.** Considered the most
comprehensive collection of Old Master drawings ever assembled privately. Archduke Albert
of Sachsen-Teschen (1738-1822) and his wife,
a daughter of the empress Maria Theresa, devoted their lives to the collection. They found
unique opportunities in the Netherlands, of
which the Archduke was governor, and also
through the breaking up of the great French
collections shortly before the Revolution. The
magnificent collection of drawings by DÜRER
bought from the emperor Francis II in 1769 can
be traced back directly to Dürer's widow. The
Albertina collection was enlarged under Albert's
successors and is preserved in the archducal
palace.

**ALBERTINELLI, MARIOTTO** (1474-1515).
Florentine painter, trained by Cosimo ROSSELLI,
in whose studio he met Fra BARTOLOMMEO. The
two collaborated until 1500. In 1508 he went
into partnership with FRATI and some years later
abandoned painting to become an inn-keeper.
Albertinelli's work exemplifies the elegantly
insipid CLASSICISM of the Florentine studios
under the influence of LEONARDO DA VINCI and
PERUGINO. His best known pictures are the
*Visitation* (Uffizi, 1503) and an *Annunciation*
(Accademia, Florence, 1510).

1188.

**ALBI,** CATHEDRAL OF ST. CECILIA. Begun 1282; finished late 14th c. An extraordinarily effective compromise between the aisleless churches of Languedoc, with their prominent internal buttresses, and GOTHIC vaults, windows, mouldings, etc. The buttresses create a series of recesses round the church but these have been neutralized by bridges from buttress to buttress, forming chapels below and a kind of compartmental gallery above. There are no other subsidiary spatial forms, and the resulting effect of spatial unity is astonishing. The exterior presents a compact mass, its walls rising vertically like a fortress from its hill above the Tarn and dominated by a single tower reminiscent of a castle keep. Indeed it was conceived as a fortress, an outpost of orthodoxy in a land still prone to heresy. But this harshness is wholly absent from the 15th-c. additions, the FLAMBOYANT porch and the ornate gallery-screen and canopies of the choir (1473-1502). The contrast is striking and illustrates the sometimes incongruous application of Flamboyant as well as its nation-wide range.

**ALBRIGHT,** IVAN (1897- ). American painter, born in Chicago. During the 1930s he came to the fore on the crest of the wave of nationalistic interpretation of the American scene. His work has a minute pin-point exactness in depicting haphazard accumulations of random articles which to some people convey a poignant impression of melancholy for a beauty that is past. In an interview in 1960 he stated that in his opinion his most important works were: *That Which I Should Have Done I Did Not Do* (Art Institute of Chicago, 1931-41); *The Dead Doll* (1931-2); *God Created Man in His Own Image* (1929-30); and the *Portrait of Mary Block* (Art Institute of Chicago, 1955-6).

**ALCAMENES.** Athenian sculptor of the second half of the 5th c. B.C., pupil of PHIDIAS. PAUSANIAS implausibly asserts that he made the sculptures of the west pediment of the temple of Zeus at Olympia. A badly mutilated marble statue in Athens is perhaps an original by Alcamenes representing *Procne with Itys.*

**ALCÁZAR** (Arabic *al-qasr*: the palace). The word came into use as an architectural term when the Christians reconquered Spain from the Moors and took possession of Moorish fortress palaces, some of which they enlarged or rebuilt. Best known are: the Alcázar of Seville, enlarged in the 14th-15th c. in MUDÉJAR style; the Alcázar of Toledo, rebuilt by COVARRUBIAS and others in the 16th c.; and the former Alcázar of Madrid, the principal Spanish royal residence from 1621 until 1734 when it was burnt down.

**ALDEGREVER,** HEINRICH (1502-c. 1555). German engraver and painter, usually grouped with the so-called LITTLE MASTERS, since he liked working on a rather small scale. His numerous engravings, usually of religious subjects, betray the all-pervading influence of DÜRER. Among the few paintings which can be attributed to him the portraits are the best (*Portrait of a Man*, N.G., London).

**ALDINE PRESS.** A famous press established in Venice in 1494 by one of the most distinguished scholar-printers of the 16th c., Aldus Manutius. During the 21 years of his activity Aldus deliberately devoted his energies to the cause of scholarship and did more than any other man to facilitate the spread of the new learning among the scholars of Europe. The work by which he is most widely known is the long series of small octavo volumes of Greek and Latin classics, bearing his device of an anchor and dolphin. Aldus was the first printer to design a small book which was convenient for the student. In order to compress the texts into the limited compass of the octavo volume Aldus needed a type quite different from the roman and gothic letters then in use for large library folios. In 1501 he therefore designed a new small type, which was based on the cursive script then fashionable in Italy. It is from this type that the letter we call *italic* derives. Aldus also designed a Greek type for which the handwriting of his friend Marcus Musurus is said to have served as a model. The wide influence of the Aldine books set a fashion in Greek letters which lasted for three centuries.

**ALDRICH,** HENRY (1648-1710). Dean of Christ Church, Oxford, and *virtuoso* architect. He designed the Peckwater Quadrangle of his college (1705-6) and probably other Oxford buildings, including All Saints' Church and the Fellows' Building, Corpus Christi College (1706-10), in which the influence of both WREN and VANBRUGH may be seen. He belonged to the short-lived English BAROQUE school, whose leading exponents were Vanbrugh, HAWKSMOOR, and ARCHER.

**ALEIJADINHO.** See LISBOA, A. F.

**ALEVIZ,** or ALEVIZO FRIASIN (ALOISIO DA CARCANO) (early 16th c.). Italian architect active in Russia. He may have been a Venetian, but nothing is known about his early life and activity in Italy. In 1505-9 he built the cathedral of the Archangel in the Kremlin in Moscow, a harmonious combination of Russian bulbous domes with a façade in the style of north Italian quattrocento architecture.

**ALEXANDER MOSAIC.** A mosaic from POMPEII (now in Naples) depicting Alexander the Great face to face with Darius at the battle of Issus (333 B.C.). The mosaic was probably modelled on a painting of *c.* 300 B.C., perhaps by Philoxenus of Eretria. (See GREEK ART.)

**ALEXANDER SARCOPHAGUS.** A marble sarcophagus, shaped like a chest with roofed lid, found at Sidon and now in Istanbul. It takes its name from the high reliefs of the panels on the

sides and ends, which show Alexander lion-hunting, etc. The sculpture, good work of *c.* 300 B.C., is exceptional for the admirably preserved and effective colouring.

**ALEXANDRIAN SCHOOL.** A useful term for art which can be reasonably connected with the Ptolemies. The term is sometimes applied to a soft and sentimental trend in HELLENISTIC sculpture, such as the interest in children and in female portraits, but there is not sufficient evidence to determine the much-debated question whether an Alexandrian style which is distinct from other Hellenistic art can be identified. (See also EGYPTIAN ART.)

**ALFARJE** (Arabic *al-farch*: the ceiling). Term in ISLAMIC architecture for the interior timber framework supporting the roof (usually hipped or domical) of Moorish buildings and adopted for MUDÉJAR buildings in Spain, Portugal, and their colonies. The structural members were enriched with carved MOULDINGS and interlacing laths were used to make decorative geometrical patterns, called *lacería*.

**ALFIZ.** Term in ISLAMIC architecture for a MOULDING in the form of a rectangular frame as a setting for a horseshoe ARCH. It was also widely employed in the MOZARABIC and MUDÉJAR buildings of Spain and Portugal. The SPANDREL or space between the arch and the *alfiz* was called *albanega*.

**5.** Detail of San Esteban doorway, La Mezquita, Cordova. Showing *alfiz* framing horse-shoe arch (9th–10th c.)

**ALGARDI,** ALESSANDRO (1595–1654). Italian sculptor, born in Bologna. He settled in Rome in 1625 and became, after BERNINI, the most considerable sculptor in the city. He was chiefly patronized by Pope Innocent X and his family, and during Innocent's papacy superseded Bernini at the papal court. His principal works are the tomb of Leo XI (*c.* 1645) and the great relief of *Pope Leo driving Attila from Rome* (1650), both in St. Peter's. He made the statue of Innocent for the Capitol and executed numerous statues and portrait busts. Algardi, a BAROQUE sculptor, was given to violent contortion and

tempestuous action but he was less extreme than Bernini, and his rise to favour under Innocent coincides with that pope's patronage of a more restrained art, showing a marked contrast to the artistic policy of his predecessor Urban VIII and his successor Alexander VII, during whose papacies Bernini reigned supreme.

**ALGAROTTI,** FRANCESCO (1712–64). The foremost Italian art critic of his day, he is dubbed by Wittkower 'no more than an able vulgarizer'. He was the friend of TIEPOLO and CANALETTO, and amassed a notable collection of paintings and drawings. He was a cosmopolitan snob of great charm, whose friendship with some of the leading men of Europe—notably Voltaire and Frederick the Great—played a part in spreading Venetian culture. His greatest opportunity for this came when he was engaged in 1743 to buy Italian pictures for DRESDEN GEMÄLDE-GALERIE, and for it he commissioned pictures by the leading painters of the day. He set out his views on AESTHETICS in letters and in his *Saggio sopra la Pittura*. In these he proclaimed a watered-down version of the NEO-CLASSICISM which was then gaining ground in Europe (though not yet in Venice). For some years he influenced the practice of Tiepolo ('restraining his wilder fantasies' as he claimed), Canaletto (encouraging architectural CAPRICCI), as well as PIAZZETTA and other Venetian painters. His real importance lies in his having helped to make acceptable the bolder ideas of other men and thus to break down the cultural isolation of Italy.

**ALHAMBRA.** The citadel-palace of the Sultans of Granada, one of the most celebrated monuments of ISLAMIC architecture in Spain. Most of it was built in the 14th c. It is enclosed within a fortified wall, red in colour, whence the name (Arabic *al-hamra*, the red house). The plan is irregular but consists principally of two oblong courts at right angles to each other and each opening into a series of halls and apartments. The smaller and more elaborate of the two, the famous Court of Lions, is surrounded by an arcade of slender alternating single and double columns with traceried capitals. The stilted arches are multi-lobed and the surface of the wall above them is decorated with interlaced ornament in STUCCO. In the centre of the court is a fountain supported on the backs of lions.

As is usual with Moorish palaces, the exterior of the Alhambra is plain, and interest is concentrated upon the rich decoration within. This consists of glazed tiles (AZULEJOS) and a type of MOSAIC known as ALICATADO on the lower parts of the walls, and intricate stucco ornament on the upper parts, with all the Moorish devices of interlaced linear patterns (ARABESQUES), interwoven floral motifs (*Atauriques*) and friezes of KUFIC script. Above this again is stalactite or honeycomb vaulting. The magnificence of the whole is increased by gilding and painting.

**6.** Stucco ornament. Detail from *Sala de las dos hermanas*, Alhambra (14th c.)

Within the precincts of the Alhambra there also stands the unfinished palace of Charles V, one of the masterpieces of Spanish 16th-c. architecture, begun by MACHUCA in 1531.

**ALICATADO** (Arabic *al-qaât*: the patios). Term of ISLAMIC and SPANISH architecture for MOSAICS formed of polygonal pieces of coloured glazed tile fitted into geometrical patterns. Alicatados were much used by the Moors in Spain and later in MUDÉJAR buildings as wall facings and pavements, particularly for the patios of houses.

**ALISON,** ARCHIBALD (1757-1839). Scottish aesthetician and divine. His *Essays on the Nature and Principles of Taste* (1790), published in the same year as KANT's *Critique of Judgement*, an early instance of the application of associationist methods to AESTHETICS, had a revolutionary influence on English aesthetic writing and important bearings on later ROMANTIC theory. Alison defined taste in accordance with the ideas of his day as 'that Faculty of the Human Mind, by which we perceive and enjoy whatever is Beautiful or Sublime in the works of Nature or Art'. He held that the apprehension of beauty is attended by a unique kind of pleasure, which he called the 'emotion of Taste'. He set out the purpose of aesthetic inquiry as (1) To investigate the Nature of those Qualities that produce the Emotions of Taste; and (2) To investigate the Nature of that Faculty, by which these Emotions are received. Alison was one of the earliest to suggest a 'symbolist' theory of beauty by his statement that 'Qualities of Matter are not beautiful or sublime in themselves, but as they are . . . the Signs or Expressions of Qualities capable of producing Emotion'. He held that previous thinkers had erred in supposing aesthetic enjoyment to be a simple emotion, whereas he believed himself to have shown that it is produced only when the arousal of a simple emotion or the exercise of some moral affection is followed by the 'Excitement of a peculiar exercise of the Imagination' and that the two constituent elements in the complex aesthetic emotion are always distinguishable and sometimes distinguished in our experience. The play of imagination which Alison held to be essential to aesthetic appreciation consists in the indulgence of an associative train of thought and imagery activated by and emotionally related to the object of appreciation.

**ALKEN.** Danish family of landscape and sporting painters who settled in England about the middle of the 18th c. SAMUEL ALKEN senior (1750-1815) did hunting and sporting landscapes in the manner of STUBBS. He was the father of SAMUEL ALKEN junior (1784-1825) and of HENRY (1785-1851), the latter of whom became one of the most prolific sporting painters and illustrators of his time. His gaunt but sprightly style was already archaic in his day, but he excelled at representing the life and movement of the hunting field and at suggesting typical aspects of the English countryside. The great popularity of coloured AQUATINTS after his paintings has persisted among CONNOISSEURS. He was also proficient in etching and published *The Art and Practice of Etching* (1849). He had four sons, of whom the work of HENRY GORDON ALKEN (1810-92) is often confused with his. His publications include *Sporting Sketches* (1817) and *National Sports of Great Britain* (1820).

32, 2471.

**ALLAN,** DAVID (1744-96). Scottish portrait and GENRE painter. He spent the years 1764-c. 1773 in Italy, where he won the prize for history painting at the Academy of St. Luke in Rome. In 1780 he settled in Edinburgh as a painter of portraits and CONVERSATION PIECES. When abroad he had made studies of French and Italian peasants and he painted scenes of Scottish life in a similar vein, which earned him the misleading title of 'the Scottish HOGARTH'. He designed and engraved the illustrations to Ramsay's *Gentle Shepherd*.

1108.

**ALLAN,** SIR WILLIAM (1782-1850). Scottish historical painter, who travelled extensively in Russia, the Middle East, and elsewhere. He was elected R.A. in 1835 and knighted in 1842. His accuracy of detail, the heroic scale of his work, and his exotic subject matter (*Murder of David Rizzio*, N.G., Edinburgh) satisfied the same appetite as did the novels of Walter Scott, who was his enthusiastic supporter. With WILKIE, he did much to establish the vogue for historical GENRE painting in Scotland.

**ALLA PRIMA.** The method of painting directly on to the GROUND, also called *direct* painting, instead of building up a planned

composition in which ground, UNDERPAINTING, and successive layers of translucent paint all have an important effect in the final appearance. In direct painting the underpainting is either dispensed with or simply outlines the main design of the painting in a colour scheme similar to that planned for the finished work: the careful utilization of changes in hue from cool to warm when an under layer of paint is seen through a translucent layer on top is no longer exploited. Each patch of colour is applied more or less as it is intended to appear in the final picture. Direct painting was practised from the 17th c., but it was not until the middle of the 19th c. that it became the chief method in oil painting. Its vogue was connected with commercial paints of a buttery consistency which retained the marks of manipulation after drying better than the earlier studio-manufactured paints. BALDINUCCI in 1681 deplored the short life of *alla prima* painting unless done with a loaded brush, and when this came into general use in the latter half of the 19th c. broad brushes of pigs' bristle replaced the finer brushes which had been used previously. The direct method is closely allied to such techniques as the 'virtuoso brush stroke' and laying on pigment with the PALETTE KNIFE or the finger, which emphasize the effect of surface texture and modelling in the completed picture.

**ALLEGRI**, ANTONIO. See CORREGGIO.

**ALLORI**, ALESSANDRO (1535-1607). Italian painter, trained in the courtly MANNERISM of the workshop of BRONZINO, by whom he was adopted. An early visit to Rome added the influence of late MICHELANGELO paintings (*Last Judgement*, Capella Montguti, SS. Annunziata, 1560) in the crowded compositions and tortured posturing figures. *The Pearl Fishers* (Studiolo, Florence) exemplifies his studied use of the nude and his continued debt to Bronzino. His frescoes include GROTESQUES for the UFFIZI (1580) and two large antique histories for the MEDICI villa of Poggio a Caiano. His last works are softer and warmer with a new interest in texture and materials (*Birth of the Virgin*, SS. Annunziata, 1602). His son CRISTOFANO (1577-1621) continued painting in a similar style.

**ALLSTON**, WASHINGTON (1779-1843). American painter, considered the most important artistic personality of the first generation of ROMANTICISM in the U.S.A. Coleridge, who met him in Rome, considered him 'a man of . . . high and rare genius . . . whether I contemplate him in the character of a Poet, a Painter, or a Philosophic Analyst'. A native of South Carolina, he spent his working life in Boston apart from two lengthy visits to Europe: during the first, 1801-11, he studied under Benjamin WEST at the ROYAL ACADEMY and exhibited three pictures there, subsequently visiting France with John Vanderlyn (1775-1852); the second stay in England was from 1811 to 1818. Up to *c.* 1818

his Romanticism expressed itself in the grandiose and dramatic and his large canvases exploited the mysterious, monumental, and terrific aspects of nature. Among the best known examples are *The Rising of a Thunderstorm at Sea* (Mus. of Fine Arts, Boston, 1804), *The Deluge* (Met. Mus., New York, 1804), and the O.T. themes *Dead Man Revived* (Pennsylvania Academy of Fine Arts, 1811-13), which emulated SEBASTIANO DEL PIOMBO's ALTARPIECE *Raising of Lazarus*, and *Belshazzar's Feast* (Detroit Institute of Arts, 1817-43). In his later period he was a forerunner of the subjective and visionary trend in American landscape painting, which relied more upon mood and reverie than upon observation or drama. Typical of this quietist style are the smaller, more dreamlike pictures *The Moonlight Landscape* (Mus. of Fine Arts, Boston, 1819) and *The Flight of Florimell* (Detroit Institute of Arts, 1819). Through his pupil Samuel F. B. Morse his art of poetic mood became indigenous in the U.S.A.

2248.

**ALMA-TADEMA**, SIR LAWRENCE (1836-1912). Dutch painter who settled in London in 1870 and took British nationality in 1873. His remarkable social and financial success has yet to be endorsed by posterity as an artistic one. He painted scenes from Greek and Roman life, vapid in content but with skilful imitation of the surface textures of statuesque women and marble baths. He became R.A. in 1879 and was knighted in 1899.

2968.

**ALSLOOT**, DENIS VAN (*c.* 1570-*c.* 1627). Flemish painter of landscapes with religious and mythological figures, especially noted for scenes of processions and fêtes. In 1599 he became a master in Brussels and worked for the court there. Until *c.* 1610 Alsloot painted in the manner of CONINXLOO and Jan BRUEGHEL, but then developed a more realistic, unromanticized style. In his earlier pictures the figures were often by Hendrick de CLERCK. His best known works are a series, painted for the Archduchess, of the Ommeganck procession in 1615, now divided between Brussels, Madrid, Turin, and London (V. & A. Mus.). He also painted several scenes connected with festivals at the Abbaye de la Cambre at Brussels. The winter landscapes are among the most attractive of Alsloot's paintings, with small brightly coloured figures set off against the light backgrounds.

**ALTAMIRA**. A site of palaeolithic rock painting 19 miles from Santander near the village of Santillana del Mar in northern Spain. The entrance to the cave was discovered by accident in 1869. Excavations were started by Don Marceliano de Sautuola in 1879 and during the operations the roof paintings were discovered by his infant daughter. The antiquity and authenticity of the paintings was at first denied by most

prehistorians and they were repudiated at the Congress of Anthropology and Prehistoric Archaeology held at Lisbon in 1880. The doubts were dispelled after the discoveries of cave art near Les Eyzies by Henri Breuil in 1901, and after E. Cartailhac's recantation of his former scepticism authorities generally accepted their origin in the Ice Age. The cave extends for 300 yards into a limestone massif but the paintings are in a gallery, often no more than 6 or 7 ft. high, about 30 yards from the entrance. The best preserved paintings are those on the roof, which comprise 25 polychrome figures of animals, mainly bison, drawn almost life-size with the contours accentuated here and there by engraving. The paintings are in naturalistic style, making full use of the irregularities of the rock, and they display a grasp of essential form and an eye for characteristic attitude and movement which impress even today. The subjects include hinds, stags, wild horses, aurochs, ibexes, wild boars, and rarely wolves and elks, all depicted with a sure realism in their habitual postures. The cave also contains fine engravings of animal heads. The polychrome paintings are assigned to the Upper Magdalenian period (c. 12,000 B.C.) and are regarded as the highest achievement of Magdalenian art both technically and aesthetically. There is little superimposition of drawings at Altamira, but the individual figures are not composed into scenes or represented in space. (See STONE AGE ART IN EUROPE.)

**ALTARPIECE.** Term in Christian church architecture for a picture or a carved or decorated screen behind and above an altar, also called RETABLE, reredos, and in Italian *pala d'altare*. The early Church, like the Synagogue, regarded the altar as a sacred table with a strictly liturgical function and allowed only the Bible and the sacramental vessels to be placed on it. The Greek Orthodox Church indeed has never placed its ICONS on the altar but attaches them to the ICONOSTASIS, which like the ROOD-SCREEN in Western churches divides the sanctuary from the rest of the building; and it was not until after about A.D. 1000 that the images of the saints, so popular in later centuries, made a first tentative appearance on Western altars. During the early centuries of Christian liturgy the celebrating clergy stood behind the altar facing the congregation and it was not until the 10th or 11th c., when the celebrants took up their position in front of the altar, turning their backs on the congregation during much of the liturgy, that it became possible either to set reliquary-retables of saints on the altar or to use the decorated screen rising high on the back of the altar. In 1105 the Doge Ordelafo Falieri ordered from Constantinople for the cathedral of St. Mark at Venice the large ,*pala d'oro*, or gold altarpiece, which still stands on the high altar in the form in which it was remade in 1345. It consists of gold panels with enamel inlay showing CHRIST in Majesty surrounded by angels and saints, as well as scenes

from the New Testament and from the life of St. Mark. But (as is shown by the *Liber ritualis* of Magdeburg) retables were still prohibited in some places late in the 13th c. and it was not until the 14th and 15th centuries that they came into universal acceptance, becoming so much a part of the altar that in the Counter-Reformation they were felt to be almost indispensable.

The retable was regarded as specially appropriate for images of saints and holy figures and from c. 1200 painted wooden retables became increasingly popular in order to accommodate these. As in St. Mark's, Venice, the titular saint of the altar usually occupied a prominent position or even usurped the whole altarpiece, as in that of St. Remaklus, recorded at Stavelot in 1150, and the panel of St. Francis painted in 1235 by Bonaventura di BERLINGHIERI for the church of S. Francesco at Pescia in Tuscany, both of which show the saint standing in the centre and flanked by episodes from his life. Local saints also occupied a position of importance, as St. Francis in Umbria and Tuscany and St. Anthony in Padua and the Veneto. In DUCCIO's great retable for the high altar of Siena Cathedral (1311) the group of saints around the VIRGIN includes the four patron saints of the city, Ausanus, Savius, Crescentius, and Victor, who kneel at her feet in adoration. When the DONOR is portrayed he is usually presented by his patron or name-saint, as Estienne Chevalier, Treasurer of Charles VII, by St. Stephen in the altarpiece of Jean FOUQUET (Berlin, c. 1450). Altarpieces also included, however, scenes and persons of general importance—APOSTLES, DOCTORS OF THE CHURCH, the CRUCIFIXION, and other incidents from the New Testament. The Crucifixion is shown alone in the arched metal altarpieces of Scandinavia (Nat. Mus., Copenhagen, 12th c.). Scenes from the PASSION are depicted on the back of Duccio's retable in Siena and, later, more elaborate altars sometimes include scenes from Christ's childhood and the Epiphany (Petrikirche, Dortmund, c. 1500; S. Jerónimo, Granada, 16th c.).

The form of medieval retables was very varied. Some of the earliest were adapted from other forms of decoration and many, as at Cividale in Friuli (1195-1205), consisted of metal frontals moved up to the top of the altar. Their long low shape influenced the design of a number of early altar-paintings (Siena Gal., 1215; altar of S. Zenobius, Florence Cathedral, 1240-50). In other cases venerated icons of the early Church were retouched and adapted as altarpieces and these, like the *Madonna Avvocata* of Sta Maria Aracoeli in Rome (originally 6th c.?), tended to set a style for contemporary painters. Byzantine icons, which were brought back in large numbers after the capture of Constantinople in 1204 and sometimes placed on the altars of Western churches, also influenced the fashion in retables. CIMABUE's *Madonna with Angels* (Uffizi), and many Italian panels like it, followed the type of the enthroned Virgin created by the Greek

Church in the 13th c. But whereas the Byzantine icons were usually rectangular, Western altar-paintings were usually set in a carved frame with gabled shape (panels by Cimabue and GIOTTO in the Uffizi).

Decorative motifs played an important part in the development of the retable, naturally taking a different course in various parts of Europe. In Italy, where the painted panel remained the chief medium, the gilt frame increased in importance as it became more elaborate, being carved into twisted columns, cusped arches, and pinnacles. Increase in the number of compartments so as to accommodate more complex pictorial themes led to the POLYPTYCH type, in which each saint was contained in a separate arch and the series of scenes from the Gospels or lives of saints were set apart on the PREDELLA below (Anconas of Bernardo DADDI in the Uffizi and Andrea ORCAGNA in Sta Maria Novella, Florence, 14th c.). But the increasing predominance of pictorial values in the art of the RENAISSANCE led to the progressive reduction of the frame and unification of the picture space, so that the number of compartments decreased and the various narrative scenes merged into a single composition. The central panel of the altar-painting, as in Fra ANGELICO's retable for St. Mark's, Florence, often took the form of a *Sacra Conversazione* (see VIRGIN), in which the Madonna and saints are shown in direct and increasingly informal converse with each other. In time the *pala d'altare* (RAPHAEL's *Sposalizio*, Brera), differed little in form from other EASEL paintings of the time, and the altarpiece came to rely more and more for its decorative effect on a single large frame of architectural proportions.

North of the Alps, especially in Germany and the Low Countries, a different type of altarpiece was evolved in the 14th c. The *winged altar*, or *Wandelaltar*, in which the central panel was flanked by hinged leaves painted on both sides so that they could be kept open or closed, had its origin in the reliquary-retable, in which the relics were preserved behind locked doors, and even where relics were not present the wings were usually kept closed on all but special feast-days. In early altars the inner panel, or 'shrine', was often borrowed from an earlier monument such as the Ottonian frontals reused at Xanten and Lüneburg in the 14th c. Later the shrine was often richly carved and painted, while the outer parts of the altar were fitted by their simpler and less delicate treatment for display on ordinary days. Sometimes a second pair of wings was included, painted on the outside in GRISAILLE for use on days of penitence, especially during Lent (Flemish altar, in the Petrikirche at Dortmund, c. 1500; 16th-c. retable with Coronation of the Virgin, Breisach Münster). The many wings had the additional advantage of providing more space for the pictorial programme. The altar of Conrad von SOEST at Wildungen in Westphalia (1403) shows the *Crucifixion*, flanked by an extensive cycle of scenes from the life of

Christ and the Virgin, with saints on the reverse of the wings; and the altar of the *Holy Lamb* by the brothers van EYCK (S. Bavon, Ghent, 1432) also presents an extensive programme, in which a procession of saints and patriarchs on the wings adore the sacrificial Lamb of the centre panel, above which GOD THE FATHER, the Virgin, and St. John appear in a separate section, while the reverse of the wings is painted with the *Annunciation*, flanked by the donors and their patron saints. As in Italy, the proliferation of narrative incident in the northern retables gave way to increased pictorial centralization; but the triptych, with central panel and wings showing related but pictorially distinct scenes, was still common in the early 17th c. when RUBENS made the altars of the *Crucifixion* and *Deposition* for Antwerp Cathedral.

The Spanish Church also favoured large retables with extensive narrative and anecdotal programmes, such as the painted altar of St. George attributed to Marcal de Sax (V. & A. Mus., 1400), which includes two large panels portraying the saint's principal battles flanked by the rest of his life-cycle and by the figures of God the Father, the Virgin, and numerous saints. The carved frame also played an important part in Spanish altars, and often the whole apse of a church is filled by a huge reredos of carved wood and stone, containing many figures and scenes in a rich setting (high altar, La Seo, Saragossa, 15th c.; Capilla Mayor, Toledo Cathedral, 1504).

Stone was the material most favoured in the making of French altars, as in the simple *Passion Retable* from Saint-Denis (Cluny Mus., 14th c.), which shows six scenes from Christ's Passion under an arched frame. The large stone altar of Notre-Dame de Brou near Bourg (15th c.) shows scenes from the life of the Virgin in a flamboyant architectural frame; and a similar pattern is used in the 16th-c. retable of Chaource (Aube) showing Passion scenes, and figures from the Old and New Testaments in a tripartite monumental setting of classical design. Painted triptychs after the Flemish pattern were also popular in France in the 15th c., such as the Virgin and Child with saints, painted by the MASTER OF MOULINS for Pierre II de Bourbon.

A special kind of reredos developed in England in the 14th c., consisting of an extensive series of niches containing figures of Christ and the saints, which covers the entire wall behind the altar in many churches (New College, Magdalen, and All Souls, Oxford, figures restored). Few painted altars have survived the Reformation in Britain, but that of Thornham Parva in Suffolk (early 14th c.) follows the Italian model, with a *Crucifixion* and saints beneath a carved frame.

The general increase in the number of altarpieces in the 15th c. was largely due to acts of private piety, from kings, high officials, merchants, lay fraternities, etc., and by the end of the century almost every altar had its retable. While the Reformation put an end to the production of

devotional pictures in Britain and much of northern Europe from the early 16th c., it was laid down for the first time as a principle by the Church of the Counter-Reformation that all altars should bear at least the image of their titular saint. The shape of the altar and its retable was no longer left to individual choice, but subordinated to the arrangement of the interior as a whole; and while the high altar often received a BALDACHIN, such as that made by BERNINI for St. Peter's in Rome, the others were set in niches or side chapels between the columns of the nave, as in VASARI's re-modelling of S. Croce and Sta Maria Novella in Florence and in the classical interiors of PALLADIO. The new retables were attached to the wall behind each altar and given architectural frames echoing the style of the church (S. Ignazio and S. Luigi de' Francesi, Rome), and in many cases were conceived from the start as an integral part of the interior design. The altarpieces of Roman BAROQUE churches, just as the frescoes on the ceiling, were treated as panels of illusionistic decoration to enrich and dramatize the interior as a whole. They were no longer designed to instruct the onlooker with scenes from the life of the saint, but directly to arouse his religious feeling with an expressive portrait or a single vivid episode. As in Bernini's carving of Sta Teresa's vision (Sta Maria della Vittoria, 1644-7), the pictorial programme was simple and its meaning clear, while the richness of the surround added to the effect of awe and splendour achieved by the whole.

The Baroque churches of Rome were imitated all over Europe, and their richly decorated altars enclosing a single pictorial section in painting, sculpture, or relief provided a universal model for Catholic altars in the 17th and 18th centuries, though in details of style these naturally followed the changing fashions of Baroque and ROCOCO art. The 19th c. produced little that was new in the design of the retable. Most churches retained their existing altars without adding to them, and the few new retables that were made followed the traditional shape.

Modern churches have a simple structural design which is rarely in tune with traditional forms of decoration. Many of them are circular or elliptical in plan, with the aim of focusing the attention of the congregation on a single free-standing altar, set well forward into the body of the church and thus unsuitable for a retable (Borgo Panigale, Bologna—architects Vaccaro, NERVI, and Libera; St. Louis, Missouri—architects Murphy and Mackey). Even in churches of a more conventional shape, with altars against the walls, the furnishings are reduced to a minimum; and in general there has been little effort to find a place for the altarpiece in contemporary religious art.

**ALTDORFER,** ALBRECHT (c. 1485-1538). German painter working in Regensburg, of which town he was a citizen from 1505 onwards.

It seems that he learned his trade during the early years of the century in Austria, where he must have been in contact with Lucas CRANACH, like whom he showed a hitherto unusual interest in landscape. DÜRER's art too was known to him through the woodcuts and engravings. Mingled with these German impressions was a knowledge of the art of MANTEGNA, perhaps through the mediation of Michael PACHER. Yet in spite of these varied influences Altdorfer's style always remained personal. His early works show preoccupation with the setting of figures in landscape, a problem which engaged all the artists of the so-called Danube School. In his mature creations, such as the altar for S. Florian near Linz (1518) or the *Christ Taking Leave of His Mother* (Wernher Coll., Luton Hoo), he achieved a wonderful unity of mood between action and landscape. Probably during the last years of his life he painted a number of pure landscapes—miniatures like collector's pieces on vellum. He was employed by Maximilian and together with Dürer and others he illuminated the margins of the Emperor's prayer-book. For the Duke of Bavaria he painted the monumental *Battle of Issus* (Munich, 1529), which formed part of a large series of famous battle-pieces from classical antiquity. Altdorfer's interest in architecture and his skill in handling intricate problems of PERSPECTIVE are demonstrated by his *Birth of the Virgin* (Munich). From 1526 until his death he was employed as town architect of Regensburg.

237, 2786, 2918, 2919.

**ALTICHIERO** (c. 1330–c. 1395). Italian painter sometimes considered to be the founder of the Veronese school, although the only surviving example of his work in that town is a fresco in Sta Anastasia dated from near the end of his life. He lived for some time at Padua, where he had a hand in fresco cycles in the Basilica of S. Antonio (between 1372 and 1379) and in the Oratory of St. George (between 1377 and 1384), in the latter of which a certain Avanzo collaborated. Altichiero's gravity and the solidity and spatial voluminousness of his figures are reminiscent of GIOTTO. But his pageant-like scenes with their elaborate architectural views express the taste of the late 14th c. for GOTHIC intricacy, while his NATURALISM in the study of plants, animals, and portraiture formed the point of departure for a new style which is reflected in PISANELLO.

408.

**ÁLVAREZ CUBERO,** JOSÉ (1768-1827). Spanish NEO-CLASSICAL sculptor. After studying at Granada, Madrid, and Paris he settled in Rome (1805-25), where CANOVA befriended him. Among his admirers were Napoleon, Metternich, and Ferdinand VII of Spain. He preferred classical themes such as *Nestor and Antilochus* (Modern Art Mus., Madrid, 1818), but was also an accomplished portrait sculptor.

7. Two daughters of Akhenaten. Fragment of mural painting (*c.* 1370 B.C.) from palace near the Temple of Aten at Tel-el-Amarna. (Ashmolean Mus., Oxford)

**AMARNA ART.** In the late 18th Dynasty (*c.* 1375 B.C.) the pharaoh Akhenaten tried to impose a form of solar monotheism upon Egypt, removing his court from Thebes northward to a virgin site now known as (el-)Amarna. The art of the period represents the only real break in Egyptian tradition, for the rejection of the old gods and more particularly of the accepted notion of the after-life implied a reappraisal of the basic concept of artistic representation (see EGYPTIAN ART). Descriptive re-creation was no longer vital, and the generalized expression of objective verity was thus abandoned for verisimilitude and the more immediate truth of visual perception. But the new 'REALISM', which accentuated trends already present in the art of previous reigns, was in itself conventional—as in the gross distortion of the royal anatomy—and it was only in the later years that MANNERISM became less extreme.

In mural decoration compositions were no longer bounded by a single surface, and painting especially might be continuous on adjacent walls. Scenes were more often localized with background details, and as well as 'registers' effective use was made of 'cavalier perspective' (the ground mounting to a high horizon as it might appear to someone on horseback or upon a hill). Traditional subjects were avoided and even in private tombs prominence was given to the king and the royal family. In palace apartments and elsewhere themes from nature were depicted with great liveliness and sympathy, and intimate vignettes of royal domestic life were for the first time

represented. Within a scene the various elements were often closely linked both physically and psychologically, sometimes to an exaggerated degree, and figures were more naturally posed, with some attempt to express emotion and individuality. Profile was used more frequently and feet and hands were often properly paired, but certain conventions such as the drawing of the eye remained unchanged and the effect was never altogether lifelike. In general there was greater play with sloping lines and curves and a marked interest in drapery and streamers, which together gave a curiously feminine allure.

In statuary the change was not so marked save in the treatment of the human body, where the same effeminate royal type was reproduced though usually with more restraint. Poses were again less rigid, as is clear from fragments of adventurous sculpture, and figures were composed also of separate elements worked in appropriately coloured stones and even in FAIENCE and glass. It was for such that many of the extant portrait heads were made, while others, including the famous painted head of Nefertiti and the many lifelike plaster masks, were evidently sculptors' studies to be used as models.

The new approach to art, in some degree inspired by the king himself, could not as such survive his death and the return to orthodox religious ideology, but certain features had a lasting influence on work of later periods.

2051.

31

**AMATEUR.** The idea of the amateur artist was foreign to the outlook of classical antiquity. The fine arts were not distinguished from the manual crafts and were therefore considered unsuitable occupations for a free-born citizen—a prejudice which persisted through the Middle Ages. Aristotle (*Politics* viii. 2) allowed that the enjoyment of music is a self-rewarding activity, and that besides being useful as a relaxation and a good moral influence it is a fit occupation for the leisure hours of a gentleman. He even agreed that musical performance should form part of the curriculum for children because it increases the capacity for appreciation, but on condition that they should cease performance when they get older. For 'professional musicians we speak of as vulgar people, and indeed we think it not manly to perform music except when drunk or for fun'. He also approved the custom of including drawing in the educational curriculum both because it is useful in daily life (helping a man to avoid being cheated when buying or selling household goods) and even more because it makes one observant of bodily beauty. But there is nowhere any suggestion that he had conceived the idea of an amateur artist practising painting for pleasure or for self-expression. The social position of prominent artists improved under Alexander the Great, but the assumption of inferiority persisted through Roman times. Seneca is reported to have said: 'We offer prayers and sacrifices before the statues of the gods, but we despise the sculptors who make them.' And Plutarch remarked: 'No generous youth, when contemplating the Zeus of Olympia or the Hera of Argos, will desire to become a PHIDIAS or a POLYCLITUS.'

In China the opposite attitude was general. Painting was looked upon as the highest mode of cultivating and expressing a man's personality and therefore an approved occupation for a gentleman and scholar. Roger Goepper sums this up when he says in *The Essence of Chinese Painting* that the Chinese painter 'is—or claims to be—primarily a member of the socially privileged class of educated men, and practises the arts—since he is generally not only a painter but also a poet, a calligrapher and perhaps also a musician—outside his true professional activity for his own pleasure: on the one hand as a means of cultivating his being, which he thereby brings into unison with the forces of nature, but on the other as pure self-expression, as a kind of aesthetic game by means of which he communicates something of his own being to a circle of initiates, an intellectual *élite*'. The painter-emperor Hui-tsung (r. 1101-26) organized contests among painters occupying official positions at his Court Academy and himself acted as judge.

During the Middle Ages in Europe painting and sculpture, though not music and poetry, were still regarded as 'mechanical' and therefore socially disreputable arts. The doctrinal basis of the distinction is set forth in St. Thomas Aquinas's commentary on Aristotle's *De Anima* i. 1. 204ª, where he discriminates the practical sciences, which are useful for a purpose and therefore good and praiseworthy, from the speculative sciences, which carry their purpose in themselves and are therefore good and honourable. The change in the social status of the arts came with the RENAISSANCE. The key work is LEONARDO's *Trattato della Pittura*, which did for painting what the impassioned writing of Giovanni d'Arezzo had done for medicine in a similar predicament. The emphasis which Leonardo and his contemporaries placed upon the intellectual and scientific aspects of painting looks back to Aquinas's distinction between the practical and theoretical sciences and was connected with the social struggle of the plastic arts to rise from the lowly status of a manual trade to the dignity of a liberal exercise of the spirit.

It was this change which made possible for the first time in Europe the idea of the amateur artist. Baldassare Castiglione wrote in *The Courtier*, i. 52 (1528), which was translated into English in 1561 and had a considerable influence on Wyatt, Spenser, and Sidney: '... those who ... so delight in contemplating a woman's beauty that they seem to be in paradise and yet cannot paint, which if they could do, they would have much pleasure, because they would more perfectly appreciate that beauty which engenders such satisfaction in their hearts.' Although this is a straight paraphrase of Aristotle's reason for including drawing in the educational curriculum, it reflects the new spirit which had come to regard painting as a suitable occupation for a man of cultivated refinement. Even princes began to submit to the lure of the arts not only as patrons but as practising amateurs. In the 15th c. René d'Anjou gave up his dukedom to devote himself to painting and landscape gardening. Prince RUPERT explored the newly discovered medium of MEZZOTINT engraving. The Earl of BURLINGTON (1694-1753), besides being one of the most prominent VIRTUOSI of his time, was an amateur architect of some standing, having to his credit the Assembly Rooms in York (1732) and his own villa at Chiswick (built in the 1720s). The first amateur painter in England, and the most important artist of his time, was Nathaniel BACON. With the development of water-colour in the 18th and 19th centuries—the amateur medium *par excellence*—amateur painters proliferated all over Europe. They included eminent men such as GOETHE and statesmen began to advocate painting as a means of relaxation—'a joy-ride in a paint-box' as Sir Winston Churchill expressed it. At the other extreme sketching and water-colour became accepted 'accomplishments' for the prototypes of the elegant young ladies depicted in Jane Austen's novels.

Local drawing and painting societies had received parliamentary recognition before the end of the 19th c. and increased steadily in numbers during the first half of the 20th c.

Although the phrase 'Sunday afternoon painter' has become a term of opprobrium, amateurs bulked largely in the recognized associations such as the LONDON GROUP and the National Association. Amateurs even invaded the once jealously guarded exhibitions of the ROYAL ACADEMY and, finally, the dubious economic status of the many professional artists who are not in regular employment has tended to obscure any sharp distinction between professional and amateur.

An equivalent term 'dilettante' became current in England after the foundation of the Society of DILETTANTI in 1733-4, at a time when 'amateur' had not yet been adopted and 'virtuoso' had already acquired a professional meaning. The dilettante interests himself in the arts for 'delight' as the amateur does for 'love'. Both words are apt to imply a lack of serious aim or study, but there are amateurs who cannot be regarded as dilettanti. In this category are some of the 'Sunday afternoon painters', who first appeared in France in the late 19th c. In general these were painters who without formal training exercised a natural talent and depicted either their idiosyncratic vision (e.g. Henri ROUSSEAU), or the simple everyday things and events around them (e.g. Louis Vivin, 1861-1936). To this category belongs the venerable 'Grandma' MOSES, who took her native America by storm with scenes of remembered childhood set down on canvas with naïve but evident sincerity. From earlier times the so-called PRIMITIVES have become a regular stock-in-trade of art dealers and antiquarians.

The word 'amateur' was also used as early as 1784 for a person who had a taste for any art or craft. About 1803 it developed the specialized meaning of a person who cultivates any pursuit purely as a pastime, and in the field of sport this meaning has become formalized into the distinction between amateur and professional. But the phrase 'amateur of the arts' is still current in the sense of a person who cultivates several of the arts as a CONNOISSEUR and neither for gain nor as an executant.

**AMBER.** A fossil resin derived from various trees and found mainly on the southern shores of the Baltic. In painting amber is used as an ingredient of some oil VARNISHES. As it is a hard resin difficult to dissolve, it is not suitable for varnishing modern pictures painted with linseed oil and turpentine, since cracks may be caused by rapid hardening over the comparatively soft layers of pigment underneath. It also turns yellow and brown, becoming cloudy with time, and can only be removed by the strongest solvents.

**AMBERGER,** CHRISTOPH (d. 1562). German portrait painter. He worked in Augsburg, a town which had many cultural and economic ties with Italy. It is therefore not surprising that he emulated the grand manner of the VENETIAN SCHOOL, paying as much attention to rich effects of dress and jewellery as to psychological subtlety. His *Charles V* (Berlin) is typical of his portrait manner. His rare figure compositions (altarpiece, Augsburg Cathedral) display an uneasy mixture of late GOTHIC and TITIAN.

**AMBO.** Term in Christian church architecture for one of two stone reading-desks or pulpits facing each other on either side of the choir enclosure in Early Christian churches. That on the north side served for reading the Epistle, that on the south for the Gospel, during Mass.

**8.** Choir enclosure with ambos, showing also 12th-c. cosmati work. (Church of S. Clemente, Rome)

**AMBULATORY.** An extension of the aisles of the choir around the APSE in a Christian church, often giving access to subordinate chapels. The increasing number of pilgrims from the 7th c. onwards desirous of visiting the tombs of saints and reliquaries put an intolerable strain on the narrow access corridors under the pavement of the apse and led to a constructional problem whose solution was found in the ambulatory with radiating chapels. This solution was first achieved in the reconstruction of the church of S. Martin at Tours (dedicated A.D. 618), and

**Fig. 2.** Plan of ambulatory, church of S. Martin of Tours, according to excavations carried out 1860–87. After *L'Architecture religieuse en France à l'époque romane* (1912), R. de Lasteyrie

became the basis of further development in ROMANESQUE and GOTHIC church architecture. The ambulatory and radiating chapels became an exterior adjunct to the apse and new aesthetic effects of space became possible by piercing the rounded apse wall with arches and thus uniting the apse visually with the ambulatory and apsidioles. In France the ambulatory is usually semicircular with radiating chapels disposed stepwise or in echelon. In certain 12th- and 13th-c. English churches it is rectangular and the chapels are parallel to the main axis of the church.

**AMERICAN ART OF THE UNITED STATES.** The story of American art is part of the larger story of the transplantation of European civilization and cultural traditions to the New World in the 16th and 17th centuries, how they took root there and how very gradually distinct national characteristics evolved in the new nations which came into being there. Distinctive artistic styles appeared sooner in Spanish America, where the contributions made by the indigenous cultural traditions were stronger. In the U.S.A. cultural dependence, though never complete, persisted long after political separation at the Revolution (1775–83). During and after the colonial period the changing art forms of Europe—BAROQUE, ROCOCO, NEO-CLASSICISM— were reflected in a more provincial milieu with as yet no native inheritance of craftsmanship or traditions of training. The first tentative academies and exhibitions made their appearance in the early 19th c.; serious art schools were not established until the 1870s. Dealing and collect-

ing began later and it was only in the 20th c. that public and private collections of the world's finest art products became available in the New World. Over the greater part of its history, therefore, the art of the U.S.A. was not a highly schooled art and it was deeply affected by the lack of an indigenous craft tradition. It was not until the 20th c. that the U.S.A. achieved independence in the field of art, taking the lead first in the mass media of cinema and jazz music. Somewhat later in the century important new advances were made in architecture, though perhaps too much under the guidance of European expatriates, and only after the Second World War autonomous developments in painting made an impact on the artistic centres of Europe.

U.S. artists have been divided between those who have immersed themselves wholly in the European milieu and those who have sought an independent path. European histories of U.S. art have usually concentrated upon the gifted cosmopolitans, often expatriate artists, such as Benjamin WEST, WHISTLER, SARGENT, Mary CASSATT, limiting their sympathies to what they had learned to understand in the European tradition and interpreting the rest as an inferior and provincial reflection of it. There has, however, been a stream of solitaries and individualists, such as Thomas EAKINS, Albert RYDER, and Winslow HOMER, who without founding indigenous schools have deliberately chosen to go their own way in searching for an interpretation of the American background. In addition to these two types U.S. art has owed an unusually large debt to untrained professionals such as Robert FEKE, Charles Willson PEALE, Chester Harding (1792–1866), and George Caleb BINGHAM, who although artists by vocation lacked for one reason or another the orthodox training in artistic techniques and traditions. There has been a tendency among Americans, in reaction from the bias of European histories, to over-emphasize the importance of the naïve and primitive in U.S. art as if it were in this chiefly that a distinctively American spirit was manifest.

1. PAINTING. Painting first came to America as a craft, serving practical purposes in the hands of missionaries, explorers, topographers, and naturalists. Though they neither aspired to nor achieved great art, many of these early artists were competent craftsmen trained in European studio tradition and adequately skilled in the practice of their profession. Others were gifted amateurs at a time when, before the usurpation of the camera, competence with the pencil was more general than it is today. Among the early artist-naturalists mention should be made of John White (active 1584–93), governor of Raleigh's colony of Virginia in 1587 and 1590, whose album of 65 water-colour illustrations is preserved in the British Museum. Another is Mark Catesby (1679?–1749), whose *The Natural History of Carolina, Florida and the Bahama Islands* (1731) was illustrated by him with 100 engravings of American birds. Whereas in

34

Spanish America religious painting was the earliest to be established, the Dutch and English settlers of North America were first interested in portraiture as a reflection of family feeling and personal pride. The earliest professional European artist to settle in what is now United States territory was Hendrick Couturier, trained at Leiden, who emigrated to the New World c. 1661, almost exactly a century before Benjamin West, the first American painter of international reputation, sailed for Europe.

During the early decades of the 18th c. the more vigorous and settled commercial life of the colony attracted not only a new architecture, adapting English PALLADIAN models, and skilled craftsmen, but also trained European artists. These were not the most distinguished or original artists of their day but at the best competent exponents of the late Baroque style which had become a somewhat dull and unimaginative international idiom for the second-rate European artist. It was unfortunate but inevitable that this uninspired introduction to the European tradition formed the basis on which the first generation of native American artists had to build. Owing to force of circumstance the first migrant painters to establish themselves in the U.S.A. had an importance in the development of native art in excess of their intrinsic merits as painters. The Swede Gustavus Hesselius (1682-1755), a cousin of Emanuel Swedenborg, painting in the manner of the Italianate Dutch masters of the late 17th c., established in Philadelphia a tradition of scientific realism, mechanical ingenuity, and a certain interest in mythological and ideal narrative subjects. Peter Pelham, who became the stepfather of COPLEY, settled in Boston in 1726 and introduced the MEZZOTINT, upon which so much of the knowledge of English art was based for the next 150 years or so. The Scot John SMIBERT was a no more than competent practitioner of the KNELLER portrait formula who developed towards a plainer and blunter realism after settling in the States at the age of 41. At the same time there were certain anonymous native painters in the Dutch settlements of the Hudson producing a naïve or 'PRIMITIVE' type of folk art and some of the first untrained professional artists, such as Robert Feke, made their appearance. This was the foundation from which the founders of U.S. art, such as Benjamin West and John Singleton Copley, both born in 1738, began.

In the 200 years of their existence two contrasting tendencies have been manifested by U.S. artists, both those who immersed themselves most fully in the European tradition and those who stood deliberately aloof from it. On the one hand, and perhaps most characteristic, a blunt, vividly colloquial realism, the distinguishing quality of the early portraiture of artists otherwise so different in their aims as William Sidney Mount (1807-68), whose simple and unsentimental GENRE owed nothing to foreign study, John Frederick PETO, George Caleb Bingham, Thomas Eakins, Winslow Homer, and the

'Ash-can' realism of the EIGHT. Compared with European naturalistic painting the work of these artists sometimes appears brusque, lacking in refinement, or even awkward; but different as they are, one may detect a common element of uncomplicated and anxious searching for significant actuality. The other current is an imaginative, poetic, sometimes visionary quietism, a subjective painting of mood. Its origins may perhaps be traced to certain pictures by West which are regarded as precursors of the ROMANTIC movement and it continues strongly in the landscape of INNESS, Homer D. Martin (1836-97), Frederick E. Church (1826-1900), Washington ALLSTON, Arthur B. Davies (1862-1928), William Morris Hunt (1824-79), John La Farge (1835-1910), George Fuller (1822-84), and Albert RYDER. The poetic and subjective trend was not inconsistent with naturalism, as for example in the work of La Farge and Hunt. There is, too, an element of visionary mysticism in many of the artists who preferred to find their personal interpretation of the American scene rather than abandon themselves to the preoccupations of European schools. Ryder, through his imaginary world with its lonely, disembodied visions, has given in painting the pictorial equivalent of the writings of Poe and Melville. Homer and Eakins, with their attachment to hard fact, their inclination for documentary observation, and their sympathetic psychological insight, have caught that racy, idiomatic, native quality which is apparent in the writings of Mark Twain.

The long influence of Benjamin West on U.S. painting was established not only by the great international reputation which he achieved in his day but through the centre which he created for young American painters in London. West's first pupil was a relation of his wife's, the stolid, pedestrian Matthew Pratt (1735-1805), who after a sojourn in England returned to paint in and around Philadelphia. Pratt was followed by the much abler artist Charles Willson PEALE, several of whose children also became painters. Another of West's pupils, William Dunlap (1766-1839), has left the earliest history of North American painting, *The History of the Arts of Design in America* (1854). From this book we can follow the careers of the other Americans who gathered around West. These included Copley himself and Gilbert STUART, the leading portrait painters of their time, John Trumbull (1756-1843), a painter of the early Republic and the men who made it, Ralph EARL, the portraitist of the Connecticut squirearchy, Washington Allston, the founder of American Romanticism, John Vanderlyn (1775-1852), who went to Paris and caused DAVID to ask why the best English painters were all Americans, and the two artists who rank among America's greatest scientists, Robert Fulton (1765-1815) and Samuel F. B. Morse (1791-1872), inventors respectively of the steamboat and the telegraph. West's dominant personality affected even Thomas SULLY, thus covering more than a century of American art.

35

A new generation, however, felt with Emerson: 'Our day of dependence, our long apprenticeship to the learning of other lands, draws to a close.' Typical of artists educated in America rather than in Europe were Chester Harding (1792–1866) and John Neagle (1796–1865). Harding, who began as a house painter and then advanced to signboards, became finally the portraitist of statesmen such as Webster, Clay, Calhoun, and Marshall, of explorers such as Daniel Boone, and of the great merchant princes such as Amos Lawrence. John Neagle caught in his sitters' faces that look of self-confidence which marked the coming age. His painting *Pat Lyon at his Forge* (Mus. of Fine Arts, Boston, 1826) is a portrait of a new class of self-made men who were to transform the American continent. The all-pervasive optimism and self-reliance of these men found expression in Walt Whitman's poetry. He commanded the Muse to migrate to America: 'For know a better, fresher, busier sphere, a wide, untried domain awaits, demands you.' National pride developed a national outlook, and painters groped for a way of interpreting their vast continent, so different from the Old World. This spirit expressed itself in a new attitude to landscape. The Hudson River School, led by Thomas Doughty (1793–1856), Asher Brown Durand (1796–1886), Thomas COLE, and John F. Kensett (1818–72), depicted the scenery of that valley and the more picturesque sections of the eastern states. Their timid brush-strokes recorded the primeval wilderness of the New World as though their thin, dry delineation of each branch, each leaf, offered security against the overwhelming vastness of the sparsely settled continent. Other artists, Albert Bierstadt (1830–1902), Frederick E. Church, and Thomas Moran (1837–1926), painted principally the country west of the Mississippi. Their large panoramas of stupendous mountains and endless plains were often as featureless and empty as many of the canvases of the Hudson River School were niggling and cluttered. There were many painters and illustrators of the Wild West, including scenes from the life of the Indians, such as George Catlin (1796–1872), Seth Eastman (1808–75), Alfred J. Miller (1810–74), and Frederick Remington. Though Walt Whitman had called for 'landscapes projected, masculine, full-sized and golden', George Inness was the first artist of his generation to possess the ability to make his landscapes at once descriptive and interpretative.

With the rise of national consciousness painting of the American scene became popular. John Quidor (1801–81) interpreted what were to become American legends as he found them in the writings of Washington Irving and Fenimore Cooper. His canvases suggest melodramas acted out by a provincial stock company. Regional painting also came into fashion. *The Old Kentucky Home* (1859) has left an unforgettable picture of the South before the Civil War, though the painter Eastman Johnson (1824–1906) was a Yankee from Maine. The Eastern scenes by William Sidney Mount, such as *Long Island Farmhouse* (after 1854), are as American as pumpkin pie. George Caleb Bingham portrayed typical aspects of frontier life, such as a farmers' shooting match, raftsmen playing cards, and election day scenes. There were many other interpreters of the American scene in the 19th c., among the best being Richard Caton Woodville (1825–55) and David G. Blythe (1815–65), but none attained the position of Quidor, Johnson, or Mount.

STILL LIFE painting also flourished. The American interest in visual realism encouraged painters to risk what Roger FRY has called 'the acid test of disinterested and contemplative vision'. Peale and his numerous offspring began the fashion of painting bowls of fruit. Occasionally they undertook more ambitious subjects. Of these Raphael Peale's remarkable canvas entitled *After the Bath* (William Rockhill Nelson Gal., Kansas City, 1823) is the best known. This meticulous realism reached a climax in the work of William Michael HARNETT, whose canvases rival in accuracy the Dutch still life paintings of the 17th c. Artist-naturalists, such as John James AUDUBON, continued working through the 19th c.

The early 19th c. was also the great period of the American primitive. Mostly painted by itinerant and anonymous artists, these folk paintings are simple, mannered, but often ingeniously designed. The portraits with their characteristically exaggerated eyes often suggest FAIYUMIC portraiture. Landscape and figure subjects were also popular, and sometimes a surprisingly sophisticated mood is suggested. At their best these paintings have the crude vigour and uncomplicated outlook of a young people. Painters such as Edward Hicks (1780–1849), a Quaker who painted numerous versions of *The Peaceable Kingdom*, and Erastus Salisbury Field (1805–1900) reflected ideals of brotherhood in their works. The tradition of the primitives has continued into the 20th c. with artists such as Grandma MOSES.

The last quarter of the 19th c. was marked by an ascendancy of the cosmopolitan trend and the century closed with the quietist and unadventurous IMPRESSIONISM of the TEN. In the third quarter of the 19th c. painting had been a popular and flourishing craft which thrived from one end of the States to the other; by the end of the century it had lost touch with popular taste and no longer afforded a livelihood to many. The first decade of the 20th c. saw academicism firmly entrenched and an intolerant exploitation of derivative and artificial pastiche. Academy exhibitions were dominated by conservative nonentities frankly hostile to creative talent. In the absence of commercial galleries there was no avenue by which young and non-conforming artists could reach the public. It is against this background of smug and complacent debility in the world of official art that one must assess the importance of the photographer, dealer, and propagandist Alfred Stieglitz, who in 1905

opened in New York the 'Photo-Secession Gallery' or 'Gallery 291' at which he showed works by MATISSE, PICASSO, and the POST-IMPRESSIONISTS and which served as a rallying point for independent artists such as John MARIN, Marsden Hartley (1877-1943), Max WEBER, Arthur DOVE, Georgia O'KEEFFE, and Charles DEMUTH. Though his methods and personality were different, the influence of Stieglitz for the transformation of American taste at the beginning of the century was akin to that of Roger Fry in the United Kingdom. In Paris in 1913 Stanton Macdonald-Wright (1890-    ) and Morgan Russell (1886-1953) founded the movement SYNCHROMISM, based on pure colour abstraction.

The other dominating personality of the decade was Robert HENRI, who has become something of a legendary figure for his pioneering crusade against academic isolationism and his unceasing endeavour to bring art back into touch with the living society of the day. He was the inspiration for the formation of the Eight, whose exhibition in 1908, long remembered, became a landmark for the impact which it made. Henri too provided the impetus for a new school of realism which came to be known as the 'Ash-can School', the counterpart of Theodore Dreiser, Floyd Dell, and Sherwood Anderson in literature. It included such painters and illustrators as George B. LUKS, William J. GLACKENS, John SLOAN, who is considered the most typically American of the school, Everett Shinn (1876-1953), and Jerome Myers (1876-1940). George BELLOWS, also influenced by Henri, won popular success from the start with his early *42 Kids* (Corcoran Gal. of Art, 1907) and was accepted as a typical expression of his time for his gusto, his crude vitality, his normality, and his brash search for the monumental in the realm of the commonplace.

In 1910 Henri and his circle organized the Independent Artists exhibition at which 27 artists were represented by 63 works, each artist submitting works of his own selection. This was the forerunner of the Society of Independent Artists, formed in 1917. It was also a precursor of the ARMORY SHOW of 1913, a mammoth exhibition designed to present a comprehensive impression of current artistic movements abroad and the most vital in contemporary United States art. The Association of American Painters and Sculptors was launched in order to organize the show and its breadth of vision owed much to Arthur B. Davies as president. The foreign section was more radical and comprehensive than the London Grafton Gallery exhibitions of Post-Impressionism in 1911 and 1912, although neither German EXPRESSIONISM nor Italian FUTURISM was adequately represented. The importance of the Armory Show in the development of 20th-c. U.S. art may be gauged from the fact that it has come to be taken as a matter of course that 'modern art' in the U.S.A. should be dated from the Armory Show. Yet this is a mis-interpretation of its significance. The show produced a certain amount of derivative CUBISM and FAUVISM, a certain amount of Neo-Primitivism; but the most original directions taken by U.S. art in the 1920s and 1930s owed more to artists who were already finding their way before the Armory Show. The purpose of the organizers was to launch an attack on the complacency and intolerance of the Academies and to bring creative art to the notice of the American public. The importance of the show lay not so much in any direct influence it had on American artists and certainly not in the immediate conversion of the artistic establishment but in the enormous impact it made on public interest. From that time new art was a living issue in the U.S.A.

During the 1920s many artists abandoned their earlier experiments with abstraction, such as Marsden Hartley, Max Weber, Macdonald-Wright. Of those who were trying to assimilate CUBISM into their personal styles, perhaps the most successful were the Precisionists or Immaculates, such as Charles Sheeler (1883-    ) and Charles Demuth, who painted industrial scenes, including factories and granaries, transforming the structures into hard-edged forms on the borderline of abstraction. Stuart DAVIS adapted the Cubist technique to works symbolic of the American scene, painted in bright colours and heavily outlined. His subjects capture the dynamism of modern urban life—jazz, advertising, electricity. John Sloan, Yasuo Kuniyoshi (1893-1953), and Edward HOPPER painted scenes of American life through the 1920s. During the 1930s the number of artists interested in social documentation increased to include urban realists such as Reginald Marsh (1898-1954) and Raphael Soyer, and the Regionalists such as Thomas Hart Benton (1889-    ), Grant WOOD, James S. Curry, and by association Charles BURCHFIELD. The latter painted rural scenes of midwest prairies, farmlands, and plantations. Other realistic trends during the 1930s included the propagandist social realism of Ben SHAHN and Philip Evergood (1901-    ); and the bizarre Surrealistic paintings of Ivan L. ALBRIGHT, Peter Blume (1906-    ), and Edwin Dickinson (1891-    ), which led, in the 1950s, to the so-called 'magic realism' of Andrew Wyeth (1917-    ). Morris Graves (1910-    ) and Mark TOBEY, both from the Pacific Northwest, became interested in Oriental calligraphy and incorporated it into their mystical, contemplative works. During the 1930s there was also a continued interest in abstraction, especially the geometric abstraction of European movements such as De STIJL and CONSTRUCTIVISM; but this trend did not receive much attention until the late 1930s and early 40s.

A change in the official attitude to the art of the younger men is indicated by the PUBLIC WORKS OF ART PROJECT of 1933, organized by the Federal Government under the relief administration with the double purpose of providing occupation

for artists who were unemployed as a result of the depression and to provide works of art for the decoration of public buildings. In 1935 the relief programme was reorganized as a Federal Arts Project within the Works Progress Administration and a new section of Fine Arts was set up within the Treasury Department. At the same time a major project of historical research was inaugurated under the title The INDEX OF AMERICAN DESIGN.

During the Second World War many European artists came to the U.S.A. Among these were the SURREALISTS, MIRÓ, DALI, TANGUY, ERNST, MATTA, MASSON, and others such as GROSZ, OZENFANT, LEGER, and MONDRIAN. Through contact with these artists Americans were influenced by the latest European movements, especially Surrealism. U.S. artists who began moving toward abstraction included Arshile Gorky (1904-48), Willem DE KOONING, Jackson POLLOCK, Mark ROTHKO, Robert MOTHERWELL, Adolph Gottlieb, Clyfford Still, and Barnett Newman. Since the early 1930s Hans Hofmann was important as a teacher of abstract painting in New York. In 1946 the term ABSTRACT EXPRESSIONISM was applied to the work of these artists. During the late 1940s they moved toward complete abstraction, such as the 'drip paintings' of Pollock and the 'black and white' paintings of de Kooning. In the early 1950s, as more painters joined the movement, distinctions could be made among them: those for whom the gesture of painting and the dynamic expressionism of the paint were most important (Pollock, de Kooning, Franz KLINE) and those who concentrated on calmer compositions of large colour fields (Rothko, Newman, Gottlieb, Still). American art has taken many directions since Abstract Expressionism. During the middle 1950s and early 1960s Jasper JOHNS and Robert RAUSCHENBERG used common objects either as actual subjects (Johns's paintings of flags, targets, numbers) or as insets (Rauschenberg's 'combines'), with expressive handling of the paint. Both these artists were highly influential especially with the POP ARTISTS such as Andy WARHOL, Roy LICHTENSTEIN, Tom Wesselmann, Jim Dine, James Rosenquist, and others whose subjects were taken from the everyday environment and the commercial world of contemporary America. Another movement of the 1960s was 'post-painterly abstraction'. This includes hard-edge painters such as Ellsworth Kelly (1923- ) and Al Held (1928- ), whose styles can be related to earlier artists such as Josef Albers (1888- ) who painted numerous *Hommages to the Square* and Ad Reinhardt (1913-67). Artists who have worked with the staining technique include Helen Frankenthaler (1928- ), Morris Louis (1912-62), and Kenneth Noland (1924- ). Frank Stella's (1936- ) work includes paintings of banded forms deriving from the shape of the canvas. OP ART, another recent movement to which Americans have contributed as varied styles as those of Larry Poons (1937- ) and

Richard Anuszkiewicz (1930- ), also had its vogue in the U.S.A.

2. ARCHITECTURE. The history of U.S. architecture presents a complex and sometimes contradictory picture with a strange pattern of opposed ideals, a continual seesaw between sentiment and practicality, between slavish imitation and bold experimentation. The colonial period reflects most conspicuously the national origins of the various colonies in direct adaptations of their several European prototypes. (See COLONIAL ARCHITECTURE IN NORTH AMERICA.) In the south-west the luxuriant Spanish Baroque was simplified by Indian craftsmen into a primitive but colourful style. At the same time the streets of New Amsterdam were lined with the neat stepped-gabled brick façades of Holland, while along the Hudson River the Dutch built long narrow farm-houses with sweeping roofs and clapboard gables. There were other national variants, but the real groundwork for the later development of American architecture is to be found in the English colonies. Their architecture can be divided into two major periods, Early Colonial (1609-c. 1700) and Late Colonial (c. 1700-80). In addition broad regional distinctions can be made between New England and the South.

During the Early Colonial period the architecture of both areas was basically Tudor. Nevertheless several important differences are apparent. The economic and social unit of the South was the plantation with its mansion and sprawling dependencies; in New England it was the small and closely knit community. As a result the domestic architecture of the South tended to emulate the smaller town and country houses of England. Bacon's Castle (Surry County, Virginia, c. 1655) is a brick structure in the Tudor GOTHIC style with Flemish gables, grouped chimneys, and a cross-plan. By contrast domestic buildings in New England were identical in many respects with the small rural houses of southeastern England. Irregular in plan and outline, constructed almost entirely of wood, they were generally built in stages over a period of time. The Whipple House (Ipswich, Massachusetts, c. 1639) is one of the finest and best preserved— a typical 'salt-box' house with its steep-pitched roof, overhanging second storey, and its lean-to addition at the rear.

In Virginia, where adherence to the Anglican Church was made mandatory by the colonial charter, the churches followed closely the small English parish churches of the late medieval period. The Newport Parish Church, Isle of Wight County, Virginia (1682), is a simple brick structure with wall buttresses, stepped gable, pointed-arch windows, and Gothic tracery. In New England the Puritan prejudice against material display led to a rejection of Gothic forms. In place of the parish church the New Englanders developed the meeting-house. This, the most original building type of the period, was a simple barn-like structure, serving both civic

and religious functions. The Old Ship Meeting-House, Hingham, Massachusetts (1681), is the only surviving example from the 17th c. Almost square rather than oblong, it reverses the traditional plan of the parish church by having the pulpit and entrance facing each other on the long sides.

In 1669 the capital of the Virginia colony was moved from Jamestown to Williamsburg. The new town, one of the earliest planned communities in America, was laid out on a simple grid with two main thoroughfares forming the major and minor axes. By 1725 it contained a considerable number of splendid new buildings including the College of William and Mary (1695-1702), the Capitol (1701-5), the Governor's Palace (1706-20), and Bruton Parish Church (1710-15; spire 1769). All exhibit the classic equipoise and decorative richness of the English Baroque of Christopher WREN. There is reason to believe that at least one, the College, was built to a design sent over by Wren himself. The Bruton Parish Church was obviously inspired by the Wren churches of London.

The magnificent mansions of the Virginia tidewater drew their inspiration from Williamsburg. Perhaps the finest is Westover in Charles City County (c. 1730-4), built by William Byrd II. Once the centre of a plantation comprising more than 200 square miles, it is a supreme expression of the aristocratic society of the South during the 18th c. Westover is both simple and refined. It is a symmetrical brick structure two storeys high with a level modillioned cornice and a high hipped roof. At the centre of each long façade is a richly ornamented door of PORTLAND STONE comparable to many found on late 17th-c. houses in England. The plan, however, is not symmetrical and the interior is panelled from floor to ceiling.

The last quarter of the 17th c. saw a marked change in the economic and social character of New England. A new aristocracy of sea-captains and merchants dominated the coastal cities. Ambitious and wealthy, these men showed less restraint than their Puritan forebears and sought a more elegant mode of architectural expression. Thus, like the Virginia planters, they turned to the architecture of the Restoration, emulating the town houses of England to the extent that local conditions permitted. The McPhaedris-Warner House, Portsmouth, New Hampshire (1718-23), with its double parapeted chimneys, is typical. Made of brick, it has a high double-pitched roof crowned by a balustrade and emphasizes the vertical more than the Virginia mansions do. This is even more true of the three-storey Usher Royal House, Medford, Massachusetts (1733-7). In this case, however, both façades are of wood, one of them made to simulate rustic masonry. This imitative use of materials was common to many 18th-c. colonial houses, especially in New England.

After 1740 colonial architecture became increasingly formal. The loose planning current during the early part of the century gave way to a stricter symmetry and ornamental features were treated in a more classical manner. In the work of Peter HARRISON English PALLADIANISM was brought to the American shores in its purest form. In the South also Palladian tendencies can be seen in a few of the later colonial mansions such as Shirley, Charles City County, Virginia (1769), and Brandon, Prince George County, Virginia (1765; see JEFFERSON). These works, however, were exceptional and in general the strict Palladian ideals of Lord BURLINGTON found little favour in the colonies. The vast majority of the buildings remained more or less in the style of the Restoration. The Wentworth-Gardner House, Portsmouth, N.H. (1760), is late colonialized Wren at its best.

The tenacity of the Wren style can be explained by several facts. By mid century the lines of architectural descent from England had become partially blurred and many colonials were beginning to consider the style as part of their own building tradition. This point of view, however provincial, formed the basis of a nascent desire for architectural independence. When combined with the natural conservatism of the affluent colonial it presented a considerable barrier to change. More important, however, was the influence of the architectural publications of James GIBBS. As an architect Gibbs had remained apart from the Palladianism of his day and in many aspects of his work he adhered to the older ideals of Wren. This attitude was reflected in his books as well as his buildings. Gibbs's books were widely circulated in the colonies and became the principal source for craftsman and amateur architect alike. For example, at Mount Airy, Richmond County, Virginia (1758-62), the architect John Ariss took both the rusticated façade and the formal plan from Gibbs's *Book of Architecture* (1728), while in New England Joseph Brown used the same source for the steeple of the First Baptist Meeting-House, Providence, R.I. (1775). It is buildings of this character that might appropriately be called 'colonial GEORGIAN'.

After the Revolution two significant developments can be observed. The first was the final breakdown of the Wren–Gibbs tradition under the impact of NEO-CLASSICISM; the second was the emergence of historicism, or the taste for a revival of the past, which was to dominate U.S. architecture for more than a century.

Neo-Classicism came to the U.S.A. during the last decade of the 18th c. Known as the FEDERAL STYLE, it was based primarily upon the Neo-Classicism of England. In addition, however, a French influence can be discerned, for a pro-French sentiment followed the Revolution and there were in the U.S.A. a number of French architects and engineers. Although nation-wide, the Federal Style achieved its greatest distinction in New England under the leadership of Samuel McINTIRE and Charles BULFINCH. Also identified with Neo-Classicism, and yet standing apart from

it, is the architecture of Thomas Jefferson, the statesman. Because of his antagonism toward the British, Jefferson rejected the Georgian tradition and turned instead to more strictly classical sources. Part of his inspiration came directly from PALLADIO, part from French Neo-Classicism. But his most important source was the architecture of ancient Rome. To him, as a nationalist, it seemed a mode of building which properly symbolized the ideals of the new republic. But Jefferson was also a historian, and by applying to architecture the precepts of history he became the first American revivalist.

Historicism, which began in the U.S.A. with Jefferson, became a national cult with the GREEK REVIVAL. The Greek style was brought into the United States in 1798 by a young English-trained architect, Benjamin LATROBE. Under his leadership and in the hands of an enthusiastic group of young American-born architects (MILLS, STRICKLAND, TOWN) building in the Greek style reached standards hitherto unknown in America. With few exceptions, however, there was little to distinguish the work of these men from Greek Revival architecture in Europe. On the other hand, the style permeated to humbler levels in America than anywhere in Europe. Coinciding with a period of ardent nationalism and rapid expansion westwards, it was carried into the newly settled areas through numerous handbooks, most of them published in America itself. As a result the Greek idiom appeared in every type of building from the greatest to the least and in as many forms as there were carpenter-builders to interpret the books.

The impulse behind the Greek Revival was Romantic, a nostalgic effort to recapture the past. But the full impact of ROMANTICISM was not felt in the U.S.A. until the revival of the Gothic (see GOTHIC REVIVAL IN NORTH AMERICA) and ITALIAN VILLA styles. Appearing in the second quarter of the 19th c., these styles had their origins in English architecture and architectural literature of 30 years earlier. Their appeal lay in their colourful irregularity. As in England, the Romantic designer stressed visual rather than structural values. The objective of the architect, who called himself 'architectural composer', was to achieve a PICTURESQUE effect.

Not all Americans were happy about the anti-structural attitude of the Romantic movement. GREENOUGH is supposed to have been a prophet of the principles of FUNCTIONALISM and urged a more organic approach to architecture, stressing the necessity of developing forms which were a frank expression of the materials from which they were made. These ideas found practical application in the last of the Romantic revivals before the Civil War, the LOMBARD ROMANESQUE. This uncomplicated brick style also had precursors in England, but more important were its connections with the round-arched style which flourished in Germany during the first half of the century. The simplicity and cheapness of the

Lombard style were attractive to many practical-minded Americans and it enjoyed wide popularity, especially in public and utilitarian building. It is significant that, following its introduction in the 1840s, it was quickly taken up for factory design. In most other sorts of building the Lombard Romanesque was overwhelmed in the 1870s by a wave of other historical styles. But these had little effect upon industrial architecture, which continued in the round-arched style until after 1900.

In the 15 years following the Civil War two European styles held the centre of the stage, the SECOND EMPIRE STYLE borrowed from France and the Venetian Gothic favoured by RUSKIN (see GOTHIC REVIVAL). In the 1880s, however, these gradually gave way to unrestrained eclecticism. Style now became a matter of fashion to be determined by the whim of the wealthy patron. Richard Morris HUNT, supreme in his command of historical styles, was able to provide the new rich with all the outward signs of power, prestige, and culture. Typical of his work and symbolic of the aspirations of both architect and patron are the great mansions of Newport (Rhode Island) built during the last quarter of the century. Unparalleled in the States for their ostentation, they were quaintly known as 'cottages'.

The creative forces of the U.S.A. were not wholly dissipated in such cultural exhibitionism. As early as 1848 the inventor James BORGARDUS was experimenting in the use of iron for construction and decoration and during the following quarter-century cast-iron buildings appeared in all the main cities. By the late 1870s Henry Hobson RICHARDSON had emerged as the most influential architect of his time. His style, based upon the ROMANESQUE churches of southern France and Spain, and the Early Christian churches of Syria, was powerful and original. Returning to the fundamental principles of masonry construction, he stressed the wall and the arch, treating them simply and without disguise. But although Richardson's recognition of structure as fundamental to form was an initial step in the evolution of modern architecture in the U.S.A., technically he was not an innovator. During the 1880s in Chicago, however, his ideals were extended to include new materials and new structural techniques. The result was America's first major architectural achievement, the modern office building. The development of the metal frame was the factor which made the office building possible. Although structural iron had been used in the interiors of English factories almost a century earlier, the technical problems of skeletal constructions were not finally resolved until 1883 in Chicago. But it was Louis SULLIVAN, America's first truly modern architect, who was the first to break completely with the historicism which had been established by Jefferson over a century before. In his Wainwright Building, erected in St. Louis in 1890-1, he developed forms which were a direct expres-

sion of materials, structure, and function. Sullivan prepared the way for several distinguished architects who practised in Chicago during the last quarter of the 19th c. The CHICAGO SCHOOL, as it came to be known, built most of the business section of the city. In 1900 this group of buildings was unsurpassed in America for daring and originality.

The unification of form and structure which was accomplished in Chicago was abruptly terminated by the Columbia World Exposition of 1893. In this triumph of monumental Classicism the prevailing eclectic attitude was given a final sanction. Vigorous leadership was provided by the New York firm of McKIM, MEAD AND WHITE. The resultant eclecticism produced an orgy of historical styles whose impact on building in the U.S.A. continued for decades.

Of all the architects who came to Chicago in the late 19th c. only Frank Lloyd WRIGHT had the will and imagination to follow Sullivan's insight to its logical conclusion. From the beginning Wright's independent spirit set him apart from his contemporaries and led him to a new conception of architecture. To him a building was 'organic', its basic element a free, plastic, and continuous space moulded by structure.

Wright was one of the outstanding architectural geniuses of his age and among the greatest that the U.S.A. has produced. In its breadth and originality his work was international in its appeal and its importance to the growth of 20th-c. architecture in the United States cannot be over-estimated. The further history of U.S. architecture in the 20th c. is mentioned in the article on MODERN ARCHITECTURE.

3. SCULPTURE. In the first quarter of the 19th c. the best sculptures were rare imported statues such as those of Lafayette and Washington by HOUDON. Native work did not rise above the level of handicraft. Samuel McIntire (active *c*. 1790) and Skillins of Boston (*c*. 1790) made figure-heads for ships and architectural ornament of crude photographic realism. The only native sculptor who at all stood out was William RUSH, who also carved ships' figure-heads and was noted for the figure *Commerce*, which he carved for the first Custom House. John Frazee (1790–1852) graduated to sculpture from the stonemason's yard and his posthumous portrait bust of John Wells (1824) is probably the first carved in the U.S.A. by a native sculptor. In his *History of the Arts of Design in the United States* (1834) William Dunlap wrote of Frazee: 'He is in full employment and the demand for sculpture in our happy country is daily increasing.' Horatio Greenough, who has been called the first sculptor of the U.S.A., left the country in 1826 and lived and worked the greater part of his life abroad. In 1833 he wrote to Dunlap: 'Sculpture, when I left home, was practised nowhere, to my knowledge, in the United States.' Hiram POWERS and Thomas CRAWFORD, also expatriates, were, like Greenough, minor

exponents of the Neo-Classical style of CANOVA, THORWALDSEN, and GIBSON, which rapidly became the vogue in the U.S.A. Powers in particular combined technical slickness with a mawkish sentimentality which De Tocqueville and later Dickens considered typical of American taste. Powers's *Greek Slave* was, however, greatly admired at the London EXHIBITION of 1851 and evoked a sonnet in its praise by Elizabeth Barrett Browning. Crawford's figure carvings were of a banality achieved only in the Neo-Classical mode at its mediocre worst. But his *Freedom*, made for the dome of the Capitol, has a somewhat surprising native vigour and a similar naïve robustness characterizes his equestrian statue of Washington in Richmond, Virginia, which Hawthorne called 'a very foolish and illogical piece of work'.

A number of sculptors active in the mid 19th c. made serious if rather dull attempts to combine Neo-Classicism with a native realism. Of these H. K. Brown (1814–86), Clark MILLS, Erasmus PALMER, William Story (1819–95), and Randolf Rogers (1825–92) enjoyed a certain local prestige. The Baltimore sculptor William RINEHART, working in the same style, gave a sobriety and sombreness to his nudes and portraits which differentiate his work from that of other American followers of Canova and Thorwaldsen. Rinehart's portraits of merchants and their families are particularly vigorous and direct.

Dr. William RIMMER, a physician and lecturer in anatomy, was one of the most interesting figures in the world of art in the third quarter of the century. His sculpture (as well as his painting) is romantic in tone. His first work of sculpture, *The Stoning of St. Stephen*, was supposed to symbolize his own fate at the hands of an unappreciative public, for this stoning was the stoning of the artist himself. Such naïve *double entendre* was a feature of almost all Rimmer's work.

The taste for sentimentalized realism reached its peak in the work of John ROGERS, whose marble or plaster groups, usually of topical subjects, were small enough to stand on the mantelpieces of the day, and had a widespread vogue. A number of copyists carried on the tradition for many years but only one, Solon Borglum (1868–1922), is worthy of note. He specialized in complex bronze groups often of Indians and horses as well as cowboys.

The surge of patriotic and nationalistic feeling which followed the Civil War created a new demand for monumental sculpture which encouraged the swing from Neo-Classical mawkishness to academic naturalism. Generals on horseback, heroes wielding swords, lawyers in robes, portraits of the near-great, and allegories of the VIRTUES were in demand to embellish the new parks and capitols and public buildings. John Quincy Adams WARD was the foremost of the new generation of nationalistic sculptors. The critic James Jarves said of Ward's *Freedman*: 'A naked slave has burst his shackles, and with

uplifted face thanks God for his new freedom. It symbolizes the African race of America, and the birth of a new people within the ranks of Christian civilization. We have nothing in our own sculpture more soul-lifting or more comprehensibly eloquent.' In the work of SAINT-GAUDENS an element of quietude and genuine pathos gives it a refined sentimentality which escapes being banal. The grieving figure of the *Adams Memorial* in Washington, D.C., ranks as one of America's masterpieces. The sculpture of Daniel Chester FRENCH, more prosaic and less refined in expression, enjoyed almost equal esteem with that of Saint-Gaudens. His *Minute Man*, a rustic figure of an American hero-type, became the symbol of the Revolution although its symbolic significance obscured its lack of sculptural quality.

Although the impact of RODIN never made itself felt in U.S. sculpture, a mild Impressionistic technique did appear in some of the work of both Saint-Gaudens and French and is discernible in the sculpture of Herbert Adams, who studied in Paris. It was also a feature of the work of the Chicago sculptor, Lorado Taft (1860–1936), but his importance lies in his pioneering work as an art critic of sculpture.

The confusion of size with quality began to infect sculpture about the time of the Columbian Exposition (1893). George Gray BARNARD conceived colossal statues in terms of 19th-c. sentimentality. *The Two Natures of Man*, an early but characteristic work, brought him fame in Paris as well as in New York but the epic concept was hackneyed. Barnard was attempting to endow his stone with the power and moral philosophy of MICHELANGELO, but the spirit of the times was not capable of such achievement. Colossal works for buildings, parks, and bridges were also produced by the eclectic Frederic MACMONNIES. The climax, however, came with the vast reliefs carved on whole mountain-sides by Gutsom BORGLUM, the largest sculptural works in the world.

During the Second World War many European sculptors emigrated to America, including LIPSCHITZ, ZADKINE, ARCHIPENKO, ARP, GABO, and MOHOLY-NAGY. Native American sculpture included a school of direct carving led by William Zorach (1887–1957) and workers in metal such as David SMITH, Herbert Ferber (1906– ), Richard Lippold (1915– ), and Alexander CALDER. Calder invented the MOBILE, a precursor of contemporary art. Smith used welded metal in abstract combinations. John Chamberlain (1927– ) has used crushed automobiles, and foam rubber for his abstract pieces. Isamu NOGUCHI worked with BRANCUSI and then went on to develop his own styles primarily in wood and marble. His early work especially is related to SURREALISM, as are Joseph Cornell's (1903– ) boxes filled with strangely juxtaposed objects. Among younger sculptors the most predominant are the Pop Art sculptors, Claes OLDENBURG, George Segal, and Marisol Escobar; and the so-called primary structure sculptors, Robert Morris (1931– ) and Donald Judd (1928– ). Morris has also experimented in 'anti-form' works, such as pieces of cut thick felt.

159, 196, 197, 199, 287, 410, 439, 448, 467, 468, 777, 804, 1005, 1102, 1160, 1310, 1334, 1337, 1338, 1674, 1712, 1823, 1888, 1889, 1920, 2175, 2247, 2427, 2476, 2527, 2592, 2616, 2618, 2691, 2842, 2879.

**AMERICAN INDIAN ART.** See INDIAN ARTS OF NORTH AMERICA.

**AMIENS,** CATHEDRAL OF NOTRE-DAME. Begun in 1220, it is the largest and perhaps the most perfectly proportioned of all French High GOTHIC cathedrals. It presents the CHARTRES elevation in its classical form. Less archaic than Chartres itself, and more elegant than REIMS, it manages to escape the charge of sterility often brought against the late Gothic design. It is perhaps the last of the great 'individual' cathedrals although the choir, which was built after the nave, is typical of the RAYONNANT style. So also is the magnificent window of the north transept. The exterior is less successful. The great height of the interior presented for the first time in a really acute form the problem of relating it to a satisfactory design for the west front. The architect, Robert de Luzarches, could do no more than increase the number of horizontal divisions and the result is singularly uninspired when compared with NOTRE-DAME at Paris. Moreover, the towers are dwarfed by the gable and from a distance the general effect is that of an upturned boat. More radical solutions of these problems were achieved at Reims and Cologne. Amiens sculpture is distinguished rather for its encyclopedic programme, fully if rather fancifully dealt with in RUSKIN's *Bible of Amiens*, than for its artistic quality, although it is important as one of the sources for the style of the later 13th c. Exceptions must be made, however, for the magnificent *Christ* of the central TRUMEAU, the quatrefoils (which some have tentatively regarded as early works of the MASTER OF NAUMBURG), and the somewhat later *Vierge d'Or* of the south transept portal (*c.* 1250).

**AMIENS,** SCHOOL OF. French school of painting. The earliest known work of the school has been identified as a votive picture presented to the Virgin by the Puy d'Amiens, one of the Confraternities of the city, in 1437. Its design recalls that of Jan van EYCK's *Virgin in a Church* (Berlin). The affinity with Flemish art is characteristic of the works attributed to the school. The best-known master associated with Amiens is Simon MARMION.

**AMIGONI,** JACOPO (1682–1752). Italian painter in the Venetian ROCOCO style. He was the last of the great Venetian decorators to come to England, in the wake of PELLEGRINI, the

RICCI, and Antonio Bellucci (1654–1726). Al-
though born in Naples, he was at work in Venice
from 1711. Like so many Rococo painters he
had an international career. It led him in 1797
to the Bavarian court, where he stayed for
10 years and decorated the castles of Nymphen-
burg and Schleissheim. From 1730 to 1739 he
was in England, except for a visit to Paris in 1736.
He began by painting decorations for Covent
Garden and Moor Park, but the rise of Lord
BURLINGTON's PALLADIAN school had stifled the
demand for decorative painting, and Amigoni
earned a comfortable income by painting elegant
portraits of the royal family and the nobility.
For the last seven years of his life he worked in
Madrid, where MENGS and TIEPOLO were later to
follow him.

**AMMAN,** JOST (1539–91). Swiss engraver.
Although born in Zürich, he spent many years
working in Nuremberg. He was perhaps the
most prolific illustrator of his day and one of
his pupils boasted that he produced more draw-
ings in four years than could be carted away in
a hay-wagon. On the whole his woodcuts and
engravings are perhaps more important as
documents of contemporary life than for their
artistic value. They were very popular, how-
ever, and some of his biblical illustrations served
as patterns for the young RUBENS.

**AMMANATI,** BARTOLOMMEO (1511–92).
Italian architect and sculptor strongly influenced
by MICHELANGELO and SANSOVINO, on whose
Library in Venice he worked. From 1550 he
worked with VASARI and VIGNOLA on Pope
Julius III's Villa Giulia in Rome, where he also
built the Jesuit Collegio Romano c. 1582–5. His
best-known works in Florence are the Ponte Sta
Trinità (1567–70) and the RUSTICATED court of
the PITTI Palace (1558–70). In sculpture his
chief work is the fountain in the Piazza della
Signoria, Florence, with its marble *Neptune* and
bronze *Nymphs* (1571–5). In old age, influenced
by Counter-Reformation piety, he wrote a
recantation of his secular works and destroyed
some.

**AMPHITHEATRE.** An oval structure de-
signed for various shows and consisting of an
arena surrounded by tiered seats, either built up
or using a natural slope. The earliest known
amphitheatres are of the 1st c. B.C.; later they

**9.** ANAMORPHOSIS. *Portrait of Edward VI.* Painted panel
(1546) attributed to Cornelis Anthonisz. Above: Distorted
view as seen from front. Below: Rectified view as seen
from side. (N.P.G., London)

became common throughout the Roman Empire,
especially in the Latin west. (See also COLOS-
SEUM.)

**ANALYTICAL CUBISM.** See CUBISM.

**ANAMORPHOSIS.** The word first appears in
the 17th c. and refers to a drawing or painting
which is so executed as to give a distorted image
of the object represented but which, if viewed
from a certain point or reflected in a curved
mirror, shows the object in true proportion, the
purpose being to mystify or amuse. (See also
PERSPECTIVE.) The earliest examples appear in
LEONARDO's notes. Anamorphoses are included

in certain 16th-c. perspective manuals—such as Vignola-Dante's and Daniel Barbero's—and were common by the 17th c. *The Jesuit's Perspective* (*La Perspective Pratiqué par un Religieux de la Compagnie de Jésus*, iii. 5, 6, 7; Paris, 1649) devotes considerable space to their construction. The underlying optical principle (i.e. negative perspective) was already understood by the ancient Greek painters and sculptors, who were probably the first to distort the proportions of their works intended for elevated positions in order that they should look right from the normal viewpoint (Plato, *Sophist* 235-6). Well-known examples of anamorphosis in painting are the portrait of Edward VI in the National Portrait Gallery, London, of 1546, attributed to Cornelis ANTHONISZ, and the distorted skull in HOLBEIN's *Ambassadors* (N.G., London, 1533).

149, 2757.

**ANASTASIS.** See HARROWING OF HELL and RESURRECTION.

**ANATOMY.** The study of human anatomy formed, and still in some degree forms, a part of the education of an art student. The artists of the RENAISSANCE, and in particular POLLAIUOLO and LEONARDO, aided and perhaps anticipated the work of the physicians in this department of science. Parts of human skeletons are depicted in the engravings of Baccio BANDINELLI's so-called 'academies', while students are shown dissecting subjects in an early picture of the Roman Academy (see ART EDUCATION). G. P. LOMAZZO in his celebrated *Trattato* (1584) gives a minute account of the structure of the body. The Académie Royale de Peinture et de Sculpture employed a surgeon to lecture to students and the ROYAL ACADEMY also has a Professor of Anatomy. In these ACADEMIES and others the Renaissance preoccupation with man confined the students to the examination of the human form; in attempts to arrive at a standard, or ideal, form anatomical study was of obvious importance.

Artistic anatomy is superficial in the sense of being confined to the form and proportion of the human body, the bone structure, and those muscles which are visible beneath the skin. For purposes of demonstration casts from the antique and from life, the skeleton and the ÉCORCHÉ were usually employed; actual work upon the subjects in the dissecting room was far less common. This branch of study has seldom been pursued with enthusiasm by teachers or pupils in academies of art. As Sir Anthony Carlisle, a Professor of Anatomy at the Royal Academy, put it, the anatomist should not 'induce the unwary student to draw aside the veil that gives pleasing concealment to our nature', while INGRES, who probably shared these sentiments and who objected to the presence of a skeleton in the life room, remarked that although he was acquainted with the muscles of the body, he did not know their names. The most fervent supporter of anatomical training was HAYDON, who maintained stoutly—and it would seem mistakenly—that the Greek sculptors dissected the human body; he believed that through the study of comparative anatomy the student could perceive what was essentially human, and therefore essentially divine, in our bodies.

Throughout the 19th c. anatomy continued to be taught in academies of art and two authoritative textbooks, Dr. Paul Richer's *Anatomie Artistique* (Paris, 1890) and Professor Arthur Thomson's *Anatomy for Art Students* (London, 1896), met a continuing demand. But anatomy was irrelevant to the main aesthetic preoccupations of the age and has to an increasing extent been abandoned in art schools. In some cases it has been replaced by a more general morphological course dealing with the structure both of animate and inanimate objects. In this modern teachers follow the example of RUSKIN, who directed his students to the study of geological and vegetable structures and barely regarded the body (it should be noted, however, that Ruskin was not concerned with the training of professional artists).

The advantage of anatomical training is that it teaches the student to examine superficial shapes with expectant curiosity, making him alert for the evidence of internal structure; the disadvantage is that the student, having learnt what to expect, draws more than he can in fact see, applying anatomical rules in defiance of the evidence of his own senses. Some form of investigation into the construction and internal forms of objects will, probably, always be of service to draughtsmen of a certain disposition and will always be attended by dangers. Whether the interior of the model can now be considered of greater moment than that of the sofa on which she lies may well be doubted.

Apart from the works already cited students in the past have used tables of proportion provided by Leonardo, DÜRER, Lomazzo (see ART EDUCATION), Jombert (see DRAWING BOOKS) and also medical books, as for instance Vesalius and Albinus.

**ANDREA DA FIRENZE,** called BONAIUTI (active *c.* 1337-77). Florentine painter, responsible for the remarkable frescoes in the Spaniard's chapel of Sta Maria Novella, a church of the Dominican Order. This painter was confused with Andrea ORCAGNA until 1916, when he was identified with one Andrea Bonaiuti who was employed in the decoration of Sta Maria Novella from 1337. The frescoes illustrate the Triumph of the Faith and the Dominican doctrine. In their descriptive detail they belong to the tradition of GIOTTO, but otherwise in the more rigid composition and impassive countenances they are a return to the Italo-Byzantine style of painting. Both the severity and the meticulous detail accorded with the expository style of the Dominican Preaching Friars. Andrea also executed frescoes of the *Life of St. Raynerius* (*c.* 1377) in the Campo Santo at Pisa.

**ANDREA DEL SARTO** (1486-1531). Italian painter. After an apprenticeship under PIERO DI COSIMO he soon absorbed the style of poise and beauty developed by Fra BARTOLOMMEO and RAPHAEL in Florence during the first decade of the 16th c. He thus became the greatest exponent of 'classical art' in Florence; witness his fresco cycles in the cloister of SS. Annunziata in Florence (*Nativity of the Virgin*, 1514; *Madonna del Sacco*, 1524), his GRISAILLES in the Chiostro dello Scalzo (1511-26), and his *Last Supper* in the refectory of S. Salvi.

The reputation of Andrea del Sarto was largely made and marred by VASARI, who said that his works were 'faultless' (introduction to Part III of the *Lives*) but represented him as a weakling completely under the thumb of his wicked wife. In Browning's poem and in a psycho-analytic essay by Ernest Jones attempts are made to link the lack of vigour in his mellifluous art with these traits of character. This, however, is hardly just. Del Sarto has suffered from being the contemporary of such giants as MICHELANGELO and Raphael. His art deserves to be studied in its own right. His mastery of compositional devices was well brought out by Wölfflin (*Classic Art*, ch. vi). More recent criticism has concentrated on those features of his art which foreshadow the MANNERIST experiments of his great pupil PONTORMO. The appeal of his dreamy portraits and dark-eyed *Madonnas* has never failed with the unsophisticated public.

920, 2473.

**ANDREA DI BARTOLO DI BARGILLA,** called ANDREA DEL CASTAGNO from the town of that name (*c.* 1423-57). One of the strongest painters at Florence in the generation after MASACCIO. According to a tradition he painted in 1440 frescoes at the Palazzo del Podestà of rebels against Duke Cosimo who were sentenced to be hanged by the heels after the battle of Anghiari. This earned him the sobriquet Andreino degli Impiccati and may have started the reputation for *terribilità* which accompanied him through life until his early death from the plague. In 1442 in collaboration with an unknown artist Francesco da Faenza he painted frescoes for the church of Sta Zaccaria in Venice. Between 1444 and 1450 he was painting again in Florence, designed a stained-glass window for the cathedral and made a sensation with his monumental frescoes of PASSION scenes and the *Last Supper* for the monastery of Sta Apollonia (now in the Castagno Mus.). These were in the manner of Masaccio, with what has been referred to as his 'scientific realism' but with vigorous design and attention to movement and dramatic presentation. In his *Assumption* of 1449 (now in Berlin), however, he followed the more decorative manner of the INTERNATIONAL GOTHIC style and from this time onwards his work may be regarded as the pictorial equivalent of the sculpture of DONATELLO, then famous and active. His most important works in this style were his

frescoes of *Famous Men and Women* (Castagno Mus.), the *St. Julian* (SS. Annunziata, 1454-5), an equestrian portrait *Niccolò da Tolentino*, a pendant to UCCELLO's earlier fresco in the cathedral, and a *Crucifixion* for the Convento degli Angeli (now in the Castagno Mus.). Whether he painted in the earlier realistic manner of Masaccio or in his later so-called Donatello manner, Castagno's work had a vigour and tautness of line and an almost harsh directness which was the measure of his originality. Echoes of this have been traced in Francesco del COSSA, MANTEGNA, and SIGNORELLI.

2371.

**ANDRIESSEN,** JURRIAEN (1742-1819). Dutch artist whose pictures were unsentimental records of everyday life. He was director of a private drawing academy in Amsterdam from 1799 until his death, and had great influence on early 19th-c. Dutch artists. TROOSTWIJCK was his pupil.

**ANGEL.** The angels of Christian art have a complicated lineage, which may be traced back to the winged messenger-spirits of ASSYRIAN sculpture (alabaster relief of Nimrud Kalan, B.M.) and the Cherubim of JEWISH ART. We know from the Bible that Moses placed Cherubim on the Ark of the Covenant, and that they decorated the walls and vaults of Solomon's Temple (Exod. xxv. 17-22; 2 Chron. iii. 10-13; and 1 Kings vi. 23-28). Cherubs are described by Ezekiel (i. 5-14 and x. 1-22) as composite, many-headed winged creatures, but it seems likely that the Cherubim of Jewish art were human figures with wings. Seraphs are also described in the Old Testament (Isa. vi. 2-7) as having three pairs of wings, with which they reverently cover both face and feet as they fly around the throne of God; and this passage provided the type for the seraphs of Christian art. The angels of the Old Testament, on the other hand, are messengers of Jehovah in human guise.

The Christian writer Dionysius the Areopagite (5th c.) enumerated nine orders of heavenly beings, divided into three triads: (1) Seraphs, Cherubs, Thrones; (2) Dominations, Virtues, Powers; (3) Principalities, Archangels, Angels. But of these only the Seraphs and Cherubs, Archangels (Michael, Raphael, Gabriel), and Angels are often portrayed in art.

Angels first appear in Christian art as men or youths, without wings, as the biblical texts imply (e.g. *Tobias and the Angel*, frescoes in the catacomb under Vigna Massimo, Rome; *Sacrifice of Isaac*, sarcophagus of Junius Bassus in the Vatican grotto; both 4th c.). Winged angels with long hair and flowing robes, derived from the classical Victory, also occur in the 4th c., but only in ornamental compositions, not in biblical contexts, as, for example, on a sarcophagus in Constantinople (Archaeological Mus.) where they hold a MONOGRAM of Christ. From the 5th c. winged angels, robed in white and with a halo,

also appear in biblical scenes, such as the mosaic of the *Annunciation* in Sta Maria Maggiore, Rome. But Old Testament angels continued to appear without wings, as in the scenes of ABRAHAM with the three Angels, and Joshua and the Angel, in the same church and the illustration of Jacob and the Angel in the *Vienna Genesis* (6th-c. Byzantine MS.). From the 9th c. the winged angel became almost universal in all contexts.

The archangels were often distinguished by their richer clothes, and in a mosaic of the 6th c. in S. Apollinare in Classe, Ravenna, they wear the embroidered tunic and cloak of Byzantine courtiers. In the lost Byzantine mosaics of Nicaea (Church of the Koimesis, 7th-8th c.) Dominations, Virtues, and Powers are shown in similar courtly robes.

The cherub figures first in the *Rabula Gospels* (6th-c. Syriac MS., Laurentian Lib., Florence), where it is shown as a tetramorph on wheels of fire, like the compound being described by Ezekiel. But more often both seraphs and cherubs have a human head and six wings, as in Isaiah's description, with the only difference that cherubs tend to be bluish in colour whereas seraphs are red.

In a fresco of Pope John VII (705-7) in Sta Maria Antiqua, Rome, the crucified Christ is worshipped by a heavenly host of seraphs, cherubs, and angels. The complete array described by Dionysius is portrayed in the 13th-c. mosaic in Florence Baptistery, and is nowhere else so clearly shown. Tuscan painters of the 14th c. also attempted to distinguish red seraphs from blue cherubs and yellow thrones (A. LORENZETTI, Siena Pinacoteca). But in the 15th c. this difference was neglected, and artists increasingly abandoned the traditional type of cherub in favour of the *genietti* and *putti* of Classical art. Cherubs became winged children, as in RAPHAEL's *Sistine Madonna* in Dresden, and took on the chubby appearance favoured in BAROQUE decoration.

As participants in the heavenly choir angels from the 14th c. often play on musical instruments, trumpets, pipes, and mandolins (ORCAGNA, altarpiece in Sta Maria Novella, Florence; MELOZZO DI FORLI, Pinacoteca Vaticana, Rome). Sometimes at this period they have a feminine appearance, as in the paintings of Fra ANGELICO; and in certain examples, such as AGOSTINO DI DUCCIO's reliefs at S. Bernardino, Perugia (1461), their femininity is clear. But usually they retain the sexless appearance traditional in medieval art, which was fused by the painters of the RENAISSANCE with the HELLENIC ideal of the beautiful youth.

REMBRANDT seems to have been the first to realize, in his painting of *Manoah's Sacrifice* (Dresden), that in the Bible angels were pictured as men and had no wings. Dante Gabriel ROSSETTI's Gabriel in his *Annunciation* (Tate Gal.) is likewise a wingless youth in the biblical tradition.

**ANGELICO,** GUIDO DI PIETRO, called FRA (1387-1455). Italian painter, now recognized as a great artist for reasons different from those which gave him his reputation in the 16th c. and confirmed and sentimentalized it when the Primitives were 'rediscovered' by the NAZARENES and PRE-RAPHAELITES in the 19th c. The 19th-c. view is summed up by RUSKIN's remark (1845): 'Angelico is not an artist properly so-called but an inspired saint.' Both halves of this sentence are misleading, for Angelico was in fact a highly professional artist (as the young DOMENICO VENEZIANO acknowledged in 1438). He was a member of the Dominican Order, which discouraged individual inspiration and sought to maintain the tradition of art in the service of religion, yet he remained in touch with the most advanced developments in contemporary Florentine art (see FLORENTINE SCHOOL). To take three examples: his fresco of the *Crucifixion* in the Dominican convent at Fiesole is an abstract of MASACCIO's *Trinity* in Sta Maria Novella, Florence; the saints on the wings of his earliest documented work, the *Madonna dei Linaiuoli* (1433), recall the then new Or San Michele statues; and the setting of his Bosco ai Frati altarpiece (1440-5) was conditioned by the architectural forms of MICHELOZZO. This altarpiece was a *Sacra Conversazione*, like those which he had executed for S. Vincenzo Annalena and S. Marco a few years before; these are among the earliest of the 15th c. (see VIRGIN).

Yet Fra Angelico did not by any means identify himself completely with the progressive movement but sometimes made use of compositions and pictorial motifs from the trecento. This traditional bias reflected the anti-humanist teaching of the Dominican Order into which he made his vows in 1408 at Fiesole under the name Fra Giovanni da Fiesole. Contrary to the 19th-c. view the religious experience embodied in Angelico's paintings was not merely personal but corporate. The justly celebrated frescoes (c. 1438-47) which he and his assistants painted for the restored convent buildings when the convent of S. Marco was recovered by the Order were at once the expression of and a guide to the spiritual life and disciplined devotion of the community.

These frescoes with their immaculate colouring, their economy in drawing and composition and their freedom from the accidents of time and place, differ considerably from the *Scenes from the Lives of SS. Stephen and Lawrence* (1447-9) in the private chapel of Pope Nicholas V in the Vatican. In the latter there is a new emphasis on the story and on circumstantial detail which brings Angelico more clearly into the main stream of 15th-c. Italian fresco painting. These frescoes show surprising affinities with the contemporary work of PIERO DELLA FRANCESCA without being influenced by it.

Despite the high esteem in which he was held not only in his own time but also in the 16th c. Fra Angelico's influence was smaller in Florence

than in central Italy. But Rogier van der WEY-DEN's *Entombment* (Uffizi), painted during a visit to Italy in 1450, shows strong affinities with Angelico's work. His particular grace and sweetness stimulated the school of Perugia and Fra BARTOLOMMEO, who followed him into the convent of S. Marco in 1500, had something of his restraint and universality.

1975, 2117.

**ANGEVIN GOTHIC.** See FRENCH ART.

**ANGKOR VAT.** Built by King Suryavarman II (*c.* 1112-53) about a mile to the south of the ancient city of Angkor Thom, this is regarded as the supreme culmination of the Khmer mountain-temple architectural style (see CAMBODIA, Art of). Its general plan is an elaboration of the model set by Ta Keo with central tower and four towers at the corners of the great pyramid, symbolizing the sacred cosmic mountain Meru, but it is immeasurably more grandiose than anything which had gone before. The total complex is surrounded by moats which enclose a rectangle 5,000 by 8,000 ft. The building itself, constructed of sandstone without morticing, consists of elaborate terraces approached by steep stairways and opening into cloistered, sunken courtyards. Its façade is almost 787 ft. long. It is surrounded by an inner gallery measuring 210 ft. by over 1,000 ft. and enclosing an area nearly ten times that of Canterbury Cathedral. The structure is a masterpiece of symmetry and by its handling of perspective and proportion conveys an unequalled impression of grandeur.

The temple was dedicated to Vishnu and most of the sculptural decoration is devoted to the avatars or the mythology of that god. The walls of many of the exterior galleries are decorated above the plinths with relief representations of *apsaras* or celestial dancers (1,750 life-size figures covering in all 7,000 sq. ft.) cut in the sandstone after construction. They are lively with a somewhat impersonal grace and all display the well-known 'Angkor smile'. To some observers they have seemed affected or monotonous; they have also been described as 'Grace personified, the highest expression of femininity ever conceived by the human mind'. The inner walls of the galleries are decorated with relief panels depicting scenes from the mythological life of Vishnu, from the *Ramayana*, and historical scenes. The effect is decorative and overwhelming. Every space is filled with pattern. The very low relief has almost the effect of painting. According to Sherman Lee: '... these reliefs have the character of an exotic, noble, and measured ritual dance not unlike that which is still performed by the court dancers of Cambodia.'

One of the most famous features are causeways bordered by railings consisting of giants holding on their knees a naga serpent, the whole depicting the story of *The Churning of the Sea of Milk*.

1049, 1176, 1763, 2183.

**ANGLO-SAXON ART.** The Roman provinces of Britain, Christian at least in name, were overrun and to a large extent repopulated by pagan Teutonic invaders, mainly Angles and Saxons, during the 5th and 6th centuries. Christianized by missions from Rome and Ireland from the end of the 6th c., the same provinces were again overrun and their northern half largely repopulated by pagan Teutons, this time Danes, in the latter half of the 9th c. The southern kingdom of Wessex, however, recovered and during the first half of the 10th c. reconquered and rechristianized the north; but the now unified English state was completely overwhelmed by renewed Danish attacks at the end of this century, though with less effect on the Church since the invaders became Christian in the course of the conquest. The former English ruling house was restored in the person of Edward the Confessor (1042-66), who, however, had spent most of his life beyond the Channel. He brought in foreign clergy and, dying childless, opened the way for a further conquest by the Normans.

The archaeology of these successive invasions is still inadequately worked out, but there have been found no secular objects definitely known to belong to the pagan period which can be discussed as art without qualification. The rich ship-burial at Sutton Hoo with its exceptionally interesting inlaid and enamelled metal-work, including animal and human forms, belongs to the period of transition to Christianity, and all surviving later work of any merit was done for the Church. The plans of a number of small churches are known, but many of the most obviously important sites (Dorchester, Athelney, Wilton) are unexplored and the dates given to well-preserved but undocumented churches such as Earl's Barton (? *c.* 1000) are received rather than established. Foreign parallels are never close: S. Pierre en Citadelle, Metz, for instance, is like but not very like Brixworth. But in any case hardly anything is known about continental churches near the Channel of comparable date throughout the period. The Kentish churches of the 7th c. (e.g. Reculver)—apsed halls usually with a triple arcade marking off the choir and one or more separate rooms (apparently burial chapels) attached to the side walls—are an isolated group. In the west the early churches of Bradford on Avon (8th c. altered in the ?10th c.) and Glastonbury (foundations), and in the north Escomb, do not have apses and their choirs are separate chambers. All are exceedingly small and, where there is evidence, can be associated with monasteries. Larger churches were built in the north (e.g. Hexham) under the aegis of St. Wilfrid (634-709) during a period of *engouement* for things Italian, and crypts imitating catacombs, arcaded aisles, and galleries are documentarily or directly assured. The unusually large church of Brixworth, a cell of the abbey of Peterborough, has arcades and an apse and is presumably to be attached to this group.

Churches, however, seem normally to have been wooden structures associated with a free-standing cross of wood (St. Bertelin, Stafford) or stone, the latter being naturally better attested by surviving examples. These crosses seem to be of all periods, the precise dating being highly speculative, and in at least one case (Reculver) the cross stood inside a (stone) church. The finest are those at Bewcastle and Ruthwell, decorated with figural as well as foliaged and formal sculpture, and seem to be of the late 7th c. and under strong Italian influence. Stone figural sculpture during the 7th to 8th centuries was hardly practised outside Great Britain, English influence being arguable in the isolated case of the sarcophagus at Jouarre made for Agilbert (d. *c.* 685), bishop ultimately of Paris but earlier of Dorchester. Of sculpture applied to buildings there are a few examples (e.g. Breedon on the Hill) apparently earlier than the first Danish invasions; and the finest (angels at Bradford on Avon, rood at Romsey) if correctly assigned to the 10th or early 11th c. are still earlier than comparable stone carving abroad. Problems of date are complicated by problems of attribution in the case of the small group of ivory carvings assigned to the end of the period; only the little triangular plaque with two angels at Winchester is of certain English provenance. The principal churches of this late Saxon period have been destroyed or altered out of recognition (Sherborne). Some important churches (e.g. the old Winchester Cathedral), though vanished, are known from rhetorical descriptions. But the interpretation of these last is peculiarly difficult since it demands assumptions about what in general a Saxon church looked like; and surviving buildings of the second rank (e.g. Breamore) are so eccentric as to discourage generalizations of any kind. Architectural enrichment (arcading at Earl's Barton, chancel arch at Wittering) is highly unclassical and possibly copied from equivalent work in wood. On the eve of the Norman Conquest the abbey of Westminster was already being built after Norman models.

The most accomplished manifestations of Anglo-Saxon art (and happily less fragmentary and problematic than the architecture and sculpture) are the illuminated books (Hiberno-Saxon and Winchester School, see ILLUMINATED MANUSCRIPTS). In spite of the existence of Italian (*Gospels of St. Augustine*, Corpus Christi College, Cambridge) and Italianizing (*Codex Amiatinus*, Florence) books in England in the 7th and 8th centuries, standard Anglo-Saxon script seems everywhere to derive from the Irish, while the decoration of books in the 8th to 9th centuries depends primarily on models found in Teutonic jewellery. Such books went abroad with the 8th-c. English missions to Germany and Frisia and were influential on the Continent. The decorated service books of the later 10th and 11th centuries adopt on the other hand a continental type of script and take classicizing continental models for their paintings, though

these have a distinctive style of their own and are of very high quality. Mention should also be made of the stole and maniple embroidered for Frithestan, bishop of Winchester (*c.* 905-32), recovered from St. Cuthbert's tomb at Durham, extremely skilful work and among the earliest surviving church vestments.

4, 318, 343, 416, 587, 1145, 1480, 1481, 2562, 2578.

**ANGRY PENGUINS.** An Australian *avant garde* journal (1941-6) devoted to arts and letters published by Max Harris and John Reed. It provided support for an Australian type of EXPRESSIONISM with allegorical and regional qualities, and fostered the early work of such artists as Sidney NOLAN, Arthur Boyd, Albert Tucker, and John Perceval.

**ANGUIER,** FRANÇOIS (1604-69) and MICHEL (1613-86). French sculptors who stood apart from the main stream which in the middle of the 17th c. was dominated by Jacques SARRAZIN. They went to Rome about 1641 and joined the studio of ALGARDI. The two brothers collaborated on many works, notably the tomb of Henry de Montmorency at Moulins (1648-52), which reveals the new Roman influence they introduced into France. Their style was based on Roman BAROQUE but was more classical than that of BERNINI with a typically French suppleness. Later the two brothers worked mainly apart. In Michel's decoration of the church of the Val-de-Grâce, Paris, the elegant Classicism which characterized his later work imposes itself on his earlier Baroque tendencies. In 1655-8 in collaboration with ROMANELLI he decorated the rooms of Catherine de Médicis in the LOUVRE. In 1674 he took over from GIRARDON the decoration of the Porte S. Denis.

**ANIMAL STYLE** (NOMAD). The expression 'Animal Style' has come to be used *par excellence* for a distinctive tradition of art in portable goods which was once spread, with local variations, among the mounted nomads of Europe and northern Asia right across the steppes from Hungary to the Gobi desert, and occasionally even beyond. The style was first studied in modern times when gold plaques representing animals were collected from western Siberia under Peter the Great of Russia, but it did not become well known until the barrows of south Russia began to be opened during the 18th c. and excavated more scientifically during the 19th c. Its origins are disputed and the whole subject is full of pitfalls.

In its fully developed form the Animal Style emerged first among the Scythian nomads of European physique and Iranian speech north of the Caucasus during the 6th c. B.C., but other forms arose not much later in west and central Siberia, in central Asia, and in Mongolia. It is agreed that no form of the developed style is as old as mounted nomadism itself. Mounted nomadism seems to have arisen about 1000 B.C.

on the western half of the steppe-belt, perhaps again north of the Caucasus, and to have spread eastward during the next centuries. The Animal Style was the creation of the western or Iranian stock of mounted nomads and declined as they were superseded by eastern peoples of Altaic speech and largely mongoloid physique. It left survivals and influences on other traditions of art in widely separated regions. Even among its originators it was not the only form of art, for they did sometimes represent the human form.

Known objects of the style come mainly from burials, but are obviously such as were used by the dead when they were alive. They were buried with much other gear and sometimes with the bodies of women, servants, and horses presumably intended to accompany their owners into the next world. From the modern excavator's point of view finds of animal figures can be classified according to two groups of materials, one durable such as bone, horn, bronze, and gold, the other perishable such as textiles, felt, leather, wood, and in one case even the tattooed body of a chief. But the style in any one area varies little with the material.

In bone, horn, or boar's tusk, and exceptionally in wood, plates, strips, and pieces are found carved in the shapes of animals or birds of prey, or parts of these, particularly the head. Or again there are pieces covered with carvings in outline. In gold there are plaques and sheets for adorning harness, clothing, armour, or weapons, including axe-handles, large plates for covering the nomad bow-cases and scabbards, torques, necklets, armlets, and pendants. In bronze there are plaques, mirrors, cheekpieces for bridles, ornamental pole-tops for standards, cauldrons and knives with ornamented handles, and mirrors with ornamented handles and backs. Flat surfaces of metal are worked in a technique that has the effect of bas-relief or sometimes, particularly in Siberia, are made in open-work with empty spaces between figures; further west diadems are known in this style. Carving in the round occurs in some pole-tops, pendants, and terminals of armlets and necklets. The textiles include rugs, hangings, and saddle-cloths decorated with figures of animals and birds in felt appliqué, mostly in bright colours. Leatherwork in the same style and colouring is found both by itself and as appliqué ornament sewn to textiles or fastened to wood backing.

The metal-work has been found chiefly in the Scythian and Sarmatian tombs of south Russia and neighbouring countries, and is supplemented by scattered finds from Siberia, central Asia, and Mongolia, many of them of unknown provenance. The textiles and other perishable objects come, with few exceptions, from the tombs of central Siberia and Mongolia. But this distribution of finds is due to the accidents of preservation. In the temperate west the perishable things have mouldered away while the metal-work has largely escaped plundering; in the harsher climate of the

**10.** Gold stag from Kostromskaya in the Kuban valley. (Hermitage, 7th–6th c. B.C.)

Altai permanent frost has preserved the perishable goods in tombs which were long ago plundered of their gold-work. Permanent damp deep underground has preserved the fabrics of Noin Ula in Mongolia, but once again most of the metal objects have been plundered. No doubt all such tombs of these nomads originally contained both durable and perishable objects. The great majority of the finds is now preserved in the HERMITAGE Museum at Leningrad. Their appearance is well known from publications.

1. GENERAL FEATURES AND SUGGESTED INTERPRETATION. In spite of variations some general remarks can be made on the Animal Style. Nearly every animal figure is at once recognizable, and even the monsters such as winged lions and eagle-griffins are of clearly defined types. But the figures of real animals are not naturalistic as they are in GREEK, ASSYRIAN, or CHINESE ART. They are sometimes bent and folded upon themselves in a special manner, which in the best conveys an extreme tenseness and vitality. For example the stag, common in Scythian pieces, is shown with its legs drawn up and folded beneath it like those of a bird in flight and with its antlers laid along its back. Sometimes the legs are in standing position and the head is turned, so that the muzzle lies along the back and the antlers reach forward, which suggests hesitancy and listening. Sometimes forward movement is shown more accurately by the forelegs bent back and the hindlegs reaching backward as after a bound. But even the first pose is not one of rest. There are some extreme examples of the outstretched flying gallop in figures of griffins from Siberia. In contrast there are animals, which may be lions or panthers, bent into a ring—a pose nearly possible in real cats or weasels but here made absolute.

A subject which occurs rather rarely in the earliest Animal Style but grows commoner with time is the so-called animal combat, in which a lion, tiger, eagle, or griffin pounces furiously upon a stag, elk, horse, hare, or other prey, biting and tearing it. Sometimes in Siberian work there is a more equal struggle, as between a tiger and a griffin or other monster. Nearly all these creatures are shown in profile, except that sometimes the head of the predator is depicted frontally making a bite. The attacked animals are often shown in a twisted pose with the hindlegs waving upwards. Another convention is the procession of beasts, shown on such objects as collars and diadems and borders of textiles. Animals rearing up in heraldic opposition are comparatively rare.

The folding and distortion may first have been adopted to fit all features on to a confined surface. But where there is room there is often another convention employed, that of carving small figures of other animals on the sides of larger figures, or again of making antlers or tails terminate in animal heads or forequarters. The style avoids smooth and featureless surfaces. One common feature of figures made in relief or in

11. Bronze standard in shape of bird's head. From Ulski in the Kuban valley. (Hermitage, 7th–6th c. B.C.)

the round is the indication of rounded bodies or bunches of muscles by a bevelling technique of slanted surfaces that meet in a ridge along the line of greatest prominence. This is a natural way of working wood and appears notably in the wooden figures from the Altai.

Animal figures of this kind had evidently a deep meaning for the nomad artists. The animals represented are wild: formidable beasts or birds of prey, and game such as stags or elks and occasionally fish. The sheep and goats are wild kinds; the horses which appear are probably wild and so also are the yaks of some eastern pieces. The nomads did not represent the tame animals of their flocks and herds when they were practising the Animal Style. Some authorities have seen in the Animal Style a direct survival of the magical art of hunters, by which representations of the animals most hunted or dreaded could be used in rituals intended to control them. But such art is usually realistic rather than deliberately distorted. None the less, among both settled cultivators and nomadic herdsmen hunting continued as a sport and as a training for war long after it had ceased to be needed for a livelihood, so that hunt animals remained a subject for art. From literary sources the nomads are known to have had a passion for hunting, as for war. Thus a close knowledge of animals continues to appear through the peculiar surface of the Animal Style. It has also been suggested that the animal figures were originally

those of totems, animal ancestors and kin of the tribes that venerated them, and that the totems then developed into gods and spirits, the rulers of the world in which the nomads lived. These divine beings continued to be imagined in animal form. Animal art at this stage would embody a mythology that we cannot fully understand, and any borrowings from more civilized art would be made to serve this theriomorphic view of the world. Certainly such animal ancestors as the hind and the wolf appear later at the head of tribal genealogies among other nomads, for instance the Turks and Mongols. The animal figures would thus be emblems, some tribal, some cosmic. Such symbolical beasts are known in other arts, not least in the medieval heraldry of Europe.

2. ORIGIN, SPREAD, AND VARIETIES. The question of the historical origins of the Animal Style is never likely to find a simple answer. The most that can be done is to trace some of its more important elements as they emerge. The first problem is to account for the combination of elements that created the earliest known form of the style at a particular place and time: north of the Caucasus and in south Russia from the 7th c. onward.

Some authorities, notably Borovka and Minns, favoured a northern or north-eastern origin for the basis of the style, referring particularly to the very ancient tradition of working bone and horn among the hunting tribes of the Russian and Siberian forests. Rostovsteff was much impressed with its eastern affinities, comparing it with early Chinese art and suggesting an origin in central Asia between Iran and China. More recently the Karasuk culture of the Bronze Age in eastern Siberia, which has Chinese links, has been drawn into the discussion. Minns also allowed much influence on the south Russian style from Near Eastern traditions—Assyrian, Urartian, Anatolian, and Iranian. This line of inquiry, further pressed by Tallgren, has yielded important results in the hands of Godard, Ghirshman, Sulimirski, and others, who have used recent discoveries in north-western Iran. Schefold, a specialist in Greek Art, makes the Scythian style at all stages one more effect of archaic Greek art on that of surrounding peoples.

In the Pontic area the Animal Style is first represented by two small carvings in bone of an eagle's head and a curled animal from Temir Gora in the Taman Peninsula, dated about 650 B.C. But these are much later than the coming of the first Scythians, which has been connected by Sulimirski with the advance of the Timber Grave culture from the Volga to south Russia between 1000 and 900 B.C. Nothing is said of the Animal Style in connection with these earliest Scythians, even when some of them reach Transcaucasia in the next century. The developed Scythian style of such sites as Kelermes, Ul, and Seven Brothers in the Kuban valley, and at Litoi in the Dniepr and Elisavetovskaya in the Don basin, is dated to the 6th c. by finds of Greek pottery along with the Scythian remains.

The elaborate gold-work in the Animal Style which appears at this date by the Kuban, Don, and Dniepr has no forerunners north of the Caucasus. Among the weapons and gear in these tombs are some things which are not Scythian but Near Eastern: Assyrian, such as the gold sheath-plates from Kelermes and Litoi, decorated with monsters and genii, and rhyta with goats' heads from Seven Brothers; Median, using the older art of Urartu in Armenia, such as sword-hilts from Kelermes and Litoi. On a gold bowl from Kelermes are figures of ostriches, a lion, and goats in Assyrian style, but also a Scythian stag. South of the Caucasus a similar combination of Assyrian and Urartian monsters with Scythian stags, ibexes, and small animals is found on a gold pectoral, an inlaid silver dish, gold sheathing, and other objects from the treasure of Ziwiye in Kurdistan, which is dated to the 7th c. and may have belonged to a Scythian or a Median chief.

That this contact with the Near East was not merely external or commercial is shown by Herodotus's account of the great Scythian irruption across the Caucasus some time before the fall of Assyria to the Medes, which is confirmed by Assyrian records and biblical references. Late in the 7th c. the Scythian horde from its base in Azerbaijan dominated a large area of the Near East for a generation or two before the Medes defeated it and drove it back across the Caucasus. During their stay in the Near East the Scythians picked up various features that then appear in the first developed Animal Style. When they left they are likely to have deported oriental craftsmen, as the Mongols regularly did much later.

Arguing from this known contact of the Scythians with the Assyrians and Medes, some scholars have claimed that the animal art of the horse-trappings, axe-heads, and pin-heads of Luristan in the Zagros Mountains of western Iran contributed to the Scythian Animal Style. Though the horsemen of Luristan are reckoned to have been a rough Iranian people, Cimmerian or Median, and so akin to the Scythians, their style is visibly not the same as the Scythian and often makes use of the human figure as an essential part of designed groupings. There was also a vigorous tradition of metal-work with varieties of animal art in Transcaucasia, and earlier still Anatolian art makes much use of the stag and the boar, well-known subjects of Scythian art. Some contribution from all these sources is possible, but the threads were not gathered together until the Scythian invasion. Greek influence is apparent from an early date in the Scythian style, but it is at first only external. When it penetrated deeper, as in the late 6th and the 5th centuries along the coast of the Black Sea, it spoiled the style as no other influence had done, and in some pieces, such as the gold plate of the scabbard from Kul Oba in the Crimea, very nearly replaced it.

In the great barrows of the Dniepr valley the Scythian style persisted with Greek influence affecting it in varying strength, but to the north-west the original quality was either unaffected or, if there was change, the influence was usually not Greek. The bronze die, with stag and beasts of prey, from Garchinovo in Bulgaria and the gold stags from Tapioszentmarton and Zold-halompuszta in Hungary show less vigorous versions of the Scythian style, in which the tradition was already failing. But the gold fish from Vettersfelde in Germany, bearing figures of other creatures and having its tail terminating in rams' heads of Greek appearance, is at least full of vigour. The Scythian style began to disappear during the 4th c. B.C.

East of the Scythians were kindred but distinct peoples, the Sarmatians beyond the Don and the Sakas of Central Asia, but before their work is noticed, the Animal Styles of the Altai and of Minusinsk on the upper Yenisei deserve immediate mention. Though these regions are so distant from south Russia, the forms of the style found in them are more like the Scythian than anything yet known in the country lying between and are roughly contemporary with it. The Animal Style of the Maiemir and Pazyryk periods in the Altai is likely to have begun and ended somewhat later than the Scythian, for in its full growth it shows features in common with the Sarmatian style and among its remains are found also those of imports such as the famous carpet from the Achaemenid Empire of Persia and a tapestry from China of the age preceding the Han dynasty. It may have arisen in the 5th c. and have lasted into the 3rd. In the valley of Pazyryk in the High Altai were found five great mounds, and near the village of Bashadar in the central Altai two. The textiles, leather-work, and woodwork from Pazyryk show the same inspiration as known Scythian work in other materials, but in conditions which must have given it freer play. The extraordinary variety of bright colour, not all of it realistic for the animals shown, is specially noticeable in the textiles, felt, and leather. Groups of animals are commoner than in the original Scythian style, and so are scenes of animal combat. The lines of composition are smoother and more flowing in the animal figures, which include the elks and tigers of the north-east as well as winged monsters. These appear also on the tattooed body of the chief from the second tomb. The procession of tigers on a coffin from Bashadar is in a style recalling Sarmatian work. In Minusinsk the corresponding culture of the Tagar period was likewise introduced by mounted nomads. They appear to have set the native bronze-workers to make pieces for them; the style of these is inferior and has been called 'underdog Scythian'. Minusinsk lies on the route of further diffusion to northern Mongolia.

Since the Pontic Scythians were always pressed from the east, they cannot have spread their style to the Altai and Minusinsk by conquest or migration. The only explanation must lie in peaceful intercourse, perhaps of very long standing. Herodotus mentions a Scythian trade route running far northward ultimately to a gold-bearing country, which should be the Altai and the gold-bearing sand of the Yenisei.

From unknown sites in the upper Ob basin of western Siberia come the famous gold plaques which were collected for Peter the Great. They show the Sarmatian version of the Animal Style, which is clearly influenced by the less nomad art of the Oxus Treasure from the north-eastern edge of the Achaemenid Empire, dated to the 5th and 4th centuries B.C. This mixed Median, Achaemenid, and Saka art has beasts and birds of prey and griffins among its favourite subjects. Some of these are covered all over with cloisonné work, but later figures have only embossed reliefs or vestigial sockets for inlays of jewels. The Sarmatian plaques show the same succession of features through time. They represent a new development of the Animal Style, distinct from the Scythian and inspired by this later Iranian tradition, which spread with the Sarmatian migration westward through Kazakhstan and western Siberia until it reached south Russia. In this style the animal combat is fiercer and more dramatic than in any other. The style is also represented by many kinds of small ornament, by diadems and arm-bands with jewelled inlays from the Kuban and from the celebrated burial ground of Novozherkassk on the Don, and by other objects from south Russia or the Danube valley, notably bronze phalerae, disc-shaped horse-trappings, which show Greek influence and sometimes that of Parthian Iran.

Much further east, in the Ordos desert of north China and in neighbouring regions of the Gobi and of China, is the source of a scattered and vaguely defined group of objects, the Ordos bronzes. They do not represent a distinct and definite version of the Animal Style, but rather successive fashions carried eastward through Zungaria by Sarmatian or other Iranian nomads. The styles were adopted by the largely Mongoloid nomads of the Gobi when they learned the techniques of mounted nomadism. The bronzes are very difficult to date, since some small pieces represent curled animals in Scythian style, some are pole-tops which might have been found in south Russia, and others are plaques which seem to be copies in bronze of well-known types of Siberian gold plaque. Others again show as marked a Chinese influence as some Scythian pieces do Greek. There should be a certain interval of time between the beginning of any south Russian or Siberian style and its reproduction in Ordos bronzes. Most of them should be dated to centuries immediately preceding or following the beginning of the Christian era, the period of Hsiung Nu domination on the steppe north of China, and of Han rule in China.

The tombs of Noin Ula in the basin of the Selenga near Lake Baikal, dated to the beginning

of the Christian era, have yielded a few bronze plaques of the Ordos type and also a felt rug bordered with repeated scenes of combat between a yak and a lion and between a winged wolverine and an elk, very much in the Animal Style of Pazyryk. Further east there are traces of the style in Manchuria, Korea, and Japan.

The Sarmatian style lasted in various forms between central Siberia and eastern Europe until a new age began with the advance of the Huns from eastern Asia in the 4th c. A.D. The Huns did not practise the Ordos styles, but something like them was known among their successors, the Avars. The influence of the Scythian style is apparent among the Celts, and of the Sarmatian style more strongly among the Germanic peoples, notably in the Vendel style which appeared in Sweden without known ancestry in the 7th c. A.D. A form of the Animal Style continued much longer in northern Tibet.

The end of the Animal Style, during the centuries after the Iranian nomad cultures disappeared from the steppes, was apparently brought about by the spread of Buddhism, Islam, and Christianity, which destroyed the religious ideas embodied in it.

Information about the art of the mounted nomads has accumulated in bulk and in variety as excavations have continued through the 20th c. Now discoveries are constantly being made not only in central Asia and Siberia but even in the better explored territory of south Russia. New light might well be thrown by excavation of the rest of the 212 barrows of Noin Ula in Mongolia. Owing to this rapid growth of new excavated material bibliographical information has fallen rapidly out of date. Much of it is contained in works on the great regions which the Animal Style once covered. The specialist works to which reference is given necessarily deal largely with the relevant ethnology and geography; discussions of the aesthetic aspects of the Style are incidental and brief. Summaries of current Russian work are often to be found in Western journals of prehistory and archaeology.

350, 437, 495, 1439, 1845, 1846, 2077, 2239, 2243, 2313, 2316, 2339, 2340.

**ANNE,** ST. See VIRGIN.

**ANNULET.** In the Doric ORDER OF ARCHITECTURE one of the FILLETS beneath the CAPITAL. In medieval work a ring round a shaft or binding a number of shafts.

**ANNUNCIATION.** See VIRGIN.

**ANTEFIX.** An architectural ornament, often of terracotta, placed at the eaves or along the CORNICE of a classical building to mask the end of each ridge of tiling.

**ANTELAMI,** BENEDETTO (c. 1150–?). The most notable figure in the history of Italian sculpture before Nicola PISANO. His name first appears on a marble panel representing the

*Descent from the Cross* in Parma Cathedral. He is chiefly known for his reliefs on the doors of the Baptistery at Parma, which was begun in 1196, and it has been suggested that he may have overseen the whole structure. On stylistic grounds he has also been credited with a hand in the sculptural decorations of Fidenza Cathedral (formerly Borgo San Donnino) and of S. Andrea at Vercelli. Little or nothing is known about Antelami's history but certain affinities of his work with Provence (particularly at S. Gilles and Arles) have given rise to the belief that he may have been trained there. His elongated figures, his compact compositions and skilful use of drapery folds to emphasize design convey to his work a gravity and dramatic expressiveness hitherto unknown to north Italian sculpture. His work, particularly that of the Parma Baptistery, though still retaining elements of stylization, went further towards naturalism than anything before it and combined rhythmical design with vitality and a sense of movement.

912.

**ANTENOR.** Athenian sculptor of the late 6th c. B.C. He made the first bronze group of the *Tyrannicides* (now lost), which was carried off to Susa by Xerxes in 480 B.C. and restored by Alexander or one of his successors. An impressively solid marble KORE from the ACROPOLIS at Athens may belong to a base signed by Antenor; and by comparison of style some archaeologists attribute to him the pedimental sculpture of the late Archaic temple of Apollo at Delphi.

**ANTHEMION.** A Greek decorative motif with radiating plant forms of honeysuckle or of LOTUS AND PALMETTE pattern. The term is sometimes

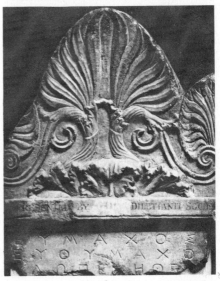

**12.** ANTHEMION. Stele of Eumachos. (B.M., 4th c. B.C.)

53

**Fig. 3.** ANTHEMION. Band decorations from Greek vases. After *The Grammar of Ornament*, Owen Jones (1856)

applied to decorative patterns which incorporate only one of these motifs.

**ANTHEMIUS OF TRALLES.** Greek mathematician, engineer, and artist of the age of Justinian, who was chosen by the latter in A.D. 532 to design Sta Sophia in Constantinople. He had a great reputation in his day as a mathematician and for experiments in applied mechanics, including experiments with the effects of compressed steam. Procopius describes him as 'the man most learned in what is called mechanical science, not only among the men of his own time but among all men for many generations back'. Agathias describes his craft as 'the application of geometry to solid matter' and adds that he could also 'make copies and as it were models of things that are', implying that he was considered a painter or *zoographos*.

**ANTHONISZ,** CORNELIS (*c.* 1499–after 1533). Dutch painter, etcher, and designer of woodcuts. He was active in Amsterdam and is known for his delicately painted map of that city, now in the Weigh House there. He worked as a cartographer in the service of Charles V and also painted group portraits (Rijksmuseum, 1533).

**ANTIPHONAL,** or ANTIPHONARY. A liturgical book containing those parts of the Mass or Divine Office which are sung antiphonally (i.e. in responses) by the choir. The *Gradual*, which has only the hymns sung after the Epistle, often forms part of it.

Although antiphonals were in common use since Early Christian days, their illumination and decoration seems to have begun only *c.* A.D. 1000. Appropriate scenes from the Bible or the lives of the saints were chosen to illustrate the text. During the Middle Ages rich pictorial cycles were preferred, but from the 14th c. onward words and music took precedence over pictures, the latter being confined to historiated initials (see ILLUMINATED MANUSCRIPTS), while scrolls and GROTESQUES framed the page.

**ANTIPODEANS.** The name adopted by a group of Australian painters who held an exhibition and published a manifesto in 1959 which championed the figurative image and was critical of ABSTRACT ART. The group included Charles Blackman, Arthur Boyd, David Boyd, John Brack, Robert Dickerson, John Perceval, and Clifton Pugh.

**ANTIQUE, THE.** The remains of antique sculpture have been for later artists an inspiration, a challenge, and a canon of perfection. Such remains have never been totally absent and seldom totally disregarded. Memories of classical ornament or drapery forms recur throughout the Middle Ages, and occasionally, as in the 13th-c. REIMS *Visitation* group, a true classic dignity was attained. The revival of interest in classical antiquity at the Italian RENAISSANCE of the 15th c. was not a new or unheralded phenomenon and evidence of persistent interest has been put forward by such art historians as for example Erwin PANOFSKY in *Renaissance and Renascences in Western Art* (1960) and Benjamin Rowland in *The Classical Tradition in Western Art* (1963). But it was in 15th-c. Italy that the recovery of the classical antique as a Golden Age in the past became a deliberate ideal. Artists and scholars found in classical sculpture a key to reality, awakening their awareness of the beauty of the human body and its expressive potentialities. GHIBERTI's writings testify to his admiration for antique statues and cameos found in his lifetime which, as we can infer, he eagerly collected. We know from a letter by Poggio Bracciolini that DONATELLO 'highly praised' antique marbles, and his *David* would be unthinkable without a close study of the antique. In the latter half of the 15th c. architects such as Giuliano da SANGALLO vied with the humanists in searching for and recording classical remains and inscriptions, and even such a conservative Sienese artist as NEROCCIO is documented as the owner of an antique marble head and plaster casts of Apollo.

When Filippino LIPPI went to Rome he carried with him a letter of introduction by Lorenzo de' MEDICI asking one of the cardinals to show the artist his collection of antiques. The role which Lorenzo's own collection in the gardens of S. Marco played in the formation of artists such as BERTOLDO and of MICHELANGELO has been vividly described by VASARI, whose account, however, may be coloured by his own academic bias.

Vasari, indeed, attributed the attainment of perfection by the generation of LEONARDO, Michelangelo, and RAPHAEL in no small measure to the discovery of the famous antiques of the

**13.** Pen-and-ink drawing after the antique (*c.* 1235) by Villard d' Honnecourt. (Bib. nat., Paris)

**14.** Pen-and-ink drawing (*c.* 1553) of the *Belvedere Torso* by Maerten van Heemskerck. (Staatl. Mus., Berlin)

Vatican collection, notably the APOLLO BELVE-
DERE and the LAOCOON (found 1505). There can
be no doubt that the challenge of these late master-
pieces did have its effect on the artists of the day,
though it was mainly the next generation, parti-
cularly the apprentices from northern Europe,
who systematically drew after the antique.
HEEMSKERCK's sketch-books are characteristic

55

of this trend. Towards the middle of the 16th c. the role of the antique in the curriculum of artists became firmly established. Vasari advises the study from statues, simply because these do not move and are easier to draw from than the live model; but he also warns (in the 'Life' of MANTEGNA) against transferring the habits thus acquired to the rendering of life. Armenini (in 1587) already gives a list of 'canonic' antiques, including the famous BELVEDERE

TORSO, the Pasquino, and the group of the river-god Nile (Vatican) which achieved a genuinely 'classical' authority and were carried by means of engravings, casts, and copies into every artist's studio.

In 17th-c. Europe every artist had to define his attitude towards the canons of the antique. RUBENS, a great student of the antique, still warned painters in a letter (printed by DE PILES) against the harsh manner that can result from

15A. *Thetis bringing armour to Achilles.* Pen-and-ink drawing by John Flaxman as illustration to the *Iliad* (1793)

15B. Engraving from the foregoing by Piroli

too much attention to the antique, while POUSSIN, no doubt deliberately, gave the figures of his later compositions a statuesque character and turned their faces into masks. The philosophical justification for this dependence on antique models was given in BELLORI's famous oration, *Idea*, where he claimed in the ancient statuary a revelation of an absolute beauty that had been discovered once and for all. To the followers of the academic doctrine each of the great antiques, to which now had to be added the FARNESE HERCULES, the Borghese warrior, the Medici Venus, and the BARBERNINI FAUN, represented a type of physique that could serve as a permanent standard for the artist.

This doctrine was given a new lease of life when the NEO-CLASSICAL movement reacted against the frivolities of Rococo fashions. The coldness of the marble seemed to symbolize the aloofness of Stoic grandeur. Art was purged of its sensuality and superficial prettiness, and antique statues were imitated in a cold and often mechanical manner. In opposition to earlier ideas WINCKELMANN preached the belief that classical artists had deliberately avoided representing extreme passions, and he regarded the antique less as a source of expressive formulas than as a model of noble restraint. This classicizing style was extended even to non-classical subjects, as for example FLAXMAN's drawing of the *Victory of Hengist*. During the later 18th c., however, travellers began to discover Greece, and the Roman copies of Greek originals which had hitherto supplied the main knowledge of classical art were supplanted by the fresher sculptures of 5th-c. Greece and the virile forms of Archaic and MINOAN ART.

349, 2009, 2017, 2403.

## ANTONELLO DA MESSINA (*c.* 1430–79).
Italian painter with a markedly Flemish style. According to VASARI he was a pupil of Jan van EYCK and brought the 'secret' of OIL PAINTING to Italy; but in fact he did not know van Eyck and is most unlikely to have visited northern Europe. He probably acquired his knowledge of northern techniques either in Naples, then artistically dominated by the Netherlands, or by contact with Flemish artists, perhaps in Milan. Early examples from the many years he spent in his home town of Messina (*c.* 1455–75) are a *Crucifixion* (Sibiu, Romania), in which the drama is played out against a background of the local landscape in the Flemish manner, and a *St. Jerome* (N.G., London).

At the same time, perhaps inspired by the visit to Sicily of the Italian sculptor Francesco LAURANA, he was developing a style based on simplified, rounded, and sculptural modelling. In another *Crucifixion* (N.G., London) the composition is Italian but the treatment of light and atmosphere is Flemish. This was painted just before a visit to Venice (1475/6). The principal work he executed in Venice itself was the S. Cassiano ALTARPIECE, of which two frag-

ments only remain, both in Vienna. Its arrangement was perhaps derived from Giovanni BELLINI's lost altarpiece for SS. Giovanni and Paolo; but it was itself influential, for several younger Venetian artists borrowed directly from it and Bellini himself admired the modelling of its figures. Antonello in turn softened his modelling under Bellini's influence, as we see in the Dresden *St. Sebastian*.

Antonello's bust portraits—in three-quarter view, of Flemish type—also enjoyed a notable vogue in Venice: their expressions were more lively than the portraits by MEMLING then being imported. His influence on the development of Venetian painting, though it cannot be exactly calculated, must have been considerable.

1581, 2753.

## APELLES. Born at Colothon on the island of
Cos and active in the late 4th c. B.C., he was reckoned in antiquity to be the greatest of Greek painters, though none of his work remains. He wrote technical treatises on painting which are lost and more anecdotes survive about him than useful information. He was court painter to Philip and Alexander of Macedon. He used the four colours (see GREEK painting), applied a special black glaze to his pictures which, according to PLINY, gave great brilliance to his colours, and he was claimed to excel all other painters in grace. He was also agreed in antiquity to have been a master of composition and of CHIAROSCURO. Among his recorded subjects are portraits of Alexander the Great (particularly famous was one for the temple of Artemis at Ephesus), *Aphrodite rising from the Sea* (for the temple of Asclepius at Cos, brought to Rome by Augustus and set up in the temple of Caesar), and *Calumny* (described by LUCIAN and emulated by BOTTICELLI).

## APHRODITE OF CNIDUS. The most ad-
mired of PRAXITELES's works (now lost), and the ancestress of the modern female nude. The execrable copies which survive show the goddess in a gently twisted pose with right hand casually masking the pudenda and left hand dropping her robe over an urn.

## APOCALYPSE. The last book of the New
Testament, known in the Authorized Version as 'The Revelation of St. John the Divine'. The book consists of a number of eschatological visions, some of which were represented in EARLY CHRISTIAN ART. *Christ enthroned with the Four Living Creatures* is shown *c.* 400 on the mosaics of Sta Pudenziana, Rome; *Christ above the Seven Lamps and Twenty-Four Elders* on the 5th-c. TRIUMPHAL ARCH of Sta Maria Maggiore, Rome; and *The Lamb standing on Mt. Sion from which flow the Four Rivers of Paradise* repeatedly on SARCOPHAGI. Early Christian manuscripts of The Revelation must have existed, but none has survived and our earliest examples date from the 9th c. They occur in the West only, since the Eastern Church for theological reasons doubted the authenticity of the Apocalypse.

CAROLINGIAN manuscripts often had full-page MINIATURES, but the majority of Apocalypse manuscripts may conveniently be divided into three principal groups: (i) a number of self-contained illustrations are distributed throughout the book; (ii) the book page is divided into several registers with only brief captions; (iii) a number of small illustrations are distributed throughout the text. Examples of the first group are manuscripts written in Spain from the 10th to the 12th c. which contain some 80 illustrations and also the important late 8th-c. commentary of the Asturian abbot Beatus of Liébana. The earliest is in the Pierpont Morgan Library, New York. The *Bamberg Apocalypse*, written in Reichenau *c.* 1000, also belongs to this group. The second type, which is iconographically distinct, was preferred in most French, English, and German manuscripts of the 13th and 14th centuries. At this time the Apocalypse enjoyed an increased popularity, having been endowed with an historical and prophetic interpretation. Most of the manuscripts are of English origin, with a Latin or French text. They are all closely related, and contain a fairly constant cycle of over 80 miniatures, which are partially derived from older versions; examples are in Cambridge (Trinity Coll.), Paris (Bib. nat.), and New York (Pierpont Morgan Lib. MS. 524). It was this type which was imitated in the first BLOCK BOOKS of the 15th c. The third type was common in late medieval Bible manuscripts and early printed Bibles, of which the *Cologne Bible* of 1479 is the best example.

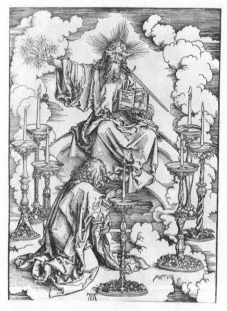

**16.** *He that holdeth the seven stars in his right hand, who walketh in the midst of the seven golden candlesticks* (Rev. ii. 1).
Woodcut (1498) by Albrecht Dürer

DÜRER for his *Apocalypse*, published in 1498, reverted to the Carolingian practice of using full-page illustrations, and though he based his subjects on a Bible of 1483 (Nuremberg), his woodcuts were revolutionary in many ways. Never before had an artist designed and published an entire book on his own initiative. Moreover, each of the 15 illustrations can be contemplated independently of the text, which is printed on the back. But Dürer's greatest achievement was purely artistic: he condensed the visions of the Apocalypse into a comparatively small number of highly dramatic woodcuts of very great power. Closely dependent on Dürer was the first Lutherian Bible published in Wittenberg in 1522, in which the cycle was expanded to 21 scenes. This reflects the influence of contemporary events, for the Dragon and the Scarlet Woman both wear the triple Crown, showing that they have become identified with the papacy.

It is not always sufficiently realized that the millennial visions of The Revelation were the most obvious source for the imagery of monumental medieval art. Subjects such as the *Majestas Domini* or the LAST JUDGEMENT—favourites on church portals and in frescoes—whatever other scriptural material they may embody, stem in the first place from certain passages in The Revelation. The (lost) frescoes, which Benedict Biscop had painted *c.* 680 at Monkwearmouth after models (certainly manuscripts) he had brought from Italy, were among the earliest large-scale works of this kind. The Moissac TYMPANUM (12th c.) is directly derived from a Beatus manuscript; others, such as the tympanum of the celebrated Portail Royal of CHARTRES—perhaps the most impressive CHRIST in Majesty—and the decoration of many cathedral and church porches, are proof of the central importance of this imagery. In fact these subjects are so common that it seems superfluous to give examples.

Of the many frescoes depicting the Last Judgement it is sufficient to mention those by CIMABUE in Assisi, the ones in the Campo Santo at Pisa, and particularly SIGNORELLI's work in the cathedral of Orvieto. The *Angers Apocalypse*, a tapestry of *c.* 1380, designed probably by Jean de BONDOL, exemplifies the importance of the subject in yet another medium.

During the Counter-Reformation in Catholic countries the Virgin Mary was frequently represented in BAROQUE paintings as the woman of the Apocalypse, and this subject was particularly popular in Spain. In the 19th c. the German painter Peter CORNELIUS designed a monumental *Apocalypse* for the Campo Santo which Frederick William IV wished to build in Berlin (1843–67), but this project was never realized.

**APOLLINAIRE,** GUILLAUME (1880–1918). Son of a Polish mother, Mme de Kostrowitzky, and an Italian of noble family, Francesco Flugi d'Aspermont, Apollinaire was one of the most

important French poets and art critics of the early 20th c. He was an active influence in shaping most of the aesthetic movements which dominated Paris artists during these years. He was among the first to acclaim PICASSO (in 1905), praised MATISSE in 1907, BRAQUE in 1908, and led the way in doing honour to the talent of Henri ROUSSEAU. He was one of the earliest champions of the CUBIST movement, publishing *Les peintres cubistes* in 1913, and helped to found the off-shoot group *Section d'Or* (see ORPHISM). He was a friend of the FUTURISTS and composed one of the Futurist Manifestos. He coined the word 'surrealist' in 1917 to describe his own play *Les Mamelles de Tirésias* and through André BRETON he influenced the views of the SUR-REALIST school. Later, in his Manifesto of 1924, Breton claimed to have given to Surrealism a different connotation from that envisaged by Apollinaire. The impact of the latter, however, on a wide range of individual artists whose names are remembered as leaders in the most creative period of the century cannot be overrated.

63, 64, 65, 2468.

**APOLLO BELVEDERE.** The most famous of the many classical representations of the Greek god Apollo. The statue (Vatican) is a marble copy from the Roman period of a classical or HELLENISTIC Greek bronze. Dis-covered towards the end of the 15th c., it was admired for over 400 years as one of the finest achievements of GREEK ART. It was often copied or adapted, sometimes with curious effect as when REYNOLDS painted his *Admiral Keppel* (1740) in the posture of the statue but in 18th-c. dress. WINCKELMANN's enthusiastic description

of it had a profound influence on NEO-CLASSICAL sculptors such as CANOVA and THORWALDSEN. Since the revelation of the PARTHENON sculptures in 1807 (see ELGIN MARBLES) and the aesthetic discovery of ARCHAIC Greek sculpture the Belvedere Apollo has seemed cold and academic and has lost much of its appeal.

**APOLLODORUS.** Athenian painter of the 5th c. B.C. PLINY records the tradition that he was called *Sciagraphus* because he was the first to model his figures in light and shade, a notable step forward in pictorial illusion which was carried still further by ZEUXIS.

**APOLLODORUS OF DAMASCUS.** Greek architect who did civil and military work for Trajan (early 2nd c. A.D.). Trajan's Forum and the Column show his perhaps novel grandeur in composition (see TRAJAN'S COLUMN). A treatise by him survives entitled *Engines of War*.

**APOPHYGE.** The small outward curve at the bottom, and sometimes at the top, of a classical COLUMN.

**APOSTLES.** The Apostles in Christian art, as in the Canon of the Mass, represent the Disciples sent out to preach the Gospel, with the addition of St. Paul. Occasionally the Evangelists Mark and John are included, but the number of the com-pany always remains 12 and they are usually grouped around their teacher, CHRIST. The physical types of the leading Apostles are fairly constant, St. Peter having a round face and white hair and beard, St. Paul a long face, a large brow, and dark hair and beard, St. John being depicted as a beardless youth, and St. Andrew with unruly

17. Mosaic from apse of the church of Sta Pudenziana, Rome (15th c.)

59

white hair. All wear long tunics and a mantle (*pallium*) thrown across one shoulder, though in the 16th c. and later they are often shown naked, as in MICHELANGELO's *Last Judgement* in the Sistine Chapel. St. Peter is sometimes dressed as pope and usually carries the Keys of the Kingdom (Matt. xvi. 9). The scrolls which the others normally carry stand for the Creed, which they are traditionally supposed to have composed together before their dispersal, each contributing one article of faith; ORCAGNA's statues of the Apostles round the shrine of the Virgin in Or San Michele, Florence (14th c.), hold the scrolls open with the 12 articles inscribed upon them.

The early paintings of the Apostles in the Roman catacombs (Domitilla, 4th c.) show them seated in a semicircle round Christ, and this group was much used both in the apses of churches (5th-c. mosaics in Sta Pudenziana, Rome, and S. Aquilino, Milan) and on SAR-COPHAGI. They also participate in the Majesty of Christ, as in the 9th-c. reliefs on the Bewcastle Cross and in the 11th-c. paintings in the church of SS. Peter and Paul at Niederzerf on the Reichenau. Another early disposition represents the Apostles standing on either side of Christ, who hands to St. Peter the Law by which he is to govern the Church, and is thus known as the *Traditio Legis*. Typically Christ is depicted as seated on a throne on the summit of a mountain whence flow the four rivers of Paradise. And in the sky above the Apostles assembled around Him are pictured four symbolical animals with the Four Gospels. Closely related to this both in meaning and in form is the sending out of the Apostles (Matt. xxviii. 19) in the mosaic of the Lateran Triclinium, Rome (9th c., restored 18th c.). The departure of the Apostles is also shown in the early 12th-c. sculptures on the façade of Angoulême Cathedral, and it became a favourite subject in French and German painting of the 15th and 16th centuries (*Très Riches Heures du duc de Berry* at Chantilly, early 15th c., and ALTDORFER's painting, Staatl. Mus., Berlin, 1525).

From the 6th c. the Apostles figure prominently in church decoration. In the two Ravenna BAPTISTERIES of the mid 5th and early 6th centuries they walk in procession around the circle of the CUPOLA. Their heads or busts, enclosed in medallions, line the choir arch or apse of many churches of this time (S. Vitale, Ravenna, 6th c., and St. Catherine's on Mount Sinai, Palestine, 6th c.). In the mosaics of Monreale and Cefalu in Sicily (12th c.) they stand below the Pantocrator (see CHRIST) of the apse. Later their statues surrounded the altar (Cologne Cathedral, 14th c.) or were set on the choir screen (as in St. Mark's, Venice, 15th c.) or frequently around the chief outer door (as at Modena, CHARTRES, and Malmesbury, all 12th c.). On such portals the 12 PROPHETS are often associated with the Apostles, whose teaching was seen as the fulfilment of their prophecies. Thus at Parma the

Prophets carved by ANTELAMI on the north door of the baptistery (late 12th c.) hold each the figure of an Apostle in a medallion, and at Bamberg (early 13th c.) the Apostles stand on the Prophets' shoulders. Other versions, such as the portable altar of Eilbertus of Cologne (Welfenschatz, Vienna, 12th c.), show them each quoting an article of the Creed or a verse of prophecy.

The Apostles are sometimes depicted symbolically as 12 lambs (see LAMB) or as doves (Matt. x. 16), as in the apsidal mosaic of S. Clemente, Rome (12th c.). In a 14th-c. picture from Wormel formerly in the Kaiser-Friedrich Museum, Berlin, they are identified with the 12 lions on the throne of Solomon, each lion bearing the name of an Apostle and an article of the Creed. Their number also leads to their association with the signs of the Zodiac, as on the 10th-c. ivory in the cathedral Treasury at Quedlinburg. They appear together in many scenes from the New Testament, such as the LAST SUPPER, the Ascension, and the Descent of the Holy Spirit, and their various martyrdoms are also frequently depicted. In later times they have been the subject of several portrait-series, as in the drawings of van EYCK (Albertina, Vienna) which were engraved for popular circulation, and in the paintings of El GRECO in the Greco Museum at Toledo.

**APOTHEOSIS** (Greek: deification). The reception into Olympus of a ruler or genius, a subject that occurs in classical art (*Apotheosis of Homer*, B.M.) and frequently in BAROQUE painting. The vista of Olympus bathed in light with the deities coming down to receive and crown a mortal lent itself particularly well to Baroque ceiling compositions. Famous examples are *The Apotheosis of James I* (RUBENS, Banqueting Hall, Whitehall), of *William III* (Thornhill, Greenwich Hospital), and of the *Medici Grand Dukes* (Pietro da CORTONA, Pitti, Florence).

**APOXYOMENOS.** See LYSIPPUS.

**APPEL, KAREL** (1921– ). Dutch representative of the European movement of ABSTRACT painting which had affinities with ABSTRACT EXPRESSIONISM and considered to be one of the most powerful exponents of this style of painting. Examples of his work are in the Boymans–Van Beuningen Museum, Rotterdam.

569.

**APPLIED ART.** The distinction between FINE ART and 'applied art' came to the fore at the time of the Industrial Revolution when politicians and economists advocated state patronage for the arts partly at any rate because of the benefits they were expected to confer in industrial competition. In a speech on the proposal to build a NATIONAL GALLERY Sir Robert Peel said: 'Motives of public gratification were not the only ones which appealed to the House in

this matter; the interest of our manufacturers was also involved in every encouragement being held out to the fine arts in this country. It was well known that our manufacturers were, in all matters connected with machinery, superior to all their foreign competitors; but, in pictorial designs, which were so important in recommending the products of industry to the taste of the consumer, they were, unfortunately, not equally successful; and hence they found themselves unequal to cope with their rivals. This deserved the serious consideration of the House in its patronage of the fine arts.' Such in part were the motives which determined the formation of museums and galleries of fine art, the setting up of government-assisted Schools of Design, the establishment of a Museum of Ornamental Art, etc.

The idea underlying this movement was that art is something distinct from the process of machine manufacture and something which must be *applied* to the object manufactured. It was held necessary to discover the best art of all periods, to teach it in art schools and schools of design and to *apply* it to the products of industry in order that they should appeal more readily to the consumer. In this context art was largely identified with ornament and through the second half of the 19th c. in many important theoretical writings on ornament various manners and degrees of STYLIZATION were recommended to make ornament fit the material, the function of the object to which it was *applied* and the technique of production. At the turn of the century reaction manifested itself in various kinds of FUNCTIONALISM often involving the repudiation of ornament, as in *Ornament und Verbrechen* (1908) by Adolf LOOS and the publication in 1924 of *Form ohne Ornament* by the DEUTSCHER WERKBUND. The doctrinaire rejection of decorative embellishment and the insistence on austerity of form and the elegance of bare simplicity in all things did not outlast the 1930s. There came a revival of interest in the ROCOCO and in Victorianism. But there has been no revival of the concept of applied art, that basically bad or indifferent design can be rendered acceptable by 'applying' artistic decoration to it. It has since been held that good DESIGN in the useful or industrial arts must combine suitability for function and respect for materials and techniques with good workmanship and a pleasing appearance.

324, 1447, 1507, 2188.

**APSE.** The east end of a Christian church or chapel when this is designed round a fixed point, the place where in a Roman BASILICA the praetor's chair stood. The apsidal recess in a Christian church was usually semicircular or sometimes polygonal.

The name *apses in echelon* was given to staggered apses, a series of parallel chapels, aisles, chancel, etc., arranged stepwise and designed to produce an arrow-head or chevron formation.

**APT,** ULRICH THE ELDER (*c.* 1465–1532). German portrait painter, working in Augsburg (*Portrait of a Man and his Wife*, Hampton Court).

**AQUARELLE.** The French term for true WATER-COLOUR painting in transparent washes of colour, as distinct from the opaque method known as GOUACHE.

**AQUATINT.** A method of ETCHING in tone which gives an effect similar in some respects to that of a wash drawing. It is frequently combined with linear etching, and the transparent tones are obtained by biting the plate with acid through a porous ground of granulated resin.

The aquatint ground is normally formed by shaking on to the copper plate a dust of finely powdered resin, which is subsequently fixed to the plate by heating. When the plate is bitten, the acid attacks the surface through the reticulations of the hardened resin, causing the copper to be pitted all over with a texture of little dots which will eventually print as a finely speckled grey tone. The coarseness or fineness of the texture depends on the size and quality of the grains of resin forming the acid resist, while the depth of tone is regulated, as in ordinary etching, by the length of time the plate is exposed to the acid. The artist forms his design and varies his tones by 'stopping out', that is to say by painting over with a varnish those areas of the plate which he wishes to protect from the acid. In this way white-line effects on grey or black are commonly obtained.

Among several variants of this procedure *sugar aquatint*, a method dating from the 18th c. and used by GAINSBOROUGH but later neglected, has been revived in the 20th c. It enables the artist to overcome to some degree the indirectness of the aquatint medium; for instead of making his design by the negative means of 'stopping out' his whites, he is able to establish his dark areas directly by drawing on the copper plate with a solution of black water-colour and sugar, applied either by pen or by brush. The plate is then varnished and immersed in water. While under water the sugar begins to swell and, lifting off the plate, bursts through the varnish, leaving the bare copper beneath, the result being a copper plate covered with varnish except where the drawing was made with sugar solution. An aquatint ground is next laid over the whole surface and the plate bitten in a slow acid. By this means the drawing alone is etched in an aquatint texture, for the rest of the plate, being protected by the varnish, remains unbitten. Finally both ground and varnish are cleaned off and the plate is printed, showing the design as a dark tone on a white background.

Attempts at printing from a granulated, tonal surface date back to the 17th c., but a satisfactory system was not evolved until the 18th, by Jean-Baptiste Le Prince (1733–81), whose first plates date from 1768. In England, a country always partial to tonal methods of print-making, aquatint soon became popular. The principal English

pioneer was Paul SANDBY, who around 1775 invented the spirit-ground method whereby resin dissolved in alcohol is poured over the plate, the evaporation of the spirit leaving the resin to crystallize so as to produce a reticulated effect. Aquatint, both hand-coloured and printed in colour by means of a separate plate for each colour (see COLOUR PRINTS), was much used in England in the late 18th and early 19th centuries for interpreting the luminosity and transparency of the washes in water-colour drawings, particularly of topographical, marine, and sporting subjects.

Until modern times few great artists used the medium. The exception was GOYA. His favourite medium was a combination in varying proportions of etching and aquatint; though one of his prints, *Por que fue sensible* from the

**18.** *Por que fue sensible.* Aquatint from *Los Caprichos* (1799) by Goya

*Caprichos* of 1799, is the perfect and classical example of pure aquatint without etched lines of any kind. The granulous texture of Goya's prints, with their vividly concentrated lights and sense of profound darkness, expresses exactly the qualities of his dramatic and fantastic imagination and the depth of his feeling. Goya's expressive use of aquatint was not emulated until late in the 19th c., when DEGAS and Camille PISSARRO made a number of highly original prints in which aquatint was combined with etching and other intaglio techniques. Between the two Wars the establishment of 'Atelier 17', S. W. Hayter's workshop of experimental engraving (see LINE ENGRAVING), introduced many artists to the possibilities of aquatint as an element in com-

posite prints of an ABSTRACT nature. Several of the greatest masters of the School of PARIS have used sugar aquatint with outstanding success, notably PICASSO (illustrations for Buffon's *Histoire Naturelle,* 1942, and the *Poems of Góngora,* 1948), ROUAULT (illustrations to Suarez's *Passion,* 1939), and André MASSON (illustrations to *Les Conquérants* by André Malraux, 1948).

427, 1326, 2148.

**Fig. 4.** Arabesque star motif from carpet of the Safavid Period (late 16th c.), with both stylized and semi-naturalistic ornament. After *A Survey of Persian Art* (1939), A. Upham Pope

**Fig. 5.** Faience mosaic decoration from the tomb of Fakhr-ed-dín Ali, Konia 13th c.). After *Denkmäler persischer Baukunst,* Friedrich Sarre (1910)

**ARABESQUE.** A scrolling or INTERLACING plant form, the most typical motif of ISLAMIC ornament. In the late Middle Ages such patterns were in Europe termed Moresques, but in the 16th c. the word 'arabesques' came into use when Europeans began to be interested in the art of the Moslem world. But the motif itself is much older, for it is found in HELLENISTIC art, notably in Asia Minor. Its Islamic form first appeared *c.* A.D. 1000 and thereafter it became the stock-in-trade of the Moslem artist, for whom it had a particular appeal since—in theory at least—his religion precluded the representing of living creatures.

In Hellenistic art the plant form had been

**Fig. 6.** Roman silver cup with repoussé decoration of naturalistic floral scrolls and birds (1st c. A.D.). Arabesque style going back to the Pergamene School. (B.M.)

**Fig. 7.** Arabesque designed (1530) by Francesco Pellegrino. After *Der Ornamentstich* (1920), Peter Jessen

rendered naturalistically, but to the Moslem artist it was an opportunity of exercising his power of imagination and invention. The only important rule that he had to observe was that of the split leaf and the continuous stem. In his hands the arabesque assumed complicated convolutions which were invariably disposed symmetrically and often the plant form itself became schematic and divorced from reality. The development of the arabesque can be best studied in the decorative arts, especially in the illuminated decoration of manuscripts. The term is, however, applied also by extension to the combinations of flowing lines interwoven with flowers and fruit and fanciful figures used by RENAISSANCE decorators.

**ARA PACIS.** The Altar of Peace set up by Augustus on the Campus Martius at Rome (13–9 B.C.) to commemorate his· return. It consists of a table of sacrifice within a precinct and approached by a stairway from the west. The screening walls are decorated externally by two superimposed zones of relief carving which occupy an important position in the history of Roman official documentary relief sculpture (see ROMAN ART). The upper zones on the south and north walls respectively represent Augustus and his family with the Consuls and Lictors in the ceremonial procession at the dedication of the altar and the other Roman civil and religious dignitaries in the same procession. Although the figures are treated in the academic HELLENISTIC style, the faces are genuinely recognizable portraits and the composition has the stately dignity of a Roman official concourse instead of the mythological impersonality of a classical Greek representation. Typically Roman also are casual, homely touches such as a frightened child and a couple chatting. The panels on the east and west walls contain allegorical figures, such as Italia flanked by the PERSONIFICATIONS of the ocean and inland waters, and scenes from Roman mythology and legend. The combination of realistic representation with symbolism and allegory set a tradition which had a long history in Western commemorative sculpture. The panels of the lower zones contain exceptionally graceful floral decoration, Hellenistic and perhaps PERGAMENE in origin but with naturalistic depiction of small animals and birds, swags of fruit and garlands of leaves which may express a Roman taste for organic nature.

In the opinion of many critics these sculptures have not been surpassed in their kind through the history of Roman art. It has been said that: 'If we would understand the Augustan period—its quiet good manners and its undemonstrative confidence—in a single document, that document is the Ara Pacis Augustae.'

**ARCADE.** A range of ARCHES carried on COLUMNS or PIERS. A *blind arcade* or *wall arcade* is applied as decoration to the face of an unpierced wall.

**Fig. 8.**

A. Lintel.  B–M. Arches: B. triangular.  C. corbelled.  D. round.  E. horse-shoe.  F. pointed.  G. tiers-point.  H. equilateral.
J. ogee.  K. nodding ogee.  L. four-centred.  M. three-centred

**ARCH.** The practical problems of joining walls or uprights of masonry overhead turn on whether the connection is to be made with one or more components. Stone LINTELS such as we find in the Gates of Mycenae, at Stonehenge, or forming the ARCHITRAVES above the colonnades of Greek temples provide obvious examples of the former.

The distance that can be covered by a single block of stone, however, is restricted by the size which can be quarried and transported and by the inherent tendency of stone to break under its own weight if the span is too great. The roof of the tomb of Theodoric at Ravenna (*c.* 526), which is a single stone slab about 35 ft. in diameter,

must approximate to the practical limit. The only other readily available building materials of which a single length could be used for large spans before the recent introduction of reinforced CONCRETE were timber beams and girders of iron and steel. In the absence of such materials the only other way of spanning spaces was to resort to two or more blocks of masonry, and this involves the problem of the arch.

An extremely crude form of arch consists of two single blocks leaning against one another and achieving equilibrium. In timber construction the crucks around which medieval houses were often built conformed to this arrangement, and on a small scale so also did the triangular apertures found in pre-Romanesque architecture.

Arches of a kind can also be made by corbelling, i.e. each successive block of stone projects beyond the ones below, and is held in position by the weight of the superstructure, operating on the cantilever principle. Perhaps the most impressive use of this kind of arch is to be found in MYCENAEAN tholos tombs, such as the Treasury of Atreus. These arches are not load-bearing and they have to be elliptical in shape. The arch proper may be said to have originated with the idea of placing a considerable number of blocks of masonry in a concentric arrangement. As every block tends to converge on the same point, each is held firmly in position by its neighbours (round arch). Not only can considerable distances be spanned in this way, but arches can carry a much heavier load than a horizontal lintel.

Arches can most conveniently be classified according to the geometry of their design. The simplest form of curved arch has one centre and a fixed radius, which yields a pure semicircle or, as in some BYZANTINE and ISLAMIC buildings, rather more than a semicircle (horseshoe arch). This sort of arch was widely used by the Romans and by medieval architects until the GOTHIC period. With the RENAISSANCE in Italy semicircular arches came once more into fashion. Although such arches are probably the most satisfying aesthetically, structurally they tend to be weak at the crown. From a mechanical point of view the most efficient curve for an arch is a catenary; and there is some evidence to suggest that catenary arches were used in buildings constructed under the influence of Greek mechanical theories, e.g. Ctesiphon in Sassanian Persia, and very late Roman buildings, e.g. Sta Sophia, Constantinople. Some crude recollection of this seems to have lingered on in later Byzantine, Armenian, and Georgian architecture, where elliptical arches are found; and something approximating to a catenary curve is represented by the pointed arch, which came into use among the Arabs (perhaps as a debased form of the Persian catenary arch). Later (11th c.) this was adopted in Western European architecture. The pointed arch consists of similar arcs struck from two or more centres. The segmental arches lean against each other and are mutually supporting. Their centres may fall above or below the base-

line of the arch, and inside or outside the space it encloses. An infinite variety of shapes is thus possible and medieval styles of architecture can often be classified according to the arch formation.

In the mature Gothic 13th-c. cathedrals of northern France there is a definite predilection for certain basic formulas, e.g. lancet and equilateral. In the latter the radius of the arcs is equal to the span of the arch, while in the former, it is much larger. In England, however, there was much greater variety. At Wells, Salisbury, and Westminster Abbey arches are sharply pointed; while at Lincoln they are almost semicircular. On the whole English medieval masons tended to handle arches without much concern for theoretical considerations. When it suited them they were prepared to use asymmetrical, i.e. lop-sided, arches and even to construct multiple arches involving several arcs of different radii, as for instance around rose windows in the eastern transepts of Canterbury Cathedral. Another curiously insular kind of arch is represented at Hereford, where we find curves of large radius sharply depressed to fit into spaces for which they were ill designed.

By the end of the 13th c. the most ambitious English architects were no longer satisfied with the large number of variations which it was possible to achieve by striking arcs from centres on or below the base-line of the arch. For decorative purposes they began to experiment with compound forms in which two centres were used, one for each half of the arch, on either side of the profile, producing a double curve, concave and convex. Arches constructed in this way are often known as ogees. A further elaboration was introduced early in the 14th c. by making the sinuous movement of the reversed curve three-dimensional, i.e. the top of the arch projects out into space in front of the lower parts. These are known as nodding ogees; they were never structural, and were used only on a small scale. Some particularly splendid examples can be seen in the Lady Chapel at Ely Cathedral.

The PERPENDICULAR style also produced its distinctive form of arch. This too was based on more than one centre, but in this case all the centres were on the same side and different radii were used. They are known as four-centred arches—not a very well-chosen name because ogees also have four centres. Essentially, Perpendicular four-centred arches consist of two sharply curved arcs with small radii at the corners which lead into two much straighter arcs meeting at the centre. A very late medieval variation of this was the three-centred arch, in which the two sections with short radii are joined by a single arc with a much longer radius.

Since the Middle Ages arches have played a less complex role in the repertory of architectural forms. This is partly due to the Renaissance prejudice in favour of simple semicircular arches and partly because in more recent times architects have preferred to solve structural problems

by exploiting the new materials at their disposal, especially ferro-concrete.

The following subsidiary terms are also used in connection with arches.

*Transverse arch*: an arch used in vaulting which runs at right angles to the vista which it spans.

*Relieving arch*: an arch constructed within a mass of masonry to relieve the wall below of the weight of the superstructure and transmit the load to fixed points at the extremity of the arch.

*Quadrant arch*: an arch constructed of half a round (semicircular) or half a pointed arch used as BUTTRESSING in the construction of flying buttresses and also in the vaults of side aisles in certain ROMANESQUE churches.

**ARCHAIC SMILE.** There was a convention in the Greek Archaic period, especially during the second quarter of the 6th c. B.C., for statues to be represented smiling. A smile was suggested by drawing the mouth upwards in a clear, flat curve applied to the surface of the face. Various and conflicting explanations have been given of the 'archaic smile'. According to one view it may have originated in the technical difficulty of fitting the curved mouth into the block-like form which the early sculptors of KOUROI gave to the head: certainly as the century progressed the increasing use of chisels led to a disappearance of the block-like character and the archaic smile gave place to a straighter, graver, and more serious or almost sulky expression of the mouth. The convention is described by John Boardman as an expression of 'strained cheerfulness' which cannot fairly be added to the few instances of emotion expressed in the features of Archaic statues. Other writers have attached to it a deeper aesthetic significance. A similar shift from a patterned smile to a more naturalistic gravity may be seen in some GOTHIC sculpture, e.g. figures carved early and late in the 13th c. at Bamberg Cathedral.

**ARCHAISM.** The taste for and imitation of earlier, especially PRIMITIVE, styles. Quintilian

**19.** Parish church of St. John the Evangelist, Smith Square, Westminster. Detail of engraving (1762)

mentions collectors who preferred Archaic Greek art to that of later periods, but he rejects this as an affectation. The existence of the Neo-Attic style bears out his reference. Whether the taste of certain RENAISSANCE collectors for early FLEMISH ART should be mentioned in this context is perhaps a moot point, for the real interest in the 'purity' and 'simplicity' of early styles only revived in Europe in the 18th c. in conjunction with the Greek and GOTHIC REVIVALS. The archaisms of the German NAZARENES and the English PRE-RAPHAELITES are matched by a renewed interest in the products of the 'childhood of art', works which were then prized for their 'charmingly naïve' character. In modern movements this taste for the naïve and archaic has been swallowed up in a general reassessment of the elemental and the primitive in the history of art.

**ARCHER,** THOMAS (1668–1743). English architect. Archer, a man of good family, was educated at Oxford and then travelled for four years before obtaining a sinecure at the court of Queen Anne. His work is more firmly rooted in the tradition of continental BAROQUE than that of any other English architect and it seems that he must have studied the buildings of BERNINI and BORROMINI at first hand. At Chatsworth he designed the bowed north front (1704) and the joyous Cascade House, but he is best known for three churches: St. Philip's, Birmingham (1710–15), and, in London, St. Paul's, Deptford (1712–30), and St. John's, Smith Square (1714–28; interior gutted, 1941). The last two were built as a result of the 1711 Commission for 50 new churches in London; a commission on which Archer sat. Though grossly out of scale with the small square it oppresses, St. John's with its curved corners, boldly stressed detail, and massive pediments broken across the sky is the most highly individual work of this artist. Surprisingly, his own house, Hale House, Hants (1715), is unobtrusively PALLADIAN.

2587, 2862.

**ARCHIPENKO,** ALEXANDER (1887–1964). Russian sculptor, born at Kiev. From 1908 he worked in Paris, taking an active part in the development of the CUBIST movement. In 1913 he was connected with the German STURM group and he taught in Berlin between 1921 and 1923, when he settled in the U.S.A. He taught in New York except between the years 1937 and 1939 when he was connected with the Chicago *Bauhaus.* Archipenko was, in the words of Guillaume APOLLINAIRE, one of the most important originators of *sculpture pure.* His works from the Cubist period have been thought to combine the impact of PRIMITIVISM with constructive sophistication (*Portrait of Mrs. Kamenev,* 1909; *The Kiss,* 1910). His semiabstract shapes show a deep feeling for rhythmic movement (*Woman with Child,* 1909; *Pierrot,* 1913; *The Gondolier,* 1914) and it has been said by Herbert Read that with him 'the object

becomes an excuse for the presentation of the concept of movement in space' (*Boxing Match,* 1913). His method of opening up the plastic form by holes and concavities created a new idiom in modern sculpture.

72.

**ARCHITECT.** Today the chief task of an architect is to design buildings and to supervise their erection. But there is not always a clearcut line of demarcation between architecture and such closely related fields as TOWN-PLANNING, landscape architecture, interior decoration, industrial design. A recognized distinction exists, however, between the designer of professional status who works for a fee and the contractor who is in business in order to make a profit by carrying out works for a client. This distinction between architect and builder is of recent date. In the past, before the professional status of the architect was assured, the two functions frequently merged and the term 'architect' had widely varying meanings, although the unifying concept of designer was never wholly lost.

The title *architekton* in Greek implies the direction of subordinate craftsmen (*tektones*) and seems to indicate that one of the main tasks of the architect then as now was the co-ordination of workers in several crafts. Both Plato and Aristotle corroborate this and point out the difference between the architect and mere artisans. A Greek architect might have to take very serious personal responsibilities towards his client, which often was the city itself. Sometimes he held an official position, and his renown and remuneration might be considerable. Architects were called from one city to another and a 4th-c. source states how much more difficult and expensive it was to obtain an architect than a craftsman. In spite of all this the architect's position in Greek society cannot have been very different from that of any other artist or artisan—not anything 'a young man of high birth or liberal sentiments' would strive for, according to Plutarch.

Names of Greek architects (e.g. ICTINUS, CALLICRATES, MNESICLES, PYTHEOS, Eupalinus) have been preserved in literary remains and in building inscriptions. The latter played an important role in the building process; as records of dedication and achievement they are more likely to mention names of donors and officials than those of architects, but detailed descriptions which were prepared before construction sometimes give the names of architects and contractors. Recently it has been argued by J. A. Bundgaard that no accurate plans and models of an entire building were used by Greek architects of the classical period but detailed specifications only as laid down in these inscriptions. Occasionally particular details were clarified by drawing or model. Such a proceeding is feasible only if the architect is very closely connected himself to workshop and building site, and works within a tradition which has been well defined over a considerable period of time. Plato in fact

once refers to the architect's need for practical training under an experienced master.

Numerous Greek architects wrote about their buildings and theories, but unfortunately all these treatises have been lost. They must have given impressive evidence of architectural scholarship and science if we may infer from references and quotations in a Roman text, the famous *Ten Books on Architecture* by VITRUVIUS.

Vitruvius was a contemporary of Cicero and dedicated his book to Augustus. He seems to have been a follower of HERMOGENES in many of his theoretical views and, writing in old age, he tended to be on the conservative side. He disapproved of his younger colleagues who had no scruples in soliciting commissions and giving unreliable estimates, while he had been taught by his masters to wait till his services were called for and to employ 'entirely accurate methods'. He was also suspicious of the new building techniques which were spreading rapidly during his lifetime. But he was filled with a genuine admiration for the greatness of architecture and he strove to set down the loftiest principles for professional training and conduct.

Some of Vitruvius's definitions and precepts remained influential until the 19th c., for instance his statement that works of architecture 'should be so carried out that account is taken of strength, utility, grace' (Bk. I, ch. iii. 2), and his demand for universality in the architect who 'should be a man of letters, a skilful draftsman, instructed in geometry, familiar with history, a diligent student of philosophy, acquainted with music, not ignorant of medicine, learned in the responses of jurisconsults, familiar with astronomy and the theory of the heavens' (Bk. I, ch. i. 3).

It is clear from such a statement that to Vitruvius, following Greek tradition, the architect was much more than simply any member of a Roman masons' guild; what he describes is a well-trained technician who knows how to draft plans and is versed in all phases of technology then in existence, including the building of machinery and clocks. This interpretation was the current one in West and East. APOLLODORUS of Damascus, who built the Forum of Trajan and a bridge across the Danube, also wrote a detailed account with illustrations of how to build military engines, and both architects of Sta Sophia, *mechanikoi* as they were called, ANTHEMIUS and ISIDORUS, wrote about problems of mathematics and mechanics. The geometer, Pappus of Alexandria, writing about mechanics in the 4th c. A.D., explained in fact that the best architects were those who had a complete training in the 'theoretical and manual part' of mechanics.

In ancient Rome *architectus*, in addition to the meaning mentioned so far, also designated certain functionaries in public administration and in the army. An architect's social position and remuneration must have varied a great deal. Cicero once refers to architecture as an art which brings nothing but honour to those who practise it, but elsewhere he qualifies the 'honourability' by restricting it to 'persons of a lower class' and he personally employed architects who were slaves.

Later in Roman history we find architects in important positions close to the emperor, who might even decree the encouragement of architectural education and the foundation of architectural schools. To Cassiodorus, standing at the very end of antiquity, the architect is 'the most diligent imitator of the ancients, the most noble institutor of the moderns' (*Var.* iv. 51) and by order of Theodoric he wrote to an architect Aloisius: '. . . which employment more honourable, which function more glorious than . . . to transmit to the most distant ages monuments which will assure you the admiration of posterity . . . you walk immediately in front of our person . . . having in hand the golden rod . . .' (*Var.* ii. 39).

The rod in hand as a sign of the architect's dignity is found again centuries later at REIMS Cathedral, on the effigy of Hugues Libergier (d. 1263), one of those highly valued medieval masters of whom a contemporary churchman wrote: 'The master masons who carry in hand the rod and the gloves tell the others: *Par cy me le taille!* and they do not work . . . and yet he receives greater wages. . . .' But between the highly qualified architect of late antiquity and his equally skilled successor of the cathedral age there is more than half a millennium during which at times the architect all but disappeared, while even the term 'architect' underwent 'curious vicissitudes'.

To the medieval mind the designation of architect must have derived a certain dignity from being linked with St. Paul's statement about himself: '. . . as a wise master builder I have laid the foundation' (1 Cor. iii. 10) and Isidore of Seville in his *Etymology* in fact refers to this when he defines 'architect'. He also uses Vitruvian categories, and, later, interest in Vitruvius was revived during the CAROLINGIAN Renaissance. But the meaning of Vitruvius was no longer understood fully and Isidore already described architects as 'caementarii . . . qui disponunt in fundamentis'. Architect here was equated with mason and throughout the Middle Ages these terms remained practically interchangeable, a terminology which corresponded to the facts. As a rule buildings were worked out by craftsmen, masons or carpenters, from a programme laid down by the patron, though sometimes a clerical dignitary, such as Bishop Benno of Osnabrück, was an expert designer himself and thus became architect and patron in one person.

The craftsmen might belong to a group that moved from building to building or they might be members of a religious order, especially during the early Middle Ages. Later we find them organized in craft-guilds, though not all countries had the kind of masonic lodges which existed in England and Germany, where written constitutions and strict rules covered the training of apprentices and journeymen and the conduct of work.

In spite of the prominence of the master-craftsman the original meaning of the term 'architect' occasionally came to the fore again. In the 13th c., it is true, John Balbi defined *architector* as one who makes roofs, but at the same time he added 'or better the principal craftsman who is in charge of buildings to be constructed', and St. Thomas Aquinas and his Dominican followers even went back to Aristotle in comparing the activity of the architect to the highest ordering activity of the human mind in philosophy. The Vitruvian striving for mastery of both practice and theory—*fabrica et ratiocinatio*—is echoed in the medieval saying 'ars sine scientia nihil est' repeated at a conference of masters about the design of Milan Cathedral. *Ars* and *scientia* here are used in the sense given to these terms in the *Summa* of philosophy attributed to Robert Grosseteste: *scientia* is knowledge of the reasons, *ars* more the mode of operation as handed down by tradition. Seen in this light the funeral inscription of Pierre de MONTREUIL, one of the great cathedral builders, which calls him 'Doctor Lathomorum', may assume a deeper meaning and relate to the striving for a true Vitruvian universality which is in evidence in Villard d' HONNECOURT's notebook. This unique collection of drawings and notes from the first half of the 13th c. reveals a great deal about the way in which a medieval master worked, and together with later sources permits us to form a fairly accurate picture of his theoretical knowledge and practical experience.

Geometry was the master's chief science; a geometry that was simplified into a few precepts which were kept secret and handed on by tradition in the same manner as the manual skills of the craft. Except for the demonstration of difficult solutions or the carving of important pieces the master did not need to do much manual work, but he was the one who understood the proper setting out of plans and elevations and he had to give the patterns and mouldings. Architectural drawings of a very fine quality occur frequently after the 13th c., showing mostly details of plans and elevations but some complete elevations also. Models have survived from the late Middle Ages only.

Medieval architects are known to have been highly esteemed by princes and bishops and to have worn the furred robes of men of quality. Quite a number of masters' names are known from all over Europe, though little relevance can have been attached to recording them for posterity in a hierarchical society where the mechanical arts were inferior to the LIBERAL ones, and everything subordinate to theology.

This aspect at least changed dramatically with the advent of the RENAISSANCE and humanism in Italy; the rediscovery of Vitruvius, who went through numerous editions and translations, brought a reintroduction of his highly personalized concept of the architect, which, however, for a long time yet existed side by side with that of the master-craftsman of the medieval type. In fact some prominent Renaissance architects came from families traditionally connected with the building trades, while others combined architecture with the fine arts or with scholarship and science. No single accepted mode of becoming an architect existed and most of the training would take place in connection with one of the big building projects of the period.

Leon Battista ALBERTI in *Ten Books on Architecture* outlines his ideal of the qualifications, training, and methods of an early Renaissance architect. Although he criticizes Vitruvius for demanding from the architect too many auxiliary attainments, his own definition is still a very embracing one: 'Him I call an Architect, who, by sure and wonderful Art and Method, is able, both with Thought and Invention, to devise, and, with Execution, to compleat all those Works, which, by means of the Movement of great Weights, and the Conjunction and Amassment of Bodies, can, with the greatest Beauty, be adapted to the Uses of Mankind: And to be able to do this, he must have a thorough Insight into the noblest and most curious Sciences' (Preface). 'Doubtless Architecture is a very noble Science not fit for every Head . . .' (Bk. IX, ch. X).

Apart from a very thorough study of Roman remains and of the best contemporaneous works, painting and mathematics according to Alberti were most essential in an architect's training. His geometrical drawings, perspectives, and arithmetical computations, however, were always to be checked by three-dimensional models. FILARETE compared the model to a child which is born from the union of patron and architect, and a great number of such models is known; some of them are still in existence. Their importance probably explains why comparatively few complete drawings exist of façades: what is mostly found are ground-plans and drawings of details, in addition to numerous design sketches for the architect's own use, and occasional presentation drawings for the client.

Based on personal achievement and fame an architect's social position and remuneration could be very satisfactory at this period, but his career depended very much on circumstances of PATRONAGE and favour and it might be full of unexpected turns. The devising of machinery of all sorts, of stage sets and fireworks were considered legitimate tasks of the architect, as town-planning and fortification, and thus he might come close to the ideal of the 'universal man'.

By the end of the 16th c. a rich literature of architecture was in existence and, partly under the influence of the newly founded ACADEMIES, training and practice began to follow an accepted pattern. It is outlined among others by SCAMOZZI, who in his voluminous compendium describes in detail methods of design and drafting.

From Italy the concept of the professional architect spread to other countries and, in spite of the entrenched position of the traditional master-craftsmen, we find a number of well-established architectural practitioners all over

Europe during the 17th c. In their training a tour of study to Italy was important, and the French Academy with its publications made its influence felt. But architects still came to architecture from many different directions: from the fine arts, from science, from military engineering, from the building trades, and last but not least from the educated gentleman's life of leisure. To be his own architect was indeed one of the recognized pursuits of a gentleman, who might share the feelings of Roger North about architects: '. . . a profest architect is proud, opiniative and troublesome, seldome at hand . . . therefore be your owne architect. . . .' Still a nobleman was not supposed to deal with architecture in its more technical aspects, as Lord Chesterfield advised his son in a letter of 1749: '. . . leave them to masons, bricklayers, and Lord BURLINGTON; who has, to a certain degree, lessened himself by knowing them too well.'

As a rule the architect continued to depend on patronage, or was attached to a court where he might hold an official position within the elaborate organization that had to be created for the vast building programmes typical of the age. These court employments still called for something of the old universality in the architect, but they also fostered a good deal of delegation of design work comparable to modern office-practice.

The architect's relations to his patron might be stormy at times, as in the late 17th-c. case of Domenico Martinelli at Vienna: when the architect discovered that during his absence some changes had been made to one of his designs he had broadsheets printed denouncing the alterations. Some of these he posted at the corners of the building with the result that he had to flee in order to avoid his noble client's rage.

Little feeling of solidarity was in evidence among architects and a very outspoken individualism the rule. They had left the old craft organizations behind but new professional associations were slow in forming. In England the first architectural club was founded late in the 18th c. and rules of professional conduct were only accepted, by a small group at first, during the first half of the 19th c.

During the 19th c. significant changes took place which are well known and which eventually led to the emergence of the architect in the modern sense of the word. Rapid progress in technology engendered the separation of engineering from architecture; the individual client began to be replaced by the corporative body, and with this the need for a fairly standardized code of practice and remuneration became more urgent. Architectural training moved to the schools from office and building site and the old academies were less and less capable of coping with increasing numbers of pupils and unprecedented problems.

By 1900 a new type of professional architect existed who had lost his close connection with the building trades and the actual process of executing building work, and who had abandoned the striving for Vitruvian universality in the face of a bewildering specialization all around him. It is interesting to note how during the first half of the 20th c. some of the greatest figures in architecture strove to recapture both these aspects in a modified form. On the one hand, institutions such as the BAUHAUS and DEUTSCHER WERKBUND wanted to bring architects into closer contact with the actual processes of production relevant to building in an industrialized age; on the other hand, city and regional planning attempted to re-integrate the single architectural creation into a more universal framework, with no less a goal than a totally balanced and harmonious human environment.

**ARCHITRAVE.** Term in architecture. The lowest of the three primary divisions of the ENTABLATURE, the horizontal LINTEL supported by two COLUMNS or PIERS. It is principally found in classical architecture or architecture derived from classical models. The word is also loosely applied to any moulding round a door or window.

**ARCHIVOLT.** The MOULDINGS round the face of an ARCH in RENAISSANCE architecture.

**ARCH OF CONSTANTINE.** A TRIUMPHAL ARCH erected to greet the return to Rome of the Emperor Constantine in A.D. 315 and described as 'the last great monument of Imperial Rome'. It incorporated or adapted reliefs from monuments of Trajan (parts of the great Trajanic frieze), Hadrian (roundels with hunting scenes), and Marcus Aurelius (panels from a triumphal arch or other monument). The carvings done for the Arch combine compositions in the centralized, static style showing the imperial figure in HIERATIC FRONTALITY, with laterally moving scenes, processional and military, in a more lively and naturalistic manner. There are allegorical carvings in the classical manner. The workmanship and technique are generally inferior to those of earlier reliefs and the composition, although sometimes vigorous, betrays a falling off from previous reigns. These Constantinian reliefs have been since the RENAISSANCE the most familiar example of later Roman sculpture. Some critics, such as Riegl, denied that there was a decline and regarded them rather as signs of a changing outlook. It is possible to see an element of truth in both views. The Arch was a composite structure and the symbol both of a failing tradition and of the new trends of an outworn civilization on the brink of the Byzantine world.

**ARCIMBOLDO,** GIUSEPPE (1537–93). Milanese painter famous for his GROTESQUE symbolical figures composed of fruits or animals, landscapes or implements. He began his career as a designer of stained-glass windows for Milan Cathedral but moved to Prague and became court painter to successive Habsburg kings. He was ennobled in 1592. His paintings, though much imitated, were generally regarded as curiosities

**20.** *Winter.* Oil painting (1563) by Giuseppe Arcimboldo. (Kunsthistorisches Mus., Vienna)

in very poor taste until the SURREALISTS revived interest in 'visual punning' and Salvador DALI sought inspiration from his bizarre inventions.

1620.

**ARCINIEGA,** CLAUDIO DE (*c.* 1527–93). Spanish architect who lived and worked in Mexico from *c.* 1545. In 1559 he designed the funeral monument for Charles V. He was made *Maestro Major* at the building of Mexico Cathedral in 1584, when he reformed the cathedral plan. He was also probably the author of the plan for the cathedral of Puebla. He was influential in introducing the severer HERRERAN style to supersede the PLATERESQUE which had previously been current in Mexico.

**ARENTSZ,** ARENT, called CABEL (*c.* 1585–1635). Dutch painter of winter and summer activities on the sea-shore and canals of Holland. His works are sometimes difficult to distinguish from Hendrick AVERCAMP's.

**ARGENTINE ART.** Argentina became an independent nation in 1816. Previously an outpost of the Spanish colonial empire, it remained a sparsely populated country until nearly the end of the 19th c. The best-known Argentine artist of the 19th c. was the painter Prilidiano Pueyrredón (1823–70), whose pictures of *gauchos* and GENRE scenes record life in Argentina before the country was opened up by large-scale immigration and the building of railways. Pueyrredón's work and that of other *costumbrista* artists (often Europeans staying in South America) provides a comprehensive record of the topography, buildings, daily life, and costumes of Buenos Aires and the pampas during the middle of the 19th c.

As elsewhere in Latin America there is a sharp break between the derivative Argentine art of the late 19th and early 20th c. on the one hand and modern art since *c.* 1920 on the other. Modern painting is represented by the work of an older generation of artists including Horacio Butler (1897–  ), PETTORUTI, and Raquel Forner, who all spent many years of their youth in Europe; and by a younger generation, among whom the abstract painters Sarah Grilo (1920–  ) and Muro were the most prominent. In contrast to Brazil there has been little development of modern architecture in Argentina.

458, 1828, 1997, 1998, 2045, 2413.

**ARMATURE.** A framework or skeleton round which a clay or plaster figure can be modelled (see MODELLING).

**ARMITAGE,** KENNETH (1916–  ). English sculptor, trained at Leeds College of Art and at the Slade. In 1958 he was the British representative at the Venice Biennale. His works have been exhibited widely in Europe and the U.S.A. and he is represented by works in New York, Paris, Rome, the Tate Gallery and the Victoria and Albert Museum, London. He had a retrospective exhibition in 1959 at the Whitechapel Gallery, London.

**ARMORY SHOW, THE.** An International Exhibition of Modern Art held in New York, 17 February–15 March 1913, at the Sixty-ninth Regiment Armory. The initiative came from a group of artists who wanted to popularize newer developments in U.S. art. The nucleus was formed by the circle of Robert HENRI, who had formed the EIGHT and later the Independent Show of 1910 (see AMERICAN ART OF THE U.S.A.). They formed an Association of American Painters and Sculptors to organize the show and the breadth of conception with which the project was envisaged and conceived was largely due to the president, Arthur B. DAVIES, whose enthusiasm for presenting a comprehensive picture of current European artistic movements largely overshadowed the original idea of an American exhibition. The Armory Show was both a mammoth exhibition in sheer quantity (estimated at 1,600 works) and a daring presentation of new and still controversial art. It was in effect two exhibitions in one. The American portion gave a cross-section of contemporary U.S. art heavily weighted in favour of the younger and more radical groups. The foreign section, which was the real core of the exhibition and became the focus of controversy, was a fairly coherent and comprehensive presentation of current movements in the ÉCOLE DE PARIS. Although it by-passed German EXPRESSIONISM and Italian FUTURISM, it was more radical and inclusive than the similar POST-IMPRESSIONIST exhibitions organized by Roger FRY in London in 1911 and 1912.

From New York the show went to Chicago and Boston. It was estimated that over a quarter of a million visitors paid to see it and over 300 pictures were sold. Its impact was enormous. Though the first reactions were ridicule or shocked indignation, the effect of the show was to revive public interest in the artistic phenomenon and from the time of the show modern art did not cease to be a living issue in the U.S.A. Apathy and indifference had been broken through and it has become a commonplace to speak of the Armory Show as the beginning of an interest in contemporary art in the U.S.A.

**ARNOLFO DI CAMBIO** (d. probably 1302, certainly before 1310). The architect and the sculptor Arnolfo, a pupil of Nicola PISANO, are probably one and the same. But attempts have been made to separate them, although VASARI regards them as one person, whom he calls Arnolfo di Lapo. A document of 1300 praises Arnolfo as the builder of Florence Cathedral (begun 1294) and describes him as a church builder, but the cathedral is his only certain architectural work. His original plan was, however, much altered and enlarged by his successors, especially TALENTI. The most important churches attributed to him are the Badia and Sta Croce in Florence. The Badia, rebuilt between 1284 and 1310, is substantially unchanged; Sta Croce was rebuilt 1294/5 and not completed until the 19th c. The plan is probably Arnolfo's.

As a sculptor Arnolfo worked on Nicola Pisano's Siena Pulpit (1265-8) and was in the service of Charles of Anjou in Rome in 1277: his portrait of Charles (Conservatori Gal., Rome) is one of the earliest post-Classical portrait-statues. His tomb of Cardinal De Braye (d. 1282), in S. Domenico at Orvieto, set the type of wall TOMB for more than a century. In Rome he made a tomb, now dismembered, and a bust of Boniface VIII (Grotte Vaticane), and built CIBORIA in S. Paolo fuori le Mura (1285) and Sta Cecilia (1293). Other works attributed to him are in Florence (Museo del Opera and Bargello); Bologna, S. Domenico Maggiore (parts of the *Arca of S. Dominic*); Boston; London (V. & A. Mus.); and the bronze *St. Peter* in St. Peter's, Rome.

1770.

**ARNTZENIUS,** PIETER FLORENTIUS NICOLAS JACOBUS (FLORIS) (1864-1925). Dutch painter and etcher of lively street scenes and café life. He lived at The Hague, was a late exponent of the HAGUE SCHOOL, and painted in the tradition of BREITNER. Works by Arntzenius are in the Municipal Museums of The Hague and Amsterdam.

**ARP,** JEAN (HANS) (1887-1966). French sculptor, born at Strasbourg. Before the First World War he came into contact with the BLAUE REITER group in Munich and participated in their second exhibition (1912), where he met Robert Delaunay (see ORPHISM). During the war he met Max ERNST at the exhibition of the *Werkbund*, Cologne, and was a member of a circle in Paris which included MODIGLIANI, Max Jacob, APOLLINAIRE, and PICASSO. In 1915 he met Sophie Taeuber (whom he afterwards married) at Zürich and collaborated with her in experiments with cut paper compositions and COLLAGES. He helped to found the DADA movement and made illustrations for the Dada publications (1916-19), during which years he also made his first abstract polychrome relief carvings in wood. In 1919-20 he worked with Max Ernst at Cologne and met SCHWITTERS in Berlin. During the 1920s he was associated with the SURREALIST movement and participated in the first Surrealist exhibition in 1925. In the 1930s he developed a type of sculpture sometimes called 'creative abstraction' which tries to convey a suggestion of organic forms and growth without reproducing actual plant or animal shapes. During the 1940s he lived first at Grasse with Sophie Taeuber, Sonia Delaunay, and Magnelli, then in Switzerland. He returned to Meudon in 1946, when he published a collection of poems under the title *Le Siège de l'Air*. In 1950 he made a monumental wood relief carving for the University of Harvard and in 1953 a monumental sculpture *Berger et Nuage* for the University of Caracas. In 1954 he was awarded the Prix International de Sculpture at the Venice Biennale and in 1958 he did a relief for the UNESCO building, Paris, and was given a retrospective exhibition at the Museum of Modern Art, New York.

1037, 1765, 2519.

**ARPINO,** CAVALIERE D'. See CESARI, Giuseppe.

**ARRETINE WARE.** A class of Roman pottery made at Arretium (Arezzo) in Italy, particularly the red ware with moulded, often classicizing decoration (*c.* 30 B.C.-*c.* A.D. 40). Fragments found in the 13th c. were very much admired by contemporary artists.

30.

**ARRICCIO, ARRICCIATO.** Term in mural painting. The rough coating of lime and sand plaster to which the INTONACO is applied (see FRESCO).

**ARRUDA,** DE. Name of two Portuguese architects who during the first half of the 16th c. were originators of the MANUELINE style. DIOGO began the chapter-house of the convent at Tomar in 1510. The west front of this building, with its extraordinary maritime symbolism, represents the extreme development of the Manueline style. FRANCISCO, probably brother of Diogo, built the Tower of Belém (1516-21) near Lisbon, the most imaginative example of the Manueline style in military architecture.

**ART BRUT.** Phrase coined by DUBUFFET for

the crude pictures of psychotics and untrained amateurs, *graffiti* on walls, and so on. The intention of the phrase is to suggest that in such spontaneous images of the ordinary man is to be found the raw material of art—art in the raw—rather than in the sophisticated productions of professional artists.

**ART DEALING.** Dealing has necessarily gone hand in hand with art COLLECTING. Particulars of art dealers have often remained obscure and we frequently have to assume their existence from casual references rather than from precise information. Such for instance is the position in regard to the dealers of the HELLENISTIC world whom we know to have supplied the Romans with masterpieces and forgeries alike.

Professional art dealers, who disappeared after the collapse of the ancient world, returned to the scene somewhat later than the great collectors. Their job was carried out by amateurs. Again and again it is the diplomat who was entrusted by his prince to purchase some work of art on his behalf. Frequently artists themselves were dealers on the side. Until the French Revolution most painters were at one time or another required to obtain 'Old Masters' or antiquities for their patrons. And at all times there has existed the *marchand amateur*, the collector who when offered a sufficiently attractive price is prepared to sell. But the history of modern dealing begins in the 16th c. with men such as Jacobo Stradon, Italian agent of the Duke of Bavaria, whom TITIAN painted. The gradual weakening of guilds and the vast increase in the number of collectors and travellers led to an increased demand for dealers. In Rome they sometimes commissioned original works of art and exhibited them in or outside their shops, usually situated near the Piazza Navona, but owing to opposition from the Accademia di S. Luca they were often forced to confine their wares to prints or Old Masters. In Spain dealers sometimes commissioned religious pictures to be exported to the American colonies. It was in the north of Europe that dealing gained most importance. In the international port of Antwerp pictures from all over Europe were imported and exported. It was an Antwerp merchant, Daniel Nys, who negotiated the most spectacular transaction in art history—the sale of the Duke of Mantua's gallery to Charles I. In the commercial society of Holland dealers assumed a position that was not rivalled until the 19th c. Auctions and exhibitions were frequent and dealers commissioned works from leading painters so as to resell them at a profit to prospective clients. Indeed some dealers induced artists to sign contracts to supply them with their whole output.

In the early 18th c. an important French art dealer inspired one of the greatest masterpieces of European painting—the signpost that WATTEAU painted for Gersaint, his friend and patron (now in Berlin). The moment was especially significant. The monopoly of art patronage that Louis XIV had established at VERSAILLES was over, and a new nucleus was formed around a few enterprising collectors in Paris. In these circumstances there was plenty of scope for a man who was at once CONNOISSEUR, gentleman, and dealer —a combination that was then new but was to become increasingly frequent in later years. There would be no point in discussing the many dealers who flourished in all the towns of Europe throughout the 18th c. Their position was the inevitable result of the pattern of collecting that had developed. Satirical literature was full of their misdeeds—notably what Horace WALPOLE called 'the interested Mysteriousness of Picture-merchants'.

In the 19th c., however, there dawned a new era in art dealing which proved of immense value to painters. This was a direct result of the gulf which had arisen between the official art of the academies, which still monopolized patronage, and the creative art which has survived. It is hardly too much to say that many of the IMPRESSIONISTS owed their survival to the dealer Charles Durand-Ruel (1831–1922). He not only bought and exhibited their work at a time when it met with nothing but contempt from the public, but tirelessly championed their cause and launched special reviews to achieve this aim. Like the Dutch dealers of the 17th c., but with very much greater generosity, he and his successors—men like Vollard, Zborowski, Kahnweiler, and many more—often bought up the entire output of certain painters; sometimes they were forced to subsidize them and put up with difficult behaviour in exactly the same way that the more enlightened patrons of earlier centuries had done. PICASSO's CUBIST portraits of his dealer Kahnweiler (whose support of the Cubists parallels Durand-Ruel's support of the Impressionists) are among his most important works. The dealers too originated the commercial galleries which afforded a link between the artist and the public (see EXHIBITIONS).

This heroic period of art dealing lasted approximately from 1870 until 1920. Since then the dealer has retained his commercial importance, but a more adventurous public taste has, for better or for worse, challenged his position as the main guardian of the misunderstood artist.

**ART EDUCATION.** This term embraces a number of activities. Those considered here are: the education of professional painters and sculptors, the education of amateurs, the education of industrial designers or craftsmen, and the instruction of children as a part of their general education.

Throughout the Middle Ages the only art education was that given to apprentices in the workshops of their masters. The aim was simple and the method technical. The pupil, engaged at the age of 10 or thereabouts, was to learn his craft so well that he could assist his master, first in purely mechanical operations and later in the

painting of complete pictures which the master could sell as his own work. This education was no different from that given to any other artificer.

It was not until the middle of the 15th c. that artists in Italy began to feel that this curriculum was insufficient. From about that time we find young painters attempting to supplement their workshop training by various forms of extra-mural activity, which probably included working from the ANTIQUE, from notable modern productions, and from MODELS. But in the next century a change in the conception of painting which caused it to be regarded as an intellectual discipline rather than a manual craft, together with the emergence of artists capable of making a learned and profound contribution to the thought of their time, the consequent desire to give painter and sculptor a training consistent with their claim to a professional standing higher than that of the mechanic and, perhaps, the arrival in Italy of foreign students who could not easily be accommodated within the rules of the guilds—all these made it necessary to provide some form of higher education for the artist, an education not in technique, but in thought. Private establishments, such as those of Diony-sius CALVAERT and the CARRACCI, showed what could be done. But the more ambitious enter-prises came to grief, and it was not until 1593 that a state-aided ACADEMY was founded in Rome.

In the Académie de Peinture et Sculpture, founded in Paris in 1648, and soon surpassing that of Rome in reputation—becoming indeed the model on which the numerous establishments of the 17th and 18th centuries were based—the teaching was not intended to replace that of the workshop. It offered an auxiliary training intended to correct and purify the student's taste. He worked there during the hours of darkness when he could not be of service to his master. He began by learning to draw 'from the flat', i.e. from engravings of eyes, noses, ears, limbs, and finally entire figures taken from the works of approved masters. He then worked from the cast, and again he would begin with isolated members, or in some cases from solid geometrical figures, and end with entire statues. Colour was forbidden until the final stages of the course, when paintings might be copied. The syllabus might also include ANATOMY, the study of human proportions and the architectural ORDERS, and, under the rule of LEBRUN, the study of facial EXPRESSION. During the 18th c. a postgraduate course was instituted in which students were able to read history and humane literature.

The grand purpose of all this teaching was to cultivate a correct vision. It was to be achieved partly through the imitation of the great Italian masters, particularly those of the Roman School, but above all by the constant study of the antique. The student was, as DE PILES put it, to learn to 'see nature as we ought to see her and to bring her back to those original intentions from which she so often departs'. Under the French system the student was encouraged by the award of a great number of prizes, culminating in the Prix de Rome. Having gained this he might travel to Italy and spend three years in the study of the great masters.

In Rome some interesting experiments in art education were undertaken. This school suffered many vicissitudes and was threatened more than once with extinction. But it must be said that the Metropolitan School, although it found imita-tors as far afield as St. Petersburg and Phila-delphia, and was the parent body of a great number of provincial establishments, was fre-quently in the most deplorable condition. The management was inefficient, and as taste changed the academic ideas of the 17th c. were expounded with decreasing conviction. Painters and critics alike found fault with the teaching methods, and although a number of reforms were made, they were not of any lasting value.

**21.** *L'étude du dessin, d'après la bosse et d'après nature.* Engraving (1763) after design by C.-N. Cochin. From *Encyclopédie, ou dictionnaire raisonné des arts et des métiers*

It was REYNOLDS's intention that the ROYAL ACADEMY should avoid the errors into which the other academies had fallen, and in particular that the students should be taught to work strictly from life without any attempt at idealization (which was far from being the case in Paris). But apart from the use of the female model the Royal Academy made no substantial innovations, and even in this point it was but following the example of the other English schools that had preceded it.

Like the French Academy the English Royal Academy established a virtual monopoly of public instruction in the higher departments, although in England the process was gradual and not enforced by Royal Decree. The students in England were, it would seem, older and a fairly advanced degree of instruction was expected of the probationer; this led in the early 19th c. to the establishment of preparatory schools. In France a number of private academies were established, of which the most famous was that of VIEN, whose methods were later to be developed by DAVID. These schools were studios organized on a whole-time basis, and in the school of David we have the prototype of the 19th-c. academy; for despite the political hostility of the Republic and the radical disapproval of the ROMANTICS, the academies survived the regime on which they were founded and persist after a fashion to this day.

At a lower level art education was disseminated in the 18th c. by drawing masters, by teachers in schools such as the École des Frères in Paris, in trade schools, and through the medium of books (see DRAWING BOOKS). COLBERT, who supported and protected the Académie, also gave drawing schools to Sèvres and Les Gobelins. In the next century Bachelier's École Gratuite de Dessin, founded in 1767, taught the elements of drawing to the children of Parisian artisans, while other academies, as for instance those of Florence and St. Petersburg, provided an opening for the student who wanted to go into industry. The most notable of these foundations was the École de S. Pierre in Lyon, which after its reconstitution by Napoleon exerted a great influence upon the fortunes of the French silk industry. In most if not all of these schools the student was trained as though he were to become a painter, study of the human figure forming an important part of his curriculum. When, however, the art education in Prussia and Bavaria was developed at the beginning of the 19th c., the *Gewerbeschule* were of a very different character. Being much more closely geared to the needs of industry, they had in fact something of the character of training workshops and were quite distinct from the academies of fine art.

The rival merits of these two very different types of art school were the subject of heated discussions in England when, in 1837, the British Government at last decided to support art schools for the benefit of industry. The Board of Trade, which was charged with the creation of these schools, employed William DYCE as superintendent and he, strongly supported by members of the Royal Academy, attempted to establish schools on the German model. This policy was fiercely denounced by Benjamin Robert HAYDON and, what was more serious, by certain industrialists who believed that a technical school would be harmful to them. The government policy was altered in response to their protests, but this change brought protests from another vested interest, that of the drawing masters.

During the 18th c. art teaching had become as much the refuge of the impecunious painter as it is today. In England painting, particularly painting in water-colours, was recognized as a polite accomplishment for the young and more especially for young ladies (see AMATEUR). The method of teaching such pupils tended, inevitably, to deviate from pure academic doctrine; for landscape was the grand object of this education. The so-called *Method* of Alexander COZENS was a product of this dilettante interest in pictorial art and a singular one in that it used LEONARDO's suggestion for stimulating the imagination through the observation of accidental forms. It was the first textbook to suggest a method whereby the student might develop his own talent. Later teachers seem to have concentrated mainly upon technical accomplishments, formulas for suggesting different types of foliage and reflections in water, and the like. The art master was in many ways a discredited figure even before he had to encounter the opposition of the art school. His opposition was the least of the misfortunes that befell the 'Schools of Design'. Far worse was the administrative inefficiency, the doctrinal squabbles, and the suspicions of industrialists, which nearly brought the whole scheme to grief.

In 1852 the art education of England was completely reorganized by Mr. (later Sir) Henry Cole. In the previous year the Committee of the Privy Council for Education had recognized the desirability of making art a subject to be taught in national schools (a matter in which this country was far behind most nations). Cole made it the business of the art school to supply the teachers. Through a judicious system of payment by results the art schools and the elementary schools of the country were brought under the control of the Central School at South Kensington. The manner in which masters and children were instructed was very different from that of the academies. The essence of the system lay in the exact delineation first of plane, then of solid geometrical forms. Until a very advanced stage was reached the work consisted entirely of copying, without reference to nature. The aim was to produce not artists but careful, accurate workmen. It was this aim which RUSKIN found particularly detestable. His own system, which he practised with great success at the Working Men's College from 1858 to 1860, was based upon a minute and reverent examination of nature, or at least of those parts of nature which would lend themselves to this process. He held very strongly to the view that the practice of art, if undertaken in the right spirit, would improve mankind, and

he was equally emphatic that if practised for the sole object of increasing profits, it would have a contrary effect. This doctrine was applied with a more coherent social theory by William MORRIS and by his follower Walter CRANE, who with other members of the ARTS AND CRAFTS MOVEMENT tried to regenerate the nation by a method of art training which placed great emphasis upon the teaching of manual crafts. Charles Robert ASHBEE, a follower of Ruskin and Morris, while sharing their social theories and seeking to replace the art school by a guild of craftsmen, came to the conclusion that although the medieval institution might serve as a social example, it was necessary to come to terms with modern mechanical processes. His ideas were disregarded in his own country, but they were developed later by Walter GROPIUS in the planning of the BAUHAUS.

Another of Ruskin's disciples, Ebenezer Cooke, together with Richard Ablett, attacked the South Kensington system from a different angle. These teachers believed that Cole's system and all other existing systems were quite unsuitable for children. He denounced the drawing of geometrical figures on the ground that abstract forms such as these were repulsive to a child and made the work unnecessarily difficult. F. Ravaisson, in France, had come to a very similar conclusion at an earlier date. This line of criticism was enormously reinforced by the speculations and discoveries of those who for the first time were beginning to make a study of child psychology (see CHILDREN'S ART). So from about 1884 the prevailing methods of teaching in schools were under constant fire. A first victory was won with the Board of Education's acceptance of the 'alternative syllabus' in 1896 and in the revised handbook for teachers in 1905. Insensibly the whole purpose of art education in schools was being diverted from the original task of forming workmen to the more difficult business of educating civilized human beings. In a sense this development may be seen as a part of the old and still unresolved struggle between those who believe that art education should, as Aristotle puts it, enable us 'to occupy leisure nobly' and those on the other hand who see in it something that will make us work better. Until the 19th c. the two aims were kept separate; the drawing master had the former object in mind, the trade school the latter. But Ruskin, like Haydon, wanted not only to establish drawing schools and chairs of fine art in the universities (an object which was realized with the Slade Professorship and the Ruskin School at Oxford), but also to permeate the taste of the masses. This view of art education produced a conflict of aim which still affects teaching in schools of art and schools of general education.

In France during the 19th c. the art of painting was to an even greater extent informed by the belief that there were no 'rules of art'—or rather that each painter must find his own rules for himself. Pushed to its logical conclusion this theory implied that the teacher was superfluous, at all events for adults, and it was symptomatic of the age that an autodidact, the 'Douanier' ROUSSEAU, was acclaimed by the critics as a serious painter. Young painters now frequented studios simply because they wanted a place to paint and masterless academies, such as the Académie Suisse, became popular. Where masters were employed, as in the studios of Gleyre and Cormon, their teachings were disregarded. Gustave MOREAU was the only teacher who, at the end of the last century, can be said to have formed young artists of ability.

It might seem, therefore, that the last thing that young painters in a state of permanent revolution would wish to do would be to create an academy of their own. COURBET, in establishing his short-lived school, was careful to explain that it was merely an association. Nevertheless IMPRESSIONISM (in the widest sense of the word) produced one very influential teacher, Horace Lecoq de Boisbaudran, who taught by cultivating the visual memory. This method, which obtained some very remarkable results, was obviously of use in assisting the artist to capture those momentary impressions whose realistic definition was one of the professed aims of the Impressionists. DEGAS probably, and WHISTLER, LEGROS, FANTIN LATOUR, and RODIN certainly, were influenced by this method of training the eye. In England it was employed by Robert Catterson Smith at the Birmingham School of Art. Smith used a lantern screen to project pictures which were memorized by his students. One of these, Marion Richardson, became a school teacher and attempting to apply her master's method, but having no lantern, described a picture verbally and asked her pupils to visualize it, thus creating what has since become a standard form of art lesson in this country, a form of instruction in which the master suggests but does not show what is to be done, leaving everything possible to the imagination and invention of his pupils.

The way in which Marion Richardson came upon this method of teaching was fortuitous, but her intention was already fixed. By the beginning of the 20th c. the whole tendency of aesthetic thought had led painters away from ILLUSIONISM towards the investigation of what later was called 'pure form'. (This tendency in fact made it possible for Paul Serusier to formulate a pedagogic doctrine based mainly upon the study of PROPORTION.) On these terms it was possible to look at the work of children with a new eye and to treat it with a new understanding and a new respect. On this point the findings of the psychologists and those of the artists were perfectly in accord. Thus Franz Cizek in Vienna and M. G. Quenioux in France (*Manuel de dessin à l'usage de l'enseignement primaire*, 1910) had arrived at or were reaching a position similar to that of Marion Richardson when she started teaching at Dudley in 1912.

The work of succeeding decades has been a continuation of that undertaken by these three

pioneers. There have been modifications and additions, a retreat from some of the more incautious ventures into licence and much experiment in new media, but no fundamental change of doctrine. In the field of child psychology, and to a lesser degree of therapy, both of which are closely connected with modern educational techniques, there has been continual research and speculation.

Broadly speaking, the tendency in the 20th c. both in schools of art and in schools of general education has been to reject all teaching methods which are based, as academic teaching was based, upon the supposition that there is one true and great style which every student should labour to acquire. Taste had become too catholic for such an objective to be thought reasonable. At the same time modern educationalists have been more and more inclined to avoid that 'elementary' method which compels the student to describe the simplest possible components of more complicated structures—as for instance, eyes, noses, and mouths; or lines, squares, and circles—and then by the use of 'grammatical' principles learn to reassemble them. The view has been widely accepted that such fragmentation places wholly unnecessary obstacles in the path of the student and may be compared to the method of one who requires that a child shall learn its alphabet before it can speak. Therefore in the art school the student is faced at once by the complexities of the living model, and in the primary school the child is invited to paint ambitious imaginative scenes. Manual dexterity is to be acquired through attempts to give expression to ideas which are of immediate interest to the student, and it is recognized that simplicity is more difficult to describe than complexity. Since the Second World War, however, attempts have been made to evolve a pedagogic doctrine which would certainly reverse the latter tendency and is not wholly consistent with the former. It was felt that the art school is still much too closely connected with the apparatus of Renaissance teaching and that something very different is required for the artists of the mid 20th c. Inspired, perhaps, by the pedagogic sketch-books of Paul KLEE, various 'basic courses' have been devised which confront the student with the simplest and most fundamental aspects of form. Rhythmic sequences are evolved from elementary shapes and geometrical forms are constructed to convey the idea of volume. Intuitive methods are favoured, it being felt that beauty will most easily be found when she is not consciously sought. Such exercises at least had the merit of leading to a serious reconsideration of the fundamental premises of modern art teaching. Meanwhile the structure of higher education in art was substantially changed in England in the 1960s by the grant of a new Diploma in Art and Design. Less than half the existing colleges were permitted to award this degree, which, it was intended, would be of a higher standard than that which it replaced, would include art history

and other humane subjects, and would be the equivalent of a first degree.

22, 229, 507, 635, 890, 1602, 1682, 2065, 2510, 2538, 2782.

**ARTESONADO** (from Spanish *artesón*, a wooden trough or panel). Term in architecture

**22.** ARTESONADO. Detail from ceiling of *Salon de cazadores*, Infantado Palace, Guadalajara (late 15th c.)

for a type of panelled timber ceilings of Moorish origin which were a special feature of the MUDÉJAR style and continued to be used in Spanish America until well into the 17th c. Sometimes flat but more often concave like an inverted trough, they were covered with endlessly repeating ornament in relief made by fitting together small wooden ribs either intersecting each other (*lacería*) or forming rows of polygonal coffers. The whole was painted in bright colours and gilded.

**ART FOR ART'S SAKE.** See AESTHETICISM.

**ART HISTORY.** In current English usage the term refers to an academic discipline which originated in Germany under the name of *Kunstgeschichte*, the first chair being established in Berlin in 1844 for G. F. Waagen. In England the first chair was established as late as 1932 at London University (Courtauld Institute of Art), though in Edinburgh it started much earlier, in 1879. In the United States the subject has been taught at university level since the early years of the 20th c. As a university discipline the history of art traditionally comprises architecture, sculpture, painting, and the applied arts,

usually with an emphasis on the stylistic development of Western art in post-classical times.

The interest in the history of these arts goes back, however, to classical antiquity. The chapters on painting and sculpture in the elder PLINY's *Natural History* (1st c. A.D.), themselves based on earlier treatises that are lost, formed a model which the Italian RENAISSANCE used for the chronicling of its own achievements. The *Commentarii* of Lorenzo GHIBERTI stands at the beginning of this new tradition, which culminated in the *Lives of the Most Excellent Painters, Sculptors and Architects* by Giorgio VASARI (1550), who proudly proclaimed that as an historian he aimed at 'investigating the causes and roots of styles and why the arts improved or declined'. Vasari had successors in the Netherlands (van MANDER), in Venice (RIDOLFI), in Bologna (MALVASIA), in Rome (Baglione, BELLORI), in Germany (SANDRART), and in France (FÉLIBIEN). The ACADEMIES, by inviting the imitation of the great masters of the past, encouraged historical knowledge, as did the great COLLECTORS, VIRTUOSI, and CONNOISSEURS.

A new approach was initiated by J. J. WINCKELMANN, whose *Geschichte der Kunst des Altertums* (1764) treats sculpture and painting as the most noble manifestation of a nation's soul. It was this view, reinforced by Hegel's philosophy of history as an unfolding of the universal spirit, which added to the academic prestige of art history in German-speaking countries. The most renowned of the historians who treated art in its cultural context was the Swiss, Jacob Burckhardt.

The influence of 19th-c. movements in art, such as IMPRESSIONISM and the aesthetics of 'pure visibility', led to attempts to base the history of art purely on an analysis of form. The leading exponents of this method are Burckhardt's pupil, Heinrich Wölfflin, and the Viennese Alois Riegl. In their writings, no less than in those of Bernard BERENSON, the study of style is based on the psychological categories current at the time. In France Henri Focillon gave a new turn to the formalist approach by his biological conception of the nature of art history. The claims for an autonomous 'science of art' (*Kunstwissenschaft*) have been much debated; scholars such as Aby WARBURG, Emil MÂLE, Julius von Schlosser, and Erwin PANOFSKY preferred to study the work of art in its historical context and emphasized the importance of the study of subject matter (ICONOLOGY).

The aesthetic discovery of exotic and PRIMITIVE art together with the spread of technically improved illustrations has increased the awareness of the vast heritage of world art among the general public and created a new demand for information and comment. The impact of this development has been dramatically described by André Malraux in *The Voices of Silence* (1951). Art history has become part of the school curriculum in many countries with all the attendant dangers of over-simplification, and its popularity makes necessary the warning that a purely visual approach uncontrolled by rigorous scholarship can be as misleading historically as scholarship without vision can be arid.

**ARTHOIS,** JACQUES D' (1613–86). Flemish landscape painter active at Brussels. He was the best of a group specializing in the decorative type of wooded landscape with figures. Few dated works exist and the development of his style is not easily followed, but a distinction must be made between his best work, such as that at Frankfurt, and the hasty, repetitious productions of his workshop. Other artists put religious or secular figures into his large landscapes, which were often used to decorate churches. D'Arthois led an unstable life, being imprisoned for debt, and dying in poverty despite his successful career. Pictures by him are at Brussels, Madrid, and Vienna.

**ARTIST.** Both the concept of the artist and the social position of artists have differed radically at various periods of human history. We can only speculate about the function of Aurignacian and later STONE AGE ART and about the nature of the impulse which sustained it. Nothing is known about the consideration accorded to the artist in Stone Age societies. PRIMITIVE and tribal art had a commercial function as craftsmanship and also in so far as art objects served ritualistic purposes was imbued with the *mana* of magic or religion. Artists were in some cases regarded as specialized craftsmen, perhaps falling under the aegis of a craftsmen's guild (see AFRICAN TRIBAL ART), or else shared something of the prestige of the *shaman* or priest. In the latter case the vocation of artist was often handed down as a prerogative of particular families. In Greek tradition the poet combined a specialized skill as craftsman with the *aura* of a prophet or seer, divinely inspired. But the painter or sculptor was ranked as a craftsman among other craftsmen. Some individual artists achieved wealth and renown during their lifetime, particularly in the age of Alexander the Great. Stories of the eccentricities and arrogance of such popular artists as ZEUXIS and APELLES came into vogue and are recorded by PLINY and other later writers. But in a society organized on aristocratic principles with a contempt for manual labour the social and economic position of artists in general persisted, with a few outstanding exceptions, unenviable throughout classical antiquity. Hauser, in *The Social History of Art*, quotes Plutarch (1st c. A.D.) as saying: 'No generous youth, when contemplating the Zeus of Olympia or the Hera of Argos, will desire to become a PHIDIAS or a POLYCLITUS', and Seneca (1st c. A.D.): 'We offer prayers and sacrifices before the statues of the gods, but we despise the sculptors who make them.'

During the Middle Ages the attitudes of antiquity persisted. Sculptors and painters, as distinct from poets and musical theorists, were

regarded as mechanics and therefore lower in the social scale than intellectual workers (see FINE ARTS). As Plato spoke of the Greek artist in the same terms as the shoemaker or metal-worker, so during the Middle Ages artists were members of craftsmen's guilds. In Brussels they were associated with goldsmiths, in Bruges with butchers, in Florence with apothecaries and spice-grocers (*speziali*). In the course of time artists organized confraternities of their own. The Florentine self-governing Compagnia dei Pittori, dedicated to St. Luke, dates from 1339. One of the intentions and results of the French Académie established by COLBERT under Louis XIV was to break the influence of the guilds and transfer the control of taste to the court.

A change in the social position of artists took place during the Italian RENAISSANCE when the concept of the artist as scholar or scientist came to the fore. It is this which gives their true significance to the elaborate comparisons between painters and poets in such works as LEONARDO's *Paragone*. From this time prominence was given to the 'philosophical' content of the visual arts and to the intellectualist character of the appreciation of beauty.

The CHINESE is the only culture which from an early time afforded full recognition for the concept of the AMATEUR artist and regarded the practice of the arts as a natural and proper occupation for the scholar and gentleman. In the West the idea of the amateur artist hardly came into its own until the emergence of the concept of *genius* in the context of 18th-c. intimations of ROMANTICISM. German Romantic Idealism gave eloquent though confused expression to the notion of the artist-genius which had certain affinities with the primitive idea of the artist as recipient and purveyor of magical inspiration. The artist-genius was supposed to be in tune with the Absolute Spirit and by creating works of art which expressed his own personality was thought to give visible embodiment to Absolute Truth. The two related ideas of art as the expression of the artist's personality and art as the embodiment of metaphysical truth persisted through the 19th and into the 20th c.

As one of the products of the 19th-c. divorce between official and creative art (see FRENCH ART) there emerged a new concept (or new in its emphasis) of the artist as a creative genius in revolt from the conventions of society and as the victim of bourgeois Philistinism. This was epitomized in the idea of the artist as *Bohemian* given currency by Henry Murger's *Scènes de la vie de Bohème* (1851; adapted for Puccini's opera *La Bohème*) and despite its patent partiality and the attacks of common sense (e.g. the de GONCOURTS' *Manette Salomon*, 1867) it remained effective with certain sections of artists and their public until the 1930s.

During the third and fourth decades of the 20th c. still a new concept of the artist established itself somewhat reluctantly among educa-

tionalists and social philosophers. The artist came to be pictured as one who cultivates the sensuous and perceptual faculties, or one who affords systematic and innocuous play to the emotional side of human nature, and so offers a valuable means for counteracting the intellectualist and practical bias which was thought to distort educational systems in a technological society.

**ART MOBILIER.** Term in common use for small movable works of art in contrast to MONUMENTAL art. Examples are the figurines, engraved stones, BONE CARVINGS, and miscellaneous objects found in caves, rock shelters, and other prehistoric sites and the art objects of nomadic tribes.

**ART NOUVEAU.** Term in art history and criticism commonly applied to a decorative style which spread widely over western Europe during the last two decades of the 19th c. and the first decade of the 20th c. Interest in it was revived by a group of Paris SURREALISTS surrounding Salvador DALI in the 1930s and by Nikolaus Pevsner in his book *Pioneers of the Modern Movement from William Morris to Walter Gropius* in 1936. During the 1950s interest in the style was fostered by a series of exhibitions which included

23. *Wren's City Churches* (1883). Title-page designed by Arthur Heygate Mackmurdo

**24.** *Toilette of Salome.* Ink drawing by Aubrey Beardsley (B.M.). Illustration for *Salome*, Oscar Wilde (Eng. trans. 1894)

an *art nouveau* exhibition at Zürich in 1952, an exhibition of Victorian and Edwardian decorative arts at the Victoria and Albert Museum in the winter of 1952/3, and an *art nouveau* exhibition at the Museum of Modern Art, New York, in 1960. Definitive studies of the style, its history and manifestations, were made by Robert Schmutzler, who described its main theme as 'a long, sensitive, sinuous line that reminds us of seaweed or of creeping plants', and by Maurice Rheims.

*Art nouveau* was a deliberate attempt to create a new style in reaction from the academic 'historicism' of the second half of the 19th c. instead of imitating and varying styles of the past. It was primarily an art of ornament and its most typical manifestations occurred in the practical and applied arts, ART MOBILIER, graphic work and illustration. Whereas most of the new aesthetic movements in easel painting and sculpture originated in Paris, *art nouveau* spread to the Continent chiefly from London. In Germany the style was called *Jugendstil* (a name connected with the popular review *Die Jugend* founded in 1896); in Austria it was called *Sezessionstil*; in Italy *Stile Liberty* after the Regent Street store which had played so large a part in the dissemination of designs; in Spain the Catalan version of the style was known as *Modernista*; and in Paris during the 1890s the name 'Modern Style' reflected its English origin.

In England *art nouveau* style is traced back through William MORRIS, Dante Gabriel ROS-

SETTI and the PRE-RAPHAELITES, to William BLAKE. Its chief exponents were Arthur Heygate MACKMURDO, Aubrey BEARDSLEY, Charles RICKETTS, Walter CRANE, and in Glasgow the architect Charles Rennie MACKINTOSH and the sisters Frances and Margaret Macdonald. The style was also propagated by a number of illustrated periodicals, among which should be mentioned Mackmurdo's *The Century Guild Hobby Horse* (1884), Ricketts's *The Dial* (1889), and Beardsley's *The Yellow Book* (1894-5) and *The Savoy* (1896-8). *The Studio*, founded in 1893, also helped to publicize English *art nouveau*, and on a different level the fabrics printed by Liberty did much to popularize it.

On the Continent *art nouveau* first assumed a clearly defined form in Brussels. Its chief exponents there were Victor HORTA, who in the staircase of the Maison Tassel originated what later became known as the 'Belgian line', and Henry van de VELDE. Starting under the influence of the English style, the Belgian *art nouveau* soon acquired a character of its own. It was stimulated by a series of exhibitions organized by the Société des Vingt after 1884, in which products of the applied arts and books illustrated by Herbert Horne and Selwyn Image, friends of Mackmurdo, were shown alongside *avant-garde* paintings. The famous painter ENSOR, one of the founders of the group, despite the highly personal character of his EXPRESSIONISM, was importantly influential in contributing to this development.

In France, despite the fashionable Anglomania of the 1890s, English *art nouveau* style made little impact except in luxury and bibelot products. It is reflected in the jewellery and glassware of René Lalique (1860-1945) and in the glassware of Émile Gallé (1846-1904). In architecture it was exemplified by Hector Guimard (1807-1942) in his design for the Paris metros.

In Spain *art nouveau* flourished mainly in Barcelona, and GAUDÍ, who worked there, has later come to be considered an outstanding genius of the whole *art nouveau* movement. Besides his work should be mentioned the Palau de la Musica Catalana built (1906-8) by Luis Domenech y Montaner (1850-1923). This building blends *art nouveau* features with an eclectic amalgam of historical styles and has been described by Schmutzler as 'the most brilliant and artistically important example of a "hybrid" Art Nouveau adulterated by historicism to be found anywhere in Europe'.

The German *Jugendstil* began in Munich virtually unheralded with an exhibition of tapestries by the sculptor Herman Obrist (1863-1927), son of a Scottish mother and a Swiss father. *Jugendstil* splits into two divergent currents. Floral *Jugendstil* was based on English floral *art nouveau* and is mainly to be found in the applied arts before 1900. Its leading exponent was considered in Germany to be Otto Eckmann (1865-1902), much of whose best work was done

**Fig. 9.** *The whiplash* (1895). After design for embroidery wall-hanging by Hermann Obrist. (State Mus., Munich)

as illustrations for the periodical *Pan*. After about 1900 there emerged an abstract form of *Jugendstil* mainly under the influence of the Belgian architect van de Velde, who began to work in Berlin in 1899. Also working in this style was the architect Peter BEHRENS.

Austria took to *art nouveau* late in the century, when there developed in Vienna an almost geometrical style free from BAROQUE and ROCOCO elements but strongly under the influence of C. R. Mackintosh and Mackmurdo's pupil Charles Annesley VOYSEY. Its chief exponents were the architect Otto WAGNER (after about 1895), the architects and designers Joseph HOFFMANN and Joseph OLBRICH, and the designer Koloman Moser (1868-1918). The style was propagated by the Viennese periodical *Ver Sacrum*. Its name *Sezessionstil* was derived from Olbrich's hall for the exhibitions of the *Wiener Sezession* (1889-99).

Italian *art nouveau* was limited to details borrowed in the main from English architecture or from Vienna. Indeed Italy was little affected by the trend, achieving no integrated national *art nouveau* idiom. Its chief exponent was Giuseppe Sommaruga (1857-1932), who originated the *Floreale* style of decoration.

*Art nouveau* is represented in the U.S.A. by two very different artists. The architect Louis SULLIVAN is considered to express the style in his decoration though not in his buildings themselves. Although he maintained that ornament should emphasize the structure and form an organic whole with the building, this principle was very loosely applied in his practice. Louis Comfort Tiffany on the other hand developed a highly personal elegance of *art nouveau* forms in his designs for glassware between 1880 and 1890.

*Art nouveau* displays a certain mood of *fin-de-siècle* and an artificial Aestheticism which have caused it to be said that the aesthete and the dandy are the key figures of the movement. It was attacked in England by Thomas Graham Jackson in lectures given at the Royal Academy Schools in 1906 (published the same year under the title *Reason in Architecture*) and this was followed in 1908 by an attack on the Glasgow School in the *Architectural Review*. The move-

ment nowhere survived the outbreak of the First World War to any significant extent.

1736, 2071, 2232, 2423, 2458.

**ARTS,** CLASSIFICATION OF. See APPLIED ART, FINE ARTS, LIBERAL ARTS.

**ARTS AND CRAFTS MOVEMENT.** English social and aesthetic movement of the latter half of the 19th c. Its origins are to be found in the idea of teaching manual processes to people of all conditions which derives from J. J. Rousseau, in the widespread dissatisfaction with the quality of manufactured goods which became vocal and important in Great Britain after the Great EXHIBITION of 1851, the growing admiration for folk art, and finally in a nostalgic regard not only for the works but for the social arrangements of the medieval craftsman, whose relationship with his apprentices and with the guild was believed to have been of a paternal and idyllic character. Many of these ideas were expressed by PUGIN and all may be found in the writings of RUSKIN, who in his turn had a profound influence upon William MORRIS. Ruskin himself may have had some idea of passing from theory to actual social organization and teaching at the time when he planned the Guild of St. George in 1871. But it was left to the business-like genius of Morris to translate Ruskin's ideas into practical activity. Morris, first in the building and furnishing of his own house, and then through the firm of Morris, Marshall & Faulkner in 1861, set about the re-creation of hand industry in a machine age, producing hand-printed, hand-woven, hand-dyed textiles, printed books, wallpaper, furniture, and so forth. Morris undoubtedly was attempting to produce an anachronism, but his distaste for the machine was not quite so complete as has sometimes been imagined and the attentive reader will discover in his socialist propaganda romance *News from Nowhere* (1891) that in his socialist Utopia the machine, although it is not evident, is by no means absent. In fact the attitude of Morris was different from that of Ruskin. For Ruskin a work of art had to be the result of a high moral intention and since the machine had no conscience it was incapable of producing art. Ironically Morris achieved his greatest success in decorating the homes of the rich, even royalty; but for him it was more and more the social system rather than the machine itself which 'made life grow uglier every day' and it is in the socialist revival of the 1880s that his work received its maximum attention and attained considerable importance, not only in the world of art but as an influence which endured at all events up to 1914 in the formation of the Labour movement in Great Britain. At this stage Morris was not only making things by hand, but exerting influence upon a talented group who were themselves craftsmen, teachers, and propagandists. Of these the most important were Walter CRANE, Cobden Sanderson, W. R.

LETHABY, Selwyn Image, and C. R. ASHBEE. Amongst the other manifestations of his influence were the Guild and School of Arts and Crafts, established by Ashbee in 1888 in London, the Art Workers Guild, established in the same year, and the Arts and Crafts Exhibition Society, which held a series of important shows during the 1890s. In this later period the movement was connected with the International style of ART NOUVEAU. It spread abroad in the early years of this century, being particularly successful in Germany and the Low Countries, Austria, where it led to the establishment of the WIENER WERK-STÄTTE, and Scandinavia, where it is still influential. In Germany it came to terms with the machine and may be considered an ancestor of that aesthetic movement which resulted in the establishment of the BAUHAUS. A similar evolution seems to have taken place in the thought of C. R. Ashbee, who towards the end of his life, influenced perhaps by his friend Frank Lloyd WRIGHT, was ready to accept new techniques and new materials. Thus the movement died out, or rather was transformed by the acceptance of modern industrial methods. It has, however, left a legacy in the persistence of studio weavers and potters, in organizations such as the Craft Centre, in the manual education both of children and of adults, which continues to be valued, at any rate for therapeutic reasons, and by some who look to it for relief from the prefabricated character of modern civilization.

81, 106, 107, 655, 656, 702, 1288, 1648, 1650, 1877, 1878.

## ARTS COUNCIL OF GREAT BRITAIN, THE.

The Arts Council of Great Britain was incorporated under Royal Charter in 1945 by King George VI with the object 'to develop a greater knowledge, understanding and practice of the fine arts exclusively, and in particular to increase the accessibility of the fine arts to the public throughout Our Realm, to improve the standard of execution of the fine arts and to advise and co-operate with Our Government Departments local authorities and other bodies on any matters concerned directly or indirectly with these objects'. The Council consists of not more than 16 members appointed by the Secretary of State for Education and Science after consultation with the Secretary of State for Scotland and the Secretary of State for Wales. There are separate committees for Scotland and for Wales. The Council's main activity in connection with the visual arts consists of the organization and circulation of exhibitions, the majority of which travel throughout Great Britain, and the issue and sale of catalogues. The greater part of the Council's funds is derived from a grant-in-aid from the Department of Education and Science.

## ARUNDEL, THOMAS HOWARD, EARL OF (1586-1646).

Collector and patron of the arts, 'father of vertu in England' (Evelyn), he gave the primary impetus to the great interest in the arts at Charles I's court. With Inigo JONES, he carried out archaeological investigations in Italy, and later British ambassadors as well as his own agents sought out antiquities which he could import from all over Europe and even the Levant. Much of his collection of statuary is now in the ASHMOLEAN MUSEUM, Oxford. He patronized living artists, notably RUBENS and van DYCK (both of whom painted him), and he brought HOLLAR to England. Of the Old Masters, he collected especially works by HOLBEIN and DÜRER. His great collections were gradually dispersed after his death.

1303.

## ARUNDEL PRINTS.

Reproductions in colour of Old Masters, issued by the Arundel Society to subscribing members. The Society (founded 1849) was dissolved in 1897, and in 1904 the Arundel Club began to issue reproductions of less-known masterpieces in private collections.

## ARYBALLUS.

A globular or tapering oil flask used by the Greeks. The mouth had a large, flat brim which was applied to the skin and rubbed on it in order to anoint without letting any oil escape. The name is also applied by art historians and archaeologists to a characteristic shape of water jar made by the Incas with conical base tapering to a point. The Inca aryballus, usually large (2 ft. or so in height), had two small handles opposed on the lower part of the body and two small rings below the lip. A moulded head or other figure protruded on the upper part of the body below the spout. A rope was passed through the rings and over the protruding knob for carrying the vessel on the back (see PRE-COLUMBIAN ARTS OF THE ANDES).

## ASAM, KOSMAS DAMIAN (1686-1739) and EGID QUIRIN (1692-1750),

brothers. Bavarian architects and decorators. They were trained in Rome and developed further the dramatic effects with which Italian BAROQUE architects had experimented. Their ecclesiastical buildings were the supreme expression of the Bavarian delight in decorative display; architecture, painting, and sculpture unite to set a scene in which light and colour are the chief actors. The best known of their churches is that of St. John Nepomuk, Munich (1732-46).

## ASHBEE, CHARLES ROBERT (1863-1942).

English architect and designer. He was one of the group of architects and craftsmen, led by VOYSEY and MACKMURDO, who about the turn of the century made Britain the pioneer country in domestic design (apart from the solitary work of Frank Lloyd WRIGHT in America), and profoundly influenced the new movements that were stirring in Europe. He visited Frank Lloyd Wright in 1901 and wrote the Introduction to the second Wasmuth volume (1911), bringing his work to the notice of the Continent.

As well as architect of many small houses, Ashbee was a designer of metal-work and jewellery, a poet and essayist, and the founder of the ESSEX HOUSE PRESS. In 1894 he founded the London Survey Committee, out of which also grew the Royal Commission on Historical Monuments.

**ASH-CAN SCHOOL.** See EIGHT, The.

**ASHENDENE PRESS.** A private printing press conducted from 1894 to 1935 by C. H. St. John Hornby, first at Ashendene, Herts., and from 1901 at Shelley House, Chelsea. Two new types, designed by Emery Walker, were specially cut for this press: 'Subiaco', used in Dante's *Inferno* (1902), based on the type employed by Sweynheym and Pannartz, the first printers in Italy, and 'Ptolemy', made for *Don Quixote* (1927), modelled upon the type used by F. Höller of Ulm for the 1482 edition of Ptolemy's *Geographia*. Among the artists connected with the press were Eric GILL and Graily Hewitt, who designed initial letters, and the illustrators Charles Gere (*Dante*, 1909) and Gwen Raverat (*Daphnis and Chloe*, 1933).

1370.

**ASHMOLEAN MUSEUM.** One of the four museums belonging to the University of Oxford. The origins of the collection go back to the provision by Sir Thomas Bodley in 1602 of a gallery for antiquities in his Library. With this were associated the collection of ancient marbles bequeathed by John Selden in 1645 and the Arundel collection of marble inscriptions in 1667. The nucleus of the Ashmolean collection was formed the 'closet of rarities' assembled by John Tradescant and given in 1659 to the VIRTUOSO Elias Ashmole, who offered it to Oxford University in 1675. The original Ashmolean Museum was built by the University to the design of Thomas Wood to house this collection and was opened in 1683—the first public museum in Great Britain. The new building in Beaumont Street by Charles Robert Cockerell was opened in 1845, and this was enlarged by the C. D. E. Fortnum extension in 1894. In 1899 the designation 'Ashmolean Museum' was transferred to the new building and the original museum of Thomas Wood was known as the 'Old Ashmolean Building'. It now houses the Museum of the History of Science.

The archaeological collections were enriched by material from the excavations of Sir Arthur Evans at Knossos (see MINOAN ART) and those of Sir Flinders Petrie in Egypt. Other notable accessions have been the Fortnum bequest (1890) of bronzes and ceramics, the Combe collection of PRE-RAPHAELITE paintings (1893), and the Ward bequest of Dutch STILL LIFES (1940). The print collection has been famous since 1846 when the RAPHAEL and MICHELANGELO drawings from the LAWRENCE collection were bought by public subscription and presented to it. In 1922 the Heberden Coin Room was opened and in 1962 the Oriental collections from the Indian Institute were transferred to the new galleries of Eastern Art.

The Ashmolean Museum also houses the RUSKIN School of Drawing, bequeathed by him to the University.

**ASPLUND, ERIK GUNNAR** (1885-1940). Swedish architect and the most prominent figure in acclimatizing MODERN ARCHITECTURE in that country, converting the generation of the 1930s from the former stylized NEO-CLASSICISM and effete ROMANTICISM to an understanding of the practical and aesthetic implications of modern technology. He began to practise in 1909, but it was not until after a visit to Italy and Greece in 1913-14 that his distinctive style made its appearance. His most important buildings during the next 15 years were the Woodland Chapel at the Stockholm South Cemetery (1918-20), the Skandia Cinema (1922-3), and the Stockholm City Library (1924-7). It was in the Stockholm Exhibition of 1930, however, that he manifested his full qualities as an architect of the modern school and his mastery of the expressive possibilities of glass and steel. His most notable buildings subsequent to this were the Bredenberg Store, Stockholm (1933-5), the Extension to the Göteborg Law Courts (1934-7), and the Forest Crematorium at Stockholm South Cemetery (1935-40).

715, 2960.

**ASSELYN, JAN** (1610-52). Dutch landscape artist who specialized in painting real and imaginary scenes of the Roman Campagna. He studied in Italy and assimilated some of the characteristics of CLAUDE Lorraine and Pieter van LAER. REMBRANDT, who was his friend, etched his portrait. Because of a crippled hand he was nick-named 'Crabbetje' (Little Crab).

**ASSYRIAN ART.** The Assyrians inhabited a country the centre of which lay about the modern town of Mosul on the Tigris. In most respects their art may be regarded as an offshoot of BABYLONIAN ART, and a general description should be sought under that heading. But the Assyrians, being of a different country and race, mingled elements of their own with the acknowledged mastery of Babylon. Production of a distinct Assyrian art began from about 1500 B.C. and continued till the destruction of the capital, Nineveh, in 612 B.C. The people had close affinities with the inhabitants of Syria and with the highland peoples to the east, and, besides, possessed materials which the Babylonians in the south lacked, especially workable stone and the ivory obtained from elephants which then lived and were hunted in northern Mesopotamia.

Bas-RELIEF in stone is the characteristic Assyrian art, which may be studied best in the galleries of the British Museum. These sculptured pictures are a less destructible form of wall-painting, which was freely used alongside them, and the reliefs themselves were coloured. Human figures

are very stiffly represented, heads and legs in profile and bodies in face, the king being always the centre of interest. With animals the artists were much more successful, and some of their figures, especially in the lion-hunts, are masterpieces. Perspective of the Western kind was unknown; the principal action occupies a flat foreground, episodes in the background being arranged in rows above, though not on a smaller scale. There are occasionally attempts to show interiors by representing the ground as vertical, with figures and objects arranged in their natural positions within this space. Landscape was also attempted, especially during the reign of Sennacherib (705–681 B.C.), who had a particular interest in technology. But it was not mastered, and sometimes gave rise to curious effects, as when hill-side trees on either side, viewed from a valley, are depicted with their tops pointing outwards. As the sculptures are devoted solely to the king, their themes are warfare, hunting, and religious ceremony, the first two being represented in great detail and often with impressive effect. The favourite warlike subject is sieges of hostile cities, in which the armament, tactics, and valour of the Assyrians are minutely displayed and invariably triumphant. In hunting the king

is pitted against various creatures endowed with swiftness to escape, but especially with strength to resist, and the noblest quarry is the lion, which the royal athlete encounters from his chariot, from horseback, and on foot, achieving prodigies of bravery and address. Among the religious sculptures the most striking are the huge winged and human-headed lions and bulls which stood at gateways as guardians of the edifices and whose functions were to greet and bless the entering king and to drive off evil spirits.

Prominent among the remains of Assyrian art, and yet not strictly belonging to Assyria, are the carved ivories and engraved bronze bowls first found at Nimrud. The ivories were decorations of furniture and toilet articles, the bowls were objects of luxury, and both were widely appreciated in the ancient Near East early in the first millennium B.C. Their makers were mostly Aramaeans and Phoenicians, whose craftsmen imitated any style, especially the Egyptian, that was likely to be popular, and whose traders brought the goods to their customers. Assyria, by conquest and purchase, was the principal recipient of these much-prized industrial products. They differ considerably in quality of

**25.** Detail of limestone carving from palace of Ashurbanipal, Nineveh (7th c. B.C.). Hunting scenes, including Ashurbanipal on horseback spearing a lion. (B.M.)

**26.** Detail of relief carving from palace of Ashurbanipal, Nineveh (7th c. B.C.). Ashurbanipal's defeat of the Elamites at the river Ulai. (B.M.)

execution, and the foreign motifs which they freely use are sometimes misunderstood and reduced to mere decoration. (See also PHOENI-CIAN ART.)

167, 168, 913, 914, 957, 1679, 1748, 2511, 2573, 2935.

**AST, BALTHASAR VAN DER** (1593/4–1657). Dutch fruit and flower painter, probably born at Middelburgh, active at Utrecht and Delft. He was influenced by Ambrosius Boss-CHAERT.

**ASTROLOGY.** Ancient astrology, which goes back to early Sumerian times, was a form of applied astronomy and among other things predicted wars, pestilence, the prospects of harvest, and similar occurrences from celestial phenomena. The Roman *dies nefasti* and the Chinese practice of examining the sky in order to discover the lucky occasion for an important undertaking are survivals of this early astrology. It is referred to in Isaiah xlvii. 13. The modern form of astrology which prognosticates a person's future by telling his horoscope requires a knowledge of the 'houses of the sun' or the twelve constellations of the zodiac. This knowledge developed in late Babylonian and Persian times between 600 and 400 B.C., the first text which mentions the zodiacal constellations dating from the time of King Nebuchadrezzar. The account

given by VITRUVIUS in his instructions for designing sundials, lifted probably from Democritus, is thought to represent substantially the Babylonian picture of the universe. From the earliest known times the constellations and the zodiacal signs were named pictorially and symbolically. The Greek system was taken from ancient Mesopotamian and Egyptian sources, though Greeks gave precedence to the Sun whereas the Babylonians had placed the Moon first among the heavenly bodies. By the 4th c. B.C. the Moon and five known planets had been assigned to various deities and the far more ancient connection with the metals had been adopted so that the Sun, the Moon, Mars, Mercury, Venus, Jupiter, Saturn stood symbolically for gold, silver, iron, mercury, copper, tin, and lead. The names of the 12 constellations, probably taken also from the Near East, had been established as: Aries (the Ram), Taurus (the Bull), Gemini (the Twins), Cancer (the Crab), Leo (the Lion), Virgo (the Virgin), Libra (the Balance), Scorpio (the Scorpion), Sagittarius (the Archer), Capricornus (the Goat), Aquarius (the Water-Carrier), Pisces (the Fishes). The Greeks of the classical period did not accept the new astrology, which came into vogue during Hellenistic times through contact with the Persian, or Chaldaean, practitioners and also from Egypt. The earlier astrological system was popularized by the Hellenistic poetizer Aratus, a contemporary of

**27.** Zodiac slab from Temple of Dendera, Egypt. (Louvre, 1st–2nd c. A.D.)

Theocritus and Callimachus, in a poem called *Phaenomena et Prognostica* (*c.* 275 B.C.), based on Eudoxus and Theophrastus, which was introduced to the Romans by Cicero's translation. Illustrated manuscripts of this poem must have existed in antiquity as the prototypes copied throughout the Middle Ages. The signs of the zodiac occur in many decorative and symbolic contexts as representing the course of the year. As such they appear linked with the OCCUPATIONS OF THE MONTHS and with calendar illustration up to the present day.

The revival of strictly astrological beliefs resulting from Arabic influence in the 13th c. inspired a number of large cycles in which classical and Oriental lore were mingled. The most famous of these are the Palazzo della Ragione in Padua of the 14th c., which also embodies a series of fictitious constellations attributed to every day of the year; the CAMPANILE at Florence with its reliefs of the planets, also according to an Oriental tradition which shows Venus with a

lute and Jove as a bishop; the Palazzo Schifanoia in Ferrara of the 15th c., in which the fictitious constellations of the decans accompany the signs of the zodiac; and PERUZZI's ceiling in the Farnesina based on classical prototypes and illustrating the horoscope of the owner, Agostino Chigi.

Among other astrological subjects frequently illustrated in the 16th c. are the so-called 'Planet Children', which usually take the form of a series of pictures of the seven planets riding in the sky with the various occupations and types that come under their domination. Thus Mercury dominates the merchants, the thieves and also the artists; Mars the warriors, etc. DÜRER's *Melencholia* has affinities with this tradition.

**ASTURIAN.** The style of architecture, painting, and ornament current during the 8th and 9th centuries A.D. in the vicinity of Oviedo, the capital of the small kingdom of Asturias, northwest Spain, the main region left unconquered by

the Moors when they overran the Peninsula in 711–18. Neither the Romans nor the Visigoths had firmly established themselves in this savage and mountainous region and it remained the area most devoid of any previous artistic tradition. The kings Alfonso II (791–842), Ramiro I (843–50), and Alfonso III (866–910), possibly with some help from artists and designers from outside, built a number of small but beautiful and highly characteristic churches and villas in and around Oviedo.

The most notable for its frescoes is the church of San Julián de los Prados built at Santullano by Alfonso II between 812 and 842. Its walls are lavishly covered with frescoes which have been described as the latest example of the great classical tradition of decorative painting with its taste for illusionistic representation of architectural subjects. Relics of murals exist at San Miguel de Lillo (842–50), San Adrián de Tuñón, San Salvador de Valdediós and others, which some historians have believed to have sufficient features in common to warrant our speaking of an Asturian school of painting. The most remarkable surviving monument of Asturian architecture is the church of Sta María de Naranco built by Ramiro I (843–50). It is a long, rectangular structure of two storeys with narrow buttresses rising the full height of the walls. Both upper and lower halls are barrel vaulted and the upper hall has arcaded loggias at either end. The construction of the walls is united with that of the vaults in a complete system very advanced for the time.

266, 2452.

**ATAURIQUE** (Arabic *tauriq* from *waraq*, leaf). A plasterwork or stucco wall facing decorated with leaf and flower motifs, much used by the Moors in Spain.

**ATLANTES.** Term used in Greek architecture to denote the colossal figures sometimes used instead of COLUMNS to support an ENTABLATURE or projecting roof. It came to be used as the masculine equivalent of CARYATIDES for any sculptured figures carrying a load. The term is the plural of Atlas, the giant who in Greek mythology supported the sky on his head. Later, after the earth was discovered to be spherical, he was often represented as bearing the terrestrial globe on his shoulders. Well-known representations of Atlas are the one in the Temple of Zeus at Agrigentum and the Farnese Atlas from the Temple of Zeus at Olympia (now in the Naples museum).

**ATMOSPHERIC PERSPECTIVE.** The IMPRESSIONISTS—particularly PISSARRO, MONET, and SISLEY—used 'atmospheric perspective' in a special sense based on the study of TURNER. By it they meant not only the suggestion of distance by a progressive diminishing in recession from the foreground of the strength of contrasts between light and dark, but also the suggestion of recession by increasing the extent to which local colours are modified by light. It was one of the main differences between CÉZANNE and the Impressionists that he refused to use this atmospheric perspective, which he looked upon as a photographic procedure adapted to rendering the transitory appearances of a scene whereas he was more concerned with the permanent aspects of the scene itself. (See also AERIAL PERSPECTIVE.)

**ATRIUM.** The forecourt of a Roman house on to which the dwelling rooms opened. It was lighted by an opening in the roof above the *impluvium* or rain-water basin in its centre and it was regarded by Varro and VITRUVIUS as the principal room. By extension the term was also applied to an open court in front of some EARLY CHRISTIAN and ROMANESQUE churches.

Fig. 10. ATRIUM. House of the Silver Wedding, Pompeii (1st c. B.C.)

Fig. 11. ATRIUM. Church of S. Ambrogio, Milan (11th c.)

**ATTRIBUTES.** In most traditions of religious and secular art figures are identified by attributes, that is to say objects which they hold in their hands or which are regularly associated with them, such as Jove's thunderbolts, the club of Hercules, St. Peter's keys, St. Catherine's wheel, or the scales of Justice or the anchor of Hope. While some of these were used over large areas and in many contexts, other attributes were more variable, and in certain periods the invention of esoteric or enigmatic attributes was rife. (See also PERSONIFICATION.)

**ATTRIBUTION.** A term in art history and criticism for the assignment to an artist of a work of uncertain authorship. Attributions are usually made either on the evidence of documents or on that of style alone. This latter method rests on the assumption, borne out by experience, that an artist's manner is personal to him and cannot be completely imitated by anyone else. Given a work that is completely authenticated by external evidence such as signatures, contracts, or contemporary accounts, we can therefore proceed to group around it works of a similar character and attribute them to the same master. Some CONNOISSEURS have based such attributions mainly on minor 'graphological' mannerisms such as the way in which an artist indicates ear-lobes or finger-nails. This method, which was hailed as scientific in the 19th c. and mainly advocated by the Italian physician Morelli, has, however, proved disappointing where used mechanically. Others have claimed to find the 'handwriting' of an artist in non-figurative background strokes, shading, etc. The scientific claims made for these methods have been opposed by many successful practitioners who have alleged that the recognition of a master's personal style, like the recognition of a voice on the telephone or of a familiar face, does not proceed from details but from the total effect, which cannot be completely analysed. It is the result of many encounters with the artist's work and can neither be proved nor disproved. The inevitable subjectivity of such attributions, combined with the enormous financial consequences which the assignment of a work to a famous master must have, creates its own difficulties and perplexities which affect the historian less than the collector and those responsible for museums and public galleries. A public impatient of scholarly caution wants to know whether it owns a REMBRANDT or not. The only way out of this difficulty appears to be moderation in the 'cult of personality' and education of both the expert and his public to realize that the intrinsic greatness of a work of art depends to a very minor extent on authorship and is not significantly enhanced or diminished by attribution.

By a convention which has been in practice for about 200 years in sale rooms and dealers' catalogues, when it is intended to attribute a work to an artist's 'school' the artist's surname alone is given. If the initials of the artist are included, this indicates that in the dealer's opinion the painting is 'a work of the period of the artist which may be in whole or in part the work of the artist'. When the artist's name is given in full, including first name or names, this is an indication that the dealer attributes the work to the artist.

248, 930.

**AUDRAN.** Family of French painters and decorators, three of whom were named Claude. CLAUDE AUDRAN I, together with ERRARD and COYPEL, painted decorations for VERSAILLES from 1661. CLAUDE AUDRAN II assisted in the decorations under LEBRUN of the *Grands Appartements* of the king and queen at Versailles between 1671 and 1681. CLAUDE AUDRAN III (1658-1734) was one of the most prominent decorators in the last decade of the 17th c. and together with BÉRAIN originated the new decorative style in ARABESQUES and GROTESQUES which heralded the ROCOCO. In 1709 he painted the SINGERIE at Marly which was the first large example of this genre. He was curator at the Luxembourg and helped WATTEAU, who worked as his assistant at Marly.

**AUDUBON,** JOHN JAMES (1785-1851). American painter-naturalist. Born at Haiti of French parentage, he was educated in France and received instruction in drawing from DAVID. He returned to the U.S.A. in 1807 and lived as a naturalist, hunter, and taxidermist, making drawings of the birds and wild life. In 1824 he visited New York, where he sat to John Vanderlyn (1755-1852) for his portrait of General Jackson. In 1826 he went to England with the project of publishing his drawings. His *The Birds of America, from Original Drawings, with 435 Plates Showing 1,065 Figures,* published in four volumes (1827-38) with an accompanying text *Ornithological Biography* in five royal octavo volumes (1831-9), has been described as 'one of the most fantastic instances of talent and energy in the history of American Art'. It was followed by *Quadrupeds of America* (coloured plates, 2 vols., 1842-5; text, 3 vols., 1846-54). His plates reveal a Romantic enthusiasm for the splendour and beauty of natural life and have been called the most dramatic pictures ever published of birds. Cuvier remarked that they were 'le plus magnifique monument que l'art ait encore élevé à la science'.

2324.

**AUREOLE.** See HALO and MANDORLA.

**AUSTRALIAN ABORIGINAL ART** (see also STONE AGE ART IN EUROPE and AFRICAN PREHISTORIC ART). Records left by early settlers in the Sydney area contain references to native rock-paintings and engravings. Since then there has been a gradual extension of our knowledge of Australian aboriginal art, culminating in the major researches of the 1940s and the 1950s. To a considerable extent this art and the culture associated with it come under the same general

category as palaeolithic cave art in Europe (though the drawing of too rigid analogies has aroused protests) and the rock art of prehistoric Africa.

A wide variety of art forms are, or were, in use by the aborigines. The most important were painting on the human body, on rock-surfaces, on the earth, on man-made objects, and on bark, and engraving, pecking, etc., on stone or wood, on shells or artefacts, and even, in New South Wales, on trees. In Cape York Peninsula and Arnhem Land today we still find wooden human figures in the round; Arnhem Land also yields lively animal figures in wood and beeswax. More unusual were the large figures which used to be made out of soil and branches on ritual occasions (South Australia), and the use of human blood and feathers as decorative materials.

The basic materials used in painting are simple. Those paintings which are not on rock are usually done on pieces of bark cut from stringy-bark trees and flattened to form 'canvases'; small pieces of chewed bark, splinters, feathers, etc., serve as brushes; and the paints are red and yellow ochres ground up and mixed with water, with charcoal, etc., for black and kaolin for white.

Various shades of these four basic colours are found, and in one area a blue has been noted. If bark is used, the paints are applied over a prepared black or red background which is often treated with the sticky fluid of an orchid to help the paint adhere.

The aborigines decorated many of the objects used in everyday life, and the man-made objects themselves generally show a sensitive appreciation of form. On paddles, spear-throwers, boomerangs, baskets, shields, message-sticks, etc., attractive naturalistic and geometric designs were made; the natural properties of the raw material were often used in a subtle manner. Today, however, the indigenous art of Australia is limited to a very few areas.

Attempts to classify the main regions of aboriginal art have usually been based on rather vaguely defined criteria such as design, art form, or the type of object decorated. No one of these classifications agrees very closely with any other, but there appears to be rough agreement on the existence of at least five regions: north-eastern Queensland, Arnhem Land, eastern, south-western, and central Australia. Some writers describe as separate regions the South and West

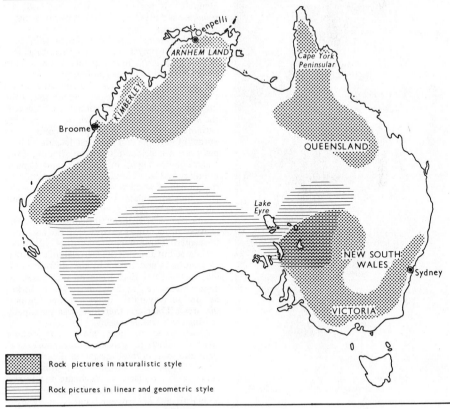

Rock pictures in naturalistic style

Rock pictures in linear and geometric style

**Map 3.** ROCK ART IN AUSTRALIA

Arid Zone, Lake Eyre, the Kimberleys, and the Broome area. There may be several 'schools' within a major region.

The rock pictures can be divided into two main groups geographically. A naturalistic group consisting of anthropomorphic and zoomorphic figures extends in an arc from the north-west to the east and south-east of the continent. With this is contrasted a second group in linear or geometric style which extends from the south-west to the south-east. No hard-and-fast line of demarcation can be drawn between the two styles and they are found merged or side by side in Queensland, New South Wales, and the extreme south-east. Experts have thought that for the last two centuries or more the geometrical style, whose motifs are ceremonial in character, has been superseding the naturalistic and that Australian aboriginal art is tending increasingly towards schematization.

Naturalistic pictures belong to two distinct

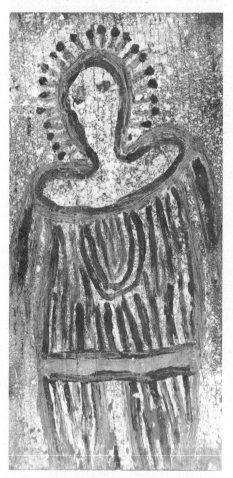

**28.** WONDJINA. Painting on board from north-western Australia. (B.M.)

styles, called the *wondjina* and the 'elegant' style. The *wondjina* paintings are anthropomorphous figures, usually represented in a posture. Only eyes and nose are represented, not the mouth. The body is painted in white, sometimes with vertical stripes. Arms and legs may be clearly defined but hands and feet are rudimentary; instead of the foot in the normal position there is often depicted the sole or a footprint. Above the main figure smaller *wondjina* figures are often depicted or indicated by the heads. They may also be accompanied by representations of animals or food-plants. The *wondjina* paintings are connected with water-holes. They are explained by the aboriginals themselves in connection with the cosmogonical myth of the creative force Ungud (conceived as a snake) and the creator Walanganda. They are found mainly in the Kimberleys on the north-west, but traces of the style occur in western, central, and southern Australia. The 'elegant' style of small elongated human figures represented in semi-profile also centres in the Kimberleys and may have preceded the *wondjina* style. A second centre, at Oenpelli in Arnhem Land, shows a style comparable in some phases with the 'elegant' style. Sites in Victoria and in western New South Wales contain paintings resembling those at Oenpelli. It has been thought that both the *wondjina* and the Oenpelli figures were associated with centres for the dissemination of cults.

The great 'galleries' of Oenpelli with their now famous polychromatic rock-paintings and the bark-paintings found in such abundance in Arnhem Land have been among the most exciting of modern discoveries. Equally striking are the 'X-ray' art of this region, which shows the internal anatomy of the animals represented; the *mimi*, Bushman-like human figures; and the extraordinary carved grave-posts, coffins, and spears of Melville and Bathurst Islands. There has been a considerable artistic stimulus from Indonesian voyagers in the past, and Papuan influence on Cape York Peninsula has stimulated the growth of wooden sculptures there, but the splendour of Arnhem Land art is by no means entirely attributable to external influences.

The comparative material richness of this part of Australia contrasts sharply with the aridity of the centre. These desert areas are not only thinly populated but also lack the materials of the artist, rock-surfaces and trees. In the shifting sand-hills of the Lake Eyre basin no rock-paintings or carvings were possible; human groups had to be continuously on the move lest they 'eat out' the area. Their art, therefore, was principally confined to portable objects.

Much stress has been laid on the striking artistic productions associated with ritual occasions and some of these are extraordinary works, often (though not always) quite unlike, and superior to, secular art. Such are the sacred objects of central Australia (*waninga*) and the animal-figures of Arnhem Land. A very great deal of aboriginal art, however, is purely secular

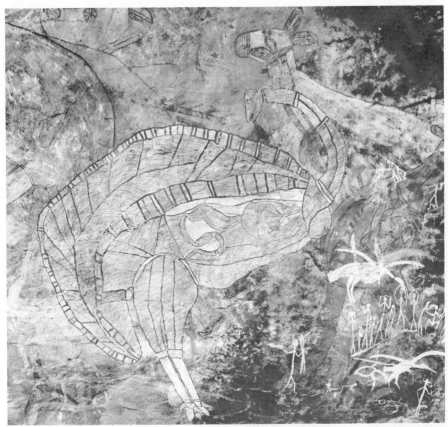

**29.** Cave painting of emu, Wellington Ranges, Arnhem Land

and decorative, aesthetic in inspiration and not magical or functional in any narrow sense. The assumption that the rock-paintings (and those of the Bushmen and of Stone Age man) must always have some magical or totemic significance is not warranted by the anthropological evidence.

Anthropologists have shown how aboriginal art is closely connected both with indigenous ritualistic and mythological world-views and also with the practical aspects of life. In a collective volume *Australian Aboriginal Art* (1964), devoted mainly to contemporary aboriginal art uninfluenced by European traditions, R. M. Berndt, Professor of Anthropology in the University of Western Australia, asserts, correctly, that the interpretation of this art requires a knowledge of its cultural context and traditional symbolism. He writes: 'On the whole this is a mature, adult art, reflective of a people's social and cultural life, and of their underlying values and view of the world. It is also deeply satisfying to both artist and others; not simply because it is aesthetically pleasing and conforms to canons of local taste but, more importantly, because in designs and subject matter it is closely integrated with both the secular and religious life of the people.' Yet

one may distinguish the sociological and iconographical interpretation from aesthetic appraisal. The Ice Age art of Europe is judged by standards of contemporary taste to include some of the finest examples of representational art that are known. Whether this claim could be substantiated for Australian aboriginal art is a matter of debate, but the fact remains that aboriginal art appeals widely to people who have no knowledge of its cultural matrix.

In recent years some of the aborigines have learnt to paint in the European tradition with remarkable success. The best known representative of these painters is Albert Namatjira, whose work is discussed under HERMANNSBURG SCHOOL. The work of the young pupils of Carrolup native school in Western Australia, closed down in 1952, was enthusiastically received when it was exhibited in London.

8, 150, 183, 257, 289, 316, 432, 1713, 2910.

**AUSTRALIAN ART.** The art of European origin in Australia may be traced back to 1788 when a British penal colony was established at Sydney Cove. The first primitive dwellings,

small timber-framed cottages panelled with cabbage-tree or wattled with the local flowering acacia, did not suit the country's hot weather and heavy rains. Consequently the typical pioneer's hut came to be constructed of hardwood slabs buried vertically in the ground or let into wall plates, the roofs being shingled or covered with bark. The story of architecture begins in 1788, also, when the first Government House was built at Sydney, a small two-storeyed GEORGIAN country residence. But shortage of lime for bonding and the lack of carpenters to provide staircases, together with the abundance of land and the warm climate, resulted in the growth of Australia's Colonial Georgian as a single-storeyed style with long low lines enhanced by verandas, which were probably popularized in Australia by army officers from India and the West Indies.

The graphic arts began in the service of science —naturalists and naval draughtsmen seeking to depict the native plants, animals, and human inhabitants faithfully for English scientists and VIRTUOSI. The best of this work reflects a charming sense of naïve wonder at nature's antipodean oddities. Even so fine a botanical draughtsman as Ferdinand Bauer came to the country with the navigator Flinders in 1801-4 to collect and draw its little known flora.

Buildings of true architectural merit were first erected during the administration of Lachlan Macquarie (1809-21). He was fortunate in the services of Francis GREENWAY, an architect of unusual talent to whom Sydney owes some of its finest colonial buildings. Macquarie also patronized portrait painters; but it was the interpretation of landscape which emerged early as the crucial problem of Australian painting. The first landscape in oil, *Sydney in 1794* (Mitchell Lib., Sydney), by a convict artist, Thomas Watling (1762–*c.* 1810), is an essay in PICTURES-QUE topography, a manner still used by Joseph Lycett (active 1810-24) when painting views in Tasmania and New South Wales in the early 1820s. A new departure was taken by another of Macquarie's protégés, John William Lewin (*c.* 1770-1819), a naturalist and landscape painter who first depicted the general effect of the local vegetation in a faithful manner.

Macquarie's ambitious building programme was censured by J. T. Bigge, sent out to report on the administration in 1819. Public building was temporarily checked, but not domestic architecture. For until 1840 both New South Wales and Tasmania (established 1803) flourished: pastoralists pushed into the interior, migration increased, and colonial wool found a ready English market. The period 1821-40 saw the flowering of Australian colonial art, when most of the finest colonial houses were built, such as Camden Park, N.S.W. (1831-3), by John Verge (1782-1861), whose houses, double-storeyed and stuccoed but featuring the single-storeyed bow-fronted wing, follow English REGENCY models closely. It was, however, the single-storeyed

house with veranda (often integrated with roof and wall, and spreading to three or even four sides of the house) which emerged as the prevailing colonial type on the mainland of Australia.

In Tasmania, however, a Colonial Georgian style, small in size but often elegant in proportion and tending to follow English models somewhat more closely than the contemporary buildings of subtropical New South Wales, made its appearance in the work of John Lee Archer (1791-1852), who was Colonial Architect (1827-38) under the able governorship (1824-37) of Sir George Arthur (1784-1854). Archer designed many public buildings, churches, bridges, jails, and barracks, including the Customs House, Hobart (1836-42), later Parliament House, and the Queen's Orphanage and St. John's, Newton (1831-5). Archer was retired when the Civil Engineer's Department was abolished in 1838 and the designing of public buildings fell to James Blackburn (1803-54), a convict transported, like Francis Greenway, for a forgery connected with building speculation. During the governorship of Sir John Franklin (1837-43) Blackburn designed many bridges, watch-houses, churches, and public buildings first as a convict in the Roads Department (1839-41) and later, after obtaining his freedom, in private practice (1841-9). Blackburn's work is Early Victorian in the range of its interests but retains that air of economy noticeable in all colonial work. He favoured a NORMAN style for some of his first churches, such as St. Mark's, Pontville (1839), with its fine arcaded screen porch in the manner of the staircase of the King's School, Canterbury; an Italian VILLA style for his domestic architecture (Rosedale, Tasmania, 1849); and a Greek Revival style for many of his designs for public buildings, including the Ancanthe Museum, Lenah Valley (begun 1842), built for Lady Franklin.

On the mainland, however, the GOTHIC REVIVAL was foreshadowed in Greenway's picturesque architecture, and James Hume (active *c.* 1837-*c.* 1841) adopted the mode for St. Andrew's Cathedral, Sydney, in 1837. The erection of a new Government House at Sydney (begun 1837) in the Neo-Gothic of the English architect Edward BLORE (designer of Scott's Abbotsford) established the style in domestic architecture. During the next 30 years castellated mansions rose above the eucalypts along the shores of Sydney Harbour. The Greek Revival made its appearance in the scholarly work of Mortimer Lewis (active 1835-65). The Darlinghurst Court House, Sydney (1835-8), is a notable example of his work. Tasmania contains some delightful examples of the Greek Revival, such as Panshanger (1835), a residence in which the long low line of the Australian vernacular is expressed with an easy grace. Such buildings, though small, often aspired to the elegance of more aristocratic prototypes; indeed the accomplishment of elegance within the limitations of a miniature scale is one of the

most pleasing features of Australian colonial architecture. Conversely the Georgian miniature ornamental building, such as the summer pavilion and the gazebo, was occasionally adapted to the larger scale of the private residence (Bungarribee, *c.* 1824).

In 1826 Thomas Shepherd arrived in Sydney, where he established the Darling nurseries. A professional gardener who claimed the acquaintance of Humphrey REPTON, by his work and lectures (1836) he made landscape gardening fashionable among owners of large estates and was perhaps the first to recommend the preservation of indigenous trees for their beauty. Landscaping was incorporated in the plan by William Light (*c.* 1786-1839) for the city of Adelaide (1837) when he reserved a ring of land encompassing the town as parkland—an act which gave Adelaide a green belt from the beginning. The 1830s also saw the arrival of two important artists from England. The first was John Glover (1767-1849), who after a highly successful career as a landscape painter in England arrived in Tasmania with his family to settle as a pastoralist (1831). In his work are clearly revealed the rival claims of tradition and environment which have continued to harry Australian artists to the present day; for at times he painted the Tasmanian landscape with penetrating clarity and freshness of vision, and at times he chose to render it after the manner of CLAUDE and Salvator ROSA, the exemplars of his youth. The second artist was Conrad Martens (1801-78), who arrived in Sydney in 1835 to become one of the finest and certainly the most prolific of Australia's colonial painters. He was an admirer of TURNER and his work ranges from country-house topography to romantic interpretations of Australian light and atmosphere.

The discovery of gold in 1851 stimulated migration and provided the economic drive to a period of great civic progress and growing national aspiration. Australia began to emerge in its modern form as a highly urbanized society in which over half the population dwelt in the capital cities. These cities, Melbourne particularly, were the scene of vast building activity between 1860 and 1890. The period was marked by the vigour and exuberance of a rapidly expanding society. As in England, historicism governed the interplay of architectural fashion, Gothic predominating in the ecclesiastical architecture, and Italianate and eclectic styles in the secular. Gothic Revival architecture was introduced into Australia by Edmund Blacket (1817-83), the architect of the main building of Sydney University (1854-60) and its Great Hall, which was his masterpiece. Blacket also designed numerous Anglican churches throughout New South Wales. William Wardell (1824-99), A. N. W. PUGIN's most talented disciple, arrived in Melbourne in 1858, where he became Inspector-General of Public Works from 1858 to 1878, and not only designed many important public buildings, including Government House,

Melbourne (1872-6), in a fine Italianate manner, but also St. Patrick's Cathedral, Melbourne (1858-97), one of the finest and largest of Gothic Revival cathedrals. But it was the use of a new building material, iron—both cast and corrugated—which gave local character to the period. After the setting-up of the iron foundry by Peter Russell in Sydney (1843), columns in the classical ORDERS and lace-like traceries for veranda decoration began to be mass-produced. In this cast-iron work Australia achieved its most characteristic form of architectural decoration. It was used for more than 50 years upon all types of building from the largest mansion to the smallest terrace. When tastefully applied it formed an effective foil to stucco or weatherboard walls and slate or corrugated iron roofs.

The graphic arts also reflect the vigour of the period. During the 1850s the popular lithographs of S. T. Gill (1818-80) recorded the colourful and at times riotous life of the gold diggings. Journalists made extensive use of the CARTOON as a vehicle for radical and nationalistic sentiment, the *Sydney Bulletin* becoming a training-ground for a number of outstanding cartoonists during the last two decades of the century. A more conservative nationalism was implicitly revealed in the construction of town halls, libraries, and art galleries, and the erection of monuments to explorers and politicians in city squares. But the finest expression of nationalism in the visual arts was achieved by painters. Between 1883 and 1885 Tom ROBERTS studied in England, France, and Spain, becoming an ardent admirer of the *plein air* realism of BASTIEN-LEPAGE and gaining a second-hand knowledge (apparently from the Spanish painter, Casas) of the principles of IMPRESSIONISM. One of Roberts's companions on this tour, the painter John Russell (1858-1931), son of Peter Russell the iron-master, remained in France to become a friend and associate of RODIN, van GOGH, and MATISSE. Upon his return to Australia Roberts gathered a number of artists about him, notably Frederick McCUBBIN, Arthur STREETON, and Charles CONDER. Working together in camps in the outlying bushland suburbs of Melbourne, these men succeeded in creating the first authentic school of Australian painting: *plein air* and to some extent Impressionist principles were applied to the interpretation of the light, colour, and atmosphere of the Australian landscape. An important aspect of their programme, especially for Roberts (*Shearing the Rams*, N.G., Melbourne, 1890) and McCubbin (*The Pioneer*, 1904), was the interpretation of the heroic aspects of Australian life and history. Streeton in such paintings as *Fire's On* (Art Gal. of New South Wales, Sydney, 1891), and Hans HEYSEN also, sought to interpret the landscape in heroic terms. The 'Exhibition of 9 × 5 Impressions' (Melbourne, 1889) by the members of Roberts's circle or HEIDELBERG SCHOOL met with a mixed reception. But their ideas quickly spread to Sydney, where a champion of Australian art

arose in Julian Ashton (1851-1942). Over a period of 50 years his art school trained many of Australia's outstanding artists.

The boom conditions of the 1870s and 1880s ended in severe economic depression in 1893, accompanied by droughts and widespread industrial unrest. Building activity virtually ceased. When it did revive at the turn of the century a QUEEN ANNE STYLE of red brick and Marseilles roofing tile, with which a few architects had begun to experiment prior to the depression, became fashionable. Turned and fretted wood replaced cast-iron upon verandas, terracotta finials of dragons and griffins (kangaroos and emus when made locally) surmounted cottage gables. Perth, flushed with wealth from the Western Australian gold discoveries of the 1890s, became virtually a 'Queen Anne' town. Before the turn of the century ART NOUVEAU appeared and within a few years was determining the decoration of everything from household appliances to railway carriages.

During the depression of the 1890s artists, unable to sell their work in a small society without the tradition of a cultivated leisured class, began to turn their eyes abroad. By 1900 most of the men who had established the Australian school of painting during the previous decade were at work in London or Paris. Indeed, between 1900 and 1914 most of Australia's best-known painters spent the greater part of their time abroad. A few of these expatriates, notably George Lambert (1873-1930) in London and Rupert Bunny (1864-1947) in Paris, gained a measure of recognition abroad, but most of them depended for both recognition and finance upon the results of exhibitions held during brief homeland visits. Those who remained at home forsook the national heroic for a neo-Romantic manner: effects of dawn and afterglow became popular. In the work of such painters as Sydney Long (1878-1954) the bushland was populated with slender *art nouveau* nudes or the more sensuous gods of classical mythology. Even the aborigine became a faun-like creature. And in the early years of the century Blamire Young (1862-1935), after working in England with the 'Beggarstaff Brothers', James PRYDE, and William NICHOLSON, introduced the *art nouveau* poster to Australia. It was, however, the highly controversial art of Norman LINDSAY which largely dominated the local scene in the decade before the First World War. By means of his fine pen drawings, books, and paintings, Lindsay, an eloquent champion of the creative imagination and the rights and joys of the flesh, engaged the wowser (Australia's 'Mr. Grundy') in mortal combat. The battle was as much a moral as an aesthetic one. Owing to Lindsay's tireless activity the role of the artist in Australian society became a matter of public debate and Australia's Victorian Age died noisily in the correspondence columns of the newspapers.

After the First World War the Californian bungalow style became popular in domestic architecture: heavy beams, rough textures, low gables, and massive porch pylons gave houses and cottages a rugged and homely look in a popular devotion to that back-to-nature movement already manifest in painting before the war. Another North American influence, the Spanish mission style, appeared in the work of Leslie Wilkinson during the early 1920s, and as a result of his practice and teaching it was widely accepted as a building style following the economic depression of the 1930s. Modern functional design appeared in Broceliande, Victoria (1915), by Desbrowe Annear, who pioneered contemporary architectural design in his work and teaching. In 1912 Walter Burley GRIFFIN and his wife, colleagues of Frank Lloyd WRIGHT in Chicago, won the international planning competition for the city of Canberra. This plan, which combines circles, water, and vistas in a threefold axial system, appears to have been based partly upon the ideas of Daniel Burnham and the Chicago World Fair (1893), and partly upon English garden city ideals (e.g. Letchworth). Griffin achieved a spacious and imaginative plan which has not been enhanced by the unimaginative character of most of the capital's official buildings erected prior to 1955.

The influence of the modern movement in painting may be traced from 1913 when Grace Cossington Smith, Roland Wakelin (1887- ), and Roi De Maistre (1894-1968), then art students in Sydney, became interested in reproductions of POST-IMPRESSIONIST work. By 1925 the influence of Post-Impressionism was apparent in the work of the Victorian artists Arnold Shore (1897-1963), George Bell (1878-1966), and William Frater (1890- ). But a great many of the earlier generation of Australian painters who had lived mostly abroad during the first two decades of the century returned to Australia during the early 1920s to become the bitter opponents of Post-Impressionism. The pictorial taste of students, critics, and collectors between the end of the war and the depression of the 1930s favoured such art as the portraiture of George Lambert (1873-1930), an able draughtsman and sculptor as well as painter, whose later canvases are in the crisp, dry manner of ORPEN; and the landscapes of Elioth Gruner (1882-1939), whose colourful topography of the settled and richer countryside of the south-east depicted the land as a rural paradise of sunshine and plenty. In Melbourne the tonal realism of Max Meldrum (1875-1955) became a dominant influence, especially on portraiture in the period between the wars.

Although the formation of the Contemporary Group (1926) in Sydney, at the instigation of Thea Proctor and Lambert, and of the Bell and Shore art school in Melbourne (1932) did much to promote the Post-Impressionist emphasis upon firm design and pure colour, it was not until the *Melbourne Herald* Exhibition (1939) that the range and diversity of contemporary art in Europe was brought directly to the notice of the Australian public. A sustained controversy

followed similar to that created by London's Grafton Gallery Exhibition (1910) and New York's ARMORY SHOW (1913). With the return, just after the outbreak of the Second World War, of a number of artists who studied abroad, such as DOBELL and DRYSDALE, together with the influence of migrant artists such as Desiderius Orban (1884– ) and Sali Herman (1898– ), the contemporary movement gathered momentum. The formation of the Contemporary Art Society (1938) enabled younger artists to reveal the varied stimuli of contemporary European art. After 1940 Sydney and Melbourne have been centres wherein SURREALIST, ABSTRACT, and EXPRESSIONIST painting especially have been practised continuously. In Melbourne a circle associated with the journal ANGRY PENGUINS, which included NOLAN and Albert Tucker (1914– ), succeeded in creating a figurative art in which Surrealistic, social, and regional interests were combined. Two artists of this circle, Arthur BOYD and John Perceval (1923– ), were among those who formed the ANTIPODEANS group in defence of the figurative image against abstraction in 1959. During the war years Melbourne also possessed an influential social REALIST group which included Josl Bergner (1920– ) and Noel Counihan (1913– ). More recently, the art of David Boyd (1924– ) has combined social comment with an interest in allegory and legend.

By contrast Sydney art during the 1950s was influenced by artists trained in London art schools such as the Slade, by an important exhibition of contemporary French painting in 1953, by medieval and BYZANTINE ART—stimulated by the Blake Prize (est. 1951) for a religious painting—and toward the end of the decade by American ABSTRACT EXPRESSIONISM. Lyndon Dadswell (1908– ) led the contemporary movement in sculpture, and a Sculptor's Society founded in 1950, under his patronage, encouraged an experimental approach to open-form, non-figurative, and junk sculpture. The members included Margel Hinder (1906– ), a talented constructivist influenced by GABO, Robert Klippel (1920– ), a lyrical exponent of junk sculpture, and Tom Bass (1916– ), whose *Falcon and the Dove* (1954), suggested by a poem by Herbert Read and commissioned by the University of New South Wales, possesses unusual distinction. The movement towards abstraction was assisted by the teaching of John Passmore (1904– ), a London-trained Cézanniste and a master of a lyrical and fluent post-Cubist manner; by Godfrey Miller (1893–1965), an impressive Slade School trained mystic who owed much to CÉZANNE, SEURAT, and oriental philosophy; and by Ian Fairweather (1891– ), a wandering Scottish solitary, also Slade-trained, whose intensely evocative and colourful arabesques achieve a fine personal fusion of Eastern and Western tradition which is quite comparable to the work of Mark TOBEY.

From this situation vitalistic and organic varieties of non-figurative and semi-figurative painting have flourished in Sydney since the mid-fifties in the work of John Olsen (1928– ), Carl Plate (1909– ), Frank Hodgkinson (1919– ), who has lived in Spain and been touched by contemporary Spanish painting, and Brett Whiteley (1939– ), who has lived mostly in London.

The early 1960s were marked by a conflict between figurative and non-figurative painting precipitated by the Antipodean Manifesto, which gave the period a vigorous and controversial tone. But Melbourne, too, has produced abstract painters of originality and distinction, notably Roger Kemp (1908– ) and Donald Laycock (1931– ), and a first-rate abstract sculptor in Norma Redpath (1928– ). Standing somewhat apart from the neo-Byzantine trend in much contemporary religious painting is the work of Leonard French (1928– ), semi-abstract, heroic in imagery, hieratic in colour. His Edmund Campion paintings (1961), inspired by the life of the recusant martyr, constitute one of the finest achievements of contemporary Australian art.

By the middle 1960s the conflict between abstract and figurative painting had declined; both camps had become increasingly interested in ambiguous imagery. Current oversea trends such as POP ART, hard-edge, and optical painting were welcomed and practised by the student generation of the mid 1960s.

Australian painting has, however, been remarkably conservative in a century characterized by innovation. Outstanding artists such as Roberts, Dobell, Nolan, Drysdale, Boyd, French, and Miller achieved originality within received forms and conventions. This was not the result, as has often been claimed, of isolation; for the links with Europe have always been strong and the interest in Eastern art continuous. It was due partly to the effect of distance. Situated at one of the extremities of the civilized world, Australia's social and physical environments have provided new soil in which traditions threatened elsewhere have flourished in novel ways; distance has made both for survival and for a degree of independence.

128, 345, 375, 1300, 1781, 1862, 2150, 2500, 2502, 2513.

**AUSTRIAN ART.** The history of the arts in what is now Austria—that is, essentially the region of the Eastern Alps—is naturally closely bound up with the historical vicissitudes of that much contested area of central Europe. In prehistoric times the salt-producing lands round Hallstatt in Upper Austria were the centre of an important culture of the Iron Age, displaying features probably characteristic of Celtic culture (see CELTIC ART). After the Roman occupation and waves of invasion during the Dark Ages the area springs into prominence during the ROMANESQUE period of the 12th and early 13th centuries, which produced a leading school of book ILLUMINATION and wall-painting in Salzburg, important

wall-paintings in the Carinthian bishop's see of Gurk, and the great Klosterneuburg Altar by NICOLAS OF VERDUN. During the political interregnum of the late 13th c. Austrian art underwent a period of decline until the consolidation of the Habsburgs' power and their close relation to the court of Prague, the principal centre of the INTERNATIONAL GOTHIC style of the late 14th c. It was in the 15th c. that this late Gothic art produced its most attractive monuments in Vienna: Wiener Neustadt, then an important centre, and many village churches with their wood-carvings and wall-paintings—the most outstanding local master being the South Tyrolean Michael PACHER, whose St. Wolfgang altar combines the northern Gothic tradition with an interest in the naturalistic achievements of the early Italian RENAISSANCE.

The Reformation and the Turkish invasions during the 16th and 17th centuries plunged the country into chaos, and it was only after the hardwon triumph over this twin menace to the Habsburg power that Austrian art re-emerged towards the end of this period. The Counter-Reformation with its attendant foundations of churches and monasteries led to an influx of Italian craftsmen, notably architects, *stuccatori*, and decorators from the region of Como, who carried the patterns and modes of the Italian BAROQUE throughout the country and lastingly influenced the character of Austrian art, including its folk art. It was on this foundation, laid in the late 17th c., that the greatest period of Austrian art sprang up in the early 18th c., the so-called 'Austrian Baroque'. It is represented by architects of international fame such as FISCHER VON ERLACH and HILDEBRANDT; but was equally the work of humble local builders, to whose inventiveness and verve we owe such buildings as the monasteries of Melk, St. Florian, and the many other churches and castles which gave the Austrian landscape its peculiar character and transformed the appearance of its principal cities. Among the painters and sculptors, mostly employed as decorators on a lavish scale, the names of D. Gran (1694-1757), H. M. Altomonte (1657-1745), MAULPERTSCH, and Raphael DONNER stand out. They were as a group under the influence of Andrea BOZZO, who went to Vienna in 1702 to decorate the Lichtenstein palace and the university church.

The Age of Enlightenment under Maria Theresa and Joseph II, so important in the history of music (Haydn, Mozart), witnessed a turn to a more restrained and sober NEOCLASSICISM which merged into the graceful BIEDERMEIER of the early 19th c. The international position of Metternich's Austria at the time of the Congress of Vienna is reflected in Sir Thomas LAWRENCE's visit, which left its impression on the development of Austrian portrait painting, whose masters, many of them miniaturists such as M. M. Daffinger (1790-1849) and J. Kriehuber (1800-76), have preserved for us the countenances of many of Beethoven's patrons

and Schubert's friends. As elsewhere the Industrial Revolution of the 19th c. coincided with a lowering of taste in official art, against which the lonely figures of WALDMÜLLER and A. Romako (1832-89) struggled in vain. The spirit of a short-lived prosperity is well epitomized in the flashy and exuberant art of Franz MAKART and in many buildings of 19th-c. Vienna. The reaction against this decline of taste drew its strength from the ARTS AND CRAFTS MOVEMENT of England and led to the foundation of the WIENER WERKSTÄTTE and to the campaigns of the architect Adolf LOOS, one of the first champions of FUNCTIONALISM. In this atmosphere of ferment, characteristic of the Vienna of Freud, Mahler, and Schönberg, the ART NOUVEAU style of Gustav KLIMT was superseded by the daring EXPRESSIONISM of Oskar KOKOSCHKA and Egon Schiele (1890-1918). Apart from Vienna, which has always reflected the principal trends of European art, Austria possesses a number of vigorous provincial schools of painting, among which Carinthia with Wiegele and Bockl may be mentioned. After Hitler's invasion of Austria in 1938 many artists of repute and promise were driven into exile, while others had perforce to conform to official taste.

86, 370, 1154, 1308, 1957, 2142, 2533.

**AUTOMATISTES, LES.** A radical group of Canadian SURREALISTS led by Paul-Émile Borduas and including Jean-Paul Riopelle, Albert Dumouchel, Fernand Leduc, Jean-Paul Mousseau, etc. In 1948 they published an anarchistic manifesto attacking art and other aspects of Canadian life. The Automatistes worked as a group until about 1951. Borduas and Riopelle later went to Paris. (See also CANADIAN ART.)

**AUTOMNE, SALONS D'.** Annual exhibitions founded by the FAUVE group in October 1903 together with certain artists from the Salon de la Nationale. MATISSE, ROUAULT, MARQUET, and BONNARD were foundation members and Frantz Jourdain, architect of the *Samaritaine*, was President. The first Salon d'Automne gave a GAUGUIN memorial exhibition which established his reputation with the younger generation and that of 1905 gave a room to CÉZANNE.

**AUTUN CATHEDRAL.** Built soon after 1120 by Bishop Etienne de Bagé, who was a close friend of Peter the Venerable, Abbot of CLUNY. It was strongly influenced by the architectural style of that abbey, though with modifications derived from the Roman buildings of Autun itself. The sculptured capitals and splendid porch (1178) with a tympanum representing the LAST JUDGEMENT are regarded as masterpieces of French ROMANESQUE sculpture. The church was believed to contain the body of Lazarus, for which a new shrine was made between 1171 and 1189; fragments of its sculptures are in the Museum of Autun and in the Louvre.

**AVED,** JACQUES ANDRÉ JOSEPH CAME-LOT (1702-66). French portrait painter. He was trained in Amsterdam and the influence of Dutch NATURALISM can be seen in his work. He achieved something of the simplicity and direct-ness of CHARDIN, whose friend he was, and was the chief exponent of a style of portraiture which depicted middle-class sitters in the avocations of daily life. His best-known portraits are *Mehemid Effendi, Ambassador to the Porte* (Versailles), *Mirabeau* (Louvre), and *Madame Crozat* (Mont-pellier). He was painted by Chardin as *Chemist in his Laboratory*.

**AVERCAMP,** HENDRICK (1585-1634). Dutch landscape painter who worked in Kampen. He and Arent ARENTSZ discovered the pictorial qualities of Holland's flat landscape. He specialized in painting colourfully dressed crowds in winter scenes. The carefully observed skaters, tobogganers, golfers, and pedestrians give a good idea of sport and leisure in the Netherlands around the beginning of the 17th c. His passion for minute and amusing detail has sometimes been attributed somewhat dubiously to the fact that he was dumb. He sold his draw-ings, many of which are tinted with water-colour, as finished pictures to be pasted into the albums of collectors. There are more of his drawings in the Royal Collection at Windsor Castle than by any other Dutch artist. His nephew BERENT AVERCAMP (1612-79) carried on his style.

2841.

**AVERLINO,** ANTONIO. See FILARETE.

**AVIGNON,** SCHOOL OF. In 1309 the papal court removed from Rome to Avignon, where it remained until 1377. The presence of this great source of patronage drew many artists to the city, mainly Italian masters. SIMONE MARTINI of Siena is the best known of these, but GIOTTO himself may have gone there. Avignon thus became one of the channels by which Italian trecento art reached France. The centre of artistic activity was the Palace of the Popes, begun *c*. 1340. The well-known frescoes of the Ward-robe, 1343, and others uncovered elsewhere, indicate the Sienese affinities of the school. Similar works painted *c*. 1360 at Sorgues near by, and an Italianate *Virgin* painted as late as 1420 by Jaques Ivernay at Avignon, show the con-tinuity of the Italian connection. After the departure of the popes Avignon became the centre of a school of painting which amalga-mated Italian with northern Flemish influences (see FROMENT, CHARONTON). The greatest single work which the school produced, the *Pietà* from Villeneuve-lès-Avignon (Louvre, *c*. 1460), is a masterpiece of such outstanding originality that it fits into none of the established stylistic cate-gories. Many works which were at one time attributed to the school of Avignon have since been reassigned and the school is no longer a clearly defined stylistic entity.

**AXIS.** English quarterly magazine of ABSTRACT ART inaugurated in 1935 and edited by Myfanwy Evans in conjunction with John PIPER. The magazine ran to eight numbers and was in-fluential in introducing into England a know-ledge of contemporary trends in abstract and CONSTRUCTIVIST art. Under its influence the first exhibition of abstract art was organized in 1936 by Nicolette Gray. Later issues of the magazine, however, reverted to a neo-ROMANTIC nostalgia for the English landscape tradition.

**AZULEJO** (Arabic *al-zulaycha*, the tile). The Spanish and Portuguese word for a glazed poly-chrome TILE, usually about 5 to 6 in. square. Such tiles were used in ISLAMIC architecture for facing walls and paving floors. The Arabs learned the technique of making them from the Persians, and introduced the art into Spain. The production of *azulejos* did not diminish as a result of the reconquest, but continued actively at Seville, Málaga, and Toledo. Other centres of the industry in Majorca, Valencia, and Catalonia became famous throughout medieval Europe for their exports.

Moorish and MUDÉJAR tile designs were pre-dominantly geometrical with each tile forming a complete unit in a repetitive pattern. At the beginning of the 16th c. a Pisan artist, who signed himself Niculoso Italiano, settled at Seville and began the method of making the tiles into panels with a single pictorial design instead of repetitive patterns in the Moorish way. Though geo-metrical patterns continued popular, the new pictorial treatment flourished and was developed in the 16th and 17th centuries, particularly at Talavera, whence *azulejos* were exported as far afield as America and India.

Up to the mid 17th c. Portuguese *azulejos* differed little from the Spanish in design and used a wide range of colours in which purples, blues, yellows, oranges, and greens predominated. By the end of the 17th c., however, a charac-teristic Portuguese style emerged, in which blue-on-white tiles were used for large compositions of religious, historical, mythological, or GENRE scenes, framed by such favourite BAROQUE motifs as garlands, shells, and urns. Throughout the 18th c. these exuberant tile pictures were applied with lavish profusion to the walls of buildings in both Portugal and Brazil, going out of fashion only in the early 19th c. The production of *azulejos* in Spain declined after the 17th c. but the art was transplanted to Mexico, where in the region of Puebla interiors and exteriors were covered with *azulejo* facings in a wide range of brilliant colours, including vermilion, on a scale unequalled elsewhere.

In the 19th c. mass-produced *azulejos* drove out the hand-painted tile and artistic quality suffered. There have, however, been 20th-c. revivals of the art, among the most successful being the large pictorial *azulejo* designs of the Brazilian painter PORTINARI used on the walls of buildings designed by Oscar NIEMEYER.

97

# B

**BABYLONIAN ART.** The southern part of Iraq is sometimes called Mesopotamia, as lying 'between the rivers' Euphrates and Tigris, but in antiquity it bore the name, among others, of Babylonia, since its capital city was Babylon, near the modern town of Hillah. Its earliest inhabitants were the Sumerians, whose history was purely local, but their remains, discovered by excavations (at sites of the ancient cities Babylon, Ur, Erech, Lagash, Kish, Eshnunna, and others), prove that the Sumerians were masters of various major and minor arts. Especially they invented writing, at a time before 3000 B.C., and by means of this their culture, religion, and artistic methods spread over the whole of ancient western Asia after being adopted by the Semites, who succeeded to the possession of the land after the time of Sargon of Akkad (2300 B.C.). In the 2000 years from then until the conquest by Alexander (331 B.C.) the history of Babylonia was dominated rather by invasions of fresh Semitic peoples (Amorites and Aramaeans) than by expansions outside her own limits, but such kings as Shulgi (2100 B.C.), Hammurabi the lawgiver (1750 B.C.), and Nebuchadrezzar II (580 B.C.) extended the rule of Babylon during their lives into wider dominions. Foreign conquest, however, was more characteristic of the neighbour kingdom of Assyria in the north, whose greatest kings Shamsi-Adad I (1800 B.C.), Ashurnasirpal II (850 B.C.), Sargon II and Sennacherib (721–681 B.C.), made themselves lords of great empires, reaching at their widest from the mountains of west Persia across to the Mediterranean. In art, literature, and religion, as in their general mode of life, the Sumerians were great originators who set a pattern not only for their successors in Babylonia but for all the peoples of the ancient East, while the Assyrians, who spoke a Semitic dialect similar to that of Babylonia, employed in their life and arts many of the ideas, methods, and materials of their neighbours, but had a more material and harder character of their own (see ASSYRIAN ART).

Babylonian artists, as in many flourishing artistic ages, were not distinguished from craftsmen or workmen but as such they enjoyed high esteem, and their skills were thought to be given by direct inspiration of the god Ea, who was himself the embodiment of all wisdom. Kings of neighbouring lands were always ready to ask from one another the loan of outstanding craftsmen (carpenters, stonemasons, metal-workers, builders) and never omitted to carry them off from cities which they conquered. Nevertheless the soil of Babylonia was not liberal to this wealth of talent, being poor in the basic materials (stone, metals, and wood) which are requisite to artistic production. On the other hand its fertility was a wonder of the ancient world, so that the Babylonians could acquire these necessities by trade with the surrounding lands (Syria, Asia Minor, and what is now Iran).

The products of the alluvial plains and swamps on the lower courses of the two rivers were in antiquity what they are today—clay, reeds, straw, palms, bitumen—and the chief Babylonian arts depended essentially upon the first two. Potting was an art brought to a high perfection before the beginning of the 3rd millennium B.C. Its finest products are found rather in the surrounding lands than in Babylonia itself, and were produced by peoples in other respects primitive, with slight material resources and no more than a village civilization. The prehistoric pottery found at Arpachiyah in Assyria and Susa in Iran (to name only the best) displays a fineness of fabric and a taste and skill in painted decoration which were never attained again in later periods, when pottery was mostly undecorated and unattractive.

Building in Babylonia was conditioned by the materials available locally, with the almost indispensable import of cedar trees from the Lebanon, for these alone provided timbers long enough to support the flat mud roofs. The invention of mud bricks, made of puddled clay with chopped straw, enabled the clay to be built up instead of merely compacted, and this simple element remained afterwards, as it is still, the staple of local building. Temples and palaces, adorned outwardly with the richest accessories, were built only of these perishable mud bricks and soon sank into mere heaps of their native earth. Much more durable were the baked bricks which were sometimes used, even in great numbers; these were large, flat, and heavy, over a foot square and 3 in. thick, often bearing a stamped inscription naming the builder and the building; they were laid in a mortar composed of bitumen reinforced with reed-mats.

Owing to their usually perishable materials Babylonian structures are seldom found preserved to any considerable height, and thus we are ill informed of their appearance. Upper storeys were certainly added, though none has survived, and windows were doubtless small and placed high up on the walls. In certain great buildings of the period *c.* 3000 B.C. the outer walls were decorated by driving into the crude brickwork cones of various colours, the heads of which

formed patterns; similar cones, no longer decorative, afterwards carried memorial inscriptions of the royal builders. Columns and true arches, with voussoir bricks, were used from early in the 3rd millennium B.C. Two characteristic elements in Babylonian architecture were the façades with slightly projecting buttresses and vertical channelling, and crenellations, either stepped or of plain triangular form. Most distinctive of all were the vast staged towers called ziggurats, essential to all the major temples. These were enormous solid masses of mud brick, perhaps with an outer facing of burnt bricks, and they were constructed as a pile of diminishing flattened cubes, each smaller than the one below. At the top was a small sanctuary, which was reached by an exterior stairway.

In the representational arts of all the Near East in ancient times the influence of the Sumerians seems to have fixed originally the purposes, the subjects, and the methods which remained in use, however locally modified. Art was almost exclusively religious and hierarchical; it embellished temples and palaces, it represented gods and kings, or individuals only in relation with these powers. About the beginning of recorded history (c. 2500 B.C.), limestone figures in the round appear with natural forms, though their gestures, especially that of the folded hands, were restrained by convention. Eyes were often inlaid with different material, now usually missing; the feet stand in a kind of niche made by the back support of the figure, and the costume is commonly the most distinct feature, the garment of fleece with hanging locks which is sometimes called *kaunakes*. The art of sculpture in the round reached its highest achievement in the celebrated statues (mostly under life size) of Gudea (2100 B.C.), now mainly in the Louvre, the finish of which is partly due to the hard stones of which they were fashioned.

Sculpture in the round was, however, at all periods much less practised than bas-relief, which is the true medium of Babylonian (but especially Assyrian) stone-craft. It is clear that sculpture in relief, which was originally coloured, developed alongside wall-painting, of which it was, in effect, only a more elaborate version, using another dimension. Wall-paintings of considerable effect and completeness have been discovered at Mari (Babylonian) and Til-Barsip (Assyrian), two ancient cities on the Euphrates. These depict typical scenes of royal ceremony, sacrifices, investiture, lion-hunting. The designs are outlined in black upon a ground of fine white plaster, and the colours employed are red and black, but there is a limited use of blue for details, and even of yellow and green. Figures are drawn with the same conventions as in the bas-reliefs, heads and legs in profile and bodies full face, the eye generally viewed as from the front.

A peculiar kind of stone carving very characteristic of Babylonia is the miniature art of engraving designs and inscriptions upon little

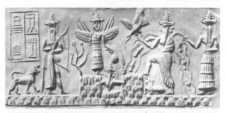

**30.** Cylinder seal of green schist. Akkadian (c. 2250 B.C.). The scene may represent the earth's awakening at the rising of the Sun. (B.M.)

cylindrical seals, mostly made of hard stones, which are found over a wide area of western Asia and remained in almost universal use from c. 3000 to 500 B.C., being both preceded and followed by the more familiar stamp-seal, also engraved. The cylinder seals have a clear order of development over this long life, in subjects, style, and even materials. The finest examples, superlative both in interest of subjects and beauty of execution, were made especially in the period of Akkad (c. 2300 B.C.). Yet other kinds of miniature carving occur in the shaped and sculptured tesserae of shell, lapis-lazuli, or other coloured stones, which were used either as inlays to decorate larger works or as pieces in a mosaic to form coloured pictures, like the celebrated 'standard' from Ur (B.M., c. 2500 B.C.), with its lively scenes of war and banqueting. To this art belong also the carved ivóries, vessels, and ornaments which are shortly described under ASSYRIAN ART.

Some use of copper (either almost pure or alloyed so as to become bronze) is found even in the prehistoric period, but it was with the first historical dynasties (c. 2500 B.C.) that metals became plentiful and superseded the fine painted pottery for purposes of display. The characteristic metals were gold, silver, and copper (or bronze). Great works were executed in these media, though generally in large figures the metal was simply a sheet hammered over a core of wood and bitumen. But in the later (Assyrian) period even the monsters standing at the entrances to temples and palaces were cast in bronze. Gold and silver objects, because of their value, have seldom survived; the most remarkable group is certainly the furnishings from the 'Royal Cemetery' at Ur (at Baghdad and Philadelphia and the B.M.; c. 2500 B.C.), notable both for design and for technique. From a slightly later age comes one of the noblest works in bronze, the head of a king, with elaborate hairdressing and beard, found at Nineveh and now at Baghdad; this heavy work was cast, not hammered, and details added with the graver. It was also Assyrian craftsmen who produced, in the 9th c. B.C., the bronze bands, with repoussé decorations of warlike scenes, from the gates set up at the entrance to a palace of Shalmaneser III at Balawat; these are now in the British Museum.

Babylonia was a great centre of the glass-making industry, but owing to destruction and soil conditions the surviving examples are much

less numerous and less pleasing than those of Egypt: the best known is a small flask inscribed with the name of Sargon II of Assyria (721–705 B.C.). A very spectacular art was that of building grand façades in burnt brick with modelled figures and covering these with bright polychrome glazes. More remarkable than the existing products are the details preserved of the manufacturing processes in certain technological documents which are unique in the ancient world. These describe the apparatus needed, and give detailed formulas for making decorative glass of different colours and qualities.

913, 914, 1522, 1679, 1748, 2035, 2036, 2037, 2573, 2933, 2935.

**BACICCIA,** GIOVANNI BATTISTA GAULLI (1639–1709). Italian painter, who shared with Pozzo the leadership in the advanced style of ILLUSIONIST BAROQUE decoration in Rome. He studied CORREGGIO in Parma, and was encouraged and influenced by BERNINI. His masterpiece, the nave vault of the Gesù in Rome, is a combination of painting and STUCCO. He painted also distinguished portraits and ALTARPIECES.

**BACKER,** JACOB ADRIAENSZ (1608–51). Dutch portrait and history painter, born in Friesland. His early works show that he was familiar with paintings of Pieter LASTMAN. In 1633 he moved to Amsterdam and fell under the spell of REMBRANDT, who was rapidly earning the reputation of Amsterdam's leading portrait painter. Backer's best known portraits are in the same vein as those done by Rembrandt between 1632 and 1635. The *Portrait of a Boy in Grey* (The Hague, 1634), his earliest dated portrait, is also one of his most beautiful pictures.

**BACKOFEN,** HANS (d. 1519). Late GOTHIC German sculptor who worked in Mainz.

**BACKSTEIN GOTHIC.** Term used to denote the distinctive kind of GOTHIC architecture developed in north Germany particularly during the 14th c. In the absence of workable stone quarries brick is the natural building material of the north German plain. In ROMANESQUE times the use of brick had little effect on style: Jerichow, for instance, is just another Romanesque church. But with Gothic architecture the case was different. Brick did not lend itself to the reproduction of Gothic decorative details, and though occasionally attempts were made to render all their intricacies, as at Brandenburg and Prenzlau, the whole Gothic system had to be simplified before a really effective brick Gothic could be achieved. The results of this modification can still be seen in the great churches of the Hanseatic ports of the Baltic coast, e.g. Lübeck, Wismar, and Stralsund. These churches rely for their effect on sheer expanse of wall surface, unbroken save for enormous vertical windows. Sometimes, as in the Marienkirche at Stralsund, façades of this kind make an overwhelming impression. The monumental simplicity of these buildings makes a vivid contrast with SONDERGOTIK, and virtually constitutes an alternative style.

**BAÇO,** JAIME, called MASTER JACOMART (*c.* 1413–61). Court painter to Alfonso V of Aragon, who called him from Valencia to Naples some time before 1442. Owing to his departure from Valencia several of his commissions were left uncompleted and were finished by the painter Juan Pexach (active 1431–82).

An ALTARPIECE by Jacomart dated 1444 (now lost) represented the apparition of the Virgin in a dream to King Alfonso V. By 1451 he had returned to Valencia, where he was the most influential painter of his time. In 1458 Alfonso V died and in 1460 his successor Juan II continued the payment to Jacomart for an altarpiece of Santa Catalina for the Royal Chapel. The only surviving documented work by Jacomart is an altarpiece for the town of Cati, a POLYPTYCH representing the martyrs St. Laurence and St. Peter, and many attributions are based on the style of this particular work. He appears to have been very little influenced by the Italian RENAISSANCE, remaining faithful to the Hispano-Flemish style.

2667.

**BACON,** FRANCIS (1910–   ). English painter, born in Dublin of an English horsetrainer. He was entirely self-taught. He took part in two group exhibitions at the Mayor Gallery in 1933, held a one-man show at the Transition Gallery in 1934, and showed in 1937 in the Agnew Gallery 'Young British Painters' exhibition. After this he dropped from sight until his *Three Studies* of figures for the base of a *Crucifixion* (1944), exhibited at the Lefevre Galleries and now in the Tate, made him overnight the most controversial painter in post-war England. Bacon satirizes contemporary types with an eye for the timelessly disgusting and highlights the repulsive in the human shape and postures by an individual idiom of ambiguous space-frame. It has been said that his approach offers 'a visual and anti-literary equivalent of what in the late 40s was called "the literature of the extreme situation"'. Bacon himself has said: 'Art is a method of opening up areas of feeling rather than merely an illustration of an object. . . . I would like my pictures to look as if a human being had passed between them, like a snail, leaving a trail of the human presence and memory trace of past events as the snail leaves its slime.'

2353.

**BACON,** JOHN (1740–99). English sculptor, who started work as a modeller in a porcelain factory. By 1769 he was working for the COADE Artificial Stone Manufactory and remained connected with it till his death. This experience left

a permanent mark on his style as a sculptor. For though he also attended the R.A. Schools, his work, even in marble, is soft, often showing much pretty detail. He was less interested in the ANTIQUE than most of his contemporaries, and never visited Rome. He became an A.R.A. in 1770 and an R.A. in 1778. He early attracted the attention of George III, his bust of the king (Christ Church, Oxford, 1774) being repeated several times. His finest work is the monument to Thomas Guy (Guy's Hospital, 1779), showing the founder succouring a sick man, but the favour of the king gained him the important commission for the monument to the Earl of Chatham (the Elder Pitt) (Westminster Abbey, 1779–83), and he also carried out much sculpture at Somerset House. His talent did not fit him to produce statues in antique dress, as can be seen in his *Dr. Johnson* (St. Paul's Cathedral, 1796), but his many smaller monuments, almost all with female allegorical figures, have considerable charm.

His practice was carried on by his son JOHN (1777–1859), who finished some of his father's work such as the equestrian statue of William III in St. James's Square. He was an uneven sculptor, his best work, such as the monument to Sir John Moore (St. Paul's Cathedral, 1810–15), showing considerable ability, but most of his large output was repetitive and mediocre.

652.

**BACON,** SIR NATHANIEL (1585–1627). The first amateur painter of note in England, he was also the finest artist of his time and the only English-born rival to MYTENS and C. JOHNSON. His six surviving paintings (at Corhambury) include an ambitious self-portrait which displays a more solid realization of space, greater subtlety of colouring, and greater power of characterization than had hitherto been achieved in English portraiture, a finely modelled and expressive portrait of his wife in profile, and two large still lifes (*The Cookmaid* and a companion piece) which, though reminiscent of the Utrecht school and CARAVAGGIO, achieved 'an amalgam that is wholly original' and for their expressive naturalism, accomplished composition, and the warm humanity combined with their grasp of realistic detail, are unequalled in English 17th-c. painting. The 'cookmaid' has been called 'the first real woman to appear in British art'. He was also responsible for the earliest known British landscape, a miniature in the manner of BRIL (Ashmolean Mus., Oxford).

**BAEHR,** GEORG (1666–1738). German architect, active in Saxony. His work lay chiefly in the field of church design, where he met the special problems posed by the Lutheran service with its emphasis on the spoken word by creating a church of unified space with a theatre-like arrangement of galleries and boxes, as seen in his best known work, the Frauenkirche in Dresden (1726–43). Similar ideas also played a

part in several smaller churches which Baehr built near Dresden. The Frauenkirche is also remarkable for a technical feature. As at St. Paul's, London, hidden buttresses carry over the thrust from the heavy dome to the side walls. It is, however, doubtful whether Baehr knew of WREN's work.

**BAEN,** JAN DE (1633–1702). Dutch portrait painter. He was a pupil of Jacob BACKER, but van DYCK's works were his main source of inspiration. He settled in The Hague in 1660 and there became the leading portrait painter of the House of Orange. Charles II summoned him to London, where he painted the king's portrait. For patriotic reasons he refused a commission from Louis XIV in 1672. Later he became painter to the court of the Elector of Brandenberg.

**BAERZE,** JACQUES DE (active end of 14th c.). Flemish wood carver from Termonde, near Ghent. Duke Philip the Bold of Burgundy (see BURGUNDY, School of) commissioned two RETABLES from him for the Chartreuse de Champmol, now in the Musée de la Ville, Dijon. The more elaborate of the two was decorated with painted wings by Melchior BROEDERLAM between 1394 and 1399. Although Baerze's work was important in the development of the sculptured altarpiece, his style was more conservative than Broederlam's. His panels are essentially flat compositions, and they are dominated by the richly gilded architectural framework.

**BAILLAIRGÉ.** Leading family of French Canadian wood-carvers in the later 18th and early 19th c. Their *atelier* was in Quebec. The founder of the family was JEAN BAILLAIRGÉ (1726–1805); others were FRANÇOIS (1759–1830) and his son THOMAS (1791–1859). Their style, with its combination of elegance and provincialism, reflected the Classicism of the LOUIS XVI style with added touches from the English GEORGIAN. Their technique was fresh and vigorous.

**BAILY,** EDWARD HODGES (1788–1867). English sculptor, the son of a noted carver of ships' figure-heads at Bristol. He was FLAXMAN's pupil and also studied at the R.A. Schools. He became R.A. in 1812. He carved the reliefs on the Marble Arch, London, and the statue of Nelson in Trafalgar Square. His prolific output of portrait busts (six of which are in the National Portrait Gallery, London) includes many of his fellow artists (Flaxman, SMIRKE, FUSELI, HAYDON) and he did a statue of TURNER in 1857. His early *Eve at the Fountain* is in the Victoria and Albert Museum (1820). He had competence and talent, but stopped short this side of greatness.

**BAKHUYZEN,** LUDOLF (1631–1708). Dutch marine painter, the most famous follower of

Willem van de VELDE II. After the latter left Amsterdam for England Bakhuyzen became the most popular marine painter in Holland. He captures the drama and movement of ships, whether in harbour, or in a regatta, or in a high wind on the open sea, but seldom achieves the poetic effects of either van de Velde or Jan van de CAPPELLE.

**BAKST,** LÉON (LEV) (1886–1925). Russian painter and stage designer. He belonged, with Diaghilev and BENOIS, to the MIR ISKUSSTVA (*World of Art*) group. His early illustrations to Gogol show some influence of the German illustrated periodicals *Jugend* and *Simplicissimus*. Later Bakst turned to stage and costume design. He was in Paris from 1908 and his ballet décors created a sensation between 1910 and 1912, and helped to revolutionize modern stage design. The impact of oriental, especially 19th-c. Persian, art can be felt in the strange riot and new intensity of his colours.

**BALDACHIN, BALDACCHINO.** A canopy supported at each corner by a pole and either carried in procession over a sacred object or hung over an altar; or a structure derived from such a canopy. In the 17th c. BERNINI, faced with the task of giving importance to the High Altar of St. Peter's in the vast space beneath the dome, designed a bronze baldacchino on a magnificent scale. The type, often with twisted columns and fringed canopy, became usual in BAROQUE churches, and when the high altar of St. Paul's Cathedral was restored in 1958 it was given a baldacchino of that type, as had been WREN's original intention.

**BALDINUCCI,** ABATE FILIPPO (1624–96). Florentine artist, art historian, antiquarian, and philologian, who was prominent in artistic circles at the court of the MEDICI Dukes. He was adviser to Cardinal Leopoldo de' Medici (1617–75) and helped to form his collection of drawings. He also selected and bought pictures for Duke Cosimo III. His *Notizie de' Professori del disegno* (3 vols. published in 1681, 3 in 1781), lives of artists from CIMABUE to his own time, is valuable for the information it gives about 16th-c. Florentine artists as well as his own contemporaries. A pioneer of historical research, he made use of every kind of document and was in the confidence of many leading artists—CLAUDE himself showed him the *Liber Veritatis*. As an art historian he was an innovator for, although his avowed intention was to continue VASARI's *Lives*, the *Notizie* is European in scope. He had an expert's knowledge of techniques and wrote the first history of engraving on copper (1686), primarily for the use of collectors, and the first dictionary of artistic terms. He was commissioned by Christina of Sweden, living in Rome after her abdication, to write the life of BERNINI (1682).

**BALDOVINETTI,** ALESSO (*c.* 1426–99). Italian painter and MOSAICIST, a characteristic representative of the FLORENTINE SCHOOL of the second half of the 15th c. He inherited standards of economy in design and of scrupulous execution from DOMENICO VENEZIANO and Fra ANGELICO, though he lacked the imaginative powers of either. He had a taste for the current repertoire of flowers, fruit, shrubs, brocades, and so on, which resulted in a curious and engaging blend of naïvety and sophistication. His works include a *Sacra Conversazione* painted for the MEDICI villa at Cafaggiolo, an *Annunciation* now in the Uffizi, a ruined fresco of the *Nativity* in the forecourt of the SS. Annunziata, and a *Madonna* now in the Louvre; the last two contain extensive background landscapes after the Flemish manner. He has also been credited with the *Portrait of a Lady in Yellow* in the National Gallery, London.

From 1450 he worked as decorator and mosaicist at the BAPTISTERY in Florence and became one of the leading mosaicists of his time. There is a mosaic by him in the TYMPANUM over the south door of the Duomo at Pisa (1467). His diary of commissions is one of the few that are known from the 15th c.

1483.

**BALDUCCIO,** GIOVANNI DA (active 1315–49). Pisan sculptor in the tradition of Nicola and Giovanni PISANO. The earliest work that has been attributed to him is a pulpit in the church of Sta Maria at Casciano. During the 1320s he worked in several places: Pisa Cathedral, Florence (S. Croce), Bologna (S. Domenico Maggiore), and elsewhere. In 1334 he came to Milan to carve the *Shrine of S. Peter Martyr* in S. Eustorgio. The conversion of Lombard sculptors to the Pisan GOTHIC is largely due to Balduccio.

**BALDUNG,** HANS, called GRIEN (1484/5–1545). German painter, who may have been trained in DÜRER's workshop until *c.* 1509. He settled in Strasbourg but was temporarily called across the Rhine to Freiburg, where between 1511 and 1516 he executed his greatest extant work, the altarpiece in the cathedral. In this as in others of his paintings can be felt the impact of GRÜNEWALD, whose *Isenheim Altar* must have been completed about 1512. Contact with the greater master enhanced Baldung's colouristic effects and his realization of the expressive value of distortion. Both artists shared a penchant for the gruesome and macabre. Baldung was a fine draughtsman and his often rather mannered style was admirably suited for woodcuts, the effects of which he heightened by the use of CHIAROSCURO technique.

1514, 1963.

**BALL,** THOMAS (1819–1911). American sculptor. He was at first self-taught, coming to

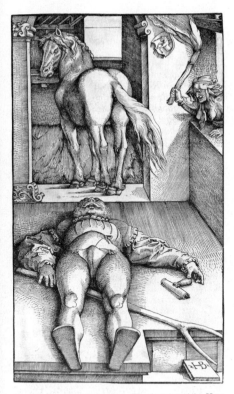

**31.** *The Bewitched Stable Boy.* Woodcut (1544) by Hans Baldung

sculpture from miniature and portrait painting, but after the age of 35 he studied for two years with the group of expatriate American sculptors established in Florence. He is best known for his *Washington* monument in Boston and *Lincoln as the Emancipator* (Washington, 1875).

**BALLA,** GIACOMO (1871-1958). Italian painter, born in Turin. From an early visit to Paris Balla brought back to Italy a feeling for DIVISIONISM and for colour and light, which he passed on in Rome to BOCCIONI and SEVERINI. In 1910 he was converted to FUTURISM by MARINETTI and such pictures as *The Swifts* (1913) and *Dog on Leash* (which shows, like a slow-motion film, the successive positions taken up by the dog's paws and the woman's legs) are characteristic of the movement. In 1913-16 he went beyond the principles of the Futurist manifesto, painting more abstract pictures, such as *The Transit of Mercury* (1916), which nevertheless originated in observations of reality. He was an innovator and his earlier work has been considered of most interest.

1786, 2526, 2628.

**BAMBOCCIATE.** See LAER, Pieter van; ROMAN SCHOOL.

**BANDINELLI,** BARTOLOMMEO or BACCIO (1488-1559). A Florentine sculptor whose reputation may have suffered owing to his unattractive character and the antipathy of his contemporaries. His work is the more difficult to evaluate because he failed to finish many of his more important undertakings, among them the tombs of Popes Leo X and Clement VII (commissioned 1536; Sta Maria Sopra Minerva, Rome); and that of Giovanni dalle Bande Nere (commissioned 1540; Piazza S. Lorenzo, Florence). But even the famous *Hercules and Cacus* (Piazza della Signoria, Florence, finished 1534) can hardly be called an unqualified success, and the ridicule bestowed on it by CELLINI is not quite undeserved. Bandinelli was a favourite of Cosimo I and his Duchess and worked as an architect on the Palazzo della Signoria and the choir of Florence Cathedral, the sculptures from which are amongst his finest achievements. Although his models and bronze statuettes have a life and a firm construction lacking in his large sculpture, he displayed all his life a fondness for colossi. He also painted, but though an excellent draughtsman he was a poor colourist.

**BANDOL,** J. See BONDOL, Jean de.

**BANKS,** THOMAS (1735-1803). English sculptor. He was apprenticed to an ornament maker but also worked in SCHEEMAKERS's studio in his spare time. He won many prizes for sculpture, including a scholarship from the ROYAL ACADEMY in 1772 which enabled him to go to Rome. While there he studied the ANTIQUE with fervour, was much influenced by the writings of WINCKELMANN and the style of the painter FUSELI, and executed several commissions for visiting Englishmen. Among the finest of these is the relief *Thetis and her Nymphs rising from the Sea* (V. & A. Mus.), notable for its harmonious linear movement. He returned to England in 1779 but went to Russia for a short time in 1781. Back in England, he settled down to become with FLAXMAN the leader of the NEO-CLASSICAL movement in sculpture.

His work was unequal. His rare portrait busts (*Warren Hastings*, Commonwealth Office, 1790) and his smaller monuments (*Martha Hand*, St. Giles, Cripplegate (destroyed), 1785) were of high quality, and his *Penelope Boothby* (Ashbourne, Derbyshire, 1793), in which the girl is not dead but sleeping, appealed greatly to the sentimentality of the age. His last works, the monuments to Captain Burgess (1802) and Captain Westcott (1802-5) in St. Paul's Cathedral, were somewhat pathetic essays in the heroic style. But to his contemporaries he appeared to be a great artist.

227.

**BAPTISM OF CHRIST** (Matt. iii. 16; Mark i. 9-10; Luke iii. 21-22). From the earliest Christian times baptism was the first of the three essential rites of Christian initiation. It was preceded by a more or less lengthy period of

probation, the catechumenate. Baptism was ordinarily administered at Easter in the Roman Church and in the East at Epiphany, the festival of Christ's birth and of His baptism. In doctrine baptism represented not only acceptance into the Christian society but mystical union with Christ, purification from sin, and regeneration into a new life. In view of the importance of the ceremony the scene of Christ's own baptism was frequently represented in Christian art, being regarded as the 'type' or precedent of baptism into the Church. The Baptism scene is first found in the Lucina crypt of the Callixtus Catacomb in Rome (c. 230), where JOHN THE BAPTIST is shown helping Christ out of the water. The more usual imagery also appears in the 3rd c.; John places his right hand on the head of Christ, who is depicted as a young boy standing naked in the water (Callixtus Catacomb, Rome). The holy DOVE, which is mentioned in the gospel texts and was to remain a constant feature of the scene, appears on some of the many SARCOPHAGI on which it is represented (e.g. that in Sta Maria Antiqua, Rome). In the 5th- and 6th-c. Ravenna mosaics Christ is grown up but youthful and beardless, as can be seen in the early 6th-c. BAPTISTERY of the Arians (the bearded Christ and much else in the mosaic of the Orthodox Baptistery result from later restoration). At Ravenna (5th-c. Orthodox Baptistery) a classical river-god was introduced, personifying the Jordan, and this figure became a common feature of the scene throughout the Middle Ages. In the 6th c. also appeared the two angels hold-

ing Christ's robes (ivory chair of Maximian, Ravenna, A.D. 546–52), which from that date remained an almost invariable part of the Baptism. In the second half of the 6th c. the mature, bearded Christ took the place of the young boy (cemetery of Ponzianus, Rome, and in the Syrian *Rabula Gospels*, Laurentian Lib., Florence, A.D. 586). And from this time the composition, though with innumerable minor variations, remained constant in its main features. Beneath the holy dove Christ stands naked, up to His waist in water; John, imposing his right hand on the Saviour's head, stands on one side and the two angels on the other. This was the common form in BYZANTINE ART (mosaic, Daphni, 11th c.), and from the 11th c. it formed part of nearly every cycle of the Life of Christ in Western art. The only striking changes were that the number of angels increased and from the 12th c. onwards God sometimes appeared in the cloud above the dove (Liège font, c. 1112). This theme became more frequent from the 15th c. onwards and it played an important part in many compositions (Rogier van der WEYDEN, Berlin, and El GRECO, Palazzo Corsini, Rome).

In the earlier period baptism by immersion was represented. This did not mean that the initiate was entirely submerged in the water. He entered the font, in which the water would not reach beyond the middle of an adult, and either water was poured over his head from the font or he stood under an opening from which a stream of water issued. Artistic representations followed this pattern (GIOTTO, Arena Chapel, Padua, 1305–6; BARNA da Siena, S. Gimignano, middle 14th c.). From the 12th c. baptism by infusion was also frequently shown (enamel altar of NICOLAS OF VERDUN, Klosterneuburg). John pours the water from a saucer or jug over the head of Christ, who is generally dressed in a loin-cloth and stands only up to the ankles or knees in the Jordan (GHIRLANDAIO, fresco, Sta Maria Novella, Florence). After the 14th c. baptism by infusion was always depicted, probably because this ritual was now becoming general.

Artists of the 15th and 16th centuries added to the scene a number of other naked or undressing figures (PIERO DELLA FRANCESCA, N.G., London), thereby combining the Baptism of Christ with the Baptism of the Multitude (Matt. iii. 6; Mark i. 5). This combination had already appeared in Byzantine Gospel illustration three centuries earlier.

The Baptism of Christ remained a popular subject during the High RENAISSANCE, but from the 17th c. onwards it was rarely depicted. (See also CHRIST; JOHN THE BAPTIST.)

**BAPTISTERY** (Latin *baptisterium*). A term used originally to describe a cold plunging-bath and from the 4th c. a Christian baptismal pool. By extension, a hall in which the sacrament of baptism is performed. No building specifically constructed to house the pool existed before the recognition of Christianity by the emperor

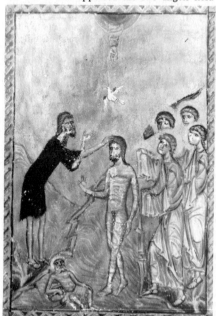

**32.** Miniature, *Baptism of Christ*, from a Psalter illuminated for Melissendra, daughter of King Baldwin of Jerusalem. (B.M., mid 12th c.)

Constantine (A.D. 313). The earliest example of a baptistery in the West is that of S. Giovanni in Laterano, Rome, dating in part from the 4th c. In EARLY CHRISTIAN architecture the baptistery was a separate building, linked to the church by a NARTHEX (Mytilene) or by a lateral nave (S. Aquilino, Milan). Sometimes it is beside the APSE (S. Stefano, Rome, and Khirbet-el-Flusiyyeh, Egypt). In Italy, Africa, Greece, and Asia Minor it was the practice to place the baptistery to the north of the church and in Syria and Egypt to the south. In construction those of central plan are of classical inspiration, being either circular or polygonal. The prototype, S. Giovanni in Laterano, is octagonal; in the interior eight porphyry columns forming a circle support an architrave, upon which rests a further tier of eight marble columns supporting the cupola. Also internally of circular plan, but externally dodecagonal, is the 4th-c. baptistery of Ephesus, the most ancient example in the East. Both square and cruciform baptisteries are found in Africa. A modification of the ceremony of baptism in the 9th c., leading to the adoption of sprinkling in place of immersion, made the construction of separate buildings unnecessary and the FONT, at which the rite could then be performed, was housed in the church. Baptisteries as separate buildings, in continuation of the ancient tradition, remain, however, a feature of Italian ecclesiastical architecture until the end of the Middle Ages. Both at Pisa and Parma work was begun on baptisteries of circular plan in the 12th c., the former being elaborately ornamented in the Gothic style in the following century and crowned with a cupola finally completed in the 14th c.

**BARBARI,** JACOPO DE' (active c. 1497, d. 1516?). Venetian painter and engraver of whose early career nothing is known. His very original style shows the influence of MANTEGNA and the late work of Alvise VIVARINI, but also of GERMAN ART, particularly DÜRER, and from 1500 he was working in Germany for the emperor Maximilian, Frederick the Wise of Saxony, and others. There he was highly regarded as the harbinger of the new Italian style and in this role gravitated c. 1509 to the Netherlands as painter to the humanist Count Philip of Burgundy and later to Margaret of Austria. He was a formative influence on the Flemish Romanism of MABUSE and van ORLEY, and his delicate engravings, many of mythological figures, helped to spread the Italian conception of the nude in northern Europe. A STILL LIFE of 1504 (*Dead Bird*, Munich) is one of the earliest examples of that genre. His works are normally signed with a caduceus.

**BARBARIAN ART IN EUROPE.** In the terminology of prehistorians the 'savagery' of the Palaeolithic Age was succeeded by neolithic 'barbarism' resulting from an economic and scientific revolution which, in the words of Gordon Childe, 'made the participants active partners with nature instead of parasites on nature'. The occasion for the change was the melting of the ice sheets at the end of the Pleistocene epoch, which converted the steppes and tundras of Europe into temperate forests and grasslands. The power to cultivate food plants and so to augment the food supply to support a growing population was the first step in the neolithic revolution. The more stable way of life which resulted made possible the development of other crafts. The neolithic revolution continued into the 'higher barbarism' of the Copper Age with the growth of specialization and the increased complexity of social organization which followed upon the discovery of metallurgy. In art history the term 'barbarian art' covers the characteristic art products of peoples in these stages of social evolution. It does not carry qualitative aesthetic implications.

Prehistoric Europe, from about 4000 B.C. onwards until the time of the emergence of the CELTIC ART styles from c. 500 B.C., was a land of simple peasant communities whose subsistence was based on farming. At first stone-using in the manner of their earlier ancestors, though with an increasing mastery over the crafts of grinding and polishing tools and ornaments of stone, these communities adopted the techniques of working in copper, bronze, and gold from the higher civilizations of western Asia around 2000 B.C., and thereafter moved from a Stone Age into a Bronze Age. This was a change in the technology of making tools and weapons, but the basic farming economies remained relatively unchanged.

The artistic expression of these scattered groups of early farmers seems to have taken two main forms. The techniques of agriculture were themselves derived from the ancient Near East, where from very early times there existed a more or less representational art style with a particular interest in the human form. It is not surprising, then, that in areas of Europe where this ultimately Oriental influence can be detected an art is found which, however formalized, is based on the representation of the human figure. Outside and on the northern fringes of the civilized ancient East a second art style, more highly stylized and employing animal motifs with a minimum of human representation, had its roots deep in the hunting and fishing traditions of the Older Stone Age and manifested itself intermittently in prehistoric barbarian Europe, making its most notable appearances in the art of the Scythians and the Celts but perceptible elsewhere at an earlier date. (See ANIMAL STYLE.)

In eastern Europe the earliest stone-using agricultural societies from at least the early 3rd millennium B.C. seem to have shared cults which are represented archaeologically by figurines of women, usually modelled in clay. These vary widely in detail, and in the finer examples possess notable qualities of plastic form. Such figurines show fairly close relationship with those of the

ancient eastern civilizations. In western Europe, however, and associated to a large degree with cults which involved the building of stone-chambered collective tombs, there is a second group of human representations, mainly to be dated from the end of the 3rd millennium B.C. and well into the 2nd. A distinctive form of obese female figurines dating from the advanced Ġgantija phase of Malta's Bronze Age (c. 2800–1500 B.C.) sometimes reveal a truly magnificent sense for plastic form (*Sleeping Lady* of Hal Saflieni; *Venus* of Haġar Qim). There was also a notable development of pottery decoration from the early Żebbuġ to the infinitely various and finely balanced curvilinear design excavated from the rock-cut tombs of Xemxija by Professor J. D. Evans in 1955. Schematic patterns similar to the earlier Malta phases occur in the west Mediterranean associated with chambered tombs along the Atlantic coasts and in the British Isles at about the same time.

Among the minor arts that of the potter was developed to a high degree of excellence in the 3rd and 2nd millennia B.C. in Europe, though without the use of the potter's wheel. (See STONE AGE ART IN EUROPE.) In eastern and east-central Europe painted pottery, in techniques again reflecting those of the Orient, was produced in a wide range of styles among the stone-using agriculturists of that region. Simple painted patterns on the wall-plaster of wooden huts are known from this context in eastern Europe, and at a later date (6th c. B.C.) on the walls of mud-brick houses in Spain. In early 2nd-millennium eastern Europe panels of decorated plaster work, scored with geometric patterns, were used in the gable ends of timber houses.

In Scandinavia rock engravings of the 2nd millennium B.C. and later show scenes which include human beings, boats, ploughs, reindeer, fish, and in the later ones chariots or carts. This art style seems to have been based in the main on ancient hunter-fisher traditions in the northern world, probably augmented by later contacts resulting from the widespread trade in bronze tools and weapons across Europe. (See CAMUNIAN ART.) But though the naturalistic style of rock engraving persisted, these neolithic and Bronze Age engravings were in the language of art like the babble of children compared with the palaeolithic paintings. In the production of metal objects much fine craftsmanship was employed: decorative vessels in particular, at first cast and later beaten from sheet metal, were produced from central European workshops. From about 1200 B.C. they were manufacturing and exporting a notable series of bronze vessels and other objects such as decorative parade helmets of types which were ultimately to reach Italy and contribute to the development of the Etruscan metal-working tradition. (See ETRUSCAN ART.)

It is in the context of this Late Bronze Age metal-work that we encounter stylized animal motifs, incised or in the round, which played their part in contributing to the art of the Celtic peoples, together with classical and probably new Oriental influences. Bulls and birds are among the most favoured subjects, and their presence must hint at cults analogous to those which we can later recognize in the Celtic religious tradition. Classical contacts were indeed being established with the world of barbarian Europe north of the Alps by the 6th c. B.C., and the imports of Greek painted pottery and metalwork naturally enough stimulated the native craftsmen to embark on new styles, again antecedent to those of the Celtic art traditions.

**BARBERINI.** Tuscan family who came to prominence with the election of Maffeo as Pope Urban VIII in 1623 and became the chief patrons of BAROQUE art in 17th-c. Rome. The Palazzo Barberini was redesigned and enlarged by MADERNO from a palace at Quattro Fontane bought by Cardinal Francesco Barberini from Alessandro Sforza Santafiora in 1625. Maderno died in 1629 and was succeeded by BERNINI, who was assisted by BORROMINI and completed the palace in 1633. The Barberini also employed Pietro da CORTONA, ROMANELLI, Andrea SACCHI, and others in the decoration of the palace and of St. Peter's.

**BARBERINI FAUN.** An original marble statue of a satyr, sprawled in drunken sleep (Glyptothek, Munich). The style, of a curious grandeur, is HELLENISTIC.

**BARBIERI,** G.-F. See GUERCINO.

**BARBIZON SCHOOL.** Group of French landscape painters who took their name from a small village on the outskirts of the Forest of Fontainebleau where its leader, Théodore ROUSSEAU, and several of his followers settled in the latter half of the 1840s. The principal members of the group were Charles-François DAUBIGNY, Narcisse-Virgile DIAZ, Jules Dupré (1811–89), Charles-Emile Jacque (1813–94), and Constant TROYON. They were all primarily landscape painters. Each of them had a personal style and a preference for a particular type of landscape (Diaz, for example, liked to paint stormy scenes with vigorous brushwork; Troyon more placid landscapes usually containing cows; and Daubigny often chose views which included ponds or rivers). But they were united in their attitude of opposition to classical conventions and by their interest in landscape painting for its own sake, a fairly new development in FRENCH ART. The inspiration came partly from England (particularly CONSTABLE and BONINGTON), where landscape painting had developed earlier, and partly from the 17th-c. Dutch painters on whom the English tradition was founded. Instead of making the traditional journey to Italy they

worked mostly in the Forest of Fontainebleau, though Daubigny visited the forest only occasionally, preferring to paint from a boat on the Seine and Oise. They were advocates of painting direct from nature. Unlike the IMPRESSIONISTS, however, they painted only studies in the open air; their finished pictures were done in the studio. Their feeling for nature, amounting almost to a cult, may be regarded as a form of ROMANTIC revolt from the drabness of urban life and coincided with a longing among the urban population in expanding cities to renew the contact with nature.

COROT is often associated with the group but his work has a poetic and literary quality which sets him somewhat apart. MILLET is with less justification regarded as a member of this School. He settled in Barbizon in 1849 and during his last period he painted pure landscape. But his idealization of peasant life is rather in line with the sentimental humanitarianism of the middle 19th c. than the love of landscape for its own sake which unites the Barbizon School proper.

2640.

**BARENDSZ**, DIRK (1534–92). Amsterdam painter, chiefly of portraits. He worked in TITIAN's studio at Venice c. 1560, and his pictures show an interesting blend of Netherlandish realism and Venetian technique (e.g. the TRIPTYCH *The Adoration of the Shepherds* in Gouda Mus.).

**BARGELLO**. The Palazzo del Podestà, Florence, begun in 1255 as the residence of the chief magistrate of the city. In 1574 it was converted into a prison and assigned to the head of the Police, the 'Bargello'. In 1857–65 it was restored and fitted up as a museum of arts and crafts, now the National Museum. The collection contains some of the most important sculptures of the RENAISSANCE, early works by MICHELANGELO including the unfinished *David*, works by DONATELLO including his *David*, the *David* of VERROCCHIO, bronzes by CELLINI and POLLAIUOLO, GIOTTO's portrait of *Dante*, terracottas by Della ROBBIA. There is a valuable assortment of ivories, enamels, medals, seals, tapestries, majolicas, etc., and it embraces perhaps the best collection of the practical arts in Italy (Carraud Bequest, 1888).

**BARKER**, THOMAS (1769–1847). English landscape and genre painter. He was born near Pontypool of humble parents and showed some talent in copying Dutch pictures when early in his life the family moved to Bath. He was entirely self-taught. A local patron sent him to Rome for three years (1790–3), but the rest of his life was spent at Bath. He was clearly influenced by the landscapes and FANCY PICTURES of GAINSBOROUGH, and made his name as a painter of rustic scenes, some of which were copied on Worcester china plates. He made money and

built a large house on Sion Hill, Bath, where he painted a fresco *Massacre of Scio*, 12 ft. × 30 ft., which excited B. R. HAYDON.

**BARLACH**, ERNST (1870–1938). German EXPRESSIONIST sculptor. His early work, ceramic figures of 1903–4 and bronzes of 1906–7, had a distinct flavour of ART NOUVEAU. In his later work he preferred wood-carving to modelling and developed the expressive aspect of late German GOTHIC. His work had great tragic power. It was condemned, and much was destroyed, during the Nazi regime. There is a small museum of surviving work near Lüneburg.

160, 161, 162, 163, 164, 489, 855, 2845.

**BARMA** (16th c.). Russian architect, of whom no biographical details are known. Under Ivan the Terrible he built, together with POSNIK, the cathedral of the Blessed Basil at Moscow (1554–60), regarded as one of the outstanding achievements of Russian architecture.

**BARNA**. Sienese painter of the second half of the 14th c. Nothing is known of his life and the only picture which can be attributed to him with any certainty is a *Crucifixion* in the Episcopal Palace at Arezzo (1369). But Ghiberti's *Commentari* (1447) associated him with frescoes in the Collegiata at S. Gimignano, and it is usually thought that he painted New Testament frescoes there c. 1350–5. The beautiful *Madonna* in Asciano (S. Francesco Mus.) is considered an earlier work. As with Simone MARTINI and Lippo MEMMI, drawing plays a predominant part in his work; where their line is a graceful arabesque, Barna's is direct and thrusting. Many of the compositions in S. Gimignano are influenced by DUCCIO's iconography and some are reminiscent of Simone Martini, but his figures have a more dramatic vigour than any previous Sienese painting.

The painter of the S. Gimignano frescoes has sometimes been identified with an earlier Sienese, Barna Bertini, active c. 1340.

**BARNARD**, GEORGE GREY (1863–1938). American sculptor. He studied at the Art Institute, Chicago, and later at the École des Beaux-Arts, Paris (1884–7). His best known work, *The Nature of Man*, was begun in Paris when he was 25. It was inspired by Victor Hugo's line 'Je sens deux hommes en moi', was first exhibited in the Paris Salon of 1894, and brought him a fame which he enjoyed for the rest of his life.

His numerous works include *The God Pan* (Central Park, New York) and *Two Natures* (Met. Mus., New York). While in France he made a collection of medieval carvings which became the nucleus of the collection at the Cloisters, an adjunct of the Metropolitan Museum of Art, New York.

**BAROCCI**, FEDERICO (1526–1612). Italian painter, trained in Urbino. In 1550 he went to Rome, where he decorated a ceiling for the Casino

of Pius IV in the Vatican Gardens (1561-2). He returned to Urbino and thenceforth painted mainly religious works which combine the influence of CORREGGIO and RAPHAEL in a highly individual and sensitive manner. His paintings of the 1570s and 1580s are either crowded MANNERIST conceptions with sweeping diagonal compositions, or more intimate Madonna groups (*Madonna del Gratto*, N.G., London), softly blurred and playfully pretty. In the *Madonna del Rosario* (Senigallia, 1588-91) and the ecstatic late *Assunta* (Dresden) Barocci is boldly experimental in the direction of the BAROQUE, while simultaneously in the *Nativity* (Prado) he experiments with lighting with the directness and simplicity of CARAVAGGIO. Barocci also produced many sensitive drawings, and he was one of the first artists to make extensive use of pastel chalks.

1970.

**BAROQUE.** A term, both adjective and substantive, which in the literature of the arts is current with both historical and critical meanings. Its origin is obscure, but there is a likelihood that it derived from mnemonic hexameters put together in the 13th c. by William of Shyreswood. In writers such as Vives, Erasmus, Montaigne, Saint-Simon the word was used to stigmatize the pedantry of late medieval logic-chopping. Until the 19th c. it remained a synonym of 'absurd' or 'grotesque'. The meaning 'irregular' is attributed on the assumption, dubiously supported, that the word derives from the Portuguese *barroco*, an irregular pearl. The word was rehabilitated and elevated to a technical term in the language of art history and criticism by Burckhardt (1855) and Wölfflin. Wölfflin first applied the concept to literature in his *Renaissance und Barock* (1888). In English the word is current in three principal meanings:

1. In art history a period of style between roughly the later 16th c. and the early 18th c., between MANNERISM and ROCOCO. In literary criticism it is applied similarly to designate a style which prevailed in European literature during roughly the century 1580-1680, between the decline of the RENAISSANCE and the rise of the Enlightenment. In music also, although the word is often loosely used, it has come to designate a roughly corresponding stylistic period. In the abstract scheme of cyclic historical evolution of styles popularized by 19th-c. German historians, Baroque, corresponding to 'decreptitude', is regarded as the culminating phase of the cycle Early Renaissance ('youth')–High Renaissance ('maturity'). The distinguishing qualities of Baroque style have not been completely defined with general agreement among historians and critics.

2. A period of time, usually the 17th c., given character by a particular ideal of style—hence the phrase 'the age of the Baroque'—or even of life. Hence such phrases as 'Baroque politics', 'Baroque science', and so on.

3. 'Baroque' (often written without the capital) is still used both in the literature of art and generally with a non-technical meaning 'capricious', 'overwrought', 'florid', though the older pejorative implications are now rarely associated with it.

CHARACTERISTICS. The following characteristics of the Baroque are derived chiefly from the fully developed style of mid 17th-c. Italy, and modifications become necessary when they are applied to other parts of Europe or points in time, and as they amalgamate with other styles and aspirations.

Despite a frequent lack of reticence, and partly through its origins, the Baroque is a style which expresses a concern for balance and above all wholeness. BELLORI wrote of the fresco by LANFRANCO in the Roman church of S. Andrea della Valle: '. . . this painting has been rightly likened to a full choir, when all the voices together make up the harmony; for then no particular voice is distinguished, but what is pleasing is the blending, and the overall measure and substance of the singing.' The passage nicely underlines the quality of large Baroque design in whatever form. The emphasis is on balance, through the harmony of parts in subordination to the whole. In this the style differs from the High Renaissance ideal of a balance of parts each of separate perfection, but has more in common with it (and with 17th-c. CLASSICISM) than with either the often wilfully unblended style of Mannerism or the nervous fragmentariness of the Rococo (into which the Baroque evolves). This ambition towards a grand unity (which does not, however, preclude a climax within the work) has as an effect the levelling of painting and sculpture to the needs of the architectural unity they serve. The separate properties conventionally supposed to be inherent in each of the three media may be deliberately run together to the end of more perfect harmony. Even in a single medium it is not unusual that architecture, for example, should be robbed of its expected inertia and made to take on the suppleness and plasticity of sculpture, or that both should exploit the expressiveness of CHIAROSCURO in a way more immediately proper to painting. Yet harmony, once more, precludes that the consistently high technical virtuosity of the Baroque artist, never concealed, should lapse into display for its own sake.

The unity of the Baroque is more than a formal and self-sufficient one; like a play (and the style had close connections with spectacle) it is incomplete without its audience. It is a mark of a Baroque work that by various means it engineers the bodily, and hence the emotional, participation of the beholder. For painting and sculpture to succeed in doing this at all they must first be persuasive in creating the illusion of the actuality and truth of their subject. The Baroque representation is, then, concerned with the reality of appearances, or at least with verisimilitude. It insists upon the substance, colours, and texture of things; it creates a space in which the subject

and the spectator may be joined in a specific and sometimes dramatic moment of time. The physical urgency of the Baroque is achieved most particularly by the calculation of light against dark, mass against void, the use of strong diagonals or curves, breaking down the expected and separating plane. The expression of substance by the use of colour and contrast of light ('painterliness') distinguishes the style from the linear preoccupations of Mannerism and Rococo: its confidence in the force of its assertions further distinguishes it from the insinuating decorativeness of the latter.

HISTORY. The Baroque was not wholly of Italian invention, even less was it Roman. None the less is it proper for a brief history of the style to be focused upon Rome. It is there, at least, that the formation of the style can be observed most clearly. More importantly, the Roman Baroque, because of its acknowledged pre-eminence and influence in the 17th c., must still be the starting-point of any wider consideration of the subject.

By the 1580s the prevailing 16th-c. style, Mannerism, had—saving an honourable exception or two—become so listless as to provoke fresh endeavour. (In northern Europe the links between Mannerism and the Baroque—both importations—would seem to have been to a greater degree continuous.) In these last decades of the century two fresh impulses in the representational arts not only heralded two separate trends of 17th-c. art—the naturalistic and the classicizing—but were both of them amalgamated into the essentially composite nature of the Baroque.

(a) The first, focused on the revitalizing figure of CARAVAGGIO (at Rome c. 1591/2), stressed observed nature rather than idealities as the proper source of art. (Caravaggio's importance is in this, and in his emotional coherence, rather than in his dramatics or his use of chiaroscuro.) Secondly, there was a turning back to the Classicism of the High Renaissance—to RAPHAEL and MICHELANGELO—and to Roman Antiquity itself. Specifically in relation to the Baroque this classicizing trend is associated with Annibale CARRACCI (at Rome 1595) and his severer pupil, DOMENICHINO (at Rome 1602). A third essential element, and the most enduring, was the scarcely broken tradition of Venice—of TITIAN in particular. From Venice, and the art of CORREGGIO at Parma, derive the colour, the light, and the opulence of the Italian Baroque. From such ingredients the style was created, first, and exceptionally, by RUBENS (returned to Antwerp from Rome 1608), and by Italian painters at Rome in the 1620s.

For convenience the Italian Baroque is usually divided into three periods: Early (c. 1585–c. 1625), High (c. 1625–c. 1675), and Late (c. 1675–c. 1715). The first is a period of transition, of beginnings. The signposts are such works as in painting: the *Conversion of St. Paul* by Lodovico Carracci (Bologna, 1589), the decorations in the Palazzo FARNESE by Annibale Carracci (completed 1604), Rubens's *SS. Gregory and Domitilla* (for the Chiesa Nuova, Rome, now Grenoble, 1607/8), and Domenichino's *Last Communion of St. Jerome* (Vatican, 1614); in sculpture: the *St. Cecilia* of Stefano MADERNA (St. Cecilia, Rome, 1600), and the *Annunciation* by Francesco Mochi (Orvieto, 1603–8); in architecture: the façade of Sta Susanna by Carlo MADERNA (1597–1603) and the Pauline Chapel in Sta Maria Maggiore with its decorations (1605–16).

The true or High Baroque style first emerges at Rome in such decorations as the ceiling with *Aurora* by GUERCINO in the Casino Ludovisi (1621–3), and the Correggiesque painting by Lanfranco in the cupola of S. Andrea della Valle (1625–7). But for almost half a century from c. 1625, Roman Baroque—and thence to some degree that of the rest of Italy and Europe—was dominated by BERNINI, Pietro da CORTONA, and BORROMINI. The first two were not primarily architects, yet to each, and to Carlo RAINALDI, are due the extraordinary buildings of the mid 17th c. Bernini's unequalled dramatic intelligence is exemplified in his Piazza before St. Peter's (begun 1656) and, within the Vatican, the Scala Regia (1663–6); Cortona's occasional architecture, more pliant in its containment of space, is shown at SS. Martina e Luca (1635–50). Borromini, an architect simply, was the most startling to his contemporaries. He remains so for the audacity of his plastic inventiveness at the expense of Renaissance conventions, manifest in the churches of S. Carlo alle 4 Fontane (1639–41), S. Ivo (1642–50), and Sta Agnese—despite the hand of Rainaldi (1653–7). Of architects outside Rome mention should be made of Baldassare LONGHENA at Venice (Sta Maria della Salute, 1631–87) and the late virtuoso of structural mathematics, Guarino GUARINI (S. Lorenzo, Turin, 1668–87).

The sculptural work of Bernini—the genius and very type of the High Baroque—overshadows almost all else in that medium. Forceful and distinct in its psychological content, intricate and technically perfected in its parts, it arrests, then implicates, the spectator in a moment in the dynamics of its transitory action. The method and the originality of his sculpture lies in his incorporation into it of what had traditionally been resources special to the architect—the interpenetration of space—and to the painter—colour and chiaroscuro—joined to lifelike NATURALISM. His range is illustrated in St. Peter's by such works as the TOMBS of Urban VIII (1628–47) and Alexander VII (1671–8), and the Baldacchino (1624–33) and the Cathedra Petri (1657–66). The Cornaro Chapel in Sta Maria della Vittoria (1645–52), containing the celebrated marble group of the *Ecstasy of St. Teresa*, was the first masterpiece to emerge from the fusion of the three material elements. Bernini's art stands in contrast to the intentions of 17th-c. classical sculpture (with moments of compromise in the case of ALGARDI), and through

such disciples as Antonio Raggi (1624–86) and the short-lived Maltese sculptor Melchiorre Caffà (1635–67/8) (who made the altar in Sta Rosa of Lima) commanded the more decorative manner of the Late Baroque and its transition into the Rococo—and that not in Italy alone.

The dominant figure of High Baroque painting in Rome was Cortona. A relatively early work, *The Rape of the Sabines* (Capitoline Mus., c. 1629), reveals a conflict between the contained energy of Roman Classicism and the rich, more immediately pleasurable manner of Venice. His great illusionist ceiling in the Palazzo BARBERINI (1633–9), perhaps the most triumphant of all of its kind, is freely Venetian; yet like his more extensive work in the Palazzo PITTI at Florence (1637–47), it maintains an exact poise between effusion and control. The ceiling in the Palazzo Pamphili at Rome (1651–4) shows him at his most suave and supple. In spirit it was ahead of its time, but its implications were not immediately remarked. In general the secondary painters at Rome were more closely aligned with Cortona's classicizing rival, Andrea SACCHI. Cortona's successors in this supreme form of Baroque painting, ceiling decoration, belong to the Late Baroque: BACICCIA's ceiling in the Gesù (1674–9) stretches the lesson of Bernini's Cornaro Chapel to its limits, and the wonder of Andrea POZZO's ceiling in S. Ignazio (1691–4) lies precisely in the precariousness of its unity. From this late style to the Rococo in Italy, and in Austria and Germany, is a short step.

Outside Rome, with the exception of Naples, Baroque painting was on the whole less full-blooded and more sporadic. Genoa produced two fine painters, Bernardo STROZZI (from Mannerist beginnings) and G. B. CASTIGLIONE. In Venice the most interesting figure was the German, Johann LISS—a forerunner of PIAZZETTA in the 18th c. Bologna, otherwise classicizing, can add Guercino in his early phase and late in the century G. M. CRESPI. Neapolitan High Baroque, flavoured in its earlier stages by the legacy of Caravaggio, is represented by the strong designs of Mattia PRETI, and the post-Roman activity of Lanfranco. The late style is exhibited in the multiplex rapidities of Luca GIORDANO, of which the most elegant and Cortonesque is the allegorical ceiling in the Palazzo Medici-Riccardi at Florence (1682–3) and one of the bravest the frescoed wall in S. Filippo Neri, Naples, of the *Expulsion from the Temple* (1684). Beyond Italy, with an exception in Flanders, and not infrequent instances in Germany and Austria especially of direct patronage of Italian artists, the Baroque style was in some manner a compromise, and in no belittling sense provincial. It existed only in terms relative to local circumstances and history. Thus, to take the example of architecture, it is common to find Baroque elements applied with a greater or lesser degree of amalgamation to buildings conceived in the GOTHIC-Mannerist, Renaissance-PALLADIAN, or such-like traditions. Architecture or other works

of art devised as an organically Baroque statement—however regional in idiom—are comparatively rare. But it is with these that the following notes are by and large concerned.

(*b*) *Belgium.* Rubens has already been mentioned under the Early Baroque in Rome. Returning to Flanders, he became the only proponent of an unequivocal High Baroque out of Italy. The bold yet still disharmonious manner of the *Raising of the Cross* (Antwerp Cathedral, 1609/10) finds coherence in the marble altar for St. Charles Borromeo, Antwerp, with its painting of *The Miracle of St. Ignatius* (now Vienna, by 1620). The great decorative commissions follow—for Marie de Médicis at Paris (1622–5), for Philip IV at Madrid (1628, etc.), and for Charles I at London (by 1634). Rubens's influence in France and Spain belongs late in the century, but at home it was more immediate, and even after his death it overshadows almost all. Two independent personalities stand out, Anthony van DYCK and Jacob JORDAENS (see FLEMISH ART). A Flemish Baroque sculpture, partly a projection of Rubens, emerges towards mid century with Artus I and II QUELLIN (1609–68 and 1625–1700) and Lucas Faydherbe (1617–97).

(*c*) *Holland.* If not exactly for the pious reasons so frequently advanced, Holland was little touched by the Baroque. For large-scale decorations Flemings were generally summoned. The great exception (perhaps because the only painter of enough grasp) was REMBRANDT in the 10 years or so ending in *The Night Watch* (Amsterdam, 1642). It is possible to speak of an affinity to the Baroque in some of the minor categories of painting within the limits open to them (e.g. certain landscapes by Jacob RUISDAEL).

(*d*) *France.* The fundamentally classicizing temper of 17th-c. France was such that works by Rubens and Guarini in Paris, and a visit by Bernini himself, produced, if anything, reaction rather than response. The affinity of taste was to Roman Classicism, the milieu of POUSSIN, rather than to Roman Baroque. Simon VOUET initiated a Grand Manner, or false Baroque (e.g. *The Presentation*, Louvre, 1641). Charles LEBRUN's borrowings from the decorative style of Cortona were contradicted by academic restraints. In the 1680s, however, Rubens stood vindicated, and there followed a late Baroque flowering with Charles de la FOSSE (the cupola of S. Louis-des-Invalides, Paris, 1692–1705) and, closer to the Rococo, Antoine COYPEL (the ceiling of the Chapel at VERSAILLES, 1708). To the same period belongs the grandiloquent, van Dyckian court portraiture of RIGAUD and the brilliant portrait busts of COYSEVOX. Significantly, France's only consistently Baroque sculptor, Pierre PUGET, was not active at Paris. In architecture Classicism and the Baroque synthesized in an original and peculiarly French style, which, through Versailles in particular, was very influential. Again in the last decades of the century Baroque hankerings (e.g. the present Institut de France, Paris, by LE VAU, begun

1662) found some gratification (e.g. S. Louis-des-Invalides by J. H.-MANSART, 1680–91).

(*e*) *Spain and Portugal*. The Spanish 17th c. betrays a fundamental austerity and in the figurative arts a preoccupation with realism, early nourished by the Carravagesque. A restrained Baroque may be discerned in the 1630s in Francisco HERRERA the Elder and RIBERA (at Naples). It is more freely, but not persistently, expressed in VELAZQUEZ in the 1630s (*The Surrender of Breda*, Prado, 1634) and in the 1650s (*Maids of Honour*, Prado, 1656). With some impetus through Rubens an unreserved Late Baroque appeared in the 1660s with MURILLO and Juan Carreño (1614–85). A peculiarly Spanish development was religious sculpture in wood, notably at Granada and Seville. In this context J. M. MONTAÑÉS, Pedro de Mena (1628–88), and the painter Alonso CANO may be mentioned. From Seville in particular stylistic eccentricities often called Baroque passed to the Spanish dominions in Central and South America, as also from Lisbon to Brazil.

(*f*) *England*. Despite knighthoods bestowed upon Rubens and van Dyck, the Baroque flourished in England little and late. There are shy hints of it in some portraits by William DOBSON. A ceiling of interest only for what it attempts is that by Robert STREETER in the Sheldonian Theatre at Oxford (1668–9); but—Italian and French importations apart—ceiling painting took on an earnest character only in the work of Sir James THORNHILL (the Painted Hall at Greenwich, 1708–27). The sculpture of John BUSHNELL was a not entirely negligible reflection of Bernini. Most of his contemporaries, however, including Grinling GIBBONS, were Baroque only in a sense modified by general derivation from the Low Countries. A particular, eclectic English Baroque architecture runs in date from WREN's still hesitant St. Paul's Cathedral (1675–1708) to the broad gesture of VANBRUGH's Blenheim Palace (1705–24).

(*g*) *Germany and Austria*. The art of these countries was notably, and not surprisingly, discontinuous in the 17th c. In painting Adam ELSHEIMER is a small yet important figure in the early story of the Baroque; Johann Liss has already been mentioned working in Venice. Late Baroque sculpture—nothing important precedes it—may be exemplified in Balthazar PERMOSER who was trained in Italy and soon after developed an early Rococo style. Architecture followed a similar pattern, with the French style of Versailles as an alternative source. J. B. FISCHER VON ERLACH, in some ways conservative, was the giant among some beguiling secondary talent, and his Karlskirche at Vienna (begun 1716) is one of the few great Baroque achievements north of the Alps.

57, 188, 201, 202, 273, 370, 398, 400, 401, 634, 936, 962, 1083, 1246, 1265, 1268, 1286, 1472, 1476, 1614, 1615, 1655, 1717, 1887, 2005, 2042, 2072, 2089, 2090, 2142, 2623, 2650, 2776, 2798, 2830, 2831, 2832, 2833, 2923.

**BARRAUD,** CHARLES DECIMUS (1822–97). Painter, born in Surrey and educated at Camberwell. A chemist and druggist by occupation, he emigrated in 1849 to Wellington, New Zealand, where he became the leading figure in the nascent city's artistic life. He was a founder and president of the New Zealand Academy of Fine Arts and painted numerous small watercolour landscapes (National Art Gal., Wellington), which are at their best distinguished by the delicacy of their colouring and a vein of genuine poetic feeling.

**BARRET,** GEORGE (1732?–84). Irish landscape painter who came to London on the advice of Edmund BURKE in 1762 and quickly made a reputation as a painter of views and PANORAMAS and was a foundation member of the ROYAL ACADEMY. Though he sometimes imitated the classical manner of Richard WILSON, his natural gift was for the TOPOGRAPHICAL landscape. He painted some large mural decorations of this kind; the panorama of the Lake District in the Circular Room at Norbury Park, Surrey, was celebrated.

**BARRY,** SIR CHARLES (1795–1860). English architect, a master of the Roman and Florentine RENAISSANCE styles, which he was largely responsible for reviving in his Royal Institution (now Art Gallery), Manchester (1824), and his designs for the Travellers' Club in Pall Mall (1830) and the Reform Club (1837) alongside it. He also designed the Houses of Parliament, where A. W. PUGIN was responsible for the GOTHIC detail and furnishings, the Treasury Buildings in Whitehall (1846), Bridgewater House, St. James's (1849), Cliveden House (1851), and the romantically silhouetted Halifax Town Hall (1862), which was completed by his son, EDWARD MIDDLETON BARRY, himself a notable Victorian architect. Two other sons were CHARLES BARRY, architect of the rebuilt Burlington House, and SIR JOHN WOLFE BARRY, engineer of the Tower Bridge.

177.

**BARRY,** JAMES (1741–1806). Irish history painter. Edmund BURKE brought him to London in 1764 and provided money for him to travel to Italy (1761–71). He was elected A.R.A. in 1772 and R.A. in 1773. Barry was the only British painter who adhered consistently to REYNOLDS's precepts for history painting in the GRAND MANNER, and his large decorations, *The Progress of Human Culture* (1777–83), for the Great Room of the Society of Arts are the finest achievement of this kind by the British School. He was elected Professor of Painting at the ROYAL ACADEMY in 1783, but after a series of quarrels was expelled in 1799.

**BARTOLI,** PIETRO SANTE (*c.* 1635–1700). Italian engraver and antiquarian. He started as

a pupil of POUSSIN but became a merchant of antiques and an engraver. His books illustrating Roman antiques in the vicinity of Rome, ancient TOMBS, etc., anticipated PIRANESI. Some of the texts were written by BELLORI.

His son, FRANCESCO BARTOLI (c. 1675–c. 1730), was also an engraver and antiquarian. His water-colour copies of Roman mural paintings (see ROMAN ART) are among the earliest surviving evidence for reconstructing the appearance of these.

**BARTOLO,** SEBASTIANO DI. See MAINARDI.

**BARTOLO DI FREDI** (active 1353–1410). Minor painter of the SIENESE SCHOOL, who continued the narrative style of the LORENZETTI but gave it a flatter, more decorative character typical of Sienese art at the end of the century. He was also influenced by Lippo MEMMI and in his Old Testament fresco cycle in the Collegiata, S. Gimignano (1367), by BARNA, who had painted there before him. There are works at Siena, Montalcino, and Pienza.

**BARTOLOMMEO,** FRA BACCIO DELLA PORTA (1472 or 1475–1517). Italian painter of the FLORENTINE SCHOOL, who belonged to the period of transition from the Early to the High RENAISSANCE. Trained as an artist in the studio of Cosimo ROSSELLI, he was deeply influenced by Savonarola and entered the Dominican Order in 1499. This affected both the iconography and the spirit of his subsequent work. From 1504 to 1508 he developed parallel with RAPHAEL—though Raphael's was the more imaginative genius—each contributing something to the new High Renaissance type of Madonna with Saints, in which the figure of the Madonna acts not merely as a centre but as a pivot about which the whole composition turns. The two artists also evolved a new treatment, first adumbrated by LEONARDO, of the theme of the *Madonna and Child with the Infant S. John in a Landscape.* There is an example by Fra Bartolommeo in the National Gallery, London.

Fra Bartolommeo's large-scale public works are restrained and austere, and his figures have a solemn monumentality which is sometimes at variance with his CHIAROSCURO. Notable are the *Vision of St. Bernard* (Accademia, Florence, 1504–7), *The Eternal Father with Mary Magdalene and St. Catherine of Siena* (Pinacoteca, Luca), the *Marriage of St. Catherine* (versions in the Louvre and the Uffizi), the *Pietà* and the *Salvator Mundi* (Pitti, Florence). He is particularly distinguished as a draughtsman and the mystical element in his nature found clearer expression in his drawings, which escape the tendency to empty rhetoric occasionally reflected in his later paintings.

955.

**BARTOLOMMEO VENETO** (active 150*-46). Minor Italian painter who worked at Ferrara (1506–8) and in 1520 moved to Milan, where he came under the influence of LEONARDO's followers and the work of DÜRER. Some of his portraits, although mannered in setting, show an acute eye for characterization (*Portrait of a Courtesan,* Frankfurt; *St. Catherine,* Glasgow; *Madonna and Child,* Ambrosiana, Milan). His *Circumcision* (Louvre, 1506) has affinities with the art of Giovanni BELLINI.

**BARTOLOZZI,** FRANCESCO (1727–1815). A Florentine, celebrated for engravings after the Old Masters. He was invited to England to engrave from the GUERCINO drawings at Windsor Castle, and in 1764 was appointed Engraver to George III. He was a foundation member of the ROYAL ACADEMY and remained in England until 1802, when he settled in Lisbon as Director of the National Academy of Portugal.

Bartolozzi popularized the stipple process of colour engraving known as the 'dotted' manner, which by the absence of firm contours and modelling achieved an easy effect of elegance and sweetness (see STIPPLE ENGRAVING). He reproduced many works by Angelica KAUFFMANN, CIPRIANI, and WHEATLEY by this method. He made a small number of prints from history

**33.** Detail from *Death of Chatham.* Stipple engraving by Bartolozzi after oil painting by J. S. Copley

paintings, of which the most important was a large plate of COPLEY's *Death of Chatham*.

2692.

**BARYE,** ANTOINE LOUIS (1796–1875). French animal sculptor. He received his early training from the sculptor F. J. Bosio (1768–1845) and laid the basis of his extensive knowledge of animal forms while employed by a goldsmith making models of animals in the Jardin des Plantes, Paris (1823–31). His work was in the spirit of the ROMANTIC movement, particularly his preference for rendering violent movement and tense posture. There are many of his animal sculptures in the Louvre. He also did the pediment *Napoleon dominating History and the Arts* on the Pavillon de l'Horloge of the LOUVRE and an EQUESTRIAN STATUE of Napoleon at Ajaccio.

2399, 2963.

**BASALT.** A hard and tough igneous stone, which is very durable and takes a fine polish. It is widely distributed and has many varieties differing in consistency and ranging in colour from black, brown or dark green to pale blue. It is almost as difficult to work as GRANITE. Black basalt was much used by the ancient Egyptians for portrait sculpture (e.g. male figure from Pre-dynastic period, Ashmolean Mus., Oxford; statuette of Nesptah, 26th Dynasty, Cairo Mus.; male portrait statue from Canopis, Ptolemaic period, Egyptian Mus., Cairo). Other interesting Egyptian examples are the *Head of a Queen* from the 26th Dynasty (Mus. of Fine Arts, Boston), the *Horus Falcon with King Nectanebo I* from the 30th Dynasty (Metropolitan Mus., New York), the British Museum *Falcon* from the 30th Dynasty and the Louvre *Dog* from the Ptolemaic period. It was also used in the Middle East, e.g. the *Stele of Tarhunpijas*, 8th c. B.C., Louvre; the statue of Atarlukas of Carchemish, *c.* 900 B.C., a fragment from which (a lion's head) is in the British Museum.

In the context of the NEO-CLASSICAL revival the potter Josiah Wedgwood experimented with pottery materials simulating the stones favoured for sculpture in antiquity. Basalt-ware, a hard black stoneware, was the first of these materials to be successfully produced, in 1766.

**BASCHENIS,** EVARISTO (1617–77). Italian painter, the most prominent of a family of artists recorded from 1400. He was ordained *c.* 1647. His fame rests chiefly on restrained and carefully composed STILL LIFES in which he made effective use of the rounded forms of musical instruments and he may have been associated with the Amati lute-makers of Cremona. The best collection of his works is at the Accademia Carrara in Bergamo, his native town.

**BASEVI,** GEORGE (1795–1845). Leading REGENCY architect, a cousin of Disraeli and favourite pupil of Sir John SOANE. He designed Belgrave Square, London (1825), and Pelham Crescent (1820–30). His most ambitious single building was the Fitzwilliam Museum, Cambridge—Greco-Roman with Corinthian colonnade and portico—where on his death in 1845 he was succeeded by Sir Charles Robert COCKERELL.

**BASILICA.** Architectural term applied in Roman Republican times to halls of justice and commercial exchanges. The word was also used of a colonnaded hall in a Roman house. It is of Greek origin (an adjectival formation meaning 'royal' or 'pertaining to a king') but no instance of its use as an architectural term has been found in the classical Greek period and the type of building to which it was then applied (if any) is not known. According to a commonly held theory the usual basilican plan was a Roman development from a Greek temple. An original meaning of 'king's house' or 'royal hall' (suggested by late Latin writers) is plausible but not proved. It may be no more than coincidence that the typical throne-room of the early Egyptian palaces consists of a long hall with an entrance on one of the short sides, two parallel colonnades, and clerestory lighting, i.e. the type of building to which architectural historians usually give the name 'basilica'. The earliest known basilicas, built at Rome in the early 2nd c. B.C., were certainly not of this type: they were 'covered markets' adjacent to the FORUM, from which they were entered by an open colonnade. They were presumably wooden-roofed; their interior disposition is not known, but all the early Italian forum basilicas so far excavated have a continuous colonnade forming an ambulatory round a larger central area. At Pompeii (*c.* 100 B.C.), as well as in other cities of the central Mediterranean outside Italy, the entrance was on one of the short sides, which perhaps reflects the influence of non-Italian buildings of the type of the previously mentioned throne-rooms. The normal basilica of Republican Italy was entered from the 'long' side, by a door more often than by a colonnade. As the basilica came increasingly to serve a judicial rather than a commercial purpose, provision was made for the magistrate, usually by the addition of a rectangular or apsidal projection opposite the entrance. In this form it spread to new regions in the early Imperial period. Besides their often elaborate architectural decoration (carved capitals, ornamented ARCHITRAVE, etc.), the more important basilicas often had both free-standing and low-relief sculpture. Buildings not intended for a public judicial or cult purpose but architecturally similar—bad-weather army drill halls (mostly in Britain) for example—were also called *basilicae*. The same name was perhaps given to the long aisled and apsed 'assembly-rooms' found in Roman palaces from the late 1st c. A.D. It was certainly used simultaneously for public buildings of very different architectural types, including the plain rectangular hall. A description is

given by VITRUVIUS, thought to be taken from an architect's specification, of the basilica at Fano, a colony founded by Augustus *c.* 27 B.C. A smaller basilica of similar plan dating from the middle of the 2nd c. B.C. has been excavated at Cosa in southern Etruria. At the beginning of the 4th c. the great 'Basilica of Maxentius' (or 'of Constantine', who finished it), the last of its kind, consisted of a central nave, with concrete vaults supported by vast pillars and two apses, one on the long, the other on the short, axis: it employed, that is, a style and technique which had made its first appearance in Rome over two centuries previously and had subsequently been used and developed in palaces, baths, and other buildings in many parts of the central and eastern Mediterranean.

In A.D. 312 when the emperor Constantine recognized Christianity as an official religion of the Empire, it became possible for the first time to celebrate the Christian liturgy in large public buildings. Probably under direct Imperial influence churches were built in the next 20 years in Rome, Jerusalem, and Bethlehem (see EARLY CHRISTIAN ART), which revived the already old-fashioned type of long wooden-roofed hall with parallel colonnades (in these examples, four), clerestory lighting, and apse and entrance on opposite short sides. In 4th-c. sources these Constantinian church-buildings are referred to as *basilicae*, but so are others of a very different plan and design: this usage seems to refer to the purpose of the building rather than to a specific architectural type. The use of the term '(Early Christian) basilica', particularly for later and surviving churches closely related to the Constantinian type—such as the late 4th-c. S. Paolo fuori le Mura (five-aisled) or the earlier 5th-c. Sta Maria Maggiore at Rome—but also for the many variants of this design found in churches of the 5th and 6th centuries, is entirely modern. But it is too convenient and too general to be abandoned.

1744

**BASSA,** FERRER (*c.* 1285/90–1348). Spanish painter and miniaturist who worked for the Aragon court. The first notice of him is in 1324 and from then until 1348 there are records of his employment both on murals and on ALTARPIECES. The only certain surviving work by his hand is a series of frescoes in the chapel of S. Miguel at the convent of Pedralbes near Barcelona, executed in 1345–6. Bassa's importance derives from his being in effect the founder of the Catalan school.

**BASSANO.** The name adopted by the DA PONTE, a family of Italian painters, from the small town of northern Italy which was the main centre of their activity.

JACOPO DA PONTE (*c.* 1517/8–92) was the most celebrated of the family. Son of a village painter of the same name, he always retained something of the peasant artist. He came to

Venice *c.* 1533, where he was a member of the prominent group of BONIFAZIO VERONESE, LORENZO LOTTO, and TITIAN. The then fashionable etchings of PARMIGIANINO and the trends towards MANNERISM made an impression on him (*Madonna between St. James and the Baptist,* Munich). He treats biblical themes in the manner of rustic GENRE scenes, as in the *Adoration of the Shepherds* (Hampton Court), *Good Samaritan* (N.G., London), and *Adoration of the Kings* (N.G. of Scotland), where the figures are genuine country types and the animals portrayed with a real interest. Towards 1560 his work began to acquire something of the elegance and iridescent colouring of TINTORETTO (*Beheading of the Baptist,* Copenhagen), while from *c.* 1560 his basically country scenes became vested with a more exaggerated search for novel effects of light against a dark and confused background (*Adoration of the Magi,* Vienna; *St. Jerome,* Accademia, Venice; *Susanna,* Nîmes). Both for his interest in pastoral genre and for his experimental innovations in composition through light Jacopo Bassano was a sign of the changing times in which he lived.

FRANCESCO (1549–92), eldest son of the foregoing, continued the Mannerist trend of his father in biblical and pastoral pictures between *c.* 1570 and 1580. In 1579 he settled in Venice and took up historical painting. He achieved a European popularity also for small canvases depicting country scenes in the style of Jacopo's *atelier.*

LEANDRO (1557–1662), the most prominent of Jacopo's sons, also specialized in country genre, although he also painted ALTARPIECES and made a name for himself by his portraits (*Man holding a Statuette,* Hampton Court).

The works of the Bassani have long been collected by those interested in pastoral genre, of which they were among the earliest popularizers. More recently their works have attracted interest for their anticipations of Mannerist characteristics seen in El GRECO and CARAVAGGIO.

**BASSEN,** BARTHOLOMEUS VAN (d. 1652). Dutch architectural painter and architect who worked at Delft and The Hague. He is best known as a painter of imaginative architectural fantasies (Glasgow) and church interiors (The Hague). The BAROQUE architecture of his buildings was in the same style that he liked to depict in his paintings, and formed a link between the earlier style of Hendrick de KEYSER and the CLASSICISM of van CAMPEN. None of his buildings has survived, but he is known to have worked on the palaces of Honselaardijk and Ter Nieuwberg for Prince Frederick Henry and he designed the Palace (1630–1) at Rhenen in Holland for Frederick V, the Winter King.

**BASTIEN-LEPAGE,** JULES (1848–84). French painter. He painted portraits (*Sarah Bernhardt,* Blumenthal Coll.) but is best known

for his scenes of peasants in the manner of
MILLET. He influenced Tom ROBERTS and
through him AUSTRALIAN ART; he had also some
followers in England.

2635.

**BATHS OF CARACALLA.** See THERMAE.

**BATH STONE.** A general name for several
limestones which occur in deposits extending
from the coast of Dorset through Somerset,
Gloucestershire, Oxfordshire, Northampton-
shire, to Yorkshire, particularly well developed
near Bath. In general they are more open in
texture, coarser and warmer in colour than
PORTLAND STONE, but there is considerable
variation both in texture and in colour. Although
somewhat porous, bath stones have been used
for building. Some modern sculptors have used
selected bath stone for exhibition sculpture,
taking advantage of the decorative effect of
colour variations. It has been so used by Eric
GILL, Frank DOBSON, Henry MOORE, etc.

**BATIK.** An art of textile designing practised
by the Toradja of central Celebes and in the
islands of Java and Madura. (See INDONESIAN
ART.) The design is produced by a negative
dyeing method, being marked out in wax before
the fabric is dipped so that the waxed portions
do not take the dye and stand out in the original
colour of the fabric. Originally the hot wax was
applied to the fabric by a shaped strip of bamboo.
The technique was improved by the invention in
the 17th c. of the *tjanting*, a copper crucible with
several spouts by which the wax could be applied
in continuous lines of varying thickness.

The earliest batik patterns were monochrome,
the design standing out against an indigo ground.
From the 18th c. onwards multicoloured fabrics
were produced by methods of dyeing introduced
through Indian Moslems and cloths of very great
beauty and rarity resulted. Many of the patterns
depend on ancient traditional designs with
symbolic meaning. In the so-called *Banji* pat-
tern the design is built up organically from this
basic motif. But the more usual form of design
is achieved by means of symmetrical interplay
of lines with design elements incorporated into
the pattern. Highly stylized intertwining flower
and leaf patterns are also used. The social posi-
tion of the owner was reflected by the beauty of
the batik designs in the ceremonial and festive
garments he wore and some of the ancient batiks
are among the most superb examples of orna-
mental textile design that are known.

**BATONI,** POMPEO GIROLAMO (1708-87).
Son of a goldsmith of Lucca and one of the most
ostentatiously wealthy and successful painters
of the 18th-c. ROMAN SCHOOL. He carried out
monumental church commissions and painted
religious and mythological canvases, many for
eminent foreign patrons. His style was a dry
and learned distillation from the ANTIQUE, the

works of RAPHAEL, academic French painting,
and the teaching of his master Sebastiano
CONCA. He won his greatest renown for smoothly
executed portraits of popes, monarchs, and
British gentry and nobility making the GRAND
TOUR. He was curator of the papal collections
and was knighted by the pope. His house was
a social, intellectual, and artistic centre, and
MENGS and WINCKELMANN were among his
friends. He was the last great Italian personality
in the history of painting at Rome and after
Mengs left for Madrid in 1761 his pre-eminence
was not challenged.

**BATTISTELLO.** See CARACCIOLO, G. B.

**BATTLE-PIECE.** In the art of ancient Egypt
and the Near East battle scenes occur as part of
the documentary function of art, but seem on the
whole to have been less common than some others
—for example the reception of hostages or
tribute, the parading of prisoners, or hunting
scenes. In Middle and Late ASSYRIAN ART, how-
ever, the recording of campaigns became one of
the predominant themes, first on panels built up
from polychrome glazed bricks and later in
carved relief on the stone slabs which covered
the lower parts of the walls in the rooms and
corridors of royal palaces. The Assyrians appear
to have invented the genre of continuous episodic
depiction in the manner of a strip cartoon. The
stone slabs were divided horizontally into two
bands and relief panels depicting scenes in
sequence constituted a true pictorial chronicle.
Examples from Nimrud illustrate the wars of
Ashurnasirpal II and from Kuyunijk come many
panels showing the campaigns of Sennacherib.
According to Henri Frankfort, this episodic
narrative style 'has no antecedents inside or out-
side the country.... One has to go to the columns
of Trajan and Marcus Aurelius in Rome to find
a parallel for the Assyrian reliefs.'

The Greeks established the heroic tradition of
the historical battle scene. In sculpture and in
vase painting mythological themes were pre-
ferred such as the sack of Troy, the battle of the
Centaurs and Lapiths, Hercules fighting the
Amazons, and so on. Contemporary incidents
were represented, if at all, symbolically in a
mythological dress—a fashion which culminated
in the vast Gigantomachy of the Great Altar to
Zeus at PERGAMUM. The only representation of
an actual battle that has survived is the famous
mosaic from the House of the Faun at POMPEII,
which is usually thought to be derived from a
Greek painting of Philoxenus, *c.* 330 B.C., depict-
ing the victory of Alexander over Darius III at
the battle of Issus.

The frieze put up at Delphi by L. Aemilius
Paullus to commemorate his victory over Per-
seus of Macedon at Pydna in 168 B.C. was in
the Greek heroic style, but the details of costume
and equipment were true to actuality. In
general the Romans preferred factual depiction of

**34.** *Struggle for the Standard* from Leonardo's *Battle of Anghiari*. Copy in grisaille attributed to Rubens. (Louvre)

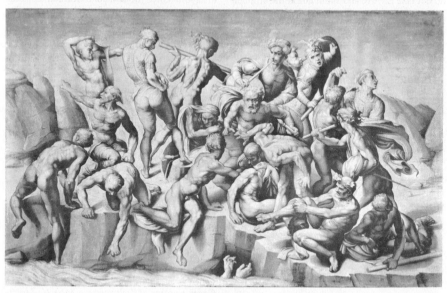

**35.** *Bathers.* Painting in grisaille (1542) after Michelangelo; attributed to Aristotile da Sangallo. (Earl of Leicester Coll., Holkham Hall)

contemporary events to mythological symbolization. PLINY traces the rise of painting in public esteem at Rome to the exhibition by Manius Valerius Messala of a picture of the battle in Sicily in which he defeated the Carthaginians and Hiero. He also records that Lucius Scipio put up in the Capitol a picture of his victory over Antiochus III in 190 B.C. (according to Appian the victories of his brother Africanus were similarly recorded) and that Lucius Hostilius Mancinus, who commanded the Roman fleet when Carthage was sacked in 146 B.C., displayed in the

FORUM a picture of the attack and explained his part in it to the public in furtherance of an election campaign. The 'strip-cartoon' technique of recording which was used by the Assyrians reappeared in later Roman times, both in reliefs on SARCOPHAGI of the 2nd and 3rd centuries A.D. and in TRAJAN's COLUMN, erected in A.D. 113 to commemorate the Emperor's Dacian campaigns. The same convention occurs in the so-called Great Trajanic Frieze (early 2nd c. A.D.), parts of which were incorporated in the ARCH OF CONSTANTINE (A.D. 312). It was the repertoire of poses and gestures provided by these late Roman battle scenes which became the model for the High RENAISSANCE when interest in the antique was revived.

LEONARDO's lost picture of the victory of the Florentines over the Pisans, the *Battle of Anghiari* (1503–6), can be conjecturally reconstructed only from small sketches and from copies of its central scene, the *Struggle for the Standard*. In the composition and choice of poses there is reason to believe that Leonardo was influenced by BERTOLDO DI GIOVANNI's (*c.* 1420–91) bronze relief of a battle scene (now in the Bargello, Florence) and Bertoldo, the acknowledged authority in his day on classical art and antiques, took the design for his bronze from a famous sarcophagus which was thought to be a model of classical style. At the same time that Leonardo was working on the cartoon of the *Battle of Anghiari*, MICHELANGELO was working on the cartoon of bathing soldiers surprised at the battle of Cascina. Sir Kenneth Clark has said: 'These battle cartoons of Leonardo and Michelangelo are the turning-point of the Renaissance. . . . It is not too fanciful to say that they initiate the two styles which sixteenth-century painting was to develop—the Baroque and the Classical.' In his *Battle of Constantine* (Vatican, 1520–4) GIULIO ROMANO combined violence of individual groups with a composition of the sarcophagus type, but opened out in a more ordered perspective. This and LEBRUN's *Battles of Alexander* (Louvre, 1662–8), which were derived from it, formed the models for the heroic battle-piece, in which great

passions were portrayed in carefully particularized figures. A different tradition was created by TITIAN's lost *Battle of Cadore* (1537–8), in which the movement and colour were more important than the individual expressions. The vigorous battle scenes of RUBENS fit into the same category.

Another type of picture perfected in the 17th c. and more particularly referred to by the term 'battle-piece' was the small battle scene representing no specific battle. Chosen for the atmospheric effect of dust and gun-smoke, movement and colour, the fight—often no more than a skirmish—was usually set in a landscape. Such pictures deliberately avoided the grand idealized passions in individual groups and had almost the quality of genre scenes. They were painted by Italians such as Salvator ROSA, Aniella FALCONE, and Il BORGOGNONE, and by a number of Dutch artists such as Adam Frans van der MEULEN and Philip and Pieter WOUVERMAN. A panoramic landscape was chosen by ALTDORFER as the setting for his vision of slanting and opposing spears in *The Battle of Issus* (Alte Pinakothek, Munich, 1529). Jacques CALLOT used a similar device to construct a formal composition and suggest the large numbers of combatants engaged. This mode lent itself to the needs of artists less concerned with aesthetics than with history, and Louis XIV employed painters such as van der Meulen and Charles PARROCEL to record his victories in panoramic scenes showing the precise disposition of the armies.

During the Napoleonic wars battles acquired a new and greater importance for painting, both because of the historical situation and the role played by the cult of Napoleon and also because war acquired a peculiar fascination for the ROMANTIC temperament with its interest in the unusual, the dramatic, and the horrific. During the first half of the 19th c. battle paintings were used as vehicles to express ideology which combined the new nationalism with the glorification of heroes and a deliberate concealment of the uglier realities of war. In manner they adopted the old heroic tradition, substituting

**36.** Etching from *Grandes Misères de la Guerre* (1633) by Jacques Callot

contemporary scenes and events for the convention of mythological symbolism or transference to ancient times. GROS, who specialized in battle pictures at the beginning of the century, captured something of the fire and movement of Rubens and expressed something of the dramatic intensity of the later Romantics (*Napoleon at Eylau*, Louvre, 1808). But in general the classical mode of battle picture begot little more than academically didactic show pieces. The battle paintings of GÉRICAULT and DELACROIX, on the other hand, achieved a wholly Romantic dynamism and drama by abandoning the classical tradition of balanced composition and formal equilibrium in favour of anonymous masses in chaotic struggle or the pathos and tension of individualized scenes, as in Delacroix's *Liberty on the Barricades* and *Massacre at Chios*. Something of the Romantic spirit shows through in *The Victory of Marius over the Cimbri* by Alexandre Gabriel Decamps (Louvre, 1833), but it was only the greatest of the Romantics who could measure up to the demands of the battle scene and in the hands of their followers it degenerated again into a new formula of academic nonentity.

In violent contrast to the ideology which fostered the idealization of war, as also to the element of escapism which is inherent in the Romantic approach, stands the attitude of the realists, of whom GOYA and DAUMIER were the most powerful. Goya's *The Battle of 2 May 1808* and *The Execution of the Rebels on 3 May 1808* (both Prado, 1814) breathe a different atmosphere from the realism of Géricault and Delacroix. And his *Disasters of War* is the strongest indictment of war in any medium. In the idiom of the 20th c., which dispenses with realistic depiction of details, PICASSO's *Guernica* has been recognized as an indictment expressive of an equally fundamental condemnation and disgust.

Most of 20th-c. war painting has turned out to be ephemeral. The change in the character of warfare brought the traditional battle-piece out of fashion and led to a search for new modes of expression. For example, Stanley SPENCER's *The Resurrection on the Macedonian Front* (Burghclere), Eric Kennington's *Kensingtons at Laventie*, NEVINSON's *After a Push* (1918), and Paul NASH's *We are Making a New World* (1918) represent the aftermath rather than the moment of battle. The first to make war pictures was C. R. W. Nevinson in 1916 (*The Road from Arras to Bapaume*, Imperial War Mus.). John NASH also painted for the Imperial War Museum, as did Henry LAMB. Examples of pictures representing actual conflict are Lamb's *Bombardment in the Judaean Hills* (Imperial War Mus.) and Wyndham LEWIS's *A Battery Shelled* (Imperial War Mus.). Prominent among artists inspired by scenes on the home front were Henry MOORE (drawings made in Tube Shelters) and Graham SUTHERLAND (*Devastation, 1941 : City, Twisted Girders* (1), War Artists' Committee). Examples of symbolic treatment are Paul Nash's *Mansions of the Dead* and John Armstrong's *The River of the Dead* and *Pro Patria*.

37. Etching from *Los Desastres de la Guerra* (1863) by Goya

**BAUDELAIRE,** CHARLES (1821–67). French poet and critic who, like Sainte-Beuve and TAINE, in his aesthetic outlook came within the ambit of the scientific NATURALISM of the 2nd half of the 19th c. His criticism and his views on the nature and principles of art are expressed in *L'Art romantique* (1899) and in various essays collected in 1923 under the title *Curiosités esthétiques*. In common with the sociological school Baudelaire held that there is no absolute and universal beauty but a different beauty for different peoples and cultures. Beauty arises from the emotions, and therefore every man has his personal beauty. Moreover the individuality of the artist is essential to the creation of beauty and if it is suppressed or regimented, art becomes banal. 'Le beau est toujours bizarre.' Despite this kinship with the sociological school, Baudelaire resisted the claims that art should serve social or moral purposes and was one of the leaders of the 'art for art's sake' school with Flaubert, Gautier, and the brothers de GONCOURT (see AESTHETICISM). In his views of literature he owed much to Edgar Allan Poe. Believing that beauty is indifferent to good and evil, he set himself the task of 'extracting beauty from evil' and gave to his poems the title *Fleurs du mal*. In the 'Hymn to Beauty' he exclaims: 'Whether thou comest from Satan or from God, what does it matter?' Yet while he maintained the primacy of art over everything else including morality, he stopped short of the view that there is any essential antipathy between the beautiful and the good.

In his poetry he was obsessed with the idea of synaesthesia, or the correspondence between sensations of different kinds: 'Les parfums, les couleurs et les sons se répondent.' The later symbolist poets Rimbaud, Verlaine, Mallarmé owed much to this aspect of his work.

In his criticisms of art he sought to assess the stature of an artist by his ability to portray the 'heroism' of modern life. DELACROIX, to whom he devoted some of his most perceptive essays, he found unsuitable owing to his predilection for ROMANTIC and exotic subject matter. COURBET seemed to him too materialistic and he finally chose the relatively minor painter Constantin GUYS as the representative *par excellence* of contemporary society and wrote a long appreciation of his work entitled *Le Peintre de la vie moderne* (1863). He was a friend and supporter of MANET and he is one of the persons depicted in Manet's *Musique aux Tuileries* (N.G., London, 1863) as well as in Courbet's *L'Atelier du peintre* (Louvre, 1855).

190, 191.

**BAUHAUS.** A school of architecture and the applied arts which became the centre of modern design in Germany during the 1920s and played a key role in establishing the relationship between design and industrial techniques. Through the emigration of staff and students after its dissolution in 1933 Bauhaus ideas were widely disseminated in many countries and became established almost as a symbol of modernity in the 1930s and 1940s.

The Bauhaus originated in 1919 by the fusion under Walter GROPIUS of the old Weimar Academy of Fine Arts and the Weimar School of Arts and Crafts (*Kunstgewerbe*), founded in 1903 by the Belgian architect Henri van de VELDE under the aegis of the last Grand Duke of Sachsen-Weimar-Eisenach. The original staff, many of whom had been connected with the EXPRESSIONIST movement in painting, included KANDINSKY and KLEE, the German painter Lyonel FEININGER, the Hungarian architect and furniture designer Marcel BREUER, the typographer Herbert Bayer, and after 1923 Laszlo MOHOLY-NAGY. Gropius's initial proclamation combined a MORRISIAN ideal of inspired craftsmanship with the idea of unity between the arts for the realization of a modern all-embracing architectonic art in which the division between monumental and decorative elements was to disappear. In 1923 he added the idea, which became central in Bauhaus doctrine, of the importance of the craftsman-designer for industrial mass-production. The Bauhaus studios became laboratories where prototype designs for machine manufacture were evolved. A close relationship was established with industry and many products of the studios (furniture, textiles, and electric-light fittings in particular) were adopted for large-scale manufacture. The characteristic Bauhaus style was impersonal, geometrical, and severe, but with a refinement of line and shape that came from a strict economy of means and a close study of the nature of the materials.

In 1925 the Bauhaus moved from Weimar to Dessau and a group of new buildings designed as a co-operative effort by Gropius and his staff and students. It was after this move that it began to exert its most powerful influence on architecture and the applied arts in Europe. Through a remarkable series of books edited by Gropius and Moholy-Nagy—14 in all—between 1925 and 1930 the Bauhaus became the intellectual centre and inspiration for a new architectural movement spreading through central Europe. In 1928 Gropius left the Bauhaus to concentrate on his own architectural practice and was succeeded as director by MIES VAN DER ROHE. Owing to opposition from the local Nazi party the Bauhaus was compelled to migrate to Berlin in 1932, where it was closed down in 1933.

198, 1173.

**BAWDEN,** EDWARD (1903– ). English water-colour painter, illustrator and designer of posters, wall-paper, tapestries, and theatre decor. He studied under Paul NASH at the Royal College of Art 1922–5. Among others he did decorations for Morley College (1928–9, destroyed 1941 and renewed 1958) and for the Festival of Britain. He taught at the Royal College of Art from 1930, was elected A.R.A. in 1947 and R.A. in 1956.

**BAYEU Y SUBÍAS,** FRANCISCO (1734–95). Spanish painter. From 1763 he was employed at the court under MENGS and painted ceilings at the royal palaces in fresco. He also did CARTOONS for tapestries, displaying a special interest in genre subjects, and succeeded Mengs in 1777 as director of the royal tapestry factory, for which his brother-in-law GOYA also worked. In 1788 he became court painter to Charles IV and director of the Academy of San Fernando. Bayeu was a talented painter within the rigid discipline of the Academy.

2381.

**BAYEUX TAPESTRY,** THE. This superb example of Anglo-Saxon embroidery—it is not really a tapestry—was executed between 1066 and 1077, probably at Canterbury, for Odo, Bishop of Bayeux and half-brother of William the Conqueror. It is 19 in. wide and, although incomplete, over 230 ft. long. In 79 scenes accompanied by a Latin text and arranged like a strip cartoon it tells the story of the Norman Conquest and the events that led up to it. These main scenes are flanked by upper and lower margins embroidered with illustrations of fables. It is an important historical document relating incidents that are not recorded elsewhere and is a source of information on such things as armour, boats, and clothes.

The view that the Tapestry, like most medieval art, was commissioned for the Church has been questioned and the view has gained ground that it may be a very rare example of the secular art of its period. There is not much in the treatment of the story that suggests any deep concern with its religious implications. Harold is portrayed as a traitor breaking his oath to William and suffering the consequences. Such stories of treachery were common in the popular contemporary *chansons de geste* and it has been suggested that the Tapestry treats the Conquest in terms of these verse romances. It is racy and colourful, full of vigorous and gory scenes of battle, and is occasionally ribald in a way that lends strength to the arguments against its ecclesiastical inspiration.

At the time of the Conquest England was a flourishing centre of arts and crafts. Its manuscripts and illumination (see ILLUMINATED MANUSCRIPTS) were unsurpassed on the Continent and its reputation for excellent needlework was widespread. Stylistically the Tapestry has much in common with English illumination of the period. The drawing is clear, vivid, and full of action and the composition leads on skilfully from one scene to the next. The colours, of which there are eight, are used for decorative rather than descriptive purposes.

**BAZILLE,** FRÉDÉRIC (1841–70). French painter, one of the early IMPRESSIONIST group. In 1862 he entered the studio of Marc Gabriel Gleyre, where he made friends with MONET, RENOIR, and Alfred SISLEY. With these three friends he left the studio the following year and went to paint out of doors near Barbizon. He later made friends with CÉZANNE, COURBET, and MANET and in 1864 was painting with Monet at Honfleur. He was killed in battle in the war with Prussia. Though he was a talented artist, Bazille's works have not the strength or promise shown by the other members of the group. His best picture is usually considered to be *Family Reunion* (Louvre, 1868). His group picture *Mon Atelier* (Louvre), showing Manet, Monet, Renoir, Edmond Maître, and Zola in the artist's studio with Bazille himself painted by Manet, was refused by the SALON in 1870. There is a portrait of Bazille painted by Renoir (*c.* 1866) in the Louvre.

695.

**BAZZI,** GIOVANNI ANTONIO. See SODOMA.

**BEALE,** MRS. MARY (1633–99). English portrait painter and copyist. Her portraits, especially of divines, survive in some quantity (N.P.G., London). Her husband Charles, a Clerk of the Patents and an artist's colourman, kept diaries of her painting activities which afford an interesting picture of the artistic circles connected with LELY's studio. Her work is commonplace and her style a derivative echo of Lely's. A son CHARLES (b. 1660) was mainly a miniaturist. Sets of his drawings are in the British Museum and the Pierpoint Morgan Library.

**BEARDSLEY,** AUBREY VINCENT (1872–98). English artist and illustrator, a leading figure in the *fin-de-siècle* AESTHETICISM. A clerk in the employment of the Guardian Insurance Office, he was encouraged by BURNE-JONES in 1891 and began to draw in the manner of the PRE-RAPHAELITES. Through his admiration for WHISTLER (which was not reciprocated) he was led to study Japanese prints. He was introduced to William MORRIS, whom he failed to impress. In 1891–2 he did illustrations to the *Morte d'Arthur* for the publisher Dent and a commendatory article by Joseph PENNELL appeared in the first number of *The Studio*. In 1894 he became the rage with the publication by John Lane of his illustrations to the English version of Oscar Wilde's *Salome* and the first volume of *The Yellow Book*. The elaborate artificiality of his decorative patterns seemed to sum up the 'decadence' of the 1890s 'in that they formed an elaborate and sterile system, as if symbols whose meaning and purpose had ceased to exist or were profoundly hidden'. His masterly use of black and white for pattern and grotesque was highly original and the ornamental quality of his linear rhythms expressed the spirit of ART NOUVEAU. Owing perhaps partly to the tuberculosis which carried him off at the age of 25, his work had a morbific suggestion of depravity which made it the most controversial illustration of its day. His popularity suffered eclipse with the fall of Oscar Wilde, but he was employed by Arthur Symons

**38.** *Self-Portrait* by Aubrey Beardsley. Pen-and-ink drawing. (B.M., *c.* 1892)

to do illustrations for a new magazine, *The Savoy*. These together with his drawings for *The Rape of the Lock* contained his best work.

2194, 2312, 2790.

**BEATUS MANUSCRIPTS.** Beatus, Abbot of Liébana in north Spain, wrote a commentary on the APOCALYPSE in 776. It proved the most popular of several similar studies and was widely copied: 24 manuscripts are known. The finest surviving illuminated *Beatus* came from the abbey of Saint-Sever in south-west France and is now in the Bibliothèque nationale, Paris. It was executed for a Spanish abbot between 1028 and 1072. The French art historian Émile MÂLE has shown that there is a close affinity between its *Vision of St. John* and the MOISSAC tympanum.

**BEAUGRANT,** GUYOT DE (d. 1551). French sculptor who worked *c.* 1525–30 in Flanders. He participated in the execution of

**39.** Prospectus for *The Yellow Book* (1894). Pen-and-ink drawing by Aubrey Beardsley. (V. & A. Mus.)

Lancelot BLONDEEL's design for the elaborate chimneypiece in the Council Chamber of the Palace of Justice at Bruges. In 1533 he settled in Spain, where he made carvings for the church of St. James, Bilboa.

**BEAUMONT,** SIR GEORGE HOWLAND, BT. (1753–1827). English collector, connoisseur, and amateur painter, who entertained and befriended artists and men of letters, especially in later years, at his estate of Coleorton in Leicestershire. He studied landscape painting with Alexander COZENS and he was a passionate admirer of CLAUDE, whose *Hagar and the Angel* (N.G., London) he frequently took with him when he travelled. His remark that every landscape painting should have a brown tree in it is much quoted but in fact his own oil sketches are often lively in colour, especially those painted after he had developed a friendship with CONSTABLE. He was a devotee of the PICTURESQUE and ROMANTIC and his most celebrated work, *Peel Castle in a Storm* (Leicester), moved Wordsworth to a sonnet. Beaumont had much to do with the foundation of the NATIONAL GALLERY, to which he presented the best part of his collection in 1826.

1144, 1627.

**BEAUNE,** HOSPICE. The best preserved of all medieval hospitals, founded in 1443 by

Nicholas Rolin, Chancellor of Burgundy. Early medieval hospitals tended to follow the plan of monastic infirmaries, which had nave and aisles like a church and an altar at one end. The hospital of Tonnerre, founded in 1292, had a new plan, resembling the great hall of a castle. This type became common in the 14th c. and was the one used at Beaune. The hospital was laid out like a great town house around a courtyard, and it had two wards combined with chapels. In one of these patients could contemplate Rogier van der WEYDEN's magnificent painting *The Last Judgement*.

**BEAUNEVEU,** ANDRÉ (active 1390-1403/13). French sculptor and illuminator from Valenciennes, who worked for the French court, Louis de Mâle, Count of Flanders, and the Duke of Berry. Of his illuminations the only certain attributions are the Prophets and Apostles of the Duke of Berry's *Psalter* (Bib. nat., Paris, 1380-5). Four of the royal effigies in Saint-Denis came from his workshop (Philip VI; John II, ordered 1364; and Charles V and his queen, both ordered 1367). Beauneveu's style was monumental but he combined monumentality with a taste for realism, which culminated in the Guesclin and Sancerre tombs, also in Saint-Denis, made under his influence by Thomas Privé and Robert Loisel.

**BECCAFUMI,** DOMENICO DI PACE (c. 1489-1551). Italian painter, son of a peasant from a village near Siena. He was alive to the new movements initiated by Fra BARTOLOMMEO, MICHELANGELO, and RAPHAEL and combined the new ideas with the bright and decorative colouring of the SIENESE tradition. His work was admired by VASARI, depreciated in the 19th c., and has later been appreciated for certain anticipations of MANNERIST developments in the next century. This quality in his work is exemplified in *Esther before Ahasuerus* (N.G., London) with its tiny elegant figures which seem lost on a wide stage scattered with architectural fantasies. He painted decorations for the Town Hall of Siena (1529-35) depicting examples of civic virtue, and made designs for the marble pavement of Siena Cathedral. Important works in the Pinacoteca, Siena, are *St. Catherine receiving the Stigmata* (c. 1514), *The Trinity* (1513), *The Mystic Marriage of St. Catherine* (1528), and from his mature period *Christ in Limbo* and *The Birth of the Virgin*.

**BECERRA,** FRANCISCO (c. 1540-1605). Spanish architect born near Trujillo, where he was engaged on various minor works before leaving Spain for Mexico in 1573. He was in charge of the construction of Puebla Cathedral from 1575 until c. 1580, when he moved to Quito and there designed the churches of S. Agustín and S. Domingo. In 1582 he finally settled at Lima where he drew up the plans for the great Peruvian cathedrals of Lima and Cuzco.

1534, 1536

**BECERRA,** GASPAR (c. 1520-70). Spanish MANNERIST sculptor and painter. He studied at Rome and assisted VASARI in the decoration of the Cancelleria. Soon after 1556 he returned to Spain and in 1558 contracted for the main REREDOS of Astorga Cathedral. In 1563 he was appointed court painter to Philip II.

**BECKFORD,** WILLIAM (1760-1844). English collector, writer, and eccentric. A millionaire from boyhood, he was a romantic traveller and recluse, who became a legendary figure in his own lifetime. As a young man he had lessons in architecture from Sir William CHAMBERS and in painting from Alexander COZENS, who accompanied him to Italy in 1782. At about this time he wrote his fantastic oriental novel *Vathek* in French. He formed a vast and largely tasteless collection of objects of every kind, both natural and artificial, which incurred Hazlitt's irony, though his library (which included that of Edward Gibbon) was compiled with discernment. James WYATT built Fonthill Abbey (1796-1807, now destroyed) for Beckford. This huge GOTHIC extravagance had long narrow wings running from a central octagonal tower as preposterously high as it was unstable. In 1826 when his fortunes had declined Beckford built Lansdowne Tower, Bath, a lesser classical folly which now enlivens a cemetery.

29, 2361.

**BECKMANN,** MAX (1884-1950). German painter who worked in Berlin and Frankfurt until 1938, when political persecution drove him to Amsterdam. He spent the last three years of his life in New York. Beckmann's experiences in the First World War led him to an art which in its greater concern for human and symbolic truths has affinities with the *Neue Sachlichkeit* of GROSZ and DIX. Although he also painted portraits, landscapes, and STILL LIFES, Beckmann's most important works were large allegorical figure compositions, often brutal in feeling. But familiarity with CUBISM and FAUVISM enabled him to create an original formal language for the social or philosophical message he sought to express.

97, 2206.

**BEECHEY,** SIR WILLIAM (1753-1839). English portrait painter, who entered the R.A. Schools in 1772 and first exhibited in 1776. He was elected A.R.A. in 1793, and R.A. in 1798, and was later Portrait Painter to Queen Charlotte and Instructor to the Princesses. Beechey's style changed little throughout his life. He was a careful if sometimes insipid painter and gave great attention to the durability of his pictures. He was knighted in 1798 in recognition of his

most ambitious painting, *A Review of the Horse Guard with King George III and the Prince of Wales* (Windsor Castle).

2276.

**BEECK,** JAN VAN DER. See TORRENTIUS.

**BEERBOHM,** SIR MAX (1872-1956). English belletrist and CARICATURIST. In both words and drawings he had a brilliantly ironic wit. Although not a great draughtsman, he was a superb caricaturist with a power to express convincingly precisely what he wanted to say. His drawings first appeared in *The Strand Magazine* in 1892 and he was reproduced in *The Yellow Book* (see Aubrey BEARDSLEY) of 1894. He became a member of the NEW ENGLISH ART CLUB in 1909 but after 1910 lived mainly at Rapallo in Italy. He published and exhibited several sets of caricatures, including some of ROSSETTI and his circle and *Poets' Corner* (1904).

**BEERSTRATEN.** ANTHONIE (active *c.* 1639-71) and JAN ABRAHAMSZ (1627-66). Dutch painters and probably brothers. Both are best known for their views of Amsterdam. Anthonie specialized in making winter pictures. Jan's masterpiece is a painting of the ruins of the Amsterdam City Hall (Rijksmuseum, Amsterdam) after it was destroyed by fire in 1652. Jan also made imaginary views of harbours and beaches.

**BEERT,** OSIAS (*c.* 1580-1624). Early Flemish painter of STILL LIFE and flower pieces, who also carried on business as a cork merchant. He became a master in Antwerp in 1602, and is specially noted for his paintings of oysters, where the colours and textures of these and other crustaceans are perfectly captured in simply arranged compositions. His pupils included Frans Ijkens or Ykens (1601-*c.* 1693), primarily a flower painter.

**BEHAM,** HANS SEBALD (1500-50) and BARTEL (1502-40). German brothers, engravers of Nuremberg, whence they were expelled in 1525 after having been found guilty of blasphemy and sedition. It was for their opinions, however, that they were sentenced; their art was not questioned at the trial. They are the most typical of the LITTLE MASTERS. Taking full advantage of the technical innovations introduced by DÜRER, they produced a great number of illustrations to the Bible, mythology, and history, and, like him, they experimented with the GRAPHIC techniques known at the time.

**BEHNES,** WILLIAM (1795-1864). Sculptor, born in London of a German father, and trained at the R.A. Schools. He quickly obtained a large practice as a maker of busts, the best of which rival those of Sir Francis CHANTREY. He also made monuments and statues (*Sir Henry Havelock*, Trafalgar Square, London, 1861). He was appointed Sculptor in Ordinary to Queen Victoria on her accession. His work was uneven in quality and despite his great vogue irregular habits brought him to poverty.

**BEHRENS,** PETER (1868-1940). Pioneer German architect at the beginning of the 20th c., and a leading influence in the growth of MODERN ARCHITECTURE and industrial design in Germany between 1900 and 1914. He came to architecture from painting when in 1899 he became a member of the Seven group at Darmstadt, whose aim was to unify the plastic arts. At this period he worked in the manner of both Henri van de VELDE and MACKINTOSH. From 1903 to 1907 he was head of the Düsseldorf Art School. In 1907 he was one of the founders of the DEUTSCHER WERKBUND, which largely grew out of van de Velde's ideas. In 1907 also the A.E.G. appointed Behrens designer not only of its buildings but also of much of its equipment and products and even its packaging, posters, showroom, and advertisement. This was an important advance, being the first occasion that a great industrial concern had used an architect as designer.

In 1909 he built for this company a turbine-factory in Berlin, the first German building in steel and glass and notable for its functional employment of modern materials for monumental effect. The steel roof is frankly allowed to dictate the outline of the building and the side walls consist of exposed steel stanchions framing large areas of glass.

Among Behrens's principal works were factories in Berlin (1909 and 1911), Oberhausen (1921-5), and Höchst am Main (1920-4); one of the first standardized office buildings at Düsseldorf (1911) and a district of workers' flats at Henningsdorf, Berlin, one of the first planned housing schemes for industrial workers since the 19th-c. experiments in England. His domestic architecture reveals a progression from an early ART NOUVEAU style strongly influenced by Mackintosh and VOYSEY to the modernistic purism exemplified by his house at Northampton (1926), which was one of the earliest applications of modern domestic architecture in England. In 1922 he was appointed Director of Architecture in the Vienna Academy and in 1936 he held a similar post at the Prussian Academy of Arts, Berlin. His influence in the 1920s was widespread, and his office became the starting-point of many new architectural developments. Among those who worked in it at various times were GROPIUS, LE CORBUSIER, and MIES VAN DER ROHE.

**BEKE,** JOOS VAN DER. See JOOS VAN CLEVE.

**BELGIAN ART.** See FLEMISH ART.

**BELGIAN BLACK.** See MARBLE.

**BELL,** CLIVE (1881–1964). English critic and writer on art who with Roger FRY was largely instrumental in propagating in Great Britain an appreciation of the POST-IMPRESSIONIST painters and particularly CÉZANNE. His name is associated in art theory with the doctrines of Significant Form and of a unique aesthetic emotion, doctrines which were primarily set forth in the essays 'The Aesthetic Hypothesis' and 'The Metaphysical Hypothesis' contained in his book *Art* (1923). Bell wrote: 'The starting-point for all systems of aesthetics must be the personal experience of a peculiar emotion. The objects which provoke this emotion we call works of art. All sensitive people agree that there is a peculiar emotion provoked by works of art. . . . This emotion is called the aesthetic emotion; and if we can discover some quality common and peculiar to all the objects that provoke it, we shall have solved what I take to be the central problem of aesthetics.' Bell found that the 'aesthetic thrill' is experienced in apprehension of the formal properties of works of art rather than their subject matter, their moral message or anecdotal content. Quite apart from the degree of importance which may be attached to his theory in the history of aesthetic philosophy, there can be no doubting the enormous importance of the influence he exerted in spreading a new attitude towards appreciation among both connoisseurs and the general public, an attitude which demanded greater rigour of attention to the sensory and formal qualities of a work of art, regarding them as always essential if not always sufficient for complete aesthetic enjoyment.

**BELL,** HENRY (c. 1653–1717). English architect of King's Lynn, Norfolk, where he designed several buildings, including the Exchange (now the Customs House), in a manner which combines Dutch influence with that of WREN. He was also responsible for All Saints' Church, Northampton, and probably the Sessions House in the same town.

**BELLA,** STEFANO DELLA (1610–64). Italian engraver, born in Florence. His style was early formed on that of CALLOT and remained close to it. After 1650 he spent some time in Paris, where he worked for Cardinal Richelieu. In Italy he worked chiefly for the Grand Duke of Tuscany. His output was enormous—masque-designs, BATTLE-PIECES, animals, landscapes—all in an extremely delicate and MANNERED style. Many of his drawings are in the Royal Library at Windsor.

309.

**BELLANGE,** JACQUES (active 1600–17). French painter, etcher, and decorator, one of a small group of artists who created a minor revival during the decadence of painting in Paris which coincided with the Second School of FONTAINEBLEAU. His highly individual style

represents a last stage of the development of MANNERIST art in Europe. Exaggerating the tradition initiated by PARMIGIANINO, he expressed a personal religious mysticism through the artificial conventions of aristocratic elegance.

**BELLECHOSE,** HENRI (d. 1440/4). Flemish painter from Brabant, who succeeded MALOUEL as Burgundian court painter at Dijon in 1415. He has been proposed as the man responsible for the more 'violent' and Flemish parts of the *Martyrdom of St. Denis* in the Louvre, begun by Malouel and one of the finer decorative pictures which have survived from the BURGUNDIAN School.

**BELLEGAMBE,** JEAN (c. 1470/80–c. 1535). Painter of ALTARPIECES and designer of buildings, furniture, frames, and embroidery. He worked out his style in Douai, where he was probably born, and was the only artist of consequence there during his lifetime. Douai, today in northern France, was then part of the Spanish Netherlands. It was neither typically Flemish nor typically French, and the same is true of Bellegambe's work. But his rich RENAISSANCE architectural settings indicate an Antwerp rather than a Paris source. This may have been the painter Quentin MASSYS.

**BELLINI.** Family of Italian painters who exercised an important influence on the course of the VENETIAN SCHOOL of painting.

JACOPO was father of Gentile and Giovanni and father-in-law of MANTEGNA. He was trained by GENTILE DA FABRIANO and achieved early popularity both in Venice and elsewhere. In 1436 he painted a *Crucifixion* at Verona by invitation of the bishop Guido Memmo. In 1441 at Ferrara he defeated PISANELLO in a competition for a portrait of the young Lionello d'ESTE. By the middle of the century he had a flourishing *atelier* with his two sons. His most notable paintings have disappeared and it is not easy to form an assessment from those that survive. The signed pictures are *Christ on the Cross* (Museo Civico, Verona), *Virgin and Child* (Accademia, Venice), and Madonnas in Lovere and Brera, Milan. There is a *St. Jerome* at Verona and an *Annunciation* at S. Alessandro, Brescia. Although he has the grace of the late GOTHIC, there is a certain dryness and stiffness in his figures. Yet he was obviously keenly alert to contemporary ideas and shared the fashionable interests in archaeology, PERSPECTIVE, and anatomy, keeping always in advance of his time.

His artistic personality is manifested best in his two surviving sketchbooks (Louvre and B.M.), containing more than 230 drawings in all —more than we have from any other 15th-c. artist. These are very various, many of them extremely fine. There are interesting experi-

ments in unusual perspective and developments of open spatial composition in landscape and architectural design. The drawings seem to have been used as a source by the two sons and by Mantegna.

GENTILE (c. 1429-1507) was the elder son and pupil of Jacopo. He carried on the reputation of his father and was greatly admired in his time. He was ennobled by the emperor Frederick III and became prominent as a portraitist. He worked at the court in Constantinople 1479-81 and from this period comes the portrait of *Mehmet II* (N.G., London). In 1472 he undertook to repaint the large canvases on which his father and brother had worked in the Doge's Palace (burnt in 1577). He painted a cycle of pictures for the Scuola di San Giovanni (now in the Accademia, Venice). In 1504 and 1506 he started the *Martyrdom of the Saint* and *St. Mark Preaching in Alexandria*, which were left unfinished at his death (Brera, Milan). His known work is distinguished by his skill in panoramic views and his treatment of crowds and processions in recording civic and religious occasions. His reputation, high in his lifetime, has suffered some eclipse in the course of the 20th c.

GIOVANNI, called GIAMBELLINO (c. 1430/40-1516), younger brother of Gentile, who by his achievement transformed Venice from an artistically provincial city into a RENAISSANCE centre next in importance to Florence and Rome. He was trained by his father Jacopo, but the major influence on his formative years was that of his brother-in-law, Mantegna. This and Bellini's own originality are made clear by a comparison of their pictures of the *Agony in the Garden*, both painted about 1465 and both now in the National Gallery, London. The similarities occur in the figures and to some extent in the compositions; the difference is in the treatment of the landscape. Mantegna's is sharp, precise, and largely two-dimensional. Bellini's is lyrical and spacious; its recession depends on subtle transitions in light and colour, and these transitions depend in turn on close observation of the way in which the light withdraws from an undulating stretch of countryside at sunset. The picture is thus grounded in fact; but fact is transformed by the imagination.

The twilight landscape in the *Agony in the Garden* shows the interest in light which was to develop in Venetian LANDSCAPE PAINTING. But Bellini was not only a master of twilight; he responded to nature in all its hours and seasons— for example, to full daylight in the *St. Francis* of c. 1480 (Frick Coll., New York), and to the cold light of an autumn morning in the *Madonna of the Meadow* of about 1510 (N.G., London). But both his landscape and the figures are always poised and still. Unlike that of most of his Florentine contemporaries, Bellini's art is essentially contemplative, not active, in mood. This is also true of his large ALTARPIECES. Beginning with that of *St. Vincent Ferrer* (c. 1465) in SS.

Giovanni e Paolo, Venice, and culminating in the *Madonna with Saints* (S. Zaccaria, Venice), these progressively increased in coherence and monumentality. The *Madonna with Saints* (church of the Frari, Venice), which RUSKIN held to be one of the three most beautiful pictures in the world, is a key picture in Bellini's development as it marks his complete emancipation from the influence not only of Mantegna but also of ANTONELLO DA MESSINA, who had visited Venice in 1475/6. This work is the first thoroughgoing example of the characteristically Venetian conception of painting, in which colour and light were the primary means of expression.

Bellini painted a large number of small devotional pictures of the *Madonna and Child* and several portraits, of which the best known is the *Doge Leonardo Loredano* (1501) in the National Gallery, London. The *Fra Teodoro* (1515), also in the National Gallery, exemplifies Bellini's tendency in his last years to make use of abstract patterning, and this picture in particular looks forward across the centuries to GAUGUIN. At about the same time he painted the *Feast of the Gods* (N.G., Washington), a picture both mysterious and comic, recalling DÜRER's remark that even in his old age Bellini remained a leading master.

873, 1291, 1881, 2003.

**BELLORI**, GIOVANNI PIETRO (1615-96). Italian antiquarian, collector, and biographer. He was one of the group of men who were engaged in excavating and recording Roman antiquities and was named 'Antiquarian of Rome' by Clement X. He was librarian and antiquarian to Christina of Sweden, who settled at Rome after her abdication. He made a large collection of antiquities, much of which is at Berlin and Dresden, and he wrote the text to some of BARTOLI's illustrated books on ancient reliefs and tombs. He wrote *Vite de' pittori, scultori et architetti moderni* (1672), which he dedicated to COLBERT, the founder of the French Academy, and in the preparation of which he was helped by POUSSIN. This work is now a basic source for the history of the BAROQUE period. In contrast to former art histories his method was to concentrate on artists selected for their importance and only these received comprehensive treatment. The Preface to the work was a lecture given in 1664 to the Academy of St. Luke at Rome, which became the seminal statement of the CLASSICAL theory of an art which mirrors the IDEAL essence of reality. In the prominence he gave to RAPHAEL, Annibale CARRACCI, and Poussin, his rational Platonism and his acceptance of the ANTIQUE as the model of excellence his formulation expressed the ideals of the Roman Academy and proved a seminal influence on French academic theory. Through Shaftesbury and REYNOLDS it influenced the ROYAL ACADEMY and later became the theoretical basis of the NEO-CLASSICISM preached by WINCKELMANN.

**BELLOTTO**, BERNARDO (1720–80). Italian painter, nephew, pupil, and assistant of CANALETTO in Venice. Bellotto left Italy for good in 1747, to spend the rest of his life working at the courts of Dresden (1747–58), Vienna (1758–62), Munich, and Warsaw, where he died. He called himself Canaletto, and this caused confusion (perhaps deliberate) between his work and his uncle's, particularly in views of Venice. Bellotto's style is, however, quite distinct, marked by an almost Dutch interest in massed clouds, cast shadows, and rich foliage. The figures populating his streets form lively scenes of high and low life, characteristic of the widespread growth of GENRE painting in Europe. In the rebuilding of Warsaw after the Second World War Bellotto's meticulous but picturesque views of the streets and churches were used as guides, even in the reconstruction of architectural ornament.

**BELLOWS**, GEORGE WESLEY (1882–1925). American painter and lithographer, a pupil of Robert HENRI. He was prominent in the movement during the first decade of the 20th c. which sought to break away from the decorative backwash of POST-IMPRESSIONISM and adapt the vivid colours and new techniques to a social REALISM

imbued with a zest for life. Bellows delighted in prize fights, religious revivals, and the teeming life of the cities. His fame rested on such pictures as *Both Members of this Club* (N.G., Washington, 1909) and *Polo at Lakewood* (Columbus Gal. of Fine Arts, Ohio, 1910) and lithographs such as *Billy Sunday* (1923). These seemed bold and exciting in their day but the novelty has palled and much of his work seemed mediocre and dated to the next generation.

360.

**BELVEDERE TORSO.** This marble TORSO (Vatican Belv. 3) of a male figure seated on a rock and bending forward to the left is late HELLENISTIC, whether copy or original. It is signed by Apollonius. The Torso, as it was called, was greatly admired from MICHELANGELO till the early 19th c. It is now neglected.

**BENCH END.** The traditional name in Christian church architecture for the upright end part of what are now called 'pews'. Seating for the congregation in the naves of medieval churches only became general towards the end of the 14th and during the 15th centuries. This was one of the symptoms of the growing im-

**40.** *Dempsey and Firpo*. Lithograph (1924) by George Bellows

portance of the laity in church life; pews were provided for their convenience and their decoration reflects secular rather than ecclesiastical taste. The subject matter of the carvings of bench ends derives from popular piety and fables and generally verges on FOLK ART, although the quality of the carving is often extremely high. In England there are two regions where they are particularly common: East Anglia and the West Country, where the prosperous middle classes were particularly strong.

**BENEDETTO DA MAIANO** (1442–97). Italian sculptor of the FLORENTINE SCHOOL, who carried over into the second half of the 15th c. many of the motifs and stylistic features characteristic of the first half. His marble tomb designs are variants on patterns established by his master, Antonio ROSSELLINO: his pictorial relief style, which found its most eloquent expression in a pulpit executed between 1472 and 1475 in Sta Croce, Florence, belongs to the narrative tradition which is associated with GHIBERTI and DONATELLO. Perhaps his most memorable achievement lay not in his figures or reliefs but in the decorative architectural settings in which they were placed. In the design and execution of the exquisite PILASTERS, CAPITALS, FRIEZES, niches, and so on which form these settings he was often assisted by his brothers GIULIANO and GIOVANNI.

His portrait bust of Pietro Mellini (1474), the donor of the Sta Croce pulpit, is in the Bargello, Florence, and there is a bust of Filippo in the Louvre. His works include the altar of Sta Fina in the cathedral of S. Gimignano (c. 1475), a fine REREDOS with a relief representation of the Annunciation in Monte Oliveto, Naples (c. 1485), and the altar of S. Bartolo in S. Agostino at S. Gimignano (1494). He did a CIBORIUM in S. Domenico at Siena and works at Loreto. There are terracotta models for panels of the Sta Croce pulpit in the Victoria and Albert Museum.

**BENIG.** See BENING.

**BENIN.** Benin art was the first African art to attract widespread attention in Europe. In 1896 Her Majesty's Consul General on the Guinea Coast took a party to Benin, against advice, during the 'annual customs' to make overtures to the king and prevent human sacrifice. The king asked him to wait, but he pushed on and in January 1897 he and his force were massacred. The next month a force of 1,200 men entered Benin city amidst the gore of sacrifices made to inhibit their advance. Benin came to be known as the 'city of blood'. Much of Benin art consisted of altar furniture on to which blood—the quickening substance representing life—had been dripped during human and animal sacrifices.

The punitive expedition collected most of the objects from the altars and house walls. Some went to the Government, but officers, doctors, and ordinary soldiers all got their share. The market was inundated with Benin bronzes and ivories, and three great collections were made. The largest, happily still intact, is the one in the BERLIN MUSEUMS. The British Museum founded its fine collection on the Government's share and has added to it since. The third collection was made by General Pitt-Rivers and is in the museum which he founded at Farnham, Dorset.

It is convenient to divide Benin art into three groups: ivories, bronze heads and other altar furniture, and secular bronze objects, chiefly plaques.

The ivories include horns, carved tusks, armlets, staffs, masks, and carved figures. The horns (blown through a mouthpiece on the side) resemble European ivory horns; the first of them to be reproduced in a European book was published in Dresden in the late 17th c., when it was not recognized as African. The carved tusks are up to 6 ft. in length. Some have a simple design of incised bands of plait pattern, and are associated with the altars of the queen mothers. Others, associated with the altars of kings, are carved with bold, grotesque figures, human, animal, and symbolic; they have a rich, full appearance but the figures are never crowded. Tusks are carved to a uniform depth; a writer who knew Benin before the massacre says that they were worked freehand without any preliminary drawing. The ivory masks were worn not over the face but suspended from a belt or girdle. They represent either human or leopard faces—here and in most African kingdoms leopards are a symbol of kingship.

The next group comprises the heads on which (or, in case of female heads, behind which) the tusks rested on the altars. They were of brass or bronze, cast by the *cire-perdue* method (many were of wood, but few of these had artistic value). The finest, those considered the oldest, are the heads of queen mothers; two are known, one in the British Museum, the other recently bought by the Government of Nigeria. The male heads of the same period, representing deceased *obas* or kings, are some of the finest *cire-perdue* castings ever made anywhere. Their thickness varies from 1 to 3 mm., and they are perfectly even and beautifully finished. Later heads show a definite deterioration both in modelling and in casting. The coral necklaces, another royal symbol, increase in size until they cover the chin. By the 18th c. the progress towards the bell shape was almost complete, and brass casting all but disappeared during the 19th c.

Other altar furniture included bronze statues of leopards (there were ivory ones as well), of cocks, and of human figures such as horsemen, horn-players, and some groups of king and retainers or of executioners.

The third group is the bronze plaques. The earliest accounts describe the houses, especially

the palace, as being richly decorated with reliefs modelled in mud or carved on the beams, posts, and doors, but by the time of the massacre hardly any of these decorations survived. Metal plaques were found set into some walls—apparently a Portuguese idea, but the workmanship is Bini. The plaques are up to 18 in. square, and the figures are in very high relief—higher, indeed, than they would be were they carved in the round, which gives them a jutting appearance both distinctive and enlivening. These plaques represent the court, and the wars and hunting activities of the Bini. Many of them show Portuguese traders, priests, and soldiers with their cross-bows and arquebuses, faithfully depicted in costumes which are almost all of the 17th c. There is a tradition that the technique of bronze casting came to Benin from IFE late in the 13th c. and the classical period of Benin bronzes is tentatively put in the 14th and early 15th centuries. The style is now thought to represent the culmination and final stages of naturalistic tendencies which at an earlier date were widely spread in the north and north-eastern regions of Nigeria.

693, 2096.

**BENING,** or BENIG. Family of 15th- and 16th-c. Flemish book illuminators. SANDERS, or as he was sometimes called, ALEXANDER (d. 1518), was the head of the family and its most important member. He was the leading MINIA-TURIST of his day at Ghent and Bruges and is probably identical with the so-called Master of Mary of Burgundy, whose illustrations introduced a new note of NATURALISM into late 15th-c. Netherlandish art. Illuminations in the *Prayer Book of Engelbert of Nassau* (Bodl. Lib., Oxford, 1485/90) are ascribed to him. His son SIMON (*c.* 1483-1561) followed his style; the famous *Grimani Breviary* (Lib. of St. Mark, Venice) was done in his workshop.

1994.

**BENOIS,** ALEXANDRE (ALEKSANDR) (1870-1960). Russian painter, stage designer, art historian, and critic; founder of the MIR ISKUSSTVA (*World of Art*) movement in 1899. He became famous through his stage designs in which the tradition of Russian folk art is harmonized with French ROCOCO elements. He was a close friend and collaborator of Diaghilev both in Russia and later in Paris with the ballet, for which he designed among others *Le Pavillon d'Armide*, *Les Sylphides*, and *Petrushka* (1909-11). He published portfolios of the art treasures of Russia (1901-7) and a *History of Russian Painting* (1904). After the Revolution he was made curator of the paintings in the HERMITAGE. In 1928 he settled in Paris, where he died.

242.

**BENSON,** AMBROSIUS (d. 1550). Flemish painter, born in Italy, who worked under Gerard DAVID. Many of his paintings were exported, notably to Spain (e.g. the triptych of *St. Anthony of Padua*, which is now in Brussels). There is a slightly southern flavour to his compositions and for a long time many of them were thought to be by an anonymous Spanish painter working under Flemish influence, known as the Master of Segovia.

**BÉRAIN,** JEAN (1640-1711). French decorator and designer. He was one of the most imaginative and influential of the designers during the last decades of the 17th c. and his ARABESQUES and GROTESQUES inaugurated a new movement which led towards the ROCOCO of the following century. His earliest official work consisted of 12 plates of ornament for LEBRUN's Gallerie d'Apollon at the LOUVRE. From *c.* 1670 he was employed occasionally as engraver by the Bâtiments du roi. He was perhaps the most important artistic force in designing the elaborate stage settings, costumes, and displays for the celebrations, out-of-door fêtes, ballet-operas, etc., given by Louis XIV. In the office of the Menus-Plaisirs he occupied the position of Dessinateur de la Chambre et du Cabinet du roi from 1682 until his death. He took an important part in the Cabinet des Médailles (1682-4) for which he designed the famous Bureau du roi executed in marquetry by OPPENORD.

He used oriental motifs both in his designs for court entertainments and in his arabesques, which were in the lighter style sometimes regarded as the first phase of Rococo; the style came into vogue shortly before 1700 and remained popular for the first quarter of the 18th c., continuing to be used for the decoration of FAIENCE at Moustiers and other provincial factories until the 1740s. He was one of the forerunners of French 18th-c. CHINOISERIE and he also seems to have begun the 18th-c. vogue for SINGERIES, though his monkey figures are as unmistakably denizens of the *Grand Siècle* as those of Huet (d. 1759) and WATTEAU belong to the 18th c.

2825.

**BERCHEM,** NICOLAES (1620-83). Dutch painter of pastoral LANDSCAPES in the Italianate manner, principally active in Haarlem. He was the son of the fine STILL-LIFE painter Pieter CLAESZ, with whom he first studied, although their work is quite distinct. Among his teachers was Nicolaes Moeyaert (1620-83). After a visit to Italy in the 1640s he used the studies made there to paint Italianate landscapes throughout his career, and is considered the leading exponent in this field. Successful and well rewarded in his lifetime, he had numerous pupils and his influence on 18th-c. English and French landscape painters was considerable. Many engravings were made after his paintings in the 18th c. Several early GAINSBOROUGH's are described as exercises in the style of Berchem.

**BERCKHEYDE** GERRIT ADRIAENSZ (1638-98). Dutch painter of architectural views

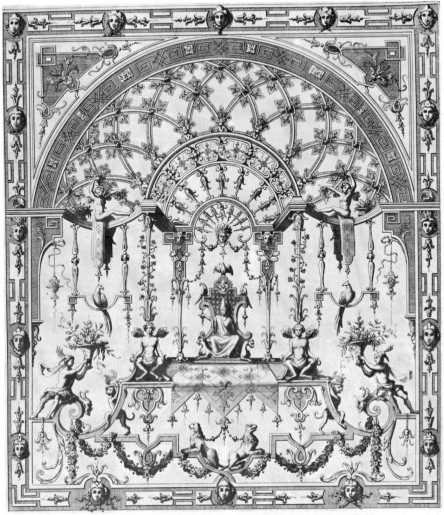

**41.** Engraving after Jean Bérain. Arabesque; chinoiserie; singerie. (Bib. nat., Paris)

who worked mainly in Haarlem and Amsterdam. His representations of those cities have great value as records of their aspect in the second half of the 17th c. Though his works have documentary accuracy, they are never dry but achieve a poetic harmony by a subtle use of light and shade. The work of Gerrit's elder brother, JOB ADRIAENSZ (1630–93), is very similar; it is also rarer and more varied. Job painted GENRE and biblical scenes as well as vistas of town squares and streets.

**BERENSON,** BERNHARD (1865–1959). Art historian, critic, and CONNOISSEUR. Born in Lithuania of Jewish descent, he went to the U.S.A. as a child, studied at Harvard and Oxford, and settled in Italy. His most widely known work

was *The Italian Painters of the Renaissance* (1930). As critic and historian he was distinguished by his use of the principle of TACTILE VALUES as a touchstone of assessment and interpretation.

**BERG,** CLAUS (active *c.* 1520–d. 1591). North German woodcarver, who worked in Lübeck but exported the products of his workshop as far as Sweden. He excelled in figures of dramatic pathos (Güstrow Cathedral, north Germany).

**BERGHE,** FRITS VAN DEN (1883–1939). Belgian artist who with Gustave de SMET and Constant PERMEKE was one of the creators of Belgian EXPRESSIONISM. He was distinguished by his imaginative fantasy, which created a fairy-like world of dream, subtly tragic and fascinating

in its nightmare quality, a world of visual imagery which was one of the earlier anticipations of SURREALISM.

1282.

**BERGOGNONE** (BORGOGNONE), AMBROGIO (active 1481-1523). Italian painter, who worked in the native Milanese tradition founded by Vincenzo FOPPA, with some admixture of Flemish features but little or no assimilation of the new RENAISSANCE ideas of LEONARDO. From 1488 to 1494/5 he worked on the enrichment of the Certosa di Pavia, painting FRESCOES, ALTARPIECES, and processional banners. There were also frescoes at Lodi (now lost) and at S. Satiro, Milan, of which fragments are now in the Brera. His style is static and undramatic, aiming at a typically late quattrocento mood of devotional calm, which is often enhanced by pale landscape backgrounds of great delicacy. There are good examples of his work in the National Gallery, London, the Brera, Milan, and the Pinacoteca, Pavia.

**BERKELEY**, GEORGE (1685-1753). English idealistic philosopher. In a Platonic dialogue he developed the 'inner sense' theory of Shaftesbury and Hutcheson, championing aesthetic feeling against reason and maintaining that beauty is a 'fugacious charm' based on symmetry and proportion and is directly felt in appreciation.

**BERLAGE**, HENDRIK PETRUS (1856-1934). Dutch architect and town-planner. He practised in Amsterdam from 1889 and was one of the leading pioneers of modern architectural design at the turn of the century. He was the founder of MODERN ARCHITECTURE in the Netherlands and was recognized by the younger generation as the outstanding personality and the creator of a new school of architecture and handicraft. He reacted vigorously against 19th-c. historicism and made a moral principle of honest craftsmanship and uncompromising integrity to the materials, even decrying the use of plaster as a species of falsification. In his early work he used brick, but later applied his principles of honesty and reason to concrete. In his early works, like his American counterpart Henry Hobson RICHARDSON, he revealed predilection for the strong and simple massiveness of the ROMANESQUE, but without direct imitation. In his later years he was to some extent influenced by EXPRESSIONISM. His masterpiece is the Amsterdam Stock Exchange (1897-1903), which exemplified his principle of undisguised rationality in the treatment of his materials and technical procedures.

**BERLINGHIERI.** A family of Italian painters active at Lucca in the 13th c. BERLINGHIERO BERLINGHIERI, the founder of the family, is called 'Milanese' in a document of 1228, which also mentions three sons, MARCO, BARONE, and BONAVENTURA. He is not otherwise known but a painted Cross (now in the Lucca Pinacoteca) signed 'Berlingeri' without Christian name is attributed to him. It is one of the finest examples of the Byzantine manner. The Cross of the Accademia, Florence, is also sometimes assigned to him.

BONAVENTURA, the most talented of his sons, is known chiefly for his signed and dated ALTARPIECE in the church of S. Francesco at Pescia (1235), which with its combination of solemn images and homely detail has been regarded as one of the most original, as it is one of the earliest, pictorial renderings of the Franciscan ideas. The *Scenes from the Life of St. Francis* in Sta Croce, Florence, and the *St. Francis receiving the Stigmata* in the Accademia, Florence, have also been attributed to him.

981.

**BERLIN MUSEUMS.** The first museum in Berlin was founded by King Frederick William III of Prussia in 1823 and was opened to the public in 1830. It was designed by Karl Friedrich SCHINKEL in the NEO-CLASSICAL style on an island in the river Spree, and was one of the first buildings to be specifically planned as a museum. The nucleus of the collection was formed by the Hohenzollern collections and those inherited from the House of Orange together with the private collections of Edward Solly (purchased in 1821) and of the GIUSTINIANI family (purchased in 1815). The first curator was a prominent art historian, Gustav Friedrich Waagen. From the unification of Germany (1871) until 1930 both the museum buildings and the collections expanded notably and the museum was under the direction of Wilhelm von Rode, one of the pioneers of modern museum organization and display.

The Berlin museum was damaged in the Second World War and since the end of that war the collections have been divided between East and West Germany. The majority of the paintings are in West Germany, displayed in an *Ehemalige Staatliche Museen*; the majority of the sculpture has been reinstated in the former buildings.

**BERMEJO**, BARTOLOMÉ (active 1474-95). Spanish painter and stained-glass designer, active in Barcelona from 1486. His *Pietà* in the cathedral, signed and dated 1490, is one of the earliest Spanish oil paintings. Representative of the Hispano-Flemish style, his intense REALISM recalls Nuño GONÇALVES.

**BERNARDINO DI BETTO.** See PINTO-RICCHIO.

**BERNINI**, PIETRO (1562-1629) and GIANLORENZO (1598-1680). Pietro, who is

best known as the father of Gianlorenzo Bernini, was a sculptor of talent with a remarkable facility in marble cutting. He was in constant demand for the many decorative schemes and ecclesiastical building projects in Rome and Naples between 1580 and his death. He was born and trained in Tuscany, but after 1584 worked principally at Naples, where Gianlorenzo was born. Outstanding among his works there is the large *Madonna* group in the Certosa di S. Martino. In 1604 he was summoned to Rome by Camillo Borghese (Pope Paul V, 1605–21) and worked with a number of other north Italian sculptors on the sumptuous decoration of the Capella Paolina (or Borghese) in the basilica of Sta Maria Maggiore, where he also carved the large relief of the *Assumption* which is now in the Baptistery. This relief displays a pictorial conception of sculpture and is in some respects akin to the painting of Ludovico CARRACCI. For the Barberini chapel in S. Andrea della Valle he carved a *St. John the Baptist* (1616), which had interesting affinities with one of Gianlorenzo's earliest groups, the *Aeneas and Anchises* (finished 1619). The latter, however, is firmer in modelling and has a surer grasp of anatomical structure.

Gianlorenzo or Giovanni Lorenzo, sculptor, painter, and architect, was the outstanding figure of the Italian BAROQUE and the greatest formative influence within it. He owed to his father not

42. *Self-Portrait* by Gianlorenzo Bernini. Chalk drawing (Windsor Castle, *c.* 1665). Reproduced by gracious permission of H.M. the Queen

only his early training in the handling of marble but his introduction to the group of powerful patrons, the Borghese and the BARBERINI, who so promptly fostered and employed his creative genius. He executed a series of marble sculptures for Cardinal Scipione Borghese which showed a fine precocity in the handling of the material and in their dramatic vigour and movement made a complete break with the then current tradition of late MANNERISM. These are the *Aeneas and Anchises* and the *David* (before 1620), the *Rape of Proserpine* (1622), and the *Apollo and Daphne* (1625). They are all in the BORGHESE GALLERY in Rome.

Upon the rise of Urban VIII Bernini became the principal artist in the papal court and in Rome. In 1629 he was appointed architect to St. Peter's, for which he made the great BALDAC-CHINO over the High Altar (finished 1633), and the sculptures decorating the piers of the crossing. At that pope's order he made the tomb of Urban VIII in the same church. But on Urban's death in 1644 Bernini fell under a cloud, partly owing to his lack of success in the construction of the lateral towers for St. Peter's but as much because of the different artistic tastes of the new pope, Innocent X. During Innocent's papacy Bernini worked mainly for private patrons. The Cornaro Chapel, with the *Rapture of St. Theresa*, in Sta Maria della Vittoria dates from this period, a comparatively small work, but an excellent example of Bernini's aims and achievement in the fusion of sculpture, architecture, and painting into a magnificent decorative whole. In 1655 he received a public commission for the fountains in the Piazza Navona.

After Innocent's death in 1655 and the accession of Alexander VII Bernini was restored to full favour. At Alexander's order he decorated the apse of St. Peter's with the group of the Fathers of the Church supporting the *Cathedra Petri* against an illusionistic background which, when viewed as the artist intended through the columns of the baldacchino, is intensely dramatic. In the same year he designed the colonnade round the piazza in front of the church and in 1663 the Scala Regia for the Vatican, making an ingenious use of false PERSPECTIVE to overcome the restricted space.

In 1665 Louis XIV invited Bernini to Paris to make plans for the LOUVRE. He was not, however, a success in France and the designs of PERRAULT were preferred to his (see FRENCH ART).

At the end of his career he made the tomb of Alexander VII in St. Peter's (1671–8) and built the church of S. Andrea at Quirinale for the Society of Jesus, with which he had always been in close contact.

In addition to these large works of sculpture and architecture Bernini executed many portrait busts, among which are the *Louis XIV* at VERSAILLES and the *Francesco d'Este* in the Modena Museum.

Besides being the official entrepreneur of the papacy in a period of its political ascendancy,

Bernini was also a brilliant wit, a writer of comedies, a CARICATURIST, and—for his private pleasure—a distinguished painter, though few of his pictures have survived. His conversations in France were recorded by Chantelou. A *Life* was published by his son Domenico in Rome in 1713. To the NEO-CLASSICAL taste of the 18th c. Bernini's approach to sculpture was anathema, but changes of fashion and taste among art historians in the 20th c. brought a more sympathetic recognition of his achievement.

144, 1311, 2923, 2925.

**BERRUGUETE.** The name of two Castilian artists, father and son, who are respectively associated with the beginnings of the RENAISSANCE and MANNERIST styles in Spain.

PEDRO (d. *c.* 1503), was court painter to Ferdinand and Isabella. He may have been the 'Pietro spagnuolo' employed in 1477 with MELOZZO DA FORLI and JUSTUS OF GHENT on the decoration of the palace library at Urbino. He was working at Toledo from 1483. Ten panels from the Dominican convent at Avila, now in the PRADO, demonstrate that his RENAISSANCE style was modified by the Flemish influences then prevailing in Spain.

ALONSO (*c.* 1488-1561), sculptor and painter, was the son and probably pupil of Pedro. For some years, between 1504 and 1517, he was in Italy. He completed Filippino LIPPI's *Coronation of the Virgin* (Louvre). This and other paintings (*Salome*, Uffizi) executed *c.* 1512 onwards at Florence in the manner of MICHELANGELO belong to the early Mannerism represented by ROSSO and PONTORMO. By 1518 Berruguete was back in Spain and had been appointed court painter to Charles V. He undertook a number of composite REREDOSES, incorporating paintings, carved reliefs, and statues within architectural settings. Characteristic of these works is the reredos of the monastery church of S. Benito, Valladolid, dating from 1526 (Valladolid Mus.). Between 1539 and 1547 he did carvings in alabaster and wood for the choir of Toledo Cathedral. His last work was the tomb of Cardinal Tavera at Toledo (1552-61). Several of his pen drawings are preserved in the UFFIZI. Michelangelo refers to him in his letters, VASARI mentions him several times in the *Lives*, and his contemporary Francisco de HOLANDA names him, with MACHUCA, as one of the pre-eminent Spanish masters or 'eagles' of his time.

1086, 1978.

**BERTOLDO DI GIOVANNI** (*c.* 1420-91). Italian sculptor, who is chiefly remembered for three things. First, he was the pupil and assistant of DONATELLO and teacher of MICHELANGELO, thus forming the link between the great masters of the Florentine 15th and 16th centuries. Secondly, he was described by VASARI as the first head of the ACADEMY of art which Lorenzo the Magnificent is said to have founded in the MEDICI

gardens by the Piazza di S. Marco. Thirdly, he developed a new type of sculpture—the small-scale bronze, intended, like the cabinet picture, for the private collector.

He was responsible for the completion of the two pulpits in S. Lorenzo left unfinished by Donatello at his death. His most noteworthy work is a bronze relief in the Bargello, Florence. Attributed to him also are a statuette *Orpheus* in the Bargello, a *Pietà* of which a replica is in the LOUVRE, and a mounted *Hercules* in the Museum at Modena.

**BESTIARY.** A moralized Natural History derived from the Greek *Physiologus*. The *Physiologus* was translated into Latin (8th- to 10th-c. manuscripts in Berne and Brussels) and this version was the direct parent of the medieval Latin Bestiary, which originated in England in the middle of the 12th c. It contains on an average 100 sections, each dealing with a particular animal or monster, of which a picture is shown, and pointing a moral. In the late 12th and 13th centuries the Bestiary was one of the leading picture books, particularly popular in England (e.g. Univ. Lib., Cambridge; Bodl. Lib., Oxford) and its images exerted a great influence in

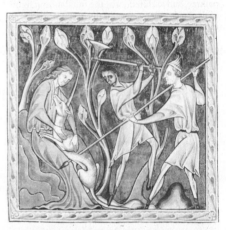

43. Miniature from English Bestiary (early 13th c.). The unicorn, a symbol of purity, is here used in an allegory of the Incarnation

medieval art, as one can see, for example, in the decoration of initials and later in MISERICORDS and roof BOSSES.

1422.

**BEWICK,** THOMAS (1755-1828). English animal artist and wood engraver, born at Newcastle upon Tyne, where he worked most of his life and established a school of engraving. In 1775 he received a prize from the Society of Arts for illustrations to Gay's *Fables*. In 1777 he went into partnership with the metal engraver Ralph Beilby (1744-1817), to whom he had been apprenticed at the age of 14. His best work is to

be found in illustrations to a number of works on natural history intended as educational books for young people. The most important are: *The Select Fables* (1784); *The Chillingham Bull* (1789); *A General History of Quadrupeds* (1790); and *A History of British Birds* (*Land Birds*, 1797, and *Water Birds*, 1804). Bewick was a bird-watcher and a countryman and drew from nature, often making his engravings from his own water-colours. His illustrations of animals, usually set in a background suggestive of their haunts, render their character as well as their superficial appearance. The animals which were unknown to him and taken from the illustrations of other artists (e.g. Buffon's *Natural History*) have a pawky vitality unconnected with realism. Bewick is most admired for his vignettes and tailpieces, which are miniature scenes of rural GENRE, showing with a rare felicity the countryside in its varying moods in all weathers and seasons and shrewdly observed pictorial comment on incidents of rustic life. In these tiny scenes and in the backgrounds to many of his animal illustrations

45A. *The Domestic Cock*. Wood engraving from *A History of British Birds*, Vol. I by Thomas Bewick

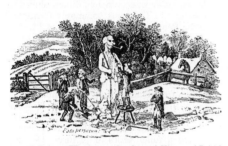

44A. Tailpiece. Wood engraving from *A History of British Birds*, Vol. I by Thomas Bewick

45B. *The Kanguroo*. Wood engraving from *A General History of Quadrupeds* by Thomas Bewick

44B. Tailpiece. Wood engraving from *A History of British Birds*, Vol. II by Thomas Bewick

Bewick's technical mastery and superb artistry reach their peak.

Bewick arrested the decline of engraving into a primarily reproductive technique and brought to it new expressive possibilities, reviving the white-line method. He used the end grain as distinct from the plank and worked it with graver or BURIN instead of a knife and with a remarkable facility he achieved a wide range of tones not by cross-hatching but by parallel lines, lowering that part of the block which was background so

that it received less pressure and printed grey. He adapted his technical skill to the expression of textures, foliage, etc. He has been called the father of modern wood engraving and although his books were popular in his own day, his reputation has stood higher since the third decade of the 20th c. not only as a technician but as an artist. The particular quality in which his work excelled was what he called 'colour', a combination of tone and texture which, together with his fine sense of design and his keen observation, have made him outstanding among English graphic artists.

Bewick's technique of wood engraving was carried on, though with less artistic talent, by a number of pupils and followers. These included his younger brother JOHN BEWICK, who was first his apprentice and then a member of the partnership with Beilby, and his son ROBERT

46A. Tailpiece. Wood engraving from *A History of British Birds*, Vol. I by Thomas Bewick

46B. Tailpiece. Wood engraving from *A History of British Birds*, Vol. I by Thomas Bewick

ELIOT BEWICK, who was also taken into the firm. John Bewick also carried on the style of book illustration and although his work is more stiff and wooden than that of his brother, there are often—as in *The Blossoms of Morality* (1796), a volume of cautionary tales for children in the Victorian manner—charming and accomplished tailpieces worthy of the hand of his brother.

2302, 2641.

**BEYEREN,** ABRAHAM VAN (1620/1–90). One of the finest Dutch painters of STILL LIFE. His earliest works are fish-pieces and this gives weight to the hypothesis that his teacher was the Dutch fish painter Pieter de Putter (1600–59). Even in his early works his talent is already apparent. The fish and crustacea he painted look as if they have just been taken from the sea. They are always wet. His virtuosity with colour enabled him to set off the browns, grey-greens, silver, and white of the creatures of the sea with the red of a slab of cut salmon or a lobster. Sometimes he painted a view of a beach and sea as background of his still lifes of fish. Around the middle of the 17th c. van Beyeren began to paint sumptuous banquet tables laden with silver and gold vessels, Venetian glassware, fine fruit, and expensive damask, satin, and velvet table coverings. These works gave him even greater opportunity to demonstrate his ability to show the play of light on surfaces and organize forms and colours into an opulently blended composition.

**BIBIENA** (GALLI-BIBIENA). Family of Italian architects and stage-designers based on Bologna, eight members of which practised from the 1670s until 1787 in practically every country of Europe. They provided fantastically elaborate stage-settings for operas, balls, state occasions, and religious ceremonies, mainly in the service of the Austrian Imperial family in Vienna and various German princelings. They also built several theatres in Italy and Germany, one of which survives: the Opera House at Bayreuth, decorated by GIUSEPPE in 1748. About 200 engravings of their designs are known, and they wrote several books, including FERDINANDO'S *Architettura civile* (Parma, 1711).

**BIBLE,** ILLUSTRATION OF THE. In the EARLY CHRISTIAN period single Books or groups of Books, rather than complete Bibles, tended to be illustrated. The most commonly illustrated were the Pentateuch (the five Books of Moses), the Octateuch (the first eight Books), the PSALTER, the GOSPELS, and the APOCALYPSE, and these remained the most fully illustrated sections in the complete Bibles of the early Middle Ages. The earliest surviving manuscripts are the fragmentary leaves from Quedlinburg (Staatsbib., Berlin, *c.* 400) with text and illustrations to the Books of Kings; the 6th-c. *Vienna* and *Cotton Genesis* MSS. (Staatsbib., Vienna, and B.M.), which contained a fuller series of pictures than any subsequent Genesis illustrations; and the *Ashburnham Pentateuch* (Bib. nat., Paris; probably Spain, 7th c.). Octateuchs, with illustrations based on Early Christian models, appeared in 11th- to 13th-c. Byzantium (Vatican Lib.; Istanbul, Serail).

Complete Bibles with illustrations (principally to Genesis and Exodus), based on Early Christian models, occur in the CAROLINGIAN period (B.M., Add. 10546; Bib. nat., Paris, Lat. 1, Tours, mid 9th c.; S. Paolo fuori le Mura, Rome; Reims, *c.* 870). Nothing similar has survived from the OTTONIAN period. ROMANESQUE art produced some of the most splendid of decorated Bibles (e.g. *Bury Bible*, Corpus Christi College, Cambridge, *c.* 1140), but illustration tended to play a smaller role than decoration and was on the whole limited to one miniature or historiated initial to each Book. GOTHIC Bibles were smaller and had still fewer illustrations, but at the same time large, sumptuously illustrated picture Bibles, often combining illustrations with scenes of historical or typological content, were produced for laymen. Most important of these are the *Bible moralisée* which contains over 5,000 small pictures (Bodl. Lib., Oxford; Bib. nat., Paris; B.M., *c.* 1240); the *Bible historiée*, combining the Bible with the more recent history of man (Bib. nat., Paris, mid 14th c.); and subse-

47. Design for pageant on the occasion of the wedding of the Prince of Bavaria. By Giuseppe Galli-Bibiena. From *Architetture e prospettive dedicate alla Maestà di Carlo Sesto, Imperador de' Romani* (1740)

quently the great typological books such as the BIBLIA PAUPERUM.

The ordinary illustrated Bible reappeared with the introduction of printing and of the woodcut (German Bible, Heinrich Quentell, Cologne, 1478-9). Subsequent editions, and in particular the Protestant translations in Germany, were illustrated by outstanding artists including BURGKMAIR (Augsburg, 1523) and HOLBEIN (Basel, 1522 and 1523). Numerous illustrated editions of the Bible were published in the following centuries, of which the 19th c. produced the most outstanding examples (e.g. Gustave DORÉ, 1866). Several modern artists, including ROUAULT and CHAGALL, have made series of etchings of biblical illustrations; and a complete illustrated Old Testament was published by the Oxford University Press in 1968-9, with work by a group of contemporary artists. (See also ILLUMINATED MANUSCRIPTS.)

**BIBLIA PAUPERUM.** The so-called *Biblia Pauperum*, or *Biblia Picta*, was the first medieval textbook of Christian typology, showing in pictures how the principal events from the life of Christ were prefigured in the Old Testament (see TYPOLOGICAL BIBLICAL ILLUSTRATION). Unlike the SPECULUM HUMANAE SALVATIONIS the *Biblia Pauperum* is strictly scriptural, admitting no historical or secular subjects among its types.

Devised in south Germany in the late 13th c. the *Biblia Pauperum* consists in its fullest form of 40 sets of subjects: an antitype flanked by two types, accompanied by four prophetical quota-

tions and an explanatory text in Latin verse. The earliest existing manuscript dates from *c.* 1300 (Munich).

Issued as a BLOCK BOOK, the *Biblia Pauperum* was particularly popular in Germany, but had little vogue in Italy or Spain. It was copied and adapted in late medieval sculpture, tapestries, stained glass, and in easel pictures (15th-c. tapestries, abbaye de la Chaise-Dieu; Collegiate Church, Tattershall, Lincs.; altarpiece, Pseudo-Blesius, Prado).

**BIEDERMEIER.** Term sometimes used to describe GERMAN and AUSTRIAN ART and architecture between the Congress of Vienna (1815) and the Revolution of 1848. Gottlieb Biedermeier was a somewhat ludicrous imaginary figure, who made his appearance in the satirical literature of the time and personified the solid yet Philistine qualities of the bourgeois middle classes. The art to which he has lent his name shares these qualities: the magic poetry of ROMANTIC LANDSCAPE PAINTING is replaced by sober realism; heroic themes give place to the illustration of fairy-tales or legends, and portraits concern themselves with the minutiae of appearance and costume rather than the imaginative projection of personality. In architecture instead of the grandiloquent NEO-CLASSICAL forms we find sound utilitarian structures of good proportions. There were, as is to be expected, no major masters of Bierdermeier but many excellent practitioners.

**BIGORDI.** See GHIRLANDAIO.

**BIGUERNY.** See VIGARNY.

**BIHZAD,** KAMAL UD-DIN (c. 1460–1535). Persia's greatest painter. Orphaned at an early age, he was brought up by the painter Mirak Naqqash at Herat, the capital of Sultan Husain Mirza, the last descendant of Timur to wield effective power in Persia. Bihzad was first employed by the Sultan's famous prime minister, Mir Ali Shir Nava'i, and subsequently joined the staff of the royal library. In 1507 Herat was captured by the Uzbeks and Bihzad remained in the city in the employ of the conqueror. But in 1510 Herat was incorporated into the new Persian kingdom by Shah Isma'il, founder of the Safavid dynasty. Bihzad was brought to Tabriz, the capital of the kingdom. In 1522 he was appointed director of the royal library and may still have held this office in the reign of Shah Isma'il's successor, Shah Tahmasp.

Many paintings have been ascribed to Bihzad, but current opinion accepts only some 32 MINIATURES as the genuine work of the master. These were executed between 1486 and 1495 and thus represent less than 10 years of his long artistic career. Five miniatures which he contributed to a manuscript of Sa'di's *Bustan*, copied in 1488 and now preserved in the National Library, Cairo, are generally regarded as the touchstone of his style. Two manuscripts of Nizami's *Khamsa* are preserved in the British Museum and contain between them 18 miniatures by Bihzad.

Bihzad seems to have been the prime influence in the school of painting that developed at Herat in the last two decades of the 15th c. (see PERSIAN ART). He accepted the established conventions of the Persian miniature but injected new vitality into it by his outstanding power of composition and his exceptional sense of colour relationships. The expressive power of his line endowed his figures with an animation that was lacking in those of his predecessors. He thus gave a new direction to the miniature which had a profound influence on succeeding generations of artists in Persia, Turkey, and India.

**BINGHAM,** GEORGE CALEB (1811–79). American artist. Born in Virginia, he settled at an early age in Missouri and set himself to paint the life of the frontier people, imparting an air of heroic grandeur to everyday scenes. His canvases such as *The Fur Traders Descending the Missouri* (Met. Mus., New York, 1845) and *The Trappers' Return* (Detroit Institute of Art, 1851) create visual poetry from the commonplace and have a pleasing graciousness of colouring despite a residuum of the primitive crudity which besets the untrained provincial artist. In 1857 he went to Düsseldorf and in 1877 became Professor of Art in the University of Missouri. But the racy idiomatic tang of his strangely formal early compositions had been infected by the mawkish sentimentality of Germanic ROMANTICISM and there is less to interest in his subsequent output.

543, 1721.

**BIRD,** FRANCIS (1667–1731). English sculptor. He went as a boy to be trained in Brussels and later visited Rome more than once. On his first return to England, c. 1687, he was employed for a time in Grinling GIBBONS's workshop. He did much work for WREN at St. Paul's, including the lively scene of *The Conversion of St. Paul* (1706) in the west PEDIMENT, treated in a fully BAROQUE manner, and a number of monuments, the finest and probably the earliest being that of *Dr. Busby* at Westminster Abbey. His work is uneven, but some of his later monuments, such as the *Dr. Ernest Grabe* (Westminster Abbey, c. 1713), have considerable quality, while his large tomb of the Duke of Newcastle (1723), also at Westminster, made from the designs of the architect James GIBBS, was to prove extremely influential.

**BISSCHOP,** JAN (1628–71). Dutch lawyer and dilettante draughtsman who travelled extensively and made accurate wash drawings of the paintings and sculpture he examined. These are valued today because many of them are records of lost works of art. He also made exquisite small drawings of the scenery which he saw on his travels and a few of these rank among the finest 17th-c. Dutch landscape drawings.

**BISSIÈRE,** ROGER (1888–1964). French painter, born in the province of Lot-et-Garonne. His early paintings were landscapes which imbued his native countryside with a monumental dignity. He came to Paris in 1910 and earned a living as a journalist while continuing to paint. After a period of experimentation with CUBISM, during which he produced pictures—since largely forgotten—of outstanding value and sensitivity in the Cubist idiom, he was for a time associated with the *esprit nouveau* movement initiated by OZENFANT and LE CORBUSIER. As a teacher at the Académie Ranson his influence on many of the younger ABSTRACT artists, such as MANESSIER and the Portuguese painter VIEIRA DA SILVA, was profound, but his own work during the 1920s and 1930s remained highly individual and almost unknown. In 1938 he retired to Lot as a virtually unknown painter. During the war his sight was dimmed by a glaucoma to less than one-third of normal vision and, unable to paint, he produced compositions pieced together from tapestry and other materials (a technique later taken up by the Spanish artist Clavé). A successful operation in 1948 enabled him to resume painting and during the 1950s he achieved the resounding recognition which had so long escaped him. He obtained the Prix National in 1952 and just before the end of his life represented France at the Venice Biennale. His large, tapestry-like compositions in rich and glowing colours were exhibited internationally

and commanded among the highest prices of any living artist. Abstract in appearance, they resulted from the careful and sensitive reduction of natural scenes to scintillating patterns of interacting colours, and Bissière himself always refused to accept the term 'abstract' for his own work. The recognition accorded to the work of his later years induced the more discriminating collectors and connoisseurs to reassess the work of his early and middle periods, which Bissière himself was accustomed to say might in course of time be valued even above that which had brought him popularity. In a letter published in the catalogue to the exhibition of his works at Amsterdam in 1958 he wrote: 'J'ai Horreur de tout ce qui est systematique. De tout ce qui tend à m'enfermer dans des barrières. Ma peinture est l'image de ma vie. Le miroir de l'homme que je suis, tout entier avex ses faiblesses aussi. Devant ma toile je ne pense pas au chef d'œuvre... La perfection d'ailleurs serait inhumaine. Un tableau sans defauts perdrait son rayonnement et sa chaleur. Il cesserait d'être l'expression vivante et concrete d'un homme.'

903.

**BISTRE.** A brown PIGMENT prepared by boiling soot. Without body and transparent, it is often used as a wash for pen-and-ink drawings, water-colours, and MINIATURES. REMBRANDT and CLAUDE were among the artists who exploited its potentialities.

**BITUMEN** (asphaltum). A transparent brown PIGMENT which at the time of using gives a rich, glowing quality, but later becomes almost black and increasingly opaque. It never completely hardens and eventually develops a characteristic CRAQUELURE. Its poor drying power has caused damage when it has been used for UNDERPAINTING, as for example by English 18th-c. painters, particularly REYNOLDS, and to a lesser degree in the 19th c. It is suitable for use as a GLAZE, as for example by REMBRANDT.

**BLAIR, HUGH** (1718-1800). Scottish divine, littérateur, and Professor of Rhetoric and Belles-Lettres in Edinburgh University. Although not a profound or original thinker, Blair's *Lectures on Rhetoric and Belles Lettres* (1783) were of immense importance in his day for popularizing aesthetic and critical speculation. There are more than 60 editions in English and nearly 50 abbreviated editions and translations into German, French, Spanish, Italian, and Russian.

**BLAKE, WILLIAM** (1757-1827). English artist, philosopher, and poet. From childhood he possessed sensual visionary powers, and the engraving of *Joseph of Arimathea* (characteristically based on a figure by MICHELANGELO), done at the age of 16, shows him already using a personal symbolism to express his mystical philosophy.

His apprenticeship to the engraver James Basire (1730-1802), for whom he made drawings of the monuments in Westminster Abbey and other London churches, led him to a close study of GOTHIC art and intensified his love of linear design and formal pattern. As he regarded art, imagination, and religion as synonymous, his rejection of what was to him the dull and woolly realism of the Academicians was accompanied by revolutionary political theories and a distaste for conventional morality. In 1778 he entered the R.A. Schools but his relations with REYNOLDS were painful; later he was to find more sympathetic spirits in STOTHARD, FLAXMAN, FUSELI, and BARRY.

From about 1787 he became engrossed in a new method of printing his own illustrated poems in colour, which he characteristically claimed to have been revealed to him in a vision by his brother Robert, then recently deceased. The first of these major works of 'illuminated printing', in which handwritten text and illustration were engraved together to form a decorative unit, was the *Songs of Innocence* (1789). In 1793 with his wife, Catherine Boutcher, he settled in Lambeth, where he completed a number of the so-called Prophetic Books and drawings for Young's *Night Thoughts*. He also engraved his principal prose work, *Marriage of Heaven and Hell*. His material success, however, was disappointing and in 1800, at the suggestion of William Hayley, poet and man of letters, he left London to settle for three years at Felpham on the Sussex coast. Here he continued the series of water-colours illustrating biblical subjects for his first and most generous patron, Thomas Butts, and carried out a number of commissions for Hayley and other local patrons. He composed in 1804 a voluminous epic poem, *The Four Zoas*, in which his mystical conception of man and the universe is expressed in elaborate symbolism, and he also began to engrave *Milton* and *Jerusalem*, the last and longest of his surviving mystical writings. On his return to London Blake made a series of drawings for Robert Blair's poem *The Grave*, and in 1809 held a small one-man exhibition for which he issued *A Descriptive Catalogue*, eloquently summarizing his aims and convictions about art. This earned him but little recognition, however, and there followed a period of eclipse, during which he appears to have been unproductive, until 1818, when the sympathetic patronage of the painter John LINNELL ensured him a livelihood for the remainder of his life. For Linnell he carried out his engravings for *The Book of Job* and his magnificent designs for *The Divine Comedy*, on which he was working up to the time of his death. Linnell introduced to him a group of younger artists, including VARLEY, CALVERT, PALMER, who were in their several ways inspired and stimulated by Blake's imaginative power. He thus passed his last years surrounded by a group of admiring disciples, who formed themselves into a kind of Brotherhood under the name 'The Ancients'.

In art as in life Blake was an individualist who made a principle of nonconformity. He had a prejudice against painting in oils on canvas and experimented with a variety of techniques in colour printing, illustration, and tempera. Some of his tempera paintings have deteriorated, but much of his work in new techniques remains in a good state of preservation. As a philosopher Blake might be called a mystical realist. He believed that the visible world of the senses is an unreal envelope behind which the spiritual reality is concealed. And he believed that the artist is engaged in a spiritual activity whose essence consists in precise delineation of reality, which is revealed to the visionary imagination. This activity can only be impeded by visual experience or by reproducing the forms of the visible world. Blake set himself the impossible task of creating a visual symbolism for the expression of his spiritual visions that would owe nothing to ordinary visual experience. He refused the easy path of vagueness and misty suggestion, remaining content with nothing less than the maximum of clarity and precision. For this he pinned his faith to line, developing a linear style characterized by a MANNERIST idiom which has been regarded as the forerunner of English ART NOUVEAU. He used colour non-naturalistically

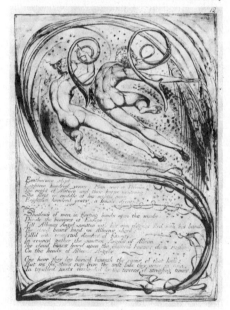

**48.** *Shadows of men in fleeting bands upon the winds: Divide the heavens of Europe.* Illustration for *Europe.* Pen-and-ink, coloured wash drawing by William Blake. (T. H. Riches Coll.)

for aesthetic or emotional effect. As an artist Blake is difficult to appraise and his work is almost impossible to divorce from the mystical philosophy expressed also through his poetry. At his finest he is generally admitted to be superb in convincingness and power: at times some would judge him mannered but rarely ineffective in his visual impact. Like most individualists and eccentrics he was inclined to exaggeration and perhaps the most telling comment on himself is his own comment on Reynolds: 'Reynolds thought Character Itself Extravagance and Deformity.' In the 20th c. Blake has had a renewed interest for such artists as Leon Underwood and Paul NASH.

277, 308, 868, 1040, 1215, 1485, 1486, 2286, 2905.

**BLANCHARD,** JACQUES (1600-38). French painter who was brought up by a painter Nicolas Bollerg, his uncle, in the late MANNERIST tradition and later studied in Italy (1624-8). He drew his inspiration mainly from the Venetians, particularly VERONESE, making delicate use of reflected light in his treatment of flesh (*Charity*, Lady Lee Coll., London University, 1637). The earlier *Medor and Angelica* (Met. Mus., New York) is more Mannerist in style. *Cimon and Iphigenia* (Louvre) and other paintings show the influence of RUBENS. As a minor painter of small religious and mythological subjects in a sensitive but sentimental manner he achieved a certain success. His son, GABRIEL BLANCHARD, attacked Philippe de CHAMPAIGNE in 1671 in the quarrel about the relative importance of colour versus drawing (see FRENCH ART, 'Poussinistes' versus 'Rubensistes').

**BLAST.** See VORTICISM.

**BLAUE REITER,** DER. The name taken by a loosely organized group of artists with revolutionary aims formed in Germany in 1911. The association had its origin when the Committee of the *Neue Künstlervereinigung*, formed by the Russians KANDINSKY and JAWLENSKY in 1909, rejected Kandinsky's picture *The Last Judgement* for their 1911 exhibition. Thereupon Kandinsky together with Franz MARC organized a rival exhibition at the Gallery Thannhauser, Munich, and a group which was named after a picture of Kandinsky's *Le Cavalier bleu*. Other prominent members of the group were Paul KLEE and August MACKE. A second exhibition was held at Munich in 1912, devoted this time to the graphic arts and including work by members of Die BRÜCKE, and in the same year an exhibition at the Sturm gallery in Berlin. In 1913 the Blaue Reiter artists participated in the German *Salon d'automne* exhibition also at the Sturm gallery, and in 1914 the group was dispersed through the outbreak of the war.

The *Blaue Reiter* association was international in its character and affiliations. Among the members were two Swiss artists, Louis-René Moilliet and Henry Niestlé. The first exhibition included canvases by the Douanier ROUSSEAU and Robert DELAUNAY. The second included BRAQUE, DERAIN, La Fresnaye (1885-1925), PICASSO, VLAMINCK, and the Russians Larionov (1881-1964) and Goncharova (1881-1962). The

**49.** Woodcut by Kandinsky for *Der Blaue Reiter Almanac* (1911)

aims of the association were never closely defined and it is obvious that the individual artists associated differed widely in their work and outlook. Their bond was a general desire to embody symbolically in their painting spiritual realities which, it was thought, had been neglected by the IMPRESSIONISTS. The Prospectus attached to the catalogue of the first exhibition contained the statement: 'To give expression to inner impulses in every form which provokes an intimate reaction in the beholder, such is the goal which the *Blaue Reiter* will aspire to achieve. We seek today, behind the veil of external appearances, the hidden things which seem to us more important than the discoveries of the Impressionists. . . . We search out and elaborate this spiritual side of ourselves in nature, not from caprice or for the sake of being different but because this is the side we see just as previously people suddenly saw violet shadows and atmosphere before anything else. . . .'

422.

**BLECHEN, KARL** (1798-1840). Highly versatile German painter with an eye for tone and light effects in town and countryside. For a time he was under the influence of such ROMANTICS as C. D. FRIEDRICH, but later he developed a more painterly style, producing rather unconventional open-air landscapes which foreshadowed IMPRESSIONISM.

2182.

**BLEED.** Painters' term for the action of an under layer of PAINT when it seeps through superimposed layers and comes to the surface, mixing with the upper layers of paint and changing their colour. This happens when the PIGMENT is soluble in the MEDIUM. It is in order to prevent bleeding that pigments used in OIL PAINTING must be insoluble in oil or 'oil-proof', colours used in FRESCO must be 'lime-proof', and so on.

**BLES, HERRI MET DE** (*c.* 1500/10-after 1550). Flemish painter of LANDSCAPES with figures, also known as Herri Patenier. Very little is known about his life, but in 1535 a painter by the name of Herri Patenier entered the Antwerp Guild. Herri met de Bles is simply a nickname meaning 'Herri with the white forelock', and it is generally assumed that he was a relation of Joachin PATENIER, who certainly had a decisive influence on his work. No signed work by Herri exists, but a *Mountain Landscape with the Holy Family and St. John* (Basel) was described as the work of Heinrich Blesii in 1568. A small group of works have been ascribed to him which are characterized by panoramic landscapes dominating the figure groups in the manner of Patenier. Yet his style is distinctive. His work was popular with Italian collectors, who called him Civetta (owl) because he often included owls in his pictures.

**BLOCK BOOKS.** Books printed entirely from WOODCUT blocks, as opposed to those printed by means of movable type. Each page of text, or of text and illustrations combined, is cut on a single block. (See WOODCUT.)

Early 15th-c. woodcuts frequently included a few lines of descriptive text as part of the design, and doubtless they were often fastened together to form a simple book. The block book was a natural development from such collections of single-sheet prints, and its place in the history of book production is therefore in fact that of a sterile descendant of the woodcut rather than an ancestor of printing from movable type. The precise date of the earliest block books is difficult to establish, as is that of the invention of printing, but the years 1440-50 may reasonably be taken to cover both. As the entire text had to be cut letter by letter on wood blocks, the process was extremely laborious and suitable only for short books in continuous popular demand. A good example is the APOCALYPSE, issued in a number of editions in the Low Countries and Germany between *c.* 1440 and 1470; other important block books were the *Ars Moriendi* and the BIBLIA PAUPERUM, both first published *c.* 1450.

Very few block books were made after 1500. They had always been largely pictorial in character, but the RENAISSANCE revival of learning and literature created a demand for books with an increasing proportion of text; and printing from movable type, where the letters are all separate and can be used again and again, was the only possible way of meeting this demand cheaply and efficiently. Since then the hand-engraved

book has appeared only in isolated instances, either as a provincial anachronism or as an artistic experiment.

**BLOEMAERT**, ABRAHAM (1564-1651). Dutch historical and landscape painter, who was active in Utrecht. He was extremely successful as a teacher: Gerard HONTHORST, Hendrick TERBRUGGHEN, Jan BOTH, Cornelis POELEN-BURGH, Jacob Gerritsz CUYP, Jan Baptist WEENIX, four of his sons, and about 20 other artists who worked in Utrecht were his pupils. And he himself learned readily from others. He began as a representative of the MANNERISM which SPRANGER made popular in northern Europe; when his pupils Terbrugghen and Honthorst returned to Utrecht from Italy with word about the spectacular things CARAVAGGIO was doing with light and shadow, he became for a time a Caravaggesque painter; during the last decades of his life he adopted some aspects of the CLASSI-CISM of the CARRACCI. His most original works are his realistic landscape drawings. All facets of his work can best be studied in the museum in Utrecht. Many of his drawings were etched and published by his son FREDERICK in a well-known DRAWING BOOK for the use of art students.
711.

**BLONDEEL**, LANCELOT (1496-1561). Flemish artist who entered the Guild of Painters in Bruges in 1519. He also worked as an architect and designed sculpture, tapestries, and pageant decorations. In 1550 he and Jan SCOREL were commissioned to make restorations on the most famous 15th-c. Netherlandish work of art: *The Adoration of the Lamb* by Hubert and Jan van EYCK. His designs for sculpture included the *Chimney Piece in the Greffe du Franc* at Bruges. The triptych of *The Martyrdom of SS. Cosmas and Damian* (S. Jacques, Bruges, dated 1523) has figures imprisoned in an elaborate framework of RENAISSANCE architecture but shows that misunderstanding of Italian forms which was characteristic of Flemish painting at that date.

**BLONDEL**, JACQUES-FRANÇOIS (1705-74). French architect, not apparently related to N.-F. BLONDEL. He had considerable influence in the latter part of the 18th c. through his teach-

50. Royal Chapel of Versailles. From *Cours d'architecture* (1771-7), Vol. IV, by J.-François Blondel

ing in the Académie, where he became a professor in 1759, and in his own school (opened 1742; the first in France outside the Académie). He was known chiefly as a theorist through his publications *De la distribution des maisons de plaisance* (1737-8), *Architecture françoise* (1752-6), a folio of engravings with commentary, and *Cours d'architecture* (1771-7), the last of which was completed by Pierre Patte (1723-1814). He was also responsible for public buildings at Strasbourg (Town Hall; theatre), Cambrai (Archbishop's palace), and Metz (Place d'Armes; Hôtel de Ville).

303.

**BLONDEL,** NICOLAS-FRANÇOIS (1618-86). French military engineer and architect. He drew up town plans (e.g. Rocheport) and plans for fortifications. The most important of his surviving buildings is the Porte S. Denis, Paris (1671 onwards). He was most active, however, in theory of architecture and was Professor of Mathematics at the Collège de France, first Director of the New Royal Academy of Architecture, and first Professor of the Academy School. In these capacities he propagated the classical and rationalistic principles of the Académie, later codified in his *Cours d'Architecture enseigné à l'Académie royale* (1675, 1683, 1698).

**BLOOTELING,** ABRAHAM (1640-90). Dutch engraver and publisher. He was probably the first artist to make systematic use of the rocker and scraper in MEZZOTINT engraving.

**BLORE,** EDWARD (1787-1879). English Neo-Gothic architect. He was chosen by Sir Walter Scott to design his GOTHIC REVIVAL mansion at Abbotsford, and he also furnished the architectural illustrations for Scott's book on Scottish antiquities. Blore completed Buckingham Palace after a Select Committee had been set up on the death of George IV to inquire into its finances and the work taken out of the hands of NASH, but little of Blore's work can be seen since the palace was refronted by Sir Aston Webb (1849-1930) in the early 20th c. Blore had a busy architectural practice, was Surveyor to Westminster Abbey, worked at Lambeth Palace, Windsor Castle, and Hampton Court, and designed a number of churches and the inappropriately ecclesiastical Pitt Press at Cambridge (c. 1830).

**BLOT DRAWING.** A technique evolved by Alexander COZENS and described in *A New Method for assisting the invention in drawing original compositions of Landscape* (1786). He prescribed the use of an accidental stain or 'blot' on the paper as a basis for an imaginative landscape

**51.** Blot drawing (landscape). Aquatint from *A New Method of assisting the invention in drawing original compositions of Landscape* (1785) by Alexander Cozens

composition. A similar suggestion was made by LEONARDO DA VINCI, who proposed that marks on wall surfaces might be used in this way. Somewhat similar techniques were used in the 20th c. by the SURREALISTS for stimulating subconscious imagery. They also devised a method of folding a piece of paper over upon a wet blot in order to obtain casual but interesting patterns. 653.

**BLUE FOUR,** THE. A name adopted by the painters KLEE, KANDINSKY, FEININGER, and JAWLENSKY when they exhibited together in Europe and America from 1924.

**BOCCADOR,** LE. See DOMENICO DA CORTONA.

**BOCCIONI,** UMBERTO (1882-1916). Italian FUTURIST painter and theorist, and the only sculptor in the movement. In Rome together with SEVERINI he learnt from BALLA the principles of DIVISIONISM, which was then the vogue. In 1910 he signed the *Technical Manifesto of Futurist Painting* and from then until 1914 was the chief exponent of Futurist theory. He advocated a complete break with the past, felt poisoned by the art of 1900, and made it his aim to give life to matter by transposing it in terms of movement, e.g. a horse's movement in a race would be rendered by painting its successive positions simultaneously. A well known painting of this kind is his *Elasticity* (1912). He knew and was influenced by the CUBISTS although their aims were different. In his sculpture, often combining in one work such different materials as iron, wood, and glass, he avoided using straight lines in favour of what he called 'lines of force' (*Unique forms of continuity in space*). He was conscripted and died in an accident in 1916.

In 1914 Boccioni published a book called *Futurist Painting and Non-Culture*. He claimed that whereas the IMPRESSIONISTS painted to perpetuate a single moment of vision, Futurism synthesizes in a picture all possible moments. In contrast to the objective outlook of Cubism he claimed that Futurist painting aspires also to express 'states of the soul'. His own 'lines of force' were explained in opposition to the META-PHYSICAL painters and were supposed to embody the 'form force' and the 'colour force' with which an object reacts to its environment. The way in which these concepts did not become clear in the work of the Futurists did not become clear.

146, 319, 320, 706.

**BODY.** Painters' term for the substance which a colouring matter must have in order to be a PIGMENT usable by artists. Earth colours and many others have body. But some colouring matters are in the nature of stains or dyes and these need to be precipitated on to an inert substance which is coloured by them and thus forms a pigment which can be ground up into a MEDIUM to form a PAINT.

Body is closely related to the *opacity* of a paint, sometimes called its *covering power* or ability to conceal the surface to which it is applied. Covering power depends on the amount of light which is either reflected or absorbed by the paint and this in turn depends on the thickness with which the paint is applied, on the nature of the pigment body, and on the medium. The converse of opacity is *transparence*, which depends on the amount of light which the paint allows to pass through to the surface below. *Luminosity* is obtained when a light and reflecting under-surface shines through a partially transparent paint. By *brightness* or *brilliance* is sometimes meant the amount of light which a paint reflects rather than absorbs or transmits.

The term 'body' has a special meaning in connection with WATER-COLOUR, referring to the white filler with which water-colour pigments are sometimes mixed in order to render the paint opaque. Thus 'body colour' is sometimes used as an alternative name for GOUACHE.

**BOECKLIN,** ARNOLD (1827-1901). Swiss painter. His early works—mainly Swiss and Italian landscapes—give evidence of acute observation united with a feeling for refined colour effects. Later these landscapes were usually peopled with mythological or symbolic figures which were used to heighten the mood. Boecklin was not satisfied with painting a Mediterranean seascape: Naiads and Tritons chase each other through the waves. In the hot glow of a southern noon Pan appears from behind the rocks and frightens some shepherds; the mysterious stillness and twilight of a forest are enhanced by the mysterious figure on a unicorn. Boecklin was a consummate craftsman and a profound student of painting techniques; but today, while the meticulous skill of his brushwork evokes admiration, his realistic nymphs and centaurs strike one as slightly ridiculous. Boecklin spent much of his life in Italy and the influence of Italian scenery is ubiquitous in his paintings. Like LEONARDO—whom he disliked—he experimented with flying machines. The best collection of his works is at Basel.

2426.

**BOETHUS.** Greek sculptor who worked in the 2nd c. B.C. PLINY (*Nat. Hist.* xxxiv. 84) mentions a bronze by him representing a *Child Strangling a Goose* by hugging it, though he adds that Boethus was better in silver. The theme of this composition has been brought into relation with a reference in the fourth sketch of Herodas to a statue of a boy strangling a goose in the temple of Asclepius at Cos and is attested for the 3rd c. B.C. by a terracotta from Alexandria. Two different Roman marble groups (in Vienna and Munich) have been thought to be copies. The group appealed to RENAISSANCE sculptors and echoes of it can be seen in sculpture from VERROCCHIO to BERNINI.

**BOFFRAND,** GABRIEL-GERMAIN (1667-1754). French architect and engineer, born at

Nancy. He was a pupil of Jules Hardouin-MANSART and was one of the most gifted architects of the Regency. He was made a member of the Académie in 1709 and became Inspector General of Highways and Bridges in 1732. Very little of his work survives either in Paris or in Lorraine and little is known of it from contemporary engravings. In Paris he was responsible for enlarging and decorating the Hôtel Soubise, remodelled the Hôtel de Livry and the Hôtel de Mayenne, did the decorations of the Petit-Luxembourg, built the house for Mme d'Argenton which from 1725 was used as the Chancellerie d'Orléans, and many more. He continued the cathedral of Nancy, which was begun by Mansart in 1703, the colonnade of the Palais du Gouvernement at Nancy, the church of S. Jacques at Lunéville, the Château de la Malgrange (begun 1711, left unfinished in 1715). He had considerable reputation outside France, followed Mansart as architect to the Elector Leopold of Bavaria (for whom he planned the archiepiscopal palace at Würzburg), and worked for the Elector of Mainz (for whom he designed La Favorite near Mainz).

**BOGART,** MARTIN. See DESJARDINS.

**BOHEMIAN SCHOOL.** This term—translated from the German *Böhmische Malerschule*—is a conventional but misleading label for the art produced in Bohemia during the second half of the 14th c. After the death of the blind King John at Crécy (1346) his son Charles (of the House of Luxembourg) succeeded to the throne of Bohemia and was made Emperor in 1348. Prague became his favourite residence. There he founded a university and drew to his court scholars and artists from all over Europe. Petrarch has left us a glowing account of the intellectual life in Prague at this time. There is nothing 'native' in the works of art commissioned by Charles IV and his circle. In fact an international style was born in Prague, which not only influenced all Bohemia but spread into Germany and towards the east just as the artists came from many parts of Europe. Matthew of Arras came from Flanders to build parts of Karlstein Castle and to begin the cathedral of S. Vitus; he was followed by Peter PARLER from Swabia. A painter from north Italy was called to do frescoes, and others came from Strasbourg and Nuremberg. Manuscripts were imported from France and Italy and inspired a local school of book illumination.

Much of the work done at the time perished in the Hussite troubles. Some panel paintings and frescoes survive; the masters for the greater part are anonymous and we know nothing about their nationality. Yet they all bear witness to a style in which were fused many influences. During the 1350s, in the work of the MASTER OF VIŠŠÍ BROD (Hohenfurth) the flavour was strongly Italian; Sienese models in particular seem to

have been used. Later with the MASTER OF THE TŘEBOŇ ALTAR (Wittingau), who must have worked during the last two decades of the century, French elements became stronger. In his art we find a fine feeling for the modelling of the human figure, combined with an expressive manner and an almost lyrical mood. Under Charles's son Wenceslas painting, and in particular illumination, still flourished but the importance of Prague as an artistic centre declined early in the 15th c.

1792, 2026.

**BOILLY,** LOUIS-LÉOPOLD (1761-1845). French painter and engraver. When he was 11 years old he painted a large picture *Saint Roche Healing the Plague-Stricken* for the Brotherhood of S. Roche. He painted portraits (*Portrait of Robespierre*), domestic and GENRE scenes, and *scènes galantes*, which brought him into disrepute at the time of the Revolution. Under the Directoire he reverted to genre and boudoir scenes and his success lasted under the Empire. In 1823 he was one of the first to experiment with LITHOGRAPHY and used this technique to popularize his scenes from contemporary life. He was extremely prolific (claiming to have executed 5,000 portraits), smooth and meticulous in his technique. His best known picture is *The Arrival of the Diligence* (Louvre, 1803), and he also painted *Isabey's Studio* (1798). There are three of his pictures in the Wallace Collection and others in the Musée des Arts décoratifs and the Musée Cognacq-Jay.

**BOIZOT,** SIMON LOUIS (1743-1809). French sculptor. He succeeded FALCONET as Director of Mme de Pompadour's porcelain factory at Sèvres.

**BOL,** FERDINAND (1618-80). Dutch painter who entered REMBRANDT's studio *c.* 1633-5. He was one of Rembrandt's most productive pupils and also one of the best. The portrait of Elizabeth Bas (Amsterdam), now acknowledged as a work by Bol, was mistaken for a Rembrandt until 1911. But *c.* 1650, following the trend of taste, he discarded Rembrandt's influence and turned to the elegant manner of van der HELST popular in Amsterdam after the middle of the 17th c. In 1669 he married a wealthy widow and seems to have stopped painting.

**BOLE** (BOLUS). A natural clay sometimes used for GROUNDS, chiefly in OIL PAINTING. Red bole is the commonest, and has served as a ground for gilding since the Middle Ages. The expression 'bole ground' may mean any ground in which a red earth pigment is used. White bole occurs in Chinese wall-paintings. Red bole grounds were used by some 17th-c. masters for ALLA PRIMA painting in which the shadows were thinly painted and the lights were in a strong IMPASTO.

BOLOGNA

Dark bole grounds were employed by Luca
GIORDANO and by CARAVAGGIO and his school.
In some of the paintings of this school the dark
ground has 'come through'—particularly in the
thinly painted shadows—and the pictures have
darkened very considerably. In general clay
grounds are considered unsatisfactory owing to
their capacity for retaining moisture.

**BOLOGNA,** GIOVANNI (GIAMBOLOGNA
or JEAN BOULOGNE) (1529-1608). In his
day the most successful sculptor of the age of
MANNERISM. Until the end of the 18th c. his
reputation was second only to that of MICHEL-
ANGELO and his small bronze statuettes were
reproduced almost continuously until the 20th c.
He was a Fleming, born at Douai, and trained
under Jacques DUBROEUCQ. He visited Italy,
probably in 1554 or 1555, and spent two years in
Rome. On the way back he stopped in Florence
and remained there except for short periods for
the rest of his life. His first important com-
mission was from Pius IV for the bronze *Fountain
of Neptune* for Bologna (1563-6) with its impres-
sive nude figure of Neptune which he had
designed for a fountain in Florence. He made
several other fountains for the various gardens
of the MEDICI, including one for the Boboli
gardens and the colossal rustic *Apennine* (1577-
81) at Pratolino; the *Hercules and the Centaur*
(Loggia dei Lanzi, Florence) and *Samson and a
Philistine* (V. & A. Mus., 1566?-1570?) once
crowned such fountains.

It is impossible to ignore the part played
by Giambologna's collaborators; not only the
bronze-founder Portigiani, but Pietro TACCA,
Antonio Susini, and above all Pietro Francavilla
executed many of his designs. This enabled him
to maintain his high output and to fulfil com-
missions for many cities, such as the bronze
statues and reliefs for the Grimaldi Chapel at
Genoa, the equestrian statues of Henry IV for
Paris (destroyed) and Philip III for Madrid, and
the bronze doors of Pisa Cathedral (finished
1603), as well as the many works for Florence.

Giambologna is best known by two works in
Florence. The bronze *Flying Mercury*, one of the
most popular of all statues, is a development of
an earlier version in Vienna. The *Rape of the
Sabines* (Loggia dei Lanzi, finished 1583),
formerly hailed as the greatest achievement of the
age, can be regarded as the culmination of his
*œuvre*, with its compact yet light grouping, its
rising and twisting lines and the lifelessness of a
brilliantly successful exercise.

**BOLOGNESE,** IL. See GRIMALDI, G. F.

**BOLOGNESE SCHOOL.** Bologna, the
Etruscan Felsina and Roman Bononia, was a
scintillating intellectual centre and university
town through the Middle Ages. Some remini-
scence of this is perpetuated in its impressive
medieval and GOTHIC churches: S. Stefano (5th-

13th c.), S. Domenico (1233) with its celebrated
*Arca* designed by Nicola PISANO and the huge
S. Petronio, whose unfinished structure dragged
on from 1390 to 1650 and was decorated with
reliefs by Jacopo della QUERCIA. In the 14th c.
the university was an important centre for
ILLUMINATED MANUSCRIPTS. Relics of frescoes in
S. Stefano and elsewhere show that painting was
early practised there and recently the interest of
scholars has been attracted to artists such as
Vitale D'Aimo de' Cavalli (early 14th c.), called
Vitale da Bologna and sometimes considered,
though on slight evidence, as the founder of the
Bolognese school of painting, Simone de Croce-
fissi and his nephew Dalmasio Scannabecchi
(called Lippo di Dalmasio or Maso da Bologna)
in the second half of the century. A revival seems
to have occurred, however, when the Ferrarese
Lorenzo COSTA decorated the Palazzo Benti-
voglio *c*. 1483, and the school took on a new
character when FRANCIA acclimatized the more
delicate and lyrical Umbrian and Tuscan styles
(Oratory of Sta Cecilia, 1506). Bolognese
MANNERISM developed under the influence of
the charm of the masters of Parma and the
contributions of PRIMATICCIO and NICCOLÒ
DELL' ABBATE, who were to migrate to France.

By the middle of the 16th c. Bologna was in
close touch with Roman art owing to the archi-
tect VIGNOLA and the painter PASSEROTTI, friend
of the ZUCCARO brothers. Considerable influence
was exerted by Pellegrino TIBALDI, who arrived
in Bologna from Rome to decorate the Poggi
palace (*c*. 1554). But towards the end of the
century conditions altered, and the Bolognese
school was liberated from the Mannerism of the
decorators by the dynamic CARRACCI family, who
from 1585 to 1595 were the motive force of the
Accademia degli Incamminati (see ACADEMIES).
They were followed by a number of individual
artists with European reputation—DOMENI-
CHINO, Guido RENI, ALBANI, and GUERCINO.
These did not stand alone but a number of lesser
painters gave the Bolognese school a distinctive
and varied character. They included SCHEDONI,
Lionello Spada (1576-1660), and Alessandro
Tiarini (1577-1668). The style of Guido was
continued at a less inspired level though not
without individuality and a certain lyricism by
Franceschini (1648-1729), Guido Cagnacci
(1601-81), and Guiseppe Maria CRESPI. In
the 18th c. the BIBIENA family with their
interest in theatrical settings took the lead
in a revival of illusionistic BAROQUE decora-
tion whose lack of creative ability caused the
Bolognese school to fall into disrepute during the
19th c. A revival of interest in the 20th c. was
stimulated by biennial exhibitions at the Archi-
ginnasio.

**BOLTRAFFIO,** GIOVANNI ANTONIO
(1466/7-1516). Italian aristocrat and painter.
He was trained in the manner of BERGOGNONE
and became one of LEONARDO's principal disciples

in Milan. His silver-point drawings are mentioned in Leonardo's notebooks. Several fine bust-length portraits are identifiable as his (including possibly *La Belle Ferronnière*, Louvre) and he also painted a number of Madonnas (one in N.G., London).

**BONAIUTI.** See ANDREA DA FIRENZE.

**BONATZ**, PAUL (1877-1951). German architect, remembered chiefly for Stuttgart Railway Station (designed 1911, built 1914-27) with its simple forms and large areas of massive masonry, and for the bridges he designed for the *Autobahnen* between 1935 and 1941, which being primarily engineering structures escaped the bombast of much Nazi architecture.

2619.

**BONDOL** (BONDOLF, BANDOL), JEAN DE (active c. 1368-81). Also known as JEAN DE BRUGES. Flemish painter and miniaturist who worked in France and became Court Painter to Charles V of France in 1368. Only two works can certainly be ascribed to him: an illustrated Bible presented to the King (now at the Meermanno-Westreenianum Mus., The Hague) and cartoons for a great tapestry (originally 470 ft. long) made for the Duke of Anjou and known as the *Angers Apocalypse* (c. 1375). About two-thirds of this tapestry is now in the Museum of Tapestries, Angers. Bondol was one of the earliest of the Flemish artists who were employed in the French court, mastered the elegant and mannered sophistication of the French court style but brought to it a tincture of direct Flemish realism in the depiction of landscape and figures. His figures have bulk and weight and he paid careful attention to details of texture and lighting. In the *Apocalypse* the elegant figure of St. John completely in the current French style contrasts with thickset and virile peasants of typically Flemish appearance. It was the union of these two modes, with certain Italianate influences, which later produced the unified INTERNATIONAL GOTHIC style of painting.

**BONDOLF.** See BONDOL, Jean de.

**BONE**, SIR MUIRHEAD (1876-1953). Scottish-born draughtsman and etcher, mainly of architectural subjects. He studied architecture and painting at Glasgow, then settled in London in 1901 and became a member of the NEW ENGLISH ART CLUB. He was an official war artist in both World Wars. He had great dexterity and was an accomplished draughtsman.

**BONE CARVING.** Bone may be used for the same kinds of work as IVORY, but it is less lustrous, more pliable, and allows little more than surface treatment because of its large soft core. While only prehistoric and primitive peoples have used bone extensively for carved or engraved work (see STONE AGE ART), there

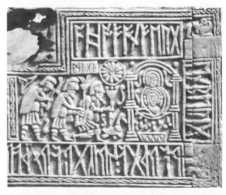

**52.** Detail from the Franks Casket showing the Adoration of the Magi, surrounded by runic inscriptions. Anglo-Saxon whalebone carving. (B.M., *c.* 9th c.)

have been occasional exceptions. For instance, bone images are preserved from early GREEK and COPTIC ART, and the Japanese carved many of their *netsuke* in bone. Examples of medieval English carving in whale's bone are the Franks Casket (B.M., *c.* 9th c.), and the *Adoration of the Magi* (V. & A. Mus., *c.* 1000).

**BONHEUR**, ROSA (1822-99). Minor French animal painter. Trained by her father, Raymond Bonheur, she exhibited regularly at the Paris Salon from 1841, where her pictures of lions, tigers, wolves, etc., were soon very popular. *The Horse Fair* (1853-5; Met. Mus., New York) gave her an international reputation. Her preferred themes were horses and ploughing.

**BONIFAZIO VERONESE DE PITATI** (*c.* 1487-1553). Italian painter. A native of Verona, he was in Venice by 1528, where he formed his style on that of TITIAN and PALMA VECCHIO. The uneven quality of the paintings attributed to Bonifazio may be perhaps explained by the very large workshop which he ran. His importance lies in the virtuosity of his handling of colour in the MANNERIST mode (*The Finding of Moses*, Brera). Jacopo BASSANO may have been his pupil.

2853.

**BONINGTON**, RICHARD PARKES (1802-28). English painter. He was born near Nottingham but at the age of 15 his family moved to Calais, where he studied under Louis Francia (1772-1839) and from him learnt the technique of LITHOGRAPHY and something of the English water-colourist tradition as exemplified by GIRTIN and VARLEY. In 1820 he went to Paris, entered at the École des Beaux-Arts, became a pupil of GROS, a pioneer of the new ROMANTIC movement, and formed a friendship with DELACROIX. He was for a time influenced by the medievalism and orientalism of the French Romantics and produced oil paintings in their manner. He established a reputation, however, for water-colour landscapes exhibited at the

SALON of 1822 and the so-called 'English' Salon of 1824, at which he saw CONSTABLE's pictures. Probably some time before 1824 he went to Italy and it may have been there that he contracted the tuberculosis which carried him off at the age of 26. In 1824 he accompanied Delacroix to England and sought out pictures by Constable, whose influence is apparent in his subsequent work.

Bonington died before his talent had matured into a fully individual style. It has been said that his *plein air* effects in landscape are 'touched with a prettiness that is not so much French as what the English expect of the French'. He was a fine natural colourist and was distinguished for his dexterity and spontaneity. Delacroix wrote of him: 'As a lad he developed an astonishing dexterity in the use of watercolours, which were in 1817 an English novelty. Other artists were perhaps more powerful or more accurate than Bonington, but no one in the modern school, perhaps no earlier artist, possessed the lightness of execution which makes his works, in a certain sense, diamonds, by which the eye is enticed and charmed independently of the subject or of imitative appeal.' These qualities are particularly apparent in the *pochades* (oil sketches done rapidly on the spot as records of transitory effects in nature), a fashion which he together with TURNER and Constable was instrumental in establishing.

**BONNARD, PIERRE** (1867-1947). French painter. Coming to Paris in 1888 he studied first at the Académie Julien, where he met Sérusier (1863-1927), Maurice DENIS, and others who formed the NABI group in their enthusiasm for the new aesthetic of GAUGUIN. Later at the École des Beaux-Arts he came into contact with Xavier Roussel (1847-1926) and VUILLARD. From 1891 he exhibited fairly regularly at the Salon des Indépendants and at the first Nabi Exhibition in 1892 he showed a caricature of the formation of the group. He was given his first one-man show by the dealer Durand-Ruel in 1896 and in the next year was taken up along with others of the Nabis by Vollard; *c.* 1899 he entered into an agreement with the dealers Bernheim-Jeune. In 1903 he was one of the founder members of the Salon d'automne, organized by the FAUVES, and exhibited there regularly from that date. Bonnard's life was as serene and uneventful as those of Gauguin and van GOGH were tempestuous; his exuberance was reserved for his art. Even in this he was distinguished rather than blatant, learning from every new experiment around him yet adapting all he learnt to the refinement of his personal style. From 1896, when he worked for the presentation of *Ubu-Roi* at the Théâtre de l'Œuvre, his gift for stage décor and decorative art developed. From *c.* 1900 he devoted himself increasingly to landscape. About 1915 he became dissatisfied with his work and undertook a radical revision of it.

'I returned to school. I turned against all that had previously excited me, the colour which had attracted me. I had almost unconsciously sacrificed form to it but it is absolutely true that forms exist and that it is not possible either to arbitrarily reduce or transpose it. Thus it is vital to study it and after drawing there comes composition which should constitute an equilibrium: a picture which is satisfactorily composed is half made.'

During the Second World War he remained in Le Cannet and did not return to Paris until 1945. On the death of Madame Bonnard in 1940 he faked a will in her name to deceive the authorities and this caused grave legal complications as a result of which the substantial part of his output which remained in his possession at his own death was sequestered from public view for many years owing to long-drawn-out lawsuits concerning inheritance. In 1947, the year of his death, a large retrospective exhibition was given at the Orangerie, Paris. Bonnard was one of the very few foreign painters to be elected a member of the ROYAL ACADEMY (1940) and in 1966 the Academy organized the largest and most representative exhibition of his works hitherto seen. The appreciation printed in the catalogue to this exhibition opened with the words: 'Pierre Bonnard's contribution as the most important "pure painter" of his generation has now become more widely and generously recognised.'

637, 2225, 2709.

**BONOMI, JOSEPH** (1739-1808). Architect. He received his architectural training in Rome and first came to England in 1767 at the invitation of Robert ADAM. He worked with Adam and later with Thomas Leverton (1743-1824) and finally settled in his own practice in London in 1784. He built a number of country houses which are remarkable for their large, far-projecting porticoes which form *porte-cochères*, an innovation in these islands. Longford Hall, Salop (1794-7), Eastwell House, Kent (1793), and Rosenheath, Dumbartonshire (1803), his most famous work which is now in decay, all show this feature in different forms. His church at Great Packington, Warwickshire, with its uninviting brick exterior, has a finely modelled stone interior of monumental power, extraordinary in so small a building and unique in Great Britain.

**BONTEMPS, PIERRE** (*c.* 1507-68). French sculptor who was assistant to PRIMATICCIO at FONTAINEBLEAU and who executed the GISANTS and bas-reliefs for the tomb of Francis I at S. Denis (1547) to the designs of Philibert DELORME. His monument for the heart of Francis I, in the same church, is more sophisticated and shows his decorative ability. Like so many other French sculptors of his time he became a religious fugitive in 1562.

**BONVICINO,** ALESSANDRO. See MORETTO DA BRESCIA.

**BOOK OF HOURS.** A Prayer Book used by laymen for private devotion. It originated from prayers gradually added by monks and priests to the Service proper, including the abridged Office of the Virgin, Psalms, Litanies, and Offices of the Dead. It was not until the 15th c. that Books of Hours became very common and included some of the most magnificent books of the period (*Très Riches Heures du duc de Berry*, Musée Condé, Chantilly, early 15th c.; *Rohan Hours*, Bib. nat., Paris, *c.* 1419).

Both the contents of Books of Hours and the illustrations vary considerably. Generally the Calendar is illustrated by the OCCUPATIONS OF THE MONTHS and the Hours of the Office of the Virgin by eight miniatures, each connected with a particular hour: Matins, *Annunciation*; Lauds, *Visitation*; Prime, *Nativity*; Tierce, *Annunciation to the Shepherds*; Sext, *Adoration of the Magi*; None, *Presentation in the Temple*; Vespers, *Flight into Egypt* or *Massacre of the Innocents*; Compline, *Coronation of the Virgin* or *Flight into Egypt*. Most of these pictures were probably derived from the PSALTER. The other prayers were also illustrated: the Hours of the Cross generally with the *Crucifixion*, the Office of the Dead with a funeral service, and the Commendation of Souls with the *Last Judgement*.

The Book of Hours outnumbers all other categories of ILLUMINATED MANUSCRIPTS because of the vast quantities which were produced in the 15th c. From the late 15th c. there are various printed versions illustrated by WOODCUTS.

1642.

**BOOK OF THE DEAD.** A somewhat misleading term which has been loosely used with reference to Egyptian funerary literature. It is now applied specifically to the 'spells of coming forth by day', a miscellaneous collection of formulae and incantations of various dates, selections from which were inscribed inside coffins and later on PAPYRI buried with the dead. Three main versions of the text may be distinguished: those current in the Middle Kingdom, the New Kingdom, and the Late Period respectively (see EGYPTIAN ART). But there is no fixed canon, and the number and arrangement of the spells (wrongly called 'chapters') may vary considerably in individual copies. The best examples, which date from the 18th and 19th Dynasties, are finely written, with headings in red, and beautifully illustrated with vignettes, often in colour. They are thus among the earliest examples of RUBRICATION, ILLUMINATION, and the art of book illustration.

**BORCH.** See TERBORCH.

**BORDONE,** PARIS (1500-71). Italian painter whose reputation in his own day rivalled that of TITIAN, under whom he may have studied. He was from Treviso, but he had settled in Venice by 1518. His CHIAROSCURO and rich colouring were highly praised and his popularity brought him commissions from patrons all over Europe, including the king of Poland and Maria of Austria. His *Presentation of the Ring of St. Mark to the Doge* (Accademia, Venice), painted for the Scuola di S. Marco in 1538, is a large ceremonial composition in Titian's grand manner. He specialized in the SACRA CONVERSAZIONE and in mythological pictures but was too conventional and unoriginal for lasting fame.

**BORGARDUS,** JAMES (1800-74). American inventor and 'architect in iron'. His substitution of the iron front for the masonry wall was an important step in the evolution of the metal frame building. Borgardus first used this technique in a factory in New York in 1848. His most famous work, also in New York, was a building for Harper and Brothers (1854). In spite of his technical daring Borgardus still adhered to traditional concepts of style.

**BORGHESE GALLERY,** Rome. This is housed in the Villa Borghese on the Pincio, and is one of the few Roman patrician collections not dispersed in the 18th c. It was acquired by the Italian State in 1902. It was begun by Cardinal Scipio Borghese (1576-1633), nephew of Pope Paul V (himself a Borghese) and patron of the young BERNINI, almost all of whose earlier works are to be found there. The villa, designed by the Flemish architect G. Vasanzio of Utrecht, was built especially as a museum and the collection is still disposed according to the Cardinal's plan. Excavations in the 18th c. yielded many important antique sculptures, which were added to the collection by Marcantonio Borghese. Many of these were later sold to Napoleon and those not returned later, which include some of the best surviving Greek sculpture, are now among the prized treasures of the LOUVRE. The pictures, mainly the gift of Pope Paul V, include works of outstanding importance.

**BORGLUM,** GUTSOM (1867-1941). American sculptor. He was born in Idaho of Scandinavian stock and studied in Paris, but settled in London in 1896, where he achieved some success and came to know George Bernard Shaw and RUSKIN. After he returned to America in 1901 he carried to an extreme the American cult for the colossal and gained notoriety by gigantic reliefs on mountain-sides executed with pneumatic drills and dynamite. The first of these, on Stone Mountain in Georgia, was never finished, although he worked on it for 10 years from 1915. He next undertook the carving of an entire 500-ft. cliff at Mount Rushmore in the Black Hills of South Dakota, which he left unfinished at his death. It includes colossal portrait busts of

Washington, Jefferson, Lincoln, and Theodore Roosevelt.

**BORGOGNONE,** A. See BERGOGNONE.

**BORGOGNONE,** IL. See COURTOIS.

**BORGOÑA,** JUAN DE (active *c.* 1494–d. 1554). Spanish painter who worked mainly at Toledo. He and Pedro BERRUGUETE were both representatives of the transition from GOTHIC to RENAISSANCE in Castile and collaborated on the main ALTARPIECE of Avila Cathedral (*c.* 1508). He also executed important works in the Chapter House of Toledo Cathedral. His style recalls late 15th-c. Florentine painting, more particularly that of GHIRLANDAIO. He had several followers, such as Antonio de Comontes (active *c.* 1500–19) and Pedro Cisneros (active *c.* 1530), and this makes many attributions to Borgoña uncertain.

54.

**BORMAN,** or BORREMAN. JAN BORMAN I (active *c.* 1480–1520). Flemish sculptor in wood. He was head of a very active workshop in Brussels which was famous for sculptured altars. The *Altar of St. George* (Musée du Cinquantenaire, Brussels, 1493) was his masterpiece. JAN BORMAN II was a member of his father's workshop and achieved distinction as an independent master. His *Saluces Altar* is in the Municipal Museum, Brussels.

**BOROBUDUR.** See INDONESIAN ART.

**BORRASSÁ,** LUÍS (d. *c.* 1425). Spanish painter, disciple of Pedro SERRA, recorded as active in Barcelona and its neighbourhood from 1388 to 1424. His style shows French and Sienese influences and is representative of the INTERNATIONAL GOTHIC style. In 1397 and 1400 he was stage manager and scene painter for two dramatic spectacles. Several of his documented works survive, for example the great composite ALTARPIECE of Sta Clara, executed 1412–15, now in Vich Museum, Barcelona.

1737.

**BORREMAN,** J. See BORMAN, J.

**BORROMINI,** FRANCESCO (1599–1667). Together with BERNINI and Pietro da CORTONA the leading architect of the Roman BAROQUE. His style, at once passionate and mathematical, subtle and apparently whimsical, was of tremendous importance in the development of the Baroque in Italy, and even more in Austria and south Germany; it was repeatedly denounced in the 18th and 19th centuries. Borromini arrived in Rome in 1614 and worked as a mason under MADERNA at St. Peter's, and on the Palazzo Barberini with Maderna and Bernini, until he began the tiny church and convent of S. Carlo

alle Quattro Fontane in 1634. The plan combines the RENAISSANCE Greek-cross type with the oval introduced by VIGNOLA, giving a sequence of undulations under an oval dome which was entirely new and entirely Baroque in its spatial effect. An example of his spatial movement may be seen in the way he unites a segmental and a triangular PEDIMENT to produce a single flowing outline built up of an ascending curve (the gable angle of the triangular pediment) and a descending curve, the whole quite distinct from the doubled forms of a triangular superimposed on a segmental pediment which was the usual MANNERIST type. In contrast to the subtlety of his architectural forms Borromini's decorative detail was almost austere, based on palm or star motifs usually in gold on white, and he abjured the sumptuous marbles employed by Bernini and others. His unfinished design for the Convent of S. Filippo Neri (1637–52) and his transformation of the interior of the Basilica of St. John Lateran (1646–50) both rely on purely architectural effects with no help from the nature of the materials.

After S. Carlo the church of S. Ivo della Sapienza (1642–61) has a still more complex plan, basically a six-pointed star but with three of the points rounded almost into semicircular apses. Externally the plan is expressed in a shaped, stepped dome, carried on a high drum which curves forward against the recessed curve of the entrance façade, the whole being topped by an incurved LANTERN terminating in a spiral. The same play of counter-curves can be found in Sta Agnese in Piazza Navona (1653–7), which Borromini took over from RAINALDI, rounding off his Greek-cross plan, adding a concave façade and stabilizing the opposition between the forward-curved drum and the façade by adding twin CAMPANILI at the ends. (WREN's west towers at St. Paul's are based on S. Agnese.) Other examples are the façade of the Collegio di Propaganda Fide and the upper part of S. Andrea delle Fratte, but the most complex expression is to be found in the façade of his own S. Carlo alle Quattro Fontane (added 1662–7), where there are two storeys, curved alike in the outer bays but in opposite directions in the centre.

Borromini's secular works include parts of the Barberini and Spada palaces and a Roman palace and a villa at Frascati for the Falconieri family.

Always neurotic, Borromini committed suicide during an attack of melancholia.

**BOSBOOM,** JOHANNES (1817–91). Dutch painter and lithographer, mainly of church interiors. He was much inspired by the works of Emanuel de WITTE—figures in many of his church interiors even wear 17th-c. costumes— and in this respect belonged to the ROMANTIC revival in the Netherlands of the 17th-c. tradition. Yet his technique also owed something to

advanced trends and ranks him with the early phases of IMPRESSIONISM in the Netherlands, often referred to as the HAGUE SCHOOL. He is represented in the Municipal Museums of Amsterdam and The Hague.

1776.

**BOSCH,** HIERONYMUS (*c.* 1450-1516). Bosch, a strangely individual figure, derived his name from his isolated native town of 's Hertogenbosch (Bois-le-Duc) in northern Brabant, where he seems to have lived throughout his life. An orthodox Catholic and a prominent member of a local religious Brotherhood, in 1480 he completed panels for their church of St. John which had been left unfinished by his father. Several Bosch paintings remained in this church until the 17th c. In the 1480s Bosch inherited a property and married into a good family—circumstances which may have given him income independent of his painting. Although his father was a painter, the origins of Bosch's style and technique, which are outside the central line of development, are far from clear like so much of our understanding of this artist. His strange manner had little in common with Jan van EYCK or Rogier van der WEYDEN, the two painters who most influenced the development of style in the Low Countries until *c.* 1500.

About 40 genuine examples of Bosch's work survive, though none is dated and no accurate chronology can be made. Yet it seems likely that the conventional compositions, such as *The Crucifixion* (Brussels), are early works. The degree to which he is unconventional depends on his subject; in a commissioned painting, such as *The Adoration of the Kings*, with the DONORS and saints on the wings, the departures from normal presentation are limited. The majority of his paintings are completely unconventional and immediately recognized by the elements of fantasy, such as half human half animal creatures, demons, etc., interspersed with human figures in a setting of imaginary architecture and landscape. Despite the variety of these paintings the basic themes are quite simple, but heavily embroidered with subsidiary narratives and symbols. Scenes from the life of Christ or a saint show the innocent central figure besieged by horrific representations of evil and temptation—*The Temptation of St. Anthony* was a favourite subject of which the large Lisbon triptych is the major version. Other subjects were allegorical representations of biblical texts or proverbs, stressing in morbid vein the general folly of human beings and the fearful consequences of their sins. Of these *The Haywain* and *The Garden of Earthly Delights* in the Prado are perhaps his best known paintings. The latter is the most medieval of his works in both composition and content, and in it the archaic features of his style are most to the fore. The most advanced aspect of his work is the fine landscape painting which plays so prominent a role in all of his paintings.

There is something strangely modern about Bosch's turbulent and grotesque fantasy and it is no accident that his appeal to contemporary taste has been strong. But attempts to discover the psychological key to his motivation or to trace the origin of his imagery or find a coherent interpretation of the symbolism remain inconclusive. In his own time his fame stood high and he enjoyed the patronage of the most eminent Catholic circles, including Philip II of Spain whose fine collection of his works is now mainly in the Prado. Through the medium of prints his works reached a wider public and imitators appeared even in his lifetime. But it was not until Pieter BRUEGEL the Elder that another artist appeared in the Netherlands to equal his sensitive gift of landscape. Apart from the riot of fantasy and that element of the grotesque which caused the SURREALISTS to claim Bosch as a forerunner of their school, the inexplicable haunting beauty of his genuine works certainly derives largely from his superb painterly technique and the glowing transparency of his finely modulated colour.

141, 597, 926, 1671, 2660.

**BOSS** (ROOF BOSS). Architectural term for a block of wood or projecting keystone to mask the junction of vaulting ribs. French GOTHIC VAULTS were usually high so their bosses were seldom elaborately decorated, but in England from the 13th to the 16th c. there is a wealth of sculptural decoration on bosses. The 13th-c. bosses of Ely Cathedral and Westminster Abbey are among the grandest ever carved; the 14th c. saw the crowded narrative of the bosses in Norwich cloisters; and the 15th c. a vast number of heraldic bosses and the development of long pendant bosses with subjects carved upon their sides, hanging like stalactites from the vault of the Divinity Schools, Oxford, and Henry VII's Chapel, Westminster.

**BOSSCHAERT,** AMBROSIUS (1573-1621). Ranks with BRUEGEL as the most important of early Flemish flower and STILL LIFE painters. Like many Flemish artists he left Antwerp to seek refuge in Holland, where he is recorded in Middelburg from 1593 to 1613 and later in the Utrecht Guild in 1616. A surviving letter written by his daughter tells how he died at The Hague, where he had to come to deliver one of his paintings commissioned by the Stadtholder.

Although he spent the major part of his life in Holland, Bosschaert's style was basically Flemish but modified by the subtle light effects of Dutch painting. His bouquets have a rich variety of flowers from different seasons arranged in a formal way. He often painted on copper and the surface of his paintings has a mysterious sheen in which individual brush-strokes are not apparent. The degree of finish and exactitude, and the subtlety of the colour, are exceptional. His style compares in some respects with that of

Roelandt SAVERY. Bosschaert may fairly be said to have initiated flower painting in Holland through his own work and that of his three sons, AMBROSIUS the Younger (1609-45), ABRAHAM (1613-c. 1645), and JOHANNES (c. 1610-c. 1650), and his brother-in-law, Balthasar van der AST. Excellent examples of his work are at Amsterdam, Copenhagen, The Hague, and the Ashmolean Museum, Oxford.

**BOSSE,** ABRAHAM (1602-76). French illustrator and engraver. In the 1630s he abandoned the later MANNERIST mode and developed an independent style of naturalistic representation. His engravings and etchings are important records of contemporary life and manners of the upper middle classes in his day. In the detachment with which he represents scenes of bourgeois life and his grasp of classical composition he has affinities with Louis LE NAIN. In 1661 he left the Académie because of his opposition to LEBRUN. Examples of his work in the British Museum are the series *Mariage à la Ville* (1633) and *Wise and Foolish Virgins* (c. 1635).

304, 305.

**BOSTON.** MUSEUM OF FINE ARTS, BOSTON. Officially described as 'a permanent public exhibition of original works of the art of Egypt, Greece, Rome, the Orient, and modern Europe and America, supplemented by reproductions of others'. In 1859 an abortive offer was made of the Jarves collection of Italian paintings as a nucleus for a public museum in Boston. The Museum was incorporated by charter in 1870. The Museum is wholly supported by private donations. It is managed by a Board of Trustees which include Harvard University, the Boston Athenaeum, and the Massachusetts Institute of Technology. The Museum was opened to the public in a building on Copley Square in 1876 and an enlargement was opened in 1890. The Museum transferred to a new building on Huntingdon Avenue in 1909. This and subsequent enlargements were planned with a view to best principles of modern museum display and are claimed to embody the four principles: separation of departments; places for rest and diversion; opportunities for study and instruction; oblique lighting for optimum visibility.

The nucleus of the Egyptian Department was formed by the Way Collection of Antiquities in 1872 and the Museum benefited from participation in an expedition directed in 1905 by Dr. George A. Reisner to the extent that its collection of Old Kingdom sculpture is claimed to be unequalled after that of Cairo. The Classical Department acquired in 1928 the famous collection of antique engraved gems belonging to Edward P. Warren. The Museum's paintings are particularly strong in IMPRESSIONIST and BARBIZON schools and in American Colonial artists, COPLEY being especially well represented. CHINESE and JAPANESE ART includes the Ross Collection and the Weld-Fenollosa Collection. The Department of Prints and Drawings is said to contain one of the richest collections of graphic art in America.

**BOTH,** JAN (c. 1618-52). Dutch painter, born in Utrecht. His teacher was probably Abraham BLOEMAERT. He was the leader of a group of Dutch painters who used imaginary and real views of the Roman Campagna as the setting for their pictures. His landscapes are peopled by peasants driving cattle or travellers gazing on Roman RUINS in the light of the evening sun. Such contemporary scenes were an innovation, for CLAUDE Lorraine and the earlier Dutch painters of the Italian countryside had populated it with biblical or mythological figures. Jan's pictures, and those made by other Italianate landscape painters of his country and generation, show the yearning of northerners for the light and idyllic life of the south, not for the grandeur of an ancient and heroic past. He was in Italy from c. 1638 to 1641. Soon after he returned the golden light and the mood of his Italian landscapes began to be reflected in the views of Dutch canals, pastures, and woods made by Dutch artists who remained at home. Jan's brother ANDRIES (1612-41) was in Italy with him and they are said to have collaborated; but Andries is best known for paintings and drawings of lively peasant scenes which have little in common with Jan's idyllic tone.

**BOTTICELLI.** ALESSANDRO DI MARIANO FILIPEPI called SANDRO (1445-1510). Florentine painter. Little is known of his youth, though it is likely that he worked under Filippo LIPPI and also assimilated the style of VERROCCHIO. By temperament he belonged to the current of late quattrocento art which reacted against the scientific naturalism of MASACCIO and his followers and revived certain elements of the GOTHIC style—a delicate sentiment, sometimes bordering on sentimentality, a feminine grace, and an emphasis on the ornamental and evocative capabilities of line. It is in this last respect that Botticelli's art is unrivalled: witness the marvellously delicate pen drawings in illustration of the *Divina Commedia* (Staatl. Mus., Berlin).

In his work of the early 1470s these qualities are not yet fully apparent. The most famous of this period, the *Adoration of the Magi* (Uffizi), which is traditionally said to incorporate many portraits of the MEDICI family, displays the varied pageantry in a firmly naturalistic setting. The same applies to Botticelli's share in the fresco cycle in the Sistine Chapel (1481), where he painted side by side with PERUGINO, ROSSELLI, and GHIRLANDAIO. Yet by this time the most characteristic idiosyncrasies of his style had

already gained shape in the celebrated poetic allegory known since VASARI as the *Primavera* (Spring). There is evidence that the patron who commissioned this and some of the other famous mythological paintings (*The Birth of Venus, Minerva and the Centaur*) was Lorenzo di Pierfrancesco de' Medici (second cousin of 'Il Magnifico'), a wealthy Florentine with strong interests in Platonic philosophy. It has been suggested that it was this philosophy, as expounded by Marsiglio Ficino, that prompted the new idea of monumental pictures with a secular content. Whatever their precise allegorical meaning it has been felt by most observers that the classical deities represented are not the carefree Olympians of Ovid's tales but the symbolic embodiment of some deep moral or metaphysical truth. In fact a philosophy which regarded Beauty as the visible token of the Divine would be most likely to account for that infusion of religious and solemn sentiments into classical myths which we can feel in Botticelli's art. Given such a conception, there would be no blasphemy in using the same facial type and expression for Venus and for the Holy Virgin.

According to Vasari, Botticelli later fell under the sway of Savonarola's sermons, repented of his 'pagan' pictures and gave up painting. The second half of this statement is certainly incorrect and the first is doubtful. It is true that Botticelli's brother was an ardent follower of Savonarola, but the artist himself continued in the employment of Lorenzo di Pierfrancesco who was an enemy of the Frate. Botticelli's art, on the other hand—as far as we can trace its development—became increasingly ecstatic, intense, and even MANNERED. The most telling monument of this phase is the *Mystic Nativity* (N.G., London, 1500), which bears a cryptic inscription from the Apocalypse seeming to imply that Botticelli expected the end of the world and the dawn of the millennium.

Botticelli's reputation was apparently restricted to a fairly small circle, and he died in obscurity. His fame was resurrected in the second half of the 19th c., when the PRE-RAPHAELITES imitated his wan, elongated types, RUSKIN sang his praises, and Walter PATER dedicated to his art one of the most eloquent essays in his *Studies in the History of the Renaissance* (1873). An offshoot of Botticelli's immense popularity at the period of ART NOUVEAU, which equated his delicate line with Far Eastern principles, is the sensitive book by the Japanese scholar Yashiro. But it was left to the documentary researches of H. Horne (1908) and J. Mesnil (1938) to disentangle legend from fact.

73, 259, 1258, 2378.

**BOTTICINI,** FRANCESCO DI GIOVANNI (*c.* 1446-97). Minor Florentine painter whose characterless eclecticism was composed of elements drawn from Fra Filippo LIPPI, ROSSELLI, and BOTTICELLI. His *Assumption* (N.G., London, *c.* 1474) has the distinction of being the only picture from the quattrocento known to have been painted to illustrate a heresy.

**BOUCHARDE,** or BUSH HAMMER. A mallet or hammer studded with V-shaped indentations, used for wearing down the surface of granite and hard stones. See STONE SCULPTURE.

**BOUCHARDON,** EDMÉ (1698-1762). French sculptor, medallist, and draughtsman, whose work marks the beginning of the Classical reaction against the ROCOCO style. His most important works are the *Fountain of the Seasons* in the rue de Grenelle, Paris, *Cupid* (Louvre, *c.* 1740), and an equestrian statue of *Louis XV* (destroyed in the Revolution). He was championed by the Comte de CAYLUS. But despite his admiration for the ANTIQUE, his own CLASSICISM was that of the academic tradition (his models during nine years in Rome were ALGARDI and François DUQUESNOY) rather than a genuine anticipation of NEO-CLASSICISM.

**BOUCHER,** FRANÇOIS (1703-70). French fashionable painter, who best embodies the frivolity and elegant superficiality of French life at the middle of the 18th c. He was summed up by de GONCOURT as 'one of those men who typify the tastes of a century, who express it, personify it, and incarnate it'. He was for a short time a pupil of François LEMOYNE and in his early years was closely connected with WATTEAU, 125 of whose pictures he engraved for Jullienne's *Œuvre de Watteau*. He was in Rome 1727-31, where he learnt much from the decorative painters TIEPOLO and ALBANI. He set the fashion in interior decoration. In 1734 began his association with the Beauvais tapestry manufacture and in 1755 he became Director of the Gobelins factory. In 1765 he was made King's Painter. He was the teacher and favourite artist of Mme de Pompadour, whose portrait he painted several times (Wallace Coll., London; N.G., Edinburgh). Boucher mastered every branch of decorative and illustrative painting, from colossal schemes of decoration for the royal châteaux of VERSAILLES, FONTAINEBLEAU, Marly, and Bellevue, to stage settings for the opera and designs for fans and slippers. He took in his stride the contemporary fashion for CHINOISERIE, making *tentures chinoises* for Beauvais tapestries in the late 1720s and the sets for Jean-Georges Noverre's ballet *Les Fêtes chinoises* in 1754. In his typical paintings he turned the traditional mythological themes into wittily indecorous *scènes galantes*.

Boucher was reproached even in his lifetime for his stereotyped colouring and artificiality. He incurred the censure of REYNOLDS for relying on his own repertory of motifs instead of painting from the life—he objected to nature,

for example, on the ground that it was 'too green and badly lit'. As a painter he had obvious faults of superficiality and a too facile charm. But as a decorator he had a rich and varied talent, brilliance of execution, and a light-hearted voluptuousness which suited the mood of his time, though it brought upon his head the execration of Diderot after French taste began to change in 1760. At his best he could achieve a magnificent decorative effect which raised his work above the purely trivial (*Rising of the Sun* and *Setting of the Sun*, Wallace Coll., London).

1949.

**BOUDIN**, EUGÈNE (1824–98). French painter. Son of a sailor, he ran a stationery and picture-framing business at Le Havre (1844–9), where his clients included COUTURE, Constant Troyon (1810–65), and MILLET, who encouraged him to paint. COURBET, JONGKIND, and COROT were among his friends. He was a strong advocate of direct painting from nature, saying: 'Everything that is painted directly and on the spot always has a force, a power, a vivacity of touch that is not to be found in studio work.' He initiated MONET into this method. His own paintings consisted mainly of beach scenes and seascapes from the coast of northern France and were distinguished by the prominence given to luminous skies. He was called by Corot the 'Master of skies'. He exhibited in the first IMPRESSIONIST exhibition of 1874. In 1905, after the exhibition of French Impressionist pictures at the Grafton Galleries, London, which included 38 of his pictures, one of his landscapes was accepted by the National Gallery.

239.

**BOULLÉE**, ÉTIENNE-LOUIS (1728–99). French architect who studied under J. F. BLONDEL and BOFFRAND. He became a member of the Académie in 1762 and was architect-in-chief to the King of Prussia. Before the Revolution he built several houses in Paris in the NEO-CLASSICAL style, including the Hôtel de Brunoy. Later he was among those who produced fancifully symbolic and impractical designs for enormous projects of geometrical architecture (e.g. a spherical *Newton Cenotaph*, 1784).

1473.

**BOULLONGNE**, LOUIS DE (1609–74). French painter, chiefly of religious works. His daughters, GENEVIÈVE and MADELEINE, painted flowers and fruit, while his sons, BON (1649–1717) and LOUIS (1654–1733), achieved considerable success painting in a lighter style near to ROCOCO (*Triumph of Amphitrite*, Tours).

**BOURDELLE**, ÉMILE-ANTOINE (1861–1929). French sculptor, born at Montauban, Tarn, son of a cabinet-maker. After studying at the École des Beaux-Arts, Toulouse, he came to Paris in 1884 and for a short while worked in the studio of J. A. J. Falguière. From 1884 to 1890 he exhibited at the Salon des Artistes français. In 1893 he received a commission from the town of Montauban for a memorial to the combatants and the dead of 1870 and this was exhibited in 1902 by the Société nationale des Beaux-Arts. In 1896 he became assistant to RODIN and worked in his studio for several years. He had his first one-man show in 1905. In 1909 he became a teacher at the Grande-Chaumière and remained there for the rest of his life. In 1911 he obtained a commission for the low reliefs *Apollon et sa méditation* for the façade of the Théâtre des Champs-Élysées, Paris, and between 1913 and 1923 he was working on a monument to General Alvéar commissioned by Argentina. In 1917 he began work on a monument to the Polish poet Mickiewicz, which was unveiled in 1929. His large statue *Héraklès Archer*, first exhibited in 1910, was purchased in 1922 for the Luxembourg. In 1924 he did the frieze *La Naissance d'Aphrodite* for the theatre of Marseilles and in 1925 a large relief for the Pavillon du Livre at the Exhibition of Decorative Arts in Paris. He had a retrospective exhibition in Brussels in 1928.

Bourdelle was a fine craftsman and a master of erudition. His own style was somewhat eclectic, but he reacted from the ROMANTICISM of Rodin towards a more severely classical conception of sculpture and was particularly interested in the relations of sculpture with architecture in contemporary conditions.

580, 1442, 1691.

**BOURDICHON**, JEAN (c. 1457–1521). Painter and illuminator, active at Tours, and chiefly famous for the *Book of Hours of Anne of Brittany* (Bib. nat., Paris, c. 1500). Bourdichon worked for Louis XI, and in 1484 he became court painter to Charles VIII. None of his paintings has survived. The style of the *Hours* derives from that of FOUQUET, but the figures have degenerated to the stature of children's toys and ornamental borders have been introduced—all of which no doubt reflects a change of taste among his courtly patrons.

1667, 1723.

**BOURDON**, SÉBASTIEN (1616–71). French painter who worked in a variety of styles, sometimes probably with intent to deceive. It is thought that in 1634 he passed off one of his own paintings as a work of CLAUDE. He also painted in imitation of LE NAIN. In Rome (1634–7) he imitated the *Bamboccisti* (see LAER) and also came under the influence of POUSSIN. In 1643 he was commissioned to paint the *Mai* for Nôtre Dame (Louvre and a small version at Chatsworth). His *Camp Scene* (Louvre) is in the realist style of Le Nain. From 1652 to 1654 he was court painter to Queen Christina of Sweden, of whom he did two portraits (Prado and Stockholm). After his return to France he won some

success as a portrait painter and developed his most characteristic style, reminiscent of Poussin tempered by elegance and sweetness.

**BOURGEOIS,** SIR PETER FRANCIS, BT. (1756-1811). Born in England of Swiss parents, he painted picturesque scenes in the manner of de LOUTHERBOURG. He became court painter to Stanislaus II, King of Poland, who knighted him shortly before he was deposed in 1794. Though he was elected R.A. and appointed Landscape Painter to George III, his work is unimportant. He is remembered because he inherited from the dealer Desenfans the pictures originally collected for King Stanislaus and bequeathed them to Dulwich College, thus forming the nucleus of the Dulwich Collection.

**BOURGES,** CATHEDRAL OF S. ÉTIENNE. The present cathedral was begun *c.* 1195, although it was projected as early as 1170. It is perhaps the most logical of all GOTHIC cathedrals. TRANSEPTS and TRIBUNES have been sacrificed to produce a rising hierarchy of spatial forms culminating in the great nave-choir, whose special glory is the unbroken row of soaring columns, the apotheosis of Gothic verticality. These columns, despite their capitals, continue through the upper walls to the springing of the vaults. In this respect Bourges anticipates one feature of later Gothic architecture. Other aspects of the building, such as the sexpartite vaults, were more archaic. The appearance of the exterior suffers from the absence of transepts. The façade with its five portals is imposing without being really beautiful. The portals retain some of their original sculpture (*c.* 1270), and the choir has some magnificent 13th-c. windows. Although less influential than its contemporary CHARTRES, Bourges affected the design of Le Mans, Coutances, and several Spanish churches.

**BOUTS,** DIERIC (d. 1475). Painter born in Haarlem who moved south to Louvain, where he spent the major part of his working life. In 1464 he was given his major commission, an ALTAR-PIECE of the Sacraments for St. Peter in Louvain. Towards the end of his life he also undertook two large panels for the Courts of Justice in Louvain Town Hall. It is difficult to determine the influence of Bouts's Dutch origins, but his figure style and his fine landscape make an interesting, if inconclusive, comparison with the work of OUWATER, an artist celebrated for his landscapes, who was working in Haarlem at the same date. In four panels for a series of the *Life of the Virgin* (Prado) which are considered to be early works, Bouts shows some influence of Rogier van der WEYDEN in the portal settings of the scenes, but the figure style is different with much simpler drapery folds. *The Last Supper* from the *Louvain Altarpiece* shows that Bouts was an artist who could overcome the problems of grouping figures by using true PERSPECTIVE and uniform

lighting, yet the *Justice of Emperor Otto* (Brussels) suggests that he was less suited to dramatic events, for the static elegant and elongated figures seem little affected by the dramatic events taking place. Bouts's individual sense of colour and the poetical feeling of his landscape backgrounds make him an artist of distinction. His influence was wide and his tradition was carried on by his sons DIERIC the Younger (d. 1490/1) and AELBRECHT (d. 1548). A typical example of the art of his followers is the *Mater Dolorosa* (N.G., London).

926, 2428.

**BOYD,** ARTHUR (1920- ). Australian painter, member of a family who have made a name in many of the arts. His father was a sculptor and potter, his mother a painter. Apart from six months' study at night in the drawing school of the National Gallery, Melbourne, he was largely self-taught as an artist. After holding his first one-man show at the age of 19, his artistic career was interrupted by the Second World War. Subsequently he became well known in Australia particularly for his large ceramic totem pole (consisting of *c.* 260 glazed terracotta bricks weighing *c.* 90 lb. each; total weight of the sculpture, which was built by Boyd entirely by hand, *c.* 10 tons), at the entrance to the Olympic Pool, Melbourne, and for his series (20 pictures) *Love, Marriage and Death of a Half-Caste*. The latter was made the subject of the film *The Black Man and His Bride*, which won a Silver Medallion in the experimental section of the 1960 Australian Film Festival. He came to England in 1959 and soon established a reputation with a one-man show, followed in 1962 by a successful retrospective exhibition at the Whitechapel Gallery. In 1964 the National Gallery of South Australia, Adelaide, and the Museum of Modern Art and Design, Melbourne, held retrospective exhibitions of his work.

2074.

**BOYDELL,** JOHN (1719-1804). English engraver and print publisher who made his fortune in the 1740s by publishing views of England and Wales which he engraved from his own drawings. He later published the work of other engravers and by developing a large foreign trade spread the fame of English artists and engravers on the Continent. In 1790 he was Lord Mayor of London. His most ambitious undertaking was the Shakespeare Gallery: he commissioned from major artists of the day 162 oil paintings illustrating Shakespeare's plays, and engraved and published them by subscription in 1802. The paintings, most of which were large, were housed in a gallery in Pall Mall. Boydell hoped by this venture to encourage the rise of 'a great national school of history painting', and he intended to leave the collection to the nation, but he had heavy losses during the French wars and it was sold by lottery in 1804.

377

**BOYS,** THOMAS SHOTTER (1803–74). English WATER-COLOUR painter and LITHO-GRAPHER. He was born in London and trained as an engraver. He travelled and lived in France, where he knew BONINGTON, and in Belgium and produced many water-colours of continental urban scenes rich in colour and firm in design. He lived in England from 1837. He published in 1839 *Picturesque Architecture in Paris, Ghent, Antwerp, Rouen, etc.,* a work which marked the transition from hand-tinted lithography to chromolithography, claiming in the Preface that the process was completely new, and in 1842 *Original Views of London as it is,* the plates of which, drawn and lithographed by himself, constitute a fine topographical record of Regency London.

378, 379.

**BOYTAC,** DIOGO (active 1490–1525). Architect, possibly of French origin, responsible for some of the first buildings of the MANUELINE style in Portugal. He worked at Setúbal (church of Jesus, 1492–8), Belém near Lisbon (Hieronymite monastery, *c.* 1502), and probably Guarda Cathedral (1504–17).

**BOZZETTO.** A sculptor's small sketch, usually in wax or clay, which serves as a preliminary model for a larger work in more durable material. See STONE SCULPTURE.

**BRACKETED MODE.** See ITALIAN VILLA STYLE IN THE U.S.A.

**BRAMANTE,** DONATO DI ANGELO (1444–1514). The outstanding Italian architect of the High RENAISSANCE. He was born near Urbino and may have obtained his training there at the palace of the Duke of Montefeltro. He started as a painter and in 1447 painted the *Philosophers* of the Palazzo del Podestà, possibly under the influence of PIERO DELLA FRANCESCA's follower MELOZZO DA FORLI. He painted the *Men at Arms* frescoes (now in the Brera, 1480–5) and may have painted the *Christ at the Column* which is also there. His interest in PERSPECTIVE and TROMPE-L'ŒIL is thought to have left its mark on subsequent Milanese painting. He was in Milan in 1481 when he signed an engraving of a romantic architectural fantasy. Shortly before this, probably, he began his first building, Sta Maria presso S. Satiro, Milan, in which his knowledge of perspective was used to create an illusion of depth in the choir which was in reality only a few feet long. This church uses classical forms such as barrel VAULTS and a coffered DOME, and it already shows Bramante's interest in central planning, which he could have studied in Romano-Lombard buildings such as S. Lorenzo in Milan, then generally believed to be the work of the ancient Romans. Bramante was also much influenced by BRUNELLESCHI.

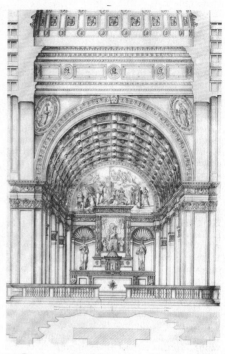

53. Perspective view of the east end of the church of Sta Maria presso S. Satiro, Milan, designed (*c.* 1480) by Bramante. From *Le fabbriche piu cospicue di Milano* (1844), F. Cassina

The tribune of Sta Maria delle Grazie (*c.* 1488–99) was Bramante's greatest Milanese work. In it he used classical forms and a modification of ALBERTI's centrally planned scheme of S. Sebastiano; but the whole has a lightness and delicacy characteristic of the quattrocento. The cloisters of S. Ambrogio (Catholic University of Milan) are based on the Court at Urbino and are similar in style to Bramante's first work in Rome, the cloister of Sta Maria della Pace. Bramante left Milan because of the French invasion of 1499 and settled in Rome, where the remains of antiquity inspired him afresh. The Tempietto of S. Pietro in Montorio (1502) adapted the classical circular temple to Christian usage and formed a type for Renaissance ecclesiastical architecture, just as his *House of Raphael* (known only in engravings) is the type of Renaissance palace. Both were adapted from classical prototypes and used the classical ORDERS OF ARCHITECTURE in a scholarly way. Bramante represents the classical ideal of a building in which each part has its distinct function and is clearly defined in relation to its neighbours, while identical forms are repeated throughout the structure.

From *c.* 1503 Bramante was engaged on two enormous tasks for Pope Julius II, patron of MICHELANGELO and RAPHAEL. These were the works at the Vatican, including the huge amphitheatre of the Belvedere, and, above all, the

designing of the new St. Peter's to replace the most famous of EARLY CHRISTIAN churches. The foundation was laid in 1506 and little had been built when Bramante died, but he had evolved a characteristically central plan crowned with a huge classical dome. It was much modified by his successors, but the general proportions, colossal scale, and the idea of a dome as fixed by Bramante were followed in part by Michelangelo (1546-64), although the existing Latin cross church shows practically no trace of Bramante's work. As head of this huge undertaking he trained many younger architects—e.g. Raphael and PERUZZI—and the history of 16th-c. architecture is the history of his influence and the reaction from it.

898, 2581.

**BRAMANTINO**, BARTOLOMEO SUARDI (*c.* 1466-1536). Italian painter and architect who worked chiefly in Milan, in particular for the Trivulzio family, for whom he designed a chapel in the S. Nazaro Maggiore church. He was influenced by BRAMANTE and FOPPA in his painting style but his later work developed to greater freedom and a mastery of SFUMATO in the treatment of flesh and drapery (*Adoration of the Magi*, N.G., London; *Crucifixion*, Brera).

**BRAMER**, LEONAERT (1596-1674). Dutch painter who lived in Delft and, like his contemporaries in Utrecht, experimented with dramatic contrasts of light and shadow. He travelled to Italy in his youth and his early works show that he was familiar with Venetian and Roman CHIAROSCURO effects. After REMBRANDT achieved his first success *c.* 1630, Bramer, although 10 years his senior, was content to follow in his wake. Bramer was one of the few Dutch artists to paint FRESCOES in Holland.

**BRANCUSI**, CONSTANTIN (1876-1957). One of the most eminent of modern sculptors, born in Romania. After studying at Bucharest and afterwards at Vienna and Munich, he settled in Paris in 1904, where he spent many years of poverty and hardship. In 1906 he was presented to RODIN, who offered to take him on as assistant but Brancusi refused. In 1909-10 he worked with MODIGLIANI in Montparnasse and about the same time abandoned modelling for direct carving. He had a one-man show in 1926 at the Brummer Gallery, New York, which gained notoriety owing to a law case against the Customs authorities who proposed to assess his *L'Oiseau dans l'espace* for duty as raw metal. In 1937 he made sculpture for the public park at Tugurju near his birthplace and in the same year he visited India to design a Temple of Meditation for the Maharajah of Indore. In this year also he produced his *Colonne sans fin*, 30 metres long in steel. In 1955-6 he had retrospective exhibi-

tions at the Guggenheim Museum, New York, and at the Museum of Art, Philadelphia.

In his later years Brancusi came to occupy an almost unique position among modern artists and was held in great respect. He had an exceptionally well-developed feeling for materials and his craftmanship was superb. His originality was one of the most important influences in abstract sculpture during the first half of the 20th c. He reduced natural forms to their ultimate simplicity both of volumes and of planes and could embody the essence of a concept in metal or stone (*The Beginning of the World*, 1924). His portraits have the same simplicity of essential truth (*Mademoiselle Pogany*, Musée national d'Art moderne, Paris, 1920; *Socrate*, 1923).

1036, 1440, 1659, 2958.

**BRANGWYN**, SIR FRANK WILLIAM (1867-1956). Painter and etcher, born at Bruges of Welsh parentage. He was apprenticed to William MORRIS 1882-4. He became known as an etcher and lithographer and later as a painter of murals. His earliest murals were for the Royal Exchange (1906) and for the Skinners' Hall (1909). He was an official war artist in the First World War. In 1930 he did panels for the House of Lords, but they were not received and were later given by Lord Iveagh to the City of Swansea. During his lifetime he had a higher reputation on the Continent than in England and there is a permanent collection of his works at the Brangwyn Museum in Bruges. He was one of the finest draughtsmen of his time, though his painting tended to the decoratively sentimental.

**BRAQUE**, GEORGES (1882-1963). French painter. Son of a house painter and amateur artist, he was born at Argenteuil and spent his boyhood at Le Havre. He came to Paris in 1900 and studied at the École des Beaux-Arts. He formed a friendship with Otton Friesz *c.* 1906 and like him painted in the manner of the FAUVES with pure pigments and bright colours. Painting at l'Estaque in the same year he was so impressed with the structural composition of CÉZANNE that when he met PICASSO the following year he was ripe to join him in the researches which led to CUBISM. Until his mobilization in 1914 he worked in close association with Picasso and the two are accounted the joint creators of Cubism. It was Braque who took the lead with the *papiers collés* technique of introducing pieces of imitation wood engraving, marbled surfaces, etc., stuck on to the canvas. On recovering from a serious wound in 1917 Braque went his own way, first concentrating on STILL LIFES in the French classical tradition with the emphasis strongly on structure and during the 1930s painting beach scenes in which patterned arabesque came into greater prominence. His development combined elegance with formal simplification

and culminated in a series of *Oiseaux* done in the 1950s. He was made a Commander of the Legion of Honour in 1951.

384, 403, 619, 807, 1368, 2040, 2354, 2743.

**BRASSES,** MONUMENTAL. A less costly form of funeral monument than the sculptured TOMB, consisting of an engraved brass sheet mounted on a stone slab, and probably first introduced during the early 13th c. in western Europe. The earliest extant example is that of Bishop Iso at Verden (d. 1231). The material used was not pure brass, but an alloy called at the time 'latten', composed of approximately 60% copper, 30% zinc, 10% lead and tin. Latten was produced in the Low Countries (Dinant) and Germany (Cologne) and imported into England, where it was engraved; large-scale English production of brass began only in the 16th c., probably made by immigrant German and Flemish craftsmen. By far the greatest number of brasses have survived in England, over 7,000 in all. The main centre of production seems to have been London, and the majority of medieval brasses are in the home counties. The earliest surviving English brass is that of Sir John Daubernon (d. 1277) in Stoke d'Abernon, Surrey, but there is evidence of a monumental brass made in 1208. The early brasses were bold in conception and execution and of frankly two-dimensional design. In England the figures were cut out and inlaid in a polished stone slab; on the Continent, where few examples have survived, the brass consisted of a rectangular sheet upon which the figure was engraved against a hatched background.

From the mid 14th c. brasses became more numerous but of smaller dimensions, and in the following century the design began to deteriorate. The engravers attempted to achieve three-dimensional effects by shading with cross-hatching, a method unsuited to the medium. Brasses fell out of fashion at the RENAISSANCE but were reintroduced in the late 16th c.

The interesting series of palimpsest brasses can be divided into two groups: (1) those on which new dates and inscriptions have been added to earlier figures; (2) those in which the plain reverse has been used for a new engraving, leaving fragments of earlier designs on the back. Many of these palimpsests show Flemish engraving on the reverse and were imported in the place of new sheets. Their use was probably due to the shortage of material following the destruction of Dinant by Philip the Good in 1466. Others were pillaged from Flemish churches during the religious wars of the later 16th c.

Monumental brasses have been of great importance as a source of detailed information on the evolution of armour and costume in medieval England.

1733.

**BRAY,** SALOMON DE (1597-1664). Dutch architect and painter of biblical and allegorical scenes, active in Haarlem. His son JAN (*c.* 1627-97) was his pupil. Jan's historical pictures (*Clothing of the Orphans*, Haarlem, 1663) and portraits have a distinction of their own, and in spite of their elegant, smooth style show the lasting influence of HALS on painting in Haarlem.

**BRAZILIAN ART.** When Brazil declared her independence from Portugal in 1822 English and French NEO-CLASSICAL influences had already to a large extent superseded the colonial BAROQUE and ROCOCO styles of the turn of the century (see PORTUGUESE COLONIAL ART). In 1816 a group of French artists arrived at Rio de Janeiro, among them the painter Nicolas Taunay (1755-1830) and the architect Auguste Grandjean de Montigny (1776-1850). They founded an Academy of Fine Arts and established French academic taste so successfully that it continued pre-eminent in Brazil for a hundred years. Consequently it was only about the middle 1920s that an art of genuinely Brazilian character began to emerge. The initial creative impulse may have owed something to European artists such as the EXPRESSIONIST painter SEGALL and the abstract painter VIEIRA DA SILVA, who lived for some years at São Paulo and Rio respectively; but the work of the leading contemporary Brazilian painters, notably PORTINARI, was original. The most spectacular of Brazil's contributions to contemporary art, however, have been in the field of architecture. The advice given by LE CORBUSIER when he visited Rio de Janeiro in 1936 as consultant on the design of a new building for the Ministry of Education and Health stimulated the executive team of Brazilian architects to construct one of the outstandingly original buildings of the 20th c. Various members of the team, notably Lúcio COSTA, Oscar NIEMEYER, Alfonso REIDY, Rino Levi, Marcelo and Milton Roberto, and Jorge Machado MOREIRA, afterwards constructed many other public and private buildings which brought Brazil to a position of world leadership for originality in the designing of buildings functionally adapted to the tropics. Among the decorative features which were adapted to new and original effects were AZULEJOS, the BRISE-SOLEIL and garden settings designed by the landscape architect Roberto BURLE MARX.

Brazil has also led the way in modern town-planning. As early as 1897 a new capital, Belo Horizonte, for the state of Minas Gerais was laid out on a radial plan. In 1922 Goiánia, the new capital of the state of Goiaz, was begun on a gridiron plan which allowed room for indefinite growth. In no other country have the special problems of tropical climate and terrain led to such radical and successful solutions. The most dramatic culmination of this development was the creation of a new capital, Brasilia, in hitherto virgin territory, which was formally inaugurated in 1960. Lúcio Costa's plan was chosen by an international jury in 1956 and became widely recognized as a model of integrated lucidity. It has been said by Henrique E. Mindlin, historian

of modern Latin-American architecture, that 'Brasilia has carried to the man-in-the-street the concept of planning to an unsurpassed degree, especially through the total elimination of traffic intersections, one of the aspects of planning most easily grasped by the general public'. It makes a superb framework for the inspired architecture of Oscar Niemeyer.

87, 201, 1103, 1677, 1689, 1828, 1844, 2389, 2518, 2547, 2707.

**BREGNO**, ANDREA (1421–1506). Italian sculptor, born near Lugano and trained in the Lombard tradition, who became the leading monumental sculptor in Rome during the second half of the 15th c. With the assistance of a flourishing workshop he produced numerous altars and TOMBS, the characteristic motif of which was the niche figure used in new and interesting ways.

**BREITNER**, GEORGE HENDRIK (1857–1923). Dutch IMPRESSIONIST painter influenced by the HAGUE SCHOOL, notably by MESDAG and William MARIS. He was one of the few Dutch artists with whom van GOGH had close contact during his early years (1881–3). At this time Breitner was the better painter of the two; yet he remained one of those minor masters whose works are known and collected by their countrymen but which are hardly known or seen in other countries. Breitner began by making pictures of manœuvring and charging cavalry. In the 1880s and 1890s he became the leading master of Impressionism in Holland. He settled in Amsterdam and made paintings of its busy harbour, its architecture, and the street life of the workers. He also made pictures of women dressed in Japanese costumes, and life-size nudes. After 1910, owing to ill health, he practically ceased to paint.

**BRERA**, Milan. The Gallery of the Brera is of relatively recent foundation, although it has been open to the public since 1809. The palace of the Brera, which had belonged to the Jesuit Order, was intended by the Empress Maria Theresa to become the home of several educational institutions. When Milan became the capital of a French province it was made the centre for paintings from northern Italy displaced by the closing of religious houses after the treaties of Tolentino (1795) and Pressburg (1805). In this way the Brera came into possession of some of the finest works of the RENAISSANCE, such as RAPHAEL's *Marriage of the Virgin* (1806) and PIERO DELLA FRANCESCA's *Madonna with Angels and with Duke Federigo of Urbino* (1811), as well as many excellent works of the VENETIAN SCHOOL. Later some of its treasures were returned to the other Italian states. But the collection has also been continuously enlarged by purchase and bequest.

**BRETON**, ANDRÉ (1896–1966). French poet, essayist, and critic, who was the chief theorist and exponent of SURREALISM. He broke with the Paris DADA movement in 1921 and was instrumental in setting up Surrealism as a separate movement from Dada. He published in 1924 the first *Manifesto of Surrealism* and helped with the first number of the periodical *The Surrealist Revolution*, which he afterwards edited. His *Second Manifesto of Surrealism* was published in the final number of this journal, December 1929. He wrote *Le Surréalisme et la Peinture* in 1927 (second edition, English, 1945) and *Genèse et perspectives du surréalisme* in 1941. He contributed an essay 'Limits not Frontiers of Surrealism' to the English volume *Surrealism* edited by Herbert Read in 1936.

387, 388, 389, 390, 494.

**BRETT**, JOHN (1830–1902). English painter, who entered the R.A. Schools in 1854, was soon after in touch with the PRE-RAPHAELITES, and was particularly influenced by RUSKIN. A handful of his early paintings such as *The Stonebreaker* (Walker Art Gal., Liverpool, 1857–8) are remarkable *tours de force* of minute and brilliant detail, but his later work degenerated into a prosaic catalogue of objects.

**BRETTINGHAM**, MATTHEW (1699–1769). English architect, who carried out Holkham Hall, Norfolk, from the designs of William KENT, and subsequently built up a practice as a PALLADIAN architect. His son, also MATTHEW (1725–1803), adopted his father's profession, but is better known for his activities in Rome, where he bought antiques for the English market.

**BREU**, JÖRG (c. 1480–1537). German painter from Augsburg, who as a young man seems to have worked for a while in Austria. His *Herzogenburg Altarpiece* (1501) shows something of the passionate manner of the masters of the Danube School. Like DÜRER and ALTDORFER he illuminated the margins of the Emperor Maximilian's prayer-book, drawing on impressions he had received on a journey to Italy about 1514. His son, JÖRG the Younger (d. 1547), was a prolific book illustrator.

**BREUER**, MARCEL (1902– ). Architect of Hungarian origin who studied first in Vienna and then at the BAUHAUS, becoming director of the department of furniture design in 1924. He initiated new methods of furniture design based on a standard modular unit and using laminated plywood on tubular steel frames. Later, in England and Switzerland he developed bent and moulded plywood designs and aluminium as a supporting structure. He left Germany in 1933 and from 1935 practised in England as an architect in partnership with F. R. S. Yorke (1906–62). In 1937 he emigrated to America and taught at

Harvard University under GROPIUS (with whom he collaborated in designing several houses in New England) until 1941. From 1946 he practised in New York. His houses are notable for their precision of finish, in which the severe geometry of Bauhaus design is softened by the free use of rough local stone and natural-surfaced timber. In 1952 he was chosen with NERVI and the French architect Bernard Zehrfuss (1911– ) to design the Headquarters Building for UNESCO in Paris (1953–8). Among his more important buildings are the De Bijenkorf store in Amsterdam, the Litchfield High School Gymnasium (1954–6), and St. John's Abbey Church, Collegeville, Minnesota (1953–61).

74, 291, 391, 392.

**BREUGHEL.** See BRUEGEL.

**BREVIARY.** A book containing the offices to be said by the clergy at the canonical hours. Although the offices date back to the 4th c., the Breviary did not come into existence until the 11th c. Usually neither the small, portable Breviary nor the larger Choir Breviary was much illustrated; sumptuous illumination was reserved for the Breviaries destined for the use of kings, nobles, or church dignitaries. Outstanding among those which survive are the *Belleville Breviary*, decorated by Jean PUCELLE (Bib. nat., Paris, *c.* 1325), the *Breviary of the Duke of Bedford* (Bib. nat., Paris, *c.* 1424–35), and the *Grimani Breviary* (Venice, *c.* 1500), which contains 110 large pictures including calendar illustrations, scenes from the New Testament, Old Testament, and the lives of saints.

**BRIGHTNESS.** See COLOUR.

**BRIL.** The brothers MATTHEUS II (1550–83) and PAUL (1554–1626) are the best-known members of this Flemish family of artists. They went to Italy independently (*c.* 1575) and there both of them received commissions to make frescoes in the Vatican. Both died in Rome. They are primarily LANDSCAPE painters and the differences between their work have not been clearly defined. Paul was probably the pupil of his older brother and lived long enough to assimilate some of the qualities of ELSHEIMER's and Annibale CARRACCI's landscapes. His work bridges the gap between the fantastic 16th-c. Flemish MANNERIST landscapes and the more plausible, idealized Italian landscapes of the 17th c. He also made views of Rome for the tourist trade, and MARINE pictures. His conception of both of these subjects had considerable influence upon Agostino TASSI, the teacher of CLAUDE Lorraine, and upon Claude himself.

**BRILLIANCE.** See BODY; COLOUR.

**BRISE-SOLEIL.** Architectural term for a slatted or louvred sun-screen incorporated in the façades of buildings in sunny countries to inter-rupt the glare of the sun while admitting light and air and permitting a view from the windows. The device was first used architecturally by LE CORBUSIER in a project for a block of offices in Algiers, published in 1933. The device has been used with fine effect in the Ministry of Education building, Rio de Janeiro, designed in 1937 by a group of Brazilian architects with Le Corbusier as consultant. Variations on the same theme occur in many later Brazilian buildings, in other South American countries, and in Egypt. The pattern of vertical and horizontal compartmented screens, whose proportions are worked out in accordance with the height and direction of the sun, gives depth and richness to the otherwise flat surface of the typical contemporary façade and establishes a different set of rhythms from those provided by the alternation of wall and window which the *brise-soleil* conceals. The aesthetic potentialities of the *brise-soleil* have aroused much interest among modern architects and it is one of the contributions that the modern style has made to the language of architecture.

**BRISTOL BOARD.** Sheets of stout drawing-paper pressed together and used for drawing or mounting. Its smooth firm surface is attractive to black-and-white illustrators, for it allows a pen line and hatchings to be drawn with great clarity and cleanness, an important factor when a drawing has to be reduced in size for reproduction.

**BRITANNIA.** A name constructed from the tribe-name Brittones and used by the Romans to denote the largest of the British Isles. In iconography it originated as a female figure representing Rome seated triumphant on the British shores which appeared on coins of the Roman emperor Claudius (41–54) to commemorate his annexation of southern Britain. A similar figure, representing England, was used on a medal to celebrate the Treaty of Breda (1667) struck by the Dutch medallist John Roettiers. On the orders of Charles II Frances Stuart, Duchess of Richmond, sat for Britannia, and the figure persists, slightly modified, on the British penny piece.

**BRITISH MUSEUM.** The national museum of archaeology and ethnography, which also houses the national library of manuscripts and printed books. Until 1881 it also contained the natural history collections now at South Kensington. The note of universality is symbolized in the tympanum of the façade, where WESTMACOTT has depicted the Liberal Arts and Sciences. The conception of the Museum was primarily related to historical and scientific rather than to aesthetic interest. Even objects now valued by the general public chiefly for their aesthetic quality as art objects (e.g. the Assyrian reliefs from the MAUSOLEUM and elsewhere) were

originally acquired and admired for their curiosity appeal or historical interest and in the middle 19th c. one of the greatest attractions of the Museum was a stuffed giraffe in the entrance hall.

Sir Hans Sloane's (1660–1753) private collection of 'books, manuscripts, prints, drawings, pictures, medals, coins, seals, cameos and natural curiosities', acquired for the nation in 1753, formed the nucleus of the collection together with the Harleian and Cottonian collections of manuscripts. Established by Act of Parliament as a storehouse of knowledge for the benefit of the 'learned and curious', the Museum was opened to the public in 1759. It was first housed in Montagu House, Bloomsbury, and for nearly 50 years it was necessary to make formal application for admission (Pastor Moritz in 1782 had to give a fortnight's notice) and only five parties of 15 were admitted on Mondays, Wednesdays, and Fridays.

With the acquisition of Sir William Hamilton's collection of classical vases and antiquities (1772), a plethora of Egyptian antiquities (including the Rosetta Stone donated by George III) on the defeat of Napoleon at the turn of the century, the magnificent library of George III (1828) and the Grenville bequest of rare books and manuscripts (1847), the marbles of Lord Townley (1805), the Phrygian marbles (1815), and the ELGIN MARBLES (1816), the collections became among the most extensive and valuable in Europe. The present structure was built by Sir Robert SMIRKE 1823–47 and the great circular Reading Room in 1857. Its dome is 106 ft. high and only 2 ft. less than the Dome of St. Peter's in diameter.

The Department of Prints and Drawings led a separate existence from 1808 onwards. It began with over 2,000 drawings from the Sloane collections, which included an album of DÜRER'S drawings. During the 19th c. the arrangement by subject matter began to give place to artistic and topographical interest and the collection attracted large numbers of bequests. Among the most important acquisitions was the Richard Payne KNIGHT bequest (1824) of over 1,000 drawings, including works by CLAUDE, REMBRANDT, and RUBENS. In 1836 the Sheepshanks collection, largely of Dutch 17th-c. works, was purchased; in 1859 one of the sketch-books of Jacopo BELLINI and 29 drawings by MICHELANGELO. In 1931 the 20,000 drawings by TURNER, given by him to the NATIONAL GALLERY, were transferred to the Print Room.

**BRIULOV.** See BRYUOLOV.

**BROEDERLAM,** MELCHIOR (active 1381–1409). Painter from Ypres, who worked at the court of the Duke of Burgundy from 1387. In 1391 he was commissioned to paint the backs of the wings for BAERZE'S RETABLE at the Chartreuse de Champmol, now in the Musée de la Ville at Dijon. This ALTARPIECE is the earliest extant example in panel painting of the Franco-Flemish style which in amalgamation with certain Italian features fused into the INTERNATIONAL GOTHIC. The presence of Italianate influence is seen in the architecture, the ornamental draperies, and the pose of the Virgin. While the figure of St. Joseph is depicted as an authentic peasant with Flemish realism, it is set against a background of calligraphically stylized rocks in the manner of the French court painting. Broederlam is important in the history of art as a typical representative of the Franco-Flemish style towards the end of the 14th c.

**BROEUCQ.** See DUBROEUCQ.

**BRONZE SCULPTURE.** Bronze is an alloy of copper and tin, sometimes having traces of other non-ferrous metals. Bronze with low tin content (less than 16%), called 'alpha' bronze, is soft and malleable with a melting-point varying from 1083 °C. (that of copper) to c. 950 °C. It can be worked both cold and hot. 'Delta' bronze (with 32% tin) is hard and brittle. The hardness of bronze with low tin content can be increased by cold hammering. Bronze is easier to cast than copper because it has a lower melting-point and is more liquid than copper at a given temperature. Its colour is affected by the proportion of tin or other metals (zinc, lead, silver, arsenic) and these also affect PATINATION. Bronze is a very responsive, strong, and enduring substance, readily workable by a variety of processes. Its great tensile strength makes possible free extension or protrusion of unsupported parts and the easy balance of large masses over a narrow base. It may be given a surface texture to suggest the flow of the molten metal or it may be wrought and chiselled to suggest sharp and hard-edged metallic planes. It can convey the effect of *plastic* (modelling), *glyptic* (carving), or *toreutic* (metal working). Most RENAISSANCE and modern bronzes reflect a plastic technique, being cast from originals modelled in a plastic medium such as clay. Archaic and early classical Greek bronzes were cast from a carved wooden original and therefore reflected a glyptic technique. Thus Professor Rhys Carpenter says: 'In exchanging metal for stone, Greek sculptural art did not cease to be glyptic, as there was no stage in the manufacture of a hollow-cast bronze to which the term "plastic" had any application.' It is conjectured that Khmer bronzes (see CAMBODIA, art of) were also cast from a carved original. On the other hand the practice of casting the head and limbs separately and fitting them together by a tongue-and-groove method gives the bronze-sculptor greater flexibility and releases him from the restraint imposed on the marble-sculptor by the shape of the block. Moreover the greater tensile strength and smaller weight of hollow-cast thin-walled bronze gives the sculptor far more

**Fig. 12.** BRONZE CASTING BY CIRE-PERDUE PROCESS

A. Wax model: a. wax layer (outer surface modelled); b. heat-proof core; c. metal pins. B. Heat-proof mould surrounding wax model: d. wax, cone-shaped mass; e. thick wax rods; f. thin wax rods; g. enveloping plaster and grog. C. Reversed mould with wax pouring out; h. air vents; j. wax runners; k. cone-shaped funnel from which the melting wax escapes. D. Molten bronze being poured in the runners: l. air escapes; m. molten bronze

freedom in representing the body in action with protruding or unsupported limbs. This superior freedom is aptly illustrated by the difficulties which Roman copyists experienced when they made marble replicas of Greek bronzes and often found it necessary to introduce arbitrary supports to take the weight of the figure or of protruding limbs. For example the copyists of MYRON's *Discobolos* left unremoved 'various barlike struts and ties of their own invention in order to strengthen the projecting limbs, together with a heavy vertical support, sketchily carved to resemble the stump of a dead tree, to stabilize the top-heavy mass of stone'.

In the earliest techniques of bronze casting figures were cast solid. It is impossible by this method to produce large or monumental sculpture because if a large mass of bronze is cast solid, it shrinks unevenly and pulls out of shape. The invention of hollow casting enabled larger works to be cast with greater accuracy. It also reduced the weight and made it easier to cast free-standing parts separately and assemble them in the completed work.

There are two methods of hollow casting: the *cire-perdue* or 'lost wax' process, and sandcasting. The wax method seems to have been the one chiefly used in classical antiquity and is still much commoner than the other for sculpture, although sand-casting is the method most used industrially today.

The principle of *cire-perdue* is as follows. A heat-proof core is enveloped in wax which has been formed to the required shape. (The wax will usually be a replica of the sculptor's work modelled in clay and is produced by means of a plaster cast taken from the clay.) This in turn is surrounded by a heat-proof mould. The wax is melted out. Molten metal is poured into the space which the wax occupied. And finally, when the metal has solidified, mould and core are removed, leaving a hollow metal shape reproducing the shape of the wax. The *core* is made from a mixture of PLASTER OF PARIS and 'grog' (pulverized crockery) or clay in roughly the shape of the intended figure but slightly smaller. On this core the figure is modelled in wax (see MODELLING), the layer of wax being ½ in. or less thick. This is the *model*. Sometimes it will be produced by the sculptor, but more usually the founder produces the wax model from a plaster cast of the artist's model in clay. Then metal pins are hammered through the wax layer into the core—not driven home but left with their upper halves protruding. Their function is to keep the core in place. At the top of the model sausage-like rods of wax are fixed obliquely so that their upper ends meet in a solid wax shape like an inverted cone. On the lower parts of the figure, and at all protruding points, thinner and longer wax rods are fixed which lead upwards and round to the cone at the top. Then the model with all its excrescences is enveloped in a mass of plaster and grog; this is the *mould*. The whole structure of core, wax layer, and

mould is now inverted so that the cone is at the bottom and is put into a kiln, where it is heated (large works have to be moulded in the kiln itself). All the wax is thus melted out or burnt away. Where the cone was there is now a hollow funnel; the thick rods of wax have given place to runners, the thinner ones to air-vents. All moisture has been evaporated and the interior of the mould is perfectly dry. The structure is now turned right side up, so that the funnel is at the top, and packed into a sandpit so that the sand gives it greater resistance to pressure. Molten bronze is poured into the funnel and down the runners until it fills all the vacant space between core and mould. The enclosed air is forced out through the vents—a delicate and dangerous part of the process since if the air, expanded by the heat of the metal, does not escape freely, the mould may burst. When the metal is cool the mould is chipped off, the cast is cleaned, the protrusions of metal which filled the vents and runners are sawn off, and the work is ready to be chased and finished by the sculptor.

In many cases the artist makes his model in clay (see MODELLING), then casts it in plaster (see PLASTER CASTS). From this plaster model he makes a mould also of plaster, complete with runners and air-vents. Then he brushes a thin layer of wax over the interior of the mould to the thickness of the future bronze. Finally he fills up the hollow with a core of plaster and grog. He has now assembled the same essential structure of core, wax layer, and outer mould, as might have been done by the other method. Usually nowadays, as has been said, the founder reproduces the sculptor's plaster cast in a waxcovered core and the sculptor may put the final touches on the surface of the wax before casting.

For casting small and elaborate figures, to avoid spoiling the surface with the large number of funnels which would be necessary, it is thought that in Java (see INDONESIAN ART) and at BENIN the outer layer of clay was mixed with finely chopped goat's hair. The hair was charred by the heat and left minute channels in the clay through which the air could escape.

*Sand-casting* is a very ancient process, which was practised in many parts of the world. It was used in 6th-c. Greece for large bronzes and was developed to great technical precision in the 19th c. because of its usefulness for making metal casts for machinery and building construction. Its results are accurate, but it has certain disadvantages for the artist. The mould is made in sections, called 'pieces', and although only two pieces are necessary for a very simple shape, a large number may be needed for the complicated forms of a human figure or where there is undercutting. The process will therefore be laborious and it has the added disadvantage that the joins between the pieces leave seams on the cast, which have to be carefully removed afterwards.

For sand-casting a plaster model must first be cast from the artist's original wax or clay model.

The mould is made of very fine cohesive sand which contains a little clay. Each piece is moulded separately as described in the article on plaster casts. The pieces are then arranged in two box-like frames which can be fastened tightly together and have a funnel at one end. The sand of each piece holds together firmly and does not—surprising though this may seem—mingle with the sand of the neighbouring pieces. When all the pieces are assembled in the frames they are surrounded with a thin layer of powdered graphite, and sand is packed round this up to the edges of the frames and rammed down firmly. The founder now has a complete mould, in two halves, made entirely of sand. He fixes an iron construction in the middle of the hollow and round this he builds a new model, also of sand, filling the hollow. Then he takes out the new sand model and scrapes the top layer off it to a depth of about ½ in. or whatever the thickness of the final cast is intended to be (it may vary in different parts of the work). Shallow channels are scratched in the surface of the mould to serve as air-vents. The sand model which, now that it is reduced in size, represents the core is fitted back in place between the two moulds, the iron holding it in position. The two parts of the frame are screwed together, the frame is stood up on end with the funnel at the top and the molten metal is poured in, filling the narrow space between core and mould. When the metal is cool the mould is removed and the seams where the piece-moulds met are removed by filing and chasing.

In sand-casting complicated figures (such as could be cast in one operation by the *cire-perdue* method) have to be cut up and cast in sections; for instance an outstretched arm may be sawn off the plaster model at the beginning and moulded and cast separately. When this is done the two casts are united afterwards by a 'Roman joint'. This means that the arm is cast with a protruding flange made to fit under the edge of the shoulder; then holes are drilled through the two thicknesses of metal and bronze pins screwed into them, after which the surface is chased until the join is barely noticeable.

*Chasing.* Bronze can be finely worked and with the help of chisels and punches the sculptor can impart a smooth finish to the surface of his cast if he so wishes. Until the middle of the 19th c. casts were very carefully chased and such details as folds of drapery, hair, or outlines of eyelids were shown as distinct and clear-cut shapes. Later, and particularly in the context of the ROMANTIC movement, many sculptors preferred their casts to retain the texture of the original clay modelling.

*Replicas.* If the model is of plaster, a new mould can be made from it and a replica cast from that mould, and this can be done several times. If on the other hand the model is of wax, it will be destroyed in the casting, and no replica can be taken except by making a mould from the bronze cast. Some sculptors make one 'unique

cast' of each work; others make several. It is a matter of choice and there need be no difference in quality or authenticity between one cast and another, though they may vary in the chasing.

*Shrinkage.* Bronze shrinks considerably as it hardens from the liquid to the solid state, and one of the advantages of hollow casting is that it prevents excessive shrinkage with consequent danger of distortion and fracture. Any replica made from an original work in bronze will therefore be distinguishable as being slightly smaller than the original.

*Patina.* Just as iron rusts, so the colour and appearance of bronze may be altered by exposure; but this process is normally very slow and far from being harmful covers the bronze with a hard protecting surface. Patina may be either natural or artificial. The natural patina is either a copper carbonate from the carbonic acid in the atmosphere, or a copper sulphate from sulphur. The first is of a light greenish colour, and the second a brownish black. Since the natural process takes many years patina is often induced artificially by treating the finished work with ammonia or liver of sulphur or some organic substance, the exact formula being usually the sculptor's secret. (See also the article PATINA.)

*History.* Bronze casting is a very widely disseminated technique both for implements and for works of art. Its origin is not known, if indeed it spread from any one centre. The Sumerian metal-workers were adept in both solid casting and hollow casting by the *cire-perdue* method (see BABYLONIAN ART) and cast copper statuettes are known from the 3rd millennium B.C. The Akkadians inherited the technique from the Sumerians and there exists (Iraq Mus., Baghdad) a bronze head thought to be a portrait of the Amorite Sargon (c. 2380-2223 B.C.). Bronze Age sites have been discovered in central Asia earlier than 2000 B.C. In China the art of bronze casting was mature by about the middle of the 2nd millennium and bronze vessels developing earlier pottery shapes with intricate ANIMAL STYLE designs date from c. 1600-1300 B.C. It is a matter of doubt whether the technique of bronze was a native invention in China or was introduced from western Asia by way of Siberia (see CHINESE ART). Bronze seems to have carried from China into Indochina about the beginning of the 1st millennium and about 600 B.C. was worked for weapons and art objects (e.g. ornamental drums) by the Dong-son culture, whence it was disseminated to Indonesia (see INDONESIAN ART). Both bronze and copper figures and utensils have been found from the Indus valley cultures c. 2200-1500 B.C.

The origin of casting in South America is obscure. It seems not to have been known to the Chavín or Paracas cultures, though it was probably known at Nazca c. A.D. 400 and examples of cast copper have been found in Mochica sites about the same period (see PRE-COLUMBIAN ARTS OF THE ANDES). Bronze became the most important material used in casting after *tumbaga*

(a gold–copper alloy). It is thought to have been discovered in Bolivia, probably c. A.D. 800–900, and to have spread from the highlands to the Peruvian coast and the Argentine. Somewhat later it was introduced into Ecuador by the Inca. South American bronzes were of the type containing less than 12% tin. For weapons and utensils the metal workers knew how to harden copper or bronze by cold hammering to a degree which gave rise to a persistent legend of a lost art of hardening copper supposedly known to the Inca. An account from Bernadino de Sahagún of casting by Aztec goldsmiths describes a *cire-perdue* method and it is believed that this was the method used in Colombia and Peru. In Colombia stone moulds for casting figurines have also been found.

The Egyptians made comparatively little use of bronze for sculpture and had no adequate technique of hollow casting from moulds. The Greeks, who derived their techniques in the Archaic period from Nilotic craftsmen, first used a technique of beating a metal sheathing round a wooden core. According to later tradition the method of hollow casting was first introduced in Greece, possibly about the middle of the 6th c., by craftsmen of Samos, RHOECUS, and THEODORUS. Greek bronze sculpture was for long assimilated to the aesthetic forms of the glyptic methods of stone carving. The surface was burnished and smoothed by graving. Gilding with gold leaf and inlaying with various metals was used instead of the bright pigments with which marble sculptures were coloured. Eyes were represented by coloured paste or by insetting semi-precious stones into the eye-sockets.

In EARLY CHRISTIAN ART large works in bronze were rare except at Constantinople. A few such works survive, e.g. the bronze doors of Sta Sophia (dating in part from the 6th c.) and the colossal 7th-c. statue of an emperor, probably Heraclius, now at Barlotte, Italy. The famous life-size seated figure of St. Peter in his titular church at Rome (5th c.) is probably of Western origin and is the last example of monumental bronze sculpture in the round until the Italian RENAISSANCE. Bronze continued to be used in the West for many small utensils required for the Church, such as oil-lamps, censers, candlesticks, as also for objects of personal adornment.

Few graves of the MIGRATION PERIOD have failed to produce bronze or bronze-gilt brooches, buckles, ear-rings or finger-rings. Documentary sources refer to large works in bronze produced at this time, such as the eagle lectern supported on a column surrounded by the four evangelists made in the 7th c. for St. Kilaire at Poitiers, but the only surviving large-scale works date from the CAROLINGIAN Renaissance of the 9th c. and were produced in Charlemagne's foundry at Aachen. These include the bronze doors with lion-head ring handles and the open-work gratings at triforium level of Aachen Cathedral. A small equestrian statue of Charlemagne himself or one of his successors (Musée de Carnavalet, Paris) may also be another 9th-c. casting. The Rhineland and Saxony continued outstanding centres of bronze casting. Mainz Cathedral has a pair of bronze doors dating from the late 10th c. The great pair of doors at Hildesheim, each having eight panels with figure scenes from the Old and New Testaments, was made in 1015. Bishop Bernward of Hildesheim (d. 1022), who was probably responsible in part for the design of the doors, was also said to have made, but probably only commissioned, the famous column at Hildesheim decorated with scenes from the life of Christ running spirally around it in the manner of Roman triumphal columns.

Bronze casting still flourished in northern Germany during the 11th and 12th centuries, but the towns in the valley of the Meuse—Liège, Huy, and especially Dinant—became the predominant centres of the art. The production of Dinant was so prolific, and through the town's trade connection with the Hanseatic ports so widely spread abroad, that small bronze-work came to be known as *dinanderie*, a rather loose term still used in modern critical literature.

A particular feature of ROMANESQUE art was the close relationship between the various crafts. Whereas later the development of the guilds forced artists to specialize, in the Romanesque period the distinction between the goldsmith and the bronze-founder hardly existed. The famous Romanesque goldsmiths, such as Renier of Huy, Godefroid de Clair, or NICOLAS OF VERDUN, were as active in bronze casting as in working gold or silver, enamelling, or mounting precious stones. The earliest of these, Renier of Huy, is known only from the great bronze font at the church of S. Barthélemy, Liège (c. 1115), the first of a long series of fonts which are the outstanding examples of medieval bronze-founding. Other Romanesque masterpieces are the huge seven-branched Paschal candlesticks, examples of which survive at Essen and at Milan (the so-called Trivulzio candlestick attributed in part to Nicolas of Verdun), and the vast chandeliers or *coronas* (examples at Hildesheim from the 11th c. and Aachen from the 12th c.). While most of the surviving Romanesque bronzes must be attributed to the Mosan and Rhine valley founders, the famous candlestick made for Gloucester Cathedral c. 1110, a fine door-knocker at Durham Cathedral, and the description of the (lost) Paschal candlestick at the same cathedral 'as high as the vaults of the aisles', are evidence of the standard reached by English bronze-founders. Of Italian achievements in this medium the most important are the series of great bronze doors made in the 12th c. after 11th-c. Byzantine importations, e.g. at Benevento, Verona, Trani, Monreale, Pisa, etc.

The social and economic changes of the 13th c. which resulted in the organization of the craftsmen into guilds and the increasing secularization of the crafts divorced the goldsmiths' craft from

that of the bronze-founders. The latter still endeavoured to compete with the precious metals by enriching their productions with gilding, silver-plating, engraving, and enamelling, but the more refined GOTHIC taste had not the same use for bronze as had the sturdy, monumental Romanesque art. In Germany the Romanesque style continued well into the 13th c. (Hildesheim font) and bronze remained popular as a material in Germany and the Low Countries till the close of the Middle Ages. The later German bronze-founders produced such *tours de force* as the 30-ft.-tall tabernacle of the Marienkirche, Lubeck (1476-9), and the Sebaldus tomb in the church of the same name made by the VISCHER workshop at Nuremberg. This latter work already heralds the Renaissance and it was during the 16th c. that Nuremberg came to the forefront as a centre of bronze-working in Germany. In England the most important achievement of the later Middle Ages in the representational arts is the series of bronze monumental effigies of the sovereigns. The earliest are that of Queen Eleanor of Castile, first wife of Edward I, and that of Henry III, both known to have been in hand in William TOREL's workshop in 1291. With few exceptions they are all in Westminster Abbey, where the course of development can be followed from the simplicity of Henry III's effigy to the striking naturalism of those of Henry VII and Elizabeth of York by the Italian sculptor TORREGIANO. Much documentary evidence concerning their manufacture survives. Thus we know that the effigy of Richard Beauchamp, Earl of Warwick, in St. Mary's, Warwick (made between 1442 and 1462), was cast by the London founder, William Austen, the slab was made by Thomas Stevens, coppersmith, and the whole was gilt by Bartholomew Lambespring, a Dutch goldsmith of London.

At the Renaissance there arose a fashion for small bronzes of the sort which were collected by the ancient Romans. Classical bronzes were copied and small figures or groups were made supposedly in the classical style, such as the *Hercules and Antaeus* (Bargello, Florence) of POLLAIUOLO, which has all the dramatic overemphasis of the late HELLENISTIC work. The techniques of bronze casting were also once again exploited for full-scale statuary and masterpieces were produced such as the *David* of DONATELLO (1430), the first nude statue since classical times, the *David* of VERROCCHIO (1476), and the *Mercury* of GIAMBOLOGNA (1574). The classic account of bronze casting is the description given by Benvenuto CELLINI in his *Autobiography* (1558-62) of the casting of his *Perseus* (Loggia dei Lanzi, Florence, 1545-54).

The quality of a bronze depends not only on the conception but on the artist's understanding of the medium and his exploitation of it for one or another of the specific effects to which bronze lends itself. During the 19th c. and after bronze came to be used for official statues erected in public streets and squares, which were not only trite and banal in themselves but were merely enlarged reproductions of models which might equally well have been rendered into any other material. In contrast with official art the great ROMANTIC artists, such as RODIN and later EPSTEIN, were interested in exploiting the potentialities of bronze to express movement and light or to render the more intimate textures of modelled clay. In the 20th c. all the various aesthetic potentialities of bronze were developed from the smooth perfection and highly polished surface of BRANCUSI's *Bird in Space* (1940) to the lava-like flow of LIPCHITZ's *Prometheus* (1944) and the sensitive modulations of DESPIAU's portraits.

505, 967, 1469, 2400.

**BRONZINO,** AGNOLO TORI DI COSIMO DI MORIANO (1503-72). Italian painter, pupil and adopted son of PONTORMO, who introduced his portrait into his painting *Joseph in Egypt* (N.G., London). His manner was superficially that of Pontormo's and like Pontormo he utilized the vogue established by MICHELANGELO. But the spirit was different and the crude energy of Michelangelo was converted into elegant posturing empty of religious feeling. The *Christ in Limbo* (Uffizi, 1552) and his completion of Pontormo's *Martyrdom of S. Lorenzo* (S. Lorenzo, Florence, 1569) belong to a secular court style not essentially different from that of the *Venus, Cupid, Folly and Time* (N.G., London) which breathes the refinement of decadence and with superb technical dexterity conveys suggestions of eroticism under the pretext of a moralizing allegory.

Bronzino's greatness lay in his portraits, cold, cultured, and unemotionally analytical, with completely controlled effects of complicated pattern and a draughtsmanship approaching that of INGRES. Their technical mastery and aristocratic detachment give them an 'icy fascination' and an almost insolent assurance. They set the tone for court portraiture in Counter-Reformation Europe and were not entirely without influence' on the portraiture of Elizabethan England. Well known examples are the portrait *Eleonora da Toledo and her Son* (Uffizi) and the *Portrait of a Young Man* (Met. Mus., New York).

1716.

**BROOKING,** CHARLES (1723?-59). English MARINE painter. Very little is known of his short career. He is said to have been employed at Deptford dockyard. His small placid sea pieces are pleasant essays in the van de VELDE manner.

**BROSAMER,** HANS (*c.* 1500-54). German painter, engraver, and designer of woodcuts, who worked in Fulda and Erfurt. He was influenced by Lucas CRANACH and the manner of the LITTLE MASTERS. Two of his portraits are at Hampton Court.

**BROSSE,** SALOMON DE (1571-1626). The most distinguished French architect in the first decades of the 17th c. Born at Verneuil, he moved to Paris after the Edict of Nantes. He was commissioned to build three chateaux: Coulommiers (1613) for the Duchess de Longueville, Blérancourt for Bernard Potier, and the Luxembourg (1615) for Marie de Médicis. In 1618 he built the new Salle for the Paris Parlement and the palace for the Parlement of Brittany at Rennes. His façade for S. Gervais, Paris (1616), based partly on the frontispiece of DELORME's château at Anet, was a novelty in applying to ecclesiastical architecture features hitherto regularly used for the entrance of a château. He also rebuilt the Protestant temple at Charenton (1623). Brosse was connected with the DUCERCEAU family, whose concern with ornament is apparent in his earlier style. His own contribution to French architecture, however, was a new attention to plastic mass instead of surface decoration. In this respect his work was revolutionary and contained features later to be developed by François MANSART.

**BROUWER,** ADRIAEN (1605/6-38). Flemish painter who spent a great part of his short working life at Haarlem in Holland. About 1623 he became a pupil of Frans HALS, Adriaen van OSTADE being a fellow pupil. In 1631 he left Holland for Antwerp. His earliest pictures possess the rich colouring of Flemish painting. In the later ones, especially those of 1631-8, he turned to a monochrome that was typical of Dutch painting at that time. The question whether Brouwer belongs to the Dutch or the Flemish school is of more than academic interest, for in his art the elements of both are represented. He is in any case one of the most interesting masters of the 17th c. He is best known as a painter of GENRE—vivid scenes of drinkers and smokers in gloomy inns, single figures of sleeping peasants, humorous series representing the *Five Senses*, and portraits of himself among his companions. The virtuosity of brushwork and economy of expression in these paintings are perhaps surpassed in his landscapes, which are among the greatest of his age. The abbreviated style of his drawings anticipates REMBRANDT's early energetic penmanship, as well as some of the effects of the 19th-c. humorists. Many anecdotes have been woven round Brouwer's Bohemian habits and unorthodox opinions.

322.

**BROWN,** FORD MADOX (1821-93). English painter, born at Calais and trained at Antwerp (under Baron Waupers), in Paris, and at Rome, where he came into contact with the German NAZARENES. Settling in England in 1845, he became a friend of the PRE-RAPHAELITES though he was never a member of the Brotherhood. Before this his work had been in the traditional style of ROMANTIC historical painting (*The*

*Execution of Mary, Queen of Scots*, Whitworth Art Gal., Manchester, 1841), though Dante Gabriel ROSSETTI saw in it colour used as a vehicle for emotion and therefore became for a short time a pupil of Brown. From *c.* 1845 to 1864 he painted in the Pre-Raphaelite manner and his *Chaucer at the Court of Edward III* (Sidney, 1851) contained portraits of several of the Brotherhood. His elaborate *Work*, which he was painting from 1852 to 1863, was swamped by excessive social documentation. His best known and probably his best picture is *The Last of England* (Birmingham, 1855), inspired by the departure of WOOLNER for Australia. His later work lost something of the harsh stridency of this period.

1382.

**BROWN,** LANCELOT (1716-83). Landscape gardener, known as 'Capability' from his habit of telling his patrons their estates had 'great capabilities'. He was one of Lord Cobham's gardeners at Stowe in 1740 when William KENT was completing the landscape park, and seeing the possibilities of the new manner, he began to practise on his own in 1749, developing Kent's ideas. Formal gardens were ruthlessly destroyed and replaced by parks and lawns broken by serpentine waters and clumps of trees. Temples and GOTHIC 'ruins' were often included, the primary intention being to make a garden resemble a landscape painting by CLAUDE. His work was greatly in demand and much of it still exists, though it is sometimes mistaken for natural landscape. In 1764 he became gardener to George III at Hampton Court. His masterpiece was the creation of the lake at Blenheim Palace, though the park at Chatsworth is perhaps a more perfect example of his pastoral style. Other major landscapes created by him are Ashridge Park, Moor Park, Audley End, Bowood, Longleat, and Wardour. He also practised as an architect. He was attacked by Richard Payne KNIGHT in *The Landscape* and defended by Humphry REPTON. (See also PICTURESQUE.)

2576.

**BROWNE,** HABLOT KNIGHT ('PHIZ') (1815-82). English book illustrator. His name is chiefly remembered for his illustrations for Dickens's novels under the pseudonym Phiz, and he created a visual imagery that is enduringly associated with these. He also illustrated Surtees, Smedley, and others, and he painted a great number of water-colours and some oils.

**BRU,** ANYE, or DE BRUN, LURICUS or EURICUS (active early 16th c.). Painter of German origin, who executed a composite ALTARPIECE for the monastery of S. Cugat del Valles, near Barcelona, in 1502-7. German, combined with Venetian, stylistic influences are apparent in the panel from this altarpiece now in Barcelona museum.

**BRUANT,** LIBÉRAL (*c.* 1635–97). French architect. He was architect to Louis XIV (1663) and member of the Académie (1671). He designed the Hôtel des Invalides, Paris (1670), to which J. H.-MANSART added the domed church, and the over-all plan of the Salpêtrière (*c.* 1670), both strong, sober buildings. He is said to have built a house for the Duke of York in Richmond in 1662. He had considerable inventiveness and talent but lacked a feeling for the spectacular. The Hall of the Marchands Drapiers (*c.* 1655–60), the façade of which is now in the Carnavalet Museum, is usually ascribed to his elder brother, JACQUES.

**BRÜCKE.** A loose association of young German painters founded in Dresden in 1905 by E. L. KIRCHNER, K. SCHMIDT-ROTTLUFF, E. HECKEL, and F. Bleyl. They were joined in 1906 by E. NOLDE and M. PECHSTEIN. Nolde, however, remained semi-independent and exhibited with the group only irregularly. In 1910, when the Berlin SEZESSION refused Nolde's picture *Pentecost* at the instigation of LIEBERMANN and Paul Cassirer, the artists of the *Brücke* formed a group for free exhibition which they called *Neue Sezession*, and in 1910 they moved to Berlin. They joined in the second exhibition of the BLAUE REITER group in 1912, which was devoted to graphic art, but in 1913 the group was disbanded when the members quarrelled over a *Chronicle* of their partnership and aims written by Kirchner.

The name—which means 'The Bridge'—was

**54.** Title-page of a *Chronik* of the *Brücke* group. Woodcut by Ernst Ludwig Kirchner

chosen by Schmidt-Rottluff and was meant to symbolize the link that held the group together. It later came to be given a deeper significance as indicating their faith in the art of the future, towards which their own work was to serve as a bridge. Yet they never succeeded in defining this art and their aims remained vague; no clear programme emerged from any of their publications. They were moved by an impulse of revolt and wanted, as others have wanted, to achieve 'freedom of life and action against established and older forces'. In practice they turned against REALISM and IMPRESSIONISM and under the influence of MUNCH and HODLER created a rather wild German version of the EXPRESSIONISM which stemmed from van GOGH, GAUGUIN, the NABIS, and the FAUVES.

Most of the members of the group were without proper training and with the exception of Nolde their handling of paint was crude and often brutal. Like the Fauves they were interested in PRIMITIVE art, which they saw in the Dresden Ethnological Museum; but the inspiration which they derived from it was different. They were interested in figure painting, landscape, and portraiture. While the subject always remained recognizable, harsh distortion and strong symbolic colours—often violently clashing—make their work uncomfortable and uncongenial to much English taste, distinguishing it from the more disciplined forms of Expressionism worked out in the Latin countries. The achievement which seems to have most lasting value was their revival of graphic arts, in particular the woodcut, for emotional expressive purposes. Strong contrasts of black and white, bold cutting, and simplified forms were used to great effect.

99, 423, 424.

**BRUEGEL.** Family of Flemish painters whose surname is variously spelt. The founder and by far the most important figure was PIETER BRUEGEL (*c.* 1525–69). A Flemish painter and draughtsman of universal popularity, who was predominant in Flemish art between van EYCK and RUBENS, he is rated with these masters. Until 1559 Bruegel spelt his name 'Brueghel' and thereafter without the 'h', which is the generally accepted spelling. His two sons, PIETER and JAN, however, retained the 'h' and are distinguished from their father in this way. Bruegel was also known as 'Peasant Bruegel' and as 'Pieter Bruegel the Elder', the latter to distinguish him from his elder son. His surname may derive from a village in north Brabant, possibly his birthplace, but neither this nor the date of his birth is established. Van MANDER's highly laudatory biography is the chief source of information about him, and has been shown to be accurate in many respects by later scholarship. Bruegel joined the Antwerp Guild in 1551, having been the pupil of Pieter COECK VAN AELST, who died in 1550 and whose daughter Bruegel married. Between 1551 and 1555 he made a prolonged journey via France to Italy,

where he travelled as far south as Naples and Sicily. In Rome he collaborated with an Italian miniaturist painter CLOVIO, who owned a number of lost Bruegel works. On his return journey through the Alps he made accurate and extremely sensitive landscape drawings. Back in Antwerp in 1555 he designed a series of landscapes which were engraved and published by Hieronymous Cock, for whom Bruegel produced many drawings of various subjects, including parables like 'the Big Fish eat Little Fish'. His interest appears to have centred on graphic work until *c.* 1562 and in this period the influence of BOSCH is apparent. A drawing of Amsterdam dated 1562 probably indicates a visit there before his move to Brussels in 1563, where he married. From this time until his death he concentrated on painting and produced his best known works. His patrons included the great Cardinal Granvella, who owned the *Flight into Egypt* (1563) now in the Seilern Collection, London; and the wealthy Jonghe Linck, who commissioned the series of *The Months*, of which five survive today. Three of these are in the remarkable collection of 14 paintings by Bruegel in Vienna, which comprises nearly a third of his surviving paintings. Bruegel enjoyed a considerable reputation in Brussels, where he died in 1569, leaving two infant sons who in their turn, by their own and their children's work, added to the stature of the name of Bruegel in Flemish painting.

In his paintings Bruegel ranges with equal

55. *Self-Portrait* by Pieter Bruegel the Elder with an art lover or connoisseur. Pen-and-ink drawing. (Albertina, Vienna, *c.* 1565)

mastery and originality over landscapes (*The Hunters in the Snow*, Vienna, 1565), peasant village scenes (*The Peasant Dance*, Vienna), religious subjects (*The Adoration of the Kings*, N.G., London), and allegories (*The Dulle Griet*, Antwerp, 1562). Works such as *The Dulle Griet*,

56. *The Big Fish eat Little Fish.* Pen-and-ink drawing by Pieter Bruegel the Elder. (Albertina, Vienna, 1550)

or *Mad Meg*, and the *Triumph of Death* (Madrid) are obvious protests against the harsh conditions of the Spanish rule in the Netherlands, as well aš parables on the folly and dire consequences of sin. Here, of course, the legacy of Bosch is most apparent. In contrast to his humorous scenes of village life his representations of events from the life of Christ, in an everyday setting, are conceived in a spirit of realism and drama such as could be achieved only by a man of deep sincerity (*Procession to Calvary*, Vienna, 1564). Bruegel's contemporary fame is well documented and after a period of eclipse it is only in the present century that the character of the man and the true status of the artist have been again appreciated. His pictorial and spiritual influence through his original works and the many prints after them in later Flemish painting, whether LANDSCAPE or GENRE, is incalculable. His technique was minutely precise yet always fluent, with the paint often thinly applied allowing the priming to give transparency to a superb variety of colour.

180, 722, 926, 1054, 1056, 1178, 1895, 2659, 2663.

**BRUEGHEL, JAN** (1568-1625), also known as 'Velvet' Brueghel. Flemish painter and draughtsman, second son of Pieter BRUEGEL the Elder. He was born at Brussels but spent the majority of his life in Antwerp. Van MANDER records that he visited Cologne and it is supposed that he was a pupil of CONINXLOO; his landscapes were influenced by BRIL through contact in Rome. From 1590 he made a prolonged stay in Italy and obtained the patronage in Rome of Cardinal Federigo Borromeo, nephew of the great St. Charles Borromeo and founder of the Ambrosiana Library. In 1595 he moved with his patron to Milan, where the Cardinal was appointed Archbishop. He returned to Antwerp the following year and enjoyed a highly successful and honourable career there. He became Dean of the Guild, and worked for the Archduke Albert and the Infanta Isabella, making frequent visits to the Brussels court. He also continued to work for the Archbishop and some of his correspondence with him has been preserved. He was a close personal friend of RUBENS and collaborated with him in paintings such as *The Garden of Eden* (The Hague). He also painted figures into landscapes by de MOMPER, and backgrounds of landscape, animals, or flowers into paintings of many artists. As a landscape painter he worked in an entirely different spirit from that of his father, specializing in very small wooded scenes, often with carriages and horses or mythological figures, exquisitely finished and brilliantly coloured. In STILL-LIFE paintings, especially flowers, he was considered the greatest artist of his age. He influenced directly Daniel SEGHERS, his pupil, and indirectly his grandson, Jan van KESSEL. His work is represented in most major galleries, and at its best has a quite distinctive quality which has been obscured by the innumerable paintings in his manner, especially

**57.** Portrait of Pieter Brueghel the Younger. Black chalk drawing by van Dyck. (Earl of Devonshire Cóll., Chatsworth)

by his sons JAN BRUEGHEL II (1601-78) and AMBROSIUS (1617-75), whose sons in their turn carried on the style as far as the 18th c.

PIETER BRUEGHEL, the Younger (1564-1638), elder son of Pieter Bruegel, was also known as 'Hell' Brueghel. He was born in Brussels but made his career in Antwerp, where he became a guild master in 1585. Van MANDER records him as a pupil of CONINXLOO, although the latter's influence is not very apparent. As a copyist of his father's paintings he may have relied on engravings and drawings, as in some cases the originals could not have been known to him (he was only 5 at the time of his father's death). These copies are generally very well done and distinctive from the work of lesser copyists such as his son PIETER BRUEGHEL III (1589-c. 1640). Although best known for copies after known and lost works by his father, he was capable of original compositions in the same vein. In his own lifetime the popularity and scarcity of his father's work allowed him an easy outlet for copies and his own originals, and today the situation is comparable. Paintings or drawings by the father are very rarely, if ever, available to collectors or museums, and Pieter Brueghel the Younger has become the most acceptable substitute. Frans SNYDERS was a notable pupil.

723.

**BRÜGGEMANN, HANS** (*c.* 1480-1540). North German sculptor and wood-carver. His large ALTARPIECE (now in Schleswig Cathedral) borrows much from DÜRER's *Small Passion*. In its very size and its technique it is one of the last examples of the monumental carved altarpiece which had been so popular during the last phase of GOTHIC.

BRÜLLOFF. See BRYULOV.

BRUNELLESCHI, properly FILIPPO DI
SER BRUNELLESCO (1377-1446). The most
famous Florentine architect of the 15th c. He
began as a goldsmith, but took part in the com-
petition for the baptistery doors (1401), which
GHIBERTI won. Soon after this Brunelleschi
appears to have begun to study architecture and
to have gone to Rome. He is often credited with
the 'discovery' of PERSPECTIVE—i.e. he studied
the mathematical laws underlying appearances.
He revived Roman architectural forms; his
mathematical studies led him to search for mathe-
matical principles of proportion in buildings, and
above all he studied Roman construction. He
was an engineer rather than a theorist (see
ALBERTI). His greatest feat was the construction
of the dome of Florence Cathedral. ARNOLFO
had planned a dome (c. 1300) but had not had to
face the problem of covering a space 138 ft.
across. Brunelleschi evolved a method (c. 1417-
20), based on his Roman studies, of raising a
dome without centering, i.e. without temporary
supports. In 1420 he was elected jointly with
Ghiberti to supervise the construction, which he
completed in 1436; the LANTERN, also designed by
him, was not begun until 1446. The GOTHIC
pointed form of the dome was essential to its
construction, but Brunelleschi's desire to re-
create the outward forms of Roman architecture
is evident in his other works. The first of these
was the Spedale degli Innocenti (Foundling
Hospital) begun in 1419, where he created the
typical form of RENAISSANCE LOGGIA with a Classi-
cal colonnade, semicircular arches, and hemi-
spherical domes, all governed by classical canons
of proportion. At the same time he began the
Old Sacristy, and later the church, of S. Lorenzo,
where the desire for mathematical proportion
and order is made clear: S. Lorenzo and S.
Spirito, a very late work, are both cruciform, but
differ from earlier Gothic churches in that the
whole building is regulated by the proportion
1:2 or 1:4 reflected in every part; the central
square crossing forming the unit of design. Thus,
the nave is four units long and each bay of the
aisles is one quarter unit.

With the Pazzi Chapel, Sta Croce, begun
1429/30, Brunelleschi initiated the centrally
planned building, i.e. a design based on a circle,
square, or some other perfect geometric shape.
This was carried further in Sta Maria degli
Angeli, begun 1434 and never finished, an octa-
gonal space with radiating chapels, all enclosed
in a regular polygon. From 1434 Brunelleschi's
style became heavier and more Roman, indicat-
ing that he probably went to Rome with his
friend DONATELLO c. 1432/4.

Brunelleschi was one of the creators of the
Renaissance, and as such a Florentine hero. An
anonymous *Life* was written c. 1485 and is one
of our main sources of information: in it his work
is made the standard by which later archi-
tecture was to be judged.

BRUSH. Some instrument for holding and
applying paint has been known to painters since
the early STONE AGE. The ancient Egyptians
used a brush consisting simply of a reed with the
end macerated to separate the fibres. Classical
painters used animal hair, which is still the only
important material. The main types today are
the soft-hair brush used for WATER-COLOUR paint-
ing and TEMPERA, and the bristle used especially
for OIL PAINTING. Both were known to CENNINI,
who describes a soft ermine-hair brush mounted
in a quill, and a brush made of hog bristles tied
round the end of a stick. Even today the quill has
not been altogether replaced by the metal ferrule.
Soft-hair brushes are ordinarily round in section
and pointed; bristle brushes are more often flat,
though this type hardly occurs before the 19th c.
Since the modern type of ready-made oil paint,
packed in a metal TUBE, is less fluid than the
mixtures which the old masters prepared in their
studios, modern brushes are much shorter and
stiffer than theirs.

The best soft brush for water-colour is the red
'sable', made from the fur of the Siberian mink.
CÉZANNE used sable brushes in his later oil paint-
ings in which thin touches of colour are super-
imposed. The 'camel-hair' brush, actually made
from squirrel hair as a rule, is softer than sable
and lacks springiness and durability. The best
quality bristle brushes for oil painting are made
of white hog bristles from Silesia. Some painters
use ox-hair brushes for oil painting; they are
cheaper and more rigid than red sable. Fitch
is also used. A brush of badger hair, flat and
widely spread, was used to blend and soften the
edges of paint, especially in oil painting. It has
not been used much by modern painters, who
generally employ frankly juxtaposed touches or
patches of colour without softening or blending.

The Chinese and Japanese, who have a variety
of brushes in common use for their particular
techniques of painting, drawing, and calligraphy,
use the hair of various animals—goat, rabbit,
hog, and sable—and usually mount them in
bamboo.

BRUSH DRAWING. The BRUSH is often an
instrument of DRAWING as well as painting. This
technique was carried to the highest pitch of
artistry in China, where no sharp line of demarca-
tion was admitted between CALLIGRAPHY and
drawing. (See CHINESE ART.) There is evidence
of this as far back as Magdalenian times. (See
STONE AGE ART IN EUROPE.) PLINY's famous
story of the contest between APELLES and Proto-
genes to see which could draw the finest line is
evidence that the brush was used for line draw-
ing in ancient Greece. Early in the Middle Ages
it was used as an alternative to the PEN, METAL
POINT, or CHARCOAL, for the drawing of MINIA-
TURES, and for the lay-in or under-drawing for
paintings. DÜRER's well-known *Praying hands*
(Albertina), a study for an ALTARPIECE, was
drawn with a fine brush-point. For composi-
tion sketches a broader and freer technique

was developed, especially in 16th-c. Venice (e.g. by TINTORETTO and RUBENS). In REMBRANDT's drawing the brush is used with particular mastery. A brush was first tentatively used for the washes in line-and-wash drawing (see WASH) in 15th-c. figure drawing; by the 17th c. it was a fully developed technique in the hands of POUSSIN, CLAUDE Lorraine, and others.

In modern times brilliant brush drawings have been made by GÉRICAULT, DELACROIX, DAUMIER, and DEGAS. The last in his 'dessins à l'essence', done on paper, drew with the brush in oil colours thinned with turpentine. ROUAULT, MATISSE, PICASSO, and indeed very many artists both in ancient and modern times have drawn with the brush.

**BRYGOS.** Signature which appears on a number of Attic red-figure vases of *c.* 500 B.C. which are considered to be among the purest representatives of Attic art at this date. Among the finest is a vase painted with scenes from the capture of Troy (Louvre). Typical also of this style is a kylix in the Metropolitan Museum of Art, New York, with a painting representing a youth carrying a *skyphos*. It is not known whether Brygos was the painter or whether he was the potter employing an anonymous artist to decorate his pots.

**BRYULOV,** KARL PAVLOVICH (1799–1852). Russian painter. He was born at St. Petersburg, son of an Italian sculptor, Pavel Bryulov, and studied at the Imperial Academy under Andrey IVANOV. Bryulov spent part of his life in Italy (1822–34 and 1849–52), where he painted his chief work, *The Last Day of Pompeii* (Russian Mus., Leningrad, 1830–3), an enormous (21 ft.) theatrical composition which brought him European fame. It was admired by Sir Walter Scott when it was exhibited in Rome, and inspired Bulwer-Lytton's novel, *The Last Days of Pompeii* (1834).

**BUCRANIUM** (Greek *boukranion*: 'ox-head'). A decorative motif based on the horned head of an ox. Of immense antiquity, it is found on the painted pottery of Iraq in the 5th millennium B.C. and occurs later in Bronze-Age Crete which inherited the cult of the Bull and Double Axe from the East. Garlanded for the sacrifice it appears carved on classical altars, replacing the actual heads which were hung there in more primitive times. Later it was taken over as a decoration for friezes, etc., on buildings. Hellenistic examples favour the whole head; in Rome the naked skull was more frequent.

**BUDDHIST ICONOGRAPHY.** In Buddhist iconography much is conveyed by an elaborate language of hand gestures (*mudras*) and by symbolic objects held in the hands. Only a few of the most important can be mentioned here. Buddhism was of Indian origin, and when it was transmitted to other countries of the Far East,

**58.** Chinese cast-iron Buddha. Represented making an esoteric *mudra* connected with initiation. (Gulbenkian Mus. of Oriental Art, Durham, *c.* 900)

although it assimilated characteristics and concepts of the indigenous religions, it retained symbols of purely Indian origin.

The Buddha is not often represented in eastern art in his common human form, though occasionally he appears as Prince Siddhartha or as an ascetic previous to his enlightenment. Theory recognized three bodies of the Buddha: the *Dharma* body, ineffable and unrepresentable; the *Nirmanakaya*, the human individualized envelope, substantially irrelevant; and the *Sambhogakaya*, the glorious body constituted of symbolic characteristics following ancient astrological and 'medical' theories. The last is the bodily form represented in Buddhist icons. Golden colour, head-protuberance (*ushnisha*), tuft of hair between the brows, webbed fingers, and long arms were among the canonically established characteristics. The need faithfully to preserve these characteristics (as formulated in the *Shilpa Shastras*) accounts for the relative sameness of Buddhist icons through the centuries. The *Nirmanakaya*, in accordance with Far Eastern interest in individual eccentricity and physiognomy, was sometimes represented in China and Japan, for example by the Sung painter LIANG K'AI.

The Buddha had passed through many previous existences before reaching the human

**59.** Buddha the golden bodied. From Tibetan painting. Represented in the gesture of the Bhumisparsha *mudra*, calling the earth-goddess to witness his right to enlightenment. (Gulbenkian Mus. of Oriental Art, Durham, *c.* 1810)

**60.** Bodhisattva Avalokitesvara. From Tibetan painting. Represented in the 'Thousand-armed' form, his thousand arms symbolizing his infinite capacity for works of compassion. (Gulbenkian Mus. of Oriental Art, Durham, 19th c.)

stage at which he could achieve enlightenment. The stories of these existences (*Jatakas*) are perhaps the commonest material of Buddhist narrative art, representing the Buddha in both animal and human incarnations. This progress serves as the pattern for the ordinary Buddhist's search for release. The human life of the Buddha is also a fertile subject for art. It is often compressed into a series of canonical incidents; conception, birth, first meditation, enlightenment, first sermon, incidents of his mendicant life, and death. These narratives were used as material for instructing the unlettered in the ultimate possibilities for man.

Following the Indian belief in endless cycles of self-repeating time, reason suggested that historical uniqueness should not be attributed to our historical Buddha, who died as an old man *c.* 480 B.C. Other Buddhas were therefore postulated, both past and future. They often appear in art as a group of five or seven. Later Buddhism of the Mahayana schools employed one or all of these Buddhas in its systems of figurative expression, without regard for any historical hypothesis. The 'Buddha-principle', being in essence one, was yet at the same time infinitely divisible. This concept is illustrated by 'Thousand Buddha' icons, and by the Buddha figures in the aureole of icons of Vairocana, for example.

Bodhisattvas are beings partaking of the Buddha-nature, who from unlimited compassion remain in contact with the world of everyday existence to help suffering humanity. They appear alone or as supporters or interlocutors of

the Buddha, and are usually dressed in royal regalia of jewels and crowns. Of the many known to Buddhism Padmapani, in the guise of Avalokitesvara, appears most commonly in Indian art. He bears a lotus flower in one hand. In China, Korea, and Japan he came to be known as Kuanyin (Japanese, Kannon). Some authorities regard Kuanyin as being of female sex, but most representations display male characteristics. The crude but widely known distinction made between the Theravada or Southern Buddhism of Ceylon, Burma, Laos, and Thailand, called Hinayana, and the Mahayana Buddhism of the north rests largely on the difference in stress laid upon the Bodhisattva ideal. In the Mahayana Bodhisattvas are numerous and important, in the Hinayana personal salvation is emphasized rather than altruistic compassion.

Terrible Deities representing in general the radiant power of the Buddhist doctrine appear in later Buddhist art. They frown fiercely, display their fangs, and usually dance vigorously. They often have many hands bearing emblems and many heads, which symbolize various powers and forms of knowledge. They are essential to the imagery of Tantric meditation as it was developed in India after A.D. 600. Tantric Buddhism travelled to Tibet (see TIBETAN ART), to China, and to Japan as Shingon. In Japanese art the terrible form of the Buddha, Fudo, is often represented in an aureole of flames.

The best known of the feminine images is Tara, who appears as a beautiful girl holding a long-stemmed lotus. Her name, from the Sanskrit

root *tri*, to cross, refers perhaps to a Buddhist prayer-spell (*mantra*) and to other Buddhist imagery of crossing the stream of existence. She causes one to cross to the other shore of knowledge. She thus represents the transcendent wisdom (Prajna Paramita) which is the goal of Buddhist study. Similar figures occur with a palm-leaf book supported on the lotus. These are incarnations of the great fundamental text of Mahayana Buddhism called Prajna Paramita. The Indian goddess of Fortune, Shri, travelled with Buddhism over the Far East, and in Japan was known as Kichijoten.

Other feminine images of terrible appearance are known, especially in India, Tibet, and Nepal. They are to a large extent parallel to similar masculine images. Feminine figures also occur in the same countries in sexual union with masculine. These have an esoteric reference to doctrine and ritual practice.

Later Buddhist figures may be represented grouped in a circular pattern (*mandala*) representing a doctrinal synthesis. This is especially common in Tantric art from Tibet and Japan. Five Buddhas, with attendant Bodhisattvas and feminine principles, are ranged, one at the centre the others at the four points of the compass, and each presides over his own special domain of experience and reality. Spell-syllables are associated with the symbolic figures, and beautiful *mandalas* are sometimes found composed of the lettered syllables alone.

Buddhist imagery often contains figures of flying celestial beings. These were in origin the commonly accepted deities of the Indian heavens and their presence, perhaps showering flowers and playing music, dignifies the Buddha's sermons. The gods of the forest, wells, and streams, Yakshas, Yakshis, and Nagas (serpents) also appear, and were exported from their native India to other Buddhist countries. So too were the 'Guardians of the Four Quarters of the World'—soldierly or terrible beings—who achieved especial prominence in Japanese art.

The Chinese and Japanese tradition of Ch'an (Japanese Zen) Buddhism was based on biographies of eccentrics or spiritual sages. These men were the subject of many works of art, especially ink-paintings. Familiar are 'The Sixth Patriarch' of the sect, Bodhidharma, its Indian founder, and two 'lunatics' Han Shan and Shih Te.

In Japanese art there are as well many representations of revered historical persons—saints, abbots, teachers, and distinguished patrons of Buddhism—in notably realistic style. Tibetan art also included paintings and sculptures of historical personages. Though individualized, these were recognized as incarnations of Bodhisattvas. Such were Padona Sambhava, founder of one of Tibet's major sectarian groups, recognized by his squarish hat with a vulture feather in its crown, and Tsong Khapa, founder of the second major sect, who wears a tall,

pointed cap. Other figures were portrayed with more or less realism in monastic garb.

In Far Eastern art are often represented the Lohan (from Sanskrit *arahan*). Their numbers are variously given from 4,000 to 5,000. They are completely enlightened beings, in some way similar to Bodhisattvas, who serve the cause of Buddhism, but lack the special characteristic of unlimited compassion. They are shown generally as fully individualized, often in groups. Sometimes the Guardians of the Quarters are considered as Lohan.

Common throughout all Chinese and Japanese art was the figure of a fantastic lion with flowing mane and tail. This is an emblem of the power of Buddhist enlightenment. Sometimes such a lion was represented instructing a baby lion, an emblem of Buddhist discipleship. Such figures came to have a very general currency, as prophylactic against evil spirits, and were used everywhere, e.g. as roof tiles and door guardians.

As in Indian art generally, conventional positions, including especially positions of the hands (*mudras*), had especial prominence in the iconography. Some of the commonest *mudras* employed in Buddhist art are described under the heading MUDRA.

268, 348, 612, 740, 814, 1105, 1106, 1157, 1203, 1455, 1633, 1782, 1885, 2396, 2442, 2634, 2636, 2966.

**BUECKELAER,** JOACHIM (*c.* 1535–73). Flemish painter of large STILL LIFES—market and kitchen pieces—at Antwerp. He seems to have been the first painter to depict fish stalls. Bueckelaer was the nephew and pupil of Pieter AERTSEN, who played a decisive part in his artistic development.

**BUFFALMACCO.** See MASTER OF ST. CECILIA.

**BULFINCH,** CHARLES (1763–1844). America's first professional architect and one of the distinguished designers of his day. His work epitomizes the restrained and gracious qualities of the traditional phase of NEO-CLASSICISM in New England. Son of a prominent Boston family, Bulfinch was educated at Harvard and upon graduation made an extended trip to Europe. Thus along with JEFFERSON he became one of the first native-born Americans to make a direct study of the architecture of the Old World. In such early works as the Massachusetts State Capitol, Boston (1798), his dependence upon the architecture of late 18th-c. England is clearly evident. From the beginning, however, his work bore the stamp of his own individuality. His style was one of severe simplicity, refined proportions, and fragile detail. He preferred brick, which he used without disguise. His walls were unadorned and the openings sharply defined, giving his work a clean geometrical quality.

Bulfinch was an influential and prolific architect. His work included such buildings as warehouses, theatres, stores, schools, and hospitals, and he established in Boston a type of urban residence that formed the architectural character of the city for a quarter of a century. Typical are the three houses he built for Harrison Grey Otis (1796, 1800, and 1805-6). In 1793 he designed Franklin Crescent, Boston, the first important multiple housing unit in America, which was inspired by the crescents of Bath. His Congregational church in Lancaster, Massachusetts (1816), is regarded as one of the masterpieces of American architecture. From 1818 to 1828 Bulfinch was in Washington as architect to the Capitol.

1499, 2097.

**BULLANT,** JEAN (c. 1520-78). One of the two dominant figures in French architecture during the period of the Wars of Religion (the other being the elder Jacques Androuet DUCERCEAU). In 1556 he is known to have been in the service of Constable Anne de Montmorency, for whom he worked on the château of Écouen. His pavilion added to the south wing is the earliest surviving use of the COLOSSAL ORDER in France, where it became popular after its use in Italy had become rare. Both his work at Écouen and the Petit Château which he built probably about 1560 for Montmorency's castle at Chantilly display an original style of MANNERISM. On the death of DELORME in 1570 he succeeded him as architect to Catherine de Médicis, continuing with the southern wing of the Tuileries. He was also responsible for several large building projects for Catherine de Médicis, including the replanning of the château of Chenonceau and the Hôtel de Soissons. He wrote a *Reigle générale d'Architecture des Cinq Manières de Colonnes* (1564), which became one of the textbooks of French architecture (third edition published by de BROSSE in 1619).

**BULLET,** PIERRE (1639-1716). French architect, member of the Académie (1685). His early Paris houses and the Porte S. Martin (1674, commissioned by the city) show the classical manner of the previous generation, which he imbibed from his master, N.-F. BLONDEL, but his later works, notably two houses he built in the new Place Vendôme for the financier Crozat (1702 and 1707), herald the ROCOCO in their free and ingenious planning. He wrote a theoretical treatise, *L'Architecture pratique* (1691).

**BULLOUGH,** EDWARD (1880-1934). Professor of Italian at Cambridge University. He made important contributions to experimental aesthetics and to the philosophy of art. His name is usually associated with his theory of 'psychical distance'.

**BUON,** BARTOLOMEO (c. 1374-1467). Venetian sculptor and architect. With his father GIOVANNI, who founded the highly successful family workshop, he worked on the Cà d'Oro (1422) and the Porta della Carta of the Ducal Palace (1438-42). His art, influenced by the Florentine Nicolò d'Arezzo (d. 1456) and by south German sculpture, epitomizes the survival of the GOTHIC style in Venice into the mid-quattrocento. A relief of the *Madonna della Misericordia* (1441-5) is in the Victoria and Albert Museum.

**BUONAMICI,** AGOSTINO. See TASSI, A.

**BUONTALENTI,** BERNARDO (1536-1608). Florentine architect, military engineer, painter, and sculptor. He was a follower of MICHELANGELO and AMMANATI and used most of the more exuberant forms of MANNERIST decoration, as in his grottoes in the Boboli Gardens. He worked mainly for the MEDICI Grand Dukes and built for them the Tribunà (c. 1580-8) and other parts of the Uffizi and Palazzo Vecchio. He also prepared a model, never executed, for the façade of Florence Cathedral (c. 1587). In Rome he built the Casino Mediceo (1570-6) and the façade of Sta Trinità (1593-4), and began the Palazzo Nonfinito—'the unfinished palace'—in 1593. He wrote two books on engineering and fortifications, designed for the theatre, and organized firework displays—whence his nickname 'Bernardo delle Girandole'.

**BURCHFIELD,** CHARLES (1893-1967). American painter. Combining ROMANTICISM with REALISM, he was prominent during the 1930s among the painters of the American scene. His works expressed the grandeur and power of industry (*Black Iron*, 1935). His later work revealed an increasing sense for the universal mystery and power of nature (*The Sphinx and the Milky Way*, Munson-Williams-Proctor Institute, Utica, 1946; *An April Mood*, Whitney Mus. of American Art, 1946-55).

195.

**BURGES,** WILLIAM (1827-81). One of the most robust and original of the English GOTHIC REVIVAL architects; also a designer of furniture. He was a pupil first of BLORE and then of Matthew Digby WYATT. He designed many churches, mostly in a 13th-c. French Gothic style, rebuilt and furnished Cardiff Castle and Castle Coch for the Marquis of Bute (1865-75), designed the cathedral of St. Finbar at Cork (finished 1876), and his own house at Melbury Road, Kensington (1870-1), fitted up with PRE-RAPHAELITE meticulousness of detail.

**BURGKMAIR,** HANS, THE ELDER (1473-1531). German painter and designer of WOOD-CUTS. After learning his trade under SCHONGAUER

he settled in 1498 in his native Augsburg. His paintings, with their warm glow of colour, their decorative classical motifs and their intricate spatial composition, show that he must have decisively transformed his late GOTHIC heritage through journeys to Italy and to Venice in particular. His woodcuts made full use of DÜRER's technical innovations in their sensitive and expressive use of line and tone. Like Dürer he contributed to the famous series of courtly woodcuts for the Emperor, the *Triumph of Maximilian*, which substituted a paper triumph for a real one and was at the same time a clever piece of imperial propaganda. He was also employed to illustrate the Emperor's own writings, the *Theuerdank* and *Weisskunig*, moralizing knightly romances. A certain clarity of characterization, which is typical of all his works, seems to have influenced HOLBEIN.

**BURGUNDY,** SCHOOL OF. In 1384 Duke Philip the Bold of Burgundy, the brother of Charles V of France, married Marguerite, heiress to the County of Flanders. Both Philip and his brother Jean, Duke of Berry, who became joint guardians of their nephew Charles VI, were enthusiastic patrons of the arts and the result of this political union was to bring more Flemish artists into the service of the court. The name 'School of Burgundy' has been given to a group of Flemish panel painters and miniaturists who worked for them between 1390 and 1420 (including Beaumentz, BELLECHOSE, BROEDERLAM, and MALOUEL). The name is misleading. Though many of their works were intended for the Chartreuse de Champmol near Dijon, their vision was the vision of Flanders. They infused a new vigour of Flemish realism into the French court style of the 14th c. and produced a modification of the Italianate influence which had been dominant. In 1420 the Burgundian court removed from Dijon to Bruges and from then on the Flemish elements became more and more pronounced, culminating in the masterpieces of the MASTER OF FLÉMALLE and the brothers van EYCK. In the courts of Burgundy and Anjou the penetrating realism of the Netherlands superimposed on the new naturalism of the Italian schools was curbed to the clarity and elegance of French taste. And with the infusion of new strength was born of their union the INTERNATIONAL GOTHIC style, a genuinely French contribution to European artistic development.

**BURIN** or GRAVER. The engraver's principal tool. It is a short steel rod, usually lozenge-shaped in section, cut obliquely at the end to provide a point. Its short, rounded handle is pushed by the palm of the hand while the fingers guide the point. See LINE ENGRAVING, WOOD ENGRAVING.

The same names are applied to the chipped flints used by palaeolithic man for engraving cave-walls, bones, etc.

**BURKE,** EDMUND (1729-97). British statesman and political thinker. His *A Philosophical Enquiry into the Origin of our Ideas of the Sublime and Beautiful* was one of the most important aesthetic documents that 18th-c. England produced. It went through 17 editions in his lifetime and after ADDISON's Essays was the most influential single work on the course of English aesthetics in the 18th c. Its influence was also felt in Germany.

Burke held that the emotions of beauty and sublimity are evoked by properties of things according to 'some invariable and certain laws', which he set himself to discover empirically. He differed from HUTCHESON and KAMES in that he did not have recourse to the doctrine of an 'inner sense' of beauty. Disagreements on matters of aesthetic judgement were ascribed to differences in natural sensibility or in attention to the object. With this proviso he assumed that in principle all men respond alike and that in consequence 'it must necessarily be allowed that the pleasures and pains which every object excites in one man, it must raise in all mankind, whilst it operates naturally, simply and by its proper powers only; for if we deny this, we must imagine that the same cause operating in the same manner, and on subjects of the same kind, will produce different effects, which would be highly absurd'. Burke was also important for formalizing the difference between the concepts of the beautiful and the SUBLIME.

**BURLE MARX,** ROBERTO (1909- ). Brazilian landscape architect and garden designer. Of German descent, he studied in Germany and at the National School of Fine Arts, Rio de Janeiro. In 1933 he specialized in garden design at the suggestion of LÚCIO COSTA and by his brilliantly imaginative planning made an important contribution to modern architectural development in Brazil. His designs are particularly effective for their pictorial sense and the success with which they integrate tropical colours to emphasize by harmonious contrasts or by picturesque settings the most striking features of the new architecture.

**BURLINGTON,** RICHARD BOYLE, THIRD EARL OF (1694-1753). English architect and patron. Burlington made the GRAND TOUR in 1714-15 and while in Rome he met William KENT, then practising as a painter, with whom he formed a lifelong friendship. Having caught an enthusiasm for PALLADIO from Colen CAMPBELL, Burlington returned to Italy in 1719, visiting Vicenza and Venice to study the master's work at first hand. Thereafter he returned to England where, in addition to the many duties of his rank, he became an architect of distinction and a liberal patron of the arts, including poetry and music. Kent, Campbell, FLITCROFT, WARE, LEONI, the sculptor Guelfi, Alexander Pope, and

John Gay were all closely associated with Burlington House. The architects of the group found work through Lord Burlington, who also encouraged them to publish books on architectural design, which were important propaganda for the style he preferred. These include Kent's *Designs of Inigo Jones* (1727), Robert Castell's *Villas of the Ancients* (1728), Isaac Ware's edition of Palladio's treatise (1738), and his own publication of Palladio's drawings for the restoration of Roman baths, which he had bought in Italy and printed as *Fabbriche antiche* in 1730. These works were widely studied, the PALLADIAN was soon the only style for aristocratic buildings, and the Burlington group with its followers dominated the secular architecture of Britain for over half a century. He was generally regarded as an arbiter of taste, thereby provoking the enmity of William HOGARTH, who attacked him in satirical engravings.

Burlington's own work is austerely classical and is now best seen in the exterior of his villa at Chiswick (*c.* 1725) and the interior of the York Assembly Rooms (1731-2). This design, taken from the Egyptian Hall which Palladio drew from the description of VITRUVIUS, consists of a rectangular space lit by a clerestory, itself supported on a rectangle of Corinthian columns. His other existing buildings are the dormitory at Westminster School (1722; rebuilt after damage in 1940-1) and Tottenham Park, Wilts. (1721; much altered in the 19th c.).

Burlington and Kent often worked in close collaboration; but it seems that Burlington was usually responsible for the exterior and Kent for the interior design.

Throughout his life Burlington made a large and very fine collection of books, drawings, paintings, and sculpture, much of which is now at Chatsworth House.

2793.

**BURMESE ART.** The art of Burma was dominated by Indian religious cults to an even greater degree than that of most other regions of south-east Asia. Both Buddhism in its two forms, Hinayana and Mahayana, and Brahminism were introduced to Burma at an early date. In the early centuries of the Christian era central and upper Burma were settled by the Pyu, a people of the Tibeto-Burman linguistic group, who have left remains of sculpture and monumental brick architecture at old Prome (Śrikṣetra) on the Irrawaddy. There survive Buddhist images in the Gupta style (see INDIAN ART), Brahmanic images and fine reliquary caskets of silver. The Pyu also had a characteristic type of STUPA in the form of a massive cylinder surmounted by a cone which became a prototype for the later Pagán building. Parts of southern Burma, particularly around Thatôn, were occupied by another people, the Mon, who lived also in Siam (see SIAMESE ART) and produced art works both Buddhist and Brahmanical in type.

The Pyu were attacked and their northern capital Pyo was sacked in 832 by the strong kingdom of Nan-chao in Yünnan and another Tibeto-Burman people, the *Mranma* or Burmese, swept over the country from the borders of Tibet and China, setting up their capital eventually at Pagán on the banks of the Irrawaddy. The conversion of these people to Buddhism was accelerated when their king Anoratha (Aniruddha) (1044-77) defeated the Mon, capturing their royal family at Thaton, and introduced Mon craftsmen and pandits into Pagán. The Pagán kings extended their dominion and ruled Burma until their overthrow by Mongols from China in 1287 and most of what is valued in Burmese art comes from their time. The ruins of old Pagán cover a broad arc 10 or 12 miles long and fully justify the majestic title of *Arimaddanapura*, 'the city that tramples down its enemies'. The palaces and other secular buildings were made of wood and have disappeared with the exception of the Sarabha Gate to the walled town. But there remain relics of a very large number of religious structures made of brick and stucco, stupas and temples.

Anoratha favoured a type of stupa based on the older Pyu model. A bell-shaped structure with shallow mouldings half-way up its height terminates in a cone which represents the old parasol and the whole rests on an octagonal base with one or more terraces for circumambulation. Examples built by Anoratha are Lokananda with two usable terraces and Shwé Sandaw with five. The Shwé Zigon, built by Anoratha's successor Kyanzittha (1084-1112) with three storeys, is regarded as the most national of Burma's monuments. Very many temples—or *ku* (caves) as they were called by the Burmese—were built by Anoratha and his successors. The temples, built of brick, combined the theme of the 'artificial mountain', which underlies the stupa, with that of a natural hill pierced by eremitic caves. The general design, derived from Mon and Pyu traditions, was that of a stupa surmounting a central pillar whose base was enclosed in a precinct wall with stepped or undulating roof. Often instead of the stupa the central feature was a *śikhara*, a bulging obelisk with a small stupa on top of it. The *śikhara* was of Indian derivation as in the Parasurameśvara temple at Orissa. Perhaps the most famous of the temples is the Ananda, a large white temple with gilt *śikhara*, a masterpiece of the Mon style built by Kyanzittha *c.* 1105. During the reigns of Alaung Sithu (1113-*c.* 1155) and Narapati Sithu (1174-1211) a more specifically Burmese style of temple building developed. The largest temple at Pagán, the Dhammayangyi, built *c.* 1160, belongs to the transition stage. In the latter part of the 12th c. closer relations were established with Ceylon and a new sect of Hinayana Buddhists, called Sinhalese, grew up in Pagán and introduced a type of stupa on the Ceylonese model, the most famous of which is that of Chapata at Nyaung-u outside Pagán.

The temples were elaborately ornamented.

The mass of the brick structure symbolized the sacred mountain and the ornamentation, richly gilded in an effulgence of light, stood for celestial palaces in miniature. As everywhere in the Far East, the DRAGON was a favourite feature. It was a symbol of flowing water and irrigation canals, the rainbow or ladder to heaven; it was also fraught with the energy of fire, spouting jets of flame and salamanders. The temples served the function of *Cetiyas* or Memorials of the life and legend of the Buddha. Scenes and incidents of Buddhist doctrine were depicted on glazed tiles and relief carvings; figures of the Buddha in characteristic postures were worked in stone and bronze. Many of the temples were rich in fresco paintings. The Ananda temple is said to have contained over 1,400 stone panels illustrating the Final Life of the Buddha. A specific type of Buddha image was introduced in the 10th c. which had closer affinities with the Indian Pala than with the Gupta and this became standard for Burma and northern Siam. Other images suggest an affinity with Ceylon. The painting has been thought to stem from the same tradition as Ajanta, perhaps through the Mon and Pyu painters whose work has not survived.

After the 13th c. Burmese art never recaptured the sublimity of the Pagán period and revivals in the 15th and 16th centuries led to no new developments of importance.

779, 919, 1158, 1177, 1259, 1883, 1944, 2965.

**BURNE-JONES,** SIR EDWARD COLEY (1833–98). English painter. He was destined for the Church, but his interest was turned to art first by William MORRIS at Oxford in 1855, and then by ROSSETTI, who remained the decisive influence on him. He went to Italy in 1859 and was in Venice and Milan with RUSKIN in 1862. He exhibited little before 1877, but then became quickly famous with a remarkably wide following abroad. He was elected A.R.A. in 1885, but resigned in 1893; the next year he was made a baronet. His early paintings are mainly of medieval and mythical subjects; later he was also influenced by Italian 15th-c. painters and particularly by BOTTICELLI (*King Cophetua and the Beggar Maid*, Tate Gal., London, 1884). The medievalism and dreamlike quality of Burne-Jones was a form of escapism from a world which he was not robust enough to face and conquer; it was not, as it has been described, a revolt against the ugliness of industrialism. But, as R. H. Wilenski has well said: 'It is in his most unreal . . . Golden-Age pictures and drawings that he made his real contribution . . . when he is content to move in the faint unreal world of his own creation, to rejoice in its unreality—and, incidentally to restrict himself to monochrome, for as a colourist he was always rudimentary—he does create an atmosphere; and within this atmosphere he sometimes makes his lines flow like the silvery melodies of Chopin.' He made many designs for tapestry and STAINED GLASS for

Morris & Co. He is well represented in the Birmingham Art Gallery.

446.

**BURR.** The ridge of rough metal left on either side of the furrow in metal engraving. In LINE ENGRAVING it is removed, but in DRYPOINT it is allowed to remain because it gives a soft, rich quality to the printed line.

**BURTON,** DECIMUS (1800–81). English architect, who was responsible for several familiar features of London. He was the leading exponent, along with John NASH, of what is now called the REGENCY style. Although he lived through a large part of Queen Victoria's reign, he retired from practice early and all his works are pre-Victorian in character. He was the son of a contractor who worked for Nash. He designed terraces at St. Leonard's, Hastings, and Brighton (Adelaide Terrace and Crescent) and the Calverley Estate at Tunbridge Wells. In London he designed Cornwall and Clarence Terraces, Regent's Park (1824), and near them his largest building, an exhibition hall with an immense dome and portico, which however was a financial failure and was pulled down. His other work in London includes the screen at Hyde Park Corner (1828), the Athenaeum (1830)—remarkable for its exceptionally pure and elegant Greek detail—Charing Cross Hospital (1831), and the arch at the top of Constitution Hill (1846). He was also the designer of one of the first large English structures in iron and glass, the elegant Palm House at Kew (1844).

**BUSHNELL,** JOHN (d. 1701). English sculptor. He was apprenticed to Thomas Burman (1618–74) but quarrelled with him and fled to the Continent, where he worked his way to Italy. While there he learnt much of BAROQUE handling and executed a TOMB with elaborate battle reliefs for the Mocenigo family in S. Lazzaro dei Mendicanti, Venice (1663/4). On his return c. 1670 he received important commissions for royal figures on Temple Bar and others, including a *Sir Thomas Gresham* for the Royal Exchange (now in the Old Bailey), and would have received more but for his difficult temperament. He also made a number of tombs, that of Viscount Mordaunt (Fulham church, 1675), with its swaggering standing figure, being the finest. He is an important figure, for he showed untravelled Englishmen something of the possibilities of Baroque sculpture, but his work is extremely uneven, and the melancholia from which he died appears to have affected his art.

833.

**BUST.** A sculptured representation of the head and upper portion of the body. The word is of uncertain origin, but it is sometimes explained as derived from the Latin *bustum*, 'sepulchral monument'. The forms of busts have varied a

good deal; the term covers many types ranging from those which only show the head, the neck, and part of the collar-bone to those which include shoulders, arms, and even hands. Such parts of the body as are shown may serve simply as a base for the portrait head and be so shaped as to give a straight line downward (see HERM), or they may be draped to serve a decorative purpose, or dressed in garments which indicate the sitter's status.

The history of the bust is closely linked with that of the portrait. It was natural that the Egyptians, convinced of life after death, should make vivid polychrome busts of the dead. The Greeks also, once they began to make portraits (in the 5th c.), often combined them with herms, e.g. the helmeted *Pericles* (Vatican Mus.). Hellenistic busts always demonstrate that the chief interest of later Greek artists was in the head, which might be either ideal, as in the famous portrait of blind *Homer* (Mus. of Fine Arts, Boston), or realistic, as in Alexandrian art of the 1st c. B.C. It is very different with the Romans, who from Republican times onwards varied and elaborated the bust form so inventively and so often that archaeologists are able to date a Roman bust from its shape.

During the Middle Ages, when there was little interest in individual portraiture, the bust almost vanished from art, although the form was sometimes used for those images of saints which served as reliquaries and for these precious metals were often employed. Frederick II (d. 1251), conscious of his role as emperor, reintroduced the bust with other forms of classical art.

Artists of the RENAISSANCE, especially those of the 15th c. in Florence, achieved a true revival of the classical bust in all its variety. Their portraits ranged from highly realistic representations sometimes based on life or DEATH MASKS (Antonio ROSSELLINO, *Giovanni Chellini*, V. & A. Mus., London) to formal idealizations (Francesco Laurana, *Ippolita Sforza*, Berlin). The 16th c. turned from the simple bust forms used in the quattrocento to a more elaborate imitation of Roman late-imperial types (CELLINI, *Cosimo I*, Bargello, Florence). New and richer forms were developed in the BAROQUE period, in particular by BERNINI; again these were sometimes highly realistic (*Scipione Borghese*, Villa Borghese, Rome) and sometimes consciously idealized (*Louis XIV*, Versailles). Later ages have added little to the store of forms; the NEO-CLASSICIST sculptors of Europe and America returned to the simpler types of Roman Republican busts (Houdon, *Voltaire*, V. & A. Mus., London, and Louvre). In the 19th and 20th centuries artists such as RODIN, DESPIAU, and EPSTEIN have used the form of the bust, but their interest in characterization has led them away from any subservience to traditional formulas. Epstein has sometimes emphasized the character of his portraits by the addition of arms and hands (*Ellen Ballon*, Mus. of Arts, Montreal). The conven-

tion of the portrait bust is still retained by academic sculptors in the modern period, but the form is used only as a point of departure by more experimental sculptors (R. Belling, *Josef von Sternberg*, P. Gargallo, *Head*, both in Mus. of Modern Art, New York).

**BUTLER,** REG (1913- ). English sculptor and architect. He was trained as an architect and practised as architect and industrial technologist under the name of Cottrell Butler 1936-50. He was technical editor of the *Architectural Journal* 1946-50. From 1941 to 1945 he worked as a blacksmith. In 1947 he took up sculpture as an assistant to Henry MOORE, and had his first one-man show in 1949. He was represented at the Venice Biennale in 1952 and in 1953 won the Grand Prize in the competition for a monument to the Unknown Political Prisoner. There was a retrospective exhibition at the Venice Biennale of 1954. He has worked mainly in forged or cast metal, at first in ABSTRACT or CONSTRUCTIVIST style but from the latter 1950s has produced figurative works with some emphasis on sensuous quality.

**BUTTERFIELD,** WILLIAM (1814-1900). One of the leading English architects of the GOTHIC REVIVAL. His work is hard, angular, and multi-coloured; and though some contend that its uncouthness lacks beauty, it unquestionably has great vigour and conviction. Butterfield was a single-minded and intensely religious man, whose work was admired especially by the ecclesiologists in the Camden Society, an influential body who tried to dictate style in church architecture. All Saints, Margaret Street, London (1850), with its novel use of red brick topped by a wooden spire, was regarded by them as a model. In 1870 he built Keble College, Oxford. He put Gothic to his own uses and had no sentimental hankering to recreate the past.

**Fig. 13.** BUTTRESS
A. Wall buttress. Fountains Abbey (late 12th c.)
B. Flying buttress, Reims Cathedral (13th c.)

**BUTTRESS.** Term in architecture for a projecting mass of masonry to give a wall additional strength to resist the thrusts imposed upon it from within by the vaults or by the roof from above. *Flying buttresses* are quadrant arches which lean on the wall at the point where it is to be supported and which are themselves supported at their fulcrums by buttresses proper.

**BUYS,** CORNELIS. See MASTER OF ALKMAAR.

**BUYTEWECH,** WILLEM (c. 1591–c. 1624). One of the most interesting artists during the first years of the great period of Dutch painting. His rapid paintings of dandies, fashionable ladies, topers, and lusty wenches are among the most spirited Dutch GENRE pictures. His terse, lively drawings of the stylish *demi-monde* anticipated something of the quality of Frans HALS's *Laughing Cavalier* (1624). The similarity may well be more than an accident, for Buytewech worked in Haarlem where Hals spent his whole life and we know that at least once the artists worked together on the same picture. Buytewech was versatile. During his short life he made drawings of peaceful family life as well as of raucous revellers. He was a book illustrator. And his etchings of the Dutch countryside are among the first REALISTIC 17th-c. landscapes.

**BYZANTINE ART.** The history of the Byzantine Empire begins in A.D. 330 when Constantine the Great gave to the Roman Empire, whose centre of gravity was shifting from west to east, a new capital on the banks of the Bosphorus: the ancient Greek colony of Byzas or Byzantion, enlarged and renamed 'city of Constantine'. It ends in the year 1453, when Constantinople was captured by the Turks and under the name of Istanbul became the capital of the Ottoman Empire. During these 11 centuries the Byzantine territories varied greatly in extent: at one time they embraced almost the whole Mediterranean basin, but from the 7th c. onwards many provinces were lost, first to the Arabs and later to the Turks.

Byzantine art, however, cannot be defined adequately in political or geographical terms. It did not come suddenly into being, and for a long time it might as properly have been called Roman as Byzantine. Nor did it cease in 1453, for during the second half of the 15th c. and a good part of the 16th the art of those regions where Greek Orthodoxy still flourished—such as Mount Athos—remained in the Byzantine tradition. And Byzantine art passed far beyond the territorial limits of the empire, to penetrate, for instance, into the Slav countries (see RUSSIAN ART).

Under Constantine Christian art, instead of being clandestine, became to some degree official. The eastern Mediterranean art of the 4th to 6th centuries is sometimes called EARLY CHRISTIAN rather than Byzantine because there was as yet no clear rift between East and West. Art forms and iconography circulated and crossed from one end of the Mediterranean to the other. In Palestine, round the Holy Places, an iconography grew up which was carried by pilgrims right into Gaul and even to Ireland. In the Asiatic east the weakening of Roman domination coincided with a decline of HELLENISTIC styles and a resurgence of local traditions. Many and various artistic currents converged in great towns like Milan, in maritime and commercial centres such as Alexandria, Antioch, Ephesus, and Thessalonica, and above all in Constantinople itself.

The first 'Golden Age' of Byzantine art reached its climax in the 6th c. under Justinian, the period of the building of Sta Sophia. It was an imperial art, glorifying the greatness and prestige of Byzantium at a time when it was still possible to believe in an imminent reconstitution of the Roman Empire. In the 8th and 9th centuries the Iconoclastic Controversy, in which the partisans of holy images (see ICON) were opposed by those who believed that all corporeal images must be removed from places of worship since their presence there led to idolatry, interrupted the development of religious art to the benefit of secular and decorative art. The period which followed, during which the Macedonian emperors reigned (867–1057), was both the zenith of the Byzantine Empire and the second 'Golden Age' of Byzantine art. What has sometimes been called the 'Macedonian Renaissance' was characterized by a new fashion for the antique, an increasing vogue for Islamic motifs and elaboration of ceremonial and pageantry. The picture changes again with the dynasty of the Comnenians (1057–1185). Western Europe was beginning to expand. There were the attacks of the Normans, then the Crusades, and in 1204 the capture of Constantinople by the Franks (it was recovered in 1261). In the economic sphere the mercantile republics of Italy were supplanting the Byzantines. But this period of disturbance was not accompanied by decadence in art. The FRESCOES at Mistra bear witness to the emergence of a new style and the period when the Palaeologans were in power (1261–1453) has also been called a 'Byzantine Renaissance' or 'Third Golden Age'. At the very time when the material forces of Byzantium were at their weakest its civilization and art were radiating over Venice, southern Italy, and Norman Sicily, over Bulgaria, Serbia, and into Russia.

Byzantine art is, above all, a religious art. Not that it treated religious subjects only. There was a fine efflorescence of the 'minor arts' of metal-work, textiles, carved ivories, enamels, jewellery, etc. Secular paintings and MOSAICS also adorned the imperial palaces. But these, which have largely disappeared, were few in comparison with the subjects taken from the Old and New Testaments, from the apocryphal books (Gospels of the childhood of Christ or of the Virgin, of Joseph the Carpenter, etc.) and

the lives of the saints. It is also a theological art, in the sense that the Byzantine artist did not aspire to freedom of individual interpretation but was the voice of orthodox dogma and subject to the Church which established the dogma. His function was to translate into the language of art, for the instruction and edification of the faithful, the thought of the theologians and the decisions of Councils. Consequently this art was impersonal and traditional. The artist's personality was suppressed, and indeed very few Byzantine masters are known to us by name. The arrangement of mosaics or paintings in a church, the choice of subjects, even the attitudes and expressions of the characters, were all determined according to a traditional scheme charged with theological meaning. If the artist attempted innovation, he risked incurring the guilt of heresy or sacrilege. His role was akin to that of the priesthood and the exercise of his talent a kind of liturgy—liturgy in a sense almost sacramental—rather than a didactic function. It is this which differentiates the essentially theological art of Byzantium from the more didactic art of the West in the medieval period.

Even when it was imperial Byzantine art hardly diverged from this theocratic and religious character. There was indeed a form of art responsible for glorifying the emperor; but at Byzantium the emperor was an oriental sovereign, an earthly image of the Deity. His court with its carefully contrived hierarchy reflected the hierarchy of heaven. The ceremonies of the Great Palace, meticulously regulated, were a kind of liturgy.

It is not surprising, therefore, that Byzantine art was an art of stylization. It was fundamentally opposed to the spirit of ancient GREEK ART, whose theme was man and his natural likeness. Byzantium shuns earthly man, the individual, and aspires to the superhuman, the divine, the absolute. By stylization it destroys humanity in art and transfuses forms with the numinous quality of symbols. It is not naturalistic but ritualistic.

Finally Byzantine art was oriental. For sculpture in the round it substituted colour. Buildings blazed with a sparkling polychrome of marble inlay, mosaic, or fresco. The techniques of weaving, embroidery, and illumination achieved a perfection in their kind. The classical search for forms which are beautiful in themselves gave place to a taste for flat ornament concealing the basic material—rich, brilliant, and preferably complicated.

ARCHITECTURE. We have only the ruins of the houses and palaces of Constantinople: for us Byzantine architecture is ecclesiastical architecture. The builders of the early Christian period continued the technical practice of antiquity, making use of hewn stone, rows of columns, and timber roofing. Two main types of plan developed. Those buildings which have a central or radiating plan were usually either *martyria*, housing the bones of martyrs or other

relics (the most famous is the Holy Sepulchre), or *baptisteries*. The buildings with an elongated or basilican plan were the churches proper. From the time of the triumph of the Church magnificent BASILICAS sprang up throughout the Greco-Roman world, their essential features being everywhere more or less the same. At Constantinople this was the original plan of Sta Sophia and Sta Irene, and it is that of St. John of Studios. Hundreds of monuments of this type were built in the 4th, 5th, and 6th centuries, sometimes later still, in both East and West, with numerous local variants. Yet Byzantine architecture proper, especially from the 6th c. onwards and in the East, favoured other building methods and different plans. It became an architecture of brick, of vaulted roofs and DOMES. The Byzantines built every type of VAULT, usually without the help of costly wooden centering, but they preferred those types which are akin to the groined vault. They also employed various types of dome, but in contriving the transition from square to circle they used PENDENTIVES more willingly than SQUINCHES. From the 6th c. onwards they built not only circular churches, such as S. Vitale at Ravenna or SS. Sergius and Bacchus

**Fig. 14.** Ground plan of S. Vitale, Ravenna (526–47)

at Constantinople, but also churches in which, while more or less preserving the old basilican plan, they completely transformed its effect by means of cupolas and vaults in place of the timber roof. These are the 'domed basilicas'.

Sta Sophia at Constantinople, inaugurated by Justinian in A.D. 537, may not be the most typical example of a domed basilica, but it is certainly

**Fig. 15.** Sta Sophia, Constantinople (537). A. Ground plan. B. Longitudinal section

the key monument of Byzantine architecture. It was built by two Greek architects from Asia Minor, ANTHEMIUS OF TRALLES and ISIDORE OF MILETUS. The church itself, which was approached through an atrium and a narthex, is almost square (250 ft. by 220 ft.). In plan it is still divided into nave and aisles separated by columns. But the nave and aisles are shortened in proportion to the breadth of the building, and the side-aisles contracted in relation to the huge nave in order to accommodate the new element, the dome. The latter, placed right in the centre, measures 107 ft. in diameter. Its mass, enormous despite the numerous windows which lighten it at its base, dominates the whole building which supports and shoulders it. To east and west are

two great semi-domes of the same span as the main one, supported in turn by small semi-domes, and these again by the larger semi-dome of the apse at one end and the narthex at the other. To north and south, where vestiges of the basilican plan impeded the design, the great dome is buttressed by a complicated system of ribs and vaults. In its dimensions, its audacity, its perfection, Sta Sophia is unique. Many domed basilicas of different types were built in the Byzantine Empire, but none of such importance. Yet it is easy to see that the combination of basilican plan and domed roof has something hybrid and unwieldy about it. Eventually the dome prevailed at the expense of the basilica, and this not merely for reasons of taste, nor even because vaults and domes and niches presently acquired certain symbolic meanings, but also because technical considerations demanded it. For a dome exerts equal pressure on its whole circumference and in every direction and therefore calls for a central plan (not elongated or axial), which alone provides equally good support everywhere. Thus, after long groping, the architectural type was established which was to dominate the second half of the long history of Byzantium, from the 10th c. to the 15th: the church in the form of a Greek cross. In this plan the central dome, usually placed on a fairly high drum, is buttressed in the four cardinal direc-

tions by four great cradle-vaults at right angles to each other, which form a cross with almost equal arms. The whole is inscribed in a rough square and the spaces left free at the corners are filled by vaulted compartments which serve in some measure as aisles. Internally, therefore, there is a great central space covered by the dome and the four cradle-vaults. Externally one sees a lofty cross with four arms enclosing a tall dome, often completed by four subsidiary cupolas within the angles of the cross. This plan, with variants, is exemplified in innumerable churches still to be found on Greek soil from Mistra to Thessalonica, churches modest in size but as pleasing to the eye, with their happy proportions and perfect balance, as they are satisfying to the mind by virtue of their clear logical conception.

SCULPTURE, MOSAIC, WALL PAINTING. In the interior decoration of churches sculpture was reduced to carved CAPITALS and CORNICES and the stone screens (*cancelli*) which separated the sanctuary from the nave or the lateral aisles from the central one. The motifs were treated in low relief, in openwork, or sometimes even in the champlevé technique of the enameller. Those which did not derive from the decorative themes of classical antiquity (ACANTHUS, egg, ornamental foliage) were often of oriental origin and had penetrated to Byzantium as textile designs.

The place which relief sculpture had lost by

**61.** Grape-harvesting *putti*. Panel from the mosaic ceiling of the so-called Mausoleum of Sta Costanza, Rome (4th c.)

comparison with antiquity was filled by mosaics and frescoes. These appeared first in the domes and vaults, then gradually descended and spread along the walls. Though there are many exceptions, the mosaic was for a long time the more frequent, especially in large monuments. Then fresco grew in importance until it was employed almost exclusively towards the end of the period. Frescoes are of course much cheaper than mosaics, but this is not the only, nor perhaps the right, explanation: the freedom of fresco painting would accord better with the taste of the time of the Palaeologans than the constraint imposed by the difficult technique of mosaic.

Iconography borrowed its motifs and themes —often endowing them with a symbolic meaning—from the pictorial repertory of ancient art, especially ALEXANDRIAN art (for example, the grape-harvesting PUTTI of the so-called Mausoleum of Sta Costanza at Rome, or the *Fisher of Souls* in the oldest Christian mosaic known, rediscovered in the Vatican excavations). In order to instruct the faithful, to provide a visual commentary on the sacred texts, the great cycles of the Old and New Testaments were created. The oldest of these schemes have disappeared, either completely (Church of the Holy Apostles, Constantinople), or in great part (Sta Sophia and the churches of Thessalonica). It is at Ravenna that the mosaic masterpieces of the First Golden Age are preserved, in the baptisteries of the Arians and the Orthodox, the so-called Mausoleum of Galla Placidia, S. Vitale (with the magnificent 'imperial' mosaics of Justinian and Theodora), S. Apollinare Nuovo, and S. Apollinare in Classe.

During the Iconoclastic crisis many monuments were destroyed and for a time the secular patterns of decoration, often inspired by Moslem art, held the field. But it culminated in the formation of a new religious iconography under the influence of those keen partisans of images, the monks. It was then that the decorative scheme of the Byzantine church was fixed, according to the mystical value attributed to each part of the building: in the dome the Pantocrator (Christ the Ruler) surrounded by archangels and ANGELS, PROPHETS and APOSTLES; in the apse the VIRGIN and Child; between the dome and apse the *etimasia* (the empty throne prepared for the LAST JUDGEMENT); in the rest of the sanctuary eucharistic scenes, chiefly the 'Divine Liturgy' with Christ officiating as a priest at the altar. The nave and aisles contained the events of the Christian year which epitomized dogma, notably the CRUCIFIXION and the RESURRECTION in its Byzantine form (the Descent into Limbo); towards the narthex there were often scenes from the life of the Virgin, and the beautiful Byzantine conception of the *deesis*, or prayer addressed to Christ on behalf of humanity by the Virgin and St. John the Baptist. And everywhere, but always in strict hierarchical order, were figures of saints, martyrs, ascetics, bishops. This is roughly the programme of one of the finest mosaic schemes preserved, that of Daphni near

Athens (11th c.). Similar scenes are to be found in St. Luke, Phocis, and the Nea Moni, Chios (both 11th c.); in St. Mark's, Venice (11th–13th c.), and at Torcello (12th c.); at Palermo, Monreale, and Cefalu (12th c.); and in Sta Sophia, Kiev (11th c.). Among frescoes the outstanding examples are at Castelseprio in north Italy, in the rock-cut churches of Cappadocia (11th c.), and in the chapels and caves of southern Italy.

Perhaps the most surprising feature in the whole history of Byzantium is the 'Renaissance' which occurred in the 14th c. despite the exhaustion and territorial losses of the empire: a Renaissance which, contrary to what has sometimes been alleged, was little, if at all, inspired by western Europe, but which rather influenced it. The style changed, as did the iconography. The scenes became much more numerous and the whole available surface was covered with a mass of compositions and figures. The subjects, often taken from the Apocryphal Gospels, were treated with more freedom, and, it would seem, more humanity. Mosaics became rarer: the last great cycle, a very beautiful one, is that of the monastery church of the Chora (Kahriyeh Djami) at Constantinople (first half of the 14th c.). Frescoes were innumerable. Those on Mount Athos, in Greek and Serbian Macedonia, and those at Mistra, capital of the Morea and last refuge of Hellenism before the Turkish conquest, were the first to be intensively studied. But every year new ones are discovered in the little churches of Crete, Thessaly, and the Greek islands.

THE LUXURY ARTS. They held an important place in the opulent, refined culture of Byzantium and reflect the tastes of the imperial court and the aristocracy of the large towns. Ivories, silks, jewels, and manuscripts were easily transported and so contributed greatly to the diffusion of Byzantine styles. The pillaging of the crusaders had happy results for western Europe.

Byzantine IVORIES figure prominently among the relics and ornaments of great cathedrals. Some are 'consular DIPTYCHS', so called because consuls offered them to friends and notables on the day of their entry into office. Some belong to official art such as the *Barberini Ivory* (Louvre), which represents the triumph of an emperor. More numerous are plaques representing religious themes, made to cover some important object; the most famous is that of the so-called Throne of Maximian at Ravenna. There are also *pyxides* or boxes, some meant for secular use, others as reliquaries. A special class is constituted by the costly 'rosette boxes', decorated with mythological scenes in a setting of rosettes and designed to meet the fashion for antiquity. Like most of the ivory objects they were made at Constantinople probably in the 11th and 12th centuries.

Stuffs, tapestries, and embroideries were specialities of Byzantium. The most beautiful, the silks, were manufactured in the imperial

workshops after the introduction of silkworms under Justinian and several of them contain patterns and designs derived from imperial iconography. Their sale was narrowly restricted, sometimes even forbidden. Many pieces of stuff were given as official presents by Byzantine emperors to other rulers. Many, too, were acquired by the crusaders, who used them as wrappings for the relics which they brought back in such quantities from the East. This is probably the origin of the *Shroud of St. Victor* (Sens Cathedral) and of the piece of silk at Bamberg on which the motif is the emperor triumphant. Another famous piece decorated with elephants in medallions is the *Shroud of Charlemagne* (Aachen). Among the masterpieces of liturgical embroidery mention must be made of the patriarchal *sakkos* known as *Charlemagne's dalmatic* (Vatican, prob. 14th c.) and the *epitaphios* of Thessalonica, which represents the dead Christ guarded by angels (Byzantine Mus., Athens).

Goldsmith's work and enamelling were among the favourite crafts of Byzantium. To shelter his throne one emperor had made a gold plane-tree in which there nested birds that moved and sang at the entry of ambassadors, while gold lions and griffins, guardians of the throne, rose up, lashed their tails, and roared. The palace was full of such marvels. The remnants which have come down to us, apart from fairly numerous jewels, comprise a few big silver discs decorated with imperial scenes; some liturgical objects, the most famous of which is the *Antioch Chalice* (Kouchakji Coll., New York, prob. 5th c.); and a few reliquaries, gospel-book covers, and icon-frames. An exceptional example of enamel-work is the *pala d'oro* of St. Mark's,

Venice, in which more than 80 enamels are set. The techniques of champlevé and cloisonné enamel, of eastern origin, were brought to perfection at Byzantium.

It was probably the illuminated manuscripts, sought after for text and illustrations alike, which were the most effective agents in diffusing Byzantine art at a distance. Better respected by men and time, they remain one of our best approaches to a knowledge of it. The study of the origins of Byzantine miniatures, their themes and iconographical cycles, again leads back to Alexandria and Antioch. Although the oldest manuscripts have disappeared, sometimes a faithful reflection of them is preserved in copies (see ILLUMINATED MANUSCRIPTS). During the Iconoclastic crisis there were two classes of illuminated manuscripts; those which respected the official ban on religious images, and others which, in the seclusion of convents such as St. John of Studios, had their margins filled with a profusion of sacred scenes or with satirical compositions aimed at the Iconoclasts. Then—if we may judge by what has come down to us—came the great period of Byzantine miniatures, the time of the Macedonians and the Comnenians. We have nothing comparable for the period of the Palaeologans: the economic exhaustion of the empire was fatal to the luxury arts. But note must be taken of the place which the secular manuscripts then assumed beside the religious.

It was at this point that Byzantium transmitted to the Latin and Frankish countries the inheritance threatened by the Turkish conquest.

212, 465, 686, 687, 717, 742, 1075, 1118, 1120, 1121, 1402, 1521, 1526, 1722, 1794, 1834, 1871, 2234, 2235, 2237, 2603, 2705, 2837, 2945.

# C

**CABEL.** See ARENTSZ.

**CADUCEUS.** In ancient Greece this was the staff carried by messengers and heralds to indicate a claim to immunity. It was also the staff of Hermes, the messenger of the gods. With his staff Hermes was the god of sleep and dreams and also the conductor of the souls of the dead in the nether world. In another function he was the god of commerce and patron of tradesmen and thieves.

In classical Greece the caduceus was a rod surmounted by a circle and a crescent, which might take the form of intertwined serpents. A similar symbol was used in the Near East by the Assyrians, Hittites, and Phoenicians and there is a possibility that the Greek caduceus was derived from there. At a later time the snakes were twined round the rod itself and the top of the rod bore a pair of wings. It is this form which is represented in the bronze *Mercury* by Giovanni da BOLOGNA (Bargello, Florence, 1567).

The serpent was also connected with the Greek god of healing, Asklepios (Latin *Aesculapius*), who was commonly represented in art as an old man carrying a staff round which a serpent is coiled, and during Roman and medieval times this device was often adopted as a symbol of the medical profession. It is still used by the Royal Army Medical Corps. The staff of Aesculapius with its single serpent and the caduceus of Hermes or the herald with its two coiled serpents were often confused in artistic representations. From another function of the god Hermes the caduceus was adopted as the symbol of commerce. It is in this capacity that it appears on the bronze entrance doors of the Bank of England.

**CAEN,** S. ÉTIENNE. The abbey was founded by William of Normandy in 1064. Many of the features already found at Jumièges were repeated in a more rational and highly developed form, and it became perhaps the most influential of all NORMAN churches, both in Normandy and in England. Early in the 12th c. Caen was given one of the earliest ribbed vaults in northern France, and this, together with the two-towered design of its west front, made an important contribution to the development of the early GOTHIC style in the Île de France. At the end of the 12th c. the choir was rebuilt in a highly decorated Gothic style which anticipated much 13th-c. Norman architecture, e.g. Bayeux.

**CAEN STONE.** A soft, fine-grained, light-coloured Jurassic limestone quarried near Caen in Normandy. It was extensively used in Paris buildings. Readily accessible to sea transportation, Caen stone was imported into England in large quantities for building purposes from the late 11th c. until the mid 15th c. Quarried in blocks from underground and brought to the surface in shafts, the stone hardens and turns white with exposure. It is particularly suitable for internal decorative work but is too absorbent for outdoor use in all climates. Caen stone was used in the construction of Westminster Abbey, Canterbury Cathedral, and Eton College. Some use has been made of it by modern English sculptors.

**CAFFIERI.** Family of French sculptors. A PHILIPPE CAFFIERI is mentioned as having carved the woodwork of the *Escalier des Ambassadeurs* at VERSAILLES for LEBRUN in 1678. JACQUES CAFFIERI (1678–1755) was a sculptor of TERRACOTTA BUSTS and bronzes in the LOUIS XV STYLE. He did the bronzes for the famous commode designed by the brothers SLODTZ for the *Chambre du roi*, Versailles, in 1738 and the bronzes of the mantel in the *Salle du Conseil*. His son, JEAN JACQUES CAFFIERI (1725–92), continued working in the Louis XV style until the end of the *Ancien Régime*. He rivalled HOUDON in popularity and was in competition with him for the honour of making portrait sculptures of Franklin and Voltaire. An example of his work is *Le Père Pingré* (Louvre).

**CAILLEBOTTE,** GUSTAVE (1848–94). French painter and collector. A naval architect by profession, he was also a prolific painter of contemporary subjects, town and country views, STILL LIFES, and boating scenes. He joined the IMPRESSIONISTS at the Second Impressionist Exhibition (1876), showing *Les Raboteurs de parquet* (Louvre). He bought pictures from the other Impressionist painters and on his death bequeathed his collection of 65 pictures to the State. Against the opposition of the officials of the Beaux-Arts and artists of the official SALON (see GÉRÔME) 40 of the pictures were accepted and formed the nucleus of the Impressionist collection of the Luxembourg.

2614.

**CALABRESE,** IL CAVALIERE. See PRETI, Mattia.

**CALDECOTT,** RANDOLPH (1846-86). English book illustrator and water-colour painter. After nine years as a bank clerk in Shropshire and Manchester he came to London and won his first big success with illustrations to Washington Irving's *Sketch Book* (1875). But his peculiar achievement was with children's books, beginning with *John Gilpin* (1878), which he illustrated with robust and spanking brilliance. He died in Florida.

290.

**CALDER,** ALEXANDER (1898-    ). American sculptor and inventor of the MOBILE. His mother was a painter and his father and grandfather were sculptors. He was trained as an engineer but became the leading figure in the school of sculpture in welded metal. From 1926 to 1932 he spent much time in England and Europe and held his first exhibition of mobiles in 1932. He has since achieved international reputation and his sculpture has been exhibited and bought by public galleries in many countries. He exhibited at Honolulu Museum in 1937, in Brazil and Mexico in 1948, at the Stedelijk Museum, Amsterdam, in 1949 and held a one-man show in the 1954 Venice Biennale. Examples of his mobiles are *A Universe* (Mus. of Modern Art, New York, 1934) and *Mobile* (1958) at the UNESCO building, Paris. His non-moving sculptures he calls by contrast 'Stabiles'. An interesting combination of moving and static metal sculpture is his *The City* (1960) at the Museo Nacional de Bellas Artes, Caracas.

79, 471.

**CALENDAR.** See OCCUPATIONS OF THE MONTHS.

**CALIARI,** PAOLO. See VERONESE.

**CALLCOTT,** SIR AUGUSTUS WALL (1779-1844). English painter, pupil of HOPPNER. He became the most fashionable English landscape painter of his day, was elected R.A. in 1811 and knighted in 1837. His early work had some freshness, which later subsided into conventional Italianate pictures with a carefully modulated reflection of TURNER for the satisfaction of the larger public who could not yet stomach either Turner himself or CONSTABLE. In 1827 he married Maria Graham, author of *Little Arthur's History of England* (1835), and the two formed a society *salon* for artistic London.

**CALLICRATES.** Greek architect who jointly with ICTINUS built the PARTHENON and later the neighbouring Ionic temple of Athena Nike.

**CALLIGRAPHY.** (This entry does not include Oriental calligraphy, for which see CHINESE ART.) The art of fine writing. If the signs or symbols which constitute the means of communication known as writing are painted or engraved on wood or stone with mechanical aids, the result is termed 'lettering'. The essence of calligraphy in contrast to lettering is that it is handwriting and free from the restraint of rule, compass, and square. Calligraphy probably reached its highest point of development in China and Japan, where little distinction was made between painting and handwriting, and among the Islamic peoples. (See CHINESE ART and ISLAMIC ART.)

In Europe there was from the beginning a marked difference between the hands used for literary works (generally called 'uncials') and that used for documents and letters ('cursive') and within each of these classes several distinct styles were employed side by side. These distinctions are apparent in the fragments of Greek handwriting which survive in the form of PAPYRI dating from the end of the 4th c. B.C. Handwriting was preceded by the cutting of characters on stone or metal with a sharp tool, hence the development of calligraphy was from the angular letters inherited from the epigraphic style to rounded ones. Documents of the mid 3rd c. B.C. already show a variety of cursive hands, well represented by the strong, nobly spaced writing of Apollonius, finance minister of Ptolemy II, in letters to his agent Zeno, and that of the Palestinian sheikh Toubias. These scripts are characterized by letters with broad flat tops which produce the effect of a horizontal line along the top of the writing. Many less elaborate examples of Greek cursive exist, varying according to the writer's skill and desire for speed. Documents of the 2nd and 1st centuries B.C. have less breadth and spaciousness, while the letters become rounder and more uniform in size.

**62.** Detail from a papyrus fragment of *Odyssey III*. Uncial script (B.M., *c.* 1st c. A.D.)

Greek papyri of the Roman period are numerous and show great variety. Noticeable qualities are roundness in the shape of the letters, continuity of formation, and regularity. By the 3rd c. stylistic uncertainty and coarseness of execution marked a period of decline and transition. Several different types of uncial were used in Roman times, remarkable among which is the handsome, round upright hand in a B.M. papyrus containing *Odyssey III*. Another Greek hand of this period, of great interest because it was the ancestor of the type called (from its later occurrence in vellum codices of the Bible) the 'biblical hand', has a square, heavy appearance, with upright uniform letters, and thick and thin strokes

well distinguished. This 'biblical hand' was the prevailing type of uncial during the Byzantine period. The three great early codices of the Bible, the Vaticanus, the Sinaiticus (both 4th c.), and the Alexandrinus (5th c.?), are all written in uncials of the biblical type. By this time papyrus had been replaced by vellum. The uncial hand was still in use, mainly for liturgical manuscripts, as late as the 12th c. but for ordinary purposes it was superseded during the 8th c. by the minuscule. An ornamental type of cursive had developed by the end of the 9th c. which bears a close resemblance to modern Greek script. This is thought to have been evolved in the monastery of Studios at Byzantium. The hand gradually gained in freedom and reached its finest development by the 12th c. In the 13th and 14th centuries there was a steady decline; the less formal hands became chaotic in their effect, while the formal style grew ever more lifeless. Punctuation marks and accents were regularly used only from the 8th c.

The Latin alphabet, as it is used in calligraphy, developed like the Greek from the epigraphic style of majuscule writing known as 'capitals'. A few fragments survive of books written in square capitals, the most famous being pages from manuscripts of Virgil. Meanwhile from the cramped and careless capitals which had been used for engraved legal texts there developed the 'rustic' capital, of which manuscripts of Virgil also provide examples. While square or rustic capitals were used for literary works, the writing of the letters and documents of everyday life was in a cursive form, which was originally simplified capital writing. By the 1st c. this writing began to develop the principal characteristics of two new types, the uncial and the minuscule cursive. The uncial is closely related to the capital writing, from which it differs only in the rounding off of the angles of certain letters; it was in existence by the latter part of the 4th c. and survives in numerous manuscripts of the 5th, 6th, and 7th centuries. The uncial hand became progressively stiff and affected.

The cursive minuscule was a necessary development when writing had to be done fre-

**63.** Detail from the *Codex Sinaiticus*. Biblical uncial script (B.M., 4th c. A.D.)

**64.** Detail from a commercial document on papyrus, dated Ravenna A.D. 572. Cursive minuscule script. (B.M.)

IMIGITURAPERTOCO

UERBICRATINILLUDS

ILLUDCAPITULUMSCI

UOLUERIS CUIUSCUN

SIT STATIMEXSUBIE

NUMERODOCEBERI

RECURRENSADPRINC

INQUIB·CANONUMES

TINCTACONCERIES

DEMQ;STATIMCANO

**65.** Detail from a Vulgate for Abbot Atto. Latin uncial script written on vellum probably in France (B.M., late 8th c.)

writers, in their desire to prevent forgery, wrote hands of intentional complexity. This complexity increased as the Middle Ages advanced, and superfluous strokes and strange abbreviations became general. The famous CAROLINGIAN minuscule, however, which appeared in the time of Charlemagne, was characterized by a much greater simplicity than the later medieval hands. And when, during the RENAISSANCE, there was a reaction from the intricacies of the GOTHIC style, it was the Carolingian script which calligraphers took as their model. Renaissance scribes did not, however, make a mere facsimile of the 9th-c. letter, but for their majuscules often adapted the geometrically formed letters of old Roman inscriptions. The secular humanistic scribes of the Renaissance were the originators of the fine round letter which is the foundation of present-day 'roman' type in printing, while the scriveners of the papal chancery first used our present-day running hand. These novel scripts were introduced and used during the Renaissance by artists and ecclesiastics, while merchants, bankers, and lawyers still wrote a tortuous, crabbed Gothic.

In medieval society the development of handwriting depended on the officials of Church and State. Hands were invented and books written in accordance with liturgical and administrative requirements. Then as now the Roman *Curia* maintained a group of canon lawyers and scriveners known as the Apostolic Chancery

quently and rapidly. From the 1st c. onwards there occur examples of transformation in the form of certain letters which correspond to the definition of minuscule rather than majuscule writing. By the 5th c. the minuscule cursive was used as a book hand, at first only for marginal notes but later for complete books also. After the fall of the Roman Empire and the establishment of the barbarians within its former boundaries, the Roman minuscule cursive hand continued to be used and was adopted by all the newcomers. Forms of minuscule writing flourished in Italy, France, Spain, England, and Ireland which are still known as Lombardic, Merovingian, Visigothic, Anglo-Saxon, and Irish. A common origin is betrayed by the close resemblance of all these hands, though in each country the Roman cursive was developed according to existing artistic traditions.

Not only was there a distinction between the hands of the different nations, but individual differences arose from the cutting of the quill and the manner of holding it, and from the custom, now more marked than ever, of using special hands for certain purposes. Outside the monastic scriptoria, where the most formal, deliberate, and upright characters were cultivated, there were several recognized classes occupied with calligraphy, such as clerks, public scriveners, and public notaries. Special hands were used in documents issued from the papal and other chanceries. Most of these classes of

fratres qui sunt inh
mis iudaei et qui inr
iudaea et pacem bo
benefaciatuobis dr̄ e
nerit testamenta sui
adabraham et isaac
locutus ē·seruorum
idelium et de tuobis c
s utcola af eum et fa

**66.** Detail from a Vulgate edited by Alcuin. Carolingian minuscule script written on vellum at the Abbey of St. Martin of Tours (B.M., mid 9th c.)

from which were issued papal bulls and other documents. By the order of Pope Eugenius IV (1431–47) a small, easily formed hand was reserved for minor documents written rapidly and known as briefs (from *brevi manu*). In the next century this script became famous as *cancelleresca corsiva* and printed and engraved copies of it were common.

The first works on letter formation date from the Renaissance, deal with capital letters and were compiled by admirers of ancient Latin INSCRIPTIONS. Andrea MANTEGNA introduced careful renderings of inscriptions into his frescoes at the Church of the Eremitani in Padua (now partially destroyed) and Feliciano da Verona compiled a collection of inscriptions which he dedicated to Mantegna as well as writing a treatise on the shapes of inscription letters. This last manuscript is dated 1463 and includes diagrams and instructions for the formation of Roman capitals. The friar and mathematician Pacioli included an appendix on letter making in his *Divina Proportione*, which was printed in 1509. Fanti of Ferrara in his *Theorica et practica Perspicassimi Sigromundi de Fantis . . . De Modo Scribendi Fabricandique* (Venice, 1514) extended the methods of designing Roman capitals to the lower-case letters. In 1522 Arrighi, a calligrapher from Vicenza, published a book of models of a current correspondence hand based upon the *cancelleresca corsiva*. This was the first of all copybooks. The script in this publication is a beautiful combination of the neo-Caroline minuscule, slightly inclined by speed, with perpendicular majuscules reminiscent of the inscriptions. Before the publication of Arrighi's book the chancery script had already gained great popularity; it now became the favourite correspondence script of the fashionable classes, absorbing many mannerisms which corrupted its original simplicity. While in the copybook flourished forms were offered as an occasional alternative to the rigid capital, later examples exhibit superfluity of display. Sixteenth-c. writing was further influenced by the art of the engraver and sought to emulate the fine, brilliant line of the BURIN. The first book in copperplate, the ornate *Libri* of Hercolani, a Bolognese notary, is valuable as a specimen of the late chancery hand distinguished by its decorative treatment of the ascending and descending letters.

Gradually the unassuming serif became the most conspicuous feature in a page of late 16th-c. Italian writing, so that it looked like a network of deliberately formed blots. Pens became finer and enabled scribes like Periccioli of Siena (1610) to execute delicate calligraphical borders to their work.

All the Italian scripts were imitated in the rest of Europe. In France the Italian calligraphers imported to FONTAINEBLEAU by Francis I found Gothic, formal, and cursive scripts all practised. The current Gothic was called *cursive françoyse*. This was the letters from which the *civilité*

type was made and which was later amalgamated with the Italian hand to produce the elegant *ronde*, which still ranks as the French national hand. In the mid 17th c. Colbert undertook the revision of French official scripts and clerks in offices of State were instructed to confine themselves to the upright *ronde* known as *financière*, the inclined *batarde*, and a running form known as *coulée*. By the end of the century Colbert's opposition and the influence of the French school of engraving with its use of Roman script had entirely ousted Gothic.

French models of calligraphy, among them Seriault's *Livre d'écriture representant la beauté de tous les caractères financiers maintenant à la mode* (1660), circulated in England and in Holland. The first English manual of calligraphy was *A Booke containing divers sortes of hands* by Jean de Beauchesne and John Baildon (1571); this has handsome forms of current Gothic and secretary hands as well as italics. Billingsley's *The Pen's Excellence* has many more Gothic than Roman hands, despite powerful French influence in the 17th c. This influence was reinforced by that of Dutchmen, such as van de Velde, Boissens, and Perlingh, who had also learned much from the French. The difference between Italian late 16th- and French and Dutch early 17th-c. hands was not considerable, residing chiefly in width of letter.

As English commerce expanded calligraphy developed. Commercial clerkships became desirable positions and gave opportunities for master calligraphers such as Smith (1693) and Seddon (1695), whose style was based on that of the Dutch masters but soon acquired its own character. Called *anglaise* in France, *letra inglesa* in Spain, it dominated Italy by the end of the 19th c. as *lettere inglese*. In contemporary France the *ronde* has almost been ousted by the *anglaise*. In the *Cours d'Inscription calligraphique* published by the École des Travaux publiques primary place is given to *anglaise*, though *batarde* and *ronde* are also extensively treated.

In Spain during the 16th c. Iciar (1550) and Brun (1583) magnificently adapted the style advocated by Arrighi's publication, but their hands were never assimilated by the Spanish. Another calligrapher, Lucas, created an upright and an inclined round hand which was popular for two centuries, when it gave way to the *anglaise*.

This script, which we call 'copperplate', is not attractive; it is dull and colourless. But precisely on this account it commended itself to those who wrote out invoices and were concerned with the particular and not the aesthetic side of writing. The early American colonists carried the copperplate style with them. The first American copybook (Jenkins, 1791) continued the mid 18th-c. English script. In 1809 Joseph Carstairs of London advocated a theory of handwriting in which the forearm and not the fingers controlled the script. His book was translated into French and Spanish and was

introduced into America by Foster in 1830. Here it was so successful that it became known as the American System.

In the 19th c. the English learned to write from Foster's copybooks, in which lithographed models expressed edifying admonitions in a sloping flawless hand of the plainest style. An upright version of the same hand known as the 'Civil Service' was and still is practised. Both scripts are rapidly declining chiefly owing to the fact that when written with the speed demanded by the pressure of present-day life they become illegible.

The present century has witnessed a remarkable attempt to revive the art of fine writing in the teaching and practice of Edward Johnston, whose *Writing* and *Illumination and Lettering* (1906) created a new interest in calligraphy and a new school of excellent scribes. Johnston, like the Renaissance masters, returned to the Carolingian minuscule and to the example of certain fine English medieval hands, though his own sober, dignified script is entirely individual. His influence has not been merely national. It has perhaps been most striking in Germany, where, despite the example of DÜRER, Gothic continued to be used until in 1910 Edward Johnston's pupil Fräulein Simons introduced his teaching with great success.

1981.

**CALLIMACHUS.** Greek sculptor of the late 5th c. B.C. According to tradition he invented the Corinthian CAPITAL. He had the reputation of paying excessive attention to finish.

**CALLISTRATUS.** The author of a book of *Descriptions* of ancient statues in the manner of the *Imagines* (see PHILOSTRATUS). On internal evidence of his familiarity with the *Imagines* Callistratus is believed to have written in the latter part of the 3rd c. A.D. Whereas the elder Philostratus set most emphasis on the REALISM of the paintings he described and the younger

Philostratus treated them primarily as depictions of character and emotional situations, the descriptions of Callistratus are exercises in rhetorical encomium, glorifying the skill of the sculptor in making his material convey the impression of life.

**CALLOT,** JACQUES (1592/3-1635). French engraver of Nancy. Working in Rome and then in Florence at the court of the Grand Duke Cosimo II, he learnt to combine the sophisticated techniques and exaggerations of late MANNERISM with witty and acute observation into a brilliantly expressive idiom. Returning to Nancy in 1621 he became one of the chief exponents of the bizarre and GROTESQUE which came into vogue in the reign of Louis XIII, combining a taste for BAMBOCCIATE, ceremonies, fairs, and in general the lure of the fantastic with a keen linear imagination. He made a speciality of beggars and deformities, characters from the picaresque novel and the Italian *commedia dell'arte*. His fertile invention and the sharp piquancy of his execution made him a favourite with 18th-c. collectors. His last great work, the *Grandes Misères de la Guerre*, followed the invasion of Lorraine by Richelieu in 1633, which brought to a head his feelings about the horrors of war, and its themes and imagery were used as a source by GOYA.

1147, 1665.

**CALVAERT,** DENYS, called DIONISIO FIAMMINGO (c. 1540-1619). Flemish artist from Antwerp who emigrated at an early age to Italy and remained there for the rest of his life. About 1560 he was in Bologna, where he studied with Prospero FONTANA and Lorenzo Sabattini; in 1570 he accompanied the latter to Rome and assisted him with work at the Vatican. Dionisio returned to Bologna completely Italianized and became one of the leaders of the BOLOGNESE SCHOOL. He established an Academy there in 1572 and before he died he had more than 100 pupils, among whom were DOMENICHINO, ALBANI, and Guido RENI.

**67.** Etching from *Grandes Misères de la Guerre* (1633) by Jacques Callot

**CALVARY.** A representation in sculpture of the scene of Christ's crucifixion on the hill of Calvary, or Golgotha, near Jerusalem. The word derives from a Latin translation of the hill's Aramaic name, which meant 'skull' (Matt. xxvii. 33). It is sometimes used for any wayside crucifix or for chapels with a series of carvings of the Passion of Christ, but is more appropriate to groups of figures which represent or symbolize the whole scene, such as those found in the open air in Brittany.

The Breton Calvaries date from the late 15th c. to the early 17th c. Some are extremely simple, others include great numbers of figures variously arranged, usually on one or more stone bases. The Calvary at Tronoën, which is one of the oldest, is also the most complete, for its massive base, on which stand the three crosses and the witnesses, is carved in relief with episodes from the entire life of Christ. The Calvaries are normally placed near a church, with the principal view towards the west, but some stand beside funerary chapels and a few form pulpits against the walls of such chapels.

According to one theory the Breton Calvaries are translations into stone of the medieval mystery plays in which scenes from the life of Christ were re-enacted in front of the churches.

At Kersantan the crosses resemble trees where branches have been lopped off near the trunk, leaving round bosses, and since many were erected in thanksgiving for deliverance from bubonic plague their curious shape has been considered an allusion to the swellings of the victims; the bosses may, however, be no more than a decorative motif. The remarkable concentration of Calvaries in Brittany is unexplained, but it is clear that only in a remote and isolated region could the creation of works which are essentially medieval have persisted so late. The Calvaries, boldly carved in granite, are vigorous, direct statements of a primitive strength and conviction. A comparable devotional intensity may be felt in the Calvaries of other countries, such as Bavaria, but their style is normally closer to contemporary sculpture. Life-size Calvaries were still being erected in Eire after the middle of the 20th c.

**CALVERT,** EDWARD (1799–1883). English painter and engraver, born at Appledore, Devon. After five years in the navy, he began to study art in 1820 at Plymouth and then at the R.A. Schools, where he came into contact with FUSELI. He met Samuel PALMER in 1826 and became his lifelong friend. In 1824 he was introduced by LINNELL to BLAKE and took up engraving on wood and copper and LITHOGRAPHY. Under the inspiration of Blake he not only achieved unusual technical dexterity in an idiom which reflected the mannerisms of Blake, but his genuine if smaller talent was fired, like that of others in the group, to a poetic fervour which was unable to survive the death of the master. After Blake's death the imaginative quality of his work was less intense.

He painted mostly in oils on paper and after visiting Greece in 1844 developed a sentimental pseudo-Hellenic arcadianism which lacked the convincingness of his earlier production (e.g. *Classical Landscape*, Ashmolean Mus., Oxford). A memoir was written by his son, Samuel (1893). 473.

**CAMAIEU.** Painting with a single colour in two or three tones; it is distinct from GRISAILLE, which is grey or greyish and may use all the tones obtainable.

**CAMAINO,** TINO DI. See TINO DI CAMAINO.

**CAMBIASO,** LUCA (1527–88). Italian painter. He worked in Genoa until 1588, when he accepted the invitation of Philip II of Spain to decorate the ESCORIAL. His style derives from CORREGGIO and MICHELANGELO but the use of dry paint and the simplification of forms are his

**68.** Study for group of figures by Luca Cambiaso. Pen-and-ink and wash drawing. (Uffizi)

own (*Adoration of the Child*, Brera). The latter is particularly noticeable in his drawings, which often utilize geometrical forms that give them a superficially CUBIST look.

**CAMBODIA,** ART OF. The kingdom called by the Chinese Funan (a Khmer word meaning 'King of the Mountain') is reputed by tradition to have been formed about the 1st c. A.D. by Indian immigrants and extended over what is now Cambodia and part of southern Vietnam. Such

69A. Head of the Buddha in sandstone. From Cambodia. Khmer. (V. & A. Mus., 10th c.)

69B. Head of the Buddha in red sandstone. From Mathura, Uttar Pradesh. Gupta. (V. & A. Mus., 5th c.)

few artistic relics as survive from this early period (rudimentary stone animal sculptures, bronze drums) seem, however, to indicate influence from the north. In the 3rd c. there was further important contact with India and Funan appears in Chinese chronicles as a great maritime power with walled cities and its capital at Phnom Da. Early in the 7th c. the kingdom was disrupted by a revolt of King Isanavarman of Chen La and the capital was transferred to Sambor Prei Kouk. During the 8th c. Chen La split into two kingdoms, one in what is now Laos and the other in Cambodia. The latter seems to have suffered from internal disorders until at the end of the century the country was reunited under the Javanese king Jayavarman II.

As elsewhere in Indochina, the Indian contacts introduced both Hinayana Buddhism and Hinduism into the country and the very great majority of surviving art objects are connected with these cults. In Cambodia Hinduism predominated and although there were numerous Buddhist monuments, the most important deities were apparently Shiva and even more Hari-Hara, a form combining both Vishnu and Shiva. (See HINDU ICONOGRAPHY.) The Buddhist figures fall within the ambit of the international Gupta style (see INDIAN ART) and the Brahmanic statues have affinities with the sensuous style which prevailed in south India during the Pallava dynasty. The sculpture of this period, from c. 6th c. to the beginning of the 9th c., is generally classified as Early Khmer. It has been said of Khmer sculpture: 'Where India produced great sculpture in an organic tradition, one emphasizing movement and sensuousness, Cambodian art moves us by a peculiar combination of sensuality allied to a very strong architectonic

character. It is almost as if it combined the sensuous elements of Indian sculpture with the formal characteristics of Egyptian sculpture into a single unity.' The sculpture of the period called Early Khmer retains something of the sensuousness and rhythmical softness of the Indian styles from which it was ultimately derived, but has a monumental and architectonic character which gives it a masculine vigour, a solidity and block-like structure, which readily distinguishes it from the Indian antecedents.

Hindu sculpture of a similar type has also been found at Shri Deb in east central Thailand contemporary with but independent of the Dvaravati style (see THAILAND, art of) and it is conjectured that this may have been an offshoot of the Early Khmer style of Funan.

Except for brick foundations and a small temple of grey basalt at Phnom Da no architecture remains from Cambodia before the 7th c. It has been thought, however, that when Funan was disrupted by the invasion of Chen La emigrants carried the architectural style to Java and may have been responsible for the buildings on the plateau of Dieng (see INDONESIAN ART). Isanavarnam built many temples of brick in a distinctive style with isolated towers and with door frames, lintels, and sometimes columns of sandstone. Sambor Prei Kuk is now covered by jungle but traces of four groups of sanctuary temples have been found there. The overthrow of Funan culture was not radical and the older style of architecture continued alongside the new. A small temple in the north group Kompong Thom at Sambor Prei Kuk built of large slabs of sandstone between massive pillars, with elaborate decorations, is evidence of this Koulen style. A

certain fusion between Buddhism and Hinduism prepared the way in Cambodia for the cult of the Devaraja, the God-King, which may in its developed form have been introduced from Java. Mature Khmer sculpture combines divine imagery with royal portraiture, the stone monuments being considered as a continuation of the God-King after death. With the Javanese ruler Jayavarnam may also have been introduced the concept of the World Mountain, which was henceforth an integral part of the temple architecture. The World Mountain, regarded as the axis of the universe, had to be represented at the site of a temple or incorporated into the actual temple structure. The notion has Indian antecedents and its most famous manifestation is at Borobudur. In Cambodia its elementary manifestation under Jayavarnam consisted of the construction of brick towers or shrines on actual mountains at Koulen, Sambor Prei Kouk, and Prei Prasat. In form they may have differed little at first from the Chen La style. In sculpture also the Koulen period was transitional, and the prominent features of the later Angkor Khmer were already present in embryo. The sensitivity of modelling often stopped at the waist, leaving the legs and lower body rigid, the famous 'Angkor smile' made its appearance and the drapery was treated as a decorative motif in its own right, being incised in linear pattern.

Khmer Art is divided into three main periods: Early Khmer from the beginnings in about the 4th c. until the beginning of the 9th c.; the First Angkor style and the Second Angkor style. Early Khmer, which has been described, divides roughly into Funan and Chen La. The First Angkor style is introduced by the mixed style of Koulen transitional from the early Khmer. This was followed by two stages in architectural development, represented respectively by Prah Koh (c. 879) and Ta Keo (c. 1000), and by two stages in sculpture in the round, associated respectively with the styles of Koh Ker and Baphuon. The Second Angkor style was the final flowering of Cambodian art and produced its most famous monuments, the ANGKOR VAT and the Bayon.

FIRST ANGKOR STYLE. Prah Koh was erected by Indravarman (877-89) in 879 for the funerary cult of Jayavarman. In 881 he built his own mountain temple at Bakong in the plain of Roluos. Prah Koh, of mixed brick and stone construction, consists of six tower shrines on a common base; it has abandoned the concept of a shrine built on a natural mountain and represents the first transition towards the idea of a temple which is in its own structure a microcosm of the World Mountain. Bakong has an artificial sandstone hill with five stone terraces in the form of a pyramid superimposed to represent the universe. Stone elephants adorned the terraces and there were the *naga* railings which later became a characteristic feature of Angkor. The idea of the mountain-temple as a microcosm of the World Mountain reached full expression at Ta Keo,

built by a usurper king, Suryavarman I. In the form of a colossal pyramid 150 ft. high and measuring 328 ft. by 416 ft. at the base, it consists of five tiers faced with sandstone and surmounted by five sanctuary towers.

There was a similar development of architectural decoration and relief sculpture through the transitional Koulen style towards the advanced Angkor. The classic example of the First Angkor style may be found in the temple of Banteay Srei, built c. A.D. 967, and one of the most beautiful masterpieces of Khmer art. It is small and in exquisite taste. The relief carving in pink and purple sandstone on lintels and historiated pediments combines a sinuous, jungle-like swirl of vegetative ornament with lively scenes from the *Ramayana*, the whole elaborately BAROQUE exuberance kept in a perfect balance and escaping the excess which so often belongs to the later and more grandiose Angkor structures.

Koh Ker was the capital of a pretender to the throne, Jayavarman IV (928–41), in the northeast of the country. There he built sanctuaries adorned with sculpture in the round which combines in the highest perfection the typically Khmer fusion of sensitive and sensual modelling with architectonic quality. There are examples in the Musée Guimet, Paris, and the Cleveland Museum of Art. The mountain temple at Baphuon in Angkor, built by King Udayadityavarman II (1050–66), is regarded as one of the finest monuments of Cambodia despite its ruined state. The lavish decoration is restrained and subordinated to the architectural structure. Sculpture is graceful and lithe, lacking the stiffness of the earlier periods, and the treatment of the clothing is firmly restrained, the pleated skirt falling in the form of a fishtail in front. There is a female torso in the National Museum, Saigon, and a graceful statuette in green sandstone at Phnom Penh. Parts of a 13-ft. bronze figure of a reclining Vishnu have been recovered.

SECOND ANGKOR STYLE. This was regarded as the final flowering of the Khmer genius. It is manifested in the many temples built by the dynasty founded by Jayavarman VI in 1080. The most famous monument is the Angkor Vat, which was acclaimed by Sir Osbert Sitwell as 'the chief wonder of the world today, one of the summits to which human genius has aspired in stone'. Second only to the Angkor Vat is the Angkor Thom with the massive Bayon, built by the Buddhist ruler Jayavarman VII (c. 1181-13th c.).

After the close of the reign of Jayavarman VII, who was mainly responsible for Bayon, Hinayana Buddhism became the religion of the people and no more important building took place. Cambodia was raided and pillaged by the Thai during the 14th c. and Angkor was fired and looted in 1353, 1385, and 1431. Wood replaced stone as a building material and Khmer art came to an end.

333, 334, 399, 780, 919, 1049, 1176, 1177, 1185, 1634, 1763, 1885, 2033, 2034, 2183, 2965.

**CAMDEN TOWN GROUP.** After SICKERT's return to England in 1905 his studio in Fitzroy Street, Bloomsbury, became a rallying-point for younger painters, including Harold GILMAN, Spencer GORE, Lucien PISSARO, Augustus JOHN, Henry LAMB, and the critic Frank Rutter; later also Robert Bevan (1865-1925), Walter Bayes (1889-1956), and Charles GINNER. Excited by the style of GAUGUIN and van GOGH, they tried to combine strong decorative colour with a realistic treatment of the contemporary scene. Since these principles seemed at variance with the importance ascribed to the representation of light effects by the NEW ENGLISH ART CLUB, they decided in 1911, largely on the persuasion of Gilman, to found a new society, the Camden Town Group. The group also included Wyndham LEWIS, James Dickson Innes (1887-1914), and J. B. Manson (1874-1945). Gore was its president. After four exhibitions it merged with the circle of Wyndham Lewis to form the LONDON GROUP in 1913.

**CAMEOS.** See GEMS.

**CAMERA LUCIDA** (Latin: 'light chamber'). An apparatus for drawing and copying, patented in 1807 by William Hyde Wollaston, a well-known man of science. It received this misleading name—for it is not a 'chamber' at all—because it performed the same function as the CAMERA OBSCURA, but in full daylight. It consists essentially of a prism on an adjustable stand. The draughtsman sets the prism between his eye and the paper in such a way that light from the object is reflected into his eye at the same time as light from the paper. Thus he has the illusion of seeing the image on the paper and can trace its outline. The apparatus has been adapted for use with the microscope.

**CAMERA OBSCURA** (Latin: 'dark chamber'). An apparatus which projects the image of an object or scene on to a sheet of paper or ground glass so that the outlines can be traced. It consists of a shuttered box or room with a small hole in one side through which light from a brightly lit scene enters and forms an inverted image on a screen placed opposite the hole. It is in this respect identical with the photographic camera. For greater convenience a mirror is usually installed, which reflects the image the right way up on to a suitably placed drawing surface.

Aristotle noted the principle on which the *camera obscura* depends, having observed how the round image of the sun passed undistorted through the angular interstices of wicker-work. Early astronomers found it helpful to observe the solar eclipse with the aid of a *camera obscura*; it is described in this connection by the Arabian Alhazen (d. 1038). Roger Bacon (1214-94) appears to have known the mirror device. VASARI refers to an invention of ALBERTI's which sounds

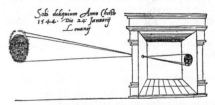

**70.** Engraving from *De radio astronomico et geometrico liber* (1545), R. Gemma Frisius. 'Observing solar eclipse of 24 January, 1544.' Claimed to be earliest illustration of a *camera obscura*

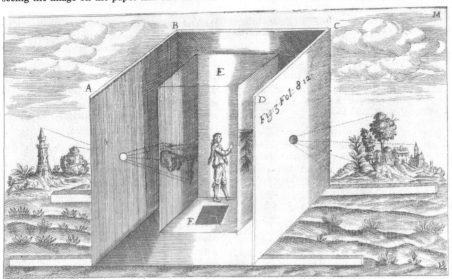

**71.** *Camera Obscura.* Engraving from *Ars magna lucis et umbrae* (1646), Athanasius Kirchner

like the earliest *camera obscura* as an instrument for drawing. He compares it with the invention of printing, which he puts in the same year (1457). LEONARDO was the first to connect the *camera obscura* with the way the eye functions. To Giambattista della Porta, a physician of Naples, must be ascribed the first written account of its use for drawing and his description in his work on popular science, *Magia Naturalis* (1558), did much to make the device widely known. Girolamo Cardano of Milan appears to have preceded della Porta in suggesting the fitting of a lens. In the early 1600s Johann Kepler, who gave the *camera obscura* its name, used it to record astronomical phenomena and also had a portable tent apparatus for drawing landscapes ('non tanquam pictor sed tanquam mathematicus', as he explained to Sir Henry Wotton). The 17th-c. Dutch painter TOR-RENTIUS, who used a dark chamber for his STILL LIFE painting, was suspected of witchcraft. The debt which VERMEER owed to this device has been analysed by L. Gowing (*Vermeer*, 1952). In 1679 Robert HOOKE built a transportable apparatus for landscape painters. By the 18th c. the *camera obscura* had become a craze. Both amateurs and professionals—such as CANALETTO—were using it for topographical painting, and we hear of an apparatus, somewhat like a sedan chair, inside which the artist could sit and draw, at the same time actuating bellows with his feet to improve the ventilation.

**CAMERON,** CHARLES (1740–1812). Scottish architect. Cameron's early life is obscure, but in the late 1760s he was in Rome, where he made a particular study of the THERMAE, and in 1772 he published in London his folio *The Baths of the Romans*. In 1779, at the invitation of Catherine the Great, he went to Russia, where all his known building work was carried out. The Sculpture (Cameron) Gallery and Agate Pavilion which he added to the Great Palace of Tsarskoe Selo (1783–5) are unmistakably derived from PAL-LADIO; the many rooms in the Palace which he redecorated are reminiscent of ADAM's later work, and he resembled Adam in the exquisite care that he gave to every detail of design. Cameron also designed the Pavlovsk Palace (1781–96) with its landscape park and ornamental buildings for the Grand Duke Paul, but the architect's increasing fondness for the most costly materials and his patron's impatience led to a breach. Cameron also designed houses in the Ukraine and the Crimea, which, like his royal works, have suffered severely in various wars.

1694.

**CAMPAGNOLA,** GIULIO (c. 1482–c. 1518). Italian engraver, trained under MANTEGNA, but by 1499 attached to the ducal court at Ferrara. His many copies from DÜRER, engraved in pure line, spread the knowledge of this artist in Italy. In 1509 he was in Venice and many of his engravings, in which he employed a dotted technique, reflect the mood and subject matter of GIORGIONE's idylls.

Giulio's pupil and adopted son, DOMENICO (1500–after 1552), made some engravings in the manner of his master but became better known as a painter and draughtsman. The persistent tradition that he worked with TITIAN in the Scuola del Carmine and the Santo in Padua remains unproved, but the influence of Titian is discernible in his work (ALTARPIECE, S. Uomo-buono, Padua, 1581). His drawings, like Titian's own, became an inspiration for the classical LANDSCAPE painters of the 17th c. and for WATTEAU.

56.

**CAMPANIA,** PEDRO DE (1503–80). The Spanish name of a Flemish painter, Pietr de Kempeneer, who prior to settling in Seville (before 1537) worked in several places in Italy, including Bologna (1529) and then Venice under the patronage of Cardinal Grimani. At Seville he executed a number of ALTARPIECES for the cathedral, among which the *Descent from the Cross* (1547) stands out as most characteristic of his work. He exercised a strong influence in Andalusia as a pioneer of MANNERISM and the style of RAPHAEL. In 1562 he left Spain to direct a tapestry factory at Brussels, where he was born.

**CAMPANILE.** A bell tower, often separate from the church and having arcaded openings at several levels.

**CAMPBELL,** COLEN (d. 1729). Architect. The pioneer of English PALLADIANISM in the 18th c. and a fervent admirer of Inigo JONES. Nothing is known of his early life and training, but he probably owed his first advancement to the Duke of Argyll and in 1711 he was building near Glasgow. On coming to England he must have devoted much time to his important folio *Vitruvius Britannicus*, the first volume of which appeared in 1715. This contained four plates giving alternative designs for his great house at Wanstead, Essex (1715–22, demolished 1822), all of which were to influence later architects. He infused Lord BURLINGTON with Palladian enthusiasm, and remodelled Burlington House (1718–19). The central block of Stourhead, Wilts., followed in 1720–2, and Houghton, Norfolk, for Sir Robert Walpole was begun in the next year, the design being later altered by James GIBBS. One of his major creations was Mereworth Castle, Kent (c. 1722–5), almost an exact replica of PALLADIO's Villa Rotonda, and the first of the series of Palladian VILLAS built in England in the 18th c. He designed a number of less important houses and in 1726 became Surveyor to Greenwich Hospital. But it is his private work and his book which had a profound effect on the course of English 18th-c. architecture.

480, 2579.

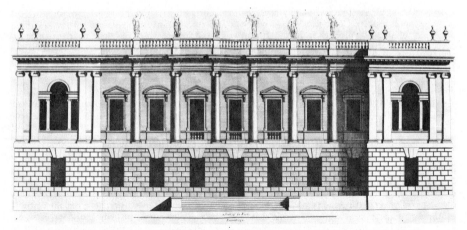

**72.** *Burlington house in Pickadilly London.* .... Engraving from *Vitruvius Britannicus* (1715-25), Vol. III

**CAMPEN,** JACOB VAN (1595-1657). Dutch architect and painter who from *c.* 1625 onwards played a part in the Netherlands comparable to that of Inigo JONES in England. He studied ANTIQUE buildings and the works of PALLADIO and SCAMOZZI in Italy (1615-21). Apparently he never had training as a master builder; collaborators helped him work out technical details and supervised the construction of his buildings. He went in for all kinds of buildings. In 1637 he designed a theatre for Amsterdam (now destroyed) which followed the antique; in 1640 he made the classical façade of the Royal Palace of Noordeinde at The Hague; the New Church at Haarlem, begun in 1645, shows how he applied classical canons to church architecture. His main work is the Royal Palace, formerly the Town Hall, at Amsterdam, which was begun in 1648. Its symmetrical façades show how well van Campen assimilated classical and RENAISSANCE principles, while the original interior includes vast halls and rooms of great beauty, notably the impressive Burgerzaal and the galleries around it. The scale of the building, which is comparable with that of the great Renaissance palaces of Italy and the civic buildings of the merchant cities Venice and Antwerp, was without precedent in the Netherlands. The most important building in Holland during the 17th c., it symbolizes the history and life of Amsterdam during its most triumphant moment.

2604.

**CAMPHUYSEN,** GOVERT (*c.* 1642-72). Dutch painter of bucolic LANDSCAPE and GENRE scenes, cows, and rustic lovers. In 1652-63 he was in Sweden and in 1655 was made court painter at Stockholm. His brother RAPHAËL (1598-1657) painted moonlight and winter scenes in the style of Aert van der NEER.

**CAMPIN,** ROBERT. See MASTER OF FLÉMALLE.

**CAMPUS.** The campus, as a problem in educational building, is unique to America. Because of limited funds and colonial building techniques the first colleges of North America were housed in single multi-purpose buildings, modest in size and domestic in character. New buildings, when erected, were arranged in a semi-formal relationship with the older ones. The area between the buildings was treated as a park and gradually became known as the campus. By the late 18th c. it was a distinguishing feature of all American colleges. Most colleges owe their campus design to this random growth. In some instances, however, attempts were made to conceive the institution as a complete architectural unit. The earliest of these was Joseph Ramee's design for Union College, Schenectady, N.Y., begun in 1812 but only partly carried out. Four years later Thomas JEFFERSON began his University of Virginia. Finished in 1826, this remarkable scheme, of wider vision and more comprehensive than Ramee's, stands out as one of the great monuments in American group planning. As at Union College, the various educational functions are assigned to separate buildings grouped symmetrically but openly around a campus. Both conceptions are in contrast with the enclosed character of the English medieval quadrangle or court. Later in the 19th c. several American colleges and universities strove to imitate the quadrangle, a tendency which reached its most extravagant form during the 1920s in the sumptuous GOTHIC of the Harkness Quadrangle at Yale. In general, however, the open plan has prevailed in America. An outstanding contemporary example of this may be seen in the Illinois Institute of Technology by MIES VAN DER ROHE.

Originating as a local feature of U.S. educational building from colonial times, the campus has in the 20th c. been artificially transplanted to several countries outside America. An example in England is Wroxton Abbey, Oxon.

**CAMUNIAN ART.** The art, mainly rock engravings, found in the Camonica Valley, which lies north of the city of Brescia in the Italian Alps. The rock carvings extend from late Neolithic times through the Bronze Age and into the Iron Age almost down to the conquest by Rome in 16 B.C. Together they constitute a valuable document of prehistoric art and culture. The Valley was explored by the Israeli anthropologist Emmanuel Anati in the second half of the 1950s.

45.

**CANADA,** NATIONAL GALLERY OF, Ottawa. The National Gallery of Canada was formed in 1880 at the same time as the Royal Canadian Academy (see below) and the first items of the collection were a group of paintings from the first exhibition of the Academy. The Gallery acquired no important examples of earlier European art until 1910. In 1907 it was put in charge of an Advisory Arts Council and in 1910 moved into a wing of the new Victoria Memorial Museum. In 1913 a National Gallery Act created a Board of Trustees of which the collector Sir Edmund Walker was chairman. Under the terms of the Act the Gallery was made responsible for the encouragement of artistic taste and public interest in the arts generally. The conception of the Gallery was for a collection of moderate size composed of works of the highest quality only, and within the limits of availability this policy has been pursued. Over a wide variety of schools, European and otherwise, judicious and selective purchase has brought to it a reputation enviable among the smaller galleries.

**CANADA,** ROYAL CANADIAN ACADEMY OF ARTS, Toronto. Founded in 1880 on the model of the R.A., under the patronage of the Governor-General, the Marquis of Lorne, and the Princess Louise. Considered at first a premature move, its foundation was evidence of a wave of national feeling which swept Canada at the time. Since 1880 it has held annual exhibitions and elections of academicians and associates. Its members have included painters, sculptors, architects, print-makers, and decorative artists. Academicians deposit diploma pictures at the National Gallery of CANADA.

**CANADIAN ART.** New France was remarkable not only for the early appearance of imported works of art, which began arriving soon after the colony's founding, but also for the variety of its own artistic productions, which included sculpture, silver, and embroidery as well as painting. In these respects Catholic New France contrasted sharply with Puritan New England, which frowned on all arts except those of building and portrait painting. By 1667 the demand for church art had become great enough for Laval, the first bishop, to found a school of arts and crafts near Quebec. Its pupils account for the early establishment of local traditions in architecture and wood sculpture. The steep-roofed

country churches and cottages by 1700 assumed the unconscious CHINOISERIE of the up-tilted eave, a feature which developed not as an adaptation to the climate—for snow gathered on the curving roof—but as an aesthetic response to the vastness of the flat Laurentian plain.

Decorative church carving by the LEVASSEUR family (the principal carvers in Quebec) followed faithfully if tardily the styles of FRENCH ART throughout the 18th c. But in the countryside the tendency was inevitably towards folk art, as in the rest of early North America. The formal simplicity and naïve characterization of the folk painter appeared in the portraits of colonial worthies and in the *ex voto* paintings which were thank-offerings for deliverances from shipwreck and the like. Probably the best of all early works of art in New France were, however, the embroideries. These were usually the work of nuns, and fine examples are preserved in the Ursuline convent, Quebec.

By the end of the 18th c. the scattered English settlements in Nova Scotia, New Brunswick, and in Upper and Lower Canada were building their houses and churches in a version of the late GEORGIAN derived from both England and the American colonies. Later, during the early 19th c., the Classical Revival influenced architectural design, with examples ranging from the PALLADIAN Province House, Halifax (John Merrick, 1811), to the ultra-Greek St. Andrew's, Niagara (1831). The second and last *atelier* of Quebec wood-carvers, that of the BAILLAIRGÉ family, filled many churches with elegant decorations which uniquely wedded the LOUIS XVI to the English Georgian style. A similar borrowing of English art forms by French Canadian artists may also be seen in the noble chalices and monstrances made by the principal silversmiths of the period, François Ranvoyzé (1739-1819) and Laurent Amyot (1764-1839).

The GOTHIC REVIVAL, which had its beginnings at the same time as the Classical, became important about the middle of the 19th c. Canada's first great buildings such as the Parliament, Ottawa (Thomas Fuller and others, 1859), were built in the full flower of the RUSKINIAN style, but their builders possessed enough feeling for the environment to give their designs a sturdiness which saved them from the flimsiness of most Victorian Gothic structures.

The painting of scenery, an essentially English pursuit, began in Canada only after Wolfe's conquest of 1759. Most of the early viewmakers were garrison officers who were amateurs of painting. Most interesting of them was Lieut. (later Lieut.-General) Thomas Davies (*c.* 1737-1812), whose series of water-colours of woods, rivers, and waterfalls, recently discovered in England and now in the National Gallery of CANADA, reveal a fresh and lively vision of nature like that of Henri ROUSSEAU. By the 1840s several artists from abroad had begun to paint the Canadian scene more or less consistently. The wandering German, Cornelius KRIEGHOFF,

stayed long enough, from 1840 to 1866, to portray the life of the people of French Canada with much animation and in great detail. Paul KANE, an amusing eclectic, made an epic painting trip across the continent from Toronto to the Pacific coast in 1846-8. Meanwhile portrait painting flowered briefly in various provincial towns before the advent of the photographer. The best exponents of this genre were Robert Field (*c.* 1769-1819), who painted in Halifax in a style reminiscent of Gilbert STUART, and the Quebec 'primitives', Antoine PLAMONDON and Théophile HAMEL with their keen characterization of their sitters and their curious suggestions of the early Italians and of GOYA.

The period between Confederation (1867) and the end of the 19th c. saw the rise of art organizations in the young Dominion. Both the Royal Canadian Academy and the National Gallery of Canada were founded in 1880. The building of the transcontinental railways in the 1870s and 1880s brought the first great private fortunes to Canada, and important art collections were formed by a few magnates such as Sir William Van Horne of Montreal, a perspicacious collector who bought paintings by El GRECO, DAUMIER, CÉZANNE, TOULOUSE-LAUTREC, RENOIR, and Albert RYDER before they were generally appreciated. The railways, connecting Canadian towns with the Great American cities, also helped to establish the hegemony of American influence in Canadian life. This was reflected in the buildings of the 1880s, the design of which was dominated by the sturdy Richardsonian ROMANESQUE, itself a reflection of the pragmatism of the age. Painting in the 'Brown Decades' (Lewis Mumford's name for the 70s and 80s, from the colour of the buildings of the period) was dominated by the objective REALISM of painters such as Robert Harris (1849-1919), known chiefly for his group *The Fathers of Confederation* (1886).

At the end of the 19th c. universal fashion dictated that the arts become refined in technique and rich in expression. The response to this fashion in Canada, which had previously known only the plain and factual in art, amounted to a serious dislocation of the development, and much of the production of the period was shallow and artificial. Even the best painting of the period was saturated with the kind of poesy found in the work of Horatio WALKER, the 'Canadian MILLET'. His elegiac scenes of peasant labour on the Île d'Orléans were eagerly sought after by the Americans in particular. Homer WATSON unfortunately defected from his early, honest style of landscape painting to the rich and the poetic after Oscar Wilde had chanced to dub him the 'Canadian CONSTABLE'. The public statuary of Louis-Philippe Hébert (1850-1917) also illustrated the late Victorian taste for the elegant and the learned. In architecture a variety of period styles was here as everywhere applied to buildings according to their functions: the Gothic for churches, the Roman for railway

stations, etc., and when a 'Canadian' style was desired the French château was used as a model for railway hotels. The Scottish Baronial and Château styles (see SCOTTISH ART) were adopted about 1900 as proper for government buildings in Ottawa.

In the early years of the 20th c. several Canadians who had studied in Paris began to employ the manner of the French IMPRESSIONISTS in the painting of the Canadian scene. Prominent among the Canadian Impressionists was Maurice CULLEN, whose atmospheric winter landscapes and Montreal nocturnes are of a high order. The best representative of the generation was, however, an expatriate, James Wilson MORRICE, the friend and contemporary of the FAUVES in Paris. His works, painted in Brittany, Venice, North Africa, and the West Indies, are superbly decorative by virtue of their simple patterns and harmonies of light colours. Morrice also occasionally painted in Canada and had an abiding influence upon Canadian art as the pioneer of 'pure' painting. Others of the period included Aurèle de Foye Suzor-Coté (1869-1937), who was also a sculptor, Ernest Lawson (1873-1939), who was mainly associated with The EIGHT in New York, and the strange archaic Ozias Leduc (1864-1955), whose early STILL LIFE paintings are reminiscent of Georges de LA TOUR.

A national movement in Canadian landscape painting was begun by a group of young painters who came together in Toronto about 1913. These were later called the Group of SEVEN. Associated with them in their early days was Tom THOMSON, whose brilliant series of sketches of the rough northern Ontario country are evidence of a remarkable development in the four years before his early death. Working with singleness of purpose, the Group of Seven worked out a formula of flat patterns, expressive forms, and strong colours by which they conveyed their passion for Canada and her stark northern landscape. The style was unique, though assorted influences from ART NOUVEAU, POST-IMPRESSIONISM, and Scandinavian EXPRESSIONISM had gone into its formation.

Two independent contemporaries of the Group of Seven made distinctly personal contributions to Canadian painting. Emily CARR in British Columbia drew inspiration both from the Group of Seven and from the forms of the Indian TOTEM POLE, but her great achievement was an intense expression of the fertility of nature in the rain forest of the west coast. David MILNE, who painted mostly in seclusion in various small Ontario towns, provides a remarkable example of a fine sensibility and an inspiration sustained over 40 years.

Painting since the 1930s has a variety of style and content unknown to the painters of the national movement. No longer limited to the austere and stylized northern landscape, contemporary painters have discovered new aspects of the Canadian scene. A Toronto group who

developed under the aegis of the Group of Seven have made solid achievements in landscape, figure, and mural painting. These include Charles Comfort (1900– ), William Ogilvie (1901– ), and Jack Nichols (1921– ). Genre painting has claimed the attention of others such as Henri Masson (1907– ). But Canadian painting was only revolutionized when, about 1940, a host of new influences came in from abroad just at the time when Canada began to take her place as a world power. Thus CUBISM, SURREALISM, and the rest were eagerly taken up by a number of Montreal painters who reacted strongly against the regionalism of the Group of Seven and the contemporary school. The new movement embraced the gentle, serious Classicism of Goodridge Roberts on its right wing and the dazzling Surrealism of Alfred Pellan on its left. The real excitement began, however, when the AUTOMATISTES published several anarchistic manifestos about 1948. This radical group was led by Paul-Émile Borduas (1905-60) and included Jean-Paul Riopelle (1924– ), both of whom have since been internationally recognized as exponents of non-objective painting, the latter particularly for the richness and brilliance of his canvases.

New schools have arisen in other parts of the country. In Vancouver the decorative abstractions of B. C. Binning (1909– ) and the 'animist' compositions of J. L. Shadbolt (1909– ) have given inspiration to a whole group of young painters whose sympathies seem to lie chiefly with certain contemporary English artists. On the other hand, the work of Toronto painters such as Harold Town has strong affinities to New York. Their work is non-figurative but has for its basis a lyric interpretation of nature. Other contemporary painters, scattered across the 4,000-mile girth of Canada, defy classification by group or school. They range in style from the 'Magic Realism' of Alex Colville of New Brunswick to the 'OP ART' of the current Montreal painters.

Sculpture never really flourished in Canada since the early Quebec wood-carvers, though one or two contemporaries of the Group of Seven essayed landscape reliefs with an expressive flat pattern. In the 1950s there began something of a new movement, as exemplified in Louis Archambault (1915– ). His inspiration has come from the modern Italians and French and from the Etruscans, but the essential feature of his work is a typically 'Canadian' tension between primitive strength and lyric tenderness—a tension also to be found in the work of Borduas and Jack Shadbolt among the painters. Neither were the GRAPHIC ARTS much cultivated in the past, though several print-makers like Clarence Gagnon (1881-1942) and W. J. Phillips (1884-1963) enjoyed an international reputation. The PRINTS of Albert Dumouchel (1916– ) and a whole school inspired by him indicate a renaissance in this field.

In architecture, the International Style has been remarkably slow in making its conquest of Canada. In the last decade, however, this situation has been reversed during the current building boom which is transforming the larger cities out of all recognition. The work of John B. Parkin Associates of Toronto is particularly noteworthy. In TOWN-PLANNING the large-scale transformation of the national capital, Ottawa, is the most spectacular undertaking. Industrial design received official backing with the appointment of a National Industrial Design Council in 1948.

Art collecting, restricted by the economic depression of the 1930s, has notably revived. The fresh public interest in museums was signalled by the National Gallery's purchase of a dozen famous paintings from the Liechtenstein collection in 1953-6. The opening of new galleries in various cities reached a climax in the centennial year of Confederation in 1967. The federal Canada Council, established in 1957 as a brave gesture in a country of great distances and sharp sectional differences, awards scholarships to artists of all lands.

420, 421, 1115, 1468, 2624.

**CANALETTO.** GIOVANNI ANTONIO CANAL (1697-1768). Venetian painter. He worked in the theatre with his father, Bernardo, and went with him to Rome in 1719. There he turned to topography under the influence of Roman topographical painters and engravers (see TOPOGRAPHICAL ART). Returning to Venice, he collaborated in producing a series of decorative canvases for the Duke of Richmond; but by 1723 he was painting dramatic and picturesque views of Venice, marked by strong contrasts of light and shade and free handling. Examples are four pictures commissioned by Stefano Conte of Lucca (now in the Pillow collection, Montreal) which can be dated 1725 and 1726 from documents in Canaletto's own hand. This phase of Canaletto's work culminated in the splendid so-called *Stone Mason's Yard* (N.G., London, c. 1730). Meanwhile, partly under the influence of Luca CARLEVARIS, the first painter in Venice to practise topography systematically, and largely in rivalry with him, Canaletto began to turn out views which were more topographically accurate, set in a higher key and with smoother, more precise handling—characteristics that mark most of his later work. At the same time he became more prolific as a draughtsman, mainly in pen and ink, and began painting the ceremonial and festival subjects which ultimately formed an important part of his work. His patrons were chiefly English collectors, for whom he sometimes produced series of views in uniform size, a notable example being in the collection of the Duke of Bedford, painted in the early 1730s. Conspicuous among his patrons was Joseph Smith, an English merchant in Venice, appointed British Consul there in 1744, who brought together a remarkable collection of 18th-c. Venetian painting and a fine library. He is often

said to have exploited Canaletto to his own advantage, though the evidence is inconclusive. In any event he seems to have been Canaletto's main support in the early 1740s, when the outbreak of the war of the Austrian Succession greatly reduced the number of visitors to Venice. Perhaps at the instance of Smith, Canaletto at this time enlarged his repertory to include subjects from the Venetian mainland and from Rome (probably based on drawings made during his visit as a young man), and by producing numerous CAPRICCI, arbitrary groupings of material drawn from different places, and *vedute ideate* or imaginary landscapes. He also gave increased attention to the graphic arts, making a remarkable series of etchings, and many drawings in pen and pen and wash as independent works of art and not as preparation for paintings. This led to changes in his style of painting, increasing an already well established tendency to become stylized and mechanical in handling and encouraging the use of dark shadows with sharply dotted lights. In 1746 he went to England, apparently at the suggestion of Jacopo AMIGONI, one of the many Italian painters who had sought their fortunes there. For a time he was very successful, painting views of London and of various country houses for, among others, the Duke of Richmond and Sir Hugh Smithson, later Duke of Northumberland. Subsequently with declining demand, his work became increasingly lifeless and mannered, so much so that rumours were put about, probably by rivals, that he was not in fact the famous Canaletto but an impostor. About 1755 he was finally back in Venice and continued active as painter and draughtsman with undiminished skill, though still highly mannered. A notable work of this period was the set of 12 elaborate drawings of ceremonies in which the Doge took part, best known from engravings from which paintings were made by GUARDI. In 1763, after an earlier unsuccessful candidature, he was elected a member of the Venice Academy. Legends of his having amassed a fortune in Venice are disproved by the official inventory of his estate on his death. Before this, Joseph Smith had sold his library and the major part of his paintings to George III, thus bringing into the royal collection an unrivalled group of Canaletto's paintings and drawings. Added to examples in English public and private collections this makes England incomparably richer in his work than any other country.

As painter and draughtsman Canaletto dominated topographical painting in Venice and his influence extended to England, notably among the WATER-COLOUR painters. Even in its mechanical phases his work is much more than a mere factual record; and by his unobtrusive skill in design, and his power of suffusing his work with light and air, he may justly be regarded as one of the precursors of 19th-c. LANDSCAPE PAINTING.

604, 1880, 2030, 2805.

**CANO,** ALONSO (1601–67). Spanish sculptor, painter, and architect. He studied painting at Seville under PACHECO and probably learned figure sculpture from MONTAÑÉS. An early example of his carving is the REREDOS in the church of Lebrija near Seville (1629–31). *St. John's Vision* (Wallace Coll., London, *c.* 1636) which combines firm sculptural modelling with a restrained use of the dramatic lighting is typical of his early painting. In 1637 Cano was called to Madrid to become painter to the Count-Duke Olivares and was employed by Philip IV to restore pictures in the royal collection. Thus he became acquainted with 16th-c. Venetian masters and his *Miracle of the Well* (Prado, *c.* 1647) illustrates the softer technique which he developed under their influence. In 1652 he left Madrid for Granada. To this period belong three large carved wood saints (Granada Mus., 1653–7), his charming small figures of the *Immaculate Conception* (1655–6), and the *Madonna of Bethlehem* (1664), the last two in Granada Cathedral. The religious devotion which these works convey is also reflected in some of his paintings, notably *S. Bernardino and S. Juan Capistrano* (Granada Mus., *c.* 1655).

Shortly before his death Cano was appointed architect of Granada Cathedral. His design for the façade was accepted and was carried out after his death. He was the foremost draughtsman of the Spanish BAROQUE and his later paintings had an important influence on the Madrid School.

2854.

**CANOPY.** An architectural canopy is a miniature ROOF above a stall, screen, niche, or effigy. It is usually ornamented by a profusion of the current architectural forms on a small scale. A late medieval canopy is an elaborate structure, clustered with pinnacles and gables, and is a favourite ornament not only in architectural decoration but as a framework to figures in ILLUMINATION and STAINED GLASS.

**CANOVA,** ANTONIO (1757–1822). Italian NEO-CLASSICAL sculptor who settled in Rome in 1781 and in the next year produced *Theseus and the Minotaur*, the first of many works with antique mythological subjects: *Cupid and Psyche* (Louvre); *Perseus* (Vatican). His tomb of Pope Clement XIII in St. Peter's (1792) made concessions to realism in the figure of the pope, but otherwise conformed to type. The Buonaparte family were his patrons.

Of three leading sculptors of the classical movement which dominated English and most European sculpture from the end of the 18th c. through the Victorian era, Canova was probably the best known. He also went further than either HOUDON or THORWALDSEN in the direction of artificiality and confused Classicism with sentimentality. Of English sculptors Richard WESTMACOTT and James Richard Wyatt (1795–1850) studied in his studio.

**CANVAS.** The word 'canvas' has become almost a synonym for an OIL PAINTING, but it was not until the end of the Middle Ages that this humble and commonplace material became the normal foundation for a painting. Until the 15th c. most movable pictures were executed on wooden PANELS. Early in that century painters in north Italy and Venice, such as MANTEGNA and Jacopo BELLINI, began to use canvas instead; and although painters in other parts of Europe were slower in adopting it, it gradually became general. Nowadays canvas is the normal ground except for special purposes.

It is not known why the north Italian painters took to canvas. Banners were painted for religious processions, and painted textiles with secular subjects were used as cheap substitutes for tapestries. These 'Flemish cloths', as they were called (*panni fiandreschi*), are mentioned in Italian inventories of the 15th c., though few examples have come down to us. It is possible that their fine execution, and the prestige which Flemish work enjoyed in north Italy at that time, suggested to the painters that canvas was an economical substitute for the woods which required long seasoning and careful preparation.

There were in any case traditional processes of preparing linen for painting. A 12th- or 13th-c. writer whose manuscript was in the collection of Jehan le Begue gives a recipe for 'painting on linen cloth', and CENNINI, writing early in the 15th c., gives substantially the same advice. Both say that the linen must be coated with SIZE and stretched; and these are, indeed, the essentials. Painting on linen was in fact a very ancient craft, even if it was seldom practised. A fragment of painted linen has been found in an Egyptian tomb of nearly 2000 B.C. This technique was also practised in PRE-COLUMBIAN ART of South America. Some of the Egyptian MUMMY POR-TRAITS, which belong to the first five centuries of our era, are painted on canvas, but in this case it is glued to a wooden support—a practice, known as MAROUFLAGE, which is recommended by experts today. THEOPHILUS mentions the use of canvas as an alternative to leather for covering wooden panels. And PLINY tells us that the Emperor Nero ordered a colossal portrait of himself to be painted on canvas, 120 ft. high.

Artists' canvas is made of linen or cotton, less commonly of hemp or jute. Cotton canvases are inferior to linen and less durable. They do not take the priming well, are usually absorbent, and have a poor surface. Canvas is not suitable for painting on until it has been coated with a GROUND which isolates the fabric from the paint; otherwise it will absorb too much paint, only very rough effects will be obtainable, and parts of the fabric may be rotted by the pigments. It must also be made taut on a STRETCHER or by some other means. Nowadays both grounding and stretching are done in the factory, and in that order; but until the 19th c. the stretching was done first, with the result that on an old canvas the ground ends where the canvas turns over the edge of the stretcher. The ground is usually an oil priming; GESSO cracks if the canvas is rolled (a canvas should never be rolled with the painted side inwards).

Experts on the technical aspects of painting allege that canvas is the most perishable of all supports, far less durable than good paper, and that it disturbs the paint layer by sagging in damp weather and contracting in warmth or drought. Many masterpieces have been preserved only by being transferred from a rotten canvas to a new one. None the less artists continue to paint on it, partly, perhaps, because they find satisfaction in its texture and its flexible response to the brush.

**CANVAS BOARD.** Chiefly used by amateurs and for sketching or making studies in oil paint, it consists of pasteboard covered with sized and primed CANVAS. It was first made commercially in the second half of the 19th c. Owing to the doubtful quality of the materials used in some commercially prepared canvas boards, professional artists have usually preferred to prepare their own boards.

**CAPITAL.** The architectural member which surmounts a COLUMN, PIER, or PILASTER and forms the transition between the column and the ARCHITRAVE or ARCH above. It can be either free-standing or engaged (attached to a wall). At the base of the capital is a moulding called the 'necking', and above it a separate stone, often rectangular, known as the ABACUS. Because of their important function of transmitting the weight from the superstructure to the column, and their prominent position, capitals were frequently given painted, stucco, or carved decoration.

Since columns are usually cylindrical and the masonry above the capital square in section, the shape of the capital was determined by the need to provide a smooth transition from the one to the other. In Egypt the forms of capitals were based on plants, such as the lotus and papyrus, while in ancient Persia they were carved in the shape of animals. The capitals evolved in Greece, the severe Doric, the elegant Ionic, and the richly decorated Corinthian, became the models for nearly all subsequent development and each of the five Orders has its own capital (see ORDERS OF ARCHITECTURE). The Ionic is distinguished by VOLUTES, the Corinthian is decorated with two ranks of ACANTHUS leaves with stems extending to the corners of the abacus. The Tuscan and Roman Doric consist mainly of abacus, OVOLO, and lower down an astragal or simple moulding round the neck. By combining the foliage of the Corinthian type with the volutes of the Ionic the Romans created the Composite type. In Byzantium classical capitals, especially the Corinthian type, were used in a slightly modified form, but entirely new types were also evolved. A typical Byzantine capital is a four-sided block, tapering down to the neck-

**73.** CAPITALS

A. Byzantine (6th c.) from S. Vitale, Ravenna
B. Islamic (14th c.) from the Alhambra, Granada
C. Romanesque plain cushion type (11th–12th c.) from Canterbury Cathedral
D. Romanesque decorated cushion type (11th–12th c.) from Canterbury Cathedral
E. Romanesque scalloped type (12th c.) from Durham Cathedral
F. Romanesque leaf-decorated type (late 11th c.) from S. Sernin, Toulouse
G. Romanesque grotesque type (11th c.) from S. Remi, Reims
H. Romanesque historiated type (12th c.) from Autun Cathedral
I. Gothic crocket type (12th c.) from Chartres Cathedral

ing and carrying a large, also tapering, abacus. The carved decoration of such a capital is flat, with a deeply undercut background creating the impression of filigree work. The Corinthian and Composite capitals were adopted by ISLAMIC ART; some notable examples of these exist in Spain. Early medieval capitals were imitations of Roman and Byzantine models, but during the ROMAN-ESQUE period several new shapes and decorative forms made their appearance. For instance the 'cushion' or 'cubic' capitals, which originated in Italy, became extremely popular in Germany and spread from there to Britain, Normandy, Scandinavia, and even Poland. In England this type underwent a further development which resulted in the creation of the 'scalloped' capital, with several flattened semicircular surfaces on each side instead of one. A great variety of motifs was used in the decoration of Roman-esque capitals, including geometric, foliage, and grotesque patterns. The most remarkable development, however, was the historical or

narrative decoration, which although known in Roman times was never very popular then. Capitals were carved with secular and religious subjects and often formed large series, distributed throughout the church or cloister. With the development of the compound pier, Romanesque capitals often had very complicated forms and their decoration assumed the character of a FRIEZE.

Soon after the middle of the 12th c., in early GOTHIC buildings in France, the 'crocket' capital, decorated with stylized foliage springing upwards from the neck and curling outwards below the abacus, made its appearance. With other French Gothic forms this spread over Europe and with the help of the Crusades even reached the Holy Land. Historiated and grotesque capitals did not altogether go out of use in the Gothic period, but foliage decoration was by far the most popular. Among the new forms the bell-shaped and the polygonal, conforming to the shapes of the piers, were the most frequent. But very often, especially in France, capitals were left plain.

With the advent of the RENAISSANCE all forms of Roman capitals were revived and have been in use ever since, but in modern architecture the classical capitals have no place.

The capital as a part of an architectural composition, especially an ARCADE, was frequently used in decorative sculpture (e.g. SARCOPHAGI), book illumination, painting, furniture, and other decorative arts.

**CAPITOLINE MUSEUM.** See ROME, Capitoline Museum.

**CAPPELLE,** JAN VAN DE (c. 1624–79). Wealthy dyer of Amsterdam who taught himself to paint during his spare time. It is apparent that he was a careful student of Simon de VLIEGER's seascapes. There is nothing of the Sunday painter in his pictures of anchored ships and their reflections in the dead calm waters of a crowded harbour. With their silver-grey tonality these pictures rank with the finest maritime paintings of their time. Cappelle also painted winter landscapes. He was affluent enough to make a distinguished art collection: he owned works by RUBENS, BROUWER, van DYCK, JORDAENS, Hercules SEGHERS, Simon de Vlieger, and about 500 of REMBRANDT's drawings. Rembrandt and HALS both painted his portrait.

**CAPRICCIO.** Etymologically identical with 'cutting a caper', the unexpected jump of the young goat, according to BALDINUCCI the term meant an 'idea of invention', a product of the imagination. It was used by VASARI when he praised the inventive conceits of his contemporaries. In the 18th c. it frequently denoted freely invented townscapes which combine existing with imaginary features (PANNINI, CANALETTO, GUARDI) and also etchings that do not illustrate any particular incident or fable but represent almost dream-like fantasies, the most famous of which are those by TIEPOLO and by GOYA.

**CARACCIOLO,** GIOVANNI BATTISTA, called BATTISTELLO (c. 1570–1637). One of the pioneers of the Neapolitan school of BAROQUE painting, who dominated the artistic life of Naples until his death. He studied under Fabrizio Santafede (d. after 1628), but the decisive influence came with the arrival of CARAVAGGIO in Naples in 1607. Caracciolo's Liberation of St. Peter, for the same chapel in Monte della Misericordia for which Caravaggio produced his Seven Acts of Mercy, was painted c. 1607 and shows the impact of the new tendency towards REALISM in contrasting light and shade. A visit to Rome some time after 1610 probably accounts for the more restrained composition and colouring of his later manner, e.g. his fresco decorations in the Certosa di S. Martino (finished in 1631), which are conceived almost as sculpture in high relief.

**CARAVAGGIO,** properly MICHEL-ANGELO MERISI DA CARAVAGGIO (1573–1610). He is named after his birthplace, a small town near Bergamo. His early experience of the works of LOTTO, SAVOLDO, and the VENETIANS was more significant than his actual training under a weak pupil of TITIAN. He was in Rome by 1592 where, apart from the frequent scandals caused by his tempestuous character, he was criticized for his Venetian method of working in oils directly from the natural model on to the canvas without the careful preparations traditional in central Italy.

Two phases in Caravaggio's early development can be distinguished: an early experimental period (c. 1592–7) and a mature period (1597–1606) in which he carried out several large commissions. The early works are usually small pictures of non-dramatic subjects with half-length figures and a preponderance of STILL LIFE, e.g. the Sick Bacchus and Boy with a Fruit Basket (Borghese Gal., before 1594). For Cardinal del Monte, an important early patron, he painted the Music Party (Met. Mus., New York) and the Lute Player (Leningrad). In the latter, more spacious work a shaft of light thrown from the left is the unifying device characteristic of his maturity. The figures gain greater plasticity, and his subsequent works (St. John Baptist and Penitent Magdalene, Doria Gal.) show solid figures clearly articulated and painted in rich deep colours with strongly accentuated shadows.

The second Roman period began with a commission for the Contarelli chapel in S. Luigi de' Francesi (Calling of St. Matthew and Martyrdom of St. Matthew, by 1600), in which Caravaggio's extraordinary advance in mastery of construction, dramatic story-telling, and handling of paint was not achieved without great effort. The ALTARPIECE St. Matthew and the Angel was

rejected but was bought by Vincenzo Giustiniani, who also paid for the replacement. Meanwhile the first versions of his pictures for the Cerasi chapel in Sta Maria del Popolo (*Crucifixion of St. Peter* and *Conversion of St. Paul*) were also refused and bought by Giustiniani. The existing second versions are astounding in the economy of their elements, the force of the pictorial vision, and the new way of seeing old subjects. These works were followed by several large religious pictures: the *Deposition* (Vatican), *Madonna di Loreto* (S. Agostino), *Madonna de' Palafrenieri* (Borghese Gal.), and *The Death of the Virgin* (Louvre). The last two were again refused on grounds of decorum or theological incorrectness. Despite this misunderstanding of his work Caravaggio was not without powerful supporters in his day and it has since been recognized that he rescued religious art from the nebulous unreality of late 16th-c. painting.

Caravaggio fled from Rome in 1606 after killing a man in a brawl, and spent the last four years of his life wandering from Naples to Malta and Sicily. He continued to paint huge religious compositions in a new style shorn of all inessentials: little colour, thinly applied paint, the crowded drama and movement of the late Roman works replaced by a moving silence and contemplativeness. Remarkable among these is *The Beheading of St. John Baptist* (Malta). Caravaggio was not yet 37 when he died from malarial fever while returning to Rome in hope of a pardon. It is ironical that his last works have all the ineffable qualities of the late works of an aged genius, and like all such works they alone found no imitators. His short but intense activity is remarkable for its rapid development, and for its impact on painting in centres as far apart as Seville and Utrecht. In the history of criticism Caravaggio's name has come to stand (rather one-sidedly) for an uncompromising and unselective NATURALISM.

931, 1458, 2737.

**CARAVAGGISTI.** Term applied to a number of young painters who went to Rome in the first decade of the 17th c. and were influenced by the technical methods of CARAVAGGIO, particularly his emphatic use of CHIAROSCURO in the interests of dramatic REALISM. They were much talked of until about 1630, when they were succeeded by the 'bamboccciata' painters who sprang up under the influence of the Dutch painter Pieter van LAER. In Italy the word *tenebristi* was also used of these painters (see ITALIAN ART). In Spain TENEBRISMO was used of a corresponding style, which grew up partly under the influence of the Italians, and the word *tenebristi* was applied to artists who painted in this style. The most prominent of the Italian Caravaggisti was Orazio GENTILESCHI, the most faithful of his direct followers was Bartolommeo MANFREDI. Others were Carlo SARACENI from Venice and Giovanni SERODINE from Ticino. In Naples CARACCIOLO, Artemisia GENTILESCHI, and RIBERA, a Valencian,

ensured that the style took firm root. The naturalism of Caravaggio made a deep impression on a number of Dutch and Flemish artists who came to Rome early in the 17th c. The most notable among them were HONTHORST, TERBRUGGHEN, and Mathias Stomer (1600–after 1650). His deeper Classicism, his calm grandeur and his severity, were reflected by ZURBARÁN, LA TOUR, and VERMEER.

**CARDBOARD.** Good quality cardboards and millboards have been used by 19th-c. and 20th-c. artists and have proved to be suitable permanent SUPPORTS for paintings. Some of ETTY's finest nudes were painted on millboard. A large number of the best works of TOULOUSE-LAUTREC are on cardboard as, also, are many paintings by BONNARD and VUILLARD. Twentieth-century painters have used cardboard which was SIZED but not PRIMED.

**CARDI,** LUDOVICO. See CIGOLI, Il.

**CARICATURE.** A word often loosely employed to denote various forms of pictorial burlesque, GROTESQUE, or ludicrous representation with exaggeration or distortion of parts, and sometimes used of any debased likeness whether intentionally or unintentionally ludicrous. Yet in art history it has a more precise and specialized application to a 'charged' or 'loaded' portrait (from Italian *caricare*, to load).

According to BALDINUCCI (1681) 'the word signifies a method of making portraits aiming at the greatest possible resemblance of the whole of

**74.** Pen-and-ink study by Leonardo da Vinci of five grotesque heads. Sometimes wrongly described as caricature (Windsor Castle, 1485–90). Reproduced by gracious permission of H.M. the Queen

the person portrayed while yet, for the purpose of fun, and sometimes of mockery, disproportionately increasing and emphasizing the defects of the features, so that the portrait as a whole appears to be the sitter himself while its elements are all transformed'. If this definition is accepted, many products sometimes called caricatures must be relegated to the wider fields of HUMOROUS ART or pictorial satire. This applies, for instance, to the comic types of classical and medieval art, to the grotesque heads LEONARDO liked to draw, and to the defamatory libels which sometimes showed the effigy of an opponent hanging upside down—abusive portraits but not 'caricatures' since the element of 'like in unlike' is absent. The word and the genre of genuine portrait caricature first made their appearance in the late 16th c. in the circle of the CARRACCI. Contemporary sources describe their exercises in graphic wit, their transformations of physiognomies into implements, as a method of relaxation from serious work. They are quoted as having defended this game as a counterpart to idealization (see IDEAL). As the serious artist penetrates to the idea behind appearances, the caricaturist also brings out the essence of his victim, the way he should look if Nature wholly had her way. Many painters of the BOLOGNESE SCHOOL, such as GUERCINO and DOMENICHINO, were brilliant caricaturists, but the greatest master of economy and expression was BERNINI, who demonstrated his skill before Louis XIV.

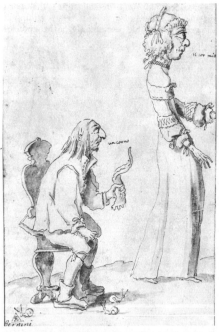

75. Two caricatured figures. Pen-and-ink and bistre drawing by Gianlorenzo Bernini. (Witt Coll., Courtauld Inst. of Art)

Towards the turn of the century P. L. Ghezzi (1674-1755) specialized in mild caricature portrayals of the many art lovers who congregated in Rome and several of the 18th-c. English artists, including REYNOLDS and PATCH, adopted his manner in humorous CONVERSATION PIECES.

It was in this way that English CONNOISSEURS became familiar with the new trick of mock portraiture, but the genre remained confined to the world of art and music till in the middle of the century George Marquess of Townshend circulated his malicious portrait scrawls of politicians and thus added a new weapon to the armoury of political pamphleteers. The way, of course, had

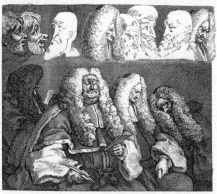

76. The BENCH. Of the different meaning of the Words Character, Caracatura and Outrè in Painting and Drawing. Drawn and engraved (1758) by William Hogarth

been prepared by HOGARTH, but this greatest of pictorial satirists explicitly dissociated himself from the fashion of caricaturing, since he aimed at the depiction of character rather than at a comic likeness. Yet his protest could not prevent the various traditions from merging, and during the last three decades of the 18th c., favoured by the hectic political atmosphere, political caricature emerged as we know it today, and was perfected as a distinct genre by the verve and skill of such masters as GILLRAY and ROWLANDSON, in whose coarse, licentious, and unbridled satires on the personalities of the day the comic likeness of a Pitt, a Fox, or even of George III was distilled into a recognizable stereotype. These masters had imitators but no equals in other European countries and English caricature remained in the lead until the gentler atmosphere of early Victorian culture diverted the energies of masters such as George CRUICKSHANK into humorous illustrations, while the weekly CARTOON of Punch, sometimes humorous sometimes rhetorical, institutionalized political caricature for the middle-class home.

It was in France that the political tensions of the 19th c. produced the greatest master of the genre, DAUMIER, who worked for La Caricature and Le Charivari, a weekly and a daily which remorselessly campaigned against le roi bourgeois, Louis Philippe, transforming his fat face into

the famous image of the *poire*. Daumier's beginnings as a portrait caricaturist are connected with the fashionable caricature sculptures by Dantan, which he surpassed in his clay busts of politicians. But as often as the censorship clamped down on political comment Daumier withdrew into social satire, and many of his LITHOGRAPHIC series on the comedy of manners belong to humorous art rather than to caricature.

Victorian England meanwhile revived Ghezzi's genre of genteel portrait caricature in the pages of *Vanity Fair*, where chromolithographs of the notabilities of the day by PELLEGRINI and others were no unwelcome signs of public attention. The witty and whimsical comments on *fin de siècle* literary London by Max BEERBOHM cunningly exploit the very lack of skill of the artist.

Many great artists of the 18th and 19th centuries produced caricatures either as potboilers or as a side-line; among the first were MONET and DORÉ, among the second TIEPOLO, PUVIS DE CHAVANNES, and PICASSO, who made caricatures in his early Barcelona days. Many of the most popular GRAPHIC artists of the 20th c. have combined some gift for caricature with social or political satire.

521, 522, 523, 1010, 1509, 1698.

**CARLEVARIS,** LUCA (1663–1730). Born in Udine and trained as a mathematician, Carlevaris is regarded as the father of 18th-c. Venetian view-painting (see TOPOGRAPHICAL ART). After a period in Rome when he studied the careful topographical work of Gaspar van Wittel (1653–1736), he settled in Venice *c.* 1700 and specialized in painting views of the city in rigorous PERSPECTIVE settings. These, and his set of over 100 engraved views of the city published in 1703, are the foundation on which CANALETTO and GUARDI built. A number of oil sketches from nature in the Victoria and Albert Museum reveal his powers of lively observation.

**CARNATIONS.** The flesh colours in a painting.

**CAROLINGIAN ART.** Term in art history used for the art of the reign of Charlemagne (768–814) and his successors, until about 900. Its first period ended with the death of Charlemagne, it reached maturity under Louis the Pious and his sons (814–*c.* 870), and its decline coincided with the decline of the eastern line of the Carolingian dynasty. The guiding idea of Charlemagne's reform of political and ecclesiastical administration was a renewal of the old Roman Empire, involving him in recreating a 'classical' culture. The outcome of this effort, unprecedented among northern peoples, was the revival of learning and art known as the 'Carolingian revival' or in the term used by Charlemagne's own circle, the Carolingian *renovatio*. The emperor himself was the real initiator of this cultural revival. He was interested in literature and theology, concerned himself with liturgical chant, the revision of the Vulgate text, and the reform of script, and he took an interest in the iconoclastic controversy in Byzantium (see BYZANTINE ART). He recognized the value of the arts for the education of his subjects.

Charlemagne's artists were compelled to take their models from Christian antiquity. Constantine and Theodosius were regarded as ideal emperors, and it was in the architecture, painting, and sculpture of Rome under those emperors that artists sought their inspiration. Works of the 6th and 7th centuries from Byzantium and its provinces also served as models. The 'back-to-Rome' movement had to contend with orientalizing tendencies on the one hand and on the other with local 'Celto-Germanic' or Anglo-Saxon traditions of anti-naturalistic linearism, which showed themselves mainly in the ornament of the minor arts (e.g. the Tassilo Chalice in Kremsmünster, 777–88). In general the models served as sources of inspiration rather than as objects to be slavishly copied, so that a variety of influences can often be seen in one and the same monument. It is the first generation of artists who betray their sources most clearly, yet on the foundation which they laid their successors were able to develop their own style and create the first masterpieces of medieval Western art. Church architecture revived the EARLY CHRISTIAN BASILICA with the T-shaped plan, unused on either side of the Alps since the 5th c. The first building of the abbey church of Saint-Denis

77. Engraving (1612) of church of S. Riquier at Centula (790–9)

(754?-75) was probably on this plan, and the abbey church of Fulda (790/2-819), parts of which are still extant, was modelled on Old St. Peter's in Rome, even in its scale and proportions. The idea of incorporating towers with the basilica appears to have originated in Asia Minor and there were other churches preserving the Eastern tradition that had played a great part during the MIGRATION PERIOD (Einhard's church in Steinbach, Germigny-des-Près, c. 800, and, most important of all, Charlemagne's own church in Aachen with its octagonal plan). The churches with western apses (S. Riquier at Centula; S. Gall, Corvey) and the Carolingian building of Cologne Cathedral influenced the later development of Romanesque architecture. The only well-preserved secular building is the Lorsch *Torhalle*, a kind of triumphal arch with a reception hall in the upper storey.

An abundance of wall-paintings must have adorned the Carolingian churches and palaces, as we know from literary sources, but few have survived apart from some fragments in small churches in Switzerland (Mals and Münster) and France (Saint-Germaine, Auxerre). The only mosaic that has come down to us is in the apse of Germigny-des-Près; it recalls the MOSAICS of Ravenna, whence the actual cubes may have come. Examples of the minor arts have survived in greater number, and it is book-ILLUMINATION, ivory-carving, and goldsmith's work that tell us most about the character of Carolingian art. Alongside the powerful influences of Italy and the British Isles the Carolingian masters exploited to the limits of their ability the prototypes of Roman and Early Christian ANTIQUE. The earliest MINIATURES and IVORIES are those of the ADA SCHOOL; these belong to Charlemagne's lifetime, as do the miniatures of the so-called Palace School, which used Greek models of an illusionistic painterly style. The best known example is the *Schatzkammer* Gospels in Vienna, whose impressionistic landscapes and vigorously modelled figures have led some historians to postulate a Byzantine origin. The airy landscapes of the *Utrecht Psalter* (816-35), organized in depth and teeming with classical PERSONIFICATIONS, are reminiscent of murals in Roman villas and palaces. Important centres of book-illumination sprang up also east of the Rhine, as at Fulda, Würzburg, and Salzburg. The Schools of TOURS, Metz, and S. Gall did not produce their best work before the middle of the 9th c., and the last two continued well into the OTTONIAN period. The extraordinarily high quality of craftsmanship can also be studied in works other than manuscripts and ivories. The *Lothar Crystal* in the British Museum, a charming work which has the story of Susanna incised in it, seems related in style to the School of REIMS; perhaps the most important piece of goldsmith's work, the gold altar (*paliotto*) of S. Ambrogio at Milan, is also related to this school. It has an inscription pointing to a date between 824 and 859.

In the realm of ICONOGRAPHY Carolingian art reinstated the interrupted tradition of classical personifications, Victories, Tritons, Nereids, etc., which had disappeared from Christian art at the beginning of the 7th c., and added to a rich vocabulary of inherited Greco-Roman images, which were permitted to figure again in a Christian context (now for the first time tolerated in scenes of the Passion of Christ) without abandoning their original nature and significance.

214, 326, 332, 599, 733, 838, 961, 975, 1047, 1074, 1121, 1329, 1515, 1622, 2131, 2257, 2363, 2433, 2602, 2967.

**CAROLUS-DURAN,** CHARLES ÉMILE AUGUSTE (1838-1917). French painter. His early works were influenced by the realistic manner of COURBET, but had not Courbet's vigour, tending towards slick, photographic reproduction (*Man Asleep*, Lille). Later he became

**78.** *Give glory to the Lord, for He is good* . . . (Psalm 106). From the *Utrecht Psalter* (Univ. Lib., Utrecht, 816-35)

one of the most fashionable portrait painters of his day (*M. Haro*; *Mme Feydeau*, Lille, 1870). In 1905 he was elected a member of the Institute and appointed Director of the French School in Rome. SARGENT was his pupil.

**CARON,** ANTOINE (*c.* 1520–*c.* 1600). French painter of the second FONTAINEBLEAU School, historically of interest as reflecting the special atmosphere of the Valois court during the Wars of Religion. He did some work on the decorations at FONTAINEBLEAU under PRIMATICCIO and contributed to the CARTOONS for the *Artemisia* tapestry. He later became court painter to Catherine de Médicis and he was closely associated with the Catholic League. His themes fall into three groups. He painted historical and allegorical subjects in the manner of court ceremonial and the *fêtes galantes* popular at the time. The theme of massacre, as in his signed painting *Massacres under the Triumvirate* (Louvre, 1566), alludes symbolically to the bloodshed in the Wars of Religion. A third group, including *Astrologers studying an Eclipse* (Sir A. Blunt Coll., London) and *Augustus and the Sybil* (Louvre), reveal an interest in magic and prediction.

**CARPACCIO,** VITTORE (active 1490–1523). Italian painter of the VENETIAN SCHOOL. He was extremely popular during the 19th c. (he was a favourite of RUSKIN), though his reputation has declined since. The main influence on his style, that of Gentile BELLINI, is especially apparent in his best known work, the cycle of paintings with *Scenes from the Life of St. Ursula*, executed in the 1490s and now in the Accademia di Belle Arti, Venice. Carpaccio's distinguishing characteristics, his taste for anecdote and his eye for the crowded detail of the Venetian scene, found their happiest expression in these paintings; indeed one of them, the *Miracle of the Cross*, looks forward to the 18th-c. compositions of CANALETTO and GUARDI. His other cycle, *Scenes from the Lives of St. George and St. Jerome*, painted for the Scuola (or 'Society') of S. Giorgio degli Schiavone, Venice, at the beginning of the 16th c., combines fantasy with detail minutely observed. Although pictorially his work was somewhat derivative, his talent for lively narrative made him outstanding among the chronicler-painters who contributed most to the fame of Venetian painting.

1580.

**CARPEAUX,** JEAN-BAPTISTE (1827–75). French sculptor and painter. The son of a mason, he worked for some months in the studio of RUDE and also studied at the École des Beaux-Arts, where he won the Prix de Rome in 1854. His *Ugolino* (Louvre, 1860–2) earned him the acclaim of the French colony in Rome, and upon his return to Paris in 1862 he won favour with the court, receiving many commissions for portrait busts. He also made several large sculpture groups, of which the most famous were *La Danse* (1869) for the Opéra and the high relief *Flora* in the Pavillon de Flore at the Tuileries. He was the leading sculptor of the Second Empire but his work is derivative and eclectic.

540, 572.

**CARR,** EMILY (1871–1945). Canadian painter, born at Victoria, British Columbia. Her training was in San Francisco (1889–95) and London (1899–1904). In 1910–11 she was in Paris, where she experienced the impact of the FAUVES and was probably also influenced by Frances HODGKINS. After her return she painted the Indian villages of British Columbia with their TOTEM POLES. Discouraged by years of neglect, she had almost ceased to paint when in 1927 she first saw the work of the Group of SEVEN in Toronto and adopted a different, more austere manner (*Blunden Harbour*, N.G., Ottawa, 1928). In the latest phase of her development her ardent spirit found freer rein. Her large studies of spiralling trees had an irresistible inner movement which expresses the power of nature in her native region. She was the author of several autobiographical works (*Klee Wyck*, 1941, etc.).

492, 493, 1985.

**CARR,** JOHN OF YORK (1723–1807). English architect, a leading exponent of English PALLADIANISM in the north of England during the second half of the 18th c., though after his collaboration with the ADAM brothers at Harewood House (1759–71) he adopted their manner of decoration. Among his houses which survive Tabley Hall, Cheshire (1760–70), is a fine Palladian building; Farnley Hall, Yorks. (1786–90), more austere externally, has elegant Adam-type decoration; and Grimston Garth, Yorks. (1781–6), is in the GOTHIC style. His large practice also included municipal and urban buildings, of which the County Court House, York (1773–7), and the Crescent at Buxton, Derbyshire (1779–84), are the most notable.

**CARRÀ,** CARLO (1881–1966). Italian painter. Trained on classical lines at the BRERA, Milan, he signed the FUTURIST Manifestos of 1910 and 1912. At this time he was trying to combine in his painting the structural severity and tonal neutrality of the CUBISTS with Futurist dynamic quality in representing the movement of crowds. In 1915 he met CHIRICO at Ferrara and was converted to his METAPHYSICAL PAINTING, producing about 20 works with Chirico's paraphernalia of posturing mannequins, half-open doors, mysteriously significant interiors, etc., but constructed more elaborately in depth. Rejecting the tradition of the French school of IMPRESSIONISM he sought to recapture the magic of GIOTTO but to give it a new meaning. Like MORANDI he soon abandoned Metaphysical

painting, but took a different path from Morandi. In the attempt to combine the best of the past with the lessons of CÉZANNE he produced a number of fine seascapes between 1921 and 1925.

1993.

**CARRACCI.** Italian family of painters. AGOSTINO (1557-1602) was the scholar of the Carracci family, and worked only intermittently as a painter. He was an able if somewhat pedantic teacher, and his systematic anatomical studies were engraved after his death and used for nearly two centuries in the drawing schools of Europe. The designation of the Carracci studio as an ACADEMY, subsequently made famous by Agucchi and BELLORI, is probably owing to Agostino. The misinterpretation of the Carracci's supposed academic programme as merely classical or eclectic had its roots in 17th-c. art theory, and it came to signify dispraise rather than praise among the critics of the 19th c. Agostino was also a competent engraver, e.g. of TINTORETTO, whom he visited in 1582. Among his works are some realistic portraits and a famous ALTARPIECE, *The Communion of St. Jerome* (Bologna, 1593-4), which was copied by DOMENICHINO. In 1597 he joined his younger brother ANNIBALE in Rome and assisted him in the Farnese Gallery until 1600, when he went to Parma. He died there two years later. His decorations in Parma show a meticulous but somewhat spiritless version of his brother's lively CLASSICISM.

ANNIBALE CARRACCI (1560-1609) was the most gifted member of the Carracci family, whose style shows constant development. His fame has always rested on his decoration of the Farnese Gallery in Rome, which for the 17th and 18th centuries ranked with RAPHAEL's *Stanze* and the Sistine ceiling as the third of the great classic decorations of Rome. He received his first training in fresco decoration with Ludovico and Agostino in several Bolognese palaces. Two paintings from his early period, probably done as studio exercises, are now highly prized as early examples of pure GENRE: *The Butcher's Shop* (Christ Church, Oxford, c. 1582) and *The Bean Eater* (Colonna Gal., Rome). Closely allied in spirit are his CARICATURE drawings. Study journeys to Parma and Venice confirmed his deep admiration for CORREGGIO and TITIAN: 'I like this straightforwardness and this purity that is not reality and yet is lifelike and natural, not artificial or forced', he wrote to Ludovico in 1580.

Between 1583 and 1595 he painted a series of large altarpieces in which monumentality is combined with warmth of colour. His ability to weld several groups of figures into a coherent rhythm is seen in the huge *Almsgiving of St. Roch* in Dresden. From the same period come several loosely constructed landscapes, such as *Fishing* and *Hunting* in the Louvre.

He went to Rome in 1595, invited by Cardinal Odoardo FARNESE. Annibale was the first artist from north of the Appennines to secure a permanent place in Rome, and he played an essential part in the 17th-c. artistic revival there. During the ten years he worked there he developed his style in the fields of fresco decoration in the GRAND MANNER, history painting, and LANDSCAPE PAINTING, and in all these fields he exerted a strong impact on succeeding generations of artists. In the Farnese Palace he first decorated the Camerino with stories of Hercules, and in 1597 undertook the ceiling of the larger Gallery, where the theme was *The Loves of the Gods*. He drew inspiration for this carefully planned system of feigned architecture, sculpture, and gilt-framed pictures from the Sistine ceiling and Raphael's decorations in the Vatican Loggie and the Farnesina. He made over a thousand preparatory drawings to clarify his intricate but logical scheme, among them many studies from the life. Although the ceiling is rich in the interplay of various illusionistic elements, it retains fundamentally the self-contained and unambiguous character of High RENAISSANCE decoration. The full untrammelled stream of BAROQUE illusionism was still to come in the work of CORTONA and LANFRANCO.

Annibale's work in history painting received fresh stimulus from Raphael's *Stanze* and tapestries: e.g. *Domine, Quo Vadis?* (N.G., London, c. 1602) and *Christ and the Samaritan Woman* (Vienna), which reveal a striking economy in figure composition and a force and precision of gesture that had a profound influence on POUSSIN and through him on the whole language of gesture in painting. He developed landscape painting along similar lines, giving great thought to its planar construction and telling accentuation of figures: e.g. *Flight into Egypt* (Doria Gal., Rome, 1604), where composition and mood point equally towards the landscapes of Poussin and RUBENS. In his last years Annibale was overcome by melancholia and gave up painting almost entirely after 1606. When he died he was buried according to his wishes near Raphael in the PANTHEON. The fame of his art declined with the anti-academic bias of the 19th c. but his greatness as an artist has again been recognized.

LUDOVICO CARRACCI (1555-1619) was only a few years older than his cousins Agostino and Annibale, but he was the leading spirit during the first years of their joint activity. He left Bologna only for brief periods. It is sometimes difficult to plot the steps of his erratic but highly personal development. In his best work there is a passionate and poetic quality indicative of his preference for TINTORETTO and Jacopo BASSANO. Painterly and expressive considerations always outweigh those of stability and calm Classicism in his work, and in this sense he was important for the whole trend of the 17th c. Two pictures from his most fruitful and significant period (1585-95) show the variety in his work: *The Madonna and Child with SS. Joseph and Francis* of 1591 at Cento is fraught with emotional

tension despite the usually tranquil character of such devotional scenes. Light and shade flicker over the picture and wild glances pass between the figures. This picture was of crucial importance for the young GUERCINO. But within a year Ludovico changed direction and in the *Preaching of St. John Baptist* (Bologna, 1592) he adopted paler colours and a sketchier application of paint. This lighter, refined style later influenced RENI, who joined the Carracci studio at this moment. The quality of Ludovico's later work is very uneven, but he continued to produce remarkable paintings of an almost EXPRESSIONIST force such as the *Christ Crucified above Figures in Limbo* (Sta Francesca Romana, Ferrara, 1614).

1784, 2924.

**CARRARA.** See MARBLE.

**CARREÑO DE MIRANDA,** JUAN (1614-85). Spanish painter. After painting mainly religious subjects for many years he was appointed painter to the king in 1669 and Court Painter in 1671. Thereafter he did the portraits of Charles II, the royal family, and members of the court for which he is best known. Except for VELAZQUEZ he was the most important court painter of the late Spanish BAROQUE. He had sensitivity, taste, and good draughtsmanship.

**CARRIERA,** ROSALBA GIOVANNA (1675-1758). Italian painter and in her day one of the most celebrated women artists. She was a sister-in-law of PELLEGRINI. As a portrait painter working particularly in PASTELS, she achieved spectacular success throughout the capital cities of Europe and was a member of the Roman and French Academies. Her visits to Paris (1721-2) and to Vienna (1730) were in the nature of royal progresses. At the time of ROCOCO painting in France her delicate style and her air of spontaneity, her power to impart graciousness without obvious flattery, made a strong impression. She did WATTEAU's portrait and converted Maurice Quentin de LATOUR to the pastel medium.

**CARRIÈRE,** EUGÈNE (1849-1906). French painter of portraits and religious pictures. As a young man he was an admirer of RUBENS and VELAZQUEZ, on whom his style was based. He painted intimate scenes of middle-class family life and had a special interest in the theme of motherhood, which he treated with an almost mystical reverence. He was a friend of Verlaine and other Symbolist writers, who admired his work, and he was considered by RODIN 'one of the greatest of painters'. Among his pictures in the Louvre are the portraits *Verlaine* and *Alphonse Daudet and his Daughter*.

2441.

**CARSTENS,** ASMUS JACOB (1754-98). German draughtsman and painter. Apart from

some initial training at the Copenhagen Academy he was largely self-educated. He was in charge of the plaster cast class of the Berlin Academy and after 1792 lived in Rome with the help of a grant from the Prussian State. Carstens dismissed MENGS's CLASSICISM as not severe enough. He considered himself a history painter and the subjects of his compositions, all figured, range from Homer and Pindar to Ossian and Shakespeare. Uninterested in colour, he concentrated on INVENTION, aiming to construct scenes which had strict unity of action as well as significance and precision of the individual characters. As with FLAXMAN, contour was the most important feature of his pictures. He had some importance as an early representative of the Classical revival and exerted a considerable influence on the next generation (THORWALDSEN, NAZARENES) through his somewhat pompous seriousness and unimaginative artistic integrity.

**CARTOON.** A full-size drawing made for the purpose of transferring a design to a painting or tapestry or other large work. The earlier painters of FRESCO simply drew freehand on the wall or copied from a small sketch, but a cartoon was indispensable in the process of making STAINED GLASS, and it was perhaps from this art that the painters borrowed it. Some frescoes of the early 15th c. show clearly that their designs have been traced from cartoons, for their outlines are either indented or punctuated with pin-pricks. The method is described by VASARI. The drawing was made on stout paper, usually with charcoal or chalk, and sometimes heightened with white or coloured with water-colours. It was then cut into sections. The section which was wanted for the day's painting was laid against the soft fresh plaster of the wall and a STYLUS was pressed heavily along the lines, or else pricks were made at intervals and powdered charcoal was rubbed through the holes. In pricking through, a sheet of paper was placed under the cartoon to receive the holes and the powdered charcoal was rubbed over this—not over the cartoon itself. The process is called 'pouncing'.

Cartoons were used for easel paintings as well as frescoes. A well known example is LEONARDO's *Virgin and Child with St. Anne and the Infant St. John* (N.G., London). Another, unusually small, is RAPHAEL's pen-and-ink drawing *The Vision of a Knight* which hangs in the National Gallery, London, beside the little panel painting which was made from it.

A cartoon did not necessarily represent the whole picture; it might show only a single figure or a group, and it might be used more than once. The BELLINI studio, for instance, seems to have had a figure of a Madonna which was used in several pictures, surrounded each time by different saints. Sometimes the cartoon was turned over and traced in reverse as in MICHELANGELO's paintings in the Sistine Chapel, where each couple of PUTTI supporting the cornice is a mirror-image of another couple. The use of

cartoons made it possible for a minor master to paint a picture from a more famous master's design. They were valuable possessions, somewhat like copyrights: Girolamo di Romano (*c.* 1484–after 1562), for instance, gave some to his son-in-law as a dowry. The drawing was often worked out very much more fully than was necessary for the mere purpose of tracing (HOLBEIN's meticulous pen-and-wash cartoons of Henry VII and Henry VIII), and was sometimes regarded as a work of art in its own right. Vasari tells us that when Leonardo finished his cartoon of the *Virgin and St. Anne* (apparently not the one in the National Gallery, London) it was put on show and visited for two days by throngs of festive people.

Little oil paintings called *cartoncini*, intermediate between the sketch and the full-scale cartoon, were sometimes made by 17th-c. painters. RUBENS left great numbers of them.

The weaver's cartoon is a painting in full colour; famous examples are the series on the *Apostles* lent from the Royal Collection to the Victoria and Albert Museum, London, painted in distemper by Raphael and his pupils in 1515–16 as designs for tapestries woven for the Sistine Chapel.

In the 19th c. designs submitted in a competition for frescoes in the Houses of Parliament were parodied in *Punch*. From this the word 'cartoon' acquired its present popular meaning of a humorous drawing or parody.

**CARTOUCHE.** 1. An ornamental tablet with edges simulating a scroll of cut parchment usually framing an inscription or shield with coat of arms.

2. Name given to the oval or oblong figures in Egyptian hieroglyphics, enclosing characters expressing royal or divine names or titles.

**CARUCCI,** JACOPO. See PONTORMO.

**CARYATIDES.** Term in Greek architecture for female figures clad in long robes which serve as COLUMNS to support an ENTABLATURE. The name means 'women of Caryae', a town in Sparta, and their use for architectural figures may derive from the postures assumed in the local folk dances at the annual festival of Artemis Caryatis. VITRUVIUS (1.1.5) records a confused legend concerning the supposed support given to Persia by Caryae or Caria. The most famous Greek Caryatides are in the ERECHTHEUM at Athens (where the caryatides were first known as *korai* or maidens) and the Treasury of the Cnidians at Delphi. They were not much used by the Romans and were uncommon in RENAISSANCE architecture. There are some by GOUJON in the LOUVRE, and they were often illustrated in editions of Vitruvius; they returned to favour with the Greek Revival of the 19th c. St. Pancras church by the INWOODS has some famous ones copied from those of the Erechtheum.

**CASAS Y CARBÓ,** RAMÓN (1866–1932). Spanish IMPRESSIONIST painter who, with Santiago RUSIÑOL and Miguel Utrillo (1863–1934), launched the *Modernismo* art movement at Barcelona in the 1890s. He stimulated many younger artists including TORRES-GARCÍA, NONELL, and PICASSO.

**CASAS Y NOVOA,** FERNANDO DE (d. *c.* 1751). Spanish architect, responsible for the completion of one of the finest BAROQUE compositions in Spain, the great façade or *obradoiro* of the cathedral of Santiago de Compostela. He was also responsible for the cloister and Lady Chapel of Lugo Cathedral.

**CASEIN.** A very strongly adhesive substance made from fresh curd. It is used in mural painting (SECCO) and in TEMPERA. Casein was the substance used to fasten the several pieces of wood together to form a PANEL as a SUPPORT for an easel painting.

**CASSATT,** MARY (1845–1926). American expatriate painter who worked mostly in Paris and became a minor figure in the IMPRESSIONIST movement. Her distinguished talent for draughtsmanship was developed on the models of the Old Masters, particularly CORREGGIO and INGRES, and she made a highly individual use of Japanese styles in maturing her gift for design. Persuaded to exhibit with the Impressionists by DEGAS, for whom as a young woman she had a great admiration, she nevertheless retained the extremely personal character of her art and her affinities with them lay less in technique and theory than in a common attitude towards the rehabilitation of the everyday scene and gesture. Paintings such as *La Loge* (N.G., Washington, *c.* 1882) and *Lady at the Tea Table* (Met. Mus., New York, 1885) with a fragile and delicate beauty evoke the elaborate refinement of the society described by Henry James. She gradually achieved firmer structure and a stronger form, particularly in the studies of mothers and children which became her favourite theme (*Mère et enfant*, pastel, Louvre, 1905).

2804.

**CASSONE** (Italian). A large chest which frequently contained the bride's dowry. Decorated *cassoni* became the fashion in RENAISSANCE Italy, and quattrocento Florence saw the development of the painted *cassone* front. These paintings usually represented episodes from classical or biblical history and mythology which pointed a lesson or contained a happy augury for the newly wed. The records of one flourishing *cassone* workshop (by Marco del Buono and Apollonio di Giovanni) have been preserved and show them to have delivered an average of one

pair of such pieces a fortnight during prosperous periods. The price for a pair was about 30 florins. Though rarely of very high quality, the *cassone* paintings reflect the taste of the Florentines for lively narrative and gay display and were therefore eagerly collected (and repainted) in the 19th c. Some major artists such as DOMENICO VENEZIANO, UCCELLO, and BOTTICELLI also seem to have decorated *cassoni* once in a while. VASARI attributed nearly the whole production to Dello Delli (*c.* 1404-71?) but in this he was certainly mistaken. Painted *cassoni* went out of fashion towards the end of the 15th c. when carved oaken chests came in.

2434.

**CASTAGNO,** ANDREA DEL. See ANDREA DI BARTOLO DI BARGILLA.

**CASTIGLIONE,** GIOVANNI BENE-DETTO, called IL GRECHETTO (*c.* 1610-65). Genoese painter, etcher, and draughtsman. His style of painting owed something to RUBENS, van DYCK, and Bernardo STROZZI, all of whom worked in Genoa, whilst his etchings depend particularly on REMBRANDT. He painted religious themes in BAROQUE style with emphasis on the elements of STILL LIFE and GENRE in a manner reminiscent of the BASSI. Among his most famous pictures of this kind are *The Crib* (S. Luca, Genoa, 1645) and *Christ driving the Money-lenders from the Temple* (Louvre). His sketches are well represented in the Royal Library at Windsor, many of them executed in an original manner in oil paint on paper.

309.

**CASTIGLIONE,** GIUSEPPE (Chinese name LANG SHIH-NING) (1698-1768). Italian Jesuit missionary and amateur painter who settled in China *c.* 1730. It is said that he studied Chinese painting by imperial command and his landscapes, animal and GENRE paintings, in which Chinese brushwork and Western REALISM were combined for the first time, enjoyed great success at the court. He was the first Western painter to be appreciated by the Chinese, and was commissioned by the Emperor to paint portraits, scenes of court life, and imperial military expeditions. Many of his works have survived, and some of the best known are in the Musée Guimet, Paris.

**CASTING.** See BRONZE SCULPTURE; PLASTER CASTS; TERRACOTTA.

**CATENA,** VINCENZO (*c.* 1480-1531). Venetian painter of good birth and independent means who moved in humanist circles and may have been the link between these circles and GIORGIONE. He is first mentioned in 1506 in an inscription on the back of Giorgione's portrait *Laura* (Vienna). His early works are awkward and stiff variants of compositions probably evolved in Giovanni's studio in the 1490s. From

*c.* 1510 his style matured under the influence of the late BELLINI, CIMA, and TITIAN and his technical competence increased. His *Martyrdom of St. Christina* (Sta Maria Mater Domini, Venice, 1520) and *Holy Family with an Adoring Warrior* (N.G., London) with their suffused light and warm colours are, if not great masterpieces, good examples of Venetian cinquecento painting.

**CATTERMOLE,** GEORGE (1800-68). English water-colour painter, born at Diss, Norfolk. He was placed at an early age with the antiquary, John Britton (1771-1857), for whom he made architectural drawings. He exhibited at both the R.A. and the British Institution from 1819. He treated antiquarian subject matter and costume scenes in a detailed, ROMANTIC style akin to that of Joseph NASH, combining accuracy with PICTURESQUE rather than archaeological aims. Some of the best of his many book illustrations were for Dickens (*Master Humphrey's Clock*; *Barnaby Rudge*); notable also were *Cattermole's Historical Annual—the Great Civil War of Charles I and the Parliament* (vol. i, 1841; vol. ii, 1845) and *Evenings at Haddon Hall* (1846).

**CAUVET,** GILLE-PAUL (1731-88). One of the most fashionable Paris interior decorators of the 1770s and 1780s, Cauvet held the special post of 'sculpteur de Monsieur, frère du Roi'. He was responsible also for individual designs, e.g. for clocks, and in 1777 published a *Recueil d'ornements à l'usage des jeunes artistes*.

**CAVALIERE D'ARPINO.** See CESARI, GIUSEPPE.

**CAVALLINI,** PIETRO (active 1273-1308). Italian painter responsible for several of the largest murals of his time, most of which have disappeared. He also restored EARLY CHRISTIAN frescoes (Old St. Peter's and S. Paolo Fuori le Mura). Among his surviving works in Rome are mosaics of the *Life of the Virgin* (Sta Maria in Trastevere, signed and dated 1291) and the concluding scene of a destroyed fresco cycle, *The Last Judgement* (*c.* 1293) in Sta Cecilia in Trastevere. In 1308 Cavallini was in Naples serving the Angevin kings. He had a considerable following there, in Rome, and in Assisi.

Although Cavallini made no radical departure from the style of the duecento, a freer interpretation of BYZANTINE themes and a softer treatment of draperies, the play of light and a certain classical majesty and a sense of space make him a link between antiquity and the revival inaugurated by GIOTTO.

2658.

**CAVALLINO,** BERNARDO (1622-54). A Neapolitan artist whose pictures, usually smallish, treated biblical scenes in a personal and attractive vein of melancholy. Little is known about

his life, which he spent in Naples, coming to the fore after the death of CARACCIOLO. His only dated picture is the *St. Cecilia* (Naples Mus., 1645). His figures are refined and elegant and his colours rich and warm, painted swiftly over a deep red BOLE ground. CARAVAGGIO, van DYCK, and TITIAN are influences on his style. The overall pattern of light and shade in his pictures is very striking, e.g. in the *St. Cecilia*. The picture *Christ Driving the Money-changers out of the Temple* (N.G., London) has a remarkable centrifugal design cleverly made to fit the theme.

**CAVE ART.** See STONE AGE ART IN EUROPE.

**CAYLUS,** COMTE CLAUDE-PHILIPPE DE TUBIÈRES (1692-1765). French antiquarian and collector. He was a member of a prominent military family, his mother being a niece of Mme de Maintenon, and abandoned a promising career in order to indulge a life-long passion for the arts and antiquity. In 1714 he spent a year in Italy and travelled through Greece to Constantinople and the Near East. Returning to Paris in 1717, he took drawing lessons from WATTEAU, learnt engraving and threw himself with enthusiasm into the reproduction of Old Master drawings, coins and gems of the Cabinet de Médailles, and antiquities. In 1722 he visited the great collections of Holland and England. In 1731 he was elected honorary counsellor of the Academy of Painting and in 1742 a member of the Academy of Inscriptions. He was an active champion of the younger artists working in a CLASSICAL style, notably BOUCHARDON, of whom he published a *Life* in 1762. He supported the ideals of classical purity and simplicity in contrast to the decorative artificiality of ROCOCO and was among the most important influences for the emergence of the LOUIS XVI style, which combined balance and proportion with comfort but was free from the frigid artificiality of the NEO-CLASSICISM of the beginning of the 19th c.

Caylus is credited with being the first to conceive archaeology as a scientific discipline and in this respect WINCKELMANN acknowledged indebtedness to him. His own collection of antiques, which he began in 1729, formed the basis of his *Recueil d'antiquités égyptiennes, étrusques, grecques, romaines et gauloises* (7 vols., 1752-67), the most serious work of antiquarian research in the 18th c. and one of the most influential in spreading knowledge and enthusiasm for the works of classical antiquity.

**CELADON.** The generally accepted name for the semi-translucent glazes of certain Chinese and Korean ceramics (see CHINESE ART, KOREAN ART). The name was adopted in the 18th c. from a green-clad rustic in Honoré d'Urfé's pastoral romance *L'Astrée*. The finest celadon wares date from the Sung period (10th–13th centuries).

1093.

**CELLINI,** BENVENUTO (1500-71). Florentine goldsmith and metal-worker who turned to large-scale sculpture. His autobiography, written in a racy vernacular, has been famous since the 18th c., when GOETHE translated it, for its vivid picture of a RENAISSANCE craftsman proud of his skill and independence, boastful, quarrelsome, superstitious, and devoted to the great tradition embodied in MICHELANGELO. It has given him a wider reputation than could have come from his artistic work alone; but to modern eyes he also appears as one of the most important MANNERIST sculptors and his statue *Perseus* one of the glories of Florentine art.

His life can be roughly divided into three periods. From the first, spent mainly in Rome, nothing survives but some coins and medals and the impressions of two large seals. During the second (1540-5), which he spent in the service of Francis I of France, he created the famous salt-cellar of gold enriched with enamel, exquisitely worked with two principal and many subsidiary figures. This (now in Vienna) is the most important piece of goldsmith's work that has survived from the Italian Renaissance. He also made for the king a large bronze relief, the *Nymph of Fontainebleau* (Louvre). The remainder of Cellini's life was passed in Florence in the service of Cosimo I. Here he cast the bronze *Perseus* (Loggia dei Lanzi, Florence, 1545-54) which, with the figures and reliefs of the pedestal, is reckoned his masterpiece. To this period also belong his marble sculptures, the *Apollo and Hyacinth* and *Narcissus* (both in the Bargello, Florence) and the *Crucifix* (Escorial).

Many goldsmith's works have been attributed to him, but of these only the mounts of an agate vase in the British Museum may be by his hand. The influence of this technique is not obtrusive in his large sculpture, but appears strongly in the dry, precise chiselling of his two bronze busts, *Bindo Altoviti* (Gardner Mus., Boston, *c.* 1550) and *Cosimo I* (Bargello, Florence).

The manuscript of Cellini's autobiography disappeared during the 18th c. and was discovered in 1805. The source of the first printed edition (Naples, 1728) is not known. The *Life* was first translated into English in 1771 by Thomas Nugent and since then there have been several English versions, including one by John Addington Symonds (1888).

505, 2105.

**CELTIC ART.** The style of Early Celtic art was first devised, with some exuberance, by skilled artificers working for Celtic chieftains in south Germany and eastern France during the second half of the 5th c. B.C. It was developed during the next five centuries and spread over much of Europe, mainly among peoples known to the ancient world as Celts.

It is the first appearance in barbarian Europe of a sophisticated art based upon that of the ancient civilized world and adopting in some

measure its criteria. Its best works were fully
conceived before execution; they show a high
sense of form, structure, and line, of the use of
voids (thereby not overloading the surface with
a spread of ornament); and of balance, poise, and
above all repose. Many of these works neverthe-
less have a dynamic vitality; but they are not
restless, for the vigorous movement, often swirl-
ing outwards from a generating centre, is caught
with calm assurance in a moment of time.

These craftsmen blended elements from
several sources—from Italy and through her
from Greece and the East—but with such vigour
and originality as to create their own new and
individual style. Some unity is maintained over
six centuries through the stylized treatment of
animals and men, sometimes aristocratic, some-
times intense or weird, sometimes no more than
hinted at in the complexity of the design; by the
persistent basis of Greek ornament, especially
plant forms and lyres, and the skilful counter-
point of asymmetry with symmetry. The Greek
rosette-flower, the half-palmette leaf, and the
tall palmette, were long in use, but new forms of
stylized leaf were devised, such as the comma
leaf, or the severely simple almond shape.

Most of the surviving work is in gold (rarely
silver) or bronze, but there is some skilled iron-
work, and wood and pottery were also orna-
mented. Coral and enamel settings and painted
pottery show that colour contrasts were sought
and appreciated, and contrasts of texture were
often rendered in monochrome by hatching or
stippling.

The earliest examples, mainly seen on per-
sonal equipment, weapons, and ceremonial metal
vessels, show aristocratic or weird human faces,
often moustachioed, with bulging or finely
moulded forceful features, in which Etruscan
models are sometimes detectable (as in the
powerful eyebrows sweeping directly out from
the top of the nose). There are also fantastic
animals with lithe strong bodies traceable to the
nomad art of the Steppe, or symmetrically set in
facing pairs, a motif more at home in Persia and
sometimes merging with the Greek lyre. The
shapes of the vessels, wine flagons and *stamnoi*,
are based on Greek through Etruscan or south
Italian sources. There is also, particularly in
engraving (sometimes in tremolo line) and in
openwork frets, much of the earlier geometric
repertory of the native workshops in which many
of the craftsmen must have been schooled, the
influence of which is also seen in the continuity
of structural design as in the decorative shapes
at the scabbard tips. There may be a strain too of
northern freehand engraving style such as occurs
in the late Bronze Age SCANDINAVIAN ART and
that of the north German plain.

During the 4th c. B.C. Greek stylized plant
forms and ARABESQUES began to dominate the
ornament, but were used with flowing freedom
to give fleshy swelling and intertwining lines,
sometimes with faces, realistic or bottle-nosed,
peering impassively or sadly from vantage points

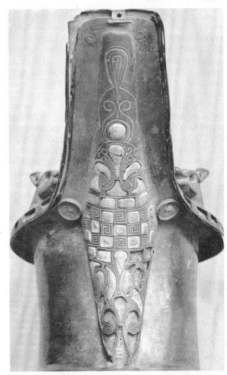

**79.** Detail of neck-ornament on Basse-Yutz flagon.
Embodying stylized head with moustache and Greek
decorative motifs. (B.M., mid 4th c. B.C.)

in the design, reflecting again Etruscan or south
Italian models. Much of this ornament is in low
relief, and is well illustrated by the metal-work
from south German chieftains' graves, as at
Waldalgesheim.

A little later plastic modelling (cast, beaten,
or tooled-up) became exaggerated like icing-
sugar and there was much engraved ornament
(especially on sword scabbards), in which the
Celtic craftsmen themselves reduced the relief
ornament to line drawing on plane surfaces.
Plant and geometric forms were still the basis of
pattern, with stylized animals or birds (their
heads often used as finials of plant stems or of
threefold whirligigs).

At this time, in the 3rd c. B.C., the style first
appeared in the British Isles, and was developed
in a distinctive British manner for some four
centuries. In the earliest works, such as the great
shields, the continental background is discern-
ible, though from the first their insular character
was prominent, and there are very few known
works from Britain which would be in place in
a continental chieftain's grave. In the 1st c.
B.C. there was a weakening of the style, but good
work was still produced. Ornament became
increasingly asymmetrical both in detail and in
over-all layout. Much of it was line engraving,

used to decorate scabbards and other plane or gently rounded areas such as mirror-backs. Cast or embossed relief ornament made a feature of the delicately shaped raised lip and twined raised lines, developed perhaps from linear patterns. Animals (but not men) assumed a prominent place in British work, both for finials and modelled in the round.

After the 3rd c. B.C. northern work continued to be influenced from time to time by southern classical models; but apart from exceptional works (such as the Gundestrup cauldron) the early exuberance had passed and the sobering influence of Roman production was increasingly felt, though the Celtic often asserted itself with stubborn persistence (as in asymmetrical elements or plan, stylized creatures, and almond-leaf finials) through the first few centuries A.D.

**80.** Bronze shield (perhaps once gilded and backed with wood or leather). From the Thames at Battersea. Showing Greek rosette, tendril and other decorative motifs. (B.M., 1st C. B.C.–1st C. A.D.)

Nevertheless there is little direct affinity really discernible between the style of pre-Roman Celtic art and that which has been called 'Celtic' in the post-Roman world. Such thread of continuity as there may be is to be sought in the crafts of the provincial Roman workshops in which Roman ideas were mingled with native skills and traditions. This is true not only of the British Isles but also of southern Scandinavia, and some persisting Celticizing undercurrent may have made a contribution even to the formation of the Germanic MIGRATION style of the 5th and 6th centuries A.D. In the earlier post-Roman products of the West all the refined sophistication of the earlier Celtic work was gone, its place taken by stiff and unventuresome Romanic ornament allied to an increasingly obtrusive ANIMAL STYLE (once again coming from the nomad art of the Steppe). It had largely reverted once more to the barbaric (see BARBARIAN ART IN EUROPE) (with little marshalling of voids), the classical elements coming from provincial Roman sources and the Greek lost to sight.

33, 132, 343, 354, 355, 416, 724, 906, 1293, 1294, 1295, 1416, 1610, 2107, 2167, 2561, 2562.

**CENNINI,** CENNINO (born *c.* 1370). Italian artist and writer. He states that he was a pupil of Agnolo GADDI, who learnt from his father Taddeo GADDI, who in turn was a pupil of GIOTTO. None of his works has survived. Cennini is now important for his craftsman's handbook *Libro dell' arte* (translated by Daniel V. Thompson as *The Craftsman's Handbook*, 1933). This stands between the medieval and the modern periods in content and outlook. He preserves the medieval precepts and technical formulae in the manner of THEOPHILUS. But he was heir to the workshop tradition initiated by Giotto and the book is a useful source of information about early TEMPERA techniques. From Giotto's school he may also have derived his precept that 'nature' is the artist's best master. The treatise is medieval in its encyclopedic scope and approach, modern in its insistence on the innovations of Giotto. The original manuscript may have been lost. The earliest extant manuscript is dated 1437 'in the debtors' prison in Florence', but may be a posthumous copy.

351, 507.

**CEPHISODOTUS.** Athenian sculptor of the early 4th c. B.C., perhaps the father of PRAXITELES. His *Peace holding the infant Wealth* is known from copies.

**CEROGRAPHY.** See ENCAUSTIC PAINTING.

**CEROPLASTICS.** The art of wax MODELLING.

**CERQUOZZI,** MICHELANGELO (1602-60). Italian painter; a pupil of the Fleming painter Jacob de Hase (1575-1634), from whom he learnt to paint battle scenes (see BATTLE-

PIECE), becoming known as 'Michelangelo of the Battles'. From 1626 he was associated with Pieter van LAER and with him popularized the small burlesque scenes known as *bambocciate*.

**CESARI,** GIUSEPPE, also called CAVALIERE D'ARPINO. Roman-born artist of Spanish descent who was extensively employed by successive popes on the most important fresco decorations in Rome between 1590 and 1615. His style is learned, elegant, and facile, but essentially old-fashioned and flaccid when compared with that of the CARRACCI or CARAVAGGIO or the rising generation of BAROQUE artists, several of whom worked at first under his direction. Caravaggio was employed in his studio soon after he came to Rome and Cesari owned two of his early works. In 1588–91 he was working on the choir of S. Martino, Naples, and his work in Rome included decorations (unfinished) for the great hall of the Palazzo dei Conservatori and the well known *Scenes from the Life of St. John Baptist* in the Lateran Baptistery.

**CEYLONESE ART.** Art in Ceylon has for the most part served Buddhism of the type called Theravada ('Fundamentalist' in principle) and although stylistic influences from India have been at times powerful, the main stream of tradition in Ceylon has been continuous and distinct. Buddhism was established in the reign of Devanampiya Tissa (247–207 B.C.), when the son of Ashoka came to Ceylon with a slip of the original Bodhi tree. From that time on numerous STUPAS were established, with attendant monasteries, adorned with sculpture of many kinds. The process began in the region of the northern capital, Amuradhapura, abandoned to Tamil invaders in the 8th c. and the ruins of the monuments of this early period still scatter the countryside. The stupas were usually tall, domed structures with several moulded bands round the base, raised on plinths, and crowned with stone tiers of umbrellas. The earliest sculptures to survive reflect the style of Amaravati in the 3rd c. A.D. Later on there emerged a Buddhist version of Pallava sculpture of very high quality indeed (see INDIAN ART).

On Sihagiri, a huge rock rearing up from flat country, a parricide king built himself a palace-eyrie in the late 5th c. To this period are ascribed a group of well known paintings on plaster of celestial nymphs preserved in two rock-pockets above the pathway to the summit. They are in a style which has affinities with contemporary work at Ajanta.

The next capital, Polonnaruwa, is particularly rich in works of art. Especially well known are the colossal cliff-carved figures of the dying Buddha with his disciple Ananda at Gal Vihara, several seated Buddhas, and the cliff statue of Parakrama Bahu. Many architectural remains,

such as the Watadage and the Nissankalata Mandapaya and the Northern Temple, bear witness to an extremely accomplished and sometimes exuberant invention. Fragmentary remains of wall-paintings survive from several monuments at Polonnaruwa, and from the shrine at Majiyanangana. Later architecture has largely followed the models of the Polonnaruwa epoch, though the painting during the period after Kandy had become the capital (A.D. 1290) developed a style of severe and schematic figure drawing with broad flat areas of brilliant colour. Especially beautiful are the bronze figurines, both large and small, made in medieval times. One such, the female gilt-bronze figure, almost life-size, in the British Museum, once believed to be *Pattini Devi* but now called *Tara*, is one of the world's most sublime masterpieces. (See also INDIAN, PAKISTANI, AND CEYLONESE ART OF THE 19TH AND 20TH CENTURIES.)

615, 737, 2766.

**CÉZANNE,** PAUL (1839–1906). French painter born at Aix-en-Provence, son of a prosperous banker. He was a schoolfellow of Zola, who introduced him to MANET and COURBET and persuaded him to take up the study of art in Paris. There at the Académie Suisse in 1861 he met Camille PISSARRO and Armand Guillaumin (1841–1927), and the following year he got to know MONET, BAZILLE, SISLEY, and RENOIR. During his early years in Paris Cézanne admired the works of MEISSONIER and DORÉ and later those of DELACROIX and DAUMIER. His own painting at this time was in a vein of unreserved ROMANTICISM with a predilection for themes of violence or eroticism. He later referred to this period as his 'manière couillarde'. From *c.* 1866 he became interested in painting direct from nature and began to impose a more disciplined restraint on his natural impetuosity. In 1872 he settled in Auvers-sur-Oise, near Pontoise, the home of Camille Pissarro, and entered upon a long and fruitful association with him. In the last year of his life he even described himself as a 'pupil of Pissarro'. He exhibited with the IMPRESSIONISTS in 1874 and again in 1877 but he never identified himself with the Impressionist group or wholly adopted their aims and techniques. He was less interested in the realistic representation of casual and fleeting impressions and the fugitive effects of light but devoted himself rather to the structural analysis of nature, looking forward in this respect to the NEO-IMPRESSIONISTS. His own aims are summarized in two of his sayings: that it was his ambition to do POUSSIN again after nature and that he wanted to make of Impressionism something solid and enduring like the art of the Old Masters. Not a highly intellectual man, Cézanne trod a solitary and difficult path towards his goal of an art which would combine the best of the French classical tradition of structure with the

best in contemporary REALISM, an art which appealed not superficially to the eye but to the mind.

Returning to Aix, he worked in comparative obscurity until he was given a one-man show by the dealer Vollard in 1895. From that time his painting began to excite the younger artists and he attempted to explain his theories and aims in letters written to Émile Bernard, Charles Camoin, and others. By the end of the century he was revered as the 'Sage' by many of the *avant-garde*. In 1901 Maurice DENIS exhibited a picture entitled *Hommage à Cézanne* (Courtauld Coll., London) at the Libre Esthétique exhibition in Brussels and in 1904 the Salon d'automne gave him a special exhibition. Since his death his reputation has increased among critics and art historians and he has exercised a profound influence on the aesthetic principles of many movements, in particular CUBISM, and among 20th-c. artists.

Cézanne's work was introduced to England with the POST-IMPRESSIONIST exhibitions organized by Roger FRY in 1910 and 1912. The analysis of Cézanne's painting was the principal foundation of a new aesthetic attitude, propagated by Roger Fry and Clive BELL, which dominated English criticism during the 1930s. In a monograph on Cézanne written in 1927 Fry urged his conception of art as a purely plastic organization of forms and on this basis spoke of Cézanne as 'a great classic master' and said: 'We may almost sum him up as the leader of the modern return to Mediterranean conceptions of art.' This whole idea of art and of appreciation as emotional apprehension of purely formal qualities was violently challenged by D. H. Lawrence in 1929. Even as early as 1914 Clive Bell had linked his theory of SIGNIFICANT FORM closely with an interpretation of Cézanne's painting and had said of him: 'He was the Christopher Columbus of a new continent of form.' In reviewing Bell's book *Art*, SICKERT (*A Free House*, 1947) claimed that Bell (and Fry) were undermining appreciation of Cézanne's real qualities by building a nonsensical theory on his palpable and tragic defects (bad draughtsmanship and 90 per cent failure). The estimation of Cézanne among English critics has remained high and much as Fry and Bell placed it; but the grounds of appreciation have gradually come to be largely those which Lawrence and Sickert suggested.

129, 265, 513, 624, 941, 945, 1242, 1725, 1813, 1923, 2057, 2223, 2271, 2735, 2741, 2770, 2771.

**CHABOT,** HENDRIK (1894-1949). Dutch artist who is best known for views of the meadows of Holland under threatening skies, and for his sombre pictures of peasants and sailors. His figure pieces, as well as some of his sculpture, show the influence of CUBISM. Chabot's studio in Rotterdam was destroyed in 1940 and with it

most of his life's work. Some of the pictures he painted later are in the Municipal Museum, Amsterdam, and the Boymans–Van Beuningen Museum, Rotterdam.

**CHADWICK,** LYNN (1914- ). English sculptor. He took up sculpture in 1946 after serving as a pilot in the Fleet Air Arm and first experimented with MOBILES, constructions suspended in space. These were followed by what he called 'balanced sculptures', ponderous metal structures supported on thin legs and often containing a mobile component, bristling and rough finished. His work has been shown in a number of international exhibitions and in 1956 he was awarded the International Sculpture Prize at the 28th Venice Biennale. He was given a retrospective exhibition by the ARTS COUNCIL in 1957.

1342.

**CHAGALL,** MARC (1889- ). Painter of the École de PARIS, born of Jewish parents at Vitebsk. He studied at St. Petersburgh under BAKST, came to Paris in 1910 and there became an intimate of the *avant-garde* circle which included Blaise Cendrars, Guillaume APOLLINAIRE, Max Jacob, André Salmon, and the artists SOUTINE, LÉGER, DELAUNAY, MODIGLIANI. In 1914 he was exhibited at the gallery of Der STURM in Berlin and returned to Russia. He founded an art school in Vitebsk and in 1917 was made director and Commissar of Fine Art for Vitebsk by the Soviet minister Lunacharsky. But the element of fantasy in his work caused difficulties with the authorities, whose conception of art demanded traditional REALISM with a social message, and he went to Moscow, where he designed for the newly founded Jewish Theatre. He returned to Paris in 1923 and among much other work illustrated Gogol's *Dead Souls* and La Fontaine's *Fables* for the dealer Vollard. From 1941 he was in the United States of America and Mexico, designed décors and costumes for Stravinsky's *Firebird* in 1945 and had a retrospective exhibition at the Museum of Modern Art, New York, in 1946. He returned to Paris in 1947 and held retrospective exhibitions at the Musée national d'Art moderne, then at Amsterdam and in the Tate Gallery, London. In 1948 he was awarded the Prize for engraving at the 24th Venice Biennale. He did two murals for the new Metropolitan Opera House, New York: *Les Sources de la musique* and *Le Triomphe de la musique* (1966).

Chagall's painting of figures and scenes has a Jewish character recognizably similar to that of Issachar RYBACK from the same region. His work became notorious for its fairy-tale fantasy, which caused André BRETON to claim him as one of the precursors of SURREALISM in his study *Genèse et Perspectives du Surréalisme* (1941). Chagall himself, however, stated

in *Ma vie* (1931) that however fantastic and imaginative his pictures appeared, he painted only direct reminiscences of his early years. Chagall's painting has been very unequal. At his best he is one of the greatest masters of the École de Paris and one of the most splendid artists of French EXPRESSIONISM.

406, 498, 578, 1829, 1830, 2736.

## CHALK METHOD OF ENGRAVING. See CRAYON MANNER.

## CHALKS AND CRAYONS. Chalks are, strictly, natural soft stones or earths, and crayons are sticks prepared from these, often with an admixture of oil or wax. But the two terms are becoming interchangeable, and both are often used for PASTEL, which is essentially a stick or cake of powdered pigment mixed with a filler and bound together with GUM or other binding MEDIUM. Only the black, red, and white chalks and crayons commonly used for drawings are discussed here; for the others, see PASTEL PAINTING. Crayons were occasionally used as an alternative to a liquid paste for the execution of rock drawings in STONE AGE ART. Black was obtained from manganese ore and from charcoal. From ochre various shades from yellowish red, through red to brown, were obtained. White, green, and blue were not used.

1. BLACK. A soft black stone is an obvious material for drawing and must have been used in very early times, but it does not seem to have been in general use in artists' workshops before the end of the 15th c. LEONARDO, MICHEL-ANGELO, and Fra BARTOLOMMEO were the first famous masters to use it. It was less easily erased than charcoal, and more permanent. The oilier and harder crayon, first prepared from lamp black, is known to have been used in the 16th c., and from then onwards both were common materials for finished work as well as studies. On toned paper the light parts were often heightened with white; or black and red might be used together.

2. RED. Red chalks and crayons are prepared from various red earths which are among the oldest substances used in painting. Red ochre sharpened into crayons has been found from the Mousterian period of the Ice Age. In the first half of the 15th c. Jehan le Begue and CENNINI refer to red chalk only as a colour used in painting, and CONDIVI reports that Michelangelo, when he was in Florence at the end of the 15th c. and was asked for a drawing, used a pen, because chalk was not then in general use. Red chalk is seen first in Leonardo's studies for the 'Horse' monument and the *Last Supper*. It soon became popular; in the early 16th c. Michelangelo and RAPHAEL were both using it, and it was the favourite drawing material of ANDREA DEL SARTO and PONTORMO. Red chalk added colour to the drawn line, and accordingly soon found favour

with the Venetians; not, however, with masters like DÜRER who valued the integrity of the line above its other qualities. RUBENS and WATTEAU are among those who have made the most effective use of it. It was specially popular in the 18th c. with French masters, who combined it with black in a non-linear mixed technique more akin to pastel painting than to drawing. Red crayon is sometimes called sanguine.

3. WHITE. White chalk is provided by various natural materials. It has been used in its natural state or, ground in a fixing medium, as a crayon. To be effective it needs a coloured ground; it has sometimes been used alone on toned paper, but its chief use has been to provide the highlights in drawings made with black chalk, or red, or both. For this purpose it largely replaced the brush and white lead used for heightening drawings until the end of the 15th c. (See also DRAWING.)

## CHAMBERS, SIR WILLIAM (1723-96). Architect, born in Sweden of Scottish parents, educated in England, he travelled in the Far East (*c.* 1740-9) in the service of the Swedish East India Company. About 1749 he passed a year in Paris under J.-F. BLONDEL, the most famous architectural teacher of the day, before spending five years in Italy. His whole approach to design was conditioned by the conservative eclecticism then practised in France and Italy, and many of the finest features of his masterpiece, Somerset House, are the result of these influences. He returned to England in 1755 and was appointed tutor in architecture to the Prince of Wales, later George III, who forwarded his career. His principal rival was Robert ADAM, whose methods and ideas Chambers detested, and he found himself, as one of the two Architects of the Works (1760), sharing an office with Adam. Before then he had published his *Designs of Chinese Buildings* . . . (1757), which exploited his travels in China (the Pagoda in Kew Gardens was another result of this exotic experience), but his *Civil Architecture* (1759; 3rd and best ed. 1791) was a more sober statement of the academic principles he upheld. His election to the ROYAL ACADEMY on its foundation in 1768 allowed him to propound these, exclude Adam, and decry the Greek innovations of STUART and REVETT; as Treasurer he was the King's representative and wielded more power than REYNOLDS who, although President, had had less to do with the actual foundation of the Academy. He was also a member of the French Royal Academy of Architecture, and in 1770 was allowed to use a Swedish knighthood.

As official architect he was commissioned to design Somerset House, made necessary by the expansion of the government services. No real precedent for such an administrative block existed in England and he therefore revisited Paris in 1774 to study such public buildings as the Ministère de la Marine (GABRIEL, 1758) and the Monnaies (T.-D. Antoine, begun 1771). His own Somerset House set a very high standard of

**81.** *View of Somerset House.* Designed by William Chambers in 1776. Detail from engraving (1797)

craftsmanship and is markedly French in feeling, but is perhaps somewhat lacking in dramatic imagination. On the other hand the needs of the users—many smallish offices, not building up to a climax—and the very difficult site, irregular and sloping down to the Thames, added to his difficulties; the really imaginative touches, such as the PIRANESIAN RUSTICATION at water level and the 'bridges' linking parts of the enormously extended river front, have lost much of their effect since the embankment of the Thames. The rich front to the Strand is a highly competent restatement of the Italian palace type where, in Chambers's own words, 'specimens of elegance should at least be attempted'. Among his other buildings are the Casino at Marino, near Dublin, and Duddingston House, near Edinburgh. Perhaps more important was his imposition of a code of professional conduct through the Royal Academy, which in SOANE's hands led to the creation of the architectural profession and its instrument, the Institute of British Architects.

517, 518, 519, 1250.

**CHAMPAIGNE,** PHILIPPE DE (1602–74). Flemish painter who came to Paris with his master Jacques Fouquières in 1621, where he soon achieved a brilliant success, becoming the most prominent portrait painter of his day. He was a lifelong friend of POUSSIN and succeeded Nicolas Duchesne (active 1599-1627) as court painter to the Queen Mother, for whom he executed a series of paintings in the convent of the Carmelites, rue S.-Jacques. He was held in favour by Louis XIII, of whom he painted two allegorical portraits. He also came to the notice of Richelieu and was commissioned by him to decorate the Palais Royal, to execute frescoes in the dome of the Sorbonne, and to paint a set of portraits of prominent personages. His portraits of Richelieu in the Louvre and the National Gallery, London, bring the personality of the Cardinal vividly to life. From 1643 he was influenced by the teaching of the Jansenists and came into close contact with the convent at Port Royal, for which many of his finest works were done. Under the influence of Jansenist teaching his later work acquired an austere and imposing simplicity. The masterpiece of this period is considered to be the votive picture which he painted to commemorate the miraculous recovery from paralysis of his daughter, a nun at Port Royal, through prayers of the nuns (Louvre, 1662).

Philippe de Champaigne has gone down to fame chiefly as a portraitist, in which genre he achieved genuine originality. He moderated the BAROQUE idiom of RUBENS to a simplicity and restraint which exemplified the classical severity of French artistic trends at the middle of the 17th c. It has been said that his portraits and his later religious works are as true a reflection of the rationalism of French thought as the classical compositions of Poussin in the 1640s.

1709.

**CHAMPFLEURY,** pseudonym of JULES HUSSAR (1828–89). One of the first novelists to call himself a REALIST and the leading spokesman for the painting of COURBET, whom he used to meet at the Brasserie Andler. He opposed traditional, religious, and classical themes, de-

claring that art should depict the social scene as it is without moralizing or idealizing it. He defended the 'ugliness' of figures in Courbet's *Burial at Ornans* (Louvre, 1850), on the ground that they were true to life. He later turned his hand to art history, publishing studies of CARICATURE (1865–80) and the LE NAIN brothers (1862). He had considerable effect upon the generation of MANET and DEGAS through DURANTY.

**CHANG HSÜAN** (early 8th c.). Chinese painter of the T'ang court, famous for his paintings of women. A painting in the Boston Museum called *Ladies Preparing Newly-woven Silk*—a pure GENRE scene with typical T'ang female figures—is said to be a faithful copy by Emperor HUI TSUNG after an original by Hsüan Chang.

**CHANTREY,** SIR FRANCIS LEGGATT (1781–1841). English sculptor, the son of a carpenter. He was apprenticed to a carver in Sheffield but left before his time and came to London, c. 1802, to work in the R.A. Schools. Until about 1804 his work included painted portraits, but after that date he confined himself to sculpture. His portrait bust of Horne Took in 1811 brought him to fame, and he succeeded NOLLEKENS as the most successful sculptor of portrait busts in England. Once famous, Chantrey, like Nollekens, did little of the cutting of the marble himself, for by this date it had become customary for the sculptor to model the bust in clay, leaving the transference to marble to assistants (see POINTING). He went to France and Holland in 1814 and to Italy in 1819. Though most renowned for his portrait busts, the grace and sentiment of his children were exceedingly popular. The NATURALISM of his figures and the simplicity of his themes made a particular appeal. His monument of the Robinson children (Lichfield Cathedral, 1817) was among the most admired work of its time, yet the workmanship is clumsy and may have been done by assistants to Chantrey's design. His lack of formal education may have been a contributing factor in keeping him free from the trammels of the NEO-CLASSICISM which was almost *de rigueur* at this date. Despite this his enormous practice brought him great wealth, and besides being very generous during his life he left £150,000, of which £105,000 was bequeathed to the R.A., the interest to be used for the purchase of 'works of Fine Art of the highest merit executed within the shores of Great Britain'. These are now housed in the TATE GALLERY.

1350, 1449.

**CHANTRY CHAPEL.** In England a chantry was a religious foundation, permanently endowed with money or lands, to pay for daily masses and prayers for the souls of the founders. Chantries were often endowed by guilds as well as by private individuals. Usually a chantry chapel was built inside a church with an altar and the tombs of the founder and his family. Guilds often added an aisle to the parish church, which accounts for many irregularities of plan in 15th-c. town churches. Many elaborately decorated chantry chapels were built after the Black Death (1348–9) until 1545, when 2,000 were suppressed. Lincoln Cathedral had at one time 36 chantries, Ely 29, and 6 now survive at Winchester. Henry VII's chapel at Westminster was the most elaborate foundation of all.

**CHAO MENG-FU** (1254–1322). Chinese painter of the Yüan dynasty, influenced by LI LUNG-MIEN, WU TAO-TZU, and HAN KAN. The influence of the last can be seen in his famous painting *Horses Crossing a Stream* (Freer Gal., Washington). Nevertheless his work was invested with a greater degree of NATURALISM than would have accorded with the traditional taste. The calligraphic lineation he favoured was one of the earliest steps towards the new dry-ink technique. A copy of WANG WEI's landscape scroll, the *Wang Ch'uan T'u* in the British Museum, is attributed to him. His wife, KUAN TAO-SHENG (1262–1319), was the most famous of China's women painters.

**CHAPTER HOUSE.** The special room in a monastery in which monks assembled daily to hear read a 'chapter' from the Rule of their Order and to transact communal business. Later canons and secular clergy also built chapter houses and they became the most important building after the church, though they were nowhere else so highly developed architecturally as in Great Britain.

The earliest chapter houses, dating from the end of the 11th c., were usually low, rectangular, stone-vaulted buildings, situated on the east of the cloister below the dormitory. In the 13th c. the height and splendour of the chapter houses of large cathedrals served by secular canons rather than by monks, such as Lincoln, Salisbury, York, and Wells, were much increased. The circular or polygonal form was used in England, the VAULT being supported by a single central COLUMN, that at Wells having 32 ribs springing from it (1290–1310). The octagonal chapter house of York Minster (1300) has a 50-ft. span covered with an imitation vault of wood. The absence of a central column gives a great effect of space.

**CHARCOAL.** Charred twigs or sticks have been used for drawing since Roman times and possibly much longer. Like lead-point and silver-point (see METAL POINT) charcoal was used for compositional and study drawings, and in outlining MINIATURES and pen drawings. Before the use of the CARTOON it was employed for drawing the outlines of compositions on walls or panels, and was later used for the preparation of the cartoons themselves. CENNINI advised making first a detailed drawing in charcoal on the GROUND; this would then be practically erased,

gone over with ink and a brush, and the surplus charcoal then removed. Charcoal has probably been most effective in the hands of the Venetian painters of the later 16th c., the BAROQUE artists, and the IMPRESSIONISTS. PENCILS and CHALKS have now taken its place to some extent, but it remains well suited to large-scale work and broad, energetic draughtsmanship. Its chief disadvantage is that it rubs off if it is not 'fixed' by the application of some liquid such as a solution of shellac (see FIXATIVE). Some painters in oil use charcoal for the initial drawing on canvas, reinforcing it with brush drawing after it has been fixed.

**CHARDIN,** JEAN-BAPTISTE-SIMÉON (1699–1779). French painter of STILL LIFE and GENRE, he was the exact contemporary of BOUCHER but his contrast in every way, representing the naturalistic tendency which persisted through the 18th c. alongside the more fashionable ROCOCO. He was received into the Académie in 1728 on the strength of a still life (*La Raie*, Louvre), which drew forth the extravagant praises of Diderot for its REALISM, and he was Treasurer of the Académie for 20 years. His small canvases depicting modest scenes and objects from the everyday life of the middle classes to which he belonged were in the tradition of the Dutch cabinet pictures which were having a great commercial success in France at the time. Like the smaller Dutch masters of the previous century he studied the science of reflected light and he adopted certain technical devices from VERMEER, such as the silhouetting of a head against a warm, light ground (*La Petite Maîtresse d'école*, N.G., London). But he developed a technique of his own, achieving great depth of tone by successive applications of the loaded brush and a subtle use of SCUMBLED colour. To ʾhe matter-of-fact Dutch realism he added a simplicity and directness of vision and an overwhelming truth to form which is rather a French characteristic and something quite distinct from verisimilitude of detail or the surface realism for which he was praised by Diderot until the latter transferred his allegiance to GREUZE. He combined a grasp of solid pictorial form and a feeling of intimacy with the substantiality of commonplace objects which few artists have rivalled before or since. His genre paintings have also an uncomplicated directness of vision without sentimentality or affectation which alone would place him among the world's greatest painters. In his last years he turned his hand to pastel portraits and exhibited in the 1775 Salon two self-portraits and a portrait of his wife in pastel (Louvre).

He was well known during his lifetime through engravings of his works, which the historian Mariette remarked were selling better than high-flown allegories in the manner of LEBRUN, noting this as a significant shift in public taste. In the present century admiration for his work has increased on account of the abstract strength of his compositions, which achieved spontaneously what became a matter of doctrine in the 1920s and 1930s. He is regarded as the greatest French painter of still life at least until CÉZANNE and as one of the greatest pure painters of realistic form that the world has known. Many contemporary painters of many schools, from CUBIST to ABSTRACT EXPRESSIONIST, have drawn inspiration from him.

950, 2881.

**CHARONTON,** ENGUERRAND (born *c.* 1410). French painter, active at Avignon *c.* 1447–61. He came from the Laonnais and his work, which belongs to the composite style uniting both Flemish and Italian influence, has also something of the monumental character of his native sculpture. The *Virgin of Mercy* (1452) at Chantilly, which he painted in collaboration with Pierre Vilette, shares more than its subject with PIERO DELLA FRANCESCA's version. The landscape passages in his splendid *Coronation of the Virgin* (1454), at Villeneuve-lès-Avignon, also have a Mediterranean flavour. The Hell scenes, however, are distinctly Flemish, while the structure of the picture recalls the design of a French cathedral TYMPANUM. Some art historians have attributed to him on stylistic grounds the masterly *Pietà of Villeneuve-lès-Avignon*.

**CHARTRES,** CATHEDRAL OF NOTRE-DAME. Perhaps the most famous of French cathedrals, equally renowned for its architecture, its sculpture, and its STAINED GLASS. Like most medieval buildings it does not reflect a uniform plan by a single architect but was built by successive generations. The west front with its splendid *Portail royal* (*c.* 1150) and Bishop Fulbert's crypt (early 11th c.) date from an earlier church, the remainder of which was destroyed by fire in 1194. The spacious interior of the cathedral and the north and south porches date from the period of rebuilding that started almost immediately and extended till far into the 13th c. There is evidence that the architects of the new GOTHIC church strove to adapt their plans to the surviving fragments of the earlier building—which accounts for the spacious proportions and the curious chapel formation. In many details of the design the influence of LAON Cathedral can be felt, but the general scheme of the Chartres elevation, with its high ARCADES and CLERESTORY windows balanced around a narrow TRIFORIUM, was a momentous innovation in the history of Gothic architecture (see GOTHIC ART). The figured porches of the Gothic transepts are among the greatest monuments of Gothic sculpture and together with the *Portail royal* allow the visitor to study the unfolding of this art from the rigid discipline of the early COLUMN FIGURES to the gracious freedom and beauty of S. Modeste. The stained-glass windows illus-

trate a similar development and in their totality make Chartres into a unique monument of the medieval mind.

3, 1490.

**CHASSÉRIAU,** THÉODORE (1819–56). French painter born in the Antilles. He was one of the most gifted pupils of INGRES and worked with him in Rome. Later, after a visit to Algiers (*c.* 1840), he conceived an admiration for DELACROIX and attempted to adapt the CLASSICAL techniques to ROMANTIC aims.

His chief work was the decoration of the Cour des Comptes in the Palais d'Orsay, Paris, with allegorical scenes of Peace and War. The palace was later burned down; the few fragments of the paintings which were saved are now in the Louvre. His *Two Sisters* (Louvre) has been called by Michael Levey a 'minor masterpiece'.

2027.

**CHAVANNES,** PIERRE PUVIS DE. See PUVIS DE CHAVANNES.

**CHEERE,** SIR HENRY (1703–81). Sculptor, possibly of French descent though born in England. After an apprenticeship to a masonsculptor, Robert Hartshorne, he went into partnership with Henry SCHEEMAKERS and executed a number of monuments and a few statues, including an equestrian figure of *William III* (1757) now in the Market Place at Petersfield, Hants. After Scheemakers left England about 1733 Cheere extended his practice, and also his interest in public affairs, being knighted when in 1760 he presented an address to George III on behalf of the County of Middlesex and created a baronet in 1766. His art is markedly ROCOCO in feeling, with an interest in small rhythms, and in his charming smaller monuments (*Dean Wilcocks*, Westminster Abbey, 1756) he often used coloured marbles. His brother JOHN (1709–87) had a yard near Hyde Park Corner which turned out a great number of garden figures (Stourhead and Longford Castle, Wilts.), some in the ANTIQUE manner and some Rococo, many of the latter being originally painted in natural colours.

**CHELLES,** DE. JEAN DE CHELLES was the master who began the transept façades of the cathedral of NOTRE-DAME, Paris, in 1258. The design is closely modelled on the transepts of Saint-Denis, and there is no doubt that he was influenced by Pierre de MONTREUIL, who in fact succeeded him at Notre-Dame. A kinsman, PIERRE DE CHELLES, was master mason of the cathedral at the beginning of the 14th c., and like RAVY worked on the apsidal chapels.

**CHEN LA.** Kingdom of Mon-Khmer ethnic type which controlled Cochin China and parts of CAMBODIA from the 6th to the 8th centuries.

United with the earlier kingdom of Fou Nan, it had its capital first at Sambor and from the reign of Ishavarnam (616–35) at Sambor Prei Kuk. The kingdoms of Fou Nan and Chen La were both of a predominantly Indian cultural type and together laid the foundations of classical KHMER art. The art was essentially religious, presenting a majestic image of transcendental kingship. The temples constituted emblems of the cosmic mountain and the icons of the deities in them symbolized the highest spiritual and temporal realities combined. The best surviving groups of buildings from the early Chen La period are those at Sambor Prei Kuk, where the splendidly carved lintel stones with elaborately flamboyant relief decoration are their chief surviving glory. Sculpture was the major art of the Fou Nan-Chen La period. Stone carvings and bronzes which have survived, both Buddhist and Hindu, represent some of the world's outstanding sculptural masterpieces. (Harihara of Phnom Da combining aspects of Shiva and Vishnu, sandstone figure of Lakshmi, sandstone Buddha of Tuol Prah: Musée Guimet, Paris. Vishnu with eight arms of Phnom Da, Vishnu of Tuol Chuk, Vishnu of Tuol Dai Buon, Balarama of Phnom Da, Harihara of Sambor Prei Kuk, Lakshmi of Koh, Krieng. Standing Buddha of Vat Romlok, seated Buddha of Phum Thmei: National Museum, Phnom-Penh.)

**CHEVET.** The eastern complex of a Christian church, comprising usually the APSE, AMBULATORY, and radiating chapels.

**CHEVRON** (from the French *chevron*, a rafter). Chevron ornament, consisting of a series of sloping lines joined at a steep angle, appeared in England between A.D. 1100 and 1115. It rapidly became a common feature in AngloROMANESQUE decoration.

**CHIAROSCURO** (Italian: bright-dark). The term was used by BALDINUCCI (1681) to describe purely tonal monochrome paintings (such as GRISAILLES) which rely for their effect only on gradations between brightness and darkness. DE PILES in his *Cours de Peinture* (1708), on the other hand, defines it as 'the art of advantageously distributing the lights and shades which ought to appear in a picture, as well for the repose and satisfaction of the eye, as for the effect of the whole together. . . . In order to understand thoroughly the meaning of this word, we must know that *claro* implies not only any thing exposed to a direct light, but also all such colours as are luminous in their natures; and *obscuro* . . . all the colours which are naturally brown . . . deep velvets, brown stuffs, a black horse, polished armour, and the like, which preserve their natural or apparent obscurity in any light whatever.' In this application the term described an essential department of the painter's art to which, for instance, James BARRY, John OPIE,

82. *Christ amid the Children and the Sick*, known as *The Hundred Guilder Print*. Etching (1649) by Rembrandt

and Henry FUSELI each in turn devoted one of his lectures in the ROYAL ACADEMY. The acknowledged master of chiaroscuro was, of course, REMBRANDT.

**CHIAROSCURO WOODCUT.** A WOODCUT in which a three-dimensional effect is obtained by printing from several blocks in light and dark tones. The method is similar to that of the colour woodcut (see COLOUR PRINTS). Two or more tones of a single colour are used, or of two nearly related colours, one of which is darker than the other. One block is cut for each tone. It is usual to make a key block with the design in outline, and to cut this first so that the main lines can be transferred to the other blocks to ensure correct registration. The key block would normally be printed last.

The method dates from the early 16th c., when it was chiefly used for the reproduction of drawings in light and shade. It developed more or less simultaneously in Germany and Italy though there is an interesting difference of approach in the work of the two schools. In Germany great importance was given to the key block, which was to all intents and purposes a complete design in itself, the resulting print being a richly worked woodcut with the addition of background tints. In Italy the medium was handled with much greater breadth, the design being visualized in large areas of tone punctuated by dark accents.

The earliest dated chiaroscuro woodcut is *The Emperor Maximilian on Horseback* of 1508,

designed by Hans BURGKMAIR; other notable German exponents were CRANACH, Baldung GRIEN, and ALTDORFER. In Italy, where the medium was used more extensively, UGO DA

83. *The philosopher Diogenes.* Chiaroscuro woodcut (*c.* 1520) by Ugo da Carpi, after Parmigianino

222

CARPI made many prints after designs by RAPHAEL and PARMIGIANINO, the latter artist being a prolific designer for the process. At a later date Anera Andreani (active 1589-1610) made a series after MANTEGNA's *Triumph of Caesar*. The prints did not always reproduce their originals exactly, nor perhaps were they meant to do so. REPRODUCTION was the general aim of engraving at the time; but though in some cases an accurate facsimile was intended, in others the cutter interpreted his original with some freedom.

The later history of the process tends to overlap that of the colour woodcut and the colour wood engraving. George Baxter (1804-67), famous for his experiments with colour printing, made prints which may fairly be called chiaroscuro wood engravings. In France the process, which is there called *gravure en camaïeu*, has been widely used for the illustration of luxury editions, both by original engravers and for reproducing in facsimile compositions designed in GOUACHE. Even today any relief print cut on several blocks with the intention of rendering light and shade as opposed to colour may be claimed as a descendant of the chiaroscuro woodcut.

**CHICAGO SCHOOL.** A phrase which has been differently applied in the history of architecture. Some historians apply it to the group of architects who designed most of the business section of Chicago from 1871, the year of the Great Fire, to 1893 when the World's Columbian Exhibition saw the official triumph of classical eclecticism and the challenge of SULLIVAN's Transportation Building in collaboration with Frank Lloyd WRIGHT. Experimenting in the use of metal as a structural material these architects developed the idea of the modern office building and did much to shake off the trammels of Beaux-Arts academicism. William Le Baron Jenney (1832-1907), an imaginative engineer, was the first to use steel frame construction in multi-storey buildings (Home Insurance Building, 1883-5). Other important technical developments were John Root's (c. 1850-91) floating raft foundation (Montauk Building, 1882) and Denkmar Adler's (1844-1900) caisson foundation (Stock Exchange Building, 1893). Sullivan was the first to evolve new aesthetic forms from the new materials and techniques and in his Wainwright Building, St. Louis (1890), found the most successful form for the SKYSCRAPER, emphasizing verticality by maintaining the continuity of the piers throughout the height of the building. Daniel Burnham chose the opposite recourse in the Reliance Building (1890-5), where horizontal bands of glass carried on light mullions were separated by narrow terracotta panels and the outer wall was totally independent of the frame. In conception this was the first building to make full use of the curtain wall and preceded by a quarter of a century the glass envelopes of LE CORBUSIER and MIES VAN DER ROHE.

Historians who use the term 'Chicago School' in this way apply the terms 'Second Chicago School' or 'New Chicago School' to the group of architects, followers of Sullivan and Wright, who worked in Chicago from 1893 until about 1914. Others use the term 'Chicago School' of the latter group and deny that those before 1893 had sufficient measure of uniformity to warrant being described as a school. In his history *The Chicago School of Architecture* (1964), published in the Columbia University Studies in Art History and Archaeology under the editorship of Rudolf Wittkower, Mark L. Peisch applies the term to the early followers of Sullivan and Wright. The contribution of the Chicago School after 1893 was found by him to have been in the social and aesthetic development of architectural ideas rather than in outright structural innovations. Their work lay in dissemination and popularization rather than in discovery.

600, 2049.

**CH'IEN HSÜAN** (1235-*c.* 1290). Chinese painter, calligrapher, and poet. He held a position in the Academy towards the end of the Sung dynasty but retired when the Mongols conquered China, devoting himself to painting and literature. He was the last of the four great masters of flower and bird painting who set the fashion during the Five Dynasties and northern Sung period. He was conservative in temper and made it his intention to revive the past. But the animation and naturalness of his vision were in tune with the spirit of his own times rather than the past which he admired. A large number of works in Japanese collections are attributed to him but their authenticity is doubtful. They do, however, provide evidence of his style, which with its fine detail and rich colouring goes back to the great times of the Sung Academy (see CHINESE ART), though he introduced a note of more lively REALISM. His most famous painting in Western collections is the *Insects and Lotus* scroll in the Institute of Arts, Detroit.

**CHILDREN'S ART.** Given the means and the opportunity all children will express themselves through line and colour or will shape any plastic material that they can lay their hands on; and this disposition, which develops into an attempt to represent objects, will persist until adolescence. So far as we can tell this has been true of children in every age, both in primitive and in advanced societies. Moreover it would seem that the stylistic development of the child up to the age of 10 or thereabouts has remained constant. Thus a battle scene painted by Horace VERNET in 1798, when the artist was 11 years old, is very much like the work of any fairly gifted child of our own day and has little connection with the aesthetic climate of the late 18th c. Little of

juvenilia has been preserved and such as there is for the most part represents outstanding work. In the art of drawing, as in other arts, there are prodigies, of whom MILLAIS and PICASSO are notable examples; at a lower level the rate of development varies enormously, while a few children hardly develop at all. Any attempt to describe the phases must, therefore, be very imprecise, while reference to the age of children, although unavoidable, is misleading.

A child in its second year, or even earlier, if given a pencil will produce a mark, usually an irregular circle repeated again and again, and if given two pencils it will readily produce two simultaneous scribbles. As the forms grow in complexity and variety they will be named, but at first different names may be applied to the same symbols or the child may, with equal assurance, say that it is 'drawing' or 'writing'. By the third or fourth year recognizable images will have been produced. These commonly take the form of heads with eyes, noses, mouths, and two dependent trailers which serve both to suggest a body and to indicate legs. Arms, often produced from the sides of the head and furnished with a few fingers rather in the manner of a lightning conductor or a toasting fork, are soon added. Many children will add details which are isolated from the main object to which they are supposedly attached. Thus a head may be drawn on one side of a page while the hair, eyes, or nose may be indicated on the other. Within the next three or four years the child obtains a stock of schematized forms, to be used and discarded with the growth of perception, representing houses, animals, celestial bodies, trees, and vehicles; from these pictures may be constructed. Objects will usually be represented in one fixed manner. There will be very little attempt to situate them in space or to suggest any form of movement. Thus the human form, although it will be represented with greater care and attention than hitherto, will remain directly facing the spectator, whatever its supposed action, while its feet, as in Egyptian sculpture, will be seen in profile. The child is concerned to make a recognizable image (recognizable by itself at all events) and the *profil perdu* or the foreshortened image are too unrecognizable for its purpose. It is, moreover, concerned with the representation of facts other than those which its eyes can perceive. If asked to draw an apple transfixed by a knitting needle, the majority of young children will produce a circle transfixed by a straight line thus $\ominus$. The fact that the needle is invisible within the apple is of less importance than the fact that it is there (compare 'X-ray' drawings of AUSTRALIAN ABORIGINES). In the same way children will show us the inside of a house or bus in order to exhibit the contents.

If the first essays of children are usually in line rather than in colour, the reason may probably be found in the natural misgivings of parents and teachers and the natural messiness of children. Unquestionably a readiness to play with colour coexists with the desire to scribble. Areas will be coloured and recoloured, at first with what looks like a purely decorative intention. But with the formation of a pictorial language colours no less than forms acquire symbolic properties. Thus water is blue and may remain blue even when it is springing from a fountain. In modelling a quasi-symbolical use is made of forms. Two holes or two blobs serve as eyes, a series of sausage shapes applied to the head may represent hair.

In the development of the art of children intelligence in other subjects frequently, but by no means invariably, goes with pictorial ability; there are cases where an ability to draw is combined with a very low intelligence quotient. During the 1950s experimental work led some educational psychologists to the more general conclusion that the measure of those cognitive functions which the traditional I.Q. tests are designed to evaluate does not always or necessarily coincide with a child's creativity, i.e. inventiveness and the capacity to innovate. Tests devised for the latter would seem more appropriate to artistic ability. Further, many attempts have been made to classify the art of children according to psychological disposition and to use their drawings both for diagnostic and therapeutic purposes. Undoubtedly they can be of use in both respects, but some of the attempts to make drawing the basis for essays in type psychology are of doubtful value. The most striking temperamental difference in drawings, and one which appears to have escaped the attention of many theorists, is that between boys and girls. Boys will, on the whole, prefer subjects involving action and the use of machinery, while girls will from an early age show greater attention to details of dress and a preference for domestic subjects. Needless to say the division is not clear cut and there are many exceptions to this rule.

The progression between the fifth and twelfth years, which must be described in a very summary manner, involves a growing enrichment and elaboration of schematic forms, an increasing interest in nature and, above all, a more highly organized rendering of space. At 7 or 8 most children have at the very least constructed a spatial composition in which figures stand upon a base line (the earth), while above them a band of blue represents the sky; the sky, being far from the earth, is separated by an interval of white paper. By 11 or 12 the sky has been brought down to meet the horizon and some more or less convincing attempt is made at recession and solidity.

It will be seen that up to this point the child's art has much more in common with the art of primitive cultures or pre-RENAISSANCE Europe than with that with which we are most familiar in the West. Nevertheless ILLUSIONIST painting does not seem to present any difficulties to the child outside its own work. From an early age it can 'read' a photograph or a de HOOCH. The change at adolescence is a change not in understanding, but in intention. The child now wants to

imitate the techniques of the adult artist. He is fascinated by exactitude and verisimilitude. The change may perhaps be exemplified in the treatment of the human arm, which, as we have already noticed, began as a simple line, sometimes drawn from the ear. By the age of 12 the child will have made it solid, joined it to the shoulder, and will probably have arrived at some compromise or evasion with which to describe hands. The adolescent will attempt not only to describe the articulation of the wrist and palm, the thumb and fingers, the biceps and triceps, but also perhaps to represent an arm pointing straight out of the paper towards the spectator in violent fore-shortening. Here the discrepancy between the concept and the thing as it is perceived will probably be insupportably great, and it is here that the student frequently decides that he cannot draw. For when the problem of perception is carried to this point, we encounter the difficulty which remains, for most of us, into adult life. Thus child art in its later stages is usually deeply concerned with techniques and is likely to develop a certain awkward reticence both in subject and in treatment. This tendency frequently ends in the abandonment of art. Even where it does not, a very difficult and deeply self-conscious period ensues and many years must elapse before the student can regain anything like the assurance of the young child.

The pellucid integrity of the work of young children, the complete absence of stylistic ostentation or calculated effects, earned it high praise from RUSKIN, while the more sympathetic attitude towards the work of the child's mind shown by writers such as Herbert Spencer (*On Education*) or James Sully (*Studies of Childhood*) created an atmosphere in which the work of children was seen as something of intrinsic merit in its own right rather than as an incompetent attempt at adult art. The preoccupation of the IMPRESSIONISTS and even more the POST-IMPRESSIONISTS, with direct expression and their indifference to craftsman-like effects and surface finish also helped to point the way to a more complete understanding of child art. The work of educationalists such as Frans Cizek in Austria, Quenioux in France, and Ebenezer Cook, Ablett, and Marion Richardson in England effected a complete revaluation. This was further assisted by the work of Roger FRY and, later, of Herbert Read. A great many modern artists, such as KLEE, Picasso, and CHAGALL, have clearly been deeply influenced by the conceptual approach of children. The extreme certainty of the work of the 5-year-old, the sensuous and uninhibited use of colour and the vivacity of expression, have aroused an admiration which may sometimes have been excessive. The art of children is not a vehicle for the greatest expression of the human mind, but within its limits it offers a rare perfection of feeling and expression. (See also ART EDUCATION.)

450, 817, 818, 895, 1186, 2189, 2323, 2585.

**CHINESE ART.** A distinguishably Chinese art has a longer continuous history than any other art in the world. The earliest pottery found in China is believed to be over 4,000 years old, the earliest bronzes and sculpture over 3,000, and throughout this period they display characteristics which stamp them as Chinese. Painting has continued in China without a break for at least 2,000 years, though both painting and sculpture came to maturity comparatively late in China's long history. Throughout their history the Chinese have preserved and developed the special character of their own culture, absorbing foreign influences and always converting their conquerors. And since their culture was not only the earliest in the Far East but also at all times the most advanced, their art exercised a strong influence on that of neighbouring lands—Japan, Korea, Manchuria, central Asia, and Tibet. Its influences have been felt as far away as the Islamic world (see ISLAMIC ART) and even in western Europe (see CHINOISERIE). Moreover the insight, subtlety, and refinement that we recognize as Chinese have been complemented by an extraordinary technical skill and some of the contributions that the Chinese have made to art have been of the most practical kind. To quote only the most obvious, they discovered how to make silk, they invented true porcelain, and they were among the first to exploit the uses of paper, and printing by movable type.

There is no evidence of Palaeolithic cave painting in China or of an indigenous Mesolithic culture. The first objects of recognizable aesthetic appeal come from Late Neolithic sites dating back to *c.* 2500 B.C. These sites have yielded many types of pottery, both plain and painted. The shapes of some of these highly accomplished pieces show that their makers were true forerunners of the Chinese spirit. The earliest settled civilization yet discovered in China had its centre in the royal city of Anyang on the Yellow River—the last capital of the Shang or Yin people, who possessed an agricultural civilization with a highly developed religious art in bronze. From *c.* 1000 to *c.* 200 B.C. Chinese civilization expanded throughout the Yellow River basin and beyond. A number of states developed, nominally owing allegiance to the Chou kingdom in the centre but virtually independent and struggling among themselves for domination. Throughout the whole period bronze vessels and JADE carvings were the primary art forms. It was in this period that Confucius lived (551–479 B.C.), whose humanistic, ethical, and philosophical teachings gained a strong hold on the mind of the Chinese and together with the more mystical tenets of Taoism influenced the course of their civilization and art.

The period of the Warring States (481–221 B.C.) culminated in the first short-lived unification of China and its consolidation into an empire by the Han dynasty (206 B.C.–A.D. 220), under whom Chinese power expanded rapidly and the Chinese state as it is known today was founded.

The foundations of Chinese art as we know it, especially in sculpture, painting, and pottery, were established in the Han period, though apart from pottery and some stone reliefs little remains. During Han times also a tendency towards the secularization of art, encouraged perhaps by the worldly teachings of Confucius, was halted by the introduction of Buddhism from India in the 1st C. A.D. Mahayana Buddhism with its exotic pantheon (see BUDDHIST ICONOGRAPHY), its doctrine of Bodhisattvas, and its complicated theology exerted a powerful influence on Chinese popular religion and with the art motifs that it brought with it from India proved to be one of the most vital streams of iconography and inspiration for the following 1,800 years.

For 400 years after the fall of the Han dynasty China was again divided into a number of independent warring states. From the extensive literary records which abound from Han times onwards and from such impressive monumental remains as the sculptures in the Yüng-kang, Lung-mên, and Tun-huang caves it may be seen that art was officially encouraged and held an important position in the life of the people. To this period belong the earliest painters of whom we have any evidence (see KU K'AI-CHIH).

When the Sui (581-618) and T'ang (618-906) dynasties united China once more into a powerful empire, a brilliant efflorescence of art in all its branches has given to the T'ang period the name of the 'Golden Age' of Chinese art. Influences from as far west as Persia can be seen, particularly in the pottery, bronze, and silver work of this brilliant, cosmopolitan age. The pottery, especially the mortuary figurines, illustrates Chinese secular art at its best. Sculpture achieved greater refinement than in the earlier periods and under Indian influences became more sensual and realistic. Little painting from this period remains but there is no doubt that the scope, aims, and techniques of Chinese painting were then formulated and in particular its close connection with poetry was established.

The Sung dynasty (960-1278) which followed after another short period of political disunity had a completely different outlook from the militaristic, expansionist T'ang. Sung art was more contemplative, introspective, delicate, and refined. Its porcelain, the first true porcelain, is still judged to be without parallel. The Chinese consider Sung painting to be their finest, especially in the field of pure LANDSCAPE, which was explored in China far earlier than in Europe.

The invasion of the Mongols and the short Yüan dynasty which they established (1260-1368) brought new vigour and colour to Chinese art. In painting, which by this time had become the most important of the arts, styles were established by great masters which later crystallized to become almost unquestionable dogma. In the Ming dynasty (1368-1644) new advances were made in ceramics, especially after the introduction of blue-and-white decorated wares.

The classical simplicity of the earlier periods had now disappeared in all the arts, the trend being towards highly coloured, elaborately decorated, grandiose styles.

The Ch'ing or Manchus (1644-1912), the last great ruling house, were again Mongol, but they were intent to foster native Chinese culture with emphasis on the more traditional modes. It would not be just to say that this period contributed nothing new to the arts of China, but in general the tendency was towards perfection of existing techniques. Imperial patronage expanded on a truly gigantic scale and an unending flow of faultlessly worked, luxurious porcelains, jades, and ivory carvings came from the imperial workshops. The various East India companies stimulated the import of Chinese wares and Chinese lacquer and porcelain always found a ready market in Europe. The Chinese were swift to exploit the European market with wares decorated with European emblems and designs from prints. East India Company china, Nanking, and the so-called 'Lowestoft' china became very popular in England.

By the beginning of the 19th c. the life-blood of Chinese art was running thin and the 20th c. has sparked but feeble flickers of past glories. The last 100 years before Communism constitute a disappointing anticlimax to a long and brilliant history.

Since it is customary to classify Chinese works of art by the names of dynasties, a list of these is appended:

| | |
|---|---|
| Shang or Yin | c. 1766 (?1950)–1028 B.C. |
| Chou | c. 1027–256 B.C. |
| The Warring States | 481–221 B.C. |
| Ch'in | 221–206 B.C. |
| Han | 206 B.C.–A.D. 220 |
| The Six Dynasties | 221–589 |
| (Northern Wei | 386–535) |
| Sui | 581–618 |
| T'ang | 618–906 |
| The Five Dynasties | 907–960 |
| Sung | 960–1278 |
| Yüan | 1260–1368 |
| Ming | 1368–1644 |
| Ch'ing or Manchu | 1644–1912 |

BRONZES. The early Chinese bronzes, and particularly the vessels for ritualistic use, are among the most exquisite masterpieces in metal ever made. They were first recovered during the 1930s in the course of excavations at An-yang, the capital of the 19th Shang sovereign, c. 1300 B.C. Subsequently during the 1950s earlier stages of this bronze casting tradition were discovered at Cheng-chou and neighbouring sites extending back to the Late Neolithic Age or c. 1500 B.C. While the earlier bronzes were cast from moulds, it is thought that the *cire-perdue* process also was used from about the 12th C. B.C. Whether bronze casting techniques were introduced to China from the West is uncertain. The virtuosity of the Chinese craftsmanship is, how-

**Fig. 16.** CHINESE BRONZES. TYPICAL SHAPES

Food cookers: a. *li* b. *ting* c. *hsien*; Food containers: d. *tou* e. *kuei* f. *tui*; Vessels for ceremonial ablutions: g. *chien* h. *p'an* j. *i*; Water containers: k. *yu* l. *hu* m. *lei* n. *fang-i*; Wine goblets: o. *chib* p. *chia* q. *chüeb* r. *ku*; Wine servers: s. *ho* t. *kuang*

ever, admittedly outstanding and has never been surpassed. The composition of the alloys varied considerably with often a high percentage of lead. This variability of metallic constitution has contributed to the rich variety of natural PATINATION so highly prized in modern times.

The Bronze Age in China extended from *c.* 1500 to the end of the Chou dynasty. The cere-

monial bronzes were used in the cult of ancestors and were frequently inscribed with the name of the ancestor in whose honour they were made. Since the cult involved offerings of food and wine, the ritualistic vessels to some extent paralleled secular utensils for cooking, containing and serving food, pouring and drinking wine, holding water, etc., though they were finer and

more elaborate than secular ware. Some of the basic shapes demonstrably go back to ceramic utensils of the Late Neolithic Age. The massive Shang forms with their powerful, architectural shapes and complicated yet balanced decorative designs, stylized yet fraught with tension, were not mere decorative adjuncts but genuine cult objects of a terrifying religious significance. Under the Chou kingdom the shapes became lighter and more graceful, the inscriptions longer and more circumstantial. About 600 B.C. appeared the distinctive, gracefully organized 'Huai' style characterized by broad bands of complicated intertwined motifs, among which reappear certain Shang motifs used with more purely decorative effect. While in Shang times the metal was sometimes inlaid with turquoise, the artists of the Huai style used gold, silver, and copper inlays and invented some new forms such as bells and mirrors. Objects of personal use such as belt-hooks were often delicately worked.

For nearly 15 centuries, until the end of the Han dynasty, bronzes continued to be produced in large quantities and a rich variety of shapes, including such things as weapons, tools, fittings for chariots, musical instruments, and all kinds of domestic utensils and objects of personal adornment. But the Han bronze-work cannot compare with the finest bronzes of early times. Owing to its cheapness the new glazed pottery largely supplanted bronze for burial purposes, and the old almost reverential feeling for bronze seems to be lacking. Old types were continued in rougher workmanship and with less attention to decoration and detail; a few new types were added—particularly a large war-drum, a square mirror, and a graceful large jar—and human figures occur more frequently. In general the products of this period were markedly inferior both in form and in craftsmanship. A revival occurred 12 centuries later in Sung times, when the motifs on the old bronzes were again copied but incompletely understood. Such objects have been made until recent times. Bronze was used for sculpture from about the 3rd c. A.D.

Throughout the history of Chinese bronzes the most popular motifs have been DRAGONS and birds, the cicada, the ox, sheep, and goat, a background of 'thunder' or cloud-pattern (lei-wên), and a demon or ogre mask called t'ao-t'ieh. The significance to the early Chinese of many of these elements has not been satisfactorily explained. The organization of the decorative motifs, which often cover the whole of the outside of the vessel, displays at its best an unrivalled control of design and technique.

SCULPTURE. The earliest examples of Chinese sculpture in stone are small marble carvings of the Shang dynasty dating to c. 1300 B.C. They are mostly architectural decorations, retaining the original block form and decorated on four sides with low reliefs of typical bronze motifs such as the ogre mask or t'ao-t'ieh (cf. bronzes, above). They do not attempt all-round sculptural form. It seems that the craftsmen were less familiar with marble than with bronze and to judge from the little that has been discovered the results were less convincing.

The beginnings of sculpture in the round are found in bronze animal figures and, towards the 3rd c. B.C., small human figures cast in bronze. The earliest existing sculptures in wood are of a totemistic character and belong to about the 5th c. B.C. It was not until the Han dynasty that monumental sculpture in stone appeared. The Han tombs have yielded a wealth of reliefs depicting historical, mythological, and contemporary subjects in various low-relief techniques but all conceived in two dimensions only and relying for effect on line and silhouette. In their rhythm and movement they have almost the effect of paintings. The earliest remaining monumental work in the round (dated 117 B.C.) represents a horse standing over a fallen barbarian. Its form is still that of a block with shallow carving on the four sides (see FRONTALITY). The small clay figures from the Han tombs represent the human form in much the same way, being flat with detail on front and back only. Influences from contemporary northern nomadic peoples who had developed an energetic bronze animal art (see ANIMAL STYLE) are seen in the Han animals such as dragons, horses, and tigers, which show a new litheness of form and vitality of movement. But at some time during the period of disunity which lasted from the 3rd c. A.D. to the 6th, Buddhism, which had by then reached China, began to influence Chinese sculpture, introducing from India a highly developed naturalistic treatment of the deities (see INDIAN ART). These centuries, together with those of the Sui and T'ang dynasties, produced a great deal of religious sculpture, not only small portable religious figures in bronze but also the vast cave temples of Yün-kang, Lung-mên, Kung-hsien, T'ien-lung Shan, and Tun-huang, which in both size and conception are among the world's greatest relics of monumental religious art. In the tens of thousands of figures and reliefs within these caves one may trace the conflict between Indian sensuousness and joy in movement on the one hand and the calm, reticent, calligraphic instinct of the Chinese on the other. The first influences from Gandhara and central Asia were slowly modified until the late 5th-c. figures had become austere and spiritual. From the India of the Gupta period new waves of influence reached China during the T'ang dynasty. These led to a relaxation of the austere 'Northern Wei' style to the rich, fully plastic, sensual modelling of that brilliant epoch. The strength and imagination of T'ang sculpture are resplendent in the lions and fantastic animals guarding the tombs which compel admiration no less than the skilful modelling and command of human expression in the countless small clay tomb-figures.

The Sung style is most typically exemplified in large wood sculptures of Buddhist deities,

especially the Kuanyin. It is the logical develop-
ment of T'ang, but mirrors the more contempla-
tive, refined, and philosophical atmosphere of
the Sung period. The type is more slender,
graceful, and relaxed, lithe and delicate instead
of powerful, dream-like rather than worldly,
friendly rather than imposing. There is a new
feeling for softness and texture.

The types and styles of sculpture during the
Yüan, Ming, and Ch'ing dynasties have aroused
less interest. The old traditions persisted but
much of their vital quality was dissipated in
triviality or heaviness. The craftsmanship was
always fine, and sometimes unusual materials
such as iron were explored, but the deep spiritual
inspiration was lacking and the results are often
merely mechanical and repetitious, the bodies
and drapery stiff and the figures imposing but
lifeless. Even the introduction of Lamaistic
sculpture (see TIBETAN ART) during the Ch'ing
dynasty, with its fierce imaginative appeal, failed
to revive the old sympathy for the materials
or the loving delight in craftsmanship. As in
Japan much of the creative sculptural talent
was diverted to miniature works in jade, glass,
ivory, etc., during the 18th and 19th centuries.

For a full understanding of Chinese sculpture
it is essential to study Japanese as well, because
Japanese sculpture has at all times been strongly
influenced by Chinese and Japan has preserved
her ancient art treasures more successfully than
China (see JAPANESE ART).

PAINTING. Painting and calligraphy have long
been considered by the Chinese as among the
chief arts worthy of the attention of a gentle-
man, the rest of the visual arts being merely
crafts. The two were closely connected in
several ways. The same brush, ink, and paper
were used for both, and both in Chinese practice
required the same kind of dexterity. Chinese
ideograms have an abstract, pictorial quality
through which a man can express himself as he

**84.** Hardstone carving, Shou Lou, Chinese patron of
longevity, holding a peach, symbolic of esoteric sexuality,
in which is a stork which is a stock emblem of spiritual
immortality. The dragon on the head of the staff refers to
his personal identification with the cosmic Yang. (Gulben-
kian Mus. of Oriental Art, Durham, c. 1750)

**85.** *Begone, I too shall drag my tail in the mud.* From the
reply of the philosopher Chuang-tzŭ (fl. c. 300 B.C. in Ch'u)
to an invitation to take high office. He compares himself to
a tortoise. Painted by K'ang Yu-wei (1858–1927). (B.M.)

would in painting. Chinese painting was greatly influenced by calligraphy, by the vitality and rhythm of its line and its economy of strokes. A piece of calligraphy would be hung on a wall like a painting and admired in the same way, each stroke being praised for its own attributes, the ink for its tone, and the whole composition for its strength, individuality, vitality, and so on.

Silk and paper, ink and water-colours are the materials most favoured by the Chinese painter. The paintings were done on silk or paper—either as hanging scrolls which can easily be stored in the house and changed to suit season or occasion, or as hand-scrolls (up to one foot in width and sometimes as much as 100 feet in length), which are unrolled from right to left and provide a continuous picture intended to be seen section by section. Albums and fan paintings were also popular. Large screens were painted but few have survived. The writing seen so often on Chinese paintings may be just the signature, or an appropriate poem or comment by the artist himself, or a few words of appreciation by a friend or later collector. Frames of the Western type are never used, but great care is taken in the choice of silk or paper for the mount. Oil paints have been used occasionally, but only after introduction from the West, and then with little success. Wall-painting flourished from at least the 7th to the 17th c., but its subjects were mostly Buddhist and few paintings survived the various proscriptions of that religion through the centuries. Western museums have preserved a few, mostly of the Ming period.

The equipment of a Chinese painter was of the simplest: a soft, very sensitive brush with a bamboo handle (as used for writing), ink made from pine soot, and water-colours. 'In ink are all colours', say the Chinese; they appreciate the subtle variations of tone that can be achieved by its skilful use. A painting was generally executed with a speed inconceivable in the West—sometimes in a few seconds—but much thought preceded it. The conception was completely present to the mind before the artist began to work and execution was automatic and spontaneous when technical mastery had been achieved. No correction was possible; the painter must have an unerring hand and complete mastery of his brush. This gives a living quality to the brush-stroke, and it is the careful comparison of strokes that sometimes enables one to detect the copies and forgeries that abound in Chinese painting.

From about the 14th c. painting became closely connected with literature, especially poetry. Painting has been called by the Chinese 'poetry without words'. The art became the pre-occupation and social accomplishment of the scholar and man of letters, and literature was increasingly used as a source of inspiration. The apt poem or literary reference was added not only as a calligraphic embellishment but also to intensify the atmosphere, explain the inspiration, or sometimes just to show erudition. With the development of this 'literary men's painting',

(*wên-jên hua*) as it was called, the amateur became more respected than the professional.

Chinese painting covers a wide range of subjects. Mythology, history, genre, and Confucian and Taoist themes have always been popular; portraits less so but they were done in most periods. Landscape, flower, and animal subjects occur more frequently than in Europe and appear at earlier periods. Certain plants were specially favoured—the prunus as a symbol of purity, the bamboo of courage, and so on—but this symbolism was a highly developed and complicated one with influences from Buddhism, Taoism, and Confucianism as well as from the vast store of literature, mythology, and folklore. The nude human figure was never represented in Chinese painting—possibly owing to a Confucian modesty regarding the human body—but in the representation of drapery the Chinese are unsurpassed.

Apart from a few painted lacquer objects the earliest remaining fragments of painting come from the Han period and consist of figures and animals on lacquer and small tiles. They already reveal a mature skill in the representation of form and the essential calligraphic line of Chinese painting. From these and from stone carvings (in such flat relief that they resemble paintings) it can be seen that Chinese artists were already exploring the problems of three-dimensional representation and above all movement in a wide diversity of subjects.

Landscape had entered Chinese art very early, as may be seen in the cast bronze mirror-backs and pottery of Han and pre-Han times. But during the troubled centuries that followed the fall of the Han dynasty attention was turned increasingly to landscape elements in compositions. One of the oldest Chinese paintings in existence (B.M.), which may be by the famous Ku K'ai-Chih though it is more probably an ancient copy of his work, already shows an attempt to place figures in landscape and to achieve an effect of PERSPECTIVE. The Chinese have never had any scientific interest in perspective or its rules. They prefer to give a bird's-eye view of landscape and induce the observer to 'read' a painting almost as if it were a piece of calligraphy, skilfully leading the eye past towering peaks or along the meanderings of a 'thousand-mile river' or the quiet reach of a rippling pool. By the 11th c. they had mastered the technique of what they called 'the far and the near'.

The infiltration of Buddhism from central Asia from the 1st c. onwards provided Chinese artists with fresh inspiration, new forms, and a wide range of new subjects. It continued to inspire them during the following centuries—particularly its mystical and more contemplative side, the side represented by the Ch'an sects (Japanese, Zen). The countless Buddhist temples gave great stimulus to wall-painting, though little survived the great proscription of the faith in A.D. 845.

A good idea of T'ang wall-painting with its

秋山起暮鐘楚雨連倉浄摩詰

**86.** *River View.* From an album of eight sketches formerly attributed to **Wang Wei** but in the style of the Yüan masters. (B.M., *c.* 1300)

strong Indian influences can be obtained from the paintings in the Horyuji Temple in Japan, recently destroyed by fire but available in excellent reproductions. Our notions of T'ang painting on silk and paper are derived from the few works which survived the various troubled periods in Chinese history. But the fragment that is left is woefully small for it was the imperial collections, into which the best painting had naturally gone, that suffered the most when a dynasty fell or in the troubled periods between. From such relics as remain we can see that landscape had been developed as a background to figural scenes. The various elements of landscape were dispersed in such a way as to resemble the wings of stage scenery and bright colours with powerful, jagged brushwork were favoured. Human figures were given individual expressions and those of animals suggested vigorous movement. A few authentic works or faithful copies remain to us from such celebrated masters of the 7th and 8th centuries as YEN LI-PEN, LI SSU-HSUN, WU TAO-TZU, and WANG WEI, and these give us an idea of the majesty, luxury, and vitality of this cosmopolitan age and the brilliant colouring used by the artists who depicted it. Wang Wei has the distinction of being the first to paint pure landscapes—many centuries before a similar development in Europe. HAN KAN specialized in horse paintings (always a favourite subject of the Chinese painter); CHANG HSÜAN in genre scenes, especially of court ladies. But in general it was Buddhist paintings which predominated. Truth to nature, sureness of line, vitality, and colour are the outstanding characteristics of T'ang painting. The art was popular with the emperors and an academy flourished at the court as early as the 8th c., providing a model for such imperially favoured academies until well into the 18th c.

After the fall of the T'ang there was a period of disorganization. Then came what is considered by most Chinese and many Westerners as the finest flowering of Chinese art. The painters of the Sung dynasty commanded a complete technique and fully explored the possibilities of brush and ink. Their technical competence was dedicated to expressing that refinement of spirit which is reflected in the other arts and crafts of the period. A delicate philosophical or mystical introspection inspired by Ch'an Buddhism or by Taoism (or often by a mixture of both) achieved its profoundest embodiment in pure ink painting in which the artist sought to express, always with the barest means, the inner essence of the reality that he saw around him—his aim being to show reflected in the smallest detail, such as a bamboo branch or sprig of plum blossom, that same mysterious life or divine quality of Tao which pervades all nature. Man was seen as only a

minute component of a vast universe, nature with its variety of moods was depicted as boundless and unfathomable, majestic and awe-inspiring. What was left unsaid or allowed to fade into the empty spaces was intended to be as significant in the composition as what was painted. The Sung artist gave meaning to the depiction of space—a development which has remained one of the primary characteristics of Chinese painting. Most of the professional painters belonged to the Imperial Academy, and although they favoured landscape, they also produced many fine flower and genre pictures. The amateur painter also gained in dignity. Amateurs might be priests, or officials who were also scholars, poets, and musicians. Typical of them were such men as Su Tung-P'o, his teacher Wên T'ung (d. 1079), and Li Lung-Mien. Despite the great rarity of genuine Sung paintings there exist a few examples of the works of such masters as Mi Yu-jên and his father Mi Fei, Ma Yüan, Hsia Kuei (active 1180–1230), Liang-K'ai, and Mu Ch'i.

The expulsion of the Sung by the Yuan, who were Mongols, interfered little with the development of painting. The trend of this short period has been summed up by Dr. W. Cohn (*Chinese Painting*, 1951) as showing 'a more unified vision, a more explicit stressing of the pictorial . . . a richer colouring and finally a tendency towards realism'. The ties between painting and literature were drawn closer and as a consequence artists sometimes relied less on pictorial means to express the subtleties they wished to convey than on literary allusion. Many of the Sung painters continued to work, but the period was dominated by the 'Four Great Masters', Huang Kung-Wang, Wu Chên, Wang Mêng, and Ni Tsan—all of whom, particularly the last, had great influence on the succeeding centuries when their idealistic landscapes were repeatedly copied and paraphrased.

The Ming were native rulers. Their dynasty saw the final ascendancy of the amateur, literary man's painting (*wên-jên hua*), idealistic in approach but paying more attention to realistic detail and truth to nature's appearances. Landscape became more intimate, less mystical and awe-inspiring. The suggestive subtlety of the Sung masters was less in evidence and little was now left to the imagination. Many dry imitations of Sung works were made—parodies which unfortunately have often been mistaken for genuine Sung paintings. Theories flourished, schools were formulated and impressive genealogies fabricated for them. Thus Tai Shin was credited with founding a Chekiang School and Shên Chou a Wu or Kiangsu School. Technical considerations became more important than inspiration. The middle of the period was dominated by the landscape masters Wên Chêng-Ming, T'ang Yin, and Ch'iu Ying. Apart from their work perhaps the finest and most typical expression of the peculiar genius of the Ming painters is seen in their detailed flower

and bird pieces based on the Sung style—somewhat overcrowded and sometimes a little dry, but masterpieces of careful observation and skilful colouring, with spirit enough still to distinguish them from the lifeless botanical studies into which this kind of painting later degenerated. Towards the end of the Ming period the leadership of the traditional schools fell into the hands of theorists, connoisseurs, collectors, and amateur painters such as Tung Ch'i-Ch'ang, Mo Shih-lung (16th–17th c.), and the Four Wangs (see Wang).

A more vital influence than the Four Wangs was exerted towards the end of the Ming period by certain eccentric personalities known in the West as Individualists. Chu Ta, K'un Ts'an (*c*. 1625–*c*. 1700), and Tao Chi protested strongly against the dry copying of the Old Masters. Their personal vision, original compositions, and eccentric brushwork had a significance for the development of Chinese and Japanese painting that cannot be over-emphasized. But their influence was not fully felt until the first century of the Ch'ing dynasty. The Manchus were foreigners and no less anxious to absorb Chinese culture than had been the Mongols of the Yüan dynasty. They encouraged all that was most traditional, the result being an enormous output of accomplished works after the great masters and elegant flower compositions based on the model-books which were becoming increasingly popular. These books of woodcut illustrations designed to furnish models of how to paint had a deadening effect on the art from the late 17th c. onwards. The new individualist approach, however, was taken up by a host of scholar-painters such as—to mention only a few—Kung Hsien (active *c*. 1660), Hua Yen (1660–1740), Kao Ch'i-p'ei (d. 1734), and the group known as the Eight Eccentrics of Yang-chou (see Individualists). They reduced their brush-work to the boldest essentials in unusual and original compositions that were often replete with humour or satire. Though *wên-jên*, many of them were also professional painters. The influence of Jesuit painters such as Castiglione, whose realism, especially in portraiture, greatly impressed the emperors, cannot be overlooked, and a number of Chinese artists learned Western perspective from them. The Western realism of the time, however, never took root in Chinese painting.

The 19th c. produced a number of capable artists but no men of genius with any significant contribution to make. For 400 years Chinese artists had been slowly freeing themselves from the sterility produced by unqualified veneration for the past and working towards a new freedom for expression of personality. But the Individualists were the last upsurge in this process.

The place of calligraphic techniques in Chinese painting has always held dangers of its own, encouraging the new generation of artists to rely excessively on well tried and conventional formulas instead of seeking new modes of

expression. This, combined with the Chinese respect for tradition and the important place given in the training of every artist to copying the Old Masters, led easily to the perpetuation of mannerisms and the sterility which is engendered by bravura for its own sake. In revolt from the vacuity of the native tradition with its endlessly repeated mountain and snow landscapes, blossoms, reeds and bamboos, the younger school of artists in 1911 began to experiment with Western methods. They copied without understanding the Western schools of POST-IMPRESSIONISM, CUBISM, SURREALISM, and the rest and brought no new vision to Chinese art. Until the Sino-Japanese war Shanghai, Nanking, and Canton were the chief centres of modern experimental schools while Peking was the home of the rival traditional-style painting. Prominent among the moderns were Hsü Peihung (1895-1953) and Liu Hai-su (1895- ), both from Kiangsu. Hsü, who combined Western academic training with Chinese subjects and mannerisms in a somewhat uneasy stylistic amalgam, gained some reputation in Europe during the 1930s and visited India in 1941 at the invitation of Rabindranath Tagore. In 1927 he was appointed head of a new art department at the National Central University of Nanking; in 1942 he directed a National Art Research Institute at Chungking; and from 1946 until his death he was Director of the National Peking Art Academy. Liu Hai-su, who by contrast was influenced by the Post-Impressionists, founded the Shanghai Art School in 1920 and taught many of the younger artists. Among the traditionalists the leader of the so-called 'Northern' school was Prince· P'u Ju (1887- ), a cousin of the last Chinese emperor, while the leader of the rival 'Southern' school was Ch'i Pai-shih (1863-1957), who was considered the foremost exponent of vigorous brush-work in the 20th c. and lived to become one of the most honoured painters in Communist China. Chang Ta-ch'ien (1899- ), who left China in 1948 and eventually settled in Brazil, worked in a virtuoso eclectic manner and has won the regard both of Chinese connoisseurs and of European art circles. From 1916 until 1949 Canton became the centre of a 'revolutionary' school of painting led by the brothers Kao Chien-fu (1879-1951) and Kao Ch'i-feng (1889-1933), whose aim was to unite the vitality of the Chinese ink-and-brush technique with Western knowledge of perspective and chiaroscuro and with modern industrial subject matter.

Both the traditional and the Western-style schools fell under a cloud when the Communists came to power in 1949 and the influence of Soviet socialist realism put a premium on politically orientated woodcuts and CARTOONS. Since 1953, however, there has been a revival of certain styles of traditional painting and the social position of the artist has become assured, although the emphasis appears still to have fallen primarily on GRAPHIC ART and on propagandist reportage.

In the Chinese language there is a vast literature on painting. Biographies of painters have been included in official histories for over 2,000 years. Art theorizing has flourished from early times; by the end of the 5th c. Hsieh Ho formulated his 'six principles' of painting, which have been constantly commented on, elaborated, and put into practice during the following centuries. They do not translate easily but may roughly be rendered as 'rhythm and vitality, structural method in the use of the brush, realistic form, correct colour, good composition, and the study of good models'.

CERAMICS. No race has achieved greater distinction in the art of pottery than the Chinese, and the invention of porcelain under the T'ang dynasty is a remarkable indication of their early superiority in matters of technique. From then until the end of the 18th c. their production of new and artistically brilliant styles continued without break, exerting an immense influence on potters in other lands.

In the Late Neolithic era painted domestic ware and funerary urns of impressive forms reveal a mature pottery technique during the several phases of the so-called Yang-shao culture (c. 2200-1700 B.C.), and the superb black pottery of the Lung-Shan culture, c. 1500 B.C., suggests that the prototypes for many of the ritual bronzes of the Shang dynasty originated in the Late Neolithic ceramic crafts.

Throughout the classical age of the Shang and Chou dynasties the craft of the potter remained largely subsidiary to that of the bronze-founder and although they were well made ceramic wares were not notable for independence of form or design. But by the Han period there were already signs of a new confidence which was reflected in the development of several more advanced techniques. Among the earthenwares recovered from Han tombs are many with lead glazes tinted green or brown, including roughly sculptured figures and models of domestic and farm buildings, besides vessels which were often decorated with mythological figures and animals in bands of moulded relief. More important still, the Han potters achieved the extremely high kiln temperatures required for the manufacture of stoneware as well as discovering a tough, closely adhering glaze of felspathic type with which to cover it. This laid the foundation for one of the most fruitful of all Chinese pottery traditions. During the Six Dynasties period much ordinary, unglazed earthenware was still made in the strife-ridden northern kingdoms, but the glazed stonewares, which were made chiefly in the Yueh district of Chekiang province (SE. China), underwent a steady improvement: their shapes became increasingly emancipated from metal prototypes, while their grey-green or olive-brown glazes and the more highly refined materials approximated more and more closely to the ideal of porcelain.

In the T'ang dynasty earthenware pottery was used lavishly for tomb furniture, and the

beautifully proportioned shapes and bold colouring of these wares convey a vivid impression of T'ang refinement and splendour. Lead glazes were again employed, tinted in golden yellow, green, and blue, and splashed in gorgeous polychrome effects over a fine white body. There was much moulded work, and many of the forms and designs, e.g. ewers and amphora vases, grapevine and PALMETTE motifs, unmistakably derived from HELLENISTIC Greece. These tombs also yielded the much-admired T'ang figures—austere guardian spirits, trains of horses and camels with their strangely foreign attendants, court ladies, and entertainers—which were intended to serve the dead in the after-life. In addition, the T'ang potters also made a variety of stonewares, glazed in brown, black, or white, as well as the green CELADONS of Yueh. Most notable of all, however, was their invention of pure white, translucent porcelain made of kaolin (china clay) and petuntse (china stone). This was usually undecorated but was moulded in vase and bowl shapes of the most chaste perfection.

Whereas T'ang art had been substantially direct and extrovert in character, that of the Sung inclined rather to subtle and sensuous richness. Neither the somewhat obvious magnificence of the T'ang coloured earthenwares nor the immaculate white porcelain satisfied the temper of the new age, which found expression rather in thick, lustrous glazes with the concealed mystery of precious stone, and in blossoming shapes recalling the organic growth of flowers and fruit. The chief Sung porcelains are the lovely, ivory-toned *Ting* wares, and the *Ying-ch'ing (Ch'ing-pai)* wares which are glazed in various delicate bluish-green tints. Both include a wealth of refined, thinly potted shapes with designs of animals or flowers freely carved or mould-stamped under the glaze. For the more richly coloured glazes, however, stoneware bodies of a more or less porcellanous composition were considered adequate. Prominent among these were the thick, semi-opaque glazes of the *Chün* wares, varying from moonlight to midnight blues, sometimes with splashes of crimson added; and the extensive family of the green celadons. The so-called 'Northern celadons' which come from Honan and Shensi bear particularly fine carved floral designs; although the greenish-blue Imperial *Ju* ware, like the *Chün*, relied for effect on the incomparably rich, jade-like texture of its glaze. The most famous of several types of brown or black glazed pottery are the *Chien* ware tea-bowls made in Fukien province, with the streaked, spotted, and dappled effects known as 'hare's-fur', 'oil-spot', 'partridge-feather', etc. These above all illustrate the Sung potter's complete mastery of glaze and his skilful management of kiln temperature and atmosphere. Rarely has ornament been so firmly subordinated to form and colour. In the *Tz'u Chou* type of stonewares, however, bold designs predominate: working rapidly in brownish-black pigments on a prepared ground of creamy slip their painters depicted plants, animals, and figures in broad sweeping brush-strokes, while on other examples the designs were carved through sandwiched layers of variously coloured slips and glazes.

The foregoing types flourished chiefly during the earlier part of the Sung period. After 1127, however, Hangchow became the centre for the luxurious *Kuan* ware made under imperial patronage. It had extremely thick glaze ranging in colour from greenish-blue or lavender-blue to a pearly grey over a wafer-thin body. At Lung-ch'üan (Chekiang province) many factories produced thickly glazed celadons of extremely pure colour. The latter were exported throughout the Far and Near East down to Ming times, especially in the form of stoutly made jars, bowls, and large dishes. Kilns at Ching-te-chen (Kiangsi province) also attained prominence in the manufacture of delicately shaped porcelains of *Ch'ing-pai* type. Apart from the prevalence of lobed and foliate features, petal-mouldings, etc., one may note in the shapes of Sung pottery a new antiquarian tendency which resulted in the imitation of archaic bronzes.

By a complete reversal of taste painted porcelain became the most general ceramic ware of China from the Ming period onwards. Not only this, but virtually all of it was made at Ching-te-chen. Aided by the importation of Persian cobalt the porcelain-makers now discovered the technique of 'underglaze' painting in blue, and by *c.* 1350 handsomely painted blue-and-white already competed with celadon in the export market. The standard Ming porcelain body was refined and white, capable of thin potting when necessary, and covered with a fairly even, clear glaze. Painted design reached its height in the reign of Hsüan Te (1426–35), when lively, well-balanced patterns of dragons, phoenixes, landscapes, floral scrolls, etc., were executed in a particularly rich, violet-toned blue. The finished refinement of the shapes was shown off also by superb monochrome glazes in blue, white, or red. At this time the addition of reign-marks first became common practice.

Alongside the popular blue-and-white wares employing 'overglaze' enamel colours were increasingly made from the Ch'eng Hua reign (1465–87) onwards. At first these colours were applied in sparing jewel-like touches over blue-painted outlines: later, however, they were utilized for a variety of bold polychrome effects employing red, yellow, green, and turquoise, in keeping with the ebullient, light-hearted mood of the period. The painted wares of the Chia Ching (1522–66) and Wan Li (1573–1619) periods delighted in charming subjects or themes, such as gatherings of poets and sages, playing children, etc., as well as the peach, the deer, the hare, and other symbols of well-being from the Taoist mythology. In one special class, the so-called '3-colour' wares, the entire surface was glazed in rich colours, the designs being outlined in raised clay to keep them separate. The Ming

potter's partiality for swelling shapes and sinuous contours is here seen at its most flamboyant.

Exports steadily expanded during this period, and sea trade introduced porcelain into many European homes. From this time date many of the thinly potted blue-and-white bowls, plates, and dishes which figure so prominently in Dutch STILL LIFES.

The mid 17th c. constitutes a transitional period during which war and civil unrest severely restricted the manufacture of fine porcelains, although much blue-and-white and some enamelled wares continued to be made. Various provincial kilns acquired a certain prominence which they retained throughout the Ch'ing period: e.g. Te-hua (Fukien province), which made the fine, undecorated *blanc-de-chine* porcelains so greatly admired in Europe; and Yi-hsing (Kiangsu province), the home of a fine, reddish-brown stoneware used chiefly for teapots; also the still unidentified makers of 'Swatow' porcelains, which are chiefly large dishes coarsely but attractively painted in red and green.

During the reign of K'ang Hsi (1662-1722) the art of ceramics was once more enlivened by original invention. This period is notable for its brilliant exploitation of decorative techniques and glaze effects. Noble ornamental vases were produced in addition to the mass of more useful wares; and if the Ming panache was lacking in the general effect, this was to some extent compensated for by a superior elegance and finish. The blue-and-white ware excelled in subtle, economical drawing and carefully graded washes laid on in overlapping strokes which reinforce the natural glow of the cobalt. For the equally numerous enamelled wares the Ming palette was adapted to the somewhat colder range of the *famille verte*, a practice which was consistently adhered to throughout the period. The varied subject matter was chosen with attention to its symbolic significance. Floral designs were much employed, particularly those representing the 'Four Seasons' (prunus, peony, chrysanthemum, and lotus), while a longer series corresponding to the 12 months of the year also came into fashion. Many designs incorporate the mythical dragon and ch'i-lin. The 'Eight Taoist Immortals' and various Buddhist and Confucian deities were favourite themes. Figure scenes were drawn from history or legend, while bird studies and landscapes were borrowed from the works of the masters. Some of these designs were boldly and broadly executed, others neatly limned and set within panels on elaborately diapered grounds. In one special class of the *famille verte*, which consists largely of tea-table and other small ornamental accessories, an especially rich effect was achieved by applying the green, yellow, and black enamels to an unglazed or 'biscuit' porcelain, and the much-praised vases of the *famille noire* and *famille jaune* groups, distinguished by their bold black or yellow grounds, were for the most part also decorated in this way.

But many people consider the most admirable wares of the K'ang Hsi period to be those with monochrome glazes. The finest, perhaps, are the 'high-temperature' effects: the brilliant red *sang-de-bœuf* and soft pink 'peachbloom'; celadon, generally combined with carved decoration; and the lustrous 'mirror-black' and mottled 'powdered blue', both frequently over-decorated in gold. At somewhat lower temperatures were fired a variety of greens and yellows, purple and turquoise, to which many more enchanting colours were added in the next two reigns. Among the well-defined, masculine shapes of the K'ang Hsi period which show off these glazes to perfection those of the 'rouleau', 'trumpet-necked', and 'beaker-shaped' vases may be mentioned as especially characteristic. The last two were combined in the five-piece *garniture-du-cheminée*, which still occupies a place on many a European mantelshelf.

This intensely creative phase continued throughout the first half of the 18th c. For painted wares the bold *famille verte* palette now gave way to the softer, more opaque colours of the *famille rose*, dominated by a new pink enamel introduced from Europe; and this was employed in delicate studies of court ladies or birds and flowers often executed on porcelain of 'eggshell' thinness. The early *famille rose* style manifests a somewhat feminine taste and indicates the beginning of that sentimentalizing tendency which increasingly marred Chinese porcelain from the mid 18th c. onwards as conscious prettiness was allied to cloying combinations of colour and the sterile display of technique resulted in gross over-elaboration of design. Meanwhile the export of porcelains to Europe had reached vast proportions, and whole table services were often made according to the fashionable Western models with decoration like-wise executed to order. Much porcelain also found its way to enamelling works in Holland, England, and Germany, where it was further decorated.

The swift decline of this trade after 1800 need cause little regret, for after the reign of Chia Ch'ing (1796-1820) the porcelain factories virtually abandoned all efforts towards originality or invention. Using poorer materials, they were content to rely on the rather ineffectual repetition of earlier styles until the collapse of the dynasty in 1912.

Although the imperial reign-mark was often applied from the 15th c. onwards, these marks are not to be relied on without expert interpretation. Very occasionally dates appear, based on a 60-year cyclical system. Both series are recorded in the standard textbooks.

47, 109, 279, 280, 374, 469, 582, 859, 1137, 1183, 1237, 1238, 1239, 1356, 1375, 1435, 1436, 1437, 1893, 1894, 2149, 2239, 2313, 2328, 2331, 2490, 2491, 2492, 2493, 2494, 2583, 2584, 2598, 2617, 2891.

**CHINESE INK.** See INK.

**CHINESE TASTE.** See CHINOISERIE.

**CHINNERY, GEORGE** (1774-1852). English painter, born in London. He first set up as a portrait painter and from 1797 practised in Dublin. In 1802 he sailed for India and never returned to Europe. His movements were: 1802-7 in Madras, 1807-27 in Calcutta, 1827-c. 1830 in Canton, c. 1830-52 in Macao. He painted a number of portraits while abroad and from time to time sent to R.A. exhibitions, but his reputation rests today on the large number of landscapes and decorative studies he made of Oriental scenes. He developed an early calligraphic style and his rapid and often fragmentary sketches show him to have been among the most visually perceptive of all European artists who travelled and worked in the East. His portraits, which are sometimes life-size, are little known and often pass under other names. In 1814 he drew a group portrait of Mr. and Mrs. Thackeray and the young William Makepeace Thackeray at the age of 3. An exhibition of his works was arranged by the Arts Council in 1957.

**CHINOISERIE.** Chinese wares, notably silk, porcelain, and lacquer, have fascinated Europeans as luxury articles from very early times. Attempts to copy or reproduce them go back at least as far as the early centuries of the Christian era. A fragment of textile decorated with a design in Han style (see CHINESE ART) was found at Dura Europos from the 3rd c. A.D. Certain motifs such as DRAGONS, phoenixes, and peacocks in BYZANTINE ART were of Chinese origin; phoenixes of Chinese derivation occur in ILLUMINATED MANUSCRIPTS of the 10th c. and on an 11th-c. ivory casket in the Cathedral Treasury at Troyes. But the term 'chinoiserie' is not properly applied to imitations of Chinese wares or designs, or to the adoption of Chinese motifs

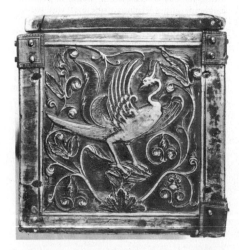

**87.** Detail from Byzantine ivory casket. Side panel showing a phoenix amid foliage in the Chinese style. (Cathedral Treasury, Troyes, 11th c.)

or symbols in European arts, though this may be a part of it. Chinoiserie is properly a *European* style in the arts and crafts reflecting fanciful and poetic notions of China which from the time of Marco Polo have been conjured up from travellers' tales and from exports of ceramics, textiles, and *objets d'art*. The idealized concepts of 'Cathay' varied from age to age and often bore so little resemblance to the real thing that from time to time oriental crafts were designed specifically for the European taste. Indeed in the 17th c. it occurred that textiles designed by Indian craftsmen for the English 'China fashion' were exported from India to China as a novelty and Chinese weavers then began to produce for the European market basing their designs on these Indian models.

The earliest paintings which appear to evidence an artistic as opposed to a purely iconographic oriental influence are *St. Louis of Toulouse Crowning King Robert of Anjou* (Naples, 1317) and *Guidoriccio Fogliano* (Siena, 1328), both by the Sienese artist SIMONE MARTINI. The strong influence of Chinese exoticism in 14th-c. textile designing may be seen from the *St. Ursula* (Prague) by the Master of Cologne. The expansion of trade through the East India Companies in the 16th and 17th centuries produced a lively vogue for Chinese fashions. Lacquers and textiles were produced in imitation of Chinese designs. Engravers such as Mathias Beilter in Holland and Valentin Sezenius in Denmark produced patterns of Oriental designs for decorative artists. The Delft blue-and-white pottery was closely imitated from Chinese porcelain, while at Nevers a less closely imitated decorative style may be regarded as the true origin of chinoiserie in European ceramics. The *Trianon de porcelaine* built for Louis XIV by Louis LE VAU in the park at VERSAILLES (1670-1) became the prototype of innumerable Chinese pagodas, kiosks, etc., throughout Europe. Towards the end of the century Jean BÉRAIN introduced Chinese motifs into his ARABESQUES and originated that peculiar offshoot of chinoiserie, the SINGERIE.

It was during the period of the French ROCOCO that artists of prominence other than decorators lent themselves to chinoiserie. Antoine WATTEAU painted c. 1709 a series *Figures chinoises et tartares* for the cabinet du roi in the Château de la Muette, which are still known from prints. The spirit of delicate fantasy which enlivened Watteau's works was further developed by the chinoiseries and *singeries* of Christophe HUET, while a more original concept of the gay and voluptuous Orient imbued the chinoiserie of BOUCHER in his tapestry designs (the *tentures chinoises* woven at Beauvais about the middle of the century), his décor for Noverre's ballet *Les Fêtes chinoises*, drawings which were engraved and published as *Livre des chinois* and also easel pictures such as *Chinese Fishing Party* (1742) and *The Chinese Lovers*. A more flimsy but very popular mode of chinoiserie, current both in

**88.** *Divinité chinoise.* Engraving designed (*c.* 1709) by Antoine Watteau and engraved by Gabriel Huquier

France and in England, were the prints and designs of Jean PILLEMENT. The vogue for chinoiseries was carried to Germany by François CUVILLIÉS. In England it gave rise to the Anglo-Chinese garden. In building one of the leading exponents was William HALFPENNY, the title of whose last book, *Chinese and Gothic Architecture* (1752), indicates that the two styles, one remote in time, the other in space, were treated on an equal footing and appreciated for similar reasons, as relaxations from classical severity. Chippendale's *Director* (1754) contains numerous essays in both styles, sometimes combined in the same object. The well known bedstead from Badminton (V. & A. Mus.) is an excellent specimen of his Chinese manner. But the most serious and objective studies of Chinese style published in England were Sir William CHAMBERS's *Designs of Chinese Buildings, Furniture, etc.* (1757) and *A Dissertation on Oriental Gardening* (1772).

Though the NEO-CLASSICAL revival which dominated the second half of the century was unfavourable to the more fanciful manifestations of the Chinese taste, the vogue lingered on a considerable time. In France under Louis XVI the furniture of M. Carlin (d. 1785) and other *ébénistes* was frequently decorated with panels of oriental lacquer; in Germany David Roentgen (1743-1807) was fond of depicting Chinese scenes in parquetry; and in England at the beginning of the 19th c. the Chinese fashion was revived in an extravagant form in the Brighton Pavilion and elsewhere.

1221, 1366.

**CHIRICO,** GIORGIO DE (1888- ). The originator of METAPHYSICAL PAINTING, Chirico was born in Greece of Sicilian parents and after studying painting in Athens was attracted to Munich by the work of BOECKLIN and KLINGER. There (*c.* 1906-9) he became interested in the philosophy of Schopenhauer and Nietzsche. In 1909-10 he was in Italy and painted his first 'enigmatic' pictures, which convey an inexplicable atmosphere of strangeness and uneasiness by the immobility of empty spaces and unexpected perspectives. After exhibiting these pictures in Paris (1911) he attracted the attention of PICASSO and became a friend of APOLLINAIRE. While in Paris he developed a more deliberate theory of 'metaphysical insight' into the reality behind ordinary objects by neutralizing the objects themselves of all their usual associations and setting them in new and mysterious relations. In order to empty the objects of his compositions of their natural emotional significance, he painted tailors' dummies as human beings, statues, plaster heads, rubber gloves, and the like, depending entirely on juxtaposition and the formal qualities of his picture space to create the disturbing quality which belongs to certain dream situations. In this he anticipated one aspect of SURREALISM.

Chirico returned to Italy in 1915 and converted Carlo CARRÀ to his metaphysical style, which had matured from a conflation of the Paris experimental researches into psychical singularity with the hallucinatory architectural vistas of Ferrara.

But the uncanniness of Chirico's pictures was a personal thing which could not be communicated to a school and neither Carrà nor later MORANDI captured it or remained long with the movement. In 1918-19 Chirico exhibited in Rome and was lionized by the Valori Plastici group, standing opposed to FUTURISM. From this time he devoted himself increasingly to technical research into the methods of the Italian PRIMITIVES and VENETIAN SCHOOL. He returned to Paris in 1924 and was accepted as a master and precursor by the Surrealists. Although he never accepted their devices of automatism, the mysterious quality of his work with its half-dreamlike and half pathological impact was close to the emotional effect at which they aimed and the movement was entirely at one with his philosophy: 'good sense and logic have no place in a work of art, which must approximate to a dreamlike or childlike state of mind.' During the 1920s he painted his most powerful and his most profoundly disturbing works, in which his technical researches were used to the best advantage: obsessive compositions of naked figures half-human, half-dummies, the famous series of riotous horses on unreal shores with broken Greek columns and even more compelling architectural constructs with strange perspectives and obtrusive shadows. After 1930 he made a break with his past friends and his pictures became technical tours de force in which little of the earlier strangeness or compulsion remained. After the Second World War his painting became more minutely detailed and technically exacting, and still more devoid of meaning, while he set himself against all that the modern movement has stood for. He has an honoured place among the creative artists of the 20th c. for his early painting, and in particular the pictures he painted in the 20s.

1012, 2521.

**CHIU YING** (active 1522-60). Chinese painter. Like T'ANG YIN, he was a pupil of Chou Ch'en (active c. 1472-1535) and worked in many styles. He is best known for his detailed paintings of splendid palace and banquet scenes, and for his delicate representations of slender, beautiful women. Many copies and forgeries of his work exist. His hanging scroll *The Han Emperor Kuang-wu Riding through a Ford* (N.G., Ottawa) exemplifies a 16th-c. modification of the T'ang 'blue and green' landscape tradition. The representational function of colour is subordinated to its intrinsic aesthetic values and it is laid on in thin glazes over the BRUSH DRAWING.

**CHODOWIECKI,** DANIEL NIKOLAUS (1726-1801). Polish painter and illustrator. He began his career by painting enamels. His early oil paintings were imitations of the French manner, and his fame rests on the book illustrations and graphic work of all kinds which he produced prolifically from c. 1770 onwards. Most attractive are the little intimate sketches he made of the bourgeois life around him, such as those made on a journey to Danzig, his home town. In 1797 he became Director of the Berlin Academy.

1463.

**CHOIR STALLS.** Term in Christian church architecture for seats arranged in one or several rows on either side of the choir for the use of clergy, from the Middle Ages a major feature of church furnishing. In the EARLY CHRISTIAN BASILICA stone seats (L. *subsellia*), usually undecorated, lined the walls of the APSE, encircling the bishop's throne (S. Clemente, Rome; S. Apollinare in Classe, Ravenna). The first references to choir stalls are made by writers of the Western Church in the early Middle Ages and the 9th-c. plan of the monastic church of S. Gallen in Switzerland indicates the existence of seats with backs for the use of the priests. By the 12th c. a form of stalls had evolved which remained basically constant throughout the Middle Ages. The back was continuous and the long bench, with ends, was divided into separate seats by low partitions. Hinged seats, which could be raised to a vertical position when the occupant was standing, were in use by this period. No complete ROMANESQUE stalls survive, but the fragmentary example at Ratzeburg, Germany, is decorated with architectural motifs. GOTHIC stalls became a vehicle for elaborate carved decoration. An early example, with high panelled dorsal and hinged seats with MISERICORDS, occurs at Poitiers (cathedral of S. Pierre), and in the course of the 13th c. the stall structure, surmounted by carved and pinnacled canopies, became increasingly splendid (Lausanne Cathedral). The seats were carried round to face the altar and make a screen between the chancel and nave. Numerous choir stalls from the later Middle Ages survive, the gabled canopies rising to a great height (Ulm Cathedral), the panelled fields of the dorsals and the end walls decorated with foliage or pictorial scenes. Sober proportions characterize RENAISSANCE stalls, either surmounted by a simple horizontal canopy or even without. Those in Italy are often decorated with intarsia (Assisi, Siena). In the great BAROQUE churches the stalls no longer serve to partition the choir from the nave, but line the oval or curved walls of the chancel. Often of walnut, inlaid or gilt, the panelled dorsals crowned with riotous scroll ornament, they form a vivacious and sumptuous background (Ottobeuren, Germany).

**CHRIST.** The Gospels are silent as to Christ's appearance, and no authentic portrait is known (though see VERNICLE and VOLTO SANTO). The Early Christian antipathy to pictorial representation, derived partly from Jewish teaching, may be one of the reasons why pictures of Christ

.do not occur until the 3rd c. Before that period He was represented only by symbols, such as the SACRED MONOGRAM, the LAMB, or the fish. The earliest figural representation, the Shepherd carrying a lamb over His shoulder, which appears in the vault of the Lucina Catacomb (*c.* 220–40) is also symbolical. The theme of Christ as the Good Shepherd remained a common one in EARLY CHRISTIAN ART, and finds perhaps its highest expression in a mosaic in the Mausoleum of Galla Placidia, Ravenna (late 5th c.).

The Good Shepherd, like nearly all the earliest representations of Christ on SARCOPHAGI and in the catacombs, appeared not as a portrait of an individual but as an ideal, classical figure of a beautiful, curly-headed, beardless youth. But after Christianity became the State religion in A.D. 313, the beardless youth was gradually replaced by an older, more dignified, bearded figure—which probably originated in the East— portraying Him as teacher and king. The idea of

Christ as king appears frequently in the Gospels and in subsequent writings, and after A.D. 313 a number of imperial attributes such as the HALO, the throne, and jewels were incorporated in representations of Christ. An early example of the bearded, enthroned Christ is that in the apse mosaic of Sta Pudenziana, Rome (5th c.), but Christ crowned became common only from the ROMANESQUE period (Moissac Tympanum, 12th c.).

The beardless and the bearded types of Christ existed side by side for many centuries. CAROLIN-GIAN and OTTONIAN ART, going back to early Christian models, favoured the beardless, and BYZANTINE ART the bearded Christ, but in both the figure of the Saviour was removed from the human sphere and given an aspect of great spirituality and solemnity. In Byzantine art the omnipotent Christ (Pantocrator) sits motionless, rigid and frontal, holding the Gospels in His left hand and blessing with the right. Busts of

**89.** The Pantocrator. Mosaic from the cupola of the church of the Martoraña, Palermo (12th c.)

the Pantocrator appear in the cupolas of Byzantine churches (Daphni, 11th c.) and in the apses of their Sicilian derivatives (Cefalu, 12th c.). From the 12th c. the solemn bearded Christ became almost universal, and the extent of Byzantine influence in the West can be seen in the highly spiritualized and hieratic portrayal of Christ in Majesty common in Romanesque art, showing Him enthroned in a MANDORLA or aureole, raising His right hand in blessing, and holding in His left a book or an orb (Vézelay, main door, 12th c.; Malmesbury, south porch, 12th c.).

The early GOTHIC period inaugurated a less solemn and more graceful image of Christ. But with the growth of religious mysticism in the writings of St. Francis, and later of St. Bridget of Sweden (d. 1373), a change occurred in the attitude to Christ (see also CRUCIFIXION). Greater stress was laid on His suffering, and in art He was portrayed as the Man of Sorrows, the agonies

**90.** Man of Sorrows. Detail from the *Crucifixion* of the *Isenheim Altarpiece* by Mathias Grünewald. (Unterlinden Mus., Colmar, 1509–15)

of the Saviour being depicted with almost exaggerated REALISM. He wears a crown of thorns. His expression is one of anguish, blood and tears trickle down His body. This Christ-type was common in Spain, England, and Germany; in the last it went on well into the Reformation, and the suffering Christ is a principal feature in the work of Matthias GRÜNEWALD.

The Italian RENAISSANCE produced a gentler, physically more beautiful and dignified image, the most sophisticated and influential version of which can be seen in the paintings of TITIAN.

This trend was reversed at the Counter-Reformation, when under Jesuit influence a new type of suffering Christ appeared which showed Him crowned with thorns and with eyes turned heavenwards (e.g. El GRECO). This type frequently degenerated into theatrical emotionalism, a contrast to which is provided by the simple, unromantic realism of REMBRANDT's image. This in turn was followed by the excessive sweetness of the 18th- and 19th-c. imitations of the 16th-c. types. In modern art there have only been a few attempts—among which those of ROUAULT and EPSTEIN may be mentioned—to create a contemporary idiom for the depiction of Christ. (For the most important scenes of the Life of Christ see separate headings: NATIVITY, ADORATION OF THE MAGI, FLIGHT INTO EGYPT, MASSACRE OF THE INNOCENTS, BAPTISM, TRANSFIGURATION, PASSION, LAST SUPPER, CRUCIFIXION, RESURRECTION. See also VIRGIN, HARROWING OF HELL, and LAST JUDGEMENT.)

1015.

**CHRISTIAN ART,** EARLY. See EARLY CHRISTIAN ART.

**CHRISTIAN MONOGRAM.** See SACRED MONOGRAM.

**CHRISTMAS,** GERARD or GARRETT (d. 1633). English sculptor. He made an equestrian figure of James I on the city gate at Aldersgate (destroyed 1761) and carved and perhaps designed an elaborate three-tiered frontispiece on Northumberland House at Charing Cross. About 1614 he was appointed Carver to the Navy, and was also much employed in devising pageantry for the Lord Mayor's Shows. His sons JOHN and MATTHIAS worked with him, the latter (d. 1654) succeeding him as Master-Carver to the shipyard at Chatham. The family were responsible for a number of monuments, the most important being the tomb of Archbishop Abbot (Holy Trinity, Guildford, 1634). Most of those signed by the two sons after their father's death have half-length figures, sometimes shrouded, such as that to Mary Cathorpe (East Barsham, Norfolk, 1640), but a few have full-length effigies. Their quality, however, is never very high.

**CHRISTUS,** PETRUS (active 1442?–72/73). Netherlandish painter, who was made Master at Bruges in 1444. He copied several compositions by Jan van EYCK and may have completed some of the works left unfinished by van Eyck on his death in 1441. The datable works of the 1440s also show the influence of Rogier van der WEYDEN. The painting of *St. Eligius with Two Lovers* (New York) reflects van Eyck's interest in the accurate depiction of minute details and the mirror on the table is certainly a direct borrowing from him; yet the painting lacks van Eyck's rich and objective subtlety, and is almost fussy

in its detail. The *Lamentation* (Brussels) is clearly based on van der Weyden's great Prado *Deposition*, but the figures arranged in a single row have lost their dramatic impact, as Christus has introduced a landscape background. Obviously Christus did not understand the deeper significance of Rogier's composition. Yet he had a special interest in the representation of space and his *Madonna with Two Saints* (Frankfurt, 1457) is the first dated example of the use of geometric PERSPECTIVE in the north. An interest in space is also seen in his portraits. He abandoned the dark backgrounds of van der Weyden and van Eyck, and set his figures before a window or in a clearly defined interior. A fine example is the *Portrait of Edward Grymestone* (N.G., London, Earl of Verulam Coll., 1446).

926.

**CHROMA.** See COLOUR.

**CHROMOLITHOGRAPHY.** See LITHOGRAPHY.

**CHRYSELEPHANTINE.** A technique used by the Greeks from the 6th c. B.C., especially for colossal statues in temples. The exposed flesh of the figure was made of ivory and the drapery of gold sheeting; the interior framework was presumably wooden.

**CHURCH.** The relationship of the Church to the arts of Christendom falls to be discussed under three heads: the Church as PATRON of the arts; the Church as a source of ICONOGRAPHICAL motifs in the arts; and the liturgical or devotional functions of the church building as a determinant influence in Christian architecture.

As chief patron of the arts throughout the Middle Ages the Church wielded an influence so ubiquitous as to be almost coextensive with the social history of art, and its gradually dwindling importance since the RENAISSANCE has kept pace with the progressive secularization of life and society. The subject is too large to be treated in detail within the scope of an article and in this place, therefore, we need do no more than remark that in the BYZANTINE period its effect was to give prominence to the devotional function of ecclesiastical art; in the West during the early medieval period the emphasis was on the anecdotal and didactic uses of the visual arts, while as time went on the potentialities of the arts were increasingly exploited, on the one hand to manifest the grandeur and majesty of the Church as an ecclesiastical institution and on the other hand to symbolize anagogically the mystical nature of the Christian faith.

The iconography of the Church as a mystical body or spiritual institution—the *ecclesia*—incorporation into which brought the reward of salvation has been richly fertile of varied symbolism in Christian art. As a guide to salvation it might be expressed by the image of a boat

(GIOTTO's *Navicella* in St. Peter's, Rome) or as a triumphal chariot. The Church Triumphant became one of the most popular types of representation as a crowned woman with banner or cross and chalice, or more rarely as a pope. Or it might appear together with the Church Militant (ANDREA DA FIRENZE's fresco in Sta Maria Novella, Florence). Frequently the personification of the Church was placed in opposition to that of the SYNAGOGUE shown in an attitude and with the attributes of defeat. Together they are represented under the cross in MINIATURES and IVORIES of the CRUCIFIXION and on a larger scale in GOTHIC cathedral sculpture (Paris, Reims, Freiburg, Strasbourg) and STAINED GLASS (Chartres, Bourges, Freiburg). The juxtaposition of Church and Synagogue after the 9th c. tended to supersede a less dramatic one in which the church of the circumcision and that of the gentiles (*ecclesia ex circumcisione et ex gentibus*) were represented sometimes as women (MOSAICS: Sta Sabina, Sta Pudenziana, Rome), sometimes as Jerusalem and Bethlehem, symbolized by buildings, walls, and gates from which sheep were emerging towards the LAMB on a mountain in the centre (mosaics: Sta Constanza, Sta Maria Maggiore, S. Clemente, Rome). In another category of imagery were the buildings which housed the Mother Church (*mater ecclesia*) enthroned or formed an architectural backdrop for the Heavenly Jerusalem, also sometimes an image of the Church (dome of St. George, Salonica). There existed other symbols also of the Heavenly Jerusalem, including large circular chandeliers with towers and gates (Aachen, Speyer, Hildesheim). But it was also reflected in the actual architecture of the church itself, and this brings us to the church as a building, and its complex bearings on Christian architecture and the related arts. These bearings are connected not only with the liturgical functions of the structure and its purpose as a place of collective worship, a centre of pilgrimage for sacred relics or images, but also with the concept of the material church building as a visible symbol of the Church Spiritual and Invisible.

Research into medieval thinking in relation to church architecture and decoration has tended to strengthen rather than diminish our idea of the importance of symbolism. The church as a building cannot be understood from technical and functional considerations alone, for in Christian thought the material building assumes its true significance only through its spiritual meaning as a place where man may confront the divine presence in a quasi-mystical communion. Medieval writers such as Sicardus and Durandus explained how the 'material church signifies the spiritual church' by stressing the anagogical meaning of forms and expounding the deeper significance of individual parts such as COLUMNS, keystones, towers, and walls. Even the plan and various dimensions and proportions might assume transcendental relevance with reference to the harmony of the universe and its numerical

order that had been established by God 'the best and greatest architect'. As the mathematical theory of music was thought to reflect the rationality of the Divine Nature, so too the systems of mathematical PROPORTION used in church planning had for the medieval mind a mystical significance as reflecting the Being of God.

From its formative stages, when the converted houses and simple meeting halls of the primitive Christians gave place to a more monumental and magnificent type of building, the requirements of liturgy and worship were determining factors. Despite its pagan antecedents, a spiritual significance was attached to the various features of the EARLY CHRISTIAN BASILICA from the ATRIUM with its fountain and adjoining BAPTISTERY and NARTHEX to the church proper. The controlling idea is that of *directional space*.

The repetition of equidistant and identical supports between the nave and two or more side-aisles, the flat or open wooden ceiling, the way in which light comes in through the CLERESTORY windows high up in the flat nave wall, all this imparts a feeling of processional movement towards the APSE, which opens in the end wall of the nave, generally in the east. In this eastern part of the church all important liturgical events except for the baptism took place. In front of the apse an area was set apart by low walls or balustrades (*cancelli*) for the choir, and an AMBO was provided as a kind of low pulpit or reading desk. In the apse itself were placed the seats of bishop and clergy and eventually the permanent altar, where communion was celebrated. Here was concentrated the richest decorative treatment, often in mosaic, and under a semi-dome that recalled the heavenly sphere all movement from the nave was collected and stilled. Here—sometimes preceded by a transept—a world seemed to begin which differed fundamentally from that of the nave with its unequivocal expression of load and support and its strict avoidance of the VAULT. The hollowed-out volume of the apse harks back beyond its Roman prototypes to the cave-like niche-sanctuaries and tombs of a remote pagan past and it is precisely as sepulchral monuments that isolated *exedrae* or groupings of them (*cellae trichorae*) occur in Early Christian architecture. Together with memorials that were placed on sites hallowed by a theophany (*martyria*), they introduced a type of space that is organized around one vertical axis in the middle and that, in contradistinction to the directional one, may be called centralized.

It is easily understood why centralized spaces should be used for buildings where attention is focused on one spot or a particular action as in the tomb, the *martyrion*, and the baptistery. Yet the history of church architecture shows that such types of plan as the circle, the polygon, and the Greek cross had a very strong appeal beyond the limits of their original purpose. This was partly due to a symbolic meaning connected with these forms, but partly also a desire to create a church more unified, more conducive to communal experience, and more suitable for preaching than the basilical type.

From similar considerations the third basic type of church space, the large hall and ceiling of equal height with or without intermediary supports between the walls, was favoured at periods when stress was placed on the corporate nature of worship and on good visibility and audibility of the service. In this category are the HALL CHURCHES of late medieval Preaching Orders and many churches of the Reformation and Counter-Reformation. They rejected the traditional basilican type because once a certain size had been reached the directional arrangement made it difficult for worshippers near the entrance to follow events in the sanctuary at the opposite end of the nave and to hear the words of the service. This condition had been aggravated as the medieval church grew into something much more complicated than the Early Christian basilica during a long and complex historical process of adaptation and alternation. As such religious movements as monasticism, the cult of relics, and the pilgrimages increased in importance, the church building had to reflect this in its typological structure. The west end and the eastern termination were elaborated, the interpenetration of transept and nave was stressed in the crossing; chapels, galleries, and crypts were provided and screens articulated the interior still further, while on the outside towers and spires together with richly carved portals lent grandeur to the edifice.

A great deal of the initial process of enrichment and articulation tended to counteract the spatial unity of the directional church, especially when the ROOD SCREEN separated the choir, reserved for the clergy, from the laity. Even so, however, the crossing and the eastern termination acted as nuclei of concentration. Partly under the impact of new liturgical developments such as the increased importance accorded to the Elevation of the Host, the trend towards spatial unification became extremely significant for Gothic cathedrals. Here eventually space and light were permitted to reign supreme, dematerializing the wall until it became diaphanous on the inside and changing the massive buttresses needed on the outside into flying buttresses, components of a three-dimensional geometry that in its apparently effortless complexity veils all concern with matter and weight.

Centralized churches had been built throughout the Middle Ages as baptisteries and palace chapels or in imitation of the Holy Sepulchre, the Dome of the Rock (*Templum Domini*), and the Roman Sta Maria Rotunda, the former PANTHEON. But generally the centralized character of such buildings was not realized fully since the altar could not be placed in the centre but stood against a wall facing the entrance and created a sense of direction. This was as little a real solution from the point of view of the inner

logic of the plan as was the comparable attempt to centralize directional arrangements. The history of architecture records an insistent struggle to overcome both predicaments in ideal solutions that would bring together directional and centralized space in one building. They varied from awkward juxtapositions of oblong and round to genuine integration which created a subtle new totality such as the Sta Sophia.

Post-medieval St. Peter's in its final state hardly qualifies as such a totality, but it may remind us of how acutely the problem was felt of fusing centralized and directional space at a period when centralized solutions were linked to Neo-Platonic doctrines of cosmic harmony in the Renaissance mind. The Jesuit church of Il Gesù in Rome may stand for a more successful solution of the same type where a domed crossing and a wide barrel-vaulted nave balance each other. Many later BAROQUE churches combined directional and centralizing tendencies by having a plan based on the oval or on more complicated interpenetrations of geometrical figures which like the oval are both directional and centralized. The reaction against these extremely exuberant yet refined spaces came with the church architecture of Classicism that marks the end of a period. Nothing new was added to the evolution of church architecture by the historicism of the 19th c. In the 20th c., owing both to liturgical reform and to new constructional possibilities, architects, almost all of whom have been trained and have practised primarily in the secular field, have been compelled to seek radically new solutions to new problems and needs.

**CHURRIGUERA, DE.** The name of a family of Madrid architects and sculptors, active chiefly at Salamanca, who were prominent exponents of a Spanish variant of BAROQUE architectural decoration known after them as CHURRIGUERESQUE. The ablest of the family, JOSÉ DE CHURRIGUERA (1665-1725), made his reputation in 1689 by designing a catafalque for Queen Maria Luisa. His high altar of the church of S. Esteban at Salamanca (1693) fills the whole east end of the church with richly gilded architectural and sculptural ornament, including gigantic Corinthian COLUMNS with twisted shafts decorated with foliage (called SALOMÓNICAS). José was appointed master of the works at Salamanca Cathedral in 1693 but from c. 1696 he worked chiefly in Madrid. There he built a town house for his patron Juan de Goyeneche which was subsequently altered by Diego de Villanueva (1715-74) and is now the Academy of S. Fernando. For the same patron he built the industrial village of Nuevo Baztán (1709-13) near Madrid, a functional design which lacks the characteristic Churrigueresque decoration and is more reminiscent of Juan de HERRERA's MANNERISM.

José's brothers JOAQUÍN (1674-1724) and ALBERTO (1676-c. 1750) were appointed masters of the works at Salamanca Cathedral in 1714 and 1725 respectively. Joaquín built the Calatrava college (begun 1717) at Salamanca. His masterpiece, the cathedral dome, was damaged by the earthquake of 1755 and rebuilt by Juan de Sagarvinaga in 1759. Joaquín and Alberto collaborated on the choir screen (*trascoro*) and choir stalls of Salamanca Cathedral (1724-33). Alberto's own works include the design for the principal square (*Plaza mayor*) of Salamanca (begun 1729), the church of S. Sebastian in the same city (1731), the completion of the west front of Valladolid Cathedral (1730-3), and the parish churches of Orgaz and Rueda (1738-47).

**CHURRIGUERESQUE.** The more extravagant architecture and ornament of the BAROQUE in Spain and Spanish America takes its name from José de CHURRIGUERA, although it was not José but his Andalusian contemporary HURTADO and the generation of architects who succeeded them who created the most advanced works of the style, which is characterized by its abundant and indiscriminate use of all the decorative forms developed by the MANNERIST and BAROQUE architects of the previous two centuries. The word 'Churrigueresque' was originally coined as a term of opprobrium by NEO-CLASSICAL detractors of the late 17th and 18th centuries. This elaborate decorative style covered works belonging to all the three principal phases of Spanish Baroque. The first of these phases (c. 1680-1720) is specially characterized by the employment of the twisted column or SALOMÓNICA. The second (c. 1720-60), in which the architectural framework was progressively submerged by more and more complex ornament, is distinguished by the widespread use of the ESTÍPITE. ROCOCO elements appear both in the second and third phases; but the latter (c. 1760-80), which coincided with the beginnings of Neo-Classicism in Spain, shows a more controlled use of ornament and a partial return to the earlier emphasis upon the structural members of the architectural composition.

Like PLATERESQUE, Churrigueresque was primarily a style of architectural ornament, first manifested during the last quarter of the 17th c. in the elaboration of interior decorative features such as carved wood REREDOSES and stucco work, but soon extended to the stone-carved decoration of exteriors with special emphasis on main doorways, façades, and towers. Like Plateresque, again, the decorative exuberance of the style eventually led to a decisive reaction against architectural ornament. The opening of the Madrid Academy of S. Fernando in 1752 was followed by the foundation of Academies at Valencia (1768) and Mexico City (1782); and in due course the Neo-Classical precepts taught at these institutions penetrated to the smaller towns and finally ousted Churrigueresque in the last quarter of the 18th c.

Among the most original exponents of the Churrigueresque style were Fernando de CASAS Y NOVOA at Santiago de Compostela, Pedro de RIBERA at Madrid, Narciso TOMÉ at Toledo, Joaquín de CHURRIGUERA at Salamanca, Vicente de Acero at Cadiz (cathedral begun 1722), Leonardo de Figueroa (d. 1730) at Seville (San Telmo portal, 1724), Francisco Hurtado at Granada, Jaime Bort at Murcia (cathedral façade begun 1737), and Hipólito Rovira at Valencia (Duas Aguas palace, 1740–4).

In Mexico Churrigueresque has a more specific stylistic meaning, being limited to the phase of Baroque in which the *estípite* was the favourite decorative motif. First used in a reredos in Mexico Cathedral designed by Jerónimo Balbás in 1718, the *estípite* was later applied by Lorenzo Rodríguez (d. 1774) to the exteriors of churches in the capital. Outstanding Churrigueresque buildings elsewhere in Mexico include the great mining churches of Sta Prisca at Tasco (1751–8, architect Diego Durán) and La Valenciana near Guanajuato (completed 1788), the Jesuit Seminary church of S. Martín at Tepotzotlán (*c.* 1755–62), the church of El Carmen at S. Luis Potosí (1749–64), and the late 18th-c. façade of the Sanctuary church of Ocotlán near Tlaxcala, in which white stucco Churrigueresque ornament is set off by hexagonal vermilion glazed tiles.

**CHU TA** or **PA-TA SHAN-JEN** (active *c.* 1630–*c.* 1705). Chinese ink-painter who, like TAO CHI, retired into the Buddhist priesthood out of loyalty to the Ming dynasty on their downfall in 1644. His ink-and-brush style, especially in painting birds, fish, flowers, bamboo, and rocks, shows his emancipation from the formulas of the traditional schools. With a few strong sure brush-strokes and ink washes, an eloquent use of empty spaces and unusual angles of vision, he expresses the essentials of a subject, often with penetrating wit. Chu Ta should be regarded as one of the forerunners of the 17th- to 18th-c. INDIVIDUALISTS such as Cheng Hsieh, Chin Nung, and Kao Feng-Han, and his influence endured almost to the present day in the painting of China and Japan (see CHINESE ART). His violent technique was in keeping with his reputation for eccentricity. He pretended to be a deaf-mute and claimed to paint only under the influence of alcohol. Examples of his work are the hand-scroll *Rocks, Plants and Fishes* (Cleveland Mus. of Art) and the hanging scroll *Mountain Landscape* in the Östasiatiska Museet, Stockholm.

**C.I.A.M.** (Congrès internationaux d'Architecture moderne). An architectural organization formed at Las Sarraz, Switzerland, in 1928 as the parent body of a number of national and regional groups through which architectural ideas are exchanged. Britain was represented on the Congress by the Mars Group, formed in 1931.

At the Athens (the fourth) Congress in 1933 a famous document, known as the *Charte d'Athène*, was produced which outlined the social principles of town-planning and was accepted as part of the dogma to which modern architects generally subscribed. The organization largely lapsed during the Second World War but was re-formed at a sixth Congress held at Bridgwater, Somerset, in 1947. Since 1947 the eastern European groups have not participated.

The Secretary-General of C.I.A.M. was Dr. Sigfried Giedion of Zürich. Successive presidents have been C. van Eesteren, Walter GROPIUS, and José Luis Sert.

**CIBBER,** CAIUS GABRIEL (1630–1700). Sculptor, the son of the cabinet-maker to the King of Denmark, who sent him to study in Italy. He arrived in England before 1668, probably via Amsterdam, and worked for John Stone, son of Nicholas STONE. His first important work was the large relief on the Monument erected in memory of the Great Fire of London, which reveals his knowledge of BAROQUE art. Other works in London included the dramatic figures of *Raving and Melancholy Madness* for the gate of old Bedlam Hospital (now Guildhall Mus.) and a fountain in Soho Square, which originally showed Charles II and the four major rivers of England. He carried out much garden sculpture at Chatsworth and elsewhere, and also the sculptured altar in the chapel at Chatsworth and the PEDIMENT showing *Hercules triumphing over Envy* on the Park Front at Hampton Court. His work is competent though seldom inspired.

845.

**CIBORIUM.** A free-standing structure consisting of a CANOPY supported by COLUMNS erected over an altar, particularly in Italy in the ROMANESQUE and GOTHIC periods. Its design is more strictly architectural than that of the BAROQUE BALDACCHINO, whose canopy bears some resemblance to drapery.

**CICCIO,** L'ABATE. See SOLIMENA.

**CIGOLI,** IL, LUDOVICO CARDI (1559–1613). Italian architect and painter. Brought up in the tradition of Florentine MANNERISM, he marks the transition to the BAROQUE, especially in his FRESCOES for the Chiostro Grande of Sta Maria Novella, Florence (1581–4). He was a student of Alessandro ALLORI and was influenced by ANDREA DEL SARTO (*Madonna and Child*, Budapest, 1582). As an architect he studied BUONTALENTI and the buildings of PALLADIO. Some of his buildings remain in Florence (Courtyard of the Palazzo Nonfinito).

184.

**CIMABUE,** properly CENNI DI PEPPI (*c.* 1240–1302). Italian painter of the FLORENTINE

SCHOOL and a contemporary of Dante, who refers to him in *The Divine Comedy* (*Purg.* xi. 94–6) as an artist who was 'believed to hold the field in painting' only to be eclipsed by GIOTTO's fame. Ironically enough this passage, meant to illustrate the vanity of short-lived earthly glory, has become the basis for Cimabue's fame; for, embroidering on this reference, Dante commentators and later writers on art from GHIBERTI to VASARI made him into the discoverer and teacher of Giotto and regarded him as the first in the long line of great Italian painters. He was said to have worked in the 'Greek' (i.e. Byzantine) manner, but to have begun the movement towards greater REALISM which culminated in the RENAISSANCE.

Documentary evidence is insufficient to confirm or deny this estimate of Cimabue's art. The only work that can be proved to be by his hand is a *St. John* forming part of a larger mosaic in Pisa (1301); but opinions about its value as a document of Cimabue's style differ widely, as it is quite likely that the design for the whole composition existed when Cimabue took over. As is natural, tradition has tended to attribute to Cimabue many works of outstanding quality from the end of the 13th c., such as the *Madonna of Sta Trinità* (Uffizi) and a cycle of frescoes in the Upper Church of S. Francesco in Assisi. If these conjectures are correct, Cimabue was indeed a master of considerable stature; but the more extreme claims sometimes made for him may still be in need of qualification. The Renaissance was due neither to him nor to any other individual master, and the movement towards greater naturalism may owe more to the school of Roman painters and mosaicists (CAVALLINI, TORRITI) than to Cimabue. In this connection a document attesting Cimabue's presence in Rome in 1272 is sometimes thought to be of significance for the contact between the Roman and the Tuscan Schools.

187, 1940.

**CIMA DA CONEGLIANO,** GIOVANNI BATTISTA (1459/60–1517/18). Italian painter of the VENETIAN SCHOOL, whose work was in the line of Giovanni BELLINI and ANTONELLO. Nine of his works are in the National Gallery, London, including three *Madonnas* and an *Incredulity of St. Thomas* (signed and dated 1504).

**CIMBORIO.** The Spanish architectural term for a drum, usually pierced with windows and supporting a DOME. Placed over the crossing of a church it serves the purpose of a LANTERN.

**CIMON OF CLEONAE.** Greek painter who according to PLINY invented foreshortened or 'three-quarter' views and represented human beings looking backwards or upwards or downwards. He showed the attachments of the limbs,

displayed the veins, and introduced wrinkles and folds in the drapery. Pliny dates him in the 8th c. B.C., but since foreshortening first appears in Greek art at the very end of the 6th c. B.C., those who consider Cimon its inventor date him about that time.

**CIONE,** NARDO and JACOPO DI. Florentine painters, collaborators, and followers of their brother ANDREA DI CIONE, called ORCAGNA.

No signed or documented work by Nardo (active *c.* 1343–66) survives but the FRESCOES in the Strozzi chapel of Sta Maria Novella are traditionally ascribed to him. These are vast panoramas of *The Last Judgement* and *Paradise*, and also *Hell* (based on Dante's *Inferno*). The style has close affinities with Orcagna's but sacred figures concede a smile, the modelling is softer, and there is the hint of a GOTHIC sweep in draperies and contours. Probably painted in 1356 by the same master is the New York *Madonna* (Historical Society).

Jacopo, apparently the youngest of the three, remained active until 1398. About the time when he joined the painters' guild (1368/9) he finished Orcagna's *St. Matthew* altarpiece (Uffizi). In 1373 he completed his own *Coronation of the Virgin* (Accademia, Florence). Another altarpiece presenting the same theme (N.G., London) is usually ascribed to him. Jacopo's pictures also retained something of the hieratic character and the solemnity of early BYZANTINE painting.

**CIONI,** ANDREA DI MICHELE DI FRANCESCO. See VERROCCHIO.

**CIPRIANI,** GIOVANNI BATTISTA (1727–85). Decorative painter and designer, a fellow student with BARTOLOZZI at the Accademia del Disegno, Florence. From 1750 he worked in Rome. In 1755 he came to London, where he became a foundation member of the ROYAL ACADEMY and designed its Diploma. He was employed in the decoration of many public buildings and private houses and in some cases designed such architectural details as plasterwork, woodwork, and stone carving. Some of his best work is at Somerset House, in the Old Library of the Royal Society, and at Houghton Hall. He also painted the panels of the Coronation Coach.

**CIRE-PERDUE.** See BRONZE SCULPTURE.

**CIVETTA.** See BLES, H. met de.

**CLAESZ,** PIETER (1596/7–1661). Painter who was born in Burgsteinfurt, Westphalia, but worked most of his life in Haarlem. He and William Claesz HEDA are the most important representatives of the monochrome style of STILL

LIFE painting in the Netherlands. He chose objects of a more homely kind than Heda and arranged them in compositions which are simple but admirably balanced. He was particularly known for his 'breakfast pieces'. Claesz was the father of Nicolaes BERCHEM.

**CLASSIC, CLASSICAL.** We speak of classic or classical art thinking in the first place of the art of the Greeks and Romans. The words were originally applied to literature and the present usage in the visual arts cannot be traced back further than the 17th c. when it was generally assumed, at least in the ACADEMIES, that ANTIQUE art had set the standard for all future achievement. Since then the words have undergone two distinct changes of meaning. First, a 'classic' is the best of its kind in any period. This is what Wölfflin meant when he gave the title *Classic Art* to his book on the Italian High RENAISSANCE. In an analogous sense historians speak, for instance, of the 'classical tradition' in Chinese art or an ethnographer such as William Fagg may write of the Fang sculptures (see AFRICAN TRIBAL ART) that they 'are classical examples of the serene beauty of which African art is capable'. Secondly, when we speak of 'classical' Greek art we refer to the art of the 5th c. B.C. This is so because the idea of organic growth was applied to ancient art and the archaic period was regarded as a seed-time before the 'flowering' of the 5th c. and the 'decay' of the HELLENISTIC period.

The idea that the art of ancient Greece set a standard for future achievement was elevated to dogma by WINCKELMANN and was elaborated by NEO-CLASSICAL critics who followed him. Winckelmann wrote in *Gedanken über die Nachahmung der griechischen Werke in der Malerei und Bildhauerkunst* (1755): 'To take the ancient models is our only way to become great, yes, unsurpassable if we can.' The concept justifying this reverence for the Greek antique was that while representing Nature they so refined away everything transitory and inconsequential as to achieve a kind of formal idealization based on Nature but portraying Nature so enhanced as to be no less worthy of imitation than Nature herself. To quote Winckelmann again: 'To those who know and study the works of the Greeks, their masterpieces reveal not only Nature in its greatest beauty, but something more than that; namely, certain ideal beauties of Nature which, as the old commentator of Plato teaches us, exist only in the intellect.'

The term 'Classicism' is also current in a second and distinct meaning as the antithesis of ROMANTICISM. This antithesis goes back to Friedrich von Schlegel (*Das Athenaeum*, 1798), who regarded Classicism as an attempt to embody infinite ideas and emotions in a finite form. The connotation of 'Classicism' has tended to vary according to the concept of Romanticism to which it was opposed. During the 19th c. the antithesis might be almost anything from 'con-servative' versus 'revolutionary' to 'bound by sterile rules' versus 'originally creative'. In the 20th c. 'Classic' has tended to denote clarity, logicality, adherence to recognized canons of form and conscious craftsmanship, or even the more obvious types of symmetry and proportion, in contrast with personal emotion and a logical inspiration.

The term 'classical beauty' is sometimes used to indicate a Greek facial and bodily type reduced to mathematical symmetry about a median axis and freed from the irregularities which are normally present in living people.

349, 774, 2403, 2623.

**CLAUDE.** CLAUDE GELLÉE, called LE LORRAIN and in England known as CLAUDE LORRAINE (1600–82). French landscape

**91.** Self-Portrait. Frontispiece to *Liber Veritatis*. Pen-and-ink and bistre drawing by Claude Lorraine. (B.M., 1660)

painter, born in Lorraine. When about 12 years of age he entered the household of the Roman painter Agostino TASSI as a pastry-cook, but became Tassi's studio assistant and in 1619 is recorded as working with him on the decoration of a villa. In his early twenties he made a two-year visit to Naples, where he worked for a 'Goffredo', who may have been the Flemish artist Gottfried Wals (active *c.* 1640). Claude was deeply impressed by the beauty of the Gulf of Naples and used the coastline in his paintings to the end of his life. In 1625 he returned to Lorraine, and worked at Nancy with Claude DERUET, whose influence may perhaps be discerned in the precious ornamentation of his architectural detail. In 1627 he was in Rome, where except for local journeys he remained for the rest of his life.

In Tassi's decorative paintings he came into contact with the landscape of the late MAN-

NERISTS, who delighted in freakish or bizarre forms of trees and rocks and in special tricks for the creation of a fantastic organization of pictorial space. The influence of this style, particularly of the northern Mannerists BRIL and ELSHEIMER, comes out in the architectural furniture, ruins, and other PICTURESQUE paraphernalia of his earlier paintings. But his profound sensitivity to the tonal values of light and atmosphere lent an unpremeditated Classical harmony to his pictures which matured with the years. In the late 1630s he painted a pair of landscapes for the French ambassador in Rome —*View of the Camp Vaccino* and *Harbour at Sunrise* (Louvre)—in which he was already attempting the unusual effect of representing the sun itself on his canvas and letting it shine straight out of the picture. These works brought him rapid success. In 1639 he painted two landscapes (*Rural Feast* and *Landscape at Sunset*, Louvre) for Urban VIII, and his work was increasingly sought after. Even by about 1634 BOURDON had thought it worth while to pass off a painting of his own as a work by Claude, and later Claude recorded his pictures in the form of sketches in his *Liber veritatis* to guard against forgeries.

From 1640 to 1660 Claude developed steadily towards the mature style of the poetic landscapes on which his enormous reputation was built. His painting shed the affectations of Mannerism and became an expression of his deep feeling for the beauty of the Roman countryside with its richness of classical associations of antique grandeur. He used this landscape not to create a heroic vision of ancient Rome but to evoke a sense of the pastoral serenity of a Golden Age. The ostensible subjects of his pictures, taken frequently from the Bible, Virgil, Ovid, or medieval epics, are subordinate to the real theme, which was the mood of the landscape presented poetically in terms of light and colour. The depicting of light and its atmospheric effects on the poetic quality of the scene grew subtle and sensitive. In his earlier paintings Claude, like Elsheimer, used light for the sake of dramatic effects; as his own style matured he began to use it for its own sake, letting it play on forms and explore their texture, and opposing to it trees, ruins, or the porticoes of temples so that the light enhanced their outlines. In the landscapes of the last two decades of his life everything was depicted in terms of light: the eye-level was raised and the view kept as open as possible so that the eye can roam at will over a spacious panorama to the distant horizon and beyond it into infinity. Forms melt and lose their material solidity; even the figures become unreal as they are elongated past recognition. Ignoring the accepted conventions of composition, Claude now painted pictures that were boldly unbalanced (e.g. *The Expulsion of Hagar*, Munich, 1668) or contained large areas of gently rippling sea (*Perseus and the Medusa*, Earl of Leicester's Coll., Holkham, 1674), or contrasted broad stretches of open land-scape with an isolated area containing the action (*The Sermon on the Mount*, Eaton Hall, Chester, 1656; *Rest on the Flight into Egypt*, Earl of Leicester's Coll., Holkham).

Claude and POUSSIN represent the two outstanding tendencies in French classical landscape of the 17th c. and both are considered artists of the first order, whose influence has been pervasive and persistent. Claude has nowhere been more admired and more influential than in England. Not only were his works keenly sought after by late 17th- and 18th-c. collectors, but they had great influence on such artists as WILSON and TURNER. His name became virtually synonymous with the ideals of the picturesque, he inspired a revolution in English landscape gardening about the middle of the 18th c. and much descriptive verse paid conventional tribute to the ideal of beautiful natural scenery which derived from him.

1006, 1323, 2320.

**CLAUDE GLASS.** A small black convex glass used for reflecting landscapes in miniature. It abstracts the artist's subject from its surroundings, simplifies it, and subdues the colours so that it is seen in terms of light and shade. It also reduces the intervals between the lights and darks, and by concentration enables the painter to see his subject broadly and to assess the relative tonality of the various parts. It was popular in the 17th and 18th centuries, and not only with artists for the poet Gray carried one with him in his travels round Britain in search of the PICTURESQUE. CLAUDE Lorraine was said to have used such a glass. An Italian artist whom Mrs. Merrifield interviewed (*Practice of the Old Masters*, 1849) told her that he possessed a black glass which had once belonged to DUGHET and POUSSIN, and before them to Bamboccio (Pieter van LAER). A view reflected in this glass, he said, looked 'just like a Flemish landscape'. In the 19th c. it was used by COROT, who regarded tonal unity in painting as supremely important.

**CLAUSEN,** SIR GEORGE (1852–1944). English painter of Danish parentage. He studied at South Kensington and worked for Edwin Long (1829–91). In the late 1870s he visited Holland and Paris, where he came under the influence of Bastien LEPAGE and was converted to the methods of the *plein air* school (*The Girl at the Gate*, Tate Gal., 1889). Later he reverted to the habit of composing in the studio from open-air studies and developed a modified IMPRESSIONIST technique. He painted landscape and bucolic scenes which have been likened to MILLET. Although his work was competent and sometimes had decorative charm, it never outgrew a strong streak of sentimentality and depended overmuch for its appeal on the superficial prettiness of the subject. He was one of the first members of the NEW ENGLISH ART CLUB founded in

1886. He was made A.R.A. in 1895, R.A. and Professor of Painting to the R.A. Schools in 1908. Eight lectures delivered to the students of the Royal Academy in 1905 and 1906 were published under the title *Aims and Ideals in Art*.

**CLAY MODELLING.** See MODELLING.

**CLERCK,** HENDRIK DE (1570-1629). Flemish painter born in Brussels, where he spent the greater part of his working life. He was the pupil of Maerten de Vos and carried the traditions of decorative MANNERISM far into the 17th c. In 1606 he was appointed Court Painter to Archduke Albert. A characteristic example of his style is the *Family of the Virgin* (Brussels, 1590), with its Italianate figures clad in restless draperies and placed in a coldly CLASSICAL building.

**CLERESTORY.** Term in Christian church architecture. The upper part of the nave wall, containing a range of windows.

**CLERK,** SIMON. See WASTELL, John.

**CLICHÉS-VERRE.** See GLASS PRINTS.

**CLODION.** The name given to CLAUDE MICHEL (1738-1814). French sculptor related to L.-S. ADAM, from whom he received most of his instruction, and son-in-law of PAJOU. He carried the ROCOCO taste for bibelot sculpture to an extreme and found scope for his special qualities of wit and verve in small statuettes, TERRACOTTAS, and bas-reliefs. His *Montesquieu* commissioned by the King is now in the Institut, Paris. After the Revolution he worked in the NEO-CLASSIC style in line with the new taste and was employed on the *Colonne de la Grande Armée* (1806-10) and the *Arc de triomphe du Carrousel* (1806-9).

**CLOUET.** A family of painters descended from JEAN CLOUET (or JAN CLOET) the elder (b. *c*. 1420), a Fleming who came to France *c*. 1460 and was painter to the Duke of Burgundy in 1475. The life and works of this artist are almost completely conjectural, although he has been insecurely identified with the MASTER OF MOULINS. The more famous JEAN CLOUET (*c*. 1485-1541), often called JANET, is thought to have been his son, but there are no documented works and much mystery surrounds his work and career. He may have been at one time a member of the circle of PERRÉAL and the poet Lemaire de Belges, by whom he is mentioned. He was evidently a portrait painter of some repute and considerable technical skill. The portraits of the *Dauphin François* (Antwerp), and of a *Man holding Petrarch's Works* (Windsor),

are usually attributed to him and show him to have belonged to the school of Flemish naturalism that was flourishing in France at this time. A collection of drawings traditionally attributed to him reveal a talent of naturalistic observation. They have been compared with HOLBEIN, though they have not Holbein's gift for descriptive outline but are modelled in terms of plastic form. His son, FRANÇOIS (before 1510-72), carried on the tradition of portraiture but worked in the international MANNERIST style which derived from PONTORMO and SALVIATI. In addition, several GENRE scenes, incorporating nude female figures of the type of the FONTAINEBLEAU School, can be attributed to him. Among the signed portraits by him are those of the apothecary Pierre Zuthe (Louvre, 1562), Charles IX (Vienna, 1570), and *Lady in her Bath* (N.G., Washington, *c*. 1570), thought to represent Marie Touchet, the mistress of Charles IX. A number of drawings mostly in the Musée Condé at Chantilly are also attributed to him.

1866.

**CLOVIO,** GIULIO (1498-1578). Painter and illuminator. He was born in Croatia but spent most of his life after 1516 in Italy. After the sack of Rome (1527) he escaped from captivity and became a monk. He was a good craftsman and enjoyed a very high reputation. In his illuminations he made frequent use of motifs from the work of MICHELANGELO and RAPHAEL. Amongst them are the *Towneley Lectionary* (Public Library, New York) and St. Paul's *Epistle to the Romans* (Sir John Soane's Mus.). He also did some work in oils (*Pietà*, Uffizi, 1553).

380.

**CLUNCH.** A generic name for harder grades of chalk stone, or soft LIMESTONE above beds of chalk, more particularly those occurring in the chalk marl of Cambridgeshire. It varies in colour from white to greenish-grey, is easy to work, and takes a good surface. It has occasionally been used as a building stone but is more suitable for interior carved work and sculpture, for which purposes it was much favoured by the late medieval sculptors of the west of England.

**CLUNY.** The reformed Benedictine Order of the Cluniacs contributed notably to the development of ROMANESQUE architecture and sculpture in western Europe (see FRENCH ART; PILGRIMAGE CHURCHES). Their monastery church at Cluny in Burgundy was a model for much ecclesiastical building which was carried out under their auspices. The first church, built by Berno and his monks (Cluny I), was probably consecrated in 916 or 917 and survived as the Abbey Sacristy. It had a single APSE. The second (Cluny II) was built by Abbot Mayeul and consecrated in 981; it had aisles, a transept with two apsidioles, a large apse with apsidioles on either side, and a choir with a square AMBULATORY and oblong

**92.** Ground plan and exterior elevation of third abbey church of Cluny. Engraving entitled *Conspectus ecclesiae Cluniacensis*, dating from the time the abbey was destroyed

chapels on either side of the choir entered from the transept and from the chancel. It may be regarded as the prototype of the Benedictine plan. The type spread across Burgundy and Normandy and in the late 11th c. influenced the German Hirsau School. The third church (Cluny III) was begun in 1088 under St. Hugh of Semur, and took from 20 to 25 years to build. It had five

radiating chapels round the apse with a rounded ambulatory, two transepts (the second wider) each containing two apsidioles in either arm, and a double-aisled nave of 11 bays. When a NARTHEX was added in 1220 Cluny became the longest church in Christendom, about 616 ft. at ground level. It is remarkable as the earliest great church (Monte Cassino perhaps excepted) in which all the arches are pointed. The nave was covered by a cross vault on cross arches rising to a height of over 98 ft. above the floor; the inner aisles had barrel VAULTS nearly 60 ft. high, the outer aisles 39 ft. high. The double TRIFORIUM had three round-headed ARCADES in each bay. The central apse contained a wall-painting of Christ in Majesty. The church was in great part destroyed between 1798 and 1811; one arm of one transept survives, together with the magnificent sculptured CAPITALS of the ambulatory, which are shown in the Tour du Farinier of the Abbey. Cluny III takes an important place in the history of architecture, alike for the elaboration of its plan, the beauty of its proportions and its sculpture, and its influence in the Order of Cluny and beyond. The Cluniac priory church of Paray le Monial and the cathedral of Autun may be cited as buildings profoundly influenced by it.

839.

**COADE STONE.** An artificial stone made in Lambeth from *c.* 1769 to *c.* 1820 and used for figure sculpture, monuments, architectural dressings, and decorative work. It is not known who

**93.** Nave of the abbey church of Cluny (*c.* 1100). Engraving (early 18th c.)

invented it or what the recipe was, but Mrs. Eleanor Coade, who came to London from Lyme Regis to open a factory in Lambeth, claimed that it resisted frost and therefore retained sharpness of outline better than natural stone. Time has proved her right. The business was an immediate success and Mrs. Coade took her cousin, John Sealy, into partnership in 1769. Many good sculptors, particularly John BACON the elder, worked for the firm. Monuments made of Coade stone exist in many English churches, e.g. those to Capability BROWN and his children at Fenstanton, and some garden sculpture remains, e.g. the figure of *Neptune* in front of Ham House.

**COCHIN,** CHARLES-NICOLAS (fils) (1715–90). Designer and engraver of a huge number of VIGNETTES, frontispieces, and fleurons, among them many illustrations of the *fêtes* of Louis XV, which gave scope for his skill in presenting vast crowds in motion. Most important were four plates celebrating the Dauphin's marriage (1745). He illustrated La Fontaine's *Contes et Nouvelles* (1743) and *Fables choisies* (1755–9) and the *Gerusalemme liberata* (1785–6) among other works. Upon his return from Italy (1751) he was appointed keeper of the king's drawings; he became an Academician and henceforth worked chiefly for the Court. For 40 years he exercised considerable influence upon art, even DIDEROT consulting him before reviewing the *Salons*. In Cochin's work are seen the beginnings of the CLASSICISM that was to overwhelm French art at the Revolution.

**COCK,** PIETER. See COECKE, P.

**COCKERELL,** CHARLES ROBERT (1788–1863). The last great English CLASSICAL architect. He was a son of the architect S. P. Cockerell (1754–1827) and a pupil of Robert SMIRKE. He spent the years 1810–17 travelling Asia Minor, Sicily, and Greece, where he made a name as an archaeologist and was instrumental in the discovery of the Phigaleian marbles (now in the B.M.). He became a Surveyor to St. Paul's and Professor of Architecture at the Royal Academy, to which post he lent great prestige owing to his knowledge of Greek antiquities. His principal works are the Taylorian–Ashmolean building at Oxford (1845) and branches of the Bank of England at Manchester, Bristol, and Liverpool. He finished St. George's Hall, Liverpool, after the death of H. L. ELMES and the Fitzwilliam Museum, Cambridge, after the death of BASEVI. He married a daughter of the engineer John Rennie.

**CODDE,** PIETER (1599–1678). Dutch GENRE and portrait painter of the fashionable world and barrack-room life, who worked in Amsterdam.

Greys and deep velvety blacks are his dominant colours. He was called upon to finish the group portrait of the Amsterdam *Civic Guards* which Frans HALS began in 1633 and refused to finish, and he succeeded so well in capturing Hals's spirit and the touch of his brush that experts still disagree where the work of the one ends and the other begins.

**COECKE** (also COCK or COEKE VAN AELST), PIETER (1502–50). Flemish painter, architect, sculptor, designer of tapestries and stained glass, and writer. A pupil of Bernaert van ORLEY, he entered the Antwerp Guild in 1527. He visited Rome and in 1533 was in Constantinople in connection with tapestry making. A series of drawings made on his journey was later published in WOODCUTS by his widow (reprinted by Sir William Stirling Maxwell in *The Turks in 1533*, 1873). In 1549 he joined with other Antwerp artists in making the pageant decorations for the entry of Charles V and the future Philip II. Coecke's translations of VITRUVIUS and SERLIO helped to bring to the Netherlands a greater understanding of the architectural ideals of the Italian RENAISSANCE. He had a large workshop and *The Last Supper* (Brussels, 1531) is a good example of his style as a painter. Pieter BRUEGEL the Elder was his son-in-law, and according to van MANDER his pupil.

926.

**COELLO,** CLAUDIO (1642–93). Spanish painter. A pupil of Francisco RIZI, he was able to study the works of TITIAN, RUBENS, and van DYCK in the Royal Collection at Madrid. In 1686 he succeeded CARREÑO as court painter, and worked in Madrid and at the ESCORIAL. His *Charles II Adoring the Host* (Escorial, 1685–8) combines a religious subject with portraiture. This great canvas is an example of BAROQUE ILLUSIONISM, repeating inversely the architecture of the sacristy in which it hangs. Of Coello's many FRESCOES scarcely anything has survived.

991.

**COLA DA CAPRAROLA.** Italian architect who built Sta Maria della Consolazione at Todi, *c.* 1508, a famous example of the centrally planned type of church. But nothing else is known about him, and it has been suggested that the design was BRAMANTE's, because it is close to some of the early projects for St. Peter's, Rome, of about the same date.

**COLBERT,** JEAN-BAPTISTE (1619–83). French statesman who, after the death of Cardinal Mazarin in 1661, became the confidential adviser of Louis XIV and his chief instrument in organizing the machine of state

control through which, among other things, he exercised a dictatorship over the arts and imposed a unified standard of taste. It was the object of Colbert and the King to present to the world a visible image of the magnificence and power of the French crown and in carrying out this purpose the grandiose reconstruction of VERSAILLES and its splendidly flamboyant decoration became a symbol of central importance. As surintendant des Bâtiments and contrôleur général des finances Colbert's influence was paramount. His right-hand man in exercising control was Charles LEBRUN and with his help the GRAND MANNER established at Versailles was imposed as a standard of taste throughout France. In the practical sphere the Gobelins tapestry factory was reorganized as the *Manufacture royale des meubles de la Couronne* with Lebrun as director in 1663, employing the cream of craftsmen in the royal service. In addition to direct patronage an official body of artistic dogma and official standards of taste were enforced by the re-establishment in 1663 of the Royal Academy of Painting and Sculpture with Lebrun as President and Colbert as Vice-Protector in 1661 and Protector in 1672. In 1666 a French Academy was founded in Rome under Charles ERRARD to provide approved training for young artists from France. Colbert was himself a man of taste and a collector of some importance and it was largely owing to his able support for the King's ambitions that France replaced Italy as the artistic capital of Europe.

**COLDSTREAM,** SIR WILLIAM MENZIES (1908-    ). English painter. He studied at the Slade School 1926-9, when he exhibited with the NEW ENGLISH ART CLUB and the LONDON GROUP, becoming a member of the London Group in 1934. From 1934 to 1937 he worked on documentary films with the G.P.O. Film Unit under John Grierson. In 1937, together with Victor PASMORE, he founded the Euston Road School of Drawing and Painting (see EUSTON ROAD GROUP) and in 1943 he was appointed an Official War Artist. In 1949 he became Professor of Fine Art at University College, London.

Coldstream has stood somewhat aloof from the aesthetic and stylistic concerns which moved his contemporaries and his own work has developed in close contact with nature towards monumental NATURALISM. In an article 'How I Paint' contributed to *The Listener*, 15 Sept. 1937, he wrote: 'I find I lose interest unless I let myself be ruled by what I see.'

**COLE,** THOMAS (1801-48). American painter, founder of the Hudson River School and one of the main sources of the native American tradition of landscape painting. His family migrated to America from England in 1819. He there became passionately devoted to the natural scenery and chose the career of painter in conse-

quence. He achieved a reputation through three paintings made after a sketching trip to the Hudson in 1825. After a trip to Europe in 1829 he turned increasingly to historical and allegorical subjects until 1842. He visited Europe again in 1841 and after his return moved even further from the depiction of natural scenery towards spiritual and religious themes.

1947.

**COLLAGE** (French: 'pasting'). A pictorial technique begun by the CUBIST painters and used by Max ERNST and other SURREALISTS from *c.* 1920. Photographs, news cuttings, and all kinds of objects are arranged and pasted on the painting GROUND, and often combined with painted passages. The cuttings and objects are sometimes selected for their associative or representational values, sometimes interest is primarily in the formal and textual qualities of the result. See also MONTAGE.

**COLLECTING.** The making of art collections involves an ability to value works of art for their aesthetic qualities or qualities of craftsmanship in isolation from the social or religious contexts for which they were made, an attitude akin to that which in the 18th c. encouraged the emergence of the concept of FINE ART. It is a phenomenon characteristic of an age of CONNOISSEURSHIP which does not always coincide with an age of great creative activity in the arts. In antiquity (see CONNOISSEURSHIP IN ANTIQUITY) private collecting on a significant scale began in HELLENISTIC times—for example the collection of pictures made by King Attalus II of Pergamum (d. 138 B.C.). The practice spread to Rome after the conquest of Syracuse in 212 B.C. The ransacking of the East for masterpieces of GREEK ART became a matter of prestige with wealthy Romans and—as often happens at times when collecting is fashionable—a roaring trade in copies and fakes grew up. Among the more prominent known collectors were such figures as Atticus, Appius Claudius, Lucullus, Varro, Pompey, Julius Caesar, and the Verres made notorious by the oratory of Cicero. PLINY complained of the inaccessibility of works of art hidden away in private collections and Agrippa (in a lost speech) advocated that they should be placed on public view. Among the emperors Nero and Hadrian were outstanding collectors.

In China, where the concept of fine art existed much earlier than in Europe, vast accumulations of art objects found their way into the royal collections and a high proportion of them perished with the successive overthrow of dynasties. One of the earliest royal collections to be preserved as a MUSEUM is the Imperial Treasure House at Nara, Japan, which contains objects dedicated to the Buddha by the Imperial Household from the 8th c. A.D. In Africa royal collections such as those of IFE and BENIN seem to have consisted

largely of works made for the court by specially employed artists rather than collections gathered from art objects existing elsewhere.

In medieval Europe collecting was taken over by the Church. The monasteries became the depositories of treasures which included not only paintings and sculptures but rare manuscripts, sacred relics, IVORIES, bronzes, precious stones, and natural curiosities. At the abbey of SAINT-DENIS Abbot SUGER accumulated 'pearls and precious stones, rare vases, STAINED GLASS, enamels and textiles' for the greater glory of the church. Collections of precious objects were also made by the courts, such as the Dukes of Burgundy. But medieval collections do not evidence a concern for fine art as distinct from rare or precious objects in general. The dawn of humanism marks a greater interest in objects from classical antiquity, anticipating to some extent the enthusiasm for antiquity which was so prominent a feature of the Italian RENAISSANCE. Such forerunners were the collections of Frederick of Hohenstauffen (1220–50), Cola di Rienzo, and Petrarch. North of the Alps collecting continued to follow more or less the medieval pattern and one of the most famous of such collections is that of the emperor Rudolf II (1552–1612) at Prague, which was later incorporated in the Vienna Kunsthistorisches Museum.

Many of the 15th-c. Italian humanists assembled collections whose pivot of interest was the ANTIQUE (e.g. POGGIO, Niccolò Niccoli) and many artists (e.g. MANTEGNA) followed in their train. The collections of the great humanist princes—the MEDICI, the ESTE, the GONZAGA, Federigo di MONTEFELTRE, and many of the popes—comprised antiques, manuscripts, and paintings and sculptures commissioned from contemporary artists. These represent the true predecessors of the modern collections. Although there was an interest in the antique for its own sake, it was already a characteristic of the times to assume that any art object from classical antiquity was necessarily a model of a perfection which had been lost through the medieval and Byzantine centuries. As the social standing of the artist rose and individual artists acquired a prestige second only to that accorded to the ancients, collectors became ever more enthusiastic to acquire examples of their work. DRAWINGS, which had for long been neglected by artists and public alike, began to be appreciated and collected in late 16th-c. Florence.

This continued through the 17th and into the 18th c. Not only pictures but whole collections were bought and sold. In 1628, for instance, Charles I bought most of the paintings and antiquities that had been accumulated by the Dukes of Mantua; and when these in turn were dispersed under the Commonwealth, Mazarin, Philip IV of Spain, the Archduke Leopold Wilhelm, Governor of the Netherlands, and many others bought masterpieces by the dozen. Queen Christina of Sweden, one of the most avid collectors of the century, acquired many of her finest pictures through the looting of the Imperial collections at Prague. Small collecting spread to the middle classes, especially in the Netherlands when royal and ecclesiastical PATRONAGE ceased, and a market was created for such novel types of painting as GENRE, STILL LIFES, group portraits, and CONVERSATION PIECES. The first treatises on collecting were written by Mancini in Rome in the first two decades of the 17th c. Dealers came into their own. Guide books and catalogues to the more important collections poured from the presses. PRINTS and ENGRAVINGS from paintings in collections circulated widely and were even collected for their own sake. By the early 18th c. the 'AMATEUR' collector was sufficiently established to have become a recognized butt of the satirist for his misuse of critical jargon.

In the 18th c. also the great private collections began to be made accessible to the general public. In 1743 Anna Maria Ludovica, the last of the Medici family, decreed that the great collections of her ancestors should pass permanently to the people of Tuscany on condition that 'none of these collections shall ever be removed from Florence, and they shall be for the benefit of all nations'. At about the same time the empress Marie Thérèse laid the royal collections at Vienna open to the public. As a concession to public clamour in France selections of the royal collections were placed on view twice a week in the Palace of Luxembourg (1750) and in 1793 the Revolution brought all the royal collections into state ownership. In England Wilkes protested that King George III had removed RAPHAEL's cartoons from Hampton Court to Buckingham Palace (1777). The actual or threatened dispersal of great collections such as WALPOLE's at Houghton or the Sacchetti in Rome was felt to injure the public as a whole. The public museum was on the way. In fact throughout the 18th c. most great collections had been readily accessible to the interested public, and in England some of the most spectacular country houses had even been open on specific days of the week.

By the end of the 16th c. men were already looking back nostalgically to the Golden Age that was past and the great artists of the High Renaissance were valued above contemporaries. Yet most of the leading collectors continued to be patrons of contemporary art—notably Francis I of France, Charles V and Philip II of Spain, Rudolf II, Charles I of England. A fine collection was still an essential adjunct of prestige and pictures were exchanged and given as part of normal diplomatic procedure.

One might have expected that the social function of the private collection would decline with the spread of public galleries and museums throughout the world. In fact, however, the function of private collectors was never more important than in the 19th c. As official taste became more stereotyped and the academies more hidebound, almost all the creative movements in the arts took place outside public

patronage and in spite of it. Although the exclusion of the IMPRESSIONISTS and the POST-IMPRESSIONISTS from official exhibitions has often been exaggerated in retrospect, there is no doubt that they—and their successors—depended almost exclusively on private collectors (with or without the mediation of dealers) and that they found their way into the public collections only after their position had been established by the art market created by private collecting. Nor was the role of the private collector restricted to contemporary art. It was the main support for the enormous interest taken in exotic and hitherto unknown art products of the world, and without private collecting the removal of the barriers which has been the most characteristic feature of the modern age and the throwing open of the artistic heritage of mankind in what André Malraux has called a 'museum without walls' could not have taken place. Japanese colour prints, African sculpture, Pre-Columbian American art, the arts of Oceania, Indonesia, Indo-China—almost everything which has added to the aesthetic vision of the 20th c.—owed their emergence in the first place either to the private art collector or to the ethnologist. From the same source came the stimulus for new interest in the more distant or obscure periods of European art. Private collectors owned 15th-c. Italian paintings long before the National Galleries were interested in them. Collectors such as Sir Hugh Lane and the Misses Davies owned superb examples of French 19th-c. painting which the official collections were reluctant to accept. And still the finest collections of Italian 17th-c. paintings in England belong to private enthusiasts who 'rediscovered' them. Thus, while the spending of public money for the public collections must always be justified by an existing reputation, the initiative and the stimulus has remained with the private enthusiast. During the thirties and after the public galleries have seemed to set the seal of their acquiescence on this anomaly as the practice has grown up for them to give temporary exhibitions of private collections, taking upon themselves the function of rendering accessible to the wider public those art objects which the private collectors have assembled.

1353, 2627.

## COLLINS, WILLIAM (1788-1847). English

painter. He was early influenced by MORLAND, trained at the R.A. Schools, and became R.A. in 1820. He painted sentimental idylls (*Disposal of a Favourite Lamb* won success at the Academy Exhibition of 1813), followed by seascapes and coast scenes, in which he showed a special gift for rendering the luminous quality of sky and shore. After a continental journey starting in 1836 he briefly attempted religious painting, but soon returned to his earlier subjects. Most of his work is competently repetitive, but occasionally he produced a fresh and arresting landscape (*The*

*Young Anglers*, R.A., London, 1820). He was a lifelong friend of WILKIE, after whom he named his elder son, who wrote his memoirs, *Memoirs of the Life of William Collins*, in 1848. His second son was CHARLES ALLSTON COLLINS (1828-73), painter of *Convent Thoughts* (Ashmolean Mus., Oxford, 1851).

591.

**COLOGNE SCHOOL.** The term 'School' is misleading in this case since it suggests a definite local style or a manner handed on through generations from master to pupil. Yet from the late 14th c. to the early 16th c. many different painters, some of them coming from far afield, worked in Cologne, a wealthy and important commercial centre. Early in the 19th c., when romantically inclined collectors began to look for old German pictures, it so happened that many of their panels came from the Cologne region, and the town with its unfinished GOTHIC cathedral became a symbol for the spirit of the Middle Ages.

The alleged founder of the 'School', Master Wilhelm, is a legendary figure and no pictures can be attributed to him with certainty. During the first quarter of the 15th c. painting in Cologne had all the characteristics of the lyrical 'Soft Style', that is of INTERNATIONAL GOTHIC. *The Virgin with the Peaseblossom* (Nuremberg) or *The Vernicle* (Munich) are typical examples of what is popularly thought to be the Cologne manner. This style may have been perpetuated by guild rules and guild supervision; in any case it was still employed by LOCHNER in the middle of the 15th c. (panel with *Four Saints*, N.G., London; *Adoration of the Magi*, Cologne Cathedral). A little later Netherlandish REALISM was taken up by artists in Cologne. The great Flemish centres are not far away, and one of Rogier van der WEYDEN's principal works (the so-called *Columba-Altar*, now in Munich) was in a Cologne church at the time. Of many anonymous masters the MASTER OF THE LIFE OF THE VIRGIN (panels in the N.G., London, and Munich) is perhaps the most attractive. The Master of the *St. Bartholomew Altarpiece* (panels in the N.G., London, and Munich) and Barthel Bruyn (1492/3-1555) show how this unreflective realism survived well into the 16th c.

**COLOMBE, MICHEL** (1430/5-*c.* 1515). French sculptor who had a great name in his day but about whose work nothing is known until the early years of the 16th c. He was commissioned by Anne of Brittany in collaboration with PERRÉAL to make the tomb of her father, Francis II, in the cathedral of Nantes (1502-7) and he made the relief carving for an altarpiece of St. George at Gaillon. He worked in a distinctively French GOTHIC style but he adapted it to the Italianate taste which was coming into vogue in the southern parts of France towards the

end of the 15th c. yet without copying particular Italian models.

2144, 2761.

**COLONIA, DE.** A family of architects and designers of sculptural decoration who successively held the post of master of works at Burgos Cathedral from about 1440 to 1540. The first of them, JUAN (d. 1481), came from Cologne (as the name indicates) c. 1440, and built the spires of the west towers of the cathedral (1442-58). SIMÓN (d. c. 1511), son of Juan, succeeded his father in 1481. His chief works were the chapel of the Constable at Burgos Cathedral (1482-98) and the façade of S. Pablo, Valladolid (between 1490 and 1504). These are among the most spectacular examples of the early PLATERESQUE or Isabelline style. The façade of S. Pablo is an early instance of a church front designed in the manner of a sculptured REREDOS, a type which was to become popular in Spain and Spanish America. Simón's son FRANCISCO (d. c. 1542) collaborated with his father on the sculpture for S. Pablo, Valladolid, and was responsible for the elaborate late Gothic RETABLE of San Nicolás, Burgos (c. 1503-5), in which some traces of RENAISSANCE influence appear. He succeeded his father as master of the works at Burgos Cathedral in 1511.

**COLONIAL ARCHITECTURE IN NORTH AMERICA.** This term covers a period of almost two centuries and reflects the varied national characteristics of the several colonies. In the south-west the luxuriant Spanish BAROQUE was simplified by provincial Spanish-American and Indian craftsmen into a primitive but colourful style. At the same time the streets of New Amsterdam were lined with the neat stepped-gabled brick façades of Holland, while along the Hudson River the Dutch built long narrow farmhouses with sweeping roofs and clapboard gables. There were other national variants, but the real groundwork for the later development of American architecture is to be found in the English colonies. Their architecture can be divided into two major periods, Early Colonial (1609-c. 1700) and Late Colonial (c. 1700-80). In addition broad regional distinctions can be made between New England and the South.

During the Early Colonial period the architecture of both areas was basically Tudor. Nevertheless several important differences are apparent. The economic and social unit of the South was the plantation with its mansion and sprawling dependencies; in New England it was the small and closely knit community. As a result the domestic architecture of the South tended to emulate the smaller town and country houses of England. Bacon's Castle, Surry County, Virginia (c. 1655), is a brick structure in the Tudor GOTHIC style with Flemish gables, grouped chimneys, and a cross-plan. By con-

trast domestic buildings in New England were identical in many respects with the small rural houses of south-eastern England. Irregular in plan and outline, constructed almost entirely of wood, they were generally built in stages over a period of time. The Whipple House, Ipswich, Massachusetts (c. 1639), is one of the finest and best preserved—a typical 'salt-box' house with its steep-pitched roof, over-hanging second storey, and its lean-to addition at the rear.

In Virginia, where adherence to the Anglican Church was made mandatory by the colonial charter, the churches followed closely the small English parish churches of the late medieval period. The Newport Parish Church, Isle of Wight County, Virginia (1632), is a simple brick structure with wall buttresses, stepped gable, pointed-arch windows, and Gothic tracery. In New England the Puritan prejudice against material display led to a rejection of Gothic forms. In place of the parish church the New Englanders developed the meeting house. This, the most original building type of the period, was a simple barn-like structure, serving both civic and religious functions. The Old Ship Meeting House, Hingham, Massachusetts (1681), is the only surviving example from the 17th c. Almost square rather than rectangular, it rejects the traditional plan of the parish church by having the pulpit and entrance facing each other on the long sides.

In 1699 the capital of the Virginia colony was moved from Jamestown to Williamsburg. The new town, one of the earliest planned communities in America, was laid out on a simple grid with two main thoroughfares forming the major and minor axes. By 1725 it contained a considerable number of splendid new buildings, including the College of William and Mary (1695-1702), the Capitol (1701-5), the Governor's Palace (1706-20), and Bruton Parish Church (1710-15; spire 1769). All exhibit the classical equipoise and decorative richness of the English Baroque of Christopher WREN. There is reason to believe that at least one, the College, was built to a design sent over by Wren himself although it was drastically modified in construction. The Bruton Parish Church is obviously inspired by the Wren churches of London.

The magnificent mansions of the Virginia tidewater drew their inspiration from Williamsburg. Perhaps the finest is Westover in Charles City County (c. 1730-4), built by William Byrd II. Once the centre of a plantation comprising more than 200 square miles, it is a supreme expression of the slave-economy and aristocratic society of the South during the 18th c. Westover is both simple and refined. It is a symmetrical brick structure two storeys high with a level modillioned cornice and a high hipped roof. At the centre of each long façade is a richly ornamented door of PORTLAND STONE imported from England and comparable to many found on late 17th-c. houses in the mother country. The interior is panelled from floor to ceiling.

The last quarter of the 17th c. saw a marked change in the economic and social character of New England. A new aristocracy of sea captains and merchants dominated the coastal cities. Ambitious and wealthy, these men showed less restraint than their Puritan forebears and sought a more elegant mode of architectural expression. Thus, like the Virginia planter, they turned to the architecture of the Restoration, emulating the town houses of England so far as local conditions permitted. The McPhedris-Warner House, Portsmouth, New Hampshire (1718-23), with its double parapeted chimneys, is typical. Made of brick, it has a high double-pitched roof crowned by a balustrade and emphasizes the vertical more than the Virginia mansions do. This is even more true of the three-storey Usher-Royall House, Medford, Massachusetts (1733-7). In this case, however, both façades are wood with one of them made to simulate RUSTICATED masonry. This imitative use of materials was common to many 18th-c. colonial houses, especially in New England.

After 1740 colonial architecture became increasingly formal. The loose planning current during the early part of the century gave way to a stricter symmetry and ornamental features were treated with greater classical emphasis. In the work of Peter HARRISON some aspects of English

PALLADIANISM were brought to the American shores. At the same time in the South Palladian tendencies can be seen in a few of the later colonial mansions such as Shirley, Charles City County, Va. (1769), and the Miles Brewton House, Charleston, S.C. (1765-9). These works, however, were exceptional and in general the strict Palladian ideals of Lord BURLINGTON found little favour in the colonies. The vast majority of the buildings remained more or less in the style of the Restoration. The Wentworth-Gardner House, Portsmouth, N.H. (1760), is late colonialized Wren at its best.

The tenacity of the Wren style can be explained by several facts. By mid century the lines of architectural descent from England had become partially blurred and many colonials were beginning to consider the style as part of their own building tradition. This point of view, however provincial, formed the basis of a nascent desire for architectural independence. When combined with the natural conservatism of the affluent colonial, it presented a considerable barrier to change. More important, however, was the influence of the architectural publications of James GIBBS. As an architect Gibbs had remained apart from the Palladianism of his day and many aspects of his work adhered to the older ideals of Wren. This attitude was reflected

**94.** Pen-and-ink study for the Palazzo di Iseppo da Porto, Vicenza, by Andrea Palladio. Elevations of façade and enclosed courtyard, the latter with Colossal Order (R.I.B.A. Coll.)

in his books as well as his buildings. Widely circulated in the colonies, Gibbs's books became the principal source for craftsman and amateur architect alike. For example at Mount Airy, Richmond County, Va. (1758–62), the architect John Ariss took both the rusticated façade and the formal plan from Gibbs's *Book of Architecture* (1728), while in New England Joseph Brown used the same source for the steeple of the First Baptist Meeting House, Providence, R.I. (1775). It is buildings of this character that might appropriately be called 'colonial Georgian'.

**COLORIMETRY.** See COLOUR.

**COLOSSAL ORDER** or GIANT ORDER. COLUMNS or PILASTERS that run up through more than one storey in a façade. The device for making one ARCH span two sections of an elevation (e.g. the abbeys of Tewkesbury and Romsey) may go back ultimately to Roman architecture (there is a Roman building at Trier where this arrangement can still be seen). But although giant columns were used in antiquity on ornamental structures such as TRIUMPHAL ARCHES, it was MICHELANGELO who first applied them to a building divided into floors, namely the Capitol at Rome. This led to a grander unit of design than was attempted in pure RENAISSANCE work, foreshadowing BAROQUE magniloquence. (See Ill. 94.)

**COLOSSEUM** (see ROMAN ART). The largest example of ancient AMPHITHEATRES, it was begun by the emperor Vespasian on the site of the Golden House of Nero in Rome and completed about the end of the 1st c. A.D. by Titus and Domitian. The elliptical plan measured *c.* 617 by 512 ft. and the total height was *c.* 157 ft. Designed to hold *c.* 45,000 spectators, it is the supreme example of Roman skill in strong and economical architectural engineering, demonstrating the principle of unit repetition on a vast and orderly scale with due regard to circulation and sight lines. The outer wall rested on 80 PIERS connected by stone barrel VAULTS and the exterior presented three superimposed rows of open ARCHES framed in applied classical ORDERS contrasting with an attic storey decorated with Corinthian PILASTERS and pierced with windows. The masonry was mainly of TRAVERTINE and the vaulting, except in the outer arches, of CONCRETE. The barrel vaulting of the higher corridors contains one of the earliest examples of the use of brick ribs. This exterior scheme became a model for much RENAISSANCE architecture but suffered through later clearance and excavation.

**COLOSSUS OF RHODES.** This bronze statue of the Sun-god, constructed by Chares of Lindos and later regarded as one of the Seven Wonders, stood over 100 ft. high beside (not astride) the harbour at Rhodes. Erected in the

**Fig. 17.** Elevation of the Colosseum, Rome (A.D. 70–82)

early 3rd c. B.C., it was overthrown by an earthquake about 224 B.C. Philo of Byzantium, author of a work on mechanics in the 2nd c. B.C., gives a puzzling account of its erection.

**COLOUR.** The study of colour falls within the fields of physics, physiology, and psychology. *Physics* studies the radiant energy of the light which stimulates vision and in general the objective physical characteristics of the stimulus situation. A special branch is the study of the *chemical* aspects of such substances as pigments and dyes in relation to their colour-producing properties. *Physiology* studies the electrochemical activity in the nerves and in general the processes which take place in the eye and brain when a stimulus situation results in an experience of colour. *Psychology* studies the awareness of colour as an element of visual experience. Different concepts of colour are used in these fields and the difficulties of the subject have often been complicated by failure to keep them distinct. All three approaches have a bearing on the problems of colour in relation to art.

PSYCHOLOGICAL APPROACH. For psychology colour is a part of what is perceived and the concept at its widest may be defined as that aspect of visual experience which remains when you abstract the spatial and temporal aspects.

1. Colours have three modes of appearance in experience:

(a) *Film* colours are colours such as are seen in a spectroscope or a patch of blue or uniformly grey sky. They appear at a certain, though somewhat indefinite, distance from the observer as if providing a back wall to the intervening space. They have a spongy quality without precise texture and there is a sense that one can penetrate more or less deeply into them. They always appear in a plane frontal to the eye. Film colours are not seen as qualities of objects or the surfaces of objects.

(b) *Volume* colours may be seen in a transparent medium such as a glass of wine or an illuminated cloud of smoke. They are transparent, i.e. objects can be seen through them, and they permeate the three-dimensional space which they occupy, i.e. they are voluminous. They cannot change their plane in relation to the eye.

(c) *Surface* colours appear to lie on the surface of objects, to be localized at a definite distance from the observer and in a plane which may be at any angle to the direction of vision. They take on the surface texture of the object and provide a resistant barrier beyond which the eye cannot penetrate. They are ordinarily seen as qualities of the object in which they inhere. Sometimes surface colours may appear on things such as non-transparent clouds or smoke which we do not usually think of as objects.

Certain other qualities of colour appearance are derivatives of the above modes.

(d) *Lustre* is a variation of brightness which exceeds the brightness of the surface colour of an object and seems to be superimposed upon the surface, breaking up and destroying the surface texture. There are various characteristic kinds of lustre, such as the lustre of silk, the lustre of glazed pottery, the lustre of metal, etc.

(e) *Metallic* colours seem to lie *behind* the perceived surface of the object and as with film colours the eye seems to penetrate to some extent into the colour. In metallic objects there is a marked difference of brightness between the lustrous and the non-lustrous parts.

(f) *Luminosity* and (g) *Glow*. A coloured object is said to be luminous when it exceeds in brightness the surrounding visual field and appears to emit light. Luminous colours have affinities in appearance with film colours or voluminous colours (e.g. a flame). An object is said to *glow* when it is seen as luminous throughout its mass.

Artists work predominantly with surface colours. Part of the craft of the painter consists in producing the appearance of film colours and volume colours, of lustre or glow or luminosity, by means of pigments which do not in fact have these qualities. The representation of other modes of colour appearance by means of surface colours is a contributory factor in enabling the observer to enjoy the aesthetic experience of being simultaneously aware of a picture as a flat pigmented canvas and seeing objects depicted in picture space with different colour and textural qualities. Volume colours are sometimes used by modern abstract sculptors who work in transparent plastic and similar materials.

2. All colours have three independently variable aspects or dimensions. These are hue, saturation, and brightness.

(a) *Hue* is the dimension of colour which is referred to a scale ranging through red, yellow, green, blue, corresponding to the sensations experienced from stimulation by light of various wavelengths and ranging over the visible section of the spectrum. There are said to be approximately 150 discernible differences of hue, not distributed evenly over the range of visible wavelengths since we have greater powers of hue discrimination in the longer wavelengths. The longest wavelengths are in the red area, decreasing through yellow, green, blue, to violet.

There are four psychological *primary* hues, each of which has no resemblance to the others. They are blue, green, yellow, and red. (These psychological primaries are not to be confused with the *three* primary colours recognized in the physical study of colour.) In general they correspond to the hues which remain constant with change of intensity and saturation.

(b) *Saturation* is the term used to describe the *purity* of a colour in the sense of the amount of apparent colour in contrast with an achromatic area of equal brightness.

(c) *Brightness* is the dimension of colour referred to a scale running from dim to bright (sometimes termed the black-grey-white scale or the dark-light scale). The term '*lightness*' is sometimes used in a sense similar to 'brightness' when opaque objects are compared on a scale ranging from black to white or when transparent objects are compared on a scale ranging from black to clear. (The former is more appropriate to body pigments, the latter to dye colours.) Sometimes 'brightness' is applied to differences resulting from changes in the intensity of the illumination and 'lightness' to differences among colours in uniform illumination. Painters, however, usually refer to this dimension as 'tone'.

Hue, saturation, and brightness constitute a unique system of co-ordinates in terms of which all variations of colour experience can be described. These dimensions of colour are sometimes represented schematically by a three-dimensional figure, the hues being ranged in a circle, degree of saturation being represented by the distance of any colour from the centre of the circle and brightness by its position on a vertical scale at right angles to the plane of the circle.

Many other 'terms' are used, particularly in the literature of art criticism, to describe the qualities of colour experience and the lack of precision or generally agreed application has been a major cause of obscurity.

(d) *Brilliance* can legitimately be used to describe a quality of colour which combines saturation and brightness.

(*e*) *Chroma* or *chromatic quality* has often been used to name the aspect of colour which includes hue and saturation but abstracts from brightness.

(*f*) *Tone* has been used indifferently to refer to variations in the dimensions of hue and brightness. Such expressions as 'warm' or 'cool' tonality refer to hue. But 'tone values' or 'tone relations' often refer to differences of brightness and when artists are said to be interested in tonality the words are usually intended in this sense. This was the meaning when COROT said that drawing comes first, then tone, and finally colour. The purpose of the CLAUDE GLASS, which Corot used, was to help artists distinguish brightness contrast in the object depicted to the exclusion of other aspects of visual experience. Emphasis on CHIAROSCURO, as in the paintings of CARAVAGGIO, REMBRANDT, VELAZQUEZ, was largely a matter of concentration on or exaggeration of brightness differences.

(*g*) *Shade* has been used with a similar ambiguity and even less precision. It sometimes refers to hue, sometimes to differences on the brightness scale, and sometimes appears to include also saturation. In the Ostwald Colour System, following traditional practice of oil painting, 'shade' was defined as a degree of black in excess of the maximum saturation and brightness (i.e. brilliance) achievable with any pigment.

(*h*) *Tint* has usually been applied to a light hue at a low degree of saturation, particularly where the degree of pigmentation is low in relation to white.

(*i*) *Intensity* is reserved by scientists for the strength of illumination, but in the literature of the arts it is applied to colour with a variety of imprecise meanings. Sometimes it may be indistinguishable from saturation. More usually, however, it refers to the insistence or prominence which a patch of colour acquires in a particular context owing to enhancement by simultaneous contrast with neighbouring colours. In this sense it is possible to speak of 'intense black'. So too TITIAN is supposed to have maintained that the test of a good colourist is whether he can make Venetian red appear to have the intensity and brilliance of vermilion. The concepts of intensity and brilliance have often been linked, and the technique of painting thin GLAZES over light GROUNDS is commonly said to produce greater intensity, luminosity, and brilliance than painting opaquely. Artists who have been interested in the depiction of form by means primarily of colour have concerned themselves with colour intensity. Thus CÉZANNE asserted a close link between intensity of colour and plenitude of form, although it is not quite clear in what sense he used the words.

Hues have a natural and circular order. Thus orange lies *between* red and yellow, purples *between* red and blue, etc., and the primaries are ordered from red through yellow, green, and blue back to red. *Complementary* colours are those which are the greatest distance apart when the hues are arranged in their natural order around the circumference of a circle. Such complementary colours produce the greatest reciprocal enhancement by simultaneous contrast when juxtaposed; also when negative afterimages are produced, these will be of the colour complementary to that which produces them. (A different concept of complementary colours is used in physics.) Colour circles have sometimes been used by artists in connection with scaled palettes (see PALETTE). They have the disadvantage, however, that two systems of constructing a colour circle cannot be combined. If the complementary primaries are set at opposite sides of the circle, the intervening sections cannot be divided into an equal number of discriminable hues. If the discriminable hues are set at equal distances round the circumference, the complementaries do not fall opposite each other. Moreover the pigment colours available to the artist do not enable him to do more than approximate roughly to an ideal arrangement of hues at equal brightness and saturation.

3. Psychology has also been concerned to study certain derivative qualities of colour, such as temperature, weight and size, and affective responses to colour. Since Theodor Fechner (1834–87) the preferred method has been experimental and the study commonly goes by the name of Experimental AESTHETICS.

(*a*) *Warm and cool colours.* It has long been a commonplace of studio tradition and the literature of the visual arts that colours may be divided as to 'warm' and 'cool', the warmest lying in the orange sector of the colour circle and the coolest in the blue-green sector. Experiment has borne out this belief and has confirmed that the 'warm-cool' aspect of colour is linked with hue rather than brightness or saturation.

(*b*) *Advancing and receding colours.* There is an equally authentic artists' tradition that warm colours tend to advance and cool colours to recede when situated in the same plane at equal distances from the eye. In order to account for this effect of colour on apparent distance, theories have been advanced suggesting that different colours focus at different distances from the eye. Experiment during the 1940s, however, suggests that this impression may be due rather to brightness or luminance than to hue. The successful use of this phenomenon in LANDSCAPE PAINTING from the 17th c. onwards, when a picture was organized in three zones of colour (brown in the foreground, yellow to green in the middle distance, and blue in the far distance), was closely linked with AERIAL PERSPECTIVE and may therefore have been an effect of representation rather than a distancing quality of hue as such.

(*c*) *Weight.* Experiment has revealed a general measure of agreement as to the apparent heaviness of dark colours and weightlessness of light colours.

(*d*) *Size.* There has been some experimental support for the impression that lighter objects tend to look larger than darker objects of the same size. But the belief that certain hues seem

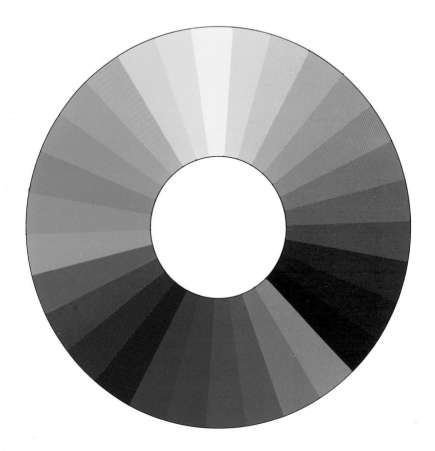

1. Colour circle

2. Recession of cooler (darker) colours

3,4. Simultaneous contrast of hue. (The enclosed hollow square changes apparent hue under influence of background)

5,6. Simultaneous contrast of brightness. (The enclosed hollow square appears brighter against the darker background)

7. Simultaneous contrast of brightness is reduced when the enclosed figure is unified into a single form

8. Effect of outline on vivacity of colour and contrast

2

3

4

5

6

7

8

to expand and others to contract within their boundaries apart from luminance has not obtained experimental confirmation. It has, however, often been affirmed by artists. KANDINSKY, for example, alleged that a yellow circle reveals 'a spreading movement outwards from the centre which almost markedly approaches the spectator', while a blue circle 'develops a concentric movement (like a snail hiding in its shell) and moves away from the spectator'.

The term 'affective response' is used for the feeling and emotional qualities of experience generally. The main purpose of the scientific study of affective response to colour has been to learn how to utilize colour so as to have a predictable effect on people. During the first half of the 20th c. experimental psychology of colour has been devoted to investigating colour preferences; results have been expressed in terms of statistical averages for single colours under laboratory conditions. Even so they have been inconclusive. In 1941 H. J. Eysenck stated that little agreement had been reached on the fundamental points, the existence of a general order of preference for colours, the relative popularity of saturated colours and differences between the sexes as regards colour preferences. In a Report of the Inter-Society Color Council published in 1941 (quoted by the writer of an article in the Summer 1965 number of *The Journal of Aesthetics and Art Criticism*) it was stated: 'There is as yet no extensive scientific knowledge about how colours affect people, but some start has been made in the experimental determination of the basic facts of colour aesthetics.'

In our natural everyday attitude to life we regard colours as properties of the objects in the surrounding world, useful as clues to help us recognize the things we see and the materials of which they are made. People do not ordinarily make colours the object of special consideration or easily dwell on or recall the colours they have just seen. To attend to colour on its own account is a highly sophisticated attitude, very recent even in the field of the arts. Throughout the greater part of the history of painting colour was regarded as no more than a decorative adjunct to the essential delineation of shape. KANT was expressing the common opinion of his day when he wrote: 'In painting, sculpture, and in fact in all the formative arts, in architecture and horticulture, so far as fine arts, the *design* is what is essential. . . . The colours which give brilliancy to the sketch are part of the charm. They may no doubt, in their own way, enliven the object for sensation, but make it really worth looking at and beautiful they cannot.' (*Critique of Judgement*, 14.) The contemporary interest in the subtleties and minutiae of colours, whether in the fine arts or in fashion fabrics or interior decoration and so on, reveals a shift of attitude in the whole outlook on colour. Modern painting, in particular, often treats colour as the very substance and structure of form rather than a superogatory embellishment to it. Affective reactions in laboratory conditions to isolated single colours divorced from practical significance are necessarily artificial and their bearing, if any, on the artistic problems of colour is problematical.

PHYSICAL APPROACH. From the point of view of physics colour is a function jointly of illumination and an object which serves as a stimulus to produce a colour-experience in some percipient. The amount of radiant energy or intensity of light determines the brightness of a seen surface. The different wavelengths of light falling upon the eye constitute the physical basis of hue discrimination. Ordinary daylight comprises all the wavelengths of the visible spectrum and is seen as white. Objects reflect, transmit, or absorb the light which falls upon them. Most objects reflect or transmit to the eye a greater proportion of light of some wavelengths than others and appear coloured in relation to the wavelengths which they reflect or transmit. Objects which transmit or reflect all wavelengths equally appear in normal illumination achromatic, that is neutral black, white, or grey.

In 1672 Sir Isaac Newton communicated to the Royal Society his experimental discovery that a beam of white light passed through a refracting prism may be dispersed into its component chromatic rays and that these may be recombined into white light. (Rays of light are of course not themselves coloured any more than sounds exist in the source of sound apart from an organ of hearing and a conscious percipient. The concept of colour in physics represents the coefficient of the reflectance index of an object and certain aspects of a light source: when light is said to be coloured or chromatic, the implication is that in certain conditions such light would cause such and such a colour experience in a normal observer.) It is now known that any colour in the visible spectrum and also white light can be matched by mixing different amounts of light from the red, green, and blue sectors of the spectrum. These are therefore called *primary* colours (a different concept from the four psychological primaries). An indefinite number of sets of primaries may be chosen (always from the same general regions of the spectrum): in any set of primaries no one of them can be matched by combining the other two. Some but not all spectral colours can be matched by combining two other colours. Two colours from widely separated parts of the spectrum (e.g. yellow and blue) may be combined to produce white light. Such colours are called *complementaries*, a concept not wholly identical with psychological complementaries. (It is worth mentioning that from the point of view of physics there are no 'steps' in the wavelength spectrum but a continuum of evenly varying wavelengths. The different 'colours' (red, blue, green, etc.) which we experience are due to factors in our optical receptors.)

(a) *Colour mixture*. When chromatic lights are

combined the resultant colour is that which corresponds with the combined wavelengths of the lights which are mixed. This is called *additive mixture*. When colouring substances, such as dyes or pigments, are mixed the reverse process occurs. For the colour of a pigment corresponds with the wavelengths of the light which it reflects upon the eye and this in turn may be equated roughly with those wavelengths from the complete visible range which it does not absorb. When two substances are combined each still absorbs its appropriate wavelengths and the light reflected (and consequently the colour seen) is reduced to those wavelengths which neither of the substances absorbs when not mixed. This is called *subtractive mixture*. The amount of light reflected by two substances mixed is less than each reflects separately since their absorption range is combined. Artists therefore tend to avoid unnecessary mixture of pigments since this causes a lowering of brightness and a 'muddy' effect. The POINTILLISTS tried to get the best of both worlds by obtaining an additive mixture with the use of pigments. The pigments are placed on the canvas without mixture in small dots which when seen from the appropriate distance away are no longer visible as separate dots. The chromatic lights reflected from the several dots are combined by the eye additively in the manner of admixture of light. The technique gives a high key but a reduced range of brightness.

Many artists, including Pointillists and MOSAICISTS, have applied their pigments in small patches in such a way that from the ideal viewing distance an ambiguous effect is produced, the colour patches simultaneously combining to give a third colour by additive mixture but also being seen as separate patches. There is an oscillation which causes an impression of scintillation over the area. The term *vibration* is used to describe this effect and painters have often sought after it as being more 'lively' or 'vibrant' than unambiguous colours.

In the (subtractive) mixture of pigments *primary* colours are said to be those three colours other than black, white, and grey no two of which can be mixed to produce the third but which together can produce all possible hues. There is no unique set of primaries but different sets differ in the saturations and brightnesses of the colours resulting from their admixture. This is of importance to the artist since he is concerned with saturation and brightness as well as hue. Indeed some hues give rise to psychologically different colours with special colour names at different levels of saturation and brightness (e.g. yellow-brown). The three pigment colours which are usually thought to produce the greatest workable range of subtractive mixtures are those which are known in colour photography as magenta, yellow, and cyan. Much, however, depends upon the chemical constitution of the actual pigments used.

Because pigments are not pure colours, in pigment mixture, unlike additive mixture of chromatic lights, many different pigments can usually be combined with any one other pigment to produce a neutral grey. There is therefore no one complementary to any hue in pigment colours as in spectral colours. The concept of complementaries is useful in regard to pigment colours chiefly in its psychological sense of colours which give each other's negative after-image or which when juxtaposed give the maximum enhancement by simultaneous contrast.

(b) *Texture*. Many objects which transmit or reflect light are composed of small particles differing in their refractive index. The light entering the object and striking upon these particles suffers directional changes and is said to be *diffused*. Light which is diffused within an object may be transmitted or reflected. When most of the light reflected by an object is diffused light, the object has a characteristic appearance called a *mat* surface. An object which transmits principally diffused light is called *translucent*. When an object reflects light with little diffusion it is said to have a *glossy* or optically smooth surface. Objects which transmit light with little diffusion are said to be *transparent*. Most objects in everyday life are intermediate, having both diffusing and non-diffusing components. The pigments and dyes which artists use have their own characteristic diffusion structure. By devices of technique artists represent by their means objects in the surrounding world which have different and even contrasting diffusion qualities. One of the sources of aesthetic enjoyment in the contemplation of works of pictorial art consists in the simultaneous awareness of the actual diffusion qualities of the pigmented canvas and of the apparent diffusion qualities of the objects represented in the created picture space.

PSYCHOPHYSICAL APPROACH. The physiological study of the organs of vision, the optical pathways, brain processes, and colour vision theories will not be dealt with in this article. Certain psychophysical considerations, however, combinations of the physical study of the stimulus situation and psychological study of the subjective response in visual experience, are essential to an understanding of colour in the context of the arts.

(a) *Simultaneous contrast*. The position of a colour area in relation to other colour areas in the visual field can cause changes of colour analogous to those which would be produced by changes in the character of the light coming from the area to the eye. As a general rule the visual mechanism accentuates differences in juxtaposed areas. The effect applies to hue, saturation, and brightness, either concurrently or separately. A great deal of illustrative work has been done on it by colour scientists and psychologists, particularly of the GESTALT school, and it will be dealt with briefly here.

(i) Juxtaposed areas of high and low brightness appear respectively brighter and darker than they would in separation.

(*ii*) Apparent saturation varies according to juxtaposed or background areas.

(*iii*) Juxtaposed areas of adjacent hues appear to be more different in hue than if seen separately.

(*iv*) Juxtaposed objects of complementary hues appear more saturated than they would if seen in separation.

A high degree of brightness contrast reduces contrast of hue. For this reason artists who have been principally interested in hue (commonly referred to as 'colour') usually avoid dramatic effects of chiaroscuro and paint for the most part at a medium level of brightness where the range of hue is greatest. Artists interested in saturation effects usually paint in a fairly narrow range of hues.

(*b*) *Spatial factors.* The foregoing principles of contrast are modified by certain spatial factors.

(*i*) A large area appears brighter and more saturated than a small area of the same hue. But a small bright area in a large dark field appears brighter than an area of identical brightness against an uncontrasted background.

(*ii*) When the contrasted areas interlock in complicated linear patterns the phenomenon of *assimilation* reverses the foregoing effects of simultaneous contrast. These two factors might account for the fact that most artists agree that the dynamics of shape cannot be separated from what might be called the integral dynamic of colour.

(*iii*) Brightness and saturation are enhanced by sharpness of outline or generally by what is called 'good Gestalt', a definite and recognizable shape.

(*iv*) An area which is seen as a single conformation may appear uniform despite being seen against contrasting backgrounds in different parts of its extent.

Artists have in the past been intuitively familiar with the above principles of colour combination and interaction in their practical application and by this knowledge they have been able to achieve a surprising variety and subtlety of effects with relatively few pigments and with a minimum of pigment admixture.

Such effects and many others depend on a fundamental peculiarity of colour vision in which it differs basically from the perception of sound. When several musical notes are sounded simultaneously a new emergent sound (the chord) is heard which is identical with none of them; a trained ear can as it were analyse the vibration and hear simultaneously the constituent notes and the chord sound. But when chromatic lights or colouring substances are mixed the eye sees only one colour and does not analyse out the components.

(*c*) *Constancy.* Colour constancy is a phenomenon akin to constancy effects in regard to shape and size (see PERSPECTIVE). Briefly, surface colours of objects, particularly familiar objects, tend to be seen not in exact accordance with the light which is reflected by them upon the eye but nearer to the colour which they would have in normal daylight illumination. Thus in ordinary everyday vision most colour perceptions are relatively independent of changes in illumination and viewing conditions. Colour constancy is a complex and variable phenomenon, not perfectly understood, and seems to combine a tendency to see things the colours they are remembered to be and a tendency to compensate for changes of illumination and viewing conditions. Colour constancy is favoured by the 'object attitude' of perception when colours are noticed incidentally to the perception of objects rather than by the aesthetic attitude when they are attended to for themselves. For this reason colour constancy is usually stronger when viewing natural objects in real scenes than when seeing them depicted in pictures, and painters have difficulty in duplicating the colour impressions of ordinary vision for this reason.

In the language of painting the term *local colour* is used for the 'natural' colours of objects towards which colour constancy vision tends to approximate. Local colour is not a precise concept but it may be practically defined as the colour which an object is seen to have against white in clear diffused daylight. For example a neutrally grey road surface illuminated by sunlight falling through green foliage may be violet; but its local colour remains grey. Some artists have been content to paint in colours approximating to local colours, giving the objects in their pictures as nearly as possible the colours which they are seen to have in ordinary everyday vision. Others, and notably the IMPRESSIONISTS, have striven to discount colour constancy and to see and depict each area of the visual field in exact accordance with the constitution of the light actually reflected from it upon the eye. This is a way of looking at the environment which requires considerable effort to counteract ingrained habits of practical 'object-recognition' seeing, and the much-debated phrase 'innocent eye' has a legitimate application to it. It is, of course, a highly sophisticated way of seeing and comes naturally to artists who are principally interested in illumination, atmosphere, and in colours as such rather than the objects to which they adhere. It leads to a manner of painting in which the shapes of objects in the visual field are apt to be broken up and to disappear into unfamiliar areas of colour.

Most objects in the daily scene are illuminated not only by the main source of light but wholly or in part also by light reflected upon them from neighbouring objects. In the literature of painting the modifications of local colour caused by such reflections are called *reflected* or *accidental* colours. The PRIMITIVES paid little attention to them and INGRES, under the influence of early Italian painting, said: 'Le reflet est indigne du peintre d'histoire.' The importance of reflected colours in European painting increased with the growth of naturalism and was closely studied by such masters as RUBENS, Rembrandt, and Velazquez. DELACROIX wrote: 'Dans la nature tout

est reflet.' But when combined with rejection of local colours, as with the Impressionists, attention to reflected colours has a contra-naturalistic effect. RUSKIN was quoted by SIGNAC as saying: 'We must consider nature purely as a mosaic of different colours which we ought to imitate quite simply one alongside the other.' This injunction was curiously exemplified in some of the semi-abstract paintings of BISSIÈRE.

The operation of colour constancy is particularly intractable in the dimension of brightness. A painter can, theoretically, match all the hues of nature and has a pretty wide range of saturation. But his range of brightness is many times less than that of nature. A black in sunlight may be much brighter than a white in shadow, yet the former continues to look black and the latter white. The painter cannot reproduce this, literally. He must scale down all brightness contrasts to fit the resources available to him, transferring the relationships into a reduced key. Moreover the closer proximity of the colours in a painting, the smaller areas, the greater uniformity of texture, and the attitude of the ordinary observer who when looking at a picture tends to pay more attention to colour as such than he does in the ordinary 'object vision' of practical life, all operate to enhance the effects of interaction and simultaneous contrast. At every point he must compromise, adjust, distort, and use effects which are not identical with those in the scene he is depicting in order to convey an impression of that scene. It is only the non-naturalistic painter who can afford to 'match' area by area. The painter, whether naturalistic or not, goes beyond naturalistic matching and seeks a certain harmony of colour within a limited range. This is partly why a fine painting which is reproduced however accurately in a small book illustration looks garish and untrue. Size plays an important part both as regards the picture in relation to the scene depicted and as regards the reproduction in relation to the picture.

(d) *Colour harmony.* There has been a number of attempts to evolve scientific principles of harmony in the combination of colours, abstracting from their representative functions. The earliest of these, which was the basis of most that followed, was that of Michel-Eugène Chevreul, whose interest stemmed from his work as chief of the dyeing department at the Royal Gobelins tapestry workshop, Paris. In *De la loi du contraste simultané des couleurs et de l'assortiment des objets colorés* (1839), translated into English as *The Principles of Harmony and Contrast of Colours* (1872), he distinguished two kinds of colour harmony, harmonies of analogous colours and harmonies of contrasts. He was followed by the critic and art historian Charles Blanc, who in *Grammaire des arts du dessin* (1867), translated as *The Grammar of Painting and Engraving* (1879), and in an essay on Delacroix (1864) enunciated 'mathematical' and 'infallible' means of obtaining harmony which, however, required delicate sensibilities and experience on the part of the artist. In *Modern Chromatics* (1879) the American Ogden N. Rood, an amateur painter, tried to discover harmonious principles of colour combination by arranging them in pairs and triads. David Sutter in *Les Phénomènes de la vision* (1880) affirmed the belief that 'the laws of aesthetic harmony of colours are learned as one learns the rules of musical harmony'. SEURAT, though probably most indebted to Delacroix, studied these scientific theories of colour harmony and in his pictures *Une Baignade* (N.G., London) and *La Grande Jatte* (Met. Mus., New York) applied the principles of harmony by analogy and contrast enunciated by Chevreul and Rood. In his later years, following the 'scientific aesthetics' of Charles Henry, he evolved a theory of colour harmony based on the supposed emotional significance of colours. A modern attempt to find a system of measuring the aesthetic quality of colour combinations is contained in G. D. Birkhoff's *Aesthetic Measure* (1933), but it has not stood up to criticism.

No precise concept of colour harmony has been worked out in these studies. Colour harmonies are reducible to combinations which are found empirically to be pleasant and as the findings have not been adequately supported by controlled experiment they remain suspect. Scientific theories of colour harmony fall short of the intuitive grasp of principles which most competent artists display.

(e) *Colour measurement* and *naming.* Different colour vocabularies have become current in the diverse fields of art, science, and industry, and workers in one field are often unable to understand the nomenclature used in another. The American Inter-Society Color Council of the National Bureau of Standards has compiled a dictionary of colour names co-ordinating 7,500 colour names current in 14 recognized systems of nomenclature.

Systems of colour naming cannot be universalized or compared unless the names can be referred to standard samples. Colour measurement or colorimetry is a technique of measuring colour stimuli (e.g. standard samples) and relating them to the calculated response of a standard observer. It is a psychophysical technique leading to a system of colour specification necessary to systematic naming.

Colour measurement presupposes a method of organizing colour samples for systematic standards. Three methods are in use. (i) By the mixture of a limited number of dyes or pigments in varying proportions to produce the whole gamut of colour. (ii) By combining systematically a few standard colours or dyes as in three-colour photography to produce the whole range of colour. (iii) By grouping samples according to minimum discriminable intervals of hue, saturation, and brilliance. That most frequently used is the Munsell Colour System, which is related to a set of 1,200 samples contained in the Munsell Book of Colour.

There is also available a number of colour

atlases or charts compiled by a combination of the foregoing methods. A handy pocket colour atlas is contained in *Methuen Handbook of Colour* (1967) by A. Kornerup and J. H. Wanscher (first published in Copenhagen as *Farver i Farver*, 1961).

293, 447, 541, 843, 960, 1354, 1408, 1471, 1520, 2296.

**COLOUR MIXTURE.** See COLOUR.

**COLOUR PRINTS AND COLOURED PRINTS.** 'Colour print' is a comprehensive term and does not imply any particular engraving process, for all the GRAPHIC techniques can be adapted for printing in colour. The usual method, equally applicable to WOODCUTS, LITHOGRAPHS, ETCHINGS, and photographic process engravings, is to prepare a number of blocks or plates, ink them with different colours, and print them successively on a single sheet of paper. 'Colour prints' are to be distinguished from 'coloured prints', which are black and white prints tinted by hand. Between these two categories stand those prints in which the colour is applied by STENCIL.

The practice of colouring prints by hand is about as old as print-making itself. In Europe many of the earliest woodcuts were tinted in this way, and there is little doubt that in the earlier part of the 15th c. one of the principal aims of the woodcutters was to provide a cheap coloured picture, the woodcut itself being a mass-produced outline which, like the children's painting books of the present day, could be filled in with flat areas of WATER-COLOUR. From this it was but a short step to the application of the colour by stencil. By the end of the 15th c. printing in colour from several blocks was already an established practice. The intention behind all these devices seems to have been less realistic than decorative; the same interest in richness of effect may be seen in several curiosities of graphic art that appeared about this time—paste prints, FLOCK PRINTS, tinsel prints, and so forth. A further development was the CHIAROSCURO WOODCUT of the 16th c., which employed the technique of printing from several blocks in order to render light and shade.

The development of colour printing did not mean, however, that the practice of hand colouring died out. Devotional woodcuts of the type current in the rural Catholic areas of Europe continued to have colour added by hand for another two or three centuries, as did many other prints of a 'popular art' type. In the 19th c., though methods of colour printing were fast multiplying, topographical AQUATINTS and lithographic illustrations of many kinds were frequently hand-tinted. In particular the celebrated American firm of CURRIER AND IVES, publishers on a large scale of popular lithographs during the last three-quarters of the century,

relied on a system of hand colouring. Among modern artists, moreover, the practice is by no means unknown (PICASSO's first etching, for example, the *Left-Handed Man* of 1899, is known to us only in the form of a single hand-tinted impression) and colours applied by stencil are often combined in a pleasing manner with the rugged lines of woodcuts and LINOCUTS.

Colour printing from several woodcut blocks was invented, as has been said, in the late 15th c., and is carried out as follows. A separate block is cut for each of the basic colours in the design. In a simple two-colour red and blue print, for example, the red shapes occur on one block and the blue shapes on the other. The blocks are then inked, one with red ink and one with blue, and are in turn printed on to a sheet of paper. Where the two colours coincide, purple will result. The principal mechanical problem in this operation is to make the two colours 'register', or coincide. It is usual, after engraving one block, to offset its impression on to the second, so that the latter may be engraved in correct registration. In prints whose design incorporates a dark outline defining the coloured forms, this outline is engraved first and forms a 'key block'. It is off-set on to the other blocks and thus enables the various colours to be placed correctly, though in printing it will generally be impressed last. The celebrated Japanese woodcuts of the UKIYO-Ē school are good examples of colour printing employing a key block in black outline. Many modern artists, however, prefer to do without a key block, which presupposed a somewhat rigid principle of design. They favour instead a free interplay of colour shapes, adjusting these by means of a succession of trial proofs in which they experiment with different shades of ink, with a different order of printing the various blocks, or with further cutting on the blocks themselves. In this way colour printing becomes a truly creative art, in which the designs develop, as it were, out of themselves, instead of reproducing more or less faithfully coloured drawings made beforehand.

This system of colour printing has been described in terms of the woodcut, but it is equally applicable to lithography or copper-plate printing, stones or plates being substituted for wood blocks. It is not the technique, however, that governs the choice of colour, but the artist's intentions. If he aims at naturalistic effects, he can achieve them by overprinting with the three primaries—red, yellow, and blue—a principle which is shown in its ultimate development in modern colour process REPRODUCTION. But if considerations of design or decoration transcend the need for naturalism or exact reproduction, his colours can be arbitrary, chosen simply in accordance with his aesthetic intentions.

The multiple block or plate method of colour printing is not, however, the only one available. The obvious alternative is to ink parts of a single plate with different colours, a process that is on the whole less practical but has quite frequently

been employed, particularly in intaglio printing from copper plates. Colour printing *à la poupée* —that is, by painting a single plate before each printing with 'dollies' or rag stumps steeped in inks of different colours—was used in the reproductive copperplate prints of the 18th c. and is employed today by artists of the ABSTRACT school of intaglio print-making. It can also be applied to woodcuts: for instance André DERAIN used it in his illustrations to Rabelais's *Pantagruel* (1946), cutting each picture on a single block, and applying the colours by hand to the different parts of each block before printing.

Colour printing was largely confined to woodcutting until the 18th c., when a number of developments occurred in the field of intaglio printing, both by the single-plate and the multiple-plate methods. Many engravings in STIPPLE ENGRAVING and CRAYON MANNER were printed in colour *à la poupée*, as were a number of English MEZZOTINTS, while Newton's theory that the whole range of natural colour may be built up from the three primaries was applied by Jacob-Christophe Le Blon (1667-1741) soon after 1710, to the multiple-plate method. Le Blon used three mezzotint plates in order to reproduce in full colour portraits and subjects after the Old Masters. His work clearly foreshadows modern three-colour process reproduction, even to the extent of using on occasion a fourth plate inked with black in order to obtain greater depth and richness. Later in the 18th c. François Janinet (1752-1813) and Philibert-Louis Debucourt (1755-1832) made colour aquatints with considerable success, often using as many as seven or eight plates for each print. By the end of the century colour printing from copper plates was common, and of a high technical standard.

A further interesting development was the combination of copper plates and wood-blocks for obtaining chiaroscuro or colour effects. The most famous name in this connection, though by no means the earliest, is that of George Baxter, who in 1835 obtained a patent for printing in oil colours from one engraved copper plate and a number of engraved wood-blocks. Baxter prints, which are reproductive in character and made with astonishing technical skill, sometimes needed as many as 20 wood-blocks to produce the desired range of colours; but, like all prints produced by means of oil inks and a large number of blocks, they have a somewhat unpleasant surface quality.

Lithography, invented at the beginning of the 19th c., was soon used for printing in colour from a number of stones. The Victorian chromolithograph, gaudy and overloaded with glossy pigment, will be familiar to all who have seen Christmas cards of the period or the coloured supplements to the illustrated weeklies. Lithography, however, made possible a development of much greater importance, namely the revival of the artist's original colour print in the 1890s. TOULOUSE-LAUTREC, Odilon REDON, BONNARD, VUILLARD, and Steinlen, abandoning the choked and glutinous effects of the commercial 'chromos', developed an art of bold shapes in subtle and transparent colours that at once established the colour print as a means of expression for the creative artist. They were inspired by the Japanese *ukiyo-e* woodcuts, which taught European artists what could be done with simple composition in flat colour without chiaroscuro— a combination of qualities which many believe to be essential to a good colour print. Nor was this influence confined to the lithographers, for the Japanese spirit strongly animates the work of Mary CASSATT, the American IMPRESSIONIST painter and friend of DEGAS, who employed a combination of DRYPOINT and aquatint in her colour prints of young girls and mothers with children. Meanwhile, the possibilities of the ancient medium of colour woodcut were being realized by the Norwegian painter Edvard MUNCH, whose neurotic yet unforgettable prints powerfully influenced the graphic art of the German EXPRESSIONISTS of the early 20th c. In the course of the century original colour prints, reflecting all the diverse tendencies of modern painting, have gained for themselves a solid footing. The older processes of woodcut, intaglio engraving, and lithography, to which has been added the new technique of SILK SCREEN, have all served to express not only traditional artistic ideas, but also the most advanced.

427, 1280, 1326, 1327.

**COLT** or COULTE, MAXIMILIAN, formerly POUTRAIN or POURTRAN (active *c.* 1600-45). Sculptor and mason, who came to England from Arras *c.* 1595. In 1605 he made the large tomb of Queen Elizabeth I in Westminster Abbey, with its revealing portrait, its canopy supported on 10 columns, the work being painted by John de Critz (*c.* 1555-1641). He carried out much work for Robert Cecil, first Earl of Salisbury, at Hatfield, including fireplaces and his fine tomb, an unusual type with the effigy lying on a black marble bier carried on the shoulders of four kneeling Virtues. In 1608 he became Master Sculptor to the Crown, an office he held till his death, though his art, competent as it was by Jacobean standards, was too conservative to please Charles I, from whom he received only minor commissions.

**COLUMN.** It is difficult to define 'column' as an architectural term more precisely than as a basically cylindrical form, although it usually denotes something of a certain magnitude. Originally and for the most part columns have been used in architecture; but in certain CLASSICAL and classically inspired periods they have been set up as free-standing trophies and MONUMENTS. As soon as the art of building aspired beyond the mere construction of walls, columns provided architects with perhaps the most versa-

tile of their secondary themes. The aesthetic quality of much architecture of many different periods depends in the last analysis on the contrast between walls and columns. Walls are continuous, flat, and usually straight; columns are discrete, they suggest volumes, and they are round. Even in Mesopotamia, where the natural building material—sun-dried brick—did not readily lend itself to the construction of columns, we find traces of ornamental half-columns attached to the walls of the earliest temples (e.g. Erech) and these in turn are decorated with geometrical MOSAIC patterns. For the first large-scale functional use of columns in architecture, however, the Egyptians were responsible. As early as the 3rd Dynasty we find columns of masonry, not merely cylindrical but tapered and FLUTED, and associated with various kinds of CAPITAL. But the most characteristic use of columns in Egyptian architecture was in the construction of gigantic HYPOSTYLE halls (e.g. KARNAK) in which rows of columns close together provided ceremonial access to the sanctuaries of temples (18th Dynasty). These halls were only rivalled by the similar constructions raised by the Achaemenid kings of Persia (e.g. at Persepolis). In Crete and MYCENAEAN Greece columns of wood were generally used. The tree-trunk is clearly the archetype of all masonry columns, and in some classical Greek temples (e.g. the Temple of Hera at Olympia) it was still possible to see a wooden column in the time of PAUSANIAS. The Cretans, however (e.g. at Knossos), inverted the normal arrangement and made their columns taper from top to bottom. At Mycenae ornamental half-columns of marble with geometric patterns like those of Erech were used to flank the entrance to the tomb known as the Treasury of Atreus. The ultimate refinements in the designing of columns were achieved by classical Greek architects (see ORDERS OF ARCHITECTURE). Masonry columns were adopted *c.* 700 B.C. from the Egyptians. From the first a characteristic curve was introduced into the profile of the column (ENTASIS). In some early Doric temples (e.g. the so-called BASILICA at Paestum, mid 6th c.) this is crudely obvious. In the PARTHENON, however, it has been handled with the utmost subtlety, so as to be barely perceptible; and there the result is extremely satisfying. The degree of tapering, the number of flutes, the relations between the columns, between columns and stylobate or steps, and columns and the inner structure which was surrounded by the colonnades, were all worked out with meticulous precision. So also was the ratio between the diameter of the column and its height (see MODULE). This ratio changed with the Orders of Greek architecture: Doric, Ionic, and Corinthian. Doric columns were relatively short and sturdy, and they had neither base nor capital. Ionic and Corinthian columns were much more slender and were provided with ornamental bases and capitals. The ultimate extreme of attenuation is perhaps best seen in the Corinthian colonnade of the Temple of Bel at Palmyra.

The Romans used columns in the Greek manner for their HELLENISTIC temples, but they also handled them in ways of their own. Their distinctive contribution to classical architecture was the exploitation of the ARCH. Greek and Egyptian columns had invariably supported flat entablatures. Eventually, i.e. in some of the EARLY CHRISTIAN basilicas, the Romans used columns to support an arcade of arches; but in the more monumental buildings of the Imperial period they used columns, either freestanding or attached against the solid PIERS that supported the arches (e.g. the COLOSSEUM, and the ARCH OF CONSTANTINE), as a very effective form of plastic embellishment. The later Romans also made great use of different coloured marbles. Sometimes they gave the fluting a spiral twist and sometimes dispensed with it altogether. In the famous columns which later formed the screen of Old St. Peter's, the whole shaft was twisted. Another Roman practice was to set up columns to commemorate the victories of their generals. Those of Trajan and Marcus Aurelius are specially elaborate examples; but the late Column of Phocas in the FORUM represents the more usual type. Nelson's Column in London derives from these ancestors.

With the development of church architecture the use of columns was confined almost exclusively to interiors. In Italy, where Roman columns were plentiful, pagan temples were often despoiled and the old material re-used. Elsewhere, however, they were often replaced by piers, square in section, and most of the classical refinements were abandoned. CAROLINGIAN architects were aware of entasis, however, and so were the 12th-c. masons of Oxford Cathedral. At Durham the great drum columns are incised with patterns, some of which (e.g. spiral and vertical fluting) seem to derive from classical sources although the design of the columns themselves is quite different. They are, in fact, more like cylindrical piers than columns in the classical sense. The medieval artists who exploited the form most effectively were probably those who designed cloisters in Rome in the 13th c., e.g. at S. Giovanni Laterano, where miniature columns are twisted both singly and in pairs and encrusted with mosaic patterns. Another medieval idiosyncrasy appeared in north Italy and Germany *c.* 1200. This was the practice of handling columns as though they were elastic not rigid forms by, as it were, tying knots in them. Continuous colonnades inside churches were still used at the end of the 12th c. in GOTHIC cathedrals such as Laon and Notre-Dame, but by the middle of the 13th c. the column had given way to the compound pier. From then until the RENAISSANCE was the only considerable period in European art when columns were out of favour. The Renaissance and Post-Renaissance periods were essentially concerned with the recovery of classical prescriptions for the making and disposition of columns. Here what VITRUVIUS had to say about the Orders was of decisive importance,

although there was singularly little agreement as to what he actually meant. As a rule it was the Roman precedents that were followed, e.g. for ALBERTI columns were decorative rather than structural members of a building. Not every Renaissance architect was restricted by the academic notions of classical correctness. BRAMANTE at Sant' Ambrogio, Milan, and Philibert DELORME produced playful imitations of early timber columns; and the celebrated spiral columns of BERNINI's BALDACCHINO over the altar of St. Peter's were directly inspired by their venerable predecessors. For the most part, however, the column has remained inextricably associated with the classical tradition, and its fortunes have fluctuated with those of classical architecture as a whole.

**COLUMN-FIGURES.** The idea of decorating doorways of churches with human figures carved in the round and attached to COLUMNS was born in the 12th c. Column-figures (French *statues-colonnes*) were first used on a grand scale on the three west doorways of SAINT-DENIS Abbey near Paris between 1137 and 1140. Four nearly life-size statues were placed on either side of the central and three on either side of the lateral doorways. Unfortunately these statues have been destroyed and only a few fragments survive, but drawings of them exist. There has been much controversy concerning the origin of this new type of sculptural decoration and many problems still remain unsolved. It is possible, however, that the doorway of the cathedral of S. Étienne, Toulouse (now in the Musée des Augustins), by the sculptor GISLEBERTUS had an influence on Saint-Denis. It also appears that the Italian experiments of the sculptor Nicolò and his followers, who carved human figures, chiefly of the prophets, on doorways (Ferrara, Verona, Ravenna), were well known to the sculptors of Saint-Denis. The statues at Toulouse represent the APOSTLES, those at Saint-Denis the PROPHETS and other characters from the Old Testament.

The figures on the west front of Saint-Denis, although they were column-figures in the sense that they were carved from the same blocks of stone as the columns and were therefore an integral part of them, had an existence of their own. But when in about 1145 the column-figures of the cloister at Saint-Denis were carved (one of these is preserved in the Metropolitan Museum, New York) they were given exceedingly elongated forms, conforming with the shapes of columns and thus becoming not only physically but also stylistically part of them. This process went even further in the decoration of the Royal Portal of the west façade of CHARTRES Cathedral, c. 1150. Here the HIERATIC, solemn figures of the ancestors of Christ practically replaced the columns. There is, however, enough of the columns showing above and below the statues to give the impression that the statues are, in some miraculous way, suspended in mid air. In this they differ fundamentally from the CARYATIDES of the ERECH-

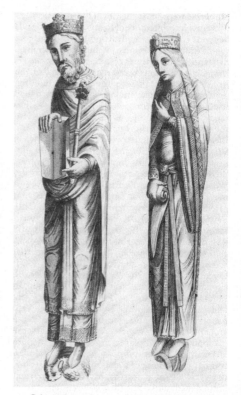

**95.** Column-figures from west portal of Saint-Denis, Paris. Engravings from *Les Monuments de la monarchie française* (1729–33), Vol. I, after drawings by Barnard de Montfaucon

THEUM, with which they are sometimes compared. The Greek figures are used instead of columns, physically carrying the weight of the ENTABLATURE.

The success of the column-figures of Saint-Denis and Chartres was enormous. In quick succession similar doorways were made in France, Spain, England, and Germany, although the most significant examples are those in the Île-de-France and the adjoining provinces. In the last quarter of the 12th c. the style of column-figures changed a great deal under the classical influences which came by way of the Mosan region. Important fragments of statues at Sens and the figures from St. Mary's Abbey, York, demonstrate this trend.

The subsequent development of the column-figures in the first half of the 13th c. can best be studied on the transepts of Chartres Cathedral, at REIMS, and at AMIENS. Not only does the style of the figures change but also their subjects and function. The classical tendencies culminated at Reims and from there were transmitted to Germany (e.g. Bamberg), but at the same time the GOTHIC style reasserted itself, especially at Amiens. The vast sculptural programmes on the façades of 13th-c. cathedrals introduced a greater variety of subjects for the

column-figures: not only prophets and apostles were now represented but also saints. Originally, at Saint-Denis and Chartres, each figure was an entity in itself although it was also part of a unified group. Then the neighbouring figures became more closely related to each other, for instance the angel of the Annunciation and the Virgin, or Elizabeth and Mary of the Visitation, and so on. The figures were no longer represented as hieratic, strictly FRONTAL, and miraculously suspended between earth and heaven. Their feet were firmly on the ground, they turned towards each other, sometimes in violent movement. They were no longer so solemn and remote; feelings of joy, tenderness, and despair were shown by gestures and facial expressions. A single figure attached to a column could no longer fulfil the aims of the sculptors. From about the middle of the 13th c. the statues used in the decoration of doorways were placed on plinths or in niches. The great age of the column-figures was thus over.

3, 1490, 2759.

**COMPER,** SIR JOHN NINIAN (1864–1960). English church architect who designed in the GOTHIC REVIVAL tradition. He was also a designer of church furniture, vestments, and STAINED GLASS. His principal works are St. Cyprian's, Clarence Gate, London (1903), St. Mary's, Wellingborough, Northants (1904–6), All Saints Chapel, London Colney, St. Albans, Herts. (1927), the Welsh National War Memorial, Cardiff (1928), Warriors' Chapel, Westminster Abbey (1931), and St. Philip's, Cosham, Portsmouth (1937).

**COMPLEMENTARY COLOURS.** See COLOUR.

**COMPOSITION.** The Latin word *compositio* usually represented the Greek *synthesis*, the most general term for structure or arrangement. Both terms were applied in all the arts in a neutral sense with no necessary implication for beauty or aesthetic value. Thus Demetrius uses *synthesis* almost as an equivalent for 'style', as for example: 'Smoothness of composition (*synthesis*) . . . is not altogether suited to forcible vocabulary' (*On Style*, 299). VITRUVIUS explains that the construction (*compositio*) of temples (where aesthetic considerations of beauty were taken for granted) depends on symmetry (iii. 1). Sometimes 'composition' was used with a meaning fairly close to *dispositio*, or the arrangement of the subject matter. The last usage became rather common in the Middle Ages, but otherwise medieval practice showed little divergence from the classical. For example, Aquinas (1225–74) said (*Summa theol.* 11a, 11ae, qu. 96a. 2 ad 2): 'The forms of art works derive from the conception of the artist; for they are nothing else than *compositio*, arrangement (*ordo*) and shape (*figura*).'

Hugo (1096–1141) used 'composition' for the arrangement of the parts of a single thing and 'disposition' for the arrangement of a number of things in a group. Bonaventura (1221–74), discussing whether the artist *creates*, distinguished between the activity of imitation (of which the portrait is a paradigm) and the activity of imagination. The latter, he asserted, does not create new things but does create new compositions. According to Tatarkiewicz the word *compositio* came into use during the Middle Ages, particularly in music and architecture, with a special reference to purely formal beauty (*Historia Estetyki*, vol. 2, p. 174).

At the RENAISSANCE the word *compositio* did not acquire a much more specific connotation. In his *Poetica Horatiana* (1561), the most detailed commentary of the century on Horace's *Ars Poetica*, Giovanni Battista Pigna distinguished the matter (*rem*) of a poem from the words (*verba*) and the combination of the two, which was composition (*compositionem*). 'To the composition', he says, 'belong the whole form of the poem and the entire power of the poet.' But Torquato Tasso in his early *Lezione sopra un sonetto di Monsignor Della Casa* (*c.* 1565) said: 'It is clear that the concepts are the end and therefore the form of discourse, and the words and composition of the verse are the material and instrument.' During the 16th c. and still more in the 17th the terminology which had its source in classical theory of rhetoric became formalized in art theory. As an illustration Franciscus Junius said in *The Painting of the Ancients* (1638) that the five components of painting are INVENTION, PROPORTION, COLOUR, motion, disposition. Disposition, or 'the ordering of the whole worke', became in the language of the ACADEMIES roughly the equivalent of *compositio* in antiquity and the Middle Ages—the ordered plan or structure of a work of art. Thus Fréart de Chambray, who was influenced by Junius, defines 'disposition' in his *Idée de la perfection de la peinture* (1662) as 'la collocation ou la position regulière des figures'.

From classical Greek times theories of composition by proportion and harmony among the parts and between the parts and the whole have envisaged the classical ideal of a work of art as an organic whole—a metaphor first used by Plato. The formulation in Aristotle's *Poetics* that the unity of a work of art should be such that 'if any of the parts be either transposed or taken away, the whole will be destroyed or changed' has been very influential through the ages. Among others Roger DE PILES emphasized the importance of harmony throughout the whole in his *Cours de peinture par principes* (1708). As an aesthetic concept this principle of composition has been formulated in modern times chiefly in *Theory of Beauty* (1952) by H. Osborne.

**CONCA,** SEBASTIANO (1680–1764). Italian painter. A pupil of SOLIMENA at Naples, he moved to Rome in 1706, where with the

Venetian-trained Trevisani (1656-1746) he was one of the most important decorative painters during the first half of the 18th c. Out of the High BAROQUE tradition he developed a distinctively Roman ROCOCO style, which through its polished elegance gives an impression of superficiality despite the grandeur of its conception. Good examples of his work are the decorations in the churches of S. Clemente (1714) and Sta Cecilia (1725), Rome. His figures are decorative rather than plastically conceived. BATONI became the most renowned of the many students at his busy studio in the FARNESE Palace.

**CONCRETE.** Mass concrete, made by mixing cement with water, sand, and pebbles or small fragments of stone, was the favourite building material of the Romans, used in conjunction with brick or stone casing. This method of building was adopted by the Byzantines.

Reinforced concrete was invented by Joseph Monier, a French gardener who in 1849 replaced the wooden flower-tubs of the Orangerie, VERSAILLES, by unusually slender cement tubs strengthened by an embedded wire mesh. The process was patented in 1867 and was first used in building a block of flats at Saint-Denis by François Coignet (1814-88) in 1850. The technique of reinforced concrete was improved for extensive use in building construction by the Frenchmen Cottancin, F. Hennebique (1842-1921), Freyssinet (1879-1962), and the American E. L. Ransome (1844-1917). It is commonly used for the skeleton frame-supporting structure. It may also be used for continuous weight-bearing walls and for 'box frame' construction, in which a honeycomb of floors, walls, and ceilings supports itself by acting as a series of gigantic hollow beams.

Reinforced concrete combines the compressive strength of concrete with the tensile strength of steel. Steel rods are embedded at the points where stress occurs or, in pre-stressed concrete, thin wires in a state of tension replace the steel rods. Shell concrete is a form used in thin sheets for barrel VAULTS and shallow DOMES.

Before STEEL CONSTRUCTION the only building material with tensile strength was timber. And owing to the limitations of timber as a building material the character of all monumental architectures has in the past derived from the use of materials in compression. The modern use of reinforced concrete, a composite material which conceals its true fibrous strength within a monolithic envelope, has opened up enormous new possibilities while at the same time removing from the designer the limitations imposed by material. When its functions are sharply defined it can take on shapes of beauty; but it has also lent itself to virtuosity and idiosyncrasy without giving rise to a characteristic style arising from the potentialities of the material itself. The aesthetic possibilities inherent in it, if any, have lagged behind the practical. The first architects to exploit the flexibility which it invites and to endow reinforced concrete construction with a particular aesthetic character were Tony Garnier (1869-1948) and Auguste Perret (1873-1954). The Swiss engineer Robert MAILLART used it for bridges with spectacular economy of form and elegance of line. In Great Britain pioneer work was done by Sir Owen Williams (1890-   ), whose chemical factory at Beeston (1931) was the most outstanding of his expressive, functionally straightforward structures. The Danish engineer and consultant Ove Arup (1895-   ) has played a part in many of the most successful reinforced concrete buildings. Yet though the material has been very extensively used, no general style has developed in association with it and some leading architects are chary of its use. P.-A. Michelis in his book *Esthétique de l'architecture du béton armé* (1963) suggested that the discipline so far lacking might lie in the *vegetable* character of the material, that is in the possibilities and limitations of continuous and fibrous structure.

**CONCRETE PAINTING.** A general term applied to those styles of modern painting which repudiate all figurative reference to an object and construct the composition from elementary pictorial elements such as the rectangle or square. It includes such movements as SUPREMATISM, CONSTRUCTIVISM, NEO-PLASTICISM, and the work of Ben NICHOLSON.

**CONDER,** CHARLES EDWARD (1868-1909). English painter, born in London. He began to paint while in Australia, 1885-90. In 1890 he moved to Paris, where he worked in the Atelier Cormon and was a friend of L. Anquetin (1861-1932) and TOULOUSE-LAUTREC. He became a member of the NEW ENGLISH ART CLUB in 1891, and settled in London in 1897. His paintings were mostly of arcadian fantasies and landscapes, and included water-colours on silk and designs for painted fans.

**CONDIVI,** ASCANIO (d. 1574). An insignificant Italian painter, whose only claim to fame rests on his *Life of Michelangelo*, published in 1553. Three years earlier the first edition of VASARI's *Lives* had appeared, and MICHELANGELO seems to have taken exception to some of the statements made there. Condivi writes not only from intimate personal knowledge, but obviously at times almost at dictation from the master. Unlike HOLLANDA he has no aesthetic theories of his own and his account is, therefore, the most trustworthy we have today.

**CONINXLOO.** A large family of Flemish painters, who used the same Christian names so

frequently that it is difficult to disentangle their personalities. One, however, is clear, the landscape painter GILLIS (1544-1607). He was born at Antwerp and emigrated to Frankenthal in 1587, where he became a leader of a group of landscape painters established there. In 1595 he settled in Amsterdam, where he worked for the rest of his life. Coninxloo's early landscapes are panoramic views of vast valleys and great mountain ranges populated by biblical or mythological personages. In later works, such as the majestic *Forest* (Kunsthistorisches Mus., Vienna), he narrows his field of vision and takes as his subject the mood evoked by luxuriant nature. His younger countrymen, Roelant SAVERY and David VINCKBOONS, who had also come to Holland at about the same time, were influenced by Gillis's late works. Van MANDER in 1604, and Lampsonius earlier, recognized the quality of his work and the importance of his influence in Holland. Among his many pupils there were two major Dutch artists, Esias van de VELDE and Hercules SEGHERS. His paintings are rarely signed and lesser artists are often confused with him.

## CONNOISSEUR, CONNOISSEURSHIP.

The development of aesthetic appreciation in RENAISSANCE Italy gave rise to the term *conoscitore* and later in 17th-c. France to *connoisseur* (now *connaisseur*), which is found in La Bruyère, Racine, and Molière. It was imported in its French form into England early in the 18th c. (Mandeville, Berkeley). *Connoisseurship* is first found around 1750 (Fielding, Richardson, Sterne). The word is derived from the Latin *cognoscere*, to get to know (Greek root in *gignōskō*), but neither the Greeks nor the Romans had a corresponding noun. The adjective *philokalos* in Greek and *aestimator* in Latin expressed the idea, with a marked utilitarian emphasis in Latin as the money term *aes* indicates.

Early in the 18th c. Jonathan RICHARDSON, in his *Two Discourses* (*An Essay on the Whole Art of Criticism as it relates to Painting* and *A Discourse on the Dignity, Certainty and Advantage of the Science of a Connoisseur*, first published 1719), argued that the attributes of a connoisseur were a proper accomplishment of the cultivated man and that the necessary grounding ought to be a recognized part of the ordinary education of an English gentleman. He stressed the social importance of a 'Gentleman of Taste' and the civilizing influence of the fine arts on a nation by 'the reformation of our manners, refinement of our pleasure and increase of our fortunes and reputation'. Richardson used the term in a sense which combined a degree of sensibility and discrimination with the basic knowledge and understanding which might be expected of an interested AMATEUR. As the century advanced the word acquired a rather more specialized implication. In 1752 the *Dictionnaire universel* ('de Trevoux') defined

'connoisseur' as a person completely knowledgeable about the qualities of any object submitted to his judgement and distinguished a connoisseur from an amateur, observing that although it is not possible to be a connoisseur without being an amateur, it is possible to be an amateur without being a connoisseur. Johnson (*Dictionary*, 1754) defined 'connoisseur' as: 'a judge, a critick. It is often used of a pretended critick.' He does not give 'amateur', which is found, however, in Burke (1784) and was described in 1803 (Rees, *Cyclopedia*) as 'a foreign term introduced and now passing current among us to denote a person understanding and loving or practising the polite arts of painting, sculpture or architecture without any regard to pecuniary advantage'.

In the 19th c. the term 'connoisseurship', without losing its more general connotation of sensibility and discrimination, became current also in a narrower sense linked with the specialized disciplines of the art historian and the museum man—the apparatus which in Germany was designated by the term *Kunstwissenschaft*. Influential in promoting this usage was Sir Charles EASTLAKE, who in his essay 'How to Observe' (1835; reprinted in *Contributions to the Literature of the Fine Arts*, 2nd ser., 1870) defined 'connoisseurship' as follows: 'The connoisseur, as the name implies, is he who more especially professes to *know*. The designation perhaps indicates an acquaintance with facts rather than truths, with appearance and results rather than with their causes. In its general acceptance it comprehends a familiarity with the characteristics of epochs, schools, and individual masters, together with a nicer discrimination which detects imitations from original works. The chief distinction between the connoisseur and the amateur is that the knowledge of the first assists the exercise of judgement, while that of the latter tends to kindle the imagination. The studies of the connoisseur may, however, take a wider range, and be directed not only to recognise excellence in works of art, but to investigate the nature and principles of that excellence; in short, in addition to a practical and habitual acquaintance with specimens, and a discrimination of their relative claims, to penetrate the causes of the world's admiration. On the whole, therefore, he may be said to combine the views of the philosophical artist with an erudition to which the artist seldom aspires.' A different, though related, narrowing of the connotation which links the term more particularly to problems of ATTRIBUTION had its chief advocate in Giovanni MORELLI, who believed that each painter has a characteristic use of schemata and techniques which can be regarded as a kind of handwriting and which the eye of a trained connoisseur can identify beyond reasonable doubt.

In the wider and more general application of the term, which has remained current and is still perhaps the most useful, a 'connoisseur' is one who is more thoroughly equipped with sound

aesthetic standards of judgement than is an amateur. This greater emphasis upon wide-ranging aesthetic appreciation also differentiates a connoisseur from an *expert* and connoisseurship from *expertise* which, although equally knowledgeable about facts and attributes and probably more so about financial values, need not include all the aesthetic satisfactions which reward connoisseurship. The connoisseur contributes insights which deepen, enlarge, and advance aesthetic judgements which lie outside the purview of the expert as such and of which he may be incapable. An expert profits by the achievements of connoisseurs in order to acquire his expertise and make his valuations and may himself become a connoisseur as a result. The possession of a sound body of knowledge gained by discipline and hard work in the service of aesthetic values together with the will and the power to advance them without regard to personal or mundane considerations is the special characteristic of the connoisseur.

930, 1353, 2627.

## CONNOISSEURSHIP IN ANTIQUITY.

Grief and concern for the dead was the earliest and most powerful stimulus in ancient times to create and select valuable and beautiful works of the craftsman's skill which would be worthy of a place in a tomb or grave. Reverence for unseen, divine powers prompting the enrichment of temples with votive offerings was another influence almost as potent. As there were vastly more tombs than temples and as the contents of early temples were very vulnerable to looters, it is from burial sites that the earliest tangible evidence of ancient connoisseurship is derived, notably from Egypt and Etruria. Where, as in Homeric Greece, the dead were cremated, their valuable possessions, chiefly a man's arms and armour, were often sacrificed in the flames.

Connoisseurship in the modern sense was a relatively late product of Greek and Roman civilization. The poverty and democratic equality of the Greeks long delayed satisfaction of their acquisitive instinct and they had no wealthy neighbours upon whom it could be exercised until Alexander the Great led them to Egypt and India. Meanwhile miracles of art had been created by their own craftsmen, but for civic and public purposes rather than for private enjoyment.

The Romans during the first five hundred years of their history seem in comparison to have had the taste of rough peasants, for they scorned the sophistication of their ancient Etruscan overlords and seem to have been singularly obtuse about the achievements of their Greek neighbours to the south. They had, said Strabo (v. 235), far graver and more vital matters on hand than the decoration of their city. Yet they were not completely immune from Etruscan and Greek influences. Once embarked upon campaigns of conquest, the Romans were inevitably exposed to more mature and developed civilizations than their own. When they captured and looted Syracuse in 212 B.C. the booty brought back opened Roman eyes for the first time to the marvels of GREEK ART (Livy xxv. 40). They were very slow to learn. When a commander of th old school, L. Mummius, led his legionaries to destroy Corinth in 146 B.C. some of the finest works of art saved from the flames were snapped up by a keen collector, the King of Pergamum. He offered so much for one picture that Mummius became suspicious and sent it with what remained to Rome, characteristically requiring the shipmasters to insure their cargo to the extent that they undertook to replace any picture or statue that might be lost or damaged on the way (Velleius Paterculus *ad M. Vinc.* i. 13. 4). Later Roman writers date the decline in the frugal ancient Roman character from this time. 'It was through the army campaigning in Asia that foreign luxury was first brought to Rome', said Livy (xxxix. 6), and he mentioned 'bronze couches, costly bed-spreads, curtains and other fabrics and what was then regarded as luxurious furniture, one-legged tables and sideboards'. Pliny the Elder and several others could not forget the contrast between the good old days when a foremost Roman general, a man who had twice been Consul, Cornelius Rufinus, was expelled from the Senate in 275 B.C. for the crime of owning 10 lb. of silverware (Pliny *Nat. Hist.* xxxiii. 50). This old Roman Republican tradition of austerity was never entirely forgotten even when it was no longer operative. Mummius celebrated his triumph over Corinth in Rome in 145 B.C., parading his baggage trains of loot through the city but, true to Republican principles, he took none of it for his own modest villa. His successors were both more discriminating and more greedy.

In the same year that Mummius burnt Corinth, Scipio Africanus the Younger destroyed Carthage. Pliny records that 4,370 lb. of silver, the wealth of Carthaginian homes, were displayed in his triumph (*Nat. Hist.* xxxiii. 50), adding 'how many a Roman has surpassed Carthage since then in his display of plate for a single table'. Scipio at his death in 129 B.C. left 32 lb. of silver. Pliny mentions a commander, Pompeius Paulinus, whom he knew who took a service of silver plate weighing 12,000 lb. with him 'in a war against most savage nations' and he makes it plain that many wealthy Romans owned masses of silver, adding, in exculpation, that 'it is not only for vast quantities of plate that there is such a rage but even more, were that possible, for the plate of outstanding artists'. He mentions Caius Gracchus (d. 121 B.C.) and Lucius Crassus (140–91 B.C.) among the earliest discriminating connoisseurs who paid exceptionally high prices for the work of outstanding silversmiths, of whom Mentor, the Greek of the early 4th c. B.C., was the most famous (*Nat. Hist.* 50, 53).

The wealth and treasures of Greece and Asia Minor poured into Rome in the last century of

the Republic mainly as war loot, partly by purchase and once at least as a legacy when Attalus III of Pergamum bequeathed his small kingdom and its heritage of art treasures to the Roman Republic on his death in 133 B.C. Needless to say, whatever could be brought to Rome was sold there to lay the foundation of many a private collection. The sinister and insatiable greed of corrupt Roman governors of conquered territories added a particularly sordid chapter to this squalid story, for they gouged out of their wretched subjects anything which took their fancy. Because his manifold crimes were denounced by Cicero in a series of searing orations, Verres is the most notorious of them all. That the ruin and devastation he wrought upon the Sicilians as governor of their island during the years 73-71 B.C. included a thorough looting of all art treasures to be found in that centre of western Greek civilization and culture was but one of his enormities. His robberies were not entirely to add to his personal possessions, for among the gifts with which he had confidently expected to be able to bribe any prosecutor and any judges should he be brought to trial, were priceless paintings, sculptures, tapestries, gold and silver ware. This lurid incident testifies to that keen artistic acquisitiveness of many Roman aristocrats which is evident also from Cicero's letters and other sources. Flourishing trade in valuable antiques of all kinds stimulated the production of copies of Greek masterpieces. Although the Romans themselves had no such creative ability in the realm of art, it is thanks to their taste that we are today able to see in the copies they commissioned far more of the Greek achievement than might otherwise have been possible. Thus some 50 copies are known of the famous statue *Venus of Cnidus* by PRAXITELES, which the Cnidians refused to sell to the King of Bithynia although he offered to redeem the whole of their huge public debt. It was one of the great tourist attractions of the ancient world.

Concentration upon the political and military affairs of Rome has obscured the light which the astonishing change in Roman attitudes in the realm of aesthetic taste throws upon their social and cultural development. Less than 200 years stand between the death of tough old Cato the Censor and the birth of Nero, the most notorious but by no means the only imperial connoisseur. His Golden House was too gorgeous for his successors, but he had put heavy pressure upon the eastern provinces and the empire generally to provide worthy objects for it. Emperors apart, there was every type of collector, from the genuine discriminating enthusiast such as the poet Silius Italicus down to the vulgar, ignorant, but wealthy parvenu such as Trimalchio in the story of Petronius, for whom antique treasures were a mere status symbol. Nothing better indicates the wealth and taste of middle-class Romans of the early Empire than their huge store of silver or perhaps golden drinking-cups, mixing-bowls, large circular trays, ladles, spoons,

caskets, mirrors, and scent bottles. Before A.D. 79 one villa in Boscoreale yielded a silver service of splendid workmanship consisting of 109 pieces. At the Casa del Menandro near POMPEII 118 pieces were found. Other chance discoveries of splendid hoards far from Rome, as at Mildenhall, near Cambridge, and at Traprain Law in Scotland, show how general was the urge to own and display valuable silver.

Rome was long the art market of the world. Dealers in gold, silver, gems, jewellery, and antiques of all kinds could rely upon an avid clientele eager to possess them as much for the social distinction their ownership conferred as for a conscious appreciation of their genuine artistic merit. Such a state of affairs would not have arisen had not leaders of society with fine and discriminating taste set and maintained the tone and the standards. Then, as now, antiquity and fine workmanship added enormously to the value of all such *objets d'art*, so much so that fictitious pedigrees dignified many a fake (Martial viii. 6, 34; xii. 59). It was a point of honour to credit one's friends with the possession of priceless bronzes by MYRON or pictures by APELLES (Statius, *Silv.* i. 3; ii. 2) or to contrast exquisite treasures with the far from exquisite moral character of their owner, if he was disliked (Martial iv. 39). Satirists then as now made wealthy but ignorant and tasteless collectors the butt of their ridicule. Trimalchio, typical of rich and vulgar freedmen, is depicted by Petronius as confusing the Trojan and Punic Wars in vaunting the merits of one of his richly decorated cups.

Some of the more candid Roman aristocrats, if the younger Pliny is a fair example (*Ep.* iii. 6), confessed to their inadequacy as connoisseurs. He had bought for a temple a statue of Corinthian bronze, a late highly finished, realistic, almost Impressionistic piece, according to his description, 'not for my own house, for I have no Corinthian bronzes yet'. His friend Silius Italicus, on the contrary, owned a number of villas which, said Pliny, he had filled before his death in A.D. 101 with many statues, books, and portraits which 'he more than enjoyed, he even adored them' (*Ep.* iii. 7). Pliny's gift to a temple points to the huge store of artistic treasures displayed for public enjoyment in the Roman world. At the beginning of the Empire Agrippa, the architect of the fortunes of Augustus, had voiced the old Republican tradition when he proposed that all pictures and statues should become public property—'a wiser plan', said Pliny the Elder a generation later, 'than to send them to be shut up in country houses' (*Nat. Hist.* xxxv. 26). There was no future for proposals to 'nationalize' private property in ancient Rome for already the leaders of society were thinking of little except their personal fortunes, as Cicero had found to his cost when he was trying to save the Republic. Nevertheless many a temple was rich with treasures, many a colonnade was graced with pictures, while the FORUM and other public places were adorned with sculptured and monumental

marvels the like of which no modern city can show and few modern citizens can even faintly conceive. The Romans themselves seem to have been as little interested in them as the average Londoner is in the NATIONAL GALLERY or the WALLACE COLLECTION today, for as the elder Pliny observed, although there was a vast collection of treasures on view the claims of duty and business were such that hardly anybody had time to look at them (*Nat. Hist.* xxxvi. 27). Public interest was nevertheless there and it was powerful enough to deprive the emperor Tiberius of a statue of a man scraping himself which he had taken from the front of the Baths of Agrippa and put in his private apartments, substituting another statue for it. There was such a public outcry at the theatre against Tiberius that, enamoured as he was of the statue, he had to restore it (Pliny *Nat. Hist.* xxxiv. 62).

In the time of troubles after the 2nd c. A.D. the whole world of beauty was increasingly in jeopardy. It was the first and most obvious prey of corrupt emperors, their cliques and agents, and the least likely to survive revolutionary upheavals. The product of a specially developed and particular outlook upon life, itself a value, it necessarily changed when the whole system of values changed, and this is precisely what occurred in the later Roman Empire. Stoicism had always recommended a stern indifference to ephemeral worldly possessions. Christianity powerfully reinforced such a doctrine by its very nature and apart from the confident expectation of the early Christians that the end of the world was imminent. The result was an other-worldly outlook in which connoisseurship had no place outside the provision of church furnishings and cult-aids.

After A.D. 400 Rome was more than once captured and looted by barbarian hordes from the north. It is not known how many of the once prized possessions of Rome survived to be cherished in Byzantium nor the full extent of successive devastating destructions there, particularly in the disastrous fourth crusade in 1204 and the final catastrophe of 1453. That so much has somehow survived fundamental change in opinion and outlook as well as successive holocausts is perhaps the most astonishing aspect of the story, just as it is the most convincing testimony to the extent, the brilliance, and the glory of the Greco-Roman heritage before it went down to ruin.

1353.

**CONSERVATION AND RESTORATION OF PAINTINGS.** The craft of conservation demands not only manipulative skill of a high order and an intimate knowledge of materials, but aesthetic sensibility and art historical knowledge. Few paintings reach their centenary without showing symptoms of physical change, much of which leads to decay and eventual loss, and their conservation and restoration is no new problem. The causes of decay, as distinct from mechanical damage, are inherent in the materials of the painting and its SUPPORT, but many of them can be inhibited by suitable treatment or by attention to environmental conditions, especially atmospheric humidity. The most important part of conservation, therefore, consists in displaying and housing paintings in the most favourable environment which circumstances allow, and regular inspection and diagnosis of deterioration. The case histories built up from such inspections indicate which paintings need the attention of the conservator. To secure a maximum amount of data about technique, materials, and condition, an examination of the painting before treatment may be made in the laboratory under the microscope and by X-rays and other radiations. Photographs can be taken to record various technical features, pathological or otherwise, before and during the conservation process. In the past the craftsman's understanding of the materials and processes of both painting and conservation was empirical, but this is now supplemented by a more exact scientific study.

The physical structure of a painting consists of the support (wall, PANEL, CANVAS, PAPER, copper sheet, ivory, etc.), the GROUND (GESSO, chalk, red BOLE, etc.), the PAINT layer, and the surface coating (VARNISH, wax, etc.). Each layer has a function and it is the aim of conservation to ensure its satisfactory performance and to offset the various forms of decay, many of which are inherent in the original materials. In practice it is the support and the surface which call most often for clinical attention.

The ideal support, in addition to its mechanical function, should be physically and chemically stable and inert, but few of the materials traditionally used are perfect in this respect. Wall paintings and FRESCOES decay because of dampness in the wall. This leads to the transport of soluble salts to the surface which effloresce and disrupt the PIGMENT particles. If FIXATIVES are used which render the surface impermeable, the pigment in time flakes off. Fixatives which permit free egress of moisture are more satisfactory, but it is better to treat the walls so that less moisture is diffused to the painted surface. Where this is not possible transfer is carried out: the mural with the upper layer of plaster is removed from the wall and attached to another support, to be refixed in isolation from the original wall or even exhibited elsewhere, as has been done, for example, with painting found at POMPEII.

With panels the daily and seasonal variations in the relative humidity of the atmosphere cause the moisture content of the wood, and consequently the dimensions of the panel, to change. Old brittle paint and ground incapable of accommodating itself to the repeated swelling and shrinking of the support becomes detached and, unless appropriate steps are taken, lost. A similar effect, though different in detail, results from moisture absorption by canvas and the SIZE

with which it is primed. More loss of paint from panel and canvas has probably resulted in this way than in any other, but it can be largely overcome by stabilizing the humidity of the atmosphere by air-conditioning. Panels may also be attacked by wood-boring insects (wood worm) and, less frequently, by fungi (dry rot). These are easily subdued by the use of modern insecticides and fungicides, but the panel may well have been so weakened as a result of the attack that it has to be reinforced by impregnation with a consolidating MEDIUM, or by adding an auxiliary support. In extreme cases restorers may have to resort to transfer by cutting away the old support, and applying the painting to a new one. Canvas was frequently chosen as the new support in transfers carried out in the 18th and 19th centuries, but it is now generally agreed that only a rigid support is appropriate to a painting executed on a panel. Transfer—or partial transfer, where all but a veneer of the panel is removed—is sometimes effected in cases of warping if attempts to flatten the panel or to fit a cradle to the back seem likely to cause splitting.

In the case of canvases which have become weak or torn the treatment known as 'lining' is carried out; the painting is stuck down on to a second canvas and re-stretched. The adhesive used is either an aqueous glue composition or a thermoplastic wax-resin mixture; the latter is the more durable. The process includes impregnation of the painting with the adhesive and thus flaking paint is made secure.

WATER-COLOURS, drawings, and PRINTS also suffer deterioration which has its origin in the support—not so much the actual paper as the mounts and the adhesives used. Unless carefully selected these are capable of providing nutriment under damp conditions for various moulds, the spores of which are always present in the atmosphere, and this results in disfigurement in the form of irregular dark spots known as 'foxing'. Mould grows also on oils on paper or millboard. Treatment consists in sterilization with a fungicide and re-mounting with high-grade materials which contain a minimum of substances that promote the growth of moulds and which have been treated with a fungicide. Stains and foxing can be removed by bleaching and washing but this may be risky in the case of fugitive water-colours, certain drawing inks such as sepia and BISTRE, and PASTELS. Prints and drawings in chalk may safely be bleached by special techniques, but care must be taken where there is water-soluble white heightening. Lead sulphide can also be bleached by converting it to white lead sulphate. The method is chiefly applicable when the medium is GUM or size and is an instance of what is rare—restoration by a chemical reaction carried out *in situ*. Other changes in pigment such as fading and chemical decomposition are not amenable to treatment.

The final layer, the varnish surface coating, is the site of the most delicate and crucial of all the operations of the restorer. In order to fulfil its function, protective and optical, the varnish should be a continuous film as clear and colourless as when first applied. Unfortunately none of the natural RESINS used for the purpose retains this state indefinitely. After say 50 years the film may be so disturbingly yellow that blues look dark green and purples black, and modelling gradations, recession, and AERIAL PERSPECTIVE are suppressed. The film may also have lost its limpid quality through CRAQUELURE.

When a varnish has decayed careful removal (euphemistically termed 'cleaning') becomes necessary. The only alternative is to regenerate the film by introducing sufficient solvent to make it re-gel *in situ*. This process was originally carried out by means of alcohol vapour, but the effect was not lasting. Better results are obtained by spraying on to the painting a balanced mixture of solvents containing a constituent which will be retained for an appreciable time; but, though clarified, the varnish is still yellow to brown in colour. The chief application of the method is in cases where it would be uneconomic to replace the repairs and retouchings that are lost when the varnish is completely removed. Under favourable circumstances a brittle decayed varnish can be removed mechanically with a scalpel or by reducing it to a powder by rubbing. The method is only permissible when the painting is in a sound state, with paint and ground thoroughly bound to the support.

Most varnish is, however, removed by being dissolved or, to a lesser extent, by mild chemical attack. The procedure depends partly on the painting—and indeed on the region of the painting being dealt with—and partly on the nature of the varnish. Pure egg TEMPERA medium produces a paint film which is immune to the action of solvents; OIL PAINT, on the other hand, imbibes solvent and swells and softens to a degree depending on a number of factors. These are mainly: the nature of the solvent or solvent mixture and the time of exposure to it; the ratio of pigment to medium in the paint (the more oil, as in a GLAZE, the greater the softening); the extent to which the paint has aged. The last often depends on the catalytic action of the pigments on the drying; for instance, in the same painting while lead white produces strongly resistant films, blacks and brown earths of the same age may be found to yield. There is also the possibility that certain constituents of the oil will be leached out and it is probable that paintings many times cleaned have suffered from such loss. The result is a lean, chalky film.

Oil paint is sometimes found to have been modified by the addition of soluble resins, particularly for glazing and transparent shadows; such films will naturally be more vulnerable. In the period of transition from egg tempera to oil, the former was modified by adding oil or resin with consequent diminution of resistance. Egg tempera paintings commonly have passages in oil, resin, or both, such as glazes over gold and tin, and in the more saturated colours.

Restoration, i.e. cleaning and re-touching, as distinct from steps to ensure preservation, must be to some degree a matter for the personal judgement of the restorer and so sometimes arouses controversy. Old discoloured varnish hides certain inevitable effects of time, such as anomalous changes in the colour of pigments and increased transparency of paint; the latter brings to light PENTIMENTI which may be disturbing to the composition, and causes dark grounds to show too strongly through thin paint. Furthermore the paint surface may show signs of attrition from a single over-cleaning or the cumulative result of several injudicious cleanings in the course of the painting's history; glazes, those thin transparent films of paint applied by the artist as final touches, are the first to suffer in this way. Thus the restorer may be obliged to resort to brush and palette in order to hide the failings of his predecessors (or sometimes possibly his own). Repainting of a different kind is necessary where tears, holes, and losses due to flaking have to be made good; this is fully justified provided it is done by in-painting, i.e. so that no original paint is hidden. When loss is extensive, restoration would call for so much invention that it is more expedient to apply a uniform tone which blends with the surrounding areas; this method is applicable to large compositions, especially frescoes, but the result in an easel painting is disturbing. Much restoration of the 19th c. and earlier, freely executed without the modern insistence on difficult and tedious in-painting, betrays the restorer's own style and reflects prevailing taste. Paintings were sometimes 'improved' to satisfy current taste and interests. Distortion of a different kind was introduced by toning the new varnish to give the work an 'Old Master glow', and by partial cleaning confined mostly to the lighter parts of the painting.

Varnish and paint are colloids and with greater knowledge of their physical and chemical nature it is now possible to reach a truer understanding of what actually occurs in cleaning. It is not a case of washing or simply of the solution of unwanted varnish, and the often quoted method of applying swabs of solvent and turpentine alternately, whereby the latter neutralizes the former, is without theoretical support and would lead to loss of paint in certain circumstances. Equally misleading is the idea that by diluting an active solvent with a less active one a threshold into safety can be crossed.

Briefly the current view is as follows. While no solvents are specifically selective between varnish and paint, they do vary in the rates of diffusion and degrees of swelling which they produce and the restorer can choose from those which swell dried linseed oil least and yet have sufficient action on the varnish. A prolonged subjection to a solvent of low activity may be as damaging as a briefer exposure to a highly active one. Solvents which evaporate quickly are therefore less dangerous than those of low volatility, even when the latter are not highly active.

When the softened varnish is absorbed and wiped off with cotton wool swabs, there is a danger of loss by attrition, particularly as the paint will have become temporarily less hard. Prominences of the IMPASTO, the canvas grain, and the curled up edges of flakes are the first to suffer; the complementary hollows, on the other hand, often remain filled with accretions which may impose a disturbing pattern on the picture yet are tedious and difficult to remove.

2104, 2341.

## CONSERVATION OF SCULPTURE.

Before discussing the principles governing the preservation of sculpture and objects of applied art it is necessary to consider the environment in which they find themselves, as this plays a major part in their life history.

Objects out of doors are subject to weathering, to the disintegrating action of frost, and to attack by acid components of industrial atmospheres. For susceptible material, therefore, the chances of survival are much less out of doors than indoors, where still further protection may be afforded by the use of cases or frames. The safest and best environment is that in which the air is fully conditioned as to temperature and relative humidity as in the ideal picture gallery—relative humidity being the percentage of moisture in the air in terms of 100% saturation. When a valuable piece of sculpture or carving in an exposed site is found to be deteriorating badly the best way of saving it is to bring it indoors, if possible, or at least give it the partial protection afforded by a CANOPY or sheltered LOGGIA.

Conditions indoors are regarded as satisfactory when the atmosphere can be maintained at an equable temperature and humidity: say 60-75 °F and relative humidity of 50-60%. In such conditions objects are protected alike from desiccation and from the dangers that attend excess damp (staining, metallic corrosion etc.). But unless the air is fully conditioned, temperature and humidity are sure to vary, and in siting a delicate object care should be taken to avoid a draughty corner, to keep the object away from radiators or panel heaters, and preferably to set it up in a room containing a quantity of textile material (carpets, curtains, cushions), as such material absorbs moisture and by so doing helps to steady the relative humidity of the atmosphere. But there are certain objects which it is not desirable to divorce from their outdoor setting or which cannot be moved, and preservation of these can only be ensured by repeated preventive treatment.

In the case of stone such treatment usually takes the form of periodic washing to remove soot, bird deposits, etc., and this may be accomplished by one of three well known techniques, namely the steam jet, the water spray, or the trickle process. It goes without saying that such work should be carried out at a season when there is no danger of frost. It is also funda-

mental that the frailer and more porous the stone, the gentler must be the treatment. Persistent stains may require to be brushed with a dilute solution of soft soap, but detergents of a more active kind should not be used and friction must be confined to the area of the stain and applied lightly. Care should also be taken to prevent dirty water from collecting in hollows.

Much attention has been given to the study of materials which claim to be stone preservatives, but it has been found that where they are applied to sculptures out of doors results have been disappointing. The so-called preservatives do not penetrate the stone but merely harden the powdery surface to form a skin which is not durable when exposed to rain and damp. Where sculpture is protected from exposure to weathering these preservatives are more effective. The ideal preservative would be one which was water-repellent and which could be made to penetrate the body of the stone uniformly. Such a substance may eventually be found in a balanced mixture of some of the modern synthetic waxes, e.g. the carbo-waxes, microcrystalline paraffin waxes, and the polythene waxes. But even here one must face the fact that by their use the colour and texture of the original stone would be affected, and this is a matter of great importance when conserving works of art.

When stone sculptures that are accustomed to an indoor climate require consolidation, there is more latitude in regard to materials and methods. This is because moisture changes are so slight as to be insignificant. Certain forms of silicon ester can be used with advantage for the consolidation of powdery SANDSTONES. Decayed LIMESTONES, on the other hand, are usually more complicated to deal with, and the results of treatment less certain. Some respond to consolidation by fluosilicates, but often the only possible method is to impregnate them with an organic substance such as an emulsion of polymetha crylate or polyvinyl acetate, or with wax. In the last case the stone is warmed by an electric heater and soft beeswax applied in the form of a salve in white spirit.

Broken fragments of stone objects often have to be joined together. Any good neutral cold-setting adhesive may be used, with a coloured filler such as slate or MARBLE dust where necessary. For joining large portions of sculpture dowelling is required, and for this purpose metal dowels are used. These are made from copper, brass, or even stainless steel, which last was employed with great success by the Building Research Station, Watford, in repairing Giovanni da BOLOGNA's marble statue of *Samson and the Philistine* for the Victoria and Albert Museum. Stainless steel is the only ferrous metal that is tolerated today, as much harm has been done in the past by using dowels of iron or other steels which in rusting have expanded and destroyed the sculpture they were designed to preserve.

Dowelling is also used for works in wood, ivory, and allied materials. When a crack develops in timber its progress may be arrested by applying dowels across the fracture. Sometimes, as in the case of ivories, a series of small ivory pins is inserted along the line of a crack, using an adhesive, and this prevents the crack from enlarging. Alternatively, gap-filling cements are available today which are equally effective. Cracks usually arise from exposure to extremes of temperature and humidity, and for this reason it is advisable to protect susceptible material from direct heating of any kind, special care being taken in the case of sunlight, electric fires, etc. Sunlight also causes loss of colour and this cannot be prevented by waxing, though such treatment may be desirable on other grounds, e.g. to keep out dust. But the most serious threat to wooden objects comes from the attacks of fungus and insects. The dry-rot fungi attack structural timber and if neglected may utterly destroy it. Wood-boring insects are a danger to all objects of wood, but these pests can be destroyed by fumigation or impregnation. Fumigation can be immediately effective since gases can penetrate where liquids cannot, but wood thus treated may be attacked by the same pests again. Impregnation takes effect more slowly, but if it can be carried out with sufficient thoroughness it may confer protection from further attack. Some of the better known fumigants are carbon disulphide, ethylene oxide, methyl bromide, and hydrogen cyanide. Of the many liquid insecticides those most frequently used today contain one or other of the following: D.D.T., benzene hexachloride, $\beta$-chlornaphthalene, and derivatives of pentachlorophenol. After fumigation or impregnation the insect holes should be filled with wax to which has been added a little D.D.T. in powder form. When the wood is much enfeebled by insect attack it may be impregnated with a solution of a plastic substance. The plastic solidifies in the tissue, consolidating any loose powder, and thus restores to the object a measure of strength.

Carvings in wood which have a natural polished surface may be kept in good condition by rubbing occasionally with a soft cloth lightly charged with white wax.

Metal works of art may also be lightly waxed if desired for aesthetic reasons, and for sculptures out of doors waxing at least once a year is essential to protect the metal from chemical action. Metal sculptures that are unprotected will develop a PATINA which may or may not be desirable. The green mineral patinas on BRONZE are often considered to enhance the aesthetic value of the object, but white powdery patinas on lead are unstable and are a sign of active corrosion which can only result in the ultimate destruction of the work.

Should a hollow casting be cracked or flawed so that rain can enter, corrosion may take place within the piece at a point where it is inaccessible for cleaning. In this event the sculpture must be washed out and dried very thoroughly before the cracks are patched. Subsequent repair work

K

should be carried out using metal of the same composition as the object. This is done by brazing, but where the metal is deformed by innumerable cracks or blow-holes it may be preferable to make good the surface by using one of the modern gap-filling adhesives designed for use with metals. Whichever method be adopted, no acidic or alkaline residue should be allowed to remain on the metal, as otherwise corrosion will ensue; and for the same reason care should be taken to avoid making permanent fixtures of dissimilar metals as this would tend in time to promote electro-chemical action and cause staining.

Where corrosion is discovered to be active treatment must be given, the choice of method depending on the nature of the metal and on the aesthetic character of the work. Electrolytic reduction, for example, which can be applied to most portable objects of metal, arrests corrosion but destroys patina. In some cases patina may be saved by having recourse to de-rusting agents or to specific chemical solvents that will remove particular incrustations. While some form of chemical treatment may be essential for a complete cure, this is not lightly to be undertaken by the amateur as experience is of the greatest importance in controlling the action of chemical reagents, and accidents may easily happen. On the other hand, where a cure can be achieved by some form of surgery or mechanical treatment a wider choice is available to the beginner, who may use small picks or chisels or selected abrasive materials and polishes, and by these means remove at least the worst part of the disfigurement.

2104.

**CONSTABLE,** JOHN (1776-1837). English painter, who is ranked with TURNER as the most important landscape painter in the history of English 19th-c. painting. Although he showed an early talent for painting and drawing and began painting his native Suffolk scenery before he left school, his great originality matured slowly. He went to London in 1795 and worked under Joseph FARINGTON and J. T. SMITH but for a time he felt a sense of failure and only committed himself to a career as an artist in 1799, when he joined the R.A. Schools. He exhibited at the ROYAL ACADEMY in 1802 and 1803 and was helped and advised by Benjamin WEST. In 1816 he became financially secure on the death of his father and married Maria Bicknell, who also inherited a competence. He became A.R.A. in 1819 and R.A. in 1829. It was not until the 1820s that he began to win recognition: his *View on the Stour* (1819) and *The Hay Wain* (exhibited at the Academy in 1820; now in the N.G., London) won gold medals at the Paris SALON of 1824 and Constable's name began to be bruited among the French ROMANTICS. He was admired among others by DELACROIX and BONINGTON. From this time also his pictures began modestly to sell.

His wife died in 1827 and the remaining years of his life were clouded by despondency.

After spending some years working in the PICTURESQUE tradition of landscape and the manner of GAINSBOROUGH, Constable developed his own original treatment from the attempt to render scenery more directly and realistically, carrying on but modifying in an individual way the tradition inherited from RUYSDAEL and the Dutch 17th-c. landscape painters. In a then new way he represented in paint the atmospheric effects of changing light in the open air, the movement of clouds across the sky and his excited delight at these phenomena stemming from a profound love of the country. He himself said: 'The sound of water escaping from mill dams, willows, old rotten planks, slimy posts and brickwork, I love such things. These scenes made me a painter.' Although the doctrine of the 'innocent eye' has a century later come to be regarded as a snare and an illusion, Constable himself believed that in repudiating the MANNERED interpretation of Gainsborough and the picturesque school he was achieving something akin to this and made it his aim to symbolize in paint a direct and immediate vision of nature: 'all is made subservient to the one object in view, the embodying a pure apprehension of natural effect.' To render this in the shifting flicker of light and weather he abandoned fine traditional finish, caught the sunlight in blobs of pure white or yellow, and the drama of storm with a rapid brush that disdained worn-out symbols.

It is usual to distinguish between Constable's finished compositions and his so-called 'sketches' and to find his main contribution in the latter. The 'sketches' were neither composed pictures nor the *pochades* (rapid notes of impressions made on the spot) of which he also produced large numbers. They were not unfinished pictures, however, but are called sketches because they reproduce immediate and fragmentary impressions not organized into formal designs. Examples are the 'sketch' for *The Valley Farm* (V. & A. Mus.), *On the Stour near Dedham* (V. & A. Mus.), *Weymouth Bay* (N.G., London). Constable often elaborated a 'sketch' into a composed picture of the same subject—and in almost all such cases the sketch is now considered to be fresher and aesthetically better. It was the sketches which inspired Delacroix and the French Romantics, anticipating certain trends later developed by the IMPRESSIONISTS. In England Constable had no successor and the many imitators turned rather to the formal compositions than to the more direct sketches until the French Impressionists had familiarized English painters with the intuition which they themselves owed in part through Delacroix to Constable. His personal achievement remains, with Turner's, the greatest splendour of English landscape painting.

131, 210, 602, 603, 1352, 1645, 2046, 2481.

**CONSTANCY.** See COLOUR and PERSPECTIVE.

**CONSTANTINE,** ARCH OF. See ARCH OF CONSTANTINE.

**CONSTRUCTIVISM.** An abstract movement in sculptural art founded by Antoine PEVSNER and Naum Pevsner (GABO) on their return to Russia in 1917. The theoretical basis of the movement was put forward in their *Realist Manifesto* (1920) which on the sociological plane challenged the then doctrine, championed by Vladimir TATLIN, that art must serve a socially useful purpose and on the aesthetic plane challenged the belief that sculpture is primarily a matter of static volume and mass in space. They proposed a new art form which would allow them to explore the aesthetic uses of movement in space, using the materials of the modern machine age and also building in transparent glass or plastic. A. Pevsner and Gabo left Russia in 1922 and 1923 and have exercised considerable influence in the West.

**CONTRAPPOSTO.** The erect human figure has from the earliest times formed one of the principal subjects of sculpture, and the history of such sculpture can be seen as a series of attempts to solve the problem of balance which it presents. Robed, the figure resembles a tree-trunk firmly planted in the ground and so offers less difficulty than when it is nude or partly clothed and becomes, for the sculptor, a large mass resting on two points. If we imagine it as architecture—and this the sculptor has to do, even if unconsciously—we see the legs as two columns supporting the pelvis. The pelvis and the chest above it form the main mass, and above this is a smaller mass, the head; the arms balance each other. Seen from the front the whole structure is symmetrical and in balance, provided that the main mass rests evenly on the two columns. Therefore the least difficult way to make an erect nude statue is to conceive it as standing firmly on both legs, facing the spectator. Sculptors in the early stages of civilization, and all those of ancient Egypt throughout its history, presented the standing figure in this way (see FRONTALITY). Most of the archaic Greek male figures, the KOUROI, stand thus. The position of the arms varies slightly and, as in most Egyptian figures, one leg may step forward, but the weight still rests evenly on both feet.

The emotional content of the symmetrical pose is limited. The symmetrical standing figure suggests solemnity, severity, and discipline, and the pose is impersonal. Towards the end of the 6th c. B.C. the Greeks began to free the standing figure from the rigid frontal position and early in the 5th c. they evolved a new scheme. The gravitational point remained in the middle but nearly all the weight of the main mass, the body, now rested upon one leg, and this leg was held obliquely. The pelvis projected on this side, and was not quite horizontal, but sank down on the side of the free leg, which therefore had to be bent at the knee. Above, the chest was inclined slightly out of the vertical, forming, with the pelvis, that curve of the torso which RODIN compared to a concertina. The head was then inclined sideways in the opposite direction. The outlines of the figure thus move upwards in strong accents on the supporting side and descend in a harmonious flow on the free side. A profile view shows the supporting leg to be pushed slightly backwards and the chest to be tilted back also, so that a long curve flows up from foot to neck. The light falls on the chest and on the projecting angle of the pelvis, and the supporting leg is in half-shadow. This new scheme, to which the RENAISSANCE gave the name *contrapposto* to describe the action and reaction of the different parts of the human figure, was one of the great achievements of GREEK ART, since it enriched its plastic possibilities of the sculptured figure. Moreover with this new freedom the sculptor could suggest an indefinite number of situations, from the figure standing harmoniously at ease to poses of greater tension and drama. The theory of this sculptural scheme was described in a lost 5th-c. treatise, the *Canon* of POLYCLITUS. During the further development of Greek sculpture it was enriched and varied but never abandoned. Memories of it survived even in later cultures with less concern than the Greeks for understanding and representing the organic structure of the body. The exaggerated S-curve of GOTHIC figures in the late 13th and 14th centuries is a variation of it. It may not be fanciful to detect in some Indian figures another variation of *contrapposto*; whether independently developed or descended from the Greek is a matter of controversy.

Renaissance masters such as DONATELLO and VERROCCHIO gave their own meaning to *contrapposto* by observing the classical pose afresh from life. MICHELANGELO transformed it by thinking in terms of the movement of masses, balancing these masses one against another. The *David* in the Accademia, Florence, is typical: because the left leg is bent and its knee thrust forward, forming a strong mass in the foremost plane, the right shoulder is pushed back, so that the chest is swung round on its axis; and then, because the right leg runs slightly backward, the left shoulder is brought forward and the arm and elbow are thrust out across the front of the body, this forward movement of the upper arm being countered by the head which leans backward. Thus playing the masses against each other, pushing one forward and another back, Michelangelo achieved a balance which is both three-dimensional and full of tensions which are immediately felt if one thinks oneself into the movement of his figures. The many protruding points of the figure cause a play of sharp lights and shadows which induce the same kind of emotion as do the tensions of the movement.

# CONVERSATION PIECE

Michelangelo's own technique of carving favoured this extreme development of *contrapposto* because, working from the front of the stone inwards, he would carve the foremost plane first, dealing simultaneously with forward knee and jutting elbow, and so progress steadily through the third dimension (see STONE SCULPTURE).

BAROQUE sculpture was deeply influenced by Michelangelo's use of balanced masses and even in the north, in German sculpture of the 17th and 18th centuries, a new vitality was imparted to the traditional figures of the Madonna or saints by using this form of *contrapposto*. In clothed figures, such as BERNINI's, the masses of drapery were balanced against one another in the same way, so that a kind of *contrapposto* of drapery was built up. In the 19th and 20th centuries no single scheme has prevailed, and each sculptor has made his own choice from among the existing possibilities.

**CONVERSATION PIECE.** A portrait group in a domestic or landscape setting in which the sitters are engaged in conversation or social activity of a not very vigorous character. Conversation pieces are usually, though not always, small in scale. They were produced in large numbers in Britain during the 18th c., but the use of the term is not confined to British painting or to this period. The more important British practitioners were the DEVIS, HAYMAN, HOGARTH, Gavin HAMILTON, the early GAINSBOROUGH, and ZOFFANY. Representative examples (with the exception of Gainsborough and Hamilton) are in the Tate Gallery, London.

**COOPER, ALEXANDER** (before 1609–after 1660). Miniaturist, brother of Samuel Cooper, and nephew and pupil of John HOSKINS. He worked mainly on the Continent, in Holland and Sweden, where he painted for Queen Christina from 1647. Few of his MINIATURES are known. His style was more in the Dutch manner, more finished but without the breadth of treatment or virile technique of his brother.

SAMUEL (1609–72) was also a pupil of Hoskins; he established an independent practice as miniature-painter in London c. 1642. Probably before this he had travelled in Europe. He achieved international renown and his clientele included most Englishmen of note. He has been called 'van DYCK in little', but he had already evolved a masterly individual style in the 1630s and his ambitious composition and BAROQUE sense of design mark a complete breach with the tradition of HILLIARD and Hoskins. He painted rather more broadly and freely than his predecessors, with a trick of slightly exaggerating the lighting. He was a superb draughtsman and his soft greyish tones are distinctive. His portraits are almost always of the BUST only, but within this limitation his range is remarkable: he presents each sitter with a force and indivi-

duality beside which the life-size portraits by contemporaries such as LELY appear doll-like. His miniatures are painted on vellum mounted on card, and usually about 2 in. high, but larger ones include his *Charles II* and *First Earl of Shaftesbury* and there is a set of five large unfinished heads at Windsor. He is well represented at the Victoria and Albert Museum and there are excellent examples of his work in the Royal Collection at Windsor Castle and in the Fitzwilliam Museum, Cambridge.

**COPAL VARNISH.** The copals are hard RESINS obtained from trees or fossils. Dissolved in LINSEED OIL or other drying oils they make a VARNISH, which, however, is apt to darken and crack, and is now little used in painting. ETTY used to 'tie-down' his underpainting with copal varnish before painting in full colour.

**COPLEY, JOHN SINGLETON** (1738–1815). American painter, born at Boston. He early developed a shrewd and forceful native REALISM which marked him out as one of the most talented of the Colonial portraitists. In his formative years he studied the works of his fellow Bostonians SMIBERT and the genre painter John Greenwood (1727–92). He was influenced by the English manner of ROCOCO portraiture through Robert FEKE and John Greenwood (1727–92) and later by the English painter-craftsman Joseph Blackburn who came to Boston in 1755. The English MEZZOTINT engraver Peter Pelham, who settled in Boston in 1726, became his stepfather. But into the empty and decorative formulas of these uninspired workers he infused an incisive and authoritative power of characterization which enabled him to create the most brilliant and convincing expression of the aristocratic ideal in American 18th-c. painting (*Mary and Elizabeth Royall*, Boston Mus. of Fine Arts, c. 1758; *Col. Epes Sargent*, N.G., Washington, c. 1760; *Mrs. Sylvanus Bourne*, Met. Mus., New York, 1766; *Mr. and Mrs. Thomas Mifflin*, The Historical Society of Pennsylvania, 1773). He had a special gift for the portrayal of older people of the professional and learned classes and he also made distinctive use of the Rococo *portrait d'apparat*, depicting the sitter in the setting of daily life.

Though he had a strong vocation, Copley was diffident and self-doubtful by nature and came to see himself as an artist afflicted with provincialism cut off from the great European tradition of painting. For a long while he hesitated to leave the security of Boston and studied the English manner in imported engravings; the elaborate costumes in some of his Boston portraits were derived from them. Urged by REYNOLDS and Benjamin WEST, however, he sailed for Europe in 1774 and the following year settled in England, where he spent the rest of his life. He never wholly adapted himself to the

278

different conditions of his adopted country and perhaps never again equalled the spontaneous vigour of his American work. The GRAND MANNER did not sit well with his Colonial bluntness of insight. But he had always been attracted by the suave sophisticated grace of English painting and when his realistic manner, which had been so popular in Boston and New York, proved unacceptable in England he gradually changed his whole approach to portraiture. He enjoyed a short period of success in London and was elected a member of the ROYAL ACADEMY in 1783. It was during this time that his historical subjects were received with considerable acclaim. Taste changed, however, and Copley gradually lost his popularity. During his last years he was constantly menaced by debt. With a few rare exceptions like *The Children of George III* (H.M. the Queen, 1785), today his fame rests upon his Colonial portraits and a few history pictures painted before the close of the 18th c., such as *Watson and the Shark* (Mus. of Fine Arts, Boston, 1778), *The Death of Chatham* (Tate Gal., London, 1779–80), and *The Death of Major Pierson* (Tate Gal., London, 1783).

42, 199, 200, 622, 884, 2029, 2155.

**COPPER POINT.** See METAL POINT.

**COPPO DI MARCOVALDO** (b. *c.* 1225). Italian painter. He served in the army of Florence and settled in Siena after his capture at Monteaperti. In 1261 he painted the signed and dated *Madonna and Child Enthroned* (called the *Madonna del Bordone*) in the Servite church at Siena. A similar panel at Orvieto (Sta Maria dei Servi) is ascribed to him on stylistic grounds. He also made FRESCOES for the cathedral at Pistoia and a painted cross which survives.

With Coppo icons begin to be human. The Virgin, superhuman in size and splendour, inclines her head towards the Child; the flesh is modelled softly and the Byzantine motif of gold feathering is no longer only an ornament for draperies but traces the volumes of the body. This humanization of the HIERATIC marks Coppo and his Sienese contemporary, GUIDO DA SIENA, as the most important forerunners of CIMABUE and DUCCIO.

**COPTIC ART.** The term 'Coptic' has a precise meaning derived through Arabic from Greek; a Copt is a native Egyptian Christian as distinct from both a Greek and a Moslem (though it is applied more specifically to the peasant and country Christian population who belonged to the sect of the Monophysites in contrast to the richer merchant classes). Coptic art, therefore, is the art of the native Christian community in Egypt and reflects its fortunes and its changing cultures.

The first and most important phase in Coptic art seems to begin with the 5th c. and to end during the 8th. Christianity had developed in Egypt within the Greek milieu of Alexandria and had only slowly affected the countryside. Very many native Egyptians had become Christian during the 4th c. but it is not until the early 5th that they are clearly discernible as a distinct community with its own culture. After the Council of Chalcedon in 451 they formed a separate church. For the whole official class in Egypt, the rich merchants and great landowners, followed the Imperial government of Byzantium in accepting and in attempting to enforce the decision of the council on the Two Natures of Christ. But the Egyptian-speaking peasantry followed their own bishops and abbots in holding the creed of the Single Nature and found support from the richer and more influential body of Syrian Monophysites.

All this helps to explain the characteristics of Coptic art in its first phase. It possessed and always retained some of the character of a peasant art; there is a delight in brilliant flat colours and a stiff naïvety in figure work. Many of the more sophisticated elements seem to be derived from Syria, like the serrated acanthus scroll, the elaborate interlacing of the vine scrolls, and perhaps the use of a receding background in reliefs. Both in animal forms and at times in composition there are obvious influences from Sassanian Persia which had probably passed through Syria. There are many echoes of ancient Egyptian beliefs in the choice both of emblems and of themes, such as the fusion between the Ankh symbol of Isis and the cross and the representation of episodes from the Horus myth in Christianized form. But there is little sign of any continuity with ancient Egyptian or Ptolemaic art forms.

We still possess some wall-paintings, many textiles, and much stone carving of this period. The wall-paintings are often fragmentary or defaced, and many have been repainted. The textiles have only recently become the subject of scientific study. A number of the Coptic textiles in great museums were probably woven in northern Syria and some in 19th-c. Paris. But there is a large residue which can be attributed with fair certainty to Egypt. Most of these are tapestry woven in linen or wool, though there are specimens of loop weaving or draw-loom weaving and some fragments of woollen rug with a cut-pile surface. There seems evidence of an increasing zest for schematization and polychromy. The carving is for the most part in soft stone and only occasionally in granite or marble. The whole surface of these vigorous if superficially rather naïve sculptures is covered with intricate patterns, and traditional Hellenistic motifs are transformed by being treated geometrically, just as in such wood-carving as survives the figure work is transformed into flowing rhythm. All this is illustrated by sculptures excavated at Baouit and Sakkarra and now in the Coptic Museum at Cairo.

Coptic art of this first phase seems to have

reached its zenith by the end of the 6th c. The conquest of Egypt by the Arabs in 641 had little immediate effect on it. But a century later the character of the Coptic community was beginning to change, while its culture was becoming more urban in character. Now that Byzantine rule had vanished many of the Christian merchant class had become Copts, while some areas of the countryside had accepted Islam. A new phase in Coptic art came into being under the normally very tolerant rule of the Tulunids and Fatimids from 868 to 1169. As a result of this tolerance it is difficult to distinguish between Coptic and ISLAMIC art in this period. Both were influenced from contemporary Constantinople and Cordoba, as well as from Iraq. Fatimid caliphs employed Christian artists and craftsmen, Christian patrons imitated the Fatimid court fashions. In the church of Abu Saifan there are carvings oddly similar to ROMANESQUE which may perhaps be linked with Christian Spain and this is also possibly true of some wall-paintings at Baouit. But as a whole Egypt was acquiring a cultural unity which is reflected in its art forms.

All this was altered by the victory of Saladin in 1169. Under the Ayyubid and Mamluk Sultans from 1169 to 1516 the Copts were increasingly segregated and their numbers dwindled. Some Coptic merchants gained great wealth through the Mediterranean trade and there is evidence that there were patrons of art with a taste for luxury and foreign fashions. Panel paintings became more common (the earliest surviving ICONOSTASIS is of the 13th c. in the church El Moallaka); whole walls were covered by mural paintings. And in both it is possible to trace occasional motifs from Constantinople, Venice, and perhaps Genoa, formalized and stiffened. There was a new development in woodwork: ivory inlaid on ebony in intricate geometric patterns. There are examples of metal-work and of ornament in stucco and TERRACOTTA. But as a whole Coptic art in this period seems sterile and in the next it slowly dies.

The Turkish conquest of Egypt in 1516 brought the Copts into closer contact with the other Christian communities in the East. Greek Orthodox influence seems apparent in church furnishings, vestments, and embroidery. Many Coptic ICONS of the 17th and 18th centuries were obviously derivative from the Italianate-Greek schools of Crete and the Ionian Islands. A history of 1,400 years ended in 1798 when Napoleon entered Cairo. The walls round the Coptic ghetto were destroyed; the Copts became a part of that Napoleonic creation, the Levant. Something of the older traditions survived through the 19th c. as archaic specimens of vanishing peasant skills.

It was only during the first two phases that the Copts had importance for the general history of art. In the 10th and 11th centuries Christian craftsmen working for the Fatimids had their share in the creation of an art which, especially in glazed ware and in pattern and design, made a far from negligible contribution to that of the Persian area, while Coptic painting and figure sculpture may possibly prove to have been one source for Romanesque through contacts with Christian Spain. But it is clear that from the 5th to the early 8th centuries Coptic art had a much more crucial significance in general art history than had once been granted. Through its textiles and carvings it played an essential part in the creation of Islamic art, not only in its own right but also as a carrier of Hellenistic motifs. Southward Coptic painting was the primary source of pictorial style in the Christian kingdoms of the Sudan and in early Ethiopia. Northward it is certain, if only from Sta Maria Antiqua in Rome, that it exerted some impact on Italy. It is impossible to compare the complex and precise interlacings of Coptic pattern with those of the *Book of Kells* without being almost convinced of a direct Coptic influence on the Irish-Northumbrian School, exercised perhaps through some imported church hangings. Further research on Coptic ivories may provide more clues to the crosses at Ruthwell and Bewcastle. When we remember the discovery of new patterns and the mastery of abstract forms achieved in the first phase of Coptic art, we cannot assume that its influence has yet ended.

213, 461, 537, 617, 790, 2043, 2849.

**COPY.** In a restricted sense, the term 'copy' is applied to a work of art which has been produced without the direct intervention of the original artist or his assistants. The copy is thus distinguished from the *version* and the *replica* which, coming from the artist's studio, have the same validity (or nearly the same, according to the extent of the artist's participation) as the original work. Versions show variations on the original composition; replicas are commonly found in the case of the portrait.

Before the invention of mechanical means of reproduction plaster casts and copies were the only means by which the knowledge of works of art was spread. The existence of copies therefore serves as an indication of the appreciation of works of art as such, regardless of their original context or purpose. The emergence of an industry of copying masterpieces of Greek sculpture and probably of painting in classical antiquity is symptomatic of this awareness of artistic values; and though many of these copies must have fallen short of their famous originals, it is to them that we still owe a knowledge of the artistic personality of masters such as POLYCLITUS or MYRON (see POINTING). Similar conditions prevailing in the Far East also led to assiduous and exact copying of the famous masterpieces and in some cases CONNOISSEURS are still divided in their opinion whether works are originals or copies. Copying in order to produce a facsimile which can serve the same purposes as the original work

of art is peculiar to times of connoisseurship when art works have a flourishing market. (See CONNOISSEURSHIP IN ANTIQUITY.)

In the Middle Ages the work of both artists and craftsmen relied to a very large extent on copies and adaptations of themes, decorative and stylistic motifs, and time-hallowed formulas from earlier periods. This kind of copying differed in purpose and conception from, say, the reproduction of famous Greek works by late Roman copyists. The training of the medieval artist began with copying the works of his master and other potentially useful prototypes which he saw on his apprenticeship journeys and entered in his pattern books. At a time when individuality counted for little no stigma of plagiarism attached to the wholesale adaptations of groups or motifs thus collected, and later, with the invention of printing, GRAPHIC ART added to the stock-in-trade of these artists (King's College Chapel windows, Cambridge, copies from Dürer).

It was only with the RENAISSANCE that more self-conscious copying of famous masterpieces re-emerged from these activities; MICHELANGELO in his youth copied MASACCIO and SCHONGAUER and the early ACADEMIES enjoined the drawing of the ANTIQUE. With the developing art trade of the 16th c. copies were sometimes passed off as originals and VASARI tells us how ANDREA DEL SARTO's copy of RAPHAEL's portrait of Leo X even deceived GIULIO ROMANO, who had a share in the original. The historian's problem is complicated by the fact that the collectors sometimes bought ALTARPIECES by famous masters and had them replaced by a copy—the tangled problem of the two versions of LEONARDO's *Virgin of the Rocks* is connected with this practice. The claims which are made from time to time by collectors that the replica of a famous masterpiece in their possession is the original, while one, say, in the Louvre is a copy, illustrates the temptations arising out of these confusions.

Naturally great artists continued to make copies for their own instruction: RUBENS's copies after TITIAN's *Bacchanal* in the Prado and POUSSIN's copy after Giovanni BELLINI are cases in point. REMBRANDT sketched Raphael's *Castiglione* at an auction and WATTEAU made many drawings after the Venetians. The sketchbooks of the Italian journeys of artists such as FRAGONARD and REYNOLDS testify to their taste and interest, and the practice continued up to the present time. The ROMANTIC conception of art with its stress on originality frowned upon copying as a method of instruction, and yet masters such as CONSTABLE or DELACROIX frequently copied and CÉZANNE drew assiduously in the Louvre. Van GOGH copied and reinterpreted works of Rembrandt, Delacroix, MILLET, and DORÉ, and PICASSO has often been inspired to make variations of great works of the past, the most famous being his variations on the *Las Meninas* of VELAZQUEZ.

The value of copying in art education is a subject of controversy, but the practice still has its partisans even outside the academies and devoted copyists may be seen at work in most public galleries.

**COQUES, GONZALES** (1614-84). Flemish GENRE and portrait painter, known as the 'Little van DYCK'. Born and active at Antwerp, he probably travelled to Holland and England before becoming a Guild Master in 1641. His small portrait groups and interior scenes are usually of fashionable personages, and his meticulous style of painting is related to Dutch masters such as TERBORCH. Although Coques's compositions derived from van Dyck, the execution and spirit of his work is distinctive and has considerable charm, especially in the family groups in a landscape.

**CORBEL.** Architectural term. A projection on the surface of a wall intended to support a weight. Corbels often provided the opportunity for elaborate carving.

**CORFU PEDIMENT.** From a temple of Artemis in Corcyra (Corfu) come the earliest large pedimental sculptures. In the Corinthian style of *c*. 580 B.C., they show a central Gorgon with Pegasus and Perseus or Chrysaor, flanked by couchant panthers, and in the corners mythological scenes. The figures are in high RELIEF or almost in the round according to their varying scale. Impressive as decoration, the pediment appeals to devotees of the PRIMITIVE. Legend attributes its unearthing to Kaiser Wilhelm II.

**CORINTH, LOVIS** (1858-1925). German painter, born in East Prussia. Corinth, like LIEBERMANN, is sometimes misleadingly called a German IMPRESSIONIST. His early style, indebted in particular to HALS and RUBENS, was, however, in the NATURALISTIC tradition and thus Corinth in some respects presents a parallel to MANET and DEGAS in France and to SICKERT in England. An apoplectic stroke incapacitated him in 1911, and when he began to paint again it was in a much looser and more powerful EXPRESSIONIST manner. As well as painting landscapes, portraits, and STILL LIFES, Corinth had a fondness for voluptuous allegorical and religious subjects.

96, 274, 1983.

**CORNEILLE DE LYON** (active 1533-74). Painter of The Hague who settled in Lyon and was employed by Henry II (1540 onwards). Contemporary references to him indicate that he had considerable reputation as a portrait painter, although no authenticated paintings by him survive. A series of small paintings of the Flemish type, often on a plain green ground, are usually attributed to him (*Beatrice Pacheco*, Versailles, and *Portrait of a Man*, N.G., London), and it

may be assumed that they represent his style. A list exists which was made by an 18th-c. collector, Roger de Caignières, who bought numerous paintings in Lyon presumably bearing traditional attributions. The Venetian ambassador Giovanni Capelli spoke of seeing in 1551 small portraits of members of the French court in his studio.

**CORNELISZ VAN AMSTERDAM.** See CORNELISZ VAN OOSTSANEN.

**CORNELISZ VAN OOSTSANEN,** JACOB (c. 1470-1533), also called JACOB CORNELISZ VAN AMSTERDAM. Dutch painter and the leading designer of WOODCUTS in Amsterdam in his day. He liberated the Dutch woodcut from the MINIATURE tradition and gave it a new power and breadth. His work, which includes ALTARPIECES, painted ceilings, and designs for STAINED GLASS and book illustrations, retains a provincial character; it does, however, indicate the beginning of Amsterdam's importance as an artistic centre. Comparatively few of his works have been preserved: among the woodcuts is a famous series illustrating the *Passion* and among the paintings there is a *Self-portrait* (Amsterdam, 1533) and an *Adoration of the Shepherds* (Naples, 1512) which contains pudgy angels playing toy-like instruments, singing, and decorating with garlands an improbable RENAISSANCE manger. Cornelisz was one of the teachers of Jan van SCOREL.

**CORNELISZ VAN HAARLEM,** CORNELIS (1562-1638). Dutch painter who ranks with Hubert GOLTZIUS and Carel van MANDER as one of the leading representatives of MANNERISM in Holland at the end of the 16th c. He is best known for his large biblical and historical pictures packed with athletic, life-size nudes in wrenched and sharply foreshortened positions which emulate the Italian Mannerists. But he also did a few forceful portraits of individuals and groups which show that he was an important forerunner of Frans HALS. Both facets of his work can best be seen in the Frans Hals Museum in Haarlem.

**CORNELIUS,** PETER VON (1783-1867). German painter. After training at the Dusseldorf Academy Cornelius went to Italy in 1811, where he joined the NAZARENES. In 1819 he was called to Munich by Crown Prince Ludwig of Bavaria; in 1825 he became head of the Munich Academy. From 1841 to his death he lived in Berlin. While still a student Cornelius was introduced to medieval German painting by the brothers Boisserée, and when GOETHE's *Faust* first appeared in 1808 he was inspired to make a series of illustrations which emulated DÜRER's

graphic style. His principal works in Munich— frescoes of mythological subjects in the Glyptothek and the enormous *Last Judgement* in the Ludwigskirche—are a self-conscious attempt to revive monumental art in public buildings. They are heavily indebted to RAPHAEL, MICHELANGELO, and the didactic philosophy of German ROMANTICISM. In an age of awakening REALISM, Cornelius despised nature and drawing from the model and held that the expression of lofty ideals is the true aim of all art. He is usually called a Romantic, but he worked in the tradition of 18th-c. ECLECTICISM even if he used different prototypes.

Cornelius's influence was considerable and it may well be claimed that his works in Munich sparked off the revival of large-scale fresco decoration in Germany and perhaps elsewhere. His advice was sought for the decoration of the Houses of Parliament, London.

**CORNICE.** Term in classical architecture for the topmost of the three primary divisions of the ENTABLATURE. The term is extended to apply to any projecting horizontal moulding forming a main decorative feature along the top of a wall or ARCH or at the juncture of the walls and ceiling of a room.

**COROT,** JEAN-BAPTISTE CAMILLE (1796-1875). French painter. At the age of 26 he abandoned a commercial career for the practice of art and from the first showed a strong vocation for landscape painting. He first became a pupil of a young landscape painter Achille Etna Michallon (1796-1822) and on the latter's death in the same year entered the studio of the Classicist Victor Bertin (1755-1842). He travelled about France making sketches from nature and from these he composed in his studio. He was in Italy 1825-8 and again for short visits in 1834 and 1843. Throughout his life Corot found congenial the advice given to him by Michallon 'to reproduce as scrupulously as possible what I saw in front of me'. He was befriended by two young painters, Edouard Bertin (1797-1871) and Claude Félix Théodore Caruelle d'Aligny (1798-1871), who were trying to introduce greater truth and naturalness into historical landscape. On the other hand he never felt entirely at home with the new school of landscape painting of Paul Huet (1803-69) and the BARBIZON group, who made it their aim to communicate the emotions felt by the painter when confronted by picturesque nature and he remained more faithful to the French classical tradition than to the English or Dutch schools. Yet although he continued to make studied compositions after his sketches done direct from nature, he brought a new and personal poetry into the classical tradition of composed landscape and a naturalness which had hitherto been foreign to it. Corot had a deeply felt but spontaneous love

for the country without the ROMANTIC idealization of the countryside as a form of escapism from urban banality. Though he represented nature realistically, he did not idealize the peasant or the labours of agriculture in the manner of MILLET and COURBET. He remained outside the current controversies between Classicists and Romantics.

From 1827 Corot exhibited regularly at the SALON, but his work went largely unrecognized until the Universal Exhibition of 1855, which established his fame. Between c. 1850 and 1870 Corot's landscapes became more misty and ethereal and they have sometimes been accused of formlessness. But his talent did not abandon him in old age. His pictures *The Studio* (Lyon Mus., 1870), *Ponte de Mantes* (Louvre, c. 1870), and *Sens Cathedral* (Louvre, 1874) are among his masterpieces. Corot stood head and shoulders above other French landscape painters of the first half of the 19th c. He was generally admired by the major landscape painters of the latter half of the century and influenced nearly all of them at some stage in their careers.

203, 625, 627, 1424, 2274.

**CORREGGIO,** ANTONIO ALLEGRI (c. 1489-1534). Italian painter, who took his name Correggio from the small town where he was born. Little is known of his life and even the year of his birth is uncertain, but his paintings suggest under whom he may have formed his style. Echoes of MANTEGNA's manner in many of his early paintings suggest that he may have studied that master's work in Mantua. He was influenced in these works also by Lorenzo COSTA and LEONARDO, adopting Costa's pearly Ferrarese colouring, and in the *St. John* of the *St. Francis Altarpiece* (Dresden, 1514) Leonardo's characteristic gesture of the pointing finger. He later initiated a style of sentimental elegance and conscious allure with soft SFUMATO and gestures of captivating charm. Among the paintings that probably can be attributed to his early period is the *Christ Taking Leave of His Mother* (N.G., London). Correggio may well at this time have visited Rome, although VASARI maintains that he never went there and the obvious inspiration of the paintings of RAPHAEL and MICHELANGELO could be accounted for by drawings and prints which were known all over Italy.

He was probably in Parma, the scene of his greatest activity, by 1518. His first large-scale commission there was for the decoration of the abbess's room in the convent of S. Paolo. The theme of the decorations is Diana, goddess of chastity and the chase, and the vaulted ceiling uses Mantegna's idea of a leafy trellis framing PUTTI and symbols of the hunt. The S. Paolo ceiling was followed by two dome paintings in which Correggio developed the ILLUSIONIST conception—already used by Mantegna and subsequently almost always employed in ceiling decorations—of depicting a scene as though it were actually taking place in the sky above. The first of these domes was commissioned for the church of S. Giovanni Evangelista in 1520. The 12 Apostles sit on clouds round the base, while Christ is shown in sharp foreshortening ascending to heaven. In the commission six years later for an *Assumption of the Virgin* in the dome of Parma Cathedral he used the same principle, but on a much larger scale and with still more daring foreshortening. True FRESCO is touched up with TEMPERA and the colours are no longer silvery but soft and glowing.

Correggio's style looks like an anachronism. His CUPOLA frescoes seem to anticipate the Italian BAROQUE and have incurred the censure of NEO-CLASSICAL taste for this very reason. His altar paintings with their emphasis on light effects and their unorthodox compositions are likewise reminiscent of 17th-c. paintings, while his sensuous mythological compositions even foreshadow the ROCOCO of BOUCHER. The great reputation which Correggio's art enjoyed in later days and the intensity with which it was studied by the CARRACCI and other academic masters have made it difficult to assess his originality in his own time. His famous altar paintings such as *The Virgin with St. Jerome and St. Mary Magdalen* in Parma, known as 'The Day', and *The Nativity* in Dresden, known as 'The Night', have a boldness of composition and an ecstatic fervour which mark the great artist. His mythologies, such as the *Loves of Jupiter* (Io and Ganymede in Vienna, Leda in the Louvre), have a lyrical sweetness and a sensitive touch which show their creator to be a not unworthy heir to Leonardo.

271, 362, 1170, 2126, 2233.

**CORTESE.** See COURTOIS.

**CORTONA,** PIETRO BERRETTINI DA (1596-1669). Italian painter and architect, an exponent of the full Roman BAROQUE style. He began as a painter in Rome with four big pictures for the Sacchetti family (now in Capitoline Gal., Rome), but was soon commissioned by the powerful BARBERINI family to paint FRESCOES in Sta Bibiana, Rome (1624-6), and the huge ceiling fresco in their Palace, the *Allegory of Divine Providence and Barberini Power*. He began the latter c. 1633, but interrupted the work in 1637 to go to Florence and paint two of four frescoes commissioned by the Grand Duke of Tuscany for the PITTI Palace. He returned to finish the Barberini ceiling in 1639. This, his most famous painting, is a triumph of ILLUSIONISM for the centre of the ceiling appears open to the sky and the figures seen from below (di SOTTO IN SU) appear to come down into the room as well as soar out of it. Cardinal Mazarin must have realized the potential value of such a painted apotheosis when he invited Pietro to Paris. The offer was, however, declined and he returned to Florence (1640-7) to finish his decorations in the Pitti Palace, where he received a new

commission for seven ceilings (completed by his pupil Ciro Ferri (1634-89)). These *Allegories of Virtues and Planets* have elaborate stucco accompaniments uniting the painted ceilings with the framework of the rooms.

From 1647 until his death Pietro da Cortona worked in Rome, and with the help of numerous pupils executed many more illusionist frescoes and easel pictures. The chief frescoes are those in the Chiesa Nuova (1647-65) and the *Aeneas* series, commissioned by Innocent X, in the Pamfili Palace (1651-4).

Pietro da Cortona's first major architectural work was the church of the Academy of St. Luke, of which he was elected President in 1634, the same year that he began to build the lower church (Sta Martina) at his own expense. In 1635 he took over the whole, which was finished as to essentials by 1650. The plan is a Greek cross of RENAISSANCE type, but the façade is given dominance with its slightly curved centre and projecting coupled PILASTERS to close the ends. The curved façade is even more important in Sta Maria della Pace (*c.* 1655-67), where it is again run into two storeys. The façade of Sta Maria in Via Lata (finished 1662) is more strictly classical with the CLASSICISM inherent in certain aspects of the BAROQUE. Pietro da Cortona was among the architects invited to contribute designs for the LOUVRE in 1664 but the competition was won by BERNINI. In 1652 he and P. Ottonelli published, under pseudonyms, a *Trattato della pittura* expressing the ideals of the Counter-Reformation. As an architect he ranks with Bernini and BORROMINI.

398.

**CORVUS,** JOANNES (probably identical with JEHAN RAF and JOHN RAVEN; active *c.* 1512-*c.* 1544). A painter, perhaps from Bruges, who worked in England *c.* 1520-30, later in France and then perhaps again in England. His portrait of Bishop Foxe (Corpus Christi College, Oxford) is rather above the general run of very similar rather wooden guild-work in northern Europe.

**COSMATI WORK.** A generic name given to coloured marble and stone decorative inlay work whose centre was at Rome between *c.* 1100 and 1300. The term derives from two craftsmen called Cosmas, whose names are inscribed on several works (e.g. the cloister of Sta Scolastica at Subiaco, the pavement at Anagni, and the Sancta Sanctorum Chapel in Rome). There were several families of 'Cosmati' workers (e.g. those of Vassallettus and Laurentius) and many individual craftsmen. They worked in a manner distinguished by white marble revetments inlaid with stars and whirling discs of coloured glass and semi-precious stones. Cosmati work was applied to cloisters, bell towers, and large surfaces such as nave floors and façades (e.g. S. Clemente, Rome, and Sta Maria Maggiore,

Toscania). Paschal candlesticks, pulpits, tombs, and bishops' thrones were also 'Cosmatized' (e.g. Sta Maria in Cosmedin, Rome; and the Upper Church of S. Francesco, Assisi).

This comprehensive use of inlays was derived from south Italy and ultimately from Byzantium, as were many of the patterns. Cosmati work also borrowed ANTIQUE forms which were sometimes transposed entire to a new site; e.g. the architrave, the lions, and sphinxes of Città Castellana (1210) and the Lateran cloister (1232-6), or they were copied, as in the flat arched porches of the Roman churches of S. Lorenzo in Lucina, S. Giorgio in Velabrio, and Sta Cecilia in Trastevere. The demand for this gay style spread even beyond Italy. Roman marble workers were summoned to Westminster Abbey (1268) to build and decorate monuments to Edward the Confessor and the family of Henry III. After 1300 the fashion changed and only a memory of its conventions survived in the ornamental detail of some Italian FRESCOES.

1397.

**COSSA,** FRANCESCO DEL (*c.* 1435-*c.* 1477). Italian painter of Ferrara. As most of his contemporaries, he had affinities with TURA and had the same background of development from MANTEGNA and PIERO DELLA FRANCESCA. His more genial temperament and relaxed urbanity found expression in the frescoes of the *Months* for three of which he was mainly responsible in the Palazzo Schifanoia ('Sans Souci') at Ferrara. In these frescoes the astrological symbols and deities of the months are related to the activities of the court throughout the year (see OCCUPATIONS OF THE MONTHS). Cossa subsequently left Ferrara for Bologna, where he painted ALTARPIECES of which three survive. The *Crucifixion* (N.G., Washington), part of a polyptych from S. Petronio (1473), has been thought to betray the influence of CASTAGNO and to indicate a Florentine basis for Cossa's style.

1943.

**COSSUTIUS.** Architect who, although his name is Roman, worked on the Olympieum at Athens *c.* 170 B.C. This temple, not completed till 300 years later, was in Corinthian style.

**COSTA,** LORENZO (*c.* 1460-1535). Italian painter, who began his career in Ferrara and was trained to the manner of TURA and Ercole de' ROBERTI. This is reflected in his early works, such as *The Concert* (N.G., London), one of the first examples of a type of picture which had a considerable vogue in later centuries.

He went to Bologna, where he decorated the Sentivoglio Palace and entered into partnership with FRANCIA. In 1506 he succeeded MANTEGNA as court painter at Mantua, where his work included two *Allegories* painted for Isabella d'Este (Louvre). His later style, tempered with a

certain Umbrian delicacy and a feel for landscape, has been regarded as one of the sources of GIORGIONE.

**COSTA,** LÚCIO (1902-63). Brazilian architect, town-planner, and art historian, born at Toulon. After graduating (1924) in architecture at the National School of Fine Arts, Rio de Janeiro, he became Director in 1931 and modernized teaching methods. His effective combination of the Brazilian colonial tradition with advanced constructional techniques in a lyrical and dynamic approach to contemporary problems rendered him the acknowledged leader of the modern movement in Brazilian architecture. He was the leading member of the team of architects who with LE CORBUSIER as consulting architect produced the epoch-making Ministry of Education building at Rio de Janeiro (1937-43). This with his Brazilian Pavilion at the New York World's Fair (1939) and his Guinle Park housing estate (1948-54) were a major inspiration to the younger generation of Brazilian architects. As a member of the National Historical and Artistic Patrimony Department from 1937 he took a major part in the historical study of Brazilian architecture and in the work for the restoration and preservation of national monuments. He achieved a world-wide reputation with his plan for the new capital Brasilia (see BRAZILIAN ART), which was chosen by an international jury in 1956.

**COSWAY,** RICHARD (1742-1821). English MINIATURE painter, who studied under HUDSON. He was elected A.R.A. in 1770 and R.A. in 1771. He was by far the most fashionable miniature painter of his day, imparting to sitters an air of great elegance. He painted some large vivacious portraits in oil, but on this scale the modishness which makes his miniatures attractive is less easily acceptable. Cosway was a friend of the Prince of Wales (later Prince Regent). In 1781 he married Maria Hadfield, who was also a miniaturist.

2900.

**COTÁN,** JUAN SÁNCHEZ. See SÁNCHEZ COTÁN.

**COTES,** FRANCIS (1726-70). English painter, who studied under KNAPTON and began his career as a painter of pastel portraits of fine quality. He turned to oils and by the 1760s was the most fashionable portrait painter in London. He became a foundation member of the ROYAL ACADEMY. His portraits are often brilliant in colour and have a refinement and a charm in the painting of accessories which suggest that, had he lived, he would have been a serious rival to REYNOLDS and GAINSBOROUGH. His studio in Cavendish Square was later taken over by ROMNEY.

**COTMAN,** JOHN SELL (1782-1842). English LANDSCAPE and WATER-COLOUR painter, together with CROME the most important representative of the NORWICH SCHOOL. Son of a well-to-do Norwich merchant, he went to London in 1798 to become an artist and was employed first by Rudolph Ackermann, proprietor of the Depository of Arts in the Strand, and later by Dr. Monro. In 1800 he was in Wales and became a member of the circle of artists around the collector Sir George Beaumont, where he met GIRTIN. In 1803, and again in 1804 and 1805, he visited Yorkshire and received the hospitality and friendship of the Cholmeley family of Brandsby Hall. In 1806 he settled in Norwich, where he opened a school for drawing and design and became Vice-President of the Norwich Society of Artists founded by Crome, and in Yarmouth, where he became drawing master to the family of the banker and antiquarian Dawson Turner. In 1834 he was appointed Professor of Drawing at King's College, London, through the good offices of Lady Palgrave, Dawson Turner's daughter. Throughout his life Cotman was subject to periods of melancholia and despondency.

In his earlier water-colour landscapes Cotman already displayed a strong sense of classical design which, as some have thought, looked forward towards CÉZANNE. He used large flat washes to build up form in clearly defined planes and austerely decorative pattern. In his later years he tried to catch the public fancy by large and gaudily melodramatic water-colours, in which he used an IMPASTO obtained with rice-paste. From c. 1810 he devoted himself also to etching as a mode of expression for the genuine love of architectural antiquities which formed a bond with his patron Dawson Turner. Between 1816 and 1818 he brought out two books on the Architectural Antiquities of Norfolk, followed by the *Sepulchral Brasses in Norfolk and Suffolk* in 1819. He spent the summers of 1817, 1818, and 1820 making sketches in Normandy, from which he did the plates for Dawson Turner's *Architectural Antiquities of Normandy* (1822) and *Tour in Normandy* (1820). Although Cotman was never as fully at home with etching as with water-colour or monochrome drawing, his *Liber Studiorum* (1838) with its 48 soft-ground plates ensures him a place of importance in the history of British etching. It has been said of him that 'at his best he stands up high and grey and serene among the world's great architectural etchers, including architectural landscape'. His work suffered a period of relative oblivion until near the end of the 19th c., after which interest in the formal aspect of landscape led to a new appreciation of the structural strength of his treatment.

1500.

**COTTAGES ORNÉES.** The picturesque rustic cottages much in fashion in England during the second half of the 18th and early 19th centuries, which might be playthings for the well-to-do or houses for workers on country estates. John NASH designed nine such cottages at Blaise Hamlet, Glos., in 1811; they are now in the care of the National Trust.

**COTTE,** ROBERT DE (1656-1735). French architect. He began his career as assistant to J. H.-MANSART, whose brother-in-law he was. His independent works date from 1710 and pioneered the ROCOCO style of architectural decoration. He was prolific in designing town houses both in Paris and in the provinces and won considerable reputation, supplying designs for buildings in Germany, Switzerland, Italy, and Spain.

**COUNTERPROOF.** See PRINTS.

**COURBET,** GUSTAVE (1819-77). French painter, born at Ornans of a landed proprietor. He was a man of independent character and

**96.** Self-Portrait by Gustave Courbet. Black chalk drawing. (B.M., 1852)

obstinate self-assurance. Coming to Paris in 1839 to study painting, he avoided the official schools and copied paintings by the 17th-c. naturalists CARAVAGGIO and the Spaniards RIBERA, ZURBARÁN, and VELAZQUEZ. His earliest pictures were in the ROMANTIC tradition, but by the age of 23 he found his true bent with *Portrait of the Artist with a Black Dog* (Petit-Palais,

Paris). He attracted attention by his large canvases *The Stone Breakers* and *The Burial at Ornans* (both in the Louvre) exhibited in the SALON of 1850 and he set himself up as the leader of the REALIST school of painting. He became a political socialist and was a friend and follower of the socialist Proudhon, who praised him in his book *Du principe de l'art et de sa destination sociale*. He was also admired by Zola.

Courbet was a realist in his choice of subject matter, choosing his themes from contemporary life and not excluding what was usually considered ugly or vulgar. He continued the realist element in GÉRICAULT and DELACROIX but without the Romantic bombast or exoticism. He had a gift for lending an air of grandeur to what had been hitherto eschewed as trivial or anecdotal and for giving dignity to the ugly or repulsive without toning down or idealization. 'Painting', he said, 'is an art of sight and should therefore concern itself with things seen; it should, therefore, abandon both the historical scenes of the CLASSICAL school and poetic subjects from GOETHE and Shakespeare favoured by the Romantic school.' When asked to include angels in a painting for a church, he replied: 'I have never seen angels. Show me an angel and I will paint one.' But Courbet's socialism was theoretical rather than an expression through his art. He was not of peasant origin like MILLET, and his pictures do not reveal an emotional concern with agricultural labour. He never attempted to follow the exhortations of BAUDELAIRE and the brothers de GONCOURT by painting the subject matter of urban life. As an artist he was conservative and developed little. He was technically very competent but a coarse colourist and he used his subject matter simply for its pictorial value rather than for emotional impact. There is nothing in his work which foreshadows the innovations of the IMPRESSIONISTS or their successors.

At the Universal Exhibition of 1855, dissatisfied with the representation allotted him, he organized a pavilion to himself in which he showed 40 canvases including the self-glorifying *L'Atelier du peintre* (Louvre), sub-titled 'Allegory of Realism' and later. described by Huysmans as 'une terrifiante ânerie imaginée par un homme sans éducation et peinte par un vieux manœuvre'. At the 1867 Exhibition he again exhibited, this time 110 canvases. In 1880 he had a retrospective exhibition. After 1855 his work became less doctrinaire, his colours were somewhat lighter and more pleasing and he no longer avoided attractive landscape subjects from the Forest of Fontainebleau, the Jura, or the Mediterranean, seascapes with distant vistas, comely and sensual nudes.

Courbet was an innovator on account of the subject matter he chose and his pictorial and unemotional treatment of realistic themes. He had an influence in his day towards the pictorial representation of daily life. But in painterly qualities he was not an innovator or

a precursor of the great experiments and discoveries to come.

642, 1618, 1724, 1735.

**COURTAULD,** SAMUEL (1876-1947). One of the earliest British collectors of IMPRESSIONIST and POST-IMPRESSIONIST French paintings. In 1923 he gave to the TATE GALLERY the sum of £50,000 for the purchase of works by French 19th-c. painters who were hardly represented in the gallery. Courtauld's own collection, whose primary emphasis was on French Post-Impressionist works produced between 1880 and 1900, was presented by him to the University of London and was first shown as a whole at the Tate Gallery in 1948. The making of the collection, begun in 1922, was an event of cardinal importance in the history of English taste in the 20th c., which had until that time been impervious to modern French art. In furtherance of his campaign for widening the appreciation of French 19th-c. art he also endowed the Courtauld Institute of Art in the University of London and made over to it the house at 20 Portman Square, which had been his residence.

**COURTOIS,** JACQUES (1621-75) and GUILLAUME (1628-79). Better known by the Italian version of their name CORTESE and both known by the epithet IL BORGOGNONE. French painters, brothers, who were born in the Franche Comté but worked mainly in Italy, where they were known principally as battle painters. Jacques was in Milan c. 1635 and served for three years in the Spanish army. He was working as a painter in Bologna c. 1638 and there came under the influence of Guido RENI and ALBANI. He settled at Rome c. 1640 and there came into contact with Pietro da CORTONA and the battle painter Michelangelo CERQUOZZI and possibly also the Flemish GENRE painter Pieter van LAER. He joined the Jesuits in 1657 but continued painting. His brother Guillaume (or Guglielmo) was also active in Rome as a painter and was an engraver of some merit. The two brothers sometimes collaborated. Another brother, a Cappuchin priest Padre ANTONIO, and a sister ANNA, were also painters.

**COUSIN,** JEAN. There are two French artists of this name. The elder (c. 1490-1560), a painter and engraver, a native of Sens, went to Paris in 1538, when he became successful as a painter and designer of STAINED GLASS. The *Eva Prima Pandora* (Louvre) is traditionally attributed to him and may have been executed at Sens before 1538. Some of the windows of Sens Cathedral are also attributed to him (*Life of St. Eutropius*, 1536). He also designed the tapestries of the life of St. Mammès, three of which survive. In style Cousin stood outside the contemporary

FONTAINEBLEAU school, although something of ROSSO's influence may be suspected and he seems to have been directly familiar with contemporary Italian art.

Attributions to his son, JEAN (1522-94), are again uncertain. He was a book illustrator and glass painter and spent most of his life in Paris. His *Livre de Fortune* contains EMBLEMS in the Rosso style and his *Last Judgement* (Louvre, 1615) combines the sentiment of CARON with treatment in the tradition of Florentine MANNERISM.

**COUSTOU,** NICOLAS (1658-1733), GUILLAUME I (1677-1746), GUILLAUME II (1716-77). Dynasty of French sculptors related to COYSEVOX, whose style they prolonged into the 18th c. The best known member of the family was Guillaume I, who made for the royal park of Marly the famous horses (1740-5) which now stand at the entrance of the Champs-Élysées in Paris.

**COUTURE,** THOMAS (1815-79). French historical and portrait painter, a pupil of GROS and P. Delaroche (1797-1856). He had a certain gift of draughtsmanship and is called by Elie Faure 'a painter without intelligence, but gifted, and sometimes powerful'. He is chiefly remembered for his vast 'orgy' picture *Les Romains de la décadence* (Louvre, 1847). PUVIS DE CHAVANNES studied under him for a short time and he was also the teacher of MANET and of FANTIN-LATOUR.

**COVARRUBIAS,** ALONSO DE (c. 1488-1564). Spanish architect and sculptor. He was one of the nine leading architects who approved the GOTHIC plans for the new cathedral at Salamanca in 1512. Despite this he was primarily an exponent of the RENAISSANCE-PLATERESQUE style. At Toledo he collaborated with Enrique EGAS on the Renaissance-Plateresque hospital of Santa Cruz, and succeeded Egas as cathedral architect in 1534. Other works of his at Toledo include the rebuilding of the ALCÁZAR as a royal palace (from 1537), construction of the Tavera hospital (from 1541), and rebuilding of the Bisagra Nueva gate (1559). These works represent the transition from Renaissance-Plateresque to Juan de HERRERA's *estilo desornamentado*.

**COX,** DAVID (1783-1859). English watercolourist. In his youth he worked as a scene painter in Birmingham and London, where he received lessons from John VARLEY. He lived in Hereford, 1814-27, and in London, 1829-41,

before retiring to Harborne, near Birmingham, from where he made annual sketching tours to the Welsh mountains. He wrote several treatises on landscape painting in WATER-COLOUR, the best known of which is the *Treatise on Landscape Painting and Effect in Water Colours* (1841; 1922). His paintings of country scenes with their anecdotal homeliness were popular in the later 19th c. His style in water-colour was versatile with occasionally penetrating observation. In 1836 he began to paint on a rough Scottish wrapping paper, which suited the broad surface effects he sought. A similar paper was made commercially and marketed as 'Cox Paper'.

649, 650.

**COYPEL.** A distinguished family of French artists, of which NOEL (1628–1707) was the head. Trained in the LEBRUN style, he was soon successful and became director of the French Academy in Rome (1672), where he brought up his son ANTOINE (1661–1722). Antoine based his painting on that of the CARRACCI and POUSSIN and developed an eclectic decorative style. He was closely associated with Roger DE PILES and during the 1690s came out as a strong admirer of RUBENS in the Colourist controversy. His work has a bombastic quality of pastiche deriving from the more melodramatic features of the BAROQUE in combination with the pedantries of the CLASSICAL style. His ceiling for the chapel of VERSAILLES is in the Roman Baroque manner of BACICCIA, depending on a melodramatic use of TROMPE-L'ŒIL for its effects (1708). This with the *Aeneas* decorations commissioned by the Duke of Orleans are the two most completely Baroque schemes found in French art of this period.

Despite his inferior quality as an artist Antoine Coypel has some importance in the history of French art as representing a taste which was at first in opposition to that of the King, but which eventually won its way to acceptance. Antoine in turn brought up his son CHARLES-ANTOINE (1696–1751) as a painter, who was to achieve a fame and success largely due to his administrative capacity in the various official positions that he held.

**COYSEVOX,** ANTOINE (1640–1720). French sculptor who collaborated at VERSAILLES with LEBRUN and MANSART. His work in the CLASSICAL manner of GIRARDON was a lifeless pastiche from the ANTIQUE (*Nymphe à la coquille*). He excelled in his decorations of the later rooms (Galerie des Glaces, Salon de la Guerre, Escalier des Ambassadeurs), where his technical virtuosity and inventive imagination found fuller play. His striking STUCCO relief of Louis XIV in the Salon de la Guerre was the most BAROQUE in spirit of anything produced at Versailles up to that time. His originality found its most complete expression, however, in his portrait busts, notable

particularly for the psychological penetration of the portraits of his personal friends (*Lebrun*, Wallace Coll., 1676). Some of the later busts, for example *Robert de Cotte* (Bibliothèque Ste-Geneviève, Paris, 1707), display a minute observation in the rendering of features and an eye for characteristic gesture which were new in French portraiture and foreshadowed the work of HOUDON.

1478.

**COZENS,** ALEXANDER (1717–86). English draughtsman. He was the son of Richard Cozens, a shipbuilder employed by Peter the Great, and is said to have been born in Russia. He seems to have been in England in 1742 and to have returned to Russia before visiting Italy in or before 1746, where he became perhaps the first major English artist to devote himself wholly to LANDSCAPE PAINTING. In or about 1763 he was appointed drawing master at Eton College. His association with William BECKFORD, probably a pupil, then patron and friend, appears to have begun in the early 1770s. Later he published a fascinating treatise called *A New Method of assisting the Invention in Drawing Original Compositions of Landscape* (c. 1785), in which he explains his method of composing ideal landscapes from so-called 'blots', a practice derived from his experience as a teacher, when he found that the accidental stains on a piece of soiled paper were stimulating to the imagination of the pupil. These 'BLOT DRAWINGS', made with a large soft brush, were then worked up into a finished composition either on the same sheet of paper or on a piece of superimposed varnished tracing paper. Many of them contain the germ of Cozens's most impressive monochrome drawings in which intense lights and darks are used with masterly effect to suggest the power and mystery of nature.

From 1778 to c. 1784 Cozens was drawing master to two of George III's sons, William and Edward, but it is uncertain whether he also taught the Prince of Wales (later George IV).

JOHN ROBERT COZENS (1752–97), landscape painter, was the son of Alexander Cozens. He travelled in 1776, probably as draughtsman to Richard Payne KNIGHT, through Switzerland to Italy, where he remained until April 1779. On his second visit to Italy in 1782 he formed part of Beckford's entourage and remained there until 15 September 1783, chiefly in Naples and Rome, returning through Switzerland. From about 1793 he was affected by a serious disorder of the nervous system and he died at an establishment in Smithfield administered by Dr. Monro. His water-colours, or 'pictured poems' as these have been called, are mostly connected with his two journeys to Switzerland and Italy. Although Cozens based them on sketches made on the spot, he by no means restricted himself to topographical exactitude and he often transposed landscape features in the interests of a more

poetical composition. But he does not seem ever to have composed wholly from imagination, as his father did. His narrow but subtly gradated range of subdued colour is intensely evocative of the serene natural effects which appealed so strongly to his poetic melancholy. He was the most talented of the English landscape artists in the PICTURESQUE tradition and his drawings in particular were admired and copied by TURNER, CONSTABLE, and GIRTIN.

653, 1971.

**CRABETH**, DIRK (d. 1577) and WOUTER (d. c. 1590). Brothers, Dutch makers of STAINED GLASS windows and designers of maps, who lived in Gouda. On 1 January 1552 a fire destroyed 46 of the stained glass windows in St. Jans Church in that city. Dirk was called upon to make nine new windows and Wouter make four. Some of their full-scale drawings for them still extant in Gouda are rare and excellent examples of Dutch RENAISSANCE art.

**CRANACH**, LUCAS (1472-1553). German painter. Cranach presents the curious spectacle of an artist who created his most important and independent work in the short span of a few years quite early in a long working life. Thereafter he sank into the easy routine of a slick court painter, always competent but rarely interesting.

We do not know where Cranach was trained. He appeared suddenly c. 1500 in Vienna, where he painted some excellent portraits (*Dr. Johannes Cuspinian* and *Anna Cuspinian*, his wife, Winterthur) and also religious panels of exceptional originality. They share with other works of this period great intensity of feeling but they stand apart in their treatment of landscape. Scenery is no longer a backcloth painted minutely in the Flemish manner; there is no longer an almost botanical correctness of detail in the foreground. Figures and scenes are contained integrally within the landscape and it is the mood of the landscape rather than its accurate appearance which is depicted. From pictures such as the *Crucifixion* (Munich) the so-called Danube School may have originated. The finest example of this manner is perhaps the *Rest on the Flight into Egypt* (Berlin), which shows the Holy Family resting in the glade of a German pine forest. It was painted in 1504, just before Cranach went as court painter to the Elector of Saxony in Wittenberg. There his manner was to change radically. A few religious pictures, painted just before the Reformation, seem stiff and lifeless when compared with his earlier work. His portraits became more formal and official, and make us regret that DÜRER was never able to fulfil his wish to portray Luther. The religious pictures which date from after the Reformation are more interesting for their Protestant ICONOGRAPHY than for any artistic merits.

The RENAISSANCE appears in Cranach's work in a curiously distorted fashion. He painted many small mythological panels of *Venus, The Graces, The Judgement of Paris, Apollo and Diana* (Hampton Court), etc. Yet he had no grasp of the true CLASSICAL spirit and his nudes, clothed only in transparent veils, necklaces, and large picture hats, always look rather 'undressed' and give these pictures an almost pornographic flavour. Two or more versions exist of many of them, and they were favourite collectors' pieces in their day. During the last years of his life Cranach was assisted by his son, LUCAS the Younger (1515-86), who carried on the tradition of the workshop.

2136, 2307, 2342.

**CRANE**, WALTER (1845-1915). English designer and illustrator, who achieved prominence chiefly for his illustration of children's books. An artist of distinction and decorative charm rather than a great original talent, he has been regarded as a forerunner of English ART NOUVEAU but is more directly descended from PRE-RAPHAELITE painting, which attracted him early along with the current vogue for Japanese prints. He was associated with BURNE-JONES and William MORRIS in their work for the reform of decorative and applied art, designing wallpapers, printed fabrics, and STAINED GLASS. He did illustrations for Morris's KELMSCOTT PRESS, among which those for Morris's own *Story of the Glittering Plain* were outstanding. He also worked for the ESSEX HOUSE PRESS, founded by C. R. ASHBEE under the influence of Morris and the ARTS AND CRAFTS MOVEMENT. From c. 1870 he was employed, with Kate GREENAWAY, by the publisher Edmund Evans to make wood blocks for the delicate colour illustrations to his new series of children's books. In 1898 Crane became Principal of the Royal College of Art. His artistic creed is expounded in *The Bases of Design* (1898) and other books.

654, 1519.

**CRAQUELURE**. The network of small cracks which appears on a painting when in the course of time the PIGMENT or VARNISH has become brittle. This was so notorious with some English masters, such as REYNOLDS, who glazed their work with BITUMEN to give it a glowing effect, that it was known in France as *craquelure anglaise*. Where the cracks are circular in form—as in Reynolds's *Mrs. Siddons as the Tragic Muse* (Huntingdon Art Gal., San Marino, California, 1783/4)—it is known as 'rivelling'.

**CRAWFORD**, THOMAS (1813-57). American sculptor of Irish descent. He studied under THORWALDSEN in Rome (1835) and worked in the CLASSICAL manner of the day. His works include the equestrian *George Washington* (1857) in Richmond, Virginia, and the *Armed Liberty* (1860) on top of the Capitol dome at Washington.

**CRAYON.** See CHALKS AND CRAYONS.

**CRAYON MANNER.** An 18th-c. engraving technique used in conjunction with STIPPLE ENGRAVING for the reproduction of crayon drawings. It was a variant of ETCHING. A copper plate was coated with an etching ground and the design drawn on it with a variety of ROULETTES and similar instruments imitating the texture and appearance of crayon lines. After the plate had been etched the ground was cleaned off and the work was amplified and completed by stippling with the BURIN. Engravings in the crayon manner are sometimes difficult to distinguish from SOFT GROUND ETCHINGS, which were used for similar purposes during the late 18th c.; in fact the two techniques were often combined on the same plate. Crayon engravings were frequently printed in reddish-brown ink in order to reproduce the effects of red chalk drawings. A further development was the PASTEL MANNER, in which a number of plates were inked with different colours to give the appearance of pastel drawings.

Invented in France c. 1750, where a number of engravers made prints after BOUCHER, FRAGONARD, and others, the crayon manner was widely used in England. It was rendered obsolete early in the 19th c. by the invention of LITHOGRAPHY.

**CREDI,** LORENZO DI (c. 1458-1537). Italian painter of the FLORENTINE SCHOOL, a fellow pupil of LEONARDO in the *atelier* of VERROCCHIO, whose assistant and manager he became. He had great technical proficiency and integrity of craftsmanship, carrying on efficiently the methods of Verrochio's workshop (e.g. the *Annunciation* of the Uffizi). His style of painting was somewhat lacking in individuality, and his work often showed close similarities with the earlier work of Leonardo. VASARI says that their works could be confused. Credi kept up with changing movements after the turn of the century and his *Madonna and Saints* in Pistoia (1510) is an ALTARPIECE in the High RENAISSANCE manner recalling Fra BARTOLOMMEO. It is said that influenced by the teachings of Savonarola in 1497 he destroyed all his pictures with profane subjects.

**CRESPI,** GIUSEPPE MARIA (1665-1747), called LO SPAGNUOLO. Italian painter, born in Bologna. He was influenced in his early works by GUERCINO and specialized in GENRE subjects, often of a satirical nature, with violent CHIAROSCURO effects of brilliant colour against dark backgrounds which sometimes impart an unearthly mysteriousness to photographically conceived detail. He was a famous teacher, numbering PIAZZETTA and Pietro LONGHI among his pupils, and he exercised a great influence on Venetian 18th-c. painting.

**CRISTOFANO,** FRANCISCO DI. See FRANCIABIGIO.

**CRITIUS.** Greek sculptor, partner of Nesiotes, active at Athens in the early 5th c. B.C. Their bronze *Tyrannicides*, erected in 477 B.C. to replace the group by ANTENOR, survives in copies, though the original relation of the two striding figures is unknown. A marble KOUROS from the ACROPOLIS at Athens (no. 698) is at least very close in style.

**CRIVELLI,** CARLO (active 1457-93). Italian painter of the VENETIAN SCHOOL. Eight of his works were bought for the NATIONAL GALLERY, London, in the 19th c., including the charming and unusual *Annunciation* (1486) painted for the town of Ascoli Piceno in the Marches, where he lived most of his life. On the basis of the crystalline and luminous manner of VIVARINI, by whom he may have been taught, he compounded elements derived from Padua and Murano and evolved a style of personal elegance in which his predilection for exquisite decorative motifs served for the expression of delicately conventional emotions.

2954.

**CRIVIJAYA.** See MALAYAN ART.

**CROCE,** BENEDETTO (1866-1952). Italian critic, journalist, and aesthetician. Croce's extremely influential views about the nature of art were set out in his *Aesthetic* (1902). In this work he regards all art as a form of imaging—a conjuring into being of images of particulars—a process which he calls 'intuition' and identifies with 'expression'. Later he explained that good art is successful expression of emotion. But Croce used 'expression' in a special sense, as a synonym for 'intuition', and not in the usual sense which involves some form of external manifestation. Croce's chief followers in England have been E. F. Carritt, and R. G. Collingwood in his early book *Outlines of a Philosophy of Art* (1924). His theories have been criticized partly on the ground of inherent confusion of concepts, more generally on the ground that his identification of the work of art with the mental process of intuition/expression does less than justice to the concrete work of art (as understood in ordinary language), the importance of embodiment in a material medium and the problems, theoretical and practical, which derive from the expression of an idea or intuition in a physical and therefore communicable form.

Croce founded the successful journal *La Critica* and edited it in close association with the philosopher Giovanni Gentile. He wrote studies of Vico, Dante, Hegel, Marx, GOETHE, Shakespeare, the RENAISSANCE, and many essays on philosophical subjects, criticism of literature and the arts, and translations (including Hegel's *Encyclopaedia*). He was Minister of Education before Mussolini came to power in 1922 and

again after the Second World War. He was one of the leaders in the opposition of intellectuals to Fascism.

664, 1977.

**CROCKETS.** Architectural term for projecting knobs with foliage decoration placed at regular intervals in much 13th-c. architecture on spires, pinnacles, and CAPITALS.

**CROME,** JOHN (1768-1821). English landscape painter, who was born, worked, and died in Norwich. Crome was of humble origin and was first apprenticed to a coach and sign painter. He was befriended by Thomas Harvey of Catton, an amateur painter and collector, in whose collection he studied works by GAINSBOROUGH and the small Dutch masters, HOBBEMA in particular. He was also influenced by WILSON and must have seen landscapes by REMBRANDT. He established himself locally as a landscape painter, was a founder member of the Norwich Society of Artists in 1803, and exhibited intermittently at the ROYAL ACADEMY and the British Institution. He earned a part of his livelihood as a drawing master. His only journey abroad was to Paris in 1814 to see the exhibition of the pictures which had been seized by Napoleon.

Crome painted a number of small pictures of woodland clearings and mills or houses by the riverside, which are Dutch in conception though not in execution. With COTMAN he was the major artist of the NORWICH SCHOOL and his reputation stands high in the history of English LANDSCAPE PAINTING. The most important of his larger works are *Slate Quarries* (Tate Gal.), *Moonrise on the Marshes of the Yare* (N.G., London), *Mousehold Heath* (Tate Gal.), and *The Poringland Oak* (N.G., London). Of these the first two are thought to belong to the decade 1800-10, the last two to 1810-20. They are marked by a broad handling of the paint, a bold realization of space, and keen appreciation of local characteristics. His work is honest sometimes to the point of clumsiness. Crome, together with Wilson, represents the transition from the 18th-c. PICTURESQUE tradition to the ROMANTIC conception of landscape. He rarely painted in the open air but composed his oils from watercolours and drawings made on the spot and from prints and etchings, of which he made a collection. His larger compositions lack the architectural quality of Classical construction and have been accused of woolliness in realization; but they are often saved by a unity of mood which anticipates the Romantics (*Yarmouth Jetty*, Norwich). He himself said in a letter to his disciple James STARK: 'Do not distress us with accidental trifles in nature but keep the masses large and in good and beautiful lines, and give the sky, which plays so important a part in all landscape, and so supreme a one in our low level lines of distance, the prominence it deserves, and in the coming years the posterity you paint for shall admire your work.'

As an etcher Crome's accomplishment was modest and during his life he never published his plates: they were published by his widow and eldest son, JOHN BERNAY (1794-1842), 13 years after his death. He is sometimes referred to as 'Old Crome' to distinguish him from this son, who painted in his manner but with inferior talent.

134, 574.

**CROQUIS,** ALFRED. See MACLISE, D.

**CRUCIFIXION** (Matt. xxvii. 26-50; Mark xv. 15-41; Luke xxiii. 25-49; John xix. 1-37). Crucifixion was a punishment meted out to criminals in Roman times and the crucifixion of Christ was used as a source of ridicule against the early Christians. It is caricatured in a Roman GRAFFITO on the Palatine representing an ass crucified with the inscription: 'Alexaminos adores his god.' During the first three centuries the crucifixion was not portrayed in Christian art (see EARLY CHRISTIAN ART). Subsequently the manner in which it is portrayed has changed as the attitude of the Church evolved. It was first symbolized in the 4th c. by a naked cross, recording the monumental cross set up by Constantine and Helena on the hill of Golgotha outside Jerusalem (mosaic, Sta Pudenziana, Rome). From the early 5th c. Christ is set on the cross, attached by four nails in hands and feet and naked except for a loin-cloth or *perizonium*, but with His eyes open and with no trace of suffering, as though to proclaim His victory over death (ivory relief, B.M.; wood carving on the door of Sta Sabina, Rome). From the 6th c. He usually wears a long tunic or *colobium* (Syriac *Rabula Gospels*, Laurentian Lib., Florence), perhaps to negate any hint of degradation; and the majestic figure, alive, clothed, and triumphing unscathed over the cross, was the model for nearly all Western crucifixions until the end of the 12th c. and beyond (9th-c. ivory, Metz school, Bib. nat., Paris; Berlinghiero BERLINGHIERI, Lucca Gal., 13th c.). In the 9th c. the Byzantine Church introduced a more realistic type of the crucified Christ, wearing only the *perizonium*, with eyes closed in death and blood flowing from His side (*Chludov Psalter*, Moscow, c. 900; 10th-c. ivory triptych, B.M.). This version, stressing the human vulnerability of Christ, emphasized the reality of His incarnation and it seems to have been evolved by the opponents of the Iconoclasts, since the doctrine of the incarnation played an important part in the justification of religious images. By the 11th c. the dead Christ on the cross was universal in BYZANTINE ART (mosaics at Daphni and Hosios Loukas), but it was not introduced in the West before the 13th c. except for rare examples painted under Byzantine influence (12th-c. mosaic, St. Mark's, Venice; 11th-c. Sacramentary, St. Gereon, Cologne).

In the 13th c. a still more realistic conception of the crucified Christ was created in Italy under

the influence of the preaching of St. Francis, which showed Christ no longer indifferent to death but suffering and 'degraded' by His ordeal, as in CIMABUE's *Crucifixion* (1260) in the Upper Church at Assisi. Here the feet are both attached to the cross with one large nail, and a new twist is thus given to the tormented body. This became the model for painters and sculptors alike (G. PISANO, reliefs on the pulpits of Pisa and Pistoia); and though the torments of Christ were progressively attenuated in Italian art under humanist influence, nevertheless the intention remained the same and from the 13th c. in the West the crucified Christ was represented as the victim whose agony was the price paid for man's redemption. The Isenheim ALTARPIECE of GRÜNEWALD gives a savage picture of His degradation, as do many Spanish sculptured crucifixions (*Cristo de las injurias*, Zamora Cathedral, mid 16th c.).

The Gospels describe many participants at the crucifixion, and these are present in varying numbers in the different versions. The two thieves are often shown one on either side of Christ, as on the doors of Sta Sabina in Rome and in the *Rabula Gospels*. Sometimes they are shown tied to the cross with cords, especially in northern versions (*Codex Egberti*, 10th-c. OTTONIAN MS., Trier); and whereas Christ's side is pierced with a lance to ensure His death, they more violently have their legs broken with a hammer (ANTONELLO DA MESSINA, Mus. of Anvers, 15th c.). Soldiers also play an important part, especially the lance-bearer and the other executioner who offers Christ vinegar on a sponge to quench His thirst. They are named Longinus and Stephaton after the *Acta Pilati*. Both are present in the *Rabula Gospels* and the *Codex Egberti*, as are the soldiers throwing lots for Christ's garment and the latter became increasingly quarrelsome as time went on (GIOTTO, fresco in the Arena Chapel, Padua).

Christ's chief companions in the crucifixion were the Virgin and His disciple St. John; they are nearly always shown standing on either side of the cross, in the Byzantine versions with right hand to cheek in the Greek gesture of sorrow. From the 14th c. the Virgin's expression of sorrow increased in violence, and her suffering, which was conceived as a parallel to that of Christ, became progressively more intense with the development of her cult (see VIRGIN) until in the 15th and 16th centuries she was often shown fainting and supported by the other women or by St. John himself (SIGNORELLI, Sansepolcro Gal.; DÜRER, woodcuts, 1508). Among the minor features which became traditional from an early period are the sun and the moon above the cross. These recall the eclipse which accompanied the crucifixion (Matt. xxvii. 45; Luke xxiii. 44), and are sometimes shown covering their faces as a symbol of that event. In Byzantine scenes there appears below the cross the head or skull of Adam, who was traditionally supposed to have been buried on Golgotha. Adam is also present

in certain Western versions: in the 13th-c. relief over the central door at Strasbourg Cathedral his skeleton lies beneath the cross. In other scenes he rises from his tomb and gathers into a chalice the blood from Christ's wound. But more often it is an angel who receives the blood (Giotto, Arena Chapel frescoes, Padua), and angels play an increasing part in later scenes, kissing the wounded hands (DUCCIO, Opera del Duomo, Siena), flying round the cross, and carrying away the soul of the repentant thief while devils carry off the other (ALTICHIERO, fresco, Oratory of St. George, Campo Santo, Padua, 14th c.).

Late medieval artists treated the scene of the crucifixion with growing freedom. Sometimes Christ was shown surrounded not by the original participants but by a group of saints, as in a mosaic in St. Mark's, Venice, in which the Doge Dandolo (1342–54) also figures (cf. also Fra ANGELICO's frescoes in S. Marco, Florence). But most popular of all were the crowded spectacles in which not only the soldiers, St. John, and the Virgin, but also the Jews, the Centurion, Mary Magdalen, and large numbers of other characters in exotic clothes follow the scene with lively gestures (Altichiero, op. cit.). Frequently the Magdalen kneels to embrace the foot of the cross (Giotto, Padua; window from the Abbey of Altenberg, V. & A. Mus.). The Council of Trent judged such worldliness unsuitable in the crucifixion, and the painters of the Counter-Reformation reduced the spectators to the essentials, darkening the sky and restoring to the scene its serious and contemplative character (El GRECO, Louvre; RUBENS, Anvers Mus. and elsewhere). Philippe de CHAMPAIGNE excluded the Magdalen from his version on the same grounds. This heroic and serious spirit is present in PRUD'HON's *Crucifixion* (Louvre, 1822), and in the more recent interpretations of Charles Dufresne (1876–1938) (Musée d'Art moderne, Paris) and Graham SUTHERLAND, whose painting in St. Matthew's, Northampton, reinterprets the medieval type of the suffering Christ.

**CRUIKSHANK,** GEORGE (1792–1878). English artist and CARICATURIST. He had no artistic training but very quickly established himself in the succession to GILLRAY as an eminent political cartoonist. The private life of the Prince Regent was one of his first targets. He began to turn to book illustration in the 1820s and his output was immense. The drawings for Grimm's *German Popular Stories* (1823) and later for the works of Harrison Ainsworth and Dickens are amongst his best known work in this field. In later life he took up the cause of temperance, producing moral narratives in woodcut (*The Bottle*, 1847; *The Drunkard's Children*, 1848) and a vast painting *The Worship of Bacchus*, which was accepted by the National Gallery, London.

As a caricaturist it has been said by G. Ashby that Cruickshank 'stands for the Fairy story, but the Fairy story without the Romanticism; he also

stands for something essentially English . . . a quality we do not find in the Celtic story, nor in the Italian Pinocchio, nor in Provence. . . . It is an individualism combined with a certain lovable grotesque. . . . No matter what his needle touched, he could give sentient expression to a barrel or a wig-block, a jug of beer, a pair of bellows, or an oyster.'

1010.

**CUBISM.** The first of the three great innovating movements in 20th-c. painting. It was originated by PICASSO and BRAQUE, broadened by Juan GRIS and later joined by many other artists, such as LÉGER, LA FRESNAYE, DELAUNAY, Villon, Marcoussis, Marcel and Raymond DUCHAMP, METZINGER, GLEIZES, Survage, Kupka, RIVERA, and others. Its main formative period lay between c. 1907 and 1914, though some of the methods and discoveries of the Cubists have remained a lasting accession to the repertory of many different schools of 20th-c. art. According to Daniel-Henry Kahnweiler, the Paris dealer who supported the beginnings of Cubism, in his book on *Juan Gris* (Eng. trans. by Douglas Cooper, 1947, p. 69, n. 2), the name originated with the critic Louis Vauxcelles (following a *mot* by MATISSE), who in a review of the Braque exhibition in the paper *Gil Blas*, 14 November 1908, spoke of '*Cubes*' and later of '*Bizarreries cubiques*'. As with IMPRESSIONISM and FAUVISM the name originated in a jibe. The principles of the movement were elaborated in *Du Cubisme* (1912) by Gleizes and Metzinger and in *Les peintres cubistes. Méditations esthétiques* (1913) by Guillaume APOLLINAIRE.

Cubism was in part a deliberate reaction from that stream in French painting which is represented by the ROMANTICISM of DELACROIX, the sensuous appeal of Impressionism and the decorative colour of the Fauves, and it had conscious affinities with the more austere and CLASSICAL tradition of INGRES. In its most characteristic form it repudiated the intrinsic interest of theme, historical, anecdotal, sensuous, emotional, restricting its chosen subject matter within a narrow range of STILL LIFE. Even within this range the objects depicted were not presented with emotional empathy or with a suggestion of personality, as for example with CHARDIN, but primarily as material for a REALIST composition of forms. Their pictures deliberately excluded the representation of atmosphere and light with the rest of the Impressionist tradition, being restricted to a narrow range of local colours or verging towards monochrome and avoiding for the most part sensuous appeal of colour. Any direct sensuous appeal either of the subject represented or of the picture itself was subordinated to the primary intellectual purpose. Lyricism and melody of rhythmic line were rejected in favour of quasi-geometric forms. The representation of movement as such was abandoned (this later proved to be the focal point of the FUTURIST attack). And perhaps

most important of all naturalistic perspective and three-dimensional illusionistic picture-space were thrown overboard in favour of a new perspective of superimposed, overlapping and interlocking semi-transparent planes with a shallow picture-space showing a minimum of recession. Part of the object of the Cubists was to represent solidity and volume in a two-dimensional plane without converting the two-dimensional canvas illusionistically into a three-dimensional picture-space. In so far as they represented real objects their aim was to depict them as they are known and not as they partially appear at a particular moment and place. For this purpose many different aspects of the object might be depicted simultaneously, the forms of the object were analysed into geometrical planes and these were recomposed from various simultaneous points of view into a combination of forms. To this extent Cubism was and claimed to be rigidly realistic, but it was a conceptual realism rather than an optical and Impressionistic realism. Cubism is the outcome of intellectualized rather than spontaneous vision.

The two most important positive influences on the emergence of Cubism were Negro sculpture and the later paintings of CÉZANNE. The former is apparent in Picasso's painting *Les Demoiselles d'Avignon*, which is generally regarded as the source-picture of Cubism because of the dislocation of interlocking planes on the right, the simultaneous combination of frontal and profile aspects in the faces of the central figures, and the logical rather than optical perspectives in the planes of the 'still life' in the lower centre. Braque was meanwhile mainly influenced by the flattening of picture space and compact composition of analytical angular planes in the late work of Cézanne, who was given an important retrospective exhibition at the Salon d'Automne in 1907 following his death in 1906. In the same year was published a letter of his to Émile Bernard in which he wrote: 'Treat nature by the cylinder, the sphere and the cone, everything in proper perspective, so that each side of the object or plane tends towards a central point.' Apropos of this Kahnweiler writes: 'From the very start of Cubism, Picasso and Braque strove to break with any form of *imitation*. They showed this in their works by the absence of all AERIAL PERSPECTIVE and the use of a linear perspective very different from that propounded by fifteenth-century theorists. Thus their pictures began to look less and less like those of Cézanne, although partaking of the same spirit.'

In 1911 was formed a group of artists at the studio of Jacques Villon in Puteaux—whence they were called the Group of Puteaux—consisting of his brothers, Gleizes, La Fresnaye, Léger, Metzinger, PICABIA and his wife Gabrielle Buffet, Valensi, Kupka, Apollinaire, and the American critic Walter Pach. They were interested in the mathematical principles of pictorial construction and formed a Salon by the name *Section d'Or* (see GOLDEN SECTION).

In 1912 a group was formed by Delaunay, Picabia, Villon, Duchamp, and others who composed abstract 'Cubist' pictures in pure prismatic colours, abandoning the conceptual realism in which the movement had started with Picasso and Braque. Apollinaire described this as an 'instinctive Cubism' lacking the 'lucidity of an artistic doctrine' and he named the movement ORPHISM.

About 1912 Picasso and Braque began the use of COLLAGE, introducing fragments of real objects into their pictures, and of *papier collé* technique. The motive was partly to underline the basic realism of their pictures and to carry to its logical extreme their repudiation of illusionistic devices and sensuous appeal deriving from painterly techniques. The synthesis of real and apparent in one art work was taken over by some SURREALISTS to serve different aims and opened up aesthetic problems and possibilities which continued to be explored for several decades. The use of *papiers collés*, not for decorative purposes but always as an intrinsic element in the composition was realistically employed so that they both stand for what they are and exist in the picture on a separate and different plane. Gris was more systematic and logical in his Cubism than either Picasso or Braque, not only using the method of analytical and dislocated planes but building on a more rationally designed basic plan. To Gris also was due almost entirely the second phase of Cubism known as 'synthetic Cubism'. Whereas in the analytical stage the painter combined simultaneously various different visual impressions of the same object all reduced to a pattern of quasi-geometrical planes, Gris attempted to recreate the object by means of 'emblems' which signified the object represented. Although the emblems are not comprehensible without previous visual experiences, all the details of these experiences are not present in the picture but are combined and fused in the visual memory of the painter into forms which differ from the forms of the real objects we meet in the visible world. The picture becomes a new construction parallel to nature and emblematic of it. The element of distortion is therefore not present in Gris since his forms are analogues but not visual presentations of the forms of reality. He himself said: 'I begin by organising my picture; then I qualify the objects. My aim is to create new objects which cannot be compared with any object in reality. The distinction between synthetic and analytic Cubism lies precisely in this. These new objects, therefore, avoid distortion. My *Violin*, being a creation, need fear no comparison.' Painting becomes creation parallel to nature rather than representation of nature even in the conceptual sense of analytical Cubism. Gris characteristically said: 'D'un cylindre je fais une bouteille.'

Exploiting the technique of *collage* to the full, Picasso began in 1913 to make high-relief constructions closely related to his paintings; like Cubist paintings translated into three dimen-

sions. His experiments were taken up by LAURENS and LIPCHITZ, and became the basis for much Cubist sculpture. Duchamp-Villon, ARCHIPENKO, and, to a certain degree, BRANCUSI also produced sculpture related to Cubism.

65, 940, 1053.

**CULLEN,** MAURICE (1866–1934). Canadian apostle of IMPRESSIONISM. He was born at St. John's, Newfoundland, and studied first in Montreal under the sculptor Philippe Hébert. From 1889 to 1895 he worked in Paris and elsewhere in France, with trips to Venice and north Africa. After his return to Canada he spent the rest of his life painting city scenes (*Old Houses, Montreal*, Montreal Mus. of Fine Arts, *c.* 1900) and landscapes on the St. Lawrence, in the Laurentian hills, at St. John's, and in the Rocky Mountains. He served as a war artist in the First World War.

**CUPOLA.** Term in Christian church architecture for a semicircular or polygonal DOMED VAULT.

**CURE,** CORNELIUS (d. 1607). Stonemason and sculptor, the best known member of a family from the Low Countries who set up a yard in Southwark. Cornelius was Master Mason to Elizabeth I and James I and was responsible for the design and erection of the monuments of *Elizabeth* and *Mary Queen of Scots* in Westminster Abbey, though the effigy of Elizabeth was carved by Maximilian COLT. His masterpiece is the tomb of Mary Stuart. The work was finished after his death by his son WILLIAM (d. 1632), who succeeded his father as Master Mason and held the post until his death. Attributed to him also is the monument to Sir Roger Aston in the church of Cranford, Middlesex. A number of monuments, mainly of ALABASTER, with recumbent effigies under a simple architectural CANOPY, are known to have been made by the Cures.

**CURRIER AND IVES PRINTS.** Popular LITHOGRAPHS published in New York by Nathaniel Currier (1803–87) and James M. Ives (1824–95). These lithographs, advertised by their publishers as 'Coloured Engravings for the People', represented every aspect of contemporary America, and included sporting, sentimental, patriotic, and political subjects, together with portraits, landscapes, disasters, scenes of city life, of railroads, of Mississippi steamboats, and so forth. A number of artists, most of whom specialized in particular subjects, were retained by the firm to draw the lithographs in black and white; afterwards the prints were coloured by hand and sold cheaply to the public by agents, print-sellers, and pedlars.

Currier and Ives prints vary a good deal in

artistic quality, but by and large they have all the virtues of good popular art, being unpretentious, vigorously descriptive, colourful, and Romantic in feeling. Like Japanese prints they were considered of little value in their time, but many of them, after becoming rare, became collectors' pieces.

666, 2062.

**CUSPS.** The projecting points formed by the intersection of two arcs in GOTHIC tracery. The earliest form is the *soffit cusp*, in England a 13th-c. type springing from the flat undersurface of an ARCH, independent of the MOULDINGS.

**CUVILLIÈS,** JEAN FRANÇOIS DE (1698-1767). French architect and engraver of ornaments of Flemish origin. He was a pupil of de COTTE and also studied under J.-F. BLONDEL. He was chief architect to the Elector of Bavaria and was instrumental in adapting the French ROCOCO to German taste (Amalienburg hunting lodge at Nymphenburg, 1734-9; Residenz Theater, Munich, 1751-3). In 1738 he published a collection of designs which popularized LOUIS XV STYLE of furniture and decoration throughout Germany.

**CUYP.** The name of three Dutch painters of Dordrecht. JACOB GERRITSZ CUYP (1594-1651/2) was a pupil of Abraham BLOEMAERT at Utrecht. He is thought of today mainly as a portrait painter—his portraits of children are particularly fine—but in old biographies is lauded principally for his views of the countryside around Dordrecht. BENJAMIN GERRITSZ CUYP (1612-52) was the half-brother of Jacob. He is noted principally for paintings of biblical and GENRE scenes which use Rembrandtesque light and shadow effects. AELBERT CUYP (1620-91), the most famous of the three, painted landscapes, views of towns, portraits, STILL LIFES, and genre scenes. He was the son and probably the pupil of Jacob Gerritsz Cuyp. His early works also show the influence of Jan van GOYEN. Aelbert was born and died at Dordrecht, but he seems to have travelled along Holland's great rivers to the eastern part of the Netherlands, and he also painted views of Westphalia. A prodigious number of pictures are ascribed to him (nearly 850), but some of these were probably painted by his father or by Abraham Calraet (1642-1722) and 17th-c. imitators. He seems to have stopped painting *c.* 1665 and from *c.* 1670 until the middle of the 18th c. he was virtually forgotten. Late 18th-c. English collectors are credited with re-discovering his merits and he is still much better represented in English collections, public and private, than in Dutch museums. His best pictures are his views of rivers and towns in the early morning or evening sun (*View of the Dordrecht*, Kenwood, London). Their rich warm and cool colours have only recently been revealed by the removal of the layers of yellow VARNISH which were applied from the 18th c. onwards. Aelbert Cuyp is one of the most important 17th-c. Dutch landscape painters, but his full significance is not easy to assess.

**CUYPERS,** PETRUS JOSEPHUS HUBERTUS (1827-1921). Dutch architect who from 1850 onwards influenced and almost monopolized the GOTHIC REVIVAL in the Netherlands. His inspiration was VIOLLET-LE-DUC, from whom he took his conception of Gothic architecture and his somewhat ruthless technique in restoring Gothic buildings. He also built numerous new Gothic churches. His main works are the most conspicuous 19th-c. buildings in Amsterdam: the Rijksmuseum and the Central Station, which are both designed in an individual style founded on late Gothic. His teachings on truthfulness in architecture were much influenced by RUSKIN and were fruitful for the Modern Movement in Dutch architecture at the end of the century.

**CUZCO SCHOOL AND STYLE.** See SPANISH COLONIAL ART.

**CYCLADIC.** The name applied to the Bronze Age art and civilization of the Cyclades (the Greek islands of the central Aegean). The pottery of Early Cycladic (*c.* 2500-1900 B.C.) is parallel in its shape (beak-spouted jugs, suspension-pots, bowls with incurving rim) to Early HELLADIC (in mainland Greece) and Early MINOAN, but its dark burnished fabric with grooved decoration shows more affinity than they do with western Asia Minor. The pottery 'frying-pans', with patterns of spirals or sometimes fishes or boats, were perhaps used, filled with water, as mirrors: copper examples are known from central Anatolia. The white marbles of Paros, Naxos, etc., were carved with small bronze saws, drills, and abrasives into statuettes; besides a common female type, more ambitious figures of a piper and a seated harper are known. Middle Cycladic (*c.* 1900-1600 B.C.) developed a matt pottery painted with simple curvilinear patterns, followed by floral and bird motifs. In the 17th c. B.C. Phylakopi in Melos, the best known site, shows strong Minoan influence (perhaps due to conquest), both importing and imitating Middle Minoan III pottery and using fresco decoration in its houses. Helladic influence is also apparent, and increases after *c.* 1600 B.C. until with the destruction of the Minoan centres, *c.* 1400 B.C., the Cycladic art was wholly assimilated to MYCENAEAN ART.

716, 1544.

# D

**DADA.** A European movement of violent revolt against smugness, in which the forces of artistic creation were diverted to the service of anti-art. It arose from a mood of disillusionment at the conditions of the First World War, to which some artists reacted with irony, cynicism, and anarchical nihilism. Emphasis was given to the illogical or absurd and the importance of chance in artistic creation was exaggerated. According to one of several accounts, the name itself—which in French means 'hobby-horse'—was obtained by inserting a penknife at random in the pages of a dictionary. The movement went to extremes in the use of buffoonery and provocative behaviour in order to shock and disrupt the complacency of a public which lived by traditional values.

Dada was founded in 1916 at Zürich by a group of artists and writers which included the Romanian poet Tristan Tzara, the German poet Richard Hülsenbeck, a German writer

97B. Cover of the prospectus *Club Dada*, Berlin 1918

Hugo Ball, and the artists Hans ARP and Marcel Janco (1895– ). Dada did not at its inception involve a specific artistic style or aesthetic. The methods and manifestos owed much to FUTURISM, but the movement lacked the militant optimism and the commitment to the principles of mechanization which were the motive force of Futurism. In painting attempts were made, particularly by Arp, to develop the CUBIST techniques of MONTAGE and COLLAGE.

A similar movement had been carried on independently in New York from 1913 led by Marcel DUCHAMP, Francis PICABIA, and Man Ray (1890– ), and in 1918 the two movements merged when Picabia went to Switzerland. After the end of the war Dadaism had some influence in Germany with artists such as ERNST, GROSZ, and SCHWITTERS. In Paris, between 1919 and 1924, its purely destructive principles were modified and became the foundations for many aspects of the SURREALIST movement.

1383, 2256.

97A. Cover of the prospectus of *Dada* 3, Zürich 1918. Woodcut by Marcel Janco

**DADDI,** BERNARDO (active 1290–c. 1349?). Florentine painter and younger contemporary of

GIOTTO. His earliest dated work, the TRIPTYCH of 1328 (Uffizi), was painted for Ognissanti and is based upon Giotto's *Madonna Enthroned* formerly in the same church. Daddi's smaller panels are finely wrought views of interiors, lovingly furnished with a miniaturist's detail (Bigallo Orphanage, Florence; Prato Gal.; Buckingham Palace; Met. Mus., New York). The large *Madonna* in Or San Michele was finished in 1347. Two frescoes in Sta Croce of the *Martyrdoms of SS. Lawrence and Stephen* are undated. In 1348, probably the year of his death, Daddi painted the POLYPTYCH now in the Gambier-Parry Coll., Highnam Court, Gloucester.

Daddi's style is a sweetened version of Giotto's, tempering the latter's gravity with Sienese grace and lightness. He favours smiling Madonnas, teasing children, and an abundance of flowers and trailing draperies. After Giotto's severity Daddi's gay, lyrical manner was extremely popular. Through the CIONI his influence endured during the second half of the century.

**DADO.** Architectural term for the part of a pedestal between the base and CORNICE; or a wainscot including base and cap MOULDING running round the lower part of a room.

**DAEDALUS.** In Greek mythology and legend the representative of handiwork and patron deity of craftsmen's guilds, legendary architect of the Labyrinth for Minos, king of Crete. To him, possibly conflated with an Archaic Greek sculptor of the same name, ancient critics were liable to attribute any unsigned early statue. According to legend he was the first sculptor to represent human figures in motion and with eyes open.

**DAHL,** JOHAN CHRISTIAN (1788-1857). Norwegian painter, often called the discoverer of the Norwegian landscape. From 1824 until his death he was a professor at the Academy of Dresden, where he was a friend of C. D. FRIEDRICH. The landscapes of J. van RUISDAEL were another influence on his work. Increasingly through life he concentrated on expressing the grandeur of the Norwegian scene; and by his deep feeling for this he was a pioneer of the new spirit of nationalism which entered into Norwegian art. Nowadays his sketches are also highly esteemed, both the Norwegian ones and those made during his travels in Italy.

**DAHL,** MICHAEL (1659-1743). Swedish portrait painter, who came to London *c.* 1682 and stayed for three years. He spent the years 1685-9 in travel, mainly in Italy, but returned to London and became established in the first rank of portrait painters. After the death of KNELLER in 1723 he had the largest practice in the country. His work has not the brilliance and

dash of Kneller's, but at his best he surpasses Kneller in sincerity and humanity beneath a somewhat ROCOCO artificiality. He painted many presentation portraits of Queen Anne. His personality appears best in the finely painted *Self-Portrait* (N.P.G., London, 1691), in which the personal colour and carefully constructed head contrast with the affected artificiality of the pose.

1945.

**DALI,** SALVADOR (1904-    ). Spanish artist, born at Figueiras. After passing through phases of CUBISM, FUTURISM, and METAPHYSICAL PAINTING, he became one of the leading figures of the SURREALIST movement *c.* 1929. He introduced the technique which he called 'paranoiac-critical activity' and described as a 'spontaneous method of irrational understanding based on the interpretative critical association of delirious phenomena'. It was an attempt to make systematic use of the organizational force of hallucinatory and obsessive experience with special emphasis on multiple figuration. His own painting employed a meticulous academic technique which enhanced the hallucinatory character of the figuration. In collaboration with Luis Bunuel he made the first Surrealist films, *Un chien andalou* (1929) and *L'Age d'or* (1930). He was repudiated by BRETON and other of the more traditional Surrealists *c.* 1937-8, when he adopted a more classical style, and in 1940 he settled in the U.S.A. where his talent for self-advertisement brought him notoriety. He had a retrospective exhibition at the Museum of Modern Art, New York, in 1941. In 1955 he returned to Spain and settled at Cadaqués. Among his numerous writings were the Surrealist work *Baboue* (1932), an exposition *La Conquête de l'irrationel* (1935), and his autobiographical *La Vie secrète de Salvador Dali* (1944).

648, 683, 684, 685, 2524.

**DALMAU,** LÚIS (active 1428-60). Spanish painter of Valencia, court painter to Alfonso V of Aragon, under whose patronage he went to Bruges in 1431, returning to Valencia by 1437. Dalmau's visit to Flanders is the first recorded contact of a Spanish painter with the Flemish School. His only authenticated work, the *Virgin of the Councillors* (Barcelona Mus., 1443-5), echoes the van EYCK ALTARPIECE at Ghent.

**DALOU,** AIMÉ-JULES (1838-1902). French sculptor, pupil of J.-B. CARPEAUX and F.-J. Duret (1804-65). Although his name is particularly associated with the NATURALISTIC movement in French sculpture, he produced many works of BAROQUE inspiration (*Triumph of Silenus*, Bordeaux, 1891), and his largest completed monument was both Baroque and allegorical (*Triumph of the Republic*, 1879-99, Place de la Nation, Paris). He spent the years 1871-9 as a political exile in England. His naturalism is

often tempered by a certain sentimental appeal in the choice of subject (*Peasant Feeding Child*, V. & A. Mus.). His most ambitious work, a vast *Monument to Labour*, was left uncompleted at his death. It was to have included figures representing all the labours of the fields and factories. Clay models for many of these figures, reminiscent of MILLET's peasants, are preserved in the Petit Palais, Paris.

765.

**DAMMAR.** One of the soft RESINS, a product of certain Indian and Australian coniferous trees, used especially for VARNISHES, or as a painting MEDIUM mixed with fatty oils. Applied to paintings it becomes transparent and does not turn yellow, but it is very soft and friable and for this reason it is sometimes mixed with AMBER varnish.

**DAMOPHON.** Sculptor of Messene, active in the early 2nd c. B.C. There remain by him the marble heads of three colossal statues at Lycosura, considered derivative classicizing work.

**DANBY, FRANCIS** (1793-1861). Irish painter, born at Wexford. He studied under J. A. O'Connor (1791-1841) but moved to England about 1816 and settled in Bristol. His bombastic apocalyptic paintings exhibited at the Academy, *The Delivery of Israel out of Egypt* in 1825 (Preston) and in 1826 *The Opening of the Sixth Seal* (bought by BECKFORD, now in the

N.G., Dublin), were a direct challenge to MARTIN. In 1826 he was made A.R.A. and in 1829 he was defeated for R.A. by CONSTABLE by only one vote. Between 1829 and 1841, owing to a domestic scandal, he settled in Switzerland. His best work consists of the romantic sunset landscapes of his later years with their mood of melancholy and more solemn serenity (*Temple of Flora*, Tate Gal., 1840).

**DANCE.** GEORGE DANCE, Senior (1695-1768). English architect to the City of London, who built a number of churches after the manner of WREN. His chief monument, the Mansion House (1739-53), is a heavy essay in PALLADIANISM.

His son NATHANIEL (1736-1811), a portrait painter, studied under HAYMAN. He spent the years 1755-64 in Rome, where he was much influenced by the sophisticated portrait convention of Pompeo BATONI. He became a foundation member of the ROYAL ACADEMY, but on inheriting a fortune in 1776 he retired from professional practice. He later became an M.P. and was created a baronet with the surname Dance-Holland. One of his best known portraits is *Captain Cook* (Greenwich, 1766).

GEORGE (1741-1825), a brother of Nathaniel, studied in Italy for several years and like his father, whom he succeeded as Clerk to the City Works in 1768, worked mainly in London, though he also had a considerable country-house practice. His CLASSICAL designs show that he had digested his Italian experience and could

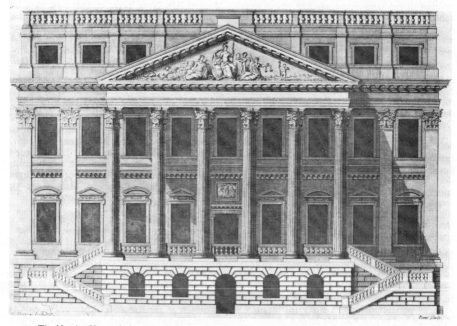

**98.** The Mansion House, designed by G. Dance. Engraving from *The History of London* . . . (1739), W. Maitland

transmit it in an original way, and his circus and crescent planning in London shows his awareness of John WOOD's work in Bath. His Church of All Hallows, London Wall, is small but very finely detailed. His most important work, Newgate Prison (1770–8, demolished 1902), had a façade which showed a sombre richness of imaginative power most unusual in 18th-c. England and reminiscent of PIRANESI's *Carceri*. The fine gallery at Lansdowne House was also designed by Dance. Later he worked less happily in the GOTHIC manner, producing in the Guildhall façade and at St. Bartholomew-the-Less compositions that it would be kinder to forget. Towards the end of the century he made a number of interesting pencil sketches of contemporary English artists which cannot have flattered his sitters.

**DANCE OF DEATH.** The terms *Dance of Death* and *Danse Macabre* have been loosely used as titles for a variety of works of art, musical (e.g. Saint-Saens), literary (e.g. Strindberg), and pictorial. In the strict sense the Dance of Death is described by James M. Clark as 'literary or artistic representations of a procession or dance in which both the living and the dead take part. The dead may be portrayed by a number of figures, or by a single individual personifying Death. The living members are arranged in some kind of order of precedence, such as pope, cardinal, archbishop, or emperor, king, duke. The dance invariably expresses some allegorical, moral or satirical idea. A single scene depicting a skeleton and a human being is not a Dance of Death, although it may be derived from such a source. The medium employed for the forms of the work varies considerably. There are poems and prose works, manuscripts and printed books, paintings on wood, stone, canvas, stained-glass windows, sculptures, embroidery, tapestry, metal-work, engravings on stone or metal, and woodcuts.' Properly speaking the Dance of Death was essentially a product of the late Middle Ages. In classical antiquity death was symbolized by a youth with an inverted torch and the soul of the dying by a bird or a butterfly. The skeleton as a symbol of death does not occur until the beginning of the 15th c. (See also GISANT.) The figurative use of 'dance' was familiar in the Middle Ages and the Dance of Death, whether poem or picture, portrayed in allegorical form the inevitability of death and the equality of all men in death.

The earliest known Dance of Death, mural paintings and poem, is the famous *Danse Macabre* which from contemporary records is known to have been executed in the cloisters of the Church of the Holy Innocents, Paris, in 1424–5. The wall was destroyed in 1669. But the theme was perpetuated by the Paris printer Guyot Marchant, who in 1485 published his *Danse Macabre* with woodcuts and verses. This went through many editions and originated a genre which spread through Germany, Switzerland, Italy, Spain, France, and Britain. The earliest extant Dance of Death pictures are those in the church of Kermaria, Brittany (*c.* 1450–60). A similar cycle was painted about ten years later at the Chaise-Dieu in the Auvergne. In England there is an example of a Dance of Death surviving in the Priory at Hexham, Northumberland, and a second in the Parish Church of Newark-on-Trent. A Dance of Death at the old Cathedral of St. Paul's, London, was destroyed in 1549. It was said by the chronicler John Stow to be similar to that at the Holy Innocents, Paris. The verses, which have been recorded, were freely translated by the minor poet John Lydgate from those at the Holy Innocents. In *The Four Last Things* Sir Thomas More said of this work: 'We were never so greatly moved by the beholding of the Dance of Death pictured in Paul's, as we shall feel ourselves stirred and altered by the feeling of that imagination in our hearts. And no marvel. For those pictures express only the loathly figure of our dead, bony bodies, bitten away the flesh; which though it be ugly to behold, yet neither the light thereof, nor the sight of all the dead heads in the charnel house, nor the apparition of a very ghost, is half so grisly as the deep conceived fantasy of death in his nature, by the lively imagination graven in thine own heart.' The only known sculptured representation of a Dance of Death in Britain was at Coventry Cathedral and was destroyed by bombing in 1940.

The most famous of all representations of a Dance of Death in art is the series of 40 woodcuts designed by Hans HOLBEIN the Younger and executed by the Swiss craftsman Hans Lützelburger. It is likely that Holbein was influenced by a very popular Dance of Death in the Dominican convent at Basel. The exact date of Holbein's work is not known, but a number of the drawings were in existence before 1527. The first Lyon edition appeared in 1538. Two sets of proof impressions were made for a Basel edition which was not produced and examples are in the British Museum, the Bibliothèque nationale, Paris, the Albertina, and at Basel, Karlsruhe, and Berlin. All subsequent artistic representations of the Dance of Death were influenced directly or indirectly by that of Holbein.

The Dance of Death has often been associated with the Legend of the *Three Living and the Three Dead*. The latter seems to have originated in France in the 13th c., when four similar poems on the theme are known. The theme is the meeting of three corpses with three living persons, who are terrified and moved to repentance. The subject became very popular both in verse and in pictorial representation in France, Germany, Italy, and probably Britain. There was a sculptured representation on the portal of the Church of the Holy Innocents, Paris. It was the subject of a painting by ORCAGNA in the Campo Santo

of Pisa. But this theme is wrongly confused with the Dance of Death. Its burden was repentance in the face of approaching death. The Dance of Death is an allegory of death itself and representations often contain features of medieval burlesque.

The Dance of Death must also be distinguished from the *Memento Mori*. The latter term was often applied to single scenes depicting a skeleton and a living human being. It was a vivid reminder of the imminence of death usually with a moral significance.

The Dance of Death had a new vogue in the 19th c. but its inspiration was either second-hand medievalism or a derivative taste for the macabre and nothing outstanding resulted from it. (See also MACABRE.)

558, 559, 1541.

**DANDRIDGE,** BARTHOLOMEW (1691–*c.* 1754). English portrait painter who had a considerable practice in London in the 1730s and 1740s. His best work is free, stylish, and lively, and in such groups as *The Price Family* (Met. Mus., New York) he contributed to the development of the CONVERSATION PIECE and approximated to the styles of HAYMAN and HOGARTH.

**DANIEL.** The prophet Daniel appears amongst the earliest representations of Christian art. His ATTRIBUTES are the lions from which he was miraculously saved (Dan. vi. 5–24; Bel and the Dragon 30–42) and the ram which he saw in his vision (Dan. viii. 3–7). Daniel among the lions was interpreted as an image of CHRIST in the tomb and of the RESURRECTION (see TYPOLOGICAL BIBLICAL ILLUSTRATION). He is depicted, with his arms raised in prayer, in the earliest preserved frescoes in the Roman catacombs (Domitilla and Lucina, late 2nd c.). The most frequent arrangement was the symmetrical one of Daniel with a lion on each side, a motif which originated in the East. Sometimes Habakkuk was depicted bringing bread and fish (e.g. on a 4th-c. SARCOPHAGUS in Brescia); on a 6th- to 7th-c. ivory pyxis (B.M.) he is led up to Daniel by an ANGEL. This scene, interpreted as a prefiguration of the Eucharist, occurs in medieval illustrations of the Bible and Psalter and on CAPITALS (Autun, 12th c.). Daniel in the lions' den continued to be rendered until the 19th c. (RUBENS, formerly Hamilton Coll., 1618; DELACROIX, Montpellier, 1849).

Daniel appears as one of the prophets in the Middle Ages; the most famous later example is in MICHELANGELO's ceiling of the Sistine Chapel. BERNINI's bronze figure (MAUSOLEUM of Agostino Chigi, Sta Maria del Popolo, Rome, 1657) reinterprets the early motif of Resurrection.

**DANSE MACABRE.** See DANCE OF DEATH.

**DANTI** (DANTE), VINCENZO (1530–76). Italian sculptor, architect, theoretician, poet. The bronze figure of Julius II (still on its original site outside Perugia Cathedral; 1555), and many of his other sculptures (such as the *Venus Anadyomene* in the Palazzo Vecchio and *Honour overcoming Falsehood* in the BARGELLO, Florence) bear witness to his admiration for the work of MICHELANGELO, for whose funeral ceremonies in 1564 he supplied sculpture and paintings. In 1571 he completed his group of *The Execution of the Baptist* on Florence Baptistery. From 1573 he resided in his home town of Perugia, where he was one of the first professors at the newly founded Accademia del Disegno and city architect. He was the author of a *Primo libro del trattato delle perfette proporzioni* dedicated to the Grand Duke Cosimo and published in 1567.

**DARET,** JACQUES (1406–68 or later). Flemish painter from Tournai. From 1427 to 1432 Daret was apprenticed along with Rogelet de la Pature (assumed to be identical with Rogier van der WEYDEN) to Robert CAMPIN. Four panels from the *St. Vaast Altarpiece* which he worked on during 1433–5 are his principal surviving works. Among these the *Nativity* (Thyssen Coll.) plays an important role in equating the MASTER OF FLÉMALLE with Robert Campin, for it is instructive to compare this work with the Flémalle *Nativity* at Dijon, which is certainly the earlier. Both artists use the same unusual ICONOGRAPHY and Daret clearly knew the Dijon *Nativity*. He also designed tapestry CARTOONS, was an illuminator, and contributed to the festival decorations in Bruges for the marriage of Charles the Bold and Margaret of York in 1468.

**DAUBIGNY,** CHARLES-FRANÇOIS (1817–79). French LANDSCAPE painter of the BARBIZON SCHOOL and one of the earliest exponents of *plein-air* painting in France. He received his introduction to painting from his father EDMÉ-FRANÇOIS, also a landscape painter, and in 1838 joined the class of Paul Delaroche (1797–1856) at the École des Beaux-Arts. He exhibited at the Salons from 1848, being awarded medals in 1848 and 1853, and at International Exhibitions in 1855 and 1867. Although closely associated with the Barbizon painters, he did not himself live at Barbizon. He visited Holland, England, and Spain. His landscapes, in which nature is observed purely for its own sake, reflect his love of rivers, beaches, and canals (he often painted from a boat), and are notable for the uncrowded quality of the composition and an almost Dutch clarity of atmospheric effect. He seems to belong more to the generation of MONET and BOUDIN, who were in fact admirers of his work (*Evening Landscape*, Met. Mus., New York; *Springtime*, Louvre; and *L'écluse dans la vallée d' Optevox*, Rouen; there are also pictures in the Tate Gal. and N.G., London).

**DAUCHER.** An Augsburg family of sculptors. ADOLF (d. 1524) worked for the Fugger family in a style which combined late German GOTHIC trends with those of the Italian RENAISSANCE. His son HANS (1485–1538) was employed by the emperor Charles V and the Dukes of Württemberg. He specialized in small decorative bronze figures.

**DAUMIER,** HONORÉ (1810–79). French painter and CARICATURIST. In his lifetime he was known chiefly as a political and social satirist, but since his death recognition of his qualities as a painter has grown. In 1830, after learning the still fairly new process of LITHOGRAPHY, he began to contribute political cartoons to Charles Philipon's anti-government weekly *Caricature*. He was sentenced to six months' imprisonment in 1832 for his attacks on Louis Philippe, whom he represented as 'Gargantua swallowing bags of gold extorted from the people'. His lithographs of this period include *Le Ventre législatif* and *La Rue Transnonain*, both of 1834. On the suppression of political satire in 1835 he began to work for *Charivari* and turned to satire of social life, creating such series as *Les Baigneuses*, *Les Bons Bourgeois*, and *Histoire ancienne*. At the time of the 1848 revolution he returned to political satire and created those greatest of all political types, 'Robert Macaire' and 'Ratapoil' —of which the historian Michelet said: 'Voilà

l'idée bonapartiste à jamais pilorisée par vous.' He is said to have made more than 4,000 lithographs, wishing each time that the one he had just made could be his last. In 1870 he made drawings to illustrate Victor Hugo's *Châtiments*. About this time also he became practically blind and he passed the remaining years of his life in a house given to him by COROT at Valmondois-sur-Seine-et-Oise subsisting on a small pension allowed him by the State.

The paintings were probably done for the most part after 1860 when lithographs became temporarily difficult to market. Although he was accepted four times by the Salon, he never exhibited his paintings otherwise and they remained practically unknown up to the time of a collective exhibition held at Durand-Ruel's gallery in 1878 the year before his death. The paintings are in the main a documentation of contemporary life and manners with satirical overtones. He was a fine and original colourist within a restricted range and was in some respects a precursor of the IMPRESSIONISTS. A ROMANTIC sensibility may be detected in pictures featuring *Don Quixote* as a larger-than-life hero. He was admired by CÉZANNE and by van GOGH. He also made 36 small painted BUSTS (*c.* 1833) including a figure of Ratapoil.

In the directness of his vision and the lack of sentimentality with which he depicts current social life Daumier belongs to the REALIST school

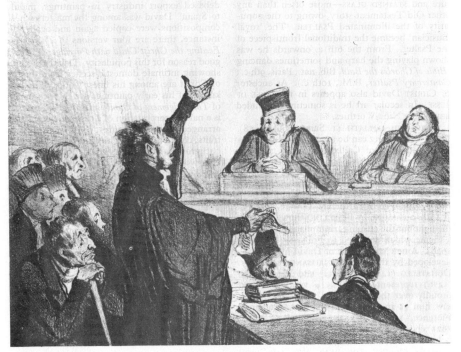

**99.** *Robert Macaire avocat. (Il plaide cinq heures sans cracher et perd son procès.)* Lithograph by Honoré Daumier from *Charivari* (23 April 1837)

of which COURBET was the chief representative. His water-colours and drawings are vivid calligraphic impressions with effective use of light and shadow. As a caricaturist he stands head and shoulders above all others of the 19th c. He had the gift of expressing the whole character of a man through physiognomy and the essence of his satire lay in his power to interpret mental folly in terms of physical absurdity, to rise beyond the individual idiosyncrasy and create the image which illuminates a concept. FORAIN said of him: 'Oh, he was different from all of us . . . he was generous.' Michelet wrote to him (30 March 1851): 'Your admirable sketch, displayed everywhere, has illuminated the whole question better than a thousand newspaper articles. . . . C'est la vigeur singulière avec laquelle vous précisez la question.' Although he never made a commercial success of his art, he was appreciated by the discriminating and numbered among his friends and admirers DELACROIX and Corot, Forain, BAUDELAIRE, Michelet, and Balzac. His works were collected by DEGAS.

15, 826, 1060, 1567, 1740.

**DAVID.** The life of David, which is first represented on the wooden doors of S. Ambrogio, Milan (4th c.), became a favourite subject of BYZANTINE ART, and in medieval Europe it was depicted—not only in manuscripts but in sculpture and STAINED GLASS—more often than any other Old Testament story, owing to the popularity of the illuminated PSALTER. The 'royal musician' became the traditional frontispiece of the Psalter. From the 6th c. onwards he was shown playing the harp and sometimes dancing (*Bible of Charles the Bald*, Bib. nat., Paris, 9th c.; *Canterbury Psalter*, B.M., 10th c.). As ancestor of CHRIST David also appears in the TREE OF JESSE. In secular art he is sometimes included among the Nine Worthies.

DAVID AND ·GOLIATH (1 Sam. xvii. 31–58). David with a sling can be seen in a 3rd-c. cemetery (Catacomb of Callixtus, Rome), and the encounter with Goliath has been depicted ever since. At first Goliath was dressed as a Roman legionary, but in the Middle Ages he wore helmet and armour and might even be mounted on a horse (capital from Parthenay, Louvre, 12th c.). A 15th-c. CASSONE by PESELLINO shows not only the fight but the ensuing triumphant procession, a theme which appealed to POUSSIN (Dulwich, 1640). A new conception of David himself was developed by the great RENAISSANCE sculptors. DONATELLO (1416 and 1432) and VERROCCHIO (1476) represented him as a youth standing proudly over the giant's head. MICHELANGELO saw him as muscular and heroic (Accademia, Florence, 1504). BERNINI (Borghese, Rome, 1623) chose the moment of concentrated tension before the stone was slung.

DAVID KILLING THE BEAR AND THE LION (1 Sam. xvii. 34–7). In the Middle Ages this story was used as a symbol of Christ repulsing the temptations of the devil, or (since David was rescuing a lamb) of Christ descending into Limbo to deliver the just (see HARROWING OF HELL). It usually appeared as two separate scenes (capital in Sainte-Madeleine, Vézelay, 12th c.).

DAVID AND BATHSHEBA (2 Sam. xi–xii). Bathsheba washing was interpreted as an image of the Church purified by baptism and saved from the DEVIL by Christ, whom David symbolized. In early representations Bathsheba is dressed and merely takes a foot-bath, but by the 15th c. she was usually depicted draped as though in preparation for a bath and was assisted by a servant (MEMLING, Stuttgart). From the Renaissance onwards into the ROMANTIC era the scene was a favourite pretext for painting the nude (RUBENS, Dresden, 1635; REMBRANDT, Louvre, 1654).

**DAVID,** GERARD (d. 1523). Flemish painter of Dutch origin, born at Oudewater near Gouda. He was probably the pupil of GEERTGEN TOT SINT JANS in Haarlem. He settled in Bruges in 1484, where he was acknowledged as the leading master after the death of MEMLING in 1494. The day of the great painters was over and the economic importance of Bruges was declining; but it still maintained its prestige as a centre of art and during the first quarter of the 16th c. it developed a flourishing though somewhat debased export industry in paintings, mainly to Spain. David was among the masters whose compositions were copied again and again; for instance, there are four versions of *The Virgin Feeding the Christ Child with Porridge*. There is good reason for this popularity. David's pictures showing intimate domestic scenes from the life of Christ are among his finest works. The best known of his early paintings are the two panels of *The Judgement of Cambyses* (Bruges, 1498). It is a naïve interpretation of a cruel subject: stiffly arranged groups of figures, some of them portraits, compete with the meticulous architectural background and its RENAISSANCE detail. But a later work, *The Baptism of Christ* (Bruges Mus., 1507) shows David's power of unifying a composition even across the three panels of a TRIPTYCH. The landscape with trees and rocks in the middle distance, and the groups of donors and their patron saints who witness the baptism in the foreground, blend together into a perfect whole. David was a contemporary of the Antwerp master MASSYS, and like him turned to the works of Jan van EYCK and Rogier van der WEYDEN for inspiration. But he was less original than Massys; his compositions do not possess the same freedom, his figures have a certain provincial stiffness, and his colour, especially towards the end of his life, lacks warmth. He excels in the representation of landscape and his treatment of light gives to the old formulas of composition a new character and meaning. Among his followers were YSENBRANDT and

BENSON, who carried on his tradition until the middle of the 16th c. One of his pupils, known as the Master of the Brandon Portraits, worked in England.

92, 926.

**DAVID,** JACQUES-LOUIS (1748-1825). French painter, who under Napoleon achieved a position of virtual dictatorship in matters artistic analogous to that of LEBRUN in the previous century. David was distantly related to BOUCHER and some of his early paintings reveal a leaning towards Boucher's method (*Combat of Mars and Minerva*, Louvre, 1771). But Boucher realized that their temperaments were opposed and sent David to VIEN. With the latter David went to Italy in 1776 when Vien went to take up the post of director of the French Academy at Rome and David had won the Prix de Rome with his painting *The Loves of Antiochus and Stratonice*. In Italy David was able to indulge his bent for the ANTIQUE and came into contact with the initiators of the new classical revival, including Gavin HAMILTON. The aesthetic outlook of those among whom he moved was voiced by the painter MENGS, who promulgated the ECLECTIC doctrine that perfection was to be achieved by combining the Greek tradition of design with the expressiveness of RAPHAEL, the CHIAROSCURO of CORREGGIO and the colour of TITIAN.

David secured election to the Academy with his painting *Date obolum Belisario* in 1780. During the 1780s his position was firmly established as the embodiment of the social and moral reaction from the frivolity of the LOUIS XV period and the ROCOCO. His uncompromising subordination of colour to drawing and his economy of statement in the rejection of the irrelevant were in keeping with the new severity of taste. His themes gave expression to the new cult of the sterner civic virtues of stoical self-sacrifice, devotion to duty, honesty, and austerity, virtues which by a romantic misconception of historical fact contributed to an uncritical admiration for ancient Rome. Seldom have paintings so completely typified the sentiment of an age as David's *Oath of the Horatii* (Louvre, 1784), *Brutus and his Dead Sons* (Louvre, 1789), and *Death of Socrates* (Met. Mus., New York, 1787). With these pictures he became the recognized symbol of the new France and head of a powerful school which spread far beyond the borders of France. They were received with acclamation by critics, CONNOISSEURS, and public alike. REYNOLDS compared the *Socrates* with the Sistine Chapel and Raphael's *Stanze* and after ten visits to the Salon described it as 'in every sense perfect'.

David was in active sympathy with the Revolution, became a Deputy and voted for the execution of Louis XVI. His position was unchallenged as the painter of the Revolution. In 1789 he was commissioned to eternalize in painting the 'Tennis Court Oath', though the project did not go beyond preliminary sketches (Fogg Mus. and Versailles). His three paintings of 'martyrs of the Revolution', though conceived as portraits, raised portraiture into the domain of universal tragedy. They were: *The Death of Lepeletier* (now known only from an engraving by P. A. Tardieu (1786-1844)), *The Death of Marat* (Brussels, 1793), and *The Death of Bara* (Avignon, unfinished). David considered the *Lepeletier* and *Marat* his best works. From this period also come his portrait of *Madame Recamier* (Louvre) and a sketch done from the life of Marie Antoinette on the way to the guillotine.

David was active in founding the new Institut which took the place of the Academy. After the fall of Robespierre he was imprisoned but was released on the plea of his wife, who had divorced him because of his Revolutionary sympathies. His *Rape of the Sabines* (Louvre), painted after his release from prison, re-established his fame and position.

David became an ardent supporter of Buonaparte and retained under him the dominant social and artistic position which he had previously held. Between 1802 and 1807 he painted a series of pictures glorifying the exploits of Napoleon. These works show a change both in technique and in feeling from the earlier Republican works. The cold colours and severe composition of the heroic paintings gave place to a new feeling for pageantry which had something in common with ROMANTIC painting, although he always remained opposed to the Romantic school (*Coronation of Napoleon, Napoleon Crossing the Alps, Napoleon Distributing the Eagles*). With the fall of Napoleon David went into exile in Brussels. Here he reverted to his earlier theories and his last pictures were drier, without the enthusiasm of the middle periods. Unlike many great artists, such as REMBRANDT, Titian, POUSSIN, David did not mature with age; his work weakened as the possibility of exerting a moral and social influence receded. Yet one of his most impressive portraits, *Trois Dames de Grand* (Louvre), dates from this last period.

712, 762, 1271, 1385, 1670, 1802, 2025, 2304.

**DAVID,** PIERRE-JEAN, known as DAVID D'ANGERS (1788-1856). French sculptor. His contemporaries saw him as a ROMANTIC, but today he would be judged to have conceded too much to academic standards for this classification to be acceptable. He carried to extremes the dogma that the nude is the highest expression of sculpture, producing in consequence some curious anomalies, for example his statue of *General Foy* in the nude (1827). In 1837 he executed the high-relief on the PEDIMENT of the PANTHEON in Paris: *The Fatherland Distributing Wreaths to Genius*. His best works are to be found among his BUSTS and medallions of famous

men, in which he reveals a talent for characterization: *Jeremy Bentham* (Saumur, 1828), *Goethe* (Saumur, 1833), *Paganini* (Angers, 1834), *Balzac* (Saumur, 1844).

**DAVIE,** ALAN (1920-   ). Scottish painter, also goldsmith and jazz musician. After early influences of KLEE and PICASSO, he was greatly impressed by post-war American painting, particularly Jackson POLLOCK. His strongly ornamental style, which marks his preoccupations with Zen-Buddhism, with myths and magic, has made him one of the most potent image-makers in mid-20th-c. British painting.

**DAVIES,** ARTHUR BOWEN (1862-1928). American painter. He was a member of the circle of Robert HENRI, a member of the EIGHT group and president of the Association of American Painters and Sculptors which was launched to organize the ARMORY SHOW. A man of wide and liberal culture, his enthusiasm for the project of presenting contemporary European art to the narrow provincialism which prevailed in the U.S.A. during the first decade of the 20th c. was largely responsible for the scope of the show and the force of its impact. As an artist he belonged to the visionary and idyllic tradition of ALLSTON and RYDER but he developed a peculiarly original ECLECTIC style of decorative tonal painting. He dabbled in the pseudo-scientific aesthetic theory invented by the zoologist Gustav A. Eisen (1847-1940) under the name 'life of inhalation', which was supposed to provide the basis of the excellence of GREEK ART. After the Armory Show his work showed a CUBIST influence but still had little in common with the analytical Cubism of PICASSO and BRAQUE. His pictures were built on a naturalistic structure of sweeping rhythmic drawing upon which was superimposed a prismatic pattern of high-keyed and arbitrary colour (*Dancers*, Detroit Institute of Art, 1914).

2076.

**DAVIS,** ALEXANDER JACKSON (1803-92). One of the most talented and influential leaders of the revivalist movement in American architecture. From 1828 to 1835 he was a partner of Ithiel TOWN in the first fully organized architectural firm in America. During this time he worked in the Greek style, but after Town left the firm he became a close associate of the critic A. J. DOWNING and made many DRAWINGS to illustrate Downing's books. This relationship stimulated Davis's natural preference for the more romantic medieval GOTHIC style. Typical of this period are Lyndhurst, Tarrytown, New York (1838), and the residence of W. C. Waddell, New York City (1844).

1931.

**DAVIS,** STUART (1894-1964). American painter, son of the art director of the Philadelphia Press who had employed LUKS, GLACKENS, and other members of the EIGHT. He studied with Robert HENRI 1910-13, made covers and drawings for the social realist periodical *The Masses* which was associated with the 'Ash-can School', and exhibited water-colours in the ARMORY SHOW. After a visit to Paris he returned to the States in 1929 and introduced a new note into U.S. CUBISM, basing himself on its synthetic rather than its analytical phase. Using natural forms, particularly forms suggesting the characteristic environment of American life, he rearranged them into flat post-like patterns with precise outlines and sharply contrasting colours (*House and Street*, Whitney Mus. of American Art, New York, 1931; *Garage Lights*, Rochester Memorial Art Gal., 1931). He later went over to pure abstract patterns, into which he often introduced lettering, suggestions of advertisements, posters, jazz, etc. (*Owh! in San Pao*, Whitney Mus. of American Art, New York, 1951; *Ready-to-Wear*, Art Institute of Chicago, 1955; *Allée*, Drake University, 1955). He was given retrospective exhibitions at the Museum of Modern Art, New York, in 1945 and at the Whitney Museum, New York, and the Walker Art Center, Minneapolis, in 1957. He held a one-man show at the Venice Biennale in 1952 and obtained the Guggenheim International Award in 1958 and 1960.

**DAYES,** EDWARD (1763-1804). English painter in WATER-COLOURS with whom GIRTIN served his apprenticeship. His treatise on LANDSCAPE PAINTING (*Instructions for Drawing and Colouring Landscapes*) appeared in his posthumously published *Works* in 1805, which included also an attack on the 'wild effusions of the perturbed imaginations' of FUSELI. It was already tending to be out of date when it was published, assuming that drawing and colouring would be distinct processes and regarding the water-colour landscape as a 'tinted drawing' in which drawn outline with shadows in neutral colours would be completed before the application of colour washes.

703.

**DEATH MASKS AND LIFE MASKS.** These are made by applying to the face a soft material such as wax, plaster, or, in modern times, agar, a vegetable gelatine. This gradually hardens and when removed serves as a mould from which a cast can be taken in plaster, wax, or any other suitable medium. When a life mask is taken breathing tubes or straws must be inserted in the nostrils. The experience is uncomfortable and may even be hazardous; it is reported that Washington was nearly suffocated. Moreover plaster generates heat as it dries. It is not always possible to distinguish life masks from death

masks because both kinds necessarily give an effect of lifelessness and alterations to the mould are sometimes made by hand, especially when it is desired to represent the eyes open.

When and why the first masks were made is uncertain. They were known to the ancient Egyptians as early as 2400 B.C. and served as models for portraiture during the AMARNA period (*c.* 1400 B.C.). They certainly played an important role in Etruscan and Roman ancestor worship and family cults. Wax masks were worn by actors in Roman funeral processions and were kept in a special shrine in Roman houses. We know little about their use in the Middle Ages but they certainly existed in 15th-c. Florence. The church of SS. Annunziata had a famous collection of them and although most are lost, the haunting death mask of Lorenzo the Magnificent has fortunately been preserved. Since then it has been quite a common practice to take death masks of the illustrious. The wax images of Queen Elizabeth I and other sovereigns in the Westminster Abbey collection are all based on death masks. Napoleon's and Goethe's features are known to us through masks, as are those of Keats, whose mask was taken during life by B. R. HAYDON. A curious variant is the plaster cast taken from the hands of musicians, artists, writers, and even statesmen.

**DE BRUN.** See BRU, A.

**DECKER,** CORNELIS GERRITSZ (before 1643–78). Dutch painter who specialized in weavers working at their home looms. He also did landscapes which show the influence of Jacob van RUISDAEL.

**DECORATED STYLE.** In T. RICKMAN's classification (1817, see GOTHIC) of the architectural styles of medieval England, Decorated came between EARLY ENGLISH and PERPENDICULAR and occupied most of the 14th c., though it has later been restricted to the period between *c.* 1250 and 1350. The term may seem singularly ill chosen, because no one of the English medieval styles can be singled out from the rest on the ground that it is more richly decorated. But Rickman's classification was based primarily on window design; and from this limited point of view it is not so inappropriate, for the windows that followed the simple Early English lancets and preceded the monotonous panelled designs of the Perpendicular period were characterized by an extreme richness and variety. These 'decorated' windows exploited a new architectural member: bar TRACERY, which consisted of narrow strips of stone, both straight and curved, providing almost inexhaustible possibilities for pattern-making, and windows became much broader than the earlier lancets. At first tracery patterns remained fairly simple, based on circles and arcs of circles, diversified with CUSPS; but after *c.* 1300 the curves began to undulate and the patterns to form shapes

like raindrops or tongues of flame. The earlier forms are distinguished from the later by the terms 'geometrical' and 'curvilinear'. It is the development of this new form of architectural decoration, and its adaptation to the older forms already in use, which provides the key to the understanding of the so-called Decorated style.

The first building in which bar tracery was used in England was Westminster Abbey (after 1245). Here it still looks like a direct importation from France, the windows repeating patterns used at REIMS and AMIENS and being set in a structure that is in many ways more French than English. But at Lincoln, in the Angel Choir, Lichfield, and in old St. Paul's, London, traceried windows were incorporated into designs which were otherwise faithful to the Early English formulas. Some of them, notably Lincoln, were remarkably successful. But when, as at Exeter (after 1280), an attempt was made to intensify all forms of decoration indiscriminately, the windows tended to be lost among the profusion of piers, arches, and ribs. This seems to have touched off a series of experiments all over the country, whose purpose was to find a satisfactory way of combining window tracery with other decorative elements. Examples are to be found at Wells, Bristol, York, and Ely, as well as London, where the eventual solution, namely Perpendicular, was devised. Together they make the 50 years between 1280 and 1330 the most exciting period in the history of medieval English architecture; and during this period the English were perhaps the most inventive architects in the whole of Europe. Briefly, their solutions took three forms. The most enterprising was to break away from the strict rectangular planning of the previous generations and to exploit polygonal shapes, which allowed windows to be seen obliquely. The polygonal CHAPTER HOUSE, which was an English speciality, was the starting-point of this development. The second was to transform the VAULT patterns by thinning out the main ribs and introducing smaller ribs at the head of the vaults (liernes), which created an effect much more akin to that of window tracery. The third, which was at once the most prosaic and the most radical, was to replace as many as possible of the masonry forms by tracery, so that the antithesis between wall and window was obliterated. This started in London during the Decorated period (St. Stephen's Chapel, Westminster Palace), but it developed organically into Perpendicular.

**DECORUM.** The Latin word *decorum*, the equivalent of the Greek *prepon* or *harmotton*, expressed one of the most pervasive AESTHETIC concepts of late classical antiquity, particularly in Roman poetics and theories of rhetoric. The notion combined the two requirements that the various elements of a work of art shall be congruent with each other and that there shall be congruence or 'appropriateness' between the

work of art and those aspects of external reality which are reflected in it.

In the *Hippias Major* Plato exposed a paradox in the identification of beauty (*kalon*) with appropriateness or what is 'becoming' (the Greek word *prepon* carried both connotations). In general, however, he condemned incongruity of style, melody, or rhythm and demanded appropriateness of expression to subject and occasion. Suitability of style to subject and purpose was a primary requirement with Aristotle and Isocrates. Aristotle's requirement that the qualities of characters in dramatic art should be appropriate to their class and situation (*Poetics*, 1454ª 22) became the basis in RENAISSANCE and NEO-CLASSICAL literary theory of the demand that characters should be 'true to type'. In Cicero, Horace, and later Roman critics the principle of decorum became paramount. Cicero quotes with approval the actor Roscius that 'a sense of fitness, of what is becoming, is the main thing in art, and yet the only thing which could not be taught by art' (*De Orat.* i. 132). Although Horace does not use the word 'decorum' in his *Ars Poetica*, the idea is a dominant principle throughout and he held that 'propriety or fitness was to be observed in a work as a whole and in its several parts; it applied to the form, the expression, and the characterization; it determined the choice of subject, the metre, the particular style or tone; while it also forbade the mixing of incongruous elements, the mingling of genres, the creation of characters that lacked verisimilitude, the improper use of the *deus ex machina*, and the like' (J. W. H. Atkins, *Literary Criticism in Antiquity*, vol. ii, p. 89). In medieval theory the word *conveniens* was often used to express the same idea. During the Renaissance and still more in Neo-Classical literary theory the demands of decorum were often applied so as to bolster a rigid and unimaginative insistence on the segregation of literary types with strict rules for each.

Although it was elaborated primarily in the field of literary theory, the idea of decorum also influenced theories of art and assumed considerable importance in the teachings of the 17th-c. ACADEMIES. There it was essentially a social idea of what was 'fitting', for example, to a nobleman or a peasant, and a breach of decorum in a painting was thought by academic critics to endanger its status as art. While RAPHAEL and POUSSIN appeared models of decorum, it was the main charge against naturalists such as CARAVAGGIO or REMBRANDT that they disregarded this rule by introducing low types into noble stories and neglected the conventions of costume, gesture, and setting which had come to be considered appropriate. The idea of decorum had its strongest hold on the traditions of portraiture of nobles and worthies.

**DE CRITZ.** A family of painters who fled from Antwerp to escape religious persecution and settled as refugees in England *c.* 1570–*c.* 1665. JOHN (before 1552–1642) was Serjeant-Painter from 1603, and was connected by marriage with the painters GHEERAERTS, Sir Robert Peake (1592–1667), and the OLIVERS. A number of decorative portraits, some of them whole-length, are associated indifferently with one or other of these names, and they may well have collaborated in them. An example of John de Critz's work as Serjeant-Painter may survive in a TEMPERA painting on the coving in the Queen's bedroom. A series of portraits of the Tradescant family, *c.* 1640–50 (Ashmolean Mus., Oxford), remarkable for realistic competence combined with a certain eccentric melancholy, are associated with EMMANUEL DE CRITZ (before 1609–55), son of the foregoing.

**DEGAS,** HILAIRE-GERMAIN-EDGAR (1834–1917). French painter. Abandoning a training for the law, he entered the École des Beaux-Arts in 1855 and studied under Louis Lamothe, a pupil and admirer of INGRES, who laid the foundation of Degas's superb draughtsmanship. In 1856 Degas went to Naples, where his family were living, visited other Italian cities and spent three years in Rome. Here he obtained the grounding of an artistic education by copying drawings and frescoes by 15th- and 16th-c. artists, including the school of LEONARDO—a practice which he continued in the LOUVRE after returning to Paris. From his Italian years there survive a number of portraits and several pictures, including *Jeunes Spartiates s'exerçant à la lutte* (originally entitled *Petites Filles spartiates provoquant des garçons*), which after being repainted was exhibited at the Fifth Impressionist Exhibition in 1880. In 1861 he returned to Paris and painted historical pictures (*La Fille de Jephté*, Smith College, Northampton, Mass.; *Sémiramis construisant une ville*, Louvre) very much in the classical manner of Ingres. In 1861 Degas met MANET while copying a VELAZQUEZ in the Louvre and was introduced by him to the circle of young IMPRESSIONISTS who met at the Café Guerbois. In 1862 Degas painted his first race-course picture, *Course de gentlemen: avant le départ* (partially repainted in 1880). During the next few years he abandoned historical pictures and painted contemporary subjects, with a special predilection for racing scenes, ballet, theatre, circus, rehearsals, café scenes, laundresses, etc. It seems that he was influenced towards this change of direction largely by Manet and the writer Edmond Duranty.

Degas exhibited in seven out of the eight Impressionist exhibitions and is regarded as one of the prominent members of the Impressionist School. He was, however, Impressionist only in certain restricted aspects of his work and like Manet stood somewhat aloof from the rest of the group. He was not interested in landscape except as a background to his racing or figure scenes, and therefore did not share the Impressionist

concern for rendering the effects of changing light and atmosphere. He was more interested in draughtsmanship than most of the others and —apart from Manet—he alone had a thorough grounding in traditional techniques and the background of Italian RENAISSANCE art. Like the other Impressionists he liked to give the suggestion of accidental, spontaneous, and unplanned scenes, even to the extent of cutting off figures in the manner of a badly executed snapshot or using unfamiliar viewpoints. Like them he was influenced by the new techniques of photography and by Japanese COLOUR PRINTS and he was interested in conveying the impression of movement. But he did not paint out of doors or directly from nature. The appearance of spontaneity and accidental effects was an appearance only; in reality his pictures were carefully composed. 'Even when working from nature, one has to compose', he said. And: 'No art was ever less spontaneous than mine.' Even when he captures most vividly the characteristic gestures and postures of his subjects his pictures were usually composed in the studio from notes taken on the spot.

Degas always worked much in PASTEL and when his sight began to fail in the 1880s his preference for this medium increased. In the 1886 Impressionist Exhibition he showed a set of pastels of nudes of 'women bathing, washing, drying, rubbing down, combing their hair and having it combed'. His colours grew stronger and his compositions more simplified.

From 1880 Degas also modelled in wax and at the Sixth Impressionist Exhibition in 1881 he showed his famous bronze *Petite Danseuse de quatorze ans* (Louvre) dressed in a real tutu. He also modelled horses in action. During the 1890s, as his fears of failing sight increased, he devoted more time to modelling, doing mostly women at their toilet or nude dancers in characteristic postures. RENOIR ranked him above RODIN as a sculptor.

Degas was one of the first of the Impressionist group to achieve recognition and his fame has endured. At the 1937 Paris *Exposition* a large retrospective exhibition of his work was arranged at the Musée de l'Orangerie.

331, 367, 415, 466, 527, 620, 623, 705, 1124, 1219, 1635, 1754, 1814, 2111, 2226, 2769, 2770.

**DE KOONING,** WILLEM (1904– ). Painter who was born in Rotterdam, went to New York in 1926, settled there and became a naturalized American. During the 1930s he was employed by the WPA Federal Arts Project. He taught at Black Mountain College in 1948 and at Yale during the early 1950s. His abstract paintings brought him within the school of ABSTRACT EXPRESSIONISM. In 1946 he began a style of black-and-white paintings, in which abstract black forms outlined heavily in white overlap and interpenetrate. His first one-man show was in 1948, by which time he was firmly established alongside Jackson POLLOCK as one of the leading Abstract

Expressionists. He first achieved widespread notoriety in 1953 for an exhibition of paintings and pastels of women, mostly single figures, done over the previous three years. In the second half of the 1950s he reverted to abstracts and city landscapes. During the 1960s, while continuing to paint abstracts, he also did paintings of women, which combine a certain barbaric repulsiveness with sometimes overt eroticism. He held a retrospective exhibition at the Tate Gallery in 1968.

**DELACROIX,** FERDINAND-VICTOR-EUGÈNE (1798–1863). French painter, son of Charles Delacroix who took an active part in the Revolution, became Foreign Minister under the Directoire and later Prefect of the Gironde. His mother, Victoire Oeben, came of a family of notable craftsmen and designers. He entered the studio of Pierre Guérin in 1816 and was a fellow pupil of GÉRICAULT. His basic artistic education was obtained, however, by copying Old Masters at the LOUVRE, where he delighted in RUBENS, VERONESE, and the VENETIAN SCHOOL. He met BONINGTON in the Louvre and was introduced by him to English WATER-COLOUR PAINTING. CONSTABLE's *Hay Wain*, exhibited in the 1824 Salon, also made a great impression on him and in 1825 he spent some months in England. Here he conceived an enthusiasm for English painting, in particular GAINSBOROUGH, LAWRENCE, ETTY, and WILKIE. Among contemporary French painters he felt affinity with Géricault and Baron GROS rather than with the Classical school of DAVID. In the Salon of 1822 he exhibited his first painting, *Dante and Virgil in Hell* (Louvre), conceived in ROMANTIC vein, which was approved by Gros, praised by the critic Thiers, and bought by the State. From the same period come his well known paintings *The Massacre at Chios* (Louvre, 1823) and *The Death of Sardanapalus* (Louvre, 1827).

In 1832 he visited Morocco in the entourage of the Comte de Mornay and there acquired a fund of rich and exotic visual imagery which he exploited to the full in his later painting (*Algerian Women*, Louvre, 1833). From the late 1830s his style and technique underwent a change. In place of luminous glazes and contrasted values he began to use a personal technique of vibrating adjacent tones and DIVISIONIST colour effects in a manner of which WATTEAU had been a master. Breaking almost completely with the traditional techniques of the schools, he gave his surfaces a harsh and expressive rugosity which put the brush-work to use instead of concealing it and made COLOUR enter into the structure of the picture to an extent which had not previously been attempted. His fresh mastery of colour was studied and admired by artists as different as RENOIR and SEURAT and his understanding of symbolic or dramatic colour expression inspired van GOGH. He is often regarded as the greatest colourist among all French painters.

Delacroix was hailed as the leader of the

L

307

Romantic school in revolt from the Classical school founded by David, and in art histories he is treated as the greatest of the Romantics. Yet his genius was too comprehensive to be confined within the limits of a school. He was a Romantic in temperament and in his choice of subjects from poets such as Dante, Shakespeare, GOETHE, Byron, or themes illustrating the Greek War of Independence. His Orientalism and exoticism were also in line with one trend in the French Romantic movement. But in painterly quality he achieved more than this. He had a BAROQUE exuberance of decorative opulence and yet his painting shows a classical appreciation of simplicity and grandeur. Defining his position in relation to the Classicism of David, he said: 'I am a rebel not a revolutionary.'

Delacroix painted a number of religious pictures at all periods of his life. He was not an orthodox religious artist but infused genuine feeling into many of these pictures. BAUDELAIRE said of him that he was the only artist who 'in our faithless generation conceived religious pictures' and van Gogh wrote: 'Only REMBRANDT and Delacroix could paint the face of Christ.' He was also one of the distinguished monumental mural painters in the history of French art. His public commissions included: decorations in the Chambre des députés, Palais Bourbon (Salon du roi, 1833-7; Library, 1838-47); in the Library of the Luxembourg Palace (1841-6), and three paintings in the Chapelle des Anges of S. Sulpice (1853-61). In the last of these his *Jacob and the Angel* and *Heliodorus Expelled from the Temple* are among the maturest expressions of his decorative richness of colour and grandiose structural integration.

At the Universal Exhibition of 1855 Delacroix was represented by 36 canvases shown in one room and he was made a Commander of the Legion of Honour. He was not accepted as a member of the Institut de France until 1857. In the year before his death he held an exhibition at which were shown nearly 200 pictures, most of them very large, and after his death he left more than 6,000 drawings and engravings in addition to paintings. He brought back into French painting the pure and scintillating use of colour which had been understood by Watteau and there has been no subsequent school where his example has not been felt. His *Journal*, begun in 1823 and continued until 1854, is the artistic record of an epoch.

130, 452, 709, 827, 1399, 1445, 1670, 2484.

**DELAUNAY, ROBERT** (1885-1941). French painter, who through most of his career experimented in the abstract qualities of COLOUR. He began his researches *c.* 1906 from the NEO-IMPRESSIONIST theories of SEURAT but instead of the POINTILLIST technique investigated the interaction of large areas of juxtaposed and contrasting colour. He was particularly interested in the interconnections between colour and movement.

In 1912 he exhibited at the Salon des Indépendants a major work *La Ville de Paris* (Musée d'Art moderne), which APOLLINAIRE declared to be the most important painting in the exhibition. He provided the main incentive for the attempt to apply the principles of CUBISM in the realm of colour and was prominent in that phase of Cubism which Apollinaire named ORPHISM. In 1912 he produced the series *Les Disques* and *Les Formes circulaires cosmiques* in which he attempted a purely abstract use of colour to combine perspective with movement. He exhibited in 1913 at the galleries of Der STURM, Berlin. In 1930 he painted the important picture *Ville de Paris* and continued his earlier experiments in abstract colour with *Rythmes colorés* and *Rythmes sans fin*. In 1937 he did coloured reliefs for the Palais des Chemins de Fer and the Palais de l'Air in the Exposition universelle, Paris. SONIA DELAUNAY (*née* Sonia Terk) (1885-  ) was the wife of the foregoing. She was a painter of the ÉCOLE DE PARIS, born in the Ukraine. After passing through a FAUVIST period she was attracted by the abstract possibilities of colour and co-operated with Robert Delaunay in his researches into colour Cubism or Orphism. She was energetic in applying their principles of colour combination in the sphere of textile design, ceramics, theatrical costume, and other forms of practical art. After the death of Robert Delaunay she worked with ARP and Sophie Taeuber (1889-1943) and with Alberto Magnelli (1888-  ). After the Second World War she was active in the formation of the Salon des Réalités nouvelles, which originated from an idea of Robert Delaunay in 1939. A large retrospective exhibition of her work was held in the Bing Gallery in 1953.

2779.

**DELORME** (also written DE L'ORME), **PHILIBERT** (*c.* 1510-70). French architect. After studying in Rome he became superintendent of buildings to Henry II and designed the tomb of Francis I and the château of Anet (for Diane de Poitiers). During this period he was the most powerful figure in the arts in France. On Henry's death (1559) he was replaced by PRIMATICCIO but after four or five years was taken into favour by Catherine de Médicis, the Queen Mother. For her he designed the palace of the Tuileries (since destroyed); and prepared plans for completing the château of Saint-Maur-des-Fossés, near Charenton, begun for Cardinal de Bellay *c.* 1540. During his years of disgrace he wrote two works on architecture, the second of which, *L'Architecture* (1567), is an exposition in nine books of the business of the architect. Although using VITRUVIUS and ALBERTI as models, it is original in its treatment. In it he proposed the addition of a new French Order to the five recognized Orders of classical antiquity (see ORDERS OF ARCHITECTURE). It was the first book of its kind and enjoyed considerable popularity in France and abroad.

100A. Perspective view of the Château d'Anet

100B. Elevation and plan of the Chapelle d'Anet. Pen-and-ink drawings by Jacques Androuet Ducerceau. Engraved in *Les plus excellents bastiments de France* (1576)

Most of Delorme's buildings have been destroyed and in assessing his work we must rely largely on engravings. His style shows his understanding of Classical design, his independence and originality of treatment and a strong feeling for national traditions and taste. He contributed more than any other architect of his time to the creation of a distinguishably French form of the classical RENAISSANCE ideal.

312, 407.

**DE LOUTHERBOURG,** JACQUES PHILIPPE or PHILIPP JAKOB (1740–1812). Painter, educated in Strasbourg, who was already a member of the French Academy when he came to London in 1771. He became a designer of stage sets for Garrick at Drury Lane (maquettes in the V. & A. Mus.) and his reputation was built on the production of PICTURESQUE scenes and large setpieces of a dramatic nature, e.g. *Battle of Valenciennes* (Easton Neston). Although a foreigner, De Loutherbourg is said to have declared

that 'no English landscape painter needed foreign travel to collect grand prototypes for his study'. He exalted the English scenery as material for the picturesque and the SUBLIME. In the words of Ephraim Hardcastle in *Wine and Walnuts* (1823): 'The scenery of our lakes, he contended, united the sublime and the beautiful, the mountainous wilds of North Wales, and the yet grander mountains of Scotia, seen under the magical effects occasioned by our humid, ever-varying atmosphere, such as inspired the poetic descriptions in Ossian, were alike directed to the painter's no less poetic observation. De Loutherbourg's practice was but a comment on this candid declaration; for until his arrival here, it rested a common prejudice with artists and amateurs alike, that our fair island did not afford subject for the higher display of the landscape-painter's art.' His invention of the EIDO-PHUSIKON, a moving panorama peep-show, was celebrated in its day, fascinated GAINSBOROUGH, and interested REYNOLDS.

1247.

**DELPHI CHARIOTEER.** Bronze statue of a charioteer, standing and wearing the regulation long dress, from a group dedicated at Delphi by Polyzalus of Gela to commemorate his victory in the games in 478 or 474 B.C. (now in the Museum of Delphi). The chariot and horses are lost.

**DELVAUX,** PAUL (1897– ). Belgian painter who after painting in NEO-IMPRESSIONIST and EXPRESSIONIST manners came late to SURREALISM in 1935 under the influence of CHIRICO and MAGRITTE. His subsequent pictures were obsessed by an ideal of abstracted female beauty, represented nude or semi-clothed, in incongruous situations, often against a meticulously executed architectural background, with the disturbing dreamlike quality which was the hallmark of Surrealist art. Delvaux became the vogue in fashionable art circles after the Second World War for a short period when the generality of Surrealist art was already *vieux jeu*.

2536.

**DEMETER OF CNIDUS.** A marble statue of *c.* 330 B.C., found at Cnidus and now in the British Museum. It represents Demeter seated; originally, perhaps, Persephone stood beside her. A bronze figure of similar style (now in Istanbul) was taken from the sea off Cnidus in 1953.

**DEMUTH,** CHARLES (1883-1939). American painter, studied at the Pennsylvania Academy under Thomas Pollock Anshutz (1851-1912) and lived in Paris in 1904 and 1910-14. He was active mainly from 1915 and during the 1920s and was an exponent of a style of simplified forms which has been called 'Cubist-Realism' and compared with the PURISM of Amédée OZENFANT. He invented a style of oblique and symbolic

portraiture which he called the 'poster portrait'. (See his portrait of the poet William Carlos Williams called *I Saw the Figure Five in Gold*, Met. Mus., New York, 1921.)

2267.

**DENIS,** MAURICE (1870-1943). French painter and writer on art theory. He was a member of the NABIS and one of the chief exponents of the theories of SYMBOLISM associated with their reaction from IMPRESSIONISM. At the age of 20 he was responsible for the formulation which has often been regarded as the key to contemporary aesthetics of painting: 'Remember that a picture—before being a war horse or a nude woman or an anecdote—is essentially a flat surface covered with colours assembled in a certain order.' In his own work, however, he set himself to revive religious painting, where subject is inevitably of importance, and in 1919 together with Georges Desvallières (1861-1950) he founded the Ateliers d'Art sacré. His writings on art are for the most part collected in *Théories* (1912) and *Nouvelles Théories* (1922). In 1939 he published a history of religious art.

718, 719, 720.

**DENTILS.** A series of square blocks set beneath a CORNICE. They probably derive from the ends of wooden beams supporting a timber superstructure.

**DE PILES,** ROGER (1635-1709). One of the leading French art historians and theorists of his day. He was employed by Louis XIV on various diplomatic missions and was thus enabled to study the arts at first hand in many European countries. He was an admirer of RUBENS and in the famous controversy of the 'Rubénsistes' against the 'Poussinistes' he took the side of those who held that COLOUR and CHIAROSCURO are of prime importance in painting against the academic emphasis on drawing. In his history he extended the concept of history painting, which in the Académie was regarded as the highest category of art, to include all kinds of subject matter. He also recognized the value of genius, imagination, and 'enthusiasm' against the excessive domination of formalized rule. He translated into French the *De arte graphica* of DUFRESNOY. Chief among his own works were: *Dialogue sur le coloris* (1673); *Dissertation sur les ouvrages des plus fameux peintres, avec la vie de Rubens* (1681); *Abrégé de la vie des peintres. Idée du peintre parfait* (1699); *Cours de peinture par principes avec une balance des peintres* (1708). The last is the most important expression of his own theories.

725, 726.

**DERAIN,** ANDRÉ. (1880-1954). French painter. As a young man he painted with

VLAMINCK at Chatou and later with MATISSE (whom he met in 1889) at Collioure. With Vlaminck he became a prominent member of the FAUVES group created by Matisse c. 1905. He became a frequenter of the group which centred round PICASSO and BRAQUE at the Bateau-Lavoir and was an early adherent to CUBISM. His picture *La Cathédrale de St.-Paul et la Tamise* (1906-7) was still Fauvist; his *La Toilette* (1908) showed the beginnings of Cubist structure. He was one of the first to 'discover' Negro art, producing sculpture under Negro influence, and later was an admirer of Italian and French PRIMITIVES. In 1919 he designed the sets for Diaghilev's production of *La Boutique fantastique* and from this time onwards he developed an ECLECTIC style based on a personal fusion between the ROMANTICISM of DELACROIX and the Romantic REALISM of COROT and COURBET.

728, 1661, 2593, 2728.

**DER KINDEREN,** ANTONIUS JOHANNES (ANTON) (1859-1925). Dutch painter, designer of STAINED GLASS windows and printmaker, whose influence was significant in the SYMBOLIST movement in the Netherlands c. 1900. His aim was the revival of monumental wall-paintings which would become an integral part of the design of a building, as opposed to the 'Dutch' cabinet picture. A series of his large murals is in the City Hall at 's-Hertogenbosch.

**DERUET,** CLAUDE (1588-1660). French painter of the School of Nancy, to which CALLOT and BELLANGE also belonged. Most of his paintings were for fêtes and ballets. He also did a series of allegories (*The Elements*) for the château of Richelieu (Orleans Mus.).

**DESCHAMPS,** JEAN (active second half of 13th c.). Architect who worked in Paris at the Sainte-Chapelle and is known to have been master-in-charge of the work at the cathedral of Narbonne in 1286 and to have been at Clermont-Ferrand in 1287. Similarities of style make it likely that he was also associated with the designs of the cathedrals at Toulouse and Rodez, and perhaps Limoges. All these southern cathedrals belong to the northern tradition, and are characterized by forms of RAYONNANT decoration.

**DESIDERIO DA SETTIGNANO** (1428/31-61). Italian sculptor of the FLORENTINE SCHOOL. He came to maturity while DONATELLO was in Padua, but like most of his contemporaries he formed his style on Donatello's Florentine work of the 1430s. He learnt from Donatello the practice of carving in very low RELIEF, and the lively, thick-set figures of children on the *Singing Gallery* made by Donatello for Florence Cathedral (1433-8) provided models for Desiderio's own reliefs of the *Madonna and Child*. Both these features appear in his *Panciatichi Madonna*, probably dating from the early 1450s and now in the Bargello, Florence. But this very beautiful work also exemplifies his originality and the delicacy of his style. He uses the technique not for heroic expression as Donatello, but with a particular refinement and a poetic fastidiousness of design. The two figures are framed in a window, anticipating by some 12 years Fra Filippo LIPPI's use of this device in a painting.

Desiderio's only important public work was the TOMB of the Florentine humanist and statesman Gregorio Marsuppini, in Sta Croce (after 1453). This is architecturally dependent on Bernardo ROSSELLINO's tomb of Leonardo Bruni, executed for the same church about 10 years earlier, but is sculpturally richer and more animated. His sensitive modelling is best exemplified by BUSTS in the Bargello, Florence, and Berlin and a *Virgin with Laughing Child* in the Victoria and Albert Museum, London.

483, 2101.

**DESIGN.** In Italian when a systematic terminology of art was being worked out the word *disegno* had a wider and a narrower connotation as has 'design' today, although the emphasis has shifted. Its primary sense was DRAWING, as for example when the 15th-c. theorist Francesco Lancilotti in his *Trattato di pittura* (1509) distinguished *disegno*, *colorito*, *compositione*, and *inventione* as the four elements of painting. So too CENNINI made *disegno* and colouring (*il colorire*) the bases of painting and VASARI set 'design' over against 'invention' as the father and mother of all the arts. In its wider meaning *disegno* came to imply the creative idea in the mind of the artist (as this was often thought to be bodied forth in the preliminary drawing). Thus BALDINUCCI defines it as 'a visible demonstration by means of lines of those things which man has first conceived in his mind and pictured in the imagination, and which the practised hand can make appear'. He then adds: 'it signifies also a configuration and composition of lines and shades which designates what remains to be coloured or otherwise executed and that represents a work already done'. A certain mystique attached to the word as a result of analogies often drawn between the creative activity of the artist and the creation of the world by the Deity or by a Platonic Demiurge in accordance with Ideas or prototypes. In this context of ideas it was the power to 'design' which was held to distinguish the artist from the craftsman. In the 17th c. Platonists such as F. ZUCCARO, BELLORI, and LOMAZZO tended to identify *disegno* with the idea'. In his *L'idea de' pittori, scultori e architetti* (1607) Zuccaro distinguished what he called *disegno interno* or 'idea' from *disegno*

*esterno*, the execution of the idea in paint, stone, wood, or other material. The Aristotelians by contrast taught that understanding of the scheme of things comes empirically by noticing what particular individuals have in common and therefore insisted that 'design' must be based on a careful observation of nature—what DE PILES in his *Cours de peinture par principes* (1708) called 'la circonscription des objets'.

In modern usage 'design' in its widest sense denotes the planning of any artefact whether for use or for show. Useful design involves the adaptation of any system so as to obtain at least an intended result or to avoid unwanted results. In *The Nature of Design* (1964) David Pye specified six conditions which must be satisfied in any design. Four 'requirements of use' are given as: (1) it must correctly embody the essential principle of arrangement; (2) the components of the device must be geometrically related . . . in whatever particular ways suit this particular result; (3) the components must be strong enough to transmit and resist forces as the intended result requires; (4) access must be provided. Added to this is the requirement for ease and economy and the requirement that the appearance of the device must be acceptable. The theory of FUNCTIONALISM, which was popular early in the 20th c. particularly in architecture and certain branches of industrial production, maintained that the requirements for use and economy of themselves wholly determine optimum design. It was expressed compendiously in the phrase 'form should follow function'. Later the more level-headed view prevailed that these other requirements restrict possibilities as to appearance and may act as a guide but do not determine optimum appearance. As David Pye has said: 'A surprisingly large proportion of manufacturing time in nearly every field is in fact taken up with useless work catering for the requirements of appearance.'

In a narrower sense the word 'design', particularly in such phrases as 'industrial design', is used with special regard to the requirement of appearance and has in view the improvement of marketability by imparting an attractive appearance or one in line with current fashions within the margins of variation imposed by the requirements of use and economy. This use of the word has a long history from the foundation of Schools of Design under government auspices about the middle of the 19th c. (see ART EDUCATION; INDUSTRIAL ART) and various influences from the ARTS AND CRAFTS MOVEMENT.

In relation to the FINE ARTS, into which considerations of usefulness do not enter, 'design' is no longer used primarily of drawing but in a sense closer to what was formerly meant by COMPOSITION. Courses in Basic Design came into vogue in the art schools around the middle of the twentieth century with instruction in the elements of artistic expression and the objective principles of their combination and manipulation. Design is therefore a concept very close to the principle of construction in any work of art.

324, 730, 1026, 1027, 1411, 2071, 2159, 2629, 2857, 2877.

**DESJARDINS** or BOGART, MARTIN (1639/40-94). Dutch sculptor who settled in France. He arrived in Paris about 1670 and soon rose to fame, becoming Director of the Académie in 1686. Besides religious works for churches, he executed many of the figures in the gardens and the building of VERSAILLES in a classical BAROQUE style that foreshadows the 18th c. He was commissioned by the Duc de la Feuillade to make a statue of Louis XIV for the Place des Victoires. Louis was so taken with it that the Duke presented it to him and ordered the artist to produce another.

**DESPIAU**, CHARLES (1874-1946). French sculptor, born at Mont-de-Marsan in the Landes. From 1907 to 1914 he worked as assistant to RODIN. He made the War Memorial at Mont-de-Marsan (1920-2) and in 1923 exhibited at the Salon d'automne and the Salon des Tuileries, of which he was one of the founders. He had a one-man show at the 17th Venice Biennale in 1930 and exhibited again at the 20th Biennale in 1936. He reacted from the ROMANTICISM of Rodin and developed a sensitive, classical style which has certain affinities with that of MAILLOL. He is best known for his portrait busts with their intimate delineation of character (*Head of Madame Derain*, Phillips Coll., Washington, 1922) but also made single figures and TERRACOTTAS (*Assia*; one cast in Boymans Mus., Rotterdam, 1938). His sculptural drawings have a directness of statement and a sensitive feeling for form which has caused them to be prized by connoisseurs.

1013.

**DESPORTES**, ALEXANDRE-FRANÇOIS (1661-1740). French artist celebrated for his pictures of dogs, game, and emblems of the chase. He was court painter to Jan Sobieski in Poland until that king's death. In 1712 he was well received in England. He was appointed by Louis XV painter of the royal hunt and kennels. He continued the Flemish tradition of realistic STILL LIFE paintings of fruit and game and with Jean-Baptiste OUDRY was among the first artists of the 18th c. to introduce landscape studies after nature. He was considered eccentric in his day for his habit of painting studies of nature in the open air. There are pictures in the Louvre and the Wallace Collection, London.

**DE STIJL.** See STIJL, De.

**DEUTSCH**, NIKLAUS MANUEL (c. 1484-1530). Swiss painter and designer, who was also a poet and politician. His most important work,

a *Dance of Death* painted for the Dominican monastery in Berne, is known from poor copies only, but his morbid preoccupation with death and ghosts can be seen from his many surviving drawings (most of them in the Kunstmuseum in Basel).

**DEUTSCHER WERKBUND.** An organization of German manufacturers, architects, and designers for the improvement of design in machine-made products. The Werkbund was formed in October 1907 at Munich by Hermann Muthesius (1861-1927). Prominent among its early members were Henry van der VELDE, Hans POELZIG, and Peter BEHRENS. Muthesius had been German cultural attaché in London (1896-1903) and was impressed by the ideas of the William MORRIS circle and the domestic architecture of SHAW and VOYSEY. On his return to Germany he became Superintendent of the Prussian School of Arts and Crafts, and became the proponent of a new style in machine industry which adopted as its shibboleths functional design and the abolition of ornament.

The Werkbund was racked by controversy from the time of its foundation, and Muthesius usually sided with Behrens in his quarrels with van der Velde. The latter set a higher value on individuality and opposed the tendency to turn the artist into a superior artisan; but Behrens advocated maximum industrialization, every possible use of mass production, and the standardization of design (*Typisierung*) as the only way of improving taste. Behrens's programme was adopted at the Werkbund's annual meeting at Cologne in 1914, when a special exhibition of members' work was arranged. This display brought to prominence some of Behrens's younger associates, in particular Bruno Taut and Walter GROPIUS, whose model factory building was the most discussed exhibit.

The Werkbund carried on after the First World War and it sponsored the international exhibition of model housing projects held in 1927 at the Weissenhof settlement near Stuttgart. After a period of eclipse it was revived after the Second World War.

**DEUTSCHE WERKSTÄTTEN.** An organization for the machine production of well designed furniture and other goods. The workshops were established in Dresden in 1898 by Karl Schmidt, a German follower of William MORRIS.

**DEVERELL,** WALTER HOWELL (1827-54). British painter, born at Charlottesville, Va., U.S.A. He studied at the R.A. Schools and shared a studio with D. G. ROSSETTI in 1851. In his brief career he gave promise of becoming perhaps the most painterly of the PRE-RAPHAELITE followers (*The Pet*, Tate Gal., 1852/3).

**DEVIL.** As Satan in Jewish and Christian theology the devil was the supreme spirit of evil, the tempter and spiritual enemy of man or the rival of God. By a misunderstanding of Isaiah xiv, 12 the name Lucifer was applied to Satan as a rebel archangel (see ANGEL) before his fall.

The popular conception of devils as a cohort of monkey-like figures with horns, hooves, and tail, prancing with a toasting-fork and tongues of flame issuing from the mouth has not been ubiquitous or even predominant in the history of Christian iconography. In EARLY CHRISTIAN and BYZANTINE ART the devil was represented as a winged figure, dark blue or violet in colour, in scenes of the LAST JUDGEMENT (S. Apollinare, Ravenna, c. 520) and the Temptation of Christ (*Homilies* of St. Gregory of Nazianzus, Bib. nat., Paris, c. 880; *Psalter of Queen Melisenda*, B.M., 12th c.). From the 11th c. the devil began to be depicted in the West as a terrifying monster and this tradition, established in ROMANESQUE sculpture of the early 12th c. (*The Parable of Dives and Lazarus*, Moissac; *The Legend of Theophilus*, Souillac; *The Devil with Moses and the Golden Calf*, Vézelay), continued until the early 16th c.

Towards the close of the 13th c. the devil began to be featured more dramatically, often dominating scenes of Hell and the damned particularly in representations of the Last Judgement (GIOTTO, Arena chapel, Padua; SIGNORELLI, Orvieto). Sometimes disguised as a woman or a monk, sometimes frankly shown as a monster, the devil is often depicted as the tempter of saints (*The Temptation of St. Anthony*, GRÜNEWALD, Colmar). By the 16th c. the image of the devil as a cloaked and winged figure with claws had become established (GHIBERTI, north door, Baptistery, Florence).

In the depiction of devils as the cohorts of Satan the Middle Ages displayed considerable ingenuity and inventiveness. They culminate in the fantastic representations by BOSCH (*The Millenium*, Prado) and BRUEGHEL (*Fall of the Rebel Angels*, Musées Royaux, Brussels). The devils of TENIERS and CALLOT in the 17th c. had already lost much of their theological character while those of GOYA in the *Caprichos* and *Disparates* were purely symbols of wickedness and oppression.

In book illustration from the late Middle Ages the influence of Dante's *Inferno* and of the *Ars Moriendi* was important. The traditional iconography of the devil was continued by BLAKE's illustrations to Milton, those of DELACROIX to Goethe's *Faust* and still later by Gustav DORÉ.

**DEVIS,** ARTHUR (1711-87). English painter, born at Preston. He probably studied under Peter Tillemans (1684-1734), with whom he may have travelled round the north and west of England. Devis perfected the small CONVERSATION PIECE. His patrons were mostly merchants and country squires whom he depicted singly or with their families in their own homes or grounds. His work is remarkable for its finely worked detail and delicate charm. The sitters are usually in repose, often somewhat artificially

posed, and the Devis type of portrait group was animated in the next generation by ZOFFANY. A small representative collection of his work is in the Art Gallery, Preston. Among others he painted a group of the WALPOLE family (private coll., U.S.A.). ANTHONY (1729-1816), his brother, was a landscape painter. His son, ARTHUR WILLIAM (1762-1822), spent the years 1783-94 in India, where he painted portraits and a series of pictures representing the arts, manufactures, and agriculture of Bengal, which were engraved. He lived in London from 1795. He is chiefly remembered for child portraits in the manner of BEECHEY, and for *The Death of Nelson* (Greenwich, c. 1806).

2044.

**DE WINT,** PETER (1784-1849). English landscape painter of Dutch extraction who served his apprenticeship with John Raphael SMITH. In London, where he settled in 1810, he frequented the house of Dr. Monro and became a successful teacher. Many of his WATER-COLOUR paintings, in which he uses broad WASHES of colour somewhat in the manner of COTMAN, are associated with Lincoln. He was a close friend of the Lincolnshire history painter William Hilton (1786-1839), whose sister he married.

**DIAPER.** An all-over pattern based on small repeated units. It is found carved in low relief on flat wall surfaces of ROMANESQUE and GOTHIC architecture, in STAINED GLASS, and on the backgrounds of manuscript ILLUMINATIONS, especially of the late 13th and 14th centuries. It was used as an alternative to the plain gold ground, and in the 15th c. in combination with backgrounds diversified by scrolls of a blending shade. It was gradually superseded by LANDSCAPE backgrounds.

**DIAZ DE LA PEÑA,** NARCISSE-VIRGILE (1807-76). French painter, born at Bordeaux of Spanish parents. He won a certain reputation with a historical picture *The Battle of Medina* exhibited at the Salon in 1853 and won a third medal with *Gypsies going to a Fête* in 1844. He then turned to forest scenes painted from nature and through MILLET met Théodore ROUSSEAU and became a member of the BARBIZON group. He used a thick IMPASTO rubbed down to give the impression of sunlight through forest greenery but his work lacks the sense of quiet communion with nature which was the characteristic feature of the school. His turgid landscapes owe something to DELACROIX and to George MICHEL (*Storm*, N.G., London), while BAUDELAIRE remarked that many of his smaller oil sketches (e.g. *Venus disarming Cupid*, Wallace Coll., London) seemed to be a conscious emulation of PRUD'HON. RENOIR stated that his meeting with Diaz led him to lighten his palette and his flickering touch had a great influence on

Adolphe Monticelli, who in turn anticipated the 'DIVISIONIST' technique of the IMPRESSIONISTS. His later work also shows reminiscences of the Landes south of Bordeaux where he spent his childhood. Diaz exhibited at the Salon nearly every year from 1834 to 1849 and received a decoration in 1851.

**DIDEROT,** DENIS (1713-84). French philosopher and critic, who is chiefly remembered in England as one of the founders of the *Encyclopédie* (1751-76). His views on theory of art and criticism, which in some sort anticipated the rise of ROMANTICISM, are chiefly contained in *Paradoxe sur le comédien* (1830), the article *Beau* (1752) in the second volume of the *Encyclopédie*, his *Essai sur la peinture* (1765), on which GOETHE wrote a *Commentary*, and his famous *Salons*, critical commentaries on the nine exhibitions between 1759 and 1781, which formed the model for the later criticism of BAUDELAIRE. He was influenced by English 18th-c. AESTHETICIANS, particularly Shaftesbury, whom he translated. Against the intellectualist bias of NEO-CLASSICISM he maintained that our ideas of beauty arise from practical everyday experience of beautiful things, based on a *sentiment* for the 'conformity of the imagination with the object'. He regarded *taste* as a faculty acquired through repeated experience of apprehending the true or the good through immediate impression which renders it beautiful. He opposed the constraints imposed by such *a priori* rules as those set forth by Boileau or the tyranny of the ancients and defended the right of genius to create beauty by the idealization of nature. His views on the relation between poetry and painting provided a basis for the *Laocoon* of LESSING.

**DIENTZENHOFER.** Two families of this name were active as architects, but the relationship between them is not clear. Both originated in Bavaria. That of CHRISTOPH I (1655-1722) settled in Prague and were notable church builders, particularly his son KILIAN IGNAZ (1689-1751). The other family worked in and around Bavaria. JOHANN (d. 1726) became court architect in Bamberg and designed the church at Banz (see NEUMANN) and the Pommersfelden palace (1710 and 1711 respectively).

**DIETRICH,** CHRISTIAN WILHELM ERNST (1712-74). A versatile German painter and etcher, who was able to imitate the style of many great masters. He was for a time Director of the Dresden Gallery and the art school attached to the famous Meissen factory. He is represented in the National Gallery and the Wallace Collection, London.

**DILETTANTE.** See AMATEUR.

**DILETTANTI,** SOCIETY OF. In their *History of the Society of Dilettanti* (1898) Colvin and Cust described it as 'A small body of gentlemen, men of education and distinction, many of whom have played a prominent part in our history and who for over 200 years have exercised an active interest in matters connected with public taste and the arts'. The Society began as merely a convivial gathering of 'young noblemen of wealth and position who had been on the GRAND TOUR'. From December 1732 they met on the first Sunday in the month in a tavern, so provoking the sneer of Horace Walpole, never one of them, that 'the nominal qualification for membership is having been in Italy and the real one being drunk'. One of them at least, Sir Francis Dashwood, was a member of the notorious Hell Fire Club. The serious interests of the group soon prevailed and after unsuccessfully supporting Italian opera, the Dilettanti turned to the architectural and archaeological remains of Greece, the Near East, and Italy, which had stirred their interest and imagination on their travels.

In the 17th c. miscellaneous collections of antiquities had been made among others by Thomas Howard, Earl of Arundel (Selden *Marmora Arundelliana*, 1628), the Duke of Buckingham, the Earl of Pembroke, Sir Hans Sloane; but it was the Dilettanti who laid the foundations of the modern serious and systematic study of classical antiquities. Independently of WINCKELMANN, and before his posthumous fame, they financed a succession of expeditions and published the results in such works as *The Antiquities of Athens measured and delineated*, 4 vols. (1762–1814); *Ionian Antiquities*, 5 vols. (1769–1814); *Some Specimens of Ancient Sculpture preserved in the Several Collections of Great Britain* (1809); *The Unedited Antiquities of Attica* (1817); *Investigations of Athenian Architecture* (1852)—all revelations of the then little known, unsuspected artistic glories of classical antiquity. They stimulated LESSING and GOETHE and contributed powerfully to the classic revival of the late 18th c. The Department of Classical Antiquities of the British Museum owes many of its finest and nearly all its earliest treasures to the enthusiasm, discernment, and public spirit of members of the Society (collections of Sir William Hamilton, Charles Townley, Richard Payne Knight, Sir Richard Colt Hoare, the Earl of Aberdeen, W. M. Leake, and others). One serious mistake, surprising also in the light of one of the Society's regular toasts, 'Greek Taste and Roman Spirit', was the failure of the Dilettanti through the misjudgement of Richard Payne Knight to give support to Lord Elgin when he rescued the sculptures of the PARTHENON.

After the 1850s the new fashions for GOTHIC and PRE-RAPHAELITE art and the discoveries in Assyria and Egypt caused interests to veer away from classical sculpture, and the aristocracy became less assiduous collectors of 'marbles'. Nevertheless from 1732 to the 1880s, when neither the Government nor the universities exhibited the smallest interest in the artistic remains of classical antiquity, the Dilettanti (never more than 50 to 70 members) gave to their study the influential support of their enthusiasm, their taste, and their money, devoting £30,000 (gold) to expeditions to Greek lands.

From their earliest meetings the Society appointed a painter, one of whose duties was to provide a portrait of each member on election at his own expense. The title has been borne successively by George KNAPTON, James STUART, Sir Joshua REYNOLDS, Sir Thomas LAWRENCE, Sir Martin Archer SHEE, Sir Charles EASTLAKE, Sir Frederic LEIGHTON, Sir F. W. Burton, Sir E. J. POYNTER, John SARGENT, Sir Oswald Birley (1880–1952), Sir James Gunn (1893–1964), and Sir William COLDSTREAM. Many portraits so commissioned are still among the Society's treasured possessions.

676.

**DILUENT.** The liquid used to dilute a PAINT and give it the fluidity that the painter desires when he applies it to the GROUND; e.g. TURPENTINE in OIL PAINTING, and water in WATER-COLOUR PAINTING (see PAINT).

**DIOCLETIAN,** PALACE OF. One of the last great architectural works of pre-Christian Rome (see ROMAN ART), the palace of the emperor Diocletian (built *c*. A.D. 300) covered an area of *c*. 8 acres. The central area of the modern town of Split lies within its encircling walls built 7 ft. thick and *c*. 60 ft. high to enclose a slightly irregular rectangle 600 ft. by 510 ft. in extent. The palace was planned symmetrically about two colonnaded streets intersecting at right angles on the analogy of a Roman camp. There were fortified gates at the centre of each wall where the streets emerged. The emperor's residential quarters lay across the southern part of the north–south road facing the sea coast, to the north of it and south of the east–west road were the domed Mausoleum (later changed into a cathedral) and a temple to Jupiter. (See plan, p. 316.)

The palace had a lasting influence on European architecture. It was studied by, among others, Robert ADAM and formed one of the inspirations of the so-called 'Adam Revolution' in style. It was studied by P. J. H. Daumet (1826–1911) in the 19th c. and in its exemplification of the Roman system of symmetrical planning about a major axis became one of the foundations of the CLASSICISM paramount in the teaching of the École des Beaux-Arts.

**DIORAMA.** 'A mode of scenic representation in which a picture, some portions of which are translucent, is viewed through an aperture, the sides of which are continued towards the picture; the light, which is thrown upon the picture from the roof, may be diminished or

**101.** Reconstruction of the ground-floor plan of Diocletian's Palace by Robert Adam. Engraving from *Ruins of the Palace of the Emperor Diocletian at Spalato in Dalmatia* (1764)

A. *Gynecium—or Apartments for Matrons and Young Women.* B. *Aulicorum Aedes—or Apartments for Courtiers.* C. *Templum Aesculapii—or Temple of Aesculapius.* D. *Peristylium—or Fore Court.* E. *Templum Jovis—or Temple of Jupiter* (Mausoleum). F. *Porticus—or Portico.* G. *Oeci, aut Triclinia Tetrastyla —or Rooms of four columns.* H. *Exedra—or Rooms for Conversation.* I. *Vestibulum—or Vestibule.* J. *Oecos, aut Triclinium . . .—or Hall . . .* K. *Spheristerium seu Coriceum—or Room for Exercise of the Ball, &c.* L. *Calida Piscina—or Lukewarm Bath.* M. *Basilica—or Room for Theatrical and Musical Entertainments.* N. *Atrium—or Great Hall.* O. *Oecus, aut Triclinium Egyptium—or Egyptian Hall.* P. *Crypto Porticus—or Gallery for Exercises and Walking*

increased at pleasure, so as to represent the change from sunshine to cloudy weather, etc. The name has also been used to include the building in which dioramic views are exhibited; and in later times has been transferred to exhibitions of dissolving views, etc.' (*O.E.D.*). The diorama was invented by L. J. M. Daguerre in 1822 and was exhibited in Regent's Park, London, in the following year, when CONSTABLE wrote to a friend: 'I was at the private view of the "Diorama"; it is in part a transparency; the spectator is in a dark chamber, and it is very

pleasing, and has great illusion. It is without the pale of the art, because its object is deception. The art pleases by *reminding*, not *deceiving*. The place was filled with foreigners, and I seemed to be in a cage of magpies.'

'Dioramas' or modelled PANORAMAS are used for display in museums. They consist of a miniature scene, viewed through a window in a screen or cabinet, in which the foreground details, modelled in the round, join imperceptibly with the more distant parts which are painted in perspective on a vertical panel.

**DIORITE.** Igneous stone of the GRANITE type but lacking quartz in its composition. It is usually black or grey and is sometimes known as 'black granite'. Like granite it is hard, compact, and resistant. It was favoured for sculpture by the ancient Egyptians and in the ancient Middle East. Fine examples are the votive statues of Gudea of Lagash (Louvre, *c.* 2100 B.C.), a head from Susa probably of Hammurabi in old age (Louvre, 18th c. B.C.), and the figure of Djehuty (Cairo Mus., *c.* 1475 B.C.).

**DIPPER.** A small cup which clips on to the oil painter's PALETTE and holds MEDIUM or DILUENT. Sometimes there are cups to hold both.

**DIPTYCH.** A pair of PANELS hinged together. The Roman writing tablet was of this form and frequently had its inner surfaces recessed to hold a wax coating. Originally it was designed for daily use, whether of wood, metal, or IVORY; the ivory tablet continued to be made in the late Empire, when its purpose was more symbolic than utilitarian. Ivory diptychs were presented by the consuls to the emperor, the Senate, and influential friends, to mark the commencement of their term of office. These consular diptychs have a special importance in the history of art because they form a series of dated carvings from the end of the 4th c. to A.D. 541, when the office was abolished. The exterior decoration varied with the recipient. Some diptychs, like that of Justinian (Met. Mus., New York, A.D. 521), are quite simply carved with wreaths and corner rosettes. Many, however, show the consul enthroned or standing in an archway, with scenes below him depicting the distribution of largess or the gladiatorial shows which inaugurated his magistracy, as on the diptychs of Orestes (V. & A. Mus., A.D. 530) and Anastasius (Bib. nat., Paris, A.D. 517). The most elaborate examples, destined for the emperor or empress, are usually of the 'five-part' type with a central panel containing the image of the ruler framed by four narrow strips, such as the *Barberini Diptych* (Louvre).

Like other secular objects diptychs were adapted to ecclesiastical use. The 'five-part' type became the model for ivory book-covers such as those of the *St. Lupicinus Gospels* (Bib. nat., Paris, 6th c.) and the *Lorsch Gospels* (Vatican and V. & A. Mus., 9th c.), and liturgical diptychs were made from the 4th c. on, which contained the names of saints, bishops, and benefactors, to be read out during the Mass. On the latter the decoration usually consisted of scenes from the life of Christ (*Alton Towers Diptych*, V. & A. Mus., 5th c.), but many consular diptychs served this purpose in later centuries and owe their survival to liturgical use. On an example at Monza the consular figures have been turned into King David and St. Gregory by altering the carving slightly. Others, less fortunately, have been completely recarved in CAROLINGIAN times to serve as book-covers (*Tuotilo Diptych*, St. Gall), or have been cut up to make smaller panels. Rare examples, such as a pair of panels divided between Dumbarton Oaks, Washington, and the Gotha Museum, indicate that the secular diptych had a limited revival at Constantinople in the 10th c., about which time a new use had been found for this form of carving in the portable ALTARPIECES from which GOTHIC diptychs and TRIPTYCHS are derived.

The protected inner surface of the diptych made it a suitable vehicle for the portable devotional pictures so popular in the Middle Ages. An early example is in fact a readaptation of a consular diptych, of which the smooth inner face was used in the 7th c. for a painting of the resurrection of Lazarus and images of three saints (*Boethius Diptych*, Mus. Cristiana, Brescia). Painted wooden diptychs of the saints have also survived from an early time (ICON of four saints, St. Catherine, Sinai, 7th-8th c.) and were used in the Byzantine church as a portable form of icon, as were more costly diptychs in miniature MOSAIC (mosaic-diptych, Mus. del Duomo, Florence, 14th c.). In the West large numbers of devotional diptychs survive from the 13th c. and later. A common Italian type showed the CRUCIFIXION on one leaf, and the Madonna with supplicants on the other (Uffizi, mid 13th c.). The English *Wilton Diptych* is a further variation of the form.

**DIRECTOIRE STYLE.** A simplification of the French LOUIS XVI STYLE, prevalent *c.* 1795-9 and representing a transition to the decorative style of the EMPIRE. Civic emblems such as the pike, fasces, and Phrygian cap were introduced among NEO-CLASSICAL motifs, materials were inferior and colours became harsher. No interiors have survived from the Directoire period, but contemporary fashion prints provide a guide to dress styles—a loose, lightly draped, semi-classical arrangement worn without corset or substructure.

911.

**DISCOBOLUS.** Discus-thrower. The name is given pre-eminently to MYRON's bronze statue (*c.* 450 B.C.) which survives in copies. The pose, at the top of the back swing, is in momentary equilibrium but occupies little depth. The head should turn to its right. The composition is exceptional for the statuary of its time, and suggests RELIEF sculpture or painting.

**DISPOSITION.** See COMPOSITION.

**DISTEMPER.** A trade term for a paint whose MEDIUM is glue or SIZE (see GOUACHE). Its principal use is in scene-painting.

**DISTORTION.** A term used in art for the intentional or unintentional difference between any representation and its prototype. Since hardly any work of art is an exact three-dimensional replica of the object represented nearly all art alters or 'distorts'. In sculpture the phenomenon is easily discussed in an objective manner: where relationships are changed and heads appear 'too small' or bodies 'too long' it is possible to compare the distorted PROPORTION against some canon of anthropometric normality even where we do not know the sculptor's model (as in the case of Akhenaten, see AMARNA ART) or where he had none (as with the COLUMN FIGURES of CHARTRES Cathedral). The problem is a little more tricky in painting because relationships are inevitably 'distorted' by perspective. It is well known, for instance, that a photograph can look distorted when a hand raised against the camera looks 'unnaturally' large. This apparent distortion is due to the constancies (see PERSPECTIVE), the tendency of our mind to restore stability to the world of our perception by minimizing change. Up to a point we see more distant objects the size we know them to be rather than a size related to the image thrown on the retina. The NATURALISTIC painter, like the photographer, usually falls in with this tendency and avoids extremes of distortion except for special effects. The ILLUSIONIST painters of BAROQUE ceilings or of stage props, on the other hand, carefully designed their works for one aspect only, with the result that they looked distorted from all other aspects (see ANAMORPHOSIS).

These complexities have led certain critics to deny that distortion is a meaningful concept, since no criterion for a correct view appears to exist. But the denial is misconceived. Even in painting it certainly makes sense to say, for instance, that fashion designers usually distort and lengthen the figure or that a CARICATURIST distorts the physiognomy of his victims. Whether or not we ever have the right to complain about distortion is a different matter. When someone remarked to Max LIEBERMANN that the arm of CÉZANNE's *Youth with a Red Waistcoat* was too long he replied 'an arm so marvellously painted can never be long enough'; and MATISSE has reminded us that if he met such women as he paints in the street he would be horrified, but, then, 'I do not create women, I make pictures'.

The deliberate use of distortion (falsification of natural proportions) for expressive purposes has been cultivated particularly in the 20th c., and during the first three decades became the occasion of some of the bitterest controversies concerning modern art styles. Sometimes such distortion was justified by empathic feel for the material on the ground that a figure cut in stone or cast in bronze or hewn from wood would look wrong if the natural proportions of a flesh and blood human body were exactly reproduced. Sometimes the source of distortion was pretty obviously a conceptual ambiguity, as for example carvings by Henry MOORE which combine aspects both of a human figure and a mountain range. Sometimes again the distortion has been used for more specific expressive aims and invites an emotional response in the observer which depends on simultaneous awareness that the work of art represents a known object (e.g. a human body) but ascribes to it shapes and proportions which in that object would be impossible, repulsive, nightmarish, or perhaps superlatively elegant or graceful. Most of the outstanding artists of the 20th c. have made a more or less deliberate use of distortion intermediate between these various types or combining several of them. The indignation and dislike with which the general public greeted even such innocuous distortions as those of EPSTEIN, Maurice LAMBERT, Frank DOBSON, and Stanley SPENCER did not survive the Second World War and since the 1940s people have taken in their stride far more radical experiments in the borderlands between representational and ABSTRACT art.

**DIVISIONISM.** A method and technique of painting by which tones and hues are obtained not by mixing PIGMENTS on the PALETTE but by applying small areas of unmixed pigment on the canvas so that they combine 'optically' in the vision of a spectator standing a certain distance away from the picture. By this method greater luminosity and brilliance is obtained because the 'optical' combination of adjacent colour patches is 'additive' whereas the admixture of pigments on the palette produces a 'subtractive' result (see COLOUR). This method has been employed to some extent by many artists in *alla prima* painting, although it is contrary to the principles of painting by superimposed GLAZES and SCUMBLES. Notable precursors of Divisionism were WATTEAU and DELACROIX. It was also employed empirically by the IMPRESSIONISTS and in particular by those who adopted the 'rainbow palette' of RENOIR. It was developed systematically and scientifically by SEURAT and the NEO-IMPRESSIONISTS and culminated in the technique of POINTILLISM. The method was described by SIGNAC as follows: 'Divisionism is a method of securing the utmost luminosity, colour, and harmony by (*a*) the use of all the colours of the spectrum and all degrees of those colours without any mixing, (*b*) the separation of local colours from the colour of the light, reflections, etc., (*c*) the balance of these factors and the establishment of these relations in accordance with laws of contrast, tone and radiation, and (*d*) the use of a technique of dots of a size determined by the size of the picture.'

'Divisionism' was also the name of a movement which grew up in Italy, a version of NEO-

IMPRESSIONISM, in the late 1880s and 1890s. Its chief practitioners were Segantini, Previati, and Pelliza da Volpedo. This movement was taken as a basis for the first phase of FUTURISM about 1908-10.

**DIX,** OTTO (1891-   ). German painter, of working-class origin. In the early 1920s Dix, like George GROSZ, turned to an aggressively realistic and political conception of art known as NEUE SACHLICHKEIT. His own REALISM took the form of a meticulous presentation of visual data seen so freshly as to give rise to the term 'magic realism' (*Portrait of his Parents*, Basel, 1921). Dix's preference for subjects taken from proletarian life and the passionate social criticism that inspired his paintings caused his suppression by the Nazis, but he resumed an active career after 1945.

**DOBELL,** WILLIAM (1899-   ). Australian painter who studied under Julian Ashton (see AUSTRALIAN ART) and at the Slade (1929) under TONKS, returning to Australia in 1939. His portraiture, rich in texture, colour, and tone, notable for exaggerated emphasis on characteristic forms, owes something to the EXPRESSIONIST work of Chaim SOUTINE, combining as it does social comment with a keen power of observation. His most notable works, such as *The Irish Youth* (1938) and *Joshua Smith* (1943), belong to the period immediately before and during the Second World War.

1052, 2512.

**DOBSON,** FRANK (1886-1963). British sculptor. Dobson worked in the tradition of sculptors such as MAILLOL, DESPIAU, and GAUDIER-BRZESKA who regarded sculpture as first and foremost an investigation into three-dimensional form. He excelled as a portrait sculptor and, like Maillol, he regarded the nude female figure as providing the most satisfactory material for organization of three-dimensional composition in form. During the 1920s and 1930s Dobson's reputation in English art stood very high. In 1925 Roger FRY wrote of his work as 'true sculpture and pure sculpture . . . almost the first time that such a thing has been even attempted in England'. Raymond Mortimer said that Dobson was (in 1926) one of the three most interesting sculptors then alive in the world and the best that England had produced for c. 600 years. Since the Second World War appreciation of his work suffered from the swing of taste and a Memorial Exhibition given by the ARTS COUNCIL in 1966 was not welcomed with enthusiasm by the critics.

**DOBSON,** WILLIAM (1610-46). Son of William Dobson, who was employed by Francis Bacon in the redecoration of Gorhambury and the building of Verulam House. He may have been taught by Francis Cleyn, manager of the Mortlake Tapestry Works, for whom he at one time worked. Regarded in his prime as the most accomplished English portrait painter before HOGARTH, he was described by J. Aubrey in his *Brief Lives* (1669-96) as 'the most excellent painter that England hath yet bred'. Although he lived at a time when van DYCK was paramount as a society painter, his extant work shows little influence of van Dyck and his technique was basically different. His colouring and texture were strongly Venetian, his feeling for character was English. Some 60 paintings by him are known, all from the years 1642-6 when he was painter to the wartime court at Oxford. He is thought to have returned to London after the surrender of that city in 1646. Said to have been 'somewhat loose and irregular in his way of living', he was thrown into prison for debt and his early death followed shortly after his release.

The earliest known portrait is the *Unknown Officer with a Page* (Knole, 1642), already showing a blunt and homely depiction of character and a solid directness which are foreign to van Dyck's method. The later *Endymion Porter* (Tate Gal.), sometimes considered his best work, is rougher and stronger, uncompromisingly English in its presentation of character. His most elaborate portrait compositions, *The 1st Lord Byron* and *Charles, Prince of Wales* (Scottish N.P.G., Edinburgh, c. 1643) represent a highly individual form of English BAROQUE. His latest stage of development is represented by two portraits dated 1645, *Sir Charles Lucas* (Woodyates Manor) and *Unknown Girl* (City of Birmingham Art Gal.), both more thinly painted and lacking something of the stolid vigour of the earlier works.

**DOCTORS OF THE CHURCH.** The title given since the Middle Ages to certain early Christian fathers distinguished for their theological learning and their sanctity. Originally they were four in the Eastern Church (Basil, Gregory of Nazianzus, John Chrysostom, and Athanasius), and four in the West (Ambrose, Augustin, Jerome, and Gregory the Great). Their number was subsequently increased, though the later additions occur only infrequently in art (SIGNORELLI, Orvieto Cathedral).

Representations of the Greek doctors were not widely diffused. Bareheaded, dressed in dalmatics ornamented with crosses, holding a book or scroll, they usually appear as a group of four (Cefalu, Monreale, and Cappella Palatina, Palermo, 12th c.). They are sometimes depicted with the four Latin Fathers (Baptistery, St. Mark's, Venice, 14th c.; Fra ANGELICO, Chapel of Nicholas V, Vatican). The four doctors of the Latin Church, sometimes denominated Church Fathers, were frequently depicted from the late Middle Ages onwards. They were commonly

represented as single figures holding books inscribed with their works, and incidents from their lives were often illustrated. St. Gregory wears a papal tiara, SS. Ambrose and Augustine the bishop's mitre, and St. Jerome appears as a cardinal with a lion or doing penance in the wilderness (Michael PACHER altarpiece, Munich, 1482; RAPHAEL, *Disputa*, Vatican; CIMA DA CONEGLIANO, N.G., London). The Church Fathers are often related to the four EVANGELISTS (GIOTTO, S. Giovanni Evangelista, Ravenna; MASACCIO, S. Clemente, Rome; SACCHI gives the Church Fathers the symbols of the Evangelists, Louvre, 1516). They were sometimes grouped round the Virgin (Antonio VIVARINI, Accademia, Venice, 1440) and were especially associated with representations of the Immaculate Conception (Dosso DOSSI, Berlin). They figure prominently in triumphal processions of the Church.

**DOESBURG,** THEO VAN. Name used by CHRISTIAN EMIL MARIES KUPPER (1883–1931), Dutch artist and architect. In 1917 he founded the magazine De STIJL. MONDRIAN, who contributed to the journal, had a strong influence on his painting.

**DOGTOOTH.** An ornament shaped like a small pyramid with the flat faces cut back. It is one of the hallmarks of 13th-c. work in England. Its development, from a small nailhead to a large object resembling a four-leafed flower with its petals bent back, covers the span between 1200 and *c.* 1280. The South Porch of Lincoln Cathedral (*c.* 1230) exhibits dogtooth at its most profuse.

**DOLCI,** CARLO (1616–86). Italian painter born in Florence, where he studied and worked all his life. He produced a very large number of highly competent paintings, mostly of religious subjects, but his over-smooth handling and sentimental approach have not appealed to modern taste. He was also an able portrait painter.

**DOME.** Architectural term for a roof or covering circular or polygonal in plan and half-circular, segmental, or half-polygonal in section. A 'square dome', common in French architecture, is a kind of hybrid between a true dome and a quadripartite VAULT. A dome may be regarded as a series of ARCHES in the vertical plane revolving on plan through 360° but meeting in a common keystone; or it may be regarded as a series of constantly diminishing circles, superimposed in the horizontal plane and diminishing to a single circular stone (or an open 'eye') at the apex. These two different conceptions are structurally important, since the first is essentially a series of arches or ribs and is therefore subject to outward thrusts and must be

**Fig. 18.** DOME

A. Concept of the dome: a. as vertical arches  b. as diminishing horizontal circles. B. Dome and its accompanying structures: a. cupola  b. lantern  c. dome  d. drum  e. square substructure. C. Pendentive. D. Squinch

A

B

**Fig. 19.** Dome of Florence Cathedral: A. section showing double-shell. B. construction of ribbed dome

Domes may be made of timber, usually with a lead covering, of brick or masonry, of cast concrete, or of metal. Nowadays it is usual to make them of light metal such as aluminium or else of reinforced concrete which is far stronger, weight for weight, than any material previously available. A ribbed dome may be of timber or masonry but the essence is that the main support is provided by a series of ribs, the function of which is like that of ribs in a GOTHIC vault, while the rest is merely infilling: one of the best examples of this type of construction is also one of the largest of pre-20th-c. domes, that of the cathedral of Florence, which is 139 ft. across. Cast domes are often stepped on the outside to reduce the weight, the lower steps serving as buttress-rings, while the inner surface is usually coffered to lighten the shell still further. The finest example of such a cast concrete dome is also the largest—the PANTHEON in Rome, which is 142 ft. 6 in. in internal diameter. Such poured domes were so constructed that the concrete of each layer hardened before the next layer was poured, thus obviating the need for the elaborate wooden centering which is required for the arched or ribbed type. The technique of casting such domes was still known in the 6th c., for the dome of S. Vitale at Ravenna is about 50 ft. across and has empty amphorae mixed in the concrete as a means of lightening the mass: this device was adapted by SOANE for his fire-proof domes in the Bank of England (1788 onwards), but the technique was apparently lost for centuries, since BRUNELLESCHI's greatest technical triumph was that he built the dome of Florence Cathedral without centering (since long enough timber was unobtainable); and to do this he combined classical Roman techniques with those of Gothic vaulting.

The earliest domes were probably constructed on the ring system, as in the Eskimo igloo or in the earliest tholos type of tomb or subterranean dome, the most famous example of which is the Mycenaean 'Treasury of Atreus' of the 14th c. B.C. This is built in regular stone courses but the section is that of a beehive and there are, naturally, no side-thrusts to take into account. These tholos tombs may have had some symbolic meaning and the idea of the dome as representing the vault of heaven may perhaps date back to this period of human history: how relevant it is for later and more sophisticated cultures is open to dispute, although there can be no doubt that it had a religious meaning for EARLY CHRISTIAN and BYZANTINE architects (cf. Procopius's description of Sta Sophia, Constantinople). The great flowering of dome construction came with the Roman engineers, as a result of their invention and exploitation of concrete, but they tended to accumulate enormous masses of abutment walling. The Pantheon, for example, is internally a semicircle raised on a low drum, but externally it is a much higher drum with a stepped dome above it. The Eastern Roman Empire in the Early Christian and Byzantine centuries

adequately buttressed at the base and sides. The second conception is essentially a dead weight and is therefore more suitable where the problems of abutment are difficult. A dome is often supported on a cylindrical substructure known as a drum, and capped by a smaller drum and dome known as the LANTERN and CUPOLA. Where the dome rises from a non-circular substructure it is usual to make the transition from the polygonal or square substructure to the circular (or, exceptionally, oval) dome by means of PENDENTIVES or, in more primitive forms, by CORBEL courses or SQUINCHES, which gradually adapt the form of the substructure to that of the dome.

continued to use the dome, usually over a central plan of greater or less complexity, but with the great difference that their domes stood over drums or at least soared above the buildings they crowned, as is the case with Sta Sophia where the massive solidity of the Pantheon is transformed into a miracle of lightness supported on pendentives. Pendentives, or spherical triangles, appear to have been a Byzantine invention to avoid the awkwardness of squinches and corbelling, but something very close to pendentives can be seen in such Roman MONUMENTS as the so-called Temple of Minerva Medica, which may well have inspired Brunelleschi to rediscover them for himself (Sacristy of S. Lorenzo and elsewhere). His invention of the double-shell dome for Florence Cathedral was carried further in the domes of St. Peter's (MICHELANGELO, della PORTA, and FONTANA), J. H.-MANSART's Invalides, Paris, and above all in WREN's St. Paul's. The cone is the strongest form of dome-shape and Wren therefore used a brick cone to carry the weight of the lantern, concealing the cone internally by a shallow open dome, shaped and proportioned to harmonize with the interior of the church, while the outside of the cone is concealed by a high lead and timber dome, the familiar landmark of London which towers over the church and city high above the shallow inner dome. Such multi-shell domes are far more flexible in the opportunities they offer the architect than would be the dead weight of a poured concrete monolith, even though the problem of thrust would be far easier. The invention of reinforced concrete allows the architect the best of both worlds, since pre-stressed concrete may be only an inch or two in thickness and will take almost any curve. The work of NERVI and Félix Candela (1910–    ) in the 20th c. has done much to exploit the possibilities of this medium on a gigantic scale (e.g. Nervi's sports stadia).

**DOMENICHINO,** properly DOMENICO ZAMPIERI (1581–1641). One of the most important artists of the BOLOGNESE SCHOOL in the generation following that of the CARRACCI. After studying with CALVAERT and Ludovico Carracci he went to Rome (1602) and joined the colony of artists working under Annibale Carracci at the FARNESE Palace. His only undisputed work there is the *Maiden with the Unicorn*, a charming, gentle fresco over the entrance of the Galleria. Between 1608 and 1615 he was showered with important decorative commissions for palaces, VILLAS, and chapels in and near Rome. His scenes from the life of St. Cecilia in S. Luigi de' Francesi (1615–17), in which the frieze-like composition of the figures reflects a renewed study of RAPHAEL's tapestries, influenced POUSSIN. The frescoes in the pendentives and apse of S. Andrea della Valle (1624–8), his chief work of this period, show a move away from this strict Classicism towards an ampler BAROQUE style; but compared with his rival

LANFRANCO Domenichino never abandoned the principles of clear firm drawing for the sake of more painterly effects. In the ceiling frescoes of the S. Gennaro chapel in the cathedral of Naples he made even greater concessions to the fashionable Baroque. He met with considerable hostility in Naples and was forced to flee precipitately in 1634, leaving his work unfinished.

Among his many notable easel paintings the landscapes are especially important; they form the connecting link between those of Annibale Carracci and those of Poussin and CLAUDE.

2116, 2460.

**DOMENICO DA CORTONA** (LE BOCCA-DOR) (1470–1549). Italian architect and woodcarver. He came to France in 1495 under the auspices of Charles VIII and remained there until his death. He probably designed the wooden model which formed the basis of the château of Chambord, interesting owing to the unusual feature that the keep is divided by a Greek cross in such a way as to leave in each corner a space in which suites of rooms were grouped into independent units (or *appartements*). The idea was almost certainly derived from Giuliano da SANGALLO and became of great importance in French domestic design for the next two centuries. Domenico also supplied the design for the Hôtel de Ville, Paris (1532).

**DOMENICO VENEZIANO** (d. 1461). Italian painter. Little is known about his life and despite his name it is not certain that he was a Venetian. He worked for the most part in Florence, where according to surviving records his influence was an important counterpart to that of MASACCIO. VASARI credits him with introducing OIL PAINTING into Tuscany. Although this is incorrect, it seems to be true that he was responsible for initiating the interest in colour and texture and the style of painting which used colour rather than simple line as the basis of PER-SPECTIVE and COMPOSITION. Only two fully authenticated works have survived. His FRESCO cycle *Scenes from the Life of the Virgin* (1439–45) in S. Egidio, Florence, has disappeared, but we know that PIERO DELLA FRANCESCA was among his assistants. He painted *c.* 1440 the *Carnesecchi Madonna* and two *Saints* (N.G., London) and *c.* 1445 his only other surviving signed work, the *St. Lucy Altarpiece* (the *Madonna* from which is in the Uffizi and the predellas dispersed in Cambridge, Washington, and Berlin). This is a very early example of the SACRA CONVERSATIONE. There is some affinity between the *Madonna* of this ALTARPIECE and UCCELLO and on this basis he has been sometimes credited with various Uccello-like portraits such as the *Matteo Olivieri* (N.G., Washington). It is also usual to attribute to him the fine TONDO of the *Adoration of the Magi* (Berlin, *c.* 1450). Despite the scarcity of his fully accredited work, there is no reason to doubt the

enormous importance of his influence at the head of the tradition of painters who have used colour and light not merely decoratively but as the elements of perspective and design.

**DONATELLO,** DONATO DI NICCOLO (1386-1466). Italian sculptor who is sometimes considered the most original and comprehensive genius of that remarkable group of sculptors, architects, and painters who created a veritable artistic revolution in Florence during the first quarter of the 15th c. VASARI, recognizing Donatello's stature, called him the pattern of the others. Vasari expressed his admiration in the language of the day by alleging that Donatello had equalled the sculptors of antiquity. Refining upon this we may say that he possessed an imaginative understanding of certain aspects of classical sculpture, probably acquired from a very few examples and conditioned by a Christian approach. He was thus the counterpart of the early Florentine humanists such as Poggio Bracciolini, with whom he is known to have been in touch. His revolutionary conception of sculpture is exemplified in the great series of standing figures in niches which he made for Or San Michele and Florence Cathedral. The series began with the *St. Mark* of 1411-12, designed five years after he had emerged from a GOTHIC training in the workshop of GHIBERTI; it included the celebrated *St. George* (1415-20), now in the Bargello, and culminated in the so-called *Zuccone* ('bald-pate') in Florence Cathedral (completed in 1436). If we compare these statues with antique Roman senator figures, we find a similar toughness and fidelity to the actual construction of the human body; but Donatello's prophets and saints have a sinewy vitality and a particularized character which indicate first-hand observation. The most specifically classical of Donatello's works, for example the bronze *David*, which is now in the Bargello but stood originally in the court of the MEDICI Palace, belong to the decade following a visit to Rome in 1430-2.

He was in Padua 1443-53. During this time he began to react against classical principles, though we must except from this new tendency his equestrian statue of *Gattamelata*, which stands in the square in front of the church of S. Antonio like the antique *Marcus Aurelius* on the Capitol in Rome. His chief undertaking in Padua was a new high altar for the church itself. This contains 7 bronze statues and 22 reliefs (though not in their original positions). Beginning with the *St. George and the Dragon* (Or San Michele, 1415-20), in which he arranged his forms parallel to the surface like a classical RELIEF, Donatello's reliefs were always the most advanced of their time, not perhaps in technical virtuosity but in dramatic effect and spatial complexity. In the four large reliefs on the Padua altar illustrating St. Anthony's miracles he exploited further than any of his contemporaries that peculiarly RENAISSANCE device, the central PER-SPECTIVE system attributed to BRUNELLESCHI. The *St. George* relief, already mentioned, is the first surviving example of this system in practice.

On his return to Florence Donatello gave more prominence to the element of dramatic and emotional intensity which had been implicit in earlier reliefs such as the *Ascension with Christ giving the Keys to St. Peter* (now in the V. & A. Mus., 1427?). Perhaps the most striking illustration of this is to be found in the high-relief sculptures which he designed towards the end of his life for two pulpits in S. Lorenzo, Florence (executed partly with the help of assistants). His exploitation of the expressive possibilities of DISTORTION for dramatic emphasis is apparent in three full-length statues which date from the same period representing *St. John the Baptist*, *Judith and Holofernes*, and *St. Mary Magdalene* (the first two in bronze, the last in wood). In these last works, so astonishingly original in style and so deeply moving in spirit, Donatello created what has been justly described as 'the first style of old age in the history of art'. Donatello was the most influential individual artist of the 15th c.

502, 1132, 1429.

**DONGEN,** KEES VAN (1877-     ). Painter, born in Holland, settled in Paris in 1897 and took French nationality in 1929. He was a precocious talent and had exceptional technical ability. He was a member of the FAUVIST group in 1906 and some years later exhibited with the German EXPRESSIONIST group the BRÜCKE. His name became associated with brilliantly executed, deliberately provocative but superficial portraits of fashionable women. He has sometimes been classed as an artist in whom great facility led to banality.

**DONG-SON.** Prehistoric culture which produced the first true Indo-Chinese works of art that are known. The culture is named from the chief site, Dong-son in the Tonkin plain and sites dating from *c*. 500 B.C. to the 2nd c. A.D. spread down the coast of Annam. The culture may also have extended to influence early INDONESIAN ART. The surviving art objects are mainly bronze tomb-furniture, ritualistic or ceremonial implements, weapons, utensils, and ornaments. Among the most important are huge bronze drums, including probably the famous 'Moon of Bali'. Although individual in style with characteristic decorative motifs, the art of the Dong-son culture fell within the Chinese sphere of influence and after the conquest of Tonkin by the Chinese in 111 B.C. it became no more than a provincial version of CHINESE ART.

**DONNER,** GEORG RAPHAEL (1693-1741). Austrian sculptor who worked in Salzburg, Bratislava, and Vienna. He began in a late

BAROQUE manner (staircase in the Mirabell Palace, Salzburg, 1725), and later became a pioneer in the movement towards CLASSICISM, thus exercising an important influence particularly through the fountain on the Neuer Markt in Vienna (1739), which assembles nymphs and river-gods in a manner reminiscent of Italian 16th-c. classical sculpture.

296, 2087.

**DONO,** PAOLO DI. See UCCELLO.

**DONOR.** A donor portrait shows the giver of a work of art, who has commissioned it as a votive offering to Christ, the Virgin, or a saint, either in thanks for favours received or in hope of future protection and salvation. By having themselves included in the picture donors sought to associate themselves in a special way with the sacred figures portrayed there. Among the earliest donors are popes and bishops, whose portraits were also intended to show the divine source of their authority. In a mosaic in SS. Cosma e Damiano, Rome, Pope Felix IV (526-30) stands under the protection of St. Peter offering a model of the CHURCH to Christ; and this set the pattern for papal donors in the following centuries. The Byzantine emperors, who also claimed to be vice-regents of Christ on earth, had themselves portrayed in a similar way, offering precious gifts to Christ or the Virgin (6th-c. mosaic of Justinian and Theodora, San Vitale, Ravenna; 11th- and 12th-c. mosaics in the gallery of Sta Sophia, Constantinople) in a way that echoes monuments of Roman imperial art, where subject peoples offer gifts to the emperor (*Barberini Diptych*, Louvre). The Slavonic rulers of the Balkans, who learned their religion and their political theory from the rulers of Byzantium, are shown making similar offerings in many frescoes of the 13th and 14th centuries (King Vladislav, Mileševa, Yugoslavia, *c.* 1235).

Private persons of sufficient means also had themselves portrayed in this way, but rather than approach Christ directly they more usually sought the intercession of the Virgin or of some personal or local saint. Just as the image itself was designed to assist communication between the saint and the worshipper (see ICON), so the presence of the donor in the same picture was felt to favour the creation of a bond between them. The citizens of Salonika commissioned votive mosaics of St. Demetrius, the protector of their city, in which they stand with the saint's hands protectively on their shoulders or with their arms upraised to him in supplication (6th- to 7th-c. mosaic panels, St. Demetrius, Salonika). Others kneel in prayer beside the image of their patron saint, like the man burning a candle to SS. Quiricius and Juditta in an 8th-c. fresco in the church of Sta Maria Antiqua, Rome. This posture, which later became universal in donor portraits, was chosen by the emperor Leo VI (886-912) to express his subjection to Christ, being the same gesture of *proskynesis* with which

he was honoured by his own subjects (mosaic in the vestibule of Sta Sophia). Pope Nicholas IV also kneels before Christ and the Virgin in TORRITI's mosaic for Sta Maria Maggiore, Rome (1295).

From the 14th c. onwards there was an increase in private commissions and the kneeling donor, often on a smaller scale than the sacred figure, is a familiar feature in works of this period. The most munificent was Enrico Scrovegni, who had the Arena Chapel in Padua built in expiation of his father's sin of usury and is portrayed there in GIOTTO's frescoes kneeling in supplication below the LAST JUDGEMENT scene. Here as elsewhere Giotto's work marks a turning-point. The 14th c. saw the rise of individual portraiture that transformed the donor's image both south and north of the Alps. ALTICHIERO portrayed the Cavalli family, who had commissioned the murals of a side chapel in Sta Anastasia in Verona, being presented to the Virgin by St. George, St. Martin, and St. James. Charles V of France and his Queen are individually portrayed under the Crucifix on the Altar frontal of Narbonne (Louvre) and Claus SLUTER placed the life-size images of Philip the Bold and Margaret of Flanders together with their patron saints on the porch of the Chartreuse de Champmol (Dijon). In the 15th c. the life-size donor portrait gained in realism and documentary accuracy. The donors on MASACCIO's *Trinity* (recently identified as belonging to the Lenzi family) and Jodocus Vijd and his wife on Jan van EYCK's Ghent ALTARPIECE exemplify this new conception, which reached its peak in the portraits of the MEDICI in GOZZOLI's frescoes in their family palace and in those of the Portinari family on the triptych by van der GOES (Uffizi). Most donors desired to be associated with their name saints as patrons, as for example Francesco Sassetti, who commissioned GHIRLANDAIO to paint frescoes of the *Life of St. Francis* in his family burial chapel in Santa Trinità, Florence. But the Virgin with her special powers of intercession was a favourite subject for votive panels, many of which commemorate a miraculous victory or cure, such as HOLBEIN's panel for Burgomaster Meyer (Kunstmuseum, Basel) or TITIAN's *Pesaro Madonna* (Frari, Venice).

In the 15th and 16th centuries the portrayal of donors became increasingly realistic, foreshadowing the rise of the portrait as an autonomous genre. This last development, and the gradual secularization of the visual arts, led to the virtual disappearance of the donor portrait, of which RUBENS's *Ildefonso* altarpiece, painted for the Archduke Albert, provides one of the latest examples (Kunsthistorisches Mus., Vienna, 1630-2), and which has only survived as a conscious archaism in modern STAINED GLASS windows.

**DOODLE.** The scrawls or scribbles which people are apt to make on blotting-paper or telephone pads have aroused increasing interest

thanks to the preoccupation of modern psychology with activities under relaxed control. The word 'doodle' gained currency through the film *Mr. Deeds Goes to Town* (1936). The ambition of some 20th-c. artists to express the content of the unconscious (see SURREALISM) has frequently led to an attempt to cultivate automatic drawing or the playful creation of shapes without deliberate intention. Nevertheless a skilled artist's doodle differs from that of the tiro. Among genuine doodles those scribbled by Dostoevsky on the margins of his manuscripts may be mentioned.

**DORÉ,** GUSTAVE (1832-83). The most popular French book illustrator of the middle 19th c. He became most widely known for his illustrations of Dante's *Inferno* (1861), *Don Quixote* (1862), the Bible (1866), and *The Pilgrim's Progress*, and he helped to give European currency to the illustrated book of large format. His work is characterized by a rather naïve and childish love of the GROTESQUE and represents a commercialization of the ROMANTIC taste for the bizarre. A gift for CARICATURE, however, is apparent in his illustrations of Rabelais and *Munchausen*, which, although not the most popular at the time, probably represent his best work. Drawings of London done in 1869-71 were more sober studies of the poorer quarters of the city and captured the attention of van GOGH. He also did large religious paintings grandiloquent in manner and of little merit.

1255, 1438, 1625.

**DORYPHORUS.** See POLYCLITUS OF ARGOS.

**DOSSI,** DOSSO GIOVANNI LUTERI (1474/9-1542). One of the last painters of the FERRARESE SCHOOL. His early life and training are obscure but the style of his paintings suggests that he was in close contact with GIORGIONE and later with the young TITIAN. VASARI says that he was trained under COSTA and he also probably visited Rome. The early *Nymph and Faun* (Pitti Palace, Florence) is soft and poetic in treatment but it clearly shows the bad draughtsmanship and smoky colours noticeable in much of Dosso's work. By 1512 he had left Venice and was engaged with his elder brother, BATTISTA (d. 1548), on decorations for the Duke of Mantua; during this period he probably came under the influence of CORREGGIO. In 1517 both brothers were working for the Duke of Ferrara, in whose service they spent much of their lives, combining with Ariosto in devising court entertainments, triumphs, tapestries, etc. The painting known as *Circe* (Borghese, Rome), but possibly representing a scene from Ariosto's *Orlando Furioso* of the sorceress Melissa who transformed people into trees, retains something of Giorgione's poetic quality. *The Poet and Muse* (N.G., London) again shows Venetian influence but is harder in treatment. The expression of the Muse with parted lips is a feature that often appears in

Dosso's work, e.g. *St. John the Baptist* (Pitti Palace, Florence). In his later works rich exotic landscapes become his chief preoccupation, as in *Circe and her Lovers* (N.G., Washington). He is notable chiefly for his deployment of glowing light to impart a poetic and mysterious impression, the magic of the early Ferrara School glimmering through a too oppressive layer of deliberately contrived ROMANTICISM.

**DOU,** GERRIT (1613-75). Dutch painter of Leiden, known chiefly as the head of the so-called 'Precise' School, of which the elder and younger Frans van MIERIS are later representatives. Dou was REMBRANDT's pupil from 1628 to 1631 and it is interesting to watch him until c. 1635 expressing neatly and precisely what Rembrandt had taught him about CHIAROSCURO. The colour is thick, the manner laborious, the effort visible. Later, after he had detached himself from Rembrandt's influence, Dou developed a style of his own, painting usually on a small scale, with a surface of almost enamelled smoothness, and attending to every detail of his carefully arranged subject. Some of his pictures were painted with the aid of a magnifying glass. His interior scenes usually contain only a few figures framed by a window or by the drapery of a curtain and surrounded by books and musical instruments. He is at his best in scenes lit by artificial light.

With Jan STEEN Dou was among the founders of the Guild of St. Luke at Leiden in 1648. Unlike Steen he was prosperous and respected throughout his life. After his death his pictures always fetched good prices until the advent of IMPRESSIONISM influenced taste against the neatness and precision of his style.

Dou had a workshop with many pupils who perpetuated his style. He was imitated far into the 19th c. and there are many works allegedly by him which belong in the history of fakes.

1787.

**DOURIS.** One of the most successful Attic vase painters active c. 500 B.C. A large number of pots decorated by him have survived and the themes are very varied (cup representing Eos and Memnon, Louvre; cup showing young women undressing, Met. Mus., New York). Douris was a fine draughtsman but it is sometimes supposed that he derived his compositions from contemporary panel or mural painters.

**DOVE.** For the dove as symbol of the divine Spirit in Christian art, see HOLY GHOST and TREE OF JESSE. The dove has also symbolized gentleness and affection, a meaning which in Christian art received added authority from the injunction of Christ to His disciples to be 'harmless as doves' (Matthew x. 16). In classical art the chariot of Venus was drawn by turtle doves and in the ancient art of the Middle East a pair of doves was used on coins and monuments in

association with the goddess Astarte. The dove bearing an olive branch in its mouth as a messenger of peace and good tidings became a common symbol in Western art and may owe something to the dove which appeared to Noah in Genesis viii. 11.

**DOVE,** ARTHUR (1880–1946). American painter. In 1904 he began illustrating magazines. He was in Europe 1907–9, where he came in contact with FAUVISM and other contemporary movements. About 1910 he developed his so-called 'extractions', among the first abstractions in modern art, paralleling KANDINSKY's abstract works of approximately the same time. In 1910 he had his first one-man show at Stieglitz's 291 Gallery. His abstractions, mostly in neutral tones, are based on natural forms, suggesting the rhythms of nature with their pulsating shapes (*Nature Symbolized, No. 2,* 1914). In *Fog Horns* (1929) he captures the experience both of seeing fog and of hearing the fog horns. Dove wrote: 'I should like to take wind and water and sand as a motif and work with them, but it has to be simplified in most cases to color and force lines and substances just as music has done with sound.' Dove did many collages (*Portrait of Ralph Dusenberry,* 1924).

**DOVES PRESS.** A private printing press founded in 1900 at Hammersmith by the bookbinder T. J. Cobden-Sanderson and the printer Emery Walker, both of whom had previously worked for the KELMSCOTT PRESS. Fifty-one publications, including a Bible (1903–5) in 5 volumes, were issued before the press was closed down in 1916 and the 'Doves' type thrown into the river Thames by Cobden-Sanderson.

**DOWNING,** ANDREW JACKSON (1815–52). Leading American architectural critic of his time. His interest in architecture was originally aroused through his work as a landscape gardener and he was first concerned with the house in relation to its natural setting. From this he proceeded to evolve theories of planning and structure which led to a freer development of interior space and a more forthright use of materials. The stress which he placed upon nature is typical of American ROMANTICISM and has interesting parallels in the ideas expressed by Ralph Waldo Emerson. Between 1841 and 1852 he published several important articles and books which did much to popularize the idea of the PICTURESQUE in America. Those which were concerned primarily with architecture were *Cottage Residences* (1842) and *The Architecture of Country Houses* (1850). (See also DAVIS, A. J.)

**DOWNMAN,** JOHN (c. 1750–1824). English portrait painter, who was in London by 1767 and was later a pupil of Benjamin WEST. He travelled to Italy with WRIGHT of Derby 1773–5. He was elected A.R.A. in 1795. Downman perfected the technique of drawing small portraits in coloured CHALKS and in pencil or charcoal lightly tinted with WATER-COLOUR. He travelled widely about the country, staying in great houses and often painting a series of small portraits of members of the family. Examples of his work are in the Tate Gallery and the Wallace Collection.

2898.

**DOYLE,** RICHARD (1824–83). English humorous draughtsman, the son of a CARICATURIST. From 1843 to 1850 he was on the staff of *Punch*, for which among other things he made the cover design used for over 100 years. He also illustrated books for Thackeray and others. Many of his drawings were spirited burlesques of contemporary life.

**DRAGON.** This is probably the commonest emblem in Far Eastern art, and the most ancient. A form with five claws on each foot (dragons normally have four) was adopted as the chief imperial emblem in China. Fundamentally the dragon represented fertilizing power, cosmic energy revealing itself in nature. It resided especially in water, in rivers, lakes, the sea, and in springtime moved in heaven among the clouds. Like the emperor it was in one sense an intermediary between heaven and earth. It also had an ancient cosmic aspect, encountered in early JADES and bronzes, as the guiding principle in the circuit of the constellations. Dragons were many, and certain of the IMMORTALS might manifest themselves in dragon guise. The Nagas of BUDDHIST ICONOGRAPHY were interpreted by the Chinese as dragons. In the art of the West the dragon appears in such contexts as St. George slaying the dragon as a symbol of threat and destruction.

**DRAPERY.** The character and handling of drapery has been an effective means of expression in European art at least since the beginnings of Greek sculpture (see GREEK ART): the meticulous folds of dress in archaic *Korai,* the free play of drapery enveloping and revealing the body so characteristic of the ELGIN MARBLES and the graceful flutter of light material marking the style of the NIKE BALUSTRADE reveal so many possibilities of this means of characterization. Classical art later was diversified into the heavily bulging rich drapery of HELLENISTIC sculpture (NIKE OF SAMOTHRACE) no less than the austere *gravitas* of the Roman toga figure (ARA PACIS). Medieval art took over the formulas and conventions of classical draped figures, CHRIST and the APOSTLES being modelled on the type of ancient teachers and orators. Thus the basic structure of classical drapery remained known to Christian art both in Byzantium and in the West long after the toga and the chlamys had

ceased to be worn. Naturally treatment continued to vary. The harsh thin folds of Byzantine MINIATURES, the calligraphic line of the Evangelists of the ADA SCHOOL, the excited nervous convention of the REIMS SCHOOL exemplify the range of possibilities. In ROMANESQUE art the drapery is generally heavy but the feeling for the natural fall of material has been lost and the folds have assumed a life of their own. It was only with the GOTHIC art of the 13th c. that interest in the interplay between soft drapery and the body revived and artists looked towards Byzantium and classical models for inspiration. (Reims *Visitation*; see FRENCH ART). Henceforward Gothic art of the north devoted increasing attention to the melodious fall of folds, an interest that reached its climax in the INTERNATIONAL GOTHIC style, also called 'soft style' for its love of sinuous uninterrupted curves characteristic of soft woollen material.

The reaction against this fashion was dramatically abrupt. MASACCIO in the south and the van EYCKS in the north stressed the heaviness and angularity of folds to emphasize a new feeling for solidity, a style which found its most fanatical devotee in the Swiss Konrad WITZ. While GHIBERTI in Florence was cultivating the mellifluous line, DONATELLO used drapery to emphasize the weight and gravity of his PROPHETS and Apostles.

The Gothic art of the north in the 15th and early 16th centuries saw the continuation of an exuberant play with angular or swirling folds in

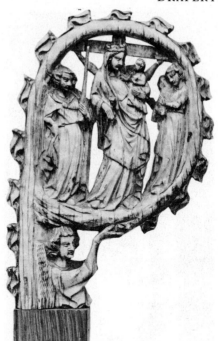

**103.** Virgin and Child attended by angels. Detail from ivory head of a pastoral staff. German, from the middle Rhine region. (V. & A. Mus., 1330-40)

such artists as SCHONGAUER, Veit STOSS, and T. Riemenschneider (1460-1531), a tendency that was echoed in the south by AGOSTINO DI DUCCIO and BOTTICELLI with linear patterns related to Neo-Attic reliefs. Here, as in other fields, the classical style of RAPHAEL strikes the perfect balance between tradition and imitation and endows the drapery of the philosophers in *The School of Athens* with natural dignity. MANNERISM led to a new crescendo of flutter that reached a climax in the BAROQUE when BERNINI found new possibilities for the expression of heightened emotion in the grand sweep and sensuous turn of his draperies—much imitated but never equalled in the northern Baroque. The return to sobriety and simple lines was as characteristic of the drapery of NEO-CLASSICISM as of its postures—WINCKELMANN's ideal of noble simplicity demanded the chaste and austere fall of garments characteristic of CANOVA, FLAXMAN, or Angelica KAUFFMANN, which was also reflected in the fashions of the EMPIRE. Nineteenth-c. ROMANTICISM, REALISM, and IMPRESSIONISM had little use for style based on manipulation of draperies and it became largely identified with hollow academic convention. But the draughtsmen of ART NOUVEAU such as Walter CRANE found novel effects in Botticelli-like flourishes of drapery which may again have owed some inspiration to contemporary movements in the

**102.** Figure of Christ enthroned. Pen-and-ink drawing by Villard d'Honnecourt. (Bib. nat., Paris, c. 1235)

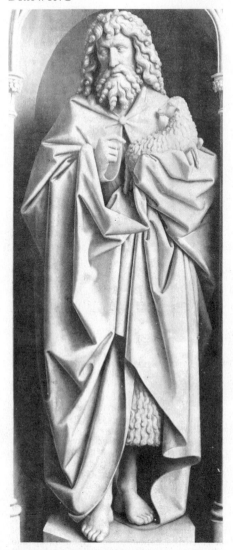

**104.** St. John the Baptist. Detail of grisaille panel from the Ghent Altarpiece, polyptych by Jan van Eyck. (S. Bavo, Ghent, c. 1426)

world of fashion—the protest against tight-laced Victorianism. It was at that time, towards the turn of the century, that art historians began to talk of the 'abstract' quality of the 'line' and paid increasing attention to the music of folds. But art historians have told us little as yet about the real differences in the fall of linen or wool and the interaction of tradition and observation in the various manners of treating drapery.

**DRAWING.** The trace left by a tool drawn along a surface particularly for the purpose of preparing a representation or pattern (see CHALKS AND CRAYONS, CHARCOAL, METAL POINT, PEN,

PENCIL). As has been pointed out since classical antiquity, drawing forms the basis of all the arts —architecture, sculpture, painting, and many of the crafts (see DESIGN). This article will be restricted to drawing, chiefly on PAPER, for the purpose of sketching. It will not include drawing which is subsequently overlaid by later stages of a process and which only comes to light by accident (see SINOPIA).

Ancient Egyptian craftsmen made independent sketches drawn with the BRUSH on potsherds. We know little of similar practice in classical antiquity and the Middle Ages, partly no doubt because sketches were considered a means to an end and were not preserved for posterity but also because the strict conventions prevalent in these periods restricted the scope of preliminary invention. During the Middle Ages the function of drawing within the context of this article, i.e. as an autonomous technique, was mainly restricted to the pattern book for the use of the workshop, the most famous example of which is that by Villard d'HONNECOURT. The rise of NATURALISM after GIOTTO demanded more complex techniques, and the first independent drawings, which made their appearance in the 14th c., are on paper with a specially prepared GROUND which facilitated delicate modelling by hatching often heightened with white. The various drawing techniques then in use were described in detail by CENNINI, who also stressed the importance of drawing for the training of the apprentice and called it the 'triumphal arch' to painting.

Drawings from nature made for the purpose of study occur in the œuvre of PISANELLO, who left a very large body of drawings (Louvre). Neither in his work, however, nor in that of other early 15th-c. masters is it easy to distinguish between preliminary sketches and leaves from pattern books, except where the purpose is obvious (e.g. Jan van EYCK's famous silver-point drawing of *Cardinal Albergati* with its colour notes added). It was in the work of LEONARDO DA VINCI that the drawing first achieved independence as a means of artistic expression. In Leonardo's notes specific reference is made to the need for a fresh approach to drawing, which he compared to the rough draft of a poem. What matters is fertility not tidiness; in fact, the unfinished drawing may suggest fresh ideas to the artist.

Leonardo's incomparable corpus of drawings (the majority of which are in Windsor Castle) shows indeed the range and wealth of his artistic and scientific inventions, as varied in subject as in technique. He was one of the first, if not the first, to use red chalk. His new conception of the preliminary sketch as a field for experimentation influenced RAPHAEL, perhaps the greatest natural draughtsman of all time. MICHELANGELO, whose close-hatching technique recalls the chisel, is said by VASARI to have destroyed most of his first ideas because he did not want posterity to know the extent of his labours. Nevertheless it was

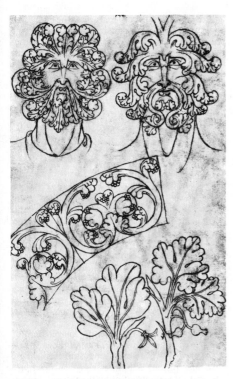

**105.** Pen-and-ink drawing of heads and frieze decoration of acanthus foliage, by Villard d'Honnecourt. (Bib. nat., Paris, c. 1235)

**106.** The preliminary sketch as a field for experimentation. A. Madonna and Child with a cat. Pen-and-ink drawing by Leonardo da Vinci. (B.M., c. 1478). B. Madonna and Child. Detail from a pen-and-ink drawing by Raphael. (B.M., c. 1508)

Michelangelo whose unique fame hastened the recognition of the drawing as an independent medium. His many admirers begged him for drawings and he himself made some for presentation to his special friends (*Phaeton* for Tomaso Cavalieri). It was at that time that Vasari conceived the revolutionary idea of collecting drawings as a record of the various manners of artists; some of those from his *Libro*, carefully mounted and framed by his hand, have been preserved. It was in this period too that the term *disegno* acquired its crucial, almost metaphysical significance within the theory of art. The role of drawing became a notorious bone of contention between the TUSCAN and the VENETIAN SCHOOLS, the latter being accused of having neglected drawing. Though this charge need not be taken at its face value, it is undoubtedly true that Venetian masters such as GIORGIONE or even TITIAN were less interested in drawing as an independent means of expression than the Tuscan PONTORMO. It was TINTORETTO who introduced a fresh interest in drawing to north Italian art, but the final acceptance of Tuscan tradition was only effected by the CARRACCI, in whose ACADEMY drawing was systematically cultivated. North of the Alps the vast and varied body of DÜRER's drawings exemplifies the

**107.** Study of man's back. Detail of close-hatching from a pen-and-ink drawing by Michelangelo. (Ashmolean Mus., Oxford, c. 1502)

important role drawing may assume as the record and storehouse of ideas. In his marginal drawings to the emperor Maximilian's prayer book, on the other hand, Dürer displayed a virtuosity of inventive penmanship that has no parallel south of the Alps. HOLBEIN and the French court artists of the 16th c. with their precise record of the sitter's face continued and developed the tradition of Jan van Eyck, though the medium was now coloured chalks.

In the œuvre of Pieter BRUEGEL the studies of GENRE figures and of LANDSCAPES are outstanding for their powers of observation. Among northerners of the next generation, Jacob de GHEYN deserves special mention since his reputation rests mainly on his very original drawings.

In the 17th c. the cleavage first adumbrated in the opposition between Florence and Venice became even more marked. Such pioneers of painterly innovations as CARAVAGGIO, HALS, and VELAZQUEZ left no identifiable drawings, while followers of the ACADEMIC tradition such as DOMENICHINO, POUSSIN, and LEBRUN used drawings in all stages of the careful and calculated planning of their compositions. REMBRANDT, by contrast, only rarely used drawings for the preparation of his paintings and etchings. To him drawing was an independent means of expression and a testing ground of ideas. Even in his lifetime his mastery of the medium was acknow-

ledged, and BALDINUCCI marvels at the high price paid by collectors for drawings made with only a few strokes of the pen. It is in the second half of the 17th c. that we hear of one artist, Nicolaus Raymond la Fage (1656–84), who sometimes made his living by supplying spirited drawings for collectors, and in the early 18th c. such connoisseurs as Mariette, the friend of WATTEAU, collected drawings on a very large scale. Watteau's use of coloured chalks for the rendering of silk and the bloom of youthful cheeks owes much to his study of RUBENS in Mariette's collection. He made these sketches from life and frequently embodied them almost unchanged into his FÊTES CHAMPÊTRES.

The corollary of this development is the appearance of forged drawings (GUERCINO being singled out for his easily recognizable and imitable manner) and of facsimiles of Old Master drawings published in England by PATCH and later by W. Y. Ottley (1771–1836). Many of the English artists and connoisseurs of the 18th c., the RICHARDSONS, REYNOLDS, and Sir Thomas LAWRENCE, were eager collectors of drawings, and it is to them that England owes the incomparable collections of Italian drawings in the BRITISH MUSEUM and the ASHMOLEAN MUSEUM, Oxford. Among the English masters, on the other hand, emphasis shifted to the medium of WATER-COLOUR, though FLAXMAN and BLAKE discovered new possibilities in outline drawings.

In the 19th c., as before, views on the function and importance of drawing differed widely. The greatest champion and master of the art was undoubtedly INGRES, whose dictum Le dessin est la probité de l'art reflects his attitude no less than the enormous bequest of his drawings still preserved at Montauban. In England similar ideals of probity and precision were pursued by the PRE-RAPHAELITES and by RUSKIN, whose Elements of Drawing sums up his attitude.

The ROMANTICS and the IMPRESSIONISTS, with their emphasis on colour, used drawing more incidentally. Van GOGH, with his interest in the expressive quality of the line, which he admired in such humble draughtsmen as KEENE, injected a new monumentality into his large reed-pen drawings. RODIN, on the other hand, used a free drawing technique to seize the movement of his models in drawings of great boldness which much influenced 20th-c. conceptions. From this time many sculptors have shown themselves masters of drawing—DESPIAU, MAILLOL, and in a different manner GAUDIER-BRZESKA stand out.

Among 20th-c. masters the facility and precision of MATISSE and the range and inventiveness of PICASSO's drawings must not go unmentioned, while KLEE brought a new dimension to impressive draughtsmanship as an independent art. In abstract art the role of the drawing has somewhat changed, though its pedagogical usefulness is denied by few.

**DRAWING BOOKS.** Term for books usually designed to teach the beginner how to construct

a plausible image of the human figure, of animals, trees, etc., by providing examples to be copied and simple diagrams to be memorized. There are many specialized books on how to draw hands, eyes, birds, flowers, or sailing boats, and whole encyclopedias providing a drawing course. These books, which are far removed from the preoccupations of 20th-c. artists, have a venerable ancestry. Villard d'HONNECOURT included similar diagrams of simplified figures in his pattern book of the 13th c. and we can infer that many similar series existed in medieval workshops. The first printed book of this kind is by Heinrich Vogtherr of Strasbourg (1538) containing pages of heads, hands, feet, and ornaments without, however, any diagrammatic analysis of the shapes. This was provided by Erhard Schön (1538) and several other south German artists, such as Hans Sebald BEHAM (1500–50, whose work was published posthumously in 1565) and Heinrich Lautensack (1564) as well as by J. Cousin in France (1593), all of whom stressed the need for schemata of PROPORTION in the construction of figures.

The spread of this genre to Italy may be connected with the Academy of the CARRACCI, Odoardo Fialetti (1608), GUERCINO (1619), and others providing examples. In the Netherlands Pieter de Jode (1629) and Crispyn van de Passe (1643) collected and enriched this visual vocabulary, the growing demand also eliciting copies of drawings from the masters such as A. BLOEMAART's *Drawing Book*, which was probably put together by his heirs.

In the 18th c. innovations such as LEBRUN's

studies of EXPRESSION were embodied in these encyclopedias, which also paid increasing attention to picturesque landscape motifs. This special field, so attractive to the AMATEUR, soon produced a genre of its own, of which the most famous and the most original is the one by Alexander COZENS (1786) teaching the transformation of 'blots' into CLAUDE-like scenery (see BLOT DRAWING).

The sketching amateur was catered for in the 19th c. by treatises of John Burnet (1784–1868) and James D. Harding (1798–1863), as well as by many more elementary drawing books. The *List of Books and Pamphlets in the National Art Library*, South Kensington (1888), gives an idea of the wealth of this production, though it is by no means complete. For the earlier period the catalogues of the great art libraries of Amsterdam, Berlin, and Vienna should also be consulted. Any subject catalogue of modern libraries under 'Drawing' will demonstrate the continued popularity of this method of instruction.

**DRAWING FRAME.** A rectangular frame which the artist sets up between himself and his subject, at such a distance that his view through it corresponds to the drawing he intends to make. It detaches the subject from its surroundings and enables him to concentrate on it. The horizontals and verticals of the frame also help to indicate the relationships of the different parts of the subject in position, direction, and size. Sometimes the frame has a grille of wires or

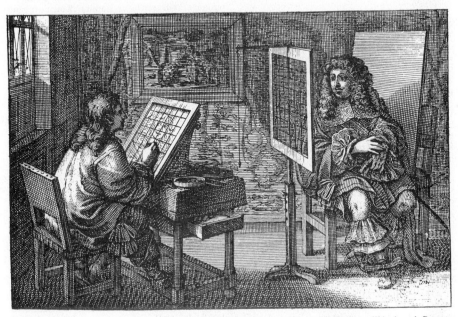

**108.** Engraving from *Recueil de figures Pour apprendre à dessiner Sans Maître le portrait, la Figure, l'histoire et le Paysage* (1737) by Abraham Bosse. Showing the use of a drawing frame

Der Zeichner des liegenden Weibes
The Designer of the lying Woman       Um 1525       Le dessinateur de la femme couchée

**109.** Woodcut from *Underweyssung der Messung* (*Treatise on Measurement*) (1525) by Albrecht Dürer. Showing use of a drawing frame

threads and if the paper is correspondingly squared, the subject can very easily be transferred to it. ALBERTI's drawing frame (mid 15th c.), the first we hear of, was provided with a grille. LEONARDO describes the apparatus in his *Notebooks*, and recommends squaring; he also suggests making a drawing on a glass pane with red chalk or the like and then tracing it through on to transparent paper or copying it on squared paper. The drawing frame is further described and illustrated by DÜRER in his *Underweyssung der Messung* (published 1525). Following Dürer's example, van GOGH constructed one and in a letter to his brother made a sketch of himself using it.

A very small frame or viewfinder, which could be held in the hand, was used in the 18th c. by TOPOGRAPHICAL painters and travellers in search of the PICTURESQUE. Later it was made adjustable, so that the ratio of upright to horizontal could correspond to that of the drawing. The viewfinder of a camera serves a somewhat similar though more elementary purpose.

**DRESDEN GEMÄLDEGALERIE.** Formed by the Electors of Saxony the Dresden picture gallery started from the nucleus of a typical RENAISSANCE KUNSTKAMMER, which is said to have included a stuffed phoenix among its curiosities but also contained paintings commissioned from DÜRER and CRANACH. The chief formative period of the picture gallery was the first half of the 18th c., under the Electors August II and August III. Among the collections acquired by the latter were that of the Duke of Modena, which included the finest masterpieces of Italian art hitherto seen in Germany, and that of Count Wallenstein. The most prized possession of the gallery, RAPHAEL's *Sistine Madonna*, was acquired independently in 1754. August III also bought, in part or whole, some of the most famous Roman collections of antique sculpture (Chigi, Albani, Odescalchi) and it was these works which served

WINCKELMANN for his *Thoughts on the Imitation of Greek Works in Painting and Sculpture* (1755). August built the palace of the Zwinger (1711) to house his collection. In 1855, however, the paintings were placed in a building designed by Gottfried Semper (1803-79). The old *Wunderkammer* is housed in the Green Vault (Grüne Gewölbe). Some of the pictures perished in a fire during the final campaign of the Second World War, in which the Zwinger was also badly damaged.

**DROESHOUT,** MARTIN (b. 1601). A member of an immigrant Netherlandish family of engravers who settled in London; a mediocre and obscure craftsman whose name lives by his engraved portrait published with the First Folio of Shakespeare, 1623. His *Dr. Panurgus* (c. 1628) was a popular satirical piece of the type to which Renold ELSTRACK's *Satire on Women* also belongs.

**DROLLERY.** A comic picture or 'clownish representation', as Evelyn expressed it when he saw 'Landscips, and Drolleries' in the annual fair at Rotterdam (13 Aug. 1641).

This term is also used for the GROTESQUES or comic figures to be found in the borders of medieval manuscripts.

**DRONSFIELD,** JOHN L. (1900-51). Painter and designer, born at Oldham, Lancashire. He designed stage-settings for Sybil Thorndike in 1923 and drew for an issue of the *Week End Book* (1936, Nonesuch Press). He settled in Cape Town in 1939 and studied Cape-coloured life, publishing *Non-Europeans Only*, privately; also posthumously *Satires and Verses* (1955) and *African Improvisations* (Cape Town, 1956). He was perhaps the most important South African designer for theatre and ballet. A Memorial Exhibition was held at the National Gallery, Cape Town, in 1955.

**DROST,** WILLEM. Dutch painter, about whose life nothing is known. A few pictures dated 1654 (*Bathsheba with David's Letter*, Louvre) and 1655 show that during those years he was a faithful follower of REMBRANDT's mature manner.

**DROUAIS,** FRANÇOIS-HUBERT (1727–75). French portrait painter. A pupil of BOUCHER and a rival of NATTIER, he specialized in portraits of the royal children (*Comte d'Artois et sa sœur Marie-Adélaide*, Louvre) and women. He painted Mme de Pompadour and Mme du Barry. His portraits have a gracious and artificial charm and at their best bear comparison with those of Boucher.

**DRYING OILS.** Also called 'fixed oils', these are fatty oils of vegetable origin which harden into a solid transparent substance on exposure to air. They do not dry in the sense of losing moisture but by oxidation together with certain molecular changes. It is this chemical character which has made them suitable as MEDIA for OIL PAINTING, so that when PIGMENTS are ground into them to form PAINTS which are applied to a GROUND the oil on setting hard binds the particles of pigment firmly in position and fixes them to the ground.

The vegetable oils which have been in commonest use since the Middle Ages are LINSEED, WALNUT, and POPPY. Almond and olive oil are not suitable as they do not harden. Sunflower oil has been used in Russia but has never become popular. Small amounts of castor oil have sometimes been used to give elasticity to VARNISHES. 'Stand oil', or linseed oil polymerized by boiling or drying in the sun, has been used since medieval times both as a medium and as a varnish or GLAZE.

**DRYPOINT.** A method of engraving on copper in which the design is scratched into the plate with a sharply pointed tool. It is thus, in principle, the simplest and most direct of all the intaglio processes (see PRINTS), though in practice it is difficult, subtle, and elusive.

The drypoint tool is either a thick steel needle or a diamond point and it is held like a pen or an ETCHING needle, though considerable force is needed to scratch the metal to any depth. Where the plate is deeply scored a BURR is thrown up alongside the furrow; this burr retains the ink when the plate is wiped, giving to the drypoint line its characteristic rich and furry appearance, as when a pen is drawn across damp paper. Drypoint is therefore a sensitive medium, for the degree of blackness of the burred line changes with the variation in pressure of the artist's hand. It is not, however, quite so fluent as etching, for the point is continuously up against the resistance of the metal, so that the lines take on a slightly angular quality as they change direction.

A drypoint plate is easily damaged and will yield only a handful of first-class impressions because the burr is flattened as the plate passes between the rollers of the press. A considerably larger edition may be obtained, however, by having the plate steel-faced—an operation which involves depositing, by electrolysis, a thin coating of steel over the surface of the copper, thus strengthening the drypoint work.

The art of executing a plate in drypoint is one that requires skill and experience, owing to the difficulty of controlling the point and foreseeing the exact effect of the burr. A bad drypoint is not hard to achieve, for anyone can scratch a copper plate; to carry out a design with full mastery of the sensitively accented line is another matter. Drypoints vary considerably in appearance, and range from simple designs in line alone to highly developed tonal compositions with concentrations of the deepest black where strongly burred lines are set close together. The burr may be removed with a SCORPER, in which case the line will print an even grey; more often it is left, for it is a major characteristic of the process.

Drypoint has from the beginning been used in combination with other processes; more often, probably, than by itself. Since it can be worked quickly and directly, it is frequently used for accenting and touching up plates which are already nearly completed in another medium. Many etchers, with REMBRANDT as an excellent example, finish their plates by adding dark accents in drypoint. LINE ENGRAVERS, on the other hand, sometimes indicate their designs lightly with drypoint before beginning to engrave with the BURIN.

From its very nature it is difficult to be sure when drypoint was first used, though this was probably in the late 15th c. DÜRER's *St. Jerome in the Wilderness* of 1512 is a true drypoint, with complete realization of the possibilities of the burred line. Rembrandt used the medium with the greatest mastery and though he usually combined it with etching, it is broadly true that the drypoint element in his plates became increasingly prominent. During the period of reproductive engraving drypoint was of little service because of its fragility, but it has been used by most modern etchers, from WHISTLER to PICASSO.

**DRYSDALE,** GEORGE RUSSELL (1912– ). Australian painter, born in England. He studied under George Bell (see AUSTRALIAN ART) and at the Grosvenor School, London, and the Grande Chaumière, Paris. Influenced by ABSTRACT and SURREALIST art, his scenes of drought, erosion, and outback country life created a new vision of the Australian scene as revolutionary and influential as that of Tom ROBERTS.

766, 791, 1781.

**DUBREUIL,** TOUSSAINT (1561–1602). French painter of the second School of FONTAINEBLEAU. He was born at Antwerp but his style was formed largely on French models and

PRIMATICCIO. His most important paintings, such as the FRESCOES of the story of Hercules for the Gallery of Diana at Fontainebleau, and the decorations in the Galerie d'Apollon of the LOUVRE, have been destroyed; but others, including a series of paintings to illustrate Heliodorus's novel *Theagenes and Chariclea* and Tasso's *Clorinda*, have survived in whole or in part. He forms a link between the MANNERISM of the first School of Fontainebleau and the academic CLASSICISM of the following century.

**DUBROEUCQ,** JACQUES (1500/10–1584). Flemish sculptor and architect. He travelled to Italy before 1535, and seems to have made a close and successful study of works by GHIBERTI, MICHELANGELO, and SANSOVINO. A commission to do carvings for the cathedral of St. Waltrudis at Mons brought him back to the Netherlands. These were his principal works (1535–48); most of them were destroyed during the French Revolution, but enough remains of the ROOD-SCREEN to show that he ranks with MONE and Cornelis FLORIS as a leading RENAISSANCE sculptor of the Low Countries. He was the teacher of Giovanni da BOLOGNA *c.* 1545–50.

**DUBUFFET,** JEAN (1901–    ). French artist. He studied painting as a young man but was engaged mainly in various commercial activities until 1942. He has made a cult of ART BRUT ('raw art'), the products of psychotics or wholly untrained persons, and of GRAFFITI, preferring untrained spontaneity to professional skill. His own work is often aggressively reminiscent of such 'popular' art. He has also made constructs —which he called *pâtes*—from sand, glass, rope, and other junk manipulated into crudely suggestive shapes.

2169, 2457.

**DUCA,** GIACOMO DEL (*c.* 1520–after 1601). Sicilian architect and sculptor who worked for MICHELANGELO on the *Julius* monument (1542) and Porta Pia (1562). After Michelangelo's death he built Sta Maria in Trivio, Rome (*c.* 1575), and added the overwhelming CUPOLA to A. da SANGALLO's Sta Maria di Loreto. Since he was the most daring follower of Michelangelo the central window of the Conservatori Palace in Rome used to be attributed to him, but it is now known to be by Giacomo della PORTA. After 1588 Duca worked in Messina, where earthquakes have destroyed most of his buildings.

**DUCCIO DI BUONINSEGNA** (active 1278–1319). The leading painter of Siena during the late 13th and early 14th centuries. Little is known of his life. The confraternity of the Virgin Mary at Sta Maria Novella in Florence commissioned a Madonna from him in 1285. In 1302 the commune of Siena paid him for another Madonna and an accompanying PREDELLA for the new Town Hall. Then, in 1308, Duccio was ordered to paint a great *Virgin in Majesty* (the *Maestà*), which was to replace an older image on the high altar of Siena Cathedral. Duccio's painting was completed in 1311. Today most of this elaborate ALTARPIECE is in the cathedral museum, but some of the predella scenes illustrating the lives of Christ and the Virgin are scattered outside Italy—in London (N.G.) and in Washington (N.G.) and New York (Frick and Rockefeller Colls.). The *Maestà* is Duccio's only fully documented surviving work and therefore the attribution of other pictures to him is based upon its style.

The so-called *Rucellai Madonna* in Florence, formerly in Sta Maria Novella and now in the Uffizi, is usually identified with Duccio's commission of 1285 though VASARI claimed it for CIMABUE. There is marked similarity of styles between the two so far as each can be identified. Duccio, however, was the more sensitive in characterization. He was a master of pictorial narrative and marks the transition from BYZANTINE to GOTHIC. The tiny *Madonna of the Franciscans* ascribed to him (Pinacoteca, Siena, *c.* 1290) is one of the most exquisite examples of this supple adaptation of the Byzantine mode. Its rich gold and glowing colours are used both as ornamental patterns and as elements of the composition. The adoring monks at the Virgin's feet are dwarfed by her; she herself is withdrawn and reflective. The fluttering mantle with its sparkling golden hem and the Child wriggling to bless the supplicants introduce a freshness of human feeling into the conventional ICONOGRAPHY.

Although Duccio was not a revolutionary like his Florentine contemporary GIOTTO, in the realm of panel painting (as opposed to frescoes) he was unsurpassed as a narrator. As no one else before him he succeeds in making the setting of a scene—a room or a slope—a dramatic constituent of the action, so that figures and surroundings are intimately bound up together. This is what gives his narratives such momentum and power. With Giotto, the figures alone embody the feeling; with Duccio emotion is conveyed by faces, sequence of colour, and arrangement of scenery. Yet he keeps his composition within the Byzantine frame which exalts action to ritual.

Duccio probably died early in 1319. He lived to see the rise of the Gothic style in Siena with Giovanni PISANO and SIMONE MARTINI. There are already Gothic touches in parts of his own work—especially the DRAPERIES and the architectural details. After him, even far into the 15th c., Sienese painting was informed by his sensitive line, his resplendent colours, and his tenderness.

381, 2823.

**110.** Château of Fontainebleau. Pen-and-ink drawing by Jacques Androuet Ducerceau. Engraved in *Les plus excellents bastiments de France* (1576)

**DUCERCEAU,** also DU CERCEAU. French family of architects and designers. JACQUES ANDROUET the Elder (*c.* 1520–after 1584), architect, decorator, and engraver-publisher, is best known for his collections of architectural and decorative engravings, particularly *Les plus excellents bastiments de France* (1576 and 1579), an essential source of information on 16th-c. French architecture. He was famous in his lifetime chiefly for his many engravings of decorative detail and ornament, which in their love of fantasy were opposed to the classical trend of the time. He designed the châteaux of Verneuil and Charleval, both fantastic in their wanton breach of Classical principles. But he built little and nothing certainly attributable to him survives. Three of his sons followed his profession. BAPTISTE (*c.* 1545–90) succeeded LESCOT at the LOUVRE; his only remaining work is the Pont Neuf, Paris (1578–1604), greatly admired by Evelyn and others. He supervised the Royal Office of Works from 1584 onwards at a remarkably high salary. JACQUES (*c.* 1550–1614) was responsible for parts of the Louvre and Tuileries, and CHARLES (d. 1606) worked at Chatellerault. Baptiste's son JEAN (*c.* 1585–after 1649) built the Hôtels Brentonvilliers and de Sully in Paris, and the horseshoe stairs at FONTAINEBLEAU.

1022.

**DUCHAMP,** MARCEL (1887–1968). French painter and artist. He was the brother of the sculptor Raymond Duchamp-Villon (1876–1918) and half-brother of the painter Jacques Villon (1875–1963). He sprang into notoriety with his *Nude descending a Staircase* (Philadelphia Mus. of Art), combining the principles of CUBISM and FUTURISM, which had a *succès de scandale* at the ARMORY SHOW in 1913. During the ensuing years he was with PICABIA the leader of the New York DADA movement, and was the inventor of the 'ready-made'. Most notorious of the ready-mades which he exhibited during these years were a bicycle wheel mounted on a kitchen stool, a bottle rack bought in a Paris store, and a urinal —the last was entitled *Fountain* and signed R. Mutt. So far as it is possible to derive a theoretical basis from the incoherences of Dadaism, the concept of the ready-made seems to derive from Duchamp's conviction that life is meaningless absurdity and his repudiation of all the values of art. He sometimes said that any object becomes a work of art if he selects it from the limbo of unregarded objects and declares it to be so. At other times he said that these ready-mades were not art but anti-art, affirming that all art is junk. From 1915 to 1923 he was engaged on his major work, a painting and construct on glass with esoteric or obscure symbolism which he called *The Bride stripped bare by her Bachelors, even* (Philadelphia Mus. of Art). During the 1920s he combined the idea of the machine with that of futility, constructing elaborate mechanical gadgets which served no purpose.

83, 1597.

**DUDOK,** WILLEM MARINUS (1884–    ). Dutch architect, who became municipal architect at Hilversum in 1915. He developed a distinctive modernist style which owed something to BERLAGE and something to the ideology of De STIJL without following either. His work represents the most effective attempt to stylize the modern idiom in architecture and to equip it with a system of elaboration as readily identifiable as the discarded period styles. He resolved the design of his buildings into an asymmetrical composition of intersecting rectangular planes, with numerous horizontal slabs and ledges set

335

against plain vertical wall surfaces and contrasting solid and void areas. His somewhat sentimental mannerisms were for a short time much imitated, especially in Great Britain (e.g. in the work of Thomas S. Tait (1882-1954)). They are seen at their most effective in a number of buildings by Dudok in the model town of Hilversum, near Amsterdam, the most important being the Town Hall (completed 1930), which has one of his characteristic asymmetrical slab-like towers. He also built Netherlands House at the Cité universitaire, Paris (1927-8).

1738.

**DUFRESNOY,** CHARLES ALPHONSE (1611-68). French painter. He studied under PERRIER and VOUET, then spent many years in Italy (1633-56) with his friend Pierre MIGNARD, copying the works of TITIAN and the CARRACCI. In 1653 he went to Venice and was impressed by the colour of the Venetians. He returned to Paris in 1656, where he worked mostly on decorative painting. He is chiefly remembered for *De arte graphica* in Latin verse, which sets out the doctrines of French academic CLASSICISM in epigrammatic form. In the importance he ascribed to colour he was in support of Roger DE PILES, by whom his work was translated and posthumously published in 1668. It was translated into English by Dryden (1695) and was later annotated by REYNOLDS, remaining influential for more than a century as an expression of academic theory.

**DUFY,** RAOUL (1877-1953). French painter and textile designer. After painting sea pieces in an IMPRESSIONIST manner, he became a convert to FAUVISM in 1905 under the influence of MATISSE until *c.* 1908 when he worked with BRAQUE at L'Estaque. During the 1920s he matured his very personal manner of witty, calligraphic drawing on brilliant background washes of gay colours evocative of Mediterranean sunlight. His favourite subjects were racing scenes, boating scenes, the glitter and sparkle of the Riviera, Deauville, London, or Nice. His enormous dexterity was devoted to a luxury drawing-room art of splendid attractiveness. In 1937 he designed an immense panel *L'Histoire de l'électricité* for the 1938 Paris Exhibition. There was a large retrospective exhibition at Geneva in 1952 and a retrospective exhibition at Paris in 1953 after his death.

264, 477, 500, 579, 581, 639.

**DUGHET,** GASPARD, called GASPARD POUSSIN (1615-75). French landscape painter, who adopted the surname of his brother-in-law Nicolas POUSSIN. He had considerable success in Rome, with landscapes combining the romanticism of CLAUDE with something of Poussin's classical quality (*Abraham and Isaac Approaching*

the *Place of Sacrifice*, N.G., London). His work was much admired by English 18th-c. collectors and influenced English painters such as Richard WILSON and the supporters of the PICTURESQUE.

**DUJARDIN,** KAREL (1622-78). Dutch painter and etcher of landscapes, cattle, GENRE scenes, portraits, and religious subjects, active mainly in Amsterdam. He is best known for his small paintings of humble bucolic scenes set in an Italianate or a Dutch landscape and diffused with a clear, warm light. These works reveal the impact of his teacher BERCHEM and his admiration for Paulus POTTER and Adriaen van de VELDE. Dujardin also did elegant life-size portraits and large religious pictures which show that his long visit to Italy (*c.* 1642-52) had made him *au fait* with the picture-making techniques of Italian BAROQUE. In 1674 he made a second visit to Italy and died in Venice four years later. Like so many of the 17th-c. Dutch artists who made the journey to Italy, Dujardin was a Catholic. His work is well represented in the National Gallery, London, and the Rijksmuseum, Amsterdam.

**DUMONSTIER,** ÉTIENNE (1520-1603), PIERRE and DANIEL (1574-1646). Family of French portrait painters, who carried on the tradition of the CLOUETS into the middle of the 17th c.

**DUNOYER DE SEGONZAC,** ANDRÉ (1884-1974). French painter and engraver. He was a friend of Jean-Louis Boussingault (1883-1943), Luc-Albert Moreau (1882-1948), Roger de la Fresnaye (1885-1925), Jean Marchand (1883-1940), and other members of the so-called *Bande noire*. During the First World War he was in charge of camouflage on the French front. His oil paintings (landscape, STILL LIFE, and figures) were usually executed in thick paint with little or no MEDIUM and emphasize the weight and earthiness of the forms. His water-colours and etchings, however, were more elegant and spontaneous, and had a wider range of subject matter, including dancers, boxers, etc. He was influenced by both COROT and COURBET as well as CÉZANNE, and was one of the foremost representatives of the naturalistic tradition in a period which is dominated by anti-naturalistic tendencies. A retrospective exhibition of his etchings and water-colours was held at the Bibliothèque nationale, Paris, in 1958.

1425, 1673.

**DUPONT,** GAINSBOROUGH (*c.* 1754-97). Nephew and assistant of Thomas GAINSBOROUGH, he made copies of his uncle's portraits, completed others left unfinished at his death, and

painted some original portraits in his manner. He made some mediocre engravings from Gainsborough's FANCY PICTURES.

**DUQUE CORNEJO,** PEDRO (1678-1757). The last important sculptor of the School of Seville. He carved statues and REREDOSES for cathedrals and churches at Granada, Seville, and El Paular, and CHOIR STALLS for Cordoba Cathedral (1748-57). His inventiveness and ingenuity contributed much to the development of the ROCOCO altar throughout Hispanic countries.

**DUQUESNOY,** FRANS or FRANCIS (1594-1643). Flemish sculptor who spent most of his life in Italy. While in Rome he was associated with POUSSIN and was one of a group of Netherlands artists including van DYCK. His most influential works were the small bronzes similar to those of Giovanni da BOLOGNA. His death prevented him from accepting Louis XIII's invitation to France. His portrait by BLANCHARD (1614-15) is in the Czernin Collection, Vienna.

753, 918.

**DURANTY,** EDMOND (1833-80). French novelist and art critic, chiefly known now as an early champion of the IMPRESSIONISTS and a friend of DEGAS. Inspired by COURBET and CHAMPFLEURY, he came within the ambit of 19th-c. social REALISM and advocated the view that artists should depict modern city life instead of the exotic subjects beloved by the ROMANTICS or the mythological themes of the Academies. Both in his paper *Le Réalisme* (1856) and in *La Nouvelle Peinture* (1876) he advocated 'removing the partition which separates the studio from everyday life' and in the latter he traced the beginnings of Impressionism from CONSTABLE, Courbet, and BOUDIN. In his novel *Le Peintre Louis Martin* (1881) MANET, Courbet, Degas, and other painters figured. Duranty was himself painted by Degas, and was one of the figures in FANTIN-LATOUR's *Hommage à Delacroix* (Louvre, 1864).

**DÜRER,** ALBRECHT (1471-1528). German painter from Nuremberg. Son of a goldsmith and godson of Anthony Koberger, one of Germany's foremost printers and publishers, he was apprenticed when 15 years old to the leading painter and book illustrator in Nuremberg, Michael WOLGEMUT, a lifelong friend of the patrician and humanist Willibald Pirckheimer. These four men exercised a powerful influence on Dürer's genius and determined to some degree his artistic career. The father must not only have taught him the rudiments of drawing, particularly with silverpoint, as is borne out by the young boy's self-portrait (Albertina, Vienna), but also instilled into him that devotion to exact and meticulous detail which is the mark of a goldsmith's work. From Wolgemut he learned the painter's trade and the technique of WOOD-

**111.** Earliest known self-portrait by Albrecht Dürer. Silverpoint. (Albertina, Vienna, 1484)

CUT. His master's influence was technical rather than profound. Through Koberger he had access to the world of books and learning, and Pirckheimer directed these interests towards Italy and the new humanism.

All this in itself is remarkable enough and has no parallel in Dürer's day, for even HOLBEIN was never so intimate with the Basel humanists as Dürer was with those of Nuremberg. From the beginning Dürer's world reached well beyond the normal medieval workshop.

After completing his apprenticeship Dürer set out in 1490 on the usual bachelor's journey. A contemporary tells us that he 'wandered through Germany'. He may have gone, as many of his day did, to the Netherlands, where he could find the leading schools of the north. He certainly went to the Upper Rhine in search of Germany's leading painter and engraver Martin SCHONGAUER, who, however, had just died when Dürer reached Colmar in 1493. He worked for a while as a book illustrator in Basel and Strasbourg, making woodcuts for Sebastian Brant's *Ship of Fools* and designing the illustrations (never executed) for an edition of the comedies of the Roman poet Terence, two undertakings which led to still closer contacts with the world of humanism.

After his return to Nuremberg and his marriage (1494) he went on a short visit to north Italy and then set up a workshop in his native town. Though also active as a painter—the

self-portrait of 1500 (Munich) and the *Paum-gärtner Altar* (Munich, 1504) being the most important early works—he was for years pre-occupied with woodcuts and engravings, among which the large series of the *Apocalypse* (1498), the *Great Passion* (1510), and the *Life of the Virgin* (1510) take first place. In spite of the traditional subject matter they are revolutionary in approach, size, and subtlety of technique. In each case, and most of all in the *Apocalypse*, the

subject was one of particular interest in the period just before the Reformation. Dürer's woodcuts are alive with dramatic tension and a pathos which is not only the result of his close study of MANTEGNA's engravings but also shows participation in the spiritual life of his day.

At the same time he began to be occupied by the RENAISSANCE problems of PERSPECTIVE, of absolute beauty, of PROPORTION and harmony. He sought instruction from Jacopo de' BARBARI,

112. *Melencolia I*. Engraving (1514) by Albrecht Dürer

a travelling Italian artist visiting Nuremberg, and he read VITRUVIUS. *The Fall* and *The Nativity*, both of 1504, are the first-fruits of these investigations. It is characteristic of Dürer that for these subtle studies he preferred LINE ENGRAVING to woodcut, but that under his hands this technique was refined, just as woodcut had been. The Venetian journey of 1505-6 was undertaken in pursuit of his new search. Dürer returned with a system of human proportions which he must have met with in circles close to LEONARDO. His great admiration for Giovanni BELLINI enhanced his sense of colour and the *Feast of the Rose-garlands* (formerly Strahov Monastery, now Prague), done actually in Venice, was meant to compete with the best Venetian painting. Yet even his graphic technique profited, and the scale of tones between black and white was now increased by an even more refined technique of cross-hatching. This change can be seen by comparing those pages of the *Life of the Virgin* done after his return with the earlier ones.

Most of the landscape water-colours also belong to this period. They are unique in several ways: as personal records, in their choice of medium and subject, but most of all since they seem to have been made for sheer pleasure and not—as was usual with sketches in those days—with larger works in view.

By now Dürer was a well-established painter, engraver, and woodcutter. Commissions for large altar-paintings came not only from his home town of Nuremberg (*Adoration of the Trinity*, Vienna, 1511) but from as far afield as Frankfurt-am-Main, whence Jacob Heller commissioned an ALTARPIECE with *The Assumption of the Virgin* (1509). This is now lost, but a magnificent series of large drawings for it survives in the Albertina, Vienna, and may serve to draw attention to Dürer's skill and inspiration as a draughtsman. After *c.* 1512 his most important patron was the Emperor Maximilian. For him Dürer designed an enormous TRIUMPHAL ARCH laden with history and allegory and a triumphal procession, all on paper and executed in woodcut by members of Dürer's workshop and others. This curious substitute for true classical pageantry must have appealed to Dürer's classical interests though the result may seem to us rather more intriguing than satisfactory. He is more himself in the marginal drawings for the Emperor's prayer book. Meanwhile many woodcuts and engravings kept Dürer busy, among them the *Small Passion* (1511) and the *Engraved Passion* (1513).

At the same time his creative spirit found outlets entirely of his own choosing: the sturdy *Knight, Death and the Devil*, the sunny contemplative *St. Jerome in his Study* (1514), and the brooding and enigmatic allegory of the *Melencolia I* (1514). During these years he also experimented with a new technique, DRYPOINT,

**113.** A painter studying the laws of foreshortening by means of threads and frame. Woodcut from *Underweyssung der Messung* (*Treatise on Measurement*) (1525) by Albrecht Dürer

and found in it the means to convey in an *Agony in the Garden* (1515) his troubled religious feelings. There is other evidence to tell us how deeply Dürer felt during the years of the Reformation and we know from one of his own letters that liberation and consolation came to him finally through Luther's writings.

In 1520-1 a journey to the court of Charles V to ask for a renewal of his pension took him to the Netherlands, where he was fêted as the acknowledged leader of his profession. The day-to-day diary that Dürer kept on this tour, together with his drawings showing the people and places he saw, is the first record of its kind in the history of art.

After his return to Nuremberg Dürer was busy with portraits and with the designs for yet another *Passion* series, but his main task was the two panels with the *Four Apostles* (Munich) which he presented to his native town in 1526, an action without precedent. Here Dürer summed up his life's work: the study of the ideal human figure and the expression of a deeply felt religious message. The Bible quotations which he affixed to his panels clearly enforce the meaning of his Protestant sermon and yet curiously enough the composition, colour, and proportions hark back to Venetian painting.

It was only natural that a man of Dürer's cast of mind should pursue theoretical studies throughout his life and that among them—according to his own testimony—proportion should take first place, other things only being attempted 'if God should give me time'. The *Underweyssung der Messung (Treatise on Measurement)* (1525) was published by Dürer himself, but the *Vier Bücher von menschlicher Proportion (Four Books on Human Proportion)* (1528) was published posthumously.

When Dürer died in 1528, though he was widely known as a painter, his real fame rested on his graphic work which was used in the north and south very much as pattern-books had been. Erasmus called him 'the APELLES of black lines', the highest praise that a student of the ancients could possibly give to any artist.

217, 511, 607, 947, 1510, 1653, 1963, 2014, 2019, 2038, 2915.

**DUSART,** CORNELIS (1660–1704). Dutch painter of peasant scenes which sometimes masquerade as the work of his master, Adriaen van OSTADE.

**DUTCH ART.** A survey of Dutch art inevitably concentrates on the painting of the 17th c. Only in this period did Dutch art acquire international fame and become of major significance in the history of European culture. Individual artists of importance do appear at other periods, but only in the 17th c. was there a continuous and original tradition of artistic achievement. Painting has always assumed the dominant role in Dutch art, followed by architecture, and sculpture seems to have made least appeal to the Dutch artistic genius.

A limiting factor in the significance of Dutch art is its susceptibility to foreign examples, with the obvious exception of the 17th c. when Dutch artists possessed an originality of style and subject constituting one of the major influences in the history of painting. There is no other country whose artists have received their influence more readily nor whose collectors have sought their works more eagerly than England.

1. DUTCH PAINTING BEFORE 1600. Painting in the northern provinces of the Netherlands began its separate history comparatively late. From near the end of the 14th c. until after 1500 the livelihood of artists depended on the patronage of the dukes of Burgundy. At first the northern artists made the considerable journey southwards to work in Dijon; later the Burgundian court established itself in the southern Netherlands. But the proximity of a strong artistic tradition did not change the basic situation. The mainstream of development took place in cities like Bruges and Ghent, and the north continued to be a backwater because artists born there could more easily find work in the centres of patronage and at the same time improve their skills. Dirk BOUTS, for example, was born in Haarlem but left his native city to make his career in Louvain. The outstanding sculptor Claus SLUTER, a most influential figure through his works at Dijon, was also a native of Haarlem. There are, indeed, isolated examples of highly talented artists who can be called Dutch rather than Flemish, but they do not constitute the same continuous tradition. The work of these artists of different periods was generally characterized by greater directness and simplicity of composition, a bolder choice of colours. Often the figure style was recognizably less convincing than that of FLEMISH artists, though the lighting was very advanced.

An early example of Dutch art is the great Missal written and illustrated for the Bishop of Utrecht, Zweder van Coulemburgh, in 1425. This manuscript, now at Bressanone, contains a full-page illustration of the CRUCIFIXION and many historiated initials where the artist reveals a powerful sense of decoration and an interest in LANDSCAPE.

A key figure in Dutch painting of the 15th c. was Albert van OUWATER, born *c.* 1450. Here was a Haarlem-born artist who resisted the appeal of the south and appears to have remained in Haarlem. It is difficult to assess the importance of Ouwater as only one certain work survives, the *Raising of Lazarus* (Berlin), and no examples of the masterly landscape passages for which van MANDER claims he was noted. The accuracy of this later claim, made in the Schilderboek of 1604, is borne out by the remarkable landscapes of artists influenced by Ouwater. Among these Gerard DAVID, another Dutch-born artist who moved south to Bruges, had outstanding qualities as a landscape painter. The same ability is seen in the work of GEERTGEN

TOT SINT JANS, almost certainly Ouwater's pupil at Haarlem. His *Lamentation Wing* at Vienna gains much of its impact from the power of the landscape. It also shows a rather static emotional force seen in Ouwater's *Raising of Lazarus*. Geertgen was able to work on a large scale (the panels in Vienna are nearly 6 ft. high) and to turn equally successfully to near miniature representations of the Madonna and Child. Clearly he was aware of the work of Flemish masters like van der WEYDEN and van der GOES but the jewel-like quality of his own work belongs to the Eyckian tradition. The slightly melancholy feeling of introspection found in his paintings is also seen in the works of a little-known artist, the MASTER OF THE VIRGO INTER VIRGINES. With this artist the mood is dramatized in a demonstrative and intense way but, like the work of a group of anonymous masters of the same date, the quality falls short of Geertgen's.

A contemporary of Geertgen was the Dutch-born artist Hieronymous BOSCH, who is claimed by both Flemish and Dutch Schools. In effect he is so isolated and individual an artist that there is only a limited connection with other painters. Bosch's isolation is as much in his style of painting as in his subject matter. Indeed the subject matter is far more perplexing and alarming to modern eyes than it was to his contemporaries, because some parallels existed in popular folklore and literature; also Bosch lived in an age of deep religious unrest and in a society where brutality and coarseness were much more in evidence than today. Bosch brought this tragicomic imaginary world to life in brilliant colour and detail, and in a spirit of sincere religious belief. His fluid yet precise technique is as remarkable as his humour and inventiveness. The imposing names of his exalted patrons, headed by Philip II, underline his high contemporary standing and the conformity of his religious outlook. Fifty years later the technique and conception of Bosch's work was revived by BRUEGEL, but in a different and perhaps more optimistic vein. By the time Bosch died in 1516 a change was taking place in Netherlandish art. The influence of the Italian RENAISSANCE was making itself felt in the north and centred on the great city of Antwerp. Jan MOSTAERT, a fashionable portrait painter, represents the transitional phase. New Renaissance elements were awkwardly assimilated into his basically 15th-c. style. A parallel phase is apparent in architecture. A Leiden artist, Cornelis ENGEL-BRECHTSEN, acquired a knowledge of this new mood through contact with Antwerp. Engelbrechtsen's work was affected by the eclectic style of the so-called 'Antwerp Mannerists'. His paintings are teeming with the restless rhythms and elongation of the MANNERIST style and form a complete contrast with the mood of the 15th c. Engelbrechtsen, however, was overshadowed by his pupil LUCAS VAN LEYDEN. This highly important artist probably studied painting with his master, but Engelbrechtsen is not known to have done any graphic work: Lucas's most original and 'Dutch' period was between 1508 and 1521. Both Lucas's engraving and his painting were strongly influenced by DÜRER and it seems likely that he had studied Dürer's work even before their meeting in 1521. In the 1520s Lucas van Leyden became increasingly influenced by Antwerp Mannerism and also by MARCANTONIO's engravings after RAPHAEL's late works. His remarkable prowess as a draughtsman and engraver is typical of the strong interest in GRAPHIC ART shown by Dutch artists, but no other artist until REMBRANDT matches his achievements in this field.

Whereas Lucas van Leyden achieved a personal version of Mannerism, whose influence he received indirectly through Dürer and Antwerp, other Dutch artists were in direct contact with Italy. The first to travel extensively in Italy was Jan SCOREL, a gifted artist whose talents embraced painting, music, and architecture. He also travelled widely throughout Europe and the Levant before settling in Utrecht. He was a successful portrait painter who, unlike Mostaert, had successfully assimilated the Italian elements into his style. A large proportion of Scorel's *œuvre* has been destroyed and many of his pictures were painted in part by his large workshop. Among the genuine surviving works the *Magdalen in a Landscape* (Rijksmuseum, Amsterdam) admirably represents his skill as a portraitist and landscape painter. Scorel's influence was most important. His principal pupils were Maerten van HEEMSKERCK and Antonio Moro. (Antonio Moro, the Spanish form of this artist's name, is most commonly used although his correct name was Anthonis MOR VAN DASHORT.) Heemskerck had renewed contact with Italy and developed a more advanced Mannerist style, ranging over single and group portraits and religious subjects. Antonio Moro became the most famous court portrait painter, second only to TITIAN, and worked in different countries of the Habsburg Empire, and briefly in London. The influence of Titian is paramount with him, but his detailed objectivity is Dutch in origin. Another, Dirk BARENDSZ, was also in close contact with Titian and brought back Venetian influence to the northern Netherlands in 1560. The over-all result was an increased demand for portraiture and the 'Group Portrait' made progress.

Heemskerck and other artists promoted a form of Mannerism which became the dominant style in the whole of the Netherlands. In northern Europe it flourished most strongly at Antwerp in the FLORIS tradition, and at the so-called School of FONTAINEBLEAU. But an artist like Pieter AERTSEN remained more recognizably Dutch in subject matter and style, and was only slightly affected by Mannerist formulas which he came across during a stay in Antwerp.

At the end of the 16th c. the most important centre of painting was Haarlem, where van Mander and Cornelis CORNELISZ founded the

Academy. This represents the last and most distinguished phase of Mannerism in the north. Van Mander had been in contact with Bartholomeus SPRANGER, an extreme late Mannerist who worked for Rudolf II at Prague. GOLTZIUS, the main draughtsman and engraver of the group, was also an enthusiastic follower of Spranger and he helped to spread his style by his engravings. The Academy was comparatively short-lived and was most important not for its influence but for the reaction against it.

The city of Utrecht, where BLOEMART and Wtewael (1566-1638) were the leading Mannerist painters, remained orientated towards Italian influence, independent of the rest of Holland. The Utrecht masters TERBRUGGHEN and HONTHORST brought back from Italy the new REALISM of CARAVAGGIO which was to sweep Mannerism aside in the north. Paradoxically and in contrast Haarlem, home of the Academy, was to be the cradle of native Dutch painting, freeing itself from foreign influences, Italian and others, which had dominated it for so long.

2. ARCHITECTURE AND SCULPTURE BEFORE 1600. (a) *Architecture.* Before the end of the 16th c. the style of architecture in the northern provinces of the Netherlands was largely dependent on that of their neighbour. During the early ROMANESQUE period the style of the churches was derived from contemporary buildings in the Rhineland. Political and religious connections were the cause of this dependence, for the bishopric of Utrecht was under the jurisdiction of Cologne until 1588. The church of St. Servatius at Maastricht, for instance, was decorated on the exterior with LOMBARD BANDS, blind arcading of a type that was popular in northern Italy and the Rhineland. St. Mary's at Maastricht and the church at Susteren, both dating from the 11th c., also had large 'westworks', complexities of towers at the west such as are to be seen in churches at Cologne and in Mainz. At Susteren there is an early example of the alternating PIERS and COLUMNS, a bay system that was to have important consequences for the development of the mature Romanesque style. The church of St. Peter at Utrecht has survived almost intact and justifies comparison with the abbeys of the Rhine. The full expression of Romanesque architecture in Holland was best represented by the 12th-c. church of St. Mary's, Utrecht. This no longer exists but the paintings of Pieter SAENREDAM and a 19th-c. drawing show that the nave was covered with an early, experimental example of rib vaulting and that the elevation included a vaulted tribune. The Rhineland continued to play an important role with the continued use of the heavy single tower at the west end of the church. At Odilienburg the choir is flanked by twin towers that are reminiscent of those at Speyer on the Rhine.

Utrecht, always receptive of international influences, also produced one of the earliest and finest examples of the GOTHIC style. The foundation-stone of the cathedral was laid in 1254, and it is likely that work was well in hand by 1300. The elevation of the choir consists of a tall slender main ARCADE, a bipartite TRIFORIUM with trefoil openings surmounted by a comparatively large CLERESTORY window. The choir derives ultimately from AMIENS through the intermediary of Cologne. But the cathedral at Utrecht proved too ambitious for the majority of architects to follow and the parish churches owed more to the modest Dominican church in Maastricht, built in the French manner after 1260. They generally followed the pattern of an aisled nave with blind triforium arcades; there was no transept and the apse was lit by tall windows that reached from just above the floor up to the VAULTS. The columns were terminated in simple foliated capitals. At the beginning of the 14th c. the HALL CHURCH was introduced at Middelburg, a type which, with its aisle roofs as high as those of the main nave, was to remain popular in Holland for a long time. A good example is St. Michael's at Zwolle. Strong foreign influence can again be seen in St. Nicholas at Kampen. During the second half of the 14th c. the renovation of the choir was undertaken by Rutger who was the son of Michael, a master builder of Cologne Cathedral, and who had worked with Peter PARLER at Prague. The square-ended chapels and the spatial effects owe much to the example of Parler.

In Brabant, where local stone was readily available, a particular regional variation of the Gothic style was developed. The master builders of Brabant worked in many parts of the Netherlands and wherever they went churches of imposing grandeur were built. Among these were the choir of St. Mary's at Antwerp and the choir of St. John's at 's Hertogenbosch. In St. John's the general effect of the elevation still derived from Cologne but the walls and blind openings were decorated with tracery that resembles the English PERPENDICULAR manner. During the 15th c. the Brabantine style was brought to perfection by an outstanding architect, Everaert Spoorwater, renowned for his work on St. Bavo at Haarlem, begun after 1445, and for the church of Dordrecht, which was largely rebuilt by him after a fire in 1457—the Grote Kerk depicted in CUYP's views of Dordrecht. Spoorwater's style was marked by a new simplicity and sense of proportion. The simplicity was emphasized as Dutch churches became free from statuary and painting, so that there was nothing to detract from the pure architectural quality. The increasing wealth of the cities at this time manifested itself in commissions for large churches, most of which had ornate towers whose very size reflected the civic pride of the townspeople. In the 15th c. there was also an increase in the number of town halls and guild-halls, particularly in the southern Netherlands, where the greater prosperity of the cities encouraged secular building. But Spoorwater built the guild-hall for the Flemish merchants in Dordrecht and similar halls at Veere and Middelburg.

The Gothic tradition of architecture persisted far into the 16th c., especially in the churches and religious foundations. As late as 1621 there is an isolated example of a church built in the Gothic manner at Goes. But the architectural ideas of the Renaissance were introduced by Italian architects working in the Netherlands. At first Renaissance detail was used on essentially Gothic buildings, but soon the style of the secular buildings themselves began to change. Pieter COECKE published a translation of VITRUVIUS in 1537 and of SERLIO's *Treatises* in 1539 at Antwerp. The façade of the town hall there instances a northern architect, Cornelis FLORIS, interpreting the Italian manner. These ideas, first made known in the south, were disseminated in Holland through the books of Vredeman de VRIES.

(b) *Sculpture.* Sculpture in the northern Netherlands cannot be dismissed, but its importance is slight in comparison with the abundance of sculpture in France, Italy, and Germany. The sculptured portal of Gothic France never found favour in the Netherlands, nor were there many commissions apart from simple tomb sculpture. The only sculptor of international fame was Claus Sluter, and he left his native land before he could either form his own style or leave behind works to interest and influence his contemporaries. Long after Sluter's departure other sculptors of the 15th c. belatedly began to work in a more lively naturalistic manner. Though they produced some works of fine quality, the medieval tradition persisted until after 1520.

The familiar pattern of Italian influence arriving in the northern Netherlands through Antwerp is repeated for the history of sculpture. Yet it was again the superficialities of the Renaissance manner, rather than its true substance, that predominated.

3. 17TH-C. PAINTING. To most people Dutch art means the phenomenon of Dutch painting in the 17th c., deservedly called the Golden Age of Dutch Art. Certain characteristics had been established by earlier artists, but from these modest seeds came a mighty growth. When compared with Flemish painting, which spread richly over three centuries and included two major developments in the 15th and 17th centuries, the history of Dutch painting appears condensed into less than a century. Yet so rich and varied is this concentration that Holland can be said to have been equally blessed with artistic talent. Above all others were three artists of genius, Frans HALS, Rembrandt, and VERMEER. Yet even if these three had not existed, RUISDAEL, Cuyp, van GOYEN, STEEN, TERBORCH and their peers would have made the Dutch School highly important. It is as well to emphasize this because the existence of the great trio has tended to overshadow their contemporaries. Nothing in Holland's previous artistic history heralded this sudden, intense flowering of talent and once it had passed nothing of its kind came to Holland again.

The political and artistic history of Holland were particularly closely linked in the 17th c. and while background factors, political, economic, and social, cannot, of course, cause artistic genius to appear, they can provide the setting in which it can flourish and expand. The key factor was the Dutch desire for freedom from foreign domination. The decades of fighting against the Habsburgs might well have drawn the people together in a common cause and unleashed their energy and pride. They began as a group of rebel provinces wanting political and religious freedom, and emerged as a nation. Of the provinces Holland was by far the largest, and as early as the 17th c. gave its name to the whole country. Today the Dutch prefer to call their land the Netherlands. The war had stimulated their industry, expanded their fleet, and made vigorous nationalism the characteristic of all. At the same time the devastation and defeat of the southern Netherlands, where so much of the fighting took place, helped to strengthen the emerging nation in several ways. Many skilled workers and artists fled to the north and Amsterdam gradually assumed Antwerp's role as a trading and financial centre, as well as becoming the principal port. From this great city and from many smaller ports the wartime 'sea-beggars' and their ever-growing fleets gradually took over a major share of the carrying trade and penetrated to remote areas of the world. Trading posts eventually became colonies, but the Dutch were above all merchants and it was upon their success at home and abroad that the economic existence of the new nation depended. Merchants, singly and collectively, played a dominant role in the political life of Holland, as well as being the principal patrons of the arts. There was virtually no land-owning nobility, so prominent in other countries, nor was the Reformed religion a source of patronage. The merchants filled the gap made by this loss of ecclesiastical commissions. Peace and prosperity gave national pride an opportunity to express itself in art. The special circumstances of Dutch history and the structure of its society were different from the rest of Europe, and helped to determine the character of the art. The efforts and courage of the Dutch in 'creating' their nation made them understandably proud and they found a real joy in their special kind of patriotism. For their subject matter Dutch artists turned to their own countryside, their own towns, and their own people. It was in many ways a new and surprisingly modern approach. When they turned to religious subject matter they represented the Bible stories in terms of familiar everyday life. Mythology and classical history were rarely sources of inspiration, and Dutch painting is seldom academic. The artists' choice of subject reflected the tastes of their buyers.

Although an important point, it is seldom realized that, unlike other countries, the buying and enjoyment of painting in Holland was by no means limited to the wealthy and educated. At the *Kermesses*, the frequent village fairs, ordinary people could see paintings of all kinds

displayed and could buy, sell, or trade them. No aspect of the story is more democratic than the patronage.

It should always be remembered that painting was only one aspect of the 'Golden Age' of the Dutch Republic. Writers, musicians, geographers, and scientists matched the achievements of the great painters.

(a) *Portraiture*. The tradition of portrait painting was well established in the northern Netherlands in the 16th c., represented at the highest level by the work of Jan Scorel. By 1600 artists like Cornelis KETEL and Michiel van MIEREVELT had freed themselves from the devices of Mannerism and were producing portraits which were comparatively realistic and distinctively Dutch in character. These set the pattern for 17th-c. developments. Mierevelt was a prolific and successful painter and his austere portraits, simple yet dignified, capture the mood of the emerging Puritan nation. Their conception, like those of his many followers, was, however, still linked to the 16th c. Among his pupils RAVESTEYN and MOREELSE produced more informal and livelier variations on the Mierevelt theme. The Group Portrait, a special and almost exclusively Dutch feature, was similarly developed by Ketel and his followers.

In the early 17th c. the pride of the Dutch people and their increasing wealth found a natural outlet in the desire for portraits. The demand was overwhelming and, unlike the earlier artists who combined portraits with other genres, painters now specialized in portraiture alone. Patrons usually included their wives in the commission. Dressed in black like their husbands, their faces framed by a broad white ruff, they were depicted seriously and without flattery. The most prominent of those who met this demand was Thomas de KEYSER, an Amsterdam painter who injected a new vigour into the setting and handling of the portrait. He certainly influenced Rembrandt when the young artist came to Amsterdam. Portraiture was also flourishing at Haarlem and in the lesser towns, each with a competent master. For example Jacob Gerritz Cuyp worked at Dordrecht and HANNEMAN at The Hague.

Rembrandt, the greatest Dutch painter, was an artist who in an age of specialists embraced every field of painting as well as graphic work, and influenced them all. From the very outset of his career, Rembrandt was fascinated by the appearance of the human face, made careful drawings and etchings of his own facial expressions, and often painted members of his family. He acquired supreme mastery in painting the eye and might well have originated the description of the eyes as the windows of the soul. Portraiture was the basis of his success in Amsterdam and although his style became less popular, with patrons turning to van der HELST, Rembrandt never ceased to paint portraits. Nowhere is this continuous interest in portraiture more obvious than in his amazing pictorial autobiography.

Portraiture was fundamental to Rembrandt quite simply because he was primarily concerned with human beings and the mysteries of their lives. In course of time the outward appearance tended to become calmer and more static as he probed deeper and deeper into the inner being. In the rapidly painted later portraits he was able, by his absolute mastery of his medium and its application, to suggest both the underlying structure of a face and its surface texture with the minimum and broadest of strokes. This mastery of the human face with all its subtleties and its range of expression played a major part in the narrative pictures. So often the drama and meaning of a biblical story are seen in the faces of the characters. Even in a large painting like the *Blinding of Samson* (1636) at Frankfort, where the story is told with movement and gesture, the eye wanders again and again back to the fascinating face of Delilah, modelled by Saskia, where relief mingles with horror and guilt at what she has done. Rembrandt's ability to present the physical appearance, allied to a magical characterization in depth, gives him a special place not only in Dutch portraiture but in all portrait painting.

The other great contemporary portrait painter, Frans Hals, although of an older generation, was working at Haarlem throughout Rembrandt's life. Comparison between the two is inevitable. In the opinion of many the comparison emphasizes the more profound nature of Rembrandt's characterization, pinpointing the different approach of these two great artists. It is probable that Hals, in the obscurity of his early career, learnt from the example of RUBENS. There is the same fluency and ability to compose on a large scale in a high range of colour, recalling in both masters the influence of Venetian painting of the previous century. Only by allowing such a probability can one begin to understand how Hals carried out his brilliantly original series of group portraits. Yet Hals's technique is closest to that of a master he is unlikely to have known, VELAZQUEZ.

The group portraits of the Guard Companies (preserved today in the Frans Hals Mus., Haarlem) broke with the tradition of the Group Portrait, which in the 16th c. tended to be like stiff and over-crowded school photographs. The innovations were not lost on Rembrandt when he came to paint groups like *The Anatomy Lesson* (Mauritshuis, The Hague) and *The Night Watch* (Rijksmuseum, Amsterdam). At the end of his life Hals drew near to the spirit of Rembrandt with his group portraits of the *Governors and Governesses* (Haarlem). But those are, perhaps, exceptions and Hals is at his most typical when he portrays a jovial officer, painted with such effortless speed that the picture seems fresh and filled with the vitality of its creator. It was a style which remained dormant until the age of MANET, and it was the success of the latter which revived the neglected fame of his great Dutch predecessor. The influence of Hals in Haarlem is most evident in GENRE paintings. His only

successful follower as a portrait painter was Johannes Verspronk (1597-1662) who, if he could not emulate the Hals technique, at least benefited from the same freshness of approach.

(b) *Landscape*. In the 15th and 16th centuries landscape painting developed as an art mainly through the work of northern artists, but it had remained a secondary interest. In the 17th c. landscape painting emerged as a major art to which, together with CLAUDE Lorraine, Holland made the greatest contribution.

Although it is impossible here to cover even briefly the full richness of this development, we can trace a central framework among important artists into which lesser figures may be fitted. In the first decade the initial impetus of this development came from Flemish art. The Mannerist landscape formula of the 16th c. had established a high horizon, often filled by imaginary mountains, with distance indicated by zones of colour—brown foreground, green for middle distance, blue background. CONINXLOO, a Flemish artist who had worked in Germany, was the principal link, bringing this convention to Holland when he settled in Amsterdam in 1595. His style became more realistic in Holland and formed a point of departure for his two important Dutch pupils, Esias van de VELDE and Hercules SEGHERS. Both painters joined the Haarlem Guild in 1612.

Esias van de Velde developed the realistic approach to Dutch scenery by lowering the horizon, eliminating artificial colour, and giving the whole a new sense of PERSPECTIVE and atmosphere. His later work is well represented by *The Ferry* (Rijksmuseum, Amsterdam, 1622). Van de Velde's pupil Jan van GOYEN was one of the great masters of Dutch landscape. Van Goyen began painting in the 1620s in a style so similar to that of his master that their works have been confused. In the early 1630s he developed a monochrome technique with fine tonal effects and limited local colour. Close parallels to this tranquil style are seen in MARINE PAINTING (Jan PORCELLIS), STILL LIFE (HEDA), and in the architectural subjects of Saenredam. Van Goyen gradually eliminated the mannered features from his compositions and developed the atmospheric effects of light. He retained his monochrome palette, but worked with increasing subtlety and fluency in the 1640s and early 1650s. He was among the most prolific of all artists, producing several thousand paintings and drawings, as he travelled up and down the canals and estuaries of Holland. He also painted on the Rhine. His contemporary, Salomon van RUYSDAEL, began with the same monochrome technique but later used strong colour, painting subjects identical with those of van Goyen. Both artists repeated subjects many times in response to an enormous demand for their simple, poetic landscapes, whose charm derived from their fidelity to nature.

Coninxloo's other pupil, the little-known Hercules Seghers, was a remarkable and wholly individual artist, who was primarily an etcher.

Seghers developed the imaginative aspects of the Flemish tradition, as represented by Coninxloo, SAVERY, and de MOMPER. The majority of his etchings and rare paintings depict a partly real, partly imagined Alpine wilderness; but he turned on occasion to naturalistic subjects, as in the two *Views of Rhenen* (Staatl. Mus., Berlin). He painted these probably in the 1620s, with low horizon and in a style ahead of his time. It influenced the landscapes of Rembrandt, Philips KONINCK, and to a lesser extent, van Goyen. Seghers evoked a mysterious grandeur whose message was understood only by Rembrandt, an avid collector of his work, and Jacob RUISDAEL.

With Jacob Ruisdael, born 1628, Dutch landscape reached its highest point. Ruisdael, nephew of Salomon Ruysdael, added a feeling for structure to the atmospheric achievements of earlier artists and in this way achieved the most fully developed landscapes. His profound understanding of landscape form derived from his almost passionate attachment to nature. In particular, his mastery of trees and their expressive power sets the mood of his paintings, often described as 'heroic'. In his later work Ruisdael painted forest scenes, influenced by EVERDINGEN's Swedish landscapes, which are less Dutch not only in content but also in feeling. More characteristic are the smaller canvases of Haarlem seen across the bleaching ground, or the rare coast scenes (*The Shore at Egmond-aan-Zee*, N.G., London). Ruisdael was too great an artist to be successfully interpreted by pupils. Apart from the many later imitators his only important pupil was Meindert HOBBEMA. But Hobbema worked in a calmer mood, painting forest scenes artificial in colouring and limited in composition. One exceptional and uncharacteristic creation by Hobbema is the best known of his pictures, *The Avenue at Middelharnis* (N.G., London).

The Dutch had an interest in landscape painting which went beyond the depiction of their beloved countryside—hence the popularity of Alpine panoramas, Scandinavian forests, and especially landscapes inspired by the sunlit Italian Campagna. Among the Dutch Italianate painters Philips WOUVERMANS, Berchem, the BOTHS, Karel DUJARDIN, and Jan ASSELYN are best known. Many of these artists were based in Utrecht, the centre of Italian influence in Holland, particularly through the work of Abraham Bloemaert. Yet the greatest exponent of the sunlit landscape, Aelbert Cuyp, never went to Italy. Cuyp began painting in the early monochrome style of van Goyen, and gradually introduced a warm, golden light into his pictures, making an Italian sun shine over Dutch scenery. He was a highly versatile artist, who specialized in putting horses and cattle into his landscapes, although not in the same way as Paulus POTTER or Adriaen van de VELDE. His style was both popular among English collectors and influential among English artists, particularly those of the NORWICH SCHOOL. A capital example of Cuyp's

work is the *View of Dordrecht* (Iveagh Bequest, Kenwood), one of the many fine views he painted of his native town. Even the half light of dawn and dusk and the paleness of moonlight called forth their own landscape master, Aert van der NEER, whose unusual works are immediately recognizable.

Dutch towns were depicted with minute accuracy by van der HEYDEN and the BERCK-HEYDE brothers, who despite a meticulous and detailed finish, exact even to the rendering of individual bricks, yet united the whole by accuracy of perspective and lighting. Individual buildings, and in particular church interiors, were the speciality of Pieter Saenredam, who painted these sparsely furnished interiors in an almost abstract way and found the secret of success in the rendering of light across the pale walls into shadow. Lesser exponents of the painted church interior were Emmanuel de WITTE and Pieter NEEFS the Younger.

Marine painting followed the development of landscape and found its greatest masters in Willem van der VELDE the Younger, and Jan van der CAPELLE, who stand far above other marine artists such as BAKHUIZEN. Their influence on English 18th-c. marine artists is often very apparent.

Indeed such was the strength and variety of the Dutch 17th-c. landscape painters that all subsequent landscape painting has been influenced directly or indirectly by them.

(*c*) *Genre.* The popularity of landscape subjects was surpassed only by that of genre painting. Unlike other contemporary schools, history painting played a very minor role in 17th-c. Holland. The early Haarlem Academy of van Mander and later the Flemish-inspired decorations of the Huis ten Bosch at The Hague are the exceptions that prove the rule. The same is true of the Italianate mythological subjects chosen by Bloemart and POELENBURGH of the Utrecht School. In place of this academic history painting Dutch artists painted a kind of social history of present events. In doing so they were free from convention and formula, and used subject-matter that had seldom in the Renaissance tradition been considered worthy of the high dignity of FINE ART. This tendency clearly accords with the Dutch people's delight in everyday features of their lives and surroundings, and the genre painters treated them with realism and sincerity. Theirs was a direct and in many ways a modern approach to commonplace unidealized material. In a brief survey of genre painting a division may be made between 'peasant' genre and 'fashionable' genre.

As in the case of landscape painting it was an older Flemish tradition that gave the initial impetus to peasant genre. The highly coloured scenes of the BRUEGHEL tradition came to Holland through Flemish artists such as VINCKBOONS, who settled there. ARENTSZ and AVERCAMP were Dutch artists who combined brightly coloured figures in this Flemish tradition with a flat

and realistic Dutch landscape. Avercamp, who might well be classified as a landscape painter, specialized in winter scenes showing people playing games on the ice. At the same time a more characteristically Dutch style of genre was developing at Haarlem, the most important city in the early history of landscape (see Esias van der Velde) and genre. Frans Hals painted genre portraits often with even greater freedom than his commissioned works, and it was his approach in these that most influenced other artists. His son, Dirck Hals, together with DUYSTER, BUYTEWECH, PALAMEDESZ, and Pieter CODDE, took up the popular subject of victorious soldiery in barrack-room and tavern. Judith LEYSTER combined the influence of Hals with a style and choice of subject derived from CARAVAGGIO.

Two other pupils of Hals were Adriaen BROUWER and Adriaen OSTADE. These two concentrated on peasant scenes set in the taverns where smokers and drinkers met. Brouwer, a Fleming by birth, was a very gifted painter who combined the influence of Hals and Rubens in his small panels. Adriaen Ostade began painting in a manner close to that of Brouwer but with a more nearly monochrome palette. As he developed he brought back the bright local colour of Brouwer and also greatly widened his subject matter, becoming the most prolific and characteristic master of the Dutch peasant theme. His brother, Izaak van Ostade, who died young, painted a similar type of subject but his rare works are quite distinctive in tone. Pupils such as DUSART swelled the volume of works painted in Ostade's style. Adriaen Ostade's position corresponds to that of David TENIERS in the Flemish School.

The Leiden painters worked in quite a different manner from those at Haarlem. The leading figure there was Gerard DOU, who painted intimate scenes in the home, and although like LIEVENS he was at first influenced by Rembrandt, he soon developed a style of his own. The work of Dou and his followers, the van MIERIS brothers, was usually on a small scale and always finely finished.

Another distinguished genre painter was Nicolaes MAES, who had been a pupil of Rembrandt in Amsterdam. Maes caught something of the spirit of his great teacher in his early genre pictures, but later he turned to fashionable portraiture which is barely recognizable as the work of the same hand. Gabriel METSU, Dou's pupil at Leiden, was perhaps the greatest master of this style of painting. His charming interiors have particularly fine colour and a meticulous finish. Metsu painted simple scenes of middle-class domestic life and in his later years turned to the leisured pursuits of the wealthier people of Amsterdam. (There are examples of this type in the N.G., London.)

The chief exponent of fashionable genre was Gerard Terborch, who cannot easily be assigned to any regional school. He developed his style from miniature portrait painting and guardroom

scenes, but even at an early date his work was distinguished by its beauty of finish and delicacy of colour. Terborch travelled throughout Europe but he does not seem to have been influenced by foreign schools of painting, although his style does seem to owe something to Metsu. He came from an educated and moneyed background and was the most refined and sophisticated of the small genre painters, recording the trivial events, often of a romantic nature, in the lives of fashionable young ladies with a superb degree of finish. In his handling of fabrics the evidence of the brush almost disappears. Among lesser exponents of the 'fashionable' genre, Caspar NETSCHER and OCHTERVELT are notable.

Jan STEEN held a special place in genre painting as he embraced both lowly and fashionable subjects. He was a humourist and painted with a rollicking vitality. As an innkeeper he had no shortage of subject matter, and in Jan van Goyen's daughter he had a wife who delighted to pose as his model. He clearly benefited from the example of Hals, and painted in the same fluent and colourful vein.

In retrospect—though this was not apparent to the Dutch patrons of the day—Dutch genre painting is seen to have reached a magnificent climax in the work of the Delft masters Jan Vermeer and Pieter de HOOCH. While Terborch and Metsu prospered, Vermeer was unable to sell his own pictures and died in debt. Vermeer must be understood through the study of his rare and supremely beautiful paintings alone, for little or nothing is known of his life, the origin of his style, the reasons for his apparently small output, or the cause of his obscurity. Rediscovery took place mainly in France in the later 19th c. when the IMPRESSIONISTS became absorbed in the effects of light and colour, which were of the essence of Vermeer's work. From long obscurity Vermeer has become, with Rembrandt, the most popular and widely reproduced Dutch painter. His small œuvre can by its subject matter be classified as genre painting, but his paintings have a pictorial and spiritual quality which lift him into an individual category above the contemporary genre painters.

Pieter de Hooch's principal works were painted during his 10 years in Delft, where he married and settled from 1653. These are magnificently represented in the National Gallery, London. After a decade of plein air de Hooch moved to Amsterdam and became a painter of fashionable society. As a result his later, less important works are different in style and quality from the creations of the Delft period. Like the works of Terborch they show the richness and elegance of Dutch life during the second half of the 17th c. when Amsterdam looked to France for an example of gracious living. This life was quite different from those early days of the new Republic and in a sense it marks the beginning of Holland's decline from power and the last phase of her Golden Age of painting.

(d) *Still Life*. Although sometimes neglected by historians, still life was a major art in 17th-c. Holland. There is a variety of reasons for this: the familiar interest of the Dutch in their surroundings and home-life, their passion for the cultivation of the tulip and other flowers, the increasing wealth of material possessions, and the advances made in optical instruments which challenged the skill of the artist in visual accuracy. Again it was Flemish masters, Ambrosius BOSSCHAERT and Roelandt Savery, who introduced flower painting into Holland. Their small pictures, often painted on copper, were subtle in tonality, formal in composition, and meticulously finished. The Bosschaert style was carried on, but without the same perfection, by his three sons and his brother-in-law, Balthasar van der AST, who specialized in still lifes containing a vase of flowers. Flower compositions became increasingly elaborate in the work of later masters such as Abraham Mignon (1640-79) and Jan Davidsz de HEEM. In the late 17th and early 18th centuries Jan van HUYSUM and Rachel RUYSCH created an almost ROCOCO style of flower painting. In the passion for detail the least drop of water or the tiniest insect was accurately depicted, and great skill was exercised in the selection and arrangement of the flowers. Most of the compositions were made from the artists' watercolour sketches so that flowers from different seasons are assembled together in their pictures.

A local tradition for still lifes misleadingly called 'breakfast pieces' was developed at Haarlem. The originators were Pieter CLAESZ and Willem Claesz Heda. Their colour was close to that of a van Goyen landscape, and their rendering of light and atmosphere was carried to an extreme pitch of refinement. These compositions group together objects of many different textures—pewter, porcelain, glass, cloth, clay bowls and pipes, and various foods—all given their exact values. Jan Jansz van de Velde was a principal follower of the Heda manner, while Abraham van BEYEREN made the painting of Holland's rich sea-foods his speciality. In the same way WEENIX was a specialist in the hunting still life and Melchior HONDECOETER in the painting of birds.

Another class of still-life painting was the 'Vanitas' or symbolic picture, analogous to the *memento mori* of earlier religious art. The formative artist was Bailly (1584-1657), who worked at Leiden. His celebrated pupil Jan Davidsz de Heem began painting in this relatively simple manner but later worked in Antwerp and blended his Dutch love of detail and finish with a Flemish formula for elaborate, large-scale banquet and flower pieces in brilliant colouring. The style became very influential in Holland.

In still life other than flower painting the highest praise is justly given to Willem KALF, whose speciality was the 'pronk' or 'sumptuous' still life, an apt name for the opulent assembly of objects usually brought together in his compositions. The quality of Kalf's work rests on his

superb treatment of many different textures and the strength of his Rembrandtesque lighting.

The spirit of still-life art permeates Dutch painting and Dutch masters were its greatest exponents.

4. 17TH-C. ARCHITECTURE AND SCULPTURE. (a) *Architecture*. The rapid economic development of the new Dutch Republic in the 17th c. gave architects their simple requirement—the need for new and better buildings. New patronage took a threefold form. Civic pride and municipal wealth found expression in new administrative buildings; of these, the Amsterdam Town Hall is by far the most impressive. The enthusiasm of a newly liberated faith created fine churches. And with their increasing wealth the powerful merchants commissioned guild-halls and suitably imposing private residences. Of the Dutch towns Amsterdam was always predominant and grew most rapidly in this period, becoming one of the largest cities in Europe. Its orderly construction on concentric, tree-lined canals gave it an individual character and beauty which is little changed today.

Amsterdam's principal architect in the early part of the period was Hendrik de KEYSER, appointed municipal architect in 1595. De Keyser interpreted the works of Serlio in a northern manner and although building in the format required by the Dutch Protestants, his ideas were still governed by the Gothic tradition. The Zuyderkerk (1603-14) has a rectangular plan, yet the simplicity of the exterior is modified by pedimented buttresses and a traditional tower. In the interior the Dutch church no longer required an altar and was designed almost as a meeting-place with a central pulpit as the focal point. In his later works, such as the Town Hall at Delft de Keyser carried the classical elements of his style as far as he was able but it needed an architect more thoroughly versed in the theory of the classical manner to achieve a decisive break with the underlying medieval traditions. De Keyser's contemporary at Haarlem was Lieven de Key (1560-1627), whose work exemplifies a parallel but different use of Serlio's treatises. His façade of the Town Hall at Leiden (1594-5) has over-heavy RUSTICATED blocks on the elaborate stairway, and the basically classical elevation is surmounted by a somewhat incongruous high gable. These two important architects represent the transition from the medieval and Renaissance styles to the beginnings of a new and distinctive classical phase.

The dominant personality of this new phase was Jacob van CAMPEN. Van Campen travelled in northern Italy and was deeply impressed by the ANTIQUE and by the Renaissance buildings he saw there. With his first-hand knowledge of architecture and his sound theoretical education, he made great innovations. His career was helped by the friendship of Constantijn Huygens, the erudite secretary of the Stadtholder, who took the lead in promoting the new style. Huygens and van Campen put their ideas into practice when they collaborated in the building of Huygens's house in The Hague (now demolished) and the renowned Mauritshuis. This was built between 1633 and 1643 for Prince John Maurice of Nassau from whom its name derives. The designs of Campen and Huygens were executed by Pieter Post (1608-69). The house was built on a regular ground plan with each façade articulated by giant pilasters. On the two main façades the central bays are surmounted by a PEDIMENT which contains reliefs of battle scenes in the antique manner. The most striking features of the Mauritshuis are its sense of harmonious proportions and the absence of unwieldy decoration. Inside the same qualities are manifested in the arrangement and decorations of the individual rooms and their relationship to one another. The Mauritshuis is, however, small in comparison to French palaces of the day and the use of plain brickwork beneath the stone pilasters is characteristically Dutch. The Court at The Hague, with both the Stadtholder and Huygens taking great interest in the arts, was a centre of French influence in architecture. For instance the courtyard in Huygens's own house —originally opposite the Mauritshuis—is one example of the introduction of French features. Van Campen's work is paralleled in England by that of Inigo JONES and in France by that of François MANSART.

Jacob van Campen's greatest fame rests on his design of the new Town Hall for Amsterdam. Not the least remarkable feature of this building occurred at the outset of construction. As in the case of most Amsterdam building, piles had to be sunk into the marshy ground to make a firm foundation and for the huge Town Hall more than 13,000 piles had to be driven 70 ft. into the ground. The ground plan derives from an older French model with a great central hall across the full width of the building. This hall is designed in accordance with the Vitruvian proportions for the ancient VILLA at Fano. As in the case of the Whitehall Palace in London, the ground plan is not based on PALLADIAN principles but in general the elevation and the details of the façade derive from Italian prototypes. Van Campen's debt to Italy had been revealed earlier in his designs for the Theatre in Amsterdam (1637, now lost) which were based on Palladio's Teatro Olimpico in Vicenza.

Only the Trippenhuis, a palatial private residence in Amsterdam, even approached the same high standards of classical harmony set by van Campen. It was built by VINCKBOONS for the Tripp brothers, whose parents are immortalized in Rembrandt's portrait in the National Gallery. Like van Campen, Vinckboons used the Giant Order (see COLOSSAL ORDER) on the façade and gave a classical elevation to the house on the canal. Normally, however, practical limitations governed the style of houses in Amsterdam. All were, of course, built on piles, and as a rule the architects tried to avoid superfluous weight; also stone was an expensive luxury as it had to be

imported. A typical Dutch house of the 17th c. was built of brick on a narrow frontage, with a high stepped gable. Buildings on a broad rectangular plan constructed of stone were rare, far outnumbered by the red brick houses that still line Amsterdam's canals.

In church architecture the search for monumental forms resulted in the development of the centrally planned church. Among these is the Nieuwe Kerk at Haarlem, built by van Campen 1645-9, which has a 'cross-in-square' plan.

Towards the end of the 17th c. the influence of France, so marked in the social habits of the wealthier Dutch, made an impact on architecture. Willem III, in the tradition of earlier Stadtholders, welcomed French ideas and like other European monarchs sought to introduce the grand style of Louis XIV. It is ironic that the Dutch should have followed the example of the 'Roi-Soleil' so eagerly when his armies were to invade their country in 1672 with considerable cruelty. The Louis XIV style was applied to the restrained architecture of Dutch Classicism. This new style was promoted and disseminated through the engravings of Daniel MAROT, a French Huguenot refugee, who worked as an architect in Holland. Thus the pattern was set for the 18th c., which in all aspects of its art was to lean heavily on the great achievements of the Golden Age.

(b) *Sculpture.* The newly found independence and increasing prosperity gave rise to a demand for sculpture unparalleled in earlier times. Elaborate tomb sculpture, portrait BUSTS and statues, decorative panels, and even garden sculpture were the new order of the day. Hendrik de Keyser, master builder in Amsterdam, was also the leading sculptor of his time in Holland. His sculpture shows an interpretation of Mannerist ideas that is similar to his understanding of Mannerist architecture. But in his portrait busts he displayed a high degree of detailed realism and a feeling for characterization. His daughter married the English sculptor Nicholas STONE, and the close personal relationship between the two men made de Keyser's style particularly influential in England.

As with architecture it required a more widely travelled artist to introduce a new and up-to-date style in sculpture. The new impetus came from two Flemish artists, Artus QUELLINUS and Rombout VERHULST. Quellinus was born in Antwerp and went to Italy, where he studied under DUQUESNOY and naturally came under the influence of BERNINI. He made fine portrait busts in Amsterdam, but his major work was the sumptuous sculpture for the new Town Hall there. He had a large team of assistants but the terracotta working models (Rijksmuseum) show the high quality of his own work. Among Quellinus's assistants was Verhulst, a native of Malines who had settled in Amsterdam in 1645. Verhulst also worked on the monument to Admiral de Tromp and that to Admiral de Ruyter, both in the Nieuwe Kerk at Amsterdam.

Many other sculptors were active in Holland during the 17th c., but none could match the quality of the Flemish-born masters. In sculpture alone among the arts Holland failed to produce an artist of international stature in the 17th c.

5. PAINTING AFTER 1700. Dutch painting in the 18th c. represents a decline after the brilliance of the previous period. Some artists continued in the style and subjects of their great predecessors, but without inspiration or originality. Others turned to a superficial imitation of the French. In general the identity of Dutch art seems lost compared to the 17th c. and only a few names need be mentioned. Among these Cornelis TROOST, who painted portraits and theatrical scenes, was the most spirited; but his style derives from French examples. The same is true of the decorative painters Jacob de WIT and Aert SCHOUMAN, who worked in a light-hearted French manner, successfully catering to new tastes. History painting, represented by Adriaen van der WERFF, was also in vogue. Jan van Huysum and Rachel Ruysch continued until the mid century painting fine flower pieces, a tradition carried on until the end of the century by Schouman's pupil, Jan van Os. These are the most highly prized of Dutch 18th-c. paintings.

At the turn of the century and in the early 19th c. Dutch art followed the general phases of European art, initiated by France. A weak form of academic, NEO-CLASSICAL painting, derived from DAVID, was pursued by Dutch artists. History painting, for example, was in demand and its chief exponent was PIENEMAN. Yet in the same period there began a revival in landscape painting. To some extent Dutch artists turned back to the realism and simplicity of the 17th-c. masters in reaction from the artificialities of the 18th c. and the academic phase. A ROMANTIC period followed, and Dutch painters wavered between Romanticism and Classicism. Romantic landscapes were done in great quantity by the KOEKKOEKS and Avy SCHEFFER, although the latter settled in France. An important figure emerged at the mid-century, Josef ISRAELS, who was at first a pupil with Pieneman. In 1870 Israels settled in The Hague and is generally called the founder of the HAGUE SCHOOL. Contemporary with him were other genuinely Dutch artists whose work had the spontaneity and freshness of the traditional realistic temper. The greatest of these, JONGKIND, settled in France and through BOUDIN in particular influenced the French IMPRESSIONISTS. Jongkind's merits and influence were not recognized until well into the 20th c. The Hague School brought together several excellent artists, of whom the best known after the Israels and MARIS families are BOSBOOM, Anton MAUVE, the WEISSENBRUCHS, and MESDAG. A lyrical quality in the landscapes of the Hague School distinguished them from the equivalent French group, the BARBIZON SCHOOL, to whom they were related. Their works were popular, especially in England and America, and commanded

high prices. Many followers emulated the subtle colouring and atmospheric mood—typically Dutch characteristics—of their landscapes. The Impressionist phase which followed was, by comparison, disappointing. Only BREITNER, in his later work, had distinction.

The great Dutch-born artist of the 19th c. was, of course, Vincent van GOGH, who does not easily find a place in the general history of Dutch art. His highly individual style, while it contains certain Dutch characteristics, is both too personal and too much affected by the art of his adopted country for him to be regarded as a native Dutch artist.

Dutch art in the 20th c. has produced worthy representatives of the diverse movements in European art. Among the older generation Jan SLUYTERS was important for his introduction of FAUVISM into Holland, although he later joined the EXPRESSIONIST 'Bergen School'. Similarly Leo GESTEL brought abstract painting to Holland. A popular artist of this generation was Kees van DONGEN, who settled in Paris and after toying with various contemporary styles became a witty recorder of social life in a colourful and fluent manner. Decorative linear art in a SYMBOLIST vein was represented by a slightly older artist, Thorn Prikker, and by Jan TOOROP, who was much influenced by Oriental art.

Since the First World War the most interesting developments have been the Bergen School and the artists of the De STIJL group. Among the moderns APPEL, an ABSTRACT EXPRESSIONIST, stands out. Bergen, in north Holland, was the centre for a group of artists, including Sluyters and Gestel, who range over various styles but are primarily Expressionistic. KRUYDER and WIEGMAN were notable members of this group. The De Stijl group included van der LECK and van DOESBURG, but the dominant figure was Piet MONDRIAN, the most significant modern Dutch painter. The beauty of Mondrian's abstract work might be regarded as a modern expression of latent abstract values which fascinated the 17th-c. painters of church interiors, above all Saenredam. In the same way the restless vitality and personal tragedy of Rembrandt are found again in van Gogh. Such parallels might be taken to show both the continuity and the diversity of Dutch painting over the centuries.

6. ARCHITECTURE AND SCULPTURE AFTER 1700. (a) *Architecture.* The style of architecture instigated by the Stadtholder Willem III at The Hague remained popular far into the 18th c. There was a great increase in the number of commissions for private houses both in towns and in the country, but as the 18th c. progressed the original purity of the style was submerged beneath ever increasing decorative detail. The doorways in particular were surrounded by carved wood, disturbing the symmetry of the façade. Inside the rooms were elaborately ornamented with stucco-work.

In contrast to the activity in private domestic building the commissions for civic construction were less lavish than in the previous century. The most successful and original architects of the day gathered round the Stadtholder. P. de Swart (1709–73), who was court architect to Willem IV had been trained in Paris, a Paris where the current trends were in a transitional stage between LOUIS XV and LOUIS XVI. The house in The Hague (1765), now the Royal Theatre, is a fine example of Swart's work.

Towards the end of the 18th c. the elaboration of house façades was countered by a conscious revival of classical forms. This Neo-Classicism in Holland is best represented in the work of Jacob Hulsy, whose design for the Town Hall at Weesp (1772) has a façade of sober, classical proportions with the central bay emphasized by attached pilasters and a carved pediment. Just as the style of the late 17th c. degenerated during the first half of the 18th c., so the grand Neo-Classical style of the 1770s declined as it persisted far into the 1800s.

Suddenly, however, there was a complete reversal with the penetration to Holland of a GOTHIC REVIVAL. King William II of the Orange Royal House was partly responsible for introducing the Neo-Gothic style from England, and the popularity of 'Gothic' forms grew and became fashionable for country houses and churches alike. At first stucco decoration was used in the English manner, but by the mid 19th c. Dutch architects had returned to the traditional material—brick. The chief exponent of the mid-century style was CUYPERS, who built fine churches as well as the Rijksmuseum in Amsterdam. Despite the vogue for the Neo-Gothic other styles of building were popular. Architects borrowed from Florentine palaces and Palladian villas at will, and the complex variety of styles closely paralleled the buildings of Victorian England.

Towards the close of the 19th c. some architects turned away from the historic, eclectic style of their contemporaries towards ART NOUVEAU and this tendency extended to the De Stijl group, who faced the problems of architecture in a new and rational spirit. RIETVELD, who built the house in Prins Hendriklaan, Utrecht, in 1924, was clearly influenced by Frank Lloyd WRIGHT.

Although cities like Amsterdam give little scope for new urban schemes of the 20th c., the city of Rotterdam, largely rebuilt after 1945, gave modern architects the opportunity to make an important contribution to the European movement.

(b) *Sculpture.* Throughout this survey of Dutch art sculpture has played the minor role which it warrants. From 1700 until c. 1870 there are few distinguished names to be found, but with Impressionism Dutch sculpture recovered some importance. The pioneers of the Impressionist movement were L. Zijl (1866–1947) and Mendes da Costa (1863–1939).

The successors of these two artists are as numerous as their styles are varied. The comprehensive selection of modern sculpture dis-

played in the Kröller-Müller Museum, and its gardens, emphasizes the belated emergence of sculpture as an active force in Dutch art.

103, 254, 297, 323, 335, 443, 593, 926, 927, 928, 937, 1171, 1172, 1372, 1381, 1419, 1749, 1775, 1836, 1837, 2010, 2023, 2146, 2300, 2308, 2548, 2950.

**DUTCH MORDANT.** An acid used for biting the plate in ETCHING. It is a solution of dilute hydrochloric acid with potassium chlorate, and as it works with a clean and regular action it is preferred to nitric acid for AQUATINT, soft-ground etching, and other fine, close work.

**DUVET**, JEAN (c. 1485-1561). French gold-smith and copper plate engraver, sometimes called the Master of the Unicorn from his series of engravings (probably from the 1540s) on the medieval theme of the hunting of the unicorn. His most famous work is a set of 24 engravings illustrating the APOCALYPSE, published at Lyon in 1561. His subject emulates the wood engrav-ings of DÜRER (1498) but his treatment is entirely different. In contrast to the mannered elegance of the School of FONTAINEBLEAU his work reflects the disturbed religious conditions which pre-vailed in his home town of Langres and breathes a mystical urgency and emotional unbalance more akin to the frenzy of early Italian MAN-NERISM.

**DUYSTER**, WILLEM CORNELISZ (1599-1635). Dutch painter of GENRE scenes and por-traits, a pupil of Pieter CODDE. His treatment of the texture of stuffs, and even more important his ability to characterize individuals and his power to express subtle psychological relation-ships between them, suggest that if he had lived to maturity he might well have rivalled TERBORCH.

**DYCE**, WILLIAM (1806-64). Painter and educationalist, born at Aberdeen. The decisive influence on Dyce came from two visits to Italy in 1825 and 1827-30; he was profoundly im-pressed by 14th- and 15th-c. Italian painting, especially that of RAPHAEL, and by the problem of fresco in relation to its architectural setting. He also came into contact with the German NAZARENES, whose Christian primitivism he tried to acclimatize in Scotland (*Madonna*, 1828). He turned to science and also became a successful, though conventional, portrait painter and a member of the Scottish Academy. Not until after 1840 was he able to devote himself to more ambitious work, designing CARTOONS for historical wall-paintings for the Houses of Parlia-ment and decorating All Saints Church, Mar-garet Street, 1858-9. He was commissioned by the Council of the newly founded Government

School of Design (see ART EDUCATION), which included EASTLAKE, CHANTREY, and CALLCOTT, to investigate state schools in France, Prussia, and Bavaria and was appointed Director in 1840 on his return. In 1844 he published his *Theory of the Fine Arts*. His *Joash and the Arrow of Deliverance*, exhibited at the Academy in 1844, stood out for its strong and simplified design. His easel pictures anticipated the PRE-RAPHAELITES in their luminous precision (*Francesca da Rimini*, N.G., Edinburgh, 1830) and he was in many ways a bridge between the Nazarenes and the Pre-Raphaelite medievalism, though stronger than either. The extent of his influence in British 19th-c. art has yet to be fully investigated.

**DYCK**, SIR ANTHONY VAN (1599-1641). Flemish master who had more influence than any other artist, except perhaps HOLBEIN, on the course of FLEMISH PAINTING. He was born in Antwerp, his father being a silk merchant, his mother well known locally for embroidery. Even in his youth the ripeness of his talent was astonishing. About 1610 he began his apprentice-ship with Hendrick van Balen (1575-1632) and there is evidence that as early as 1615-16 he painted a series of *Apostles* with the help of assis-tants. This was highly irregular because accord-ing to the rules of the Antwerp Guild of St. Luke it was illegal for an artist to sell his work or have pupils unless he was a master of the Guild. Van Dyck was only admitted as a master in 1618. About this time he entered RUBENS's workshop. Strictly speaking he should not be called Rubens's pupil, as he was an accomplished painter when he went to work for him. Never-theless the two years he spent with Rubens were decisive and Rubens's influence upon his paint-ing is unmistakable, as in the *Carrying of the Cross* (St. Paul's, Antwerp, 1617-20). But con-versely the hand of the young van Dyck can be recognized in many of the large works which left Rubens's studio (*Le Coup de Lance*, Antwerp). In 1620 van Dyck went to London, where he spent a few months in the service of James I; then in 1621 to Italy, where he travelled a great deal. A sketch-book of his drawings at Chats-worth contains a record of his Italian impres-sions. In Italy he toned down the Flemish robustness of his early pictures and created the refined and elegant style which remained charac-teristic of his work through the rest of his life. It was there, while painting the great series of BAROQUE portraits of the Genoese aristocracy, that he created the 'immortal' type of nobleman with proud mien and slender figure enhanced by the famous 'van Dyck' hands. The years 1628-32 were spent mainly at Antwerp. From 1632 until his death he was in England—except for visits to the Continent—as painter to Charles I, from whom he received a knighthood. During these years he was occupied almost

entirely with portraits. Perhaps the strongest evidence of his power as a portraitist is the fact that today we see Charles I and his court through van Dyck's eyes. It is customary to accuse van Dyck of invariably flattering his sitters, but not all his patrons would have agreed. When the Countess of Sussex saw the portrait (now lost) van Dyck painted of her she felt 'very ill-favourede' and 'quite out of love with myself, the face is so bige and so fate that it pleases me not at all. It lokes lyke on of the windes puffinge —but truly I think tis lyke the originale.'

Van Dyck's fame derives chiefly from his portraits and his influence on English portraiture has been profound and lasting. But he also painted religious and mythological subjects, and a surprising facet of his activity is revealed by his landscapes in water-colour. His *Iconography* (1645) is a series of etchings or engravings of his famous contemporaries. Van Dyck etched 11 of them, and a handful were begun by him and finished by others. Many more were engraved after his drawings and oil sketches.

675, 1055.

**DYING GAUL.** Famous copy (Capitoline, Rome) of a Greek statue in the 'PERGAMENE' style of the late 3rd c. B.C. The figure, whose accessories are scrupulously Gallic, supports itself wearily on one arm. The common title 'Dying Gladiator' is a misnomer.

# E

**EAKINS,** THOMAS (1844-1916). American painter. Born in Philadelphia, he passed the majority of his life there with the exception of a period of training in Europe, 1866-70. There he learnt much from the Spanish realists VELAZQUEZ and RIBERA and from the taut and disciplined naturalism of his master, Jean-Léon GÉROME, he absorbed a precise and uncompromising sense for actuality which he applied to portraiture and GENRE pictures of the life of his native city. His love of factual statement combined with a strong scientific interest, which culminated in an enormous painting *The Gross Clinic* (Jefferson Medical College, Philadelphia, 1875). In advance of its time, this picture was refused for the American section of the Centennial Exhibition. Eakins was interested in the subtle and dramatic play of light but preferred sombre Rembrandtesque tones to the scale introduced by the IMPRESSIONISTS. As a teacher at the Pennsylvania Academy of Fine Arts, he created a revolution by his emphasis on drawing from the life and had a lasting influence on many of the younger painters of his day. Among his many outstanding works are *The Biglen Brothers Racing* (N.G., Washington, 1873) and a portrait of his father *The Writing Master* (Met. Mus., New York, 1881).

1100, 1732, 2135.

**EARL,** RALPH (1751-1801). American painter, perhaps the most notable of the 18th-c. New England untrained professional artists. Though he was in England 1778-85, studied with Benjamin WEST in London and exhibited at the ROYAL ACADEMY in 1783, this made little impression on the archaic severity of his provincial REALISM. His art was devoted to the faithful portrayal of the Connecticut squires, their wives, their farms, and their homes, and his portraits convey the immense pride these New Englanders took in their possessions. For instance in the portrait *Oliver Ellsworth and his Wife* (Wadsworth Atheneum, Hartford, Connecticut, 1792) a window shows a view of the very house in which the proud owners are sitting. Such naïvety is redeemed by a sincerity and a freshness of vision which make Earl one of the most distinctively American of Colonial painters.

2401.

**EARLOM,** RICHARD (1743-1822). The first British engraver to combine the processes of ETCHING and MEZZOTINT by his use of the etched line on a mezzotint ground. His most celebrated work, the 200 plates after CLAUDE's *Liber Veritatis*, was published by BOYDELL in two volumes in 1777.

**EARLY CHRISTIAN ART.** Although most medieval European art was Christian, the term 'Early Christian art' is commonly used in art history for the Christian art of the centuries c. 300-750, particularly in Italy and the western Mediterranean. The present article will be concerned with this. The art of the eastern empire during these years is dealt with under BYZANTINE ART and the art of the barbarian Germanic tribes under MIGRATION PERIOD ART. There are no hard-and-fast demarcations between these divisions and a certain amount of overlapping is inevitable.

In the period of alternate toleration and persecution before the emperor Constantine made Christianity an official religion of the empire (A.D. 313) and throughout the 4th c. Christian art adapted the artistic language and styles of classi-

cal paganism for the expression of its own icono-
graphical ideas. The Christian emphasis on the
immaterial world of the spirit brought disregard
for the classical ideals of beauty and nobility of
physical form and the Christian adaptations were
valued for their symbolic significance rather than
for visual beauty or technical perfection. No
new artistic style was evolved but a new ICONO-
GRAPHY was born, much of which remains still
integral to the Christian cult. In summary,
therefore, Early Christian art, was stylistically
undifferentiated from the Late Antique (c.
A.D. 300–500) period of classical art, technically
inferior, new in its iconography.

Early Christian painting is exemplified in
the decorations of the catacombs, subterranean
burial galleries cut out of the tufa alongside the
highways. Catacomb burial was not peculiar to
Christianity but was originally an Oriental custom
and the purpose was not concealment, although
in the special conditions of Christianity in Italy
during periods of persecution concealment be-
came a factor of importance. Catacomb burial
declined after Constantine and came to an end
with the first quarter of the 5th c. The fresco
decorations of these narrow galleries, mainly on
ceilings, were inferior examples of the tradition of
Italian mural painting which is represented at
its best by the 'Fourth style' of POMPEII. The
motifs were taken over and adapted to Christian
symbolism (e.g. the Good Shepherd signifying
CHRIST, the Heavenly Banquet, the peacock signi-
fying immortality, the DOVE standing for the
soul, the anchor for hope, and so on). Simplified
renderings of Old Testament stories such as that
of Jonah and the Whale were used as emblems or
'types' of salvation. As the 3rd c. progressed it
became increasingly usual to depict scenes of
Christ's miracles, in which Christ was always
represented as beardless. The same century also
produced the first example of what was later
to be the favourite theme of Christian art,
the Madonna and Child, and more doubtfully the
earliest known Annunciation. As paintings the
catacomb murals were mediocre in execution and
design. Their purpose was contained in the
iconography and was not aesthetic: they were
visual emblems of prayer rather than works of
art and the symbolism was what mattered.
Naturalism tended to degenerate to a sketchy
formalism; scenes and stories were not fully
depicted but were indicated by a few figures or
emblems.

In the Near East, if not elsewhere, the intro-
duction of representational art into churches
began almost as early. The walls of the Dura
Europos meeting room in eastern Syria were
covered with paintings of Old Testament scenes
and miracle stories treated in a much more ela-
borate way than the corresponding paintings
in the catacombs. Here the REALISM of late
HELLENISTIC art was tempered by a more abstract
treatment of the human form and its setting
characteristic of the Near East: although the
details of the style were local, the Dura paint-

ings illustrate the orientalizing trend in the art
of late antiquity, which Christianity encouraged
but did not initiate.

Christian sculpture in the 4th and 5th cen-
turies was little more than the output of stone-
masons, working in the earlier part of this period
for pagan as well as Christian patrons and follow-
ing standard patterns. As catacomb burial
declined a favourite form of Early Christian
sculpture was the stone or marble SARCOPHAGUS,
often elaborately if uninspiringly carved, ex-
amples of which survive in great numbers from
Arles to Asia Minor. On the sculptured friezes
of one group of these sarcophagi occur some of
the earliest representations of Christ and the
APOSTLES. An example is the sarcophagus used
for Junius Bassus, a Roman consul (d. A.D. 359),
now in the Vatican. A rather finer example is
a fragment from Psamatia (Staatl. Mus., Berlin,
c. A.D. 400). Here the youthful beardless Christ
continues the type of the Greek god Apollo
and he is clothed in what appears to be a pal-
lium, a garment associated with philosophers
and teachers or with priests and initiates in the
mystery cults of late antiquity. In the worst
examples the frontally staring figures, artlessly
combined and varying in size in a crude attempt
to indicate depth, show how far antique figure
art had declined. In the better ones the plastic
and naturalistic classical treatment is replaced
by a linear formalism which succeeds in convey-
ing a naïve and unsophisticated HIERATIC charac-
ter not out of keeping with the symbolization of
a new spiritual ideal.

A generally higher level of artistic achievement
is to be found in the illustration of similar themes
on IVORIES manufactured for liturgical and private
use in all regions of the Mediterranean. Those
of the later 4th c. show considerable extension of
the subject matter of Christian art. Scenes of
Christ's PASSION were here represented for the
first time and shortly afterwards appeared also
on sarcophagi made predominantly in north Italy
and southern Gaul. Not until the early 5th c.,
however, on an ivory now in the British Museum,
was there any representation of Christ on the
Cross. CRUCIFIXION was a form of punishment
reserved for criminals and held to be shameful in
antiquity. Christ's crucifixion was a source of
ridicule to Christians and in the early centuries
representations were abstract and symbolic, such
as the relief carving on the doors of Sta Sabina in
Rome (c. A.D. 432). By this time the earliest
opposition to the use of visual imagery had almost
entirely disappeared among Christians. Eusebius
early in the 4th c. still objected to attempts to
portray Christ as God Incarnate in Man; later
writers occasionally criticized the depiction of the
Crucifixion and the portrayal of persons recently
dead, however saintly, in close association with
Christ and the Apostles. But the use of pictures
to instruct and inspire the faithful was widely
advocated by the 5th c. (St. Augustine's doubts
were exceptional). Literary descriptions make
it clear that the decoration of a church's entire

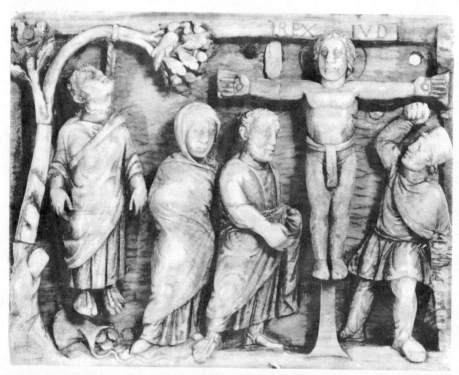

**114.** Ivory carving of the Crucifixion. (B.M., 5th c.)

wall space with narrative and symbolic illustration was usual by the end of the 4th c. The earliest surviving large-scale example is to be found at Sta Maria Maggiore, Rome (A.D. 432–40): here MOSAIC illustrations of the Septuagint, in an untypically naturalistic style and probably derived from a manuscript, fill the walls above the nave colonnade; and scenes from Christ's life, also in mosaic, occupy the arch over the entrance to the apse.

Both Alexandria and Syria seem to have played important parts in the development of a specifically Christian manuscript illustration. Comparison of the Alexandrian London Cotton *Genesis* illustrations (*c.* 500) with those in the Vienna *Genesis* from Antioch of slightly later date seems to confirm the evidence of ivories that, contrary to a widely held view, Syria was maintaining more of the spirit of Hellenistic naturalism than was Alexandria, where landscape and figures were treated in a more abstract style. But in the first surviving illustrated Gospel manuscript, also from Antioch, the early 6th-c. *Rossano Gospels*, the effect of an Asiatic, non-classical style is more evident. The most complete elimination of classical, naturalistic features in Christian art before the 7th c. is, however, apparent in the art of the Coptic areas of Egypt (see COPTIC ART). In Northumbria, a totally distinct, Germanic and Celtic tradition is apparent in the 7th-c. ornamentation of manuscripts, as in

*The Book of Durrow* and *Lindisfarne Gospels* (see ILLUMINATED MANUSCRIPTS).

The buildings associated with the Christian cult in the first three centuries were not without their effect on later periods. 'House-churches' continued to be built in 4th-c. Syria, and even in the 6th c. the simple rectangular hall with a free-standing clergy bench and altar in front of it was still being used for churches in north-east Italy; while the circular or rectangular tomb-monument provided the model for the typical BAPTISTERY of later centuries as well as for many of the buildings erected in the 4th and 5th centuries on sites of special Christian veneration. After the recognition of Christianity in A.D. 313, however, the regular liturgical ceremonies of the Church were provided with an entirely new architectural setting, which even today constitutes the typical scheme for a Christian church building. The temple of classical antiquity housed the god and the altar for sacrifice was outside. The new type of Christian church building represented the solution to a new problem arising from the liturgical need to house the congregation inside. For this purpose the traditional meeting hall or basilica was taken as model. The development of the Christian church from the Roman basilican plan is discussed in articles under BASILICA and CHURCH.

The apse of the basilican church became the favourite place for mosaic decoration. The

**Fig. 20.** Plan of Old St. Peter's, Rome (*c.* A.D. 330). *a.* Atrium *b.* Baptistery *c.* Apse

familiar bearded Christ apparently originated in the art of Syria. He appears surrounded by the Apostles seated as an emperor on a throne in the apse of the church of Sta Pudenziana, Rome. The characteristic mingling of styles which went to the formation of Christian art is best illustrated by the mosaics of Ravenna in the century A.D. 450–550. But as the art of the mosaic was most elaborately developed in Byzantine art, it is discussed under that head.

Much inferior in quality to their immediate predecessors, works of art produced in the generation after Justinian show an increasing divergence of styles between the Greco-Asiatic east and the Latin west, although the almost simultaneous appearance in Italy and Byzantium of the first Christian PANEL paintings (of saints and of the Virgin) in the 7th c.—a momentous development—indicates that the artistic links were still close. Among the finest Western works of art in the 7th c. are those from newly converted Northumbria where—as, for example, on the Ruthwell Cross—the artist had been inspired by but was not merely imitating older or contemporary Mediterranean models (see ANGLO-SAXON ART). Artists of the CAROLINGIAN and later medieval periods made use of both the classical and non-classical elements in Early Christian art; but the style and vocabulary of their creations were something new and distinct.

33, 463, 465, 687, 724, 1113, 1117, 1119, 1121, 1521, 1526, 1722, 1853, 1871, 1910, 2315, 2768

**EARLY ENGLISH STYLE.** The terminology which is still used to distinguish the several kinds of English medieval architecture was evolved at the end of the 18th and beginning of the 19th centuries. Before then GOTHIC had often been

a term of abuse, and when medieval architecture began to be appreciated again efforts were made to find another name for it. At first the term 'Pointed style' was used. Then in 1802, with characteristic insularity, the appellation 'English' was proposed for the pointed style because its appearance coincided with the formation of the truly English monarchy of Henry II. Later, in 1817, RICKMAN introduced the further subdivisions of the English style with which we are familiar, namely Early, DECORATED, and PERPENDICULAR. The Gothic or Pointed style as a whole had been identified by the use it made of pointed ARCHES but Rickman's more detailed classification was based on window forms. Thus Early English was distinguished by long narrow windows without mullions (see TRACERY). In 20th-c. architectural history, however, though the name is retained its connotation has become very much wider.

The style spread over England from three regional centres, the south-east, the west, and the north. It is generally considered that the choir of Canterbury Cathedral (after 1174) was the first truly Gothic building in the country. The Canterbury design was provided by a Frenchman, William of SENS, and it was a compromise between a typical north French Gothic church of the period and the remains of the early 12th-c. NORMAN choir which determined the plan. This leaves Canterbury in a rather curious position: it was influential but was not copied.

The Gothic of the West Country, which was fully developed at Wells Cathedral (started in the 1180s), was of a much more insular character. It had very elaborate PIER profiles and ARCADE MOULDINGS, which hardly disguise the underlying thick walls. In the north the long series of TRANSITIONAL buildings culminated after 1200

355

in a style based wholly on the enrichment of the visible parts of the interior walls with shafts and mouldings (the choir at Rievaulx Abbey).

At first in all these regions the VAULTS played a comparatively subordinate part in the design and in the north they were not even considered essential in spite of the fact that the earliest ribbed vaults in Europe had been built at Durham by 1104. It was not until Lincoln Cathedral (after 1192) that English masons began to explore the visual possibilities of vaults and to accord them equal prominence with the rest of the building. The vast interior of Lincoln Cathedral was a particularly successful attempt in which piers using a good deal of PURBECK MARBLE shafting, arch mouldings, and ribbed vaults were combined harmoniously together, and it is not surprising that this set the standard of what a great church should look like for the next 50 years. The choirs of Worcester, Beverley, and Ely all betray their several debts to Lincoln. The one important exception was Salisbury Cathedral (started 1220), where interest seems to have shifted somewhat from the masonry forms to the windows. This was a characteristic development; during the early part of the Gothic period windows were used sparingly, and they cannot have admitted very much light. By the middle of the 13th c., however, single lancet windows were being grouped together and some splendid façade designs, such as the Five Sisters at York, were constructed entirely out of lancets.

Early English churches show a marked preference for rectangular planning and from the outside they must have presented long, low outlines broken only by the numerous gables. The typical Early English west front took the form of a great screen (Lincoln, Wells, and Salisbury); although one outstanding exception was the west front of Peterborough, which consists of three enormous recessed PORCHES.

**EASEL.** Some kind of stand must have had its place in the painter's workshop at all times when portable pictures were made. The oldest representation of an easel is on an Egyptian relief of the Old Kingdom (see EGYPTIAN ART). PLINY mentions a *machina* in an anecdote about APELLES. RENAISSANCE illustrations of the artist at work show all kinds of contrivances, the commonest being the three-legged easel with pegs such as we still use today. Light folding easels were not made until the 18th and 19th centuries, when painters took to working out of doors and sketching became a pastime for the AMATEUR. The studio easel, a 19th-c. invention, is a heavy piece of furniture which runs on castors or wheels, and serves to impress the clients of portrait painters. The oil painter needs an easel which will support his canvas almost vertically or tip it slightly forward to prevent reflection from the wet paint, whereas the water-colourist

**115.** *Le Noble Peintre.* Etching (1642) by Abraham Bosse

**116.** Easel for sketching out of doors. Designed by Frederick Harvey. From the official catalogue of The Great Exhibition of 1851

must be able to lay his paper nearly flat so that the wet paint will not run down.

**EASTER SEPULCHRE.** Term in Christian church architecture. A recess in the north wall of the choir found in many English churches near the altar, representing the shrine of the Body of our Lord, at which the Host was worshipped on Good Friday and from which an image of the Resurrected CHRIST was carried in procession on Easter Sunday. Usually such sepulchres were of wood, temporarily erected. The earliest stone niches date from the 13th c., while those of the following century are more elaborate, surmounted by CROCKETED CANOPIES and some richly sculptured (Lincoln Cathedral; Navenby, Lincs.). Sometimes a tomb served as an Easter sepulchre (Irnham, Lincs.). Such monuments are only found in England. Elsewhere in Europe a sculptured group of the *Entombment* served a similar purpose.

**EASTLAKE,** SIR CHARLES LOCK (1793-1865). English painter, born at Plymouth. He studied under HAYDON and at the R.A. Schools, and was in Italy 1813-30 with a visit to Greece in 1818. He became A.R.A. in 1827 and R.A. in 1830. Beginning as a history painter he turned in Italy to romantic peasant GENRE and won acclaim with *Pilgrims arriving in sight of St. Peter's* (Woburn Abbey, 1825). It is, however, as administrator and public servant that his record is most remarkable. He was Librarian of the R.A. (1842-4), Secretary to the Fine Arts Commission (1842), Keeper of the NATIONAL GALLERY (1843-7), Commissioner for the 1851 Exhibition, P.R.A. (1850), and Director of the

National Gallery from 1855 until his death. Among his writings, *Materials for a History of Oil Painting* (1847) was a pioneer work. His informed purchases of early Italian paintings for the National Gallery, London, were invaluable. His wife, Elizabeth Rigby, who wrote his *Memoir* (1870), published along with his own *Contributions to the Literature of the Fine Arts*, was in her own right a figure in the literary-artistic world of the day. She translated Waagen's *Treasures of Art in Great Britain*, 1854-7. His nephew CHARLES LOCKE EASTLAKE published *Hints on Household Taste* (1868), which had an important influence during the last quarter of the century when taste in interior decoration became more restrained and austere.
795, 796, 797.

**ECCLESIA AND SYNAGOGUE.** Derived from Early Christian literary sources (Augustine, Leo, and Gregory the Great) the figures of *Ecclesia* and *Synagogue* appear until the 16th c. as PERSONIFICATIONS of the Old and New Covenant. An early example occurs in a MOSAIC in Sta Sabina, Rome (422-32). *Ecclesia* is represented as an imperial woman, sometimes with NIMBUS, holding a sceptre or cross and the model of a church or a chalice to receive the blood of Christ (Konrad WITZ, Basel). She occasionally rides a tetramorph (*Hortus Deliciarum*, formerly Univ. Lib., Strasbourg, 12th c., now destroyed). *Synagogue* is most frequently personified by a woman with bandaged eyes, her crown falling, holding a broken spear or the tables of the law (Strasbourg Cathedral, 13th c.), sometimes riding a donkey or a pig; or by the figure of a Jewish priest (COLOGNE SCHOOL, Art Institute of Chicago, 15th c.).

From CAROLINGIAN times *Ecclesia* and *Synagogue* frequently appeared on either side of Christ in CRUCIFIXION scenes (9th-c. ivory, V. & A. Mus.). The idea of the marriage between Christ and *Ecclesia* (alluded to in Eph. v. 22-23 and developed in Cyprian's doctrine of the Church), illustrated from the 11th c. in Byzantine and Syrian manuscripts (Bib. nat., Paris), is found in later Western representations, where *Ecclesia* on the right of the Lord is led to the cross and *Synagogue* on the opposite side is turned away by an angel (N. PISANO, Pisa pulpit, c. 1260). *Ecclesia*, often wearing a triple crown, is presented in BAROQUE versions of the *Triumph of the Church* (17th-c. Brussels tapestry, Kunsthist. Mus., Vienna). (See also CHURCH.)

**ÉCHOPPE.** An old-fashioned type of etching needle, large in diameter and with the point cut off diagonally. It was much used in the 17th c. by CALLOT, BOSSE, and others for imitating the swelling lines produced by the BURIN in LINE ENGRAVING. (See ETCHING.)

**ECKERSBERG,** CHRISTOFFER WILHELM (1783-1853). Danish painter. After

being trained in Copenhagen and studying in Paris (1810-13) under J.-L. DAVID, he continued his studies in Rome (1814) where he executed a masterly portrait of THORWALDSEN. His views of Rome, in light greens, yellows, and blues, are NATURALISTIC but still classically composed. Returning to Copenhagen in 1816, he occupied himself mainly with portraits, minutely rendering the features of his models with a NEO-CLASSIC feeling for clarity and purity of line. Later he painted many seascapes, remarkable for their luminosity; but these are not held comparable with the early views of Rome. As a teacher at the Copenhagen Academy (from 1818) Eckersberg had a sound and stimulating influence on the next generation of Danish painters.

**ECLECTIC, ECLECTICISM.** Term in criticism for a person or style which conflates features borrowed from various sources. Such a style often arises from the overt or tacit doctrine that the excellences of great masters can be selected and combined in one work of art. The expression was first applied in philosophy to those who without belonging to any recognized school selected tenets from a number of different schools. In criticism the doctrine is traceable to the ancient teachers of rhetoric and was actually applied by LUCIAN to sculpture and painting. After VASARI had praised RAPHAEL for his skill in selecting the best from the art of his predecessors, the literati of the 16th and 17th centuries liked to use the same formula in their eulogies of other artists. Thus it was said that TINTORETTO had set himself to combine the drawing of MICHELANGELO with the colour of TITIAN.

In the 18th c. 'eclectics' became a label for the CARRACCI family and the painters who worked in their manner or attended the 'Accademia degli Incamminati' which they conducted in Bologna (1585-95). The best known of these were DOMENICHINO, Guido RENI, ALBANI, and GUERCINO. In this application the term is somewhat misleading because it implies that the Carracci adopted eclecticism as the fundamental principle of their school, an assumption which modern research has shown to be false. As Denis Mahon has said: 'Annibale Carracci, the greatest member of the family and one of the founders of 17th-c. painting, was . . . contemptuous of art theory, and (far from being a dispenser of learned recipes and synthetic systems) was in practice one of the most insatiable experimentalists known to the history of art.'

**ÉCOLE DE PARIS.** See PARIS, School of.

**ÉCORCHÉ FIGURE** (French: 'flayed'). A figure without the skin, displaying the muscles. There exist 16th-c. examples of such models, which were then part of the normal equipment

117. Pencil drawing by George Stubbs. Engraved in *The Anatomy of the Horse* (1766). (R.A., London)

of an artist's workshop. Later écorché figures of the horse and other animals were prepared. Drawings and engravings served the same purpose, among the finest being those of the horse by STUBBS.

**EDELFELT,** ALBERT (1854-1905). Finnish painter, trained chiefly in Paris. By his scenes of peasant life, dependent on those of BASTIEN-LEPAGE, he gave a fresh interpretation of Finnish country life. Like the German F. von UHDE, he also depicted biblical scenes in modern settings. His *Christ and Mary Magdalene*, for instance (Atheneum, Helsinki, 1890), is set in the Finnish countryside. The best known of his portraits is that of Pasteur (Sorbonne, Paris, 1885). Edelfelt was also a talented book illustrator.

**EDRIDGE,** HENRY (1769-1821). English painter born in London, where he appears to

have worked all his life. The greater part of his output consisted of small portraits in pencil, India ink, or water-colour, but he also did ROMANTIC landscapes. He is chiefly remembered for MINIATURES though these are less numerous than his portraits in other media. He was elected A.R.A. in 1820.

**EDWARDS,** EDWARD (1738-1806). English landscape and history painter, Professor of Perspective at the Royal Academy from 1788. He painted *Two Gentlemen of Verona* for BOY-DELL's Shakespeare Gallery. He is remembered today for his *Anecdotes of Painters* (published in 1808) as a supplement to the *Anecdotes* of Horace WALPOLE.

**EECKHOUT,** GERBRANDT VAN DEN (1621-74). HOUBRAKEN, the 18th-c. biographer of Netherlandish artists, noted that Eeckhout was one of REMBRANDT's best friends. He also states that this Amsterdam artist, who studied with Rembrandt c. 1640, remained faithful to his master's style all his life. This is true as far as Eeckhout's religious pictures are concerned; his *St. Peter Healing the Lame* (M. H. De Young Memorial Mus., San Francisco, 1667) shows how well he understood the broad touch and warm colours of Rembrandt's late works; other examples are in the Rijksmuseum. But some of his GENRE pictures are like TERBORCH's and a group of his lovely drawings have been mistaken for works by VERMEER.

**EGAS.** A family of architects and sculptors of Flemish origin active in Spain during the 15th and 16th centuries. Their work echoes in architecture and sculpture the same strong Flemish influence which dominated contemporary Spanish painting.
    HANEQUIN (d. c. 1475) is recorded from 1448 to 1470 as master of the works at Toledo Cathedral, where he made the late GOTHIC Door of the Lions (1452-c. 1465) in the south transept. His brother and collaborator EGAS (d. 1495) is described in contemporary documents as 'Egas Cueman de Bruselas', from which it seems probable that Hanequin and Egas belonged to a well known 15th-c. Brussels family of masons and sculptors named Coeman. In 1467-8 he carved the tomb of Alfonso de Velasco at Guadalupe. Later he assisted Juan GUAS on the carved screen round the sanctuary of Toledo Cathedral (1483-c. 1491).
    ANTON, son of Egas, succeeded his father in 1495 as assistant master of the works at Toledo Cathedral. In 1510 he and Alfonso Rodriguez (d. 1513) drew up plans for the new cathedral of Salamanca, and two years later he attended the conference of nine architects convened to report upon the project.
    Both Anton and his brother ENRIQUE (d.

1534) adopted their father's first name Egas as their surname. From c. 1498 Enrique was cathedral architect at Toledo, assisted by his brother; and they there continued the PLATER-ESQUE style of Juan Guas. In 1505 Enrique became master of the works at Granada, where he built the chapel royal (begun 1506) and designed and started the cathedral (1521) on a Gothic plan, but in 1528 Diego de SILOE took over and completed the building in RENAISSANCE style. Though primarily a Gothic-Plateresque architect, Enrique Egas was not immune to Italian Renaissance influence. This notably appears in his use of the cruciform plan for the royal hospitals of Santiago de Compostela (begun 1501)—a plan which was followed within the next ten years for royal hospitals at Toledo (Santa Cruz, begun 1504) and Granada (begun 1511).

**EGG TEMPERA.** See TEMPERA.

**EGYPTIAN ART.**

HISTORICAL TABLE

| | |
|---|---|
| Badarian Period | before 4000 B.C. |
| Early Predynastic Period (Amratian: Naqada I) Middle-Late Predynastic Period (Gerzean-Semainean: Naqada II) | 4th millennium B.C. |
| Union of Upper and Lower Egypt | 3000 B.C. ± 150 years |
| Protodynastic Period | 3100-2686 B.C. |
| 1st Dynasty | 3100-2890 B.C. |
| 2nd Dynasty | 2890-2686 B.C. |
| Old Kingdom | 2686-2181 B.C. |
| 3rd Dynasty | 2686-2613 B.C. |
| 4th Dynasty | 2613-2494 B.C. |
| 5th Dynasty | 2494-2345 B.C. |
| 6th Dynasty | 2345-2181 B.C. |
| First Intermediate Period | 2181-2040 B.C. |
| 7th Dynasty | 2181-2173 B.C. |
| 8th Dynasty | 2173-2160 B.C. |
| 9th Dynasty | 2160-2130 B.C. |
| 10th Dynasty | 2130-2040 B.C. |
| 11th Dynasty | 2133- |
| Middle Kingdom | 2040-1786 B.C. |
| 11th Dynasty | -1991 B.C. |
| 12th Dynasty | 1991-1786 B.C. |
| Second Intermediate Period | 1786-1567 B.C. |
| 13th Dynasty | 1786-1633 B.C. |
| 14th Dynasty | 1786-1603 B.C. |
| 15th Dynasty (Hyksos) | 1674-1567 B.C. |
| 16th Dynasty (Hyksos) | 1684-1567 B.C. |
| 17th Dynasty | 1650-1567 B.C. |
| New Kingdom | 1567-1085 B.C. |
| 18th Dynasty | 1567-1320 B.C. |

| (Amarna Period | 1375–1355 B.C.) |
| 19th Dynasty | 1320–1200 B.C. |
| 20th Dynasty | 1200–1085 B.C. |
| Late Period | 1085–332 B.C. |
| 21st Dynasty | 1085–935 B.C. |
| 22nd Dynasty | 935–725 B.C. |
| 23rd Dynasty | 817–725 B.C. |
| 24th Dynasty | 725–710 B.C. |
| 25th Dynasty | 751–656 B.C. |
| 26th Dynasty | |
| (Saite Period) | 664–525 B.C. |
| 27th Dynasty | |
| (Persian Period) | 525–404 B.C. |
| 28th Dynasty | 404–398 B.C. |
| 29th Dynasty | 398–378 B.C. |
| 30th Dynasty | 380–343 B.C. |
| Second Persian | |
| Domination | 343–332 B.C. |
| Rule of Alexander and | |
| his Heirs | 332–305 B.C. |
| Ptolemaic Period | 305–30 B.C. |
| Roman Period | 30 B.C.–A.D. 395 |
| Byzantine Period | A.D. 395–640 |
| Islamic Period | A.D. 641–1517 |

(Dates earlier than the 7th c. B.C. must be regarded as approximate.)

The art of ancient Egypt lies outside familiar definitions and should not be assessed by reference to extraneous standards. It does not, in particular, belong to the tradition of European art, and the ideals of GREEK sculpture or RENAISSANCE painting are irrelevant to their Egyptian counterparts. Nor can it reasonably be classed with any of the forms of PRIMITIVE art which have so influenced contemporary movements. Far from being inept or immature it is a highly civilized and sophisticated art which at its best is comparable to any other. Merely is it different, a unique solution to the problem of communication, and to appreciate its ideographic processes some understanding of its basic principles and underlying purpose is essential.

The Egyptians, like the Greeks, had no word for 'art' and did not recognize it as distinct from handicraft, though on a different plane the act of representing something had peculiar significance. Belief in magic as an elementary force implied that anything correctly reproduced might by appropriate ritual be called into being, and it was thus possible to re-create not only living creatures and material objects but even activities and situations—and by so doing to preserve existence. A statue, properly inscribed, was an effective dwelling for the spiritual essence of the deity or individual it represented, a perpetual body which a man might still inhabit after death. So too a tableau of the owner of a tomb enjoying the pleasures of this life made certain of their prolongation in the next, while the portrayal of religious rites assured the eternal well-being of the gods; even records of historical events were at the same time guarantees of Egypt's everlasting power. As a corollary the reproduction of unpleasant subjects was to be avoided, the Egyptian repertory reflecting an ideal view of life as it should be.

In order to fulfil its purpose any representation had to be explicit and informative. The artist therefore expressed a rational objective truth independent of time and space, and things were shown in what were deemed their real and immutable forms rather than accidental and changing appearances to visual sensation. Essential attributes and abstract qualities were indicated symbolically—importance, for example, being rendered by appropriate size—nor was there any difficulty in realizing imaginary creatures (such as the SPHINX). Conventional colouring was intrinsic to an effective likeness, and descriptive 'labels' and inscriptions (see HIEROGLYPHS) were added to define what was not otherwise apparent. The prevalence of straight lines and block shapes has been interpreted as the expression of a rectilinear space concept, but though such forms were clearly satisfying to the Egyptian mind they were more practical in origin. The cubic character of statuary was not determined by aesthetic norms but by the sculptor's method of approach, while the bold lines of pharaonic architecture were derived largely from the structural forms of early building.

The Egyptian attitude to art being such, the artist was not thought of as an individual creative personality. Rigidly trained, perhaps initially in a specific medium, he was an artisan who worked as one of a team, though expertise and versatility might bring him recognition. And while the names of master-craftsmen are preserved, the man responsible for a particular piece of work can rarely be identified. Credit was often arrogated by the patron, and even where a single master may be thought to have exercised control the extent of his involvement in the actual execution cannot be gauged. Indeed despite individualism in the treatment of some compositions and the handling of certain statues, it is likely that most works in their completed form were in fact the product of collective effort.

The Egyptians' natural conservatism and the limitations of their magical approach were obstacles to great artistic innovation, and almost any pharaonic work, of whatever period, is readily identified as such. But if in some respects Egyptian art remained impervious to change through nearly three millennia, the impression of absolute inflexibility is false. The essential features of its style, established in the earliest dynasties, survived indeed until the Greco-Roman period; but clear lines of development may be discerned. The effects of social-economic changes and a gradual increase in external influences are mirrored in the evolution of distinctive characteristics in the art of the great ages of Egyptian culture and to a less extent in that of intervening periods. Yet only during the short years of the AMARNA interlude was there a real

break in the basic continuity, for then alone was the religious outlook changed.

The descriptive character of Egyptian art is most apparent in RELIEF and painting, which may be classed together, the former being in effect a reinforced type of drawing and never three-dimensional in concept.

The earliest reliefs occur on predynastic objects, a characteristically 'Egyptian' style being

Old Kingdom belong the first distinctively 'Egyptian' compositions, and from the 6th Dynasty (when there is evidence of EASEL work) painting began to supersede relief in tombs. Some fine Middle Kingdom murals have survived and there are also painted coffins of this period, but it was from the 18th Dynasty that painting came into its own. Apart from its extensive use in tomb décor it was employed for

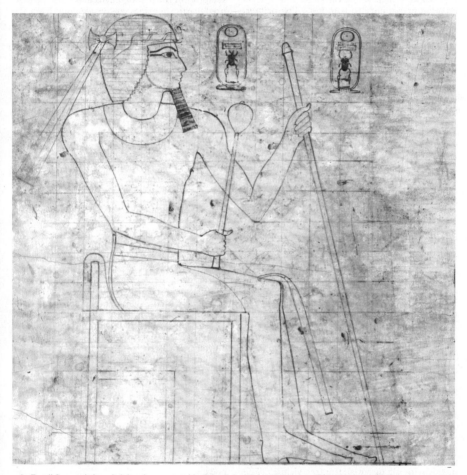

118. Detail from artist's scaled drawing over a grid. On wood surfaced with gesso. From Thebes. (B.M., 1400–1000 B.C.)

first defined on ceremonial PALETTES and mace-heads of the 1st Dynasty. By the time of the Old Kingdom low relief had reached a level in many ways unequalled later, but sunk relief (*en creux*) was little used until the Middle Kingdom. Both forms were common in the 18th Dynasty, though from the mid 19th the latter was more usual in architectural decoration. The oldest paintings too are predynastic, including scenes with human figures and boats, and painted patterning is known from tombs of the 1st Dynasty. To the

ornamenting coffins, furniture, and other objects, and to illuminate PAPYRI. After the 19th Dynasty the quality of painted work declined.

The first stage in the execution of a relief or painting was to prepare the GROUND. For relief the surface was merely smoothed and patched where necessary, though poor stone was sometimes coated with a layer of GYPSUM. For painting a good surface might be treated similarly, but walls were often levelled with a coat of mud and finished with a wash of plaster. Wood was as

a rule surfaced with GESSO. The composition was then drafted, either freehand or more usually with guide-lines or a grid to ensure that human figures were proportioned in accordance with the accepted canon. In general the first sketch was red, corrections being made where necessary in black. The sculptor then chiselled round the drafted outlines, making occasional alterations, and for low relief reduced the background. Figures were then worked in detail and defects repaired preparatory to painting. The painter, whether working independently or on relief, washed in the background and then coloured individual items, which were finally outlined and had internal details added. VARNISH was used in a few tombs and on some wooden objects.

Egyptian painting was not FRESCO but a distemper or GOUACHE. The VEHICLE was gum or water, and the common PIGMENTS (except carbon black) were either mineral substances or artificial frits. Brushes of different sizes were made from vegetable fibres. The six basic colours used were red, yellow, blue, green, black, and white, though others were produced by overlaying and mixing, even subtle tints being not uncommon, and experiments were made in shading and creating the illusion of transparency. A striking harmony of form and colour was achieved in ceiling patterns and other purely decorative work.

Most compositions entirely fill the space prepared yet at the same time are contained within it. With few exceptions subjects are typically portrayed without specific detail, and defined only by descriptive hieroglyphs. Tomb pictures reiterate accepted themes and even records of historical events have little visual identity. Scenes are rarely localized and background, if sketched in, is usually schematic. Three-dimensional PERSPECTIVE was unknown and all but simple pieces are divided into registers, the lowest corresponding to the foreground, while within a register objects behind or inside others appear above. Sometimes the division is temporal, the registers or separate figures representing stages in an action, like a strip cartoon. In either case the principle is similar: to show things not as they appear to one observer at a given moment, but descriptively.

A like convention governs individual objects, the simplest being shown in their most characteristic view and the more complex artificially composed, with all essential features visible. The ideal human figure is thus reconstructed with the head in profile (but the eye in virtually its frontal aspect), the shoulders seen as from the front, the breast in profile, and the waist and hips in a three-quarter view—and both feet showing the inside. True profile, though used for inanimate objects (including statues) and for animals, is with human beings practically confined to aliens and servants, as also are the very few full-face, back, and three-quarter views. Moreover while the important figures are always calm and dignified, inferiors are depicted with much greater liveliness. There are attempts to show

them in unusual and awkward poses, even to indicate emotion, and the portrayal of wretchedness is not uncommon, as for example in battle scenes. Such freedom may be noted also in the sketches made on OSTRACA.

The static calm of the main figures in reliefs and paintings is paralleled in sculpture in the round, the obvious relationship between the media reflecting the technique developed by sculptors of the first two dynasties. The earliest, predynastic figurines are crude, but from the 1st Dynasty there is a marked improvement in technique and evidence that more ambitious pieces were produced. The first unmistakably 'Egyptian' statues date from the late 2nd Dynasty, the characteristic form being crystallized from the beginning of the Old Kingdom, the period also of the oldest known colossi.

In executing stone statues (normally monolithic) sketches were made on two or more sides of a cuboid block, with guide-lines or a grid to ensure correct PROPORTIONS, the side view of the figure being drawn in true profile. The block was then reduced by pounding off successive layers, so that throughout the statue had a certain form, though not until the end were details cut. Hard stones were jarred and rubbed with stone implements and cut with saws and drills, while for softer stones chisels and adzes were also used. Blades were of copper until the Middle Kingdom, when bronze was introduced; iron was not employed before the 6th c. B.C.

The finished statue, being the combination of a profile and a frontal view, retains the cubic aspect of the parent block. The profile attitude may vary, but the median plane is always vertical and rigid, with the shoulders and the hips at right angles, and there is never sideways movement of the body. Most statues face straight ahead, though scribes and colossi may glance slightly downwards. Rarely, and always for a reason, is the head turned to one side, as in the case of monumental lions. With very few exceptions standing men step forward on the left foot, while women have their feet together or barely separated. The space between is nearly always solid and the legs are usually attached also to a dorsal pillar. Those of seated figures are consolidated with the block which forms the seat, and men who squat or kneel are similarly treated. The arms are generally a single unit with the body.

Wooden and metal statues—the former carved like the soft stones, the latter cast or hammered up from sheet—were regularly made in several pieces. In general form they differ little from stone figures, but treatment of the limbs is less restricted, the legs being separated and the arms freed from the sides.

The human form is more or less idealized in its prime. Men have the virile strength and confidence of early middle age or, less frequently, the comfortable flesh of seniority, while women keep the firm breasts, slim hips, and graceful curves of youth. Senility, disease, and physical

deformity are rarely represented, though a few instances are known. The upper body is as a rule more carefully sculptured than the legs and feet, which may be summarily worked and disproportionate, and modelling of the head is normally more meticulous than the rest. Striking effects were obtained with colouring and artificial eyes, especially in the Old Kingdom, and often there was some attempt to reproduce the actual features of an individual, though without varying the usual blank expression. The quality of portraiture was in any case considered less vital than the inscription of the name, by which identity was fixed, and being incomplete the head or bust as such had no significance. None of the Amarna pieces is actually a finished product, some being elements of composite statues and others studio models.

The tendency to concentrate upon essentials was the first step towards simplicity of form. During the Middle Kingdom many figures were conceived as shrouded in a mantle with only head, hands, and feet protruding, and the so-called block statue was introduced. This type, in which the squatting figure is reduced to little more than a shaped block, became common in the New Kingdom, when other compact forms were also favoured. Sometimes, however, and especially in work of Saite times and later, this subordination of the subject seems to stem from a genuine appreciation of the possibilities of purely formal composition and a desire to create a pleasing shape.

A feature of Egyptian sculpture is the sure handling of materials with evident appreciation of their qualities—and this despite the fact that surface niceties were often masked by paint. In the Old Kingdom most wooden and stone statues were entirely painted, though some of hard stones were but partly so, and this was increasingly the case in later periods. From the Middle Kingdom onwards, while colour was still used extensively on wood and stones like limestone, sculptures in hard decorative rocks had often only details painted or were left untouched. During the New Kingdom, and more particularly in the Late Period, the possibilities of varied surface treatment were explored. Smoothness and high polish were contrasted with elaborate ornamental detail in the modelling of individual features and on occasion use was made of natural veining in the stone.

The Egyptian craftsman's feeling for materials and his instinctive sense of form and beauty are revealed most clearly in the applied arts, which were less inhibited by magico-religious concepts. Egypt was rich in gold and semi-precious stones (though lacking lapis lazuli and silver) and jewellery flourished from the 1st Dynasty. Some notable Old Kingdom pieces have survived, but the most refined date from the 12th Dynasty, the best New Kingdom work, while perhaps technically superior, being often somewhat vulgar in design. The standard of metal-working was in general high, and fine vessels, statuettes, and other objects were produced, particularly from the New Kingdom onwards. Much use was also made of gilded decoration, sometimes on a base of modelled gesso.

Egyptian FAIENCE (glazed quartz frit) appeared in predynastic times, becoming subsequently very common for beads, amulets and inlay, and for larger items such as bowls and vases, statuettes (especially SHAWABTI figures), tiles, and

**119.** Detail from wall-painting at Thebes (*c.* 1380 B.C.). Showing Egyptian craftsmen at work

architectural ornaments. Unglazed blue frit was also used for beads and similar small objects from the 4th Dynasty, and on a larger scale during the New Kingdom. Glass, however, was not made intentionally until the 18th Dynasty, being then employed principally for beads and inlay, and for vases though less frequently for bowls, small figurines, and other purposes. The vogue for glass declined after the 20th Dynasty, and a new material, 'glassy faience', was developed.

Despite the poorness of Egyptian timber, carpentry prospered from the 1st Dynasty and by the Old Kingdom was a developed craft. In the Middle Kingdom and again during the 18th and 19th Dynasties considerable sophistication was attained, and furniture was often finely decorated with veneer, inlay, and marquetry. Trinket boxes and cosmetic requisites, stick handles, gaming pieces, and the like were elegantly carved in wood and ivory and delicately painted and inlaid.

The manufacture of stone vases was advanced in the predynastic period and reached its peak during the early dynasties, when vessels were precisely fashioned from the hardest rocks. From the 4th Dynasty less difficult materials were favoured, but save for some 12th-Dynasty cosmetic jars the quality of work declined and shapes became increasingly elaborate. A similar trend is noticeable in Egyptian pottery, the finest pieces dating from Badarian and predynastic times, whereas dynastic pots are generally less pleasing.

Few other crafts gave opportunities for aesthetic treatment, though in the New Kingdom decorative leatherwork was not uncommon, baskets were frequently patterned, and ornamental woven and embroidered fabrics were produced.

ARCHITECTURE. The oldest constructional materials were reeds and rushes (often reinforced with mud) and baulks of wood, brick first appearing in late predynastic times. Occasional dressed slabs were used from the 1st Dynasty, but not until the 3rd was stone employed for an entire building. During the Old and Middle Kingdoms limestone was the usual material, with granite not uncommon, while from the New Kingdom sandstone was preferred. Work which was not visible, such as foundations, was often poorly executed, and ordinary dwellings, even palaces, were always simply built of brick and timber.

Dynastic buildings were rectilinear in plan and elevation, their straight lines seldom varied by arched contours, and many features, like the torus MOULDING and cavetto CORNICE, were derived from primitive construction. Most columns copy vegetable growths or are refinements of the square PIER. The former group includes the variant papyrus columns, lotus and palm types, and some ribbed and fluted forms of the 3rd Dynasty, while among the latter are both eight- and sixteen-sided pillars (occasionally fluted). Others are shaped like Hathor-headed sistrum rattles or in one case tent-poles, and

many composite plant CAPITALS are known from Greco-Roman temples.

From the New Kingdom onwards temples had a similar basic plan—often obscured by subsequent additions, as at KARNAK. Set within a high brick wall a PYLON gateway gives on to a colonnaded court. Beyond is a columned hall (see HYPOSTYLE) leading, often through a second, to the sanctuary and its associated chambers, the sense of mystery increasing at each step. Of earlier shrines little has survived other than mortuary temples: two modest chapels of the Middle Kingdom and the ruins of a 5th-Dynasty sun-temple with a court bounded by passages and containing a huge OBELISK.

The earliest tombs were pits covered with sand or rubble, from which evolved the brick-built royal MASTABA of the first two dynasties. This was in turn the basis for the step pyramid type of the 3rd Dynasty and so of the true PYRAMID, the characteristic royal tomb of the Old and Middle Kingdoms. The largest pyramids, constructed of enormous blocks, are of the 4th Dynasty, the scale and quality of work declining later, with eventual use of brick. Old Kingdom nobles favoured mastabas, though rock-cut tombs were not unknown and by the Middle Kingdom were predominant, the most developed having forecourt, hall, chapel, shaft, and burial chamber. In the New Kingdom both royal and private tombs were normally rock-cut, with great care to conceal their whereabouts. Those in the Valley of Kings were tunnelled deep into the cliffs, the shaft replaced by a long corridor, and mortuary temples were erected separately and at a distance.

THE ART OF GRECO-ROMAN EGYPT (332 B.C.– A.D. 326). With the flight of Nectanebos to Nubia before the invading army of the Persian emperor Artaxerxes Ochus in 343 B.C., the long and remarkably stable history of dynastic Egypt is formally concluded. No native Egyptian ever again occupied the pharaoh's throne. Liberated from Persian rule in 332 B.C. by Alexander the Great, Egypt became first a dependency of his short-lived Macedonian Empire and then was ruled for more than three centuries by the Macedonian dynasty of the Ptolemies. It was the last of the great Hellenistic successor-states, carved out of Alexander's conquests, to succumb to the Romans. In 30 B.C., after the ambitious plans of Mark Antony and Cleopatra VII had been shattered in the decisive naval battle off Actium, Egypt was annexed as a province of the Roman Empire and subjected to the rule of a prefect appointed by the emperor from the equestrian order.

Under the Ptolemies Greek replaced Egyptian as the official language. Alexandria, founded on the site of the obscure village of Rhakotis by Alexander himself, became the capital. Its citizens were racially mixed, but its art and architecture, literature and thought, were those of a Greek city. Its geographical position emphasized its cultural separateness from the

Nile valley. In antiquity it was recognized as being next to, rather than of, Egypt. A cosmopolitan body of Greek-speaking, Hellenized families settled throughout the country, becoming a permanent and privileged minority group, alienated from the mass of their fellows by speech, education, and a conviction of their intellectual superiority.

These political and social changes, more profound, more persistent than at any other period of Egypt's past, portended the end of the indigenous culture, which the country's geographical isolation in the ancient inhabited civilized world of the Near East, the natural strength of its frontier and the abundant richness of its resources had in the past fostered. There was no swift, no catastrophic collapse. Both the Ptolemies and the Roman emperors deliberately protected and patronized Egyptian temples and estates as a matter of political expediency. In Upper Egypt the temple of Horus the Behdetite at Edfu, the most complete of its kind to have survived, was begun in 237 B.C. under Ptolemy III Euergetes and completed 180 years later, in 57 B.C., in the reign of Ptolemy XII Neos Dionysos (Auletes). On Philae, the 'pearl of Egypt' until its disappearance under the waters of the reservoir formed by the Aswan Dam in A.D. 1912, the temple of Isis, one of the most harmonious in Egypt, its plan subtly adapted to the configuration of the ground, was constructed mostly in the 2nd c. B.C., but it was still receiving embellishment and decoration under the Antonine emperors of the 2nd c. A.D. Elsewhere, at Dendera, Esna, Kom Ombo, and south from Aswan to the frontier at Hierasykaminos, the construction and decoration of temples continued on no mean scale.

Characteristic of the period is the greater freedom and innovation in the ornamentation of composite stone capitals, inspired as in the earlier art of Egypt by the flora of the Nile valley, particularly the lotus, papyrus, and date-palm. This is perhaps the most pleasing and original feature of the temples of the Greco-Roman period. The quality of the relief, carved in the

**Fig. 21.** EGYPTIAN CAPITALS
A. Derived from papyrus plant. B. Derived from lotus bud

traditional way by cutting away the background and modelling the figures, is not in the main remarkable. The various stages of the work are admirably illustrated in a row of six rooms at Kom Ombo. The work is executed in sandstone, mostly from the quarries of Gebel es-Silsila, which hardly allows of delicate work. Doubtless painting gave the scenes more detail. In composition the reliefs of the Greco-Roman period are cramped; a greater number of registers fills the walls along with columns and gateways with long texts appended in ornamental hieroglyphs which convey more on one wall of the purpose of the rooms and of the festivals celebrated than whole rooms in the temples of the dynastic period. A certain monotony in the choice of subject matter is observable. The majority of scenes depict kings and queens making offerings to the various deities of the Egyptian pantheon; there is nothing so striking as the great narrative scenes of the campaigns of the 19th and 20th Dynasties which are found, for example, at Luxor and Medinet Habu. Only occasionally is there a representation of an original nature, as the zodiac from a ceiling at Dendera (now in the Louvre), the surgical instruments at Kom Ombo, or the mythological scene of the combat of Horus and Seth at Edfu. Crypts and screen walls were incorporated in temples and a number of smaller buildings called *mammisi* were constructed in the style of the old peripteral chapels, in which the mysteries of the birth of deities were celebrated. No major innovation in architecture can be expected—such would have required a revolution in liturgical practice.

Patronage for sculpture in the round, with which the temples were embellished by longstanding practice, was ensured by the prosperity of the temples. Statues of private individuals, at least of men—those of women are very rare—were erected within the precincts, as well as images of deities and kings. A renaissance of Egyptian sculpture had occurred in the Late Period beginning in the 25th (Kushite) Dynasty. It had developed through the 26th (Saite) Dynasty and the Persian Period, and continued under the Ptolemies, particularly in the earlier half of the dynasty. A considerable number of statues of high quality was made, often in hard ornamental stones capable of receiving a high polish, so finely worked that all traces of tool marks were erased. The range of types was limited and traditional. Frontal and static poses were still the rule. Heads were carved with greater emphasis upon human moods and character, more in keeping with modern ideas of true portraiture. In many pieces the traditional method of representing hair and drapery was replaced by conventions which more faithfully reproduced contemporary appearance. A red granite colossal statue of Alexander IV from Karnak, now in Cairo, shows a row of short curly hair protruding from the *nemes* head-dress. If, on the whole, there was a certain reserve in abandoning the strict ICONOGRAPHY for official

works of this kind, there was certainly less inhibition in the case of statues of private individuals where the most successful examples of this mixed style are to be found. Under the Romans, in the 1st c. A.D., there was a decline in the quantity of production and also, in general, of quality. By the 2nd c. sculpture in the round had virtually disappeared and works which have survived were executed mainly in the softer limestones and sandstones and were seldom of monumental proportions. A number of factors brought this about: the impoverishment of provincial families, an understandable reluctance of officials to draw attention to themselves by an ostentatious display of their own statues; possibly also the exploitation of the quarries of the eastern desert for ornamental stone, PORPHYRY and green breccia for export to Italy drained from the valley many of the skilled craftsmen in stone.

In marked contrast with the work officially or privately commissioned for temples there was during this period little imposing construction of private tombs, which in the past had always marked periods of stable and prosperous government. A notable exception is the necropolis of the important provincial centre of Hermopolis (Eshmunein) at Tuna el-Gebel. Here, at the beginning of the Ptolemaic Period, a certain priest, Petosiris, had constructed a tomb chapel in the form of a miniature temple. The façade is decorated with offering bearers and inscriptions which are purely Egyptian: inside on the walls of the porch and of the chapel proper are agricultural and industrial scenes, drawn from the familiar repertory of pharaonic tombs but treated in an unfamiliar way: the strict canon maintained in the past in drawings and paintings of the figures and their garments has been abandoned, though at the same time the Egyptian practice of dividing scenes into formal registers is retained. The effect is wholly incongruous. Parallels for the style of the Petosiris reliefs can be found on painted linen shrouds of the Roman period. On more formal monuments the experiment is unique, as if the ancients themselves adjudged it unsuccessful. In the chapels which were subsequently built behind the tomb of Petosiris in the following centuries the style of decoration is less mixed. It consists of either crude paintings of funerary scenes in the old conventions (found also in a group of Roman tombs at Akhmim) or of Hellenistic, provincial echoes of the art of Alexandria.

Of art in the pure Greek tradition little has survived of real distinction. The quality of the work is in general that current throughout the Mediterranean world. The poverty of masterpieces may be due to the absence of surviving remains from Alexandria itself. Its tombs, to the east and west of the old city walls, have yielded a rich variety of small objects, particularly painted funerary urns and terracottas as well as painted loculi slabs and frescoes, but of the art and architecture of the city itself virtually nothing is known except from literary sources. The original appearance of its most striking monument, the lighthouse on the island of Pharos, one of the seven wonders of the ancient world, can only be surmised from such late representations of it as a 6th-c. mosaic at Gasr el-Lebia (Cyrenaica). To what extent Alexandria was a creative centre it is clearly impossible to say. Much has been written in an attempt to isolate its contribution, in subject matter, in technical devices, and in mood and feeling. It is thought, for instance, that Alexandria may have been the centre of the invention and development of blown-glass techniques in the 1st c. A.D. The popularity of certain themes, for instance rural scenes of the Nile valley, the general abundance of Egypt, or studies in bronze of the heads of Negro children, are doubtless due to Alexandrine influence. But the various stylistic idioms which have been said to be Alexandrine, for example the contrast of light patterns, are now known to be current also elsewhere.

Though the Hellenized families of Egypt preserved their own culture and so far as it was possible the social and political institutions of a Greek city-state, they mummified their dead and adopted the belief in the efficacy of the attendant ritual to ensure individual immortality. Even in Alexandria, where incineration was the custom, by the Roman period there are to be found in the catacombs clear indications of the intrusion of Egyptian beliefs, in painted scenes in a tomb at Anfushi or in the sculptured representation of the jackal-headed Anubis with a snake's body at Kom ech-Chafuga. Considerable care was lavished on the decoration of the mummies and coffins. The result can scarcely be considered great art; it shows a clumsy mixture of Greek and Egyptian elements, juxtaposed without coherence or fusion.

An exception must be made in the case of the series of portrait paintings which have survived from a number of cemeteries of Roman date throughout Egypt, particularly from Hawara and Er-Rubbiyat, for which reason these portraits are frequently called Faiyumic. The earliest examples date from the first half of the 1st c. A.D. They became more common in the 2nd c. and persisted until the 4th. They were painted on thin panels of wood, on average measuring about 17 in. high and 9 in. wide, or sometimes directly upon the linen shroud enveloping the mummy. Two techniques were used. Some were painted in TEMPERA, particularly in the later period; in others, the majority of the portraits, the pigments were mixed in beeswax, resulting in a luminosity reminiscent of modern oil painting. Such painting is commonly referred to as ENCAUSTIC, though so far as the mummy portraits are concerned the colour was not applied by artificial heat. The plain background, the drapery, and hair were painted with full strokes of a brush and the brush may also have been used for the features for which the wax had been laid on in a thicker and creamier state.

The style of the portraits owes nothing to

ancient Egypt. The subjects are shown with the head turned slightly to the left or the right, sometimes full-faced, but never in profile. They wear the normal costume of everyday life current throughout the Hellenized world and the jewellery of the women derives from the same source. In the arrangement of the hair they follow the fashion favoured by members of the imperial ruling family. Head, shoulders, and the upper part of the breast are usually shown. Gradations of the individual colours and the use of highlights give to the portraits a startlingly modern look. At close quarters the paint seems to have been casually applied—the heavy lines of the eyebrows, the white streak down the nose, the thick red smear of the lips separated by a black line, and the shading under the chin. At a distance of 4 to 5 ft. the colours merge and blend. The portraits owe their survival to the fact that they were roughly trimmed and secured beneath the bandages over the face of the mummy; many no doubt, particularly from the 2nd c. onwards, were painted for the mummy. But in the case of some of the earliest examples so great is the degree of individual character portrayed that it is likely that they were painted from life and the use to which they were put was secondary. The impressionistic handling of the paint and suggestion of movement in the pose derive from classical Greek traditions of portraiture. With the exception of some similar examples of portraiture on wall-paintings at POMPEII, destroyed in A.D. 79, the portraits from Egypt are the only surviving examples of the skill and craft of the ancient portrait painter and furnish a unique contribution to the history of art.

A second point of contact between the Egyptian and Greek civilizations was the cult of the healing and saviour gods, which resulted in the production of terracotta and bronze representations of deities with a mixed iconography. Isis appears in the guise of Demeter or Aphrodite, Anubis is given the insignia of Hermes in his role as conductor of the dead and the falcon-headed Haroeris assumes the armour of a Roman soldier. Particularly characteristic from the 2nd c. A.D. onwards are the engraved stones (so-called gnostic gems) which brought their wearers magical protection against bodily ailments or help in the attainment of their desires. They are for the most part INTAGLIOS, with crowded designs often carelessly cut, in semi-precious stones, used by their wearers as pendants, ring-stones, or beads. Greek is the language of the inscriptions but the iconography is drawn from Egyptian, Greek, and other sources in a synthesis as monstrous as some of the demons represented.

26, 27, 90, 317, 361, 417, 429, 496, 506, 568, 805, 820, 908, 913, 915, 1253, 1410, 1491, 1559, 1576, 1619, 1700, 1818, 1926, 2177, 2439, 2515, 2516, 2517, 2542, 2723, 2724, 2755, 2921.

**EGYPTIAN TASTE.** During the first quarter of the 19th c. attempts were made to introduce ancient Egyptian ornament into furniture, silver, pottery, and other decorative arts. Scholars and connoisseurs had begun to interest themselves in ancient Egypt in the middle of the 18th c., and in 1769 PIRANESI published a number of designs of Egyptian ornament in his *Diverse Maniere di Adornare i Cammini*. But the fashion did not become widespread until Napoleon's Egyptian campaign in 1798 made it topical and D.-V. Denon's lavishly illustrated *Voyage dans la Haute et dans la Basse Égypte* (1802) provided artists and designers with a large repertory of ready-made ornament—Egyptian mummy-cases and idols, cats, hawks, SPHINXES, winged globes, OBELISKS, HIEROGLYPHS, etc. For Denon himself G. Jacob (1739-1814) made a set of 'Egyptian' furniture, and in England the younger Chippendale made furniture in the style for Stourhead and Thomas Hope (1770-1831) designed a special Egyptian room in his house, Deepdene, to contain his collection of Egyptian antiquities.

**EIDOPHUSIKON.** An ingenious system of moving pictures within a proscenium arch which, by a clever disposition of lights, coloured gauzes, and the like imitated views in and about London with varying atmospheric effects at different times of day, to the accompaniment of appropriate musical effects. The inventor was J. P. De LOUTHERBOURG who exhibited the Eidophusikon in London in 1782 with immediate popular success, appealing to lovers of ROMANTIC and PICTURESQUE scenery and deeply impressing both GAINSBOROUGH and REYNOLDS, who 'honoured the talents of the ingenious contriver by frequent attendance whilst it was exhibited in Panton Square, and recommended the ladies in his extensive circle to take their daughters, who cultivated drawing, as the best school to witness the powerful effects of nature . . .'. His masterpiece was the realistic representation of a storm at sea with sound effects which were hailed as a new art: 'the picturesque of sound'. There is an interesting eyewitness account of the Eidophusikon and its effects in *Wine and Walnuts* by Ephraim Hardcastle (1823).

**EIFFEL, GUSTAVE** (1832-1923). The most famous of those French engineers who during the last three decades of the 19th c. explored the possibilities of rolled iron and steel in place of inelastic cast iron to cope with new engineering problems and showed the contribution these materials could make to the new spatial conceptions that were soon to change the whole nature of architecture. He founded his own firm in 1867 and developed a novel system of construction based on the use of the lattice beam. His imaginative use of structure to permit light and air to flow freely through a building was first shown in his design (made in collaboration with the architect Boileau) for the *Magasin au Bon Marché* in Paris (1876). It had a lightly constructed iron interior consisting of tiers of galleries supported on slender columns and

surrounding a glass-roofed central space rising the full height of the building, a pattern on which many department stores were subsequently modelled.

Eiffel also designed a number of outstanding iron bridges, notably the bridge over the Douro, Portugal (1875), with a central arch spanning 520 ft. and its crown 200 ft. above the water, and the Garabit viaduct (1880-4) over the River Thuyère, spanning 536 ft. In these he perfected the technique of using precisely dimensioned factory-made parts. He also designed the skeleton that supports internally the copper Statue of Liberty at the entrance to New York harbour (1886). But his most significant works appeared in successive Paris exhibitions. His ideas on iron construction partly inspired the highly successful *Galerie des Machines*, by J. B. Krantz, at the exhibition of 1867, and he designed parts of the exhibition of 1878. The climax was the exhibition of 1889 and its central feature, the 1,000-ft. tower, which became universally known by the name The Eiffel Tower. It rises in three stages with the intermediate and top platforms accessible by lift; it rests on four pylons, the bases of which are linked by arches. One of the most controversial structures of modern times, it marks an important stage in the contribution of engineering and technological developments to the aesthetics of modern architecture. Eiffel was also responsible for a tall, non-utilitarian metal structure in the centre of Lisbon. He subsequently devoted himself to aerodynamic studies and in 1911 built the first wind-tunnel for aeroplane testing.

**EIGHT, THE.** A group of American painters formed in 1907. The original group consisted of: Arthur B. DAVIES, Maurice Prendergast (1861-1924), Ernest Lawson (1873-1939), Robert HENRI, George LUKS, William J. GLACKENS, John SLOAN, Everett Shinn (1876-1953). They were later joined by George Wesley BELLOWS. The members of the group were not united by any common style. The first three painted in a lyrical and imaginative style. The others belonged to the realist tradition deriving from EAKINS. Glackens, Luks, Sloan, and Shinn were illustrators working with the *Philadelphia Press*. They established what was later called the 'Ash-can School' of painting—an earlier version of the 'Kitchen-Sink' manner whose leading exponent was John Bratby (1928-    ) in the United Kingdom. The dominant personality in the group was Robert Henri and their common significance lay in the revolt from the then current academic Aestheticism and a determination to bring painting back into direct touch with life. The group came into being when the National Academy of Design rejected the work of Luks, Sloan, and Glackens, and Henri in protest withdrew his own pictures from the exhibition of 1907. Arthur B. Davies

was then asked to organize an independent exhibition at the Macbeth Gallery in New York. This exhibition, which took place in February 1908 and was the only occasion on which the Eight exhibited together, was subsequently shown by the Pennsylvania Academy and circulated to eight other museums over a period of a year. The impact which it made is a measure of the vacuity which prevailed in the official second-generation IMPRESSIONISM and derivative ECLECTICISM of the time. A useful assessment of the significance of this group is to be found in the catalogue by John I. H. Bauer of a retrospective exhibition at the Brooklyn Museum, 1943-4.

**ELEMENTARISM.** A modification of NEO-PLASTICISM published by van DOESBURG in the middle 1920s. While continuing MONDRIÁN'S restriction to the right angle Elementarism abandoned the insistence on the horizontal-vertical relation to the picture plane. Van Doesburg also reintroduced inclined planes and sought to achieve a more dynamic quality by an element of deliberate instability. His views were followed for a time by the painter César Domela (1900-    ), who used natural materials such as wood and metal in his constructions.

**ELGIN MARBLES.** Those sculptures of the PARTHENON (most of what had survived) and some other pieces which Lord Elgin procured from the Turks in 1801-3 and sold to the nation for £35,000 in 1816. They are now in the British Museum. By their exhibition in London original Greek sculpture of the Classical age first became generally accessible in modern times; until then people had been familiar only with ROMAN and late HELLENISTIC copies. Their first impact was enormous.

2368.

**EL GRECO.** See GRECO, El.

**ELIASZ, NICOLAES,** called PICKENOY (1590/1-1654/6). A leading portrait painter of Amsterdam until the rise of REMBRANDT in 1631.

**ELMES, HARVEY LONSDALE** (1815-47). English architect of great promise who died young of consumption in Jamaica. He is known for one building, St. George's Hall, Liverpool, which is generally considered the finest English building in the style of the Classical Revival. It was the subject of a competition which Elmes won in 1839 and was finished after his death by C. R. COCKERELL. It has a Corinthian colonnaded exterior and an interior based on the tepidarium of the Baths of Caracalla (see THERMAE) in Rome but Greek in its detail. Elmes's father was JAMES ELMES (1782-1862), architect and author of *Metropolitan Improvements, or London in the 19th Century* (1827) and *Modern Athens* (i.e. Edinburgh).

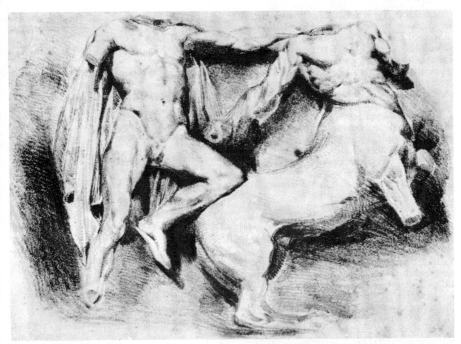

**120.** *Theseus victorious over the centaur Eurytus.* Lithograph (*c.* 1825) by Delacroix after a Parthenon metope

**ELSHEIMER,** ADAM (1578–1610). German painter and etcher. He received his first training in the somewhat dry Flemish REALISM of the late 16th c. (*Sermon of St. John*, Munich). When he went to Italy in 1598, however, he acquired a new understanding of colour during a stay in Venice, and in Rome, where he lived from 1600, he must have been in contact with CARAVAGGIO himself or his followers. Elsheimer's pictures were invariably on a small scale and were sometimes painted on copper. He tells his stories in a simple and straightforward manner and in this respect he was strongly in reaction against the complexity of MANNERISM. He combined an intense feeling for warm and glowing colours with a thorough understanding of the new problems of light and realism. Besides these purely visual features Elsheimer had a lyrical temperament which imparted to his little scenes —usually taken from the Bible or from Ovid— a charm of their own. Landscape and figures are fused into a harmonious unity and assigned equal importance in the presentation of his themes. The *Tobias* and *Coronis* (St. Paul in Malta), both in the National Gallery, London, both painted and partly engraved on copper, are good examples of his work.

Almost from the beginning Elsheimer achieved European popularity. There are workshop replicas of many of his works. His paintings were engraved and he himself made a number of etchings. In consequence his influence can be traced far into the 17th c. Artists of REMBRANDT's generation were often deeply indebted to him in their early development.

2840.

**ELSTRACK,** RENOLD (active *c.* 1607– *c.* 1646). Engraver of title-pages and portraits, whose style was close to that of the van de PASSE family.

**EMBLEMA.** See MOSAIC.

**EMBLEMS AND EMBLEM LITERATURE.** Emblem books were books of symbolic pictures accompanied by explanatory texts. For example one of the most famous emblems depicted a dolphin and an anchor with the motto *Festina Lente* ('Make haste slowly'), to symbolize the idea that maturity is achieved by a combination of the speed and energy of the dolphin and the steadiness and gravity of the anchor. The aim of the emblem therefore was to give symbolic expression to a moral adage.

The emblematic concept arose through the attempts of Italian humanists to create a modern equivalent of the Egyptian HIEROGLYPH, an attempt which was triggered off by the discovery in 1419 of the *Hieroglyphica* of Horapollo. Its background was Renaissance Platonism, which laid stress on the visual image as a vehicle for hidden philosophic mysteries. Many of these hieroglyphs were disseminated through the woodcuts in Francesco Colonna's classical

romance, the *Hypnerotomachia Polyphili* (1499), which paved the way for the earliest and most influential emblem book, Andrea Alciati's *Emblemata* (1531). This work gave rise to the emblem book as a literary genre which enjoyed its heyday in the 16th and 17th centuries when both general and specialized (e.g. love emblems, sacred emblems) collections were produced. A famous English example is Geoffrey Whitney's *Choice of Emblemes* (1586). Collections of emblems which were borne as personal devices by particular people (e.g. the emperor Charles V's device of the Pillars of Hercules with the motto *Plus Ultra*), known as *imprese*, were also published in great numbers.

The sources drawn upon by the emblematists were diverse and included the Bible (e.g. the rainbow as an emblem of peace); medieval lapidaries and BESTIARIES (e.g. the ermine as an emblem of purity); fables (especially Æsop); anecdotes from classical myth and legend (e.g. Xenophon's story of Hercules's choice between Virtue and Pleasure). The emblem book was part of that vast codification of symbolism which led to Cesare Ripa's *Iconologia* (1593).

Among the painters who drew motifs from the hieroglyphs were Andrea MANTEGNA (*Triumphs of Caesar*, Hampton Court, c. 1486–94); PINTORICCHIO (Borgia Apartments, Vatican, c. 1492–5); Giovanni BELLINI (*Allegories*, Accademia, Venice). Emblems appear in LEONARDO drawings (e.g. the ermine, Clarke Coll., Cambridge, c. 1494; the lizard, Met. Mus., New York, 1496). *Imprese* often occur in portraits (e.g. the cannon in TITIAN's portrait of Alfonso d'Este, Met. Mus., New York, c. 1522) and most frequently of all on the reverses of medals. Emblems and devices were also widely used in the decorative arts throughout the 16th and 17th centuries (e.g. Gonzaga emblems in the Palazzo del Tè, Mantua, 1527–9, 1530–5). Designers of festivals and triumphs made extensive use of them (see Inigo JONES). The vitality of the emblematic formula as a vehicle for moralizing in the visual arts lasted through the 17th and well into the 18th c.

**EMPIRE STYLE.** The term is applied primarily to a style of furniture and interior decoration which started in Paris after the French Revolution and spread through Europe. It corresponds to the REGENCY STYLE in England. Its origin was largely due to the architects PERCIER and Pierre-François-Léonard FONTAINE, who decorated the state apartments of the First Consul. Interiors designed by them survive at FONTAINEBLEAU, Compiègne, and Malmaison. Their new style, which rapidly became internationally fashionable, was set out in *Recueil de décorations intérieures* (1801 and 1812). Basically the style is NEO-CLASSICAL but with an increment of archaeological interest and an attempt to copy what was known of ancient furniture and decorative motifs. There was also an affectation

of Egyptian motifs owing no doubt to interest inspired by Napoleon's Egyptian campaigns. The period saw the creation in furniture of the chaise-longue, the *lit bateau*, and the *psyche* or long, free-standing looking-glass. In women's dress the Empire style coincided with a distinctive high-waisted fashion embellished with dazzling embroidery.

**EMULSION.** A watery liquid combined with an oily or resinous one in such a way that they will not separate out. Oil proverbially will not mix with water, but if an emulsifying agent—such as albumen—is added, it will surround the drops of oil and prevent them from coming together. The MEDIUM of TEMPERA painting is always an emulsion. The natural emulsions used in painting are egg-yolk and CASEIN. Both have the advantage that once they have set they are not soluble in water. Besides these many artificial emulsions are used in painting, such as gum and oil, wax and glue, gum and egg-white.

**ENCARNADO** (Spanish: 'flesh-coloured'). Used in connection with a technique of painting in Spanish ecclesiastical art for colouring the flesh of faces, hands, etc., on figures carved in wood. The wood was primed with GESSO and flesh-coloured paint applied direct (in contrast to the more elaborate ESTOFADO process used for representing garments). In the 16th c. the flesh paint was given a glossy finish, but in the 17th c. a mat finish was adopted for greater REALISM, PACHECO being one of the first *encarnadores* to make this change.

**ENCAUSTIC PAINTING.** Painting with PIGMENTS mixed with hot wax. Its name derives from a Greek word meaning 'burnt in' and it was one of the principal painting techniques of the ancient world (see GREEK ART). The technique was said to have been perfected in the 4th c. B.C. by PAUSIAS, who painted with it small figures on ceiling panels. The most remarkable surviving examples are the MUMMY PORTRAITS from Faiyum, dating from the 1st c. B.C. to c. 3rd c. A.D. PLINY describes two methods which were already 'ancient' in his day (one of them on ivory) and a third newer method which had been devised since it became the practice to paint ships and records that it stood up to sun, salt, and winds. Plutarch also pays tribute to its durability: 'A beautiful woman leaves in the heart of an indifferent man an image as fleeting as a reflection on water. But in the heart of one who loves the image is fixed with fire like an encaustic painting which time can never obliterate.' The older methods described by Pliny were done with a spatula; the newer technique with a brush. Signs of the brush can be seen in some of the Faiyum portraits.

Encaustic painting was the commonest technique in the early centuries of the Christian era

but fell into disuse in the 8th or 9th c. In the 17th c. attempts were made unsuccessfully to revive it, notably by Count CAYLUS. Various mixtures involving wax dissolved in turpentine were tried in France and England during the 19th c. An encaustic technique more like the ancient one was developed by Julius SCHNORR VON CAROLSFELD, who painted several scenes in the Residenz at Munich in 1831. More recently the use of electrical apparatus has been suggested to keep the wax paint warm and fluid, but even so the technique finds few exponents, probably because it is too troublesome. Nowadays the wax is mixed with RESIN in order to make the colours easier to apply; for work on canvas it is mixed with oil, in which case the method is close to oil painting.

It may be added that in the past many artists working in oils have added wax to their colours, notably van GOGH and, it is believed, Sir Joshua REYNOLDS.

**ENDELL,** AUGUST (1871-1925). German architect and designer. He was self-taught but contributed to the ART NOUVEAU movement in Germany one of its most admired monuments in the Elvira Photographic Atelier, Munich (1897-8, now destroyed), the exterior of which was dominated by 'a very large abstract relief of orientalizing character resembling something between a dragon and a cloud' (Hitchcock). Historically more important than his subsequent buildings in Berlin (e.g. Bunte Theater, 1901) and elsewhere were his writings, which in attempting to analyse the psychological value of forms as a basis for design gave theoretical support to the first ABSTRACT artists in Germany.

**ENDOIOS.** Athenian sculptor of the latter part of the 6th c. B.C. His marble seated *Athena*, dedicated by Callias on the ACROPOLIS at Athens, survived the Persian sack, was seen by PAUSANIAS, and much damaged exists today (Acropolis Mus., Athens). Comparison of drapery and mobile pose has suggested that Endoios also designed the north and east FRIEZES of the Siphnian Treasury at Delphi (c. 525 B.C.).

**ENGELBRECHTSEN,** CORNELIS (1468-1533). Dutch painter born at Leiden. He served his apprenticeship in Brussels and seems to have returned home through Antwerp. His principal works are the two triptychs from the Marienpoel Convent (Municipal Mus., Leiden). Although his style shows the influence of the Italianate tendencies prevalent at Antwerp, Engelbrechtsen's work has a deeper intensity of emotional feeling. Contorted linear rhythms and resonant colouring characterize his highly personal art that is closer to the MASTER OF THE VIRGO INTER VIRGINES than to any Antwerp artist. LUCAS VAN

LEYDEN was his pupil and tends to overshadow his achievements.

**ENGLISH ART.** The history of English art is full of surprises. At times the quality has been very low and the output a provincial rendering of continental styles. More often continental ideas have been used by English artists, who have added something new of their own. Occasionally, though very rarely, England is to be found in the van of a new movement and her artists have themselves influenced continental developments. Many strands have gone to make up this uneven history and terms which can be applied with precision to continental movements are often dangerous when used for English art, which is seldom clear-cut and logical in its intentions.

Naturally the racial mixtures which produced the English have left a profound mark on English art. The Celtic peoples (CELTIC ART) had before the Roman occupation produced objects, notably in metal, adorned with fine scroll patterns, and a love for linear rhythms was to be one of the most constantly recurring features in many phases of English art. The Romans contributed a sense of order, seen in the layout of their towns such as Verulamium and in the military architecture of Hadrian's Wall, and a feeling for monumental sculpture. These had no lasting effect on native craftsmen, though the patterns used in the MOSAIC pavements of many Roman VILLAS held greater significance.

5TH-12TH CENTURIES. The 5th-c. invasions of the MIGRATION PERIOD, bringing the Anglo-Saxons from Germany, helped reinforce the love of abstract patterns, into which men and beasts were sometimes woven (see ANGLO-SAXON ART). The remarkable burial treasure from Sutton Hoo, Suffolk, now in the British Museum (c. 650-70), includes inlaid metal-work probably of pagan origin. Soon the pagan patterns were to be turned to Christian ones. The superb *Lindisfarne Gospels* (c. 700) have initials pages with intricate INTERLACINGS, while the figures of the EVANGELISTS show in their human proportions a new link with Mediterranean art. The same impressive combination is carried into sculpture in the Ruthwell and Bewcastle crosses, the finest examples of a considerable group. The mutilated church of Brixworth, Northamptonshire, and records of a church at Hexham suggest that building on a large scale also existed. Danish raids, however, caused destruction and a long period of turmoil, and by the 10th c. VIKING motives appear in both northern and southern England. The great achievement of this century is, however, found in the Anglo-Saxon ILLUMINATED MANUSCRIPTS of the so-called Winchester School, though the manuscripts came from Canterbury and elsewhere. The style, linked with CAROLINGIAN ART, is characterized by nervous and expressive line drawings, sometimes

combined with the gay colours seen in the *Benedictional of St. Aethelwold* (975–80).

The effect of the Norman Conquest, the last major impact of a new race in England, was quickly evident in architecture. Most late Saxon buildings were modest, but by 1090 great cathedrals in the Anglo-Norman variant of the ROMANESQUE style were being erected in many places (see NORMAN). Of exceptional length, and massive in appearance, they differ in design according to district, but the supreme monument of the style is Durham Cathedral (1093–1130), which anticipated by several years the use of ribbed VAULTS in France. In sculpture England has rarely produced work comparable with the best continental standards, though reliefs at Chichester (*c.* 1140), Lincoln (*c.* 1145), and the south porch at Malmesbury (*c.* 1160–70) suggest that fine things were done. Much 12th-c. work retains variations of the interlace patterns of earlier ages, sometimes, as at Ely, combined with a monumental figure composition; but in general English Romanesque sculpture is provincial. Manuscript painting, however, and in all probability the minor arts, of which little remains, reached a high level. Colours were harsher than in Anglo-Saxon painting and lines heavier, as in most Romanesque painting; interlacings persisted, though changed; and gradually the love of dramatic narrative, which found unique secular expression in the BAYEUX TAPESTRY, prevailed. New contacts with Mediterranean art, probably from Byzantium via the OTTONIAN Empire, led to a greater naturalism, acceptable to a more humane society on the threshold of the GOTHIC age.

13TH–15TH CENTURIES. English Gothic art, though much influenced by France, is by no means merely a poor relation. English architects, retaining the long naves and wide transepts of the Anglo-Norman period, evolved a style which was less single-minded than the French with its ceaseless striving for great height. Churches were lower and so there was less need for flying BUTTRESSES; vaulting shafts did not rise from the ground; horizontals were more important; and the number of mouldings on shafts, ARCHES, and vaults greatly increased, so that the linear surface rhythms were everywhere stronger. Even when French influence was direct, as at Canterbury (1174) and Westminster (1245), linear qualities were present. This love of line led in the 13th c. to the addition of extra vaulting ribs (Lincoln and Exeter), and in the 14th c. to the development of the lierne vault (Gloucester choir) with its small ribs, sometimes in star patterns, cast like a net over the whole surface. In the PERPENDICULAR STYLE, the final phase of English Gothic architecture, panelled tracery covers the whole church, repeated on walls and in window bars, and culminating in that purely English invention, the fan vault. Perpendicular architecture had a long life (*c.* 1330–*c.* 1540) and may be seen in many great churches (Sherborne Abbey, York Minster, Canterbury nave); but it was also much

used in the 15th c. for parish churches, especially those in Gloucestershire (Cirencester, Northleach) and East Anglia (Lavenham and Long Melford, Suffolk; Walpole St. Peter, Norfolk), districts which had become rich through the wool trade. Such churches were seldom vaulted but were covered with splendid timber roofs, often springing from angel CORBELS (March, Cambridgeshire), which are one of the great glories of English medieval carpentry.

Although many English Romanesque cathedrals had used the French apse, in the Gothic period the east end is invariably rectangular, except where French influence is direct (Canterbury, Westminster). Great east windows are therefore a feature of English cathedrals (Lincoln, York, Gloucester); and octagonal CHAPTER HOUSES, vaulted from a central shaft, are another purely English development (Salisbury, Wells, Westminster). West fronts with twin towers occasionally appear (Canterbury, York, Beverley), but a great screen-like front (Lincoln, Peterborough) is an original invention, unparalleled on the Continent.

In this period too sculpture was less original than architecture, but the great array of standing figures on the screen-like west front of Wells Cathedral have a fine and monumental gravity, and the angels in the transepts at Westminster a classical dignity not far below that of the 13th-c. masterpieces of France. Much of the best English sculpture that has survived is on TOMBS, for many religious figures were destroyed either at the Reformation or by the Puritans. Most is in stone, or the dark PURBECK MARBLE, but bronze effigies of supreme linear beauty adorn the tombs of Henry III and his daughter-in-law at Westminster, and in the later Middle Ages the soft ALABASTER found in the Midlands permitted sculptors to indulge their taste for elaborate details of armour and heraldry. The alabaster quarries provided one of the two types of art much exported from England, namely sculptured RETABLES of many panels, usually with biblical themes, mainly of the 15th c. and often clumsy in execution. The other export art, *opus anglicanum*, was embroidery of the highest quality, and many foreign cathedrals were enriched by vestments adorned with figure subjects worked in silk and gold thread. Fine STAINED GLASS was also produced. Though much has been lost, enough remains to trace changes in style from the late Romanesque period (Canterbury choir) right down to the early 16th c. (York Minster, King's College Chapel, Cambridge).

Illuminated manuscripts, often of great beauty, and presenting a great variety of styles for so small a country, were in demand throughout the Gothic period. The 13th c. not only used the full colour technique on a gold ground but also, in the works of Matthew PARIS of St. Albans, continued the tradition of the tinted drawing. In the 14th c. perhaps the most characteristically English manuscripts are the group of East Anglian Psalters, with their highly decorated

pages with GROTESQUES in the borders, while later works of the century suggest a knowledge of Italian art combined often with an English love of pattern. Some but not all the works produced in the late 14th and early 15th centuries fall within the INTERNATIONAL GOTHIC style, the supreme example being the exquisite Wilton Diptych showing Richard II presented to the Virgin by his patron saints, though not all scholars agree that the painter was English. Painting in the 15th c. displayed many styles but towards the end the influence of Flanders was dominant, the most notable example being the Eton Chapel wall-paintings (1479–83) of the miracles of the Virgin by William Baker.

16TH–17TH CENTURIES. The new realism, derived from Flanders or Germany, can also be seen in the sculpture in Henry VII's Chapel at Westminster Abbey, though architecturally it and King's College Chapel, Cambridge, are the final flowering of English Gothic art. Both, however, contain works in the RENAISSANCE idiom. Henry VII's tomb with its splendid bronze effigies was made by a Florentine, Pietro TORRIGIANO, and the screen and stalls at Cambridge have Italianate ornament, coming probably by way of France.

By 1540, owing to the dissolution of the monasteries and the break with the Roman Church, the cathedral workshops almost disappeared and religious art ceased. Interest was centred on those things which foster the importance of the individual or still more of the family —the portrait, the tomb, and the house. One of the great portrait painters of Europe, Hans HOLBEIN, recorded in paintings and drawings Henry VIII himself and the members of his court. But he founded no school, and most 16th-c. portraits, stiffly posed and flat, are of clothes rather than of people, though the work of the miniaturists, Nicholas HILLIARD and his successors, has an exquisite refinement. Sculpture, even when English craftsmen were reinforced by refugees from the Low Countries during the Wars of Religion, was extremely provincial, and it was only in the design of great country houses that the Elizabethans produced a vernacular art of distinction. Although much of the somewhat coarse ornament is derived from Flemish pattern books, houses such as Wollaton Hall and Hardwick Hall show an inventive grouping of masses and variation in window shapes which owe nothing to the Renaissance, though the increased desire for symmetry must surely have come from Italy through France.

Royal patronage under Elizabeth I hardly existed, and this is at least one factor in the great disparity between the history of art in England and in France. The Stuarts, however, were aware of the value of art for propaganda purposes, and though English artists never for long received that patronage of an absolute monarch or an all-powerful papacy which nourished the full BAROQUE of the Continent, English art no longer appeared as a provincial backwater. Inigo JONES, the first Englishman with a profound knowledge of Renaissance and ANTIQUE art, broke sharply with English tradition, and brought Italian architecture and Italian theatre design to this country. His correct and refined designs

121. *The Banqueting House at Whitehall by Inigo Jones.* Engraving from *Vitruvius Britannicus*, Vol. I (1715) by Colen Campbell

**122.** *The Generall Front of Blenheim Castle.* Designed by Sir John Vanbrugh. Engraving from *Vitruvius Britannicus*, Vol. I (1715) by Colen Campbell

were, however, less sculptural than their Italian counterparts, and his mouldings lighter and more linear. New continental standards were set in painting by RUBENS's acceptance from Charles I of the commission to paint the ceiling of Inigo Jones's Banqueting House, and van DYCK's sojourn in England (1632–41) left an indelible impression on English portrait painting. The brittle elegance of the Caroline court, so well reflected in van Dyck's English portraits, was swept away by the Civil War, but later foreign artists, Sir Peter LELY and Sir Godfrey KNELLER, managed in their best works to give to Englishmen a virile distinction. Both were sound craftsmen, but the enormous practice of the latter caused him to leave too much to assistants.

The Restoration period has much of distinction to show in architecture. Inigo Jones's Italianism was an important formative influence on the style of the great dominating figure, Sir Christopher WREN; but French and Dutch building had become familiar to the court in exile, and Wren himself visited France. The Great Fire of London of 1666 gave him his most splendid opportunity in the rebuilding of the City churches and St. Paul's Cathedral, the dome and west towers of which were the climax of his long career. There, and in the many buildings he undertook for the Crown and the universities, he experimented freely with ideas drawn from manifold sources, and his early years passed in the pursuit of science gave him a flexibility of mind which was invaluable for the compromise solutions he was often compelled to adopt. His reticent form of Baroque, itself a compromise, is essentially English as is, indeed, the more dramatic though less polished building of his associates, Sir John VANBRUGH and Nicholas HAWKSMOOR. Unlike Wren's, Vanbrugh's work lay almost entirely in the field of country houses, and Castle Howard and Blenheim Palace mark the culmination of the English Baroque.

The period from about 1725 to about 1840 is perhaps the greatest age of English art. Not only was work of very high quality produced, but ideas which originated in England can be seen to have influenced the Continent. The reign of George I saw the first reaction against the Baroque towards a more rational and restrained architecture based on the work of Inigo Jones and through him on that of the Italian PALLADIO. With Lord BURLINGTON and Colen CAMPBELL in the lead design both in the great country houses and in the newly introduced VILLA became both more chaste and more monotonous, but it is one of the many surprising aspects of English art that the interiors of such houses were decorated with the richest plaster work, at first Baroque and later ROCOCO in feeling.

Town architecture, too, is of interest. GEORGIAN London saw the development of the West End squares (Grosvenor Square, Berkeley Square, etc.) surrounded by houses with simple and sometimes uniform exteriors, but often with rich and varied interior planning. The fashion for spa treatment led to the development at Bath, Tunbridge Wells, and Buxton of planned towns using not only the square but also the crescent and the circus; and London TOWN-PLANNING achieved its climax in the early years of the 19th c. with John NASH's schemes for Regent Street and Regent's Park.

Sculpture, which in the 17th c. had lagged behind architecture and painting, was now to become a far more lively art. The classical type of portrait bust appealed greatly to Englishmen, many of whom were by now buying real or fake antiques during their GRAND TOUR in Italy. Noble portraits in this manner were made by the Flemings Michael RYSBRACK and Peter SCHEEMAKERS and the Frenchman Louis François ROUBILIAC, though the penetrating busts in contemporary costume of the last are perhaps his finest work. Tomb design also was enriched by these and other foreign artists. The 17th c. had seen the abandonment of the specifically Christian tomb, and the replacement of the effigy in death by one in life: the early 18th c. introduced a wide range of allegory and more varied and more ambitious patterns, of which Rysbrack's monument to Sir Isaac Newton (Westminster Abbey, 1732) is a splendid example. English-born sculptors adopted the types used by the foreigners, and competently designed works, showing the overriding passion for classical reference (though often interpreted in a Baroque

spirit), may be found in countless village churches.

The change in painting came more slowly and the influence of Kneller remained paramount in portraiture till almost 1750. Before then, however, William HOGARTH had in his 'modern moral subjects' developed a new and lively form of GENRE painting, which, with its emphasis on narrative, appealed greatly to the literary instincts of the English at the moment when the English novel was rising to importance. Hogarth also painted small portrait groups—CONVERSATION PIECES—which won a special place in English art and continued throughout the century, largely though not entirely for middle-class patrons.

The aristocracy, however, had to wait until the 1750s and 1760s before artists appeared who were capable of doing for them what van Dyck had done for the Caroline court. Sir Joshua REYNOLDS and Thomas GAINSBOROUGH, the former with his enormous repertory of poses drawn consciously or unconsciously from his studies in Italy, the latter with his tender understanding of character and wonderfully fluid technique, lifted portraiture from the rut into which it had fallen. Both made other contributions to English art. Artists had long felt the lack in England of opportunities of bringing their work before the public and of any centre of academic training. The foundation of the ROYAL ACADEMY in 1768 provided both. Reynolds was its first President, and by his own artistic distinction and intellectual powers, which found expression in his Discourses (his yearly addresses to Royal Academy students), he did much to raise the status of artists in England. Gainsborough's contribution outside portraiture was of a different kind, for his real love was for landscape painting.

In this field, to which so many Englishmen have been devoted, TOPOGRAPHICAL and MARINE subjects had appeared in the 17th c., deriving chiefly from Dutch painting. The Venetian CANALETTO had visited England in 1746 and had left his impress on painters such as Samuel SCOTT; but Gainsborough's greatest English contemporary in this art was Richard WILSON. Wilson's stay in Italy 1750-7 and his deep admiration for the painting of CLAUDE colour most of his work, but his personal application of the southern landscape tradition to English subjects served to produce pictures of outstanding quality and influenced profoundly the leading landscape painters of the early 19th c. Gainsborough, who never left England, started in the Dutch tradition, fell under the spell of Rubens, and in his late and most fluent landscapes created a new art. He also made tinted drawings and so is to some extent allied with the prolific school of painters in WATER-COLOUR who were so active through the middle years of the 18th c. and on into the 19th. They took their start from topographical painting—the portrait of the house or the estate—but in the hands of John Robert

COZENS, with his delicate Swiss and Italian scenes, the art realized a new quality of poetry, an interest in 'feeling', which characterized much late 18th-c. art in England and can best be termed 'Pre-Romanticism'.

English 18th-c. art indeed reflects a great variety of taste—and to be a 'man of taste' was the ambition of most educated Englishmen at that time. Lord BURLINGTON's Palladian Classicism, seen in its most developed form in the Assembly Rooms at York, gave way in the middle of the century to the even purer architecture of James STUART, whose book The Antiquities of Athens (1762) was to herald the NEO-CLASSICAL movement. At the same time Horace WALPOLE, whose Anecdotes of Painting (1762-71) are a sure indication of the taste of his day, was building his villa at Strawberry Hill in the Gothic style, and showing a romantic nostalgia for the past (see GOTHIC REVIVAL). English landscape architecture achieved great importance and became a fashion in Europe. Formal gardens were swept away, and parks were 'landscaped' by William KENT and 'Capability' BROWN to resemble paintings by Claude. Later in the century the taste for the PICTURESQUE, that is for the irregular and the rustic, affected both garden design and the work of innumerable painters of views, as well as Gainsborough in his FANCY PICTURES and George MORLAND in his stable scenes. Architects such as James WYATT or Robert ADAM were prepared to design in either the Gothic or the classical manner, and the latter's happy marriage of antique decoration, very freely and lightly interpreted, with complex grouping of rooms is perhaps the last major contribution to the development of the great house, which has had so long a history in England.

Before the end of the century the majority of artists were aware of the increasing demand for imagination as opposed to reason. Some, like John FLAXMAN, contrived an art in which antique forms were imbued with a new sentiment. William BLAKE followed a more personal course, and though in his visionary art he often borrowed from other styles, his intensity of expression and his personal treatment of the linear tradition were unique. Sir John SOANE developed an architecture which used both Gothic and classical forms, but which in its spatial novelties was allied to neither. The tide was running fast towards ROMANTICISM, that great European movement in which England led the van.

It is perhaps characteristic that the two greatest English painters in the style of Romanticism, TURNER and CONSTABLE, were both primarily landscape painters. History painting, through which DELACROIX was later to express his Romanticism, had been given lip-service by 18th-c. England, but though history paintings had been produced, notably by James BARRY and the American Benjamin WEST, their careful respect for the best patterns could not give life

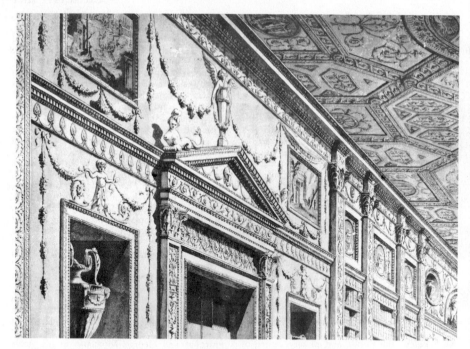

**123**. Detail of an engraving from *The Works in Architecture of Robert and James Adam*, Vol. III (1822). Showing stucco decoration in the Long Gallery at Syon House

to their art. Turner in his long career painted many pictures with historical, or at least literary, titles, pictures which are successful because of his disregard for convention and because, like all his work, they are infused with imagination, saturated with colour, and drenched with light. Though Turner was a fine draughtsman, his primary interest was not with forms but with atmospheric effects, and in his vast output of both oils and water-colours his greatest triumphs are floating, ephemeral visions of changing light. Turner drew his subjects from many countries in Europe; Constable is essentially the painter of the English scene. He, too, was much occupied with fleeting effects of light upon the countryside, but until almost the end of his life it was in his oil and water-colour sketches, rather than in his finished Academy pictures, that this is most movingly conveyed. His ceaseless studies of nature led him to abandon the conventional colour schemes used by his predecessors such as Wilson, and even by his contemporary John CROME the Norwich painter, and he developed a brighter, lighter palette and a looser handling which was greatly to excite Delacroix. The influence of the brilliant colours and direct study of nature of Turner and Constable changed the direction of English landscape painting, above all in water-colour; the tinted drawing tended to disappear and water-colour artists attempted the full range of oils.

In portraiture the chief exponent of Romantic painting was Sir Thomas LAWRENCE, who added to the Reynolds tradition a glitter, and at his best a force, which makes his great series of portraits at Windsor Castle, painted to commemorate the Congress of Vienna, without rival in Europe. Sir Henry RAEBURN in Edinburgh produced richly coloured, vigorous portraits, though without the suavity of Lawrence.

At the same time the demand for narrative painting was increasing, for it was greatly to the taste of the newly powerful middle class who were making money in industry. Rustic scenes by Sir David WILKIE were followed by Shakespearian and historical paintings, treated as genre scenes and not in the GRAND MANNER, and ultimately by paintings of Victorian life by a host of competent though uninspired artists. Sculpture, however, found it much harder to free itself from the classical tradition. Sir Francis CHANTREY, more robust than Flaxman, employed an equal combination of the classical and the sentimental, and it was not until almost 1840 that a movement away from classical idealism began to appear in Samuel Joseph's Wilberforce monument in Westminster Abbey. The majority of English 19th-c. sculptors, however, found it impossible to throw off the shackles of antiquity, a notable exception being Alfred STEVENS, who in his sculpture and in his painting as well turned to the High Renaissance for inspiration. Much more precise knowledge of older styles was available to 19th-c. artists than had been the case

in the preceding century. The 'Battle of Styles' between classical and Gothic, centring mainly round the new Houses of Parliament (Gothic; 1840-60, Sir Charles BARRY and Augustus Welby PUGIN) and the new Government Offices (classical; Home Office and Foreign Office, 1860-70, Sir Gilbert SCOTT), was fought with a full archaeological armoury, though to Pugin, and to that most influential figure John RUSKIN, medieval art had a moral beauty that was separate from its visual beauty.

And it was an earnest moral approach that induced a group of young artists in the 1840s to declaim against the emptiness of contemporary art, indeed of all art since the age of RAPHAEL, and to turn to the Italian PRIMITIVES for inspiration. The PRE-RAPHAELITE Brotherhood quickly fell apart, but for a few years after 1848 they produced pictures, often religious and always moral in content, painted in brilliant, jewel-like colours, with sharply defined forms. They made little headway against the strong current of academic painting, and indeed in their insistence on narrative they were not far from it; genre scenes and romantic historical pieces (notably those of George Frederick WATTS, who found his inspiration in TITIAN and VERONESE) continued to be the official art of England, apart from innumerable portraits, up to the end of the century and beyond. One Pre-Raphaelite of the second generation, however, William MORRIS, with his interest in design left a lasting mark. His books with their fine line decoration, his stained-glass windows designed by Edward BURNE-JONES, his designs for wall-papers and printed stuffs, carried on the abiding English tradition for linear patterns and laid an important foundation for fin-de-siècle art in Europe (see ART NOUVEAU).

The work of the later Pre-Raphaelites was tinged with an AESTHETICISM which culminated in the 'Aesthetics Movement' of PATER, Wilde, and the *Yellow Book*. The leading protagonist among artists of the 'art for art's sake' movement was WHISTLER, and BEARDSLEY the brilliant flower of its later phases. The efforts of William Morris to raise the standards of applied art and to bring the arts on a wider basis to the people had their most important influences abroad. But in England they were the inspiration for a series of PRIVATE PRESSES and for such movements as that represented by the OMEGA WORKSHOPS of Roger FRY. England had led the way in the 18th c. with the use of iron as a building material in arch and suspension bridges and roof and dome structures for several-storeyed buildings (Abraham Darby's arch bridge near Coalbrookdale, 1777-9, the Sunderland Bridge, 1793-6, the first large-scale cast-iron framework for a flax mill at Shrewsbury in 1796). About the middle of the 19th c., despite Ruskin's statement in *The Seven Lamps of Architecture* that 'True architecture cannot endure iron as a structural material', England again led the way in exploiting the inherent qualities of iron for structure and style alike. Notable works were the Palm House in Kew Gardens (1845-7) by Decimus BURTON and Richard Turner and the Crystal Palace (1851) by Joseph PAXTON (see EXHIBITION ARCHITECTURE). Notable also in the field of domestic architecture was the work of Norman SHAW and C. A. VOYSEY, which established a tradition carried on in the 20th c. by LUTYENS.

In the second half of the century the Royal Academy touched its lowest ebb and in 1886 the NEW ENGLISH ART CLUB was formed by artists outside the Academy to support a movement towards simple naturalism against the officially supported fancy-dress Classicism of LEIGHTON and ALMA-TADEMA. The founders were a group of artists such as CLAUSEN, Wilson STEER, and SARGENT, many of whom had been influenced by the *plein air* school of BASTIEN-LEPAGE. In 1889 the Club came under the influence of a minority group led by SICKERT and for a time it stood for a modified form of IMPRESSIONISM. From about the second decade of the 20th c. the importance of the Club in English art began to dwindle as the Academy exhibitions were liberalized and as the Club itself took on a more 'academic' character in opposition to *avant garde* movements. On the occasion of the Club's 86th exhibition in 1936 Eric Newton could speak of 'this cheerful and well-preserved semi-centenarian' and draw the moral 'that it is one of the most dangerous things in the world to win a battle'. During the last decade of the 19th c. England was the chief seat of the new style of *art nouveau*, which in architecture, ART MOBILIER, and the graphic and illustrative arts spread through Europe. British *art nouveau* stemmed from William Morris and the Pre-Raphaelites, found expression in the linear style of Aubrey Beardsley, and had among its chief exponents members of the 'Glasgow School', who broke away from the New English Art Club. Among the most influential in this style were the Glasgow architect Charles Rennie MACKINTOSH, Charles RICKETTS, and A. H. MACKMURDO.

A powerful stimulus was given to the younger generation of English painters by the POST-IMPRESSIONIST exhibitions organized by Roger Fry in 1910 and 1912. A new society, the CAMDEN TOWN GROUP, was formed in 1911 under the influence of Sickert as a rallying point for the younger artists who were interested at once in social REALISM and in the decorative and symbolic treatment of colour as against the exclusive importance still placed by the New English Art Club on the Impressionistic representation of light effects. Under the influence of Italian FUTURISM the short-lived but vociferous movement of VORTICISM was formed in 1913 by Wyndham LEWIS, who was joined by NEVINSON and the young sculptor GAUDIER-BRZESKA. And from the Camden Town Group and the Vorticists sprang the LONDON GROUP, which survived the Second World War. In 1933 a group of 11 artists combined to form UNIT ONE, which purported to represent the 'modern movement' in English.

painting, sculpture, and architecture. But they stood for no concrete common principles or styles and after one exhibition they did not hold together. Also short lived was the EUSTON ROAD GROUP, formed in 1938 around COLDSTREAM. Working also during the 1920s and 1930s were the more loosely organized Bloomsbury Group, including such artists as Duncan GRANT, Roger Fry, Vanessa BELL, with Matthew SMITH and Mark GERTLER on the fringe. The 1930s saw not only the Jubilee Exhibition of the New English Art Club (1936) and an exhibition of its acquisitions held by the Contemporary Art Society (founded in 1909) to celebrate its 25th birthday in 1935, but also in 1935 the first Empire Art Exhibition.

The first half of the 20th c. was also notable for the emergence of a number of outstanding individualist sculptors. Among the older generation were Frank DOBSON, Leon Underwood, Maurice Lambert, Jacob EPSTEIN, Henry MOORE, Barbara HEPWORTH, and among the younger Reg BUTLER, Lynn CHADWICK, and Kenneth ARMITAGE.

The most prominent artists in England from the period between the two wars were Henry Moore, Paul NASH, Graham SUTHERLAND, and the anomalous figure of Stanley SPENCER. All owed more to the English Romantic tradition than to the aesthetic movements current abroad. Since the Second World War the new generation of English art has become more international in character. Among CONSTRUCTIVISTS primacy falls to Ben NICHOLSON, who achieved international reputation, and to Victor PASMORE. William SCOTT, Roger Hilton (1911–   ), and Alan DAVIE fall within the school of ABSTRACT IMPRESSIONISM. A school of realists or social realists is represented by such painters as John Bratby (1928–   ) and Jack Smith (1928–   ). Francis BACON stands out as perhaps the most powerful and certainly the most individualist of post-War British artists.

4, 119, 137, 138, 182, 230, 278, 318, 347, 385, 454, 470, 665, 690, 751, 806, 831, 832, 901, 944, 974, 977, 1098, 1128, 1136, 1218, 1260, 1263, 1391, 1407, 1451, 1479, 1487, 1612, 1613, 1616, 1683, 1685, 1958, 1960, 2066, 2067, 2068, 2092, 2151, 2152, 2228, 2229, 2257, 2318, 2346, 2397, 2398, 2402, 2404, 2482, 2562, 2563, 2586, 2587, 2625, 2677, 2686, 2700, 2701, 2718, 2791, 2800, 2812, 2813, 2861, 2864, 2872, 2893, 2917, 2931, 2955, 2956.

**ENGRAVING.** The various processes of engraving for reproduction are enumerated in the entry on PRINTS, and are discussed in more detail in separate articles (LINE ENGRAVING, WOOD ENGRAVING, etc.).

**ENRIQUE,** MASTER (d. 1277). First recorded architect of the GOTHIC cathedrals of Burgos (begun 1221) and León (mainly built c. 1254–c. 1288). If not of French origin he probably served his apprenticeship in northern France, as both cathedrals show the influence of French Gothic, in particular of REIMS Cathedral.

**ENSINGEN,** ULRICH VON (c. 1350–1419). German architect, responsible from 1392 onwards for the tall spire of Ulm Cathedral and for transforming the original HALL CHURCH into a five-aisled BASILICA. He also built the one completed spire of Strasbourg Cathedral up to the octagon, and altered the Frauenkirche in Esslingen. Unlike earlier medieval masons who supervised work on the spot, Ensingen after 1399 directed several projects simultaneously from an office in Strasbourg. His predilection for gigantic scale—Ulm became the largest German cathedral after Cologne and the spire of Strasbourg was to be the tallest completed in the Middle Ages—is typical of this late phase of German GOTHIC art. Ensingen enjoyed an international reputation and was called to Milan in 1394 to advise on the completion of the cathedral.

**ENSOR,** JAMES (1860–1949). Belgian artist whose father was English and mother Flemish. He was born at Ostend, where his parents kept a souvenir shop, and apart from his training in Brussels rarely left his home town. His best work was done before 1900, his first important painting being produced at the early age of 19. In the first period he painted provincial bourgeois interiors in a sombre palette strongly contrasting with contemporary French IMPRESSIONISTS. Like van GOGH he gradually adopted a lighter key as with *Woman Eating Oysters* (Antwerp, 1882), the first of several controversial works which were refused by the Salons. During the 1880s his subject matter changed and he began to introduce the fantastic and macabre elements which are chiefly associated with his name. He made much use of carnival masks, grotesque figures, skeletons, bizarre and monstrous imaginings with a gruesome and ironic humour reminiscent of BOSCH and BRUEGEL. His paintings and even more his graphic work took on a didactic or satirical flavour involving social or religious criticism. His *Cathedral* expresses defiance of human limitations and his later *War of the Snails* is in a similar satirical vein. The colossal *The Entrance of Christ into Brussels* (Antwerp, 1889) provoked his expulsion from the Salon of The Twenty Group.

Ensor drew his subjects from Bosch, Bruegel, and CALLOT, vitalized by his own fertile fantasy, and he treated them in the techniques of MANET and RUBENS. Yet he remained an isolated and entirely original artist whose importance has been recognized as presaging much in the 20th c. He was one of the formative influences of EXPRESSIONISM and was claimed by the SURREALISTS as a forerunner.

120, 821, 866, 1209, 1644, 2622.

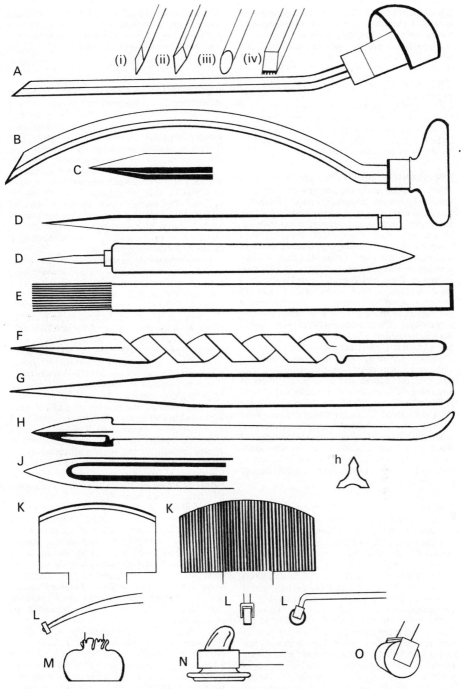

**Fig. 22.** ENGRAVING AND ETCHING TOOLS

A. Burin or graver  (i–iv) Shapes of burin-tips  B. Stipple graver  C. Punch tool  D.D. Etching needles  E. Multiple etching needle  F. Heavy drypoint needle with burnisher  G. Burnisher and scraper  H. Scraper with (h) section showing triple blade  J. Mezzotint scraper  K.K. Mezzotint rockers (back and front views)  L.L.L. Roulettes  M. Soft ground dabber  N. Etching hammer  O. Hard ground roller

**ENTABLATURE.** Term in classical architecture for the whole assemblage of parts supported by the COLUMN. The three primary divisions of the entablature are the ARCHITRAVE, FRIEZE, and CORNICE.

**ENTASIS.** Term in classical architecture to express the swelling of a COLUMN, one of the refinements practised in the classical period (see GREEK ART). Most Greek columns begin to diminish in thickness about a third of the way up from the base and there are various formulas for the curve of diminution.

**EPIPHANIUS OF EVESHAM** (1570- after 1633). English sculptor, perhaps the first personality in English sculpture since the Reformation. He was the son of a Herefordshire squire and though not much is known of his training, he was in 1592 in the London workshop of a refugee sculptor from Brabant, Richard Stevens, who died in that year. From 1601 to c. 1614 he was working as a master-sculptor and master-painter in Paris, but though he had a studio of some size and several works in both arts are recorded, none has survived. After his return to England he made a number of tombs of some originality. That to Edmund West (Marsworth, Buckinghamshire, 1618) is decorated with engraved brasses, while his signed tomb of Lord Teynham (Lynsted, Kent, 1632) has, in addition to the recumbent effigy, a distinguished kneeling figure of the widow and a series of reliefs of mourning children, full of humanity and charm. A few other works, including the tomb of Lord Rich at Felstead, Essex (probably erected about 1619), with its unusual series of allegorical reliefs, can be assigned to him, and at a period when most English tomb-sculpture was mass-produced his work, though small in quantity, stands out for its refinement and its freshness of invention.

**EPSTEIN,** SIR JACOB (1880-1959). Monumental and portrait sculptor, occasional painter and draughtsman, born in New York of Polish-Jewish parents. He settled in London in 1905, became a British citizen in 1907, and was knighted in 1954. His first commission, to carve 18 figures for the British Medical Association headquarters in the Strand (1907-8, since destroyed), roused violent controversy and this attended much of his monumental work throughout his life. In 1910-11 he carved the Oscar Wilde memorial at the Père Lachaise cemetery, Paris. He was a foundation member of the LONDON GROUP in 1913 and in 1919 exhibited his controversial figure *Christ.* He did the *Rima* for the W. H. Hudson memorial in Hyde Park in 1925 and the figures of *Night* and *Day* for the St. James's Park Underground station in 1928-9. His principal sculptures include: *Consummatum Est* (1937), *Adam* (1939), *Lucifer* (1945), *Lazarus* (1949), *Youth Advances* (1951), *Virgin and Child* (1950), *Social Con-*sciousness* (1957-8), *Christ in Majesty* (1957). He also did many portraits. Epstein was regarded as the greatest sculptor of his day in the ROMANTIC tradition descending from RODIN.

428, 822, 823, 2722.

**EQUESTRIAN STATUE.** The equestrian monument has presented the sculptor with a formidable problem. It involves the balance of a vertical element on a large horizontal mass which in turn rests on very slender supports; and this problem leads to another, that of combining the two forms into a structural unity. Furthermore, nearly all equestrian statues are portraits—portraits of a special kind, because the character of the rider may be suggested by that of his mount. The horse at rest evokes a sense of authority, the rearing horse implies the man of action. Most of the statues may in fact be classified by the pose of the horse as belonging to one of these two types.

Free-standing equestrian statues were made in antiquity, but we know the Greek works only through literature and very few examples now remain of the Roman: two marble ones from the forum of POMPEII are in the museum of Naples. Of the many equestrian bronzes to be found in Rome in late antiquity, the only one now surviving is that of Marcus Aurelius (2nd c. A.D.) which, formerly at the Lateran, was moved in 1538 to the Capitol, where it now stands. It was preserved throughout the Middle Ages because it was believed to represent the first Christian emperor, Constantine. Aurelius rides without stirrups, checking the trotting pace of his steed with one hand while the other arm is outstretched in a gesture of command. The group has a measured forward movement and great dignity. A rare example of the equestrian statue in the CAROLINGIAN Renaissance, the small bronze of Charlemagne or perhaps Charles the Bald (Musée Carnavalet, Paris), is a symbol of authority rather than a portrait.

The Middle Ages abandoned the idea of the personal monument. The stone statue of Otto I or Otto II, Magdeburg (mid 13th c.), is a symbol of justice. Similarly the equestrian statues and reliefs of St. Martin and St. George must be understood as representations of virtues. The most famous and impressive of these Christian horsemen, the *Bamberg Rider* (Bamberg Cathedral, c. 1235), presumably has some meaning of this kind, which has been interpreted in various ways.

As a funerary monument the equestrian statue reappears with the *Cangrande della Scala* (Verona, 1329), a stocky and slightly comic figure of a knight rigidly encased in armour. The masses of cloth which cover the horse act as a support for its legs and thus solve one of the technical problems. The RENAISSANCE often used equestrian monuments to commemorate the dead. UCCELLO's *Sir John Hawkwood* (1436) and CASTAGNO's *Niccolo da Tolentino* (1456), both

in Florence Cathedral, are paintings in GRISAILLE imitating sculpture. The Venetians at the end of the century liked to place gilded wooden riders on the tombs of nobles (Cappella Colleoni, Bergamo).

The first free-standing equestrian bronze since classical antiquity was created by DONA-TELLO. This is the *Gattamelata* (Padua, *c.* 1446). While working at Padua Donatello was within range of Venice, where he would have seen the four bronze horses over the porch of St. Mark's, Hellenistic (or Roman) works brought there from Constantinople in 1204. It is clear that he also knew the *Marcus Aurelius*. VERROCCHIO's *Colleoni* (Venice, 1485–8) has more drama and tension, achieved by a system of crossing diagonals: the *condottiere* checks the horse's forward movement, rising slightly in his stirrups as though to give a command to his troops.

When LEONARDO designed the Sforza and Trivulzio monuments he experimented with the traditional type but also developed an entirely new one, the prancing horse. His ideas are known to us only through his drawings and various small 16th-c. bronzes, and it was not until the 17th c. that sculptors tackled the severe technical problems which such a composition involved. Pietro TACCA's statue of Philip IV on a rearing horse (Madrid) is derived from a painting by RUBENS of the same monarch. BERNINI's terra-cotta sketch for *Louis XIV* (Villa Borghese, Rome, *c.* 1667) mounted the young king on a massive rearing horse, but when the sketch was executed in marble for VERSAILLES it met with such disapproval that it had to be transformed into a *Marcus Curtius* and relegated to a distant corner of the gardens. French academic taste preferred the older formula of imperial dignity, and this was adopted by GIRARDON in his statue of 1699, which, though destroyed in the Revolution, is known through a wax model. Bernini's ideas were taken up by FALCONET, however, and developed in a masterly way in his spirited bronze monument to Peter the Great (Leningrad, 1766–78). The horse rears up on a stone pedestal shaped like a cliff—a dramatic composition which must have inspired DAVID's painting *Napoleon Crossing the Alps* (Versailles, 1800).

The 19th c. with its love of monuments cluttered the streets and squares of European capitals with equestrian statues which too often lacked artistic merit; the 20th c. has erected few. Well known examples of somewhat varying merit include: *Marko Kraljević* by Ivan Mĕstrović; *The Valkyrie* (Copenhagen) by Stephen Sinding; *Kaiser Wilhelm I* (Berlin) by Reinhold Begas; *Physical Energy* (Kensington Gardens and Cape Town) by G. F. WATTS; *Sigurd* (Tate Gal.) by Gilbert Bayes; *General Sherman* (New York) by Augustus Saint-Gaudens; *Jeanne d'Arc* (Paris) by Emmanuel Frémiet; and groups *The Union Monument* (Bratislava) by Ladislav Sǎloun and *Wrestlers* (Brussels) by J. de Lalaing. The equestrian statue has led to no new conquest of sculptural form in the modern period, but has sometimes provided occasion for the *tour de force*, as for example: A. H. Hussmann's bronze *Finish* depicting two jockeys in a close finish of a race, C. J. Bonnesen's *Life and Death* (Copenhagen), Sir Thomas Brock's *A Moment of Peril* (Tate Gal.), Gilbert Bayes's *The Fountain of the Valkyries* (Auckland, New Zealand), Frederick MacMonnies's *Pioneer Monument* (Denver, Colorado). MARINI has found inspiration in Etruscan and Geometric Greek art for many figures of horse and rider which are arresting images of generalized forms but not equestrian portraits. The history of the equestrian monument seems to be near its end, since great men of the future are unlikely to be commemorated on horseback.

The casting of these very large bronzes was always done by the *cire-perdue* process, except in the 19th c. when the sand method was often preferred. The procedure was that described in the article on BRONZE, with certain differences. All stages of the work had to be carried out in the same place, because the apparatus was too big to be moved. The wax was burnt out of the mould, rather than melted out, because the mould could not be inverted; and when the metal was to be poured in the mould was enclosed in an iron cage instead of being packed into a sandpit. Ideally the whole monument would be cast in one piece, but often it was found convenient to cast certain parts separately, and attach them afterwards with 'Roman joints'. The casting of so large a work required exceptional skill, a fact which was recognized. The statue of the Great Elector in Berlin (1696–1700), one of the most powerful BAROQUE treatments of the theme of horse and rider, gained less credit for its creator, Andreas SCHLÜTER, than for the bronze-founder, Jacobi, who was presented with a golden chain and had his portrait engraved at the State's expense. This idea that the casting of an equestrian statue was a greater achievement than its invention persisted until the 19th c., when the pouring in of the metal could still be a ceremonial occasion attended by the court who watched from a dais. Sometimes the operation miscarried. When Falconet's *Peter the Great* was cast, the figure of the rider and the upper parts of the horse were found not to have been reproduced. Falconet made a new wax model of the missing parts and with great ingenuity contrived to cast it into one piece with the part which had been reproduced at the first attempt.

In order to avoid the risk and expense of casting in bronze a method was devised in the 18th c. of making these large statues of beaten copper. A model was first carved out of oak, and over each part of it in turn a thin sheet of copper was laid, which, being relatively soft, could be hammered until it took the form of the carving, as in repoussé work. Finally the copper plates were assembled and mounted on a framework. SCHADOW's famous horses on the *Brandenburger Tor* in Berlin (1791) were made in this way, and

so were many of the horses on the elaborate fountains of the 19th c.

**ERAGNY PRESS.** A private printing-press established by Lucien PISSARRO in 1894 at Bedford Park, London, and transferred to Hammersmith in 1903. It was named after the Normandy village where Pissarro lived before coming to England. From 1894 to 1903 the Eragny books were printed in the 'Vale' type designed by Charles RICKETTS. After 1903 the 'Brook' type, designed by Pissarro himself, was used. Characteristic of Eragny books, many of which were issued in small format, were coloured frontispieces, woodcuts, initials, and decoration designed by Pissarro and executed by himself and his wife. The press closed down in 1914.

**ERCOLE.** See ROBERTI, Ercole de'.

**ERDMANNSDORF,** FRIEDRICH WILHELM FREIHERR VON (1726-1800). German architect, who proudly proclaimed himself an amateur. He travelled in Italy and visited England with his friend and employer, the Duke of Anhalt-Dessau. The country seat he built for the Duke at Woerlitz near Dessau is very much like an English 18th-c. country house. From 1787 to 1789 Erdmannsdorff worked for the King of Prussia in Berlin and Potsdam.

**ERECHTHEUM.** A temple of the ACROPOLIS at Athens, built c. 421–c. 406 B.C. for several cults. Its irregular plan—a rectangle with a normal porch at the east end, a deep porch overlapping the north side, and the CARYATID porch on the south—is best explained by curtailment during building. Its Ionic detail is exceptionally fine.

**ERNST,** MAX (1891-1976). German-born painter, resident for long periods in France and the U.S.A., Ernst was prominent in the SURREALIST movement. He taught himself to paint while studying philosophy at the University of Cologne. In 1910 he met MACKE, and in 1913 exhibited at the first German Autumn Salon and met ARP at the DEUTSCHER WERKBUND exhibition in Cologne. In 1919, with Arp and Johannes Theodor Baargeld, founder of the Communist periodical Der Ventilator, Ernst founded a DADA group in Cologne. He soon came into contact with Tristan Tzara and André BRETON in Paris, and in 1921 he moved there to become a founder-member of the Surrealist group. He lived in Paris thereafter, except for a stay in the U.S.A. from 1941 until 1956.

Ernst was one of the first to develop the technique of FROTTAGE and he used COLLAGE and photomontage for the expression of his own visionary imaginings. With Breton, Paul Éluard,

PICABIA, and others he undertook the first experiments in 'automatic writing'. In his book Dada (1965) Hans Richter writes of him: 'His weird visions have their origins in German art of the Middle Ages and the Romantic period. They recapture the fearful concreteness and depth of a DÜRER or a SCHONGAUER, the emotional, often sentimental Romanticism of a Caspar David FRIEDRICH, and the allegory, often inflated to the point of bathos, of BOECKLIN and KLINGER, two artists whom Ernst admired. In Max Ernst's work these fragments of tradition are twisted into spectral combinations. Ernst subjects the satanic aspect of the German soul to a process of vivisection. The genial is linked with the abominable, and the product is Evil . . . which lies outside the sphere of conventional art altogether: not art, but indictment or prophecy.'

98, 824, 1935, 2355.

**ERRARD,** CHARLES (1606-89). French painter and architect. He spent many of his early years in Rome drawing from the ANTIQUE and working in POUSSIN's studio, and later returned to be first Director of the French Academy in Rome (1666). His work in Paris (at the Palais-Royal, LOUVRE, Tuileries, and FONTAINEBLEAU) was mainly decorative.

**ERWIN VON STEINBACH** (d. 1318). German architect, who in the early 14th c. worked at Strasbourg and was responsible for portions of the west façade of the cathedral. The fact that on his tombstone he is called 'master-mason of Strasbourg cathedral' gave rise to the romantic legend that he was the builder of the whole fabric. This story was given wide currency when GOETHE, in his famous essay Von deutscher Baukunst (1772), made Erwin the embodiment of the spirit of the GOTHIC age and invested him with all the characteristics of the dedicated medieval German artist. The 19th c. liked to see him as the medieval mason par excellence, but modern research has shown that he was no more than a minor figure.

**ESCORIAL.** A small village about 30 miles north-west of Madrid at the foot of the Sierra de Guadarrama, which Philip II chose as the site for what is perhaps the most remarkable monument of Spanish architecture and one of the great buildings of the world. It comprises a royal palace and mausoleum combined with a Hieronymite monastery, college, and church.

Constructed entirely of granite, it was begun in 1563 by Juan Bautista de TOLEDO, of whom there is little known apart from the fact that he was installed as chief architect of the king in 1561. Juan de HERRERA was assistant to Toledo from 1563, during all the early stages of the project, and succeeded him as superintendent of construction on his death in 1567. He remained in charge till the building was completed in

1584, mainly concerning himself with the Escorial façades and the erection of the church. The Italian Giambattista Castello (d. 1569) built the great staircase and another Italian, Francesco Paciotti or Pacciotto of Urbino, submitted several projects for the design of the church, but to what extent they were used is not known. When Philip II decided to double the monastic establishment the chief foreman, Antonio de Villacastín, proposed the solution which was adopted of adding an extra storey to provide the additional accommodation required. But it was Herrera and Philip II himself who were mainly responsible for the architectural character of the Escorial. Especially remarkable is the deliberate avoidance of ornament, reflecting the austere temperament of Philip II and conferring an impression of severity in keeping with the grandeur and solitude of the setting.

The plan is a large rectangle, 530 ft. by 670 ft., and the layout has been compared to a gridiron, the attribute of St. Lawrence, to whom the monastery was dedicated in acknowledgement of Philip II's victory over the French at St. Quentin on St. Lawrence's day, 1557. The plan can be divided into six parts. On the central axis is the great forecourt and behind that the church, on the left the college and the palace, and on the right the monastery and main cloister.

The Escorial occupies an area of over 12 acres, including the great paved terrace or *Lonja* on the north and west sides, which is an integral part of the composition. At the four corners of the building are plain square towers surmounted by the so-called 'Austria' spires which were to become a feature of Spanish architecture. The prismatic mass of the church with its two towers and dome effectively dominates the whole building. The modified Greek-cross plan of the church suggests the influence of St. Peter's, Rome; but it has much originality and the great central domed space with its four heavy piers is particularly impressive.

Philip II did not succeed in persuading TITIAN to come to Spain to paint altarpieces for the Escorial; and El GRECO was rejected after his *St. Maurice* had failed to obtain royal approval (1580). The Italian MANNERISTS Pellegrino TIBALDI and Luca CAMBIASO painted a number of altarpieces and large fresco decorations in the church, cloister, and library. Other altar paintings were executed by Federigo ZUCCARO, NAVARRETE, and SÁNCHEZ COELLO. A school of painting was thus established at the Escorial in which younger artists such as RIBALTA were trained. The principal sculptors employed by Philip II were Leone and Pompeo LEONI and Juan Bautista Monegro (d. 1621).

In 1688 Claudio COELLO completed the sacristy altarpiece and a few years later Luca GIORDANO painted the vaults of the church and the cloister staircase. In the 18th c. Charles III used the Escorial as a hunting seat and furnished the hitherto unoccupied state rooms of the palace. The ceilings were painted by Maella

and the walls hung with tapestries many of which were designed by GOYA. Other outstanding works of art in the Escorial include a crucifix carved by Benvenuto CELLINI and paintings by DÜRER, BOSCH, Titian, El Greco, RIBERA, and VELAZQUEZ.

In the park below the Escorial is the Casita del Principe, a masterpiece of Spanish NEO-CLASSICAL architecture built by VILLANUEVA (1768–72) for Charles III's heir, the future Charles IV.

**ESKIMO ART.** See INDIAN ARTS OF NORTH AMERICA.

**ESQUIVEL, ANTONIO MARÍA** (1806–57). Spanish painter. At the Seville School of Fine Arts he was taught to imitate the style of MURILLO. In 1831 he moved to Madrid with his fellow townsman José Gutiérrez de la Vega (*c.* 1805–65). He painted religious, historical, and genre subjects; also accomplished portraits, including a portrait group, *Zorrilla Reciting his Poems* (Modern Art Mus., Madrid, 1846), showing the poet in Esquivel's studio, surrounded by the leading figures of the literary and artistic society of mid 19th-c. Madrid.

**ESSEX HOUSE PRESS.** A private printing-press founded in 1898 by C. R. ASHBEE and the Guild of Handicrafts to continue the traditions of William MORRIS's KELMSCOTT PRESS. The ink, paper, and vellum were the same as those used in the Kelmscott books, though a special watermark was employed and experiments made in printing on grey paper with various colours. Ashbee employed Walter CRANE and other artists of note to illustrate his publications. In 1902 the press was transferred from Essex House, Mile End Road, to Chipping Campden, Gloucestershire. Eighty-four titles were issued before the press closed down in 1909.

105.

**ESTE.** Lords of Ferrara, Modena, and Reggio from the late 13th c. until 1598 and thereafter of Modena and Reggio only until the end of the 18th c. They were notable patrons of the arts and letters. LEONELLO (1407–50) was the friend of ALBERTI, a patron of Jacopo BELLINI and PISANELLO, and owned a highly prized painting by Rogier van der WEYDEN. His brother BORSO (1413–71) was in touch with the young MANTEGNA and PIERO DELLA FRANCESCA, made Cosimo TURA his chief court painter in 1458, and employed Francesco del COSSA on the frescoes in the Palazzo Schifanoia (see FERRARESE SCHOOL) between 1467 and 1470. During his reign Taddeo CRIVELLI and Franco del Russi illustrated the Bibbia di Borso, one of the finest manuscript books of the Italian RENAISSANCE. ERCOLE (1431–1505), bigoted, weak, and superstitious, carried out grandiose plans for the development of Ferrara which were

largely put into effect by his architect Biagio Rossetti. He continued to employ Cosimo Tura, and also Ercole de' ROBERTI and Lorenzo COSTA. His daughter ISABELLA, married to Francesco GONZAGA in Mantua, secured paintings from Mantegna, PERUGINO, Costa, and later COR-REGGIO to decorate her famous Studiolo. In this she was imitated by her brother ALFONSO, the next Duke of Ferrara (1486–1534), who commissioned paintings by Bellini (*Feast of the Gods*) and TITIAN for a somewhat similar room. Dosso and Battista DOSSI, GAROFALO, GIROLAMO DA CARPI, and SCARSELLINO were the painters principally employed by the Estes during the 16th c. In the next century they continued their collections in Modena, and FRANCESCO I (1610–58) commissioned portraits from BERNINI and VELAZQUEZ. But in 1744 FRANCESCO III sold 100 of the most splendid pictures in his collection to Augustus III at Dresden.

**ESTÍPITE.** Spanish word for a COLUMN or pilaster with a shaft shaped like an inverted obelisk or cone. BAROQUE versions of the *estípite* were already being used by José de CHURRIGUERA and Francisco HURTADO at the end of the 17th c. in Spain; and from *c.* 1720 the *estípite* superseded the twisted column or SALO-MÓNICA as the favourite decorative element of Spanish Baroque architecture. In Mexico it was very popular from *c.* 1740 and became extremely complex in the work of Lorenzo Rodríguez (1704–74) and other architects of his generation. Built up of a series of elaborately carved components incorporating abstract, floral, and sometimes human decorative elements, the *estípite* of 18th-c. Spanish and Mexican architecture epitomized the effect of structural dissolution which was one of the characteristics of the middle phase of CHURRIGUERESQUE.

**ESTOFADO.** A technique used in Spanish ecclesiastical art for colouring carved REREDOSES and the wooden figures of holy personages. The name (*estofa*: woven material) was given because it was especially suited to represent the rich materials of their robes. The carving was coated with gesso, was gilded, and paint was then applied over the gilt. A warm luminous tone was imparted to the colours by the gilt undercoat and where gold was required in the design the paint was erased with great skill to reveal gilding beneath. The *estofado* technique, practised by craftsmen known as *estofadores*, achieved great popularity in the second half of the 16th c. but did not long survive the demand for a more realistic colouring introduced by Gregório FERNANDEZ in Castile and somewhat later by Alonso CANO in Andalusia.

**ETCHING.** A method of engraving in which the design is bitten into the plate with acid. A plate of polished copper, as used in the various other intaglio processes (see PRINTS), is first coated with a substance that will resist the action of acid. This acid resist or 'etching ground' is usually compounded of beeswax, bitumen, and resin and is applied by melting a solid lump on to the heated plate, rolling the mixture flat with a leather roller, and blackening it with the soot of burning tapers. The etcher then draws his design upon the grounded plate with a steel etching needle which he holds lightly in his hand like a pen, allowing the point to cut through the dark ground and expose the bright metal beneath. After covering the back and edges of the plate with an acid-resisting varnish called 'stopping-out varnish', he immerses it in a bath of dilute acid, commonly nitric, which bites into the metal wherever the ground has been pierced by the needle. If any parts of the design are to remain lighter than the rest they may be 'stopped out', i.e. painted over with varnish, after which the plate is again immersed in the acid and the remainder of the design bitten to a greater depth. This process of graduated biting by means of 'stopping out' may be repeated any number of times if the etcher wishes to introduce several tones into his design. Finally, when all is bitten as required, the ground is cleaned off and the plate is inked and printed according to the intaglio method described in the article on PRINTS. Etching is frequently combined with other processes, particularly DRYPOINT, both because by this means additional work may be done on the plate after proofing and without re-laying the ground and because the drypoint lines provide a convenient method of adding strong black accents to the design.

The foregoing account is necessarily simplified, for there are alternative ways of performing some of the actions and different recipes for making up the various substances and chemicals. The ground, for example, may be applied in a number of ways or even in liquid form; zinc plates are often used instead of copper; and other acids, such as DUTCH MORDANT, can take the place of nitric. The principle, however, remains the same in every case.

A characteristic of etching, as practised in the past 200 years, is a spontaneity of line which comes from drawing in the same direct way as with pen or pencil on paper. It thus differs from LINE ENGRAVING where the deliberate and indirect nature of the technique tends to produce an air of precision, contrivance, and formality. It is even possible to put a grounded etching plate in one's pocket to be used as the occasion demands like a sketch-book. A quick portrait sketch can even be made direct from the sitter, ready for biting and printing when convenient. This would be unthinkable with line engraving, where the action of pushing the BURIN through the metal is clearly incompatible with drawing from life. Close examination of the lines themselves will sometimes reveal further differences. For whereas the engraved line, pointed at its extremities, swells and tapers according to the pressure of the engraver's hand, the etched line remains of constant width because it is produced

chemically, by the action of the acid, and not manually. Etched lines, especially if bitten with nitric acid, sometimes have slightly irregular edges; engraved lines are hard and true.

An understanding of these differences often makes it possible to decide whether a print is an etching or a line engraving, but the oldest etchings are not identified so easily. For etching was invented as a labour-saving method of line engraving and consequently in its early days it had to resemble engraving as closely as possible. Moreover, the practice arose, again in order to ease the engraver's labours, of beginning a plate with etching and finishing it by engraving. Thus etching was closely linked to line engraving and was not at the beginning the free and spontaneous art that it became in the hands of REMBRANDT. The first etchings date from the early years of the 16th c., though the basic principle, that of corroding a design into a metal plate, had been utilized earlier for the decoration of armour. DÜRER made a few etchings, of which the best known is the *Canon* of 1518. He used iron plates, the biting is strong and rather coarse, and there is no stopping out to vary the tone of the lines. Other northern pioneers were Urs GRAF, ALTDORFER, and LUCAS VAN LEYDEN. In Italy PARMIGIANINO was etching soon after 1520. Parmigianino's prints are attractively luminous and free in drawing, indicating the direction etching was to take in later years.

Of great importance in the history of etching in the earlier part of the 17th c. are the works of Jacques CALLOT and Abraham BOSSE. Callot's etchings, though small, show a remarkable sense of scale and breadth in handling crowded compositions. Bosse, a less lively artist, etched a large number of genre subjects which he treated with a classic gravity and simplicity of composition. Moreover in 1645 Bosse published his *Traité des Manières de Graver en Taille Douce*, the first textbook on etching. This little book is of the utmost interest because it throws much light on the technical procedures of etchers and engravers at that time and on their attitude towards their art.

Both Bosse and Callot were representatives of the old school of etching, that is to say they regarded it as a substitute for line engraving. They used the archaic hard etching ground, containing linseed oil and burnt on to the plate, and also the ÉCHOPPE, a tool with an oval cutting edge with which they were able to imitate the swelling and diminishing line of the burin. When cutting the design they deeply scored the metal beneath the ground and after biting strengthened the lines with the burin. Yet there were signs of transition, for Callot was a master of graduated biting by stopping out, while Bosse had much to say in his book about the newly introduced soft etching ground. This soft ground was the wax ground that is used today (and has nothing to do with SOFT-GROUND ETCHING, an entirely different technique). It enabled the etcher to draw more freely and to dispense with many of the practices inherited from the engraver. A little before the publication of Bosse's book the Dutchman Hercules SEGHERS, who etched a number of curious and emotional plates of wild mountain landscapes and similar subjects, had made many technical experiments not only with grounds of his own invention but also with printing in colour on tinted papers and on linen fabrics.

The first of modern etchers was, however, Rembrandt, who made some 300 prints of which the earliest date from 1628. Rembrandt made a complete break from the long domination of line engraving, drawing freely on the plate with great vigour and power, correcting and often radically transforming his designs as he went along. His early plates are in the medium of etching alone. Later he added drypoint to the etched lines, and finally he came to rely still more on drypoint in plates that are astonishing for their boldness of handling, breadth, and lack of mannerism. Yet Rembrandt's prints, so full of feeling, humanity, and power, have not had an altogether beneficial influence on the art of etching. Seizing on inessentials, as lesser followers often do, many etchers of little more than amateur talent have claimed Rembrandt's freedom as justification for empty and inexpert sketches—hence the many tedious prints of picturesque types and trivial landscapes which were a feature of 19th- and early 20th-c. etching, particularly in England. On the whole, those etchings which we admire as brilliant sketches are the work of masters who were fully capable of highly developed compositions yet threw off from time to time smaller, slighter notations as by-products of their main creative effort.

In the 18th c. G. B. TIEPOLO showed in his small etchings of fantastic subjects much of that feeling for light, air, and space which is characteristic of his large paintings. G. B. PIRANESI, a Venetian who lived in Rome and spent much of his life etching topographical subjects, produced in 1750 one of the most remarkable sets of prints in the history of the medium—the *Carceri*, a series of architectural fantasies of forbidding and imaginary prisons. At the end of the century, in Spain where there had been little print-making of importance, GOYA began to etch his famous series of satirical and fantastic plates. Goya usually combined etching with AQUATINT, but he was in any case one of the greatest of etchers. His *Desastres de la Guerra* (1810–20), the harsh cry of genius outraged, are etched mostly in line with very little use of aquatint. Many of the celebrated French painters of the 19th c., including MILLET, COROT, PISSARRO, and DEGAS, made use of etching, their prints being extensions of their painted work on a smaller scale and in graphic terms. To these we may add JONGKIND, the Dutch landscape artist who worked in France. WHISTLER found in etching a process admirably suited to his delicacy of touch and feeling for atmosphere. He and his brother-in-law Seymour Haden, an English

amateur, felt, no less than Jongkind, the continuing influence of Rembrandt's landscape style. Also of the 19th c. are the Frenchman Charles Meryon and the Belgian James ENSOR, whose works, though dissimilar in subject, have in common an oppressive feeling of gloomy fantasy and inner tension.

Most of the artists prominent in the various aesthetic movements of the 20th c. have used etching along with other techniques of printmaking as an expressive medium, both for the illustration of books for the specialist market and for very limited editions designed for the connoisseur. An outline of this exuberant output of prints which claim high standing as works of art in their own right is given in the article on PRINTS. Here it will suffice to mention in the particular field of etching the work of PICASSO, who began to etch before he left Spain and has continued throughout his career. His first etchings for book illustration were done for Henry Kahnweiler's editions of Max Jacob in 1911 and 1914. Throughout the CUBIST period he, together with BRAQUE, GRIS, and others, turned the etching into an autonomous Cubist technique, avoiding depth of picture space and giving prominence to texture, pattern, and tone. His 'classical' period is noteworthy for both line engravings and the 15 etchings done for the Skira edition of Ovid's *Metamorphoses* and Vollard's 1931 edition of Balzac's *Le Chef-d'Œuvre Inconnu*. During the 1930s he worked on illustrations for Buffon's *Histoire naturelle* and in the late 1950s returned to etching and aquatint in his *Tauromaquia* (1959). Outstanding work was done by ROUAULT during the 1930s in a mixture of etching, aquatint, and drypoint, MATISSE has produced notable etchings, and CHAGALL's illustrations for the Old Testament (1956) are outstanding in the post-war period. Among minor artists SEGONZAC's line etchings for Virgil's *Georgics* marks him out as a master of the technique. It is significant that in the 20th c. the finest work in etching has been done by the great all-round artists and not by those who have made themselves specialists in this particular technique.

14, 418, 427, 679, 1279, 1280, 1326, 2291, 2944.

**ETRUSCAN ART.** Whoever the Etruscans may have been, Etruscan culture first appeared in northern Italy towards the end of the 8th c. B.C., widely influenced central Italy and continued until the 2nd or 1st c. B.C., when it was absorbed into the Roman. Etruscan art as we know it is composed of three recognizable strands: native Italian, which is relatively unimportant over most of the time; an oriental element, which soon ceased to have direct connections with the East; and a strong Greek basis which was propagated at times by immigrant Greek craftsmen and manifested both in style and in subject matter taken from Greek mythology. How far these strands fused in the creation of a distinctively

Etruscan spirit is debated. Some critics and historians particularly in the 19th c. have tended to regard Etruscan art works as inferior and provincial manifestations of GREEK ART. Others assert the independence and originality of a specifically Etruscan vision of forms. There are various shades of intermediate opinions such as that indicated by Professor M. Pallottino, who suggests (*The Etruscans*, 1942) that the native Etruscan element may vary from one period to another and in the different arts.

The principal surviving forms of Etruscan art are painting, sculpture, metal-work, and architecture. The surviving examples of the figurative arts derive mainly from tombs and sanctuaries. The most important artistic centres appear to have been the towns of Caere (Cerveteri), Tarquinii, Vulci, and Veii (Veio).

PAINTING. The greater part of the Etruscan painting, which has survived in relatively large quantity, consists of murals from tombs of a type which was not used in Greece at that time. It is possible to trace the influence of Greece in details of technique and pattern, in themes, and by stylistic analogies with Greek vase painting. But how faithfully or successfully the Etruscan paintings followed their Greek models must ultimately remain a matter of speculation since, apart from inferences from vase painting, which in the 5th c. developed canons of its own, our knowledge of Greek picture painting comes mainly from Etruscan and Italian derivatives. The most important source of wall-paintings is the necropolis at Tarquinii. Other centres are Clusium (Chiusi), Orvieto, Vulci, Veii, and Caere. The surviving paintings fall chronologically into two groups: an older sequence, usually referred to as Archaic, appears to date from the early 6th to the early 5th c. and then after a gap the so-called HELLENISTIC group from the closing decades of the 4th c. until the 1st c. B.C.

The oldest examples have come mainly from Caere and Veii, and exhibit decorative painting from the fabulous stylizations of the oriental bestiary. The five *Boccanero* slabs, now in the British Museum, were a narrative sequence, as also were the *Campana* slabs in the Louvre which date somewhat later to the mid 6th c. In general the murals depict gay and animated scenes from the daily life of a wealthy and luxurious class, in which the dead are shown banqueting to the accompaniment of music and dance or watching athletic performances. In the 4th c. and onwards, however, the realistic and quotidian character tends to change and the shades of the dead may be pictured in a monstrous and murky underworld devoid of earthly delights. The frieze of the second chamber of the Tarquinian Tomb of Hunting and Fishing is the most elaborate of the very few surviving examples from Archaic or early classical art where the human figure is subordinated to the landscape scene. A high standard of draughtsmanship is displayed in the Tarquinian Tomb of the Triclinium (*c.* 470 B.C.) and the Tomb of the Funeral Couch (*c.* 460 B.C.).

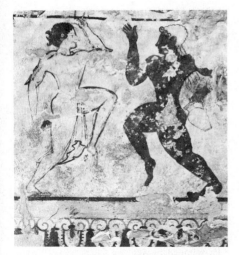

**124.** Details of wall-paintings from Tomb of the Lionesses, Tarquinii (6th c. B.C.).
A. Dancers. Figures recall Greek vase painting          B. Reclining Etruscan banqueting

In the 3rd c. the quality of drawing and execution declines while the taste for the macabre and horrific in scenes of the world beyond the tomb becomes more prominent. In this period also portraiture begins.

SCULPTURE. The materials of Etruscan sculpture are various local stones (but not marble), bronze, and terracotta, which was used even for statues larger than life. Most of our remains come from sarcophagi and cinerary caskets, which often have reliefs on the sides and effigies on the lids, or are architectural. The earliest works, of the 7th and 6th centuries B.C., are sometimes strongly reminiscent of orientalizing decorative style and sometimes quite individual in effect. But in the course of the 6th c. the influence of Greek Archaic style became dominant, though the extent to which it was modified varied in different places and workshops. Among late Archaic terracottas the life-size *Apollo of Veii* (Villa Giulia, Rome, 5th c. B.C.) is by Greek standards sleekly sinister, the larger *Warrior* in New York monstrously solid, though some of the satyrs and maenads from antefixes accord pretty closely with Greek types. The terracotta fragment called the *Apollo of Faberii* (Villa Giulia, Rome) has been compared with the APOLLO BELVEDERE. Though the Archaic style persisted through the 5th c., some Etruscan sculptors attempted the more difficult classical style, and from the 3rd c. Hellenism in its various forms was accepted. Among late Etruscan sculptures the most curious are figures with faces suggestive of individual portraiture and even caricature: here Roman influence may have been at work.

METAL-WORK, ETC. Etruria was naturally rich in copper, and there survives from the earliest period a large assortment of utensils and furnishings of bronze (including even a chariot). The engraved hand-mirrors deserve special mention. They date from the 6th to the 3rd c. B.C. and are decorated on the back with scenes of Greek mythology or from life, with a predilection, increasing as time went on, for the female form. The early gold jewellery is remarkable for its fine granulation, and there are a few good classical gems. In both metal-work and jewellery the standard of craftsmanship was often of a high level, though sometimes too flamboyant in the search for effect.

ARCHITECTURE. Tombs and models convey some idea of Etruscan houses and there are interesting fortifications, but the principal though scanty architectural remains are of temples. The typical Etruscan temple, little longer than it

**Fig. 23.** Ideal reconstruction of an Etruscan temple. Drawn after A. Andrien, *Architectural Terracottas from Etrusco-Italic Temples* (1939)

was wide, stood on a high platform of stone with a stairway in front. This led up to a portico four columns wide and one to three rows deep, behind which the *cella*, sometimes tripartite, occupied the rear part of the platform. Since the superstructure was of wood, the columns were very widely spaced. The ENTABLATURE was shallow, the roof low and gabled, with widely projecting eaves. Terracotta was used

for roof-tiles, antefixes, ACROTERIA, revetments of cornices and ARCHITRAVE and even the ends of the ridge beam, the tiling of the pediment floor, and facings for door jambs; sometimes COLUMNS too were cased with terracotta. Pedimental terracottas had appeared by the 4th c., but before this a late Archaic temple at Veii seems to have had terracotta statues along the ridge. Besides the Tuscan column, which has a base, is often unfluted and inserts a collar between shaft and Doric CAPITAL, there are Aeolic volute capitals as well as more orthodox Greek forms. (See ORDERS OF ARCHITECTURE.) Granted the difference due to materials and plan Etruscan temples owe much to Greek architecture, especially of the period before its conventions became fixed. The characteristically Roman temple, with its frontal emphasis and approach, is a more Hellenized development of the Etruscan.

VASE-PAINTING. Much early Etruscan pottery is native Italian made from crude and unpurified clay. The best, which was common from the end of the 7th c. to the beginning of the 5th c., is the so-called Bucchero, a well-shaped surface-polished ware fired through to a greyish black. There were also derivatives of Greek Geometric (Italo-Geometric), of Corinthian (Italo-Corinthian), and from the middle of the 6th c. of Attic, first black-figure and from the middle of the 4th c. red-figure vases. A later type of pottery gave rise to the Arezzo industry which flourished towards the beginning of the Imperial age and led to the characteristic Roman *terra sigillata*.

The term 'Etruscan' was in the 18th c. applied generally to black-figure and red-figure pottery, Greek included: and this error, though officially abandoned for more than a century, is not yet extinct.

206, 208, 299, 939, 1068, 1755, 2001, 2002, 2246, 2263, 2553.

**ETTY,** WILLIAM (1787–1849). English painter, a native of York. He trained at the R.A. Schools and then with LAWRENCE, whose great influence on him was modified by subsequent visits to Italy. He is remembered mainly for his studies of the nude in which, for all their weaknesses of draughtsmanship, he had an unusual command of sumptuous texture and colour, and he has been called a painter primarily of sheen and sinuosity. He could also produce large and complicated compositions (*Youth at the Prow and Pleasure at the Helm*, Tate Gal., London). His picture *The Combat*, 10 ft. 4 in. by 13 ft. 3 in., exhibited at the Academy in 1825, was seen and remembered by DELACROIX and represents an achievement of English IDEAL art. In 1837 he produced *Ulysses and the Sirens*, 9 ft. 9 in. by 14 ft. 6 in., to which he gave the alternative name *The Wages of Sin is Death*. In 1849, the year of his death, the Society of Arts arranged a collective exhibition of his works, at which the star exhibit was his trilogy *Joan of Arc*, completed in 1847.

854, 1041.

**EUPHRANOR OF CORINTH.** Greek painter and sculptor of the mid 4th c. B.C., who was celebrated for the heroic dignity of his figures, perhaps because he reverted to heavier proportions. He wrote a treatise on symmetry, which is lost.

**EUSEBIAN CANONS.** Tables, drawn up by Eusebius of Caesarea (*c.* 260–340), indicating parallel passages in the four Gospels. In ILLUMINATED MANUSCRIPTS they are enclosed within ornamental COLUMNS surmounted by ARCADES and other architectural features. This decorative treatment, first found in the *Rabula Codex* (Laurentian Lib., Florence), written in A.D. 586 in Syria, became a prominent feature of late antique and CAROLINGIAN illuminated manuscripts.

**EUSTON ROAD GROUP.** This name was first applied in 1939 (the year in which the school itself closed down) to the group of painters centred round the 'School of Drawing and Painting' in the Euston Road, London, which had been founded by William COLDSTREAM, Victor PASMORE, and Lawrence Gowing (1918–  ) in 1938. Other artists associated with the group were Rodrigo Moynihan (1910–  ), Geoffrey Tibble (1909–52), William Townsend (1909–  ), Anthony Devas (1911–58), Graham Bell (1910–43). To some extent these artists were united by a return from abstract and esoteric styles of modernism to a more straightforward naturalism, but the coherence of the group before the onset of the Second World War was too short for the development of significant stylistic affinities.

**EVANGELISTS AND EVANGELIST SYMBOLS.** The four Evangelists, Matthew, Mark, Luke, and John, were represented either in human form, symbolically by the four winged animals of Ezekiel's version (Ezek. i. 5–14; Rev. iv. 6–8), or by a zoomorphic combination. The two Apostles, Matthew and John, were distinguished from the younger Mark and Luke by their elderly bearded faces and pensive attitudes. An early representation of Christ standing among the four Evangelists, dressed in tunic and pallium, occurs in the catacomb of Marco and Marcelliano, Rome, *c.* 340.

The custom of using portraits of the Evangelists, either standing or seated, as a frontispiece to their Gospels was derived from the HELLENISTIC custom of placing the author's portrait at the beginning of his work. Since the types of Evangelist portraits differed in the various centres of book production, none of them is considered to be an authentic portrait. The 6th-c. *Gospels of Rossano*, in which only the figure of Mark is still preserved, is the earliest extant example.

The symbols of the Evangelists are the Lion (St. Mark), the Angel (St. Matthew), the Eagle (St. John), and the Calf (St. Luke). The symbols were not adopted in Western art before the 5th c. and are infrequent in the East until about 1300. Early examples occur on the wooden doors of Sta Sabina, Rome (*c.* 430), and on the 5th-c.

125. Eusebian Canons, from the *Rabula Codex* (Laurentian Lib., Florence, A.D. 586)

Milan book-covers (Milan Cathedral). On the 6th-c. mosaics of S. Vitale, Ravenna, each Evangelist is portrayed book in hand seated below his symbol—one of the methods employed by MINIATURISTS. On the mosaics of SS. Cosmas and Damian, Rome (c. 530), and S. Apollinare in Classe, Ravenna (c. 549), each animal appears alone with a book. The symbols, soon generally accepted, became very widely diffused and were frequently represented above or below the canon tables of Gospels. They were an important decorative feature in early Irish manuscripts (*Book of Kells*, Trinity College, Dublin; *Evan-*

*gelistary of Lothair*, Bib. nat., Paris). They were continuously used in all Western countries; a rare early Eastern example occurs in the Ascension miniature of the *Rabula Gospels* (Laurentian Lib., Florence, 586). The zoomorphic figures of the Evangelists bearing the heads of their symbols probably originated in COPTIC ART. They occur early in Spain, southern France, and Ireland (8th-c. *Sacramentary of Gellone*, Bib. nat., Paris), but did not reach Germany, Italy, or northern France until the ROMANESQUE period. In the Middle Ages the Evangelist symbols became a decorative feature on the

**126.** St. Matthew the Evangelist below the symbol of the angel. The figure behind the curtain may represent Christ, in keeping with the classical tradition of the portrait of the author accompanied by his Muse. Miniature from the *Lindisfarne Gospels*. (Northumbrian MS., B.M., early 8th c.)

**127.** Christ in mandorla with symbols of the Evangelists. Miniature from the *Stavelot Bible*. (Flemish MS., B.M., c. 1097)

façades of Romanesque and GOTHIC churches (S. Rufino, Assisi; Chartres; Siena). On crosses the four symbols are sometimes found at the end of each branch, for example on the cross of the Holy Roman Empire (Schatzkammer, Vienna, c. 1030) and on an Anglo-Saxon walrus ivory crucifix (V. & A. Mus., c. 1000).

From the 15th c. onwards the Evangelists were very frequently depicted, usually as single figures with their symbols (Fra ANGELICO, chapel of Nicholas V, Vatican, c. 1450; DOMENICHINO, S. Andrea della Valle, Rome, 1623), and in large religious compositions (A. VIVARINI, *The Throne of the Trinity*, S. Pantaleone, Venice, 1444). In 16th- and 17th-c. Netherlandish painting the four Evangelists, holding their books and with their symbols, are grouped ·together (Peter AERTSEN, Vienna, c. 1559; JORDAENS, Louvre, c. 1625).

**EVENEPOEL,** HENRI (1872–99). Belgian painter who spent most of his life in France and Algeria. He studied in Paris under Gustave MOREAU and in spite of his early death left a number of significant works, including some penetrating portraits. Most of his pictures are in Belgian private and public collections.

1552.

**EVERDINGEN,** ALLART VAN (1621–75). Dutch landscape and marine painter. He was born in Alkmaar and worked with SAVERY in Utrecht and MOLYN in Haarlem. When he was 20 he went to Norway (and perhaps to Sweden), where he made pictures of rocky scenery and waterfalls; he continued to depict these motifs when he returned to Holland. Jacob van RUISDAEL used Allart's pictures as one of the sources for his own majestic waterfalls. Allart also did etchings, most of which show the mountainous terrain of Scandinavia. His etchings for *Reynard the Fox*, penetrating characterizations of animals, reveal an unexpected side to his talent. His elder brother CAESAR (1617–87), who painted portraits and historical pictures, was attracted by the south not the north. Although he never went to Italy but learned his Classicism in Utrecht from Jan Gerritz van Bronchorst (c. 1603–61), he captured the spirit of Italian academic art better than many of his countrymen who crossed the Alps: witness his beautiful *Muses* in the Huisten Bosch, at The Hague. But his nudes remain more palpably solid than any Italian's, and his interest in the play of light and shadow and in the texture of flesh, hair, satin, and wood show that his spirit was rooted in his native Holland for all its flutterings towards Arcadia.

**EWORTH** or EWOUTS, HANS (c. 1520–after 1573). Flemish painter who came to England from Antwerp c. 1549. His earliest portraits (*Sir John Luttrell*, Dunster Castle, 1550) are in the Antwerpian MANNERIST tradition, burly and realistic but often filled with allegorical scenes

in the FONTAINEBLEAU style. In his middle period he sometimes resembled a less substantial HOLBEIN, as in his *Lady Dacre* (Ottawa, *c.* 1555), and in some the influence of Anthonis MOR is apparent (*Queen Mary*, Society of Antiquaries, 1554). But some of his portraits of the 1560s presage the late Elizabethan manner, with emphasis on decorative pattern of costume and accoutrements or tapestry background (*Lady Burghley*, Hatfield). He is known also to have painted for pageants and masques. A painter of great technical proficiency and some individual vision, but uneven and not an artist of the first order, he is the key figure in the history of English painting in the mid 16th c.—a sensitive talent responding to changing taste. He was confused till recently with Lucas de Heere (1534–84) from a misreading of his monogram HE.

**EXECIAS.** Most famous of Greek black-figure vase painters, active in the second half of the 6th c. B.C. Among the best known works with his signature are an amphora showing Achilles and Ajax playing dice and on the reverse side Castor and Pollux returning (Vatican Mus.); and a splendid cup showing Dionysus in his boat (Munich Mus.). Many of the works signed by Execias contain battle scenes, but he was able to impart an air of dignity and grandeur even to the most ordinary activities.

**EXEDRA.** Term in Greek and Roman architecture. An open and often detached alcove, rectilinear or curved, containing statues or seats.

**EXHIBITION, THE GREAT,** of 1851. The first of the modern industrial exhibitions, descendants of the medieval trade fairs, was arranged in London by the Society of Arts (now the Royal Society of Arts) in 1756–7. The first national exhibition conceived as a formal display of manufactured goods was organized by the French in 1798 and from 1819 large industrial exhibitions have been a regular feature of French life. In England industrial exhibitions with good design as a major consideration were organized by the Society of Arts from 1847, the prime movers being Henry Cole and the Prince Consort. These two men of vision were also mainly instrumental in bringing about the exhibition of 1851, the first international industrial exhibition ever held. Its full official title was 'The Great Exhibition of the Works of Industry of all Nations, 1851'. The Exhibition was held at a site on the south side of Hyde Park in a vast building of glass designed by Joseph PAXTON, popularly known as the 'Crystal Palace', a term first applied to it by *Punch* in its issue of 2 November 1850. On a site of *c.* 26 acres the building covered *c.* 19 acres. The main building was 1,848 ft. long by 408 ft. broad and an extension on the north side measured 936 ft. in length by 48 ft. in breadth. The height of the nave was 63 ft. and of the transept 108 ft. The decoration, interior and exterior, was supervised by Owen Jones, who

**128.** Frontispiece to the official catalogue of The Great Exhibition of 1851. Engraving designed by J. Tenniel

also designed the railings surrounding it. There were nearly 14,000 exhibitors (7,381 British and 6,556 foreign) with over 100,000 exhibits. The Exhibition was opened to the public on 1 May 1851 and remained open until 11 October. The total number of visitors was over six million. During the summer of 1852 the building was taken down and erected in a modified form at Sydenham, where it was opened by the Queen in 1854 and burnt down in 1936. The Royal Commission set up for the organization of the Exhibition was appointed as a permanent body in 1851 to apply the surplus funds, amounting to £186,000, in promoting the knowledge of science and art and their applications in productive industry. This they did by the acquisition of *c.* 87 acres in South Kensington as a site for the group of museums and colleges which include the VICTORIA AND ALBERT MUSEUM, the Science Museum, the Natural History Museum, the Imperial College of Science and Technology, the Royal College of Art, and the Royal College of Music. From the turn of the century the Commission also financed scholarships for the promotion of science and art.

In the *Commemorative Album* of the Exhibition issued by the Victoria and Albert Museum in 1950 the Great Exhibition of 1851 is described as 'one of the most outstanding success stories

**129**. Opening ceremony of The Great Exhibition of 1851. Lithograph by Joseph Nash (1809–78)

of the nineteenth century'. The intangible benefits were widespread and permanent.

1029, 1339, 1701, 2068.

**EXHIBITION ARCHITECTURE.** There are at least two reasons why exhibitions have served as a nursery of new architectural ideas. Exhibition buildings are usually temporary, and their architects therefore feel more free to experiment with them; and since they are either in themselves non-utilitarian or designed for entertainment, exhibition buildings allow freer rein to the imagination.

The most famous of all exhibitions, the Great EXHIBITION of 1851, had little immediate influence on architecture. Joseph PAXTON's enormous Crystal Palace, erected in Hyde Park, was popularly admired but for the most part despised by architects and serious critics. RUSKIN wrote: 'It is to this, then, that our Doric and Palladian pride is at last reduced. Our taste, thus exalted and disciplined, is dazzled by the lustre of a few panes of glass; and the first principles of architectural sublimity, so far sought, are found all the while to have consisted merely in sparkling and in space.' Yet in recent years the building has come to be recognized as a pioneer example of large-scale prefabrication, since it consisted of sheets of glass in standard sizes, and cast-iron beams and ribs manufactured in standard lengths, brought to the site ready for rapid assembly. Sparkle and space are now high among

the acknowledged virtues of MODERN ARCHITECTURE.

The Great Exhibition was followed by a series of exhibitions held in Paris in 1867, 1878, and 1889, which did rather more to establish the architectural respectability of sheer engineering. Structural steel had by then supplanted cast iron, and in the exhibition of 1889 a vast machine hall by Cottancin and a 1,000-ft. high tower by Gustave EIFFEL demonstrated the structural possibilities of steel in a spectacular fashion. The tower was for half a century the tallest man-made building in the world, was allowed to remain when the exhibition closed, and stands on the Champs de Mars a landmark of Paris and a stock symbol of engineering futility.

There is one instance of a great exhibition having an adverse effect on the progress of architecture: the Chicago Exhibition of 1893. In the years before the exhibition was planned Louis SULLIVAN was designing large city buildings which foreshadowed the new style of architecture that was one day to emerge from new structural techniques. His ideas for the exhibition's architecture were rejected in favour of conventionally grandiose Roman Renaissance style, and American architecture suffered a setback from which it did not recover for a generation.

At the Stockholm exhibition in 1930, designed by Gunnar ASPLUND in an uncompromisingly modern idiom, modern architecture, which had

hitherto only been seen in the form of isolated buildings, could for the first time be apprehended as a self-contained world of its own. The national pavilions in the Paris exhibition of 1937 demonstrated new ways of using materials and techniques which have since been absorbed into everyday architectural practice. In particular the use of timber in the Finnish pavilion by Alvar AALTO, the first of a series of remarkable exhibition buildings by the same architect, exercised a widespread influence. PICASSO's *Guernica* was painted to decorate one of the walls of the Spanish pavilion (architect J. L. Sert, 1902–  ), an example of the alliance of architecture with other arts in which exhibitions provide a useful field of experiment.

Subsequent exhibitions of architectural note were the Glasgow exhibition of 1938 (principal architect, T. S. Tait, 1882-1954) where modern display techniques were first used in Britain on a large scale, the New York World Fair of 1939, a lavish spectacle employing a somewhat flashy version of the modern architectural idiom, and the Zürich exhibition, also of 1939, which presented a unified design of unprecedented sophistication and maturity but, owing to the imminence of war, did not make the mark it deserved. The recurrent exhibitions of the Milan Triennale have set a notably high standard of design, especially in display techniques and the arts of interior decoration.

The liveliness, sparkle, and gaiety of the buildings of the South Bank exhibition of the 1951 Festival of Britain demonstrated to the British public that modern architecture is capable of decorative as well as utilitarian effects. Symmetry and formality were discarded and buildings were grouped in irregular fashion round a series of courtyards. Variety of scale and character contained the elements of contrast and surprise, exemplifying the picturesque principles which contemporary town-planners had lately adopted from the landscape gardeners of the 18th c.

288.

**EXHIBITIONS.** So long as the artist's social position was that of one craftsman among others his wares were shown along with theirs, at the seasonal fairs and religious festivals, particularly the processions of Corpus Christi. Even after the change in the status of the artist which took place at the RENAISSANCE there was little or no incentive for exhibiting so long as patronage from the Church and the nobility remained assured. During the 17th c. yearly exhibitions were held at Rome, notably at the PANTHEON on St. Joseph's day and in the cloisters of the church of S. Giovanni Decollate on the day of the patron saint (29 August). But these exhibitions were designed rather to honour the saint than as opportunity for display by artists and the only two artists who are known to have shown at the Pantheon in the 17th c. are VELAZQUEZ, a foreigner, and Salvador ROSA, a noted rebel against convention with a flair for publicity.

Officially sponsored exhibitions began with the institution of the SALON in France in 1667. They were planned to be held every other year in the LOUVRE and lasted for about three weeks. Partly they helped the policy of COLBERT to familiarize the public with the work of native painters in opposition to the current Italianate fashion and partly they helped the state control of public taste by being restricted to members of the Académie (see ACADEMIES) and so strengthening the stranglehold of that institution on artistic production. Printed catalogues of the Salons were issued and by the middle of the century criticism was regular, culminating in the famous Salons of DIDEROT and later BAUDELAIRE.

Other countries were slow in following the French lead. In Italy the nearest equivalent was a yearly exhibition held outside the church of S. Roch in Venice which was illustrated in a painting by CANALETTO now in the National Gallery, London. In England regular exhibitions began with the Society of Arts in 1760. Occasionally individual artists would throw open their studios to show their most recent works. Examples are the Roman painter Marco Benefial (1684-1764) in 1703 and the exhibitions arranged by GREUZE from 1770 after the refusal of the Académie to admit him as a 'history painter'. Such independent exhibitions, either by individual artists or by groups of artists acting outside the official organizations, became much more important during the 19th c. when the gulf between the official art of the academies and experimental or creative art widened. In 1855 COURBET, dissatisfied with the showing accorded to his work at the Exposition Universelle, built at his own expense a Pavillon du Réalisme where he exhibited 50 pictures including two which had been rejected. From this time the independent exhibitions rivalled the official Salons in interest at any rate among CONNOISSEURS.

In 1883 complaints at the narrowness of the Salon juries induced Napoleon III to set up a Salon des Refusés. But the scandal caused by MANET's *Olympia* caused the scheme to be dropped and it was not until 1884 that a group of painters, including leading IMPRESSIONISTS, formed the Salon des INDÉPENDANTS which organized exhibitions without jury selection. For the next 20 years the most significant work of the *avant-garde* appeared at these annual exhibitions. The Salon d'Automne was inaugurated by the FAUVES and subsequently, during the 20th c., most of the new movements and artistic groups have arranged exhibitions over longer or shorter periods. A more enlightened type of officially sponsored exhibitions was inaugurated by the Venice Biennale in 1895, which shows work from all over the world organized in national pavilions. The example has been followed by São Paulo, Brazil, and other towns.

The Paris dealers Vollard and Kahnweiler led the way during the last decade of the 19th c. in organizing commercial exhibitions and

throughout the 20th c. the commercial art galleries have played an invaluable role in bringing the art public into contact with new or lesser known artists whose works were unrepresented or not easily accessible in the official collections. The young artist in contemporary society has come to be dependent upon exhibition by the commercial galleries in order to get a footing into the market and become known to a potential public. Despite the necessity under which the commercial gallery rests of meeting overheads and dealing at a profit, exhibitions by the galleries have constituted the most important means by which the general public can keep in touch with current activity in the arts.

**EXPRESSION.** From ALBERTI onwards the theorists of the Italian RENAISSANCE recognized expression as a special department of knowledge which it was incumbent on the successful artist to master. Alberti believed that a good painting affects the spectator because he responds to the emotions he sees depicted in the figures represented in the painting. For this reason he attributed great importance to the ability of a painter to render the emotions by means of gesture and facial expression. In his *Della Pittura libri tre* (1436) he wrote of historical painting: 'The narrative will move the mind when the men painted therein exhibit much of their own emotion. . . . But these emotions are to be recognised from the motions. So it is best for the painter to know very well all the bodily motions, which are certainly to be learned from nature. . . .' LEONARDO, who agreed with Alberti's view that history painting is the highest and noblest kind of painting, repeatedly emphasized the importance of showing the emotions and ideas in a person's mind by means of his gestures and facial expressions and he developed a whole theory of expression to this end. He advised a sort of 'candid camera' technique and would have the painter observe and record in rapid sketch the ways in which people spontaneously express their feelings, recommending a particular study of the dumb since they have only the language of gesture and their movements are therefore most expressive. In this way he envisaged the formation of a sort of repertory or catalogue of emotional expression based on direct observation and to this extent foreshadowed the systematizations of succeeding centuries. The systematization of expression, as of all else which touches the painter's art, was carried further by LOMAZZO in his *Trattato dell' arte de la pittura* (1584), where in the book on Motion he discusses 'the movements which may be produced in the body by the different emotions of the soul', and attempts a classification of all the possible human emotions and the gesture and facial movements by which they are expressed.

The 17th c. was the golden age of astrological or 'celestial' physiognomy, and such pseudosciences as metoposcopy and cephalogy, combined with the doctrine of 'complexions' and physiological types based on the 'temperaments'. The first steps towards an objective study of physiognomic expression were taken by the Neapolitan Giovanni Battista Della Porta, who in 1623 attacked 'judicial astronomy' and whose six books *Della Fisionomia dell' huomo* (1623) became a standard source-book through the 17th and into the 18th c. The first approach to a scientific physiognomy was, however, made by the Swiss divine Johann Kaspar Lavater (1741–1801), a poet and a painter, who gathered together some 500 plates from his own pencil drawings of faces into *The Physiognomical Bible* (1772). Nearly a century before this, however, rules for the pictorial expression of emotions had become officially recognized. LEBRUN, founder of the French Académie, published in 1698 a *Méthode pour apprendre à dessiner les passions proposée dans une conférence sur l'expression générale et particulière*. This small but influential book, which was repeated in lectures to the Académie over many years, gave the basic principles for the depiction of expression. The word 'expression' was used in a wide sense: 'Expression, in my opinion, is a naïve and natural resemblance of the things which are to be represented. . . . It is expression that marks the true character of each thing; by means of it is the nature of bodies discerned, the figures seem to have movement and all that is pretence appears to be truth . . . expression is also a part that shows the emotion of the soul and makes visible the effects of passion.' The foundation of the academic doctrine was the belief that painting appeals to the reason and its instruction can be reduced to a rational body of rules, including the manner of representing emotions. In 1680 Henri Testelin, the secretary of the Académie, published his *Sentimens des plus habiles peintres sur la pratique de la peinture et sculpture mis en table de préceptes*, tabulating the accepted views of the Académie on all matters relating to painting, including expression, in a set of rules.

The possibility of reducing to rule did not go entirely unquestioned. DUFRESNOY in his *De arte graphica*, published posthumously by DE PILES in 1668, wrote that: 'A true and lively Expression of the Passions is rather the Work of Genius than of Labour and Study.' The Count of CAYLUS offered a prize at the Académie for an expressive head taken not from a copy book but from a posed model. Yet pattern books, engraved or later photographed, based upon rather rudimentary analysis and classification of the emotions in the manner of Lebrun, remained common. In 1809 De Rubeis, an Italian from Udina, published a book on the way to seize character types in portraiture, *De' retratti ossia trattato per cogliere le fisionomie*. Outstanding in this field was the work of the physiologist Sir Charles Bell, *The Anatomy and Philosophy of Expression as connected with the Fine Arts*, first published in 1806, which first linked the study of emotional expression with anatomical structure and function. In 1862 G. B. Duchenne

published a treatise on the mechanism of the countenance (a book which was commended by Darwin) under the title *Mécanisme de la physionomie humaine ou analyse électro-physiologique de l'expression des passions* with a set of photographs now in the École des Beaux-Arts, Paris. This line of research really culminated in the work of Charles Darwin who, dissatisfied with Sir Charles Bell's assumption that men are born with certain muscles specially designed for the expression of their feelings, assembled material over many years for a comparative survey of emotional expression to show an evolutionary origin for modes of expression which are now, he thought, innate but once served a biological function. His book *The Expression of the Emotions in Man and Animals* was published in 1872. The 20th c. has seen a renewed interest in the physiognomy of expression regarded as a GESTALT phenomenon not built up from a study of the particular features in isolation, but the idea that artists can learn expression from standardized patterns or models has gone out of fashion.

CARICATURE, which existed long before the word was coined in the 17th c., was defined by Murray in 1893 as 'grotesque or ludicrous representation of persons or things by exaggeration of their most characteristic features', a definition which is perpetuated by the Oxford English Dictionary. But as C. R. Ashbee has shown, modern caricature essentially involves the vivid expression of an idea inherent in a situation or characterization. The pictorial representation of emotions experienced by the personages depicted may or may not be an element in the expression of the idea. Where it does play a part, or where depiction of character type enters in, humorous exaggeration of some particular aspect or feature is likely to be employed. This sort of thing has not lent itself to systematization or precept and caricature has always remained one of the most personal and spontaneous departments of graphic art.

Besides the concept of expression for which a convincing representation of emotions supposed to be experienced by the personages depicted in a historical painting has been taken as exemplary, there are other primary usages of the word in connection with pictorial art. The idea that by means of the work of art the artist 'expresses' his own feelings or emotional attitudes, although comparatively modern and more or less restricted to the European tradition, has become a commonplace of 20th-c. AESTHETICS, repeated by artists and by theorists often without a full understanding of its implications. For example, in an interview printed as introduction to the catalogue of his 1958 exhibition, Stedelijk Museum, Amsterdam, BISSIÈRE said: 'Ma peinture est l'image de ma vie—Le Miroir de l'homme que je suis—tout entier avec ses faiblesses aussi.'

This idea belongs properly to the field of art theory and is too vague and indeterminate in its ramifications to be discussed at length here. Some mention, however, may be made of a more particularized theory that emotions in the abstract can be expressed or that definite states of feeling can be induced in the viewer (these two forms of the theory were not held distinct) by specific arrangements of pictorial elements which, it was thought, might be systematized or reduced to rule. This form of the theory did not depend on realistic portrayal of an expressive face or gestures: it was equally applicable to the abstract elements of painting. The theory was put forward by Nicolas POUSSIN in a letter to Fréart de Chantelou (24 Nov. 1647) as a doctrine of pictorial *modes* on the analogy of ancient musical modes which he derived from the *Institutioni Harmoniche* (1558) of Gioseffo Zarlino. These ideas were popularized in the Académie by Lebrun and FÉLIBIEN and were later revived by Paillot de Montabert in his *Traité complet de la peinture* (1829). About the same time Humbert de Superville published his very influential treatise *Essai sur les signes inconditionnels dans l'art* (1827-32), which also associated predictable expressive values with abstract configurations of colours and lines. The ideas of these two works were popularized by the critic and historian Charles Blanc (1813-82) in his *Grammaire des arts du dessin* (1867) and through this and the aesthetician Charles Henry they became the basis of the aesthetic theories of SEURAT in his latest phase, 1884-7, which he formulated in a letter to Maurice Beauberg of 28 August 1890. On the evidence of SIGNAC it appears that PUVIS DE CHAVANNES had also derived his aesthetic from a knowledge of Poussin's theory of modes. The belief in the intrinsic 'expressiveness' of pictorial elements became, after Seurat, one of the major principles underlying modern EXPRESSIONISM and one trend of modern ABSTRACT ART.

226, 694, 769, 1584, 1599, 2633.

## EXPRESSIONISM, EXPRESSIONIST.

Term in art history and criticism for a 20th-c. aesthetic movement which deliberately turned away from the representation of nature as a primary purpose of art and thus broke with the traditional aims of European art since the RENAISSANCE. Expressionists proclaimed the direct rendering of emotions and feelings as the only true goal of all art; line, form, and colour were to be used entirely for their expressive possibilities. Balance of design and traditional conceptions of beauty were sacrificed in order to convey a sensation more forcibly, and DISTORTION became an important means of emphasis.

The beginnings of Expressionism can be traced to the 1880s, but these trends did not crystallize into a distinct programme until about 1905. The Expressionist movement began in France, but developed almost simultaneously in other countries. Expressionism found more congenial soil in Germany than elsewhere and

continued there until it was suppressed by the Nazis in 1933.

The term 'Expressionism' was first used by German critics in 1911 to describe the FAUVES, the early CUBISTS, and other painters who were consciously opposed to IMPRESSIONISM and the imitation of nature. Some confusion has been caused by applying it to painters such as GRÜNE-WALD or El GRECO, and it has since acquired currency as a critical and aesthetic concept analogous to such terms as 'Romanticism' and 'BAROQUE' in their more general connotations. But before the end of the 19th c. there had never been a complete break with convention, even when beauty of form and harmony of composition were subordinated to the clear delivery of an emotional message. It is therefore necessary to distinguish a wider and more general usage of 'Expressionism' from its original application to a more specific 20th-c. aesthetic trend.

The most important forerunner of Expressionism in its specific sense was van GOGH, and the thoughts which he recorded in his letters remain the clearest exposition of the Expressionist creed. Although he considered himself in the tradition of the Impressionists and adopted their palette of bright colours, to his emotional and symbolic nature these were the means to an end more positive than the mere rendering of light. He consciously exaggerated nature 'to express . . . man's terrible passions'. This is the beginning of the emotional and symbolic use of colour, and line is used to the same end: the direction given to a line is that which will be most expressive of the feeling which the object arouses in the artist. Van Gogh and the Expressionists after him relied on impulse and feeling for their emotional use of colour and line, and in this they are distinguished from SEURAT's attempts to work out a scientific system of formal expression.

GAUGUIN broke more consciously and definitely with Impressionism. Strictly speaking Gauguin was not an Expressionist, but he was the first to accept explicitly the principles of SYMBOLISM, which in turn became of importance for Expressionism proper as a vehicle of communication. Under the influence of Émile Bernard, whose aesthetics stemmed from the French symbolist poets, he simplified and flattened all forms and used colour in a way which gave up all semblance of realism. The fierceness of *Jacob Wrestling with the Angel* (Edinburgh) is made explicit through the red field on which the combat takes place. To the same end Gauguin also abolished the representation of shadow and in this the Expressionists followed his lead. As a counterpart of his new style he sought for simplicity of subject matter; he found it first in the peasant communities of Brittany and later in the islands of the South Pacific. In turning away from European urban civilization Gauguin discovered PRIMITIVE art and FOLK ART, both of which became of absorbing interest for the later Expressionists.

**130**. *The Cry*. Lithograph (1895) by Edvard Munch

At the same time the Norwegian, Edvard MUNCH, who knew the work of van Gogh and Gauguin, began to explore the possibilities of violent colour and linear distortions with which to express the most elemental emotions of anxiety, fear, love, and hatred. His search for pictorial equivalents for his hysterical obsessions led him to realize the potentialities of graphic techniques with their simple directness. Munch had a wide influence, particularly in Germany (he exhibited at the Künstlerverein, Berlin, in 1892), which extended even to sculpture in the work of Ernst BARLACH, who used Munch's idiom to great effect for religious and social subjects.

Among the early Expressionists must also be counted the Belgian painter, James ENSOR. He pictured the baseness of human nature by the use of grotesque and horrifying carnival masks, and his weird and uncanny art became widely known, particularly through his etchings. The Swiss artist HODLER must also be numbered among those who influenced German Expressionism.

In 1905 Expressionist groups appeared almost simultaneously in Germany and France. The Fauves combined in their art the theories of van Gogh and Gauguin; in 1908 MATISSE, the leader of the group, summed up their aims: 'What I am after above all is expression. . . . The chief aim of colour should be to serve expression as well as possible. . . . To paint an autumn landscape I will try to remember what colour suits the season; I will be inspired only by the

sensation the season gives me.' Matisse applied these ideals to large figure compositions, DERAIN to landscape, and ROUAULT to a new religious art of great power and simplicity.

In 1905 Die BRÜCKE (The Bridge) was founded in Dresden and held its first exhibition in 1906. Whereas the painting of the Fauves, even at their most violent, always retained harmony of design, and colour never lost a certain decorativeness and lyricism, in Germany restraint was thrown to the winds. In spite of undeniable French influence, violence was exploited for its own sake; forms and colours were tortured in the attempt to give psychological and symbolic vent to a vaguely conceived creative urge and a sense of revolt against the established order. In 1913 KIRCHNER wrote: 'We accept all the colours which, directly or indirectly, reproduce the pure creative impulse.' So the German work displayed a harshness and inchoateness which were always foreign to the more Classical French temperament.

During the first decade of the 20th c. other German painters turned in the same direction. Paula Modersohn-Becker (1876–1907), who joined the colony of artists at Worpswede in 1897, translated Gauguin's refined and noble art into a gauche and earthy German primitivism. Emile NOLDE—who belonged to the Brücke for a short time only—was deeply impressed by the works of Ensor. The Austrian Oscar KOKO-SCHKA, with his agitated line and sonorous colours, was typically Expressionist in his landscapes and portraits. So also was the violent and theatrical art of BECKMANN.

England stood aside. Except for Matthew SMITH, who saw the work of the Fauves and painted in their style with hot bright colours, Expressionism with its lack of restraint was uncongenial to English taste. The experiments of Wyndham LEWIS and VORTICISM—even if they can properly be classed as Expressionist—were short-lived and confined to a small, internationally minded circle.

In France Fauvism was superseded by the purely formal CUBISM after 1907, although it lingered for a few years in the art of Matisse and his friends. Italy had—slightly later than France and Germany—an Expressionist movement in FUTURISM; in his famous manifesto of 1909 the poet MARINETTI attacked all art of the past and called for a truly contemporary style. While the idiom of the Futurists is in the main similar to that of the Cubists, BOCCIONI and CARRÀ aimed at expressing the spirit of the machine age through the symbolism of swirling abstract forms.

Shortly before the First World War the German painters also grafted the schematic forms of Cubism on to the ideals of earlier Expressionists, and under the influence of theosophy and Indian mysticism attempted to evolve a pictorial system of universal implication. In 1911 Franz MARC, the Russian KANDINSKY, and others founded the BLAUE REITER Group, which held important exhibitions at Munich in 1911 and 1912 and at Berlin in 1912. Marc used animals to express somewhat sentimental ideas about the universe and 'the great chain of being', but in the end he turned to pure abstraction. Kandinsky, whose theoretical exposition Über das Geistige in der Kunst appeared in 1911, employed the results of studies in psychology of perception to find pictorial equivalents for emotions divorced from concrete objects. In this he came close to SUPREMATISM, whose aim was to express the supremacy of pure feeling through simple geometric forms rendered in simple colours.

It is perhaps in the highly individual art of Paul KLEE, who for a time belonged to the Blaue Reiter, that the fusion of abstract forms and pure expression is most complete. It is no accident that his pictures are reminiscent of the expressive art of children. Conversely, it was Expressionism which first drew attention to CHILDREN'S ART.

After the First World War Expressionism became the fashion in Germany. Those artists of the Blaue Reiter who had survived became more theoretical and abstract, and they exerted a considerable influence on the younger generation. This may be due to the fact that Klee and Kandinsky taught for some years at the BAUHAUS. The outlook of the Brücke painters hardly changed at all and former members of this group painted as late as 1950 in a manner reminiscent of their earliest works. In France Expressionism survived in the dream-like art of CHAGALL and the violent paintings of SOUTINE. In England Matthew Smith continued to paint Fauvish still lifes and figure studies. Even artists such as George GROSZ and Otto DIX in Germany, who sought a new and hard realism—NEUE SACH-LICHKEIT—kept much of the distortions and exaggeration which had been one of the chief devices of earlier Expressionism.

Even if ill defined and divergent in aims, Expressionism has left its definite mark on contemporary painting. TACHISME and ABSTRACT EXPRESSIONISM are its lineal descendants, while small groups have even returned to the methods of the Fauves and Die Brücke.

423, 539, 856, 1903, 2456.

**EYCK, CHARLES HUBERT** (1897–1962). Versatile Dutch painter, sculptor, and designer. Unlike many Dutch artists he had a preference for working on a large scale. He made impressive decorations for Catholic churches in Limburg. His large bronze sculpture group in Maastricht commemorates the liberation of that city, the first Dutch city freed from the Germans, in 1944.

**EYCK, VAN.** The family name of two painters of the first half of the 15th c., who are popularly believed to have 'founded' the FLEMISH School and 'invented' OIL PAINTING. JAN and HUBERT van Eyck seem to have been brothers. They were

**131.** *Arnolfini and his Wife* by Jan van Eyck (N.G., London, 1434)

natives of Maaseik or of the larger town of Maastricht near by. There are few known facts about Hubert but he is generally assumed to have been the elder as he died in 1426. Jan's life, on the other hand, is well documented after 1422 when he entered the service of the Count of Holland, John of Bavaria. In 1425 he was appointed Court Painter and 'varlet de chambre' to Philip the Good, Duke of Burgundy. Apparently he was highly esteemed by the Duke and travelled on secret diplomatic missions to Spain and Portugal for him. About 1430 Jan moved

from Lille to Bruges, where he lived until his death.

Scholars have tried to establish Hubert's individual style and to distinguish it from his brother's; but no conclusion is entirely convincing as there are no authenticated pictures by Hubert alone, though there are many by Jan. *The Three Maries at the Sepulchre* (Boymans Mus., Rotterdam) seems to be an early painting on which they collaborated. If documents relating to the great ALTARPIECE of the *Adoration of the Lamb* at Ghent are authentic, it is established that Hubert died leaving it unfinished and that it was completed by Jan. But it is difficult to isolate Hubert's hand conclusively though by and large the more 'old-fashioned' parts are ascribed to him.

There are a number of signed and dated works of the 1430s by Jan and on the basis of these it is possible to assign others to him with a reasonable degree of certainty. The *Virgin in the Church* (Berlin) is generally accepted as an early work, although it differs widely in character from the *Ghent Altarpiece*; the architecture, though accurately delineated, is deliberately diminutive in relation to the standing figure. The scale of the Madonna is increased to convey the idea that she stands as a symbol of the Church. Another painting that is probably early is the *Annunciation* (Washington), set inside a ROMANESQUE church. Rich colours glow in a supernatural light, for in both these paintings the light streams in through the north windows of the church. A single church interior unifies the three panels of the *Triptych of the Virgin* (Dresden) and shows with what perfection the artist could integrate figures into an architectural setting. In the *Altarpiece* painted for Canon van der Paele (Bruges, 1436) the architectural setting is reduced to make the figures the undisputed centre of interest. This monumental composition is extremely highly finished and glows with colours used at their maximum strength. The *Madonna of Chancellor Rolin* (Louvre), with large figures in the foreground set against the distant panoramic landscape, shows that 'his eye was at one and the same time a microscope and a telescope' (E. Panofsky, *Early Netherlandish Painting*, 1953).

Among the signed and dated works of Jan van Eyck there are a number of portraits. The *Tymotheas* (N.G., London) is dated 1432 and depicts a young man holding a scroll. He faces the source of light and the play of light and shade on the cheekbones is analysed with infinite care. There are also two other portraits by Jan in the National Gallery: the *Man in the Red Turban* (signed and dated 1433), which is generally considered to be a self-portrait, and *Arnolfini and his Wife* painted for their marriage in 1434. Both pictures display unrivalled proficiency in the reproduction of contrasting textures and in their union of technical mastery with a cool objective eye for actuality they represent the high-water mark for realistic painting. The latter picture in particular exemplifies Jan's mastery not only of tangible appearances but also of light and space. Cardinal Albergati was sent to Bruges by the pope in 1431 and must almost certainly have sat for Jan, for a drawing (Dresden) with colour notes in the margin can only be by the master himself. The finished portrait is now in Vienna and may have been executed a little later (*c.* 1433). As a portrait painter Jan is preoccupied with the realities and textures of the human face and in this as in his inanimate interiors he records the subtleties of appearances rather than commenting on them as did his great contemporary Rogier van der WEYDEN.

Jan's technical skill and great inventiveness established his fame throughout Europe as the greatest Netherlandish painter of the 15th c. The Neapolitan humanist Fazio (mid 15th c.) included him among the illustrious men of his time, VASARI allotted him a special place in his story of the progress of the arts, and his works were eagerly collected in RENAISSANCE Italy. DÜRER greatly admired his paintings and the German ROMANTICS rediscovered the miracle of his meticulous style. While he is usually seen as the harbinger of a new age, J. Huizinga in *The Waning of the Middle Ages* (1924) has discussed the many ties which link his art with late medieval culture. For van Eyck's contributions to the technique of oil painting see article on that subject.

142, 721, 926, 928, 2811.

# F

**FABRÉ,** JAIME or JAUME (active early 14th c.). Architect of the Dominican church at Palma, Majorca (begun 1296). From 1317 for at least 20 years he was architect in charge of Barcelona Cathedral and was probably responsible for the choir and crossing, the designs of which recall Narbonne Cathedral.

**FABRITIUS,** CAREL (1622–54). Dutch painter of distinction, who worked in REM-BRANDT's studio and forms a link between Rembrandt and the school of Delft. He may have influenced VERMEER, who succeeded him as syndic of the Guild of St. Luke in Delft. He was a versatile artist and painted portraits, architectural PERSPECTIVES, GENRE, STILL LIFE, and animal pieces such as the celebrated *Gold-finch* at The Hague. This picture and a small number of portraits are all that survive of his work, for most of it was destroyed by an explosion at the Delft powder factory in which the artist himself was killed. His younger brother BARENT (1624–73), of lesser talent, began to paint in Rembrandt's manner even before he left his home town of Middenbeemster. Carel probably introduced him to Rembrandt's warm colours, broad touch, and chiaroscuro. Barent's figure compositions have a distinctive frieze-like effect. Like his brother he also did pictures which have the light tonality of the Delft painters (*Portrait of Van der Helm Family*, Rijksmuseum, 1655). In these works one can see the impact of another pupil of Rembrandt, Nicolaes MAES, upon his work.

**FAIENCE.** Earthenware partly baked and coated with an opaque white glaze containing tin oxide, giving a surface which not only shows up the painted designs to advantage but also preserves them during the firing. A clear lead glaze is added before the complete firing. Faience was invented in the Near East (see ISLAMIC ART) and spread to Spain, and thence to the rest of Europe. That made in Italy was called MAIOLICA and the Dutch and English form was called Delftware.

The French and German faience of the 17th and 18th centuries was similar to maiolica but its improved finish owed something to the Dutch Delftware. On account of its relative cheapness it became widely adopted as a substitute for plate, and remained in vogue until late in the 18th c.

FRANCE. By late medieval times floor tiles and other wares in the 'green-and-purple' maiolica style were already being made in the south. In the 16th c. Italian potters at Lyon (1512–*c.* 1600) and Nevers (from 1585) made wares scarcely differing from those of their native Urbino, while the drug-vases characteristic of Rouen or of Nîmes, with their polychrome scrollwork and portraits, were hardly less Italianate. Almost alone Nevers carried over this rich tradition of painting into the age of Louis XIV, developing a florid, BAROQUE style of figure drawing which often echoed the art of VOUET and POUSSIN. At the same time various exotic Oriental styles were also practised.

During the 18th c. superior faience was made in many parts of France, and especially in the north the Rouen factories provided an early formative influence. At first stiff 'lacework' patterns based on those of Jean BÉRAIN and others were executed in blue or blue and red; then *c.* 1725–50 somewhat freer designs of a part-Baroque, part-Oriental character followed, in a polychrome palette based on that of the Chinese *famille verte*. In the south the Marseilles and Moustiers factories made some particularly fine dishes with hunting scenes after engravings by A. Tempesta (1555–1630), etc., in which the robust Nevers tradition lived on; these were replaced from *c.* 1510 by the airy, swagged frameworks of the RÉGENCE STYLE, which after the introduction of polychrome (*c.* 1740) shrank to the stature of mere border designs for brisk miniature painting of mythological subjects.

Until *c.* 1750 only high-temperature (*grand feu*) colours had been used; but after the introduction of overglaze (*petit feu*) enamels at Strasbourg these were widely adopted (see POTTERY). This highly original factory conducted by the Hannong family from 1721 to 1780 produced extensive table services which vied with those of German porcelain in their fanciful elaboration and bold ROCOCO modelling; they were painted chiefly with scrollwork and floral designs in subtly shaded tones of crimson and green. Niderviller in the same region made many charming small figures, and during the next 25 years much delightful faience enamelled with flowers, birds, and landscapes was made also at Marseilles, Aprey, Meillonas, and Sceaux.

GERMANY AND SCANDINAVIA. A somewhat limited use was made of maiolica techniques by the Nuremberg Hafner early in the 16th c. By the second half of the 17th c. numerous factories were springing up to compete with the Dutch and much 'blue-and-white' was produced, notably

at Hamburg, Hanau, and Frankfort. Jugs, dishes, and punch-bowls were among the popular shapes, which were painted with coats of arms, flower sprays, or figure scenes after Chinese porcelain. Sometimes the decoration was in yellow and purple. Apart from this high-temperature work, much independent enamelling of white faience was carried on from this time onwards at Nuremberg, Augsburg, and elsewhere by Hausmaler. Factories at Nuremberg also made their own wares in a florid, Baroque style, and the faience of Bayreuth and Ansbach *c.* 1720-60 includes some of the most accomplished ever produced in Germany—the former excelling in formal scrollwork painted in blue only, the latter in richly coloured variations on the Oriental *imari* and *famille verte*. The variety of floral, landscape, and figure styles and patterned borders at this time eludes simple classification, nor can more than a few of the factories be referred to here. Mention must, however, be made of the influence of Adam von Löwenfinck (1714-54), who worked successively at Bayreuth, Ansbach, Fulda, Höchst, and Hagenau (as well as at Meissen on porcelain). He excelled in the painting of pseudo-Oriental subjects, and the invention of naturalistic bird tureens and other fancies has also been attributed to him.

The most important northern factories of the mid 18th c. were at Kiel, Stockelsdorf, and Eckernförde. In common with factories in Sweden (Marieberg, Rörstrand), Denmark (Copenhagen), and Norway (Herreböe), these were chiefly influenced by the lively Rococo modelling and fresh colouring of Strasbourg in France.

**FAITHORNE,** WILLIAM (1616-91). English engraver. He fought as a Royalist and later spent some time in France working with NANTEUIL; but by 1650 he was established in London and became the most distinguished of English 17th-c. engravers, especially of portrait heads. He engraved the work of other painters (van DYCK, DOBSON, SOEST, LELY) and also made engravings of his own drawings from the life. He also drew very sensitive heads in crayon (*John Ray*, B.M.).

**FAIYUMIC PORTRAITS.** See EGYPTIAN ART.

**FALCA,** PIETRO. See LONGHI, P.

**FALCONE,** ANIELLO (*c.* 1600-56). Neapolitan painter. He was probably the first to specialize in BATTLE-PIECES, though he was later surpassed in that genre by his pupil Salvator ROSA.

**FALCONET,** ÉTIENNE-MAURICE (1716-91). French sculptor and theorist who worked for a time under J. B. LEMOYNE. He was the favourite sculptor of Mme de Pompadour, who made him Director of Sèvres porcelain factory (1757-66). His work for Mme de Pompadour is exemplified in *L'Amour menaçant* and *La Baigneuse* (Louvre). Through the influence of DIDEROT he was employed by Catherine II of Russia in 1766 and worked until 1769 on the EQUESTRIAN STATUE of Peter the Great at St. Petersburg, the subject of a poem by Pushkin. The statue is notable for the vivid arrested movement of the rearing horse, whose balance with the forelegs unsupported is secured by various devices such as the lengthened tail and the serpent intended to symbolize rebellion defeated. The vigour of this conception made a sharp break with the somewhat weak and affected grace of his French work. The pose was later borrowed by DAVID for his equestrian portrait of Napoleon. Falconet's study of the horse made in preparation for this monument led him to criticize the Roman equestrian monument of Marcus Aurelius and his *Réflexions sur la sculpture* (1761), containing one of the earliest defences of contemporary work against the ancients, aroused the enthusiasm of the young GOETHE for its fearless REALISM.

2196.

**FANCELLI,** DOMENICO DI SANDRO (1469-1519). Italian sculptor from Settignano (Florence). He was one of the first artists to introduce Italian RENAISSANCE style into Spain. Working at Carrara with brief visits to Spain in order to install his work and sign new contracts, he executed the tomb of Cardinal Hurtado de Mendoza (Seville Cathedral, 1509); that of prince John, son of Ferdinand and Isabella (St. Thomas, Avila, 1513); and that of Ferdinand and Isabella (Chapel Royal, Granada, 1517).

**FANCY PICTURE.** A term applied at the end of the 18th c. to pictures of a kind between portraiture and GENRE. Rural scenes in which idealized peasants behave rather more as if they were in the studio than the countryside are 'fancy pictures', and GAINSBOROUGH's paintings of this type were so called in his own day. The term is elusive and cannot be defined with precision.

**FANTIN-LATOUR,** IGNACE HENRI JEAN THÉODORE (1836-1904). French painter and lithographer, born at Grenoble. He was first taught by his father, a landscape painter of Italian descent, and later in Paris by Lecoq-de-Boisbaudran and at the École des Beaux-Arts. He was also a pupil at the school of the academic painter Marc Gabriel Gleyre, where he knew WHISTLER, DEGAS, and LEGROS. He exhibited at the Salon from 1861 until 1899. He made several visits to London, where he was a friend of Whistler and Edwin Edwards, and he exhibited at the ROYAL ACADEMY. He is much admired in France for his sensitive and intellectual figure groups, in particular: *Hommage à Delacroix,*

showing MANET, Whistler, Legros, BAUDELAIRE, the engraver Bracquemond, and others grouped around a portrait of DELACROIX (exhibited in the Salon of 1864, now in the Louvre); and *L'Atelier des Batignolles* (Luxembourg), a group of artists in Manet's studio. He also developed a romantic admiration for Wagner's music and did imaginative lithographs illustrating the music of the Romantic composers (*La Féerie*, Montreal). He has been most known and admired in England for STILL LIFES and flower pieces which seem to catch the evanescent vitality of the subject—'flowers that live today and die tomorrow and are not petrified in the stage of perfection, as they were by the flower painters of an earlier age'.

1030, 1460, 1466.

**FARINGTON,** JOSEPH (1747-1821). English landscape painter and topographical draughtsman. He studied under Richard WILSON and entered the R.A. schools in 1768, becoming an A.R.A. in 1783 and an R.A. in 1785. His views of the English Lakes were engraved and published in book form in 1789 and 1816. Farington is best known today for his copious diaries (1793-1821), which contain valuable information about the London art world of the time. The manuscript is in the Royal Library, Windsor Castle.

**FARNESE.** A family of humanists and patrons of the arts who rose to importance with the election of Cardinal ALESSANDRO FARNESE (1468-1549) to become Pope Paul III in 1534. He began the Palazzo Farnese in 1517 and on his election to the papacy had it enlarged by Antonio da SANGALLO the Younger: MICHELANGELO was appointed architect in 1547 on Sangallo's death and was succeeded in the 1560s by VIGNOLA. On the latter's death in 1573 the work was given to Giacomo della PORTA, by whom the Palace was completed in 1589.

PIER LUIGI (1503-47), the natural son of Paul III, was made Duke of Parma and Piacenza. Another son, ALESSANDRO, known as 'Cardinal Farnese', was acknowledged to be the greatest patron of his day, surrounding himself with artists and men of letters. He built up the largest collection of antiquities in Rome. He was instrumental in bringing TITIAN to Rome (1545-6), encouraged VASARI to write his *Lives*, commissioned Vignola to build the Farnese Villa at Caprarola, and was responsible for some of the most important MANNERIST frescoes. He also purchased the villa across the Tiber from the Palace which was henceforth known as the Villa Farnesina. He gave special support to the Jesuits and built for them the church of Il Gesù of which Vignola and later della Porta were the architects. Alessandro's great-nephew, Cardinal ODOARDO (1573-1626), great-great-grandson of Paul III, was responsible for employing Annibale and Agostino CARRACCI to decorate the Farnese Gallery in the Palace.

Annibale Carracci's frescoes for the Farnese Gallery are considered one of the finest masterpieces of BAROQUE art. When the Gallery was opened the Abbate Lanzi wrote in 1795: 'Rome beheld in it a certain grandeur, which might claim third place after the Sistine Chapel and the Stanze of the Vatican.'

The Farnese also had connections with Spain. ALESSANDRO (1545-92), third Duke of Parma and Piacenza, was regarded as the greatest military expert of his time. He served Philip II of Spain, was appointed governor-general of the Netherlands on the death of Don John of Austria in 1578, and by the capture of Antwerp in 1585 secured the southern Netherlands for Spain. ELISABETTA, second wife of the Bourbon King Philip V, was a Farnese and through this connection Charles III brought the majority of the Farnese antiquities to Naples, where they still are.

1784.

**FARNESE BULL.** This stupendous group, found in Rome and assigned to Apollonius and Tauriscus, Greek sculptors of the School of Rhodes, represents life-size Dirce, her two stepsons with the bull they are hauling along to trample her, and as extras another woman and a dog. Whether copy or original, it is substantially late HELLENISTIC in style.

**FARNESE HERCULES.** Colossal marble statue of an over-developed giant leaning sideways on his club (Naples), a free adaptation of a type traditional from the 4th c. B.C. The original is by some imputed to LYSIPPUS.

**FASCIA.** An overlapping band in the classical ARCHITRAVE (see ORDERS OF ARCHITECTURE), derived from courses of weatherboarding protecting the timber beams supported by the COLUMNS.

**FAUVISM, FAUVE.** Fauvism was the first of the great aesthetic movements in 20th-c. painting. The movement was based on the exaltation of pure colour and *Les Fauves* began as a loose association of painters who had for several years similar technical interests. The first pictures in a Fauvist manner were executed *c.* 1899 by MATISSE, who remained always the dominant figure in the group. The name came later, when the critic Louis Vauxcelles, entering the room at the Salon d'automne of 1905 where the artists were exhibiting together, pointed to a quattrocento-like sculpture in the middle of the same gallery and exclaimed: 'Donatello au milieu des fauves!' (Donatello among the wild beasts). The Fauvists were a conflation of three main groups: the pupils of Gustave MOREAU (Matisse, MARQUET, ROUAULT, Henri Charles Manguin (1874-1943), Charles Camoin (1879-1965), and Jean Puy (1876-1960)), also VLAMINCK and DERAIN from Chatou, and three late-comers from Le Havre (Friesz, BRAQUE, DUFY). The Dutchman van DONGEN was also associated with them. They were influenced in varying degrees by

van GOGH, GAUGUIN, NEO-IMPRESSIONISM, and CÉZANNE, and the outstanding characteristic of their work was the extreme intensity of its colour: pure colours, which they used arbitrarily for emotional and decorative effect, but sometimes also, as Cézanne had done, to mould space. Apart from this, they had little or no programme in common.

The movement reached its peak in the Salon d'automne of 1905 and the Salon des Indépendants of 1906. With most of the group Fauvism was a temporary phase through which they passed in the development of widely different styles and at no later period did their work display again such a degree of similarity.

1886, 2729.

**FEDERAL STYLE.** The traditional phase of NEO-CLASSICISM in the U.S.A., current between *c.* 1780 and *c.* 1820. Based on the work of Robert and James ADAM in England, it reached America primarily through their publications and those of William Pain and James Paine. It is characterized by slender proportions, flat surfaces, thin mouldings, and small but delicate ornament. Notable features are the elliptical fanlight and the freestanding colossal portico. Walls were generally of brick, with their flatness emphasized by crisply defined openings. Windows were frequently framed by shallow wall arches. In the interior the graceful elliptical rooms and circular flying staircases reflect the curvilinear quality of the decorative features. The purest examples of the style are found in the work of the New England architects BULFINCH and McINTIRE. Elsewhere it was modified by other influences, especially French.

**FEICHTMAYER** (FAICHTMAYER, FEUCHTMAYER). Family of stuccoists and sculptors from Wessobrunn, Bavaria, active in the 17th and 18th centuries. Outstanding among them are JOHANN MICHAEL (1709/10-72), whose inventiveness and skill brought him commissions to decorate several of the finest buildings of the period (including the abbey churches of Zwiefalten and Ottobeuren and the palace at Bruchsal), and JOSEPH ANTON (1696-1770), who did a great deal of decorative sculpture for buildings in the Lake Constance area (Neubirnau chapel, the Franciscan church at Überlingen; also choir stalls in S. Gallen abbey church, Switzerland). Joseph Anton's devotional sculptures (*Virgin of the Immaculate Conception*, realistically coloured limewood, Berlin) show the virtuoso carving and flamboyant line typical of Roman Catholic religious sculpture in central Europe at this time. See also STUCCO.

**FEININGER,** LYONEL (1871-1956). American painter of German origin. Feininger studied in Germany, and worked first for newspapers as a graphic artist. In 1907 he turned seriously to painting and after 1912 was linked with the Section d'Or branch of CUBISM. He evolved

**132.** Cover for Walter Gropius's first Bauhaus proclamation (1919). Representing the Cathedral of Socialism. Woodcut by Lyonel Feininger

a personal Cubistic style in which natural forms were treated in terms of a rhythmic pattern of clearly defined planes bounded by straight lines —a manner which he applied particularly to architectural and marine subjects, in which he delighted. Feininger worked with GROPIUS at the BAUHAUS 1919-33, and returned to the U.S.A. in 1937.

1306.

**FEKE,** ROBERT (*c.* 1706-before 1767). American Colonial portrait painter. Nothing is known of his early life until 1741 when he executed a large portrait group in Boston, *Family of Isaac Royall*. He was active from that time in Newport and Philadelphia until 1750, when his life is once more veiled in obscurity. He had a bold and vigorous talent but his work betrays the fragmentary training of a painter born into a country without an established tradition of craftsmanship. His works have strong decorative power with bold BAROQUE rhythms and brilliant colour but are lacking in characterization. They express aristocratic dignity and the ideal of formality and elegance.

893.

**FÉLIBIEN DES AVAUX,** ANDRÉ (1619-95). French architect and writer, who was a friend of

Nicholas POUSSIN in Rome. On his return to Paris he supported COLBERT's policy in the arts. His *Imaginary Conversations on the Lives and Work of Outstanding Painters, Ancient and Modern* (1666-8), which served as a handbook for academic teaching, contained the best contemporary biography of Poussin. In 1676 he published a textbook on artists' techniques and a dictionary of art terms.

**FELTON BEQUEST.** The bequest made by Alfred Felton to the National Gallery of Victoria, Australia, in 1904, by means of which works of art to the value of £900,000 have been presented to the Gallery. Notable purchases include the Welbeck REMBRANDT *Self-Portrait*, the TIEPOLO *Banquet of Cleopatra* from the Hermitage, the Radnor POUSSIN *Crossing the Red Sea*, 36 *Illustrations to Dante's Divine Comedy* by William BLAKE, and the Barlow Collection of DÜRER's engravings.

**FEODOTOV,** PAVEL (1815-52). Russian painter. He began his brief artistic career as a self-taught amateur and early successes encouraged him to take lessons at the Imperial Academy of Fine Arts. The main influence on his development came from 17th-c. Dutch genre painters, the works of Sir David WILKIE, and, probably, the genre scenes of the Austrian painter Josef Danhauser (1805-45). He is known as the 'Russian Hogarth' and may have known the work of HOGARTH through engravings. But his own works lack Hogarth's moralistic purpose and are smoother in technique. His gently satirical and sentimental scenes from daily life became favourites with the Russian public. In his last years his work expressed disenchantment with the dreariness of life. He died in a lunatic asylum.

**FEOFAN GREK.** See THEOPHANES THE GREEK.

**FERGUSSON,** JOHN DUNCAN (1874-1961). Scottish painter and, to a lesser degree, sculptor. His early influences were WHISTLER; the painters of the so-called Glasgow School, especially Arthur Melville (1855-1904); and, after settling in Paris in 1905, the FAUVES. Between about 1910 and 1920 he developed a highly personal style, with which he associated the word 'rhythm', which interestingly parallels the EXPRESSIONISM being developed at the same time in Germany. In 1914 the war brought him back to Britain and the rest of his life was spent between London, Paris, and, after 1940, Glasgow. In the inter-war years, with his old friend S. J. Peploe (1871-1935) and with Leslie Hunter (1879-1931) and F. C. B. Cadell (1883-1937), he belonged to a loosely associated group, descriptively labelled the Scottish Colourists, which had something of a cousinly relationship to the École de Paris (see PARIS, School of).

**FERNANDEZ,** ALEJO (*c.* 1470-1543). Spanish painter, referred to as 'Maestro Alexos—pintor Alémán' and probably of German birth. He married the daughter of the painter Pedro Fernandez at Cordova and took her name. He worked mainly at Seville, where he was employed on the main ALTARPIECE of the cathedral in 1508. The best known work, attributed to him on stylistic grounds, is *La Virgen de los navegantes* (Archivo de las Indias, Seville) probably painted in the early 1530s, which is basically Flemish in style and similar to the work of Quentin MASSYS. Other signed works are the *Virgen de la Rosa* (church of Sta Ana de Triana, Seville, 1510-20) and an altarpiece of the *Lamentation of Christ* in the cathedral of Seville (1527).

53.

**FERNANDEZ** or HERNANDEZ, GREGÓRIO (*c.* 1576-1636). Spanish sculptor, active at Valladolid from *c.* 1605. Continuing the tradition of painted religious sculpture, he worked in the manner of JUAN DE JUNI but with greater realism of expressive gesture. He was one of the first masters of BAROQUE naturalism in Spain, though he sometimes sacrificed form to dramatic effect. He abandoned the earlier practice of using gold and brilliant colours and insisted upon realistic colouring from the polychromists who painted his sculptures. Among the numerous REREDOSES emanating from his workshop are those of S. Miguel, Valladolid (1606) and Plasencia Cathedral (1624-34). He is represented in Valladolid Museum by a *Pietà* (1617) and a *Baptism of Christ* (1630), and other works.

1092.

**FERRARESE SCHOOL.** Although the cathedral of Ferrara, built in the 12th c., is one of the principal works of the Lombard ROMANESQUE style, this city, which was the capital of a Duchy extending over the Po delta, did not become a centre of art until after 1440, when the remarkable patronage of the ESTE princes began. The arrival of masters from other parts—PISANELLO, PIERO DELLA FRANCESCA, Jacopo BELLINI, and even a few Flemings—created a peculiar climate in which a kind of GOTHIC richness blended with RENAISSANCE forms, as in the romances of chivalry then fashionable. The Estes built many villas and town houses famous for their taste. They did not neglect TOWN-PLANNING: at the end of the 15th c. Ercole d'Este I drove straight avenues across his now prosperous city and lined them with palaces in the new style (Palazzo dei Diamanti, by Biagio Rossetti, *c.* 1447-1516).

Manuscript ILLUMINATION was cultivated in its richest form (Bible of Duke Borso, Bib. Estense, Modena). There was a remarkable development in fresco painting: in the Palazzo Schifanoia ('Sans-Souci') a resplendent series of frescoes (now partly destroyed) displays the life of the Este court with astrological repre-

sentations. Francesco del COSSA and Ercole de' ROBERTI worked on this series. They had the stimulus of a third great Ferrarese artist, Cosimo TURA, who was slightly their senior. Tura elaborates his profusion of tormented forms, little hard folds, and scalloped outlines until they are almost pure ornament. Cossa is heavier and more monumental, but sometimes achieves a delicate balance. Ercole is the richest and most inventive of the three. The drawing of these Ferrarese masters is sharp and their colour strident, but compositions such as Tura's *Roverella Altarpiece*, or the *Griffoni Polyptych* in which Cossa and Ercole collaborated, give an odd impression of grandeur.

At the end of the 15th c. the 'soft' style of the UMBRIAN SCHOOL made itself felt in Ferrara through Lorenzo COSTA. A little later the Romantic Dosso DOSSI, who knew the great Venetians, became the painter of the court which Ariosto has made famous. After him the School of Ferrara died out. It became unexpectedly topical in the 20th c., when the founders of METAPHYSICAL PAINTING (e.g. CHIRICO) were impressed by the Schifanoia masters.

976, 1943.

**FERRARI**, GAUDENZIO (*c.* 1471/81–1556). Italian painter born at Valduggia in Piedmont, who worked in Lombardy, eastern Piedmont, and Milan. His early style was strongly influenced by LEONARDO and his Milanese followers and also by PERUGINO's work at the Certosa di Pavia. Throughout his life he remained ECLECTIC, absorbing into his highly charged, emotional style elements from PORDENONE and LOTTO. The forceful ILLUSIONISM of many of his works may perhaps be associated with the devotional traditions of the mountain shrines of the area, and at one of these, the Sacro Monte, Varallo, he produced a theatrical *Crucifixion* in which the foreground figures are carved in the round and the rest of the scene painted behind them. A more sophisticated use of illusion deriving from CORREGGIO is found in his *Assumption* for the dome of Sta Maria dei Miracoli, Saronno (1534). There are works in the Galleria Sabauda, Turin, the Brera, Milan, and the National Gallery, London.

**FÊTE CHAMPÊTRE.** A genre which became immensely popular in French painting in the early years of the 18th c. Resuming a theme represented in the Gardens of Love of courtly medieval art and transfigured in the Venetian PASTORAL of GIORGIONE's *Concert champêtre*, the vogue is linked historically with the swing of the pendulum of taste from the academic pantheon of RAPHAEL, POUSSIN, and LE SUEUR in favour of the warmer, more open, and sensuous appeal of Venetian and Flemish art. The taste for the *fête champêtre* or *fête galante* is therefore a direct if minor outcome of the Quarrel of Ancients and Moderns. The most famous painter of *fêtes*

*champêtres* was WATTEAU, who was received into the Académie in 1717 'pour un tableau qui représentait une fête galante' (*Embarquement pour l'Île de Cythère*, Louvre). Watteau's subjects, which consist almost entirely of scenes of well dressed dalliance in a park setting, have a quality of restraint, of unexpressed melancholy which link them emotionally with their famous prototype, although in actual physical presentation they are worlds apart. This element of mystery is completely lacking in the work of Watteau's pupils LANCRET and PATER, whose *fêtes champêtres* represent listless groups trying hard to amuse themselves under a few trees. An element of licence, very far from Watteau's understated eroticism, is apparent, and the effect is stale. The genre was short lived and died a quiet death in the early 1740s. BOUCHER's pastorals and FRAGONARD's landscape and figure sketches are linked only very loosely with the original conception.

**FETI** (FETTI), DOMENICO (*c.* 1589–1624). Italian painter, born at Rome where he studied under Ludovico CIGOLI. He continued CARAVAGGIO's interest in exaggerated CHIAROSCURO and he also painted small GENRE scenes which were popular in many countries and in which he often adopted from ELSHEIMER the device of using several sources of light in one picture. From 1613 to 1622 he was court painter to Vincenzo GONZAGA at Mantua and several of his works purchased by Charles I with the Gonzaga collection (1627–8) are now at Hampton Court. From 1621 until his death he worked in Venice as one of a group of non-Venetian artists settled there, including the German Johann LISS and the Genoan STROZZI. He turned religious themes into genre scenes of contemporary life (*Good Samaritan*, Met. Mus., New York) and adopted the high and opulent colouring of the VENETIAN SCHOOL (*Melancholia*, Louvre).

**FEUERBACH**, ANSELM (1829–80). German painter, studied at the Düsseldorf Academy, then with the history painter Gustaaf Wappers (1803–74) in Antwerp, and finally (1852–4) with COUTURE in Paris, where MANET must have been his fellow pupil. His father, a professor of classical archaeology, had written a famous book on the APOLLO BELVEDERE and the son—on his own showing—grew up in an atmosphere saturated with the high-minded ideals of humanistic philosophy. Violently antagonistic both to purely decorative painting and to an art based on the study of nature, he wished to become the founder of a new school which was to combine noble, didactic, and idealistic subjects with a style derived from the grand manner of Venetian 16th-c. painting. His subjects are usually taken from Greek tragedy (*Medea*), Greek legend seen through the eyes of GOETHE (*Iphigeneia*), from Dante (*Paolo and Francesca*) or even, in the case of his most celebrated painting, from one of

Plato's Dialogues (*The Banquet*, Karlsruhe, later version in Berlin). Feuerbach was one of those 19th-c. painters like Hans von Marées (1837-87), or the English PRE-RAPHAELITES (with whom he had nothing else in common), who wanted to preach a philosophy through pictorial means. He failed to realize that his art could appeal only to a small circle of people fully conversant with classical technique. Throughout his life Feuerbach complained that he was being misunderstood and not receiving the recognition due to a very great artist. It is this element of self-pity which makes his book *Ein Vermächtnis*—an account of the genesis of some of his works, interspersed with aphorisms about life and art—one of the most pathetic and repellent autobiographies ever written.

**FIAMMINGO** (Italian: 'Fleming'). The name given to, or adopted by, a number of Flemish artists working in Italy, especially in Rome in the 17th c., when the Flemish colony was considerable. The collective influence of the Fiamminghi in Italy was significant, but there were few outstanding masters among them. Perhaps the greatest was the sculptor Frans DUQUESNOY, who frequently signed himself 'Fiammingo' and is as well known under that name.

**FIAMMINGO,** DIONISIO. See CALVAERT, Denys.

**FIBONACCI SERIES.** A system of expanding relationships connected with the GOLDEN SECTION. Leonardo of Pisa, called Fibonacci (1175-1230), discovered that if a ladder of whole numbers is constructed so that each number on the right is the sum of the pair on the preceding rung, the arithmetical ratio between the two numbers on the same rung rapidly approaches the Golden Section. Thus, for practical purposes, the Golden Section may be approximated by such mathematical ratios as 5:8, or 13:21. However, arithmetic teaches us that beginning with any two numbers whatsoever, we are led by successive summations towards pairs of numbers whose ratios to one another converge to the Golden Section. For example, instead of 1, 2, 3, 5, 8, 13 start with 2, 7, 9, 16, 25, 41.

In the study of phyllotaxis or leaf-arrangement it has been found that fractions representing the screw-like arrangement of leaves round the stems of plants are often members of the Fibonacci Series. A. H. Church in his treatise *Relations of Phyllotaxis to Mechanical Laws* (1901) sees in the arithmetics of phyllotaxis an organic mystery. Modern botanists, however, no longer take this doctrine very seriously (see D'Arcy Thompson, *On Growth and Form*, ch. 14, 1948).

**FIEDLER,** KONRAD (1841-95). German art theorist who in his *Schriften über Kunst* (1876-87), written in opposition to the Hegelian conception of art as a stage in the self-realization of an Absolute Spirit and also in opposition to the French sociological school of art history, developed a theory of 'pure visibility' according to which artistic activity is the record of a special sort of awareness of reality, exclusively visual in character. His views involved emphasis on the formal and stylistic qualities of art.

**FIELDING,** ANTHONY VANDYKE COPLEY (1787-1855). English landscape painter, who studied under John VARLEY. For many years he was associated with the Old Water Colour Society, becoming its President in 1831.

**FIGARI,** PEDRO (1861-1938). Uruguayan painter of Italian descent who was one of the first South American artists to develop a distinctive style. He had a distinguished career as a lawyer and politician but early took up painting, and in 1912 published a book on AESTHETICS. From 1920 he devoted himself entirely to painting and spent the years 1925-33 in Paris. His favourite subjects included IMPRESSIONIST landscapes of the pampas and provincial social events such as Negro and Creole dances.

**FILARETE,** properly ANTONIO AVERLINO (c. 1400-c. 1469). Florentine sculptor and architect. In 1445 he completed the bronze doors of St. Peter's, Rome, in a muddled version of GHIBERTI's style, with reliefs of religious subjects, scenes from the pontificate of Eugenius IV, and involved classical allegories. Forced to leave Rome, he went to Milan as an architect and began the hospital there in 1456. He attempted to introduce the CLASSICISM of BRUNELLESCHI into north Italy, but his most interesting work was his treatise, *Il trattato d'architettura* (1461-4). This devotes 21 books to architecture and three to painting and drawing. It includes a vision of a new city, Sforzinda (named after his patron, Francesco SFORZA), to be planned and decorated in the new style, which is the first symmetrical TOWN-PLANNING scheme of modern times. The treatise, presented as novel and dialogue, reflects the tastes and practices of his time and contains information of value to the historian of art.

869, 874, 1593, 2648.

**FILLET.** A narrow flat face between mouldings, e.g. between the FLUTES of an Ionic COLUMN: also the unfluted surfaces at each end of a column beyond the APOPHYGE. In GOTHIC architecture fillets may be worked on the faces of larger mouldings.

**FINE ARTS.** As the ancient and medieval conceptions of art were not tied to the notion of beauty, so the older classifications of art did not cover those activities which are now denoted by the expression 'fine arts' or by the term 'art' in an aesthetic context. Painting, sculpture, and architecture were not ranked among the LIBERAL

ARTS and no Muse was assigned to them. The aesthetic conception of the arts emerged gradually. Near the end of antiquity the elder PHILOSTRATUS (*De Gymnastica*, 1) distinguished the arts of poetry, music, painting, and sculpture from craftsmanship and classified them with the 'sciences' as forms of wisdom. But this distinction was lost through the Middle Ages (for example in the designs of GIOTTO for the Campanile at Florence, 1334–87, Sculpture and Painting are included in a group with Grammar, Arithmetic, Music, Logic, and Harmony, while architecture is included with the useful 'arts' of agriculture and trade) and it was not until the RENAISSANCE and LEONARDO that the plastic arts were again held separate from manual skills and classified with the liberal or theoretical arts. The intellectualization of the arts continued through the Age of Enlightenment and it was not until the 17th c. that they began to be distinguished from the sciences without being reduced to the level of crafts. The conception of the fine arts, or as they were known in France *les beaux arts*, was not established until the 18th c. when poetry, music, painting, sculpture, architecture, and dance were united into a single category through recognition of the common relation in which they stood to beauty.

There were intimations of such a classification earlier. The French architect Nicolas-François BLONDEL bears witness to the existence of the idea of such a connection among the arts when he wrote in his *Cours d'Architecture* (1675), p. 169: 'Some people, whose opinion I share to a certain degree, are convinced that there exists a natural beauty. They say that in architecture as well as its two companions—that is, eloquence and poetry—and even in ballet there is a certain uniformity of harmony.' Again on p. 783 he says: 'The pleasure which we derive from architecture and other works of art, such as poetry, eloquence, comedy, painting, sculpture and the like, is based in all cases on the same principle.' There was as yet no common term for this group of 'arts' and this first came into general acceptation as a result of the systematic attempt to classify such arts in terms of beauty by Charles Batteaux (1713–80) in his influential work *Les Beaux Arts réduits à un même principe* (1746). Batteaux divided the arts into the useful arts, the beautiful arts (sculpture, painting, music, poetry), and those which combined beauty and utility (architecture, eloquence).

Finally in the Introduction to DIDEROT's *Encyclopédie ou Dictionnaire raisonné des Sciences, des Arts et des Métiers* (1751–80) D'Alembert listed the fine arts as: painting, sculpture, architecture, poetry, and music. This list established itself and in England the term 'five arts' was sometimes used in its place with similar meaning.

**FINIAL.** An ornament finishing off the tip of a gable, pinnacle, or any upward projection. Medieval finials are often elaborately, if coarsely, carved with foliage.

**FINIGUERRA,** MASO (1426–64). Florentine goldsmith, the most famous craftsman in niello of the 15th c. VASARI asserts that he was the inventor of copper engraving and although this has been discredited, Finiguerra was certainly one of the earliest to use that medium, which was first developed in Italy as an extension of niello work (see LINE ENGRAVING).

**FIORAVANTI,** ARISTOTELE (*c.* 1415–*c.* 1485). Italian engineer and architect, born at Bologna of a family of architects and active at Rome, Bologna, Milan, and elsewhere. In 1475 he was called to Moscow to build the cathedral of the Assumption (Uspenskii Sobor) on the Kremlin. He had to conform to the traditional style of Russian church architecture; although there is little to suggest that the cathedral was the work of an Italian RENAISSANCE artist, some details seem to be conscious 'quotations' from Western European ROMANESQUE.

**FISCHER,** JOHANN MICHAEL (1692–1766). Bavarian architect. He designed a remarkable series of ROCOCO churches, including those of Diessen (1732), Ottobeuren (1737), Zwiefalten (1738), and Rott-am-Inn (1759), which with their serene spaciousness provided an ideal setting for the light-hearted fresco and STUCCO decoration of that time.

1214.

**FISCHER VON ERLACH,** JOHANN BERNHARD (1656–1723). Austrian architect, the oldest and greatest member of a generation which was to replace the travelling Italian virtuosi who dominated Austrian 17th-c. architecture. His training in sculpture, combined with a knowledge of Italian design acquired during 16 years in Rome and Naples, gave him a special sympathy for the plastic style of BORROMINI, as may be seen in his first major work, the church of the Trinity, Salzburg (1694). The University church (*Kollegienkirche*, 1696) already shows him moving towards his distinct style, characterized by a lucid articulation of all the elements of the building. He built two other churches in Salzburg, and in Vienna the church of St. Charles (Karlskirche, 1716), an astounding piece of architectural assemblage uniting a noble PALLADIAN portico, two replicas of TRAJAN's COLUMN disposed like minarets, and two lateral towers reminiscent of St. Peter's, Rome, with an oval interior and a tall oval drum and DOME. From 1689 Fischer was architectural tutor to the future Joseph I, and it was for him that he began his series of Vienna palaces with his designs (1692 onwards) for Schönbrunn Palace, the earliest palace in central Europe which vied consciously with VERSAILLES. The Court Library, Vienna (1723), is typical of

Fischer's late style. The interior is dominated by a splendidly decorated oval domed centre-piece, but the exterior, strongly influenced by French design, is cool and classical. His *Entwurf einer historischen Architektur* (1721) shows a wide knowledge of architectural history. His architectural work was continued by his son JOSEF EMANUEL (1693-1742).

2444, 2952.

**FITZWILLIAM MUSEUM.** The museum and art gallery of the University of Cambridge. It was founded in 1816 and is one of the oldest public museums in Great Britain. Like the ASHMOLEAN MUSEUM in Oxford it has been built up almost entirely from private benefactions. The founder, the 7th Viscount Fitzwilliam, bequeathed to the University a typical gentle-man's collection of the 18th c., which included Italian High RENAISSANCE paintings, and a very fine collection of engravings by REMBRANDT. He also left money for a building, which was begun by BASEVI (1837) and finished by C. R. COCKERELL (1845). Among later bequests, a gift of Greek coins (McLean, 1906-12) ranks next to that of the BRITISH MUSEUM. The Marlay bequest (1924), almost equal in size and quality to that of the founder, enriched all departments of the museum and provided for an extension to the building. The department of paintings reflects the taste of the 18th- and 19th-c. collectors; the early Italian and Spanish pictures are particularly important. The museum also possesses an outstanding collection of pottery (J. W. L. Glaisher bequest and others).

**FIVE SENSES.** The division into five senses is a commonplace of antiquity that was handed on to the Middle Ages, where the first rare illustrations occur. Thus in an allegorical poem by Alanus de Insulis (12th c.) the five senses are represented as horses drawing the chariot of the soul, an image going back to Plato. It was only in the late Middle Ages, however, that the cycle evolved in connection with the pleasures of the senses. The tapestry series of the *Virgin with the Unicorn* (Cluny Mus., c. 1510) is one of the earliest instances. A series of PERSONIFICATIONS in prints by Cornelis de Vos is based on the definitions of the senses given by the Spanish philosopher Vives. Subsequently the cycle be-came popular for the opportunity it afforded to display GENRE scenes and STILL LIFE and many of the groups of people eating, making music, smelling flowers, making love, and gazing, listed in museum catalogues as genre pictures, are really representations of the senses.

**FIXATIVE.** A preparation which is sprayed over a chalk or charcoal drawing to prevent the PIGMENTS from rubbing off, by binding them together and securing them to the GROUND. It is usually a transparent resin, such as shellac, dissolved in alcohol. It is most needed for PASTELS, but it tends to reduce their brilliance by making the particles of pigment more transparent.

**FIXED OILS.** See DRYING OILS.

**FLAMBOYANT STYLE.** Term in architectural history introduced by Arcisse de Caumont early in the 19th c. to denote the latest phase of GOTHIC architecture in France, extending from c. 1370 into the 16th c. It is derived from a form of TRACERY in which reversed curves are opposed to produce a 'flame-like' shape. The presence of this tracery is a sign of late Gothic. But it is not the only peculiarity of the style, which reflects an attitude towards architecture already discernible in advanced RAYONNANT later to be intensified into an excessive preoccupation with decoration. Structure is even more brittle and sparse; ARCADES are wider, and their ARCHES occasionally flattened by the use of four-centred curves; CAPITALS are often abolished entirely and subsidiary ribs introduced into the VAULTS to form star patterns. Inside churches Flamboyant tracery was usually restricted to features such as choir screens, as at Albi. But outside it was applied more extensively and often completely transformed the whole appearance of a church. The origin of this tracery is controversial. Its first known use in France was on the west façade of ROUEN Cathedral, c. 1370. Reversed curves in window tracery were certainly used in England 50 years before, e.g. at Beverley Minster c. 1330 (see DECORATED STYLE); but it does not follow that the French style was a direct importation from England. We know relatively little of Parisian architecture in the mid 14th c., and it may well have been developed there. In any case the gulf between the English examples and Rouen is wide enough to suggest an intermediary. There are few completely Flamboyant churches, although Notre-Dame-de-l'Épine, near Chalons, and St. Maclou, Rouen, are attractive examples. Generally Flamboyant appears in the form of rose windows as at the cathedrals of SENS, Beauvais, and Évreux; or towers such as the Tour de Beurre of Rouen Cathedral and the north tower of CHARTRES; or façades like those of Rouen Cathedral and La Trinité, Vendôme. Individually these features are often very fine but the lack of substance or rigidity, which recalls metal-work rather than the more strictly architectural decoration of earlier periods, creates a peculiar impression and Flamboyant additions seldom harmonize with earlier work. Moreover few changes could be rung on the original theme and there was a constant temptation to avoid monotony by mere complication of design. This often resulted in works of incredible virtuosity, the crowning achievements of masonic skill; but the avidity with which, for example in Normandy c. 1510, RENAISSANCE forms were assimilated into the style, suggests that it concealed a creative bankruptcy.

FLEMISH ART

FLAXMAN, JOHN (1755-1826). English sculptor, the son of a moulder of plaster figures, who joined the R.A. Schools when he was 14. From 1775 to 1787 he was working for the potter Wedgwood, and the discipline which this necessitated was of great benefit to his art. His designs for Wedgwood include a few medallion portraits, a number of plaques, such as that showing *The Dancing Hours* (V. & A. Mus. and other museums) and a set of chessmen (B.M.). He gradually built up a practice as a sculptor, obtaining a few commissions for monuments and figures before 1785. In 1787 he went to Rome and stayed there for seven years, studying both the antique and Italian medieval art, which greatly attracted him. While there he drew his illustrations, much influenced by Greek vase painting (see GREEK ART), to the *Iliad* and the *Odyssey*, engraved and published in Rome in 1793, followed by illustrations to Æschylus (1795) and Dante (1802). These engravings, which were republished in several editions, won him international fame almost immediately. His later illustrations to Hesiod (1817) were engraved by BLAKE. He returned to England with a well established reputation in 1794 and immediately became a busy sculptor. His monument to the poet Collins (Chichester Cathedral, 1795) and the more important one to Lord Mansfield (Westminster Abbey, 1795-1801) were commissioned while he was in Rome. The latter, which breaks with the mid 18th-c. tradition of setting figures against a pyramid background, did much to establish his reputation. He became an A.R.A. in 1797 and an R.A. in 1800. His enormous practice as a maker of monuments included large groups with standing figures (*Lord Nelson*, St. Paul's Cathedral, 1809), but his most characteristic work appears in simpler and smaller monuments, sometimes cut in low relief, which, though not Christian in imagery, are strongly Christian in sentiment. In these his great gift for linear design was given full play. He was less successful in standing figures of which he made several, including those of Sir Joshua Reynolds (St. Paul's Cathedral, 1803-13), William Pitt (Glasgow, 1812), and Robert Burns (N.P.G., Edinburgh, 1822). He was appointed the first Professor of Sculpture at the ROYAL ACADEMY in 1810. Flaxman represents the full tide of the NEO-CLASSICAL revival in England and he is one of the very few English sculptors who has had a European reputation, though this was based principally on his drawings.

595, 605, 880, 2539, 2865.

FLEMISH ART. In certain periods Flemish art has had an importance for general European culture far in excess of the size of the country. The southern Netherlands roughly corresponds with modern Belgium and Luxemburg and was formed by the grouping together of various regions, of which the County of Flanders was the largest. In the same way that the largest pro-

vince of the northern Netherlands, Holland, gave its name to the whole country, so Flanders became the name of the south. Its population and its culture were inevitably linked with its two great neighbours, France and Germany, and there was constant interaction with Holland. Flanders was also intimately tied in with the fortunes of the Burgundian and Habsburg dynasties and only in the 19th c. did it become the independent sovereign state of Belgium. In the 15th and 16th centuries, therefore, Flanders, or the southern Netherlands, was a consolidation of Counties, such as Flanders, Artois, and Hainault, of Duchies, notably Brabant, and Margravates, such as Namur, with people of different strains, Flemings, Walloons, and Germans. Despite its small area it was a very productive and densely populated region, whose central position in Europe and fine sea-ports fitted it to become a trading and manufacturing nation. Yet its situation has also led to disaster when stronger neighbours have clashed on its soil, and not without cause has it been called the Cockpit of Europe. War, revolution, iconoclasm have taken heavy toll of Flemish art works and in the earlier periods even of the records. Periods of adversity have, however, sometimes coincided with artistic efflorescence, as, for example, when RUBENS worked in Antwerp. In the 16th c. Catholic Flanders remained under Habsburg rule while Protestant Holland achieved independence. Thus the patronage of Flemish art continued to be primarily courtly and ecclesiastical, in contrast with the Dutch.

As with Dutch art, the history of Flemish art is dominated by painting. In the 12th and 13th centuries fine sculptors and craftsmen worked in bronze and enamel, and in the 14th c. there emerged a very active school of manuscript illuminators closely linked with England. From this tradition of illumination arose in the 15th c. a major school of painting, marking a high point in the culture of Flanders. This Golden Age of Flemish art, the age of van EYCK and van der WEYDEN, was largely independent of the art of Italy; indeed, the northern masters exercised a direct and important influence on the Italian artists. In the 16th c. a waning of this native tradition appears to coincide with the predominance of Italian RENAISSANCE art headed by MICHELANGELO and RAPHAEL. Whereas in the 15th c. only a few leading Flemish artists went to Italy and that by invitation as distinguished guests, in the 16th c. they went there in great number seeking inspiration. The change marks a basically derivative phase of Flemish art. A few were successful abroad and remained in Italy or elsewhere, but the majority returned home and worked in the MANNERIST mode which became general in Europe. In many cases the lessons of Mannerism were only partially absorbed, and the grafting of this style on to a basically medieval tradition presented many problems. One purely native artist matched the genius of his predecessors in

409

the 15th c., namely Pieter BRUEGEL. In the context of his own age he was a stabilizing influence on Flemish painting in the 16th c. and his influence went well beyond his own century. In the 17th c. Rubens mastered and made his own the lessons of Italy, both classical and contemporary, and returned to Antwerp to give, together with van DYCK, new impetus to Flemish painting. But with the passing of these leaders the general level weakened and the decline went still further in the 18th c. As in Holland French taste tended to predominate both in the 18th and 19th centuries. Flemish art, therefore, has not since the 17th c. assumed a major role in Europe, although there have been a few isolated modern artists of importance.

PAINTING BEFORE 1500. At the beginning of the 14th c. Flemish manuscript illuminators were clearly in connection with England, for in both countries they showed an immense delight in the secular imagery used to decorate the page. Such marginalia often ran riot and outweighed the more serious religious narrative illustration. But it must not be forgotten that Paris with its famous university exercised a powerful attraction on the craftsmen who illuminated manuscripts. Artists like Jean BONDOL, born in Bruges, entered the service of the Royal House and established themselves in Paris.

In 1384 Philip the Bold, Duke of Burgundy, inherited the territory of Flanders from his father-in-law and summoned Flemish artists to work in the south at his court in Dijon. Among these was Melchior BROEDERLAM who, in the wings of an ALTARPIECE made for Philip (Dijon), exemplifies the painting style known as INTERNATIONAL GOTHIC. He uses Italianate architectural forms but combines them with an exaggeration of facial types bordering on the grotesque. Agitated draperies and exaggerated gestures are employed to create dramatic effect.

Also working for Philip the Bold before 1399 was the sculptor Claus SLUTER, a native of Haarlem. In that year he completed the *Well of Moses* at the Chartreuse de Champmol in a new and masterly style. His large, monumental figures of saints are the work of an artist deliberately turning away from the soft elegant style of earlier years. Powerful faces are strongly characterized and the figures have weight and reality beneath the heavy draperies. In the doorway designed by Sluter for the Chartreuse the sculpture is no longer subordinated to the architecture as at REIMS and AMIENS but acquires a new independence.

Jean, Duke of Berry, the younger brother of Philip the Bold, was an avid collector of books and vied with his brother for the services of the best artists of the day. In 1402 Jacquemart de Hesdin became his court painter, and his *Book of Hours* (Bib. royale, Brussels) contains a full-page illustration of the Madonna and Child, a Madonna with earthly grace and humanity. Draperies fall over the throne in soft, heavy folds, and its 'International' character can

be seen in the small mouth and almond eyes of SIENESE painting, in the long, slim fingers characteristic of Bohemian art. In 1409 Jacquemart was replaced as court painter by the LIMBURG brothers. Their most famous work, the *Très Riches Heures* (Musée Condé, Chantilly), contains calendar pages which were largely finished in 1416, and evidence of a remarkable development in the treatment of landscape. Great vistas reach into the distance, castles and trees are drawn with loving care, and the sky pales as it nears the horizon. Although horizons are still set unnaturally high, there is a new attempt to obtain AERIAL PERSPECTIVE. The courtly OCCUPATIONS OF THE MONTHS become full-page illustrations instead of marginal insets and are rendered with a novel delight in detail.

With Sluter at Dijon and the Limburg brothers working for the Duke of Berry the basis for the Golden Age of the 15th c. was laid. Two traditions were established, one of purposeful monumentality and the other combining courtly elegance with a vivid feeling for landscape.

In 1419, with the accession of Philip the Good to the Duchy of Burgundy, the court left Dijon and moved to his Flemish territories. Philip reigned with splendour over Flanders for nearly half a century, consolidating the country in an era of great prosperity. Artists were able to work for their Burgundian patrons in their native land and Flanders also flourished as a cultural centre. Among the artists working for the Duke was Jan van Eyck, whose fame was to outlive by far that of his patron. Of Jan's elder brother Hubert virtually nothing is known except that they seem to have collaborated on the famous Altarpiece for St. Bavo at Ghent. Jan van Eyck held an unassailable position in the court and received commissions from the most famous men in Bruges, including Philip the Good himself, Giovanni Arnolfini, a merchant from Lucca who lived in Bruges, the Duke's chancellor Rolin and Cardinal Albergati. The quality of his paintings is sufficient explanation of the success of his religious works. The *Rolin Madonna* (Louvre) and the *Van der Paele Madonna* (Bruges) are fine examples. In the *Rolin Madonna* of the early 1430s the figures are set convincingly in a space that is emphasized by the patterned, tiled floor. The Madonna is given a detached, idealized demeanour that contrasts with the realistic portrait of the chancellor. Through the archway van Eyck has painted an imaginary landscape of exquisite and detailed beauty. In contrast the *Van der Paele Madonna* of 1436 is enclosed in a ROMANESQUE church. But in this picture also the contrast between the saintly Madonna and the donor is emphasized. The figures stand easily in the space, which is carefully indicated by the carpet and the lighting. In both pictures the exquisite finish and minute attention to detail have the effect of precluding any transitory emotional appeal and conferring on them a quality of static, almost timeless monumentality.

Jan van Eyck aspires to a similar quality in portraiture. *The Man in the Red Turban* (N.G., London, 1433) and the even more famous Arnolfini portrait (N.G., London) by their dispassionate recording of textures and the unified impression of unemphatic actuality achieve a perfection of realistic painting which was never surpassed. Though the achievement of Jan van Eyck was acknowledged in his day and though his impact outlasted the century, it was Rogier van der Weyden who had the greater immediate influence on his contemporaries. Petrus CHRISTUS of Bruges was the only artist who tried to emulate van Eyck but only in his portraits did Christus begin to approach van Eyck's quality.

Rogier van der Weyden, a pupil of Robert Campin who is generally identified with the MASTER OF FLÉMALLE, was working in Brussels from 1435 when Jan van Eyck was at the height of his fame in Bruges. *The Deposition* in the Prado shows the extent of the difference between the two. It is an altarpiece with the figures crowded into a narrow space before a plain backdrop. The flat plane of the surface is articulated by linear rhythms which lead the eye from figure to figure and pinpoint the tragedy and pathos of the subject. The figures are intentionally tall and willowy, and the 'old-fashioned' use of draperies blown by the wind heightens the dramatic tension. Although infinitely more skilled than his master, Rogier never achieved the virtuosity of van Eyck. His interest lay rather in the emotional and dramatic content of his scenes, as may be seen from a comparison between Eyck's *Rolin Madonna* and *St. Luke Painting the Virgin* (Boston). Rogier's work clearly derives from the *Rolin Madonna*, but is far more intimate with the Mother uncrowned, offering her breast to the Child, while St. Luke, half rising, gives a sense of movement that contrasts with the static timelessness of the van Eyck. In portraiture, too, the same differences are discernible. Rogier also pays minute attention to detailed physiognomy but his faces are given expression, often one of introspective melancholy.

Dieric BOUTS was one of the finest of Rogier's followers, and the National Gallery *Portrait of a Man* (1462) reflects the far-reaching consequences of Rogier's style. The man is set in the corner of a room beside the window rather than against a plain background, but stylistically the head is very close to van der Weyden. As his altarpiece at Louvain shows, Bouts was no mere imitator. In the central panel of the *Last Supper*, the figures are set away from the foreground, and are carefully lit by the daylight coming through the windows. Care is also taken with the PERSPECTIVE, which leads to a simple vanishing point. But the figures have a curiously static, unemotional quality different from those of Rogier.

Hans MEMLING had even closer connections with Rogier van der Weyden, for he was probably trained by him and many of his paintings, as, for instance, the *Floreins Altarpiece* (Bruges), derive from Rogier's compositions. But neither Bouts nor Memling equalled Rogier's ability to capture the significance of a dramatic event, to display deep emotion or great pathos. Even their portraits lack Rogier's searching appraisal of the sitter.

Nothing is known about the early years of Hugo van der GOES, and there is little formal evidence of stylistic influence from Rogier. Yet in a broader sense he can be regarded as Rogier's spiritual successor. Both artists are prepared to sacrifice realism to dramatic effect; Rogier will revert to unnatural, blowing draperies of the Gothic era to add poignancy to a *Crucifixion*, and Hugo van der Goes obtains emphasis by varying the scale of figures in his *Portinari Altarpiece* (Uffizi) in accordance with their thematic importance. With the death of Hugo van der Goes the succession of original and genuinely creative artists came to a close, for their heirs were fine artists but not in general innovators.

Italy played an indirect role in the formation of the 15th-c. Netherlandish School, but it was not until the mid century that the art of Flanders made any great impact there. Rogier van der Weyden's visit in 1450 was an undoubted success, but the more lasting impression was upon him rather than on Italian art. In the 1470s the Flemish artist Justus of Ghent (see JOOS VAN WASSENHOVE) was in the service of Duke Federigo da MONTEFELTRO and seems to have collaborated with PIERO DELLA FRANCESCO in certain works at Urbino. But it was Hugo, though he probably never went to Italy, who played the most important part in introducing Flemish characteristics into Florentine art. GHIRLANDAIO's *St. Jerome* shows strong Flemish influence in the treatment of detail, his *Adoration* of 1485 evidences his knowledge of the *Portinari Altarpiece*, and even his portraits have a Flemish mode of characterization. Memling's portraits, too, were influential on some northern Italian artists such as BELLINI.

Towards the end of the 15th c. Memling's position as chief painter in Bruges was taken by Gerard DAVID, who turned chiefly to Jan van Eyck and the Master of Flémalle for inspiration, although some debt to his own master, GEERTGEN, can be detected. His intimate pictures of the Madonna and Child were very popular with the pious, and suggest that he was aware of LEONARDO DA VINCI. The introduction of PUTTI and garlands is further indication of contact with Italy. His landscape backgrounds are particularly fine and may possibly be accounted for by his early training in Holland. The Rijksmuseum has two wings from an altarpiece that are very early examples of pure LANDSCAPE PAINTING, with animals but no human figures. David did not die until 1523, yet his method became outdated in his lifetime by the new Italianate style of Antwerp.

Manuscript illuminations continued to be of account through the 15th c. but the artists, who had led the pictorial developments during earlier

centuries, now in the main followed the lead of the panel painters. So for example the French-born Simon MARMION, who worked for Philip the Good, was indebted to Rogier van der Weyden and Jan van Eyck in the *Fleur des histoires* (Bib. royale, Brussels). In Ghent and Bruges there was a number of *ateliers* which produced fine books throughout the century; the BENING family, for example, were responsible for illuminating a great many manuscripts, and the *Grimani Breviary* (Venice) shows the minute perfection of their work.

ARCHITECTURE UP TO *c.* 1500. Early architecture in Flanders is closely associated with developments in France and Germany. Many of the churches of the 12th c. have been destroyed, including S. Bavo and S. Pierre at Ghent and S. Donatien at Bruges; yet the survival of Tournai Cathedral gives an indication of the high quality of Romanesque architecture. At this time the cult of the Virgin turned Tournai into a pilgrimage centre and in 1146 it became an independent see. As a result the building of Notre-Dame was begun, and it is this church which survives to the present day. It was planned on an ambitious scale, with a trefoil complex at the east end based on the CHEVET of Ste Maria im Capitol at Cologne. There are five towers at the crossing and a richly articulated elevation of four storeys in the nave. The design of the nave is very robust, with strong horizontals eliminating the sense of height. During the 13th c. the original trefoil east end was modified by the introduction of an extended choir with slender piers and an elevation that closely resembles Soissons in France.

Initially the influence of the French Gothic style was overwhelming in Flanders. Burgundian Cistercians building churches at Orval and Villers made no concessions to local tradition, and at Louvain the French Dominicans used their own architects. In the building of SS. Michael and Gudule at Brussels (begun 1220) a variation of the French style was evolved. In aspect the building is far more Romanesque than contemporary architecture in France, and the many French features are handled with a robust solidity that is often seen in provincial architecture. Other fine examples of this simple Gothic style are Notre-Dame at Tongres (1240) and Notre-Dame at Huy (1311).

In the district of Brabant local stone was readily available during the 14th and 15th centuries and the masons of Brabant travelled through the Low Countries and established a style which dominated building programmes until the coming of Italian forms in the 16th c. The earliest example of the Brabantine School is the church of the Béguinage at Louvain (1305). Based on a fairly simple ground plan, this church has a wooden roof instead of stone vaults. The cathedral at Antwerp was built 1352-1411 by Jean Amel de Boulogne, also known as Jan Appelman. It is perhaps the finest building in the Brabantine style with a wide nave and three aisles. The choir is clustered with chapels, yet the transepts are without aisles. Tracery panelling decorates the elevation, which has slender pier shafts and very large clerestory windows.

Flemish domestic architecture at this period had many distinctive characteristics. Whereas in Italy palaces were built for the ruling aristocracy, in Flanders halls were built for the civic guilds and houses for the wealthy merchants. The peculiar Flemish style is already recognizable in the stone houses of the 13th c., some of which survive at Ghent, Tournai, and Bruges. For the halls of the great merchant guilds and the municipal offices the style of building used for private dwellings was enlarged but the basic characteristics remained the same. The City Hall at Brussels (begun in 1402) and Louvain Town Hall (1448-63), built by Mathieu Layens (d. 1483), are fine examples of secular Brabantine architecture. They have high triangular gables and abundant decorative mouldings which when examined in detail are seen to be executed with meticulous care yet remain subordinated to the over-all architectural design.

SCULPTURE UP TO *c.* 1500. During the 12th c. Flanders was internationally famed for the small bronze sculptures and enamels made in the valley of the Meuse. The Font at S. Barthélemy, Liège, which was carved by Renier de Huy (*c.* 1107), was cast in bronze and supported on 12 bronze oxen. The relief on the basin of the font is of extremely fine quality, and gesture and attitude are handled with a naturalness in advance of the general practice for the period. In the field of enamel work Godefroid de Claire (*c.* 1100-75) and NICOLAS OF VERDUN stand out as two named artists whose works bear witness to the great flowering of the Mosan School. Nicolas of Verdun is best known for his *Reliquary of the Three Kings* (Cologne, 1195-6) and the *Reliquary of Notre-Dame* (Tournai, 1205). It was not until after 1220 that French influence modified the Mosan style. Portal sculpture never achieved the widespread popularity it had known in France, but isolated examples of Flemish figure sculpture of the next 100 years show that sculptors generally followed French tradition. Yet by and large statues tended to be heavier and in the late 14th c. there were already signs of an inclination for the more realistic manner which reached fruition only with sculptors who travelled south to work for the Dukes of Burgundy in Dijon. In contrast ecclesiastical sculpture in the Netherlands at that date became rather dry and mannered. During the 15th c. sculptors grew increasingly aware of the achievements of the great painters and examples of their art are to be found in the large wooden altarpieces (Bruges Cathedral), in the misericords which adorn churches at Louvain, Diest, and Bruges, and in small stone narrative panels (S. Pierre, Louvain).

THE 16TH C. It is tempting to consider the year 1500 as a dividing line between two distinct styles of painting. Although this would be

artificial, it is certain that the period around 1500 offers a confused picture of conflicting tendencies in the development of Netherlandish art. As a centre of international importance Bruges was on the decline. Not only was the river silting up, but the discovery of a new route to the East round the Cape called for a port that could harbour much larger ships. Antwerp, conveniently placed on a broad estuary, was ideal and the merchants and wealth of Flanders concentrated there. A new kind of patronage from merchant guilds and municipal authorities led to new pressures and demands. Humanist scholars such as Erasmus, famous artists like DÜRER and HOLBEIN, visited the city and a new generation of artists emerged there who differed in many respects from the great figures of the 15th c. In accordance with the change in the status of the artist which began during the Renaissance, he was no longer regarded as a mere craftsman but as a man of culture and social importance. Originality was now rated above tradition, and patrons began to set great store by novelty and the contemporary fashion. New techniques of ENGRAVING enabled artistic ideas to be transmitted more rapidly from country to country and painters became aware of the most up-to-date styles of Italy.

The principal artist of the transition between the 15th c. and 16th c. was Q. MASSYS. When he painted his *Altarpiece of St. Anne* (Brussels), and the *Lamentation* (Uffizi), in the first decade of the new century, he was already a mature artist. He emerges as an artist strongly attracted by tradition yet at the same time he can be seen to be grappling with new Italianate forms. A possible visit to Italy may account for his ever-increasing interest in the art of Leonardo, which is reflected both in his religious paintings and in his portraiture. Contrasts between youth and age, ugliness and beauty, are deliberate in paintings like *The Ill-matched Pair* (private coll., Paris). Massys's style had repercussion on the works of a group of artists including JOOS VAN CLEVE, J. S. van HEMESSEN, and MARINUS VAN REYMERSWAELE whose *Excisemen* (N.G., London) has the same satirical flavour as the allegorical portraits of Massys.

The influence of Italy on Massys, though strong, was by no means typical of the period, for he never specifically came under the spell of Rome. J. GOSSAERT, on the other hand, visited Rome and Florence (1508/9) at a time when Michelangelo was at work on the Sistine ceiling, and Raphael was engaged on the *Stanza della Segnatura*. There he made drawings of antique sculpture, over-emphasizing the rippling muscles and adding crumpled, unclassical drapery to nude figures. The portrayal of the nude, which had previously been restricted to restrained representations of Adam and Eve, became increasingly popular with the aristocracy. Philip, Bastard of Burgundy, who had taken Gossaert to Italy, ordered paintings of mythological subjects with nude figures. Gossaert handled these

with little understanding either of Italian ideas or of Dürer, whose work he so greatly admired. Yet Gossaert was a very successful artist who worked in the service of the highest princes of his day. By the time of his death many other artists shared his enthusiasm for the Italian manner.

In 1516-19 Raphael's tapestry CARTOONS were at Brussels and were seen by the artist Bernaert van ORLEY, whose paintings earned him the title of 'The Raphael of the Netherlands' although he understood Italian Renaissance ideas and forms little better than Gossaert. L. LOMBARD, who may have spent some time with MABUSE, founded a school at Liège where he taught the 'Italian' manner to Franz FLORIS, Willem KEY, and Hendrik GOLTZIUS. Floris, once trained as a sculptor, went to Italy and studied the work of Michelangelo at first hand. His *Fall of the Rebel Angels* is an anatomical *tour de force* and reflects the style of the great master; also it has Venetian colouring. Many other artists, among them BLONDEEL, P. COECKE van Aelst, and Pieter POURBUS, contributed to swell the great 'Roman' movement that flourished in Flanders at this date. It is interesting to note that these Flemish painters, toying with the Italian ideal, were far more successful when they turned to portraiture, which was more closely attuned to their native genius and tradition.

16TH-C. ARCHITECTURE. Renaissance forms penetrated Flemish architecture soon after the turn of the century. As in France and England, the acceptance of the Italian Renaissance was at first restricted to ornamental motifs. With the addition of Italianate decoration to essentially Gothic buildings the assured confidence of the Brabantine School was weakened.

The influence of Italy stemmed from the court circles. In 1515 the decorations at Bruges for the triumphal entry of the future emperor, Charles V, were ornamented with GROTESQUES and medallions with relief heads; scrolls and SWAGS were used on the façade of the palace built for Margaret of Austria at Malines. From 1507 to 1530 Malines was the capital of the Netherlands and artistically in direct contact with Italy through Italian artists working there such as Jacopo di BARBARI and TORRIGIANI. Renaissance motifs are also combined with basically Flemish architecture on the façade of the Greffe du Franc (now the Court House) at Bruges and the House of Salmon at Malines (both 1530). It is unlikely that their architects had more than a second-hand knowledge of Italy but the palace of the Bishop of Arras, better known as Cardinal Granvella, is far closer to an Italian design. Now only known from engravings, the palace is believed to have been built c. 1550 by Sebastian van Noye (c. 1493-1557) in a mixture of BRAMANTE and PERUZZI, SANSOVINO and PALLADIO. Italian architecture was made available to a larger public by the translation and publication of SERLIO's treatises in Antwerp in 1539.

Perhaps the finest and most influential building of 16th-c. Flanders is the Antwerp Town

Hall (1561-6). Italians and native architects vied for the commission, which eventually went to Cornelis FLORIS de Vriendt, a native of Antwerp, who had been in Rome *c.* 1538. Flat classical pilasters, used on the façade above a rusticated arcade, are treated in a fairly correct manner, but a memory of the past survives in the central block where there is strong emphasis on verticality. The block projects forward too far and the old-fashioned high triangular gable is retained. The style of Cornelis Floris was popularized by the engravings of Hans Vredeman de VRIES, which carried his influence well into the 17th c. Later 16th-c. building was limited by the war with Spain, and the best examples can be seen in the domestic architecture in Antwerp.

16TH-C. SCULPTURE. The transition between 15th-c. and 16th-c. sculpture can be seen to advantage in the tombs at Brou. The late Gothic *atelier* of Louis van Böghem was responsible for the decorative statuary on the tombs of Margaret of Bourbon, Philibert le Beau, and Margaret of Austria in 1516-22. The small elegant figures are set in Gothic niches decorated with elaborate tracery. The effigy of Margaret of Austria was made (1526-31) by Conrad MEIT, a native of Worms who worked in Malines. Its sober eloquence contrasts with the delicate work of Louis van Böghem, and reflects the influence of the Italian Renaissance. Meit also used Italianate *putti*, which were taken up by Jean MONE in his tomb sculpture (for example in the tomb at Braine-le-Château) and by Lancelot Blondeel in the famous mantelpiece in the Greffe du Franc at Bruges. Jacques DUBROEUCQ, working in the mid 16th c., appears to have made a closer study of Italian sculptures and was the only Flemish artist who ventured to execute large sculptures. The fragments from the rood-screen of St. Waltrudis at Mons show the influence of Jacopo SANSOVINO. Dubroeucq, however, is best known as the master of Giovanni da BOLOGNA, who spent his working life in Italy, and it is significant that Flanders's greatest sculptor should have found Italy a more rewarding and inspiring place than his native land.

LANDSCAPE PAINTING IN THE 16TH AND EARLY 17TH CENTURIES. The artistic awareness of landscape is a prominent quality of Flemish painting from a very early date. In the 15th c. the landscape background is often superb in itself and plays an important part in the picture. The 16th c. saw the acceptance of landscape as an autonomous subject for paintings, which was a predictable extension of the northern artists' interest and aptitude. In accordance with the tradition even where landscape is the real subject a conventional narrative was often depicted in the foreground, giving the painting a nominal subject, such as the FLIGHT INTO EGYPT, with the figures perhaps by a different artist (see also LANDSCAPE PAINTING). In the early 16th c. PATENIER was an outstanding landscape specialist, rivalled only by his contemporary of the Danube School, ALTDORFER, and by Dürer, who praised his work.

Patenier painted imaginary, panoramic landscapes whose high viewpoint takes the eye back across rocky valleys to distant and often mountainous horizons, yet within the over-all perspective individual areas might be presented from a different viewpoint in order to give them greater prominence. This high panoramic style is sometimes aptly called 'the world landscape' concept, and Patenier may have owed it to BOSCH's treatment of his backgrounds. Yet however unrealistic the perspective concept, the details of nature within it were often rendered with minute and scrupulous fidelity. Patenier found a congenial material in the jagged rock formations of his native Meuse valley, but even if he had been born elsewhere he would probably have sought similar material in the Alps. The fascination of rocky and mountainous landscapes remained very strong for Flemish and Dutch painters. Patenier's intense colour followed the scheme of brownish or green foreground, green middle distance, and radiant blue background. Thus was established the convention of landscape, artificial in colouring, imaginary in structure, and remotely seen from high viewpoints. A younger landscape painter, Henri met de BLES, also worked in the Bosch and Patenier tradition, but so little is known of him except for his presence in Italy that his merits are difficult to assess.

In 1544, at about the time of Patenier's death, was born Pieter Bruegel who ranks among the greatest of all Flemish painters. He was the originator of a long dynasty of painters in Flanders. The universal fame of his bucolic GENRE scenes tended in the past to obscure the importance of his landscape painting and earned him the misleading name of 'Peasant' Bruegel. The foundation for his splendid landscapes was provided by pencil drawings made mainly on a journey to Italy, France, and Switzerland in the early 1550s. They were executed with many small strokes and dots to build up a view of an Alpine lake with a distant village or a walled city in Italy; while the accuracy of the perspective and detail is remarkable, it was nevertheless secondary to the rendering of light and atmospheric effect. Here was real scenery carefully recorded without recourse to colour for recession or conventional composition. Some of the Alpine scenery was treated in the 'world landscape' manner; but the accuracy of some topographical drawings has enabled parts of his route to be traced. With the exception of a few rare drawings by Dürer, such as the *Scheldt Gate* of 1520, no other artist made pure landscape sketches combining such realistic fidelity with acute sensitivity before the Dutch masters of the 17th c. In his paintings of the 1560s Bruegel retained the strong colour of his forerunners but with greater range and subtlety, and he largely freed himself from the rigid colour formula. The luminosity of his colour in the large panels and the sparkle of his brush-work recall Bosch, but in landscapes such as the *Series of the Months* there is no element of satire or moralization.

These paintings are the first of their kind and the summit of Bruegel's achievement as a landscape painter, an achievement recognized by contemporary writers and by his distinguished patrons. The influence of Bruegel's landscape innovations was far-reaching, but less apparent in terms of immediate followers than was the genre aspect of his work. It was easier for another artist of genius, Rubens (who owned a lost Bruegel, *View of the St. Gotthard*), to understand his landscapes than for lesser masters of the later 16th c. Among Bruegel's younger contemporaries the VALKENBORCH brothers, Lucas and Martin, stand out but the influence they might have wielded was diminished by their leaving the war-torn Netherlands for Frankfurt. Their abilities were not confined to landscape, for they painted fine genre scenes in the Bruegel tradition.

In the latter part of the century fashion changed in favour of small paintings which could easily be hung in a collector's study. Their mood is quite different from the great vistas of Bruegel. They concentrated on close-up woodland scenes with minute and profuse detail in a rather stylized vein. It was in this direction that CONINXLOO's work evolved in his mature period. The mysterious atmosphere of forests appealed equally to German artists like ELSHEIMER and Coninxloo may have been further influenced by his stay in Frankenthal. In recent times Coninxloo's importance as an artist and a teacher has been better appreciated. His move to Holland in his last years, where he became the master of Hercules SEGHERS and Esias van de VELDE, put him in a key position for the development of Dutch landscape painting in the 17th c. The BRIL brothers also painted woodland scenes, but nothing is known of their work before the Italian period, and in their adopted country they developed an advanced but idealized style influential on both Italian and Flemish artists but not characteristic of native Flemish landscape. Pieter Bruegel's second son, Jan BRUEGHEL the Elder, became the greatest exponent of the small woodland scene peopled with travellers or mythological figures. He generally worked on a near miniature scale with a wealth of minute and superbly painted detail. Although he lived through the first quarter of the 17th c., renowned in both Antwerp and Italy, his style belongs to the 16th c. The same is true to a lesser extent of his STILL LIFE paintings and his luxurious backgrounds full of tiny plants and animals. And much the same can be said also of his slightly younger contemporary, Roelandt SAVERY, whose best landscapes are the paintings and drawings done on his Tyrolean journeys in the service of Rudolf II. This great collector also owned the finest menagerie in Europe, and many of Savery's paintings depict exotic animals crowded into a landscape. Savery's style underwent no significant change when he moved to Holland, although by the time of his death in 1639 Dutch artists were developing a completely different type of landscape, more realistic in content and colouring. The absence of such a development in Flemish landscape, and the persistence of this 16th-c. style far into the 17th c., provide the most obvious points of contrast between the two schools.

Among the many followers of Jan Brueghel Joost de MOMPER was the most interesting, and developed an individual style combining elements from Pieter and Jan Brueghel, although he did not adopt the latter's miniature technique. Like Savery, de Momper followed the tradition of Alpine landscapes; but he was sufficiently versatile to be capable also of painting a winter landscape in a realistic, almost Dutch manner. De Momper's influence was strong in Antwerp because like Jan Brueghel he remained there, whereas Coninxloo, Savery, and other lesser artists such as Gillis de HONDECOETER went to Holland. Kerstiaen de Keuninck (*c.* 1560-1635), of the same generation as de Momper, is distinctive for a more ROMANTIC type of landscapes which were important precursors of 17th-c. developments. The appeal of the 16th-c. landscapes depends on their brilliant colour and detail; and certainly, as is proved by their rare drawings, their creators were more aware of the true nature of landscape than is apparent in their beautiful but basically artificial paintings.

LATER 16TH-C. AND EARLY 17TH-C. RELIGIOUS, NARRATIVE, AND PORTRAIT PAINTING. In the later 16th c. and early 17th c. no outstanding personality emerged in these fields, nor did the general development of Flemish painting run an easily discernible path. The two opposing trends of CLASSICISM and Mannerism continued to have their strict adherents, but many artists combined elements of both to different ends and with different results. Indeed it is the very lack of any clearly marked style which chiefly characterizes the period. Hendrik de CLERCK rose to success in Brussels, where he made many altarpieces and worked for the court, carrying his decorative version of Mannerism well on into the 17th c. Yet the more extreme forms of later Mannerism were developed by artists away from Antwerp, e.g. SPRANGER working in Prague. Antwerp became something of a centre of resistance or Classicism, where Hieronymus and Frans FRANCKEN attempted to paint with chilling precision of draughtsmanship in a consciously stilted manner; and it was this style which persisted in provincial centres. Three artists stood out. In 1585 Otto van VEEN returned from Italy where he had been a pupil of the arch-Mannerist ZUCCARO in Rome, but pursued a line of development which gradually deflected him towards a moderate form of Classicism. Within 10 years of his return there remained little or no trace of the earlier Mannerist extravagances he had derived from PARMIGIANINO. Seriousness, solidity, and balance tended more and more to replace the elegance, the eccentricity, and the occasional frivolity. It was in this mood that van Veen taught Rubens from 1596 to 1598. A similar

course of development was followed by a contemporary, Adam van NOORT, also a teacher of Rubens, and by Jacob JORDAENS. The principal representative of Classicism, however, was Abraham JANSSENS, who reacted in an opposite way to his two short stays in Rome. Janssens also took the lead in introducing the CARAVAGGESQUE idiom to the Netherlands. He was a very competent artist, whose reputation remained high even after the return of Rubens to Antwerp. Yet like van Veen and van Noort, and the portrait painter Frans Pourbus the Younger, Janssens was influenced and overshadowed to some extent by Rubens, who returned from Italy with a dynamic vigour and virtuosity which had escaped these good, though basically uninspired, artists.

17TH-C. RELIGIOUS, NARRATIVE, and PORTRAIT PAINTING. After a period of uncertainty and general mediocrity in the latter part of the 16th c. a new impetus was necessary to revitalize the major theme of Flemish art, religious painting. The return to Antwerp in 1608 of Rubens provided an impetus which affected all Flemish painting, for Rubens like REMBRANDT encompassed every branch. Yet comparison between the two masters, as between Dutch and Flemish painting in the 17th c., reveals few parallels. Among the many obvious contrasts the most striking is that between the persistence of religious patronage in Flanders and its virtual absence in Holland. Whereas Dutch painting spreads richly through the century with three major artists, HALS, Rembrandt, and VERMEER spanning 80 years, the vital years of Flemish painting are those from 1609 to 1640, with Rubens and van Dyck as the dominant figures. Nor were there in Flanders important secondary artists in anything like the same numbers or variety as in Holland. The favourable conditions of the victorious north were also more conducive to great painting than those in Flanders. Instead Rubens left declining Antwerp to seek a career in Italy and only the chance of the Twelve Years Truce (1609–21) gave him the opportunity to settle in Flanders. It also allowed the Spanish rulers to stabilize their position and Antwerp to make some financial recuperation; but essentially it afforded the Counter-Reformation, led by the Jesuits, a fertile opportunity. While in Italy Rubens, not a precocious artist like van Dyck, studied Italian art, classical Renaissance and contemporary; formulating a style which was to blossom forth in Antwerp as a synthesis of Michelangelo's form with Venetian colour and painterly quality, allied to compositional devices of the great Mannerist painters. Rubens made himself artistically qualified to bring to life religious imagery for every Catholic who entered the great churches, and in doing so revived the older Flemish tradition of large-scale altarpieces and introduced the decoration of the ceilings. This was the greatest of his many roles and one that had inestimable influence on a wide public, in contrast to his private role as the painter of portraits and decorative cycles glorifying the ruling families of Europe. As an international figure he was a leader of the BAROQUE movement and had some influence on artists abroad; but in Flanders his domination was complete and determined the course of much of Flemish painting within and even far beyond his lifetime. The very success of his career ensured the domination of his style because it attracted to his necessarily large workshop the leading younger artists van Dyck and Jordaens, who became thoroughly imbued with his idiom, diffusing it in turn to their followers.

Van Dyck stands out as an artist of greatness and importance in his own right, quite different from the many competent painters who simply followed or worked for Rubens. The artistic differences between the two men are aptly reflected in their differences of character; where Rubens was extrovert, flamboyant, assured, van Dyck was frail, sensitive, subtle, and certainly more temperamental. Though his religious and historical paintings were clearly influenced by Rubens, he absorbed this influence and shaped his work in accordance with his own very different personality. Rubens was also his starting-point in his portraiture, but here van Dyck developed independently and made his greatest contribution to Flemish art. The full story of his innovations in this field belongs to the history of the English portraiture in the 18th c. Indeed van Dyck anticipated and conditioned the direction of the whole of European portraiture, perhaps the most far-reaching achievement of Flemish painting.

JORDAENS AND THE LESSER MASTERS. Inevitably many minor artists produced historical and religious works whose style was recognizably derived from Rubens and van Dyck, with varying degrees of individual distinction. In these subjects van Dyck was generally more restrained and harmonious than Rubens and proved an easier and more attractive model. The notable exception was Jacob Jordaens, who in his own distinctive style carried something of Rubens's vitality and colourfulness into the second half of the century. Jordaens qualified as a master of water-colour and his palette can vary from the light shades of water-colour to the strong colours and bold lighting of his Caravaggesque manner. Similarly his handling ranges from delicacy to a loose broadness and vigour hardly found in Rubens himself. Jordaens was an accomplished composer of decorative cycles, with a workshop to help in their production, having learnt from assisting Rubens. The important commission he received from Charles I for the Queen's House at Greenwich remained unfulfilled until the king's death, but he worked successfully for the House of Orange. Yet he is best known and admired for his robust genre paintings, where his uninhibited vitality makes him the Flemish counterpart of the Dutchman Jan STEEN. Perhaps the domination of the two major painters stifled creative imagination among younger

artists, for Jordaens alone stood out as a narrative painter in the second half of the century. Among the good painters of secondary importance Gaspar de Crayer of Brussels painted religious scenes of merit, as did Cornelis de Vos, though the latter was mainly notable as a portrait painter. The pattern of development in such artists generally is given by an early dependence on Rubens, with hints of Caravaggio's influence, and a gradual movement towards the calmer, gentler mood of van Dyck. Some painters working away from Antwerp remained much more directly linked to Caravaggio, as for example Gerhard SEGHERS, Theodoor ROMBOUTS, Theodoor van Loon (1581/2–1667), and Jacob van Oost (1601–71). Their genre paintings, especially van Oost's *Christ at Emmaus* (Bruges), parallel the work of the Dutch Utrecht masters TERBRUGGHEN and HONTHORST, although they did not generally achieve the quality and lighting effects of the Dutch artists. There is evidence that Bruges was directly affected by Dutch influence at the mid century. The three currents, the Baroque of Rubens, the more classical van Dyck, and the appeal of the Caravaggesque, all continued into the later 17th c. in the hands of various masters whose inability to add to the legacy of the founders makes them of little significance in narrative and portrait painting.

LANDSCAPE PAINTING IN THE 17TH C. Flemish painters gave the early impetus to landscape painting, none more than Pieter Bruegel, but in the 17th c. the initiative passed to the Dutch with only isolated instances of superb Flemish landscape painters. The trends which prevailed in the latter part of the 16th c. continued right through to the second half of the 17th c. without essentially fresh inspiration. Frans de Momper continued in the style of Joost de Momper, Jan Brueghel II occupied himself with copies after his father, Theobald Michaud (1676–1765), carried a prettified version of the small Bruegel landscape with figures far into the 18th c.

It was Rubens, always the innovator, who introduced that combination of intimacy and grandeur so influential to later English and French artists. The change he effected is best illustrated by the development of Jan WILDENS from the manner of Jan Brueghel and van ALSLOOT to large decorative painting apt for collaborating with Rubens. Lucas van UDEN was among the best of the artists who responded to the impact of Rubens. He was influenced also by Adriaen BROUWER, who in his rare landscapes seems to combine the vitality of Rubens with the palette and tonality of the great Dutch masters. Unlike the Dutch, the Flemish artists preferred their landscapes well populated with figures. Yet the characteristic Dutch sense of lighting gradually made its impression on them and helped the transition from the strong and crude colours of the Brueghel tradition to a more subtly descriptive handling.

The inherently decorative quality of Flemish painting found expression with the painters at Brussels, headed by Jacques d'ARTHOIS, and their large decorative landscapes were translated into smaller format, to suit the homes of ordinary buyers, by prolific artists such as Pieter Bout (1658–1719) and Frans Boudewijns (1644–1711), who collaborated and signed their paintings jointly. Even in these unpretentious works there were elements of Romanticism and artificiality which remained always typical of Flemish landscape in contrast with the unadorned Dutch realism.

In contrast to artists who liked to introduce Romantic Italianate features into their pictures were those who actually went to Italy, notably Jan Frans van Bloemen (1662–1748), called Orisonte, and his brother Pieter (1657–1720), though for Flemish art their earlier works are the more interesting. Jan SIBERECHTS, who visited Italy, was also influenced by Dutch Italianizing landscape painters. But his later topographical work done in England had more charm than merit.

GENRE PAINTING IN THE 17TH C. The abundance of religious and historical works in Flanders did not affect the popularity or output of the painters of everyday life, whose comparatively humble subjects were often acceptable to the celebrated patron of a great altarpiece. As in Holland, however, the majority of genre paintings were available to anyone to purchase and were not painted on commission. As with landscape, traditions of genre painting deriving from Bruegel continued in the 17th c., both peasant subjects and refined cabinet pictures. Among the painters of low life Brouwer, claimed by both Dutch and Flemish Schools, was an innovator of exceptional skill, whose deceptively simple compositions were brought to life by the sensitivity of their brush-work. His influence in Haarlem and Antwerp was profound and Rubens was among his most fervent admirers. The most popular painter of peasant life, less complex than Brouwer, was David TENIERS. Some of his early works show the influence of his father-in-law, Jan Brueghel, but many are in the style of Brouwer with something of the latter's painterly brush-work. From Dutch art Teniers learnt the importance of still lifes, and painted them independently as well as including them in farmyard and interior scenes. Some of his finest work recalls in a minor way the colour and vitality of a *Kermesse* by his friend Rubens. Egidius van Tilborch (1625–78) worked in a more idealized vein than Teniers and under the influence of Jan Steen became a painter of portraits in a genre setting. Of the same generation was an amusing artist called Hieronymus Janssens (1624–93), who specialized in interior scenes of music making. Such painters depicted a more refined home life than the early tavern scenes of Teniers, yet one distinct from the fashionable world. The leading figure in this mode was certainly Gonzales COQUES, painter of fine portraits in landscape and interior settings,

with the attitudes of van Dyck but on a smaller scale and executed with a meticulous detail reminiscent of Dutch painting. As with landscape painting Flemish genre painters worked also in an Italianate manner, and some remained permanently in Italy, like Jan Miel (1599-1663). The outstanding master of the picturesque Italianate genre picture was Michel SWEERTS of Brussels, whose work has some affinity with the Dutchman DUJARDIN. Scenes of cavalry actions were of lasting popularity from the time of Sebastian Vrancx (1573-1647) to that of Adam Frans van der MEULEN. The latter, who went to Paris and worked for Louis XIV, painted precise and veridical topographical scenes and authentic soldiery, as did his master Pieter Snayers (1592-c. 1666). But specialist genre painters of this kind were exceptional and the predominant feature of Flemish genre painting in the 17th c. was the portrayal of simple peasant scenes, gay and colourful, as in the work of Teniers and the many lesser painters who followed and modified his style.

STILL LIFE IN THE 17TH C. The tradition of still-life painting, like that of landscape, is strongly rooted in Flemish painting, and finds its origins in the earliest Netherlandish paintings. Dutch and Flemish artists were largely responsible for the emergence of still life as a separate genre in the later 16th c. The high level of still life is not surprising when one considers details from 15th-c. Flemish paintings, such as the Arnolfini portrait by van Eyck, where the dispassionate observation and recording of common objects has already become an end in itself. This is the spirit which persists in the work of the early painters of pure still life. They can be divided into two related groups, painters of flower pieces and painters of other forms of still life. Jan 'Velvet' Brueghel was the finest exponent of the flower piece, whether a simple bouquet in a vase or as garlands in the surround of a figure subject. However intense his preoccupation with detail and accuracy, it is never allowed to stifle his natural painterly style and this alone enabled him to paint so many garlands, sometimes consisting of hundreds of flowers each individually perfected. Among his contemporaries Ambrosius BOSSCHAERT was second only to him, but in Holland developed a quite different style where atmospheric effects were more pronounced and composition more controlled and formalized. The same is true of the rare flower paintings of Roelandt Savery, who also passed his later years in Holland. Their influence on Dutch still life was paramount. Their Flemish contemporaries who painted still lifes, but only occasionally flower pieces, also felt their influence as well as Jan Brueghel's. Of these Osias BEERT was perhaps the best known, specializing in simple compositions of oysters where the silvery greys and warm colours compare with early Dutch 'breakfast pieces' by CLAESZ or HEDA. Clara Peeters (1594-after 1657) also liked to paint oysters and shellfish, but could

turn equally well to flowers, glasses, and pewter vessels set out on a table or stone ledge in the archaic fashion which is typical of these early masters. There are two examples of Peeters's work in the Prado, both dating from 1611. Jacob van Hulsdonck (1582-1647) specialized in fruit placed either in a basket or in a blue-and-white dish, sharply drawn and meticulously finished. Hulsdonck is nearest in technique to Jan Brueghel, with his brilliant and transparent colour.

After long neglect in favour of later, more elaborate styles, the works of these earlier painters have become much sought after, and the abstract qualities of their composition has been found to appeal to modern taste. It was a style linked with the 16th c. and did not continue long into the 17th c. Alexander Adriaensen (1587-1661), Frans Ykens (1601-c. 1690), and Jacob van Es (c. 1596-1666) perpetuated it for a while, but eventually went over to the decorative style of de HEEM.

To the same generation belonged Daniel Seghers the Jesuit painter, who contributed magnificently to the tradition of flower painting. Although he was a pupil of Jan Brueghel, Seghers's technique was quite different, fluent but solid with rich impasto, and his bouquets in vases have a majesty of composition which is more sophisticated than that of his master. Seghers was followed by Jan van Thielen (1618-67), and influenced de Heem. In the later part of the century Nicholaes van Verendael (1640-91) maintained a high standard of flower painting. Of the younger artists Jan van KESSEL stands out because in his small paintings of insects, animals, fruit, and flowers he recalls his grandfather, Jan Brueghel.

In the still-life painting of Flanders the animals and festivities connected with hunting predominated. Frans SNYDERS, who probably began in the style of Jan Brueghel, became a leading exponent of the animal and hunting piece. Under the influence of Rubens, Snyders painted large canvases of considerable vigour and strong rhythm best seen in his wild-boar hunts where the dogs swarm round their prey. His principal pupil, Jan FYT, preferred the dead game elaborately arranged in complicated groups with sweeping diagonals—a type of picture often called 'trophies of the hunt' to distinguish it from actual hunting scenes. It was a very popular type of painting, which continued into the 18th c. and also found favour in the country houses and hunting lodges of England and France.

Jan Davidsz de Heem was the most influential of Flemish still-life painters and hundreds of paintings were done by his pupils or under the influence of his Antwerp manner. In his Flemish mode he developed a sumptuous type of still life with fruit, flowers, vessels, and glasses, which was the counterpart of the elaborate 'trophies of the hunt' pieces. Though both had a decorative function, this was not the primary motive for their creation, but rather a culmina-

tion of the tradition, whether simple or sumptuous, of Flemish interest in still life.

ARCHITECTURE IN THE 17TH C. Flemish architecture in the 17th c. cannot be claimed to have had more than secondary importance compared either to Flemish painting or to other European architecture. Resources for building were depleted by the war and priority was given to ecclesiastical building. Yet even such opportunities as there were did not bring forth an architect of greatness or distinctive character. The prevalent Baroque style required an understanding and vision denied to lesser talents. Just as in the 16th c. northern architects had tried to attach new Renaissance motifs on to a basically Gothic building, so in the 17th c. Flemish architects grappled with the ideas of the Baroque although their inclination continued to be directed towards traditional styles in planning and elevation. In the early part of the century, and even into the fourth decade, the 16th-c. styles of Cornelis Floris and Vredeman de Vries persisted with only regional variations. A major role throughout the century was played by Jesuit architects, and not surprisingly for an Order based on Rome many of their churches were modelled on those built in 17th-c. Rome. But Baroque features did not appear until after Flemish architecture had passed through a transitional phase in which older Mannerist motifs are apparent. Two Jesuit churches built at this time were thus basically Mannerist with little reference to the Baroque. The Jesuit church at Brussels (begun in 1606, now destroyed) had a BASILICAN plan with three apses, and the great church at Antwerp, St. Charles Borromeo, was on a similar plan. The present St. Charles building is a reconstruction in restrained form of the original, destroyed in 1718 when the Rubens cycle of paintings, which must have transformed the ceilings, perished. A typical figure of this phase was Wenceslas Coebergher (c. 1560–1634), who returned from Italy and designed a lost façade (1605) directly based on Roman examples like MADERNA's façade of St. Susanna. But in his façade of the pilgrimage church at Scherpenheuvel (north of Louvain) tentative Baroque motifs appear though the church as a whole was too complex to be successful. A younger architect, Jacob Francart (1583–1651), took over the design of the façade for the lost Jesuit church at Brussels in 1616 and built a three-storey façade, which was to be the popular Flemish custom. Even though Francart and another contemporary, Pieter Huyssens (1577–1637), returned fresh from study in Rome, they never achieved entirely satisfactory results. Huyssens's interior of St. Lupus at Namur is impressive as Flemish Baroque architecture, but the most important church is St. Pieter's at Ghent (begun in 1629). It is not known who was the architect, but the plan was very original with a domed area at the western end and a well-lit interior. It was an ambitious building and took the century to complete.

In the later 17th c. building continued in the hands of Jesuits, such as Willem van Hees, called Hesius (c. 1601–?). He designed a church at Louvain in 1650, using the domed western end introduced at St. Pieter's at Ghent. Lucas Faydherbe (1617–97), better known as a sculptor, was also active as an architect. His church at Malives, however, is both bizarre and unsuccessful. It typifies the rather amateur approach and the mediocrity of architecture in the later 17th c. New ideas were lacking and the war of 1670 with France curtailed building activity. Two churches in Brussels, Notre Dame de Bon Secours (begun in 1664) and the Minimes church (1700), should be mentioned as more original works. In secular architecture the rebuilding in the Grand Place at Brussels of Guild Houses destroyed by the war produced some Baroque façades on new buildings which kept to the narrow sites of the originals. Such work is typical of the persistence of tradition in Flemish 17th-c. architecture, and of its partial absorption of the spirit of the Baroque.

SCULPTURE IN THE 17TH C. After the turmoil of the Spanish wars there was a growing demand for ecclesiastical sculpture at the beginning of the 17th c. Yet the 16th-c. style of Cornelis Floris and Jean MONE held the field for some while. The brothers Hans and Colijn de Nole and Hieronymus I Duquesnoy worked in that tradition, and the most brilliant sculptor of the earlier part of the 17th c., Frans DUQUESNOY, left Brussels for Italy. There, nicknamed Il Fiammingo, he met POUSSIN and BERNINI and became a member of the Accademia di S. Lucca. He did almost no work in his native country but he established a studio in which his younger brother Hieronymus II Duquesnoy (1602–54) and Artus QUELLINUS were trained. Although François made the two small *putti* on the tomb of Bishop Anton Triest in Ghent (c. 1640–54), it is basically the work of his pupil Hieronymus II, who emerges as an eclectic artist well versed in the styles of contemporary Italian sculptors. Artus Quellinus, on the other hand, was of greater significance. He had a high regard for the antique, but his own style combines monumental composition with plasticity. The decorative sculpture of the Amsterdam Town Hall is his principal work. He controlled a large workshop and became very influential in Holland. Naturally Rubens played some role in the formation of many sculptors' repertories and reflections of his art can be seen in Quellinus's work; but it was Lucas Faydeherbe who really came under his spell. Faydeherbe, who was also an architect, is known to have made ivory carvings after designs by Rubens and his sculpture even retains a painterly quality (monument to Bishop Andreas Cruesen, Malines). Jean Delcour (1627–1702), like so many of his predecessors, studied in Italy; he is notable because the art of Bernini was more important for him than for any other Flemish sculptor, though he lacked the dynamic quality of Bernini. The

Tomb of Bishop Allamont in Ghent Cathedral is a typical example of his work. But Jean Delcour and his pupils in the Walloon district formed a group isolated from the main stream of Flemish sculpture.

18TH-C. PAINTING. With few exceptions Flemish painting in the 18th c. was a low point in an otherwise strong and continuous tradition. In common with general European taste the fashion was for decorative rather than realistic painting. Religious and narrative, so strong in the previous century, declined in favour of more popular and light-hearted genre pictures, which were turned out in great quantity and found a wide market. What little narrative painting there was was for the most part uninspired pastiche of Rubens or van Dyck or an exercise in a dull NEO-CLASSICAL vein. But Pieter Josef Verhaeghen (1728-1811), with his broad vigorous brush-work, was a distinct personality, whose numerous works in churches and monasteries were unaffected by outside influences. Another colourful painter, who gave life to his Neo-Classical style, was Andreas Lens (1739-1822). Still-life painting was used for decoration rather than as a work of art in itself, and most artists followed the Dutchman van HUYSUM.

The Romantic landscape with picturesque horsemen, inseparably linked to WOUWERMAN, was very popular and many minor artists worked to satisfy the demand. Paul Ommeganck (1755-1826) did produce more down-to-earth landscapes with cattle for a more bourgeois market. And one landscape artist must be mentioned among those who sought their career in Italy, Hendrick van Lint (1662-1748). As a painter of small topographical scenes of classical remains he could achieve excellent results. In figure painting the tradition of Teniers lived on most strongly and had innumerable exponents. The best known was Jan Josef Horemans (1682-1759), who could also paint elegant little portrait groups in the earlier manner of the Dutch masters of fashionable genre. Leonard Defrance (1735-1805), after a period of portrait and altarpiece painting, turned to a similar type of genre after a visit to Holland in 1770/3. The final expression of this type of genre painting came with Louis Joseph Watteau (1731-98), called 'Watteau de Lille', who carried on an elegant version of Teniers to the end of the century.

ARCHITECTURE IN THE 18TH C. The course of architectural development in the 18th c. is foreseeable. Emphasis in the previous period had been on church building, but now secular architecture predominated and regional characteristics tended to be more pronounced. Throughout the century there were links with French architecture, becoming even closer in the second half of the century. A very reserved style was popular in Liège (the Town Hall, 1714), where the most important work was a new wing to the Palace (1735). In Antwerp the chief architect was Jan Pieter van Baurscheit

(1699-1768), whose style was allied to that of the French architect Daniel MAROT, who worked in Holland from 1715. Thus Baurscheit's Hôtel de Fraula, built for a wealthy private family in Antwerp, resembles Marot's Royal Library at The Hague. A particular characteristic of both is the deep arch above the entrance enclosing a large window and aperture above. In the Hôtel van Susteren, now the Royal Palace, which Baurscheit built in 1743, this arch breaks above the cornice, an innovation echoed in other later buildings. A notable residence in Ghent, the Hôtel Faligan (1755), was the work of Bernard de Wilde (1691-1772). Here the cornice runs over the circular dormer windows and follows the line of the capitals on the giant ornamental columns. Again the feeling is French, but distinct from the style of Marot. In the later 18th c. there was a movement away from the Baroque and ROCOCO towards Classicism in accordance with the general development of European architecture. Laurent Benoit Dewez (1731-1812) built a fine country house at Seneffe, with Ionic colonnades, Corinthian pilasters, and domed pavilions, classical, restrained, and elegant. Such buildings might as easily have been the work of a Frenchman or an Englishman because they were part of an international movement which Flanders followed. The same is true of Claude Fisco's (1737-1825) work in the Place des Martyrs at Brussels, yet the over-all effect is spacious and impressive. Although there were good architects working, it is indicative of their lack of real imagination that the rebuilding of the Place Royale in Brussels, the major architectural event in the period, was endlessly delayed and finally completed by two French-born architects. The result was successful but might have been even more so in the hands of Fisco or Dewez.

18TH-C. SCULPTURE. Flemish sculpture in the 18th c. was as devoid of important achievement as painting. This was partly due to the emigration of Flemish sculptors, such as SCHEEMAKERS and RYSBRACK, both of whom enjoyed success in England. In the same way, Pieter VerschaffElt (1710-93) worked abroad in Paris and Rome. Among those working in Flanders few displayed a style sufficiently distinctive from French contemporaries to be significant for Flemish art. In wood-carving large and elaborate pulpits were made for several churches. For Brussels Cathedral Hendrick Verbruggen (1655-1724) carved an outstanding pulpit; but the most elaborate was undoubtedly that of Michel Vervoort (1667-1737) for Malines Cathedral, where figures and plants cover the whole spiral surface in a dramatic array. But later he changed his style to one of academic restraint in works like the bust of van Caverson (Brussels). Another artist working in stone, Gabriel Goupello (1664-1730), created a charming fountain for the House of the Fishmongers (now in Brussels), but soon afterwards he too left the Netherlands. In the latter part of the century both Rococo and later

the Neo-Classical spirit are apparent. The best of the classicist sculptors was probably Gillis Godecharle (1750-1835), who later worked in Paris. His reliefs on the palace at Laken are charming and less academic than much of his extensive output. The large commissions of the previous century fell off. Those who remained can only be rated as secondary and this may have been a reason for the emigration of several talented sculptors.

19TH-C. PAINTING. A new wave of enthusiasm for Neo-Classicism resulted when DAVID settled in Brussels in 1815, but of his many followers only François Joseph Navez (1787-1869) had some success as a portraitist, and he was influenced by INGRES as much as by David. In contrast to his cold intellectualist manner, the Romanticism of Gustave Wappers (1803-74) was acclaimed by the patriotic revolutionaries of 1830. His *Episode of the September Days of 1830* in Brussels, commemorating the foundation of the Belgian state, has less artistic merit than historical interest. A Romantic tendency made itself felt also in the strange paintings of Antoine WIERTZ, who ranked his own works ahead of all Flemish art up to his time. The long tradition of genre painting was continued in the 19th c. by Henri de Brakeleer (1840-88) with his early paintings of simple scenes of domestic life such as women at their laundry and bleaching. Later he developed an increasing interest in effects of light with a broadening of his technique.

The artistic milieu of Paris continued to attract Belgian artists and among those who went there to live were Alfred STEVENS and Henri EVENEPOEL. Alfred Stevens, who is frequently confused with his English contemporary of the same name, reacted against his academic training under Navez and Ingres. He painted charming scenes of elegant society women of Paris in a very meticulous style but with a palette of great delicacy comparable to that of his friend TISSOT. His seascapes and beach scenes were done in a much more painterly style which certainly influenced the first generation of IMPRESSIONISTS, among whom he was a respected figure. Evenepoel, too, spent his brief life in Paris and apart from his formal training with Gustave MOREAU he learnt much from DEGAS and TOULOUSE-LAUTREC. His portraits of children have a tender immediacy and such works as *The Spaniard in Paris* (Ghent) achieve a measure of poignancy which sets them above the rank and file.

The only figure of international importance in the 19th-c. painting of the Low Countries was James ENSOR, whose best work was done before 1900 although he lived on until 1949. A master of the macabre and a biting satirist of human weaknesses, he was a precursor of EXPRESSIONISM and in certain aspects a forerunner of the SURREALIST movement.

ARCHITECTURE AND SCULPTURE IN THE 19TH C. For the better part of the 19th c. architecture in Belgium followed general European trends without distinctive regional characteristics. The close ties with France at the beginning of the century brought French architects to Brussels and the Théâtre de la Monnaie, with its noble classical portico, was built by a Frenchman (begun 1819). The generation of Belgian architects which followed was very obviously dependent on foreign sources of inspiration. They were led by Joseph Poelaert (1817-79), whose school in the rue de Schaerbeek, Brussels (1852), reveals a rationalistic handling of classical formulas but who is best known for his later Palace of Justice, Brussels (designed in the 1860s), which is probably the grandest building of the age, towering high above its surroundings. In contrast to Poelaert's originality, Alphonse Balat (1818-95) continued in a more restrained and academic classical manner. His Palais Royale des Beaux-Arts, Brussels (1875-81), is severely correct in its classical detail. Balat was also the professor of architecture at the local Academy and there his most celebrated pupil was Victor HORTA, one of the early originators of MODERN ARCHITECTURE in Europe. His Tassel House (1892) caused a stir. Henri van de VELDE was also instrumental in developing the principles of ART NOUVEAU in architecture on the Continent and in particular for his emphasis on the decorative features of the style. But *art nouveau* was little more than a flash in the pan in Belgium and nothing was built in that style after 1910.

Sculpture in Belgium was dominated during the first half of the century by the Neo-Classicism introduced by David and its influence may be seen even in the *Glorification of Art* on the Palais Royale des Beaux-Arts by Paul de Vigne (1843-1901). The only sculptor who stands out from this academic style is Constantin MEUNIER, who adopted a frankly realistic manner in his treatment of peasants and workmen.

20TH-C. BELGIAN ART. Despite close links with France, modern art movements in Belgium have retained a strong impress from the national heritage and a sufficiently distinctive character to warrant a chapter devoted to 'L'École Belge' in Jean Cassou's *Panorama des arts plastiques contemporains* (1960). Apart from the solitary and individualistic figure of Ensor, who had made his contribution by the turn of the century, and Evenepoel, who died in 1899, Jakob SMITS and Eugene Laermans (1864-1930), whose careers straddled the turn of the century, stand out as founders of the Belgian form of Expressionism. Rik WOUTERS also, in his short life of 27 years, stands out for his vitality and ebullience both as a painter and as a sculptor. In the first years of the century there was formed at the village of Laethem St. Martin a group of artists centring round the poet Karel van de Woestijne, whose ambition was to combine in their life as in their work a primitive and religious simplicity in close contact with nature. They included Albin van den Abeele (1835-1918), Valerius de Saedeleer (1867-1941), the sculptor George Minne (1866-1941), illustrator of Maeterlinck, and Gustave van de Woestijne, brother of the poet.

A younger generation of artists who also settled at Laethem together created the body of painting which became known as Belgian Expressionism. Chief among them were Frits van den BERGHE, whose fantastic and fairylike temper had affinities with Surrealism, Gustave de SMET, who combined a classical purity with lyrical fervour, and Constant PERMEKE, who with his vigorous and vital drawing becoming increasingly abstract in the later decades won recognition as one of the most powerful artists of the first half of the century.

Within the Surrealist movement René MAGRITTE and Paul DELVAUX won international recognition, while Victor Servranckx (1897-    ) was one of the earliest exponents of abstract painting with his exhibition in 1917. Among others of the abstract school who have made their mark are Louis van Lint (1909-    ), Anne Bonnet (1908-60), Gaston Bertrand (1910-    ), and René Guiette (1893-    ).

In architecture Victor Horta and Henri van de Velde were not followed by a progressive school of Belgian architecture and it is significant that the most imposing building of the first half of the 20th c. in Belgium, the Stoclet House (Brussels, 1905-11), was built by an Austrian architect, Joseph HOFFMAN. Unlike painting, no distinctively Belgian school of architecture ensued.

323, 585, 593, 787, 889, 926, 927, 928, 937, 1018, 1207, 1419, 1637, 1749, 1836, 2010, 2532, 2548, 2673, 2726, 2863.

**FLEURY,** S. BENOÎT-SUR-LOIRE. An important Benedictine abbey, especially famous in the 10th c. as a centre of monastic reform and intellectual activity. The church was rebuilt many times. The present choir dates from about 1075. It has the ribbed barrel vault and the ambulatory with chapels of the PILGRIMAGE CHURCHES, but there is no tribune or triforium. On the other hand it has a clerestory, a feature not often found with a barrel vault, and the beginnings of a second transept as at CLUNY. The porch, with its upper chapels which are modelled on CAROLINGIAN examples, has been attributed to Abbot Gauzlin earlier in the 11th c., but the attribution is doubtful. Fleury has an extensive cycle of sculptured capitals which foreshadow the practice of many 12th-c. ROMANESQUE churches such as VÉZELAY.

**FLICKE,** GERLACH (active c. 1547-58). German portrait painter from Osnabrück, who worked in England from c. 1547 till his death. His style is competent, rather metallic, typically Westphalian in his Lord Grey de Wilton (N.G., Edinburgh, 1547), but less brutal in Archbishop Cranmer (N.P.G., London, 1548).

**FLIGHT INTO EGYPT** (Matt. ii. 13-14). The event is treated very briefly in the Gospels,

but it was considerably enlarged in apocryphal gospels (e.g. Pseudo Matthew, xvii-xxiv). No EARLY CHRISTIAN version of the scene is known, nor does it seem to occur in CAROLINGIAN ART. Among the earliest examples are those on the late 7th-c. Ruthwell Cross (Dumfriesshire) and in an 8th-c. fresco fragment in Sta Maria Antiqua, Rome. From the 11th and 12th centuries onwards the scene appears very commonly, especially in Byzantine and Italian cycles of the life of Christ (12th-c. doors of St. Zeno, Verona). Usually the Virgin Mary sits on the donkey holding the Child, while Joseph leads the donkey. Sometimes Joseph carries the Child on his shoulders, as on a 12th-c. mosaic in the Cappella Palatina, Palermo. Frequently a youthful figure, perhaps James the brother of Christ, brings up the rear, and occasionally he takes the place of Joseph as guide. This type remained almost invariable for a long period. Among the outstanding examples are those of GIOTTO (Arena Chapel, Padua) and REMBRANDT (Tours Mus.). Yet in the 16th and 17th centuries this scene was surpassed in popularity by a variant depicting the Rest on the Flight, in which the Holy Family is generally seated in a landscape (ALTDORFER, Berlin; CORREGGIO, Uffizi; Rembrandt, N.G., Dublin). At this period both scenes often play a very subsidiary part to the landscape in which they are set (PATENIER, Flight into Egypt, Antwerp; CLAUDE, Rest on the Flight, Galleria Doria, Rome). (See also HOLY FAMILY.)

**FLINCK,** GOVERT (1615-60). Dutch painter, born at Cleves. He settled in Amsterdam in 1632 and worked there until his death. He studied with REMBRANDT from c. 1632 to 1635, and for the first 10 years was much influenced by him. When he broke free c. 1645 he adopted the elegant style of van der HELST, and this new way of painting brought him great success. He worked for the burgomasters of Amsterdam, for John Maurice of Nassau, who built the Mauritshuis of The Hague, and for the Elector of Brandenburg. In 1659 he was awarded the most important commission a Dutch painter of his time could receive: he was asked to paint 12 pictures for van CAMPEN's new City Hall of Amsterdam, eight of which (each measuring c. $17\frac{1}{2} \times 17$ ft.) were to represent the story of The Revolt of the Batavians. But Flinck died three months after signing the contract and the commission was not given to one artist but divided among Rembrandt, LIEVENS, and JORDAENS.

**FLITCROFT,** HENRY (1697-1769). English architect. He trained as a joiner, but was befriended by Lord BURLINGTON after an accident at Burlington House, and was employed as a draughtsman, becoming known as 'Burlington Harry'. For this patron he re-drew many of

Inigo JONES's plans and elevations for William KENT's *Designs of Inigo Jones* (1727), and to Burlington he owed his first appointment at the Office of Works, of which he became Comptroller in 1758. Flitcroft was an able builder but he lacked originality. He was the only member of the Burlington group to build churches, and in designing them he had to look elsewhere for precedent: St. Giles-in-the-Fields, which he rebuilt (1731-4), is a poor relation of James GIBBS's St. Martin's. His houses, however, are uncompromisingly PALLADIAN. The centre block at Wentworth Woodhouse, Yorkshire, which he rebuilt from 1749 onwards, is taken from Colen CAMPBELL's Wanstead House designs, and his work at Woburn Abbey, Bedfordshire (1747-61), is an elongated version of Houghton. Flitcroft was happier when working on a smaller scale and the building at No. 10 St. James's Square, now known as Chatham House (1734), was an excellent example of a small Palladian town house. His garden temples at Stourhead also are well sited and admirable in effect.

**FLOCK PRINTS.** Prints which imitate patterned velvet. They were apparently made by coating an ordinary carved wood block (see WOODCUT) with a brownish glue or paste, impressing it on paper, and then sprinkling the paper with cloth shavings which adhered to the paste. Very few such prints exist, all made probably in south Germany in the third quarter of the 15th c.; an example is the *Christ on the Cross with the Virgin and St. John* in the Ashmolean Museum, Oxford. A similar process was used in the 17th c. for wallpapers.

**FLORENTINE SCHOOL.** The city that produced GIOTTO, BRUNELLESCHI, DONATELLO, LEONARDO, and MICHELANGELO was for two and a half centuries the principal centre of Western art. It was from Florence that the revival of classical forms in architecture spread through Europe; it was here that PERSPECTIVE was discovered, that scientific curiosity was wedded to the visual arts, and the first ACADEMY of art founded by the chronicler of these achievements, VASARI. The Florentines have always given pre-eminence to the intellectual problems of DESIGN (*disegno*). And they have always been conscious of their leadership in the arts, which they first assumed gradually in the 13th c. at the time of Dante.

Florence, in its favoured position on the river Arno in the centre of a wide valley, was for long confined within the limits of a Roman settlement on the north bank. From the 11th c., when the city began to play a part in Italian politics, its aspect began to change. The unique Florentine style became apparent in a few remarkable buildings. Among these were the church of SS. Apostoli (before 1075) with its nave arcades,

and S. Miniato al Monte (completed 1062; façade completed in 12th c.), simple in design, with the typical decoration of many-coloured marble panels. The Florentines always retained a special affection for their Baptistery, which dates perhaps from the 5th c., was consecrated in 1059, became a great centre of MOSAIC work in the 13th c., and in the 15th a centre of sculpture, led by GHIBERTI.

During the 13th c. the growth of the *Arti*, or Guilds, assured to the city, now a republic, a fervid political life. The Florentines took part in the quarrels between Empire and Church (and witnessed the triumph of the Black Guelphs and the exile of Dante in 1302), meanwhile extending their dominion over Arezzo and Pisa. At this time the arts in Tuscany were reacting to the French GOTHIC style which the mendicant RELIGIOUS ORDERS had adopted, and to the revival of painting which became manifest in Rome and Assisi towards the end of the 13th c. The Franciscan church, Sta Croce, and the Dominican, Sta Maria Novella, prepared the way for a grand conception, the new cathedral of Sta Maria del Fiore. This, planned by ARNOLFO DI CAMBIO from 1296 onwards, had an interior design of classical spaciousness and an exterior facing of coloured marbles which still conformed to ROMANESQUE taste (the dome was not built until 1420-6 by Brunelleschi). The cathedral was to form, together with its Campanile (by Giotto, 1331, completed 1355) and the Baptistery, the city's ecclesiastical centre. Its construction gave rise to a permanent group of workshops, which was also employed on the other great complex of buildings, the municipal centre (Palazzo Vecchio, Loggia dei Lanzi, Bargello, Or San Michele). The mosaics of the Baptistery were perhaps the first place of training for CIMABUE and for Giotto, who renewed Italian painting by interpreting Gothic monumental art in Mediterranean terms. Works of Giotto's maturity survive in Florence, chiefly at Sta Croce (Bardi and Peruzzi chapels). His pupils gave a more picturesque turn to his massive art, just as in sculpture Andrea PISANO employed a more precious form of Gothic which Nino PISANO brought even closer to the French mode. In all the arts a meticulous style prevailed, laborious and often dry, as in ORCAGNA's painting and ARNOLDI's sculpture.

In the 15th c. the expansion of Florence was guided by her MEDICI leaders, her culture by energetic humanists, her art by men of strong personality (see RENAISSANCE). Brunelleschi's great invention of perspective was employed by MASACCIO in his frescoes (Brancacci Chapel, *c*. 1425) and codified by ALBERTI in his treatise on painting (*c*. 1435). Brunelleschi, besides completing the cathedral, was the first to re-employ classical forms; his churches (S. Lorenzo, S. Spirito), which belonged to the BASILICA-type, became models.

In painting Masaccio returned to the monumentality of Giotto. The sculptor Donatello

alternated between unsparing naturalism and a classical concern with elegance. Florentine taste enjoyed contrasting Donatello's vigour with the more picturesque and delicate art of Ghiberti, author of the second and third pair of doors at the Baptistery, and of Luca della ROBBIA, primary source of the delicate marble sculpture in which DESIDERIO DA SETTIGNANO and MINO DA FIESOLE excelled. POLLAIUOLO, in bronze sculpture and LINE ENGRAVING, demonstrated the anatomy and mechanics of the human body. It was VERROCCHIO, the master of Leonardo, who reconciled the two strains of realism and delicacy.

Masaccio's example impelled painters like UCCELLO and ANDREA DI BARTOLO towards discipline in drawing. But this impetus was countered by the taste for colour and clear light, a taste which, introduced perhaps by DOMENICO VENEZIANO in the late 1430s, dominated the art of Fra ANGELICO and Fra Filippo LIPPI. The last generation of the century was the time of Lorenzo the Magnificent. The atmosphere pervading Florence was at once romantic and bourgeois. Thus we can see appearing in the art of Verrocchio, Leonardo, and BOTTICELLI a subtle Aestheticism, while GHIRLANDAIO's and Lorenzo di CREDI's manner, by contrast, was prosaic.

In the course of the century the city filled with palaces, not of the type created by Alberti in the Palazzo Rucellai, where pilasters are ranged along the façade, but of the more robust and simple kind designed by MICHELOZZO in the Medici Palace (1444-59). Apart from GIULIANO DA MAIANO and Simone del Pollaiolo Cronaca, who together built the Palazzo Strozzi, the architect of the day was Giuliano da SANGALLO, who designed the Palazzo Gondi, the church of Sta Maria delle Carceri at Prato, and the Villa at Poggio a Cajano. The church and villa were prototypes, the one of the centrally planned church based on the Greek cross, the other of the country house with classical portico—half a century before PALLADIO (see VILLA).

The death of Lorenzo (1492), the French invasion (1494), the fall of the Medici, and the experiment of a 'Christian republic' led by the Dominican preacher Savonarola (1494-8) were followed by the return of the Medici (1512), whose rule was supported, and after a few upheavals imposed, by Spanish overlords. Siena was absorbed and Florence became the capital of the Grand Duchy of Tuscany in 1569.

Just after 1500 it seemed for a short while that Florence might once again, as at the beginning of the 15th c., become the focus of Italian art. Leonardo had returned and created, in his cartoon of *The Virgin and Child with St. Anne*, a harmonious style based on the use of SFUMATO; the young Michelangelo had carved the stupendous *David*; and RAPHAEL had just arrived. But the leadership was usurped by Rome. Tuscany was left to elaborate, in painting ANDREA DEL SARTO's tender Classicism and PONTORMO's

elegant yet troubled style, and in sculpture Andrea SANSOVINO's strict conventionality—all of which prepared the ground for MANNERISM. The new Sacristy of S. Lorenzo, built by Michelangelo when he carved the Medici tombs, confirmed the direction which Florentine art was taking. It led to the artifices and inventions, often charming, of architects such as AMMANATI and BUONTALENTI, sculptors such as CELLINI and BANDINELLI, and painters such as BRONZINO. But through Vasari, great historian of Italian art, architect of the UFFIZI and founder of the Academy (1563), an official standard was imposed. This belated Mannerism is best expressed in those great Florentine gardens— the Boboli and those of the villas outside the city —which are enlivened by the statues of the virtuoso Giovanni da BOLOGNA. It survived in the painting of ALLORI and CIGOLI and the sculpture of G. B. Foggini (1653-1737).

Florentine art gave little to the BAROQUE except the church of S. Firenze by F. Ruggini and some decorative work by Pietro da CORTONA and Luca GIORDANO. Since the 18th c. Florence has been the goal of the art-loving tourist rather than a centre of creative activity.

58, 244, 245, 921, 1817, 1964, 1991.

**FLORIS** (DE VRIENDT). Flemish family of artists active in Antwerp. The most important members were the brothers CORNELIS (1514-75) and FRANS (1516-70). They went to Italy *c*. 1540-5 and returned to Antwerp with a desire to emulate the Italian RENAISSANCE manner. Both became principal representatives of 'Romanism' in Flanders.

Cornelis was an architect and sculptor. Like Lancelot BLONDEEL he also published engravings of Italianate motifs, which were used by many northern artists. Such motifs are used for purely decorative effect on the *Tabernacle of Leau* (*c*. 1550). His principal achievements were in the field of architecture. Antwerp Town Hall (1561-5) was perhaps the finest and most influential building of the 16th c. in Flanders, and in comparison to his sculpture reveals a deeper understanding of Italian forms.

Frans Floris studied painting with Lambert LOMBARD and later went to Italy, where he witnessed in 1541 the unveiling of MICHELANGELO's *Last Judgement* in the Sistine Chapel. This made an indelible impression on him and he concentrated on making large religious and mythological pictures crowded with athletic nudes (*Fall of the Rebel Angels*, Antwerp, 1554). In his portraits, however, he combined powerful brush-work with sensitive characterization (*Portrait of an Old Lady*, Caen, 1558). According to van MANDER every Flemish youth with artistic leanings studied with him.

1284.

**133.** *Grand urna di porfido.* Engraving from *Le antichità romane*, Vol. II (1756), by Piranesi. Antique sarcophagus with foliage decoration and *putti* harvesting grapes

**FLUTING, FLUTES.** Architectural term for vertical channels of rounded section cut for decorative effect in the shafts of COLUMNS or PILASTERS.

**FOLIAGE (FOLIATE) SCULPTURE.** Plant motifs can be used in sculpture in many different ways: as incidental additions to figural scenes, as symbolic representations or as purely decorative forms. It is this last type that is known as 'foliage sculpture'. The most frequent application of this kind of sculpture is found in architecture, where it is either carved directly in stone or added as a decoration in stucco or in other media. Foliage sculpture was also used to enrich religious and secular movable objects in stone, ivory, metal, and wood.

Although an occasional use of foliage sculpture can be traced back to very ancient times, it was in Greece that it developed along the lines that became decisive for the future. Greek sculptors adopted as the basis of their foliage decoration the ACANTHUS, a common plant in the Mediterranean, and used it most conspicuously on the Corinthian CAPITALS (see ORDERS OF ARCHITECTURE). Another form of foliage sculpture, the ANTHEMION (honeysuckle ornament), was evolved from the acanthus and used to decorate steles, friezes, cornices, and neckings of certain types of columns. Roman sculptors

took over both these forms of sculpture and in addition used a variety of other foliage motifs, of which the vine and the ivy were the most popular. Because of their long wavy scrolls these two lent themselves admirably to the most complicated architectural decorations, for they could be arranged to cover any given surface.

Foliage sculpture was, together with other late classical art forms, inherited by Byzantium. Highly stylized acanthus, palmettes, and vine leaves were favourite motifs of decoration in BYZANTINE ART for many centuries. From Byzantine and Roman sources foliage sculpture found its way on the one hand into ISLAMIC ART and on the other into the medieval art of western Europe. For instance in Anglo-Saxon Britain the vine scroll of classical origin became the chief enrichment of free-standing crosses. ROMANES-QUE art made use of foliage sculpture on a scale and in a variety of forms hitherto unknown. All these plant motifs were stylized and far removed from the actual plant forms found in nature. It was not until the GOTHIC period that sculptors began to copy from nature. This new naturalism originated in France and found its most striking expression in the decoration of REIMS Cathedral. The outstanding English example is the decoration of the Chapter House at Southwell Minster. Seaweed and fern foliage were characteristic of the later Gothic period and some spectacular

**134.** Islamic ivory casket from Cordova. With Kufic writing and acanthus foliage decoration. (V. & A. Mus., 960–5)

examples exist among German wood-carvings. Italian sculptors of the Middle Ages never quite lost classical traditions and they were on the whole little affected by the Gothic foliage forms which prevailed in France. They copied classical foliage types long before RENAISSANCE artists turned to the ANTIQUE as their chief source of inspiration. With the appearance of learned treatises on the antique in the 15th and 16th centuries, however, this copying became more accurate.

In the subsequent development of sculpture foliage motifs diverged freely from classical types until, with the advent of ROCOCO decorations using thin, stylized plants and flowers, the break was complete. The GOTHIC REVIVAL, notably with RUSKIN, brought about a fresh wave of interest in foliage sculpture for decorative purposes but since then this art has declined and has almost completely disappeared in the 20th c.

**FOLK ART.** Objects and decorations made in a traditional fashion by craftsmen without formal training, either for daily use and ornament or for special occasions such as weddings and funerals. Decorative wood-carving, embroidery, lace, basketwork, and earthenware are among the typical products of folk art. The term is not properly extended to include articles which are mass-produced to appeal to popular taste, such as Christmas cards or Coronation mugs.

In the 19th and early 20th centuries it was thought that folk art was a belated reflection of the professional art of a bygone period: that, for example, the devotional images of the 19th c. in Catholic countries were derived from the BAROQUE. The term *Gesunkenes Kulturgut*, invented by German scholars, expresses this false or partial idea. Specialists now tend rather to recognize in folk art an autonomous tradition of craftsmanship and design which is at times influenced by professional art but tends to retain its own character and techniques through the centuries. Folk art is little subject to fashion and changing taste. Its methods are handed down in the home from generation to generation, and traditional patterns and designs persist with little alteration. The perpetuation of a folk art seems to depend upon the continuation of a peasant population or other relatively settled social structure. Attempts to revive or artificially reproduce folk art in the context of ARTS AND CRAFTS movements among the urban intelligentsia are frequent but rarely successful.

**FONT.** A receptacle for water of bowl form, usually supported on a pedestal, used for the sacrament of baptism. As the ceremony of baptism changed in character, admitting children to the rite, immersion eventually gave way to affusion and, from the 9th c., Christian churches began to have their own small fonts, usually at the west end of the nave or in an adjoining chapel. Early fonts are usually square or circular, fitted with a flat lid. They are commonly of stone (Baptistery, Parma) but also of such materials as marble, lead, copper, or bronze. An early 12th-c. bronze circular font, supported on a stone base and ornamented with scenes, including the Baptism of Christ, in high relief, is in the church of S. Barthélémy, Liège. English 12th-c. lead circular fonts are notable, sometimes decorated with seated figures within ROMANESQUE arcades (Dorchester). Square

**135.** Bronze font (*c.* 1107) by Rainer of Huy in the church of S. Barthélemy, Liège. With oxen carrying baptismal font on the analogy of the Molten Sea in the Temple of Jerusalem (1 Kings vii. 23-6). The twelve oxen symbolize the twelve Apostles

fonts, with a circular well, rest on a central stem, the corners supported on shafts. Fonts of black marble, dating from the 12th c., are found throughout Belgium, France, and Germany and occasionally in England (Winchester Cathedral). An octagonal form became usual from the 13th c., GOTHIC fonts being surmounted by highly ornamented and lofty CANOPIES (Ufford, Suffolk). Early RENAISSANCE Italian fonts retained this basic shape (Siena) but by the late 17th c. variously coloured and richly carved marble fonts reflect the sumptuous surroundings of the great BAROQUE churches (Maria Einsiedeln, Germany).

339.

**FONTAINE,** PIERRE-FRANÇOIS. See
PERCIER.

**FONTAINEBLEAU.** The Château of Fontainebleau is the outstanding monument of French Renaissance decoration and architecture. Francis I began to rebuild the medieval castle on his return from Spanish captivity (1528), starting with the Cour Ovale and then the Cour du Cheval Blanc, the two linked by a straight wing containing the Gallery of Francis I, decorated by ROSSO and PRIMATICCIO. The latter

also decorated the Gallery of Henry II, whose architect was DELORME. In 1568 Primaticcio added the Aile de la Belle Cheminée, and during the religious wars Catherine de Médicis cut the moat of which traces still remain. Henry IV enlarged the Cour Ovale, placing the splendid Baptistery at its entrance; he also added two further courts to its north and east and laid out the park. Jean A. DUCERCEAU designed the horseshoe stairs on the west front (1634). Artists of the Second FONTAINEBLEAU School had meanwhile continued the work of decorating the interior. But their work has been largely obscured through the alterations and restorations of later ages, particularly under Marie-Antoinette and Napoleon.

**FONTAINEBLEAU,** SCHOOLS OF.
FONTAINEBLEAU was the most brilliant expression of the ambition harboured by Francis I to emulate the great humanist princes of Italy and to glorify the prestige of the French crown by bringing about a national revival of the arts under the aegis of lavish court patronage. Lacking an indigenous tradition of mural painting adequate to his grandiose conceptions, he inevitably brought in Italian masters to lead the work, which was carried out between 1528 and 1558.

**136.** General view of the Château of Fontainebleau. Pen-and-ink drawing by Jacques Androuet Ducerceau. Engraved in *Les plus excellents bastiments de France*. (1576)

The MANNERIST Giovanni Battista ROSSO came to France in 1531 and PRIMATICCIO, a follower of GIULIO ROMANO, in 1532. Primaticcio was joined by NICCOLÒ DELL' ABBATE in 1552. Rosso was engaged on the decoration of the Great Gallery of the king until his death in 1540 and Primaticcio's decorations of the Ulysses Gallery aroused the later admiration of both RUBENS and POUSSIN. The Italian masters succeeded in adapting their own styles to the courtly ideals of the French taste and were

assisted by French and Flemish artists. From the combination was born a distinctive style of Mannerism, a composite of sensuality and decorative flair, of boudoir voluptuousness and etiolated elegance. The union of stucco ornament with mural painting introduced an original feature which came to be known as the 'French style'.

Rosso's decorations in the Francis I Gallery have been twice over-painted and Primaticcio's work has suffered a similar fate so that despite

**137.** Arabesque decoration designed by Primaticcio for ceiling of the Ulysses Gallery at Fontainebleau. Detail from engraving by Jacques Androuet Ducerceau

attempts at restoration one can do little more than conjecture what the originals were like from surviving designs and from the known influence they had in bringing about a new decorative style which not only established a strong tradition in France but rapidly spread beyond the French borders. In the new taste for artificiality of mythological setting, idyllic landscapes, elongated elegance, and simpering nudes, they belonged perhaps rather to a glorified fashion of interior decoration than to serious and splendid painting. The only painter of the School to have achieved something akin to lasting distinction was Jean COUSIN the Elder.

After the hiatus caused by the Wars of Religion the decorative painting of royal palaces was revived under the patronage of Henry IV. The name SECOND SCHOOL OF FONTAINE-BLEAU is usually given to the artists who carried out this work for Henry IV, the Flemish-born painter Ambroise Dubois (1543–1614), Toussaint DUBREUIL, and Martin FRÉMINET. Their work is generally considered to have been mediocre and without the inventive talent for decoration which characterized the best artists of the First School.

219.

**FONTANA,** CARLO (1634–1714). Italian architect who with his numerous pupils continued the BERNINI tradition well into the 18th c. He never left Italy, but Spanish, Austrian, and south German architects were influenced by his Jesuit College at Loyola (designed 1681/2 and built by the Spaniards from his designs 1689–1738) and by his designs for Viennese noblemen. Through his pupil GIBBS his influence even extended to England. JUVARRA and HILDE-BRANDT were also his pupils. In Rome he worked for Bernini on Sta Maria de' Miracoli (finished 1679: begun by RAINALDI) and completed the Palazzo di Montecitorio (1694 onwards). His independent works include the curved façade of S. Marcello (begun 1683), which shows the influence of BORROMINI, the Cappella Cibo in Sta Maria del Popolo (c. 1685), SS. Apostoli (1702), and the Casanatense Library (1708). He also worked in Genoa and elsewhere. As surveyor of St. Peter's he published the important *Templum Vaticanum* . . . (1694).

632.

**FONTANA,** DOMENICO (1543–1607). Italian architect and engineer, born near Lugano. From 1574 he worked for Cardinal Montalto, who became Sixtus V (1585–90), and after 1585 they undertook much replanning of Rome in the course of which they demolished the Septizonium (1589) and considered converting the COLOSSEUM into a wool-factory. Fontana became famous for the feat of transporting the OBELISK to its present site outside St. Peter's (1585–6), and he also worked as an engineer with Giacomo della PORTA on the completion of the dome of St. Peter's (1586–90). He built parts

of the Vatican and Lateran Palaces, including the Sistine Library of the Vatican (1587–9), which cuts across and spoils BRAMANTE's Belvedere Court. After 1592 he worked in Naples, mainly on the Royal Palace.

**FONTANA,** PROSPERO (1512–97). Bolognese painter who worked in many different cities of Italy, notably in Rome and Florence, assisting 16th-c. decorative masters such as Perino del VAGA, VASARI, and ZUCCARO. He worked at FONTAINEBLEAU (c. 1560) under PRIMATICCIO, but soon returned to Bologna. He is important in the history of the BOLOGNESE SCHOOL as the first master of Lodovico CARACCI, and Denys CALVAERT also studied with him. As a portraitist he is overshadowed by his famous daughter LAVINIA FONTANA (1552–1614).

**FONT-DE-GAUME.** See LES EYZIES.

**FONTENAY.** A Cistercian abbey, founded 1118 and consecrated 1147; the best surviving example of an early Cistercian church. The style is a very simple version of contemporary BURGUNDIAN architecture, adapted to meet the distinctive needs of the Order. The pointed arches, the barrel VAULTS and the flat CHEVET of Fontenay were carried throughout Europe with the first wave of Cistercian expansion, e.g. Rievaulx and Fountains abbeys in England. The simplicity and purity of this early Cistercian architecture did not long survive the death of St. Bernard in 1153. (See PONTIGNY.)

**FOPPA,** VINCENZIO (c. 1427–1515). Italian painter, the leading figure in the painting of Lombardy and Milan until LEONARDO DA VINCI. According to VASARI he obtained his training in Padua and it is thought that he may have derived his interest in atmospheric colour and light from Jacopo BELLINI. He had many contacts with Provençal and with Flemish art, and after c. 1480 under the influence of BRAMANTE and others assimilated new stylistic trends which art historians particularly associate with the RENAISSANCE. His importance to the development of art in northern Italy has been compared to that of TURA in Ferrara. In London there is an early work *Boy reading Cicero* in the Wallace Collection and an *Epiphany* from his later years in the National Gallery.

**FORAIN,** JEAN LOUIS (1852–1931). French painter, illustrator, and CARICATURIST, a native of Reims. He studied at the École des Beaux-Arts and as a young man was particularly interested in REMBRANDT and GOYA. He started his career as a caricaturist on Paris journals such as *Le Scapin* and *La Vie Parisienne*, taking his

subjects mainly from the legal and theatrical worlds. As a social satirist it has been said that he belonged to the grand lineage of Rabelais and Molière. He had the gift of expressing a quality of disposition by a characteristic attitude or gesture in a few lines. He exhibited in four of the IMPRESSIONIST exhibitions but in painting he worked, like DAUMIER, in a restricted and usually subdued palette (*Le Tribunal*, Tate Gal., London; *Maison close* and *La promenade du voyou à la campagne* shown at the fifth Impressionist Exhibition in 1880). Forain was influenced throughout his life chiefly by MANET, DEGAS, Daumier, and COURBET. Among his many friends were numbered Verlaine, Rimbaud, CÉZANNE, and TOULOUSE-LAUTREC.

1194, 2370.

**FORGERY.** The forgery of works of art appears to have been practised throughout history wherever there has been a market, and the victims of today have rich Romans as their predecessors. This means that to the forgeries made today must be added those of the past, which will have acquired genuine physical signs of age; so also will old copies produced without intent to deceive. In cases such as these technical evidence is less likely to be of assistance, and detection rests more on CONNOISSEURSHIP. Another problem is the over-restored object which may have a mere fragment of original work: forgers commonly compile their products out of old material. Allied to this is the practice of 'improving' a minor work or a school piece so that it will sell as a master work. The works of lesser painters who are obviously inspired by a movement of the recent past, e.g. POST-IMPRESSIONISM, have the signature removed and replaced by a greater name. Thus the falsehood may consist of anything from out-and-out counterfeit to misrepresentation and is probably more prevalent than the occasional sensational unmasking of a forgery suggests.

Supply is created to meet a demand and forgery follows the fashions of taste. The few who first collected Italian PRIMITIVES in the first half of the 19th c. secured paintings of the finest quality, but their successors of 50 and more years later faced a high chance of acquiring forgeries or much restored fragments. The 20th-c. vogue among collectors for IMPRESSIONISTS and POST-IMPRESSIONISTS operated in a similar way. Another instance of demand being met occurs when the forger surveys a collection for gaps the owner is seeking to fill. Equally promising to the forger is a hiatus in the *œuvre* of a particular artist, or a hitherto undiscovered work which might be inferred to exist from historical data; van Meegeren (1880-1947), for example, chose religious subjects for his VERMEER forgeries. In general forgers prefer to imitate either the very rare, hoping to deceive even the experts because of the lack of comparable material other than photographs, or the very numerous and popular, as in the notorious example of COROT: false Corots outnumber the genuine. A distinctive and easily recognized style commends itself to the uninitiated buyer, and thus BOTTICELLI, El GRECO, van GOGH, MODIGLIANI are frequently the forger's choice.

Though perfectly genuine paintings and objects without a documented history do emerge from obscurity in curious ways, forgeries on the other hand always lack provenance or are accompanied by fictitious documents, and carry undecipherable seals on the stretcher or panel. Signatures have less significance than the layman sometimes supposes—artists do not always sign, but forgeries draw what support they can from a signature. It is usually possible to determine by technical means whether a signature is coeval with the paint to which it is applied, but it must be borne in mind that a signature is sometimes a later addition to a genuine painting. Graphological methods used in the examination of writing on paper have generally a limited application to the painted inscription. The removal of the signatures of minor painters (in current estimation) and the substitution of a more esteemed name is by no means uncommon, particularly with Dutch masters.

The publicity given to the role played by science in detecting falsification probably over-emphasizes its importance and overlooks aesthetic and historical criteria, to which in fact is due the suspicion that prompts the undertaking of a laboratory examination. In the case of paintings lack of aesthetic quality is often coupled with anachronisms in the costume, armour, or objects portrayed, in the sources of the composition; inconsistencies are seen in the ICONOGRAPHY, etc. Forgers of ability do exist, however, and a verdict on the authenticity then requires an examination of all the available evidence from art and science.

A generalization which can be made is that the chance of successful detection by technical means is directly related to the number of variables in the materials and technique. To take a striking illustration of this fact from outside art: owing to the large number of moving parts in a typewriter no two machines are alike, and the attempt to forge a script on another machine can always be detected. In paintings the components such as the SUPPORT, GROUND, paint layer, and their constituents provide a fair number of variables which can be specified technically and compared with data from genuine material. In the case of sculpture in stone, on the other hand, the single material is simply carved and little technical evidence is to be expected.

The starting-point of a technical investigation is thus the specification of the materials and physical structure of the work in question. Success in the interpretation of the results depends on how well established is the norm, and the limits of acceptable deviations, for the genuine article. As the technical study of works

of art extends, so much more certain will our knowledge of the normal characteristics become. Until recently data of this kind were limited to what could be found by chemical and other analysis of the materials—PIGMENTS and MEDIA in the case of paintings—but the increasing use of microscopy, X-ray, infra-red and ultra-violet rays has added considerably to our knowledge of the actual techniques of the various schools and of the kinds of structure which result therefrom. This is the main purpose of such studies, but the results also establish a set of conditions which it is not always easy for the forger to satisfy. What so often emerges from a technical examination of this kind is the difference in purpose between the artist and the forger, or for that matter the copyist. In the one it is possible to see the step by step efforts of the artist to create forms, space, light and shade, etc.; in the other the paint is applied without feeling for these elements of art, since the purpose is to imitate the surface appearance of an old picture.

The most difficult task of the forger undoubtedly is that of simulating the effects of age such as cracking, PATINA, corrosion, etc., and it is on the examination of these features that the most positive detection so often depends. It is hypothetically possible for the forger to secure the correct materials and carry out the techniques appropriate to what he is imitating, though he rarely does so since most of his efforts go into producing the appearance of age.

In the case of paintings the CRAQUELURE is a particularly useful criterion. The genuine causes of cracking are manifold but the two main ones are contraction of the paint and ground (some of this occurs to a limited extent during the initial drying), and the failure of old brittle paint under the repeated swelling and shrinking of the PANEL, or the changes in canvas tension (both brought about by changes in atmospheric humidity). Among the various methods known to have been employed by forgers are the following. The paint medium is so modified as to result in pronounced cracking on drying, or in a very brittle film which can be fractured mechanically. These fractures are sometimes achieved by wrapping the painting round a cylinder, as the parallel cracks suggest a dependence on the wood grain of a panel; the canvas or paper support is afterwards stuck on an old piece of wood. Another form of 'craquelure' is simply a pattern painted or drawn on top of the paint, or scratched in the paint. Artificial cracks are often filled with dark paint to subdue their freshness.

The problem of the canvas or panel is faced by making casual damages in new material (these look contrived) and covering with an artificial patina, for example of grime and glue, or by searching for old material which can be reused. The adaptation of an old piece of wood which has served some other purpose—even that of being a support for another painting—is usually detectable, particularly by X-rays. Incompletely removed original paintings, on both panel and canvas, have been known to appear this way. Another clue is seen on a radiograph when the worm channels in an old piece of wood have been filled in by the forger before starting to paint.

The craquelure problem in the case of paintings is paralleled by that of patina in the case of bronzes. The most naïve and easily detected attempt is by means of green paint. Products with some visual resemblance to a patina can be produced by chemical attack on the metal, but it is possible for the expert to distinguish between the result of a comparatively simple process such as this, and what results from the slower and more complex natural corrosion.

A form in stone is perhaps technically the simplest kind of work of art, and little can be done to detect forged sculpture by scientific means beyond the fact that restoration and recutting show by their differing fluorescence under ultra-violet rays. The forger's technical efforts are therefore mainly confined to fracturing and repairing his finished work, and to weathering it out of doors. If the subject is some primitive type of art, success would not seem difficult; but where the finest ANTIQUE, GOTHIC, or RENAISSANCE examples are being imitated, only an expert sculptor would succeed.

Among the most notorious forgeries of the 20th c. were the van Meegeren 'Vermeers' which were for a time accepted as genuine by experts. Another well known modern example was a bronze figure of a horse which had been regarded as the 'quintessence of the ancient Greek spirit', purchased in 1923 by the Metropolitan Museum of Art, New York, and announced in December 1967 by the Museum to be a fifty-year-old forgery.

691, 1492.

**FORMENT, DAMIÁN** (d. 1540). Spanish sculptor of REREDOSES, representing the transition between GOTHIC and RENAISSANCE. His early works at the church of the Pilar, Saragossa (completed 1512), and Huesca Cathedral (begun c. 1520) incorporate Renaissance style figure sculpture within Gothic architectural settings. He evidently preferred the 'Roman' style and by 1527, when he contracted for the reredos of the monastery church at Poblet (Tarragona), he had finally abandoned Gothic for Renaissance-PLATERESQUE. He worked mainly in ALABASTER but shortly before 1539 he began a large wooden reredos (subsequently gilded and polychromed) for the church at S. Domingo de la Calzada, in which Alonso BERRUGUETE's influence may be discerned.

5.

**FORTUNY Y CARBO** (or MARSAL), MARIANO JOSÉ BERNARDO (1838-74). Spanish painter, son-in-law of Federico de MADRAZO. He studied at Barcelona and Rome (1858-9). Thereafter, spending only short

periods in his native country, he stayed mainly in Rome, and made visits to Morocco (1859 and 1862), where he painted BATTLE-PIECES, and to Paris. His small panel *La Vicaria* or *The Spanish Wedding* (Barcelona Mus.) has a suggestion of the cabinet pictures of MEISSONIER: it was exhibited at Paris in 1870 and its virtuosity and dazzling colour were greatly admired.

1043.

**FORUM.** The Forum, in a hollow running for a quarter of a mile to the east of the Capitoline hill, was the civic centre of ancient Rome. In or around it there came to be the tomb of Romulus, the prison, the Senate House, the meeting place of the popular assembly, the house of the Pontifex Maximus, the temple of Vesta and the house of the Vestal Virgins, various other temples, BASILICAS, and TRIUMPHAL ARCHES, and the central milestone of the Roman Empire. The present plan was determined by Julius Caesar and Augustus in the later 1st c. B.C., but considerable alterations and additions were made till the 4th c. A.D. In the Middle Ages much of the site became derelict and was used as a source of supply for building materials, though a few structures (notably the Arches of Septimius Severus and of Titus, the temples of Antoninus and Faustina and of Romulus Augustulus, and the Senate House) found new uses and so protection. The systematization of the Forum, by clearance and excavation, was undertaken in the late 19th c.; the site and its successive buildings have been made much clearer, though perhaps less attractive to the eye.

**FOSTER,** MYLES BIRKET (1825–99). English painter. He was trained as an illustrator and designed many book illustrations between 1847 and 1863. After *c.* 1858 he devoted himself primarily to water-colour painting of roadside and woodland scenery with rustic figures.

**FOUQUET** (FOUCQUET), JEAN (*c.* 1420–*c.* 1481). Regarded as the leading French painter of the 15th c. He was born at Tours and is known to have been in Rome between 1443 and 1447, when he painted a portrait, now lost, of Pope Eugenius IV. Perhaps he accompanied a French delegation of 1446, which included Guillaume Jouvenel des Ursins, whose portrait, now in the Louvre, Fouquet painted *c.* 1455. Much has been made of this Italian journey, the influence of which can be detected in the PERSPECTIVE essays and classical architecture of his subsequent works. While there he may have come across the works of Fra ANGELICO and PIERO DELLA FRANCESCA, but the monumental, sculptural character of his own painting, deeply rooted in his native tradition, did not succumb to Italian influence. On his return from Italy Fouquet entered the service of the French court. His first patron was Étienne Chevalier, for whom he produced a *Book of Hours* (1450–60),

now dismembered, and who appears in the *Diptych of Melun* (*c.* 1450), now divided between the galleries of Antwerp and Berlin. The Virgin in this work, at Antwerp, is rumoured to be a portrait of Agnes Sorel, the king's mistress, whom Chevalier had also loved. (The attribution to Fouquet has been disputed.) It was not until 1475 that Fouquet became 'Peintre du Roy', but in the previous year he was asked to prepare designs for the tomb of Louis XI, and he must have been the leading court artist for many years. His only documented works are illustrations in the *Antiquités Judaïques*, a Josephus manuscript (Bib. nat., Paris), which dates from the last period of his career (1470–6). From the same period dates the *Pietà* in the parish church at Nouans (Indre-et-Loire). Whether he worked on miniatures or on a larger scale in panel paintings Fouquet's art had the same monumental character. His figures are modelled in broad planes defined by lines of magnificent purity. He was essentially a draughtsman, and it was his drawing that imparted to his compositions their balance and clarity. He used perspective in order to define his forms more precisely rather than from an interest in space for its own sake and in his latest works, such as the Nouans *Pietà*, the forms virtually generate their own space. This sculptural sense of form went with a cool and detached temperament. The Jouvenel portrait and the Melun *Virgin* illustrate in their different ways the utterly unromantic character of his imagination. In this he stands at the opposite pole from his great contemporary, the Master of the Rohan Hours. But the gravity of Fouquet's expressions, like that of the MASTER OF ST. MARTHA, has its own impressiveness.

651, 786, 2848.

**FRAGONARD,** JEAN HONORÉ (1732–1806). French painter who identified himself with the taste for 18th-c. frivolity and gallantry under Louis XV. He was a pupil of CHARDIN for a short while and also of BOUCHER and Carle van Loo (1705–65). In Rome he studied TIEPOLO and he travelled through southern Italy and Sicily with Hubert ROBERT, developing a landscape style which he was to use with good effect (*Gardens of the Villa d'Este*, Wallace Coll., London). He returned to Paris in 1761 and in 1765 became a member of the Academy with his historical picture in the GRAND MANNER, *Coresus sacrificing himself to save Callirhoe* (Louvre). He soon abandoned this style, however, for the smaller erotic canvases by which he is chiefly known (*The Swing*, Wallace Coll., London, *c.* 1766). After his marriage in 1769 he painted children and family scenes. He was patronized by Mme de Pompadour and Mme du Barry. For the latter he did *The Progress of Love* (Frick Coll., New York). In technique and use of colour he was influenced by painters of the Netherlands, Frans HALS, RUISDAEL, and RUBENS. A tour through Italy, Holland, and Germany in 1773 introduced

him to the work of REMBRANDT, whose influence shows in some of his best subsequent pictures (*The Schoolmistress*, Wallace Coll., London). He was ruined by the Revolution and helped by DAVID, who admired the quality of his work. After an unsuccessful attempt to adapt himself to the new NEO-CLASSICAL vogue he was made penniless by the edict of 1806 and died in poverty.

Fragonard was a painter of great versatility, who made use of many styles and different techniques. But his work has always tremendous verve and an air of happy spontaneity. His technical virtuosity ranged from the luminosity and transparent colour of Rubens to the rich IMPASTO and almost brutal strength of his Rembrandtesque oils. He had something of WATTEAU and something of the clear-cut vision of Chardin. But he remains an original artist whose painterly achievement might have been exercised on a more solid substance.

44, 2197, 2885.

**FRANCESCO DI GIORGIO** (1439-1501/2). Italian painter, sculptor, and architect, a versatile and dominating personality who figures prominently in the renaissance of art at Siena. He painted mainly during his youth and though during his lifetime the successes he achieved in other fields eclipsed his reputation as a painter, this aspect of his work has returned to appreciation. He assimilated current stylistic developments at Florence and the poetic realism of his *Nativity* (1475) at Siena and the *St. Dorothy* (N.G., London) are noteworthy. By 1477 he was working in Urbino as a military engineer and made a name as a fortress designer. He is also said to have exploded the first mine. On journeys to Naples he made drawings of antique remains; and LEONARDO, who knew him, owned one of his architectural manuscripts. His treatise on architecture, composed *c*. 1495-1502, is based on ALBERTI but is more practical: like Alberti and FILARETE he included a section on TOWN-PLANNING. It is controversial whether he worked on the palace at Urbino (cf. LAURANA), and his only certain building is Sta Maria del Calcinaio, near Cortona, begun 1484.

2843.

**FRANCIA**, FRANCESCO RAIBOLINI (*c*. 1450-1517). Italian goldsmith of Bologna who turned to painting about 1486. He entered into a partnership with COSTA after the latter came to Bologna *c*. 1483 and modified the harshness of the FERRARESE manner by a delicate and poetic if somewhat monotonous elegance which set the tone for the BOLOGNESE SCHOOL of painting. After Costa left Bologna for Mantua Francia's style showed increasingly the influence of RAPHAEL and the Umbrian softness (*Madonna enthroned with Saints*, Pinacoteca, and *Scenes from the Life of St. Cecilia*, S. Giacomo Maggiore, Bologna). His work achieved great popularity

and was the starting-point for later MANNERIST painting at Bologna.

**FRANCIABIGIO,** FRANCISCO DI CRISTOFANO (1482-1525). Italian painter. He was an eclectic artist. The pupil of PIERO DI COSIMO, he assimilated the more superficial qualities of RAPHAEL and of ANDREA DEL SARTO, with whom he collaborated while working in Florence in the cloisters of SS. Annunziata and in the Chiostro dello Scalzo, where he painted *The Last Supper*. He painted a *Triumph of Cicero* in the Salone at Poggio a Caiano. The *Holy Family* (Vienna) and the *Madonna del Pozzo* (Uffizi) recall both these masters. He is most successful as a painter of young men. He was a minor but genuine talent of the classical style of LEONARDO and RAPHAEL.

**FRANCKEN.** Five generations of Flemish artists, whose personalities can best be disentangled in the museum of Antwerp, which has a good collection of their work. Here some of the members of two generations are discussed. AMBROSIUS (1544-1618), HIERONYMUS I (1540-1610), and FRANS I (1542-1616) were brothers, and their pictures, in common with most others painted at Antwerp in their day, bear the stamp of both Frans FLORIS and the Italian RENAISSANCE. Ambrosius echoed the grace of RAPHAEL; Hieronymus was attracted to MICHELANGELO's movement and *terribilità*. Frans, like his two brothers, mainly painted religious and historical compositions. His early works were frequently life-size; the late ones were small, usually done on copper, and crowded with exotic figures and accessories. FRANS II (1581-1642) was his son, but signed himself Frans the Elder when his father died and frequently adopted his father's subjects and style. To add to the confusion, their relatives and pupils made replicas of their pictures. Yet Frans II's range is wider than his father's; he painted LANDSCAPES and GENRE scenes as well as historical pictures. He was one of the first artists to use the interior of a picture gallery as a subject, giving faithful miniature reproductions of the works in the collection. His paintings were even smaller and more crowded than his father's; they were also more colourful. Frans II was frequently employed by his fellow artists in Antwerp to paint the figures in their landscapes and interiors.

**FRANQUEVILLE** (or FRANCHEVILLE, or FRANCAVILLA), PIERRE (1548-1615). French sculptor who spent much of his life as a student of, and assistant to, Giovanni da BOLOGNA. Henry IV recalled him to France (1601), where he executed the slave figures at the base of Bologna's equestrian statue of Henry IV

(now destroyed) set up by Marie de Médicis on the Pont Neuf, Paris (Louvre).

**FREESTONE.** Any good quality, fine-grained sandstone or limestone suitable for carving or building.

**FRÉMINET,** MARTIN (1567-1619). French artist, one of the leaders of the Second School of FONTAINEBLEAU. In 1602 he was recalled by Henry IV to Paris from Italy, where he had been influenced by the work of the Cavaliere d'Arpino (see CESARI, G.). Few of his works have survived, but his style may be seen in his ceiling (begun 1608) for the chapel of the Trinité at Fontainebleau.

**FRENCH,** DANIEL CHESTER (1850-1931). American sculptor. He studied under Thomas BALL and William RIMMER and was a friend of Emerson. When he was still untrained, French won the competition for the *Minute Man,* a monument to commemorate the rising of the citizens of Concord during the early years of the Revolution. Emerson's poem written for the dedication contains the well-known lines:

By the rude bridge that arched the flood,
Their flags to April's breeze unfurled,
Here once the embattled farmers stood,
And fired the shot heard round the world.

His works include *The Republic,* a personification 64 ft. high for the Columbian Exposition in Chicago in 1893, the largest figure ever constructed in America; the seated marble figure of Lincoln (1919) in Washington, D.C., 19 ft. high; a statue of General Cass in the Capitol at Washington; and of John Harrard at Cambridge, Mass.

658.

**FRENCH ART.** MEDIEVAL. Medieval France remained broken up into independent counties and duchies until centralization began with the spread of power from the royal domain of the Île-de-France towards the end of the 12th and the beginning of the 13th c. Up to that time the story of French art falls naturally within the context of the broad European movements rather than in terms of a distinctive national style. Our knowledge is most ample in the field of church architecture.

Although little materially has survived, the Merovingian period was a time of extensive building on French soil. Many venerable cathedrals and churches go back to the 5th or 6th c. (Clermont, Lyon, S.-Martin at Tours, Saint-Germain-des-Prés, Paris). Many of the large abbeys date from the time of Dagobert in the 7th c. Most of these churches were variations of the traditional Roman BASILICA in plan. They were timber roofed and their most characteristic feature was the bell-tower. In the second half of the 8th c. a massive reconstruction programme

under the aegis of Charlemagne provided scope for the dynamic and imaginative character of the French genius. Although the basilican plan was still dominant, French architecture of the CAROLINGIAN period was rich in novel and experimental features of design, many of which can now be seen as precursors of the French ROMANESQUE. These innovations included the AMBULATORY, the west-work, and the use of composite PIERS in place of the simple COLUMN. As we know from chroniclers and poets, both the Merovingian ecclesiastical buildings and those of the Carolingian period were richly decorated with MOSAICS, tapestries, goldsmiths' work, and above all mural paintings. The reign of Charlemagne coincided with iconoclasm in the East (see BYZANTINE ART) but Charlemagne took a middle course and placed Alcuin (782-96) in charge of organizing the arts for providing religious instruction by pictorial means. We know that church murals represented scenes from the Gospels and illustrations of the lives of the saints. There were also important schools of manuscript illumination at many monastic centres in France, including notably those at REIMS, TOURS, Metz, St. Gall, and Paris. (See ILLUMINATED MANUSCRIPTS.)

Through the 11th and 12th centuries France led the way in exploring the new architectural ideas which have come to be known as Romanesque. Even during the 10th c. an important impetus was given by the Benedictine monastery of CLUNY in southern Burgundy, which from the time of its second abbot, Odo (927-42), began to bring other monasteries under its rule until at the zenith of its influence it controlled a network of some 1,450 houses, resembling a monastic Order in the modern sense. Cluny became a centre of cultural and artistic progress from which reforms spread to other monasteries and over a period of more than two centuries Cluniac builders brought about a measure of stylistic unity falling short of a 'school' in the full sense. It was in Burgundy that two solutions, both profoundly important for the later development of church architecture, were broached for the problem of the east end which was created by the growth of pilgrim congregations on the one hand and on the other by liturgical requirements of an augmented priesthood. The solutions were the staggered apse or echelon, which from the second monastery church at Cluny spread across Burgundy and Normandy, and the chevet or apse with ambulatory and radiating chapels as at the sanctuary of S.-Martin at Tours and S.-Philibert at Tournus (end of 10th c.). By uniting the pierced apse with ambulatory new aesthetic possibilities of articulating the interior space were opened up. Increasing prosperity and better civil order during the first half of the 11th c. made greater resources available both for cathedrals and for monastic building, and the growing popularity of the pilgrimage to Santiago de Compostela encouraged the construction of capacious

churches along the Pilgrimage Road (see PILGRIMAGE CHURCHES). Throughout France there was a splendour of church building and as the Cluniac monk Raoul Glaber wrote in his chronicle in 1003: 'It was as if the world renewed itself, spreading a glittering robe of churches over everything.' Attempts to distinguish regional styles of French Romanesque (Burgundy, Poitou, Aquitaine, Auvergne, Normandy, Provence) have not proved successful and classification in terms of a few basic types are hardly more plausible in view of the numerous variants from each model. Their most general characteristics were the vaulting of the entire structure in stone and the more plastic articulation of the interior surfaces. Externally Romanesque churches were conceived as balanced masses reflecting the structure of the interior and conveyed an impression of regular and ordered solidity rather than the verticality of the GOTHIC.

Under the influence of Bernard of Clairvaux the Cistercian Order favoured a more standardized and austere style of building. Sculptural embellishments were prohibited in 1124 and coloured glass was removed in 1182. Apart from this French Romanesque was richly ornamented with murals, sculpture, and glass (see S.-SAVIN-SUR-GARTEMPE; S.-GILLES-DU-GARD). Although not in a good state of preservation, enough remains of Romanesque mural painting to bear witness to the rich variety of local styles. Two main types are distinguished: brilliant colours on dark grounds, mainly in Burgundy and Auvergne, and lustreless colours on a lighter ground in the west. The themes were doctrinal and instructive and the influence of the Byzantine was pronounced, particularly in Cluniac paintings. Majestic figures were dramatically presented against a flat background and the wall plane was not recessed into imaginary space.

Sculpture is the most distinctive art form of the Romanesque period. It was developed earliest in France and there its most splendid masterpieces are to be found. Like the painting it was completely integrated with its architectural setting. In ICONOLOGY it was apocalyptic and teratological. Though stylized, the figures and decoration were replete with energy and angular movement; at once abstract and visionary, HIERATIC and rhythmically plastic. The chief flowering of Romanesque sculpture was under the Abbot Hugh of Cluny (1049-1109) and his successor Abbot Pons. Early examples of impressive solemnity and grandeur are at the pilgrimage church of S.-Sernin in Toulouse and S.-Pierre at MOISSAC. Splendid masterpieces of Romanesque survive at Autun and the Cluniac abbey of VÉZELAY (Burgundy), at SOUILHAC, S.-Trophime at Arles, and S.-Gilles-du-Gard (Provence). In Auvergne MOZARABIC influences are apparent, and from France the style spread to northern Italy, Germany, and Spain and through the Normans to England.

The Gothic style of architecture was born and matured in France during the period of industrial and commercial revival and the ferment of new ideas which attended the emergence of scholasticism about the middle of the 12th c. It was not a sudden or unheralded invention but a consolidation of experimental devices which began to make their appearance at the height of the Romanesque. The pointed ARCH was used in Burgundy at the beginning of the century. Other features, such as ribbed vaulting, were adopted in northern France, particularly Normandy. In the Île-de-France these various features coalesced into a unified style which radiated out over the rest of France in the second half of the century, creating a visual expression for the new philosophy and aspirations of the age. By the end of the century a pure Gothic style had been perfected and the 13th c. was the century of the great classic Gothic cathedrals of France. About the middle of the 13th c. the French Gothic style was carried by itinerant builders to Germany and Spain. By the end of the century, when elsewhere the Gothic was in full flower, French creative vigour was already beginning to flag.

Early French Gothic is considered to have emerged with the reconstruction of the monastery church of Saint-Denis by Abbot SUGER (begun in 1137). Little of the original plan of Saint-Denis survives the rebuilding of the nave in the 13th c. by Pierre de Montéreau and the reconstruction by VIOLLET-LE-DUC in the 19th c., but something of the design may be reflected in the cathedral at SENS, the first large church in the royal domain to be covered with rib VAULTS. Sens has the same general disposition as the cathedral of CHARTRES, with three storeys, tall main ARCADES, and a CLERESTORY. About the middle of the century a distinctive style known as Angevin Gothic developed in the valley of the Loire, at that time under the dominion of the Plantagenet kings of England. The most notable examples are the cathedrals of Angers and Poitiers. It was a transitional style, the treatment of light more akin to Romanesque but the configuration of volumes and structural techniques belonging to the Gothic. By the beginning of the 13th c. the style had been refined to an astonishing degree, as in the abbey church at Candes and the church of S.-Serge at Angers, but it remained outside the main line of Gothic development in France.

The typical features of the Gothic which were experimentally worked out at the cathedral of NOTRE-DAME in Paris and at Chartres are exemplified in their classical perfection at REIMS (1210-c. 1300). The cathedral of AMIENS (1220-c. 1269) by the architect Robert de Luzarches adopted the same basic plan but incorporated innovations in the direction of even greater virtuosity. The search for height and lightness of fabric reached an extreme in the cathedral of Beauvais, whose choir rose to 157 ft. with piers even more slender and wider apart than at Amiens (completed 1272, collapsed in 1284). About the middle of the 13th c. the rayonnant phase of Gothic (see RAYONNANT STYLE) spread

over Paris and with certain modifications became standard in France for more than a century. It carried to extremes the tendency to treat the walls as screens of coloured light, making the TRIFORIUM an extension of the great rose windows. A late Gothic style, known as FLAMBOYANT, lasted from the last decades of the 14th into the 16th c. It combined perfection of structural technique with a loss of creative spirit and diminution of interest in the logic of design. There was an efflorescence of decoration for its own sake or for the display of virtuosity and a loss of contact between decorative and functional elements. A number of Parisian churches belong to this time, including S. Séverin. Other outstanding examples are Notre-Dame-de-l'Épine (1410-24) in Champagne, S. Nizier at Lyon, the cathedrals of Moulins in the Bourbonnais and of Tours in the Loire valley. In Normandy, which was particularly rich in this style, excellent examples are the churches of Notre-Dame at Caudebec, of S. Maclou at ROUEN, and of Notre-Dame at Alençon. Gothic church architecture was accompanied by a notable development in the associated arts of STAINED GLASS, sculpture, embroidery, and painting.

Though it was not without importance in the 12th c., the most splendid achievements of glass painting came from the workshops associated with the great cathedrals built during the 13th c. The glowing and radiant colours were attuned to the mystical significance attached to light in the religious outlook of the cathedral builders. Local schools at Chartres, Paris, Bourges, and elsewhere spread their influence far afield to Spain and Italy. During the 14th c. the colours became lighter; under the influence of the miniature painters the designs became more graceful and perspective was introduced in the representation of architecture and interiors (see STAINED GLASS).

From the middle of the 12th c. architectural sculpture began to lose something of the ecstatic and agitated quality of the Romanesque and developed in the direction of naturalism, reflecting the general changed attitude towards nature which caused people to regard it as a reality in itself, a thing of interest and wonder. Though still idealized, the figures were given more natural proportions and achieved a new impression of rounded solidity beneath the robes. The themes were greatly expanded during the 13th c., comprising not only scenes from the life of Christ and the Virgin but such secular subjects as the OCCUPATIONS OF THE MONTHS. The gradual progress towards naturalism may be seen in the sculptures of Chartres and Amiens cathedrals. In the second half of the 13th c. and into the 14th c. the figuration tended also to lose something of its hieratic stiffness and displayed a taste for elegance and grace which had its counterpart in the court style of painting. A classical example of this trend is the *Vierge Dorée* of the south transept portal at Amiens (c. 1258).

Ecclesiastical Gothic in France did not favour the development of either mural or panel painting. But during the 13th c. Paris became a notable centre of miniature painting (see ILLUMINATED MANUSCRIPTS), whose impetus was felt in many other countries. The newly awakening interest in nature is apparent in this field also. The flat gold background began to give way to a more realistic setting and the pictures acquired depth and space with the introduction of rudimentary perspective. Subjects from daily life became common and by the end of the century manuscripts were being decorated with a world of men and animals in a mode of satirical verve which was the pictorial equivalent of the *fabliaux*. Outstanding examples of French miniature painting at this time are two manuscripts made for S. Louis, the *Psalter* (c. 1253-70), which shows the mutual influences of illuminators and glass painters, and the *Legend of St. Denis*, which included 60 pictures of trades and of life in the streets and markets of Paris. The greatest of the French miniaturists is considered to be Master Honoré (*Bréviaire de Philippe le Bel*, c. 1300). We know also from literary sources that there existed in France at this time an aristocratic art fostered by the court and nobility which was perhaps the earliest in Europe frankly given over to secular themes of gallantry and idyllic pastoral scenes. The *Roman de la Rose* lists the subjects of the art of painting and mentions: 'Knights armed in battle on fine chargers covered with caparisons in heraldic blues, yellows and greens . . . scenes of gallantry, dances, rounds, fair ladies finely adorned.' The scenes of nature depict: 'Beautiful little birds in green thickets, fish in all the streams, all the wild animals which graze in these woods, all the plants and the flowers that youths and maidens come to the woods in spring to gather, tame birds and domestic animals. . . .' The poem mentions both panel paintings and murals.

In the 13th c. under S. Louis (1226-70) Paris established an international reputation as an art centre which lasted well into the following century. French court painting evolved a style of refined elegance and sophisticated charm which later became an important basis of INTERNATIONAL GOTHIC and Paris became the leading centre of book illustration in Europe (see PARIS, School of). The most important artist of the period was Jean PUCELLE, whose flat vision of linear arabesque perhaps owed something of its vibrant quality to perspective and ICONOGRAPHIC innovations of DUCCIO and who yet foreshadowed the more realistic vision of Flemish genre. An important impetus to the arts was given by Charles V and his brothers the Dukes of Anjou, Berry, and Burgundy, later in the century. Charles V's reconstruction of the LOUVRE turned it from a fortress to a palace suitable for housing the royal collections. He took into his employment the painter Jean BONDOL of Bruges and the sculptor André BEAUNEVEU of Valenciennes. Thus together with the Dukes of Berry and

Burgundy (see also BURGUNDY, School of) he initiated that combination of northern with Italian influences which, building on the foundations of French taste expressed in the mannered charm of the French court style, led to the emergence of the International Gothic style which later spread outwards from French court centres to the neighbouring countries of Europe (see INTERNATIONAL GOTHIC).

During the 15th c., or the greater part of it, French artistic activity seems to have lacked the verve and the vitality which had in the past made it an important source of European inspiration. The late Gothic was an art of increasing virtuosity but declining vigour. Court life found a new focus at Tours, where the painter Jean FOUQUET achieved some recognition outside French borders. But Fouquet founded no school. Nicolas FROMENT and Enguerrand CHARONTON were strongly under Flemish influence. From the reign of Charles VIII the most important names are those of Jean BOURDICHON, known primarily as an illuminator, and Jean PERRÉAL, none of whose works has survived. The stage was prepared for the great Italianate revival which was the dream of Francis I.

RENAISSANCE TO MANNERISM. The French Renaissance was an Italian importation which is conventionally dated from the end of the 15th c. and connected with the dynastic ambitions of the French kings from Charles VIII to Francis I. Its first phase was seen chiefly in domestic architecture and in decoration. In the châteaux of the Loire, at Amboise (c. 1495) and later at Chambord (1526-36), a veneer of Italianate decoration was superimposed on a still Gothic structure. The new trend spread to the great princely residences of the Île-de-France, prominent among them the Château de Madrid known from an engraving by DUCERCEAU, and elsewhere in France. From 1540, with the arrival in France of PERUZZI's pupil SERLIO, the classical preoccupations of Renaissance architecture grew dominant, adapted, however, to the French taste. Serlio's influence was paramount in the great works of FONTAINEBLEAU. With VIGNOLA, Philibert DELORME, and Lescot introduced the cult of BRAMANTE and SANSOVINO purporting to go back to the classical principles of VITRUVIUS. Lescot worked at the reconstruction of the Louvre as a royal palace from 1546 and Delorme began the Tuileries and built the château of Anet (1547-52), where the emphasis on harmony and proportion, the correct use of the ORDERS combined with a certain fantasy in mouldings and a predilection for a broken skyline, expressed most perfectly the national French adaptation of Renaissance Classicism.

Francis I was an enthusiastic collector and patron of the arts, who thought to model himself on the Italian humanist princes and made it his ambition to stimulate a national revival of painting by introducing to France the leading Italian painters and schools. He bought and commissioned paintings by RAPHAEL, TITIAN, LEONARDO, and others. Leonardo himself was persuaded to settle at Amboise in 1516, where he died three years later. ANDREA DEL SARTO entered the king's service in 1518 and painted the *Holy Family* now in the Louvre, but returned to Italy in 1519. Although the School of FONTAINEBLEAU included French and even Flemish as well as Italian artists, it was essentially the creation of the Florentine ROSSO and the Bolognese PRIMATICCIO, a former associate of Giulio ROMANO at Mantua, joined after 1552 by NICCOLÒ DELL' ABBATE. Just as in an earlier generation Flemish REALISM had adapted itself to the French court style to such good effect that from their union sprang the French International Gothic style, so at Fontainebleau Italian MANNERISM acclimatized itself to the French taste and the fairy-like quality of the long etiolated nudes, the boudoir provocativeness, and the almost playful presentation of mythological themes in place of the traditional religious iconography combined to form a distinctively French school of Mannerism which not only established itself as the main stream of national painting until after the turn of the century, but spread its influences also in neighbouring countries alongside the Italian Mannerist trends from which it derived.

Northern realist trends continued to make their impress in France during the 16th c. mainly in the field of portraiture, which enjoyed a hitherto unprecedented vogue both in court circles and with the newly emerging upper middle classes. Indeed it has been truly said that at no other period before the popularity of photography in the 19th c. is the physical appearance of the chief personages so accessible to us as in France during the reigns of Francis I, Henry II, and Henry III. The most prominent of the portraitists were the CLOUET family, of Flemish origin. But a large number of other less famous artists are known to have practised, including the QUESNEL who extended the art into the following century.

Among painters who followed local traditions mention should be made of Jean COUSIN of Sens, father and son, and from Lorraine the painter Claude DERUET and the engravers Jacques BELLANGE and Jacques CALLOT.

In sculpture and metal-work the visit of CELLINI (1540-5) made a powerful impression on French craftsmen although little has survived of his work from this period. His influence was felt by Jean GOUJON, who evolved a personal compromise between Classical purism and the sinuous elegance of the new French Mannerism. BONTEMPS, who worked as assistant to Primaticcio at Fontainebleau, recovered something of the virility of the Gothic and his pupil Germain PILON, the favourite sculptor of Catherine de Médicis, formed a link between the Gothic and the BAROQUE.

17TH CENTURY. Following the Wars of Religion and the Edict of Nantes France emerged

under Henry IV to a period of reconstruction in all walks of life and a revival of agriculture, trade, and industry. During this reign and the regency of Marie de Médicis Paris was transformed from a medieval town to a modern city. The Place Royale or Place des Vosges was started in 1605 and the Place Dauphine in 1607, while the even larger Place de France, designed in 1610, was only partially executed. The practical principles of town-planning which were fostered by the king dominated the development of Paris for several centuries to come and the simple design which he favoured in brick and stone remained standard for small country houses until well into the 18th c. The most important designers of private houses during this period were Jean Ducerceau, who built the Hôtel de Sully, and Pierre Le Muet. Both combined a feeling for the new simplicity with features of late Mannerist fantasy. Salomon de Brosse, perhaps the most distinguished architect of the period, more clearly heralded the new Classicism of the next generation. In painting the first two decades of the century produced little of note. In Paris the Second School of Fontainebleau revived the tradition of Primaticcio and Rosso in the decoration of royal palaces under the patronage of Henry IV but little of their work has survived and its impact on French artistic tradition was small. An artistic revival at Nancy associated with the names of Jacques Bellange, Jacques Callot, and Claude Deruet represented a last flowering of religious and mystical Mannerism outside the court style of Fontainebleau. Claude Vignon was also painting in Paris in a late Mannerist style which owed more to the Italian traditions than to the Fontainebleau School.

During the ministries of Richelieu and Mazarin the position of France was established as a great European power. In the arts, as in literature, it was the period in which French Classicism came to birth. In architecture the most important representatives were Jacques Lemercier, who built for Richelieu the Palais Royal and the Sorbonne, François Mansart, and Louis Le Vau. Lemercier is important for having brought to France the academic style inaugurated in Italy by Giacomo della Porta current before the Baroque. Depending in his early years on the work of de Brosse, Mansart achieved in his mature style the purest and most complete embodiment of the French Classical spirit in the 17th c. Le Vau, more brilliant in his eye for effect if less consistent in design, adapted the French decorative tradition to the requirements of the Classical spirit, becoming Architect to Louis XIV from 1661. Among other artists of talent at the mid century was Antoine Le Pautre, whose reputation rests chiefly on his Hôtel de Beauvais.

The reign of Louis XIII was a time of multiple experimentation in painting, when France first began to produce painters of leading stature internationally. Simon Vouet worked in an eclectic manner fluctuating from the dramatic Baroque of the early work of Guercino to the more Classical style of Domenichino and Guido Reni. His importance in the development of French art lay in his introduction of Italian idioms and in certain decorative innovations whose influence persisted for a century. He was versatile and brilliant rather than profound but as the teacher of such men as Le Sueur, Lebrun, Pierre and Nicolas Mignard, he stands at the head of the main current of French painting through the second half of the century. Philippe de Champaigne stands head and shoulders above other portrait painters of his time and by moderating the Baroque features of Rubens to a more restrained Classicism his work became a genuine reflection of the French rationalist spirit of the mid century. Poussin and Claude represent the two main tendencies of 17th-c. French Classical landscape and are regarded as the architects *par excellence* of the concern for Classical structure which has never wholly disappeared from French painting. (We may remember Cézanne's statement of his ambition 'refaire Poussin d'après la nature'.) Although both worked mainly in Rome, they belong pre-eminently to the history of French painting. In quite another manner the monumental simplicity and powerful composition of Georges de La Tour converted the naturalism derived from the followers of Caravaggio into a Classicism which breathes something of the same spirit as Poussin and Philippe de Champaigne. Naturalism of a less Classical type was also exemplified by the brothers Le Nain and the engraver Abraham Bosse.

French sculpture did not achieve anything comparable to the splendours of architecture and painting before the reign of Louis XIV. During the first three decades the tradition created by Goujon and Pilon was continued by such minor craftsmen as Simon Guillain (1581–1658), who made the bronzes for the Pont au Change monument (Louvre), the tomb sculptors Thomas Bourdin (c. 1575–1637) and Michel Bourdin (c. 1585–1645), and the medallist Jean Varin (1604–72). The most important monuments, such as the equestrian statues of Henry IV on the Pont Neuf and of Louis XIII in the Place Royale, were done by foreign artists. French sculpture at the middle of the century was dominated by Sarrazin, in whose studio most of the sculptors of the following generation were trained. His peculiar amalgam of Classicism and Baroque, exemplified in the Monument to the Prince of Condé in the church of S. Paul–S. Louis (1648–63), set the model for the sculpture of Versailles under Louis XIV and Lebrun. Michel Anguier, who like Sarrazin was trained by Simon Guillain, introduced together with his brother François a modified form of Roman Baroque but tended in his later years towards conformity with the approved French form of Classicism. None of these artists exerted strong influence in the next period when sculpture rose to importance with Girardon and Coysevox.

From 1661, when on the death of Mazarin Louis XIV took the reins of government into his own hands and appointed COLBERT as his adviser and administrator, France entered upon one of the most brilliant periods of its history. The State had become a highly organized and powerful machine autocratically controlled from above and the regulation of artistic taste and practice was only one of the many spheres which were subject to centralized direction. Under the dictatorship of Colbert, ably supported by Lebrun, Paris replaced Rome and Italy as the artistic centre of Europe. From the typically French Classicism of Louis XIII was born the Grand Manner of Louis Quatorze. The taste of VERSAILLES—combining the richness and grandeur of the Baroque with a tempering of French rationalism and *bon goût*—was imposed on the rest of France and became a standard for Europe.

All possible scope and incentive were given by the king's enthusiasm for grandiloquent schemes of reconstruction and decoration. After the rejection of BERNINI's designs for the new front of the Louvre and his abortive visit to Paris in 1665, the famous Colonnade designed by Le Vau in collaboration with PERRAULT was built. Le Vau also designed the façade overlooking the Seine to match the Colonnade. The greatest monument to the reign was Versailles, which Louis XIV intended as the symbol of his greatness and to which he transferred his court. Here a new magnificence was ably supported by the association of a few men of outstanding talent, brought up in the tradition of French Classicism but stimulated by the ambitions of the king to unprecedented heights of ostentation and display. In 1678 Jules Hardouin-MANSART succeeded Le Vau at Versailles and by 1685 its appearance had been transformed. Le Vau had been assisted by his son-in-law, François II d'Orbay. Jules Hardouin-Mansart was the nephew of François Mansart; Robert de COTTE, who collaborated with him and completed some of his work, was his son-in-law. Le NÔTRE, who had designed the gardens for Le Vau's château at Vaux le Vicomte, realized his masterpiece at Versailles and was indeed the creator of the new artistic concept of the French Classical garden. Lebrun, a Classicist in his theory, introduced an element of Baroque splendour in the vast decorative schemes which he executed or planned. Apart from the decorative magnificence of Lebrun, painting underwent a decline. Neither LA FOSSE nor Antoine COYPEL came up to the stature of the outstanding figures of the middle of the century. But in sculpture Antoine Coysevox and François Girardon were true exponents of the Grand Manner and Pierre PUGET, working in the Italian tradition, had a robust quality new in French sculpture of this century.

The imposition of standards of taste from above was consistent with a rationalistic age whose spirit was expressed in Descartes's doctrine of 'clear and distinct' ideas. Creative art, it was held, must appeal to the intelligence and must conform to rules which can be rationally deduced and taught. It was assumed that the practice of good taste could be learnt by the study of precepts which are discoverable and justified by reason. These principles were crystallized in the Academy, which had been established in 1648 but was reorganized as an instrument of control by Colbert and Lebrun in 1663. Through the Academy artists were brought more directly within the orbit of royal patronage and out of the control of the guilds, while at the same time it became a prime instrument for the universal imposition of the king's preferences in matters of taste. With Colbert as Protector and Lebrun as President and virtual dictator the Academy drew up an official hierarchy of merit among artists of the past running from the ancients at the top through Raphael and the Roman School to the exemplification of Classicism in Poussin, deprecating the Venetians for their too great attention to colour and belittling the Flemish and Dutch Schools because their realism and concern with the petty and insignificant conflicted with the high seriousness of the Grand Manner. Lebrun published a treatise on the representation of the passions which followed certain theories of Poussin and attempted to reduce to rule the manner of depicting any given emotion or psychological situation. Finally, through its secretary Henri Testelin, the Academy published in 1680 a rigid and comprehensive set of precepts covering every known aspect of painting. This was followed by a domestic revolt and a quarrel between 'Poussinistes' and 'Rubensistes' almost as famous in art history as the quarrel of the Ancients and Moderns in literature. The revolutionaries, led by Roger DE PILES and the painter Charles de La Fosse, argued for the importance of colour as in the VENETIAN SCHOOL and Rubens and for a measure of realism. The orthodox party, with André FÉLIBIEN as spokesman, stood for the superiority of drawing, Poussin, and idealism. Appealed to in 1672, Lebrun gave his verdict in favour of drawing and this became the official view of the Academies until well into the following century. Thus in France of the second half of the 17th c. Classicism became Academicism and formal authority was given to those conceptions of teaching and criticism in the arts which have ever since been associated with the academic idea.

18TH CENTURY. The 17th has been called the royal century and the 18th an aristocratic one. The Revocation of the Edict of Nantes in 1685, the year also of Colbert's death, marks the real term to the glory of *le grand monarque, le Roi-Soleil*, and the monotonous magnificence of Versailles. Reaction from the forced austerity of Mme de Maintenon and the political reversals which had clouded the closing years of the 17th c. found their expression in a growing relaxation of morals and a lighter note in art, which found

full scope during the Regency of the libertine Duke of Orleans (1715-23). On the death of Louis XIV the court of Versailles was dissolved and the young Louis XV was brought to the Tuileries. The tone of society changed and there developed a new refinement of taste in art and in life. Elegant frivolity became the vogue. CON-NOISSEURSHIP spread and art collectors became more numerous outside the ranks of the old nobility. It was now the city which set the tone to the court. The era of boudoir art had begun. While patronage for the grandiose and the magnificent had become a thing of the past, minor and decorative works of art became the rage and an organized trade grew up in response to the demand. It was the age of elegance and refinement, of the artificial and the gay. A fashion for CHINOISERIE was completely in accord with the new spirit of the age.

It is customary to distinguish four styles in French 18th-c. art, named after political periods: RÉGENCE; LOUIS XV; LOUIS XVI; and DIREC-TOIRE. There is of course no absolute line of demarcation and the stylistic periods do not exactly correspond with the political periods from which they are named. The *Régence* extends roughly from 1705 or the beginning of the century to 1730, Louis XV to 1750. Louis XVI style began about 1760 and the simplification of this style known as *Directoire* came in with the Revolution.

Architecturally in the 18th c. the accent was less on great houses (a notable exception to this rule was the Hôtel de Soubise in the rue des Francs-Bourgeois) than on small town houses in the newly fashionable district of the Faubourg Saint-Germain, or fragments of urban development which have given many French towns their characteristic charm: the Place du Peyrou at Montpellier, the Palais des États at Dijon, the Place Bellecour at Lyon, the landscape gardens at Nîmes, the magnificent Place Stanislas at Nancy, and of course the Place Louis XV or de la Concorde (by GABRIEL) in Paris. The new style gave even royal residences the air of summer villas, e.g. Gabriel's Petit Trianon at Versailles (1762-4), and permitted the rapid completion of buildings under the direction of the architect who planned them (Bélanger's Bagatelle was erected in the record time of six weeks). Discreetly splendid façades hid a wealth of fantasy, for the ROCOCO style was essentially a revolution in interior decorating, which in its turn brought about minor revolutions in painting and sculpture. Gone were the strong cornices and entablatures, the tapestries and painted ceilings, that made a 17th-c. room look like a series of heavy frames; 18th-c. rooms were inclined to be oval, white, and inset with mirrors, painted panels, and Chinese hangings, while the cornice, as in BOFFRAND'S oval salon at the Hôtel de Soubise, was a mere arabesque which was allowed to dip down the walls and invade the cove of the ceiling. Paintings for such rooms naturally had to be smaller, lighter in colour, and far less weighty in

subject. Sculpture was more Baroque, stemming from Coysevox rather than Girardon, and became smaller to fit the smaller rooms, with an etiolated prettiness and grace until with Michel CLODION it reached the extreme limit of bibelot-sculpture. This general scaling down is perhaps most notable in the evolution of painting. WATTEAU had a certain poetic gravity and a melancholy which contrasted with the frivolity of the age as exemplified in FRAGONARD and GREUZE, but his themes were the imaginary and fantastic world of *fêtes galantes*. Greuze, with the encouragement of that sensual moralist DIDEROT, guilty at his worst of mawkish sentimentality, portrayed the virtuous peasantry in a series of self-conscious *tableaux vivants*. BOUCHER, the protégé of Mme de Pompadour and the most typically Rococo artist, painted charmingly indelicate mythological scenes in which the gods and goddesses all posture as unheroic adolescents of 16. Fragonard painted sentimental and gallant subjects in an erotic vein. LANCRET and PATER, followers of Watteau, vulgarized his style without coming nearer to it than a certain mechanical delicacy.

A superficial and frivolous society, delighting in its own image, gave impetus to the fashionable portrait. Society portraits, representing the sitters as gods and goddesses or embellishing them with details and accessories, were produced by Nicolas de LARGILLIÈRE, Jean-Marc NATTIER, and his son-in-law Louis TOCQUÉ. Jacques André AVED among others specialized in depicting his subjects in the characteristic occupations of private life. A fashion for pastel portraiture was exploited by Jean-Baptiste PERRONEAU and Maurice Quentin de LA TOUR. Among portrait sculptors Jean-Baptiste FALCONET, Jean-Jacques CAFFIERI, and Jean-Antoine HOUDON displayed a certain power of observation and a gift for catching the fugitive expression, but the affected grace and elegance demanded by current taste was not conducive to solid sculptural quality. Falconet's statue *Peter the Great* in Leningrad and Houdon's *George Washington* at Mount Vernon were considered in their day to be profoundly philosophical conceptions, but to modern taste they seem superficial and too urbane. There was greater profundity in the works of foreign-born sculptors such as L. S. ADAM and M. A. SLODTZ.

In the second half of the century Rococo gave place to a new Classicism, whose ideals were clarity of outline and simplicity of statement, an austere directness rather than elegance. People tired of boudoir art with its sugary sentimentality and sly eroticism. The return to the ANTIQUE lay at first in the direction of the Greek rather than the Roman, influenced by archaeological discoveries in southern Italy and POMPEII and by theories of WINCKELMANN and his clique of collectors. The first painter in this NEO-CLASSIC style was Joseph VIEN (1746-1816) and under his influence the early DAVID. But the new Classicism of the Revolution was a very different thing

from the aesthetic Neo-Classicism of Winckel-mann. The French revolutionaries sought to model themselves on Republican Rome and to emulate the stoic virtues of simplicity, order, and justice. Their conception of the Roman Republic was an unhistorical and romantic illusion, but was none the less powerful for that. Their art was required to reflect the ideals of stern simpli-city and to inculcate the civic virtues, eschewing frivolity and licence. David became the arch-priest of the new aesthetic. His *Oath of the Horatii*, painted at Rome in 1784 and first exhibited in Paris at the SALON of 1785, was hailed as the manifesto of Revolutionary Classi-cism and he became accepted as the official artist of the Revolution, being employed to design a new national costume, plan Revolu-tionary fêtes, and so on. In architecture a Classi-cism based on Roman patterns under Louis XVI, such as may be seen in the Panthéon, Paris, built by Germain SOUFFLOT as the church of Sainte-Geneviève, soon gave way to a preference for the 'true' Doric as revealed at Paestum. The most characteristic examples of this tendency are, in Paris, Saint-Philippe-de-Roule by Jean-François Chalgrin (1739-1811), and also the works of Claude-Nicolas LEDOUX, particularly the magnificent salt pits of Arc-et-Sénans near Besançon, and Victor Louis's Grand Théâtre at Bordeaux and Préfecture at Besançon. Yet the transition in architecture was less abrupt than in the other arts. There is comparatively less difference in conception between Peyre and de Wailly's Odéon of 1779-83 and Brongniart's Bourse of 1808-16, between Victor Louis's arcading of the Palais Royal and the arcading of the rues de Rivoli, de la Paix, and de Castiglione of 1811, or between Chalgrin's Saint-Philippe-de-Roule of 1768 and the Nôtre-Dame de Lorette (1826) by L. H. Le Bas (1782-1867).

David became the official painter to Napoleon and in collaboration they abolished the old Academy and set up in its place the Académie des Beaux-Arts as a section of the Institut National. Napoleon's impact on taste was force-ful but short-lived. It is manifested in the erection of the Colonne Vendôme and the Arc de Triomphe de Carrousel; a number of Pompeian or Egyptian interiors by PERCIER and FONTAINE at Malmaison, Fontainebleau, and Compiègne; the development of the chaise-longue and the invention of the *psyche* or long mirror. It led to a revolution in women's dress. The slightly monotonous interiors of the EMPIRE period, olive-green, dark red, or dull yellow, with their copious use of leather, walnut, and bronze mounts, foreshadow the bourgeois interiors of Louis-Philippe with one important difference. Napoleon had no use for comfort, and a con-temporary letter speaks of the agony of trying to sit down anywhere; the restoration of the Bourbon monarchy coincided with the intro-duction of upholstery, the 19th century's great, but isolated, contribution to the development of interior decoration.

19TH CENTURY. Perhaps the most signi-ficant feature in the history of French art in the 19th c. is the gradual breakdown of official patronage and the rise of individualism with its many consequences. As the dealer and the sale room replaced the patron, the intimate con-nection of painting and sculpture with archi-tecture in comprehensive decorative schemes embracing all the arts, major and minor, was gradually severed. The 19th c. became the century *par excellence* of easel painting and independent sculpture. New aesthetic doctrines were elaborated to justify an art which no longer had an established social function. Thrown back upon his own resources the artist had to find his own market and his own public. It is probable that the moneyed middle classes upon whom artists came increasingly to depend were, during the 19th c. at least, less appreciative of original artistic merit than had been the aristocratic patrons of a former age. It was against this back-ground of changed social conditions that there grew up in the course of the 19th c. the sharp cleavage, which persisted into the 20th c., be-tween 'official' art sponsored by the academies and 'creative' art acclaimed by the critics and future historians. With the loss of official patronage and the consequent deprivation of traditional social function there also became apparent the first stirring of that sense of spiritual isolation—the so-called divorce of art from life—which has harassed creative artists until the present time, bringing in its train the feeling of frustration which has been so characteristic of the modern age. The isolation of the creative artist and his segregation from social purpose were emphasized by the characteristic 19th-c. ROMANTIC ideal of the solitary genius in rebellion against his epoch and by a belief that the conflict between the artistic temperament and bourgeois philistinism was no mere temporary misunder-standing but a permanent hostility belonging to the nature of things. Whereas a painter like Boucher regarded himself as half craftsman and half public official, the 19th-c. Romantic cul-tivated the ideal of eccentricity and non-conformity exemplified in Murger's *Scènes de la vie de bohème* (1849).

An incidental consequence of the new situa-tion of the artist in society was the collapse of the old system of apprenticeship, which had been bound up first with the guilds and then with official patronage and had carried with it the conception of the artist as three-quarters crafts-man. The studio or workshop apprentice was transformed in the course of the 19th c. into the art-school student of today. Along with this went a serious deterioration of technical effi-ciency, a tendency which was enhanced by the increasing popularity of industrially manu-factured pigments and materials. The break-down of studio tradition also contributed to that aspect of individualism which was reflected in a tendency to lay exaggerated emphasis on idio-syncrasies of personal style and an aesthetic

which set preponderant importance upon idio-syncrasy under the guise of originality. Further-more the need to wrest a living from a highly competitive and often unsympathetic market, readily influenced by vicissitudes of fashion, put a premium on easily recognizable traits of individual style.

During the first decade of the century the new Classicism reached its climax with the dominating personality of David as the acknowledged dictator of taste. The aesthetic creed of French Neo-Classicism was expressed by the critic Quatre-mère de Quincy, who held that the ultimate per-fection of art is to be sought in an idealization of natural beauty transcending the actual beauties of nature and that this ideal had been estab-lished once for all by the Greeks, who had dis-covered the principles which enabled PHIDIAS and others to 'correct nature through herself'; hence all that remained for contemporary artists was to follow the example of antiquity. This exaltation of classical antiquity was perpetuated by followers of David such as GUÉRIN, who numbered GÉRICAULT and DELACROIX among his pupils, and Girodet-Trioson (see GIRODET DE ROUCY). GROS, who desired loyally to head the Classical School after David's emigration, was himself too vital and Romantic a realist in his first-hand recording of Napoleon's campaigns to fall into the ranks of the Neo-Classical con-formists. PRUD'HON's individual genius bridged the centuries with a tender and non-doctrinaire antiquarianism imbued with the feeling of Leonardo and CORREGIO.

Within the classicizing trend INGRES was an artist of such towering stature that he cannot be confined within the frontiers of a school. He carried the French linear tradition to its highest point of achievement and his almost sensuous delight in the calligraphic functions of line gave his work an expressive power verging on the Romantic in feeling. But great artist and draughtsman as he was, and important as his example has been found by certain 20th-c. movements, his immediate influence was almost wholly pernicious in giving authority and direction to the 'academicism' which throughout the 19th c. in France exaggerated the growing rift between official and creative art. His direct followers encouraged all that was most banal in the academic tradition and gave vogue in parti-cular to that type of conventional and unreal nude dubbed Femme de l'École. He was accepted as master by the group of minor and uninspired artists who gained control of the Académie des Beaux-Arts and the École des Beaux-Arts, set before themselves the aim of maintaining the principles of David—ideal beauty and the cult of the antique—and persistently opposed the new endeavours initiated by independent artists.

French Romantic art of the 19th c. is complex in origin and difficult to define. There were elements of Romanticism in both David and Ingres, though the leaders of the so-called Romantic movement in the visual arts were Géricault, CHASSÉRIAU, and Delacroix. The restoration of the Bourbons brought a vogue for historical pictures which embodied an idealized medievalism and the so-called Troubadour style, akin in some respects to the PRE-RAPHAELITE movement in England and parallel to the literary revival of medievalism in such writers as Sir Walter Scott, Chateaubriand, and that most typical Romantic of all, Lord Byron. Another aspect of the Romantic revolt from the drabness of present reality was the exoticism apparent in The Massacre at Chios exhibited by Delacroix in 1824 and in his subsequent Oriental pictures following his journey to Morocco in 1832. One may see in GAUGUIN's retirement to Tahiti the same spirit of escapism. The Romantic nostalgia for the past is typified by MOREAU and DAUMIER's effort to invest commonplace reality with a hitherto unsuspected grandeur may also be regarded as a manifestation of Romantic attitude.

At the opening of the 19th c. landscape was the weakest point in French painting, being virtually restricted to historical landscapes in the manner of Poussin and Claude. As the century advanced landscape grew in importance and in excellence, drawing valuable lessons both from the English School and from the Dutch. The classical tradition of the historical landscape was perpetuated by such artists as Pierre Valen-ciennes, Jean Bidault, and Achille Michallon without any achievement of interest. Land-scapes combined with neat and precise genre scenes in the manner of the 17th-c. Dutch School were painted for the well-to-do middle-class clientele by artists such as Louis BOILLY, François GRANET, and Georges MICHEL. Most interesting of these were Michel's emotive pictures of sub-urban Paris street scenes, which in some respects foreshadowed the BARBIZON painters. Interest in the English landscape School—particularly BONINGTON and CONSTABLE—was encouraged by the Anglophil trend which survived the Napoleonic wars. A key position in the develop-ment of French landscape is occupied by the Barbizon School. These artists were important not only for the value of the works they pro-duced but because, in the words of Clive BELL: 'They made of Constable's splendid but idio-syncratic and untidy vernacular a teachable language of widest application, in which com-petent students of any nationality might learn, as only too many have learned, to paint what they have been taught to observe. This was of im-portance because the new instrument for record-ing observations fell into the hands of the IMPRESSIONISTS, who were beholden to it as a poet of genius might be beholden to some un-usually sensible grammar unearthed from a dusty corner in a schoolmaster's library.' By the end of the century independent landscape had arrogated for itself a position of respect and importance in French painting, and French landscape painting had achieved a quality and a distinction which brought it to international recognition.

A persistent trend towards realism in opposition to the idealizing unreality of the Academy on the one hand and the Romantic medievalism of the Troubadour School on the other manifested itself in two main phases. Social realism ran parallel to the movement of sociological realism fostered by writers such as Michelet and Auguste Comte. It came also as a reaction from the literary AESTHETICISM of writers such as Gautier, who preached an exaggerated form of the doctrine of 'art for art's sake'. There had, of course, been realism within the Romantic movement. Géricault's *Raft of Medusa* was a realistic representation of the horrible and there was among the Romantics a strong bent towards exotic or escapist realism. The sentimentality of MILLET lies between the Romantic and the realist attitudes. But the founder of the new realism in painting, as Zola in literature, was COURBET, with whom must be associated the satirist Daumier and the illustrator Constantin GUYS. Courbet's ideal of portraying the world and society as they are, however uncouth or unprepossessing, and his feeling for ordinary workaday humanity, came close to George Sand's conception of an art which 'would be neither classical nor romantic and which would respond to the modern idea of Man'. Impressionism was, at least in one aspect, a form of scientific realism without the sociological implications that the art of Courbet and others shared with the literary realism of the middle of the century.

By 1850 the population of Paris had reached about a million. The suburbs had grown haphazard without plan and the over-crowded centre with its narrow and sordid streets became the haunt of misery and vice depicted with sinister eloquence by the 'realist' novelists Balzac and Eugène Sue. The radical reconstruction undertaken by the Baron Haussman, an administrator rather than an architect, is still debated. Iron and glass tributes to middle-class tastelessness such as the Gare du Nord and the Bibliothèque Ste Geneviève were proudly erected and that 'great anomaly of modern engineering', for half a century the highest man-made structure in the world, functionless and styleless, the Eiffel Tower (1889), became a symbol of Paris as famous as the Seine itself. The gulf between official and creative art grew wider and the artistic hegemony of France came to depend exclusively on the independent movements outside the SALONS. In 1863 the emperor Napoleon III instituted a Salon des Refusés, where artists could show who had been refused for the official Salon. One might, somewhat arbitrarily, see in this the origin of the *avant-garde* in art. But the emperor and empress were shocked by MANET's picture *Le déjeuner sur l'herbe* (Louvre) and the Salon des Refusés was not repeated. In 1884 SIGNAC, REDON, and SEURAT formed the Société des Artistes Indépendants. Its annual exhibition had no selecting jury but membership was open to all. The second exhibition (1886) contained two canvases which have become landmarks in the development of modern painting: Seurat's *Un dimanche d'été à la Grande Jatte* (Art Inst., Chicago) and H. ROUSSEAU's *Un soir de carnaval*. The founding of the Société marks one of the crucial dates in the formation of modern Western art. One may date the beginning of modernism from about 1885.

As the divorce between creative art and the official art of the schools widened it has been the former which has interested art historians while the latter belongs rather to the sociology of taste and manners. The history of French art during the second half of the 19th c. will be found in articles on the successive movements—IMPRESSIONISM, POST-IMPRESSIONISM, the NABIS, the SYMBOLISTS—and certain dominant individual figures such as CÉZANNE, Le Douanier Rousseau, GAUGUIN, van GOGH, who cannot be wholly confined within any school or group. Finally, in the closing decade and at the turn of the century, came that strange style of decorative arabesque, spreading internationally and making its presence felt in all the arts, which has been characterized and distinguished under the name ART NOUVEAU.

Of high standing among the leaders of official art in the second half of the century, and celebrated even by Théophile Gautier as a master of the Neo-Greek genre, was Jean Léon GÉRÔME, pupil of Paul Delaroche (1797-1856). An uninspired painter who goes down to history as having dubbed Impressionism 'le déshonneur de la France', Gérôme spent his life in search of the superficially exotic and picturesque and his *œuvre* might be likened to a travel brochure through historical time. Much of the academic and Salon art of the time was derivative realism in character, peasant scenes, intimate interiors, portraits, etc., all empty and featureless reproductions of Dutch models. The public wanted pictures of the sort they were familiar with and were offered plagiarism and pastiche. This kind of thing was turned out by Jules BASTIEN-LEPAGE, whose *Hayfield*, now in the Louvre, made a sensation when first shown in the Salon, Charles Durand, Joseph-Léon Bonnat, whose classes were attended by Othon Friesz (1879-1949), and Raoul DUFY. Slick and popular Dutch-type scenes by Ernest MEISSONIER might be DALI without the Surrealism. At the same time the art of the schools included unchallenging and uninspired popularizations of the great revolutionary aesthetic styles once these had made their way and become acceptable to public taste. Thus Impressionism was accepted when vulgarized by the safe formulas of Henri Martin, Gaston Latouche, and Le Sidaner and even the slick and facile work of Eugène CARRIÈRE, which influenced the development of 'art' photography at the turn of the century, and the popular watercolourist Charles Cottet.

2OTH CENTURY. In the 20th c. French art became international and the École de Paris (see PARIS, School of) both attracted the finest creative artists from many countries and disseminated

throughout the world the results of the aesthetic ferment which led to constant experimentation and innovation. The art of 20th-c. France is to be studied in the history of the great aesthetic movements whose names have become household words: FAUVISM, CUBISM, SURREALISM, TACHISME, and the rest. Not until the rise of ABSTRACT EXPRESSIONISM after the Second World War was the position of Paris seriously challenged as the centre of advanced artistic and aesthetic activity in the world.

50, 112, 115, 116, 223, 243, 251, 306, 307, 344, 383, 499, 536, 592, 667, 679, 731, 732, 733, 745, 746, 747, 756, 771, 773, 794, 829, 830, 838, 839, 841, 853, 857, 858, 885, 932, 975, 996, 1047, 1048, 1095, 1107, 1162, 1270, 1377, 1378, 1400, 1495, 1540, 1543, 1553, 1572, 1573, 1585, 1617, 1632, 1681, 1742, 1743, 1745, 1766, 1771, 1902, 1987, 2131, 2133, 2186, 2198, 2199, 2264, 2284, 2290, 2430, 2465, 2486, 2497, 2554, 2556, 2745, 2758, 2759, 2760, 2762, 2831, 2887.

**FRENCH ORDER.** A 16th-c. invention of the architect Philibert DELORME. He placed RUSTICATED rings round his COLUMNS, arguing that, since the nature of the local stone necessitated the building up of shafts from jointed drums, the appropriate decorative treatment would make a feature of this necessity (see ORDERS OF ARCHITECTURE).

**FRESCO** (Italian: 'fresh'). A method of wall-painting in which pure powdered PIGMENTS, mixed only in water, are applied to a wet, freshly laid lime-plaster GROUND. The colours penetrate into the surface and as it dries they become fixed and insoluble in water. The plaster acts as the binding MEDIUM, and is also the only white pigment used. The painting will last as long as the wall itself, being now an integral part of it. This is the true fresco, which the Italian masters called *buon fresco* or *fresco buono*; painting on dry walls they called by analogy *fresco secco* or simply SECCO.

Fresco is probably the best method for monumental wall-painting, and certainly the most permanent if the climate is dry. But if damp penetrates the wall, the plaster may crumble and the paint with it. Consequently the art has been practised chiefly in dry countries, particularly in Italy (though not in Venice), and seldom in northern Europe.

The Italian practice was described in detail by CENNINI in the early 15th c. The wall was first given a coating of plaster, prepared from lime and sand in water. On this rough surface (the ARRICCIATO) the design was drawn in charcoal; next the assisting lines and some of the main contours were incised, and the outlines and shading indicated with pigment mixed in water; thirdly the lines of the design were painted in a red ochre called *sinopia*, which was the chief red used in fresco (the other important red, *cinabrese*, was a mixture of sinopia and lime white). Until the introduction of the CARTOON *c.* 1500 the

design was worked out directly on this first plaster ground or copied from a small sketch. A layer of finer plaster, called the INTONACO, was now applied over one section of the rougher *arricciato*. This was the actual painting ground and was made very smooth. Each day just so much of the design was covered with the *intonaco* as could be painted on that day; no more, because the plaster had to remain wet during the painting. On this small area of fresh plaster the design—perhaps a head or a draped figure—was first drawn with the brush in *verdaccio*, a mixture of black, lime white, and *cinabrese*. Flesh parts received an undercoating of *terra verde*, a green earth pigment. The actual flesh tint was prepared in three tones by mixing *cinabrese* with varying quantities of lime white. For the drapery, or other parts where modelling had to be indicated, similar sets of three tones were prepared, as in the TEMPERA painting of the time. Since blending was difficult, the final effects were produced by hatching. Finishing touches were sometimes added after the plaster was dry (*al secco*), but this of course had to be done with egg tempera or size paint instead of pure pigment and water, and VASARI called it a 'vile practice'.

The fresco painter thus had to work rapidly, before his plaster could dry; corrections were almost impossible, and he needed a sure hand and purpose. Further he had to work directly because his preliminary design was covered by *intonaco*. The colours available to him were few—in the 15th and 16th centuries painters believed that only natural pigments were suitable for fresco—and apt to become lighter in drying; depth of tone was unattainable. But these difficulties and limitations themselves encouraged him to design his subject broadly and treat it boldly, and did much to foster the purity, strength, and monumentality of Italian RENAISSANCE painting.

Fresco painting is an ancient art. The Minoan and Greek wall-paintings were probably in fresco; the Greco-Roman paintings at POMPEII certainly are. VITRUVIUS describes a method much like Cennini's, in which an underlayer of plaster was used for the preliminary design and a coating of wet plaster for the painting. In the early Middle Ages wall-painting seems to have been done in a number of mixed methods, but not in true fresco. In the 12th and 13th centuries, however, true fresco formed part of the craft of MOSAIC. The mosaicist set out his whole design on a layer of rough plaster and then applied a smooth layer in daily sections, painting his design on that to help him in placing his tesserae. It was this art, apparently, that inspired the beginnings of fresco painting in Byzantium and Italy. A true fresco in which the divisions into sections can be seen is a fragment of a painting of the Madonna and Saints in the convent of Sta Francesca Romana, Rome, dating from about the middle of the 13th c. Pietro CAVALLINI, a mosaicist and painter, produced his *Last Judgement* in the church of Sta Cecilia in Trastevere,

**138.** Astrological print (*c.* 1465) attributed to Maso Finiguerra. Artisans and merchants under the sign of Mercury. The scenes represent *inter alia* grinding colours and mural painting

Rome, towards the end of the century. GIOTTO, the first really great master of fresco, had come under the influence of Cavallini in Rome, and had himself worked in mosaic. Thenceforth most of the great Italian masters produced works in fresco. Examples are those of Giotto in the Arena Chapel, Padua; of MASACCIO, in the Brancacci Chapel, Florence; of PIERO DELLA FRANCESCA, in S. Francesco, Arezzo; RAPHAEL's *Stanze* at the Vatican; MICHELANGELO's ceiling in the Sistine Chapel; and CORREGGIO's work at

Parma. From the 16th c. onwards wall-painters began to forsake true fresco, but the method was still employed to some extent up to the time of the great decorator TIEPOLO. In the 19th c. the German NAZARENES and the English PRE-RAPHAELITES, among others, attempted to revive the traditional Italian technique, and it was used not very successfully by William DYCE for murals in the Houses of Parliament. Owing to the difficulty of recovering the technique of pure fresco many painters, such as DELACROIX and PUVIS

DE CHAVANNES, used instead the method of MAROUFLAGE.

In Asia the traditional method of wall-painting is with glue on dry plaster, but the fresco technique was known there in the 11th or 12th centuries, as a technical examination of mural paintings at Tanjore, in India, has revealed.

**FRET.** Key-pattern. *Fretted*, however, is a loose term which may imply various kinds of decoration, e.g. carving or embossing.

**FRIEDRICH, CASPAR DAVID** (1774–1840). German painter. Though now generally recognized as one of the chief exponents of the ROMANTIC movement, Friedrich remains a solitary figure among his contemporaries. After some years at the Copenhagen Academy, he settled permanently in Dresden in 1798. There he led a quiet life, interrupted only by occasional excursions to the mountains or the coast of Pomerania. Neither his classical training nor his friendship with GOETHE could induce him to visit Italy. The scientific outlook of his friend DAHL was no less antipathetic to him, and he pursued with a rare and instinctive single-mindedness his personal insight into the spiritual significance of landscape. During his last years his brooding 'Ossianic' nature—to use a contemporary expression—was steeped in a passive melancholy.

His first oil paintings (1808) created a sensation and became the centre of controversy. His choice of subjects broke new ground and he discovered aspects of nature so far unseen: an infinite stretch of sea or mountains, snow-covered or fog-bound plains seen in the strange light of sunrise, dusk or moonlight. In each picture the unifying effect of light created a unity of mood and the formal composition sprang from and expressed the character of the scene depicted. Although Friedrich was a teacher at the Dresden Academy from 1816 onwards, his influence has been negligible, though there are traces of it in the work of BLECHEN, Dahl, and SCHINKEL.

192.

**FRIEZE.** Term in classical architecture for the middle of the primary divisions of the ENTABLATURE, a horizontal band between the ARCHITRAVE and the shelving CORNICE above. In the Doric style the frieze usually contains TRIGLYPHS, in the Ionic, Corinthian, and Composite (see ORDERS OF ARCHITECTURE) it is often used for figure sculpture in relief.

**FRITH, WILLIAM POWELL** (1819–1909). English painter who studied at Sass's Art School and the R.A. Schools and became R.A. in 1853. He began with illustrative paintings of classics such as *The Vicar of Wakefield*, but *c.* 1851 he turned to contemporary life and had a great commercial success. Although he himself denied the influence of the PRE-RAPHAELITES, he was one of the artists who followed the formula which Holman HUNT took over from RUSKIN: 'Go to nature, rejecting nothing, selecting nothing and scorning nothing.' Unlike Hunt, he was pretentiously satisfied with a commonplace recording of minutiae. Trivial in artistic imagination, he recorded pullulating scenes from Victorian middle-class life, as in *Ramsgate Sands* and *Derby Day* (N.G., London, 1858), with accurate verve and technical dexterity. His *Autobiography* (3 vols., 1887/8) is a useful record of the conservative academic conception of art and of contemporary gossip.

**FROMENT, NICOLAS** (active *c.* 1450– *c.* 1490). Painter from Uzès, Languedoc, who worked at Avignon. A triptych in the UFFIZI, painted in 1461, and the *Altarpiece of the Burning Bush* (1475–6) in the cathedral of Aix-en-Provence reveal him as a painter with a highly developed sense of sculptural form. His figures have strong if sometimes clumsy expressions and gestures, while his draperies have a characteristic angularity reminiscent of some of the works of the Spanish and German followers of Rogier van der WEYDEN.

**FROMENTIN, EUGÈNE** (1820–76). French painter of Oriental themes who studied under L.-N. Cabat and by 1847 was exhibiting in the Salon. His *Chasse au faucon en Algérie* and *Halte de cavaliers arabes* are in the Louvre. His exoticism was the target of criticism for the NATURALISTS such as DURANTY. He is perhaps best known for *Les Maîtres d'autrefois* (1876), studies of Dutch and Belgian painting written after a visit to these countries, which includes an analysis of the effect of Dutch landscapes on French painters such as CLAUDE and Théodore ROUSSEAU. He also wrote a lyrical novel, *Dominique* (1862).

**FRONTALITY.** A term coined by the Danish scholar Julius Lange, who in his *Die menschliche Gestalt in der bildenden Kunst* (1899) enunciated the principle that the art of early civilizations presents its subject from the main, or front, view. This he called the 'law of frontality'.

As now generally applied to sculpture the term involves two features. First, in much archaic sculpture the figure displays a central axis rigidly aligned from top to bottom and is symmetrical about this axis so that each half is the mirror image of the other. Second, the internal details of features, clothing, muscles, etc., are orientated so as to face a viewer who stands directly in front of the statue and there is no foreshortening. These features are characteristic of much Archaic Greek sculpture. The Greeks gradually modified this main-view approach (see CONTRAPPOSTO), but during their

early experiments they composed figures in quite complicated poses by putting together frontal elements without foreshortening of the internal details. For instance the reclining warrior of the Aegina Pediment (Glyptothek, Munich) lies in a twisted position on his elbow, but his chest and pelvis are each conceived as they would be in a frontal view without the transitions that the movement requires. Vestiges of frontality can still be seen in some HELLENISTIC sculpture. Although similar conventions are found in much aboriginal and some medieval art, the 'law' is now known to be not as strict and all-embracing as Lange thought. The early bronze statuette of a dancer from Mohenjo-Daro (Nat. Mus., New Delhi) (see INDUS VALLEY ART) would alone disprove it. Various psychological explanations for the convention of frontality have been advanced but are generally contested. Lange thought that frontality was due to the dominance of memory images in primitive art. It is now usual to explain frontality as the consequence of a 'noetic' rather than a direct visual approach. The sculptor fashions his figure as he knows the object to be rather than as he sees it from this or that angle. The convention of axial rigidity results from recognition of the symmetry of anatomical structure with paired elements and the introduction of this into the noetic image, producing exact correspondence between the two halves of the body about a vertical axis. The second feature, namely the frontal orientation towards the viewer, results from the fact that noetically the silhouette is the most important element in the shape of an object. The archaic sculptor chooses the most important silhouettes—front, back, and side views—and he makes a figure in which each of these four views is frontal to an observer directly facing it. The figure is conceived as four silhouettes. Within each silhouette the internal details—features, hair, muscles, ears, clothing, etc.—are 'drawn' on the surface of the block in unforeshortened outline. Thus the ears are frontal to the side view, the buttocks to the rear view, and so on. Such sculptor lacks the ability, highly regarded by many modern sculptors and critics, to apprehend the object as a three-dimensional organization of space. It is apprehended as a small set of silhouette shapes, each with internal patterning.

An interesting development of frontality occurred in ROMAN historical reliefs, the purpose of which was apparently to give an air of authority and dominance to the members of the imperial family. This is noticeable in the *adlocutio* on the column in the old Campus Martius (Piazza Colonna, Rome) celebrating Marcus Aurelius's victories over the barbarians, where the emperor is raised high above his audience on a *podium* and gazes full-face at the beholder. The same thing is noticeable in the *adlocutiones* panels of the TRIUMPHAL ARCH which was erected in A.D. 203 in honour of the eastern victories of Septimius Severus and even more in the posture of the imperial group representing the triumphal entry of Septimius on the Arch erected *c*. A.D. 203 at Leptis Magna, Libya. As has been said by Professor Toynbee: 'The imperial group has been deliberately pulled round to a frontal view in order to give it a hieratic aspect and rivet our attention upon it.' The culmination of this deliberate use of frontality for HIERATIC effect in Roman historical sculpture may be seen in the reliefs carved on the base of the obelisk set up in the hippodrome of Constantinople by the emperor Theodosius in A.D. 390. But the use of frontality to emphasize the imperial cult had its counterpart and continuation in the convention which right through BYZANTINE ART demanded that icons should present holy personages and saints looking out squarely and frontally into the eyes of the devotee with a sense of real presence and potency (see ICON).

**FROTTAGE** (French: 'rubbing'). A technique employed by Max ERNST and other SURREALISTS to create a design. The paper on which the painting is to be executed is placed over some rough substance such as grained wood or sacking, and rubbed until it acquires the surface quality of the substance beneath. The resulting design is usually taken as a stimulus to the imagination, the point of departure for a painting which expresses imagery of the subconscious.

**FROTTIE.** The transparent or semi-opaque brushings in of colour with which some artists begin their paintings. English painters sometimes refer to this method of starting a painting as 'rubbing in', since the thin colour is lightly rubbed in over the GROUND. INGRES began his paintings with thin *frotties* and always recommended the addition of a small quantity of white with the colour to avoid cracking. *Frotties* can be seen in the most thinly covered portions of the UNDERPAINTING, particularly in shadow passages and in thinly painted backgrounds. They are clearly visible in DAVID's unfinished portrait of Madame Récamier (Louvre, 1800) and in his painting of the dead Joseph Bara (Musée Calvet, Avignon, 1794). Another example is the portrait of Pope Innocent X by VELAZQUEZ (Doria Gal., Rome).

**FRY,** EDWIN MAXWELL (1899– ). English architect, prominent in the generation that saw the establishment in England of the international style of MODERN ARCHITECTURE identified with C.I.A.M. Trained at Liverpool University under Sir Charles REILLY, he has also practised as a town-planner. He was the partner of Walter GROPIUS during the latter's residence in England from 1934 to 1938. Fry's principal buildings in the 1930s were his flats at Kensal Rise (1936) and Ladbroke Grove (1938), London, and Impington Village College, Cambridge

(with Gropius; completed 1939). After 1945 he designed many educational buildings in Nigeria and the Gold Coast, working with his wife, Jane Drew. He was senior architect, in collaboration with LE CORBUSIER, at Chundigarth, the new capital city of the Punjab, 1951-4.

**FRY,** ROGER ELIOT (1866-1934). English critic and painter. After taking a degree in science he took up painting and then turned to criticism. He was art critic of the *Athenaeum* in 1901, was with the Metropolitan Museum of Art, New York, 1905-10, and he was also editor of the *Burlington Magazine*. Up to this time his criticism was orthodox and his edition of *Reynolds's Discourses* (1905) contained little to shock academic opinion. In 1906 he 'discovered' CÉZANNE and became the ardent champion of modern French schools of painting, introducing the POST-IMPRESSIONISTS to Great Britain by exhibitions which he arranged at the Grafton Galleries in 1910 and 1912. From this time his critical writing was aligned with the aesthetic attitude which assigns pre-eminent importance to the plastic qualities and formal relations of visual art.

In 1913 he founded the OMEGA WORKSHOPS for the production of well designed objects of daily use instead of the pretentious and 'arty' objects which were then the fashion. He founded and supported the LONDON GROUP. As a painter himself he developed a careful but uninspired naturalism within the general style of the Blooms-bury group of painters.

Fry was a brilliant teacher and lecturer. As a critic it has been said of him by Sir Kenneth Clark that: 'In so far as taste can be changed by one man, it was changed by Roger Fry.' After being rejected by Oxford for the Slade Professorship in 1910 and 1927, he was elected by Cambridge in 1933. His unfinished Slade lectures, published posthumously in 1939 as *Last Lectures*, stand out as one of the greatest works of criticism for breadth and perceptive-ness produced in Great Britain during the present century. His other writings on art and criticism are collected in *Vision and Design* (1920) and *Transformations* (1926). He wrote monographs on *Cézanne* (1927) and *Matisse* (1930).

228, 942, 945, 946, 2932.

**FUGA,** FERDINANDO (1699-1781). Italian architect, born in Florence, whose style was alternately influenced by BORROMINI and by the rise of NEO-CLASSICISM. He was Papal Architect from 1730 and his principal works were the rebuilding of Sta Maria Maggiore and its façade (1743-50), and the Palazzo della Consulta (begun 1734), both in Rome. He also worked in Naples and south Italy, building the Capodimonte porcelain factory, from 1772.

**FÜHRICH,** JOSEPH (1800-76). Austrian painter. He came at first under the influence of DÜRER, but his style and outlook were really shaped by his contact with the NAZARENES in Rome (1827-9), where he assisted with frescoes in the Villa Massimi. While Professor of Historical Composition in Vienna he executed many paintings and frescoes in churches and public buildings. He also did various biblical cycles in line engravings which gained him the nickname of 'the theologian with the pencil'.

**FULLER,** GEORGE (1822-84). American painter. In his youth he was an itinerant portrait painter in a meticulous and undistinguished style. In 1859 he retired to work his family farm in the Connecticut Valley and became an occasional painter in the poetic and dreamlike manner of the later ALLSTON. An exhibition of his work was received with considerable enthusiasm in Boston in 1876. His craftsmanship was defective and his crepuscular technique was amateurish but his pictures have a strange suggestion of visionary beauty which gives him a place in the tradition of American subjective mood-controlled painting (*Winifred Dysart*, Art Mus., Worcester, Mass., c. 1881; *The Tomato Patch*, Detroit Institute of Arts).

**FULLER,** ISAAC (c. 1606-72). English decorative and portrait painter, said to have studied in France with F. PERRIER. He worked in Oxford and then in London, painting for both churches and taverns. The larger-than-life self-portrait (Bodleian Library, Oxford, 1670) has a 'raffish pathos' and a bravura of technique which sets it apart. His murals included a *Last Judgment* in the chapel of All Souls College, Oxford, which was described by Evelyn, and mythological scenes for the Mitre Tavern, Fenchurch Street, but none of his decorative painting has survived.

**FUNCTIONALISM.** The theory that beauty results from or is identical with functional efficiency goes back to antiquity. In the *Memorabilia* of Xenophon (4th c. B.C.) Socrates is made to argue that human bodies and all things which men use 'are considered beautiful and good with reference to the objects for which they are serviceable'. Thus the same things may be both beautiful and ugly according to the uses to which they are applied. In the *Banquet*, also attributed to Xenophon, Socrates is made to ridicule the functionalist theory at least in connection with human beauty since it would lead to the absurd conclusion that he, Socrates, was more beautiful than the handsome Critobulus because his protuberant eyes commanded a wider angle of vision, his simian nostrils were better adapted to snuff the air, and so on. In the *Topica* (102ᵃ6 and 135ᵃ13) Aristotle discusses the definitions of beauty as 'the fitting' and 'the efficient for a good purpose', both with reference to Plato's *Hippias*

*Major* (293ᵃ6–294ᵉ10). Both these definitions belonged to the popular senses of the Greek word *kalon* and both have reappeared in modern times in more or less close connection with functionalist theories.

Functionalism was again discussed by 18th-c. writers on aesthetic matters. BURKE uttered a word of warning in *A Philosophical Enquiry into the Origin of our Ideas of the Sublime and Beautiful* (1757) when he wrote: 'It is said that the idea of a part's being well adapted to answer its end, is one cause of beauty, or indeed beauty itself. . . . In framing this theory, I am apprehensive that experience is not sufficiently consulted.' DIDEROT, however, succumbs. In his *Essai sur la peinture* (1765) he wrote: 'Le bel homme est celui que la nature a formé pour remplir le plus aisément possible les deux grandes fonctions: la conservation de l'individu . . . et la propagation de l'espèce. . . .' HOGARTH recognized that for useful objects fitness or efficiency is an important aesthetic quality. 'When a vessel sails well, the sailors call her a beauty; the two ideas have such a connection.' But he distinguished between beauty in the sense of something that is good to look at and beauty in the sense of functionalism. There is no reason to deny that perception of functional efficiency and the intricate adaptation of parts to purpose can be an aesthetic experience analogous to the appreciation of intellectual beauty in a philosophical or mathematical theorem. But visual beauty does not necessarily follow from it. A watch or electronic computer or an efficient organism need not be a visually beautiful object.

The concept of function entered the language of architecture at least as early as the 1840s, when Horatio GREENOUGH spoke in a letter to Emerson of the relation of form to function, and it was later taken up by Louis SULLIVAN, who in *Kindergarten Chats* (1901) originated the famous phrase 'Form follows function', which Frank Lloyd WRIGHT amplified as follows: ' "Form follows function" is but a statement of fact. When we say "form and function are one," only then do we take mere fact into the realm of creative thought' ('On Architecture' in *Selected Writings, 1894–1940*). Functionalism was preached as a new aesthetic creed after the First World War by LE CORBUSIER (*Towards a New Architecture*, 1927) and for a decade it became the rage. Le Corbusier defined a house as a machine for living in, in a phrase most reminiscent of the Socrates of the *Memorabilia* ('Should not he who purposes to have a house such as it ought to be contrive that it may be most pleasant and at the same time most useful to live in?') During the 1930s the word 'functional' was used to describe the severely utilitarian design for furniture and other domestic equipment which became popular partly as a result of BAUHAUS influence. In 1938 MOHOLY-NAGY could still say: 'In all fields of creation, workers are striving today to find purely functional solutions of a technical-biological kind: that is, to build up each piece of work solely from the elements which are required for its function' (*The New Vision*). But a word of caution and restraint had already been uttered in 1934 by Herbert Read, who declared: 'That functional efficiency and beauty do often coincide may be admitted. . . . The mistake is to assume that the functional efficiency is the cause of the beauty; *because* functional, *therefore* beautiful. That is not the true logic of the case' (*Art and Industry*). When applied in a literal sense to architecture the theory is inevitably misleading because although a main achievement of the modern movement in architecture (see MODERN ARCHITECTURE) has been to relate the design of buildings to the purpose they serve, in the design of any building there are many dimensional relationships which cannot be functionally determined; they are decided by the taste of the designer or the tradition in which he works, and on these the building's aesthetic qualities may well depend. Le Corbusier's own work was far from being a mechanical expression of function. By the mid 20th c. functionalism was orthodox doctrine as one element in the aesthetic basis of all practical and utilitarian arts, but it was no longer preached in a doctrinaire fashion as the ultimate or sole principle of beauty.

**FUSELI**, HENRY. JOHANN HEINRICH FÜSSLI (1741–1825). Painter, a native of Zürich, took holy orders in 1761 but never practised as a priest. He spent some time in Berlin, where his drawings from *Lear* and *Macbeth* impressed the British Ambassador, at whose suggestion he came to London in 1765. Here REYNOLDS encouraged him to take up painting, and he spent the years 1770–8 in Italy engrossed in the study of MICHELANGELO, whose manifestations of the SUBLIME he sought to emulate for the rest of his life. On his return he exhibited works of a character at once imaginative and grotesque, such as *The Nightmare* (1782) and *The Witches in Macbeth* (Shakespeare Memorial Theatre Gal., Stratford-upon-Avon). He was elected A.R.A. in 1788 and R.A. in 1790; and in 1799, following the example of BOYDELL's Shakespeare Gallery, he opened a Milton Gallery in Pall Mall with an exhibition of 47 of his own paintings. In the same year he was elected Professor of Painting at the ROYAL ACADEMY, and he became Keeper in 1804.

Fuseli's aspirations to the sublime tended towards the horrifying and fantastic, and he often attempted subjects of this kind on a scale which demanded a greater technical equipment than he possessed. His extravagant Germanic imagination and exaggerated Italian MANNERISM heralded the more undisciplined aspects of ROMANTICISM, which too deliberately exploited the horrific. The strong fascination exercised by many of his pictures appealed later to the imagination of the EXPRESSIONISTS and SURREALISTS. He was a friend and admirer of William BLAKE, whom he introduced to the mystical speculations

**139.** Study for Self-Portrait. Black-and-white chalk drawing by Henry Fuseli. (V. & A. Mus.)

of Lavater. His lectures to the Royal Academy, which were published, were influential, as was his translation of WINCKELMANN's *Reflections on the Painting and Sculpture of the Greeks* (1765). Among his pupils were numbered ETTY, HAYDON, LANDSEER, and CONSTABLE.

59, 954, 971, 1421, 1513, 1790, 2141.

**FUTURISM, FUTURIST.** An artistic movement with political implications founded by the poet MARINETTI in Milan in 1909. It sought to free Italy from the oppressive weight of her past, and glorified, in a series of exuberant manifestos, the modern world, machinery, speed, violence. The movement had its iconoclastic side, vociferating destruction against museums, libraries, academies, and other establishments. The painters Umberto BOCCIONI, Carlo CARRÀ, Luigi Russolo (1885–1947), Giacomo BALLA, and Gino SEVERINI publicly proclaimed their adherence to the movement in March 1910, following this a month later with a technical manifesto of Futurist painting, and Boccioni published a manifesto of Futurist sculpture in 1912.

A Futurist exhibition at Paris in 1912 was accompanied by a further manifesto which set out the theoretical bases of the movement. In 1910 the Futurists followed the colour techniques of the NEO-IMPRESSIONISTS, which Severini and Boccioni had learnt from Balla.

By the time of the exhibition the movement appeared as an attempt to infuse fresh dynamism into CUBISM and Carrà adopted the restrained tonalities of the Cubists. They aspired to bring art into closer contact with life, which they conceived as force and movement. They held that movement and light destroy the static materiality of objects, forms interpenetrate and objects fuse with their surroundings. Movement was to be rendered by simultaneous presentation of successive aspects of forms in motion or by 'lines of force' (cf. RAYONISM). But the Futurist doctrine of simultaneity differed from the more exclusively visual simultaneity put forward by APOLLINAIRE in 1911 in that the Futurists spoke of simultaneity of plastic states of the soul in artistic creation. The Futurists were also the first to advocate a new conception of picture space whereby the observer would be situated at the centre of the picture.

Although the number of professing Futurist painters had increased to some 500 by 1930, the active phase of the movement did not last much beyond the death of Boccioni in 1916 or the end of the First World War. It had considerable influence in Russia, however, both on the Rayonist movement and on Vladimir TATLIN, the chief figure in Russian CONSTRUCTIVISM before the PEVSNERS. The DADAISTS owed something to it, particularly in their noisy publicity techniques, and in England it had some influence on VORTICISM and C. R. W. NEVINSON. In France Marcel DUCHAMP and Robert DELAUNAY among others developed in their own ways the Futurist ideas about the representation of movement.

147, 319, 320, 1786, 2526, 2628.

**FYT,** JAN (1611–61). Flemish painter of STILL LIFE and hunting pieces, active in Antwerp. Like his master, Frans SNYDERS, Fyt painted in the elaborate style of large decorative still life which originated in the circle of RUBENS. After becoming a master in 1630, he travelled to Paris and Italy before returning to Antwerp in 1641, where he enjoyed a successful career. In his best work his colouring and finish are excellent and however various the multiplicity of miscellaneous objects he included in a canvas, he could achieve balance and refinement in the whole. Many of his paintings depict trophies of the hunt, dead stags, hares, and birds, all treated with a feeling for texture and detail akin to the manner of Dutch still life. The rare flower paintings by Fyt are exceptionally fine and more attuned, perhaps, to modern taste. Examples of his work are in many museums, including the Fitzwilliam Museum, Cambridge, and the National Gallery and Wallace Collection, London.

# G

**GABO,** NAUM (1890- ). Russian-born artist, brother of Antoine PEVSNER. He studied medicine and science at Munich 1909-14 and began to move in artistic circles, making friends with painters of the BLAUE REITER group, KANDINSKY and others. He took up sculpture in 1914 and in 1917 returned with Pevsner to Russia. There he took part in the formation of the CONSTRUCTIVIST movement with Pevsner and MALEVICH. From 1922 to 1932 he was in Berlin and taught at the BAUHAUS. During the 1930s he was in England and collaborated with Ben NICHOLSON in the publication of *Circle*, an international survey of Constructivist art. He went to the U.S.A. in 1946 and became an American citizen in 1952. He was a professor at Harvard 1953-4. Gabo has been recognized as the chief exponent of the Constructivist movement in sculpture and was distinguished for his constructs in coloured transparent plastics which inaugurated a new concept of sculptural space. He expounded his ideas on art in his Mellon Lectures delivered at the National Gallery of Art, Washington, in 1959 and published under the title *Of Divers Arts* (1962).

**GABRIEL.** Family of French architects connected with the Hardouin-MANSART family and with that of Robert de COTTE. JACQUES GABRIEL (1667-1742), architect, engineer, and town-planner, accompanied de Cotte to Italy in 1689 and on his return in 1690 was appointed Autre Architecte in the Department of Bâtiments du Roi. He was elected to the Académie in 1699, was made chief engineer of Ponts et Chaussées in 1712, and in 1734 succeeded Robert de Cotte as Chief Architect to the king. He was responsible for many houses in Paris, including the Hôtel Biron, and supervised the decoration of royal apartments at VERSAILLES. He planned the reconstruction of Rennes after the fire of 1720 and the Place Royale at Bordeaux. Other works in the provinces included the façade of the cathedral of La Rochelle and the Bishop's Palace at Blois. As engineer he built a number of bridges at Poissy, Charenton, Lyon, Blois, and elsewhere. According to contemporary accounts his talents lay in organization rather than artistic ability. During the earlier part of his career he could lean on LE PAUTRE, later he worked in partnership with Jean Aubert (d. 1741) and towards the end of his life collaborated with his son. ANGE-JACQUES GABRIEL (1698-1782), son of the foregoing,

was, unlike his father, a facile draughtsman and designer. He was admitted to the Académie in 1728, was made Contrôleur de Versailles in 1734, and succeeded his father as First Architect in 1742. He built the Opéra of Versailles, designed and began the Petit Trianon and drew up plans for a reconstruction of the palace which were prevented by financial difficulties from being put into effect. He also built the École Militaire (1751), the Place de la Concorde (1754), and carried out important works at the LOUVRE and at FONTAINEBLEAU. He also built the Bourse at Bordeaux. Ange-Jacques Gabriel was the last and one of the most sensitive masters of the French Classical tradition inaugurated by Jules Hardouin-Mansart, and his Petit Trianon has been regarded as the most purely 'Attic' gem of French architecture.

363.

**GABRIEL,** PAUL JOSEPH CONSTANTIN (1828-1903). Dutch LANDSCAPE painter who specialized in views of meadows, canals, and windmills. He was a pupil of the ROMANTIC painter B. C. KOEKKOEK and later had contact with the HAGUE SCHOOL, although he never was a member of that group.

**GADDI,** TADDEO (c. 1300-c. 1366) and AGNOLO (active 1369-96). Florentine painters, father and son. According to Cennino CENNINI (Agnolo's pupil), Taddeo was GIOTTO's godson and for 24 years his disciple. His best known works were painted for S. Croce, Florence: they are frescoes devoted to the *Life of the Virgin* in the Baroncelli chapel (finished 1338), the *Last Supper* (undated) in the refectory, and the panels illustrating the *Life of Christ* (c. 1330) originally meant for the doors of a sacristy cupboard and now scattered among museums in Florence (Accademia), Munich, and Berlin. In 1347 he headed a list of the best living painters compiled for the purpose of choosing a master to paint a new high ALTARPIECE for Pistoia Cathedral. Taddeo excelled as a narrative painter. Although transmitting the tradition of Giotto, he strove for vividly picturesque effects and met the popular taste for pictures full of episode and incidental detail.

Agnolo was brought up in the same Giotto tradition but modified still further the narrative manner of the trecento as in his frescoes in the chancel of S. Croce (after 1374) and in the chapel

of the Holy Girdle in Prato Cathedral (1392–5). His pictures are handsome tapestry-like decorations. Agnolo's cool pale colours, crisp swinging lines, and fantastic landscapes anticipate the more refined late GOTHIC art of LORENZO MONACO, his pupil, and Starnina (c. 1354–c. 1409). (See GIOTTESQUES.)

**GAÏLDE,** JEAN (active c. 1493–1519). French mason and sculptor who worked at Troyes in the early 16th c. His masterpiece was the screen in the church of the Magdalen, Troyes, which he made between 1508 and 1517, and beneath which he was buried. One of the last great GOTHIC achievements, it has all the traditional mason's skill, and is even more elaborate than that of Albi. Its very conservatism, however, and the confusion of its design betray the creative exhaustion of the Gothic tradition.

**GAINSBOROUGH,** THOMAS (1727–88). English painter of portraits, landscapes, and FANCY PICTURES, born at Sudbury, Suffolk. He went to London in 1740 and worked with the French engraver GRAVELOT, returning to Sudbury in 1746. In 1752 he set up as a portrait painter at Ipswich. His work at this time consisted mainly of heads and half-lengths, but he also painted some small portrait groups in landscape settings which are the most lyrical of all English CONVERSATION PIECES (*Heneage Lloyd and his Sister*, Fitzwilliam Mus., Cambridge). His patrons were the merchants of the town and the neighbouring squires, but when in 1760 he moved to Bath his new sitters were members of Society, and he developed a free and elegant mode of painting seen at its most characteristic in full-length portraits (*Viscount Kilmorey*, N.G., London, 1768). From Bath he sent pictures to the exhibitions of the Society of Artists in London, and in 1768 he was elected a foundation member of the ROYAL ACADEMY. In 1774 he moved permanently to London, where he further developed the personal style he had evolved at Bath, working with light and rapid brushstrokes and experimenting with a palette of delicate and evanescent colours, as in *Mary, Countess Howe* (Kenwood, London, 1774). He became a favourite painter of the Royal Family, and one of the masterpieces of his later years is *Queen Charlotte* (Buckingham Palace, London). Gainsborough sometimes said that while portraiture was his profession landscape painting was his pleasure, and he continued to paint landscapes long after he had left a country neighbourhood, often making imaginative compositions from studio arrangements of glass, twigs, and pebbles. He produced many landscape drawings, some in pencil, some in charcoal and chalk, and he occasionally made drawings which he varnished. These, like his paintings, have a spontaneity and mastery which place them in a category far above the conventional landscape sketches of most of his contempories. He also, in later years, painted fancy pictures of pastoral subjects (*The Harvest Waggon*, University of Birmingham, Barber Institute of Fine Arts, c. 1770; *The Cottage Door*, Huntington Gal., San Marino, California, 1780).

Gainsborough's early works show the influence of French engraving and of Dutch LANDSCAPE PAINTING. At Bath he very clearly owed his change of portrait style partly to a close study of van DYCK, and in his later landscapes (*The Watering Place*, N.G., London, 1777) he is sometimes influenced by RUBENS. But he was an independent and original genius, able to assimilate to his own ends what he learnt from others, and he relied always mainly on his own resources. While he had not the scholarship of REYNOLDS, nor any strong convictions as to the etiquette and status of his profession, he had a natural sense of style, a gift for painting, and an eye for character far surpassing any of his fellow Academicians. Even when he set out to paint the conventional portrait as a pot-boiler his delight in painting and his individuality won through. He is one of the few British painters whose work can take its place in the European tradition. Unlike most of his contemporaries he employed no drapery painter.

2799, 2874, 2928.

**GALILEE.** A chapel or vestibule at the west end of a church enclosing the PORCH, also called a narthex. It formed an important part of the elaborate 12th-c. west fronts, and examples survive at Durham, Ely, and Lincoln, where the galilee is on the west side of the south transept.

**GALLEGO,** FERNANDO (1440/5–after 1507). Spanish painter, considered the most important representative of the Hispano-Flemish style working in Castile during the latter part of the 15th c. His works include a retable of *San Idelfonso* in the cathedral of Zamora (c. 1467), reminiscent of the naturalism of BOUTS, a TRIPTYCH of *The Virgin, St. Andrew and St. Christopher* in the new cathedral of Salamanca, and in the Prado the *Piedad* and *Calvario*. Between 1479 and 1493 he was painting the ceiling of the Old Library in the University of Salamanca, but only fragments of the work survive in a poor state of preservation. FRANCISCO GALLEGO, perhaps the brother of the foregoing, active c. 1500, painted the *Martyrdom of St. Catherine* preserved in the new cathedral of Salamanca.

**GALLEN-KALLELA** (1865–1931). Finnish painter who began in a naturalistic vein with a sharp eye for the harshness of life and nature in Finland (*Old Woman with Cat*, Turku, 1885). But during the 1890s he turned to a more

abstract and linear style, and particularly with his series of paintings illustrating the *Kalevala* epic (Helsinki and Turku, 1866-1901), he was the pioneer of a nationalistic Finnish art. Both the decorative quality and the themes of these severe and moving works, painted on sacking, recall old folk-textiles.

**GALLERIES.** See MUSEUMS AND GALLERIES.

**GALLERY.** Term in Christian church architecture for an upper storey above the aisle. The gallery is also called *tribune*.

**GALLERY VARNISH.** In the early days of the NATIONAL GALLERY, London, when pictures were exhibited without glass, some of them were protected from the noxious effects of the atmosphere by layers of a preparation known as the 'Gallery Varnish', a mixture of MASTIC in turpentine with boiled linseed oil. The varnish at first imparted a warm golden glow which was thought appropriate to the Old Masters, but it soon darkened disastrously and became almost opaque. Gallery Varnish was roundly condemned by the Select Committee which reported on the National Gallery in 1853, but all the pictures which had been treated with it—among them masterpieces such as van EYCK's *Arnolfini and his Wife*—remained sealed in their dark-brown coating until the 1940s, when means were found of removing it.

**GANDON,** JAMES (1743-1823). English architect, a pupil of Sir William CHAMBERS, who with John Woolfe published in 1767-71 two volumes in continuation of Colen CAMPBELL's *Vitruvius Britannicus*, the second containing his own design for Nottingham County Hall. His chief works, however, are in Dublin, and include the Custom House (1781-91) and the Four Courts (1786-1802), both of which reveal an admiration for Sir Christopher WREN as well as the influence of Chambers, and are among the finest buildings of their generation.

965.

**GARDEN CITIES.** The Garden City movement began as a reaction against the overcrowded slum conditions that had grown up in English cities since the Industrial Revolution. Its prophet was Ebenezer Howard (1850-1928), a law-courts shorthand writer who spent his life developing and trying to interest the nation in his plans for a series of newly built towns that would offer a healthier and socially more desirable way of life than the huge urban conglomerations. He put his ideas forward in a book entitled *Tomorrow: a Peaceful Path to Real Reform* (1898). When it was reissued in 1902 its title was changed to *Garden Cities of Tomorrow*, by which name it is generally known. Howard's theories, inspired partly by those of Edward Bellamy (1850-98), the American social reformer and author of the Utopian romance *Looking Backward*, demanded self-contained towns, complete with industries and all educational, social, and recreational facilities, each one designed as a whole with a generous provision of gardens and parks and surrounded by a belt of open country. He advocated limiting their growth so that their inhabitants would always be near to work, shops, social centres, and the open country, and retaining ownership of all land, including the surrounding agricultural belt, in public hands.

Eight months after publication of the book a Garden City Association was formed to promote discussion of Howard's ideas and try to get them put into practice. Conferences were held at the two places in England, the Cadbury village of Bourneville and the Lever village of Port Sunlight, where for the more limited purpose of housing the workers of a single industry experiments had already been made with a similar type of decentralized planning.

In 1902 a company was formed to acquire a site and establish the first garden city, which led to the building first of Letchworth (begun 1903; architect-planners Raymond Unwin and Barry Parker) and later of Welwyn Garden City (begun 1919; architect-planner Louis de Soissons), both in Hertfordshire. These two garden cities—or at least the style of widely spaced cottage-housing contained in them—were soon being imitated throughout Europe, the ground having been prepared earlier in the century, especially in Germany, by the writings of Hermann Muthesius (1861-1927), who in his *Das Englische Haus* (1904) proclaimed the virtues of the informal, unacademic domestic architecture evolved by VOYSEY and others (see DEUTSCHER WERKBUND).

The garden city has subsequently had an immense influence on the layout and architectural character of residential areas in all parts of the world. It has not been a wholly good influence, because the emphasis laid on wide spacing and the exclusive use of cottage style have been largely responsible for the pattern followed in suburban housing estates which, since about 1920, have been destroying the shapeliness of towns and cities, cutting off the inhabitants of their central areas from access to the country and using up agricultural land that could ill be spared.

Though Letchworth and Welwyn remain the only garden cities in Britain communally owned in the full sense that Howard intended, the new towns started by the Government after the Second World War to draw off population from London and other overcrowded industrial areas were conceived and planned on the basis of his theories.

1373, 1979, 2156.

**GARDENS AS AN ART FORM.** The earliest authentic note of gardening for aesthetic as well as for utilitarian ends is in the brief tomb inscription of an Egyptian official, Methen, almost at the dawn of civilization in the Stone Age *c.* 2580 B.C.

Later wall-paintings in tombs, the remains of temples and houses, and the evidence of papyri, testify to the enduring love of gardens and the place they occupied in the lives of the richer Egyptians over the ensuing 2,000 years. The expectation of being able to return in spirit from the next world to the perpetual enjoyment of the gardens so greatly relished during life formed one of the consolations by which many Egyptians fortified themselves in the face of death. Royalty was not alone in enjoying gardens, as the remains of the houses of court officials and others testify at Tell-el-Amarna. There are records of expeditions to Somaliland for incense trees (Queen Hatsheput, c. 1505-1485 B.C.) and of campaigns in Syria yielding new plants for temple gardens (Thutmosis III, c. 1500-1450 B.C., and Ramses III, 1198-1166 B.C.). Such gains were the more valued because of the relative poverty of the flora of ancient Egypt. Plant breeding was unknown and the flowers of the Egyptians were all wild flowers. The lotus then served as the rose in later history, notably on social occasions. Together with other native flowers the lotus and the papyrus were prominent among the offerings to Amun, to Ra, and to Ptah. The often exquisite artistic sense of the early Egyptians found evident scope in the arrangement and display of flowers and in the design and adornment of their gardens, conditioned though they were by the imperative necessity of devising irrigation channels to keep their gardens alive. Egyptian garden design, like EGYPTIAN ART in general, seems to have adhered faithfully to one stylistic tradition, so they maintained the rectangular forms of their gardens with rows of trees along irrigation channels or pools or small lakes, also rectangular, adorned by lotus, papyrus, and ornamental waterfowl.

In other centres of early civilization few except royalty possessed hunting parks or gardens designed for aesthetic satisfaction. No other peoples enjoyed the long peace of the Egyptians, except the Minoans of early Crete. Evidence that gardens graced the palaces and mansions there has not survived, but it seems probable that flowers were grown in large pots set in the lightwells of Cretan houses before 1400 B.C. The Mesopotamian plains had ample water supplies but their inhabitants mostly lived shut up within walled towns in which a pleasure garden was a privilege enjoyed by few except the kings. Some, such as Merodach Baladan II (721-703 B.C.) of Babylon and Sennacherib (705-681 B.C.) of Assyria, record the new plants they brought back as booty from their bloodthirsty campaigns to grace the royal gardens. Late in Babylonian history the roof gardens or 'hanging' gardens of Nebuchadrezzar II (605-562 B.C.) survived in memory long enough to be listed by Greeks who had never seen them as one of the Seven Wonders of the World. When the Persian Empire won supremacy in western Asia (550-330 B.C.) its rulers developed hunting parks and plantations with perhaps sufficient flowers to give rise to the idea of the paradise garden of later biblical tradition.

The democratic equality in poverty of the Greeks, their constant wars, forced them to live crowded together within the protecting walls of cities in which water was as scarce as land, so there could be no question of gardens in Egyptian fashion. Dim folk memories of the splendour of Minoan and Mycenaean gardens of the second millennium B.C. have been detected in Homer's description of the garden of Alcinous, a mythical garden as was the Garden of the Hesperides, both of which, like the Garden of Eden, entered profoundly into folk memories of historical times. Yet the love of flowers was general in Greece. Garlands and chaplets of flowers, reserved for divinity in earlier times, became common in Sappho's day (c. 600 B.C.) when the rose of many petals seems first to have won the pre-eminence among the flowers of Europe which it has since retained. Flowers must have been grown on a commercial scale, but no details have survived. The first effort to beautify a city by planting trees seems to have been that of Cimon (c. 512-449 B.C.), who set out plane trees in the Agora at Athens. More notable was the garden of trees and shrubs set out round the Temple of Hephaistus in the Agora c. 330 B.C. The Academy of Plato (c. 429-347 B.C.) and the garden begun by Aristotle and continued by Theophrastus (between c. 335 and c. 285 B.C.), like the later garden of Epicurus (306-270 B.C.), wrongly said by Pliny later to have been the first garden within the city walls of Athens, were little more than grass plots with a few trees. The so-called Gardens of Adonis were a mere one-day religious observance in which Greek women set out a small pot containing a flower or plant. Apart from Xenophon's march of the ten thousand, it was Alexander the Great's conquest of Persia (334-323 B.C.) that gave many Greeks their first sight of large parks and gardens. Although the Greeks created AESTHETICS, they do not seem to have discussed garden art, but all the Greek manuals on gardening have been lost and their contents are unknown.

The Romans first created and popularized gardens in Europe. Like the Egyptians they had water and they had peace after they had conquered their empire. Of no other ancient people except the Egyptians can this be said. Unlike the Greeks and the Israelites, they had a traditional religious veneration and awe for groves of trees. They had the example of whatever the Greeks may have achieved in city-planning. Cato the Censor (234-149 B.C.) recommended that decorative shrubs and bushes should be grown but Pompey, almost 100 years later, was the first to plant trees in Rome as part of the layout for his new theatre. Roman gardens at this time do not seem, according to Cicero's letters (c. 54-43 B.C.), to have progressed beyond the attractive arrangement of trees, shrubs, and ivy along with pillars and Greek statues. Together with water in streams, pools, and fountains they

were and remained the essence of Italian gardens. The wealth of millionaires created the gardens of Lucullus after 64 B.C. and of Sallust after 44 B.C. on the Pincian Hill in Rome at the end of the Republic. During the early Empire, if not before, it is evident from the ruins of POMPEII and Herculaneum that ornamental gardens with trees, shrubs, and flowers set out in pleasant designs had begun to grace the peristyle interiors of larger country houses of the prosperous middle classes. Varro (116–27 B.C.), a friend of Cicero's, throws light on aspects of Roman gardening in his work on agriculture. He and Cicero's friend and rival, Hortensius, had extensive grounds outside Rome containing aviaries and semi-wild animals rather in the style of the 'paradise' gardens of the Persians. The most ambitious such 'paradise' was that of Nero, whose immense parks round his Golden House built in the very heart of Rome after the devastating fire of 64 B.C. was, for its time, as grandiose an achievement as the VERSAILLES of Louis XIV. Far too greedy a monopolization of valuable urban building land, it did not long survive its creator.

The *Natural History* of the elder Pliny is the most detailed source of information upon plants and their uses in Roman times, while two of the letters of his nephew, Pliny the Younger (*c.* A.D. 100), contain the only surviving detailed descriptions of the gardens of rich Romans. The latter seems to have been the first to refer appreciatively to the beauty of natural landscape and to distinguish it from the arranged beauty of the formal garden. The grateful shade of planes, cypresses, bushes cut into fancy shapes, ivy, fountains and running water, ample space to exercise at ball-games, to walk, ride, and drive amid grass, acanthus, and a few flowers—roses, violets, rosemary, and scented shrubs—were the main elements of Pliny's gardens. Pavilions, shelters, marble seats, and installations to facilitate eating outdoors in suitable weather were also provided, usually placed to afford varied views. By Pliny's day porticoes facing the garden were supplementing the peristyle enclosures of earlier times. It is evident from his letters that rich Romans enjoyed gardens at their country villas, such as the many around Lake Como where Pliny himself had more than one. The immense estate of the emperor Hadrian (A.D. 117–38) on the slopes below Tivoli is of course in a class apart. Such was the aesthetic satisfaction which the Romans got from gardens that when urban land became too valuable to allow space for them in the city window-boxes became common, while many an interior wall was adorned by realistic paintings of garden scenes. Apart from the old Campus Martius and one or two much shrunken groves, Rome had no notable public gardens beyond the Tiber in 44 B.C. In later imperial times gardens were set around some of the great THERMAE, the recreation centres and baths which became a central feature of everyday life. The private gardens of the emperor also grew by confiscation

and obsequious legacies to form a 'green belt' almost round the city.

The profound change in the way of life of many Romans which was brought about by Christianity made them take a new view of the pleasures of the senses and gardens may have been thought to be among them. The biblical tradition, especially the New Testament, had little to say about gardens, although in time the Garden of Eden, the rose of Sharon, and the lilies of the field replaced the garden of Alcinous in popular imagination. References to the gardens of Byzantium are so meagre that it seems plausible to believe that whatever there were, apart from the palace gardens, would have been mainly utilitarian. The new, other-worldly outlook may have combined with the advent of the northern nomadic peoples, who lacked a gardening tradition, to spell the doom of the gardens of antiquity in the 5th and 6th centuries. One tenuous link with them may be suggested in the cloister gardens of the early monasteries. Among the habitations of the devotees of the early Church would have been some large houses bequeathed by rich converts. Their peristyle gardens may have been maintained to provide flowers for the altar and healing herbs. The Rule of St. Benedict (*c.* A.D. 529) prescribes gardening as a monkish employment, but for purely utilitarian ends. In Gaul some pleasure gardens survived into the 5th and 6th centuries, as they are mentioned by Sidonius Apollinaris and Ausonius. There also gardens enclosed within fortified villas may, in time, have been the origin of the gardens in some medieval manors. The decline in garden art and the poverty of ideas about it is well revealed in the *Geoponica*, an agricultural and horticultural manual of *c.* A.D. 950.

While gardens were everywhere decaying in the West, they were being brought to new excellence in the East. The Persians and Arabs came to attach immense importance to them. With the Moslem faith fine gardens were spread to India by Babar (A.D. 1526–30) and to Spain by the Caliphate. Neither affected the still backward European civilization. Save for Marco Polo's occasional references, nothing was known of the gardens of China or the poetical and sensitive pleasures of the pine, bamboo, plum blossom, peonies, water, and rocks. Since 1000 B.C. Chinese civilization had been developing from the basin of the Yellow River to reach a heightened sensitivity far in advance of anything glimpsed in Europe before the RENAISSANCE and modern times. After the 6th c. A.D. much of the garden lore and art of the Chinese was copied and translated by the Japanese into their own idiom, largely under Buddhist influence.

When gardens as a form of art were revived in the West at the Renaissance it was not as an expansion of monastery gardens, nor in emulation of the gardens of the Arabs, the Moors, or the Far East, but in so far as earlier influences

were powerful as a conscious revival of the gardens of Pliny. The change was appropriately foreshadowed by Petrarch (1304-74) with his devotion to classical learning and his love for his gardens at Avignon. The revival fittingly came in Italy, where architects gave a new dimension to the luxurious villas they began to plan in the 15th c. by adding to them gardens of their own design. The construction of gardens was taken out of the hands of the men wielding the spade and the hoe and given to others for whom rational aesthetic satisfactions of proportion, symmetry, balance, light and shade meant more than giant asparagus tips, prolific roses, or beds of violets. The new, planned architectural gardens soon overshadowed the small medieval gardens which had been mainly utilitarian, mostly in the care of housewives who grew in them herbs and a very few vegetables for the kitchen. Walled castles and manor houses sometimes contained small, private, enclosed gardens for the ladies. This *hortus inclusus*, hedged around with painted trellis and provided with turfed seats, was usually graced by a few flowers: roses, violets, columbine, daisies, gilliflowers; little different from the wild flowers of the fields which in the Middle Ages were never more than a few steps from anybody's door.

When, in the 15th and 16th centuries the genius of RAPHAEL and MICHELANGELO and the talent and creative imagination of BRAMANTE or VIGNOLA could be harnessed to the task of garden making, the whole conception of what a garden might be was suddenly transformed. The surroundings of the fine new houses of rich men by the magic of their art were suddenly endowed with fountains, stone stairways, balustraded terraces set within an enchanting paradise of green and black shade under the strong Italian sun with cypresses, plane trees, box, and the fragrance of flowers and shrubs. Much was for public ostentation but within were often small, secluded, private gardens maintaining the tradition of the medieval *hortus inclusus*. Garden art was carried to new heights to become, with the equally sudden efflorescence of Italian painting, sculpture, printing, and other arts, the admiration and the despair of succeeding generations of imitators. The result of so much genius and talent in the gardens of Florence, of Rome, and many other places in Italy, the Villa d'Este at Tivoli, Caprarola, the Villa Lante, first revealed in modern times the full scale of the artistic and intellectual appeal of gardens. Human aesthetic experience was suddenly and rewardingly enlarged: not by the senses alone, through colour, scent, light, and shade, but also by intellectual qualities of form, proportion, symmetry, blending by design into a splendid harmony.

A BAROQUE decline in Italy from this high point was masked by the transfer of attention to France, where in the 17th c. Italian inspiration stimulated new endeavour. Directly inspired by Italian gardens, the French under Henry IV and Marie de Médicis created large new gar-

dens at FONTAINEBLEAU, Saint-Germain, and in Paris in the Tuileries and the Palais and Jardin du Luxembourg (1611-20). A succession of able French gardeners culminating in André LE NÔTRE carried garden art far beyond the medieval and Renaissance tradition of merely providing some pleasant embellishment immediately around the house. In addition new views were now planned on increasingly ambitious lines by taking charge of the whole surrounding landscape as it were and by opening vistas to command distant horizons. French garden design in the grand manner, intended for a northern landscape very different from that of Italy, was usually planned to give long views either down immense approaches planted as noble avenues of two or three rows of trees or along clearings in forests carrying the eye from the house to a far distance. At the back of the house a series of flower beds or parterres was laid out, often in intricate 'embroidery' designs, to catch and to retain the eye from the windows. Beyond were long stretches of grass, shrubberies, hedges, radiating avenues, sometimes of very tall clipped hedges of beech, hornbeam, or chestnut, graced with statues and again giving on to distant prospects. Water in large ponds, pools, or lakes, or in canals, was also essential and it yielded remarkable effects in fountains and cascades after Torricelli and others had developed a knowledge of hydrostatics. Flowers were not very conspicuous in these French gardens, and vegetables, herbs, and fruit trees were relegated or concealed. No gardens designed for wealthy, sophisticated aristocrats have exceeded the grandeur of the creations of André Le Nôtre, royal gardener to Louis XIV from 1637 to 1700. The gardens he planned and executed for the ill-fated Nicholas Fouquet's splendid new château at Vaux-le-Vicomte in 1656 were a prelude to the vaster garden landscapes of Versailles which remain his greatest achievement and the culmination of French garden art. Emulated on varying scales by other rulers—in Spain at Aranjuez and Granja; in Italy at Caserta; in Portugal at Queluz; in Hungary at Esterhazy; in Russia at the Peterhof and elsewhere—Le Nôtre's grand style of landscape gardening set the fashion for several generations. The formula had been devised in all its essential features by his predecessors, but his was the good fortune to be able to apply it and to develop it with courageous talent on a truly regal scale. Formality and intelligibility characterized much of the art of Louis XIV. Suitably amended and reduced in scale, it appeared also in the design of smaller gardens. The Dutch found the style congenial and it influenced the English also after the Restoration of 1660, and with the advent of Dutch William III in 1688. Charles II wanted to borrow the services of the great Le Nôtre, who sent plans for Greenwich and St. James's Park, but his actual presence in England remains not proven.

The vogue of the formal style in England did

not last long. Among the possible reasons for its decline were the growing formality of much of the English countryside as a result of the enclosure of common fields and the cultivation of waste lands; the hangover of medieval garden patterns with which formal parterres had some affinity; and above all that ingrained English love of nature, evident already in the poetry of Chaucer, of Shakespeare, and of 17th-c. lyricists such as Herrick and prose writers such as Isaac Walton. They did not write of gardens, but Francis Bacon had done so in a memorable essay of 1625 in which he specifically recommended that at least a third of a noble garden should be a wild garden. The influence of the grand scenes depicted by Nicolas POUSSIN and CLAUDE Lorraine swayed many who were able to see them, and their works formed a basis of the PICTURESQUE style. Whatever the reasons, the formal style of gardening became obnoxious to the new amateurs of 'taste' who were accepted by polite society as leaders of fashion during the early 18th c. Wordsworth in 1805 said that poets and painters had been responsible for the change. ADDISON probably did as much as any man to launch the new ideas, beginning in a much read and long remembered essay in his *Spectator* in 1712. He was soon aided by the powerful, acid wit of Alexander Pope. Together they poured scorn on the artificialities of the formal style of gardening. Echoing Sir William Temple, a generation earlier, Addison praised the Chinese for 'concealing the art by which they direct themselves', but neither he nor Temple had any real knowledge of Chinese garden art. Addison's emphasis upon 'the pleasures of the imagination' and the cultivation of good taste proved infectious. Here was the germ of that new ROMANTIC movement which was to revolutionize garden art years before it became manifest in painting and literature. 'Back to nature' was of its essence and the call began to win converts. Meanwhile, from early Elizabethan times onwards, the valiant efforts of intrepid plant-hunters who followed the trails of the explorers and travellers were quietly providing an ever growing stream of striking new plants, trees, and shrubs—the lilac, larch, tulip among them. Cultivated with loving care and skill, they began enormously to enrich the resources of the gardeners of England and Europe, providing, for example, colour and interest between October and March when older gardens had mostly been bare. It was not until later in the 18th c., however, that the desire for these novelties amounted to something like a passion.

In the second quarter of the century Batty LANGLEY, Charles Bridgeman, Sir John VANBRUGH, and William KENT—the last with the powerful patronage of the Earl of BURLINGTON—had begun the transformation of some of the old formal gardens of the aristocracy. A growing predilection for rustic, country scenes began to favour 'ornamental farms', of which William Shenstone's (1714-63) 'The Leasowes' in Shrop-

shire won most renown. The 'back to nature' movement gained momentum. A new reforming zeal swept away many old traditional gardens around country houses in favour of large landscaped parks. Flowers were virtually banished; avenues were felled; formal parterres were swept away; hedges and trellis work were rooted out; moats were filled in and water was impounded in artificial lakes with subtly curving green, mossy banks. Distant woods and copses disappeared while the cleared fields were planted out with clumps of trees sometimes so numerous that Horace WALPOLE said that they made lawns 'look like the ten of spades'. He had commended William Kent for having seen that 'all nature is a garden' and despite a somewhat critical appraisal, he defended Lancelot 'Capability' BROWN, who after 1750 came to the fore as the chief instigator of the new style. The English nobility spent lavishly to transform their estates and were ready to consider, but not by any means always to follow, advice. An exotic note was sounded by the effort of Sir William CHAMBERS to popularize his ideas of a Chinese garden, but it left little enduring trace except for the pagoda which remains among the curiosities of Kew Gardens.

Landscape gardening became an established profession in England when Humphrey REPTON sought to pick up Brown's lucrative practice after 1783. Meanwhile convergent contributions from painters, plant-breeders, and collectors, as well as from gentlemen searching for a satisfactory theory of aesthetics and an analysis of the essence of natural beauty, deepened both the interest and the perplexity of garden-planning. BURKE was widely read and other contributions included the poetry of Shenstone, Thomas Whately's *Observations on Modern Gardening* (1770), the works of Sir Uvedale PRICE, of the Revd. William GILPIN, Richard Payne KNIGHT, William Mason (1724-97), and Archibald ALISON.

The new 'English Garden', so keenly debated, became fashionable for a time on the Continent in France, Germany, and even in Italy, but Schiller was not alone when, in 1795, he hoped for 'a middle way between the formality of the French gardening style and the lawless freedom of the so-called English style'. Brown and especially Brown's followers, had gone too far, sometimes with results little short of disastrous. Uvedale Price annoyed Walpole, Repton, and others by pointing this out; but he was right, as Repton subsequently admitted in practice although he would never say so. Price's own brand of the picturesque was never defined clearly enough to win converts, but his dissatisfaction with Brown had a useful effect. A change was more or less forced on Repton, who found that he could do well by serving the rising number of the well-to-do upper middle class who were building pretentious villas around which might be no more than an acre or so of garden space. They wanted flowers and fruit

and a pleasant retreat, and for this Brown's formula made no provision. As the numbers of such people grew and as ordinary middle-class people swelled the ranks of suburban gardeners, the whole aspect of horticultural enterprise in England rapidly changed. Throughout the 19th c. it was powerfully stimulated by the arrival of new and exotic plants from North and South America, from Africa, and later in the century particularly from China and the Far East. That part of the globe had escaped the last Ice Age and its floral wealth, double that of the Western Hemisphere, presented the plant hunters with some splendid prizes. Before they had begun to pour into England, John Claudius Loudon (1783–1843) was in the thick of his herculean labours on behalf of British gardeners. Conventional adjectives of praise but poorly characterize the massive achievements of this giant of a man. He and his wife spent themselves with an intensity of industry and application in the service of gardening the like of which has not again been seen. At this time, partly to show off the new plants and partly because it seems to have accorded with contemporary taste, flowers returned to the gardens of England. Repton had helped, but now flower-beds were dotted about over lawns, sometimes cut into fancy shapes. Trellises and rustic arches abounded in what now seems appalling taste. Loudon called it the 'gardenesque' style. To grow all the chrysanthemums, moutan peonies, wistaria, dahlias, viburnum, and the many other attractive novelties offered by the now numerous commercial plant-sellers; to take account of all the new possibilities of garden design; to select tasteful garden ornaments from the competing welter of statues, figures, bird-tables, sun-dials, garden shelters, and so forth were tasks before which many enthusiasts came to grief. Slowly better canons of taste developed. A return to greater simplicity was perhaps inevitable. The man who did most to call for it was William Robinson (1838–1935), who had begun life as a gardener's boy in Ireland in the early days of Queen Victoria. In his *Wild Garden . . . with a Chapter on the Garden of British Wild Flowers* (1870) he struck a blow for a natural garden that had been among Bacon's recommendations in 1625. Robinson wanted to see traditional English flowers such as primroses, wallflowers, michaelmas daisies planted out in massed profusion. He won an early convert in Miss Gertrude Jekyll, who with the aid of Sir Edwin LUTYENS showed how the job could be done. She had herself converted several acres of a wild Surrey heath into just such a 'natural garden'. Herbaceous borders, often deeply planted, where lupins and hollyhocks backed up arrays of smaller, brightly coloured perennials, captured many a heart, while lawns were more frequent and more easily as well as better maintained thanks to the invention of the mechanical lawn-mower after 1830.

Thousands of middle-class dwellers in town and suburb with their little back-yards and small plots could not take Miss Jekyll for a model, much as they may have liked her garden. Within their limits they laboured to adorn their small domains with a degree and intensity of devoted labour which was nothing if not aesthetic in nature and purpose. A revived formalism such as that trenchantly advocated by Sir Reginald Blomfield in *The Formal Garden in England* (1892) was often more to their purpose than what he condemned as 'the vaunted naturalness of landscape gardening'. He found attentive readers in Germany and also in France, where after 1870 some of the great classical gardens were being restored such as those at Voisins, Vaux-le-Vicomte, Villandry, Champs, and others. Smaller German gardens, despite the good show of formal designs in successive horticultural exhibitions, retained more elements of natural, free garden growth along English lines than did the more mannered formalism of the French. The difficult climate of the east coast of America delayed gardening progress there and the great age of splendid American gardens did not dawn much before the 20th c.

The 19th c. saw a steady development of public parks and gardens. Robinson sought to excite the English to emulate the astonishing progress of the French during the Second Empire in beautifying Paris with parks and wide, tree-lined boulevards. Action was badly needed as the population explosion of the 19th c. condemned and immured people within the bricks and mortar of ever-expanding cities. Burke's uncared-for 'swinish multitude' had little prospect of escaping 'the filthy and depressing narrow streets of London', as Robinson fresh from Paris described them in 1868. Slowly more parks and open spaces were taken over in England and even more slowly improved. Flowers were a novelty in Hyde Park in 1860 when some were set down, crude in colour and stiff in arrangement. When relays of flowers began to be planted or 'bedded out' to ensure a succession of blooms, a sharp wail of anguish arose. Robinson protested and William MORRIS said that the practice made him sick.

By the mid 20th c. garden art had developed prodigiously, yet it remained predominantly and universally traditional in style at a time when all other visual arts were undergoing the tremendous revolutionary shake-up of the modern art movement. Some call began to be heard for a 'modern' garden style, more attuned to the functionalized life of factory workers and city dwellers. Some simplification began to be forced upon many garden-lovers because of the impossibility of getting sufficient help to continue the elaborate care and cultivation that a garden of any size demands. Grass replaced some flower-beds and concrete made inroads upon grass. The traditional Japanese 'flat garden' and gardens of sand, rocks, and stones seemed to offer another escape from the conventional English garden. But none of these novelties has excited general enthusiasm. The call to make gardens 'functional' and

'expressive of our age' has been heard without response, if only because its meaning has not been evident. Enthusiasm for gardens of the traditional type has, on the contrary, steadily mounted as is shown by the rising membership of the Royal Horticultural Society, the growing attendance at the flower shows which it and other local garden societies provide, and the work of the numerous societies devoted to the cultivation of a single species of flower, such as the rose or chrysanthemum. Every traveller through the English scene in summer is easily able to see sufficient gardens large and small from his railway carriage or automobile window to be in no doubt of the vigour of the enthusiasm which the English give to garden art. Gardening as 'a work of art using the materials of nature', in Repton's phrase, probably still remains the one form of active participation in creative aesthetic experience which is more universally shared and more generally relished, both for itself and its products, than any other form of artistic effort now within the reach of the masses.

301, 792, 1392, 1560, 1598, 2214, 2215, 2216, 2282, 2858.

**GARGOYLE.** A spout in the form of a grotesque figure, animal or human being, projecting from a CORNICE or parapet and allowing the water from the roof gutters to escape clear of the walls. Both the Greeks and the Romans employed spouts of a decorative nature in the form of foliage, palmettes, or masks. Gargoyles do not appear as a feature of ROMANESQUE architecture in Europe, but many examples on GOTHIC cathedrals and churches throughout the Continent bear witness to the lively imagination and spirited fantasies of medieval craftsmen. In the 14th and 15th centuries sculptures similar to gargoyles but not serving their function were used to decorate walls, and with the introduction of lead drain-pipes in the 16th c. gargoyles were no longer needed.

**GARNIER,** TONY (1869–1948). French architect. He was a pupil of the academic Julien Gaudet (1834–1908) and won the Prix de Rome in 1899 with a typically academic design for a national bank. He nevertheless became, with Auguste PERRET, a pioneer in the exploitation of reinforced CONCRETE with understanding of its aesthetic and technical potentialities and he was later known in France as the father of MODERN ARCHITECTURE. In 1901–4, when he was in his early thirties, he designed a project for a model industrial town (published in 1917 as *Cité Industrielle*) which despite academic survivals was hailed as revolutionary and did in fact anticipate some fruitful developments of modern TOWN-PLANNING. The smaller buildings of the project in particular constituted Garnier a forerunner of later developments in architecture. Although the project was designed for an ideal site as a theoretical exercise without any prob-

lems of an actual town in view, many of the ideas contained in it were later put into effect in his native town of Lyon, under the auspices of the enlightened Mayor Edouard Herriot, between 1906 and 1920. The major work was an enormous stockyard and abattoir with ancillary buildings for cold storage, power plants, etc. They also included the hospital centre of Grange Blanche (1915–30), the city Stadium (1913–16), and a residential district known as Les États Unis (1928–35). In 1931–4 he collaborated in the Town Hall of Boulogne-Brillancourt. His work shows an interaction between classical leanings and technical necessities and stands comparison with the industrial projects of such contemporaries as BEHRENS, POELZIG, and SANT' ELIA.

**GAROFALO,** BENVENUTO TISI (1481–1559). Italian painter. He studied in Cremona and after visits to Venice and Rome, where he came under RAPHAEL's influence, he settled in Ferrara. There he associated with DOSSO DOSSI and produced numerous paintings in a competent but unoriginal style, many of which may be found in Ferrarese churches (*Madonna del Pilastro*, S. Francesco). In 1550 he went blind. Among collectors, Garofalo once enjoyed the reputation of 'The Ferrarese Raphael' but his art is repetitious and sentimental.

**GAUDIER-BRZESKA,** HENRI (1891–1915). French sculptor, who studied in England and settled in London from 1911. His own name was Gaudier. He met Sophie Brzeska in Paris in 1910 and from 1911 used their joint names. In London he was a member of the circle which included Ezra Pound, T. E. Hulme, and Wyndham LEWIS. In 1913 he was a founder member of the LONDON GROUP and in 1914–15 of the VORTICISTS, contributing to *Blast* and to the Vorticist exhibition of 1915. He joined the French army and was killed in action in June 1915. Gaudier-Brzeska's early death renders it difficult to conjecture what his mature style would have been. His early work showed the influence both of current abstractionism and of Negro forms. Both as a sculptor and as a draughtsman he had great precocity and stood above the other members of the Vorticist group. His reputation has increased rather than diminished with the years. A retrospective exhibition was organized by the Arts Council in 1956–7.

803, 1657, 2139.

**GAUDÍ Y CORNET,** ANTONI (1852–1926). Spanish architect who worked chiefly in Barcelona, where he graduated in 1878 at the School of Architecture. His work is regarded as one of the most original and striking expressions of ART NOUVEAU in Europe and for its wealth of fantasy has sometimes been claimed as a precursor of SURREALISM. As a young man he was swept into the current Catalonian nationalist

**140.** Detail of spires from the church of the Sagrada Familia by Gaudi

neo-Medievalism which had been fostered by the aesthetician Milá y Fontanals, a follower of the NAZARENES, and while still a student he obtained practical experience as an assistant on the church of Montserrat. In 1878 he proclaimed his emancipation from traditional academic principles by the Casa Vicens, where certain of the details went back to ISLAMIC prototypes and his incipient use of naturalistic forms was apparent in the decoration of ironwork and painted tiles. The Palau Güell (1885-9) with its conical pinnacles and parabolic arched doorways also foreshadowed the development of an increasingly personal, 'biological' style. This develop-

ment is seen in the Casa Battló (1905-7) and the Casa Milá (1905-10), in which organic forms are no longer confined to decoration but intrude into the essential structure and freely curving lines, both in elevation and in plan, create an impression as if the stone had been soft and modelled like clay or wax. During this time he was engaged on what was to be his masterpiece, the church of the Sagrada Familia at Barcelona, a vast structure of cathedral dimensions (370 ft. × 280 ft.) which was begun by Francisco del Villar in 1882 to a Neo-GOTHIC design and taken over by Gaudí in 1883, remaining incomplete at the time of his death. In it religious symbolism combines with the fluid structural lines, undulating membranes, and conical spires which became characteristic of Gaudí's compositions, the whole encrusted by a mass of decoration incorporating abstract and organic elements in conjunction. The plastic fluidity and the fabulous riot of fantasy which characterized his mature style are to be seen in the Colonia Güell church and the Güell Park (both completed in 1914), where architecture takes on the characteristics of organic sculpture and where his early Islamic tendency has developed into a fantasy of ceramic and glass mosaic, in which he incorporated everyday objects and broken fragments in the manner of a Surrealist COLLAGE.

551, 588.

**GAUGUIN, PAUL** (1848-1903). French painter, born in Paris of a journalist from Orleans and a Peruvian Creole mother. He spent his childhood in Lima, joined the merchant marine in 1865, and from 1872 worked successfully as a stockbroker. In 1874 he met PISSARRO, saw the First Impressionist Exhibition and soon afterwards became a spare-time painter and sculptor and began to make a collection of IMPRESSIONIST pictures. In 1876 he had a landscape accepted by the Salon. He was invited to exhibit in the Fifth Impressionist Exhibition of 1880 and exhibited in the remaining three Impressionist exhibitions. His *Étude de nu: femme raccommodant sa chemise* was acclaimed by Huysmans in his review of the Sixth Exhibition. In 1883 he gave up his employment to become a full-time artist. During the next few years he was unsuccessful in marketing his pictures and sold his collection to support himself and his family. After the last Impressionist Exhibition in 1886 he settled in Brittany, first at Pont Aven and then at Le Pouldu, and became the pivot of a group of artists who were attracted by his picturesque personality and new ideas in aesthetics. In 1887-8 he went to Panama and Martinique and in 1888 he spent a short time at Arles with van GOGH, a visit which culminated in van Gogh's madness.

Gauguin was imbued with the *fin de siècle* yearning for the simple life of nature, idealized

**141.** *Bretonnes à la barrière.* Zincograph (1889) by Paul Gauguin

the PRIMITIVE and looked upon civilization as a disease. In 1891 he left France for Tahiti and in the book *Noa Noa* which he wrote about his life there he said: 'I have escaped everything that is artificial and conventional. Here I enter into Truth, become one with nature. After the disease of civilization life in this new world is a return to health.' His theory and practice of art reflected these attitudes. He was one of the first to find visual inspiration in the arts of ancient or primitive peoples (Javanese linear decorations, Pre-Columbian Peruvian pottery, etc.). He reacted vigorously from the realism of the Impressionists and the scientific preoccupations of the NEO-IMPRESSIONISTS. Freeing colour from its primary representational function, he used it in relatively flat contrasting areas which emphasized its decorative or emotional effect and he reintroduced emphatic outlines forming rhythmic patterns suggestive of Japanese colour prints or the technique of STAINED GLASS. He described his method *c*. 1887 as 'Synthetist-Symbolic', using the term 'symbolic' in the sense then current to indicate that the forms and patterns in his pictures were meant to suggest mental images or ideas and not simply to record

visual experience. By 'synthetist' he seems to have meant that the forms of his pictures were constructed from such symbolic patterns of colour and linear rhythms, built up from expressive distortions, and not either empirical or scientific reproductions of what is seen by the eye. Both the NABIS and the SYMBOLIST movements were formed under the inspiration of these new ideas, though after 1889 Gauguin himself repudiated Symbolism. Gauguin also did woodcuts in which the black and white areas formed rhythmical, almost abstract patterns and the tool marks were incorporated as integral parts of the design. He claimed to have revived the art of the woodcut, which had declined since it had had to compete with engraving in the 15th c.

In Tahiti Gauguin endeavoured to 'go native' and despite the constant pressure of poverty he painted his finest pictures there. His painting became more profound, the colours more resonant, and the drawing more grandly simplified. Amid the tropical world with which he identified himself and through his sympathetic contact with the primitive mentality his originality burgeoned and his art attained a new dimension of magnificence. He became interested in traditional Tahitian cults and native carving. In 1893 he returned to Europe but was back in Tahiti in 1895. At the end of 1897 he painted his great picture *D'où venons-nous? Que sommes-nous? Où allons-nous?* (Mus. of Fine Arts, Boston) before attempting suicide. In September 1901 he settled at Dominica in the Marquesas and was at last free from financial worries through a regular stipend paid by the dealer Vollard in return for pictures. During his first residence in Tahiti he wrote: 'Primitive art comes from the spirit and makes use of nature. So-called refined art proceeds from sensuality and serves nature. Nature is the servant of the former and the mistress of the latter.' Some critics have thought that he never again completely captured his first contact with the primitive spirit. But until his death he worked continuously in face of poverty, illness, and lack of recognition.

The First Salon d'Automne in 1903 included a Gauguin Memorial Exhibition, which laid the basis of his future reputation. The First POST-IMPRESSIONIST Exhibition held in London in 1910–11 contained 41 paintings by Gauguin, which were ridiculed by *The Times* along with the paintings of van Gogh and MATISSE. A large exhibition of his work was held at the Wildenstein Galleries, New York, in 1936. Both for the intrinsic quality of his achievement and for the influence which he has had Gauguin stands out as one of the most significant figures in modern art. Because of the romantic appeal of his life and personality Gauguin has been with van Gogh the most common subject for popular and fictional biography, including the story *The Moon and Sixpence* by Somerset Maugham.

**142.** *Noa Noa.* Woodcut (*c.* 1893) by Paul Gauguin. A variation of this design was applied as a colour monotype on the fly-leaf cover of Gauguin's autobiographical book *Noa Noa* (1901)

91, 364, 689, 984, 985, 986, 987, 1080, 1126, 1140, 1195, 1243, 1244, 1697, 1874, 2059, 2224, 2882.

**GAULLI,** GIOVANNI BATTISTA. See BACICCIA.

**GAVARNI,** pseudonym of SULPICE GUIL-LAUME CHEVALIER (1804-66). French CARICATURIST. After passing his adolescence as an industrial draughtsman he spent three years wandering in the Pyrenees and drawing from life. In 1828 he returned to Paris, where he earned his living with drawings of costumes for dress-makers and the theatre. In 1830 he joined the journal *La Mode*, and from 1831 contributed to *L'Artiste*. He began to publish GENRE pieces in the early 1830s (*Loge à l'Opéra* in *La Mode*, 1831), but it was not until 1837, when he began to contribute to *Charivari*, that he specialized in the humorous drawings of social manners for which he is famous (*Fourberies de Femmes en Matière de Sentiment*, 1837-41; *Les Débardeurs*, 1840; *Le Carnaval*, 1846). From the time of his visit to England (1847-51), where he studied the life of the poor in London and graphically con-trasted it with that of the rich (*Gavarni in London*, 1849), the benign irony of the earlier works gave way to a more trenchant satire with political implications, embodied in the character of Thomas Vireloque (*Les Propos de Thomas Vireloque*, 1851-3), of whom Théophile Gautier said 'this tatterdemalion of the hedgerows, how-ever limited his outlook, sees life with an eye as penetrating, as profound and cynical as Swift or Voltaire'. It has been said that much of Gavarni's work, at any rate from 1837, is not caricature at all but comedy of manners, as is that of LEECH and du Maurier, only stronger and more salacious. He depicted the miseries of the 1840s before the socialist conscience had become alert to them. He lacked the genius of DAUMIER as an artist, but as a satirist of French bourgeois life he has few equals. His work was admired and collected by many writers and artists, among them DEGAS.

1096, 2499.

**GEDDES,** SIR PATRICK (1854-1932). Scottish sociologist and planner on whose ideas many of the principles of contempory TOWN-PLANNING are founded. Leading town-planners, including Raymond Unwin, Lewis Mumford, and Sir Patrick ABERCROMBIE, began as his disciples. Geddes studied biology under T. H. Huxley, but gave it up owing to failing eyesight and turned philosopher. In 1892 he acquired the Outlook Tower, Castlehill, Edinburgh, where he established 'the world's first socio-logical laboratory'. While earning his living as Professor of Botany at Dundee (until 1919) he studied civic design and town and regional planning, and made the Outlook Tower an inter-national centre of research and propaganda. He advocated social surveys as the basis of all good planning, and opposed the ruling conception of town-planning as the laying down of street patterns. His philosophy was based on the whole-ness of life and the key role played in it by environment. Arising from this was his con-cept: Place—Work—Folk, a rediscovery of the Le Play formula, which he made famous. From 1919 most of his time was spent in India, where he was Professor of Sociology at the University of Bombay (1920-3) and made planning reports on many regions at the invitation of princes and governors. The views put forward in them, especially those on village planning and housing, were too far in advance of their time to be often acceptable. In 1904 he had published his book *City Development* and in 1911 had devised a Cities and Town-planning exhibition in portable form, which was shown in Britain, the Continent of Europe, and India, bringing his ideas for the first time before large numbers of people. On his death an Outlook Tower Association was formed to publish his writings and propagate his beliefs.

**GEERTGEN TOT SINT JANS** (*c.* 1460-*c.* 1490). Dutch painter born in Leiden but active in Haarlem, probably the pupil of OUWATER. His name means 'Little Gerard of the Brethren of St. John', after the Order in Haarlem for which he worked. For the monastery church of the Brethren he painted a recorded ALTARPIECE of which two large panels (originally two sides of a wing) survive in Vienna, the *Lamentation of Christ* and the *Burning of the Bones of St. John the Baptist*. Both scenes show Geertgen's ability to set his strongly coloured figures in convincing depth against a superb landscape background, with each character defined as an individual. The whole scene is unified by the well modulated light. The female figures in the *Lamentation* scene are slender and doll-like, the best known characteristic of Geertgen's style, and typical of his small *Madonna* panels (London and Rotterdam). These, and his other rare paintings, are all un-documented works attributed on grounds of comparison with the Vienna pictures, and prob-lems arise in such comparisons because of the very different scale of the documented panels and the near miniature attributions in some cases. Only about 15 paintings are attributed to him today. The *Holy Kinship* (Rijksmuseum) shows the Holy Family in the interior of a church, recalling Ouwater's setting of the *Raising of Lazarus*. Even among the playful children and colourful detail, Geertgen's typical feeling of sad introspection shows in each face and so per-vades the whole scene. It is interesting to think that Geertgen's sole documented work, the remarkable panels in Vienna, might well have been in England now, as they were presented to Charles I by the Dutch, but they were sold under the Commonwealth and so passed to the Habsburgs.

926.

**GELDER,** AERT DE (1645–1727). Dutch painter of Dordrecht who became the pupil of Samuel van HOOGSTRATEN and then *c.* 1661 entered the studio of the aged REMBRANDT in Amsterdam. He settled again in Dordrecht—it is not known when—and there he probably furnished HOUBRAKEN with material for the biography of Rembrandt the latter published in 1718. De Gelder was one of Rembrandt's most talented and imaginative pupils, and although he transformed his dark palette into the light one favoured by 18th-c. artists, he remained a faithful admirer of Rembrandt during his long life.

1666.

**GEMMAUX.** The product of a new medium, related to MOSAIC and STAINED GLASS, and developed in France from 1938 onwards by the painter Jean Crotti with the help of the inventor Roger Malherbe and his family. *Gemmaux* are composed of splinters of coloured glass, of which 500 to 600 shades are available, which are built up in layers to produce the desired tones. The complete *gemmail* may be displayed against the daylight or lit artificially from behind. It is important that the light should shine through and be infused into the colours. Though the *gemmiste* may work from an original CARTOON, he usually follows a known painting; and PICASSO and BRAQUE among others have welcomed the reproduction of their works in this medium.

**GEMS.** Engraved gems are either *intaglios*, with the design cut into the stone, or *cameos*, with the design in relief; cameos may, and often do, use the stone's colouring to differentiate the design from the ground, and even to achieve elaborate naturalistic colour effects, but this is not an essential qualification of a cameo. Three qualities have ensured the popularity of gems for 7,000 years: firstly the beauty of the stone itself, secondly the skill and delicacy of their workmanship, and thirdly the superstitious belief in their magical properties. To this one may add the utility of intaglios as seals. The same qualities have been an artistic disadvantage: the love of adornment and the ostentatious display of wealth characteristic of the late Roman Empire were satisfied by unengraved stones, skill in craftsmanship led some RENAISSANCE artists into mere virtuosity, and aesthetic qualities were irrelevant to magical power. By the 17th c. crests and coats of arms of little artistic value were found to be the most suitable subjects for seals.

The hardest stones of all, the corundums such as rubies and sapphires, have occasionally been used and even very rarely the diamond. But the most popular have always been the varieties of silica, ranging from the transparent rock-crystal, through amethyst, chalcedony, sard, cornelian, and the jaspers, to the onyxes with their different coloured strata so well suited for cameos. The softer steatite and haematite were favoured in technically primitive periods. Although shells are not strictly gems it is convenient to include them, and to remember also that glass, besides being engraved in much the same manner as gem-stones, has been used since Cretan times to make cheaper reproductions; this art reached its height in the 17th c. when artists such as James Tassie (1735–99) made sets of reproductions of famous gems.

The earliest tool for working gems was a splinter of a harder stone, preferably diamond. But as early as 2000 B.C. drills were introduced, and these were gradually developed, the elementary bow-drill being replaced by the treddle and later by water-power, and the diamond-point was reserved for details. Drills and wheels do not cut, but are fed with diamond-dust mixed with oil which slowly abrades the stone.

The belief in the magical properties of stones has a long history, but was probably most prevalent in the Middle Ages, when not only the ignorant but men such as St. Thomas Aquinas subscribed to it. It was common in antiquity, and by the 2nd c. A.D. the Gnostic sects produced quantities of so-called 'Abraxas gems'. The stone itself was thought to have power—the amethyst, for instance, derives its name from Greek words describing its supposed ability to prevent intoxication. But this power was increased by an appropriate engraving.

The earliest known gems are the cylinder seals made in Babylon about 4000 B.C. The practice spread throughout the Middle East, the gems being nearly always pierced and either set in rings or suspended from the body as amulets. The Egyptian form of the SCARAB, their sacred beetle, with the design engraved underneath, continued to be used in early Greek and in Etruscan work, though the beetle had no significance in these cultures; it is even probable that the beetles carved in relief, or the other subjects which the Greeks sometimes substituted for them, were the forerunners of the cameo.

The Cretans produced gems of a different style, representing ordinary warriors as well as gods and rulers, and quite naturalistic animals.

The development of naturalism from the Archaic period in GREEK ART, when the first signatures are found, to the freer style of the 5th c. had its counterpart in gem cutting. Scenes from daily life as well as the heroic legends became increasingly popular. The best gems, such as those of Dexamenos, are clear and simple, with a remarkable sense of spaciousness. Engravers of the HELLENISTIC period achieved an almost perfect mastery of their medium without falling into mere virtuosity; they instinctively avoided cluttering their compositions with too many figures or carrying out a design on more than one or at the most two, planes. Cameos now first became general. Many Hellenistic engravers are known, but of the most famous, Pyrgoteles, who, like LYSIPPUS and APELLES in their respective arts, alone had the

privilege of portraying Alexander the Great on gems, no certain works have survived.

In Italy the ETRUSCANS imported gems and probably even engravers from Greece, and as a result Etruscan gems are hard to distinguish from Archaic Greek. This style continued in the Roman Republic, but the predominant school favoured the contemporary Greek style, and the so-called Greco-Roman gems of the early Empire are very close to the Hellenistic. The most famous artist was Dioscorides, who worked at the time of Augustus. By the 2nd c. a decline had set in with the lower standards of workmanship and artistic invention general in the late Empire. Bowls, cups, and other vessels carved from semi-precious stones and often richly decorated in relief were greatly treasured in Hellenistic and late imperial times. The *Tazza Farnese* (Naples) is a magnificent example of Hellenistic work from Alexandria (the *Portland Vase* in the British Museum is made of glass worked in a similar manner). Busts and statuettes were also carved in these luxurious materials. The taste for such things continued (cf. ROCK-CRYSTAL).

Most gem engravers moved with the seat of empire to Constantinople, and with the other so-called 'minor arts' gem-cutting, enamels, metal-work, and ivory carving flourished during the Byzantine period. The few Western gems of the Middle Ages are extremely crude, with the exception of the crystals of the CAROLINGIAN Renaissance. But numerous classical gems were known and many were donated to the church. These were often given a Christian interpretation, e.g. a group of Athena and Poseidon under a tree (Bib. nat., Paris) was converted into Adam and Eve, Jupiter with his eagle became St. John, and even a blatantly pagan Venus could be venerated as the Virgin.

A few medieval rulers such as the Duke of Berry owned private collections, but the great period for collecting was the Renaissance, and among the most notable connoisseurs were Lorenzo de' MEDICI and Pope Paul II. Italy led the world not only in collecting gems but also in engraving them. Antique gems were a source of inspiration, though genuine Renaissance works are more vigorous and often more complex in style. One finds cameos of landscapes with figures such as those by Alessandro Masnago (second half of 16th c.), or crowded intaglios such as the *Education of Bacchus*, known as 'Michelangelo's Ring' (Bib. nat.). Milan was one of the principal centres of gem engraving, and, as in so many of the near-industrial arts, north Italy produced the leading artists, who worked not only in the rest of Italy but also abroad, e.g. Jacopo da Trezzo (*c.* 1514-89) in Spain, and Gian Giacomo Caraglio (*c.* 1500-65) in Poland. Masnago and several of the Miseroni family served Rudolf II of Austria, and Matteo del Nassaro (1515-47 or 48) founded a flourishing school in France, already known for its shell cameos. The Frenchman Julien de Fontenay

(active 1590-1611) may have come to England; but though Thomas Simon (1623-65), better known for his medals, did practise the art, it did not flourish here.

Most 17th-c. gems are insignificant, and were made for decorative uses such as mounting in goldsmiths' work. The first half of the 18th c. saw some good work by Johann Lorenz Natter (1705-63), Jacques Guay (1711-93) (a protégé of Mme de Pompadour), and others. The Classical Revival towards the end of this century saw a sudden antiquarian interest in antique gems. This is not hard to understand when we remember that these small durable objects provide some of the best preserved examples of classical art; in fact, since classical engravers not infrequently copied contemporary statues and paintings, the gems may be our best evidence for the appearance of a vanished or mutilated masterpiece. Collectors vied with each other, and friendships might be severed over a dispute as to the genuineness of a treasured acquisition. Naturally many contemporary engravers were prepared to supply 'antiques' to meet the great demand; as in the Renaissance, antique gems were re-worked, classical signatures forged, and new fakes carved. But there were highly accomplished artists working all over Europe, such as the Pichlers (Anton, Giovanni, and Luigi) in Italy and Austria, Pistrucci in Rome and London, Burch, Marchant, and William Brown in England, and Jeuffroy and the Simons (descendants of Thomas) in France.

This revival did not last beyond the middle of the 19th c. and since then the art has virtually died out. Gems do not show up well in museums, for they need to be examined and handled at leisure, not peered at awkwardly through the top of a glass case. Neither magic nor craftsmanship is popular today, and we prefer our gem-stones cut plain; even shell cameos, produced commercially in Rome and Naples since the last century, have now sunk to the level of costume jewellery.

121, 951, 997.

**GENRE.** Term in art history and criticism for paintings depicting scenes from daily life, especially the type of subject matter favoured by Dutch 17th-c. artists. The term 'genre' did not become current until the middle of the 18th c. and even then its meaning was wider than now. It was used in France by critics such as Wattelet and DIDEROT to describe painters who specialized in one particular branch or kind (*genre*) of picture such as flower or animal subjects. It gained recognition when GREUZE was admitted to the French Academy in 1769 as a *Peintre du genre*, a specialist in the type of 'moral' subjects from middle-class life which he had brought into vogue. Since the other specialisms, notably LANDSCAPE and STILL LIFE, already had a label, it was perhaps natural that the term was gradually confined to paintings that could not be otherwise

pigeon-holed. In RUSKIN, for instance, the meaning is still fluid, but in Jakob Burkhardt's lecture on *Netherland Genre Painting* (1874) it is the same as that current today.

This meaning permits us to describe such heterogeneous objects as Egyptian tomb paintings with scenes of harvesting, Greek vases with practising athletes, Chinese scrolls with travellers or shepherds, and the triumphant tractor drivers of social realism, indiscriminately as genre. It is more helpful, however, to remember the origin of the label and to confine the term to a 'kind' of painting produced by a specialist for a particular 'kind' of taste. We hear of at least one such specialist in classical antiquity. PLINY (*Nat. Hist.* XXXV. 37) mentions the painter Piraeicus among those who were famous for technique in a minor style of painting. He painted genre subjects in the Dutch style, specializing in barbers' shops and cobblers' stalls, asses, viands, and the like and was dubbed *rhyparographos*, painter of low-life subjects. Pliny adds: 'in these however he gives exquisite pleasure, and indeed they fetched bigger prices than the largest works of many masters.' The ghost of this artist, by whom no work is extant, has haunted the history of genre ever since. Genre scenes were also popular in the south Italian painting of Roman times. They included both aristocratic and plebeian themes, scenes of home and family life, market and street scenes, theatre subjects, and the like. They were done both in the exquisite and artificially elegant Neo-Attic style and in the more lively caricatural Campanian manner. Examples of the former are the famous *Knuckle-Bones Players* from Herculaneum (Mus. Naz., Naples) and a series of panels on the walls of the Triclinium of the Imperial Villa at Porta Marina, Pompeii. The lively popular type of genre subjects were executed both in mural and panel painting and in mosaic. They are exemplified by a mosaic of *Street Musicians* by Dioscourides of Samos from the Villa of Cicero, Pompeii, by the *Cave Canem* mosaics (Mus. Naz., Naples), the *Baker's Shop* wall-painting from Pompeii (now transferred to panel and in Mus. Naz., Naples).

In later European painting genre was long frowned on by academic critics, and when the term came into use in the 18th c. it was quickly fastened as a derogatory label on the Netherlandish specialists of peasant scenes from Pieter AERTSEN to Pieter van LAER, whose small humorous scenes of low life painted in 17th-c. Rome were popular with collectors but despised as *bambocciate* (childishness) by the upholders of the GRAND MANNER.

It was not only the literary and learned tradition that led to this antagonism. Italian painting had always excelled in religious and historical subjects on a heroic scale, and shunned the trivial and minute. It is true that the VENETIAN SCHOOL in the 16th c. cultivated the PASTORAL and such topics as concert parties or a woman with a mirror, but even these paintings were usually connected with some religious or allegorical theme. The excursions into genre made towards the end of the 16th c. by the CARRACCI and CARAVAGGIO may themselves have been a response to the challenge from the north.

The predilection of northern European art for realistic scenes from daily life can be traced to medieval tradition. The term 'realistic', though, must be qualified; what we find, in literature no less than in art, is not a scientific interest in real life as such nor what was later known as 'social realism', but rather the humorous detachment of the prince or feudal lord for whom the 'clownish villain' was a figure of fun and only the court the seat of elegance and beauty. To characterize the rich gamut of these social types (familiar to the student of literature from Chaucer) the GOTHIC artists of the late Middle Ages developed all the resources of realistic observation. DROLLERIES and MISERICORDS are rich in incidents alluding to comic types, and *fabliaux* and didactic cycles, such as the OCCUPATIONS OF THE MONTHS, the DANCE OF DEATH, or illustrated Proverbs, gave ample scope to this tendency. The growing mastery in the rendering of texture and surface developed by the van EYCKS, moreover, tempted the artists to a display of skill. Both Jan van Eyck and Rogier van der WEYDEN are reported to have painted secular subjects such as a bathing woman.

The combination of this pictorial realism with the didactic tradition may be the work of Hieronymus BOSCH, certainly the first 'specialist' who acquired a European reputation for a particular genre. Many of his enigmatic paintings—the *Haywain*, the *Ship of Fools*—may be interpreted as satirical sermons in which the peasant and the down-and-out are made to symbolize the vices and follies of mankind. When the Reformation in the north curtailed the demand for religious painting, the display of virtuosity for connoisseurs and the castigation of folly were the principal domains (apart from portrait painting) left for the painter. The kitchen and market scenes of Pieter Aertsen represent the first aspect, the great art of Pieter BRUEGEL the Elder the second. It was Bruegel, above all, who turned the weird types of Bosch into living beings and set the key for genre with his realistic peasant scenes painted for sophisticated town-dwellers. No less an artist than RUBENS admired Bruegel and paid tribute to him in the famous *Kermesse* in the Louvre. It was in his aura that BROUWER developed the lasting type of the small, brilliantly painted scene from low life with his brawls, his smokers, and his topers. TENIERS (father and son) exploited this vein with less vigour but more tact and the OSTADES transferred the subject to Holland. The history of genre in Holland in the 17th c. is almost the history of Dutch painting. Its gamut is so rich that the 'kind' splits up into any number of subdivisions. The tradition of virtuosity was cultivated by masters such as DOU and METSU with their closely observed and minutely painted figures, that of satire by Jan STEEN with his crowded

scenes at the village inn, sometimes illustrating a proverb. In the quiet art of TERBORCH or Pieter de HOOCH the last traces of condescension disappear and VERMEER van Delft transfigures his glimpses of domestic life into sheer poetry.

The remainder of Europe in the 17th c. had nothing to set beside these riches. The main energies of Caravaggio's naturalism still went into religious painting, though his *Soldier and Gypsy* and his *Card Sharpers* were frequently imitated by his followers. How far his conception of genre influenced the early VELAZQUEZ with his *Water Carrier* or MURILLO's endearing *Street Arabs* is still a matter of some uncertainty. Even more mysterious are the roots of the principal school of French genre in that century, the brothers LE NAIN whose grave and stolid peasants are so far removed from the Dutch merry-makers.

In the early 18th c. there was a revival of the satirical genre with TROOST in Holland and the new type of moral subject created by HOGARTH in England. While LONGHI in Venice and CHARDIN in France lovingly looked at simple scenes of middle-class life (*The Benedicite*), the name of GREUZE and the 'genre' of sentimental sermonizing he introduced with DIDEROT's approval brings us back to the origin of the term. GAINSBOROUGH's gipsy children take up the sentimental vein in England.

The 19th c. witnessed another efflorescence of genre painting, sometimes sentimental, coy, humorous, or satirical, in the anecdotal pictures of WILKIE and his French and German successors, many of whom enjoyed tremendous popularity but are all but forgotten today except for prints still hanging in old-fashioned boarding-houses. In contrast to this anecdotal illustration MILLET and COURBET raised the representation of the peasant and the worker to a new heroic dignity. The call for art as such, mirroring *la vie contemporaine*, raised by the GONCOURTS and the influence of Japanese prints of the UKIYO-E School, led to a new approach in IMPRESSIONISM which did away with the traditional compartmentalization of subject matters.

In England during the early decades of the 20th c. SICKERT in one of his artistic personalities was a master of genre, JOHN indulged in it, Dame Laura KNIGHT specialized in circus genre, while in the next generation there stand out Jack Smith (1928- ), and the 'kitchen sink' school exemplified by John Bratby (1928- ). But the most important developments in genre since the end of the 19th c. have taken place in the art of the film.

**GENTILE DA FABRIANO** (*c.* 1370–1427). Italian painter and one of the main figures in the GOTHIC revival of the 15th c. He was one of the Italian artists whose work was least local in character—he came to Venice in 1408 where he painted frescoes for the Doge's Palace (finished by PISANELLO and now lost), executed the ALTARPIECE of the *Adoration of the Magi* (Uffizi, 1423)

and the *Quaratesi* polyptych (1425, of which the *Madonna* is in the English Royal Collection, saints in the Uffizi, and predellas distributed in Rome and Washington) at Florence. He then worked in Siena and Orvieto and came to Rome in 1427, where he painted frescoes (destroyed in the 17th c.) for the Lateran Basilica. Among his pupils in Venice was Jacopo BELLINI. It is difficult to assess Gentile's place in Italian art since the major part of his work is lost. There seems no reason, however, to doubt the traditional view that he was the most accomplished exponent of the aristocratic and decorative INTERNATIONAL GOTHIC style.

1133.

**GENTILESCHI,** ORAZIO, properly ORAZIO LOMI (1563–*c.* 1647). Italian painter, who was born in Pisa but went to Rome before he was 20. He was one of the few artists influenced by CARAVAGGIO who had direct personal contact with him. Gentileschi developed a blander version of Caravaggio's mature style, using few figures clearly disposed and painted in cool colours with sharp-edged drapery—qualities also characteristic of Tuscan painting. Gentileschi's work lacks the force of Caravaggio's (*The Annunciation*, Turin, *c.* 1623). His transitions are less abrupt and his colour gradations more refined. He worked in Genoa 1621–3, and then for Marie de Médicis in Paris *c.* 1625 before being called to the court of Charles I in 1626, where he was held in great esteem and remained until his death. His decorations for the Queen's House at Greenwich (1635–40) are now, much damaged, at Marlborough House. *Joseph and Potiphar's Wife* at Hampton Court is a good example of the courtly version of Caravaggism which Gentileschi helped to disseminate throughout northern Europe.

ARTEMISIA GENTILESCHI, properly ARTEMISIA LOMI (*c.* 1597–after 1651), Orazio Gentileschi's high-spirited daughter, was born in Rome. She spent the years 1621–4 in Florence, and after 1630 settled permanently in Naples, where she was instrumental in popularizing a romanticized type of Caravaggism. Her bloodthirsty scenes (*Judith and Holofernes*, Pitti, Florence), are painted in disarmingly bright, clear colours. She visited her father in England in 1638–9, and a fine *Self-Portrait* is still at Hampton Court.

**GENTZ,** HEINRICH (1766–1811). German architect, mainly active in Berlin. In 1792 he was called by GOETHE to Weimar, where he built the banqueting hall in the castle in a restrained NEOCLASSICAL style.

**GEORGIAN STYLE.** A term loosely used for English 18th-c. architecture, decoration, furniture, and silver produced at any time during the reigns of the first three Hanoverian kings

(1714-1820. But see also REGENCY STYLE). Although the style had many phases, beginning with PALLADIANISM, and including the taste for GOTHIC, for the Chinese, and after *c.* 1770 for NEO-CLASSICAL art, almost all its products are characterized by good design and fine workmanship. William KENT and Robert ADAM had each in his day a profound influence on design, in applied arts as well as in decoration, and the importance of craftsmen's manuals, such as that produced by the cabinet-maker Thomas Chippendale, was great.

**GÉRARD,** FRANÇOIS-PASCAL-SIMON (1770-1837). French painter, pupil and later assistant of DAVID. In the Salon of 1796 he won a *succès de réclame* with his portrait of *Isabey* (Louvre) and became the most sought after court and society portraitist of his day (*Mme Récamier*, Louvre; *Head of a Boy*, N.G., London). He was made First Painter to the King and a member of the Institute, received a Barony and the Legion of Honour. After his position was established by his portraits he took up again historical paintings in the manner of David (*Battle of Austerlitz*, Versailles Gal.).

**GÉRARD,** JEAN-IGNACE-ISIDORE. See GRANDEVILLE.

**GERHAERT VAN LEYDEN,** NICOLAUS (active 1462-73). Sculptor whose name suggests that he was born in the northern Netherlands, though his work indicates that he was trained in a Burgundian workshop where Claus SLUTER's style was still predominant. There is evidence that he worked in Trier, Strasbourg, and Vienna. This is almost all that is known about one of the most unconventional sculptors of this period in northern Europe. None of his contemporaries captured the warm sympathy and humour that he gave to his religious figures and portraits.

2847.

**GÉRICAULT,** JEAN LOUIS ANDRÉ THÉODORE (1791-1824). French painter of outstanding originality, who is usually regarded as one of the founders of the French ROMANTIC School. He was born at Rouen but came to Paris as a boy and after studying for two years with Carle VERNET entered the studio of the academic painter Pierre Guérin (1774-1813), where DELACROIX also studied. At the same time he made copies of the Old Masters at the Louvre and developed a passion for RUBENS. From his youth Géricault was particularly interested in horses and racing, and he developed a brilliant and rapid execution capturing vividly the sense of movement. His picture *Light Cavalry Officer* (Louvre, 1812), painted when he was 21, was awarded the gold medal and its realistic treatment was regarded by the younger artists as a repudiation

of the conventions of the classical school of DAVID. He spent the years 1816-18 in Florence and Rome and there became an enthusiastic admirer of MICHELANGELO and the BAROQUE. On his return to Paris the picture for which he is most famous, *The Raft of Medusa* (Louvre, 1817), created a furore both on account of its realistic treatment of the macabre and because of the political implications. Exhibited also in England, the picture had a *succès de scandale* and Géricault himself spent the years 1820-2 in England, where he painted jockeys and horse races (*Derby at Epsom*, Louvre; painted without spectators and with the racecourse romantically pictured as a blasted heath). He conceived an admiration for the paintings of CONSTABLE and BONINGTON and was one of the first to introduce English painting to the notice of French artists.

In the 11 years of his tempestuous career as an artist Géricault displayed a meteoric and many-sided genius which never matured into a unified or settled bent. His fine disregard for the orthodox doctrine of conventional types, his Baroque exuberance, the sense of swirling movement and even his taste for the macabre all point in the direction of Romanticism. He was, at the same time, virile and inspiring in his realism (*The Mad Kidnapper*, Mus. of Fine Arts, Springfield, Mass.). His naturalistic treatment of horses in movement set a model which served both DEGAS and TOULOUSE-LAUTREC. One of his most original traits was his predilection for investing contemporary incident with epic massiveness and Baroque grandeur.

252, 571.

**GERM,** THE. The literary organ, in prose and verse, of the PRE-RAPHAELITE Brotherhood. It survived for only four numbers, January to April 1851. Its sub-title was *Thoughts towards Nature in Poetry, Literature, Art.* Its editor was W. M. Rossetti, and contributors included D. G. ROSSETTI, F. Madox BROWN, and Coventry Patmore. Original copies became very rare, but a facsimile edition with an explanatory preface by W. M. Rossetti was published in 1901.

**GERMAN ART.** The term 'German Art' embraces greater differences than 'French Art' or 'English Art'. Until the end of the 19th c. Germany lacked a central political authority which could impose its own taste as the French court did for centuries; furthermore what is geographically termed Germany is inhabited by peoples not only vastly different in temperament and outlook but also, since the middle of the 16th c., of different religions: the south and west upheld the Catholic faith whilst the north went over to Protestantism. Neither the Rhine in the west nor the Alps in the south have ever been effective frontiers as far as art is concerned. The realm of Charlemagne spread along both banks of the Rhine and consequently CAROLINGIAN ART is claimed by German historians as the very

foundation of their own national art whilst their French colleagues have claimed it with equally strong arguments; throughout history the western parts of Germany show in any case strong links with France. The Alps on the other hand did not prevent INTERNATIONAL GOTHIC from reaching Austria or southern Germany and they were no barrier against either the RENAISSANCE or BAROQUE. For clarity's sake it seems best to treat as 'German Art' the developments which took place in that region which became politically Germany in 1871, though it will be necessary at times to discuss here what is also AUSTRIAN ART, Swiss art, and SCANDINAVIAN ART.

From the art historian's point of view the Roman occupation is the first important fact to be noted. The west and south, up to a line roughly coinciding with the Danube and the hills flanking the right bank of the Rhine, were Roman provinces. Important settlements developed, e.g. at Trier and Cologne, and Carnuntum in Austria. Finds from these and other places include not only provincial sculpture and pottery but also metropolitan imports. In many cases—Cologne is an example—the plan of the Roman military camp influenced the later medieval town plan. A line of fortifications with a continuous ditch and wall—the *limes*—secured the Roman empire against the East. From the 4th c. onwards, however, as the Roman empire grew weaker, pressure on its frontiers increased and migrating Germanic tribes from the north and east finally overran it. This MIGRATION PERIOD produced its own art from traditional native elements, little influenced by ROMAN ART. The objects were small and mostly meant for personal adornment, such as brooches, fibulae, etc. The decorative patterns were strictly geometrical, the goldsmith's technique employed usually being highly intricate *cloisonné* work.

The latinized West settled down first under the Merovingian kings and Merovingian art combined elements of the Migration Period with the Mediterranean heritage. It was not until the political reorganization under Charlemagne at the turn of the 9th c., however, that monumental art and art of a more permanent character were once more produced. Carolingian art was a conscious renaissance of classical antiquity directed by the will of the emperor himself. Late classical manuscripts and ivories were used as models in the workshops and the octagonal ground-plan of the cathedral at Aachen was derived through Ravenna from the eastern Mediterranean. The fact that Charlemagne extended his empire to the east and that he moved his court from place to place helped to spread Carolingian art. Under his successors the empire was split into a western and an eastern part. For centuries, however, Germany went on taking its patterns from France and refashioning them. OTTONIAN ART was the first step in the development of ROMANESQUE in Germany. Imposing Romanesque BASILICAS such as Mainz, Worms, and Speyer were built. Monumental sculpture both in bronze and in stone began to appear, Hildesheim under Bishop Bernward (d. 1022) being the most important centre of bronze casting. Wall-painting covered the interiors of the churches, as remains on the island of Reichenau in Lake Constance still show. Here book illumination was also flourishing; the *Gospels of Otto III* (now in the State Library in Munich) are perhaps the finest example of the work done by the REICHENAU SCHOOL during the 10th c. when it enjoyed the patronage of emperors and archbishops.

Romanesque sculpture found its place in the porches of the churches, on the big crosses set high up in the choir arches and on the walls of choir-screens. The Meuse School of goldsmiths, from which came such important pieces as the *Shrine of the Three Kings* in Cologne Cathedral, gave its stamp to similar work all over Germany. Art during this period owed a great deal to imperial patronage, notably in architecture. When GOTHIC came to Germany in the 13th c. the central power had grown much weaker and was preoccupied with other problems. The church, and notably such reformed orders as the Cistercians, became the most important patrons. Gothic architecture, at first preponderantly French in character, gradually developed along national lines. Cologne Cathedral—of which only the choir and a portion in the west belong to the 13th c.—looks almost like a French cathedral on German soil—but Ulm and Freiburg are more independent. In the 15th c. in particular the mendicant friars in Germany as elsewhere created a new type of church, the HALL CHURCH, suited to their special needs. At the same time richly adorned spires were made the chief ornament of the structure of the great cathedrals, as at Strasbourg, Ulm, and Freiburg. On the north German plain the absence of stone led to a Gothic architecture in brick, the so-called BACKSTEIN GOTHIC, with churches designed on a large and massive scale, as at Lübeck and Danzig. Examples of it can also be found in the Scandinavian countries, whilst the colonizing work of the Teutonic Knights carried Gothic art to the Vistula and beyond.

The monumental heaviness of the late Romanesque statues in the choir of Naumburg Cathedral was succeeded by the greater agility and grace which is displayed by those in the south porch and Princes' porch of Bamberg or the west porch of Strasbourg. How much this sculpture still owed to French inspiration is shown by a comparison between the famous *Bamberg Rider* and the one at REIMS. Sculpture finally found a new field in the carved and painted ALTARPIECES which became the fashion from the early 15th c. onwards. Southern Germany in particular led in this field and wood-carvers of the early 16th c. such as Tilman Riemenschneider and Veit STOSS worked in this late Gothic tradition. Since a Gothic church

offered far less wall space than a Romanesque one, the importance of wall-painting declined, but the great number of large windows encouraged the development of the art of STAINED GLASS. PANEL painting, furnishing the many altars, now came into its own whilst book illumination declined.

The fact that the imperial court during the 14th c. was established at Prague had an important bearing on German art. There the PARLER family rebuilt St. Vitus's Cathedral. A BOHEMIAN SCHOOL of painting developed, inspired by French, Burgundian, and north Italian examples, and this kind of International Gothic in its turn travelled along the main routes linking Prague with the rest of Germany. We find traces of it in the north in Hamburg (MASTER BERTRAM), in central Germany, in Nuremberg, and as far south as the Tyrol. Its powerful influence was only superseded when during the 15th c. the more vigorous painting of Flanders, and in particular the School of Rogier van der WEYDEN, dominated German painting to such an extent that much of it might well be included in the FLEMISH School. SCHONGAUER at Colmar, the leading master in the Upper Rhine region at the end of the 15th c., was at one time even regarded as a pupil of Rogier. By this time the hold of the emperor had grown very weak and power and wealth were concentrated in the thriving merchant cities of the Hanseatic League. The domestic and ecclesiastical architecture of towns like Lübeck echoes the merchants' wealth and power. Their patronage of painting led to important local schools such as the School of COLOGNE or the School of Nuremberg. On the Upper Rhine the REALISM of the Flemish School found expression in a strong and vigorous style, with artists showing a keen eye for the beauties of nature. We can see its beginning in the work of Lukas MOSER and find it fully developed in that of Conrad WITZ, who worked mainly in Basel and Geneva.

At the same time there was a great change in religious outlook. The growth of mysticism and private devotionalism brought in their train not only new themes, such as the Pietà, but also new and cheaper forms of popular art for the general public, particularly the WOODCUT and a little later LINE ENGRAVING. These techniques were used too for popular broadsheets, and after the invention of printing the woodcut played an ever increasing role in book illustration. Basel, Ulm, and Nuremberg in particular excelled in profusely illustrated books. The influence of DÜRER was not restricted to fine art engraving but extended to popular work. (See GRAPHIC ART.) In the early 16th c. woodcut and engraving were the leading arts in Germany, at a time when GRÜNEWALD in his Isenheim Altar painted the last monumental Gothic altarpiece.

Dürer was also the first German artist who travelled to Italy to study the new art of the RENAISSANCE at its source. Hans HOLBEIN the Younger, who had been trained in a late medieval

workshop, likewise attained maturity through a journey to Italy. From the beginning of the 16th c. we find Italian forms spreading rapidly over Germany. Architecture was affected in a rather curious way. Church building was soon to be held up by the Reformation and such small buildings as there were continued on traditional lines; but in domestic architecture we find façades, walls, and ceilings overspread with often misunderstood Renaissance ornaments. The Residence at Landshut and the older parts of Heidelberg Castle are cases in point. Painters, notably in Augsburg and Nuremberg, begin to represent German burghers as if they were Venetian patricians, whilst the Fugger family at Augsburg emulated the MEDICI as patrons of art. Goldsmiths, notably in southern Germany, imitated Italian forms, also following such Italianizing ornamental models as those designed by P. Flötner, and sculptors such as the DAUCHERS and Peter Fischer the Younger introduced classical deities and with them classical nudity. Lucas CRANACH, when court painter to the Elector of Saxony at Wittenberg, painted whole series of pagan deities which combine a classical appearance with a strange northern clumsiness. Yet despite the Italianate character of German art at this period and its continuing subordination to the art of the Netherlands, credit is attributed to the so-called Danube School for at least a formal advance in the field of LANDSCAPE. The vogue for landscape, particularly in VENETIAN painting, had created a new and increasing enthusiasm for the Flemish landscape backgrounds and a tendency to give more and more prominence to the landscape setting and less to the incident illustrated. The delight in landscape preceded the landscape painting as a picture in its own right. ALTDORFER and perhaps also HUBER were the first to paint 'pure' landscape without story or incident to give it a raison d'être.

The strife following the Reformation affected the arts adversely in Germany and the Thirty Years War retarded artistic development throughout the latter part of the 17th c. At the same time the cleavage between Catholic and Protestant Germany became more and more pronounced. In the Catholic south and west the arts flourished, but they found little encouragement in the Protestant north. The south accepted whole-heartedly the BAROQUE. Though Italian influence penetrated via Austria, south German architecture and decoration on the whole lacks the pathos and grandeur of its Italian counterpart, but has in its place an exuberance, gaiety, and colour unknown south of the Alps (e.g. in the work of the ASAM brothers in Bavaria). J. B. NEUMANN's church at Vierzehnheiligen, with its unorthodox elliptical plan, its riot of colour and profusion of sculpture, represents German church Baroque at its height, whilst the same architect's archiepiscopal palace at Würzburg is its worldly counterpart. The fact that the frescoes over the great staircase of this palace

are by G. B. TIEPOLO shows where German Baroque painting was turning for its inspiration and models. Indeed MAULPERTSCH, the most important Austrian Baroque painter, followed the Venetian master closely.

The north was much poorer in art at this time and in both architecture and sculpture took its tone from the more restrained forms of French Baroque, as is best seen in the work of SCHLUETER in Berlin. In Dresden PÖPPELMANN, the architect of the Zwinger, and KNOBELSDORFF at Berlin turned later to the lighter and more playful forms of ROCOCO. PERMOSER, clearly deriving his style from G. L. BERNINI, and I. GÜNTHER, who gave his figures almost the animation and contours of dancers, show the development from Baroque to Rococo sculpture, and 'Dresden china', decorative, lively, and colourful, became the ideal medium for genre sculpture in a lighter vein. Since interest in the Rococo revived during the 1930s and 1940s some art historians have thought to isolate a characteristic Germanic version of Rococo.

Throughout the 17th and 18th centuries the Church had remained the wealthy and powerful patron of the arts in the south, whilst in the north the Protestant Church showed little interest in the arts apart from attempts to find a church plan suitable for Lutheran services, a problem solved successfully by G. BAEHR in his Frauenkirche at Dresden. The only Protestant princes of note, the Prussians, were scarcely patrons except for Frederick the Great, whose favourite residence Sans Souci reveals his taste for French Rococo.

During the second half of the 18th c. also the impact of the ROMANTIC movement emanating from England began to be felt in Germany. English landscape GARDENS became the vogue, Wörlitz being perhaps the finest example. GOTHIC REVIVAL architecture, when it first appeared, also followed English patterns. J. J. WINCKELMANN was a protagonist of NEO-CLASSICISM and his aesthetic of the ANTIQUE, falsely based as it is now known to have been, provided a theoretical justification for a revolution in taste which was European in its scope. The last decade of the 18th c. and the beginning of the 19th c. saw the heyday of this Classical revival in Germany, when architects like WEINBRENNER gave to Karlsruhe its essential flavour, as KLENZE did for Munich and SCHINKEL for Berlin. SCHADOW produced sculpture fitted to the taste of the time, and the bloodless creations of the Danish master THORWALDSEN were greatly admired all over Germany. GOETHE's house in Weimar exemplified what was good of this taste, which was imitated in England by the Prince Consort in parts of Osborne House.

There was, however, a strong reaction against this international Neo-Classical style which savoured strongly of nationalism and patriotic feelings. As early as 1771 Goethe, in an essay on ERWIN VON STEINBACH the legendary architect of Strasbourg Cathedral, had praised the Gothic style in dithyrambic language, though he was later to turn away from this youthful enthusiasm. Just as by the end of the century Gothic began to be regarded as the German style *par excellence*, so painters reacted violently against their academic training. The NAZARENES, a group of German painters who banded together in Vienna in 1809 and emigrated to Rome, set up lofty ideals of Christian medievalism, trying to revive Catholic painting much as A. W. PUGIN later tried to revive Catholic architecture in England.

The Romantic spirit of the period gave rise also to a new vogue for emotionally charged landscape, as in the paintings of C. D. FRIEDRICH and the pantheistically inspired allegories of P. O. Runge, and must be held responsible for a rather flat-footed historical realism which did its utmost to represent stirring patriotic events in their proper and accurate setting. The School of Düsseldorf most clearly represents the latter trend, which led in the end to the horrific pomposity of official painting of the late 19th c. Munich was the real centre of German art during the 19th c., and there tradition and modernity were bitterly at war. There too we find the first satirical weeklies, such as *Fliegende Blätter* (founded 1844) to which many leading artists contributed. The *Münchner Bilderbogen* were a means of popularizing art of a rather anecdotal character, the genre-piece of the Munich School owing a good deal to David WILKIE.

The more modest tastes of the new middle class were catered for by the BIEDERMEIER painters, who excelled in a straightforward and 'honest-to-goodness' if somewhat humdrum realism in portraiture, for which a corresponding interior decoration provided an appropriate setting. Against all these developments idealists such as FEUERBACH and Hans von Marées (1837-87) upheld in the face of public opposition the great traditions of classical painting, while A. von HILDEBRANDT tried to return to the simplicity of Greek sculpture of the classical period. Architecture, having run through all the ancient and medieval styles in a vain search for a new one, finally arrived at a kind of Neo-Renaissance, which, however, in the hands of so tasteful and knowledgeable a practitioner as G. Semper (1803-79) looks almost original.

Reaction against all this 'second-hand art' set in during the last quarter of the century. Max LIEBERMANN found the inspiration for his IMPRESSIONISM first in nature and only later in the straightforward realism of A. MENZEL, who had been rather outside the main stream of German 19th-c. painting. He also studied the BARBIZON SCHOOL and Dutch painting of the 17th c. French Impressionism made little impact on Germany.

To architecture and the applied arts the lead was given by the disciples of such English pioneers of modern design as William MORRIS and C. A. VOYSEY. *Jugendstil*, the German form of ART NOUVEAU, broke with historicism and by stressing the importance of materials and

function prepared the way for the BAUHAUS. Peter BEHRENS and OLBRICH were the forerunners of GROPIUS.

Painting in the early 20th c. was strongly influenced by GAUGUIN. Painters such as Paula Modersohn-Becker (1876-1907) went in for strong colours and flat patterns and were precursors of EXPRESSIONISM, the one characteristically German aesthetic movement of the century, which made the expression of a strong emotion before the object and not reproduction of the visual impression the aim of art. The BRÜCKE, founded about 1904, and the BLAUE REITER, founded in 1911, were artists' associations which tried to spread these ideas. Painters such as the Austrian O. KOKOSCHKA and M. BECKMANN had strong affinities with them. LEHMBRUCK and BARLACH had similar ideals in their sculpture. Käthe KOLLWITZ, while distorting her forms less than her contemporaries, nevertheless made a strong appeal through her subject matter to the social sense of the time.

Although the First World War with its profound emotional backwash at first gave added impetus to these tendencies, by c. 1925 Expressionism had spent its strength. The movement called NEUE SACHLICHKEIT, a kind of sober and disillusioned realism, became the new fashion. The savage social caricatures of G. GROSZ and the harsh portraits of O. DIX showed the wider potentialities of this new manner. The cool matter-of-factness of FUNCTIONALISM, best represented perhaps by Ernst May's (1886-1970) Römerstadt Estate in Frankfurt (1925-30), is a parallel in architecture.

When in 1933 the Nazis came to power Expressionism and modern art in general were banned as 'degenerate'. A hard, heroic REALISM, not unlike 'socialist realism', took its place. In architecture a new, rather dry and unimaginative Neo-Classicism was regarded as most suitable for the vast building schemes of the new régime. The various buildings for the party rallies at Nuremberg are typical of Nazi architecture.

152, 193, 216, 273, 346, 370, 400, 404, 425, 438, 442, 457, 707, 864, 1019, 1050, 1051, 1074, 1182, 1286, 1430, 1431, 1470, 1622, 1654, 1916, 1933, 1990, 2090, 2142, 2283, 2289, 2295, 2409, 2545, 2650, 2824, 2832.

**GERMIGNY-LES-PRÈS.** One of the earliest surviving church buildings in France (between A.D. 798 and 818). The plan, a square with apses opening off each side and small square chapels at the corners, is Oriental in origin and shows how diverse were the influences that affected CAROLINGIAN architecture. The church is vaulted throughout and the central tower is crowned with a dome. A similar church survives at S. Miguel de Lino in northern Spain. Germigny contains some 9th-c. mosaics, but the whole church was drastically restored in the 19th c.

**GÉRÔME,** JEAN LÉON (1824-1904). French painter and sculptor. He was a pupil of

Paul Delaroche (1791-1856), a good draughtsman and an upholder of the academic tradition. He opposed the acceptance of the Caillebotte bequest of IMPRESSIONIST pictures by the Luxembourg. Among others he taught J. F. Raffaelli (1850-1924), VUILLARD, and Le Douanier ROUSSEAU. His picture *The Cock Fight* (Louvre, 1847) was once extremely popular and the Tate Gallery, London, has his picture *Polytechnic Student*.

1870.

**GERTLER,** MARK (1892-1939). English painter of figures and STILL LIFE. Born of poor parents, he spoke only Yiddish up to the age of 8. He was sent to the Slade School by the Jewish Educational Aid Society (1908) and studied there until 1912, winning a Slade scholarship (1909) and a British Institute scholarship (1912). He was a member of the NEW ENGLISH ART CLUB 1912-14 and became a member of the LONDON GROUP in 1915. Gertler was influenced by certain POST-IMPRESSIONIST trends, but worked in a quietly individual style which lent him distinction among British painters of the 1930s. He arranged his still lifes meticulously in his studio or painted his nudes, preferably from the back view, with attention to the pictorial quality of paint and design. He held his first one-man show at the Goupil Gallery in 1921 and through the 1920s and 1930s exhibited regularly at the Leicester Galleries and elsewhere, including exhibitions in Cambridge under the auspices of the Cambridge University Arts Society. He committed suicide in 1939. Memorial exhibitions were held by the Leicester Gallery in 1941, the Ben Uri Gallery in 1944, and the Whitechapel Gallery in 1949.

**GESSNER,** SALOMON (1730-88). Swiss painter, etcher, and poet. He illustrated his own *Idylls* with charming ROCOCO vignettes and painted small landscapes in a similar vein. His *Brief über die Landschaftsmalerei* (Zürich, 1787; English edition 1798) is an account of his own studies in which he shows that love of nature and imitation of the great masters, in particular of CLAUDE Lorraine, are the best training for the landscape painter who wishes to express true feeling.

**GESSO.** A material used during the Middle Ages and the RENAISSANCE as a GROUND to prepare a panel or canvas for painting or gilding. It is made from plaster (dehydrated calcium sulphate prepared by roasting gypsum or alabaster) mixed with size. In preparing a ground the gesso was applied in several layers. According to CENNINI the underlayers were of relatively coarse and heavy gesso, which he called *gesso grosso*; over this was laid a coat of *gesso sottile*, fine and smooth to paint on and brilliantly white. The gesso could also take the impress of the tools used in the decorative gilding which often adorned a panel painting. When applied to frames and

furniture it could be painted and gilded in the same way, and was often modelled (*gesso rilievo*).

In the 20th c. the term 'gesso' came to be used loosely for any white substance that can be mixed with water to make a ground; in reference to sculpture it often means PLASTER OF PARIS.

**GESTALT.** The German word for 'configuration', adopted as the term for a school of psychology associated with the names of Wertheimer, Köhler, and Koffka, which came to prominence in the first half of the 20th c. Its basic principle that the ultimate elements of experience are structures and organizations which cannot be broken down into 'atomic' components was not entirely new or original but was supported with more systematic experimental research than hitherto. Five subsidiary principles constitute the special features of the Gestalt school: (i) the 'figure/ground' principle maintains that every perceptive experience is a pattern discriminated against a background; (ii) the principle of 'differentiation' which maintains a relation between patterns of stimuli and the formation of structures in perception; (iii) the principle of 'closure' which maintains that incomplete stimuli patterns tend to be distorted in perception into completed structures; (iv) the principle of 'good Gestalt' which maintains that one perceptual structure will tend to supersede another based on the same stimulus pattern; (v) the principle of 'isomorphism' which asserts a structural correspondence between physiological or brain processes and what is perceived.

Gestalt psychology has devoted more attention than other schools of psychology to the artistic aspect of experience, illustrating its own theories from artistic phenomena and applying itself to elucidate the facts of artistic appreciation. Its perceptual configurations have been thought to have a special relevance to the emergence of formal artistic qualities which cannot be reduced to a measurable aggregate of more elementary constituents. The work of such writers as Rudolph Arnheim initiated a new line of approach to problems of artistic appreciation.

The Gestalt psychologists also launched an attack on the older theory of empathy and maintained that the so-called 'aesthetic' or 'emotional' qualities, such as cheerfulness, elegance, solemnity, grace, are directly perceived in the objects of perception and are not projected upon them. This theory gave rise to the concept of 'tertiary' qualities which are supposed to permeate and suffuse all experience but particularly the experience of art objects and are regarded as of central importance to artistic appreciation. It was maintained that 'emotional' qualities, although described in the language of subjective mood, are directly perceived in the object and not reflected upon it from subjectively experienced emotion. Sometimes the principle of isomorphism has been called upon at this point and it has been alleged that there is a structural correspondence between perceived artistic configurations and the basic patterns of human feeling and emotion.

**GESTEL,** LEO (LEENDERT) (1881-1941). Dutch painter who was one of the first to experiment with CUBISM and EXPRESSIONISM in Holland. From this basis he elaborated a decorative and lyrical manner for colourful landscapes, nudes, and STILL LIFES.

**GHEERAERTS,** MARCUS, THE ELDER (*c.* 1516-before 1604). Flemish engraver and painter, born at Bruges and active in England from 1568. No paintings of his English period are certainly identified. His son MARCUS the Younger (1561-1635), pupil of Lucas de Heere (1534-84), had a flourishing portrait practice in England, working in conjunction with the DE CRITZ and OLIVER families from whose works his own are difficult to disentangle. An example is the portrait of Lady Russell in the Duke of Bedford collection, Woburn Abbey (1626).

**GHEYN,** JACQUES DE, II (1565-1629). Dutch draughtsman, engraver, and painter. He was born at Antwerp and was probably a pupil of his father JACQUES DE GHEYN I, a glass painter and miniaturist. From *c.* 1585 to 1590 he studied with Hendrick GOLTZIUS. He worked for the Court of Orange at The Hague and designed a garden for Prince Maurice. His drawings and engravings show that he had three things in common with Goltzius: a keen eye for realistic detail, a taste for ROMANTIC landscape, and a flair for capturing the airs and manners of the fashionable world. His son JACQUES DE GHEYN III (*c.* 1596-1641) was also an artist; the scarcity of his pictures substantiates the contemporary report that he had difficulty in getting down to work.

39.

**GHIBERTI,** LORENZO (1378-1455). Italian sculptor of the FLORENTINE SCHOOL. He was trained as a goldsmith, then worked as a painter. In 1401 he competed successfully (defeating BRUNELLESCHI) for a commission, offered by the merchant guild, to make a pair of bronze doors for the Baptistery of Florence. The work on these took 23 years. In 1425 he was asked to make a second pair of doors for the same building, which occupied him until 1452. These two commissions lay at the focus of the civic and religious life of Florence; the fulfilment of them necessitated the formation of a large workshop in which most Florentine artists of the period received at least part of their training. Ghiberti also served on the committee in charge of the architectural works of Florence Cathedral (an episode of which VASARI has preserved the highly biased account circulating among Brunelleschi's followers). He designed stained glass windows, goldsmiths' work, reliquaries, and two important

statues for the Or San Michele, Florence. He was also a writer and left a large incomplete manuscript under the title of *Commentarii*. Apart from a survey of ancient art based on PLINY and notes on the science of optics, this manuscript contains valuable records of Italian painters and sculptors of the trecento and also Ghiberti's autobiography, perhaps the first ever penned by an artist. The same interest in the new humanist ideals that is reflected in Ghiberti's writings also prompted him to collect classical sculptures and to appreciate any new discovery in this field.

Despite this prominent place which Ghiberti occupies in the classical revival, his style was deeply rooted in the tradition of GOTHIC craftsmanship. Not only was his first pair of Baptistery doors closely modelled on the pattern of Andrea PISANO's earlier doors, but its 20 episodes from the Life of Christ and its eight saints reflect the INTERNATIONAL GOTHIC style with its emphasis on graceful lines, lyrical sentiment, and minute attention to landscape detail. While these traits survive in Ghiberti's second pair of doors, they are here subordinated to the new principles of the RENAISSANCE. The doors are divided into 10 large panels in which episodes from the Old Testament are represented on carefully constructed PERSPECTIVE stages. As most of these reliefs were planned and laid out by 1437, they must rank among the most 'advanced' works of Florentine art, particularly in the mastery of COMPOSITION within a spatial framework. Some of them, such as *The Visit of the Queen of Sheba*, point forward to BOTTICELLI's frescoes in the Sistine Chapel, and even to RAPHAEL's *School of Athens* (Vatican). The fame of these doors always stood high. MICHELANGELO's dictum, recorded by Vasari, that they were worthy to form the Gates of Paradise secured their prestige even in times less sympathetic to quattrocento art. They were publicized in an engraving in the 18th c. by T. PATCH, who also brought plaster casts of them to England. When they were taken down for safety during the Second World War the original gilding was discovered under the dust and grime of centuries. Cleaning not only revealed many subtleties, but almost changed their character—we can now see them again as the last fruit of the medieval tradition of goldsmiths' work.

1069, 1527.

**GHIRLANDAIO,** DOMENICO BIGORDI (*c*. 1448–94). Italian painter in fresco who established a flourishing workshop in Florence with his two younger brothers. His manner was eclectic and a popularization of the then old-fashioned styles of MASACCIO and Filippo LIPPI. He had little inclination for the *avant-garde* of the day or for the movements we associate with BOTTICELLI (with whom he worked at the Sistine Chapel) and obtained few commissions from cultivated or aristocratic patrons. But his prosaic naturalism achieved a great vogue and ALTAR-PIECES from his *atelier* are widely disseminated. His *Christ Calling the First Apostles* in the Sistine Chapel (1481–2) was swamped with portraits of Florentines living in Rome and this habit of introducing contemporary portraits into his religious pictures may well have secured him further commissions, such as that by Francesco Sassetti for the *Scenes from the Life of St. Francis* (1482–5) in the family chapel at Sta Trinità, Florence. It was a fantasy which suited the middle-class taste of the day.

Ghirlandaio's largest undertaking was the fresco cycle in the choir of Sta Maria Novella, Florence, illustrating *Scenes from the Lives of the Virgin and St. John the Baptist* (1486–90). This cycle was commissioned by Giovanni Tornabuoni, a partner in the Medici bank, and Ghirlandaio tells the sacred story as if it had taken place in the home of a wealthy Florentine burgher. It is this talent for portraying the life and manners of his time that has made Ghirlandaio popular with many visitors to Florence. But it should not allow us to overlook his considerable skill in the management of complex compositions, which contain more than one hint of later High RENAISSANCE developments. It is probable that MICHELANGELO owed more to the sound craftsmanship of Ghirlandaio, to whom he was apprenticed, than he cared to acknowledge.

There is a Flemish spirit about the realism of some of Ghirlandaio's work (*Birth of St. John the Baptist*, Sta Maria Novella, Florence) and the tenderness expressed in the well-known *Old Man and his Grandson* (Louvre) is inseparable from the ruthlessly unidealized representation of elephantiasis. This aspect of his work cannot be merely attributed to the influence of van der GOES but reveals that genuine feeling for nature as fact which is the basis and excuse for all great realism.

Ghirlandaio's son RIDOLFO (1483–1561) was a friend of RAPHAEL and a portrait painter of some distinction.

698, 1582.

**GIACOMETTI,** ALBERTO (1901–66). Swiss sculptor and painter, born at Stampa in the Bregaglia valley, son of the Swiss IMPRESSIONIST painter, Giovannia Giacometti. He displayed a talent for painting and sculpture at an early age and spent six months when he was 18 as a student at the École des Arts et Métiers, Geneva. After a short period in Italy, where he studied Byzantine MOSAICS and BAROQUE architecture, he went to Paris and there worked under BOURDELLE from 1922 to 1925. In 1925 he abandoned naturalistic sculpture and began to produce bronzes in the CUBIST manner as represented by LIPCHITZ and LAURENS (*Spoon-Woman*, 1926). In 1930 he attached himself to the SURREALIST movement and during the 1930s developed the highly individual attenuated manner and open-cage construction by which he later came to be

chiefly known (*The Palace at 4 a.m.*, Mus. of Modern Art, New York, 1933; *Woman Walking*, 1934). Throughout his career he was obsessed with the specifically sculptural theme of spatial relationships and it has been said by Sir Herbert Read that in his work of this period the whole purpose and effect of Surrealist sculpture is expressed—'the construction in space of precise mechanisms that are of no use but are neverthe-less profoundly disturbing'. From 1940 onwards these mechanisms became 'transparent con-structions' of human figures, sometimes dis-posed in groups, notable for their thin, elongated, and nervous character. The influence exerted by this style was manifested in many of the entries for the *Unknown Political Prisoner* com-petition, and to a greater or less degree became ubiquitous. His extremely personal conception of space and figuration matured after the Second World War and he developed still further his elongated and isolated figures with a suggestion of existentialist tragedy, skeletal and emaciated groups which created their own spatial environ-ment in a unique way and an individual rendering of plastic form which seemed to many to be symptomatic expression of the 20th-c. plastic consciousness. Between 1940 and 1945 he produced works on a miniature scale which nevertheless created a symbolic impression of magnitude. Thereafter he executed some of his most impressive larger works (*The Pointing Man*, Tate Gal., 1947).

He exhibited at the Venice Biennale in 1956 and 1962. A retrospective exhibition of his work was organized in England by the ARTS COUNCIL OF GREAT BRITAIN in 1955 and he figured pro-minently in the 1959 Arts Council exhibition of Swiss art from HODLER to KLEE. A large retro-spective exhibition of his sculpture, painting, and drawing was organized by the Arts Council and held in the Tate Gallery in 1965. At the same time a retrospective exhibition was held at the Museum of Modern Art, New York.

82, 1007, 1932.

**GIAMBOLOGNA.** See BOLOGNA, Giovanni.

**GIANT ORDER.** See COLOSSAL ORDER.

**GIBBINGS,** ROBERT (1889-1958). Artist and engraver, who was born in Cork and studied at the Slade School and the Central School of Arts and Crafts. He ran the GOLDEN COCKEREL PRESS from 1924 to 1933 and was later lecturer in Wood Engraving and Typography at Reading Univer-sity. He was largely instrumental in the forma-tion of the Society of Wood-engravers. He was probably the first artist to make pencil drawings on xylonite under water and an account of his passion for submarine life is contained in his semi-autobiographical book *Blue Angels and Whales* (1938).

**GIBBONS,** GRINLING (1648-1721). Sculp-tor, born in Rotterdam of an English father and probably trained in Holland. He came to England before 1668. His genius was soon recognized by Sir Peter LELY, John Evelyn, and Hugh MAY, and they recommended him to Charles II and Sir Christopher WREN. His best work, and that for which he is most famous, is his carving in wood of fruit and flowers, small animals, and cherubs' heads, and he is un-surpassed in England at this type of decoration. Examples may be seen at Windsor, Hampton Court, and in the choir stalls of St. Paul's Cathedral. Although in his large studio he carried out many commissions in both marble and bronze, he was never happy in these materials and seems to have relied much upon assistants. His large marble tombs, such as the *Sir Cloudesley Shovell* (Westminster Abbey, c. 1707), are often clumsy, but the best bronze statues, among them the *James II* (Trafalgar Square), are of finer quality, and may well have been designed by his partner, Arnold QUELLIN.

1146, 2653.

**GIBBS,** JAMES (1682-1754). Scottish archi-tect, born in Aberdeen of Catholic parents. In 1703 he went to Rome to study for the priesthood but after a time turned to architecture, working under Carlo FONTANA. In 1709 he came to London, where his acquaintance with the Earl of Mar helped him to become established. Ap-pointed one of the Surveyors for the 1711 Act for

**143.** *Church of St. Mary-le-Strand*, by James Gibbs. Lithograph by Thomas Shotter Boys. From *Original Views of London as it is* (1843)

building 50 new churches, he erected his first public building, St. Mary-le-Strand, Westminster (1714–17). It is a restrained Roman MANNERIST design and brought him into such prominence that for the next 25 years, in spite of difficulties caused by his religion and politics, he produced a large number of buildings, both public and private. His most celebrated church, St. Martin's-in-the-Fields (1722–6), with its finely modelled steeple riding gaily on the roof ridge, has been frequently imitated in Great Britain and in America. Gibbs rebuilt All Saints, Derby, and at Cambridge designed the Senate House (1722) and the Fellows' Building at King's College (1724), these admirable buildings being parts only of much larger schemes.

Gibbs had an early connection with the rebuilding of Burlington House and was the architect most concerned with Cannons House, Middlesex (demolished 1750). At Ditchley, Oxon. (1720–5), he built a great stone house, PALLADIAN in plan but not in detail, and at Sudbrooke House, Surrey, a brick house with a colonnaded stone entrance, a feature which shows a return to the earlier English tradition in design. From 1730 onwards he was at work on St. Bartholomew's Hospital, and in 1737 work was begun on the circular Radcliffe Library (or Camera), the dome of which is a prominent feature of the Oxford skyline. Here he owed much to the earlier designs by HAWKSMOOR, but the detail is in Gibbs's Roman manner.

The thoroughness of Gibbs's early grounding in Rome is apparent in all his work, which is always finely co-ordinated and detailed, and in his interiors he employed the best Italian plasterers, Artari and Bagutti, for rich decoration in depth. But in spite of his continental experience Gibbs is primarily the successor to WREN, whom he much admired. His influence was much increased by the publication in 1728 of his *Book of Architecture*, which was designed to help the provincial builder, and by his *Rules for Drawing the Several Parts of Architecture*, which followed in 1732.

1676.

**GIBSON,** JOHN (1790–1866). English sculptor. The son of a Welsh market gardener, he was apprenticed in turn to a cabinet-maker, a woodcarver, and a sculptor in Liverpool. He was a protégé of the Liverpool banker and CONNOISSEUR William Roscoe. In 1817 he went to London, where he was taken up by FLAXMAN, on whose encouragement he went to Rome the following year with an introduction to CANOVA, whose pupil he became. He spent nearly all the rest of his life in Rome apart from occasional visits to England, the longest being from 1844 to 1847 when he supervised the erection of his statue to William Huskisson in the mausoleum built by John Foster (1786–1846) in the St. James's cemetery. Gibson represents the culmination of English NEO-CLASSICISM and won recognition internationally as the third star in

the Neo-Classical firmament, after Canova and THORWALDSEN. Lord Lytton wrote of him: 'In you we behold the three great and long undetected principles of Grecian Art, simplicity, calm and concentration.' In his enthusiasm for the Greek Gibson experimented with the colouring of statues and he is best known for his controversial *Tinted Venus* which was one of three coloured statues he exhibited at the Exhibition of 1862. Lost to sight from 1916, the *Tinted Venus* turned up in 1962 at Walcot Hall, Northamptonshire, and was exhibited by the Victoria and Albert Museum in that year. In 1850 Gibson had previously introduced coloured details in a statue of Queen Victoria. His *Hylas and the Nymphs* is in the Tate Gallery and his *Bacchus, Cupid and Butterfly* and *Wounded Warrior* are in the Diploma Gallery of the Royal Academy.

798.

**GIEDION,** SIGFRIED (1894–1965). Swiss art-historian, a pupil of Wölfflin, Secretary-General of C.I.A.M. from its foundation, and an important influence on modern architecture in Europe and America.

1032, 1033, 1034.

**GIERSING,** HARALD (1881–1927). Danish painter, who was the most energetic advocate of modern art in Denmark at the beginning of the 20th c. His own broad and roughly painted STILL LIFES and figure compositions, usually constructed within a narrow range of tones, have a monumental quality.

**GILBERT,** SIR ALFRED (1854–1934). English sculptor and metal-worker, best known for his Shaftesbury Memorial Fountain in Piccadilly Circus with its famous figure of *Eros* (unveiled 1899). Its celebrity has overshadowed Gilbert's achievements in metal-work. The epergne in silver, parcel-gilt, that he made for Queen Victoria's Jubilee in 1887 was an early example of ART NOUVEAU. From 1909 Gilbert lived in retirement in Bruges, but in 1926 he returned to England at the request of King George V to complete his masterpiece, the tomb of the Duke of Clarence at St. George's Chapel, Windsor, which he had begun in 1892. There is a statuette of *Victory* in the Diploma Gallery of the Royal Academy and a bust of G. F. Watts in the Tate Gallery.

455, 1267, 1710.

**GILDING.** See GOLD.

**GILL,** ARTHUR ERIC ROWTON (1882–1940). English sculptor, engraver, typographer, and writer. After studying at the Central School of Arts and Crafts, London, he began to earn his living as a letter cutter in 1903. In 1913 he became a convert to Roman Catholicism and was commissioned to make the *Stations of the Cross*

**144.** Incised alphabet of capitals (1909) designed and cut by Eric Gill from a Hoptonwood stone slab

at Westminster Cathedral (1914–18). This and the *Prospero and Ariel* on Broadcasting House are his best known sculptures. After the First World War he became a Tertiary of the Order of St. Dominic and formed a Guild of St. Joseph and St. Dominic, which was to be a guild of craftsmen with the object of promoting a revival

**145.** 'Venus and Cupid with the Golden Cockerel.' Wood engraving by Eric Gill. Opening page to *The Canterbury Tales*, Geoffrey Chaucer (1928), published by The Golden Cockerel Press

of a religious attitude to art and craftsmanship in opposition to the social and economic trends of the time. In 1924 Gill began his association with the GOLDEN COCKEREL PRESS of Robert GIBBINGS, for which he illustrated many books. He also designed the 'Perpetua' and the 'Gill Sans-serif' printing types for the Monotype Corporation.

2541.

**GILLOT,** CLAUDE (1673–1732). French decorative painter. From the large number of his drawings which are preserved his ARABESQUES, which enjoyed a high reputation in their day, appear to have closely resembled those of AUDRAN. His predilection for painting scenes for the *commedia dell'arte* was inherited by WATTEAU, who worked in his studio from 1703 to 1708. Few of his paintings have survived (*La Scène des carrosses*, Louvre).

**GILLRAY,** JAMES (1757–1815). One of the more eminent English CARICATURISTS. He began his career as an engraver of letter-heads and although he later studied at the R.A. Schools, he seems to have been largely self-trained. After the publication of *A New Way to Pay the National Debt* (1786), a satire on the Royal Family, he found his bent in caricature and achieved enormous popularity. His work covered the period of the Napoleonic war and in 1802 a French émigré in London wrote: 'If men be fighting over there for their possessions and their bodies against the Corsican robber, they are

fighting here to be first in Ackermann's shop and see Gillray's latest caricatures. The enthusiasm is indescribable; when the next drawing appears, it is a veritable madness.' He enlarged the scope of HOGARTH's satire, making his caricature more personal than Hogarth's general social comment. The richness of his imagination rivalled FUSELI's. He was scurrilous, coarse, biting but always witty in his travesty (*John Bull's Appetite,* caricaturing the Admirals serving up the ships to John Bull at table; *Dido in Despair,* travestying Lady Hamilton; *Supplementary Militia turning out for Twenty Days' Amusement*). His fantastic and grotesque inventions, the pointedness and wit behind his bludgeoning attack and his gift for likeness beneath travesty set the key for English graphic satire during the period of its greatest influence at home and abroad. His career was cut short by insanity in 1811.

1314.

**GILLY,** FRIEDRICH (1772–1800). German architect, active in Berlin. Although he was responsible only for a few unimportant buildings during his short life, he nevertheless profoundly influenced north-German NEO-CLASSICAL architecture, particularly through his most gifted pupil, SCHINKEL. Gilly's intentions can be gauged from designs for a monument to Frederick the Great: an austere Doric temple on a high pedestal, set on a vast square adorned by obelisks. The design is an imaginative and original fusion of ideas borrowed from antiquity and from the architecture of the French Revolution.

**GILMAN,** HAROLD (1876–1919). English painter, trained at Hastings Art School and at the Slade School. He was a member of SICKERT's circle at Fitzroy Street, a member of the CAMDEN TOWN GROUP, and first President of the LONDON GROUP. Influenced by Sickert's interest in the scenes of daily life he held an exhibition with Charles GINNER at which they called themselves 'Neo-Realists'. He was also interested in the POST-IMPRESSIONISTS and their brilliant palette, building up his forms in colour with a bold simplification of planes in the manner of CÉZANNE (*Leeds Market,* Tate Gal.).

**GILPIN,** SAWREY (1733–1807). English animal painter, who began his career as an apprentice to Samuel SCOTT, the marine painter, but turned early to the painting of horses. The Duke of Cumberland employed him to make 'portraits' of celebrated racers, and Gilpin developed this vein, anticipating the work of WARD and MARSHALL in a later generation. He was elected A.R.A. in 1795 and R.A. in 1797. In occasional large canvases (*The Election of Darius,* York) he contrived his own admixture of horse and history painting. His son, WILLIAM SAWREY GILPIN (1762–1843), was the first president of the Old Water Colour Society.

The Revd. WILLIAM GILPIN (1724–1804), brother of Sawrey Gilpin, was the most im-

**146.** Aquatint with mezzotint from *Remarks on Forest Scenery and other Woodland Views (Relative chiefly to Picturesque Beauty),* illustrated by the *Scenes of the New Forest in Hampshire* (1791) by William Gilpin

portant influence in the development of PICTURESQUE taste through the second half of the 18th c. His *Essay on Prints* (1768) achieved a lasting success in this country as the standard work on print collecting, reaching a fifth edition in 1802, and was translated into French, German, and Dutch. In 1768 he also started his 'picturesque' travels, making a trip into Kent that year, a journey to Essex, Suffolk, and Norfolk in 1769, to south Wales and the Wye valley in 1770, to the Lakes in 1772, north Wales in 1773, the south coast in 1774, the west of England in 1775, and the Highlands in 1776. He recorded his impressions and illustrated them by drawings. These became so popular among friends that in 1882 he began to issue them as *Picturesque Tours* illustrated by plates from his own drawings. The *Essay on Prints* contained *Remarks upon the Principles of Picturesque Beauty*, but the most theoretical of his works on the picturesque was *Three Essays : On Picturesque Beauty : On Picturesque Travel : and On Sketching Landscape* (1792). The principles expounded in the *Essays* were applied to landscape in *Remarks on Forest Scenery, and other Woodland Views (relative chiefly to Picturesque Beauty) illustrated by the Scenes of the New Forest in Hampshire* (1791). Gilpin set himself the task in the *Essays* of defining those features which constitute the picturesque as a mode of beauty. He never succeeded in reaching a consistent definition, but he was chiefly responsible for highlighting the various characteristics which came to be associated with the taste for the picturesque in the visual sphere. In 1776 Gilpin sent the script of his *Essays* to REYNOLDS through Mason and Reynolds returned an ambiguous reply. Fifteen years later, just before publication, Reynolds gave his view that the qualities described by Gilpin as contributory to the picturesque are 'applicable to the excellences of the inferior schools, rather than the higher. The works of Michael Angelo, Raphael, &c. appear to me to have nothing of it; whereas Reubens, and the Venetian painters may almost be said to have nothing else.' Gilpin was the first to establish the picturesque as an aesthetic category and by his *Picturesque Tours*, and his other writings on the picturesque, illustrated by his own fine aquatints, he exerted a profound and lasting influence on both English and European taste in natural and artificial scenery and landscape painting. In certain respects he prepared the way for the ROMANTIC outlook on nature and natural beauty.

156, 1044.

**GINNER,** CHARLES (1879-1952). English painter, born at Cannes. He studied in Paris and in 1910 settled in London, becoming a member of the informal group of artists who foregathered in SICKERT's studio in Fitzroy Street (see ENGLISH ART). In 1914 he joined with Harold GILMAN in forming the Neo-Realist School, which opposed the contemporary IMPRESSIONIST and NEO-IMPRESSIONIST trends, claiming that creative art must be founded on the objective translation into paint of the artist's intimate research into nature. His views were expressed in an article 'Neo-Realism' contributed to *New Age* and used as a preface to the catalogue of an exhibition which he held with Gilman at the Goupil Gallery in 1914. Ginner is chiefly known for his street scenes, in which he chose for preference conventionally unattractive buildings and while apparently defining every brick yet succeeded at his best in accentuating an interesting impression of pattern. A commemorative retrospective exhibition of his work was organized by the ARTS COUNCIL OF GREAT BRITAIN in 1953.

**GIOCONDO,** FRA GIOVANNI (*c.* 1433-1515). Italian architect who worked in Naples (1489-93), went to France and built the Pont de-Notre-Dame, Paris (1500-8). During BRAMANTE's last illness he became a supervisor of St. Peter's, Rome (1513), and after Bramante's death shared this post with RAPHAEL and Giuliano da SANGALLO. His edition of VITRUVIUS (Venice, 1511) established his reputation as a scholar.

**GIORDANO,** LUCA (1634-1705). The most important Italian decorative painter of the second half of the 17th c., Giordano, nicknamed 'LUCA FA PRESTO' because of his prodigious speed of execution, came from Naples. He began in the studio of RIBERA, but was impressed by the Neapolitan works of LANFRANCO and later by VERONESE. Giordano's lively art brilliantly combined Neapolitan and Venetian styles, and was the necessary antidote to mid-century Roman Classicism. His output was prodigious and he could imitate any style of painting. Among his most important works is the ceiling of the Salone of the Medici-Riccardi Palace in Florence (1682-3). In 1692 he was called to Spain by Charles II and stayed there for 10 years painting in Madrid, Toledo, and the ESCORIAL. His last work when he returned to Naples was the ceiling of the Treasury Chapel of S. Martino. In his personal self-confidence and courtliness, and in the open, airy compositions and light luminous colours of his work, Giordano presages such great 18th-c. painters as TIEPOLO.

**GIORGIONE,** GIORGIO BARBARELLI or GIORGIO DEL CASTELFRANCO (1475-1510). Italian painter, who is recognized by critics to mark a turning-point in VENETIAN painting, but the fact that no signed and dated works remain makes him a most controversial figure. The position is further confused because after his early death, probably from the plague, many canvases left unfinished in his studio were completed by his pupils, including the young

TITIAN. The sources for most of our information about his life are VASARI and the notes of Marcantonio Michiel. Little documentation for his paintings remains, for most of them were smallish works which he executed for a select group of intellectuals and sold privately. Indeed, he was one of the first artists to paint small oil paintings for private collectors rather than large decorative works for public or ecclesiastical patrons, and he was the initiator of what is now called the 'landscape of mood' at a time when LANDSCAPE for its own sake was a novelty.

It is usually accepted that in the 1490s Giorgione was a pupil of Giovanni BELLINI, in whose studio he would have met Titian. By c. 1507 he was sufficiently well established to be commissioned to paint pictures for the audience chamber in the Doge's palace and frescoes on the façade of the Fondaco dei Tedeschi. The former are completely destroyed and the latter are known only from later engravings although faint traces of the originals remain. They appear to have represented mythological figures, but even in his own time the subject was uncertain.

The *Castelfranco Madonna* (S. Liberale, Castelfranco, Veneto) shows the influence of Giovanni Bellini's later paintings and has something of PERUGINO's Umbrian softness. It is composed with a strong horizontal division, above which the Madonna is enthroned before a dreamy landscape; the lower portion containing the two saints is badly restored. The *Judith* (Leningrad) is probably of the same period. With the *Tempesta* (Accademia, Venice) the complete change of mood which made Giorgione so much admired in his own day and so influential on his successors, begins to ·be apparent. The subject may be the Infant Paris (X-rays show another naked woman sitting where the shepherd now stands) but it was already in doubt when Michiel saw the picture in 1530. Its great innovation is the subordination of details of the landscape and figures to the heavy atmosphere of the storm which breaks over the city. The whole scene · is permeated by this oppressive sultriness and the colours are modified to render it more intense. This is probably the first painting of the RENAISSANCE in which atmosphere plays so important a part. The *Three Philosophers* (Vienna), which is thought to represent the Magi watching for the star, shows a further development in the relation of landscape to figures. The composition, with the three figures on the right echoing the shape of the cave on the left, is a distinct advance on the rigid quattrocento symmetry of the *Castelfranco Madonna*. The picture was finished, according to Michiel, by SEBASTIANO DEL PIOMBO and alterations have been revealed by X-rays. The portrait *Laura* (Vienna) bears an inscription on the back in a 16th-c. hand saying that it was painted by Zorzo di Castelfranco in 1506. The laurel branches, alluding to the sitter's name, and the SFUMATO technique show Giorgione's familiarity with the portraits of LEONARDO.

Among the paintings left unfinished at Giorgione's death were the *Sleeping Venus* (Dresden) and the more controversial *Concert champêtre* (Louvre). The former was seen by Michiel, who states that Titian completed it and mentions a cupid on the right-hand side which is now only visible under X-rays in a very damaged condition. The *Concert champêtre* has been attributed wholly to Titian although it seems more probable that at least the two nude women are by Giorgione. Copies show that the landscape has been altered considerably. There is also a number of paintings, mostly small, which have been attributed wholly or in part to Giorgione.

Even with such scanty remains to go by Giorgione emerges as the initiator of a new conception of painting. Using Bellini's achievements in colour and composition, he contributed a new sense of unity between the figures and their natural setting by means of colour, atmosphere, and proportion. In his own lifetime he was admired by a comparatively small group of collectors and artists, but his experiments were continued and expanded by Titian, and with him he may be said to have brought a new dimension into the concept of painting.

584, 2253, 2737.

**GIOTTESQUES.** A term applied to the 14th-c. followers of GIOTTO. The best known 'Giotteschi' are the Florentines Taddeo GADDI, MASO, Bernardo DADDI, and to a lesser extent the MASTER OF ST. CECILIA. They borrowed Giotto's square block-like figures and his roomy settings, and like him they studied human action and expression. Giotto's most loyal follower was Maso. He gave only the essential and maintained Giotto's high seriousness; but after him Giotto's almost stark simplicity had no other heirs. Taddeo Gaddi developed Giotto's methods of rendering light and depth, but the profusion of life-like details in his scenes is foreign to the spirit of Giotto. Daddi brought to the style bright colour, delicate ornament, and a temper of gaiety. Gaddi's liking for narrative and Daddi's for rich decoration culminated, towards the middle of the century, in ORCAGNA's reaction against the profoundly human qualities of Giotto. Orcagna is sometimes labelled as a Giottesque, but he can be so classified only in so far that he used Giotto's physical types, which by then had become conventional.

**GIOTTO DI BONDONE** (c. 1267-1337). Italian painter. In a statement which has become famous VASARI claimed of Giotto that he alone, 'although born amidst incompetent artists and at a time when all good methods in art had long been entombed beneath the ruin of war, yet by the favour of heaven he alone succeeded in resuscitating art and restoring her to a path that may be called the true one. And it was in truth a great

marvel that from so rude and inept an age Giotto should have had strength to elicit so much that the art of design, of which men of those days had so little, if any, knowledge, was by his means effectually recalled to life.' These words exemplify an out-moded but long prevalent attitude in art history which assumed as a matter of course that the so-called PRIMITIVES and indeed all painting between the ANTIQUE and the RENAISSANCE was incompetent bungling. None the less Giotto's reputation has remained high and he is accepted as the main source of that revival of NATURALISM which is regarded as one of the most important features of the Italian Renaissance.

Although Giotto's fame was already proclaimed in his own lifetime, not a single document pertaining to extant paintings ascribed to him is known. The facts of which we have some record are these. He owned a house in Florence in 1305 and joined the local painters' guild in 1311; two years later, still in Florence, he laid claim to household goods from his landlady in Rome—which shows that he must have visited Rome at some previous date—and he was in Florence in 1318 and 1320. From 1329 to 1333 he was in Naples as court painter to Robert of Anjou and painted many murals (of which hardly a trace remains) for the king's private rooms and chapel. In 1334 he was named, in the most flattering terms, overseer (capomaestro) of works for the cathedral and fortifications of Florence. According to a contemporary chronicler, Villani, the foundations of the Campanile were laid in the same year. Villani states that during 1335 and 1336 Giotto worked for Azzone Visconti in Milan and that he died in January 1337. Giotto's widow is cited in a document of July 1337. Antonio Pucci, writing in 1373, says that Giotto was in his 70th year when he died.

Various paintings are mentioned in contemporary accounts as by Giotto. They include unspecified works in S. Francesco at Assisi (Riccobaldo da Ferrara) and pictures in the Arena chapel at Padua (Francesco da Barberino, c. 1312-14), and a crucifix in Sta Maria Novella, Florence (testament of 1312) frequently identified as the painted cross now in the sacristy. But of these the only work universally accepted as Giotto's is the fresco cycle covering the interior of the Arena chapel.

The Arena chapel, which was built as a family oratory for Enrico Scrovegni between 1303 and 1306, was dedicated to the Annunciation. The Lives of the Virgin and Christ (1305-8) are told in three tiers of scenes that cover all the walls. Giotto's scheme was the high point of a revival in monumental narrative which was initiated by the CAVALLINI circle in Rome and Assisi at the end of the 13th c. Giotto's representations seem to be based upon personal observation; they are revolutionary because they break with the rigid copying of medieval formulas. In his telling of the story the effect is one of moral weight rather

than divine splendour. He abjures the brilliant colour and elegant line of Byzantine and contemporary Sienese painters. Giotto's genius lay in his power to seize the essential in human action and feeling. His pictures are experiences rather than illustrations. In the supporting framework below the narrative scenes Giotto aims at illusion, depicting a row of personified Virtues and Vices which simulate stone reliefs. They are the first known GRISAILLES.

The large ALTARPIECE of the Madonna Enthroned from Ognissanti (Uffizi) is identified as Giotto's because it is in the same style as the Paduan frescoes. In both of these works the square massive shapes of the figures recall sculpture by ARNOLFO DI CAMBIO and Giovanni PISANO—artists who broke with the past somewhat earlier than Giotto.

The Arena frescoes and the Ognissanti Madonna belong to Giotto's middle years. Both are very different in style from the celebrated fresco cycle of the Life of St. Francis in the Upper Church of S. Francesco at Assisi, though it is known that this cycle was painted during the years 1297-c. 1305, that is immediately before Giotto's Arena frescoes. The older tradition which accepts Giotto as the author of the Assisi frescoes has been called into question by 20th-c. art criticism (see also MASTER OF THE ST. FRANCIS LEGEND and MASTER OF ST. CECILIA).

There is some, but far less, controversy about the authorship of the frescoes in S. Croce, Florence, all of which are in a ruined state. Those in the Bardi chapel (restored 1958) show events from the life of St. Francis. As in the Paduan series, shallow box-like settings frame the figures. The frescoes in the adjacent Peruzzi chapel, which illustrate the lives of St. John Baptist and St. John Evangelist, are frequently regarded as the latest of Giotto's murals. Here the figures live and move about in the setting and the light is painted as if it came from the actual chapel window.

Giotto immensely expanded the means of pictorial representation. The human figure and human feeling and the analytical exposition of the visible world became the central themes of Florentine painting. Giotto began this great tradition and remained an abiding source of its inspiration. In his day he was a great figure in Florence. Dante, his contemporary, declared that his fame had obscured CIMABUE's (Purg. xi. 94-6):

Credette Cimabue nella pittura
    tener lo campo, ed ora ha Giotto il grido,
    si che la fama di colui è oscura.

(Cimabue believed to hold the field in painting, and now Giotto has renown, so that the glory of the former is dimmed.)

Boccaccio and Sacchetti in their stories make him good-natured, witty, and shrewd—a great man and the greatest painter since antiquity.

1057, 2265, 2379, 2651, 2652.

**GIOVANNI DA MAIANO.** Tuscan sculptor, one of those artist-craftsmen whose historical importance lies in their share in the dissemination of Italian RENAISSANCE art rather than in any outstanding artistic achievement. His terracotta roundels of Roman Emperors at Hampton Court (he requested payment for them in 1521), and perhaps also the relief of PUTTI holding the Wolsey Arms on the same building (1525), are remnants of decorative sculpture undertaken for the English court and are among the first signs of Renaissance fashion in English architecture.

**GIOVANNI DI PAOLO** (active 1420–82). Italian painter, the most individual, the most shamelessly archaizing, and with the exception of SASSETTA the most engaging of the major painters of the 15th-c. SIENESE SCHOOL. His ecstatic figures inhabit an irrational world, yet the total effect of his pictures is direct and emotionally convincing. After a period of neglect his reputation was revived by BERENSON, who called him 'the El GRECO of the Quattrocento'. There are good examples of his small-scale work in the National Gallery, London, the Metropolitan Museum, New York, and the Art Institute of Chicago.

382, 2118.

**GIRARDON,** FRANÇOIS (1628–1715). French sculptor who collaborated with LEBRUN in the decoration of VERSAILLES and whose work embodied most fully the classical doctrines of the Academy. He worked at the Galérie d'Apollon in the LOUVRE and his group *Apollo Tended by the Nymphs*, commissioned in 1666 for the grotto of Thetis at Versailles but moved in the 18th c. to a more picturesque setting in the grotto of Les Bains d'Apollon, has been considered the most purely classical work of French 17th-c. sculpture. Deriving from SARRAZIN, his style reflects the theories of the Academy and an interest in HELLENISTIC sculpture. *The Rape of Persephone* at Versailles challenges comparison with the more BAROQUE treatment in BERNINI's group on a similar theme and with the MANNERISM of Giovanni da BOLOGNA's *Rape of the Sabines*. His Classicism also found expression in the monument to Richelieu (1675–7) in the church of the Sorbonne and in an equestrian statue of Louis XIV made (1683–92) for the Place Vendôme but destroyed in the Revolution.

910.

**GIRODET DE ROUCY,** ANNE-LOUIS, called GIRODET-TRIOSON (1767-1824). French painter who studied in DAVID's studio and won the Grand Prix in 1789. In 1792 he exhibited *The Sleep of Endymion* (Louvre), painted in Rome. In style and technique he followed David, but for his choice of themes and his emotional treatment he was acclaimed by the young ROMANTICS. He was interested in unusual colour effects and in the problems of concentrated light and shade. In 1806 his picture *Deluge* (Louvre) was awarded the prize in competition with David's *Rape of the Sabine Women* and David said of it that it would be studied by future generations of artists as they study *The Last Judgement* of MICHELANGELO. He illustrated books, including Virgil and Racine, and his most popular work, *The Entombment of Atala* (Louvre, 1808), drew its subject from Chateaubriand, of whom he painted a Romantic portrait (St. Malo).

**GIROLAMO DA CARPI** (1501–56). Italian painter and architect. He worked mainly in his native town of Ferrara, where he designed and decorated villas and palaces for the ruling dynasty of the ESTE. Like many artists of his generation he was much influenced by the leading masters of the early cinquecento, CORREGGIO, RAPHAEL, GIULIO ROMANO, and others. But he lacked neither ability nor individuality, as witness the beautiful *Portrait of a Lady in a Green Dress* at Hampton Court.

**GIRTIN,** THOMAS (1775-1802). English landscape painter in WATER-COLOURS. He was apprenticed to Edward DAYES and was later employed together with TURNER by Dr. Monro to copy drawings, including drawings by J. R. COZENS, CANALETTO, and others. During this time both he and Turner made topographical drawings for a living. In 1796 he went to Scotland and painted in Yorkshire and many parts of the north of England. In 1801 he went to Paris and made a series of etchings of Paris views which were published in 1803. In 1802 he exhibited an enormous Panorama of London painted in oils. His innovations in water-colour technique had a revolutionary influence on English landscape painting. His earlier works were tinted drawings in the 18th-c. tradition, line drawings shadowed with monochrome washes with added suggestions of colour. In his mature style he made his water-colours true paintings, using strong colour in a broader and more naturalistic way, thus pointing the way to the 19th-c. water-colour style (*White House at Chelsea*, Tate Gal., 1800). Some of his paintings were suggestive of mood and initiated the ROMANTIC manner which was developed by Turner and CONSTABLE (*Kirkstall Abbey*, V. & A. Mus.).

1046, 1807.

**GISANT.** Term used from the 15th c. onwards for a lying or recumbent effigy on a funerary monument. The *gisant* typically represented a person in death and the *gisant* position was contrasted with the *orant*, which represented

the person as if alive in a kneeling or praying position. In Renaissance monuments *gisants* often formed part of the lower register, where the deceased person was represented as a corpse, while on the upper part he was represented *orant* as if alive. In the 15th c. *gisants* often took on a macabre character. French royal tombs of the 16th c. often had *orantes* above a monument which enclosed a *gisant*. (See also article on TOMBS.)

**GISLEBERTUS.** The sculptor of the great TYMPANUM of the west doorway of the Burgundian ROMANESQUE cathedral of St. Lazarus at AUTUN carved his signature—Gislebertus hoc fecit—beneath the feet of the central figure of Christ. It has been established that the same sculptor was also responsible for most of the carved decoration of the cathedral, including the west and north doorways and the majority of the CAPITALS. On the strength of this work, which he carried out between the years 1125 and 1135, it is clear that Gislebertus was an artist of the first rank. The unusually prominent position of his signature suggests that his greatness was appreciated in his own time.

It is highly probable that Gislebertus was trained in the workshop that was responsible for the decoration of the abbey of CLUNY, the most influential of all Romanesque monasteries, and that he worked at the nearby cathedral at VÉZELAY before going to Autun. He was already a mature artist when he started at Autun and his style changed little while he was there.

Working within the general conventions of the Romanesque style of the school of Cluny, Gislebertus produced some of the most powerful and original sculpture of the period. The tympanum of the west doorway is his greatest work. It represents the LAST JUDGEMENT and is a masterpiece of expressionistic carving and a superb technical achievement. His carving of Eve, one of the few surviving fragments of the north doorway, is a large-scale reclining nude without parallel in medieval art. The fecundity of Gislebertus's imagination is vividly displayed in the 60 or so capitals he carved for the interior and the doorways. Most of them illustrate scenes from the stories of the Bible and are very skilfully composed within their architectural frame. The range of feeling that Gislebertus expresses in his work is wide, varying from the tenderness and humanity of the capitals dealing with the infancy of Christ to the terrifying scenes of judgement and damnation in the tympanum.

The influence of Gislebertus has been traced in other Burgundian churches at Saulieu, Beaune, and Moûtiers-Saint-Jean and even at CHARTRES. Many of his ideas had a long-term effect on the development of French GOTHIC sculpture.

1159.

**GIULIANO DA MAIANO** (1432-90). Florentine wood-worker and architect, brother of GIOVANNI and BENEDETTO DA MAIANO and a follower of BRUNELLESCHI. He worked on the Palazzo Pazzi-Quaratesi, Florence (c. 1460-72), designed Faenza Cathedral (1474-86), and in Naples (1484-90) the royal villa, Poggio Reale, now destroyed.

**GIULIO ROMANO** (prob. 1499-1546). Architect and painter, born in Rome and one of the founders of MANNERISM. He was RAPHAEL's chief pupil and assistant although exactly what part he played is controversial. About 1515 he was working on Raphael's *Sala del Incendio* in the Vatican. After Raphael's death in 1520 Giulio completed a number of his unfinished works, including the *Transfiguration*, the *Sala di Constantino* frescoes in the Vatican, and the decorations of the Villa Madama. As independent works he also painted the *Madonna* in Sta Maria dell' Anima, Rome, and the *Stoning of St. Stephen* (1523) in S. Stefano, Genoa, under the influence of MICHELANGELO, which exaggerate the melodramatic tendencies in Raphael's latest style. Having designed pornographic prints he had to flee from Rome to Mantua in 1524, where his most important work is the Palazzo del Tè, begun in 1526 for Federigo GONZAGA. This was one of the first Mannerist buildings, deliberately flouting the canons of BRAMANTE in order to shock and surprise the spectator. The same tendency is continued in Giulio's own fresco decorations, especially in the *Sala de' Giganti*, where the whole room is painted from floor to ceiling to give an over-all illusionistic effect and the spectator feels himself overwhelmed by the rocks and thunderbolts hurled down on the rebellious Titans who attempted to storm Olympus. Giulio painted several other frescoes in the Palazzo del Tè and in the Sala di Troia of the Ducal Palace at Mantua, which testify to his classical learning, exuberant invention, and dubious taste. Among several other buildings in or near Mantua the most important is his own house (1544-6), a bizarre variation on the Bramante type exemplified by the 'House of Raphael'.

1256.

**GIUSTINIANI.** A family which seems to have originated in the Greek islands. Branches settled in many parts of Italy, especially Genoa and Venice, where they played an important role in politics, literature, and religion. For the arts the most interesting member of the family was MARCHESE VICENZO (1564-1638), who owned the finest collection of antique sculpture in Rome—published in the *Galleria Giustiniana* —and was an enthusiastic and discriminating patron of painters, especially CARAVAGGIO and his northern followers.

**GLACKENS,** WILLIAM JAMES (1870-1938). American painter and draughtsman. He

worked for the *Philadelphia Press* and as illustrator for other papers. He was a member of The EIGHT and for a short time fell in with the concepts of the 'Ash-can School'. His social REALISM was, however, limited to representing the life of the people as a colourful spectacle (*Washington Square*, Mus. of Modern Art, New York, 1914). As early as 1905 he was gravitating towards IMPRESSIONISM (*Chez Mouquin*, Art Institute, Chicago, 1905) and by the time of the ARMORY SHOW he was painting in the manner of the early RENOIR.

768.

**GLAIR.** White of egg when used as the MEDIUM in ILLUMINATING MANUSCRIPTS, in TEMPERA painting, and in gilding with GOLD dust. It is also used as a mordant to fix gold leaf (see PAINT).

**GLASS PRINTS** or CLICHÉS-VERRE. Prints made by exposing sensitized photographic paper to the sun beneath a glass plate on which the design has been drawn. The glass is covered with an opaque GROUND and the design is drawn on it with a fine point, leaving the glass transparent where the lines are to be printed in black. The resulting print resembles an etching. Glass prints were produced in the 1850s by etchers such as COROT, DAUBIGNY, Jean François MILLET, and Théodore ROUSSEAU.

**GLAZE.** A transparent layer of paint applied over another colour or GROUND, so that the light passing through is reflected back by the under surface and modified by the glaze. Glazing is an old method, used particularly in medieval TEMPERA painting and also in WATER-COLOUR. It was adopted for OIL PAINTING in 15th-c. Italy and from then until the 19th c. oil paintings were generally built up as an elaborate structure of superimposed layers, glazes, and SCUMBLES, over an UNDERPAINTING with highlights and necessary details added by direct painting. The effect of an under-colour through a glaze is not the same as any effect obtainable by mixing the two pigments in direct painting. The glaze imparts a special depth and luminosity and moves the under-colour from cool to warm. In general, but not inevitably, the under-colour is of lighter tone than the glaze and the undertone has BODY while the glaze is without body. Glazed colours seem to advance, while body colours recede in relation to them. Many artists lay series of glazes one over another, a method which RUBENS particularly favoured.

Some pigments, e.g. lake colours, are permanent only when used transparently in the form of glazes. The brilliant crimsons in the draperies of pictures by TITIAN and El GRECO were obtained by glazing a crimson lake over an opaque underpainting. Some VARNISH was used as an ingredient in most glazing media.

In the 19th c. glazes and scumbles were largely abandoned in favour of direct painting.

In order to bring unity of surface and harmony of tone to such painting the practice was sometimes adopted of covering the painting with a uniform final coat of tinted varnish, which was sometimes referred to as a glaze. But whereas the earlier glaze was part of the structure of the painting and planned in order to obtain the desired iridescence of tone and the planned degree of depth and luminosity, the varnish glaze of the 19th c. was intended to hide imperfections and to impart a spurious harmony of colour to a painting which had failed to achieve it.

In his middle period when TURNER was dominated by the wish to paint the effects of light and atmosphere he adapted to oil painting the technique of water-colour, using mainly transparent glazes or thin layers of light body paint on a light ground.

The word 'glaze' is also used in a special sense in connection with POTTERY. This should not be confused with its meaning as a technical term in painting.

**GLEIZES,** ALBERT (1881-1953). French painter and writer. After beginning in 1901 to paint in a manner derived from IMPRESSIONISM, he associated himself in 1909 with the members of the CUBIST group. In 1912 he wrote with METZINGER the book *Du Cubisme*, which was regarded as the most important exposition of the theoretical principles of the Cubist aesthetic. Gleizes met Metzinger in 1910 and during 1911 joined with LÉGER, DELAUNAY, Marcel DUCHAMP, Jacques VILLON, and others who were concerned with widening and publicizing the Cubist doctrines initiated by PICASSO and BRAQUE. In 1912 he was among those who founded the SECTION D'OR group and the *Section d'Or* exhibitions of Cubist works. He exhibited at the ARMORY SHOW, New York, in 1913 and at the first Berlin Salon d'Automne. In 1917 he experienced a religious conversion while in the U.S.A. and subsequently wrote several books in which he interpreted the laws of art in terms of Catholic truth and religious experience of the Middle Ages. He illustrated the *Pensées* of Pascal with 57 etchings and in 1947 had a retrospective exhibition in Lyon.

**GLORY.** See HALO.

**GLOSSY.** See COLOUR.

**GLOW.** See COLOUR.

**GLYPTOTHEK,** MUNICH. Created by Ludwig I (1786-1868) of Bavaria as a museum for his collection of antique sculptures when he acquired the pediment sculptures of the temple at Aegina. The Glyptothek was designed by KLENZE in NEO-CLASSICAL style. The interior was intended to recreate the setting of a Roman palace, while the exterior was decorated with

modern sculptures and the state-rooms were painted with frescoes by Peter von CORNELIUS.

**GOD THE FATHER.** The First Person of the TRINITY is usually represented in EARLY CHRISTIAN ART as a young man by association with the Second Person, His Son. Thus on a 4th-c. SARCOPHAGUS in the Vatican a youthful God banishes Adam and Eve from Eden, and holds back Abraham's hand from Isaac. In the 5th-c. mosaics of Sta Maria Maggiore, Rome, this young God watches from the clouds in many of the Old Testament scenes. He is especially common in early medieval versions of the Creation (9th-c. Carolingian Bibles of Tours in the B.M. and the Bib. nat., Paris; MOSAICS of the 12th c. in Monreale, Sicily, and of the 13th c. in St. Mark's, Venice; 13th-c. sculptures at Chartres).

The hand coming down from the clouds also signifies God the Father at this period, its earliest appearance being in the 3rd-c. frescoes of the vision of Ezekiel from Dura Europos, Syria (Damascus Mus.). It figures in Old Testament scenes on Sta Maria Maggiore, Rome (5th c.), and in S. Vitale, Ravenna (6th c.), in Monreale, Sicily (12th c.), and in St. Mark's, Venice (13th c.). It lifts Christ into the sky in a 5th-c. ivory carving of the RESURRECTION in Munich. In the BAPTISM it appears above the DOVE (11th-c. mosaics, Daphni, Greece).

It was not until c. 1300 that the familiar type of the 'Ancient of Days' was created, with long white hair and beard (Dan. vii. 14). This God looks down in many Italian scenes of the Baptism (GIOTTO, Arena Chapel, Padua; BELLINI, Sta Corona, Vicenza; GHIBERTI, carved font in S. Giovanni, Siena). He figures in the Annunciation (MELOZZO DI FORLI, painting in the Pantheon; Fra BARTOLOMMEO, SS. Annunziata, Florence), and often in the Creation (sculptures of della QUERCIA on the door of S. Petronio, Bologna; paintings of MICHELANGELO in the Sistine Chapel, Vatican). Sometimes God is shown with the crown and robes of the pope (van EYCK, retable, Ghent; Botticelli, *Coronation of the Virgin*, Accademia, Florence), sometimes with those of a king, as in a carved head of the 14th c. in Winchester Cathedral.

**GODWIN,** EDWARD WILLIAM (1833–86). English architect and designer. His buildings were unimportant but his influence on English taste was considerable. He was one of the first of the aesthetes (see AESTHETICISM), a designer of wall-papers and furniture, an early admirer of JAPANESE ART, and a dress reformer; and as a result of his friendship with the actress Ellen Terry (with whom he eloped, rescuing her from her child-marriage to the painter WATTS) he became a designer of theatrical scenery and costumes. He first practised as an architect in Bristol and then in London. He was successful in architectural competitions, including that for Northampton Town Hall (1864), which is thought to have owed something to RUSKIN's *The Stones of Venice*. His other buildings include Dromore Castle, N. Ireland (1867), and many houses and studios for his artist friends, including the White House, Tite St., Chelsea, for WHISTLER.

**GOES,** HUGO VAN DER (active c. 1467–82). Flemish painter born in Ghent and mainly active there. He was a member of the Ghent Guild of Painters in 1467, and in 1468 he went to Bruges to design a pageant for the marriage of Charles the Bold and Margaret of York. In 1473/4 and 1475 he was Dean of the Guild but then he entered the Rouge Cloître at Brussels, although he still continued to paint. His death in 1482 was brought about by mental illness.

None of the works by Hugo is signed, but his fame is based on the *Portinari Altarpiece* (Uffizi), which is datable to c. 1475/6, and all other attributions are based on this. The great ALTARPIECE was commissioned by Tommaso Portinari, the representative of the House of MEDICI in Bruges, for the church of the Hospital of Sta Maria Nuova in Florence. It is a large-scale composition of the Nativity set in a landscape that spreads into the wings, where the DONOR and his family are seen with their patron saints. When closed the wings show an *Annunciation* painted in GRISAILLE. The great size gave full scope to the artist's powers. He has mastered the problems of space and is able to use great depth to give room for effective interrelation of the figure groups. The focal point, the Christ Child, is isolated on bare ground and stands in effective contrast with the closely knit group of shepherds. Yet at the same time the artist is fully aware of the surface pattern, which is skilfully handled for decorative effect; cool but rich colours lead the eye back and forth across the picture plane. Hugo's technical mastery over draughtsmanship and oil technique is self-evident in the handling of the symbolic STILL LIFE in the foreground of the picture.

It is difficult to establish a chronology for the rest of his works, but the *Monforte Altarpiece* (Berlin) must be close to the *Portinari* in date and ranks with it as one of the finest. This too is on a large scale and the figures are handled with supreme confidence. Colour and lighting enhance the scene, and lend it a serene grandeur. The diptych representing the *Fall of Adam and Eve* and the *Lamentation* (Vienna) seems to be an earlier work, but the *Lamentation* shows that Hugo already had great powers of expression. Two wings (N.G., Edinburgh), which may originally have been organ shutters, probably date from c. 1479–80 and are substantially the work of Hugo. They show an interesting synthesis of borrowed motifs; the *Trinity* seems to derive from the MASTER OF FLÉMALLE, the angel playing the organ is reminiscent of the angel in the Ghent *Altarpiece*, and Queen Margaret's patron saint is copied from Jan

van EYCK's *St. George* in the *Van der Paele Altarpiece*. But Hugo's expressive qualities were all his own. The late *Death of the Virgin* at Bruges is fraught with tension. The colouring is deliberately cold and the restless unseeing eyes of the Apostles impart a sense of melancholy that emphasizes the realism and drama of the event.

735, 926.

**GOETHE,** JOHANN WOLFGANG (1749-1832). The major poet of the German ROMANTIC movement. Throughout his life he devoted much time to the study of painting and although his talent was no more than modest, his writings on art were very influential in the upsurge of Romantic ideas in Germany. His first publication, *Von deutscher Baukunst* (1772), was inspired by youthful enthusiasm for the GOTHIC cathedral at Strasbourg and was one of the earliest appreciations in Germany for the robust strength of the 'primitive' Gothic in opposition to the stereotyped criteria of NEO-CLASSICISM. Identifying art with 'nature', Goethe held that great art must simulate and carry on the blind creative force in nature. Goethe also advocated the typically Romanticist view that art should concentrate on what is individually 'characteristic' rather than the generic type. After a journey to Italy in 1787, where he came into contact with German artists such as TISCHBEIN in Rome, his taste changed to an appreciation of the CLASSICISM of the RENAISSANCE. Identifying art with 'style', he now maintained that beauty is symbolic expression of the inner laws of nature and that this expression had been supremely achieved by the art of antiquity. His exaltation of the concept of 'genius' was of central significance for the development of European Romanticism. In contrast to the speculative character of post-Kantian German Idealism Goethe set his chief emphasis on intuition (*Anschauung*) in regard to the apprehension of beauty.

Goethe's conversion to a classical concept of beauty is described in his *Italienische Reise* (1816-17). It is reflected in articles contributed to *Die Propyläen*, which he edited (1798-1800) with the Swiss Heinrich Meyer (1760-1832), and in *Über Kunst und Altertum* (1816-32). He defended the classical ideal of beauty in *Winckelmann und sein Jahrhundert* (1805) but the First Part of *Faust*, published in 1808, was accepted by his generation as the triumph of Romantic art. Goethe also wrote a book on theory of colour (*Zur Farbenlehre*), in which he purported to refute the *Optics* of Newton. He wrote a commentary on DIDEROT's *Essay on Painting* and in 1818 he published an essay on the paintings described by PHILOSTRATUS.

**GOETZENBERGER,** JACOB (1800-66). German painter. A favourite pupil of CORNELIUS, he acquired early fame through his large histori-cal and legendary fresco cycles (University, Bonn; Trinkhalle, Baden-Baden). For some years after 1847 he worked in England, where he executed frescoes for Lord Ellesmere in Bridge-water House as well as numerous portraits now in private collections.

**GOGH,** VINCENT WILLEM VAN (1853-90). Dutch POST-IMPRESSIONIST painter. He was born at Groot-Zundert in northern Brabant, son of a Protestant pastor. In 1869 he began work as an employee of the La Haye branch of the Goupil Gallery, which had formerly been owned by his uncle. In 1873 he was sent to the London branch, fell unsuccessfully in love with the daughter of his landlady in London, and moved to Paris in 1875. Influenced by the humanitarian ideas in vogue, he abandoned the art business and returned to Holland with the intention of embracing a religious career. But he did not persevere in his studies for the ministry and in 1878 went as a lay preacher among the Belgian miners of Borinage. Here he went to extremes in his asceticism and self-sacrifice and was relieved in the following year. There followed some months of grave spiritual anguish while he lived as a tramp. Returning to the home of his parents at Etten in 1881 he then first decided to become an artist. From this time he worked at his new avocation with single-minded frenzy and although he often suffered from extreme poverty and undernourishment, his output in the 10 remaining years of his life was prodigious. He left over 800 paintings and about 850 drawings.

At the beginning he had some advice from his cousin MAUVE and for some months in 1885 he studied the technical problems of painting at the Antwerp Academy. But he was impatient of regular training and adapted the REALISM of the La Haye School to an extremely individualistic form of EXPRESSIONISM. In keeping with his humanitarian outlook he painted peasants and workers and said of his work: 'My intention was that it should make people think of a way of life entirely different from that of our refined society.' From this period perhaps his most famous pictures are *Les Souliers* and *The Potato Eaters*. Of the latter picture he wrote that he tried 'to instil by this painting the idea that the people it depicts at their meal have dug the earth with the hands they are dipping into the dish.... I really would not wish everyone to admire it or think it beautiful straightaway.'

In February 1886 van Gogh left Antwerp for Paris, where he met PISSARRO, DEGAS, GAUGUIN, SEURAT, and TOULOUSE-LAUTREC. At this time his painting underwent a violent metamorphosis under the combined influence of IMPRESSIONISM and Japanese woodcuts (see UKIYO-E), losing its moralistic flavour of social realism. Van Gogh became obsessed by the symbolic and expressive values of colours and began to use them for this purpose rather than, as the Impressionists, for

the mere reproduction of visual appearances, atmosphere and light. 'Instead of trying to reproduce exactly what I have before my eyes,' he wrote, 'I use colour more arbitrarily so as to express myself more forcibly.' Of his *Night Café* (Stephen C. Clark Coll., New York, 1888), which he called one of the ugliest things he had ever done and a counterpart to *The Potato Eaters*, he said: 'I have tried to express with red and green the terrible passions of human nature. . . . Look! Through the contrasts between the delicate pink, the blood-red, the colour of vine-leaves, the soft Louis XV green, the malachite opposite the yellow-green, the hard blue-green, and all this in the saltpetre-like blackness of the infernal, over-heated atmosphere—through all this I try to give expression to the power of darkness that is in the café.' In technique also he abandoned the delicate manner of the POINTIL-LISTES for broad, vigorous, and swirling brush-strokes.

In February 1888 van Gogh settled at Arles, where he painted more than 200 canvases in 15 months. During this time he sold no pictures, was in poverty, and suffered recurrent nervous crises with hallucinations and depression. He became enthusiastic for the idea of founding an artists' co-operative at Arles and towards the end of the year he was joined by Gauguin. But as a result of a quarrel between them van Gogh suffered the crisis in which occurred the famous incident when he cut off a piece of his right ear (*Self-Portrait*, Courtauld Gal., London). In May 1889 he went at his own request into an asylum at St. Rémy, near Arles, but continued during the year he spent there a frenzied production of tumultuous, delirious pictures such as *Yellow Cornfield* (Tate Gal., London), *Starry Night* (Mus. of Modern Art, New York). ·He did 150 paintings besides drawings in the course of this year. In 1889 Vincent's brother Theo married and in May 1890 Vincent moved to Auvers-sur-Oise to be near him, lodging with the patron and connoisseur Dr. Paul Gachet. There followed another tremendous burst of strenuous activity and during the last 70 days of his life he painted 70 canvases. But his spiritual anguish and depression became more acute and on 29 July 1890 he died from the results of a self-inflicted bullet wound.

Van Gogh's stormy and dramatic life has provided the most auspicious material for the 20th-c. vogue in romanticized psychological biography and the voluminous correspondence with his brother Theo (more than 750 of his letters are extant) is an abundant source of information about his aesthetic aims and his mental disturbances. In the history of painting van Gogh occupies a position of the first importance as a formative influence in the movement from the optical realism of the Impressionists to the abstract use of colour and form for their intrinsic symbolical and expressive values.

586, 813, 825, 1064, 1127, 1244, 1450, 1545, 1662, 1697, 1816, 1907, 1953, 2084, 2406, 2679.

**GOLD.** Gold has been used to embellish pictures and their frames from the earliest times throughout the Near and Far East, in China and Japan, in Egypt, and in Greece and Rome. In BYZANTINE ART it was very extensively used for architectural enrichment and decoration, and in painting for backgrounds and haloes and for the decoration of robes and accessories. Medieval art made extensive use of gold for ILLUMINATED MANUSCRIPTS, bookbinding, gilding on furniture, etc., and for all types of painting including murals. The gold background was a common feature of panel paintings until the RENAISSANCE. Gold was occasionally used in the late 15th c. (e.g. by BELLINI and MANTEGNA) for highlights and to emphasize details, but from the 16th c. onwards its use became rare except for special purposes.

Gold was used both in the powdered form as a PIGMENT and in thin leaves applied to the GROUND. Powdered gold with oil paint is used in the hair of figures in BOTTICELLI's *The Birth of Venus* (Uffizi, c. 1486). When beaten into thin sheets it was known as 'gold foil' in the thicker form and as 'gold leaf' when very thin. CENNINI says that 145 leaves can be beaten from one ducat, though he does not advise more than 100—that is, enough leaf to cover an area of 64 to 86 square feet. The application of thin sheets of gold to a surface is called 'gilding'. This is done with the help of an adhesive called a 'mordant' and it was customary to use a pigment, usually a reddish earth colour called BOLE, which gives the translucent gold leaf a richer glow. After application, whether in leaf or in powdered form, gold can be 'burnished' by being rubbed with a hard smooth surface, a hard stone (garnets, agates, topazes, emeralds were recommended) shaped like a dog's tooth. (The earliest manuals recommended the use of an actual tooth.) This increases its smoothness and reflecting power so that it picks up the shadows as well as the lights and looks both more brilliant and darker than an unburnished surface. An important feature of the use of gold leaf, particularly in panel painting, was 'tooling'. Lines were incised round the areas of gold leaf and incised patterns were tooled on the gold itself. The effect of tooling was to provide textural variation instead of the flat glitter of the gold leaf and at the same time the play of light on the broken surface enhanced its brilliance and luminosity.

**GOLDEN COCKEREL PRESS.** A private printing-press founded in 1920 at Waltham St. Lawrence, Berkshire, by Harold Taylor, taken over by Robert GIBBINGS in 1924 and transferred to Staple Inn, London. From 1936 it was directed by Christopher Sandford and Owen Rutter. Under Gibbings's influence illustration received equal emphasis with typography. The *Four Gospels* (1931), the press's outstanding production, which has been compared with the KELMSCOTT *Chaucer* and the DOVES *Bible*, contains wood engravings by Eric GILL, who also

designed the special 'Golden Cockerel' type. The books issued by this press have been described in a bibliography *Chanticleer* (1936) and its successor *Pertelote* (1943).

**GOLDEN SECTION.** The name given in the 19th c. to the proportion derived from the division of a line into what Euclid called 'extreme and mean ratio' and defined in Bk. 6, Prop. 3 of the *Elements* as follows: 'A straight line is said to have been cut in extreme and mean ratio when, as the whole line is to the greater segment, so is the greater to the less.' This ratio occurs several times in the theory of regular polygons and polyhedra. It is the only ratio (i.e. quantitative relation between two magnitudes) that is also a proportion (similarity between ratios). A proportion requires at least three terms, but in the Golden Section the third term is the sum of the first and second. Consequently it is more economical in terms than any other proportion. It can

**Fig. 24.** AC:CB::CB:AB and AB = AC+CB

be expressed algebraically as $a/b = b/(a+b)$, or arithmetically as $\frac{1}{2}(\sqrt{5}\pm 1)$, or numerically as a progression 0·618, 1·618, 2·618, 4·236. . . . Geometrically it may be constructed by various methods all of which involve making a geometrical equivalent of the numbers $\frac{1}{2}(\sqrt{5}\pm 1)$ by means of a diagonal of a rectangle composed of two squares. From the diagonal of a rectangle of 1 × 2 add or subtract one and place the remainder against the longer side of the rectangle.

It is traditionally held that Plato began the study of 'The Section' as a subject in itself. The construction of the pentagon by means of the isosceles triangle having each of its base angles double the vertical angle (72°, 72°, 36°) was due to the Pythagoreans (Euclid, Bk. 4, Prop. 10). In this triangle the base forms a Golden Section with the longer sides. The triple interwoven triangle, the pentagram, which makes multiple 'Sections', was used by the Pythagoreans as a symbol of recognition between members of the brotherhood and was called by them Health.

From the beginning of the 15th c. great interest was taken in the regular solids. Luca Pacioli (*c.* 1445–*c.* 1514), a Franciscan, the most famous mathematician of his day, who was a close friend of LEONARDO and of PIERO DELLA FRANCESCA and knew ALBERTI, wrote a book on the Golden Section called *Divina Proportione* (1509). Pacioli's book was in accordance with the tendencies of the time and credits this 'divine proportion' with various mystical pro-

perties and exceptional beauties both in science and in art. There are three parts of the book. In the first the author gives various theorems relating to this proportion, with reference to Euclid, finding a noble adjective for each property, as if he were carried away by so much harmony and wished to distinguish the individual themes. Like many other learned men of the Middle Ages and RENAISSANCE, Pacioli was anxious to harmonize the knowledge of pagan antiquity with the Christian faith, and in the chapter in which he justifies his choice of title he explains that this ratio cannot be expressed by a number and being beyond definition is in this respect like God, 'occult and secret'; further, this three-in-one proportion is symbolic of the Holy Trinity. But the most worthy property of the Divine Proportion is that without it no regular pentagon can be made, 'nor the noblest of all the regular bodies called the Dodecahedron, which the divine Plato attributed in the Fifth Essence, namely the Heavens'. Here Pacioli follows Plato who, in his dialogue *Timaeus*, associated the tetrahedron, octahedron, cube, icosahedron with the four elements, fire, air, earth, water (in this order), while in the remaining regular solid he sees in some sense the figure of the universe as a whole.

In the *Divina Proportione* Pacioli believes he can detect an aesthetic principle which is found in architectural forms, in the human body, and even in the capital letters of the Latin alphabet. The third part of the book is an Italian translation of the treatise on the regular bodies, *De Quinque Corporibus Regularibus*, by his compatriot, Piero della Francesca, with only a few alterations and without acknowledgement (a work of which Piero speaks in the dedicatory letter to Duke Guidobaldo of Urbino as having been composed in his extreme old age 'in order that his wits might not go torpid with disuse'). This part deals with polygons and polyhedra and plane figures, deriving mainly from Euclid.

The greatest ornament of *Divina Proportione* are the 60 drawings of regular and semi-regular bodies made by Leonardo, as Pacioli himself states elsewhere: '. . . which it would not be possible to make better in perspective drawing even if Apelles, Myron and Polycletus and others were to return among us, made and shaped by that ineffable left hand, most fitted for all the mathematical disciplines, of the prince among mortals of today, that first of Florentines, our Leonardo da Vinci, in that happy time when we were together in the most admirable city of Milan, working for the same patron [Ludovico il Moro].'

It is often claimed that the Golden Section is aesthetically superior to all other proportions and if it is admitted that what pleases the eye is unity in variety, it may be said that this proportion fulfils the condition better than any other. The claims have been supported by an immense quantity of data, collected both from nature and from the arts (see e.g. T. A. Cook, *The Curves of Life*, 1914, on spiral forms;

J. Hambridge, *Dynamic Symmetry*, New Haven, 1920, on Greek vases and temples; F. M. Lund, *Ad Quadratum*, 1921, on medieval cathedrals; Matila Ghyka, *A Practical Handbook of Geometrical Composition and Design*, Tiranti, 1952). Statistical experiments are said to have shown that people involuntarily give preference to proportions that approximate to the Golden Section. But this weakens the case for maintaining that when such forms are found in a work of art they have been put there intentionally. In fact, the Golden Section is likely to turn up fairly frequently in any design derived from the square and developed by applying a pair of compasses.

*La Section d'Or* was the collective name used by a group of CUBIST painters who exhibited together in Paris in 1912. They, however, were not referring to Euclid's 'extreme and mean ratio', but to the ratio between the side of a square and its diagonal (the 'root-2 rectangle'). (See also FIBONACCI SERIES.)

609, 1026, 1027, 1028, 1226, 1704, 1995.

**GOLDIE,** CHARLES FREDERICK (1870–1947). Painter, born in Auckland, New Zealand, and trained in Paris at the Académie Julien. Brought up at a time when the Maori people were commonly regarded as a 'dying race', he spent his mature years in producing for posterity an immense series of portraits and figure studies of aged Maori models done with a photographic fidelity (Auckland City Art Gal.). These works, still highly prized by moneyed collectors of conservative taste, have little more than historical—almost archaeological—interest for an age which has seen the rebirth of the Maori and a large increase in their numbers.

**GOLTZIUS,** HENDRICK (1558–1617). Dutch artist of German descent, the outstanding line engraver of his day. His teacher was Dirck Coornhert, the Dutch humanist, politician, and theologian who made his living as an engraver. He was the leader of a group of MANNERIST artists who worked in Haarlem (see van MANDER). In 1590 he went to Rome, where he studied classical sculpture and High RENAISSANCE art, and upon his return to the Netherlands he abandoned his Mannerist style for a more classical one. His MINIATURE portrait drawings were of exceptional beauty and the landscape drawings which he made after 1600 mark him as a forerunner of the great 17th-c. landscape artists. His paintings are less interesting than his drawings.

1333.

**GONÇALVES,** NUÑO (active 1450–71). Portuguese painter, recorded in 1463 as court painter to Alfonso V. His importance depends upon his presumed authorship of six large panels (Lisbon Mus., *c.* 1460–70) portraying the court and the various ranks of Portuguese society praying in the presence of a saint, usually identified as St. Vincent, the patron saint of Portugal. The style is rather dry and powerfully realistic. There are affinities with contemporary Burgundian and FLEMISH ART, especially in the work of BOUTS. The arrangement of the panels, and the identification of the series of nearly life-size portraits which they contain, present problems to which no entirely convincing solution has been found.

2392.

**GONCOURT,** EDMOND HUOT DE (1822–96) and JULES (1830–70). French critics of painting who reintroduced a taste for the art of the 18th c., neglected since DAVID, and helped to popularize JAPANESE ART (*L'Art au XVIIIᵉ siècle*, 1859–65, and *L'Art japonais du XVIIIᵉ siècle*, 2 vols.: *Outamaro*, 1891, and *Hokusaï*, 1896; the latter was by Edmond only). They devoted a long study to the work of their friend GAVARNI (1868) and praised such different artists as ROPS, DEGAS, and MOREAU. They disliked COURBET and they were not amongst the first to acclaim MANET. They combined adherence to the 'art for art's sake' movement (see AESTHETICISM) with an ideal of naturalistic objectivity and non-attachment.

**GONZAGA.** Lords of Mantua between 1329 and 1708. At several different periods they attracted to their court some of the greatest Italian and other European artists. Under LODOVICO (1445–78) and his immediate successors MANTEGNA was employed as court painter (*Camera degli sposi* and *Triumphs of Caesar*) and ALBERTI began the church of S. Andrea. The presence of Isabella d'ESTE, who married FRANCESCO II in 1490, helped to make Mantua one of the greatest centres of art collecting and patronage. Under FEDERIGO (1519–40) GIULIO ROMANO built and decorated the Gonzaga pleasure house, the Palazzo del Tè, and turned Mantua into one of the main centres of MANNERIST art. Under VINCENZO I (1587–1612) RUBENS was made court painter; and the reign of FERDINANDO (1612–26) saw the employment of van DYCK, Domenico FETI, ALBANI, and other artists. The spectacular collections built up over the years were sold by VINCENZO II in 1628 principally to Charles I of England, and important Gonzaga patronage came to an end after the sack of Mantua in 1630.

**GONZÁLEZ,** JOSÉ VICTORIANO. See GRIS, Juan.

**GONZALEZ,** JULIO (1876–1942). Sculptor, born in Barcelona. He learnt to work metals under his father, a goldsmith and sculptor, and also experimented for a time with painting. He came to Paris in 1900, the same year as PICASSO, and formed a lifelong friendship with him. After a long period of research, he turned to sculpture in 1927 and made his first sculptures of welded iron. His works are imaginative and varied.

They include abstracts with a suggestion of monstrosity (*Hombre-Cactus*, 1939-40) and violently expressive metal masks (*Mascara de Montserrat gritando*, 1936).

**GORE,** SPENCER FREDERICK (1878-1914). English painter of landscapes, music-hall scenes, and interiors. He studied at the Slade School and subsequently joined SICKERT's circle in Fitzroy Street and was influenced both by Sickert and by Lucien PISSARRO. He became the first president of the CAMDEN TOWN GROUP in 1911, and a member of the LONDON GROUP in 1913. Working for a short time in France he acquired the orthodox IMPRESSIONIST technique. But like many young painters of his time he was excited by the POST-IMPRESSIONISTS and his later works show simplified planes with decorative pattern and form built up by strong outlines in a manner acquired from GAUGUIN and van GOGH.

**GOSPELS,** ILLUSTRATION OF MANUSCRIPTS. Although the evidence is fragmentary, it is clear that manuscripts of the Gospels were copiously illustrated in the EARLY CHRISTIAN period. The earliest surviving example for the West is the 6th-c. manuscript in Corpus Christi College, Cambridge, which in its original state contained four Evangelist portraits (an adaptation of the classical author portrait) and many scenes from the Life of Christ in small compartments. In the surviving examples from the East Old Testament prophets and kings point to each scene as a fulfilment of their Messianic prophecies (*Gospels of Rossano*, *Codex Sinopensis*, Bib. nat., Paris; Syria or Mesopotamia, 6th c.).

After the fall of the Roman empire the BARBARIAN tendency to purely ornamental decoration was matched by the temporary disappearance of the full illustrative cycle. Irish manuscripts have decorated pages and Evangelist portraits only (*Book of Durrow*, Trinity College, Dublin, 7th c.; *Lindisfarne Gospels*, B.M., 7th c.) and only in a late example are there a few illustrative scenes (*Book of Kells*, Trinity College, Dublin, 8th c.). The same is true of the CAROLINGIAN period and it was not until the late 10th c. that full cycles of New Testament illustrations, based on Early Christian models, reappeared (*Gospel Book of Egbert of Trier*, Stadtbib., Trier, c. 980; *Gospels of the Emperor Otto*, Aachen Cathedral).

In Byzantium illustrated Gospels reappeared sometime after the end of the Iconoclastic Controversy (Bib. nat., Paris, 10th c.) and were common in the 11th and 12th centuries. Most fully illustrated were those manuscripts with unframed miniatures in the form of friezes distributed in the text (Bib. nat., Paris; Bib. Laurenziana, Florence; both 11th c.). After the 12th c. the illustrated Gospels all but disappeared

in both East and West; only the Evangelist portraits remained. Illustrations of the Life of Christ continued to occur frequently in other manuscripts, especially PSALTERS, but seldom in manuscripts of the Gospels. (See also ILLUMINATED MANUSCRIPTS.)

**GOSSAERT,** JAN (c. 1478-1533/6). Also called MABUSE. Flemish painter who probably came from Maubeuge in Hainault. In 1503 he was registered in the Guild Master's list at Antwerp and in 1508/9 he went to Rome in the service of Philip Bastard of Burgundy, an ambassador to the Vatican. His early style seems to derive from Hugo van der GOES, Gerard DAVID, and DÜRER, whose influences can be seen in the *Adoration of the Magi* (N.G., London). The fact that there is nothing specifically Italian in this work suggests it was painted before 1508, although the date is much disputed.

The *Malvagna triptych* (Palermo), on the other hand, still shows a Davidian Madonna beneath an elaborate late GOTHIC canopy, but the artist has introduced Italianate music-making PUTTI. Unfortunately his first dated work is as late as 1516 (*Neptune and Amphitrite*, Berlin). The stylistic difference between this and the earlier *Adoration* is overwhelming, and reflects the impact made on him by Italy. In the latter picture the life-size figures are in fact closer to Dürer than to any Italian contemporary; but they are set in a curious, totally misunderstood Doric temple. Several other large, nude compositions are evidence of Gossaert's success with these subjects. The *Hercules* (Barber Institute, Birmingham), painted with a metallic sensuality, and the *Danäe* (Munich) are characteristic examples.

Gossaert was highly thought of by his contemporaries. Cardinal Carondelet and the Royal House of Denmark were among his patrons. Italian biographers such as VASARI acclaimed him for being the first 'to bring the true method of representing nude figures and mythologies from Italy to the Netherlands'. But Dürer's assessment of him as better in execution than in invention ('nit so gut im Haupstreichen als im Gemäl') seems more accurate to modern eyes. Jan van SCOREL was Gossaert's pupil for a short time from 1517.

926.

**GOTHIC.** Term in art history and criticism originally coined by Italian artists of the RENAISSANCE to denote the type of medieval architecture which they condemned as barbaric (implying thereby that it was the architecture of the Gothic tribes who had destroyed the classical art of the Roman Empire). In England the word 'Gothick' was often used by 17th- and 18th-c. writers in the sense of 'tasteless', 'bizarre', or at least contrary to the rules of academic art. But when English antiquarians began to develop an

interest in the monuments of the Middle Ages the term gradually lost its derogatory overtones. The ROMANTIC predilection for the past eventually led to an appreciation of medieval styles of building in their own right and thus to a study of those stylistic elements which are now regarded as Gothic—elements which were consciously revived in the GOTHIC REVIVAL movement. The most influential of these English antiquarians was Thomas RICKMAN, who introduced the subdivisions of Gothic architecture which are still current in England—EARLY ENGLISH, DECORATED, and PERPENDICULAR. The most prominent student of Gothic architecture in France, VIOLLET-LE-DUC, restorer of many cathedrals, initiated an interpretation of the style in terms of structural necessity, an interpretation which has been challenged but not quite superseded. As with many names of styles, the application of the term 'Gothic' was soon extended from its more precise architectural connotation to the ornament, sculpture, and painting of the period in which Gothic architecture was built. German critics have even gone so far as to expound the psychology of 'Gothic Man'. However, for the purpose of this article it is advisable to concentrate first on the more definable core of the term, which remains architectural.

ARCHITECTURE. It is generally agreed that the vaulting of churches in stone presented a considerable difficulty to the medieval mason. The weight of the solid VAULT tended to push the walls outwards and to lead to collapse. The answer to this challenge was the developed skeleton structure of rib and shaft which lightened the weight of the vault and allowed the walls to be mere panels. At the same time the introduction of the pointed arch reduced the outside pressure and allowed the vaulting of areas of varied plan, while the main stress was diverted from the walls to BUTTRESSES. The functional advantages of these and other devices such as flying buttresses and pinnacles are undeniable, yet the explanation of the style in purely mechanical terms is not sufficient. It has been shown that the great cathedrals are not 'miracles of engineering'; in fact modern engineers have criticized their constructional devices. Aesthetic instinct rather than calculation was certainly at work when the rib was introduced to hide irregular groins and shafts were combined to give an impression of lightness and grace; buttresses and flying buttresses together with FINIALS and pinnacles complete the impression of infinite subdivision into rich and variegated parts. This applies even more to the character of the walls, which dissolve into an even more complex network of geometrical TRACERY and STAINED GLASS.

These individual elements which, combined, make up the Gothic style originated in different times and regions. The earliest datable ribs are to be found in Durham Cathedral (1109). The pointed arch had been in use in Moslem archi-

**147.** Façade of the abbey church of Saint-Denis. Engraving from *Le Moyen Age monumental et archéologique* (1843)

tecture (see ISLAMIC ART), whence it may have come to Europe through the Crusaders. Some pointed arches can be found in ROMANESQUE churches such as St Lazare, Autun (1116–32). The welding of these elements into a consistent style took place in the Île-de-France just before the middle of the 12th c. It is commonly assumed that the choir and CHEVET of the Royal Abbey of SAINT-DENIS near Paris, begun under Abbot SUGER in 1140, constituted the first truly Gothic building. There followed, among others, NOTRE-DAME of Paris, begun in 1163, and BOURGES and LAON, both begun about the same time. Saint-Denis embodied features which were to become frequent in Gothic cathedrals, the rose window on the west front, and the sculptured west porch with an elaborate theological programme. The cathedral as a type was perfected in the early 13th c. with the building of CHARTRES after the fire of 1194, of REIMS, begun in 1211, and of AMIENS, the foundation-stone of which was laid in 1220. Amiens is perhaps the purest example. It is here that the Gothic system is at its most logical: the shafts of the pillars continue into the ribs of the quadripartite vaults, the AMBULATORY round the choir continues the aisles, and the west façade with its three entrances reflects the layout of nave and aisles. The two towers (which are incomplete, as so often in French cathedrals) add to the impression of upward soaring. Amiens served as a model for Cologne Cathedral (choir begun

in 1248), the culmination of the first, French, phase of Gothic building in Germany.

In England this phase is represented by the choir of Canterbury Cathedral, begun by the Frenchman William of SENS in 1175. The cathedral in England, however, soon developed on lines different from French Gothic: the choir is not rounded off by an ambulatory but ends in a rectangular Lady chapel, there are sometimes two transepts instead of one, and the rib pattern of the vault is enriched, though at the expense of structural clarity. Perhaps the most typical Early English cathedral is Salisbury, begun in 1220, with its characteristic shafts of black PURBECK MARBLE which introduce an ornamental colour effect unknown to the French builders.

With the advance of the 13th c. the Gothic style ceases to be mainly the style of the great minsters; its elements gain currency in monastic architecture, parish churches, and domestic architecture. This multiplicity of tasks and solutions leads to many national and local variations, from the purity of the Sainte-Chapelle in Paris (1232) to the bizarre inventions of the Lady chapel and choir of Wells Cathedral (1320) or the open-work tower of Freiburg (1310). Different building materials modified the style, an important instance being the BACKSTEIN GOTHIC (brick Gothic) of the north European plain; different liturgical functions modified the church plan, as in the many churches of mendicant friars which sprang up all over Europe with the Franciscan movement in the late 13th c. and were adapted to popular preaching rather than ceremony. For these reasons Germany and north Italy began to prefer the relatively bare hall type (see HALL CHURCHES).

These were the dominant new types, but cathedral building continued into the 14th and 15th centuries, though the emphasis on structural purity gave way to an elaboration of decorative detail. In England this style is called Decorated and continues into the Perpendicular, of which the richly panelled fan vaults are characteristic. The ornate façades of York, Cologne, Orvieto, Rouen, or Burgos all reflect this tendency, seen too in the greater intricacy of the pillars which adds a touch of fantasy to the design of the interior (Wells, Siena). The trend even increases in certain styles of 15th-c. architecture, such as the FLAMBOYANT with its defiance of the material limitations of stone and its marvels of 'fretwork' masonry, familiar in England in chantries and rood-screens and in Germany in the steeple-tops which the late Middle Ages added to the cathedral towers of Ulm or Strasbourg.

It is in the nature of things that most extant examples of Gothic domestic architecture date from this late medieval period. Town halls, guild halls, market crosses, college buildings, monasteries, castles, and fortifications all over western Europe exhibit some of the characteristics of late Gothic, not necessarily in their structure, which remained subservient to utility, but in the application of ornament. They range from the fantasies of the Ca' d'Oro in Venice to the sober surfaces of New College, Oxford.

When, at the beginning of the 15th c., BRUNELLESCHI inaugurated Renaissance architecture with a return to classical modes of building, Gothic architecture still continued vigorously in most parts of Europe. Even in Italy there is evidence that the Gothic style was preferred, by many at least, for church buildings; the projects for the façade of S. Petronio, Bologna, and the completion of Milan Cathedral belong to the 16th c. In the northern countries the Gothic tradition proved even more tenacious and in the 16th c. Renaissance details are strangely superimposed over Gothic forms and sometimes transformed in a Gothic spirit. These very individual mixtures appear in the Tudor Gothic of Hampton Court, in Hatfield House, or the courtyard of the Bodleian Library, Oxford, in England; in S. Eustache and Écouen in France; in La Greffe in Bruges; and in some of the gabled houses in Augsburg and Nuremberg.

SCULPTURE. If architecture be taken as the standard for determining the Gothic period, it may be said to have lasted over 400 years, from 1140 to the middle of the 16th c. and beyond. The term 'Gothic' is used of sculpture and painting in a slightly more restricted sense. The birth of monumental sculpture in the Middle Ages roughly coincides with the evolution of the west porches of the French abbey churches and cathedrals. The most famous early example is the Portail Royal of Chartres Cathedral, c. 1140. Whether these HIERATIC elongated pillar-like

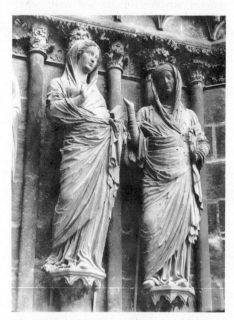

**148.** *The Visitation* (*c.* 1240). From the centre portal of the west façade, Reims Cathedral

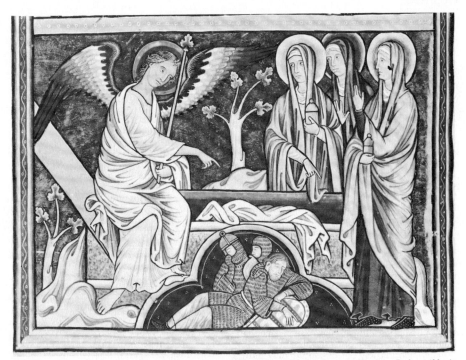

**149.** *Le sepulcre.* Representing the three Marys at the Sepulchre. Miniature from the *Ingeborg Psalter.* (Musée Condé, Chantilly, *c.* 1200)

figures should be called ROMANESQUE or Gothic is an open question. On the whole historians agree that the typically Gothic development of sculpture does not come to fruition until the early 13th c. with such sculptures as those of Reims and Bamberg cathedrals, works which are distinguished for their classic poise and truth to nature (REIMS SCHOOL). Here the emancipation from the massive rigidity of Romanesque architectural sculpture is complete. Each of these lyrically inspired figures stands by itself and there is no doubt that, for instance, the Master of the Reims *Visitation* must have seen classical sculpture. In this sense it might be said that the real turning-point in the history of Western art from hieratic symbol to the rendering of observed nature is to be found in the work of the masons' lodges for the great cathedrals of the 13th c. The degree of naturalism in the foliage capitals of Reims and the Chapter House at Southwell, the vigour and individual characterization of the Naumburg founder figures (*c.* 1260), are the northern counterpart of what is sometimes described as the beginning of the Renaissance in Italy—the sculptures of Nicola PISANO (*c.* 1260).

The trends of Gothic architecture in subsequent centuries can be paralleled in Gothic sculpture. Here, too, the development is from the monumental and heroic to the intricate and intimate. The proportions are stretched, the expression of emotion is emphasized, and cascades of drapery envelop the body, as in the *Apostle* figures of the choir of Cologne Cathedral (*c.* 1330). The same features are displayed by goldsmiths' work and IVORIES which were exported from France in large numbers. New subjects are elaborated in connection with the religious movements of the 14th c., which laid stress on individual devotion and mystical contemplation—e.g. the *Pietà,* which seems to have originated in Germany. These artistic trends of the 14th c. led to the INTERNATIONAL GOTHIC style of the early 15th c. with its unbroken flow of draperies and its tendency to prettiness. At the same time the vigorous naturalism of Claus SLUTER prepared the ground for the final phase of Gothic sculpture where the fluttering draperies and angular gestures accord well with the Flamboyant architecture. This is the period when wood-carving takes precedence over stone sculpture: during the 15th c. the large POLYPTYCHS, which combine painted wings and a shrine with carved figures (see ALTARPIECE), formed the most important commissions of the northern workshops of men like Michael PACHER, Veit STOSS, and Tilmann Riemenschneider. The destruction of church furnishings by the zeal of the reformers accounts for the paucity of examples in England.

PAINTING. In the 12th c., which saw the beginning of Gothic architecture, the scope for painting was relatively limited. In fact the gradual elimination of wall space resulted in less

room for wall-paintings. In their place STAINED-GLASS windows gave new opportunities for the display of a sense of design and colour. In ILLUMINATED MANUSCRIPTS the border-line between Romanesque traditions and Gothic style is particularly hard to find, though most students regard as typical of the new outlook the classical draperies and the 'Gothic sway' and lyrical refinement of such manuscripts as the *Ingeborg Psalter*, which shares so many characteristics with Gothic sculpture. In the late 13th c. Paris became the most influential centre of book illumination and its books, like the French ivories, were treasured all over Europe. 'Quell'arte, che illuminar si chiama a Parigi', says Dante. French style and probably French masters also influenced the style of Gothic illumination in England, which produced its finest examples in the 14th and early 15th centuries. (*Queen Mary's Psalter*, early 14th c., and the *Bedford Book of Hours* span this development.)

The new public for art and literature which was growing up in the towns and castles of the 13th c. also stimulated the production of illustrated Romances, such as Heinrich von Veldecke's *Eneit* (*Aeneid*) in Germany or Benois de St. Moire's Troy Romance, a type of subject matter which was also popular in Gothic wall-hangings and wall-paintings, though few examples dating from before 1400 have come down to us.

Panel painting was not developed fully until altars were furnished with painted RETABLES. Although isolated examples can be dated in the Romanesque period, the practice did not become general until the 14th c. DUCCIO's *Maestà*

for Siena Cathedral and SIMONE MARTINI's *Annunciation* are early examples of the jewel-like quality of Gothic panel painting on gold grounds which spread over the continent of Europe with International Gothic. BOHEMIAN art, centred on the court of Prague, determined the style of German painting in the first half of the 15th c., and echoes of it can be found as far afield as in the Chapter House of Westminster Abbey. The *Wilton Diptych* stands for this phase of painting in England.

How far the general development of painting, beginning with GIOTTO in the early 14th c. and culminating in Rogier van der WEYDEN or BOTTICELLI in the late 15th, can usefully be described as Gothic is largely a matter of emphasis. If stylization, linear quality, and 'Gothic sway' are regarded as the chief hallmarks of this period, we cannot but call these features 'Gothic'. But if we see in it what VASARI saw—if a new understanding of nature and a continuous striving for the classical ideal are to us the dominant features of the history of painting from Giotto to MASACCIO, from van EYCK to MEMLING—then, indeed, we are on the threshold of the Renaissance. (See also BACKSTEIN GOTHIC; SONDERGOTIK; PLATERESQUE.)

50, 114, 340, 344, 346, 383, 732, 778, 879, 886, 916, 917, 977, 1260, 1261, 1377, 1378, 1551, 1561, 1572, 1669, 1745, 1789, 1902, 2011, 2120, 2151, 2264, 2465, 2488, 2813, 2834.

**GOTHIC REVIVAL.** A revival of the GOTHIC style which began in the 18th c. as a romantic interest in medieval forms and fancies. It was

**150.** *Library at Strawberry Hill.* Engraving from *A Description of the Villa of Mr. Horace Walpole at Strawberry Hill, near Twickenham, Middlesex* (1784)

**151.** *South West View of Fonthill Abbey.* Engraving from *Delineations of Fonthill* (1823) by J. Rutter of Shaftesbury

partly of literary origin and partly a breakaway from the rigid PALLADIAN rules of architectural design then prevailing. With a few exceptions such as Horace WALPOLE's Strawberry Hill (1747) and William BECKFORD's Fonthill (by James WYATT, begun in 1796), the earliest examples were simply GEORGIAN buildings with Gothic ornament. But early in the 19th c. the style became closely identified with a religious revival; it was advocated by architects such as A. W. N. PUGIN as the only one suitable for churches, as opposed to the 'pagan' RENAISSANCE style. Churches were built in careful imitation of the Gothic constructions of the Middle Ages. At first the period most imitated was that of the 14th c. ('middle pointed'), but as the 19th c. progressed other medieval styles, English and foreign, became fashionable (e.g. the English PERPENDICULAR in which Charles BARRY's Houses of Parliament were clothed by Pugin, and the Venetian Gothic which RUSKIN praised in his writings). Scholarly imitation in turn gave way to more original adaptations of Gothic principles by such architects as William BUTTERFIELD and G. E. STREET. Other leading practitioners were Sir Gilbert SCOTT and J. L. PEARSON. The Gothic style dominated English 19th-c. architecture, even for civic and commercial buildings, until the so-called 'battle of the styles' ended with a victory for the advocates of the more rational classical designs. Churches, however, have continued to be built in the Gothic style through into the 20th c.

The Gothic Revival in its fullest sense was exclusive to Britain, but throughout Europe and America buildings of all kinds were designed in various Gothic styles as part of the vogue for stylistic revivals characteristic of the 19th and early 20th centuries.

Sir Charles EASTLAKE, who himself belonged to the movement, wrote *A History of the Gothic Revival* in 1871. From that time it remained unchronicled until Sir Kenneth Clark's *The Gothic Revival* (1928), in which he refers to it as 'the most widespread and influential artistic movement which England has ever produced' and as 'perhaps the only purely English movement in the plastic arts'.

562, 796, 2283.

**GOTHIC REVIVAL IN NORTH AMERICA.** GOTHIC motifs began to appear in North American architecture in the late 18th c. but the style did not become widespread until after 1825. It continued, concurrently with the GREEK REVIVAL, until mid century. Initially inspired by the GOTHIC REVIVAL in England, its first important application in America was in Episcopal and Roman Catholic churches. The architects TOWN, DAVIS, UPJOHN, and RENWICK were its leading supporters. Their work ranges from traditional meeting-houses decorated with Gothic ornament to more accurately detailed examples drawn directly from English and French prototypes. The most interesting applications of the Gothic occur in the domestic architecture during the first half of the century, of which Davis was one of the most facile and original designers. The writings of RUSKIN, especially *Stones of Venice* (1851–3), brought to America after the Civil War a resurgence of enthusiasm for the Gothic—not, however, the medieval architecture of England and France, but the lavishly adorned and colourful Gothic of Venice. Pointed arches of multi-coloured stone, compound windows, and richly carved colonnaded arcades were the dominating features.

The style was used in all types of building. Perhaps the most characteristic and finest example is Memorial Hall at Harvard, by Ware and van Brunt (1870). The National Academy of Design in New York and the Boston Museum of Fine Arts, both influential centres of artistic endeavour, were built in this Venetian or, as it is sometimes called, 'Victorian' Gothic.

**GOUACHE.** Opaque WATER-COLOUR painting, sometimes also known as BODY colour. It differs from transparent water-colour in that the pigments are bound with glue and the lighter tones are obtained by the admixture of white pigment. Its degree of opacity varies with the amount of white which is added, but in general is sufficient to prevent the reflection of the GROUND through the paint and it therefore lacks the luminosity of transparent water-colour painting. A gouache technique was used in ancient EGYPTIAN painting, the pigments being bound with traganth glue or with honey. During the Middle Ages it was much used in ILLUMINATED MANUSCRIPTS. It was used in conjunction with transparent water-colour by the early MINIATURISTS and later for picking out the highlights. DÜRER's water-colour landscapes and flower and animal studies were mostly in gouache technique. It became popular with the French, Swiss, and Italian water-colourists of the 18th c., who exploited the tendency of gouache colours to lighten in drying and to acquire a pearly and pastel-like translucency. BOUCHER was a particular master of this effect. Gouache has remained popular with French water-colour painters through the 20th c. In this century also it has been widely applied for various specialized purposes such as POSTERS, costume and stage designs, and various types of illustrations. The colours sold as Poster Paints by commercial colourmen are usually a form of gouache. Although gouache lacks the special transparency effected by the white ground of 'true' water-colour, it is easier to handle because earlier trials and errors can be painted over and do not show through to the same extent.

A closely related method of water-colour painting uses SIZE or gelatine glue as a binder. Size was the medium normally used in the Far East for painting. It was popular in Europe sometimes as an independent technique in mural painting and sometimes as part of more complicated techniques. VASARI does not differentiate gouache from TEMPERA. It was sometimes used by the Old Masters in combination with egg tempera and sometimes as an underpainting for OIL PAINTING.

**GOUJON, JEAN** (c. 1510–68). French sculptor who at the middle of the 16th c. created a form of MANNERISM in sculpture analogous to the Mannerist School of painting and decoration founded by PRIMATICCIO at FONTAINEBLEAU. Very little is known about his origins and early life but attribution to him in 1540 of the fine

columns supporting the organ loft in the church of S. Maclou at Rouen makes plausible the conjecture that he was born in or around that town. The pure Classicism of these columns has also caused some critics to assume that he had firsthand knowledge of Italy and Italian work. The tomb of Louis de Brézé, husband of Diane de Poitiers, also at Rouen, is generally ascribed to him. His mature style is first displayed in work done at Paris from 1544, when he was working on the screen of S. Germain-l'Auxerrois, in collaboration with LESCOT. Panels (now in the Louvre) from this screen with figures of the Evangelists in low relief, reminiscent of MICHELANGELO's Sistine ceiling, show that Goujon had evolved a style of extreme grace and purity which fitted into the architectural surroundings to form a homogeneous work of art. This style, which owed something to the influence of Benvenuto CELLINI, is seen at its most mature in his decorations for the *Fontaine des innocents*, Paris (1547–9). Though they have been moved and reassembled in a different form, the nymphs with their elongated figures and rippling drapery display Goujon's great technical and decorative ability. Goujon's later work at the Hôtel Carnavalet and the LOUVRE was also done in collaboration with Lescot and consisted mostly of decorative panels forming part of the architectural scheme. All the external sculpture on the Louvre has been restored and cannot be judged in detail, but a certain amount of interior decoration remains, including the astonishingly classical conception of the CARYATIDES in the Salle des Caryatides.

Goujon was a scholar of the ANTIQUE, and as early as 1547 had attained a sufficient reputation as artist and classicist to be asked by Jean Martin to provide an introduction and illustrations for the first French edition of VITRUVIUS. His sculptural style owed less to Primaticcio than to Cellini and combined classical purism with the mannered elegance of Fontainebleau. His development was parallel to that of the group of writers round Ronsard and du Bellay, who were adapting classical forms to the French language about the middle of the century.

Goujon ended his life in Bologna, where he sought refuge from the persecution of the reformed church. There is no indication of any work executed after 1562 during his years of exile.

772.

**GOWER, GEORGE** (active from c. 1570 to 1596). An Englishman of gentle birth who was established as a portrait painter in London after 1570 and was appointed Serjeant-Painter for life in 1581. His *Sir Thomas Kitson* and *Lady Kitson* (Tate Gal., 1573) show his clear and individual if unsubtle style. Somewhat finer is his *Self-Portrait* (Milton, Peterborough, 1579) in its combination of character portrayal and decorative quality.

**GOYA Y LUCIENTES,** FRANCISCO JOSÉ (1746–1828). Spanish painter and etcher, born at Fuendetodos (Aragon), the son of a master gilder. After serving his apprenticeship at Saragossa he appears to have worked at Madrid for

**152.** *Francisco Goya y Lucientes, Pintor.* Self-Portrait by Goya. Aquatint and etching from *Los Caprichos* (1799)

the court painter Francisco BAYEU. In 1771 he was at Rome but returned to Saragossa before the end of the year. In 1773 he married Bayeu's sister, and by 1775 had settled at Madrid. Between 1776 and 1791 he painted for the royal tapestry factory a series of tapestry CARTOONS (Prado). The subjects range from idyllic scenes to realistic incidents of everyday life, conceived throughout in a gay and romantic spirit and executed with ROCOCO decorative charm. During these years Goya's reputation grew rapidly. He was elected to the Academy of San Fernando in 1780 and became assistant director of painting in 1785. In 1789 he was nominated a court painter to the new king, Charles IV.

His early portraits followed the somewhat stiff manner of MENGS, but stimulated by the study of VELAZQUEZ's paintings in the royal collections he gradually developed a more natural, lively, and personal style which is especially apparent in his portraits of women and children such as the young Manuel Osorio de Zúñiga (Met. Mus., New York, 1788) and the Countess of El Carpio (Louvre, 1791).

In 1792 he fell ill, probably with acute labyrinthitis, and when he finally recovered in 1794 he was stone deaf. His artistic activity remained unaffected but signs of emotional change became apparent. In 1795 he succeeded Francisco Bayeu as director of painting at the Academy of San Fernando. To the years 1794–7 belong some of his finest portraits, notably that of the actress *La Tirana* (Juan March Coll., Madrid, 1794),

masterpiece of the so-called 'silver period' during which he showed a predilection for grey and silver colour schemes. In 1798 he painted the dome, apse, lunettes, and pendentives of the church of S. Antonio de la Florida in the outskirts of Madrid with the scene of *St. Anthony of Padua bringing the dead man to life.*

Meanwhile he had begun to draw, etch, and paint subjects which gave fuller scope to his extraordinary fantasy and invention. As he grew older he devoted himself more and more to the peculiar genre themes and imaginative scenes in which darker elements of fantasy, terror, and menace began to predominate. Early examples are paintings executed in 1793 for the Academy of San Fernando, among them *The Village Bullfight* and *The Madhouse.* In 1799 he issued a set of 82 plates in etching reinforced with aquatint entitled *Los Caprichos* (Caprices) which were executed *c.* 1793–8, and their humour is constantly overshadowed by an element of nightmare. Technically revealing the influence of REMBRANDT, they were in subject savagely satirical attacks on social customs and abuses of the Church with elements of the macabre in scenes of witchcraft and diabolism.

In 1799 he was appointed First Court Painter, and in 1800 completed his most famous portrait group, the *Family of Charles IV,* which hangs in the Prado together with preliminary studies for some of the individual portraits. The weaknesses of the royal family are revealed with unsparing realism, though apparently without deliberate satirical intent. His many portraits during the next few years show increasing mastery of pose and expression, heightened by dramatic contrasts of light and shade. Outstanding among these are the portraits of Isabel Cobos de Porcel (N.G., London, *c.* 1806) and the actor Isidoro Maiquez (Prado, 1807). To these years also belong the two celebrated pictures, the *Maja nude* and the *Maja clothed* (Prado, *c.* 1797–1800).

Goya retained his appointment of court painter under Joseph Buonaparte during the French occupation of Spain (1808–14). But his activity as a painter of court and society decreased, and he was torn between his welcome for the regime as a liberal and his abhorrence as a patriot against foreign military rule. The masterpieces of this period, inspired by the resistance to the French, have tremendous dramatic force which reached its height in *The Shootings of May 3rd 1808* (Prado, 1814). Equally dramatic, but much more savage and macabre, are the 65 etchings *Los Desastres de la Guerra* which he executed in 1810–14. These nightmare scenes are the most brutally savage protest against cruelty and horror which the visual imagination of man has conceived. After the restoration of the Bourbons in 1814 Goya still remained court painter but he was soon superseded in the royal favour by Vicente LÓPEZ. The relatively few portraits which he painted during these years include two Self-Portraits (Prado and Academy, Madrid,

1815). To the year 1819 belongs the most profound and moving of his religious pictures, *The Last Communion of St. Joseph of Calasanz* (Escuelas Pías, Madrid).

Towards the end of 1819 Goya fell seriously ill for the second time. He had just bought a country house in the outskirts of Madrid, the Quinta del Sordo; and it was here that between 1820 and 1822 he executed 14 large murals, sometimes known as the *Black Paintings*, now in the Prado. Painted almost entirely in blacks, greys, and browns, they epitomize the morbid trend of his imagination. Parallel in inspiration are the 22 plates of *Disparates*, which he etched between 1820 and 1824.

In 1824 Goya obtained permission from Ferdinand VII to leave the country for reasons of health and settled at Bordeaux, making only a few brief visits to Spain before his death in 1828. In these last years he took up the new medium of LITHOGRAPHY while his paintings, such as the portrait of J. B. Muguiro (Prado, 1827), illustrate his progress towards a style which foreshadowed that of the IMPRESSIONISTS.

Goya completed some 500 oil paintings and murals, nearly 300 etchings and lithographs, and many hundreds of drawings. He was exceptionally versatile and his work expresses a very wide range of feeling and emotion. In his own day he was celebrated for his portraits, of which he painted more than 200; but his fame has since been greatly enhanced by his drawings, lithographs, the *Disasters of War*, the *Black Paintings*, and other works only made public many years after his death. He himself wrote that he had three masters, 'Nature, Velazquez and Rembrandt'. After having been court painter for a third of a century he had the distinction at the age of 62 of representing Spanish sentiment during the drama of the French invasion which brought fire and destruction to the Peninsula.

260, 514, 983, 1254, 1508, 1547, 1571, 1687, 2344, 2394.

**GOYEN**, JAN VAN (1596–1656). Dutch painter who was born in Leiden and died at The Hague. Van Goyen, a very prolific artist, was one of the foremost pioneers of Dutch realistic LANDSCAPE painting. He was one of the first painters to capture the quality of the light and air in a scene and to suggest the movement of clouds. He created a manner of his own: monochrome landscapes in browns and greys with touches of vivid blue or red to catch the eye; gnarled oaks; wide plains, usually seen from a height; low horizons and clouded skies. Most of his paintings seem to be based on drawings made as he travelled about the countryside, and he apparently used the same drawings again and again because the same motifs recur repeatedly in his work. They include views of Dordrecht with its squat tower on a wide river; views of Nijmegen on the river, dominated by the castle; sand dunes and shipping scenes. He had many pupils and imitators, such as Jan Coelenbier (active 1632–71), who produced paintings which passed for van Goyen's.

2780.

**GOZZOLI.** BENOZZO DI LESE (*c.* 1421–97). Italian painter of the FLORENTINE SCHOOL. Apprenticed as a goldsmith, he worked in his early years both with GHIBERTI on the Baptistery doors, Florence, and with Fra ANGELICO in Rome and Orvieto. His talent was primarily decorative and in this he displayed verve and imagination.

Piero de' MEDICI's choice of Gozzoli in 1459 to decorate the chapel in the Medici Palace, Florence, was an appropriate one. Patron and artist, sharing a taste for pageantry, ceremonial, and Burgundian tapestries, conspired to produce the most glittering fresco paintings of the century, recalling, and perhaps consciously rivalling, GENTILE DA FABRIANO's *Adoration of the Magi* of 1423. Gozzoli took the same subject but distributed the processions of the Three Kings over three of the walls of the chapel, making each procession converge on the central point beneath the star represented in the coffering of the ceiling and in front of the altar.

Gozzoli's other major work was a fresco cycle with scenes from the Old Testament, now badly damaged, in the Campo Santo at Pisa, begun in 1467. He also painted ALTARPIECES, one of which, dated 1461, is in the National Gallery, London.

**GRAF**, URS (*c.* 1485–1527/8). Swiss goldsmith, engraver, and designer, working as an apprentice in Strasbourg and later in his native Berne. Apart from his numerous designs for goldsmiths' work, stained glass, and woodcuts, Graf is noteworthy for his lively and uninhibited drawings of mercenaries, peasants, and ladies of easy virtue.

**GRAFF**, ANTON (1736–1813). German portrait painter, active in Dresden. He produced a large number of portraits of the outstanding intellectual personalities of his time and country in a simple and direct manner reminiscent of REYNOLDS.

**GRAFFITO** or SGRAFFITO (Italian: 'scratched'). A drawing or ornament scratched on a wall; or more specifically, the technique of producing a design by scratching through a layer of paint or other material to reveal a ground of a different colour. In a medieval panel painting, for instance, the ornamental parts would be covered with gold leaf, burnished, and painted, and a design would then be scratched through the paint. In wall-painting too the technique was in use in the Middle Ages, and on many façades of RENAISSANCE palaces; in these cases the layers were both of plaster, differently coloured. The technique still survives, but nowadays less linear

and more pictorial effects are sought by cutting away the plaster overlayer from whole areas and graduating the amount removed in order to produce middle tones. In graffito pottery the design was produced by scratching through the overglaze.

The predilection in certain 20th-c. aesthetic movements for an appearance of accidental and undesigned decoration combined with a heightened interest in surface texture for its own sake has sometimes directed attention to the effects of random markings and scratchings on walls and other surfaces. These have been photographed and reproduced. Some non-figurative painters have tried to develop this into special kinds of textural effects which formed the predominant motif of their painting.

**GRANDEVILLE.** Pseudonym of JEAN-IGNACE-ISIDORE GÉRARD (1803-47), French CARICATURIST and illustrator. Having been trained in Nancy by his father, a MINIATURIST, he came to Paris at the age of 20 and published a series of lithographs: *Le Dimanche d'un bon bourgeois.* These were followed by four series depicting the activities of childhood, youth, maturity, and old age. He then turned to political caricature: *Métamorphoses du jour* (1892), *Processions politiques.* His illustrations to the *Fables* of La Fontaine (1838) achieved lasting popularity for their witty blending of human and animal features (a device which he had already used with telling effect in his political caricatures). Towards the end of his life he showed a predilection for macabre and fantastic subjects (*Danses macabres*) which later attracted the interest of SURREALISTS. He died in a lunatic asylum.

**GRAND MANNER.** The lofty style of history painting as advocated in the ACADEMIES, notably in REYNOLDS's Third and Fourth *Discourses* (1770 and 1771), where he asserts that 'the *gusto grande* of the Italians, the *beau idéal* of the French, and the *great style*, genius and *taste* among the English, are but different appellations of the same thing'. Reynolds attributed this excellence to the ROMAN, the FLORENTINE, and the BOLOGNESE SCHOOLS, regarding the French masters such as POUSSIN and LEBRUN as 'a colony from the Roman School'. He expressly denied this character to the Venetians since even in history painting 'there are two distinct styles . . . the grand, and the splendid or ornamental'. These distinctions, like so many categories of style, go back to the classical handbooks of Rhetoric, which distinguished, for example, between the elevated, the elegant, the plain, and the forcible style. It was in 17th-c. Italy that such categories were first applied to painting; BELLORI (1672, in the *Life of Domenichino*) quotes a passage from a treatise by Agucchi attributing to MICHELANGELO *lo stile grande*, and includes among the notes of Poussin a disquisition on *la*

*maniera magnifica* which Professor A. F. Blunt has shown to derive from a 17th-c. historian and which, in its turn, provided the keynote for Reynolds.

As in the literary theories represented for example by Dr. Johnson, the Grand Manner in painting demanded subordination of the particular and emphasis on the generic. The artist who aspires to the Grand Manner 'will consider nature in the abstract, and represent in every one of his figures the character of its species'. The style also repudiated interest in the vulgar or trivial and a preference for the heroic and aristocratic to the exclusion of low life. Hence a reflex of the attitude reflected in the Grand Manner was depreciation of Dutch STILL LIFE and of rustic GENRE.

**GRAND TOUR.** From the Restoration and during the 18th c. a journey of one or two years to the Continent, chiefly to France, the Netherlands, and Italy, and sometimes in the company of a tutor, became a conventional feature in the education of the English gentleman. The practice had a noticeable effect in bringing a more cosmopolitan spirit to the taste of CONNOISSEURS and virtuosi of the arts and laid the basis for many collections among the landed gentry. It helped the spread of the fashion for PALLADIANISM and NEO-CLASSICISM and an enthusiasm for Italian painting. Among the artists who catered for this demand were PIRANESI, BATONI, CANALETTO, and PANINI.

**GRANET,** FRANÇOIS-MARIUS (1775-1849). French painter of Aix-en-Provence. He was a pupil of DAVID and subsequently spent the years 1802-19 in Rome. He made a speciality of sombre tonal effects and changing light in dimly lit interiors. His highly individualistic style recalls Dutch interiors rather than the NEO-CLASSICAL School in which he was trained. His *Choir of the Capuchin Monastery* (1819), depicting monks celebrating mass, was so popular that he made 16 copies, one of which is at Buckingham Palace. His Italian landscapes are often constructed with firm, cubic volumes in which some critics have seen a foreshadowing of CÉZANNE. In 1826 he became curator of the LOUVRE Museum and was made Keeper of Pictures at VERSAILLES in 1830. During the Revolution of 1848 he retired to Aix, where he founded the museum which bears his name. It contains a portrait of him by INGRES.

**GRANITE.** A general term for any crystalline, granular, unstratified igneous stone which is an intimate amalgam of quartz, potash feldspar, and mica. Granite is of world-wide distribution and has many varieties, differing in texture and coarseness. It occurs in a wide range of colours—grey, green, rose, yellow—and the small scales of mica give it a lively sparkle. It takes a brilliant

polish on a mirror-smooth surface but is one of the most difficult stones to carve because it is physically very compact; its ingredients are harder than ordinary steel. Nevertheless its durability and resistance to weather have made it popular for MONUMENTAL SCULPTURE and at all times when permanence was valued. In ancient Egypt granite from Syene near Aswan was used for many monuments, including the Luxor obelisk and Cleopatra's Needle (now on the Victoria Embankment, London, and the companion obelisk in Central Park, New York). It was also used in Egypt for portraiture, e.g. red granite head of Thutmosis III (Cairo Mus., 18th Dynasty). In China the Great Wall is composed entirely of granite and it was used extensively by the ancient Ceylonese for their Buddhist temples and also in India (Ellora). There are fine granite deposits in Scotland which have been much used for building. Granite has been used comparatively little for sculpture on a small scale since its properties preclude delicate projections, deep undercutting, or a broad and impressionistic treatment of the surface.

**GRANNACCI,** FRANCESCO (1477-1543). Minor Florentine painter, pupil of GHIRLANDAIO, chiefly remembered for his friendship with MICHELANGELO.

**GRANT,** DUNCAN (1885- ). Scottish-born painter, decorator, and designer for textiles, pottery, stage scenes, and costume. He studied at the Slade and in Italy and Paris. A member of the Bloomsbury circle of Roger FRY and Clive and Vanessa BELL, he exhibited at the NEW ENGLISH ART CLUB and with the LONDON GROUP. He was one of the first English artists to be influenced by the FAUVES and CÉZANNE, and contributed to the second POST-IMPRESSIONIST Exhibition in 1912. From about 1913 he was also influenced by Negro sculpture (see AFRICAN TRIBAL ART). Grant has been called 'a traditional artist, carrying forward the most recent discoveries'. There are pictures of his in the Courtauld Gallery, London.

**GRANT,** SIR FRANCIS (1805-78). Younger son of an old Scottish family, he was largely self-taught as a painter. His clientele was mainly English and he became the most fashionable portrait painter of his day. He succeeded EASTLAKE as President of the ROYAL ACADEMY. Though informed with a certain elegant dash, he was technically ill-equipped for great painting and his undoubted talent shows to best advantage in his smaller sporting CONVERSATION PIECES. He is well represented in the National Portrait Galleries, Edinburgh and London.

**GRAPHIC ART.** In the *O.E.D.* the graphic arts are defined as 'the fine arts of drawing, painting, engraving, etching, etc.' but the term has become current with a more restricted application to engraving and illustration in their various forms. A further limitation now generally current restricts the term to the aesthetic rather than the reproductive or illustrative functions of graphic processes and histories of 'graphic art' in general concentrate on engraving, lithography, etc., as art forms rather than their commercial and reproductive uses. As the reproductive uses of the woodcut were in part superseded by the invention of movable type, and those of the engraving were later superseded by methods of photographic reproduction, the artistic applications of these techniques survived or were revived. There grew up an opposition, particularly strong during the 19th c., between the specialist engravers, who were masters of technique and craftsmanship, on the one hand and on the other hand the artist-engravers who used graphic processes, often without specialized training in craftsmanship, as one medium among others for artistic expression. The distinction is not absolute. Many artists have had a particular feeling for subtlety of tones and for that 'mysterious marriage of ink and paper' in which the peculiar beauty of the art resides, and this has enabled them in some cases to make a useful contribution to technical advance. On the other side many professional engravers have achieved a certain level of artistry. None the less the appreciation of an engraving is a specialized skill and CONNOISSEURS need special knowledge and experience in addition to that required to appreciate beauty of design or colour in plastic art generally.

The foregoing matters have been broached in the article on PRINTS and in the related articles

153. *Imago Erasmi Roterodami.* Copper-plate engraving (1526) by Albrecht Dürer

there mentioned. In the present article something will be said very briefly about the particular application of graphic processes as an art form.

The vast output of prints in the 17th and 18th centuries was the work largely of professional engravers, who copied the works of other artists and fulfilled a function which has since been taken over by photographic techniques. The first of these professional engravers interpreting the work of other artists was MARCANTONIO RAIMONDI. But even in the 16th c. some artists worked their own plates—notably DÜRER, the first artist to engrave portraits, and LUCAS VAN LEYDEN. The painters Lucas CRANACH and Albrecht ALTDORFER also used etching and woodcut for original productions. During the 17th and 18th centuries van DYCK excelled in portraiture, CANALETTO and PIRANESI in topographical art, CLAUDE Lorraine and RUISDAEL in landscape. REMBRANDT did more etching than most artists, more than 300 plates being authenticated, and developed the expressive possibilities of the medium in many fields. During the 18th c. etching experienced a period of decline except for the English satirists HOGARTH and ROWLANDSON, and the decorative use of etching by Giovanni Battista TIEPOLO. Towards the end of the century and in the early 19th c. the figures of GOYA and BLAKE overtop all others in creative and dynamic force.

In the 19th c. the conflict between the artistic and the professional use of the graphic arts became accentuated. While lithographic processes were developed commercially, their aesthetic uses were explored by a number of painters. Goya in Spain, GÉRICAULT and DELACROIX among the ROMANTICS, MANET, REDON, FANTIN-LATOUR, TOULOUSE-LAUTREC, DEGAS, RENOIR, GAUGUIN, VUILLARD, and many others of the IMPRESSIONISTS and POST-IMPRESSIONISTS used the lithographic process in new and original ways as an aesthetic and expressive medium. DAUMIER and FORAIN made a major use of both lithograph and engraving in their œuvres.

But despite the interest among creative artists in the expressive potentialities of graphic processes, dealers and collectors and publishers continued to concentrate on reproductive engraving by professionally competent but artistically nugatory craftsmen. It was not until near the end of the 19th c. that the artistic value of graphic work by original artists became the subject of renewed appreciation among critics, connoisseurs, and eventually the general public. A special feature of the 20th c. has been the creation of a new type of books, the *livres de peintre*, under the leadership of such publisher-dealers as Ambroise Vollard and Henri Kahnweiler, which were issued in expensive limited editions for connoisseurs and whose whole appeal lay in the graphic illustrations done expressly for them by a chosen artist. To this type of illustration as well as to single prints most modern artists have devoted part of their energies and there are few

prominent painters of the 20th c. who have not been concerned with graphic art in one form or another. While great attention is paid to the development of the peculiar expressive qualities of each process and a sense for the particular values most appropriate to it, a lifetime apprenticeship in the minutiae of craftsmanship is no longer considered necessary among artists who use this as one only among a number of other artistic modes of expression.

14, 275, 418, 679, 714, 1151, 1279, 1280, 1412, 2148, 2291, 2319, 2817.

**GRASSER**, ERASMUS (*c.* 1450-1526). German sculptor and wood-carver, working in Bavaria after training in the Tyrol and possibly north Italy. He represents the elaborate yet lively late GOTHIC manner which was so common in the Germany of his day. His most characteristic and best known work is the naturalistic and highly expressive *Moreska Tänzer* (Bayerisches Nat. Mus., Munich, 1480).

**GRAVELOT**, HUBERT-FRANÇOIS BOURGUIGNON (1699-1773). French designer and engraver of book illustration. He helped to introduce the French ROCOCO style to England, where he was active 1732-55 with a short absence from 1745. In London he became a friend of HOGARTH, taught GAINSBOROUGH, and caricatured WALPOLE and Lord BURLINGTON. He illustrated Gay's *Fables* and both Shakespeare and Dryden. He was one of the first artists to illustrate the novel, designing illustrations for Richardson's *Pamela* (1742) and Fielding's *Tom Jones* (1750). He was at his best depicting scenes of contemporary life rather than tragic subjects or the classical and allegorical themes then fashionable. Thus, in Corneille's *Théâtre* (1764) the comedy scenes are more successful than the scenes of tragedy. He also illustrated Rousseau's *Nouvelle Héloïse* (1761) and Marmontel's *Contes moraux* (1765), for which he is perhaps best remembered. Although not an artist of outstanding talent, he is important as a link between French and British styles in the mid 18th c.

**GRAVER.** See BURIN.

**GREAT EXHIBITION.** See EXHIBITION, The Great.

**GRECHETTO**, IL. See CASTIGLIONE, Giovanni Benedetto.

**GRECO**, EL (1541-1614). Painter, sculptor, and architect, born at Phodele near Candia in Crete but active mainly at Toledo. He was known as El Greco (the Greek), but his real name was Domenikos Theotocopoulos; and it was thus that he signed his paintings throughout his life, always in Greek characters, and sometimes followed by *Kres* (Cretan). Despite his

Cretan origin and early Italian training, he is regarded as a Spanish painter.

Little or nothing is known of his youth. It is probable that he originally learned to paint in the late BYZANTINE school of Crete, but no work of this period has been identified. He studied at Venice for some years prior to 1570, in which year his arrival at Rome is recorded by the miniaturist Giulio CLOVIO, who describes him as a disciple of TITIAN. Of all the Venetian painters TINTORETTO influenced him most, and MICHEL-ANGELO's impact on his development was also important.

Among the surviving works of his Italian period are the *Purification of the Temple* (Minneapolis), the *Healing of the Blind* (Parma), and the portrait of Giulio Clovio (Naples). By 1577 he was at Toledo, where he remained until his death, and it was there that he matured his characteristic style. Among the many pictures which he painted during his first 10 years in Spain *The Assumption of the Virgin* (Art Inst., Chicago, 1577), probably the first work which he executed at Toledo, reveals the influence of the Spanish environment alternating with the Italian; the *Christ Stripped of his Garments* (Toledo Cathedral, 1579) is a fusion of his Byzantine heritage, his Venetian technique, and the elements that made his Spanish style; but the *Burial of Count Orgaz* (S. Tomé, Toledo, 1586) is a masterpiece of mature and unified idiom. His expression of profound religious emotion and supernatural vision reached its climax in his last paintings, notably the *Assumption* (S. Vicente, Toledo, completed 1613).

He principally painted religious subjects, and his picture of the classical theme *Laocoon* (N.G., Washington, c. 1610) is therefore exceptional. In another exceptional work belonging to his later years, the *Toledo Landscape* (Met. Mus., New York), he anticipated the painting of pure landscape without figures. He excelled in portraits, about 40 of which are known. Notable examples are *Cardinal Guevara* (Met. Mus., New York, c. 1601) and *Félix Paravicino* (Boston Mus., 1609).

El Greco designed complete altar compositions, working as architect and sculptor as well as painter, for instance at the high altar of the Hospital de la Caridad, Illescas (1603). PACHECO, who visited El Greco in 1611, refers to him as a writer on painting, sculpture, and architecture. The inventory of his effects compiled after his death records 50 models in plaster, clay, and wax; while his library included a collection of books on architecture.

As a painter his most striking characteristic is his choice of a cold, bluish, range of colours and silvery-grey tones, at a time when many masters favoured warm reds and browns. His cold tonality, his harsh light, his free brush-strokes, his disregard of traditional rules, and the tormented spirituality of his figures have all contributed to the high estimate in which his genius is held. While he lived his work was greatly admired by a select but very small minority in Spain, and among the general public he became popular for his paintings of St. Francis (of which over 100 are catalogued). VELÁZQUEZ possessed several of his works, but in general his influence was slight. His only followers were his son MANUEL THEOTOCOPULI (1578-1631) and Luis TRISTÁN. Interest in his work was revived at the end of the 19th c. The strangeness of his art inspired various theories, for instance that he changed his style to avoid confusion with Titian, or simply that he was mad. More recently his distortions have been attributed to astigmatism. But his MANNERED disproportions were certainly deliberate and when his *Assumption* (S. Vicente) was censured for this reason, he replied: 'No worse fate can befall a figure than that it should be undersized.' He had completely assimilated his artistic inheritance into a personal aesthetic which he made a supremely effective instrument of spiritual expression.

479, 628, 1067, 1088, 2360, 2856, 2903.

**GREEK ART.** I. GENERAL SURVEY. Greek art has been until the present century a principal source of inspiration for European art, although next to nothing was known of it directly until the middle of the 18th c., when an interest developed in Greek as distinct from Greco-Roman art and was made fashionable by WINCKELMANN. The first objects of this new interest were architecture and painted vases, but it was not until the ELGIN MARBLES were exhibited in London early in the 19th c. that Greek sculpture of the classical period became at all widely noticed.

Even today few people realize the magnitude of the losses and how very few Greek art objects of first or even secondary worth survive. Of Greek buildings, tombs excepted, not one remains intact, though various ruins (usually preserved owing to their remoteness or because they were converted into churches) give a fair impression of public architecture from the 6th c. B.C. onwards. From Greece proper paintings on walls survive only in a very few fragments and there are now no panel paintings. But painted pottery is plentiful over the whole period as long as the art lasted. MOSAICS of HELLENISTIC and Roman date are common enough, but mosaics are an unsatisfactory medium for an art which was above all naturalistic. In statuary the Archaic style is fairly well represented by originals, the Classical and Hellenistic styles very poorly so that here we have to rely on copies of Roman date. Some notion of the losses may be obtained from the fact that at Rome 3,785 public statues of bronze were listed in the 4th c. A.D. and 1,000 years later perhaps five were left.

The special character of Greek art is an exact and ordered idealism. It is naturalistic—the first great naturalistic art movement to emerge—so that, for example, the progress of Greek sculpture till the late 5th c. can be expounded (though

very incompletely) in terms of progress in anatomical representation. The aim of Greek sculpture was to reproduce for the eye an ideally beautiful human shape rather than—as is the case in much 20th-c. sculpture—to create in the sculptor's material an interesting organization of three-dimensional spatial forms. Intellectual principles of symmetry were imposed to correct imperfections or irregularities such as occur in ordinary human beings.

Largely for these reasons the attitude to Greek art in the present century has been notably ambivalent. Creative artists and their interpreters and critics in the modern movement have come under the influence of African, Indian, proto-American, Chinese, and other types of art which tend to rely predominantly on precisely the forms of sensibility in which the Greeks were weak. Admiration for classical Greek art has correspondingly declined, or there has been a tendency to prefer the Archaic, partly because of its relative novelty. Many art historians and archaeologists, however, continue to admire Greek art and see its development up to Hellenistic times as a growth not only in technical mastery, but also in excellence of aesthetic achievement.

The history of Greek art is commonly divided into four periods and for convenience this division will be adopted. They are: Geometric (late 11th to late 8th c. B.C.); Archaic (late 8th c. to 480 B.C.); Classical (480-323 B.C.); and Hellenistic (323-27 B.C.). This scheme excludes the art of the Mycenaean and Minoan peoples, which is dealt with separately. It also excludes the art of the Roman period, which in many ways prolonged or continued the Greek tradition.

(a) *The Geometric period* (late 11th to late 8th c. B.C.). MINOAN and MYCENAEAN art, which in ideals and expression differed radically from Greek, had been intimately connected with the royal palaces; and when the palaces came to their end architecture, wall-painting, metal-work, ivory carving, and writing ended too. Only painted pottery continued, and that by the 11th c. B.C. had lost most of its old character and was finding a new one, based on a simple geometrical logic of pattern. Of major arts there is no trace and textiles, which might perhaps have rivalled vase-painting, have vanished. The numerous terracotta figurines are undisciplined and naïve, but in the later 8th c. some miniature bronze figures, especially of horses, show a simple abstract formula suited to their scale and have aroused the admiration of those who favour certain modern aesthetic movements.

(b) *The Archaic period* (late 8th c. to 480 B.C.). Towards the end of the 8th c. a new spirit was moving Greek art and society. Trade and civic life grew rapidly, and with them new standards and needs. Many artistic motifs and some ideas were taken from the East, particularly Syria, and much Greek work of this period is called Orientalizing. But Oriental art was elaborate and sophisticated, and the Greeks did not imitate closely; instead they adapted modestly and developed their own styles. Sculpture and public architecture appeared in the early or middle 7th c. and proceeded slowly and steadily. Painting probably began about the same time, metal-work became bolder and more skilful, vase-painting flourished. Archaic art was cautiously experimental; at its best it manifests an ingenuous or perky gaiety. The anatomy of the human figure, already the principal interest of representational artists, was more or less understood by the end of the period, which is conventionally fixed by the Persian sack of Athens in 480 B.C.

(c) *The Classical period* (480-323 B.C.). In the 5th c. civic wealth and pride increased, especially at Athens. Sculpture and architecture now reached a serene and restrained majesty, which became lighter and less Olympian in the 4th c.: their technical quality surpassed anything ever achieved in the East, and remained a standard throughout antiquity. Painting was exploring the third dimension, and the ancient critics put its maturity in the 4th c. at least half a century later than sculpture. Vase-painting, unable or unwilling to follow, declined in status and slowly expired. Metal-work and the engraving of gems and coin-dies are often excellent. There was a steady progress in technical mastery and a gradual shift in ideals, but within the tradition, not in defiance of it. Classical art aimed at ideal beauty of proportion, form, and expression, and some artists wrote treatises (unfortunately lost) explaining the principles of their work. This was the age also of the Greek dramatists, the great prose-writers, and the Athenian democracy.

(d) *The Hellenistic period* (323-27 B.C.). The HELLENISTIC era is more sharply defined politically than in art. The conquests of Alexander the Great, who died in 323 B.C., finally ruined the old Greek system of independent city republics and substituted monarchical empires staffed by Greeks and extending to Egypt and beyond Iraq. Private wealth and patronage became important, and collecting and copying developed. In art technical skill and versatility still advanced, and though some artists looked back to classical models, others exploited novel ideas—dramatic and emotional effects, pomp, and the display of idiosyncrasy. But there is an appearance of confusion in Hellenistic art that cannot be explained away by our ignorance of its chronology or the hypothesis of local schools. Different trends existed side by side.

Sculpture in relief, painting, and vase-painting developed fairly closely together in the 7th and 6th centuries, and in the Hellenistic period statuary sometimes, and relief more often, borrowed from painting. But generally the various branches of Greek art did not proceed in parallel and so are best described separately.

The art of the Classical period, continued or developed in unbroken tradition through the Hellenistic and Roman, was admired until the 3rd c. A.D., occasionally until the 6th, and some traces of its effects are visible in the BYZANTINE

and in the illustration for medieval manuscripts. The new Classicism of the RENAISSANCE was based mainly on Hellenistic and Roman models. Classical models did not become available for architecture till the mid 18th c. and for sculpture till the early 19th.

2. ARCHITECTURE. Architecture had died in Greece with the Mycenaean civilization. The next five centuries produced only simple narrow buildings of rubble or adobe, apsidal or rectangular in plan. The door, usually at one end, might be protected by a rough porch; the roof was thatched and steep, or of mud and flat. Terracotta models from Perachora, near Corinth, and the Argive Heraeum suggest that this kind of structure was still normal in progressive regions in the late 8th and early 7th c. B.C. But soon the existence of formal architecture with gabled, low-pitched roofs is indicated by the appearance of heavy roof-tiles, of which the earliest known examples are dated c. 650 B.C., and by terracotta METOPES from Thermon some 20 years later. Greek architecture, it seems, sprang up suddenly and much at the same time as sculpture; the reason was perhaps the same—the development of civic feeling and wealth. These remained the principal supporters of Greek architecture. Private houses, however, never became so elaborate.

(a) *Materials and Methods.* The earliest Greek architecture still made much use of adobe and timber, sheathed at the exposed CORNICES by revetments of painted terracotta. But early in the 6th c. hewn blocks of stone became the standard material, with timber roof-beams and tiling made of terracotta slabs. At first LIMESTONE was common, often coated with a fine stucco. But gradually whitish MARBLES were preferred, even for the roofs, since in Greece increasing prosperity encouraged quality rather than greater size; the buildings of the Classical period —those, for instance, of the Athenian ACROPOLIS—are exquisite but not big. The structural units were large blocks of stone, balanced on each other and secured by metal clamps and dowels. No mortar was used, from choice and not through ignorance since the Greeks were familiar with cement. Precise jointing was obtained by dressing back adjoining surfaces so that they touched only along the edges. After erection such details as FLUTINGS were cut and surfaces were polished if marble, stuccoed if limestone. Finally such parts as CAPITALS, FRIEZE, and cornices were painted in strong colours. The impression aimed at was that of a monolithic structure, or almost of a sculptured mass. It was not till the Hellenistic period that the separate blocks of the wall were sometimes emphasized by drafting their edges. In general Greek architects were more interested in form than economy of construction; so they preferred the solid lintel to the arch, which very occasionally appears in Classical substructures and Hellenistic gateways. In private houses adobe and rubble remained normal building materials.

(b) *Types of Public Buildings.* The standard type of Greek architecture is the TEMPLE, a building that had no congregational purpose since public ceremonies took place at the altar outside. The temple consisted primarily of the *cella*, an enclosed room opening at the east end and housing the statue of the patron deity. The cella block often had a columned porch at the back as well as the front, and the whole might be surrounded by a PERISTYLE, or continuous colonnade. The *stoa* was a long portico, with COLUMNS along the open front and a solid wall behind; normally there was an inner row of columns, spaced twice as widely, and often shops along the back. The *propylon*, a grand formal gateway, could be made of two columned porches back to back. The 'fountain house', a communal watersupply, was sometimes embellished with a light columned façade. The term *tholos* is applied

**Fig. 25.** Plan of Tholos Tomb, Epidaurus (c. 350 B.C.)

loosely to any building round in plan; if elaborate, it had a circular peristyle and a conical roof. In all these types of buildings form was dominant —an obvious instance is in the obligatory three steps of the platform, which are proportionate to the size of the building not of the human leg. But the THEATRE, as an open-air place for dramatic performance or political assembly, set special conditions. The ideal, reached in the later 5th and 4th centuries, was a tiered auditorium set in a hillside and forming more than half a circle or threecentred curve round a circular *orchestra* (or dancing floor), behind which stood the stage buildings. The size of the theatre depended on the population of the city, the largest seating 20,000. The seating arrangement was sometimes adapted for rectangular covered buildings, such as the *odeum* (or concert hall) and the *bouleuterion* (or council-chamber).

(c) *The Orders.* There were two principal Orders or styles of Greek architecture, Doric and Ionic. With Ionic go Aeolic and Corinthian. The canonical forms are described under ORDERS OF ARCHITECTURE. Here only their development is outlined.

*The Doric style* is first recognizable about 630 B.C. in the metopes from Thermon and

became the regular style of European Greece and the colonies in south Italy and Sicily. Its origins are obscure. Some details recall the Mycenaean, but if they are connected at all they may be derived from such surviving monuments as the façades of beehive tombs at Mycenae rather than through continuous tradition. Other details reproduce in stone forms proper to timber, but are not all structurally intelligible. Whatever its antecedents, the Doric style seems to have arisen suddenly and established its general rules quickly, though variations in details continued for over a century. At first Doric temples were long and narrow, later they became broader; so the Heraeum at Olympia in the beginning of the 6th c. has 6 columns at the ends by 16 at the sides, the Theseum c. 450 B.C.

**Fig. 26.** Plan of Theseum, Athens (c. 450 B.C.)

has 6 by 13, and the temple of Asclepius at Epidaurus of the early 4th c. 6 by 11. Early columns are thick (with a few exceptions from unusually small buildings), later they grew slenderer till the 2nd c. B.C. Similarly the *echinus* of early capitals is wide and strongly curved, later on it grew smaller and straighter till in late Hellenistic it became little more than a slanting collar. The slender Hellenistic Doric also reduced the size of the ENTABLATURE, so that the metopes were much smaller and instead of two there are often three, or even four, between each pair of columns. Though apparently simple, the Doric style shows many calculated irregularities, called 'refinements'. The earliest and most obvious are the curving diminution of the columns (ENTASIS), which is most pronounced in the 6th c., and their unequal spacing to provide a wider entrance, to ease the relation of columns and TRIGLYPHS, or to give an appearance of stability at the corners. The subtlest and completest use of refinements is in the PARTHENON (c. 440 B.C.), where no major line is precisely vertical or horizontal. The Hellenistic

age in its major buildings went in for effects less austere and delicate; and though it evolved an elegant Doric, it gave more importance to other styles.

*The Aeolic style.* A number of capitals, found principally in Aeolis (the northern stretch of Greek Asia Minor), consist of VOLUTES joined in a deep V. These Aeolic capitals, which have close parallels in the decorative arts of Syria, are sometimes called Proto-Ionic, a name which begs the question of their relation to the flat volutes of true Ionic. From Aeolis too come capitals decorated with long-pointed leaves flattened down on the drum: some may have served as lower members to volute capitals. Yet other capitals have upturned leaves which curl out and over at the top. These Aeolic forms had some currency in the 6th c., but did not establish themselves.

*The Ionic style* is less strict than the Doric and its origin is obscure. The first surviving examples are from the 6th c. The earliest capitals are very wide, with the volutes clear of the shaft. Since there is a strong difference between front and side faces, the capital at the corner of a peristyle presented a problem; this was first solved by giving it two adjacent front views, with the volute between turned out at 45°. A later rationalization was the capital with four fronts and all the volutes turned out. In Classical Greece Ionic was sometimes used as an interior order in stoas and other buildings externally Doric; a bold example is the PROPYLAEA at Athens, where the advantage of greater height for the same diameter is skilfully exploited. The Ionic style with its slenderer columns, lighter entablature, and profuser mouldings appealed to the more superficial sense of Hellenistic and Roman architects and, enriched by the Corinthian capital, has spread throughout the world.

*The Corinthian style.* It is not disputed that the Corinthian capital was invented or introduced to architecture in the late 5th c. B.C. Its pioneer, CALLIMACHUS, worked in metal and the inspiration of its sharp foliage may be metallic. Adopted into the Ionic Order, it was at first used timidly for interior columns and such toy buildings as the choragic monument of Lysicrates. But about 300 B.C. it was admitted in the peristyle as in the temple of Zeus at Diocaesarea, and its merits secured a popularity that lasted till the end of antiquity. Earlier Corinthian capitals are relatively bare, and the canonical form was not established till the late 1st c. B.C.

(*d*) *Town-Planning.* Early Greek settlements grew in natural confusion but by the 7th c. the chequerboard system was being applied to new cities. For sanctuaries and the *agora* (or civic centre) such regularity was less acceptable. At Athens the 5th-c. buildings on the Acropolis show a rough, though partly accidental, balance; and in the Agora, where the Persian destruction had left an even freer opportunity, there are only some incomplete alignments. Hellenistic planners preferred a rectangular agora,

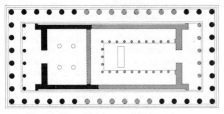

**Fig. 27.** Plan of Parthenon, Athens (c. 440 B.C.)

but neglected or rejected symmetry. In general the Greeks regarded the individual building, not the group, as the object of architectural expression and enjoyment, and it is characteristic that in their sanctuaries they preferred that the view of the main temple from the propylon should be oblique.

(e) *Private Houses*. Early Greek houses, so far as is known, were unpretentious in style and materials. At Olynthus, destroyed in 348 B.C., the plan of upper-class houses consisted of a courtyard with a portico on its north side, and the principal room and kitchen behind it; bedrooms were upstairs. At Priene in the 3rd c. B.C. the court was entered by a long passage at the side, and the main room with columned porch lay again to the north. In the 2nd c., as luxury advanced or houses were more lived in, it was more usual for the square court to be framed by a peristyle of cheapish stuccoed columns; Priene and Delos provide examples. All these houses looked inwards and on the ground floor their outer walls were largely blank; upstairs there may have been windows and balconies. Their average size was rather under 60 ft. square.

3. SCULPTURE. (a) *Materials and Technique*. The principal materials of Greek sculpture were bronze and whitish marbles. Less important were limestone and terracotta. Some temple statues were chryselephantine, that is composed of ivory for the flesh and gold for the other parts on a wooden frame.

Bronze statues were at first made of beaten sheets, but in the later 6th c. B.C. the knowledge of hollow casting was spreading and by the 5th c. bronze was the medium preferred for free-standing statues. The process used was *cire-perdue* (SEE BRONZE SCULPTURE). Marble was the normal material for reliefs and architectural sculpture, common enough for free-standing statuary, and the regular medium of the later copyists. It is not known what use sculptors working in marble made of preliminary models, but since the process of POINTING was not developed till the 1st c. B.C. it can hardly have been extensive. The principal tools then as now were chisels, punches, and drills. When the figure had been blocked out, the sculptor proceeded layer by layer all round, and the final polishing was done with emery. As time went on the drill was used more obtrusively, and towards the end of the Hellenistic period finer abrasives became popular; hence the dead gloss of Roman copies. Limestone served as an easier or cheaper substitute for marble. So too did terracotta, though less often and mainly for the ACROTERIA and ANTEFIXES of the roofs of buildings.

The Greeks embellished their sculpture. Colours, at first conventional, but gradually becoming more natural, emphasized hair, eyes, lips, nipples, and drapery of stone and terracotta figures, and often the flesh too was tinted (see POLYCHROME SCULPTURE). Such accessories as fillets and weapons were frequently added in metal. For bronzes the eyes were regularly filled in natural colours, and often eyelashes of wire were inserted and lips and nipples inlaid in a nobler metal; the surface was kept bright and perhaps was sometimes tinted. The colours have generally perished, and for that reason the modern world usually thinks of all Greek sculpture as monochrome.

(b) *Archaic Sculpture* (early 7th c.-480 B.C.). Our earliest Greek sculptures come from the second quarter of the 7th c. B.C., and they appear to have very little tradition behind them. Two stock types, the naked standing male and the draped standing female (known conventionally as *kouros* and *kore*), served as images of gods, thank-offerings, and monuments on graves. Their pose is rigidly FRONTAL; the male has arms hanging by his sides and left foot forward, the female is allowed more movement of the arms but her feet are closer together. At first glance there is something Egyptian about the *kouroi*, and though there are important differences and those examples that look most Egyptian are not the earliest, an indirect connection may have passed through Syria, whence the Greeks probably derived the idea of large sculpture. But the development of Greek statuary was independent.

Its earliest phase, which has been named Daedalic in honour of the mythical DAEDALUS, is widespread, if not universal, in Greek lands. At first the sculptor was preoccupied with the front view of the face and neglected the side view and the body. Gradually, as Daedalic passed into full Archaic, the face became less triangular, the body was studied and the profile received attention though intermediate views were still not considered. Development was not towards freer poses, but in understanding the structure of the human anatomy or rather the male anatomy, since when (during the 6th c.) lighter drapery became the mode for *korai* it was tricky folds and coiffure that attracted sculptors and, buttocks excepted, not the body beneath. At last by c. 500 B.C. the major problems of the *kouros* were mastered, and the new trend was to loosen the rigidity by slightly shifting the axes of hips and shoulders and the angle of the head. The fresh importance given to the body was matched by a severer treatment of the head, which renounced its cheerful ARCHAIC SMILE, and of the drapery, which now fell in heavy, roughly vertical folds. Some transitional works show an uneasy juxtaposition of old and new.

Reliefs also concentrated on the human figure, though necessarily in action. Greek sculptors till well into the Hellenistic period did not admit depth in reliefs, but the action takes place in a shallow vacuum against a plain background usually of dark red or blue. The recognized Archaic postures were profile head, profile or frontal chest, and profile hips and legs. Gestures were bold and forceful. At the end of the 6th c. other views of body and legs appear, but not of the head, and the waist is convincingly twisted. Pedimental sculpture, which began early in the

6th c. and was at first partly in relief but soon wholly in the round, in general followed the style of relief sculpture.

(c) *Classical Sculpture* (480–323 B.C.). The sculptors of the 5th c. started with a general comprehension of the framework of the male body and they proceeded to improve the detail and to devise greater variety of poses. The Greeks, unlike the Egyptians and Asiatics, had no hieratic tradition to restrict them and it is often difficult to discover what deity (if any) a particular statue represents. In the new sculpture the frontal view remained the most important, and even so abnormal a composition as MYRON's DISCOBOLUS occupies very little depth. The ideal pose was now relaxed, though not slack. One leg takes the weight while the other touches the ground a little behind, and often the arms are similarly contrasted, one taut and the other loose. So the standing figure was subtly varied by small shifts and turns of its various parts, and the gentle curving of the median line. The face too expressed an easy dignity, reflective and melancholy, admitting pain (if pain was required) only by a furrowing of the forehead and a slight parting of the lips. In drapery the monotony of heavy parallel folds was broken by the thrusting forward of the relaxed thigh against the skirt, or thinner veiling began to reveal the form below, and by the time of the Parthenon drapery was exploited to give an illusion of motion, to emphasize the roundness of the underlying form, or to tie up the composition. Hair was stylized in simple strands or short flat curls. The effect, devoid of passion and personality, offers a generalized ideal of mature man, not a portrait of the contemporary Greek. The great masters of this style were PHIDIAS and POLYCLITUS.

The 4th c. was less austere. SCOPAS is often said to have originated the expression of intenser emotion by deep-set eyes and parted lips. PRAXITELES preferred serenity of expression and a casual indolence of pose. To LYSIPPUS everything has been attributed. The general contributions of the period are a sensuous appreciation of flesh, on both body and face, and a more melting look, slighter forms, an interest in the female or rather the feminine figure, more deeply cut and often tousled hair, and drapery which not only looks but is natural and with its heavy swags and shadows contrasts effectively with the smooth flesh. The female nude now entered the sculptor's repertory. At the end of the period a new feeling for space is visible in the *Apoxyomenos*, probably by Lysippus, a shifting figure that reaches boldly forward. Fourth-century sculpture remained ideal, but had a closer perception of the natural.

Classical statuary, the later still more than the earlier, depended very much on accuracy and subtlety of detail. So the loss of quality in the average careless copy was almost complete: a comparison of the ERECHTHEUM CARYATIDES with their Roman replicas is a salutary warning against judging Classical art by coarse and vapid imitations.

Reliefs of the early 5th c. were learning the PERSPECTIVE of the figure, and later the strictly profile or frontal view became abnormal. Poses ranged from an almost acrobatic vigour to a graceful calm. Drapery floating behind shoulder or body was soon developed as an effective foil or space-filler. But the direction and massing of the figures remained more or less in the plane of the surface. Friezes naturally tend to exhibit battles or processions, linked by crossed legs and arms; the relief was often very low—on the Parthenon frieze the many overlapping surfaces have a total depth of only two inches. Grave reliefs (see STELE), the work frequently of monumental masons, favoured family groups, at first dispassionate but by the 4th c. charged with pathos and often crowded within the architectural frame. Pedimental sculpture, once the problem of the triangular field had been solved, seemed to lose heart. Within its limits Classical relief sculpture was thoroughly accomplished. Its skill in foreshortening and wide range of poses probably owed something to contemporary painting.

(d) *Hellenistic Sculpture* (323–27 B.C.). The history of the three centuries of Hellenistic sculpture is perplexed and of few of its products is the date closely known. It seems that various trends flourished at the same time, and also in the same place; for what have been called local schools were probably local preferences for one or other of the more general trends. Those trends may be roughly classed as progressive or conservative.

The progressive trend ventured beyond the limits of Classical sculpture, improving its technical mastery and exploring the phenomena of violence, passion, character, sensuality, and sentiment. Anatomy was studied systematically. Drapery tended to be more dramatic. Poses were contrived which were effective from more than one view. In the so-called PERGAMENE SCHOOL, of which the finest remains are the high reliefs of the Great Altar of PERGAMUM, bodies were contorted into postures of momentary strain and faces into masks of anguish. Character was expressed in psychological portraits, such as that of Homer, which do not aim at naturalistic truth, but to show the subject as it was imagined he should have been. The genre types, such as the old fisherman and the drunken old woman, make a similar impression. The female nude was exploited and the hermaphrodite added to the sensual repertory. Personification became more popular. There were also sentimental trivialities —infants strangling geese, sleeping PUTTI, and the precocious lovers Cupid and Psyche; Classical sculptors were uninterested in depicting children, the Hellenistic only too successful. These less heroic subjects reflect a social change. In the past public patronage had set the standard of taste and execution; now there was also the private collector, requiring cheaper statuary for

his personal enjoyment. Painting too had its influence, as most obviously in the trick of showing the folds of a lower garment through an upper.

Much Hellenistic sculpture makes an impression of realism, but this is less a faithful imitation of individuals than a sort of idealization of trivial or extravagant types. Even in portraits detailed fidelity was probably not usually attempted or expected.

The conservative trend continued the Classical style, often combining features from different dates or adapting the style to new poses. The *Aphrodite of Cyrene* (Terme, Rome) is fairly faithful to the Praxitelean manner. The *Aphrodite of Melos* (VENUS OF MILO) recalls the 4th c. in her expression and anatomy, while the omnifacial pose is fully Hellenistic. In the 1st c. B.C. the so-called Neo-Attic reliefs prettify Classical types, but a purer Classicism persisted to inform the Augustan style of Rome.

Hellenistic reliefs show the same trends as freestanding statues. But there was also a small interest, presumably derived from painting, in the setting and in architectural perspective, though this is usually faulty.

(e) *Sources of Knowledge*. Besides the surviving originals and copies we have many signed bases and more references in ancient literature. But it is not often that a particular piece can be identified from a text. Though we have the names of over 500 Greek sculptors, most are only names; and of the original statues which ancient writers mention, not a dozen can now be identified with certainty. Greek sculpture is now, and must remain, largely anonymous.

4. PAINTING. In their own time Greek and Roman painting were valued as highly as sculpture. For the Roman period wall-paintings of fair quality survive, but our knowledge of earlier pictorial art must be built up from secondary and second-hand works supplemented by a few names and dubious comments in PLINY and other writers. This permits some ideas of principles, little of quality.

The character of vase-painting in the Geometric period does not suggest the existence of any larger painting. Of this the first direct evidence is some terracotta metopes from Thermon containing simple figures or compact groups in a field about 2 ft. square. The style resembles that of Corinthian vase-painting of about 630 B.C., except that colours are used and the linear detail is painted, not incised. A few rather earlier Corinthian pots, where similarly male flesh is light brown, may reflect larger pictorial compositions such as battles. Wall-paintings from Etruscan tombs show that in the late Archaic period picture-painting still did not differ essentially from vase-painting and relief sculpture (see ETRUSCAN ART).

The first important advance in these related arts, visible at the very end of the 6th c. B.C., was the introduction of oblique views of the human body and the drawing of legs as seen from in front or behind. These innovations are sometimes connected with CIMON OF CLEONAE. By the middle of the 5th c., to judge by the abnormalities of a few Attic vase-paintings, bolder foreshortening of faces and limbs was regular and pictorial depth was being attempted by setting the more distant figures higher up, though without diminution of size, in a landscape suggested by rocks and a few formal shrubs. POLYGNOTUS and Micon were the great masters at this time. Perspective was the next problem, posed perhaps by stage scenery rather than picture-painting. Some vase-painting and reliefs of the later 5th c. indicate experiments in foreshortening furniture and buildings, and the philosophers Anaxagoras and Democritus (so it is said) expounded the theory.

The modelling of the human figure developed rather later. Although from the early years of the century some painters had roughly shaded certain inanimate objects, for the human figure—their principal interest—they were still content with line drawing and flat washes of colour. But a little before 400 B.C. (the date is given by a few Attic *lekythoi*), APOLLODORUS applied shading to drapery and the brownish flesh of men, though not to the paler flesh of women. This halfmeasure can be seen in the Etruscan *Tomb of Orcus*, in minor arts, and in a picture from Herculaneum of girls playing knucklebones which from other evidence may be supposed to derive from an original of *c.* 400 B.C. By the middle of the 4th c. south Italian vase-painting used highlights; and soon both shading and highlights were extended to women, perhaps by NICIAS. His contemporary APELLES was reckoned the greatest painter of antiquity. The ALEXANDER MOSAIC from POMPEII, depicting the crowded climax of the battle of Issus, is as good a copy as mosaic allows of a masterpiece of this time, though the restriction of the palette to the four colours, black, red, yellow, white, seems to have been a practice that was never universally accepted, and the absence of scenery and distance (though not of depth) may in part be attributed to the subject.

The evolution of painting in the Hellenistic period is much more obscure, in spite or partly because of the numerous copies and adaptations among later paintings found at Pompeii, Herculaneum, and Rome. Less elevated subjects became commoner; STILL LIFE was popular, at least for mosaics; there were reflections of the style called in sculpture Pergamene; a sketchier, Impressionistic technique was available; and we find landscapes, architectural and natural, in which human figures are subordinate. But at the same time the tradition of the 4th c. lived on, and copying became important. Among the most significant of Hellenistic achievements are the pictures from the *Odyssey*, found on the Esquiline in Rome and dating from the mid 1st c. B.C. but perhaps reproducing originals of rather earlier date; they show a wild, almost ROMANTIC scenery with long perspectives, gradation of

colour according to distance, and dramatic and assured contrast of light and shadow.

The painters of the late 1st c. B.C. and beginning of the Roman period reverted to earlier ideals. The portraits, of which we soon have a long series from Egyptian mummies, suggest a closer attention to the genre; but the so-called Pompeian styles belong properly not to painting but to interior decorating. In general there was an alternation between academic Classicism and a livelier, more Impressionistic manner. So the Augustan period preferred strong lines, statuesque poses, and a misty background; but with Nero (A.D. 44–68) light and colour again broke through.

The 2nd c. reverted to a Classical manner, in the generation around A.D. 200 a rough Impressionism intruded, and that was followed by a feebler return to Classicism. In the late 3rd and early 4th centuries style collapsed—perspective, modelling, even anatomical knowledge seemed doomed. Yet within a few years painting had recovered competence and assurance, and a broad Classical style continued for a century or more side by side with that odd compromise between simplicity and sophistication that developed into BYZANTINE and medieval art. To the end the human form remained the principal constituent of ancient painting.

5. GREEK VASE-PAINTING. Painted Greek pottery, of which very much survives, engaged good and even great artists till the 5th c. B.C. But its technique and decorative principles are now strange. The Greeks did not use glaze, though they obtained a smooth sheen by a method (lately rediscovered) of refining their clay (see *Note on Technique*). In shapes they had a liking for sharp definition of the parts, realizing that the potter's wheel permits turnery. The decoration, which depends on line—painted or engraved—for its detail, was imposed on the pot with due regard to the shape, and did not until very late pretend to pictorial depth.

By the late 11th c. B.C. the Mycenaean style had become degenerate. Now there was a sudden reformation, aiming at sharper definition of shape and ornament. Freehand spirals, for instance, were replaced by sets of circles and semicircles drawn with compasses. The decoration was simple and sparing, and soon it became usual to fill in the undecorated areas with dark paint. This *Proto-Geometric* style began at Athens, but quickly spread throughout Greek lands. At the end of the 10th c. the Geometric style proper made shapes tauter and decoration more precise. Of its ornaments, constructed still of straight lines and circles, the most characteristic is the key meander, large and lightly hatched, often running round the pot like a belt. Again Athens initiated and most other Greek districts followed. In the 8th c. a richer taste multiplied the bands of decoration over most of the surface of the pot and added the human figure, adapted to Geometric rules of construction.

The *Orientalizing* style, which appeared in the late 8th c. at Corinth and soon elsewhere, replaced the Geometric ornaments by lotus flowers, palmettes, volutes, and a varied fauna mostly culled from Syria. More significant were the enlargement of the main field and the evolution of the human figures which sometimes occupied it. The strictly Orientalizing style, with its groups or files of lions, bulls, boars, goats, etc., soon became decoratively conventional, and interest turned to human or mythological scenes. The painted terracotta metopes from Thermon show the Corinthian concept of the human figure about 630 B.C., though the technique of vase-painting was different. Geometric vase-painters had been content with silhouette, which some of the Greek Orientalizing schools enlivened by drawing the heads in outline. But Corinth quickly preferred the so-called 'black-figure' technique of incising —that is, engraving—details on a full silhouette, with dashes of accessory colour, first purple and then also white. The steady competence of the Corinthian workshops encouraged wide export and imitation until, in the early 6th c., they succumbed to their Attic rivals, who after two generations of erratic grandeur had around 630 B.C. accepted the black-figure discipline. At Corinth Orientalizing animals remained the staple decoration; Athens in the second quarter of the 6th c. put its faith in human figures, and its well made products with their improved orange-brown clay and black paint set the standard for other Greek schools. The mature Attic black-figure style has a precise vigour and elegance, but the technique was not suited to

**154.** Red-figure style. Detail showing woman carrying loutrophoros. Loutrophoroi were used for the bride's bath in the wedding ritual and were also put on the graves of unmarried people. (Met. Mus., New York)

express quiet moods; and though this was achieved by Execias, its greatest master, it is not surprising that one of his pupils introduced the 'red-figure' technique.

Meanwhile the other Greek schools, which had shown a promising diversity in the 7th c., were more or less exhausted. The fitful skill of Crete soon flickered out. The showy clumsiness of 'Melian', which in the Cyclades had followed several small groups of pleasant mannerists, expired in the early 6th c. Laconian, naïvely sturdy, lasted a generation longer. The Greeks of the eastern Aegean maintained a costive Orientalizing style, which at the end of the 7th c. disastrously adopted the black-figure technique of Corinth; though in the 6th c. eastern Greek workshops occasionally showed

originality, they could not withstand the Attic invasion. Boeotia and Etruria, which for long retained some degree of clumsy stylistic indepen-dence, were still producing painted pottery, but now it was in awkward imitation of black-figure Attic.

The red-figure technique was a draughtsman's technique. The figures were sketched in outline, details drawn in thin lines of paint, and the back-ground filled in with black. The lines used for details were of two kinds—the 'relief line', which stands up like a wire thread, and a flush line, varying in density of colour from black to a golden brown. So far views of figures had been fairly strictly in profile, except that the chest might be frontal. Just before 500 B.C., as in relief sculpture and painting proper, new views of body

**Fig. 28.** GREEK VASE SHAPES

Drinking cups: A. *skyphos* B. *kylix*, continuous curve shape C. *kylix*, offset lip shape; Bowls for mixing wine and water: D. *column krater* E. *volute krater* F. *calyx krater* G. *bell krater*; Wine jugs: H. *oinochoe* J. *oinochoe (chous)*; Water jar: K. *hydria (kalpis)*; Oil flasks: L. *lekythos* M. *aryballos*; Storage jars: N. *amphora (panathenaic)* O. *neck amphora* P. *pelike*; Wine or water container: Q. *stamnos*

and limbs were mastered, though the three-quarter head was not accepted till the later 5th c. Expression too of face and gesture grew subtler, and action was no longer essential. In the early 5th c. the red-figure style reached its perfection, if by that is meant the combination of skill and art. The next generation vainly followed picture-painters in the representation of spatial depth or else lost heart, and though respectable work in a mildly Classical style continued into the 4th c. and technical ability was misapplied in more elaborate confections, vase-painting sank to a minor art. In Athens the end came around 325 B.C.; a little later in south Italy, where the red-figure style had been transplanted in the later 5th c.

Besides red-figure there was in Athens the 'white-ground' style, best known from the grave *lekythoi* of the second half of the 5th c. These *lekythoi* have a tall cylindrical body, on which is the main field of decoration; it is covered with a white slip. The drawing is often softer than in red-figure, and a wide range of colours is used for drapery. The earlier *lekythoi* show a melancholy grace in their scenes of domestic life or farewell; the later, with a few exceptions, are less competent and more emotional.

The principal shapes of Greek painted pottery served constant functions; their variations from one time and place to another were mainly in proportions and finish. The finest period is from the mid 6th c. to the mid 5th c. at Athens. The current names of shapes, though mostly Greek, are not always applied correctly.

*Note on Technique.* No account survives of the processes used by Attic potters, but recent research has found a practicable solution to the more difficult problems. The principles involved are first that oxides of iron (which are present in most Greek clays) give a red or black colour according as they are exposed during firing to an oxidizing or reducing atmosphere, and secondly that if the particles of clay are fine enough, they will have a sheen. Clay of this fineness cannot be prepared by simple washing; but if such chemicals as potash are added, there is a 'peptic' effect which breaks up the larger coagulations of particles that remain, and the further addition of a 'protective colloid' (as for instance urine) prevents new coagulations. It seems likely then that the Attic practice was roughly as follows. The potter threw his pot, whole or in sections; then he let it dry to a leathery hardness; and next he proceeded to assemble, trim, and paint it. In painting he first gave the surface a thin coating of dilute 'peptized' clay which quickly dried on. Next, with or without the aid of preliminary sketches, he painted in the areas which were to be black, using as his pigment a denser solution of the 'peptized' clay; if further detail was wanted—incision, or purple or white paint—it was added at this time. The pot was now ready to be put in the kiln and fired. Since the maximum temperature of firing was c. 950 °C., there was no danger of fusion or running, and so pots could be stacked in direct contact with each other. The firing was done in three stages. At first the atmosphere was oxidizing so that the iron oxides became red, the denser 'peptized' parts being naturally deeper in tone. Next, by

**155.** Detail from vase painting showing pottery making, including a kiln being fired. (Staatliche Antikensammlungen, Munich)

sealing up the kiln, and perhaps using damp fuel or water, a reducing atmosphere was obtained and the iron oxides turned to grey and black. Lastly, an oxidizing atmosphere was restored and the change back to red begun, but since the denser 'peptized' clay was less pervious or had sintered its reoxidation was retarded or prevented: so in the period when it was not reoxidized and still remained black, but the rest of the pot was reoxidized and so had turned brownish red, the firing was stopped. These tricky processes most completely mastered in Attic in the 6th c. to the 4th c. B.C., but they were practised with more or less success on most good Greek pottery.

10, 35, 76, 205, 207, 315, 490, 491, 497, 608, 626, 748, 1506, 1556, 1578, 1588, 1703, 1796, 1946, 2254, 2255, 2279, 2368, 2411, 2439, 2607, 2819, 2947.

**GREEK REVIVAL IN NORTH AMERICA.** Of all modes of building in America during the ROMANTIC period of the first half of the 19th c. the Greek Revival came the closest to assuming the proportions of a national style, and together with the LANDSCAPE and GENRE painting of the same period it became one of the first popular statements of American cultural independence. Born in a period of exuberant nationalism and nurtured by a naïve enthusiasm for ancient Greece (witness the names of many American towns: Troy, Ithaca, Athens, etc.), the Greek Revival brought to American architecture a freshness and vigour which had been lacking in the time-worn academic graces of the Colonial GEORGIAN style. Introduced into the United States by the young English architect Benjamin LATROBE, the Greek mode was simple and readily executed in wood. It was also solemn and noble. For these reasons it appealed to both the practicality and to the cultural ambitions of the youthful nation. Furthermore, the change from English to Greek Classicism was more a change in proportion and detail than a change in fundamental form. Thus a New England meetinghouse of the WREN-GIBBS type, like the one in Madison, Connecticut, could incorporate a Greek Doric portico, a deep ENTABLATURE under the eaves, and a Choragic monument for a spire without departing in the least from existing concepts of structure and mass. It is because of this that so many Greek Revival towns in the Middle-West, not built until the 19th c., seem to the uninformed observer like the much older COLONIAL ARCHITECTURE of the New England communities.

The use of the Greek style varied with the intentions and background of both patron and architect. For the classically minded founder of Girard College in Philadelphia, designed by Thomas U. Walter in 1833, only an exact imitation of a Corinthian prostyle temple would suffice. On the other hand in many provincial examples scattered throughout the eastern half of the nation the Greek forms, communicated by architecture handbooks, were treated in a bold

and original way so that little remains of their Greek origin except certain fundamental shapes.

During the Greek Revival most architects and builders were inclined toward a more individual treatment of the house than of the formal public building. Planning was less restricted, less emphasis was placed upon authentic reproduction of detail. In many of the smaller houses the effect of the Greek mode was little more than a change in decorative idiom, in others the interpretation was naïvely unorthodox and original. It is here that the most fascinating folk aspects of the style are to be found. Among the works of the leading architects one also frequently encounters rich and imaginative exploitations of the style. One of the finest is Belmont in Nashville, Tennessee (1850), where STRICKLAND's refined creative powers are revealed at their best. Most of the great plantation houses of the deep South are Greek Revival buildings.

**GREEN,** VALENTINE (1739-1813). English engraver, who was trained at Worcester as a line engraver but on coming to London in 1765 practised almost wholly in MEZZOTINT. His great reputation is largely based on the numerous plates he made from the female portraits and groups by REYNOLDS, of which the most celebrated, and perhaps the best, is *The Ladies Waldegrave*. He was elected A.R.A. in 1775 and in 1789 obtained a patent from the Duke of Bavaria to engrave and publish prints from the Düsseldorf gallery. He ranks with EARLOM as one of the most brilliant, if uneven, of British mezzotint engravers.

**GREENAWAY,** CATHERINE (KATE) (1846-1901). English artist famous for her illustrations for children's books, with titles such as *Kate Greenaway's Birthday Album*. Her delicate skill and fragile sentimentality, often imitated but never rivalled, won her many distinguished admirers, including RUSKIN, and (perhaps for her feeling for flat pattern) Paul GAUGUIN. (See Ill. 156.)

**GREENHILL,** JOHN (*c*. 1644-76). English portrait painter of moderate talent and little originality, who became a pupil of LELY and evolved a simplified version of Lely's style. He specialized in pastel portraits of actors in costume (*Thomas Betterton as Bajazet*, Kingston Lacy, 1663; *Joseph Harris as Cardinal Wolsey*, Magdalen College, Oxford, 1664).

**GREENOUGH,** HORATIO (1805-52). American NEO-CLASSICAL sculptor who spent the greater part of his working life in Italy, returning infrequently to the U.S.A. in connection with commissions. He is sometimes said to be the first professional American sculptor. He was described by Emerson as a mediocre sculptor but a promising intellectual. His aesthetic theories and in particular his theory of architecture have been claimed as precursors of

**156.** *P. Peeped in it.* Water-colour drawing by Kate Greenaway for an illustration to *A. Apple Pie* (V. & A. Mus., 1886)

modern FUNCTIONALISM and are sometimes thought to have influenced the ideas of SULLIVAN. His views, however, appear to have resembled closely the ideas of Neo-Classical theorists of the previous century and to have been lacking in originality. In 1832 he received the first important commission given to an American sculptor, that for the colossal figure of Washington intended for the rotunda of the Capitol. It represented the 'Father of the Country' seated half draped in a Roman toga with arms gesturing expansively in opposite directions. The statue was judged too heavy for the rotunda and stands outside the Capitol. Greenough also made the design used for the construction of the Bunker Hill Monument. His major works show a lack of inventiveness and the portrait heads are now regarded as typical of the absence of underlying structure which characterized so many of the minor Neo-Classicists.

**GREENWAY,** FRANCIS HOWARD (1777–1837). Architect, born at Mangotsfield, Bristol. He studied under John NASH and practised with his brother OLIVE GREENWAY as an architect and landscape gardener at Bristol (1805–12). In 1812 he was convicted of forgery and sentenced to 14 years' transportation to New South Wales,

arriving in Sydney in 1814. Two years later Governor Macquarie appointed him Civil Architect and Assistant Engineer. Greenway planned and erected many fine buildings between 1816 and 1821, including the Macquarie Lighthouse, Sydney Harbour (1818), Convict Barracks, Sydney (1819), St. Matthew's Church, Windsor (1820), and St. James's Church, Sydney (1824). He was an original architect who adapted the late GEORGIAN style (with references to WREN, Nash, and SOANE) to local requirements and materials.

815.

**GREUZE,** JEAN-BAPTISTE (1725–1805). French painter, a pioneer of anecdotal GENRE subjects. He infused his genre scenes with a moral and social import, capitalizing on the appeal of the rustic virtues and Rousseauesque sentiment. His work was praised by DIDEROT as 'morality in paint', and as representing the highest ideal of painting in his day (*The Village Bride*; *The Return of the Prodigal Son*, Louvre). He was accepted into the Académie on the strength of an historical painting *Septimus Severus Reproaching Caracalla* (1769), but he never achieved success in this style of work. He is now valued most highly for his unmoralized portraits

(*Head of a Girl* and *Girl with Apple*, N.G., London; *Girl with Doves*, Wallace Coll., London; *The Milkmaid*, Louvre), for which his wife usually served as model. Greuze was a fine painter, foreshadowing certain aspects of DAVID and even GÉRICAULT. His failings were the artificiality, insincerity, and hints of misplaced voluptuousness which stemmed from a desire to pander to popular taste. With the swing of taste towards NEO-CLASSICISM his work went out of fashion and he sank into obscurity at the Revolution.

1799, 1857.

**GRIEN,** HANS BALDUNG. See BALDUNG.

**GRIFFIN,** WALTER BURLEY (1876–1937). Architect. Graduate of the University of Illinois, who practised in Chicago in partnership with Frank Lloyd WRIGHT. In 1912 he won, in partnership with his future wife, MARION MAHONEY, a pupil of Wright's, the international planning competition for the City of Canberra (see AUSTRALIAN ART). Griffin practised in Australia for 21 years. By means of his domestic architecture, and such buildings as Newman College and the Capitol Theatre, Melbourne, he introduced a more adventurous approach to architectural design in Australia.

**GRIMALDI,** GIOVANNI FRANCESCO, called IL BOLOGNESE (1606–80). Italian landscape painter. He developed, probably under the influence of ALBANI, an attractive landscape style in the CARRACCI manner. He worked in fresco on the decoration of Roman palaces (Quirinal and Villa Doria-Pamphili) and produced numerous cabinet pictures which were popular with collectors and helped to spread the Carracci landscape tradition in Europe.

**GRIMM,** SAMUEL HIERONYMUS (1733–94). Water-colour painter, born at Burgdorf, near Berne. He was chiefly skilled as a topographical draughtsman, and was responsible with J. L. Aberli for the illustrations to G. S. Gruner's *Eisgebirge des Schweizerlandes* (Berne, 1760). He settled in London in 1765 and exhibited regularly at the Royal Academy, 1769–84. He was employed to make drawings in Nottinghamshire and Derbyshire by Sir Richard Kaye, and by Sir William Burrell to draw the plates for his *Sussex Collection*. Both collections are now in the British Museum.

**GRIMMER.** Two Flemish LANDSCAPE and GENRE painters, JACOB (*c.* 1526–90) and his son ABEL (*c.* 1570–*c.* 1619). Both were active in Antwerp in the style of Pieter BRUEGEL, and Jacob's landscapes were praised by van MANDER and others. Their fidelity in depicting country and town views, and the fine quality of their genuine works, place them high among the followers of Bruegel. Examples by both may be seen at Antwerp.

**GRIS,** JUAN (1887–1927). Spanish-born painter of the École de Paris (see PARIS, School of), his real name was JOSÉ VICTORIANO GONZÁLEZ. He came to Paris in 1910 and was an associate of PICASSO. After early work for the illustrated papers, his serious painting was almost entirely in the CUBIST manner and he is regarded as the chief originator of the 'synthetic' type of Cubism. He exhibited at the Salon des Indépendants and with the Cubist group *Section d'Or*. In 1912 he was taken up by the dealer Henri Kahnweiler, who later wrote a monograph *Juan Gris, sa vie, son œuvre, ses écrits* (1946). According to this Juan Gris claimed that whereas CÉZANNE and the earlier Cubists sought to reduce visual actuality to its abstract, formal properties, he worked from the abstract quality in order to create a new reality, concrete and particular, in the work of art. 'Cézanne d'une bouteille fait un cylindre, moi, je pars du cylindre pour créer un individu d'un type spécial, d'un cylindre je fais une bouteille, une certaine bouteille. Cézanne va vers l'architecture, moi j'en pars. . . . Cette peinture est à l'autre ce que la poésie est à la prose.'

1467, 2522.

**GRISAILLE.** Monochrome painting in grey or greyish colour. RENAISSANCE artists used it for effects of modelling and often imitated sculpture with it. GIOTTO's series of *Virtues and Vices* in the Arena Chapel, Padua, suggests grey stone, and in the van EYCKS' *Adoration of the Lamb* (Ghent) the two St. Johns are like statues. In Florence Cathedral the equestrian figures of the English *condottiere* John Hawksmoor by UCCELLO and of Niccolò da Tolentino by CASTAGNO both simulate sculptured monuments. MANTEGNA used grisaille to convey the austere character of the Romans with masterly effect. RUBENS and his school sometimes used monochrome techniques in sketching compositions for engravers. Miniature painters used grisaille, especially for subsidiary decoration, but in their hands it became less dependent on sculpture. Jean LE TAVERNIER made a speciality of it. Grisaille has also been effectively used in STAINED-GLASS painting. Grisaille enamel ware obtains a design in light and shade by painting over an opaque white background in one colour. The term 'grisaille' is sometimes used also for monochrome UNDERPAINTING.

**GROPIUS,** WALTER (1883–1969). German architect, son of an official architect and nephew of Martin Gropius (1824–80), who was Principal of the School of Arts and Crafts in Berlin and Director of Art Education in Prussia. He stands out as one of the leading personalities in modern architecture, both as designer and teacher. His special contribution in the early years of the modern movement (see MODERN ARCHITECTURE) was to bring architecture into closer relationship first with social needs and secondly with the

industrial techniques on which it was increasingly coming to rely. The latter objective he achieved as Director (1919-28) of the BAUHAUS School of Design.

Gropius's work as an architect equally with his teaching and his influence on design reflected the paramount importance he attached to the proper use of industrial principles and techniques. It is logical, based on penetrating research, and austere. He was a pupil of Peter BEHRENS and with him one of the founders of the influential DEUTSCHER WERKBUND. He set up in practice in 1910 and his first important work, the Fagus shoe-lace factory at Alfield, near Berlin (1911), built in conjunction with Adolf Meyer (1881-1929), carried the idea of a rational, functionally conceived, architecture of steel, concrete, and glass a stage further than Behrens's epoch-making turbine factory of 1909. His other notable early work was a model factory and office-building at the 1914 Werkbund exhibition at Cologne.

The most important work while director of the Bauhaus was his contribution to the new buildings at Dessau when the Bauhaus moved there from Weimar in 1925. He also designed with Meyer the rebuilding of the Municipal Theatre of Jena in 1923. In 1928 he resigned from the Bauhaus to concentrate on large-scale planning and building, and his interest in the social side of architecture found an outlet in numerous working-class housing schemes. Of these, that at Siemensstadt, Berlin (1929), is the most ambitious and has been most frequently imitated. In 1934, finding his ideas unpalatable to the Nazi regime, Gropius came to England, where he designed several buildings in partnership with Maxwell FRY, including Impington Village College, near Cambridge (1936-9), film laboratories at Denham (1936), and a house in Old Church Street, Chelsea (1935). In 1938 he was appointed Professor of Architecture at Harvard University and later Chairman of the Department of Architecture. Under his direction, continued until 1952, the Harvard School became an influential centre to which students came from many parts of the world.

During his first years in America Gropius designed a number of country houses in New England in partnership with Marcel BREUER, one of his old staff from the Bauhaus. Among other things they built the Pennsylvania Pavilion at the New York World's Fair of 1939 and a housing estate for aluminium workers near Pittsburgh. The partnership ended in 1941. In 1946 Gropius founded a group partnership of eight, mostly composed of recent Harvard students, known as the Architects' Collaborative. With them he built (1949-50) a number of private residences, the Graduate Centre for Harvard University and the Harkness Commons (1949-50), and the McCormick Office Building (1953). He maintained his influence over architectural developments in Europe through his presidency of C.I.A.M. (Congrès internationaux d'Architecture moderne). He was a predominant force in 20th-c. architecture, a great believer in team work, in standardization and prefabrication, and in rational and intelligent restraint in the adaptation of contemporary materials to contemporary social needs.

878, 1035, 1173, 1174, 2816.

**GROS,** ANTOINE-JEAN (1771-1835). French painter, son of a MINIATURIST, he was trained by DAVID and succeeded him as leader of the Classical school of painting. But his own temperament and the emotional involvement expressed in his best work caused him to be regarded as a precursor of the ROMANTIC school. He went to Genoa in 1793 and there studied the work of RUBENS and van DYCK. He was made by Napoleon a member of his staff and as official war painter he followed the Napoleonic armies. In 1797 he was made a member of the Commission set up to choose pictures for the LOUVRE after Napoleon's Italian campaign. His battle paintings were received with enthusiasm for the vividness of first-hand experience with which he rendered the realities of battle (*The Battle of Aboukir*, 1806; *The Battle of Eylau*, 1808). His popularity continued after the Restoration. In 1816 he was made a member of the Institute and was commissioned to paint the cupola of the Panthéon. In the 1820s, however, he endeavoured unsuccessfully to revert to the Classical style of historical painting in David's manner and fell into obscurity. He committed suicide in 1835.

**GROSZ,** GEORGE (1893-1959). German-American CARICATURIST, illustrator, painter, and writer. Making his reputation first as a caricaturist for satirical papers, Grosz was a leading member of the DADA group in Berlin after 1918. His anti-militarism and anti-capitalism, expressed in bitingly critical drawings of Berlin bourgeois society in the post-war era, soon led him to a more down-to-earth realistic conception of art that became known as NEUE SACHLICHKEIT. In 1932 he settled in New York as a teacher at the Art Students League and his work gradually combined a certain romantic and idyllic quality with social satire directed against middle-class materialism and complacency. After the Second World War he produced work of a nightmare character which had affinities with earlier SURREALISM.

285, 1179, 1180, 1181, 1345.

**GROTESQUE.** From the Italian *grotta*, the word originated as a descriptive term for the fanciful mural decorations with mixed animal and human forms and floral ornament which were found in Roman buildings such as the Domus Aurea of Nero excavated *c.* 1500. This style quickly became the popular fashion and was adopted into contemporary decorative

schemes throughout Europe. One of the earliest examples of 'grotesque' ornament can be found in the frieze in Carlo CRIVELLI's *Annunciation* (N.G., London, 1486). In 1502 PINTORICCHIO was commissioned to decorate the ceiling vaults of the cathedral Library, Siena, in this style and SIGNORELLI's decorations for Orvieto Cathedral (1499-1504) make even more extravagant use of it. Throughout the 16th c. this manner of ornament remained extremely popular in most countries of Europe. The style was distinguished by its disintegration of natural forms and the redistribution of the parts in accordance with the fantasy of the artist. It thus acquired the extended meaning of 'fanciful decoration'.

Grotesque decoration was thus considered to be the antithesis of reality. When applied to other fields of art the word came to mean what is intrinsically strange, incongruous with ordinary experience, contrary to the natural order. Thus Sir Thomas Browne states: 'There are no Grotesques in nature.' During the 18th-c. Age

of Reason it ceased to be a purely descriptive term and acquired a pejorative implication as something monstrous, unnatural, ridiculous. During the GOTHIC REVIVAL and thereafter in certain phases of the ROMANTIC movement the grotesque became a term of meritorious connotation. Poe's title *Tales of the Grotesque and Arabesque* (1839) is symptomatic of this change. RUSKIN's treatment of the grotesque had the effect of establishing it as a respectable artistic genre, not only in the sphere of decoration, although he himself was unwilling to allow it a place in the highest branches of art. Thus in *Modern Painters* he wrote: 'A fine grotesque is the expression, in a moment, by a series of symbols thrown together in bold and fearless connection, of truths which it would have taken a long time to express in any verbal way.' A standard analysis of the concept was given by SANTAYANA in *The Sense of Beauty* (1896), where he defines it as 'the suggestively monstrous'.

1475, 2082.

**157.** Ceiling of the sepulchre at the Villa Corsini discovered *c.* 1674. Hand-coloured engraving from *Recueil de peintures antiques trouvées à Rome, . . . d'après les dessins coloriés par Pietro Santo Bartoli* (1783)

**158.** Detail of frieze from *The Annunciation* by Carlo Crivelli, with grotesque ornament. (N.G., London, 1486)

**GROUND.** Term which is sometimes used loosely in the sense of SUPPORT for any surface on which a painting or drawing is executed, for example the paper on which a WATER-COLOUR is done or the plaster under a FRESCO; but in its correct technical sense it means a prepared surface on which the colours are laid and which is applied to the panel, canvas, or other support before the picture is begun. Its purpose is to isolate the paint from the support so as to prevent chemical interaction, to render the support less absorbent, to provide a satisfactory surface for painting or drawing on, and to heighten the brilliance of the colours. The ground should be consistent so that the artist can calculate his effects on any part of it. It should not be too smooth to accept pigment from brush or pencil nor so rough as to impede handling. It should have an even tone and, unless very opaque pigments are used, a certain luminosity and reflecting power. It must not be too absorbent. And above all it must be durable and not liable to flake or crack.

In ancient times PANELS, sometimes covered with hide or canvas, were PRIMED with a ground of GESSO mixed with a binder of glue or size according to methods which have been described by THEOPHILUS and Cennino CENNINI. In northern countries chalk was sometimes used. The methods of applying the ground were technical and complicated. Since this priming is inelastic it was found to be unsuitable for canvas, which contracts and causes the ground to crack. Other techniques were therefore devised. Heraclius Presbyter (10th c.) describes a method of using a thin priming of gesso after the canvas has been smeared with a glue made from sugar and starch. It is known that the device of rendering a gesso priming more liquid by adding soap and honey was introduced into Italy from Byzantium. The Venetians developed a thin elastic ground so that canvases could be rolled without danger of cracking. In the 17th c. painters used an oil ground above a layer of vegetable glue, adding litharge for rapid drying. But this has not proved durable and various preparations with gypsum and glue are generally preferred.

Galen (2nd c. A.D.) mentions the use in ancient times of lightly tinted GLAZES in cool colours over the ground in order to avoid the glare of the white gesso. A similar practice was adopted in the Middle Ages and in the early RENAISSANCE painters toned their grounds with thin coats of earth colours (IMPRIMATURA). Two unfinished pictures by MICHELANGELO have a light wash of green earth colour as a ground for flesh tints. LEONARDO's recommendation to use perfectly white ground for *transparent* colours implies that ordinarily the ground would be tinted. The Venetians often used darkish grounds, TITIAN's being by preference brown or brownish red. The Florentines preferred light tones, in VASARI's time usually grey. RUBENS sometimes used solidly painted grey grounds and sometimes laid a coat of white with ground charcoal over his gypsum ground. In the 17th c. and afterwards many masters used red or brown pigment in oil-based grounds. Some painters mixed a little pigment with the last coat (*imprimatura*) of the ground. Holman HUNT devised a method of painting in transparent pigments over a second wet ground laid over the drawings done on a hard dry ground. In general white grounds give the greatest possibility of colourfulness but offer no help to the painter in relating his colours into a harmonious and balanced scheme. Coloured grounds require more opaque painting, reduce the colour range of the picture, and weaken contrasts.

The preparation of a ground for mural painting is a very specialized craft, which depends partly on local conditions (incidence of damp, etc.), partly on the style of painting (fresco, secco, encaustic, etc.), and partly on the effect which is desired (illusionistic, decorative, etc.). This is discussed in part under FRESCO.

For drawing with METAL POINT a coating of Chinese white is applied to the paper, parchment, or other support to provide a slightly abrasive ground. This rubs off tiny particles of metal from the point and without it the tool would make no mark.

In some engraving processes the ground is the acid-resisting mixture which is spread over the plate before work is begun. (See ETCHING, AQUATINT.)

**GRÜNER,** LUDWIG (1801–82). German engraver and painter. He studied in Dresden and Milan; from 1828 onwards he travelled extensively in France and Spain, and between 1841 and 1856 stayed frequently in England.

His connection with the Prince Consort and his influence on the Queen's Garden Pavilion (1844-6, formerly in the grounds of Buckingham Palace) helped to introduce continental artistic trends into England. His main activity was in the field of LINE ENGRAVING, done largely for the Arundel Society. He acted as artistic adviser to the Prince Consort and to Sir Charles EASTLAKE.

**GRÜNEWALD, MATHIAS** (c. 1460-1528). It is a curious fact that the most popular German 16th-c. painter apart from DÜRER should have been known for some 300 years by a wrong name. The mistake was due to a misunderstanding by the 'German Vasari', SANDRART, author of the *Teutsche Akademie* (1675). Modern research, by methods worthy of detective romance, has at last revealed the master's true name: MATHIS NEITHART, called GOTHART, which tallies with the monogram MGN appearing on four of his works. The date of his birth is unknown, and attempts to identify him with a 'Master Mathis' working in Würzburg between 1480 and 1500 are unsound. Grünewald's style betrays a study of the MASTER OF THE HOUSEBOOK, and—even more important—strong resemblances with some works done by the elder HOLBEIN around 1500, pointing to a possible apprenticeship in Augsburg. There Grünewald may have learned some tricks of style which became almost idiosyncrasies: strong colouristic effects thrown into bright relief by a dark background; twisted, at times even convulsed limbs; and highly expressive individual heads. There is no evidence that Grünewald ever visited Italy as Dürer and Holbein did.

From 1501 to 1525 Grünewald had his workshop in the little town of Seligenstadt, near Frankfurt, but his tasks took him as far afield as Isenheim in Alsace and Halle in central Germany. He was employed by two successive archbishops of Mainz: from 1511 to 1514 by Uriel von Gemmingen, for whom he seems to have done some decorative work in Aschaffenburg castle, and from 1516 to 1525 by Albrecht von Brandenburg, who was also archbishop of Magdeburg. For the latter Grünewald executed a number of important paintings for altars in Halle Cathedral. In 1525 he seems to have been involved in the Peasants' Rising, and seems to have been favourably inclined towards the doctrines of Luther. In consequence he must have lost the patronage of the archbishop. He died in Halle in 1528, when he was described as a painter and 'Wasserkunstmacher', i.e. a kind of hydraulic engineer.

One of Grünewald's earliest surviving works—an attribution—is the *Derision of Christ* (Munich), datable to 1503 through a (now lost) inscription. In this we already find the strongly marked characteristics of his style which are still more in evidence in his next two works: the GRISAILLE wings with saints which he painted for Dürer's *Heller-Altar* about 1510 (Frankfurt and Donaueschingen) and his *magnum opus*, the celebrated

*Isenheim Altar* (Colmar). In this great ALTARPIECE dramatic vigour is well matched with glowing colours. The mystical elements which a work destined for an Antonite house demanded seem to have appealed to his temperament. His nervous late GOTHIC linear style has made this sequence of pictures from the New Testament and the Legend of St. Anthony one of the most moving examples of late medieval art. It is not so typically German as has been represented. The altarpiece was commissioned by an Italian and there are indications that the *Temptation of St. Anthony* and the figure of St. Sebastian on one of the outer wings were inspired by Italian models. The date is uncertain but the work must have occupied Grünewald for a considerable time at the turn from the first to the second decade of the 16th c. Very few of the works executed for Cardinal Albrecht survive. The *Lamentation* (Aschaffenburg) is remarkable for its depth of expression and psychological interpretation of grief; the splendid panel with the saints *Erasmus and Maurice* (Munich)—the former an allegorical portrait of Grünewald's patron—impresses by its rich colourful surface and the monumental simplicity of its composition. To the last years of Grünewald's activity as a painter belong a *Carrying of the Cross* and a *Crucifixion* (both at Karlsruhe); the exaggerated, almost tortured, expressions in these pictures and the strained compositions seem to indicate the mental torment to which the artist must have been subjected.

Grünewald produced no woodcuts or engravings and in this he differs from most of his German contemporaries. A few of his powerful drawings survive, but it may be added in passing that those in the bundle found near Marburg after the Second World War are certainly not from his hand and are most probably forgeries.

Grünewald is often compared with Dürer. They shared an interest in the religious problems of their day, and both stem from similar late-Gothic traditions. But Dürer transmuted his style by grappling with the formal problems of the Italian RENAISSANCE and his religious qualms were answered for him by Luther. Grünewald accepted but little of the Renaissance: the calligraphic line, the glow of colour, and medieval distortions of the human form are his chief means of expression. The religious upheavals of his day seem in the end to have paralysed his creative powers, for there is no indication of any artistic activity during the last years of his life.

445, 2073, 2431, 2839.

**GUARDI.** Family of Italian painters. GIACOMO (1678-1716) founded the family *bottega* or workshop of *veduta* painting in Venice and the business was carried on by his two sons, GIANANTONIO (1699-1760), one of the founders of the Venetian Academy, and FRANCESCO (1712-93). Francesco is the most famous of the family, although the two brothers often worked

together on the same pictures. From about the middle of the century he began to specialize in 'views' in the manner of CANALETTO, although he was less popular during his life than Canaletto. His modern fame dates from the end of the 19th c. when those qualities which distinguish his work from Canaletto's were more readily appreciable. Where Canaletto aimed at firm structure in his paintings, Guardi preferred the effects of a vibrant atmosphere on buildings and water. His handling of paint derives from MAGNASCO, whose sharp angular touch he adopted.

Recent researches have radically altered our conception of Guardi's development and training. Previously known as a painter of views and commemorative pictures of state visits, it is now certain that he only began to specialize in this genre towards 1760 after a long period of association with his brother Gianantonio, a painter of large ALTARPIECES. Francesco worked under Gianantonio in the family studio, and their individual contributions to joint works during the period 1730–60 is not determined. There are a few signed drawings from this period. Most of the paintings concerned are altarpieces with a few large figures and very little landscape. An exception is the organ loft in the church of the Archangel Raphael in Venice, where figures and landscape are of equal importance; but it is the attribution of these pictures which is most hotly disputed.

Gianantonio was elected a foundation member of the Venetian Academy in 1756, possibly through the influence of his brother-in-law TIEPOLO, who was president in that year. Francesco was not elected until 1784, during the presidency of his nephew Giandomenico Tiepolo. He never achieved Canaletto's social, academic, or financial success. John Strange and John Ingram commissioned works from him, and Peter Edwards gave him a cautiously worded commission to paint four views of the ceremonial visit of Pius VI. It was well known that Guardi did not hesitate to utilize the compositions of other artists. The most startling example of this is the sparkling *Gala Concert* in Munich, one of a series to commemorate the visit of Prince Paul Petrovitz, which is unexpectedly based on an engraving.

Guardi's many beautiful drawings have an unmistakable style. In general his pictures are small (some in London measure half the size of a postcard), but at Waddesdon, Bucks. (Nat. Trust), there are two colossal views measuring 9 × 14 ft. His CAPRICCI, dating from the latter part of his life, are more purely imaginative than Canaletto's. They represent an international trend towards greater fantasy, seen also in the late landscapes of GAINSBOROUGH and the exotic fairy-tale romances and plays of the period.

1882, 2470, 2731.

**GUARINI,** GUARINO (1624–83). Philosopher and geometer and the leading Italian architect of the later 17th c. He became a

Theatine monk in 1639 and spent the years 1640–7 in Rome, where he gained first-hand knowledge of BORROMINI's architecture. He travelled to Sicily and came into contact with French Classicism in Paris, where he designed the Ste Anne for Mazarin (c. 1662/5; destroyed 1823). Three of his churches in Messina were destroyed by the earthquake of 1908. From c. 1666 he lived in Turin, where his major works were executed. About 1668 he took over the chapel of the Holy Shroud (S. Sindone) in Turin Cathedral, and redesigned it on a simple circular plan. The chapel becomes more complex in form as it rises to a stepped dome reminiscent of Borromini's S. Ivo. The interior of the dome is a complicated web of intersecting arcs—a demonstration in solid geometry like so many of Guarini's works. The Theatine church of S. Lorenzo (1668–87) is his best central plan, with an indescribably complex structure of 16 ribs supporting interlaced octagonal vaults pierced with windows, the whole crowning a series of piers and columns which move on elliptical paths into the central space. It has been suggested that these forms were influenced by Spanish Moresque architecture, but there is no evidence that Guarini ever went to Spain or Portugal, although he designed Sta Maria da Divina Providencia in Lisbon. It is, however, certain that his mathematical fantasies were extremely influential in Spain and Portugal and also in south Germany and Austria.

His church of S. Filippo, Turin (1675), collapsed in 1714 and was rebuilt by JUVARRA. For Philibert of Savoy Guarini designed his major secular building, the Palazzo Carignano (1679–after 1683). The street façade has a double curve in the centre set between rectangular wings and the curve of the façade follows that of the two great staircases, which in turn echo the shape of the great central oval room.

After Guarini's death his pupil Vittone published his *Architettura Civile* (1737), which shows the fundamentally mathematical nature of his genius and the way in which he evolved spatial complexities surpassing those of BERNINI and even Borromini.

**GUAS,** JUAN (d. 1496). Architect and sculptor of French origin who may have trained in Brussels. He came to Toledo probably c. 1450, where he and his father are recorded in 1459 as working on the Door of Lions, Toledo Cathedral, with Master Hanequin (see EGAS). He was master of works at Segovia Cathedral 1473–91 and at Toledo Cathedral c. 1483–95. From c. 1478 to 1495 he was employed as Royal Architect to design and build the queen's monastery of S. Juan de los Reyes (1479–80), an original design for which is preserved in the Prado. He was also mainly responsible for the Infantado Palace at Guadalajara (1480–c. 1483) and probably the façade of S. Gregorio in Valladolid, though some historians have attributed the latter to Gil de SILOE.

Guas was the most prominent architect of Spain in the latter part of the 15th c. and one of the most important exponents of the Isabelline form of the PLATERESQUE style.

**GUERCINO.** GIAN-FRANCESCO BARBIERI (1591-1666), called GUERCINO on account of his squint. Italian painter of the BOLOGNESE SCHOOL. Born at Cento, he started his career as a provincial painter working under the influence of Bolognese and Ferrarese artists, but soon gained the patronage of the papal legate at Ferrara and the archbishop of Bologna. His earliest and best manner, with its lively and capricious lighting and characteristic north Italian naturalism, owes a good deal to Lodovico CARRACCI. An example is *St. William Receiving the Habit* (1620) in the Pinacoteca at Bologna. In 1621, on the election of the Bolognese pope Gregory XV, Guercino was summoned to Rome, where he painted the celebrated ceiling fresco of *Aurora* at the Villa Ludovisi and an ALTARPIECE for St. Peter's. The preference of his Roman patrons for the classical manner of Annibale Carracci and DOMENICHINO led to a gradual change of style, which continued after his return to Cento in 1623 on the death of the pope. There he remained until 1642, when he succeeded Guido RENI as the leading painter in Bologna. His manner became increasingly classical, losing much of the liveliness and movement of the early works whilst approaching nearer to the lighter, more delicate, and less naturalistic style of Reni. Guercino was a brilliant draughtsman, the finest collection of his drawings being in the Royal Library at Windsor.

1758.

**GUERRERO Y TORRES,** FRANCISCO ANTONIO (d. 1792). Mexican BAROQUE architect. In 1774 he succeeded Lorenzo Rodríguez (1704-74) as leading architect in Mexico city and designed town houses and churches including the elliptical Pocito chapel (1777) at Guadalupe, one of the outstanding masterpieces of SPANISH COLONIAL architecture.

**GUGLIELMO DELLA PORTA** (1500?-1577). North Italian sculptor, who worked first in Genoa and then (from 1537) in Rome, where he succeeded SEBASTIANO DEL PIOMBO at the Papal Mint (1547). Most of his work was carried out as part of larger schemes designed by others, e.g. the figures he made for Paul III's tomb in St. Peter's. He also produced numerous small devotional and pagan statuettes and was known as a restorer and copier of antique works (both activities typical of his age). A bronze bust of Pius IV (before 1565) in the Victoria and Albert Museum, London, is attributed to him.

**GUIDO DA SIENA.** Sienese painter active during the 13th c. Nothing is known about Guido except for his signature on a *Madonna and Child* in Siena Town Hall, which has been regarded as the beginning of modern painting in Siena. The picture is dated 1271, but this has also been regarded as controversial. While following the BYZANTINE conventions of ICONOGRAPHY, the figures are more natural in posture and the painting achieves an air of majesty though to some extent relaxing the stiff linear patterns which had been conventional in central Italian painting up to that time. The throne too is set in a deeper picture space, which adds to the realism of the figures.

On the basis of this picture a number of other panels, most of which are in the Siena Pinacoteca, have been assigned to Guido or his school.

**GUILLOCHE.** Sometimes called 'Interlacement Band', is a mode of ornament in the form of two or more bands or strings interlaced or plaited over each other so as to repeat the same figure in a continued series by the spiral return of the bands and usually symmetrical with a longitudinal axis. The principle is that the interlacing broad lines shall pass over and under one another alternately (see INTERLACE). Guilloche ornament has been very widely used in architecture, textiles, pottery, for the decoration of manuscripts, picture frames, mouldings, etc. It is found in most styles and periods, though more common or varied in some than in others. In antiquity the interlacing lines were often distinguished from each other by colour or in raised ornament were fluted or channelled. In CELTIC, ANGLO-SAXON, and early SCANDINAVIAN ART the guilloche was the most conspicuous form of ornament and often achieved very complicated interlacings with the special feature that the same band appears in different colours in different sections of a continuous band of ornament. In the Middle Ages the guilloche was most popular with BYZANTINE and ROMANESQUE and the angular band was added to the forms used in antiquity. In ISLAMIC and particularly Moorish decoration the guilloche was extensively used, often in a special style in which the bands are straight rather than curved, bending at angles of either 90° or 135°. A very great variety and elaboration of the guilloche were developed at the RENAISSANCE, based chiefly on elements taken from medieval, Moorish, and classical models.

**GULLY,** JOHN (1819-88). Painter, born in Bath and largely self-taught. In 1852 he migrated to New Zealand whose scenic beauties became his exclusive preoccupation throughout a prolific career. His labours earned him in his day the title of 'New Zealand TURNER', a sobriquet that indicates the source of his inspiration rather than the level of his achievement. None the less his large water-colour landscapes have a pleasing, pensive charm, and only

when they are hung in bulk (as in the Bishop Suter Art Gallery, Nelson, and the National Art Gallery, Wellington) are their limitations and their monotonous repetitiveness obtrusive.

**GUM.** Plant gums, which set hard through evaporation, and unlike RESINS are soluble in water, have been used as painting MEDIA from ancient times. Gum is the normal medium of WATER-COLOUR paints and PASTEL, and since it readily emulsifies with oil, it has long been a medium in TEMPERA. Gum arabic, obtained from a species of acacia, the best from the Sudan and Senegal, is the variety most favoured.

**GÜNTHER,** IGNAZ (1725-75). Bavarian sculptor. After a varied training culminating in some years at the Vienna Academy he settled in Munich. His short career was productive of a considerable quantity of wood-carving combining a very elegant ROCOCO style with a highly emotional religious content. In 1761/2 he produced his chief work, the almost entire furnishing of FISCHER's church at Rott-am-Inn.

**GUTTUSO,** RENATO (1912- ). Italian Communist painter. About 1931 he turned towards EXPRESSIONISM and reacted sharply against the NEO-CLASSIC academicism upheld by the Fascists. In 1942 he painted an anti-clerical *Crucifixion* and later, after fighting in the Resistance movement, he produced a series of works against the Nazi massacres in Italy published in book form under the title *Gott mit uns*. After the war he also wrote newspaper articles and became the leader of the social REALIST movement. In spite of attacks on CUBISM, he has been influenced by PICASSO (particularly in the simplification of his forms) as well as by CARAVAGGIO and COURBET. Characteristic of his large, vigorous pictures with subjects of contemporary relevance is the *Battle of Ponte Ammarigho* shown in the 1952 Venice Biennale.

249.

**GUYS,** CONSTANTIN (1805-92). French illustrator, considered a precursor of the REALIST School of COURBET. Not very much is known about his life. He was a soldier as a young man and travelled widely. According to Baudelaire, who immortalized him as the 'Painter of Modern Life', he began to draw without instruction in 1847—but this is probably putting it too late. In 1854 he went through the Crimean War as Special Correspondent of *The Illustrated London News*. He is most remembered, however, for his pictorial record of Paris life during the Second Empire in witty and lively drawings reinforced by thin washes of tone or colour depicting all facets from the elegance of the court to the demi-monde. His talent was recognized by both DAUMIER and MANET. On his death he left several hundred drawings anonymously to the Musée Carnavalet, Paris.

1000, 1223.

**GYPSUM.** A natural mineral (hydrous calcium sulphate) with various uses in the arts. See ALABASTER, GESSO, PIGMENTS, and PLASTER OF PARIS.

# H

**HACKAERT,** JAN (1628-99). Dutch landscape painter, chiefly of Italian scenes, who travelled extensively in Switzerland and Italy (1653-8). *Lake Trasimene*, in the Rijksmuseum, shows how well he could capture the golden sunlight of Umbria. *Ash Tree Lane* in the same gallery, a view of a Dutch canal, proves that he was also sensitive to the light and atmosphere of Holland. The elegant figures were painted by Adriaen van de VELDE and in fact Hackaert usually had his figures painted by this master or by BERCHEM or Johannes Lingelbach (1622-74).

**HACKERT,** JAKOB PHILIPP (1737-1807). German painter, who became court painter to Ferdinand IV of Naples. His works show him as a sensitive landscape painter in the CLAUDE tradition, which he seasoned with touches of ROMANTICISM. He was a personal friend of GOETHE, who wrote his biography.

**HAES,** CARLOS (1829-98). Landscape painter. He was born in Brussels, the son of a Dutch merchant, but brought up at Málaga. A member of the Madrid Academy of San Fernando, he taught Aureliano de Beruete (1845-1912), Darío de Regoyos (1857-1913), and many other representatives of the late 19th-c. Spanish School of landscape painting.

**HAGGADAH** (Hebrew: 'telling'). The Jewish domestic service for the Eve of Passover, and the only Hebrew book with a long and consistent tradition of illustration. Among manuscript Haggadahs the most famous are those of Sarajevo (Spanish, 14th c.) and Darmstadt (German, 15th c.), both the subject of important monographs. The printed editions of Prague (1526), Mantua (1560, 1568), Venice (1609), and Amsterdam (1695) are also artistically noteworthy.

**HAGNOVER,** NICLAS (early 16th c.). German wood-carver. He made the figures for the shrine of the Isenheim altar, the wings of which were painted by GRÜNEWALD.

2765.

**HAGUE SCHOOL.** Group of Dutch artists who worked in The Hague between 1860 and 1900. Their aim was to make REALISTIC pictures of the milieu they knew: dunes and meadows, the sea and the beach, street scenes, views of everyday life, and church interiors. In some ways this was a ROMANTIC revival of the 17th-c. tradition, and this romantically nostalgic strain—particularly in pictures made during the first years the group worked together—is one of the things which distinguishes them from their French counterparts, the painters of the BARBIZON SCHOOL and the IMPRESSIONISTS. A quality the best members of the Hague School shared with great Dutch artists of every century is a special sensitivity in recording light and atmospheric effects. Leading members of the group include H. J. WEISSENBRUGH, BOSBOOM, J. ISRAELS, MAUVE, the MARIS brothers, and MESDAG. Their works are well represented at the Municipal Museum and the Mesdag Museum at The Hague and at the Rijksmuseum.

593.

**HALFPENNY,** WILLIAM, alias MICHAEL HOARE (d. 1755). English architect, chiefly notable for the publication of about 20 pattern books of domestic architecture, which range from the PALLADIAN (*Magnum in Parvo*, 1722) to Chinese ROCOCO and GOTHIC (*Rural Architecture in the Chinese Taste*, 1750-2; *Chinese and Gothic Architecture properly ornamented*, 1752). Although the engravings are poor, the books were much used by provincial craftsmen. His buildings included Holy Trinity, Leeds, and Coopers' Hall, Bristol.

**HALL,** PETER ADOLF (1739-93). Swedish portrait MINIATURIST, who went to Paris in 1766 and soon made a reputation, being elected member of the Académie 1769. He used a spirited, almost Impressionistic technique with comparatively broad brush-strokes—quite rare in the field of miniature painting. Fine specimens of his work may be seen at the National Museum, Stockholm, and in the WALLACE COLLECTION.

**HALL CHURCHES.** Term used by historians to describe the type of late GOTHIC churches in which the aisles are of the same height as the nave. The increasing frequency of such designs towards the end of the Middle Ages has been used as evidence to show that even without the influence of the Italian RENAISSANCE spacious and lucid designs replaced the upward movement of 13th-c. Gothic north of the Alps.

**HALO** (Greek *halōs*: 'disc') or NIMBUS (Latin: 'cloud'), also called Aureole or Glory. A circle or disc surrounding the head of a saint or person endowed with divine light. The nimbus is first seen in the garland with rays surrounding the heads of Greek gods, notably the Sun-god Helios, in a number of Attic vases (see also metope from temple of Athena at Hissarlik, now in B.M.). This was transformed into a crown of rays and adopted as a symbol of divinity, first by the Ptolemies of Egypt and then, on coins of the 1st c. A.D., by Roman emperors. A similar circle of rays surrounds the head of Helios or *Sol salutis* in a 3rd-c. mosaic in a MAUSOLEUM discovered below St. Peter's, Rome.

The simple circular nimbus used by Christian painters was probably derived from the Roman portraits on circular medallions (*imagines clipeatae*) common in ROMAN ART from the 1st c. A.D. This simple halo adorns the heads of certain gods and heroes in Pompeian frescoes. It was taken over by Christian emperors to replace the radiated crown associated with the pagan emperor-cult. (Imperial coins, 4th c.; silver missorium of Theodosius I, Historical Academy, Madrid, A.D. 388.)

From the middle of the 4th c. Christ too usually received this imperial attribute (fresco in the Domitilla Catacomb and mosaic in Sta Costanza, Rome, 4th c.), and from the end of the 4th c. the LAMB of God likewise (apse mosaic in Sta Pudenziana, Rome). In the 5th c. it was sometimes given to angels (mosaics in Sta Maria Maggiore, Rome). But, although St. Lawrence has a halo in the 5th-c. mosaic in the Mausoleum of Galla Placidia at Ravenna, it was not until the 6th c. that this became a customary attribute of the Virgin, the Apostles, and of other saints.

From the 5th c. onwards the SACRED MONOGRAM or, more often, a simple cross was incorporated into the halo of Christ (5th-c. mosaic, chapel of S. Aquilino, S. Lorenzo, Milan; 5th-to 6th-c. mosaic, St. David, Salonika).

The square nimbus, found earliest in Egypt, seems usually to have implied that its wearer was a living person of high, but not necessarily saintly, rank. Thus the DONORS of a series of mosaics in S. Demetrius, Salonika, wear square haloes, as do Pope John VII, Zacharias, and Paul in the 8th-c. frescoes of Sta Maria Antiqua, Rome.

The halo became an essential part of medieval painting, both as a decorative element and for purposes of identification. It was less welcome to artists of the 15th c. and later, who first of all tried treating it as a solid object seen in perspective (MASACCIO, frescoes in Sta Maria del Carmine, Florence) but later reduced its importance in their compositions. MICHELANGELO and TITIAN abandoned it altogether but it was reinstated by the painters of the Counter-Reformation, who showed it as a play of light around the head of Christ (TINTORETTO, *Christ before Pilate*, Scuola di San Rocco frescoes; VELAZQUEZ, *Crucifixion*, Prado).

In the first centuries A.D. the circular nimbus was also given to the Buddha in Gandhara sculpture under the influence of HELLENISTIC ART, and from here it was carried by Buddhist influence throughout India and the Far East. (See also MANDORLA.)

**HALS.** Dutch family of painters. Only one, FRANS (1581/5–1666), is of international stature. He was probably born in Antwerp of Flemish parents who immigrated to Holland in 1585. His parents settled in Haarlem in 1591 and he spent his long life there. Little is known about his life and character. The old story that he was a drunkard and wife beater is based upon a mistaken identity; the tale that he spent the last years of his life in the Old Mens' Alms House of Haarlem is without foundation. It is certain, however, that he was plagued by financial difficulties all his life. Even during the 1630s, when he apparently had as many commissions as he could handle, he was sued by his butcher and cobbler for unpaid bills. During his last years he was destitute and the municipal authorities awarded him a small annual stipend four years before his death.

Frans Hals was primarily a portraitist and even his GENRE pictures have a portrait-like quality. Within his range he has the reputation of a supreme master of outstanding originality. Few painters ever matched his technical ability or the surety of his touch. In view of this, it may appear strange that his extant œuvre is so small. But it is likely that a great many of his pictures have disappeared because from the time of his death until about the middle of the 19th c. few people thought them worth saving. When interest in his work revived forgers began to make fakes, specializing in genre pictures. The true standard of his rapid oil sketches of children is set by the *Boy with a Glass* and *Boy with a Flute*, formerly in Schwerin. Estimates of the number of extant authentic works by Frans vary from 109 (N. Trivas, *Frans Hals*, 1941) to about 300 (W. R. Valentiner, *Frans Hals*, 1923). Later research places it at about 250. It is noteworthy that not a single drawing can be attributed to him with certainty and this is perhaps an indication of the directness of his approach. He may have found it unnecessary to make preliminary studies for most of his pictures.

The influence exerted by his teacher, the Dutch MANNERIST Karel van MANDER, cannot be appraised until the mystery of his missing juvenilia is solved. His earliest extant picture is the fragment of a portrait, *Zaffius* (Haarlem, 1611), and upon the basis of stylistic evidence a couple of paintings can be dated a year or two earlier. None of these recalls van Mander's way of painting, and nothing he did before 1616 suggested that he would shatter well-established traditions with his life-size group portrait *The Banquet of the Officers of the St. George Militia Company* (Haarlem) painted during that year.

Perhaps, like some other artists who lived long lives, he was a slow starter. In any event there is no precedent in either his own work or that of his predecessors for the vigorous characterization of that picture. This 1616 group portrait has become a symbol of the strength and healthy optimism of the men who established the new Dutch Republic. It also shows his genius as a colourist and foreshadows the detached brushwork which remained his hallmark for the rest of his life. HOUBRAKEN reports that it was his practice to add touches of broken colour to a picture after it was finished in the traditional manner because, Frans said, they showed the character of the artist.

From 1616 onwards his artistic development is clear. The light tonality of pictures done during the 1620s (*The Laughing Cavalier*, Wallace Coll., 1624) shows that he was aware of the innovations Dutch followers of CARAVAGGIO such as TERBRUGGHEN or HONTHORST brought back from Italy. His debt to the Caravaggists is most evident in his genre pictures (*The Merry Drinker*, Rijksmuseum; *The Gipsy Girl*, Louvre), but there are also important differences. Unlike the Caravaggists, he tried to exploit the dramatic possibilities of the CHIAROSCURO effects which can be produced by painting artificial light; the instantaneous expressions he depicted never freeze into grimaces.

Almost all Frans's genre pictures were done during the first half of his career. It is difficult to establish a precise chronology for them because very few are dated. It is also hard to correlate them with dated portraits because they are always painted more freely than his commissioned portraits—an excellent example of a BAROQUE painter following the ancient idea of adjusting his style to the subject he depicted. Only during the last decades of his life did Hals use in his commissioned portraits the bold brushwork and the ALLA PRIMA technique which he had previously reserved for genre pictures.

Frans was at the height of his popularity during the 1620s and 1630s. During these decades he made five large group portraits of civic guards; one is in the Rijksmuseum and the others are in the Frans Hals Museum, Haarlem. The latter gallery, which also contains the 1616 guard piece and Frans's three group portraits of regents, is the only place where one can get a comprehensive view of his full range and power. During the 1630s he painted pictures of greater simplicity and monochromatic effects took the place of the bright colours of the earlier works (*Lucas de Clercq* and *Feyntje van Steenkiste*, Rijksmuseum, 1635). The group portrait of the *Regents of the St. Elizabeth Hospital* (Haarlem, 1641) sets the key for the sober restraint of the late period when his pictures became darker and his brush-strokes even more economical. The culmination of this phase—and perhaps of his entire career—are his group portraits of the *Regents* and the *Regentesses of the Old Men's Alms House* (Haarlem, 1664). These two pictures

rank among the most moving portraits ever painted.

Frans's brother DIRK (1591-1656) painted small charming scenes of interiors. A second brother JOOST (d. before 1626) also painted, but none of his pictures has been identified. Five of Frans's sons became artists: portraits by JAN (Johannes) (active c. 1635-50) can be deceptively close to his father's; HARMEN (d. 1669) painted coarse life-size genre pictures; NICOLAES (Claes) (1628-86) did landscapes; FRANS II (1618-69) and REYNIER (1627-72) are nebulous figures. Artists of the Hals family, as well as Frans's pupils Judith LEYSTER, Jan Miense MOLENAER, Adriaen van OSTADE, Adriaen BROUWER, and Philips WOUWERMAN, are usually spoken of as the 'Frans Hals School', but strictly speaking Frans never gathered followers in the way that RUBENS and REMBRANDT did. Judging from the way the members of his circle painted, none of them grasped the nature of his artistic achievement. With a few rare exceptions—REYNOLDS was one of them—few critics before 1850 applauded Frans's work. Only after the 19th-c. REALISTS and IMPRESSIONISTS taught the public how to appreciate new values in the Old Masters did Frans Hals take his place among 17th-c. Dutch painters as second only to Rembrandt.

2687, 2715.

**HAMEL,** THÉOPHILE (1817-70). Canadian painter of portraits and religious subjects, born at Sainte-Foy, Quebec. He was a pupil of PLAMONDON and his earliest portraits combine the latter's Classicism with the simplicity of FOLK ART (*Léocadie Bilodeau*, Université Laval, Quebec, 1842). Later he went to Europe (1843-6) and was influenced by the ROMANTIC painters.

**HAMILTON,** GAVIN (1723-98). Scottish painter, archaeologist, and picture-dealer, who spent most of his working life in Italy. He settled in Rome c. 1755, and was a leading member of the NEO-CLASSICAL circle of MENGS and WINCKELMANN. His archaeological excavations near Rome resulted in many important additions to contemporary collections, and his interest in antiquity exerted a decisive influence on the young CANOVA. Hamilton's history paintings, mostly of Homeric subjects, were partially influenced by POUSSIN as well as by the ANTIQUE. They were well known through engravings, and greatly influenced the development of the Neo-Classical style amongst both his contemporaries and the younger generation, including DAVID. Hamilton was little known as an artist in England; his name was more familiar in connection with classical sculpture sold to British collectors. Together with BARRY, and the Anglo-Americans WEST and COPLEY, he is one of the few painters to have made a significant contribution to history painting in Britain.

**HAMILTON,** THOMAS (1784-1858). Edinburgh architect who worked chiefly in the Neo-Greek manner. His principal work was Edinburgh Royal High School (1825), a brilliant Greek Doric composition on a hillside site with affinities to the contemporary Munich School. Other work includes choragic monuments to Burns at Alloway (1818) and Edinburgh (1830) and Arthur Lodge (1830), Dean College (1833), and the Royal College of Physicians (1845), all in Edinburgh.

**HAMMERSHØI,** VILHELM (1864-1916). Danish painter of quiet interiors in muted colours, principally grey tones with occasional stronger accents. Characteristically enough they are all interiors of the First Empire period; his art is at the same time an escape into the past and to the timeless. Its mysticism is still more apparent in a remarkable group portrait of five artist friends (Thiel Gal., Stockholm, 1901). Although no radical, Hammershøi had to wait long for recognition. Among artists, however, his refined art was always respected. The rejection of his work at several of the annual exhibitions of the Copenhagen Academy was the occasion of controversies which ended with the foundation of the Independent Exhibition in 1891.

**HANEQUIN.** See EGAS.

**HAN KAN** (active c. 720-c. 780). Considered by the Chinese as their greatest painter of horses. Little is known of his life and work and only two of his paintings survive: *Horse Bound to a Stake* (Sir Percival David Coll., London) and *Horses Led by Grooms* (Freer Gal., Washington). In both powerful animals from the western regions of China are depicted with a vigorous realism reminiscent of T'ang tomb figures of horses. Han Kan established a model for horse painting which has remained popular with the Chinese to the present day (see CHINESE ART).

**HANNEMAN,** ADRIAEN (c. 1601-71). Dutch portrait painter, a native of The Hague and a pupil of Anthony van RAVESTEYN. From c. 1623 to 1637 he was in England, where he came under the influence of Cornelis Jonson (1593-1661) and Daniel MYTENS. But much more important for his development was his contact with van DYCK's English portrait style. Van Dyck became his model, and upon his return to Holland c. 1637 he achieved great success with his portraits in this manner among the aristocracy in The Hague. The portrait *Constantijn Huygens and His Five Children* (Mauritshuis, The Hague, 1640) shows how well Hanneman assimilated van Dyck's spirit and technique.

**HARD EDGE.** Term used to denote a style of ABSTRACT ART subsequent to ABSTRACT EXPRES-

SIONISM and NEO-PLASTICISM. It was characterized by the fact that the abstract shapes are clear-cut with sharp outlines but are not geometrical.

**HARDOUIN-MANSART.** See MANSART, J. H.-.

**HARDWICK,** THOMAS (1752–1829). English architect. The son of a mason-turned-architect, Hardwick was the pupil and faithful follower of Sir William CHAMBERS, on whom he wrote a memoir first published in 1825. He travelled in Europe, spending most of his time in Rome, and then set up practice in London. Three pleasant but unremarkable churches by Hardwick are Wanstead, Essex (1787–90), St. James's, Hampstead Road (1791–2), and St. John's Wood Chapel (1814). His most important building is the parish church of St. Marylebone (1813–17). This has canted 'wings' at the altar end, a large Corinthian portico, and a domed steeple of uncomfortable design. Hardwick was much employed in an advisory capacity, and as surveyor to the St. Bartholomew's Hospital Estate he made repairs to St. Bartholomew-the-Great and St. Bartholomew-the-Less and designed the small houses round King Square. He also rebuilt St. Paul's Church, Covent Garden, after the fire of 1795, keeping faithfully to Inigo JONES's original design. His son PHILIP (1792–1870) was the architect of Euston station (1847), where the massive entrance arch in the Greek Doric Order (see ORDERS OF ARCHITECTURE) was one of the most effective monumental designs of the 19th c., and the Shareholders' Meeting Room, based on PERUZZI's chamber in the Palazzo Massiani, one of the most successful interiors. He was helped at Euston by his son, PHILIP CHARLES, who carried on the work after him. He also designed Goldsmiths' Hall (1835) and was responsible with his son for the Great Western Hotel at Paddington, which started a vogue for French features in hotel building.

**HARMONY.** See COLOUR.

**HARNETT,** WILLIAM MICHAEL (1848–92). American STILL LIFE painter of Irish birth, who worked mainly in Philadelphia and New York, with a stay in Europe in 1880–6. He specialized in still lifes of simple everyday objects painted in a realistic manner but chosen and grouped expressively. He made a masterly use of texture and luminosity (*Old Models*, Mus. of Fine Arts, Boston, 1892). His work was neglected until after 1945, when the abstract qualities of the compositions attracted attention.

**HARPIGNIES,** HENRI (1819–1916). French landscape painter and engraver. He did not take up painting until 1846 and then studied in Rome (1850–2). He is sometimes classed with the BARBIZON SCHOOL but his work shows rather an influence of COROT, with whom he went to Italy in 1860. Examples of his work in the Tate Gallery are *A River Scene* and *Ilex Trees at Villefranche*.

**HARRISON,** PETER (1716–75). American architect. Trained in England, he was a man of highly developed and sophisticated taste. He worked entirely from books and his buildings reflect some of the PALLADIAN ideals of England. The Redwood Library, Newport, Rhode Island (1749), is a Doric temple form which he took directly from an English edition of the Fourth Book of PALLADIO. In this building his use of wood to imitate RUSTICATED masonry is one of the earliest examples of the technique in the colonies. King's Chapel, Boston, designed by Harrison in 1749, was built for the oldest Anglican congregation in New England. Constructed of granite, it was the earliest stone masonry building in the colonies and the most thoroughly GEORGIAN building of its day.

396.

**HARROWING OF HELL.** In the canonical writings Christ's descent into 'the lower parts of the earth' is mentioned only in the Epistle to the Ephesians (iv. 9), and the earliest detailed accounts of the story, probably Eastern in origin, are attached to the *Gospel of Nicodemus*. It is included in certain early 4th-c. creeds but not in the Nicene Creed. It gained dogmatic importance during the Nestorian controversy and was included in the Athanasian Creed and the liturgy of St. Basil. In Byzantine homiletics it acquired the significance of the final defeat of a plot which the Devil had been maturing against mankind since Christ's presence on earth. The Harrowing of Hell was depicted mainly in the Greek Church, where it superseded the RESURRECTION. A common feature was the rescue of the souls of the righteous dead (referred to in Matt. xxvii. 52). The first known version of the *Anastasis*, as it was called, dates from the Iconoclast period, among the frescoes of the Greek pope John VII (705–7) in Sta Maria Antiqua, Rome, and shows Christ striding forward over the body of Satan and stretching out a hand to ADAM AND EVE. In later versions St. JOHN THE BAPTIST and kings DAVID and Solomon also appear, and the gates of Hell as well as Satan are trampled under the feet of Christ (9th-c. paintings in the rock churches of Cappadocia; 11th-c. mosaics in Daphni, and Nea Moni; 14th-c. wall-paintings in St. Saviour in Chora, Istanbul). A typical scene is that of the Docheiarion, Mount Athos, where Christ is pictured treading the gates of hell while on His left are Jonah, Isaiah, Jeremiah, two Just Kings, David, John the Baptist, Adam, and on His right Eve and others accounted righteous under the old dispensation: beneath the gates of hell an angel is chaining Beelzebub and broken locks are scattered (1568).

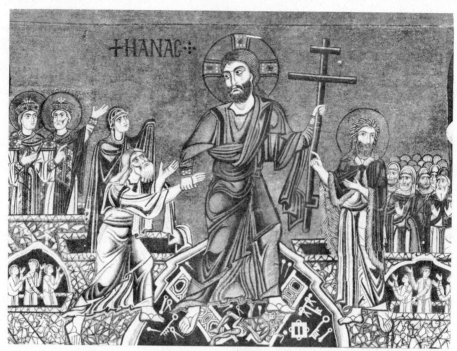

**159.** The Harrowing of Hell. Christ trampling on Satan and the gates of Hell, rescuing Adam and Eve. St. John stands on His left, kings David and Solomon on His right. Detail from mosaic on west wall of Torcello Cathedral (12th c.)

The Harrowing of Hell was more rarely depicted in the West, usually only under Greek influence (OTTONIAN ivory bucket, 10th-c., V. & A. Mus.; 13th-c. mosaics, St. Mark's, Venice). It is shown on a carved stone slab of the 12th c. in Bristol Cathedral, and is one of the scenes on an altar frontal of the 12th c. at Klosterneuburg, Austria. In Italian paintings Christ is shown amongst the souls of Hell, carrying the banner-cross of the Resurrection and putting the devils to flight (Spanish Chapel, Florence, 14th c.; Fra ANGELICO, St. Mark's, Florence; BRONZINO, Uffizi, 16th c.). DÜRER in his wood-engravings of the PASSION gives a modified version showing Christ meeting with Adam and Eve before the gates of Hell. The Harrowing of Hell was a subject of medieval Mystery Plays. In the Chester Cooks and Innkeepers' play, for example, the souls of Adam, Isaiah, Simeon, St. John the Baptist, Seth, and David rejoice that the time of their release from hell is at hand. There is a great consternation among Satan and the demons. Jesus knocks at the doors of Hell, proves His superiority over Satan, and releases the souls in bondage. The archangel Michael leads forth Adam and the saints to Paradise, where they meet Enoch and Elijah and the saved thief, the only human souls which had not entered Hell. All these themes were represented in popular art.

**HARUNOBU, SUZUKI** (1720?-1770). Japanese master of the UKIYO-E or colour print. His early work was not distinguished, but after the introduction of the fully polychrome print (*nishiki-e*) c. 1765 his magical gifts as a colourist found full scope and he established for himself a position of leadership in the development of the new process. He was supreme in grace of line and in subtlety of colour combination. Unfortunately many of the more delicate gradations of colour have not lasted. He was a prolific book illustrator and in an effort to raise the moral level of the *ukiyo-e* he took themes from poetry, history, and tradition, adapting them to everyday life. He was famous in his time for his ability to portray idyllic love and his night and snow scenes are now greatly admired. His work has been extensively forged both in his own time and since.

**HAWKSMOOR** or HAWKESMORE, **NICHOLAS** (1661-1736). English architect. He entered WREN's office at the age of 18, and was closely associated, either as draughtsman or clerk of the works, with all Wren's later buildings. By 1700 he was in touch with VANBRUGH and collaborated with him at Castle Howard and Blenheim. His share is hard to define: the ideas were probably Vanbrugh's though almost all the

drawings are by Hawksmoor. Easton Neston, Northants. (exterior completed 1702), was his own creation, and was already surprisingly mature in plan and elevation.

In the two first decades of the 18th c. he was occupied at both Oxford and Cambridge, producing plans for both of a Roman grandeur, though neither was executed. At Oxford he designed the Clarendon Building (1712-15) with its great Doric portico, the north quadrangle of All Souls, which is GOTHIC without but classical within, and made many designs, only partly executed, for Queen's and Worcester Colleges. The Radcliffe Camera, built by James GIBBS, owes much to Hawksmoor's projects. His most distinguished work lay in the six London churches designed under the Commission of 1711, to which he became a Surveyor. More monumental and sombre than Wren's churches, they bear witness to Hawksmoor's profound respect for antiquity and his originality in space composition. None remains unaltered, but St. George's, Bloomsbury (1720-30), St. Alphege, Greenwich (1712-14), and Christchurch, Spitalfields (1723-9), suffice to prove that in spite of his long association with other architects, he had great independence of mind.

763, 1099.

**HAYDON,** BENJAMIN ROBERT (1786-1846). English painter, who in reaction from the anecdotal conception of WILKIE and others aspired to redeem English painting by historical and religious work in the GRAND MANNER preached by REYNOLDS. His name was closely linked with the ROMANTIC movement in literature, particularly with Wordsworth (who wrote a sonnet to him) and with Keats, of both of whom he did portraits (N.P.G., London). Conscious of genius, he failed to achieve greatness. His life was one of bombastic frustration and intransigent opposition to the establishment, fighting continuously for personal recognition and for the cause of social patronage for the arts. He is now remembered chiefly for his *Autobiography and Memoirs* selected from the 27 volumes of his journals by Tom Taylor and published in 1853. Students of the psychology of artistic creation find exemplified in this all the traits traditionally ascribed to the Romantic concept of genius, though objectively his achievement fell short of his ambition.

1009, 1276, 1277, 1278.

**HAYMAN,** FRANCIS (1708-76). English painter born at Exeter. He is thought to have begun his working life as a scene painter at Covent Garden Opera House. He was also a designer and engraver and collaborated in book illustration with GRAVELOT, from whom no doubt he acquired the ROCOCO lightness of touch which characterizes much of his work. His largest undertaking was the painting of decorations for the boxes and pavilions at Vauxhall

Gardens, of which two are now in the Victoria and Albert Museum. His CONVERSATION PIECES anticipated those of the early GAINSBOROUGH, who almost certainly worked with him in Gravelot's studio. Hayman was President of the Society of Artists, 1760-8, and became a foundation member of the ROYAL ACADEMY.

**HAYTER,** SIR GEORGE (1792-1871). English historical and portrait painter. He studied at the R.A. Schools and in Rome, and was appointed portrait and history painter to Queen Victoria in 1837. He is known chiefly for his royal portraits (official portrait of the Queen in Coronation robes) and his huge groups (*House of Commons*, N.P.G., London, 1833), unexciting in their handling, but composed with dexterity and accomplished grandiloquence.

**HEAPHY,** CHARLES (c. 1820-81). Painter, born in London. He studied at the R.A. Schools, and in 1839 was appointed artist and draughtsman to the New Zealand Company. For three years he travelled through the country, exploring the little known wilderness while struggling to express his vision of a new landscape and the native people. The paintings and sketches he made (Alexander Turnbull Lib., Wellington) form a unique record of early colonial New Zealand and in their bold modification of traditional English techniques pointed to his successors a way which, unhappily, few have followed. Since a raw colony had no place for professional painters, Heaphy gradually abandoned art for a distinguished career as soldier, administrator, and politician.

**HEARNE,** THOMAS (1744-1817). English topographical draughtsman, who worked for Sir Ralph Payne as draughtsman in the Leeward Isles and later collaborated with William Byrne on the *Antiquities of Great Britain* (1786), for which he made 52 drawings.

**HECKEL,** ERICH (1883- ), German painter. While studying architecture in Dresden, he met KIRCHNER and SCHMIDT-ROTTLUFF and founded with them the BRÜCKE. His early subjects were mainly circus folk and clowns. Later he became more interested in landscape painting and his works lost much of the hectic violence of his *Brücke* days.

**HEDA,** WILLEM CLAESZ (1593/4-1680/2). Dutch painter who worked in Haarlem. He and Pieter CLAESZ are the most important representatives of *ontbijt* (breakfast piece) STILL LIFE painting in Holland. Like Claesz he arranged his objects into a diagonal composition and unified them by means of an over-all grey-green or

brownish tonality. His taste was more aristocratic than that of Claesz. He showed a preference for ham, mince-meat pie, and oysters, and after 1629 never included a herring in his pictures. RUBENS owned two of his still lifes.

**HEEM,** JAN DAVIDSZ DE (1606–83/4). It is difficult to decide whether this STILL LIFE painter should be called Dutch or Flemish. He was born at Utrecht; his rare early pictures are in the style of his teacher B. van der AST and show that he studied the restrained and simple works of the Haarlem still life artists CLAESZ and HEDA. In 1636 he moved to Antwerp, became a citizen of that city in 1637, and spent most of his very productive life there. In Flanders he did the paintings for which he is renowned: splendid flower pieces and large compositions of exquisitely laid tables which breathe all the opulent exuberance of Flemish BAROQUE painting. He had many pupils and imitators in both Flanders and Holland, and some of the pictures attributed to him were painted by them. CORNELIS DE HEEM (1631–95) was his son and a close follower.

**HEEMSKERCK,** MAERTEN VAN (1498–1574). Dutch painter who worked with Jan van SCOREL c. 1527–9. Although Heemskerck was only one year younger than Scorel and was a mature man when he entered his studio (he had already studied with two other teachers), the experience left a distinctive mark on him. In some pictures, particularly the portraits, experts still have difficulty distinguishing their hands. As a rule, however, Heemskerck's paintings are more crowded and nervous than Scorel's balanced and harmonious compositions. Equally important for Heemskerck's development was a visit to Italy (1532–6), where he was impressed —or overwhelmed—by MICHELANGELO. When he returned to the Netherlands he emulated Michelangelo by painting huge works packed with muscle-bound figures in wild movement. His colossal ALTARPIECE for the church of S. Laurentius in Alkmaar (1538–41) survived the fury of the iconoclasts because it was sold to Russia in 1581, but the ship carrying it was shipwrecked off the Swedish coast and the altar finally brought to the cathedral of Linköping, Sweden, where it is today. During his stay in Rome Heemskerck made drawings of ancient and modern buildings and sculpture. Two of his Italian sketch-books are in Berlin; they are valuable historical documents as well as sensitive impressions of the marvels of Rome.

**HEIDELBERG SCHOOL.** The circle of Australian artists led by Tom ROBERTS who foregathered at the painting camp at Eaglemont, Heidelberg, Victoria. It included, among others, STREETON, McCUBBIN, and CONDER. Roberts had previously established camps at Box Hill (1885) and Mentone (1886), Victoria. The art of the school, based on *plein air* and IMPRESSIONIST painting, also featured local subject matter and was associated with the emergence of a distinctive Australian literature. It flourished, appropriately enough, between 1888 (the centenary of Australia) and 1901 (the foundation year of the Commonwealth). The school's artistic programme was first presented at the '9 × 5 Exhibition of Impressions' (1889) held at Buxton's Galleries, Melbourne. While the general public remained indifferent and hostile, the school found some support in academic, professional, and business circles. Lack of patronage at home and desire for overseas training and experience had forced most of its members to Europe by 1900. But their vision of Australian life and landscape came to dominate Australian art during the 1920s (see STREETON) and has found a renewed response in the work of some Australian landscape and social realist painters in later decades.

**HELLADIC.** A term conventionally applied to the culture of the Greek mainland during the Bronze Age. Late Helladic is alternatively called MYCENAEAN.

**HELLENIC.** The usual and most reasonable application of this term is to the cultures of Greek-speaking societies from the beginning of the Iron Age (late 11th c. B.C.) to about 323 B.C. Earlier periods in Greece are 'Prehellenic', or HELLADIC, to which MINOAN and MYCENAEAN ART belong; the subsequent period is called HELLENISTIC. The term 'Hellenic' is also sometimes used so as to include the Hellenistic period.

**HELLENISTIC.** A term conventionally applied to Greek culture between Alexander and Augustus, say from 323 to 27 B.C. During this period Greece itself had lost its political importance and new centres of art and patronage arose in the Greek kingdoms of Asia Minor and Egypt; at its end Rome had become the metropolis of the Mediterranean world.

2819, 2820.

**HELST,** BARTHOLOMEUS VAN DER (1613–70). Dutch portrait painter. When the fashionable burghers of Amsterdam had their portraits painted around the middle of the 17th c. they chose artists who could make realistic and slightly flattering likenesses, arrange them in tasteful poses and depict the texture of their expensive clothes. They believed that van der Helst filled the bill best, and he was the leading portrait painter in Amsterdam from c. 1640 to 1670. He was born at Haarlem, settled in Amsterdam in 1636 and was probably a pupil of ELIASZ, and was also influenced by REMBRANDT

and HALS. Most of his contemporaries believed he surpassed them as a portrait painter and as late as 1781 REYNOLDS wrote that van der Helst's *Banquet of the Amsterdam Civic Guard in Celebration of the Peace of Munster* (Rijksmuseum, 1648) 'is, perhaps, the first picture of portraits in the world', adding that it as far exceeded his expectations as Rembrandt's *Night Watch* fell below them. Van der Helst's influence during his lifetime was great. For example, Rembrandt's talented pupils BOL and FLINCK abandoned the style of their master in order to follow the more popular manner of Helst.

**HEMESSEN,** JAN SANDERS VAN (*c.* 1500–*c.* 1575). Flemish artist who did religious and GENRE pictures and portraits. The facts of his life are obscure, but in 1524 he was made a free master of the Antwerp Guild. He is reputed to have moved to Haarlem *c.* 1550 and to have died there. His paintings illustrating popular proverbs and religious parables, and his satirical portraits, link him with Quentin MASSYS and MARINUS VAN REYMERSWAELE and Hemessen ranks with them as one of the founders of Flemish genre painting. An example of his work is *The Prodigal Son* (Brussels, 1536). In the background of some of his paintings there are well drawn figures which are very similar to those in pictures attributed to the MASTER OF THE BRUNSWICK MONOGRAM. This has led some connoisseurs to conclude that the Brunswick Monogrammist is Hemessen, but the stylistic evidence is inconclusive.

**HENDRIKS,** WYBRAND (1744–1831). Dutch painter of STILL LIFES. He also made drawings after the 17th-c. Dutch masters (e.g. HALS and REMBRANDT). His works are best seen in the museums and collections of Haarlem, where he was custodian of the Teyler Foundation from 1786 to 1819.

**HENRI,** ROBERT (1865–1929). American painter who studied first at the Pennsylvania Academy under Thomas Pollock Anshutz (1851–1912) and then in Paris, 1888–91. He returned to Philadelphia in 1891 to teach at the School of Design for Women and became the intellectual inspiration of the EIGHT in their revolt against current academic dreariness. Henri's energetic propagation of the creed that the artist must be a social force, one whose 'work creates a stir in the world', his sense of the dignity and importance of an art in touch with contemporary life, were the impulse which led to the emergence of a new school of American REALISM which became famous under the name of the 'Ash-can School'. Henri's importance in the 20th-c. art of the U.S.A. derives from his influence as a teacher and a crusader. His own work was not only mediocre and superficial but now seems to be little different from that of his conservative contemporaries. It no longer appears either radical or revolutionary.

**HEPHAESTEUM.** See THESEUM.

**HEPWORTH,** DAME BARBARA (1903–75). English abstract sculptor. She was trained at Leeds School of Art and at the Royal College of Art. She was married to Ben NICHOLSON until 1951. Since 1939 she has lived and worked in St. Ives, Cornwall, where she helped to create an artist colony. In 1953 she obtained second prize in the International Sculpture Competition for *The Unknown Political Prisoner*, in 1959 the Grand Prix at the 5th São Paulo Biennale, and in 1963 the Foreign Minister's Award at the 7th Biennale, Tokyo. She was created C.B.E. in 1958 and D.B.E. in 1965. Her work, unlike that of Henry MOORE, is not representational in origin but conceived as abstract forms. Yet she has consistently professed a ROMANTIC attitude of emotional affinity with nature. She has spoken of carving both as a 'biological necessity' and as an 'extension of the telluric forces which mould the landscape'. Her outlook was already clearly formed in the short contribution she wrote for UNIT ONE (1934): 'I do not want to make a stone horse that is trying to and cannot smell the air. How lovely is the horse's sensitive nose, the dog's moving ears and deep eyes; but to me these are not stone forms and the love of them and the emotion can only be expressed in more abstract terms. I do not want to make a machine which cannot fulfil its essential purpose; but to make exactly the right relation of masses, a living thing in stone, to express my awareness and thought of these things. . . . In the contemplation of Nature we are perpetually renewed, our sense of mystery and our imagination is kept alive, and rightly understood, it gives us the power to project into a plastic medium some universal or abstract vision of beauty.' Dame Barbara has for the most part concentrated on carving with increasing attention to subtleties of surface movement and texture. Since *c.* 1950 she has given greater attention to bronze, using this medium to express essentially the same structural principles as in her carved sculpture, with the fundamental purpose 'to infuse the formal perfection of geometry with the vital grace of nature'. A retrospective exhibition of her work was held at the Tate Gallery in the spring of 1968.

1031, 1297, 1341.

**HÉRÉ,** EMMANUEL (1705–63). French architect, pupil of BOFFRAND, architect in chief to the Queen's father, Stanislas Leszczinski, Duke of Lorraine. He is best known for the Place Stanislas (1756) and the royal chapel of Bonsecours at Nancy (1752). The wrought-iron work by Jean Lamour is an excellent example of provincial ROCOCO.

**HERING,** LOY (*c.* 1485–*c.* 1554). German sculptor, who worked in Bavaria. He excelled in work that was both technically and metaphorically refined and highly polished, using hone-stone as his favourite material and specializing in small figures and reliefs. His style shows traces of a late GOTHIC heritage and at the same time a knowledge of the Italian RENAISSANCE. His subjects were both religious and courtly. He liked to borrow motifs from DÜRER's graphic work, which in common with many others he used as a pattern book. Among his few monumental sculptures the figure of *St. Willibald* (Eichstätt Cathedral, *c.* 1514) may be mentioned. A relief such as *The Garden of Love* (Berlin) gives an idea of his sensuous charm in the contemporary Renaissance idiom.

**HERKOMER,** SIR HUBERT VON (1849–1914). Painter, born in Bavaria, who immigrated to England with his father, a wood-carver, and was largely self-taught as a painter. He established himself as a master of sentimental genre with his *Last Muster* (Lady Lever Art Gal., Port Sunlight, 1875). He then became an outstandingly successful and prolific portrait painter, working in an illusionistic manner with melodramatic lighting in a coarse but cunning style. He is well represented at the National Portrait Gallery, London. He wrote his recollections in *The Herkomers* (1910/11).

1299.

**HERLIN,** FRIEDRICH (active *c.* 1460–1500). German (Swabian) painter whose works (in Nördlingen and Rothenburg) show how deep into the south of Germany the manner of Rogier van der WEYDEN had penetrated. He borrowed some of the Flemish master's compositions and followed closely his late GOTHIC REALISM.

**HERM.** Whatever its origins, the Greek herm first appears in the 6th c. B.C. as a rectangular shaft supporting a bearded head and exhibiting a phallus below. Such herms were set up in Athens at street corners and outside the city as milestones. From the 4th c. B.C. the herm was increasingly domesticated and used for portrait and other heads, sometimes copied from full-length statues.

**HERMANNSBURG SCHOOL.** Albert Namatjira (1902–59), a full-blooded aborigine of the Aranda tribe, had worked as a blacksmith, carpenter, stockman, etc., in and around Hermannsburg Mission near Alice Springs, Central Australia, before the meeting with Rex Battarbee, the Australian water-colourist, which stimulated him to take up painting. In 1938, two years after his first lesson, he held his first exhibition in Melbourne, and became one of the most popular of all Australian artists. He worked in crayon and oils, but water-colour was perhaps his best medium. Many of his works now hang in galleries the world over, and his work has received widespread recognition. His son, Enos, and at least a dozen other aborigines at Hermannsburg have also produced many excellent paintings, all within the European formal tradition, but suffused, like the elder Namatjira's, with a powerful feeling for their Central Australian homeland and capturing the vivid colours of that part of Australia.

**HERMITAGE,** Leningrad. The largest public MUSEUM and art gallery in the Soviet Union and one of the most important in the world. The initiative was given by Peter the Great and the plans for the first Hermitage building and the Academy of Arts (founded in 1757) were made for the Empress Elizabeth by the architect Vallin de la Mothe (1729–1800) as an extension of the famous Winter Palace of RASTRELLI. The basis of the collection was laid by Catherine the Great, one of the most voracious collectors of all time. She was fortunate that a number of the richest private collections came opportunely into the market and among those she acquired were that of the Count de Brül in Dresden, that of Gaignat, the former secretary of Louis XV, the Crozat Collection, 46 pictures and 6,000 drawings from Count Coblentz, the Choiseul Collection, the collection of Sir Robert Walpole, the collection of the comte de Baudouin. Among her agents was DIDEROT. At Catherine's death in 1796 it was estimated that the imperial collections totalled 3,926 pictures.

From 1802 pictures by Russian artists began to be added to the imperial collections. In 1837 the Winter Palace was ravaged by fire and the New Hermitage was built by the Munich architect Leo von KLENZE, 1840–9. In 1849 the Curators drew up an inventory of the emperor's 4,500 pictures. In 1852 the Hermitage was opened to the public by Nicholas I. In 1853 the Czar sold over 1,200 pictures. But the collection continued to grow, doubling the number of its pictures between 1910 and 1932 despite extensive sales by the Soviets. In the 1950s it comprised over 8,000 pictures, 40,000 drawings, and 500,000 engravings. Thanks to the fine judgement of Serge Schukin and Ivan Morosov the Hermitage contains one of the finest collections in the world of French IMPRESSIONIST paintings and of paintings from the subsequent École de Paris (see PARIS, School of).

After the Soviet Revolution the imperial collections came into public ownership. Western European painting forms only a fraction of the collection, which includes art objects from India, China, ancient Egypt, Mesopotamia, Pre-Columbian America, Greece, and Rome. Special emphasis is laid upon illustrating the continuity of Russia in history and art, from prehistoric art consisting chiefly of archaeological material from the Soviet Union to the present day. About a million and a half people visit the Museum every

year and the sections devoted to the 'heroic past of the Russian people' remain the most popular.

**HERMOGENES.** Greek architect from Priene of the 2nd c. B.C. He built the temples of Dionysus at Teos and Artemis Leucophryene at Magnesia on the Meander. It is widely held that he fixed the rules for the Ionic Order (of Attic variety) which were accepted by VITRUVIUS and handed down in later European architecture. (See ORDERS OF ARCHITECTURE.)

**HERNANDEZ,** G. See FERNANDEZ, G.

**HEROIC.** One of the terms taken over by art criticism from the terminology of poetry (e.g. the 'Heroic Epic'). Denoting, as it does, everything that is elevated and noble, it was used in particular with reference to a style of LANDSCAPE PAINTING in the 17th and 18th centuries which concentrated on SUBLIME rather than idyllic motifs. The term was also used to indicate a size of statuary between life-size and colossal.

**HERRERA,** FRANCISCO. The name of two Spanish artists. FRANCISCO HERRERA the Elder (c. 1576-1656), painter and engraver, was a representative of the transition from MANNERISM to BAROQUE. With his older contemporary ROELAS, under whose influence he developed, he helped to prepare the way for the new naturalistic style of the School of Seville in the early 17th c. This style, probably reflecting the influence of CARAVAGGIO, had also been anticipated in Spain to some extent by the work of NAVARRETE and by popular realistic sculpture. A number of the early *bodegon* pictures of kitchen scenes and incidents from peasant life, with their strong contrast of light and shade, are attributed to the elder Herrera. VELAZQUEZ is said to have been his pupil for a short time (1611-12). His *St. Basil Dictating* (Louvre, c. 1639) illustrates the development of his style towards the Baroque.

His son, FRANCISCO HERRERA the Younger (1622-85), painter and architect, spent many years in Italy and may have studied architecture and fresco painting in Rome. Returning to Spain after his father's death, he joined MURILLO in founding an academy of painting at Seville in 1660. Soon afterwards he moved to Madrid, where he was appointed Painter to the King in 1672 and Master of the Royal Works in 1677. His greatest achievement was the design (subsequently modified) of the church of El Pilar at Saragossa, begun in 1681. This huge BASILICA, 425 ft. long by 225 ft. wide, which approximately follows the plan of Juan de HERRERA's cathedral of Valladolid (1585), well exemplifies the basic conservatism of Spanish 17th-c. architecture.

**HERRERA,** JUAN DE (1530-97). The most famous and influential of Spanish architects. Educated at Valladolid, he joined the retinue of Prince Philip (later Philip II) in 1548 and accompanied him through Italy to Flanders. He studied mathematics at Brussels before returning to Spain in 1551. He was again in Italy and Flanders from 1553 as a soldier, and later in the bodyguard of the emperor Charles V. The details of his architectural education are unknown. His bent was scientific rather than artistic. He possessed a considerable library of mathematical and scientific books, invented navigational instruments and was later responsible for the foundation of the Academy of Mathematics at Madrid (1582).

His career as an architect began in 1563 when he was appointed assistant to Juan Bautista de TOLEDO, the designer of the ESCORIAL. After Juan Bautista's death in 1567 increasing responsibility devolved upon Herrera. The Italian Giambattista Castello built the great staircase and another Italian, Pacciotto of Urbino, was consulted on the design of the church. When Philip II decided to double the monastic establishment the chief foreman, Antonio de Villacastin, proposed the solution which was adopted of adding an extra storey to provide the additional accommodation required. But it was Herrera who was primarily responsible for carrying the enormous task through to its conclusion in 1584, thus justifying his title as architect of the Escorial.

The Herreran style, noble and majestic but frigid and monotonous, follows the principles of contemporary Italian MANNERISM with a deliberate avoidance of ornament which has given it the name of *estilo desornamentado*. This characteristic severity of the Herreran style can be attributed to the personal intervention of the ascetic Philip II, and it became the official style during his reign. The magnificent, though unfinished, cathedral of Valladolid (begun c. 1585) was Herrera's last major work, but the Herreran style was continued by his successors in the office of Royal Architect, notably Francisco and Juan Gómez de MORA; and it thus remained the dominant influence in Spanish architecture throughout the 17th c.

2345.

**HEYDEN,** JAN VAN DER (1637-1712). Dutch painter, important in the development of LANDSCAPE and architectural painting in the Netherlands. His style represents the changed character of Dutch painting in the second half of the 17th c. His views of towns are done with great precision, but without being meticulously detailed. The harmonious colours and sunny light of his elegantly composed pictures prevent the precise way he rendered foliage, bricks, and architectural detail from appearing dull and dry. Though he was not the creator of *vedute*, his works precede in time the views of Venice by CANALETTO, and like Canaletto's include both 'portraits' of

S

towns and CAPRICCIOS. Painting was only a minor part of van der Heyden's activity. In Amsterdam, where he lived from 1650 until his death, he organized street lighting and supervised improvements in the Fire Brigade; the fire hose is said to have been his invention. He demonstrated his innovations in a series of interesting engravings.

**HEYSEN,** SIR HANS (1877-1968). Australian landscape painter, born in Hamburg, Germany. His HEROIC interpretation of the Australian landscape, a development upon the innovations of the HEIDELBERG SCHOOL, was once popular throughout the country. He later turned to the interpretation of the more arid lands of the interior (*Land of the Oratunga*, N.G., Adelaide, 1932).

**HIERATIC** (Greek *hieros*: sacred). Term applied to a style such as EGYPTIAN or BYZANTINE ART in which certain fixed types or methods are conventionally adhered to. Hence the term is extended to other religious or even secular painting or sculpture which makes use of rigid or frontal figures. (See FRONTALITY.)

**HIEROGLYPHS.** One of the early functions of representational art was to record and re-create facts and events, and Egyptian hieroglyphic writing was essentially a development of such use of the pictorial image, further employing the principle of the rebus. Throughout its history it remained a form of picture-writing supplemented by phonetic elements. On some slate PALETTES and other objects of the 1st Dynasty (see EGYPTIAN ART) it is difficult to determine what is purely pictorial and what may be hieroglyphic, and this close relationship between writing and representation persisted in later times. In relief sculpture and painting hieroglyphs are treated as an integral part of the whole composition and occur as 'labels' accompanying objects or actions which are not self-explanatory, or as columns of text describing in greater detail the scene depicted. The Egyptians also appreciated the decorative value of the signs, and inscriptions were carefully composed of symmetrical groups without unsightly gaps. Individual hieroglyphs were often executed with minute care and beautifully coloured, birds frequently receiving particular attention. Living creatures occurring in inscriptions were sometimes mutilated to prevent their taking flight or becoming noxious. (See also INSCRIPTIONS, Greek and Roman.)

From the Ptolemaic period onwards the knowledge of hieroglyphs was largely confined to the priesthood, dying out altogether during the 4th c. A.D. with the triumph of Christianity. A work of perhaps the 4th or 5th c., ascribed to one Horapollo, combined correct interpretations of some signs with fantastic and allegorical explanations of others. Rediscovered early in the 15th c. it enjoyed a considerable vogue during the RENAISSANCE and contributed to the fashion of EMBLEMS. Succeeding centuries saw various attempts to decipher Egyptian inscriptions until the discovery of the Rosetta Stone in 1799 enabled 19th-c. Egyptology to solve the problem.

**HIGHMORE,** JOSEPH (1692-1780). English painter who studied at the KNELLER Academy and established himself in the 1720s as a painter of competent portraits in the manner of DAHL and RICHARDSON. He responded to the ROCOCO influences that began to pervade English painting in the 1730s, and his portraits from this time began to gain in elegance. He was a friend of the novelist Samuel Richardson and painted a series of 12 illustrations to *Pamela* (Tate Gal.; Fitzwilliam Mus., Cambridge; Melbourne), which link him with HAYMAN and HOGARTH as one of the initiators of a British school of narrative painting. He retired from professional practice in 1762.

**HILDEBRANDT,** JOHANN LUCAS VON (1668-1745). Austrian architect, born in Genoa. He worked first as a military engineer and then settled in Vienna, where his palace designs (Schwarzenberg, 1697; Daun-Kinsky, 1713; and Prince Eugene's Belvedere, 1714 onwards) show a graceful style based on a knowledge of north Italian design, particularly that of GUARINI. In his churches, notably St. Lawrence, Gabel (1699), he prepared the way for the intricate space conceptions of NEUMANN and others.

1156.

**HILL,** CARL FREDRIK (1849-1911). Swedish landscape painter, who went to Paris in 1873 and, inspired by COROT and the BARBIZON painters, evolved a personal manner of sentimental landscape using intense colour ranges. In 1876 he was struck by an incurable mental illness. This was long considered as a great loss to art, but today Hill's reputation rests no less on the thousands of drawings and pastels which he produced during his years of insanity. These reveal a keenness in design and imagination and a subtlety of colour to which the word 'insane' no longer seems applicable.

**HILLIARD,** NICHOLAS (*c.* 1547-1619). English MINIATURE painter. Son of an Exeter goldsmith, Hilliard was trained as a jeweller. He was appointed Court Miniaturist and Goldsmith *c.* 1570, but was in France *c.* 1577-8. Between 1580 and 1600 he was the leading miniaturist in England and his reputation extended to France; but after the turn of the century Hilliard lost ground to his former pupil Isaac OLIVER. The two were head and shoulders above their contemporaries and dominated the LIMNING of their era.

In his pamphlet *The Art of Limning* Hilliard declared himself to follow HOLBEIN's manner of limning. But while for Holbein a miniature was always a painting reduced to a small scale, Hilliard developed in the miniature an intimacy and a subtlety of grace which were peculiar to that art. His linear style and modelling with flesh tints instead of shadow may have been due, as he tells us, to the personal preference of Queen Elizabeth; but his miniature style had some effect upon certain characteristics of the Elizabethan style of portrait painting in oils. His later work shows awareness of continental MANNERIST developments; but he brought these into the service of a purely Elizabethan art, combining them with a jeweller's exquisiteness in detail, an engraver's elegance in calligraphy, and a unique realization of the individuality of each sitter. His miniatures are often freighted with enigmatic inscription and intrusive allegory (e.g. a hand reaching from a cloud); yet this literary burden usually manages to heighten the vividness with which the sitter's face is impressed. Many of the great Elizabethans sat for him: Elizabeth herself in 1572 (N.P.G., London) and again later (V. & A. Mus.); also Sidney, Raleigh, Drake, Hatton, and Cumberland. But perhaps his finest work was with sitters not hedged by public greatness (*Mrs. Mole*, Lady Clinton Coll.). He painted on vellum mounted on card (often cut from a playing-card).

118, 2121.

**160.** Shiva seated on a lotus throne with his wife Parvati on his knee. She holds a mirror. Stone relief carving from Orissa. (B.M., late 12th c.)

**HINDU ICONOGRAPHY.** Hindu religious art is dominated by the many Hindu deities, though in temple sculpture, especially that of south India, saints, teachers, heroes of poetry, and the deeds of kings are represented. Classical Indian theory classified most major ICONS as manifestations of one or other of three principal deities: Shiva, Vishnu, and the mother-goddess Devi, also called Kali, Durga, etc. Brahma and Surya appear always in their own guise.

Shiva appears most commonly in the form of the *lingam*, a stylized phallus, which is the focus of worship in far the greater part of India's temples. In early times Shiva was also represented, often accompanied by his wife, as an ithyphallic figure. He was also the patron of many orders of ascetics, and so appears with matted hair (*jatamukuta*) almost naked, perhaps seated on a tiger skin in meditation, on his forehead the third eye of knowledge (Sanskrit root √*vid* is the base of both 'to see' and 'to know' in the special sense of sacred knowledge).

There are numerous icons devoted to special aspects of Shiva. One such is the *Tanda-valakshanam* or *Natarajah*; here Shiva is shown dancing on a demon with one leg raised and his many arms extended in an aureole of flames. This icon, like the others, is explained in legends collected in the *Puranas*. Another icon is the *Lingodbhavamurti*. This, which recalls sectarian disputes, represents Shiva appearing in the midst of a massive fiery *lingam* in cosmic space, the two ends of which the gods Vishnu and Brahma are not able to fathom. Shiva as *Dakshimamurti*, very popular in the south of India, appears as a handsome youth seated, teaching, with an aureole of his own bright long hair. In the north of India especially Shiva often appears with his wife Parvati, a form of the goddess, on his knee. She holds a mirror. This icon incorporates a special doctrine of the primal light and its 'reflection' as constituting the original act of creation. The legend of Shiva's marriage to Parvati is a favourite narrative subject, and in the south a popular icon, *Somaskanda*, shows Shiva and his wife seated side by side. The *Ardhanarisvara* icon shows Shiva as half masculine, half feminine, reminiscent of the alchemical Hermaphrodite. It refers to a conception of masculine-feminine polarity within the single godhead. Some icons refer to Shiva's ancient role as the lord of beasts by showing an animal, perhaps an antelope, springing from his fingers.

Shiva also appears in terrible (*Bhairava*) forms—the *Tandava-lakshanam* is often terrible —with bared fangs and furious countenance. These generally refer to Shiva's role as the destroyer of the universe, the power of time. The great *Trimurti* at Elephanta is a remarkable syncretist formulation of many aspects of the god. It recalls by its shape the *lingam*; its three faces are: peaceful; terrible; and feminine. In medieval and later art Shiva often appears with

many heads and arms. Frequently, too, images of Shiva have a small crescent moon in the chignon, and sometimes a small figure of the goddess of the Ganges descending from heaven to earth, the impact of her descent received on Shiva's head. Shiva is often accompanied by his 'host' of gods and semi-demonic figures, who are sometimes represented in the act of emanation from the god himself. All icons of Shiva show him as holding a trident. His followers in India also carry tridents and draw on their foreheads three horizontal lines.

Vishnu is generally distinguished by the emblems he carries: a club with a flanged head, a discus marked with spokes, petals, or rays, and a conch shell. He appears in straightforward, frontal iconic form, sometimes with his wife Lakshmi, or riding on the beak-faced, winged deity called Garuda. He is also often represented lying asleep on the cosmic serpent Ananta ('Endless'), who personifies the negative ocean of undifferentiated being. In this icon a lotus emerges from Vishnu's navel, bearing the active creator, Brahma, on its pericarp. Vishnu here represents the passive ground of being. He is also represented as *Trivikrama*, the 'three strider', a form based on a legend in which he responds to a challenge by traversing the earth and remotest regions of space in three strides. This icon often has one leg raised.

A number of specific incarnations came to be attributed to Vishnu in the course of the Brahmanical effort at syncretism early in the Christian era. Those most commonly represented in art are: the Boar, the guise in which Vishnu rescued the Earth Goddess from a demon when the other gods could not; Narasimha, the Man-lion, who appears in human form with a lion head, devouring the corpse of a villainous king; and Krishna, a handsome blue-skinned cowherd god, whose heroic and erotic exploits were the subject especially of RAJPUT PAINTING. Rama, the hero of ancient Sanskrit epic, is also recognized as an incarnation of Vishnu especially popular in the south. He is usually represented leaning on his bow.

An icon *Hari-Hara* was employed in India and south-east Asia, into which are combined the peaceful aspect of Vishnu and the terrible aspect of Shiva, half and half.

The goddess appears generally as an attractive young woman endowed with all the canonical marks of beauty. Many of her *personae* are virtually indistinguishable save by the emblems they carry in their hands. There are parts of India, notably the north east, where the goddess is accorded a respect and devotion perhaps even greater than the gods, representing as she does the contingent aspects of nature and reality.

Apart from the female divine images mentioned above, there is one special form frequently encountered in art, *Durga Mahishasuramardini*. Here the goddess, either riding or supported by a lion, kills a buffalo demon. As *Durga*—or, in Bengal, *Jagaddhatri*—she rides a lion.

The goddess had a number of terrible forms. Some, *Chamunda* and *Sitala* for example, are emaciated, grimacing figures associated with disease. The well known *Kali*, black and hideous, with garlands of human heads and hands, symbolizes again the destructive forces of nature, and is often represented in more recent art from the east and far south of India.

Brahma is fundamentally a personification of the transcendent power of the Brahmins and Brahmin learning. Often bearded, with four heads representing the four *Vedas*, he sometimes rides the goose. Surya is the Sun-god, cognate with Apollo. He stands above a charioteer and four horses in his heavenly chariot. He wears calf-length boots. The temple of Konarak is dedicated to him.

Important popular deities are: the portly elephant-headed Ganesha (Ganapati), son of

**161.** Ganesha, five-faced and ten-armed, with Parvati on his knee. Stone carving from Bihar. (B.M., 12th c.)

Shiva and Parvati, who is the god of wealth, patron of worldly success, and Hanuman, the monkey-hero of ancient epic, personification of loyalty and courage.

The Hindu heavens are populated by a large number of deities, some of them undifferentiated, like the beautiful *Apsarases*, the *Kinnaras*, and *Gandharvas*, who appear on the fabric of

medieval temples flying, posing, or playing music. Named gods who appear less often are the Vedic Indra, cognate with Zeus; Agni, the god of the Brahmanical sacrificial fire; Kartti-keya, the god of war, who rides a peacock; and the gods of the planets.

43, 151, 611, 1455, 1944, 2634, 2966.

**HIPPODAMUS.** A Greek Sophist from Miletus who about the middle of the 5th c. B.C. systematized and is wrongly credited by Aristotle (*Politics*, ii. 5) with having invented the chequer-board system of laying out a city in blocks. He used this system in planning the Piraeus during the time of Pericles and in 443 B.C. according to Diodorus (xii. 10) he applied it to the Athenian colony of Thurii. He is also credited by Strabo (xiv. 2. 8) with having planned Rhodes, which was founded in 408 B.C., but the time factor is against this. (See also TOWN-PLANNING.)

**HIROSHIGE,** ANDO (1797-1858). With Kunisada (1785-1864) and Kuniyoshi (1797-1861), the last of the great Japanese masters of the colour-print (UKIYO-E). A pupil of Toyohiro (1774-1829), who was himself taught by Toyo-hara (1735-1814), the founder of the Utagawa School, he first designed prints of women (1804-18), but after *c.* 1832, when he formed his own school, he concentrated on flower and bird themes and the landscapes for which he is famous. His *Views of the Eastern Capital* (1826) was the first of the many sets of views of Japan which he produced until his death. He was particularly sensitive to light and colour and had a genius for depicting atmosphere. But the European dyes which were then being introduced make some of his colours seem coarse by comparison with the soft tones of the earlier masters, and there exist many late impres-sions from Hiroshige's blocks which are inferior to the rare early ones. His paintings and travel sketch-books are perhaps his finest work. More than any other artist of the *ukiyo-e* movement Hiroshige embodies the instinctive Japanese attitude of poetic reverence towards nature and was able to create the mood of natural scenery, to which the Japanese were so sensitive.

**HIRSCHVOGEL,** AUGUSTIN (1503-53). German etcher. His numerous landscape etch-ings, charming but not very original, derive from the so-called Danube School, particularly Wolf HUBER with whom he may have been in personal contact. He was also a painstaking cartographer and made a large map of Austria (1542) for the emperor Ferdinand I.

**HISPANO-MORESQUE POTTERY.** A term used particularly for wares made in Spain by the Moors in late medieval to RENAISSANCE

times, especially those painted in lustre pigments; the name is, however, used loosely of all Spanish wares of this period, and the more purely Spanish MAIOLICA and FAIENCE of later times will be discussed here also.

The ISLAMIC technique of painting in golden lustre was already practised in Andalusia by the 13th c. One rare 14th-c. specimen, the famous wing-handled *Alhambra vase*, which is painted with gazelles among stylized foliage and rough, KUFIC writing on a deep blue ground, is still preserved in the palace at Granada. From this time onwards, however, the finest LUSTRE POTTERY was made at Manises, a suburb of Valencia. These wares, which include many large dishes, basins, and cylindrical drug-vases of noble form, were decorated with bold brush-work on a characteristic cream-white tin-glaze ground (see FAIENCE). They bear a great variety of semi-abstract or foliaceous designs, in addi-tion to rampant lions, eagles, and occasionally superbly drawn ships, which generally spread over the entire surface of the ware. During the 15th c. they were in demand throughout Europe, and many pieces are painted with the arms of illustrious families. When this patronage failed, however, the designs became gradually more commonplace, while the rich golden tone gave way to a cheaper, coppery red.

Apart from the lustred ware much handsome pottery painted with strong, GOTHIC designs was made during the 14th c. at Paterna near Valencia. This was followed in the 15th c. by blue or blue and purple painted wares which were also popular abroad especially in Italy, where they contributed to the development of maiolica. Much later Spanish maiolica was influenced by the richer Italian polychrome styles. But bold brush-work and extravagant colouring remained national characteristics. On the 17th-c. wares of Talavera (Castile), for example, hunting scenes, fantastic birds, and luxuriant vegetation are painted with immense *brio* in strident harmonies of strong green, orange, purple, and blue. Painting of great delicacy nevertheless appears on the finely made ROCOCO faience of Alcora (1727-85), a factory established with the aid of painters from Moustiers in France.

A particular feature of Spanish–Moorish ceramics were the fine tiles (see AZULEJO).

**HITCHENS,** IVON (1893- ). English painter of flower pieces and landscape in the lyrical tradition, reducing the scene to an interplay of rich and vibrant colour in a semi-abstract mode conformable to the contemporary idiom. He has done murals for the Cecil Sharp House, London (unveiled 1954), Nuffield College, Oxford (1959), and for the University of Sussex (1963).

**HITTITE ART.** The art of the Hittites, pro-perly belonging to central Anatolia, was, like its

authors, utterly forgotten until rediscovered in the middle of the last century, thanks chiefly to the work and enthusiasm of a British scholar, the Revd. Archibald Henry Sayce, of Oxford. The Hittites' most characteristic works of art mainly cover the brief period from about 1400 to 1200 B.C.; but the origins of those works go back well into the third millennium B.C., and their survivals can be traced almost into classical Greek times. With this art is closely associated the contemporary art of Syria, over which the Hittite emperors extended their rule from the 14th to the 12th c. (see SYRIAN ART). The art of both areas was basically a provincial, western form of the art of Hither Asia, and followed the same devices, conventions, and techniques. The main source of the art of Hither Asia was Sumer and Babylon, where a civilization, brilliant in learning and supported both by industrial and commercial skill, was early developed (see BABYLONIAN ART). But intertwined with this Mesopotamian tradition there lay in Anatolia an equally old, if not older, pre-Hittite thread of culture, purely local in style, which found expression in the third millennium in the rich gold ornaments and bronze standards found at Alaca, and perhaps was derived from the even older chalcolithic and neolithic civilizations found at Hajilar and Chatal Hüyük, of the fifth and seventh millennium.

The Hittites were an invading stock, a ruling class who probably infiltrated into central Anatolia from the east c. 2000 B.C. They are the first of several peoples of Indo-European speech who then began to appear on the stage of history. They gradually seized the whole bend of the Halys river (modern Kizil Irmak), which flows across the great Anatolian plateau in a vast loop, and by 1400 B.C. dominated all eastern Asia Minor. They then issued out of Asia Minor, eventually to conquer the whole of the Syrian plain as far as its southernmost stronghold at Hamath (modern Hama), which they made their southern bastion, and were recognized as equals by the great powers of the day—Egypt, Babylon, and the kingdom of Mitanni (in north-west Syria). The Hittites were good assimilators. To write their language they (like most peoples of Hither Asia) used a somewhat simplified form of Babylonian cuneiform. But they also employed, probably by adoption from the earlier native population of Anatolia, a decorative and highly pictorial HIEROGLYPHIC script, primarily, it seems, for monumental purposes, and so carved it in high relief, or alternatively incised it on stone or live rock. Until 1947—when a Phoenician-Hittite bilingual was discovered at Karatepe in Cilicia—this mysterious script eluded decipherment, though some partial progress had been made. In their pantheon, the Hittites combined alike some gods of the native pre-Hittite population with others derived from Mesopotamia, and others, belonging to a race called Hurri located mainly in north Syria. The names and characteristics of these various deities and the details of their worship have been recovered from the library of cuneiform tablets written on clay, first discovered by the German excavators in 1908-11 at the Hittite capital Hattusas (modern Boğaz-köy, near Yozgat). A striking feature in the appearance of these deities is their dress: male deities wear usually a high pointed hat (like the dervish of Ottoman times), kilt, and boots with curling toes; female deities often wear a high square hat and a long, often pleated, dress. This attire differs greatly from divine fashions in Mesopotamia, and indeed from those actually worn by the Hittites themselves, among whom the men wore a long garment reaching to the feet and a shawl, with a skull-cap on the head. This divine dress was probably the dress of the pre-Hittite human residents of Anatolia and north Syria in the third millennium B.C. yet resembles that still preserved in parts of modern Turkey. Very often these gods are represented standing each on the back of their sacred animal, real or mythical. One of the most interesting of these sacred animals is the double eagle, which is to be found at Alaca. This strange motif was apparently seen and seized upon (in medieval times) by the immigrant Seljuk Turks in the 11th c. A.D., who passed it as a state badge first to Byzantium, which passed it to Russia; and from the Seljuks and Saracens it went through Frederick II of Hohenstaufen to the Holy Roman Empire and the Austrian crown.

Hittite and north Syrian artists worked in their own native variety of metals such as bronze, copper, silver, gold, even iron—then a very precious metal—and could carve stones both in the round and in relief, often carving for preference on the living rock. But the main part of their art was apparently executed in the service of religion, and depicts gods and goddesses (e.g. the rock-carved reliefs at the Great Sanctuary of Yazilikaya near Boğaz-köy), gateway figures of guardian lions and sphinxes (e.g. at Hüyük or Boğaz-köy) and scenes of cult or mythology, as at Frakdin or Malatya or Carchemish: only rarely and in a limited form do we see narrative representations of human activities, as for example the musicians and hunting scene on the palace walls at Hüyük, c. 1400 B.C., or in the family procession of King Araras at Carchemish c. 750 B.C., where his children are depicted with nurse, whipping-top, and pets. Here and there other domestic scenes occur. A scene, probably of domestic life, perhaps a marriage, is depicted on the surviving fragments of a fine polychrome vase with figures in relief from Bittik, near Ankara. Throughout Hittite art there runs a characteristic sturdy liveliness and robustness and an interest in humanity which strikes one as vaguely un-Oriental. There is a striking contrast between the extreme vivacity with which attitude and gesture are caught in individual figures and the poverty in sense of design and grouping of individual figures into scenes. The contrast

with ASSYRIAN ART is noticeable: whereas there it is the animals that are full of life and men seem to be lifeless dolls, totally lacking in real emotions, to the Hittites human beings matter deeply and animals are strictly subordinate to them. The Hittite artists were good at animals, but Hittite lions looked like large rather playful dogs, as those of Chinese art; whereas Assyrian lions are the finest, most realistic, and fiercest represented anywhere in the ancient world.

The minor arts are represented by charming and amusing vases, perhaps ritual in purpose, in the form of animals—models of rabbits, cats, snails, leopards, sheep—or of domestic objects such as boots. Examples were excavated at Ališar. The Hittites' ordinary pottery was made on the wheel with fine red burnished walls, sometimes painted on a slip. The shapes have often long-beaked spouts, high-looped handles, and bellies boldly narrowing to a pointed bottom or a small foot. Clearly these imitate fine copperwork vessels, almost all of which have been lost. Another form of the minor arts in Hither Asia is the engraved seal. Having no PAPYRUS, the Hittites, following Mesopotamian methods, used the stylus and clay tablets for writing in cuneiform script. But whereas the peoples of the Mesopotamian plain evolved the use of a seal in the form of a small engraved cylinder, which was used to roll across the clay tablet while still soft, their neighbours of the highlands, from Persia to the Mediterranean, notably Iranians and Hittites, for some reason obstinately preferred a circular stamp-seal or signet for the same purpose, though the cylinder seal was sometimes used. The Hittite form of stamp-seal often had a convex back with a handle and bore quite commonly an inscription in hieroglyphics, occasionally in cuneiform as well.

In gold work the Hittites were exceptionally skilled. In the British Museum is a set of minute figures of a king, deities, and sacred monsters carved out of lapis lazuli and encased in golden *cloisons*. They were originally attached to a golden garment woven of strands, each threaded with microscopic golden beads forming real 'cloth of gold'. This was apparently the traditional royal robe of the kings of Carchemish, and was found with some buried human remains, perhaps of the last titular king of Carchemish who fell when the city was captured by the Egyptians in 606 B.C. The robe may already then have been 600 years old.

Hittite architecture is best known from Boğaz-köy where massive city walls and great stone substructures of temples and other buildings still remain. The Hittites in north Syria made a speciality of a kind of porticoed entrance or hall approached by steps through pillars, its axis at right angles to that of its entrance. This was much admired by the Assyrians, who called it *bit-hilani*, 'house of the court'. The Hittites also greatly developed an architectural feature common in Syria and Mesopotamia—the heavily fortified double gateway. This gate was usually flanked by a tower on each side and by a protective figure of a sphinx or lion, threatening the approaching enemy. This feature proved of lasting fascination to men's minds, outlasting the Hittites for many centuries. It was introduced into the West (doubtless by Syrian artists) and copied in ROMANESQUE churches of Provence, surviving in some churches of Savoy into the 15th c. A.D. The roof of the Hittite gateway itself was apparently of arched form but the Hittites, like the Mycenaeans, were ignorant of the true ARCH and used for their passages the false or corbelled arch (e.g. Gavur-Kale). Sometimes the inner faces of the gateway were decorated with a bottom dado course of slabs, ornamented in relief with mythical or magical groups or single figures of gods, men, or monsters, often arranged in quasi-heraldic symmetry, and with a preference for making every slab a self-contained scene (Alaca, Malatya, Sakce-gözü, Carchemish, Karatepe). Similar slabs were set up in the outer faces of temple-palace walls at Carchemish and Tell Halaf in north Syria, but this system is unknown elsewhere. Of the internal appearance of Hittite buildings we know nothing, though at Boğaz-köy and Atchana in north Syria there are remains of wall-paintings executed in FRESCO strongly recalling, and doubtless connected with, the brilliant highly developed use of the same art in Crete (see MINOAN ART). Both Anatolia and Crete no doubt derived their knowledge of the art from Syria, where it was practised, e.g. at Mari, in the 18th c. B.C.

21, 357, 913, 914, 1063, 1204, 1348, 1679, 1680, 1748, 1911, 2751, 2933.

**HJORTH**, BROR (1894-1968). Swedish sculptor and painter, who studied under BOURDELLE in Paris (1921-3). Hjorth evolved a PRIMITIVE style based on peasant art, with seemingly awkward, naïve forms and crude colouring. His wooden reliefs are characteristic, roughly hewn and gaily painted, usually representing erotic subjects or cult-symbols. Even when working in bronze—as in his masterly portrait busts and medals—he used a harsh style of his own.

**HOARE**, WILLIAM (c. 1707-92). English portrait painter. He spent the formative years of his working life in Italy where, like Allan RAMSAY, he was a pupil of Imperiali (Francesco Ferdinandi). By 1738 he had settled in Bath, where he died, and until the arrival of GAINSBOROUGH in 1760 he was the leading portrait painter of that city. He was elected R.A. in 1789. Many of his best portraits are in crayon.

**HOBBEMA**, MEINDERT (1638-1709). The last of the great 17th-c. Dutch painters of

LANDSCAPE. At least one of his paintings, *The Avenue at Middelharnis* (N.G., London, 1689), ranks among the most widely known achievements of DUTCH ART. Hobbema was a native of Amsterdam and a friend and pupil of Jacob van RUISDAEL. Some of his pictures are very like Ruisdael's but his range was more limited and he lacked the latter's power to capture the majesty of nature. He painted a narrow range of favourite subjects—water-mills and trees around a pool—over and over again. At the age of 30 he took up a clerical appointment with the municipality of Amsterdam and seems to have practically ceased to paint. What his reasons were we do not know, but it is certain that by the later 1660s the demand in Holland for the type of landscapes he produced had greatly decreased.

409.

**HODGES, WILLIAM** (1744-97). English landscape painter and engraver, who worked as a pupil and assistant of Richard WILSON, many of whose compositions he imitated on a small scale. His work acquired a more personal style after two periods of travel. In 1772 he sailed to the Antarctic as a draughtsman to Captain Cook, and in 1780 on the invitation of Warren Hastings he went to India. He painted a number of views of the Pacific Islands for the Admiralty, which are now at Greenwich, and in these he combined with some success the divergent methods of the topographical draughtsman and the 'classical' landscape painter (see LANDSCAPE PAINTING, TOPOGRAPHICAL ART).

**HODGKINS, WILLIAM MATHEW** (1833-98). Painter, born in Liverpool. With little formal education and no training in the arts, he began in early manhood to paint in water-colour. In 1859 he left England for Australia and the following year went on to Dunedin, New Zealand, where he practised as solicitor and amateur painter. Taking the lead in the young city's artistic life, he was a foundation member and president of the local society, and organized the building of a gallery. A follower of TURNER, he devoted himself almost exclusively to landscape (Public Art Gal., Dunedin).

FRANCES MARY (1869-1947), a painter, born in Dunedin, was the second daughter of William Hodgkins. She attended the Dunedin School of Art and had built up a local reputation as painter and teacher when she left for Europe in 1901. After extensive travels through Europe and Morocco, in 1908 she established herself in Paris, where she taught at the Académie Colarossi and also on her own account. For some years she alternated between the two hemispheres, twice visiting New Zealand before she finally returned to Europe in 1913. Until about 1916 she worked only in water-colour along conventional lines and exhibited both with the R.A. and the Salon. During the war years, when she settled in England, she began to paint in oils and

gradually developed the highly individual style which in the early 1930s carried her into the *avant-garde* of modern English painters. Belated recognition came in 1940 with her selection as a British representative at the Venice Biennale, and finally with a retrospective exhibition in 1946. She is represented in the Tate Gallery, London, and in most galleries of Britain, Australia, and New Zealand, very notably in the Auckland City Art Gallery.

842, 1374, 1719.

**HODLER, FERDINAND** (1853-1918). Swiss painter who passed most of his life at Geneva. His early work (till 1890) was rather dully naturalistic, and his landscapes were hardly more than rather ambitious colour postcards for tourists. But with his *Night* of 1890 began a sudden change of style. From then on Hodler's canvases were filled with monumental and simplified flat figures, composed into a coherent design by a rhythmic and repetitive pattern of lines, forms, and colours—a method which the artist himself called 'Parallelism'. Contacts with the ROSICRUCIANS in Paris (1891/2) and possibly knowledge of the aims of Maurice DENIS gave a markedly SYMBOLIST flavour to his art (*The Disappointed*, Berne, 1892; *Eurythmics*, Berne, 1894/5). He applied the same principles to monumental history painting (*The Return from Marignano*, Zürich, 1896-1900) and to his Swiss landscapes. In both manner and content Hodler must be counted among the harbingers of EXPRESSIONISM.

1196, 1686.

**HOFER, KARL** (1878-1955). German painter and teacher, best known for his pictures of figures whose loneliness and desolation are expressed by sharp angular outlines and harsh muted colours. He also painted landscapes in which his debt to CÉZANNE is obvious. His art resembles that of the NEUE SACHLICHKEIT painters, but is visionary rather than political in intention. After the destruction of his studio by the Nazis in 1943 his work took on a more overtly EXPRESSIONIST quality.

**HOFFMANN, JOSEF** (1870-1956). Austrian architect. He was a pupil of Otto WAGNER, whose rationalistic principles had a lasting effect upon him although Hoffmann's own inclination was rather towards refinement and elegance than the austerity of LOOS. He was interested in craftsmanship, taught from 1899 at the School of Applied Arts and was co-founder of the WIENER WERKSTÄTTE. In 1897 he founded the Vienna SEZESSION with OLBRICH and others. He was much influenced at this time by the Glasgow school of MACKINTOSH and was active in introducing ART NOUVEAU principles somewhat belatedly into Austria. In 1905 he was a member of the KLIMT group when the Sezession split. His

most famous buildings were the severe, flat-roofed Pukersdorff Sanatorium (1903) and the house built for the Stoclet family in Brussels (1905). In 1914 he designed the Austrian pavilion for the DEUTSCHER WERKBUND exhibition at Cologne and after the war, in 1920, he was made city architect of Vienna. With the progress of the new stylistic influences of LE CORBUSIER and the BAUHAUS, however, Hoffmann's distinctive work began to seem somewhat anachronistic and he reacted towards a still more extreme architectural purity and austerity.

**HOGARTH, WILLIAM** (1697–1764). English painter and engraver. According to his own autobiographical notes he had a good eye, a fondness for drawing, and a taste for mimicry from early childhood. At the age of 15 he was apprenticed to an engraver of silver plate, where he learnt to engrave in the ROCOCO tradition, and by 1720 was established in London independently as an engraver on copper of bill-heads and book illustrations (Illustrations to Samuel Butler's *Hudibras*). He studied painting in his spare time, first at the St. Martin's Lane Academy and later under Sir James THORNHILL, whose daughter he married in 1728. By 1729 he had begun to make a name with small CONVERSATION PIECES, achiev-

ing a popular success with *A Scene from the Beggar's Opera* (one version is in the Tate Gallery), and about 1730 he set up as a portrait painter. At about the same time he invented and popularized the use of a sequence of anecdotal pictures 'similar to representations on the stage' to point a moral and satirize social abuses. *A Harlot's Progress* (6 scenes, c. 1731; destroyed by fire) was followed by *A Rake's Progress* (8 scenes, Sir John Soane's Mus., London, c. 1735), and *Marriage à la Mode* (6 scenes, N.G., London, c. 1742–4), which each portray the punishment of vice in a somewhat lurid melodrama. Each series was painted with a view to being engraved, and the engravings had a wide sale and were popular with all classes. They were much pirated and led to the Copyright Act of 1735. 'I have endeavoured', he wrote, 'to treat my subjects as a dramatic writer: my picture is my stage, and men and women my players.' Hogarth, however, was much more than a preacher in paint. His satire was directed as much at pedantry and affectation as at immorality, e.g. *Taste in High Life* (Iveagh Bequest, Kenwood, 1742), and he saw himself to some extent as a defender of native common sense against a fashion for French and Italian mannerisms. He himself visited Paris in 1743 and 1748 and was at various stages in his career influenced by French Rococo. He made engravings after single pictures as well as

**162.** *Scene in Bridewell*. Engraving from *A Harlot's Progress* (c. 1731) by William Hogarth

**163.** Detail of Plate 1 from *The Analysis of Beauty* (1753) by William Hogarth. 'Waving-lines [23-5] . . . The precise serpentine line, or *line of grace*, is represented by a fine wire, properly twisted around the . . . figure of a cone [26] . . . Though all sorts of waving-lines are ornamental, . . . yet . . . there is but one precise line, properly to be called the line of *beauty* . . . number 4 [49].'

sequences, and by this means encouraged an increase of interest in contemporary art.

Hogarth was a man of many parts and some ambition. In *Captain Coram* (Foundling Hospital, London, 1740), which he himself regarded as his highest achievement in portraiture, he showed that he could paint a portrait in the BAROQUE manner with complete confidence and without artificiality but he could not flatter or compromise and had not the disposition for a successful portraitist (*William James*, Worcester Mus., Mass., U.S.A.). In two large compositions for the staircase of St. Bartholomew's Hospital (1735) he attempted history painting. His small group portraits (*A Fishing Party*, Dulwich) are lively in execution and have their place in the development of the conversation piece. In 1753 he published *The Analysis of Beauty*, a treatise on aesthetic theory which he wrote with the conviction that the views of a practising artist should carry greater weight than the theories of the CONNOISSEUR or dilettante. He there satirized academicism and the 18th-c. school of taste and proposed a 'precise serpentine line' as a concrete key to pictorial beauty. His work was an anticipation of modern aesthetic trends in the emphasis it laid on the apprehension of three-dimensional form. His serpentine 'line of beauty and grace' is illustrated in his *Self-Portrait* (1745). Some of his smaller canvases have a vitality and directness which give them a place as acknowledged masterpieces of English painting. In the sketch *A Shrimp Girl* (N.G., London) and *Hogarth's Servants* (N.G., London) he produced two of the most spontaneous of 18th-c. British paintings.

60, 209, 444, 1349, 1972.

**HOKUSAI,** KATSUSHIKA (1760-1849). One of the most renowned masters of the Japanese colour print (UKIYO-E); a prolific painter, print designer, and book illustrator. A disciple of SHUNSHŌ and comparatively slow in finding his own style, he did not produce his greatest work until 1818-30. In his youth he had begun with portraits of women and actors; but

his fame rests chiefly on his direct and imaginative perception of landscape, which was an innovation to the *ukiyo-e* movement. His striking and original colour, vigorous sense of simplified design, his humour and understanding combined with a fine grasp of form to produce something new in Oriental landscape and nature art. It has been said that he was assisted in this not only by his study of the KANŌ SCHOOL and Chinese painting of the Ming Dynasty, but also by European painting which entered Japan through the foreign settlement at Nagasaki.

In his illustrations Hokusai achieved the same

**164.** *Self-Portrait* by Hokusai. Ink and brush drawing. (Musée Guimet, Paris)

540

dramatic vigour in recording the restless life of the city and his sketchbooks *Hokusai Mangwa* (1814-78) not only show his virtuosity with the brush but constitute a unique panorama of the contemporary scene through the vivid eye of an artist. In his bird and flower pieces dating from the end of the 1820s he brought to the colour print a branch of art which had hitherto been the prerogative of the painters.

His fame rests largely on his dramatic landscape sets such as *The Amusements of the Eastern Capital* (1799; 2nd edn. in colour, 1802), *Picturesque Views of Famous Bridges in the Provinces* and *Waterfalls of the Provinces* (both before 1829), the *Large Flower* set (*c.* 1828), *The 36 Views of Mount Fuji* (1834-5), *The Hundred Poems Explained by the Nurse* (1839), and above all the *Random Sketches* in 15 volumes, sometimes called an encyclopedia of Japanese life.

372, 1318, 1319.

**HOLANDA** (or HOLLANDA), FRANCISCO DE (1517-84). Portuguese writer on art theory and miniaturist, of Dutch descent. He was in Rome in 1538, and back in Portugal by 1545. He left a volume of drawings (now in the ESCORIAL) which contains interesting portraits (MICHELANGELO, BRAMANTE'S *Nicchione*, etc.) and drawings of Roman antiquities which are an important source of information about 16th-c. collecting and archaeology. On his return to Italy he was commissioned to do portraits of the Portuguese royal family. His influence in propagating the Italianate style in Portugal was exercised, however, mainly through his writings. In 1548 he completed a manuscript entitled *Da Pintura Antigua* (*Of Ancient Painting*), which was not published until 1890-6. It was in two books, the first containing 44 chapters on art theory and the second four Dialogues (Eng. trans. by A. F. G. Bell, 1928) in which Holanda himself discusses theories of art with Michelangelo, Vittoria Colonna, the miniaturist Giulio CLOVIO, and others. As an appendage he completed in 1549 10 Dialogues entitled *Do tirar polo natural* (*On Drawing from Nature*). He made a number of proposals for improving Lisbon in the Roman manner, including plans for a new castle, city walls, sea forts, a royal palace, a copious water supply, bridges over the Tagus, paved roads, and two new churches.

**HOLBEIN**, HANS (1497/8-1543). Painter and designer, the younger son of an Augsburg painter of the same name. He was trained in his father's studio but no doubt also learnt much from the goldsmiths for whom Augsburg was famous. As he grew up RENAISSANCE forms were becoming known in the north, and Holbein was later to add much to his knowledge of them and to break completely with the GOTHIC style. About 1514 he moved to Basel, working probably first as a journeyman for Hans Herbster

(1468-1550), but quickly finding employment as a designer for printers, one of his earliest works being the title-page, cut in 1515, for Johann Froben's edition of Sir Thomas More's *Utopia* (1518). He also met Erasmus, and in 1516 painted the portraits of Burgomaster Meyer and his wife (Basel). These reveal that from the first he used the method, probably learnt from his father, of making careful drawings from the life and painting from them. The Meyer drawings are surprisingly mature, but the paintings a little harsh and unsubtle.

From 1517 to 1519 he was working in Lucerne on the decoration of a house for the von Hertenstein family (now destroyed), using scenes from Roman history and a classical triumph derived from MANTEGNA. It is probable, though not certain, that during this time he crossed the Alps to Lombardy, for on his return to Basel, where he was to remain until 1526, his style was less harsh, his modelling softer, and his composition more monumental. One of the most beautiful of all his works, the portrait of the scholar and collector *Bonifacius Amerbach* (Basel, 1519), shows the richness of colour and warmth in the flesh tints which characterize his new style. *The Madonna and Child with Saints* at Solothurn (1522) had a new grandeur and simplicity of composition, and the unforgettable *Christ in the Tomb* (Basel, 1521) a power of expression combined with a CHIAROSCURO almost akin to LEONARDO. Indeed the *Last Supper* (Basel, cut down), painted for Amerbach probably about this time, suggests a first-hand knowledge of Leonardo's work.

He was now the leading painter in Basel, and gained an important commission for decorating the Town Hall with scenes of *Justice* taken from classical history. Apart from fragments in the Basel Museum these are lost, but are known from copies. He also continued to work for printers, designing the title-page of Luther's Bible (1522) and producing between 1523 and 1526 his best known work in this field, the 51 plates of the *Dance of Death*. Since these reflected the new critical outlook of the Reformation, they were not published until 1538 in Lyon, when they enjoyed enormous popularity, running into many editions. These little plates, showing Death visiting rich and poor alike, have a wonderful narrative power obtained with great economy of means. (See DANCE OF DEATH.)

His most notable portraits in these years are those of Erasmus (Louvre, 1523) and The Earl of Radnor (Longford Castle). In them, perhaps by the sitters' wish, he used for the first time the formula of the scholar in his study, first devised by the Fleming, Quentin MASSYS, for a portrait of *Erasmus* (Mus. Naz., Rome, 1517). Holbein's Louvre portrait, with the figure writing, silhouetted against a curtain, is one of the most powerful and intimate of his character studies.

A short visit to France in 1524 gave him further knowledge of Renaissance painting, especially through the works of RAPHAEL in the

royal collection, and the effect may be seen in the *Madonna of Burgomaster Meyer* (coll. of Prince and Princess Ludwig von Hessen, Darmstadt, 1526). Mother and Child alike have an ideal beauty which is quite un-German, though the DONOR portraits have a splendid and mature REALISM.

The disturbances of the Reformation meant a decline of patronage in Basel, and in 1526, armed with an introduction from Erasmus to Sir Thomas More, Holbein sought work in England. His great group portrait of the More family (lost, but later copies in the N.P.G., London, and Nostell Priory) is a landmark in European art, for no previous artist had produced a group portrait of full-length figures in their own home. A drawing for this group portrait, which was sent by More to Erasmus, is in the museum at Basel. The beautiful studies for individual heads (Windsor) are among the finest of the artist's many portrait drawings. A number of single portraits, *Sir Henry Guilford* (Windsor), *Archbishop Warham* (Lambeth Palace and Louvre), and *Nicholas Kratzer* (Louvre) date from this visit, but Holbein obtained no commissions for subject pictures and returned home disappointed in 1528.

Basel, however, had changed. Religious pictures were banned and there was much religious strife. Holbein accepted the Reformed religion, continued his work at the Town Hall,

and made many designs for stained glass. In 1532, leaving his family, of whom he had painted a penetrating group portrait (Basel), he returned to England, perhaps bringing his last religious painting, the *Noli me tangere* (Hampton Court) with him. More was now out of favour and Holbein found new patrons in the German Steelyard Merchants, for whom he painted several portraits (*Georg Gisze*, Berlin, 1523; *Dirk Born*, Windsor, 1533), decorations in GRISAILLE illustrating the *Triumph of Wealth and of Poverty* (lost) for their Banqueting Hall, and designed a triumphal arch *Parnassus* (drawing, Berlin) for the coronation of Anne Boleyn in 1533. He also made many designs for goldsmiths' work and jewellery, using a full range of Renaissance forms, which are of much importance in ENGLISH ART.

Through the Steelyards he probably met Thomas Cromwell (portrait, Met. Mus., New York, 1533/4), who may have obtained for him the commission for his famous double portrait *The Ambassadors* (N.G., London, 1533), square and solid in design, but spaceless compared with the More group and overloaded with meticulous STILL LIFE painting. And Cromwell almost certainly helped him to gain royal patronage. By 1536 he was working for Henry VIII, and in the next year undertook his most famous English work, the wall-painting in Whitehall Palace of Henry VIII with his father and mother and his

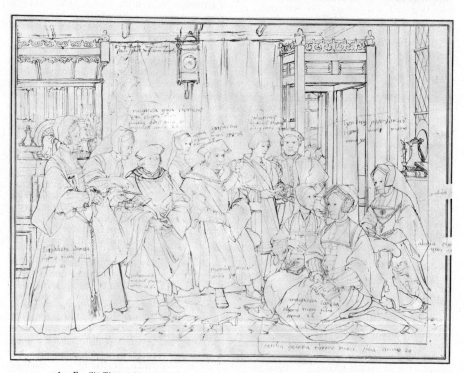

**165.** *Familia Thomae Mori Angl: Cancell:* Pen-and-ink drawing by Hans Holbein. (Basel, 1526)

third wife, Jane Seymour. Though the painting perished in 1698, part of the CARTOON survives (N.P.G., London) and copies were made, especially of the familiar and formidable figure of the King standing full-face and staring at the spectator (Mus. Naz., Rome; Walker Art Gal., Liverpool). Other royal sitters include *Jane Seymour* (Vienna, 1537), *Anne of Cleves* (Louvre, 1539/40), *Catherine Howard* (Toledo, Ohio, 1540/41), and, most beautiful of all, *Christina, Duchess of Milan* (N.G., London, 1538).

These late portraits became increasingly frozen, spaceless, and impersonal, and their meticulous technique may be connected with his new interest in MINIATURE painting. Of this the *Mrs. Pemberton* (V. & A. Mus., *c.* 1540) is an outstanding example. Many portrait drawings, and also designs for decoration, survive from his last years; but though he died comparatively young, his self-portrait miniature (Duke of Buccleuch Coll., 1543) suggests a disillusioned man, crushed by the narrowness of English court patronage, which had failed to use the full range of his enormous talent.

178, 516, 972, 2031, 2335, 2415.

**HOLDEN,** CHARLES (1875-1960). English architect who, as designer of London underground railway stations and station equipment in the 1920s and 1930s, played a great part in promoting rational design in England and therefore in paving the way for the more revolutionary style of MODERN ARCHITECTURE that was to follow. He also designed many large buildings (less advanced stylistically) in conjunction with his partners Adams and Pearson. Among them the best known are the London Transport Offices at Westminster (1929), one of the first buildings of its kind with a cruciform plan allowing all windows to look outwards instead of into internal courts, and the Senate House and other buildings for London University (1933 onwards). In 1946-8 he collaborated with Sir W. G. Holford (1907- ) on a plan for rebuilding the City of London.

**HOLGUÍN,** MELCHOR PÉREZ (*c.* 1660-*c.* 1725). Spanish-American painter, born at Cochabamba in Bolivia and founder of the Potosí School. He painted in an entirely personal mode of MANNERISM with a ROCOCO flavouring; with a loving attention to detail and a delight in anecdote he could nevertheless endow his figures with spirituality and inner life. Through all his work there is an exotic reminiscence of local decorative tradition. His earliest work, *Rest on the Flight into Egypt*, a popular theme with the Cuzco School (see SPANISH COLONIAL ART), is in the Banco Central, La Paz. Paintings of his are in the church of S. Lorenzo, Potosí, and the Merced at Sucre, and many are in private hands in Bolivia. His picture depicting the *Entry of Viceroy Fray Diego Morcillo Rubio de Aunón into*

*Potosí* (1716) is in the Museo de América, Madrid, and his last works, the *Four Evangelists* (1724), are in the Casa de Moneda, Potosí.

**HOLLAND,** HENRY (1745-1806). English architect, the son of a substantial London builder in whose business he was trained from an early age. In 1771 he became assistant to his father's friend 'Capability' BROWN, whose daughter he subsequently married. His first independent commission, for Brooks's Club (1776-8), brought him to the notice of the Prince Regent, for whom he refashioned the Marine Pavilion at Brighton, later to be transformed by John NASH. Carlton House (1783-5, demolished 1827-8), the Prince's London residence, was a transformation on the grandest scale and Holland rose to the occasion with a great NEO-CLASSIC portico and fine reception rooms. He made large alterations at Woburn Abbey, Althorp, and Broadlands, and rebuilt Southill, Bedfordshire (1795), his most complete surviving work. In Holland's houses the grandeur and lavish display of PALLADIANISM was set aside; his aim was to provide an elegant background, delicately scaled for civilized family life. He favoured contemporary French work and employed French craftsmen for his interiors. Although he had many important commissions, the tone of his work was too subdued to attract many followers.

2577.

**HOLLAR,** WENZEL (1607-77). Born in Prague and trained in the workshop of MERIAN in Frankfurt, he became one of the foremost engravers of topographical views in the 17th c. In 1636, while working in Cologne, he met the English connoisseur, the Earl of ARUNDEL, who took him on a tour of Europe to make views for his private collections. On account of his English connections Hollar finally settled in London—during the Civil War he fought on the Royalist side—and we owe to him some important engravings showing the city before the Great Fire. He also excelled in costume and animal pictures.

**HOLY FAMILY.** The *Sacra Famiglia*, in which the Virgin and Child are accompanied by Joseph and other relatives, differs from the devotional group of the *Sacra Conversazione* (see VIRGIN) in its predominantly domestic atmosphere. Although they figure from an early date in scenes of the NATIVITY, ADORATION, and FLIGHT INTO EGYPT, the simple group of Joseph, Mary, and the Child is not found before the 15th c.; it appealed in its homeliness and sentiment to the painters of the RENAISSANCE. MICHELANGELO made of it a figure study, with a group of naked youths in the background (Uffizi). ANDREA DEL SARTO (Prado) and RUBENS (Vienna

and Antwerp) painted lively family groups with their own wives and children as models.

Often the group is concentrated in some action such as the reading of a book (SIGNORELLI, Uffizi), the Virgin teaching the Child to read (BORGOGNONE, Rijksmuseum, Amsterdam), or together Joseph and Mary supporting His first steps (MASTER OF THE MAGDALEN legend, Antwerp Mus., 15th c.). In some groups the Child is asleep on the Virgin's lap with Joseph (and often St. JOHN THE BAPTIST) watching silently (BRONZINO, Pitti, Florence; El GRECO, Toledo). In others Mary is feeding Him at her breast (SOLARIO, Louvre, 16th c.; BOLTRAFFIO, N.G., London), a scene which at its early medieval origin had a doctrinal meaning now forgotten. The favourite of all such domestic scenes was that of Joseph the carpenter at work with Mary and the Child playing or resting in the foreground (REMBRANDT, Kassel; Hermitage; CORREGGIO, *Madonna of the Basket*, N.G., London). Another popular setting was the Rest on the Flight, where the Holy Family is shown resting in a landscape (van DYCK, Munich), usually shaded by a tree, and often entertained by a crowd of dancing cherubs (CRANACH, engraving).

In the second half of the 16th c. the Council of Trent condemned the intimate domestic portrayal of the family of Christ and urged a more solemn treatment, arguing that the three figures should be regarded as the terrestrial parallel to the heavenly Trinity. This approach is reflected in MURILLO's painting of the Holy Family under the protection of the Trinity (N.G., London). The Holy Family is often joined by Mary's elderly cousin Elizabeth, with her little son St. John the Baptist. According to a Franciscan legend (*Meditations* of Pseudo-Bonaventura) this meeting took place on their way back from Egypt, and is also usually portrayed in a landscape (RAPHAEL, *Canigiani Holy Family*, Munich; Andrea del Sarto, Louvre; Nicolas POUSSIN, Chatsworth). More often the young St. John the Baptist plays with Christ without Elizabeth, while Mary with or without Joseph looks on (Raphael, *La belle jardinière*, Louvre, and two pictures in Ellesmere Coll., Edinburgh; TITIAN, Uffizi). This legend also provides the setting for LEONARDO's famous *Virgin of the Rocks* (N.G., London and Louvre). Here the Virgin kneels before the holy children. St. John no longer plays as an equal but kneels in adoration, encircled by the Virgin's arm, whose other hand is held spread above the head of the infant Christ. John typifies the human race in need of salvation. The infant Christ blesses mankind and is supported by the figure of an angel who points to John.

Mary's mother, St. Anne, often appears with the *Sacra Famiglia*, and her participation gained significance from the growing doctrinal importance of the immaculate conception and the notion of St. Anne as the forerunner and her possible identification with the Church. The most famous example is Leonardo's Cartoon (N.G., London; a painting is in the Louvre), a lost version of which is known to have contained the sacrificial LAMB, the *Agnus Dei*. In German and Flemish pictures of the Holy Family Anne was sometimes represented with her three husbands and their sons (two paintings by Cranach, Städel Institute, Frankfurt, and Academy, Vienna; Q. MASSYS, Brussels; M. SCHAFFNER, carved altar of Ulm Cathedral, 1521), all of whom traditionally formed part of the family of Christ.

**HOLY SPIRIT, THE.** The Holy Spirit was described by St. John the Baptist (John i. 32) as 'descending from heaven like a dove', and this image became its symbol not only in pictures of the BAPTISM but generally in Christian art. In Acts ii. 3-4 the Holy Ghost descends in 'cloven tongues like as of fire' on to the heads of the APOSTLES, and this fire is shown in the early illustrations of the scene (6th-c. Syrian *Rabula Codex*, Laurentian Lib., Florence; 9th-c. Carolingian *Bible of S. Paolo fuori le Mura*, Rome). In later scenes the Dove too has a place, as in the *Benedictional of Aethelwold* (B.M., 10th c.), where the fire streams from its beak, in mosaics of Hosias Loukas, Greece (11th c.), and in St. Mark's, Venice (13th c.), where the fiery beams flow down from the enthroned Dove in the centre of the cupola to the Apostles seated in a circle below. The Dove symbol also represents the Holy Spirit as third Person of the TRINITY. It likewise appears in some representations of the Annunciation (Luke i. 35) descending from the sky (5th-c. mosaics of Sta Maria Maggiore, Rome; 12th-c. mosaics, Cappella Palatina, Palermo), hovering above the Virgin's head (van EYCK, RETABLE, Ghent), sent down by God (Fra BARTOLOMMEO's painting in SS. Annunziata, Florence). In picturing the Creation the Dove symbolizes the Spirit of God 'upon the face of the waters' (13th-c. mosaic in St. Mark's, Venice). Isaiah's prophecy (xi. 2) of Christ's seven gifts of the Spirit of the Lord is portrayed as seven doves around Christ (12th-c. windows in Chartres and S. Denis, Paris). The Dove also signifies the Holy Spirit in certain lives of Saints, and in portraits of Pope Gregory the Great it illustrates the legend of his inspiration by God (11th-c. ivory carving, Staatliche Mus., Berlin; GHIBERTI's relief on the Baptistery door in Florence).

**HOME, HENRY, LORD KAMES** (1696-1782). Scottish moralist and writer on AESTHETICS. His *Elements of Criticism* (1762) has been described as one of the most elaborate and systematic treatises on AESTHETICS and criticism of any age or nation and ranks along with Archibald ALISON's *Essays on Taste* as the major production of philosophical aesthetics in the English 18th c. It went through six editions between 1762 and 1785 and was long used as a textbook until the predominance of Germanic philosophy in the 19th c. brought it into oblivion.

**166.** The Holy Ghost descending in 'cloven tongues like as of fire' on to the heads of the Virgin and the Apostles. Miniature from the *Rabula Codex*. (Laurentian Lib., Florence, 6th c.)

**HOMER,** WINSLOW (1836-1910). American landscape, marine, and genre painter. He came to painting from illustration, chiefly for *Harper's Weekly*, and his *Prisoners from the Front* (Met. Mus., New York, 1866) was sent to the Paris Exposition of 1867 among the works representing American art. He painted pictures of outdoor life, combining imagination and strength, which are considered to be an outstanding expression of the American spirit. He aspired to naturalistic recording and expressed his attitude in the words: 'When I have selected the thing carefully, I paint it exactly as it appears.' He explored the rendering of light and colour in a direction other than that of the IMPRESSIONISTS: instead of dissolving outline into light and atmosphere, he sought luminosity within a firm construction of clear outline and broad planes of light and dark (*Long Branch, New Jersey*,

Boston Mus. of Fine Arts, 1869). From 1881 he painted for two years at Tynemouth in England and on returning to America settled on the coast of Maine. He is best known for his pictures of the Maine coast, which represent the power and solitude of the sea and the contest of man with the forces of nature. He used watercolour with the force and authority of oil, achieving monumental simplicity without losing the boldness of direct vision (*The North-easter* and *Cannon Rock*, Met. Mus., New York, 1895; *Saguenay River*, Worcester Art Mus., Mass., 1899). Homer was an artist of considerable originality who through a naturalism of his own interpretation created an imaginative vision of nature which has come to be accepted as a reflection of American pioneering spirit.

1101.

545

**HONDECOETER.** The family name of three generations of Netherlandish painters. GILLIS D'HONDECOETER was a Flemish LANDSCAPE painter who moved to Holland and died in Amsterdam in 1638. GYSBERT (1604-53), his son, painted landscapes and STILL LIFE. MELCHIOR (1636-95), the best known, was the pupil of his father Gysbert and his uncle Jan Baptist WEENIX, and was active in Utrecht, The Hague, and Amsterdam. He made still-life paintings and a TROMPE L'ŒIL piece, *The Dead Hen*, is in the Museum in Brussels. But most of his pictures show birds in action: wild fowl in the field or stream; poultry in a barnyard; exotic birds in an aviary. They have given him the sobriquet of 'Raphael of the Birds'. Some of his compositions tell a story or point a moral; they are often called the 'feathered choir'. His output was large and was popular in Dutch country houses.

**HONE,** NATHANIEL (1718-84). Irish miniaturist and portrait painter, who appears to have come early in life to England, working in York before he settled in London. He was in Italy *c.* 1750. He began as a painter of MINIATURES on enamel and when he came to paint in oils his portraits were characterized by a smooth, enamel-like surface. He became a foundation member of the ROYAL ACADEMY. He painted occasional subject pieces: in *The Conjurer* (J. Maher Coll., 1775) he satirized the practice of 'borrowing' from Old Masters. The picture was refused by the Royal Academy and Hone in protest organized a one-man show in St. Martin's Lane, the first of its kind recorded in Britain.

**HONNECOURT,** VILLARD D' (13th c.). French architect from Picardy who owes his fame to a manuscript volume now in the Bibliothèque nationale, Paris. Half sketch-book, half pattern-book or treatise, this volume, compiled *c.* 1235 and the only one of its kind prior to the 15th c. to have survived, offers a unique insight into the working practices of French architects during the period of the great GOTHIC cathedrals. His material combines geometrical principles inherited from antiquity through medieval studio traditions and contemporary workshop practice. It contains sections on technical procedures and mechanical devices, hints for the construction of human and animal figures, notes on the buildings and monuments that the author saw on his travels (which took him as far as Hungary), and some indication of his own work (which includes the rose window of Lausanne Cathedral). The existence of books of this kind helps to explain the rapid spread of Gothic forms throughout Europe.

1364, 1365.

**HONTAÑÓN,** DE. Family of Spanish architects mainly responsible for the construction of the 16th-c. GOTHIC cathedrals of Salamanca and Segovia. These buildings were the final expression, on a monumental scale, of Spanish resistance to the RENAISSANCE style.

JUAN GIL the Elder (d. 1526) was one of the nine architects called together in 1512 to decide the plans for the new cathedral at Salamanca, and the construction was entrusted to him. He also directed construction at Seville Cathedral (1513-17), and himself designed Segovia Cathedral, which was begun under his supervision *c.* 1525. He was assisted by his son JUAN GIL the Younger, who succeeded him as cathedral architect at Salamanca (1526-31).

RODRIGO GIL (d. 1577), another son of Juan Gil the Elder, was cathedral architect at Salamanca (from 1538) and at Segovia. He continued both cathedrals in a Gothic style of imposing severity and also directed the continuation of the Gothic cathedrals of Astorga and Palencia. He was, however, in addition a master of the Renaissance-PLATERESQUE style, which he used for the façade of the University of Alcalá de Henares (1541-53).

**HONTHORST,** GERRIT VAN (1590-1656). Dutch painter of biblical, mythological, and GENRE scenes and of portraits. At Utrecht, his birthplace, he was a pupil of BLOEMAERT, but his style was formed by a long stay in Italy (*c.* 1610-20) and upon his return to Holland he became along with TERBRUGGHEN a leading representative in the Netherlands of the style of CARAVAGGIO. Honthorst himself never met Caravaggio, who died about a year before he arrived in Rome. The candlelight effects he favoured in his early biblical pictures (*Christ before the High Priest*, N.G., London) and genre scenes (*The Concert*, Borghese Gal., Rome) earned him the nickname 'Gherardo della Notte' (Gerard of the Night Scenes). Some of REMBRANDT's early works show that he was impressed by Honthorst's use of CHIAROSCURO for dramatic effects. During the last three decades of his career Honthorst abandoned his Caravaggesque style for a lighter and more classical way of painting, in which he achieved great success as a court painter. He was employed by the Elector of Brandenburg and by King Christian of Denmark. He gave painting lessons to Queen Elizabeth of Bohemia and to her daughter. In 1628 Charles I called him to England, probably on trial as a court painter. And from 1637 to 1652 he was court painter at The Hague.

**HOOCH,** PIETER DE (1629-83). Dutch painter of indoor and garden scenes and views of courtyards. He is generally counted among the

painters of the school of Delft, although he was born in Rotterdam and died in Amsterdam. His very name evokes the quiet and peace of Dutch domestic scenes of the 17th c. With him, as with his younger contemporary VERMEER, who may have influenced him, the representation of an interior or courtyard as such becomes as important as the human figures which people it. De Hooch is at his best when representing a sunny yard (*Courtyard*, Earl of Strafford Coll., on loan to N.G., London, 1658) and light streaming into the interior of a corner of a burgher's house (*The Pantry*, Rijksmuseum, Amsterdam). His talent ran its course long before the end of his working life, and after he settled in Amsterdam (*c.* 1667) the quality of his paintings was less remarkable than their quantity. Instead of the simple brick and plaster backgrounds of his earlier groups he chose sumptuous marble interiors, mainly derived from the Amsterdam Town Hall, and towards the end these backgrounds acquired something of the harsh quality of a painted dropscene.

136, 2717.

**HOOGSTRATEN,** SAMUEL VAN (1627–78). Dutch painter of GENRE scenes in the style of DE HOOCH and METSU, portraits, and TROMPE L'ŒIL pictures. One of his 'perspective boxes', which shows a painted toy world through a peep-hole, is in the National Gallery, London (see PEEPSHOW BOX). Only in his early works can it be detected that he was a pupil of REMBRANDT. He travelled to London, Vienna, and Rome. He was an etcher, poet, director of the mint at Dordrecht, and art theorist. His *Inleyding tot de hooge schoole der schilderkonst* (*Introduction to the Art of Painting*, 1678) contains one of the rare contemporary appraisals of Rembrandt's work.

**HOOKE,** DR. ROBERT (1635–1703). English architect and designer. He was Secretary to the Royal Society and an intimate friend of WREN, sharing his interest in science, astronomy, and the latest developments in continental architecture, as well as his taste for coffee-drinking. His plan for the rebuilding of London after the Fire of 1666 led to his appointment as one of the City Surveyors together with Peter MILLS and Edward JERMAN. He thus became the official colleague of Wren, the Surveyor-General appointed by the king, and assisted him in supervising the rebuilding of the City churches. His diary records his activities from 1672 to 1680.

Apart from the Monument to the Fire of London, which he designed in collaboration with Wren, nearly all his architectural works are lost (St. Mary Magdalene, Willen, Bucks., 1678–80).

They included the Royal College of Physicians (1672), Old Bedlam Hospital (1675), and Montagu House (1675).

185.

**HOPPER,** EDWARD (1882–1967). American painter. He was a pupil of Robert HENRI and sold his first painting at the ARMORY SHOW. He remained unrecognized as an artist, however, until the 1920s, when he sold another picture in a water-colour exhibition at the Brooklyn Museum. During the 1930s he came to the fore as a leading exponent of the new interpretative REALISM of the American scene, opposing the French influence in U.S. art and the abstract painting of mood. Hopper had, however, advanced far from the social realism of the 'Ashcan School' to a personal rendering of the provincial realities of American life. In an interview given in 1960 he stated in answer to a question whether there was any social content in his work: 'None whatsoever' (*The Artist's Voice*, Katharine Kuh). In 1930 he had stated: 'My aim in painting has always been the most exact transcription possible of my most intimate impressions of nature.' From the 1930s to the 1960s his work revealed an increase in formal precision and in the intensity of purely visual comment which may be illustrated by the following sequence: *Early Sunday Morning* (Whitney Mus. of American Art, New York, 1930); *Cape Cod Afternoon* (Carnegie Institute, Pittsburgh, 1936); *Nighthawks* (Art Institute of Chicago, 1942); *Second Story Sunlight* (Whitney Mus. of American Art, 1960). In 1950 he held retrospective exhibitions at the Whitney Museum, the Boston Museum of Fine Arts, and the Detroit Institute of Arts. He held a one-man exhibition at the Venice Biennale of 1952.

**HOPPNER,** JOHN (1758–1810). Portrait painter, born in London of German parents. He was trained as a chorister in the Chapel Royal, and later received an allowance from George III to study at the R.A. Schools. This favour and the fact that he received commissions for royal portraits as early as 1785 led to rumours that he was the king's son, but these were never proved. In 1789 he was appointed Portrait Painter to the Prince of Wales and from this time was associated with 'the Prince of Wales's Set'. He became A.R.A. in 1792, and R.A. in 1795, and after the death of REYNOLDS he and LAWRENCE shared, with some rivalry, the more important portrait commissions. Hoppner was at his best in male heads, and occasionally in portrait groups (*The Misses Frankland*, N.G., Washington), but he was too often a careless painter and in his attempts to emulate first Reynolds, then Lawrence, never matured a personal style.

1729.

**HOPTON WOOD STONE.** A very hard limestone quarried at Middleton, Derbyshire. It can be cut to a smooth face and sharp ridge and takes a good polish. It is compact in structure and its colour varies between light grey and light tan. It is speckled with dark-grey glistening crystalline masses, often geometric in shape, giving a surface appearance which some sculptors have welcomed. It has been effectively used by Henry MOORE, Barbara HEPWORTH, and others.

**HORN.** Horn and bone are among the earliest materials in which carvings have survived from prehistoric times, particularly from nomadic peoples without elaborately developed techniques. The horn of reindeer and caribou were frequently used and walrus tusk (morse) has been regarded as an inferior sort of IVORY. Whalebone has also been used by Scandinavians and more recently among the Eskimos.

A few bone carvings from the 11th c. exist in England. A knife-handle depicting two lions (B.M.) attests Scandinavian influence in *art mobilier* of the time. There is also in the British Museum a bone plaque from Old Sarum showing two gryphons confronted.

**HORTA,** VICTOR (1861–1947). Belgian architect, a disciple of VIOLLET-LE-DUC. He was one of the earliest and most original exponents of ART NOUVEAU on the Continent, devised a rich and inventive idiom of ornament and was an innovator in introducing new structural forms in steel and glass. His revolutionary Hôtel Tassel (1892–3) is one of the most significant manifestations of *art nouveau* and his Hôtel Solvay (1895–1900) exemplifies *art nouveau* in its most mature form, combining the ideals of classical directness with BAROQUE exuberance. The Maison du Peuple at Brussels (1896–9) and the Grand Bazar, Frankfurt, with their wide curving façades of glass and iron, were equally significant, anticipating the transparent screens which have led to the abandonment of the load-bearing wall. He became Professor at the Académie des Beaux-Arts in 1912 and its director in 1927. From 1916 to 1919 he was in the U.S.A. and his style changed from the picturesque to a more austere line. His Palais des Beaux-Arts, Brussels (1922–8), in concrete is the outstanding example of this later phase.

**HOSKINS,** JOHN (c. 1595–1665). The leading English portrait miniaturist between c. 1625 and c. 1640. His early work is a development of HILLIARD's style. He later became a specialist in miniature copies of van DYCK's portraits in oils—a fashion which remained much in demand throughout the 17th c.—but his miniatures often have a charm and originality of their own (*Henrietta Maria*, Rijksmuseum, c. 1632, and at Chatsworth). He was 'LIMNER' to Charles I in 1640, but thereafter was overshadowed by the work of his nephew and pupil, Samuel COOPER.

**HOUBRAKEN,** ARNOLD (1660–1719). Dutch painter known for his biographies of Netherlandish painters (*De Groote Schouburgh der Nederlantsche Konstschilders en Schilderessen*, 3 vols., 1718–21). This was the first comprehensive study of Netherlandish art since van MANDER published his *Schilderboeck* in 1604. In spite of errors, interesting but apocryphal anecdotes, and curious gaps—VERMEER is not mentioned—this work remains the most important source-book on 17th-c. Netherlandish artists. Arnold's son Jacobus (1698–1780) was a leading portrait engraver. He engraved plates after his father's designs for the *Groote Schouburgh* and after Thomas Birch's *Heads of Illustrious Persons of Great Britain*, 1743–51.

**HOUCKGEEST,** GERRIT (c. 1600–61). Dutch painter of architectural views, mainly church interiors. He was active in Delft from 1635 to 1652.

**HOUDON,** JEAN-ANTOINE (1741–1828). French sculptor, a pupil of Jean-Baptiste LEMOYNE and of Jean-Baptiste Pigalle (1714–85). He was in Rome 1764–8 and there produced two works of sculpture which assured his renown: *L'Écorché* was an anatomical *tour de force* and *St. Bruno*, commissioned for the Carthusian monastery, executed in a direct and unpretentious classical style. Returning to Paris in 1769, he was successful in the popular mythological style, becoming a member of the Academy in 1777 on the strength of his *Morpheus* (Louvre). Other works of this kind were *La Frileuse* (Montpelier, 1783), *Diana* (Gulbenkian Coll., 1780), *Minerva* (Institut, Paris). His greatest strength was in his portrait busts. He had the highest repute of French 18th-c. portrait sculptors and his work exemplifies the 18th-c. interest in the psychological depiction of individuality. His many portraits include: *Cagliostro* (Aix-en-Provence), *Diderot* (1771), *Gluck* (1775; an example in the Royal College of Music, London), *Jean-Jacques Rousseau* (Louvre), and *Voltaire* Comédie Français, Paris, and V. & A. Mus., London), *Benjamin Franklin* (1778). By the middle 1780s he was acknowledged as the leading portrait sculptor of Europe. In Belgium and Switzerland he was asked to adjudicate models submitted for national monuments, the Dutch East India Company commissioned a bust from him, the princes of Mecklenburg-Schwerin and Prussia visited him in his studio, Catherine of Russia possessed several of his works, including the *Diana*. In 1785 the State of Virginia commissioned from him a statue of Washington and he visited America in order to study his model

face to face before doing his famous statue of Washington as the modern Cincinnatus called from the ploughshare to wield the reins of government (bronze copy outside the N.G., London). In his portraiture Houdon had a knack of catching characteristic tricks of gesture and expression and a brilliant gift of depicting the marks of individuality rather than a profound penetration into human character. He survived the Napoleonic era but produced little of importance after the turn of the century.

2200.

**HUANG KUNG-WANG** (1269-1354). Eldest of the 'Four Great Landscape Masters' of the Yüan dynasty (WU CHÊN, NI TSAN, WANG MÊNG, see CHINESE ART). Modelling himself first on the 10th-c. landscape masters Tung Yüan and Chü-jan, he developed an individual style, generally omitting the foreground and, in contrast to Sung style, covering most of the picture surface with details seen from a high, distant vantage point. With Ni Tsan he introduced the dry ink and slanting brush technique, an innovation which radically changed the development of Chinese brush and ink painting. He is credited with the saying: 'The painter should always have with him some brushes in a bag, then when he comes across some startling trees in a beautiful landscape, he should at once make sketches of them so as to preserve their natural idea.' Compositions in the style of Huang Kung-wang abound from the 15th to the 19th centuries.

**HUBER**, WOLF (c. 1490-1553). German painter working in Passau. He is usually counted among the masters of the so-called Danube School. As a young man he must have been in close contact with ALTDORFER. In spite of his figure compositions and PERSPECTIVE studies Huber was first and foremost a poetic interpreter of his native landscape. His studies of windblown trees and views over the Danube valley often look like the work of a 17th-c. master such as SEGHERS. Huber was a sensitive draughtsman and engraver.

2829.

**HUDSON**, THOMAS (1701-79). English painter who studied under Jonathan RICHARDSON and married his daughter. By 1735 he was established as a fashionable portrait painter. Within 10 years he had the largest flow of commissions in town, and he retained this position until he retired from professional practice c. 1755. REYNOLDS was one of his pupils. Hudson was an accomplished but unoriginal painter, whose portraits followed a stereotyped pattern. He employed Joseph van Aken (1699?-1749), and later van Aken's younger brother, as drapery painters.

**HUE.** See COLOUR.

**HUERTA**, JUAN DE LA. Spanish sculptor who in 1443 received the commission left unfinished by Claus de WERVE for the tomb of John the Fearless, Duke of Burgundy (d. 1419), and his wife, at Dijon. Huerta completed most of the minor figures, which closely follow those of the tomb of Philip the Bold, but he absconded in 1457, leaving the monument to be finished by Antoine le MOITURIER.

**HUGHES**, ARTHUR (1830-1915). English painter who studied at the R.A. Schools and later became one of the most distinguished of the PRE-RAPHAELITE sympathizers, remarkable for his lyrical delicacy of colour and drawing. His best work comes mostly from the 1850s (*The Long Engagement*, Birmingham, 1859) apart from his illustrations for such books as Christina Rossetti's *Sing Song* (1872). He was shy and withdrawn, and in later life he lived in suburban obscurity.

**HUGUET**, JAIME (active c. 1448-92). Spanish painter and the most prominent figure in the Catalan School during the second part of the 15th c. His earliest documented work is the ALTARPIECE of San Antonio Abad (1455), which was destroyed in Barcelona in 1909. He is thought to have settled in Barcelona about 1448; though some historians claim to trace earlier activity in Aragón and Tarragona, where he was born, his fully documented work extends only from 1455. He continued the Catalan tradition of Bernardo MARTORELL (see SPANISH ART) but was more mature in pictorial and decorative composition. He built up a large studio of followers through whom he exercised a wide influence on the painting of Catalonia and Aragón. Among his surviving works are an *Epiphany* from an altarpiece commissioned by Dom Pedro, Constable of Portugal (Chapel Royal, Barcelona, 1463), and a *Consecration of St. Augustine* commissioned by the Tanner's Guild (Barcelona Mus., commissioned 1463, completed by 1486). To his pre-Barcelona period is also sometimes attributed a *St. George and the Princess* (Barcelona Mus.).

18.

**HUI TSUNG** (1082-1135). The last Chinese emperor of the Northern Sung dynasty and one of the four recognized masters of the flower-and-bird (*hua niao*) category of painting which dominated the academies in the Five Dynasties and Northern Sung period (see CHINESE ART). Many paintings and examples of calligraphy bear his signature but in most cases this is either forged or inscribed on the works of other painters as a mark of his approval. On stylistic grounds, however, Benjamin Rowland has upheld the genuineness of four paintings traditionally ascribed to the emperor. His style seems to have been intermediate between the older academic

tradition and the new 'boneless' (*mei ku*) technique in which line contour is subordinated to the indication of form by means of colour. In composition Hui Tsung seems to have been an innovator, using 'balanced asymmetry' in such a way as to isolate and throw attention upon a single subject, reducing background setting to the merest indications.

Hui Tsung expanded the Academy, established entrance examinations, and dictated a style which continued to influence one school of Chinese painting for at least 700 years until the reaction against it stimulated the non-realistic styles of the amateur painters which gained the initiative from the Ming dynasty onwards (see CHINESE ART). Hui Tsung owned a large collection of ancient bronzes and paintings. A catalogue of it survives, and to the biographies it contains we owe much of our knowledge of early Chinese painters. When the dynasty fell and Hui Tsung was taken prisoner, the 6,396 paintings in his collection were moved to Peking. Their subsequent fate is unknown, although a few have survived.

**HUMOROUS ART.** The essence of humour is notoriously elusive: yesterday's fashionable hat is the 'funny hat' of today. Nations laugh at each other but find each other's jokes deplorable. Who would dare to tell for certain, across the chasm of centuries, which images of foreign civilizations were intended to evoke a smile and which were solemn? The 19th c. tended to look at distorted shapes as funny and praised BOSCH and BRUEGEL for their comic genius. Today's critics prefer to stress the 'expressive' character of distortions and to dwell on the depths of insight and despair revealed in the images even of professional humorists such as DAUMIER. These interpretations need not be mutually exclusive. The magic character of phallic fertility demons, the Egyptian Bes, the Greek Satyrs, the Roman Priapus, certainly did not stifle laughter. It is hard to tell whether illustrated animal fables such as we find on Sumerian implements and Egyptian PAPYRI were considered humorous, didactic, or mythical. We are on firmer ground when figures and scenes from Greek comedies are represented on south Italian vases of the 4th c. B.C. or when the painters of POMPEII make children, dwarfs, or animals enact mythological scenes. The terracotta figures of crippled slaves and dwarfs of HELLENISTIC and Roman times also probably correspond to the comic types of mimes.

With the rise of Christian art these whimsicalities disappear from the repertory. One can hardly imagine a humorous art of the Dark Ages or of Byzantium, though we cannot exclude the possibility that even these centuries did not take all the dragon and animal fights of their decorative art entirely seriously. For it is indeed out of these weird and bizarre inventions that humorous art emerges again when their spell was broken.

**167.** *Les deux Pantalons.* Etching (1616) by Jacques Callot

168. *There was an Old Person of Anerley, whose conduct was strange and unmannerly; He rushed down the Strand, with a pig in each hand, But returned in the evening to Anerley.* Illustration from *The Book of Nonsense* (1835) by Edward Lear

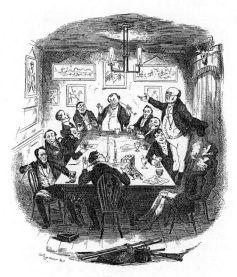

*Mr. Pickwick addresses the club.*

169. *Mr. Pickwick addresses the club.* Illustration designed by Robert Seymour for *The Pickwick Papers* (1836), Charles Dickens

The medieval DROLLERY derives directly from them. It was heralded by the marginal scenes on the BAYEUX TAPESTRY with their fables and mild obscenities. The vehemence with which St. Bernard of Clairvaux denounced the idle fancies of ROMANESQUE carvers with their monsters and creatures of fantasy also indicates that these inventions were felt by then to be playful. In GOTHIC art the comic marginal drollery, the humorous scenes and monsters of the misericords, the antics of 'wild men' on wall hangings and chests, lead straight towards the new subjects of GENRE with its townsman's view of country folk. In the 15th and 16th centuries the borderline between genre and humorous art is indeed hard to draw. Both categories flourished in the north. It was this tradition that developed the characterization of the comic type, the swaggering mercenaries of Urs GRAF, the ugly topers of WEIDITZ, the comic cripples and yokels of Bosch and Bruegel, and finally the picaresque types of CALLOT's inspired etchings with their echoes of the Italian *Commedia dell' Arte*.

The contribution of Italy to this tradition of humorous art was restricted by the demand for dignity and DECORUM. VASARI tells us of many Italian painters who liked to indulge in practical jokes, but their humour found outlet in life rather than in art. It was only towards the end of the 16th c. that Italy made its decisive contribution to graphic humour with the invention of portrait CARICATURE by the CARRACCI. Even this invention, however, only came to full fruition once it had merged with the northern traditions of comic genre.

Most of the comic themes had been developed in the cheaper and more ephemeral media of PRINTS and illustrations; and though humorous incidents did of course play their part in Dutch and even Italian genre painting, it was only in the 18th c. that HOGARTH in England, TROOST in Holland, and LONGHI in Venice exploited the taste for comic subjects. Of these Hogarth is incomparably the greatest and the most influential. It was he who opened up the whole human comedy for the observant painter and illustrator. Henceforward humorous art flourished in England with such outstanding exponents as

ROWLANDSON, the CRUIKSHANKS, Edward LEAR, Dick DOYLE, and KEENE. It is no accident that the classic of humorous literature, *The Pickwick Papers*, started as a sequence to be illustrated by Robert Seymour (1800–36).

In the 20th c. the centre of humorous art shifts across the Atlantic, where the artists of the *New Yorker* have developed new levels of sophistication. Draughtsmen such as James Thurber or Saul Steinberg depend for their effect no longer on literary content, comic distortion, or traditional types but on a purely visual wit.

It is not devoid of significance that 'humorous art' is almost inevitably held to mean art with humorous subject matter. Such art either reproduces something which, if seen in real life, would be funny or illustrates a story or an incident which is comic in itself. Such is the 'humorous art' which has so far been described; its typical, if not its most distinguished, exponents are the comic illustrators, the run of the mill *Punch* artists, whose vision is banal but who illustrate comic situations. At the other end of the scale are pictures whose humour lies wholly in witty vision and witty or sly execution. It is 'a purely visual comedy pertaining to forms alone, a joke that can be rendered only in line and colour. . . . It is a joke about forms told in forms, and it could be told in no other way.' This is a non-literary humour and 'no word of explanation will help anyone see it'. Thus wrote Clive BELL in *Enjoying Pictures* (1934) and he gave DEGAS (*La Plage*, Tate Gal.) and G. B. TIEPOLO (fragment of decoration, Correr, Venice) as examples of

purely visual humour in art. Between these extremes are artists who are capable of witty vision and of expressing their vision wittily but use this power for illustrating situations which are objectively comic. Their art is not pure but partly literary and the humour lies only partly in the vision and expression: it is equally derived from the scene or incident depicted. As instances of this type of artist Bell mentions FORAIN, Charles Keene, Rex WHISTLER, Max BEERBOHM, and the younger TIEPOLO. The work of Thurber belongs often to this class but, as has been said, he occasionally comes into the class of artist whose humour lies entirely in the visual forms and cannot be explicated in words.

**HUMPHREY,** OZIAS (1742-1810). English MINIATURE painter, who worked for a time in Bath but settled in London in 1763 on the encouragement of REYNOLDS. In 1772 an accident which affected his eyes made it necessary for him to abandon miniatures and in 1773 he went with ROMNEY to Italy. On his return to London in 1777 he practised in oils. From 1785 to 1788 he was in India, where he resumed miniature painting but again he found the work too great a strain. He took up crayons and in this medium was highly successful. He became A.R.A. in 1779 and R.A. in 1791, and was later given the title of Portrait Painter in Crayons to His Majesty.

**HUNEKER,** JAMES GIBBONS (1857-1921). One of the most prolific and influential critics of his day in the U.S.A. It was said of him that: 'Almost singlehanded he brought the new currents of European art and thought to America and made them fashionable.' His biographer adds: 'The first effective opponent of the "genteel tradition", he also encouraged the most daring and enduring American writers, composers, and painters of his day.'

2437.

**HUNT,** RICHARD MORRIS (1827-95). American architect, born of a distinguished New England family, and the first American to study at the École des Beaux-Arts in Paris. He became one of the most powerful and influential leaders in the radical eclecticism of the late 19th c. His facility with historical styles is attested by the mansions which he designed for the wealthy of New York and Newport. Typical is the fabulous Italian RENAISSANCE palace 'The Breakers' (1892-5), built for the Vanderbilts in Newport. His Tribune Building, New York City (1874), was one of the first SKYSCRAPERS.

**HUNT,** WILLIAM HOLMAN (1827-1910). English painter, co-founder of the PRE-RAPHAELITE Brotherhood in 1848. He was a revolutionary and reformer by temperament and together with John Everett MILLAIS, his fellow pupil at the R.A. Schools, he set himself to oppose traditional rules of painting and the frivolity of contemporary art. Throughout his life he remained faithful to the Pre-Raphaelite aims, which he summarized as finding serious and genuine ideas to express, direct study from nature in disregard of all arbitrary rules, and to envisage events as they must have happened rather than in accordance with the rules of design. From 1854 he made several journeys to Egypt and Palestine to paint biblical scenes with attention to accuracy of local detail. His work was remarkable for its minute precision, its accumulation of incident, and its didactic emphasis on moral or social symbolism (*The Scapegoat*, Port Sunlight; *The Light of the World*, Keble College, Oxford). He was a crude and rudimentary colourist, without taste or sensibility, who scorned to cultivate grace or charm of design. Most of his works are now regarded as failures, although the strength of conviction in his fervent devotion to his dogmas compels respect. His autobiographical *Pre-Raphaelitism and the Pre-Raphaelite Brotherhood* (1905) is the basic source book of the movement, although it has a certain bias which requires correction.

**HURTADO,** FRANCISCO (1669-1725). Spanish BAROQUE architect. He was appointed architect to Cordova Cathedral in 1697 and designed the cathedral *sacristia* (vestry). In 1705 he was appointed architect to Granada Cathedral and designed the sacristy there. His most remarkable works were executed for the Carthusians, namely the sacristies (*sagrarios*) of their monasteries at Granada (1702-20) and El Paular, near Segovia (begun 1719); and he may also have designed the famous *sacristia* of the Carthusian Granada monastery (mainly executed after his death *c.* 1730-42). In 1712 he settled at Priego, and there founded a school of Baroque architects and decorators.

**HUTCHESON,** FRANCIS (1694-1747). English aesthetician. He was a follower of Shaftesbury and the most systematic exponent of the doctrine that beauty is passively perceived by means of an 'inner sense'. In his treatise *An Inquiry into the Original of our Ideas of Beauty and Virtue* (1725) he attempted to work out a law for assessing beauty in terms of the ratio between uniformity and variety.

1395.

**HUY,** JEAN DE (active first half of 14th c.). Carver of TOMB effigies, born in the marble district of the Meuse, but active chiefly in Paris. By the 14th c. effigies had become the rule for the

tombs of the French nobility. The result was a wholesale expansion of the industry and a tendency towards standardization. The tomb became a symbol of social position and what mattered was the type rather than the quality of the sculpture. Jean de Huy was one of the most successful of these prototypes of the modern 'monumental mason'. The tomb of Robert d'Artois in Saint-Denis (c. 1317) is his work.

**HUYSUM, JUSTUS VAN** (1659–1716). Dutch artist, primarily known as a flower painter. At his death he left more than 600 paintings and he had four sons who were also painters. The most famous was JAN (1682–1749), who did landscapes and had an international reputation during his lifetime as one of the greatest of flower painters. The light colours he used, the even lighter backgrounds, and the openness of his intricate compositions became distinguishing features of 18th-c. Dutch flower painting.

1129, 2868.

**HYPOSTYLE.** The term is properly applicable to any large hall the roof of which rests on columns. With reference to Egyptian architecture it tends to mean one in which the central rows of columns are higher than the rest, thus forming a clerestory. A typical example is the great hypostyle hall of the temple of Amon-rē at KARNAK.

# I

**IBBETSON, JULIUS CAESAR** (1759–1817). English painter. He was a Yorkshireman and first attracted attention by painting a stage back-cloth at Hull when he was 17. Soon afterwards he went to London, where he gradually established himself as a painter of scenes from country life. From 1800 he lived mostly in Yorkshire. His small landscapes, coast scenes, and records of rural amusements have much in common with the work of George MORLAND; of the two Ibbetson was the more consistently good painter in an ECLECTIC style within the general range of the 19th-c. PICTURESQUE. He was called by WEST 'the BERCHEM of England'; but while this title effectively suggests the nature of his subjects, it does not do justice to the integrity and essentially English quality of his painting. His painting of Robert Burns against a picturesque Scottish background is typical of one aspect of his work.

**ICON.** Derived from the Greek *eikōn* the word means etymologically 'likeness', 'image', 'representation'. It has, however, acquired three distinct categories of meaning in different contexts. Its oldest and relatively unspecialized meaning lies within the history of Christian religious art and doctrine. From certain schools of Germanic art studies in the latter part of the 19th c. it acquired a more generalized meaning virtually equivalent to 'subject matter' of works of art and in this sense gave rise to such terms as ICONOLOGY and ICONOGRAPHY. Finally it has been adopted by certain schools of 20th-c. semantics and art theory to express highly specialized concepts. This article is restricted to the first of these senses.

In everyday language and Christian art history icons are images of saints or holy personages within the context of a cult, especially when such images have been believed to facilitate contact between the devotee and the sacred personage to whom his prayers are directed. The term has been applied particularly to sacred images of the Byzantine Church and the Orthodox Churches of Russia and Greece. The use of sacred images to which it points has a long and somewhat complicated history. Christian use of imagery began early, while the religion was still proscribed, and received an impetus with the recognition of Christianity as a state religion in A.D. 313. By the end of the 5th c. it was an established custom to decorate the walls, ceilings, and even the floors of Christian churches, funerary chambers, and BAPTISTERIES with pictures and mosaics. Their purpose was primarily didactic but also decorative and for glorification. There is no evidence that they were venerated or made the recipients or channels of prayer. The emergence of the Christian cult image at the end of the 5th c. and during the 6th c. was stimulated partly by the veneration paid to the imperial effigies in the Roman Empire. The Imperial Image signified the presence of the emperor by proxy and honour or insult to the Image (rather in the manner of the modern flag) was regarded as honour or insult to the emperor himself. By a natural analogy the presence of the saints or Christ or the Virgin was signified by their images around the altar or carried in procession through the church. Further, it was a doctrine of

Neo-Platonic philosophy, taught by Porphyry among others, that visible images could show forth invisible truths of religion. Thus the attitude of the educated mind was changing and by the time of Justinian, in the middle of the 6th c., it was normal for educated Christians to regard the sacred images as objects for veneration and contemplation, although there is no evidence that they were worshipped or invoked. Parallel to this but not to be confused with it was a popular development of the portable image as a cult object with close affinities to the miracle-working relic. Among the earliest may have been images of the Stylite saints, in which devotees found the same spiritual power as had resided in the saints themselves. At the beginning of the 7th c. the emperor Heraclius carried Christ's image in the standards of his army in his victorious Persian campaign, and Constantinople itself was believed to have been saved from the combined attack of the Slavs and Persians in A.D. 625 by a huge icon of the Virgin paraded along the city walls. By the beginning of the 8th c. the veneration of images had reached its culmination and reaction set in.

Led by the Iconoclasts, or Image-breakers, the attack on the cult of images became an attack on the images themselves. Their central tenet was that images of sacred personages must be removed from the churches and places of worship since their presence there inevitably became an occasion of idolatry. Some also impugned the Platonic view that spiritual things can be represented in visible and sensible symbols and argued in particular that the icons of Christ were unable to represent His double nature of divine and human. The Iconoclast movement had the support of the emperors and political motives entered into and kept alive the controversy. It appears not to have been actuated by a repudiation of art and beauty as such like the Puritan movement in England, nor did it involve a repudiation of imagery (naturalistic representation) as such, in the manner of ISLAMIC ART. In 730 the emperor Leo III, the Isaurian, promulgated a decree enjoining the destruction of all sacred images in human form. The most concerted attempt to eradicate image worship was made by his son Constantine V (741-75), who set himself to destroy every kind of icon except the symbol of the Cross. The destruction was indeed extensive, including panel paintings, frescoes, mosaics, and those illustrated manuscripts which contained pictures of the saints. Only a small number of icons has survived from the 6th and 7th centuries. Of these the finest group is that preserved in the monastery of St. Catherine on Mount Sinai, of which a good part were taken to Kiev by a visiting Russian bishop in the 19th c. Painted in wax (ENCAUSTIC) on wooden panels, they have a natural and lifelike appearance much like the MUMMY PORTRAITS of an earlier period from Faiyum. They were designed to conjure up the image of the saints in the same way that the tomb portraits held for the living the physical presence of their ancestors. Like them they are painted looking out of the picture with wide and brooding eyes; and this intense gaze, which assists communication between the image and its worshipper, has remained a constant feature in the later, more stylized icons throughout the Christian world. Rome too contains icons from this period, including two of the Virgin, also in encaustic, in Sta Maria Nuova and Sta Maria in Trastevere. It was probably at this time that the famous and much restored icon of Christ in the Sancta Sanctorum of the Lateran was first made.

Those who defended the liturgical use of the image, called Iconodules, won their point by a Decree of the Second Council of Nicaea under the empress Irene in 787. But icons were not finally restored to a place of honour in the Church until 843 when the ecumenical authority of the Second Council of Nicaea was reasserted at the Council of Constantinople and the Decree as interpreted by St. John of Damascus became official doctrine. The Decree asserts that whereas true worship belongs only to the Divine Nature, men are stimulated by painted representations to give worship-of-honour to their prototypes. The Damascene explains that in the veneration of images honour was not paid to them as mere objects of sense but through them to their prototypes. But both he and the 9th-c. Abbot Theodore of Studios brought in the Neo-Platonic doctrine of a mystical quasi-identity between the material image and the supersensible prototype with God as the ultimate prototype from whom all creation emanates. Thus the icon can serve as a means of approach and as a channel through which strength, knowledge, and sanctity can pass from the heavenly counterpart down to the worshipper. But for this mystic contact to become effective the icon had to conform to certain rules and stylistic criteria, for the painting of icons was closely allied to the underlying dogma. It had to be a likeness, based if possible on a description or a contemporary portrait of the saint; and this characteristic appearance, together with vestments, and if necessary an inscription, had to render the image clearly recognizable. It was important too that the figure should face out of the picture, ready to receive the prayers of the worshipper. Clarity, and the repetition of recognized types were for long characteristic of BYZANTINE painting.

With the victory of the image-worshippers in the Eastern Church the sacred images soon came to hold a dominating place not only in the minor arts but also in monumental painting, fresco, and mosaic. Portable images in tempera on wood or linen were produced in large numbers, as well as more precious panels in miniature mosaic. Many of these later icons show scenes instead of simple figures, as in the mosaic picture of the Annunciation (12th c.) in the Victoria and Albert Museum, and in the British Museum a painted panel with scenes from the life of Christ (13th c.). The painting and cult of icons was

introduced into Russia and the Balkans from the Greek Church (see RUSSIAN ART). Icons aroused there the same popular devotion as in Byzantium itself, and flourishing and gifted local schools of icon painting were set up in provincial centres, some of which continued up to the Soviet revolution. In recent centuries the decoration of icons has become increasingly ornate, and the custom has grown up of decorating all parts of the image except the face with a silver covering. Particular images, such as the Madonna Nikopeia at St. Mark's in Venice, the Black Madonna of Częstochowa, and the Virgin of Copacabana in Bolivia, are regarded with special reverence and credited with miraculous powers of healing and intercession.

**ICONOGRAPHY.** A term in art history which used to mean—among other things—the identification of portraits, especially on coins, but was extended in the 20th c. to cover the whole descriptive investigation of the subject matter of the figurative arts. It is closely associated with a way of doing art history which was largely influenced by the work of Aby WARBURG and Émile MÂLE. In his Inaugural Lecture *Art History Today* (1961) Professor L. D. Ettlinger summed up the then current middle-of-the-path attitude by claiming that iconography was a preliminary study as indispensable to the art historian as formal analysis, but denying that it was the whole of art history.

Iconography is usually divided into religious and secular. Before Émile Mâle the French scholar Didron made a contribution of paramount importance to the study of religious iconography in his *Annales Archéologiques* (1844 onwards). Besides Warburg the study of symbolism in secular art owes most, perhaps, to PANOFSKY. In their hands iconography is not merely an aid to identification. It studies the development of the themes which artists use, for instance the transformation of the images of planets in astrological manuscripts, the rise of GENRE painting, the origins of STILL LIFE, and the use of political satire. Ideally it would attempt in each case to analyse the relationship between idea and image and thus contribute to our understanding of the various elements that go to the making of a work of art.

860, 1464, 1465, 1746, 1959, 2906.

**ICONOLOGY.** *Iconologia* is the title of Cesare Ripa's handbook of PERSONIFICATIONS for the use of artists, first published in 1593. The term was adopted by Erwin PANOFSKY to distinguish his broader approach to analysis of meaning in the visual arts from ICONOGRAPHY which merely identified subject matter. By contrast iconology takes account of the tradition of pictorial motifs and their meaning. Panofsky himself laid emphasis on the need to treat the work of art as a concrete historical document in the study of a civilization or period and to bridge the gap between art history and other historical studies. Outstanding

examples of studies deriving from this school of thought are his own *Renaissance and Renascences in Western Art* (1960) and Rudolf Wittkower's *Architectural Principles in the Age of Humanism* (1952). Professor Ettlinger has warned that this method of studying art may be as dangerous as any other unless allied with aesthetic sensibility, a sense of historical relevance, and scientific rigour in the assessment of evidence. It may be appropriate to recall Panofsky's own insistence that: 'There is . . . some danger that iconology will behave, not like ethnology as opposed to ethnography, but like astrology as opposed to astrography.'

2009, 2018.

**ICONOSTASIS.** In Byzantine and Russian church architecture, a screen shutting off the sanctuary from the main body of the church. Paintings and ICONS were placed upon it.

**ICTINUS.** One of the most celebrated Greek architects, active second half of the 5th c. B.C. He collaborated with CALLICRATES on the building of the PARTHENON, worked on the Telesterion at Eleusis (a square hall with five rows of columns inside), and perhaps built the temple of Apollo at Bassae, which was much admired in antiquity.

**IDEAL.** 'Ideal' and its correlates have acquired two distinct meanings in the language of art history and criticism. Both senses derived from classical antiquity and both persisted through the Middle Ages and the RENAISSANCE.

1. The term is applied to art which reproduces the best of nature but improves and perfects it, eliminating the inevitable imperfections of particular examples. In the *Poetics* (1448$^a$) Aristotle states that dramatists 'imitate' men either above or below the average and introduces an analogy with painting: 'For POLYGNOTUS used to paint men better than the average and Pauson men who were worse and Dionysius representative ones.' Pliny mentions the legend that the painter ZEUXIS when commissioned to produce a picture of Helen for the temple of Hera in the city of Croton 'held an inspection of maidens of the place paraded naked and chose five, for the purpose of reproducing in the picture the most admirable points in the form of each' (*Nat. Hist.* xxxv. 64). Similar stories are recorded by Cicero and others. The method is referred to with approval by ALBERTI in his *De pictura* (1436) and DÜRER said he had examined some 200 or 300 individuals for the ideal type of beauty.

2. The other sense of 'ideal' derives from Plato's Theory of Ideas, according to which all perceptible objects are imperfect copies approximating to unchanging and imperceptible Ideas or Forms. It was against this background that Plato based his 'metaphysical argument' against painting as a copy of a copy at two removes from reality. Later, notably by the Neo-Platonist Plotinus, it was maintained that the work of art can directly mirror forth the essence of the Idea.

These ways of thinking reappeared with the revival of Platonism at the Italian Renaissance.

Its most influential formulation was in the lecture by BELLORI delivered before the Academy of St. Luke in Rome in 1664 and published as a Preface to his *Lives* in 1672. Here the true artist is conceived as the seer who gazes upon eternal verities and reveals them to mortal men. It is this gift that separates him from the mere mechanic, the slavish copyist of appearances. But this gift must be developed through the study of ancient marbles in which the 'ideal' was first revealed. The artist who was taken as the exemplification of this doctrine was POUSSIN, whose example became binding for the French Academy of the 17th c. The doctrine provided the philosophical justification for the GRAND MANNER and could be cited to confound admirers of CARAVAGGIO or of Dutch painting. REYNOLDS's *Discourses* prove how great a hold this by that time official doctrine of art had on the empirically orientated, shrewd, and matter-of-fact 18th-c. portrait painter; even the 19th-c. controversies, such as the conflict between the followers of INGRES and those of DELACROIX, were fought around the banner of 'ideal beauty'.

Cicero used the term in the sense of 'artist's imagination' or 'mental image', as when he said that PHIDIAS copied an imagined ideal form rather than an actual model when he carved his *Zeus* or his *Athena* (*Ad Brutum*, 2). A similar usage occurred in RAPHAEL's letter to CASTIGLIONE (published posthumously in 1514), where he said that he had not painted his *Galathea* after any particular model but had fashioned her according to a certain idea he had in his mind. It might of course be claimed that the 'idea in the artist's mind' was an 'idealization' of nature in sense 1 or an approximation to the Platonic Idea. In more recent times Schopenhauer claimed that visual art, by representing the permanent and essential character of phenomena, mirrors the Platonic Idea. 'Its one source is knowledge of Ideas; its one aim the communication of this knowledge.'

The artistic 'ideal' in the sense of the CLASSICAL prototype of perfection was worked out in the theories of the Academies and later by NEOCLASSICISM.

**IDEOPLASTIC.** A term originated by Max Verworn in *Zur Psychologie der primitiven Kunst* (1917) to mean a form of representation which derives from what the draftsman thinks and knows about the subject rather than from direct observation or from a memory image. Applied primarily to the abstract and schematic drawings of children and some primitive peoples, the term suggests that children and primitives draw what they know rather than what they directly see, in the sense of drawing from intellectual concepts rather than from visual memory images. This intellectualist theory has been controverted by exponents of GESTALT psychology and notably by Rudolf Arnheim, who in a paper 'Perceptual Abstraction and Art' (reprinted in *Toward a Psychology of Art*, 1966) argues that the simplified schemata of children and primitives are not progressive abstractions from the observation of a number of instances but represent global general features and structural characteristics which are inherent to primary perception, the differentiation of individual cases being secondary.

2748.

**IFE.** The oldest fine art from Negro Africa and the one which most deserves to be called 'classical' is that of Ife, the religious centre of the Yoruba people of western Nigeria. The Ife bronze and terracotta heads rank as some of the most sensitive naturalistic sculpture from any part of the world. Their art also included quartzite stools or 'thrones', stone figures of crocodiles, some fine glazed pottery of a sort unknown in later Africa, and other objects.

Ife heads became known about 1912 when Leo Frobenius, the German ethnologist, visited Yorubaland and publicized a bronze head which he called the 'Olokun head' because it was found in the sacred grove associated with Olokun, the sea-god. British authorities supported the Yoruba when they objected to its removal to Germany, and so far as is known it was kept in the grove until 1934, when it was taken to the palace of the Oni (king) of Ife for safe keeping. No further specimens were described until 1937, when the Oni published photographs and a description of a bronze mask. In the next few years the rest of the bronze heads were dug up in the course of building within the precincts of the palace.

In 1946 British Museum authorities suggested to the Oni that his bronzes should be sent briefly to England for treatment, examination, and display. During the cleaning the Olokun head was pronounced a copy. A panel of experts published their evidence in detail (W. Fagg and L. Underwood, 'An Examination of the So-called Olokun Head', *Man*, Jan. 1949). The most important single fact was that the Olokun head was sand-cast, whereas the other heads were cast by the *cire-perdue* method, like most other African bronzes. Although some of them have flaws they are expertly cast, varying in thickness from 1 to 3 mm. The bronze heads are life-size or smaller and some of them have been cast with holes to allow hair and beard to be affixed. Most of the terracotta heads are in the same style, though apparently by different hands; they are smaller, usually about 6 in. high or a little more.

Of all African art the Ife heads excel in restrained naturalism. Their difference from most African sculptural styles led early historians to seek a foreign source for them. But a more complete knowledge has led to the belief that they represented an indigenous culmination of naturalistic tendencies which may have gone as far back as ancient Nok culture, as also the typical bodily proportions with head nearly a quarter of the total height.

2889.

**ILLUMINATED MANUSCRIPTS.** Books written by hand, decorated with paintings and ornaments of different kinds. The word 'illuminated' comes from a usage of the Latin word *illuminare* in connection with oratory or prose style, where it means 'adorn'. The decorations are of three main types: (*a*) *Miniatures* or small pictures, not always illustrative, incorporated into the text or occupying the whole page or part

170A. Historiated initial representing the Prophet Amos. From the *Bury Bible*. (Corpus Christi College, Cambridge, *c.* 1140)

170B. Decoration of acanthus foliage, interlace pattern, and animal's head. Opening initial from an English Psalter (B.M., Harley MS. 2904, late 10th c.)

170C. Foliate border of acanthus intertwining around a double framework and forming decorative rosettes. From the *Benedictional of St. Aethelwold*. (B.M., mid 10th c.)

of the border; (*b*) *Initial Letters* either containing scenes (historiated initials) or with elaborated decoration; (*c*) *Borders*, which may consist of miniatures, occasionally illustrative (*Bury St. Edmunds Psalter*, Vatican), or more often are composed of decorative motifs. They may enclose the whole of the text space or occupy only a small part of the margin of the page.

1. TECHNIQUE. Manuscripts are for the most part written on skin, PARCHMENT, or vellum. From the 14th c. paper was used for less sumptuous copies.

There are two main types of illustration: the fully coloured and the outline drawing. In the former, after the preparation of the vellum a sketch was first made. This was often quite rudimentary and omitted many details. The portions destined for gilding were covered with a base in order that the gold would stick more securely, and the gold was burnished. The main blocks of colour were then laid on. Enough of the under-drawing remained visible to guide the later stages of the work. Finally the details of the drapery and complexions were added. The stages of the work may be seen in the following manuscripts: B.M. Cotton MS. Claudius B. IV (11th c.); B.M. Add. MS. 42555 (mid 13th c.); *Metz Pontifical* (Fitzwilliam Museum, Cambridge, early 14th c.). The colours were usually mixed with a TEMPERA medium made with egg and gum dissolved in water.

A number of books have miniatures and ornaments executed in outline drawing only (*Utrecht Psalter*, 9th c.). These drawings may be in plain ink or in colour (copy of the *Utrecht Psalter* made at Canterbury *c.* 1000, B.M. Harley MS. 603).

2. TYPES OF ILLUMINATED BOOKS. There is no class of manuscript which did not receive decoration in some form or another, but certain books were more apt to be lavishly decorated than others and in particular books connected with the services of the church which were presented by rich patrons to monasteries and other ecclesiastical institutions. Before A.D. 1000 GOSPEL books were fashionable, to be followed in the 11th and the two following centuries by the PSALTER. In the 14th and 15th centuries the BOOKS OF HOURS gained first place. The other lavishly illuminated books were often those which by long tradition possessed an elaborate series of illustration (APOCALYPSE, BESTIARY, *Psychomachia* of Prudentius, Herbals, etc.).

3. LATE ANTIQUE AND BYZANTINE ILLUMINATED MANUSCRIPTS. The earliest illuminated manuscripts are the BOOKS OF THE DEAD from the Egyptian tombs and it is likely that pieces of classical literature, such as scientific texts, were provided with illustrations at an early date. Books from the early Christian centuries lack ornamental initials. Their miniatures are executed in the style of late antique painting, as may be seen in the illustrations in the 5th-c. Vatican *Virgil* or the fragments of an illustrated Bible from Quedlinburg, now in Berlin, of the same date. From the Greek world are the 6th-c. manuscripts on purple vellum (*Vienna Genesis*, and *Rossano Gospels*) and the *Dioscorides* in Vienna, dated c. A.D. 512. Another early dated manuscript is the Syriac *Gospels of Rabula*, A.D. 586 (Laurentian Lib., Florence).

Byzantine illumination retained a good deal of the technique of early painting, but at the same time underwent a number of stylistic changes. Very little survives from before the Iconoclast period of the 8th c., but from the second half of the 9th c. examples occur such as the *Gregory of Nazianus* made for the emperor Basil I between 880 and 886 (Bib. nat., Paris). From the 10th c. there are close copies of classical manuscripts (*Nicander*, Bib. nat., Paris) as well as books whose illuminations, though not directly copied from antique manuscripts, are constructed from antique elements (*Paris Psalter*, Bib. nat., Paris, and the *Joshua Rotulus*, in the Vatican). Other books show a less derivative style. Among the most striking examples are the Psalters with marginal illustration (*Chludov Psalter*, Moscow, c. 900, and the *Theodore Psalter*, B.M., 1066). In the 10th c. there appeared new and elaborate types of ornament of great splendour and complexity which were stylistically derived from the Middle East with no classical antecedents. They can be seen best in the headpieces which began to be very popular (see *Bodleian Picture Book No. 8, Byzantine Illumination*, pl. 29).

From the 10th c. also figures became more stylized and the most distinctive features of BYZANTINE ART were combined with an unsurpassed magnificence of colour (*Homilies of the monk James*, Bib. nat., Paris, and the *Menology*

of *Basil II*, Vatican, 976–1025). With the capture of Constantinople in A.D. 1204 the production of finely illuminated books declined and with certain notable exceptions later manuscripts rarely attained the quality of the manuscripts of the 11th and 12th centuries.

4. HIBERNO-SAXON MANUSCRIPTS. In western Europe also the production of highly decorated manuscripts declined with the fall of the Roman Empire. Some increase of production during the second half of the 7th c. accompanied the revival of learning in northern England which is associated with the name of Benedict Biscop and his monasteries at Wearmouth and Jarrow. The main feature of Hiberno-Saxon illumination is its wealth and elaboration of linear ornament composed of spirals, INTERLACE, and intertwined monsters. There is very little naturalism and even when earlier Mediterranean models were used, as in the miniatures of the Evangelists in the *Lindisfarne Gospels*, they were much stylized. The decoration consists mainly of large pages of pure ornament and the enlarged and highly elaborate initials at the beginning of books and passages (*Lindisfarne Gospels*, B.M., 7th c., and the *Book of Kells*, Trinity College, Dublin, 8th c.). Early examples are found in manuscripts of the late 6th c. (*Cathach of St. Columba*, Royal Irish Academy). The style continued until the 9th c. and is to be found not only in manuscripts from Great Britain but also in some from continental centres colonized by English or Irish monks. Other well known manuscripts in this style are the *Book of Durrow* (Dublin, 7th c.) and the *Echternach Gospels* (Bib. nat., Paris, early 8th c.).

5. CAROLINGIAN MANUSCRIPTS. A group of manuscripts loosely associated with the emperor Charlemagne and the revival of learning in the 9th c. (see CAROLINGIAN ART) comes mainly from northern France and western Germany and dates from the late 8th to the early 10th centuries. The style is extremely eclectic, with features derived from antique, Byzantine, and English sources. An important innovation was the introduction of pages composed of large initials derived from Hiberno-Saxon manuscripts. The figure style was much influenced by late antique models. Some miniatures were direct copies of antique books (*Aratus*, Univ. Lib. lat. quart. 79, Leiden; *Terence*, Vat. lat. 3868). Much of the ornament is derived from earlier Mediterranean sources combined with insular motifs. Separate centres of production can be observed though their exact location cannot always be determined. The main schools were: Court School of Charlemagne (see ADA SCHOOL; *Ada Gospels*, Trier, and B.M. Harley MS. 2788), Palace School (*Coronation Gospels*, Vienna; *Aachen Gospels*), Metz (*Drogo Sacramentary*, Paris), REIMS (*Ebbo Gospels*, Epernay, and *Utrecht Psalter*), TOURS (*Alcuin Bibles*, Bamberg), Franco-Saxon, and St. Gall.

6. OTTONIAN MANUSCRIPTS. From the middle of the 10th c. to the second half of the 11th c. there were a number of German monastic centres

which produced a series of magnificently decorated books in many cases at the command of the German emperor or his immediate entourage (see OTTONIAN ART). Among the most important were REICHENAU on Lake Constance, Fulda, Trier, Echternach, Regensburg, and Cologne. Their products were chiefly liturgical and biblical texts. As with Carolingian manuscripts the sources were varied and EARLY CHRISTIAN and Byzantine models were used, though these do not seem to have been the same as those of the Carolingian artists. They had access to a long series of pictures of the Life of Christ (*Codex Egberti*, Trier, *c.* 980, and the *Codex Aureus*, Escorial, 1045-6). Their initial ornament is marked by the use of highly burnished gold-leaf with little use of colour.

7. WINCHESTER SCHOOL. This famous school developed in southern England in the middle of the 10th c. under the impetus of the monastic reforms introduced at that time. Though some splendid manuscripts came from Winchester, books decorated in the 'Winchester' manner were certainly made in other southern English monasteries. The style is marked by a characteristic fluttering leaf-ornament and by the tossing folds of the draperies (*Benedictional of St. Aethelwold*, B.M.). Simultaneously with the fully painted manuscripts books were produced whose miniatures are executed in outline only; some in plain ink (*Caedmon MS.*, Bodl. MS. Junius II, Oxford, 11th c.), others in various colours (B.M. Harl. MS. 603, an 11th-c. copy of the 9th-c. *Utrecht Psalter*). Many manuscripts have decorative initials only, composed of interlaced and gripping animals' heads. They are derived from early insular sources though transformed by contacts with Carolingian illumination.

8. ROMANESQUE ILLUMINATION. The far-reaching monastic reforms of the 11th and 12th centuries bore fruit in many new foundations and religious orders, accompanied by increases in books and libraries. The majority of the schools of illumination flourished in the 12th c., though there were some important centres in the 11th c. (Saint Vaast at Arras and Mont Saint Michel). It was a period of large books decorated with splendid initials of great variety and magnificence. The repertory of ornamental motifs was enriched by the inclusion of a welter of biting, struggling monsters and men. This was accompanied by a much greater use of the historiated initial. Certain categories of manuscript began to be fashionable, especially the Psalter preceded by a series of miniatures (*St. Albans Psalter*, Hildesheim, *c.* 1120). Large Bibles are almost equally characteristic (*Lambeth* and *Winchester Bibles*, mid 12th c.). Figures in the first half of the century were stylized, with strong accent on folds and gestures but little indication of the body beneath. Towards the middle of the century the stylization began to diminish with the spread of certain Byzantinisms (*Winchester Psalter*, B.M. Cotton MS. Nero C. IV). By the end of the

century the style had developed into early GOTHIC where more classical forms are to be seen (*Ingeborg Psalter*, Chantilly, late 12th c.). In Germany and Italy the development towards Gothic was much more gradual, and both regions retained Byzantinisms to a much later date.

9. GOTHIC ILLUMINATION lasted from the early 13th c. to the end of the Middle Ages. It finds its purest expression in French and English manuscripts of the 13th c. and its latest flowering was in the Low Countries during the 15th c.

From the end of the 12th c. it appears that the production of illuminated books passed from the monastic scriptoria into the hands of lay artists. With the rise of the universities and the increase in non-monastic readers the size of books was reduced, and Gothic illumination is on the whole smaller in scale than that of the Romanesque period. One of the most characteristic features was the development of the marginal GROTESQUE, when the hybrid monsters of the Romanesque initials invade the borders of the page. These DROLLERIES became highly elaborate at the end of the 13th c., particularly in manuscripts from France, England, and the Low Countries. In some manuscripts they develop into a series of marginal pictures unrelated to the text near which they are to be found. They are taken from many sources: the Bible, Lives of Saints, Bestiaries, and Romances (*Queen Mary's Psalter*, B.M., early 14th c., *Romance of Alexander*, Bodl. MS. Bodley 264, Oxford, 1344).

Towards the end of the 13th c. the conventional leaf-work was gradually superseded by naturalistic leaves and plants (*Alfonso Psalter*, B.M., *c.* 1284). In England these changes can be clearly seen in the early 14th-c. East Anglian manuscripts. In France, Paris was the most advanced centre and it is there that the emergence of the individual artist can best be seen in such figures as Honoré (late 13th c.) and Jean PUCELLE (*Hours of Jeanne d'Évreux*, Met. Mus., New York; *Belleville Breviary*, Bib. nat., Paris). Pucelle was also influenced by contemporary Italian painting.

The influence of Italian art is more clearly seen in the Bohemian manuscripts of the second half of the 14th c. produced under the influence of the emperor Charles IV, where it is particularly evident in the figure style (*Liber Viaticus of Johann von Neumarkt*, Lib. of the National Museum MS. XIII. A. 12, Prague, after 1360). It is also found in certain Catalan manuscripts.

Though wonderful manuscripts were produced in the 15th c., illumination now tended more and more to follow the lead given by painters. In the early part of the century there were some famous collectors. Perhaps the greatest was Jean, Duke of Berry, whose library contained magnificent books including the *Très Riches Heures* by the LIMBURG brothers, now in the Musée Condé at Chantilly. Perhaps the most important developments are to be found in the

Flemish manuscripts made in the last quarter of the century. The illuminations were remarkable for their borders, where flowers, insects, and other objects were rendered with the utmost accuracy and realism. Certain important experiments in the manner of knitting the borders to the miniatures were made by the Flemish illuminator known as the MASTER OF MARY OF BURGUNDY. In France the most famous illuminator of the century was Jean FOUQUET of Tours, who decorated the *Hours of Etienne Chevalier*, now at Chantilly. He introduced important innovations in the representation of space.

With the invention of printing the illuminated book gradually went out of fashion. During the early years of the 16th c. fine manuscripts were still being made (*Grimani Breviary*, Venice; *Hours of Anne of Brittany*, Paris), but even at this time they were becoming an anachronism.

During the 15th and 16th centuries illuminations were added to printed books. These usually consisted of initials and borders; miniatures were less common. Some of the finest come from Italy.

306, 326, 327, 328, 332, 583, 710, 751, 1074, 1515, 1840, 1841, 1958, 1987, 2024, 2131, 2176, 2375, 2602, 2818, 2837, 2967.

**ILLUSIONISM.** In much 20th-c. writing on art and aesthetics the term 'illusionism' is applied to the basic principle of NATURALISTIC art whereby verisimilitude in representation causes the spectator in various degrees to seem actually to be seeing the object represented, or the space in which it is represented, even though with part of his mind he knows that he is looking at a pictorial representation and not at the real object or scene. In a somewhat narrower sense 'illusionism' refers to the use of pictorial techniques such as PERSPECTIVE and foreshortening to deceive the eye (if not the mind) into taking that which is painted for that which is real, or in architecture and stage scenery to make the constructed forms

**171.** Detail of painted ceiling by Andrea Mantegna from the *Camera degli Sposi*, Castello del Corte, Mantua (completed 1474)

**172.** Detail of stage in the *Teatro Olimpico*, Vicenza (1580‑4). Designed by Andrea Palladio.
Illusionistic perspective extends the apparent recession

seem visually more extensive than they are. In this sense of the word TROMPE L'ŒIL is the logical perfection of illusionism.

Illusionistic painting and decoration were well known in the HELLENISTIC age and were highly esteemed in imperial Rome. Fictive architectural decorations giving the illusion of spacial recession, illusory wall-paintings with fictive frames, false vistas, painted imitations of decorative marbles or mouldings, were all features of the various styles of POMPEIAN painting, which anticipated most of the forms of illusionism later developed at the RENAISSANCE and BAROQUE periods.

In antiquity and at the Renaissance illusionism was much used in designing interiors, as for example in the patterns of tiled floors, in mosaics, and in the fictive framing of wall-paintings. The shallow forms of a pattern or moulding lend

themselves easily to a *trompe l'œil* effect. The practice of fictive framing was taken by GIOTTO or his associates from late ANTIQUE painting. The framings of the frescoes of the *St. Francis* cycle in the Upper Church of St. Francis at Assisi have fictive painted mouldings and actual three-dimensional mouldings in juxtaposition and the two are indistinguishable from a distance of a few feet away or in a photograph. In the tomb of his *Deposition* (1512) at Orvieto SIGNOR-ELLI mingled real with fictive architectural elements. RAPHAEL used fictive framing in the Vatican *Stanze* (*Mass of Bolsena*, 1512). One of the most impressive examples of illusionism in paint is Baldassare PERUZZI's wall-painting in the Chigi Palace, Rome (1520), showing the view which lies beyond the wall as if seen through an open portico: the painted marble matches the real marble and the light on the fictive columns

appears to come from the real windows, making the highlights truly deceptive. A ceiling painting at Mantua by MANTEGNA in the *Camera degli Sposi* of the Castello del Corte (completed 1474), a product of the 15th-c. fascination with perspective, is prophetic of the great illusionistic Baroque decorations. One of the finest examples of mature Baroque illusionistic decoration is Andrea POZZO's ceiling in the church of St. Ignatius, Rome (*c.* 1690).

Renaissance architects also used perspective devices to extend illusionistically the apparent scale of their buildings. (BRAMANTE's apse of the chancel in the church of S. Satiro, Milan; Francisco BORROMINI's portico at the Palazzo Spada, Rome, which appears to extend much further than it actually does.) A famous example of a similar technique used for the theatre is PALLADIO's *Teatro Olimpico* at Vicenza (1580-4).

The term 'illusionism' is also applied to the techniques used for the construction and painting of the 17th-c. Dutch PEEP-SHOW cabinets, which afford entertaining examples of visual deception contrived by means of a rigorous application of the principles of scientific perspective, particularly the principle of the single fixed eye-point. A good example is that by S. van HOOGSTRATEN in the National Gallery, London.

**IMMORTALS** (Chinese *Hsien*, Japanese *Sennin*). A very common feature in the ICONOGRAPHY of Far Eastern art. They are sages, generally of the Taoist persuasion, recorded in legend as achieving immortality or extreme longevity by means of medicinal and other practices. They are represented as eccentric individuals, often very ancient, with various distinguishing marks of their own. They are especially associated with the feminine symbolism of the peach and the peach garden of the Goddess of the West, Hsi Wang Mu. The God of Longevity, Shou Lou, is represented as a gnarled old man with an unnaturally elongated skull, who holds a peach. Other common symbols of Far Eastern art with a special reference to the cult of longevity are the twisted pine tree, the stork or crane, and the turtle bearded behind with weed.

**IMPASTO.** Painters' term for the application of oil paint in thick solid masses and therefore in contrast to GLAZES and SCUMBLES. Many of the older artists used impasto specially for the highlights (the methods of RUBENS, KNELLER, REMBRANDT). Used more extensively it makes possible the exploitation of variations in surface texture by perpetuating the marks of the brush or other instrument of application. Most notable among the older artists for their utilization of impasto for this purpose are Frans HALS, VELAZQUEZ, MANET, SARGENT, van GOGH. Some modern artists, working with palette knife or fingers or squeezing paint from the tube, have treated oil paint almost as if it were a substance for modelling. Impasto is not possible with WATER-COLOUR or TEMPERA PAINTING and these techniques lack the possibilities of OIL PAINTING for surface and textural variety.

**IMPRESSIONISM.** Impressionism was not a homogeneous school with a unified programme and clearly defined principles but a loose association of gifted artists linked by some community of outlook and banded together for the purpose of exhibiting. Different artists in the group gave prominence to different ideas within the complex of attitudes which art historians have later regarded as distinctive of the movement. Many artists can strictly speaking be called Impressionists during certain periods of their careers only, and some abandoned Impressionism for a time and later returned to it. Even techniques held to be most characteristic of the Impressionist movement were not uniformly practised by all Impressionists. Yet despite this looseness of structure the movement had a kind of coherence and represents something of importance in the development of French painting during the second half of the 19th c.

The first nucleus was formed by MONET, RENOIR, SISLEY, and BAZILLE, who had been fellow students of Marc Charles Gabriel Gleyre (1806-74), a painstaking teacher and an industrious but uninspired painter who had taken over the School of DELAROCHE. In 1863 MANET's exhibition at the Martinet gallery had brought to a head their growing discontent with academic teaching and decided them to branch out on their own. Soon after leaving Gleyre's studio they established friendships with Camille PISSARRO, CÉZANNE, Berthe MORISOT, Armand Guillaumin (1841-1927), and began to meet regularly in the cafés of Montmartre, first the Café Guerbois and later the Café de la Nouvelle-Athènes, and in the studio which Bazille shared with Renoir. The group was joined by DEGAS and by Manet himself. Their meetings included the critics Théodore Duret and Georges Rivière, who edited a paper called *L'Impressioniste*, and they were supported by the dealer Durand-Ruel. In 1873 the Salon rejected pictures by Pissarro, Monet, Renoir, Cézanne, and Sisley and this served as a spur to their decision to take the then unusual step of organizing independent exhibitions of their works. In the first exhibition, opened in April 1874 at the studios of the photographer Nadar, the artists called themselves 'Société anonyme des artistes peintres, sculpteurs, graveurs'. The title of one of Monet's paintings—*Impression : Soleil levant*—prompted the journalist Leroy in *Charivari* to dub the whole group 'Impressionists' and the name, coined in derision, was later accepted by the artists themselves as indicative of at least one significant aspect of their aims. There were eight Impressionist exhibitions in all (in 1874, 1876, 1877, 1879, 1880, 1881, 1882, and 1886) and the name 'Impressionist' was used in all except the first, fourth, and last. The exhibitions were not restricted to members of the group proper and not all members exhibited in all the exhibitions. The

first exhibition included BOUDIN, who had encouraged Monet to paint directly from nature. Gustave CAILLEBOTTE joined in the second exhibition and others, such as Mary CASSATT and FORAIN, came in later. Manet never exhibited with the group, preferring to court the favour of the Salon though with indifferent success. Camille Pissarro was the only one who showed at all eight exhibitions.

It is dangerous to lay down rigid criteria for defining so individualistic a group of artists and the Impressionist movement must rather be described in terms of very general attitudes and techniques from which numerous exceptions have to be noted. By and large the group was in opposition to the academic training of the schools, although Manet and Degas at least were well grounded in the principles of classical art derived from an extensive study of the older masters. They were in revolt from the basic principle of ROMANTICISM that the primary purpose of art is to communicate the emotional excitement of the artist and that the recording of nature is secondary. Against this they were generally in sympathy with the REALIST attitude that the emotional condition of the artist is secondary and the primary purpose of art is to record fragments of nature or life in an objective and scientific spirit as impersonally as possible. They repudiated imaginative art, including historical subjects, and were interested rather in the objective recording of contemporary and actual experience. From one aspect the movement may be regarded as a manifestation of that scientific realism which prevailed during the second half of the 19th c., and just as novelists such as Balzac and the brothers de GONCOURT regarded their novels as pure documentation, though they were not, so most of these painters thought of their job as dispassionate recording of fragments of contemporary life and experience. Their outlook was nevertheless distinct from that of social realism. Social amelioration was not one of their aims and they saw no merit in the representation of vulgarity or ugliness. Within these limits they varied greatly in the subject matter of their recording. In pictures such as *Le déjeuner sur l'herbe, Olympia, Le philosophe,* Manet created a scandal by producing realist versions of traditional themes from Old Masters. Renoir gave expression to his delight in pretty women and children, gay materials, charming landscapes. Degas was interested in horse races, dancers, laundresses, sempstresses, but relatively uninterested in landscape. Sisley, Pissarro, and Monet were primarily interested in landscape.

The idea of recording immediate uninterpreted experience led these painters in many of their pictures to avoid the appearance of formal composition and to seek to convey the effect of accidental and chance disposition as if a camera had photographed a scene at haphazard. This may be seen in such works as Manet's *Le bateau de Folkestone*, Monet's *Le pont neuf*, Degas's *Voiture aux courses*. Yet the impression of accident was deliberate and planned. Degas, for example, composed his pictures in the studio from sketches done on the spot and himself admitted that his compositions were very carefully thought out, and Manet at this time did not paint in the open.

Their ambition to capture the immediate visual impression rather than the permanent aspects of a subject led the Impressionist landscapists to set great store by painting out of doors (in which they had been anticipated by the BARBIZON SCHOOL) and on finishing a picture on the spot before the conditions of light should change. But Manet was converted to the PLEIN AIR doctrine only after 1870 and Degas never reconciled himself to painting in the open. Manet's early Impressionist painting was 'photographic' in the sense that it emphasized tonal values, reproducing the effects of a scene in terms of the light-dark scale at a particular moment of time in particular conditions of light. A major change of direction resulted from Renoir's introduction of the 'rainbow palette' and 'broken colour' or DIVISIONIST technique with the elimination of black shadows and outlines. Landscape painting became an attempt to reproduce the actual image on the retina, to recreate in pigment an equivalent of the animation of a scene in bright sunlight, merging but never dogmatically suppressing local colours. Shadows were not painted in grey or black but in a colour complementary to the colour of the object. With the suppression of outline the object tended to lose prominence and Impressionist paintings became paintings of light and atmosphere, a play of direct and reflected colour. These innovations were introduced by Renoir towards the end of the 1860s under the influence of a chance meeting with the Barbizon painter DIAZ DE LA PEÑA and can be seen in such pictures as *Canotiers à Chatou* and *Le Moulin de la Galette*. They were taken up in the early 1870s first by Pissarro, then by Monet and Sisley. Manet himself, perhaps under the influence of Monet and Berthe Morisot, experimented with the method in the late 1870s, fusing Renoir's spectrum colouring with his own *peinture claire*.

Degas was the leader of the *tranche de vie* aspect of Impressionism, but except in his pastels was hardly influenced by the characteristic Impressionist colour theories. Apart from Renoir, who went his own way, the landscape painters Monet, Pissarro, and Sisley took the lead in experiments with light and colour. The importance attached to rendering immediate impression may be illustrated by Monet's practice of painting many pictures of the same subject seen in different conditions of light and atmosphere (e.g. Sens Cathedral). In their landscapes, painted out of doors or from a window, they developed a sensibility to the effects of weather or season as expressed through light and atmosphere which enabled them to make a genuine contribution to the landscape style created by CONSTABLE and

TURNER. The custom of working in bright sunlight and the adoption of a range of pure hues in an effort to convey the luminosity of nature led to the high tonality and brilliance which is one of the salient characteristics of Impressionist landscape. Their elimination of black and their use of strokes of unmixed pigment on canvases primed with white instead of the traditional brown was empirical and based on direct observation (e.g. that shadows are not grey but are tinted with reflected light in complementary colours). It was this technique which SEURAT and the NEO-IMPRESSIONISTS later endeavoured to put on a scientific basis by the method of POINTILLISM, to which Pissarro for a time succumbed. Monet was the only one who remained consistently and always true to the Impressionist concept and his work is central to an understanding of this aspect of Impressionism. The preoccupation with light and atmosphere—the envelope which surrounds form—and the gradual dissolution of objects as a result of the refusal to model by means of tone, so that the subject matter loses substance, is particularly marked in the later work of Monet, where may also be seen its corollary, the dissolution of space. Nothing is clear-cut or solid, nature disappears into an almost abstract pattern of vibrating colours.

Cézanne was in close contact with the Impressionist Group during the 1870s and went through what is referred to as an 'Impressionist period'. But basically his aims were different from those that were central to the Impressionists. He was not concerned to reproduce the appearance of a scene in terms of transitory effects of light and atmosphere, or with the casual and accidental or seemingly so, but to record his personal vision of the formal relations which pertain among the permanent characteristics of the scene itself. Although his concern with structure was fundamentally opposed to the Impressionist outlook, Seurat considered himself not as the founder of a new style in revolt from Impressionism but as a reformer of Impressionism from within. As has been said, Pissarro was for a period lured to Seurat's Neo-Impressionism. Renoir also during the 1880s abandoned the main features of his Impressionist technique, to return with an added maturity of conception. GAUGUIN collected Impressionist pictures and exhibited in the fifth and subsequent Impressionist exhibitions. Van GOGH's style was revolutionized by his first contact with Impressionist paintings when he came to Paris in 1886. In his paintings after about 1888 TOULOUSE-LAUTREC was largely an exponent of the realist aspect of Impressionism as practised by Degas. At the end of the century MATISSE passed through a brief Impressionist period before his adhesion to the aesthetics of Gauguin. BONNARD and VUILLARD both knew the influence of Impressionism. But the severity of the restrictions which the Impressionists imposed on their artistic aims, in theory if not always in practice, did not commend itself to their successors.

The ideal of realistically recording the immediate visual impression with repudiation of all imaginative elaboration, the elimination of anecdotal and literary content, the rejection of emotional warmth and appeal in the interests of objectivity, and the concentration on the fleeting and casual at the expense of the enduring and monumental —all these proved too austere and the history of subsequent aesthetic movements in European art is very largely a history of the attempt to bring back 'meaning' into the art work. Thus from Gauguin and van Gogh there began a long series of movements which attempted to free colour and line from a purely representational function and to discover how to manipulate them for their intrinsic emotional or symbolic values. A concern for the permanent structure of reality rather than its casual appearances extends from Seurat and Cézanne to the CUBISTS and beyond. The various forms of EXPRESSIONISM from KANDINSKY to Action Painting (see ABSTRACT EXPRESSIONISM) have followed aims diametrically opposed to Impressionist objectivity. The various schools of abstract painting, such as SUPREMATISM and the NEO-PLASTICISM of MONDRIAN, have usually claimed for non-representational art a transcendental or metaphysical truth. Thus the scientific realism professed by Impressionist theory has not survived in the progress of aesthetic theory and aims. Yet it has remained as the main starting-point for modern artistic theory and there have been few if any schools of European art since the Impressionists which have not owed them a debt of one sort or another.

During their lifetime the various Impressionist artists varied greatly in the extent to which they were able to market their pictures. But in general except for a small circle of understanding connoisseurs Impressionist painting was received with bewilderment or suspicion, if not abuse. Of the 1876 exhibition Le Figaro wrote: 'five or six lunatics, one of them a woman—a collection of unfortunates tainted by the folly of ambition— have met here to exhibit their works. . . . What a terrifying spectacle is this of human vanity stretched to the verge of dementia. Someone should tell M. Pissarro forcibly that trees are never violet, that the sky is never the colour of fresh butter, that nowhere on earth are things to be seen as he paints them. . . .' When the academician J. L. GÉRÔME was conducting President Loubet round the exhibitions at the Exposition Universelle of 1900 he stopped him at the door of the Impressionist room with the words: 'Arrêtez, monsieur le Président, c'est içi le déshonneur de la France!' The Impressionist exhibition held in London in 1905 was equally controversial.

In 1884 Manet's paintings were sold by his executors for ridiculously low prices—the Olympia went for £400 and La serveuse de bocks (which cost the Tate £10,000 in 1924) went for £100. But Durand-Ruel had built up a profitable clientele in New York by the middle 1880s; in Russia the Tschoukine Collection was begun

in the 1890s and the Berlin Nationalgalerie began buying Impressionist pictures in 1896. England came later on the scene. The novelist George Moore and Lord Grimthorpe bought a few Impressionist pictures, mainly by Manet and Degas, before 1900, but the Lane Collection was acquired between 1905 and 1912 and the Courtauld Collection between 1922 and 1929. In 1889 Degas's painting *L'Absinthe*, now in the Louvre, was sold at Christie's to a Glasgow dealer for 180 guineas. In 1899 Renoir's *Déjeuner des canotiers* was priced at £884 (sold by Durand-Ruel in New York for *c.* £50,000 in 1923); in 1900 Degas's *Le Ballet* was priced at £564, Pissarro's *River Bank* at £320, and Sisley's *Inondation* at £614. There was a steady but moderate increase in sale-room prices until about 1912, from which time rapid acceleration set in until the cult of the thirties. During the 1950s prices rose tremendously even for inferior Impressionist work and even after allowance is made for the decrease in the real value of money. Some indication of the change may be gathered from the fact that in 1958 the National Gallery raised to a quarter of a million the insurance value on Renoir's *Les parapluies* (bought by Hugh Lane *c.* 1910 for £1,000) and in 1959 valued Degas's *On the beach* (bought by Hugh Lane in 1912 for £3,310) at £50,000.

204, 783, 956, 1651, 1795, 2112, 2221, 2280, 2295, 2461, 2734, 2739.

**IMPRESSIONS.** See PRINTS.

**IMPRIMATURA.** Following the practice of classical and medieval GOTHIC painters (see GROUND) some 15th-c. Flemish and Italian masters of the early RENAISSANCE and also some modern painters toned their white grounds with a thinly applied GLAZE of transparent colour, which reduced the absorbent quality of the ground and could also be used as a middle tone in the painting. This *imprimatura* was sometimes warm (brown, reddish, or yellowish), but usually cool greenish or grey, according to the intended result. It was applied with various media, e.g. resin oil, oil tempera, or glue size. Sometimes, as in the pictures of van EYCK, the *imprimatura* was applied after the preliminary drawing had been made in Indian ink or colour on the panel or canvas; some painters used *imprimatura* over GRISAILLE underpaintings. ETTY applied a thin coat of umber mixed with copal varnish over his under-paintings in black, white, and Indian red to warm them up before the final painting in full colour. (See also PRIMING.)

**INDÉPENDANTS,** SALON DES. Exhibitions of the Société des Artistes Indépendants, founded in 1884 by SEURAT, SIGNAC, and others. The constitution of the Society, which remained unchanged until the First World War, allowed any artist to exhibit on payment of a fee without any selection committee. The exhibitions had

great importance for the development of modern art.

**INDEX OF AMERICAN DESIGN.** A project undertaken by the Federal Government of the U.S.A. during the administration of President Franklin D. Roosevelt to give relief to unemployed artists. Its aim was to record the FOLK ARTS and crafts of the United States from early Colonial times to the end of the 19th c. Under a national director individual States organized local groups of artists. With professional guidance they made faithful water-colour renderings of objects in museums and private collections. It was found that the methods developed in the use of transparent superimposed water-colour washes by Joseph Linden Smith (1863-1950) in connection with the Egyptian department of the Boston Museum of Fine Arts were most suitable for the purposes of making visual substitutes for the originals.

The Index contains coloured drawings of ceramics, furniture, wood-carving, glassware, metal-work, tools and utensils, textiles, costumes, and other objects not so readily classifiable. Some 15,000 finely executed drawings and about 5,000 photographs may be studied at the National Gallery of Art, Washington, and are also sent out on exhibition.

**INDIAN ART.** INTRODUCTION. The art of the sub-continent of India, now comprising India, Pakistan, and Ceylon, can be divided into five groups: INDUS VALLEY ART; Buddhist, Hindu, and Jain art from the 3rd c. B.C.; ISLAMIC ART IN INDIA; RAJPUT PAINTING; and INDIAN, PAKISTANI, AND CEYLONESE ART (19th and 20th centuries). This article deals with the second of these groups.

From the time of the eclipse of the Indus Valley civilization there supervened a period of some thousand years during which any art there may have been in India is unknown to us. Such pottery as has been found is on the whole purely utilitarian, and cannot be rated as art. To this empty period may also belong a number of terracotta figurines substantially of Indus Valley type, with pinched faces, hand-squeezed bodies, and eyes of cut pellets, as well as rock-shelter paintings. The date-attributions of both of these types, however, are highly doubtful.

MAURYAN ART. The historical epoch of Indian art opens during the reign of the third Maurya emperor Asoka (d. 232 B.C.), who ruled almost the whole of India. On a number of stone monuments he caused inscriptions to be engraved in Brahmi characters which supply a great deal of general information about the life and culture of these times. Some of the monuments themselves are excellent works of art of the highest importance, and others that can on grounds of style be associated with the inscribed examples help to form a body of sculpture and stone-cut architecture that constitutes 'Mauryan art'.

The largest group are the pillars scattered in many parts of India from the far north west to the extreme south. They are monolithic polished shafts without footings that bear carved capitals in the symbolic form of full-blown lotus flowers with down-turned petals on the pericarp of which is an animal or group of animals—lion, bull, or horse. Bead and reel mouldings and occasional animal figures in relief complete the decoration of the capital. Other Mauryan works bearing the same high polish on the stone are a group of small caves excavated in the Barabar hills. They are mostly plain, but one, the Lomas Rishi, has a decorative doorway carved in imitation of a wooden arch with relief figures of elephants *passants* alternating with STUPAS. The Lomas Rishi and one other of these caves have an almost rectangular anteroom leading to an almost circular *cella* which probably once contained a stupa. They were most likely intended as shelters for monks of mendicant orders during the rainy season. Other important related early works, some of them of Asokan date, others later, include, at Dhavli, the forepart of an elephant carved in the round out of a rock bearing an Asokan inscription, and at Bodhgava, a number of colossal human figures, male and female, generally referred to as Yakshas and Yakshis, and a large stone throne-slab with a frieze of geese and palmettes around its edge.

EARLY BUDDHIST ART. The earlier Buddhist stupa sites constitute the next important group of monuments with sculptured decoration. The most important early stupas probably existed at the sites associated with the life of the Buddha (see BUDDHIST ICONOGRAPHY). But as these great sites were repeatedly worked over little early evidence now remains there. At Sarnath, for example, the place where the Buddha preached his first sermon, fragmentary remains of carved stupa railings from the early 2nd c. B.C. were found. At Bodhaya, where the bodhi tree, not a stupa, was probably the focus, was found an early railing carved with figures and story reliefs. At Piprawa a very early stupa, scarcely more than a tumulus with relic deposits, was excavated. At Barhut part of a stupa railing—but no stupa—was found which illustrates admirably an early phase of relief sculpture. It is at the site of Sanchi, however, that the successive early stages of the evolution of the stupa can be traced. Some of the members, the gates especially, bear excellent sculptured ornament.

There are three chief types of sculptured ornament at this early stage, all in relief. The first and oldest is the vegetation design, the second the large-scale individual figure, the third the narrative scene. All remained standard types of architectural ornament. It is characteristic of early Buddhist art that the person of the Buddha himself is never represented in the story reliefs. He is indicated only by symbols—such as throne cushion or footprints—a positive means of expressing his transcendant character.

During the 1st, 2nd, and early 3rd centuries A.D. in the Amaravati region, at Nagarjunakonda, Goli, and other sites, a large number of stupas were adorned with elaborately carved relief panels of white laminated stone in a style which was a development out of that which we know from Barhut and Sanchi. Even the facings of the stupa domes were carved. The exuberant sensuousness of the many figures and the lavish complexity of the ornament represent one of the high points of Indian artistic achievement. The bulk and richness of this work testifies to the healthy condition of Buddhism in the south. Much early Sinhalese and south-east Asian Buddhist art, especially the Buddha types, derived from the 3rd-c. art of Amaravati.

MATHURA SCULPTURE. An extremely important centre of art during the early centuries of the Christian era, under the Kushan dynasty, was the region round the great cosmopolitan city of Mathura, not far from the present-day Delhi. Here a great school of sculpture developed whose work, executed in a characteristic pink, mottled sandstone, was exported to far distant parts of India. Much of what survives consists of ornamented pillars and railings for Buddhist and Jain stupas; the earliest examples of this type are in styles not far from those of Barhut, Bodhagaya, and Sanchi. But later developments produced figures in high relief of great plasticity and voluptuousness, the female ones often having a frankly sexual appeal. Among the reliefs are what may be the earliest Buddha figures made on Indian soil. The most characteristic achievement of Mathura was the assimilation of the standing colossus of Mauryan style to Buddhist purposes. Dedicatory figures and developed Buddha figures were derived from this type, whilst deeply plastic figures of the seated Buddha flanked by two regal attendants established the canonical form of image for all succeeding Buddhist art. The art of the Gupta period in central India owed its origin to three centuries of development at Mathura. The massive depth of relief, which was the achievement of 2nd-c. Mathura sculpture, gave place to suave and smoothly linear perfection in the 5th c. The later Buddha figures from Mathura are characterized by their large haloes exquisitely ornamented with foliated scroll-work.

GANDHARA. The Kushan dynasty also ruled the region between the Upper Indus river and Kabul known in ancient times as Gandhara. Here, between the 2nd c. and the 6th c. A.D., was produced a vast quantity of art associated with Buddhist religious architecture. It was paid for by the enormous wealth its patrons gained from trade between the Roman Middle East, India, and China. Its style reflected the cosmopolitan connections of its patrons, for it was deeply influenced by the HELLENISTIC art of Egypt and Syria of the 2nd c. A.D., and in its turn it gave rise to schools of art in central Asia, Wei China, and ultimately Japan. The stupas and monasteries of Gandhara were highly ornate. PILASTERS with Western ACANTHUS capitals were

everywhere, as were acanthus and vine scrolls with PUTTI. Figures wore heavily draped toga-like costume, muscular anatomy was emphasized, Hellenistic comedy mask-types were used, and Greco-Roman legends, such as that of Cassandra and Laocoon, figured in the lavish relief decoration, which extended even to the risers of stairways. Both schist and STUCCO were employed as materials and sculptures were always painted.

The buildings to which sculpture and, no doubt, painting were applied were either stupas, raised high on multiple plinths and surrounded by chapels, or monasteries on the open serai pattern—a court or courts with surrounding rooms. Important sites were at Shahji-ki-Dheri, Takht-i-Bahai, the Taxila region, Sar Dheri, Sahr-i-Bahlol. A hoard of 1st-c. A.D. works of art, including superb Indian IVORIES, Chinese lacquer, Roman glass and reliefs, discovered at Begram illustrates the wide range of taste and the extensive exchange that prevailed in Gandhara at that time. At Bamiyan, a cliff-cut cave-monastery in Afghanistan, two colossal gilt and painted figures of Buddha were carved c. A.D. 350, one 175 ft. high, the other 120 ft. These seem to have served as examples for the colossi of the cave excavations in China at Yun Kang, Lunge Men, and Tun Huang. In central Asia, at oasis sites around the Takla-Makan desert on the East-West trade routes, many Buddhist establishments existed, lavishly sculptured and painted in a style directly derived from that of Gandhara, which formed the basis for the styles of Buddhist sculpture and painting in China, Korea, and Japan, as well as for that of the Tang tomb figurines. Until c. A.D. 1200 the kingdom of Kashmir maintained an influential art style, derived from that of Gandhara, the history of which is little known.

BUDDHIST ROCK-CUT CAVES. In the general vicinity of Bombay there exists a large number of rock-cut caves which contain huge quantities of ancient sculpture and painting. The oldest of these caves belong to c. 200 B.C., and the most recent to c. A.D. 900. The earlier ones are in general Buddhist, most of the later ones Hindu, few are Jain.

The Buddhist caves are of two main types, called *chaityas* and *viharas*. *Chaitya* caves are apsidal BASILICA-like vaulted preaching halls, with arcades and two aisles, and a rock-cut stupa-emblem within the semicircle of the apse. The façade of a *chaitya* cave is characterized by a large, horseshoe-shaped window framed in an ogival hood-moulding, opening into the clerestory above the entrance porch. A wooden lattice would have filled it, and an internal gallery runs across just inside. One or two *chaityas* served generally as the focal centres of a cave-monastery. *Vihara* caves were living caves with the plan of a central court surrounded by cells, sometimes two or three storeys high, and they often had decorated external verandas. A developed monastery naturally contained far more *viharas* than *chaityas*.

The oldest cave in western India is probably cave XIII at Ajanta. It is a small *vihara* with polished walls like those of the Mauryan caves, and so must date from c. 200 B.C.

Thereafter, from c. 150 B.C. to c. A.D. 100, a large number of *chaityas* with attendant *viharas* were cut at such places as Bhaja, Nasik, Pitalkhora, Ajanta, Kondane, Karle, Karnheri, and Manmoda. The age of these caves is determined by the closeness with which they approximate to wooden prototypes for it is clear from many details that they represent as it were sculptured replicas of a type of building made commonly in wood, the originals of which have long perished. The ground-plan of a similar structural *chaitya* has, however, been traced at Sanchi aligned with the main stupa. The earliest caves of this group left important parts of their structure, such as porch, window, and roof-ribs, to be completed in wood. They were also less highly ornamented, though some crude figure sculpture and such motifs as simple rosettes, griffons, and *chaitya*-window designs were employed on them. The later caves of the group were carved out completely in stone and lavishly ornamented with sculptural sequences. Kondane, for example, bears on the façade and on pillar capitals excellent relief panels of dancing couples. Karle, the grandest of them all, a huge excavation comparable in style and date with the gateways of Sanchi, has a complete set of pillar capitals adorned with human couples riding addorsed beasts (save for seven, symbolically crude).

173. Limestone head of Buddha. From Gandhara. (V. & A. Mus., 4th-5th c. A.D.)

The façade bears four colossal couples in massive relief, of deliberate and overwhelming sexual attractiveness, and the sides of the porch are supported by the colossal foreparts of elephants. A later cave, at Kanheri (*c.* A.D. 220), imitates the achievement of Karle on a smaller scale, and with less success. Very much later, in the 6th and 7th centuries at Ajanta and in the 8th at Ellora, *chaityas* were cut on very similar patterns but with ornate, faceted pillars, friezes of Buddha figures, and complex stupas bearing images of the Buddha on their faces.

In the course of time the *vihara* increased in size and its decoration became more elaborate. The earliest, that at Bhaja, is small and contains some relatively crude reliefs of soldiers and narrative subjects which sprawl somewhat over the wall surface. The later *viharas* down to *c.* A.D. 700, such as caves I and II at Ajanta, contain elaborate decoration, both floral and figurative, and reliefs illustrating Buddhist iconography. They also contain a cell in the back wall in which is a colossal rock-cut Buddhist ICON. A special feature of the development of rock-cut art in the western Deccan is the frequent addition on *chaityas*, as well as *viharas*, of later sculpture and painting, older work being sometimes obliterated or recut.

Mention must be made here of three early and still enigmatic *viharas* in the hills of eastern India: the Rani Gumpha, the Ganesha Gumpha, and the Aranta Gumpha on Khandagiri-Udayagiri. They probably date from the 1st c. B.C. Only the Rani has a court, the others consist of cells fronted by a veranda. There are narrative reliefs running over and round the doors, and the remains of large guardian soldiers and beasts, some in the round.

The series of caves at Ajanta is especially famous for its numerous beautiful wall-paintings, all of them dealing with Buddhist legends. They are painted in once-brilliant colours mixed with gum on a plaster ground. The oldest are in caves IX and X and date from the early 1st c. A.D., the latest, in caves I and II, from *c.* A.D. 700. They are vigorous in drawing and their range of invention is enormously various. Some of them, such as the early Shad-danta Jataka in cave X, span a great stretch of wall-space with a continuous narrative. Others, especially the later ones, represent specific Buddhist icons with grace and suavity. Another group of 7th-c. paintings survives in a *vihara* at Bagh. At Aurangabad there is in one cell a magnificent free-standing sculptural group of a female dancer with musicians.

GUPTA PERIOD. The Gupta epoch in northern India is usually held to be the 'classical' age of Indian culture, when literature and learning flourished. Very little Gupta art, however, survives. The Guptas were an imperial dynasty who first emerged *c.* A.D. 320 and had lost their empire by *c.* A.D. 500. The earliest authentic Gupta monument is a huge rock carving of the Boar incarnation of Vishnu at Udayagiti, dated 401, but the main bulk of Gupta art consists of

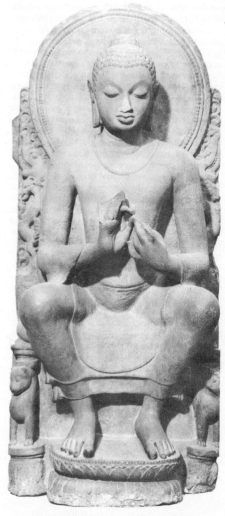

174. Buddha in a position of *Dharmacakra-mudra* connected with the setting in motion of the Wheel of Doctrine, and seated in a natural posture called Bhadrāsana. Sandstone carving from Sarnath. Gupta Period. (B.M.)

Buddhist sculpture, chiefly from Sarnath. This is characterized by an extreme suavity and perfection of surface, and by highly developed relief floral ornament employed with restraint and elegance. Its subject matter is confined to Buddhist icons and stereotypes of canonical incidents in the Buddha's career (see BUDDHIST ICONOGRAPHY). A number of terracotta panels from buildings of Gupta date are known and also a few non-Buddhist stone sculptures.

HINDU TEMPLES, 5TH–9TH CENTURIES. The earliest type of Hindu temple known, of the 5th c. A.D. (e.g. at Sanchi), consists of a simple cell to contain an icon with a small porch of the

same width supported over the entrance by a few pillars. The characteristic doorways carry ornamental bands, framed series of human couples, an image of Shri on the lintel, and images of the goddesses of the sacred rivers Ganges and Jumna at the base of the jambs. This type of ornate cell door became standard for all later Hindu temples. The evolution of the temple proceeded at first most quickly in the south, in the Deccan especially; here a number of shrines which display interesting developments were built between c. 450 and c. 740 under the Chalukya kings, at Aihole, Badami, and Pattadakal. The Lad Khan at Aihole had the usual porch but the cell was enlarged, perhaps following the plan of *viharas* at Ajanta, into a columned court with icon (lingam) cell against the back wall. The Durga temple at Aihole was enclosed in a veranda-ambulatory, and was crowned with a small version of that towering spire which was to become the salient feature of the Hindu shrine. Further north, in central India, between A.D. 600 and 700, the temple of Deogarh was built, consisting of a central spire-crowned cell with four verandas and a cruciform plinth. About two centuries later a large brick temple of similar plan was built at Paharpur with many terracotta reliefs as sculptural ornament.

Under the Pallava dynasty in the extreme south-east on the plains of Tamil country another characteristic style developed, which was imitated by the temple builders of the Deccan. At Badami and Pattakakal temples in this style have a wide pillared hall interposed between the porch and the cell; the interior carries a heavy, deeply curved drip-moulding, and the spire is developed pyramidally from tiers of mouldings alternating with miniature blind pavilions. The sculptures on the exterior of these temples are chiefly icons sparsely set between pilasters. The earliest phase of this development can be seen in some of the *Rathas*—monolithic pavilions—on the cliff at Mamallapuram. These are associated with the magnificent Pallava cliff-carving, containing a vast number of figures on a colossal scale representing a Hindu mythological scene (c. A.D. 650). About A.D. 700 were built in this style the large shore temples at Mamallapuram and Kanchipuram, where the ground plans have been developed into an aligned system of separate pavilions contained in a high perimeter wall. The external tiers of small pavilions, the pilasters, and moulded caves remain. Characteristic columns and pilasters stand upon caryatid lions and have flat, faceted cushion capitals.

One of the most impressive achievements of Indian art is the series of Hindu cave temples cut between the 6th and 9th centuries in the Deccan. The first, at Badami, took advantage of the types of structural temple already in existence, with their mythological panels and decorative brackets carved with affectionate couples. The pillars too owed something to the Badami structural style, with elaborate stepped profiles and panels of relief decoration based on the standard ornamental forms of later Hindu decoration—the flowering vase, laced strings of jewels, and foliated scrolls. At Ellora a huge series of cave temples was cut, culminating in the colossal free-standing monolithic Kailas-a-natha. The glory of these works is their sculpture. Architecturally their plans are simple, but their walls bear a mass of deep-relief sculpture, much of it on a colossal scale and of monumental plasticity, illustrating Hindu mythology and theological doctrine. The wealth and variety of ornamental carving were also enormous. The pillars especially had a wide range of forms, all very broad, variously banded and faceted, with elaborately moulded bases and neckings, bulging capitals that give a true sensation of the weight of the earth above the ceiling and lavish, deeply cut foliate ornament. Perhaps the best known of the Hindu caves is the Shiva cave at Elephanta, near Bombay, with its cruciform plan, superb carvings of the Shiva legend, and its famous *Trimurti*, a triple-headed bust of Shiva, of enormous size and expressive force.

BUDDHIST TEMPLES, 6TH–13TH CENTURIES. In the northern part of India Buddhism continued to flourish, and developed after about A.D. 600 a 'Tantric' form known as the *Vajrayana*, which cultivated an elaborate ritual and elaborate hierarchies of personalized spiritual principles: Buddhas, Bodhisattvas, feminine and terrible 'deities'. By about A.D. 1000 a large number of monasteries had been built, some of them almost the size of cities. Not much of the art of this era has survived, but Udayagiri in Orissa, where a whole hill was given over to a Buddhist establishment with many chapels and stone images, and Nālandā, the great Buddhist university of ancient times, have been excavated. Nālandā particularly yielded many fine Buddhist bronzes. At Sarnath the Gupta school of sculpture continued in existence and many extremely fine later figures in a delicate and slightly more ornate style were produced. From the times of the Pāla kings of Bihar and Bengal especially much art has survived, particularly icons of both Buddhist and Hindu figures in a characteristic black stone and ornate style. Their special importance lies in the fact that in Pāla times, from about 750 onwards, small versions of the great images at the Buddhist pilgrimage centres which lay in the Pāla domains were widely diffused throughout the Buddhist world and strongly influenced its art. When Bihar and Bengal were finally overrun by Islam in 1236, and the monasteries had been destroyed, many monks and artists fled northwards and found refuge in Tibet, there to perpetuate the Buddhist styles of northern India.

LATER HINDU ART. Northern India is scattered with hundreds of medieval Hindu temples in a variety of different styles. Except in specially favoured localities, such as Suashtra and Orissa, the coming of Islam put an early stop to the development of the temple. The surviving buildings follow the common plan of

cell, hall, and entrance-hall; they are raised on often lofty plinths; their curvilinear spires, later with multiple accretions of smaller spires, are emblems of the cosmic mountain which pierces the earth and heavens. Bands of sensuously sculptured figures, representing the inhabitants of the heavens, run round the structure and the whole exterior is covered with complex stepped recesses, mouldings, foliate panels, and tiered flanges to give an effect of great richness and life. Many of the finest of these temples, in western India at Modhera for example, and at Khanjuraho in central India, also contain complex and beautifully fretted stone ceilings, and pillars compounded of bands of dancing figures.

Temples of this epoch were often painted with narrative and iconic scenes, though few examples in good condition survive. At Madanpur in western India is a 12th-c. temple with a ceiling bearing flying figures of the 14th c. and at Tiruparuti Kundram is a wooden ceiling covered with 14th-c. mythical narratives in an 11th-c. Jain temple (see JAIN ICONOGRAPHY). In the west, until about A.D. 1250, the temples became more and more elaborate and profusely decorated, with great open colonnaded dancing halls and tiered verandas. In Orissa a strong local style developed at the temple cities of Bhuvanesvara and Puri, where hundreds of shrines big and small are crowded together. From the early Parasuramesvara (8th c.) to the great Lingaraja at Bhuvanesvara (c. 1000) and Jagannatha at Puri (c. 1100) there was a steady evolution in size, roofing skill, and complexity of ornament, though the high-shouldered curvilinear Orissan spire was retained. At Khiching there was a small but distinguished local school. But perhaps the best known Orissan temple is the Sun temple at Konarak, now a spectacular ruin. Built c. 1200 as an emblem of the Sun God's chariot, with huge ornate stone wheels and colossal draught horses and elephants, it is covered with hundreds of sculptures of heavenly musicians and dancers as well as many erotic scenes. In the far south of India, which escaped Islamic domination if not occasional pillage, artistic styles remained vital until about 1700. Between 1050 and 1300 in Mysore, under the Hoyshalas especially, at Halebid and Belur, a style emerged which was related to the northern style. Its ground-plans and its fantastic incrustation of foliate ornament developed, however, a ROCOCO exuberance. Starshaped cell plans, multiplication of cells mounted on single plinths, were matched by exteriors covered with horizontal bands of deeply undercut sinuous and jewelled ornament and figure sculpture. In the Deccan kingdom of the later Chalukyas and of Vijayanagar (destroyed 1565), which maintained Hinduism in the Deccan in the face of Moslem sultanates, a slightly less ornate derivative style prevailed, as at Palampet. Many of the ruined temples display characteristic smooth, sinuous sculptures of feminine figures in contrast with heavy block-like masculine images in hard, dark polished stone. The temple

architecture is characterized by columns with deep flanges that look as though they have been turned on the lathe. The many stone ruins at Hampi, subjected to a year's systematic destruction by Moslem conquerors, testify to the eclecticism and spiritual exhaustion of the artists of the 16th c.

The true heirs of the Pallava style in the Tamil plains were the builders of the Chola dynasty (c. 985–13th c.). The temples built in this time, some of them very large such as the Brihadisvarasvamin at Tanjore, are marked by pyramidal spires (sikharas) under which may be accommodated the shrine and an ambulatory with radiating cells whose interiors are painted with figures of deities and dancing girls. The plinths of the cell and aligned pavilions are treated with elaborate mouldings, which are also applied in bands to the tiered superstructures. On the relatively plain walls pilasters are interspersed with niched icons of Hindu deities in a characteristic restrained style.

The later phases of the Chola style and the styles of southern architecture which followed were marked by progressive multiplication of the ornamental mouldings of the plinth and the eaves and an increase in size, reflecting the growing wealth and importance of the temples as institutions. Huge gateway towers (gopurams) were added to the extensive enclosures, as at Chidambaram. In the latest phases (17th–18th centuries), for example at Madura, Ramesvaram, and Trichinopoly, the interiors of the colossal halls and colonnaded passageways that filled the enclosures were especially developed. The ranks of complex pillars, based ultimately on the lion-caryatid type of the Pallavas, expanded into enormous bracketed piers incorporating extremely elaborate systems of figure sculpture. Plaster was used to finish the serried external sculptures on sikhara and gopuram, which were painted in brilliant and crude colours.

During the Middle Ages in south India there was an exuberance of bronze sculpture cast by the cire-perdue method (see BRONZE). Processional images, up to about two-thirds life size, were made of favourite deities and Hindu saints and thousands of small images for household worship. These can be dated by comparison with architectural sculpture. Excellent bronze and brass figures were still being made until recent times. Smaller bronze and brass icons were made in many other parts of India, including western India, Bengal, and Orissa.

MANUSCRIPT ILLUMINATION. One characteristic type of medieval Indian art is the painting of miniature illuminations in palm-leaf manuscripts. Excellent examples in the eastern Indian style containing brilliantly coloured iconic figure-compositions are known from Bengal, Bihar, and Nepal; they are chiefly Buddhist texts, though some Hindu texts also survive. From them and work like them are descended the wood-cut and Thangka styles of Tibet (see TIBETAN ART).

In Orissa, from medieval times down almost to the present day, palm-leaf Vaishnava texts were illuminated by drawing with the stylus, rubbing blue into the outlines, and then rubbing in colour. In western India other manuscripts, especially Jaina, were executed with the brush in a vivid calligraphic line and bright colour. There c. 1400 paper came to be used instead of palm-leaf, and later prepared cotton cloth. The styles of these schools were closely linked with the related styles of sculpture.

6, 68, 69, 70, 71, 117, 125, 175, 267, 268, 281, 411, 412, 413, 414, 610, 611, 612, 613, 614, 615, 616, 740, 862, 966, 967, 1061, 1062, 1184, 1203, 1273, 1274, 1469, 1523, 1524, 1525, 1577, 1782, 2172, 2184, 2185, 2207, 2327, 2328, 2333, 2442, 2514, 2600, 2636, 2916, 2949.

**INDIAN ARTS OF NORTH AMERICA.** American Indian art is the product of many different peoples whose cultures varied from those of simple hunting groups to complex agricultural societies which were and still are conditioned by different religious, social, economic, and geographic factors. In many areas of North America—among the Eskimos, the North-west Coast Indians, the Pueblo and Navajo Indians of the south west—this rich artistic heritage has survived with little or no change in workmanship or style for more than a millennium.

It is generally agreed that the ancestors of the American Indian migrated from Asiatic Siberia by way of the Bering Strait, some 20,000 to 25,000 years ago. Their skeletal remains have been found in association with those of mammoth, mastodon, and other extinct mammals. Apparently they came in several waves, and although they all seem to have shared a Mongoloid racial composition, they had different linguistic affiliations. These early immigrants, who travelled with nothing but their crude though efficient weapons and their only domestic animal, the dog, could not have set social and artistic standards. We must assume, therefore, that for the most part the development of American Indian art was indigenous to the American continent, with the exception of some sporadic influences which might be ascribed to trans-Pacific contacts.

As may be expected, art styles show a great diversity throughout the North American continent. Some cultures, or tribes, excelled in weaving or pottery making, others in wood, bone, shell, or ivory carvings. Still others specialized in bead-, feather-, or metal-work, basketry, or the graphic arts. Many of the Indian groups stayed in relative isolation throughout their history, which resulted in the development of more or less homogeneous art styles and techniques. This fact enables the anthropologist to classify the North American continent into six major areas coinciding with well established linguistic, geographic, and climatic regions.

THE ARCTIC. This area comprises the most northerly lands of North America—a vast treeless tundra, which stretches for about 6,000 miles from the Diomede Islands of the Bering Strait to the Labrador Peninsula and includes Greenland and Baffin Island. This is the homeland of the Eskimos. Cultural homogeneity with little or no outside influences prevails, and the arts centre around ivory carving, with an approximately 2,000-year-old stylistic heritage. In spite of this, or possibly because of it, it is one of the liveliest and most dynamic arts of the entire continent. The Eskimos are quite different from the rest of the American Indians and their culture is similar, in many ways, to that of north-eastern Siberia. They are not recent arrivals, however, since archaeological finds indicate their presence in the Arctic area for more than 2,000 years. Living in one of the most inhospitable regions of the world, they are eminently well adjusted to their environment. They have taken full advantage of the limited supply of raw materials at their disposal: walrus ivory and bone, whalebone, seal skin, and some stone and driftwood. They produce skilfully decorated tents, canoes (*kayak* for men and *umiak*, a larger type, for women), clothes, tools, and ornaments. They decorate their ivory objects in a traditional geometric style consisting of engraved lines, concentric circles, and herringbone borders, or with descriptive and abstract motifs taken from their everyday life or mythological past. Their ivory sculptures are miniature figures of men, seals, walruses, polar bears, dogs, and birds, and combine simplicity with realism. The Labrador Eskimos have recently undertaken slate-stone carvings of familiar subjects from everyday life and by the middle of the 20th c. these were rapidly becoming favourite items of the booming PRIMITIVE art markets and metropolitan museums.

THE NORTH-WEST COAST. This area consists of a narrow, 1,500-mile landstrip of cedar, fir, spruce, and hemlock forest, Pacific Ocean off-coast islands and fjord-like inlets, from south Alaska to the State of Washington. This is another isolated culture area, inhabited by the sedentary fisherman groups of Tlingit, Tsimshian, Haida, Kwakiutl, Nootka, Salish, and Chinook Indians, who were obsessed with warfare, caste, prestige, and the acquisition of wealth. Apart from such less developed arts as weaving and basketry the output consisted of totemic or heraldic art, which was developed with exceptional aesthetic sensibility and technical skill, manifested in the exquisitely carved wooden masks and monumental cedarwood sculptures of house posts and grave posts, commonly referred to as TOTEM POLES. The most important motif of the North-west Coast art was the human figure. Images usually represented important chiefs, or such spirits as the 'Bear Woman', 'Wild Woman of the Woods', 'Double-headed Serpent (*Sisiutl*)', the wolf-shaped 'Sea-monster', and the 'Trickster Raven'. Totemic animals, often in human shape, were used as crests by the nobility and were frequently depicted with such extreme stylization that the animal was practically unrecognizable. The most frequently represented

animals were the bear, beaver, wolf, raven, eagle, crane, hawk, frog, shark, and the mighty killer whale. These animal motifs were often combined on totem poles to relate a story or mythical event. Another important characteristic of Northwest Coast art was the concept of bilateral symmetry: splitting a stylized animal motif into halves and stretching it out to show both sides, the heads either facing each other (in the case of mammals), or facing away from each other (to represent birds). The so-called 'X-ray' representations of animals were also utilized by Northwest Coast artists: animals were drawn as though transparent, with parts of their skeleton, joints, heart, and digestive tract visible. Metallurgy was practised prior even to the arrival of the Europeans. Daggers, rattles, bracelets, and masks were hammered out of native copper. The so-called 'coppers', made of heavy sheet copper and used as symbols of wealth, represented the economic and social status of their owners. Fishing gear was lavishly carved and decorated. The people tattooed their bodies with curvilinear symbols and wore ornaments of shell.

CALIFORNIA AND THE GREAT BASIN AREA. The relatively simple food-gathering and fishing tribes of California, parts of Oregon, Utah, and Nevada were the master basket-weavers of the continent. Pottery making was practically unknown, but beautifully executed, realistic steatite amulets of whales, sharks, and fishes were carved by the ancestors of the present-day Chumash and Gabrieleño Indians. Basket-making was of a high technical quality, simple and of good design. Many different basket-weaving techniques were employed, with the spiral-weave method predominant in southern California, the imbricated, double-strand type being preferred in the north, while a mingling of both techniques was characteristic of the central area. The raw materials employed were fibres, roots of willow and spruce, fern stems and hazel bark, in their natural colours of black, brown, cream, and yellow. The general shape of the baskets was conical or spherical, and they ranged in size from a yard in diameter to miniature ones no bigger than the size of a pearl. Decorative motifs were generally geometric combinations of rectangles, triangles, zigzags, and stylized designs of plants, animals, and human beings. The most famed basketry artists were the Pomo Indians north of San Francisco, but the Klamath of Oregon and the Paiute of Nevada are also well known. The Pomos were the manufacturers of the so-called 'jewel' or 'gift' baskets that were richly decorated with colourful feathers and shell ornaments and were used primarily as wedding gifts.

THE SOUTH-WEST. This area includes New Mexico, Arizona, the southern portions of Utah and Colorado, and the eastern section of Nevada. The area affords many different opportunities for food, shelter, and raw materials but imposes severe limitations, chiefly those of aridity. There were two major cultural emphases in the southwest—that of the upland Pueblos, or adobe and cliff house dwellers, and that of the desert peoples, such as the Papago, Pima, Maricopa, Mohave, Walpai, Havasupai, and Yavapai tribes. Both cultures represent sedentary agricultural units. Maize, beans, squash, chili, and cotton were the major crops which, among the southern desert dwellers, were grown with the aid of irrigation. Arts in basketry, pottery, and weaving were carried on in both upland and desert areas, but with different techniques and degrees of conservation of styles. Pictorial and ceramic arts have an almost uninterrupted cultural continuity from about A.D. 200 to 1700, as indicated by the visual remains of such prehistoric south-western cultures as those of the Anasazi, Mogollon (Pueblo), and Hohokam (Pima, Papago). The most celebrated branch of Pueblo art, both ancient and modern, is painted pottery. Each Pueblo had, and still has, its own style and the gradual development of these since A.D. 200 can be traced almost to the present day. Its main attraction lies not only in its form but in its painted decoration. The evolution of geometric design can be followed from simple patterns to complicated frets and coils. Other designs include abstract representations of plant, animal, and human forms, which reached their artistic heights in the so-called Classic Mimbres pottery c. A.D. 1000–1200. The principal types of Pueblo pottery are bowls and jars. Handles are rare. As in most other parts of America, pottery-making was and remained the monopoly of the women. The potter's wheel, as in other native areas of the continent, is unknown and the vessel is gradually built up with coils of reddish-grey clay pressed on top of one another and then scraped and smoothed on both the outside and inside of the vessel. This is followed by the more elaborate technical devices of 'slipping' (with the use of red ochre) and polishing with a smooth stone. Then the vessel is painted and finally fired in the open air.

The strength of Pueblo art lies in its graphic rather than its plastic quality, as witnessed by the large polychrome prehistoric wall-paintings in their *Kiva* (underground ceremonial chambers and shrines). In their agriculturalist, rain-producing ceremonies the Pueblo Indians, like many other native American tribes, use painted and carved wooden masks, decorated in bright colours, representing a diversified pantheon of deities and spirits. Small models of these masked spirit dancers (*Kachinas*) are made as educational toys for the Pueblo children, introducing them at an early age to the religious beliefs and mysteries of the tribe. Besides basketry and weaving already mentioned, silver jewellery work, with shell, bone, and especially turquoise mosaic inlay, was introduced after the middle of the last century.

There are other peoples in the upland (plateau) area who are culturally quite distinct from the predominantly agricultural Pueblos. There are the southern Athabascan tribes, known as Navajos and Apaches. Originally a rather simple

hunting and food-gathering type of society, they moved into the south-west from the north in pre-Spanish times and soon adopted Pueblo agriculture and ceremonialism. After the arrival of the Spanish in 1540 the Navajos and some Apache groups adopted stock raising (mainly sheep), which became even more important in their economic life than agriculture. The Navajos are known today for their beautiful textiles, especially the colourful blankets, decorated predominantly with geometric patterns and more recently with pictorial designs of birds, cattle, horses, and human figures. Some blankets even reproduce designs from the sacred SAND-PAINTINGS, another art form in which the Navajos were masters. Like the refinements of the textile arts, the art of silversmithing was also introduced by the Spaniards to the Navajos, c. 1850. They obtained the silver from old Mexican *pesos*, which they hammered or cast in sand moulds. The popular 'squash blossom' necklace is a copy of the Mexican pomegranate flower. Navajo silverwork is distinguished by its massiveness, simplicity, and by the use of large chunks of turquoise.

The Apaches (particularly the San Carlos group), like the desert-dwelling Papagos, Pimas, and Mohaves, are known mostly for their artistry in basketry. Large, shallow basket trays and great jar-shaped food storage baskets are decorated with geometric designs and interlocking motifs of animals and men.

THE GREAT PLAINS. This is the area of the nomadic, bison-hunting warrior tribes, who lived on the great grassy plains between the Rocky Mountains on the west and the Mississippi river on the east. The Indian tribes (the archetypes of the popularly known 'redskin') who lived in this area (Blackfoot, Flathead, Shoshone, Ute, Cheyenne, Arapaho, northern and southern Sioux, Crow, Omaha, Dakota, Iowa, Kiowa, Comanche, etc.) were dependent on the buffalo (bison) for subsistence, although they also hunted elk, deer, antelope, porcupine, and the much feared grizzly bear. Agriculture was not practised except by tribes (Mandan, Pawnee, Caddo, Ponca, etc.) on the eastern margin of the Great Plains area, where villages and maize agriculture flourished.

The best known characteristics of Plains culture—the mobile hunting of bison on horseback and the extensive warfare—did not come into existence until the introduction of horses from Spanish settlements in the south c. A.D. 1600. At this time many Indian groups of the Great Plains gave up their permanent earth-lodge villages in favour of temporary camps and conically shaped, collapsible bison-skin tents (*tipi*). They abandoned the ancient art of pottery because all their utensils had to be portable, and so the well known *parfleches* (rectangular rawhide pouches in which the dried pounded meat or pemmican was carried), folding backrests or beds, buckskin bags, etc., came into being. Plains Indian artists concentrated on these portable objects and decorated them with highly stylized, colourful symbolic designs. Inspired by the urge for personal ostentation after newly acquired wealth and leisure followed the change from a more or less static to a mobile culture, the Plains Indians took to decorating practically everything they used. The women specialized in the geometric decoration of clothes, moccasins, bags, horse-trappings, etc., while the men's exclusive province became the realistic style of hide painting which, as an anecdotal art form, became almost equivalent to picture writing. The men painted the *tipi* covers (an art that reached its height among the Blackfoot), the drumheads, and the medicine shields. The Crow medicine shields were especially artistic, usually representing a wounded bear or buffalo facing a shower of arrows or bullets. The realistic art style of the Plains Indian men often bears the mark of individuality. The geometric style of the women, however, is essentially traditional and conventionalized. Although some of the geometric designs had names and meanings, these differed from tribe to tribe.

In addition to the painted decoration of hides, the Plains Indians employed dyed, porcupine-quill embroidery to decorate utensils and articles of dress. This art was replaced by colourful bead-work after the introduction of commercial glass beads by white traders in the 19th c.

Stonework was rather limited. Lance-tips and arrow-heads were chipped and club-heads and hammers were ground from siliceous rocks. Pipes were made of reddish-clay stone (catlinite) or from soapstone (steatite) and often had elaborately carved and decorated wooden stems.

THE EASTERN WOODLANDS. Prehistoric Indian art in North America culminated in the stone and pottery sculptures of the so-called 'Moundbuilder' or 'Old Woodland' culture of the eastern portion of the United States, including the Ohio and Mississippi valleys. These prehistoric Indians constructed earthen mounds and gigantic earthworks of different shapes and dimensions (some are several hundred feet long and over 50 ft. high) and for various functions. There are burial, effigy (in the shape of serpents, panthers, birds, etc.), and truncated pyramid-like temple mounds throughout New York, Ohio, Illinois, Wisconsin, Minnesota, the valley of the Mississippi, Arkansas, eastern Oklahoma and Texas, Georgia, and even as far south as Florida. Whether these culture areas were separate or related is not yet clear. The ancient artists of the Hopewell culture (c. 300 B.C.–A.D. 500) in Ohio, Michigan, and Wisconsin, excelled in realistically carved, flat mica sheets. They also excelled in stylized ornaments cut out of copper sheet and in bone incising. The artisans of the earlier Adena culture in Ohio (c. 1000–200 B.C.) produced masterpieces of stone pipes carved in the shape of human figures. The Spiro mound in Oklahoma (c. A.D. 1200) yielded beautifully carved shell gorgets and large stone effigy and T-shaped pipes. Etowah in Georgia

(c. A.D. 1200–1400) has repoussé copper plates in human and bird forms and Key Marco in Florida (c. A.D. 1500) produced beautiful figure carvings in wood. Everywhere, but especially in the Mississippi valley, pottery was made and decorated with geometric and curvilinear designs, and the Caddo area of eastern Oklahoma, eastern Texas, and Arkansas (c. A.D. 1200–1400) is famous for its beautifully shaped effigy vessels. It is very likely that the roots of these well organized, theocratic city states go back to a pre-agricultural, pre-ceramic, hunting, palaeo-Indian horizon, best known for its masterly chipped spear-points and recognized as the Folsom culture (c. 10,000 B.C.). This was followed by an Archaic period (c. 5000–500 B.C.) characterized by its various and beautifully carved steatite and stone artefacts ('banner stones', 'gorgets', 'boatstones', mortars, pestles, scrapers, projectile points, awls, plummets or sinks for fish nets, fish-hooks, etc.). About 3000 B.C. a localized Archaic group, the 'Old Copper' culture, of the Wisconsin and Minnesota Great Lakes area yielded the first hammered-copper tools of the continent (socketed spear-points, adzes, tanged knives, harpoon heads, crescent-shaped knives, etc.). The Boreal Archaic was followed by the Early Woodland period (c. 500–100 B.C.), when agriculture was introduced, the cord-marked, textile-impressed, incised, or stamped pottery appeared, and the first earthen mounds were built. The new agricultural base (maize, beans, squash, tobacco, gourds, etc.) made it possible for the 'Old Woodland Indian' societies to develop and elaborate a well-knit social and religious system to some degree comparable with that of the Maya and Chimu theocratic city states of Central and South America (see PRE-COLUMBIAN ARTS OF MEXICO AND CENTRAL AMERICA). The artistic climax was reached during the ensuing Middle and Late Woodland (100 B.C.–A.D. 1600) and Mississippi (A.D. 1200–1600) periods, after which gradual disintegration set in.

The historic and present-day inhabitants of the north-eastern and central Woodland area are the Algonquian and Iroquoian Indian groups. They developed a decorative art of remarkable quality. As among the Plains Indians, dyed porcupine-quill embroidery on buckskin died out during the 18th c. At this time coloured cloth and glass beads were introduced along with other items of European manufacture, which intensified the decay of native cultures and radically modified Indian Woodland culture.

The Algonquian groups (Ojibway, Cree, Naskapi, and Montagnais) excelled in the utilization of birch bark, from which they produced utensils, vessels, and boxes decorated with scraped silhouette designs of animals (bear, caribou, beaver, etc.) and plant-like abstractions. Weaving still survives among such Great Lakes Siouan and Algonquian groups as the Winnebago and Menomine. In addition to quill-work the Algonquians embroidered birch-bark and buck-

skin with moose, elk, and horse hair, but again the original designs were replaced in the 1890s with European folk motifs and Victorian-style floral decorations made with imported glass beads.

The Iroquois of upper New York State (Lakes Erie and Ontario) cultivated maize, beans, and squash and lived in palisaded villages of elm-bark houses; they hunted, fished, and constructed elm-bark canoes. Until c. 1700 they made pottery with a wide, heavy, squared rim, which was decorated with incised geometric designs and effigy heads at each corner. They carved spoons, bowls, and elegantly designed war clubs from hard wood. They evolved a powerful style of fantastic wooden masks, used by members of the Seneca ('False-face') mutual-aid societies during religious and curing ceremonies. These masks, with their twisted and contorted faces, represented demons and forest spirits and were 'dreamed up' by someone who then proceeded to carve the mask out of living tree, so that it would be endowed with magic powers. The masks were usually painted red, black, and white and had long horsetail or real human hair inserted in the small holes around the edges. The Iroquois also made masks of maize-husks, which were used by the 'Husk-face' societies in commemorative ceremonies.

Other important examples of Iroquois handicrafts (produced in particular by the Huron and Delaware Indians) were the ceremonial or *wampum* belts, made of small tubular beads of white and purple shell *wampum* woven on a small loom into a strip. They were made in order to commemorate famous peace treaties and negotiations.

No important art, except some basketry, survives today among the inhabitants of the once unique civilizations of the lower Mississippi area. In the 18th c. this was the homeland of the famed 'Five Civilized Tribes' (Cherokee, Creek, Choctaw, Chickasaw, and Seminole), but their members are now widely dispersed. In the north-west Woodlands (Mackenzie–Yukon area), the northern Athabascan, nomadic, hunting groups (Kutchin, Sarsi, Ingalik, Dene) seem never to have produced any important art forms, with the exception of some wooden dishes and masks copied from their Eskimo neighbours.

460, 760, 1404, 1477, 2711, 2908.

**INDIAN, PAKISTANI, AND CEYLONESE ART** (19TH AND 20TH CENTURIES). Apart from a few survivals of earlier traditions, especially in the sphere of miniature painting, INDIAN ART suffered an almost complete eclipse under the British regime. A number of European artists worked in India, and during the late 18th and early 19th centuries Indians learned from them the techniques of oil and water-colour painting. There survive a number of early oil portraits by unknown artists in the European mode, but in a genuinely Indian style. In the late 19th c. Ravi Varma achieved fame and prosperity with his

sentimental oil paintings of Indian subjects in a Victorian manner.

In the bazaars of the larger cities of British India, especially in the Ganges valley, from *c.* 1790 onwards Indian artists were prolific of GOUACHE paintings, often on mica, made expressly for the Europeans. These were done in sets illustrating such subjects as *Indian Festivals* or *Indian Types*. Mica was used in effect as tracing paper, and the figures were stereotyped. Nevertheless, a number of genuine native traditions of art survived, generally at a primitive level, out of touch with British influence. These were to play an important part in the revival of Indian art during the 20th c. Such were the Patua paintings of eastern India—illustrated scrolls used by itinerant story-tellers, full of sprawling and vivid figures of gods and heroes—and the Kalighat paintings from the temple of that name in Calcutta. The latter were very low-priced, swiftly and broadly washed-on compositions in water-colour to decorate the homes of pilgrims, and the drastic simplification of forms is reminiscent of the more sophisticated work of such artists as LÉGER. Their subject matter embraced absolutely everything, from gods to cats and Englishmen with umbrellas.

Amid much heated discussion the British established art schools of the Victorian type in India, often with departments catering for the specifically Indian crafts. These still survive, and still turn out, as they did at first, large numbers of capable but uninspired representational artists, most of whom have found it very hard to make a living. Calcutta art school, however, was blessed with E. B. Havell as its head (arrived 1896). He almost alone among the British conceived a passionate enthusiasm for the old Indian art, which at that time was largely the preserve of detached antiquarian study. One of his pupils, Abanindranath Tagore, succeeded him in 1905 and the Bengali revivalist movement began to get under way, sponsored and aided by Abanindranath's uncle, the great writer, Rabindranath Tagore, who was then reaching the peak of his fame. Artists such as Abanindranath, Asit Kumar Haldar, and Nandalal Bose attempted, in a water-colour technique still owing a great deal to Victorian outline drawing and pallid colour, to reconstitute a truly Indian tradition. They painted subjects from Indian history and legend and used many Oriental accessories. Their knowledge of ancient Indian art was, however, very limited. Some of them had worked as copyists of the Ajanta Cave paintings but post-Moghul Delhi paintings seem to have supplied their chief inspiration. The artists came to be revered, despite the somewhat febrile appearance of their pictures, as heroic exponents of the growing nationalist movement. When the Tagore art school was established at Shantiniketan (1921) Nandalal Bose became its head. Perhaps the most artistically successful exponent of the style of painting which emanated from it was the Pakistani Rahman Chughtai.

The next phase of artistic development in India consisted of the deliberate assimilation of Western ideas by Indian artists who aimed at more than parochial achievement. In 1928, at the age of 67, Rabindranath Tagore began to exhibit pictures of his own. These were free, semi-automatic drawings and water-colours, perhaps inspired by the example of KLEE. They gained world-wide acclaim, even for a time in the Soviet Union. But their fluid, deliberately unprofessional manner was too personal to serve as the basis for a school.

In the 1930s and 1940s a number of artists reached a more satisfactory synthesis of Eastern and Western modes. The chief of these was Jamini Roy (1887- ), who attempted a revival of Patua and Kalighat ideas executed in a dense, highly finished gouache medium. Such deliberate revivalism was only possible in the context of Western modernism with the new value it placed on so-called PRIMITIVE arts. His attempt at joint workshop effort in producing pictures in bulk has not been generally regarded as successful. Amrita Sher Gil (1913-41), whose father was a Sikh and mother Hungarian, studied art in Paris before going to India. Under the influence of GAUGUIN she then began to paint the humble people of India in large, carefully constructed and colourful compositions (*Hill Women, The Brahmacharis*), that are by any standard great works of art. When death cut short her career at the age of 28 she was opening a new phase of her art. But even so her influence was considerable on many of India's leading contemporary artists, such as N. S. Bendre and K. K. Hebbar, both in subject matter and in technique.

A number of Indian artists have worked with success outside India, giving an Indian flavour to various contemporary idioms. In India itself many of the most promising artists were patently indebted to influences from the West. Both V. S. Gaitonde and R. Gade owed much both to analytical CUBISM and to Klee. K. S. Kulkarni worked out an interesting interpretation of reality elements in depth based ultimately on PICASSO. S. Dave effected a reconciliation between the soberly dignified abstractions of De Stael, Amrita Sher Gil's iconography of village life, and the strong unsubdued colour which is indigenous to Indian tradition. Amina Ahmad assimilated something from DUBUFFET and ART BRUT, while Laxman Pai represented Indian legend with expressiveness and dignity, painting in a contemporary idiom which owed less to specific influences. M. B. Samant and M. F. Husain, two of the most important of 20th-c. Indian painters, use heavy IMPASTO and violent colours for much simplified images of human form.

In Ceylon George Keyt (1901- ) modelled himself on the deliberate dislocation of reality by interpenetrating lines and angular overlapping planes which characterized Picasso's work from 1929 to 1931, applying this technique to traditional Indian subjects drawn from Buddhist and Vaishnava legends. In Ceylon also

J. Daraniyagala evolved a style in which he assimilated vigorous EXPRESSIONIST brush-work to Eastern decorative modes.

Sculpture as a living modern art began again in India only during the late 1930s. Ram Kinker, an alumnus of Shantiniketan, specialized in architectural sculpture in a style strongly influenced by RODIN and often on a large scale with a leaning towards social REALISM and occasionally brutal execution. Dhanraj Bhagat produced rapid figure groups based on looped tubular forms in many media. Amar Nath Seghal learned from LAURENS and ARCHIPENKO, but was still content on occasion to make elegantly stylized versions of the generally accepted nationalist iconography of village life. Chintamoni Kar gained international recognition as a realist. Amina Ahmad executed some adventurous concrete reliefs in non-figurative style for the buildings of the All India exhibition at Delhi in 1955.

2333, 2514, 2600.

**INDIVIDUALISTS.** A term applied comparatively recently by some Western historians of Chinese painting to a number of artists of the 17th and 18th centuries. Their styles differ greatly; what they have in common is an almost startling freshness of approach to the traditional subjects of Chinese painting. They were mostly outside official circles and their unusual brush-work—sometimes crude, sometimes at first sight careless—seems deliberately to flout the staid, established styles of brush-work fostered by the officially recognized and favoured schools. It is true that in their writings the Individualists often paid lip-service to the Old Masters, but their calligraphy and painting reveal a conscious revolt against the traditional, often wearisome repetitions which the *wên-jên* painters of the Ming period (see CHINESE ART) had made into dogma. Their work, which is often full of humour and spontaneous, unexpected ink-effects, constituted the most vital stream of painting in China after 1600. Their influence in their own time was strong and even 20th-c. Chinese painting owes much to the movement which they initiated. Nineteenth-century Japanese painting also was indebted to them.

Noteworthy among the Individualists are CHU TA, TAO CHI, Wang To, and a group of eight scholars, poets, calligraphers, and painters whose activities were centred on the provincial city of Yang-chou, famous for its brilliant social and cultural life. These 'Eight Eccentrics of Yang-chou' were Chin Nung (1687–1764) and his pupil Lo P'ing (1733–99), Chêng Hsieh (1693–1765), Li Shan (active *c.* 1710–*c.* 1740), Li Fang-yin (1695–1745), Kao Hsien (*c.* 1650–1700), and two others, sometimes named as Kao Fêng-han (1683–1743) and Min Chên (*c.* 1740–1800).

The so-called Individualists stand out the more prominently in the history of Chinese painting because the reverence for tradition was in general far stronger in China than in the cultures of the West and the premium set upon originality and novelty was correspondingly less. The notion of art as a mode of individual self-expression arose primarily from the association of art and literature which produced the talented amateur, the artist scholar, who regarded calligraphy and painting as a form of aesthetic play.

**INDONESIAN ART.** The prehistory of Indonesia begins with the Neolithic Age, from which period characteristic rectangular stone axes of expert workmanship and excellent shape have been found in central and southern Sumatra, Java, Bali, and elsewhere in Indonesia. Small stone adzes from this period indicate that the Indonesians must have engaged in wood-carving of a fairly delicate kind in neolithic times. Dolmens marking burial grounds and megalithic monuments carved with lively representations of human beings and animals have also been found extending from the Neolithic Age into the cultures where bronze and iron were used.

From the Bronze Age come axes which, owing to their different shape and structure (the haft is socketed into the blade and not vice versa), are thought not to be a development from the stone axes but the result of a new influx from the Dong-Son culture of Tongking and northern Annam. But ceremonial bronze axes found in Indonesia have a characteristic asymmetry which contrasts with those of Dong-Son. There have also been found drums of cast bronze decorated with figures and geometrical designs, including the 'Moon of Bali'—a magnificent piece of bronze casting and described as the largest kettle-drum known in the world. But it is not certain whether these drums were cast in Indonesia or imported at a later date. In this period also, extending from the latter half of the first millennium B.C. to the 1st c. A.D., there first comes into evidence, probably under influences from the Dong-Son and late Chou cultures (see CHINESE ART), the unusual fertility of decorative motifs and techniques which has remained a distinguishing feature of Indonesian art through the Indian and Islamic periods until almost the present day. The felicity with which figure and other representational themes are combined with decorative motifs and the partiality for decorative representation in the designs of fabrics and other articles of use already gives a special *cachet* to objects of Indonesian provenance.

Except in the islands of Java and Bali, where the effects of Hindu and Buddhist infiltration were more persistent, the general pattern of ornamental design which was established about the beginning of the Christian era survived as the main formative current in applied and ceremonial art until relatively modern times. Plaiting and weaving techniques were used in the manufacture of textiles and ornamental patterns, often complex, were obtained by the tie-dyeing method.

Many of the motifs were associated with ceremonial or ritual occasions, but apart from religious significance ornamental designs were held in esteem for their intrinsic beauty. Beadwork developed to considerable complexity, glass beads being imported from Venice in the 15th c. Ceramic techniques were not highly developed but terracotta figures of human beings and animals from southern Celebes and elsewhere achieved something of the air of serenity which characterizes the wood-carvings. Apart from decorative wood-carving for the ornamentation of houses, free-standing figures were made both for the purposes of ancestor cult and for apotropaic magic, to provide protection against the powers of evil (so-called *hampatongs*). The ancestor figures in particular achieve an impression of serene dignity and poise which removes them from any suggestion of the primitive. The decorative facility of the Indonesian peoples found expression in innumerable other articles of applied art, often made in perishable materials. In general they lacked that feeling for permanence which dominated for example the art of the Egyptians, but rather made the love of decorative beauty a universal feature of daily life.

Indian penetration began in Java about the 8th c. and lasted until *c.* 1450 when the spread of Islam caused its collapse. With it came Hinduism and Buddhism, both modified in accordance with the mystical and syncretistic Indonesian outlook, and the corresponding artistic styles and iconography. The religious and cultural Indianization was in the main an aristocratic movement, exercised through the princely dynasties or *kratons*, and the earlier artistic values no doubt continued relatively unaffected among the peasant population. Bali began to come under Javanese domination in the last decade of the 10th c., and after the collapse of the Javanese kingdom of Madjapahit *c.* 1520 Hindu-Javanese art and culture were perpetuated there until that island came into the possession of the Dutch in 1908, since Bali escaped the dominance of Islam. From the Hindu-Javanese period come some of the most magnificent monuments of the East, though preservation has been bad and in many cases deterioration went too far for effective restoration to be possible. In the central Javanese period both architecture and sculpture showed affinities with the Indian Gupta style (see INDIAN ART). Modifications in the later eastern Javanese period have been attributed by some to renewed influence of more ancient indigenous concepts, particularly that of ancestor worship, though Indian art historians find in them evidence of greater eclecticism in the combination of various Indian religions.

The *tjandi*, a combined temple and sepulchral monument, was characteristic of Indonesia. Although the Javanese *tjandis* evince the influence of Indian architectural styles, examples have not been found in India. The oldest group of *tjandis*, now in ruins, are on the Dieng plateau of central Java. They fell within the orbit of Brahmanism, being dedicated to Shiva. The earliest datable *tjandi* (A.D. 778) was built under the inspiration of Mahayana Buddhism of Bengal and dedicated to the goddess Tara. The large bronze statues which were originally housed by this and other *tjandis* are no longer extant. Borobudur, an example of STUPA architecture, surpasses in size and magnificence the temples of India and with the ANGKOR VAT of Cambodia is reckoned to be one of the wonders of the Orient. Built *c.* 800 during the Shailéndra dynasty, it was allowed to fall into ruin after the end of the Indian period and was restored in 1907-11. The Borobudur is a symbol in stone of the cosmic system of Mahayana Buddhism, designed for the purpose of worship, veneration, and meditation. The bas-reliefs on the base depicted events and scenes of everyday life when man is still bound by desire and subject to the law of Karma. From here the pilgrims ascended through four receding galleries decorated by bas-reliefs depicting the life of the Buddha and representing the successive stages towards perfection, culminating in Enlightenment. According to the Indian historian Radhakmal Mukerjee (1964), if laid end to end these reliefs would cover a space of about three miles. They were described by the great orientalist Coomaraswamy as 'a third great illustrated Bible, similar in range, but more extensive than the reliefs of Sañchi and the paintings of Ajanta'. Above the reliefs are niches for statues of *dhyani* Buddhas, each pointing with a symbolical gesture or *mudra*. Above the terraces are three concentric galleries with 32, 24, and 16 open stupas and culminating in a supreme closed stupa rising from a lotus pedestal in the exact centre of the edifice. As a metaphysical cosmology in stone this structure has not anywhere been surpassed. Of the same order of importance as Borobodur was the *tjandi* complex of Prambanan, built *c.* 915 by King Daksha of the Shivaist dynasty of Mataram. It was partially restored in the 20th c. but owing to extensive demolitions and the use of the stone for commercial building only part could be reconstructed. The whole monument follows the plan of Indian hierarchical temple architecture and the largest and most important, central *tjandi* of Lara Djonggrang contains an impressive statue of Shiva incarnate as the supreme god Mahādéva in the standing posture with four arms, holding the traditional implements. On either side, beside the entrance gates, are statues of other incarnations of the deity, Mahākāla and Nandisvāra. There are 42 bas-reliefs illustrating part of the story of Ramayana. The whole has been compared with the temple of Kandariya Mahādéva at Kharjuraho, as the two most exemplary gems of temple architecture inspired by the Indian religions. The most important monument of the eastern Javanese period is the temple complex of Panataran, with three temple courts set asymmetrically one behind the other.

After Java fell under the domination of Islam

the Indian-Javanese culture was perpetuated in Bali, forming a synthesis with indigenous Balinese elements, and many features continued to be an integral part of the life of the people until the 20th c. Bali has been called the island of a thousand temples. In addition to shrines of national importance each village has its temple (*pura-désa*) about which the life of the community gravitates. The basic plan of the Balinese *pura* (which allows of many variations) consists of three open temple courts enclosed by walls and connected by gates, which are often elaborately constructed and carved and may be approached by terraced stairways. In general Balinese ornament was more florid and exuberant than in Java. The temples do not contain images of deities, for whose spiritual and invisible presence a stone lotus-seat was provided. The deities are represented by *merus*, symbols of the celestial mountain, many-storeyed structures with up to 11 roofs receding one above the other over an elaborately decorated stone base. The eminence of the god is indicated by the number of roofs. Most characteristic among the many other shrines are the temples to the dead (*pura-dalem*) erected near the cremation grounds. Outstanding among the temple structures of Bali is the 14th-c. sanctuary of Besakih of the kingdom of Gèlgèl on the slopes of the mountain Gunung Agung. Sculpture in Bali was chiefly developed in lavishly ornamental and polychromed woodcarving, which included apotropaic representations of demonic powers.

Islam spread to Indonesia not by conquest but through commercial channels from northwest India as local princes in Sumatra and Java accepted it for economic and political reasons. Further impetus was given by the fall of Malacca first to the Portuguese in 1511 and then in 1641 to the Dutch, who established a monopoly of the valuable spice trade. The mystical aspect of Islam appealed to the Indonesian temperament and the traditional Indonesian ancestor cult was accommodated into the Islamic ritual, while the Moslem ban on the making of images was not strictly enforced. But the period of great building and stone sculpture was over, whereas the centres of wood-carving were affected by the period of unrest which followed the introduction of Islam and the discovery of Indonesia by the early European traders. Of most interest in the field of applied art were BATIK textiles and decorated armoury. The kris was not only a national weapon but had ceremonial and religious significance, endowed with magical powers through a recondite traditional iconography. The elaborately decorated krises represent a high peak of ornamental metal-work. Important also are the *wayang* puppet shows of Java and Bali and the masked dances of Bali and other islands. The *wayang* shows had a religious and mystical significance going far back in native tradition and survived both Indian and Islamic cultural infiltration. The puppet figures, cut in parchment and elaborately coloured and decorated, belong to traditional types and developed a characteristic form of stylization, influences from which have sometimes been alleged in carvings of the eastern Javanese Indian period. These figures are among the most individual manifestations of Indonesian art and have become most generally known in Europe from reproductions and reflections in textiles and embroideries.

During the 19th and 20th centuries the traditional folk arts have been progressively eliminated in most areas by economic contacts with the West and by importations of Western textiles and other factory-made goods. Attempts to mechanize the *batik* technique and to establish an indigenous weaving industry led to a decline in craftsmanship and economic changes caused the disappearance of many other skills such as woodworking and metal-craft. The influence of Christian missions also told against the perpetuation of traditional decorative motifs, whose profound significance belonged to a way of life and belief which were passing. In Bali a new painting style, tight, tapestry-like and decorative, has some interest and since the recognition in 1949 of Indonesia as an independent state there have been attempts to create a new national art based upon deliberate primitivism.

258, 481, 613, 647, 919, 1185, 1409, 1531, 1885, 1901, 2183, 2412, 2580, 2747, 2783, 2965.

**INDUSTRIAL ARCHITECTURE IN THE U.S.A.** The factory, as a building type, came to America from England in the late 18th c. (Slater Mill, Pawtucket, Rhode Island, 1793). The earliest American mills, such as the Lippitt mill, Lippitt, Rhode Island (1809), were small and domestic in scale. At one end or at the centre of the roof was a cupola which housed the factory bell. Another distinguishing feature was the monitor window, a long continuous dormer-like window which ran the entire length of the roof and gave light to the attic storey.

As the century progressed the factories increased in size and the monitor window disappeared, leaving a common pitched roof. The cupola was replaced by an outside tower which housed the stairs and also contained a water tank for the sprinkler system. These towers became the centre of decorative interest and were used as monumental features in the design. A good example is the White Rock Mill, Westerly, Rhode Island (1849).

The construction of the American factory was conservative. The British, in an effort to make their mills fireproof, had used iron as a structural material as early as the 1780s. But the American iron industry, overwhelmed by the demands of an expanding railroad, was not capable of keeping up with factory construction. The builders developed instead a technique of masonry walls with wooden interior framing consisting of large widely spaced beams carried on wooden posts and supporting a 4-in. double plank floor. Known as 'slow-burning construction', it was so successful in reducing the loss by fire that it remained

the standard method of mill construction until the early years of the 20th c.

Stylistically the American factory remained simple. In some areas of New England the conservative Classicism of the FEDERAL STYLE prevailed well into the mid 19th c. (Bay State Mills, Lawrence, Massachusetts, 1850). Elsewhere Greek and Italian VILLA details appeared, especially as decorative elements in the tower. In general, however, the main body of the mill remained starkly unadorned (Harris Manufactory, Harris, Rhode Island, 1850). From the 1850s onwards the LOMBARD ROMANESQUE, because it could be built in brick with economy and simplicity, was taken up by mill designers and was continued as the predominating style into the early 20th c. (Berkshire Manufacturing Company Mills, Adams, Massachusetts, 1889 and 1896).

During the first half of the 19th c. the architecture of the workers' houses was remarkably good. In the town of Harrisville, New Hampshire, they exhibit the same level of architectural taste as the mill or the owner's house or the church. In some of the large planned communities, such as Lowell, Massachusetts, the boarding-houses built for the female workers were comparable to the Boston town houses of the BULFINCH era. After the Civil War the situation was reversed. The mills increased in size and impressiveness but the houses of the workers degenerated into the endless terrace houses of the late Victorian era.

The general form of the American factories of the 19th and early 20th centuries was determined largely by the fact that the power, whether provided by water or steam, was communicated to the machines by shafts, pulleys, and belts. The most efficient building type for this technique proved to be the long narrow rectangular box several storeys high. This is the familiar form of the 19th-c. American factory, and no fundamental change in its character was possible until the introduction of electricity as a source of power, early in the 20th c. With the power fed through electric cables directly to the machines themselves, a greater flexibility in the design of interior space became possible and, together with the introduction into factory construction of steel and reinforced concrete, it produced a wide variety in factory design, with each building arranged to accommodate the work to be performed within its walls. Perhaps the most dramatic innovations were those to be found in the automobile industry, beginning with Albert Kahn's Ford Factory in Highland Park, Michigan (1910–17) and culminating, under the pressures of assembly-line production, in the low horizontal stretch of the famous Willow Run Factory for the Ford Motor Company (1942), also designed by Kahn. Since the 1930s other outstanding architects have become increasingly involved with industrial buildings. Among the more imaginative and humanized works of the 20th c. are Frank Lloyd WRIGHT's Johnson Wax and Research Center, Racine, Wisconsin (1936–

9), famous for its daring use of reinforced concrete, and the General Motors Technical Center, Warren, Michigan (1949–56), designed by Eero Saarinen (1910–61), son of Eliel SAARINEN.

**INDUSTRIAL ART.** The term 'Industrial Art' is peculiar to the English language. It embraces all design related to objects produced in industry, from bottle tops to aeroplanes. Together with the term 'Industrial Design' it has advantages over APPLIED ART or *arts decoratifs*, which carry an overtone of artificiality or preciosity and embrace both more and less than 'industrial art'.

Taken in a wider sense, industrial art is as old as industry and includes important early efforts like Wedgwood's manufactures at Etruria and the manufacture of Sheffield plate. The use of the term in the narrower sense has developed during the past hundred years parallel with modern architecture and with a growing consciousness of the aesthetic responsibility of the manufacturer and the designer. The history of industrial art is complicated by the fact that since the middle of the nineteenth century, and particularly since the Great EXHIBITION of 1851, to a small but eminently vocal group industry and art became incompatibles (see ARTS AND CRAFTS MOVEMENT). The atrocities of taste and the ineptitude of applied art, which culminated in that exhibition, turned many artists, notably William MORRIS, away from mass production altogether. Any history of design, not only in England but in the whole Western world, has to reckon with two seemingly opposed viewpoints, the one in favour of, the other against, the machine. The notion that it is not only a duty but a privilege for the modern artist to design for industry came very late, despite the fact that much industrially produced art of the second half of the 19th c. is far from contemptible. The Austrian architect Adolf LOOS was among the first, in the 1890s, to point to the fact that the good machine-made object is not only a possibility but a fact, and is often preferable to the hand-made object which represents a way of life no longer in keeping with the times. Conscious efforts to make designs for machine goods which were not imitations of designs for hand-made products gained in importance from *c.* 1900. Holland gave a lead in this endeavour, with designs notably for glass (BERLAGE and De Bazel). Between the wars the development of the motor industry enhanced the general consciousness of the task of design in industry. It is noteworthy that Voisin, the motor manufacturer, financed LE CORBUSIER's now famous Pavilion at the Paris Exhibition of 1925. Le Corbusier's role in the future growth of FUNCTIONALISM cannot be overestimated, nor should the BAUHAUS be forgotten as a laboratory of ideas on design. Since the Second World War new fields have been opened, both in Europe and America, and some progress has been made

towards universal standards. In England, especially since the consolidation of the Council of Industrial Design and the 1951 Exhibition, the training and employment of qualified designers for industries has made rapid strides.

909, 2067.

**INDUS VALLEY ART.** The earliest true works of art found on Indian soil come from the city sites of the Indus Valley civilization. The four most important of these sites are Mohenjo-daro, Harappa, Lothal, and Chanhu-daro. The first two were probably capitals. Harappa was the most important but its site was almost entirely destroyed in the late 19th c. for railway ballast. Mohenjo-daro has been archaeologically excavated in part. Chanhu-daro, much smaller than the others, seems to have contained a bead factory.

About the year 4000 B.C. semi-nomadic peoples on either side of the Iranian plateaux adopted a settled form of life, and by about 3000 B.C. had developed styles of painted pottery adorned with schematic animal figures, and the rudiments of pictographic scripts closely related to the schematic pottery ornament. A number of sites are known in Baluchistan and round the fringes of the upper Indus Valley which to some extent shared in this cultural heritage. From one or other of the branches of this culture-type—possibly of Rana Ghundai type—the great Indian cities of the 2nd-1st millennia B.C. developed. At that time the Indus Valley must have been well watered and densely forested. The cities were built largely of fired brick, with wooden floors, staircases, and roofs. A raised 'citadel' dominated the site and on top of it at Mohenjo-daro there was a bathing tank and a 'collegiate' building, possibly of ritual significance. The street plan was almost perfectly rectangular, with broad main thoroughfares, smaller side streets, and still smaller alleys. The houses themselves were of rectangular plan, in the form of enclosed courts. There was an elaborate, well-built drainage system and baths in the larger houses. The extreme conservatism of this people, perhaps a natural consequence of stringent rule, is revealed by the fact that for some 1,500 years the streets and street frontages of the houses remained the same. Other evidence of this conservatism is the continued use of flat blades for spear and sword, when Mesopotamia had discovered the virtues of the centre rib, and adherence to the stamp seal, whereas Mesopotamia had come to use the cylinder: this despite the fact that trade relations were established between the two riverine cultures.

It is most extraordinary that no trace of decoration, in colour or plastic, was found on any of the houses. Altogether relatively few works of art have come to light at all. What there is falls into five chief classes: painted pottery, seals, terracotta figures, bronzes, and carved stone. There was a large number of decorative objects, especially beads and bangles, but they were in general of no great artistic interest.

The painted pottery found consists of jars and sherds of pots of many sizes, up to large storage jars, of reddish or buff ware. The designs were painted chiefly in black over a red ochre slip. Variations of the 'tree of life' pattern, trefoils, diapered quatrefoils composed of intersecting circles and the stylized images of animals, birds, and occasionally men, form the bulk of the designs, which are drawn freely on the body of the pot. Some of the shapes of the wheel-thrown pottery are magnificent in themselves.

The stamp seals, with the fired terracotta sealings made from them, constitute the largest and far the most interesting group of works of art from the Indus Valley. They are all more or less rectangular in shape, 2 in. or less, and are incised with emblems and/or pictographs of the as yet undeciphered Indus Valley script. The most elaborate of them bear what can only be described as miniature pictures in intaglio (see GEMS), often with several figures in a well developed spatial relationship. There are representations of divinities: one is horned, ithyphallic, seated knees akimbo, said to be an ancient prototype of Shiva, lord of beasts; another is crowned with a sacred emblem among the branches of a tree. There are bulls, elephants, garial, snakes, and men, and even scenes of bull-wrestling and bull-vaulting. The best explanation of these seals is that they were the personal insignia of individuals, used in marking merchandise and attesting contracts.

The terracotta figures form a large group. They are of many types. Some are probably toys, such as the little humped bulls with clay carts and monkeys, some with jointed parts to be moved with a string. Others appear to have had a religious significance, particularly the bull-headed human figures and the 'Mother Goddess' types formed by a characteristic pinching technique at the waist and on the beaked face, with eyes made of applied pellets and the surface incised and dotted with a stick. Both animal and human figures are covered, like the pottery, with a red ochre wash. Some of the human figurines are clothed in sheets and strips of folded clay, with elaborate head-dressing, and the females are thought to presage the Śunga figurines of the Goddess of Fortune some 1,500 years later.

Bronze-craft was of particular importance in the Indus Valley. Tools, weapons, and implements of all kinds were of bronze, and there was a number of bronze sculptures including the famous 'dancing girl'. There were also sculptures in stone, although those which survive are all very small. The best are the bust of a bearded man, wearing a robe with a trefoil pattern, and two male torsos with sockets for inlaid pieces. One of these torsos has a sensuous sophistication of workmanship which is not again paralleled before the HELLENISTIC era.

The Indus Valley settlements seem to represent a predominately commercial and trading

civilization whose achievements in the arts were not outstanding although certain forms of craftsmanship were well developed and produced objects of aesthetic worth. It is not possible to relate the known arts of this civilization to the main trends of Indian art from the 4th c. B.C. except speculatively or to reach any assurance as to its provenance in western Asia.

1728, 1783, 2086, 2860.

**INGLÉS,** JORGE (active mid 15th c.). Painter, probably of northern origin, who was one of the first representatives of the Hispano-Flemish style in Castile. His only documented work is an ALTARPIECE commissioned in 1455 by the Marquess of Santillana (Duke of Infantado Coll.). There are many works attributed to him, of which the altarpiece, the *Entierro de San Jerónimo* (Valladolid Mus.), is the most probable.

**INGRES,** JEAN AUGUSTE DOMINIQUE (1780–1867). French painter, born at Montauban. His father was a mediocre sculptor and miniature painter. After an early academic training in the Toulouse Academy he went to Paris in 1796 and was a fellow student of GROS in DAVID's studio. He won the *Grand Prix de Rome* in 1801 with a NEO-CLASSICAL history painting *The Envoys of Agamemnon* (École des Beaux-Arts, Paris), which was praised by FLAXMAN. Owing to the state of France's economy he was not awarded the usual stay in Rome until 1807. In the interval he produced his first portraits. These fall into two categories: portraits of himself and his friends, conceived in a ROMANTIC spirit (*Gilibert*, Montauban, 1805), and portraits of well-to-do clients which are characterized by purity of line and enamel-like colouring (*Mlle Rivière*, Louvre, 1805). He was commissioned to paint *Bonaparte as First Consul* (Liège, 1805) and *Napoleon as Emperor* (Invalides, 1806). These early portraits are notable for their calligraphic line and expressive contour, which had a sensuous beauty of its own beyond its function to contain and delineate form. It was a style which formed the essential basis of Ingres's painting throughout his life.

During his first years in Rome he continued to execute portraits and began to paint bathers, which were to become his favourite themes (*Bather of Calpincon*, Louvre, 1808). He remained in Rome when his four-year scholarship ended, earning his living principally by pencil portraits of members of the French colony (*The Family of Lucien Bonaparte*, Fogg Mus., Cambridge, Mass., 1813). But he also received more substantial commissions, including two decorative paintings for Napoleon's palace in Rome (*Triumph of Romulus over Acron*, École des Beaux-Arts, Paris, 1812; and *Ossian's Dream*, Montauban, 1813). In 1814 he painted the *Grande Odalisque* (Louvre), of which it has been said that it might have been painted by an Italianate Frenchman at the court of Francis I.

From 1814 to 1820, after the fall of Napoleon, he produced a considerable number of small paintings with medieval and RENAISSANCE subjects (*Don Pedro of Toledo Kissing the Sword of Henry IV*; *Paolo Malatesta and Francesca da Rimini*) which were close in feeling to the then fashionable Troubadour style. In 1820 he moved from Rome to Florence, where he remained for four years, working primarily on his *Vow of Louis XIII*, commissioned for the cathedral of Montauban. Exhibited at the Salon of 1824, this was widely acclaimed and Ingres returned to Paris as the recognized leader of the official academic opposition to the new Romanticism. He became a protagonist of the new idealization of Greek antiquity, sharing to a considerable extent the views of the Neo-Classical critic Quatremère de Quincy. He spent much of the next 10 years executing two large paintings: *The Apotheosis of Homer*, for a ceiling in the LOUVRE, and *The Martyrdom of St. Symphorian* (Salon, 1834) for the cathedral of Autun, but at the same time he continued to paint portraits and subject pictures and nudes. At the end of 1834 he was appointed Director of the French School in Rome, a post he retained for seven years. He produced few major works in this period. The most important was his *Stratonice* (Chantilly, 1834–40), minutely executed with sharp colours and described by him as a 'large historic miniature'.

In the late portraits, painted after his return to France in 1842, he often set great emphasis on the sumptuous gowns of his sitters (*Baroness James de Rothschild*, Mme Moitessier, N.G., London, 1848, 1856). These works epitomize a whole class of 19th-c. French society with its sense of security and well-being based on immense wealth.

From 1843 to 1848 he worked on two decorative wall-paintings for the Château de Dampierre, neither of which he finished: *The Age of Gold* and *The Age of Iron*. In 1853 he received a commission to decorate the ceiling of the Salon de l'Empereur in the Hôtel de Ville, Paris. The principal painting in this scheme was the *Apotheosis of Napoleon* which, with the other decorations, was destroyed by fire in 1871.

He completed a *Venus Anadyomene* (Chantilly) in 1848 from drawings he had made under the influence of BOTTICELLI during the first Italian journey; and in 1856 he painted *La Source* (Louvre), which had also been planned much earlier in Rome. The last of his Bather or Odalisque themes was the *Bain Turc* of 1862 (Louvre).

Ingres was the most generally admired French painter of his day and, as Director of the French School in Rome and Professor at the École des Beaux-Arts, one of the most influential. He was Grand Officer of the Legion of Honour in 1855 and a Senator in 1862. In 1855 he was given a retrospective exhibition at the Exposition Universelle.

Ingres is a puzzling artist and his career is full

of contradictions. Yet more than most artists he was obsessed by a restricted number of themes and returned to the same subject again and again over a long period of years. He was a bourgeois with the limitations of a bourgeois mentality. His portraits are sentimental and vacuous and his subject pictures vapid. Running through his work is a strong feeling for the sensuous qualities of the female nude, a trait which is differently interpreted by different critics. M. Élie Faure writes: 'It is in him that we find the affirmation of that hymn to woman of which the painters of the eighteenth century had given the outline with more verve than love.' Mr. Michael Levey says: 'Only in his female nudes, often in oriental settings where he can indulge in almost cruel sensuality, did Ingres succeed in giving any satisfactory expression of his imagination.' As a draughtsman he is supreme. He wished as a child to be a musician and it has been said: 'The music is in his line.' His own artistic creed in opposition to Romanticism and DELACROIX is expressed in his maxim: 'Le dessin est la probité de l'art.' According to David and the strict academic school Ingres drew badly: 'the feet are weak, the hands are badly placed and the necks have goitre, joints are disconnected, and arms and legs a third too long or too short.' It was in the quality of line itself and its use for expressive effect that he excelled.

Unfortunately the influence of Ingres was mainly seen in those shortcomings and weaknesses which have come to be regarded as the hallmark of inferior academic work and he can justly be regarded as the father of academicism. As a great calligraphic genius his true continuators are DEGAS and PICASSO.

24, 2416, 2417, 2883.

**INK.** Fluid containing colouring matter in suspension, used for writing or DRAWING. Inks have usually staining power without BODY but printers' inks are PIGMENTS mixed with oil or varnish. Copying inks are usually formed by adding glycerine to ordinary ink.

The use of inks goes back in China and Egypt to at least 2500 B.C. Ink was usually made from lamp black or a red ochre ground into a solution of glue or gums. It was moulded into dry sticks or blocks, which were then mixed with water for use. In the development of CHINESE ART ink and brush techniques were of major importance. Particular significance was attached to the grinding and preparation of the ink. Blocks and bars of solid ink were supplied in decorative moulds designed by prominent artists and famous centres of ink manufacture became established with family industries which published expensive sample catalogues. An extensive aesthetic literature grew up around the materials and techniques of the painter's craft. Chinese art perfected the expressive possibilities of the varying tone values to be obtained from transparent ink washes without addition of body

colour. The wash technique was adapted to render atmospheric effects while simultaneously suggesting spatial depth. In China also the aesthetic value of the vermilion ink seal in contrast with a calligraphic brush technique was early recognized.

Ink brought from China or Japan in sticks or cakes has come to be known in the West as 'Indian ink'. The name is also given to a similar preparation made in Europe, a dispersion of carbon black in water usually stabilized by some alkaline solution, gum arabic, shellac in borax solution, etc. It is used chiefly as a drawing ink.

**INNES,** JOHN DICKSON (1887–1914). Welsh painter. He studied at the Slade School and became a member of the NEW ENGLISH ART CLUB. He worked in Wales and in the Pyrenees with Augustus JOHN and Derwent Lees (1885–1931). His landscapes, usually painted on a small scale, combine a strong sense of decorative pattern with a range of hot colour not dissimilar from that of DERAIN and MATISSE.

**INNESS,** GEORGE (1825–94). American landscape painter. He was without formal training but developed his style from much study of LANDSCAPE PAINTING in the course of frequent visits to Europe. He was particularly influenced by the BARBIZON SCHOOL and had special affinities with DIAZ and Theodore ROUSSEAU. His work falls into two fairly distinct periods. In the first he attempted to bring greater breadth to American ROMANTIC realism, dissolving hard outline into a play of atmosphere and colour, but with something of the ordered beauty of CLAUDE (*Peace and Plenty*, Met. Mus., New York, 1865). From *c.* 1859, when he went to live in the village of Medfield outside Boston, his style began to change to a more intimate manner of landscape in which he chose deliberately unpicturesque subjects and relied for pictorial appeal on subtle harmonies of colour and broad massing of light and shade. His aesthetic attitude was expressed in the words: 'a work of art is beautiful if the sentiment is beautiful, it is great if the sentiment is vital' (*Harvest Time*, Cleveland Mus. of Art, 1864). Inness has often been considered the greatest American landscape painter of the 19th c.

GEORGE INNESS, JR. (1854–1926), son of the foregoing, was born in Paris and studied under his father. He exhibited at the Salon, obtaining a gold medal in 1900. He was made a member of the National Academy in 1899. He published *Life and Letters of George Inness* in 1917.

1714.

**INSCRIPTIONS,** GREEK AND ROMAN. The elegance and beauty of Greek monumental inscriptions have rarely had adequate recognition, obscured as they have been by the later and

longer development of the many times more numerous inscriptions in Latin which they inspired. Yet Greek craftsmen were not only creators of the European tradition of monumental inscriptions in stone, marble, and bronze but they were the first to confer upon them an artistic form so that they should serve as an integral part of the composition and design of a monument as a whole. Such rare, severely practical early inscriptions as have survived from the 9th–8th c. B.C. give little promise of the splendid achievements of the 5th and later centuries. The Greeks by then had given up reading from left to right and their lettering craft, whether exercised on cylindrical seals, coins, pottery, or monuments, or as public pronouncements on wood, copper, or stone, blossomed into a distinctive art form established in its own right over and above the mere technical necessities to which it owed its origin. The Greek alphabet thereby acquired definitive form, serving in due course to guide the relatively crude Romans of the early Republic towards a similar progress in the use of Latin. Until the 3rd c. B.C. the Romans lacked a literature and their public written statements seem to have been few. Among them were the famous Twelve Tables, the first declaration of the laws of the Republic. They were engraved on bronze tablets and exhibited for all to read c. 450 B.C. Some few early treaties and important pronouncements were also published in this way but none of these early inscriptions has survived. By the 2nd c. B.C. Rome had become the principal power in the Mediterranean world and the Latin alphabet had acquired greater stability and regularity and more definite form; but it was not until the later 1st c. B.C., in the days of Julius Caesar and Augustus, that the classic Roman letter-form first began to shine forth in splendid monumental inscriptions. The development then begun achieved a calm, majestic dignity and grandeur by the first half of the 1st c. A.D. which was substantially maintained for 200 years down to the time of troubles following after the Antonine emperors. From then onwards there is evidence of change and a decline not to be attributed only to poor skill, for that is evident at all periods in some inscriptions, but to a change in taste also. Tall, thin, clumsy letters in a calligraphic rather than a monumental style, often poorly cut and imperfectly aligned, began to be frequent. Yet many ancient examples survived to continue to uphold standards of classic perfection. How they stimulated emulation, even if in a somewhat new idiom, may be seen in inscriptions such as those on the ARCH OF CONSTANTINE and especially in the notable, although mannered and highly distinctive style of Filocalus, the letter-cutter employed by Pope Damasus I (A.D. 366–84) on the tombs of the martyrs in the Catacombs of Rome. The careful artistry of such inscriptions put them in a class of their own.

In ordinary, everyday writing both Greeks and Romans used a cursive lettering, usually set out with little regard for aesthetic appeal. As the scribbling and the advertisements on the walls of POMPEII remain to show, there was scant reflection in these humdrum announcements of that careful work with ruler and compasses by which the artistry of Greek and Roman monumental lettering had been achieved. Centuries later, as humanistic culture slowly revived in Europe, discerning eyes began to notice the strength and refinement of the magisterial proclamations of Imperial Rome on temples such as the PANTHEON, on monuments such as TRAJAN's COLUMN, and on tombs such as that of Cecilia Metella. Such is the force of their aesthetic appeal that they still inspire architects, stone-cutters, printers, and illuminators.

1104, 2930.

## INTAGLIO METHODS OF ENGRAVING.
See PRINTS.

## INTAGLIOS. See GEMS.

## INTENSITY. See COLOUR.

**INTERLACE.** A type of pattern in which a number of lines or bands are interlaced or plaited together on the principle that the interlacing elements pass over and under each other alternately. Interlace pattern often takes the form of an *interlacement band* in which the interlacing elements are symmetrical about a longitudinal axis and can be continued indefinitely. Sometimes, however, the interlace may bend back upon itself as in the *rosette* or other form of closed pattern.

Interlacement patterns are found in many different styles and periods, though they were more popular in some than in others. They vary considerably and take on many of the characteristics of the style in which they occur. They can be found in pottery and textiles, in manuscript decoration, in the decoration of craft objects and they have extensive uses in architecture.

Interlace ornament in antiquity consists usually of wavy interlacing bands round regularly spaced knobs or eyes, the whole characterized by symmetry and regularity. The interlacing elements are often distinguished from each other by colour or shading or in plastic ornamentation by FLUTING.

Interlace patterns are particularly characteristic of European art, pagan and Christian, from about the 5th to about the 12th centuries. Medieval interlace, both BYZANTINE and ROMANESQUE, made use of antique models, adding to them an angular bend. The Roman interlace, as seen for example on late Roman mosaic pavements, was somewhat rigid and stylistically in contrast with the flowing, fleshy intertwining of stems and tendrils characteristic for example of some early CELTIC ART. In Celtic, ANGLO-SAXON, SCANDINAVIAN, NORMAN and other northern European styles interlace is the most

conspicuous form of ornament. It is often extremely complicated and may be freely drawn without rigidity. It is a feature of these styles that the same band often appears in sections of different colours. Interlace was often combined with animal decoration.

Alternate colouring of single bands also occurs in ISLAMIC interlace decoration. The Moorish style favoured a pattern in which straight bands form angles of 90° or 135°.

Considerable elaboration occurred at the RENAISSANCE, particularly in the decoration of book covers, intarsia, typographical borders, etc., and from then until the present day interlacement has remained eclectically a popular mode of ornament.

**INTERNATIONAL GOTHIC.** Term in art history used to designate a style in painting, first distinguished by Louis Courajod in 1892, which spread widely over western Europe between c. 1375 and 1425 and was reflected in miniatures, mosaics, tapestries, illuminated manuscripts, enamels, embroideries, stained glass, etc. Its most prominent characteristic was a tendency towards STYLIZATION in a fluid, curvilinear manner of elegance and refinement combined with restrained vitality. It was marked also by a new interest in secular themes of aristocratic life often with an artificially bucolic tone. Its emergence is usually traced to the court style which arose in France about the middle of the 13th c. (see FRENCH ART) with its canon of an elongated and supple human form modelled with a new appreciation of sensuous qualities. SIMONE MARTINI's merging of the French grace with the Italian naturalism of GIOTTO and DUCCIO, together with a flavour of the ANTIQUE from late Roman painting, is regarded as the first stage of the International Gothic style and a forerunner of the *Très Riches Heures* painted for the Duke of Berry. In France Jehan PUCELLE with his linear arabesque of movement and elegance injected new life into the French style and laid a basis for the Franco-Flemish art which at the court of the Duke of Berry brought into being a fusion of styles which became genuinely international in character. Netherlandish artists working there c. 1400—Jean de BONDOL, André BEAUNEVEU, Jacquemart de Hesdin, Melchior BROEDERLAM —brought the Flemish taste for realism and talent for keen observation into unison with the new Italian naturalism and yet adapted themselves to the aristocratic refinement and spirit of the French court. Some influence must also be attributed to the delight of the LORENZETTI brothers in depicting details of natural scenes and rustic genre, the PERSPECTIVE advances of ALTICHIERO and Jacopo Avanzo, the sculptural modelling of Giovanni da Modena. From these trends a composite style achieved genuine originality in such masterpieces as the miniatures of the Master of Boucicault and the LIMBURG brothers. By the end of the 14th c. the International Gothic had emerged with Franco-Flemish Burgundy and Lombardy as its main formative sources.

At the end of the 14th c. the chief centres of the Franco-Flemish International Gothic under the auspices of the Dukes of Berry and Burgundy were at Mehun-sur-Yèvre, where André Beauneveu was in charge of painting and sculpture, Bourges, Dijon (at the Chartreuse de Champmol), and finally in Paris. From France the style spread to other countries of Europe. In northern Italy such artists as Michelino da Besozzo (active c. 1388–1445) and GENTILE DA FABRIANO were attracted by the sinuous line, the polished elegance, the exotic and bizarre 'Gothic' features of the style and with STEFANO DA ZEVIO and PISANELLO International Gothic reached its most ornate and flamboyant. In Bohemia the style is apparent in the *Trebon Altarpiece* (N.G., Prague, c. 1390). It spread to the Rhineland towns in the early 15th c. and was modified, e.g. in Konrad of Soest and MASTER FRANCKE by Germanic middle-class affectation. In England the influence of International Gothic can be seen in the *Wilton Diptych* and in some illuminated manuscripts (e.g. the Oxford *Marco Polo* and the Cambridge *Chaucer*). The style spread to Spain through Avignon and Perpignan, which was at that time Spanish, and was introduced to Catalonia primarily by Luis BORRASSÁ. It can be traced in the work of Jaime Ferrer and in the landscape backgrounds of Bernardo MARTORELL.

International Gothic was nurtured in the cosmopolitan courts of France and Burgundy from the soil of the French aristocratic court style. It was perpetuated into the early years of the 15th c., long after its decline in France, by the strong commercial links which bound southern Spain with Genoa, Naples, and Venice.

**INTONACO.** Term used in mural painting for the final layer of lime plaster on which FRESCO painting is done.

**INVENTION.** Term which originated as one of the stock elements of rhetoric in classical antiquity, as set forth for example by Quintilian (*Inst. Orat.* iii. 3): invention, disposition, style, memory, delivery. Invention and disposition referred to the selection and arrangement of subject matter. The word 'invention' carried no implications of originality or creativity in the modern sense. In antiquity the artist was not expected to be original or creative but to follow the approved models well. The word continued during the Middle Ages and into the RENAISSANCE with similar implications. For example, in his *Le tre fontane* (1526) Niccolò Liburnio advised young writers to cultivate the best authors of the past—Cicero, Quintilian, Horace—since these would provide them with 'invention' as well as elocution (style). In his *La Poetica* (1536) Bernadino Daniello gave rules for the poet's 'invention' or selection and utilization of subject matter.

The word was transferred from poetics to the visual arts with similar meaning and implications. In Lodovico Dolce's *Dialogo della Pittura* (1557) *inventione*, *disegno*, and *colorito* very roughly correspond with *inventio*, *dispositio*, and *elocutio* in the classical treatises on rhetoric. But as in the course of the Renaissance the status of the artist began to change and he assumed the dignity of a scholar and gentleman rather than a manual worker, as painting and sculpture began to be accepted along with poetry as LIBERAL ARTS, the artist began to claim the right and ability to select his own subject matter rather than follow the dictates of scholars and patrons. When Isabella d'Este attempted to prescribe a subject for Giovanni BELLINI, Bembo reminded her that great artists preferred to work out their own inventions. Similarly, Benvenuto CELLINI rebuffed the scholars who wanted to suggest ideas for his salt-cellar, and when GIULIO ROMANO was asked to design jewellery for Cellini to execute, he politely assured the patron that Cellini could do the invention himself. It should not be overlooked, however, that emphasis on the mental conception rather than the execution sometimes threatened the standards of solid craftsmanship which the medieval guilds had assured. The consequences of this shift of ideas can be seen in the work of many of the great Renaissance artists. LEONARDO too often remained satisfied with the invention and shrank from the labour of carrying it out; RAPHAEL was so carried away by his inventive power that in his later years he tended to leave execution to inferior hands. The new status of art as a liberal discipline and the emphasis on invention led to an intellectualist conception of aesthetic activity which became incorporated in the academic ideal and was a reason why portraiture, STILL LIFE, and landscape were rated lower than historical painting because they made less demand on the artist's intellectual power.

**INWOOD**, HENRY WILLIAM (1794-1843). English architect. Inwood visited Athens as a young man, afterwards publishing a book on the ERECHTHEUM. His London churches show the profound influence of Greek models, especially the parish church of St. Pancras (1819-22), with its pure Greek detail and reminiscences of the Erechtheum (Caryatid Portico) and the Tower of the Winds (steeple). Inwood's father WILLIAM (1771?-1843) and his brother CHARLES FREDERICK (1798-1840) were both architects and both worked with him at St. Pancras.

**IRON SCULPTURE.** Molten iron contracts as it cools and is therefore unsuitable as a medium for casting. Wrought iron has been used for sculpture and in the 20th c. there has been a new interest in making abstract sculpture by welding iron. The first experiments with this technique were made about 1930 by Julio Gonzalez (1876-

1942) in association with PICASSO. Among those who followed their example are the American David SMITH, Reg BUTLER (in his early work), and many of the younger sculptors who have followed their lead.

**ISABELLINE STYLE.** See PLATERESQUE.

**ISAKSON,** KARL (1878-1922). Swedish painter, mainly active in Denmark. In a series of STILL-LIFE paintings and nudes, which appear sketchy but are really carefully composed, he explored the relations between colour, space, and surface. With great sensitivity for colour he painted exquisite landscapes from the island of Bornholm (1918-21). In Paris (1913-14) Isakson was one of the first Scandinavians to confront the problems of formal structure raised by CÉZANNE and the CUBISTS. Later he also painted religious subjects, treating them with the same regard for structure.

**ISENBRANDT.** See YSENBRANDT.

**ISIDORE OF MILETUS.** Greek mathematician and engineer who collaborated with ANTHEMIUS OF TRALLES in designing Sta Sophia, Constantinople, and was recognized as his successor. He was the author of a fifteenth book of Euclid's *Elements*.

There was a younger ISIDORE, who rebuilt the dome of Sta Sophia and was praised by Agathias in the 5th book of his *Historia* for the geometrical improvements which he introduced.

**ISLAMIC ART.** Islamic art is first and foremost a religious art, the Arabic word *Islam* meaning 'surrender to God'. It is more homogeneous than Christian art, and its works can at once be recognized as products of a distinct civilization. It is above all an art of ornament. In architecture the Moslems introduced few structural innovations, but rather adapted existing techniques to their own requirements. The special character of the MOSQUE and minaret lies not so much in their form as in the nature of their decoration and the way it is used. The finest examples of Islamic architecture introduce ornament to underline the structural beauties of the building. In the Mosque of Ibn Tulun in Cairo the profile of the arcade arches is emphasized by the surrounding friezes of carved stucco; the severe simplicity of the Giralda at Seville is relieved by a delicate network of brick, and the ribs which support the lovely cupola of the Mausoleum of Timur in Samarkand are rendered in brilliantly coloured faience. In the minor arts, too, there is no great repertory of forms; what is new is the decoration and the manner in which it is organized. For these reasons the study of Islamic art is concerned primarily with surface decoration and the evolution of decorative forms.

This dominance of ornament is itself an example of the way in which the religion of Islam conditioned the values of the Moslem artist. He

resorted to ceaseless experiment in ornamentation and exercised all his imaginative powers in devising new decorative forms because he was prohibited from portraying living creatures. The Koran itself contains no pronouncement on this question, nor does it appear that the prohibition was observed by the first generation of Moslems. The doctrine was first expounded by Moslem theologians of the 2nd c. on the basis of certain allusions in the *Hadith*, which is a collection of traditions concerning the Prophet's life and sayings. It was held that the artist who represented living creatures would arrogate to himself the Divine prerogative of creation. Hence there is no depiction of living creatures in any Moslem religious building and if human or animal forms are represented in secular art, they are made to conform to the general scheme or ornament. Sculpture in the round is rare and the rather stylized stone lions which support the basin in the Court of Lions in the Alhambra at Granada are exceptional. Generally, if the artist portrays a living creature in three dimensions, such as the bronze winged griffin in the Campo Santo in Pisa, he covers the surface with irrelevant decoration; and if in two dimensions, as in manuscript illustration, he tends to make it stylized and subordinate to a general decorative pattern. Even portraiture in painting seems to have been unknown before the 16th c., when it was introduced largely under the influence of European art. In the great manuscript illustrations it is rare that any attempt is made to delineate character, still less emotion. Dramatic tension is represented by means of a limited repertory of symbolic gestures or is suggested by the subject itself.

In ornament, too, the Moslem artist avoided naturalistic representation and preferred stylization or abstraction. The most typical ornament is the swirling plant form to which RENAISSANCE Europe gave the name of ARABESQUE. Other plant forms occur besides the arabesque, such as the full palmette and rosette, both found in HELLENISTIC ART, the lotus, both in the form in which it appears in ancient Egypt and in its Chinese form, and the chrysanthemum. All these were often combined with the arabesque. Other motifs were purely abstract: frameworks of GUILLOCHE and STRAPWORK, INTERLACING and geometric forms, among which the many-pointed star was especially popular. In the organization of the ornament certain rules were observed. No single element was given undue prominence, with the result that the eye enjoys a general impression rather than any particular detail and the work conveys a feeling of harmony. Usually the Moslem artist fills his entire surface with ornament, for he seems to have had a *horror vacui*. What might have led to a feeling of overcrowding and unrest was avoided by rigid adherence to another rule, that of symmetry, in which each member is balanced by a corresponding one. These principles of composition produce a remarkable sense of tranquillity.

The Arabic script has a very important place in Islamic decoration. To the Moslem Arabic is the language which Allah chose for His revelations to the Prophet, and the Koran, the record of these revelations, contains the actual words of God. The copying of the Koran was considered a meritorious act of religion and much care was devoted to producing the finest copies. Verses from it were inscribed not only on the walls of mosques, but even on secular buildings and household objects. But it is often the actual forms of the letters that seem to fascinate the artist. It is not uncommon to find him using a meaningless series of Arabic letters simply for the sake of the pattern they make, a use of Arabic script which even found its way to Europe (see KUFIC AND NASKHI SCRIPTS). The Moslem artist often inscribes his letters against a background of arabesques and floral scrolls, with a happy effect of contrast.

The Moslem craftsman employed materials of a modest and sometimes fragile nature. Near the Mediterranean the tradition of building and carving in stone persisted, but in the eastern regions, where stone was scarce, fired or sun-dried bricks were common. Architectural decoration was carried out in carved stone, carved or moulded stucco, or tiles painted in coloured

**175.** Stucco ornament combining Arabic script with stylized foliate patterns. Detail from the *Patio de Arrayanes*, Alhambra (14th c.)

glazes. Unassuming, too, were the materials used in the decorative arts. Few objects in gold or silver have survived for, according to the Traditions, the Prophet had forbidden the use of vessels made of precious metals, and it is possible that the lustre-painted pottery of the Moslems was produced as a substitute. Durable household objects were usually of bronze or brass, with engraved ornament or a thin inlay of gold, silver, or copper. The fabric of Islamic pottery is earthenware, but is concealed by a rich palette of glazes and enamels that includes turquoise, lapis and cobalt blue, yellow, red, and green.

The Moslem artist manifests a profound love of colour and an understanding of its harmonious uses. Carved stone or stucco depends for its effect on the contrast of light and shade; minaret and dome and walls dazzle the eye with their glowing faience decoration; and the brilliant hues of Persian and Turkish pottery have seldom been surpassed. It is the same with manuscript illumination and illustration. But perhaps the finest achievement in colour are the wonderful carpets.

ICONOGRAPHY presents few problems. Objects are decorated with scenes depicting the ruler and his court, hunting, battles, and astronomical symbols. In books illustrations are either explanatory, as in medical or scientific treatises, or diverting as in literary or historical works. The scenes and incidents and the manner of depicting them do not vary much in the manuscripts of any one work. Religious iconography can hardly be said to exist since the proscription on representations of living creatures made it impossible for Islam to have religious art in the sense that Buddhism and Christianity have. It is true that Islamic book illustrations included religious subjects such as Mohammed's ascent to Heaven, but these were exceptions and in any case scarcely of a devotional nature.

While Islamic art may be thought lacking in the qualities of humanity and compassion which irradiate much Christian and Buddhist art, it is not inferior in the dedication of the artist which lies at the root of all great artistic creation.

UMAYYAD PERIOD (660-730). The Islamic faith was first preached early in the 7th c. A.D. in the caravan cities of western Arabia, but it was not until after Mohammed's death in 632 that the universal mission of Islam was proclaimed.

176A. Part of façade of the palace of Mshatta (c. 743)

176B. Detail of foregoing, representing affronted griffons and small animals merging into a vine scroll foliage pattern

Then, in less than 20 years, the Arabs wrested from the Emperor of Byzantium the provinces of Egypt and Syria, and from the Sassanian dynasty the whole of Persia and Mesopotamia. The vast empire so acquired was ruled by a Caliph. The first four Caliphs were men who had been the Prophet's close companions but in 660 the Caliphate fell to a member of the Umayyad family, aristocrats of Mecca, and this dynasty ruled the Islamic empire from Syria for over 90 years. It was during the Umayyad period that the foundations of Islamic society and civilization were established. The Arab rulers, half-urbanized nomads, found themselves confronted by standards of civilization far higher than their own. Their subjects lived in luxuriously equipped houses surrounded by finely wrought objects, in comparison with which their own tents and utensils cut a poor show. In Syria they found in the Christian churches a highly developed architecture, but their own mosques scarcely yet qualified as architecture at all. Thus the first essays in Islamic art and architecture were due to a spirit of emulation; but they were not made by the Arabs, who had no tradition of craftsmanship and seem rather to have despised the artisan, depending on foreign craftsmen for their few amenities. The craftsmen of the Umayyad period were Syrians, Egyptians, or Persians, working in their own traditions; few were even Moslems, for the subject peoples were slow to accept the new religion. For these reasons the earliest examples of Islamic architecture and decoration are curiously eclectic. The façade of the palace of Mshatta, for instance, was a puzzle to archaeologists when they first began to consider it seriously towards the end of the last century, because it looked like a Hellenistic building dating from at least a century before Islam. This palace, which was never completed, stands in the desert about 25 miles east of the Dead Sea and was probably built in the closing years of Umayyad rule. It incorporates a basilical hall with three vaulted aisles of which the central one terminates in a square dome chamber with a semicircular apsidal niche in each of its three sides. The same arrangement is found in the Byzantine architecture of Egypt. The façade itself is composed of great triangles with carved decoration, much of which is Hellenistic in style and includes vine and other floral motifs and even the centaur and SPHINX. At the same time other motifs, such as the dragon with peacock tail, were obviously inspired by Persia. The buildings of the Umayyad period conform so closely with the traditions of the countries in which they appear that it is doubtful whether any of them can justifiably be regarded as establishing an identifiable Islamic style. The Dome of the Rock in Jerusalem and the Great Mosque of Damascus, the ruined palaces of Mshatta and Qusair Amra east of the Jordan, and the western Qasr al-Hair between Damascus and Palmyra, are based on Hellenistic traditions; the

castle of Kharane east of the Dead Sea, on the other hand, is more in line with Mesopotamian tradition. Umayyad art had no single integrated style but three separate elements occur, often in the same work: the naturalistic style of Syria, where the Hellenistic tradition was strong; the more purely decorative style of COPTIC Egypt; and the style of Sassanian Persia, which combined Hellenistic forms with the earlier traditions of the Achaemenid period (see PERSIAN ART).

It has been mentioned above that the early Moslems did not meticulously observe the proscription against representing living creatures. Excavations at Qusair Amra have revealed large-scale fresco paintings purely in the Hellenistic tradition. These depict scenes of the chase, portrait busts, naked women, and a group of royal persons. The façade of the western Qasr-al-Hair includes human figures carved in stucco which are reminiscent of Palmyrene art.

ABBASID PERIOD. In 750 the Umayyad Caliphate was overthrown and replaced by that of the Abbasids, a Meccan family descended from the Prophet's uncle, Abbas. The new dynasty established its headquarters in Mesopotamia and founded the city of Baghdad in 762 on the banks of the Tigris. Hitherto the Islamic world had formed an Arab empire, but the change of dynasty brought about a Persian ascendancy; Persian ideas now prevailed and the Abbasids ruled in great magnificence as Oriental monarchs. But the vast empire which extended from Sind to Spain had become unwieldy, its central administration grew weak and after a century rival Caliphates were established by the Umayyads in Spain and the Fatimids in Egypt.

Under the Abbasids there was intense intellectual and artistic activity. Palaces and mosques were built and industries established to supply the demand for luxury articles. The pottery and textiles which were produced at this time began to assume an identifiable Islamic character, and there emerged a unified art style inspired by ancient Persia rather than Christian Syria. We

177A. Reconstruction of entrance towers of the western Qasr-al-Hair. (Damascus Mus., c. 728)

589

**177B.** Detail of stucco figures from the foregoing

can obtain a clear picture of it from the ruins of Samarra, a city on the Tigris occupied by the Caliphs for more than 60 years during the 9th c. just before the decline in their power. In architecture the constructional methods were those introduced under the Sassanians. The decorative arts, too, seem to have developed from Iranian traditions. In the ornamental stucco, which was the commonest form of wall decoration in Samarra, the so-called 'bevelled' manner can be traced back to the Scytho-Siberian art of the steppes of central Asia. In this style the ornament is abstract though ultimately derived from plant forms; there is no background, since the lines which divide the elements are cut slantwise and produce a contrast of light and shade. Another influence which appears for the first time is that of China, for the rarity and high value of the Chinese porcelain which reached Persia by trade was a challenge to the Moslem potters. But the imitations which they produced, though following the Chinese originals in technique, retained an Islamic character. White wares imitating porcelain were decorated with Arabic inscriptions and palmettes painted in cobalt; imitations of the T'ang 'splashed' ware were incised under the glaze with designs of an Islamic character, a technique not found in the Chinese wares.

From the 10th c. the Islamic world was divided into three: an eastern region comprising north-western India, Turkestan, and Persia; a central region including Mesopotamia, Asia Minor, Syria, and Egypt; and a western region composed of North Africa and Spain.

TURKISH DYNASTIES. In the eastern and central regions the predominant influence was that of the Turks. A Turk, Ahmad ibn Tulun, obtained the government of Egypt and Syria, and a

Turkish dynasty, the Ghaznavida, won for themselves a kingdom comprising eastern Persia, Afghanistan, Turkestan, and north-western India. Although the Tulunid dynasty was short-lived in Egypt and Syria, a distinctive art was produced under their patronage. The greatest memorial to their achievement is the mosque which was founded by Ahmad ibn Tulun in 879 in Cairo. This is essentially a Mesopotamian building and its decoration is treated in the manner of Samarra architecture. Pottery and vessels of carved crystal have also been attributed to this period. Little has survived of Ghaznavid art, but the two great tomb towers which still stand at Ghazni give some idea of its magnificence. These have a monumental quality and in section are constructed on the plan of an eight-pointed star. Their surfaces are decorated with abstract ornament in brick, relieved by Kufic inscriptions.

The Ghaznavids were expelled by another Turkish tribe, the Seljuks, who entered Baghdad in 1055 and made themselves masters of Persia, Mesopotamia, Syria, and Asia Minor. The Seljuks made a deep impression on these regions and during their rule there was a revival of activity in the arts. Seljuk architecture has a classical quality and achieves a rare harmony of form and decoration. The basilical form of mosque was replaced by the cruciform plan in which each side of the court contains a vast niche —a type of mosque which is characteristic of Persia from this time onwards. In the decorative arts, too, there was an outburst of activity, though most of the surviving material belongs to the last years of Seljuk rule in Persia. Pottery production, which seems to have declined after the 9th c., revived about the middle of the 12th c. Wares with carved or moulded decoration were sometimes provided with a monochrome glaze, turquoise or cobalt or green; others were painted in lustre or enamels and these are the only surviving examples of Persian painting in this period. Bronze objects with incised decoration or copper inlay and a few examples of the goldsmith's art have also survived. Particularly precious are the woven silk textiles of this period. Seljuk ornament is distinguished by the decorative use of Arabic script and an inventiveness in developing floral motifs and human and animal forms.

By the second half of the 12th c. the Seljuk empire had disintegrated into several kingdoms, in which, however, the tradition of its arts was maintained. The Seljuk rulers in Asia Minor have left a remarkable series of architectural monuments, especially in Konya. In Mesopotamia, which was parcelled out among Turkish dynasties, the first illustrated manuscripts began to appear. Mosul on the Tigris became the centre of a metal-work industry which was famous in the Islamic world. Magnificent examples of brass or bronze vessels inlaid with gold, silver, or copper can be seen in most of the great museums.

MONGOL PERIOD. From the 13th c. a wedge

was driven between the eastern and central regions of the Islamic world by the invading Mongols, devastating hordes without respect for Islam or its institutions. They overran Persia and Mesopotamia and under their rule the eastern part of the Islamic world became part of an empire that included China. The Moslem artists quickly responded to the taste of their new patrons. Now that direct relations with the east were established there was a taste for Chinese motifs. The Chinese lotus, phoenix and dragon, and cloud scrolls began to appear in manuscript illustration and in the decorative arts. Nor was this development interrupted when Persia became the victim of a new invasion, this time headed by Timur (Tamerlane), a Moslem of Turkish stock. By the time of his death in 1405 Timur had conquered Persia and Afghanistan and much of northern India. The Timurid dynasty, from their successive capitals of Samarkand and Herat, inaugurated a period of great artistic activity. Fortunately the Timurid mosques and monuments still stand in Samarkand and—in a ruined state—in Herat. They are extremely elegant in form and are brilliantly decorated in polychrome faience. The many illustrated and illuminated manuscripts which exist in the libraries and museums of Europe and America reveal a delicacy of treatment and an imaginative quality comparable to that of contemporary European miniature painting.

EGYPT. Meanwhile in Egypt the Fatimids (973–1171) were lavish patrons of the arts. Their mosques carried on the tradition of Tulunid architecture and perhaps two of the best examples are those of al-Azhar (972) and al-Hakim (completed in 1003). They also introduced another type such as that of Juyushi, in which the founder's tomb is incorporated in the mosque. These still stand in Cairo and are interesting above all for their decoration. It is c. A.D. 1000 that the form of the arabesque became fixed. Use was also made of the Kufic script in geometric and floral motifs. Fatimid decoration can also be studied in the pottery, carved woodwork, crystals, bronzes, and textiles, in which animal and human figures were introduced.

The Fatimids were followed by the Ayyubids (1171–1250), Kurds from Mesopotamia, who united Syria and Egypt. They introduced into Egypt the *madrassa* or school mosque which had first appeared in Mesopotamia in the second half of the 10th c. In most things the Fatimid tradition was preserved, though Naskhi script gradually began to replace the Kufic. The Ayyubids are famous for their military architecture, and it was Saladin who, as leader of the counter-offensive against the Crusaders, built the citadel of Cairo.

In 1250 the Ayyubids were replaced by the Mamluks, who ruled Egypt and Syria until 1517. A magnificent series of mosques and public buildings in Cairo is due to the good taste and patronage of these sultans and their courts. Among the most famous are the Madrassa of Sultan Hasan (1356) and the mosque of Qait Bey (1472). Much use was made of stone, both carved and smooth, and of variously coloured marbles arranged to form patterns. Mamluk ceramics, metal-work and illuminated copies of the Koran are well represented in museums. The decoration is mainly geometric and floral, and epigraphic. The arabesque is prominent and its forms become more and more divorced from reality. Mamluk decoration has a stiffness and precision which sometimes tends to monotony.

SPAIN AND NORTH AFRICA. The western division of the Islamic world also developed independently. In 929 Abdul Rahmann III, a descendant of the dispossessed Umayyad Caliphs who had established themselves in Spain in 756, proclaimed himself Caliph at Cordova, and this city then became the centre of a brilliant civilization. Its great mosque, which dates mainly from the 10th c., is among the most beautiful of surviving Moslem monuments. If the form follows the traditional Islamic plan, the decoration has a wonderful harmony and richness of invention. Geometric patterns are less prominent than floral ornament, which makes much use of the acanthus and certain elements derived from the BYZANTINE.

When, towards the end of the 11th c. and again in the 12th c., Spain was conquered by Berber peoples, Spain and North Africa were united under their rule, and in this way the art of Umayyad Spain was transplanted to North Africa. The Almoravids were the dynasty which led this second invasion. The mosques which they built in Tlemcen and Algiers were inspired by the mosque of Cordova. Two of their finest creations are the minaret of the Kutubiya in Marrakesh and the Giralda in Seville. The decorative arts, too, flourished in Moslem Spain: textiles, pottery, and metal-work. Carved ivory objects made in Cordova and Cuenca between 950 and 1050 compare with Byzantine and European IVORIES.

Meanwhile the Christian kingdoms of northern Spain had begun a counter-offensive and the Moslem power in Spain dwindled to the kingdom of Granada, which was to survive until its conquest in 1492 by the united crowns of Castile and Aragon. The memory of the rulers of Granada (Nasirids) is perpetuated in the Alhambra, built for the most part in the 14th c. Even in Christian Spain Islamic art had a potent influence in the so-called MUDÉJAR style, and in North Africa too its traditions were carried on, especially in Morocco.

At the close of the Middle Ages the Islamic world, like Europe, saw the rise of new and well organized states. Northern and central India were united under the Moguls (see ISLAMIC ART IN INDIA); Persia was ruled by the Safavids, a native dynasty; and in Asia Minor the Ottoman Turks ruled over their dominions, which in the course of the 15th and 16th centuries came to include the Balkans, Egypt and Syria, Mesopotamia, and the greater part of North Africa. Owing to the encouragement given by the rulers

of these empires this period must be reckoned one of the greatest of Islamic art.

The Ottoman architects adapted Byzantine forms. The Sulaimaniya mosque in Constantinople, for instance, is inspired by Sta Sophia, but its faience decoration and slender minarets are in the Islamic tradition. Turkish pottery and textiles were famous in Europe. In the second half of the 16th c. pottery vessels and tiles were painted in brilliant colours including a vivid tomato red. Designs consisted of geometric ornament and more frequently of stylized flowers, among which the tulip, rose, and dianthus, and the cypress were especially popular. Flower forms also appeared on the brocades and velvets made in Brusa and were even copied in Italy. Fine carpets were woven in beautifully harmonious abstract or geometric colour designs.

From the end of the 17th c. the political power of Islam declined in the face of pressure from the West, and with it artistic creativeness. An increasing taste for European forms undermined the Moslem artist's confidence in his own values and it is only in recent times that the heritage of Islamic art has been assessed at its real value.

POTTERY. Pottery of a distinctively Islamic character has been made throughout the Near East since the 9th c. The works produced in the medieval period, i.e. up to the 14th c., were particularly adventurous in design, and remain unmatched in the subtle luxuriance of the colour. They were the result of new techniques of glazing and painting which were to change the whole character of European pottery in the following centuries.

(a) Mesopotamia and Persia (9th–10th c.). Since Roman times the manufacture of lead-glazed pottery had spread widely throughout the region, and for some time after the Islamic conquest this was continued with little change of style. From Egypt to Persia green or yellow glazes were used to cover a variety of moulded ornament, ranging from Hellenistic vine-scrolls, birds, and animals to the more abstract interlaced patterns in the Sassanian tradition. It was under the Abbasid Caliphs, who established their capital at Baghdad in the 8th c., that a more distinctively Islamic style came into being. This owed much to Far Eastern influence; and among finds of 9th-c. pottery at Samarra on the Tigris appeared Chinese lead-glazed earthenwares decorated with splashed patterns in the T'ang green-and-yellow style, together with almost identical pieces of local manufacture. There is evidence also of an attempt to imitate the Chinese white porcelain, and although doomed to failure by the very nature of their loose-grained, buff-coloured material, this was not without its momentous results: for in endeavouring to simulate the appearance of porcelain the Mesopotamian potters invented opaque-white glaze containing tin, which was found to present an ideal surface for painting. The painting was at first chiefly executed in blue, or in a combination of green and purple. Soon, however, these

wares were joined by the magnificent golden lustre pottery for which Islam is so justly famous. The use of this metallic pigment, which required its own special firing, long remained a closely guarded secret. At the same time there grew up an essentially Islamic repertory of design, which included a variety of formal patterns based on the palmette as well as brief Koranic texts in bold Kufic writing; birds, hares, and other animals, also human figures, soon found a place—the keynote, however, being provided by the nervous, angular rythms of the script.

Meanwhile in eastern Persia much fine lead-glazed pottery was made by less sophisticated techniques. At Samarkand, for example, were produced bowls and dishes painted with a variety of bold patterns in coloured slips, especially in red, yellowish green, and brown. From Nishapur come even more brightly painted wares in the same technique, and others in which coloured glazes were applied over designs incised in the body. A further type, in which broad areas of slip are carved away leaving animal and figure designs in strong relief on a dark background, is especially associated with the Garrus district.

(b) Egypt. Under the Fatimid Sultans (969–1171) a substantial production of fine lustred wares was carried on in Egypt. This has been attributed to the influence of the potters migrating from Mesopotamia, where this had now virtually ceased. The Egyptians' wares were hardly of comparable refinement in their material or workmanship, but show much handsome painting of animals on a characteristic background of scrolling foliage. They disappeared as swiftly as they had come, leaving under the Ayyubids (1171–1250) a somewhat pedestrian production of GRAFFITO ware for domestic purposes.

(c) Persia: the Selijuk period (c. 1050–1220). The Seljuk Turks were a vigorous race whose conquests in Persia brought about a noticeable quickening of the artistic tempo. During the second half of the 12th c. potters there were once more inspired to experiment by the example of Chinese porcelain, and succeeded in developing pure white, semi-glassy material which, although brittle and less hard than the Chinese ware, could be made up into pots of extreme fineness, and to cover it alkaline glazes (containing potash) replaced those of lead. It was used for a particularly wide variety of shapely vessels including beakers, handled cups, wine ewers, and so on, in which broad angular carved designs often reduced the walls to paper thinness, and which were covered with a range of coloured glazes—opaque turquoise, warm blue, soft purple, green, and yellow—which are among the loveliest of all pottery. Painted designs took on a livelier, more naturalistic character than hitherto. Designs of running beasts and figures were especially animated when shown in black silhouette under a green glaze; while in the so-called minai style, which introduced the use of overglaze enamel

colours and gilding, crowded compositions of minute figures sometimes covered the whole surface. It was in the revival of lustre painting, however, that the Persian genius for design manifested itself most fully. The finest examples of this style, in which princes and courtly ladies were depicted in numerous episodes from Firdausi's *Shah Nameh* and the works of other celebrated poets, are distinguished by nervous, rhythmic drawing of the figures and the consummate handling of complex background detail. These wares come chiefly from Rayy and from Kashan, a city noted especially for its lustred tiles.

(*d*) *The Mongol Period (13th–14th c.).* Painting in black and blue under colourless glazes was already becoming popular in the later days of Seljuk Persia. Despite the immense destruction which accompanied the Mongol conquests (*c.* 1220) by the second half of the 13th c. kilns near modern Sultanabad were again making fine wares in this style, characterized by feathery plant motifs and the use of turquoise, purple, and other colours as well. Mongol taste is more apparent in bowls with men and animals half hidden in a field of foliage minutely outlined in black and white on a cool grey ground, or in the Chinese motifs of crane and lotus.

(*e*) *Later wares (15th–18th c.).* Persian pottery underwent yet another phase of Chinese influence in the 14th c. with the arrival of Ming blue-and-white porcelain. More or less faithful imitations of Chinese blue-and-white, some of them by no means without merit, continued to be made down to the 18th c. and later, the finest coming from Kirman and Meshed. In addition monochrome blue or celadon-glazed wares became popular, sometimes with arabesque designs in thick, opaque colours, while in the 16th and 17th centuries a much wider range of monochromes or two-coloured wares of deliciously soft and harmonious tone showed that native ingenuity was by no means extinguished. Kubachi, in the Caucasus, gives its name to certain very attractive polychrome painted dishes, with female portraits and figure subjects framed by flowers, which were also made at this time.

(*f*) *Turkey.* At Isnik (Nicaea) in Asia Minor there flourished from the late 15th c. onwards a tile and pottery industry producing tin-glazed, painted wares of great boldness which were formerly ascribed in error to Rhodes and Damascus. Beginning with strongly stylized adaptations of Chinese blue-and-white designs, the Turkish potters developed during the early years of the 16th c. a totally independent style in which tulips, carnations, and other flowers were cunningly mingled with leafy curving arabesques, and at times imprisoned within geometric patterns of the utmost complexity. Carefully painted over large areas of the brilliant white ground, these designs convey an impression of great breadth and savage splendour which is reinforced by their strong colouring. At first blue and turquoise alone were employed; to

these, however, were added sage-green and a soft purple from *c.* 1525; and from *c.* 1550 a uniquely brilliant sealing-wax red. Apart from numerous dishes, ewers, mugs, bottles, etc., some very large mosque lamps and standing bowls were made. But it is perhaps in the tile-work which adorns so many Turkish mosques that the Isnik style appears at its most splendid. From the early 17th c. the standard of execution gradually fell off, and the manufacture was virtually extinct by the end of the century.

283, 659, 660, 744, 1138, 1537, 1555, 1558, 1760, 1761, 1804, 1805, 1806, 1838, 2114, 2242, 2935.

**ISLAMIC ART IN INDIA.** Moslems conquered Sind in A.D. 712 with no effect upon the arts. Between 1193 and 1236, however, Islam established military dominance over the whole of northern India, and from this epoch date the earliest works of Moslem art on Indian soil. Islam favoured particular types of art. The chief was the MOSQUE with its minarets, which is a focus for the gathering of local Moslems for prayer and study. The second was CALLIGRAPHY which also supplied motifs for architectural decoration. The other types were functions of personal and dynastic aggrandizement—the palace, the tomb, weapons, and legendary or historical miniatures. The chief means by which Islamic art gains its effect are: first PROPORTION, which usually follows a rigid mathematical scheme; and second opulence of surface texture, achieved by the use of rich materials or serried ornament.

ARCHITECTURE. The mosque is at bottom simply a walled enclosure and within it a niche or niches, usually ornate, indicate the general direction of Mecca, towards which the faithful address their devotions. The enclosure may be open—as it commonly is in India—or vaulted. The latter is rare in India, though Indian mosques usually have cloisters or aisles covered with vaults or domes and some sort of elaborate gateway, which may be so large as to rate as a building in its own right.

The earliest Indian Islamic buildings are simple structures of stone. The enclosure of the Great Mosque of Ajmer, for example, consists chiefly of a succession of solid rectangular panels with shallow mouldings, each of which frames a pointed arch. Around the ARCH within the panel are calligraphic texts carved in low relief. The arches of the screen are slightly more complex. The Kutb Mosque at Delhi follows a similar pattern, and its relief ornamentation is of the greatest beauty. The Kutb Minar, a battered tower on a complex stellate plan, with five balconied stages and relief ornament, is a familiar landmark in Delhi.

These early structures and many later buildings in, for example, Ahmedabad were not constructed according to the principles of Islamic architecture established elsewhere. The invaders were obliged to employ native Indian craftsmen,

who had never had occasion to develop any of the more complex structural types of arch and vault. Corbelling was the only method they had used. Materials, often only very slightly recut, taken from the hundreds of Hindu temples the Moslems had destroyed were reused in the construction of Moslem buildings, and much of the beauty of the relief ornament was due to the skill of the native Indian stone-carvers.

The earlier tombs and the mosque gateways were again of relatively simple construction, virtually rectangles in plan and elevation with interiors covered by small plain domes. The plain walls were relieved by bands and patterns of vari-coloured stone, occasionally by bands and tiers of arcades. In the styles of the Deccan, especially in Bijapur, exteriors were marked by wide drip mouldings supported on blind arcades or brackets, by fretted crenellations and often by an extravagant fantasy of arcading or dome structure. It was, however, under the Moghul emperors in the northern part of India that Indian Moslem art reached its highest achievement. During the reigns of Akbar (d. 1605), Jehangir (d. 1627), and Shah Jehan (d. 1666) the characteristic masterpieces were produced. Under Akbar was built Humayun's Tomb, a huge structure in red stone with white marble inlay and a white marble dome, in a somewhat Persian style that seems to have served as a model for the Taj Mahal. Most impressive of all Akbar's works is the palace city of Fatchpur Sikri, virtually abandoned after 1605. This brilliant collection of pavilions, courts, and mosques represents a vast fund of architectural invention, from the sinuous free-springing brackets that support its deep, shadowed eaves to the pierced panels of tracery that protect the interiors. Jehangir was responsible for a number of great buildings, the best perhaps being the small tomb of Itimad-ud-Daula, near Agra, where pierced panelling and pietre-dure inlay were lavishly employed. But it was under Shah Jehan that the best known monuments of Islamic building in India were produced—the Pearl Mosque at Agra, the Delhi Palace, and the Taj Mahal.

The Delhi Palace, itself a complex of buildings, contains many original formal inventions of pillar and arcading, as well as lavish ornament. The Pearl Mosque is rightly famous for the exquisitely simple proportions of its white arcades and crowning domes. The Taj Mahal, however, is the most renowned structure in India. To build this monumental mausoleum with its fabulous gardens for his dead wife Mumtaz Mahal, Shah Jehan drained the exchequer of the empire. It was begun in 1632, and 20,000 men worked on it daily. By 1634 it was officially complete though work continued for many years longer. It has often been claimed that a Frenchman or a Venetian designed this magnificent work, but these claims cannot be entertained against those of an Islamic genius from outside India.

PAINTING. The earliest Indian Islamic paintings known are the illustrations to a cookery book, the *Nimatnamah* (c. 1500), from Malwa, preserved in London. These represent the earliest assimilation of the Persian style to native Indian traditions. In the Sultanates of the Deccan, too, Islamic Indian miniature styles were established during the 16th c., which developed parallel to and in mutual relationship with the great school of the north, established at the Moghul court as part of a cultural plan conceived by the fertile and tolerant spirit of Akbar. Persian artists came to work there and Hindu artists trained in the Persian miniature technique achieved great distinction. The names of many are known. The paintings illustrated works of Persian classical literature, Persian translations of Hindu literature, and especially notable court events—an incident on a royal hunt, or an elephant running amuck across a bridge of boats. As well as Persian and Hindu themes the Moghul miniatures adopted a number of elements from European, especially Italian, engravings which reached Delhi with the Jesuits tolerated by Akbar. The characteristics of the developed Akbar style were technical perfectionism in varied, brilliant colour; vital but predominantly linear drawing with some shaded modelling; close fidelity in the portraiture of even unimportant figures; elaborate landscapes with Persian rock forms and often European trees; and a banded spatial structure based on a continuously rising viewpoint. Its world was a masculine, Moslem one with much bloodshed and little romance. The artists often worked as a group on a single picture, one drawing the outline, another the portraits, a third perhaps adding the colour.

Following the taste of Jehangir albums were compiled of quasi-zoological interest recording rare birds and flowers in heightened colour. Under his rule and that of his successor, Shah Jehan, the events represented became more commonplace, chiefly durbars, and a great number of single-figure portrait miniatures were made. Under the neurotic Aurangzeb (d. 1707), who proscribed all the arts, artists of the Delhi School, driven to seek other than imperial patronage, bent their highly sophisticated talents to subjects of a wider appeal—romantic scenes of princes and ladies in splendid landscapes, often moonlit, hawking, hunting, or making love. The post-Moghul tradition persisted at Delhi through the 19th c., in a somewhat debased form, down to the present day.

**ISRAELS.** Dutch family of artists. JOZEF (1824-1911) studied with J. A. KRUSEMAN in Amsterdam, and afterwards in Paris. He finally settled in The Hague, where he became one of the leading members of the HAGUE SCHOOL. He is known principally for his pictures of fishermen and the milieu in which they lived. His son, ISAÄC (1865-1934), also worked at The Hague, but in a style almost completely independent of

his father's. Contact with BREITNER, the leading Dutch Impressionist, was decisive for Isaäc's development; his pictures of the social life of his time are characterized by the vivid colours and vigorous brush-work of the IMPRESSIONISTS. Works by both father and son are in the Municipal Museums of Amsterdam and The Hague.

808, 2079.

**ISTRIAN STONE.** A limestone of varying shades of yellow, speckled with minute fossils, quarried at Istria. It was used extensively as a building stone in the later years of the Roman Empire and in the Middle Ages and is still used today. Known also as Roman stone.

**ITALIAN ART.** The Italian peninsula has been destined to transmit from antiquity the formal systems and the concern with the monumental which have from time to time given new life to Western art and decided its course. With the decentralization that followed the ending of the Roman Empire regional traditions began to make themselves felt. The political dismemberment of the peninsula favoured the growth of local schools of art, whose isolation did not break down until the 15th c. and which ended only in the 19th. Yet Italian art has possessed qualities of its own since ROMANESQUE times. First, it has been closely linked with public life. The result is a certain taste for the spectacular: there is a willingness to subordinate all the arts to architecture and the architecture itself responds, as it were, to the landscape. Only thus could Venice, Siena, or Genoa have come into being, cities whose unity of character is as striking as their planning is original. Secondly, links between art and the intellectual or religious life of the country were both close and self-conscious. Thirdly, a genuine reverence for masterpieces has constantly impelled artists to revive or carry on the schools of the past. The weight of the classical tradition might have been crushing; yet the Italians have been able to borrow selectively from the works of antiquity—or of Byzantium or the West—only what would further their own particular artistic development. Whenever they have failed in this they have succumbed to a kind of formal rhetoric which in bad periods has been the major defect of Italian art.

MIDDLE AGES. It is true of all western Europe, but particularly true of Italy, that the development of art cannot be understood except by beginning with the creations of the Roman Empire after the Flavians. An architecture of great spaces unified by massive vaulting and rich decoration, of urban buildings grouped for monumental effect—this great style was international, common to all the centres of the Mediterranean whether eastern or western: to Antioch as well as Rome and Milan. As the Empire expanded ROMAN ART intermingled with that of the provinces and a new style appeared, not only in sculpture but also in precious ornaments, IVORIES, and the like (see MIGRATION PERIOD).

Figures began to lose their clear definition and to form a general pattern together with the background. From the 5th to the 11th c. forms of art were evolving everywhere to meet the demands of a civilization which was moving further and further from the unity of the Roman world and yet never wholly forgetting its works.

The part played by Christianity in the development of church architecture and the formalization of classical naturalism lies outside the scope of this article. (See EARLY CHRISTIAN ART, BASILICA, etc.)

(a) 5th–9th Centuries. The vicissitudes of the Empire brought shifts of political centres and changes in power. In Ravenna Latins were succeeded by Romanized Goths and these in turn by Byzantine Greeks (540–751), who were prolific of masterpieces, such as the basilicas of S. Apollinare Nuovo, S. Apollinare in Classe, S. Vitale, and the classically serene Mausoleum of Galla Placidia (see BYZANTINE ART). Ravenna's inheritance passed to Venice, where St. Mark's was founded in 829 and rebuilt in 1008.

We cannot properly speak of medieval art until after a more complete disintegration of the Latin culture. This was effected partly by the Lombard invasions of the north during the 6th c. (which decided the importance of the goldsmith's crafts in that part of Italy), and partly by the devastations of the Saracens in the 7th c. all over the south and as far as Rome. Even the attempt of Charlemagne to restore the Empire in the 8th and 9th centuries could not arrest the process. By the time of the Carolingians the divergent forces which were shaping the artistic styles of various regions resisted any imposition of unity from above. Venice remained true to the Byzantine tradition as did the south, where Benedictine monasteries like Monte Cassino exerted the strongest influence. In the north, especially in Lombardy, under the inspiration of the *maestri comacini* (probably 'masters from Como') there appeared a massive and simple architecture which preluded the Romanesque.

(b) Romanesque. After c. 1000 Italy was closely involved in the concerns of the Holy Roman Empire, which from the time of the Ottonians united the peninsula with Germany. There followed the great struggle between Papacy and Empire (12th c. onwards) and the Crusades. Drawn by these into the affairs of western Europe, Italy made an original contribution to Romanesque art. The new basilica of S. Ambrogio, Milan (c. 1100), with its huge portico and its nave flanked by two aisles, offers an early example of massive ribbed VAULTING. In the churches of Pavia and Como and the cathedrals of Modena, Ferrara, and Parma, the basilican plan is emphasized and the outer walls are enlivened by arcades and galleries. French influence was brought to Modena by the sculptor WILIGELMO and to Parma a century later by Benedetto ANTELAMI, an assured and vigorous master. In Parma the monumental Baptistery also received a series of beautiful and solemn frescoes

U

(c. 1260). The Byzantine area, which extended to Verona (S. Zeno), had its centre in Venice, where St. Mark's was rebuilt and consecrated in 1094. The plan of the new church was imported from Constantinople; the architecture was still Early Christian in spirit; the MOSAIC work involved the establishment of a permanent workshop, which became important for the future of Venetian painting. The Florentines proclaimed their own style with the church of S. Miniato, characteristically Tuscan in its purity and severity, and decorated geometrically with marbles of many colours; and around their Baptistery grew up a school of mosaic during the 13th c. The art of Pisa reflects an eastern taste, whose only parallel is at Bari in Apulia. There, grouped round Buschetto's huge cathedral with its nave and four aisles and oval dome, are a circular baptistery and a CAMPANILE built in arcaded galleries (the *Leaning Tower*). Even Rome, whose venerated churches were falling into ruin, contributed the polychrome marble decoration known as COSMATI WORK. In southern Italy and Sicily, where the Normans ruled, Byzantine, Arab, and Norman styles were mingled to produce the striking cathedrals of Catania, Cefalù, Palermo, Monreale, and the dazzling Cappella Palatina. The mosaics at Cefalù and Monreale bear witness to the renewed power of Byzantine art.

(c) *The 13th Century*. From c. 1250 we can speak of 'Italian' art whereas before this the various regional styles each with its inter-European affinities had insufficient characteristics in common to be so identified. It was this that led Burckhardt and many historians after him to date the beginnings of the RENAISSANCE to the middle of the 13th c. It is true that the great architecture of Tuscany, the monumental sculpture of the PISANI, the works of the Roman mosaicists, and the paintings of the Assisi school all appeared together at about this time. They were all reactions from the powerful GOTHIC and Byzantine influences which had dominated the first half of the century.

The struggle between Papacy and Empire ended with the triumph of the Papacy in Rome and the Crusades with the partial conquest of the Byzantine Empire, Venice and Genoa being the gainers. The renewal of Italian art can only be understood if seen against this background. Between the pontificates of Innocent III (d. 1216) and Boniface VIII (d. 1303) French influence continued to grow in Italy, exerted by the great religious orders such as the Cistercians, who introduced the new Gothic forms into Lombardy (Chiaravalla), Tuscany (S. Galgano), and Latium (Fossanova). It flourished also in Norman Sicily, and when Charles of Anjou, brother of S. Louis, had destroyed the imperial power (1266) and become protector of the Papacy, the power of Anjou in the south of Italy helped Gothic forms of decoration to permeate secular art. On the other hand, owing to the capture of Constantinople by the Latins (1204),

the connection between Italian and Byzantine art became closer and some of the Greek workshops were actually brought to Italy, especially to Venice and Rome, to assist in the revival of mosaic and rich ornament. The two influences, Byzantine and Gothic, were combined in the works created under Frederick II—Ghibelline strongholds such as the castles of Apulia (Castel del Monte) and the sculpture of Nicola PISANO. They were apparent in central Italy in the rise of Franciscan art. The Gothic style of architecture, already familiar through Cistercian foundations such as Fossanova, was now adopted by the mendicant RELIGIOUS ORDERS: the basilica of St. Francis at Assisi was begun in 1228. The new Order was at first inclined to austerity, and the earliest Franciscan pictures recall popular Byzantine art. But by the end of the century the impulse for display manifested itself in a great cycle of paintings in honour of St. Francis which revealed an Italian genius—the MASTER OF THE ST. FRANCIS LEGEND—traditionally identified with GIOTTO. Thereafter it became the custom to reserve large expanses of wall for paintings. It is also worth mentioning that at about the same time a change in the Roman liturgy permitted the priest celebrating mass to stand in front of the altar instead of facing the congregation from behind it—a change which gave a new importance to the design of the altar itself and brought about the development of the retable or ALTARPIECE. Thus in 13th-c. Italy the conditions were again present for change in all the arts. From c. 1280 onwards the originality of the Italian genius began to assert itself.

(d) *Gothic*. The unified Italian art which emerged in the 13th c. fell increasingly into line with the Gothic style which was spreading through western Europe, though in Italy it took on distinctive features. Early in the 14th c. the exile of the popes at Avignon and the eclipse of the Empire led to the rise of the city states and the great age of town building. Throughout Italy were constructed civic palaces, monumental fountains and bridges. The Florentines were especially active: from these years date the Franciscan church of Sta Croce, the Dominican church of Sta Maria Novella, the cathedral, the Palazzo Vecchio, and the Bargello. The whole city was laid out; the cathedral dome and Giotto's Campanile were projected (see FLORENTINE SCHOOL). The Sienese, with the same civic pride, set up a huge tower beside their Palazzo Pubblico, laid out the square in front of it, and embarked upon a complete transformation of the cathedral (see SIENESE SCHOOL).

Nicola Pisano, a sculptor of Apulian origin, combined classical forms with a powerful realism. It was in his workshop that the architect-sculptors of the 14th c. formed their style, notably Giovanni Pisano with his highly personal and daring works, such as the Pisa Cathedral pulpit and the façade of Siena Cathedral. Giovanni's sculpture seems to burst out of its architectural frame, as does that of his fellow

pupil ARNOLFO DI CAMBIO. This art, diffused by TINO DI CAMAINO at Naples and 'gothicized' by Lorenzo MAITANI at Orvieto, conquered all Italy. But in the 1330s it was overwhelmed by a delicate 'minor Gothic' whose chief representative was Andrea Pisano, author of the first pair of doors of the Florentine Baptistery.

In painting CIMABUE strengthened the formal qualities of the inherited Byzantine style. He may have worked at Assisi at the same time as TORRITI, who with Pietro CAVALLINI had introduced a new note of antique grandeur into the decoration of Roman basilicas. From Assisi, where nearly all the important masters went, spread the fame of Giotto, whose mature style was exemplified by the Arena Chapel, Padua, and Sta Croce, Florence. His contemporaries admired him for his dramatic realism, which was glibly reproduced by his successors, the GIOTTESQUES. At Siena the innovator was DUCCIO DI BUONINSEGNA, who was a more subtle and sensitive colourist than Cimabue. Duccio's pupil SIMONE MARTINI, a friend of Petrarch at Avignon, is a particularly endearing master of Sienese Gothic. A more dramatic follower of Giotto was Pietro LORENZETTI, whose brother Ambrogio has left us the first landscapes.

Towards the middle of the 14th c. began the long reign of the flowery Gothic style of painting and sculpture, decorative and mannered rather than realistic. The dry and complicated art of Andrea ORCAGNA gave rise to a school. The fashion was for great cycles of frescoes with elaborate programmes, but the only one which has true grandeur is the *Triumph of Death* (c. 1350) by Francesco Traini in the Campo Santo at Pisa (damaged in 1944). The INTERNATIONAL GOTHIC in vogue c. 1400 suited the Sienese temperament (e.g. SASSETTA) and it was a Sienese illuminator, LORENZO MONACO, who carried this precious fairy-tale art to Florence. From Verona GENTILE DA FABRIANO and his pupil PISANELLO set the example with their delightful paintings, rich in realistic detail. The only sculptor to maintain the grandeur of the Pisani was the Sienese Jacopo della QUERCIA, who was defeated by GHIBERTI in a competition held in Florence (1401) for the new doors of the Baptistery. In architecture the great achievement was not the rather forced adaptation of northern Gothic in the cathedral of Milan but the art which produced the façade of St. Mark's, the Doges' Palace, and the Ca' d'Oro, in Venice. There, until the middle of the 15th c., FLAMBOYANT Gothic and Byzantine traits were blended together into a richly coloured decoration in which the surfaces of the walls seem to dissolve.

THE RENAISSANCE. When papal authority was re-established in Rome stable governments were already beginning to be established in the regions. Powerful states arose, disposed to spend money on luxury. Such were Lombardy; Venice, established on the mainland from the beginning of the 15th c.; Mantua with its ruling family, the GONZAGA; Ferrara with the ESTE;

Urbino with the MONTEFELTRO; and Florence dominated by the MEDICI. The political balance was upset in 1494 when the French invaded Milan and Naples, starting the wars which drew the western powers into Italy. But these events occurred at a time when the culture and art of Italy had attained that pre-eminence in Europe which is claimed for the Renaissance.

(*a*) *15th Century*. While this florescence of the arts was thus creating new styles of individuality in Italy, secular knowledge was being advanced by the humanists. The new learning opened up fresh realms of thought and coincided with a more liberal attitude to art (see LIBERAL ARTS). It was now that the first treatises appeared on architecture (ALBERTI, FILARETE) and painting (Alberti); PROPORTION and PERSPECTIVE were scientifically studied. In line with the new optimistic philosophy of man there developed a movement away from International Gothic towards greater naturalism—particularly in Florence between 1420 and 1440. Florence was the main centre of the new art and great undertakings were concentrated there, as for example the second and third pairs of doors for the Baptistery, on which Ghiberti worked for half a century at the head of a large studio, San Michele, for which DONATELLO made some of his early works, and the cathedral, which BRUNELLESCHI completed with his cupola. Brunelleschi (a close associate of the humanists) was a technician with the vision of a town-planner. He used classical forms, disposing the elements of his buildings clearly and with a sense for proportion. His style was adapted by MICHELOZZO to the palaces and VILLAS of the Medici. Fidelity to the ANTIQUE and care for exact proportion were carried still further by Alberti, nobleman and humanist, both an innovator in theoretical studies and inventive in the creation of new forms. In sculpture Donatello moved from his youthful realism to the discovery of classical balance (CONTRAPPOSTO) and pictorial RELIEF. Then after a period in Padua, when he imitated the antique with still more exact fidelity, he ended his career in an emotional expressiveness too advanced for his contemporaries to accept. Ghiberti, whose first bronze door at the Baptistery still retained many of the elements of International Gothic, showed in his monumental second door that he had absorbed the achievements of contemporary painting. The marble wall-TOMBS by such masters as Bernardo and Antonio ROSSELLINO, DESIDERIO DA SETTIGNANO, and MINO DA FIESOLE show how a traditional type was changed under the impact of classical taste. In contrast the charming glazed and coloured terracotta reliefs of Luca della ROBBIA and his workshop enjoyed great popularity in wayside shrines, chapels, and even private houses.

The new kind of painting begins in Florence with MASACCIO, who died young in 1428. Masaccio returned to the grandeur of Giotto, but commanded a scientific understanding of perspective together with rare gravity of feeling.

Just before 1440 DOMENICO VENEZIANO united the scientific approach of the Florentines with an interest in colour and Fra ANGELICO learned much from both before he finally adapted the now old-fashioned Gothic to new uses. Others who demand mention are Filippo LIPPI, Andrea del CASTAGNO, GOZZOLI, BALDOVINETTI. From c. 1460 onwards Florentine artists took greater liberties with naturalistic representation, as may be seen in the agitated forms of Antonio POLLAIUOLO.

All the Italian centres of art reacted to the example of Florence, though in different ways. In Siena Sassetta and MATTEO DI GIOVANNI retained something of the Gothic 'handwriting', while FRANCESCO DI GIORGIO kept the imaginativeness and tension of the Sienese style despite all that he learnt from the Florentines. In Umbria PIERO DELLA FRANCESCA combined a subtle luminosity with consummate geometrical skill (see UMBRIAN SCHOOL). Federigo da Montefeltro turned his capital, Urbino, into an important centre of culture where Alberti, Piero, and UCCELLO all worked and where the first modern palazzo was built for him by Luciano LAURANA and Francesco di Giorgio. Rome badly needed rebuilding and the popes, from Nicholas V onwards, were town-planners. To decorate the Vatican chapels they summoned sculptors like the brothers Pollaiuolo, the architect Bernardo Rossellino, and celebrated painters from central Italy. Sicily produced a great painter, ANTONELLO DA MESSINA, who brought the lessons of FLEMISH ART to Italy, particularly to Venice.

Northern Italy developed independently. The Lombard architecture of Filarete and Amadeo displayed a taste for over-abundant decoration based on forms of classical origin. In Padua, under the influence of Donatello and the antique, MANTEGNA created a hard, sculptural style of painting, full of expert foreshortenings and archaeological details. He also excelled in LINE ENGRAVING. In Ferrara the Este dukes built palaces admired for their charm, and the painters (TURA, COSSA, Ercole de' ROBERTI) combined vigorously modelled and contorted forms with fantastic ornament (see FERRARESE SCHOOL). The vogue of marquetry (*intarsia*), which became a specialized application of perspective, is fairly typical of the taste of these northern provinces.

In Venice (see VENETIAN SCHOOL) architecture was absorbing Lombard influences. The 'hard' style of painting on the mainland induced the VIVARINI to adopt a brilliant, vitreous colour, while CRIVELLI derived a light, mannered style from the emotional art of Ferrara. The BELLINI epitomize the whole century. Jacopo Bellini, a Gothic artist, made perspective a principle of his style; Gentile was a poetic story-teller and a student of light; Giovanni, taking Mantegna as his starting-point and evolving through contact with Antonello da Messina, achieved a noble style, serene yet warm in atmosphere, which prepared the way for GIORGIONE and TITIAN.

The end of the 15th c. saw some remarkable innovations. Almost at the same time several architects returned to the domed church with central plan. It appealed to their exact sense of spatial values, and they saw a cosmic symbolism in its harmonious order. They were Giuliano da SANGALLO, who also revived the villa type, Francesco di Giorgio, BRAMANTE, and LEONARDO. The sculptor VERROCCHIO, by enlivening his bronze surfaces and imparting movement to his forms, obtained striking effects which exploited the play of light; and the best of his art was inherited by Leonardo, his pupil. In painting BOTTICELLI sounded a new note and the expressive discord of his latest works was echoed in the bizarre 'romances' of Filippino Lippi and PIERO DI COSIMO. But the 'hard' style was a relic of Gothic taste. All over Italy it was being superseded by a new 'soft' manner. Thus in Umbria SIGNORELLI had no following for all his grandeur and technical accomplishment, while PERUGINO, happy in composition but for some tastes monotonous and over-sweet, enjoyed wide success. Leonardo stands above these antitheses. His modelling was admirably fused (SFUMATO), but lost nothing of precision. His concern was with everything the eye can see, and the whole world was to him a spectacle of light, shadow, and colour. Scholar, scientist, artist, and philosopher, he embodied more than any other the Renaissance-humanist ideal of the *uomo universale*.

(*b*) *The Classical Phase in Rome and Venice.* The whole 16th c. was dominated by an extraordinary revival of interest in Roman art (see ROMAN SCHOOL) concentrated between 1506, the year when MICHELANGELO arrived in Rome, and 1527, when the city was sacked by the mercenaries of Charles V. Bramante was the very architect needed to realize Julius II's great ambitions for Rome; he put in hand a scholarly project for unifying the complex of buildings at the Vatican, and having demolished the old St. Peter's he proposed a domed cathedral on a central plan—a monumental solution which was modified by his successors. After 1547 Michelangelo claimed to be reverting to Bramante's scheme, but his own more compact design was in turn altered, for liturgical reasons, by the building of MADERNA's nave. The Sangallo family, particularly Antonio da Sangallo the Elder (S. Biagio at Montepulciano), introduced the heritage of Tuscan forms into the architecture of Rome.

The pontificate of Julius II gave opportunity to the genius of RAPHAEL. He had assimilated what was best in Perugino, had learnt from Leonardo and the antique and had still to learn from Michelangelo and the Venetian colourists when, with that sureness of judgement that came natural to him, he executed his masterly frescoes at the Vatican—the *Stanze*. Their formal composition, breadth of conception, and occasional management of dramatic effect made them the most perfect expression of the classical Renais-

sance art. His great decorative works in the Farnesina and the Vatican prepared the way for the academicism of the 16th c.

Michelangelo's tensely dramatic art, with its cult of the human body and its union of Christian faith with humanistic culture, occupies a place apart. After the *Pietà* in St. Peter's and youthful yet highly accomplished works such as the colossal *David* in Florence, he approached his greatest tasks: the tomb of Julius II, the ceiling of the Sistine Chapel, and the Medici Chapel in Florence. In Michelangelo there is a conflict of opposites, expressing the struggle of the human soul torn between action and contemplation. Conflict is present in the dramatic vision of the *Last Judgement* (Sistine Chapel), and in the last unfinished *Pietà* what seems at first sight an almost formless mass is given meaning by a deeply felt spirituality. Only the choir and dome of St. Peter's achieve a happy equilibrium.

The works executed in Rome during the first two decades of the 16th c. established a style of architecture, painting, and sculpture which spread throughout Italy. Bramante's pupils established the centrally planned building in Milan and Umbria, and Jacopo SANSOVINO, having assimilated Roman teaching, went to Venice in 1527 to become the most representative of Venetian architects. Leonardo's pupils formed a Lombard school of painting which thanks to SODOMA extended its influence to Siena. In Florence it was again Leonardo's feeling for ideal form that made possible the grandeur of Fra BARTOLOMMEO and the Classicism of ANDREA DEL SARTO.

Art flourished in Venice in spite of political and economic troubles in the early 16th c. Here painting was the dominant art, and the peculiarly Venetian ideal of beauty was defined by that formula of light and tone which was worked out between 1505 and 1510 by the aged Giovanni Bellini, the mature Giorgione, and the youthful Titian. It was Giorgione who realized this poetic quality most fully, achieving a rare unity between figure and landscape, form and light. Few Venetians could resist the domination of Titian and his immense international prestige has made his form of Venetian painting a canon of perfection. Beyond the Venetian border Dosso DOSSI at Ferrara developed a ROMANTIC style of painting rich in colour, and CORREGGIO at Parma composed soft and sensuous pictures. In his frescoes, already BAROQUE, order and form were dissolved into light and movement.

(*c*) *Mannerism.* Around 1530 Italy experienced every kind of catastrophe. Rome was sacked (1527), the Florentine Republic fell (1530), the Spaniards installed themselves in occupation (from 1530). Soon afterwards came the rigours of the Counter-Reformation and the climate of oppression which it created. The feeling of crisis was intensified by factors within art itself—a less robust attitude to the past and the notion that everything had been said by the great masters. Contact with foreign artists had a like effect. Moreover masterpieces now began to be more widely known through engravings and this tended to encourage PASTICHE. Regimented by pedantic amateurs who drew up rules for the newly founded ACADEMIES, artists were drawn towards anti-natural, inharmonious, and arbitrary forms or became involved in puerile symbolism or found what freedom they could in burlesque and the bizarre. Their striving after grandeur was accompanied by an odd craze for realism in small details. These factors gave birth to a certain artificiality of style which lasted until the end of the century and is conventionally known as MANNERISM.

In Mantua GIULIO ROMANO, a pupil of Raphael, created the first typical work in this style—the Palazzo del Tè, a piece of paradoxical pseudo-rustic architecture with theatrical or erotic frescoes. In Parma the sophisticated painting of PARMIGIANINO heralded the International Mannerism which flourished at FONTAINEBLEAU (PRIMATICCIO) and in Flanders. In Tuscany the artistic policy of Duke Cosimo I almost foreshadowed that of Louis XIV, for Cosimo had his Academy and his official artist, the painter-architect VASARI, whose cold overelaborate style spread through all the cities of the Grand Duchy. The sculptors CELLINI, BANDINELLI, and AMMANATI were true court artists. Later on BUONTALENTI, inventive and fond of syncopated rhythms, and Giovanni da BOLOGNA, a graceful virtuoso, arranged gardens and grottoes for princes, worked for public festivals, and were occupied with the decoration of fountains. In painting the restless PONTORMO with his sinuous compositions in clear colours had a strange, obsessive attraction. ROSSO FIORENTINO, a tormented personality with an abrupt bizarre style, was presently summoned to France, where he became the prolific decorator of Fontainebleau. BRONZINO presents a contrast to these distraught artists: he is smooth and impassive, and his solemn old-fashioned manner, touched by Flemish influence, made him a model portraitist to the court.

In the Veneto there was a revival of architecture—a classical revival, but marked by Mannerist features. PALLADIO may have been a theorist and archaeologist, but first and foremost he was a man of taste. He was scrupulous in maintaining rational forms and clear principles of proportion; but he regarded these as purely optical effects, so that his buildings were 'organic' and could be adapted to the Venetian countryside and the Lagoon. In painting TINTORETTO exemplified Mannerism by his composition in diagonals, his perspective tricks and his long sinuous figures and cultivated uncertainties of lighting; while his vast paintings accentuated the dramatic and prodigious and were fraught with a verve and energy which make them the fullest manifestation of the potentialities of invention inherent in the style. VERONESE, returning to the clear tones of Giovanni Bellini, displayed the splendour, opulence, and virtuosity of an

inexhaustible talent for decoration. BASSANO, with his interest in light and his emphasis on realism, was a precursor of the Baroque in his scenes of GENRE.

At Rome fashion favoured the rapid executants in fresco. One of these, ZUCCARO, had influence as a theorist and was the moving spirit of the Accademia del Disegno. Mannerism prevailed in architecture and in the decoration of villas famous for their gardens, such as the Villa d'Este at Tivoli or the Villa Farnese at Caprarola. VIGNOLA, the architect of Caprarola, created a prototype when he designed the Roman church of the Gesù with its aisleless nave. The layout of Rome was set for centuries by the bold and practical planning of FONTANA.

Lombardy contributed little. Galeazzo Alessi (c. 1512-72), an architect working in Genoa and Milan, lacked originality. CAMBIASO, a hasty muralist, has left some essays in light effects and some curious attempts to reduce the human body to a geometrical diagram. The public was enthusiastic about the still-life arrangements of ARCIMBOLDO, oddly composed into anthropomorphic shapes, and the melting tones of BAROCCI.

THE BAROQUE. In the 17th c. Italy was politically divided and subservient to the Spanish Habsburgs. The arts received a powerful impetus from the papacy, which had triumphed in Europe with the Counter-Reformation. With Baroque, Italy was once more at the centre of initiative in the arts. There the achievements of the Renaissance were directed towards an aesthetic of the theatre and the opera, an aesthetic of luxury and illusion, of luscious naturalism and irrepressible energy. Architecture, sculpture, and mural painting were merged in a single art, in which open forms, played upon by light and extended in real or false perspectives, combined to create and furnish an imaginary space. The re-planning of Rome set the example. BERNINI's colonnade in front of St. Peter's (1656-7) showed how the eye could be guided, the sense of distance misled, and the points of emphasis distributed. Rome was filled with decorative features and public squares which borrow from the scene-painter's craft (Piazza Navona; steps of Trinità de' Monti; Trevi Fountain). Elsewhere, in picturesque and lively gardens and whole cities contrived for the sake of their vistas, we can appreciate the genius of great theatrical decorators such as the BIBIENA family of Bologna. About 1630 three great architects appeared in Rome: Pietro da CORTONA; Gianlorenzo Bernini, whose churches, designed to suggest grandeur, have a radiant and solemn pathos; and BORROMINI, a highly individual master remarkable for his daring composition and strange geometrical forms. In painted ceilings the rule was for TROMPE L'ŒIL perspective (Pietro da Cortona, Padre POZZO), whereby the whole building becomes a vast illusion and melts away into an imaginary sky. In sculpture Bernini, a virtuoso in the management of materials, light, and setting, had mastered every effect of movement and his finest works had a forensic eloquence untried before him. ALGARDI competed in vain, often producing no more than a subdued version of his rival's inventions. Piedmont had two great architects, GUARINI (a follower of Borromini) and JUVARRA. In Parma Aleotti (1546-1636) established what was to remain for 200 years the standard type for theatrical stage and auditorium. Florence had no Baroque architecture, though several large palaces were decorated with frescoes by Pietro da Cortona and Luca GIORDANO. In the south, however, the Baroque blossomed exuberantly. VANVITELLI created a Neapolitan VERSAILLES at Caserta and Giovanni Battista Vaccarini (1702-68) left his imprint on Palermo. Whole cities in Sicily and Apulia were subordinated to an often intemperate passion for decorative effect. Naples was the home of two of the great ceiling painters, Giordano and SOLIMENA. Venice went her own way: the splendid church of Sta Maria della Salute, by LONGHENA, is a translation of Palladio into Baroque terms. After 1700 we find a number of dazzling mural painters such as PIAZZETTA, Federico Bencovich (c. 1677-1753), and above all TIEPOLO, a virtuoso of international fame, full of life, light, and romantic fancy, though sometimes a little facile in his effects.

All these were works of spectacle. But there had also been a powerful growth of painting in its own right. The decisive years were 1600-10, when Annibale CARRACCI and CARAVAGGIO, both at Rome, laid the foundations of the two rival styles which dominated the century. Caravaggio sought to be revolutionary through an ostentatious naturalism; this was emphasized by the grandeur of his powerful figures and the artful light which causes his forms to emerge abruptly from the shadows in startling relief. He had many followers, among them MANFREDI, GENTILESCHI, and SARACENI. But his influence spread far beyond Italy: two centuries of still life, of CHIAROSCURO, and ROMANTICISM are unthinkable without him. The other style, academic (see BOLOGNESE SCHOOL), traced its ancestry through the Carracci to Raphael and the High Renaissance; but it was also concerned with the expression of pathos and after its own fashion with realism. Of the academic masters DOMENICHINO comes closest to Annibale Carracci; Guido RENI slips easily from a classic, if somewhat contrived, harmony into sentimental piety. The most vivid and personal of the group was GUERCINO, whose composition has breadth and whose handling of light, despite its individuality, owes something to the CARAVAGGISTI.

Landscape had been an important element in the art of Annibale Carracci and Domenichino, but the veduta (townscape) was destined to become a separate genre (see TOPOGRAPHICAL ART). The Roman scene was celebrated in PANNINI's superb decorations and became in the 18th c. the property of all Europe through PIRANESI's imaginative etchings. As for Venice, its dignity

and order were depicted by CANALETTO, its poetry and atmosphere by the almost IMPRESSIONIST touch of GUARDI. Fantastic landscapes, often with uncanny light effects, were painted by CASTIGLIONE and MAGNASCO, who had both settled in Naples.

THE MODERN AGE. From the middle of the 18th c. Italy had been assisting in the search for an antidote to the Baroque. This was NEO-CLASSICISM. It had its origin in a new obsession with the antique, which was encouraged by excavations (POMPEII), theoretical writings (Francesco Milizia, Tommaso Temanza), and the activities of foreigners settled in Rome (MENGS, WINCKELMANN, THORWALDSEN). Under the influence of Napoleon and his chosen painter DAVID it evolved from a rather prim Hellenism to a Roman solemnity. The most exalted of its Italian interpreters, and the only one with a major talent, was the sculptor CANOVA.

Italy emerged from the Napoleonic upheavals still weaker and more divided. The struggle for unity (*Risorgimento*) which dominated the 19th c. gave a great impetus to literature but hardly influenced the arts. Italy knew only the outward forms of the Romantic movement—pastiche, tactless restoration, and the construction of monumental edifices in a mixture of historical styles. Sculpture inclined to a naturalism of doubtful merit and painting to *bravura* pieces or sentimental genre scenes. SEGANTINI with his symbolic landscapes and the severe forthright artists known as the Macchiauoli (1860-80) were alone in asserting the methods and effects proper to painting.

A modern art was foreshadowed between 1910 and 1920 by the rowdy FUTURIST movement with its doctrine of 'dynamism', and the strange stillness of CHIRICO and METAPHYSICAL PAINTING. No theoretical justification was needed for MORANDI's lofty and austere painting or for the sensitive art of MODIGLIANI (who associated himself with the School of PARIS). Later in the century Italian artists covered the whole range from realism to abstraction; their strength has been an awareness of style and its demands. The sculptors MARINI and MANZÙ both strove to create freely in the spirit of the great masters. Architecture was strangled in the Fascist years by a pretentious monumentalism which only a few rare minds escaped (Giovanni Michelucci, Giovanni Ponti), but has since flourished in a very modern spirit and shown the imaginative daring and feeling for site and function which are traditional in Italy.

23, 48, 58, 147, 170, 188, 220, 244, 245, 246, 313, 352, 397, 532, 533, 534, 561, 577, 596, 631, 661, 754, 921, 933, 978, 981, 1083, 1114, 1234, 1264, 1265, 1459, 1614, 1655, 1717, 1739, 1764, 1767, 1777, 1786, 1810, 1817, 1847, 1964, 1991, 1996, 2005, 2006, 2020, 2072, 2080, 2119, 2120, 2122, 2124, 2129, 2130, 2132, 2145, 2273, 2372, 2375, 2384, 2466, 2505, 2526, 2529, 2694, 2699, 2714, 2733, 2740, 2749, 2776, 2798, 2832, 2870, 2901, 2922, 2927.

**ITALIAN VILLA STYLE IN THE U.S.A.** One of the most picturesque of early 19th-c. architectural styles, this had its origins not in an architectural prototype but in the rural Italian VILLAS found in the landscape paintings of CLAUDE, POUSSIN, and ROSA. During the first quarter-century the villa became a common feature of English architectural pattern books. It appeared in America *c.* 1830 and remained popular in some areas down to the Civil War. Irregular in massing and extremely flexible in plan, its most conspicuous formal features were towers like CAMPANILES and wide overhanging eaves supported on brackets, which caused the style to be known as the 'bracketed mode'. It was frequently used in mixtures with several other eclectic styles, especially the Greek, GOTHIC, and LOMBARD ROMANESQUE. Distinguished examples in the domestic field are Henry Austin's Morse House, Portland, Maine (1859) and UPJOHN's King Mansion, Newport, Rhode Island (1845-7). Among public buildings the Hospital for the Insane, Raleigh, North Carolina (1850), designed by A. J. DAVIS, is a bold and original handling of the style. The bracketed mode was recommended by A. J. DOWNING for its 'picturesqueness and variety'. He also says that it gave 'a character of lightness' to the design of wooden buildings.

**IVAN.** See PERSIAN ART.

**IVANOV,** ALEXANDER ANDREYEVICH (1806-58). Russian painter. He was born in St. Petersburg and studied there at the Academy of Fine Arts under his father, the painter ANDREY IVANOV (1772-1848). In 1830 he travelled abroad, first to Dresden and then to Rome, which became his second home and where he spent nearly all the rest of his life. Under the influence of the NAZARENE School he turned to religious painting. His main work, which occupied him for about 20 years, is *Christ's First Appearance to the People* (Tretyakov Gal., Moscow, 1833-55). This enormous painting, which combined a Raphaelesque composition with modern realism, achieved European fame long before its completion, but proved disappointing when it was finally exhibited. He also hoped by biblical illustrations to create a new religious art which was to combine his own mysticism with the rationalistic biblical criticism of the German School (D. F. Strauss) and historical exactitude. None of these illustrations got beyond the stage of drawings, but many of them show a strikingly original visual imagery. In 1858 he returned to his home country and died shortly afterwards. In Russia one of the first to proclaim the greatness of Ivanov was Gogol. Interest in his work has grown in recent years, particularly in his drawings.

**IVORIES.** Carvings in a wide variety of materials are embraced by this term. Usually they are of elephant or walrus tusk, but from earliest times narwhal and rhinoceros horn,

stag-horn, and even bone have been used almost interchangeably.

True ivory is easily worked with saws, chisels, drills, and rasps, but the size and shape of a carving are usually limited by the dimensions of a tusk rarely exceeding 7 in. in diameter (to advantage in the case of the OLIPHANT and the PYXIS, which retain its basic shape). Being close-grained, ivory lends itself particularly well to low relief, but it has also been used for statuettes, the curvature of the tusk being sometimes exploited to give a graceful swing to the figure. Though often painted over in the Middle Ages, its natural lustre, translucence, and satin smoothness have always made it the preferred material for smaller objects such as chessmen and Japanese *netsuke*, which must be handled to be appreciated.

In the ancient world ivory was classed with gold and precious stones as a luxury material, and appears as such in the poetic imagery of the *Odyssey* and the Song of Songs. Triumphal monuments of Egypt, Assyria, and Rome show tusks being brought as tribute by captives. By more peaceful means, too, the Egyptians obtained them from African sources, while Assyrians bargained with Phoenicians for supplies from India, as did Solomon when he made his famous throne. Besides its physical charm ivory still retains something of the aura of mystery and legend which surrounded it throughout the Middle Ages. For centuries it was associated with the rarely seen elephant and the only slightly more fabulous unicorn, whose horn was said to neutralize poison contained in a cup made from it. In the Far East, as Marco Polo learned to his surprise, the unicorn was identified with the unlovely rhinoceros; but in Europe the actual source of the long horn with corkscrew grain was the narwhal of the Arctic Ocean. Even morse (walrus) ivory was rare enough in the 9th c. to make King Alfred listen eagerly to a Norwegian explorer who had seen herds of these 'horse whales' off the coast of Russia.

While the ancient civilizations of the eastern Mediterranean did produce such miniature masterpieces as the vivid portrait of an aged Pharaoh of the 1st Dynasty and the restrained but powerful Assyrian reliefs of standing figures in the British Museum, they had little feeling for the intimate qualities of ivory, treating it chiefly as a veneer for furniture. The Greeks used it for colossal CHRYSELEPHANTINE (gold and ivory) cult-statues, the most famous of which were those of Zeus at Olympia and Athena at Athens by PHIDIAS. Only the faces, hands, and feet were of ivory, but even these areas were very large and it is not known how the sculptor contrived to cover them. The Romans, too, seem to have used ivory as a decorative material for toilet articles such as combs, hairpins, and pyxides, for the curule chair and sceptre conferred by the Senate on tributary rulers and consuls, and for the DIPTYCHS which consuls gave as presents when they took up office.

In Egypt and Syria, nearer the source of supply, ivory carving flourished in the 3rd and 4th centuries A.D., and the workshops of Alexandria turned out numerous small plaques which revived the style and content of HELLENISTIC art. In a debased form these persisted into COPTIC carving of the 5th and 6th centuries. In Syria, also, classical models are suggested by individual figures on EARLY CHRISTIAN ivories such as the *Brescia Casket* and the *Berlin Pyxis*, although the subjects are biblical and the composition primitive. The proximity of Constantine's new capital on the Bosphorus undoubtedly stimulated production in these centres and confirmed the importance of ivory in the symbolic art of Empire and Church. The chair and sceptre of secular power had their counterparts in the episcopal throne and pastoral staff, which were also frequently of ivory, and the most famous carving of its period is the throne of Bishop Maximian (546–56) in Ravenna, decorated with scenes from the lives of the Virgin and Christ and the story of Joseph. The variety and excellence of its style suggest that an important Eastern centre like Constantinople or Alexandria was responsible for its manufacture.

With other arts in the Eastern Empire ivory-carving declined during the Iconoclastic Controversy of the 8th and 9th centuries, but began to flourish again under the Macedonian dynasty, and magnificent TRIPTYCHS and caskets were produced in the 10th and 11th centuries (see BYZANTINE ART). The former, which seem to have developed out of the diptychs, were evidently for devotional use, since the important carving (usually of Christ or the Virgin and Child flanked by saints) is on the inner surface, protected by the wings when they are closed. The exterior is often quite simply decorated with crosses in low relief, but elaborate examples like the *Harbaville Triptych* (Louvre) are fully carved both inside and out. The subjects on the caskets sometimes suggest ecclesiastical use, as do the half-length Christ, Virgin, and Apostles on an example in Florence. But more often they are pagan, like the scenes from classical mythology on the *Veroli Casket* (V. & A. Mus.). Almost invariably the framework enclosing the panels is carved with rosettes, sometimes alternating with heads in roundels.

In the West, under Charlemagne and his successors, caskets (Louvre) and liturgical combs and fans (*Flabellum of Tournus*, Florence, decorated with scenes from the *Eclogues* of Virgil) were produced in emulation of Early Christian and Byzantine examples. But for the most part ivory workers confined themselves to carving book-covers, which vary in style with the manuscript illustrations inside from hieratic stiffness in the covers of the *Lorsch Gospels* (Vatican and V. & A. Mus.) to lively narrative in those of the *Psalter of Charles the Bald* (Bib. nat., Paris).

These divergent tendencies reappeared in OTTONIAN and ANGLO-SAXON ART of the 10th and 11th centuries. On the one hand the hieratic

style of Ottonian ivories was strengthened by contact with Byzantium, though the most typical examples (such as the *Christ Raising the Widow's Son* in the British Museum and other plaques from the same altar-front in Liverpool and on the Continent) have an intensity of expression quite distinct from the detached calm of Byzantine work. On the other hand Anglo-Saxon ivories such as the *Nativity* from a book-cover (Liverpool) and the *Alcester Tau* (T-shaped pastoral staff, B.M.) reflect the agitation and linear fantasy of the 'Winchester' style of manuscript ILLUMINATION.

Ivory carvings may well have played a part in the revival of stone sculpture in France at the end of the 11th c., judging by the close parallels between ROMANESQUE ivories and the carved capitals and porches of churches. A tau in Florence, with scenes from the story of Dives and Lazarus, echoes a favourite theme of churches in Languedoc, and the standing Apostles on a plaque in Berlin (Staatl. Mus., Berlin) are strikingly paralleled on the lintel of the south door of S. Sernin in Toulouse. In England, however, the ivories are more often linked with manuscript styles, as the king from an *Adoration of the Magi* (Dorset County Mus.), which is related to the *Shaftesbury Psalter* (B.M.). A transitional phase between the Romanesque and GOTHIC styles is suggested by a late 12th-c. English crozier (V. & A. Mus.) on which episodes from the infancy of Christ and the life of St. Nicholas are represented. But even in France there is a gap of over 50 years between the latest ivories of the 12th c. and the earliest of the 13th. The new style appears to emerge fully formed, as if without evolution. The change is marked by the sudden appearance of free-standing statuettes after *c.* 1240. Among the finest are those in the Louvre forming a *Coronation of the Virgin*, which in a photograph might be taken for stone sculpture from over a cathedral door, and a *Deposition*, one of the most expressive works of the period. Equally striking is the revival of the devotional diptych and triptych, *c.* 1300. Unlike their Byzantine prototypes many of these, such as the *Soissons Diptych* (V. & A. Mus.), are carved with crowded rows of figures in an architectural framework, set one above the other and forming continuous narratives similar to the elaborate biblical cycles of contemporary manuscript illustration. This new taste for the anecdotal rather than the dogmatic

corresponds to a change in patronage. Like the manuscripts, ivories were increasingly commissioned and executed by laymen, and secular objects decorated with scenes from romance and courtly love, such as combs, caskets (*La Châtelaine de Vergy*, Met. Mus., New York), and mirror cases (*The Elopement from the Castle of Love*, Liverpool), were produced in the same workshops. For the first time the names of craftsmen are recorded, and although the French style dominated the whole of Europe, a *Virgin and Child* in Pisa Cathedral can be identified with one carved by Giovanni PISANO in 1299, and a large ALTARPIECE made by Baldassare degli Embriachi for the Certosa di Pavia *c.* 1400 is the key to a group of works by other members of this family which are made up of separately carved strips of bone. An English group has been identified through a triptych (B.M.) made for Bishop Grandisson of Exeter (1327-69).

After the 14th c. ivory-carving as an art declined steadily, despite revivals in the 17th and 18th centuries. The Baroque tankards, statuettes, and reliefs of German and Flemish carvers such as Georg Petel (*c.* 1590-1634), Gerard van Opstal (*c.* 1597-1668), and Lukas Faydherbe (1617-97) are usually three-dimensional reproductions of RUBENS's compositions. The ivories of a sculptor such as Balthasar PERMOSER merely repeat his monumental works on a reduced scale, while the portrait medallions of David le Marchand (1674-1726) and Jean Cavalier (active 1680-1707) belong to the field of the medallist. With the elaborate standing cups and ornaments produced on the lathe by German craftsmen of the 17th c. art descended to mere skill, only to be outdone by extreme patience in the 'magic balls' (hollow concentric spheres of open-work) carved in China then and since. Only in the lacy fans and elegant *râpes à tabac* (snuff-graters) of 18th-c. France are the intimate qualities of the medium recaptured.

The total eclipse of the art since the beginning of the 19th c. has been broken only by brief periods of interest, such as the Belgian revival at the end of the century resulting from the Congo expeditions, and frequent attempts at forgery, to which the material lends itself. But the jealously guarded treasures of the past bear witness to its unending fascination.

847, 1075, 1119, 1162, 1685, 1910.

# J

**JACOB.** Despite the prominence of Jacob as one of the three Hebrew Patriarchs, he played no great part in EARLY CHRISTIAN ART. Scenes from his life are illustrated in MOSAICS (Sta Maria Maggiore, Rome, 5th c.; Cappella Palatina, Palermo, 12th c.; St. Mark's, Venice, c. 1220) and in early illustrated Bibles (*Vienna Genesis*, Bib. nat., Vienna, 6th c.; *Ashburnham Pentateuch*, Bib. nat., Paris, 7th c.; Bible of S. Paolo fuori le Mura, Rome, 9th c.). The two scenes most frequently represented are Jacob's dream and the struggle with the Angel.

*Jacob's Dream* (Gen. xxviii. 10-22). This scene is first represented in the Synagogue at Dura Europos (Damascus Mus., 2nd c.). It occurs on the Lipsanotheca at Brescia, c. 360-70. In the Middle Ages it acquired symbolic significance as a prefiguration of the Ascension (SPECULUM HUMANAE SALVATIONIS). The fresco in the Vatican Loggie (1512-14) by RAPHAEL and PERUZZI shows the ladder replaced by an imposing central staircase. The subject was popular in BAROQUE art, where it was considered as a prototype of the promise of Christ to Nathaniel (RIBERA, Prado; REMBRANDT, Dresden; TIEPOLO, Archbishop's Palace, Udine). In the 19th c. BLAKE introduced a spiral ladder in his version (B.M.).

*Jacob's Struggle with the Angel* (Gen. xxxii. 24-32). In Early Christian art the divine stranger with whom Jacob wrestled at Peniel was depicted as the figure of God (Lipsanotheca at Brescia; *Vienna Genesis*), but later the figure of an ANGEL was substituted (8th-c. fresco in Sta Maria Antiqua, Rome). The scene occurs in the *Psalter of S. Louis* (Bib. nat., Paris, 13th c.) but was not frequent in medieval art and only became popular in the 17th c. (Rembrandt, Berlin; CLAUDE, *Evening*, a pendant to the meeting of Jacob and Rachel, *Morning*, Leningrad). It is depicted in ROMANTIC art by DELACROIX (S. Sulpice, Paris, 1857); and was represented in GAUGUIN's *Vision after the Sermon* (N.G., Edinburgh, 1888).

As a Patriarch Jacob appears in BYZANTINE ART in representations of the LAST JUDGEMENT (The Lavra, Mt. Athos, 1512), but rarely in Western art. The single figure of Jacob as a Patriarch occurs on a fresco in Sta Maria Novella, Florence, by Filippino LIPPI.

**JACOBEAN STYLE.** A term of art history which strictly used denotes works produced in England between 1603 and 1625. But it is also applied to slightly later architecture, decoration, and furniture, when this includes lavish ornament derived mainly from Flemish engravings, a somewhat clumsy STRAPWORK being the dominant form. Furniture in this style is invariably of oak and heavy in design, with bulbous legs; plaster work and fireplaces are extremely rich, but often clumsy.

**JACOMART.** See BAÇO.

**JADE** (CHINESE). The carving and love of jade is one of the most persistent elements in Chinese civilization and has been regarded as an embodiment of the impalpable mystique of Chinese culture. J. G. Andersson has said: 'The penchant for, not to say the worship of jade, the substance itself, seems to have formed a bond that links prehistoric and dynastic China together, differentiating the Chinese race from the rest of mankind.'

Two main types of material have gone by the name of jade and neither of them is indigenous to China. The essential jade, what the Chinese call *chen yü* or true jade, is nephrite. In its pure form it is white but owing to the presence of chemical impurities it takes on a characteristic range of neutral colours, notably green. Its source was Khotan and Chinese Turkestan in central Asia. The translucent green stone usually known in the West as jade is in fact a jadeite and there is no evidence that it was worked in China before the 18th c., when it was introduced from Burma. Jade is an extremely hard material upon which metal tools make no impression and it must be cut by means of abrasives such as quartz sand, powdered garnets, or corundum.

The qualities of true jade as set forth in the *Shuo wen chieh Tzu* of Hsü Shen (c. A.D. 100) and elsewhere frequently in Chinese literature are five: it is cold to the touch and does not warm in the hand; it is translucent when cut into thin flakes; it cannot be scratched by steel; it emits a musical note when struck; it allows a high, oily polish. It was also held to symbolize or embody many virtues: charity, rectitude, wisdom, purity, courage, equity.

Jade carving is believed to have been introduced into China in the Late Neolithic period, perhaps about the middle of the 3rd millennium B.C. The neolithic carvings belong to two groups: amulets and other objects of personal adornment, and ceremonial or ritualistic objects. The latter include thin plaques, called *kuei*, which native tradition regards as symbols of power or rank. The shapes are for the most part non-figurative and have been compared by some to

contemporary abstract sculpture by Barbara HEP-
WORTH or BRANCUSI. A long tradition going back
to the Chou period ascribed ceremonial and
ritualistic functions to the various categories of
jades. But a more modern opinion, argued for
example by William Willetts, regards them as
simplified versions of tools and utensils in com-
mon use and holds that they were made primarily
for use in honour of the dead. This does not
exclude the possibility that some types may have
had a more specialized function or that some may
have been intended for the delight and glorifica-
tion of the living.

About the beginning of the Shang dynasty
there was an efflorescence of decorative carvings
in animal form. They are stylized and abstract
rather than realistic but express the essence of
the animal type represented with extraordinary
vigour and vitality. After these carvings of the
Shang period a tendency to extend the decora-
tive use of jade is noticeable during the Chou
dynasty (c. 1027-256 B.C.). The designs became
more elegant and sophisticated, the lines more
cursive. Yet the workmanship reached a level of
mastery and refinement which was hardly
equalled at any later time. The jades of the Han
dynasty (206 B.C.-A.D. 220) often reflect the
vigorous quality of the bronzes of that period.
But from the 3rd c. to the 17th there was so much
imitation, so much archaizing, that it is often
impossible to distinguish between the style of
one period and that of another. T'ang jewellery
settings often contain jade; occasionally a vase
can be assigned to the Sung period because of its
shape, or an animal figure such as a lion will
show by its modelling that it is Ming. Under the
Ch'ing dynasty, however, and particularly in the
Ch'ien-lung period (1736-95) there arose a new
style that was not archaic. Eccentricity and
showiness marked the voluminous output from
the imperial workshops. Though these luxury
objects do not always accord with modern taste,
they were without doubt masterpieces of pains-
taking workmanship. Screens carved with
detailed landscapes, great bowls and vases,
imitations of antique bronze vessels, animals,
and even trees with their trunks, branches, and
flowers carved from jades of different colours—
all seem to vie with one another in dazzling
extravagance.

Of all Chinese works of art, jade carvings are
the most difficult to date. The intractable nature
of the stone and the Chinese reverence for the
antique have both tended to make the workmen
preserve the old forms with their simple geo-
metric designs. Techniques have changed little.
Even now clever imitations are made, for early
jades were often so simple that it is not over-
difficult to repeat their designs. The material
seldom shows signs of age unless it has been
buried. Stylistic comparison is often the only
guide to dating, but it is a highly dangerous one
because there is no range of scientifically exca-
vated pieces to serve as a basis for comparison.
Splendid collections of early jade are in the

Fogg Museum, Cambridge, Mass., the Freer
Gallery, Washington, and the British Museum.
The later jade in the Metropolitan Museum,
New York, is representative in every sense.

1237, 1239, 1435.

**JAIN ICONOGRAPHY.** In medieval times
the Indian religion of Jainism adopted much of
the same complex mythology of the heavens and
their population as Hinduism (see HINDU ICONO-
GRAPHY). The fundamental ICONS of Jainism,
however, have remained virtually unchanged
from the 1st c. A.D. to the present day. These are
the images of the Tirthankaras, the founder-
saints of the religion, especially of Mahavira, a
historical personage who lived during the 5th c.
B.C. The images are usually naked, with a hair-
tuft between the breasts, sometimes sitting cross-
legged with folded hands, sometimes standing,
rigidly symmetrical, with their arms at their
sides. Images made in medieval times often
show creepers growing up the legs and arms.
Jainism cultivates the principle of non-injury
(ahimsa) and the saints of Jainism are those who
carry this principle to its logical extreme in

**178.** The Tirthankaras. Stone stele probably from the Jain
cave temples at Khandagiri, Orissa. (B.M., 12th-13th c.)

avoiding both eating and movement. The creepers are visible evidence of heroic abstinence from all motion whence injury might spring.

Jain temples, whose focus is usually an icon of the type mentioned, and Jain manuscripts may also be ornamented with scenes from the lives of Jain saints.

**JAMES**, JOHN, 'of Greenwich' (1672–1746). English architect, who worked at Greenwich Hospital under WREN, VANBRUGH, and HAWKSMOOR, succeeding the latter as Clerk of the Works in 1736. In 1711 he became Master Carpenter at St. Paul's and later was assistant surveyor of the cathedral and surveyor of Westminster Abbey, where he completed the west towers to Hawksmoor's designs. His chief work is St. George's Church, Hanover Square (1721–5), which has an imposing Corinthian portico of six columns. His rebuilding of St. Mary's Church, Twickenham (1714–15), has echoes of St. Alphege's, Greenwich, to which he added a tower (1730), pretty enough in itself but trivial in scale for Hawksmoor's monumental structure. He also worked (1714–15) at Canons House, Stanmore (now destroyed), and may have been responsible for the design.

The translations of modern theoretical works which James published were the first of the many architectural books to appear in 18th-c. England. These included Andrea POZZO's *Rules and Examples of Perspective* (1707), PERRAULT's *Treatise of the Five Orders of Columns in Architecture* (1708), and in 1712 an account of LE NÔTRE's principles of garden design entitled *The Theory and Practice of Gardening*, which was widely used in England.

**JAMESON**, GEORGE (c. 1590–1644). Scottish portrait painter, whose name is attached indiscriminately to a great number of Scottish portraits of the period; his style was somewhat similar to Cornelius JOHNSON's, but is very difficult to assess as most of the works that are certainly his are in a bad state of preservation.

**JANET.** See CLOUET.

**JANSSENS**, ABRAHAM (1575–1632). Flemish narrative and portrait painter, active at Antwerp until 1598, when he is recorded in Rome. He returned to Antwerp by 1601 and became Dean of the Guild in 1606, also a member of the Society of Romanists, and thus held a respected and influential position. In later years he painted less and in a weaker vein, although until at least 1620 his works commanded very high prices. From a typical MANNERIST style Janssens developed a strongly classical bent which gradually predominated. A probable second visit to Italy c. 1604 influenced this stylistic development. His *Scaldis and Antwerpia* (Antwerp, 1609) was an important commission for the

States Chamber of the Town Hall. The *Lamentation* (S. Janskerk, Malines) and *The Crucifixion* (Valenciennes) are notable religious works, where balance and harmony do not exclude decorative beauty and detail. His pupils were Gerard SEGHERS and Theodoor ROMBOUTS.

**JAPANESE ART.** Through most of her history Japan has borrowed the inspiration of her art from China, and Japanese art has followed CHINESE ART through nearly all its phases. Its favourite media and its techniques were for the most part Chinese. Even the themes were predominantly of Chinese origin, although occasionally subjects were taken from Japanese history or mythology or from the Shintō religion. Buddhism has been a powerful force in Japanese religion and art. Nevertheless, within the framework of art forms and techniques brought over through the centuries from China, the Japanese have created much that is their own, for example in the painted scrolls of YAMATO-E, in colour-prints, and particularly in the crafts of the potter, lacquer-maker, and metal-worker.

The Japanese, like the Chinese, are great lovers of nature, but their approach to it in art is more sentimental. What in Chinese art is noble, broad, and restrained, tends in Japanese art to become formal, decorative, and superficial. Though technique is studied and meticulous, the Japanese artist often lacks depth and slips easily into mannerisms or playfulness. On the whole, rather than originality, profundity, or dynamism, the most characteristic features of Japanese art are a sensitive appreciation for surface textures, an emphasis on technique, a love of bright colours and dramatic compositions, striking and unusual effects of design, and above all a striving for decorative effect. As decorative art some of its achievements are unsurpassed, but works of the spiritual stature of the Tempyō sculptures or the Kamakura portraits were isolated incidents rarely attained. As skilled craftsmen and imitators the Japanese have proved themselves second to none, but often their virtuosity has reduced a noble art to a craft and individuality has been restricted to minor variations in the stereotyped formulas of highly conventionalized schools.

The earliest cultures known in the Japanese islands are the Jomon, which advanced from a pre-Stone Age, hunting and fishing pattern of life to a Neolithic status, and the Yagoi who infiltrated by invasion from Korea during the time of the Chinese Han and Ch'in dynasties. From the Neolithic period comes a characteristic monochrome pottery decorated by incised patterns or impressions of cord or matting (hence the name, Jomon = cordpattern). The craft of bronze casting was introduced from China about the beginning of the Christian era and the earliest instances of pictorial art from Japan are line engravings and simple scenes in low relief on bronze bells, called

*dōtaku*, from this period. The Chinese Iron Age began about the 3rd c. A.D. and from this period come the 'tomb figures' or *haniwa*, clay cylinders some of which were decorated with human or other figures. Though still in the realm of primitive craftsmanship rather than fine art, these figures have been admired for the directness and candour of their expression and a certain softness

**179.** Tantric Buddhist deity *Fudo*. Wooden statue of the Heian period. (B.M., late 11th c.)

of modelling. There is an example in the Museum of Fine Arts, Boston.

From the 6th c. onwards Japanese art, like most of Japanese culture, was founded on the Chinese. Buddhism reached Japan by way of Korea *c.* 575, bringing in its train the highly developed culture of China to a still comparatively unsophisticated people and revolutionizing many aspects of Japanese life. The Japanese rapidly mastered and developed the alien art. Some very great sculpture belongs to the century after Buddhism was introduced (the Asuka period, 552–646) but it is very difficult to say whether it was made by Japanese or by KOREANS.

Direct contact with China was established during the T'ang dynasty (618–906). Japanese buildings such as the Hōryū-ji monastery with its wall-paintings, as well as pottery and metal-work, were derived from Chinese models with such central Asian influences as the latter had incorporated. The first settled capital of Japan, at Nara (710), was built on a grand scale with magnificent wooden temples and fine bronze sculpture, much of which is still preserved. An indication of the strength of the Chinese influence is the Shōsō-in, an imperial repository of the 8th c. which still stands and houses the works of art and household objects of the royal family, all of which are either Chinese or modelled on Chinese prototypes. This vast and authentic collection is one of the outstanding art treasures of the East and is indispensable for our knowledge of T'ang China.

Partly to escape the growing power of the Buddhist priesthood the capital was moved in 795 to Kyoto, where a new city was built, modelled on the Chinese capital of Ch'ang-an. During this period (the Heian, 784–1185) new Buddhist sects, such as the Shingon and Tendai, came across from China and these influenced the development of sculpture and painting in the direction of greater mysticism and symbolism, a larger pantheon, and elements of Tantric Buddhism with its terrifying deities (see BUDDHIST ICONOGRAPHY). At the same time the demand for a more refined art from the aristocratic society of Kyoto, combined with the decline of the T'ang dynasty in China, encouraged the Japanese to incorporate more native elements into their art, especially in the picture scrolls (*emaki-mono*) of the *yamato-e* style. Thus the Japanese, though still dominated by the Chinese styles in art, managed to liberate themselves from complete dependence from the 9th to the 12th c. This can be seen in works of literature such as the *Tale of Genji* as well as in the visual arts. In 1185 a new military government was established at Kamakura, 200 miles north of the old Kyoto capital. The knightly caste (*samurai*) rather than the nobility now controlled the country and a more masculine realism manifested itself in painting and sculpture. The powerful Zen sect of Buddhism, introduced from China during the Sung period, made a strong impress on Japanese painting. But by

the end of the Kamakura period (1332) the great age of Japanese religious sculpture was over.

In the Ashikaga period (1338–1523) the capital returned once more to Kyoto. Despite almost incessant clan warfare the arts and crafts flourished—especially ink painting, in which the meditative and contemplative influences of the Zen were most marked. The Tosa School flourished and a new combination of Chinese style and Tosa style was created by the Kanō family. Peace came to Japan under the strong military dictatorship of Nobunaga and Hideyoshi during the Momoyama period (1573–1615). In the luxury-loving age which followed art in divorce from religion took on a more secular character and sumptuous decorative works such as the glittering ornate screens for which Japan is famous came into vogue (see Kanō School).

The last great period of Japanese art, that of the Tokugawa dictatorship (1615–1868), lasted for nearly 250 years. The capital was now at Tokyo, whose old name of Edo is sometimes used to describe this period. During this time the country was almost entirely cut off from the rest of the world by order of its rulers and it may be partly due to this that of all the periods of Japanese art the Tokugawa is the most distinctively 'Japanese'. The inherent national taste for the decorative had free rein to explore the realms of fantasy, as in the works of the Kōrin School. Yet even so the influences of Chinese art forms were still powerful. The Nanga School of painting, popular among the intellectual classes, drew its inspiration from the Chinese wên-jên styles (see Chinese art). Among the common people the vogue of the colourprint (see ukiyo-e) was perhaps the most vital of all artistic currents throughout the period and through its influence on many Post-Impressionist painters and others, such as Whistler, became responsible for the most significant impact of Japan on modern European art movements. Sculptural art found its main outlet in miniature objects such as netsuke and dolls. The crafts of lacquer and textiles flourished. Pottery and porcelain were manufactured in countless small kilns.

European art was introduced to Japan in the early 18th c. by way of the Dutch settlements which were permitted at Nagasaki in order that the Japanese government might have access to European scientific knowledge. Its influence at first was small, although the European treatment of perspective caught the fancy of some Japanese painters; but ever since the opening of the country to the West in the mid 19th c. Japanese painters have been dominated by one or other of the European aesthetic movements. But in ceramics and other folk arts such as lacquer, textiles, and decorative paper the native Japanese tradition remained very much alive and a highly organized folk art movement enjoyed great popularity. The strong, individual pottery of artists such as Kawai, Hamada, and Kenkichi commanded respect throughout the world.

The following is a summary of those periods of Japanese history whose names are used in describing works of art:

| | |
|---|---|
| Jomon and Yayoi cultures | c. 10th–1st c. B.C. |
| Old Tomb period | c. 1st–5th c. A.D. |
| Asuka | 552–646 |
| Nara | 646–784 |
| Heian: Konin and Jogan | 784–897 |
| Fujiwara | 897–1185 |
| Kamakura | 1185–1332 |
| Ashikaga (or Muromachi) | 1333–1573 |
| Momoyama | 1573–1615 |
| Tokugawa (or Edo) | 1615–1868 |

SCULPTURE. There was no serious sculpture in Japan before the introduction of Buddhism. The Buddhist missionaries brought with them Korean workmen who initiated the Japanese into the art of making religious statues. Buddhism rapidly became the religion of the court and under imperial patronage an intense artistic activity was fostered in support of the new cult. Among the few sculptures in bronze and wood that remain from this time it is often difficult to distinguish the work of immigrants from that of native craftsmen. Some of them are outstandingly beautiful and are considered among the finest and most deeply felt religious sculpture in the world. According to recent Japanese opinion three main styles can be distinguished, called Tori, Kudara Kannon, and Chūgūji. The Tori style, named after the sculptor Kuratsukuri-no-Tori (active c. 600–30), is best represented by a bronze triad in the Hōryū-ji monastery, Nara. The style is conventionalized, symbolical, and symmetrical, especially in the drapery, and the influence of the Chinese northern Wei style is strong. The Kudara Kannon style, which seems to have flourished in the mid 7th c., takes its name from a famous wooden statue of the Buddhist goddess of mercy, Kuanyin (Kannon being the Japanese word), which is in the Hōryū-ji monastery and is said to have been brought from Kudara, i.e. from the old state of Paikche, Korea. Its tall form and slender flowing lines contrast with the heavy austerity of the Tori style. More attention is paid to the side view, the sharp folds of drapery are different and generally speaking it is more three-dimensional than the Tori statues. In the Chūgūji style, the latest of the three (named after a wooden Kuanyin in the Chūgūji nunnery), the effect of carving in the round is produced by full, realistic modelling rather than by massiveness and linear treatment. The body and drapery are soft and supple, the expression of the face more kindly and calm. More attention is paid to surface texture. The Kudara Kannon and Chūgūji styles depend more on later northern Wei Chinese types and also on those of the following Sui period as seen in the later works at Yün-kang and Lung-mên (see Chinese art).

---

**180.** Kuanyin, the Buddhist goddess of mercy. Replica of the wooden statue in the Horyu-ji monastery. Kudara Kannon style. (B.M., mid 7th c. A.D.)

The expression of the faces in all three styles is highly spiritual. The quality both of the bronze casting and of the wood-carving was already superb.

The Nara period which followed has been called the Golden Age of Japanese sculpture. The acme came in the late Nara (sometimes called Tempyō) period (725–84). Increasing imperial patronage, combined with powerful influences from the culturally brilliant Chinese court of the T'ang dynasty, created a new art, monumental rather than spiritual. The native craftsmen improved their techniques, found new means of rendering their works expressive, and used a wider range of materials, particularly dry-lacquer. Colossal bronze statues were made. The sensual poses and the feeling for the body that are characteristic of T'ang art were reflected in the Tempyō; but towards the end of the period they were tempered by a typically Japanese delicacy and restraint. Portraiture appeared, and the masks used in ritual dances held a sculptural quality which has been widely admired.

During the Heian period (784–1185) Buddhism came under the influence of a stern, mystical sect which forced the sculptors to concentrate on facial expression rather than on elegance of form. The trend was away from the realism of the Nara period towards an austere stateliness with massive shapes and deep, sharp chisel-work. Statues were made from a single block of wood. During the later Heian or Fujiwara period an easier, milder Buddhist sect prevailed and artists such as the celebrated Jōchō (d. 1057) produced softer, more benign works in a more naturalistic key. The seclusion from China which Japan now imposed upon herself forced sculptors to develop along more independent lines. Unfortunately the large demand for elegant, extravagant works from an art-hungry society led to a method of mass production in schools and *ateliers*. Sculptures were made in hollow sections by assistants and fitted together so that the final touches could be added by the master. The inevitable consequence was loss of individuality and sincerity. The great art of dry-lacquer was abandoned, few cast bronzes were made and henceforward wood, which always seemed best suited to Japanese talents, was the commonest material.

In the Kamakura period (1185–1332) two influences predominated—the virile military government with its uncompromising austerity and the Zen sect of Buddhism, more democratic, deeply concerned with the individual. These combined to check for a while the trend to superficiality. Simple, realistic, and vigorous works, especially in portraiture, were produced, reminiscent of the spirit of the 8th c. but owing much also to the flowing line and easy elegance of the Chinese Sung art. The restoration of the Nara monasteries which followed the civil wars at the beginning of the period gave rise to a demand which produced something of a renaissance in sculpture. Unkei (active 1175–1218) was the most prominent sculptor of the time.

It was not until the Muromachi period (1333–1573), sometimes called Ashikaga, that sculpture began consciously to dissociate itself from Buddhism. The religious works of this period were generally rather empty of feeling and trivial in execution. The more original artists devoted themselves to architectural sculpture both in relief and in the round. They produced their best work in the short but brilliant Momoyama period which followed, when the scale and grandeur of buildings was sufficient to give them scope.

The long and peaceful Tokugawa period (1615–1868) produced no statuary of note and its architectural sculpture, although extremely dexterous, degenerated into over-elaborate, uninspired, and often meaningless formalism on a grand scale—as, for example, at Nikkō. There was an unprecedented demand for miniature objects of personal adornment such as ornamental buttons (netsuke) and for dolls, of which the output was enormous. The workmanship, ingenuity of design, and faultless taste of many of these tiny masterpieces are astonishing and it is no wonder that they became collectors' treasures. Since 1868 Japanese sculptors have been almost completely overwhelmed by European art movements.

PAINTING AND COLOUR-PRINTING. The principal styles and schools of Japanese painting and their approximate dates are set out below. Each is discussed in a separate entry.

| YAMATO-E (continued by TOSA) | 10th–15th c. |
| SUIBOKU | 14th–16th c. |
| TOSA SCHOOL | 15th–19th c. |
| KANŌ SCHOOL | 15th–19th c. |
| KORIN SCHOOL | 17th–19th c. |
| NANGA SCHOOL | 17th–19th c. |
| NAGASAKI SCHOOL | 18th–19th c. |
| MARUYAMA SCHOOL | 18th–19th c. |

For colour prints, see UKIYO-E, SURI-MONO, and entries on individual artists.

CERAMICS. In Japan pottery was made at numerous village kilns scattered throughout the principalities. Despite the early infiltration of Chinese techniques, few centres aspired to high standards of refinement until about the 16th c., when a new type of demand was created partly by wealthier patronage and partly by the now thriving cult of the tea ceremony (cha-no-yu). The last was responsible for many of the features of Japanese pottery which the West has found most exotic. From the time of the early tea masters tea-bowls, jars, kettles, and small dishes have been among the commonest of all Japanese wares. Of rough finish and often of crudely bizarre design, they stood for those ancient ideals of simplicity and conformity with nature which became a recognized part of Japanese daily life.

During the resplendent Nara period leadglazed earthenwares with splashed decoration in green and yellow were made in the Chinese T'ang style, and examples of these are still preserved in the Shōsōin repository. Also inspired from China was the CELADON glazed stoneware which flourished at Seto (Owari province) in the 13th to 15th centuries and included handsome vases stamped or carved with floral designs and covered with uneven, brownish glazes. The borrowing of the brown-black temmoku glazes may also date from this time. Meanwhile another formative influence, that of Korea, may be detected in the rough, grey- and white-glazed wares of Karatsu (north Kyushu), and the popularity of white and black slip inlays (mishima) for decoration.

The growing importance of the tea ceremony during the latter part of the Muromachi and Edo periods was reflected in various distinctive Seto productions, such as Shino ware, which is characterized by roughly painted, near-abstract designs in brown covered by a thick, uneven white glaze veined with crackle; also Oribe ware, with somewhat similar painting combined with patches of green and areas of the red clay showing through a transparent glaze. The famous Raku is a very soft glazed ware widely used for deliberately misshapen vessels which may be said to epitomize the taste of the tea masters.

Among various artists who contributed to raise the standard of pottery decoration in the 17th c. the most famous was Ogata Shinshō (1660–1743), better known as Kenzan. Working chiefly in brown, black, green, and white, he painted bold figure and plant designs with a few sweeping brush-strokes. Nomura Seisuke (Ninsei) was equally renowned as a master potter: his work included boxes in the form of naturalistically modelled birds and some noble vases with hanging wistaria and other plant designs brilliantly enamelled in colours, silver and gold. These and other styles reminiscent of the great contemporary screen-painters were taken up by numerous decorators working in the Kyoto district, where the cream-glazed earthenwares and stonewares were admirably suited to this purpose. Mokubei, Ninami Dohachi, and Eiraku Hozen were especially prominent Kyoto potters of the early 19th c. who often worked in a similar idiom. Somewhat later the overelaborate 'Satsuma' wares, many of which were made at Kyoto, vulgarized the style for what were presumed to be the requirements of Western taste.

PORCELAIN. There are various legends concerning the introduction of porcelain manufacture from China during the 16th c., but little evidence of it before the 17th c. when Arita (Hizen province) became the main centre of the industry. By c. 1650 the Dutch were already trading in Arita blue-and-white through their concession at Deshima: it is distinguishable from the Chinese chiefly by its purplish blue and rougher, more masculine style of drawing. The overcrowded Imari ware (from nearer 1700), with its superimposed enamels, was evidently designed for Western eyes, while the lighter, more sparing KAKIEMON palette met the home demand. For refinement of shape, material, and

decoration these *kakiemon* wares fully equal their Chinese counterparts: their simple, rounded, or many-sided forms are eminently graceful and the slight asymmetrical designs both charming and original. During the same period (*c.* 1650–1725) rather more boldly enamelled jars, bottles, dishes, etc., were produced at Kutani (Kaga province), with unusually strong greens and a deep red. The refined *Nabeshima* ware, with more complex and delicate designs than the *kakiemon*, was made near Arita and probably reached its greatest perfection *c.* 1725–50.

20, 47, 279, 280, 282, 433, 764, 814, 859, 948, 1153, 1320, 1321, 1401, 1488, 1489, 1539, 1594, 1835, 1892, 1893, 1952, 1999, 2328, 2362, 2396, 2442, 2480, 2530, 2558, 2567, 2598, 2599, 2621, 2655, 2794, 2795, 2796, 2948.

**JAPANESE PRINTS.** See UKIYO-E.

**JAVANESE ART.** See INDONESIAN ART.

**JAWLENSKY,** ALEXIS VON (1864–1941). Russian-born painter who after studying under REPIN at Moscow settled at Munich in 1896. He there knew KANDINSKY and was with him one of the founders of the *Neue Künstlervereinigung* in 1909. He was closely associated with the BLAUE REITER, although he did not participate in their exhibitions. In 1924 he exhibited jointly with Kandinsky, KLEE, and FEININGER in Germany and the U.S.A. His own style of EXPRESSIONISM, with simplified forms and flat areas of colour defined by heavy outlines, had more in common with the symbolic and expressive use of colour by GAUGUIN and van GOGH than with the cruder violence of German Expressionism. From *c.* 1917 he concentrated on the human head, and by reducing it to abstract architectural forms attempted to make it the vehicle for the expression of religious mysticism. His favourite saying was: 'Art is nostalgia for God.' His series of *Têtes mystiques* in 1917 led on to the *Abstract Heads* which formed the bulk of his subsequent *œuvre.*

2827.

**JEAN DE BRUGES.** See BONDOL, Jean de.

**JEAN DE LIÈGE** (active 1360–75). Flemish sculptor who worked in Paris on portraits and tomb sculpture for Charles V and other members of the royal family. His works have something of the robust quality of the Flemish illuminator Jean de BONDOL. Jean de Liège is not to be confused with a sculptor and cabinet-maker of the same name who was active in Dijon *c.* 1390.

**JEFFERSON,** THOMAS (1743–1826). President of the United States, also an architect and one of the last great figures in the humanistic tradition of the RENAISSANCE. Jefferson's interest in architecture seems to have begun in the early 1760s while a student at the College of William and Mary at Williamsburg. Methodical and scholarly, and skilled as a draughtsman, his approach to architecture was largely through

books. Ultimately he brought together the largest architectural library in America of his day.

Jefferson was as critical of English buildings as he was of English political institutions and in his own designing he sought to develop an architecture that would be expressive of the ideals of the new nation. This is seen even in his earliest works, which are strongly PALLADIAN. In the first designs for his own home, Monticello, near Charlottesville, Virginia (1769–70), he rejected the English style of the Virginia tidewater and turned instead directly to PALLADIO for the façade motif. After the Revolution, however, Jefferson turned to a far more important source, the architecture of ancient Rome. As a classicist Jefferson had long been interested in Roman literature and law, and his discovery of Roman architecture came during his sojourn abroad as Minister to France (1784–9). Here he not only saw the ancient Roman buildings in Provence but also became a close friend of the French NEO-CLASSICIST, Clérisseaux. For Jefferson Roman architecture was not only non-English, but in its dignity and grandeur it provided the very qualities he was seeking. As a result his design for the State Capitol in Richmond, Virginia (1785), was a direct adaptation of the Roman temple at Nîmes known as the Maison Carée. He thus became one of the first architects in the Western world to apply the classical temple form to a monumental building, and the first American architect to reject the English tradition in favour of a style more appropriate to the ideals of the democracy he had helped to shape.

In the rebuilding of Monticello, from 1796 on, the earlier Palladian design was completely done away with in favour of Roman ideas, especially those associated with the VILLA. Jefferson was familiar with the Roman villa through his reading of Varro and Pliny the Younger and he conceived his great estate, both agriculturally and architecturally, largely in Roman terms. At the same time Monticello also shows strong French influence. During his visit to France he saw several important French town houses of the Neo-Classical era and many of their most significant features were incorporated into his design for Monticello.

In his direct application of Roman forms Jefferson was the first classical revivalist in America. But his work had also imagination and vitality. His practicality, his analytical mind, and his broad sense of social responsibility made him one of the great architectural planners of his age. His University of Virginia, Charlottesville (1817–26), for which he planned the curriculum as well as the buildings, is one of the achievements in America's architectural history which stands out for breadth of vision and maturity of conception.

As Secretary of State under Washington Jefferson exerted considerable influence in the planning of the new national capital, Washington

D.C. The city was laid out by the French engineer Major Charles L'Enfant. The design was based upon plans of European cities provided by Thomas Jefferson. The system of wide avenues radiating from points of architectural interest and imposed upon a grid is typically Baroque. The designs for the Capitol and President's House (now the White House) were selected by a competition, an idea also suggested by Jefferson. Both prize-winning schemes were thoroughly English. James Hoban's design for the President's House shows a striking relationship with Wood's Palladian mansion, Prior Park at Bath. The Capitol, designed by Dr. William Thornton, is a mixture of elements but particularly English are the rusticated basement and the engaged giant pilasters above pedimented windows. The present building is an enormous enlargement of the original scheme. The great dome, made entirely of cast iron, was added in the mid 19th c. by Thomas U. Walter.

255, 1497, 1624.

**JEHAN DE PARIS.** See PERRÉAL, Jean.

**JERMAN** or JARMAN, EDWARD (d. 1668). Carpenter to the City of London and one of the surveyors for its rebuilding after the Great Fire. The new Royal Exchange, completed by Thomas Cartwright (1671), betrays the somewhat lumpish hand of the artisan designer. He designed the new buildings for the richer City Companies' Halls—the Drapers', Fishmongers', Goldsmiths', Merchant Taylors', Haberdashers', and Mercers'. The façade of the last was later transferred to the Town Hall at Swanage.

**JERVAS** (pronounced Jarvis), CHARLES (c. 1675-1739). Irish painter, who studied with KNELLER c. 1694/5. He appears to have lived in Rome from 1703 to 1709, when he settled permanently in London. Jervas had a great reputation and succeeded Kneller as Principal Portrait Painter to the king in 1723. He was a favourite in literary circles. He gave lessons to Alexander Pope when the latter took up painting c. 1713. *Dean Swift* (N.P.G., London) is a typical example of his work. The quality of his work hardly justifies the praise he received, and he cannot be ranked today above any other of Kneller's pupils or followers.

**JESPERS.** Belgian family of artists. OSCAR (1887– ) a sculptor and his brother FLORIS (1889– ) a painter and print-maker had strikingly parallel careers. Both began as IMPRESSIONISTS and were subsequently influenced by CUBISM and EXPRESSIONISM, and the works of both reveal the impact of the native art they saw on a visit to the Congo. The War Monument at Oost-Duinkerken was designed by Oscar.

449, 2260.

**JEWISH ART.** The attitude of the Jews to visual art was conditioned in antiquity by the stern prohibition of images contained in the Ten Commandments and elsewhere in the Bible (Deut. iv. 16-18, etc.). Yet they had their decorative arts, as is shown in the descriptions of the building of the Tabernacle in the wilderness (Exod. xxv. 8-xxxi), where Bezaleel is named as the master-craftsman responsible for the decorative metal-work. The Cherubim were in the form of winged creatures; and again, in the Temple built in Jerusalem c. 950 B.C. by Solomon the great bronze laver was supported by figures of oxen (1 Kings vii. 25), most of the decorative work, however, being carried out by Phoenician craftsmen. Hebrew art of the period of the First Temple does not appear to have had many distinctive features and few examples of it have survived, with the exception of some finely engraved seals and the ivory ornaments (perhaps by Tyrian craftsmen) discovered in the ruins of the palace of the kings of Israel at Samaria. In the period of the Second Temple (c. 450 B.C.–A.D. 70) Jewish art came strongly under the influence of GREEK, and later of ROMAN, ART. The Jewish attitude towards art was influenced alternately by imitation and by revulsion, for whenever nationalist feeling was strong the traditional religious inhibitions were intensified. There is evidence that in the 1st c. B.C., the beginning of the period of Roman domination, the only images that were prohibited in orthodox circles were sculptures of the human form; but when the great revolt broke out in A.D. 66 an ordinance was passed banning all representations, even of animals and on flat surfaces. Later, as the country settled down again under Roman rule, a more liberal attitude seems to have established itself. The ruins found in Palestine show that from the 3rd c. A.D. onwards even synagogues were decorated with human masks and sculptured animal forms (though there were interludes of reaction): while roughly modelled human forms are found in the catacombs of Beth Shearim in Galilee. Mosaics on the synagogue floors depicted biblical scenes (e.g. the *Sacrifice of Isaac*, as at Beth Alpha). It is probable that this convention was continued in wall-painting, but the only example that has survived is in the 3rd-c. synagogue at Dura Europos on the Euphrates. Here the synagogue interior was decorated by several series of illustrations vividly depicting various aspects of the biblical narrative. It is possible that these continued the tradition set by illuminated Jewish codices of the Bible, which provided the model and example for some early Christian codices such as the Ashburnham Pentateuch. In the Middle Ages iconoclasm triumphed again under the influence of the stern Moslem example on the one hand, and of revulsion against Catholic iconolatry on the other. The former was very powerful, and the nearer the Jews were to the Moslem sphere of influence the less likely they were to produce representational art. Thus in Spain, where Islamic influences were powerful, Jewish manuscripts tended for a long time to concentrate on decoration rather

than illustration, and to divorce the illuminations from the text by concentrating them in a special section. But in France and Germany Hebrew manuscripts illuminated in the fullest contemporary tradition begin to appear (or reappear) from the 12th c. onwards. Certain categories of manuscript were especially favoured, e.g. the HAGGADAH service for Passover eve and at a later period the MEGILLAH or Scroll of Esther. Not all the illuminators were Jews, though many were.

The SYNAGOGUE did not rely on aesthetic effect to the same extent as the contemporary Christian church or Moslem mosque, and was perforce generally modest to a degree. Nevertheless in some places there were erected impressive Jewish places of worship (such as those which have survived to our own day in Worms, Toledo, Prague)—again possibly in some cases the work of Jewish architects. In the German synagogues stained-glass windows and frescoes sometimes embodied animal forms: in Spain the decorative effect was achieved largely by the incorporation of ornamental inscriptions after the style of arabesques. In northern Europe, moreover, from the 16th c. human forms and biblical scenes were embossed on some of the religious appurtenances of the synagogue and the home.

Few Jewish artists as distinct from craftsmen are known from the Middle Ages, and though research can bring together the names of numerous individuals, little of their production can be identified. The reason for this is partly that there was social discrimination against Jews, and partly that so much medieval and post-medieval European art was closely associated with the Christian religion. There is nevertheless positive evidence that there were Jewish artists who worked anonymously, even for specific Christian purposes. Jewish goldsmiths and jewellers were numerous, some of them working for royal and princely courts: e.g. Salomone da Sessa (later converted to Christianity as Ercole de' Fedeli) who was active at Ferrara and other Italian centres in the 16th c. From the 17th c. portraits, even of strictly orthodox Rabbis, sometimes by Jewish amateurs, became numerous in western Europe. At this time, moreover, some of the itinerant Jewish seal-cutters and metal-engravers common in central Europe began to extend their interests, becoming miniature painters like the Pinhas family in Cassel and medallists like Jacob Abraham (1725–1800) and his son Abraham Abrahamson (1745–1811) at the court of Prussia and the Wiener family in Belgium. Jewish painters now became relatively common in northern Europe though

**181.** Passover scenes. Illuminations from a *Haggadah* (1756) by Abraham Sofer of Eiringen, Aer-Breisach (The Jewish Mus., London)

**182.** Beginning of the *Megillah* or Scroll of Esther with silver case embossed with vignettes illuminating episodes from the story of Esther. German. (The Jewish Mus., London, 17th c.)

the most successful (e.g. Raphael MENGS, and according to report, John ZOFFANY) were not professing Jews. The 19th c. saw numerous Jewish artists in various European countries, some of whom enjoyed considerable reputation in their day: one may mention S. A. Hart (1806-81) in England, Philipp Veit (1793-1877) and Eduard Bendemann (1811-89) in Germany, Maurice Gottlieb (1856-79) in Poland, and so on. For the most part (if one excepts the PRE-RAPHAELITE Simeon Solomon, 1840-1905, in England) they reflected, however competently, the placid bourgeois fashions of the period. A few, such as Moritz Oppenheim (1800-82) in Germany and Isidor Kaufmann (1853-1921) in Austria, are remembered for their highly

romanticized treatment of scenes of Jewish religious and social life. Towards the end of the century there appeared several Jewish painters of outstanding ability though indeed with no Jewish characteristics. Such were ISRAELS in Holland, Camille PISSARRO in France, LIEBER-MANN in Germany. Then with the 20th c. the studios of Paris were flooded with a wave of Jewish artists of the ultra-modern schools emerging for the most part (though there were exceptions, such as MODIGLIANI) from the ghettos of eastern Europe, and showing in their work a violent reaction against the drab atmosphere of their birthplace: it is enough to mention SOUTINE, CHAGALL, and Moïse Kisling (1891-1953). Indeed the Jewish contribution

to the École de Paris which centred in Montparnasse in the years before the First World War was notable. Perhaps through deep-seated religious inhibitions (which were strongest against this form of art) Jews turned to sculpture relatively late, no outstanding name emerging before Marc Antokolski (1843-1902), whose reputation was, however, far exceeded in the 20th c. by that of EPSTEIN. Among artists inspired by themes of Jewish life the most notable is Issachar Ryback (1897-1933), whose work is now collected in the Ryback Museum at Tel Aviv.

No common traits are readily discernible in the artistic productions of Jews in different lands, and to designate them as 'Jewish Art' is hardly legitimate. A remarkable artistic activity has become apparent in Israel, with painters such as Rubin (1893- ) and sculptors such as Z. Ben Zevi (1904-52). But their work bears all the characteristics of their various lands of origin, and it is too early to decide whether a distinctive Israeli art style has begun to emerge.

1696, 1908, 2317, 2582, 2620.

**JOEST,** JAN (*c.* 1450-1519). Dutch painter who settled in Haarlem *c.* 1510. With MOSTAERT he was one of the leading members of the School of Haarlem at the beginning of the 16th c. His principal work, *The Life of Christ* (St. Nicholas at Calcar, 1505-8), shows the influence of Mostaert and of GEERTGEN, but is handled with a monumentality that is original. Joest has been regarded as the link between Geertgen and Jan SCOREL.

**JOHAN,** PEDRO (1398-after 1458). Catalan GOTHIC sculptor trained in the tradition of the 14th-c. sculptor Jaime Cascalls. He executed the reredos of Tarragona Cathedral (1426) in ALABASTER enriched with gilding, and began the reredos of Saragossa Cathedral before being called to Naples by Alfonso V of Aragon in 1447.

**JOHN,** AUGUSTUS EDWIN (1878-1961). English painter, born in Wales and trained at the Slade School, where he was the most brilliant student of his day. He became a member of the NEW ENGLISH ART CLUB in 1903 and for a short while taught at Liverpool, where his influence was felt in the Sandon Society which rejected official art and encouraged originality. During the first quarter of the 20th c. John was the leader of all that was most independent and rebellious in English art, the type of the Bohemian, and one of the most talked-of figures of his day. He became A.R.A. in 1921 and R.A. in 1929. John's early work had great painterly brilliance, which later sometimes degenerated into bravura approaching bombast. As BURNE-JONES created an etiolated type of beauty, John in his day created a robuster type of gipsy beauty romanticizing the gipsies of north Wales. He was taken up by society and became a fashionable portrait painter, but he neither flattered his sitters nor showed

penetrating powers of psychological insight (*George Bernard Shaw, c.* 1914). His best known portrait is that of his wife, *The Smiling Woman* (Tate Gal., 1910). Some of his best work was done during holidays in Wales and the south of France between 1911 and 1914 in company of J. D. INNES. Between 1941 and 1948 he published in *Horizon* rambling notes under the title *Fragment of an Autobiography*.

GWEN (Gwendolen) JOHN (1876-1939), painter, was the sister of Augustus John. After studying at the Slade School she took lessons in Paris from WHISTLER, and adopted from him the delicate greyish tonality which characterizes her work. She was a belated follower of the PRERAPHAELITES, painting a narrow range of subjects: single figures of girls or nuns in interiors, water-colours of schoolgirls and cats, and occasional landscapes. She lived mainly in France after 1898 and became a devoted Roman Catholic and a recluse.

**JOHNS,** JASPER (1930- ). American artist, born in Allendale, South Carolina. In 1952 he began working in New York, then the centre of ABSTRACT EXPRESSIONISM. In his *Flag* (1954), the American flag was the format for a richly worked surface of red, white, and blue encaustic brush-strokes. With this painting and subsequent ones Johns challenged the ambiguous relation between art and reality in a strikingly new way by asking and provoking the viewer to ask: 'Is it a flag or is it a painting?' Johns also achieved a new synthesis of form and content. Because Johns used commonplace subjects (flags, targets, numbers, alphabets, maps) he opened a new range of subject matter for young artists who were searching for alternatives to Abstract Expressionism. During the 1950s and early 1960s Johns incorporated into abstract compositions objects such as coat-hangers, eating utensils, rulers, brooms as well as stencilled letters, handprints, and footprints. He also used painters' implements. Later he eliminated objects and used silk-screening. Since 1960 he has worked extensively with lithography.

**JOHNSON,** or JONSON VAN CEULEN, CORNELIUS (1593-1661). Portrait painter born in London of Dutch parents, and perhaps trained in Holland. He painted a large number of portraits in England between 1619 and 1643, and in the latter year he established himself in Holland. He was at his best in his very sensitive and individual portrait heads, but in his larger designs was extremely susceptible to the influence of others, at first MYTENS, then van DYCK. He worked for Charles I (portrait at Chatsworth), but had a wide clientele outside court circles.

**JOHNSON,** GERARD (formerly GARET JANSSEN) (d. 1611). Sculptor and mason, a

refugee during the Wars of Religion, who came to England from Amsterdam in about 1567, settled in Southwark, and gradually built up a large practice chiefly as a TOMB maker, though chimney-pieces and basins for fountains were also made in the workshop. He married an Englishwoman, anglicized his name, and had four sons, BERNARD, JOHN, NICHOLAS, and GERARD, who followed his profession. Among the earliest known works by this family are the monuments to the 3rd and 4th Earls of Rutland in Bottesford church, Leicestershire, executed by Gerard the elder and erected in 1591. In 1611 Nicholas made a monument for the 5th Earl. All are of ALABASTER, with recumbent effigies competently cut, under simple architectural CANOPIES, and all were originally painted. The younger Gerard, though less accomplished, is famous as the maker of Shakespeare's monument at Stratford-upon-Avon. The Johnson family was also employed in building, Bernard being the principal mason for Northumberland House and Audley End.

**JOHN THE BAPTIST.** Important doctrinally as the forerunner (*Prodromus*) of Christ and last of the prophets, John the Baptist was usually pictured as a bearded ascetic or hermit. He was placed beside MOSES and DAVID in DÜRER's *Allerheiligenbild* (Kunsthist. Mus., Vienna). The Gospels tell of his annunciation and birth (Luke i. 11–21), his preaching in the desert and his BAPTISM OF CHRIST, the latter of course being one of the subjects most frequently illustrated in Christian art. The Gospels also narrate more briefly his imprisonment and his execution by Herod (Matt. xiv. 1–12; Mark vi. 16–39). John has been painted at all ages: often as a child, playing with the child Jesus (see HOLY FAMILY), more rarely as a youth starting his life in the desert (DONATELLO, Bargello, Florence; DOMENICO VENEZIANO, Washington). But he was most familiar as adult, with dark hair and beard uncut and a sheepskin as his chief garment, carrying a lamb and a scroll inscribed *Ecce Agnus Dei* (see LAMB), or raising his hand in prophecy of Christ's coming (6th-c. ivory throne of Maximian, Cathedral Mus., Ravenna; 13th-c. portal of north transept, CHARTRES). Late BYZANTINE painters, without otherwise modifying his appearance, sometimes gave John wings like an ANGEL, recalling the prophecy of Malachi (iii. 1), repeated by Matthew (xi. 10): 'I send my messenger before thy face' (16th-c. painting, Accademia, Florence). But Western artists have concentrated above all on the human details of his emaciated body (statues by Donatello, Frari, Venice, and Siena Cathedral, and by RODIN, Tate Gal.).

The cult of John the Prodrome had already developed in Palestine by the 6th c. and the incidents of his life were made into a pictorial cycle decorating BAPTISTERIES and baptismal FONTS

(10th-c. church of Toqale Kilisse, Cappadocia; 14th-c. mosaics, Baptistery, Florence; della QUERCIA and others, font, Siena). The incident of the annunciation in the Temple to his incredulous father Zacharias occurs from an early time (initial in the *Drogo Sacramentary*, 9th-c. Carolingian MS., Bib. nat., Paris; 12th-c. mosaics, Monreale), and Zacharias is also shown at the nativity, writing his name on a tablet and getting back his power of speech (Fra ANGELICO, fresco, S. Marco, Florence; 15th-c. St. John retable, Boymans Mus., Rotterdam). His preaching in the desert and baptism of Christ constitute the most important episodes in his life (14th-c. mosaics, St. Mark's Baptistery, Venice). But his passion, too, has been illustrated from early times. This includes his denunciation of Herod and Herodias (11th-c. bronze column of Bishop Bernward, Hildesheim) and his consequent imprisonment and execution (13th-c. portal of St. John, Rouen Cathedral; Andrea PISANO, reliefs on door of Baptistery, Florence). But the most popular scene has been the dance of Salome, often portrayed as an acrobat by medieval artists (12th-c. bronze door, S. Zeno, Verona; 13th-c. window, BOURGES Cathedral), and Salome claiming his severed head brought in on a platter by the executioner (Donatello, font, Siena). Herod's Supper is represented in the *Gospel of Sinope* (Bib. nat., Paris, 6th c.) as a HELLENISTIC banquet with a servitor bringing in the head, and in the Baptistery of St. Mark's (14th c.), where Salome dances with the head and there is only one other guest besides Herodias. Both the execution and the supper are pictured in frescoes at Caryes, Mount Athos (14th or 15th c.). Among the best known modern treatments are BEARDSLEY's illustrations to Oscar Wilde's *Salome*. The head on a platter was sometimes represented alone in the later Middle Ages to symbolize John's martyrdom (15th-c. alabaster reliefs from Nottingham; A. SOLARIO, N.G., London).

After his death the Baptist descended into Limbo, from where he was released by Christ in the HARROWING OF HELL. His high place in the heavenly hierarchy gave him special powers of intercession and he often appears with the Virgin in the Byzantine *Deesis*, in which Christ enthroned is attended by His mother and forerunner on His right and left side respectively, and in representations of the LAST JUDGEMENT. Likewise he often presents supplicants to Christ or the Virgin, as for example Richard II in the *Wilton Diptych* (N.G., London).

**JONAH.** The theme of Jonah and the whale was popular in EARLY CHRISTIAN ART because it was held to be a symbol typifying the three days' entombment and RESURRECTION of Christ, neither of which was depicted in the early centuries. Two incidents from the story occur most frequently: Jonah thrown into the water and swallowed by the whale, and Jonah cast out

again on the shore. Nearly 60 catacomb paintings are known and an even larger number of representations on sarcophagi, the earliest being a 3rd-c. sarcophagus at Arles. The theme was less often depicted after the 6th c. It occurs in a number of Byzantine manuscripts (9th-c. Psalter, Bib. nat., Paris) and in typological works (see TYPOLOGICAL BIBLICAL ILLUSTRATION) of the Middle Ages (see BIBLIA PAUPERUM). Jonah appears in representations of the HARROWING OF HELL and he is depicted with the prophets on MICHELANGELO's ceiling of the Sistine Chapel (1508-12). Subsequently the theme was mainly confined to the FLEMISH and DUTCH Schools (RUBENS, Nancy Mus.).

**JONES,** INIGO (1573-1652). English architect and stage designer, the son of a London craftsman. Nothing is known of his early life and training or how and why he first visited Italy (probably *c.* 1600). While there he bought a copy of PALLADIO's *Quattro libri dell'architettura* (now at Worcester College, Oxford), which he was to annotate on a later Italian journey, and presumably started his lifelong admiration for Palladio's architecture.

**183.** Portrait of Inigo Jones. Black chalk drawing by van Dyck. (Devonshire Coll., Chatsworth, *c.* 1632)

The first known mention of him as an artist is as a 'picture maker' in 1603 (no paintings can be identified), when he may perhaps have visited Denmark. In 1605 he began his long association with the court masque, for which he designed both scenery and costumes. In these lavish entertainments movable scenery and the proscenium arch were used for the first time in England. In the many drawings which survive (Chatsworth), running down to 1640, Jones's fluency as a draughtsman and his knowledge of Italian stage design may be seen; but the full effect of the masques, dependent on movement and on lighting effects, can hardly now be grasped.

By 1608 he was consulted by Lord Salisbury over the building of Hatfield House and the New Exchange for Merchants in the Strand, though the extent of his work cannot now be determined. In 1609 he visited France, and in 1611 was made Surveyor to Prince Henry, heir to James I, advising him not only on building but also on his collection of works of art. After the Prince's premature death, Jones made a long journey to Italy (1613-14) in the train of the great collector the Earl of ARUNDEL, advising him on the purchase of Italian antiques while developing his own knowledge of Italian and antique architecture, and probably buying a large number of Palladio's original drawings (R.I.B.A.). On his return he became Surveyor to the Crown, and soon began his two most famous buildings, the Queen's House, Greenwich (1616-35), and the Banqueting House, Whitehall (1619-21). Both were revolutionary, the first being an Italian VILLA, and the second an Italian palace. In both Jones leans heavily on Palladio, using his system of proportions in planning and elevation and borrowing many motifs from him. His architecture is, however, less massive and sculptural than that of Palladio, and his delicate mouldings more suited to the northern light.

As Royal Surveyor his time was much taken up with minor business; and though Charles I with his taste for RENAISSANCE art greatly appreciated his talents, he produced relatively few other buildings. The Queen's Chapel, St. James's (1623-8), the first church in England in the classical style, has a splendid coffered roof in the antique manner. The portico which he added to the west front of Old St. Paul's Cathedral, after having re-cased the nave in a classical dress, had Corinthian columns (see ORDERS OF ARCHITECTURE) 50 ft. high, and was unmatched for grandeur in northern Europe. He was also associated with town-planning schemes, laying out the Piazza at Covent Garden with uniform houses above loggias, and completing the design with St. Paul's church (1638), an austere building in the Tuscan Order, which was damaged by fire in 1795 and restored by Thomas HARDWICK to the original design.

The chapel he built for the Queen at Somerset House is lost without adequate record, but many drawings exist (Chatsworth and Worcester College, Oxford) for ambitious rebuilding schemes for Whitehall Palace. These, though drawn by his pupil John WEBB, certainly show the ideas of Jones, and reveal his continuous reverence for Palladio and for the ideals of High Renaissance architecture. He was completely untouched by the BAROQUE trends which were developing on the Continent during his lifetime, though towards the end of his life he was influenced by contemporary French decoration. Since the Queen's House is now stripped of the interior decoration he devised in the late 1630s, his style can best be judged by the Double Cube Room at Wilton House (1649-52) with its fine pedimented doorway, its overmantel with figures flanking a van DYCK painting, and its rich use of ropes of fruit and flowers.

Jones's career was broken by the outbreak of Civil War in 1642, but his work had revolutionized English architecture by its introduction of a pure Italian style in place of the JACOBEAN hybrid. He was one of the most influential of English architects. WREN, early in his career, owed much to him, and when the 18th c. turned its back on the Baroque of VANBRUGH, it was from Jones, and through him from Palladio, that new inspiration was found.

1112, 1613, 2588.

**JONGKIND,** JOHAN BARTHOLD (1819-91). Dutch landscape painter and etcher who had close affinities with the French IMPRESSIONISTS. Although he was better appreciated during his lifetime than van GOGH—his talent was recognized by leading French painters of his day (COROT, MILLET, MANET) and by a set of discerning critics (e.g. BAUDELAIRE) and collectors—in some ways his career is similar to that of his more famous countryman. Both Jongkind and van Gogh made a greater impression abroad than in their own country; both failed to adjust to the society of their time; both were troubled by serious psychological problems; and sensational aspects of their lives—in Jongkind's case it was alcoholism—have interfered with a balanced appraisal of their achievement.

Jongkind studied in The Hague with the ROMANTIC painter SCHELFHOUT. In 1846 he moved to Paris, where he had contact with Louis-Gabriel Eugène Isabey (1803-86), and from then onwards he was in close touch with leading French artists. He worked and exhibited with members of the BARBIZON SCHOOL, and during the 1860s played an important part in the development of Impressionism. His marine pictures and views of ports, which are beautiful studies of the effects of air and atmosphere, influenced MONET and BOUDIN. Unlike some of the Impressionists he did his oil paintings of open-air scenes in his studio, basing them on spontaneous drawings and water-colours he made out of doors.

1292, 1867, 2485.

**JOOS VAN CLEVE** (*c.* 1490–1540). Flemish artist whose name was originally JOOS VAN DER BEKE. He is generally identified with the Master of the Death of the Virgin, so called after ALTARPIECES of this subject in Munich (1515) and Cologne. Joos was made a master painter in Antwerp in 1511 and was active there. But he travelled, too, moving mainly in court circles, where he was popular as a portrait painter. Portraits of Henry VIII (Hampton Court, *c.* 1536) and Francis I (Philadelphia Mus. of Art) are attributed to him. There is a flavour of LEONARDO in some of his late pictures. He probably became familiar with work by Leonardo and his followers on a visit to Italy, or he may have seen some of it in France. The homely, sentimental quality in many of his religious pictures is exemplified by the *Holy Family* (N.G., London), where in the background a bespectacled Joseph, wearing a straw hat, peers at a biblical text or his household accounts.

143, 926.

**JOOS VAN WASSENHOVE**, called JUSTUS OF GHENT (active *c.* 1460–80). Flemish artist who became a member of the Antwerp Guild in 1460. From 1464 to 1465 he was a member of the Painter's Guild at Ghent, where he met Hugo van der GOES. From 1470 to 1475 he was in the service of Federigo da Montefeltro in Italy, where he was known as Giusto da Guanto, 'Justus of Ghent'. During this time he painted the *Communion of the Apostles* (1473–4), which is still at Urbino. No other works are documented but the *Crucifixion* in Ghent Cathedral is generally considered to be his. The rather quiet simplified style of Joos is important, as his stay in Italy provides a positive link between the art of the Netherlands and that of Italy. A series of 28 *Famous Men* (Urbino and Paris) is often attributed to him, although the Spanish master BERRUGUETE and even MELOZZO DA FORLI have been suggested as their possible authors.

926, 1583.

**JORDAENS**, JACOB (1593–1678). Flemish painter of Antwerp. He was the pupil and son-in-law of Adam van NOORT. His name is associated with large canvases of hearty rollicking peasants, painted in thick impasto with strong contrasts of light and shade. But Jordaens began his career with religious works and continued to paint them throughout his life. The *Crucifixion* (St. Paul's, Antwerp, 1617) still shows the influence of his older contemporary RUBENS, but the *Adoration of the Shepherds*, painted a year later (Stockholm), is already in an independent manner. About this time Jordaens began the series of *The Satyr and the Peasant*, a subject taken from popular legend which he was to represent in many variations. Here the integrity of the realism is so great that we accept the satyr as we accept the peasants. The CARAVAGGESQUE devices which he employs in his early works and

the use of 'worm's eye' perspective add to the effect of direct naturalistic expression. Another of his favourite subjects was *The King Drinks* (versions in Brussels and Vienna), which depicts a boisterous group enjoying an abundant Twelfth Night feast. During the 1640s he painted a greater number of religious subjects than before; and to this period, too, belong his best known portraits. In 1652 he obtained a commission to paint part of the decorations for the Huis ten Bosch at The Hague, and after FLINCK's death in 1660 he was commissioned, along with REMBRANDT and LIEVENS, to make paintings for the Town Hall in Amsterdam. During the last decades of his life his colours became more subdued. His conversion to Calvinism in 1655 was a religious parallel to this change in his art; the *Last Supper* (Antwerp) is perhaps the strongest evidence of it.

2158, 2298.

**JOSEPHSON**, ERNST (1851–1906). Swedish painter, one of the most distinguished colourists in Scandinavian art. His paintings are characteristic for their intensity and depth of colour, but they vary greatly in manner. The brilliant portraits of his Parisian colleagues and some of the scenes painted in Spain (1881–2) use the technique of broad, vigorous brush-strokes to achieve an infectious vitality; other works, such as the enchanting portrait *Jeanette Rubenson* (Göteborg Mus., 1883), have an almost enamel-like surface and are meticulous in detail. This ambivalence was partly due to his divided and strongly emotional personality. He became the leader of the Swedish artists in Paris when during the 1880s they were in conflict with the old-fashioned Academy at home. But lack of recognition and personal conflicts led to a breakdown. In 1889 he became insane and never recovered. None the less, during his insanity he produced pen drawings with graceful lines and exquisite detail in a careful dotting technique of his own.

**JOUVENET**, JEAN (1644–1711). French painter, born at Rouen. He went to Paris in 1661 and joined the studio of LEBRUN. His early works, including decorations for the Salon de Mars at VERSAILLES, were closely imitative of the style of Lebrun and LE SUEUR (*St. Bruno in Prayer*, Nat. Mus., Stockholm). He was the most distinguished of the group of artists who collaborated with LA FOSSE in the decorations at Trianon and Les Invalides, but he had less originality than the latter. An incipient tendency towards the BAROQUE became more prominent in his later historical and religious paintings, including four colossal canvases painted for Saint Martin des Champs (1706). His later work was marked both by Baroque emotionalism and by a realistic treatment foreign to the principles

encouraged by the Academy. It is recorded, for example, that before painting his *Miraculous Draught of Fishes* (Louvre, 1706) he studied similar scenes on the spot at Dieppe.

**JUAN DE FLANDES** (d. *c.* 1519). Flemish painter active in Castile from 1496. He was one of a number of north European artists employed by Queen Isabella, who by her extensive patronage of the arts started the Spanish royal collection. At Palencia Juan de Flandes executed ALTARPIECES for the cathedral (commissioned 1506) and for the church of S. Lázaro (four panels now in the Prado).
256.

**JUAN DE JUANES.** See MACIP.

**JUAN DE JUNI** (*c.* 1507-77). Sculptor, probably of Burgundian origin, active in Spain from *c.* 1533. He worked at León and Salamanca before settling at Valladolid in 1540. He was a prolific sculptor of religious subjects, concentrating his great technical skill on the dramatic expression of emotion. The huge reredos which he executed 1545-61 for Sta María la Antigua, Valladolid (now in Valladolid Cathedral), is a MANNERIST composition of elaborate ingenuity. His most famous works are the two versions of the *Entombment* in Valladolid Museum (1539-44) and Segovia Cathedral (1571). In his later works he was a forerunner of the BAROQUE in Spain.

**JUÁREZ,** JOSÉ (*c.* 1615-*c.* 1665). Mexican painter, son of a painter called Luis Juárez (*c.* 1585-*c.* 1645). Working in the 'tenebrist' style introduced to Mexico by the Sevillian painter Sebastián de Arteaga (1610-56), he was the most important of the Mexican painters who followed the High BAROQUE manner of ZURBARÁN. His paintings were very large and often modelled closely on pictures of Zurbarán.

**JUDITH** (Apocrypha, Judith viii-xiv). The first known illustration from the story of Judith, showing her return to Bethulia, is in an 8th-c. fresco in Sta Maria Antigua, Rome. The use of this scene in a fresco may indicate an earlier pictorial tradition in manuscripts and ivories now lost, but the first extant biblical illustration is in the CAROLINGIAN Bible of San Paolo, Rome (second half 9th c.). The story is also illustrated in Byzantine, Catalan, and English Bibles (*Bible of Leo*, Vatican, Rome, first half 10th c.; *Farfa Bible*, Vatican, Rome, 11th c.; *Winchester Bible*, 12th c.).
In the Middle Ages the Judith story was an accepted subject of religious art (north door of CHARTRES Cathedral, 13th c.; window of the Ste Chapelle, Paris, *c.* 1248; pavement of Siena

Cathedral, 1473). The beheading of Holofernes and Judith's triumphant return with the head to Bethulia were frequently themes from the 15th to the 17th c. (BOTTICELLI, Uffizi; CRANACH, Gotha; TINTORETTO, Prado; CARAVAGGIO, Casa Coppi, Rome). In the late RENAISSANCE Judith triumphant, usually richly dressed, was occasionally depicted nude in spite of the text (Jan MASSYS, N.G. of Canada, Ottawa).
For the Florentines the figure of Judith became a symbol of freedom from tyranny and after the expulsion of the Medici in 1495 DONATELLO's statue was moved to a public position in the Piazza della Signoria.
From the 15th c. Judith appears as one of the Jewish heroines among the Nine Worthy Women.

**JUEL,** JENS (1745-1802). Danish painter of intimate portraits and family groups. He worked mainly in a personal mode of the Danish naturalistic tradition, yet showed certain affinities with other trends. During his early years in Hamburg, for example (1760-5), he was stimulated by 17th-c. Dutch painting, and when he stayed in Geneva (1777-80) he made acquaintance with the art of LIOTARD and, perhaps, with the English style of portraiture.

**JUGENDSTIL.** See ART NOUVEAU.

**JUMIÈGES.** An ancient Merovingian monastery which was revived by the Normans and reformed by disciples of William of Volpiano. It was rebuilt 1037-67 and is now in ruins. Jumièges had an importance for NORMAN architecture. Many of the features which were fully developed at Caen and in England make their appearance there, including the alternating system of columns and compound piers as supports, the two-tower façade, and the use of the 'thick wall' technique of building, which allowed passages to be opened in the thickness of the upper walls. Some of these ideas were imported from other parts of France and the Rhineland, but the style of Jumièges was unmistakably Norman, and the building illustrates admirably the capacity of the Normans to grasp and improve upon the achievements of their neighbours.

**JUSTE,** JEAN. Sculptor, active at Tours in the early 16th c. In his work the Italianate tendencies of the late 15th c. matured into a fully developed RENAISSANCE style. His masterpiece is the tomb of Louis XII and Anne of Brittany, made at Tours in 1517-18 and set up in the abbey of Saint-Denis by Francis I in 1531. It is surrounded by seated figures of the 12 APOSTLES in purely Italian style, allegorical figures of the VIRTUES, and reliefs depicting the king's Italian victories. Perhaps the only concession to the medieval tradition is the presence of GISANTS,

the corpses on the SARCOPHAGUS; but even these have been subtly idealized.

**JUSTUS OF GHENT.** See JOOS VAN WASSENHOVE.

**JUVARRA** (JUVARA), FILIPPO (1678-1736). Italian architect, a pupil of Carlo FONTANA. He was influenced by BORROMINI and by his predecessor in Turin, GUARINI, but also owed something to NEO-CLASSICAL trends in the French architecture of the time. From 1714 he worked for Vittorio Amedeo in Turin, building the Basilica of the Superga (1716-31), the huge hunting lodge at Stupinigi (begun 1729) on an X-shaped plan, which may have included echoes from the French, and the Palazzo Madama in Turin (1718-39), a reworking of an older building. Like Guarini, Juvarra made his influence felt in Spanish and Portuguese architecture. He made drawings for a royal palace and a cathedral in Lisbon (c. 1719-29), and in 1735 went to Madrid to rebuild the destroyed royal palace. He died in Madrid, but the palace and two others were built from his plans afterwards in Aranjuez. VERSAILLES, the great contemporary model for a royal palace, was not without its effect on the plans.

# K

**KAKIEMON.** A highly original style of decoration on Japanese (Arita) porcelain, introduced by Sakaida Kakiemon, c. 1650, and at its height c. 1700 (see JAPANESE ART). Its sparing, asymmetrical designs in yellow, turquoise, red, and blue enamels were widely copied on European porcelain.

**KALF,** WILLEM (1619-93). Dutch painter who was in Paris from c. 1642 to 1646, where he did pictures of peasant kitchens and courtyards. Upon his return to Holland he concentrated upon STILL LIFES of fruit and precious objects: Chinese porcelain, oriental rugs, Venetian glass, BAROQUE gold and silver bowls. His monumental compositions, his mysterious CHIAROSCURO effects, and his ability to manipulate warm and cool colours (he frequently contrasts red wine in a glass and the reddish browns in a carpet with the yellow of a peeled lemon and the blue and white of porcelain) put his pictures among the most impressive still lifes painted in Holland during the 17th c. There are excellent examples in Amsterdam and Berlin.

**KAMES,** LORD. See HOME, Henry.

**KANDINSKY,** WASSILY (1866-1944). Painter and writer on art, who was born in Moscow and studied law and political economy at Moscow University. He abandoned a promising legal career partly under the impact of an exhibition in Moscow of French IMPRESSIONISTS, at which MONET's picture *The Haystack* made a particularly lasting impression upon him, and in 1896 went to Munich to study painting. By 1901 he had already formed an artist's association called the *Phalanx* and in 1902 he joined the Berlin SEZESSION and founded a school of painting. Between 1903 and 1908 he travelled widely in western Europe and Africa. In 1910 he painted what is considered to have been the first purely ABSTRACT work, depending entirely on the emotional significance of colours and form without figurative suggestion, and thus became the founder of ABSTRACT EXPRESSIONISM. From 1911 he was one of the most active figures in the BLAUE REITER, editing with Franz MARC the *Blaue Reiter* almanac. In 1914 he returned to Russia, becoming Professor at the Moscow Academy of Fine Arts in 1918, Director of the Moscow Museum of Pictorial Culture in 1919, Professor at Moscow University in 1920, and founding the Russian Academy of Artistic Sciences in 1921. When social REALISM was imposed in Russia he returned to Germany and taught at the BAUHAUS 1922-33. He left Germany for France in 1933 and lived at Neuilly-sur-Seine.

Kandinsky was one of the most influential artists of his generation both for his own painting and for his writing. He was in the forefront of those who investigated the basic elements of design and the non-figurative composition of 'pure' abstract painting on the analogy of musical composition. His chief works setting forth his theories of abstract pictorial composition were *Über das Geistige in der Kunst* (*Concerning the Spiritual in Art*, written 1910; Eng. trans. by Francis Golffing, Michael Harrison, and Ferdinand Ostertag, 1947); *Rückblicke* (*Reminiscences*, published in Berlin by Herwarth Walden in 1913; Eng. trans. in *Modern Artists on Art*, ed. Robert L. Herbert, 1964); and *Punkt und Linie zu Fläche* (*Point, Line and Surface*, published in 1926 as a Bauhaus pamphlet).

405, 1167.

**KANE,** PAUL (1810–71). Pioneer Canadian painter of landscape and Indian subjects. Born near Cork, he was brought by his parents to Canada in 1818 or 1819. In his youth he was an itinerant portrait painter in and about Toronto, his home. After some travels in the United States (1836) he made a tour of the European museums (1841–4). On his return he made a preliminary expedition to Lake Huron, where he painted Indian encampments; then in 1846–8 made his longest journey with the Hudson's Bay Company to the western plains and the Pacific coast. His travels and adventures are published in his *Wanderings of an Artist* (1859). The largest collection of his pictures is in the Royal Ontario Museum, Toronto. His style was ambitious to the point of being ludicrous. When painting his groups of Indians (e.g. *Blackfoot Chiefs*, N.G., Ottawa) he arranged them in a composition borrowed from RAPHAEL, and his Indian portraits have the aristocratic features of the sitters of REYNOLDS and RAEBURN.

**KANŌ SCHOOL.** A school of Japanese painting which originated in the mid 15th c. from a union of the SUIBOKU and TOSA styles, and persisted until the 19th c. It represented the standards of professional training and the lofty military tradition as opposed to the scholar-artist approach. Masanobu (1453–90) is credited with founding it and his son Motonobu (1476–1539), who epitomized the idealism of the Muromachi period, established the firm brush line which came to be regarded as distinctive of the Kanō style. The school was maintained by artists of the Kanō family, who worked in a wide range of styles from highly coloured scenes to bold black-and-white studies in the Chinese manner. A decorative effect often seems to be the aim—especially in the large folding and sliding screens, which display such profusion of colour and detail, such a deliberate attempt to overwhelm the eye with splendour, that they come perilously near to vulgarity. But from this danger they are generally saved by a certain bravery and boldness of stroke and a brilliance of design. The school also produced landscapes of austere Chinese type.

The school rivalled the Tosa for official patronage from the 17th c. to the 19th, led the art movements of the time, and produced a flood of highly accomplished but often somewhat uninspired works. The finest examples are from the 17th and 18th centuries by such masters as Eitoku (1543–90), Sanraku (1559–1635), Tanyū (1602–47), Naonobu (1607–50), Sansetsu (1590–1651), and Tsunenobu (1636–1713).

**KANT,** IMMANUEL (1724–1804). German philosopher. Kant's writings on AESTHETICS are contained in *Observations on the Feeling of the Beautiful and Sublime* (1764), in the second book of *Anthropology from a Pragmatic Viewpoint* (1798), and principally in *The Critique of Judgement* (1790). According to Hegel, Kant 'spoke the first rational word on aesthetics', and it has been generally agreed that *The Critique of Judgement* is the most important systematic study of the theory of art and beauty and the basis of most modern aesthetics. Kant distinguished judgements about beauty from scientific judgements, moral judgements, judgements of utility, and judgements about pleasure. As against the empirical trend of English 18th-c. aesthetic writing he maintained that the judgement of beauty claims universal acceptance and is not derivable from or reducible to empirical conformity. As against intellectualist aesthetics he maintained that beauty is not reducible to rule or concept but results from a direct verdict of feeling. He seems to have resolved this antinomy by his view that beauty is 'purposiveness without purpose', consisting in the adaptedness of the object to human faculties of contemplation.

**KARNAK.** The name of one of the Arab villages on the site of ancient Thebes and of the nearby temple complex, the greatest in Egypt and one of the most impressive in the world. The earliest monuments are of the Middle Kingdom but most of what survives, including the imposing HYPOSTYLE hall, dates from the 18th and 19th Dynasties (c. 1570–1200 B.C.), with considerable additions down to the Ptolemaic period. The area within the enclosure wall of the great precinct of Amon-rē is about 62 acres, the temple itself being the largest religious building extant. The main portion measures some 1,200 ft. along its axis and exceeds 300 ft. in breadth; the first PYLON is 370 ft. across. To the south, approached by an avenue of ram-headed SPHINXES, lies the precinct of Mut, and to the north that of Mont, while in the south-west corner of the great enclosure is a shrine of Khons, a typical example of a small New Kingdom temple. From it another avenue of sphinxes, almost a mile in length, led to the temple of Luxor.

1619.

**KAUFFMANN,** ANGELICA (1740–1807). Swiss decorative painter. She travelled with her father J. J. Kauffmann from an early age in Switzerland and Italy; on her later visits to Rome she was greatly impressed by the NEO-CLASSICAL vogue and on this she formed her style. She there painted a portrait of WINCKELMANN (Kunsthaus, Zürich, 1764). She came to London in 1766 where her work and her person were vastly admired. She was a friend of REYNOLDS and became a foundation member of the ROYAL ACADEMY. Her association with Reynolds was attacked by the Irish painter Nathaniel HONE in a satirical picture *The Conjurer* (N.G., Dublin), which also seemed to accuse Reynolds of plagiarism.

In a somewhat timid manner she adapted the allegorical and historical subject matter of contemporary French painting to the Neo-Classical

convention. Her best work was on a small scale and the brothers ADAM frequently employed her in the decoration of ceilings, walls, and furniture for the houses they designed. Good examples may be seen in London at 20 Portman Square and 30 Berkeley Square. In 1782 she settled in Rome. She married her second husband, the decorative painter Antonio Zucchi, R.A. (1726–95) in 1781.

1752.

**KAULBACH, WILHELM VON** (1805–74). German painter who specialized in a rather bombastic brand of history painting; in his day one of the most celebrated of German painters. He became famous through his cartoon of the *Hunnenschlacht* (1834–7), which held all the ingredients of his later style: a patriotic subject—the victory of the Germans over the invader from the East—and a firm outline style, paradoxically combined with the liveliness and drama of the BAROQUE. Today, however, this didactic kind of history painting impresses only as hollow theatricality. A number of drawings from nature and charming illustrations to GOETHE's *Reinecke Fuchs*, which admirably catch the spirit of this animal satire, show Kaulbach in a much more favourable light.

**KEENE, CHARLES SAMUEL** (1823–91). English CARICATURIST, who was called by Joseph Pennell the greatest English master since HOGARTH. Although largely self-taught, he was an outstanding draughtsman. In order to secure certainty of touch and spontaneity in impression he always drew straight in ink. His caricature is delicate and reserved, raising a smile rather than a laugh. 'Charles Keene,' it has been said, 'better than any other draughtsman, could emphasize the absurdity of a City man's hat, twist a drunkard's coat awry or an old lady's bombazeen about to pop; and he does it with such delicacy we are left in doubt as to whether or not it is caricature.' He had a gift of seizing momentary action and suggesting situation in a gesture. From 1851 until his death he was one of the group of artists associated with *Punch*.

1380, 1590.

**KEENE, HENRY** (1726–76). English architect, Surveyor to Westminster Abbey from 1752 until his death. He carried the knowledge of GOTHIC gained there into much of his own work, such as the remodelling of Arbury Hall, Worcester (1750 onwards), and various undertakings at Oxford, including alterations to the hall of University College. He also worked in the classical style, his major building being the Guildhall, High Wycombe, Bucks. (1757).

**KELMSCOTT PRESS.** A private printing-press founded in 1891 by William MORRIS at Hammersmith and named after the village near Oxford where Morris had lived since 1871. Between 1891 and 1898, two years after Morris's death, the press issued 55 titles in a total of 65 volumes. Deeply influenced by his study of early printing, Morris himself designed most of the type, borders, ornaments, and title-pages, taking as his basic unit the double-page seen when the book lies open. Woodcut frontispiece titles, a characteristic of Kelmscott books, were first introduced in the *Golden Legend* (1892) illustrated by BURNE-JONES. Printed sometimes in white letters on a background of dark scrollwork, sometimes in black letters on a lighter background, these titles were surrounded by a border harmonizing with that on the first page of text which they face. Morris employed three founts of type: 'Golden', used in the *Golden Legend*, 'Troy', based on a 15th-c. 'Gothic' type used by Anton Koberger at Nuremberg, in the reprint of Caxton's *Recuyell of the Historyes of Troye* (1892), and 'Chaucer', a smaller form of 'Troy' made for the double-columned *Chaucer* (1896), the most important production of the press (see Ill. 184, p. 624).

2540.

**KENT, WILLIAM** (1685–1748). English painter and architect. He was apprenticed to a Hull coach-painter before his abilities were recognized by a group of gentlemen who sent him to Italy in 1709. There he made some reputation, painting a ceiling in the Roman church of S. Giuliano in 1717. He acted as guide and agent for English noblemen on the GRAND TOUR and thus met Lord BURLINGTON, 1714–15; in 1719 Burlington invited him to return with him to London and from then until Kent's death in 1748 the two were inseparable partners in the conversion of England to PALLADIANISM. After some rather unsuccessful decorative painting at Burlington House and Kensington Palace, Kent began to find himself as an ,architectural impresario and interior decorator. He edited, for Burlington, the *Drawings of Inigo Jones* (1727), and at the same time began the decoration of Burlington's villa at Chiswick and the layout of the garden. The richness and fantasy of his interior decoration and the imagination displayed in his gardens are probably his chief claim to fame, and the perfect complement to the somewhat rigid classicism of Burlington's architecture. Horace WALPOLE said that Lord Burlington, 'the Apollo of arts, found a proper priest in the person of Mr. Kent.... He was a painter, an architect, and the father of modern gardening. In the first character, he was below mediocrity; in the second, he was a restorer of the science; in the last, an original, and the inventor of an art that realizes painting, and improves nature.... He leaped the fence, and saw that all nature was a garden.' His ideas on informal landscape were developed by 'Capability' BROWN. As an architect Kent's most important work is Holkham Hall, Norfolk,

**184.** *The works of Geoffrey Chaucer now newly imprinted.* Title-page designed by Edward Burne-Jones. Printed by William Morris at the Kelmscott Press (1896)

**185.** Design for new Houses of Parliament. Pen-and-ink drawing by William Kent. (V. & A. Mus., 1732)

begun in 1734 for the Earl of Leicester, whom he had first met in Rome. Here, however, the design was closely supervised by the Earl himself and also by Lord Burlington and was largely executed by Matthew BRETTINGHAM; it is a measure of Kent's adaptability that he was able to satisfy everybody. He produced designs of striking originality for new Houses of Parliament (1732 and 1735-9). Among his works in London are 44 Berkeley Square (1742-4) and the Horse Guards (posthumous, 1750-8), while Rousham, Oxon., and Stowe, Bucks., are among the grounds laid out by him.

1454.

**KENTISH RAG STONE.** A limestone quarried near Maidstone, Kent. It is greenish grey in colour and its structure is compact and crystalline, containing grains of quartz and glauconite. It has been much used in churches and other buildings in the south and south-east of England, particularly for window tracery and other kinds of enrichments.

**KENZAN** (1663-1743). Japanese calligrapher, scholar, and painter, the brother of KŌRIN. He was most famous for his pottery, now rare and very highly appreciated, which he decorated in the new style with which his brother's name is associated.

1594, 2480.

**KERSTING,** GEORG FRIEDRICH (1785-1847). German painter. After studying at the Copenhagen Academy he settled in 1808 at Dresden, where he specialized in small portraits set in delicately rendered interiors. In 1818 he was made supervisor (*Malervorsteher*) of the designers in the famous Meissen manufactory. In this capacity he was responsible for the dinner-set presented by King Frederick Augustus IV of Saxony to the Duke of Wellington (Apsley House, London).

**KESSEL,** JAN VAN (1626-79). Flemish STILL-LIFE and flower painter active in Antwerp, where he became a Guild member in 1645. He continued the traditions of his grandfather, Jan 'Velvet' BRUEGHEL, in the latter half of the century and was also influenced by Daniel

SEGHERS. Van Kessel painted garlands and bouquets of flowers, but his particular specialities were insects or shells against a light background, executed with strong colour and great exactitude. These quasi-scientific little paintings, often on copper, have a jewel-like quality which in his lifetime was popular with the ruling Habsburgs—hence the large collection in the Prado. Excellent examples are in many museums, including the Fitzwilliam Museum, Cambridge.

**KETEL,** CORNELIS (1548-1616). Dutch portrait and history painter, a pupil of Anthonis Bloklandt van Montfoort (1532/4-83). He worked at FONTAINEBLEAU (1566); from 1573 to *c*. 1581 he lived in London; and afterwards in Amsterdam, where he died. He was one of the leading portraitists of his day. Van MANDER, who was well informed about him, mentions that he painted a portrait of Queen Elizabeth for the Earl of Hertford in 1578, but the picture is not known. The portrait of Martin Frobisher (Bodleian Library, Oxford) and the Company of Captain Rosencrantz and Lieutenant Paul (Rijksmuseum, Amsterdam) are fine examples of his individual and group portraiture.

**KETTLE,** TILLY (1735-86). English painter. He studied at the St. Martin's Lane Academy, and exhibited portraits with the Incorporated Society of Artists from 1765 and at the Royal Academy from 1777. He was one of the first British painters to risk a long visit to India, where he spent the years 1769-76 and made a great reputation. He died on his way out a second time. He had an eye for pattern but was unable to build up a popular practice. His style was derivative from that of REYNOLDS, COTES, and ROMNEY.

**KETUBAH** (Hebrew: 'writing'). The Jewish marriage contract, which—especially in Italy—from the RENAISSANCE period at least was frequently ILLUMINATED, some extant specimens being of considerable artistic merit.

**KEY.** Family of Flemish painters of the 16th c. who are best known for their portraiture. WILLEM KEY (*c*. 1515-68) painted religious pictures and portraits. He was a pupil of

Lambert LOMBARD *c*. 1540 in Liège. In 1542 he was made a master of the Antwerp Guild, where he spent the rest of his working life. His nephew, ADRIAN THOMASZ KEY (*c*. 1544–after 1589), was probably his pupil. The latter became a master of the Antwerp Guild in 1568. Both artists did assured and proficient portraits of famous people. The portrait of William the Silent, which appears in several versions, has been attributed to Adrian.

**KEYSER, DE.** Dutch family of architects and artists. HENDRICK DE KEYSER (1565–1621), architect and sculptor, worked chiefly in Amsterdam and left his mark on the city when it expanded rapidly at the beginning of the 17th c. His architectural style forms a link between the imaginative decorative designs of Netherlandish RENAISSANCE architects, such as Vredeman de VRIES, and the Classicism of van CAMPEN. Several of his towers still dominate the inner city of Amsterdam. His South Church (1603–14) was the first large Protestant church built in Holland, and was a successful solution to the new problem of church designing in which the focus was upon the pulpit instead of the altar. The much larger and higher West Church (begun 1620) is his most impressive building. Hendrick's principal work of sculpture is the tomb of William the Silent (1614–*c*. 1621) at Delft. He also made some fine realistic portrait busts and a statue of Erasmus (1618) at Rotterdam.

THOMAS DE KEYSER (1596 or 1597–1667), Hendrick's son and pupil, was municipal architect to the City of Amsterdam from 1662 until his death, but he is better known as a portrait painter. He began by painting life-size group portraits. Compared to those of his contemporaries Frans HALS and REMBRANDT they are dull and stiff. He is more attractive and original on a small scale. *Constantin Huygens and His Clerk* (N.G., London, 1627) is an excellent example of one of his small portraits of full-length figures in an interior; a forerunner of the CONVERSATION PIECES which became so popular in Europe during the 18th c.

Two other sons of Hendrick, PIETER and WILLEM, were sculptors.

1924, 1969.

**KEYSER, NICAISE (NICASIUS) DE** (1813–87). Popular Belgian painter of portraits and historical scenes—particularly battles. De Keyser was a leader of the Belgian ROMANTIC artists who reacted against the CLASSICISM of DAVID and sought a link with the great colouristic tradition of 17th-c. FLEMISH painting.

**KEYSTONE.** Architectural term for the central wedge-shaped stone of an ARCH or VAULT.

**KHMER.** Cambodian empire which succeeded the disintegration of CHEN LA. It was established by Jayavarman II (*c*. 790–850), who had lived a substantial part of his life in Java and who drew his inspiration from the Shailendra dynasty of Indonesia and imported Indonesian cultural conceptions. Jayavarman also laid the basis of the royal cult of the Khmers. Like the monuments of Javanese art, the Khmer monuments were emblems of the sacred mountain, on whose summit dwelt the king's divinity in intimate contact with the cosmic deities.

At Sambor, Banteay Prei Nokar, and Roluos Jayavarman set up temples in the old Chen La style. But at Phnom Kulen, where he set up the sacred lingam, and at Amarendrapura he had built temples in the form of multi-tiered brick pyramids symbolizing the cosmic mountain. In the elaborate sculptured ornament of these temples influences from both Java and Champa are apparent. Although under Jayavarman the main lines of the inspiration of Khmer art were laid down, the real Khmer renaissance is considered to have begun with Indravarman (877–89), who laid the foundations of Angkor. An account of Khmer art will be found under CAMBODIA, art of.

**KILIAN.** German family of engravers and publishers active in Augsburg during the 16th to 18th centuries, founded by BARTHOLOMAEUS I (1548–88).

**KIP, JOHANNES** (1653–1722). Dutch topographical engraver who migrated to England in 1697 and died at Westminster. He engraved views of English castles after drawings by Leonard Knyff (1650–1721) for the sumptuous *Nouveau Théâtre de la Grande Bretagne* (London, 1707).

**KIPRENSKY, OREST** (1783–1836). Russian painter who studied at the Academy at St. Petersburg. From 1816 to 1823, and again from 1828 until his death, he lived in Italy. He is best known for his ROMANTIC portraits in which he combined the then fashionable attitude of 'Byronic' melancholy with an integrity which earned him the epithet 'the Russian van DYCK'. Examples of his work are the portraits *The Hussar E. D. Davydor* (1809) and *Yekaterina Avdulina* (1823), both in the Russian Museum, Leningrad.

**KIRCHNER, ERNST LUDWIG** (1880–1938). German artist. He studied architecture at the Dresden Technical School and painting in Munich (1903–4). He was one of the originators of the BRÜCKE in 1905 and was probably the most brilliant and most restless of the group. He was influenced by an exhibition of the NEO-IMPRESSIONISTS held at Munich in 1904 and later by the FAUVES. In his search for expressive simplification the graphic work of MUNCH and late GOTHIC woodcuts made a strong impression on him. But the strongest impact was probably from OCEANIC and other PRIMITIVE art, which he studied in the ethnographical section of the Zwinger Museum. With these various examples

in view he made it his concern to distil directly from nature what he referred to as primordial signs and hieroglyphics and to use these harshly simplified forms to express contemporary states of mind. From 1911 he employed this EXPRESSIONIST technique in Berlin street scenes which both capture the human situation in a large city and are one of the best examples of mature German Expressionism.

Shortly after his mobilization in 1914 he suffered a nervous breakdown and during a period of mental unrest did the woodcut illustrations for *Peter Schlemihl* (1916). In 1917 he moved to a sanatorium at Davos, Switzerland, and from

**186.** *Mountain Melancholia.* Self-Portrait. Woodcut (1926) by E. L. Kirchner

this time painted mainly formalized landscapes in which the emotionally tortured quality of his earlier work achieved in serenity what it lost in vigour. From *c.* 1928 his painting became more rhythmic and abstract and he conceived it as a sort of hieroglyphic picture writing: 'The hieroglyph, this unnaturalistic formation of the inner image of the visible world, broadens and takes shape according to optical laws that had not hitherto been used in this way in art. . . .' In this last phase he was considerably influenced by certain experimental ideas of PICASSO.

767, 1164.

**KITCAT CLUB.** A dining-club founded towards the end of the 17th c. The secretary was Jacob Tonson, the publisher, and the members were mostly leaders of the Whig Party. It met first at a tavern near Temple Bar kept by Christopher Cat and took its name from his mutton pies, which were known as 'Kit-cats'. Later it met at Tonson's house at Barn Elms near Putney, and Tonson commissioned KNELLER to paint a series of portraits of the members designed to hang in the room in which the meetings were held. With one exception the portraits measured 36 × 28 in., and the term 'Kit-cat' is often used to denote a portrait, or a canvas, of this size. The whole series of Kneller's portraits, which were painted *c.* 1702-17, is now in the National Portrait Gallery, London.

2091.

**KITSCH.** A German term for 'vulgar trash' which became fashionable in the early 20th c. Its application ranged from commercial atrocities such as touristic souvenirs and fake decoration to any pretended art which is considered lacking in honesty or vigour. A museum of such products was organized at Stuttgart. Although the battle against Kitsch was healthy in its origin, in Germany it frequently led to an unbalanced fear of all obvious beauty or sentiment.

**KIYONAGA,** TORII (1752-1815). Japanese colour-print artist, in whom the UKIYO-E movement culminated. He was the leader of the fourth generation of the famous Torii family of artists and during the 1780s, his period of greatest development, he dominated the movement.

He developed a highly individual style in his portraits of beautiful women, portraits in which the stately elongated body had a strongly rhythmical pose, simple gestures, and a quiet dignity. Kiyonaga was one of the first to exploit fully the colour-print triptych (i.e. three full-sized prints which will unite to form one picture although each is complete in itself). Although he retired from active print designing *c.* 1792, he exercised a very great influence not only on contemporary artists but also, through his school, on the whole movement. In his work, for the first time in Japanese colour printing, landscape became an integral part of the composition. Towards the end his designs suffered from lack of inventiveness, but at his best he was a supreme draughtsman.

**KLEE,** PAUL (1879-1940). Swiss painter, born near Berne. He was trained in Munich, where he settled in 1906 after visiting Italy and Paris. He began as a graphic artist and was influenced by BLAKE and GOYA and later by BEARDSLEY, ENSOR, and TOULOUSE-LAUTREC. Ten of his etchings were included in the exhibition of the Munich SEZESSION in 1906. From 1911 he was associated with the BLAUE REITER group and from 1924 exhibited with KANDINSKY, JAWLENSKY, and FEININGER as the 'Blue Four'. Up to 1920 his reputation depended almost

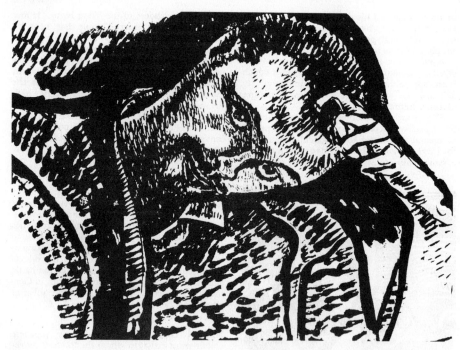

187. *Self Portrait 1911.* Woodcut reproduced in Paul Klee *On Modern Art* (1948)

entirely on his black and white work. He began
the use of colour seriously after 1914 when he
visited Tunisia with MACKE, having previously
met DELAUNAY in Paris in 1912 and translated
his essay *Sur la lumière* in 1913. In 1920 he was
appointed to the staff of the BAUHAUS and taught
there until 1933, when he left Germany for
Switzerland. From *c.* 1920 Klee was famous
internationally and his position became estab-
lished as one of the most sensitive and original
artists of modern times. During the Nazi régime
102 of his works were confiscated from German
museums and 17 of them were included in the
*Degenerate Art* exhibition at Munich in 1937.
Klee's reputation has increased in the years since
the Second World War and his works are
included in most important galleries.

1038, 1166, 1168, 1212, 1502, 1503, 1504, 1505,
1708, 2387.

**KLENZE,** LEO VON (1784-1864). German
architect, mainly active in Munich. He studied
in Paris under PERCIER and visited Italy and
England. Klenze was an orthodox upholder of
NEO-CLASSICAL doctrines, who only occasionally
found his models in the RENAISSANCE. His public
buildings in Munich—particularly those round
and near the Königsplatz—gave to the capital
of Bavaria a stately grandeur. The earliest of
them, the GLYPTOTHEK (1816-30), built to house
a collection of antiques, was one of the first build-
ings conceived as a museum, and remained until

its destruction in the Second World War one of
the finest examples of this type. Klenze also
built a picture gallery, the Neue Pinakothek, and
the HERMITAGE in St. Petersburg (completed
1852). His most characteristic works are monu-
mental, as the Propyläen, a gateway to the
Königsplatz (1846-63), or oddly ROMANTIC, as
the so-called Walhalla, near Regensburg (1830-
42), a Greek temple high above the Danube
valley destined to house statues of great Germans
of the past.

**KLIMT,** GUSTAV (1862-1918). Austrian
painter. After an early IMPRESSIONIST phase
Klimt came under the influence of SYMBOLISM
and of ART NOUVEAU while he was a prominent
member of the Vienna SEZESSION (1898-1903).
His own mature style, manifested in large
allegorical paintings as well as in female portraits,
combined a mannered linear construction with a
somewhat superficial flavour of modernity which
links him with the following generation of
EXPRESSIONISTS.

2572.

**KLINE,** FRANZ (1910-62). American
ABSTRACT EXPRESSIONIST painter. After an
academic training at Boston University and the
Heatherley School of Fine Art, London, he
painted non-figurative compositions in a style
which has often been likened to that of Pierre
Soulages (1919- ) and to Chinese calligraphic

brush writing. Kline, himself, however, denied the influence of Oriental calligraphy and said that he did not think of his work as calligraphic. He worked mainly in black and white until the late 1950s. He had a one-man show at the Institute of Design, Chicago, in 1954 and at the Venice Biennale in 1960.

**KLINGER,** MAX (1857–1920). German painter, etcher, and sculptor. Klinger tried to revive monumental painting, combining at times classical and Christian traditions, but to a later generation his works seem turgid and vulgar (*Christ on Olympus*, Vienna, 1896). His attempt to revive polychrome sculpture in the manner of the Greeks resulted in a theatrical statue of Beethoven modelled on the *Zeus* of PHIDIAS (Leipzig).

**KNAPTON,** GEORGE (1698–1778). English portrait painter, who studied under RICHARDSON and set up on his own in the early 1720s. He was in Italy 1725–32. In 1736 he became official painter to the DILETTANTI Society, of which he was a Foundation Member. From *c.* 1737 he confined himself chiefly to crayons and he appears to have painted little or nothing after 1763. His pleasing portraits are good examples of the work of a painter trained in the KNELLER tradition who adapted himself to the lighter idiom of the reign of George II. He was the teacher of COTES.

**KNELLER** (originally KNILLER), SIR GODFREY (1649?–1723). Fashionable portrait painter, born at Lübeck. He studied in Holland under BOL, a pupil of REMBRANDT, and later in Rome, where he met Carlo MARATTA, Naples, and Venice. He came to England in 1674/5, where the opportune death of serious rivals and his own arrogant self-assurance enabled him to repeat and surpass the success stories of van DYCK and LELY. These qualities may be seen in the *Self-Portrait* (N.P.G., London, 1685). He painted Charles II, by whom he was commissioned for a portrait of Louis XIV, and by the beginning of the reign of James II his dominance as court and society painter was established. He was appointed Principal Painter to William and Mary at their accession, was knighted in 1692 and created a baronet in 1715.

Kneller established a workshop-studio in London with a large team of specialized assistants, many of them foreign, organized for the mass production of fashionable portraits. Sitters were required to pose only for a drawing of the face and efficient formulas were worked out for the accessories. He is said sometimes to have accommodated as many as 14 sitters in a day. The average quality of the work turned out from his studio was that of a slick though efficient fashion painter. Kneller himself was a com-petent if not inspired draughtsman, a somewhat insipid colourist and had the knack of creating a standard image for the royal and official portrait that became the vogue. His best work stands up to comparison with contemporary fashion portraiture in France, Holland, and Italy. Interesting examples of his style are: *The Chinese Convert* (Kensington Palace, 1687), *Matthew Prior* (Trinity College, Cambridge, 1700), and the portraits of the KITCAT CLUB (N.P.G., London, *c.* 1702–17). Though Kneller was partly responsible for one of the first Drawing Academies in London, the influence of his mass-produced work was stultifying. It needed a HOGARTH and a REYNOLDS to break through the conventions he popularized.

**KNIGHT,** DAME LAURA (1877–1970). English painter. She studied at Nottingham Art School and exhibited at the ROYAL ACADEMY from 1903. She was made A.R.A. in 1927 and in 1936 became the first woman Academician since the original women members Angelica KAUFFMANN and Mary MOSER. For a while she painted with her husband HAROLD KNIGHT (1874–1961) at Newlyn and her picture *Spring in Cornwall* was bought by the Chantrey Fund in 1936. She was chiefly known for her pictures of the Russian ballet and of the circus. Her work was extremely competent by academic standards of technique but was judged to be lacking in aesthetic taste and sensibility.

**KNIGHT,** RICHARD PAYNE (1750–1824). English scholar and CONNOISSEUR, an advocate of the PICTURESQUE. He was a prominent member of the DILETTANTI Society and one of the principals in the ELGIN MARBLES controversy. His collection of CLAUDE's pictures was the most valuable in Europe and his collection of antique coins and bronzes formed the nucleus of the BRITISH MUSEUM collection. He wrote a didactic poem in the manner of Pope entitled *The Landscape* (1794) and *An Analytical Inquiry into the Principles of Taste* (1805), both of which were important documents in the literature of the picturesque.

**KNOBELSDORFF,** GEORG WENCESLAUS VON (1699–1753). Favourite architect of Frederick II of Prussia. With Frederick he designed the Sanssouci, Potsdam (1744–7), a delicate pleasure-house aspiring to the light-hearted 18th-c. French charm. His Town Palace, Potsdam (1745–51), was more pompous, though enlivened by a gay use of colour in paint, stone, slate, and gilding.

2570.

**KØBKE,** CHRISTEN (1810–48). Danish painter, pupil of ECKERSBERG. Conscientious in

all his work and with exceptional sensitivity for colour, he rendered the beauty of everyday scenes in the suburbs of Copenhagen. His portrait of the artist Sødring (Hirschprung Gal., Copenhagen, 1832) is worthy of note.

**KOCH,** JOSEPH ANTON (1768-1839). Austrian painter, working mainly in Rome. He was largely self-taught but came strongly under the influence of CARSTENS, whom he met in Rome in 1795. His subjects were taken by preference from Ossian, Dante, etc. He worked with the German NAZARENES on the decorations of the Casino Massimi (1825-9), choosing Dante's *Inferno* for his subject. His landscapes were directly descended from the heroic and ideal landscape of POUSSIN.

**KOEKKOEK,** BAREND CORNELIUS (1803-62). The best known member of a family of Dutch painters. He frequently travelled in Belgium and Germany, where he found inspiration for the ROMANTIC views of forests and mountains which he painted in a very precise and detailed style.

1110.

**KŌETSU,** HONNAMI (1558-1637). Japanese painter, calligrapher, and decorative artist, reputed founder of the KŌRIN SCHOOL with Nonmura SOTATSU. He was an artist of great versatility and some originality, considered one of the three leading calligraphists of his day, famous as a potter for his tea-bowls with Raku glaze, a devotee of the tea ceremony, an innovator in the craft of decorative lacquer and a landscape gardener. In painting he was probably a pupil of the great Momoyama artist Kaiho Yūsho (1533-1615) and may well have inherited from him his gift for rich and brilliant colour. Kōetsu, however, oriented himself more towards the old classical Japanese traditions than the Chinese models of Yūsho. Kōetsu did much to bring about the unification of literature, calligraphy, and decorative art in a single art work, and in particular invented a new type of poem scroll with decorative designs which did not illustrate the theme of the poem but rather conveyed an atmosphere and mood appropriate to its appreciation.

1594, 2480.

**KOKOSCHKA,** OSKAR (1886- ). Painter of Czech and Austrian parentage. His formative years were spent at Vienna amid the intellectual and artistic ferment brought about by the somewhat belated introduction of ART NOUVEAU to Austria in the early years of the century associated with Gustav KLIMT, Adolf LOOS, and the designers for the WIENER WERKSTÄTTE. He made a name for himself c. 1909-10 by his 'psychological portraits' in which the soul of the sitter was thought to be laid bare and he worked for the *avant-garde* Berlin periodical *Der Sturm*. At the same time he produced striking and some-

**188.** Front cover of *Die traeumenden Knaben* (1908). Lithograph by Oskar Kokoschka. First publication of the artist

times shocking lithographs and posters. He was seriously wounded in the First World War and after recovery taught at the Dresden Academy 1919-24. From this time he came to the fore as a painter of EXPRESSIONIST landscapes and a particular kind of 'portrait' picture of town scenes from a high viewpoint. He settled in England in 1938, becoming a British citizen in 1947, and continued to paint landscape and portraits as well as large decorative and allegorical pictures such as the *Prometheus Triptych* (1950) and *Thermopylae Triptych* (1954). A retrospective exhibition of his works was given by the ARTS COUNCIL in 1962. His collected writings 1907-55 were published in 1956.

95, 434, 1344, 1347, 1516, 1517, 2103, 2912, 2913.

**KOLBE,** GEORG (1877-1947). German sculptor. He was trained as a painter but a meeting with RODIN in Rome decided him to turn instead to sculpture. He settled in Berlin in 1903 and remained there apart from travels to Italy, Greece, and Egypt. Kolbe worked mainly in bronze, modelling classically proportioned nudes, and his style showed little development. He also executed a few portrait heads (*Liebermann, Paul Cassirer, Henry van de Velde*).

276.

**KOLLWITZ,** KÄTHE (1867-1945). German graphic artist and sculptor. She lived for most of her life in the poor quarters of north Berlin, and her work is permeated by sympathy and understanding for the poor and the oppressed. Her feeling of solidarity with the working class led her to Communism. She began as a painter, but turned to engraving and lithography, and a

notable series of prints inspired by Hauptmann's play *The Weavers* was published in 1898. After 1920 she concentrated on the woodcut, a medium that lent itself to the kind of popular art she wished to produce. Her subjects were few, and often—as in her favourite *Mother and Child* group—assumed symbolic importance. Käthe Kollwitz's sculptures include the War Memorial at Dixmuiden in Flanders, completed in 1932.

286, 1906, 2435, 2568.

**KONIJNENBURG,** WILLEM ADRIAAN VAN (1868–1944). Dutch painter of murals and portraits and designer of STAINED-GLASS windows, who continued the SYMBOLIST tradition founded by Jan TOOROP, DER KINDEREN, and THORN PRIKKER. His designs are remarkable for their mathematical construction. His books on AESTHETICS (*Het wezen der schoonheid*, 1908; *De aesthetische idee*, 1916) expound his belief in a connection between mathematical PROPORTION, rhythm, and STYLIZATION on the one hand and the struggle between good and evil on the other.

**KONINCK.** The family name of two cousins, both followers of REMBRANDT. SALOMON (1609–56), a pupil of Claes Moeyaert (1592–1655), imitated the pictures Rembrandt made during the 1630s of hermits, old men, and philosophers in their studies. His large historical compositions tend to exaggerate Rembrandt's early predilection for rich exotic costumes, emphatic gestures, and dramatic contrasts of light and shadow. During the 18th and 19th centuries Salomon's works were frequently confused with Rembrandt's. PHILIPS KONINCK (1619–88) took his point of departure from Rembrandt's landscapes of the 1640s but achieved a more personal style. His panoramic views of great winding rivers, dunes, and hills are among the most powerful works produced in Rembrandt's circle. There is a fine example in the National Gallery, London. He also made GENRE pictures and portraits. Like many Dutch painters he had a second occupation; he was the captain of a barge which plied between Leiden and Rotterdam. He was prosperous enough to collect and his drawing of *Calvary* by MANTEGNA is now in the British Museum.

1017.

**KORE.** Greek word for 'maiden', conventionally appropriated to the draped standing female statues of Greek Archaic style (GREEK ART).

**KOREAN ART.** During most of its 2,000 years of history Korea has been a vassal of China and came within the Chinese cultural sphere. But it has also provided a bridge for the passage of Chinese culture into Japan (see JAPANESE ART). It is often difficult to distinguish with certainty early Korean works of art from those of China, and it is equally difficult to say if many early Japanese art objects were made by Koreans or by

native Japanese craftsmen. This intermediary position of Korea has caused the special character of Korea's own art to be overlooked until after the Japanese occupation of the country in 1910.

The history of Korean art begins in the period of the three native kingdoms, Koguryo (*c.* A.D. 50–663), Paekche (*c.* A.D. 313–663), and Silla (*c.* A.D. 380–935). The Chinese settlement of Lolang (called by Koreans Nakuang), which lasted in the northern kingdom of Koguryo until A.D. 313, and Tafang (Tapang), which flourished in Han times, were centres for the Chinese influence which dominated Korean art in the Bronze Age. Many objects found at Lolang were certainly imported from China and some of the gold and painted lacquer works are among the finest examples of CHINESE ART preserved from the Han dynasty. Korean influence in turn was particularly strong in protohistoric Japan from the 3rd to the 6th centuries both in spreading Korean culture (ornaments and black pottery) and in the transmission of Chinese artefacts and styles. Korean influence in Japan reached its peak with the introduction of Buddhism from the kingdom of Paekche.

Wall-paintings in tombs of the Koguryo kingdom discovered just across the Yalu river at Toung-kou, the then capital, and dating from the 4th or 5th c., derive largely from Chinese Han painting and are one of the important links in the history of Chinese painting styles during this period. They include large and brightly coloured pictures of animals, dancing figures, wrestlers, divinities, musicians, banquet and hunting scenes, tournaments, etc. They have a vitality and linear rhythm such as is also apparent in paintings of animals in a tomb discovered at Uhyon-ni near Pyong-yang which is traditionally assigned to the 6th c. Unlike the Koguryo tombs those of the Silla kingdom survived unplundered and the gold objects found there are among the most important early art objects of eastern Asia. Little is known about the art of the Paekche kingdom except from the work of Paekche craftsmen in Japan.

The unification of the country under the royal line of Silla in A.D. 668 brought about a unification of art styles and a new art with close affinities to that of the T'ang art of China. Buddhism entered Korea in the 4th c. and remained the official religion until the end of the Koryu period (A.D. 1392), when its state subsidies were ended on the ground of its weakening effect on the valour of the people and Confucianism was revived in its place. Buddhism had a considerable effect on Korean sculpture and architecture of the 6th to 8th centuries and the classical simplicity and archaic dignity of the Buddhist statuary is distinctive of Korean work even when it is closest to the Chinese styles. Korean sculpture reached its peak in a 10-ft. figure of the seated Buddha, an 11-headed Kuanyin, and reliefs of the 10 disciples of the Buddha in the rock temple of Sokkulam, *c.* A.D. 752. (See BUDDHIST ICONOGRAPHY.) In pottery native

characteristics were marked both in shapes and in decorative techniques, particularly a distinctive patterning of small juxtaposed circles.

The Silla period was succeeded by the Wang dynasty, who called the kingdom *Koryu* (A.D. 918-1392). The 11th and 12th centuries were the Golden Age of Korean pottery, particularly CELADON ware. Although the shapes were largely modelled from the Chinese, they were more imaginative, more varied, and closer to nature than the latter. Flower shapes were particularly popular for tea-pots, drinking cups, and incense burners. The soft bluish green of the Korean celadon distinguishes it from the Chinese and in the latter part of the 12th c. the 'Sanggam' technique of inlaid celadon was unique to Korea. White and black slips were used in engraved patterns of ducks, reeds, willows, etc., and the characteristic celadon glaze was then applied on top. During the 13th c. the firing technique deteriorated and the later celadons have a brownish or speckled hue.

Some of the inlaid or incised metal-work, too, and the painted or carved lacquer was as fine as anything from China itself. In sculpture the figures were heavier and perhaps more clumsy than contemporary Chinese models. A number of miniature pagodas or STUPAS in stone have survived, sometimes with as many as eight roofs and decorated with low reliefs of flowers or Buddhist figures. Their simplicity and restraint are typical of Korean architecture of the time and were not, as sometimes in China, ruined by over-decoration.

The Wang dynasty was weakened by invasion of the Mongols in the 14th c. and was succeeded in 1392 by the Yi dynasty, which remained in power until the usurpation of the country by the Japanese in 1910. The Yi dynasty corresponds roughly to the Ming and Ch'ing dynasties of China. An administration was established on the Ming model and Confucianism replaced Buddhism as the state religion. The rulers encouraged the development of printing with movable type, which had been invented in Korea during the 13th c., and in order to make literature more readily available to the masses an alphabetical script was introduced in place of the Chinese ideograms. A Korean state printing house was set up *c.* 1395. Pottery suffered from the Japanese invasions at the end of the 16th c., the widespread destruction of kilns, and transplantation of potters forcibly into Japan. But a blue-and-white porcelain with decoration of cobalt blue underglaze was characteristic of the Yi period and lasted into the 19th c. Painting was encouraged by the rulers and a court style based on the T'ang painting of China was taught at an imperial academy, the Tohwa-so. The influence of Chinese Sung and Yuan painters such as MA YÜAN is detected in the work of artists such as Kang Hi'an (1419-65), An Kyn (15th c.), and Yun Doo-soh (b. 1668). The Chinese *wên-jên* movement of cultivated amateur painters had its counterpart in Korea from the 15th c. The influence of Chinese *wên-jên* can be seen in such artists as Sim Sa-chung (1707-69), Kang Sie-whang (1713-91), and Sin Whui (1769-1845). The Korean style differs from the Chinese, if at all, by a certain freedom from traditional restraint, a heaviness of ink and brush-work, and a more schematic execution. A landscape style expressive of the Confucian concept of nature as an ordered and patterned system had its chief exponent in Yi Sang-chwa (middle of 16th c.). In the 18th c. a trend of GENRE painting akin to the northern Sung academy but with a freer humour and almost CARICATURE-like realism was developed by Kim Duk-sin (1754-1822) and Sin Yun-bok (1758-?). The important printer Chong-Son was influenced by the Wu style and some masters of woodcut such as Kim Hong-to (active *c.* 1800) are reminiscent of Japanese genre prints.

89, 800, 1158, 1357, 1428, 1493, 1494, 1720, 1980, 2442, 2598.

**KŌRIN, OGATA** (1658-1716). Japanese artist who renewed and extended the so-called KŌRIN SCHOOL which was founded in the Edo period by KŌETSU and SOTATSU. Kōrin's paintings and decorative designs on pottery and lacquer screens first made the school internationally known and were largely instrumental in bringing Japanese art to the attention of the West. In Japan his reputation ran so high that art historians have claimed him as a pupil both of the TOSA and of the KANŌ Schools. Besides the vigour and exuberance of his purely decorative works Kōrin excelled as a painter of natural objects, flowers, animals, and also landscape. In the latter field he dispensed with the exaggerations of decorative design and achieved an unrhetorical simplicity and a direct naturalism which he linked for decorative purposes with the love of pattern for its own sake. An example of his treatment of pure landscape may be seen in the Matsushima screen in the Boston Museum.

**KŌRIN SCHOOL.** School of Japanese painters called by Laurence Binyon 'the great decorators'. The school was founded in the Edo period (see JAPANESE ART) by Honnami KŌETSU in conjunction with Nonomura SOTATSU; it was continued and brought to international importance by Ogata KŌRIN. In common with artists of the Momoyama period the school combined lively naturalism with decorative splendour and flamboyant colour. But whereas the Momoyama painting was largely Chinese in source, the Kōrin style represented a reversion to classical Japanese tradition. Until the end of the 17th c. the school was associated chiefly with Kyoto, where classical Japanese taste and Japanese poetry were the fashion. In its decorative extravagance and its florid sensuous appeal this school of painting appealed to the rich merchant classes of Kyoto.

1594, 2480.

**KORYŪSAI,** ISODA (active 1765–84). Japanese colour-print (UKIYO-E) master, famous for his long 'pillar-prints', particularly of women in gorgeous dress. He was a disciple of HARUNOBU and somewhat overshadowed him when changing fashion favoured his more robust manner rather than the frail delicacy of Harunobu. His series called 'New Patterns for Young Leaves' was continued by KIYONAGA. Towards the end of his life he concentrated on book illustration and painting.

**KOUROS.** Greek word for 'young man', conventionally appropriated to the nude standing male statues of Greek Archaic style (GREEK ART).

**KRAFT,** ADAM (c. 1460–c. 1508). German sculptor of Nuremberg. His most celebrated work, the CIBORIUM (c. 60 ft. high) in the choir of St. Lawrence, Nuremberg, is perhaps remarkable for artistry rather than art. The whole is a gigantic stone imitation of a subtle piece of goldsmith's work. The over-richly decorated structure houses a multitude of human figures, animals, amphibia, etc. One of the supporting figures is supposed to be a self-portrait. Kraft's other works, mostly in Nuremberg, show the highly elaborate manner of carving common to many late GOTHIC sculptors.

2438.

**KRIEGHOFF,** CORNELIUS (1815?–72). Itinerant German painter resident in Canada c. 1840–66. What lessons he had were probably at Düsseldorf, and he had studied the minor Dutch masters. His wanderings brought him to New York c. 1837, at which time he is said to have joined the United States Army and painted scenes of the Seminole War. He appeared in Canada after 1840, settling near Montreal in 1849. There and in Quebec (1853–66) he assiduously painted the Indians, French Canadian life, and the landscape in a detailed and often anecdotal style. His pictures were sought after by the English garrison at Quebec as souvenirs. They present the life of the people in a highly coloured dramatic aspect, and have not been popular with the French Canadians. He had an eye for microscopic detail and a taste for brilliant colour (*Winter Landscape*, N.G., Ottawa, 1849).

**KROHG,** CHRISTIAN (1852–1925). Norwegian painter, who was in Paris during the 1880s and there came into contact with the REALISTIC theories of Zola. He applied these in a novel as well as in his paintings, most of which depicted the life of prostitutes and the poor. As a painter he was quite unsophisticated.

PER KROHG (1889–1965), son of Christian, grew up and was trained in Paris, where he developed in contact with modern aesthetic trends. CUBISM, in particular, served him as a vehicle for his rich and fantastic imagination. His many mural paintings in Oslo, teeming with bizarre and poetic allegories, are without the heroic quality which usually marks monumental art.

**KRØYER,** PAUL SEVERIN (1851–1909). Danish painter, Norwegian by birth. Influenced by VELAZQUEZ, he painted scenes of Spanish and Italian workmen (1878–80), the pathos and realism of which caused much discussion in Denmark. He used a broad technique and was particularly interested in effects of light—the fusion of daylight and lamplight, the effects of the sun at different times of day, etc. From 1882 he was an influential leader of a colony of Scandinavian artists at the seaside village of Skagen and the pictures which he painted there are more cheerful in tone. But his last years, from 1900 onwards, were clouded by mental illness.

**KRUSEMAN,** CORNELIS (1797–1857). Dutch painter who was a pupil of the Anglo-Dutch portrait painter C. H. Hodges (1764–1837). He painted ROMANTIC GENRE scenes of life in Italian villages and historical pictures in the classical manner. But his best works are his straightforward portraits, spontaneous drawings, and the sketches for more ambitious works in oils.

**KRUYDER,** HERMAN (1881–1935). Dutch painter who was one of the foremost representatives of EXPRESSIONISM in the Netherlands. In his barnyard scenes the animals are as sharply characterized as the sad, phlegmatic peasants.

**KUBIN,** ALFRED (1877–1959). German graphic artist and book illustrator. He settled in Munich, where he was a member of the BLAUE REITER group. The influence of ENSOR and the freedom he learned through his contacts with EXPRESSIONISM gave him a pliable linear technique. His illustrations are often uncanny and morbid; they exemplify the more neurotic trends of German Expressionism.

**KUFIC AND NASKHI SCRIPTS.** The Arabic script is read from right to left and obtains its decorative effect by the rhythmical contrast of its vertical and horizontal strokes. Broadly speaking there are two types of script, each with its derivatives. The form which was first used for monumental purposes about the end of the 7th c. is known as Kufic. It is angular and square and particularly well suited to architectural decoration. The other form, known as Naskhi, is curved and flowing and was probably developed from the ordinary cursive script. As a monumental script it was developed and popularized by the Ayyubid rulers of Egypt and Syria in the second half of the 12th c. A fine example of monumental Kufic is the inscribed frieze on the so-called Tower of Mahmud at Ghazni in Afghanistan, which was built between

**189.** Kufic script from the frieze on the Tower of Mahmud at Ghazni, Afghanistan (early 11th c.)

1117 and 1149 for the Ghaznevid prince Bahramshah. The letters, set in relief against a scroll background, make a pleasing contrast to the simple geometric decoration of the brickwork. Naskhi inscriptions are common in architecture and the decorative arts.

Sometimes a meaningless series of Arabic letters is used merely for decorative effect. This use of the script found its way to Europe, where Kufic lettering occurs in the decorative arts of the ROMANESQUE and GOTHIC periods.

**KU K'AI-CHIH** (*c.* 345–405). Great Chinese master of the second half of the 4th c., traditionally considered one of the founders of Chinese LANDSCAPE PAINTING. The scroll in the British Museum *Admonitions of the Imperial Instructress* (ink and colour on silk) is considered to be a T'ang or Sung copy of an original by this artist. It exemplifies the early method of composition (also used in the European Middle Ages) in which size is governed by psychological importance rather than by optical perspective. The 9th-c. painter and art theorist Chang Yen-yüan described Ku K'ai-chih's procedure in a statement which became part of the orthodox dogma of Chinese aesthetic literature: 'His conception was fully formed before he set brush to paper. When the picture was finished it embodied this conception; hence it was imbued with spiritual life force.'

**KULMBACH, HANS (SUESS) VON** (*c.* 1480–1522). German painter. He was a pupil of DÜRER, but also came under the influence of Jacopo de' BARBARI when this Italian artist visited Nuremberg between 1500 and 1503. His chief works, mainly ALTARPIECES, are in Nuremberg and Cracow.

2544, 2914.

**KUNSTKAMMER.** While the medieval princes had mainly collected relics of saints, those of the RENAISSANCE and later assembled collections of pictures and of small objects which can be best described as 'curios'. Though the collecting habit was by no means confined to German monarchs, the German term *Kunstkammer* (literally 'art chamber') has been adopted by some art historians to describe these collections of cabinet pieces which might include anything from a watch to a fossil. In the 16th- and 17th-c. inventories the term *Kunstkammerstück* means an object of art, a jewel, or a devotional article of particularly remarkable character or quality ordered specially for display in the *Kunstkammer*. (See also COLLECTING.)

# L

**LABENWOLFF, PANKRAZ** (1492–1563). Unimportant German sculptor, trained in the VISCHER workshop, who has wrongly been credited with the famous 'goose-boy' fountain (*Gänsemännchen Brunnen*) in Nuremberg. There is no evidence for this and its real author is unknown.

**LACERÍA.** The Spanish word for geometrical ISLAMIC decoration of straight lines forming intersecting polygons and star shapes. Inherited as a decorative motif from Moorish sources, it

was much used by MUDÉJAR craftsmen in Spain and Portugal.

**LA-CHARITÉ-SUR-LOIRE, PRIORY OF.** A CLUNIAC house founded by St. Hugh of Sémur in 1052; the existing church was consecrated in 1107. Only part of the choir, the tower, and part of the nave wall survive. The nave of nine bays had double aisles; the original east end had three apsidioles of diminishing depth on either side of the central APSE. In the middle of the 12th c. this was modified to take radiating chapels like those

of the third church at Cluny. The pointed ARCHES of the AMBULATORY are surmounted by a richly CUSPED blind arcade and another round-headed and fenestrated. The whole church was ornamented with sculptured arcading. Two interesting TYMPANA survive in side doors. The church had considerable influence in its region, notably on its daughter house of Saint-Révérien.

**LAER,** PIETER VAN (1592–1642). Dutch artist, called *Il Bamboccio* because of his deformed body, who was in Rome *c.* 1625–7 and painted small pictures of Roman street life. Such pictures were called *bambocciate* (French *bambochades*) and the word came to designate a type of small picture, popular in the Low Countries and Italy, depicting low-life and peasant scenes. Van Laer was one of the leaders of the SCHIL-DERSBENT (Band of Painters), a fraternal organization set up by the Netherlandish artists in Rome to protect their interests.

**LA FOSSE,** CHARLES DE (1636–1716). French painter, who during the 1670s worked mainly as an assistant to LEBRUN and was responsible for part of the decoration of the Salon de Diane and the Salon d'Apollon at VERSAILLES. He had spent the years 1658–60 in Italy and during the 1680s the influence of the northern Italian schools, particularly VERONESE and CORREGGIO, was prominent in his work. He was a friend of Roger DE PILES and a supporter of his party in the controversy of colour versus drawing (see FRENCH ART, 'Poussinistes' versus 'Rubensistes'). He was one of those who were responsible for bringing echoes of RUBENS into French painting during the 1680s and his *Presentation of the Virgin* (Musée des Augustins, Toulouse, 1682) was more completely in the mature style of Rubens than anything which had been done in France up to that time. La Fosse was in London working for the Duke of Montagu on the decoration of Montagu House (formerly on the site of the BRITISH MUSEUM) from 1689 to 1692, in which year he returned to Paris to paint the dome of the Invalides for J. H.-MANSART. La Fosse showed more originality of invention than most artists during the period of decline in French painting over the concluding decades of the 17th c. and his work heralds something of the lightness and elegance of the ensuing ROCOCO.

**LAGUERRE,** LOUIS (1663–1721). French decorative artist. After working for a short time under Charles LEBRUN in Paris he came to England as a young man, *c.* 1683/4. He worked at Windsor with VERRIO, but soon proved his superiority and obtained important commissions for the chapel and ceilings in five state rooms at Chatsworth (1689–94) and at Blenheim (1719), where the ILLUSIONIST decoration of the Saloon,

with its design of figures representing the Four Continents looking into the room through a classical colonnade, is derived from the Escalier des Ambassadeurs, VERSAILLES (demolished), painted by his master, Lebrun. He worked in a number of other country houses and was the most successful decorative artist of his day. THORNHILL, his pupil, succeeded him in popularity from *c.* 1710.

**LA HYRE,** LAURENT DE (1606–56). French painter, born at Paris. His earlier work was influenced by PRIMATICCIO and the FONTAINE-BLEAU schools but his figures had a staid and realistic quality of their own. From *c.* 1638 he came under the influence of POUSSIN's earlier style but the romantic character of the landscape and the treatment of the figures is individual. From 1648 he produced his most original landscapes but during the same period painted more classical and austere figure compositions, in the manner of Philippe de CHAMPAIGNE. An artist of minor talent, La Hyre still made some personal contribution and it has been said of him that 'he embodies in a small way the good sense and the good taste of French seventeenth-century culture'. The *Landscape with Bathers* (Maisons Lafitte) and *Pope Nicholas V before the body of St. Francis* (Louvre, 1630) are typical of his first phase and *Mercury giving the Infant Bacchus to the Nymphs* (Hermitage, 1638) exemplifies the middle period.

**LAIRESSE,** GERARD DE (1641–1711). Painter and etcher from Liège who settled in Amsterdam in 1665. He was the foremost representative of CLASSICISM in Holland in his day. Like other classicists who judged REM-BRANDT's work by academic rules he found little to admire in him, though, ironically, he would be far less known today but for Rembrandt's superb late portrait of him (Lehman Coll., New York, 1665). But he somewhat naïvely confessed in his *Het Groot Schilderboek* (1707) that he had a special preference for Rembrandt until he 'learned the infallible rules of art'. Lairesse's *Groot Schilderboek* was a compilation from lectures which he gave on art and art theory after he went blind *c.* 1690. It was frequently re-printed and was translated into French, German, and English. In 1874 Robert Browning wrote on the fly-leaf of his first edition of the English translation (*The Art of Painting . . .*, 1738): 'I read this book more often and with greater delight when I was a child than any other; and still remember the main of it most gratefully for the good I seem to have got from the prints and wonderful text.'

2649.

**LAM,** WIFREDO (1902– ). Afro-Cuban painter. He studied in Havana and Madrid and

went to Paris in 1937, where he met PICASSO and André BRETON, who encouraged him to join the SURREALIST movement. Lam has been hailed as a champion of the renewal of African visual art and the first great artist of 'Neo-African' painting. Aimé Césaire, poet of Martinique, has written lyrically of his work: 'In a society where money and machines have immeasurably increased the distance of men from things, Wifredo Lam conjures up on his canvas the rite for which they are all there: the rite of the physical union of man and the world. Committing intelligence and technical skill to a unique fable-making adventure, he celebrates the transmutation of the world into myth and enchantment.'

528.

**LAMB.** The image of the Lamb has a twofold significance in Christian ICONOGRAPHY. It can (i) stand for CHRIST as the Redeemer expiating the sins of mankind by His sacrifice. This symbol is taken from John i. 29: 'Behold the Lamb of God, which taketh away the sin of the world', but the idea of the expiatory sacrifice of the lamb is also found in the Old Testament. The image gained added force from the Revelation of St. John, where the triumph of the Lamb signified the victory of Christ, and the invocation of the *Agnus Dei* is still used in Christian services. But (ii) Christ was also represented as the Good Shepherd of the lambs and in this context lambs in Christian art can stand for believers or members of the Church, as in the paintings of the Roman catacombs (2nd-4th c.), where the Christ Shepherd carries the lambs on His shoulders.

In the 4th and 5th centuries Christ the Lamb became a favourite subject for the carvings on SARCOPHAGI. The Lamb stood on Mount Sion (Rev. xiv. 1) and was often approached by a line of 6 or 12 lambs of the flock. Usually this procession was set below a group of Christ and His APOSTLES in human shape, to which it formed a symbolic parallel (Matt. x. 16) as in a late 4th-c. sarcophagus in S. Ambrogio, Milan. Roman artists long used such a frieze of lambs in the apses of churches (e.g. mid 12th-c. mosaic, S. Clemente, Rome).

The Christ-Lamb normally had the nimbus with cross (or sometimes SACRED MONOGRAM) and was often entirely enclosed by a roundel or triumphal wreath, as on an ivory relief of the 5th c. in the treasury of the Duomo, Milan. Often it carried a cross-staff, as on the silver reliquary presented by Justin II (565–78) to St. Peter's, Rome, and on later crosses of this pattern. From the 12th c. a flag was added to the staff, as on a portable cross in the Landmuseum at Darmstadt. An identical banner-cross, symbol of His triumph over death, was carried by Christ in pictures of the RESURRECTION at this time and later. The Lamb with cross-staff or banner was a favourite subject of ROMANESQUE and GOTHIC sculpture (e.g. capital at Hersfeld, Germany, c. 1100; font at Helpringham, Lincs., 12th c.; roundel on ceiling of Troyes Cathedral, 14th c.).

From an early time a lamb was a regular

**190.** Christ-Lamb. Sarcophagus from the Mausoleum of Galla Placidia, Ravenna (5th c.)

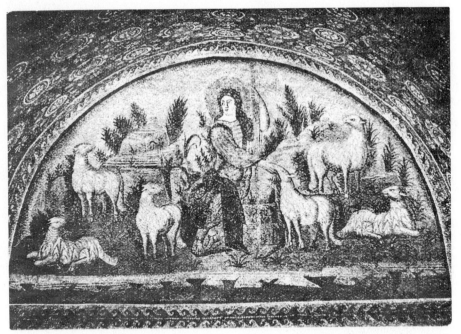

**191.** Christ as the Good Shepherd. Mosaic from the Mausoleum of Galla Placidia, Ravenna (5th c.)

attribute of JOHN THE BAPTIST. On the stone crosses at Ruthwell and Bewcastle (see ANGLO-SAXON ART) St. John carries a lamb, as do his statues on CHARTRES and REIMS Cathedrals, and it was still used by TITIAN (Accademia, Venice) and later painters. This image represented St. John's Christian baptism, the sacrament giving membership of the Church.

The Lamb often figures in illustrations to the APOCALYPSE, both in manuscript-cycles and in monumental scenes. It is carved together with the four beasts of the Apocalypse (Rev. iv. 7), symbols of the EVANGELISTS, over the main door of many churches (e.g. 12th-c. portal of S. Ambrogio, Milan). It is also associated with the Eucharist, recalling Christ's sacrifice, and shown with blood flowing from its breast into a chalice, as on the central panel of the Ghent altarpiece (c. 1320-30) by the brothers van EYCK. On one of the carved columns of the ciborium of St. Mark's, Venice (12th c.), the Lamb is substituted for the figure of Christ on the cross. Occasionally it replaces the Second Person in the TRINITY, the first extant example of this being in the illustrations of the Utrecht Psalter (830-40).

Apart from its doctrinal significance in Christian religious iconography, sometimes the image of a lamb is used to represent the virtues of Temperance, Patience, or Charity, as in the 13th-c. carved roundel on the west front of Amiens Cathedral, where the figure of Charity carries the lamb on a shield.

**LAMBERT,** GEORGE (1700-65). English painter, a pupil of John WOOTTON, from whom he learned the rules of CLASSICAL landscape composition. His importance in the development of English LANDSCAPE PAINTING lies in the fact that he applied these rules to the English scene and painted views which are at the same time compositions. In 1732 he collaborated with Samuel SCOTT in a series of views of the East India Company's settlements, and in 1736 he was appointed scene painter to Covent Garden Opera House. There is little doubt that his landscape paintings had some influence on the development of Richard WILSON.

**LAMI,** EUGÈNE-LOUIS (1800-90). French painter, pupil of Horace VERNET and Baron GROS. He started his career as a LITHOGRAPHER (*Collection of French Army Uniforms, 1791-1814*, in collaboration with Vernet, 1822). Between 1830 and 1837 he made his name as a painter of battle scenes. After the inauguration of the VERSAILLES Museum in 1838 he became official painter of festivities at the court of Louis-Philippe (*Wedding of the Duke of Orléans*; *Queen Victoria's Arrival at Tréport in 1843*). He was in England in 1826, when he met REYNOLDS and LAWRENCE, and again in 1848-52. He is known chiefly for his charming series of WATER-COLOURS of English life and scenery, and he was a founder of the Société des Aquarellistes.

1636.

**LANCRET,** NICOLAS (1690–1743). French painter. He was a fellow student of WATTEAU in GILLOT's studio and had considerable success in imitating the style and the themes which Watteau had made popular, though he lacked Watteau's talent. He was patronized by Crozat and six pictures were ordered by Louis XV. His series *Four Seasons* (Louvre) was commissioned for the Château de la Muette, for which Watteau had designed Chinese ARABESQUES. He was interested in the theatre and in GENRE subjects, in which he often shows a good sense of composition (*Déjeuner de jambon*, Chantilly). An excellent example of his work is *The Music Lesson* (Louvre, 1743). Several of his pictures are in the Wallace Collection, London.

2884.

**LANDSCAPE PAINTING.** The term 'landscape', originally a painter's term of Dutch derivation, was first used in the late 16th c. to describe the rendering of natural scenery in painting. Elements of landscape and natural features were of course from a very early time incidental background accessories of historical, mythological, commemorative, anecdotal, and other types of painting. In the hieratic art styles of EGYPT, BYZANTIUM, and ROMANESQUE Europe landscape elements introduced as a setting for the main theme of a picture were usually highly conventionalized, and standard formal conventions were used to indicate mountains, rivers, trees, etc. In Greek painting of the classical period rivers and other natural features were frequently indicated symbolically by the figure of the appropriate deity or indirectly by drawing in fishes, birds, etc. But landscape as the principal theme of a picture, painted for its own sake, was not possible until artists and their patrons had learned to see landscape. This happened slowly and very gradually. It seems that until fairly recent times men looked at nature as an assemblage of isolated objects, without connecting trees, rivers, mountains, roads, rocks, and forest into a unified scene. The ability to see nature as 'scene' may have been developed largely by artists, was certainly crystallized in hardly won pictorial devices and painterly know-how, and spread to the general public. The slow growth of PERSPECTIVE was not merely a matter of mastering a difficult technique; it was the expression of a way of seeing. Thus conventional formulas rather than naturalistic transcripts of nature were the starting-point of pictured landscape. The artist or amateur who sits down in front of a subject presupposes a long evolution in which the vocabulary of rendering natural scenery gained shape side by side with the power to see nature as scenery.

In HELLENISTIC and ROMAN ART landscape was never wholly emancipated from the double ties of illustration and decoration. The literary associations of ALEXANDRIAN art were with pastoral poetry and with the stage properties of the Satyr plays (see PASTORAL). There is a strong pastoral element too in the landscape paintings which have survived from POMPEII. But landscape was given a large place in Campanian art and it was in Roman times that there first emerged an art where natural scenery was obviously enjoyed and utilized for its own sake. Whether or not the Romans were pioneers in the field of landscape, their great fondness for the country is attested by their poetry, in collections of letters, in oratory, and by their choice of sites for their country villas. There is therefore some appropriateness in the tradition recorded by PLINY that an Italian painter (the name is variously given as Spurius Tadius, Ludius, or Studius) 'introduced the most attractive fashion of painting walls with pictures of country houses and porticoes and landscape gardens, groves, woods, hills, fish-ponds, canals, rivers, coasts, and whatever anybody could desire, together with various sketches of people going for a stroll or sailing in a boat or on land going to country houses riding on asses or in carriages, and also people fishing or fowling or hunting or even gathering the vintage'. Even in this account landscape is closely allied with the pastoral GENRE. But in the paintings that have survived from Pompeii and elsewhere landscape is often a major interest, forming the principal theme: nature is depicted as unified scene and enjoyed for its own sake.

In China, on the other hand, the development of landscape painting is closely bound up with an almost mystical reverence for the powers of nature. The subject matter of 'mountain and water' received early attention from Chinese writers on art even before the advent of Buddhism, but the cult of solitude and the mood of withdrawal of the Zen sect seem to have had their share in the sublime creations of the Sung painters (see CHINESE ART). Through later derivations in JAPAN and particularly through the popular colour prints (UKIYO-E) of the late 18th and early 19th centuries, Far Eastern landscape conventions also made their impact on European developments.

Landscape as an independent genre did not emerge in Europe until the 16th c. It was brought into being by a variety of impulses. In RENAISSANCE Italy LEONARDO had propagated and embodied a new conception of the painter's art. To him the artist was not a mere illustrator but, like the poet, a creator of worlds. Though Leonardo left no landscape painting, his notes are full of observations relating to that art. At the same time the humanist interest in the classics created a public for poetic pastoral illustrations, which gained an enormous vogue in VENETIAN painting with and through GIORGIONE. Then again the study of VITRUVIUS suggested the creation of frescoes with landscape vistas such as were executed by PERUZZI and Paolo VERONESE. All this created a new receptivity for the marvels of FLEMISH landscape backgrounds with their meticulous detail. Works of this kind

were eagerly collected in Venice and the demand for much background and little story seems to have induced Flemish painters such as Joachim PATENIER to paint vast, fantastic panoramas as a setting for such religious episodes as the Flight into Egypt. It was in this European atmosphere of the early 16th c. that the first 'pure' landscape was painted midway between Italy and Flanders, in the Danube area. To ALTDORFER must go the credit for breaking with the convention that a picture must tell a story. He made landscape a subject acceptable for its own sake, not only by his paintings in Munich but also in his ETCHINGS and WATER-COLOURS.

The final impulse in this complex development, however, was probably the onslaught of the Reformation on religious painting in general. The Flemish painters, finding that their churches now gave them no employment, naturally bethought themselves of the 'speciality' for which they were famous all over Europe, and by the second half of the 16th c. a fair proportion of the picture export from Antwerp must have consisted of pure landscapes. In the words of Edward Norgate, purchaser of pictures for Charles I, such pictures were 'of all kinds of painting the most innocent, and which the Divill himselfe could never accuse of idolatry'. These landscapes were rarely NATURALISTIC in our sense. They were crowded with fantastic motifs arrayed according to a rather rigid formula: a brownish foreground, a green middle zone, and a vast blue panoramic background. The MOMPER family supplied the 'collectors' cabinets' of the turn of the century with many specimens of this kind. From this stream of production only the work of the elder BRUEGEL stands out by its power and originality.

In the late 16th c. a group of Protestant refugees, who led by CONINXLOO formed one of the earliest Artists' Colonies at Frankenthal in the Palatinate, specialized in woodland scenes. Northern landscape artists continued to be in demand as specialists in Italy; the Fleming Paul BRIL, for instance, made a living by painting landscape lunettes in the Rome of Sixtus V. It was in this milieu of decorative landscape that the convention of the IDEAL landscape emerged in Rome at the end of the 16th c. It owed much to the serene landscape lunettes of Annibale CARRACCI and to the cabinet pictures by ELSHEIMER, who had been in contact with the Frankenthal group. Elsheimer died young, but the vein he had struck was developed by another painter from the north—CLAUDE Lorraine, who gave lasting expression to the pastoral mood and the nostalgic melancholy of the Roman Campagna. In an analogous way Nicolas POUSSIN in his mythologies created the HEROIC landscape of grandiose and austere simplicity.

This Italian development towards the ideal and the heroic is usually contrasted with the turn towards REALISM taken by landscape painting in the liberated parts of the Netherlands. It is true that a sober and realistic type of landscape

picture began to be favoured in Holland from about 1615 onwards—a new taste, which Esaias van der VELDE and Jan van GOYEN were the first to exploit. But the simple motifs which they chose—a village street, a row of trees, a ferry—should not cause us to overlook the stylistic contacts which DUTCH ART always maintained with the south. This applies not only to the overtly Italianate landscape artists of Holland such as PYNACKER, ASSELYN, or BERCHEM, but also to the great masters who discovered and transfigured the beauty of the Dutch plains, dunes, and woodlands: the mature van Goyen, Salomon van RUYSDAEL, Jacob van RUISDAEL, KONINCK, CUYP, and HOBBEMA. It was these masters who first recognized that a mere view—a scene in nature, not one composed by the painter—could be a subject worthy of a great artist's highest powers. VERMEER's *View of Delft* is a simple visual record, completed, perhaps, with the mechanical aid of the CAMERA LUCIDA, yet it is miraculously transmuted into a poem of light and colour.

Different modes of landscape had thus been created—ideal, heroic, pastoral, naturalistic. European painting of the 18th c. drew freely on all of them. The ROCOCO taste favoured a revival of the pastoral moods, which is manifest in the work of WATTEAU in France and GAINSBOROUGH in England. But the main achievement of the century lay, perhaps, in an increasing adaptability of taste and mood that allowed the grandeur and charm of Claude's ideal visions to be projected into the English countryside, both physically in the shape of landscape gardens and also in the new taste for 'picturesque' scenery and the aesthetic philosophy of the PICTURESQUE. Richard WILSON is one of the first to demonstrate that Claude's pictorial idiom can be applied to such subjects as Cader Idris, but as the process went on, through the water-colour painters such as GIRTIN and the early TURNER, the language soon lost its foreign accent. Finally, CONSTABLE turned from the traditional vocabulary of 'picturesque' and 'pastoral' embellishments to seek in Ruysdael and Hobbema the source for a language of visual truth.

The impact of Constable's uncompromising art on the ROMANTIC painters of France has often been described. His methods and his fresh vision excited the painters of the BARBIZON SCHOOL, among whom COROT revived the pastoral mood. Meanwhile, of course, poetic landscape had not lost its followers. In Germany it was cultivated by the Romantic C. D. FRIEDRICH, and in England the ageing Turner advanced ever further into a dreamland of light and colour. The possibilities of atmospheric effects that Turner explored also left their mark on MONET, who had perhaps been prepared for these discoveries by the influence of the Dutch painter JONGKIND. It was Monet's IMPRESSIONISM which finally elevated landscape to the highest position in the artist's hierarchy of subjects, for in landscape all non-pictorial, 'literary'

elements can be eliminated and the painter surrenders himself completely to the visual impression. Landscape, then, remained the chosen field for the generation of POST-IMPRESSIONISTS such as CÉZANNE, van GOGH, and SEURAT. But, as modern art retreats from reality, only the Sunday painters who follow ROUSSEAU still record a given view with the intention of faithfulness.

In the 20th c. SURREALISM discovered the charms and terrors of the dream landscape where such artists as CHIRICO and Yves TANGUY broke new ground. On the other hand various lines of abstract or semi-abstract work, stemming from Cézanne through the CUBISTS and leading to such varied styles as those of Juan GRIS, DERAIN, BISSIÈRE, and Ivon HITCHENS, had in common a tendency to treat landscape as STILL LIFE and to use natural scenery as the raw material for creating constructs of colour and form.

436, 929, 1128, 1433, 2548, 2583.

**LANDSEER,** SIR EDWIN (1802-73). English animal painter, son and pupil of an engraver, John Landseer, and pupil of Benjamin HAYDON. He was an infant prodigy and of the 18 etchings of his in the Victoria and Albert Museum one, of cows, dates from his eighth year (published by Colnaghi in 1852). At the age of 11 he won the silver palette of the Society of Arts for animal drawing and exhibited dogs at the Royal Academy two years later. In 1818, when he was 16, his picture *Fighting Dogs getting Wind* was exhibited at the Society of Painters in Oil and Water-colour and was bought by Sir George Beaumont; two years afterwards a *Hunting Scene* was also exhibited. The Romantic painter GÉRICAULT was impressed by his picture *Rat Catchers* at the Royal Academy of 1821. Through a long life he was the most popular painter of his day, known particularly through the medium of engravings; he was the favourite painter of Queen Victoria. He was elected A.R.A. in 1826, as soon as he reached the statutory age of 24, R.A. in 1831; he was knighted in 1850 and in 1865 he refused the Presidency of the Royal Academy.

Despite great natural talent as a draughtsman and a real gift for animal observation, Landseer's work was superficial, the potentiality of greatness ruined by the attributes which conduced to his unprecedented popular success. He possessed and cultivated the knack of humanizing his animals, posing as the New Aesop. He developed an attitude towards animal painting which appealed to the public at large rather than to the genuine painter or the expert and knowledgeable observer, investing his humanized animals with sentimental attributes to tell a sentimental story or point a moral. In 1848 seventeen of his etchings were published in portfolio. Some of the best have an easy movement and an expressive line; but they suffer from a coquettish daintiness

which too often descends to the effeminate pretty-pretty. In his etching as in his painting he pandered to popularity and squandered a fine gift. His elder brother THOMAS (1795-1880), also an engraver and an R.A., had more strength of bite and an occasional turn of humour which if less fashionable was more genuine than his brother's work. As a sculptor Edwin Landseer is best known for the lions which he modelled in 1867 for the base of Nelson's Column in Trafalgar Square.

**LANFRANCO,** GIOVANNI (1582-1647). Italian painter, who with GUERCINO and Pietro da CORTONA is ranked as one of the founders of the mature BAROQUE style of painting in Rome and Naples. He was born in Parma, the city whose churches CORREGGIO had decorated half a century earlier. He was trained under Agostino CARRACCI in Bologna and in 1602 went to Rome to work under Annibale Carracci in the Farnese Palace. Returning for a short while to Emilia after Annibale's death in 1609, he again studied the works of Correggio and Ludovico Carracci and may have looked with interest at the work then being done in Parma by Bartolomeo SCHEDONI. He went back to Rome c. 1612 and carried out a number of decorative schemes for palaces and churches, including the ceiling of the Casino Borghese (1616). The most revolutionary work of this period was his painting of the *Assumption* in the dome of S. Andrea della Valle (1621-5), having obtained part of the commission from DOMENICHINO. He used Correggio's SOTTO IN SU type of ILLUSIONISTIC design but carried it to extremes. As with Correggio, the groups of figures on clouds diminish with brilliant foreshortening, but in Lanfranco's work the clouds are irradiated by light streaming from the figure of Christ in the LANTERN. BELLORI compares this magnificent design to the harmonious blending of cadences in a full choir. It became a pattern and inspiration for the whole school of illusionist decorators in Europe. Lanfranco used the scheme again in an even more showy form in the S. Gennaro chapel in Naples Cathedral (1641) and this version was followed by Pietro da CORTONA in his dome of the Chiesa Nuova in Rome, and by MIGNARD in the church of the Val de Grâce in Paris.

Between 1633 and 1646 Lanfranco was in Naples, where his resplendent Baroque decorations were an inspiration to such Neapolitan masters as Mattia PRETI, Luca GIORDANO, and SOLIMENA. He returned to Rome in 1646 and his last work in the apse of S. Carlo ai Catinari exemplifies the airy luminosity of his late period.

Lanfranco did a series of eight biblical paintings for the church of S. Paolo fuori le Mura, Rome. By 1668 these had been affected by damp and were replaced by copies. The originals were bought by Cardinal Fesch, Napoleon's ambas-

sador to the Holy See 1803-6 and were dispersed when the Fesch collection was sold 1845-6. *The awakening of Elijah by the angel in the desert* was rediscovered in 1967 and bought by the Rijksmuseum. *The return of the messengers sent by Moses to spy out the Promised Land* (Numbers xiii. 23) was rediscovered and sold by Christie's in 1968. Two of the set are in the Dublin Museum, one in Marseilles and one in Poitiers.

**LANGHANS,** CARL GOTTHARD (1732-1808). Chief architect to Frederick William II of Prussia. His Brandenburg Gate, Berlin (1789), ushered in the Prussian NEO-CLASSICISM of which GILLY and SCHINKEL were the chief exponents.

**LANGLEY,** BATTY (1696-1751). English architect. With his brother THOMAS, an engraver, he started a school of Architectural Drawing in London. He is chiefly remembered for his book *Ancient architecture, restored and improved . . . in the Gothick mode* (1742), in which he attempted to rationalize the GOTHIC style into a system of Orders (see ORDERS OF ARCHITECTURE). The ridicule this aroused has obscured the real value of Langley's other works—20 or more well-illustrated practical handbooks on almost every aspect of building and the allied arts of garden layout and plant cultivation, produced from 1726 onwards and widely read in the 18th c. He designed a Gothic Temple (*c.* 1740) for Painshill Park, Surrey.

**LANG SHIH-NING.** See CASTIGLIONE, Giuseppe.

**LANTERN.** Architectural term for a turret which crowns a ROOF or DOME and is pierced with windows or ARCADING.

**LAOCOON.** A marble group, rather under life size, representing the Trojan priest Laocoon and his two sons being crushed to death by snakes as a penalty for warning the Trojans against the wooden horse of the Greeks (Vatican Mus., parts of two arms restored). The incident is related by Virgil in the *Aeneid* ii. 264-95. The precise date and authorship of the sculpture is not known. It is usually assigned to the HELLENISTIC period and probably to the school of PERGAMUM, which was particularly interested in the portrayal of suffering and emotional anguish. The date is thought to be about the middle of the 2nd c. B.C. or later. In his *Historia Naturalis* PLINY states that in his time it stood in the palace of the emperor Titus in Rome and records that it was made by the sculptors Hagesander, Polydorus, and Athenodorus of Rhodes. He described it as 'a work to be preferred to all that the arts of painting and sculpture have produced'. This praise captured the imagination of

192. *Laocoon.* Engraving from *L'Antiquité expliquée* (1719) by Bernard de Montfaucon

the Middle Ages and the early RENAISSANCE after the sculpture had disappeared. Its dramatic rediscovery in 1506 made a great impression, particularly on MICHELANGELO, who was already seeking to widen the emotional range of sculpture, and its impact continued to be important on BAROQUE sculpture. Knowledge of the sculpture was widely disseminated through casts and engravings, and archaeological discussions were frequent, such as Jonathan RICHARDSON's *An Account of Some of the Statues, Bas-reliefs, Drawings and Pictures in Italy* (1728), later drawn on by LESSING.

It was given a new aesthetic significance by WINCKELMANN, who knew it through a cast at Dresden and made it the subject of some of the most striking passages in his *Gedanken über die Nachahmung der griechischen Werke in der Malerei und Bildhauerkunst* (1755). Winckelmann described it as 'eine volkommene Regel der Kunst'. He saw it as a supreme symbol of the moral dignity of the tragic hero and the most perfect exemplification of the 'noble simplicity and quiet majesty' which he regarded as the essence of Greek idealistic art and the key to true beauty. So whereas the group was for Michelangelo a liberating influence for the expression of emotions hitherto unexpressed in sculpture, Winckelmann—somewhat strangely to modern thinking—saw it as embodying the serenity which attends a great and heroic spirit in tragic conflict. In 1766 Lessing chose *Laokoon* as the title of the book in which he attacked Winckelmann's conception of the tragic

hero and refuted the NEO-CLASSICAL idea of antique beauty.

1647.

**LAON, CATHEDRAL OF NOTRE-DAME.** Designed about 1170, Laon was perhaps the first great building to break completely with the ROMANESQUE. The four-storey elevation, inherited from NOYON and Tournai, had been purged of every trace of Romanesque repose. Every line, plane, and mass seems to have been deliberately broken to produce an unprecedented *tour de force* of controlled complexity. The exterior reveals the same brilliant but bewildering handling of forms, especially in the west front, where the deep porches, masked BUTTRESSES, recessed rose window, and octagonal towers constitute the unmistakable yet fantastic prototype of the High GOTHIC façade. It is only fitting that such a highly original building should be the only French cathedral to have a square east end, added early in the 13th c. in place of the original APSE. Yet despite its many idiosyncrasies Laon proved enormously influential, in both France and Germany.

**LAON, COLART DE.** French painter active at the end of the 14th c. He served several royal patrons, including Charles VI, his brother the Duke of Orleans, and Louis, Duke of Anjou, and presumably his style was that of Parisian court art.

**LARGILLIÈRE, NICOLAS DE (1656-1746).** French artist who enjoyed considerable reputation as a historical painter, working with LEBRUN at VERSAILLES, but who is now remembered as a portraitist. He spent his youth in Antwerp and *c.* 1674-80 worked as assistant to Sir Peter LELY in London. His precocious portrait *Mrs. Middleton* dates from this period (N.P.G., London). Returning to Paris in 1682, he established his position as a leading portraitist, his only rival being Hyacinthe RIGAUD. He became a member of the Academy in 1686 for his portrait of Lebrun and was made its Director at the age of 87. Typical of his prodigious output of portraits is *Louis XIV and His Heirs* (Wallace Coll., London). He also painted a large picture commissioned by the city of Paris as an *ex voto* offering to the church of Ste Geneviève (1696), now in S. Étienne-du-Mont, Paris.

**LAROON.** In the first half of the 17th c. a French artist MARCEL LAURON settled in The Hague. His second son, MARCELLUS LAURON (1653-1772), came to England as a young man and was studio assistant to KNELLER. In his book *Marcellus Laroon* Robert Raines says of him that 'his versatility as painter, miniaturist, engraver and draughtsman, probably exemplify the life of the lesser but successful craftsman at the end of the 17th c.'. His illustrations for *The Cryes of the City of London*

were perhaps the earliest in this genre and anticipated HOGARTH's vein of realism by almost half a century.

'Laroon' was the anglicized version of 'Lauron' and was used occasionally by the foregoing, consistently by his better known son MARCELLUS LAROON (1679-1772). Through nearly 90 years of strenuous life as musician, singer, professional soldier, and man of pleasure, he drew and painted 'for diversitions' to use the words of VERTUE. His CONVERSATION PIECES, musical parties, portraits, and genre scenes have more than a historical interest. His nearly monochromatic, feathery style added a touch of French daintiness to the stolid English manner and anticipated GAINSBOROUGH by its lightness of touch. After a long period of almost total obscurity he was 'rediscovered' in the 20th c., when his works appealed to such diverse connoisseurs as the painter SICKERT, Osbert Sitwell, and Tancred Borenius. A monograph by Robert Raines (1967) was one of the first volumes on English artists to be published in a series financed by the Paul Mellon Foundation for British Art.

2171.

**LARSSON, CARL (1853-1919).** Swedish painter. In France during the 1880s he was producing excellent WATER-COLOURS, soft yet rather thickly painted. Returning to Sweden in 1889 he soon freed himself from his French manner and from then on mainly depicted the idyllic everyday life of his own home in Dalecarlia. The style which he developed was linear and somewhat decorative with light and transparent colouring. His gay water-colour interiors became popular in colour reproductions and have influenced the Swedish attitude towards furnishing and interior decoration.

**LASCAUX.** Cave near Montignac (Dordogne), one of the finest and most publicized stations of Ice Age art in Europe (see STONE AGE ART IN EUROPE). It was discovered in 1940 and the murals were subsequently studied by H. Breuil and F. Windels. The paintings were in a fine state of preservation, have attracted great public interest, and have become a tourist curiosity. Certain features, such as gigantic aurochs and the frieze of swimming stags, are unique in known Ice Age art. Many of the figures are grouped in scenes, some of which appear to be anecdotal in character. A common feature is the 'twisted perspective' whereby horns or antlers are depicted from the front view although the body is in profile. This and other indications have led to a tentative dating in the later Aurignacian period. Both technically and artistically these murals display a very high level of achievement.

**LAST JUDGEMENT** (Matt. xxiv. 30-31 and xxv. 31-46; Mark xiii. 24-37; Rev. xx. 11-15.

There are several allusions in the Epistles, e.g. 2 Cor. v. 10, and certain texts from the Old Testament were traditionally taken to refer: Job xix. 25; Dan. vii. 9-14). The idea of a Last Judgement was prevalent in antiquity before the foundation of Christianity and was even ridiculed by the Roman poets Lucretius (c. 98-55 B.C.) and Juvenal (c. A.D. 47-after 127). Its detailed ICONOGRAPHY in Christian art derived largely from the 9th-c. *Apocalypse of Mary*, which was itself based on the late 4th-c. *Apocalypse of Paul*. In these works the 'moralizing' tendency is already apparent which was later exploited in pictorial representations: thus, for example, among the damned were included those who get up late on Sundays or who fail to rise on the entry of a priest. Christianity, being a religion directed towards the after-life, has attached great importance to the Last Judgement and it has had a prominent place in Christian art. Its didactic and hortatory value was exploited by the Church. It gave an opportunity to portray the eternal blessedness of the righteous side by side with the damnation of the rejected; and it provided means for social and moral criticism by putting amongst the damned some of the great of this earth—popes and archbishops, emperors and princes—and amongst the rescued many of the humblest.

In eastern and western Christian art alike the main features of the Last Judgement are: Christ the Judge sitting upon His throne of glory, often heralded by angels blowing trumpets; underneath Him the resurrection of the dead; to His right the righteous in Paradise, to His left the damned in Hell. In the Middle Ages the scene took on a panoramic character, in which the amount of incident included and the symbolic completeness were more important than aesthetic balance or composition. It was usually arranged in three horizontal registers. In the top register were, typically, the ANGELS and the APOSTLES seated beside Christ as assessors. The VIRGIN and JOHN THE BAPTIST stand or kneel on either side of Christ as intercessors for the souls under the new and the old dispensations. In the centre is Christ in Glory with the river of fire (Dan. vii. 10) issuing from His feet. The middle register contains the *hetimasia*, or preparation of the throne (see below), choirs of patriarchs and PROPHETS, bishops, martyrs, hermits, pious kings, holy women. On Christ's left, or below the enthroned Christ, was pictured the weighing of souls, often represented by the archangel Gabriel with a balance who was sometimes shown refuting the DEVIL seated on the other side from him. The bottom row shows the righteous seeking admission through the gates of Paradise. Sometimes ABRAHAM sits in Paradise holding the souls in his bosom, while Satan presides in Hell with the rich man of Luke xvi. 19-31 in his lap. Paradise is often pictured as a city, the Heavenly Jerusalem. Hell is frequently symbolized by the mouth of a monster (hell mouth), or the 'undying worm' of Mark ix. 44. The gates of hell may be literally pictured and a red light may be cast by hell fire. A diversity of tortures may be in evidence. The contrast between salvation and damnation was pointed up by ECCLESIA AND SYNAGOGUE, by the five wise and five foolish virgins (Matt. xxv. 1-13) and by the works of mercy.

Neither EARLY CHRISTIAN nor CAROLINGIAN ART developed a detailed iconography of the Judgement proper. In BYZANTINE ART it was symbolized by the *hetimasia* or preparation of the throne for the Judgement (Pss. ix. 7 and lxxxix). The earlier type of *hetimasia* consisted of a draped throne surmounted by a cross; later the lance which pierced Christ's side and the reed with a sponge were added, with book, DOVE, and footstool, and the figures of ADAM AND EVE might be shown prostrate before it. Simple scenes of the judgement of the soul were frequent in the Roman catacombs and there is a relatively simple version in a 6th-c. mosaic in S. Apollinare Nuovo, Ravenna, where Christ, sitting on a little hill and flanked by two angels, separates rams from ewes or white from black sheep. An ivory of the 9th c. in the Victoria and Albert Museum and illustrations in manuscripts of the Apocalypse (Stadtbibliothek, Trier, MS. 31, early 9th c.) are further early instances. About the year 1000 the more elaborate iconography of the Last Judgement appeared simultaneously in Byzantine, GERMAN, and ANGLO-SAXON ART (*Byzantine Gospels*, Bib. nat., Paris; fresco at Reichenau-Orbenzell; *Apocalypse* in Bamberg; New Minster Register, B.M.). From then on it became one of the most popular themes, for which the most conspicuous place inside or outside the church, usually the west wall or the west front, was reserved. In Italy the most famous monuments are the mosaics in Torcello (12th c.) and in Florence (13th c.), the frescoes in S. Angelo in Formis (11th c.), and in the Arena chapel, Padua (GIOTTO, c. 1305). Through the impact of Dante's *Divina Commedia* (c. 1300) the subject underwent certain modifications in Italian art, as exemplified by the fresco in the Strozzi chapel at Sta Maria Novella, Florence. In France and Germany the Last Judgement occupied the sculptured TYMPANA of the centre doorway of cathedrals: AUTUN, Beaulieu, Conques (12th c.), CHARTRES, AMIENS, REIMS, BOURGES (13th c.); Basel, Bamberg, Freiburg (13th and 14th centuries). In the 15th and 16th centuries this tradition was continued in large ALTARPIECES where Christ and the resurrected were represented in the centre panel, heaven and hell on the wings (Rogier van der WEYDEN, Beaune; MEMLING, Danzig; BOSCH, Vienna). The attitude and attributes of Christ the Judge changed in course of time: first He was fully dressed; later on His right side was uncovered so as to display His wounds; later still sword and lily, symbols of justice and mercy, protrude from His mouth (Isa. xlix. 2 and xi. 4).

This long and well established tradition was profoundly altered by MICHELANGELO in his

fresco in the Sistine chapel (1536-41): Christ is here standing, naked like a pagan god, and the horizontal registers are discarded; to the right and left are two surging masses of people, the redeemed moving upwards, the condemned downwards; the gulf between them is bridged by Charon in his barque. RUBENS (Munich), among others, followed this example. El GRECO used many of the symbols of the traditional Last Judgement in his *Dream of Philip II* (Madrid, *c.* 1579-80) but has unified the scene into a dramatic pictorial composition. Stanley SPENCER transplants his *Resurrection of the Dead* (Tate Gal., 1923-6), an intensely personal vision, into an English churchyard with a portrait of himself as one of the resurrected right in the centre of the picture.

**LASTMAN,** PIETER (1583-1633). Dutch historical painter who came under ELSHEIMER's influence during a visit to Italy, 1604-7. Lastman was a master at representing crowds in dramatic situations. REMBRANDT was his pupil in Amsterdam for six months *c.* 1625 and was probably inspired by him with the idea of becoming a painter of historical and religious subjects. Rembrandt's *Clemency of Emperor Titus*, one of his earliest works, shows how faithfully he attempted to imitate Lastman's glossy colour, grouping, animated gestures, and realistic facial expressions. Although Rembrandt soon surpassed his teacher, he continued to make copies of Lastman's paintings for a decade.

923.

**LAST SUPPER** (Matt. xxvi. 17-30; Mark xiv. 12-26; Luke xxii. 7-39; John xiii). The Gospels (with the exception of St. John) make the institution of the Eucharist and CHRIST's announcement of His betrayal the essential features in their accounts of the Last Supper. Christian art throughout the centuries has treated the scene either factually by representing the meal itself and often incorporating indications of the role of Judas, or symbolically by laying stress on the sacramental character of the event. The eucharistic interpretation already occurs in EARLY CHRISTIAN ART when the fish, as the symbol of Christ, appears on the table (S. Apollinare Nuovo, Ravenna, 6th c.) and this symbol continued to be used till the 15th c. Chalice and wafer appear for the first time in a 7th-c. Gospel book (Corpus Christi College, Cambridge), but they became usual only from the 15th c. onwards. There are many well known examples such as: Fra ANGELICO, S. Marco, Florence; Cosimo ROSSELLI, Sistine Chapel, Rome; Dirck BOUTS, Louvain. Controversies during the Reformation and Counter-Reformation about the nature of the Eucharist gave these representations a new lease of life: one of DÜRER's late woodcuts prominently displays the chalice on an otherwise

**193.** *The Last Supper.* Woodcut (1583) by Albrecht Dürer

**194.** The Last Supper. Gold and enamel panel from the *Klosterneuburg Altarpiece* by Nicolas of Verdun. (Klosterneuburg Abbey, 1181)

empty table, while TINTORETTO (Lucca Cathedral, and S. Giorgio Maggiore, Venice) shows Christ in the act of giving the Host to the APOSTLES (Matt. xxvi. 26; Mark xiv. 22). Where the Last Supper occurs in a typological context (see TYPOLOGICAL BIBLICAL ILLUSTRATION), that is, in juxtaposition with such Old Testament scenes as the gathering of manna and the offerings of Melchisedek, its eucharistic character is invariably stressed, since typological cycles by their very nature teach the salvation of man as embodied in the New Testament.

The Gospels vary in describing the indication of the traitor. In Matthew and Mark it is the one 'that dippeth with me in the dish'. In John it is the one 'to whom I shall give a sop'. Luke leaves the indication more vague. Hence representations of the Last Supper have emphasized the figure of Judas in different ways according to the account followed. The oldest pictures follow Matthew and Mark: Christ and Judas simultaneously put their hands into the dish (*Gospels of Rossano*, 5th c.) or Judas touches the symbol of Christ, the fish. From the 10th c. pictorial representations often followed the account given in John. From the 14th c. onwards artists found a particularly striking device for separating Judas from the rest of the Apostles by placing him alone on the opposite side of the table (CASTAGNO, Sta Apollonia, Florence). But it may also happen that all these elements are combined in one dramatic composition: Judas receiving the sop, hiding the fish behind his back, and being isolated at the front of the table occurs

as early as the late 12th c. (Klosterneuburg Altar, Austria).

Early Christian representations of the Last Supper group Christ and the Apostles in recumbent positions round a semicircular table, dining in classical fashion (*Gospels of Rossano*; S. Apollinare Nuovo, Ravenna), and this type was revived in the 17th c. by POUSSIN (Ellesmere Coll., Edinburgh). When in the early Middle Ages habits changed, Christ and the Apostles were shown sitting. The table was sometimes round, but a rectangular table with Christ placed centrally opposite the spectator became the most common form. Where space was restricted the number of Apostles was limited, as on the 13th-c. choir screen in Naumburg. From the 15th c. artists tried to combine the eucharistic character of the scene with a dramatic presentation, but it was not until LEONARDO painted his *Last Supper* in the Refectory of Sta Maria delle Grazie, Milan (1496–8), that the drama of Christ's announcement 'One of you shall betray me' was fully realized. Tintoretto heightened the drama by placing the table obliquely and underlining the excitement of the moment by violent effects of light. Later ages have added little to these traditional compositions and even Stanley SPENCER's *Last Supper* of 1920, with its horseshoe table, repeats a type which can be traced back to the 12th c. even if it was rarely used.

Occasionally the Last Supper is combined with the washing of the Apostles' feet (John xiii. 4) as a symbol of Christian humility.

St. John is often distinguished from the other Apostles. In the Middle Ages he was represented as a youth (see EVANGELISTS) and from the 11th c. he usually sits next to Christ, resting his head on His shoulder (John xiii. 23). Medieval devotional imagery from the 13th c., particularly in Germany, liked to represent these two figures alone, thus making John a symbol of man's trust in Christ.

**LA TOUR,** GEORGES DE (1593–1652). French painter who worked at Lunéville in the duchy of Lorraine. We know very little about the style of his early works and his chronology is often confused. He used the dramatic lighting of CARAVAGGIO, probably learnt from Utrecht artists such as HONTHORST (*St. Jerome*, Stockholm, 1620–5), for it is unlikely that he ever went to Italy. In his later works (*St. Sebastian*, Berlin, *c.* 1650, and *The New-Born Child*, Rennes, *c.* 1650), he achieved classical monumentality and stillness by simplifying the figures into smoothly rounded geometrical shapes. His style was in contrast with the MANNERISM of the Nancy school of BELLANGE and CALLOT and may reflect the sentiment of the Franciscan revival in Lorraine with which he was connected. In his own way he is considered to represent the spirit of 17th-c. French CLASSICISM no less than Philippe de CHAMPAIGNE and POUSSIN in their different fields.

300, 949, 1426.

**LA TOUR,** MAURICE QUENTIN DE (1704-88). With PERRONEAU the most celebrated French PASTEL portraitist of the 18th c. As a young man he paid a visit to England and returned to Paris in 1724, announcing himself as an English painter. His success was immediate and prolonged. The vogue for pastel portraits is sometimes attributed to the Italian artist Rosalba CARRIERA, who worked in Paris 1720-1, but in fact Joseph Vivian (1657-1735) had preceded her. La Tour exploited the resources of the technique to the full. Some of his portraits are lightly sketched impressions (*Mlle Fel*, Saint-Quentin), others elaborate and detailed studies (*Duval de l'Epinoy*, Gulbenkian Coll.). In both the essence of his art lies in his swift and accurate draughtsmanship; his colour, which is never very deep, and his superb velvet finish are always subordinate. Despite an occasional vulgarity of treatment, his portraits have great vivacity. He prided himself on expressing the personality of the sitter.

1643.

**LATROBE,** BENJAMIN (1766-1820). English-born architect who emigrated to America in the late 18th c. Widely travelled and trained as both architect and engineer, he brought to his new country a competence in construction and design which had hitherto been unknown there. This was recognized by JEFFERSON, who appointed him architect to the Capitol in 1803. During his 14 years in this office he was able to redesign most of the interior of the Capitol and bring large parts of it to completion. Latrobe brought to America the rational attitudes which characterized the later phases of European NEO-CLASSICISM. His Bank of Pennsylvania in Philadelphia, designed in 1798, was the first masonry vaulted building in America. It was also the first to employ a Greek ORDER. The Baltimore Cathedral (1806-18) has an impressive domed interior which is reminiscent of Sir John SOANE's graceful vaults in the Bank of England. It was the first church in America to break completely with the tradition of WREN and GIBBS.

1229.

**LAUB- UND BANDELWERK** (German: 'foliate and STRAPWORK'). The last phase of BAROQUE ACANTHUS-leaf ornament, in which the foliage becomes more delicate and is interspersed with interlacing straps. Introduced by Jean BÉRAIN and Daniel MAROT towards the end of the 17th c., it gained general acceptance amongst designers of ornament during the first quarter of the 18th c. It is more appropriately known as Régence ornament.

**LAURANA,** FRANCESCO (c. 1430-1502?). Sculptor born near Zara in Dalmatia, at that time subject to Venice. From 1453 he probably worked on sculptural decorations to the Triumphal Arch of Alfonso I at Castelnuovo,

Naples. Thereafter he divided his time between France and southern Italy. In France c. 1466 he produced a number of signed and dated MEDALS for René of Anjou and on a later visit a RELIEF of *Christ carrying the Cross*, now in S. Didier, Avignon, and the Chapel of St. Lazarus (completed 1481) in the Old Cathedral, Marseilles, which is one of the earliest RENAISSANCE monuments on French soil. In Italy he was probably best known for his portrait BUSTS of members, mostly female, of the Neapolitan royal house and their relatives. In these simple NATURALISM and a search for basic geometric shapes combine to produce formal likenesses well adapted to the taste of a society which was both humanist and courtly. There are examples in the Frick Museum, New York, the N.G., Washington, Berlin, and the Bargello, Florence.

**LAURANA,** LUCIANO (c. 1420/5-79). Dalmatian architect probably related to Francesco LAURANA. His most important work is the palace at Urbino. It was begun before his arrival, but he was appointed principal architect in 1468 by a letter-patent from the Duke extolling his eminence. The court is probably his and is one of the finest designs of the 15th c., combining the grace of the Florentine arcaded type with the massiveness of the Roman into a harmonious style parallel to that of PIERO DELLA FRANCESCA, who also worked at Urbino. It was one of the models from which BRAMANTE drew his inspiration. The west front of the palace resembles the Arch at Castelnuovo, Naples, where Laurana probably worked in the 1450s. Three pictures of architectural subjects (at Urbino, Baltimore, and Berlin) have been attributed, probably wrongly, to him.

**LAURATI,** PIETRO. See LORENZETTI.

**LAURENS,** HENRI (1885-1954). French sculptor, born at Paris. He was apprenticed to a decorative sculptor and later worked as a stone mason. In 1911 he became a friend of BRAQUE, met PICASSO, LÉGER, and GRIS, and began to experiment in the mode of CUBISM. His work remained highly individual, including figures which had the appearance of ARMATURES in wood or iron, polychrome TERRACOTTAS, COLLAGES, and MONTAGES. His output was more influenced than most by the painters with whom he associated, but he retained a genuine sculptor's feeling for mass which became more apparent in his later productions. In 1935 he won the Helena Rubinstein prize and executed various decorative works for her. In 1937 he showed the high RELIEF *La Mer* for the Pavilion of Sèvres at the Exposition de Paris and *La Nuit* for the Palais de la Découverte. He had a retrospective exhibition at the Palais des Beaux-Arts, Brussels, in 1949 and at the Musée Nationale d'Art Moderne, Paris, in 1951.

1066.

**LAVERY,** SIR JOHN (1856–1941). English painter, born at Belfast. He was first a follower of the Glasgow School of painting, subsequently working in London and Paris. His early work was influenced by WHISTLER and the IMPRESSIONISTS, and held a promise which was not fulfilled as in later life he succumbed to the facile lures of a society portrait painter. He was knighted in 1918, and made R.A. in 1921.

2472.

**LAWRENCE,** SIR THOMAS (1769–1830). English painter. He was a child prodigy, who by the age of 10 was well known for the pencil profiles he drew at his father's inn at Devizes. From 1780 to 1786 he was in Bath, where he worked in PASTEL and by 1787 had settled in London, where he began to use oils. He was almost entirely self-taught. He was commanded to paint Queen Charlotte (N.G., London) in 1789 and this commission, with *Miss Farren* (Met. Mus., New York, 1789), brought him astonishing success. He was elected A.R.A. in 1791 and R.A. in 1794. For the next 20 years he consolidated this early triumph without showing any great development, though such works as *Sir Francis Baring and Partners* (Earl of Northbrook Coll., 1807) and *J. P. Kemble as Hamlet* (Tate Gal., 1801) established a reputation and on the death of HOPPNER in 1810 he was recognized as the leading portrait painter of the time, and also to some extent as head of the profession of painting in Britain. The great opportunity of his career came in 1818, when he was sent to Europe as the envoy of the Prince Regent to paint the heads of state and military leaders on the occasion of the allied victory over Napoleon. As a preliminary gesture he was knighted, and on his return in 1820 he succeeded Benjamin WEST as President of the ROYAL ACADEMY. The portraits painted on this tour are now in the Waterloo Chamber, Windsor Castle.

Lawrence was devoted to the memory and example of REYNOLDS and in some respects he was the last of the great portrait painters in the 18th-c. tradition. In others he was a ROMANTIC, responding to the glamour of the historic years through which he lived. His fluid, brilliant, and sometimes careless brush-work was imitated by all the younger portrait painters and a Lawrence tradition held good in English portraiture until the advent of WATTS.

Some of his child portraits, e.g. *The Calmady Children* (Met. Mus., New York, 1825) were immensely popular both in the United Kingdom and in France, but his masterpieces are the Windsor portraits and others less celebrated in his own time, such as *John Nash* (Jesus College, Oxford, 1827). Lawrence was a man of great taste and his collection of Old Master drawings was one of the finest ever made.

979, 2892.

**LAY FIGURE.** An articulated model of the human figure, jointed so that it can be given all kinds of poses. It may be anything from a few inches in height to life size. Its function is to give the artist an indication or serve to remind him of the general mass, proportions, form, and attitudes of the human body. Articulated dolls and marionettes were known in antiquity, but the first description of an artist's lay figure is given by FILARETE in the third book of his *Treatise on Architecture* (1451–64). Although VASARI mentions a life-size wooden model made by Fra BARTOLOMMEO, the early lay figures were mostly small and were called manikins. The 18th-c. portrait painter used a life-size model, completely jointed and covered with knitted fabric. He could arrange the costumes and drapery on it and work on that part of the picture in the absence of the sitter.

**LEAD POINT.** See METAL POINT.

**LEAD SCULPTURE.** Lead is a heavy, bluish-grey, lustrous metal, extremely malleable, ductile, and so soft that it can easily be scratched with a knife. The very ease of shaping lead constitutes its greatest hazard for the sculptor; great understanding is necessary to keep a leaden statue from being a dull and amorphous mass. Lead may be worked directly, by being hammered or beaten into shape, or indirectly, melted and cast as with BRONZE, or it may be cast in the rough and then finished by hammering. It was used by the Greeks for small statuettes and RELIEFS (6th-c. Spartan figures), and by the Romans for garden ornaments and vases. Since then its uses have ranged widely from the baptismal FONTS of the 12th c., produced in great numbers in central workshops of lead-mining districts (Derbyshire and the Mendips), to the most varied forms of decoration in the GEORGIAN period: fan-lights, balustrades, garlands, gilt and painted frets, and, most conspicuously, as garden sculpture in the form of vases or figures. These figures, usually derived from Roman or RENAISSANCE models, are regarded as rather poor in quality as individual works but mildly pleasing as ornamental adjuncts in their landscape settings. Lead has probably never been used more skilfully than by Georg Raphael DONNER (1693–1741). His figures from the *New Market Fountain* (Vienna, 1739, now in the Baroque Mus.) possess the easy flow of molten lead and yet are given enough sharp edges, accents, and turns of direction to seem lively, animated, and resilient forms.

**LEAR,** EDWARD (1812–88). English artist, author, and traveller. He wrote *The Book of Nonsense* (1846) and worked as a draughtsman to the Zoological Society. His hilarious illustrations are inseparable from his nonsense verses. From 1836 he devoted himself to LANDSCAPE PAINTING and travelled to India and elsewhere. His WATERCOLOURS of Greece and the Near East, with clear WASHES over delicately shorthand pen-and-ink sketches, are particularly proficient.

1596.

**LEBRUN,** CHARLES (1619-90). French painter and decorator, trained in the studio of Simon VOUET. In 1642 he went to Rome and there working under POUSSIN became a convert to the latter's theories of art, which he was later instrumental in making the chief basis of academic doctrine. On his return to Paris in 1646 he found his true bent in large and flamboyant decorative paintings, the most important at this period being his BAROQUE ILLUSIONISTIC ceiling for the gallery of the Hôtel Lambert, built by LE VAU. From 1661 he became established in the employ of Louis XIV and COLBERT as the chief impulse behind the grandiose decorative schemes at VERSAILLES, and as Colbert's right-hand man in implementing his policy of imposing unified standards of taste and enforcing a strong centralized control over artistic production. He was raised to nobility in 1662 and named *Premier Peintre du roi*. In 1663 he was made director of the reorganized Gobelins factory and supplied designs for the artists and craftsmen who were there employed in the production of furniture and decorations for the royal palaces. Also in 1663 he was made director under Colbert of the reorganized Académie and turned it into a channel for imposing a codified system of orthodoxy in matters of art. His lectures came to be accepted as providing the official standards of artistic correctness and, formulated on the basis of the CLASSICISM of Poussin, gave authority to the view that every aspect of artistic creation can be reduced to teachable rule and precept. In the controversy concerning the relative importance of colour and drawing (see FRENCH ART) he gave his verdict in favour of the latter. In 1698 he published a small treatise *Méthode pour apprendre à dessiner les passions proposée dans une con-férence sur l'expression générale et particulière*, in which again following theories of Poussin he purported to codify the visual expression of the emotions in painting.

Despite the Classicism of his theories, Lebrun's own talents lay rather in the direction of flamboyant and grandiose decorative effects. His activities were many and his influence pervasive. Among the most outstanding of his works for the king were the Galerie d'Apollon at the LOUVRE (1661), the famous Galerie des Glaces (1679-84) and the Great Staircase (1671-8, destroyed in 1752) at Versailles. His importance in the history of French art is twofold: his contributions to the magnificence of the GRAND MANNER of Louis XIV and his influence in laying the basis of academicism.

**LEBRUN,** MARIE-LOUISE ELISABETH VIGÉE-. See VIGÉE-LEBRUN.

**LECK,** BART (ANTHONY) VAN DER (1876-1958). Semi-ABSTRACT Dutch painter. His early realistic pictures of factory workers revealed an interest in social reform. From 1916 to 1919 he was in contact with MONDRIAN and the STIJL movement in Holland, and experimented with abstract compositions. By 1920 he had worked out a personal style based upon patterns of lines and geometrical shapes—usually in red, yellow, blue, or black on a white ground. His works are best seen at the Kröller-Müller Museum, outside Amsterdam.

**LE CORBUSIER** (1887-1965). The pseudonym of CHARLES EDOUARD JEANNERET, French architect, who probably had more influence than any other on the development of MODERN ARCHITECTURE, through his

**195.** The Great Staircase at Versailles. Engraving by Louis de Surugue (1686-1762)

buildings, his projects, and his writings. He was of Swiss parentage and was first a watch engraver and then a painter of semi-ABSTRACT compositions. He studied architecture under Auguste PERRET in Paris (1908-9) and Peter BEHRENS in Berlin (1910-11). He began architectural practice in Paris in 1922 in partnership with his cousin, Pierre Jeanneret. Young architects from all over the world were attracted to their office by Le Corbusier's provocative writings, especially *Vers une architecture* (1923; tr. F. Etchells as *Towards a New Architecture*, 1927), and by the partnership's first buildings (mostly small houses), which already showed Le Corbusier's genius for subtle manipulation of pure geometrical forms as well as his imaginative application of new technical ideas. In 1925 in *Urbanisme* (tr. F. Etchells as *The City of To-morrow*, 1929) he put forward ideas for the reshaping of cities to accord with, and make the most of, new developments in transport and technology.

Le Corbusier's name became widely known when in 1927 he and Jeanneret won the competition for the League of Nations building at Geneva, but for political reasons their design was discarded. Most of their important buildings were constructed during the six years that followed: the house at Poissy (1928-30), the Centrosoyons (co-operative) building in Moscow (1928), the Salvation Army building in Paris (1929-31), and the hostel for Swiss students at the Cité Universitaire, Paris (1931-3), in which one of Le Corbusier's favourite devices—raising a whole building on *pilotis*, leaving the ground floor open to the air—was first used with monumental effect. To this period also belongs *La Ville radieuse* (published 1935), Le Corbusier's principal contribution to TOWN-PLANNING theory and his project for replanning the city of Algiers (1931-4).

During the following years France made little use of Le Corbusier's genius. He received no major commissions, yet he exercised increasing influence in many countries, as a theorist and as designer of ambitious and original town-planning projects. These included his plan for the Normalm section of Stockholm (1933), an application of the principles of his *Ville radieuse*, for Nemours (1934), for Zlin (1935), for a linear town (1942), and for the reconstruction of S. Dié (1945). He visited Rio de Janeiro in 1936 and helped a group of Brazilian architects to plan the Ministry of Education, the first important building of the modern architectural movement in Brazil, the course of which has since greatly been influenced by Le Corbusier's ideas.

In 1943 he founded ASCORAL (*Assemblée de Constructeurs pour un renouvellement architectural*), a research body of architects, engineers, and scientists which became one of the regional groups of which C.I.A.M. was comprised. In 1946 he was appointed to the international team of architects for the United Nations buildings in New York, and the Secretariat (1951) owes its

basic conception and its clarity of form to his ideas. His one substantial post-war building is the vast apartment-block called Unité d'Habitation outside Marseilles (1945-52). In 1950 he was appointed by the Indian Government as consultant architect and planner for a new capital city for the Punjab, the chief executive architects being Pierre Jeanneret and the English architect E. Maxwell FRY.

292, 329, 989, 1296, 1603, 1604, 1605, 1606, 1607, 1608, 2022.

**LECTERN.** Term in Christian church architecture for the reading desk. This was at first part of the AMBO (St. Clement's, Rome) but in the later Middle Ages, when the ambo ceased to be used, part of its functions were taken over by a movable lectern, commonly of wood but also of bronze, brass, and rarely iron. Early examples, supported on a tripod base, derive from the antique. This type developed in the 13th c. into a pattern, still in use in many churches today, in which the book-rest consists of an eagle with outspread wings, mounted on a baluster support. Many late medieval eagle lecterns survive, those of brass emanating from the valley of the Meuse (Namur Cathedral). A type of wooden lectern with the pedestal mounted on a finely carved cupboard made its first appearance in Italy in the RENAISSANCE (Sta Maria Novella, Florence) and was widely adopted in the BAROQUE period in Germany.

**LEDOUX,** CLAUDE-NICOLAS (1736-1806). French architect of the Revolutionary and pre-Revolutionary era. Under Louis XVI he built a number of houses in Paris and its vicinity. Using bold, classical forms, such as the baseless squat Greek Doric column, he produced highly original, sometimes fantastic, architecture often based on simple geometrical forms with large surface planes. Among his surviving works are four of the 46 city gates that he designed for Paris in 1785, and a good part of the magnificent industrial city he designed at the Salines de Chaux (1775-9). He was imprisoned in 1793 and wrote in captivity *L'Architecture considerée sous le rapport de l'art, des mœurs et de la legislation* (1804). It has been claimed for his architectural theories that they anticipate many ideas of the modern movement.

1473, 2181.

**LEECH,** JOHN (1817-64). English CARICATURIST and illustrator, one of the leading artists of *Punch* from 1841. He made over 3,000 pictures for *Punch* alone (including 600 cartoons) and nearly a thousand for the sporting novels of Surtees. His other book illustrations included *The Ingoldsby Legends* and Dickens's *Christmas Books*, the former of which in particular displays his gift for the light-heartedly GROTESQUE. His satire was delicate and he pictured the Victorian

comedy of manners in an idyllic vein with a gentle irony which ignores rather than castigates vice and ugliness. Dickens said of his pictures that they were 'always the drawings of a gentleman', and he more than any other set the gentlemanly tone for *Punch*.

2303.

**LÉGER**, FERNAND (1881–1955). French painter. After studying architecture at Caen he worked in Paris under GÉRÔME and at the Académie Julien from 1903. From 1910 to 1914 he was one of the ORPHIST group of CUBISTS and exhibited with GLEIZES, DELAUNAY, METZINGER, etc. After the First World War he became obsessed with the machine, introducing parts or suggestions of machines into abstractly composed pictures. He has been called the 'PRIMITIVE' of a machine age. During the 1920s he continued to work in a twofold manner, using on the one hand static, tubular, and somewhat naïvely presented figures and on the other abstract complexes suggestive of machinery. From 1940 to 1945 he taught at Yale in the U.S.A. and painted acrobats, cyclists, etc., in static, tubular style. His colour is lacking in subtlety and it has been thought by psychologists that he suffered from defects of colour vision. In 1924 he collaborated with Man Ray in the film *Ballet Mécanique*. He has painted murals, and has done pottery, theatre designing, and LITHOGRAPHY.

618.

**LEGROS**, ALPHONSE (1837–1911). French painter and engraver, born at Dijon. He was a fine draughtsman in the tradition of INGRES but was overly given to sentimentality. Among his early pictures the best known are *Ex-Voto* (Dijon, 1861) and *The Angelus* (Louvre, 1859). He came to England in 1863 and was naturalized in 1881. He taught at Kensington School of Fine Arts and was Professor of Etching at the Slade School (1876–92). Among his pupils was Sir William Rothenstein. The Tate Gallery contains his *Women at Prayer* and *Le Repas des pauvres*.

1621, 2369.

**LEGROS**, PIERRE (1629–90). French sculptor. He was a pupil of Jacques SARRAZIN and worked chiefly with TUBY at VERSAILLES, where he executed the *Vénus de Richelieu*. His son, PIERRE (1666–1719), settled in Rome, where he worked for the Jesuits in the BAROQUE manner.

**LEHMBRUCK**, WILHELM (1881–1919). German sculptor, who studied art at Düsseldorf but who lived in Paris 1910–14 and owed much to the formative influences of the École de PARIS. A follower of RODIN, he stood between EXPRESSIONISM and CLASSICISM. With BARLACH he was regarded as one of the leaders in the revival of German sculpture during the early decades of the 20th c. His treatment of the human figure in his

mature bronzes, such as *Youth Ascending* (1913) and *Seated Youth* (1918), has something of medieval elegance in the elongation of the limbs and an expression of MANNERED lyricism.

104, 1346, 1626.

**LEIBL**, WILHELM (1844–1900). German painter. His meeting with COURBET at Munich in 1869 exercised a decisive influence on his art in both style and subject matter. Subsequently he spent some months in Paris just before the outbreak of the Franco-Prussian war. Disgusted with the intrigues of the Munich art world Leibl withdrew to the Bavarian countryside, where he found his favourite models in the simple country folk. These he wanted to represent as faithfully as he could; he himself saw that 'solidity' was the real aim of his art. He must have made a close study of HOLBEIN, for such a typical work as the *Three Women in Church* (Hamburg, 1878) is in technique and manner much nearer to that master than to his French contemporaries. Leibl also painted a number of portraits.

**LEIGHTON**, FREDERIC, LORD (1830–96). English painter and sculptor. He travelled widely in Europe as a boy and first began to study painting seriously in Florence. He later worked in Frankfurt under E. J. von Steinle (1810–86) and in Paris. He first made his name with a large quattrocento PASTICHE, *Cimabue's Madonna carried in procession*, which was exhibited at the Royal Academy and bought by Queen Victoria in 1855. He settled in London in 1860, becoming A.R.A. in 1864, R.A. in 1868, President in 1878; he was made a baronet in 1886 and a peer in 1896. With ALMA-TADEMA and Edward POYNTER he set himself to oppose PRE-RAPHAELITE Romantic realism with an over-refinement of pseudo-Hellenistic CLASSICISM. He had qualities of draughtsmanship and his illustrations (e.g. to George Eliot's *Romola*) have greater vigour. Some of his major exhibition pieces (e.g. *The Captive Andromache*, Manchester, exhibited at the R.A. in 1885) have distinction as academic exercises. Leighton was a man whose culture surpassed his achievement. He was eminently successful in the office of President of the Royal Academy. His home in Holland Park Road, Kensington, celebrated for its Arab hall, became a museum.

**LEINBERGER**, HANS (early 16th c.). South German wood-carver and sculptor. His main work, the ALTARPIECE at Moosburg, Bavaria, is typical of the excited manner of German late GOTHIC art.

**LELY**, SIR PETER (1618–80). Portrait painter, born at Soest, Westphalia, of a Dutch family, Van der Faes, and trained at Haarlem. He came to London *c.* 1643, and established a considerable practice in portrait painting by 1650. In 1654 he was described by James Waynwright as

'the best artist in England', and his popularity continued through the Commonwealth period. In 1660, at the Restoration, he became Principal Painter to the King, and with his team of assistants he maintained an enormous output; he was knighted in the year of his death. His early portraits have more of Dutch solidity than van Dyckian elegance (e.g. *The Hales Family*, Guildhall, London, *c.* 1656). He was a more superficial artist than van DYCK and had not van Dyck's facility. But at his best he was a fluent and lively colourist with a gift for impressive composition and a brilliant fabricator of decorative portraits which could flatter self-esteem without descending to banality. His portraits provide an excellent mirror of the court of Charles II: devoid of psychological insight, they are sound in technique and present an elaborate panorama of external appearances. The women are large, fleshy, sleepy in the spread of their silks (*The Windsor Beauties* and series of *Maids of Honour*, Hampton Court); the men are conscious courtiers swagged with robes and wigs. Occasionally he produced character studies of greater strength (*Flagmen*, Greenwich, 1666-7), but his poses and even his faces tended to be repetitive. He dominated portraiture in his time, and the tradition of the society portrait which he consolidated, developed by KNELLER, JERVAS, and HUDSON, endured for almost a century until it was challenged by HOGARTH.

135, 211.

**LEMERCIER,** JACQUES (1585-1654). French architect, son of the builder PIERRE LEMERCIER, who worked on the church of S. Eustache, Paris, and S. Maclou in the Pontoise. Jacques is regarded as one of the three main creators of the French classical style of architecture in the 17th c., the others being François MANSART and Louis LE VAU. He was in Rome (*c.* 1607–*c.* 1614) and on his return became architect to Richelieu and was commissioned to put into effect the plans of Louis XIII for enlarging the LOUVRE. He built the Pavilion de l'Horloge at the Louvre and worked at the Square Court. For Richelieu he built the Sorbonne (begun 1635) and the Palais Cardinal (later the Palais Royal, begun 1633), the château at Rueil and the château and new town at Richelieu. His church building included the Oratoire and the church of S. Roche, and he succeeded Mansart at the Val-de-Grâce in 1646. Lemercier combined the current French style with classical idioms he had mastered in Rome.

1472.

**LEMOYNE.** French sculptors, who worked mainly as portraitists. JEAN LOUIS LEMOYNE (1665-1755) was a pupil of COYSEVOX (bust of the Duke of Orleans, Versailles Mus., 1715). His son, JEAN BAPTISTE LEMOYNE (1704-78) was official sculptor to Louis XV, of whom he did equestrian

statues for Bordeaux, Rennes, and the École Militaire. There is a bust of Montesquieu by him in Bordeaux Museum (1760) and a *Baptism of Christ* in the church of S. Roche, Paris. Among his pupils were FALCONET, HOUDON, and Jean Baptiste PIGALLE.

**LEMOYNE** or LEMOINE, FRANÇOIS (1688-1737). French decorative painter, who carried on the tradition of LEBRUN. He became official painter to Louis XV in 1736. His ceiling for the Salon d'Hercule, VERSAILLES, was inspired by PELLEGRINI's ceiling for the royal bank in Paris. He also worked at the church of S. Thomas d'Aquin and at S. Sulpice, Paris. Among his pupils was BOUCHER.

**LE MUET,** PIERRE (1591-1669). French architect born at Dijon. In 1623 he published a treatise *Manière de bien bastir pour toutes sortes de personnes*, with an enlarged edition in 1647. It was an up-to-date version of DUCERCEAU's first book on architecture and besides describing his own main works provided various types of design for large and small town houses. His style was formed in the 1620s and he never entirely assimilated the later trends of Classicism. His best known building is the Hôtel Tubeuf, enlarged in 1641 and now part of the Bibliothèque nationale.

1638.

**LE NAIN,** ANTOINE (*c.* 1588-1648), LOUIS (*c.* 1593-1648), and MATHIEU (*c.* 1607-77). French painters, brothers, who were born at Laon but had all moved to Paris by 1630. Mathieu was made painter to the city of Paris in 1633, and all three brothers were foundation members of the Académie. Their work belongs to a type of naturalistic GENRE which had no previous tradition in French painting and was exceptional at the time. Although apparently popular in their day, it is a matter of some speculation who their purchasers were. They went out of fashion and were largely forgotten until the latter half of the 18th c., when peasant scenes were again in demand under the influence of J.-J. Rousseau.

The signatures on their paintings being without initials, historians have tentatively divided their works into three groups on stylistic grounds, although there is a tradition that they collaborated in many cases. The first group, attributed to Antoine, consists of naïve family scenes in brilliant colours, mostly painted on copper. The second, and by far the most powerful, consists of larger peasant scenes in silvery grey-green colours and is attributed to Louis. *The Forge* (Louvre), a work in which Louis and Mathieu possibly collaborated, and *Peasants before their House* (New York) have a classical monumentality learnt perhaps from the DUTCH

and possibly connected with the school of naturalistic SPANISH painting of the same period. To this group is also sometimes attributed the *Portrait of an Old Man* (Avignon, 1644). In the third group, attributed to Mathieu, are placed most of the paintings of a more eclectic and versatile style. These are chiefly portraits and group portraits (*Family Reunion*, Louvre), of a character near to Dutch painting of the HALS type.

The most talented artist of the three was Louis, who was described by contemporary writers as a painter of *bambochades* (see LAER). But he paints his simple scenes of peasant life with sympathy and feeling, free of any satirical or comic intention such as one finds in BRUEGHEL and TENIERS; yet free also from sentimentality and affectation. Yet a spontaneous Classicism has been claimed for the composition and grouping of his scenes. Louis and probably Mathieu also painted some religious pictures, not essentially different in treatment (*Adoration of the Shepherds*, Louvre).

867.

**LENBACH,** FRANZ (1836–1904). German painter active in Munich and elsewhere. Combining a Venetian technique with photographic accuracy Lenbach became the most popular portrait painter of the prosperous ruling class of the new Germany. His 80 portraits of Bismarck established his popular image.

221.

**LE NOIR,** JEAN. French miniature painter, a follower of Jean PUCELLE and a protégé of King John II (1350–64).

**LENOIR,** MARIE-ALEXANDRE (1762–1839). French painter who distinguished himself during the Revolution by saving works of art from the monasteries which had been suppressed and from noble houses which had been sequestrated. He arranged in the cloister and gardens of the Petits Augustins at Paris a 'Musée des Monumens français', in which were some 500 examples of French art that included the finest French work of the Middle Ages now known to us. The Museum was suppressed in 1816, and most of the exhibits divided between the LOUVRE and the École des Beaux-Arts.

**LE NÔTRE,** ANDRÉ (1613–1700). French landscape gardener. From the 1630s until his death he was engaged on the design of the grounds of many great châteaux and town houses. His greatest works were the parks of Vaux-le-Vicomte and of VERSAILLES, the supreme examples of the formal French gardens laid out with avenues, fountains, and woods, which were widely imitated on the Continent and in England.

907, 964.

VITA DI LIONARDO DA VINCI
PITTORE, ET SCVLTORE
FIORENTINO.

**196.** *Leonardo da Vinci.* Engraving from the Life of Leonardo included in second edition of *Le Vite de' piu Eccellenti Pittori, Scultori, e Architettori*, Florence (1568) by Giorgio Vasari

**LEONARDO DA VINCI** (1452–1519). The most variously accomplished artist of the Italian RENAISSANCE, Leonardo was born at Anchiano close to the small town of Vinci in the Tuscan countryside. His father Piero was a Florentine notary and Leonardo was his illegitimate son by a peasant girl, Caterina. Little is known of his youth and upbringing, though VASARI and others have provided probable enough speculations, till in 1472 he was enrolled as a painter in the fraternity of St. Luke in Florence. Almost certainly, on traditional and stylistic evidence, he was at this time the pupil of VERROCCHIO, and contemporaries attributed to him one of the angels in Verrocchio's *Baptism* (c. 1472), now in the Uffizi. Here in the angel's head is the first expression of that combined languor and intensity which is the predominant mood of much of Leonardo's work. Something of the same feeling informs the *Annunciation* (Uffizi), also carried out in Verrocchio's workshop, a little uncertain in drawing and less immediately arresting than the angel of the *Baptism*. Of other early paintings, the *Benois Madonna* and the *Madonna Litta*, both in Leningrad, are much repainted works, but associated with drawings that are certainly from Leonardo's hand. The *Virgin with the Vase of Flowers* in Munich is a more problematic and less interesting work, but is generally accepted as authentic. The portrait of a young woman, the so-called *Ginevra Benci* (Liechtenstein Coll., Vaduz), though cut down, is far better preserved and has a skill in modelling that alone

would ensure its repute were not all technical accomplishment subordinate to the completeness of the character study: this still, close-lipped face, half determined, half foreboding, preserved by the hand of genius for posterity. The greatest work of his first Florentine period was, like so much that Leonardo undertook, unfinished. Commissioned in 1481 for the monks of S. Donato a Scoperto, the *Adoration of the Kings* (Uffizi) was interrupted, presumably in 1482, when Leonardo left Florence for Milan. Much of it, in particular the central figure of the Virgin, has advanced little beyond the ground painting, but there is sufficient to make the full conception plain, and in a series of drawings it is possible to follow Leonardo's process of thought and his gradual abandonment of quattrocento reserve for this strangely agitated crowd, full of gesticulating hands, while in the background prancing horses and a staircase leading to a broken ruin suggest something of the quality of a SURREALIST dream far removed from traditional renderings of the Epiphany. The rearing of horses and the flicker of hands were henceforth permanent obsessions in his work.

and water effects, children in the womb. He searched insatiably for knowledge, and in the vast medley of his manuscripts he seems constantly on the verge of discoveries, some achieved, some not yet reached. He never formulated his results or attempted any coherent systematization; when he put theories into practice, whether methods of painting or diversions of rivers, the results were generally faulty. It was the quest which absorbed him: the limitations of human knowledge rather than its potentialities were his interest. His affections, largely centred on a worthless pupil, Giacomo Salai, were also doomed to frustration. It is only in painting, even more in drawing, that this restless, acute intellect has expressed itself in any easily knowable form, and it is as the artist rather than the scientist that he exists today; but there was never the single-minded concentration on his art which most great masters have brought to it, and some of its disturbing quality may come from this partial commitment to it. In Milan, in the 17 years' sojourn between 1482 and 1499, his three great works, apart from portraits represented now by *Cecilia Gallerani* (Czartoryski Gal., Cracow, *c.* 1483) and

**197.** Pen-and-ink studies of horses for the *Battle of Anghiari* by Leonardo da Vinci. (Windsor Castle, *c.* 1504.) Reproduced by gracious permission of H.M. the Queen

Leonardo was recommended to Lodovico Il Moro primarily as a musician, a player on the lyre: in a document urging his continued stay in Milan Leonardo writes mainly of himself as an 'artificer of instruments of war'. From then on schemes of applied science, flying machines, fortifications, waterways, were to occupy much of his energy, while his notebooks were filled with studies of flowers, birds, skeletons, cloud

the *Musician* (Ambrosiana, Milan, *c.* 1485), were the *Virgin of the Rocks*, the *Sforza Monument*, and the *Last Supper*. The first of these exists in two versions, the earlier, probably painted before he left Florence, in the Louvre, covered with darkened varnish, the later, commissioned in 1483 and worked on at intervals up to 1508, in the National Gallery, London, and very thoroughly cleaned. The exact relationship between them is a

complex one about which much has been argued, and the difference in their condition makes comparison all the harder. The Louvre version has, despite its strange cave setting, a gentleness that now is lacking from the cold, livid colouring of the London example, where, almost certainly, a pupil's hand was liberally employed. The *Sforza Monument*, never completed, is known only in preliminary drawings, for the full-size model of the horse was used as a target by the French soldiery when they entered Milan in 1499 and eventually, having been moved to Ferrara, crumbled to pieces. The *Last Supper*, in the refectory of Sta Maria delle Grazie, Milan, has had a history befitting the strangeness of its creator. It early began to show signs of perishing; Vasari in 1556 described it as 'a muddle of blots'. It was frequently restored. Then, on 16 August 1943, the church was hit by a bomb and one of the side walls of the refectory was completely overthrown. Behind its elaborate protection the *Last Supper* was preserved, and on its re-emergence was skilfully cleaned so that today it can be more easily appreciated than for many years past. A ruin, pitted and rubbed, it still retains immense authority, and before it there can be no doubt that one is in the presence of a MASTERPIECE.

Between 1500, when he returned for a time to Florence, and 1516, when he left Italy for France, Leonardo's life was full of movement, but his artistic output was chiefly centred on Florence, particularly in the years 1504-5 when he was working on the cartoon and the fresco of •the *Battle of Anghiari* in the Palazzo Vecchio, which was hailed by contemporaries as 'a miraculous thing' but was destroyed in 1565 in Vasari's redecoration of the Sala di Gran Consiglio. In Florence also he painted his portrait of *Mona Lisa* (Louvre), 'older than the rocks among which she sits' in PATER's famous phrase, and was working out variations on the theme of *The Virgin and Child with St. Anne and the Infant St. John*, which are known today in the cartoon in the National Gallery, London (bought for the nation in 1962), and the large oil painting in the Louvre. He also completed a painting of *Leda and the Swan*, known from a copy by Cesare da Sesto (Wilton House), which must have been a disturbingly sensuous piece, imbued with thoughts of fertility. Strangest and latest of all his paintings is the *St. John* (*c.* 1515) in the Louvre. Here we have the enigmatic smile, the emergence from shadow, the pointing finger, the thick, coiling hair which are such familiar ingredients of Leonardo's mystery. A full-length seated version of the St. John, which was at Fontainebleau, was later converted into a *Bacchus* (Louvre), a transformation rendered easily possible by the pagan undertones inherent in Leonardo's strange concept of the Forerunner, in whom the sexes seem to be fused in an elemental creature, half angel, half sprite. It is a long and frightening journey from the devotional insight of the *Last Supper*.

Leonardo died at Cloux, near Amboise, on 2 May 1519.

535, 560, 563, 924, 1070, 1309, 1376, 1639, 1640, 1641, 2048, 2127, 2334.

**LEONI,** GIACOMO (*c.* 1686-1746). Architect, born in Venice, who worked for the Elector Palatine before settling in England *c.* 1715. His edition of PALLADIO's *I quattro libri dell'architettura* (translated by Nicholas Dubois), for which he redrew the plates (1715-16), played an important part in the PALLADIAN movement in England. His translation of *The Architecture of L. B. Alberti* (1726) had less influence. He built a number of houses, Clandon Park, Surrey, being the chief remaining example.

**LEONI,** LEONE (1509-90) and POMPEO (d. 1610). Leone Leoni was an Aretine sculptor who worked in many parts of Italy and in the service of the emperor Charles V in Germany, the Netherlands, and probably Spain, before settling in Milan. He was trained as a goldsmith, but none of his works in that medium survives, though the Metropolitan Museum, New York, possesses a sardonyx cameo by him (1550). He was coin engraver to the Pope and to the court of Milan, and made MEDALS of his patrons Andrea Doria and Cardinal Granvelle, of members of the imperial court, and of artists such as MICHELANGELO. His sculpture consists mainly of portraits. Many of his works for the emperor were sent to Spain, where his son Pompeo gave them the finishing touches. Indeed, the Prado contains many of his best portraits, including the *Charles V* (with removable armour) *victorious over a Fury*. In Milan Cathedral is his TOMB of Gian Giacomo Medici (1560-2).

The bronze statues of the RETABLE for the Capilla Mayor of the ESCORIAL were cast by Leone and finished by Pompeo, who also collaborated on the flanking memorial groups. Pompeo executed several tombs in Spain on his own account, and was, like his father, a goldsmith and medallist.

2106.

**LE PAUTRE,** ANTOINE (1621-81). French architect. Architect to the king (1655), member of the Académie (1671), and surveyor of work to the Duke of Orleans (1660). He built the monastery of Port Royal (before 1650) but his reputation rests chiefly on the Hôtel de Beauvais, Paris (1652-5), for its bold and ingenious solution of problems presented by an irregular site. In 1652 he published a volume of engravings of unexecuted designs for country and town houses notable for their imaginative and fantastic features and their vast proportions. Some of these may have had some influence on WREN and other architects of the English BAROQUE period. JEAN LE PAUTRE (1618-82), engraver and decorator, was a brother of the

foregoing. He was a prolific designer of ornament and had much influence on the decorative style of the second half of the 17th c. The Le Pautre family continued as decorators through many generations and were a formative influence on the French ROCOCO.

**LEPICIÉ,** NICOLAS-BERNARD (1735-84). French painter of portraits and domestic GENRE subjects. His best work, timid and devout, consists of small narrative pictures which, although not entirely free from the sentimentality of the period, have in their treatment something of the objectivity of CHARDIN (*La Leçon de lecture*, Wallace Coll., London). He was a teacher of Carle VERNET and for a while Secretary of the Académie.

**LES COMBARELLES.** See LES EYZIES.

**LESCOT,** PIERRE (1510/15-78). French architect who represents the classical RENAISSANCE style in France. He worked on the reconstruction of the LOUVRE from 1546, designed the Cour Carrée, worked on the Fountain of Innocents (1547-96), and built the Hôtel Carnavalet (c. 1545). His reputation depends chiefly on his work on the Louvre since most of his other work has either been destroyed or radically altered.

**LESE,** BENOZZO DI. See GOZZOLI.

**LES EYZIES.** French village in the Dordogne, a main centre of discoveries of Palaeolithic cave art. Early excavations by Lartet and Christy began in this area in 1861. The discovery of the paintings and engravings in the cave of La Mouthe by Émile Rivière in 1895 and the discovery in 1901 of Les Combarelles and Font-de-Gaume were turning-points in the discovery of Old Stone Age culture (see STONE AGE ART IN EUROPE).

Les Combarelles extends 250 yards into a limestone rock-face near Les Eyzies, consisting of two narrow galleries which meet in a more spacious chamber. The decorations, mainly in the left gallery, are restricted to engravings and comprise several hundred figures of animals, including mammoths, horses, and felines. Both in quality and in quantity these are among the finest engravings discovered. The majority are dated by Breuil to the Early and Middle Magdalenian period, though there are also some stiffer representations which may be Aurignacian. The cave also contains engravings of human beings wearing animal masks.

Font-de-Gaume in the valley of the Beaune is a narrow corridor with two lateral galleries running over 100 yards into the mountain. It is one of the richest stations of Ice Age art in France. Some 200 pictures have been deciphered, including fine friezes of polychrome bisons, horses, reindeer, and other animals. There is an unusual picture of a woolly-haired rhinoceros from the Aurignacian period and numerous mammoths. Many of the pictures are superimposed on earlier ones and stylistic comparison shows that the cave was frequented during all periods of the Upper Palaeolithic Age.

**LESLIE,** CHARLES ROBERT (1794-1859). Anecdotal painter born in London of American parents. He was brought up in the U.S.A. but studied and worked in England, becoming an R.A. in 1826. He specialized in literary and narrative painting (*Uncle Toby and the Widow Wadman*, Tate Gal., 1842) and was in his day regarded as a leading exponent of this GENRE. His *Life* of his friend CONSTABLE, 1843, remains a classic, and Constable's letters to him were published in 1931. His autobiography was edited by Tom Taylor (1860).

**LESSING,** GOTTHOLD EPHRAIM (1729-81). German scholar and critic who is remembered chiefly for his essay *Laokoon: oder über die Grenzen der Malerei und Poesie* (1766), in which he attacked the NEO-CLASSICAL conception of antique beauty and WINCKELMANN's ideal of the tragic hero. Whereas Winckelmann had seen perfection in serene restraint under suffering, Lessing believed that it lay in a just balance between fullness of action and fullness of emotion and brought back the Greek heroes to reality as fully human beings who gave rein to their emotions without becoming the slaves of their passions. In defining the frontiers of the various arts Lessing revived the distinction between the 'conventional' character of verbal communication and the 'natural' character of pictorial signs, a distinction which goes back to Plato's *Cratylus*. The differences between the scope of poetry and painting or sculpture arising from the differences of their media had been recognized in antiquity and specifically in the 1st c. A.D. by Dio Chrysostom. More recently, in contrast to the accepted doctrine *ut pictura poesis*, the differences in scope and potentiality had been discussed by such writers as James Harris, whose *Three Treatises* (1744) were translated into German in 1756, by BURKE, DIDEROT, and the German philosopher Mendelssohn, a friend of Lessing's.

Lessing argues in the *Laokoon* that the purpose of art is to create a pleasing illusion of the beautiful. Perfect illusion is not the result of exact verisimilitude, but derives from the artist's capacity to make the beholder believe in the reality of the artistic creation. Each art achieves its illusion by the means appropriate to its medium and the artist must exploit the potentialities of his medium to the full, respecting its limitations. Poetry, he held, is most adapted to the representation of human action in time but lacks visual vividness. Painting and sculpture are best adapted to the representation of idealized human beauty in repose. Owing to the

non-temporal character of the medium they cannot well represent the body in action. Only by selecting the 'critical' or 'fruitful' moment, which simultaneously preserves physical beauty and concentrates within itself the suggestion of past and future action, can the plastic artist even indirectly represent a sequence of events in action. He thought that the LAOCOON group was a masterly example of this, a work whose beauty and significance made it at once a delight to the eye and a stimulus to the imagination.

The important impact of Lessing's *Laokoon* arose from its emphasis on the aesthetic functions of art in contrast with the traditional view of art as the handmaid of religion and philosophy whose duty was primarily to instruct. Its achievement lay in the general effect it had on habits of thinking about art, emancipating art from religious and social pressures and directing attention to the realities of the artistic process itself.

**LESSING,** KARL FRIEDRICH (1808-80). German painter, the leader of the Düsseldorf School of history painting. He combined REALISM with studiously correct historical detail, so that many of his pictures look like stills from plays or pageants. His subjects were often taken from the life of Reformers such as Luther or Huss and were in their day considered manifestos of a liberal spirit.

**LE SUEUR,** EUSTACHE (1616-55). French painter. In his own day and through the 18th c. he was almost as well thought of as POUSSIN, but today he is much less admired. He was a pupil of VOUET, whose influence is strong on his early works, e.g. *The Presentation of the Virgin* (Hermitage, 1640-5) and panels decorating the Cabinet de l'Amour and Cabinet des Muses in LE VAU's Hôtel Lambert. He may have known Poussin when the latter visited Paris (1640-2). In any case he was profoundly influenced by Poussin's paintings of the 1640s, and his own work acquired a new interest in psychological presentation and in CLASSICAL principles of modelling, as is apparent particularly in a series of 28 paintings illustrating the life of St. Bruno done for the Charterhouse of Paris and now in the Louvre. From the end of the 1640s his paintings indicate a greater interest in the tapestry designs of RAPHAEL (*St. Paul at Ephesus*, Louvre, 1649).

**LE SUEUR,** HUBERT (*c.* 1595-*c.* 1650). Sculptor, born and trained in France and not, as was supposed by Horace WALPOLE, by Giovanni da BOLOGNA, though he was probably in contact with pupils of the latter. He came to England *c.* 1625 and obtained much work at the court of Charles I, his patrons being dissatisfied with the conservative art of older men such as Maximilian

COLT. His most famous commission was the BRONZE EQUESTRIAN STATUE of Charles I (1630) at Charing Cross, buried during the Commonwealth and re-erected in 1674. His skill as a bronze-worker is shown by the statues at Oxford of the *Earl of Pembroke* (Schools Quadrangle) and *Charles I and Henrietta Maria* (St. John's College), but these and his BUSTS of the king reveal the lack of subtlety in modelling which is his main limitation as an artist.

**LE TAVERNIER,** JEAN I (before 1434-after 1460). Flemish painter of book illuminations, born at Oudenaarde. He worked for the court of Burgundy and was influenced by van der WEYDEN and van EYCK. He illuminated the *Miracles of Our Lady* (Bib. nat., Paris).

JEAN LE TAVERNIER II, a miniature painter active at Bruges *c.* 1450-70, is identified by some scholars as Jean I but most reject this as improbable.

**LETHABY,** WILLIAM RICHARD (1857-1931). One of the English architects who tried to apply William MORRIS's ideas on craftsmanship and carried through his moralistic attitude into the 20th c. Apart from an office building in Birmingham, Lethaby's principal buildings are country houses: Avon Tyrrell, near Christchurch, High Coxlease in the New Forest, and Melsetter House in the Orkneys. These have Classical simplicity and dignity, and other fine qualities of a largely traditional kind. Lethaby's contribution to MODERN ARCHITECTURE is to be found rather in his writings, especially in his *Architecture: an introduction to the history and theory of the art of building* (1912) and his volume of collected papers called *Form in Civilization* (1922), which contain some penetrating analyses of the role of the designer in contemporary life. They were far in advance of their time and have not quickly dated. Lethaby was also an influential teacher. He was Professor of Design at the Royal College of Art (1900-18) and Principal of the London County Council's Central School of Arts and Crafts (1896-1911) and an authority on medieval building. He was for many years Surveyor to Westminster Abbey. His works included *Medieval Art* (1904) and *Westminster Abbey and the King's Craftsmen* (1906).

1648, 1650.

**LEU,** HANS (*c.* 1490-1531). Swiss painter. He was a pupil of DÜRER, as is clearly shown by an early drawing in the British Museum. He settled in Zürich about 1514, painting small ALTARPIECES and designing glass windows. He was one of the earliest LANDSCAPE painters, perhaps influenced by the masters of the so-called Danube School.

704.

**LEUTZE,** EMANUEL (1816-68). German-American painter, a pupil of the Düsseldorf

School. His *Washington Crossing the Delaware* (1850) and the mural decorations for the Capitol in Washington introduced the sentimental REALISM of German history painting into America.

**LEVASSEUR.** Canadian family, the leading Canadian woodcarvers of the mid 18th c. Their *atelier* was in Quebec. They made decorations and figures for a number of churches in a style mainly inspired by the French RÉGENCE (e.g. RETABLE of the Ursuline Chapel, Quebec, 1734-9). Members of the family included NOËL (1680-1740), PIERRE-NOËL (1684-1747), JEAN-BAPTISTE ANTOINE (1717-75), and FRANÇOIS-NOËL (1703-94).

**LE VAU,** LOUIS (1612-70). One of the most brilliant and versatile French architects of the 17th c. Born in Paris of a master mason, he settled *c.* 1639 in the Île S. Louis and built a number of houses for wealthy patrons, among them the Hôtel Tambonneau, the Hôtel Hesselin, and the Hôtel Lambert, all in the early 1640s. While F. MANSART derived from de BROSSE, perfecting the CLASSICAL elements implicit in the latter's work, Le Vau based his style on the decorative tradition of DUCERCEAU. In 1657-61 he built for the Superintendent of Finances, Nicolas Fouquet, the splendid château and gardens at Vaux-le-Vicomte which were the occasion of the latter's downfall in 1661, and

from that time Le Vau worked in the service of Louis XIV and COLBERT. The Collège des Quatre Nations, now the Institut de France, which he designed in the 1660s for the executors of Mazarin's will, had more in keeping with the spirit of the BAROQUE than almost any other French building. Even before the accession of Colbert, Le Vau had succeeded LEMERCIER in 1654 on the Square Court of the LOUVRE. In 1667 as First Architect he was one of the commission of three appointed by the king to prepare a project for the East Front of the Louvre after the rejection of BERNINI's plan. His final and greatest work, the Garden Front at VERSAILLES, reveals a true grasp of the principles of classical architecture together with a feeling for grandeur of scale, and represents the culmination of the French classical tradition before the new era of Jules Hardouin-MANSART and Robert de COTTE.

**LEWIS,** WYNDHAM (1884-1957). English painter and writer. He was born in America of English parents, came to England as a child, and studied at the Slade School. He worked for a short while with Roger FRY at the OMEGA WORKSHOPS and then formed the Rebel Art Centre in 1913 and was the chief figure in the foundation of VORTICISM, whose journal *Blast* he edited. At the Slade he had the name of being the best draughtsman since JOHN. Before 1914 he developed a semi-abstract style which has been likened both to CUBISM and to FUTURISM, angular, machine-like, and suggestive of mechanical impersonality.

**198.** *Veue du Chasteau de Versailles, du costé du Jardin.* From the engraving (1674) by Israël Silvestre

He carried this style into his war pictures as official war artist and into the portraits for which he is famous. They include portraits of Ezra Pound (Tate Gal., 1938-9), Edith Sitwell, and T. S. Eliot. He was an original member of the LONDON GROUP but soon resigned. In 1920 he joined in an attempt to revive Vorticism as Group X. His reputation as a novelist and writer of criticism and social satire is even higher than his reputation as an artist. He had, however, an important influence on many younger artists and founded a tradition of portraiture which may be seen in Graham SUTHERLAND's portrait *Somerset Maugham* (Tate Gal., 1949).

1233.

**LEYDEN,** LUCAS VAN. See LUCAS VAN LEYDEN.

**LEYSTER,** JUDITH (1609-60). Dutch painter of GENRE scenes and portraits who married Jan Miense MOLENAER in 1636. She was one of Frans HALS's most talented pupils and so clever at imitating and copying his life-size pictures that sometimes it is difficult to tell whether a work was done by master or pupil. But if her copy of the *Lute Player* (Rijksmuseum) is compared with the original in the Alain Rothschild collection in Paris, it can be seen that she fails to capture the bulk and movement of the musician and lacks Hals's decisive touch. Judith is at her best in small genre pieces. There is an excellent one in the National Museum in Stockholm. Her monogram includes a star, a play on 'Ley/ster' (lode star).

**LIANG K'AI** (*c.* 1140-1210). Chinese painter of the Sung Academy who in the second part of his life became a Ch'an (Zen) monk and developed an individual style known as *chien-pi* or 'abbreviated brush technique'. This lay between the firm outline manner of LI LUNG-MIEN (by a pupil of whom Liang K'ai was taught) and the cursive style of the ink-bamboo specialists. It was a 'wet ink' technique and the impression was obtained less by clearly formed lines than by the black-and-white effect of fluid patches of ink on a light ground. Despite the apparent spontaneity and impressionistic character of his figures, it is clear that the soft, broad brush was used with perfect control, and the apparently chance flow of ink masses conceals a carefully calculated rendering of the pre-conceived intention of the artist.

**LIBERAL ARTS.** The classification of the arts most generally prevalent in antiquity was the division between vulgar and liberal arts. Though it became known to the Middle Ages mainly in the Latin terminology of *artes vulgares* or *sordidae* and *artes liberales*, it was born of the aristocratic spirit of the Greek city states expressed in educational and social theories which distinguished between activities suitable for 'liberal' or free-born citizens and menial occupations fit only for foreigners or serfs. The most complete statement of the distinction in antiquity is that of Galen (*Protrepticus* 14) in the 2nd c. A.D. A century earlier the younger Seneca (*Epistolae* 88, 21) combined it with a variant classification going back to the Stoic philosopher Poseidonius into arts which instruct (*pueriles*) and those which amuse (*ludicrae*). Later on the liberal arts came to be referred to as 'encyclic', meaning the comprehensive circle embracing all that was necessary to an educated man. In these, as in all classifications which preceded the concept of the FINE ARTS, the word 'art' carries a very different signification from that which it bears in AESTHETIC discourse today, and one closer to the meaning which survives in academic terminology such as 'arts degree'. The Greek conception of *techne* and the Latin *ars* embraced the pursuit of knowledge, theoretical and practical sciences, and craftsmanship. The supreme art was held to be philosophy, and the division of the arts into liberal and vulgar was an expression of the Greek preference for activities of the mind and their contempt for salaried labour. It was a preference which in one form or another survived through the Middle Ages up to the RENAISSANCE.

Aristotle accepted music among the liberal arts, though with the proviso that a free-born man should not become a virtuoso performer. (The Greeks generally thought of what we call fine arts from the point of view of performance rather than appreciation.) He somewhat doubtfully included an elementary knowledge of painting in the educational curriculum of the citizen. Galen mentioned rhetoric, geometry, arithmetic, and astronomy among the arts which were considered to be liberal. He included the theory of music and acoustics but not its practice (a distinction which remained prevalent through the Middle Ages). About painting and sculpture he was hesitant, writing 'if one wishes, one may consider them as liberal arts'. The classical tradition was systematized in the Middle Ages, one of the earliest formulations being a verse hand-book written by Martianus Capella (5th c.) which divided the liberal arts into groups of three and four. This was taken up by Boethius, who gave the name *quadrivium* to the sciences which studied physical reality (arithmetic, astronomy, geometry, and music) and *trivium* to the arts of grammar, rhetoric, and logic. This systematization of the seven liberal arts was elaborated in encyclopedic fashion by Cassiodorus in Book II of his *Institutes*.

In this medieval system 'music' meant the mathematical theory of music as proportion and none of the activities which later came to be recognized as 'fine arts' was included. The ancient depreciation of the practical activities, including such arts as painting and sculpture and architecture, in comparison with theoretical knowledge and speculation was perpetuated in the theological distinction between *praiseworthy*

and *honourable* pursuits. Its classic formulation is in a commentary by St. Thomas Aquinas on Aristotle's *De Anima*, where he says: 'Every science is good and not only good but honourable. Yet in this regard one science excels over another. . . . Among good things some are praiseworthy, namely those which are useful for an end; others are honourable, namely those which are useful in themselves. . . . The speculative sciences are good and honourable; the practical sciences are only praiseworthy.' It was against this medieval depreciation of the plastic arts that LEONARDO protested in his *Trattato della Pittura*, providing a theoretical basis for the social struggle which took place at the Renaissance to raise them from the lowly status of manual skill to the dignity of a liberal exercise of the spirit. This was achieved by emphasizing the intellectual and scientific aspects of painting in a way which imparted a rationalistic and intellectual bias to art theory for centuries to come, and which is foreign equally to the ROMANTIC and to contemporary outlook.

In Capella's handbook the liberal arts are personified as women holding various ATTRIBUTES and being followed by famous masters of the arts concerned (e.g. Cicero with Rhetoric) and as such they were frequently illustrated throughout the Middle Ages. On the west porch of CHARTRES Cathedral (12th c.) Geometry is accompanied by Pythagoras. The full system is to be found in 14th-c. works of art such as ANDREA DA FIRENZE's murals in the Spanish Chapel of Sta Maria Novella in Florence or the illustrated manuscripts of Pietro de Bartoli's *Canto delle Virtù e delle Scienze* (Chantilly).

In the Italian Renaissance the tradition was continued but treated with greater freedom. Sometimes, as in the Tempio Malatestiano at Rimini (*c.* 1455), the Arts and the Muses appear together; elsewhere the cycle is enlarged, as on the tomb of Sixtus IV by POLLAIUOLO (*c.* 1490) where 10 Arts are represented. PINTORICCHIO in the *Appartamento Borgia* (*c.* 1495) surrounds his seven enthroned Arts with large groups of anonymous followers. The scheme of RAPHAEL's *Stanza della Segnatura* (*c.* 1510), representing the followers of Poetry, Philosophy, and Theology, is influenced by this tradition. For the BAROQUE age the types of the liberal arts were codified by Cesare Ripa in his handbook of PERSONIFICATION.

**LIBON** OF ELIS. Greek architect of the temple of Zeus at Olympia (*c.* 460 B.C.).

**LICHTENSTEIN,** ROY (1923–    ). American POP ARTIST. He studied at the Art Students' League in 1939 and at Ohio State College. He taught at various colleges until 1963. His Pop Art style emerged *c.* 1961, when he began painting objects from the commercial, mass media environment in a hard-edged style simulating printing techniques. Examples are *Pie* (1962), *Golf Ball* (1962), and *Ball of Twine* (1963), and

most characteristically his numerous scenes of love and war from comic books. He often enlarged the original image and simplified it to fit his composition. He painted in primary colours and heavily outlined in black. Words also played an important part in his comic images, e.g. 'Okay, hot-shot . . . Okay! I'm pouring! Voomp!' He has painted landscapes, seascapes, and canvas stretchers, as well as copies of MONET, PICASSO, and MONDRIAN. He has done sculpture and ceramics also.

**LIEBERMANN,** MAX (1847–1935). German painter. His importance in the history of German painting lay in his susceptibility to foreign influences. He was one of the first to overcome parochiality and to broaden the outlook of German painters to IMPRESSIONISM and other contemporary European trends.

1984, 2410.

**LIÉDET,** LOYSET. Flemish MINIATURIST who worked in Bruges 1468–78, and left a larger *œuvre* than any of his contemporaries. He is famous for his ILLUMINATIONS in the *Chronicles of Froissart* (Bib. nat., Paris).

**LIEVENS,** JAN (1607–74). Precocious Dutch painter, who also did ETCHINGS and WOODCUTS. Like REMBRANDT, he was born in Leiden and studied in Amsterdam with Pieter LASTMAN. He returned to Leiden, where he worked with Rembrandt from *c.* 1625 to 1631. The young painters were close friends, shared the same studio and models, and even worked together upon the same pictures. Contemporaries considered their talents equal. But about 1632 their paths separated. Rembrandt went to Amsterdam, where he immediately achieved fame as a portrait painter. Lievens left Holland. There is evidence that he was in England *c.* 1632 to 1634. From *c.* 1635 to 1643 he was active in Antwerp. In Flanders his style underwent a radical change. He adopted RUBENS's and van DYCK's manner for his portraits and history pictures, and he used BROUWER's landscapes as inspiration for his studies of nature. He certainly chose the best Flemish painters for his models, but his attempt to emulate them was not a complete success. After 1635 his paintings did not have the grandeur of invention or the boldness which characterized his early works. In 1644 he returned to Holland, where he remained for the rest of his life and during the last three decades was popular in official circles in Amsterdam and The Hague. He was one of the artists selected to make paintings for the Town Hall in Amsterdam.

2425.

**LIFE MASKS.** See DEATH MASKS AND LIFE MASKS.

**LIGHTNESS.** See COLOUR.

**LIGORIO,** PIRRO (*c.* 1500–83). Italian architect, painter, and antiquarian, born at Naples. For his patron Cardinal Ippolito d'ESTE he designed the Villa d'Este at Tivoli, and for Pius IV he built the Casino in the Vatican Gardens (1560–1). Appointed MICHELANGELO's successor at St. Peter's, he was dismissed for altering Michelangelo's designs (1565). He published several important collections of Roman antiquities but has also been suspected of forging antiques.

**LI LUNG-MIEN** or LI KUNG-LIN (1049–1106). Pen-name of Chinese artist Li Po-shih, an eclectic traditionalist of the Northern Sung dynasty with a special gift for animal studies and a preference for Confucianist subjects. Wang K'o-yü, a writer on art belonging to the first half of the 17th c., uses Li Lung-mien as an example of an artist who paid more attention to essential spiritual beauty than to formal likeness: 'Li Lung-mien, for example, was the only important figure painter after WU TAO-TZU, nevertheless he too sometimes violated formal likeness. But his merits lay in the brush-work, in the resonance of the life force and in the nature of his personality; formal likeness came last of all.' The figure painter Chang Wu of the mid 14th c. is said to have worked in his style. The pictures which bear his own name are not well authenticated.

**LIMBURG,** POL (PAUL) DE (active *c.* 1399–*c.* 1416). The leading member of a family of MINIATURE painters who may have been nephews of the painter MALOUEL. They are first heard of as apprentices to a Parisian goldsmith, and this training emerges in the quality of their work. Two of the brothers worked for Philip the Bold, Duke of Burgundy, but by 1411 all three were in the service of the Duke of Berry, for whom they produced at least two important manuscripts, the *Belles Heures* before 1413, and the *Très Riches Heures,* their masterpiece. This latter book, now in the museum at Chantilly, was left unfinished at the Duke's death in 1416, and only completed *c.* 1486 by Jean Colombe. The Calendar ILLUMINATIONS are the most perfect extant expression of French INTERNATIONAL GOTHIC style. They also mark an important stage in the development of northern interest in LANDSCAPE and GENRE painting, while the rendering of spatial values may have been nourished by a visit to Italy. This second aspect of the Limburgs' style was developed by Flemish painters. In France their influence was less profound and more sporadic.

**LIMESTONE.** Sedimentary rock composed essentially of carbonate of lime. It varies in hardness from easily worked and quickly weathered lias and FREESTONE to fine-grained oolites, some of which weather well and can be carved with precision. Some limestones will take a polish and are incorrectly known as MARBLES (e.g.

PURBECK MARBLE). Limestones include many important building stones, such as PORTLAND STONE, BATH STONE, CAEN STONE, ISTRIAN STONE, TRAVERTINE.

**LIMNER.** This term, a form of *luminer,* was used in the Middle Ages for an illuminator of manuscripts. From the 16th c. onwards it usually meant a painter of MINIATURE portraits, though it was also used for painters generally. It became obsolete in the 19th c.

**LINDSAY.** A notable family of Australian artists, the children of Dr. R. C. Lindsay of Creswick, Victoria. Among them were: PERCY LINDSAY (1870–1953), painter and GRAPHIC artist; SIR LIONEL LINDSAY (1874–1961), art critic, WATER-COLOUR painter, and graphic artist in pen, ETCHING, and WOODCUT, who did much to arouse an interest in the collection of original prints in Australia; NORMAN LINDSAY (1879–1969; see AUSTRALIAN ART), graphic artist, painter, critic, and novelist; RUBY LINDSAY (1887–1919), graphic artist; and SIR DARYL LINDSAY (1889– ), painter and Director of the National Gallery of Victoria (1942–56). For over half a century this family through one or the other of its members played a leading role in Australian art.

**LINE ENGRAVING.** Engraving with the BURIN for the purpose of taking PRINTS. It is an intaglio method, the design being cut into the surface of the plate and the ink rubbed into the incised lines, which are then printed under heavy pressure. The plate is usually of copper. The engraver, holding the burin in his right hand, pushes it slowly through the surface of the copper, cutting a clean V-shaped furrow, while the shred of metal removed from the line is thrown up in a continuous spiral from the moving point. Both hands are in action, for the engraver steadies the plate with his left hand against the pressure exerted by the burin and, when cutting curves, holds the burin still with the right hand while the left rotates the plate on to the point of the tool. The shreds of metal excavated by the tool and the slight BURR thrown up at the sides of the lines are cut off by the scraper, which is also used for making corrections. The printing of the plate follows the method employed in all the intaglio techniques and is described in the article on PRINTS.

Line engraving, though simple enough in principle, is not an easy technique to learn, for long practice is necessary before the burin can be handled with confidence. But when the necessary skill and touch have been acquired, it is exhilarating, for the burin, moving steadily forward in sweeping curves, travels through the very substance of the metal—not merely across its surface as the etching needle does—now coming to the surface when the pressure of the hand is eased and now plunging deeper when a stronger line is required.

It follows from this that the essential character of this medium is linear, though shading and tone may be suggested by parallel strokes, cross-hatching, or textures compounded of various dots and flicks. Line engraving has a curious quality of metallic hardness and austere precision which comes partly from the nature of the materials and partly from the slow calculated driving of the lines, essentially an indirect procedure compared with the easy, spontaneous drawing of the etcher or LITHOGRAPHER.

Line engraving seems to have originated towards the middle of the 15th c. in the workshops of the goldsmiths, arising independently in Italy and Germany, though perhaps slightly earlier in the latter country.

The early German engravers are mostly anonymous and have to be designated by a system of initials and *noms de plume*. The most notable prints were produced on the upper Rhine by the MASTER OF THE PLAYING CARDS (active *c.* 1435–50) and by the MASTER E.S. (active 1440–67), who were certainly goldsmiths as well as engravers. Their works are linear and ornamental in character with a certain amount of shading and enrichment by means of parallel lines and stippled textures. The first German artist of importance to use the medium, Martin SCHONGAUER, was not only an engraver and goldsmith but also a painter, and his prints show a more ambitious treatment of form and texture by cross-hatching and by lines that follow the variations of surface modelling. His designs, though frequently GOTHIC in charac-

**200.** Head of a woman in profile. Florentine print. (Print Room, Berlin, *c.* 1460)

ter, achieve at times a satisfying simplicity and nobility. He represents that period of transition when engraving was passing from the orbit of the goldsmiths into that of the painters.

The beginnings of line engraving in Italy were connected both with goldsmith's work and with a related kind of decorative metal-work, niello (see NIELLO PRINTS). The niello craftsmen used to take impressions from their plates on paper, for reference or as tests of progress. Some of the early line engravings resemble niello work so closely that it is hard to say which were made by the niellists for their own purposes and which were intended as prints from the outset. In other prints the connection with the goldsmith's art comes out clearly. For instance in the magnificent profile *Head of a Woman* (Berlin), which was engraved in Florence *c.* 1460 and already epitomizes all the basic qualities and virtues of line engraving, the profile is executed in an austere but expressive line without shading and it is the ornamental head-dress and jewellery that give decorative emphasis to the design. In an early print which depicts various arts and sciences being practised, a goldsmith's shop is prominent. This print, the *Mercury*, is one of an astrological series of Planets usually ascribed to Maso FINIGUERRA, a celebrated figure of the goldsmith-niello school of engravers. Finiguerra worked in what is termed the 'fine manner', whose

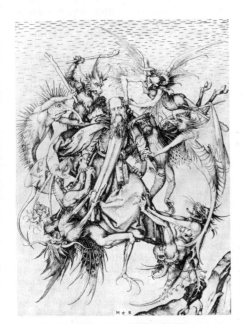

**199.** The Temptation of St. Anthony. Copper engraving (*c.* 1475) by Martin Schongauer

characteristic feature was the use of fine lines of shading, sometimes cross-hatched. Somewhat later, c. 1470, there appeared prints in the so-called 'broad manner', which employed simple broad lines of parallel shading. These distinctions, however, are of minor importance in the history of the art. What is far more significant is that two great Italian painters were pre-eminent in it: POLLAIUOLO, the Florentine, and MANTEGNA, of Padua and Mantua.

Pollaiuolo, goldsmith and sculptor as well as painter, is certainly known to have produced only one print, the formidable *Battle of Naked Men*, in which the outlines are strong and vigorous and the modelling of the figures is indicated by open parallel lines with shorter lines laid obliquely between them. Because of the treatment of the leafy background, and the way in which the figures are set closely against it, the whole design has something of the character of a low relief. This character is also seen in the works of Mantegna, who engraved a larger number of plates and had a considerable following in northern Italy. Mantegna must have found the medium congenial, for in his austere and metallic yet deeply moving engravings he conveys much of the spirit and feeling of his greatest paintings.

The early years of the 16th c. saw three of the most celebrated RENAISSANCE engravers reach maturity: Albrecht DÜRER, Raimondi MARCANTONIO, and LUCAS VAN LEYDEN. Dürer was a virtuoso, who drove the technique to its furthest limits in his search for a system by which the forms and colour values of natural objects could be represented. Marcantonio, who troubled Dürer with his plagiarisms, was an equally skilful engraver, but he is chiefly known for his reproductive work after RAPHAEL. Lucas, a friend of Dürer, was a precocious artist who seems to have engraved his first plate at the age of 14. His *Milkmaid* (1510) shows his great ability and his typically Dutch interest in GENRE subjects, though his later allegorical works, done under Italian influence, are of less interest.

At this high point of technical excellence line engraving ceased to be used as a means of original expression and, following Marcantonio's system and example, entered its long phase as a reproductive medium: a phase which is discussed more fully in the article on REPRODUCTION. But if the countless engravings produced during the 16th, 17th, and early 18th centuries were nearly all reproductive, their quality from the technical point of view was often exceedingly high. Hendrik GOLTZIUS, for example, who worked towards the end of the 16th c., was a fine exponent of the swelling burin line, which gives his prints a brilliant surface quality and great variety of tone. RUBENS, though he probably never engraved himself, realized the value of having his works reproduced by means of engraving and for this purpose a talented school of engravers existed early in the 17th c. under his patronage. A little later there arose in France a celebrated school of portrait engraving, in which the greatest names were those of Claude MELLAN and Robert NANTEUIL. Across the Channel Nanteuil's contemporary, William FAITHORNE, also a portraitist, deserves mention as one of the few English line engravers of any distinction.

Certain technical developments date from this period. ETCHING, invented in Dürer's time as a labour-saving method of engraving, began to be combined with line engraving. The design was begun by etching, in order to ease the task of the engraver, who then took over and completed the plate with his burin. Later, plates worked by other copper-plate processes, particularly the hazier ones such as MEZZOTINT, were frequently punctuated and finished with the burin at points where the design required precision.

During the 18th c. line engraving began to decline in importance even as a reproductive process, especially in England where tonal processes such as mezzotint and STIPPLE were popular. Steel engraving, in which extremely fine lines and subtle tones are possible, was widely practised in the first half of the 19th c. but was rendered obsolete by the discovery that engraved copper-plates could be steel-faced by electrolysis and thus enabled to withstand a large printing. Line engraving reached its lowest ebb during the later 19th c., when very little work of any interest was done either reproductive or original.

In the 20th c., however, line engraving has been revived as a means of original expression. During the 1920s Jean Laboureur (1877-1943) engraved many prints and book illustrations in an angular and stylized manner. Joseph Hecht (1891-    ), a Polish artist who lived in Paris, produced a remarkable series of engravings of animals and landscapes in a simple linear style that recalls the early creative line engraving of 15th-c. Italy. But the greatest impetus to the revival of line engraving was provided by 'Atelier 17', an experimental workshop for the graphic arts which was established in Paris in 1927 by the English artist Stanley William Hayter (1901-    ) in collaboration with Hecht. This workshop, which was moved to New York during the Second World War but later returned to Paris, produced non-representational line engravings of such vitality and technical accomplishment as to demonstrate that the medium is inherently suited to the expression of space and movement in ABSTRACT terms.

**LINNELL,** JOHN (1792-1882). English painter of LANDSCAPES, portraits, MINIATURES, and biblical illustrations. He was intimately connected in his youth with BLAKE and Samuel PALMER, who was his son-in-law. His early landscapes in oil and water-colour have something of their visionary quality. Until about 1845 he also painted and engraved portraits, but thereafter matured in a lush and empurpled style, assiduously producing idyllic scenes of a glorified Surrey. He helped and encouraged

Blake, introducing many younger artists to his circle, including VARLEY, Palmer, and CALVERT. 2565.

**LINOCUT.** A 20th-c. development of the WOODCUT, in which linoleum is used instead of wood. Various tools are employed, including woodcutting knives and gouges of different section which may be pushed through the material like engraving tools. The medium stands, in fact, somewhere between woodcutting and WOOD ENGRAVING, and partakes a little of the character of each, while having distinctive

**201.** *The Wrestlers.* Linocut in broad masses (c. 1914) by Henri Gaudier-Brzeska

**202.** . . . *Dors, dormeuse aux long cils.* . . . Illustration to *Pasiphaë* (1944), Henri de Montherlant. Linocut by Henri Matisse

qualities of its own. The linoleum, though relatively soft and friable, is without grain and presents a true and even working surface. It may therefore be engraved freely with white lines, cut in broad masses, or worked with a variety of STIPPLES and textures.

Linocutting has been much used for teaching art in schools, and this circumstance has caused it to be somewhat lightly regarded, but creative artists have used it with much skill and it has been greatly developed. MATISSE turned to it when he illustrated Montherlant's *Pasiphaë* in 1944, engraving the block with simple white lines of great freedom and sensitivity. For colour prints it has obvious advantages, since a number of large blocks may be used without undue expense, while the fact that the surface can be cut rapidly and spontaneously means that the process is highly suitable for big prints boldly conceived in large masses of flat colour and decorative texture.

**LINSEED OIL.** Oil from the seeds of flax; the commonest MEDIUM in OIL PAINTING. Most modern painters have used raw linseed oil diluted with TURPENTINE as a medium, but the Old Masters generally preferred polymerized oil, known as *stand oil*, which was prepared by boiling linseed oil or drying it in the sun. Stand oil was thinned to a painting consistency by mixing it with turpentine, or used as an EMULSION mixed with yolk of egg. Boiled oils withstand atmospheric conditions better than raw oils. Linseed oil tends to turn yellow with age but has less tendency to crack than nut oil or POPPY OIL.

**LINTEL.** Architectural term for the horizontal beam or slab which spans the opening of a door or window and supports the wall above.

**LIOTARD,** JEAN ETIENNE (1702–90). Swiss PASTEL painter and engraver. He travelled widely in Europe and the Near East and painted fashionable sitters in eastern costume. He worked in Paris (1725–38), in Holland (1755–72), and in England (1733–5 and 1772–4), where he painted the Princess of Wales and exhibited at the Royal Academy (*Empress Maria Theresa*; *Madame d'Épinay*, both Geneva).

**LIPCHITZ,** JACQUES (1891–1973). Sculptor, born at Druskieniki in Lithuanian Russia. He came to Paris in 1909 and worked at the École des Beaux-Arts and the Académie Julien. About 1912 he became intimate with the circle of MODIGLIANI, PICASSO, Max Jacob, MATISSE, and in 1916 formed a friendship with Juan GRIS. He took French nationality in 1925 but settled in the U.S.A. in 1941. From 1914 he worked in the CUBIST manner, but a BAROQUE exuberance marks his work off from that of the other Cubists (*La Joie de vivre*, for the Vicomte Charles de Noailles, Hyères, 1927; *La Chant des voyelles*,

Kunsthaus, Zürich, 1930). During the 1920s he became preoccupied with the problems of space and transparency in sculpture. In 1944 he made a second version of his *Prométhée* (1937) for the Ministry of Education, Rio de Janeiro, and in 1944–50 worked on *La Naissance des Muses* for Mrs. John D. Rockefeller. A large exhibition of his work was shown in various European capitals in 1958–9. As the years went on his work became more and more infused with imaginative quality and he sought to capture something of the mysterious magic inherent in the sculpture of primitive peoples.

1079, 1231, 1369.

**LIPPI,** FILIPPINO (*c.* 1457–1504). Italian painter of the FLORENTINE SCHOOL, son of Filippo LIPPI and Lucrezia Buti. He was trained by his father and probably in the workshop of BOTTICELLI. There evolved a popular formula for painted CASSONI and devotional pictures (*Angel Adoring* and the *Madonna with SS. Jerome and Dominic*, N.G., London). He was capable, however, of sensitive and poetic lyricism such as the *Vision of St. Bernard* (*c.* 1486) in the Badia, Florence. Filippino enjoyed a great reputation in his lifetime, being described by Lorenzo de' MEDICI as 'superior to APELLES', and he received important commissions for FRESCOES in Florence (Strozzi Chapel, Sta Maria Novella), and Rome (Sta Maria sopra Minerva). In these he strove for picturesque, dramatic, and even bizarre effects which sometimes anticipate MANNERIST and BAROQUE developments. He also completed MASACCIO's frescoes in the Brancacci Chapel with considerable tact.

1915, 2407.

**LIPPI,** FRA FILIPPO (*c.* 1406–69). Italian painter of the FLORENTINE SCHOOL. He was a Carmelite monk, but less devoted than the Dominican Fra ANGELICO. It was not inappropriate that one of his first paintings was a fresco representing *The Relaxation of the Carmelite Rule* (*c.* 1432) in Sta Maria del Carmine, Florence. He seems to have left the monastery shortly afterwards. His love affair with a novice, Lucretia Buti, romantically embroidered by VASARI, has given rise to the picture of a worldly RENAISSANCE artist, rebelling against the discipline of the Church, which inspired Browning. But there is little documentary evidence of his character and personality.

His early works, notably the *Tarquinia Madonna* (1437), now in Milan, reflect the influence of MASACCIO's bold, massive, and three-dimensional style. The *Annunciation* (*c.* 1438) in S. Lorenzo, Florence, was one of the most advanced and carefully composed works of the period, and in it Filippo made skilful use of the newly discovered principles of PERSPECTIVE. From *c.* 1440 onwards his style changed direction. He abandoned his interest in Masaccio, became preoccupied with decorative motifs—thin,

fluttering draperies, brocades, and so on—and his forms took on a linear, more elusive character. In that sense his later work represented a revival of GOTHIC features; and in an important series of frescoes with *Scenes from the Lives of SS. Stephen and John the Baptist* in Prato Cathedral (1452–*c.* 1465) he used a Gothic landscape and adopted the Gothic habit of including several incidents in one unit of space for the scenes taking place out of doors—though the interiors have architectural settings derived from BRUNELLESCHI. Characteristically he preferred subjects which have the Madonna as the central figure, and like his contemporaries in sculpture he stressed the human aspect of the theme. The Uffizi *Madonna and Child*, with its distant landscape steeped in idyllic light, is a good example. Work of this sort prepared the way for BOTTICELLI. Although Filippo began as a follower of Masaccio, he evolved a style which served as a major source for the 19th-c. PRE-RAPHAELITES.

1962, 2094.

**LISBOA,** ANTÓNIO FRANCISCO (*c.* 1738–1814). Brazilian mulatto sculptor and architect, son of the Portuguese architect MANUEL FRANCISCO LISBOA. He was known as the *Aleijadinho* (little cripple) on account of a disease which from his middle thirties gradually deprived him of the use of his limbs so that he worked with chisel and mallet tied to half paralysed hands. He was ·the leading exponent of provincial ROCOCO and is considered the greatest sculptor and architect of colonial Brazil. His work may be seen in the churches of São José and São Francisco, Ouro Preto, and the church of Nossa Senhora do Carmo, Saborá. His masterpiece is the open air life-size group of statues of the *Twelve Prophets* (1800–5) in front of the Bom Jesus de Matozinhos at Congonhas do Campo. He also designed the church of São Francisco at Ouro Preto.

**LISS** or LYS, JOHANN (*c.* 1595–1629/30). German painter. He had his training in the Netherlands and afterwards visited Rome, where he fell under the spell of CARAVAGGIO's art. His best paintings are vivid and realistic, exploiting to the full the effects of strong lights and deep shadows on intricately composed groups. He died in Venice.

2551.

**LISSANDRINO,** IL. See MAGNASCO, A.

**LI SSU-HSUN** (651–716). Chinese Minister of State who is traditionally regarded as the father of the 'blue-and-green' style of LANDSCAPE PAINTING, which had its heyday in the T'ang period and remained an archaistic tradition through the whole later course of Chinese painting. Later Chinese historians made Li Ssu-hsun and his son LI CHAO-TAO the founders of what they called the Northern School, in which they placed Chao Po-chü, Chao

Po-su, MA YÜAN, Hsia Kuei, and many others. Whatever may be the validity of such grouping, it has had a great influence on later Chinese and Japanese painting (see CHINESE ART).

**LI T'ANG** (1049-1130). Chinese painter who belonged to the Academy of the emperor HUI-TSUNG and became the first director of that founded by Kao-tsung (1127-63). In the development of 'texture drawing' (*ts'un-wen*), by which the internal shape of rocks and mountains was indicated within the outline silhouette, Li T'ang's work was a bridge between the style represented by Hsü Tao-ning (active *c.* 1030) and that of Kuo Hsi (*c.* 1020-90). To him is attributed the invention of sweeping brush-strokes in dry-ink technique for representing the texture formation of rocks in the foreground.

**LITHOGRAPHY.** A method of surface printing from stone. The design is neither cut in relief as in a WOODCUT nor engraved in intaglio as in LINE ENGRAVING, but simply drawn on the flat surface of a slab of special limestone known as lithographic stone. The process is based on

203. Lithographic press. Illustration from *A Complete Course of Lithography by Alois Senefelder, Inventor of the Art of Lithography and Chemical Painting* (1819) by R. Ackermann

204. *Lithography or the Art of Making Drawings on Stone for the purpose of being Multiplied by Printing* (1813). Title-page of the first book printed in English on the subject of lithography by H. Bankes of Bath

the antipathy of grease and water. The artist draws his design with a greasy ink or crayon on the stone, which is then treated by the lithographic printer with certain chemical solutions so that the greasy content of the drawing is fixed. Water is then applied. The moisture is repelled by the greasy lines but is readily accepted by the remainder of the porous surface of the stone. The stone is now rolled with greasy ink which adheres only to the drawing, the rest of the surface, being damp, remaining impervious. A sheet of paper is placed on the stone, the whole is passed through the lithographic press, and an exact replica of the drawing is transferred, in reverse as with all prints, to the paper.

This 'planographic' or surface method of printing, the most recent of the principal GRAPHIC techniques, was discovered in 1798 by Aloys SENEFELDER, a Bavarian playwright who was experimenting with methods of duplicating his plays. Senefelder, who wrote a book on his invention in 1818, appears to have realized at once what its significance was and how it could be used. He called it 'Chemical Printing', insisting that the chemical principles involved were of more importance than the stone on which the designs were made, and in this he was right for metal and plastic plates, particularly zinc surfaced in a special way, are frequently used today instead of stone. Senefelder was also responsible for the use of transfer paper whereby the design is drawn on paper and transferred subsequently to the stone for printing—a method much used by artists ever since.

Senefelder took out patents for his invention in various countries and the first set of artists' lithographs to be published appeared in England in 1803 under the title *Specimens of Polyautography*. They included designs by Benjamin WEST and Henry FUSELI and were all drawn with pen and greasy ink, for the lithographic crayon was not introduced until some three or four years later. As its inventor foresaw, lithography has proved to be an exceedingly flexible medium. Instead of being drawn with pen or crayon, the design may be painted on the stone with a brush; the WASHES may be opaque or dilute, they may be scratched or scraped to produce white lines on a background of black, or they may be textured in any way the artist's ingenuity can suggest. COLOUR PRINTS may be produced in much the same way as in any other graphic method, that is by preparing a separate stone for each of the colours in the design. Lithographs have in consequence taken on a number of appearances, ranging from simple linear designs made with pen or crayon to colour prints with the most varied effects of transparency and texture.

The modern commercial applications of the lithographic principle are strictly outside the scope of this article, but they will be briefly mentioned because they show the range and possibilities of Senefelder's discovery and because they are used in many ways that affect the fine arts, including the reproduction of paintings,

book illustration, and so forth. Offset lithography, in which the ink is printed from the stone or zinc on to a rubber-coated cylinder before being transferred to the paper, allows the design to be made the right way round instead of in reverse and also enables a very thin film of ink to be used, thus permitting the reproduction of the finest lines. Photo litho offset involves the photographic printing of an image, usually by means of a half-tone screen (SEE REPRODUCTION) on to a sensitized zinc plate, which is then, after certain chemical treatments, printed on an offset lithographic machine.

By contrast with these complex commercial procedures, lithography in its simpler forms has always attracted artists as a means of original

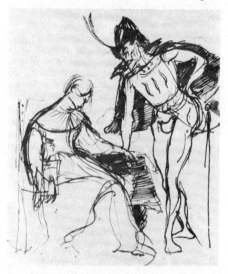

205. *Méphistophélès et Marguerite*. Lithograph (1828) by Eugène Delacroix. Illustration for *Faust*, Goethe

expression. It is very direct and, since its technical side can be left to the lithographic printer, the artist need do no more than draw upon the stone.

Lithography was invented in time for GOYA, in his old age at Bordeaux, to make a number of striking designs in the new medium. GÉRICAULT and DELACROIX also used it. The latter's lithographs for GOETHE's *Faust*, dating from 1828, are the quintessence of ROMANTIC illustration. The well drawn portraits by Achille Deveria (1800–57) show us the leading artistic and literary figures of the day. GAVARNI and DAUMIER found the process admirably suited to their satirical vision: Daumier in particular executed the largest part of his life's work in lithography.

Among the French painters of the IMPRESSIONIST period MANET and DEGAS made perhaps the most important contribution. Manet, in 1874, made a remarkable set of illustrations to Edgar Allan Poe's *The Raven*, drawing them with

a brush on transfer paper, and Degas executed a number of stones outstanding for their powerful draughtsmanship and technical ingenuity. The final years of the 19th c. saw a brilliant flowering of the art of colour lithography. Influenced by Japanese woodcut prints (UKIYO-E) which had recently appeared in Europe, a number of artists, including TOULOUSE-LAUTREC, BONNARD, and VUILLARD, began making lithographs in colour which were quite unlike anything made before in the West by reason of their avoidance of heavy shading, their use of large areas of flat yet transparent colour, and their unusual and provocative sense of pattern. Lautrec, indeed, may perhaps be claimed as the greatest figure in the history of lithography. His influence has been profound, not least upon the POSTER, of which he is acknowledged to have been the supreme master. Contemporary with this movement, but wholly different in feeling and subject, were the strange, visionary prints of Odilon REDON and WHISTLER'S impressions of the London river with their soft and subtle gradations of tone. Meanwhile, Whistler's compatriots in the U.S.A. were producing a series of lithographs which had little in common with the sophisticated European prints of the period but are none the less of the greatest interest. From 1840 to 1890 the prints issued in New York by the firm of CURRIER AND IVES, ingenuously drawn in black and white but frequently hand-coloured, show us a cross-section of the life of the American nation in terms of a genuine, popular, and Romantic art.

In the 20th c. lithography, like most of the other graphic processes, has been used by most of the celebrated figures of the School of PARIS for free prints and for book illustration. PICASSO is, as usual, outstanding, and has produced, mostly since the Second World War, a vast œuvre of lithographic prints, chiefly in black and white, of great imaginative and technical variety.

1151, 1280, 2817.

**LITTLE MASTERS.** The English term is a misleading translation of the German *Klein-meister*. 'Masters in Little' sounds cumbersome but would describe more adequately a group of 16th-c. engravers who delicately worked plates of small dimensions, illustrating biblical, mythological, or GENRE scenes. Outstanding practitioners of work of this kind were the Nuremberg masters Hans Sebald BEHAM, his brother Bartel BEHAM, and Georg PENCZ, all of whom were strongly influenced by DÜRER. Albrecht ALT-DORFER, Heinrich ALDEGREVER, and Hans BRO-SAMER may be joined with the group on account of some of their work.

**LOCAL COLOURS.** See COLOUR.

**LOCHNER,** STEFAN (active 1442-51). German painter born at Meersburg on Lake Constance. He worked in Cologne from 1442 till his death and was the leading master of the

COLOGNE SCHOOL at this time. Like his contemporary Fra ANGELICO, he combined late GOTHIC traditionalism with an eye for the new REALISM and a feeling for pure colour. The 'modern' elements must have come to him from Flanders and Burgundy. His main work, the so-called *Dombild*, is an ALTARPIECE now in Cologne Cathedral (hence the name) but was originally painted for the Town Hall of that city. It was much admired by DÜRER, who notes in the diary of his journey to the Netherlands that he had to pay a tip to see it.

899.

**LOGGAN,** DAVID (1633-92). Topographical draughtsman and engraver, born in Danzig of Scottish descent and active in England. He is best known for his *Oxonia Illustrata*, 1675, and *Cantabrigia Illustrata*, 1688, topographical studies of the Universities, and for his small portrait drawings in plumbago (graphite on vellum). Of the best of the latter it is stated in *The Oxford History of English Art* that 'for all their modest size and unassuming patterns there are few more sensitive and appealing English portraits'.

**LOGGIA.** An external gallery with open ARCHES. Popular in Mediterranean architecture, *loggie* were adopted in the north in the first flush of RENAISSANCE enthusiasm in defiance of the climate, but most have since been glazed, as at Hatfield House. The Roman prototypes have also in many cases been enclosed to protect the paintings within them. RAPHAEL's works at the Farnesina, Villa Madama, and Vatican were originally open to the sky.

**LOMAZZO,** GIOVANNI PAOLO (1538-1600). Italian painter, a pupil of Gaudenzio FERRARI. At the age of 33 he went blind and took to writing on the theory of art. His two major works on art theory were *Trattato dell' Arte de la Pittura* (1584) and *Idea del Tempio della Pittura* (1590). He represents the outlook of the later MANNERISTS, which has been described by Sir Anthony Blunt as follows: 'Whereas for the writers of the Early and High RENAISSANCE nature was the source from which all beauty was ultimately derived, however much it might be transformed by the artist's imagination, for these Mannerists beauty was something which was directly infused into the mind of man from the mind of God, and existed there independent of any sense-impressions. The idea in the artist's mind was the source of all the beauty in the works which he created and his ability to give a picture of the outside world was of no importance, except in so far as it helped him to give visible expression to his idea.' The *Trattato* dealt comprehensively with all the problems which might conceivably confront an artist. It was divided into seven books, whose themes were PRO-PORTION, Motion, COLOUR, Light, PERSPECTIVE, Practice, and History. The last book contained a complete prescriptive guide to Christian and

classical ICONOGRAPHY. Throughout the book runs the assumption that the arts can be taught by detailed precepts. It was widely translated and used as a handbook until the 19th c. Lomazzo had a strong predilection for current ideas of Neo-Platonism and the *Idea* makes use of a complicated system of ASTROLOGICAL symbolism and the symbolism of numbers. His writings are nevertheless useful for incidental information about Milanese traditions.

1682.

**LOMBARD, LAMBERT** (1505–66). Flemish painter, draughtsman, engraver, architect and antiquarian. He was probably a pupil of GOSSAERT and was influenced by Jean SCOREL. He travelled through the Low Countries, Germany and probably France. He was in Rome *c.* 1537 and there became a convert to the RENAISSANCE aesthetic of the ANTIQUE. From 1532 he had as his patron the enlightened Erard de la Marck, bishop of Liège, where he was born. On his return from Italy he settled in Liège and founded a school. Among his many pupils and followers were Frans FLORIS and Hubert GOLTZIUS and Willem KEY. He had a very high reputation in his time. He corresponded with VASARI, providing him with information about Netherlandish artists and Vasari said of him: 'Of all the Flemish artists I have named none is superior to Lambert Lombard of Liège, a man well versed in letters, a painter of judgement, a learned architect and—by no means his least title to merit—the master of Frans Floris and Willem Key.' This opinion was confirmed by van MANDER, who wrote in 1604: 'Lombard was no less skilled as a teacher than learned in the arts of painting, architecture and perspective. One can confidently rank him among the best Netherlandish painters, past and present.'

Most if not all Lombard's paintings have been lost. A large number collected by the bishop Maximilien-Henri of Bavière were destroyed when his palace at Bonn was burnt in 1703. Other paintings mentioned by Canon Hamal in churches of Liège were already in a bad state of preservation at the end of the 18th c., and most of them have since disappeared or were destroyed in the French Revolution. There now exists no painting which can be attributed to him with certainty and his work is known from drawings, copies, and engravings. A *Portrait of the Artist* in the Musée de l'Art Wallon, Liège, has been thought to be his; but critics are divided whether to attribute it to Lombard or to Frans Floris.

In 1966 the Musée de l'Art Wallon, Liège, staged an exhibition *Lambert Lombard et son Temps* and the excellent catalogue published for the exhibition contains the best summary of what is known about Lombard, his work and his school.

**LOMBARD BANDS.** Architectural term for flat strips of PILASTER which were used to articulate an expanse of wall surface and often con-

**Fig. 29.** Exterior view of the east end of the church of S. Vincenzo in Prato, showing Lombard band decoration (*c.* 10th c.)

nected at the top by small ARCADES. They were one of the distinctive features of early ROMANESQUE architecture, found in north Italy, Germany, north Spain, and parts of France, and persisted in Germany until the 13th c.

**LOMBARDO.** Family of Italian sculptors and architects, three of whom, PIETRO (*c.* 1433–1515) and his sons TULLIO (d. 1532) and ANTONIO (d. 1516), were the leading Venetian sculptors of their day.

Pietro, although under some influence from the Florentine manner in his youth, exemplifies in his tomb of *Pietro Mocenigo* (SS. Giovanni e Paolo, Venice, finished 1481) the forceful modelling of northern Italy. He was an artist of considerable originality and fine craftsmanship and although he made the usual use of workshop assistants, including his sons, he was mainly responsible for the church of Sta Maria dei Miracoli (1481–9), which in architecture and sculpture has been called the choicest jewel of RENAISSANCE work in Venice.

Tullio was, like his father, a master of technique. His quite superficial Classicism lay rather in the fashionable folds of the drapery than in the structural composition of his figures. The monotony of this formula is obvious in the somewhat jejune relief of the *Coronation of the Virgin* (S. Crisostome, Venice). More successful was the earlier *Vendramin* tomb (mostly now in SS. Giovanni e Paolo), while the beautiful *Guidarello Guidarelli* (Ravenna, finished 1525) shows the heights to which he could sometimes rise.

Antonio's style, as seen in the *Madonna della Scarpa* (Zen Chapel, S. Marco) and his relief for the Santo, Padua, is barely distinguishable from his brother's, though some critics consider it less rigid and more humane.

**LOMBARD ROMANESQUE IN THE U.S.A.** A round-arched style, generally executed in brick, which was popular in America between *c.* 1846 and *c.* 1870. It is characterized by the CAMPANILE tower, the CORBEL table, and the wall ARCADE. There are two principal sources of the style, the *Rundbogenstil* of Germany, an early 19th-c. revival of the German ROMANESQUE, and the contemporary English adaptation of the north Italian Romanesque. In American architectural literature of the mid century it was referred to loosely as the 'round-ARCH', 'NORMAN', or 'Lombard' style. The earliest important building designed in this mode was RENWICK's Smithsonian Institute in Washington (1846). This thoroughly ROMANTIC building was acclaimed in its day not only for its picturesqueness but also because of the economy of its construction and the highly functional nature of its plan. It inspired Robert Dale Owen, son of the English social reformer, to write his *Hints on Public Architecture* (1849), which did much to popularize the round-arched style. Owen contrasts the Romanesque with the GOTHIC, stressing its ease and economy of construction and simplicity of ornamental detail. For the same reasons the Congregational Church, in its *Plans for Churches* (1853), recommended the Lombard Romanesque as the most desirable style for new churches.

**LOMI.** See GENTILESCHI.

**LONDON, NATIONAL GALLERY.** See NATIONAL GALLERY, LONDON.

**LONDON GROUP.** An exhibiting society of English artists formed in 1913 by an amalgamation of the CAMDEN TOWN GROUP with several smaller groups together with various artists who had shown in the Allied Artists' Exhibitions organized by Frank Rutter in the Albert Hall from 1908. Among the members were NEVINSON, WADSWORTH, John and Paul NASH, and the sculptors GILL and EPSTEIN. Roger FRY became a member in 1918 and brought with him a number of his followers. The first President was Harold GILMAN, a member of SICKERT's circle. The group held its first exhibition at Brighton in 1913 and its first London exhibition in the Goupil Gallery in 1914. There was no selection and the hanging committee was chosen by rote. The strong interest of the early members in POST-IMPRESSIONISM was deprecated by TONKS, who said: 'The leaders of the London Group have nearly all come from me. What an unholy brood I have raised.' Thus began an opposition between 'advanced' art and the semi-academicism of the Slade. Unlike most other associations the London Group survived opposition, was revived after the Second World War, and came to be looked on as something of an institution. But with the dignity of an institution it lost its early sense of mission and by 1950 it would not

have been easy to say what were the artistic principles for which it stood.

**LONGHENA, BALDASSARE** (1598–1682). The chief architect of Venetian BAROQUE, a pupil of SCAMOZZI whose Procuratie Nuove he completed. He built many Venetian churches and palaces, but is best known for his Sta Maria della Salute, begun in 1631 and consecrated in 1687. The design of the Salute is based on an octagonal central plan with an added choir which has its own dome subordinated to the great dome of the octagon. The latter is supported by huge VOLUTES surmounted by statues. The plan of the choir, with turrets at either side, derives from PALLADIO's Redentore, but the whole has a richness of effect, picturesque and slightly oriental, which makes it essentially Venetian as well as Baroque.

Longhena's principal palaces are Ca' Rezzonico (now a museum: the third floor is later) and Ca' Pesaro, both of which depend on SANSOVINO's Palazzo Corner. His many other works include the Scuola dei Carmini, the grand staircase of S. Giorgio Maggiore, and Chioggia Cathedral.

**LONGHI** (family of architects). See LUNGHI.

**LONGHI, PIETRO,** properly PIETRO FALCA (1702–85). Son of a Venetian silversmith, he turned to painting and studied for a time under G. M. CRESPI at Bologna. From 1734 onwards he remained in Venice, and although he carried out some FRESCO commissions he is known principally as a painter of small GENRE scenes of contemporary patrician and low life. These charming and often gently satirical scenes were very popular, although surprisingly he does not seem to have been patronized by English visitors to Venice. In 1763 he became director of a private academy of painting founded by the Pisani family of Venice, and in 1766 a member of the Venetian Academy. Longhi occasionally painted more than one version of his own compositions, and these again were often duplicated by pupils and followers.

ALLESANDRO LONGHI (1733–1813), the son of Pietro, specialized in portraiture, which he studied under Giuseppe Nogari (1699–1793). His portraits show that he inherited his father's sense of irony. The Pisani family were his patrons, and he was the official portrait painter to the Venetian Academy, so that he was in a good position for compiling his *Compendio delle Vite de' Pittori Veneziani Istorici* (1762) with portraits etched by himself.

1883.

**LOOS, ADOLF** (1870–1933). Austrian architect, one of the acknowledged pioneers of MODERN ARCHITECTURE at the turn of the century. In the U.S.A. from 1893 to 1896 he imbibed the doctrines of SULLIVAN and the early

CHICAGO SCHOOL and on his return attacked ART NOUVEAU decoration and the Vienna SEZES-SION, opposing to their aestheticizing tendencies an extreme form of doctrinaire FUNCTIONALISM deriving from Sullivan and Otto WAGNER. He based his rejection of ornament on the view that the *art nouveau* ornamental style is symbolic of a decadent culture and beauty free from orna-ment symbolizes lucid thought and a high level of civilization. His Steiner House in Vienna (1910) was one of the first private houses in con-crete and anticipated LE CORBUSIER and others in its purity of design and its articulation of internal space. His work during the first decade of the 20th c. made little local impact, but GROPIUS, who lived for a time in Vienna immediately after the First World War, acknowledged his influence.

Loos was in charge of municipal housing in Vienna 1920-2. From 1923 to 1938 he lived in Paris, associated with the DADAISTS, and built a house for Tristan Tzara (1926). One of his best works after his return to Vienna in 1928 was his Muller house at Prague.

1897.

**LOPES**, GREGÓRIO (*c.* 1490-1551). Court painter to Manuel I and John III of Portugal. Between 1536 and 1539 he executed several altar paintings for the Convent of Christ, Tomar. No other painter conveys a better idea of the sump-tuousness of Portuguese life in the 16th c.

**LÓPEZ Y PORTAÑA**, VICENTE (1772-1850). Spanish painter. An accomplished por-traitist, he was influenced by MENGS, whose style he projected into the 19th c. In 1815 he became first court painter to Ferdinand VII (who pre-ferred him to GOYA), in 1817 director of the Academia of San Fernando, and in 1823 director of the PRADO.

**LORENZETTI** or LAURATI, PIETRO (active 1320-48) and AMBROGIO (active 1319-48). Italian painters, brothers, who worked in the Sienese tradition as modified by DUCCIO, taking further the NATURALISTIC trend towards figural solidity and emotionally expressive form. Study of their development is difficult because the chronology of their early works is con-troversial; all their securely dated pictures are from the last three decades of their careers. Pietro's first dated work is the ALTARPIECE of 1320 in the Pieve at Arezzo. It is already a mature work. The Madonna and Child both in their posture and in their statuesque form be-speak kinship with the contemporary sculpture of Giovanni PISANO, and the Annunciation group shows an already sophisticated understanding of PERSPECTIVE. Panels in Cortona Cathedral and the Uffizi are attributed to Pietro on stylistic grounds. They must be earlier than the Arezzo altarpiece, for they recall older renderings of the *Maestà* by Duccio and his school. These panels show a closer relationship with the early SIENESE

SCHOOL than do any works by Ambrogio, and for this reason it is suggested that Pietro was the elder brother. Probably somewhat later are Pietro's frescoes of the *Crucifixion* in Siena (S. Francesco) and the *Deposition* at Assisi (Lower Church of S. Francesco). In these pictures the compact grouping and the strong expressions of emotion pervading the whole figure are GIOTTESQUE.

Ambrogio's earliest dated work, inscribed '1319', is the *Madonna and Child* at Vico l'Abate, a village then in Florentine territory. He also worked in Florence itself. There are records of debts there in 1321 and of his membership of the painters' guild in 1324. Compared with his brother's work Ambrogio's is less solemn, the figures are fuller, and they move with greater ease. The colours tend to be warmer and the textures softer. His REALISM broke new ground in the painting of scenery: the view of Siena in the allegory of *Good and Bad Government* (Town Hall, Siena) is the first great landscape in Italian painting. The famous figure of Peace in that picture suggests that Ambrogio was a student of classical sculpture, but at the same time he was an acute observer of his fellow men, as witness the talkative crowds of the Siena frescoes (S. Francesco and Town Hall) and his *Virgins*, fond mothers who kiss their fat-cheeked Infants or hold them close (Pinacoteca, Siena; Town Hall, Massa Marittima).

Apart from collaborating in a cycle of the *Life of Mary*, now lost, which they painted in fresco on the façade of Siena's public hospital in 1335, the brothers worked independently. But the style of their pictures from about this time onwards became more alike. Pietro's *Birth of the Virgin* (Cathedral Mus., Siena) and Ambrogio's *Presentation in the Temple* (Uffizi), both painted in 1342, show a similar absorption in naturalistic description and perspective which anticipated developments in FLORENTINE paint-ing by a hundred years. After 1347, neither brother is mentioned as alive, and it is presumed they were victims of the plague of 1348.

739, 2330, 2489.

**LORENZO MONACO** (active 1388-1422). Italian painter who, though born in Siena, seems to have spent all his professional life in Florence. As a monk of the Camaldolese monastery of Sta Maria degli Angeli renowned for its MINIATURE painters, Lorenzo illustrated several manu-scripts which survive in the Laurentian Library, Florence. He also painted many ALTARPIECES for his Order, among them two versions of the *Coronation of the Virgin* (Uffizi, 1414, and N.G., London, *c.* 1415). His best known murals are the scenes of the *Life of Mary* in the Bartolini chapel of Sta Trinità, Florence.

Even in panels and frescoes Lorenzo's style is basically that of the miniaturist, although in his treatment of light and picture-space he went beyond the limits of miniature art. He chose luminous reds, blues, and gold and his swing-

ing, rhythmical line is all-pervasive and a decoration in itself. He copied some of SIMONE MARTINI's compositions (e.g. *Annunciation*, Accademia, Florence) and began a polyptych of the *Deposition* which Fra ANGELICO finished (S. Marco Mus., Florence). The association of these two painters with Lorenzo is significant, for they all belong to that strain of elegant fantasy in Tuscany to which MASOLINO and BOTTICELLI also contributed.

1081.

**L'ORME,** PHILIBERT DE. See DELORME.

**LORRAIN,** CLAUDE LE. See CLAUDE.

**LOTTO,** LORENZO (*c.* 1480–after 1556). Italian painter. Although he was a contemporary of GIORGIONE and TITIAN and, according to VASARI and RIDOLFI, trained with them in the studio of Giovanni BELLINI, Lotto's work remains fairly distinct. In spite of similarities to Bellini in the colouring and landscape of the early works (*Madonna with St. Peter Martyr*, Naples, 1503, and *St. Jerome*, Louvre, 1506), the predominant influences in the development of his mature style were Alvise VIVARINI and CATENA. From *c.* 1508 to 1512 Lotto was in Rome, although no trace of his work there remains, and after this period his painting had a new lightness with echoes of RAPHAEL and feathery trees like PERUGINO's.

After leaving Rome Lotto spent much of his time in Venice and neighbouring towns painting works which at their best combine the richness of the VENETIAN tradition with a northern, Romantic sentiment. His penetrating portraits, while deriving from Titian, have a new warmth and directness, as in the fine declamatory portrait *Man on a Terrace* (Cleveland). His work was very uneven but his achievement at his best has received recognition in the 20th c.

247.

**LOTUS AND PALMETTE.** Architectural ornament of the classical ANTHEMION pattern, formed by a stylized version of the Egyptian lotus alternating with the palmette, which is a descendant of the Mesopotamian 'sacred tree'. (See Ill. 206.)

**LOUIS XV STYLE.** Term used for the high period of French ROCOCO style, primarily in the minor and decorative arts. In interiors PILASTERS and CORNICES gave place to a free merging of wall and ceiling in curvilinear scrolled motifs of plaster or wood. Rooms were made smaller and adapted to their function; walls were divided into panels and were set with mirrors, leaving no space for the large canvases or murals of the previous century. Sinuous and sensuous forms, ROCAILLE with plant and floral designs mixed with shells, garlands, tendrils, and sprays in wildly imaginative but refined and playful confusion, became the fashion. Such

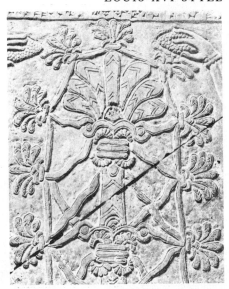

206. Sacred tree. Detail of Assyrian stone slab from walls of the Palace at Nimrud, built by Ashur-nasirpal II. (B.M., *c.* 884 B.C.)

decorators as Nicolas PINEAU and Juste Aurèle MEISSONIER set the tone in ornamentation and Meissonier's fertile invention created new forms of ARABESQUE and fantasy which were used for gold- and silver-work and household furniture as well as for interiors. Chinese motifs became popular (see CHINOISERIE) and ormolu came into vogue. In furniture twisted and irregular designs took the place of the more sombre splendour of Boulle and a more fanciful type of ornament prevailed in place of the nobler style of LE PAUTRE. The most celebrated cabinet-makers of this period were Jean-François Oeben (d. 1763), Charles Cressent (1685–1768), and Robert Gaudraux (d. 1751). Among the best examples of the Louis XV Rococo are the rooms which were designed by the architect Gabriel-Germain BOFFRAND for the Hôtel Soubise, Paris (1738–9). BOUCHER's picture *Le Déjeuner* (Louvre) depicts a typical scene of middle-class comfort in a pretty Louis XV setting.

2745.

**LOUIS XVI STYLE.** Term used for the final phase of French ROCOCO, prevailing from *c.* 1760 to the Revolution. It coincided with a reaction against the frivolity of LOUIS XV STYLE and the return of a new Classicism based on a revived interest in the ANTIQUE (see NEO-CLASSICISM). ROCAILLE went out of fashion, straight lines replaced curves, and decorative schemes were designed in rectilinear panels enclosing ornament with classical motifs. The prevailing colour scheme was white and gold. In architecture orders of colossal columns (see ORDERS OF ARCHITECTURE) became the dominant feature

(Church of Ste-Geneviève, Paris; now the Panthéon), but soon gave way to a preference for the true Doric as revealed at Paestum, where the shaft of the column rests directly on the ground without a base. For churches the early Christian BASILICAS were taken as models (S.-Philippe-du-Roule by Jean François Thérèse Chalgrin (1739–1811) and the Capuchin convent, Paris, by Brogniart). In the decoration of houses the architectural draughtsman C.-L. Clérisseau (b. 1722) introduced the Etruscan or Pompeian manner, already popular in England. In furniture design also there was an added restraint and severity with a preference for classical motifs:

*rais-de-cœur*, OVOLOS, FLUTING, ACANTHUS, palmettes, etc. Furniture was made more rich by the use of exotic woods and coloured lacquer, and porcelain plaques were added to marquetry and ormolu. The chief furniture designer to the court was Georges Jacob (1739–1814). Typical examples of the style are the rooms created for Marie-Antoinette at FONTAINEBLEAU and VERSAILLES.

**LOUTHERBOURG,** DE. See DE LOUTHER-BOURG.

**LOUVRE,** PARIS. The national museum and art gallery of France, an epitome of the nation's

**207.** The Louvre. Detail of miniature from the *Très Riches Heures du duc de Berry* illuminated by the brothers Limburg. (Musée Condé, Chantilly, 1411–16)

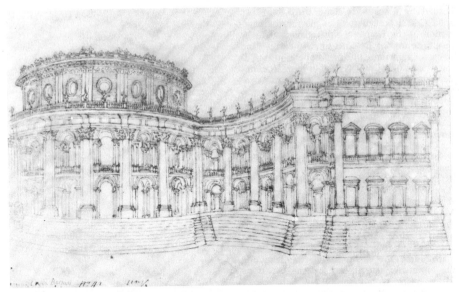

**208.** Design for the Louvre façade. Pen-and-ink drawing by Bernini. (Sir A. Blunt Coll., 1664)

history and culture. The first building on the site, begun by Philip Augustus *c.* 1190 as a fortress and arsenal, held the royal treasures of jewels, armour, illuminated manuscripts, etc. It became a royal residence *c.* 1400, and was enlarged and beautified by Charles V who laid the foundations of the library which is the nucleus of the Bibliothèque nationale. It was plundered by the British troops after Agincourt. Francis I demolished the old Louvre and built in its place a palace splendid for its day and an inspiration to future aspiration. He also set the pattern for royal collecting and patronage which persisted until the Revolution, associating the arts with the glorification of the throne in the manner of the Italian princes of the RENAISSANCE and luring to his service the most prominent artists of his day (LEONARDO, ANDREA DEL SARTO, PRIMATICCIO, CELLINI). His own acquisitions (which included the *Mona Lisa* of Leonardo and RAPHAEL's *Belle Jardinière* among the earliest items) began the royal collections which formed the nucleus of the Louvre as a national collection.

In 1546 LESCOT was commissioned to build a new palace of four wings around a square court, roughly of the same size as the old castle and on the same site. Only the west and half the south wings were completed by Lescot. But the Petite Galerie was begun, extending southwards from the south-west corner of the intended square, and in 1564 DELORME began the Tuileries for Catherine de Médicis to the west of the Louvre, completing the centre pavilion and the adjoining blocks. BULLANT continued the building southwards, slightly changing the elevation, until work ceased in 1572. The idea of linking the Tuileries

to the Louvre by galleries probably originated with Catherine, but the Grande Galerie along the Seine was not begun till the reign of Henry IV when the Petite Galerie also was completed and the southern arm of the Tuileries with the Pavillon de Flore was finished by Jacques II DUCERCEAU. Already in Lescot's time it had been decided to quadruple the size of the square court of the Louvre and in 1624 LEMERCIER began to extend Lescot's west wing northwards, building the Pavillon de l'Horloge and then repeating Lescot's elevation. In 1641 the decoration of the Grande Galerie was undertaken by POUSSIN and assistants.

Under Louis XIV COLBERT increased the royal collection from some 200 pictures to over 2,000. In 1661 he acquired the greater part of the collections of Cardinal Mazarin, at that time considered the most magnificent in France; in 1671 he obtained the collections of the banker Jabach (the drawings from which form the backbone of the Louvre's department of drawings); and in 1667 he bought for the crown the enormous collection of prints of Michel de Marolles. In support of the policy for state control of the arts and taste some of the king's pictures were opened to public view in the Louvre from 1681 and the exhibitions of the new Académie were held there from 1673.

After 1652, when the court moved into the Louvre, internal alterations were carried out first by Lemercier and then by his successor LE VAU; the latter also continued the construction of the main court (north and south wings) and rebuilt the Petite Galerie after the fire of 1661, the first floor of which was then decorated by a team of painters and sculptors

headed by LEBRUN (Galerie d'Apollon). In 1664 Colbert called for designs for the completion of the Louvre. Not satisfied with the result, he invited BERNINI to send designs and to come in person. The first stone of his building was laid by Louis XIV, but after Bernini's departure the work stopped, a committee consisting of Le Vau, Le Brun, and PERRAULT was appointed, and, in 1668, the east front was begun to their noble design. In 1678, however, the court moved to Versailles and relinquished the Louvre. Under Louis XVI the conversion of the Grande Galerie into a museum was begun.

As a result of the democratic fervour incidental to the Revolution the Louvre was opened as the first national public gallery in 1793 (though as a public gallery it was preceded by the ASHMOLEAN, the VATICAN, and the Charleston Museum). Napoleon exhibited in the Louvre the art works which he had gathered from conquered territories, most of which were restored after his fall from power though the antique marbles from the BORGHESE collection including the NIKE OF SAMOTHRACE and the VENUS OF MILO remain.

In 1806 PERCIER AND FONTAINE began a gallery connecting the northern extremity of the Tuileries (built by Le Vau to balance the southern arm); this was completed by Visconti and Lefuel under Napoleon III.

Conceived as a comprehensive collection of European art the Louvre was reopened by Napoleon III in 1851 with the addition of the Medici cycle from the Luxembourg. The inauguration in 1818 of the Luxembourg Palace as a museum of contemporary French art made possible the practice of transferring accepted masterpieces to the Louvre in course of time. One of the events most symptomatic of late 19th-c. confusion of taste was the refusal to admit the Caillebotte Bequest of French IMPRESSIONISTS (1894) until 1929. To relieve congestion after the Second World War a special museum for Impressionist art was formed at the Jeu de Paumes in the gardens of the Tuileries.

**LUCAS VAN LEYDEN** (1494-1533). Dutch painter of portraits and religious subjects, also active as a glass painter and maker of engravings and WOODCUTS. He was the pupil of his father and of Cornelis ENGELBRECHTSEN, but both these were painters whereas Lucas van Leyden was an outstanding GRAPHIC artist. Where he learnt engraving is unknown, yet he was highly skilled in that art at a very early age. In 1514 he entered the Painters' Guild at Leiden. He seems to have travelled a certain amount, and visits are recorded to Antwerp in 1521, the year of DÜRER's Netherlandish journey, and to Middelburg in 1527, when he met GOSSAERT.

An unbroken series of dated engravings makes it possible to follow his career as a print-maker and to date many of his paintings, but no clear

**209.** Self-Portrait. Engraving (1525) by Lucas van Leyden

pattern of stylistic development emerges. The engraving of *Mohammed and the Monk* is dated 1508, and reveals Lucas as a mature and accomplished artist at the early age of 15. Technically the engraving is a masterpiece and he has approached the problems of space and foreshortening, of figure groups and landscapes, with an assured ease. The large engraving of *Ecce Homo* (1510) shows a similar grasp of the problems presented by an architectural setting. A variety of buildings, handled with accurate perspective, form an imposing backcloth to the scene enacted before them. Lucas was a prolific draughtsman, yet it is remarkable that he never again paid such attention to space and depth. He tended to concentrate on the anecdotal features of the narrative and to take pleasure in CARICATURES and GENRE motifs. The engraving of *The Adoration of the Magi*, for example, is filled with unusual, slightly satirical heads. This interest in genre distinguishes him very clearly from Dürer. Lucas must have been acutely aware of the German master's prowess in the graphic arts and clearly he used his models for engravings such as the *Passion Series*, but he never attained Dürer's single-mindedness of approach.

In his paintings the genre subjects of the *Chess Players* (Berlin) and the *Card Players* (Wilton House) are paralleled by works of MASSYS and MARINUS VAN REYMERSWAELE and are early examples of a great Netherlandish tradition.

The best example of Lucas's religious painting is the large triptych of the *Last Judgement* (Municipal Mus., Leiden, 1526). It shows some Italian influence derived from his visit to Antwerp and is a RENAISSANCE design filled with nude bodies in movement. Yet the whole is

unified by a brilliant light that creates a vast area of space. The wings showing SS. Peter and Paul are very powerful with the full length figures of the Apostles draped in brilliant colours and set against a landscape of strongly contrasting hues.

Lucas died when he was still a comparatively young man and left no pupils or followers to carry on his style. Contemporary critics and art historians throughout the ages generally regard him as the principal figure in Holland in the 16th c. VASARI even rated him above Dürer and it is perhaps fitting that the man who came nearest to understanding his work was another Leiden-born artist, REMBRANDT.

926.

**LUCCHESINO,** IL. See TESTA, P.

**LUCIAN OF SAMOSATA** (2nd c. A.D.). Greek satirist and rhetorician, who lampooned the empty virtuosity and exhibitionism of his day. His comments on art were sometimes perceptive and his works contain several descriptions of GREEK paintings which are now lost, though as usual in his time these accounts were mainly devoted to subject matter, the 'story' of the picture, with appreciation in terms of illusionistic verisimilitude. His description of *Calumny* by APELLES inspired BOTTICELLI.

**LUDOVICE,** JOÃO FREDERICO (J. F. LUDWIG) (1670-1752). Portuguese architect of German origin. He was trained as a goldsmith, perhaps studied architecture in Rome, and emigrated to Portugal *c.* 1701. John V appointed him architect of the combined palace and monastery of Mafra near Lisbon (begun 1717, dedicated 1730, finished 1770), and in 1750 he was made 'Grand Architect' of Portugal. He also built the apse of the cathedral at Évora (1716-29) and designed (1716) the University Library at Coimbra.

**LUDOVISI THRONE** (so called because of its connection with the Ludovisi family). A deep marble fender, perhaps from the end of a large altar, probably south Italian Greek work of *c.* 460 B.C. (Terme, Rome). A counterpart is in Boston. The Boston 'throne' shows a winged youth weighing souls in scales between their seated mothers, one jubilant and one mourning fate; on the sides are, seated, a naked youth playing the lyre and a wrinkled old woman. The Ludovisi 'throne' has two women helping an emerging goddess; on the sides sit a draped woman with incense and a naked woman playing the double flute. These enigmatic and unequal sculptures are often, but unconvincingly, denounced as forgeries.

**LUINI,** BERNARDINO (*c.* 1485-1532). Italian painter whose slight, naïve, and sentimentalized version of LEONARDO's style ensured him great popularity with the Victorians, notably RUSKIN. There are many examples of his work in Milan

(Brera) and in the churches and monasteries of Lombardy. The National Gallery at Washington possesses his fresco cycle *Cephalus and Procris* from the Casa Rabia (*c.* 1520).

1986, 2895.

**LUKASBRÜDER** or LUKASBUND. See NAZARENES.

**LUKS,** GEORGE (1867-1933). American painter, member of the EIGHT and of the 'Ashcan School' of social REALISM. He was a flamboyant character who identified himself with the poorer classes and made a pose of Bohemianism, delighting to shock the conventional. His work was uneven. It had vigour and spontaneity but too often lacked anything else than an ebullient superficial vitality. Examples of his work are *The Spielers* (Addison Gal., Andover, Mass., 1905) and *The Wrestlers* (Mus. of Fine Arts, Boston). In some of his work he reveals an affinity for the bravura technique of Frans HALS.

**LUMINOSITY.** See BODY; COLOUR.

**LUNDSTRØM,** VILHELM (1893-1950). Danish painter who in 1918 provoked much discussion by COLLAGES in the manner of PICASSO and ARCHIPENKO. His later work consisted of CUBIST STILL LIFES and large abstract figure compositions. His role in Denmark is comparable to that of LÉGER in France.

**LUNGHI** or LONGHI. Family of Italian architects who worked in Rome. MARTINO the Elder (born near Milan, d. 1591) was in Rome from 1573, and was papal architect from 1575. He worked on MICHELANGELO's Capitol scheme, adding the tower of the Senate, and built the churches of S. Girolamo degli Schiavoni (1588-90), the Chiesa Nuova (1575-1605), parts of Sta Maria della Consolazione and others in a late MANNERIST style dependent on VIGNOLA and Giacomo della PORTA. He also finished the Palazzo Altemps, built part of the Borghese Palace, and collaborated with PONZIO and Domenico FONTANA on the Villa Mondragone, Frascati. ONOFRIO (*c.* 1569-1619), son of the foregoing, began S. Carlo al Corso, Rome, in 1612. It was continued (1619-27) by his son MARTINO the Younger (1602-57), who also built the façade of SS. Vincenzo ed Anastasio (1650) in a High BAROQUE style. The three generations thus represent the full transition from Mannerism to Baroque in Rome.

**LUSTRE.** See COLOUR.

**LUSTRE POTTERY.** The technique of painting in metallic lustre pigments is one of the most characteristic innovations of Islamic POTTERY (see ISLAMIC ART). It involved the application of silver or copper oxides to the already glazed and fired vessel, and a further low-temperature firing

under conditions which precipitated a shiny metal deposit. In late medieval and RENAISSANCE times lustre painting became a prominent feature of both HISPANO-MORESQUE pottery and Italian MAIOLICA; and it enjoyed a further revival among English potters during the 19th c., when silver and pink lustres (employing platinum and gold) were introduced.

938.

**LUTERI**, GIOVANNI. See DOSSI.

**LUTTICHUYS**, SIMON (1610–61) and ISAAK (1616–73). Brothers, Dutch painters, born in London. They emigrated to Amsterdam, where they worked as STILL LIFE and portrait painters. Simon's still lifes have affinities with those of de HEEM.

**LUTYENS**, SIR EDWIN LANDSEER (1869–1944). The foremost English architect during the first three decades of the 20th c. and the last of those eclectic architects, employing reminiscences of past styles, who had flourished throughout the preceding hundred years. Lutyens made his reputation as a designer of country houses for wealthy clients, to whom economy and practicality were less important than character and charm. He was thus able to exploit the fertility of ideas, the sympathetic handling of traditional materials, and the ingenious adaptation of all kinds of period detail which were his outstanding qualities.

His houses owed much to Norman SHAW's but had a sophistication of their own which sometimes betrayed him into oddity and whimsicality. His first houses, built in Surrey, were in a romantic red-brick style; subsequently he used many other styles, but his later houses became more formal with PALLADIAN and early GEORGIAN features.

After c. 1910 his immense practice included churches and other buildings at Hampstead Garden Suburb, a huge NEO-CLASSICAL office-block, Britannic House, Finsbury (1920–8), the British Embassy, Washington (1926), flats in Westminster (1928) with façades covered with a chequer-board pattern, and war-memorials, including the Cenotaph, Whitehall (1922). The

most important of all his works, however, is the imperial capital of India at New Delhi (1915–30). Lutyens played a large part in determining the layout, as well as designing the main building, the Viceregal Palace (now the President's house) and other structures. This was a truly monumental work, a masterly blending of Oriental motifs (such as Mogul DOMES and a type of flat eastern CORNICE suited to the glaring light) into a western RENAISSANCE conception. The layout is marred by an unfortunate error in the levels, which resulted in the view of the Viceregal dome, the climax of the plan, being cut in half by a rise in the ground in the middle of the main approach.

Lutyens's lifelong interest in the application of mathematical rules of proportion to architecture appears especially in his last important design, that for the Roman Catholic cathedral at Liverpool.

462, 1393.

**LYSIPPUS.** Celebrated Greek sculptor of Sicyon, active in the middle and later 4th c. B.C. He was prolific of bronze athletes and became official portraitist to Alexander the Great. A marble statue of Agias, found at Delphi, appears to be a contemporary replica of a lost *Agias* at Pharsalus which Lysippus signed. The figure, lean and small-headed, is conventional and dull, so that some archaeologists piously relegate it to Lysippus's assistants. A copy of an *Apoxyomenos* (an athlete cleaning himself) is attributed reasonably to his maturity. The pose is novel. The Apoxyomenos is shifting his weight from one foot to the other and stretching an arm out into the foreground; so the statue occupies more depth than its predecessors and provides a variety of good views. According to a tradition current in antiquity Lysippus introduced a new scheme of proportions for the human body to supersede that of Polycrates.

**LYSISTRATUS.** Greek sculptor of the later 4th c. B.C., brother of LYSIPPUS. PLINY says he introduced the technique of taking casts from statues and making life masks (see DEATH MASKS AND LIFE MASKS), although there is no independent evidence that the practice originated at this time.

# M

**MABUSE.** See GOSSAERT.

**MACABRE.** The word '*macabre*' was first used as an ordinary adjective by French Romantic writers in the 19th c. and was applied by them to anything both lugubrious and grotesque. Its original application was to the *Danse macabre* (see DANCE OF DEATH) and the use of *macabre* or *macabré* in popular slang to mean 'corpse' probably derived from *danse macabre*. The earliest example of the word in this sense, quoted by Gaston Paris, is from a poem *Le Respit de mort* by Jean Lefèvre in 1376. The word was adopted into English, Dutch, German, Italian, Spanish, and Portuguese.

The etymology of the word is obscure and various theories have been propounded linked with attempts to trace the origins of the Dance of Death or *Danse macabre*. In the 14th and 15th centuries Macabré was a French surname and Gaston Paris assumed it was the name of the painter of the *Danse macabre* of the Holy Innocents, Paris. John Lydgate assumed that it was the name of the poet who wrote the verses. But there is no evidence to support either assumption. The Paris librarian J.-B.-B. van Praet was the first to suggest, in 1822, a theory which had some popularity among scholars that the word derived from the Arabic *maqbara*, a graveyard, connecting the *danse macabre* with a class of popular graveyard dances which he supposed to derive from traditional Arabic funeral rites. In 1948 Robert Eisler proposed to derive 'macabre' from the Hebrew and Yiddish word *meqaber*, grave-digger, with the corollary that the *danse macabre* derived from a burlesque funerary pantomime of Jewish and Syrian grave-diggers. None of these derivations can be regarded as convincing and the origin of the word and the Dance remain in doubt.

As a term in modern art criticism 'macabre' has lost its association with the Dance of Death and indicates anything lugubrious or gruesome with a relevance to reminders of mortality in its more repellent aspects.

559, 1541.

**MACCOLL,** DUGALD SUTHERLAND (1859-1948). Painter and critic born in Glasgow. He studied under Frederick Brown (1851-1941), became a member of the NEW ENGLISH ART CLUB, and was art critic of the *Spectator* (1890-6), the *Saturday Review* (1896-1906 and again 1921-30), and of the *Weekend Review*. He was keeper of the TATE GALLERY (1906-11) and of the WALLACE COLLECTION (1911-24). He was an influential fighting critic and made a notable though unsuccessful stand against the London County Council for the preservation of John Rennie's (1761-1821) Waterloo Bridge. His books include *Nineteenth Century Art* (1902), one of the first true assessments of French IMPRESSIONIST painting, *Confessions of a Keeper* (1931), and *Philip Wilson Steer* (1945).

**MCCUBBIN,** FREDERICK (1855-1917). Australian painter who worked with Tom ROBERTS at Box Hill (see HEIDELBERG SCHOOL). His *Lost Child* (N.G., Melbourne, 1886) is the first of the 'bush' subjects of the Heidelberg School. The melancholy mood and strong vein of national sentiment in his GENRE painting recall the stories of Australian writers such as Marcus Clarke and Henry Lawson. After 1904 he developed a freer and lighter touch, stimulated by the late work of TURNER.

**MACDONALD,** JAMES EDWARD HERVEY (1873-1932). Canadian LANDSCAPE painter and member of the Group of SEVEN. Born in Durham (England) of a New England and Canadian family, he came to Canada in childhood and went to art schools in Hamilton and Toronto. While working in London (1904-5) he was influenced to some extent by paintings of the BARBIZON SCHOOL which he saw there, but his early work remained an unaffected and straightforward rendering of the southern Ontario landscape in the spirit of Thoreau whose writings he admired. Later, with the Group of Seven, he painted in the Georgian Bay and Algoma districts of Ontario, and in Nova Scotia and the Rocky Mountains.

**MCEVOY,** ARTHUR AMBROSE (1878-1927). English painter. He was encouraged by WHISTLER to enter the Slade School, and began by painting LANDSCAPES and interiors with figures, in low tones. From about 1915 he gained success as a portrait painter, mainly of women and often in WATER-COLOUR. He was an admirer of GAINSBOROUGH and he was judged by R. H. Wilenski to have brought back into English portrait painting Gainsborough's ROMANTIC air of refinement, even surpassing Gainsborough in his ability to suggest gracefulness of attitude.

**MACHADO DE CASTRO,** JOAQUIM (1731-1822). Portuguese sculptor. He worked for the Italian Alexandro Giusti (1715-99) at Mafra from 1756 to 1770. His masterpiece, the

bronze equestrian statue of Joseph I at Lisbon, was completed in 1774.

**MACHUCA,** PEDRO (d. 1550). Architect and painter, the first great master in Spain to break entirely with the medieval tradition and show a full understanding of the Italian cinquecento. His panel, the *Madonna del suffragio* (Prado), signed and dated 1517, was evidently executed in Italy, and recalls something of the manner of the early CORREGGIO. Machuca was back in Spain by 1520, when he undertook the colouring of a carved reredos in Jaén Cathedral. He settled at Granada and received a number of commissions for ALTARPIECE paintings between 1521 and 1549. Some of these have survived and are completely Italianate in style. Machuca is, however, most famous as an architect. He designed the palace of Charles V in the grounds of the ALHAMBRA, projected during the emperor's visit to Granada in 1526 and begun by 1531 but never completed. The approximately square plan enclosing a circular courtyard suggests the influence of PERUZZI. The impressive and richly decorated exterior is reminiscent of Italian MANNERISM and is comparable with the work of Matteo Sanmicheli (1480–1529).

1086.

**MCINTIRE,** SAMUEL (1757–1811). Woodcarver and architect of Salem, Massachusetts, outstanding among the many craftsmen-carpenters of New England during the early years of the American Republic. Coming from a family of woodworkers, he combined natural taste with superb craftsmanship and created for the wealthy merchants of Salem some of the most exquisite interiors of the FEDERAL period. The Gardner-White-Pingree House (Salem, 1804–5) exemplifies his work at its best.

1496, 1542.

**MACIP.** The name of a family of Spanish painters representative of the 16th-c. Italianate style in Valencia. VICENTE (d. *c.* 1550) was responsible for the main ALTARPIECE of Segorbe Cathedral (completed 1535). His style was influenced by YÁÑEZ and Llanos, but he also retained some elements from the Flemish tradition of earlier Valencian painting. During his later years he collaborated with his son and follower JUAN VICENTE, better known as JUAN DE JUANES (*c.* 1523–79). Juan's work, for example his *Assumption of the Virgin* (Provincial Mus., Valencia), suggests a direct acquaintance with the paintings of RAPHAEL and his school. He was the leading painter of his time in Valencia and had many followers. There are several of his works in the Prado, including an altarpiece series of the life of St. Stephen.

**MACKE,** AUGUST (1887–1914). German painter and one of the most gifted members of the BLAUE REITER. He studied under CORINTH

and as a student visited Paris (1907 and 1908). In 1910 he saw in Munich an exhibition of works by MATISSE and met Franz MARC, with whom he founded the Blaue Reiter in the following year. His most mature works were the result of a trip to Tunis in 1914 with Paul KLEE. It was not by chance that Macke learned a good deal from Matisse and DELAUNAY, for among German EXPRESSIONISTS he had perhaps the finest feeling for colour and form. His sensitive WATERCOLOURS reveal an artist of talent, who died prematurely in the First World War.

1730, 1731.

**MCKIM, MEAD, AND WHITE.** American architectural partnership, led by C. F. MCKIM (1847–1909). It was responsible for so many important buildings that its full-blooded period revivalism represents American architecture at the turn of the century more truly than do the innovations of Louis SULLIVAN and Frank Lloyd WRIGHT.

Along with other architects of similar outlook, many of whom were trained in Paris at the École des Beaux-Arts, the McKim partnership created the paradoxical situation that a young and growing country was the home, not of experiment, but of outstanding skill and scholarship in reviving styles from the European past and adapting bygone models to modern purposes. Their Boston Public Library (1895) was modelled on the Library of Ste Geneviève in Paris; their University Club, New York (1900), on the Palazzo Riccardi, Florence; and the Pennsylvania railroad station, New York (1906), on the tepidarium of the Baths of Caracalla, Rome (see THERMAE).

2208.

**MACKINTOSH,** CHARLES RENNIE (1868–1928). Scottish architect and designer, leader of the Glasgow School of ART NOUVEAU, and precursor of several of the more advanced trends in 20th-c. architecture. His furniture design and interior decoration, often done in association with his wife, Margaret Macdonald (1865–1933), showed the characteristic MANNERIST calligraphic quality of *art nouveau* but avoided the exaggerated floral ornament often associated with that style. As an architect he opposed himself vigorously to the current eclectic academicism and 'period revival' fashion, while he became a pioneer in the new conception of the role of function in architectural design and his simple geometrical manipulation of space looked forward to the purist work of LOOS, BEHRENS, and POELZIG.

His domestic architecture evolved in a number of houses built near Glasgow from *c.* 1899 to 1910. While in certain external details they have affinities with the Scottish 17th-c. architecture, their restrained and dynamic structure looks forward to the Dutch STIJL. Outstanding among these are Windyhill, Kilmacolm (1899–

1901), and Hill House, Helensburgh (1902–3). His fame rests to a large extent on his Glasgow School of Art (1897–9) and its library block and other extensions (1907–9). Vigorously modelled, boldly geometrical, with emphasis on the straight line, they had little ornament, but the twisted iron window-balconies had a quality of energy and directness which made a great impression on the Continent. His interior decoration was perhaps most spectacularly expressed in the four Glasgow tea-rooms designed with all their furniture and equipment for Miss Kate Cranston (the first of them in collaboration with George Walton, 1867–1933) during the period c. 1897–1912. In a competition for the design of a connoisseur's house organized by the *Zeitschrift für Innendekoration* of Darmstadt in 1901 he was awarded second prize; and in 1902 he laid out the Scottish section of the Turin exhibition.

Mackintosh's influence on the *avant-garde* abroad was very great, especially in Germany and Austria, so much so that the advanced style of the early 20th c. was sometimes known as 'Mackintoshismus'. He was the first British architect to acquire an international reputation since the 18th c. HOFFMAN and OLBRICH owed much to him. In 1900 he exhibited with the Vienna SEZESSION and later Fritz Wäärndorfer, one of the founders of the WIENER WERKSTÄTTE, took some of its members to study his buildings in Glasgow. His work was exhibited in Budapest, Munich, Dresden, Venice, and Moscow, arousing interest and excitement everywhere.

In 1914 he settled in London. Thereafter, apart from a house in Northampton, none of his major architectural projects reached the stage of execution, though he did complete some work as a designer of fabrics, book covers, and furniture. In 1923 he retired to Port Vendres, where he devoted himself to water-colour painting.

**MACKMURDO,** ARTHUR H. (1851–1942). Scottish architect and designer working in England. For much of his career he was a follower of William MORRIS. His style of domestic design in the 1880s was more advanced than anything else in Europe, even than that of VOYSEY, who was a few years his junior. His influence was deeply felt on the Continent, especially by van de VELDE and the founders of the DEUTSCHER WERKBUND. He was a pupil of James Brooks (1825–1901) and went to Oxford to attend RUSKIN's lectures. Ruskin recognized his qualities and took him travelling and sketching in Italy. In 1875 he set up practice in London, where he made William Morris's acquaintance. His early work was influenced by Norman SHAW, but he soon developed the simpler and more personal style which was chiefly responsible for his influence abroad. In 1880 he founded the Century Guild, a group of artist-craftsmen which included Selwyn Image (1849–1930) and William de Morgan (1832–1911). In 1884, with Herbert Horne, he started the magazine *The Hobby Horse* which was the

focus of the new art movement for many years. Its high standard of printing and design, achieved with the help of Emery Walker (1851–1933), aroused Morris's interest in printing and was one of the influences that led him to found the KELMSCOTT PRESS.

Mackmurdo and his followers helped to establish the architect's leadership in contemporary efforts to reunite the arts and to counteract the antiquarian influence of Morris over the designs produced by the ARTS AND CRAFTS MOVEMENT. Among Mackmurdo's architectural works were a vaulted gymnasium in Liverpool (1890), the house at 25 Cadogan Gardens, London (1899), and, in partnership with Herbert Horne, the Savoy Hotel, London (1889).

**MACLISE,** DANIEL (1806–70). Irish painter and CARICATURIST. He won great admiration in England among painters of anecdotal and 'subject' pictures, and FRITH states in his *Autobiography* that Maclise was spoken of in academic circles as 'out and away the greatest artist that ever lived'. He painted illustrative canvases of historical and literary themes, especially from Shakespeare, and laboured on huge wallpaintings such as *The Death of Nelson* (1864) for the Houses of Parliament. He is now chiefly remembered for his lively sketches of eminent figures for *Fraser's Magazine*, published under the pseudonym Alfred Croquis. Many of the drawings for these are now in the Victoria and Albert Museum and the 84 plates constitute one of the finest collections of English portrait caricatures. He was a close friend of Charles Dickens.

1961.

**MACMONNIES,** FREDERICK (1863–1937). American sculptor. He studied under SAINT-GAUDENS and in the École des Beaux-Arts, Paris, and at Munich. He became a versatile and ECLECTIC artist, and produced many public monuments, among them *The Ship of the Republic* for the Columbian Exposition in Chicago in 1893 (27 heroic figures arranged about a trireme); a statue of Shakespeare (The Library of Congress, Washington, D.C., 1898); army and navy groups at Prospect Park, Brooklyn (1900); an equestrian statuette of Theodore Roosevelt (1905).

**MADERNA,** CARLO (1556–1629). Leading Italian architect of the early BAROQUE. He worked in Rome for his uncle Domenico FONTANA, some of whose undertakings he completed. His first major work was the façade of Sta Susanna, Rome (1596–1603), which, though based on VIGNOLA's Gesù, is generally regarded as the first truly Baroque façade on account of its greater architectural simplicity and sculptural richness. His largest work was the transformation (1606–26) of MICHELANGELO's St. Peter's into a Latin cross church by the addition of a

nave. This involved the addition of a long façade to mask the width of the transepts without concealing the dome. Maderna's design, though much criticized, was an ingenious solution to a difficult problem for he retained Michelangelo's Giant Order (see COLOSSAL ORDER) and other architectural elements, giving his façade a palace-like appearance by the use of a single order only. The projected end towers had to be abandoned on account of the instability of the foundations, although the project was revived by BERNINI who completed the layout of the Piazza. Maderna also worked on S. Andrea della Valle (1608–28). The only building entirely by him is the Palazzo Mattei di Giove (1606–16). But he began the most important Baroque palace, the Barberini, in 1625, although the design is at least partly Bernini's and BORROMINI also worked there.

**MADERNO,** STEFANO (1576–1636). Italian sculptor, who, like many of the full BAROQUE architects and sculptors after him, came from the Ticino region. During the papacy of Paul V Borghese (1605–21) he assisted in many of the great sculptural undertakings in Rome, particularly in Sta Maria Maggiore. But he also made sculptures on his own account. Among these are the famous recumbent figure of Sta Cecilia in Trastevere, carved soon after her body was found in 1599; the fine standing statue of S. Carlo Borromeo (S. Lorenzo in Damaso, Rome, 1610); and some mythological groups, including a *Hercules and Cacus* (1621), which was clearly influenced by BERNINI's vigorous early works in the same genre.

**MADRAZO,** DE. Family of Spanish 19th-c. artists. JOSÉ (1781–1859) worked with DAVID at Paris and became the leading academic painter of his day in Spain. His son and pupil, FEDERICO (1815–94), studied at Paris under INGRES and at Rome. He was appointed court painter to Isabel II and succeeded his father as director of the Madrid Academy.

**MAES,** NICOLAES (1634–93). Dutch painter, born in Dordrecht, who entered REMBRANDT's studio *c.* 1648. His early works show the influence of Rembrandt's warm palette of the late 1640s. Maes concentrated on GENRE pictures, amongst which his studies of old women praying or sleeping were the most popular. He visited Antwerp between 1665 and 1667, and shortly after his return to Holland his style changed. He abandoned the reddish tone of his earlier manner for a wider, lighter, and cooler range (greys and blacks in the shadows instead of brownish tones) and devoted himself mainly to elegant portraits, mostly small, which were very successful. They are closer to van DYCK than to Rembrandt. Maes's late works (an excellent example is in the Fogg Art Mus., Cambridge, Massachusetts) are so different from his early Rembrandtesque genre pieces that it was once thought that they

were the work of another painter of the same name. But it is now clear that the shift in his style was part of the general change which occurred in Dutch painting about the middle of the 17th c. Maes was following the example set a few decades earlier by his countrymen LIEVENS, FLINCK, and van der HELST.

2716.

**MAESTÀ.** See VIRGIN.

**MAFFEI,** FRANCESCO (*c.* 1600–60). Italian painter of markedly individualistic style who was born at Vicenza and worked mainly in the north Italian province of the Veneto. His work carried on the great painterly tradition of TINTORETTO and BASSANO, reinforced by the example of LISS, FETI, and STROZZI. In its bizarre fantasy and opulent colour tonalities it links GRECO and GUARDI. It ranged from huge and richly decorative allegorical portraits of Doges and mythological scenes influenced by contemporary opera settings to the moving religious pictures of his late period. His work remained comparatively unknown until an exhibition held at Vicenza in 1956.

**MAGI.** See ADORATION OF THE MAGI.

**MAGNASCO,** ALLESSANDRO, called IL LISSANDRINO owing to his small stature (1667–1749). Italian painter of Genoese birth who spent most of his working life in Milan and Tuscany. He painted melodramatic scenes set in storm-tossed landscapes, ruins, convents, and gloomy monasteries, peopled with small, elongated figures of monks, nuns, gipsies, mercenaries, witches, beggars, and inquisitors. On a darkly primed coarse canvas he used violent brush-strokes and rich deep blues, greens, and browns, very often flecked over with white. His tatterdemalion figures step straight from CALLOT's etchings. Magnasco in his turn had some influence on the style of Marco RICCI and GUARDI.

1002.

**MAGRITTE,** RENÉ (1898–1967). Belgian painter, a friend of the French SURREALIST poet Paul Éluard and one of the leading figures of the Surrealist movement, which he joined in 1925. He did not follow the path of automatism advocated by André BRETON and others of the Surrealists and designed to liberate imagery from the unconscious by the suppression of rational control, but sought rather to reveal an inner, poetic meaning of objects in the external environment by setting them in startling and disturbing juxtapositions, creating dissociation which embodies a half-intellectual element of suggestion. Intelligence, sensitivity, and imagination combine in his works, which he regarded as an instrument of knowledge, though knowledge not reducible to conceptualization. He parodied the

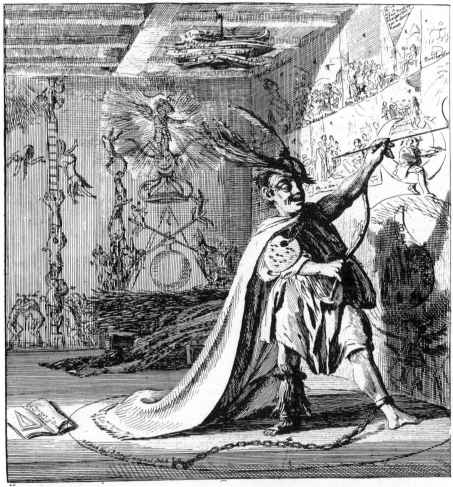

**210.** *The Author run Mad.* Caricature of William Hogarth and his *Analysis of Beauty.*
Engraving (1753) by Paul Sandby

Madame *Récamier* of DAVID and MANET's *Le Balcon,* replacing the figures by coffins. His *The Red Model* (1935) is a paraphrase of van GOGH's paintings of old boots. Such canvases as *On the Threshold of Liberty* (1930) and *Quand l'heure sonnera* (1933) are among the most frequently reproduced pictures of the Surrealist movement.

**MAHLSTICK** or REST-STICK. A stick with a pad at one end which the painter uses to steady his wrist. It is first recorded in the 16th c., after the introduction of oil painting, and appears in REMBRANDT's *Self Portrait* in the Louvre and VERMEER's *Interior of an Artist's Studio.* In Paul SANDBY's caricature of HOGARTH called *The Author run Mad* the mahlstick represents 'the line of Beauty'.

**MAIANO,** BENEDETTO DA. See BENEDETTO DA MAIANO.

**MAILLART,** ROBERT (1872–1940). Swiss structural engineer, specializing in bridges and one of the leading designers in reinforced CONCRETE. A pupil of F. Hennebique (1842–1921), whose structures consisted of a framework of beams and posts on which inert slabs rested, Maillart made the slab itself part of the structure. In his bridges the flat concrete slab or deck is reinforced so as to eliminate the need for beams, and the customary solid arch is replaced by curved slabs and slab-like vertical supports, producing a homogeneous reinforced concrete structure possessing spectacular lightness and grace. The first bridge integrated in this way was the Tavanasa Bridge (span 165 ft.) over the Rhine at Grisons, built in 1905 and swept away by a landslide

681

ın.1927. Among his other bridges, mostly spanning deep Swiss ravines by means of a single arch, are those over the Salgina-Tobel (1929-30) with the huge span of 300 ft.; the Schwandbach, Canton Berne (1933), which was curved in plan —a shape that could not have been designed economically before Maillart evolved his technique; the Thur, near Saint-Gall (also 1933); the Arve, near Geneva (1936-7); and the Simme, Bernese Oberland (his last bridge, 1940). The designs became increasingly daring and inventive.

From 1910 Maillart also designed many multi-storey buildings, creating new technical possibilities with his system of mushroom-headed columns and, once again, a reinforced slab in place of beams. In 1912 he was invited to Russia, where he remained for five years, constructing factories and warehouses at Kharkov, Riga, and Leningrad. Perhaps his most remarkable achievement was the pavilion for the Swiss Portland Cement Co. at the Zürich exhibition of 1939. It consisted of one immense parabolic vault in reinforced concrete, 39 ft. high and 52 ft. across but less than $2\frac{1}{2}$ in. thick, resting on only two pairs of slender supports. His work combines economy with flexibility and strength with elegance in appearance.

**MAILLOL, ARISTIDE** (1861-1944). French sculptor. He was born at Banyuls in the Pyrénées

**211.** *L'Action enchaînée.* Torso for the monument to Louis-Auguste Blanqui by Aristide Maillol. Lead sculpture. (Tate Gal., 1905)

orientales and the Virgilian quality of this idyllic Catalan countryside left a permanent impression upon him. He came to Paris in 1882 and studied at the École des Beaux-Arts first under Jean-Léon GÉROME, and then under Alexandre Cabanel (1823-89). In 1883 he became a friend of BOURDELLE and met GAUGUIN, whose influence was expressed in his tapestry designs; in 1886 he started a small tapestry manufacture at Banyuls. In 1893 he came into touch with the NABIS and exhibited with them until 1903. It was not until the turn of the century, when he was approaching 40, that Maillol turned to sculpture. He restricted himself to the female nude, expressing his whole philosophy of form through this medium. Commissioned in 1905 to make a monument to the tribune Louis-Auguste Blanqui, he was asked by the committee, which included Clemenceau and Mirbeau, what form he proposed to give it. He replied: 'Eh! une femme nue.' A torso for the monument, *L'Action enchaînée,* is in the Tate Gallery, London. In 1908 he visited Greece with the German collector Kessler and the influence of this contact with the Greek countryside may be seen in his illustrations done in 1926 for Virgil's *Eclogues* and in 1937 for the *Daphnis and Chloë* of Longus. Maillol had a retrospective exhibition at the Musée des Beaux-Arts, Basel, in 1935 and at the Petit Palais, Paris, in 1937.

Maillol was the most distinguished figure of the transition from RODIN to the moderns. He tempered the emotive ROMANTICISM of Rodin with classical restraint and sensibility. More than any artist before him he brought to conscious realization the concept of sculpture in the round as an independent art form stripped of literary associations and architectural context. After his return from Greece he worked for 25 years with the female nude to construct an infinitely subtle art of three-dimensional plastic forms, seeking unification without loss of plenitude, and he was pre-eminent in giving to his figures that sculptural 'fourth dimension' consisting of a controlled tension of centripetal and outward pulsating forces. This last aspect of his work was carried further, though not always without flabbiness, by the English sculptor Frank DOBSON.

371, 476, 552, 1011, 2222, 2227, 2332.

**MAINARDI, SEBASTIANO DI BARTOLO** (*c.* 1455-1515). Florentine painter, pupil and collaborator of his brother-in-law Domenico GHIRLANDAIO. Some of his individual paintings, such as the *Madonnas* in Pisa (Museo Civico), London (N.G.), and New York (Met. Mus.), give hints of the more nervous manner of VERROCCHIO joined to the gay descriptive style of Ghirlandaio.

**MAIOLICA.** The characteristic painted, tin-glazed FAIENCE of the RENAISSANCE, and more

especially of Italy. Its name refers to Majorcan traders who shipped the similar HISPANO-MORESQUE POTTERY from Spain. The fame of Italian maiolica led to the establishment of other manufactures in northern Europe during the 16th c., which for convenience are generally classed with the later faience and Delftware manufactures.

Italian maiolica of the 14th to early 15th c. was painted in green and purple only with simple GOTHIC designs, much like the Paterna ware of Spain. Following this a more original class of jars appeared at Florence, with bold oak-leaf motifs executed in purple and a thick, blackish blue; and by 1480, both here and at Faenza, a fuller palette including orange, yellow, and green was in use. Large jugs, dishes, globular vases, and cylindrical drug-jars were among the nobly proportioned forms introduced at this time. Their designs, which often depict in allegory the pangs of love, contain splendid figure drawing clearly inspired by the masters of the day. In the 16th c. many new factories were established, especially in Tuscany (Siena, Cafaggiolo) and the Duchy of Urbino (Castel Durante, Urbino, Gubbio, Pesaro), and the pictorial style was developed further. Much LUSTRE POTTERY including some handsome portrait dishes was made at Deruta (near Perugia), and also at Gubbio. The main emphasis, however, was on splendid polychrome display; and episodes from classical authors or the Bible, more or less freely adapted from engravings, often now covered the vessels completely. The greatest exponent of this *istoriato* manner was Nicola Pellipario (active *c.* 1510–40), who worked first at Castel Durante, then at Urbino, where the style was perpetuated by a number of talented painters.

Soon after 1550 this factory introduced a style of RAPHAELESQUE GROTESQUE designs which once more allowed the white ground to appear; and this reaction in taste was soon carried even further in the *bianchi di Faenza*—white wares intended for table use, which although often elaborately moulded bore little or no colour: perhaps a coat of arms, or some sketchy cupids and scroll-work in orange and blue only. Venetian factories also favoured a somewhat linear style of drawing, and made especially fine dishes with landscapes in white and blue on a pale-blue ground.

In general the 17th-c. wares possess more charm than splendour. The influence of Chinese porcelain is evident in many wares painted in blue alone, especially those decorated with birds and animals amidst foliage, ships, scenery, etc., at Savona and Genoa (see CHINOISERIE). By the 18th c. new factories in Milan, Turin, Faenza, and elsewhere were occupied in making practicable table-ware after the style of German porcelain or French faience. But further south the old *istoriato* tradition enjoyed a fresh lease of life in the ornamental productions of Castelli (near Naples) and Siena.

**MAITANI,** LORENZO (*c.* 1275–1330). Sienese sculptor and architect who in 1309 was put in charge of the works at Orvieto Cathedral and began the façade. The reliefs on the façade at Orvieto are also attributed to Maitani, but how large a hand he actually had in them or in the façade is conjectural.

**MAKART,** HANS (1840–84). Austrian painter, who studied under PILOTY in Munich, then the chief centre of history painting. His own MYTHOLOGICAL, historical, and allegorical subjects were only a pretext to cover huge canvases with feverishly composed and carelessly executed decorative arrangements in turgid colour schemes. From 1869 onwards he worked in Vienna but had a European reputation, chiefly in the fields of decorative art and pageantry.

**MALATESTA,** SIGISMONDO (1417–68). Effective lord of Rimini from 1422 till his death. He is the prototype of the megalomaniac, paganizing tyrant once thought to be characteristic of the Italian RENAISSANCE. A brilliant and totally unscrupulous *condottiere*, his name is indissolubly linked to one of the most sublime creations of 15th-c. art—the *Tempio* which ALBERTI created for him in Rimini out of the medieval church of San Francesco. On it between 1450 and 1460 were employed PIERO DELLA FRANCESCA, AGOSTINO DI DUCCIO, and Sigismondo's favourite, Matteo de'Pasti (*c.* 1420–90). Under Sigismondo's direct inspiration it became the most self-conscious return to the ANTIQUE yet seen. His glorification under the image of Apollo and the prominent place given to his mistress and later wife, Isotta degli Atti, led to the charge by Pope Pius II that 'it seems a temple for the worship not of Christ but of the pagan gods'.

**MALAYAN ART.** The peninsula of Malay formed a natural bridge for the spread of Indian culture northwards into Indochina and also through Sumatra and to Indonesia. Indian penetration is thought to have begun about the 2nd c. A.D. and from the fragmentary remains of STUPAS and sculpture seems to have brought Mahayana Buddhism to the region. Our chief source of information about the early period derives from Chinese chronicles, which regard the area as a vassal of the kingdom of Hunan. There appears to have been no centralized state but a number of fortified trading cities. Very scanty remains are known but a few statuettes show affinities with the Amaravati and Gupta styles (see INDIAN ART). Towards the end of the 7th c. the greater part of the peninsula came within the ambit of the Shrivijaya kingdom with its capital at the present city of Palembang in Sumatra. An account of this style will be found in the article on the art of THAILAND.

1177, 2965.

**MÂLE,** ÉMILE (1862-1954). A pioneer in the study of French medieval art. He gave lectures on this subject at the Sorbonne and was made Professor of the History of Art in 1912. Among his chief works were *L'Art religieux du XIIIᵉ siècle en France* (1902, translated as *The Gothic Image*), *L'Art religieux de la fin du Moyen Âge en France* (1908), and studies on the 12th c. and European art after the Counter-Reformation. He explored the sources which inspired the medieval carvers and glass painters and was perhaps the first to point out the Eastern origins of medieval ICONOGRAPHY. He was a Director of the French School in Rome and was made a member of L'Académie Française in 1927.

**MALEVICH,** KASIMIR (1878-1935). Russian painter, born at Kiev. He went through phases of NEO-IMPRESSIONIST and FAUVIST influence and was closely linked with Larionov (1881-1964) and the Russian *avant-garde* movement (see RUSSIAN ART). After 1912, influenced by PICASSO, he began to paint in a style similar to that of LÉGER. He became the founder of the SUPRE-MATIST movement, exhibiting his first Suprematist pictures (probably painted 1913-14) in 1915. He was with MONDRIAN the most important inaugurator of the geometrical ABSTRACT style. Apart from a visit to Germany in 1927, he remained in Russia. From 1918 he was for a short time teacher at the Moscow School of Higher Technical Studies, and later continued teaching in Leningrad, where he died. His Suprematist theories were published in a series of brochures, the first of which dates from 1915. A number of these were translated into German and appeared in 1928 under the title *Die gegenstandslose Welt*.

1747.

**MALOUEL,** JEAN (d. 1419). Flemish painter who was employed in Paris in 1396. From 1397 to 1415 he was court painter to the Dukes of Burgundy, but he returned to Paris at the end of his life. He has been suggested as the painter of several works, including part of the *Martyrdom of St. Denis*, and a TONDO of the *Trinity*, both in the Louvre. They have all the refinement of French court art combined with a strength of modelling and a realistic naturalism derived from Flanders.

**MALVASIA,** CONTE CARLO (1616-93). Italian painter, art historian, and antiquarian. His *Felsina pittrice: vite dei pittori bolognesi* (1678) is an important source for knowledge of the great period of the BOLOGNESE SCHOOL. His guide to the paintings of Bologna (1686) was one of the first of its kind.

**MANDER,** CAREL VAN (1548-1606). Painter and writer, born in Flanders, who settled in Haarlem in 1583. He is sometimes known as the 'Dutch Vasari', for like VASARI he was a painter of some distinction, but his chief claim to fame rests upon his writing. In 1604 he published *Het schilderboeck* (*The Painter's Book*), a handbook for artists, divided into three parts. The first part is made up of about 175 biographies of Netherlandish and German artists from van EYCK to van Mander's own younger contemporaries. This section of the book is the first systematic account of the lives of northern European artists. Despite a few major errors and some slips, van Mander was a scrupulous historian, and to this day his book is a principal source, and in some cases our only source, of information about many 15th- and 16th-c. Netherlandish artists. The second part of the book contains the lives of Italian artists from CIMABUE up to his own time. Most of this material is a condensed translation into Dutch of Vasari but some of it deals with artists who worked after 1568 (when the 2nd edition of Vasari's work was published) and has valuable information collected by van Mander himself when he was in Italy in 1573-7 or from friends and correspondents. The third part of the book, the *Lehrgedicht*, a long poem divided into 14 chapters, gives practical advice to artists. The main ideas are taken from Italian theorists. But parts of it, such as the chapter on LANDSCAPE PAINTING, a subject that did not interest many Italian RENAISSANCE artists, was very largely original. The *Lehrgedicht* sums up much of the theory and practice of 16th-c. Netherlandish art, but made little contribution to the great achievements of 17th-c. Dutch painting.

Van Mander's own pictures, which were mainly religious and allegorical, adopted the elongated forms of the MANNERISTS, but his later works showed a tendency towards REALISM. This was the aspect of his work to which Frans HALS, his best pupil, must have responded. With the Dutch Mannerists CORNELISZ VAN HAARLEM and Hubert GOLTZIUS, van Mander founded at Haarlem an academy where artists could draw from nude models.

**MANDORLA** (Italian: almond), also called aureole or *vesica piscis*. An almond-shaped outline or series of lines surrounding the body of a person endowed with divine light, usually CHRIST Himself. Its origin, like that of the HALO, is controversial. Some see a forerunner of the mandorla in the semicircle which Greek vase painters occasionally placed round deities (e.g. Poseidon and Amymone, Naples Mus.); others think it came from the Roman custom of placing portrait busts within circular shields or medallions (*imagines clipeatae*). The mandorla proper is first seen in EARLY CHRISTIAN ART, surrounding one of the angels addressing Abraham in the 5th-c. mosaic in Sta Maria Maggiore, Rome. It often encloses Christ in the TRANSFIGURATION (6th-c. mosaic, Monastery of St. Catherine, Mt. Sinaï) and in the Ascension (6th-c. Syriac *Rabula Gospels*, Laurentian Lib., Florence), where Acts i. 9 mentions a cloud

receiving Christ out of the sight of the APOSTLES. It also occurs in the HARROWING OF HELL (9th-c. fresco, S. Clemente, Rome) and the LAST JUDGEMENT (12th-c. portal relief, Autun Cathedral). The mandorla with the four symbols of the EVANGELISTS often surrounds Christ in Majesty (12th-c. relief on Royal Door, Chartres). In the later Middle Ages the mandorla also enclosed the VIRGIN, as in the Last Judgement (Campo Santo, Pisa, 14th c.), and in ORCAGNA's relief of the Assumption (Or San Michele, Florence, 14th c.). But the mandorla, like the halo, became less popular in the 15th c. and was abandoned by the painters of the RENAISSANCE.

**MANESSIER,** ALFRED (1911– ). French ABSTRACT painter. He met and was influenced by BISSIÈRE at the Académie Ranson in 1935. After a retreat in a Trappist monastery during the war he executed a number of designs for stained-glass windows and many of his paintings acquired a religious significance, achieving an atmosphere of mysticism with abstract forms and colours.

**MANET,** ÉDOUARD (1832–83). French painter. Son of a Paris magistrate, he abandoned the study of law and after a voyage from Le Havre to Rio de Janeiro he entered the studio of COUTURE in 1850 and remained a pupil there for six years. His own painting style was, however, based rather on a study of the Old Masters at the Louvre, and particularly Spanish masters such as VELAZQUEZ, MURILLO, and RIBERA, than on

**212.** Portrait of Édouard Manet. Etching (1864) by Edgar Degas

the classical training of the schools. During the 1850s he visited museums in Holland, Germany, Austria, and Italy, but despite the strong affinity of his own work with the dramatic intensity of the Spanish school he did not visit Spain except for about 10 days in 1865. In 1859 his *Absinthe Drinker* was rejected by the Salon but in 1861 his *Spanish Guitar Player* and *Parents of the Artist* were accepted. The former won the approval of both DELACROIX and INGRES. His *Déjeuner sur l'herbe,* exhibited in 1863 at the Salon des Refusés, created a scandal which led to the closing of the exhibition, and his *Olympia,* exhibited at the Salon in 1865, also caused a scandal although BAUDELAIRE and Zola came forward in his support. From this time Manet began to be recognized as a Master by the younger artists of the *avant-garde.* But Manet himself was a fashionable gentleman-artist rather than a Bohemian type. He was a respected and admired member of the group of young IMPRESSIONISTS, including MONET, RENOIR, BAZILLE, SISLEY, CÉZANNE, who met at the Café Guerbois and elsewhere. It was in part Manet's one-man exhibition in the gallery of the dealer Martinet which inspired Monet, Renoir, and Sisley to leave the studio of Marc Charles Gabriel Gleyre (1806–74) and paint on their own. But despite their admiration for him, Manet stood somewhat aloof from the group and did not participate in the Impressionist exhibitions but continued with indifferent success to seek recognition from the official Salon.

Manet was a superb technician and worked out a personal method of handling pigment known as *peinture claire,* which aims at a high-keyed colour ensemble by direct painting of the light passages in flowing and 'fat' pigment into which the half-tones and darks are subsequently painted while the pigment is still wet—the reverse of the academic technique, which worked upwards from the dark passages to the light. This personal style was first apparent in his *Portrait of Victorine Meurend* (Boston, 1862) and was progressively perfected in *La femme au perroquet* (Met. Mus., New York, 1866), *La Prune* (1878), and his last major work *Un bar aux Folies-Bergère* (Courtauld Coll., N.G., London, 1882). Manet was essentially a REALIST. He was without the sort of imagination which is required for mythological and historical painting. His imagination was visual only and he painted the world around him as he saw it. The indignation which his paintings aroused can be explained by their challenge to the Old Masters through the introduction of an air of contemporary reality into themes which had become hallowed and innocuous by the unreality conferred on them by distance in time and place. Thus his *Déjeuner sur l'herbe* was a realist version of GIORGIONE's *Concert champêtre* with the composition based on an engraving by Marcantonio RAIMONDI after RAPHAEL, the *Matador mort* (1864) was a realist challenge to a 17th-c. Spanish painting *Orlando muerto* (N.G., London), the *Olympia* (1863) was

a realist version of the recumbent Venus motif common to many Italian masters, and so on. Manet was opposed to the ROMANTIC attitude, including that of the BARBIZON SCHOOL, in that he did not seek to communicate through his paintings the emotional excitement of the artist in face of his subject but to paint objectively and in an impersonal scientific fashion the world as it is. He shared this realistic outlook with the young Impressionists and also to some extent their interest in representing fragments of the external world as if accidental and uncomposed. He was interested in reproducing tone values as a pattern of light and shade rather than local colours and this also he shared with the early Impressionists before the adoption of Renoir's 'rainbow palette'. In these respects his picture *Le bâteau de Folkestone* (1869) was attempting the same sort of thing as Monet's *Le Pont neuf* (1870) and something quite different from, for instance, Renoir's *Canotiers à Chatou* (1872). During the 1870s, under the influence of Monet and Berthe MORISOT, he became converted to the Impressionist practice of painting out of doors on the spot and made some use of their DIVISIONIST technique and rainbow palette.

There was an important Manet Memorial Exhibition at the École des Beaux-Arts in 1884 and a Manet Exhibition at the Salon d'Automne of 1905. Manet was represented by 19 works at the Exhibition of French Impressionist Pictures held at the Grafton Galleries, London, in 1905 and it is a sign of his growing reputation that the official title of the first Post-Impressionist Exhibition, organized by Roger FRY in 1910–11, was *Manet and the Post-Impressionists*.

181, 294, 643, 1125, 1228, 1427, 1785, 1868, 2060, 2249, 2310, 2322, 2385, 2613, 2788.

**MANFREDI,** BARTOLOMMEO (1580–1620/1). Italian painter, born in Mantua and trained in Rome, who imitated with considerable skill the scenes of fortune-telling and card-playing which CARAVAGGIO painted in his early period. His work was popular and it was largely through him that this aspect of Caravaggio was transmitted to painters from France and Holland who came to Italy. He painted chiefly for private patrons, such as Caravaggio's Roman patron the Marchese Vincenzio GIUSTINIANI, and he was in great favour at the MEDICI court in Florence.

**MANIÈRE CRIBLÉE** or DOTTED MANNER. Relief engravings on metal, printed by the same method as WOODCUTS, appeared in the latter half of the 15th c. They bear a certain resemblance to the WOOD ENGRAVINGS of a later period, for they are dark in general aspect, with the design showing as a combination of white lines and dots. The metal usually employed was copper. The lines were engraved with the BURIN and the remaining black areas were then decorated or shaded with a texture of white dots, made with punches of varying size and shape. In some examples the white dots are more in evidence than the lines; in others the lines predominate. But the general term *manière criblée* is used to describe all prints of this class (*crible*, the French word for a sieve, refers to the sieve-like effect produced by the multiple punches used in the process).

Plates engraved in the *manière criblée* were used in the same period for the making of paste prints. Few of these curiosities have survived, and many of the existing examples are in poor condition, so that it is not always easy to determine how they were printed. Some at least were produced as follows: a sheet of paper was covered with a glutinous tinted paste and the *criblée* plate impressed upon it. The effect of this was to leave on the pasted paper an embossed impression of the engraved design. Parts of this impression were then hand-coloured, or covered with gold-leaf. Occasionally the plate was inked as for intaglio printing before being pressed on to the paste; in this case the paste itself was sometimes covered with gold-leaf before receiving the impression. Whichever method was used, the result was an embossed print, rather like stamped leather-work, with the raised portions differing in colour from the remainder.

**MANNERISM, MANNERIST, MANNERED.** A group of terms current since the 17th c. in the literature of the fine arts and by transference in literary criticism and poetics with a confused medley of combined historical and critical connotations. In its primary historical sense 'Mannerism' normally refers to a period of style in Italian art chiefly manifested in Rome between roughly 1530 and 1590. In this sense it has sometimes been regarded as a degeneration of High RENAISSANCE CLASSICISM. Others have regarded it as a reaction against Classicism and a bridge or interlude between the High Renaissance and BAROQUE. Others again have represented it as a positive style complete in itself and of European scope. In a secondary historical sense it has been applied to any stylistic period which is considered to have analogous features to those regarded as characteristic of the primary period. But its secondary applications have been vitiated by built-in prejudices of taste and valuation towards the primary period. German 19th-c. art historians, exemplified by Wölfflin, introduced 'Mannerism' as a general definition for a stage in their abstract evolutionary scheme of successive styles but incorporated into its meaning the critical judgement that it was a degeneration from the 'slender peak' of perfection reached in RAPHAEL. The baleful influences of this muddled conflation of historical and critical concepts survives in such later formulations of Mannerism as 'an academicism which has reached degeneracy', or 'the last expression of a dying style' which 'comes to the fore in the art of an ageing select society at times of spiritual crisis', and so on.

In the early years of the 20th c. a revived interest in the artists of the primary Mannerist period led to dissatisfaction with Wölfflin's treatment of Mannerism as a mere bridge between Renaissance and Baroque. Led by Dvorak, critics and historians in Germany began to present Mannerism as a European movement culminating in El GRECO. Its distinguishing features were presented with a curious blindness as a reflection of Germanic EXPRESSIONISM—aesthetic violence and spiritual intensity. Again from c. 1925 some German critics chauvinistically promulgated the view that Mannerism was a movement in reaction from Renaissance Classicism and a manifestation of the 'eternal GOTHIC spirit'.

As a general, non-technical critical term 'mannered' in English embodies the 19th-c. prejudices of taste, referring to no specific style or period but suggesting exaggerated or obtrusive cultivation of the superficial tricks of any style; 'mannerism' is defined in the Oxford English Dictionary as 'excessive or affected addiction to a distinctive manner'. Until the middle 1930s most English historians preferred the term 'late Renaissance' and regarded the late work of MICHELANGELO and pretty well all Italian art outside Venice as 'decadent'. It was the realization that this terminology imported what was in effect a moral judgement into art history, together with a growing realization that much 16th-c. art is extremely exciting to contemporary taste, that led to the study of it as a style in itself. Hence since c. 1935 most English art historians differentiated 'mannered' from 'Mannerism', using the latter term only for European art c. 1525-1600 in its primary application, and interpreting its tensions and exaggerations as a reflection of the general malaise caused by such events as the Reformation, the Sack of Rome (1527), the crisis in the Church which led to the Council of Trent (1545-65), the Counter-Reformation, and the Wars of Religion in the north. Since 1960 some of the newer school of art historians in England proposed to restrict the term to the art practised by VASARI and his contemporaries in the late 16th c., excluding from its denotation PONTORMO, PARMIGIANINO, and the anti-Classical works of Michelangelo from the Laurentian Library onwards. Their argument was based on the apparent fact that none of the generation before c. 1550 were conscious of any divergence from the ideals of Raphael or the early Michelangelo. The theorists such as Zuccaro and LOMAZZO were all much later in the century and they regard Vasari as the watershed, translating his 'maniera' as 'stylishness' rather than 'style'.

Like 'manière' in French courtly literature from the 13th to the 15th centuries the Italian word 'maniera', applied both to general human behaviour and to the arts, carried a meaning analogous to the unqualified use of 'style' in English, as when we say something 'has style'. In the language of Vasari and his contemporaries maniera was a desirable quality of any work of art, analogous to 'grace', and bella maniera or la maniera moderna signified the highest artistic expression of the age, as exemplified for example in the St. Michael of Raphael, in Michelangelo's Ignudo and the Teste divine. The qualities to which it gave precedence were idealized beauty and elegance, cultured poise, sophistication, and facility rather than truth to nature.

The maniera was cultivated by a number of brilliant artists born about the turn of the century: Jacopo Pontormo and G. B. ROSSO, both born in 1494, Domenico BECCAFUMI, some years older, Parmigianino, PRIMATICCIO, BRONZINO; slightly older were SALVIATI, a pupil of ANDREA DEL SARTO, Vasari, Daniele da VOLTERRA, Bartolomeo AMMANNATI, pupil of BANDINELLI, NICCOLÒ DELL' ABBATE, and of the next generation GIULIO ROMANO, Giovanni BOLOGNA, Luca CAMBIASO, Giuseppe ARCIMBOLDO. There is no evidence and no reason to believe that any Italian artists of the 16th c. set themselves up in conscious opposition to the Renaissance ideals of classical beauty and harmony, nor were they regarded by their contemporaries as introducing a break with tradition. Rather they sought to achieve even more subtle and sophisticated effects of elegance and saw themselves as carrying on the supreme perfection reached by CORREGGIO, Raphael, and Michelangelo. But in keeping with Neo-Platonic doctrines greater emphasis was placed on the ideal beauty in the mind of the artist than on the reproduction of beauties discovered in nature and the ever more frenzied pursuit of aesthetic effects put a premium on originality and imagination which often passed over into exaggeration, morbidity, and the bizarre. Surprise, novelty, recondite allusions, and in general a priority for INVENTION characterized an art which appealed to a public of CONNOISSEURS and a narrow intellectual élite. The ascending corkscrew or figura serpentina of Michelangelo appealed to the Mannerists, as they were later to be called, owing to the emphasis they placed on motifs of movement and contrast. It is prominent in The Rape of the Sabine Women by Giovanni Bologna (Loggia dei Lanzi, Florence, 1583). The ideal of an etiolated elegance produced the elongated forms of Pontormo and Parmigianino which were put in movement by a deliberate instability and writhing, sinuous rhythms. Forms taken from reality were transformed into fantasy, translated into an unreal space with no firm perspective structure. In the later decades the Renaissance ideal of ease and facility developed into self-conscious virtuosity and a delight in complication for its own sake; the juxtaposition of contrasts became an end in itself and ingenuity ran riot as in the ambiguous arrangements of Arcimboldo, which anticipated one feature of SURREALISM. No one artist embodied all these features but together they provide some sort of characterization for a period when the classical balance of the Renaissance and the sense of harmony between nature

and reason were beginning to disintegrate and splendid lessons brilliantly learnt were applied in the service of ever more phrenetic idiosyncrasy.

The Mannerist cult of the bizarre ran riot among the group of artists congregated at the court of Rudolf II of Prague, where in an atmosphere of Neo-Platonic magic, astrology, alchemy, and fantasy such eccentrics as Arcimboldo worked alongside northern artists such as SAVERY, ROTTENHAMMER, and Bartholomaeus SPRANGER. Those art historians who like to represent Mannerism as a positive phenomenon of European extension point to El Greco in Spain as the culmination of that element of religious ecstasy which in certain of the Italian Mannerists seemed a feature of excess. In France the decorative elegance and the cerebral eroticism of Italian Mannerism were tempered to French taste in the First and Second Schools of FONTAINEBLEAU. Rosso and also Primaticcio, who had collaborated with Giulio Romano in Mantua, and after 1552 Niccolò dell'Abbate and Salviati, acclimatized the new Italian *maniera* in France, creating an artistic culture which remained predominant for a century. In England Mannerist influence has been alleged in the Elizabethan MINIATURISTS, in particular Nicholas HILLIARD who acknowledged a debt to the theories of Lomazzo. But at the most this was a fringe manifestation. As Eric Mercer has said in the *Oxford History of English Art*: 'The similarities between English portraiture and Mannerist portraiture are clear enough; but equally clear are the differences between English painting and Mannerist painting. Mannerism was very much more than a style of portraiture coupled with a preference for a linear rather than a plastic technique. It was an art which showed both by its slavish copying and its wilful defiance of the canons of the past its deep roots in the Italian Renaissance. It was simultaneously rigidly disciplined and wilfully licentious, elegant and farouche, pornographic and ecstatically religious, lost in the "other world" of antiquity and yet vividly conscious of the horrors of the sixteenth century. It was the art of men of splendid talents and a glorious tradition robbed of their heritage, by the necessities and accidents of European history, at the very moment that they were about to enter upon it. It was the art of a tortured and often despairing society. Of all its varied aspects only the formalized linear portrait is found in England.'

The death-blow to Mannerism as a historical movement was given by the realism of CARAVAGGIO and the new Classicism of the CARRACCI in the 1590s. It was then only that the terms came into use with a derogatory sense to designate a style which was going out of fashion. The term *'maniériste'* was coined by Fréart de Chambray (1662) as a term of abuse for a group which included ARPINO and LANFRANCO and it was used by L. Lanzi (1792), who also coined the term *manierismo*. BELLORI in his life of Annibale

Carracci (1672) associated *'maniera'* with a historical movement which he traced back to Raphael and MALVASIA with a group of artists roughly contemporary with Salviati. Both disapproved of it as an elegance too artificial and capricious— 'totally chimerical and schematic'—and regarded the NATURALISM of the Carracci as a healthy reaction from it. As a general stylistic term combining historical and critical connotations 'Mannerism', starting with Lanzi, carried the implication of excessive virtuosity and capriciousness which through Burckhardt and Wölfflin was taken over as an uncritical prejudice by 19th-c. historians. There was a brief revival of interest in Mannerist painters by some ROMANTICS at the end of the 18th c. In the 20th c. the Surrealists found affinities with certain features of Mannerism. But the general revival of interest in the 20th c. was ambiguous in its motivation and led to conflicting interpretations. The basis for a more solid historical assessment was furnished by an Exhibition called 'The Triumph of European Mannerism' held in Amsterdam in 1956.

Art historians have also, although more tentatively, applied the term 'Mannerism' to architecture. It has been pointed out that Michelangelo's architecture sometimes has features which parallel the surprise effects and deliberate clashing of styles or contravention of accepted rules which characterized Mannerist painting. Thus his entrance hall to the Laurentian Library in Florence has columns which carry nothing and are, moreover, encased in narrow niches. There is a sense of unresolved disharmony in the proportions of this building which has been thought to echo the eccentric compositions of some Mannerist painters. Giulio Romano also, working in the intellectual hothouse atmosphere of the GONZAGA court at Mantua, treated the Classical conventions with capricious indifference to the rules: keystones are out of line, pilasters twist and turn, and a heavy RUSTICATION aims at picturesque effect. The Palazzo del Tè is full of bizarre effects, flaunted with self-conscious virtuosity. Similar qualities are revealed by much of the work of Michele SAMMICHELE of Verona (who erected the Palazzo Grimani in Venice) and even by some of PALLADIO's, notably the Palazzo Valamarana (begun 1566) and the Palazzo Porto-Colleoni at Vicenza (1552). In France comparable features appeared in the work of Jean BULLANT and Jacques Androuet DUCERCEAU. In northern Europe much of the so-called Mannerist architecture came into being rather as a somewhat incongruous blending of imperfectly understood Classical norms with a still potent Gothic tradition. What might be taken for a playful or capricious disregard of the rules of Classical construction in such buildings, for example, as the Gate of Honour at Gonville and Caius College, Cambridge (1572), was the result in fact of a mechanical application of the ORDERS to a structure still Gothic in

feeling. This unpremeditated clash of conflicting traditions should not be confused with the deliberate conflict of forms and styles which was sought by the Italian 'Mannerist' architects. The chief effect of Mannerism in England came from the use of such treatises as the *Treatise on the Five Orders* (1598) by W. Dietterlin and the pattern books of Hans Vredeman de VRIES. The results can be seen in the extravagant ornament, for example, of Elizabethan chimney-pieces and STRAPWORK gables.

188, 397, 561, 933, 1269, 1472, 1898, 2329, 2474, 2946.

**MAN OF SORROWS.** See CHRIST.

**MANSARD ROOF.** A roof having the lower part steep pitched and the upper part much flatter. It is associated with the name of François MANSART but was used before his day by LEMERCIER at the LOUVRE.

**MANSARD STYLE.** See SECOND EMPIRE STYLE IN THE U.S.A.

**MANSART, FRANÇOIS** (1598-1667). French architect, who is considered the most complete embodiment of French 17th-c. CLASSICISM. He was trained by Germain Gaultier, his brother-in-law, and probably worked under de BROSSE at Coulommiers. His first work, the façade of the church of the Feuillants in Paris (1623), was closely modelled on the latter's S. Gervais. His design for the château of Berny (1624) already foreshadowed his mature Classicism and in Balleroi (1626) he revealed a full mastery of the Classical implications of de Brosse. His little church of Ste Marie de la Visitation, Paris (1632), was an ingenious adaptation of DELORME's chapel at Anet, a Classical conception curiously incorporating late MANNERIST traditions of decoration. In 1635 he designed the Hôtel de la Vrillière, Paris, which set the model of the Classical town house for many decades. Its staircase was much admired, being one of the earliest with an open well on a square plan. In the same year Mansart began the rebuilding of the château of Blois for Gaston d'Orléans. His plan was for a large palace disposed about a rectangular court, with long galleries for the Duke's collections and a magnificent *salle des fêtes* on the town side. Only the central block and the quadrant colonnades were built, but even in this the masterly treatment of the elevation and the noble simplicity of the masses make it one of the chief monuments of French 17th-c. Classicism.

In the decade following 1640 Mansart's planning became more plastic in conception and his decoration more uniformly Classical. Mansart's most complete surviving work and that most fully representative of his genius as an architect is the château of Maisons (1642-6), built for René de Longueil, magistrate of the Paris Parlement.

While this was being built Mansart designed the church of Val-de-Grâce, commissioned by Anne of Austria in 1645. In 1646 he was replaced by LEMERCIER, but already the church stood complete to the first CORNICE and so the plan and a good part of the elevation were certainly to his design. After 1645 he executed many buildings in Paris for private patrons. In the Hôtel du Jars (1648) the main block was two rooms deep, an important innovation in French town-house design. In 1655 he remodelled the Hôtel Carnavalet, his latest remaining work. Ten years later he designed a remarkable staircase for the Hôtel d'Aumont (by LE VAU), ingeniously adapted to a very limited space.

Throughout his life Mansart's career had been hampered by his uncompromising disposition and his obstinate refusal to keep any final plan for a building; at Maisons, not satisfied with his work, he had been allowed to pull it down and start again, but at the Val-de-Grâce he was deprived of the commission for some such reason. His temperament was unsuited to the stricter organization of the arts initiated by COLBERT after 1661. He was indeed approached in 1664 to submit designs for the east front of the LOUVRE but refused to commit himself to a final design. In 1665 Colbert again turned to him for a design for a vast Bourbon mausoleum chapel for Saint-Denis, but this was not carried out.

Of all French architects Mansart shows in the highest degree the qualities usually associated with the spirit of French Classicism: 'clarity combined with subtlety, restraint with richness; obedience to a strict code of rules coupled with flexibility within them; and concentration by the elimination of inessentials.' The following lines of Voltaire (quoted by Sir Anthony Blunt) are believed to refer to Maisons:

Simple en était la noble architecture,
Chaque ornement en sa place arrêté
Y semblait mis par la nécessité:
L'art s'y cachait sous l'air de la nature,
L'œil satisfait embrassait sa structure,
Jamais surpris et toujours enchanté.

310.

**MANSART, JULES HARDOUIN-** (1646-1708). French architect, the great-nephew by marriage of François MANSART, whose surname he added to his own. He had a brilliant and successful career. At the early age of 28 he was commissioned by Louis XIV to build the little château du Val near Saint-Germain; in 1676 he rebuilt the château of Clagny for Mme de Montespan, by which time he had several private houses to his credit. He was made Architect to the King in 1675 and from 1678 he was in charge at VERSAILLES. He was responsible for the final plan of Versailles, including the new Orangerie and the Trianon. For their execution he organized a large office in which many of the chief architects of the succeeding age received their training, and thence came the designs for the

royal château of Marly, the church of the Invalides in Paris, and town-planning schemes such as the place des Victoires and place Vendôme in Paris. He was made First Architect to the King in 1685 and Surveyor of the Royal Works in 1699. He was ennobled and created baron of Jouy and count of Sugonne. He has been regarded as a mere architectural factory-manager owing his success to flattery of the king, but he seems to have had genuine ability in design and great organizational gifts. Most of all he had a sense of the dramatic and a talent for the magnificent which were well suited to the needs of the time and enabled him to enrich a failing CLASSICISM by BAROQUE manipulations of space and decoration.

**MANTEGNA,** ANDREA (1431–1506). Italian painter, who worked for the first 12 years of his career (1448–60) in Padua. Padua was the first north Italian city in which humanism took root, and this fact, coupled with DONATELLO's activity there during the 1440s, determined the formation of Mantegna's style. It was a style distinguished by sculptural modelling, by archaeological accuracy—made possible owing to the relative abundance of classical remains in northern Italy—and by scholarly austerity of feeling. In addition Mantegna possessed a mastery of foreshortening unequalled in the 15th c. His chief undertaking at Padua was the FRESCO decoration with *Scenes from the Lives of SS. Christopher and James* in the Ovetari Chapel of the church of the Eremetani (badly damaged in the Second World War). The other major work of this period was an ALTARPIECE for S. Zeno, Verona (1459).

In 1460 Mantegna was appointed court painter at Mantua, a city which was then beginning to take its place among the leading centres of humanist culture in Europe. The aspirations of that culture found exact expression in the *Camera degli sposi* in the palace of the ruling family, the GONZAGA, which Mantegna completed in 1474 and dedicated to his patrons, the Marquis Lodovico II Gonzaga and his wife. Glorification of the ruler was the main theme of these decorations. Group portraits of the Gonzaga family, arranged as narrative pictures, surrounded the walls; the corners of the ceiling contained bust medallions of the Caesars, indicating that the reigning house was worthy of the Roman Empire; and finally, in harmony with the learning of the court, the intervals between the pictures were painted with motifs from classical architecture. The style of the frescoes was no less significant than their content. 'Here for the first time in modern art the different subjects are not applied to the wall like single pictures side by side or over one another: they seem to be actually happening in and outside the space in the room, as if the walls had disappeared' (P. Kristeller, *Andrea Mantegna*, 1901). The illusion is continued in the painting of the ceiling, the centre of which appears to be open to the sky and framed by a circular balcony with figures leaning over it.

In 1484 Lodovico's grandson Francesco succeeded to the marquisate and commissioned from Mantegna the *Triumph of Caesar*, composed of nine canvases each 9 ft. square, which were bought by Charles I in 1627 and can now be seen in the Orangery at Hampton Court. For the private room of Francesco's brilliant and cultivated wife Isabella d'ESTE, Mantegna painted two pictures of a more private and sophisticated kind, the *Parnassus* (1497) and the *Triumph of Virtue* (c. 1500), both now in the Louvre. These have a complicated allegorical meaning, but the *Parnassus* at least is handled with a freshness, charm, and feeling for movement unique in Mantegna's œuvre. Mantegna had a considerable influence on Giovanni BELLINI, who was his brother-in-law. Furthermore he was one of the few quattrocento artists whose fame never declined. Northern artists in particular—from DÜRER to POUSSIN—found his version of the ANTIQUE particularly easy to assimilate.

548, 1529, 2647.

**MANUEL,** NIKLAUS, called DEUTSCH. See DEUTSCH.

**MANUELINE.** A national style of architectural decoration representing the latest phase of GOTHIC architecture and ornament in Portugal, named after Manuel I (1495–1521) with whose reign it roughly coincided. Like PLATERESQUE in Spain, Manueline was a transitional style of composite origin in which the Gothic tradition was modified by MUDÉJAR and eventually by RENAISSANCE influences. The additions made by Manuel I to the Gothic palace of Sintra, near Lisbon, incorporate such mudéjar features as the pyramid capped merlon, the twin-light window (AJIMEZ), ornate ceiling carpentry (ALFARJE), and glazed polychrome tiles (AZULEJOS).

The best known Manueline monument is the CHAPTER HOUSE of the convent of Christ at Tomar, famous for its windows surrounded by carved stone frames of twisted tree trunks, stumps of branches, coral, artichokes, ropes, and knots. These fleshy organic forms, large in scale and realistically treated, are characteristically Manueline; and a similar feeling is apparent in the use of gross CUSPS and FINIALS, very large nodal BOSSES and thick VAULT ribs, for example at the royal monasteries of Belém and Batalha. The most striking feature common to nearly all Manueline work is the twisted rope motif, which is used indiscriminately for aperture frames, string courses, window TRACERY, pinnacles, spires, vault ribs, and even COLUMNS and BUTTRESSES.

Little is known of the architects who created the style. The most prominent were Mateus Fernandes, principally active at Batalha, Diogo

**213.** Window from the exterior of the Chapter House at the convent of Christ, Tomar (early 16th c.)

BOYTAC; the brothers Diogo and Francisco de ARRUDA; and João de Castilho. VASARI mentions Andrea SANSOVINO's essays in the 'difficult' Portuguese style at the turn of the 15th c., but none has been identified. Manueline architecture was not confined to Portugal. Fine examples survive at Funchal in Madeira and at Velha Gôa in India. Manueline features also appear in certain 16th-c. mission churches in Mexico, attributable to Portuguese members of the missionary orders.

The most famous example of the Manueline style in decorative art is the gold and enamel Belém monstrance (Lisbon Mus., 1506) commissioned by Manuel I from the goldsmith Gil Vicente.

2054, 2391.

**MANZÙ**, GIACOMO (1908- ). Italian sculptor, born at Bergamo, the son of a sacristan in a convent. At the age of 11 he went to work with a carver and gilder and later with a worker in STUCCO. In 1928 he was called to Verona to do his military service and obtained permission to study at the Verona Academy, where he conceived an admiration for the works of DONATELLO and made his first contact with modern art. He visited Paris and was attracted by IMPRESSIONISM. In 1930 he exhibited at Milan and in 1933 returned to Bergamo. His mature style was formed under the influence of Medardo Rosso (1858-1928), RODIN, and MAILLOL. In 1948 he was appointed Professor of Sculpture at the Brera Academy, Milan, and in the same year won the First Prize for sculpture at the Venice Biennale. He was commissioned in 1950 to make a door for St. Peter's, Rome, winning an international competition. The subject of the panels is Death in its various forms. In 1958 he also completed doors for Salzburg Cathedral. Manzu is considered the leading Italian sculptor of the mid 20th c. His works have been exhibited at the Tate Gallery, London, which possesses examples. He is also a painter and book illustrator.

1756, 1757, 1992, 2220.

**MAORI ART.** See POLYNESIAN ART and NEW ZEALAND ART.

**MAQUETTE.** A small preliminary model for a work of sculpture. The word implies something in the nature of a rough sketch, not so fully worked out as a BOZZETTO.

**MARATTA** (MARATTI), CARLO (1625-1713). Leading painter in Rome in the latter part of the 17th c. As the pupil of Andrea SACCHI he continued the tradition of the Classical GRAND MANNER, based on RAPHAEL. His later style inclines towards the greater freedom and movement of the High BAROQUE painters such as Pietro da CORTONA. His ability as a portrait painter is seen in the *Clement IX* of the Vatican Gallery. The type of his large religious compositions was continued into the 18th c. by his numerous pupils.

**MARBLE.** (From the Greek *marmaros*: a crystalline rock; root from *marmairein*: to sparkle.) The word is loosely applied among masons and in the building trade to any hard LIMESTONE which can be sawn into thin slabs and will take a good polish so that it is suitable for decorative work. In a stricter sense true marbles are metamorphosed limestones whose structure has been re-crystallized by heat or pressure. Marbles are widely disseminated and occur in a wide variety of colours and patterns, the latter resulting from the presence of matter other than calcite. In the United Kingdom marbles are rare. The best known are those from Connemara in Ireland and from the islands of Skye, Iona, and Tiree. Imported marbles have been used for building

and carving since Roman times in Great Britain.

Marble was the indispensable material of architectural work in ancient Greece and was employed by the greatest Greek sculptors. Generally the Greeks preferred the white marbles, though they often used them as a ground for the application of colour, whereas the Romans made great use of coloured and patterned marbles. The most famous of Greek white marbles in the ancient world was the close-grained *Pentelic*, which was quarried at Mt. Pentelicon in Attica. This marble was used for the PARTHENON, and the ELGIN MARBLES are carved in Pentelic. Widely used also were the somewhat coarser-grained translucent white marbles from the Aegean islands of Paros and Naxos. *Parian* marble was used for the celebrated MAUSOLEUM, the tomb of King Mausolus of Caria, for the statuary on the temple of Zeus at OLYMPIA, and for the Venus de Medici. Use was also made of a softer white marble from Sunium in southern Attica and of clouded blue marbles from Hymettus, near Athens.

The pure white *Carrara* marble—the *marmor lunense* of ancient Rome—was quarried at Massa, Carrara, and Pietra Santa in Tuscany from the 3rd c. B.C. It supplied the material for TRAJAN'S COLUMN, was used for the columns of the PANTHEON and the Palace of Domitian, and the APOLLO BELVEDERE was cut from it. Italian RENAISSANCE sculptors favoured a variety of clear translucent Carrara—it is recorded that MICHELANGELO visited the quarries some 10 times to select material for his works—and the NEO-CLASSICAL sculptors, such as CANOVA, also favoured it because of its power to take a smooth, sleek surface.

*Apollino* is a white and green banded marble which was quarried in ancient times in the island of Euboea. It was known to the Romans as *marmor carystium* and it was used by them at Colchester. It is still quarried today, the modern term deriving from the Italian *cipolla*, an onion, in reference to the undulating green bands with which the marble is marked. A near approximation to the original Euboean variety is obtained from Canton Valais in Switzerland. The ground colour is pale green, relieved by straight or wavy bands of darker green. It has been used both for exterior work and for interior decoration.

*Rosso antico* is an unpatterned marble varying in shade from pale to purplish red, liver and blood red, quarried at Taenarum, now the Matapan peninsula of Greece, and known to the Romans as *marmor alabandicum* and *marmor taenarium*. Quarries have been rediscovered in various localities in Greece in recent times. *Rosso antico* was also the name given by Josiah Wedgwood to his red stoneware.

*Verde antico* is a green mottled serpentine marble, known to the Romans as *lapis atracius*. Quarried at Larissa in Thessaly, it varies in shade from a pale cloudy green with black, white, and a few yellow fragments to a medium green with black and white angular fragments and a very dark green mottled with almost black and a few white spots. Much admired in the early Middle Ages, both Sta Sophia and S. Giovanni Laterano, Rome, contain re-used pillars of *verde antico*.

*Belgian black* is a compact fine black marble quarried near Tournai and earlier known as 'Tournai marble'. There are many medieval fonts dating from the 12th c. carved in this marble throughout Belgium, France, and Germany, and some exist in England (Winchester and Lincoln Cathedrals). Belgian black is much favoured by sculptors today.

**MARC,** FRANZ (1880–1916). German painter, one of the leading members of the BLAUE REITER. During his formative years he twice visited Paris and his early works show the influence of MATISSE. After *c.* 1908 he tried to express his mysticism and veneration for nature through animal paintings which utilized all the EXPRESSIONIST devices of distortion and colour symbolism. In his own words, he did not want to paint the animal as we see it but as the animal feels its own existence. His most famous painting *Tierschicksale* (*The Fate of the Animals*, Basel) is an apocalyptic vision of some primeval catastrophe. Just before the First World War Marc fell under the influence of CUBISM, and through contact with his friend KANDINSKY developed towards abstraction.

435, 1565.

**MARCANTONIO RAIMONDI.** See RAIMONDI.

**MARCKS,** GERHARD (1889–    ). German sculptor. He taught at the BAUHAUS 1919–25, yet his EXPRESSIONISM is very restrained. He completed BARLACH's series of statues on the gable of the Catherine church in Lübeck (1947) and some of his over-refined figures are reminiscent of LEHMBRUCK (*Melusine*, Walker Art Centre, Minneapolis). On the whole, however, his somewhat sentimental style was more indebted to the NEO-CLASSICAL tradition.

1788, 2262.

**MARGARITO OF AREZZO** (called by VASARI MARGARITONE) (active *c.* 1262). One of the very few 13th-c. Italian painters and the only early Aretine by whom we have signed works (*Madonna and Child Enthroned* with scenes from the lives of various saints, N.G., London; others in Washington, Siena, and Arezzo). Margarito's scenes have the vividness and lucid brevity of the comic strip; the shapes are neat and the pattern simple. His freedom from formal BYZANTINE conventions of drawing and decoration has led some critics to consider him in advance of his time, though others have held that his was a meagre talent beside that of such contemporaries as COPPO DI MARCOVALDO and GUIDO DA SIENA.

**MARIN,** JOHN (1870-1953). American artist. He studied at the Pennsylvania Academy under Thomas Pollock Anshutz (1851-1912) and at the Art Students' League. He worked in Europe from 1905 to 1910, acquiring some facility as an ETCHER and WATER-COLOURIST in the manner of WHISTLER. He first came into contact with the *avant-garde* movements after his return to America in 1911, when he became a member of the Stieglitz circle at the 291 Gallery (see AMERICAN ART OF THE UNITED STATES). He developed a personal vision and a highly individual style, alternating a turbulent emotional EXPRESSIONISM with a planimetric structure derived from an original adaptation of CUBIST concepts of picture space. During the 1920s he provided the dominant force in the movement away from naturalistic representation towards an art of expressive abstraction. He wrote in 1928: 'My works are meant as constructed expressions of inner senses, responding to things seen and felt.' This attitude is expressed in the titles of many of his pictures such as *Pertaining to Deer Isle, Maine Series, No. 27.*

2894.

**MARINE PAINTING.** The sea is of course a feature in many paintings which illustrate ancient legend or incidents such as naval battles or piracy. Known examples go back to the Campanian art of classical antiquity, such as the *Harbour Scene* from Stabiae (Mus. Naz., Naples), the *Venus on her Seashell* from POMPEII and even earlier the fishing scene from the Tomb of the Hunt and Fishing, Tarquinia. The themes of Perseus and Andromeda (Pompeii, Mus. Naz., Naples), Daedalus and Icarus, Polyphemus and Galatea, and Medea were often set in seascapes. Other examples occur in the famous 'Odyssey landscapes' from the 1st c. A.D. And it is apparent from the descriptions in the *Imagines* of the PHILOSTRATI that sea scenes continued to be a regular feature of narrative and anecdotal art. But throughout the classical era interest was primarily concentrated on the human form or human activities, sea and rivers were frequently represented conventionally or even by the figures of the appropriate divinities, and the interest in LANDSCAPE scenery for its own sake which developed to some extent during the Roman period seems not to have extended to seascape.

When landscape for its own sake emerged once again during the 16th c. marine painting lagged somewhat tardily behind. The paintings of Henry VIII leaving Dover in 1520 (Hampton Court), usually attributed to Vincent Volpe (active 1514-30), and of Portuguese carracks off a Mediterranean harbour (Greenwich), perhaps by Cornelis ANTHONISZ, show no specialized interest in seascape. Pieter BRUEGEL the Elder also displayed an interest in ships, though they were usually incidental to the main subject, as in his *Fall of Icarus* (Brussels). Towards the end of his life, however, his painting of ships in a rough sea (Vienna) showed an interest in the sea itself, which foreshadows the naturalistic sea painting of the 17th c.

With the rise of the Dutch Republic came painters who devoted themselves to marine painting. The earliest of them was Hendrik Cornelisz Vroom (1566-1640) and such was his reputation that he was commissioned to make the CARTOONS used for the tapestries (formerly in the House of Lords) which showed the defeat of the Armada in 1588. His most important painting is the one in his native Haarlem, showing ships running into Flushing. In the same tradition as Vroom were Cornelis CLAESZ, Wieringen (1580?-1633), Aart van Antum, and Adam Willaerts (1577-1664).

There were new influences at work in the first quarter of the 17th c. Andries van Eertvelt (1590-1652) produced romantic sea-pieces in a colourful Flemish style, which was carried on by Bonaventura PEETERS, Pieter Mulier (d. 1670) (*Tempesta*), Abraham Storck (*c.* 1635-c. 1710), and eventually in France by the stormy sea-pieces of Claude-Joseph VERNET. A different influence was Jan PORCELLIS, a pupil of Vroom, who painted naturalistic seas with ships pitching and rolling and peaceful calms in the Dutch estuaries. He had the most direct effect on his son Julius and on Simon de VLIEGER; the latter's earlier works combine the atmospheric calms of Jan Porcellis with the rocky landscapes of Adam Willaerts, but his later ones have all the liveliness of the grey tumbling seas of the Dutch shallows. Both his styles influenced his pupil, Willem van de VELDE the Younger, the greatest of the Dutch marine painters and the one who had the most powerful effect on marine painting for two centuries or more. He was accorded high praise by RUSKIN. He was an extremely accurate draughtsman like his father, from whom he learnt to make careful drawings of the ships intended for inclusion in his paintings. The two van de Veldes came to England in the winter of 1672-3 and thereafter were mainly occupied in painting the historical sea-pieces in which they excelled all others. Contemporary with them but working almost entirely in Holland were Jan van de CAPPELLE, whose forte was the painting of calms, and Ludolf BAKHUYZEN, noted for his stormy seas.

In the 18th c. the best marine painting followed the shift of sea-power from the Dutch to the English. There was Peter MONAMY, who so often copied van de Velde's compositions slavishly, and Samuel SCOTT, who was more of an outdoor artist and in his historical works approached van de Velde in accuracy and skill in composition. Charles BROOKING had great natural talent and in his short life mastered a pearly quality copied from van de Velde's early work, adding to it a breeziness of his own which may have come from his first-hand experiences of the sea as a profession.

The British naval victories in the second half of the 18th c. were subjects for many uninspired

marine painters. Above the general level were Nicholas Pocock (1740-1821) and the Frenchmen who came to work in England, Dominic SERRES and J. P. DE LOUTHERBOURG. In their own country the few French marine painters got little encouragement. In the 19th c. Ambroise-Louis Garneray (1783-1857), who started his painting career in the prisoner-of-war hulks in Portsmouth harbour, had some popularity and large engravings were made of his battle-pieces and whaling scenes. There was no important new influence in British marine painting until J. M. W. TURNER brought a new era in the painting of the sea, though he fell well below van de Velde and Bakhuyzen in the drawing of ships.

In the 19th c. exquisite sea-pieces by such artists as BONINGTON and COTMAN blurred the distinction between sea and landscape painters. Of those who can be regarded as exclusively marine painters, George Chambers (1803-40), Clarkson Stanfield (1793-1867), and Sir Oswald Brierly (1817-94) stand out above the rut of those who portrayed the beautiful ships of the last days of sail. Bridging the gap to modern times was W. L. Wyllie (1851-1931), who did much to encourage, particularly through his water-colours, many amateur as well as professional marine painters.

2146, 2287, 2797, 2902.

**MARINETTI,** FILIPPO TOMMASO (1876-1944). Italian poet, who in 1909 published the first manifesto of FUTURISM in the *Figaro*. He originated the *mot* that 'a speeding automobile is more beautiful than the *Victory of Samothrace*'.

**MARINI,** MARINO (1901-66). Italian sculptor, trained at the Academy of Fine Arts, Florence. He first worked as a painter and engraver and took up sculpture from *c.* 1928. He won the First Prize for sculpture at the Rome Quadriennale in 1935 and in 1940 was appointed Professor of Sculpture at the Brera Academy, Milan. He travelled extensively in Europe, lived in Switzerland 1942-6, and then returned to Milan. In 1952 he was awarded the town of Venice Prize for Sculpture at the Venice Biennale. He worked largely in BRONZE and sought to exploit the sensuous and surface qualities of the material. His works have been widely exhibited and are represented in the Tate Gallery, London, and in many Italian and American collections. In Herbert Read's *A Concise History of Modern Sculpture* there are illustrations of his *Horse and Rider* (1949-50), *Igor Stravinsky* (1951), and *Dancer* (1954).

66, 1564, 1774, 2359, 2684.

**MARINUS VAN REYMERSWAELE** (active *c.* 1509-d. after 1567). Flemish painter who had two specialities: half-length, life-size figures of St. Jerome in his study, and GENRE scenes of bankers, usurers, and excisemen. The genre scenes were not satirical but intended to show the sin of avarice and the vanity of earthly possessions: for according to a Flemish proverb a banker, a usurer, an exciseman, and a miller were the four evangelists of the Devil. Marinus's paintings were very popular and numerous versions of them are extant. There is an excellent painting of *Two Excisemen* in the National Gallery, London; it gives a good idea of the fanciful costumes in which he dressed these unpleasant characters, and the scrupulous attention which he paid to every detail of the miscellany of objects which clutter his pictures.

**MARIS.** Family of three brothers who played a leading part in Dutch painting during the second half of the 19th c.

JACOB (JACOBUS HENDRICUS) (1837-99) became one of the leaders of the HAGUE SCHOOL. He studied at the Academies in The Hague and in Antwerp, and also worked in Paris (1865-71), where he was influenced by COROT and E.-P.-T. ROUSSEAU. In his later years he painted principally views of the Dutch countryside, with some portraits and figure studies. His manner has affinities with IMPRESSIONISM, though he frequently composed his pictures indoors and did not paint directly from nature.

MATTHIAS (MATTHIJS, THIJS) (1839-1917), a younger brother of Jacob, received the same education but had an entirely different approach to art. He was influenced by German ROMANTIC painters like SCHWIND and KAULBACH, and after he moved to Paris in 1869 by Corot and MILLET. He settled in London in 1877 and remained there until his death. During this latter period his admiration for the PRE-RAPHAELITES showed itself in his choice of subjects but not in his style. His paintings are visionary and poetic; shades of grey predominate.

WILLEM (1844-1910), a third brother, was a pupil of the other two and was influenced by MAUVE. His subjects are almost entirely confined to meadows and cattle. In his later years he became a leader of Dutch Impressionism, urging his pupils—among them BREITNER—to paint in the open air and to use vivid colours.

925.

**MARKELIUS,** SVEN (1889- ). Swedish architect of the FUNCTIONALISTIC school of LE CORBUSIER. His first important works are from *c.* 1930, e.g. buildings for the Stockholm Fair of 1930, the college building for the Technical High School of Stockholm (1929-30), and he first attracted international attention by the Concert Hall at Hälsingborg (1931-2). A collective settlement which he erected in Stockholm in 1935 came to be regarded as a model of its kind. He won international recognition by his design for the Swedish pavilion at the New York Fair of 1939. In later works he reveals an increasing tendency towards formalism (e.g. the annexe to the Stockholm college building, 1953). As chief of the Town-Planning Department he

was responsible for the new satellite town of Vällingby, near Stockholm. His ECOSOC Session Room at the U.N. Building, New York (1953), is notable for its bare ceiling showing the whole network of ventilation pipes and constructive elements. In 1960 he built the Stockholm Folkets Hus (Trade Union Centre), combining theatre, congress hall, assembly halls, meeting rooms, and restaurant.

**MARLOW**, WILLIAM (1740-1813). English LANDSCAPE painter, a pupil of Samuel SCOTT and possibly also of Richard WILSON. His early landscapes were topographical views, but after a visit to the Continent (1765-8) he painted largely from his memories of France and Italy. He retired from professional practice c. 1785.

**MARMION**, SIMON (d. 1489). Painter. He was at Amiens 1449-54 but may have been Flemish. He was a member of the Tournai guild in 1468 and spent the greater part of his working life at Valenciennes. Marmion is usually regarded as the painter of the *Retable of S. Bertin* (1459; most of it in Berlin, fragments in the N.G., London). He was also a MINIATURIST. His style, which is light and 'gossipy', characterized by its gay colours and many small figures, does not belong to the main stream of either French or Flemish painting.

**MAROT**. French family of architects and decorators. JEAN (1619-79) produced important volumes of engravings of French architecture and some architectural designs (e.g. for the east front of the LOUVRE, 1664). His son DANIEL (1663-1752) left France after the Edict of Nantes (1685), worked as decorator for the Prince of Orange and King of England (Hampton Court and Kensington Palace, 1695/6), and influenced English ornamental design. His work was derivative from that of BÉRAIN and Pierre LE PAUTRE but his ornament engravings along with those of Bérain became popular in Germany.

1988.

**MAROUFLAGE**. Painter's term for gluing a canvas down, whether before painting it or afterwards, on to a PANEL or a wall. In French *maroufle* means a sticky mixture of the remains of paint left in the artist's pots, and *maroufler* may describe almost any operation which might be carried out with this powerful glue, such as lining one CANVAS with another to strengthen it, or coating the back of a stretched canvas to increase the tension, or pasting strips of linen across the back of a panel to prevent it from splitting.

**MARQUET**, PIERRE-ALBERT (1875-1947). French painter, born at Bordeaux. He came to Paris in 1890 and studied under Gustave MOREAU at the École des Beaux-Arts, where he became a close friend of MATISSE. Although associated

with the FAUVE movement, he stood apart from the group. He was by temperament a REALIST in the tradition of COROT and COURBET. His talent lay in rendering a scene with limpid clarity and intelligibility and he spent much time between 1912 and 1914 and again between 1925 and 1938 travelling in search of subjects. He preferred port and coastal scenes and worked often in WATER-COLOUR. Like most realists, Marquet was a superb draughtsman. Matisse once called him the French HOKUSAI.

1452, 1779, 1780.

**MARSHALL**, BENJAMIN (1767-1835). English sporting painter, an able follower of STUBBS. He was a pupil of the portrait painter L. F. Abbott (1760-1803) but from c. 1792 he turned to animal painting. From 1796 his work was published in the *Sporting Magazine* and in 1812 he settled in Newmarket, where he concentrated on pictures of horses and hunting and racing scenes.

**MARSHALL**, EDWARD (1578-1675). English mason and sculptor, who was admitted a freeman of the Mason's Company in 1626 and became Master Mason to Charles II in 1660. He also made memorial BRASSES, one to Sir Edward and Lady Filmer at East Sutton in Kent being signed. He had a considerable business as a maker of MONUMENTS, two of the finest being those to Lady Culpeper, Hollingbourne, Kent (1638), and to the Cutts family at Swavesey in Cambridgeshire (1631). In his later work he was assisted by his son JOSHUA (1629-78), who also became Master Mason to the Crown (1676-7). Besides working on the royal palaces Joshua was much employed in the rebuilding of the City of London after the Fire. His monuments are less accomplished in cutting than those of his father, perhaps the most notable being that depicting the standing shrouded figures of Lord and Lady Campden at Chipping Campden, a somewhat macabre form of monument which was popular in the 17th c.

**MARTIN**, ELIAS (1739-1818). Swedish LANDSCAPE painter and ETCHER; an admirer of CLAUDE Lorraine. In 1768 he went to England, where he became interested in the art of GAINSBOROUGH, HOGARTH, and WILSON. When he returned to Sweden in 1780 he found himself in great demand for depicting Stockholm and the estates of the nobility in the new ROMANTIC style. Later he created visionary paintings and engravings illustrating the Lord's Prayer (1803); they oscillate between the naïve and the sublime. His OIL PAINTINGS are rather uneven, and are surpassed by his numerous WATER-COLOURS.

**MARTIN**, JOHN (1789-1854). English painter of large visionary and apocalyptic LANDSCAPES of cosmic, biblical, or oriental import, which exerted a powerful appeal on the ROMANTIC

imagination. He leapt to fame with his *Joshua commanding the Sun to stand still* (1816) and this was followed by a series of canvases which compelled attention by the sheer grandiosity of their themes. Among the most famous were *The Fall of Babylon* (1819), *Destruction of Sodom and Gomorrah* (painted twice, one in the Laing Art Gal., Newcastle, one in Wolverhampton, and a water-colour of the same subject was exhibited at the Royal Academy in 1852, besides engravings), *Belshazzar's Feast* (1826), *The Fall of Nineveh* (1827–8), *The Deluge* (exhibited at the Salon, 1834). He did illustrations for the Bible and *Paradise Lost* in a similar grandiloquent style. Engravings of his pictures circulated widely, were pirated and faked, and he soon achieved a European fame, particularly in France where he received a gold medal from Charles X in 1829 and was later honoured by Louis-Philippe. He appealed to the imagination of writers like Sainte-Beuve, Huysmans, and Victor Hugo, fascinated Gautier and Michelet. In 1863 M. W. Bürger wrote: 'Martin got all Europe talking of him and is perhaps of all English painters the one who achieved the highest reputation on the continent.' But his success depended partly on sensationalism and partly on his appeal to the literary imagination: as Gustave Planche wrote at the Salon of 1834, 'he is the poets' painter'. It was CONSTABLE, not Martin, who impressed the artists and Martin had no successors if we except perhaps Gustave DORÉ.

148.

**MARTORELL**, BERNARDO (active 1433–52). Spanish painter and MINIATURIST of the School of Catalonia. Influenced by BORRASSÁ and by Franco-Flemish painting and ILLUMINATION, he was a precursor of HUGUET. His documented works include the ALTARPIECE of Pubol (Gerona Mus., 1437). Among the paintings attributed to him are panels from an altarpiece of St. George now divided between the LOUVRE and the Art Institute, Chicago.

1192.

**MARUYAMA SCHOOL.** A school of Japanese painting founded at Kyoto by Maruyama Ōkyo (1733–95). By combining typical features of CHINESE painting (especially from 18th-c. bird and flower paintings) with European sketching techniques, he created a new semi-naturalistic style which met with an immediate success especially among the merchant classes. Some authorities say that the NATURALISTIC elements had already been absorbed by Chinese artists such as Shen Nan-p'in, who lived at Nagasaki 1731–3 and influenced Ōkyo. Unlike the artists of the KANŌ and TOSA Schools with their emphasis on traditional subjects Ōkyo sought his models in a direct study of nature; but his style owes so much to the Chinese brush-work practised by the Kanō School that it would not strike a European as particularly realistic. His realism is exemplified particularly in animal studies (especially birds), which he and his followers sometimes incorporated in LANDSCAPES which were Chinese in their general character.

Ōkyo had a large following, among whom were Komai Genki (1750–97), Nagasawa Rosetsu (1755–99), Tessan (1755–1841), and Goshun Matsumura (1752–1811). The last of these formed a subdivision of the Maruyama School called the Shijo School—a fusion of the Maruyama naturalistic approach with the IDEALISTIC tendencies of the NANGA SCHOOL which he inherited from his teacher Yosa no Buson (1716–83).

**MARVILLE**, JEAN DE. The first master in charge of the TOMB of Duke Philip the Bold of Burgundy at Champmol, near Dijon, begun 1383. He was succeeded in 1389 by SLUTER, to whom is due the sculpture which made the tomb revolutionary. The general conception of a tomb with mourners set in arcaded niches had been current for more than a century, for example the tomb of Louis of France in the abbey of Saint-Denis (*c.* 1260). (See also GISANT.)

**MARZAL DE SAX**, ANDRÉS (active 1394–1410). Painter, probably of German origin, who worked in Valencia. He was paid in 1400 for an ALTARPIECE of St. Thomas, the central panel of which survives in Valencia Cathedral, and he may have collaborated in the altarpiece of St. George (V. & A. Mus.), which is painted in the same REALISTIC manner.

**MASACCIO**, TOMMASO GIOVANNI DI MONE (1401–28). Italian painter, born at S. Giovanni Valdarno, some 30 miles from Florence where he lived from *c.* 1422 until he left for Rome (probably 1428). He died there at the age of 27. Only four undertakings unquestionably by him have survived, and in two of them, the *Virgin with St. Anne* (Uffizi) and the FRESCOES in the Brancacci Chapel of Sta Maria del Carmine in Florence, he collaborated with the more conservative, less gifted MASOLINO. The other two are the POLYPTYCH painted in 1426 for the Carmelite church in Pisa (of which some of the panels have been dispersed and others lost) and the great fresco of the Trinity in Sta Maria Novella, Florence.

Both the revolutionary character of Masaccio's achievement and its place in the Florentine tradition at the head of the 15th-c. phase of RENAISSANCE painting in Italy were authoritatively demonstrated by VASARI. Vasari also recognized Masaccio's debt to his older contemporaries in the new artistic movement—the architect BRUNELLESCHI and the sculptor DONATELLO. He learnt from Brunelleschi the central PERSPECTIVE system (a geometrical construction designed to regulate the depiction of a contained space on a flat surface) and used it most notably in his

fresco of the Trinity. He took from Donatello the hard directness of modelling characteristic of his early figures, particularly the Virgin and Child from the *Virgin with St. Anne* group, and the crucified Christ (now in Naples) from the Pisa polyptych. Masaccio shared in principle the new attitude to nature which Donatello had reached through an intelligent study of classical sculpture. Both artists were concerned less with surface appearances and isolated detail than with the construction of objects in nature, chiefly the human figure under the stress of some significant emotion. This represented an acceptance of the new Renaissance scale of values. In practice there were of course differences in technique and emphasis between the two artists. Masaccio's great discovery consisted in the use of light to define the construction of the body and its draperies (and also, in the later frescoes, to unify a whole composition). But the figure style he evolved was not adapted to the representation of violent movement—a characteristic not unconnected with his manifest admiration for GIOTTO, whom he understood better than any trecento artist. These factors in combination resulted in the monumental and austere yet convincing figures, the slow rhythms and the Classically ordered compositions of the Brancacci Chapel frescoes.

It has been said that Masaccio inherited the tradition of Giotto and was the true ancestor of MICHELANGELO. In contrast with the INTERNATIONAL GOTHIC style prevailing at the time in painting he represented the humanistic spirit of scientific NATURALISM which Brunelleschi and Donatello stood for in their respective spheres. Despite his short life he made a great impact and few 15th-c. artists of Florence remained impervious to his influence.

1827, 2153, 2552.

**MASEREEL, FRANS** (1889-    ). Prolific Belgian EXPRESSIONIST painter and print-maker who is best known for his *romans in beelden* (novels in pictures), which are series of WOODCUTS telling a story without a text.

2969.

**MASKS.** See DEATH MASKS AND LIFE MASKS.

**MASO DI BANCO.** A 14th-c. Italian painter by the name of Banco was held in high regard by such early 15th-c. writers as Filippo Villani and Lorenzo GHIBERTI. The latter was the first to ascribe to Maso the frescoes illustrating the legend of St. Sylvester in the Bardi chapel of Sta Croce, Florence. This Maso is probably the painter Maso di Banco cited in a document of 1346 relating to the Bardi family. On the basis of the style of these murals other works in Florence and elsewhere have been attributed to the same master. His stately figures are even more massive and the spaces deeper than GIOTTO's, and these features are resolved into harmonious compositions of geometric clarity. The expressiveness of his poses and the treatment of draperies have been particularly admired. The painter of these works was one of Giotto's greatest followers. Yet he had few imitators; to find Maso's heirs one must skip two generations to MASACCIO and PIERO DELLA FRANCESCA. VASARI believed Maso to be a certain 'Tommaso called Giottino' but modern critics do not accept the identification and even doubt whether Giottino ever existed. (See GIOTTESQUES.)

**MASOLINO DA PANICALE** (c. 1383–1447?). Italian painter who began his career in the Florentine late GOTHIC tradition of LORENZO MONACO. From about 1424/5 he came under the influence of MASACCIO while collaborating with him on the *Virgin with St. Anne* (Uffizi) and the frescoes in the Brancacci Chapel of Sta Maria del Carmine in Florence. Masaccio's influence on Masolino continued into his Roman period (c. 1428–31) when he painted a triptych with *The Miracle of the Snow* in Sta Maria Maggiore and a fresco cycle in S. Clemente. The panel containing SS. Jerome and John the Baptist (from the former work and now in the N.G., London) is so like Masaccio's work that it is sometimes thought the two influenced each other. After Masaccio's death he reverted to the more decorative style he had practised as a young man (frescoes at Castiglione d'Olona, near Como). Masolino was a strong but versatile and varied artistic personality who stood at the convergence of two trends which run through Italian art—the approach by modelling and spatial organization on the one hand and on the other hand the decorative interest in colour.

1833.

**MASONOBU, OKUMURA** (1691–1768). One of the leading masters during the early phase of the Japanese UKIYO-E movement before the invention of the fully polychrome PRINT (*nishiki-e*) c. 1765. He has sometimes been credited with inventing the *urushi-e* ('lacquer-pictures'), in which the colour of the print was enhanced by a transparent lacquer. To him also was attributed the invention c. 1740 of the narrow 'pillar print' or *hashira-e* and he excelled in prints with perspective background in the Western mode (*uki-e*). His versatility contributed to the vitality and variety of the *ukiyo-e* movement in its early stages.

**MASSACRE OF THE INNOCENTS** (Matt. ii. 16–18). The scene occurs rarely in EARLY CHRISTIAN ART, but a 5th-c. mosaic (Sta Maria Maggiore, Rome) shows the moment before the massacre begins, with Herod seated on the left while a guard is about to take a child from one of the assembled women. A different tradition, in which the children are being dashed to the ground, is exemplified on a 5th-c. SARCOPHAGUS in S. Maximin, Provence; and this version was not

infrequent in the early Middle Ages (ivory book cover, Bodleian Lib., Oxford, *c.* 800). Most commonly, however, the massacre is shown carried out with swords and spears, generally in the presence of Herod on one side and a group of wailing women on the other (*Codex Egberti*, Trier, *c.* 980; GIOTTO, Arena Chapel, Padua, 1305). In the 15th c., though the basic composition remained unchanged, the movement and expression became more violent, as in the painting by MATTEO DI GIOVANNI in S. Agostino, Siena. After the appearance of a famous engraving by Marcantonio RAIMONDI after RAPHAEL, the Massacre became a favourite theme for displaying virtuosity in compositions of violent action, as in the works of TINTORETTO (Scuola di S. Rocco, Venice), RUBENS (Pinakothek, Munich), and POUSSIN (Musée Condé, Chantilly).

**MASSON**, ANDRÉ (1896- ). French painter, engraver, and illustrator. After studying at the Académie des Beaux-Arts, Brussels, he came to Paris on the advice of the poet Verhaeren and in 1922 met the dealer Daniel Henri Kahnweiler, who made it possible for him to devote himself entirely to painting. He was influenced for a time by the CUBIST doctrines. A symbolic picture *Les Quatre Éléments* was exhibited by Kahnweiler at the Galerie Simon in 1924 and attracted the attention of André BRETON and other SURREALISTS, with whose movement Masson was associated for some years. He was a highly cerebral artist, who developed a personal mythology (*Combats de poissons*, *Tauromachies*, etc.) expressed with great purity, energy, and restlessness of line. In 1947 he settled in Provence and found a new style of LANDSCAPE which has been compared to the deep spiritual rapport with nature which is reflected in some Chinese paintings. In 1939–40 he designed the décor for *La Faim* by Knut Hamsun at the Théâtre de l'Atelier and for Milhaud's *Médée* at the Opéra. In 1946–9 he did illustrations for *Les Conquérants* of André Malraux. He had a large retrospective exhibition with GIACO-METTI at Basel in 1950.

1216, 1631.

**MASSYS** (also MATSYS, METSYS), QUENTIN (1465/6–1530). Flemish artist born at Louvain, who worked in Antwerp from 1491 until his death. His early life is obscure until in 1507 he emerges as a completely accomplished artist. The *Altarpiece of St. Anne* (Brussels, 1507–9) and the *Lamentation* (Antwerp, 1508–11) breathe a solemn and refined spirit. In many respects Massys harks back to an earlier age, yet the St. Anne altarpiece combines a monumental composition with a highly sophisticated colour scheme that draws attention to the surface pattern. He was clearly aware of Italy as he attempts to place his figures in an Italianate building. His portraits and GENRE pictures indicate that he must have known the work of

LEONARDO. Like him, he shows a keen interest in the contrast between youth and age (*The Ill-matched Pair*, private coll., Paris; the *Profile Drawing of an Elderly Man*, Jacquemart André, Paris), and the pose and composition of the *Magdalen* (Antwerp) convey a strong suggestion of Leonardo. The satirical quality in his pictures of bankers, tax-collectors, and avaricious merchants has been linked with the writings of the great humanist Erasmus. Certainly the two met, for Massys painted a pair of portraits of Erasmus (Palazzo Barberini, Rome) and Petrus Egidius (Earl of Radnor Coll., Longford Castle) as a gift for Sir Thomas More in 1517.

Towards the end of his life the quality of Massys's religious paintings declined as they became more sentimental and the gestures turned into wild gesticulations. But his ability and success as a portrait painter should not be underestimated.

926.

**MASTABA.** A type of Egyptian TOMB so called by the Arabs from its resemblance to the long, low bench before their houses. Mastabas are massive brick or stone structures, generally rectangular in plan and with battered sides, the earliest panelled and recessed in imitation of a house façade. The best known are the mastabas of nobles of the Old Kingdom. In these the superstructure covers a shaft leading to the burial-chamber and contains various rooms—originally a small chapel and a hidden chamber (*serdab*), to which were added others, their walls decorated with RELIEF with scenes of daily life.

**MASTER BERTRAM.** German painter from Minden in Westphalia, who worked in Hamburg 1367–87. His main work, the *Grabow Altar* of 1379 (Kunsthalle, Hamburg), shows how the influence of the BOHEMIAN SCHOOL extended as far as Hamburg. From there the style seems also to have reached England for the *Apocalypse* frescoes in the Chapter House of Westminster Abbey (*c.* 1400) have very close links with Master Bertram's workshop. An *Apocalypse Altar* in the Victoria and Albert Museum, which, however, was not in England originally, must also come from his circle.

757.

**MASTER E.S.** (sometimes called the MASTER OF 1466 from the date on one of his engravings). German engraver and goldsmith working about the middle of the 15th c.; he was the most prolific and influential of the early German engravers. His imaginative representations of devotional subjects, such as the Annunciation, NATIVITY, or the Man of Sorrows, make subtle use of the possibilities of the new technique of LINE ENGRAVING. Earlier engravers had been content with pure outline, but E.S. managed to produce rich tonal effects by the ingenious use of parallel and cross hatchings.

**MASTER FRANCKE** (early 15th c.). German painter who worked in Hamburg, where in 1424 he painted an ALTARPIECE for the guild of merchants trading with England (*England-fahrer*, now in the Kunsthalle, Hamburg), showing Passion-scenes and incidents from the life of St. Thomas of Canterbury. Francke was a leader of the northern German version of INTERNATIONAL GOTHIC. He had close links with the west and Burgundy in particular. His influence was widely spread over north Germany and along the shores of the Baltic. An altarpiece from his workshop, once in a Finnish church, is now in the Museum at Helsinki.

**MASTER JACOMART.** See BACO.

**MASTER OF ....** In the study of art history, anonymous works which show an individual hand are sometimes grouped under an invented name for convenience in discussing them. This practice is more commonly applied to painting and GRAPHIC ARTS than to sculpture, and historians of architecture hardly ever resort to it. It began in Germany in the early 19th c. with the description of early FLEMISH painting. The choice of names was then more lyrical than descriptive: for instance the 'Master of the Pearl of Brabant' (who later turned out to be BOUTS) got his name from a picture which had received that poetical title simply because it caught the imagination. Nowadays invented names are more prosaic and more directly appropriate; the tendency has been to name an anonymous master after a particular picture and the collection to which it belongs, e.g. 'Master of the Mansi Magdalen'. The practice of creating artistic personalities in this way has been overdone, but it has a certain usefulness in the survey of styles and schools.

**MASTER OF ALKMAAR** (active 1490–1520). Dutch artist whose principal work is the *Altarpiece of the Seven Works of Mercy* painted for the church of St. Lawrence in Alkmaar (now Rijksmuseum, Amsterdam). He is probably identical with CORNELIS BUYS (d. 1520), who was the brother of Jacob CORNELISZ VAN OOSTSANEN. The ALTARPIECE shows that the artist was influenced by the style of GEERTGEN TOT SINT JANS. His work is important as an early instance of the characteristically Dutch delight in the representation of everyday life.

**MASTER OF FLÉMALLE** (1378/9–1444). Artist who ranks with the van EYCKS as one of the founders of the Netherlandish school of painting. He is named after paintings in Frankfurt that are wrongly supposed to have come from Flémalle, near Liège. The identity of this artist remains an open question, but the majority view is that he was Robert Campin. Campin was active by 1406, and from 1427 to 1432 he had Jacques DARET and Rogelet de la Pâture (who is generally assumed to be Rogier van der WEYDEN) as his pupils in Tournai. Others identify the Master of Flémalle with the youthful Rogier van der Weyden, but stylistically this is less plausible. There is no argument, however, about this master's achievement. A chronology of the main works of the Master of Flémalle can be established on stylistic grounds, but only the *Werle Wings* (Prado) are dated (1438). The *Marriage of the Virgin* (Prado) and *The Entombment* (Count Seilern Coll., London) seem to be early works, and show that he made a radical break with the elegant INTERNATIONAL Style popular in the courts of Europe *c.* 1400. His figures are given a new sense of volume which recalls the sculpture of Claus SLUTER and the artist has made an ambitious, if not altogether successful, attempt to set his figures in space. The *Dijon Nativity* is more accomplished and is tentatively dated 1420–5. The true value of the new figure style can be estimated in the Frankfurt panels. Among these is a GRISAILLE of the *Holy Trinity* from a lost altarpiece, and a fragment of the *Crucified Thief* from a *Deposition* triptych (a copy of the lost composition is at Liverpool). In both the inert, half-naked figures are handled with solidity and strengthened with careful lighting used to obtain dramatic REALISM. In contrast to these figures of grand pathos is the *Merode Altarpiece* (Met. Mus., New York), which is set in a comfortable, bourgeois interior. The artist has still not mastered the PERSPECTIVE of the setting, but this is less noticeable in the wing that shows St. Joseph at his carpenter's bench. The scene is rendered with detailed observation of both the room and the view beyond, and the domestic objects are treated with loving care. The *Werle Wings* show a great improvement in the artist's understanding of perspective and it seems certain that by this time (1438) the Master of Flémalle was being influenced by his younger contemporaries. The mirror is directly borrowed from van Eyck's *Arnolfini* portrait and the figure style has been made more fluid, probably owing to the influence of Rogier van der Weyden. The National Gallery, London, has a pair of portraits which are generally thought to be by him. These contrast with the more refined work of Jan van Eyck and are handled with broad sculptural plasticity. Each head is barely contained within the frame, and the faces turned away from the light are modelled with strong contrasts of light and shade. A comparison between these two artists is valid and constructive, for it emphasizes the importance of each. Although the Master of Flémalle never attained the technical mastery of Jan van Eyck, his inventions and innovations were almost as important in their newly found realism.

2661.

**MASTER OF 1466.** See MASTER E.S.

**MASTER OF FRANKFURT** (active *c.* 1500). Anonymous Flemish artist to whom some 40

pictures are attributed which indicate that he may have been a follower of Quentin MASSYS. He is named, inappropriately, from the *St. Anna Altar* painted *c.* 1505 for the Dominican Monastery in Frankfurt (now in the Staedel Institute there).

**MASTER OF HOHENFURTH.** See MASTER OF VYŠSI BROD.

**MASTER OF LIESBORN** (active *c.* 1470). German painter, named after an ALTARPIECE painted for the Benedictine abbey of Liesborn, near Münster; eight fragments of it are in the National Gallery, London. His manner shows strong affinities with the style of the Netherlands (see FLEMISH ART).

**MASTER OF MARY OF BURGUNDY.** See BENING.

**MASTER OF MOULINS** (active *c.* 1480–1500). This name designates the unknown painter of a triptych in Moulins Cathedral representing the Madonna with Saints and Donors and datable *c.* 1498. The style of this work is quite distinctive, and has enabled a considerable *œuvre* to be built up around it, including *The Meeting of Joachim and Anna* in the National Gallery, London. The earliest of these attributions suggest the influence of Hugo van der GOES, but the Master of Moulins was much closer to FOUQUET in the exquisite sculptural precision of his forms, the poise of his individual figures, and the harmony of his compositions. With this sculptural conception of form goes the brilliant palette of a glass painter and a taste for splendid and meticulous details which make him one of the last exponents of the Franco-Flemish courtly style of INTERNATIONAL GOTHIC. Various unconvincing attempts have been made to identify this artist, e.g. with Jean PERRÉAL, Jean Prévost, Jean Hay, etc.

1065.

**MASTER OF NAUMBURG.** The sculptures in the west choir of Naumburg Cathedral were produced between *c.* 1250 and *c.* 1570. They include 12 statues representing the benefactors of the original cathedral and a series of RELIEFS of the PASSION with a CRUCIFIXION group on the choir screen. They are generally regarded as the finest works of GOTHIC sculpture in Germany. The head of the workshop, who is called for convenience the 'Master of Naumburg', is known only by his style. He was probably trained in northern France but there is little doubt that he was a German by birth; his Germanic temperament emerges in the pathos and vehement gestures of his figures. It is especially these manifestations of emotion and feeling that make his contribution to Gothic art so important. Yet he loses nothing of the monumental dignity and idealism of his predecessors,

and in his art the two worlds of feeling seem to meet and enrich one another as in the work of perhaps no other medieval artist.

**MASTER OF ST. CECILIA.** Early 14th-c. painter named after the *St. Cecilia Altarpiece* in the Uffizi. Presumably he was a Florentine but nothing is known about him. Other works have been attributed to him because of their resemblance to the Uffizi picture. These include the two panels devoted to the Virgin and to St. Margaret at Montici, near Florence, and the three concluding scenes of the great fresco cycle of the life of St. Francis in the Upper Church of S. Francesco at Assisi (see MASTER OF THE ST. FRANCIS LEGEND). The painter of these scenes resembles GIOTTO in the lucidity of his narrative and the solid drawing of his figures, but he is a more genial story-teller. His figures are more vivacious, his colour warmer and sweeter. The architectural settings, fastidiously moulded and coffered, are his hall-mark and they place him in kinship with contemporary Roman painters, especially with the CAVALLINI circle who were also active in Assisi. The completion of the great cycle in the Upper Church would only have been entrusted to an established master. Some critics have suggested that he may be the famous Buffalmacco who appears in tales by Boccaccio and Franco Sacchetti. Buffalmacco is mentioned in 1320 as a member of the painters' guild, but no documented works have survived.

**MASTER OF ST. GILES** (active *c.* 1480–*c.* 1500). Unidentified painter who has been named after two panels representing scenes from the life of St. Giles (N.G., London). Other paintings in the same style have been grouped round them. The PERSPECTIVE of the paintings in this group is sometimes shaky and their intimate, narrative character suggests the work of a MINIATURIST. Their attention to detail and their meticulous finish have caused some to consider that the artist was trained in the Netherlands, but views of SAINT-DENIS and the Sainte Chapelle indicate that he worked in Paris whatever his origin. One of them, a *Betrayal of Christ* (Musées royaux, Brussels), is an interesting early essay in CHIAROSCURO lighting.

**MASTER OF ST. MARTHA.** Sculptor of the statue of St. Martha (*c.* 1515) in the church of the Magdalene, Troyes. Several other statues in the same region must be by the same hand, including a *Pietà* from Bayel and the mourners of an entombment group at Chaource. The style is a reaction from the turbulent emotionalism of much 15th-c. sculpture. The restrained and rather fastidious carving of the draperies, and the equally controlled, mature, but intensely moving expressions of the women seem to recall the monumental gravity of the 13th c.

**MASTER OF SEGOVIA.** See BENSON, Ambrosius.

**MASTER OF THE AMSTERDAM CABINET.** See MASTER OF THE HOUSEBOOK.

**MASTER OF THE BRUNSWICK MONOGRAM** (active *c.* 1520-40). Anonymous Flemish artist so named after a painting in the Herzog-Anton-Ulrich Museum in Brunswick of *The Parable of the Great Supper* (Luke xiv). There is no agreement how the monogram should be read. A dozen or so small pictures have been attributed to the same hand; about half depict religious subjects in the open air, and most of the others scenes in brothels. The quality of the pictures is uniformly high. The artist's observation of nature, his fine drawing and ability to integrate figures into a LANDSCAPE make him an important forerunner of Pieter BRUEGEL the Elder. Attempts have been made to identify him with Jan Sanders van HEMESSEN and Jan van Amstel (*c.* 1500-*c.* 1540).

**MASTER OF THE DEATH OF THE VIRGIN.** See JOOS VAN CLEVE.

**MASTER OF THE HOUSEBOOK** (late 15th c.). German painter and engraver so called from a number of drawings contained in a kind of commonplace book in Castle Wolfegg. He used to be called the Master of the Amsterdam Cabinet, since the largest collection of his engravings is in the Print Room of the Rijksmuseum. His LINE ENGRAVINGS often represent very worldly subjects and his use of DRYPOINT gives them a curiously sketchy and lively character. DÜRER must have studied them fairly closely as their influence can be traced in several of his early drawings.

2546.

**MASTER OF THE LEGEND OF ST. BARBARA** (active *c.* 1470-*c.* 1500). Netherlandish painter who followed Rogier van der WEYDEN. He probably came from Bruges and worked in Brussels. He is named after the subject of a TRIPTYCH (*c.* 1475) the centre panel of which is now in the Brussels museum, the left wing in the Confrérie du S. Sang, Bruges, and the right one lost. Pictures attributed to him in the National Gallery of Ireland and the Rijksmuseum, Amsterdam, were probably painted for an ALTARPIECE upon which the MASTER OF THE VIEW OF ST. GUDULE also worked.

**MASTER OF THE LIFE OF THE VIRGIN** (active *c.* 1470-80). German painter of the COLOGNE SCHOOL, who worked under the influence of FLEMISH ART and particularly that of Dirk BOUTS and Rogier van der WEYDEN. The name is taken from a series of eight panels illustrating the Life of the Virgin, of which the *Presentation in the Temple* is in the National Gallery, London, and the remainder are at Munich. These paintings reveal the artist as a colourful REALIST and a lively story-teller of

considerable talent. Perhaps by the same hand are four panels in the National Gallery, London, which come from Werden Abbey, near Düsseldorf. None of the pictures attributed to him is dated, but a *Crucifixion* at Cues on the Moselle, generally accepted as his work, is probably from 1465. The painter of these pictures was at one time known as the Master of the Lyversberg Passion from a *Passion* series at Cologne, but the latter are now thought to be by a different hand although the relationship between the two groups of paintings is admittedly close.

**MASTER OF THE MAGDALEN** (active *c.* 1250-75). Italian painter, so named after a panel in the Accademia, Florence, which represents Mary Magdalen with scenes from her life. His execution is vigorous and rather heavy but he is a lively story-teller. He dabs his warm colours with many white highlights and so achieves, naïvely, an effect of quickness and spontaneity. The picture conveys the impression of being a folk-art version within BYZANTINE conventions.

Other works have been ascribed to the same artist at Compiobbi and Rovezzano, near Florence, and an ALTARPIECE in the Musée des Arts décoratifs, Paris. The ascription is, however, doubtful.

**MASTER OF THE PLAYING-CARDS** (mid 15th c.). German engraver of a set of playing-cards depicting human figures, animals, flowers, etc. Attention to realistically observed detail and elegance of line make him one of the outstanding early engravers in Germany.

**MASTER OF THE ST. FRANCIS LEGEND.** A name for the unidentified painter of the famous cycle of frescoes on the nave walls of the Upper Church of S. Francesco in Assisi, depicting the life of St. Francis. This cycle was praised by VASARI as one of the principal works of GIOTTO and figures as such in many histories of art. Nineteenth-century critics found it particularly fitting that the saint whose life and legend is imbued by a new humanity and love of nature should have been celebrated by the pioneer of a new NATURALISTIC art. Stylistic criticism of the 20th c., however, has undermined this pleasing construction. Giotto's documented works in Padua differ so thoroughly from those of Assisi in both sentiment and formal organization that it is hard to imagine that he should have painted both. It was found, moreover, that no earlier source than Vasari specifically makes this attribution, though we do hear (from Giotto's contemporary Riccobaldo of Ferrara) that he painted in the church of Assisi. Circumstantial evidence suggests that the St. Francis cycle was painted between 1297 and *c.* 1305 and that it may be the work of a Roman master of CAVALLINI's school. The last three scenes differ in style from the rest and have been attributed to the Tuscan MASTER OF ST. CECILIA.

**MASTER OF THE TŘEBOŇ ALTAR-PIECE** or OF WITTINGAU. Painter of the BOHEMIAN SCHOOL, named after his main work (Prague, c. 1380). With him the art at the short-lived imperial court of Prague reached its climax. His style points west rather than south and shows particular affinities with Burgundian art and Melchior BROEDERLAM. He combines a feeling for linear rhythm with a strong sense of colour and an arrangement of his figures suggesting space and depth (see INTERNATIONAL GOTHIC).

**MASTER OF THE VIEW OF ST. GUDULE** (active c. 1470–c. 1500). Netherlandish painter who is named from a panel in the Louvre which has in the background a view of the façade of St. Gudule in Brussels. Other Brussels buildings figure in pictures attributed to this artist. In the background of his *Portrait of a Man Holding a Heart-shaped Book* (N.G., London) there is a view of Notre-Dame-du-Sablon. He belonged to the circle of Rogier van der WEYDEN and probably collaborated with the MASTER OF THE LEGEND OF ST. BARBARA.

**MASTER OF THE VIRGO INTER VIRGINES** (active 1470–1500). Artist born in the northern Netherlands, whose name derives from a picture representing the VIRGIN Mary surrounded by virgins (Rijksmuseum, Amsterdam). He probably worked in Delft, and his style shows affinity with the craft of WOODCUT, which flourished locally. *The Crucifixion* (Uffizi) and *The Lamentation* (Walker Art Gal., Liverpool) reveal an artist of strong religious fervour, who obtains a dramatic effect through intense colours, desolate landscapes, and gaunt figures. This highly personal, deeply religious art is to some extent paralleled by the work of much greater masters, BOSCH and GRÜNEWALD.

**MASTER OF VYŠŠI BROD** or OF HOHEN-FURTH. Painter of the BOHEMIAN SCHOOL, so called after his main work, a big ALTARPIECE with scenes from the life of Christ (N.G., Prague) painted for a Bohemian monastery of that name c. 1350. These panels show the beginnings of the Bohemian variant of INTERNATIONAL GOTHIC. Another important painting from his workshop, a *Death of the Virgin*, is in the Museum of Fine Arts, Boston.

**MASTER OF WITTINGAU.** See MASTER OF THE TŘEBOŇ ALTARPIECE.

**MASTERPIECE.** In the Middle Ages the term meant the piece of work by which a craftsman, having finished his training, gained the rank of 'master' in his guild. In that sense the diploma pictures of the ROYAL ACADEMY might be said to be masterpieces. Nowadays the term is used of, and should be confined to, the few outstanding works in which the artistic personality of a great artist finds its fullest expression.

**MASTER THEODERIC.** Painter of the BOHEMIAN SCHOOL, employed by Charles IV in 1367 to decorate the Holy Cross Chapel of Karlstein Castle near Prague. He shows even more clearly than the MASTER OF VYŠŠI BROD the evolution of a distinct Bohemian School from Italian and French antecedents.

**MASTIC.** A soft resin from the tree *Pistacia lentiscus*, native of the shores of the Mediterranean. Since classical antiquity it has been obtained from the island of Chios. It is the commonest resin used in commercial spirit VARNISHES.

**MAT.** See COLOUR.

**MATEO DE COMPOSTELA** (active late 12th c.). Spanish ROMANESQUE sculptor and architect responsible for the Portico de la Gloria (1168–88) at the cathedral of Santiago de Compostela (see PILGRIMAGE CHURCHES).

**MATER MISERICORDIAE.** See VIRGIN.

**MATISSE**, HENRI (1869-1954). French painter. From c. 1920 he enjoyed an international reputation as the foremost painter, with PICASSO, of his time and he was the supreme master in those trends in 20th-c. art which are represented by CALLIGRAPHIC pattern and decorative ABSTRACTION in the field of pure colour. Born at Le Cateau in Picardy, he abandoned the study of law and came to Paris in 1892 as a student of art under the academic painter Adolphe-William Bouguereau (1825–1905), where he became a close friend of MARQUET. In the same year he worked also in the Académie Julien and at the École des Beaux-Arts under Gustave MOREAU, with whom he remained until 1896. Here he met ROUAULT, and was joined in 1894 by Marquet and Henri Charles Manguin (1874-1943) and in 1897 by Charles Camoin (1879-1965), all of whom were later associated with him in the FAUVIST movement. During these years he painted STILL LIFES and LANDSCAPES in a sober range of colour reminiscent of CHARDIN and COROT. In 1896 he exhibited at the Salon de la Société nationale des Beaux-Arts and his picture *La Liseuse* was bought by the nation. In the summer of this year, painting in Brittany, he began to adopt the lighter palette of the IMPRESSIONISTS and seems to have been influenced by the landscapes and table pieces of RENOIR. In 1899 he began to experiment with the NEO-IMPRESSIONIST technique, which was still applied in his painting *Luxe, calme et volupté*, exhibited at the Salon des Indépendants in 1905 and bought by SIGNAC. During the same years he had been painting with Marquet and Manguin, had met DERAIN and through him VLAMINCK, and in 1905 together with these and

other friends from Moreau's studio he made the sensational exhibition at the Salon d'Automne which gave birth to the name 'Fauves'. His picture *La Femme au chapeau* was bought by Leo and Gertrude Stein, who in the following year also bought his large composition *Le Bonheur de vivre* (now at the Barnes Foundation). In 1907 he founded his own Académie, which was frequented mainly by American and Scandinavian students. He met Picasso as early as 1906 and like him was excited by Negro sculpture. But he never allied himself to the CUBIST group, remaining always sceptical of Cubist aesthetics and preferring to develop his own researches into the practical aesthetics of decorative colour. This he did with alternating periods of more naturalistic and more abstractly composed work, his reputation constantly increasing. In 1909-10 he painted his famous *La Danse* ánd *La Musique* (Moscow). In 1913 he exhibited with the Berlin SEZESSION and in the ARMORY SHOW. From 1916 he spent part of each year at Nice, where some of his most important work was done. In 1918 he did a series of *Odalisques*, a theme which remained a favourite with him through the 1930s. He was made a chevalier de la Légion d'honneur in 1925. In 1933 he did a large mural *La Danse* for the Barnes Foundation at Merion. In 1943 he made his home at Vence, where his decorations of the Chapel of the Rosary are a source of interest to visitors. He had a retrospective exhibition at the Salon d'Automne in 1945 and in the same year exhibited with Picasso at the Victoria and Albert Museum, London. His latest works were exhibited in 1949 at the Pierre Matisse Gallery, New York, and at the Musée nationale d'Art moderne, Paris, and in the same year a large retrospective exhibition was arranged at Lucerne. The Musée Matisse was inaugurated at Le Cateau in 1952.

Matisse studied sculpture first in 1899 and his first sculptures were shown in 1905. His BRONZES of figures and portrait heads were characterized by strong simplification of planes indicative of his interest in Negro art. He designed for the Russian Ballet of Diaghileff in 1920 and for Massine in 1938. His first LITHO-GRAPHS and WOODCUTS date from 1906. Among other things he illustrated the *Poésies* of Mallarmé (1932), Baudelaire's *Fleurs du mal* (1944), the *Lettres portugaises* of Marianna Alcaforado (1946), the *Visages* of Paul Reverdy (1946), and in 1948 *Les Amours* of Ronsard.

His own philosophy of art was formulated in an article in *La Grande Revue*, December 1908, and in a letter published in the catalogue of his exhibition given at the Museum of Art, Philadelphia, in 1948. In the chapel at Vence he has left a definitive statement of his artistic career (1951): 'Toute ma vie j'ai été influencé par l'opinion courante de mes débuts, époque où l'on acceptait seulement de consigner les observations faites sur la nature, où tout ce qui venait de l'imagination ou du souvenir était appelé "chiqué" et sans valeur pour la construction

**214.** 'La chevelure, vol d'une flamme. . . .' Pen-and-ink drawing by Matisse. Illustration for the *Poésies* (1932) of Stéphane Mallarmé. (Bib. nat., Paris)

d'un œuvre plastique. Les maîtres des Beaux-Arts disaient à leurs élèves: "Copiez bêtement la nature."

'Pendant toute ma carrière j'ai réagi contre cette opinion à laquelle je ne pouvais me soumettre et cette lutte a été la source de différents avatars de ma route, pendant laquelle j'ai cherché des possibilités d'expression en dehors de la copie littérale, tel le divisionisme et le fauvisme.

'Ces révoltes m'ont conduit à étudier séparément chaque élément de construction: le dessin, la couleur, les valeurs, la composition, comment ces éléments peuvent s'allier à une synthèse sans que l'éloquence de l'un d'entre eux soit diminuée par la présence des autres, et à construire avec ces éléments, non diminués de leur qualité intrinsèque par leur réunion, c'est-à-dire en respectant la pureté des moyens.'

166, 173, 741, 828, 943, 1198, 1663, 1934, 2453, 2744.

**MATTA ECHAURREN,** ROBERTO SEBASTIÁN (1912- ). Chilean-born painter. He was trained as an architect in Santiago and in Paris under LE CORBUSIER in 1934-5, but turned to painting in 1937. An active member of the SURREALIST movement from 1938 until 1947 and a friend of Marcel DUCHAMP, Matta worked on the borders of abstraction. His pictures are sometimes full of fantastic creatures in a dreamlike architectural setting, but sometimes they are like explosions of light and colour and abstract forms. During the Second World War he was in New York with BRETON, TANGUY, Max ERNST, MASSON, etc., and his influence there was strong.

**MATTEO DI GIOVANNI** (active 1452–95). Italian painter who settled in Siena and became one of the most prolific and popular painters of the SIENESE SCHOOL during the second half of the 15th c. He is thought to have been a pupil of VECCHIETTA. His decorative linear manner (*Assumption*, N.G., London, 1475) reveals affinities with POLLAIUOLO. The technical skill and decorative elegance of his Madonnas support his reputation. There are three versions of a *Massacre of the Innocents* painted in a flat but otherwise dramatically REALISTIC way.

**MAULPERTSCH**, FRANZ ANTON (1724–96). Austrian painter and ETCHER. His many historical and religious FRESCOES show the influence of Venetian decorative painting. The nervous and expressive elegance of his etchings reveals the technical influence of REMBRANDT.

**MAUSOLEUM.** The tomb of Mausolus of Caria at Halicarnassus, erected by his widow Artemisia *c.* 350 B.C. This vast pile was one of the Wonders of the World and is one of its puzzles. Its architecture (by PYTHIUS?) is variously restored. Its sculpture is said to have been undertaken by SCOPAS, Bryaxis, Leochares, and Timotheus, among whom modern historians attempt to apportion the remains, mostly extracted by the British Navy from a medieval castle. The name has afterwards become a regular term for any stately structure erected as a TOMB for a person of distinction.

**MAUVE**, ANTOINE (1838–88). Dutch painter of the HAGUE SCHOOL who was influenced by the French painters MILLET and COROT. He was remarkable among his contemporaries for his small pictures of unpretentious subjects—dunes, meadows, beaches—painted in light, silvery tones. His sincere and modest spirit made a deep impression upon his nephew van GOGH, who spent some time in his studio.

819.

**MAY**, HUGH (1622–84). English architect. Nothing is known of his training, but in 1660 he was made Paymaster to the Office of Works, probably for services to the Royalist cause, and in 1668 became Comptroller. He was largely responsible for the introduction of Dutch PALLADIAN elements into English country-house building, Eltham Lodge, Kent (1664), being the best surviving example of this manner. His most important work, however, was the remodelling of the Upper Ward at Windsor Castle (1675–83; since much altered), which contained the first fully BAROQUE interiors in England, decorated by VERRIO and Grinling GIBBONS. He was a friend of Pepys, Evelyn, Roger North, and Sir Peter LELY.

**MAY**, PHIL (1864–1903). English draughtsman who contributed humorous pen-and-ink drawings, mainly CARICATURES and scenes of Cockney life, to *St. Stephen's Review, The Daily Graphic, Punch*, etc. His work was also published in albums such as *Phil May's Gutter-snipes* (1896).

**MAYNO** (MAINO), JUAN BAUTISTA (1578–1649). Spanish painter, born at Pastrana, near Madrid. He came to Toledo sometime before 1611 and there is an unconfirmed legend that he was a pupil of El GRECO there. He was in the service of Philip III and Philip IV, whose drawing master he had been. His style has little in common with that of El Greco but belongs rather to the High BAROQUE and was derived from CARAVAGGIO through such followers as Orazio GENTILESCHI. He was an accomplished portraitist (*Man with Gloved Hand*, Prado; *Head of a Monk*, Ashmolean Mus., Oxford, *c.* 1635). His important set of paintings for the altar of the church of St. Peter the Martyr in Toledo (commissioned 1612) are dispersed: *The Epiphany* at the Prado; *Pentecost* at Toledo; *The Nativity* and *The Resurrection* at Villanueva y Geltrú. There is an *Adoration of the Shepherds* (Hermitage, Leningrad), and *The Recovery of Bahia in 1625* (Prado, 1635).

**MA YÜAN** (active *c.* 1190–1224). Chinese painter and member of the famous Ma family of painters founded by Ma Fen in the first half of the 12th c. He belonged to the Southern Sung Academy and was notable for his development of the principle of 'balanced asymmetry', for which he obtained the nickname 'one corner Ma'. By a dramatic interplay between full and empty spaces he riveted attention on the subject and at the same time suggested the infinitude of empty space. In his precise brush-line he was influenced by LI T'ANG. Originals of Ma Yüan's work are very rare, the best being in Japanese collections. Two works attributed to him, now in the Museum of Fine Arts, Boston, give a good idea of his style. He is one of the most copied of all Chinese artists.

**MAZEROLLES**, PHILIPPE DE (d. *c.* 1480). One of the leading Flemish MINIATURISTS, who worked in Paris and was influenced by FOUQUET. He became painter to Charles the Bold at Bruges in 1467. His best known work is the *Conquest of the Golden Fleece* (Bib. nat., Paris).

**MAZO**, JUAN BAUTISTA MARTÍNEZ DEL (*c.* 1612–67). Spanish painter. He was a pupil of VELAZQUEZ, married his daughter in 1634, and succeeded him as court painter in 1661. Among his very few signed works is a portrait of Queen Mariana (N.G., London, 1666).

261.

**MECKENEM**, ISRAHEL VON. Name of two German engravers of the second half of the 15th c. The son is the more distinguished of the

two. He was trained by his father and by MASTER E.S. Much of his work consists of copies after other engravers. A series of illustrations of the PASSION is the most important work done from his own design. He was the first German artist to engrave his own features (in a double portrait together with his wife).

**MEDALS.** A medal is a small commemorative design in metal. This commemorative element distinguishes medals from PLAQUETTES, whose subjects are arbitrary (usually legendary or religious), and from coins, which may incidentally commemorate, but are primarily, as medals never are, a medium of exchange with a fixed value. But the dividing lines cannot be firmly drawn.

Medals are usually round and often two-sided, the front, or obverse, nearly always being a portrait, and the reverse a design related to it. These reverses can be of great interest and exquisite beauty, and one quite frequently finds them cast independently as plaquettes. In Italy they might represent the *impresa*, the personal device so beloved of the RENAISSANCE, or the artist could indulge in allegories more or less fanciful. In Germany reverses were less popular, and when not left blank usually consisted of a coat of arms. Even in Italy the Florentines, who produced some masterly portraits, paid little attention to the reverses, frequently using the same design for several sitters. The widespread habit of borrowing reverses from other medals or even other artists complicates the task of ATTRIBUTION.

Medals are usually found in bronze or LEAD, for those in gold or silver are more likely to have been melted down. In the early Renaissance they were cast by the *cire-perdue* method (see BRONZE SCULPTURE) and the freedom of working in wax encouraged a broad style. But by the mid 16th c. medals struck like coins became increasingly frequent. In this method the heated metal disc is laid between two engraved dies, into which it is forced by the blows of a hammer or by a screw mechanism. This, while giving crispness and clarity, tends to produce a dry and tight style and the seeming advantage of being able to produce a larger number of copies in fact made the medal available as a medium of propaganda, both laudatory and satirical, whereas the artistic medal was a personal gift for a few friends. Benvenuto CELLINI can probably be held responsible for the technique in striking whereby the various elements of the design were cut on punches which were then stamped into the die; although this was simpler than engraving the die in intaglio, it could hardly help to achieve a coherent composition. But wax was not free from its own dangers. By the mid 16th c. artists were becoming interested in the wax model for its own sake, and elaborating it to the detriment of the cast medal. Some schools in particular evolved a subtle MANNERISM better suited to wax than to bronze. The final blow has been the recent invention of the reducing machine which, by reducing the artist's large design, makes it extremely difficult for him to maintain any sense of scale.

Modern medals provide us with an excellent collection of portraits of rulers, and of artists, writers, and scholars; in this they differ from the medallions of ancient Rome, which were exclusively official. Not only the 'intelligentsia' but also ordinary members of the middle classes patronized the medallist, and the number of unfamiliar names on medals is an indication of their widespread popularity. Being easily reproduced and transported, they fulfilled many of the same functions as photographs today. But in the 18th c. the private patron became less important than the institution or society, whose patronage, like that of the state with its military decorations, has had a deadening effect.

It is significant that the first great medallists in Italy, Germany, and Holland—PISANELLO, DÜRER, and MASSYS, who were probably never surpassed in their respective countries—were all painters, whereas sculptors, such as Francesco SANGALLO, were often unsuccessful in this delicate art. Naturally many of those artists who engraved dies for coins also struck medals, as did many GEM engravers. In Germany the technique was similar to that employed by goldsmiths, who therefore often cast medals, and some medallists achieved independent importance as carvers of WOOD or STONE. The interest in medals was closely linked to the Renaissance love of classical coins, as is shown most plainly in the number of fake coins made by medallists. The two early Carrara medals struck in Padua in 1390 are directly imitated from classical coins, and this influence continued throughout the Renaissance and never entirely died. The other famous precursors of the Renaissance medals, the two medieval medals of Constantine and Heraclius, are rather nearer the contemporary medieval seals.

**215.** Portrait of the emperor of Constantinople, John VIII Palaeologus. Bronze medal by Pisanello. (B.M., *c.* 1438)

Despite its classical and medieval antecedents, the medal as we know it today was the invention of the Italian Renaissance, and the medal of John VIII Palaeologus (c. 1438) was the first known medal by the first and probably the greatest real Renaissance medallist, Antonio Pisano called Pisanello. There is space to mention only a few of the many medallists, who came mostly from the north of Italy, though there was an important school in Florence; Rome relied mostly on artists from elsewhere. Matteo de' Pasti (c. 1420-90) was the most accomplished of Pisanello's immediate successors; Sperandio Savelli (c. 1425-1504), praised above all others by Goethe, was a prolific artist but a clumsy draughtsman and coarse executant. In Florence the principal medallist was Niccolò di Forzore Spinelli, called Niccolò Fiorentino (1430-1514), an excellent portraitist. In the 16th c. the descent to dull academic competency begins: the medals of Benvenuto Cellini are dry, uninteresting, and undistinguished, and those of Pastorino da Siena (1508-92) attractive but superficial. In the 15th c. Italian medallists worked in Flanders, France, and Poland; Jacopo da Trezzo (c. 1515-89) went to Spain and made medals of, amongst others, Mary Tudor, and Antonio Abondio (1538-96) brought the enervating influence of the 16th-c. Italian medal to Germany, whose vital native school was already passing its prime.

In Germany Albrecht Dürer designed and may have cast medals, but had little effect on the course of the art. His successors in Nuremberg were mostly goldsmiths; the most prolific was Matthes Gebel (active 1526-55), many of whose sensitively modelled but sometimes rather crowded works were once attributed to the goldsmith Peter Flötner (c. 1485-1546). The greatest German medallist was Hans Schwarz (1492-after 1535), whose portraits, cast from wooden models, have a bold REALISM. His successors Friedrich Hagenauer (active 1525-46) and Christoph Weiditz (before 1523-60), both of the Augsburg School, are more finished but still broad in treatment and hardly inferior in characterization. German medallists often included more of the body than was common in Italy, and were skilled at so working the bust as to suggest the sitter's general physique. Hans Reinhardt the Elder, Hans Bolsterer, and Joachim Deschler, all working in the mid 16th c., mark the beginning of the decadence, when technical achievement became of supreme importance and the commonplace, to which German realism was prone, descended all too often to vulgarity. Quentin Massys's masterly medal of Erasmus had little influence on his Netherlandish successors. The poet Jean Second (1511-36) cast some sincerely felt if amateurishly executed medals; the prolific Jacob Jonghelinck (1531-1606) inherited the mannered Italian style of Leone LEONI, while Stephen van Herwyck (active 1557-65) worked in a simpler, more homely style, nearer the contemporary Dutch

painted portrait. This artist did some of his most pleasing work in England.

In the last decade of the 15th c. France produced some interesting medals struck by various cities to present to Queen Anne of Brittany to commemorate her state visits. The first medallist of importance was Germain PILON, but the greatest was Guillaume Dupré (active 1576-1643), a master of detail and texture. Jean Warin (1604-92) was a not unworthy successor, and his relative Claude Warin (active 1630-54) produced similar if duller work.

At least one of the Warins worked in England, where foreigners—mostly Frenchmen like Nicolas Briot (1579-1646)—were employed by the Mint and as medallists. Nicholas HILLIARD may have made some of the interesting medals of Queen Elizabeth, but even the Simons (Abraham, 1622-92, and Thomas, 1623-65) came from Guernsey. They and their contemporary Thomas Rawlins (active 1620-70) were the greatest English medallists.

After the mid 17th c. one finds everywhere a dull, mechanical quality and a lack of invention not disguised by artificiality. The French began on the long and uninspired series of the *Histoire métallique* (a series of medals illustrating the main events of each reign), and medals became a means of publishing and commemorating the glories of the ruler, while engravings were issued after them to satisfy the demand caused by the new antiquarian interest in medals. The 18th c. produced a few interesting artists, such as André Schega (1711-87) and the Swiss Jean-Charles Hedlinger (1691-1771). Late in the 19th c. came a revival of the medal as an art form, with a renewed interest in lettering and a return of the private patron. Modern artists have seemed unable to adapt themselves to the conventions of the medal and nothing of importance has been done.

123, 1315, 1316.

**MEDICI.** Florentine family of bankers and merchants which became the ruling house of Tuscany in the 16th c. and was famous for its patronage of learning and the arts throughout the RENAISSANCE. While the benefits bestowed by this family on artists and writers may sometimes have been somewhat exaggerated by their own court historians, among whom VASARI did most to perpetuate their reputation, even the sober historian will find their record impressive. GIOVANNI DI BICCI DE' MEDICI (1360-1429), founder of the family fortune, commissioned BRUNELLESCHI to build the Old Sacristy of San Lorenzo. COSIMO (1389-1464) spent lavishly on religious foundations such as the Florentine monasteries and churches of San Marco and San Lorenzo and the Badia of Fiesole, and had his own palace and country house erected by MICHELOZZO (built 1444-59; now known as the Palazzo Medici-Riccardi). He also commissioned important works from DONA-

TELLO. His son PIERO (1416-69) commissioned the sumptuous tabernacles of SS. Annunziata and San Miniato (Florence) and Benozzo GOZZOLI's frescoes in the family palace. He was in contact with most of the famous painters of the day, such as DOMENICO VENEZIANO, Filippo LIPPI, and Matteo de' Pasti (c. 1420-90), and commissioned many illuminated manuscripts and tapestries. His son and successor, LORENZO THE MAGNIFICENT (1449-92), seems to have turned his main attention to the collecting of classical gems and coins and to the building and equipment of his villa at Poggio a Cajano. We have no record of any major painting he commissioned but he lives in history as the first patron of MICHELANGELO, whom he set to copy ANTIQUES in his garden near San Marco. His second cousin, LORENZO DI PIER-FRANCESCO (1463-1503), seems to have been the principal patron of BOTTICELLI. His second son, GIOVANNI (1475-1521), who became Pope Leo X (1514), was patron of RAPHAEL and Michelangelo. His cousin GIULIO (1478-1534), who became CLEMENT VII, continued the tradition as far as the turbulent times and the sack of Rome (1527) made this possible. Meanwhile a member of the younger line, COSIMO I (1519-74), established his power as Duke of Florence and after 1569 as Grand Duke of Tuscany. While he failed to persuade Michelangelo to re-enter his native city that had thus lost its freedom, he gathered around him all the leading artists of the late Renaissance in Florence, notably PONTORMO, BRONZINO, AMMANATI, CELLINI, Giovanni BOLOGNA, and Vasari, and laid the basis for the Uffizi collection. The contributions of later Medicis are mentioned in the article UFFIZI.

**MEDIUM.** The liquid substance into which a PIGMENT is ground in the preparation of paint. The two functions of the medium are to render the pigment capable of being applied, and to bind the particles together and to the GROUND. If it binds only, it is called a binding medium (e.g. the FIXATIVE applied to a drawing or PASTEL painting to prevent the pigment from rubbing off). The different types of media and their qualities are discussed in the article on PAINT.

Some of the Old Masters used more than one medium in the same painting. For example colour ground in an oil medium might be used over a TEMPERA painting. The UNDERPAINTING was thus 'lean' in quality while the overpainting was 'fat'—a sound practice which is still followed by house painters. Jan van EYCK used an oil medium over a solid tempera underpainting, and this Flemish practice was inherited by the painters of the VENETIAN SCHOOL, such as BELLINI and TITIAN. This method has the advantage that the underpainting dries quickly and luminosity of colour is secured. A more difficult method of underpainting in oils and finishing with tempera was sometimes practised by the Venetians and was introduced into

Flanders by van DYCK. But whites and blues were often painted in tempera since these colours tend to yellow in an oil medium. It used to be mistakenly supposed that the Venetian masters used a mixed medium of oil and egg tempera and this was referred to as the *a putrido* method of Titian and VERONESE. The mistake arose from a misreading of an old manuscript by Mary Merrifield (*Original Treatises Dating from the XII to the XVIII Centuries on the Art of Painting*, 1849). In fact the manuscript states that both oil media and egg tempera were used severally but does not mention a mixture from oil and egg tempera.

There has been much speculation about the medium employed by RUBENS, which imparted exceptional flexibility and freedom. Max Doerner has stated that he used a resin oil paint with LINSEED OIL sun-thickened to the consistency of honey, with Venice TURPENTINE (an exudate of larch) and MASTIC VARNISH. REMBRANDT too is thought to have used a medium composed of a RESIN varnish and boiled or sunthickened oil. Certainly the qualities obtained by Rubens and Rembrandt cannot be produced with raw linseed oil and turpentine, which are used by the majority of modern painters.

Colours used with an oil medium (particularly blues) tend to yellow in time. To correct this tendency the Old Masters put their pictures out of doors in sunlight.

**MEGILLAH** (Hebrew: 'scroll'). The name applied to the Book of Esther, read in the synagogue on the feast of Purim. It is one of the few Jewish works which has a consistent tradition of ILLUMINATION in modern times, dating back at least to the 16th c.

**MEGILP.** A solution of MASTIC RESIN in TURPENTINE with LINSEED OIL, sometimes added to OIL or WATER-COLOUR PAINT in order to improve their working qualities. It is a dangerous aid, because in time it renders the paint yellow and brittle.

**MEISSONIER, ERNEST** (1815-91). French painter, ETCHER, LITHOGRAPHER, and sculptor. His very highly finished paintings of the Napoleonic campaigns have been likened to 'a symphony by Berlioz played without drums and with tin for brass' (*1814*, Louvre). His smaller GENRE paintings have little to recommend them apart from antiquarian exactness. His work was popular in his day and among others the Marquess of Hertford, one of the first English collectors of French 19th-c. painting, purchased 16. Meissonier was MANET's commander in the Franco-Prussian war and there is an unauthenticated tradition that he left drawings for Manet to see and was chagrined when the latter ignored them. He had a personal enmity for COURBET and may have been instrumental in inducing the government to impose a fine on him after the suppression of the Communists.

1143.

**MEISSONNIER,** JUSTE-AURÈLE (1695–1750). Goldsmith and decorator, born at Turin of French parentage, he worked in France. He was appointed Dessinateur de la Chambre du Cabinet du Roi (1726), a position previously held by Gerain. In 1726 also he put forward a plan for the façade of S. Sulpice. Few of his architectural designs were executed, but his fantastic grottoes and twisted asymmetrical metal-work were influential in spreading the ROCAILLE type of decoration which became popular after 1720. Meissonnier had great fertility of invention and was perhaps the most important originator of the early ROCOCO forms which spread through Europe after becoming the vogue in Paris. His charming and fanciful designs were used in all the minor arts.

**MEIT,** CONRAD (c. 1475–c. 1545. German sculptor and WOOD-CARVER. His chief work is in Notre-Dame-de-Brou, Bourg, where between 1526 and 1532 he executed a number of monuments for the family of Margaret of Austria. He worked in a polished, courtly style. In his small, highly finished statuettes of boxwood or ALABASTER, such as the famous *Judith* (Bayerisches Nationalmuseum, Munich), he created from Italian and Flemish elements a German RENAISSANCE style with a peculiarly personal flavour, combining excellent workmanship with a sensuous rendering of the human body. During the last years of his life he had his workshop in Antwerp.

**MELANESIAN ART.** The term 'Melanesia' here includes the whole of the island of New Guinea as well as the wide fringe of smaller islands lying to the north and east. European colonization in this region developed slowly and many tribal cultures still exist in more or less their traditional form. Thus, unlike most varieties of tribal art, the products of Melanesia can still be studied in their proper context. It is a context very unlike the art gallery pedestals on which such objects are likely to be poised if we encounter them in Europe or America.

Melanesians are technically primitive. Until recently they possessed no metal and their cutting tools were made of stone or shell. POTTERY, where it existed, was coarse and fragile and unsuited for delicate ornamentation. Woven textiles existed only in the form of mats, though bark-cloth, a perishable material, was made in some areas. While everyday clothing was at best rudimentary, gala costumes were often spectacular and colourful. These were mostly *ad hoc* improvisations of grass and feathers and face paint but the designs were as stereotyped as those of the Chinese stage. Melanesian dwelling-houses are lightly constructed and perishable but many communities also build ceremonial club houses which are relatively substantial structures elaborately ornamented with carved and painted decorations. Structures of masonry or earth-work are rare. Human life in traditional Melanesia was vigorous but short. Head-hunting, cannibalism, and various kinds of orgiastic ritual were of common occurrence. Few Melanesian societies had any system of hereditary chieftainship; a man's power was personal to himself and died with him.

In such a context works of art are not made to endure for eternity; they are the casual decoration of the moment. The WOOD-CARVINGS and ritual masks of Melanesia are objects of festivity, gaily coloured in red and white and black, but they have about them a certain brutality and frankness which some may find disturbing. The quantity and variety of Melanesian objects which have found their way into European and American collections is immense and there are no obvious principles by which some may be distinguished from others and rated as 'works of art'. The distinction between 'fine arts' and 'useful arts' does not apply: all artefacts served a purpose and in all the aesthetic motive had a significance. The numerous attractive picture books which aim at introducing the European reader to the arts of OCEANIA tend to concentrate upon those aspects of Melanesian design which have proved especially acceptable to contemporary European taste. During the period 1915–40 Melanesian art made a considerable impact upon European painting and sculpture and in consequence art books give an exaggerated emphasis to certain particular Melanesian styles, e.g. those of the Sepik river, which are believed to have influenced Max ERNST and BRANCUSI, and those of New Ireland, which are said to have provided precedents for GIACOMETTI and Henry MOORE. In actual fact Melanesian styles are enormously varied and few ethnographic museums possess collections even approximately representative of the whole range. The following regional types include most of those which commonly appear in book illustrations.

From Geelvinck Bay on the north coast of western New Guinea comes a style of wood-carving characterized by open scroll-work and careful symmetries of design. The principal motifs of wood-carvings are human figures. INDONESIAN influence is marked. The same area produces charming panels of bark-cloth painted free-hand with black and red designs in which stylized fish and crustacea predominate.

Further east the Sepik river area produces a wealth of carved figures, masks, drums, and other ritual furniture in a great variety of styles. A distinctive type of coarse-grained pottery with deeply incised polychrome decoration also comes from this area. Linton and Wingert consider that 'Sepik River art derives its unique character from its remarkable ability to make plastic forms the carrier of strong emotions'. Dramatic effect is achieved by a variety of means, including painted designs and appliqué decoration with bone and shell, but the emotional power probably derives from the disguised sexual and

cannibalistic implications of many of the designs. For example the masks of the type known as *mwai* are worn by boy initiates impersonating their semi-divine ancestors: the human face may be made pig-like by adding tusks and a snout, but the snout itself may then be given a snake-headed elaboration which makes it look like a penis. Such tightly packed symbolism can be explained by psycho-analytic theory; Melanesians explain it by reference to local myth and ritual. Pigs are sacrificed and eaten in order to secure fertilizing grace from the spirits of dead ancestors; the man-pig symbolism refers to this and also to a head-hunting ritual which contained elements of cannibalism; the snake-like penis-nose of the mask is said to represent a sago weevil, a creature credited with powers of spontaneous generation. The rough logic is that in an initiation ritual which turns boys into men it is appropriate to wear a magical growth mask.

To the south, along the northern coast of the Gulf of Papua, symbolic conventions are different though more uniform. A recurrent motif here is a distorted human face within an oval frame. Here again what looks like a mere convention acquires deep religious significance when considered in its ethnographic context. The design ultimately refers to a ritual in which boy initiates are 'devoured' and 'reborn' through the jaws of a wickerwork monster, which looks like a cross between a pig and a crocodile. Mystically considered, this monster (*kaia-imunu*) seems to represent both protecting deity and ultimate ancestress, and the tooth-patterned oval design is a symbol both for the jaws of the monster and the vagina of the first mother.

Such examples show something of the complexities of Melanesian mythical thought. Europeans who express appreciation of Melanesian art forms without a knowledge of the ethnographic facts are clearly making purely subjective judgements which may have no connection at all with the ideas and feelings of the native Melanesian artist. The artist's productions, in their context as adjuncts to traditional rituals, are intended to provide in traditional forms readily recognizable descriptions of incidents in traditional story; for most European observers they are simply decorative patterns almost devoid of representational significance.

A more severe and disciplined style is characteristic of the Massim area at the south-east tip of New Guinea. The phallic element is here restrained. Bird motifs and spiral decoration have suggested to some a remote link with NEW ZEALAND Maori art; but there are similar analogies with the Indonesian styles of western New Guinea. Most carvings are decorated with incised designs emphasized with white lime and red ochre. It is a stereotyped, handicraft art of high technical accomplishment but limited individuality. These Massim people are great sea voyagers. The carved and painted prow-boards of their canoes are often to be seen in museum show-cases incongruously jumbled with

lime gourds, tobacco pipes, war clubs, and dancing shields. At home in Melanesia these prow-boards are objects of importance. They are looked upon as constituting the 'mouth' of the canoe, and at its first launching they are the subject of elaborate magical ceremonial designed to give speed and prosperity to the whole boat.

Further east in the Solomon and Admiralty Islands wood-carving is similarly severe in form; it is devoted mainly to objects of secular ceremonial such as canoes, shields, and oversize drinking bowls, though some cult objects in the form of human figures, fish, and birds also occur in museum collections. A characteristic feature is the use of mother-of-pearl inlay to produce a surface pattern. This, however, is largely an art style of the past. In this area European colonization resulted in wholesale depopulation and the virtual destruction of traditional native cultures.

In contrast nearby New Ireland still produces authentic specimens of the extraordinary artistic products for which it is celebrated. In this island the creation of works of art is a highly developed professional activity. The artist's products include both STONE SCULPTURE and brilliantly coloured compositions of carved wood and fibre. Complex heraldic designs are the property of particular families, and for certain ritual occasions, such as funerals, professional artists are employed to produce manifestations of these 'coats of arms'; the outcome is a mask or one of the decorated boards called *malanggan*. The elements of this heraldry are mythological motifs easily recognized by the native beholder but of less significance to others. A European might discern that a design included snakes and a bird and a circle but he could not know that the bird is a *kania*, associated with shark fishing, that the snakes are the totemic snakes of the Sinpop clan, that the circle represents the dawn, and that all these things together recall a well known mythological incident. The motifs are usually set out in a complex of aerial forms brightly coloured in black, white, and red. Although the component parts of any particular design are defined by tradition, the individual artist is allowed great freedom as regards the precise way in which he combines the assorted stereotype motifs at his disposal. For European observers the finished objects, though devoid of meaning, can be strangely exciting, especially perhaps for those who find satisfaction in SURREALIST painting.

Despite the care lavished on the construction of their masks and ritual furnishings, Melanesians seldom treat their art products as treasures. New Irelanders casually discard their *malanggan* after use; the superb masks of the Orokolo *hevehe*, which may take years to construct, are finally burnt. Their nature is that of a stage costume. The real European parallel to Melanesian art will be found in the workshops and wardrobes of a repertory theatre rather than in the salons of an art exhibition.

The exotic element in the styles of the Sepik, the Papuan Gulf, and New Ireland has been stressed, but there are other localities such as New Britain and the New Hebrides which yield objects no less startling. Here again we find that the furnishings of ritual drama are constructed of such ephemeral materials as tree fern and clay-covered palm leaf. The people who make such things would be astonished to learn that some Europeans regard them as treasures fit for permanent preservation.

Few generalizations apply to Melanesian art as a whole, yet the common European judgement that Melanesian art is somehow hot-blooded and passionate is not wholly without foundation. Any random collection of objects from Melanesia placed side by side with a comparable collection of objects from the MICRONESIAN area a few hundred miles to the north will immediately make this clear. The Micronesian objects are functionally logical, cold, precise; the Melanesian collection is abandoned, reckless, ecstatic. These are subjective judgements certainly, but the contrast is very striking and no European observer can fail to be impressed by it.

1929, 2421, 2422.

**MELDOLLA,** ANDREA. See SCHIAVONE.

**MELLAN,** CLAUDE (1598–1688). French engraver. After 12 years' training in Rome he won considerable popularity in Paris, particularly for his engravings of compositions after VOUET. His use of long sinuous lines with no cross-hatching gave his work at its best (portrait of Fabri de Peresc, c. 1637) great directness and clarity. Excessive skill turned much of his work into a sheer display of virtuosity, as in his *Head of Christ* done in one spiral line.

**MELOZZO DA FORLI** (1438–94). Italian painter, an energetic follower of PIERO DELLA FRANCESCA, who achieved a high reputation in his own time. No certain works survive from his earlier period, and his name is particularly associated with the Vatican during the pontificate of Sixtus IV (1471–84). His picture of the court of Sixtus IV is now in the Vatican Library. His monumental fresco decoration of the cupola of SS. Apostoli (before 1480) was considered one of the most important paintings of the period in Rome. It has since been dismembered, and only the *Ascension* and some of the vigorous and brilliantly foreshortened figures of angels remain. Melozzo was associated with the device of exaggerated foreshortening which went by the name of SOTTO IN SU.

456.

**MEMLING,** HANS (1430/5–94). Flemish painter who was born in Germany but in 1465 was made a Free Mason of Bruges, where he spent the rest of his life. Nothing of his German heritage survived in his paintings but these show the closest connections with Rogier van der WEYDEN, with whom according to tradition he was trained. His output was enormous and he must have had a large workshop. During the course of his working life his style changed very little, and it is difficult to place undated paintings in a chronological scheme. But the *Donne Triptych* (N.G., London), which is a fine example of his work, probably dates from c. 1468, when Sir John Donne was in Bruges for the marriage of Charles the Bold. By comparison with his contemporary Hugo van der GOES, Memling's style is quiet and restrained. His technique is impeccable, and space and depth present no problems to him. Yet he fails to translate the drama or excitement of his narrative into visual terms. The well balanced, calm compositions found great favour in his day, and Memling was a celebrated portrait painter. Among his patrons were Italians then living in Bruges (*Tommaso Portinari and his wife*, New York, c. 1468). Giovanni Candida (c. 1450–c. 1491), a medallist whose portraits can be seen in Antwerp, gave him commissions and others took portraits home to Italy, where they seem to have influenced artists such as BELLINI in northern Italy. The *Diptych of Martin van Nieuwenhove* (St. John, Bruges, 1482) in which the DONOR appears with the Madonna and Child, shows a well characterized portrait set before windows which give on to the flat, quiet landscape of Flanders. The *Portrait of a Young Man* in the Thyssen Collection is also ascribed to Memling and is particularly interesting as the reverse has a very early example of pure STILL-LIFE painting. The Hôpital de St. Jean at Bruges has a number of works by Memling, and his style can best be studied there. His popularity during his own lifetime surpassed even that of van EYCK, yet today his harmonious paintings appear to lack the invention and imagination of the very great masters of the Netherlands in the 15th c.

140, 926.

**MEMMI,** LIPPO (active 1317–47). Sienese painter who was SIMONE MARTINI's brother-in-law and his most able follower. Several of Lippo's works, such as *The Virgin in Majesty* of 1317 in S. Gimignano Town Hall, are based upon Simone's compositions. Sometimes the two painters collaborated, as in 1333, when they jointly signed the famous *Annunciation* (Uffizi). Like Simone, Lippo went to the papal court at Avignon, where he painted a *Madonna* for the Franciscan church.

Though not an innovator, Lippo at his best—as in the Servi *Madonna* at Siena—even surpassed Simone in his delicate palette and his extremely sensitive modelling. He had cultivated an almost too MANNERED, overly refined style. He exaggerates Simone's slender forms and complicates his line as if tightening an already tightly coiled spring. Younger Sienese painters, parti-

cularly BARNA, drew on these qualities to intensify their dramatic feeling. (See SIENESE SCHOOL.)

**MENA,** PEDRO DE (1628–88). Spanish sculptor. He was CANO's assistant at Granada 1652–8. In 1658–62 he carved 40 panels for the choir stalls of Málaga Cathedral. His much admired *St. Francis* (Toledo Cathedral, *c.* 1663) shows that like ZURBARÁN he was deeply in sympathy with the mendicant saints. His *Magdalen* (Visitation convent, Madrid, 1664) recalls Gregorio FERNÁNDEZ. In his more dramatic work Mena typifies the theatrical aspect of the later BAROQUE in Spain. His workshop at Málaga turned out numberless sculptures which were sold as far afield as Madrid, Cordova, and Granada.

**MENDELSOHN,** ERICH (1887–1953). German architect, trained in Berlin and Munich. He set up in practice in 1912 and first attracted attention in 1918 by drawings of architectural projects which displayed EXPRESSIONIST tendencies, symbolizing the purpose of the building by the form, in contrast to the functional character of the international style of the BAUHAUS, and by their rounded masses and curvilinear shapes suggesting the sculptural possibilities of CONCRETE. His Einstein Observatory at Potsdam (1920) was followed by a number of department stores and other buildings in Germany during the 1920s. He settled in England in 1933, where his best known work is the De la Warr Pavilion, Bexhill (1934–5), and during the 1930s he also did work in Israel, including the Anglo-Palestine Bank, Jerusalem (1938), and the University Medical Centre (1937–9). In 1941 he went to the U.S.A., setting up in practice in San Francisco in 1945. Influenced by the ORGANIC quality of Frank Lloyd WRIGHT he built there a number of synagogues and community centres. His chief work in the U.S.A. was the Maimonides Hospital in San Francisco (1946).

801, 1825, 2875.

**MENGS,** ANTON RAFFAEL (1728–79). German painter. He was the son of a court painter of Dresden, by whom he was brought up to be a great painter on the models of CORREGGIO, RAPHAEL, and the ANTIQUE. He was taken to Rome in 1741 and there established the reputation of an infant prodigy. In 1755 he met WINCKELMANN, was influenced by his theories, and won for himself European fame as the leading exponent of NEO-CLASSICISM. In 1762 he formulated his views in a treatise on Beauty in Painting which was plagiarized by Daniel Webb in his book *Inquiry into the Beauties of Painting* (1760). His best known work, the *Parnassus* (Villa Albani, Rome, 1761), was perhaps the first ceiling painting to break completely with the ILLUSIONISM of the Baroque. It is composed of drawings from the antique treated orthogonally, as if at the spectator's eye-level. In his later frescoes, such as the Sala dei Papiri (Vatican, Rome) and at Madrid for the palace of Charles III, to whom he was court painter, he combined traditional foreshortening with his Neo-Classical innovations. Mengs was perhaps at his best as a portrait painter (*J. J. Winckelmann*, Glasgow). His work was impoverished by lack of true imagination and a defective sense of colour. He is now regarded as a precursor rather than a leading exponent of Neo-Classicism. His reputation and influence in his day were nevertheless important.

**MENORAH** (Hebrew). The seven-branched lamp of the Sanctuary in the wilderness (Exod. xxv. 31–40), later a prominent feature of the Jerusalem Temple, as shown in the Arch of Titus. Through the ages it has figured on tombstones, seals, etc., as a symbol of Judaism and Jewish craftsmen have made fine models in silver and other metals.

**MENZEL,** ADOLF (1815–1905). German painter and illustrator. He was trained as a LITHOGRAPHER, but his best known work in the field of book illustration was done in drawings for WOOD ENGRAVING (Kugler, *Life of Frederick the Great*, 1840–2). He is best known for his many paintings from the life of Frederick the Great, such as *Frederick at Dinner with his Friends* (Berlin, 1850, destroyed in 1945), and *The Flute Concert* (Berlin, 1852). For Bismarck's Prussia Menzel created the popular image of the founder of the Prussian state. Yet there is also a different side to his art, perhaps more appealing. All his life he loved to sketch and paint directly from nature very much in the manner of CONSTABLE, some of whose work he had seen in an exhibition in Berlin in 1839. *The Berlin-Potsdam Railway* (1840), *The French Window* (1845), and scenes from his garden in Berlin are forerunners of IMPRESSIONISM. Yet Menzel never exhibited these works, and he disliked those among his French contemporaries who had similar aims. He visited Paris in 1855 and 1867 but found nothing better to admire than MEISSONIER, though his *Afternoon in the Tuileries* (1867) reminds us strongly of MANET. Menzel was also one of the first German painters to note the picturesque qualities of modern industry (*The Steel Mill*, 1875). Berlin has the best collection of his works.

2789.

**MERIAN,** MATHÄUS (1593–1650). German engraver and publisher. He brought out hundreds of topographical prints of European towns which are of greater historical than artistic interest. Only a few are based on his own drawings and much of this vast output came from the hands of assistants. Among his pupils was Wenzel HOLLAR. His daughter MARIA SIBILLA MERIAN (1647–1717) was an artist who settled in Holland and visited Surinam from 1699 to 1702. She is best known for her

coloured drawings of insects and butterflies, which are as remarkable for their scientific accuracy as for their delicate beauty.

**MERZ.** A variety of DADA invented by the German artist Kurt SCHWITTERS at Hanover in 1920. The name was reached by chance: when fitting the word 'kommerz' into a COLLAGE Schwitters cut off the first three letters and used what was left. According to Werner Haftmann it denoted in practice 'pictures that were arrangements not of forms but of different materials'. Schwitters collected objects obsessively such as bus-tickets, nails, stamps, hair, discarded refuse, old catalogues, and built them up into pictorial compositions.

**MESDAG,** HENDRIK WILLEM (1831–1915). Dutch painter and collector. He abandoned the profession of banking in 1866 to devote all of his time to art and soon became the leading MARINE PAINTER of the HAGUE SCHOOL. His tremendous panorama (1881) of the fishing village of Scheveningen—its circumference is 131 yards—is housed in a specially designed building in The Hague. The Mesdag Museum, in the same city, contains his excellent collection of paintings by members of the BARBIZON and Hague Schools of painting.

**MESSEL,** ALFRED (1853–1909). German architect, numbered among the pioneers of modern German architecture on account of his Wertheim department store, Berlin (built in stages between 1896 and 1904), where he combined the use of a widely spaced steel frame and functional design with large areas of glass and ornament tending first to *Jugendstil* and then to German late GOTHIC.

**MESTIZO STYLE.** Term sometimes applied to a decorative style of architectural carving

**216.** *Calavera Huertista*. Engraving on type metal (1913) by José Guadalupe Posada

which flourished in the Central Andes *c.* 1650–1750 with its main centres at Cuzco, Ayacucho, Sucre, Potosí, Arequipa, Cajamarca, and Puno. The term points to a combination of traditional indigenous features with Christian elements, but as the word 'mestizo' carries disparaging connotations many writers prefer to speak of 'provincial highland' style. The style is characterized by prolix RELIEF carving on two levels with edges deeply undercut so that in sunlight they are outlined with heavy shadows. The symbolically abstract designs often echo traditional textile patterns and the carving extends in continuous carpet-like areas over façades, round frames, and over columns, vaults, and cupolas.

The term is sometimes also applied to the Mexican *tequitqui* style (a word which, like MUDÉJAR, means 'vassal'), which from *c.* 1550 achieved a synthesis of traditional indigenous patterns and motifs with European features. A good example may be seen at the open-air chapel of Tlamanalco.

Later examples of the colonial synthesis of native and European decorative design may be seen outstandingly in the Jesuit church at Arequipa (façade, 1698; cloister, 1738), the church of Santiago at Pomata (*c.* 1722), the church of San Francisco at La Paz (façade, 1753–72), and in Mexico the Cathedral of Zacatecas (façade, 1718–52).

**METAL CUT.** An engraving made on a metal plate for relief printing in the manner of a WOOD-CUT. One example of this type of print is the MANIÈRE CRIBLÉE of the 15th c.; another is BLAKE's experiment with 'woodcuts on pewter', which were in fact BURIN engravings on metal for printing by the relief method (see PRINTS).

In more recent years wood engravers have frequently used type metal as a substitute for wood; the resulting print is often indistinguishable from a true WOOD ENGRAVING and the tools used are the same. A notable exponent of the method was the Mexican satirical engraver José Guadalupe POSADA, whose skeleton caricatures are in the true tradition of popular woodcut art.

**METAL POINT.** A small metal rod pointed at one end has been a drawing instrument since classical times (see STYLUS), and was used during the Middle Ages and RENAISSANCE. It may be of lead, copper, silver, or gold. Lead point, probably the earliest, began in the 16th c. to give place to the graphite PENCIL. All the metal points except lead need an abrasive drawing surface, as otherwise they leave no mark. This surface is a coating of Chinese white, or Chinese white mixed with another water-colour PIGMENT to give a coloured GROUND.

The commonest metal point is the silver point, which gives an attractive fine grey line.

The strength of tone can hardly be varied at all, so the technique depends on the quality of the drawn line and is best suited to work on a small scale. Moreover it demands great certainty

of purpose and hand, for the line cannot be removed except by disturbing the ground.

As a drawing instrument the silver point appeared first in medieval Italy, but it was popular with 15th-c. Flemish artists and pictures by Rogier van der WEYDEN and GOSSAERT show artists drawing with silver point. Working drawings were often made on PRIMED PANELS which could be used repeatedly by scraping away the ground and applying a fresh one. Finished drawings were usually on parchment or paper.

A masterpiece in silver point is DÜRER's *Self-portrait* (Albertina, 1484). The instrument was used by Nicholas HILLIARD and other MINIATURISTS, but it went out of fashion in the 17th c., probably because the graphite pencil was coming in. It was revived in the 18th c. by miniature painters, especially in France.

**METAPHYSICAL PAINTING.** This term is generally applied to the work of CHIRICO and his follower CARRÀ from 1915 to 1918 and to that of MORANDI, who came together with Carrà towards the end of the war. The poet Alberto Savino, brother of Chirico, said that it involved 'the total representation of spiritual necessities within plastic limits—power to express the spectral side of things—irony'. Chirico himself wrote in 1938: 'To be truly immortal a work of art must stand completely outside human limitations; logic and common sense are detrimental to it. Thus it approximates dream and infantile mentality. . . . One of the strongest sensations left to us by prehistory is that of presage. It will always be with us. It is as it were an eternal proof of the non-sense of the universe.' Although Chirico had read Schopenhauer and Nietzsche, the actual metaphysics of the movement are obscure; in practice it involved using objects (often mannequins and statues) as signs, placing them in unusual combinations and strange architectural perspectives, which create an atmosphere of mystery and hallucination. Chirico's earlier painting (*Enigma of an Autumn Evening, 1910*), particularly that done in Paris 1911–15, where he knew PICASSO, Paul Guillaume, and APOLLINAIRE, already possessed these qualities, especially the powerful but mysterious sense of presage. They were intensified in the work he did when he was confined to hospital as a conscript at Ferrara in 1915. Some of his *Metaphysical Interiors* painted in Ferrara were apparently suggested by shops 'in which one could see cakes and biscuits of extremely metaphysical and odd shapes. . . . We who know the signs of the Metaphysical Alphabet know what joys and sorrows are present in a portico, on a street corner, within the walls of a room or inside a box.'

Metaphysical painting arose partly as a reaction against FUTURISM, though it was extremely personal to Chirico. Carrà was converted from Futurism, Morandi had passed through the influence of BOCCIONI. Carrà was more interested in visual qualities of line, colour,

and pictorial problems than the strange psychological suggestiveness which lends to Chirico's works their intensely personal character.

Morandi, a more isolated painter, was said by Chirico to have 'sanctified' Metaphysical painting in his works of 1918-19, which were mostly STILL LIFES reminiscent of the PURIST school. He used the enigmatic 'Metaphysical' images rather for plastic and pictorial effect than for psychological suggestiveness, and relied a great deal on his fine linear gift. Metaphysical painting did not long survive the First World War, but while it lasted it had some influence; it had its own magazine, *Valori Plastici*, and both Carrà and Morandi went on to produce other interesting work. Chirico's metaphysical pictures exerted a powerful impact by their sheer greatness and contained obvious prognostications of SURREALISM, which movement he joined on his return to Paris 1924-9.

**METOPES.** Term in Greek architecture, meaning according to VITRUVIUS (iv. 2. 3-4) the spaces or intervening openings between the beam sockets or DENTILS (i.e. the blocks forming one of the members of the CORNICE) or in the Doric Order (see ORDERS OF ARCHITECTURE) the spaces between the TRIGLYPHS of the FRIEZE. These spaces were originally left open. For example in the *Iphigenia in Tauris* of Euripides (l. 113) Orestes makes his way into the temple of Artemis at Tauri through one of these openings. They were afterwards filled with panels of wood or slabs of MARBLE (Paestum) which were sometimes decorated in low RELIEF (temple of Zeus at OLYMPIA). In the classical period they were often filled by figures in relief (THESEUM; PARTHENON). The term *metopes* is also sometimes extended to sculptured slabs which are not between triglyphs but attached to the walls of the *cella* (temple of Zeus at Olympia).

**METSU,** GABRIEL (1629-67). Dutch painter of Leiden who died in Amsterdam. He specialized in intimate scenes of middle-class life and his best works, such as the *Mother and Sick Child* (Rijksmuseum, Amsterdam, *c.* 1660), have an intensity surpassed only by VERMEER. His talent was a great, but pliable one. During his short life he responded readily to the work of his great contemporaries. His earliest GENRE pieces show the impact of his teacher DOU; when he moved to Amsterdam *c.* 1655 he adopted the CHIAROSCURO and warm palette of REMBRANDT; around 1660 he was influenced by the interiors of de HOOCH, TERBORCH, and STEEN, as well as Vermeer. But even when he adopted the style and devices of others Metsu impressed his personal stamp upon his pictures, manifested in his carefully balanced compositions and colour schemes, and his quiet observation of people and STILL-LIFE details.

**METSYS.** See MASSYS.

**METZINGER,** JEAN (1883-1956). French painter, born at Nantes. In youth he was excited by INGRES and after subsequently passing through periods of interest in the NEO-IMPRESSIONISTS and the FAUVES, in 1908 he joined the group of young artists who developed the CUBIST manner of PICASSO and BRAQUE. He exhibited in the Salon des INDÉPENDANTS of 1911 and at the SECTION D'OR. In 1912 he collaborated with GLEIZES in writing *Du Cubisme*, which became the accepted statement of Cubist principles and aesthetic. He never became purely abstract but used the Cubist technique of shallow planes to bring out the characteristic features of his subject matter.

**MEULEN,** ADAM FRANS VAN DER (1632-90). Flemish painter and tapestry designer, pupil of Pieter Snayers (1592-1666) in Brussels. Upon the advice of LEBRUN he went to Paris *c.* 1665 and was made one of Louis XIV's court painters. His paintings and designs for Gobelin tapestries are accurate historical documents of the battles which they represent, for he accompanied the king on his campaigns and made careful drawings of the participants, the uniforms, the disposition of troops, and the terrain, afterwards incorporating these into his compositions. He also made LANDSCAPES and GENRE pictures of hunting parties, castles, and FÊTES CHAMPÊTRES.

**MEUNIER,** CONSTANTIN (1831-1904). Belgian sculptor and painter who worked in the spirit of social REALISM, glorifying the nobility of labour. He found his subjects mainly among miners, factory workers, and stevedores. The Belgian Government commissioned him in 1896 to do a *Monument to Labour*, which he was unable to complete before his death. The pieces he executed for it are on view in Brussels.

544.

**MEXICAN ART** (MODERN). Mexican art in the 20th c. has been unusually closely tied in with the social and political situation and its sociological condition has not been paralleled in any contemporary culture. It has been ideological, educational, and deliberately subserving the propagation of the ideals and aspirations of the revolutionary state. Since the Revolution of 1910 official patronage, both federal and national, went further than in any other country and brought about an almost total commitment of artists to their social responsibilities within the new cultural orbit. Even the most prominent and individual artists, OROZCO, SIQUEIROS, RIVERA, whose names have transcended the national boundaries, devoted their talents to furthering the revolutionary ideals and furnishing for the new cultural ideas firm roots in native tradition. The position of art in the state as the chief cultural manifestation of the Revolution determined both its ICONOLOGY and its genre.

Over most of the period until the Second World War mural painting and GRAPHIC ART preponderated. Mexican art was figurative with a strong element of CARICATURE and social symbolism, some admixture of lyrical primitivism and inevitably a prominent didactic motive. After the Second World War easel and ABSTRACT painting began to come to the fore in the work of TAMAYO and a group of younger artists, some of whom were known in international exhibitions by the 60s.

The Revolution in its first decade had no clearly expressed positive programme. It was, however, in violent opposition to foreign domination, the power of the church, special privilege, large estates with the exploitation of the peasant population, the concentration of wealth, and the tyranny of office. These attitudes formed the dynamic inspiration of Mexican artists, many of whom had been actively involved in the revolutionary wars, and to them they added the ideals of bringing enlightenment to the masses and constructing a popular art based upon national Mexican traditions. During the first revolutionary decade the most significant work was perhaps that of Francisco Goitia (1882– ), who painted scenes of Indian peasant life with emphasis on its tragic aspect (*Viejo del Muladar*, Museo Nacional de Artes Plásticas, Mexico, 1916; *Tata Jesucristo*, Philadelphia Mus. of Art). Important too was José Guadalupe POSADA, whose violently propagandist broadsheets (*calaveras*) were a genuine manifestation of popular art. In these artists appeared two features which are profoundly characteristic of Mexican art: a preoccupation with death and a gift for caricature. During this period also Orozco was producing a series of caricatures and revolutionary drawings depicting the horrors of civil war in Mexico.

A powerful impetus to the development of a 'Mexican renaissance' in art was given during the administration of Alvaro Obregón (1920–4) by the cultural ideals of the Minister of Education, José Vasconcelos, who took over and actively extended the policy of government patronage of artists and laid the real basis of the characteristically Mexican system of open-air rural art schools as a central feature of his programme of popular education. Dr. Atl (Gerardo Murillo, 1875–1964), one of the most active and stimulating personalities of the Revolution, a combination of scholarly intellect and violent artistic temperament, became the pivot around which congregated a group of artists actuated by creative fervour and social idealism rather than any precisely formulated aesthetic programme. Orozco, who had been in the U.S.A. from 1917 to 1919, returned to join the movement; it was strengthened by the arrival of Diego Rivera and Siqueiros from Europe in 1921 and 1922 respectively, and the stage was set for much of the future development of Mexican art. In 1921 Siqueiros published a famous manifesto in which he advocated the abandonment of easel painting

in favour of mural and propounded the principle that the theme and doctrine of a picture are as important as style and execution. He put forward the ideal of 'a monumental and heroic art, a human and public art, with the direct and living example of our great masters and the extraordinary cultures of pre-Hispanic America'. Mexican art has been above all a public art.

With the coming of the Calles regime Orozco and others were dismissed from government employment, the Syndicate of Technical Workers, Painters, and Sculptors, which had been the hub of the movement, was disbanded and the progress of a national art in Mexico suffered a setback. It was not until the appointment of the liberal Minister of Education, Narciso Bassols, in 1933 that revolutionary art began once again to flourish. From this time it became the fixed policy for all new Federal schools to be decorated with murals. During the intervening period the lack of government patronage and the generally reactionary attitude brought about an escapist turning away from current social problems and the most important works of Mexican painters were done abroad. In Mexico itself a group of easel painters were more open to the influences of current European movements, combining the Classicism of PICASSO and BRACQUE with a characteristic monumentalism and an interest in Mexican popular art rather than retrospective folklorism. This monumental Classicism was particularly evident in the work of Manuel Rodríguez Lozano (1896– ) and his influential follower Julio Castellanos (1905–47), whose work achieved a typically Mexican quality without recourse to picturesque folk types (*The Dialogue*, Philadelphia Mus. of Art; *La Manteada*, fresco, Melchior Ocampo School, Coyoacán). The Guatemalan Carlos Mérida, known chiefly for his WATER-COLOURS, changed from a lyrically nativist style to increasingly abstract STILL-LIFE compositions. Rufino Tamayo held his first one-man exhibition in Mexico City in 1926, showing still lifes and simple everyday themes in techniques derived from the School of PARIS. His statement of his aesthetic aims is diametrically opposed to that of Siqueiros previously quoted: 'to pretend that the value of painting is derived from other elements, particularly from ideological content which is not otherwise related to plastic content, cannot but be considered a fallacy. . . .'

The election of Lázaro Cárdenas in 1934 inaugurated a new era of liberal reform favourable to progressive socialistic art. The L.E.A.R. (League of Revolutionary Writers and Artists) and the Workshop of Popular Graphic Art (*Taller de Gráfica Popular*) were formed to support the reform programme and through the L.E.A.R. was planned a new art movement for the masses whose first expression was an enthusiastic, though not strikingly successful, project of co-operative mural painting in the Abelardo Rodríguez market. The Taller was formed in 1937 under the leadership of Leopoldo Méndez

(1903– ) and the United States-born artist Pablo O'Higgins (1904– ). It favoured communal activity and group projects of a propagandist nature and set more store on the dramatic impact of a picture's message than on formal aesthetic qualities. Among the members were Antonio Pujol (1914– ), a pupil of Tamayo and Mérida, Alfredo Zalce (1908– ), known for his cement murals at the Ayotla School, Tlaxcala, and for his fine series of *Estampas de Yucatán* (1945), and the Bolivian Roberto Berdecio (1910– ). During the 30s and on into the 40s many collective murals were executed by O'Higgins, Méndez, and other members of the group in a style which became increasingly derivative from the decorativeness of Rivera combined in varying proportions with the more vigorous style of Orozco. Except with a few artists such as Zalce it showed a growing tendency to rhetoric and bombast. More individual in style, though tending to the pedantic, was the work of the architect-painter Juan O'GORMAN, whose anti-fascist and anti-church frescoes at Mexico City airport were destroyed in 1939 during a political swing to the right. His enormous mural (15 metres by 12½ metres) in the Gertrudis Bocanegra Library at Pátzcuaro, portraying in narrative 1,000 years of the history of the state of Michoacán, is one of the most elaborate murals ever painted. In 1952 he did decorations for the Library Building at the new University City. As head of the Department of Construction in the Ministry of Public Instruction he was in charge of the building of 30 new schools (1932–5) and he became one of the leaders of modern Mexican architecture.

The rapid industrialization of Mexico from the middle 40s was reflected in such works as the machine-art mural by Orozco at the National School for Teachers (1947), the Siqueiros mural in the National Polytechnical Institute (1952), and a number of murals by Jorge González Camarena for industrial and commercial buildings. An active era of building gave rise to a new school of Mexican architecture which attracted attention abroad. The emergence of a moneyed middle class led to the appearance of private galleries and created a public for the easel painter. In 1950 the Government organized a Salón de Plástica Mexicana where independent artists could exhibit without charge and sell their works without commission. A department for technical research in plastics set up in the National Polytechnical Institute brought to light new materials for the painter such as the vinylites and pyroxilins. Vinylite was used by Camarena for his large mural on the Social Security Administration building depicting the growth of the new Mexico City. Camarena, perhaps the best of the mural painters at the mid century, developed an original style with a rather self-consciously poetic and mannered symbolism reminiscent of a latterday ART NOUVEAU. Outstanding among the easel painters of the 50s were Tamayo and Martínez de Hoyos. The latter became known for an

original treatment of formalized spatial organization which makes a mystical, symbolic impact somewhat akin to that of CHIRICO. Tamayo had matured the formal quality of his work and enriched it with a disturbing symbolism sometimes akin to that of Francis BACON and achieved a stature which gave him prominence on an international plane (*Singing Bird*, Venice). His experiments in abstract murals (Palacio de Bellas Artes, Mexico City, 1952–3) have been somewhat less regarded outside Mexico.

From 1910 until well into the 50s Mexican painting was socially committed to a degree unequalled in any other country without, as in the U.S.S.R., being dominated by an ideology imposed from above. The artists were, on the whole, among the most important proponents of the ideologies they fostered.

Some information about artistic developments in Mexico before the 20th c. may be found in PRE-COLUMBIAN ARTS OF MEXICO AND CENTRAL AMERICA and SPANISH COLONIAL ART.

512, 863, 1206, 1689, 1828, 1904, 2203, 2204, 2504, 2559, 2730.

**MEZZOTINT.** A method of engraving in tone, much used in the 17th, 18th, and early 19th centuries for the REPRODUCTION of paintings. A copper plate is first roughened by means of a tool with a serrated edge known as a ROCKER. The rocker is systematically worked over the surface of the copper in every direction, raising a BURR as it goes. The design is formed by scraping away the burr where the light tones are required and by polishing the metal quite smooth in the highlights. The plate is then filled with ink and wiped with a series of rags. Where the plate is rough the ink is retained and will print an intense black, but where it has been smoothed by the scraper less ink will be held and a lighter tone will occur. A mezzotint is thus evolved from dark to light and is characterized by soft and hazy gradations of tone and richness in the dark areas. Engraved or ETCHED lines are sometimes introduced if greater definition is required; this procedure is known as mixed mezzotint.

The process was invented by Ludwig von SIEGEN of Utrecht, whose first dated mezzotint was made in 1642. Another pioneer, formerly thought to be the inventor, was Prince RUPERT, nephew of Charles I. The early mezzotinters, however, whose work was largely in the field of portraiture, did not prepare their plates as described above, but worked from light to dark, using ROULETTES to roughen limited areas of the copper as required, and combining this procedure with lines and STIPPLES engraved with the BURIN.

In England taste has always tended to favour the tonal processes of engraving. Mezzotint was ideally suited to the reproduction of the 18th-c. portrait, and Valentine GREEN, John Raphael SMITH, and a number of other mezzotinters engraved plates after REYNOLDS, ROMNEY, and

GAINSBOROUGH. David Lucas (1802-81) devoted his life to the interpretation of the landscapes of CONSTABLE. The plates of landscape subjects which constitute J. M. W. TURNER's *Liber Studiorum* (1807-19) were executed under Turner's direction in mezzotint combined with etching and, occasionally, with AQUATINT.

At this period a number of mezzotints were engraved on steel plates in an attempt to overcome the drawback that the medium shares with DRYPOINT, namely that it will yield only a small number of good impressions, owing to the wearing down of the burr in printing. In spite of this, however, it shared the eclipse suffered by all the reproductive copper-plate techniques in the 19th c. and has become virtually extinct.

696, 2482.

**MICHEL,** GEORGES (1763-1843). French painter who specialized in LANDSCAPES and street scenes from the suburbs of Paris. His treatment had more in common with the Dutch landscape school than with the French Classical tradition of historical landscape. He was one of the earliest to paint in the open air and because of this and his intimate, emotional depiction of nature he has sometimes been regarded as a forerunner of the BARBIZON SCHOOL (*Mill at Montmartre*, Louvre). He worked as a cleaner and restorer of pictures at the LOUVRE, but as a painter he went almost unknown until his landscapes were shown posthumously at the International Exhibition of 1889.

**MICHELANGELO BUONARROTI** (1475-1564). Italian sculptor, painter, architect, and poet, one of the greatest figures of the RENAISSANCE and, in his later years, one of the forces that shaped MANNERISM. He was born on 6 March 1475 at Caprese, near Sansepolcro, where his father was *podestà*. Michelangelo's father was a member of the minor Florentine nobility and throughout his life Michelangelo was touchy on the subject; it may have been pride of birth that caused the family opposition to his apprenticeship as a painter and Michelangelo's own insistence in later life on the status of painting and sculpture among the LIBERAL ARTS. Certainly his own career was one of the prime causes of the far-reaching change in public esteem and social rating of the visual arts. He was formally apprenticed to Domenico GHIRLANDAIO for a term of three years on 1 April 1488 and from him he must have learnt the elements of fresco technique, since the Ghirlandaio workshop was then engaged on the great fresco cycle in the choir of Sta Maria Novella, Florence: indeed an attempt has recently been made to ascribe parts of the frescoes to Michelangelo himself. He could not have learnt very much else, however, since he seems to have transferred very quickly to the school set up in the MEDICI gardens and run by BERTOLDO DI GIOVANNI. More important than either master was what he learned from the

MICHELAGNOLO BVONARRVOTI

*Vita di Michelagnolo Buonarruoti Fiorentino Pittore, Scultore, & Architetto.*

217. Michelangelo Buonarroti. Engraving from the Life of Michelangelo included in *Le Vite de' più eccellenti pittori, scultori, e architettori*, Florence (1568) by Giorgio Vasari

drawings he made of figures in the frescoes of his true masters, GIOTTO and MASACCIO. His work in the Medici gardens soon brought him to the notice of Lorenzo the Magnificent himself and one of Michelangelo's earliest works, the *Centaurs* relief (Bargello, Florence), may have been made for Lorenzo and left unfinished because of his death on 8 April 1492. After the death of Lorenzo the political situation in Florence deteriorated, first with Savonarola's oppressive theocracy and then with his judicial murder (1498). In October 1494 Michelangelo left Florence for Bologna, where he carved two small figures and an angel for the tomb of S. Dominic. On 25 June 1496 he was in Rome, where he remained for the next five years and where he carved the two statues which established his fame—the *Bacchus* (Bargello, Florence) and the *Pietà* (St. Peter's). The latter, his only signed work, was commissioned in 1497 (the contract is dated 27 August 1498) and completed about the turn of the century. It is completely finished and highly polished and is in fact the consummation of all that the Florentine sculptors of the 15th c. had sought to achieve—a tragically expressive and yet beautiful and harmonious solution to the problem of representing a full-grown man lying dead in the lap of a woman. There are no marks of suffering—as were common in northern representations of the period —and the Virgin herself is young and beautiful.

There is a story that objection was taken to the fact that the Virgin seemed too young to be the mother of the dead Christ, and Michelangelo countered this by observing that sin was what caused people to age and therefore the Immaculate Virgin would not show her age as ordinary people would. The story is told by Michelangelo's pupil and biographer CONDIVI and is therefore presumably true in essentials. No other living artist except LEONARDO DA VINCI would have thought out the implications of his subject and linked the desire to achieve the utmost physical beauty and the maximum technical virtuosity with so considered an interpretation of the Christian mystery. Still in his twenties, Michelangelo returned to Florence in 1501 to consolidate the reputation he had made in Rome. He remained there until the spring of 1505, the major work of the period being the *David* (Accademia, Florence, 1501-4), which has become a symbol of Florence and Florentine art. The nude youth of gigantic size (approx. 18 ft. high) expresses in concrete visual form the self-confidence of the new Republic. It is really a relief although actually carved in the round. It displays complete mastery of human anatomy, and it is taut with imminent action and latent energy. Both anatomy and movement summarize the achievements of predecessors like CASTAGNO and POLLAIUOLO, while the virility and classical proportions of the figure descend directly from the Florentine tradition of Giotto, Masaccio, and above all DONATELLO.

Other works of this productive period include the *Madonna* (Notre-Dame, Bruges) and the *Apostles* intended for Florence Cathedral (contract of 24 April 1503), of which only the *St. Matthew* (Accademia, Florence) was even begun. He probably also carved the *Madonna* relief (Royal Academy, London) and painted the *Doni tondo* (Uffizi) during these years. Immediately after the *David* was completed (March 1504) Michelangelo received a commission from the Signoria of Florence to paint a huge BATTLE-PIECE for the new Council Chamber in the Palazzo Vecchio, a commission which he shared with the older Leonardo. This painting was never completed, but Michelangelo began work on the full-size CARTOON in the winter of 1504, and the fragment known as the *Bathers* (i.e. a group from the *Battle of Cascina* as a whole) was, while it existed, a model for all the young artists in Florence—including RAPHAEL—and was one of the prime causes of Mannerist preoccupation with the nude figure in violent action. There is a copy of the *Bathers* (Earl of Leicester Coll.) and an engraving, as well as some drawings by Michelangelo himself (e.g. in the B.M.). These drawings allow us to reconstruct the project with some accuracy and they are also important in that Michelangelo's intentions can be seen in them. He is one of the first great artists whose drawings have survived in sufficient quantity for us to be able to follow the stages of creation. Somewhat later he made a number of highly finished drawings for presentation to friends (examples survive at Windsor, Oxford, the B.M., and elsewhere). These were the first drawings to be regarded as major works of art in their own right and their value is one of the reasons for the survival of so many drawings by him (perhaps as many as 500, although at one time a lower figure was generally accepted).

In the spring of 1505 Pope Julius II summoned Michelangelo to Rome to make him a tomb. The *Battle of Cascina* was never painted, and the 'Tragedy of the Tomb' (as Condivi described it) was about to begin. Julius II was one of the greatest of patrons, but his ardent temperament was too like that of Michelangelo himself and they soon quarrelled; on 17 April 1506 Michelangelo went back secretly to Florence and for some time held out against the Pope's demands for his return until the Florentine Government itself put pressure on him. In November he went to Bologna and there he made a colossal bronze of the Pope in his role of conqueror of the Bolognese. They destroyed it in 1511. In the spring of 1508 he was again in Rome, working for Julius II once more, this time on the frescoes of the Sistine Chapel, and the grandiose project for the papal tomb seems to have been temporarily shelved: in fact the original design, which provided for more than 40 large figures, was never begun and the greater part of what was actually carried out—the *Moses* and two *Slaves* (both now in the Louvre)—was in accordance with a second contract (1513) made with the heirs of the Pope. After the death of Julius Michelangelo had no peace from his successors and other great personages, all of whom tried to make him break his contractual obligations to Julius's heirs, who naturally resented such conduct. Further contracts, each reducing the amount of work to be carried out by Michelangelo himself, were signed in 1516, 1532, and the fifth and final one on 20 August 1542. Under the terms of this a much reduced and mutilated version of the original titanic idea was set up in S. Pietro in Vincoli in 1545. Only the *Moses* retains his superhuman grandeur, and from the point of view of style may best be compared with the *Prophets* of the Sistine Chapel.

The vast fresco cycle which covers the whole of the vault and part of the upper walls of the Sistine Chapel was painted almost entirely by Michelangelo's own hand in a very short time, and in some ways it is the most complete work of his early maturity that has come down to us (a small part of the cycle on the altar wall was destroyed to make way for Michelangelo's own *Last Judgement*). Work began in the spring of 1508 and the first half was completed in September 1510. Then followed a long break, while fresh scaffolding was prepared, the first half being officially unveiled on 15 August 1511. After this work on the second half proceeded rapidly and the whole was unveiled on 31 October 1512. The ceiling of the Sistine Chapel is a shallow barrel-VAULT, approximately 118 ft. by 46 ft., with the windows

cutting into the vault so as to produce a series of alternating lunettes and SPANDRELS. The central field is almost flat and is defined by a painted CORNICE which is cut laterally by five pairs of ribs, which in turn define five small and four large rectangles containing scenes from the Old Testament. The small one over the altar represents the *Primal Act of Creation*; the last, also small, over the entrance used by the laity, represents the *Drunkenness of Noah*—i.e. the sinful state of Man. Each of the smaller fields has at each corner a nude youth (usually called the *Ignudi*), whose exact significance is uncertain: most probably they have been thought to represent the Neo-Platonic ideal of humanity, an interpretation which explains their position near the sacred scenes and above the figures of the *Prophets* and *Sibyls*, who foretold the coming of the Messiah but were nevertheless human and therefore subject to Original Sin. The *Prophets* and *Sibyls* occupy the triangular shapes between the windows and are seen, together with their thrones, in normal PERSPECTIVE: by contrast, the *Ignudi* are not subject to the laws of foreshortening. At each of the corners of the ceiling there is a double spandrel and these are occupied by the *Brazen Serpent*, the *Crucifixion of Haman*, *Judith and Holofernes*, and *David and Goliath*, i.e. four scenes of Salvation. Finally, the spaces above and beside the windows are filled with representations of the purely human *Ancestors of Christ*. They occupy the lowest and darkest part of the vault furthest from the Histories in the central part, which is apparently open to the sky. From the moment of its completion the Sistine Ceiling has always been regarded as one of the supreme masterpieces of pictorial art, and Michelangelo was at the age of 37 not only recognized as the greatest artist of his day but was also regarded as having raised the status of the arts to a point where he could be referred to as 'il divino Michelangelo'. He himself began by regarding the whole undertaking as an unwanted task to be got over as soon as possible with the help of assistants. But he could not find any to measure up to his standards and the ceiling, which grew under his hands, was almost entirely painted by him. To some extent he came to regard it as a substitute for the Julius Monument, but as soon as the ceiling was finished he returned to the carving of figures for the Tomb. The stylistic affinity between the *Moses* and the *Prophets*, the *Slaves* and the *Ignudi*, is very evident.

The problem of designing the architectural parts of the Julius Monument led Michelangelo to consider the art of architecture, and in December 1516 he was commissioned by the new Pope, Leo X, to design a façade for the Medici parish church in Florence, S. Lorenzo, which had been left unfinished by BRUNELLESCHI. In fact the project came to nothing and wasted a good deal of Michelangelo's time, but it led to two other works for S. Lorenzo—the Medici Chapel, or New Sacristy, planned as a counter-

part to Brunelleschi's Old Sacristy, and the Biblioteca Laurenziana. The Medici Chapel was planned from November 1520 as a mortuary chapel for the family to contain the monuments of four members, but it was abandoned when the Medici were again expelled from Florence in 1527, restarted in 1530 and left incomplete in 1534 when Michelangelo finally settled in Rome. The commission for the Library was given in 1524 and it too was left incomplete in 1534, but the vestibule was finished by AMMANATI. These buildings are, with GIULIO ROMANO's Palazzo del Tè, Mantua, the earliest important manifestations of Mannerist architecture. In addition the Medici Chapel was intended to be a union of architecture and sculpture (like the projected S. Lorenzo façade), with the view from the altar leading to the climax of the whole composition in the figures of the *Madonna and Child* (unfinished) and with the Active and Contemplative Life symbolized by figures on the wall-tombs of Giuliano and Lorenzo de' Medici. The figures of the Medici are set above the reclining figures symbolizing *Day* and *Night* (for *Vita activa*) and *Dawn* and *Evening* (for *Vita contemplativa*). One of the reasons why the Chapel was unfinished is that when the Medici were expelled from Florence in 1527, Michelangelo declared himself a Republican and took an active part in the defence of the city. After the capitulation in 1530 he was pardoned and set once more to work on the glorification of the Medici until in 1534 he settled in Rome and worked for the papacy for the 30 years that still remained to him. He was at once commissioned to paint the *Last Judgement* in the Sistine Chapel and began the actual painting in 1536. It was unveiled on 31 October 1541, 29 years to the day after the unveiling of the Sistine Ceiling but a whole world away from it in feeling and meaning. In the interval the world of Michelangelo's youth had collapsed in the horror of the Sack of Rome and its confident humanism had been found insufficient in the face of the rise of Protestantism and the new, militant austerity of the Counter-Reformation. It is significant that Michelangelo knew St. Ignatius Loyola, the founder of the Society of Jesus, and all his last works reflect his intense preoccupation with religion. Apart from the apocalyptic *Last Judgement* itself, the works of his old age are the *Conversion of St. Paul* and the *Crucifixion of St. Peter* (1542–50), frescoes in the Cappella Paolina commissioned by the same pope, Paul III, who had commissioned the *Last Judgement*. There is also a series of drawings of the CRUCIFIXION and carvings of the Dead CHRIST, one of which (now in Florence Cathedral) was intended for his own tomb and contains a self-portrait as Nicodemus. And most important of all, the greatest commission in Christendom, was the completion of New St. Peter's, which remained almost as BRAMANTE had left it. Michelangelo began work on it in 1546 when he was 71, and when he died on 18 February 1564 the BASILICA was so far advanced that completion was possible within

the next half-century, although the church as we know it retains hardly any traces of his own work except in the APSE. His design was for a centrally planned church dominated by a vast hemispherical DOME: in fact the executed dome, by Giacomo della PORTA and Domenico FONTANA, is probably a good deal more pointed than Michelangelo intended. The addition of a nave and west front by Carlo MADERNA completed the transformation of his original design. It was at this time that Michelangelo wrote some of his finest poetry, as pessimistic in feeling as his drawings, paintings, and sculpture:

Nè pinger nè scolpir fia più che quieti
l'anima volta a quell'Amor divino
ch'aperse, a prender noi, 'n croce le braccia.

(Neither painting nor sculpture can soothe the soul which is turned toward that Divine Love that opened, on the Cross, His arms to embrace us.)

The figure style of all these late works is in keeping; heavy and sombre, and almost exclusively concerned with expressive use of the male nude. His mastery of anatomy allowed him to employ complicated poses which by their sheer difficulty (like the *Jonah* of his Sistine Ceiling) inspired emulation rather than understanding among the younger men. Against this must be set the abstract beauty of his last work, the *Pietà* (Castello Sforzesco, Milan), on which he was working in the last few days of his life. Here the forms of the Dead Christ and His Mother merge into one another and all the rules of anatomy are abandoned in the search for that emotional intensity which Michelangelo's contemporaries recognized as his *terribilità* and which earned him the veneration of his juniors to an extent that has never been paralleled.

7, 157, 573, 601, 1072, 1073, 1257, 1820, 1872, 2357, 2432, 2609, 2662, 2828, 2880.

**MICHELOZZO,** MICHELOZZI (1396–1472). Florentine architect and sculptor who was in partnership with GHIBERTI from *c*. 1420, and with DONATELLO 1423–38. He executed the niche at Or San Michele, Florence (for Donatello's *St. Louis*, 1425), which is one of the earliest examples of revived Roman architecture, and also the architectural parts of the TOMBS of Pope John XXIII, Cardinal Brancacci, and Bartolommeo Aragazzi (Montepulciano), all in progress in 1427, and the PULPIT at Prato (1428–38). The Aragazzi Tomb (now destroyed: two *Angels* in the V. & A. Mus. and pieces at Montepulciano) was largely by Michelozzo; his only other certain work in sculpture is the silver *St. John Baptist* (Museo del Opera, Florence, 1452).

Michelozzo was the favourite architect of Cosimo de' MEDICI, for whom he built the Medici Palace, now called the Palazzo Medici-Riccardi (1444–59), the most important palace design of the quattrocento. It is in three storeys divided by Classical string-courses and with RUSTICATION

graded from bottom to top, the whole being crowned with a huge Classical CORNICE. The plan is nearly symmetrical, around a central ARCADED court, similar to BRUNELLESCHI's Innocenti Loggia. All these features were constantly copied in later Florentine palaces. For Cosimo he also rebuilt the Convent of S. Marco (*c*. 1436–43), VILLAS at Careggi and Caffagiuolo, and possibly the Medici Bank in Milan. In 1444 he designed the tribune of SS. Annunziata (completed by ALBERTI), closely copied from the ANTIQUE 'Minerva Medica' in Rome. He succeeded Brunelleschi as supervisor of Florence Cathedral (1446–52), and his works in Venice (1433–4), Milan (e.g. Portinari Chapel, 1462), and Ragusa (1462–4) helped to spread the new style.

1875.

**MICRONESIAN ART.** 'Micronesia' is a term used to describe that part of the north-western Pacific which includes the Mariana, Caroline, Marshall, and Gilbert Islands. Language, geography, and physique suggest that the population of this area forms a link between the Indonesian peoples of the Philippines on the one hand and the Polynesian peoples of the Central Pacific on the other; but the aesthetic style of the region is surprisingly distinctive. Secular POLYNESIAN ART tends to be formal, geometrical, and heavily ornamented with surface patterns; INDONESIANS seem to delight in the interweaving of complex tracery; MELANESIANS are prone to distort and exaggerate natural forms so as to provide a visual merging of symbols, somewhat in the manner of some SURREALIST painters, with sexual motifs usually prominent. But Micronesian style contrasts with all of these. Its most marked characteristic is extreme functional simplicity. Long before the coming of European (and later Japanese) colonists, Micronesian boat-builders and navigators achieved an extremely high level of technical proficiency, despite the fact that they inhabited small coral atolls providing only the bare minimum of natural resources. They seem to have approached the whole problem of living with high intelligence and scientific forethought. Wood being scarce, they cultivated the breadfruit tree artificially, a proceeding that yielded timber only 40 years ahead. Their boats and many of their furnishing designs have the streamlined finish of supersonic aircraft; housing is spacious and elegant with unfussy functional lines. Almost every kind of man-made object, from racing canoes to string, is marked by high-quality finish and strict appropriateness to its mode of use. Surface decoration either in colour or otherwise is rare; the aesthetic effect is always achieved by smoothness of finish and balance of over-all design. The sense of orderliness and logical system that is apparent in Micronesian artefacts also pervaded their political institutions. Little is known of the ancient religious system, and cult objects are thinly represented in museum

collections; such as there are conform to the same severe streamlined conventions as secular objects.

**MIEREVELT,** MICHEL VAN (1567–1641). Dutch portrait painter, a pupil of Blocklandt (1533–83). He was portrait painter to the House of Orange and was one of the most successful and prolific artists in his trade. SANDRART reports that Mierevelt himself estimated that he made about 10,000 portraits.

**MIERIS.** Dutch family of painters in Leiden. FRANS VAN MIERIS (1635–81) is the most important. His style was determined by contact with the founder of the Leiden School, Gerrit DOU. He did lively pictures of interior scenes which have the precise drawing and high finish characteristic of Dou's followers. Two of his sons were painters. Works by JAN (1660–90) are rare. He is said to have made pictures with life-size figures, but none is extant. WILLEM (1662–1747) was a wax modeller. His paintings are similar to his father's but not equal to them in quality, for they suffer from an over-scrupulous attention to detail and the colour is dry. Willem's son FRANS VAN MIERIS II (1689–1763) continued in the manner of his father and grandfather.

**MIES VAN DER ROHE,** LUDWIG (1886–1969). German-born architect, a leader of the purist school of MODERN ARCHITECTURE, whose buildings, devoid of ornament or any qualities that cannot be exactly controlled (such as those arising from the effects of weather and the varying textures of natural materials), depend on subtlety of proportion and mechanical precision of finish.

Son of a stonemason, he picked up architecture practically until he worked with Peter BEHRENS (1908–11) at the same time that GROPIUS and LE CORBUSIER were among his designers. In 1912 he worked in Holland, where he came under the influence of H. P. BERLAGE. From 1919 he was a leading propagandist and exponent of the modernist movement in Berlin with pioneer projects for SKYSCRAPERS and country houses. He built a number of houses, and was superintending architect of the 1927 Stuttgart housing exhibition which contained the famous Weissenhof-Siedlung, a group of experimental houses by Walter Gropius, J. J. P. OUD, Le Corbusier, Mies van der Rohe himself, and others. He designed the German pavilion at the 1929 Barcelona exhibition, now regarded as the classic example of pure geometrical architecture, and in the following year the Tugendhat house in Brno, Czechoslovakia, which has been considered the finest of his European buildings. He also pioneered in furniture design, including the first tubular metal cantilevered chair (1927).

In 1930 he succeeded Walter Gropius as director of the BAUHAUS at Dessau. In 1937 he emigrated to the U.S.A. and obtained American citizenship in 1944. There he designed a number of buildings for the Illinois Institute of Technology, Chicago, and became Director of Architecture in 1938. Among his most important works in America are the Crown Hall for the Illinois Institute of Technology (1952–6), the Lake Shore Apartments, Chicago (1957), and the Seagram Building, New York (1958). His first retrospective exhibition was given by the Museum of Modern Art, New York, in 1947. His principal follower was the architect and historian Philip Johnson (1906– ), who wrote the catalogue to this exhibition.

292, 295, 1446.

**MI FEI** (1051–1107). Chinese painter of the Sung dynasty, famous also as a CALLIGRAPHER, poet, critic, and writer on the theory of painting. Very few works can now be attributed to him with certainty but his style became a recognized model for later painting, especially painters of the so-called Southern School (see CHINESE ART). He was a master of the 'ink splashing on' (p'o-mo) style in which the spattering of ink blots was used in place of precise calligraphic outline to depict form. Characteristic of his LANDSCAPES is an atmospheric spatiality created by subtle mist effects which span the transition in depth, as in a painting attributed to him in the Freer Gallery, Washington.

**MIGNARD,** NICOLAS (1608–68) and PIERRE (1612–95). French painters born at Troyes. Both passed through the studio of Simon VOUET and achieved considerable success as portrait painters. Pierre, the more celebrated brother, succeeded LEBRUN at the Académie and was made First Painter by the king in 1690. He was one of the principal supporters on the side of DE PILES and the 'Rubensistes' in their battle against the CLASSICISM of the 'Poussinistes' (see FRENCH ART). His own historical and religious paintings, however, did not exemplify his theories but fitted into the scheme of the academic Classicism in the tradition of DOMENICHINO and POUSSIN. His portraiture alone shows some originality and in contrast to Philippe de CHAMPAIGNE he introduced a style of court portrait which came to be associated with his name based partly on Venetian artists such as Forabosco. He also revived allegorical and MYTHOLOGICAL portraiture.

**MIGRATION PERIOD ART.** In art history this term refers to the art produced by the Teutonic tribes—Visigoths, Ostrogoths, Lombards, Vandals, Franks—who overran the declining Roman Empire c. A.D. 370–c. 800. The collapse of the Roman Empire was not a sudden cataclysm or primarily the work of external agents but the result of movements of barbarian peoples who had for long been included within the borders of

the Empire. These Germanic tribes occupied central Europe between the line of the Rhine–Danube in the west and the Vistula in the east. They were impelled to migrate westwards as attacking Huns impinged upon the Goths of the northern shores of the Black Sea. The capture of Rome by the Visigothic king Alaric in A.D. 410 was an early incident in these migratory movements. The final incidence of the Dark Ages is usually dated from the death of Justinian in A.D. 565, which left Europe open to barbarian rule. Although the destruction wrought by these barbarians' incursions has been exaggerated, it was none the less immense. Material civilization reverted to a more primitive level of existence. The ferocity of the Lombards brought disruption to Italian society and with it the collapse of the arts of culture and a breaching of traditional techniques.

The art of the migrant tribes was restricted to portable objects, articles of personal use or adornment. They excelled chiefly in goldsmiths' work and jewellery—fibulae, decorated buckles, and crowns. Examples have been found in graves and also in treasure deposits (Petrossa, eastern Hungary, Spain) concealed for safety during the Moslem invasions. A particular feature of migration style was gold with garnet or enamel inlays showing a predilection for isolated units of colour. This style has been described as 'primitive in its repetition of chevrons, crosses, lines, and dots . . . and unlike earlier classic ornament'.

Little migration architecture or carving has survived. The most important architectural monument is Theodoric's TOMB in Ravenna, built before his death in A.D. 526. It is a small two-storeyed polygonal structure of cut stone, roofed by a single slab of ISTRIAN STONE in a manner reminiscent of the dolmens of megalithic building. What little carving there is suggests WOOD-CARVING translated into stone. The degradation of the classical tradition under the Lombards is illustrated both by deterioration of sculpture technique and by the transformation of classical figures, tritons or nereids, into flat surface ornament with braided and interlaced designs, faces degenerating into crudely fashioned masks, and a complete absence of sculptural quality. Examples may be seen in part of a SARCOPHAGUS built into the wall of the cathedral of Calvi, near Capua, and in the altar of Ratchis at Cividale.

In Britain most surviving traces of Roman culture were erased by the Anglo-Saxon invasion after A.D. 450. The Christian church retreated to Ireland and the invading Jutes, Angles, and Saxons developed the migration style in brooches, cloisonné ware, and other personal ornament.

Manuscript illumination declined less completely than most other arts during the migration period and pockets of continuity were provided by the monasteries. In Ireland and later in northern England a style grew up which is known in art history as the *Hiberno-Saxon* or *northern* in contrast to the *Roman* or *southern*, and which had some affinities with migration ornament style. It is not appropriate, however, to regard this as a true manifestation of Migration Period art. (See ILLUMINATED MANUSCRIPTS.)

4, 33, 724, 1293, 1295, 1744, 2167, 2477, 2578.

**MILLAIS,** SIR JOHN EVERETT (1829–96). English painter. He began as an 11-year-old prodigy at the R.A. Schools. In 1848, with ROSSETTI and Holman HUNT, he founded the PRE-RAPHAELITE Brotherhood. In 1853 he was elected A.R.A. His greatest period, characterized by brilliant, minute accuracy and sincerity, lasted till *c.* 1863, when he became an R.A. His *Order of Release* (Tate Gal., 1853) was admired by DELACROIX. In 1854 he married Effie Gray, formerly wife of RUSKIN (till then a warm champion of Millais). His later work is coarser and chiefly devoted to portraits, generally superficial but sometimes powerful (*Gladstone*, N.P.G., London). It brought him great wealth, a baronetcy, and, in the year of his death, the Presidency of the ROYAL ACADEMY. He has been stigmatized by R. H. Wilenski as 'fundamentally philistine—commonplace, conceited, and sentimental'.

1839.

**MILLBOARD.** See CARDBOARD.

**MILLER,** SANDERSON (1717–80). English amateur architect, chiefly notable for his PICTURESQUE buildings in the GOTHIC style (Gothic Castle, Edgehill, War., 1745–9; Gothic Castle, 1747–8, and Rotunda, Hagley Park, Worcs., 1749–50; and the new hall at Lacock Abbey, Wilts., 1753–5). He also designed Hagley House, Worcs. (1754–60), with an orthodox though dull PALLADIAN façade.

**MILLES,** CARL (1875–1955). Swedish sculptor, who since 1929 worked much in the United States (Cranbrook, Mich.). Originally inspired by RODIN, with whom he came into contact in 1900, he turned (*c.* 1912) to a harder, more decorative manner of sculpture, though essentially imaginative and exuberant. Archaic Greek, ROMANESQUE, Chinese, and particularly Italian MANNERIST sculpture served to stimulate him. His many fountains and monuments in Stockholm and other Swedish cities are fraught with the rhythm of joyful life, sometimes even a grotesque humour. His bronze *Solglitter* for a fountain in Stockholm suggests the life and sparkle of waters in the sun. On the other hand his enormous figure of *Gustav Wasa*, carved, gilded, and painted oak, 20 ft. high, dominates the Central Hall of the Nordiska Museet. His monument to *Sten Sture* at Uppsala commemorates the national liberator. Later he gave preference to more mystical subjects, expressed in figures which seem to be floating or walking in their sleep (*Orpheus Fountain*, Stockholm, 1936;

the gigantic fountain *The Rivers' Meeting*, St. Louis, 1940; the *Resurrection Monument*, National Memorial Park, Washington, *c.* 1946). His home at Lidingö, Stockholm, has been made into an open-air museum notable for the *Triton Fountain* which is one of the most important examples of his attempt to combine bronze with the play of water in a unity of design.

2294.

**MILLET,** JEAN FRANÇOIS (also called FRANCISQUE) (1642–79). Flemish-born LANDSCAPE painter who worked most of his life in Paris. He was a competent but usually unimaginative follower of Gaspard DUGHET and is known chiefly for Italianate landscapes adroitly enlivened by touches of the PICTURESQUE in the manner of Salvator ROSA (*The Storm*; *The Cities of the Plain*; N.G., London). JEAN FRANÇOIS MILLET (1666–1732), son of the foregoing, was also a landscape painter and was an acquaintance of WATTEAU. Neither of these is to be confused with the 19th-c. artist of the same name.

**MILLET,** JEAN FRANÇOIS (1814–75). French painter. He was born of a peasant family at Gruchy, near Cherbourg in Normandy, and he practised painting in conditions of poverty. He was taught painting by a Cherbourg artist Langlois, a former pupil of GROS, and later entered the studio of Paul Delaroche. His early pictures consisted of conventional MYTHOLOGICAL and anecdotal GENRE scenes and portraits. His first picture of rustic life, *The Winnower* (Louvre), was exhibited at the Salon in 1848. In 1849 he moved from Paris to settle at Barbizon and there became a close friend of Théodore ROUSSEAU. From this time he devoted himself to the painting of peasant life upon which his fame is established. His first *Sower* was exhibited at the Salon in 1850, *The Gleaners* (Louvre) in 1857, and in 1859 *The Angelus* (Louvre), a picture which has perhaps been more widely known from reproductions than any other in that century. His success began from *The Man with the Hoe*, exhibited at the Salon in 1863. In 1870 he was working on *The Death of the Pig* (Cleveland Mus. of Art), when the outbreak of war caused him to leave Barbizon for Cherbourg. In 1871 he was elected a member of the newly founded Fédération des Artistes.

Unlike the REALISM of COURBET, Millet's painting had a strongly emotive character expressing a romanticized feeling for the soil. Unlike the DUTCH School, such as BRUEGEL, he did not picture the lighter side of rural life with village festivities or peasants at play. He had little in common with the rustic pictures of the LE NAIN and nothing at all with 18th-c. fancy dress PASTORALISM. He emphasized the serious and even melancholy aspects of country life, emotionalizing the labours of the soil and the sad solemnities of toil. His fault lay in senti-

mentality and after enjoying an enormous popularity his work has tended to be undervalued as a result of the 20th-c. reaction from sentiment. As a colourist Millet was mediocre, with little sense of tone values or of the sensuous qualities of colour. His greatness lies rather in his drawing, which for its elimination of the inessential and solid modelling has been compared with that of SEURAT. His almost sculptural simplification of masses enabled him to invest the ordinary with monumental weight and dignity.

Millet's influence may be seen in Jozef ISRAELS, Max LIEBERMANN, and perhaps even in Camille PISSARRO.

1189, 1869, 2459, 2639.

**MILLS,** CLARK (1815–83). American sculptor, who was born in New York and lived in Charleston. As a craftsman and jack-of-all-trades he discovered a way of making life masks, and made busts of eminent personages of South Carolina. He designed the monuments of General Jackson in Washington and New Orleans (1853), building his own foundry in order to cast the equestrian figure. He also designed a statue of Washington which was dedicated in 1860.

**MILLS,** PETER (*c.* 1600–70). English architect and designer. He was a bricklayer by trade, Clerk of Works to the City of London, and one of the Surveyors appointed by the City for the rebuilding of London after the Great Fire. He had probably been concerned with the erection of houses in Great Queen Street, Lincoln's Inn Fields (*c.* 1639) and must then have come in contact with Inigo JONES and John WEBB. Thorpe Hall, Northants., which he built for a leading Parliamentarian in 1654, is a somewhat naïve version of a Jones design, and he may also have built other houses in this manner.

**MILLS,** ROBERT (1781–1855). American architect. A vigorous proponent of rational NEO-CLASSICAL ideals in America, he worked with both LATROBE and JEFFERSON. He was as much engineer as architect. As his writings reveal, Mills was acutely aware of social as well as architectural problems and saw clearly the need of relating a building to its time and place. He was also a thoroughly practical man, who stressed 'convenience and utility' and made 'the object of the building' central to his planning. His monumental church in Richmond, Virginia (1814), was one of the earliest auditorium type churches in America, so designed by Mills to accommodate new trends in the church service.

In solving structural problems Mills was one of the most ingenious and skilful men of his day. The Record Office, Charleston, South Carolina (1822–7), which is VAULTED throughout, was his attempt at fire-proof construction; in the great Treasury Building in Washington (1836–42) the basic MODULE of the plan is derived from the bays of the vaulting system.

Although he preferred the Greek to the Roman orders he simplified them to the point of starkness and combined them with severe unadorned wall planes in the best rational manner. Mills's most famous work, the Washington Monument (1836), exemplifies both the boldness of his engineering and the simplicity of his form.

**MILNE, DAVID BROWN** (1882-1953). Canadian LANDSCAPE painter, born in Bruce County, Ontario. In 1904 Milne, a retiring school-teacher, turned to painting and went to the Art Students' League, New York. There he was influenced by Maurice Prendergast (1859-1924) and by what he saw in 1913 at the ARMORY SHOW, in which he himself exhibited. His early work was FAUVIST in character (*Boston Corner*, 1917, N.G., Ottawa). For years he worked in seclusion in the Berkshire Hills (1915-23) with an interval spent as a Canadian war artist. After a winter in Ottawa and Montreal he painted in the Adirondacks from 1924 to 1928. The rest of his life after 1928 was spent in various Ontario villages. His style throughout his career combined delicacy and strength. A very personal and calligraphic quality is seen at all periods. His work after 1937 was entirely in WATER-COLOUR, a medium which he used in an Oriental way as a sensitive means of expressing his emotional response to nature (*Rites of Autumn*, N.G., Ottawa, 1943).

**MINIATURE.** 1. A picture in an ILLUMINATED MANUSCRIPT. The word derives from the Latin *minium*, the red lead used to emphasize initial letters, decorated by the *miniator*. Since the 17th c. the term has been applied to all types of manuscript illustration on account of a mistaken etymology: the word was connected with 'minute' (small). What we call today a 'miniature' was called *historia* in the Middle Ages.

2. The term 'miniature' is also used to describe small paintings, particularly portraits such as those by HILLIARD and others, named 'limnings' or 'pictures in little' by the Elizabethans. They were painted on vellum (occasionally on ivory or card), mounted, and often could be worn like lockets or cameos.

The portrait miniature seems to be a development of two older traditions: the medieval illumination of manuscripts and the RENAISSANCE portrait MEDAL, which was itself a revival of a classical form. The earliest detached miniatures appear in France towards the end of the 15th c., but the real breeding-ground was probably the Netherlands and it was perhaps a family of Flemish artists who established the art in England —the Horenbouts, who were working there when HOLBEIN arrived in 1526 and one of whom is said to have instructed him in the technique. Perhaps less than a dozen of Holbein's miniatures now survive, but they rank among the greatest ever painted. Yet they show exactly the same quality and the same analytical artistry as his oil paintings; his *Anne of Cleves* (V. & A.

Mus.) is but a portable concentration of his larger portrait of the same sitter, both deriving from an initial drawing. At this time the miniature was simply a painting done small; for practical purposes one was personal, the other household, furniture. Toward the end of the 16th c. the miniature began to be worn fairly commonly as an ornament of dress and the standard shape changed from round to oval, to the shape of a locket, while the frames were often highly wrought jewels of great value. The miniature acquired an aesthetic of its own, an intimacy and delicacy of charm not derived from or possible for the full-size oil portrait. In this mode the Elizabethans produced the best of their visual art in the work of Nicholas Hilliard. His was not a naturalistic art; he sublimated decorative adornments into masterpieces of the imagination. But he probably needed a rarefied climate, as provided by the late Elizabethan court, to stimulate him. His pupil, Isaac OLIVER, worked in a more NATURALISTIC manner, for a different type of client. In the 17th c. while the artist's social position improved steadily, the standing of portraiture did not. Serious painters aspired to historical or religious themes and by the end of the century portrait painters were known as 'face-painters'. The miniature, regarded as something even slighter, a toy branch of face-painting, was generally ignored. This decline in the prestige of the miniature was reflected in the work of the generations immediately following Hilliard and Oliver. Their techniques were ably but uninventively continued by their sons, Lawrence Hilliard and Peter Oliver, and by John HOSKINS, but with one exception they no longer led the way. Full-size portraits of the Elizabethan era seem to be but inflated miniatures; after van DYCK the situation was reversed; the full-size portrait won a standing that it never lost and the miniature became dependent on it. The exception was Samuel COOPER, society painter of the Commonwealth and of the Restoration. Even he was known as 'the van Dyck in little', and indeed he effected no startling technical or formal revolution. His triumph was based on subtle observation allied to a superb technique. After Cooper the decline was resumed. Thomas Flatman stemmed it briefly, painting miniatures of some individuality, melancholy in temperament but coarser in feeling and skill than Cooper's. The rest aped the life-size painters with very considerable dexterity into the most tedious stylization. N. Dixon and P. Cross were the best of them, with the immigrants at the beginning of the 18th c., the Lens family, C. Richter, and the enamellist C. Boit. A revival began about 1750, the age of the English equivalent of the ROCOCO, the bijou, of Horace WALPOLE (perhaps the greatest English collector of miniatures). The large sweeping rhythms of BAROQUE were broken up and men looked again for the detailed, the minute. After 1700 artists began to work with thinner colour on ivory instead of vellum, achieving far greater brilliance. Allied

with this came a freshness of vision, first noticeable perhaps in the work of N. HONE and Jeremiah Meyer. And then in the portraits of the late 18th-c. miniaturists flowered an incomparable, pretty elegance, which probably conveys the atmosphere of the 18th-c. drawing-room and boudoir better than any other witness. COSWAY with his bold MANNERISMS drove this elegance almost to abstraction, and after him miniaturists fell back on the full-size oil painting for their model. A. Robertson based his style squarely on RAEBURN's, painting solidly as if in oils. And so at the beginning of the 19th c. the art of miniature entered upon its final decline. Sir W. Ross, the last of the great men, is typical; his large miniatures, rectangular, often over a foot high, are in fact pictures in small, while the BONE family had a great vogue for painting miniature enamel copies of the Old Masters. Miniatures ceased to be personal jewels and became part of a toy picture gallery. From *c.* 1850 photography began to sweep the country, and almost overnight the miniature was obsolete. Its *raison d'être* had always been the demand for intimate, esoteric portable likenesses; the PHOTOGRAPH offered these more cheaply, more accurately, and the miniature died.

283, 583, 901, 1683, 1954, 2154, 2228, 2375, 2897, 2917.

**MINOAN ART.** The art of Crete in the Bronze Age (*c.* 2300-1100 B.C.), named after Minos, King of Crete in ancient Greek legend, was wholly lost until the excavation by Sir Arthur Evans, begun in 1899, of the 'Palace of Minos' at Knossos, near modern Heraklion. His work was rapidly followed and supplemented at the palaces of Phaistos (with its neighbour at Hagia Triada), Mallia, and many other sites. Evans's first finds were regarded as belonging to the MYCENAEAN civilization—already known in mainland Greece from the excavations of Schliemann and others; but further investigation showed a long and distinct history of development in Crete, the similarities with Mycenae being in fact due to Cretan influence on the mainland. It is, however, a serious error (into which Evans fell) to regard Mycenaean art as a provincial branch of Minoan. The Minoan period may be subdivided as follows, but absolute dates (based on contact with Egypt) are uncertain before *c.* 1600 B.C.

Early Minoan (E.M.) I to III, *c.* 2800-2000 B.C.

E.M. I-II see the introduction of metal from Asia Minor to Crete, Greece, and the Aegean islands.

Middle Minoan (M.M.) I and II*, *c.* 2000-1750 B.C.

Middle Minoan (M.M.) III, *c.* 1750-1580 B.C.

Marked developments, perhaps due to dynastic changes and new racial elements from the Near East.

Late Minoan (L.M.) I, *c.* 1580-1400 B.C.

Minoan influence first appears in mainland Greece.

Late Minoan (L.M.) II*, *c.* 1475-1400 B.C.

Period of closest affinity between Crete and Mycenae. Sack of Knossos, Phaistos, etc. *c.* 1400 B.C.

Late Minoan (L.M.) III, *c.* 1400-1100 B.C.

Period of decline.

(* These phases are peculiar to Knossos; elsewhere M.M. III succeeds M.M. I and L.M. III succeeds L.M. I.)

Most of the famous works of Minoan art—architecture, FRESCO-painting, carved IVORY, FAIENCE RELIEFS and inlays, painted POTTERY, engraved signets of semi-precious stone—belong to the periods M.M. III to L.M. II, within which Minos (if a historical figure) must be placed.

The beginnings and early development of Minoan art are best traced in the painted pottery, the successive styles of which form the basis for relative chronology of the period. E.M. pots are decorated with simple abstract linear designs in dark red or brown on a light ground, superseded in E.M. III by a white or cream paint on a dark ground. In *Vasiliki ware* decoration consists of an irregular mottling (red to black) produced in the firing of the clay. Shapes include jars with grotesque tea-pot spouts, less exaggerated in E.M. III and M.M. In M.M. II the addition of a second paint-colour, red, goes with increasing variety of patterns and techniques, e.g. plastic decoration (including such tricks as impressing natural sea-shells upon the soft clay) and the imitation of the thin-walled and fluted forms of metal vessels. The latter gives rise to the 'egg-shell' *Kamares ware* (first found at the sacred cave of Kamares on Mt. Ida) which bears some of the very best of Minoan decoration, with some floral motifs possibly derived from geometric forms rather than copied from nature. We have, nevertheless, some examples of modelling in clay—both plastic vases and votive figurines in the form of men or animals—which show humour and sympathy in the direct representation of nature.

The progress of Minoan pottery towards this first climax seems to have been mainly self-propelled, though there may have been impulses from Anatolia or SYRIA that we know little of. Certainly it seems to owe little to EGYPT, though Crete borrowed obviously from that country in other ways. From there the Minoans learnt to mould charming bowls and jars in stone, an art technically most laborious but rewarding in its exploitation of the natural colours and grain of variegated stones. From Egypt, probably, came the fashion of stone signets, engraved with simple counter-change spiral or meander motifs—the beginning of an art that was later to be the medium for some of the most characteristic expressions of Minoan artistic vision. Their immediate development in Middle Minoan, however, was pictographic rather than pictorial.

With the M.M. III period a new era opens, lasting through to the end of L.M. II. This is

the great period of the building or reconstruction (for they were founded long before) of the palaces at Knossos, Phaistos (with its 'summer palace' near by at Hagia Triada), and Mallia. These were the seats of a centralized and perhaps increasingly authoritarian government, whose character it is not too fanciful to see at times reflected even in the pottery. The free introduction of NATURALISTIC motifs—flowers, leaves, and grasses—goes with a slightly conflicting tendency to more geometrical arrangement in zones or panels. The conflict appears in varying degree, complicated sometimes by the use of elements which were primarily religious symbols —the double axe, the sacred horns, etc. It was solved partly by the stylization of motifs originally naturalistic, and their combination with abstracts such as spirals; more effectively, however, and with a singular charm, in the 'marine' style of L.M. I–II, in which seemingly untrammelled elements—seaweeds, sea-stars, and helically tentacled argonauts and octopods—are arranged in schemes of subtly unobtrusive regularity, a regularity not of the parade-ground but of the ballet. At the same time the large and noble jars of the Palace Style show that even this humble material, pottery, was at times enlisted in the service of grandeur. One feels that a restraint and discipline had been imposed on the M.M. freedom; but it is only in the closing phases that there seems any risk of its becoming a restriction.

The art of fresco decoration belongs almost entirely to this second flowering of Minoan art.

From early beginnings in coloured dados, sponge-printed to resemble cut stone, the fresco painter soon began to paint naturalistic scenes, not murals in the common sense but separate pictures on the wall, each within a painted frame. In the earlier stages human subjects were rare. A cat stalking a bird in a landscape of rocks and flowers; a group of dolphins on a marine ground; an ape in a field of saffron flowers—these are among the best. There is movement—the bird or animal is seen in momentary action—there is gaiety of colour (not entirely naturalistic) and a delight in the rich detail of flowers and rocks that are the foil to action. But there is little or no depth, no perspective; the third dimension is suggested, if at all, by other means, as by the border of stylized rock-forms that often surrounds the subject on all four sides. The human figure was not long in taking its place in the Palace frescoes, yet often with a certain uneasiness as though the subjects were outside the range of the artists. The famous fresco depicting a religious festival illustrates this, even in its fragmentary state: it is so much better in the parts than as a whole. The artist is at home observing and painting (as he would have done a bevy of peacocks) a few court ladies, all finery and chatter, but he cannot so well portray a crowd. Only the individual exists for him; and so his crowd is an infinite repetition of one head. Nevertheless there were some notable successes on the monumental scale. There is an unquestioned stateliness in the life-size cup-bearer figure from the south porch at Knossos, an exciting vigour in

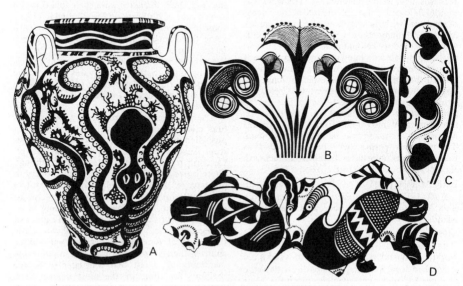

**Fig. 30.** MINOAN VASE DECORATION

A. Amphora decorated with octopus and marine growths. From Palace of Minos, Knossos (L.M. I). B. Conventionalized sprays of papyrus and ogival designs with double rosettes. Decoration on Knossos ware, from Mycenae (L.M. I). C. Two-stalked ivy motif. From Kakovatos (L.M. I). D. Fragment of an amphora decorated with geometrically ornamented ducks amid tufts of papyrus plants. From Palace of Minos, Knossos (L.M. II). After *The Palace of Minos at Knossos* (1935), Sir A. Evans

the charging bull from the north corridor, and in both the fresco is enhanced by excellent relief modelling.

Of monumental sculpture there is none; but we have a number of examples of miniature statuary in clay, BRONZE, and IVORY. Some of the most noteworthy are inspired by the exciting acrobatics of the Minoan bull-ring and again we see the preference for the individual subject in rapid movement. Small-scale reliefs are well represented by the lovely FAIENCE plaques, coloured in soft browns, greens, and yellow, of a cow and calf or a goat and her kids, showing that same gentle sympathy for the animal world noticeable in some of the frescoes, which appears again in the best of the engraved signets—master-pieces, these, in composition too. In stone, besides bowls and lamps with formal foliate designs, we have some exquisite relief on vases of steatite. The fragmentary *Harvesters Vase* is perhaps the finest—a scene of many figures, with more suggestion of depth than usual. Such work was possibly meant to be overlaid with gold as a substitute for repoussé vessels, though nothing in the latter medium survives unless the well known cups from Vaphio in the Peloponnese are indeed of Minoan craftmanship.

On the whole it is in small-scale works that the Minoan artists are at their greatest; in larger works, such as the bigger frescoes of Knossos, it is the individual figure that we select for admira-tion. Possibly the same was true of their architec-ture—that the parts were better than the whole. But here our estimate is hampered because we have little to go on beyond ground plans and remains of ground floors devoted mainly to severely functional purposes. One cannot judge a palace aesthetically from its cellars. Neverthe-less we can see that there must have been dignity and strength in the broad, shallow steps of the north-west approach and the severe lines of the west façade at Knossos; the great staircase to the domestic quarter there, and the little peri-style court at Phaistos, show a fine, even brilliant, decorative use of COLUMNS; and the builders doubtless recognized the value of the contrasting textures of LIMESTONE, conglomerate, GYPSUM, timber, and painted plaster. Over-all planning we cannot judge; certainly there can have been little of that axiality and symmetry which the Romans taught Europe to expect in large-scale architecture; the Minoans probably preferred the more subtle balance, familiar in our own day, of unequal masses and varied levels.

359, 836, 1482, 1773, 1796, 2008, 2890, 2957.

**MINO DA FIESOLE** (*c.* 1430–84). Italian sculptor of the FLORENTINE SCHOOL. He divided his activity mostly between Florence and Rome. He is best known for his male portrait BUSTS, of which perhaps the finest is the *Dietisalvi Neroni* (Louvre, 1464). The vigorous NATURALISM of Mino's authentic busts contrasts with his RELIEF compositions, which are curiously archaic and

awkward. He also executed a number of TOMBS, the arrangement of which derives from DESIDERIO DA SETTIGNANO (e.g. that of Francesco Torna-buoni in Sta Maria sopra Minerva, Rome, 1480).

**MINYAN POTTERY.** See MYCENAEAN ART.

**MIR ISKUSSTVA.** The title of a Russian periodical, *The World of Art*, founded in 1898 and edited by Diaghilev; among his contributors and collaborators were Léon BAKST and Alex-ander BENOIS. The name of the periodical has come to stand for a whole movement in art running parallel to ART NOUVEAU in western Europe, with which there were many ties. The artists of this group were chiefly responsible for the new ballet décors which revolutionized European stage design when Diaghilev brought them to Paris in 1909.

**MIRÓ, JOAN** (1893– ). Spanish painter of the École de PARIS. He was trained at Barcelona and his early work showed the influence of van GOGH and the FAUVES. But in 1919 he came to Paris and associated with PICASSO and his CUBIST followers. From *c.* 1923 he was among the most prominent of the SURREALISTS and over the years he evolved an easily recognizable style of great power and originality lying between Surrealist fantasy, abstractionist construction, and decora-tive ARABESQUE. In 1928 André BRETON wrote: 'Miró is probably the most Surrealist of us all.' Yet his work almost alone among the Surrealists survived the disruption of that movement with development but no essential change. A feature of many of his pictures consists of enlarged amoebic forms in rhythmically balanced com-position. In 1937 he did a large mural for the Spanish Pavilion at the Exposition Universelle, Paris. He did several other frescoes in the U.S.A. during 1947 and subsequently worked in Spain. In 1958 he designed a tiled wall for the UNESCO building in Paris. A large retrospective exhibition of his work was given in the Tate Gallery, London, in 1965.

342, 549, 1148.

**MISSAL.** The celebrant's book which contains all the recited and chanted text of the Mass. It generally replaced the Sacramentary (which contained only the Canon of the Mass, the variable prayers and prefaces during the liturgical year) in the 11th and 12th centuries, and by the 13th c. the latter had all but disappeared. Generally the Sacramentary and the Missal contained only two large MINIATURES: the CRUCIFIXION before the Canon of the Mass, and CHRIST in Majesty. Often there were also historiated initials for the Masses of the principal feasts as, for example, in the *Sacramentary of Drogo of Metz* (Bib. nat., Paris, 9th c.). Luxury editions of the Sacra-mentary or Missal containing a series of full-page New Testament scenes were exceptional

(*Sacramentary of St. Gero*, Bib. nat., Paris; Cologne, late 10th c.; *Missal of Robert of Jumièges* —actually a Sacramentary—Rouen, Bib. municipale, early 11th c.; *Missal of Henry of Chichester*, Rylands Library, Manchester, mid 13th c.).

**MNESICLES.** Architect of the PROPYLAEA at Athens, 437-432 B.C.

**MOBILE.** This name was first used by Marcel DUCHAMP to designate certain sculptures by the American Alexander CALDER which performed rhythmical movements, and has since been generally adopted for sculptures of this type. Although a *Kinetic Sculpture* with a single moving element was made in 1920 by Naum GABO, the mobile is essentially the creation of Calder, who began making motor- and wind-operated sculptures *c.* 1931. The majority consist of a number of metal shapes suspended from wires so as to allow controlled rotation or swing. The English sculptor Lynn CHADWICK is among those who have followed Calder's example.

1707.

**MODEL.** The term is commonly used in connection with painting and sculpture of a figure, generally a human figure, posed for the artist to copy. 'Drawing from the life', which usually means from the nude, is taken for granted as an element in the curriculum of any art school, a fundamental part of the painter's as well as the sculptor's training. The tradition of drawing from the nude goes back to the RENAISSANCE but probably not before. In classical Greece the nude male was an everyday sight in the gymnasia and was regularly featured in sculpture. The nude female form, except possibly in Sparta, accorded less with social convention. In the *Memorabilia* (III. xi) Xenophon speaks of a woman of easy virtue and outstanding beauty who, when painters went to her to take her portrait, 'showed as much of her person as she could with propriety'. In his book on *The Nude* Sir Kenneth Clark says: 'So rare are nude figures of women in the great period of Greek art that to follow the evolution of Venus before Praxiteles we must not look for absolute nudity, but must include those carvings in which the body is covered by a light, clinging garment, what the French call a *draperie mouillée*.' The story of the Cnidian Venus (*c.* 350 B.C.) designed by PRAXITELES from the nude model of Phryne made its impact in antiquity precisely because it was something out of the usual. In medieval art the figures were, with certain permissible exceptions, normally clothed and modesty could sometimes cause even Adam and Eve to be depicted in long robes. Through most of the Middle Ages nudity was not distinguished from nakedness and it was not until the new NATURALISM of the 13th c. that

work from the living model can be conjectured, as for example in the *Adam and Eve* of van EYCK's *Ghent Altarpiece*, the nudes in MASACCIO's frescoes for the Brancacci chapel in Sta Maria del Carmine, Florence, and later Hugo Van der GOES's painting *The Fall* (Vienna).

The earliest practice drawings from the nude model which have survived are by PISANELLO. Their delicate outlines represent a woman in various natural poses, and are so faintly shaded as to suggest that a veil was hung between the draughtsman and his model. Fifteenth-century figure studies were more often of men, not only because they were less likely to incur the disapproval of the Church, but also because it was generally felt that the male form was the nobler and the female one lacking in proportion. The duty of posing fell naturally to the apprentices in the workshop, and there are several drawings from POLLAIUOLO's circle representing youths, clothed or naked, standing with long staves in their hands in attitudes suggesting an attendant saint. Even a study for a female character would often be taken from a male model. The monastic painter of course could not do otherwise, unless he used a LAY FIGURE. MICHELANGELO's *Sibyls* in the Sistine Chapel look like men.

In his search for ideal proportions of the human figure DÜRER related his mathematical system to a type taken from antique sculpture, but such drawings as the naked *Hausfrau* (1493), the *Women's Bath* (1496), and *Four Witches* (1497) were certainly taken from the life.

Drawing from the nude had its opponents even in Renaissance times. VASARI has a story that Fra BARTOLOMMEO burnt his drawings after hearing an impassioned sermon by Savonarola, but changed his mind after seeing Michelangelo's works in Rome, and when this back-sliding aroused complaint, justified it by producing an execrable painting of St. Sebastian. The models chosen were generally tall and slender. LEONARDO recommended that they should have long limbs and not too much development of muscle. SIGNORELLI and Michelangelo, however, chose to stress the strength and sinew of the male body, and this was the tradition that the CARRACCI took up and handed on to posterity.

The first drawings of what are obviously professional models belong to the latter part of the 15th c. In the following century Italian painters, took to forming groups which met to draw a hired model—a custom which van MANDER noticed on his visit to Italy and introduced to Holland in 1583. To this time belong the beginnings of the 'life class' as a part of the painter's education. When Federigo ZUCCARO, in the 1570s, was trying to reform the Accademia del Disegno in Florence he suggested a room for life drawing, and though his advice was not taken at the time, by the end of the century the life class had become a feature of such ACADEMIES as then existed, whether public or private. A male model was constantly available at the school of life

drawing established by the Carracci at Bologna and female models were posing for 17th-c. artists in Rome. Yet few academies introduced nude female models before the second half of the 19th c. The French Académie, founded in 1648, employed a full-time male model, made the life class the culmination of its educational course and acquired a monopoly by inducing Louis XIV to prohibit all life drawing elsewhere. The student prepared for it by drawing from PLASTER CASTS of the ANTIQUE. The class occupied four hours each day and it was a duty of the professors to 'set' the pose. There was less formality in the Netherlands and 17th-c. artists drew and painted from the nude. A drawing representing REMBRANDT's studio in 1650 shows a female model on a dais and several pupils drawing her, while the master looks critically at the work of one—the whole scene exactly like a life class of today except that the pupils are working with pen and ink. In fact Rembrandt's close adherence to the model with all its imperfections was a stock accusation advanced by academic critics. In 18th-c. England life classes organized by artists jointly preceded the foundation of the ROYAL ACADEMY, where the model was posed by a professor usually in imitation of conventional types. It was in an attempt to avoid the unnatural posturings of such academy figures that in the late 19th c. RODIN made his models move freely around the studio.

The retreat from naturalism in the 20th c. has made the life class problematical, though it is still part of the curriculum in most art schools. There have been few 20th-c. artists who have not recognized the value of life drawing, in the schools or elsewhere, as a discipline and as a means of acquiring a repertory and a mastery of forms.

**MODELLING.** The word 'modelling' is used (1) as a painting term for the indication of solid form and receding planes in a three-dimensional representation; and (2) to denote a process of sculpture by fashioning a soft and malleable material. Modelling in the latter sense requires a pliable material which will permit the utmost freedom and delicacy of shaping and one moreover which can be kept supple for the long periods of time which it may take to complete a work. The chief materials used are clay and wax.

CLAY. Clay can be used either as a transitory modelling medium for building a model to be converted into some other material or it can be used as the final material of the completed work. It is eminently plastic, retains the shapes into which it is moulded, and with care can be kept moist and supple over long periods.

When the clay is used as a transitory medium the model is built up over an ARMATURE, a rough central framework of iron or wood or a skeleton of wire or lead tubing attached to a central support. While the work is in progress the clay is kept moist by periodic spraying and by cover-

ing it with damp cloths since otherwise it would dry out and crumble. When the model has been completed in clay a PLASTER CAST is usually made from it. This may serve as a model for a carving, being translated more or less exactly into the carving medium by means of POINTING. Or it may be reproduced in metal. In the latter case a negative mould is made from the plaster cast and a positive in BRONZE (or other metal), a facsimile of the plaster, is cast from the mould. The preservation in metal of the tooling marks on the clay, or the small flattened pellets by which the surface planes have been built up, is considered to conduce to an animated and rippling effect which has been much exploited by sculptors since the 18th c. (EPSTEIN is exemplary). Others

**218.** *Albert Einstein.* Bronze by Jacob Epstein (1933)

have sought to prepare in the clay model the flat planes and sharp edges which they consider appropriate to the material of metal and which they perfect by subsequent working on the metal cast itself.

Some clays are capable of being fired to become hard and durable and so can be used both as a transitory and as the final medium of sculpture. Sculptures produced in this way are called TERRACOTTAS. There are two alternative techniques for making them. One process is to use the terracotta clay as a casting medium. The clay is cold-cast in a piece-mould which is made from a clay or plaster model in the same way that a piece-mould may be made for casting a bronze. The cast is then fired. The other technique is

to make the original model in a firing clay and to fire it when it is finished instead of making a plaster cast from it. The famous TANAGRA figurines of the 3rd c. B.C. were made by the former process by means of a piece-mould. Some of the beautiful Mochica ceramic sculpture from PRE-COLUMBIAN Peru was also made from piece-moulds.

Because clay is fired at high temperatures and shrinks notably in the firing, the sculptures to be fired must be cast hollow unless they are very small. Similarly, if a terracotta is modelled to be fired direct, it cannot be built up on an armature and it must be made hollow. This involves considerable technical difficulties and one way of solving them is to make the model (or cast) solid in the first place, then cut it in half and scoop out the centre.

WAX MODELLING. The wax used in the sculptor's studio is beeswax or a substitute based on paraffin wax. It is usually brownish yellow but may be given almost any colour by folding earth pigments into the soft wax or by mixing oil paint with it while it is hot and liquid. Wax becomes very hard in the course of time and is durable as long as it is kept cool and safe from accident; but it breaks easily and therefore is suitable for small works rather than large. It does not shrink as clay does. Small wax figures need no internal framework (armature); large ones are modelled over a core of clay. The hardness of the material and the necessity of using heated tools enforce a certain discipline on the wax modeller. The final product has a sharpness which makes it suitable for casting in bronze; a bronze which has been cast from a wax model is therefore distinguishable by its surface and forms from one which was done from a clay model.

The principal use of wax in sculpture is as an auxiliary material either for preliminary sketches (MAQUETTES) or for making models to be reproduced in metal. Wax sketches reasonably attributed to MICHELANGELO show how he worked out his forms as a preparation for carving. CELLINI described the way in which a wax model was used for bronze in the elaborate preparation for the casting of the *Perseus* (Loggia dei Lanzi, Florence, 1554).

Wax has also been used as material for permanent works, especially portraits, funeral effigies, and other figures intended to simulate the appearance of life. Not only is its peculiar transparency somewhat like that of human skin, but it can be modelled very exactly and sensitively, coloured naturalistically, and even have hair and other materials attached to it. Funerary uses of wax (see DEATH MASKS) are among the most ancient, dating at least from ancient Egypt and continuing with different ceremonies in Rome. In later periods full-length wax figures were substituted for the bodies of nobles and monarchs in state funerals; several of these effigies, including that of Elizabeth I, are still preserved in Westminster Abbey. 'Waxworks', in fact, had macabre associations long before

Mme Tussaud modelled the heads of victims of the French Revolution. The craft was brought to England by Huguenot refugees after the Revocation of the Edict of Nantes (1685). Changes of taste and fashion were quickly incorporated in these wax portraits, from the more elaborate examples using bits of lace, glass eyes, seed-pearls, and other precious jewels to the simpler and more spirited characterizations of the 18th c. The quieter elegance of the NEO-CLASSIC style achieved a cameo-like effect which was finally translated into 'jasper' and 'Basalt' in the Wedgwood potteries. Wax portraiture, especially in relief, flourished until it was superseded by the daguerrotype and the PHOTOGRAPH.

**MODELLO.** A drawing or painting of a composition, made for a patron in the hope that he would commission a picture. Such drawings were sometimes made for a competition. Since the object was to impress the patron and give him a clear idea of the picture which the artist had in mind, the *modello* was more elaborate and accurate than the ordinary composition sketch.

Some of the finished landscape compositions in pen and wash by CLAUDE are *modelli* for paintings (*Ascanius and the Stag*, *modello* and final painting, are in the Ashmolean Mus., Oxford). A painted *modello* exists for the large equestrian portrait of Charles I by van DYCK (N.G., London). RUBENS's small sketches for the *Marie de Médicis* cycle of large paintings in the Louvre show how completely a great painter could use *modelli* to present his intentions as regards composition and colour scheme. In painting his finished pictures based on the *modelli* Rubens made alterations and developments, and the qualities of the final work are superior to those of the *modelli*—fine as these are.

**MODERN ARCHITECTURE.** As a stylistic term these words have come to be used in a more particular sense than 'contemporary architecture' and usually carry the implication of a new kind of building which is regarded as the special contribution of the 20th c. to the art of architecture. The idea of modern architecture was born in the reaction from the excessive historicism which began to prevail in the third decade of the 19th c. But in addition to the revolt from artificiality the impulse gained vigour from the many new materials and technical processes which became increasingly available as the century wore on. In no previous age had man been content to build less skilfully than he knew how. Along with the opening up of new possibilities was the need for new kinds of buildings. It was practicable, even if unenterprising and a little absurd, to go on building houses and churches, public libraries, and blocks of flats in period styles from the past; but it verged on the ridiculous to design factories and hospitals, railway termini and department stores in styles which had evolved before such things existed.

For these reasons from the middle of the 19th c. onwards a succession of clear-sighted persons condemned fancy-dress architecture and pioneered the way towards a style of design more in keeping with the contemporary world. Some, such as William MORRIS, were chiefly concerned with recapturing the lost traditions of good craftsmanship and bringing back an honest use of materials instead of the prevailing indulgence in meaningless machine-made ornament and the imitation of one material by another. In spite of its failure to come to terms with machine industry the ARTS AND CRAFTS MOVEMENT was destined to have a profound influence for the development of a saner attitude towards design, especially on the continent of Europe. Other English reformers such as Richard Norman SHAW, Baillie Scott (1865-1945), and Charles Annesley VOYSEY, reintroduced into late 19th-c. architecture the natural building materials of the countryside, reviving interest in the charm of the English farmhouse tradition. Voysey in particular created a minor revolution with his simply designed small houses, almost devoid of ornament and relying for their effect on articulate massing and solidity of form. These, however, were still traditional in construction and it was not till the turn of the century that the first steps were taken on the Continent towards a positive new style based on new techniques and materials. It is true that a hundred years earlier the great creative engineers—Telford, Brunel, Rennie, Robert Stephenson, and the rest—used iron and STEEL rationally with impressive and often dramatic effect. But their work had little influence on the architects and the fine tradition of forthright design they built up, imaginatively exploiting the possibilities of new constructional techniques, was allowed to die out. A later generation of engineers, this time in France, explored in a somewhat similar spirit the possibilities of structural steel and the newly invented reinforced CONCRETE. Among them were Hennebique (1842-1921), de Dion, Cottancin, and Gustave EIFFEL, some of whose most spectacular structures were built for the succession of exhibitions in Paris that followed the Great Exhibition of 1851 in London (see EXHIBITION ARCHITECTURE).

The impact of new AESTHETIC ideas in architecture about the turn of the century was associated with the ART NOUVEAU movement, which spread from London and Glasgow. Its influence was short-lived, however, and it often degenerated into a decorative mode divorced from the realities of structure and technique. A more immediate forerunner of what is understood by modern architecture was the establishment in 1907 of the DEUTSCHER WERKBUND through whose influence Peter BEHRENS was appointed by the electrical firm A.E.G. as their architect and designer. Modern architecture was in itself a product of industry since it derived its revolutionary character in part from the fact that the new building materials were largely mass produced in factories. Among the pioneers in the early experimental stages were Josef HOFFMANN, Otto WAGNER, and Adolf LOOS in Austria, Hans POELZIG in Germany, H. P. BERLAGE in Holland, and the brothers PERRET in France. The last carried on into the 20th c. the French tradition of an architecture based on engineering practice and were pioneers in the expressive use of reinforced concrete. In America Frank Lloyd WRIGHT, though little in sympathy with the newer trends of industrial building, founded a new aesthetic of domestic architecture.

Modern architecture, although its advocates were still a struggling minority among professional architects, took a big step forward after the First World War, particularly in Germany where the dominant influence came from Walter GROPIUS and the BAUHAUS. Other leading architects of the modern movement during the period between the two World Wars were Bruno Taut (1880-1938) and Ernst May (1886- ) in Germany, J. J. P. OUD in Holland, Gunnar ASPLUND in Sweden, Alvar AALTO in Finland, and LE CORBUSIER in France. Le Corbusier, a writer and painter as well as an architect, was the prophet of a new aesthetic vision, with the aid of which the new architecture developed not only its practical, functional qualities but its ability to create works of imaginative art. He and Gropius were leaders of two tendencies which are distinguishable in modern architecture: an imaginative conjuring with form and space associated with Le Corbusier, and a rational treatment of the problems of industrialization associated with Gropius and the Bauhaus.

In England modern architecture hardly existed until the early 1930s. The pioneer work of men like Morris, Voysey, Philip WEBB, and LETHABY in the 19th c. was lost to sight during the prosperous Edwardian era and the lessons they tried to teach had to be learnt again from the Continent, a process which was facilitated by the arrival of refugees from the Nazi regime including Gropius, MENDELSOHN, and BREUER.

In the U.S.A., too, modern architecture was slow to establish itself in spite of the example set by Louis SULLIVAN and others of the CHICAGO SCHOOL. When it did arrive it was regarded at first merely as an alternative and more fashionable ECLECTIC style. The first buildings to draw attention to the real significance of what became known in America as the International Style were the contrasting country houses by Richard Neutra (1892- ) and the California school on the one hand and the New England school inspired by Gropius and Breuer on the other. But by the end of the 1930s modern buildings were beginning to be widely accepted. SKYSCRAPERS gradually discarded their period trimmings and modern ideas in construction and design penetrated even into that stronghold of eclectic historicism, the college CAMPUS. Most significant of all, industrial enterprises (including such epoch-making undertakings as the Tennessee Valley Authority)

began to incorporate modern architects into their teams of severely practical technicians.

The modern architect is first and foremost a planner. Instead of being the result of some preconceived pictorial idea to which planning must be made to conform, his buildings are the result of careful study of the purpose they have to fulfil; from this emerges a plan that puts the various parts into a proper relationship and at the same time suggests the most appropriate structure and materials and the most natural and effective external form. The external appearance evolves as a three-dimensional conception simultaneously with the plan and the structure, instead of consisting, as in the 19th c., of a number of two-dimensional façades planted on to a structure independently determined. Structure greatly influences a building's visible form, and many of the characteristics of modern architecture are directly derived from the new building materials. The most important of these are steel and reinforced concrete, the use of which has produced among other things the wide windows and uninterrupted interior spaces specially associated with modern buildings. Even more significant is their use for large buildings as a skeleton structure—that is a kind of cage resting on the ground at a few points only. This allows much greater freedom in planning, since there are no solid walls to obstruct the flow of space. It also gives buildings a less massive, more lightly poised character, since walls take on the nature of protective screens (opaque or transparent as the occasion demands) instead of weight-bearing masses of brick or stone pierced with holes for doors and windows. As well as new structural materials, new finishing materials have also done much to change the aesthetic character of modern architecture, and their use has been encouraged by the change in the conception of the wall. Solid self-supporting walls provided their own outer surfacing; the new curtain type of walls brought into use special surfacing materials, generally light and often synthetic, though bricks and tiles continued to be used to provide a well-insulated outer wall for frame buildings. The new materials are generally industrially produced. In fact large buildings are made to an increasing extent from pre-fashioned machine-manufactured components. The aesthetic qualities natural to these are the qualities produced by the machine: precision, elegance, exactness of line and surface. These are the characteristics especially aimed at in place of the more rugged picturesque features natural to stone and brick. Applied ornament was discarded because its appeal lay largely in craftsmanship and when it was machine produced it lost much of its validity.

It is partly for these reasons that modern buildings have simpler lines, with more precise geometrical details, than those conceived according to traditional principles; partly also because of the stress laid by modern architects on the close relationship between form and function and their new interest in the engineering aspect of their work; and partly because the designer's eye, in a world dominated by the products of machines, naturally tends to accord more admiration to the precision beauties inherent in them. Appreciation of the clean, elegant lines of aircraft and other productions of the machine age has greatly influenced architects' aesthetic ideals. The combined result of these various factors was to produce during the 1920s and 1930s a vigorous insistence on the use of techniques and forms peculiar to the new era. Although according to all the principles of modern architecture every material, new and traditional, is equally valid for contemporary use and should only be chosen or rejected on its merits, there being no virtue in novelty for its own sake, it was natural for new forms and techniques to be emphasized as a kind of declaration of independence from the confused architectural standards that existed previously. A somewhat puritanical rejection of anything irrational and decorative thus resulted in what has wrongly been called FUNCTIONALISM. Functionalism was never in its literal sense the basis of modern architecture.

This puritanical phase in the evolution of modern architecture can also be described as an International phase, because the emphasis laid on the new resources gave modern buildings a certain sameness in whatever country they happened to be built. But once modern architecture was successfully established, and especially after the end of the Second World War, renewed interest began to be shown in the warmer and less severe qualities that were desirable if modern buildings were to fulfil their social as well as their technical functions in the fullest human sense. Traditional materials, valued among other things for their richness of texture, were reintroduced, though not in the form of traditional motifs or ornaments. Modern architecture in each country began to develop its own characteristics, founded on differences of climate, available materials, and social usage. This tendency was prominent during the 1920s and 1930s in Scandinavian countries. Subsequently Mexico and Brazil led the way.

40, 153, 222, 590, 690, 1032, 1034, 1035, 1173, 1230, 1310, 1335, 1338, 1444, 1448, 1538, 1539, 1608, 1889, 1890, 2070, 2245, 2395, 2467, 2505, 2506, 2507, 2876, 2953, 2961.

**MODERNISTA.** See ART NOUVEAU.

**MODERN STYLE.** See ART NOUVEAU.

**MODIGLIANI,** AMEDEO (1884-1920). Painter of the École de PARIS, born at Leghorn. He came to Paris in 1906 and first worked as a sculptor, influenced by BRANCUSI and by Negro carvings (see AFRICAN TRIBAL ART). He turned to painting in 1915 and his best pictures were done in the next few years. Modigliani, who was tubercular, frequented the cafés and night-life of Paris, joining in the gatherings of artists at

the Bateau-Lavoir and other studios, living in conditions of extreme poverty until he was supported from *c.* 1916 by the CONNOISSEUR Zborowski and by Paul Guillaume. In 1912 he worked in Kisling's (1891–1953) studio and became a close friend of Pascin (1885–1930) and SOUTINE. His style was marked by an essentially original mode of MANNERISM and he was recognized as one of the greatest masters of his day.

508, 509, 575, 1848, 2358, 2844, 2846.

**MODILLION.** One of a series of horizontal brackets placed under a CORNICE; usually in the form of a scroll, but sometimes a plain block. In the Doric Order they are replaced by MUTULES (see ORDERS OF ARCHITECTURE).

**MODULAR DESIGN.** An architectural term for design on the basis of units of fixed dimensions, a practice that results naturally from the prefabrication of building components which is one of the dominating technical factors in MODERN ARCHITECTURE. It facilitates the use of interchangeable standard parts, as was exemplified in a series of nearly 50 schools built by the Hertfordshire County Council after 1946. These were designed on a horizontal and vertical grid of 8 ft. 3 in., i.e. all important dimensions in plan and elevation were a multiple or a simple subdivision of this basic dimension. The available range of PROPORTIONS is in this way fixed and limited, and the method accentuates the tendency, characteristic of modern architecture, to rely for many of its effects on the rhythmical repetition of identical units.

Modular design has revived interest in the various theories according to which beauty resides in given mathematical ratios, a subject explored by many great architects of the past, including VITRUVIUS and PALLADIO. The most important new addition to these theories is that worked out by LE CORBUSIER (see MODULE).

**MODULE** (Latin *modulus*). In architecture a unit of measure or PROPORTION. In classical and RENAISSANCE architecture the relative sizes of all the parts of an order were traditionally given in *modules*, expressed in terms of the diameter of a COLUMN just above its MOULDED base, which is then subdivided into minutes. Among the principal theorists VITRUVIUS gives the module as one diameter (iii. 3) or two diameters (iv. 3); VIGNOLA and PALLADIO use semidiameters, but Vignola divides the Tuscan and Doric modules into 12 minutes and the other Orders into 18 while Palladio gives 30 in each case (see ORDERS OF ARCHITECTURE). It has not, however, been possible to fit the proportions of the best Greek and Roman buildings to the theoretical exposition of Vitruvius.

It is characteristic of the Greek system, in contrast for example to the Egyptian and medieval systems, to express the dimensions of a building not in terms of a unit of length (feet,

metres, etc.) but of a small part of the building itself conceived as a common fraction of larger parts and of the whole. Such a system is commonly referred to as Modular Proportion. It was spoken of by Vitruvius as a means to securing the organic relation of parts to part and to the whole which he called *symmetria* and regarded as aesthetically important. The classical system was somewhat obscurely related to the various CANONS of proportion recognized from time to time as relevant to ideal beauty in Greek sculpture: these also expressed the consonance of the parts with each other and with the whole in terms of a small element (e.g. a finger).

A system of architectural proportion also based on the human figure was revived by LE CORBUSIER (1942) and is usually known under his title *Le Modulor.* (*Le Modulor. Essai sur une mesure harmonique à l'échelle humaine applicable universellement à l'architecture et à la mécanique,* 1949. Eng. trans. *The Modulor,* 1954; and *Modulor 2,* 1958.)

**MOHOLY-NAGY,** LÁSZLÓ (1895–1946). Hungarian-born painter and CONSTRUCTIVIST. After studying law and then painting in Hungary, he was influenced in 1919 by the Russian SUPREMATIST Casimir MALEVICH and by El Lissitsky (1890–1947) and devoted himself throughout his life chiefly to constructivist techniques, using transparent and semi-transparent film or plastic material for the organization of space. From 1923 to 1928 he taught at the BAUHAUS with GROPIUS and experimented with various new techniques in this field which he described as 'photograms' or painting with light. After two years in London, where he began his series of coloured constructs in translucent materials which he called 'space modulators', he settled in the U.S.A. in 1937 and founded a school which he called the 'New Bauhaus' in Chicago. He was always particularly active in film, PHOTOGRAPHY, and theatre. Although not a creative artist of the first order, he experimented in many new modes of expression and exercised an important influence in introducing constructivist techniques in the U.S.A. In 1927 he published *Malerei, Photographie, Film* as a Bauhaus booklet, which was revised and translated as *The New Vision* (1947), and in the same year his *Vision in Motion* was posthumously published.

1849, 1851.

**MOISSAC.** A Benedictine (CLUNIAC) abbey which is chiefly celebrated for its sculpture, especially the cloister CAPITALS (*c.* 1100) and the great TYMPANUM of the APOCALYPSE in the porch. The porch itself was built in the 1130s but the tympanum may be earlier. It is probably the most famous of all the ROMANESQUE tympana on account of the superb composition of its central group, organized in a closely knit pentagonal design around the tremendous and rather terrifying figure of CHRIST. It seems closer in spirit to

**219.** Apocalyptic Vision. Tympanum from the porch of the abbey church of S. Pierre, Moissac (c. 1110)

BURGUNDY than Languedoc. MÂLE has identified the subject with a MINIATURE in the *Beatus* manuscript of Saint-Sever.

**MOITURIER,** ANTOINE. Sculptor from Avignon, who (1463-76) took on from HUERTA and completed the tomb of John the Fearless, Duke of Burgundy, at Dijon. The tomb of Philippe Pot, Seneschal of Burgundy, made for the Abbey of Cîteaux, c. 1477, and now in the Louvre, has also been attributed to him. His style owed much to Jacques MOREL.

**MOLA,** PIER FRANCESCO (1612-66). Italian painter of the ROMAN SCHOOL. His style was formed in north Italy, and when he came to Rome shortly before 1650 the VENETIAN elements in his painting were instrumental in forming the later BAROQUE style of the second half of the century. He was much patronized by the Chigi family. His masterpiece, *St. Bruno*, is known from versions in many collections, including the Vatican Gallery and the Louvre.

**MOLENAER,** JAN MIENSE (c. 1610-68). Dutch painter and ETCHER. He married Judith LEYSTER in 1636; both belonged in their youth to the circle of Frans HALS. He and his wife probably collaborated and sometimes it is difficult to differentiate their work. Molenaer's range is wide, from pictures of the crude, indecorous activities of peasants to small, exquisitely finished portraits and domestic scenes of well-to-do families. In accordance with the general development of Dutch painting from c. 1625 to 1650 Molenaer's early works have a grey-blond

tonality and wide range of colour, whereas the later ones have less variety of colour and tend to a brownish tone.

**MOLYN,** PIETER DE (1595-1661). Dutch LANDSCAPE painter, a prolific draughtsman and ETCHER. Around 1626-8 he, van GOYEN, and S. van RUYSDAEL began to make small monochromatic landscapes of dunes and farmers' cottages which are generally agreed to mark the beginning of the great age of REALISTIC landscape painting in the Netherlands. It is not known if these three painters worked together, if they arrived at similar solutions independently, or if one of them began experiments with tonal painting and the others followed his lead. *The Sand Dune* (Brunswick, 1626) by Molyn suggests that he may have taken the initiative since the earliest known pictures by van Goyen and S. van Ruysdael which used a monochromatic tonal technique to suggest air and atmosphere post-date Molyn's Brunswick painting. But barely a handful of Molyn's later paintings can match the many masterly paintings which van Goyen and van Ruysdael did during the following decades.

**MOMPER,** DE. Family of Flemish painters of the 16th and 17th centuries who occupy a significant place in the history of Flemish and Dutch LANDSCAPE. The most important member was JOOST (JOSSE) II DE MOMPER (1564-1635), who was active at Antwerp. He was influenced by Pieter BRUEGEL and later by ELSHEIMER and his compositions stand half-way between the constructed landscapes of the 16th c. and the NATURALISTIC landscapes of the 17th,

734

which were mostly Dutch. He enriched the traditional colour scheme of 16th-c. landscape painting, hitherto largely confined to cool blues and greens, until it ranged from brown to grey via green, yellow, and blue. In his mountain views he retained the old device of a subject in the foreground, usually painted by one of his assistants, but some of his views of plains are almost pure landscape. His smaller paintings are invariably PANELS; the larger ones, which are on canvas, may have been used as substitutes for tapestries. Joost de Momper is important for his influence on TENIERS the Younger and Hercules SEGHERS.

**MONAMY,** PETER (1689–1749). English MARINE painter, born in Jersey. He came to London as a house painter when a boy, taught himself drawing and painting and found his subjects almost entirely in shipping on the Thames. He developed a meticulous style based on that of the van de VELDES, and his work has little variety. In 1726 he presented a large sea-piece to the Painter-Stainers' Company. He was one of the artists employed on the decorations at Vauxhall Gardens. There are typical examples of his work at the Victoria and Albert Museum and at Dulwich.

**MONDRIAN** (MONDRIAAN), PIET (PIETER CORNELIS) (1872–1944). Dutch painter who gained international recognition as a leader of the geometrical ABSTRACT style. He was born at Amersfoort and studied at the Amsterdam Academy. His early painting was naturalistic and direct, often delicate in colour though greys and dark greens predominated. Between 1907 and 1910, partly under the influence of TOOROP and perhaps partly owing to his conversion to theosophy, his painting took on a SYMBOLIST character and he began to work with primary colours. In 1911 he went to Paris, where he came into contact with CUBISM and executed the now famous series of successive abstractions on a single theme (*Trees*). He was caught in Holland by the outbreak of the First World War and continued there his study of abstraction, developing theories about the horizontal–vertical axes. With Theo van DOESBURG he founded the periodical De STIJL in 1917 and became the main exponent of a new kind of abstract painting which he named NEO-PLASTI-CISM. His pictures were designed by horizontal and vertical lines marking rectangles of primary colours with black, white, and grey. In 1920 he published an exposition *Le Néoplasticisme*, a German translation of which was published by the BAUHAUS in 1925. In 1939 Mondrian left Paris for London and from 1940 to his death lived in New York. There he did a gayer and more lively set of abstracts of which *Broadway Boogie-woogie* and the unfinished *Victory Boogie-woogie* are the best known.

Mondrian's concept of 'pure plasticity' con-sisted partly in the simplification of the means of expression to the bare essentials. He not only banished representation and three-dimensional picture-space but also the curved line, sensuous qualities of texture and surface, and the sensu-ous appeal of colour. The basic elements were straight lines meeting at right angles and a limited number of primary colours. This restrictedness he regarded as a sort of mystical pursuit of the Absolute which he justified in terms of his theosophical beliefs. His extensive influence on the art and taste of the 1930s onwards was not limited to artists such as Ben NICHOLSON, Max Bill (1908–   ), and others whose style had direct affinities with his own. He also had a profound influence on contemporary fashion in com-mercial and advertisement design.

811, 1389, 1854, 1855, 2464.

**MONE,** JEAN (*c.* 1500–*c.* 1550). Sculptor who was born in France and settled in the Low Countries *c.* 1520. In some documents he is called Jean de Metz or Jean Lartiste, which is probably the earliest use of the word 'artist' as a surname. He was court sculptor to Charles V. Mone broke completely with the late GOTHIC tradition of FLEMISH sculpture and was one of the principal Italianate sculptors working in the Netherlands during the first half of the 16th c. One of his chief works is the high altar (1533) in the church of Notre-Dame at Hal, near Brussels.

**MONET,** CLAUDE (1840–1926). French painter of the IMPRESSIONIST group. He was introduced to LANDSCAPE PAINTING as a youth in Le Havre by BOUDIN, from whom he derived his firm predilection for painting out of doors. In 1859 he studied in Paris at the Académie suisse and formed a friendship with PISSARRO. After two years' military service in Algiers, he returned to Le Havre and met JONGKIND. He then entered the studio of Marc Charles Gabriel Gleyre (1806–74) and met there RENOIR, SISLEY, and BAZILLE, with whom he left to paint landscape in the Barbizon district. In 1865 he worked with COURBET at Trouville and in the following year he came under the influence of MANET. During the Franco-Prussian war he was in England with Camille Pissarro and from a study of TURNER developed his concept of AERIAL PERSPECTIVE. Between 1872 and 1878 he worked primarily at landscape near Argenteuil and in 1878 moved to Vretheuil. After having experienced extreme poverty he now began to achieve a moderate success and in 1883 he settled at Giverny, where he made an ornamental lily pond which served as the theme for his *Nymphéas* pictures.

Monet did not study the masters of the past or make copies in the Louvre, but taught himself from the work of his contemporaries. In early pictures he experimented with the painting of tonal values used by Manet (*Le Pont neuf*, 1870), but later he abandoned this for the representation of light and hue, in which he was the most consistent of all the Impressionists.

From *c.* 1870 he restricted himself almost completely to landscape and to rendering harmonies of colour hue in varying conditions of light. Among the most celebrated are the series of Rouen Cathedral painted at different times of day in different lights (1892–4), the views of the Gare Saint-Lazare (1876–8), and the water-lily pictures which prepared the way for an astonishing set of murals he did in the Musée de l'Orangerie towards the end of his life.

Since his death Monet's reputation, already high, has tended to increase with critics and he has been regarded as perhaps the most powerful exponent of that aspect of Impressionism which is concerned with the representation of atmosphere and colour. Zola said of him: 'Voilà un homme dans la foule des eunuques.'

88, 999, 1574, 1798, 2321, 2446, 2822.

**MONNIER,** HENRI BONAVENTURE (1799–1877). French CARICATURIST and actor. After some training under GIRODET DE ROUCY and then under GROS he turned to caricature in the 1820s and in 1830 he wrote and illustrated his *Scènes populaires*, famous for the character of *Joseph Prudhomme*, type of middle-class pomposity.

1759, 1819.

**MONNOYER,** JEAN-BAPTISTE (1634–99). Flemish painter and engraver, who after studying in Antwerp achieved a considerable reputation as a decorator in France and England. As assistant to LEBRUN he supplied designs of GROTESQUES for tapestries executed at Beauvais and painted flower pieces for Lebrun's decorations of the Galerie d'Apollon at the LOUVRE and elsewhere. He came to England *c.* 1685 with the Duke of Montagu and contributed to the decorations at Montagu House, Hampton Court, Windsor, and Kensington Palace.

**MONOGRAM.** See SACRED MONOGRAM.

**MONOTYPE.** A term used in GRAPHIC ART. A design is painted in oil colours on a sheet of plate glass and paper is pressed upon it; when the paper is peeled off a proportion of the colour adheres to it in the form of a PRINT in reverse of the original design. Various modifications of this principle are known: ETCHING plates or LITHOGRAPHIC stones have been used instead of glass, and printing INKS, sometimes partly scraped away, can replace the oil colour. With glass plates it is necessary to apply the pressure to the back of the paper by hand; in other cases monotypes may be printed in a press. Strictly speaking, only one print may be taken by this process; in practice the colour on the slab may be reinforced after printing and another one or two impressions taken, although they will differ considerably from the first.

G. B. CASTIGLIONE made monotypes on etching plates in the 17th c., William BLAKE's monotypes were apparently done on pieces of card,

and DEGAS used the medium later in the 19th c., notably for a number of designs which were later reproduced by Ambroise Vollard as illustrations to Pierre Louys's *Mimes des courtisanes*. The medium is not infrequently used by 20th-c. artists, primarily for its interesting and original textural qualities.

2180.

**MONTAGE** (French: 'mounting'). A pictorial technique in which cut-out illustrations, or fragments of them, are arranged together and mounted. Illustrations alone are used, and they are chosen for their subject and message; in both these respects montage is distinct from COLLAGE and *papier collé*. The technique has affected advertising. Photomontage is montage using photographs only. The word 'montage' also refers to the selection, cutting, and piecing together of the separate shots taken for a film.

**MONTAGNA,** BARTOLOMEO (*c.* 1450–1523). Italian painter, who worked principally at Vicenza and Venice. In 1482 and 1483 he painted two biblical compositions for the Scuola di San Marco and the Pala for the Venice Hospital. He also worked for the Scuola del Santo, Padua. About the turn of the century he produced a number of monumental works, which included *The Madonna Enthroned between Four Saints* (Brera), a *Pietà* for the Madonna del Monte Berico, and a *Nativity* for the church at Orgiano. His *forte* lay in the modelling of his figures and his compositions were unified against architectural or rock backgrounds. He also painted a number of village *Madonnas* towards the end of his career.

**MONTAÑES,** JUAN MARTÍNEZ (1568–1649). The leading sculptor of the Sevillian School in Spain. His polychrome sculptures continued the tradition of the 16th c. but their heightened realism and more direct appeal savour of the BAROQUE (cf. FERNÁNDEZ in Castile). His first important work was the REREDOS of St. Isidore at Santiponce, near Seville (begun in 1609), in which he had the collaboration of PACHECO as his polychromist. Among his several versions of *The Immaculate Conception* that in Seville Cathedral combines a Classical serenity and simplicity of pose with direct and naturalistic treatment. In 1636 he was called to Madrid to undertake his only recorded secular work, a portrait head of Philip IV to serve as model for the equestrian statue of the king executed by Pietro TACCA in Florence.

He directed a flourishing workshop at Seville and exported statues and reredoses to Peru. He exercised an important influence on his younger contemporaries, including ZURBARÁN, VELAZQUEZ, and CANO.

1301.

**MONTEFELTRO.** The Counts of Montefeltro were the rulers of Urbino from 1234 with

short intervals until 1508, on the extinction of the family. Under the guidance of FEDERIGO (b. 1422, ruled 1444-82) the city became one of the most important centres of RENAISSANCE culture. He was a brave *condottiere* and the implacable enemy of Sigismondo MALATESTA, but is significant chiefly as an enlightened patron of literature and the arts. His library was the finest in Italy. He employed Luciano LAURANA and possibly PIERO DELLA FRANCESCA to build a splendid palace, to which he attracted writers and artists, especially from Flanders. In his own day he was enthusiastically celebrated by the humanists; for us he chiefly survives— broken nose, warts, and all—in the famous portrait by Piero della Francesca (Uffizi).

**MONTHS,** LABOURS OF THE. See OCCU-PATIONS OF THE MONTHS.

**MONTREUIL,** PIERRE DE (d. 1267). French architect in the RAYONNANT style. Montreuil is near Amiens, and he was probably trained in the local cathedral lodge. But he was at SAINT-DENIS at least from 1247, and he may well be the Pierre de Montereau whom tradition names as the architect of the Sainte-Chapelle— in which case he probably designed the Sainte-Chapelle at Saint-Germer. He also worked at Saint-Germain-des-Prés and succeeded Jean de CHELLES at Notre-Dame, Paris. Two of his kins-men worked for St. Louis. The two families of Montreuil and Chelles made Paris the head-quarters of Rayonnant GOTHIC art and the centre of its dissemination.

**MONUMENT, MONUMENTAL SCULP-TURE.** A work intended to celebrate and preserve the memory of a person, an event, or an idea; or, in a wider sense, a relic of almost any kind which by its survival bears witness to things past. It is with the former sense that this article is concerned. In advanced civilizations man-made monuments are usually either architecture or sculpture. Owing to its less durable character painting has seldom seemed so suitable a medium for preserving a memory into the indefinite future, though the distinction is of course no more than a matter of degree. Monarchs have had their court painters, as witness Alexander the Great and the colossal painted portrait of the emperor Nero which, the elder PLINY records, was struck by lightning soon after being exhibited in public, and portraits of the eminent are still painted for posterity despite the prevalence of photography and other mechanical methods of perpetuating a man's appearance.

The idea of the monument in connection with works of art is associated with a certain character of grandeur, nobility, permanence, and often, though not essentially, of size. That which is preserved to distant posterity tends to be repre-sented as worthy of preservation. Hence the word 'monumental' came into use as a critical term which could be applied with a stylistic connotation to works of art which were not intended primarily as monuments in the sense discussed. When the term 'architecture' was reserved for that branch of building which, in the words of REYNOLDS, is 'capable of inspiring great and sublime ideas', almost any work of architecture could be referred to as a monument —a usage which is no longer generally current. Among works of architecture with most specific monumental purpose from the past may be men-tioned the PANTHEON, the TRIUMPHAL ARCH, the OBELISK, the cenotaph, the war memorial, and the TOMB. From this point of view tombs fall into two categories: those which were intended as a permanent dwelling place for the surviving spirits of the dead or even, as in ancient Egypt, to serve as instruments to secure survival; and those which were intended primarily to preserve the memory of the dead. The latter purpose was most prominent in cultures, such as that of classical Greece, where the idea of a future life was not dominant and was expressed also in STELAE and grave sculpture. It has continued in Christian times alongside the idea of a future life away from the tomb and the original sense of 'monument' is preserved in the modern term 'monumental mason'.

Apart from architecture sculpture is capable of creating a sense of the triumph of art over time more emphatically than most other arts. This is due partly to a combination of the effect of physical presence which the three-dimensional image naturally exerts with the character of per-manence which is suggested and within reason ensured by the materials. Size too can conduce to the glorification of a memory which often attends the desire to preserve it. The ultimate in the direction of the colossal is to turn a moun-tain into a monument, as the 4th-c. Macedonian architect Deinocrates planned for Mt. Athos, and MICHELANGELO in his old age deplored the lack of opportunity which had kept him from turning one of the mountains above the Carrara quarries into a statue. Though colossal figures cut out in the turf of mountain-sides date from prehistoric times, it was left to the modern age to produce a BORGLUM at Mt. Rushmore in the U.S.A.

An important though often unnoticed role is played by the pedestal. It elevates the image above the mundane realm of common nature and sets it apart. Apt congruence between pedestal and image in form and size can enhance an im-pression of dignity and endurance, to which the inscription can also contribute.

Much monumental sculpture in the past has combined religious or ritual motives with the purpose of perpetuating a memory; and while the impressiveness remains, the precise nature of their original significance is often a matter of speculation. Such are the figures from Easter Island and those at San Agustin in Colombia. Medieval tomb sculpture combined devotional and commemorative functions and a complex purpose inspired the TOTEM POLES of the North

American Indians. Imposing structures of combined religious and monumental character have survived from the ancient Near East and from Egypt. Egyptian sculptures such as the SPHINX at Gizeh and the statues at Abu-Simbel are distinguished by their great size, the hardness of the materials, the careful workmanship, and stylization within a system of rectangular coordinates which conveys an impression of inscrutable purpose and timeless endurance. For this reason they have sometimes been imitated in monuments of later ages.

Monumental tomb architecture was unknown in classical Greece and portrait sculpture was not in vogue until the latter part of the 4th c., when it was first devoted to idealized representations of eminent men of the past. But the Greeks nevertheless established a number of monumental types which, often through late copies, had a long influence on European monumental sculpture: among these were the types of the athlete, the gravestone figure, the charioteer, the equestrian general, the ruler leaning on his spear (first used for Alexander the Great), the standing orator, and the seated philosopher. Monuments in the Greek style were very popular in the Roman Empire and Rome itself was 'filled with a people of bronze'. Statues were often placed on tall monolithic COLUMNS of which Hadrian's Column is the outstanding example. The triumphal arch was also exploited and the EQUESTRIAN STATUE is exemplified in that of Marcus Aurelius, which was set up in its present position on the Roman Capitol by Michelangelo.

With some doubtful exceptions such as the *Bamberg Rider* the Middle Ages produced no monumental sculpture apart from tombs and destroyed many of those which they inherited. The first outstanding monuments of the RENAISSANCE are DONATELLO's *Gattamelata* in Padua and VERROCCHIO's *Colleoni* in Venice, both equestrian statues of *condottieri* whose doubtful claim to be remembered is ennobled by the universal character of the monuments. Among the works of the Renaissance whose loss is most regretted are Michelangelo's statue of Julius II in Bologna, which was destroyed by a mob soon after completion, and LEONARDO's *Francesco Sforza* in Milan, the model of which was destroyed by soldiers before it was cast. The number of public monuments created during the Renaissance was, however, surprisingly small. Louis XIV showed perseverance in setting up monuments to himself and set an example for similar efforts in the later 18th c. The French Revolution was given to erecting spectacular but perishable statues, such as the *Goddess of Reason* in plaster, none of which has survived. The English gardens and their imitations on the Continent not infrequently harboured statues of great men in appropriate spots, but as late as 1870 the city of Paris did not contain more than nine public monuments.

The 19th c. and early 20th c. were prolific of public monuments, but since the gradual divorce of creative art from official art many of those erected under official auspices have tended to be considered very indifferent works of art. Typical examples of such official monuments may be seen in war memorials and equestrian statues. Tomb sculpture, however, went out of fashion and, except in the realms of science and the arts, the glorification of the individual as a motive for monumental sculpture has come to seem somewhat foreign to the spirit of democratic societies.

**MOORE,** HENRY (1898–1986). English sculptor. Son of a Yorkshire mining engineer, he was trained in art, after service in the British Armed Forces, at Leeds School of Art and from there obtained a scholarship to the Royal College of Art (1919–23). He taught at the Royal College 1925–32 and at Chelsea School of Art 1932–9. During the 1930s he lived in Hampstead in the same area as Ben NICHOLSON, Barbara HEPWORTH, the critic Herbert Read, and others of the *avant-garde*. In 1940, after the bombing of his studio, he moved to Much Hadham in Hertfordshire. Between c. 1930 and c. 1945 Henry Moore was the most important figure in British art. His international reputation became established in the 1940s, helped partly by an illustrated record of his work published in 1944. In 1946–7 he had one-man shows in the Museum of Modern Art, New York, the Philips Memorial Gallery, Washington, the Art Institute, Chicago, the Museum of Modern Art, San Francisco; and an exhibition toured Australia in 1947. Since that time his works have been continuously exhibited in most major countries. He represented Britain at the 24th Venice Biennale in 1948 and took the International Sculpture Prize. He also won the International Sculpture Prize at the second São Paulo Biennale in 1953 and at Tokyo in 1959, the Sculpture Prize of the Carnegie Institute of Pittsburgh in 1958, and the Feltrinelli Prize, Rome, in 1963. He was made a Companion of Honour in 1953 and received the Order of Merit in 1963. Moore's public commissions included: the figure of *North Wind* on the London Underground Railway Headquarters at St. James's, London (1928); *Madonna and Child* for the church of St. Matthew, Northampton (1943–4); *Three Standing Figures* for Battersea Park, London (1947–8); *Madonna and Child* for Claydon church, Suffolk (1949); *Reclining Figure* commissioned by the ARTS COUNCIL for the Festival of Britain in 1951 (now at Temple Newsam Gal., Leeds); *Screening Wall, and Draped Reclining Figure* for the *Time-Life* building, London (1952–3); *Reclining Figure* for the UNESCO building, Paris (1957–8).

Moore brought a new impulse into British sculpture. His primary interest was always research into three-dimensional spatial construction. But with this he combined a sensitive feeling for the material, bringing back the tradition of direct carving so long lost (see STONE SCULPTURE), and a ROMANTIC sensibility which

imparts a moving and telluric character to his figures. Although he produced pure ABSTRACT sculptures, unlike Barbara Hepworth he never made the abstract his major concern but throughout his career produced figural sculptures with the emotional impact of natural conformations. Early in his career Moore rejected the classical and RENAISSANCE conception of beauty and put in its place an ideal of vital force and formal vigour which he found exemplified in much ancient sculpture (Mexican, Sumerian, etc.) which he studied in the British Museum. In his contribution to UNIT ONE he wrote in 1934:

carving, in a CYCLADIC stone figure and a Nukuoro wooden statuette.'

Moore was also an outstanding sculptural draughtsman with a style recognizably his own. His drawings done as an official war artist 1940-2 of the London Tube shelters are among the most poignant records that exist of the effects of a bombing war on the civilian population.

1163, 1224, 1859, 1860, 1861, 1921, 2191.

**MORA,** JOSÉ DE (1642-1724). Spanish sculptor, pupil of CANO at Granada. Appointed court sculptor to Charles II, he spent the years 1666-7

220. *Pink and Green Sleepers.* Pen, wash and gouache drawing by Henry Moore. (Tate Gal., 1941)

'For me a work must first have a vitality of its own. I do not mean a reflection of the vitality of life, of movement, physical action, frisking, dancing figures, and so on, but that a work can have in it a pent-up energy, an intense life of its own, independent of the object it may represent. When a work has this powerful vitality we do not connect the word Beauty with it. Beauty, in the later Greek or Renaissance sense, is not the aim in my sculpture.' He was conscious that the vitality at which he aimed is to be found in much sculpture of different peoples and different ages, constituting a unifying force independent of the Greco-Renaissance tradition. In 1941 he said: 'The same shapes and form-relationships are to express similar ideas at widely different places and periods in history, so that the same form-vision may be seen in a Negro and a Viking

and 1676-80 at Madrid. His works, more mannered and less profound than his master's, nevertheless include some deeply moving figures, such as his *Crucifixion* (San José, Granada) and *Dolorosa* (Maravillas convent, Madrid, and Granada).

**MORALES,** LUÍS DE (d. 1586). Spanish painter, active in Estremadura. He expressed the intense religious feeling of his time in a series of devotional paintings of a popular kind, which earned him the name 'Morales el Divino'. There are versions of some of his favourite subjects (*Virgin and Child, Ecce Homo*, etc.) in the Prado.

994, 2682.

**MORANDI,** GIORGIO (1890-1964). Italian painter and ETCHER. He was born at Bologna

and lived there all his life, standing aloof from the intellectual turmoil and aesthetic experiments of the 20th c. apart from his adhesion to CHIRICO's idea of METAPHYSICAL PAINTING for a few years from 1918. More than most contemporary artists he went his own way and worked in isolation from current movements. After early LANDSCAPES he painted almost exclusively STILL LIFES, eschewing literary and symbolic content. Working for subtle combinations of colour within a narrow range of tones, he concentrated on purely plastic expression and created a poetic impression by uncomplicated means. His style has something in common with the PURISM of OZENFANT but is more subtle and intimate, breathing an air of serenity and cultivated sensibility. His work won great respect among younger Italian artists for its pure devotion to aesthetic values and its poetic quality. In 1957 he achieved international recognition by being awarded a prize at the São Paulo Biennale.

1059.

**MORBIDEZZA** (Italian: 'delicacy' or 'softness'). The rendering of the flesh-tints in painting with softness and delicacy.

**MOREAU**, GUSTAVE (1826-98). French painter who, like certain of the Parnassian poets, exploited the Romantic possibilities of long-dead civilizations and mythologies, creating fantasies of the false antique. He used a meticulous and ornate style reminiscent of certain 15th-c. Italian masters. He was a painter of the literary idea rather than the visual image and his pictures appealed to the imagination of certain contemporary authors. Long descriptions of them were introduced by J.-K. Huysmans in *À rebours* and by Jean Lorrain in *Monsieur de Phocas*. In 1891 he succeeded Élie Delaunay as professor at the École des Beaux-Arts and numbered MARQUET, ROUAULT, and MATISSE among his pupils. Apart from a slight interest taken in his work by some SURREALISTS, his main importance lay in his intelligent and tolerant teaching.

1936.

**MOREAU**, JEAN MICHEL, LE JEUNE (1741-1814). French designer and engraver of PRINTS and VIGNETTES, interesting historically for their keenly observed details of contemporary life and manners. The plates engraved for De La Borde's *Choix de chansons* (1773) and the *Monument du costume* (1776 and 1783), a series of 24 costume plates designed as scenes from court life, record and sum up the society of Louis XVI. Moreau illustrated the 1773 edition of Molière, perhaps the best known book of this period, and the works of Rousseau and Voltaire. His engravings of the fêtes given by the City of Paris in 1782 to celebrate the birth of the Dauphin are the last productions of this kind and mark the end of an epoch and way of life. The rise of CLASSICISM at the Revolution affected Moreau's later work; a frigid reserve characterizes his illustrations to *Ouverture des États généraux* (1789) and *Constitution de l'Assemblée nationale* (1789).

2408.

**MOREAU**, LOUIS GABRIEL (1739-1805), French LANDSCAPE painter, of greater delicacy and sincerity than most contemporary landscapists, though less popular than VERNET and ROBERT (*View of the Bellevue Hillside*, Louvre).

**MOREELSE**, PAULUS (1571-1638). Dutch painter and architect who worked in Utrecht and helped found the St. Lucas guild there in 1611. He is best known for his portraits, which are similar to those made by his teacher MIEREVELT, but softer and uneven in quality. His portraits of shepherds and blonde shepherdesses with a deep *décolletage* were popular during his lifetime. He designed the Catherine Gate and the façade of the Meat Market in Utrecht.

**MOREIRA**, JORGE MACHADO (1904- ). Brazilian architect, trained at the National School of Fine Arts, Rio de Janeiro. He collaborated with Lúcio COSTA, NIEMEYER, REIDY, and others on the Ministry of Education building at Rio (1937-43). Most important of his independent works is the university city of Rio de Janeiro (begun 1953).

**MOREL**, JACQUES (d. 1459). French sculptor. He was the son of ÉTIENNE MOREL and grandson of PERRIN MOREL, both sculptors at Lyon. In 1418 he was nominated master of works at the cathedral there and in 1420 made the monument, now destroyed, of Cardinal de Saluces with a statue of him kneeling before an angel holding a crucifix. He left Lyon about 1423 and travelled through the Midi. By 1448 he was superintendent of work at Rodez Cathedral but neglected it in order to make the Bourbon tombs at Souvigny. He went on to Angers to make the tomb of King René, and died there heavily in debt. His surviving work shows great skill in the ornamental treatment of DRAPERY.

**MORELLI**, GIOVANNI (1816-91). Italian critic, born at Verona. He was educated at Bergamo and in Switzerland and attended university at Munich, where he studied natural philosophy and medicine. Returning to Italy in 1846, he was active in the patriotic movement for the liberation of Italy from Austrian rule. From 1873 he began to write on Italian art, at first under the pseudonym Ivan Lermolieff. In 1880 he published under his own name *Die Werke Italienischer Meister in den Galerien von München, Dresden und Berlin* (translated into English in 1883). His *Kunstkritische Studien* were published in 1890.

As an art critic Morelli concentrated mainly on

the problems of ATTRIBUTION and claimed to have reduced this to scientific principles. He maintained that an artist's method of dealing with insignificant details, such as the treatment of the hands or the ears, is tantamount to a signature and that by systematic study of such technical details attribution can be put beyond doubt. This method is still sometimes referred to as 'Morellian criticism' but it has proved somewhat less productive of scientific certainty than he hoped.

**MORETTO DA BRESCIA,** ALESSANDRO BONVICINO (c. 1498-1554). Italian painter, most of whose works were religious paintings for churches of Brescia. *Elijah woken by the Angel* (S. Giovanni Evangelista) exemplifies the poetic treatment of nature that characterizes his best pictures and *Sta Justina* (Vienna) the strength of his composition. He had a directness in portraiture that he passed on to his pupil, MORONI (*Portrait of a Nobleman*, N.G., London, 1526).

**MORISOT,** BERTHE (1841-95). French IMPRESSIONIST painter. She was a daughter of Tiburce Morisot, Secretary-General of the Crédit financier, who had studied painting and architecture in his youth and who entertained one of the artistic 'sets' of the Second Empire. There she met COROT and was his pupil 1862-8. The chief formative influence on her work was MANET, whose pupil she became in 1868, and whose brother she married in 1874. She was painted several times by Manet and she is said to have persuaded him to experiment with the Impressionist 'rainbow' palette, abandoning the use of black. After Manet's death she came under the influence of RENOIR. Her personal style matured c. 1880 (*Jeune Femme au bal*, Luxembourg, Paris, 1880). Her pictures were regularly accepted for the Salon and she exhibited in all the Impressionist exhibitions except the fourth. The London Impressionist exhibition of 1905 included 13 of her pictures.

51, 905, 1876.

**MORLAND,** GEORGE (1763-1804). English LANDSCAPE and GENRE painter, the son of HENRY MORLAND (1730-97), a successful London painter of domestic scenes, to whom he was articled 1771-84. At the end of this period he began to produce in quantity the small scenes of middle- and lower-class rural pastimes which are particularly associated with his name and which were popularized in mezzotint by William Ward (1761-1826), his brother-in-law. He painted broadly, sometimes coarsely, in a style suited to his bucolic subjects. These, as time went by, were drawn more from the stable and the tavern than the cottage. Much of his time was spent in avoiding creditors, and in 1799 he spent some months in the Isle of Wight, where he painted a number of coast scenes. His production was large and the quality of his painting uneven.

With WHEATLEY and IBBETSON he established the village scene in the English painter's repertory. His representations of a picturesque and contented English peasantry found favour with the taste of the time and the Rousseauian idealism popular at the beginning of the 19th c. increased their vogue.

2896.

**MORO,** ANTONIO. See MOR VAN DASHORST.

**MORONE,** DOMENICO (c. 1442-after 1517). Italian painter of the School of Verona in the Classical manner of MANTEGNA. His *Madonnas* show the influence of the Paduan School (see SQUARCIONE), but his most important work, *The Fight between the Gonzaga and the Bonacolsi* (1494), now in Mantua, is a wide, many-figured townscape recalling Gentile BELLINI and CARPACCIO. With his son FRANCESCO he founded an *atelier* in which many minor artists received their training.

**MORONI,** GIOVANNI BATTISTA (c. 1520/5-1578). Italian painter who studied under MORETTO in Brescia. In his religious paintings he followed closely the manner of his master and it is rather for his portraits that he is famed. These are outstanding for their psychological penetration and air of dignity (*The Tailor*, N.G., London).

**MORRICE,** JAMES WILSON (1865-1924). Canadian LANDSCAPE and figure painter, born in Montreal of a wealthy Scottish merchant family. Quitting law school, he went to Paris about 1890. He was a pupil of the Académie Julien and later of HARPIGNIES but his first inspiration came from WHISTLER and CONDER. Later, his style became gently FAUVIST; and he was the friend and associate of MATISSE and MARQUET. Morrice lived in Paris but made frequent trips to North Africa, Venice, Brittany, the West Indies, as well as to Canada, where he sketched in Quebec, Montreal, and along the St. Lawrence (*The Ferry, Quebec*, N.G., Ottawa, c. 1907). His influence has been strong and abiding in Canada. (See also CANADIAN ART.)

**MORRIS,** ROGER (1695-1749). English architect. He was so closely associated with Henry, 9th Earl of Pembroke, in activities such as the Palladian Bridge at Wilton House, Wilts. (1736-7), that it is hard to say which was the designer. Their collaboration also included the White Lodge, Richmond Park (c. 1727), Marble Hill, Twickenham (1728-9), and other works in a dry Palladian manner, though in 1746 Morris designed a GOTHIC castle at Inveraray. His kinsman and pupil, ROBERT MORRIS (active after 1734-57), with whom he is sometimes confused, was a prolific author of pattern books, such as *Rural Architecture* (1750) and *Select Architecture* (1757), the latter of which was much used in both England and America.

**MORRIS,** WILLIAM (1834–96). English
poet, artist, craftsman, decorator, and social
reformer. At Oxford he formed a lifelong friend-
ship with BURNE-JONES, began to write poetry
and to study medieval architecture, reading
RUSKIN and PUGIN. In 1856 he was apprenticed
to the architect G. E. STREET. He followed the
profession of painter from 1857 to 1862, and
worked with ROSSETTI and others on the PRE-
RAPHAELITE frescoes in the Oxford Union. In
1858 he published his *The Defence of Guinevere
and other Poems*. The next year he married Jane
Burden (who sat for Rossetti and others), and
for him and his bride the famous Red House,
Bexley Heath, was built by his friend Philip
WEBB. This led to the foundation in 1861 of the
manufacturing and decorating firm of Morris,
Marshall, Faulkner & Co., in which Rossetti,
Burne-Jones, Madox BROWN, and Philip Webb
were also partners and through which Morris
exercised a profound influence on English in-
dustrial design and interior decoration during the
latter part of the century, helping to bring about a
genuine revolution in public taste. The Morris
wall-paper patterns have become famous, but his
influence on design extended also to furniture,
tapestry, stained glass, furnishing fabrics, car-
pets, and much more. He produced tapestries
at his Merton works. He played an important
part in the development of the private printing-
press, founding in 1890 the KELMSCOTT PRESS
with the object of improving the standards of
printing and book design. He himself designed
for it ornamental letters and borders as well as
founts of type, favouring a revival of the medieval
black-letter face. In 1877 he founded the Society
for the Preservation of Ancient Buildings.

In 1883 he joined the Social Democratic
Federation, whose doctrines under his guidance
developed in the direction of socialism, and on its
disruption in 1884 he organized the Socialist
League. The particularity of his socialist doc-
trine lay in his belief that the fault of modern
society lay in the separation of work from joy
and of art from craft. He repudiated the concept
of FINE ART as a thing apart in the category of
luxuries, defining art as 'man's expression of his
joy in labour', and he insisted that aesthetic
activity embraces the whole of life, making it his
endeavour to reintroduce the ideal of universal
craftsmanship. His medievalism found its justi-
fication in his belief that the Middle Ages more
than any other period in European history
exemplified the fusion of art with life and the
universality of craftsmanship in which he saw
the salvation of the society in which he lived.
Himself an all-round craftsman, Morris was
a prime mover in the English ARTS AND CRAFTS
MOVEMENT in its dual aspect, being equally con-
cerned with its sociological and its aesthetic aims.

There was a romantic element in Morris's
medievalism, which was even more strongly
present in the Pre-Raphaelite artists who col-
laborated with him, and their work in the field
of design—good as much of it was—has dated.

His ideal of universal craftsmanship and his
glorification of manual skill proved unrealistic
in so far as it ran counter to or failed to come to
terms with modern machine production. But
his work bore lasting fruit, in England and
abroad (see WIENER WERKSTÄTTEN, DEUTSCHE
WERKSTÄTTEN, and DEUTSCHER WERKBUND), in
the emphasis which it laid upon the social im-
portance of good design and fine workmanship
in every walk of life.

655, 702, 1288, 1727, 1877, 1878, 2540, 2802.

**MORTIMER,** JOHN HAMILTON (c. 1741–
79). English painter, a pupil of HUDSON at the
same time as Joseph WRIGHT. His development
ran parallel to Wright's in that he worked both at
portraiture and at subject pieces of a ROMANTIC
nature. His CONVERSATION PIECES bear com-
parison with those of ZOFFANY. His anecdotal
pictures representing the exploits of *banditti* and
the more dramatic moments of British history
are now known chiefly from engravings. He was
elected A.R.A. shortly before his death.

**MOR VAN DASHORST,** ANTHONIS
(c. 1517/20–1576/7). Dutch painter, often called
by the Spanish version of his name, ANTONIO
MORO. He was the leading portrait painter
in the Spanish-Burgundian circle of princes
and noblemen on the eve of its disappearance
in the troubles of 1568. Born at Utrecht of a
distinguished family, he was a pupil of Jan
van SCOREL. In the *Two Jerusalem Pilgrims*
(Berlin, 1544) the latter's influence is obvious.
But he soon showed himself an independent
master in the portrait of *Cardinal Granvella*
(Vienna, 1549); yet comparison with the portrait
which TITIAN made of the same sitter in the pre-
vious year (Kansas City, Missouri) shows how
great was his debt to that master, whose composi-
tions and accessories he continued to borrow.
His later portraits are more solemn and less grace-
ful than Titian's, and when he depicts the
members of the great European royal families—
and he seems to have painted them all—he
emphasizes the austere and ceremonious aspects
of their personalities (e.g. *Maximilian of Austria*,
Prado; *Philip II*, Escorial). Mor travelled widely
and frequently. He was in Italy, Portugal, and
probably Spain. In 1554 he visited England,
where he painted a magnificent portrait of Mary I
(versions are in the Prado and at Fenway Court,
Boston). He died in Antwerp. His best known
works include the *Man with a Dog*, formerly
thought to be a self-portrait (N.G., Washington,
1569) and *Sir Thomas Gresham* (Amsterdam).

926, 1778.

**MOSAIC.** Mosaic is the art of making patterns
and pictures by arranging coloured fragments of
glass, marble, and other suitable materials and
fixing them into a bed of cement. It was first
developed extensively by the Romans in pave-
ments. But it is also well suited to the adornment
of walls and vaults, and great use was made of

wall mosaic by the Christian churches of Italy and the BYZANTINE Empire throughout the Middle Ages. As an exterior decoration it has sometimes appeared on the façades of medieval churches and in modern architecture. More rarely it has been made into portable pictures, or inlaid in furniture and small objects as in the Aztec art of Mexico; but it is in monumental compositions that mosaic is at its best.

Mosaics of a kind were made 5,000 years ago by the Sumerians (see BABYLONIAN ART), who ornamented their houses and temples with cones of coloured TERRACOTTA sunk into the mud-plaster of the outer walls. The EGYPTIANS, expert manufacturers of glass, used a simple form of glass mosaic on parts of their interior walls, as in the temple of Rameses II near Heliopolis. In MINOAN Crete small cubes of gold and precious stones have been discovered, which must have been used in miniature mosaics.

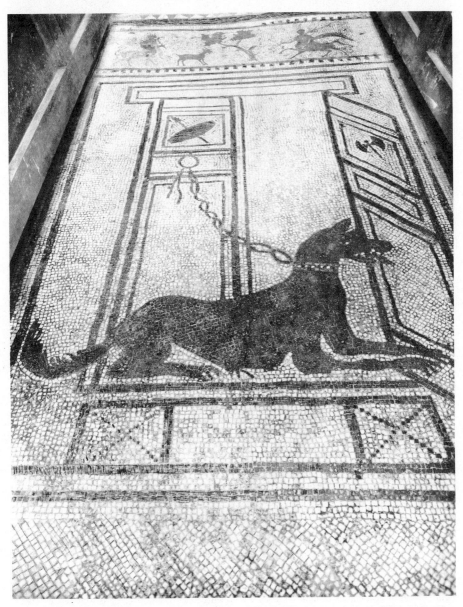

**221.** Chained Dog. Detail of mosaic pavement from House of Publius Paquius Proculus, Pompeii (1st–2nd c. B.C.)

**222.** Part of mosaic pavement of the triclinium in the Roman villa at Chedworth, Gloucestershire (end of 2nd c. A.D.)

Pebble floors of geometric design are also found, there and throughout the east Mediterranean, from the Neolithic period. But the oldest pictorial scenes known to us were made by the Greeks. At Olynthos in Macedonia, from the 5th c. B.C. onwards, the floors of temples and other buildings were paved with unshaped pebbles of natural colouring. These mosaics, mostly in black and white with the addition of pale green and red, depicted MYTHOLOGICAL subjects, satyrs, nymphs, and scenes from Homer. Similar pavements are found at Olympia dating from the HELLENISTIC period.

The crucial technical advance was made in Italy, however: the invention of a durable and waterproof cement or *cocciopesto*. A water-resistant volcanic sand, called *pozzolana*, which is common in south Italy, was mixed with powdered marble and lime, and broken pottery was added to the mixture to give it strength. Simple pavements of *cocciopesto*, in which the pattern is formed partly of these potsherds and partly of marble cubes, are found in the earliest paved layers at Aquileia on the Gulf of Venice (*c.* 1st c. A.D.). Later the pottery fragments were replaced by stone or marble, cut into regular cubes or tesserae (Latin for 'dice'), and laid to form the close-fitting pavements of *opus tessela-tum* so popular in public and private buildings throughout the Roman Empire. These pave-ments were mostly black-and-white, with simple figure scenes or geometrical designs. They were made on the spot, as part of the construction of the house; and the marble was chipped into cubes on the site with a sharp hammer on a pointed anvil. Since this *opus tesselatum* was waterproof, it was suitable for paving courtyards as well as rooms; it also enlivened Roman baths, public and private, with fish, sea-monsters, and Nereids.

Into the centre of this black-and-white paving, in the principal rooms of a Roman VILLA, more elaborate panels of mosaic were often set, called *emblema*. These panels were made by a more complicated and finer process, *opus vermiculatum*. They were sent out from specialized workshops, ready prepared on a plaster base inside a frame, and could thus be carried to the site and laid whole into their surround of *opus tesselatum*. To obtain a greater range of colour many other materials besides marble were used: semi-precious stones such as lapis lazuli, cornelian, or ALABASTER, and brightly coloured glass pastes of red, yellow, green, and turquoise. The glass was coloured chemically under heat, oxide of copper producing blue, for example, and chromium, green. It was allowed to cool into rounded slabs, from which the tesserae were chipped as if from marble. In *opus vermiculatum* the fragments were much smaller than in *opus tesselatum*, and were grouped according to the composition of the picture, like colours in a painting.

The origin of *opus vermiculatum* was in Egypt where the tradition of glass mosaic was oldest. Many *emblema* were exported from there to

Italy, and have been found in Rome, POMPEII, and Aquileia. Their subjects are most various: scenes from the theatre, mythology, GENRE, fish, birds, and animals, e.g. the cat with a captured dove from Pompeii (Naples Mus.) and the doves drinking from a vase (Capitoline Mus., Rome). Most of the *emblema* are fairly small, but large ones are found as well. One from Pompeii (Naples Mus., *c.* A.D. 75) occupied the whole of a large APSE and pictured the battle of Issus between Alexander and Darius; it was made in Alexandria and based on a Greek wall-painting of the 4th c. B.C. (see ALEXANDER MOSAIC). Another large mosaic from Egypt is the Nilotic pavement at Palestrina (Palazzo Barberini), near Rome, dating from the 2nd c. A.D., where a whole watery landscape is shown, dotted with islands and secluded temples and peopled with hunters, fishermen, crocodiles, and wild boar.

In large coloured floors the two kinds of mosaic tended to merge. In the rich series of mosaics at Antioch, dating from the 1st to the 6th c. A.D., there are few distinct *emblema*; glass tesserae and coloured marble are used together over the whole area in a unified pictorial design. Separate *emblema* became rare from the 2nd c.; and though plain marble and stone remained the basic materials, they were everywhere supplemented by coloured marble and glass. The glass was manufactured locally (at Gerasa in Palestine a smelting works has been found on the same site as the mosaics). Pavements of this type were made in all the Roman provinces. Examples in Britain are *Europa and the Bull* and other mythological subjects at Lullingstone, *Orpheus* at Woodchester, and *The Muses* at Aldeborough. Not all are pictorial; sometimes a design of vine or acanthus spreads over the whole floor, as in the prosperous villas of Roman Africa. The subject often suits the room: thus a meal is pictured in the banqueting hall of a villa at Antioch, and brawny athletes in the palaestra of Caracalla's Baths (see THERMAE) in Rome. The technique is appropriate to large scenes like the *Hunting of Wild Beasts* (*c.* A.D. 300) uncovered at Piazza Armerina in Sicily, or aquatic subjects, like that in the EARLY CHRISTIAN BASILICA of Aquileia, where the story of JONAH and the whale takes its place in a seascape of fish and fishing PUTTI. In 5th-c. pavements at Constantinople and Antioch scenes of hunting and country life are dispersed freely, as in a tapestry, inside frames of vine and acanthus.

In the last centuries of the Empire the subjects became stylized and the pictorial elements were treated more and more as part of an abstract design, as in the Phoenix mosaic from Antioch (Louvre). Purely decorative pavements of vine and acanthus or geometrical patterns became common, sometimes interspersed with tiny scenes of human and animal life. An extreme example is the late 6th-c. pavement at Grado on the north Adriatic, where the names of the DONORS are inscribed in geometrical frames over the whole area of the floor.

Wall mosaic, or *opus musivum*, was also used by the Romans in their houses, and Seneca writes of 'walls hidden by glass' as typifying the extravagant luxury of early imperial architecture. Since a high proportion of the tesserae are of glass paste, as in *opus vermiculatum*, this technique too probably came from Egypt. No large compositions have survived from the Roman period, but mosaics of coloured glass adorn doorways, pillars, and niches in Herculaneum and Pompeii; and others from the 2nd c. exist at Ostia, Aquileia, and Leptis Magna in Roman Africa. These are similar in both texture and design to the floor mosaics, and it is from this tradition that the earliest Christian wall mosaics developed. The spreading vine, often found in pavements of the 3rd and 4th centuries, covers the walls and vaults of a Christian mausoleum of *c.* A.D. 300 in the cemetery beneath St. Peter's in Rome; the story of Jonah is pictured on the walls, and on the VAULT the sun-god Apollo stands as the symbol of Christian salvation.

In spite of its similar appearance, *opus musivum* differed in technique from both types of floor mosaic, and it could also be more ornamental and expressive. But it was only after the reign of the emperor Constantine, and under the patronage of the Church, that its possibilities came to be fully realized. In wall mosaics greater use may be made of glass, which is not strong enough to be used extensively on floors; and the mosaics of the Christian period, which contained more and more glass tesserae, took on a new range and intensity of colouring. Gold tesserae too were introduced for the first time on a large scale, and became the customary background in church mosaics. The making of these required a special process, adapted from a technique used for decorating glass vessels. The gold, instead of being chemically fused with the paste like other colours, was applied in a fine strip to the concave side of a thin plate of glass, and fixed under heat. The resulting saucer was filled with molten glass and pressed while still soft into a flat slab, with the gold foil sandwiched inside it, ready for the mosaicist's hammer. Silver cubes made in the same way are occasionally found in Christian wall mosaics. Yet another material was terracotta. But the use of marble persisted in the landscape parts of narrative scenes and also for white robes, though for the latter opaque white glass often took its place; and pink and white marble, together with various shades of glass, rendered the flesh tones. The tesserae of Early Christian mosaic were irregular in shape and of fairly uniform size, but in later Byzantine work they became more regular and were graded in size to suit the work: those used in flesh modelling might be as small as $\frac{1}{8}$ in. across, while the largest, in robes or backgrounds, reached $\frac{1}{2}$ in. Christian mosaics rarely contained semi-precious stones used in *opus vermiculatum*, though the brooch of the emperor Justinian, in his portrait in S. Vitale at Ravenna, contains a large cornelian.

*Opus musivum* was also set in a special way.

The setting-bed, seldom deeper than 2 in., was laid in three layers. The first, attached directly to the masonry, was made of a strong, coarse cement, roughened to receive the second slightly finer layer: the top layer was prepared fine and smooth to receive the cubes. The consistency and strength of the cement determines the durability of the mosaic, and the layers tend to peel if not carefully keyed to each other and to the wall. (In order to protect the mosaics of St. Mark's in Venice a Decree was issued in 1648 forbidding the firing of salutes or fireworks in the Piazza, since this was found to be disturbing the cement.) The top layer was painted with FRESCO to guide the mosaicist in setting the tesserae, and these were laid directly into the plaster one by one, without previous arrangement, each colour being kept ready in a separate container. The work was probably divided between the fresco-painter and the cube-setter, and the mosaicists in Ravenna Cathedral are known to have worked in pairs. This method was used at least as early as the late 3rd c. A.D., and large patches of the underlying fresco may be seen in the funerary mosaic beneath St. Peter's, Rome, in the parts where the cubes have fallen away. The practice was passed down with few variations throughout the Middle Ages, though differences occur in the thickness of the various layers of cement and the manner of setting the cubes.

Wall mosaics, unlike pavements, need not be quite level, and here the technique of *opus musivum* allowed for a certain irregularity in the surface, producing a softness and variety of colour which no other method could achieve. This undulation was especially valuable in the large areas of gold which occurred in Byzantine mosaics; and in these the cubes themselves, as well as the bed, are set at different angles, so that the light reflected from the gold is thrown from one facet of the mosaic surface to another, giving an effect of vibration and life. When the tesserae are laid in flat sections on a canvas or paper backing, as is sometimes done in restoration and almost always in modern mosaic, the variations of colour are lost and the gold reflects a dead, metallic light. The reflecting power of mosaic also caused its effect to be enhanced when it was used on contrasting surfaces over a wide area, and the vaults and upper walls of a CHURCH constituted its ideal setting.

The Early Christian period (4th–9th centuries) was a time of rapid development in the art, and the mosaics of Pope Sixtus III in Sta Maria Maggiore in Rome (A.D. 432–40) show a marked advance on the traditional pavement style. Here both sides of the nave and the TRIUMPHAL ARCH over the altar are covered with scenes from the Old and New Testaments in which great use is made of brightly coloured tesserae while the more distant sky is gold. This golden light gives the scenes a transcendental and supernatural quality; and the angels, whose faces are of fiery orange tints, are also shown as part of the heavenly order. Although Hellenistic features persist in the landscape and figures, the mosaics of Sta Maria Maggiore no longer belong to the human world of the classical period; and in them one can already see how well the art of *opus musivum* could express the mystical visions of the Christian faith. Here, however, its potentialities were not yet fully realized, and the pictures lose much of their power through their small size and isolated position high on the walls. The role of mosaic was still secondary, and it was only in the smallest buildings, such as the Mausoleum of Galla Placidia in Ravenna, that it began to dominate the interior scheme. Another conservative trait is the blue glass background inherited from the classical period and common in Rome and south Italy as late as the 6th c.

The richest mosaics of the Early Christian period have been preserved in Ravenna, at that time the capital of the Roman Empire in the West. The mosaics of the emperor Justinian in S. Vitale (A.D. 530–50) reveal a new understanding of the art. The scenes are reduced to those elements necessary for telling the story and the figures underline its meaning with firm gestures. Facing each other on the walls of the presbytery, the emperor and empress offer gifts to the Church, accompanied by the archbishop and their courtiers ranged in a line towards the altar, against a background of gold and coloured glass. The bold decorative patterns on the ARCHES and vault follow and emphasize the lines of the building; and here for the first time mosaic and architecture play equal and complementary parts in the internal appearance of the church. The same is true of the mosaics of Bishop Ecclesius in S. Apollinare Nuovo, Ravenna, where two long lines of saints clothed in white move in rhythmical progress on a gold ground along the walls of the nave: their splendour arises not from the quality of the figure drawing, which is insubstantial and flat, but from the effect of colour and light, and the formal harmony between the line of saints and the colonnade below.

In the eastern Empire fewer Early Christian mosaics have survived, but the process of adaptation there was similar and perhaps more rapid than in Italy. Gold is first found in the mosaics of St. George in Salonika, dating probably from the early 5th c. A.D. Here stylized plant and bird designs from contemporary pavements decorate the lower arcade, while saints, framed in stylized architectural CANOPIES, stand stiffly facing out from the CUPOLA. The same formal and austere style is found in the mosaics of St. Demetrius in Salonika from the 6th and 7th centuries (many of which were lost in the great fire of 1917). Here there is no unified scheme but a series of small separate panels in which the donors are shown with the saint against a stylized architectural or landscape background. The dominating theme is the protection offered by St. Demetrius not only to the donors but to the whole city of which he was patron; and the FRONTAL stance of the saint puts

him in contact with the spectator, at whom he seems to gaze out from the wall. The desire to emphasize this sense of a direct visible contact between image and worshipper was a reason for the increasing use of such frontality in Byzantine art, and mosaic was particularly well suited for the expression of the HIERATIC religious attitude because its vivid decorative quality enhanced by contrast the austere pose of the figures and because its vibrant colours and shifting lights imparted to them an unearthly life and reality of their own.

Works like these in Salonika and other provincial towns in Cyprus, Palestine, and the West are all that remain to give us an idea of the Early Christian mosaics in the imperial city, Constantinople. For it was there, where the Iconoclast emperors ruled most strongly (see ICON), that religious art suffered its greatest losses. In Sta Sophia there remain a few decorative mosaics from Justinian's time, acceptable to the Iconoclasts because lacking in imagery. In Sta Irene, dating from the Iconoclastic period itself, there is a cross on a plain gold ground, the only image then permitted to religion. But the Iconoclast movement was not entirely negative in its effects, since the mosaicists, deprived of their subject matter, were led to explore the ornamental qualities of their medium. In Sta Irene they varied the gold ground by undulations in the plaster bed, by setting the rows of cubes at different angles, and by using several shades of gold, and it was at this time that the plain gold ground took its place as the chief decorative element in Byzantine mosaic.

Wall mosaics by Greek artists embellished the earliest MOSQUES of the Moslem invaders of the 7th and 8th centuries in Palestine and Syria. Following the Moslem prohibition (see ISLAMIC ART), these also contained no figures, but were rich in design. At Jerusalem scrolls and garlands, similar to those of the latest pavements at Gerasa, climb over the walls and ARCADES of the Dome of the Rock. The mosaics of the Great Mosque at Damascus show the same stylized plant patterns, in which gold, blue, and green predominate; but over the larger surfaces stretch uninhabited landscapes, rivers lined by huge trees, and oriental palaces of fantastic PERSPECTIVE, in which NATURALISTIC elements of the Greek tradition mingle with Eastern formalism in a style of unique and strange beauty.

The West, meanwhile, impoverished by barbarian invasions and the breakdown of the Empire, produced few mosaics, and those few largely dependent on Greek models. But in the early 9th c., when Rome became the spiritual centre of the western Empire revived by Charlemagne, a series of mosaics was produced in the Lateran Palace, Sta Prassede, and other churches, strongly reminiscent of the Early Christian period when Rome was still capital of the Empire. The mosaic with which Charlemagne himself adorned his palace chapel at Aachen has been lost; but a fragment from this time still remains in France, made by the CAROLINGIAN Bishop Theodulph for the little church of Germigny-des-Près near Orleans. The Western revival was short-lived, however; and it was in the East, after the final defeat of Iconoclasm in the mid 9th c., that the art reached its height.

In this period (9th-11th centuries) the whole interior of the church began for the first time to be drawn together in a unified scheme of decoration, to which the architecture was subordinate. The exterior was left almost unadorned. Inside the church was conceived as a cosmology, or epitome of the heavenly and earthly kingdoms, and the vaults and upper walls formed the setting for a hierarchy of sacred images, each facing out from its own section of the vaulting. Narrative scenes were few, and for the most part confined to the outer PORCH, or NARTHEX. The highest vaults were reserved for the figures of greatest importance; CHRIST Pantocrator in the central cupola, the VIRGIN in the apse, and the saints ranged in their established order below. The lower walls were faced austerely in marble, grey or dull green or red, from which the coloured glass mosaics shone out like gems; and the shifting brightness of the golden vaults lent them a rarefied mystical atmosphere, in which the images seemed to live in a world of their own, but in direct communion with their worshippers in the church below. The finest mosaics of the 11th c., at Daphni near Athens, Hosios Loukas in Phocis, and Nea Moni on the island of Chios, all follow this scheme. The remains of a similar mosaic series from the 11th and early 12th centuries have also been uncovered at Sta Sophia in Constantinople, where the upper galleries contain portraits of the emperors, the vice-regents of God on earth.

In later Byzantine churches of the 12th to 14th centuries narrative scenes became more frequent. They now illustrated not only the NATIVITY, TRANSFIGURATION, BAPTISM, and CRUCIFIXION, but also the Life and Miracles of Christ, and the Childhood of the Virgin. Such individual scenes became increasingly prominent at the expense of the unity and coherence of the scheme as a whole; and the narthex was often built very large, as at St. Saviour in Chora at Constantinople, in order to accommodate them. At this period framed and portable mosaic pictures were also made, as for example the DIPTYCH showing the Life of Christ (Cathedral Mus., Florence), and the icon of the Transfiguration (Louvre). In these the technique is similar to that of wall mosaics, but the cubes are minute and finely graded in proportion to the size of the picture, and set in wax instead of cement.

As pilgrims and crusaders spread the fame of Byzantium and its arts, Byzantine mosaicists were summoned to decorate more distant churches. At Kiev they made a series for the church of Sta Sophia in the mid 11th c. and for the monastery of St. Michael in the 12th; and

the Norman kings of Sicily called on Greek artists to decorate their newly built churches at Cefalu, Monreale, and Palermo. The style of these mosaics was not always purely Greek, since local craftsmen assisted. In Sicily the whole system suffered a change in its adaptation to the Western architectural style of the churches: the Pantocrator was placed in the apse, with the Virgin, APOSTLES, and other saints ranged below; the long walls of the nave were set with biblical scenes; and further decoration of a Moorish flavour, in carved and painted wood, stucco, and intarsia, competed with the mosaic for dominance.

Byzantine artists came to Venice c. 1100, and the Cathedral of St. Mark and the island churches of Torcello and Murano contain work by Greek mosaicists and their pupils dating from the 12th and 13th centuries. The architectural model of St. Mark's was itself Byzantine, and the mosaicists here imitated the Byzantine scheme, but with Western modifications in both style and content. In the 13th and 14th centuries the narthex was set with scenes from the Creation to the life of MOSES, by many different artists, in varying styles. By then most of the mosaicists in Venice were Italian, and the art became firmly established there in schools which have their descendants in the Venetian workshops of today. Their influence soon spread to Florence, where the Baptistery was decorated with scenes from the Bible, including a great *Last Judgement*; and from there to Pisa and Lucca. In Rome too the art was revived, and was used by GIOTTO, CAVALLINI, and TORRITI in St. Peter's, St. John Lateran, Sta Maria in Trastevere, and other churches.

Mosaic sometimes appeared on the outsides of churches, for example on the façade and end wall of Parenzo Basilica in the 6th c., and on the façades of Siena and Orvieto Cathedrals in the 15th. But as in Byzantium, so in Italy, the interior offered the best setting, and there mosaic played the same part as STAINED GLASS in the GOTHIC churches of the north. Like stained glass it was best suited to the simple figure style and narrative scenes of the Middle Ages, and its quality declined as the search for pictorial REALISM progressed. In Constantinople the Turkish conquest of the 15th c. forestalled this development. But Italian painters never lost interest in mosaic, which they valued for its durability and its association with antique art, regarding it as *pittura per l'eternità*, which should be adapted as far as possible to the style of contemporary painting in fresco and oil.

The Florentine painters GHIRLANDAIO and his brother Davide made several pictures in mosaic, including the *Annunciation* (c. 1490) over the north door of the cathedral in Florence. They were encouraged by Lorenzo the Magnificent to draw up a scheme for lining the whole interior of the dome with mosaic, but this project was never completed. In Rome the Chigi chapel in Sta Maria del Popolo was decorated by the Venetian mosaicist Luigi da Pace with a mosaic of the Creation (1516), after a CARTOON by RAPHAEL. In the 15th and 16th centuries several improvements were made in technique, including the invention of a stronger and lighter cement, in which powdered TRAVERTINE and lime were mixed with LINSEED OIL. A continuous effort was made to increase the number of colours and shades and to bring the art nearer to painting; and sometimes too paint was laid over the finished mosaic to soften the transition from one tone to another and enhance its plastic and ILLUSIONISTIC effect. These refinements, however, brought no improvements in artistic quality, as can be seen in the extensive repairs and additions to the mosaics of St. Mark's from the 16th c. onwards. In Rome too great efforts were made to imitate the style of contemporary painters, and the Vatican School of Mosaic, founded in the 18th c., employed several thousand tones to this end. Since the 18th c. Italian craftsmen have done much work abroad in Europe and America, but most of it has been disappointing. Too often they have worked from ready-made cartoons produced by local artists and executed the commission in their workshops rather than on the site, as in the case of the mosaics designed by WATTS and STEVENS for St. Paul's Cathedral in London (1863–92).

Among the most recent religious mosaics in London are those of Westminster Cathedral by Boris Anrep (1883–1969), Gilbert Pownall, and Anning Bell (1863–1933), set in a building which is itself of Early Christian and Byzantine inspiration. The TATE GALLERY and the NATIONAL GALLERY, London, contain several pavements made by Anrep in Paris (1936 and 1954). Mosaic has been used with varying success in many modern buildings in Europe and America, and often on exteriors, as for example on the new University Library of Mexico City (1953–4). In mosaic, as in stained glass, the symbolic and anti-naturalistic trend in modern art finds a more suitable medium of expression than did the earlier striving for realism. But one of the most successful modern works is that done by the Italian artist Venturino Venturi for the Pinocchio monument at Collodi in Tuscany (1953–5), where a low, undulating wall of mosaic, telling the story of Pinocchio in simple, brightly coloured scenes, surrounds an open courtyard in the hills.

61, 717, 742, 1120, 1434, 1656, 1690, 2571, 2705, 2951.

**MOSER,** GEORGE MICHAEL (1704–83). Goldsmith, enameller, and MEDALLIST, born at Schaffhausen. He came to London perhaps as early as 1720 and appears to have established a practice quickly. He was manager and treasurer of the St. Martin's Lane Academy from its foundation, a member and director of the Incorporated Society of Artists, and a foundation member of the ROYAL ACADEMY, of which he was first Keeper. He was drawing master to

George III in the latter's boyhood, and on his accession engraved the first royal seal.

His daughter MARY MOSER (d. 1819) was a flower painter, whose small pieces in the DUTCH manner were greatly esteemed. She exhibited at the Society of Artists 1760-8 and was a foundation member of the Royal Academy; at the Academy's troubled presidential election of 1805 her name was irresponsibly put forward as a candidate by FUSELI. Queen Charlotte employed her to decorate a room at Frogmore. In 1793 she married Captain Hugh Lloyd as his second wife.

**MOSER,** LUKAS. 15th-c. German painter. Though we know only one work by this master— the ALTARPIECE with the story of *Mary Magdalene and Martha* at Tiefenbronn, near Constance (signed and dated 1431), we must regard him as one of the most significant German artists of the early 15th c. He has much in common with WITZ who worked in Switzerland nearby and with Jan van EYCK. The vigour and plasticity of his figures, their grouping in space, and the interest in light and LANDSCAPE herald a new style.

The altarpiece has a curious inscription which runs 'schri kunšt schri vnd klag dich ser din begert iecz niemen mer' ('Cry out, art, cry out and wail! No one wants you now'). This may be no more than the lament of an underpaid artist, for there is no reason to suppose that there was then any lack of interest in art generally.

189.

**MOSES.** As witness and forerunner of the Messiah, leader of the chosen people and instrument of their salvation, Moses holds a prominent place in Christian art. When represented alone he appears as PROPHET or law-giver, usually bearded, holding either the tables of the law or the phylactery (a small box containing texts) which is a substitute for them (12th-c. figures at Chartres and Reims; SLUTER, *Puits de Moïse,* Dijon, 1405; REMBRANDT, Staatl. Mus., Berlin, 1659). The horns with which Moses is often endowed from the 12th c. onwards are the result of a mistranslation of Exod. xxxiv. 29 in the Vulgate. An early example occurs in the *Bible of Bury St. Edmunds* (Cambridge, c. 1148). MICHELANGELO also represented Moses thus (Tomb of Julius II, 1513). But Moses as a single figure did not appear until the Middle Ages, whereas scenes from his life were illustrated very early in the Christian era (frescoes in the Synagogue at Dura Europos, 245-6) and remained a frequent subject for painters as late as the 17th c. (POUSSIN, Louvre and N.G., London). The miracles were usually represented in the early period (mosaics of Sta Maria Maggiore and wooden doors of Sta Sabina, Rome, both 5th c.), but later art tended rather to emphasize his role of lawgiver and saviour of the Jews, prefiguring CHRIST as Saviour of mankind (The Brazen Serpent, doors

of S. Zeno, Verona, 12th c.). Scenes from Moses' life were prominent not only in medieval Bibles and Psalters (*Ashburnham Pentateuch,* 7th c.; *Queen Mary's Psalter,* B.M., early 14th c.), but also in RENAISSANCE frescoes (GOZZOLI, Campo Santo, Pisa, 1470; BOTTICELLI, PINTORICCHIO, and ROSELLI, Sistine Chapel, 1482; RAPHAEL, Vatican Loggie, 1516).

*Finding of the Infant Moses* (Exod. ii. 3-10). This scene is one of the most popular in all Christian art. It first appears at Dura Europos and is also found on the Lipsanotheca at Brescia (c. 370). Together with the exposure it was illustrated in the *Bible moralisée* of the Middle Ages, and various versions occur in the 16th and 17th centuries (VERONESE, several pictures; Rembrandt, Philadelphia, 1635).

*Moses and the Burning Bush* (Exod. iii). This scene is found at Dura Europos and in the Roman catacombs (cemetery of Callixtus, 3rd c.). A mosaic in S. Vitale, Ravenna (6th c.), shows Moses as a shepherd taking off his sandals before approaching the bush. In the Middle Ages the bush which burns without being consumed was seen as a symbol of Mary's virginity or of the Church undestroyed by the flames of persecution—meanings which are illustrated in the BIBLIA PAUPERUM and the SPECULUM HUMANAE SALVATIONIS. The story continued to be frequently represented until the 18th c.

*The Exodus.* The crossing of the Red Sea (Exod. xiv) is also represented at Dura Europos. It appears frequently on SARCOPHAGUS reliefs (*Red Sea sarcophagus,* Aix-en-Provence, c. 400), and in BYZANTINE MINIATURES (*Paris Psalter,* Bib. nat., Paris, 10th c.). In medieval thought it prefigured the BAPTISM and the saving of men's souls by Christ and therefore was often depicted on FONTS (Hildesheim, 13th c.).

*Moses Striking the Rock* (Exod. xvii. 1-7). This scene occurs over 200 times in the catacombs. There it is usually at its simplest—Moses holding the rod and the water flowing from the rock. But on sarcophagi a crowd of Hebrews hurries towards the water (Lateran Mus., Rome, 5th c.). In the Middle Ages this miracle became a symbol of the water of the Baptism and of the blood which flowed from the wound in Christ's side (13th-c. window, Bourges); its popularity lasted until the 16th and 17th centuries (TINTORETTO, Scuola di S. Rocco, Venice, 1576).

*Moses Receiving the Tables of the Law* (Exod. xix. 1-8). On sarcophagi of the 4th and 5th centuries Moses stretches out his hands to receive the roll from God. In the *Vatican Bible* (10th c.) the children of Israel look up in wonder from the foot of the mountain—an idea which is eloquently rendered by GHIBERTI on his second door of the Florentine Baptistery (c. 1436).

*The Transfiguration of Christ.* Moses was also a traditional figure in representations of the TRANSFIGURATION.

**MOSES,** ANNA MARY ROBERTSON called GRANDMA MOSES (1860-1961).

American painter, born in Greenwich, N.Y., of Scottish-Irish descent. Her first large picture was painted in 1918, when she also did a number of embroidered worsted pictures. She painted actively during the 1930s and held her first exhibition in a drugstore at Hoosick Falls, N.Y., in 1938. She was then 'discovered' by a collector, Louis J. Calder, and became internationally known as a modern PRIMITIVE. She had her first one-man show in New York in 1940 at the age of 80. In 1949 she was received at the White House by President Truman and in 1960 Governor Rockefeller proclaimed her birthday, 7 September, 'Grandma Moses Day' in New York State.

Grandma Moses painted scenes from her childhood and vanishing American occupations (*Catching the Turkey for Thanksgiving*) in a naïve style with bright and uncomplicated colours. From 1946 her works were reproduced on Christmas cards and elsewhere and achieved widespread popularity for their unsophisticated directness and the air of romance with which they invested humble scenes of provincial life.

**MOSQUE.** The Moslem place of public worship. Its main disposition results from the ritual practice of the Islamic religion. The *imam*, or leader of prayer, faces in the direction of Mecca and behind him are ranged the congregation, who copy his gestures and repeat his prayers. The wall nearest to Mecca is known as the *qibla* and in its centre is the *mihrab* or prayer niche. In the more important mosques there is also a pulpit, called the *mimbar* (see PULPIT). Attached to the mosque is the minaret or tower from which the crier (*muezzin*) summons the faithful to prayer at the prescribed times of the day.

The earliest mosque was the courtyard of Mohammed's house in Medina. The *qibla* end was provided with a shelter formed by a roof of palm leaves supported on palm trunks. But the first truly architectural mosques were built in the Umayyad period (A.D. 661-750). Their plan was an adaptation of the rectangular BASILICA, with nave and aisles, that first appears in HELLENISTIC architecture. The mosque is a rectangular court. On one of the sides is the aisled prayer hall: the aisles are either parallel or perpendicular to the *qibla* wall. The remaining three sides are provided with shallow PORTICOES. This is the plan of the Great Mosque of Damascus (A.D. 705). In other examples, such as the Great Mosques of Qairawan (836) and Córdoba (9th c.), the aisles are set at right angles to the *qibla*.

Another type is the cruciform plan, in which each side of the court contains a vast niche. This was evolved in Persia during the 12th c. and one of the earliest examples is the Great Mosque of Isfahan, rebuilt at that time. This type was also adopted by the Mamluks of Egypt.

A third type, in which a rectangular hall is surmounted by a great DOME, was much favoured by the Ottoman rulers of Turkey and was inspired by the Christian CHURCHES of BYZANTIUM like Sta Sophia, which was itself taken over as a mosque. A magnificent example is the Sulaimaniya Mosque in Constantinople (1550).

**MOSTAERT,** JAN (*c.* 1475-1555/6). Dutch painter born in Haarlem. He probably trained with GEERTGEN TOT SINT JANS, or at any rate was influenced by him, and he carried the traditions of 15th-c. Haarlem well into the 16th c. He was appointed painter to Margaret of Austria, Regent of the Netherlands, and accompanied her on her travels, making portraits of her courtiers. Possibly to satisfy his patron, Mostaert introduced RENAISSANCE motifs into his work, yet his meticulously executed portraits and religious panels retain the essentially Dutch characteristics of calmness and objectivity. Surprisingly Mostaert did pictures of the New World, which he can only have known from hearsay and perhaps sketches (*Landscape of the West Indies*, Frans Hals Mus., Haarlem, *c.* 1525-30). Many of his paintings were destroyed in the Great Fire of Haarlem in 1576, but a typical example of his portraiture is the *Man with the Tiburtine Sybil* (Brussels, *c.* 1525-30).

2085.

**MOTHERWELL,** ROBERT (1915- ). American painter, born in Aberdeen, Washington. At the age of 11 he obtained a fellowship to the Otis Art Institute in Los Angeles and in 1932 studied painting briefly at the California School of Fine Arts in San Francisco. In the same year he entered Stanford University and took a degree there in philosophy in 1936. In 1937 he continued his study of AESTHETICS at Harvard University and wrote a thesis on the aesthetic theories contained in the *Journals* of DELACROIX. After two years in Europe he entered Columbia University as a graduate student in 1940 and after becoming an intimate of the refugee artists then in New York decided in 1941 to devote himself to painting. Although deeply interested in the principles of SURREALISM, particularly automatism, his own work belonged to the school of ABSTRACT EXPRESSIONISM and he soon won recognition as one of the most significant of American artists. His first one-man exhibition was held in 1944 at the Peggy Guggenheim 'Art of this Century' Gallery in New York and included three COLLAGES, a technique which continued to be of especial interest to him and of which he wrote: 'The sensation of physically operating on the world is very strong in the medium of the papier collé or collage, in which various kinds of paper are pasted to the canvas. One cuts and chooses and shifts and pastes, and sometimes tears off and begins again. In any case, shaping and arranging such a relational structure obliterates the need, and often the awareness, of representation. Without reference to likenesses, it possesses feeling because all the decisions in regard to it are ultimately made on the grounds of feelings.' Motherwell continued

to write extensively on art and artists, directing from 1944 among other things a series of illustrated publications on modern art called *The Documents of Modern Art*. His attitude to Abstract Expressionism was put in a statement made in 1957 for the Exhibition Catalogue to an exhibition 'The New American Painting' at the Museum of Modern Art, New York. He said: 'I believe that painters' judgements of painting are first ethical, then aesthetic, the aesthetic judgements flowing from an ethical context. . . .

Without ethical consciousness, a painter is only a decorator. Without ethical consciousness, the audience is only sensual, one of aesthetes.' A retrospective exhibition was arranged by the Museum of Modern Art in 1965.

1937.

**MOULDINGS.** Architectural term for continuous curved surfaces leading from one surface to another or serving to give linear emphasis to a portion of a vertical surface. In classical

**Fig. 31.** CLASSICAL MOULDINGS

A. Ovolo (Greek) B. Ovolo (Roman) C. Cyma-recta or ogee D. Cyma-reversa or ogee E. Cavetto F. Scotia G. Astragal H. Torus J. Fillet band (running between mouldings)

**Fig. 32.** ENRICHMENT PATTERNS FOR MOULDINGS

A. Classical: *a.* egg-and-dart on ovolo *b.* anthemion on cyma-recta *c.* leaf-and-tongue on cyma-reversa *d.* bead-and-reel on torus; B. Romanesque and Gothic: *e.* billet *f.* nailhead *g.* dog-tooth *h.* chevron or zigzag *j.* beakhead *k.* ball-flower *l.* tablet-flower *m.* vine-scroll

architecture mouldings were used to resolve the change of plane from CORNICE to ARCHITRAVE, and at the CAPITAL and base of COLUMNS (see ORDERS OF ARCHITECTURE). In medieval buildings they were used chiefly at the base and capital of columns, on the voussoirs or wedge-shaped stones of ARCHES, and to articulate large wall surfaces. They are similarly used in the decoration of furniture, metal-work, etc.

Classical mouldings were built up of simple curves which in strong sunlight give sharp contrasts of light and shade. Balance and stability were provided by flat strips called FILLETS, either vertical or horizontal, set between the curved mouldings. Where greater enrichment was required, as between the VOLUTES of the Ionic capital, the mouldings were carved with a repeating ornament such as 'egg-and-dart' or 'bead-and-reel'.

In ROMANESQUE architecture ornament was concentrated on the orders or concentric rings round the arches and a variety of carved mouldings were developed, ranging from geometric shapes, such as the 'dog-tooth' and 'chevron', to stylized forms such as the 'beakhead' and figure sculpture as in the angels on the voussoirs of the façade of S. Trophime, Arles. With the Cistercian reforms and their demand for greater austerity (12th c.), figure carving was replaced by curved mouldings and in EARLY ENGLISH buildings the capitals and bases of PIERS, as

well as the voussoirs of the arches, were often a complex system of curved mouldings made more interesting by deep undercutting. Similar mouldings were used to tie the shafts to the body of the pier and to define the horizontal divisions of the walls of churches. Every structural member was refined by mouldings—the window TRACERY, the ribs of VAULTS, the surface PANELLING, and string courses of walls.

Subsequent architectural decoration has been dependent to a large extent on the basic forms of classical and medieval mouldings, with the variety in detail and proportion which stamps each period. But in the 20th c. architects have tended to dispense with mouldings altogether or to simplify them in keeping with the functional styles of buildings.

**MOZARABIC.** The name 'Mozarab' was given to the Spanish Christians who endeavoured to maintain their traditional faith and culture, resisting complete absorption, under Moslem rule. The term 'Mozarabic' is also applied to the characteristic art and architecture which they developed and which persisted alongside ISLAMIC ART in Spain until it was gradually superseded by the ROMANESQUE in the 11th c.

The Christians living under Moorish rule were allowed under certain conditions to practise their faith and to build places of worship. There grew up what was virtually a hybrid between a

**223.** Horseshoe arches in the nave of the church of S. Miguel de Escalada, León (early 10th c.)

traditional folk art and the brilliant manifestations of the dominant Islamic style. It has been described as the most anarchic and exaggeratedly individual art style that has existed anywhere. As religious resistance stiffened in the second half of the 9th c. and toleration gave place to suppression, there began a steady migration of Mozarabs from the south to the independent Christian kingdoms in the north of the Peninsula. Established there, the Mozarabic art began to assume clearer definition as an identifiable form distinct from Spanish Islamic on the one hand and from survivals of the VISIGOTHIC traditions on the other.

Few relics survive of churches built in Moslem territory, the chief example quoted being the ruined church of Bobastro built by the architect Tachubí for Omar-ben-Hafsún in the mountains of Málaga. Toledo enjoyed a period of semi-independence from 852 to 932 and it may be that the church of Sta María de Melque, whose ruins may be seen near Montalbán 36 kilometres from the town of Toledo, dates from this time. The largest surviving monument of Mozarabic architecture is the BASILICA of S. Miguel de Escalada near León, founded by refugee monks from Córdoba and consecrated in 913. The three naves are separated from each other by ARCADES comprising five bays of horseshoe ARCHES on marble COLUMNS with beautifully carved CAPITALS, some of which are of similar design to Moorish capitals in the MOSQUE at Córdoba. In Mozarabic churches cruciform as well as basilican plans occur with horseshoe APSES derived perhaps from the *mihrab*, or prayer recess, of Islamic mosque architecture. Other Islamic features include the ribbed 'melon' DOME, the twin-light window or AJIMEZ, and the horseshoe arch, sometimes set in a rectangular frame (ALFIZ).

Not least among the activities of the Mozarabs was the creation and enlargement of monastic libraries. There emerged a school of MINIATURISTS and manuscript ILLUMINATORS with a distinctive style combining certain elements of Islamic ICONOGRAPHY and design with Christian themes. Most important is a series of *Beatos*, or illustrations to the commentaries of Beatus of Liébana on the *Book of Daniel* and the *Apocalypse* painted mainly in the 10th and 11th centuries.

There was some interaction between this Hispano-Arabic art and artistic currents elsewhere in Europe. Under Alfonso VI of Léon and Castile (1065–1109) the schools of learning at Toledo attracted scholars from all over Europe, including England and Scotland. The *Roda Bible* from Catalonia, a late example of Mozarabic illumination, has affinities with the rolling ground-line, fluttering drapery, and vigorous movement which characterized the English style in the second half of the 11th c. And in its turn Mozarabic art transmitted Islamic features to European ROMANESQUE. The TYMPANUM at MOISSAC represents CHRIST holding court like an Umayyad or Buwaiyid prince and the flattened draperies are in the same tradition as a series of ivory panels on caskets at Oviedo and S. Millan de Cogolla from *c.* 1070 to 1100.

**MU CH'I** (active mid 13th c.). Chinese painter from Szechwan who spent much of his life as a Ch'an (Zen) monk in a temple near Hangchou. He was one of the leading exponents of the 'ink splashing' (*p'o-mo*) style and was an advocate of the 'worn-out brush' manner, a technique used to obtain splayed strokes in order to give a free and unconstrained effect. He was sometimes considered the greatest master of the Sung 'flower-and-bird' school in impressionistic ink monochrome. In LANDSCAPES he suppressed the linear graphic element in favour of ink washes applied in patches like paint and by subtle gradations with the colour of the paper to create the impression of volume standing out from a hazy atmospheric background. His work had a great influence on Japanese painting.

**MUDÉJAR.** A term in art history for a style of architecture and decorative art, part ISLAMIC and part GOTHIC, which grew up in Spain and Portugal during the gradual reconquest of the Peninsula from the Moors (12th–15th centuries). The word 'mudéjar' is derived from the Arabic word for 'vassal' and was originally applied to the characteristic style of work executed by Moslem craftsmen for Christian masters. It has since been extended to cover later Spanish work in the Islamic tradition, especially brick, plaster, wood, and tile treated in the Moorish manner.

**224.** Detail from the tower of S. Salvador, Teruel, showing *ajaracas* (13th c.)

Mudéjar styles also occur in book-binding, textiles, ceramics, ivory, furniture, and inlays of wood (*taraceas*) and metal (damascene work).

There are several important mudéjar palaces. The most elaborate is the ALCÁZAR at Seville, which was begun by Peter I of Castile (1350–69) on the site of a 12th-c. Moorish palace, and is almost purely Islamic. The palace of Sintra near Lisbon, on the other hand, is basically Gothic and its Islamic features, notably the twin-light windows (AJIMECES), were not introduced until the early 16th c. when Manuel I of Portugal (1495–1521) altered and enlarged the building. Other striking examples of mudéjar architecture are the 13th- to 14th-c. SYNAGOGUES (subsequently converted into the churches of Sta María la Blanca and El Tránsito at Toledo), and the magnificent Aragonese belfry towers of the 13th–16th cen-

turies at Teruel, Saragossa, Calatayud, and elsewhere. These towers follow the design of Moorish minarets. They are built of brick, are square or octagonal in shape, and are decorated with intersecting blind ARCADES, low RELIEF trellis patterns (*ajaracas*), and glazed plaques.

Mudéjar modes of architectural decoration contributed to the MANUELINE and PLATERESQUE styles, in which Gothic and RENAISSANCE motifs are treated in a way which strongly reflects inherited Islamic taste. As examples of the persistence of mudéjar influence in Spanish and Portuguese architecture may be quoted the widespread decorative use of the AZULEJO and constructional features such as the lattice shuttered balcony (*muxarabi*), the ornate Moorish system of roof framing (ALFARJE), and the panelled wooden ceiling (*artesonado*) painted, gilded, and decorated with geometrical patterns of interlacing laths (LACERÍA) or coffered. Features of the mudéjar style also spread in the 16th–18th centuries to much of the architecture of Spanish and Portuguese America.

1498, 1536, 2054.

**MUDRA.** In INDIAN and Asian art, a symbolic conventional gesture of the hands. Among the most common *mudras* are:

226. Buddha in position of *Abhaya-mudra*, seated on a lion throne. Stone sculpture from Bodh-Gaya. (B.M., 10th c.)

225. Octagonal tower of S. Andrés, Calatayud (14th c.)

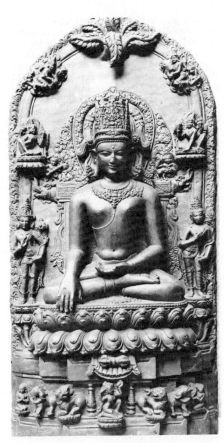

**228.** Bodhisattva Avalokitesvara seated on a lotus throne. Right hand in the position of *Varada-mudra*. Bronze sculpture from north-eastern India. (B.M., 10th-11th c.)

**227.** Buddha in the position of *Bhumispársha-mudra*, seated on a lotus throne surrounded by attendant Bodhisattvas, and celestial beings. Black carboniferous sculpture from Bengal. (V. & A. Mus., late 11th c.)

*Abhaya-mudra*: The right hand (or in Thailand sometimes both hands) raised with palm turned outwards. A gesture signifying the protection of the faithful and dispelling fear.

*Anjali-mudra*: The two hands palm to palm pointing upwards with fingers extended. A gesture of reverence.

*Bhumispársha-mudra*: The right hand resting on the right knee and hanging down with fingers, or the middle finger, touching the earth. Gesture most common in images of the Buddha, signifying the Buddha calling the earth to witness his good deeds when tempted by Mara.

*Dharmacakra-mudra*: The hands raised to the breast with the fingers indicating the motion of a wheel. Gesture reminiscent of the First Sermon of the Buddha and signifying the setting in motion of the Wheel of Doctrine.

*Dhyana-mudra*: Hands in the lap with palms turned upwards. Gesture signifying meditation.

*Varada-mudra*: Right hand resting on the knee with palm turned outwards. Gesture indicating compassion and the bestowal of favours.

*Vitarka-mudra*: Right arm raised (or in Thailand sometimes both arms raised) with finger and thumb forming a circle. Gesture indicating exposition of doctrine.

2396.

**MULREADY, WILLIAM** (1786-1863). Irish-born painter, pupil and brother-in-law of John VARLEY. He specialized in GENRE paintings of contemporary life in the vein made popular by WILKIE. A meticulous technician and draughtsman, he first followed the DUTCH and FLEMISH 17th-c. manner; but after 1816 he painted more brilliantly and thinly, conferring a special poetic quality on the incidents he depicted by unusual combinations of brown, green, and violet. He was a friend of John LINNELL and in his youth he did book illustration for William Godwin. He is well represented in the Sheepshanks Collection, Victoria and Albert Museum, London.

**MULTSCHER, HANS** (*c*. 1400-67). German (Swabian) painter and perhaps also sculptor. His heavy, rounded figures with their rather ugly faces are a somewhat coarsened German version of contemporary Burgundian art (see BURGUNDY, School of). His most important works are the Wurzach ALTARPIECE of 1437 (Berlin) and the High Altar in Sterzing (Tyrol) of 1456.

1020, 2179.

**MUMMY PORTRAITS.** The full-face portraits on some mummies of the Roman period (2nd and 3rd centuries A.D.), the majority from the Faiyum, are quite un-Egyptian in inspiration. They were executed in TEMPERA or, more usually, in wax (the so-called ENCAUSTIC technique), sometimes on the actual linen wrappings but generally on wooden panels bound into them. The panel, its grain vertical, was normally about 17 by 9 in. and $\frac{1}{16}$ to $\frac{1}{4}$ in. thick, roughly trimmed round at the top, though some portraits seem originally to have been larger and were perhaps not made expressly for the mummies (one has been found framed). The ground was prepared with a thin coating of GYPSUM or whiting, and on this the subject was outlined in black, or more rarely in red, with facial details indicated. The background, commonly grey, was then brushed on quite thinly with liquid wax, and the drapery and hair were similarly applied. The flesh tones, which never reveal fresh brush marks, were treated rather differently. The wax was laid on in a thicker and more creamy state, a characteristic ridging suggesting that it was brushed continuously until it congealed or that a blunt rounded implement was used—possibly the butt end of a brush or one with fibres stiffened through repeated use. Outlines were finally softened by scraping through the paint with a hard point, but there is no evidence that a spatula or palette knife was used at any stage.

**MUNCH, EDVARD** (1863-1944). Norwegian painter who was considered one of the main modern interpreters of the ancient Nordic spirit and who also became one of the chief sources of German EXPRESSIONISM. After early studies at Oslo he travelled extensively in France, Italy, and Germany until 1908, when he suffered a serious mental illness. The remainder of his life was spent in Norway. From the time of his first visit to Paris in 1885 the manner of his work was influenced by the IMPRESSIONISTS and after 1890 by the NABIS and POST-IMPRESSIONISTS, particularly van GOGH, GAUGUIN, and TOULOUSE-LAUTREC. But his subjects had an uninhibited and almost neurotic emotionalism which anticipated the later Expressionist movement (*The Sick Girl*, 1886; *Spring*, 1889; *The Day After*, 1886, preserved only in later versions). The violence and hysteria of his work appeared also in WOODCUTS and engravings. In 1892 he exhibited more than 50 pictures at the Künstlerverein in Berlin and these made such an impact that the exhibition had to be withdrawn. It was one of the causes which led to the formation of the Berlin SEZESSION group.

During the 1890s he was occupied with a sequence of pictures which he called the 'Frieze of Life'—'a poem of life, love and death'—which had affinities with the early style of ART NOUVEAU but had an intense emotionalism foreign to most manifestations of *art nouveau*. Twenty-two of these paintings were exhibited in Berlin in 1902. They were executed in deep colours, and were imbued with the anguished and sensual symbolism of the time. Several of the subjects, e.g. *The Kiss* and *The Shriek*, were also translated by Munch into ETCHING, LITHOGRAPHY, or woodcut—arts in which his summary manner was to be felt as revolutionary. The woodcuts, in particular, had a wide influence.

After his return to Norway in 1908 his art became more extroverted. In landscapes, portraits, and pictures of workmen in the snow, his technique grew more and more sketchy and energetic, his palette bright and vigorous. The great achievement of this period was a series of large oil paintings for the University Hall of Oslo (1910-15) exalting the positive forces of nature, science, and history. In 1916 he settled at Ekely, Oslo, thenceforth living a solitary life. During the 1920s his art again became strongly emotional, harking back to the symbolism of his earlier days. Indeed his work never lost its violently evocative character, and the passion for visual symbolism expressive of strong emotion may be seen even in the last of his numerous self-portraits, *Between the Clock and the Bed* (Oslo, 1940).

Munch is the most powerful of modern Norwegian artists and his work was one of the starting-points of one trend in contemporary painting. His influence has been strongest in Scandinavia and in Germany, where he and van Gogh are regarded as the two founders of Expressionism.

93, 236, 708, 1343.

**MUNICH, ALTE PINAKOTHEK.** Picture gallery which until 1918 was in the private ownership of the former ruling family of Bavaria, the Wittelsbachs, and which with the DRESDEN GEMÄLDEGALERIE is one of the richest of the princely collections of Germany. Its nucleus was a KUNSTKAMMER formed by the Dukes Wilhelm IV (1493-1550) and Albrecht V (1550-79). The Archduke Maximilian (1597-1651) founded the *Kammergalerie* or Court Gallery in the Residence at Munich. He commissioned four hunting scenes from RUBENS and had an outstanding collection of DÜRER. The Flemish paintings in the collection were notably increased by the Archduke Max Emmanuel (1679-1726), Regent of the Netherlands, who among other things acquired Rubens's sketches for the Medici cycle, TITIAN's *Crowning with Thorns* and *Portrait of Charles V* (now in the N.G., London), and TINTORETTO's GONZAGA cycle. Early in the 19th c. the Dutch and Flemish collection of Johann Wilhelm of the Palatinate branch of the family (1619-1716) and Italian works of his wife Anna Maria Luisa Medici were incorporated with the Munich collection. Ludwig, first king of Bavaria (ruled 1815-48), added a fine collection of Italian PRIMITIVES and had the building designed by KLENZE in the style of a late RENAISSANCE palace. The Pinakothek is notable particularly for its collection of works by Rubens.

**MUNKÁCSY,** MIHÁLY VON (1844-1900). Hungarian painter. His real name was LEÓ LIEB, but he took the name of his birthplace. After training in Budapest, Munich, and Düsseldorf Munkácsy settled in Paris. His theatrical costume pictures (*Milton and his Daughters*, Lenox Library, New York, 1877-8) were enormously popular in their day, but Munkácsy did more lasting work in GENRE and LANDSCAPE. He was much admired by LEIBL and LIEBERMANN. In Paris he had little contact with his French colleagues and it seems worthy of note that he despised the IMPRESSIONISTS and abused MANET.

**MUNNINGS,** SIR ALFRED JAMES (1878-1959). English painter who specialized in the painting of horses, especially race-course scenes, and LANDSCAPE. He painted 45 pictures of the First World War for the Canadian Government. He was President of the ROYAL ACADEMY, 1944-9, and was one of the most outspoken opponents of modern art in England.

**MURILLO,** BARTOLOMÉ ESTEBAN (1617-82). Spanish painter. Born at Seville, he spent most of his life there, working principally for religious houses. He was brought up in the NATURALISTIC style of painting then prevailing at Seville and may also have seen there works of RUBENS, van DYCK, RAPHAEL, and CORREGGIO.

The naturalism and CHIAROSCURO of his early style are illustrated by *S. Diego de Alcalá feeding the Poor* (Academy, Madrid), one of a series on the lives of the Franciscan saints painted for the convent of that order at Seville (1645-6). This work, although rather awkward in composition, may be compared with VELAZQUEZ's early *Bodegones*; but at the same time it anticipates the new type of pure GENRE which Murillo introduced in his pictures of poor children. An early realistic example is *The Ragged Boy* (Louvre), while the idealized children portrayed in *The Flower Girl* and *Peasant Boys* (Dulwich) demonstrate his later and more characteristic manner. To the same category belongs the well known painting of two young women at a window, *Las Gallegas* (N.G., Washington). His fame outside Spain first derived from his many pictures of this type. Though not well known as a portraitist, he executed several masterly portraits such as *Canon Miranda* (Alba Coll., Madrid).

In his religious paintings Murillo appealed to the popular imagination of his time by his idealized treatment of such favourite devotional subjects as *The Immaculate Conception*, of which numerous versions are extant. He early departed from the naturalistic manner in which he had been trained, developing greater transparency of colour, soft rounded outlines, increased depth of background, and atmospheric effects. The extensive series of paintings which he undertook for the Capuchin convent at Seville (1665-70; now in Seville Mus.) and for the Hospital de la Caridad in the same city (1670-4) illustrate the increasing lightness and fluency of his colour and technique. In his last works, such as the *Two Trinities* (N.G., London), the sweet expressions and graceful attitudes of his figures, surrounded by vaporous clouds, anticipate the ROCOCO of the 18th c.

In 1660, with the collaboration of VALDÉS LEAL and Francisco HERRERA the Younger, Murillo founded an ACADEMY of painting at Seville and became its first president. He died at Seville in 1682, apparently from the after-effects of a fall from scaffolding while painting a *Marriage of St. Catherine* for the Capuchins in Cadiz. He had many assistants and followers, and his style continued to influence Sevillian painting throughout the 18th c.

**MUSEUMS AND GALLERIES.** A museum generally is an institution, or building, where either works of art or antiquities are kept and displayed. In Great Britain the word 'museum' generally carries an implication that ethnological or antiquarian interest predominates and 'art gallery' is used where the emphasis is placed on pictures and sculpture. But this distinction has no historical basis. In Greece the *mouseion* was originally a temple of the Muses, then a place dedicated to the works of the Muses. It came to signify an institution dedicated to learning, literature, and the arts. The most famous 'museum' of antiquity was the literary academy founded at Alexandria by Ptolemy II in the 3rd c. B.C. The origin of the picture gallery as distinct from the museum is sometimes traced to the Pinacotheca (a word still in use), a part of the PROPYLAEA of the ACROPOLIS at Athens where pictures by POLYGNOTUS were displayed. In Rome also colonnades were used for displaying paintings.

With the revival of private COLLECTING, particularly of relics of classical antiquity, at the RENAISSANCE the word 'museum' came to denote the study of a humanist scholar or prince, where he surrounded himself with ANTIQUE GEMS, coins, portraits, inscriptions, manuscripts, etc. First in Italy and by the middle of the 16th c. also in the north both ancient and contemporary works of art began to be collected for their aesthetic qualities rather than solely for antiquarian interest. The criteria of the late Renaissance collector formed the starting-point for the modern museum or art gallery and many of the collections themselves became the nucleus of national collections (LOUVRE; UFFIZI; VATICAN).

The democratic ideas which followed the French Revolution coincided with a transference of official collecting from an aristocratic privilege to a public right. The change went along with a new national pride of possession and a growth of interest in the national past. In the countries conquered by Napoleon the treasures of the dispossessed royal houses and of secularized monasteries and churches were handed over to public ownership. (See RIJKSMUSEUM; BRERA; ACCADEMIA DI BELLI ARTI.) Other rulers

voluntarily turned their inherited collections into public museums and galleries. The NATIONAL GALLERY, London, was founded as a result of public pressure arising from a growing awareness of the richness of English private collections and a fear that their sale and dispersal would result in national loss. Another stimulus to the public museum came from educational interest connected closely with the spread of industrialism. The Conservatoire des Arts et Métiers was founded in 1793 and the Musée des Arts décoratifs became an important part of the Louvre. The VICTORIA AND ALBERT MUSEUM and several of the English provincial museums owe their origin to the state schools of design. (See ART EDUCATION.)

Museums gradually became centres for the study of taste and ethnology combined. The old court custodians, who had often been artists, were replaced by learned curators and a new branch of knowledge and specialization was created based on the museum and gallery. Catalogues from being little more than inventories became the object and expression of the specialism combining art history, attribution, CONSERVATION, history of taste and styles, together sometimes with a modicum of aesthetic discrimination. In the 20th c. revolutionary ideas of display have invaded many of the public museums and galleries with emphasis increasingly upon the aesthetic rather than the antiquarian interest.

Newer foundations, particularly in the Americas, have favoured modern architectural designs with facilities for display intended to encourage rather than overawe the public and with ancillary services such as lecture rooms, concert halls, libraries, laboratories, restaurants, and so on. The industrial magnate has to some extent taken the place of the prince or aristocrat and many of the newer public galleries and collections, particularly in the Americas, are the result of private gifts. Examples are the Mellon Gallery in Washington, the Frick Collection in New York, the São Paulo Museum in Brazil. The public institution has also become to some extent a patron of contemporary art, as the Contemporary Art Society founded in 1909 and the Friends of the Tate Gallery formed in the 1950s for the purchase of works of art for the TATE GALLERY from private contributions.

**MUTULE.** See ORDERS OF ARCHITECTURE.

**MUZIANO,** GIROLAMO (1528–92). Painter and engraver of Brescia. He combined the local tradition of his master, Romanino (c. 1484–c. 1562), with TITIAN's feeling for colour and LANDSCAPE (*St. Jerome*, Accademia Carrara, Bergamo). About 1548 he visited Rome, where he came under the influence of MICHELANGELO and RAPHAEL. Throughout his life he made much use of his native mountain scenery.

598.

**MYCENAEAN ART.** 'Mycenaean' is the name applied, since Schliemann's first discoveries at Mycenae in the 1870s, to the art and civilization of the Late Bronze Age (Late Helladic Period) in Greece. This may be subdivided as follows:

Mycenaean or Late Helladic I, c. 1580–1500 B.C.
      ,,       ,,      ,, II, 1500–1400 B.C.
      ,,       ,,      ,, III, 1400–1100 B.C.

Mycenae in the Peloponnese was the chief centre of this civilization, which in L.H. III eclipsed that of MINOAN Crete and extended its artistic influence all over the Aegean and as far as Cyprus and beyond. In its origins Mycenaean art owes much to Minoan, but it cannot be understood without some reference to the Middle Helladic (Middle Bronze Age) period, when the first foundations of the Hellenic race were laid. Artistically we best know the invaders whose coming marks the beginning of the Middle Helladic period (c. 1900–1600 B.C.) by their Minyan POTTERY, plain silvery grey in colour, dignified in shape, smoothly and meticulously made on the wheel. It is austere and (till its companion, yellow Minyan, appears) cold, but not lifeless; it shows a disciplined restraint which remains a significant ingredient in both Mycenaean and later Greek art. Alongside it there developed matt-painted ware, decorated with simple linear designs marked (in contrast with Minoan) by their structural relation to the parts of the vase rather than by any subtlety of rhythm or imagination. Not till towards the end of the period does warmth of polychrome decoration show itself, along with occasional cheerful bird motifs, introduced perhaps from the CYCLADES. Then suddenly some revolutionary change, the nature of which is still a matter for speculation, opened the way to a flood of Minoan influences. Whatever the cause, the result was a rapid artistic *rapprochement* between Crete and the Greek mainland, richly illustrated by Schliemann's famous finds in the Mycenae Shaft Graves (c. 1600 B.C.). Here were pottery and vessels of gold and silver, some purely Middle Helladic in style, some purely Minoan (L.M. I), others a blend of the two. Essentially it is this blending which produced the art we call Mycenaean. Yet there was much also that is neither Middle Helladic nor Minoan in style and inspiration. Above the graves stood stone slabs rudely carved in RELIEF with scenes of chariot-driving and fighting. These had no antecedents of technique or subject either in mainland Greece or in Crete. Again the daggers from the graves, with pictorial inlays in precious metals and niello, represent a highly developed technique of unknown derivation. Minoan style has been recognized in one which shows leopards chasing water-fowl in beds of papyrus; but the subject suggests EGYPT rather than Crete, and there is nothing Minoan about the lion-hunt scenes which adorn another. The same is true of the siege scene shown in relief on a fragmentary

silver funnel. We must look for some other influence, presumably among the sophisticated cultures of the Near East. But the general character of the profuse display of wealth in these graves is barbaric. The kings of Mycenae had come suddenly into wealth and magnificence; the patrons were less cultivated than the artists working for them.

In the centuries that follow (*c.* 1600–1400 B.C.) the new Mycenaean art was consolidated and refined. As always, the pottery is our best illustration of the trend. Yellow Minyan, technically superior to anything yet produced in Crete, is enhanced by the addition in a glossy black or red-brown paint of Minoan ornament, which acquires a fresh discipline in Helladic hands, a discipline that even had its counter-effects at Knossos. The Palace Style of the 15th c. was virtually common to both centres, and as much Helladic in spirit as Minoan; the Ephyraean goblets, however, with their single flower in a plain field, are essentially Helladic, and Minoan imitations were a failure.

In other spheres surviving remains are less plentiful. The early Mycenaean palaces have been obscured by later rebuilding; and we have mere fragments of their FRESCOES, though enough to prove strong Minoan influence. Of work in precious metal the gold cup from Dendra, with sprawling octopods in repoussé, is perhaps an heirloom from this age. In carved IVORY there is nothing to surpass a delicate little statuette group of two women and a child from Mycenae. Is it a domestic scene merely: or some holy family such as Demeter, Persephone, and Triptolemos?

So for a while Mycenaean and Minoan art ran neck and neck. In some genres they should perhaps be regarded as one. Crete was the more imaginative partner; but Mycenaean discipline brought new possibilities to the Minoan repertory. The results of the collapse of the Cretan centres about 1400 B.C. were inevitable: Mycenaean art survived by living on its own inherited capital of decoration. As though determined not to waste it, the potter, whose art was rapidly becoming an industry, confined free-hand decoration to a single flower or other device, progressively stylized, on the shoulder of the pot, and achieved his main effect by the use of well grouped horizontal bands and stripes, painted on the wheel. The effect is not barren, as might have been expected; for the pot shapes are excellent and the decoration is delicately related to them. The most characteristic shapes are the stirrup-jar (*Bügelkanne*, false-necked jar), a globular or pyriform bottle with two vertical handles attached to a small closed neck and a short tubular spout a little to one side; and the kylix, a tall-stemmed goblet. These wares won acceptance even at the hypersophisticated court of Tell-el-AMARNA in Egypt (*c.* 1375–1360 B.C.). Other arts, free from any such mechanizing influence as the potter's wheel, were far less rapid in the flight from NATURALISM. We have plenty

of work that argues a lively school of ivory carving. Here objects such as sword-pommels, mirror-handles, toilet-boxes, as well as inlays on furniture, gave scope for self-contained relief groups, among which a favourite theme was a lion or a griffin pulling down its prey. But we also see established a repertory of conventional decorative motifs. In fresco there was still originality in subject: scenes of fighting and hunting were, to judge from fragments, developed in quite elaborate compositions on the palace walls at Mycenae and Tiryns. Yet here too the stylizing force is apparent, most clearly in unrealistic colour conventions and in the formal treatment of landscape detail of rocks or plants. In some directions the formal spirit of Late Helladic art gives it a certain strength. The treatment of the Tiryns plaster floor in a chequer pattern charged with alternating octopods and pairs of dolphins is masterly. And the confronted lions carved in deep relief above the gate of the Mycenae citadel are not merely 'heraldic'; they have life and power. Their nearest equivalent at Knossos, the fresco griffins that flanked the throne of Minos, are flat and dull by comparison.

It is in architecture that the constructive discipline of Mycenaean art finds its greatest scope. Despite the Minoan features of the palaces at Mycenae, Tiryns, and Pylos in Messenia, we notice foremost of all a non-Minoan centralization in the planning, with the simple old-fashioned *megaron*, the great hall of a heroic community, as the focus. And in the great beehive TOMBS we have masterpieces of engineering which are also masterpieces of art. The structure of the circular underground chambers is based on the elaboration and perfection of the corbelled VAULT. They have been found at sites all over the southern Greek mainland; only one or two in Crete. Of nine at Mycenae itself the finest is the 'Treasury of Atreus' (*c.* 1360 B.C.) with a vault over 45 ft. high and 45 ft. wide. The entrance façade was adorned with relief carving, mainly geometrical, substantial parts of which are in the British Museum (others in Athens). But this kind of architecture has beauty and dignity independent of superficial ornament. It is at once powerful and refined. It is inspired by the same spirit that later produced the PARTHENON. The fructification of this artistic skill was due to external stimuli—Minoan Crete and the contemporary cultures of the Near East—just as classical GREEK ART was preceded by an orientalizing period. But the power of harnessing and civilizing these exotic elements seems peculiarly Greek.

In the eastern contacts of Mycenae, Cyprus was an important intermediary. Though not fully Hellenized, it received enough settlers for there to arise a separate school of Cypriot Mycenaean pottery, closely linked to the homeland but with some fashions of its own, notably a figured style in which chariot scenes and friezes of animals gave scope for free drawing denied

to the metropolitan Mycenaean potters. Occasionally the subjects suggest inspiration from major fresco painting; but whether such models were actually to be seen in Cyprus we do not know. The animal subjects almost certainly owe something to the East, and conceivably to textiles; and in its turn the Mycenaean pottery traded round the Levant left some marks on indigenous wares. In Cyprus especially we can see how the more expensive arts—work in precious metals and ivory—tended, as so often, to be somewhat cosmopolitan. It is difficult to estimate to what extent, for example, the silver bowl from Enkomi with gold and niello inlay (now at Nicosia) is to be called Mycenaean. The bulls' heads on it are an Aegean motif, the lotus buds Oriental; and as to the technique, we know that Syrian goldsmiths were famous in this age. If Mycenaean ivories in Cyprus show a mixed style, it need not surprise us; for Syria was probably the source of the raw material, and points of technique and style would tend to be exported with it.

The prosperity of Mycenaean art was inevitably bound up with this eastward intercourse and with the stability of the Mycenaean world as a whole; and the 12th c. B.C., unsettled by major political and military disturbances of which the Trojan War, historical though it be, is but a symbol, saw the disappearance of all the finer works of Mycenaean genius. They were produced for an aristocratic society; it could not be otherwise; and fine art could not survive when the general political disruption had removed its patrons. There were no more palaces to furnish and adorn. Of that last century only the everyday work of the potter survives to tell a tale of unadorned utilitarianism. The golden bowl was broken; but the pitcher still went to the fountain.

952, 953, 1773, 1796, 2008.

**MYRON.** Athenian sculptor of the mid 5th c. B.C. He worked mainly in bronze and his animal sculptures were renowned for their truth to nature. Copies survive of his *Discobolus* and the *Athena* and *Marsyas*. Their poses suggest an originality contrary to the trend of his time. His masterpiece was considered to be the *Cow* in the market-place at Athens which was celebrated in some 36 epigrams surviving in the *Greek Anthology*.

**MYTENS,** DANIEL (*c.* 1590–*c.* 1648). Portrait painter, born and trained in Holland. He came to England some time before 1618 and together with Cornelius JOHNSON was instrumental in establishing the competent school of portrait painting which flourished prior to the arrival of van DYCK in 1632. Mytens was an efficient draughtsman and established a distinguished style in full-length portraiture. His work occasionally shows a quality of cavalier ROMANTICISM which looks towards the future. In 1624 he entered the royal service and was appointed by Charles I 'one of our Picture-Drawers' on a life pension in 1625. His work was above the average of contemporary court painting in England and on the Continent and it has been said that his finest portraits could hang beside the more formal portraits of Philippe de CHAMPAIGNE. His masterpiece, *The Third Marquess of Hamilton* (N.G., Edinburgh, 1629), has been called 'the most mature portrait of its kind painted in England before the advent of van Dyck'. Soon after 1632 he returned to Holland, where he died.

**MYTHOLOGICAL PAINTING.** When the Dutch painter and critic Carel van MANDER published a handbook for artists in 1604 he included a full summary of Ovid's *Metamorphoses* subtitling this rich storehouse of classical mythology *The Painter's Bible*. The name sums up the role that classical mythology played in the repertory of painters of the West: next to subjects taken from the Bible and from legend the stories of the ancient gods loom largest in European galleries and museums. Ovid, that elegant purveyor of the Olympian *chronique scandaleuse*, has always held a special place in the affection of artists and poets, and the story of his reception and illustration forms the largest part of the history of mythological painting. The largest, but not the whole. The other constant source of inspiration was the classical works of art themselves, especially SARCOPHAGI depicting mythological incidents. Renderings of divinities are of course the rule in most religions, including those of ancient Egypt and Mesopotamia, but the illustration of mythological and legendary incidents such as the Judgement of Paris or the Hercules cycle appears to be an achievement of GREEK ART that excelled in the vivid characterization of physical action and psychological reaction. The pediments of temples, Greek pottery, and the murals and mosaics of POMPEII and other towns testify to the enormous range of mythological narrative in ancient art and the classical writers such as PLINY and LUCIAN have preserved the fame of works such as APELLES' *Venus Anadyomene*, a fame that in its turn fired the imagination of later artists and patrons.

The rise of Christianity did not extinguish the tradition of mythological illustration altogether. BYZANTINE silver dishes and ivory caskets are decorated with such themes and even in the West copper bowls with the Deeds of Hercules were produced in the 12th c. This continued interest is explained by the role assigned to pagan authors in medieval education. Attempts were not wanting to assimilate these texts into the teaching of the Church by drawing on the ancient tradition that the myths should not be taken literally as stories of rape and adultery but were intended to hide profound wisdom from the uninitiated, a sacred lore that was not in conflict with Christian teaching. The most thorough attempt at such assimilation is Berçuire's *Ovide moralisé*, of which illuminated manuscripts also exist. In

these illustrations, of course, the ancient gods and heroes are represented as knights and damsels of the artist's own time, much in the way Chaucer pictured his Trojans or his Venus.

That growing interest in the authentic texts of the classics that was one of the features of the RENAISSANCE affected these illustrations only gradually. Stories from Ovid represented on 15th-c. CASSONI often show the figures in contemporary costume, though certain features of classical or Byzantine attire were introduced to lend an air of authenticity. For all their charm, however, these are decorative works and mythological painting might have remained confined to the sphere of decoration and illustration had it not been for the continued tradition that saw in the ancient images of the gods something more than the relic of naughty fables. BOTTICELLI's paintings *The Primavera* and *The Birth of Venus* reflect this belief in the dignity and continued import of ancient myth as a symbol. They are among the first paintings striving to evoke the spirit as well as the subject of the lost masterpieces of pagan art. What was then a daring innovation became more commonplace during the next generation. On the other hand RAPHAEL's frescoes in the Farnesina, TITIAN's paintings after PHILOSTRATUS for the Duke of Ferrara, and CORREGGIO's stories from Ovid for the king of France evoke that carefree world of love and revelry that we associate with the word 'pagan'. But in the Renaissance it is never quite easy to separate allegory from mere illustration. After all Mars can always stand for a personification of War and Minerva may be either the goddess or an allegory of Wisdom. Mythological painting of the cinquecento in fact extends over the whole gamut from the rendering of supposed 'mysteries' culled from learned handbooks, such as we find in VASARI's or ZUCCARO's fresco cycles, to mere pretext for the display of pretty nudes.

decorating the fashionable MAIOLICA dishes of the mid century. This latter purpose is particularly apparent in the art of the courts north of the Alps, that of PRIMATICCIO at FONTAINEBLEAU, of CRANACH at Weimar, or of Hans von Aachen at Prague, not to speak of the many engravers such as FLORIS who specialized in erotic mythologies.

It was RUBENS who restored to the subject its ancient pathos and innocence. Steeped as he was in the knowledge of ancient art and literature, he became without doubt the most fertile master of mythological painting the world had seen. In POUSSIN, a generation later, the desire for authenticity and gravity sometimes conflicts with the evocation of primitive ages, while the few mythologies of REMBRANDT, notably his *Ganymede*, flaunt the painter's contempt for the rules of DECORUM.

The 18th c. witnessed extremes both of the erotic interpretation in the works of BOUCHER and his school and of the grave antiquarianism of MENGS fostered by the ACADEMIES and reinforced by WINCKELMANN and the finds of POMPEII and Herculaneum. Despite such masters as INGRES and DELACROIX the vitality of the ancient themes appeared to have drained away in the course of the 19th c., when DAUMIER's hilarious parodies seemed the only way to approach the stale old topics.

By the 20th c. pictorial themes from classical mythology had become almost as exotic as the Orientalism of the early ROMANTICS. Not PICASSO's *Ovid* illustrations or his lovely series of line engravings in the manner of Greek vase paintings, neither MAILLOL's illustrations of Virgil nor those of MATISSE in the bucolic vein served to acclimatize the classics again or indeed represented any profound interest of the artists concerned in classical mythological themes today.

2009.

# N

**NABIS.** A group of painters formed in 1892 by members of the Académie Julien, Paris, who were converted by Paul Sérusier (1863–1927) to GAUGUIN's expressive use of colour and rhythmic pattern. The group included Maurice DENIS, Pierre BONNARD, Edouard VUILLARD, K.-X. Roussel (1867–1944), and the Swiss Félix Vallotton (1865–1925). TOULOUSE-LAUTREC was associated with them and MAILLOL was a member of the group before he took up sculpture. The musician Debussy was also attached to the set. The name 'Nabis' was coined by the poet Cazalis from a Hebrew word meaning 'prophets' because of their half serious, half burlesque pose as adepts and their attitude to the new Gauguin

style as a kind of religious illumination. The group was supported by the *Revue Blanche* (founded in 1891 by the brothers Alexandre and Thadée Nathanson), which had Félix Fénéon as art critic and Marcel Proust and Alfred Jarry among its literary contributors. The first Nabis exhibition was held in 1892 in the gallery of the dealer Le Barc de Bouteville and all the members of the group worked for the Théâtre de l'Œuvre. After a successful exhibition held in 1899 together with certain of the SYMBOLISTS in the gallery of the dealer Durand-Ruel, the members of the group gradually drifted apart. They had little essential unity of purpose or outlook apart from their common reaction from IMPRESSIONISM

and a certain interest in the decorative or emotional use of colour and linear DISTORTION.

530.

**NAGASAKI SCHOOL.** Japanese school of REALISTIC painting which originated in the 18th c. Its inspiration came from two sources: first works by CHINESE artists, particularly the 'Southern' bird and flower painter Shên Nan-p'in (Chin Nampin), who visited Japan in 1731, and secondly European painting, which entered Japan through Nagasaki, the only foothold allowed to foreigners during the Tokugawa period (1615-1867). The works of the Nagasaki School had great influence on modern Japanese painting. Among its adherents were So Shiseki (1716-80), his son Shizan (1733-1805) and his pupil Genkei (end of 18th c.), Yūhi (1712-72) and his pupil Kakutei (d. 1785), Keizan (d. 1723), Sessai (1755-1820), and Kakushū (1778-1830).

**NAILHEAD.** A small, pyramid-shaped object used as a decorative adjunct to MOULDINGS, especially in the later 12th and early 13th centuries; almost the only embellishment permitted in Cistercian architecture in England. The motif may be derived from the appearance of real nails studded into woodwork. (See DOGTOOTH.)

**NAIRN,** JAMES MCLACHLAN (1859-1904). Painter, born in Glasgow and trained at the Glasgow School of Art. In Europe he absorbed IMPRESSIONIST theories which he introduced into New Zealand, where he migrated in 1890. He established himself in Wellington, occupying there a place as painter and teacher similar to VAN DER VELDEN's in Christchurch. His competence in both LANDSCAPE and figure painting is witnessed by a large oil, *Tess*, completed in 1893 (National Art Gal., Wellington).

**NANGA SCHOOL.** School of painting which arose in Japan at the end of the 17th c., grew to maturity in the 18th c., and persisted until late in the 19th. It is the Japanese equivalent of what in China is called 'literary men's painting', *wên-jên hua*; indeed an alternative name is *bun-jin ga*, which is simply a Japanese transliteration of the Chinese term. The word *nanga* means 'southern painting', in reference to a Chinese classification into Northern and Southern Schools (see CHINESE ART). This means little more than that the adherents of the Southern School were cultivated AMATEURS, poets, or scholars. They trace their ancestry back to WANG WEI. Painting done by men of letters for their own pleasure had been a feature of Chinese art for centuries and had developed characteristics of its own. The Japanese adherents of the style took their models direct from Chinese painting, but since these models might come from any period from the 13th c. (Yüan) onwards, the Nanga School displays a great variety of individual styles. The

Nanga painters were not all amateurs, but they spurned the professional schools of their day (KANŌ and TOSA); in general their work represented the art of the intelligentsia as opposed to UKIYO-E, which was that of the people.

Nanga painting is so clearly modelled on Chinese that it is sometimes difficult to distinguish the two, but a Japanese work tends to be weaker, its brush-work softer and more cursive, its execution more clear-cut. What in the Chinese work is subtle or merely suggested becomes in the Japanese explicit and often exaggerated. And native Japanese features often find their way into what is intended as a purely Chinese landscape. The earliest artists to paint in the *bun-jin ga* manner were Yū Hsi (1713-72), Ho Hyakusen (1698-1753), and So Shiseki (1716-80), who introduced the style to Edo. Gion Nankai (1677-1751), a Confucian scholar and student of Chinese learning, was the first to practise it in Kyoto and is regarded as the founder of the School. Among the artists who gave it an impetus which endured into the 19th c. were Ikeno Taiga (1723-76), who was also renowned for calligraphy and the first artist to make a living by selling painted fans, and Yosa no Buson (1716-83), who emphasized the poetic affiliations of the School. Other prominent exponents of the style were Gyokudō (1745-1821), Mokubei (1767-1833), Bunchō (1764-1840), Chikuden (1777-1835), and Kazan (1793-1841).

**NANNI DI BANCO** (c. 1385/90-1421). Italian sculptor of the FLORENTINE SCHOOL, trained by his father, ANTONIO DI BANCO, who collaborated with Niccolò d'Arezzo (c. 1350-1417) on Florence Cathedral. Much of his work was designed for one or other of two architectural settings, the cathedral and Or San Michele, which together formed the chief source of demand for sculpture in Florence during the first quarter of the 15th c. Nanni can justly be counted among the first artists of the 15th-c. RENAISSANCE and his sculpture often formed part of a series to which DONATELLO also contributed. But his relationship with the Renaissance movement was an equivocal one. His figures, especially the heads, superficially resemble ANTIQUE statues more closely than do those of any of his contemporaries: for example, his group for Or San Michele of the *Quattro Santi Coronati* (the patron saints of the sculptors' guild) are carefully modelled on antique Roman senator figures. But Nanni put classical flesh on GOTHIC skeletons, so to speak. He had neither the understanding of classical principles nor the first-hand knowledge of natural forms that distinguish Donatello.

2708.

**NANTEUIL,** ROBERT (1623-78). French draughtsman and engraver, whose reputation as an engraver of portraits was the counterpart of that of Philippe de CHAMPAIGNE among painters. He had considerable technical ability and his

busts from POMPEII, and some 60 from the Papyrus Villa of Herculaneum. It also contains the best collection anywhere to be found of ancient south Italian ceramics, paintings, and MOSAICS from Pompeii, Herculaneum, Stabiae, and also from Campanian sites. The mosaics include such famous examples as *Alexander's Victory over Darius* (see ALEXANDER MOSAIC) from the House of the Faun and the *Street Musicians* from the so-called Villa of Cicero. The collections also cover Mediterranean art beyond Italy.

**NARTHEX.** A wide PORCH at the west end of a CHURCH, used in the Early Church by those who were not in full communion, i.e. penitents or those not yet confirmed; in England called a GALILEE.

**NASH,** JOHN (1752–1835). The most successful English architect of the early 19th c. He was the son of a millwright and a pupil of Sir Robert TAYLOR. He practised at first in Wales, obtaining commissions there and in Ireland. In 1806 he became architect to the Office of Woods and Forests, and in 1815 (jointly with Sir John SOANE and Robert SMIRKE) to the Board of Works. He worked closely with Humphry REPTON, and created the architectural analogue of the PICTURESQUE movement. This is evident in the Tudor-style rustic village he designed at Blaize Castle, near Bristol, and to a less degree in the houses at Park Village, adjoining Regent's Park. As early as 1800 he built for his own occupation a GOTHIC mansion, East Cowes Castle, in the Isle of Wight.

A master of the scenic use of the classical idiom, Nash left a strong imprint on London through the planning and building enterprise that he carried out for George IV, who launched into ambitious schemes of 'Metropolitan Improvement' when the Marylebone Park lands reverted to the Crown in 1811. Nash's contributions to these were all in his favourite material, STUCCO, and included Regent Street with its famous quadrant (1813; rebuilt since), All Souls' Church (1822), Park Crescent and the Regent's Park terraces (1821–8)—excluding those by Decimus BURTON—and Carlton House Terrace (1827–32). For George IV he also designed Buckingham Palace (see also BLORE) and the Marble Arch, which originally stood at its entrance, and reconstructed Brighton Pavilion (completed 1823) in a mixture of Oriental styles.

700, 2589.

**NASH,** JOHN (1893– ). English painter and illustrator. He was without formal training but began to paint shortly before the First World War and exhibited with the LONDON GROUP, and painted for the Imperial War Museum. He is best known for English LANDSCAPE, mainly in WATER-COLOUR, which though less ABSTRACT than

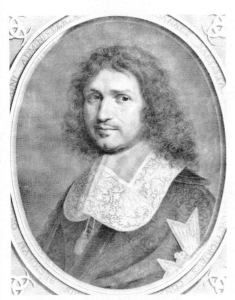

**229.** Portrait of J.-B. Colbert. Engraving (1668) by Robert Nanteuil

portrait engravings, which include Mazarin, FOUQUET, Louis XIV, and COLBERT, now provide a valuable record of prominent personages during the middle years of the 17th c.

2063.

**NAPLES,** NATIONAL MUSEUM. The Museo Nazionale of Naples was established in 1738 by Charles, the first Bourbon king of Naples, when he transferred there the rich collections of the FARNESE family which he inherited through his wife Elizabetta of the Parma branch of that family. These included the famous TITIAN portraits of the Farnese and the collection of Roman antiquities deriving partly from excavations carried out by Paul III and later members of the family at the Baths of Caracalla (see THERMAE) and the Palatine. At the beginning the antiquities were housed in the Casino Reale of Portici, the pictures at the king's villa at Capodimonte and the Farnese library in the Palace of Studies begun by the Duke of Ossuna and completed by the Viceroy Count of Lemos (1616) on the hill of St. Teresa. After having served as a university until 1770, the building was restored and adapted as a MUSEUM from 1850 to 1870. In 1822 the classical antiquities and picture collection were brought together there, and in 1927 the library was moved out to the Royal Palace in order to leave more space for the art collection.

The Museum has one of the most imposing collections of ancient classical sculpture, including such items as the FARNESE BULL, the FARNESE HERCULES, a large number of bronze statues and

**230.** *The Quadrant, Regent Street.* Engraving from *Metropolitan Improvements or London in the nineteenth century* (1827), J. Elmes

his brother's work retains formal beauty and design. Like his brother he is regarded as a typical English artist in spirit (*The Wood*, V. & A. Mus.). As an illustrator he has shown great versatility but has excelled in meticulous flower drawings for botanical publications.

PAUL (1889-1946), brother of the foregoing, was a painter trained at the Slade School. He was appointed an official war artist in the First World War, was a member of the NEW ENGLISH ART CLUB, of the London Group, and of UNIT ONE. In 1931 he visited the U.S.A. as British representative on the jury for the Carnegie Exhibition. He helped to organize and exhibited in the SURREALIST exhibition of 1936. In the Second World War he was official war artist for the Air Ministry. A memorial exhibition of his work was held at the TATE GALLERY in 1948 and a memorial volume was edited by Margot Eates. His writings, edited by Herbert Read, *Outline: An Autobiography and Other Writings*, were published in 1949.

It has been said of Nash that 'essentially a landscape painter, no artist has interpreted the beauty and rhythm of the English countryside as perfectly as he'. Wilenski ranks him with 'the greatest lyric artists of the English school'. Writing of English art in the *Unit One* volume (1934) Nash said: 'There seems to exist, behind the frank expressions of portrait and scene, an imprisoned spirit: yet this spirit is the source, the motive power which animates this art. These pictures are the vehicles of this spirit but, somehow, they are inadequate, being only echoes and reflections of familiar images (in portrait and scene). If I were asked to describe the spirit I would say it is of the land; *genius loci* is indeed almost its conception. If its expression could be designated I would say it is almost lyrical.' Nash saw himself as the successor of BLAKE and TURNER in this tradition. Nash was given to visions of metaphysical significance which he depicted with the clarity and REALISM of Blake. Suggestive similarities merged into metamorphoses and identities. It is this aspect of his work which explains the fascination which CHIRICO held for him (*Landscape from a Dream*, Tate Gal., 1938). His latest pictures expressed a profounder prophetic vision in which sun and sunflower are united in a mystic marriage and the bursting magnolia takes the place of what the Spanish called the 'rose of death'.

799, 1909.

**NASKHI SCRIPT.** See KUFIC AND NASKHI SCRIPTS.

**NASMYTH,** ALEXANDER (1758-1840). Painter, born in Edinburgh, who studied under

Allan RAMSAY in London. He spent some time in Rome and on his return to Scotland practised as a portrait and LANDSCAPE painter, ultimately confining himself to landscape. He seems to have been little affected by the classical landscape compositions with which he must have become familiar in Rome, and he specialized in scenes of a TOPOGRAPHICAL character. In 1822 he published 16 engravings of views of places mentioned in the Waverley Novels, taken from his own paintings.

PATRICK (1787-1831), son of the foregoing, also born in Edinburgh, worked mainly in London as a landscape painter in a manner deriving from the DUTCH 17th-c. masters. As these swung into fashion in England at the end of the 18th c. he became extremely popular. He was prolific, competent, and unoriginal. His reputation has suffered because the works of many forgotten painters of rustic landscape are labelled as his, and he is sometimes confused with his father, who survived him.

**NASONI** (or NAZZONI), NICCOLÒ (d. 1773). Italian architect and painter born near Fiesole and trained in Rome. He worked in north Portugal from c. 1731 and introduced the elaborate ornamental manner of carved decoration which set the fashion for the subsequent development of northern Portuguese BAROQUE and ROCOCO architecture. His most important work was the oval church of San Pedro dos clérigos at Oporto (1732–50).

**NATIONALE,** SALON DE LA (sometimes called SALON DU CHAMPS DE MARS). A usual name for the exhibitions given by the Société nationale des Beaux-Arts, founded in 1890 by PUVIS DE CHAVANNES, Eugène CARRIÈRE, RODIN, and others seceding from the Salon des Artistes françaises.

**NATIONAL GALLERY,** LONDON. The idea of a national COLLECTION of pictures was mooted by John Wilkes on the occasion of his protest to Parliament at the sale of Sir Robert Walpole's collection to Catherine of Russia (see HERMITAGE) and the consequent impoverishment of the nation's artistic wealth. The proposal met little response from the landed gentry, many of whom already had their own collections, and there was as yet no vocal public for a national collection. Support came first from artists connected with the ROYAL ACADEMY, including Sir Joshua REYNOLDS, Benjamin WEST, James BARRY, John OPIE, and others. It was opposed by many artists either on the ground voiced by SMIRKE that accessibility of the Old Masters

**231.** Trafalgar Square before the addition of the Landseer lions. Showing the National Gallery in the background

would damage the market for contemporary painters or in agreement with CONSTABLE that artists would tend to model themselves on the work of previous painters rather than on nature. A British Institution for the Promotion of the Fine Arts in the United Kingdom was formed in 1805 with the Prince Regent as President. In 1823 Sir George BEAUMONT, one of the Governors, offered his collection to the nation as soon as a gallery was available. Owing to the conflict of views and interests, however, little headway was made until Parliament purchased in 1824 the far more important collection of John Julius Angerstein. This was housed at 100 Pall Mall, which was opened to the public as a national collection. The present edifice in Trafalgar Square was built 1833–7 to the designs of William WILKINS (preferred to that of John NASH) and the new National Gallery was opened to the public in 1838, sharing the premises with the Royal Academy until 1869, by which time it had grown into one of the great collections of the world.

Following a Report of a Select Committee set up in 1853 a Treasury Minute of 1855, which remained in force until 1894, promised a regular annual grant for purchasing pictures and made the Director's decision final as to purchases and matters concerning the management of the Gallery. During this period the Directors were Sir Charles EASTLAKE, a portrait painter William Boxall (1800–79), and Frederick Burton (1816–1900). In 1897 the TATE GALLERY was founded as an annexe to the National Gallery and became independent in 1955.

**NATIVITY** (Matt. i. 25; Luke ii. 7). Most of the details of the Nativity popularized by the pictorial arts were derived from later sources than the GOSPELS. The ox and the ass appear in the earliest dated version, a Roman SARCOPHAGUS of 343 (now lost), though no written source for them is known from this time. On EARLY CHRISTIAN sarcophagi, such as one of the 4th c. in the Lateran Museum, the VIRGIN is shown seated, to emphasize the painless nature of the birth, while the Child lies in His manger, with the ox and ass beside it, under a barn-like structure. Generally one or more shepherds, and often also the Magi, appear on the scene (sarcophagus, Ancona Cathedral). In the Eastern centres a festival was universally observed by the 4th c. on 6 January which commemorated the birth of CHRIST, His Epiphany to the gentiles (the ADORATION OF THE MAGI), and His BAPTISM. In Rome and Africa the Nativity was celebrated on 25 December from about the same date.

The earliest Eastern versions of the Nativity differ from the Western in that the Virgin lies on a mattress and Joseph sits at her side (ampulla, Monza Cathedral, 6th c.). The tradition that the birth took place in a cave (which tended to prevail in the East) derives from the apocryphal *Protevangelium of James* or the *Pseudo-Matthew*. The Virgin is generally lying down, Joseph is seated, and two midwives bathe the Child in the foreground (possibly a derivation from classical scenes of the birth of Bacchus or Dionysus) while ANGELS hover around. Although the scene is pictured in a cave, the ox and the ass may be present. In the background the annunciation to the shepherds is shown and frequently also the arrival of the Magi (11th-c. *Gospels*, Bib. nat., Paris). This version was current in medieval Italy (Nicola PISANO, PULPIT, Pisa Baptistery, 1260). But in the rest of Europe a simplified version, derived from a mixture of East and West, was evolved with the manger set not in a cave but in a barn, as in the Early Christian sarcophagi. DUCCIO represents the stable in the entrance to a cave (Staatl. Mus., Berlin, 1308–11).

In the late 14th c. a change occurred. The Virgin was shown on her knees adoring the Child (*Revelations of St. Bridget*, 1370) as in a fresco in Sta Maria Novella, Florence. Sometimes Joseph kneels with her. This version remained current in the West throughout the RENAISSANCE (Hugo van der GOES, *Portinari altarpiece*, Uffizi, 1473–5), and was the form usually adopted in the construction of Nativity cribs. At the time of the Counter-Reformation a more realistic type reappeared: CARAVAGGIO shows the Virgin reclining on the straw, clutching the Child (Mus. Naz., Messina, 1609). Very often the scene was again combined with the Adoration of the Shepherds. The introduction of the Christmas card in the 19th c. made it one of the most familiar subjects of popular religious art.

**NATTIER,** JEAN-MARC (1685–1766). French portrait painter, son of the MINIATURIST Marie COURTOIS. He was successful in the vogue for painting women in MYTHOLOGICAL or allegorical fancy dress—or undress—transforming his matrons into goddesses (*Mme de Lambesc as Minerva*, Louvre, 1737). In 1717 he was summoned to Amsterdam to paint Catherine of Russia and painted also Peter the Great (Hermitage, Leningrad). In 1734 he succeeded Jean Raoux as painter to the Chevalier d'Orléans. He won favour at the French court and by the 1750s his fame had become European. As well as being official artist to the daughters of Louis XV, he painted portraits of the Queen Marie Leszczyńska, the Dauphin, and Mme de Pompadour. He was later attacked by DIDEROT on puritanical grounds and he has been accused of painting 'avec du fard'. But there is fine, painterly quality in some of the last of his work, such as *Madame Henrietta* (Uffizi), *Mlle de Beaujolais* (Musée Condé), and *Lady with Carnation* (Baron de Rothschild Coll., Paris).

1951.

**NATURALISM.** The term 'naturalistic aesthetics' is applied to a philosophical theory which arose out of 19th-c. positivism and culminated in the literary theories of Zola. It rejected teleological explanations and attempted

to apply scientific methods of impartial and experimental observation of reality in the arts. The stylistic correlate of this philosophical outlook, exemplified in Flaubert's novel *Madame Bovary* (1856) and in the paintings of COURBET, was called REALISM. It was motivated by reaction from IDEALISM and from the intrusion of personal emotion encouraged by ROMANTICISM.

As a stylistic term, however, 'naturalistic' is commonly used in a more general sense and one conflicting in some aspects with the foregoing. It is used in art history and criticism to denote a type of art which endeavours to represent natural objects as they appear in contrast to a STYLIZED or 'conceptual' art such as that of the Egyptians. In this sense the art of the Greek classical period is often claimed to be the first truly 'naturalistic' art and that of the Italian RENAISSANCE is spoken of as a revival of naturalism. Where beauty is sought in such a naturalistic art, it is the beauty of the natural object reflected through the work of art, not a beauty inherent in the work of art itself. The work of art is conceived as a mirror for natural beauty. In this sense naturalism is not inconsistent with the idealization of nature. It is, or may be, inconsistent with some of the senses of 'realism'.

As applied to a particular school of painting the term was first used by BELLORI (1672) of the followers of CARAVAGGIO such as MANFREDI, RIBERA, VALENTIN, and HONTHORST with reference to their doctrine of copying nature faithfully whether it seems to us ugly or beautiful.

**NAVARRETE,** JUAN FERNÁNDEZ DE (*c.* 1526-79). Spanish painter, called 'El Mudo' because he was a deaf mute. After studying for many years in Italy he returned to Spain shortly before 1568 and was appointed court painter to Philip II. He was commissioned to paint 32 ALTARPIECES for chapels in the ESCORIAL, but he had only completed eight at the time of his death. His eclectic style shows the influence of north Italian, especially VENETIAN, painting. In his use of dramatic lighting effects, notably in his *Burial of St. Lawrence* (Escorial, 1579), he anticipated the TENEBRISM of the 17th c.

**NAZARENES.** Originally a derisive nickname given to a group of German painters, mainly of religious subjects. They are also known under the name *Lukasbrüder*—The Brotherhood of St. Luke. The group was founded in Vienna in 1809 by Friedrich OVERBECK and Franz PFORR. Dissatisfied with current academic training and its routine they turned to the Italian, Flemish, and German PRIMITIVES for inspiration, admiring in particular DÜRER and PERUGINO, and including the early works of RAPHAEL. In this choice of models they were certainly influenced by German ROMANTIC writers such as Tieck, Wackenroder, and F. Schlegel. In 1810 the Brethren moved to Rome, where they occupied for a time a disused monastery. Here they were joined by Peter

CORNELIUS and some others. One of the aims of these artists was the revival of monumental FRESCO as it had been practised in the Middle Ages and the RENAISSANCE. They were fortunate in obtaining two important commissions which made their work internationally known (Casa Bartholdy, 1816/17, now in Berlin; Casino Massimo, Rome, 1817-29).

As a coherent group the Nazarenes had ceased to exist even before the Casino Massimo frescoes were completed, but their ideas continued to be influential. Cornelius had moved in 1819 to Munich, where he surrounded himself with a large number of pupils and assistants who in turn carried his style to other German centres. Overbeck's studio in Rome was a meeting-place for artists from many countries; INGRES admired him and Ford Madox BROWN visited him. William DYCE introduced some of the Nazarene ideals into English art.

The Nazarenes were among the first Primitives of the 19th c. They wished to express true feeling and genuine religious beliefs, yet they believed that all art since the middle of the 16th c. had betrayed these ideals for the sake of artistic virtuosity. The result was their regression to the alleged simplicity of the late Middle Ages and the early Renaissance. In retrospect credit must be given to their sincerity, though we can hardly suppress doubts as to their artistic ability. Their compositions are stilted and overcrowded; they never learned how to handle colour, and they did their best work in simple but sensitive landscape and portrait drawings.

49.

**NEEFFS.** PIETER NEEFFS THE ELDER (*c.* 1578-1656/61) was a Flemish painter who worked in Antwerp. Most of his pictures are interiors of GOTHIC churches seen from the nave. Some are night scenes illuminated by artificial light. They are generally small, painted on copper, and executed in a precise, neat way. His son PIETER NEEFFS THE YOUNGER (1620-75) painted the same subjects. His manner is drier and harder than his father's, but it is not always easy to distinguish their hands.

**NEER.** AERT VAN DER NEER (1603/4-77) was an Amsterdam painter who specialized in night scenes and winter LANDSCAPES. HOUBRAKEN reports that he began his career as a dilettante; his early works show the influence of the CAMPHUYSEN brothers, whom he met in Gorkum. None of Aert's contemporaries surpassed his paintings of the Dutch countryside and canals at night. These pictures are usually lit by a full moon; sometimes the light of a building in flames breaks the peace of the night. His winter scenes always capture the crispness of the cold winter air and the effects of moonlight on a frozen river are particularly brilliant. He also painted sunsets and views of Dutch scenery at dawn and twilight. He was a master of subtle

modulations of colour and conveyed the impression of light and air by slight changes in the value of his warm browns, pinks, delicate greys, and whites. Today he is ranked with the greatest colourists of the DUTCH School, but in his lifetime his paintings sold poorly. In 1658 he opened a wine shop in Amsterdam, but as this venture was also a failure he closed the business in 1661 and declared himself bankrupt. Aert's work is represented in many museums, especially the National Gallery, London (nine paintings).

Two of his sons were artists. EGLON (1634–1703) was a pupil of his father and of Jacob van Loo (1614–70). His works have little in common with his father's. He painted idealized landscapes peopled with biblical and mythological figures but is best known for GENRE pieces done in the style of TERBORCH and METSU. On the other hand the few works which can be attributed to JAN (1638–65) show that he followed closely on his father.

**NEGRETTI,** JACOMO. See PALMA VECCHIO.

**NEGRETTI,** JACOPO. See PALMA GIOVANE.

**NEO-CLASSICISM.** An AESTHETIC movement and artistic style which spread through Europe in the second half of the 18th c., combining reaction from ROCOCO and the excesses of the late BAROQUE with a new interest in the ANTIQUE. The latter was furthered by archaeological enthusiasm excited by excavations carried out at Herculaneum, Paestum, and POMPEII in the years 1738–56 and was popularized by a number of finely illustrated volumes devoted to the archaeological finds and to the art of antiquity in general. The best known of these are *Recueil d'antiquités égyptiennes, étrusques, grecques, romaines et gauloises* (1752–67) by Count CAYLUS, *Vedute di Roma* (1750), *Magnificenza di Roma* (1751), and *Antichità romane* (1756) by PIRANESI, Stuart and REVETT's *Antiquities of Athens* (1762), and the works of the brothers ADAM. The prime propagandist of the movement was the German art historian WINCKELMANN and its most celebrated exponent was the painter MENGS. The headquarters of the movement were in Rome, where Mengs established his studio in 1752 and made it a sort of international foyer for the dissemination of the new ideas. Among the artists who congregated there along with a constant stream of CONNOISSEURS and AMATEURS were: Benjamin WEST, from America; DANCE, HOLLAND, James BARRY, Gavin HAMILTON, and the brothers Adam from England; Angelica KAUFFMANN from Switzerland; VIEN, Natoire (1700–77), and Quatremère de Quincy from France. Although an indifferent artist, Mengs was a teacher of considerable influence and owed his reputation to the fact that he formulated what appeared to be a comprehensive recipe for the GRAND MANNER based on elements from RAPHAEL, CORREGGIO and TITIAN, and certain

antique prototypes (the *Apollo Belvedere*, the *Medici Venus*, the *Laocoon*, the *Antinous*, the *Niobe*), the whole to be expressed with due regard for the 'antique' ideals of calm simplicity and noble grandeur. In practice this resulted, particularly in sculpture, in an insipid and artificial style, as may be appreciated from Mengs's own *Parnassus* (Villa Albani, Rome, 1761) and from the works of his closest followers such as Gavin Hamilton and Joseph-Marie Vien. But practice was overshadowed by theory, and the theory, as formulated by Winckelmann (*Gedanken über die Nachahmung der griechischen Werke*, 1755, and *Geschichte der Kunst des Altertums*, 1764), was impressive. Like Mengs, Winckelmann predicated that modern art should follow nature as ideally expressed in the sculpture of antiquity, but in addition he emphasized the moral qualities to be found in ancient art, qualities which should be the standard of every artist worthy of the name.

As an aesthetic movement Neo-Classicism in France represents a reaction from the frivolities of the Rococo and a nostalgia for the Grand Style of Louis XIV and the CLASSICISM of POUSSIN. Nevertheless it held strong ethical implications and was associated with a change of social outlook and a desire to restore the 'ancient Roman' virtues into civil life. Significant of this change was the engraver COCHIN's *Supplication aux orfèvres* (published in the *Mercure de France* in 1754), deriding the love of curves, scrolls, and ornaments which threatened to undermine the dignity of design and pleading for a return to simplicity and classical grandeur. This aspect of the movement found its most typical expression in DAVID, who had been taught by Vien, in such pictures as *The Oath of the Horatii, Death of Socrates*, and *Brutus and his Dead Sons*.

Neo-Classicism was most successful, perhaps, in architecture, as in the works of the Adams brothers in England, LANGHANS in Germany, Jean-François Chalgrin (1739–1811), Alexandre-Théodore Brongniart (1739–1813), and Claude-Nicolas LEDOUX in France. Its most prominent sculptors were CANOVA and THORWALDSEN. The movement spread to America (see NEO-CLASSICISM IN THE U.S.A.) with the work of such artists as the sculptors Hiram POWERS and Horatio GREENOUGH and the painter John Vanderlyn (1776–1852).

Neo-Classicism differs from previous classical revivals in Europe by the fact that it was a deliberate and conscious imitation of antique models. It differed from the 19th-c. 'Neo-Greek' movement by the fact that despite the high-falutin language of Winckelmann and others about the Greek spirit, their knowledge of it was almost entirely derived from late HELLENISTIC and Roman reproductions.

24, 1407, 2145.

**NEO-CLASSICISM IN THE U.S.A.** The earliest phase of American NEO-CLASSICISM, the FEDERAL STYLE, was a provincial extension of

**232.** Monticello. Home of Thomas Jefferson

the ADAM style in England. In its basic characteristics it did not represent a radical break from the architecture of the late colonial era. Fundamental building types were modified only slightly, if at all, and those changes which did occur were primarily refinements in proportion and scale. Because of this the Federal style is strongly traditional in character.

The second phase was the architecture of Thomas JEFFERSON. In a deliberate effort to break with English tradition Jefferson sought an architecture which would speak for the new nation. He found his appropriate idiom both in the architecture of ancient Rome and in that of his own contemporary France. From these sources he was able to create a highly personal and symbolic style which, although strictly CLASSICAL, was totally unlike the conservative Federal style.

The third or Rational Phase centred around the work of the English-born architect Benjamin LATROBE and his American follower Robert MILLS. Derived from the highly rational work of later European Neo-Classicists, such as LEDOUX in France and SOANE in England, it was a severe, vigorous style based on VAULTING techniques which up to that time had been unknown in America. It thus brought to American architecture a greater flexibility and a new boldness and strength which were expressive of the youthful nation. It inspired in American architects more professional attitudes and led to a more searching curiosity about structure than had ever been possible with the limited masonry wall and framing techniques of the colonial years. The work of Jefferson and the architects of the Federal style differed from that of the rational architects in that it continued the earlier structural methods.

The fourth and final phase was the GREEK REVIVAL. Like Jefferson's adaptation of Roman architecture it was a revival rather than an evolution, for it reached back over the centuries and removed intact certain facets of an ancient style which were then applied to the needs of a rapidly expanding and intensely self-conscious new nation. Stimulated in part by American sympathy for the Greeks in their war for independence from the Turks, the Greek Revival became identified for many Americans with the ideals of democracy and thus provided an expressive symbol of American social and political ideals; it was also non-British in origin and served to strengthen American cultural independence. Moreover because it was a classical style it was readily attractive to the prevailing classical taste inherited from the colonial years. Before it was brought to an end by the Civil War it permeated every corner of the land and in the hands of the local carpenters blossomed into one of the most remarkable flowerings of FOLK ART in Western history.

**NEO-IMPRESSIONISM.** The name was first given by the critic Félix Fénéon to a movement originated by the artist SEURAT which was both a scientific development of certain IMPRESSIONIST techniques and also a CLASSICAL revival in reaction from the empirical REALISM of the Impressionists. The first Neo-Impressionist picture was Seurat's *Baignade* (Tate Gal.), which he exhibited in May 1884 with Le groupe des Indépendants. Seurat, who was then 25, there met SIGNAC, who was to become the chief mouthpiece for his theories, and together they formed a new group, the Société des Artistes INDÉPENDANTS. At the first exhibition of the Société in December 1884 Seurat exhibited a sketch for his next picture, *Un dimanche d'été à la Grande Jatte* (Art Institute of Chicago) and in the same year Fénéon, then 22, founded the *Revue indépendante* to help the new movement. In 1885 Signac introduced PISSARRO, who was for a time won over to Seurat's methods. Other adherents were Henri-Edmond Cross (1856-1910), Albert Dubois-Pillet (1846-90), Maximilien Luce (1858-1941), and Théo van Rysselberghe (1862-1926). The movement had a passing influence on the important individualistic artists van GOGH, TOULOUSE-LAUTREC, and GAUGUIN.

The technical basis of Neo-Impressionism was DIVISIONISM or the use of pure COLOURS, without mixture of PIGMENTS, in small areas so that intermediate colours would be created by optical painting in the eye of the observer. This method achieves a maximum of luminosity with saturation of colour since admixture is by the additive rather than by the subtractive principle. The method was by no means new. It had been practised to some extent by WATTEAU, by DELACROIX (whose works Seurat studied with great thoroughness), by TURNER, and others. Among the Impressionists it had been introduced by RENOIR and elevated into a deliberate doctrine by MONET, who was familiar with the colour theories of Helmholtz and Chevreul. It was in relation to Renoir and Monet that the word POINTILLISM was first used, since they applied pure pigments in small dots rather on the principle of modern colour printing processes. Seurat and the Neo-Impressionists preferred the word 'divisionism' to describe their more scientific development of the technique. It was described as follows by Signac: 'Divisionism is a method of securing the utmost luminosity, colour and harmony by (*a*) the use of all the colours of the spectrum and all degrees of those colours without any mixing, (*b*) the separation of local colours from the colour of the light, reflections, etc., (*c*) the balance of these factors and the establishment of these relations in accordance with laws of contrast in tone and radiation, and (*d*) the use of a technique of dots of a size determined by the size of the picture.'

Seurat made Renoir's rainbow palette a more scientific instrument of technique, restricting himself more consistently to spectrum colours and juxtaposing them according to principles he had worked out not only from the study of Delacroix and other precursors but from scientific optical theory. The main source of this aspect of Neo-Impressionist theory was: *Grammaire des arts du dessin* (1867) by the eminent critic and art historian Charles Blanc; this contained an analysis of Delacroix's views about colour and a résumé of the theories of colour admixture in Michel-Eugène Chevreuil's *De la loi du contraste simultané des couleurs* (1839). They also knew *Modern Chromatics: Students' Text-Book of Color* (New York, 1879) by Ogden N. Rood, a physicist and amateur artist, and the views of the Swiss David Sutter, who wrote and taught on AESTHETICS at the École des Beaux-Arts in strong reaction from the ROMANTIC reliance on feeling and instinct and whose *L'Esthétique générale et appliquée* (1865) was summarized in a series of six articles published in the periodical *L'Art* (1881) under the title *Phénomènes de la vision*.

After 1886 Seurat, and through him the group, were influenced by the views of the young scientist and aesthetician Charles Henry, who had published an elaborate theory of art in *La Revue contemporaine*, August 1885, under the title 'Introduction à une esthétique scientifique'. Between 1887 and 1891 Seurat was working out the possibilities of reducing to scientific principles the expressive or emotional qualities of colours and lines, thus linking up with a long-established theory of the ACADEMIES. The belief that specific arrangements of pictorial elements can induce definite states of emotion and mood had been expressed by POUSSIN in a letter to Fréart de Chantelou (24 Nov. 1647) and had become an accepted doctrine of the Académie, popularized by Charles LEBRUN and André FÉLIBIEN.

This later doctrine was consistent with the Classicism which Seurat brought back with his first Neo-Impressionist painting and from which he never receded. Besides systematizing Impressionist techniques the Neo-Impressionists introduced a spirit which went directly counter to the empirical realism of the Impressionist School and to their ideal of an exact reproduction of casual and uninterpreted experience. They reintroduced the idea that a picture is to be deliberately planned and composed for an intended and foreseen effect scientifically calculated. It is for this reason that Seurat, along with CÉZANNE, stands as the great renovator at the headstream of modern painting.

2484.

**NEO-PLASTICISM.** Term coined by Piet MONDRIAN for his style of geometrical ABSTRACTION, the AESTHETIC basis of which he set forth in the periodical De STIJL. It was distinguished from CUBISM in that it did not make use of figurative elements even as a starting-point for abstraction. He also restricted design to the right angle in a horizontal–vertical relation to the

frame and to primary colours together with white, black, and grey. He claimed that art should be 'denaturalized', by which he meant that it must be freed from any representational relation to the individual details of natural objects, being built up solely from abstract elements. In this way he thought that one might escape the individualism of the particular and achieve pure spiritual expression of the universal. A col-

lection of his essays in German was published by the BAUHAUS in 1925 and an English translation under the title *Plastic Art and Pure Plastic Art* appeared in 1945.

1854.

**NEROCCIO DEI LANDI** (1447–1500). Italian painter and sculptor of Siena, who was in

**233.** Part of the UNESCO building, Paris, with *Reclining Figure* by Henry Moore in the foreground

partnership with FRANCESCO DI GIORGIO until 1475. Three examples of his work are in the National Gallery, Washington: a *Madonna with Saints*, a CASSONE panel of *Antony and Cleopatra*, and a *Portrait of a Girl* which is one of the loveliest portraits of the 15th c. He had a narrow range of subject but in his delicate and vivid colour he typifies the soft SIENESE manner.

621.

**NERVI,** PIER LUIGI (1891–   ). Italian architectural engineer, who graduated at Bologna in 1913, lectured in structural engineering at the University of Rome from 1945, and was awarded an honorary degree by the University of Buenos Aires in 1950. He is regarded as one of Europe's greatest architectural designers of the 20th c. for his mastery of modern technologies and new materials, particularly reinforced CONCRETE, and his creation of a new structural AESTHETICS deriving from their special qualities. His best known works are the Giovanni Berta stadium at Florence (1929–32), notable for its dramatically exposed concrete structure, and the exhibition hall at Turin (1948–9). From his designs for military hangars, beginning in 1935, Nervi worked on the problem of 'strength through form', lightening his structures and designing enormous ROOFS, of which the roof of the great hall for the Turin Exhibition building (called by Kidder Smith the finest exhibition building since PAXTON's Crystal Palace) was the supreme example. In 1952 he was appointed engineer to collaborate with the architects Marcel BREUER and Bernard Zehrfuss (1911–   ) in the design of the UNESCO building in Paris (see Ill. 233, p. 771). Nervi was also responsible for various technical improvements in reinforced concrete prefabrication and these were put to striking aesthetic ends. The outstanding buildings during the 1950s for which he has credit are the new Railway Station at Naples (1954), the Palazzetto dello Sport at Rome (in collaboration with Annibale Votellozzi, 1957), the Pirelli SKYSCRAPER in Milan (with Gio Ponti (1891–   ), 1958), and, as engineer, the circular exhibition building at Caracas (1956) and the Palazzo del Lavoro at Turin (1961).

75, 1398, 1917, 1918.

**NESIOTES.** See CRITIUS.

**NETSCHER,** CASPAR (1639–84). Painter born at Heidelberg and active in Holland, where he died. The subjects of his early GENRE pictures and his predilection for depicting costly materials —particularly white satin—are derived from his teacher, TERBORCH. His fondness for painting exquisite fabrics continued all his life, but *c.* 1670 the subject matter of his pictures changed. From that date until his death he specialized in elegant, half-length portraits, small in scale, for court circles in The Hague. His son CONSTANTIN (1668–1723) worked in his father's style.

**NEUE SACHLICHKEIT.** A movement in GERMAN ART and literature that arose in the mid 1920s. It represented a sharp reaction against experimental and IDEALISTIC art of any sort, but in particular against the prevalent EXPRESSIONISM and ABSTRACTION. Instead artists strove for an 'honest objectivity' (*Sachlichkeit*), depicting with matter-of-fact literalness their everyday existence without seeking to hide its unpleasant aspects. The paintings of *Neue Sachlichkeit* were often cynical in sentiment and reactionary in style, closely related to the hard, linear manner of van EYCK and DÜRER. The chief painters were GROSZ and DIX, but the work of others, such as BECKMANN and HOFER, displayed similar tendencies. The leading literary representative of the movement was the poet and playwright Bertolt Brecht.

**NEUMANN,** BALTHASAR (1687–1753). German architect. After a period as military engineer, he became court architect to the Prince Bishop of Würzburg, who in 1723 sent him to Nancy and Paris to study the best contemporary French work. Neumann designed the staircases of the palaces of Würzburg and Bruchsal (1719 and 1731 respectively), perhaps the greatest achievements of secular BAROQUE in Germany. The same spatial richness and ingenious construction is seen also in his CHURCH designs, where he was deeply influenced by the Baroque style of the DIENTZENHOFERS. But a comparison of Johann Dientzenhofer's church at Banz with Neumann's church near by at Vierzehnheiligen (1743) shows the latter's greater delicacy and sophistication—the designs of both are based on intersecting ovals, but Dientzenhofer's stands firmly as though carved out of a solid block, whereas Neumann's is light and immaterial, far more complex, and carrying something of the elegance of ROCOCO.

2217.

**NEVINSON,** CHRISTOPHER RICHARD WYNNE (1889–1946). English painter, who studied at the Slade School and in Paris. Before the First World War he experimented with CUBISM and was associated with Wyndham LEWIS at the formation of the VORTICIST group. He was temporarily swept away by FUTURISM and associated with MARINETTI in issuing the manifesto *Vital English Art* in 1914. His exhibition of war pictures at the Leicester Gallery in 1916 was the first and its success led to the appointment of other official war painters. After the war he visited America and lived much in France. He painted all that was modern as well as landscapes and portraits in a variety of styles, but the work he did during the war is considered his best. His vision was commonplace but he was skilled to avoid banality of idiom and he has been described as a 'high class journalist in paint'.

**NEW ENGLISH ART CLUB.** During the second half of the 19th c. the standing of the ROYAL ACADEMY was lower among creative artists than at any other time. George Moore expressed the general feeling among them when he wrote in his *Modern Painting* (1898): 'that nearly all artists dislike and despise the Royal Academy is a matter of common knowledge.' The New English Art Club was formed in 1886 by artists outside the Academy who were interested in reviving NATURALISTIC painting. In the *Art Journal* (1889) Alice Meynell described their aim as 'following, in England, the methods long practised in France—vivid and simple study of nature'. Writing in 1937 Mary Chamot described it as 'unquestionably the most vital artistic movement in English painting of the last half century'.

The founders were largely artists who had worked in France and had been influenced by the PLEIN AIR School and BASTIEN-LEPAGE. They included CLAUSEN, Wilson STEER, Stanhope Forbes (1857–1948), SARGENT, La Thangue (1859–1929), and Frederick Brown (1851–1941). Many of them subsequently joined a group of painters in Cornish fishing villages known as the Newlyn Group and some of these drifted into the Academy. A Scottish contingent, including Sir John LAVERY and Sir James Guthrie (1859–1930), broke away and formed the Glasgow School. In 1889 the Club came under the control of a minority group led by SICKERT, who had joined in 1888, and these later formed the nucleus of the CAMDEN TOWN GROUP. They were interested in the IMPRESSIONISTS, particularly MONET and DEGAS, rather than in Bastien-Lepage and in 1889 they held an independent exhibition under the name 'The London Impressionists'. All the contributors to the 1894 *Yellow Book* (see Aubrey BEARDSLEY) were members of the Club. Others were TONKS, William Rothenstein, and Roger FRY.

From 1887 to 1904 the Club held regular annual exhibitions and from *c.* 1889 to the first POST-IMPRESSIONIST exhibition in 1910 it contained most of the noteworthy painters in England. They received support from the critics when MACCOLL became art critic to *The Spectator* in 1890 and George Moore began writing for the *Speaker*. Frederick Brown was secretary of the Club and the backbone of the revolt against the Academy. As head of the Westminster Art School he had raised its work to a high level before being made Slade Professor in 1893 and head of the Slade School with Tonks and Sir Walter Wesley Russell (1867–1949) as his assistants.

Among the more prominent painters who made their début with the New English Art Club or were associated with it have been Augustus JOHN, ORPEN, McEVOY, CONDER, Sir Charles Holmes (1868–1936), Bernard Meninsky (1891–1950), Lucien PISSARRO, Ethelbert WHITE, Spencer GORE, Ethel WALKER. From the First World War the Club occupied a position midway between the Academy and the *avant-garde* groups. With the gradual liberalization of the Academy exhibitions its importance diminished.

520, 1858, 2643.

**NEW YORK.** METROPOLITAN MUSEUM OF ART. Founded in 1866, its collection of works of art now ranks with those of the older galleries of Europe. The history of its foundation and growth illustrates the rapid rise of New York at the end of the 19th c. as the financial and cultural capital of North America, and the growing economic supremacy of America over Europe. Between 1880 and 1925, at a time when the major public collections in Europe were engaged in consolidation relying largely on their purchase grants and other state aid, the Metropolitan Museum was being built up entirely out of the private fortunes of great businessmen, who collected rather for prestige than out of CONNOISSEURSHIP, but collected only first-class works of art. It could also profit from a number of endowed purchase grants, many of them unconditional, which have enabled it to progress not only as a collection of outstanding works, but as a comprehensive and representative one. The present building was erected in 1880 and has been enlarged several times. Many of the most important paintings came with the Marquand bequest (1888), while the Altman bequest (1913) brought 13 pictures by REMBRANDT and many PRIMITIVES, in which the museum is now richer than many European galleries. The Huntington, Morgan, and other bequests further enriched the department of painting. The sculpture collection, begun in 1906, has been built up chiefly by purchases and is outstanding for its GREEK and ROMAN works. In accordance with the policy generally prevalent in America, the exhibits are arranged so as to have the widest possible appeal, as far as the somewhat unsuitable building allows.

**NEW YORK.** MUSEUM OF MODERN ART. Exemplary of the American conception of a MUSEUM through its permanent collections of FINE and APPLIED ART displayed according to a didactic programme and its many other activities, it exercises a strong influence both on taste and on artistic production. The collection of paintings and sculpture was begun in 1929 and enriched by several large bequests, notably the Bliss collection (1934), the Rockefeller (1935–7) and Guggenheim (1938) bequests. Since 1954 the policy of the Museum has been to collect only works vital to the development of art since the middle of the 19th c.; of these only a carefully chosen nucleus are exhibited at one time. This collection contains some of the epoch-making works of the 20th c., such as PICASSO's *Demoiselles d'Avignon* and his *Guernica*, and an outstanding collection of modern AMERICAN ART. The Museum has also been noted for some time for its championship of modern sculpture, and particularly of the work of BRANCUSI.

The departments of architecture and INDUSTRIAL design, founded in 1932 and 1940 and now amalgamated, have a permanent collection unique of its kind and conduct an ambitious programme of sponsorship.

Other main tasks of the Museum include the building up of its film library (begun in 1935), the sponsoring of films, and an extensive range of publications which has produced some of the standard literature on modern art.

**NEW ZEALAND ART.** In surveying the field of New Zealand art the critical observer can scarcely refrain from looking back with regret to a native tradition now supplanted and effaced. Maori art developed in the isolation of centuries and, adapting itself to unique surroundings, gradually acquired the character which set it apart from other variants of POLYNESIAN culture. The more complex tradition introduced by the colonists of 1840 was less easily moulded to a new environment and in its short history has been continuously open to influences from abroad. So it is that European New Zealanders have created no masterpiece to compare with the carved Maori canoe, nothing so distinctive as the decorated cloak of dressed flax. Nevertheless in the early years of settlement, unconsciously following Polynesian example, they did achieve minor but positive success, notably in the basic art of architecture. From this period there survive, unhappily in diminishing number, simple, finely proportioned buildings—houses, CHURCHES, council chambers—fashioned from local materials to meet the limited needs of a pioneer society. Eloquent witnesses to an age when faith was joined with taste are the Selwyn churches of the Auckland Province, wooden modifications of GOTHIC planned with the active assistance of the Bishop himself. Even more striking is the church at Otaki, near Wellington, erected under the supervision of Archdeacon Samuel Williams and completed by its Maori builders in 1851. The interior of this lofty building, supported by solid trunks of *totara*, is decorated with Maori scroll designs and reed work which add to an unforgettable impression of soaring height and soft, rich colour. The building, unique in its successful fusion of Polynesian and European, marks a lonely peak of original achievement. From this point the descent is steep to the wayward eclecticism from which New Zealand architecture was retrieved in the 1930s.

Beginnings in the FINE ARTS were also mildly auspicious. Even before colonization there had come, in the train of British and French navigators, professional painters of whom the most accomplished was William HODGES, R.A., draughtsman with Cook's second expedition. Preserved for nearly two centuries in the Admiralty and elsewhere in London, his large oils of New Zealand and the South Seas were little known outside Britain until shown in a loan exhibition which had stimulating effects on modern New Zealand painting. Similarly unknown to the local public before they were lent by the National Library of Australia (Nan Kivell Coll.) were the WATER-COLOURS and SKETCHES of Augustus Earle (1793-1838), the first artist to pay an extended visit to the country. Following protracted travel in Europe and the two Americas, Earle settled for a time in New South Wales and spent the summer of 1827-8 in northern New Zealand. His landscapes and Maori studies are competently done and of great historical value, but they are the impressions of a temporary sojourner, inferior in skill and insight to the finest work of the colonial years.

Though youngest of the larger colonies, New Zealand was founded in time to catch some faint lustre from one of the great periods of British painting. There were among the original colonists many practised AMATEURS who discovered in the new country and its native people an inexhaustible range of subjects. Their renderings in water-colour were modest enough in intention (pictorial equivalents of the later colour slide) and for the most part have today no more than historical interest. Sometimes, however, in the landscapes and botanical studies and sketches of Maori life one lights on some work which communicates a mild but authentic emotion—nostalgia, awe, the excitement of discovery—and passes from the sphere of record to that of art. Conspicuous examples of such transmutation are found in the water-colours of Sir William Fox (1812-93), politician and four times colonial premier. A gentlemanly amateur, Fox sketched assiduously for most of his life and along with a vast output of the indifferent and the bad produced a few exquisite landscapes, the outcome of his early expeditions in the South Island (Alexander Turnbull Library, Wellington). Similar, if less spectacular, surprises are yielded by the pencil drawings of William Swainson (1789-1855), sensitive studies of landscape and bush, often underlining the moral of man's insignificance before nature (National Art Gal., Wellington), and by the water-colours of the Revd. John Kinder (1819-1903), who transferred to the colonial scene his vision of a tamed and ordered English countryside (Auckland City Art Gal.). More substantial in achievement, potentially the basis of a local tradition, was the best work of John Alexander Gilfillan (1793-1863) and Charles HEAPHY. Gilfillan's sketchbooks (Hocken Library, Dunedin), covering his life in Scotland as well as the years in New Zealand, illustrate with exceptional force the quickening effects that sometimes resulted from migration. Talent is evident in the early sketches, but with the artist's arrival in New Zealand and especially with his discovery of the Maori, the work widens in range and acquires a new vitality. Without idealizing or sentimentalizing them, he sketched his Maori models in an endless variety of pose and occupation, and in his most ambitious painting, *Interior of a Native Village* (c. 1850), now surviving only in LITHOGRAPHIC

reproduction, portrayed with zest and humour the close, warm, sociable community of the Maori *pa*. Heaphy, too, painted the Maori, but he was pre-eminently the interpreter of New Zealand landscape, one of the earliest and one of the most perceptive. Today, as one examines the water-colours he completed while draughtsman to the New Zealand Company, it is astonishing to reflect that they were the work of a young man barely 20 years of age. Not only does the pre-cocity startle but also the clear evidence of a mind aware of the landscape painter's problem in a new country. While he employed the tech-nique and media of European art, Heaphy tried to ignore its distorting preconceptions, painting New Zealand not as a wilder and emptier England, but, as far as he could, in acknow-ledgement of its individual, alien character.

Gilfillan's career in New Zealand was cut short by a personal tragedy, while Heaphy's diverse talents were increasingly applied to the practical world; they founded no tradition and left no disciples. Their successors in the later 19th c. were a quartet of talented amateurs—GULLY, RICHMOND, HODGKINS, and BARRAUD—who showed no interest in the promising field of GENRE and rarely grappled with the contours of the local scene in the strenuous manner of Heaphy. Their aim was to render New Zealand landscape in terms of the English ROMANTIC idiom. Tireless in their search for 'beauty spots' and prodigies of natural grandeur, they spent the leisure of week-ends and summer holidays in sketching excursions whose spoils were later elaborated in the privacy of well equipped studios. The resulting water-colours, with their subdued harmonies and nostalgic yearnings for a TURNERISH other-world, often charm, some-times impress, but rarely excite. For stimulus, for insight into the structure of New Zealand landscape, the spectator must look elsewhere—to the work of an architectural draughtsman, George O'Brien (1821-88) (Early Settlers' Mus., Dunedin), or to that small, fortuitous master-piece, *Milford Sound* (Hocken Lib.), by John Buchanan (1819-98), who also in his day aspired only to the humble designation of draughtsman. These, rather than the set pieces of the Gully School, may ultimately be regarded as the crown-ing achievement of the years from 1860 to 1890. One further achievement must, however, be noted: the founding by Hodgkins, Barraud, and others of the institutions of organized art. In these decades the machinery of galleries, art schools, and regular EXHIBITIONS was set in motion; conditions were created that made it possible for professional artists to exist.

The professional artists appeared, but they were not at first New Zealand born. In the early 1890s, at the point where Gully and his associates were ending their careers, there arrived three painters of European experience: Petrus VAN DER VELDEN established himself in Christchurch, James NAIRN settled in Wellington, while G. P. Nerli (1863-1926), after teaching for a time in Dunedin, moved to Auckland. In each centre they found young painters who eagerly followed their lead and who half a century later would recall their names with affectionate reverence. Reasons for the immense and prolonged influence of the masters (more especially Nairn and Van der Velden) are not hard to find. They were pro-fessionals in a land of amateurs; all were gifted painters and teachers; they brought with them not only exciting, novel doctrines but also the glamour of foreign places—Rome, Amsterdam, Paris, the South Seas; and with their disregard of money and conventional appearances they revealed to middle-class disciples the liberating example of Bohemianism. All three added to the total of significant New Zealand painting—Nerli a series of portraits and the theatrical *Aïda* in which he flaunted his audacious theories of colour and composition (Public Art Gal., Dunedin), Van der Velden his genre pieces in the DUTCH manner and his landscapes, Nairn his proto-IMPRESSIONIST idylls and portraits. But their art was, of its very nature, exotic, and they may owe their justly high place in the hierarchy of New Zealand painters as much to the force of their precepts and personalities as to the intrinsic merits of their work. At any rate their advent hastened tendencies already present in the late 1880s: the growth of professionalism; the dis-placement of water-colour by oils as the favoured medium; the dislodgement of landscape from its dominating place; and the movement towards Europe in quest of training and careers.

Like a watershed the European triumvirate divides the first colonial-born generation from their fathers. On one side is the calm, lucid, positive stream of landscape painting in water-colour, on the other are innumerable runnels and rivulets branching in every direction and often, alas, trickling to an end in futility and deserved oblivion. In the 1890s and succeeding decades New Zealand art became more versatile, more abundant, and more varied but also lost its sense of purpose. Of the painters who in these years arrived at maturity only Alfred Wilson Walsh (1859-1916) continued to produce in water-colour the traditional landscapes, seascapes, studies of native bush (Robert McDougall Art Gal., Christchurch); and he alone, it is signi-ficant, remained in the country for the whole of his career. More usual was the record of his con-temporary, Alfred Henry O'Keeffe (1858-1941), who, after training at the Dunedin School of Art, left for Paris and the Académie Julien, returning thence to apply and expound the principles absorbed in the one memorable excursion to Europe. The pattern was repeated with varia-tions in the lives of numerous men and women. C. F. GOLDIE, also in his time a student at Julien's, established a conception of the Maori absorbed in his formative years. Margaret O. STODDART, forced to return after her brave assault on an unresponsive Europe, won in Christchurch modest fame as a painter of land-scape and STILL LIFE, a career that was closely

paralleled by Dorothy K. RICHMOND's in Wellington. Then, in a slightly younger generation, there were two men, Raymond McIntyre (1879-1933) and Owen Merton (1887-1931), who in their relatively brief careers made some slight impact on the distant metropolis; again there was Archibald F. NICOLL, most ardent, most accomplished of Van der Velden's pupils, and that unquiet spirit, Sydney Lough Thompson (1877-    ), dividing his allegiance between two hemispheres, never quite at rest in either. To these might be added a score of other names now forgotten or remembered only in the darker recesses of art galleries and the drawing-rooms of aged CONNOISSEURS. Finally, and above all, there is the name of Frances HODGKINS. Daughter of a pioneer water-colourist, pupil of Nerli, master of every medium, painter in every field, traditionalist, modernist, New Zealand nationalist, New Zealand exile, she sums up in her person an era of art history and, in a sense, defines its meaning. The meaning lies not wholly in the story of her laborious self-realization nor at all in the circumstances of her late and transient fame; but in the fact that her art could mature only in the soil of its original home. She is the fine flower of the colonial phase in New Zealand painting.

It takes a great deal of history to make a little art (to adapt an observation of Henry James), and New Zealand may have done well to produce in its first century a handful of pleasing talents and one painter of distinction. Even before that century had quite drawn to a close, moreover, there was evidence that the country's finer spirits would not always be compelled to seek the full development of their gifts at the cost of permanent exile; and since 1940 signs of emergence from colonial status in the arts have been accumulating. As in the first period of British settlement, one distinctive expression of the national life has been discernible in architecture, more especially in its secular and domestic branches—for gone is the age when faith could raise soaring pillars of *totara*. Here a new impulse was felt in the late 1930s, deriving from a number of sources: to a small extent from an awakened sense of the past and an appreciation of the merits in buildings of the pioneer years; from the training of the School of Architecture in Auckland and (both in emulation and in dissent) from theories expounded by its most stimulating teacher, Vernon A. Brown (1905-65); but even more decisively from ideas evolved abroad which have been applied to local conditions by the native-born and by gifted immigrants alike. Similar agents and similar influences have been at work more recently to infuse fresh life into institutions grown moribund in the slack years that followed their initial heyday. The appointment in 1952 of a professional director for the gallery at Auckland has resulted in the adoption of vigorous and imaginative policies affecting not only that city and the surrounding area but the country as a whole. Art teaching at all levels has

also benefited from the forces of change and reform which have revolutionized schools and curricula elsewhere. Finally, the setting up on the British model of the Queen Elizabeth II Arts Council in 1963 has codified official recognition of the visual arts along with related activities and secured for them a measure of state patronage.

These are encouraging signs, but support for qualified optimism comes less from large public gestures or institutional reforms than from the presence of original artists, including sculptors, at every stage of development. Of these men and women, dispersed throughout the two islands, four may be singled out who, after careers spent almost wholly in New Zealand, have received the tribute of a retrospective exhibition. T. A. McCormack (1883-    ), veteran of the group, has affinities with an earlier period, for working in virtual isolation he has confined himself for the most part to water-colour and has rarely ventured outside his chosen *métier* of landscape and flower painting (National Art Gal.). John Weeks (1888-1965) is a more robust and adventurous painter. Since he returned in 1929 from the customary term in Europe, he has ranged widely with a tireless virtuosity, to find in still life and landscape the most satisfying outlets for his gifts as colourist and draughtsman (Auckland Gal.). Separated from their elders by a generation and an aesthetic revolution, M. T. Woollaston (1910-    ) and Colin McCahon (1919-    ) at the outset of their careers broke decisively with prevailing conventions in landscape and figure painting; and each has followed his independent line with great tenacity. Both have worked chiefly in oils, often on an ample scale, and if Woollaston is the more consistent, McCahon is the more prolific and tirelessly inventive (Auckland Gal.). In an even younger generation mention should be made of the considerable and growing number of Maori painters, artificers, it may be, of a second indigenous tradition.

176, 1718.

**NICCOLÒ DALL'ARCA,** called NICCOLÒ DI BARI or DA BOLOGNA (active *c.* 1460-94). Italian sculptor. He takes his name from the TOMB of St. Dominic in the church of S. Domenico, Bologna, for which he made the CANOPY and most of the small free-standing figures, beginning in 1469 and continuing until his death. He also executed a highly emotional *Lamentation over the Body of Christ* in Sta Maria della Vita, Bologna.

**NICCOLÒ DELL'ABBATE** (*c.* 1512-71). Italian painter who spent much of his life in France and exerted an influence on French LANDSCAPE PAINTING. He was trained in the tradition of his birthplace, Modena, but he developed his mature style in Bologna (1548-52) under the influence of CORREGGIO and PARMIGIANINO. There he decorated palaces, com-

bining painted stucco with figure compositions and landscapes (Palazzo Pozzi), and painted some portraits of the PONTORMO type. He was invited to France in 1552, probably at the suggestion of PRIMATICCIO under whom he worked at FONTAINEBLEAU. Most of his work in the palace itself has been lost. But his latest paintings, executed independently for Charles IX, included some landscapes with MYTHOLOGIES (*Landscape with the Death of Eurydice*, N.G., London) through which Niccolò became the direct precursor of CLAUDE and POUSSIN and one of the sources of the long-lived tradition of French classical landscape.

**NICHOLSON,** SIR WILLIAM NEWZAM PRIOR (1872-1949). English painter and engraver. He collaborated 1893-*c.* 1898 with his brother-in-law James PRYDE in designing posters under the name 'The Beggarstaff Brothers', then made a reputation as a painter of elegant STILL LIFE, LANDSCAPE, and portraits. He was a founder member of the National Portrait Society in 1911 and was knighted in 1936.

BEN NICHOLSON (1894-     ), son of the foregoing, was born at Denham, Buckinghamshire and became one of the leading British painters of his generation. He painted both landscape and STILL LIFE during the 1920s and 1930s, but his name is chiefly associated with, and his international reputation rests primarily on, that whose closest affinity is with the school of NEO-PLASTICISM which arose in Holland under the inspiration of MONDRIAN. Nicholson was married to the painter Winifred (Dacre) Nicholson. His second wife was the abstract sculptor Barbara HEPWORTH. His first one-man show was at the Adelphi Gallery, London, in 1922 and his first retrospective exhibition was arranged by Sir Philip Hendy at the Leeds City Art Gallery in 1944. He was a member of the 7 and 5 Group (1925-36), of UNIT ONE (1933), and of Abstraction-Création, Paris (1933-5). In 1937, together with the architect J. L. Martin and the CONSTRUCTIVIST Naum GABO, he was co-editor of *Circle*, an international review of 'constructive' art. He lived in London 1932-9 and in 1940 moved to St. Ives, Cornwall, where with Barbara Hepworth, John PIPER and others he became the centre of a local art movement.

His work was first shown at the Venice Biennale in 1934 and in 1936 was included in an exhibition 'Cubism and Abstract Art' at the Museum of Modern Art, New York. He was represented in the British section of the international exhibition held at New York in 1939, which went on to San Francisco, Ottawa, Toronto, Montreal, Boston, and Chicago. In 1946 he was represented in the British section of the international exhibition held by UNESCO in Paris. He had a one-man show at the Phillips Memorial Gallery, Washington, in 1951 and at the Galerie de France, Paris, in 1956. He did a

mural for the Festival of Britain in 1951 and one for the Time-Life Building, London, in 1952. In 1952-3 a retrospective exhibition of his work was held at the Detroit Institution of Arts, at Dallas, and at the Walker Art Center, Minneapolis. In 1954 he had a retrospective one-man exhibition in the British Pavilion at the XXVIIth Venice Biennale, which was subsequently shown at the Stedelijk Museum, Amsterdam, the Musée National d'Art Moderne, Paris, the Palais des Beaux-Arts, Brussels, the Kunsthalle, Zürich, and the Tate Gallery, London. Among his awards were: First prize for painting at the Carnegie International, Pittsburgh (1952); Ulissi prize, Venice Biennale (1954); Governor of Tokyo prize, 3rd International Exhibition, Japan (1955); Grand Prix, 4th Lugano International (1956); First Guggenheim International Award (1956); First International prize for painting at the 4th São Paulo Biennale (1957). He was awarded the O.M. in 1968.

In 'Notes on "Abstract" Art' published in *Horizon*, October, 1941, Nicholson expressed aesthetic views which were symptomatic of the outlook of much contemporary art. Among other things he said: '. . . so far from "abstract" art being a withdrawal of the artist from reality (into an "ivory tower") it has brought art once again into every-day life—there is evidence of this in its common spirit with and influence on many things like contemporary architecture, aeroplanes, cars, refrigerators, typography, publicity, electric torches, lipstick holders, etc. . . . Many people expect one kind of art to exclude all others, but I don't see why all the different forms can't proceed at the same time: there is a place for abstract art, for surrealist art or indeed for an art based more directly on representation, though since abstract art is painting and sculptural expression free and uninhibited it must have a special potency. . . . One of the main differences between a representational and an abstract painting is that the former can transport you to Greece by a representation of blue skies and seas, olive trees and marble columns, but in order that you may take part in this you will have to concentrate on the painting, whereas the abstract version by its free use of form and colour will be able to give you the actual quality of Greece itself, and this will become a part of the light and space and life in the room—there is no need to concentrate, *it becomes a part of living.*'

**NICIAS.** Greek painter who worked in Athens during the latter part of the 4th c. B.C. and was a younger contemporary of the sculptor PRAXITELES, whose statues he coloured. He painted mainly by the method of ENCAUSTIC. None of his work survives but in classical tradition he was famous for his skill in making his figures stand out by the use of CHIAROSCURO. He also had a reputation for painting female figures in dramatic situations and he held that a great artist should concentrate on noble and heroic themes rather

than on STILL LIFE. PLINY records that he refused an offer of 60 talents from King Attalus of Pergamum for a *Necyomantea* (Interrogation of the Dead by Odysseus) and presented the picture instead to his native town. Pliny also states that his picture *Hyacinthus* so delighted Augustus that he brought it back from Alexandria and it was dedicated by Tiberius in the Temple of Augustus in the FORUM of Rome.

**NICOLAS OF VERDUN** (active late 12th-early 13th c.). Goldsmith, metal-worker, enameller, and sculptor (see BRONZE SCULPTURE). Two major works of his are signed: the enamelled PULPIT frontal for Klosterneuburg, near Vienna, (completed in 1181, damaged in 1320, and then remodelled into its present TRIPTYCH-altar form) and the St. Mary shrine for Tournai Cathedral, dated 1205. Amongst his earlier work is probably the *Trivulzio* candlestick in Milan Cathedral and four small figures of PROPHETS (Ashmolean Mus., Oxford). The most ambitious work attributed to him is the *Shrine of the Three Kings* in Cologne Cathedral (*c.* 1190–1200, remodelled later). Nicolas was the last of the great ROMANESQUE goldsmiths; in his figure modelling it is possible to detect a tendency towards the greater NATURALISM and more sensitive feeling for the human form characteristic of GOTHIC art.

**NICOLL,** ARCHIBALD FRANK (1886–1953). Painter, born in Canterbury, New Zealand, and trained at the Canterbury College School of Art, Christchurch. After further training in London and Edinburgh he returned to the Canterbury School as director (1920–8), and became New Zealand's leading producer of formal portraits. A favourable example is *G. Harper, Esq.* (Robert McDougall Art Gal., Christchurch).

**NIELLO PRINTS.** Niello plates were plates with engraved designs filled in with a black composition of metallic alloys used for decorative purposes. Niello PRINTS are impressions taken from such plates or from plaster casts of such plates. They are Italian work of the second half of the 15th c. They were probably taken as proofs by niellists who wanted to see their work clearly. But it appears that these craftsmen then took to engraving plates with the express purpose of taking impressions from them, and many early examples of Italian LINE ENGRAVING show the influence of the niello craft. Maso FINIGUERRA, whom VASARI credits with the invention of line engraving, was both niellist and line engraver. POLLAIUOLO's *Battle of the Naked Men* (print in B.M.), with its dark background bringing out the figures in RELIEF, gives an effect like that of niello work.

**NIEMEYER SOARES FILHO,** OSCAR (1907– ). Leading figure in the modern school of BRAZILIAN architecture. He graduated in architecture from the Rio de Janeiro School of Fine Arts in 1934 and worked with Lúcio COSTA, the acknowledged leader of MODERN ARCHITECTURE in Brazil and leader of the team of architects responsible for realizing LE CORBUSIER's design for the Ministry of Education at Rio de Janeiro (1936–45). It was this building with its towering façade relieved by an intricate pattern of BRISE-SOLEIL, together with the Brazilian Pavilion at the New York World's Fair of 1938 (in the design of which Niemeyer also collaborated with Costa) which first drew attention to the enterprising new architecture of South America. Niemeyer and his colleagues have created something new and exciting in 20th-c. architecture, imparting a distinctive harmony and elegance to the International Style and giving it a BAROQUE quality in line with the tradition of PORTUGUESE COLONIAL architecture together with a spontaneous and uninhibited decorative style reviving the PLATERESQUE tradition of the AZULEJO and adapting the new *brise-soleil* to suit the climatic conditions. Niemeyer himself, though influenced by Le Corbusier and fully at home with the FUNCTIONALIST aspects of contemporary architecture, was extremely versatile.

Outstanding among Niemeyer's buildings during the 1940s were a hotel at Ouro Preto (1940), his own house at Rio (1942), the casino, a restaurant, and yacht club at Pampulha, which won international recognition for its successful use of new forms and the integration of architecture with sculpture and painting (1942), a new holiday resort near Belo Horizonte (1942), a church at Pampulha (1943) of highly original conception, consisting of a series of concrete parabolic VAULTS with their end walls ornamented externally with pictorial tiles and an open-work bell-tower tapering from top to bottom, the Boavista Bank at Rio de Janeiro (1946), the Municipal Theatre and Cataguazes Academy at Belo Horizonte (1946), and staff housing units for the Aeronautical Technical Centre at São José dos Campos (1947). In 1947 also he was one of the team of architects which drew up designs for the United Nations headquarters at New York. In 1951 he was leader of a team of architects who designed the spectacularly imaginative exhibition buildings for the Parque Ibirapuéra at the Fourth Centennial fair of the City of São Paulo. The opportunity for his supreme achievement was afforded when he was commissioned to design the main public buildings of Brasilia (1950–60) within the master plan drawn up by Lúcio Costa. The conception of this new capital struck the public imagination and caused the eyes of the world to be turned upon it: Niemeyer's work caused him to be universally acknowledged one of the most splendid and original architects of the century. In 1966 he designed the new building for the French Communist Party in the place du Colonel Fabien, Paris.

2021.

**NIKE.** The Greek word for 'victory', personified in art as a winged woman.

**NIKE BALUSTRADE.** The MARBLE parapet (*c*. 410 B.C.) round the Nike bastion at the south-west corner of the ACROPOLIS at Athens was carved in low RELIEF with figures of NIKE (Victory)—with Athena, sacrificing, tying her sandal, etc. The exquisite remains, graceful women in partly transparent drapery, are in Athens (Acropolis Mus.).

**NIKE OF SAMOTHRACE.** Larger than life MARBLE statue (Louvre) representing winged Victory alighting on the bows of a galley. The figure, which perhaps held up a light chaplet, is lithely outstretched and draped with dramatic swirls. Erected on Samothrace soon after 200 B.C. above a rocky pool, it showed its best view obliquely and from below.

**NIMBUS.** See HALO.

**NIOBIDS.** The fate of Niobe and her children was a favourite subject of artistic representation in antiquity. There survive various MARBLE copies of Greek statues of Niobe and her dead or doomed children which may be divided stylistic-ally into two groups, one restrainedly CLASSICAL of *c*. 440 B.C., the other of the late 4th c. B.C. and grandly pathetic. The poses and sideways exten-sion of the figures suggest that each group was designed for a PEDIMENT. The former group was discovered at Rome in 1583 and is now in the Uffizi, Florence. The group is mentioned by PLINY as being in the Temple of Apollo at Rome and it was even then disputed whether the original was by SCOPAS or PRAXITELES.

**NI TSAN** (1301-74). The most individual of the 'Four Great Landscape Masters' of the Yüan dynasty (HUANG KUNG-WANG, WU CHÊN, and WANG MÊNG: see CHINESE ART). His com-positions are less crowded than those of the other three, his INK is generally paler in tone than theirs, and his brush-work is delicate without being weak; his landscapes are serene and still, covered in snow or bathed in strong light. Together with Huang Kung-wang he was responsible for popularizing the technique of the slanting brush-stroke used with very dry ink which gave interesting textural effects and made for the clear articulation of shape. The method tends to reduce the calligraphic character of the brush-stroke and suppresses the strong emo-tional quality which for the Chinese was inherent in calligraphic line. In his bamboo paintings Ni Tsan eschewed technical brilliance in favour of quiet simplicity of statement. His works have been copied and imitated so often that dis-tinguishing a genuine Ni Tsan is one of the most difficult problems of ATTRIBUTION in Chinese painting.

Ni Tsan did not start painting until his 38th year. From 1356 he spent 15 years travelling about the rivers and lakes of his native province of Kiangsu. Born to the wealthy classes, he treated painting as a kind of AESTHETIC indul-gence in the play of self-expression. He described his attitude to art in the following way: 'In my bamboos I am really only setting forth the un-trammelled feelings in my breast; how then could anyone ascertain later whether the painting shows a formal likeness or not, whether the leaves were close together or sparse, the stems slanting or straight? Often, after I have been spattering around for some time, other people look at it and take it for straw or rushes, and I myself can scarcely tell any better whether it really repre-sents bamboos. But I really cannot serve the spectator in any other way.'

**NOGUCHI,** ISAMU (1904- ). American sculptor, born in Los Angeles of the Japanese poet Yone Noguchi and an American mother. He worked for a short time in 1921 with BORGLUM and with BRANCUSI in 1927-8, when he held a Guggenheim Fellowship. From this time he worked mainly with sheet metal ABSTRACTIONS often based upon a suggestion of natural forms. He has said: 'What Brancusi does with a bird or the Japanese do with a garden is to take the essence of nature and distill it—just as a poet does. And that's what I'm interested in—the poetic translation.' Among his best known works are: *Kouros* (Met. Mus., New York, 1945); sculptural designs in reinforced concrete for two bridges in Peace Park, Hiroshima (1951); *Japan-ese Garden* at UNESCO, Paris (1956-8); *Even the Centipede* (Mus. of Modern Art, New York, 1952).

**NOLAN,** SIDNEY (1917- ). Australian painter, one of a distinctive group of young Melbourne painters, which included Arthur BOYD, Albert Tucker (1914- ), and John Perceval (1923- ), all closely associated with the art and literary journal ANGRY PENGUINS (1941-6), and with the early exhibitions of the Australian Contemporary Art Society (from 1939 on). Nolan uses highly expressive and oddly juxtaposed images set usually in broad, fluid washes of rich opalescent colour, their impact depending greatly upon contrasts be-tween symbols of European civilization and the antipodean landscapes in which he sets them. He has also, beginning with his *Ned Kelly* paintings of 1946, occupied himself with the interpretation, often whimsical and at times HUMOROUS, of events from Australian colonial history around which legends have gathered. After 1953 he worked outside Australia, mainly in England, and his work acquired a new dimension of fantasy and imagination devoted to Leda and the Swan, Shakespeare's Sonnets, the Gallipoli Campaign, 1915-16, and his travels in Greece, Africa, and Antarctica.

567, 1824.

**NOLDE,** EMIL (1867–1956). German painter. He was probably the most gifted and powerful exponent of EXPRESSIONISM in Germany. His studies took him from his native north Germany to Munich and Paris, and from 1905 to 1907 he was a member of the Dresden BRÜCKE. He visited Russia, the Far East, and the South Sea Islands in 1913–14. Strident colours, distorted mask-like heads, and emotional brush-work make his pictures into arresting if not always pleasant images carrying conviction by their sincerity. Nolde did his best work in landscape and religious pictures. While he used some of the devices of James ENSOR (whom he greatly admired), his ends were different: he meant to revive religious imagery and tried to express

**234.** *The Sculptor* or *Preparations for the Academy. Old Joseph Nollekens and his Venus.* Engraving and water-colour (*c.* 1800) by Rowlandson

deeply felt beliefs through his moving New Testament scenes. Nolde was also a notable painter in WATER-COLOUR, specializing in flower pieces which show the application of Expressionism to the most tranquil of genres.

1111, 1211, 1948, 2414, 2455, 2706.

**NOLLEKENS,** JOSEPH (1737-1823). Sculptor, the son of an Antwerp painter of the same name who came to London in 1733. He went first to work with SCHEEMAKERS but in 1760 went to Rome where he stayed for 10 years, making while there a handsome profit out of copies of and repairs to ANTIQUES. He also made a few portrait BUSTS including those of David Garrick (Althorp, Northants.) and Lawrence Sterne (N.P.G., 1766), the latter a splendid character study in the antique manner. On his return to England he quickly built up a very large practice, and became an R.A. in 1772. His finest busts, including those of Fox and Pitt, reach a very high standard, and because the numerous repetitions were sometimes largely the work of assistants, his great gifts as a portrait sculptor have been underrated. He also made statues in a slightly erotic antique manner, and had a large practice as a TOMB sculptor. In this field, too, he paid lip-service to the antique, but avoided the dedicatory attitude of true NEO-CLASSICAL sculptors. He and his wife were well-known figures in the artistic circles of the late 18th and early 19th centuries in London, both of them being notorious skinflints, though he left a fortune of £200,000.

2508.

**NONELL Y MONTURIOL,** ISIDRO (1873-1911). One of the pioneers of modern painting in Spain. A native of Barcelona, he there belonged to the group of artists, including CASAS, RUSIÑOL, and the young PICASSO, who met at the Quatre Gats café. He exhibited with some success at Paris in the 1890s, but did not achieve general recognition at Barcelona until 1910. He is best known for his figure studies of very poor people, idiots, and gypsies, and for his STILL LIFES.

**NONESUCH PRESS.** A publishing firm founded in 1923 in London by Sir Francis Meynell, Vera Mendel, and David Garnett for the production of books characterized by 'significance of subject, beauty of format, and moderation of price'. The books were printed at various presses, as well as a few at the Nonesuch, with the aim of extending the standards of book design already achieved in a more limited field by the PRIVATE PRESSES. Although typographical excellence was the primary aim, many Nonesuch books were remarkable also for their illustrations. Among the artists employed were Stephen Gooden (*Anacreon*, 1923), E. McKnight

Kauffer (Burton's *Anatomy of Melancholy*, 1926), and Paul NASH (*Genesis*, 1929). The first hundred books issued by the press are described in the *Nonesuch Centenary* (1936).

In 1938 the controlling interest in the Nonesuch Press was sold but after the war an arrangement was reached whereby the existing Nonesuch titles were transferred to the Heritage Press, New York, and Sir Francis Meynell obtained sole use of the Nonesuch Press imprint for subsequent publications.

2610.

**NOORT,** ADAM VAN (1562-1641). Flemish history and portrait painter who is remembered chiefly because he was a successful teacher: RUBENS was his pupil for a time and he was the teacher and father-in-law of JORDAENS.

**NORMAN STYLE.** Until the end of the 18th c. the architecture of the Normans in England was not clearly distinguished from that of the Saxons. Both were regarded as debased forms of the Roman style which was thought to have lingered on until displaced by the Pointed or GOTHIC style. By 1800, however, some writers were prepared to consider Norman as a preliminary stage of the Pointed style, or even to use the term as an alternative for the Pointed style as a whole, i.e. instead of Gothic. It was only with T. RICKMAN's classification (1817) of medieval architecture in terms of window forms that Norman became a fairly precise concept. Like most words of its kind its use has been sanctioned by long tradition, but it has perhaps become more misleading than apt. In 20th-c. architectural history it may denote simply the ROMANESQUE architecture of England and could imply that the Romanesque style was imported into England exclusively from Normandy, after the Norman Conquest. This is not strictly true, and to describe buildings of the end of the 12th c. also as Norman conceals the fact that architecture in England during this period underwent a very characteristic development which had no parallel in continental Normandy.

The first Norman building in England was Westminster Abbey, built by Edward the Confessor before the Norman Conquest; and even after the Conquest Norman influences, though predominant, were not the only ones. In the West Country BURGUNDIAN features can be found, while the great English crypts (e.g. Worcester) and cushion CAPITALS derive from the Rhineland via the Low Countries rather than from Normandy. It was during the first generation after the Conquest that Norman buildings in England were most like those of Normandy. The type of elevation established at S. Etienne, Caen, with its three storeys—main ARCADE, GALLERY, and CLERESTORY—of more or less equal height; with walls thick enough to support a wall passage at clerestory level; and PIERS,

etc., encased with supporting shafts, can be recognized in a series of English buildings, such as Winchester Cathedral transepts, Ely, Norwich, and Peterborough. The only essential difference is the increased scale of the English buildings, which entailed a characteristic elaboration not found in Normandy. But at Durham Cathedral an important structural innovation was made with the ribbed vaulting which was used in the choir before 1104, and subsequently throughout the church (see VAULT). About the same time new forms of architectural ornament such as the CHEVRON, the DIAPER, and billet-moulding made their appearance (see MOULD-INGS). From the point of view of English architecture the latter innovation was more important than the former. A few later Norman churches in England received ribbed vaults during the 12th c., as in the nave of Lincoln, but this revolutionary idea was only really exploited on the Continent—first in Normandy itself and then in the Île-de-France, where it was crucial in the development of Gothic. On the other hand, English architects in the 12th c. became increasingly adept in the art of embellishing masonry with ornament and handling major architectural forms in an imaginative and decorative way without regard for structural logic. The new choir and crypt at Canterbury Cathedral—built during the first three decades of the 12th c.—set a fresh standard in the use of colour and

sculpture in architecture, while in the West Country a series of churches, of which Tewkesbury and Gloucester provide the best remaining evidence, developed the four-storeyed elevation and exploited the Giant Order. One bay in the nave of Romsey Abbey (mid 12th c.) and Oxford Cathedral (c. 1180) survive to prove how gifted and sophisticated late Norman architects in England could be. For the most part, however, masons were content to increase the amount of ornament to saturation point (e.g. the doorway in Durham Castle) and by the end of the 12th c. the creative impetus of the style was exhausted.

1487, 2562.

**NORTHCOTE,** JAMES (1746-1831). English portrait and history painter. He was REYNOLDS's pupil, assistant, and biographer. He spent the years 1777-80 in Rome and settled in London in 1781. Rome had given him ambitions to history painting and he completed a number of large, competent, and dull canvases. His *Alexander I of Russia rescuing a Peasant Boy from Drowning* (Royal Society of Medicine), which won the Gold Medal of the Royal Humane Society, displays the melodramatic bathos of the sentimental ROMANTICISM then coming into vogue. He contributed to BOYDELL's Shakespeare Gallery. One of his best known pictures, *The Murder of the Princes in the Tower* (1791;

235. West façade of the Cathedral of Notre-Dame, Paris. Engraving from *Topographie françoise ou Representations des villes, bourgs et châteaux . . . de France* (1641), Claude de Chastillon

destroyed by enemy action), belonged to this series. He was elected A.R.A. in 1786 and R.A. in 1787. Northcote was something of a character, admired in his own day as a writer as well as a painter. His *Life of Sir Joshua Reynolds* (1813) is of value for its personal recollections.

**NORWICH SCHOOL.** English regional school of LANDSCAPE PAINTING, unpretentiously provincial and unconcerned to rival the réclame of official art. It has been said that English landscape painting was in origin an art of rural landscape: 'a form of modest self-expression by provincials, a record by simple men of their own happiness in their fields and villages.' The Norwich School is important in the history of English painting because of its two great masters, CROME and COTMAN, and because of the work which was done in widening the expressive possibilities of WATER-COLOUR technique. In 1803 the Norwich Society was founded by John Crome 'for the purpose of an Enquiry into the Rise, Progress and present state of Painting, Architecture, and Sculpture, with a view to point out the Best Methods of Study to attain the Greater Perfection in these Arts'. From 1805 until 1825 exhibitions were held every year at Sir Benjamin Wrench's Court, an old house in Norwich which had become the meeting-place of the Society. When Crome died in 1821, his place as president was taken by John Sell Cotman and the activities of the Society continued until his departure for London in 1834.

Whatever the principles professed or debated by the Society, the Norwich artists consisted almost entirely of landscape painters in oil and watercolour, working chiefly under Crome's influence with a bias in favour of Norfolk scenery. They were united by ties of artistic sympathy and often also of family relationship. Apart from Crome and Cotman the principal artists were James STARK, George Vincent (1798–1830), John Bernay Crome (1794–1822), Robert Ladbrooke (1770–1842), Miles Edmund Cotman (1810–58), John Joseph Cotman (1814–78), John Thirtle (1777–1839), David Hodgson (1798–1864), Robert Dixon (1780–1815), and Thomas Lound (1802–61). Their work is best represented in the Norwich Museum.

**NOST** (or VAN OST), **JOHN** (d. 1729). Sculptor, born in Malines. He came to England about 1678 and in 1686 was foreman to Arnold QUELLIN, whose widow he subsequently married. He made a number of TOMBS with lively, somewhat mannered figures, the only signed example being that of the Earl of Bristol (Sherborne, Dorset, *c.* 1698). He is, however, chiefly notable as a maker of lead garden statues, some based on Italian or ANTIQUE models but others of his own creation. Examples remain at Melbourne Hall, Derbyshire, Hampton Court, and many other places. His nephew, of the same name (d. 1787), an indolent character, continued the practice, but settled in Dublin about 1750, where he

**236.** *Le Stryge.* Etching (1853) by Charles Meryon

783

carried out several commissions, including an EQUESTRIAN STATUE of George III.

**NOTRE-DAME, CATHEDRAL OF, PARIS.**
As originally designed in 1163 with double AMBULATORY, no chapels, and transepts flush with the outer aisles, Notre-Dame presented a plan of great simplicity and uniformity. It was the first GOTHIC monument to surpass the scale of CLUNY, and the first in which an effort was made to increase the lighting of the CLERESTORY. But its fame depends chiefly on the west front, where the cacophony of LAON has been purified to classically harmonious Gothic at its best. The portals were damaged in the Revolution, but they retain most of their original sculpture in the TYMPANA and ARCHIVOLTS. The transept façades and the chapels are all later additions, and belong to the RAYONNANT STYLE of the period 1250–1320 (see de CHELLES, de MONTREUIL, and RAVY). The transepts contain two magnificent rose windows and their portal sculpture has an easy elegance which is realized most perfectly in the VIRGIN of the north transept. The cathedral was thoroughly restored by VIOLLET-LE-DUC, who added the GARGOYLES made famous by Meryon's (1821–68) well known print. (See Ills. 235, 236.)
113.

**NOUVEAU RÉALISME.** A French version of POP ART founded in Paris during the early 1950s. Its chief spokesman was the critic Pierre Restany.

**NOYON, CATHEDRAL OF NOTRE-DAME.** One of the earliest GOTHIC cathedrals, Noyon illustrates several phases in the evolution of the style. The choir, begun before 1150, is still rather archaic, its AMBULATORY recalling that of Saint-Germain-des-Prés. But the transepts of about 1170 have a lightness of construction that is genuinely Gothic and which anticipates some of the effects of LAON. The four-storey elevation of Noyon comes from Tournai, as also do the transept APSES. These latter appear in several other churches of the neighbourhood and period, e.g. Soissons, Chalis, and the old cathedral of Cambrai. The form seems to have been derived from the triple-apsed churches of Cologne, but the Gothic masons of Noyon transformed it so completely that it became a distinctive feature of early Gothic architecture.

**NUREMBERG LITTLE MASTERS.** See LITTLE MASTERS.

# O

**OBELISK.** A tall, generally monolithic, stone shaft, square in section, slightly tapered, and with a pyramidal apex. The obelisk originated in Egypt as a solar symbol, the earliest being the massive, squat ones in the 5th Dynasty sun-temples and small examples from contemporary private TOMBS. Later, and particularly during the New Kingdom, a pair of obelisks with royal inscriptions were often erected before the PYLON of a temple. Few now remain standing in Egypt, the tallest being that of Hatshepsut at KARNAK (97 ft.), though one which lies unfinished in the Aswan quarries measures 137 ft. Many were removed to Rome in imperial times (including one over 100 ft. in height) and their rediscovery during the RENAISSANCE led to the adaptation of the obelisk form for MONUMENTS and architectural ornament. During the 19th c. others were transferred to Paris, London, and New York (the so-called 'Cleopatra's Needles').
820.

**OBJET TROUVÉ.** A found object which is displayed as a work of art. It may be a natural object, such as a pebble, a shell, or a curiously contorted branch, or a man-made object such as a piece of pottery or old piece of iron-work or machinery. The essence of the matter is that the finder-artist recognizes such a chance find as an 'aesthetic object' and displays it for appreciation by others as he would a work of art. The practice began with the SURREALISTS and was cultivated for a time in England chiefly by Paul NASH.

**OCCUPATIONS OF THE MONTHS.**
Ancient Egypt and Mesopotamia both had lunar

calendars of a religious nature but Egypt first introduced a civil calendar of 12 months with 30 days each. Yet calendar illustration occurs rarely in EGYPTIAN ART and was limited to portraying the divinity connected with each month. In the earliest extant Greek calendar illustration, the 1st- to 2nd-c. B.C. frieze on the church of S. Eleutherios in Athens, the celestial origin of the calendar is indicated by the signs of the zodiac (which were to remain a constant feature) while mundane life is illustrated by religious festivals. The fullest Roman representation of the months is that in the calendar written by Philocalus in 354 (known from copies: Staatsbib., Vienna, 15th c.; Vatican Lib., 17th c.). Each month is illustrated by a single figure within an architectural framework, referring either to a religious festival or to a human activity. Variations of this type occur quite frequently in ROMAN ART (mosaics: Hermitage, 2nd c.; B.M., from Carthage, 4th c.; Beisan, Israel, 6th c.), but rural 'occupations' appear outside the field of actual calendar illustration (Triumphal Arch, Reims; mosaics, Zliten, Tripolitania, 2nd c.). A MOSAIC of the four seasons from S. Romain-en-Gal (Louvre, 3rd–4th c.) shows with each season a group of seven activities such as sowing, reaping, and treading grapes. Therefore, although classical art did not portray the occupations of the months in the strictest sense, it laid the foundations for future development.

In the early 9th c., when calendar illustrations can again be traced, they had developed away from the rather static allegorical and religious figures of the Romans towards a representation of the active daily life of the Christian. The earliest extant medieval examples are two Salzburg manuscripts (Munich, c. 818; Staatsbib., Vienna, before 830), in which all but one of the months are illustrated by occupations. They were probably derived in part from Roman calendar illustrations and in part from other classical sources. A similar development occurs in other western manuscripts (*Martyrology of Wandalabert of Prüm*, Vatican Lib., 9th c.) and to a lesser degree in BYZANTINE ART (Marciana, Venice, 11th c.; Octateuchs, Vatican Lib., 11th–12th c.).

In the West this period of experimentation had ended by the 12th c., when the occupations of the months became very frequent both in the Calendars of liturgical manuscripts and in the cosmological schemes on sculptured portals of churches and cathedrals. There was no universal system but the following is typical for France: January, feasting (with or without Janus); February, warming; March, pruning; April, flower bearer or shepherd; May, hunting; June, mowing; July, reaping; August, threshing; September, treading grapes; October, knocking down acorns or feeding hogs; November, killing hogs; December, feasting (AUTUN; VÉZELAY; Portal Royal; CHARTRES; SENS, 12th c.; AMIENS, Chartres, NOTRE-DAME, Paris, 13th c.). Variations occur in other countries in accordance with regional habits and customs. Thus the cooper, for August, is peculiar to Italy (S. Zeno, Verona; Baptistery, Parma; 12th c.), while the English climate accounts for the summer activities being a month later than in France and two months later than in some of the Italian series (font, Burnham Deepdale, Norfolk; *York Psalter*, Univ. Lib., Glasgow, 12th c.).

The 14th c. was no longer an age of the great 'encyclopaedic' cathedrals and the occupations of the months were again confined chiefly to illustrated manuscripts. In French, and later Flemish, manuscripts the calendar scene was the principal place for experiments in realistic LANDSCAPE PAINTING and ultimately it often became a full-page composition rather than a marginal scene (*Très Riches Heures du duc de Berry*, Musée Condé, Chantilly, before 1416). The aristocratic patronage of such manuscripts was reflected in the subjects: April, for instance, was transformed into a refined scene of courtly love and in general aristocratic amusement took the place of the labours of the peasant. In 14th- to 15th-c. England the months were often represented on misericords (Gloucester; Worcester, 14th c.; Malvern; Ripple, 15th c.). The Italian RENAISSANCE sometimes connected the months with ASTROLOGICAL cycles (frescoes, Palazzo Schifanoia, Ferrara, 1469–72); a more traditional series are the Luca della ROBBIA plaques from the Palazzo Medici, Florence (V. & A. Mus., c. 1450). But although they had been a principal and influential repository of classical forms throughout the Middle Ages, the occupations of the months gradually disappeared from post-Renaissance art.

2818.

**OCEANIC ART.** Oceania, also referred to as the South Seas, comprises those islands of the South Pacific, including New Guinea and New Zealand, which extend to Hawaii and the Sandwich Islands in the north and to Easter Island in the east. It is customary to refer to the inner belt of islands as MELANESIA and to divide the outer belt into POLYNESIA in the east and MICRONESIA in the north. (See Map 4, p. 786.) The art of Oceania is discussed under these headings.

8, 316, 432, 1197, 1611, 1672, 2421, 2501, 2654, 2909, 2910.

**OCHTERVELT,** JACOB (c. 1635–c. 1710). Dutch portrait and society painter whose works show the influence of his greater and slightly older contemporaries, VERMEER, TERBORCH, and METSU. In his interiors the figures are usually larger than theirs, and he had a special preference for orange-coloured fabrics.

**OFFSET.** A reproduction made by damping a sheet of paper and pressing it against a drawing in CHALK, Indian INK, BISTRE, etc. Offsets were often made for working purposes by designers of ornament who needed to have a copy of a design

**Map 4.** OCEANIC ART

in reverse. There exist many offsets of French 18th-c. drawings in red chalk, some of them made fraudulently for sale as originals. The term is used in engraving for an impression taken from a PRINT instead of from the block or plate itself. The transfer made in this way is in reverse as regards the print from which it is taken, but in the same sense as the drawing on the block or plate. The term is also used as an abbreviation for 'offset LITHOGRAPHY', where the ink is transferred from the lithographic plate or stone on to a rubber roller and thence while still wet to the printing paper.

**OGEE.** Architectural term for a MOULDING consisting of a curve and a hollow, having an S-shaped section. Hence the term is sometimes extended to any S-shaped curve.

**OGIVE.** Architectural term of French origin for a pointed ARCH, VAULT, or window. Also used of a diagonal rib of a vault.

**O'GORMAN,** JUAN (1905- ). Mexican architect and painter. In 1929 he was appointed by Diego RIVERA to the School of Architecture at the Academy of San Carlos and the house which he built for Rivera at Coyoacán was one of the first examples of modern domestic architecture in Mexico. The 30 new schools which he built (1932-5) for the Ministry of Education confirmed his leadership in progressive architecture. His FRESCOES for Mexico City Airport (1937-8) were an interesting contribution to Mexican mural painting; the greater part of them were destroyed in 1939 owing to their anti-ecclesiastical and anti-fascist propaganda. In 1941-2 he did a large mural (15 metres by 12½ metres) for the Bocanegra Library at Pátzcuaro, in which he depicted 1,000 years of the history of the state of Michoacán. His MOSAIC decorations for the Library at the new University City, done in 1951-3, were among the most progressive developments of MEXICAN ART. His style is characterized by meticulous and rather dry draughtsmanship combined with imaginative subject matter and a gift for CARICATURE. In his PANEL painting he was one of the few Mexican artists who went in for LANDSCAPE.

2504.

**OIL PAINTING.** The term 'oil painting' is used both of a method of picture making and of pictures made by that method. In fact it covers a very diverse range of methods and materials so that oil paintings from different periods and schools of technique differ vastly among themselves in structure and appearance. The common feature which justifies calling any picture an oil painting is the substantial use of certain DRYING OILS in the MEDIUM. These oils turn into a solid, transparent substance after prolonged exposure to the air and serve to hold the particles of PIGMENT in position and bind them to the GROUND. The transparency is, however, a matter of degree

and oils often turn yellow or brown with age. This, as well as discoloration of the VARNISH, accounts for the dark 'Old Master' appearance of many old paintings which were painted in a lighter range of COLOURS, though in the 18th and 19th centuries the 'Old Master' appearance was sometimes deliberately reproduced by artists at the first painting.

The origin of oil painting in Europe is obscure. VASARI's attribution of its invention to Jan van EYCK at the beginning of the 15th c. is well known. He states that van Eyck while searching for a varnish which would dry without being put in the sun discovered these qualities in LINSEED OIL and nut oil, which he then used as a medium for his pigments. Unfortunately, however, it is known that these oils were used as a medium in the Middle Ages long before van Eyck. THEOPHILUS among others specifically advocates grinding pigments into linseed oil or WALNUT OIL, although it is clear from his account that it was the practice to dry each layer in the sun before applying the next layer. The precise nature of van Eyck's innovation is therefore unknown, but there is no doubt that he was responsible for a revolution of the techniques of oil painting in Europe, bringing greater flexibility, richer and denser colour, and a wider range from light to dark. It would have been impossible, for example, to produce in TEMPERA such a work as *Arnolfini and his Wife* (N.G., London), with its gradation of detail, its NATURALISM of colour and atmosphere, its three-dimensional modelling of forms into space, and its subtle transition and blending of tones. Nor is there any reason to doubt that van Eyck's 'secret method of painting in oil'—whatever it was—was brought to Italy by ANTONELLO DA MESSINA. From this time the greater potentialities of the new oil method began to be exploited and it gradually increased in popularity over tempera. In Italy its use developed more slowly than in the north. Well into the 16th c. a mixed technique was used and oil painting was still often executed in the meticulous manner traditional to tempera painting. Throughout the RENAISSANCE pictures were built up in thin transparent GLAZES with little or no admixture of white, which allowed light to be reflected back from the luminous ground or UNDERPAINTING, and full advantage was taken of the modifications of colour and tone which are produced when an under-layer of paint makes its influence felt through a partially transparent over-layer. Giovanni BELLINI achieved a particular richness of colour and his *Doge Leonardo Loredano* (N.G., London, c. 1501) was one of the earliest attempts to produce texture by the use of IMPASTO.

From this time attention was given to the expressive use of paint as a substance with textural qualities of its own, a method which is peculiar to oil among the various painting techniques. This method of using oil paint reached a peak among Renaissance artists in the later works of TITIAN, which depend so largely

on colour and pigment for their structure and modelling. Even Vasari, who deplored any method which did not show an obvious dependence on DRAWING, admired these works which, he said, were executed 'roughly, with bold strokes and blots' and appeared to have been 'achieved without labour'. During the 17th c. the three artists who contributed most to the perfection of their various techniques of oil painting were RUBENS, VELAZQUEZ, and REMBRANDT. Rembrandt used a method depending partly on light reflected from the ground and partly on light from a solid body of pigment: his shadow passages were painted thinly and transparently, the lights solidly. Unlike Rubens he preferred a dark ground. Frans HALS and Velazquez exploited the possibilities of a thick impasto and bold, varied brush-work to produce expressive surface textures. There were, however, two schools of thought in oil painting right up to the revolution which took place in the middle of the 19th c. One school sought ever new and more varied means of rendering paint expressive as a substance by allowing signs of handling to remain in the completed picture; the other school aimed at an even, glassy surface from which all evidences of manipulation had been banished.

The revolution which took place in the techniques and appearance of oil painting about the middle of the 19th c. coincided with a breakdown of the workshop traditions of tempering paints and other materials as the commercial colourman took over manufacture of artists' materials. The invention of the collapsible tin TUBE, which took the place of the inconvenient and messy bladders which were in use as paint containers during the first half of the century, brought about changes of practice which were fundamental in their effects. In particular it now became possible for oil painters to work out of doors and paint directly from nature. The use of POPPY OIL as a medium produced paint which dried slowly but had a thick, buttery consistency which preserved the roughnesses of brushstrokes and other signs of handling which before had tended to flatten out and disappear during drying. Later colour manufacturers found means of adding waxes, metal soaps, and other adulterants to a linseed medium in order to give it similar qualities. The change in the character of the paint favoured in turn the practice of 'direct' or *alla prima* painting, in which instead of building up the picture by successive layers of transparent or semi-transparent paint in glazes and SCUMBLES the artist lays on each patch of colour more or less as it is intended to appear in the final picture. A slow-drying paint keeps the painting moist and malleable and is therefore not a disadvantage for this method, whereas when each layer had to be dry before the next layer was put on top quick drying was a great convenience to the painter. Direct painting also encouraged spontaneity and impulse, or what passed as such, in place of the older system of the planned com-

position. Pictures were no longer carefully built up stage by stage on a meticulous drawing and careful underpainting but were finished either in a single layer or with relatively few overpaintings done while the under-paint was wet. Direct painting also required the paint to be laid on thick and large brushes of pigs' bristle came into use. The exploitation of the large loaded brushstroke as a display of virtuoso skill, imposing an independent pattern on the finished picture, turned out to be one of the most characteristic features of certain of the most popular schools of oil painting in the second half of the 19th c. It was cultivated by MANET, who derived it from Velazquez, and one of its most fashionable exponents was SARGENT. It was very closely connected with the change in the character of artists' paint and with the consequent stimulus given to direct methods of painting. For many 19th-c. painters the decorative brush-stroke was no longer an expressive adjunct to painting but an essential element in the picture and a distinguishing mark of their style.

A second and hardly less important change during the latter part of the 19th c. was that brought about by and under the influence of the IMPRESSIONISTS. The painters of the 16th and 17th centuries had relatively few bright colours and those they had they preferred to use in the deeper tonal ranges where they could be exhibited at their maximum beauty and intensity. By the middle of the 19th c. many more bright colours, and particularly metallic colours, were available to the artist: the richer PALETTE included mauves, violets, bright greens and oranges, different blues, and intense yellows. This was by no means an unmixed blessing but it did fit in with the new method introduced by the Impressionists of painting for the optical admixture of colours which were not mixed on the palette or by reflection through superimposed layers of paint. The new methods did not produce brighter or richer effects of paint but new possibilities of representing light and atmosphere.

The history of oil painting in the 20th c. reveals a perpetual restlessness of experimentation but no major revolution comparable to those which occurred at the beginning of the 15th and middle of the 19th centuries, where new aesthetic developments were closely connected with the introduction of new technical methods in the manipulation of the medium. The most characteristic features of innovation in the 20th c. have been the combination of oil painting with three-dimensional construction and the exploitation of the apparently accidental in action painting (see ABSTRACT EXPRESSIONISM).

**O'KEEFFE**, GEORGIA (1887- ). American painter who became an adherent of the circle of Stieglitz (see AMERICAN ART OF THE U.S.A.) in 1916 and during the 1920s was ranked as one of the leading artists in the style of expressive ABSTRACTION. Her formalized representations of architectural subjects had at one time a high

reputation (*The American Radiator Building*, Alfred Stieglitz Coll., Fisk University). She developed a precise and disciplined line and a style of decorative form expressed either in abstractions (*Blue and Green Music*, The Art Institute of Chicago) or, from *c.* 1925, microscopic close-ups of organic shapes (*Calla with Roses*). Retrospective exhibitions of her works were given by the Art Institute of Chicago (1943), the Museum of Modern Art, New York (1946), Dallas Museum of Fine Arts (1953), and Worcester (Mass.) Museum of Art (1960).

**OLBRICH**, JOSEPH MARIA (1867-1908). Austrian architect, a pupil of O. WAGNER. He was one of the founders of the Vienna SEZESSION, for which he designed the first exhibition building in the ART NOUVEAU style (1908). Called in 1899 by the Grand Duke of Hesse to Darmstadt, he designed an artists' colony and was the architect for most of the exhibition buildings on the Mathildenhöhe. His *Hochzeitsturm* at Darmstadt (1907) was particularly distinguished. He also executed a great number of public and private buildings, including country villas, a railway station, a modern department store (Tietz, Düsseldorf, 1907/8), which revealed a tendency away from the elegantly ornamental towards a more functional style.

**OLDENBURG**, CLAES (1929- ). American sculptor, born in Stockholm. He passed his childhood in both the U.S.A. and Norway and studied at Yale University, where he got his B.A. in 1950. As with the POP ART painters, his subjects derive from the everyday environment. In 1960 he held an exhibition called 'The Street' and in 1961 'The Store', in which his earliest plaster reliefs and objects were shown (*Girl's Dresses* and *Oranges Advertisement*). In 1962 he switched to more massive free-standing renditions (*Giant Ice Cream Cone* and *Giant Hamburger*), both made of painted canvas stuffed with foam rubber. By altering scale he could charge the most commonplace things with new expressive possibilities. Oldenburg used diverse materials, questioning the qualities of texture, hardness, and softness of each. For example in his bathroom series, toilet, sink, bathtub, etc., were each represented in three different materials: soft, sagging vinyl, rigid cardboard, and white 'ghost' canvas. Other subjects include bedroom, typewriter, plug and outlet, light switch, ice cream sundae, raisin bread, soft drum set. He also did a series of drawings for colossal monuments suited to different large cities (*Lipstick for Piccadilly Circus*).

**OLIPHANT**. A primitive musical instrument of the Middle Ages which served as a hunting-horn, a military bugle, a watchman's horn, or, on occasion, a reliquary. It was usually made from the tusk of an elephant (*olifant* in Old French), and was one of the most typical forms of ivory-carving, since it retained the basic shape of the raw material (see IVORIES). Most oliphants are, or have been, encircled by metal bands near both ends, to which slings or cords were attached for suspension.

For centuries the oliphant has been associated with the *Chanson de Roland*, in which the paladin sounds the horn with his dying breath on the field of Roncevaux, and a horn in Aachen Cathedral is traditionally connected with Charlemagne. Neither poem nor horn, however, can be taken as evidence for the use of the oliphant in the 8th c., since the epic dates from the 11th c., and the history of the horn at Aachen cannot be traced earlier than the 10th.

The designs apparently originated in Fatimid Egypt in the 10th c., and one of the most characteristic is an all-over pattern of animals in roundels carved in flat RELIEF against a plain background and interrupted by borders of conventionalized foliage on either side of the metal bands (V. & A. Mus.; Louvre). BYZANTINE artists of the 10th and 11th centuries apparently copied this design, converting the roundels into a continuous tree springing from a vase (Met. Mus., New York), and invented new ones based on the hippodrome subjects of consular DIPTYCHS (B.M.).

In Italy, too, imitations were made in the 11th c. which are distinguished from Fatimid and Byzantine oliphants by slight differences in style (Rijksmuseum; Kestner Mus., Hanover), and both originals and copies found their way into the cathedral treasuries of the West in great numbers during the 12th c. Many of them were converted into hanging reliquaries by stopping the ends, and an early example which must have served this purpose is apparently a Fatimid oliphant of which the centre section was re-carved in Italy to represent the Ascension (Musée Cluny, Paris).

In the 14th and 15th centuries ivory horns were superseded by metal ones, but one of the finest, as well as one of the latest, examples of the oliphant is a 16th-c. French hunting-horn in the Rothschild Collection (Paris), ornamented with ARABESQUES in high relief on a plain background in imitation of metal-work.

**OLIVER**, ISAAC (before 1568-1617). Miniaturist, born at Rouen, who came to England in 1568 and worked under HILLIARD. He continued the spirit of Hilliard and the two dominated the art of MINIATURE painting. In his maturity he worked in a more NATURALISTIC manner with marked contrast of light and shade, and his matter-of-fact style appealed to the wider public which, after about 1600, looked rather for plain recording than for delicate subtlety in the miniature. His miniatures were generally of the head and shoulders, but he also painted full-lengths and probably also life-size portraits in oils. His son, PETER (1594-1647), continued in his style, but specialized also in miniature copies after the Old Masters.

**OLYMPIA PEDIMENTS.** Greek pedimental sculptures, MARBLE and over life-size, from the temple of Zeus at Olympia (where they still are), which may be dated *c.* 460 B.C. The east (and front) PEDIMENT, commemorating the chariot race between Pelops and Oenomaus, is tamely composed of static figures—Zeus flanked by the two antagonists, each with his woman, chariot, and attendants. In the west pediment Apollo directs the confused groups of Lapith women resisting and men fighting Centaurs. The style is bold and severe, reticent of emotion. Some modern admirers of its simplified forms forget that the figures stood more than 50 ft. above the ground.

**OMEGA WORKSHOPS.** An undertaking with certain affinities to the firm of William MORRIS in interior decoration and DESIGN, founded by Roger FRY in 1913 and active in London until 1919. The enterprise was the out-come of new views about the function of art in society developed by Fry perhaps under the influence of Veblen's *Theory of the Leisure Class* and was an attempt to bring the new sensibility of modern art into touch with daily life by the production of decorative art. Among his chief associates in this enterprise were Duncan GRANT and Vanessa Bell.

The Omega artists believed that the creative joy of the artist and craftsman should go into the making of articles for everyday use. Examples of their work are in the Courtauld Institute Galleries, London, and in the Victoria and Albert Museum. They include furniture, textiles, pottery, tiles, puppets, and many more.

**OOSTSANEN.** See CORNELISZ VAN OOSTSANEN.

**OP ART.** Term which became current in the second half of the 20th c. to denote a style of

**237.** *Fall 1963* by Bridget Riley (Tate Gal.)

ABSTRACT ART which seeks to give an illusion of movement by exploiting optical effects. Whereas this practice has been a feature of much art in the past, so-called Op Art made it the central or sole object of the work of art.

**OPIE, JOHN** (1761-1807). English painter, son of a Cornish carpenter, who showed a precocious talent for DRAWING and attracted the notice of John Wolcot ('Peter Pindar'), who launched him in London in 1781 as a prodigy ('The Cornish Wonder'). Opie was then painting strongly modelled portraits and rustic FANCY PICTURES with REMBRANDTESQUE lighting which were praised by REYNOLDS. He advanced to more ambitious subjects with *The Schoolmistress* (Lockinge Coll., 1784), and he later attempted history painting. *The Death of Rizzio* (formerly Guildhall City Gal., destroyed in Second World War, 1787) which he painted for BOYDELL was widely popular. He was elected Professor of Painting at the Royal Academy in 1806 but despite this success he cannot be said to have fulfilled the promise of the early years, to which his best work belongs. He ranks with NORTHCOTE and BEECHEY in the second class of portrait painters of the day. He had a sense of pattern and a gift for catching significant expression which at his best gives his work an interest, but he was too often insipid and ordinary.

793.

**OPPENORD, GILES-MARIE** (1672-1742). French architect and decorator. Architect to the Duke of Orleans. From 1719 he worked on Saint-Sulpice, and built the nave and the PORCH of the south transept. As a decorator he played an important part in the development of the RÉGENCE style (Hôtel de Pomponne and Hôtel d'Assy, Paris). Many of his designs, mainly decorative, were engraved and published.

**OPUS MUSIVUM.** See MOSAIC.

**OPUS SECTILE.** The name given by the Romans to MARBLE inlay, where the pieces are cut into shapes which follow the lines of the pattern or picture. It is to be distinguished from MOSAIC, where the pieces are cut to a uniform size, and where their grouping and not their shape gives the composition its form. It is a rarer and more luxurious art, since the plates of marble are larger, more fragile, and more precious than the mosaic fragments; and it was in Egypt and Asia Minor, lands rich in coloured marble, that it had its origin. The Book of Esther (i. 6) describes 'a pavement of red and blue and white and black marble' in the palace of Ahasuerus. But little survives from before Roman times, except fragmentary remains from the Ptolemaic period which have been found in Alexandria.

This Alexandrian inlay, of plaques of coloured marble laid in a plain surround, is imitated in the earliest Roman wall-paintings. But the first examples of *opus sectile* are the pavements in the richer VILLAS at Herculaneum, laid in large squares and triangles of yellow, green, and red (1st c. B.C.). Small mural PANELS of the same period have been found in POMPEII, showing dancing figures in coloured marble laid in a matrix of black stone (Naples Mus.). In Rome similar panels from the late 1st c. A.D. show the legendary foundation of the city (Colonna Coll.). But the richest surviving group of classical marbles comes from the BASILICA of Junius Bassus on the Esquiline (early 4th c.), where the walls were decorated all over with brightly coloured inlay. Of these there remain some pictures of fighting beasts (Capitoline Mus.) and a large composition showing a consular triumphal chariot, perhaps that of Junius Bassus himself (Palazzo del Drago).

Coloured marbles for such inlay were brought to Rome in large quantities from Egypt, Numidia, and Asia Minor. The blocks were sawn into plates from $\frac{1}{4}$ in. to 2 in. thick, polished on one side, and from these the required shapes were cut according to a given CARTOON. The smaller pieces of an ornate design or picture were assembled apart. Sometimes they were set in a single plate of stone, cut to receive the various parts of the picture, as at Pompeii. Otherwise they were arranged face downward over the cartoon and backed with an adhesive mixture of RESIN or cement, ready to take their place in the whole. The simpler designs and the larger shapes were laid direct into their cement bed on pavement or wall. In this work technical skill and precision rather than artistic talent were needed. Even more than mosaic, *opus sectile* has essentially decorative rather than pictorial qualities. The *marmorarius* earned his name by his ability to choose and work fine marbles, and he did not have the same freedom as the mosaicist in the placing of his pieces and the interpretation of the picture.

The Christian Church of Rome also employed *marmorarii*, and their work has survived in the simple patterns of the 5th c. on the walls of the Lateran BAPTISTERY and Sta Sabina. Similar panels were made in Ravenna for the Baptistery in the 5th c. and S. Vitale in the 6th c., and in S. Ambrogio, Milan, there is a LAMB cut from a single plate of white marble and laid in a patterned surround (5th c.). The APSE of the basilica at Parenzo is set with plates of PORPHYRY and serpentine, inlaid with ornate designs in marble, glass, and mother-of-pearl; the finest of these designs date from the classical period and must have been borrowed from an earlier Roman building.

But it was in the BYZANTINE Empire that the art of *opus sectile* was preserved during the early Middle Ages. Sta Sophia in Constantinople is lined on walls and pavement with rich panels of coloured marble borrowed from classical MONUMENTS. The palace too contained much inlay and the big roundels of the pavements were used

791

in the grouping of imperial ceremonial. A floor with similar roundels of coloured marble survives in the 11th-c. church of St. Luke in Phocis (Greece).

In the 11th c. Greek *marmorarii* were called to Monte Cassino in Italy, and from here the art of *opus sectile* spread once more to Rome, where the COSMATI set up their workshop in the 12th c. Greek *marmorarii* also worked in the Norman churches of Sicily, where the pavements as well as the PULPITS and balustrades are covered with squares, roundels, and ARABESQUES, richest of all in the Capella Palatina at Palermo. In north Italy the fine pavement of St. Mark's, Venice, where linking circles were made up from small squares and triangles of coloured stone, also dates from this time; and similar floors have survived at Murano and Pomposa.

Figured pavements in black and white were developed in Tuscany in the 13th c. In S. Miniato al Monte, Florence, the floor is laid in squares of white marble inlaid with intricate patterns, signs of the zodiac, and other symbols. Siena Cathedral is almost entirely paved in black and white marble inlay, begun in the early 14th c. and finished by Domenico BECCAFUMI *c.* 1540. The subjects include portraits of the classical philosophers, PERSONIFICATIONS, and scenes from the Old and New Testaments.

Another kind of *opus sectile* developed at this time was the Florentine art of PIETRE DURE, in which tiny shaped fragments of marble and other bright materials were bound with resin on to a base of hard stone or slate. This industry was encouraged by the discovery of coloured marbles in the Tuscan hills in the mid 16th c. and became very popular in the 17th and 18th centuries, reaching a new level of technical perfection. It was used chiefly in furniture, but a rich display of *pietre dure* may also be seen in the Medici chapel in Florence.

**OPUS TESSELATUM.** See MOSAIC.

**OPUS VERMICULATUM.** See MOSAIC.

**ORANS** (pl. *orantes*). See GISANT.

**ORBAIS,** JEAN D' (active first half of the 13th c.). The names of the first four master masons of the High GOTHIC cathedral of REIMS were recorded in a labyrinth set out on the old floor of the nave. They are known from 18th-c. transcriptions. Jean d'Orbais is said to have begun the '*coiffe de l'église*' which is usually understood as the APSE of the cathedral. Hence he is regarded as the first of the four and responsible for the general design. E. PANOFSKY, however, thinks that he was the second master, and that he began the VAULTING. The work was begun in 1211 and the choir was consecrated in 1241, so on either reading his activity falls between these dates. The fact that the names of the masons were recorded is itself an interesting development. Before 1200, masons' names occur

less frequently, and the change indicates a general improvement in their social and economic position as they acquired a quasi-professional status.

**ORCAGNA.** ANDREA DI CIONE (active *c.* 1308–*c.* 1368). Leading FLORENTINE artist of the third quarter of the 14th c. He was painter, sculptor, architect, and administrator. His nickname 'Orcagna' was local slang for 'Archangel'. In 1343/4 he was admitted to the guild of the painters and nine years later to that of the masons. From 1355 to 1359 he supervised the most ambitious sculptural project of the time, the MARBLE shrine for the Madonna in the oratory of the public granary (Or San Michele). To this period belong the few surviving paintings by him: the FRESCO fragments from the grim trilogy *Triumph of Death*, *Last Judgement*, and *Hell* (Sta Croce, *c.* 1350); and the ALTARPIECE of *The Redeemer* (1354–7) in the Strozzi chapel of Sta Maria Novella. From 1359 to 1362 Orcagna was intermittently in Orvieto directing the construction of the cathedral. He also served as an architectural adviser for the cathedral of Florence. During 1368 he fell mortally ill while painting the *St. Matthew* altarpiece (Uffizi) and this work was subsequently finished by JACOPO DI CIONE, his brother.

Orcagna's pictorial style is a reversion to the BYZANTINE of the preceding century. His figures, despite their massiveness, live in a golden world far removed from the onlooker, remote, unsmiling, immobile, and tense. By contrast GIOTTO's NATURALISTIC colours are prosaic. The very materials of Orcagna's sculptural and architectural decorations are a return to those of the 13th c.: at Orvieto he revived MOSAICS, and the inlays of the Or San Michele tabernacle are an elaboration of the COSMATI WORK.

Orcagna was a versatile and powerful figure, the first 'universal artist' of stature to appear since Giotto. Although he repudiated the spirit of Giotto's innovations and reverted to an older tradition, he was by no means a mere revivalist but brought a new though different sense of modernity to the Byzantine GOTHIC which he continued.

1169.

**ORDERS OF ARCHITECTURE.** As a term in architecture an Order is a total assemblage consisting of a COLUMN with its appropriate ENTABLATURE, the primary divisions of the column being the shaft, the base (if any), and the CAPITAL. The Doric, the Ionic and its offshoot the Corinthian Orders were evolved by the Greeks and their forms were taken over and modified by the Romans, who added the Tuscan and Composite, making five Orders in all. The Doric and the Ionic grew independently, the former developing in mainland Greece and the Ionic in the lands east of the Aegean more subject to the influence of older Asiatic styles.

TOSCANO DORICO IONICO CORINTHO COMPOSITO

**238.** The five Orders of Architecture. Engraving from *Regola delli Cinque Ordini d'Architettura*, Rome (1607) by Vignola

The massive Doric column of the Greeks had no base but rose directly from a stepped platform (stylobate). It had 20 broad FLUTES whose channels met in sharp edges. It was crowned by a low, spreading capital with an OVOLO MOULDING (called 'echinus' because its curve resembled that of a sea-urchin shell) beneath the square slab called the ABACUS. Beneath the echinus ran three FILLETS. The entablature had three main members; first a plain ARCHITRAVE and then a FRIEZE composed of alternate TRIGLYPHS and METOPES, which are commonly alleged to manifest their adaptation from the timber structures of the older wooden TEMPLES. The triglyphs, one above each column and one in each intervening space, represent the wooden beams; the little drops (guttae) beneath them echo the wood pegs that secured them; the flat metopes replace the boarding or TERRACOTTA plaques that filled the spaces between the beams. The third member of the entablature is the CORNICE, which in the Doric Order projected strongly and had on its underside broad, shallow blocks (mutules) over triglyphs, with guttae. In some early stone examples (e.g. the small temple of Athena Pronaia at Delphi) the columns are slender, but in larger buildings a squat form more

suitable to stone was very soon in use. The later, often MARBLE, examples grew less stocky until from unpretentious origins they achieved a level of architectural refinement that has seldom been equalled. The Greeks, instead of directing their attention to experimental engineering like the Romans, concentrated on delicate optical corrections within the traditional forms. Their excellent marbles were suitable for the finest precision cutting, and made possible the lines of the PARTHENON where the long horizontals of stylobate and entablature are subtly curved throughout their length, as is the PEDIMENT above; each column leans a little towards the axis of the building, the corner ones being doubly canted and also set in towards their neighbours lest the play of light around them should make them appear weaker; the entire pediment has a slight tilt forward to redress the backward tilt of the columns. The great mass of masonry is thus shot through with vitality and springing grace.

Ionic is comparatively rare on the Greek mainland, where the columns are given the Attic base as opposed to the Asiatic base favoured in the East (temple of Artemis at Ephesus). The slender shafts have flutes, usually 24, which

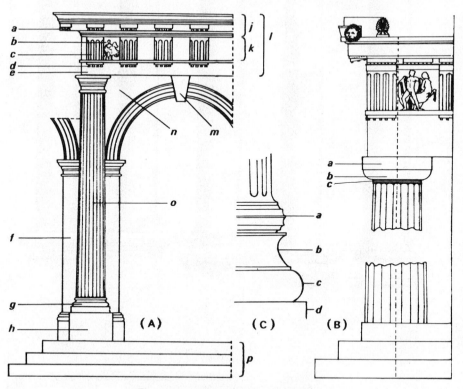

**Fig. 33.** SOME TERMS OF CLASSICAL ARCHITECTURE

A. Classical Arch: *a.* mutules *b.* metope *c.* triglyph *d.* guttae *e.* architrave *f.* pier *g.* base *h.* pedestal *j.* cornice *k.* frieze *l.* entablature *m.* keystone *n.* spandrel *o.* flutes *p.* stylobate;

B. Doric Column: *a.* abacus *b.* ovolo moulding (echinus) *c.* fillets; C. Attic Base: *a.* torus moulding (fluted) *b.* scotia moulding *c.* torus moulding *d.* plinth

except in the earliest examples are divided by fillets. Above an egg-and-dart moulding the capital bears the scroll-shaped feature typical of the Order, the sides curving down to form two large spiral VOLUTES. The entablature is more adaptable than the Doric, having an architrave with overlapping courses (fasciae), and above it enriched mouldings and a continuous carved frieze or a row of DENTILS under the cornice or, in later examples, the two together.

Corinthian is chiefly distinguished from Ionic by its capital, first found in interior work at Bassae on the mainland. It may have originated in a fillet of bronze leaves fitted round a shaft. As standardized later, it has a tall, circular bell, rows of ACANTHUS leaves above the necking, and above these the volutes. There are four volutes to each face. Two spread out to support the projecting corners of the concave abacus; the other two bend towards the centre to touch a flower at the middle of the abacus's hollow curve. Two stalks (cauliculi) run up each face of the bell, and from them sprout the volutes.

These Orders passed into Roman use. The Doric column was thinned out and set on a base, but both it and the Ionic fell somewhat out of favour. As in the HELLENISTIC period there was some fusion of the two. The Tuscan Order was a simplified version of Doric. This had an unfluted shaft, and the base, capital, and entablature were treated with the utmost reticence.

The Composite capital was concocted, however, to please a more lavish taste by adding Corinthian acanthus to Ionic volute; mouldings were enriched with carving and entablatures loaded with sumptuous decoration. But the real interest of the Roman builder was the bridging of vast spaces with VAULTS and ARCHES; he was not so much a stonemason as an engineer working in brick and CONCRETE. The Orders therefore became a means of surface decoration in front of, but no longer supporting, the walls. Within the Baths of Caracalla (see THERMAE) are capitals where Hercules rests among the acanthus leaves and the lines of the volutes are cluttered by miniature foliage.

Earlier than such developments, during the great 1st-c. building programme of Augustus, a treatise on architecture was written by VITRUVIUS who gave, somewhat confusedly, detailed proportions of the various Orders. It happened that this was the only work on the subject to survive, and in consequence it dominated the RENAISSANCE approach to antiquity. SERLIO, VIGNOLA, PALLADIO, and others published treatises redefining the Orders and trying to work out the correct proportions. As the Greek originals were unregarded until the later 18th c., Vitruvius's rules represented all that was 'correct' in architecture. From Serlio onwards, however, although a pedestal under a column was not an essential part of the Order, appropriate pedestals are given by the theorists. Until the present century the first concern of the architect, at least in theory, was to master the discipline of the Orders and their proportions.

See also COLOSSAL ORDER.

**ORDÓÑEZ, BARTOLOMÉ** (d. 1520). The first Spanish sculptor to show clearly the impact of the Italian High RENAISSANCE. He was at Naples c. 1515 working with Diego de SILOE on the marble REREDOS of the Caracciolo chapel in the church of S. Giovanni a Carbonara. In 1517 he undertook part of the carved decoration for the choir of Barcelona Cathedral, executing in wood and marble a series of reliefs in a pure Renaissance style. There followed a number of contracts for TOMBS, including that of Charles V's parents, Philip and Juana, commissioned by Charles himself for the chapel royal at Granada. Ordóñez died while carrying out these commissions with Italian assistants at Carrara; but his testament records that he had completed the greater part of the work, including most of the royal tomb.

1086.

**ORGANIC.** The comparison of a work of art to an organism goes back to classical antiquity. In a famous passage from the *Phaedrus* (264 c) Plato maintains that a good oration must have a coherent principle of composition determining the order and relation of the parts, that it 'ought to be constructed like a living creature, with its own body as it were; it must not lack either head or feet; it must have a middle and extremities so composed as to suit each other and the whole work'. Aristotle in the *Poetics* (1450 b) shows familiarity with the analogy when he argues that the plot of a tragedy must have a determinate length neither too long nor too short, since 'a beautiful thing, both a living creature or any artefact composed of parts, must have not only an orderly arrangement of these parts but a size that is not accidental'. (The size, he maintains, must be large enough to enable observers to discriminate the parts and their relations, yet not so large that 'the perception does not take place all at once and the sense of oneness and wholeness is gone from the viewers' vision'.) A more distant use of the analogy occurs in the *Politics* (1254ª), where Aristotle argues that the institution of slavery in the body politic is in accordance with nature since every composite thing where a plurality of parts is combined to make a single common whole has a ruling and a subject factor. This, Aristotle says, is not only a characteristic of living things but there is also a ruling principle in things which do not partake of life, instancing the musical 'mode'. The 'organic' comparison was applied by Cicero to rhetoric and by VITRUVIUS to architecture.

Aristotle enunciated the principle of unity in regard to narrative art (with an analogy to other representational arts) as requiring that 'the constituent incidents should be so put together that if any one of them is moved or removed the whole is disjointed and dislocated'. The ideals of unity and completeness here assumed by

Aristotle were characteristic of the AESTHETIC outlook of antiquity. Perhaps following the Alexandrian Neoptolemus of Parium, they are introduced by Horace at the beginning of his *Ars Poetica* as fundamental concepts in his doctrine of poetic form. In modern times within the class of 'Formalistic' aesthetic theories the concept of 'organic unity' has been defined as including a structural relationship of parts such that no part could be changed or removed without affecting and to some extent spoiling the whole. This modern usage has none of the metaphysical and mystical overtones which beset the adoption of the organic comparison by German Romantic idealists, as for example when Schelling wrote: 'As reason immediately becomes objective only in the organism, and as the eternal intellectual Ideas turn objective as souls of organic bodies, so philosophy becomes immediately objective through art, and the Ideas of philosophy grow objective as the souls of real objects' (*Philosophie der Kunst*, sec. 17).

The 'organic' metaphor prevailed at the RENAISSANCE, as when VASARI described PERUZZI's Villa Farnesina as a thing which 'appeared to be born rather than made'. And in modern times Frank Lloyd WRIGHT was prominent in demanding an ORGANIC ARCHITECTURE. In the language of 20th-c. criticism 'organic' has become current almost always in a commendatory sense though with no clearly defined connotation, suggesting that a work of art is a living and harmonious whole rather than a contrived or unrelated patchwork of elements.

**ORGANIC ARCHITECTURE.** A term used to describe one of the two opposing schools of MODERN ARCHITECTURE. Organic architecture lays special stress on a close relationship between building and landscape and uses for the most part natural materials such as masonry and timber. In planning it is irregular and apparently casual, and its aim is that the building should seem to grow out of the landscape or at least be securely rooted in it, whereas the opposite school gives its buildings an appearance of being lightly perched on the ground and as far as possible detached from it, underlining their remoteness from nature by employing more fragile-looking, mechanically finished, materials.

The leading exponent of organic architecture, and the inventor of the term, was the American architect Frank Lloyd WRIGHT, whose writings claim that the architect's chief inspiration should be the *genius loci* and the nature of his materials. His ideas strongly influenced the succeeding generation of architects, although increasingly close contact with industry and technology

**239.** The Guggenheim Museum, New York (designed 1943–6; built 1956–9) by Frank Lloyd Wright

worked in a counter direction. But since the Second World War stylistic developments resulting from reaction against the intellectuality and geometrical purism of the 1930s and 1940s arrived by a process of trial and error at many of the same results which Wright reached instinctively half a century earlier.

Outside the U.S.A. the countries whose modern architecture has come most closely into accord with Wright's organic ideas are Sweden, Denmark, and Japan. The contrary, geometrical trend in modern architecture, with LE CORBUSIER as its leading prophet, has been most characteristic of France, central Europe, and Latin America.

**ORLÉANS,** D'. French painters. GIRARD D'ORLÉANS (d. 1361) was appointed court painter in 1344, and is reputed to have shared the captivity of the French king John II in England after Poitiers, 1356. On this somewhat slender evidence the vigorous but crude portrait of the king now in the Louvre has sometimes been ascribed to him. JEAN (active until 1420) was the son of Girard and his successor as court painter. He is known to have served Charles V, Charles VI, and the Duke of Berry.

**ORLEY,** BERNAERT VAN (c. 1490–1541). The principal painter and decorator in Brussels, who ranks with GOSSAERT as one of the leading 'Romanists' of his day. He may have visited Italy: *The Trials of Job* (Brussels, 1521) shows that he was familiar with RAPHAEL's *Expulsion of Heliodorus* FRESCO (1510/11) in the Vatican and he probably saw Raphael's CARTOONS when they were sent to Pieter COECKE van Aelst's workshop c. 1515 to be woven into tapestries. The designs of the best tapestries made in Brussels c. 1520–40 are attributed to van Orley. He was in demand as a court painter and was employed in 1518 by Margaret of Austria and her successor Mary of Hungary to make portraits and ALTARPIECES. None of his paintings bears a date later than 1530; after that time he was chiefly occupied with designing tapestries and STAINED-GLASS windows. The transept windows in the church of St. Gudule in Brussels are his.

926.

**ORME,** PHILIBERT DE L'. See DELORME.

**OROZCO,** JOSÉ CLEMENTE (1883–1949). Mexican painter, often regarded as the greatest figure in modern Mexican socialistic art. He was born at Zapotlan, Jalisco, and in 1888 moved with his family to Mexico City, where he first studied agricultural engineering and later architectural drawing, taking occasional courses in art at the Academy between 1908 and 1914. During this period the popular art of POSADA made a strong impact on him. In the years immediately following the revolution of 1910 he was doing political cartoons and bordello scenes

in a vein of social satire, which he exhibited in 1916. From the same years are usually dated his famous wash drawings *Mexico in Revolution*, which have been compared to GOYA's *Desastres de la Guerra*. But despite similarities of theme and compositional motifs, Goya's etchings had a private, primarily psychological purpose to express the artist's reactions to the horrors of war, whereas Orozco worked with a deliberate practical aim of converting the illiterate and heterogeneous masses to a realization of the miseries and futilities of war. His style also shows a deliberate reaction from academic drawing and a reversion to the direct and crude manner characteristic of popular CARICATURE.

From 1917 to 1919 Orozco lived in the U.S.A., returning to Mexico in time to participate in the artistic revival inaugurated by the Obregón régime. In 1923–4 he did his first, controversial murals in the National Preparatory School, all of which except the *Maternity* and *The Rich Banquet while the Workers Quarrel* were subsequently destroyed or altered. Their too caricatural and tendentious manner matured into his classically monumental style of more philosophical and generalized symbolism manifested in the frescoes he did in 1926 in the Casa de los Azulejos (House of Tiles) and the Industrial School at Orizaba, and the second series of frescoes done in 1926–7 at the Preparatory School.

From 1927 to 1934 Orozco worked in the U.S.A. and besides easel paintings and drawings in a more ABSTRACT EXPRESSIONIST manner executed a number of important commissions for murals. These included frescoes at Pomona College, Claremont, the New School for Social Research, New York, and Dartmouth College, New Hampshire. Returning to Mexico in 1934, he was occupied through the 1930s on the most stupendous of his mural paintings, outstanding both for the grandeur of their symbolic message and for their technical virtuosity. The *Katharsis* in the Palacio de Bellas Artes, Mexico City (1934), was followed by a series of fine frescoes in the University, the Palace of Government, and the Cabañas Orphanage of Guadalajara, the latter covering some 1,200 square metres. In 1940 he began work on a commission for murals in the Gabino Ortiz Library at Jiquilpan which included the famous fresco *Allegory of Mexico*, and while engaged on this work he did the movable mural *Dive Bomber* for an Exhibition of Twenty Centuries of Mexican Art at the Museum of Modern Art, New York. In 1941 Orozco began work on decorations for the Supreme Court of Justice in Mexico City and in 1942 did murals for the Chapel of Jesús Nazareno, the ancient Hospital founded by Cortez in the 16th c. His next great work, done in 1947, was the *National Allegory* mural, executed in the new material ethyl silicate, for the National School for Teachers built by Mario Pani. He also designed outdoor murals for the Normal School, executed the extraordinary composition *Juárez and the*

*Reform* in the National Museum of History, and began decorations for the new National Conservatory of Music. His last work, finished in August 1949, was the *Hidalgo and the Liberation of Mexico* fresco for the Senate Chamber of the Palace of Government in Guadalajara.

During this last period his work became ever more violent in emotional expressionism while the symbolic grandeur of his humanistic and sociological conceptions increased in profundity. Moved by a passionate concern for the suffering and miseries of mankind, he went further than any other contemporary artist in seeking pictorial symbols for humanistic and humanitarian allegories.

2205.

**ORPEN,** SIR WILLIAM NEWENHAM MONTAGUE (1878-1931). Painter, born in Ireland and trained at the Dublin Art School and the Slade. In 1899 he won the Slade Prize with *Play Scene from Hamlet*, a composition of some originality and unusual complexity for a student. He made his début at the NEW ENGLISH ART CLUB in 1900 with a portrait of Augustus JOHN. He was elected A.R.A. in 1910, sending in an interior showing the dealer Charles Wertheimer surrounded by his pictures, and he became R.A. in 1919, having been knighted in 1918. In 1918 he attended the Peace Conference as official painter and *The Signing of the Peace Treaty, at Versailles* (Imperial War Mus.) is the most famous of his pictures. Orpen was a brilliant, prolific, and somewhat superficial painter, the most successful artist of his day. His imagination was literary rather than pictorial and he is now remembered mainly for his GENRE portraits and CONVERSATION PIECES, which are talented records of the personalities of his day. His *Homage to Manet* (Manchester, several times repainted) shows George Moore, Wilson STEER, Henry TONKS, Hugh Lane, with D. S. MACCOLL and Walter SICKERT standing in the background. His *Café Royal* (1912) contains William NICHOLSON, James PRYDE, Augustus John, George Moore, and others. He wrote *Outline of Art* (1923).

**ORPHISM.** A short-lived movement which arose *c.* 1912 among certain of the adherents of CUBISM. The word 'Orphism', which had previously been used by the SYMBOLISTS, was applied to the movement by Guillaume APOLLINAIRE and indicated the new element of lyricism which they attempted to introduce into the austere intellectual Cubism of PICASSO, BRAQUE, and GRIS. The group included the brothers DUCHAMP, Robert DELAUNAY, Roger de la Fresnaye (1885-1949), Frank Kupka (1871-1957), and for a time LÉGER, CHAGALL, GLEIZES, METZINGER, PICABIA, André Lhote (1885-1962), Marcoussis (1883-1941), and some others. Jacques Villon (1875-1963) was the principal inspiration of a group who took over the NABI

interest in a mathematical system of PROPORTION and organized them under the name *Section d'Or* (GOLDEN SECTION). They held an exhibition under this name at the Galérie la Boétie in 1912 and founded a periodical with the same name. Robert Delaunay led the way with experiments in pure colour and in 1912 produced series of constructs *Circular Rhythms* and *Simultaneous Discs* composed of abstract elements of colour revolving and interpenetrating without representational implications.

**ORSI,** LELIO (1511-87). Italian painter of the Parmesan School. *The Walk to Emmaus* (N.G., London) shows his leaning towards the dramatic and the bizarre, with stage-lighting effects from CORREGGIO, and figures derived by exaggeration from MICHELANGELO together with suggestions from German WOODCUTS. Some less pretentious works, such as *The Rest on the Flight into Egypt* (York), are attractive examples of the Parmesan School, delicately coloured and fraught with PARMIGIANINO's elegance.

**OS,** VAN. Dutch family of painters active during the late 18th c. and 19th c. JAN (1744-1808) was the founder. He and his daughter MARIA MARGRITA (1780-1862) and his son GEORGIUS JACOBUS JOHANNES (1782-1861) specialized in painting flowers and fruits. They worked in the tradition of van HUYSUM and many of their numerous works have acquired his name, or that of some equally famous artist. Georgius settled in France in 1826, where he worked at the Sèvres porcelain factory.

**OSONA,** DE. The name of two Spanish painters of the Valencian School. RODRIGO the Elder (active 1476-84) painted the ALTARPIECE of St. Nicholas, Valencia (1476), which is basically FLEMISH in style, recalling Hugo van der GOES, but also shows Italian RENAISSANCE influence. His son RODRIGO the Younger was active in Valencia at the beginning of the 16th c. His *Adoration of the Magi* (N.G., London) shows that like his father he introduced Italian Renaissance elements into a style dependent on Flemish REALISM. His most important works are a *Nativity* and an *Adoration of the Magi* in the Prado.

**OSTADE,** ADRIAEN VAN (1610-84). Dutch artist who spent his life in Haarlem. He painted every subject except marine pictures and was also a talented ETCHER. But he is known principally for his GENRE scenes. According to HOUBRAKEN both he and BROUWER were pupils of Frans HALS. His work, however, is closer to Brouwer's than to that of Hals. His early pictures depict lively scenes of peasants carousing or brawling in crowded taverns or barns. In these works his PALETTE is limited to brown tones with a few accents of red, violet, or grey; sharp contrasts of light and shadow heighten the dramatic

effect. In his later works (after 1650) his peasants learn better manners and the rooms they live in are tidier. These later pictures are lighter in key and more colourful; thus they follow the general trend of Dutch painting around this time. After his death his pupil Cornelis DUSART, who worked in his style, inherited some of his unfinished paintings and put the finishing touches upon them. His most talented pupil was his brother ISAAK (1621–49), also of Haarlem. The latter's subjects were also mainly drawn from peasant life. His LANDSCAPES, especially the winter scenes which are distinguished by their fine silver tonality, single him out from the run of his contemporaries.

958.

**ÖSTBERG,** RAGNAR (1866–1945). Swedish architect who is chiefly known for having built the Town Hall of Stockholm (1903–23), which for its combination of different historical styles into one impressive unity became the most celebrated Scandinavian contribution to MODERN ARCHITECTURE and exercised considerable influence internationally, for instance in Holland. It marks Östberg as an imaginative ROMANTIC far from orthodox FUNCTIONALISM. An adept use of materials, usually rather flat bricks, is characteristic of his manner.

**OSTENDORFER,** MICHAEL (c. 1490–1559). German painter and designer of WOODCUTS. He worked in Regensburg and was perhaps a pupil of its greatest master, ALTDORFER. A portrait by him is in Buckingham Palace.

**OSTRACON.** Ostraca were flakes of LIMESTONE and potsherds used by the EGYPTIANS in lieu of PAPYRUS for such purposes as writing exercises, jotting down letters and accounts, and making freehand DRAWINGS. These drawings, which date mainly from the New Kingdom, include trial SKETCHES, subjects from nature, copies of known MONUMENTS, and parodies of familiar scenes with animals in place of human beings—perhaps illustrations of popular fables. Many are done in colour, and the best are executed with extraordinary sureness and great freedom, though retaining some conventions.

**OTTONIAN ART.** By the end of the first millennium A.D. a distinctive style began to develop on German soil. It is usually named after the Ottonian emperors (919–1024) although it actually extends further into the 11th c. This art is a curious amalgam of various elements. Otto I (936–73) wished to revive the political and cultural ideals of Charlemagne's empire and thus much of Ottonian art was no more than a revival of CAROLINGIAN ART. Yet at the same time there was a renewed interest in EARLY CHRISTIAN ART, and contemporary BYZANTINE ART exerted a strong influence, partly perhaps

through personal relations between the two courts, since the consort of Otto II (973–83), Theophanu, was a Byzantine princess. There was finally an admixture of certain Northern traditions. CHURCH architecture adopted and further developed a Carolingian type of BASILICA with east and west choirs and transepts, or with an elaborate western APSE. St. Michael at Hildesheim (1001–36) is an outstanding example of the first type, and this church, just as S. Cyriacus at Gernrode or S. Pantaleon at Cologne, can still give us an idea of the fortress-like exterior of an Ottonian basilica with its groups of towers and massive walls pierced by relatively small windows.

Ottonian sculpture, unlike the Carolingian, was no longer satisfied with IVORY or metal-work on a small scale; the *Gero Crucifixus* (969–76) in Cologne Cathedral is the earliest surviving over-life-size medieval sculpture in WOOD. Bishop Bernward of Hildesheim commissioned monumental BRONZES for his cathedral, notably famous doors (1015) with vividly told biblical scenes in high RELIEF. Large gold *antependia*, such as that of Henry II (Musée Cluny, Paris) or the figure *The Virgin enthroned with the Child* (Minster, Essen), are witnesses to the high standards of goldsmiths' work. Ivory-carvers continued in the Carolingian tradition and at the same time were influenced by Byzantine patterns. Their most important workshops were at Echternach (Moselle) and on the isle of Reichenau in the Lake of Constance, where the outstanding Ottonian School of painting flourished (see REICHENAU SCHOOL). Though wall-paintings still survive (at S. Georg, Oberzell) we can best gather the character of this particular School from a rich store of manuscripts. This centre exerted its influence naturally on other Ottonian scriptoria, notably those of Trier and Echternach, of which the latter produced its finest works under the second Salian king, Henry III (1039–56). COLOGNE was another important centre, where influences from the Reichenau School intermingled with Byzantine elements but where in addition the painterly style of one of the Carolingian Schools was continued. Hence the ascendancy of colour over line gives a distinctive flavour to the manuscripts ILLUMINATED by this School (*Hitda von Meschede Gospels*, Darmstadt). The Byzantine strand, always present in Ottonian art, was particularly strong in the School of Regensburg, though inspiration was also found in a Carolingian *Codex Aureus* (now in Munich) which had been in Regensburg (see REIMS SCHOOL). Even though Schools such as Regensburg paid more attention to decorative details (*Niedermuenster Gospel-lectionary* of the Abbess Uta, Staatsbib., Munich) than others, or the School of Fulda specialized in architectural backgrounds in its illuminations, all Ottonian manuscript illumination has certain things in common: the human figure is the most important element in all picture making; this figure is invariably imbued with a strong expression and

its gestures—often exaggerated—are made to underline the pictorial content.

214, 752, 961, 1074, 1161, 1264, 1379, 1431.

**OUD,** JACOBUS JOHANNES PIETER (1890–1963). Dutch architect who played a prominent part in the development of modern FUNCTIONALISM through all its stages. Starting with an admiration for BERLAGE, he reinterpreted his ideas in terms of modern materials and techniques. For a time he was associated with the De STIJL movement, working to translate their theoretical ideology into practical building terms. In 1918 he became city architect of Rotterdam and from then onwards his workers' houses and flats combined social responsibility with functionalist principles tempered by aesthetic refinement. Among the most interesting of his schemes were his Tusschendijken flats at Rotterdam (1920) and his terrace housing at the Hook of Holland (1927). From 1935 he renounced a strictly functionalist style in favour of formal symmetry and restrained use of symbolic ornament (Shell Building at The Hague, 1938; Children's Convalescent Home, Arnhem, 1952–60).

**OUDRY,** JEAN-BAPTISTE (1686–1755). French painter, pupil and admirer of LARGIL-LIÈRE. Like François DESPORTES he first established his name as a painter of STILL LIFES and animals. Like Desportes also he achieved considerable technical brilliance and was interested in LANDSCAPE for its own sake (*The Wolf Hunt*, Nantes). His *Chasses de Louis XV* (Fontainebleau), made for tapestry design, have been called the 'finest evocations of natural scenery in 18th-c. France'. He was also known for his illustrations of La Fontaine. But his chief renown rested on his designs for the Beauvais tapestry works, of which he was made Director in 1734.

**OUWATER,** ALBERT VAN (active *c.* 1450–80). Dutch painter of Haarlem, who was the master of GEERTGEN TOT SINT JANS. He was famed for his LANDSCAPE backgrounds (van MANDER) but his only undisputed work, *The Raising of Lazarus* (Berlin), is set in the APSE of a ROMANESQUE church. Little is known about painting in Haarlem at this date, but Ouwater's painting shows that he must have been aware of the great masters Jan van EYCK and Rogier van der WEYDEN. Either he travelled south or he may have been connected, directly or indirectly, with Dieric BOUTS, who left his native Haarlem for Louvain. The two Haarlemers have a similar figure style and tend to a rather static type of composition. Although his figures are still not

individualized, there is a new freshness of direct observation in Ouwater's work.

**OUWATER,** ISAAK (1750–93). Dutch TOPO-GRAPHICAL painter who worked in the tradition of van der HEYDEN. He was mainly active in Amsterdam and meticulously portrayed the quiet 18th-c. life of that city.

**OVERBECK,** FRIEDRICH (1789–1869). German painter, who from his student days in Austria took as his ideal the German and Italian PRIMITIVES, regarding them as an expression of genuinely religious minds satisfying the spiritual needs of the community. In 1809 with PFORR and others he founded the *Lukasbund* (see NAZARENES) to put into practice these ideals. His own work made extensive use of religious symbolism with minute attention to detail and somewhat elementary DRAWING and composition. After the death of Pforr and his own conversion to Roman Catholicism in 1813 the range of his themes became more and more restricted. The CARTOON for his picture *The Triumph of Religion in the Fine Arts* (Frankfurt, 1847) was bought by the Prince Consort and the didactic bent of his work generally ensured it a more sympathetic acceptance in England than its artistic quality alone merited. PUGIN, DYCE, and Ford Madox BROWN were among his supporters and there were affinities between his aspirations and those of the PRE-RAPHAELITE BROTHERHOOD.

**OVOLO.** Term in classical architecture for a convex MOULDING whose profile is a quarter of a circle. One of the elements of the Tuscan and Roman Doric CAPITAL. Also called 'quadrant moulding' in medieval architecture.

**OZENFANT,** AMÉDÉE (1886–1966). French painter. In 1915–17 he worked out his AESTHETIC theory of PURISM and in 1918 published with Charles-Édouard Jeanneret (LE CORBUSIER) *Après le cubisme*, the manifesto of his theory. From 1920 to 1925 he published with Jeanneret the periodical *L'Esprit nouveau*, in which all contemporary tendencies in art were to find a forum and a synthesis. It began with the words: 'Une grande époque a commencée, animée d'esprit nouveau: un esprit de construction et de synthèse, conduit par une conception claire.' During this time he painted an enormous composition which he called *Les Quatre Races* (Musée d'Art moderne). A still larger painting, *Vie*, in which more than 100 figures sing of the solidarity of mankind (Musée d'Art moderne), took him seven years to paint. He opened a school in London 1935–8 and in 1938 left Europe for New York, where he formed the Ozenfant School of Fine Arts. His *Foundations of Modern Art*, published in London in 1931, has been widely read.

# P

**PACHECO,** FRANCESCO (1564–1654). Spanish painter, scholar, and writer, who established his painting academy in Seville. Among his pupils were VELAZQUEZ (also his son-in-law), Alonso CANO, and perhaps ZURBARÁN. In his painting he belonged to the transition between MANNERISM and Spanish BAROQUE. But he inclined towards a NATURALISTIC style, holding that in the imitation of nature art should have a spiritual purpose in the service of religion. He was himself a censor of paintings for the Inquisition. His *El arte de la pintura, su antigüedad y grandeza* (1649) is an important source for the history of Spanish painting.

**PACHER,** MICHAEL (active 1465?–98). Austrian painter and WOOD-CARVER. His most celebrated work, the High Altar in the church of S. Wolfgang on the Abersee with scenes from the *Life of the Virgin* and the *Legend of St. Wolfgang*, was commissioned in 1471 and completed in 1481. Like all his German and Austrian contemporaries Pacher came under the spell of Rogier van der WEYDEN. But the proximity of

the Tyrol to Italy brought him also into contact with Paduan painting and with MANTEGNA in particular. Pacher learned from him how to render space convincingly and the curious monumental effect which results from taking a low viewpoint. His colourful and highly dramatic representations painted in this way profoundly influenced AUSTRIAN and south GERMAN ART.

34, 1287.

**PADUAN SCHOOL.** See SQUARCIONE.

**PAEONIUS.** Sculptor from Mende in Thrace active in the second half of the 5th c. B.C. His marble statue of Victory (NIKE), made *c.* 420 B.C. for the Messenians, survives at Olympia. It stood on a triangular pillar some 30 ft. high, with wings raised and drapery pressed revealingly against the front of the body and legs and swirling out behind. PAUSANIAS incredibly asserts that Paeonius made the sculpture of the east PEDIMENT of the Temple of Zeus, also at Olympia.

**240.** Wardour Castle, Wiltshire (1770–6). Designed by James Paine

**PAGODA.** See STUPA.

**PAINE,** JAMES (1716-89). English architect, who studied at the St. Martin's Lane Academy, and at 19 designed Nostell Priory, Yorkshire, the first of the long series of large country houses with which his life was mainly occupied. Nostell, as originally planned, had the fully PALLADIAN arrangement of a central block with four corner pavilions attached to it by quadrant colonnades. Like all Paine's houses it was well arranged and finely constructed, though his later work showed a greater variety of interior planning and of detail. The Mansion House at Doncaster (1744) was his next important commission and here his fluency in ornament is well displayed. His practice was chiefly in the north of England and he had a special facility for handling the coarse gritstones found there, his feeling for texture being particularly well displayed in the stables at Chatsworth, Derbyshire (1756). Kedleston, Derbyshire (1756), was laid out by Paine though the work was handed over to Robert ADAM half-way through. The chapel at Gibside, Durham (1760), has the dignity and serenity of a master-piece and makes one regret that Paine had no major ecclesiastical opportunities. Many of Paine's great houses are now in decay; Wardour Castle, Wilts. (1770-6), still in good condition, is probably the finest example of his work on the grand scale now in existence (see Ill. 240, p. 801).

**PAINT.** Paint consists of dust-fine solid particles of PIGMENT dispersed in a MEDIUM. Painting at its simplest requires nothing more of the medium than that it should fulfil the two functions of enabling the pigment to be applied to the GROUND and then preserving it *in situ*. The study of painting techniques, however, shows how artists have been attracted by the variety of surface textures which it is possible to produce both by the quality of the paint, which may be thin and ink-like or a viscous liquid or a thick paste, and by the method of application and manipulation. For paint has not only COLOUR but a gamut of expressive textures and contours. REMBRANDT'S IMPASTO, van GOGH's moulding with PALETTE KNIFE, CHINESE CALLIGRAPHY, and the dribbling of Action Painting (see ABSTRACT EXPRESSIONISM) are but a few examples of different surface qualities.

Before proprietary paint in TUBES and pans was available artists ground their own pigments, powdering them with a muller (a stone with a flat surface which was held in the hand and rubbed against the slab) on a stone slab (usually made of PORPHYRY), and mixed them with the medium. This process was called 'tempering', and the result a TEMPERA. Illustrations may be studied in the title-pages to Boltz, *Farbbuch* (V. & A. Mus., 1549), and A. van OSTADE, *A Painter's Studio* (Rijksmuseum, Amsterdam, 17th c.). Each pigment has a certain optimum proportion of medium if a satisfactory paint is to result. If there is insufficient the film will be

**241.** Title-page from *Farbbuch oder Illuminierbuch*, Basel (1549), by V. Boltz

weak and powdery when dry; if there is an excess, troublesome changes in dimension may occur unless the application is restricted to thin films (GLAZES). Up to the 19th c. tempering was an important part of the craft of the painter, and techniques were handed down by studio tradition. Since then manufacture has been taken over by the artists' colourman.

Tempering normally produces a paste-like consistency and, since it is not advisable to depart greatly from the optimum requirement of a pigment, a third constituent is added to modify the fluidity. This is the DILUENT, a volatile liquid compatible with the medium. The diluent makes the paint thinner and more mobile during application but is not present in the dried film and takes no part in the binding action. Historically, no problem arose of finding a diluent for the aqueous media—such as GUM, SIZE, egg white, and egg yolk—but the oil medium could only be used to advantage after a suitable oil-compatible diluent in the form of TURPENTINE had been discovered. (See OIL PAINTING.)

MEDIA. The following are among the more important media:

(*a*) *Animal glue* or *size* made from bones, hides, or parchment when dissolved in water forms the simplest and most primitive kind of paint medium, used from prehistoric times. It is the

medium of the GESSO and chalk grounds of the RENAISSANCE CARTOON for FRESCO and tapestry, and of scene painting up to the present day.

(*b*) *Egg white* is prepared by beating the white of an egg into a foam, which is then allowed to stand for a few hours and subside into a clear, mobile liquid. Known as *clarum* or GLAIR, this medium was much used by the medieval illuminators (see ILLUMINATED MANUSCRIPTS), since it possesses the qualities needed for precise and delicate work. It was also used in mordant gilding.

(*c*) *Gums* of vegetable origin are media of great antiquity in all civilizations. The most widely used is gum arabic, the medium of WATERCOLOUR and GOUACHE. Cherry gum is sometimes assumed to be the medium used by Nicholas HILLIARD and his school, and in the water-colours of DÜRER.

The foregoing water-soluble media are colloidal substances known as 'gels'. Drying is accompanied by contraction, and they tend to crack and detach unless the film of paint is well keyed to a partly absorbent surface and thinly applied. These conditions are ideally present in the water-colour technique.

(*d*) *Yolk of egg* (or sometimes the whole egg). What has been achieved in this medium ensures it a place second only to oil. About one-half of the yolk consists of water, and rather less than a quarter of oily, fatty substances finely dispersed in the form of an emulsion. Paint made from it differs considerably in handling qualities from that made from oil or the aqueous media already described. It can be of a thick consistency without exerting much drag on the brush, and no IMPASTO results because of the loss of bulk when the water evaporates. This loss, however, occurs without contractile tensions, and any number of layers may be applied. The binding action takes place in two stages: the first is a rapid drying which safely permits further applications of paint after a minute or so; and the second is a coagulation which in a week or two produces a paint film of great stability, immunity to solvents, and constancy of optical properties. When dry, egg tempera has a matt texture.

(*e*) *Oil.* Certain vegetable oils—as far as fine art is concerned, LINSEED, WALNUT, and POPPY seed—have the natural property of drying when exposed to air and light. Though referred to as drying, the process is not one of evaporation as with the water-soluble media, but a complex chemical action which causes the molecules to link together in a manner peculiar to drying oils. The result is that the fluidity disappears, and the medium acquires a jelly-like consistency, and the paint is 'dry'. Unlike the temperas, the drying process is slow. There is an initial stage in which after a day or so a no longer tacky film is produced; this is followed by long-term changes which proceed at a decreasing rate for many decades and result incidentally in a gradual increase in the transparency of the paint which renders PENTIMENTI visible. Certain pigments,

especially those containing lead, speed the rate of drying, while others have an adverse effect which is overcome by the incorporation of suitable driers during manufacture. The drying occurs without the large changes in volume which result from the evaporation drying of the various temperas. It is this feature of oil which makes thick impasto possible and preserves the most sensitive marks of handling, and this is but one of several attributes which have ensured for the medium a dominant place in painting. Among others are the optical ones: the greater range from pale tones to deeply saturated ones and from opaque to rich transparent colour. This is particularly true when these qualities have been fully brought out by the application of VARNISH.

(*f*) *Wax* in ENCAUSTIC PAINTING is now rarely employed, but examples such as the Faiyum portraits are a tribute to its permanence. Wax is also sometimes used in solution, in combination with RESINS, for 'spirit fresco' painting.

It remains to point out that the pigments in *buon fresco* and in PASTEL are bound (somewhat loosely in the latter) without any medium, simply by being enmeshed in the plaster and the paper respectively.

PIGMENTS. The choice of a material for use as a pigment is much circumscribed. Possession of a desirable colour does not in itself suffice—there must be physical and chemical stability, and inertness towards the medium and the environment. For this reason fewer than a hundred substances have found their way on to the artist's PALETTE, and of these many have become obsolete because time has shown up their doubtful qualities or because they have been superseded by better products.

Even if a pigment has the necessary qualities, it will make a satisfactory paint only when sufficiently fine grained and when the particles have been dispersed in the medium by the grinding operation. The machine-ground paint of the last hundred years is more finely and evenly dispersed than the older hand-ground paints made with muller and slab, which were sometimes deliberately used in coarse-grained form. In consequence paint formerly had a greater range from opaque to transparent—a necessity for techniques of painting where the colour of the ground and the UNDERPAINTING played an important part in the finished picture. The fineground modern paints are in general more opaque and better suited to the direct method of painting (ALLA PRIMA).

Pigments with the longest history, from the Magdalenian period (see STONE AGE ART) to the present day, are the earths, such as yellow ochre and various dark reds and browns. They are the most readily available and the easiest to prepare. The green called *terra verte* and the umbers and siennas are also earths. Allied to them are the mineral rocks which need only to be pulverized, such as azurite (blue), malachite (green), orpiment (yellow), cinnabar (red), haematite (red).

These have been identified in EGYPTIAN works of art and were used until the 18th c. The mineral pigments, with one or two exceptions, constituted the palette of the mural painters— ROMAN, POMPEIAN, medieval, and Renaissance. Lapis lazuli does not appear to have been much used as a pigment before the discovery of a process for extracting ultramarine from it some time in the 13th c.

The richness of medieval and early Renaissance paintings was enhanced by the strong metallic brilliance of GOLD and tin. Gold was used as a pigment and both gold and tin were used in the form of thin leaf or foil, which was sometimes further embellished with transparent coloured glazes.

Chemical processes, by which the majority of modern pigments are made, were used to some extent before the 19th c. White lead, minium (red lead), and massicot (yellow) were manufactured in classical antiquity, as well as a remarkable frit known as Egyptian or Pompeian blue, made from sand, lime, and a copper salt. In the 9th c. the Moorish alchemists synthesized vermilion. Throughout the Middle Ages there seems to have been endless experimentation with pigments, the most important success being the production of lakes from various organic dyes. In general dyes lack permanence, but it is possible to select a few which are satisfactory; since the advent of synthetic dyes in 1856 the choice has been wider, and those now used are reasonably stable.

The history of pigments from the 18th c. has benefited from the advance of technology. Many new and important pigments became available during the following century: cobalt blue, French ultramarine, Chinese white, the various compounds of chromium and of cadmium, to mention but a few. Some of these were on the market in time for TURNER, and more for the IMPRESSIONISTS and their successors.

**PAINTING.** In principle a painting is composed of the following layers: (1) the SUPPORT (PANEL, CANVAS, PAPER, wall, etc.); (2) the GROUND (a preparation applied to the support in order to make it more suitable to receive the paint and to keep the paint from direct contact with it); (3) the PRIMING (a thin top layer over the ground); (4) the PAINT; (5) a protective coat or VARNISH over the paint. In certain cases some of these elements may be omitted or combined (e.g. paint may be applied directly to a support as is done in WATER-COLOUR and PASTEL, or the top layer of a complex ground may serve as priming). The purpose of the whole is to bind the structure, to preserve the PIGMENTS *in situ* and to protect them from the hazards of change. In the past extremely complicated and often recondite traditions of craftsmanship have been handed down in connection with these processes and most great artists have modified in some respects the traditions they inherited. Since the manufacture of artists' materials began to be commercialized in the 19th c. the greater part of this tradition has been lost to practising artists. The durability of pictures and their resistance to unintended change depends upon the workmanship and suitability of all the elements of which they are composed. The various types of paintings are discussed under the appropriate headings.

**PAJOU,** AUGUSTIN (1730–1809). French sculptor, Keeper of the King's Antiquities at the LOUVRE (1777), and director of the scheme of decoration for the Opera at VERSAILLES (1768–70). Pajou's main work, like that of his master J.-B. LEMOYNE, consisted of portrait BUSTS (*Lemoyne, Buffon,* and *Mme du Barry*, Louvre; *Descartes* and *Bossuet*, Institut, Paris).

**PAKISTANI ART.** See INDIAN, PAKISTANI, AND CEYLONESE ART.

**PALA D'ALTARE.** See ALTARPIECE.

**PALAMEDESZ,** ANTHONIE (1601–73). Dutch portrait painter who studied with MIEREVELT. His pictures resemble his teacher's, but are more wooden. His GENRE pieces of soldiers, cavaliers, and their ladies are in the style of Dirk HALS and CODDE.

**PALETTE.** The term has several distinct meanings in connection with art.

1. In Egyptology the word 'palette' is used not only of the scribe's writing equipment but also of the slate or schist slabs on which cosmetics were ground. In the early predynastic cultures (Badarian, Nagada I) the possessions placed in the grave regularly included a cosmetic palette, square or lozenge-shaped or in the form of an animal, together with a pebble for grinding and a small bag of eye-paint (malachite or galena). In the late predynastic period (Nagada II) there developed from the earlier functional palettes a large and elaborately carved ceremonial type whose broad surfaces gave abundant scope for decoration, its original function being recalled by the circular mortar in the centre. These palettes represent some of the first examples of RELIEF, and the most famous, that of Narmer (1st Dynasty) in Cairo, has the earliest conventional figures and division of the ground into registers (see EGYPTIAN ART).

2. In connection with European painting the term is primarily used of the flat wooden plate, usually oval or rectangular with a hole for the thumb, on which artists arrange their PAINTS ready for use. Some artists have preferred glass slabs or (mainly for WATER-COLOUR and TEMPERA) porcelain or enamelled metal receptacles. Some artists in order to keep both hands free prefer to use the top of a table standing beside the EASEL.

3. The term is also used in a derivative sense of the range of COLOURS which a painter uses and the way in which he arranges them. Thus the

term 'restricted palette' refers to the limited range of colours to which many painters restrict themselves from the many available to them, either for a particular picture or in general. The term 'scaled palette' is used for the selection of a restricted number of paints, including black and white, which are arranged systematically on the palette with a particular painting in view in such a way that by mixing them on definite principles the artist can obtain the sequences and the variations of intensity and hue which he requires for his subject. The purpose is to systematize the artist's work and to avoid random and untried mixtures of PIGMENTS which may produce dull and muddy effects.

For many artists choice of their pigments and the order in which they are set out on the palette is a very important and personal matter. DELA-CROIX once said to his assistant Andrieu: 'When I have arranged the whole combination of contrasts of tone on my palette my picture is made.' BAUDELAIRE describes Delacroix as setting out the pigments on his palette with the fastidious care of a woman arranging a bouquet of flowers. COURBET is said to have prepared his palette by graduating all his pigments in various strengths with white.

The Old Masters used more restricted palettes than most modern painters, but by using them in conjunction with well considered UNDER-PAINTINGS they made a very few pigments do a great deal of work. Some of REMBRANDT's pictures appear to have been painted with no more than four pigments, whereas CÉZANNE's palette—according to John Renald—contained no less than 14. Some of the VENETIAN masters of the late RENAISSANCE organized their colours in pots (as is still often the practice in water-colour). A portrait of TINTORETTO in the Scuolo di San Rocca shows the painter without a palette but with a number of pots of colour.

Our knowledge of the palette in the 17th and 18th centuries is fairly detailed, for numerous books on painting practice were written and it is possible to compare their advice with paintings which represent the artist at work. Every master had his own habits and fancies, but it is clear that there were certain approved methods which were generally followed. The painter first set out a row of those colours, usually about eight, which were to form the basis of his picture: next to the thumb there would be white, and beside it, from right to left, the yellows, reds, greens, browns, and black, in that order. Then, perhaps in a separate row, he would set out the blues and the subsidiary colours; and finally, below these, the various 'tints', which would be numerous. The flesh painting, for instance, would be provided for by as many as a dozen varieties of flesh tint, some for strong light, some for shadow, some for half-tones, with cool and warm colours in each group. Engravings of the palettes of 18th-c. masters often show 20 or 30 little heaps of colour neatly arranged in three rows like the keyboard of a typewriter. More-

over the very fact that it was thought worth while to execute such engravings shows that the arrangement of the palette was regarded as fundamental to the art of painting. All this orderly preparation meant not only that the painter could work very rapidly, but also that he left nothing to chance. He visualized his picture clearly from the beginning, and the colours which he had in mind, or which he saw in the subject before him, could be matched for the most part from among the selection which lay ready on the palette. Conversely, he must have tended to conceive any picture in terms of his customary mixtures, and this may have been the reason why the traditional methods did not long survive the advent of IMPRESSIONISM.

2311.

**PALETTE KNIFE.** A flexible spatula used for mixing oil PAINTS on the PALETTE or for scraping paint off the CANVAS. The spatula seems not to have been used until the 18th c., before which time an ordinary knife served the purpose. The trowel shape commonly used today is said to have been invented by COURBET. Some artists use the palette knife (or a variant of it called the 'painting knife') for laying on the paint. Various effects can be achieved with it, such as a thick IMPASTO showing the impressions of the knife-point, or a rough, whitish outline made by scraping with the point, or a pattern of straight lines made with the flat of the knife. REYNOLDS says (Discourses, xii): 'REMBRANDT, in order to take the advantage of accident, appears often to have used the pallet-knife to lay his colours on the canvas. . . . Whether it is the knife or any other instrument, it suffices if it is something that does not follow exactly the will.'

**PALLADIANISM, PALLADIAN.** Terms applied to a phase of English architecture from c. 1715, when a revival of interest in the ideas and designs of Andrea PALLADIO and his English follower, Inigo JONES, led to a reaction against the BAROQUE. In both country and town houses exterior design was shorn of exuberance and based on Palladian patterns; but interiors remained very rich. The chief contributors to the style were: Colen CAMPBELL, Lord BURLING-TON, William KENT, Giacomo LEONI, Henry FLITCROFT, and Isaac WARE. Their influence persisted almost to the end of the century. The style also had a vogue in the U.S.A.

**PALLADIO, ANDREA** (1508-80). Italian architect who was born in Padua but grew up in Vicenza. With VIGNOLA he was the most important architect and theorist of the later 16th c. in Italy. A profound knowledge of ROMAN antiquity conditions all his buildings: his CLASSICAL conception of an all-pervading harmonic PRO-PORTION, based on mathematics, informs every part and is responsible for the balance of his style,

**242.** Elevation of the Basilica (Palazzo della Ragione), Vicenza, showing the 'Palladian motif'. Engraving from *I Quattro Libri dell'Architettura*, Venice (1570), by Andrea Palladio

243. Plan and elevation of La Malcontenta. Engraving from *I Quattro Libri dell'Architettura*, Venice (1570), by Andrea Palladio

relatively unaffected by MANNERIST ideas. He began as a mason, working in 1536 for the humanist Tressino, who gave him his classical name (from Pallas), and took him to Rome in 1540-1 on the first of several visits. Later Palladio published a guide to the antiquities of Rome which was still current in the 18th c., illustrated Barbaro's edition of VITRUVIUS (1556), and made drawings of the Roman Baths which were published by Lord BURLINGTON in 1730. In 1545 he was commissioned to recase the Basilica (Palazzo della Ragione) in Vicenza. This owes much to SANSOVINO's library in Venice and employs the so-called 'Palladian motif', which actually goes back to the early 16th c. and has been widely used ever since. Before this Palladio had built the Villa Godi-Porto at Lonedo (1540), which already contains the main elements of all his later villas, perhaps his most important architectural type. They were intended as workable farms which should also be suitable as summer residences for the owners. The plan of the Villa Godi consists of two symmetrically disposed side blocks with a centre block recessed on one façade and projecting an equal distance on the other. The façade is traditional, with symmetrically disposed windows. In later villas, such as La Malcontenta (*c.* 1560), the Barbaro at Maser, and most notably the Villa Rotonda at Vicenza (*c.* 1550), the plans are still further

schematized and centralized. The Rotonda has a central DOMED hall with four exactly symmetrical units around it, even the PORTICO being repeated four times for symmetry. Most of Palladio's villas have colonnades, sometimes curved, connecting the villa proper with its farm buildings and reaching out, in Palladio's own words, 'like arms to receive those that come near the house'. The façades are generally adorned with a portico like an antique temple, since Palladio considered this an ancient domestic usage. In the same way his many palaces at Vicenza show strong classical reminiscences, such as the Palazzo Chiericati (1550; now a museum), based on a Roman forum. Others, like the Porto-Colleoni (1552), are dependent on the BRAMANTE type, while the later ones, such as the Valmarana (1556), are influenced by Mannerism and, especially, by MICHELANGELO.

Palladio also designed the churches of S. Giorgio Maggiore and Il Redentore and the façade of S. Francesco della Vigna, all in Venice. Again the façades adapt the classical temple front to the Christian nave-and-aisles type by interlocking two or more PEDIMENTS. At the end of his life Palladio designed the Teatro Olimpico, Vicenza, as a re-creation of an antique THEATRE. It was completed, with some of his other works, by his pupil SCAMOZZI.

In 1570 Palladio published *I Quattro Libri*

*dell'Architettura* which expounds his views and illustrates many of his buildings. The book was enormously influential and is the basis of the style of Inigo JONES and the English PALLADIAN movement. In England Palladio's villa type was adopted for the country house and his palaces influenced many public buildings, e.g. the Banqueting House, London.

2000.

**PALMA GIOVANE,** JACOPO NEGRETTI (1544-1628). VENETIAN painter, great-nephew of PALMA VECCHIO. He was trained by his father and probably also by TITIAN, whose *Pietà* (Accademia, Venice) he completed after Titian's death. He then travelled in central Italy, working in Urbino and Rome where he came under the spell of MANNERISM. Returning to Venice sometime after 1568 he became one of the most important of the followers of TINTORETTO and VERONESE. This style is seen at its best in the cycle *The Doge Pasquale Cicogna* in the Oratorio dei Crociferi (1583-95). After the deaths of Veronese, BASSANO, and Tintoretto, he dominated Venetian painting during the early part of the 17th c.

**PALMA VECCHIO,** JACOMO NEGRETTI (1480-1528). Italian painter who was born at Serimalta in Lombardy but worked in Venice. His short career was given up to painting rich, sensuous pictures, unproblematic and directly appealing, of religious and secular subjects, and portraits. They were bought avidly by the Venetian middle class. Only a fraction of them is known today, and of the many pictures which have been consistently attributed to him since his own time not one is signed or dated.

The first mention of Palma in Venice occurs in 1510. It seems clear from what are evidently his early works that he was trained in the studio of BELLINI: they are marked by firm modelling and simple compositions in the quattrocento spirit. About 1510 he painted the first of his popular female half-figures, a pictorial type inspired by the ideal female figures of the LEONARDO circle and introduced to Venice by GIORGIONE. He continued this type of picture throughout his career, ending possibly with the picture *Flora* (N.G., London). According to their costume and ATTRIBUTES these ladies could play the parts of MYTHOLOGICAL or of biblical personages; but they are all essentially women of Venice and are differentiated chiefly by the artist's developing sense of colour, composition, and CHIAROSCURO. The same qualities distinguish Palma's few altar paintings and portraits.

1084, 2537.

**244.** *A Rustic Scene.* Pen, brush, and sepia drawing by Samuel Palmer. (Ashmolean Mus., Oxford, 1825)

**PALMER,** ERASTUS DOW (1817-1904). American sculptor, who began with cameo portraits and had no training outside America. His most famous works include *White Captive* (Met. Mus., New York, 1858), in conception much like POWERS's *Greek Slave* but lacking the refinement and finish of that work; *The Indian Girl* (marble copy, Met. Mus., New York); and *Morning Star* and *Evening Star*.

**PALMER,** SAMUEL (1805-81). English visionary LANDSCAPE painter, considered to be the most important of the followers of William BLAKE. He showed a precocious talent and exhibited landscape drawings at the Royal Academy when he was 14. At this time the work of TURNER made a great impression on him. He met LINNELL when he was 16 and was introduced by him to Blake in 1824. Palmer had had visionary experience from childhood and the effect of Blake upon him was to intensify an inherent mystical bent to pictorial expression in a highly personal world of potent moonlit forms. Nothing comparable had been seen in English landscape before. While others in the circle—Linnell, CALVERT, VARLEY—took over Blake's idiom, Palmer converted it into a new and original, if lesser, creation. In 1826 he went to work in Shoreham, near Sevenoaks, Kent, producing WATER-COLOUR and sepia drawings which combined deeply religious feeling with a visionary sense of other worlds. In 1837 he returned to London to be near his friend Calvert and in 1838 he married Linnell's daughter, and then visited Italy for two years.

Palmer's finest work was done in his early years and in the Shoreham period (*Moonlight Landscape with Sheep*, Tate Gal.; *In a Shoreham Garden*, V. & A. Mus.). His later work, though distinguished, lacked the intensity and visionary fervour of what had gone before. Interest in Palmer revived in the 1920s and 1930s for the formal qualities of his work and he has influenced modern ROMANTIC landscape artists such as Paul NASH and Graham SUTHERLAND.

1152.

**PALMETTE.** See LOTUS AND PALMETTE.

**PALOMINO Y VELASCO,** ACISCLO ANTONIO (1655-1726). Spanish painter, scholar, and writer on art. In 1688 he was appointed a painter to the king. Famous in his day for the frescoes which he executed in churches at Madrid, Salamanca, Granada, etc., he is now best known for his book *Museo Pictórico y Escala Optica* (Vol. 1, 1715; Vol. 2, 1724). The second volume included a third part entitled *Parnaso Español Pintoresco Laureado*, a collection of biographies of Spanish painters, which is an important source for the history of Spanish painting and sculpture from the 15th to the 17th centuries.

**PANAENUS.** Athenian painter of the mid 5th c. B.C., a relative of PHIDIAS. PLINY records a tradition attributing to him the picture of the battle of Marathon which hung in the Painted Portico at Athens (also attributed to POLYGNOTUS and to the 5th-c. Athenian painter Micon).

**PANEL.** Term in painting for a SUPPORT of wood, metal, or other rigid substance, as distinct from CANVAS. Wood was used for that purpose in antiquity, which also knew the practice of glueing canvas to wood (MAROUFLAGE). In the Middle Ages leather was often stretched on panels before PRIMING, particularly in Russia. Until the adoption of canvas in the 15th c. nearly all the movable paintings of Europe were executed on wood, and even up to the beginning of the 17th c. it is probable that as much painting was done on the one support as on the other. Some of the LITTLE MASTERS of the Netherlands worked on copper, whose use is also mentioned by ALBERTI and LEONARDO. VASARI says that SEBASTIANO DEL PIOMBO 'showed how one can paint over silver, copper, tin and other metals'. In the colonial art of South America copper and tin and even lead and zinc were used (see SPANISH COLONIAL ART and PORTUGUESE COLONIAL ART).

For wood panels the Italian masters of the RENAISSANCE preferred white poplar, the French and Flemings oak, the Germans pine, but all used the planks of many other trees on occasion. Analysis of the contents of art galleries has yielded a long list of woods, including beech, cedar, chestnut, fir, larch, linden, mahogany, olive, and walnut. In the 20th c. cedar, teak, and dark walnut are favourites. The panel must be well seasoned to remove resin and gum as otherwise it may warp and split. CENNINI advised that small panels should be boiled to prevent splitting, presumably because this removes some of the resin, and modern experts recommend steaming for the same reason. For a large picture several pieces had to be accurately jointed together and glued with CASEIN (cheese glue), a difficult operation which is described in medieval treatises. In the 20th c. painters have used plywood, fibre-board, and other synthetic materials (see also ACADEMY BOARD).

Painting directly on wood is not satisfactory because the wood absorbs too much of the paint and does not reflect enough light, besides reacting chemically with some of the PIGMENTS. Moreover, some woods darken in course of time. Normally, therefore, after the holes had been filled up if necessary, the panel was SIZED and coated with several layers of GESSO, or of chalk, so that it presented a smooth, even GROUND. The backs of panels also require protection against wood-worm and against damp, which can cause warping and rot.

**PANINI** (PANNINI), GIOVANNI PAOLO (GIANPAOLO) (*c.* 1692-1765). Italian painter,

born in Piacenza and trained in the school of stage designers at Bologna, possibly under one of the BIBIENA family. He settled in Rome in 1717, where he was for a time the pupil of Benedetto Luti (1666-1724) and in 1718 he decorated the Villa Patrizi. He came to prominence about this time as a painter of *vedute* or town scenes and he was the first painter to make a special feature of RUINS—an aspect of his work which links him with Hubert ROBERT and PIRANESI. He did several fresco commissions for cardinals and for Pope Innocent XIII and also became known chiefly for his paintings of public festivities and events of historical importance (e.g. the birth of the Dauphin in 1729 and his wedding ceremonies when he married Maria Theresa in 1745). He is best known nowadays for his large pictures of Roman ruins with anachronistic figures of soldiers, biblical characters, and the rest. These had great influence in their day and started a vogue, although in their calm and carefully organized design they had nothing of the romantic turbulence or SURREALIST character of Piranesi. Panini taught PERSPECTIVE at the French Academy in Rome and his connections with France were always close.

1989.

**PANOFSKY,** ERWIN (1892-1968). German art historian. Educated at Berlin, Munich, and Freiburg Universities and at the Warburg Library at Hamburg, he was professor at Hamburg University 1926-33 and visiting professor at New York University 1931-3. From 1935 he was professor at the Institute for Advanced Study, Princeton University. His study *Hercules*

*at the Crossroads* (1930) and his study of DÜRER's *Melencolia* jointly with F. Saxl marked the beginnings of his ICONOLOGICAL approach and he became recognized as the most prominent figure in this school of ART HISTORY. His *Meaning in the Visual Arts* was a collection of papers representing a cross-section of his work in the historical technique which reveals the themes and ideas inherent in the history of art and examines them as manifestations of cultural tradition. His *Early Netherlandish Painting* (1953), representing the Charles Eliot Norton Lectures of 1947-8, combines ICONOGRAPHIC interpretation with analysis of style. His *Renaissance and Renascences in Western Art*, published at Uppsala in 1960, was a synthesis of his conception of art history in western Europe.

**PANORAMA.** 'A picture of a landscape or other scene, either arranged on the inside of a cylindrical surface round the spectator as a centre (a *cyclorama*), or unrolled or unfolded and made to pass before him, so as to show the various parts in succession' (*O.E.D.*). A patent for such a device was granted to a certain Robert Porter in 1787. 'Panorama painting seems all the rage', CONSTABLE wrote in 1803. In 1805 R. K. Porter displayed a huge painting of *The Battle of Agincourt* occupying more than 2,800 sq. ft. of canvas. A panorama of Scheveningen, by MESDAG, is in the Mesdag Museum at The Hague. (Cf. DIORAMA, EIDOPHUSIKON.)

**PANTHEON.** The Pantheon at Rome is almost the only building of GREEK and ROMAN antiquity which has survived practically intact as regards its walls, ARCHES, and ROOF, and is

**Fig. 34.** The Pantheon, Rome. Section

**245.** Exterior view of the Pantheon, Rome, converted into the church of Sta Maria Rotonda. Showing the function of relieving arches. Engraving (1660)

considered to be one of the greatest architectural monuments of ancient Greece and Rome. According to an inscription it was first built between 27 and 25 B.C. by Marcus Vipsanius Agrippa on the Campus Martius, its original purpose being unknown. The present structure was the work of the emperor Hadrian (c. A.D. 126), though restoration was done in A.D. 202 by Septimius Severus and Caracalla. It was probably dedicated to the seven planetary deities.

Over a circular wall 19 ft. thick rises a DOME in the shape of a hemisphere, whose radius is equal to the height of the wall (62 ft.). In front is a PORTICO in the form of the façade of a Corinthian TEMPLE, with 16 Corinthian columns the CAPITALS of which were much admired during the RENAISSANCE. The interior of the dome is divided into five rows of deeply sunk panels (*lacunaria*), 28 in each row, and the interior is lightened by a central opening 27 ft. in diameter at its summit. Unlike most Greek temples the building was conceived as an interior and it is from this point of view that it is now chiefly admired.

In A.D. 609 the Pantheon was turned into a Christian church dedicated to Sta Maria ad Martyres (now called Sta Maria Rotonda) and the bones of many early Christians who had been buried in the catacombs were translated there. In later years it came to be regarded as the shrine for men of genius and RAPHAEL was appropriately buried there. MICHELANGELO was to have been buried there but at the instigation of Duke Cosimo I his body was brought to Florence. After the unification of Italy it became a royal MAUSOLEUM as well.

The British 'Pantheon' is Westminster Abbey with its Poet's Corner (to which artists and musicians are admitted as well), which grew up about the tomb of Chaucer. The 'Pantheon' in Paris was originally a church (Ste Geneviève, by SOUFFLOT). The archaeologist Quatremère de Quincy was commissioned to transform it into a fitting burial-ground for the heroes of the Revolution but under the pressure of subsequent political events many of the bodies deposited there were again removed. The United States Capitol has to some extent the function and the aspect of a Pantheon. Under the dome is the 'rotunda', where on occasion are performed funerary services for statesmen, and adjacent to it is the National Hall of Statuary which contains MONUMENTS to distinguished public servants. Underneath the 'small rotunda', which at one time was intended to become the centre of the building, there still exists an empty TOMB which was prepared to hold the remains of George Washington.

The Pantheon in Rome greatly influenced the development of Renaissance architecture. BRUNELLESCHI had it in mind when he built the CUPOLA of the cathedral in Florence, and BRAMANTE and Michelangelo looked upon the task of building the new church of St. Peter at Rome as that of raising the Pantheon upon the shoulders of the BASILICA of Constantine.

Places of princely burial were occasionally erected in imitation of the interior of the Pantheon and also assumed its name, as for example the MEDICI 'Pantheon' in Florence and that of the kings of Spain in the ESCORIAL. Among imitations of the entire structure may be named PALLADIO's church near the Villa Barbaro at Maser, CANOVA's 'Tempio' at Possagno (which he built for his own place of burial), and the church of San Francesco di Paolo at Naples. How adaptable the form of the Pantheon is to tasks of a different nature may be seen in the interior of the reading room of the BRITISH MUSEUM.

**PANTOGRAPH.** An instrument, known since the 17th c., for copying a drawing on a larger or smaller scale. By a simple system of levers the outline of the original work traced with a point attached to one arm can be repeated on to another surface by a drawing instrument attached to another arm. The pantograph has been used chiefly for preparing MINIATURE portraits from large sketches or paintings.

**PAPER.** A tissue of vegetable fibres, an Oriental invention carried from the Far to the Middle East by the Turks during the Dark Ages. In Europe it is first traceable in the 12th c. among the Moors in Spain, where it was made as well as imported. It was known in southern Italy at much the same time.

In the early part of the 14th c. the district of Ancona, where some of the finest papers are still made, became famous for the manufacture, and Genoa soon rivalled it. France, southern Germany, and Switzerland had well-developed industries in paper by the end of the century. White paper was first made in England in 1495, but not on a large scale until the 18th c.

Until 1800 European paper was made entirely of rags pulped in water by simple water-driven machinery. Drawing-paper of the best quality is still made by hand in the traditional way by dipping a close-meshed wire mould in the pulp, giving it a peculiar shake to consolidate the sheet, drying and sizing it. Hot-pressing or the cheaper process of calendering between cylinders is done to harden the sheets. Paper called 'mould-made', produced on a special type of machine, has many of the properties of hand-made paper. Writing-papers, less expensive drawing-papers, and some book papers are machine-made of a mixture of cotton, hemp, esparto, and wood, with a good deal of china clay added to make them smooth and opaque, SIZE to make them non-absorbent, and starch to make them stiff. Cheaper papers are machine-made wholly of wood.

Oriental papers made of bamboo, rice straw, and mulberry bark are imported for artists' use: very thin sheets of Japanese mulberry paper (*kodsu*), hand-glazed by rubbing with stones, are preferred by WOOD-ENGRAVERS for their proofs.

Paper-making machines, invented shortly before 1799 in France, produced paper in rolls; but for most purposes the product is sold cut to the sizes traditional in earlier manufacture. The commonest are Foolscap $13\frac{1}{4} \times 16\frac{1}{2}$ in., Crown $15 \times 20$ in., Large Post $16\frac{1}{2} \times 20$ in., Printing Demy $17\frac{1}{2} \times 22\frac{1}{2}$ in., Drawing Demy or Printing Medium $18 \times 23$ in., Royal $20 \times 25$ in., Imperial $30 \times 22$ in., Atlas $34 \times 26$ in., and their multiples. The roughest finish is called 'antique' and the normal one 'machine-finished'; a smoother surface is called 'plate-pressed' and an extremely smooth 'super-calendered'. Paper coated with china clay ('art' paper) is used for printing by the half-tone process. The marks left by the wires of the mould and the watermark in the hand-made product are simulated in some machine-made papers by impressing them before drying.

The English paper-makers James Whatman I (1702-59) and James Whatman II (1741-98) have given their name to hand-made linen rag papers in thick sheets used for WATER-COLOUR PAINTING.

**PAPWORTH,** JOHN BUONAROTTI (1775-1847). English architect whose simple but elegantly ornamented STUCCO houses are the embodiment of the qualities associated with the epithet 'REGENCY'. He was the son of a plasterer and worked as craftsman, builder, architect, TOWN-PLANNER, and designer of ships' interiors, on all of which subjects he wrote treatises. He made the first serious study on the causes of dry rot. Papworth was for a time a pupil of CHAMBERS. He built villas in London suburbs and adopted his second name when friends praised one of his designs as resembling the work of MICHEL-ANGELO. After 1824 his most important work was done in Cheltenham, and it is largely due to him that that town contains so much Regency architecture of high quality. He laid out the Montpellier estate there and designed the Rotunda. He was also known for his designs for Romantic rustic cottages, and his book on *Rural Residences* (1818) had a great influence on taste (see COTTAGES ORNÉES).

**PAPYRUS.** A writing material prepared from the stem of the marsh plant of the same name, growing in antiquity principally in Egypt and now in the Sudan. It was used in Egypt from the third millennium onwards and was the standard writing material in ancient Greece and throughout the Roman empire. From the 4th c. A.D. onwards it was increasingly replaced by PARCHMENT though it continued to be used, for example in the Papal Chancery, until the 10th c. It was used from the earliest times to take PAINT as well as INK; illustrated papyri survive from the Middle and New Kingdoms (Egypt) and there are a few fragmentary examples of ILLUMINATED classical texts as well as, for example, weavers' patterns.

**PARCHMENT.** Animal skins, sheep or calf, less frequently pig, goat, and other animals,

prepared for writing and painting, and occasionally for printing and bookbinding. Strictly it is the inner section of a split skin. Vellum is a fine kind of parchment, prepared from the skin of young animals. The use of animal skin as writing material is mentioned by Herodotus (v. 58). PLINY (*Nat. Hist.* xiii. 11) claims that parchment—meaning, perhaps, a skin prepared by special methods—was discovered by Eumenes II (197–159 B.C.) of Pergamum, after the Ptolemies

**246.** Virgin and Child. Miniature from the *Historia Anglorum* (B.M., 1250–9). The figure of the monk below has been thought by some to be a self-portrait of Matthew Paris

had banned the export of PAPYRUS from Egypt in an attempt to prevent the growth of the Pergamene library; hence the name 'parchment' from the Latin *pergamena*, 'of Pergamum'.

**PARIS,** MATTHEW (*c.* 1200–59). English artist and historiographer. He became a monk at St. Albans in 1217 and succeeded Roger of Wendover as monastery chronicler in 1236. In 1248 he visited Norway to reform the monastery of St. Benet-Holme, but otherwise seems never to have travelled further than London. In the early 13th c. St. Albans was, however, in the unusual position of including properly trained artists among its community. This is no doubt why Paris's surviving historical manuscripts (the *Chronica Majora* divided between Corpus Christi College, Cambridge, and the B.M.; the *Liber Additamentorum*, containing the 'Lives of the Offas', B.M.) are almost unique in being illustrated with numerous marginal scenes and symbols from his own hand (but cf. Caffaro's *Annals*, mid 12th c., French Foreign Office). Paris also composed several Lives of the Saints (the *Life of St. Alban*, Trinity College, Dublin, is autograph) in which the illustrations occupy the upper half of the page and are of equal importance with the text.

Apart from a panel painting of St. Peter from Faaberg (now in Oslo) which has been attributed to him, his known artistic production consists entirely of tinted drawings and there has been a mistaken tendency to assign all mid 13th-c. English work of this character, notably the great series of illustrated APOCALYPSES, to St. Albans in general and, if at all plausible, to his hand. That the style was not confined to St. Albans, from which an unusually large number of books happen to have survived, is proved by the head of a king (cloister of St. George's Chapel, Windsor) executed by court artists.

Paris's work, which dates, as preserved, from *c.* 1240–55, was nevertheless certainly appreciated, and 'circle of Matthew Paris' will no doubt remain the standard term for work which resembles it. It is a narrative and decorative art, lacking both grandeur and earnestness, whose origins are presumably to be sought in France in the sort of milieu which produced the CARTOONS for the STAINED-GLASS windows in Chartres Cathedral *c.* 1210–25.

**PARIS,** SAINT-MARTIN-DES-CHAMPS. This church, dedicated in 1067, was given to CLUNY as a priory by Philip I of France in 1079. It was enlarged after 1093, and the APSE rebuilt between 1130 and 1142, when Peter the Venerable was Abbot of Cluny, with an unusually complicated plan of five radiating chapels and an elaborate vaulting system. Unequal vaulting spaces are avoided by doubling the number of the outer supports, giving alternate triangles and rectangles of groin vaulting. The radiating chapels are themselves linked by an aisle round the AMBULATORY, and the central one, much

larger than the others, is itself formed of three shallow apses. The choir and apse are treated as one, all vaulted by a system of eight ribs, sustaining gore-shaped cells with rounded sections that fall away sharply from the centre of the VAULT. All is still ROMANESQUE, but it is significant that some of the early experiments in GOTHIC vaulting occur in priories of this house such as Notre-Dame d'Airaines. The nave is of the middle of the 13th c. The church serves as the museum of the Conservatoire des Arts et Métiers. The refectory, an admirable building by Pierre de Montereau, architect of the Sainte-Chapelle, is now the library. A fine 12th-c. wooden *Virgin* from the church is now at Saint-Denis.

**PARIS,** SCHOOL OF. (1) In the medieval period the term applied primarily to the manuscript illuminators who under St. Louis (1226–70) made Paris the leading centre of book illustration in Europe (see ILLUMINATED MANUSCRIPTS). Dante speaks of it as:

quell'arte che alluminare è chiamata in Parisi.

They developed a distinctive style of figure drawing quite different from the passive forms of the cathedral portals: slight, flat, and sinuous, with elegant decorative folds suited to CALLIGRAPHIC art. It was adopted by the makers of IVORIES and precious statuettes such as the *Virgin of Jean d'Évreux* in the Louvre. In the form of books and ivories the style was exported over most of Europe. The tradition was carried on by a succession of illuminators and painters such as Master Honoré (active *c.* 1300) and Jean PUCELLE. It was strong enough to absorb foreign influences from Italy and Flanders in the 14th c. A typical work of the late 14th c. is the *Parement de Narbonne*, a monochrome drawing on silk representing Charles V and Queen Jeanne de Bourbon kneeling on either side of a CRUCIFIXION (Louvre). The School reached its climax in the early years of the 15th c. when Jacquemart de Hesdin, André BEAUNEVEU, and the brothers LIMBURG were all at work in Paris. It made important contributions to the formation of the INTERNATIONAL GOTHIC style in Italy.

(2) The term 'School of Paris' is also applied to those movements in modern painting which followed the IMPRESSIONISTS—NABISM, FAUVISM, CUBISM, SURREALISM, etc.—and which had their focus in Paris although many of their exponents were from other countries. The term sufficiently marks the intense concentration of artistic activity, supported by critics, dealers, and CONNOISSEURS, which made Paris the world centre of advanced AESTHETIC ferment during the first 40 years of the 20th century. In 1951 an exhibition of the works of the École de Paris was given by the Royal Academy of Arts covering the period 1900–50. In the Introduction to the Catalogue, written by Frank McEwen, it was said that Paris then had 130 galleries as opposed to 30 in any other capital, the work of some 60,000 artists was shown there, of whom one-third were foreigners, and over 20 large salons

exhibiting annually an average of 1,000 painters each, mostly semi-professional persons. The exhibition itself contained a 20% foreign element. ABSTRACT or semi-abstract paintings were roughly 35%, although pure abstracts were only 15%. From consideration of the owners who lent their pictures for exhibition it was said that: 'Intellectual influence appears more in the list than the support of Society.' The following is a list of the artists shown: André Bauchant (1873-1958); Jean Bazaine (1904- ); André Beaudin (1895- ); Paul Berçot (1898- ); Maria Blanchard (1881-1932); Camille Bombois (1883- ); Pierre BONNARD; Francisco Borès (1898- ); Georges BRAQUE; Victor Brauner (1903-66); Maurice Brianchon (1899- ); Massimo Campigli (1895- ); Marc CHAGALL; Pierre Charbonnier (1897- ); Giorgio de CHIRICO; Lucien Coutaud (1904- ); Robert DELAUNAY; André DERAIN; François Desnoyer (1894- ); Oscar Dominguez (1906-57); Kees van DONGEN; Marcel DUCHAMP; Raoul DUFY; DUNOYER DE SEGONZAC; Max ERNST; Maurice Estève (1904- ); Jean Fautrier (1898-1964); Louis Fernandez (1900- ); Eugène Nestor Kermadec (1899- ); Helmut Kolle (1899-1931); Laci Barta (1905- ); André Lanskoy (1902- ); Charles Lapique (1898- ); Marie Laurençin (1885-1956); Fernand LÉGER; Raymond Legueult (1898- ); Jean Le Moal (1909- ); André Lhote (1885-1962); Jean Lurçat (1892-1966); Alberto Magnelli (1888- ); Alfred MANESSIER; André Marchand (1907- ); Pierre-Albert MARQUET; André MASSON; Henri MATISSE; Joan MIRÓ; Amedeo MODIGLIANI; Piet MONDRIAN; Willy Mucha (1905- ); Julius Pascin (1885-1930); Amédée de La Patellière (1890-1932); Jean Piaubert (1900- ); Francis PICABIA; Edouard Pignon (1905- ); Serge Poliakoff (1906- ); Jean Pougny (1894-1956); Suzanne Roger (1899- ); Georges ROUAULT; Henri ROUSSEAU.

**PARLER.** The name of a family of masons prominent in south Germany in the second half of the 14th c. They were responsible for many important works, such as the choirs of the Kreuzkirche at Gmund (1351), Freiburg Münster (1354), the first design for Ulm (1377), and several Bohemian churches, including Prague Cathedral. The family style was developed at Gmund by JOHANNES PARLER, who came from the cathedral lodge at Cologne. It was his son PETER (c. 1330-99) who became Baumeister at Prague in 1353. Another Parler, HEINRICH, took an ineffective part in the Milan Cathedral debates of 1392. The Parlers were the German equivalent of Raymond du TEMPLE in France and Henry YEVELE in England. They made a considerable contribution to the development of SONDERGOTIK.

**PARMIGIANINO,** FRANCESCO MAZZOLA (1503-40). Italian painter and etcher. He evolved a distinctive, calligraphic manner of figure painting which combined virtuosity with extreme MANNERIST elegance and which was widely imitated both in his own country and time and later in France and Germany. In *The Marriage of St. Catherine* (Canonica di Bardi, near Parma, 1521) Parmigianino's personal style is already apparent, the figures being freely adapted to conform with his sense of linear rhythm and composed not on the High RENAISSANCE principle of balance but on the Mannerist one of tensions. At the same time he began the decoration of some chapels in S. Giovanni Evangelista, Parma. CORREGGIO was then engaged on painting the dome and PENDENTIVES of the same church, and Parmigianino's work, rich in movement and depth and highly dramatic, reveals his admiration of the older master's manner.

In 1524 Parmigianino travelled to Rome, possibly via Florence. Few paintings of his Roman years remain (it is likely that he spent much of his time on ETCHING and other GRAPHIC ARTS), but those that there are reveal a new maturity under the influence of Roman CLASSICISM. Amongst them is *The Marriage of St. Catherine* (Earl of Normanton, Somerley, Ringwood, Hants), an elegant interpretation of RAPHAEL's classical manner, and *The Vision of St. Jerome* (N.G., London), Mannerist in composition and in the proportions of the panel, deriving some of the figures from MICHELANGELO and Correggio, and yet imbued with Raphael-esque nobility and grandeur. It is painted in a smooth and more finished technique which permanently replaced Parmigianino's earlier more Impressionistic manner.

Like so many other artists he left Rome when it was sacked in 1527 and settled in Bologna. There he developed a new interest in LANDSCAPE as a shallow background to his subject pictures, as in the *Madonna with St. Zachary, the Magdalen and St. John* (Uffizi, c. 1530). His landscapes have a mysterious and visionary character which was much admired and were imitated by NICCOLÒ DELL' ABBATE, who introduced them into FRENCH ART. About the same time Parmigianino painted the *Madonna della Rosa* (Dresden). VASARI says that this was painted for Pietro Aretino, which would explain the overtly sensual character of this supposedly devotional work.

In 1531 he returned to Parma and contracted to paint in FRESCO the semi-dome and vault over the high altar in Sta Maria della Steccata. Only the decoration of the vault was completed, and this largely by assistants. To the same period belongs the *Madonna dal Collo Lungo*. In composition, in the elongation of the figures (always a characteristic of Parmigianino's work, but here quite extraordinary), in the exciting contrasts of scale between the figures in the foreground and the figure and columns some indeterminable distance behind them, one may see the extremes of Parmigianino's Mannerism; and yet this picture is informed by a sense, true if precarious, of balance, and is notable for the beauty of the forms employed.

Parmigianino's failure to complete the Steccata frescoes within the twice extended time of the contract brought him for a short while into prison. When released he left Parma for Casalmaggiore and painted there his last work, the *Madonna with SS. Stephen and John the Baptist and a Donor* (Dresden, 1539), a grave and monumental picture, expressing for once a truly religious spirit. The next year he died, after an artistic career of only 21 years.

Parmigianino, whose draughtsmanship was exquisite, made designs for engravings and for CHIAROSCURO WOODCUTS and appears to have been the first Italian artist to produce original etchings from his own designs.

922, 2128.

**PARRHASIUS.** Greek painter of the later 5th c. B.C. Born at Ephesus, he was with ZEUXIS the chief representative of the Ionic School. He had a reputation for portraying psychological states and strong emotion and relied arrogantly but as far as we can judge justifiably on contours. In a dialogue Xenophon represents Socrates discussing with him the power of the artist to portray feeling and emotion or character in a face.

**PARTHENON.** The principal TEMPLE of Athena at Athens, on the ACROPOLIS. Erected by ICTINUS and CALLICRATES from 447 to 433 B.C., it measures over-all 110 by 237 ft. and has 8 by 17 COLUMNS. The style is Doric, though with an Ionic FRIEZE (barely visible) high up outside the *cella* walls. The architectural detail is subtle and exquisite, the sculpture exceptional for quality and quantity. The Byzantines gutted its interior, probably in the 6th c. A.D., for conversion to Orthodox Christianity; the Franks in the 13th c. put in a campanile, which the Turks after 1458 prolonged into a minaret; the Venetians in 1687 destroyed the middle by bombardment and part of one PEDIMENT by incompetence; and Lord Elgin in 1801–3 removed most of the surviving sculptures (see ELGIN MARBLES). It remains a noble ruin.

626.

**PASITELES.** Greek sculptor of south Italy, active at Rome in the mid 1st c. B.C. Famous in his time, he seems to have been an ingenious CLASSICIZER. PLINY says on the authority of Varro that he used preliminary models for his MARBLE sculpture and that he wrote a kind of Greek *Companion to Art*.

**PASMORE,** VICTOR (1908– ). English painter. While at school at Harrow he displayed a gift for painting and he was included in the *Objective Abstractions* exhibition held in 1934 at the Zwemmer Gallery. His early work, partly under FAUVIST and CUBIST influences, combined the contrasting tendencies of a natural gift for lyrical expression and an interest in the theoretical basis of modern AESTHETIC movements. In 1937 he combined with COLDSTREAM in forming the EUSTON ROAD GROUP. In the late 1940s he underwent a dramatic conversion from figurative to pure ABSTRACT painting and in the 1950s, partly under the influence of Charles Biederman's book *Art as the Evolution of Visual Knowledge*, he went over to the construction of abstract RELIEFS in which the representation of ILLUSIONISTIC space, integral even to abstract two-dimensional painting, is done away with. His earlier reliefs had a hand-made quality but later, through the introduction of transparent perspex, he gave them the impersonal precision and finish of machine products. Many of these reliefs were done as essential elements in architectural projects. As a teacher at Newcastle and elsewhere he was an enthusiastic exponent of the principles of 'basic DESIGN'.

**PASSAROTTI,** BARTOLOMEO (1529–92). Italian painter, who except for some years in Rome (c. 1551–c. 1565) worked in his native town of Bologna. There he had a large studio, which became the focal point of the city's artistic life, and set himself in opposition to the influence of Florentine and Roman MANNERISM. His *St. Ursula with her Companions* (Sta Maria di Pietà, Bologna) marks the furthest point in his development towards the BAROQUE style of the CARRACCI, one of whom, Agostino, was his pupil. He was a talented portraitist, and the creator of a singular type of GENRE and STILL-LIFE painting depicting peasants with flowers and fowls.

**PASSE,** VAN DE. A Netherlandish family of engravers based on Cologne (c. 1594–1612) and then on Utrecht; founded by CRISPIN (d. 1637), who had four children: SIMON (1595?–1647), WILLEM (1598?–c. 1637), MAGDALENA, and CRISPIN. Between them the family produced a large number of engraved portraits of British sitters, both in England and Holland. Their work in *Herwologia Anglica*, 1620—a portrait book of English heroes—had great influence on British portrait engravings.

**PASSERI,** GIOVANNI BATTISTA (1610–79). Mediocre Italian painter but an important biographer of contemporary artists. His *Vite dei Pittori, Scultori ed Architetti che anno lavorato in Roma morti dal 1641 al 1673*, not published till 1772, contains a lively and on the whole accurate account of the lives of 36 artists.

**PASSION CYCLE** (Matt. xxi. 1–xxvii. 61; Mark xi. 1–xv. 47; Luke xx. 28–xxiii. 56; John xii. 12–xix. 42). The prelude to CHRIST's Passion was His triumphal entry into Jerusalem on Palm Sunday, and it is with this scene that the cycle begins in art, following the story as told in the four GOSPELS up to His death and entombment. Scenes of the Passion were first portrayed on Christian SARCOPHAGI of the 4th c.; the earliest cycles are simple and allusive, showing only the chief exponents of each episode and omitting

the more violent incidents of degradation which took place between the trial and CRUCIFIXION. The cycle acquired greater prominence after the doctrinal affirmation of Christ's proper humanity at the Council of Chalcedon in 451 and it was developed in later centuries both by the addition of new scenes and through the elaboration of the individual episodes. The Passion scenes, with their liturgical and doctrinal importance, occupied a dominant place in the New Testament cycles of the Middle Ages (GIOTTO, Arena Chapel, Padua; DUCCIO, *Maestà*, Opera del Duomo, Siena; Fra ANGELICO, S. Marco, Florence).

The sarcophagus of Junius Bassus (Vatican Grotto, 4th c.), shows Christ's *Entry into Jerusalem* on a donkey, but limits the scene to the central figure of the rider. A complete picture is given for the first time in the *Gospels of Rossano* (S. Apollinare Nuovo, Ravenna, 6th c.), where Christ is met by a crowd of men and children coming out of the gate of the city, waving palm branches and casting their cloaks before the hooves of the donkey. This version was repeated with few variations in the medieval cycles (mosaic, St. Mark's, Venice, *c.* 1200; cycles by Giotto and Duccio), and was followed by GHIBERTI in his relief for the door of the Baptistery, Florence. The next scene of the Passion is the LAST SUPPER, followed by Christ's withdrawal to the Mount of Olives. In the mosaics of S. Apollinare Nuovo, Ravenna (6th c.), Christ stands on the mount, praying with raised arms like a standing *orant* (see GISANT), while the disciples sit calmly conversing at His feet. Three—Peter, James, and John—are sleeping. Other versions of this period (*Rossano Gospels*) divide the scene into two moments: in the first Christ prays on the ground apart; in the second He wakes the sleeping disciples. The same division is observed in most early medieval versions (mosaics of St. Mark's, Venice, *c.* 1220). Later artists again united the scene, showing Christ kneeling on the slope and His disciples sleeping below, while in some versions an ANGEL appears to Christ revealing to Him a chalice or the instruments of the Passion (MANTEGNA, N.G., London; DÜRER, engraving, 1508).

The focus of the *Arrest* which follows is the *Betrayal* by Judas with a kiss. The mosaics of S. Apollinare Nuovo show the soldiers and priests following Judas on the left and the disciples with Peter drawing his sword on the right; and this scheme became established. The main incidents, shown separately or together, were the kiss, the arrest, and Peter's attack on Malchus. In the BYZANTINE mosaics at Daphni (11th c.) Peter cuts off the ear of the High Priest's servant, and Western artists also adopted this idea (mosaic, St. Mark's, Venice, *c.* 1200; Giotto). In many later versions the other disciples flee in panic (Duccio), while on the bronze doors of Benevento (12th c.) the soldiers fall down with fear at the sight of Christ (Fra Angelico, loc. cit.; *Très Riches Heures du duc de Berry*, Musée Condé, Chantilly). An example of modern treatment of the theme is MANET's *Christ in the Garden of Olives*. As time went on attention was directed rather to the spiritual agony and struggle of Christ than to the more picturesque incidents.

Certain early cycles show Christ being led to judgement (mosaics of S. Apollinare Nuovo; 5th-c. ivory casket, Brescia). But in most the next scene is His *Trial by the High Priest*, *Caiaphas*, who sits enthroned with one or more of his colleagues while Christ is led before him by the soldiers. Sometimes Caiaphas tears his garments to mark the blasphemy of Christ's claim to be the Son of God (OTTONIAN Gospels, *Codex Egberti*, Trier, 10th c.; Giotto). There follows the *Trial before Pilate*. In the earliest versions (sarcophagus of Junius Bassus; ivory relief, B.M., *c.* 400) the episode is recalled by the seated figure of Pilate washing his hands over a basin, the famous gesture with which he declined responsibility for Christ's fate. In Ravenna (S. Apollinare Nuovo) Christ, with the Jewish priests, stands facing Pilate's throne and this composition was adopted both in the medieval cycles (Giotto; Duccio) and by the artists of the Counter-Reformation (TINTORETTO, fresco in the Scuola di San Rocco).

Two subsidiary scenes, the *Denial of St. Peter* and the *Repentance of Judas*, accompany Christ's trial. The former is evoked in the early cycles by the crowing cock perched on a column, while Christ prophesies Peter's betrayal (4th-c. sarcophagus in the Lateran; *Andrew's Diptych*, ivory, V. & A. Mus., 5th c.). In Ravenna he is shown meeting the maidservant outside the courtroom, and later sitting with a group of men round a fire (late 13th-c. frescoes, Ochrid; Duccio). The effects of CHIAROSCURO made this a popular scene with painters of the 16th and 17th centuries (CARAVAGGIO, Galleria Corsini, Florence; REMBRANDT, Rijksmuseum, Amsterdam). Judas's repentance was popular in early cycles as a pendent to the Crucifixion (ivory, B.M., *c.* 400, where he is shown hanging dead from the branch of a tree). In Ravenna he offers back the money to the High Priest outside the Temple; and the *Gospels of Rossano* show both scenes. The repentance of Judas rarely appears in the medieval cycles, but his suicide is associated with the carrying of the cross in later series (Jean FOUQUET, *Heures d'Étienne Chevalier*, Chantilly, 15th c.).

The *Flagellation* and the other episodes of cruelty between Christ's trial and His Crucifixion are not described at length in the Gospels, and were not dwelt on in the early art cycles. The first portrayal of the flagellation is in the *Codex Egberti* where Christ, fully clothed, is tied to a column by one soldier and beaten by a second. In this and in other early versions there are few spectators, though usually Pilate himself supervises and sometimes the Jewish priests also watch (bronze doors of S. Zeno, Verona, 12th c.). The ferocity of the ordeal, and the number of the

hostile spectators, increased at the close of the Middle Ages with the vogue for devotional pictures dwelling on the sufferings of Christ (MASTER FRANCKE, Hamburg Mus., 15th c.). In most versions of the flagellation Christ stands with His back to a tall column, similar to the relic of the flagellation in the Church of the Holy Sepulchre at Jerusalem. But after the Counter-Reformation He was shown bowed over a small pillar, representing the other relic of the flagellation preserved in S. Prassede, Rome; this also increased the humiliation of his position (CARRACCI, Pinacoteca, Bologna).

The *Crowning with Thorns*, which followed the flagellation, was also rare in early cycles, though it appears on a sarcophagus of the 4th c. like an imperial coronation ceremony, without the implications of degradation inherent in later versions. The type of coronation introduced by Giotto and Duccio, showing a frenzied attack by the soldiers on the calm and suffering Messiah, became very popular in the 15th c. (H. BOSCH, N.G., London) and was carried to an extreme of savagery in TITIAN's pictures in Munich and the Louvre (1560-70). The crown of thorns has fascinated Graham SUTHERLAND among 20th-c. artists. Another scene of late appearance was the *Ecce Homo*, showing Christ exposed by Pilate to the Jews, standing on a platform above the crowd, bearing the marks of flogging and wearing the crown of thorns (H. Bosch, Johnson Coll., Philadelphia, *c.* 1500; G. FERRARI, *Madonna delle Grazie*, Milan, 16th c.).

The *Carrying of the Cross* was depicted in two alternative versions, in one of which Simon of Cyrene carries the cross, as told in the Synoptic Gospels, and in the other Christ Himself. The former is common in EARLY CHRISTIAN ART (S. Apollinare Nuovo, Ravenna; fresco, Sta Maria Antiqua, Rome, 8th c.), and was also preferred by Byzantine artists (rock chapel of Elmale-Klissé, Cappadocia, 11th c.; Nagorića, Yugoslavia, 14th c.). In a few early scenes (ivory relief, B.M., *c.* 400) Christ Himself carries the cross, and here it is small and borne with ease: in late medieval versions of this type its weight increased and the sufferings of Christ grew more atrocious, just as the crowd of spectators increased in size and brutality (Giotto, Arena Chapel, Padua; SCHONGAUER, engraving, 15th c.; P. BRUEGEL, Vienna, 16th c.). The VIRGIN herself appears in some versions, either helping to bear the cross (*Très Belles Heures de Notre-Dame*, Bib. nat., Paris, 15th c.) or fainting with horror (*Lo Spasimo*, school of RAPHAEL, Prado, Madrid).

From the 14th c. onwards, under Franciscan influence, the *Carrying of the Cross* was expanded into a series of *Stations*, which decorate the naves of many churches and mark the hillsides leading to certain sanctuaries, evoking the painful series of halts with which Christ's progress to Golgotha was supposed to have been punctuated. The *Stations of the Cross*, which form a separate cycle, are represented in the *Calvary* of G. Ferrari at the Sacro Monte of Varallo (16th c.).

The *Preparation of the Cross* on Golgotha has been treated in various ways. In some scenes Christ sits bowed with sorrow on a low stone (Dürer, *Small Passion*, woodcut, 1511) or is stripped of His garments (El GRECO, Toledo Cathedral, 16th c.). Byzantine PSALTERS depict His nailing to the cross, illustrating the prophetic verse of Psalm xxi. 7 (Psalter, B.M., 11th c.; *Barberini Psalter*, Vatican, 12th c.); and this episode is also shown in later Western painting (G. DAVID, N.G., London; Philippe de CHAMPAIGNE, Toulouse Mus.). Byzantine fresco cycles of the 14th c. show Christ climbing a ladder to reach the standing cross (Nagorića, Yugoslavia; Peribleptos Church, Mistra, Greece), and Fra Angelico also painted this scene (S. Marco, Florence).

The *Deposition* and *Entombment* had slight doctrinal or liturgical significance and did not form part of the earlier Passion cycles, where the Crucifixion was followed immediately by scenes of the RESURRECTION. But a 9th-c. Byzantine manuscript of the sermons of Gregory Nazianzen (Bib. nat., Paris) shows Joseph of Arimathea and his helper Nicodemus, watched by the Virgin Mary, lifting Christ down from the cross. The *Codex Egberti* omits the Virgin; but she takes an increasing part in later portrayals, kissing His right hand (Toqale-Klissé, Cappadocia, 10th c.) or supporting His falling body (Peribleptos Church, Mistra, 14th c.; Duccio, *Maestà*, Siena). The number of participants increased with time: ladders were added to assist the work (ANTELAMI, relief in the Baptistery, Parma; Fra Angelico, S. Marco, Florence), and St. John and Mary Magdalen help to support the body (SODOMA, Siena, 16th c.). The ROMANTIC treatment of the theme may be exemplified by the *Pietà* of DELACROIX.

The *Lamentation* and *Entombment* of Christ conclude the later passion cycles. In the earliest portrayal, that in the *Codex Egberti*, Joseph of Arimathea and Nicodemus alone carry the body to the tomb. In the frescoes of S. Angelo in Formis, south Italy, they are assisted by the lamenting Virgin; and in Byzantine frescoes of the 12th to 14th centuries Christ is shown resting on the tomb or on a flat stone, wept over by the Virgin and her companions (Karies, Protaton, Macedonia). This scene of lamentation was taken over by Western painters (Giotto, Padua), and developed into an independent composition, sometimes known as the *Pietà* (see VIRGIN), in which the body of Christ is held increasingly upright by His mourners (Giovanni BELLINI, Brera; Fra BARTOLOMMEO, Pitti, Florence). Artists of the RENAISSANCE evolved a separate scene for the burial, in which the body is carried by the bearers towards the tomb, and the study of their physical effort conflicts with their display of emotion (Raphael, Borghese Gal., Rome; Titian, Louvre). This effect is modified by BLAKE, in his water-colour of the entombment (Tate Gal.), where Christ is carried on a funerary bier.

**PASTEL MANNER OF ENGRAVING.** See CRAYON MANNER.

**PASTEL PAINTING.** A method of painting in dry colours. Pure powdered PIGMENTS, mixed with just enough GUM or RESIN to bind them, are made up into sticks, called pastels, similar to CHALKS AND CRAYONS. Pastel differs from other methods of painting in that no MEDIUM or VEHICLE is used. In other methods the colour as applied is different from the colour when dry; in pastel this is not so, and the artist may know at once what effect his colour will give. The practical disadvantage of pastel is the difficulty of securing adhesion to the GROUND and its liability to be disturbed by the slightest touch or even by vibration. As with drawings in chalk or CHARCOAL this may be counteracted by spraying with a FIXATIVE, the most satisfactory being a very weak solution of parchment SIZE, but fixing is apt to impair the characteristic surface quality and reduce the brilliance of the colour. Protection under glass and careful handling are perhaps the best safeguards.

Pastel is opaque, and the colour of the ground does not influence the final effect unless parts of it are left bare. The usual ground is a neutral-toned PAPER. Sometimes the design is made up of individual strokes of colour not blended together, and sometimes the pastel is drawn lightly over the rough ground to produce a half-tone—a process known as 'scruffing'; in such cases the ground will show through and its tone is important. In its restricted range of tone pastel approaches FRESCO and GOUACHE, but the brilliant powdery surface is peculiar to pastel.

Pastel painting derives from the use of chalk for drawings, developed from the end of the 15th c. (see CHALKS AND CRAYONS). LOMAZZO records that LEONARDO used variously coloured chalks for some of his studies for the *Last Supper*. The combination of black, white, and red or flesh-colour grew in popularity through the 17th and 18th centuries, especially in France. If line was eliminated and the few colours were blended, such drawings became in effect paintings in a restricted range of hues. The invention of pastel painting in a full range of colours has been ascribed to the landscape painter and etcher, Johann Alexander Thiele (1685-1752), and also to his contemporaries Mme Vernerin and Mlle Heid of Danzig. Essays in using a full range of colours had been made earlier, but Thiele perhaps used the method more extensively than any of his predecessors, and the first artist to devote herself almost exclusively to it was another contemporary of his, Rosalba CARRIERA, who introduced the technique to France. In the 18th c. many of the French portrait painters practised pastel: Maurice Quentin de LA TOUR was one of the most brilliant, and BOUCHER, GREUZE, NATTIER, PERRONNEAU, DROUAIS, CHARDIN, and Mme VIGÉE-LEBRUN all worked in it. Simon Mathurin Lantara (1729-78) was one of the first to use pastel for landscapes. In England

pastel painting was first practised extensively by COTES, who had worked under Rosalba Carriera. He was followed by his pupil John RUSSELL, and by HUMPHRY, COSWAY, LAWRENCE, and others. In Switzerland LIOTARD was influential. During the first half of the 19th c. the art declined; pastel had been used in the main for portraiture and the great age of portraiture was over. But in the second half of the century the medium became popular with the French IMPRESSIONISTS, and there was a general revival. In 1870 the Societé des Pastellistes was founded in Paris, and the first exhibition of the Pastel Society in London was held in 1880. The possibilities of the technique began to be more fully exploited. The earlier method had been to blend the colours together by rubbing with the finger or stump. Now, in pastel as in oil painting, a variety of techniques was developed. The new practitioners saw the value of the individual stroke, of the outline enclosing a flat area of colour, and of a more open technique in which the colours were juxtaposed without blending. Their subjects were also far more various. Among the many artists who have used pastel may be mentioned MILLET, Léon-Augustin Lhermitte (1844-1925), Paul Albert Besnard (1849-1934), DEGAS, RENOIR, REDON, TOULOUSE-LAUTREC, BONNARD, and MATISSE in France; WHISTLER and TONKS in England; and the American Mary CASSATT.

**PASTE PRINTS.** See MANIÈRE CRIBLÉE.

**PASTERNAK,** LEONID (1862-1945). Russian painter, who studied in his native Odessa and in Munich, where he came under NABI influence. He became an intimate friend of TOLSTOY, whose works he illustrated (*War and Peace*; *Resurrection*), and whom he portrayed on many occasions (*Tolstoy's Family in Yasnaya Polyana*, 1902). In 1905 he became an Academician of the St. Petersburg Academy of Fine Arts. He left Russia in 1921 and settled in Berlin, where he painted portraits of Max LIEBERMANN, Albert Einstein, and others. He left Germany during Hitler's regime, and spent the last years of his life in London and Oxford, where he died.

**PASTICHE, PASTICCIO.** A hotch-potch; 'a picture or design made up of fragments pieced together or copied with modification from an original, or in professed imitation of the style of another artist; also, the style of such a picture, etc.' (*O.E.D.*). The term 'pastiche' is generally applied in a derogatory sense to ECLECTIC work with the implication that the artist has not welded his borrowings together into a unified style of his own.

**PASTORAL.** There is evidence that at Alexandria near the beginning of the 3rd c. B.C. there existed a pastoral art tricked out with a traditional apparatus of grottoes and bowers, featuring

country shrines and MYTHOLOGICAL figures of nymphs and SATYRS, Dionysus and Pan. Some of the *Epigrams* of Theocritus (*c.* 325–*c.* 267) might serve as inscriptions for such works of art, and the pastoral episodes in his *Idylls*, as also in Herodas and Moschus, show familiarity with the furniture of the pastoral painting. It is likely that later in the century such pastoral scenes included ordinary human beings. From the Second POMPEIAN Style onwards pastoral or idyllic LANDSCAPE was common, painted in an apparently spontaneous manner but often with a studied elegance and incorporating the standard motifs of rustic shrines under leafy trees, domestic animals grazing around and wayfarers in attitudes of reverence. The pastoral scenes create an imaginary and deliberately artificial world fraught with poetic glamour. EARLY CHRISTIAN and medieval art had little place for the pastoral GENRE. But when the RENAISSANCE revived the Virgilian genre Sannazaro's *Arcadia* (1504) included imaginary descriptions of such idyllic works of art which were soon translated into reality in VENETIAN painting by GIORGIONE and his followers. The *Fête champêtre* in the Louvre is the outstanding instance of this mood. A touch of the pastoral survives in the 17th-c. versions of ITALIAN genre, notably by Netherland artists such as BERCHEM or ASSELYN, and in the creation of the pastoral landscape by CLAUDE. In the 18th c. WATTEAU drew on this tradition in his magic *fêtes galantes* while BOUCHER exploited the fashion for his version of elegant eroticism. There are echoes of the pastoral in GAINSBOROUGH's landscapes and subject pictures but the French Revolution put an end to the tradition last symbolized by the Petit Trianon.

**PA-TA SHAN-JEN.** See CHU TA.

**PATCH,** THOMAS (1725–82). English painter and engraver born in Exeter. He went to Italy in 1747 and remained there the rest of his life. He studied under VERNET and first made a reputation, especially among the English tourists, as a painter of the Roman scene. When in 1755 he was expelled from the State of Rome for reasons that are obscure, he settled in Florence and there began the CARICATURE CONVERSATION PIECES by which he is chiefly remembered today. He had no political or other axe to grind and his caricatures were good-humoured. They were popular with the English and many still hang in the houses to which they were brought back by their purchasers.

2803.

**PATEL,** PIERRE THE ELDER (*c.* 1620–*c.* 1676). French LANDSCAPE painter. He was a pupil of VOUET but worked rather in the manner of CLAUDE. He painted the landscape panels for the decorations in the Cabinet de l'Amour of the Hôtel Lambert, by LE VAU. He also did

a detailed painting, now in the VERSAILLES museum, of the first palace of Versailles by Le Vau. His son PIERRE-ANTOINE the Younger (1648–1708) painted landscapes and TOPOGRAPHICAL views in his father's manner.

**PATENIER,** H. See BLES, H. met de.

**PATENIER** (PATINIER, PATINIR), JOACHIM (before 1500–24). Flemish painter of LANDSCAPES with figures. Nothing is known of his early life, but in 1515 he became a member of the Antwerp Guild. In 1521 he met DÜRER, who made a SILVER POINT drawing of him and described him as a 'good landscape painter'. There are only a very few signed works, but a great many other paintings have been attributed to him with varying degrees of probability. Among the signed works are: *The Baptism of Christ* (Vienna), *The Flight into Egypt* (Antwerp), and *St. Jerome* (Karlsruhe). Patenier also painted landscape backgrounds for other artists and *The Temptation of St. Anthony* (Prado) was done in collaboration with his friend Quentin MASSYS. Patenier was the first Netherlandish artist to allow the landscape to dominate a narrative scene. Although his landscape does not constitute the subject of the picture, craggy mountains and lush valleys dwarf the tiny figures which act out the FLIGHT INTO EGYPT or Charon crossing the Styx. His landscape style is characterized by a threefold colour scheme of warm browns in the foreground, shades of green in the middle distance, and a background of translucent blues. This system had already been used by BOSCH and by Gerard DAVID, but Patenier's importance lies in his intuitive understanding of this new field of painting and in this he presages the great 16th-c. exponent of landscape painting, Pieter BRUEGEL.

926.

**PATER,** JEAN-BAPTISTE-JOSEPH (1695–1736). French painter, pupil and imitator of WATTEAU, with whom he had a somewhat touchy relationship. Legend has it that Watteau dismissed him from his studio (*c.* 1713) because he was disturbed by the threat offered by his progress to his own pre-eminence; in view of Pater's mature productions it is difficult to understand how this story came into being. Unlike Watteau's other imitator, LANCRET, Pater was a poor draughtsman but a sensitive though hesitant colourist. He commercialized Watteau's method and achieved some success in Paris, being received into the Académie in 1728. Examples of his FÊTES CHAMPÊTRES are in the Wallace Collection, and at Kenwood, London. Two GENRES in which he showed some originality are groups of *Baigneuses* (Angers and Wallace Coll., London) and scenes of military life, in which he expressed himself with surprising breadth and confidence

(*Les Vivandières de Brest*, Wallace Coll., London).

1403.

**PATER, WALTER HORATIO** (1839–94). English critic and essayist. He was a fellow of Brasenose College, Oxford, and associated with the PRE-RAPHAELITES. He was regarded as an apostle of the 'aesthetic movement' (see AESTHETICISM) and the somewhat exaggerated cult of beauty which set a supreme value upon the enjoyment of aesthetic experience. He first made his name by an essay on WINCKELMANN contributed to the *Westminster Review* in 1867 and subsequently included in his volume *Studies in the History of the Renaissance* (1873). His aesthetic creed was also expressed in a philosophical romance *Marius the Epicurean* (1885) and in 1889 he published a collection of critical essays entitled *Appreciations*.

2039.

**PATINA.** Patination is a process for changing the surface appearance of a metal object and the patina is a surface coat usually the result of chemical corrosion. The chemical patination of metallic objects is usually by means of thin adhering surface films of sulphides or oxides. Many metals acquire a natural patina by exposure to the atmosphere or by being buried in the earth. BRONZES that have been buried undergo chemical reaction with the substances of the particular soil in which they lie, are corroded, and acquire colour by oxidation and decay. These natural patinas have often been greatly prized since the RENAISSANCE, when large numbers of ANTIQUE bronzes were recovered discoloured from exposure to soil or sea, and many modern artificial patinas are attempts to reproduce these effects. The French sculptor BARYE made a particular study of the various sorts of bronze patinas. The Chinese carried the art of patination to great lengths and developed many ornamental, multi-coloured, mottled, and cloudy patinas which have not elsewhere been paralleled.

**PATRONAGE.** In popular imagination the ideal patron of the arts is a person who supports artists and buys their work for the sake of art alone. It is doubtful whether such a person has ever existed. The idea that Art is a cause to be supported is at any rate of very late origin and hardly goes back beyond the 17th c. Before that time works of art were considered either as articles of use or as evidence of conspicuous wealth which could contribute as much to the glory of the owner as to that of the artist. It was natural for wealthy persons or communities to take pride in having the best craftsmen available to work for them, and the actions they took to secure such service sometimes look like pure beneficence. Yet it is doubtful whether even SUGER of Saint-Denis felt himself to be patronizing the arts rather than simply enhancing the

glories of his church. Similarly the Duke of Berry hardly saw himself in the role of a promoter of artistic activity as such.

Perhaps the first document to give evidence of the belief that it is worth while for a community to support and honour its famous artists is the decree for the employment of GIOTTO by the commune of Florence in 1334. It invokes Giotto's universal fame as a reason why he should be honoured in his fatherland and holds out the hope that his presence in Florence will redound to the prestige of the city. The competition arranged for the Baptistery doors in Florence in 1401 betokens a similar spirit. A Florentine merchant of the 15th c., Giovanni Rucellai, thanked God for giving him the opportunity to employ such artists as DOMENICO VENEZIANO, UCCELLO, and others. At the same time the Italian humanists made propaganda for the idea of a disinterested patronage of letters and learning, invoking the name of Maecenas, the proverbial example of a benefactor to genius. To the degree to which the artists tried to achieve equality with men of letters they expected similar treatment—MANTEGNA, for instance, applied to Lorenzo de' MEDICI for a large sum of money, simply relying on the Medici family's reputation for generosity.

There is evidence that the ambitious artistic undertakings of the papal curia in the 15th and early 16th c. followed a deliberate plan to impress the might and power of the papacy on the minds of the faithful. The greatest patron among the popes, Julius II, strove to bring about a new Augustan age and therefore planned, with the help of BRAMANTE, MICHELANGELO, and RAPHAEL, to restore Rome to its imperial grandeur. The fashion set by the Italian RENAISSANCE princes was followed north of the Alps. Francis I enlisted LEONARDO and CELLINI; Maximilian employed DÜRER and BURGKMAIR; and Henry VIII HOLBEIN and TORRIGIANO. From this time onwards it became a point of honour for a ruler to have it said of him (whether truthfully or not) that art flourished under his sceptre.

The commercial as distinct from the propaganda value of state patronage was first seen by COLBERT, who set out deliberately to raise the standard of French DESIGN in connection with his export policy. From then on this aspect of official patronage became an issue frequently discussed, though in England there was no deliberate action on these lines before the 19th c. There, initiative was left to the private patron to try to raise the level of the country's taste—a task which Lord BURLINGTON regarded as his mission. The reliance of the English 18th-c. gentleman on foreign examples and foreign artists provoked the wrath of HOGARTH, who was one of the first artists to deplore the absence of patronage and the corresponding disadvantage under which the English artist suffered. The foundation of the Academy under royal auspices, in imitation of the French institution, included among its aims the raising of the status of English

art in the eyes of patrons. The growing alienation of the artist from his public in the 19th c. made the problem still more acute. The isolation of BLAKE and the suicide of HAYDON were symptoms of the artist's refusal to pander to what he regarded as the taste of the vulgar. The artist came to expect of the patron that he should accept unconditionally whatever genius offered; but such patrons were rare, either in England or on the Continent. The best chance for an artist was to find a modest member of the middle classes who would buy his work out of friendship rather than as a collector. The few friends whom the IMPRESSIONISTS found among lawyers and doctors are examples of this kind of patronage.

Among the new types of patron the enlightened ART DEALER deserves special mention. Though not more disinterested than other types, dealers such as Duret and Vollard often staked their reputation on a young artist or a new movement and would even pay an annuity to a painter to enable him to carry on his work.

Despite a number of attempts to find work for artists on official projects, the insufficiency of patronage has been widely felt. But no real remedy has been found. The degree to which the State intervenes varies from country to country. The complaint of the artist that progressive movements are so often stifled for lack of patronage has led, in the course of the 20th c., to the formation of various official and unofficial bodies, all trying to promote contemporary art. Their task is not a grateful one, for their funds can never be sufficient to keep many artists in bread and butter and they will always incur the hostility of those who do not get their share. But perhaps the root cause of the discontent lies deeper. The highest principles cannot replace a real demand and affection for the things that artists produce; patronage for the sake of patronage is felt by many to be as sterile as art for art's sake.

699, 1265, 1353, 2627.

**PAUSANIAS** (2nd c. A.D.). Greek traveller and geographer who journeyed through Greece, Macedonia, Asia Minor, and north Africa and left an *Itinerary* in 10 books. His descriptions of works of art which he saw are one of the few accounts of GREEK ART surviving at this period.

**PAUSIAS OF SICYON.** Greek painter of the mid 4th c. B.C. He was the first painter who fully mastered the ENCAUSTIC technique, an important medium of GREEK and ROMAN painting. According to tradition he also introduced the painting of VAULTED ceilings.

**PAXTON,** SIR JOSEPH (1803-65). English architect, renowned chiefly as the designer of the Crystal Palace. Son of a Bedfordshire farmer, he made his way as a gardener, becoming head gardener to the sixth Duke of Devonshire at Chatsworth in 1826 and eventually his business

agent and trusted adviser. During the following 25 years he travelled widely in England and abroad, made a name for horticultural building and as a designer of parks and suburbs, designed conventional masonry houses (mansions at Ferrières, near Paris; Mentmore, Buckinghamshire; Lismore Castle, Ireland), became the leading landscape gardener in the country and as an early railway speculator made himself financially secure. In connection with his experiments in horticultural building he invented the 'ridge and furrow' roof and developed the idea into a sloping glass roof with the 'Paxton' gutter, which collected internal and external moisture, and light wooden spars supported on hollow cast-iron columns. This principle was put into effect in the Great Conservatory he built at Chatsworth (1836-40/1), which led to the building of the Palm House at Kew Gardens (1844), designed by Decimus BURTON. The same principle of construction was employed in his design for the Great EXHIBITION Building in Hyde Park (1851), the largest building ever erected to that time, covering a floor area of 772,284 sq. ft. with an additional 217,100 sq. ft. of galleries. In his *History of the Modern Styles of Architecture* (1862) James Fergusson said: 'There is, perhaps, no incident in the history of architecture so felicitous as Sir Joseph Paxton's suggestion of a magnificent conservatory to contain that great collection.' The building was a completely prefabricated structure based on standard units which were mainly multiples of 24. The building was first dubbed 'Crystal Palace' in *Punch* and the name caught on. After the Exhibition the materials were used in the erection of the more elaborate Crystal Palace at Sydenham (1852-4), destroyed by fire in 1936. Paxton also designed glass palaces in Paris and New York.

As a landscape gardener Paxton is most noted, after his work at Chatsworth, for the grounds of the Crystal Palace and the park at Birkenhead. He was described in *The Times* obituary as 'the greatest gardener of his time, the founder of a new style of architecture, and a man of genius, who devoted it to objects in the highest and noblest sense popular'. He was interested in drainage and sanitation. Among schemes for Metropolitan improvement the most important were the Thames Embankment (1864-70) and his project for the Great Victorian Way (1855), an 11-mile glass-roofed road to encircle central London.

Paxton was knighted in 1851 and was a Member of Parliament from 1854 until his retirement in 1865.

515, 861.

**PEALE,** CHARLES WILLSON (1741-1827). American painter of portraits and STILL LIFE, generally considered the most gifted of the Philadelphia Colonial artists. He spent two years in London (1767-9), where he studied

247. Building for The Great Exhibition of 1851. Pen-and-ink sketch by Sir Joseph Paxton. (V. & A. Mus., 1850)

248. Paxton's building for The Great Exhibition of 1851

under Benjamin WEST, but otherwise he had virtually no formal training. A natural craftsman, he came to painting through skilled craftsmanship and he established the first art school in America. He was a man of broad sensibility and lively enthusiasms. He fought as a colonel of the militia in the War for Independence and became a Democratic member of the Pennsylvania Assembly. In 1780 he retired from politics and began his most prolific period as a painter. In 1782 he opened an exhibition gallery next to his studio, the first art gallery of the United States, and there displayed his own portraits of leading personalities of the Revolutionary War, diplomats, and other portraits of historical significance. By 1784 there were 44 such likenesses in the gallery. After the departure of COPLEY he was recognized as the leading portrait painter in the colonies and he has left some of the most memorable portraits of the period. In style his work retains little of the ROCOCO elegance but initiated the American equivalent of European NEO-CLASSICISM. He also painted in MINIATURE and in 1795 a life-size TROMPE L'ŒIL, *The Staircase Group*, showing his sons RAPHAELLE and TITIAN RAMSAY PEALE mounting a staircase (now in the Philadelphia Museum of Art), was exhibited. His portrait of his brother JAMES, *The Lamplight Portrait* (Detroit Institute of Art), was painted when he was 81 years old.

James Peale, the brother, and Raphaelle Peale, the eldest son, of Charles Willson attained some distinction as painters of miniatures. Of his other sons RUBENS became a painter of still life after retiring and Titian Ramsay was a distinguished artist-naturalist. REMBRANDT achieved notoriety by his itinerant mural *The Court of Death* (11 ft. 6 in. by 23 ft. 5 in., Detroit Institute of Arts), which he called a Moral Allegory and which was exhibited with success in public for over half a century. He was a gifted though uneven portrait painter (*Thomas Jefferson*, 1805, and *Self-Portrait*, 1828, both Detroit Institute of Arts).

809, 2450, 2451.

**PEARCE,** EDWARD. See PIERCE.

**PEARSON,** JOHN LOUGHBOROUGH (1817–98). English architect of the late GOTHIC REVIVAL, renowned as an expert on VAULTING. His chief work is Truro Cathedral in EARLY ENGLISH style (begun in 1879). He also designed several London churches, the best of which were St. Augustine's, Kilburn (1871–80), and the destroyed St. John's, Red Lion Square.

**PECHSTEIN,** MAX (1881–1955). German painter. He joined the Dresden BRÜCKE in 1906 and was exceptional among these young artists in having had a proper academic training. In order to give German EXPRESSIONISM coherence and its representatives the possibility of holding

exhibitions he founded the *Neue Sezession* in Berlin in 1910. Technical skill gave Pechstein's pictures a superficial charm and made him more popular than many of his contemporaries. Yet his friend KIRCHNER summed him up best when he called him sneeringly a 'Matisse-Imitist'— a close imitator of MATISSE. He shared the Expressionists' interest in PRIMITIVE art and visited the South Sea Islands in 1914.

**PEDIMENT.** Term in CLASSICAL architecture for the space formed at the gable end of a pitched roof by the sloping eaves and horizontal CORNICE. It was usually a shallow isosceles triangle, the height of which was approximately one-eighth of its width. The lower border was formed by the cornice, and the sides, called slanting or raking cornices, were formed of similar members. The type was established in Greek temples and the decoration was usually completed by filling the TYMPANUM (or back wall) with sculpture and adding decorative blocks called ACROTERIA to the three angles. The classic example is the east and west pediments of the PARTHENON (447–433 B.C.), filled with sculpture attributed to PHIDIAS, most of which is now in the British Museum. The idea of a pediment which was segmental rather than triangular in shape certainly occurred to the Romans, who also used both forms to shed the rain from window and door-heads as well as for their original purpose as roof-ends, and both types became part of the RENAISSANCE vocabulary. In the MANNERIST style it was common to use broken or interrupted pediments as decorative elements and this negation of the original function culminated in the Porta delle Suppliche of the Uffizi, Florence (after 1580), where BUONTALENTI broke a segmental pediment into two halves which he then reversed, filling the central space with a bust on a CORBEL. Most BAROQUE architects used broken

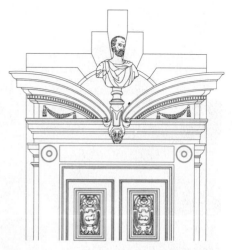

**Fig. 35.** Pediment from the *Porta delle Suppliche* of the Uffizi, by Buontalenti

pediments, though few were as deliberately contra-functional except in interiors. KENT was much criticized for such illogicality and the NEO-CLASSICAL masters were careful to restore pediments to their original function and to use them in relation to the COLUMNS and PORTICOES which are their natural accompaniment.

**PEEPSHOW BOX.** A cabinet with scenes portrayed on the interior walls giving the strong illusion of three-dimensional reality. The spectator has to look through a small opening or eye-piece situated at the centre of projection (see PERSPECTIVE). It seems that ALBERTI was the first inventor of a peepshow box; for some such device is ascribed to him in a contemporary, anonymous biography. There is a type of peepshow described in the famous Jesuits' perspective book by Du Breuil (1649) in which illusionary vistas are extended by the use of mirrors. In yet another type of box an ANAMOR-PHOSIS was drawn on an interior wall, which took on natural proportions when viewed through the eye-piece. Instructions for making such a drawing are given in VIGNOLA's perspective book (1583). The 17th-c. Dutch painter HOOGSTRATEN was famous for his peepshow cabinets.

**PEETERS,** BONAVENTURA (1614-52). One of the few notable Flemish MARINE PAINTERS. He was born at Antwerp, but went to live in Hoboken after clashing with the Jesuits. In his early work Peeters was influenced by Dutch masters, such as Simon de VLIEGER. In the later years of his short life he tended to introduce elaborate motifs and bright colour in a decorative vein less impressive than his earlier style. Examples are in many museums including the National Maritime Museum, Greenwich.

**PELLEGRINI,** GIOVANNI ANTONIO (1675-1741). VENETIAN painter, a pupil of the Milanese Paolo Pagani (1661-1718) and influenced by Sebastiano RICCI, combining the latter's opulent Venetian manner with the more fluid handling of Jan LISS. He played a major part in the spread of the Venetian style of large decorative painting in northern Europe, painting at Düsseldorf (1713/14), at Mannheim (1736/7), and at Paris (1720), as well as in the Low Countries and Vienna. He was the first Venetian artist to visit England, arriving in 1708 in the train of the Earl of Manchester and working on decorative projects at Kimbolton Castle, Castle Howard, and Narford Hall, Norfolk. His airy, ILLUSIONISTIC compositions, with their bright, flickering colour and purely decorative intention, set a new standard of ROCOCO elegance for English decoration.

**PEN.** The word 'pen' originally meant a quill, the universal writing instrument from Early Christian times until the 19th c. Like all pens the quill was first used for writing, and except for manuscript illustrations it did not come into general use for DRAWING until about the 12th c. Most of the pen drawings of the Old Masters were done with the quill. It was prepared—as it still is by professional scribes—by shaving off the barbs and then, with a sharp, narrow-bladed knife ('pen-knife'), cutting off the end obliquely so as to produce a point. The point was then cut across, squarely or at an angle, sharpened further if necessary, and slit so that the INK would flow more easily. A well cut quill has a peculiarly elastic stroke, sympathetic to the hand of both draughtsman and scribe, but the point wears down very quickly and must then be re-cut (in the early 19th c. there were various attempts to cover or tip quills with metal). Goose, swan, and turkey quills have commonly been used for writing and crow quills provide a very fine point for drawing.

The reed pen was already in use in classical antiquity and is probably older than the quill. The length of reed, or cane, is cut in much the same way as a quill, but the point is much coarser, producing a bold, angular line sometimes slightly blurred at the edges. During the Middle Ages and the RENAISSANCE the reed pen served for very large scripts. For drawing it has been used much less than the quill, though it has appealed to particular masters. Some of REM-BRANDT's drawings illustrate the broad energetic technique appropriate to it.

Even the metal pen is not a modern invention: a bronze one was found at POMPEII, and bronze or silver pens were occasionally made during the Middle Ages. Steel nibs of the modern type, however, were not made until late in the 18th c. and only began to replace the quill when they were produced by machine, c. 1822. Most artists today use a flexible steel nib with a fine point, but they will draw with anything that comes to hand—even a ball-point, whose light, rapid line tones well with WATER-COLOUR.

No other drawing tool can produce such a variety of texture or reveal so intimately the personal 'handwriting' of an artist. The pen is the ideal medium for rapidly noting down the first idea and has been used in this way by masters of drawing as different as PISANELLO, MICHEL-ANGELO, DÜRER, and Rembrandt. But apart from its use for the hasty or inspired SKETCH, in which the fire of execution is reflected in the line, the pen has been used with great effect in a careful, calligraphic manner, as in BOTTICELLI's illustrations to Dante's *Divine Comedy*.

Pen-and-wash drawing, in which the pen lines are reinforced by brush-work in diluted Indian ink or some similar PIGMENT, has been practised since the Renaissance (see WASH).

**PENCIL.** Until the 17th c. the word 'pencil' meant a BRUSH, and was often a symbol for the painter's art. The 'lead' pencil, actually not lead but graphite, took its name from the lead point (see METAL POINT) which it superseded. A new writing instrument of mineral origin which has replaced the silver point is mentioned in 1564 by

Johann Mathesius, who says that it will write on PAPER, and in the next year the Swiss scholar Konrad Gesner, in a treatise on fossils, describes and illustrates a wooden holder containing what is probably a stick of graphite. As a drawing instrument graphite had several advantages over the metal points: it had a deeper and more pleasing tone, it did not require a specially treated surface, the strength of its line could be varied at will, and it could be easily erased. At first it was known as 'Spanish lead'. Later, the chief source was the mines in Borrowdale, Cumberland, opened in 1664. There arose a flourishing English manufacture of wooden pencils (known as *crayons d'Angleterre*) and in 1683 Sir John Pettus, deputy governor of the royal mines, remarked that 'Black Lead . . . of late . . . is curiously formed into cases of Deal or Cedar, and so sold in Cases as dry Pencils'. But the manufactured product, in which the powdered graphite was mixed with GUM or some other adhesive, was very rough for drawing and artists seem to have found sticks of the raw mineral more reliable in texture. Pencils of predetermined hardness or softness were not produced until 1790, when Nicolas-Jacques Conté, the French chemist, undertook to solve the problem of making pencils when France was cut off from the English supply of graphite. He found that the graphite could be eked out with clay and fired in a kiln and that more clay meant a harder pencil. Conté obtained a patent for his process in 1795. It was only then that the pencil became the universal drawing instrument that it is today. Its qualities were extolled with eloquence by James Duffield Harding in 1834, in his *Elementary Art, or the Use of the Lead Pencil Advocated and Explained*.

**PENCZ**, GEORG (*c.* 1500–50). German painter and engraver of Nuremberg, who probably received his training in DÜRER's workshop. As a young man he must have been to Italy for GIULIO ROMANO's influence is clearly traceable in his later paintings as also is BRONZINO's, particularly in his forceful portraits. His WOODCUTS and engravings prove him a clever illustrator. He usually worked on a rather small scale (see LITTLE MASTERS).

**PENDENTIVE.** Architectural term for a curved, triangular feature whose purpose is to enable a circular DOME to be supported above a square or polygonal drum.

**PENNETHORNE**, SIR JAMES (1801–71). English architect, assistant to John NASH and rumoured to be a son of the Prince Regent by Mrs. Nash. His works include the original part of the Record Office, Fetter Lane (1851–66), a building later incorporated in the ROYAL ACADEMY (1866), and the demolished Geological Museum in Piccadilly.

**PENNI**, FRANCESCO (*c.* 1488–*c.* 1528). Italian painter, nicknamed 'il Fattore', who was

born in Florence and was RAPHAEL's assistant in Rome. In this capacity he has been held responsible for various portions of the works of his master and of his fellow apprentice GIULIO ROMANO. But he remains a shadowy figure.

**PENTIMENTO.** Painters' term for the sign of a change of mind or concealed mistake by the artist in executing a picture. In many cases an artist covers such changes with opaque PIGMENT, but as in the course of years the covering pigment may become transparent the lower layer begins to show through, revealing the artist's first statement and subsequent change.

**PEPERINO.** A type of volcanic tuff composed of an impasto of ash and containing isolated minerals and fragments of eruptive rock. Found in the neighbourhood of the Lake of Albano in Italy, this grey stone, sometimes spotted with black, is sufficiently coherent to be used as a building stone. Known to the Romans as *Lapis Albanus*, it was used in the construction of ancient Rome and it is still used today in Rome and its surroundings.

**PEPPI** (PEPI), CENNI DI. See CIMABUE.

**PERCELLIS.** See PORCELLIS.

**PERCIER**, CHARLES (1764–1838) and FONTAINE, PIERRE-FRANÇOIS (1762–1853). French architects and furniture designers who, after studying together in Rome (Fontaine also spent an instructive year, or more, in England), worked in partnership until 1814, when Percier retired. They were the favourite architects of Napoleon, and Fontaine was appointed *premier architecte* to the Emperor in 1807. They carried out under his orders numerous schemes of restoration, reconstruction, and redecoration, notably in the LOUVRE and Tuileries, and the palaces at Malmaison, FONTAINEBLEAU, Saint Cloud, Compiègne, and VERSAILLES. One of their principal surviving MONUMENTS is the Arc de Triomphe du Carrousel built in honour of the Grand Army in 1806–7. In interior decoration and furniture design they were the leading exponents of the so-called EMPIRE STYLE and their *Recueil de décorations intérieures* (1812) is the best compendium of early 19th-c. ornament published in France. After the retirement of Percier and the fall of Napoleon, Fontaine continued to enjoy the patronage of the French crown right up to his death in 1853.

**PEREDA**, ANTONIO DE (*c.* 1608–78). Spanish painter. His early work was under the influence of VELAZQUEZ and van DYCK; but he is best known for his STILL LIFES and for the *Dream of Life* (Academy, Madrid, *c.* 1655), an allegory on the theme of vanity. He was a talented representative of the Madrid school of BAROQUE.

**PEREIRA**, MANUEL (d. 1683). Portuguese sculptor who worked chiefly in Spain. Among

his surviving works are six statues of saints in the church of S. Placido, Madrid (*c.* 1650), and two versions of *S. Bruno* (Academy, Madrid, and Charterhouse of Miraflores, Burgos), which rank among the masterpieces of Iberian sculpture for their vigorous REALISM and expressive characterization.

**PÉRELLE,** GABRIEL (1603–77) and his son ADAM (1640–95). French draughtsmen and engravers of TOPOGRAPHICAL views and LANDSCAPES. Their engravings of buildings are of great importance to the architectural historian.

**PERGAMENE SCHOOL.** A trend in HELLENISTIC sculpture, beginning in the late 3rd c. B.C. and probably continuing into Roman times, which combines CLASSICAL forms with violent movement and expression and has been thought to display an advanced sense for composition. The great period of Pergamum was the century 240–140 B.C. when the Attalid kings Attalus I, Eumenes II, and Attalus II aspired to make their capital a magnificent centre of culture. The new city was planned in a series of colonnaded terraces up the 1,000-ft. hill which rises beside the river Caicus, with the palaces at the top and a theatre seating 10,000 persons cut into the side of the hill. On the Acropolis of Pergamum Attalus I erected a series of dedications to celebrate his victory over the Gauls. They included a central group representing a Gaul supporting the dead body of his wife and stabbing himself, surrounded by figures of expiring Gauls the most famous of which is the DYING GAUL (Capitoline, Rome). Above the *agora* and below the temple of Athena Eumenes II erected the Great Altar of Zeus to celebrate his own victory over the Gauls. Beneath the Ionic upper colonnade and beside the stairs it is encircled by a colossal FRIEZE representing the battle of the gods and the giants. Other works attributed to the Pergamene School on stylistic or compositional grounds but without certain authentication are: a group showing Menelaus carrying the dead body of Patroclus (Loggia dei Lanzi, Florence); Artemis with the body of Iphigenia (Ny Carlsberg, Copenhagen); Achilles with the body of Penthesilea (Geneva); Marsyas and Apollo (Conservatori, Rome); a sleeping satyr (Munich), and a sleeping female head (Terme, Rome). A collection of RELIEFS which decorated the sanctuary at Kyzikos built by Eumenes II and Attalus II in honour of their mother is described in epigrams collected in the third book of the *Greek Anthology*.

Some scholars deny that there is adequate reason for supposing there was a local school of Pergamum. Others, as for example T. B. L. Webster in his *Hellenistic Poetry and Art* (1964), take the view that although the artists employed by the Attalid kings came from various places, they 'achieved a unity of style which justifies the name Pergamene'. From the incomplete knowledge at our disposal it is clear that the style

emphasized the dramatic in individual groups in contrast with the aloof classical calmness and serene dignity of the OLYMPIAN and PARTHENON figures. Roger FRY in his *Last Lectures* (1939) made the important point that for the first time in Greek sculpture the frieze on the temple of Zeus established systems of correspondence and balance throughout the whole design and knit the individual figures into a single coherent composition. He also points out that in execution the sculptor has used light and shade deliberately, carving the stone so that the shadows suggest the forms instead of cutting the actual forms as we know them to be. He describes this as 'a definite breakaway from the dominance of conceptual imagery' and 'a much further adventure into the world of appearance than any hitherto attempted'. Both Fry and others have also made the point that the Pergamene sculptors were far more conscious than previous masters of the function of the reliefs in the architectural whole which they decorate. It has also been suggested that although the temple of Athena and the theatre were earlier, Eumenes II conceived the temple of Zeus as an architectural unity with them.

**PERGAMUM ALTAR.** The Great Altar of Zeus at Pergamum, perhaps the 'Satan's seat' of Rev. ii. 13, dedicated in the early 2nd c. B.C. This masterpiece of the Pergamene style (see PERGAMENE SCHOOL), rescued from the lime kiln in 1876, is displayed in the BERLIN MUSEUMS.

**PERISTYLE.** Term in CLASSICAL architecture for a continuous colonnade surrounding a temple or court. The term is also applied to the inner court of a large house, surrounded on three sides by colonnades.

**PERMEKE,** CONSTANT (1886–1952). One of the outstanding Belgian painters of the 20th c. With Gustave de SMET and Frits van den BERGHE he created the Belgian school of EXPRESSIONISM. His colossal figures and strong, vigorous drawing had certain leanings towards social REALISM and his LANDSCAPES are as sombre as his figures. His paintings lend an air of magnificence to the heavy FLEMISH realism.

1562, 2259.

**PERMOSER,** BALTHASAR (1651–1732). German sculptor, who studied in Italy and came under the influence of BERNINI. His chief work was the sculptural decoration of PÖPPELMANN's Zwinger palace, Dresden. He was the master of ROUBILIAC.

**PERPENDICULAR STYLE.** The term 'Perpendicular' was introduced into architectural history by T. RICKMAN in 1817, to distinguish the last phase of what he called Christian (i.e. medieval) architecture in England. He made it begin at the end of the 14th c., but it was

subsequently realized that the style was already fully developed in the transepts and choir of Gloucester Cathedral (after 1329). It lasted until the end of the Middle Ages, and even persisted until the 17th c. in places such as Oxford. Like the term 'DECORATED' it is derived from a classification of window TRACERY. Certainly vertical mullions are prominent in Perpendicular windows; but what really distinguishes them from earlier windows are the regular horizontal divisions which result in rows of panels. At Gloucester Cathedral this tracery panelling is extended from the windows to the surrounding masonry, and it is carried over the openings in the old NORMAN walls. The effect is that of a delicate cage suspended inside a sturdy framework. Many authorities think that the Gloucester design reflects the current court style of London; and its antecedents are sought in two London buildings: St. Stephen's Chapel, Westminster (1291), and the CHAPTER HOUSE of St. Paul's (1320s), both of which have disappeared. The essence of the style is the use of tracery as a universal form of decoration. The bulky, convex, sculptural forms of earlier PIER profiles and ARCH MOULDINGS have gone, and the dominant visual impression is of a flat network of lines. The only discordant note at Gloucester is to be found in the VAULTS, where a lierne vault of unequalled complexity was used. Density of pattern was essential, but it was achieved by this means only at the price of utter confusion. The appropriate form of Perpendicular vault was soon found. This was the fan vault, which was used in the cloisters at Gloucester (after 1351). In fan vaults the traditional notion of a diverging set of ribs was abandoned in favour of a self-developing system of tracery cells, starting from a point and spreading in a conoid shape. This was as near as could be got to the panels of window tracery; and the cloister arms at Gloucester, with walls, windows, and vaults all covered with the same kind of tracery pattern, present the most homogeneous vistas in the whole of English medieval architecture. By using tracery in this way English masons came rather belatedly into line with their GOTHIC colleagues on the Continent; and the court was certainly the channel through which continental ideas reached them. But the way in which tracery was handled remained distinctively English. The only important later development of Perpendicular was the adaptation of fan-vaulting for major spans. Although it was visually well suited to the style, fan-vaulting had no structural function; and it was a long time before masons would use it for anything except small spans, such as cloisters or side aisles. The Perpendicular style as a whole originated in smaller buildings. Gloucester Cathedral itself is really an enlarged chapel. The cathedral Perpendicular which followed, e.g. at York, Canterbury, and Winchester, is much more conservative. Not until quite late in the 15th c., and the beginning of the 16th, did the style reach its climax in the three royal chapels at Windsor, Westminster, and King's College, Cambridge; and in the abbeys of Sherborne and Bath. Except at Windsor, fans were used for the main spans in all these buildings. Nevertheless the great bulk of architecture dating from the Perpendicular period was not of the most ambitious kind. Perhaps its most characteristic products were the great parish churches of East Anglia and the Cotswolds. There was also a great volume of secular building which prepared the way for the architecture of the post-medieval world.

**PERRAULT,** CLAUDE (1613-88). French architect. Though trained as a physician, Perrault was associated with LEBRUN and LE VAU on the Commission appointed by Louis XIV in 1667 to draw up plans for the east front of the LOUVRE. He designed the Paris Observatory (1667) and the château of Sceaux for COLBERT (1673-4). He published an edition of VITRUVIUS in 1673 and in 1683 *Ordonnance des cinq espèces de colonnes selon la méthode des Anciens.*

1225, 2056.

**PERRÉAL,** JEAN, or JEHAN DE PARIS (active *c.* 1483-1530). French painter, architect, sculptor, and decorator of very considerable reputation in his day. He was in the service of Charles VIII, Louis XII, and Francis I and visited Italy on three occasions, with Charles VIII in 1494 and with Louis XII on his campaigns of 1502 and 1509. He has sometimes been identified, though on uncertain evidence, with the MASTER OF MOULINS. His activities were manifold. He was employed to design elaborately sculptured TOMBS such as that of Francis II of Brittany at Nantes; he was a specialist in arranging and designing public ceremonials; he was a designer of MEDALS and had a special interest in portraiture. The *Louis XII* at Windsor is attributed to him with considerable probability and reveals influences of Milanese painting which may have been acquired on his Italian journeys.

1801.

**PERRET,** AUGUSTE (1874-1954). French architect, for a short time pupil of the academic Julien Guadet (1834-1906) but later became, with Tony GARNIER, an important figure in the formation of the generation which was responsible for producing MODERN ARCHITECTURE in France. He first worked (as engineer as well as designer) in a family building firm and he had a thorough grasp of the practical problems of construction. He was one of the pioneers in the use of reinforced CONCRETE and succeeded in making it an aesthetically acceptable building material. But his achievement lay rather in bringing it within existing architectural concepts than in expanding or creating new formal concepts for

the new technical potentialities of ferro-concrete. His influence derives mainly from three buildings put up before 1914. His apartment house in the rue Franklin, Paris (1903), was a building of considerable originality in its plan but the structure is not determined by the special qualities of concrete. The garage in the rue Ponthieu (1905) was claimed by Perret to be 'the first attempt at an aesthetic of reinforced concrete'. But what he had in mind, and what he achieved, was an expression of the aesthetic of the Beaux-Arts in a concrete building and not the creation of a new architectural aesthetic deriving from the structural possibilities of ferroconcrete. The third of his important pre-1914 buildings was the Théâtre des Champs-Élysées (1911-14), which he began in collaboration with van de VELDE. It and his church of Notre-Dame at Le Raincy were considered by his followers to be his finest works.

In his later buildings Perret evolved a more sophisticated style with marked NEO-CLASSICAL affinities. The reinforced concrete structure was resolved into a system of clearly articulated COLUMNS (often emphasized by FLUTING), beams, and wall-panels resulting in an easily recognizable style which has strongly influenced several younger architects. His industrial buildings have been particularly influential for their functional lucidity of structure and harmonious proportions (e.g. marine laboratories, boulevard Victor, Paris, 1928; watch factory at Besançon, 1939; aircraft hangar, Marseilles, 1950). As a teacher, too, Perret has exerted a strong influence. In 1923 students of the École des Beaux-Arts set him up as their *maître d'atelier* and he was on the way to becoming the recognized patron of the new architecture. Several famous architects, LE CORBUSIER among them, once worked in his *atelier*. In 1923 also he was invited to write a preface to Morancé's periodical *L'Architecture vivante*, one of the chief organs of the modern movement in architecture. After 1930 he contributed importantly to the standardization and rationalization of building components. In 1946 he was appointed chief architect and planner for the reconstruction of Le Havre. His chief importance to the development of contemporary architecture is, in the words of Reyner Banham, 'as the man who, more than any other, made reinforced concrete acceptable as a visible building material in the eyes of those who practised architecture as an art, and did so by endowing it with an easily recognized, and easily digested, rectangular aesthetic'.

2293.

**PERRIER**, FRANÇOIS (1590-1650). French history painter and engraver. He visited Rome on two occasions and worked in the studio of LANFRANCO, by whom and by Piero da CORTONA together with a study of the works of the CARRACCI his own style was formed. In 1630 he became a collaborator of VOUET at Chilly. He was a foundation member of the Académie in 1648 two years before his death. His light-hearted decorations (now replaced by 19th-c. copies) for the Hôtel de la Vrillière are his best known works. Together with Vouet he was a teacher of LEBRUN.

**PERRONNEAU**, JEAN-BAPTISTE (1715-83). French portraitist who usually worked in PASTEL. He was overshadowed in his lifetime by Quentin de LA TOUR, whose psychological power he lacked. But his DRAWING was accomplished and his colouring has a delicacy which is prized by collectors, uneven but more vivid than La Tour's. A quality of restlessness, which sent him on journeys to Holland and Russia, destroyed the unity of his work but inspired an occasional masterpiece (*Mme de Sorquainville*, Louvre; *Self-Portrait*, Tours; *Girl with Cat*, N.G., London).

**PERSIAN ART.** CHRONOLOGY. (The early chronology of Persia is still speculative. During the later periods, when the influence of Persia extended beyond the political boundaries, regions under Persian influence are given in brackets.)

*c.* 7000 B.C. Mesolithic remains.

*c.* 6000 B.C. First agriculture and domestication of animals.

*c.* 5000-3000 B.C. Copper Age. Decorated pottery. Engraved seals.

*c.* 3000-1150 B.C. Bronze Age. Cultural relations with Elam.

*c.* 1150-700 B.C. Early Iron Age. Luristan culture. Influx of Medes and Persians.

*c.* 700 B.C. Mannai culture. Signs of Scythian art style.

645 B.C. Destruction of Susa by Ashurbanipal of Assyria.

559-333 B.C. Achaemenid rule.

333 B.C. Conquest of Persia by Alexander the Great. Followed by Seleucid rule.

*c.* 250 B.C.-A.D. 224. Parthian supremacy.

A.D. 224-642. Sassanians (Mesopotamia, Transoxiana, and Afghanistan).

638-642. Arab conquest of Persia.

661-819. Persia ruled by Moslem governors appointed by the Umayyad and Abbasid caliphs.

819-1055. Various Persian dynasties.

1055-1256. Seljuks and their successor states (Mesopotamia, which they continued to rule until 1262).

1256-1353. Mongol Il-Khans (Mesopotamia and Transoxiana).

1370-1500. Timurids (Mesopotamia and Transoxiana).

1502-1736. Safavids (Mesopotamia until 1638).

EARLY HISTORY. Civilization in Persia (Iran) goes back a very long way. In the Caspian Sea area the mesolithic remains, dated by the Carbon 14 method, belong to about the 7th millennium B.C., while agriculture and the

domesticating of animals began about 6000 B.C. But Persia is so vast, and excavation has been restricted to so few areas, that it is not possible to speak in general terms of the whole country. In the south-west, in the province of Fars, and in Khuzistan a fine civilization grew up in the Copper Age, about 3500 B.C., known to us chiefly by the most beautifully decorated POTTERY and an art of engraving seals found at Susa and Persepolis. In the south-east, in Kirman and Baluchistan, some vaguely similar painted pottery has been discovered which has connections with India. But in the Bronze Age, while cultural centres certainly existed in various parts of Persia (e.g. Astrabad and Tepehisar in the north-east), as far as can be at present established the main area of culture was in the south-west, where the kingdom of Elam was established from very early times with its capital at Susa on the Kherka river. The Elamites possessed a tradition of writing of their own, using at first a system of HIEROGLYPHS, then a form of cuneiform script, and were in close contact with the Sumerian civilization of Mesopotamia and their successors in Babylonia (see BABYLONIAN ART), with whose prosperity their own was closely linked. Owing to accidents of excavation the Elamite civilization is not as well known as it might be, but it seems to have possessed a generally similar character to that of Mesopotamia but one with very considerable independence not merely of language.

A well preserved *ziggurat* or temple-tower at Choga-zembil, near Susa, excavated in the early 1950s, is identical with those of Mesopotamia. Metal-work and the art of glazing bricks particularly flourished in Elam, and from inscribed tablets it would appear that there was a great industry in weaving, tapestry, and embroidery.

LURISTAN CULTURE. Luristan in the west has become famous for large finds of engraved BRONZE articles and castings of peculiar half-barbarous character, many of them horse-trappings, others weapons, others forming standards or symbolic objects. They mainly cover the period from the 12th to the 8th centuries B.C. but it is not yet certain what people made them. Excavations at Tepe Sialk and Surkh Dum—the only scientific excavations in which any of this material has as yet been found—have been held to show (though it is still unproven) that the Luristan bronzes are the handiwork of the Medes, an Indo-European people who, in close association with the Persians, began to infiltrate into Persia at about this period. The Medes and Persians are first mentioned in Assyrian documents of the late 8th c. B.C. but it is quite possible that they were already in Persia well before this.

MANNAI. In about the 8th c. B.C. a provincial form of art, combining local Persian features with those of ASSYRIA and Urartu (eastern Turkey and Soviet Armenia) evolved in the north-west corner of Persia, in the district anciently called Mannai, west of Lake Urmia,

and at Hasanlu. A splendid hoard of gold, bronze, and ivory objects was found in 1947 at Ziwiye (Sakkiz). It is particularly significant because it also contains elements which seem to be the earliest examples of Scythian art (see ANIMAL STYLE). These elements in the Ziwiye hoard may well belong to the 7th and early 6th centuries, at which date it was apparently hidden away. Excavations by the University Museum, Philadelphia, at Hasanlu have found remains chiefly of palaces between 1400 and 800 B.C., including a magnificent gold bowl with a mythological scene.

THE ACHAEMENIDS. Susa was violently destroyed in 645 B.C. by Ashurbanipal, King of Assyria. As a result a political vacuum was created, which the growing nations of the Medes and Persians who had infiltrated into the north-west of Iran during the 8th and 7th centuries B.C. were sucked in to fill. The Persians established themselves around Khuzistan with their capital at Susa, and the Medes around Ecbatana, the modern Hamadan, on the high-road from Persia to the west. Hamadan has not yet been scientifically excavated, and of Median art very little is yet known. The Medes were soon displaced as the leaders of the joint empire by the Persians. Cyrus called the Great (559–530 B.C.), the first great Persian king, enlarged his empire to extend from Anatolia to the Persian Gulf incorporating the former realms of both Assyria and Babylonia; and Darius the Achaemenid (522–486 B.C.), who succeeded him after various disturbances, extended the boundaries of the empire further still. Fragmentary remains of the palace of Cyrus at Pasargadae in Fars indicate that Cyrus favoured a monumental style of building and decoration based partly on Urartian, partly on the older Assyrian and Babylonian art, as was natural, since he wished his empire to seem to be the rightful heir of Urartu, Assur, and Babylon. Under Darius the forms of that art became finally established. The best known example of its architecture is the stupendous palace built by Darius and completed by Xerxes at Persepolis, though remains of other Achaemenid buildings are known from Susa and elsewhere. In ground plan the Persian palaces differed from those of Assyria and Babylon, the main feature of the Persian being a large audience hall, called an *apadana* (possibly reflecting a vast nomad tent), the roof of which was supported on a forest of COLUMNS. Since the reforms of the Persian prophet Zoroaster rejected the complex polytheism of Mesopotamia, there are found in Persia neither the cult-figures nor the innumerable temples of Mesopotamia, only fire-temples and fire-altars. The rock-cut TOMBS of the early Achaemenid kings at Pasargadae, Naqsh-i-rustam, and elsewhere are the only surviving source of information about many architectural forms used in Persia. The presence of Ionic CAPITALS in one of the earliest of these tombs (called Da-i-dukhtar) suggests the serious possibility that this important architectural form

was introduced into Ionian Greece from Persia, contrary to what is commonly supposed.

The decoration of the palaces at Persepolis includes the use of carved wall slabs in low RELIEF, recalling the art of Assyria and Babylon of the 9th-7th centuries B.C. They represent there endless processions of courtiers, guards, and tributary nations from all parts of the Persian empire and are executed in a dry and almost coldly formal, though neat and elegant, style which was henceforth characteristic of Achaemenid art and contrasts sadly with the movement and zest of Assyrian and neo-Babylonian art at its finest. The same lack of vigour is met in the excessively formalized though massive gateway figures at Persepolis in the form of winged human-headed bulls, which were likewise borrowed from Mesopotamian art. But of superb technical skill there was no lack in Achaemenid court art. Silverwork, glazing, goldsmiths' work, bronze casting, and inlay work are all well represented. Persian wealth and luxury were proverbial to the contemporary Greeks and in spite of little excavation many fine specimens of these crafts survive, having been widely exported, some coming from as far away as Egypt, the Oxus river, and the Altai Mountains (Pazyryk). In some of these works the influence of GREEK ART can be traced. Achaemenid art, however, was also capable of influencing that of others and its impress is most noticeable in the early art of INDIA, with which it probably came into contact through Bactria.

HELLENISTIC PERIOD: THE PARTHIANS. After Alexander the Great conquered the Persian Empire (333 B.C.), its art underwent a revolution. Greek conceptions of space and PERSPECTIVE, of the use of DRAPERY, gesture, and other devices to suggest movement or various emotions, but with insistence on balance and symmetry, restraint and PROPORTION, swept aside the outworn art of the Persian empire. The victors, represented by the Seleucid dynasty of Macedonian origin, replaced the old Oriental art by Hellenistic forms of representation in which, however, some Oriental features still remained. When in 250 B.C. a new Iranian people, the Parthians, re-established an Oriental empire over Mesopotamia, extending to the Euphrates, a reaction in favour of Oriental traditions of art and representation was accelerated, though the detailed history of the art of this period has not yet been fully recovered. By the 1st c. A.D. Parthian art was established in its own right. Stiff figures, often heavily bejewelled, wearing Iranian dress with its drapery emphasized mechanically and monotonously, were now shown systematically facing to the front, staring straight at the spectator. This was a device used in ancient Mesopotamian art only for figures of exceptional importance. The Parthians made it the rule for most figures, and from them it passed into BYZANTINE ART. A fine bronze portrait statue (from Shami) and some decadent low reliefs (e.g. at Tang-i-Sarwak and Bisutun) are

known. TERRACOTTAS and bronzes show a shrewd sense for representing animals. Glazed pottery with a pleasing bluish or greenish lead glaze, painted on shapes of Hellenistic inspiration, is frequently found. Ornate jewellery with large inlaid stones or glass GEMS made its appearance in this period.

Parthian art forms an important transitional stepping-stone—it leads on the one hand to the art of Byzantium, on the other to that of Palmyra, the Sassanians, and India.

THE SASSANIANS. In many ways the Sassanian period (A.D. 224-642) witnessed the highest achievement of Persian civilization. The Sassanian dynasty, like the Achaemenid, originated in the province of Fars and having wrested the Persian kingdom from the Arsacids they set out to emulate their predecessors. At its greatest extent the Sassanian empire stretched from Syria to north-west India; but its influence was felt far beyond these political boundaries. Sassanian motifs found their way into the art of central Asia and CHINA, the Byzantine empire, and even Merovingian France.

In reviving the glories of the Achaemenid past, the Sassanians were no mere imitators. The art of this period reveals an astonishing virility. In certain respects it anticipates features later developed during the ISLAMIC period. The conquest of Persia by Alexander the Great had inaugurated the spread of Hellenistic art into western Asia; but if the East accepted the outward form of this art, it never really assimilated its spirit. Already in the Parthian period Hellenistic art was being interpreted freely by the peoples of the Near East and throughout the Sassanian period there was a continuing process of reaction against it. Sassanian art revived forms and traditions native to Persia; and in the Islamic period these reached the shores of the Mediterranean.

The religious architecture of the Sassanian period is limited to the fire-temple. Judged from the scanty remains its form was of no great consequence. A far more important contribution was the secular architecture. A number of Sassanian palaces have been revealed by excavations in the 20th c. These combine features already known in Parthian times: an inner court and a façade punctuated either by blind niches or by vaulted niches open to the outside and known as *ivans*. Some of these brick VAULTS display considerable technical skill. The ARCH of the great vaulted hall at Ctesiphon attributed to the reign of Shapur I (A.D. 241-72) has a span of more than 80 ft. Many of the palaces contain an inner audience hall which consists, as at Firuzabad, of a chamber surmounted by a DOME. The Persians solved the problem of constructing a circular dome on a square building by the SQUINCH. This is an arch built across each corner of the square, thereby converting it into an octagon on which it is simple to place the dome. The dome chamber in the palace of Firuzabad appears to be the earliest surviving

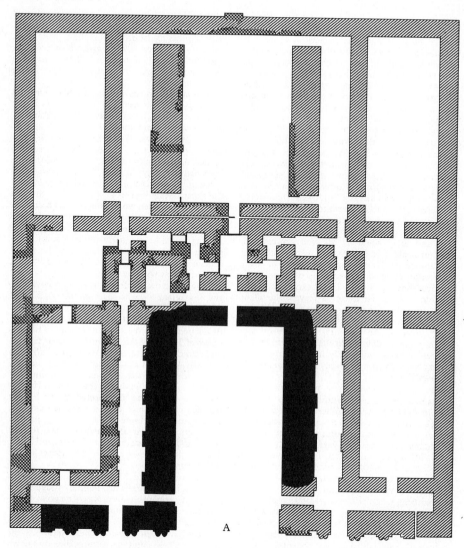

**Fig. 36**

■ Existing walls    ⠿ Excavated walls    ░ Restored

Ground plan of the palace at Ctesiphon, Taq-i-Kisra (3rd c. A.D.), based on excavations of 1928-9. On either side of the central *ivan* arch (A) the great wall is composed of engaged columns, entablatures and blind niches. From the back wall of the vaulted *ivan*, an opening gives access to a series of small connecting rooms, and from there into a very large enclosed room. After *A Survey of Persian Art* (1939), A. U. Pope

example of the use of the squinch and so there is good reason for regarding Persia as its place of invention. The system of cross-vaulting in the Ivan-i-Karkh (probably 4th c.), where the vault is supported on massive arches, anticipates by many centuries that of the ROMANESQUE and GOTHIC builders.

The aesthetic principles of Sassanian are quite distinct from those of CLASSICAL architecture. The Sassanian architect conceived his building in terms of masses and surfaces; hence the use of

massive walls of stone or brick decorated with moulded or carved STUCCO. The façade of the palace at Ctesiphon is essentially surface decoration and lacks the functional articulation of a classical façade. The same principles are bequeathed to Byzantine and Islamic architecture.

Sassanian sculpture affords an equally striking contrast to that of Greece and Rome. Some thirty rock sculptures survive. Like those of the Achaemenid period they are carved in relief

832

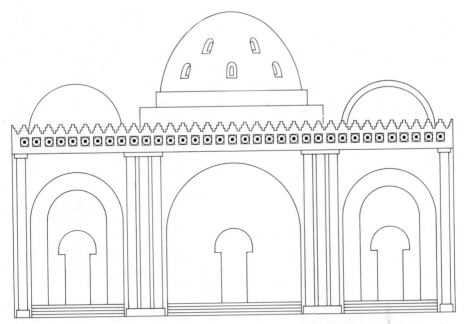

**Fig. 37.** Reconstruction of the façade of the palace of Sarvistan (4th c. A.D.). Across the front are three vaulted *ivan* arches. The central *ivan* is covered by a dome. The side *ivans* are deep tunnel-like arches. The façade is covered by a series of engaged columns connected by a cornice. After *A Survey of Persian Art* (1939), A. U. Pope

often on remote and inaccessible rocks. Some are so deeply undercut as to be virtually free-standing; others are hardly more than GRAFFITI. Their purpose is the glorification of the monarch. Many depict the investiture of the king by the god Ahuramazda with the emblems of sove-reignty; others the triumph of the king over his enemies. They may have been inspired by Roman triumphal reliefs (see ROMAN ART) but the manner of treatment and presentation is very different. Roman reliefs are pictorial records always with an attempt at REALISM. The Sas-sanian sculptures commemorate an event by depicting symbolically the culminating incident: for instance in the sculpture at Naqsh-i-rustam (3rd c.) the Roman emperor Valerian kneels at the feet of the victor Shapur I. Divine and royal personages are portrayed on a scale larger than that of inferior persons. Compositions are as a rule symmetrical. Human figures tend to be stiff and heavy and there is an awkwardness in the rendering of certain anatomical details such as the articulation of shoulders and TORSO. But at their best the sculptors achieved a striking sense of movement: wind-blown streamers flutter from an elaborate head-dress or an arm with a spear is raised aloft and ready to strike. One of the most remarkable reliefs is that at Taq-i-bustan (5th c.). The king is portrayed hunting on horseback; and the rendering of the wild animals is worthy of the great traditions of the Assyrian hunt-reliefs. There is no attempt at portraiture in Sassanian art, either in these sculptures or in the royal figures depicted on

metal vessels or in the heads on the obverse of coins. Each emperor is distinguished merely by his own particular form of crown.

In the minor arts the Sassanian period is best represented by its metal-work. A large number of metal vessels have been attributed to this period; many of these have been found in southern Russia. They have a variety of forms and reveal a high standard of technical skill. Castings were in bronze and silver and included bowls, dishes, and ewers sometimes in the form of animals and birds. Vessels were decorated with designs executed in several techniques; parcel gilding, chasing or engraving, real or applied repoussé, cold inlay, and cloisonné enamelling. Motifs include gods and goddesses of the Zoroastrian religion, hunting scenes in which the king has the central place, and fabulous animals like the winged griffon. These same designs occur in Sassanian textiles. Silk weaving was introduced into Persia by the Sassanian kings and Persian silk weaves even found a market in Europe.

Perhaps the most distinctive feature of Sas-sanian art is its ornament, which was destined to have a profound influence on Islamic art. Designs tended to be symmetrical and much use was made of enclosing medallions. Animals and birds and even floral motifs were frequently pre-sented 'heraldically', that is in pairs, either con-fronted or back to back. Some motifs, such as the Tree of Life, have an ancient history in the Near East; others, like the peacock, DRAGON, and winged horse, reveal the perennial taste of

**Fig. 38.** Sassanian ornament from the archway of the great *ivan* at Taq-i-bustan (5th c.). Pilaster containing panel made up of swirling foliage terminating in lotus buds and blooms. After *A Survey of Persian Art* (1939), A. U. Pope.

Asiatic art for the fantastic. Floral ornament utilized classical elements, the palmette and ACANTHUS plant, but made of these something new and original. Palmettes were arranged to form geometric compositions, and from the palmette itself was developed the wing palmette. LOTUS and pine-cone were added to a rich store of floral forms. A characteristic and beautiful example of Sassanian ornament may be seen in the great *ivan* at Taq-i-bustan, where in the PILASTERS on the façade swirling foliage terminates in lotus buds and blooms and on the pilaster capitals on the rear wall a central stem with rather stiff leaves is topped by a winged palmette.

ISLAMIC PERIOD (see also the article ISLAMIC ART). The Arab conquest in the 7th c. A.D.

brought Persia into the Islamic community of peoples. Thereafter the country was constantly subjected to invasions and for the most part ruled by foreigners: Arabs, Turks, Mongols, and Afghans. But such was the tenacity of Persia's cultural tradition that her art reveals a continuous development and retained its own identity; at the same time it bears the unmistakable stamp of Islamic civilization.

Artists and craftsmen put themselves at the disposal of the new rulers and the needs of the new religion, and Moslem buildings adopted the methods and materials of the Sassanian period. Few secular buildings of the early period have survived, but judging from the remains it is probable that they retained many features of the Sassanian palaces, such as the domed audience chamber and the ground plan arranged around a central court. During the period of Arab domination the type of MOSQUE current throughout the Arab empire and inspired by the Great Mosque of Medina was reproduced in Persia and Mesopotamia. But with the establishment of independent Persian dynasties (9th c. onwards) and of the Seljuk Turks (1055–1256) a distinctive form of mosque was introduced. Its most striking feature is the vaulted niche or *ivan* which had figured prominently in the Sassanian palaces and had been known even in the Parthian period. In this so-called 'cruciform' mosque plan an *ivan* is introduced into each of the four enclosing walls of the court. Such a plan was adopted for the rebuilding of the Great Mosque of Isfahan in 1121 and was widely used in Persia until recent times. A notable example is the Masjid-i-shah or Royal Mosque founded by Shah Abbas at Isfahan in 1612 and completed in 1630.

Another contribution by Persian architects was the tomb tower consisting of a polygonal or round tower surmounted by a dome or cone. Sassanian structural forms such as the domed CUPOLA set on squinches, barrel vaulting, and outlines of arches continued to be used in Islamic times as well as the articulation of wall surfaces by engaged or free-standing pillars and blind niches.

Moulded or carved stucco remained one of the principal forms of surface decoration. Early surviving examples come from the ruined palaces of the city of Samarra on the Tigris (9th c.) and the mosque of Nayin in Persia (10th c.). A rival to stucco was the use of glazed and coloured tiles. Polychrome tiles were applied to the exteriors and interiors of buildings in order to emphasize structural features such as the ribs of a cupola or the vertical lines of an *ivan* arch.

In earlier periods it seems that the most vital form of artistic expression had been sculpture. But now Islam did not tolerate the three-dimensional representation of living creatures; and in order to compensate for this restriction Persian craftsmen developed and extended the existing repertory of ornamental forms, which they then rendered in stone or stucco. These

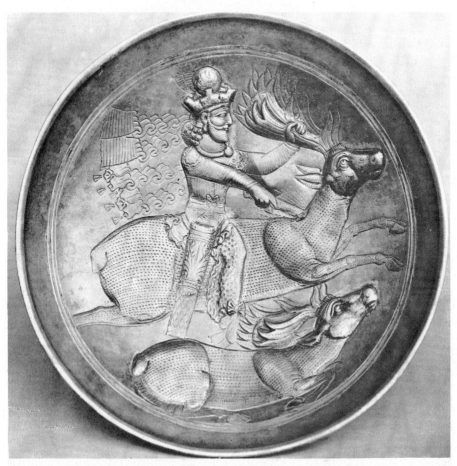

**249.** Sassanian king hunting stags. Shallow drinking bowl of silver executed in the technique of applied repoussé, engraved and partially gilt. The bowl was hammered into shape, then turned on a lathe. The raised parts of the figures were embossed and cut separately, then soldered on to the background, leaving the back of the bowl smooth. (B.M., 4th c. A.D.)

provided a common stock on which artists in other media drew. Many of the motifs can be traced back to the ancient civilizations of the Near East: they include fabulous beasts such as the human-headed SPHINX with wings, wild beasts or birds at grips with their prey, 'heraldic' pairs of animals or birds, and purely ornamental devices like the winged palmette and the rosette. The Persians were quick to appreciate the decorative value of the Arabic script and developed every variety of floral and abstract ornament. Persian ornament is usually distinguishable from that of other Islamic countries. The treatment of the ARABESQUE tended to be freer in Persia than elsewhere and usually, though by no means always, retained natural and recognizable plant forms. Palmettes, FRETS, GUILLOCHES, interlacings, and elaborate geometric figures such as the polygonal star also occur. From the Mongol period onwards (see ISLAMIC ART) CHINESE motifs, including the lotus, chrysanthemum, and cloud-scroll, found their way into the Persian repertory. For the most part decorative schemes were arranged symmetrically.

The most significant feature of Persian decoration is the combination of line and colour. The Persian artist at his best reveals himself as a master of colour harmony, for ever striving after polychrome effects. This is apparent throughout the minor arts of Persia.

Metal-workers carried on the great traditions of their predecessors and in the early period it is often difficult to distinguish whether a vessel is of early Islamic or Sassanian date since techniques, shapes, and decoration underwent little change. But in the 12th c. to the techniques of repoussé and engraving was added that of inlaying bronze or brass with gold, silver, copper, and niello. A remarkable example is the bronze bucket inlaid with silver and copper now preserved in the Hermitage Museum, Leningrad. According to its inscription it was made at Herat

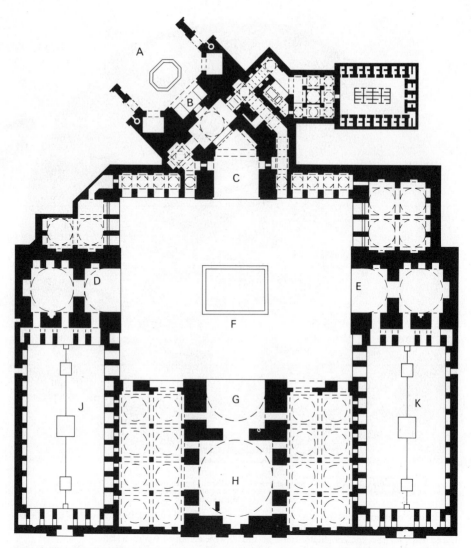

**Fig. 39.** Ground plan of the Masjid-i-shah, or Royal Mosque, Isfahan (1612-30). The Mosque Building is rectangular in plan, surrounded on three sides by courtyards. Each of the four enclosed walls of the main court contains an *ivan* opening and from this arrangement the 'cruciform' plan results. After *A Survey of Persian Art* (1939), A. U. Pope. A. Portal of the Mosque B. Main entrance C. *Ivan* D, E. *Ivans* (leading to domed chambers) F. Main court G. *Ivan* (leading to Mosque sanctuary) H. Sanctuary and main dome J, K. Courtyards

in 1163. By means of inlay the metal-worker was able to impart a polychrome effect.

Such an effect was more easily produced in textiles. The Sassanian silk weaves had found markets far beyond the confines of Persia. In the Islamic period, too, Persian silks travelled even to Europe. Many show the same motifs as are to be found on the Sassanian silks. A famous silk weave originally in the Treasury of the church of S. Josse, Pas-de-Calais, and now preserved in the Louvre, has depicted on it elephants, camels, and peacocks; it dates from *c.* A.D. 960. The beautiful weaves of the Safavid period

(1502-1736) are composed of every variety of floral and human and animal forms and are often executed in astonishingly complex weaves. Colour was never used with greater effect than in Persian carpets, the finest of which date from the 16th c. It might justly be claimed that the carpet is Persia's greatest contribution to art.

In ceramics many of the pottery shapes used in Parthian and Sassanian times survived the Arab conquest. But the Islamic potters of Persia far surpassed the technical achievements of their predecessors both in handling and in the range

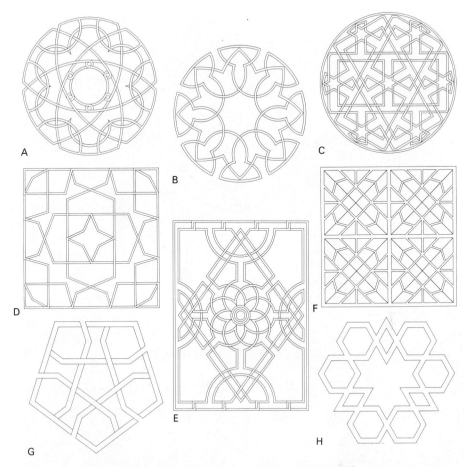

**Fig. 40.** PERSIAN INTERLACING AND STAR THEMES (Islamic period)

A. Curvilinear theme: six-pointed star and hexagon composition B. Circular theme: eight half-circles with two complex segments attached C. Six-pointed star theme, combined with broad banded lattice of double squares D. Theme confined to a repetition of the three angles found within the square: the central unit a four-pointed star set in a square E. Theme of a double eight-petalled rosette formed from multiple circles against an implied and partly delineated lattice F. Eight-pointed star theme broken into elements which include lozenges, pentagons and crosses G. Inverted pentagon theme resulting in angular cinquefoil H. Nine-pointed star theme: six-pointed star and hexagon combination on a partially implied lattice scaffold. After *A Survey of Persian Art* (1939), A. U. Pope

of glazes. They appear too to have discovered the art of underglaze painting.

Painting is the branch of Persian art most easily accessible for study since many examples are preserved in the museums and libraries of the West. There are manuscript MINIATURES, miniatures detached from manuscripts, or album pages. Various historical and literary sources describe how the walls of palaces were embellished with what were evidently large-scale paintings depicting the exploits of the prince and his ancestors. It is a tragedy that, as with the palaces which they adorned, only a few imperfect fragments have survived the hazards of time and the vicissitudes of princely houses. Fortunately a series of such paintings, commissioned by the great Safavid ruler, Shah Abbas, is preserved in

the palaces of the Ala Qapi and the Chihil Sutun at Isfahan. Besides geometric and floral ornament, the subjects include youths and maidens and figures of European men and women rendered in the rather mannered style which was then the fashion.

The art of the book afforded special opportunities and scope for the exercise of skill and artistic imagination. Calligraphy has always been highly esteemed in the Islamic world: and at least one type of script was invented in Persia. The written page was enriched by the art of the ILLUMINATOR and in some manuscripts by that of the painter, who added small-scale illustrations.

Evidence of painting before Islam is confined to a few fragmentary wall-paintings dating from Parthian and Sassanian times. There may also

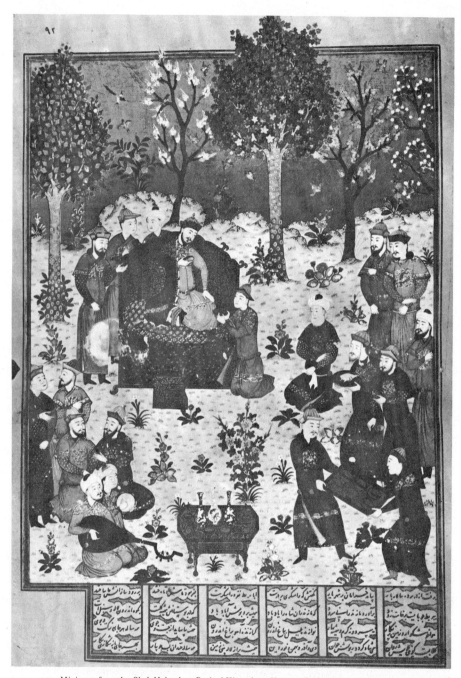

**250.** Miniature from the *Shah Nahmeh* or *Book of Kings*, from Herat.   (Imperial Lib., Teheran, 15th c.)

have existed a tradition of book painting. But the earliest surviving book illustrations belong to the end of the 12th c. and a truly Persian style of painting did not emerge until the end of the 14th. A beautiful example of this style can be seen in the illustrations to a manuscript of the poems of the Persian poet Khwaju of Kirman, executed in Baghdad in 1397 (B.M.).   In the

following century this style was perfected under the patronage of the Timurid rulers of Persia; and Persia's greatest painter, BIHZAD, began his career at the Timurid court in Herat. The finest manuscripts were produced for the libraries of princes and notables. The range of works chosen for illustration is not very great. It includes the *Shah Nameh* or *Book of Kings* (the national epic of Persia), the *Khamsa* or *Five Poems* of Nizami, histories of the Mongols and of Timur and his successors, fables and romances, and scientific works such as botanical and astronomical treatises. Purely religious subjects are rare though not unknown. The purpose of the miniatures was as much to divert as to illustrate; and the painting together with text and illumination form a unified design. Text often obtrudes itself into the picture or the latter extends beyond the text into the margin of the page.

The painter strove to capture a mood: the turmoil and clash of the battlefield; the splendour of the prince surrounded by his retinue, or banqueting beside the streams and amid the blossoming trees and flowers of his parks or in his favourite pursuit, the chase; scholars and poets discoursing in a meadow; or the rapturous meeting of lovers in a starlit garden. The scenes, which might appear to be the creation of the painter's fancy, are in fact a true picture of the age and society in which he lived.

The style and manner of presentation may vary with changes in fashion, but certain features remained constant. Pages were not as a rule filled with superfluous figures and irrelevant detail. The artist allowed himself considerable freedom in the treatment of scale: figures of people were often disproportionately large and flowers executed in minute detail were necessarily greater than they would appear to the eye. In order to indicate the relationship between objects in space the Persian did not adopt the Western system of perspective with its single viewpoint but preferred a system in which the scene is observed from more than one viewpoint; thus a carpet was often depicted as a simple rectangle so that its pattern is clearly revealed in preference to a more natural view based on perspective. Distance was suggested by the placing of figures and objects at different levels or by arranging them in diagonals. In the earlier period there was no difference in scale between near and distant figures, nor did the artist attempt to indicate distance by varying the depth of tones. Only towards the close of the period was shadow used in order to suggest plasticity. Little or no attempt was made to portray emotion in the faces. The artist relied for this on symbolical gestures; anger or astonishment was indicated by the biting of fingers. Often imagination has to provide what a convention has merely suggested. Night might be indicated by the introduction of moon and stars in the deep blue of the sky; and contending armies by a handful of horsemen emerging from behind a fold in the mountains or a few helmeted warriors peering over the horizon. The PALETTE is brilliant but harmonious and never disturbing to the eye. For mastery of the subtle use of tones Bihzad can stand beside the painters of the West.

The Persians discovered the art of LANDSCAPE at a time when the Flemish and Italian painters were making their first essays in this genre. In the Persian miniature the landscape is no mere adjunct to the main action of the scene, a backcloth before which the performers play their allotted roles. Nature is lovingly perceived and man is portrayed in the wider context of his natural surroundings.

Persian art retained its vitality and originality until the close of the Safavid period (1736). Thereafter political instability and a surrender to the spell of European art vitiated the national creative spirit which had so surprisingly weathered many a storm in its long past. Lack of a definite orientation was accompanied by a steady decline in craftsmanship. Nor in the first half of the 20th c. had there yet appeared any trends significant of a renaissance in the arts.

67, 253, 357, 474, 1023, 1024, 1025, 1138, 1304, 1305, 1679, 1748, 2114, 2239, 2316, 2325, 2935.

**PERSONIFICATION.** The embodiment of ideas or concepts in human form is deeply rooted in human psychology. Indeed the borderline between divinities or spirits and personifications is often difficult to draw, as witness such personifications as Love, Death, or Fate. Some of these concepts have been accorded temples and sacrifices like any deity and in CLASSICAL art figures representing Victory, Truth, Kairos (the favourable moment), Eris (strife), etc., appear side by side with the gods of Olympus. Rivers, streams, mountains, were commonly represented in ancient art by the figures of the local deities and such figures as Echo or Hymen lie on the borderland between artistic personification and mythology. Even in medieval art, both Eastern and Western, it is not always easy to distinguish personifications from relics of mythology. In Ravenna the river Jordan watches the BAPTISM OF CHRIST, and in the *Paris Psalter* Echo listens to David playing the harp. Earth and Heaven, Sun and Moon, are rendered in human form, according to the classical tradition, in CAROLINGIAN Bibles. In medieval modes of thought personifications tend to merge with spirits; St. Gregory the Great, following Dionysius the Areopagite, placed the Virtues, Powers, and Thrones among the choirs of ANGELS, and Divine Wisdom appears personified in both biblical and didactic contexts. In medieval poetry personification was a favourite device for symbolizing abstract concepts and states of mind. The popularity of such works as Alanus de Insulis, *De Planctu Naturae*, the *Roman de la Rose*, or the *Somme le Roi* (all of which exist in illustrated manuscripts), show that the public knew how to appreciate these modes of thought. It is rare, however, to find these more recondite

creations taken out of their context and applied to monumental art, which had a more restricted repertory, dominated by VIRTUES AND VICES, the LIBERAL ARTS, ECCLESIA AND SYNAGOGUE, and OCCUPATIONS OF THE MONTHS. The didactic picture books such as Herrad of Landsberg's *Hortus Deliciarum* (12th c.) are an exception.

With the rise of humanism, however, and the fashion for EMBLEMS and the literary 'conceits' of the 16th c. the invention of new and esoteric personifications and attributes became a favourite game in court circles. VASARI and other MANNERIST painters liked to honour their patrons by introducing elaborate and cryptic personifications of this kind into public pageants and fresco cycles. At the end of this period Cesáre Ripa compiled a handbook of personifications in alphabetical order with detailed descriptions based on classical allusions often culled from recondite sources. This *Iconologia* became the standard source-book for painters and patrons alike and therefore provides the key to many BAROQUE personifications. In the NEO-CLASSICAL period WINCKELMANN and others reacted against the obscurities of this tradition and advocated a return to a purified classical mode. Personifications proliferated again on 19th-c. official buildings and MONUMENTS (*Statue of Liberty*). Painters such as WATTS and MOREAU attempted to turn personifications into poetic symbols of topical issues (Mammon). In 20th-c. art the traditional and socially recognized personifications lost their appeal and gave place to private and idiosyncratic symbolism not easily labelled; but commercial art has continued the age-old formula ('Mr. Therm burns to serve you') and postage stamps, banknotes, and coins carry on the classical tradition.

**PERSPECTIVE.** In the context of pictorial and scenic art the term 'perspective' may refer to any graphic method, geometrical or otherwise, that is concerned with conveying an impression of spatial extension into depth, whether on a flat surface or with form shallower than that represented (as in relief sculpture and theatre scenery). (See also AERIAL PERSPECTIVE.) Perspective representation or composition results when the artist adopts a visual approach to drawing and consequently portrays perspective phenomena such as the diminution in size of objects at a distance and the convergence of parallel lines in recession from the eye. Perspective is by no means common to the art of all epochs and all peoples. For example, the pictorial art of the ancient Egyptians, although a richly developed tradition, did not take account of the optical effects of recession. And the drawing of primitive peoples and of young children tends to ignore perspective phenomena.

In ancient Sumerian, EGYPTIAN, and Mesopotamian art one may find close observation of nature in the drawing of human beings, animals, or even plants. Yet observed forms are invariably presented in characteristic profile and never in the distorted shapes in which they come to our eyes. Some prehistoric cave-paintings seem to reflect an optical approach and come near to producing a visual impression and certain ancient Mexican paintings contain striking foreshortenings, yet none of these examples leads to far-reaching developments. According to Heinrich Schaefer (*Von ägyptischer Kunst*, 1919) perspective phenomena were not depicted by any people on earth who had not come into contact directly or indirectly with the works which had been painted by the Greeks since the 5th c. B.C. The instances found are isolated cases that remained without consequence.

Western painting started to develop along optical lines first in Greece and received a geometrical bias from its early association with the optics of classical antiquity. The illusion of the dimension of depth has been its distinguishing characteristic and to this end geometrical perspective one of its principal aids. The idea of the single static focus of RENAISSANCE perspective and the characteristic system of central convergence (see below) owed much to the recurrence of themes demanding the representation of interiors. The only other highly developed pictorial tradition in which spatial values are paramount, i.e. the Chinese, evolved on the other hand principally from landscape and took for granted a travelling eye. Hence Chinese artists with rare exceptions adopted the convention of parallelism (see below) when they represented buildings, a system which, although denying the optical principle of the convergence of receding parallels, yet had the virtue of allowing the eye to glide easily from scene to scene.

THE MEANING OF THE WORD. The word 'perspective' derives from the Latin (*ars*) *perspectiva*, a term adopted by the Roman philosopher Boethius (d. A.D. 524) when translating Aristotle to render the Greek *optikē* (optics). In the 15th c. 'perspective' came to mean seeing through a transparent plane on which the scene is traced from a single fixed eye-point. It then became in Latin *perspectiva artificialis* or *perspectiva pingendi* to distinguish it from the older science *perspectiva naturalis* or *communis*.

THE SCIENTIFIC BASIS OF THE PERSPECTIVE IMAGE. Scientific perspective, known variously as central projection, central perspective, or picture plane or Renaissance or linear or geometrical perspective, may be regarded as the scientific norm of pictorial representation. The story of its development belongs as much to the history of geometry as to that of painting. It is the perspective of the pin-hole camera and (with certain reservations as regards lens distortion) of the CAMERA OBSCURA and the photographic camera. It derives from geometrical optics and shares with that science its basis in physics: the rectilinear propagation of light rays. In central perspective the picture surface is regarded as a transparent vertical screen (the picture plane), placed between the artist and his subject, on which he traces the outlines as they appear from a

single fixed viewpoint. Ideally such a picture, suitably coloured and seen with one eye from the correct point, should evoke the illusion of the real scene viewed through a window. 'Perspective', wrote LEONARDO, 'is nothing else than seeing a place (*sito*) behind a pane of glass, quite transparent, on the surface of which the objects which lie behind the glass are to be drawn. They can be traced in pyramids to the point in the eye and these pyramids are intersected by the glass plane.' The 'pyramids' are composed of the light rays which link the visible surfaces of objects to the eye by straight lines called *visual rays*. Their points of intersection with the transparent plane (the picture plane) form the perspective image.

THE PSYCHO-PHYSIOLOGICAL BASIS OF PERSPECTIVE ILLUSION. The eyeball is a little dioptric camera and receives projected images of the outside world upon its interior surface. This is a light-sensitive membrane called the retina. Images are formed by the projective action of light. When light passes through a small hole the rays behave like straight lines intersecting in a point. The images of the pin-hole camera, the *camera obscura*, the photographic camera, and the eye all depend on this phenomenon. The image-screen intercepts the rays. No point of it receives light from more than a single point of the object. When the hole is enlarged to admit more light and give brighter images, a divergent beam of light from each object point enters the camera. It is the function of the lens to correct this divergence and to concentrate the beam on to the screen or retina.

We may assume for our purpose that each object point is linked to its representation on the

Fig. 41

retina by one straight line, called a *direction line* or *line of sight*. Although in normal circumstances the eye moves continuously in its orbit, when a number of object points are involved all the direction lines may for practical purposes be considered to cross at a nodal point within the eye, very near the centre of rotation. This point is the 'eye' or *centre of projection* of perspective. When a luminous point A moves along a direction line, its perspective on the picture plane (A¹) and its retinal image (a) all remain in coincidence provided the head is kept still, even though the retinal image continuously moves over the surface of the retina. Thus the point A¹ on the picture plane is the perspective of every point in the same direction line AA, and all points on AA

give equal stimuli and hence give rise to identical perceptions. This is why the eye can be deceived and is the basis of perspective illusion. There is ambiguity inherent in all images. In order that a three-dimensional object be correctly represented to the beholder he must know what the object is.

CLUES FOR THE PERCEPTION OF DEPTH. The retinal image is two-dimensional and can convey to the brain only directional messages about the location of objects in space. The points of stimulation can tell us nothing directly about distance or absolute size. But in binocular vision the *fusion* of two dissimilar images presents to consciousness a three-dimensional pattern that gives us very accurate judgements of distance quite impossible of achievement with one eye. Stereoscopic perception, however, ceases at a certain distance from the eyes. In monocular vision, and in binocular vision at distances in excess of about 50 ft., the perception of depth depends upon indirect factors. These are *clues for the third dimension*, which may be grouped into nine classes. Five of them are used by painters to create an impression of depth by their flat pictures: overlapping contours; linear perspective; aerial perspective; distributions of light and shade (the direction of light being known); interpretation of size (the judgements of absolute size and distance are interrelated).

Four other clues work against the impression of depth in pictures: parallactic movements; muscular efforts of accommodation and of convergence; stereoscopic influence of dissimilar images.

SOME FACTS AND DEFINITIONS FOR THE THEORY OF CENTRAL PERSPECTIVE, GIVEN FOR THE VERTICAL POSITION OF THE PICTURE PLANE. In Fig. 42:

E is the eye: the centre of perspective or projection.

PP (i.e. the plane AZRT) is the *picture plane*. It is of indefinite extent (as are the other principal planes), and in its usual position is perpendicular to the ground plane.

GP is the horizontal *ground plane*. The 'height' and 'distance' of the eye are measured from these two planes.

GL, the *ground line*, is the *intersection line* in which the picture plane and the ground plane meet.

HL, the *horizon line*, is the line in which the horizontal plane containing the eye meets the picture plane. It is the *vanishing line* of the ground plane and of all other horizontal planes and is the locus of the vanishing points of all horizontal lines.

C is the *central or principal vanishing point*: the point of convergence of the perspectives of all *orthogonals*, i.e. horizontal parallel straight lines of indefinite extent that meet the picture plane at right angles, such as L, Q, M, N. (Orthogonals are parallels that are objectively perpendicular to the picture plane. Their perspectives converge to a point exactly opposite the eye of the artist.)

Fig. 42

S is the *station point*.

EC is the *central ray* from the eye drawn perpendicular to the picture plane and therefore parallel to the orthogonals.

C and D are examples of *vanishing points*, of which there can be an indefinite number. They are found by drawing a line from the eye parallel to the given line or system of parallels. Thus EC and ED are drawn parallel to AQ and AB respectively.

In order to draw the perspective of a given line of indefinite extent, it is sufficient to know its vanishing point, such as C or D, and the point in which it meets the picture plane, such as A, Y, Z. These points are called the *intersection points* or near ends of the given lines. In perspective each group of parallels is drawn to a single, particular vanishing point.

D D are *distance points*. They are the vanishing points of horizontal straight lines that make angles of 45° with the picture plane, such as the line AB, whose perspective is contained in AD, and are the same distance from C as the eye: hence their name. They are traditionally used for measuring in perspective along orthogonals and may be regarded as the earliest *measuring points*.

THE PERSPECTIVE CONSTRUCTIONS OF BRUNELLESCHI AND ALBERTI. BRUNELLESCHI is generally acknowledged to have been the originator of the first construction of scientific perspective (see below, pp. 859 f.). Of his actual construction, which must date from about 1420, there is no detailed contemporary record. From VASARI'S Life of Brunelleschi we learn only that he invented an ingenious system that included a plan and elevation and an intersection and that by the aid of this he painted the two famous panels (now lost) representing the Florentine Baptistery of San Giovanni and the Signoria. This was presumably similar to the construction given in

Fig. 43

Fig. 43. It is a mechanical system based exclusively on the principle that visual rays are straight lines. These are represented in plan and elevation by the lines joining selected points of the object to the eye. The points of intersection which form the image of the visual rays with the picture plane are first found on the plan and the side elevation and from there are transferred to some part of the paper representing the picture surface by the method of rectangular co-ordinates. The mechanical principle of Brunelleschi's construction is exemplified in Dürer's woodcut, *Draughtsmen Drawing a Lute* (1525). The ring in the wall is the 'eye' and the mobile thread serves for the visual rays. While one artist directs the ray to the selected points on the lute, his companion notes the points in which the ray passes through the frame, i.e. the picture plane, and transfers them one by one to the drawing-board. The plan and elevation construction with visual rays was particularly suitable for drawing individual architectural or geometrical forms of some complexity and was used for this purpose notably by Uccello and Piero della Francesca.

use of a vanishing point for the orthogonals, his 'centric point' (c). This enabled him to dispense with a ground plan. The artist could set to work straightaway on his panel, mark in the squares along the base line and join up the orthogonals to the centric point, placed centrally at the height of a man represented in the picture standing on the base line.

For regulating the measurements in depth, i.e. for spacing his transverse parallels, he drew, like Brunelleschi, a separate side elevation with visual rays and vertical intersection. Finally he proved his perspective to be correct by drawing a diagonal across the foreshortened grid to show that the diagonals of the individual squares formed into continuous straight lines (Fig. 44), just as in a real chequerboard. For if an artist drew the foreshortening by some arbitrary method, such as that of making each successive space between transversals a constant fraction of the preceding one (Fig. 45), the diagonals would not lie in straight lines. 'Those who would do thus would err', wrote Alberti. Perhaps this is why Alberti's system is usually known as the

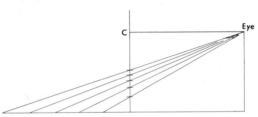

Fig. 44

The latter applied it also to the drawing of heads. It did not include the use of vanishing points.

Shortly after Brunelleschi made his perspective demonstrations his fellow architect Alberti devised a perspective construction for the special use of painters, which he described in detail in his famous treatise *On Painting* (1436) written first in Latin and then immediately in Italian for his friend Brunelleschi and the *avant-garde* artists of Florence (Fig. 44). This is the first known written account of a fully scientific perspective construction. He chose for demonstration a simple squared floor or chequerboard pavement that became in perspective the ground plane of the picture and could be extended, he wrote, 'almost to infinity'. Furthermore it could easily be elaborated into a three-dimensional grid for measuring heights in perspective. Its primary aim was to enable the history painter to locate and measure in perspective all the figures and objects in his picture, which would then appear to the spectator placed at the predetermined viewpoint as a real scene viewed through an open window: for 'he who looks at a picture done as I have described', wrote Alberti, 'will see a certain cross-section of the visual pyramid'. Alberti's method included the

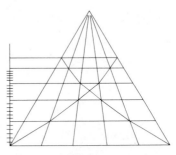

Fig. 45

'costruzione legittima', a term of modern Italian origin. Some authors, however, apply this term also to Brunelleschi's construction. Alberti's construction is most commonly found in the abbreviated form in which the two diagrams are combined into one (Fig. 46). (For an example of curved diagonals see the tiled floor in Giovanni di Paolo's painting, *The Presentation*, Pinacoteca, Siena, *c.* 1448.)

PRINCIPLE TYPES OF PERSPECTIVE, SCIENTIFIC AND OTHERWISE. (*a*) *Parallel Perspective*. The term may refer to parallelism, i.e. the representation of parallels as parallel (Fig. 47), which is a

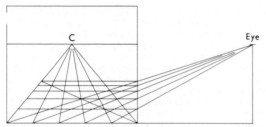

**Fig. 46**

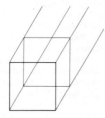

**Fig. 47**

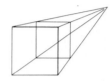

**Fig. 48**

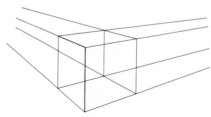

**Fig. 49**

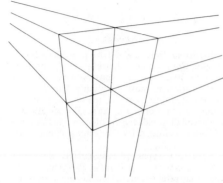

**Fig. 50**

non-scientific form and when found in early painting may be regarded as an IDEOPLASTIC element. In combination with the high viewpoint it is a traditional convention of Chinese painting (see the book of Jên-wu from *The Mustard Seed Garden Manual of Painting* (1st ed. 1679), included in *The Tao of Painting* by Mai-Mai Sze, 1957). It is also a convention of modern stereometry. The term may also refer to the case in scientific perspective when the picture plane is parallel to a principal surface of the object (Fig. 48), as is commonly found in Renaissance pictures. Then none of the parallels of the frontal surface converge, but if the object is rectangular, for example a house or room, the parallels in depth become orthogonals and converge to a central vanishing point.

(*b*) *Angular or oblique perspective.* A term of scientific perspective used when a rectangular form is represented at an angle to the plane of the picture such that its horizontal parallels recede into depth to the left and the right, thus requiring two vanishing points, but its verticals remain parallel to the picture plane (Fig. 49).

(*c*) *Three-point or inclined picture plane perspective.* A term of scientific perspective used with regard to a rectangular form placed so that none of its sides is parallel to the picture plane

**251.** Illustration from the book of Jên-wu, part of *The Mustard Seed Garden Manual of Painting* (1679)

Fig. 51 A          Fig. 51 B

the Middle Ages and even survive the Renaissance. In many cases the central pair of beams meets unrealistically on the posterior border of the ceiling in a V, and sometimes artists disguised this with a CARTOUCHE or a nimbus (see HALO). Often the central meeting point was placed out of sight and some degree of convergence was given to the outside parallels (Fig. 51B). But always the spacing of the central section was unrealistic. The same principle was applied to the

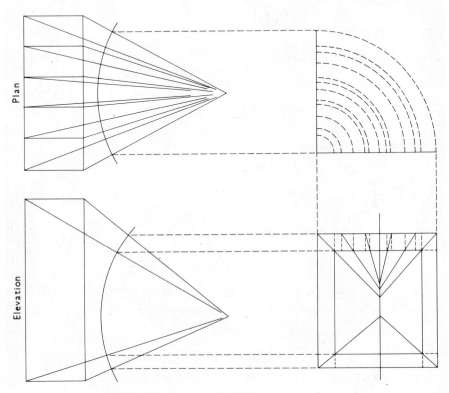

Plan

Elevation

Fig. 52

and the three groups of parallels vanish each to its respective vanishing point (Fig. 50). Three-point perspective may also refer to the distance point construction.

(d) *Axial perspective*, also called *vanishing or vertical axis perspective*. This is the earliest systematic form of punctual convergence and is much in evidence before the invention of scientific perspective. In its original form it is simply the symmetrical convergence of parallels to points on a central vertical axis taken mirror-like right and left in pairs, and as such is a form of parallelism (Fig. 51A). Early examples are to be seen in the drawing of the parallel beams of ceilings. They are first found on Apulian Greek vases of the 4th c. B.C. There are variations of this construction which persist through antiquity and

Fig. 53

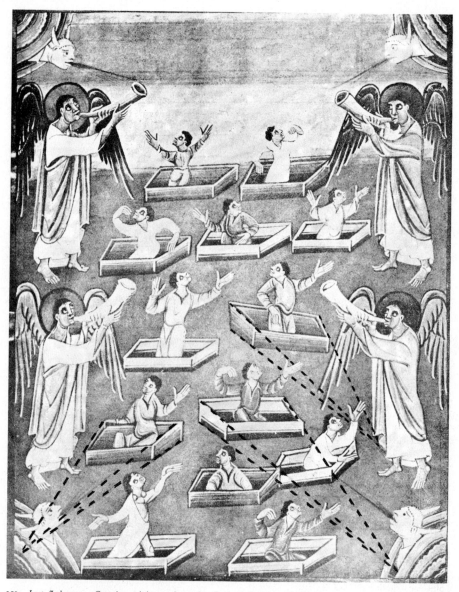

**252.** *Last Judgement.* Ottonian miniature from the *Book of Pericopes* of Henry II (Bayerische Staatsbibliothek, Munich, early 11th c.). Dotted perspective lines added

drawing of walls and floors, and led in this case to an inconvenient encroachment upon one another of neighbouring planes.

Why was this method universally preferred to the simpler device of the single vanishing point? Indeed, central convergence is virtually never found before the 15th c. A.D. except in one brief period of POMPEIAN painting and then only in the upper parts of the pictures. The answer to this question may be found in the way in which

we actually perceive parallels. Recent experiments have proved that we do not normally perceive more than two objective parallels as though they are directed towards a common point (G. ten Doesschate, *Perspective*, ch. 23). The more a pair of parallels is situated towards the left or right the less the degree of apparent convergence will be, a fact that agrees with modifications of the axial construction as found in some pictures. This principle was presumably known to artists

in a general way through direct observation, and it deterred them from using one single convergence point for the whole group of parallels until central convergence was demonstrated with the aid of a projection plane and a fixed eyepoint and shown to be 'scientific'. But PANOFSKY has suggested (E. Panofsky, 'Die Perspektive als symbolische Form', *Warburg Journal*, 1925) that there may also have been a theoretical justification for the axial construction in the Euclidean theory of visual angles (see below). If the visual rays are projected on to subtended arcs or their dimensions transferred from the arcs or their chords to the picture plane, the resulting perspective of a centrally viewed rectangular interior approximates to a vertical axis construction (Fig. 52).

(*e*) *Inverted perspective.* For the representation of rectangular foreground objects 'inverted perspective' is the common rule in pre-Renaissance painting (Fig. 53). Although it contradicts scientific perspective and seems wrong to modern eyes, there is a basis for it in experience. The fact that we do not easily see convergence in foreground objects but rather parallelism or even divergence of parallels can easily be verified by observation. But experience may have been reinforced by a naïve interpretation of the visual ray theory. The divergent construction is abundantly exemplified in an OTTONIAN *Last Judgement*. The universal acceptance of central convergence belongs essentially to the age when science acquired overriding authority.

(*f*) *Negative perspective.* A term used to describe the application of lines of sight to the adjustment of proportions in large-scale decorations, paintings, or statuary in order to counteract the perspective effect of the more remote parts. In Dürer's example (Ill. 253) all the letters will appear equal to an observer placed at the viewpoint because they have been designed to subtend

equal angles at the eye. Plato refers to such a procedure employed by Greek artists of his time (*Sophist*, 236).

(*g*) *Bifocal perspective.* A term for an empirical construction that uses two vanishing points placed symmetrically on the margins of the picture for the purpose of drawing a diagonal floor-grid (Fig. 54). It is a system without a central vanishing point and is thought to be a workshop tradition associated with the GIOTTESQUE perspective of the trecento. It is the construction given by P. Gauricus in his *De Sculptura* (printed in Florence, 1504). A famous example may be seen in the *sinopia* of UCCELLO's *Nativity* fresco at Florence. It may also refer to

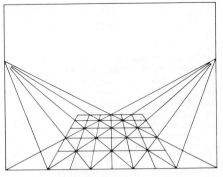

**Fig. 54**

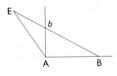

**Fig. 55**

the examples of angular perspective given by Viator and called by him *perspectiva cornuta* or *diffusa*.

MEASURING IN PERSPECTIVE. There can be no measuring in perspective in the strict sense of the term (i.e. the establishment of a two-way metrical relationship between a given object and its representation on the picture plane) unless the relative positions of the eye, the picture plane, and the object to be represented are given. In Fig. 55 the problem is set out in two dimensions. E is the eye, AB the object, EB and EA are visual rays and Ab is the perspective measurement of AB. It is clear that this situation could not exist before the invention of the picture plane (by Brunelleschi, as far as is known). Examples have been found, however, both in Pompeian painting and in the work of Giotto, in which the representation of a coffered ceiling appears to have been correctly *foreshortened* (not the same as *measured* in the strict sense). The artist may have arrived at his result from a drawing in plan by means of a simple intuitive development. This could proceed in four steps (similar to Fig. 56)

**253.** Illustration from *Underweyssung der Messung* (1525), Albrecht Dürer

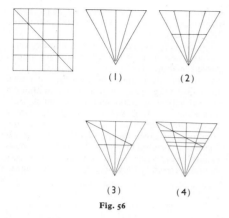

(1)    (2)

(3)    (4)

Fig. 56

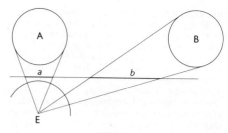

Fig. 58

once he had decided to converge his orthogonals to a central point. Such a drawing might appear to be the result of a distance point construction, since the protracted diagonal would meet the horizon line in a point coincident with a distance point, given a certain position for the eye. But there is no evidence to justify the conclusion that the perspective of either Giotto or the Pompeian artists was other than intuitive.

There are basically two methods of measuring in perspective, (1) by the visual ray and section system of Brunelleschi and Alberti; and (2) by the modern method of measuring points, a simple geometrical device of great utility which first appears in print in *La Perspective spéculative et pratique du Sieur Aléaume*, edited by Étienne Migon (Paris, 1643). Both Migon and Aléaume were professional mathematicians. Distance points are the measuring points for orthogonals and are a particular case of the general rule as described in all modern handbooks.

MARGINAL DISTORTIONS. In geometrical optics the apparent sizes of objects are shown to be proportional to the visual angles they subtend at the eye. Because of this objects appear to decrease in size in all directions as they recede from the eye. An angle is measured by its subtending arc, but perspective produces flat projections on a plane. This inevitably leads to discrepancies between angular size and projected size. But when a flat projection is viewed from the projection centre the angular dimensions are restored by the natural foreshortening of the picture plane. This is the principle of ANAMORPHOSIS. Two well-known paradoxes arise from this situation.

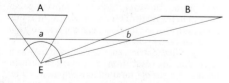

Fig. 57

Planes parallel to the picture plane have unforeshortened perspectives however far they recede from the eye. Suppose A and B (Fig. 57) to be a plan or elevation of two equal windows in a wall parallel to the picture plane, with the eye at E. B is seen under a smaller angle than A, yet the perspective projection b is equal to that of A, because it forms similar triangles. This is why the façade of a building drawn frontally in perspective is a true elevation. The second paradox concerns solids. A and B (Fig. 58) are two solids seen from E. B produces the greater intersection yet it is seen under a smaller angle than A. Such discrepancies are particularly noticeable in the case of objects of known regularity: *par excellence* the sphere, which in perspective retains its familiar circular outline only when its centre coincides with the central vanishing point. If A and B were two spheres the perspective of B would be elliptical in outline. Some painters have been in doubt whether they should draw in conformity with the plane projections or with the visual angles. Illustration 254 is from a 17th-c. French manual which insists that in order to avoid a double foreshortening of the image the former should be the case (A. Bosse, *Traité des pratiques géométrales et perspectives*, Paris, 1665). In RAPHAEL's *School of Athens*, a famous example, the architecture is drawn from a central viewpoint while the figures have in each case been drawn from a viewpoint in front of them, in fact possibly from life studies. This shifting of viewpoint is particularly observable in the case of the sphere held by the astronomer Ptolemy which, although eccentrically placed, shows no sign of marginal distortion. This method is a practical solution to the perspective problem of large-scale wall-paintings.

In order to keep discrepancies within tolerable limits it has always been the practice amongst artists to work within a narrow angle of vision whenever possible: ideally between 30° and 60° or so. Most paintings are designed to be viewed from a distance of not less than their major dimension, giving a viewing angle of about 60°.

When the angle of vision is small every visual ray will be nearly perpendicular to the picture plane. Then the perspective projections will most nearly correspond to the subtending arcs and marginal distortions be minimized.

THE THEORY AND THE RULE OF VANISHING

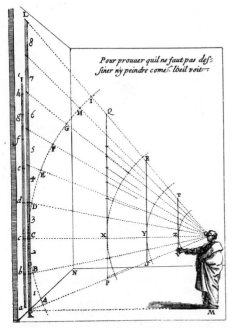

Pour prouuer quil ne faut pas def-
finer ny peindre come l'œil voit

**254.** Illustration from *Traité des pratiques géometrales et perspectives* (1665), A. Bosse

POINTS AND DESARGUES'S THEOREM. The perspective of a given line is normally considered to be contained between its intersection point or 'near end' (the point which is its own image) and its vanishing point. The validity of these two points is established respectively in two theorems of theoretical solid geometry: the Vanishing Point Theorem and Desargues's Theorem. These form the basis of perspective geometry (W. Abbott, *The Theory and Practice of Perspective*, 1950).

The theory of vanishing points may be explained in simple terms as follows:

In Fig. 59 the eye is looking through a sheet of glass at two parallels. The upper parallel produced through the glass passes through the eye and therefore appears as a point at V on the glass.

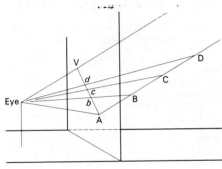

**Fig. 59**

A plane containing our two parellels will obviously intersect the glass in the line VA and if we take a series of points B, C, D, etc., on the lower line, these will appear as a series of points b, c, d, etc., where the lines joining B, C, D, etc., to the eye meet AV. As the points on the lower line recede from A they will appear to approach V on the glass and if we conceive of a point on our line at a very great distance from A it will appear on the glass so inconceivably close to V as to be coincident with it, so that V is called the vanishing point of that line. And similarly for any other line parallel to A and V.

From this we have the useful rule: The vanishing point of a given line is that point where the line from the eye drawn parallel to the given line meets the picture plane. 'Vanishing point' is a modern term and a misleading one, for it is not the point on the picture plane that vanishes but the point that it represents. In general usage the term has varied meanings. It may refer to a mere operational point of convergence in a picture. Furthermore there is no separate term for the 'natural' vanishing point—that imaginary point in the distance towards which receding parallels may appear to converge, or that 'point of diminution' (Leonardo's term) to which remote objects tend to diminish.

Brook Taylor, Fellow of the Royal Society and famed amongst mathematicians for Taylor's Theorem, coined the English term 'vanishing point', which first appears in his *Linear Perspective* (1715). This is the first perspective handbook in the English language to be entirely founded on the principles of projective geometry. During the 18th c. some excellent manuals were written based on 'Dr. Brook Taylor's Method'.

Before 1600 there was no general theory and no general term for vanishing points. The points of convergence used by the Renaissance pioneers of perspective were operational points. They were without a theoretical proof and were used as postulates. Arguments in support of their validity were based on the direct experience of the eyes or on the visual ray theory: as an object recedes it subtends an ever smaller angle at the eye. For 'vision makes a triangle', wrote Alberti, and 'from this it is clear that a very distant quantity seems to be no larger than a point'. The results of the constructions using vanishing points were proved to be correct by empirical demonstration, for example by using the DRAWING FRAME, or geometrically by an elaborate application of the theory of similar triangles.

The 15th c. named only the *centre point*, to which the 16th c. added *distance points* and *particular* or *accidental points*. The true antecedent of the modern vanishing point is the *punctum concursus* (point of concurrence) of the Marchese Guidobaldo Del Monte of Pesaro. This distinguished man of science, pupil of Federigo Commandino the famous translator of Euclid, was first to formulate the general rule (*Perspectivae Libri Sex*, 1600). To Guidobaldo

goes the distinction of being first to see that the line through the eye parallel to a given line is in the same plane with the given line and is the common line of intersection of all the planes containing the eye and the given parallels. But his exposition was repetitive and diffuse. It was the French mathematician and engineer, Girard Desargues of Lyon, friend of Descartes, who first stated this important theory in clear, axiomatic terms. It was first printed in his *Méthode universelle* (1636). At the end of this pamphlet (which describes an ingenious but mathematically unimportant perspective construction), Desargues appended in the manner of an afterthought a few paragraphs addressed not to the artists but to 'les contemplatifs' in which the vanishing point theory is expressed in terms that make a break with the past and herald the projective geometry of the modern age. The following extract deals with the case in which the given parallels are not parallel to the picture plane: 'When the given lines are parallel and the line from the eye is not parallel to the picture plane, the perspectives of the given lines all tend towards the point in which the line from the eye meets the picture plane, in as much as each of these lines is in a same plane with the line from the eye in which all these planes intersect as in their common axis and all these planes are cut by another plane, the picture plane' (Fig. 60).

Shortly after this Desargues enunciated the theorem that bears his name. And again, in 1639, he broke new ground when he defined a

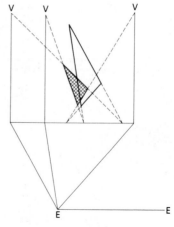

Fig. 62

group of parallels as a pencil of lines whose vertex is at infinity. Desargues's Theorem states that when plane figures are in perspective corresponding lines are either parallel or meet in a straight line (*Traité de la section perspective*, 1636). Corresponding lines are pairs of lines of which the one is the perspective of the other. The points in which they meet are called their intersection points and the line in which they meet is the intersection line of the picture plane and the object plane, i.e. the plane containing the plane figure (e.g. the ground plane). (See Fig. 61.)

Desargues's Theorem and its converse are of the first importance to mathematicians by reason of their complete generality. But in the limited field of pictorial perspective its conclusions tend to be self-evident and the perspective practitioner can afford to ignore it. It is, of course, foreshadowed in the type of construction that shows the ground plane 'hinged' to the picture plane along the ground line: for example in Guidobaldo's construction (see below), although in fact Desargues's Theorem had not yet been formulated. Guidobaldo's book contains the earliest constructions to be effectively based on these two theorems.

Fig. 62 is Guidobaldo's *First Method* and shows how a given triangle may be drawn in perspective by means of vanishing points and intersection points. The ground plane, containing the plan of the given triangle, has been rotated into the plane of the picture as though hinged on the ground line. The eye, and the parallels drawn from the eye that determine the vanishing points, are also represented in plan. The vanishing points in plan are transferred to the picture plane by elevating them to eye level. Lines are then drawn from the intersection points to the respective vanishing points. The intersections of these lines form the perspective (shaded area) of the original triangle.

Both the theory of vanishing points and

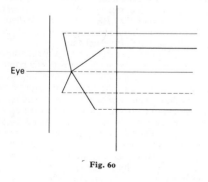

Fig. 60

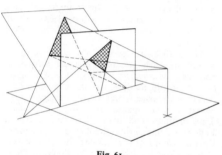

Fig. 61

Desargues's Theorem are printed in A. Bosse's *Manière universelle de M. Desargues pour pratiquer la perspective* (Paris, 1648). This book does not, however, make use of the general vanishing-point construction in its practical examples. The theoretical advances in perspective did not reach the popular, vernacular handbooks until the 18th c., the age in which the classical ideal of beauty based on a mathematical order was already in the process of being challenged and the authority of perspective undermined. The quasi-empirical methods of the 15th and 16th centuries (summed up in VIGNOLA's *Le Due Regole Della Prospettiva Pratica*, 1583), lacking, as they did, the general rule for vanishing points, were entirely satisfactory for the needs of painters. And it is very doubtful if the BAROQUE owed anything at all to Desargues and Guidobaldo. For example, the great TROMPE-L'ŒIL ceiling of Andrea POZZO in the church of S. Ignatius at Rome was designed by the aid of 15th-c. methods clearly described by the artist in his *Perspectiva Pictorum et Architectorum* (1693).

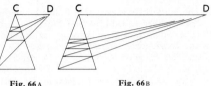

**Fig. 66 A**  **Fig. 66 B**

**Fig. 67**

THE DISTANCE POINT OR THREE-POINT CONSTRUCTION. This is historically the most important construction after Alberti's *costruzione legittima* and is by far the best known. It is an interesting case of practice preceding theory and provides an easy way of measuring in depth along the orthogonals and of drawing a chequerboard of squares in parallel perspective.

A distance point is the vanishing point of lines that make angles of 45° with the picture plane. When a perspective line is drawn to a distance point so that it cuts across a pair of orthogonals (Fig. 63) the points of intersection define two diagonally opposed corners of a square drawn in parallel perspective. This is the key to a useful system for measuring into depth (Fig. 64) and is the easiest way of drawing a chequerboard.

In each vanishing line, of which the horizon line is the principal example, there are two distance points placed symmetrically about its centre (Fig. 65). They are the same distance from this point as the eye; hence the origin of the term. Because the position of the distance point predetermines the distance of the eye and vice versa, the artist must choose the distance with discretion as it affects the character of the perspective drawing (Fig. 66 A and B).

The modern analysis shows that the lines from the eye, EC, ED (given in plan in Fig. 67), that determine the vanishing points of the orthogonals and diagonals of the given square, form right-angled isosceles triangles with the picture plane, making EC = CD. But without knowledge of the vanishing-point theory it is not possible to furnish this simple proof. Hence Renaissance theorists were in difficulty when they wished to show that the distance point rule was in accordance with geometry.

The distance point construction is of uncertain origin. It first appears in literature in Piero della Francesca's *De Prospectiva Pingendi* (*c.* 1480), briefly and only once, as a control for another construction, and the reader is referred to a *costruzione legittima* diagram for an explanation.

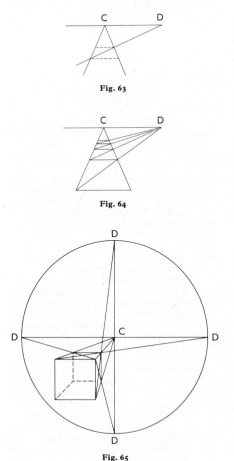

**Fig. 63**

**Fig. 64**

**Fig. 65**

Some authorities regard this isolated example as having been added by a later hand.

The widespread popularity of the distance point construction started in France. There Jean Pèlerin, called Viator, in his *De Artificiali Perspectiva* (Toul, 1505) presented it as the basic construction. Viator was a canon of the Benedictine abbey church at Toul and secretary to Louis XI. Being an amateur of perspective drawing he dispensed with geometrical proofs. His book, the first printed on perspective, written in parallel French and Latin texts, was illustrated with many fine woodcuts and went into four editions in his lifetime. In Vignola's words 'it was more copious in drawings than in text' and his rule 'more difficult to understand than to execute'.

Viator ('The Traveller'), called his distance points 'tiers points'. They should be placed 'equidistant from the centre: closer in near and farther in distant views'. He presumably came across this construction in the course of his many travels north of the Alps, where it may have become established as a workshop tradition. It does not appear in Italian texts before Viator's time, except in the isolated example mentioned above. Yet it is unlikely that the Italians were previously unaware of its existence. Their reticence on the subject is perhaps accountable to their greater concern for theory than the more empirical northerners.

A confusion arose amongst theorists over the identity of the operative diagonals. Were they graphic lines of the same nature as the orthogonals, or were they visual rays? They may have been prompted by the experiment of observing the orthogonals in a mirror which are seen to converge towards the reflection of the observer's eye. FILARETE recommends using a mirror for examin-

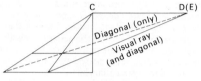

Fig. 69

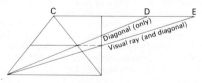

Fig. 70

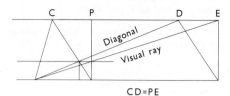

CD=PE

Fig. 71

ing the convergence of parallels (*Trattato di architettura*, 1461–4). If the diagonals were visual rays, the construction could be shown to be sound, being basically the same as Alberti's construction. For this to be so, diagonal and visual rays should coincide and this happened only in the special case where the centre point and the vertical intersection were brought together as in Fig. 69; and there were practical disadvantages in this arrangement. In the normal arrangements of the *costruzione legittima* the centre point and the vertical intersection are apart and then the diagonal and the ray do not coincide (Fig. 70). To some this was evidence enough that the distance point construction was faulty. Yet the greater economy of this construction made it popular with practitioners.

Vignola set out in his treatise *Le Due Regole della Prospettiva Pratica* (printed in Rome, 1583) to demonstrate that both the distance-point construction and Alberti's construction were equally sound. But he could only succeed in showing that if a square, frontally placed, is drawn in perspective by means of the *costruzione legittima*, its protracted diagonals meet in the distance points and that these points are the same distance from the centre point as the 'eye' of the *costruzione legittima* is from the vertical line of intersection (Fig. 71). In the absence of a general theory of vanishing points, this quasi-empirical demonstration was the nearest Vignola could come to a geometrical proof.

Dürer, who journeyed to Bologna in October 1506 to receive instruction in the art of 'secret perspective' and who afterwards at home must

Fig. 68

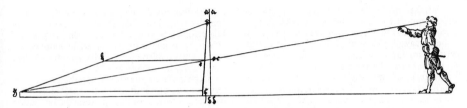

**255.** Illustration from *Underweyssung der Messung* (1525), Albrecht Dürer

have come across the 1509 Nuremberg pirate edition of Viator, was inevitably confused over the relationship between the Italian and the French constructions. When he came to write his perspective treatise, printed first in 1525 as a section of his *Underweyssung der Messung*, he gave in addition to the Italian plan and elevation construction his own version of the distance-point rule, which he called his '*näherer Weg*' or 'shorter way'. This was a *costruzione legittima* with the centre moved over to the vertical line, an arrangement which causes the Albertian and the French constructions to coincide. It has the practical disadvantage of doubling the total angle of vision and of increasing the marginal distortions. In Dürer's *St. Jerome at Home* engraving, 1514, the total angle is about 108°, which results from placing the centre of vision at the side instead of near the centre. A close examination of Dürer's works reveals that apart from the *St. Jerome* engraving and the *Melencolia* bearing the same date, he never again used a consistent perspective construction throughout a picture (H. Schuritz, *Die Perspektive in der Kunst Albrecht Dürers*, Frankfurt, 1919).

SPHERICAL PERSPECTIVE. The idea that apparent magnitudes depend exclusively on the visual angles so that their relation has to be expressed in terms of arcs, not in terms of sections on a straight line, has led some people to maintain

that our visual field approximates to a projection on a concave spherical surface centred in the eye. On this basis some theorists have held that plane perspective is unsatisfactory not only because of the wide-angle distortions inherent in every plane projection but also because it consistently represents objective straight lines as straight whereas they maintain that in natural vision some of them would appear curved.

There are some strong arguments against this view. Vision is by no means exclusively conditioned by the geometry of light rays. Visual perception is partly an acquired faculty in which pre-knowledge and recognition play an important role. Most people do not see objective straight lines as curved except in unusual circumstances. If they habitually do, they will also see the picture plane as curved. When an impression of curvature is experienced it can usually be attributed to the movements of the eyes. For example, when the eyes are made to travel along a high horizontal straight line, the impression is very distinct that the point of vision glides along a line which is not straight but concave to the eye. On the other hand, as soon as the eye is arrested and caused to gaze steadily at some point on the line, the portion of the line in the vicinity of the point of fixation will appear to be horizontal and straight as it really is (Helmholtz's *Treatise on Physiological Optics*, 1925 ed.).

**256.** Illustration from the *Codex Huygens*. (Pierpont Morgan Lib., New York, *c.* 1570)

Partisans of the curved visual space theory draw support from the ancient Greeks. Euclid wrote that 'planes elevated above the eye appear to be concave' (*Optics*, Prop. 10). And VITRUVIUS, writing on Greek architecture, stated that the architect must take steps to counteract the 'false judgements of the eyes': for example, the apparent concavity of a horizontal stylobate (*De Architectura*, iii. 4; v. 9; vi. 2). The well known ENTASIS of columns (also explained by Vitruvius), and other subtle curvatures built into Doric temples, also testify to the sensitivity of the ancient Greeks to subjective curvatures.

The concavity of the retina is another fact adduced in favour of the theory that our visual space is curved. There are, of course, no straight lines in the retinal image. But as we do not see our retinal images, this fact is quite irrelevant. As Helmholtz said, the retinal images have to be left out of account in localizing objects; they are only means by which the rays of light from one object point are focused on one nervous fibre.

Practising artists may run up against the problem of a curved visual field when they measure the scene they are drawing by the traditional method of holding a pencil or brush handle at arm's length at right angles to the line of vision and sighting across it with one eye. The measurements thus gained are the angular proportions of the scene and theoretically they are incapable of being projected on to a plane surface (in practice this method works very well when the total angle of view is fairly small). It may be objected that the attempt to transfer these measurements made on the arc to the flat picture will produce a double foreshortening of the image because of the natural foreshortening of the picture plane.

It is a mathematical truism that a spherical surface cannot be developed into a plane. Nevertheless, over the years, several systems have been devised that set out to give an approximate solution to this problem. Guido Hauck's system is the best known (*Die subjektive Perspektive und die horizontalen Curvaturen des dorischen Styls*, Stuttgart, 1879). It has been argued by John White, who coined the term 'synthetic perspective' for this type of construction, that Leonardo was first to invent such a system and that before him the first artist in post-classical times to represent optical curvatures in his paintings was the 15th-c. French painter Jean FOUQUET (*The Birth and Rebirth of Pictorial Space*, 1957). But Leonardo does not appear to have used curved perspective in his paintings.

Methods of perspective incorporating a curved projection surface may be of some help to an artist who is confronted with the problem of representing a wide-angled view. But they have never had many followers. They disrupt the system of vanishing points and tend to be complicated to use. Furthermore, they produce curved images of objective straight lines (unless the lines pass through the centre of vision).

The multiplicity of systems of curvilinear perspective is witness to the impossibility of arriving at a completely satisfactory solution. In practice artists have generally preferred to employ the much simpler plane perspective and to make the necessary adjustments by eye.

PERSPECTIVE IN ANTIQUITY. In the Greek red-figure vases of about 500 B.C. (see GREEK ART) we find expressed for the first time the beginning of a completely new approach to drawing: a gradual break from the conceptual or ideo-plastic towards a visual or optical attitude. This change in art is part of the general break-away from age-long habits of thought that the Greeks achieved in the 5th c. B.C. The beginnings of perspective belong to this period.

Perspective in ancient Greece and Rome was known as *skenographia*, a term that covered all devices to regulate the effects of space between the observer and the thing seen and included the application of the rules of optics to painting, sculpture, and architecture. It was first applied in the theatre of Dionysus at Athens in the second half of the 5th c. B.C., when drama began to require more elaborate scenic arrangements. Vitruvius writes that the painter AGATHARCHUS OF SAMOS was the inventor of scenography and that he first applied it when he 'made the scene' for a tragedy by Aeschylus (525–456 B.C.) given at Athens, probably at a revival in the 430s (T. B. L. Webster, *Greek Theatre Production*, 1956), and that he wrote a commentary on his method. Furthermore certain scientist-philosophers took up the subject and also wrote about it, working out rules of perspective. They showed how 'if a fixed centre is taken for the outward glance of the eyes and the projection of the rays, we must follow these lines in accordance with a natural law, such that from an uncertain object certain images may give the appearance of buildings in the scenery of the stage, and how what is figured on vertical and plane surfaces can seem to recede in one part and to project in another'. We can only gather from this description that optical rules were applied to illusionistic scenery from the start, though we cannot deduce precisely in what manner. None of these treatises on scenography survives. But they were perhaps the prototypes of Euclid's *Optics*. Here, as in many other fields, practical recipes preceded theoretical investigations.

Although virtually nothing remains of classical Greek painting, the figured vases give some indication of development in practical perspective. By *c.* 500 B.C. artists were beginning to experiment with foreshortening and with drawing untypical aspects—a shield from the side, a foot from the front. Soon too artists drawing architectural forms employed a rudimentary perspective in the representation of planes and lines in depth. Convergence was still unsystematic and was applied only, if at all, to individual planes and never to the picture as a whole. The receding parallel edges of solid objects, such as tables in the foreground, were

mostly drawn parallel or divergently. Central convergence is used fairly consistently only in one short phase of the antique painting that has come down to us: in the illusionistic wall decorations of the Architectural (or so-called Second) Pompeian Style (see POMPEII) dating from about 80–30 B.C., examples of which have been excavated in and near Rome and Pompeii, the best preserved being from Boscoreale. These corroborate Vitruvius's statements on wall decoration in his own time as well as his brief and somewhat obscure definition of scenography as used by architects: 'Scenography is the sketching of the front and the retreating sides and the correspondence of all the lines to the centre of a circle.' This seems to confirm that some kind of functional system of central convergence was in use during the 1st c. B.C., at least amongst architects. In the following generation the fashion changed to a more decorative and fanciful mode in which the perspective was less systematic.

The question remains, did the Greeks have a theory of central perspective? Did they at any time conceive of a painting as a transparent projection plane with a theoretically fixed eyepoint? It used to be thought that they did not, until H. G. Beyen discovered that some mural paintings in Pompeii, Rome, and Boscoreale showed a construction with a point that functionally corresponded with the vanishing point of central perspective (*Die antike Zentralperspektive*, Jahrbuch des Deutschen Archäologischen Instituts, Berlin, 1939). The lower parts of these paintings do not, however, show the same regard for central convergence and are more haphazard in their perspective treatment. G. ten Doesschate (*Perspective*, Nieuwkoop, 1964) suggests this may be because the artists who drew these pictures were not original masters, but copied more or less accurately pictures they had seen on the stage. As on the raised platform the lower part of such a construction was missing, they therefore had to fill in this deficiency from their own resources and made use of the more common parallel perspective.

Our familiar pair of railway lines that 'vanish' to a point have an equivalent in ancient literature. Lucretius (*De Rerum Natura*, iv) describes how a colonnade may appear to vanish into the obscure point of a cone. But the geometrical principle of vision did not receive universal acknowledgement in antiquity. It had a popular rival in the Epicurean theory of images, according to which objects are continually throwing off *eidola* or surface films of very fine texture that traverse the air at infinite speed. These impinge upon our eyes and give us vision by direct contact. This theory of vision led to the paradoxical belief that the heavenly bodies are the size they appear. Perhaps Euclid wrote his *Optics* to combat such views. We may believe that the ancients possessed a system of perspective which had close resemblance in its

effects to Renaissance perspective, but it is not certain that this was a system of central projection. The first complete rationalization of the picture space seems to have been the achievement of the 15th c. A.D.

CLASSICAL OPTICS: EUCLID ON PERSPECTIVE PHENOMENA. The oldest extant book on geometrical optics is by the great Greek mathematician, Euclid of Alexandria, written about 300 B.C. It consists of 58 theorems (20 belong to optics proper and 38 deal with perspective phenomena) preceded by 12 definitions or postulates. Euclid's *Optics* laid the foundations upon which geometrical optics could be developed to its present high level. It exerted a great influence upon medieval writers on optics and indirectly was of great consequence in the evolution of Renaissance perspective. The following are the first four definitions: Let it be assumed

(i) That straight lines proceeding from the eye diverge through a space of great extent. (Euclid adhered to the centrifugal theory of visual rays.)

(ii) That the form of space included within our vision is a cone with its apex in the eye and its base at the limits of what is seen.

(iii) That those things upon which the visual rays fall are seen and that those things upon which they do not fall are not seen.

(iv) That those things seen within a larger angle appear larger and those things seen within a smaller angle appear smaller, and those things seen within equal angles appear to be of the same size.

The purpose of the *Optics* is to express in geometrical propositions the exact relation between the real quantities found in objects and the apparent quantities that constitute our visual image. Euclid connected, in pairs, object points with image points as is done in modern constructions. He shows the apparent size of objects to be directly proportional to the visual angle subtended at the eye. He deals geometrically with common deceptions of vision on the basis of the visual angle theory. The following are some of the propositions which have a bearing upon perspective.

Prop. 6. Parallel lines seen from a distance seem to be an unequal distance apart (Fig. 72).

The proof follows logically from Def. 4. BD is seen within a smaller angle than PN; the angle PKN is smaller than the angle XKL. The intervals then between parallels do not appear equal but unequal.

Prop. 10. Of a horizontal plane situated below

**Fig. 72**

**Fig. 73**

the observer's eye those parts which are farther away appear to be the more elevated (Fig. 73).

In the proof the eye at B is connected with z, D, and G of the horizontal ground plane. The connecting lines intersect the perpendicular EH. H is more elevated than L, etc.

Similar proofs deal with planes above eye level that appear to descend as they recede, with planes on the left that appear to move to the right, and planes on the right that appear to move to the left.

Prop. 36 deals with an example of foreshortening, explaining why chariot wheels appear oval when seen obliquely.

Of particular interest is Prop. 10 since it shows that Euclid knew the principle that lies at the foundation of central perspective, namely that the objects are projected by the eye upon the picture plane. Yet there is no evidence to show that Euclid ever thought of his proof in this way. He wrote about perspective phenomena, but the etymological synonymity of optics and perspective has often led to the misconception that he wrote about perspective constructions.

It is noteworthy that in Prop. 6 Euclid does not conclude that parallels if produced indefinitely will ever appear to meet in a point. The 13th-c. writer on optics, Vitellio, who follows similar lines in discussing this theorem, concluded that parallel lines are never seen to meet in a point because the interspace between them will always subtend some angle at the eye. Nowadays one would say that at infinity the subtended angle is zero. But in the 13th c. the concept of limit was not yet accepted by mathematicians in their proofs. G. J. Kern believes that Vitellio's qualification indicates the existence of two opposing schools of thought as regards the geometrical validity of vanishing points and that it may go some way towards explaining the tardy adoption of the central vanishing point for orthogonals by the artists of that time.

EUCLID'S PROPOSITION 8. Something must be said about Euclid's Prop. 8, which has often caused confusion in the minds of those who study the history of perspective. This theorem states that 'equal and parallel magnitudes unequally distant from the eye do not appear (inversely) proportional to their distances from the eye'. Euclid wished to discover whether there existed a simple geometrical proportionality between the apparent size of equal and parallel lines and their distances from the eye. He found that this

simple relationship did not exist. E is the eye; A and G are the two parallel magnitudes. A is twice as far from the eye as G but the angle it subtends is appreciably greater than one-half of the angle subtended by G (Fig. 74).

The confusion has arisen because Leonardo wrote: 'A second object as far away from the first as the first is from the eye will appear half the size of the first, though they be the same size really.' In other words, if you double the distance you halve the apparent size: hence apparent size and distance *are* inversely proportional. The apparent contradiction does not

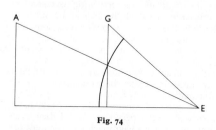

**Fig. 74**

in fact exist because Euclid is speaking about the visual angles of natural perspective, which are measured by their subtending arcs, while Leonardo has the picture plane in mind, which produces straight projections and forms a series of similar triangles with the visual rays.

By considering the projections on the picture plane with regard to their proportional relationships Leonardo (and Alberti and Piero della Francesca before him) were introducing the *classical concept of proportionality*, with its cosmological and aesthetic connotations, into the theory of perspective. Leonardo goes on to affirm that the same proportional intervals obtain in perspective space as in music. (See PROPORTION.)

PERSPECTIVE IN BYZANTINE ART. The postclassical age was a period of regression for perspective. After the division of the Roman Empire and the break-up of the West, Constantinople became the artistic centre of Christendom and conserved for 1,000 years and more much of the classical heritage of drawing, though in a much schematized form, while in the West the taste for abstraction and ornament led to the complete transformation of classical models and the breakdown of perspective schemata. The Byzantine artist, in common with the rest of the post-classical world, did not follow any consistent system of perspective. To start with, Constantinople copied 3rd-c. official ROMAN ART, the tendency of which was already to turn away from Classicism and illusionism. But whereas the art of the West went through many changes between the collapse of the Empire and the Renaissance, Byzantine art soon settled into a comparatively rigid style. Official Byzantine art was from the start HIERATIC and anti-illusionistic. Yet artists never ceased to draw upon

classical sources. HELLENISTIC illuminated manuscripts provided them with a rich quarry of classical forms, which at times they imitated freely, as for example the *Joshua Rotulas* (Vatican, Rome) executed at Constantinople in the 10th c., in which we find a use of shadow and aerial perspective almost unique in medieval art.

The practice and theory of perspective in Byzantine art has been less closely studied than that of antiquity and the Renaissance, and authorities differ on several points. P. A. Michelis (*An Aesthetic Approach to Byzantine Art*, 1955) held that the Byzantine artist 'followed no rational system of perspective' but had a 'knack' of seeing and representing objects in perspective. Gervase Mathew (*Byzantine Aesthetics*) held on the contrary that Byzantine art was to the end 'also a form of applied geometry'.

The *Optics* of Euclid was current in the Byzantine world through Pappus and Theon of Alexandria, and Proclus (A.D. 412–85), in commenting on Euclid, describes scenography as the branch of optics which 'shows how objects at various distances and of various heights may be so represented that they will not appear out of proportion and distorted in shape'. Byzantine painting never became a window opening on to a world outside in the manner of illusionistic Hellenistic art and the Renaissance conception initiated by the *stil nuovo* of Giotto. At most the pictures create the appearance of a box-like space or niche in the wall which they occupy. Byzantine wall-painting was primarily a functional adjunct to architecture and some authorities have maintained (though not all accept this interpretation) that the picture space was characteristically that of the church or room in which the picture was placed (and in which the observer stood), the perspective opening out into the actual room-space. One device sometimes used for suggesting depth of picture space is an 'inverted perspective' in which the viewpoint of the picture might be taken to be behind the scene, not in front of it, figures being smaller in proportion to their distance from the viewpoint. It has been pointed out that this system of perspective fits naturally to the Euclidean theory of vision, which supposes rays to proceed from the eye to the object. On the assumption that equal sizes subtend equal angles at the eye, an artist who had misunderstood Euclid might assume that a more remote figure or object should be drawn larger than a nearer one since it would span a wider part of the visual pyramid. In the later period a high viewpoint is often used so that the scene is visualized as it would appear from above. Very often different systems or different viewpoints are combined in one composition and the same structure is made to carry planes belonging to successive acts of vision. The idiosyncrasies of Byzantine perspective have been attributed to the fact that Byzantine art derived from two irreconcilable traditions; Greek illusionism and oriental schematic abstraction. Furthermore in the 8th c. it suffered the doctrinal severities of ICONOCLASM. In the last phase of Byzantine art there is evidence of cross-fertilization between the East and the Gothic West and of a movement towards spatial unity: witness the mosaics and frescoes in the church of St. Saviour in Chora, Istanbul. It is only during the late 12th to the early 15th centuries that the representation of functional space became a dominant concern of Byzantine artists both in panel- and wall-paintings and in mosaics.

PERSPECTIVE IN POST-CLASSICAL AND MEDIEVAL WESTERN PAINTING. The shift of art to the transcendental and the symbolic that began during the break-up of the Roman Empire produced in the West many vicissitudes of style. Between the EARLY CHRISTIAN and the late GOTHIC periods regional differences were at times very marked, but everywhere perspective was in low esteem. In Italy, much under Byzantine influence, painting preserved more of the classical tradition than elsewhere, but on the borders of the Roman Empire the classical heritage was submitted to the disintegrating pressure of Barbaric traditions. Artists trained in a style of abstract linear pattern and who knew nothing of narrative painting could not immediately interpret and assimilate the representational forms of Mediterranean origin which they tried to copy. In certain phases of medieval painting the third dimension was virtually eliminated. Examples may be found in CELTIC, MOZARABIC, Ottonian, and High ROMANESQUE illumination. The CAROLINGIAN attempt to revive the classical tradition was short-lived and it was not until the Gothic period that Western art turned finally towards NATURALISM. In Gothic illumination figures and objects again acquired relief and were set in a shallow stage space.

*Spatial inconsistencies* are a common feature in medieval painting. They testify to its disregard for material values. To modern eyes they are a part of its charm. One of the most characteristic is the drawing of pillars as discontinuous. This was done to avoid overlapping in the interest of the overriding demand for narrative clarity. In certain cases such spatial *non sequiturs* may have been intended to underline the universal validity of the religious scene by introducing transcendental values. In medieval painting there was often a return to ideoplastic elements. Table tops were drawn as though vertical with the utensils sliding off them. Disproportion between figures and their surroundings was the rule. Symbols were preferred to descriptive realism. Knowledge of geometry and geometrical optics virtually died in the West until the revival of the 12th c. A unique and important document in the history of medieval drawing is the sketch-book (*c.* 1235) of Villard d'HONNECOURT. This includes four pages of 'the elements of portraiture' with the preface: 'Here begins the art of the elements of drawing, as the discipline of geometry teaches it, so explained as to make the work easy.' But the precepts do not include any

cost u mafons      Jon ozologz

**257.** A clock-tower. Pen-and-ink drawing by Villard d'Honnecourt. (Bib. nat., Paris, c. 1235)

instruction in perspective and when the author himself draws buildings he has seen on his travels (and there are several in his sketch-book) the lack of such knowledge is visibly a handicap. Illustration 257 shows his drawing of a clock-tower, which although admirably observed in all its parts appears unstable because the horizontals are not related to an eye-level. It shows how necessary was the seemingly naïve perspective rule given by the Italian Cennino CENNINI in his *Book of Painting* (c. 1400): 'And you put the buildings in by this uniform system: that the mouldings that you make at the top of the building should slant downwards . . . the moulding in the middle should be quite level and even; the moulding at the base must slant upward, in the opposite sense to the upper moulding. . . .' Cennini's book was a late product of the Byzantine tradition—the *maniera greca*—which survived in Italy right through the Middle Ages. Cennini epitomizes the medieval attitude when, on the first page of his book, he states that the purpose of painting is to 'discover things not seen, hiding themselves under the shadow of natural objects . . .'. These words make a vivid contrast with one of the opening statements of another famous book on painting written a generation later by that pioneer of the Renaissance movement, Leon Battista Alberti: 'No one would deny that the painter has nothing to do with the things that are not visible. The painter is concerned solely with representing what can be seen.'

THE REVIVAL OF PERSPECTIVE. The beginnings of a return in the West to three-dimensional realism and to the drawing of architectonic space are to be found in 13th-c. Rome, whose early churches still preserved many pictorial examples of the late antique style, for example the 5th-c. mosaics of Sta Maria Maggiore. The greatest of the Roman early realists was Pietro CAVALLINI. His mosaics in Sta Maria in Trastevere (c. 1280) such as the *Annunciation*, the *Birth of the Virgin*, and the *Presentation* show that he possessed a firm grasp of vertical axis perspective. Nearly all of his frescoes have been destroyed. He used a unified focus for each separate structure or main architectural part, though not for the whole picture. For example, the two interior rooms that form the background of the *Birth of the Virgin* are each drawn to a separate central axis, implying two distinct viewpoints. The three aedicules in the *Presentation* are represented from high and low viewpoints alternately, as in the traditional Byzantine manner. Cavallini was by no means without immediate predecessors in Rome. Elaborate architectural backgrounds can still be glimpsed in the much damaged 11th-c. frescoes in the lower basilica of S. Clemente, by an unknown hand. And the fresco cycles in the portico of S. Lorenzo fuori le Mura, painted between the 1260s and 1280s by painters only known as 'Paulus and his son Filippus', constitute a veritable pattern-book of architectural forms. It was in Rome through the art of late antiquity that the Italian painters first rediscovered perspective space.

The two greatest monuments of the rapid advance made in spatial realism in Italy at the turn of the century are the great fresco cycles of the Upper Church of St. Francis at Assisi and of the Arena chapel at Padua. The clerestory frescoes of the south wall of the nave at Assisi are of the Roman school and show some of the earliest convincing interiors. (Early interiors are always seen from the outside. The real interior, seen from within, does not appear in painting before the 1440s.) The 29 frescoes of the St. Francis cycle at Assisi are traditionally ascribed to Giotto, though experts disagree on this and their authorship remains uncertain. They were painted about 1300. Giotto painted the frescoes of the Arena chapel, Padua, in or about 1306. Striking examples are to be found there of empirical perspective. The two little Gothic chapels painted at eye-level on the walls of the chancel arch, on the right- and the left-hand side as one looks towards the altar, are drawn towards a common vanishing point, indicating that Giotto aimed at an illusionistic piercing of the walls. His fresco of the *Suitors Praying* has a ceiling that appears to have been drawn to a central point and to an empirical distance point. Nevertheless Giotto's perspective, in common with the whole of the trecento, was intuitive and practical rather than scientific.

The floor plane, which was to become the key feature of the Renaissance picture space, was the

last to be brought under perspective control during this empirical phase. The Sienese of the trecento made a habit of introducing tiled floors into their designs. Two early examples may be compared from DUCCIO's *Maestà* of 1311 (Opera del Duomo, Siena): the scene representing *Christ amongst the Doctors* has a floor whose squares are barely foreshortened, while the *Temptation of Jesus on the Temple* displays a strip of chequered floor that leads the eye deep into the interior of the building. In the final phase before the formulation of scientific perspective the works of the LORENZETTI brothers are outstanding. The architecture in Ambrogio Lorenzetti's big fresco of *The Blessings of the Good Government of Siena* (Town Hall, Siena, 1338) is a strikingly realistic portrait of the town. No less remarkable for its perspective is Pietro Lorenzetti's *Birth of the Virgin* (Opera del Duomo, Siena, 1342) with its three architectural bays drawn to a single focus, while Ambrogio's *Annunciation* (1334) contains what is said to be the first example of a floor drawn to a central vanishing point. The foreshortening of the tiles, however, is not geometrically controlled. After a period of standstill caused by the Black Death, further advances were made in the last quarter of the century at Padua by ALTICHIERO, and Giusto de' Menabuoi (d. before 1391).

MEDIEVAL OPTICAL STUDIES. Euclid's studies in optics had been carried further by Greek and Arab mathematicians in Egypt, notably by Claude Ptolemy (active 2nd c. A.D.) and Alhazen (d. 1038). By about 1200 some of the treatises

had become available to the West through Latin translations made from the Arabic in Spain and Sicily and these stimulated great interest in the subject, besides providing material for further treatises by the scholastics in the 13th c. (Robert Grosseteste, Bishop of Lincoln; Roger Bacon; John Peckham, Archbishop of Canterbury; Vitellio) whose works were consulted up to the time of Kepler. This revival of optics in the West coincides with the return of naturalism in art. The two events were not directly connected yet both were part of the widespread movement that combined the revival of learning with a growing interest in the natural world and a belief in the importance of mathematics and experimental science.

BRUNELLESCHI. In Florence of the 15th c. and elsewhere these optical treatises were much studied (witness GHIBERTI's *Third Commentary*, c. 1440, which is composed of extracts taken from the better known optical works). It seems that Filippo Brunelleschi was already acquainted with them when he made his famous perspective experiments early in the century. His first demonstrations are described by his biographer, Antonio Manetti. Brunelleschi placed himself just inside the central doorway of the cathedral of Florence and from there he made a picture of the Baptistery 'showing as much as could be seen at one glance'. It was a panel about a foot square, painted with the precision of a miniature, and the sky was represented by burnished silver that was to reflect the real sky and the passing clouds. Having completed his panel, Brunelleschi

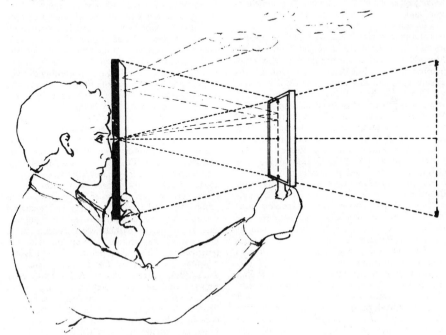

**258.** Illustration from *Studi su la dolce Prosettiva* (1964), Alessandro Parronchi

bored a hole through it at that point in the view which had been exactly opposite his eye when he painted it: that is at the centre of vision. The spectator was instructed to look through the hole from the back, at the same time holding up a mirror on the far side in such a way that the painting was reflected in it. 'When one looked at it thus,' says Manetti, 'the burnished silver . . ., the perspective of the piazza, and the fixing of the point of vision made the scene absolutely real.'

This was the first recorded centrally projected image in the history of painting. The question remains how did Brunelleschi make it? D. Gioseffi (*Perspectiva Artificialis*, Trieste, 1957) suggested that he used a burnished silver ground as a mirror and traced the lines of the reflected buildings on its surface, thus producing a reversed image. (This would explain why the spectator was asked to look at the painting in a mirror.) If this was Brunelleschi's procedure he may have started from a suggestion found in Ptolemy's *Optics*, where an experiment of marking the reflection of an object on the surface of a mirror is described and accompanied by a geometrical diagram. Perhaps the next stage was to make diagrams of the whole experiment, complete with plan and side elevation, showing where the visual rays intersect the picture plane. Such an order of events would reconcile the opinion of the 15th-c. Florentine architect Antonio Filarete, who believed that Brunelleschi discovered perspective while considering reflections in a mirror, with Vasari's statement that Brunelleschi proceeded with the aid of a plan and elevation 'and by means of the intersection'.

The earliest painting in which the architectural perspective is exactly based on Brunelleschi's rules is the fresco of the *Trinity* in Sta Maria Novella, Florence, by his friend MASACCIO, painted in 1427. But Brunelleschi's influence is already apparent in the reliefs of *St. George and the Dragon* (Or San Michele, Florence, *c.* 1417) and *Salome* (Siena Baptistery, *c.* 1425), both by DONATELLO, who was his close friend and perhaps the first to share the discovery. It is also strong in other works of the time; MASOLINO's *St. Clement* frescoes at Rome (*c.* 1430), Uccello's fresco of *Sir John Hawkwood* (Florence Cathedral, 1436), and in panels of Ghiberti's *Porta del Paradiso* (1425–52). Shortly after Brunelleschi made his perspective demonstrations Alberti devised his perspective construction for the special use of painters (see above), which he described in his famous treatise *On Painting* (1436). In the same work he explained the drawing frame which he claimed as his own invention.

PERSPECTIVE IN THE NORTH. The new Italian discoveries took some time to reach the north. There the advance towards realism was achieved without central perspective. Jan van EYCK's *Madonna in a Church* (Berlin) is not drawn in central perspective, though it was perhaps painted about the same time as Masaccio's

**259.** The perspective of Jan van Eyck's *Arnolfini and his Wife* (N.G., London, 1434). Illustration from *Die Grundzüge der Linear-Perspektivischen Darstellung* (1904), G. J. Kern

*Trinity*. Nor is his *Arnolfini and his Wife* (N.G., London) drawn to a central point, but ceiling, floor, and walls each to separate points. Evidently it is not easy to tell without a minute examination whether a systematic construction has been used. None of the Flemings used central convergence consistently, i.e. for the whole picture, until Petrus CHRISTUS (*c.* 1445). Geometrically controlled foreshortening did not appear north of the Alps until the next century, after the treatises by Viator (1505) and by Dürer (1525) had become widely known.

PERSPECTIVE IN MODERN TIMES. Over the ages many great names in art and science have been linked with the story of perspective. Perhaps the last great painter to be learned in this subject was J. W. M. TURNER, who was Professor in Perspective to the Royal Academy from 1807 to 1828. Today most artists who paint representational pictures acquire their perspective empirically and possess only the rudiments of theory. Already in the 1860s no less a painter than Jean François MILLET was inquiring after a professional 'perspecteur' to help him with the perspective of his ceiling painting for the Hôtel Thomas (A. Sensier, *La Vie et l'œuvre de J.-F. Millet*, Paris, 1881). And DEGAS told SICKERT that he had to employ a 'perspecteur' for his *Miss Lola* (N.G., London) hanging by her teeth from a trapeze near the ceiling (marginal note in Sickert's hand in his copy of Sensier's book, now in the library of University College, London). Through photography we become so

habituated to the perspective image that artists acquire a sense of perspective almost unconsciously, and even make efforts to find new ways of representation. Recent investigations made by experimental psychologists suggest that geometrical perspective provides an inadequate account of our visual perceptions, which are found to be strongly influenced by size, shape, and colour 'constancy'. Moreover, objects within close proximity to the eye do not follow the laws of scientific perspective—a fact that has been exploited by many modern artists since CÉZANNE and was no doubt observed by artists before the rule of science took over. Nevertheless it is wrong to call perspective a 'convention'. It may be a convention to paint pictures according to strict geometrical perspective, but perspective itself is not a convention: it is a part of the theory of central projection. And it is a fallacy to suppose that the 'visual truth' may be represented by a flat image, if by 'visual truth' is meant the way we see the world through our two moving eyes forming successive perceptions conditioned by 'constancy'. The perception of representational paintings—or photographs—is usually a very different process from the perception of the actual scenes in depth. Finally, pictures may be regarded as an arrangement of symbols for reality. Central perspective is unique in so far as it enables the picture to send to the eye of the beholder, who respects its conditions, the same distribution of light as the objective scene.

2, 28, 356, 729, 781, 1045, 2013, 2016, 2050, 2143, 2405, 2436, 2612, 2626, 2754.

**PERUGINO.** PIETRO VANNUCCI (c. 1445/50-1523). Italian painter from Umbria, who worked as a young man in Florence, possibly learning the new oil techniques from VERROCCHIO, and by 1481 had made himself sufficiently well known to be commissioned to paint frescoes at the Sistine Chapel along with ROSSELLI, GHIRLANDAIO, and BOTTICELLI. His assistant at this time was PINTORICCHIO. His painting *Christ Delivering the Keys to St. Peter* established his reputation and in 1500, when he decorated the Audience Chamber of the Collegio del Cambio at Perugia with RAPHAEL, he was called by Agostino Chigi the best painter in Italy. He was hard-working and prolific and developed a sentimentalized, prettified manner which even during his lifetime brought criticism in some quarters for excessive 'sweetness'. His glorification by the PRE-RAPHAELITES in the 19th c. led to a reaction against the too easy charm. But at his best—as in the Vatican fresco, the Uffizi *Assumption*, and the *Pietà* in the Accademia, Florence—he has the authority of a great master.

482.

**PERUZZI,** BALDASSARE (1481-1536). SIENESE painter, architect, and one of the first modern stage-designers. He began as a painter

and went to Rome in 1503, where he came under the influence of BRAMANTE and probably worked for him on St. Peter's. In fact nearly all the problematical early drawings for St. Peter's are by Peruzzi, though most of them presumably represent Bramante's ideas. In 1509-11 he built the Villa Farnesina, Rome, for the Sienese Agostino Chigi, the patron of RAPHAEL, to whom the building has also been ascribed. Its architecture is simple and still quattrocento in feeling, unlike the early designs for St. Peter's—a fact which confirms that Peruzzi's part in those designs had been a merely subordinate one. The decorations are the most important part of the Farnesina (cf. Raphael, SODOMA, SEBASTIANO DEL PIOMBO), and Peruzzi's own Sala delle Prospettive, with its false PERSPECTIVE view through the walls, confirms early accounts of his skill in perspective and stage-design.

After Bramante's death (1514), Peruzzi worked for the rest of his life in various capacities on St. Peter's. He was captured in the 1527 Sack of Rome, but escaped to Siena, stayed there till 1530/1, and became architect to the Republic. His last major work was the Palazzo Massimo alle Colonne, Rome (begun c. 1532/5). This is entirely different from the Farnesina, and with its heavy upper part, curved façade, and combinations of PILASTERS and COLUMNS is one of the first MANNERIST buildings. The curved façade breaks with RENAISSANCE solidity, and also makes the best of an irregular site.

**PESELLINO,** FRANCESCO DI STEFANO (c. 1422-57). Italian painter of the FLORENTINE SCHOOL, who was probably trained by Fra Filippo LIPPI. He is chiefly known as a painter of romantic and flowery CASSONI and for the ALTARPIECE of the *Trinity with Saints*, begun 1455, left incomplete at his death and finished in Lippi's studio. It was afterwards cut into several pieces, which entered the National Gallery, London, at different dates and have since been reunited.

**PETERS,** MATTHEW WILLIAM (1742-1814). English GENRE painter, a pupil of HUDSON in the 1750s. He was in Italy, 1772-6, and in Paris in 1775 and 1783. The influence of French painting is clear in the sentimental, moralizing, and mildly salacious groups of pretty women which he painted. He also painted theatre and history pieces but there is always a drawing-room elegance about his heroics. Scenes from *The Merry Wives of Windsor* (for BOYDELL's Shakespeare Gallery) were among the most popular of his engraved pictures. He was elected A.R.A. in 1771 and R.A. in 1777. He took Holy Orders in 1782 and retired from professional practice in 1788.

377, 1751.

**PETO,** JOHN FREDERICK (1854-1907). American STILL-LIFE painter. Born in Philadelphia he was a friend of HARNETT, who

# PETTIE

exercised a strong formative influence on his work. The latter part of his life was spent in seclusion at Island Heights, New Jersey, and he was completely forgotten until rediscovered in 1947 by the critic Alfred Frankenstein. Like Harnett, Peto concentrated on still life but his style was more poetic and relaxed. In the words of Frankenstein he made still life a poem on the 'fantasticality of the commonplace and the pathos of the discarded' (*After Night's Study*, Detroit. Institute of Arts).

**PETTIE,** JOHN (1839–93). Scottish painter, a pupil of Robert Scott Lauder (1803–69). In 1862 he went to London with Sir William Orchardson (1835–1910) and in 1873 was elected R.A. He was close to the contemporary English anecdotal school, specializing in dramatic and Romantic historical subjects, particularly themes from the Civil War period (*Cromwell's Saints*, N.G., Edinburgh, 1862). His style was free and dashing; wide, cool, and brilliant in colour, to some extent influenced by van DYCK.

1249.

**PETTORUTI,** EMILIO (1893– ). Argentine painter. He studied and worked in Italy (1913–23), where he attached himself to the FUTURIST movement, and in 1924 experimented with the CUBISM of Juan GRIS in Paris. After his return to Argentina in 1924 he exercised a formative influence on the younger generation of painters there.

**PEVSNER,** ANTOINE (1886–1962). Russian-born sculptor, elder brother of Naum GABO. He was trained at Kiev and at St. Petersburg. From 1913 to 1915 he lived in Paris, where he associated with ARCHIPENKO and MODIGLIANI. Returning to Russia in 1917, he became professor at the Academy of Fine Arts, Moscow, where MALEVICH and KANDINSKY also taught. In 1920 he was associated with Gabo in drawing up the manifesto of CONSTRUCTIVISM and in 1922 he helped to organize the exhibition of Soviet art in Berlin. In 1923 he settled definitively in Paris and took French nationality in 1930. During the 1930s he gained recognition as one of the leaders of non-figurative and constructional sculpture (*Projections dans l'Espace*; *Construction pour l'Aéroport*). In 1950 he executed a work for the University City of Caracas.

**PFORR,** FRANZ (1788–1812). German painter. He fell under the spell of Romantic literature (Tieck) and early German and Dutch painters (DÜRER, BRUEGEL). His illustrations to his own sentimental tale *Maria und Sulamith* and to GOETHE's *Götz von Berlichingen*, and paintings such as *The Entry of the Emperor Rudolf of Habsburg into Basle, 1273*, reflected this interest in an artificial and exaggerated PRIMITIVISM. In 1809 he founded the *Lukasbund* with OVERBECK (see NAZARENES).

**PHIDIAS.** Athenian sculptor of the mid 5th c. B.C. He and PRAXITELES were regarded in antiquity as the two greatest masters. His colossal statues—the CHRYSELEPHANTINE *Athena* of the PARTHENON, the *Zeus* at Olympia, and the bronze *Athena Promachos*—are known from the raptures of ancient critics and little more: the fragments of moulds for the *Zeus* found recently at Olympia do not help. From his life-size statues the *Lemnian Athena* is preserved in copies, among which a head in Bologna is remarkably sensitive. Phidias also supervised Pericles' architectural programme, but how closely the sculptures of the Parthenon (447–432 B.C.) reveal his personal style will always be debated. The characteristics traditionally ascribed to him are a supple, gracious dignity, calm and melancholy and beautiful. His influence is visible in the best of contemporary vase-painting and in the sculpture of his successors. Quintilian comments that his *Zeus* added something to traditional religion. When Pericles fell out of favour Phidias was accused of misappropriating gold supplied him for the statue of Athena. But according to Plutarch, having cleared himself of this charge, he was thrown into prison for 'impiety' on the ground that he had introduced portraits of Pericles and himself on the shield of the goddess.

**PHILLIP,** JOHN (1817–67). Scottish painter, born at Aberdeen. He specialized in portraiture and in paintings of Scottish life and character in the manner of WILKIE. Following a visit to Seville and other cities of Spain he became celebrated for picturesque Spanish GENRE scenes and was known as 'Spanish' Phillip or 'Phillip of Spain'. His work combined technical efficiency with early Victorian sentiment and period charm.

**PHILO.** Greek sculptor of the time of Alexander the Great. To him are attributed statues of *Hephaestion* and *Zeus Ourios* at the entrance to the Bosphorus, mentioned by Cicero (*Verr*. II. iv. 129). PLINY mentions him as a sculptor who did athletes, warriors, hunters, and celebrants at sacrifices.

**PHILO.** Greek architect who *c*. 330 B.C. added a PORTICO to the Telesterion, the great temple to Demeter at Eleusis, which had been reconstructed by ICTINUS after having been destroyed by the Persians. He also built an arsenal in the Piraeus (later destroyed by Sulla), the detailed specifications for which survive in an inscription.

**PHILOSTRATUS.** A Lemnian family of sophists and rhetoricians in the 3rd and 4th centuries A.D. PHILOSTRATUS (b. *c*. A.D. 190), the son of Nervianus, sometimes called Philostratus the Lemnian, is generally credited with being the author of the earlier series of *Imagines* and has sometimes been inaccurately called the 'father of art criticism'. His grandson, referred to as PHILOSTRATUS the Younger,

wrote a second set of *Imagines* on the same model about A.D. 300. The *Imagines* are literary descriptions of particular paintings developed into a rhetorical genre. In his Introduction the elder Philostratus states that unlike previous writers on painting his interest lies not in historical details about artists but in the paintings themselves, which he describes for the young 'that by this means they may learn to interpret paintings and to appreciate what is esteemed in them'. There is a tendency to describe paintings as if they were literary art and the writers do not confine themselves to what is actually depicted in the picture but in common with the fashion of the time range freely over into elements of the narrative which are suggested by but lie outside the actual picture. The excellence of a picture is assessed, particularly by the elder Philostratus, in terms of its ILLUSIONISTIC REALISM and the sentiment expressed in the story or scenes depicted, the effective delineation of character, the emotion expressed, and the pathos of the situation represented. The younger Philostratus gives in his Introduction a succinct theory of pictorial art which may be taken as representing the view current in his day. He states that it is the function of painting to depict the character and the state of mind of the persons represented, by illusionistic realism to bring about the delightful and innocent deception whereby men are induced to confront objects which do not exist as though they existed, to make proper use of the laws of symmetry and the balance of parts laid down by men of old, and to present visually what poets through words present to the eye of the imagination. He himself sets most emphasis on the delineation of character and dramatic suggestion of the thoughts, feelings, and intentions of the persons depicted.

The *Imagines* were admired and translated by GOETHE, who in 1818 published an essay entitled *Philostrats Gemälde*.

**PHIZ.** See BROWNE, Hablot Knight.

**PHOENICIAN ART.** The Phoenicians, a gifted Semitic people, were established chiefly along the coasts of what is now the state of Lebanon, where they had their home from at least 2000, perhaps from 5000 B.C. Their origins are very obscure, but they were apparently racially more or less identical with the Canaanite population of adjacent Palestine.

The excavations of Byblos, according to some the oldest stratified site of a Phoenician city, indicate the arrival of a new population at about 3000 B.C. which continued without great interruption till 2100 B.C., a time of Amorite invasions. The new population must certainly have been the Phoenicians. Indeed Herodotus quotes a tradition of the Persians that the Phoenicians were a people who had immigrated by an overland trek past the Dead Sea to the Levant coast from the Persian Gulf. In any case the newly established Phoenicians, protected from

their enemies at their rear by the mountain ranges of Lebanon and Anti-Lebanon, with their chief port at Byblos (Gebal of 1 Kings v. 32, modern Jbail), from the beginning made the sea their livelihood and developed an important carrying trade, especially with Egypt. Phoenicia stood under Egypt's suzerainty. In the 2nd millennium Sidon ranked as the principal Phoenician city. By the 18th Dynasty (c. 1400 B.C.) Phoenician craftsmen were settled in Egypt itself in the Delta and made or imported Phoenician and Syrian works of art which noticeably influenced some of Egypt; while EGYPTIAN wares of all kinds flowed into Phoenicia, particularly through Byblos. At the same time Mycenaean goods from Greece (see MINOAN and MYCENAEAN ART) were exchanged through the northerly Phoenician colony of Ugarit (modern Ras Shamra, near Latakia). From their Egyptian neighbours the Phoenicians took over into their art a 'top-dressing' of Egyptian forms and symbols, which they seem often to have misunderstood or misapplied; they mingled these with many Mycenaean and many Asiatic motifs, but used them in a new way to illustrate their own native ICONOGRAPHY and their own religious or magical ideas. Thus Phoenician gods appear in a mixture of Egyptian and Syrian dress. This capacity for assimilation and adaptation was an asset in material fields. Thanks to the skill and industry of their merchants the riches of the kings of Phoenicia rapidly grew. Their commercial talent was greatly aided by the epoch-making invention (probably in the 15th c. B.C.) of the alphabet —whether this was a Phoenician invention or that of a neighbouring Semitic people, possibly in Canaan, is not quite clear; but it was one which they made their own. The alphabet vastly simplified the mystery of writing, which it took out of the hands of the priests and professional scribes and put into those of ordinary laymen and merchants. In the disastrous invasion of the 'Land Raiders' and 'Sea Peoples', who included the Philistines, c. 1190 B.C. Sidon was sacked and refounded with colonists from Tyre. When the civilization of the Bronze Age gradually slumped and collapsed c. 1100 B.C., and Babylon and Egypt withdrew into isolation, the Phoenicians established themselves as the main channel through which intercourse was revived between the nations of the newly shaping eastern Mediterranean and their neighbours. It is a measure of their importance that they were employed to build for King Solomon the great temple and palace at Jerusalem described with such detail in 1 Kings v, vi, and Palestinian art bears a deep Phoenician imprint as can be seen in the IVORY work and much metal-work found in Palestine. Phoenicians supplied luxury goods (either originals or copies) and raw materials of the Near East to Greece and Italy, to the rapidly awakening Western markets. In the late 8th-7th centuries B.C. they stimulated Greek and ETRUSCAN artists to such a pitch of imitation of those imports that the contemporary phase of

GREEK ART is called the Orientalizing period. Their Greek trade is described in the poems of Homer. They joined with Solomon in the dispatch of merchant fleets to India (Ophir; see 1 Kings ix. 26–28).

Indications of Phoenician export trade can be easily found in western Iran and the degree of their wealth by the 6th c. B.C. is pictured in Ezekiel's poetic lament for Tyre (Ezek. xxvii).

Excavations in the homeland of the Phoenicians have been mainly at the site of Byblos. But examples of their art have been best supplied by finds in the countries to which the Phoenician traders brought their exports. Such finds have been made in Etruria, Spain, Greece, and Egypt and their colonies. In the Iron Age we find their art at several sites in Cyprus, particularly where they founded cities. In the western colonies such as Ibiza in the Balearics, Malta, Tharros, Sulcis or Nora in Sardinia, and sites in Sicily such as Motya, or in north Africa at Utica in the neighbourhood of Carthage. Gold jewellery, FAIENCE and glass beads, figurines, glass and alabaster bottles, ivory boxes, furniture, and bronze bowls and weapons are amongst their exports which have been found in excavations. Certainly they must have brought raw materials too, such as ivory or cloth. To their industry in dyeing cloth with the famous blue or purple colour masses of crushed murex shells from which the dye was made bear witness at Sidon and many other Phoenician sites.

But this art of the Phoenicians, however decorative, skilful, and resourceful or playfully arresting, is rarely on the same plane as the best art of Babylon or Egypt. A piece of ivory carving found in Assyria at Nimrud in 1952 illustrating a lion devouring a Negro in a thicket, inlaid with coloured stones and glass, is of exceptional quality. In general their art was derivative, lacking in real vigour though it often expressed its own ideas through a medium borrowed from others. The Phoenicians were the great middlemen of the ancient world, and were eventually surpassed in everything by their all-too-gifted pupils, the Greeks.

154, 788, 913, 1248.

**PHOTOGRAPHY AND ART.** Though it had been practised earlier, photography was introduced to the world in 1839. Its significance for art was immediately recognized. On one hand it could supply artists with 'sketches' from nature of a fidelity hitherto unknown. On the other it threatened to render obsolete those artists whose sole function was to reproduce the literal appearances of the physical world. Not only did photographs provide a vast amount of visual information but in their peculiarities of form imaginative artists discovered new means of representation. In painting and drawing the greater authenticity of TOPOGRAPHICAL views and popular GENRE themes set in the Near East can be attributed to the influence of photography. The use of blurred forms by COROT and DAUBIGNY to effect the appearance of movement in LANDSCAPE forms and later, in the paintings of the IMPRESSIONISTS, to impart a sense of motion to pedestrian figures very likely originates in certain idiosyncrasies of the camera image.

Portrait painters could now dispense with the many uncomfortable sittings previously required and, utilizing a few photographs, produce the necessary likenesses with much saving of time and trouble. But by the same token the art of portraiture was in danger of being superseded by the photograph. In fact the demise of MINIATURE painting and the diminishing importance of larger portraits on canvas was a direct result of the increased efficiency and productivity of the photographic camera and the greater preoccupation of the public with photographic accuracy.

Photographic 'Academies' or collections of nude studies were put out for the use of artists and students. The shift away from the IDEAL nude based on ANTIQUE prototypes to a more apparent NATURALISM is also attributable to the nonselective character of the lens. This can be seen in the work of DELACROIX and COURBET, both of whom employed photographic nudes. Delacroix, a charter member of the first photographic society in France (1851), positively advocated their use though he warned artists that photographs must be handled with great care. They were interpretations of nature, he wrote; they revealed her secrets: 'If a man of genius uses the Daguerreotype as it should be used, he will elevate [his art] to a height hitherto unknown.'

Photographers were not content to be designated merely factotums to art. Not only were many of them practising painters and sculptors as well, but their talents as artists were brought to bear in the manipulation of the camera. They conceived of their medium as an art. They held their own exhibitions, and they saw no reason why they should not enjoy all the advantages bestowed on the other arts. Though a small number of photographs had been shown earlier in official exhibitions of FINE ART in 1859 the French SALON contained a photographic section. Considering this an impertinence, probably, and reacting to the proliferation of photographic styles in French painting, Charles BAUDELAIRE called photography 'the mortal enemy of art' (Salon review of 1859). He attacked the public who look 'only for truth'. With typical irony he wrote: 'Since photography gives us every guarantee of exactitude that we could wish, then photography and Art are the same thing. . . . If photography is allowed to stand in for Art in some of its functions it will soon supplant or corrupt it completely. . . . It must return to its real task, which is to be the servant of the sciences and of the arts, but a very humble servant.'

Three years later a decision was announced by a French court in which photography was declared to be an art. This provoked a hostile response in the form of a petition on which the

name of INGRES headed an imposing list of artists. Never, they stated, could photography 'be compared with those works which are the fruits of intelligence and a study of Art'. Ingres and other academicians resented the obvious development towards a tonal style in painting. They blamed photography for the decline of 'good drawing', which was considered essential for the expression of all the 'noble' elements of art. 'I greatly fear', wrote Hippolyte Flandrin in 1863, 'that photography has dealt a death blow to Art.'

The phenomenal expansion of the photographic industry not only worried painters but made artistic photographers uneasy as well. The cost of a photograph was only a fraction of that for a painting and considerably below the price of a good engraving. According to calculations made in 1863 (*Photographic News*, 27 February), based on the sale of photographic materials, over 105 million photographs were produced the previous year in Great Britain alone. This economic factor and the greater ease with which photographs could be made by even the least experienced should be considered in estimating the chain of consequences from the more 'artful' use of photography to the ascendancy of POST-IMPRESSIONISM.

As early as 1842 a writer in *The Spectator* said: 'The artist cannot compete with the minute accuracy . . . of the Daguerreotype but . . . not all the delicate truth of photographic delineation can supply the want of colour. By imitating the local colour and atmospheric effect alone can landscape painters hope to stand against such a formidable rival as Nature. [Artists should also] strive to imitate the appearance of movement in figures and foliage, water and clouds.' Advice of that kind was frequently offered. Yet in 1863, the year of the famous Salon des Refusés, some of the earliest examples of natural colour photographs (though impermanent) were exhibited in the same building. From the 1860s artists and critics became sensitive to the imminence of colour photography. The apparent dichotomy in Impressionist painting between its photographic accuracy of tone and its more arbitrary colour and brush-work may well have reflected the general artistic dilemma resulting from the progress of photography.

From about 1860 large quantities of 'snapshot' photographs were produced, usually in stereoscopic form. Their inevitable peculiarities of composition were undoubtedly exploited by DEGAS in the formulation of his characteristic style. With the appearance in 1878 of Edward Muybridge's instantaneous photographs a previously unknown universe was brought to light. In these sequential views every intermediate phase of human and animal locomotion was clearly defined. They demonstrated the inaccuracies of conventional representations and deficiencies of human vision. Many artists, battle painters particularly, immediately subscribed to the revelations of the high-speed

camera. But others objected to them. Not what actually exists, they said, but only what can be seen to exist may, legitimately, become the subject of art.

In the 1880s important variations of Muybridge's consecutive series photographs were made by the artist Thomas EAKINS and the physiologist Etienne Jules Marey. These are generally known as chronophotographs, characterized by the superimposition of forms and often combining both blurred and instantaneous images. They showed more clearly the patterns of the movements themselves, and Marey's photographs were undoubtedly the source of Marcel DUCHAMP's *Nude Descending a Staircase* (1912) and some of the paintings and sculpture by the Italian FUTURISTS: BALLA, BOCCIONI, and SEVERINI.

The appearance in the 1880s of the Kodak camera and cinematography marks a turning-point in the visual arts. Not only painters but many photographers too were deliberately moving away from purely imitative towards more interpretative representations of the natural world. Photographers had never really been divorced from the prevailing currents in art and in many ways they matched the virtuosity of even the most imaginative painters. Despite the intrinsic limitations of their medium, photographers like Alfred Stieglitz, Edward Steichen, Robert Demachy, Paul Strand, and Edward Weston, among many others in the 20th as well as the 19th c., have demonstrated that photography too can be a creative art.

But the intrinsic power of the photographic image was recognized by many artists in the 20th c. By the use of actual photographs and by rendering their subjects in a highly photographic manner DADA and SURREALIST artists, Max ERNST in particular, gave a pictorial logic to the irrationality of disparate juxtapositions. In the photograms of Man Ray (1890-    ), Tristan Tzara, and Kurt SCHWITTERS, called pure Dada objects, the metamorphosis of real things was supported by the credibility of photographic CHIAROSCURO. Among BAUHAUS artists photography was brought into a closer relation with the other visual arts than had ever been possible before. The photomontages of MOHOLY-NAGY, Hannah Höch, and others revealed again the potential of the photographic form, even when that form was fragmented and used in different contexts.

1016, 2821.

**PIAZZETTA,** GIOVANNI BATTISTA (1683-1754). Italian painter. He was the son of a WOOD-CARVER and a feeling for sculptural form is always present in his pictures, emphasized by a strong play of light and shade. After preliminary training in Venice he worked under G. M. CRESPI in Bologna, where he was impressed by the early works of GUERCINO with their rich colours and dramatic story-telling.

He returned to Venice in 1711 and executed a number of commissions (*Glory of St. Dominic*, SS. Giovanni e Paolo, 1727). In the 1720s his style became more dramatic as a result of his interest in works done almost a century earlier by LISS, STROZZI, and FETI and many of his compositions follow closely after theirs. Piazzetta was a slow worker, and often painted the same subject several times with subtle modifications. He had a large family and produced numerous drawings and book illustrations to earn money, though he was not without wealthy patrons, such as ALGAROTTI, Tessin, and the English impresario Owen McSwiny. His illustrations for Albrizzi's 1745 edition of Tasso's *Gerusalemme Liberata* were outstanding in their day. His nudes drawn in CHARCOAL heightened with touches of CHALK were in considerable demand.

Piazzetta's finest and most mature work comes from the period 1740–50, which in tonality and the softened use of contrasts anticipated and to some extent influenced 18th-c. painting in Venice. Examples are *The Fortune-Teller* (Accademia, Venice) and *The Standard-Bearer* (Dresden). He was made Director of the Venice Academy of Fine Arts in 1750 but in his last years was eclipsed by the new generation.

The young Giovanni Battista TIEPOLO was a pupil of Piazzetta and worked with him on an ALTARPIECE for Sta Maria del Rosario del Gesuati. Piazzetta's drawings, particularly the drawings of heads, had an influence on Richard WILSON and did something to establish a style and the engravings of his paintings by Pietro Monaco (c. 1707–c. 1775) were widely disseminated.

**PICABIA,** FRANCIS (1879–1953). Artist born in Paris of Cuban Spanish extraction. After painting in an IMPRESSIONIST manner he came under the influence of CUBISM in 1909 and in 1911 was one of the group which founded the *Section d'Or* (see ORPHISM and GOLDEN SECTION). He visited the U.S.A. and exhibited in the ARMORY SHOW in 1913. In New York again in 1915 he collaborated with Marcel DUCHAMP and contributed to the magazine *291*. Anarchistic, subversive, and highly individualistic by temperament he was one of the most active and original members of the DADAIST movement both in Europe and in the U.S.A. At Barcelona in 1916 he founded the Dadaist periodical *391* which continued to appear irregularly until 1924. He was associated with the Dadaist group of Tristan Tzara and Jean ARP in Zürich, returned to Paris in 1919 and for a time associated with the SURREALISTS. Without himself remaining for long within the confines of any one school or movement, Picabia had a great influence on many artists and helped to inspire many different trends in contemporary art. In the anthology *Dada Painters and Poets*, edited by Robert MOTHERWELL (1951), his wife Gabrielle Buffet

said of Picabia: 'It must be stressed in any case that his activity was utterly gratuitous and spontaneous, that it never had any programme, method, or articles of faith.' Picabia himself published *Poèmes et dessins de la fille née sans mère* (1918).

2081, 2388.

**PICASSO,** PABLO (1881–1973). Spanish artist and leader of the École de PARIS, son of José Ruiz Blasco, a drawing-master of Malaga, and María Picasso. Until 1898 Picasso always included his father's name, Ruiz, as well as his mother's when signing his pictures, but from c. 1900 he dropped the name Ruiz from his signature.

Picasso's personality dominated the development of the visual arts during most of the first half of the 20th c. His versatility, technical brilliance, and imaginative depth have not been surpassed in this or probably in any other age, and he provided the incentive for most of the revolutionary changes during the half century. His superb draughtsmanship, visual originality, and power of construction have come to be universally admitted. While he was supreme master of the CLASSICAL tradition, his most important influence during his lifetime has been to strengthen the conception of art as an emotional medium and to swing the emphasis of taste towards dynamic power and vitality rather than formal or abstract perfection.

Picasso painted at Corunna (1891–5) and then mainly at Barcelona (1895–1904). He visited Paris first in 1900 and alternated between Paris and Barcelona until 1904. His precocious talent matured unusually early and some of his work done before the age of 14 reveals the qualities of a master (*Girl with Bare Feet*, 1895). On his first introduction to the artistic milieu of Paris he was influenced by the drawings of Théophile-Alexandre Steinlen (1859–1923) and TOULOUSE-LAUTREC (*Le Moulin de la Galette*, Thannhäuser Coll., New York, 1900). But his work during the years 1901 to 1904, known as his Blue Period, in the main combined an interest in plastic representational form with emotional subject matter in the Spanish tradition and showed little concern for the atmospheric effects of IMPRESSIONISM. His subjects were mainly drawn from poverty and the social outcasts and the predominant mood was one of slightly sentimentalized melancholy. His paintings were dominated by cold ethereal blue tones (*La Vie*, Cleveland Mus. of Art, 1903; *Child Holding a Dove*, Courtauld Coll., London). He also did a number of extraordinarily powerful engravings in a similar vein (*Célestine*, 1903; *Le Vieux Guitariste*, 1903; *The Frugal Repast*, 1904).

In 1904 Picasso took a studio in the Bateau-Lavoir and became the centre of an *avant-garde* circle which included Max Jacob, Guillaume APOLLINAIRE, André Salmon, Marie Laurençin. He had begun to attract the notice of CONNOIS-

SEURS such as the Russian Shukin and Leo and Gertrude Stein, and *c.* 1907 he was taken up by the dealer Kahnweiler. The two or three years from 1905 are known as his Rose Period. The predominant blue tones of his earlier work gave way to pinks and greys and the mood became less austere. His favourite subjects were acrobats and dancers, particularly the figure of the harlequin. During these years he produced his first sculptures and some of his painted nudes took on a sculptural solidity which foreshadowed the majestic nudes of the early 1920s. In 1906 he met MATISSE, but although he seems to have admired the work being done by the FAUVES, he did not himself follow their method in the decorative and expressive use of colour. During the years 1907 to 1909, called his Negro Period, he pursued an independent path, concentrating on the analysis and simplification of form and taking his direction from his studies of CÉZANNE and Negro sculpture. The researches of these years culminated in the painting later named by André Salmon *Les Demoiselles d'Avignon* (Mus. of Modern Art, New York, 1906-7), which in its treatment of form was as violent a revolt against traditional Impressionism as the paintings of the Fauves in the realm of colour. At the time the picture was incomprehensible to artists, including Matisse and DERAIN, and it was not publicly exhibited until 1937. It is now seen by art critics not only as a crucial achievement in Picasso's personal development but as the most important single landmark in the development of contemporary painting and as the herald of CUBISM.

During the years 1910 to 1916 Picasso worked in close association with BRAQUE and later with Juan GRIS for the development of Cubism, first Analytical Cubism and from *c.* 1912 Synthetic Cubism, introducing incidentally such techniques as COLLAGE, *papier collé*, and the incorporation of real elements into the structure of a picture. Cubism represents the most rigorous exploration of a conceptual art at the opposite pole both from ROMANTIC emotionalism and from Impressionist techniques aiming at an exact reproduction of the visual image. Although the austerity of the restrictions which were imposed during the first formative years was not maintained, Picasso himself never ceased to explore further the discoveries which were made and Cubism has been rightly regarded as the most widely influential AESTHETIC movement of the 20th c. One of its most important results was to establish firmly the idea that the work of art exists as an object in its own right and not merely as an image or reflection of a reality outside itself.

In 1917 Picasso went with Jean Cocteau to Rome to design costumes and scenery for the ballet *Parade* and during the next few years after his return to Paris he was painting further pictures in an obviously Cubist manner and also monumental, classical nudes (*Three Musicians*, Mus. of Modern Art, New York, 1921; *Two Seated Women*, Mus. of Modern Art, New York,

1920). Picasso was hailed by André BRETON as one of the initiators of SURREALISM (*Le Surréalisme et la Peinture*, 1928). His works were shown in Surrealist exhibitions, illustrated in the Surrealist periodical *Minotaure*, etc. But his predominant interest in the analysis and synthesis of forms and his conviction that painting should be conceptual rather than purely visual were at bottom opposed to the irrationalist elements of Surrealism, their exaltation of chance, and equally to the direct realistic reproduction of dream or subconscious material. From the latter part of the 1920s, however, Picasso's work became increasingly fraught with a new and mounting emotional tenseness, a mood of foreboding and an almost clinical preoccupation with anguish and despair. He was concerned with the mythological image of the Minotaur and the images of the Dying Horse and the Weeping Woman. It was a period which culminated in his second pivotal painting *Guernica* (the first being *Les Demoiselles d'Avignon*), produced for the Spanish Pavilion at the Paris Exposition Universelle of 1937 to express universal horror and indignation at the destruction by bombing of the Basque capital Guernica. It was followed by a number of other great paintings, from *Night Fishing at Antibes* (Mus. of Modern Art, New York, 1939) to *The Charnel House* (Chrysler Coll., 1945), expressing his horror at the cruelty and destructiveness of war. In treating such themes Picasso universalized the emotional content by an elaboration of the techniques of expression which had been developed through his researches into Cubism.

After the Second World War Picasso settled first at Antibes (1946) and then at Vallauris, where he added POTTERY to his many activities. In 1955 he moved to Cannes and in 1958 bought the Château de Vauvenargues. His painting remained vigorous, varied, and continuously inventive of new modes for the solution of new problems. Particularly interesting were a series of 15 variations on *Les Femmes d'Alger* by DELACROIX (1954-5) and 58 paintings done in 1957, of which 44 were variations on *Las Meninas* of VELAZQUEZ, which Picasso had seen at the age of 15, and the remainder views over the bay from the window of his studio.

Picasso's output has been more splendid than that of any contemporary artist and divisions into periods are to some extent arbitrary since he was at all times working on a wealth of themes and in a variety of styles. As few other artists, he had the power to concentrate the impress of his genius even in the smallest and slightest of his works.

100, 172, 250, 314, 325, 550, 681, 775, 776, 812, 1039, 1371, 1568, 1570, 2187, 2250, 2266, 2366, 2550, 2719, 2742.

**PICTURESQUE, THE.** Today the word 'picturesque' means vivid, charming, quaint, colourful, striking in an undramatic way, but has no clear descriptive content and calls up no

precise image. In the 18th c. it was introduced as a substantive and had generally accepted pictorial connotations. An attempt was made to establish it as an AESTHETIC category alongside 'beauty' and 'SUBLIMITY' and it came to represent the standard of taste, mainly concerned with LAND-SCAPE, which gained general acceptance in the second half of the century. In 1801 the *Supplement* to Johnson's *Dictionary* by George Mason defined the word as: 'what pleases the eye; remarkable for singularity; striking the imagination with the force of painting; to be expressed in painting; affording a good subject for a landscape; proper to take a landscape from.' In his *Picturesque Antiquities of the English Cities* of 1830 John Britton said: 'It has not only become popular in English literature, but as definite and descriptive as the terms grand, beautiful, sublime, romantic and other similar adjectives . . . about scenery and buildings it is a term of essential and paramount import.'

Etymologically there is some reason to think that the Dutch 'schilderachtig' (worthy of a picture) may have preceded the Italian 'pittoresco' and the French 'pittoresque'. The word came into use in English in the last decades of the 17th c. for bold and vivid manner of execution in painting. When applied to literary style it meant 'vivid' or 'graphic'. It was used in this sense by Steele as early as 1705 and by Pope. As

an aesthetic concept of taste as applied to painting or landscape it looks back both to the 'classical picturesque' style exemplified for the 18th c. chiefly by the works of CLAUDE Lorraine and Gaspar POUSSIN and also to the Romantic picturesque which derived from ELSHEIMER through Salvator ROSA. The concept could either apply to natural scenery which seemed to possess the features most suitable for paintings of the sort which were admired or to painting. And in the latter case it might mean either composition (with an implied reference to the classical picturesque) or it could mean roughness, irregularity, and a quality of *non finito* or spontaneity of the sort which anticipated the ROMANTIC taste of the following century. A study of the changes and ambiguities and inconsistencies in the concept of the picturesque constitutes a history in itself of developing taste in the 18th c. and of the momentous transition from NEO-CLASSICAL regularity to Romantic emphasis on the characteristic, the imaginative, and the moving.

The apostle of the picturesque in the sphere of taste was the amateur artist and writer William GILPIN. The qualities which Gilpin regarded as picturesque constituted a mixture of personal preferences and aesthetic qualities: 'roughness or ruggedness of texture, singularity, variety and irregularity, CHIAROSCURO, and the power to stimulate imagination.' He also spoke of the

**260A.** Severely Palladian house set in a close mown lawn with a serpentine approach and Chinese bridges, every feature hard and distinct

**260B.** Tudor Gothic house landscaped in the picturesque manner; the artificial wilderness, rough foreground, rustic bridge, illustrate the picturesque ideal of the 'beauteous whole'. Engravings by Thomas Hearne from *The Landscape* (1794), Richard Payne Knight

necessity for the artist to supply 'COMPOSITION' to the raw material of nature in order to produce a harmonious design. There is evident throughout his writings an increased emphasis on the visual qualities of nature, which had been to some extent anticipated in such works as Thomson's *Seasons* and which also found expression in GAINSBOROUGH's so-called Impressionism and in certain developments of landscape gardening.

But although Gilpin eminently expresses the diversities of picturesque taste which he did so much to develop, he was not a systematic thinker. On the one hand he tried to set up the picturesque as a category alongside beauty and sublimity; on the other hand he saw no incongruity in the ambiguous phrase 'picturesque beauty' and found no better theoretical ·definition for the picturesque than 'expressive of that peculiar kind of beauty, which is agreeable in a picture'.

The theoretical development of the picturesque doctrine came rather from Uvedale PRICE and Richard Payne KNIGHT after the picturesque ideal in taste had caught the popular imagination. Uvedale Price, in his *Essay on the Picturesque* (1794-8), sought primarily to discredit 'Capability' BROWN's system of landscape improvement which, he claimed, destroyed the essentially visual values that he designated 'the picturesque' in English scenery. In Price's analysis, at once broader and more technical than Gilpin's, the

picturesque comprised all qualities in nature and art appreciated through study of 'modern painting', i.e. painting since TITIAN, rather than through academic precept. In the manner of BURKE, he conceived the picturesque to consist of physical qualities affecting the observer's sensibilities. Objects characterized by 'intricacy', 'irregularity', 'roughness', and analogous colouring produced a reaction in the observer definable as 'curiosity', and, he showed, they also evoked the most forcible effects from these landscape painters whose broad merging or 'connection' of them in sensuous tonality constituted essentially picturesque vision. So regarded, much previously ignored as ugly could be enjoyed as picturesque. Price's aesthetic inspired much architecture of the early 19th c., that of John NASH particularly. Humphrey REPTON disputed its application to landscape gardening but largely demonstrated it in his work. Payne Knight's poem *The Landscape* (1794) had foreshadowed Price's *Essay*, but in his mature *Analytical Inquiry into the Principles of Taste* (1805) he set out to demolish its objective basis. So-called 'picturesque beauty', he argued, consists in (i) those effects of refracted lights which painting has revealed by separating them from other kinds of beauty—a definition anticipating the Impressionism of CONSTABLE and TURNER; (ii) objects rendered significant through

associations with paintings—the definition promulgated to the 19th c. by Archibald ALISON. Though ridiculed by RUSKIN in the sixth of his *Seven Lamps of Architecture*, notable trends in later 19th-c. architecture and gardening, as well as in current planning, stem from the insistence on visual rather than literary values which was one of the chief features of the Picturesque movement.

1331, 1394, 1511, 2147.

**PIECE-MOULD.** See PLASTER CASTS.

**PIENEMAN,** JAN WILLEM (1779–1853). Dutch painter of historical pieces and portraits. His reputation and fortune were established by his painting of *The Battle of Waterloo* (Rijksmuseum), which has greater historical interest than artistic merit. Like so many of his Dutch contemporaries he was at his best when painting unpretentious portraits.

**PIER.** Architectural term for a support of solid masonry, usually square or compound in section, between door, window, or other openings. Piers are essentially part of the carrying structure of a building but may be decoratively overlaid with PILASTERS, half-columns, etc. A 'fasciculate pier' is a pier made up of numerous attached colonnettes or small COLUMNS. An 'angle pier' is an L-shaped pier used to turn the corner of a rectangular building.

**PIERCE** (PEARCE), EDWARD (c. 1635–95). English sculptor and mason, son of a painter of the same name. Little is known of his youth, but by 1671 he was well established in London and was much employed by WREN on the rebuilding of the City churches, both as a mason and as a stone-carver, particularly at St. Lawrence Jewry and St. Clement Danes. His best work, however, is as a sculptor of portrait BUSTS, the most notable being the splendid BAROQUE bust of Sir Christopher Wren (Ashmolean Mus., Oxford, c. 1673), which shows Wren as the man of genius. The marble bust of Cromwell, also in the Ashmolean, is another fine work, though it was probably not made from the life. Pierce also had some ability as an architect, the Bishop's Palace, Lichfield (1686–7), being his chief known work.

2113.

**PIERO DELLA FRANCESCA** (PIERO DEI FRANCESCHI) (c. 1410/20–1492). Italian painter, who worked outside Florence for the whole of his career as an independent artist. We hear of him at various times in Borgo San Sepolcro (his home town), Ferrara, Rimini, Arezzo, Rome, and Urbino. But he found the origins of his style in Florence, and we may take it as certain that he lived there as a young man for some time during the 1430s, although the surviving documents only record that he was 'with' DOMENICO VENEZIANO (then working in S. Egidio) in 1439. His POLYPTYCH of the *Madonna della Misericordia*, commissioned for Borgo San Sepolcro in 1445 but not completed until much later, shows that he had studied and absorbed the great artistic discoveries of his FLORENTINE predecessors and contemporaries—MASACCIO, DONATELLO, Domenico Veneziano, Fra Filippo LIPPI, UCCELLO, and even MASOLINO, who anticipated something of Piero's use of broad masses of colour. Piero unified, completed, and refined upon the discoveries these artists had made in the previous 20 years.

Piero's figures are solid, round, and measured, like the columns of BRUNELLESCHI's architecture: the group in the foreground of the *Flagellation* at Urbino (c. 1456/7) seems like an extension of the loggia behind. The corresponding figures in the earlier *Baptism* (N.G., London) are on the other hand extensions of nature: they seem to draw strength from the soil like the tree. Yet these two paintings do not betray a division of purpose: Piero was one of the rarest of artists in finding a synthesis of the artificial and the natural, the sophisticated and the rustic. When he came to paint the FRESCOES of the *Legend of the Holy Cross* in the choir of S. Francesco at Arezzo (c. 1455–c. 1465), no adjustment of style was necessary to portray both the peasants surrounding the dying Adam in the lunette and the ritual reception of the Queen of Sheba below, or the solemn, graceful figure of the empress Helena identifying the Sacred Wood opposite. The world of Piero's artistic imagination was not bloodless, yet it was pre-eminently a world which had clarity, dignity, and order. The synthesis was achieved partly by an extraordinary precision in the drawing of outlines, partly by subtlety in the use of light. The outlines of Piero's figures tend towards the grace and regularity of curves in geometry. But geometry was not only used to create a pattern on the surface of the picture: geometry was the foundation of PERSPECTIVE (on which Piero wrote a treatise in his later years), and perspective was the means of defining space in three dimensions. Piero's lucid intelligence was complemented by a unique feeling for the cool, crystalline daylight which envelops the Tuscan landscape. The backgrounds to his portraits of the Duke and Duchess of Urbino in the Uffizi (1465?), and both his ALTARPIECES in the National Gallery, London—the *Baptism* (c. 1442) and the *Nativity* (c. 1472)—in their different ways are beautiful examples of this.

For a long time forgotten, Piero was 'rediscovered' by modern art historians and has been regarded in 20th-c. criticism as perhaps the greatest of quattrocento painters.

270, 564, 1684.

**PIERO DI COSIMO** (c. 1462–1521?). Italian painter of the FLORENTINE SCHOOL, a pupil of Cosimo ROSSELLI. His pictures are of two kinds: more or less conventional religious works influenced by his master, by SIGNORELLI and, after 1500, by LEONARDO; and MYTHOLOGICAL fantasies which are highly individual and sometimes even bizarre.

The latter have one quality in common—a preoccupation with primitive modes of life, that accords well with what VASARI tells us of the artist's unconventional character and Bohemian outlook. The *Discovery of Honey* (Worcester, Mass.) and the *Discovery of Wine* (Fogg Mus., Mass.) are fanciful mythological inventions in the spirit of low comedy. But Piero di Cosimo somehow conjured up a vision of prehistoric life which looks disturbingly plausible. His *Hunting Scene* in the Metropolitan Museum, New York, has nothing to do with a Golden Age: it is a struggle for survival between man, satyrs, and beasts, with the distinctions not altogether clear between them. Yet a rather similar picture in the National Gallery, London, *The Battle of the Lapiths and Centaurs*, contains a scene of the utmost pathos and tenderness, and the whole of the so-called *Death of Procris* (N.G., London) is similar in sentiment. His portraits have a strangely compelling power, e.g. *Giuliano Sangallo* (Rijksmuseum), *Simonetta Vespucci* (Musée Condé, Chantilly).

124, 761.

**PIETÀ.** See VIRGIN.

**PIETRE DURE** (Italian: 'hard stones'). A term applied to a particular kind of MOSAIC work in which coloured stones, such as lapis lazuli, agate, and PORPHYRY, are used to imitate as far as possible the effect of painting. The main centre of the art was Florence, where in 1588 the Grand Duke Ferdinand established a factory in the UFFIZI which continued to work well into the 19th c. The productions of the workshop consisted mainly of table-tops and panels for cabinets, decorated with birds and flowers or landscapes which were executed with a NATURALISM and polychromatic brilliance that made them celebrated all over Europe. A cabinet designed by Robert ADAM in the Victoria and Albert Museum is inset with landscapes signed by Baccio Cappelli, one of the Uffizi workmen active between 1621 and 1670.

**PIETRO D'ANGELO**, JACOPO DI. See QUERCIA, Jacopo della.

**PIGALLE,** JEAN-BAPTISTE (1714–85). French sculptor, pupil of LEMOYNE, contemporary and rival of FALCONET. He oscillated between GENRE pieces and the GRAND MANNER. Under the influence of Mme de Pompadour, to whom he devoted such allegories as *L'Amitié* (Louvre, 1758), he produced a number of graceful and sentimental studies of nymphs, babies, etc. His MONUMENT of the comte d'Harcourt (Notre-Dame, 1776) combines BAROQUE grandeur with classical elegance. He broke new ground with his nude statue of Voltaire (Palais de l'Institut, Paris, 1776), and his conception of *Le Citoyen*, part of a monument to Louis XV at Reims, and he was responsible for one of the most spectacular TOMBS of the period, that of the maréchal de Saxe (St. Thomas, Strasbourg, 1753–6).

**PIGMENT.** A pigment is a colouring substance which, finely ground and held in suspension in a MEDIUM, constitutes a PAINT. A painter's COLOURS must ordinarily have BODY so that they can be manipulated and applied to the GROUND. They are distinguished in this way from purely visual colours. Some colours, as for example the earth colours, have body of themselves and can be ground directly into a medium. Others, like some metallic and coal-tar colours, have no body but are like INKS or stains or dyes. These are sometimes dissolved in a medium and used to stain the surface of a ground; but more usually they are precipitated on to some inert substance (wax or hydrate of alumina is often used) which acts as a substratum and forms an insoluble compound that can be ground up and incorporated into the medium. Many well known colours such as crimson lake, rose madder, cadmium yellow, ultramarine, cobalt, cadmium are treated in this way.

The optical qualities of pigments, that is their hue and their brightness, depend on the amount and range of light which they absorb and the amount which they reflect. The size and shape of the grains into which a pigment is ground are among the factors determining its optical properties, so that if for example some pigments are ground too fine they lose their colour because too little light is reflected. When two pigments are mixed both absorb and only such light is reflected as is common to both, so that the brightness is reduced (subtractive mixture). The IMPRESSIONIST technique was to juxtapose pigments on the ground so that optical, or additive, mixture occurs as with the mixture of coloured lights. (See COLOUR.)

The physical qualities required of a pigment are stability and inertness. A pigment is stable in so far as it does not change or disintegrate under the influences of light, moisture, impurities in the atmosphere, and other ordinary hazards. It is said to be inert to the extent that it does not suffer chemical changes in contact with other substances. It should not, for instance, dissolve in the medium or interact with other pigments with which it may be used. Finally the pigment should solidify and should not change volume or crack. (Defects of this sort, for example in BITUMEN, have caused damage to pictures.)

Apart from colour, pigments are classified in various ways for various purposes and these classifications overlap. On the basis of chemical composition pigments are divided into 'organic' and 'inorganic'. Organic pigments may be of plant or animal origin, such as the purple of the Greeks and Romans (a dye from the murex or purpura), sepia (from the cuttle fish), carmine (from the cochineal), indigo, gamboge, and the coal-tar dyes; or they may be manufactured or synthetized. A large number of new vegetable colours were added during the Middle Ages, when they were used for ILLUMINATION. Inorganic pigments are also found often in the

natural state, such as many earth colours and oxides and sulphides of metals, and are also manufactured artificially. The chemical composition of pigments has a bearing on their permanence and pigments of natural origin tend in general to be less pure than those which are manufactured chemically. The history of pigments is a highly specialized field with little practical importance today for artists who use commercial paints but often vitally important to the expert in relation to authentication and attribution.

**261.** View of the east end apse of the abbey church of Cluny, from an 18th-c. chalk drawing. The apse is surrounded by an ambulatory with radiating chapels

**PILASTER.** Decorative representation in RE-LIEF of a COLUMN against the surface of a wall. The function of pilasters is ornamental but they may be the visible portion of a PIER built into the wall or they may serve, as 'responds', to thicken the wall where it supports a VAULT.

**PILGRIMAGE CHURCHES.** The shrine of St. James the Greater at Santiago de Compostela in north-west Spain attracted a local pilgrimage as early as 844, which acquired an international character before the end of the century. In the second half of the 11th c. it had become one of the most popular centres of pilgrimage in Europe and was fostered by the monastic Orders, including the monks of CLUNY, who joined in making provision for the pilgrims along the main routes of travel. The pilgrimage roads were the main routes of communication and passed through many important local shrines, such as those of S. Martin at Tours on the Paris-Bordeaux road, S. Martial at Limoges on the Vézelay-Périgueux road, S. Foy at Conques on the Le Puy-Moissac road, S. Sernin at Toulouse on the Arles-Jaca road. The churches, all of which were built or rebuilt during the 11th c., displayed common architectural features distinct from the regional styles and had an international or inter-regional character known as the 'Pilgrimage type'. They were on a grand scale, the finest being that of Santiago itself, spacious with long nave and wide transept, strongly built of fireproof construction, and richly decorated with RELIEF sculpture. With them can be associated the churches of S. Étienne at Nevers, and Cluny itself. Tours, Limoges, and Cluny have more or less completely disappeared, but Conques, Nevers, Toulouse, and Compostela, in spite of alterations and restorations, are still standing. The Pilgrimage churches were distinguished by three features: APSES surrounded by an AMBULATORY with radiating chapels; tribunes, or galleries above the aisles, opening into the nave or choir; and ribbed barrel-VAULTS over their naves. None of these features was unique, but they were combined to produce a highly original type of church, peculiarly suited to meet the demands made by the crowds of pilgrims. The origin of the type is not known. St. Martin at Tours has often been put forward as the first of the series, but the formula may have been derived from the large monastic churches further east, in Burgundy and Champagne. For all their common features Pilgrimage churches were not standardized but differed within the general pattern. Toulouse, and later Tours, had double aisles which, in the absence of a CLERESTORY, made the interior lighting very indirect. Nevers on the other hand had a clerestory between the tribunes and the vaults, and this plan was followed at Cluny. Toulouse and Compostela are extremely long churches; Conques is short. But Conques, although small, was perhaps the first western church to make a deliberate attempt to exploit the aesthetic effects of great height, effects in which the wall-shafts and the ribs of the barrel-vaults play an important part as well as the high, narrow ARCADES. Generally the later churches in the series have much less undisturbed wall surfaces, but the effect never becomes GOTHIC. The structure remains passive and inert. A new factor in exterior design was introduced by the multiplication of chapels. These opened up new possibilities for the massing and organization of shapes, which culminated in the fully developed CHEVET of Toulouse, a wonderful ascending hierarchy of forms, grave and dignified, each element distinct yet related to the whole, like Pope Gregory's dream of medieval society itself. These churches are perhaps the most perfect expression of the religion, as they are the most complete realization of the architectural ambitions, of the 11th c. but they do not contain the seeds of future developments. The Gothic churches of the 12th and 13th centuries are indebted to other features of ROMANESQUE architecture rather than the Pilgrimage churches.

2133.

**PILLEMENT, JEAN BAPTISTE** (1727-1808). French painter and designer. As a painter of decorative LANDSCAPE his work was often derivative from that of BOUCHER. But he was an exquisite draughtsman and prints made from his drawings were popular throughout Europe, helping to spread the ROCOCO taste. They were published in England as well as France. He was particularly important in the spread of CHINOISERIE. As a painter he was one of the group of minor French artists who influenced the trend of 18th-c. painting in Portugal.

**PILO, CARL GUSTAF** (1711-93). Swedish portrait painter who migrated in 1740 to Copenhagen and there became the leading artist in his field. Unlike most of his compatriots he worked in a style which owed nothing to French influence. His formal portraits are strangely frozen, but his more private studies have warmth and charm. In 1772 Pilo returned to Sweden. His greatest work there was a huge canvas representing *The Coronation of Gustavus III* (unfinished, Nat. Mus., Stockholm, 1782), by far his most genial composition.

**PILON, GERMAIN** (1537-90). French sculptor, born in Paris and regarded as the successor to GOUJON. He was, however, an artist of a very different type from Goujon and his early manner was based rather on the decorative use of stucco by PRIMATICCIO, for whom he worked at the monument for the heart of Henry II, on the figure work and drapery of Domenico del Barbiere (1506-65/75) and the reliefs of BONTEMPS (*Three Graces*, Louvre, 1561-3). A development towards NATURALISM, with greater freedom of movement and feeling for the material, can be observed in the tomb of Henry II and Catherine

de Médicis (1563-70), particularly in the kneeling figures of the King and Queen and the GISANTS under the canopy. His later style is seen in groups executed during the 1580s for the Valois Chapel commissioned by Catherine de Médicis and for the Birague family. Notable among these works are *The Virgin of Pity* (Louvre), the *St. Francis* (church of S. Jean-S. François), and the bronze figure of René de Birague (Louvre). In this later period Pilon's debt to the school of MICHELANGELO is apparent. The emotional use of naturalism and the new freedom of modelling represent a transition from MANNERISM in the direction of the BAROQUE.

122.

**PILOTY, KARL** (1826-86). German painter. After training in Antwerp and Paris Piloty settled in Munich, where in 1856 he became professor and in 1874 Director of the Academy. He gave to the 19th-c. public the kind of sensational and gorgeous feast for the eye which had the same sort of novelty as Cinerama in its day. His enormous history paintings—usually of tragic incidents such as *The Death of Alexander the Great* and *Mary Stuart condemned to Death*—were based on meticulous historical research. Settings, furnishings, and costumes were reconstructed with great accuracy. Yet the pathos of these large machines is hollow and their tragedy never rings true.

**PINEAU, NICOLAS** (1684-1754). French sculptor and decorator, son of JEAN-BAP-TISTE PINEAU (d. 1694) who was employed as a carver at VERSAILLES and elsewhere from *c.* 1680. Nicolas went to Russia in 1716 with the architect Alexandre Le Blond and on the latter's death in 1719 was the leading French decorative artist at the court of the Czar. His masterpiece while in Russia was the carving of the Cabinet of Peter the Great in the Grand Palais at Peterhof. He left Russia *c.* 1727 and from *c.* 1732 became with MEISSONIER one of the leaders in the lighter style of ROCOCO decoration. He was associated with the architect Leroux in many works and his decorations for the Hôtel Rouillé (*c.* 1732), the Hôtel de Villars (1732-3), the Hôtel de Roquelaure (1733), etc., had considerable influence in popularizing the asymmetrical motifs of Rococo both in France and abroad.

**PINPRICKT PICTURES.** Lace-like designs pricked into paper with pins. For drawing lines and filling large areas, wheels with sharp points were used. Pinprickt pictures probably derive from the practice of pricking the outlines of a design in order to transfer it to the painting GROUND. Most examples appear to be English, of the 18th and early 19th centuries.

**PINTORICCHIO** (PINTURICCHIO) BER-NARDINO DI BETTO (*c.* 1454-1513). Italian painter of the UMBRIAN SCHOOL. He was trained

by Fiorenzo di Lorenzo (*c.* 1440-1522/5) in Perugia and secondly by PERUGINO, whom he possibly assisted in the execution of frescoes in the Sistine Chapel, Rome (1481/2). He was a very prolific artist, with a dangerous facility. His chief works are the frescoes in the lunettes of the Borgia rooms in the Vatican (1492/5) and the colourful *Scenes from the Life of Aeneas Sylvius Piccolomini* (i.e. Pius II) in the Piccolomini Library of Siena Cathedral (1503). The former are more interesting for the choice and arrangement of their subject matter than for their style. In addition to the usual *Scenes from the Life of Christ*, Pintoricchio painted some *Scenes from Egyptian Mythology*, and a series of allegorical frescoes with PERSONIFICATIONS of the LIBERAL ARTS. These, together with their decorative borders, interested RAPHAEL some six years later.

**PIPER, JOHN** (1903- ). English painter and decorative designer. After beginning a law career he began to study art in 1926 at the Richmond School of Art and then at the Royal College. From 1928 to 1933 he wrote as an art critic for the *Listener* and the *Nation*. In 1935 he became art editor to the *avant-garde* quarterly *Axis*, edited by Myfanwy Evans, whom he married in 1937. Piper's early paintings were ABSTRACT and almost always non-representational. Under the influence partly of the more poetic forms of SURREALISM he reverted in the later 1930s to a ROMANTIC NATURALISM. Reverting to his early interest in architecture, he painted TOPOGRAPHICAL fantasies of great houses in decay. He was a war artist and was commissioned to record the effects of the war on Britain. Piper's work diversified and achieved greater maturity during the 1950s. His work for the ballet *Job* at Covent Garden with music by Vaughan Williams led to many important commissions for stage designs at Glyndebourne and elsewhere. He did STAINED GLASS for Llandaff and Coventry Cathedrals and worked with Osbert Lancaster on the spectacular main vista of the Festival Gardens and designed a large decoration for the Homes and Gardens pavilion at the Festival of Britain. His easel pictures during this period took on something of the rich character of tapestries or theatre backcloths.

**PIRANESI, GIOVANNI BATTISTA** (1720-78). Italian etcher, archaeologist, and architect. Born near Venice, he settled in Rome in 1740. Although trained as an architect, he built only the church of Sta Maria del Priorato, Rome (1764-5). In his violently controversial *Della magnificenza ed architettura de' Romani* (1761) he maintained the superiority of ROMAN or ETRUSCAN architecture over the GREEK. His feeling for the poetry of RUINS and for Italian antiquities was expressed in his *Vedute*, 137 ETCHINGS of ancient and modern Rome published from 1745, which had a great vogue among British visitors to Rome and had an important

**262.** *Column of Trajan.* Etching by Giovanni Battista Piranesi from *Le Vedute di Roma* (1745). The church in the background is that of the Santissimo Nome di Maria, built in 1738

effect in shaping the ROMANTIC idea of Rome which for long prevailed. Walter Scott owned a complete set of the *Vedute*. His most original work was a series of *Carceri d'Invenzione*, fantastic imaginary prisons, begun *c.* 1745 and reworked in 1761. These striking and obsessive works were later claimed by the SURREALISTS as an anticipation of their principles. In his dramatic use of light and shade and his adaptation of PERSPECTIVE for romantic effects Piranesi stands out among the great masters of etching. His numerous other works include *Antichità romane*, 1756; *Diverse maniere di adornare i cammini*, 1769, designs for chimney-pieces; and *Vasi, candelabri*, 1768–78, a collection of decorative details.

887, 1325, 1808, 2637.

**PISANELLO,** properly ANTONIO PISANO (*c.* 1395–*c.* 1455). Italian painter who lived as a young man in Verona and may have been a pupil of STEFANO DA ZEVIO. He collaborated with GENTILE DA FABRIANO in frescoes for the Doge's Palace at Venice (1415–20) and later completed Gentile's frescoes at the Lateran Basilica, Rome (1431–2). From this time he was in great demand and was probably regarded as the successor to Gentile in the INTERNATIONAL GOTHIC style. Of his paintings only two frescoes and four or five panels have survived. The frescoes are *The Annunciation* (S. Fermo, Verona, 1423–4) and *St. George and the Princess of Trebizond* (Sta Anastasia, Verona, 1437–8). The smaller paintings include a portrait of Lionello d'Este (Bergamo, *c.* 1441) and one of a Princess (? Ginevra) of the House of Este (Louvre, *c.* 1443) and two pictures in the National Gallery, London — *Vision of St. Eustace* and *Virgin and Child with SS. Anthony and George*—attributed to him. He is considered the most brilliant Italian master of the International Gothic style, turning it to original uses and giving evidence of a keen and penetrating power of observation and a lively fantasy within the decorative scheme. At times he recalls more than any other major Italian painter the spirit of the *Très Riches Heures du duc de Berry* (see Pol de LIMBURG). He was an accomplished draughtsman and more of his drawings survive than of any other quattrocento artist except Jacopo BELLINI. The fastidious and enchanting drawings of birds and hunting animals and costume confirm his keen and alert eye for natural detail. He was also pre-eminent in the art of portrait MEDALS, beginning with the famous medallion of John VIII Palaeologus (*c.* 1438). He travelled extensively and many of the heads of the city states of northern Italy commissioned him to make portrait medals. He made a set for Alfonso of Aragon, King of Naples (1448–9). The portrait medal was a conscious revival of the ancient Roman practice, which had begun a little before Pisanello's time. But his own medals are neither ANTIQUE nor Gothic but set a standard of delicacy, precision, and clarity which has not been surpassed.

**PISANO,** ANDREA (*c.* 1290–1348) and NINO (d. probably 1368). Italian sculptors, father and son. They are not related to Nicola and Giovanni PISANO.

Andrea is first mentioned in 1329, when he received the commission to make a pair of bronze doors for the Baptistery at Florence. The doors, admirably cast and finished in 1336, represent, in 28 RELIEFS, 20 scenes from the life of St. JOHN THE BAPTIST, and 8 VIRTUES. His only other known works are reliefs (the *Weaver*, the *Rider*, *Sculpture*) and perhaps some of the figures on the Campanile, Florence, where he succeeded GIOTTO. Andrea's reliefs contain fewer figures than had been customary and he restricted his space by stressing the solidity of the rear plane. He has a melodious line and a jeweller's refine-

ment of execution. Andrea became master of works at Orvieto Cathedral in 1347 and was succeeded there by his son. Nino is known from documents to have been active as goldsmith and architect, but all his surviving works are sculpture in marble. There is a small group of signed works by him: the *Madonna* of Sta Maria Novella, in Florence; the VIRGIN of the *Cornaro Monument* in SS. Giovanni e Paolo, Venice (*c.* 1367), and the statue of a bishop in S. Francesco, Oristona, Sardinia. Others are attributed to him, of which the most important are the TOMB of Archbishop Saltarelli in Sta Caterina, Pisa; the *Madonna* from Sta Maria della Spina and the *Madonna del Latte*, both in the Museo Nazionale, Pisa, and the *Madonna* in the Cathedral Museum, Orvieto. Nino was one of the earliest sculptors to specialize in free-standing life-size figures.

2657.

**PISANO,** NICOLA (active *c.* 1258–78) and his son GIOVANNI (active *c.* 1265–1314). Italian sculptors. Nicola was the pre-eminent figure of what PANOFSKY has called the 'classicizing proto-Renaissance of the 12th c.' and was called by him 'the greatest—and in a sense the last—of medieval classicists'. He was brought up in Apulia, where the emperor Frederick II was encouraging a ROMAN revival, and inheriting this new CLASSICAL interest within a GOTHIC framework he succeeded in synthesizing the two currents to create a Christian art with the grandeur and REALISM of the Roman ANTIQUE. In his PULPIT (*c.* 1260) in the Pisa Baptistery, his earliest authenticated work, amid Gothic trefoiled ARCHES and clustered colonnettes he transformed a Dionysus into Simeon at the Presentation of CHRIST, a nude Hercules into a PERSONIFICATION of Christian Fortitude, and a Phaedra into the VIRGIN Mary. But instead of following the ROMANESQUE convention of separating episodes into compartments arranged in bands, he combined them into the formal unity of single pictures on each side of the pulpit with great power and dramatic effect. Secondly, his figures were much more than motifs borrowed from the ancient SARCOPHAGI of the Campo Santo near by: they recaptured the classical feeling for the dignity of the human figure. In Nicola's second series of RELIEFS on the pulpit for Siena Cathedral (1265–8) the Gothic elements became stronger in movement and dramatic expression. The carving is deeper, the contrasts between light and shadow sharpened, the pace of the narrative quickened. By then Nicola had a large *atelier*. He was able to leave assistants, among them Fra Guglielmo, to carry out his design for the shrine of St. Dominic at Bologna (1264–7) while he personally carved the Siena pulpit with the help of his son Giovanni and ARNOLFO DI CAMBIO. Nicola's last great project was the large fountain in the public square of Perugia, which he and Giovanni finished in 1278. The dozens of

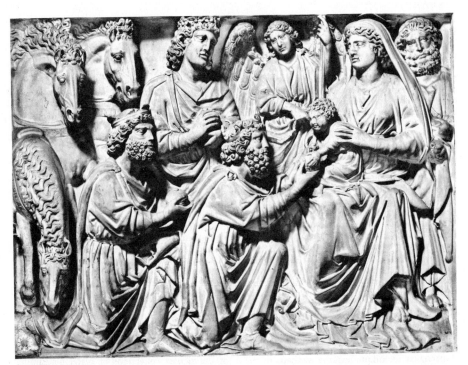

**263.** Adoration of the Magi. Relief panel from the pulpit (*c.* 1260) by Nicola Pisano in the Pisa Baptistery. The seated Virgin was derivative from the figure of Phaedra on a sarcophagus carved with the legend of Hippolytus in the Campo Santo, Pisa

reliefs are a typical medieval mixture: biblical scenes, heraldic beasts, personifications of seasons and places, and local dignitaries; but the vigour and spontaneity of the carving express a new freedom and naturalness.

By 1284 Nicola was dead. Between the Perugia fountain and this date, Giovanni, alone or in company with his father, had carved the series of saints and PROPHETS for the outside of the Pisa Baptistery. Here for the first time in Tuscany a scheme of MONUMENTAL statuary was incorporated into architecture. Giovanni developed this much further in Siena, where from 1284 onwards he was occupied with the façade of the cathedral. His design was carried out only as far as the tops of the gables over the portal area. It is a Gothic scheme which has often been compared to those of French cathedrals, although Giovanni's approach is much more ponderous and dramatic. The three recessed doorways are framed by a rippling sequence of pink and white marble jambs elaborately carved. From the ledge above them a great company of free-standing statues prophesy the Virgin's birth. They command tremendous energy and will. While thus engaged at Siena, Giovanni also served as a consulting architect (1287) for Massa Marittima Cathedral. He was again in Pisa in 1298. Giovanni's tragic power reached a climax in the reliefs completed in 1301 for the pulpit of

S. Andrea at Pistoia. His larger pulpit in Pisa Cathedral (1302–10) is distinguished more for its heroic CARYATIDES than for the overcrowded reliefs, which were mainly carved by assistants.

During his last years Giovanni executed a series of superb statues: among them the *Madonna and Child with two Acolytes* (*c.* 1305) in the Arena Chapel, Padua; the graceful *Madonna della Cintola* (*c.* 1312) in Prato Cathedral; and, his last recorded commission, the monument to Margaret of Luxemburg (1313; surviving fragments in the Palazzo Bianco, Genoa). In this last work his obsession with dramatic action produced a new type of funerary monument, for he presented his subject not as dead or sleeping, but rising from her grave.

Without abandoning the classicizing interests of his father, Giovanni succeeded in integrating them with the Gothic at a profounder level and it is his achievement to have carried further what his father set in motion and to have created that trecento Gothic which made possible the 'modern' manner of Jacopo della QUERCIA, GHIBERTI, and DONATELLO. In this sense he may be claimed the father of modern sculpture.

486, 662, 1939, 2732.

**PISSARRO,** CAMILLE (1830–1903). French painter, born at St. Thomas in the Danish West

Indies of a Jewish father and a Creole mother. In 1855 he entered the École des Beaux-Arts and there fell under COROT's influence, calling himself for a time his pupil. He later met MONET at the Académie Suisse and became a member of the IMPRESSIONIST group. He exhibited in all the eight Impressionist exhibitions (1874–86), being the only member of the group who was represented in all of them. His first picture, *Paysage à Montmorency*, was accepted by the SALON in 1859 and he exhibited there every year except in 1867. In 1863 he was represented by three LANDSCAPES at the Salon des Refusés. During the Prussian invasion of 1870–1 his house at Louveciennes was overrun and all his pictures destroyed. He himself joined Monet in England and came under the influence of the English landscape school, particularly TURNER and CONSTABLE. In 1872 he settled at Pontoise, where he had lived 1866–9, and for some years painted there in close friendship with CÉZANNE, who had settled at Auvers-sur-Oise. He acted as a friend and guide to GAUGUIN and introduced him to the Impressionist group. After his death Gauguin said: 'Ce fut un de mes maîtres. Je ne le renie pas.' From 1884 he lived at Eragny, near Gisors, and there met SIGNAC through Armand Guillaumin (1841–1927) and came to know SEURAT. For some years during the 1880s he flirted with the POINTILLIST technique and the methods of the NEO-IMPRESSIONISTS under Seurat's influence, but later reverted to his earlier style. In 1892 the dealer Durand-Ruel arranged a one-man show of 100 of his pictures which was one of the two most successful shows of the year. He was represented by eight pictures at the Exposition Universelle of 1900. About 1896 his sight began to fail and he was compelled to paint indoors from a window overlooking the street. His last painting was done from a window at Le Havre in 1903.

Pissarro was a hard worker and a prolific artist. He won universal respect both as a man and as an artist and his great gifts as a teacher gave him an often unsuspected influence even among artists of greater stature than himself. Cézanne said of him: 'Ce fut un père pour moi. C'est un homme à consulter et quelque chose comme le bon Dieu.' Mary CASSATT said he was such a teacher that he could have taught the stones to draw correctly.

LUCIEN PISSARRO (1863–1944), eldest son of Camille, was taught by his father and other leading members or associates of the Impressionist group, particularly MANET and Cézanne. He exhibited in the Impressionist exhibition of 1886 and with Seurat in the Second Salon des Indépendants. He painted with the Pointillist technique and was also an engraver. In 1890 he settled in England, where he became an associate of SICKERT and SHANNON and founded the ERAGNY PRESS. As a member of the CAMDEN TOWN GROUP and afterwards of the LONDON GROUP, he helped to diffuse an understanding of Impressionism and POST-IMPRESSIONISM in England.

2093, 2218, 2615.

**PITATI, DE.** See BONIFAZIO VERONESE DE PITATI.

**PITTI, FLORENCE.** The Pitti Palace was begun in 1440 by the wealthy rival of the MEDICI, Luca Pitti. It remained unfinished until it was acquired in 1549 by Duke Cosimo I, who completed it and made it the Medici residence. The building, designed by BRUNELLESCHI and completed by AMMANATI, is notable as the most colossal attempt to construct an artistic façade from unhewn blocks of stone. Behind the Palace lie the famous Boboli gardens, planned in the 16th c.

The Pitti Gallery on the upper floor in the left wing contains about 500 masterpieces from the Medici collections, which rival those of the UFFIZI in importance. The State Apartments contain a profusion of art treasures outstanding among which are a famous series of Gobelin tapestries representing the Story of Esther, CANOVA's *Venus coming from the Bath* (made to replace the *Venus de' Medici* when the latter was taken from the Uffizi to Paris in 1799), and a *Madonna* by Filippo LIPPI. On the ground floor is the Museo degli Argenti, which contains one of the richest collections of plate, goldsmiths' work, IVORIES, enamels, vestments, etc., most of which were originally from the Medici collections.

**PITTONI, GIOVANNI BATTISTA** (1687–1767). Venetian painter of religious, historical, and MYTHOLOGICAL pictures which are ranked among the best early Venetian ROCOCO before TIEPOLO. He was very popular in his day and was President of the Venice Academy of Painting 1658–61. Pittoni never left Italy, but he nevertheless received important foreign commissions, notably from the English impresario Owen McSwiny and from the Swedish, Austrian, and German courts, where he was regarded as the most distinguished representative of Venetian Rococo after the death of RICCI. Examples of his work are *The Rest on the Flight into Egypt* (Sidney Sussex College, Cambridge), *St. Prosdocimus baptizing St. Daniel* (York), and *Multiplication of the Loaves* (Accademia, Venice).

**PLACE, FRANCIS** (1647–1728). English gentleman artist, a member of a distinguished circle of VIRTUOSI at York. He was a close friend of HOLLAR, something of whose spirit he captured in his DRAWINGS and ETCHINGS. His later drawings (e.g. those of Scarborough and Knaresborough in the British Museum) rely on a fuller use of wash and are among the more important anticipations of English 18th-c. WATER-COLOUR style.

1217.

**PLAMONDON,** ANTOINE (1804-95). Canadian painter of portraits, religious subjects, and figure compositions. Born at Ancienne Lorette and active mainly in Quebec, Plamondon was the first Canadian to study in France after the Conquest in 1759. In Paris (1826-30) he was the pupil of the classicist Paulin Guérin (1783-1855). His portraits, which are his best work, are painted in a provincial version of *Classicisme* (e.g. the INGRES-like *Portrait of a Nun*, N.G., Ottawa, 1841).

**PLAQUETTES.** Small decorative RELIEFS in metal, usually bronze or lead. They were almost always cast by the *cire-perdue* process (see BRONZE SCULPTURE) and new editions could be made from the wax image of an existing plaquette; if this wax were altered a new 'state' would result. A very few were struck like coins (cf. MEDALS). After casting, the best plaquettes were usually chiselled and chased, and finished with a PATINA or gilding.

They were often made as cheaper replicas of goldsmiths' work, especially in Germany where the practice of carving models in wood or hone-stone made reproduction easier; works such as the circular reliefs on the inside of shallow dishes were frequently cast as lead plaquettes. These replicas were useful in the workshop—and not only that of the original artist, so that Flötner's (c. 1485-1546) plaquettes, for instance, helped to make his designs common property among German artists. Plaquettes were mounted as sword-hilts, ink-wells, or caskets, and applied as decoration to a variety of objects; small ones served as buttons, and a religious subject might be mounted as a pyx for use in the Mass. But they must also have been collected for their own beauty.

Reliefs in precious metal provided one source of duplicating or perpetuating designs. Many plaquettes were cast from the classical engraved GEMS so avidly collected in the RENAISSANCE, or from contemporary gems—witness the number reproducing crystal intaglios by Valerio Belli (1468-1546) and Giovanni dei Bernardi (1496-1553). Sometimes seal impressions were cast in bronze, and medal reverses were often cast independently. The makers of plaquettes were not ashamed to borrow designs from contemporary engravings (Renaissance customs in this respect were quite different from ours) and some of the best works by RICCIO, the greatest Italian bronze worker, were based on engravings by MANTEGNA. The favourite subjects were either religious or taken from classical mythology, including those scenes of SATYRS and nymphs so beloved of Renaissance humanists.

Most Italian plaquettes were made by artists from north Italy, particularly Padua, famous for its bronze work. One exception to this was DONATELLO, the greatest name connected with plaquettes though his were probably made in his studio and not by his own hand. Riccio made some of the most beautiful of all plaquettes, and

the unidentified artist who signed his works 'Moderno' achieved a goldsmith's delicacy without indulging in too minute detail. In Germany, apart from Peter Flötner other goldsmiths such as Jonas Silber (active 1572-89) and 'H. G.', who may have been Hans Jamnitzer (1538-1603), produced some fine works. But to the greater number of plaquettes from these countries and elsewhere we can set no name.

During the brief period in which plaquettes flourished (the end of the 14th to the middle of the 16th c.) one finds that, being so easily transportable, they were copied both in their country of origin and abroad, and not only in other minor arts but in important sculptural works as well. Like the engravings of which they are the plastic counterpart, they helped to disseminate the taste of the Renaissance.

1734.

**PLASTER CASTS.** Plaster casts may be made as replicas of existing sculptures or they may be made from clay models (see MODELLING) or natural objects as a guide to the stone-carver. Since a clay figure rapidly crumbles or disintegrates unless it is kept moist or fired (see TERRACOTTA), it is usual to make a plaster cast of it for the sake of preservation. This may then be used as a model for casting in BRONZE or other metal, or it may be used by a stone-carver, who by POINTING can reproduce the model in stone.

PLINY attributes the invention of plaster casts to the sculptor LYSISTRATUS, a contemporary of Alexander the Great (*Nat. Hist.*, Bk. xxxv, 153). 'Lysistratus of Sicyon was the first who made plaster masks from the living subject and he instituted the practice of making final corrections on a wax model taken from the plaster. The same man also invented taking casts from statues, and this practice increased to such proportions that no figures or statues were made without the clay.' Pliny is here describing a change-over from the direct to the indirect method of stone-carving (see STONE SCULPTURE). In the latter method the sculpture is first modelled in clay, a plaster cast is made from the clay and the cast is copied in stone by the process of pointing. Plaster casts of limbs, TORSOS, etc., may also be made direct from the human body and then used as models by the stone-carver. The earliest example of such casts have been found at Tel-el-Amarna c. 1400 B.C.

During the period of Roman CONNOISSEUR-SHIP the practice of making plaster casts from famous GREEK statues became very popular. The art went out of use with the fall of the Roman Empire and was not revived again until the RENAISSANCE. VASARI attributes to VERROC-CHIO the revival of the practice of making plaster casts of parts of the human body so that the artist could have them continually before his eyes 'for the more convenient imitation of them in his works', and also says that the practice of making DEATH MASKS began about the same time.

The traditional home of the plaster cast reproduction is the art school and the MUSEUM. The practice of drawing classical statues began in Italy, at the time when numbers of them were being excavated in Rome (see ANTIQUE). MICHEL-ANGELO kept fragments of classical sculpture in his studio, and LEONARDO advocated drawing from RELIEFS before drawing from nature. An engraving of Baccio BANDINELLI's *Academy*, dated 1531, shows a group of artists drawing antique statues. It is difficult to say how soon plaster casts began to be used as substitutes because our only evidence is from paintings and engravings, in which cast and original look much alike. In the Paris Académie des Arts the drawing of casts was a prescribed part of the curriculum from its foundation in 1648. The students were first set to copying the drawings of their professors, then to drawing casts, and only after this were they allowed to draw the living model —a practice vigorously championed by BERNINI when he visited the Académie in 1665. This programme was followed and elaborated in almost all the ACADEMIES of art in Europe. A series of drawings showing the activities of the Berlin Academy in 1696 includes a scene which is entitled 'drawing from plaster'. THORWALD-SEN, who entered the Copenhagen Academy in 1781, spent four years there before he attained the 'plaster class', and remained in that class for a year until he was promoted to drawing from the model. The Vienna Academy, at about the same time, had a plaster-casting workshop of its own and devoted a whole floor of its palatial building to its collection of casts. Similar collections are still preserved today in many museums, academies, and schools of art, and drawing from casts has continued into the 20th c. as a preliminary to life drawing. That this practice may continue in the future is suggested by MATISSE's counsel to pupils disappointed at being set to draw from a cast: 'It is better to learn to walk on the earth before walking a tight-rope.'

There are various methods of making the moulds for plaster casts. Where the shape of the model is fairly simple and involves no undercutting it may be possible to make a mould in two, or a small number of, pieces which will still lift readily from the model without damaging it and can after hardening be lifted from the cast and kept for further use. Where the shape is complicated or undercutting is present a plaster mould may be made in the manner known as a 'waste mould' or else it must be made up in as many pieces—and they may be very many indeed—as are necessary to enable every piece to be lifted from the model without damage so that they will again be able to be lifted from the hardened cast.

A waste mould does not involve this trouble but is made in as few pieces as can be conveniently dragged from the model, doing a certain amount of damage in the process. The clay which is pulled off with the mould is cleaned out before casting. After casting the mould has to be chipped off the hardened cast, being destroyed in the process. Waste moulds are feasible only when the model is of a flexible or soft material (e.g. human flesh or clay), so that it can be removed from the model without damage to the mould. When a cast is to be made from an existing statue or relief which must not be damaged in the process, it is normally necessary either to make a fairly elaborate piece mould of plaster or to make a flexible mould of some substance such as gelatine. Non-rigid moulds such as those made with agar or rubber have the advantages of flexibility and greater ease in manipulation but in general preserve details less accurately than PLASTER OF PARIS.

It is usual to cast heads hollow round a core, but complicated shapes of protruding limbs, etc., are cast solid round a metal rod to support their weight. There is a considerable body of technical knowledge involved in making moulds and casts which has to be learned in the studio or workshop and perfected by trial and error. All casts need a certain amount of finishing. This may be restricted to removing the seams and ridges at the junctures of the piece-mould, or it may involve a much more extensive removal of flaws and cleaning of the surface.

**PLASTER OF PARIS.** A powder made by the calcination or dehydration of GYPSUM. When mixed into a slurry with water it sets rapidly into a uniform, solid, and inert mass. It is one of the most important materials for sculptors since it is one of the most universal and satisfactory casting mediums.

Plaster is used to make negative moulds which are ancillary features of many processes both commercial (e.g. dental work) and artistic. Positive casts are also made of plaster of Paris. One of the commonest and most ancient uses is for the life mask or DEATH MASK, when the living or dead human face is cast in its natural size in order to perpetuate a record of a person's appearance. Casts have also been made of other parts of the human body—limbs, TORSOS, etc.—for use as MODELS by sculptors who work in stone or other materials. Sometimes sculptors in stone or MARBLE first produce their sculpture in clay and from this make a PLASTER CAST, which is then reproduced more or less mechanically by POINT-ING in the required material. This is known as the 'indirect method' of stone carving. (See STONE SCULPTURE.) Plaster of Paris is also used for making the plaster casts or facsimile reproductions of existing sculptures with which art schools and public galleries used at one time to be stocked. Negative moulds of plaster of Paris are sometimes used commercially for casting non-ferrous metals. Sculptors who work in clay usually make a plaster cast of the clay model and have this subsequently reproduced in bronze or other metal. (See BRONZE CASTING.)

Plaster of Paris is well adapted for all sculptural processes which involve reproduction of existing forms because it sets in a compact mass of even

consistency. It is capable of reproducing fine surface detail since it expands slightly in setting and so fills out the negative mould, preserving even the finest shapes. It is, however, completely inelastic and therefore involves difficulties where there is undercutting. For this reason complex subjects require more or less elaborate negative piece-moulds which can be removed piecemeal from the finished cast or else the mould must be chipped away and ruined in the process. The latter method is the easier but it is more dangerous since if the cast has not set perfectly, the original form will be irrevocably lost; the mould is ruined as it is chipped away.

The art of making wax models of the human face from plaster moulds was said to have been invented by the sculptor LYSISTRATUS, a contemporary of Alexander the Great. PLINY reporting this (*Nat. Hist.*, Bk. xxxv, 153) connected the practice with the rise of REALISTIC portraiture. Negative moulds have, in fact, been discovered from the HELLENISTIC period but the process was still more ancient. The earliest death mask is believed to be that of King Tety of the 6th Dynasty of Egypt (*c.* 2400 B.C.).

Plaster of Paris has a dull, matt, lifeless surface. While this can be coloured, waxed, or treated with shellac or VARNISH, it can never acquire the lively appearance of marbles or most other stones. Plaster casts of other sculptures therefore have the same sort of diluted impression that is found in photographic reproductions of oil paintings.

Plaster was sometimes used by the Greeks as a MODELLING medium over a core or ARMATURE. The process is sometimes used today, but chiefly for sculptural work of a temporary nature. Blocks of plaster may also be carved and chiselled, but it is fragile compared with stone and apt to chip and fracture. The complete absence of grain or texture makes carving difficult and unrewarding.

When plaster is to be modelled, SIZE or glue is added to the mixture. This slows down the setting process so that the modeller has time to work; it also makes the final product harder. In plaster modelling, as in clay modelling, an armature or skeleton framework is necessary for a free-standing figure. The plaster mixture is dabbed on with spatulas, or simply thrown on and allowed to run down in streaks and drops. The modeller may seek to achieve a pictorial texture by making use of chance effects, but if he prefers a smooth and highly finished surface he can work the plaster with tools after it has set.

**PLASTER PRINTS.** A 20th-c. development in intaglio printing (see PRINTS). A LINE-ENGRAVED or ETCHED plate is inked in the normal way and is then surrounded by a frame into which PLASTER OF PARIS is poured. By this means a PLASTER CAST of the intaglio plate is obtained, with the black lines standing in relief.

**PLATERESQUE.** A late GOTHIC and early RENAISSANCE style in SPANISH architecture and ornament. The word implies a likeness to silver-smiths' work, which in Spain remained gothicizing until about the middle of the 16th c. It was first used in this way by Cristóbal de Villalón in 1539 to describe the decorated façade of Leon Cathedral. As a stylistic term it is vaguely defined and differently used by different authors. Two phases are commonly distinguished. The earlier phase, sometimes called 'Gothic-Plateresque', combined FLAMBOYANT Gothic with traditional Spanish features. It is commonly equated with the 'Isabelline' style, so called in recognition of the energy displayed by Isabella of Castile (1474-1504) in the support of architecture and art during the last decades of the 15th c. In the second phase (first half of the 16th c.), the Renaissance-Plateresque, Renaissance decorative motifs and constructional principles, often incompletely understood, were combined with the Isabelline and gradually displaced them. The period of maturity of Renaissance-Plateresque extended approximately from 1526, the date of the publication of SAGREDO's *Medidas del romano*, until *c.* 1552, when VILLALPANDO published his translation of Books III and IV of SERLIO's *Architecture*. The chief common element of both phases of Plateresque was a profusion of elaborate ornament in RELIEF covering large surfaces without essential relation to structural form and following neither the medieval principle of segmentation by repetition of similar units nor the Renaissance principle of derivation from a unitary composition. Throughout all variants of Plateresque the influence of MUDÉJAR art, representing the ISLAMIC heritage which contributed so much to the forming of Spanish taste, is discernible in the rich and intricate character of the ornament and its manner of application. (Among historians who have used the terms differently the following may be noted. Mrs. Frankfort in *The Cambridge Modern History*, Vol. I, p. 166, uses 'Isabelline' of the earlier phase and reserves 'Plateresque' for the later phase 'marked by the introduction of Italian influence'. Camón Aznar in *La arquitectura plateresca*, 1945, also confines the term 'Plateresque' to Italianizing work of the first half of the 16th c. Professor Kubler in *Art and Architecture in Spain and Portugal and their American Dominions 1500-1800* (1959) distinguishes four phases: late medieval (i.e. Isabelline) under Ferdinand and Isabella; first and second stage of Plateresque under Charles V; and 'Herreran' under Philip II.) The expressions 'Isabelline' and 'Plateresque' are both used of sepulchral MONUMENTS and ALTARPIECES as well as architectural decoration proper.

Gothic-Plateresque was essentially a Castilian style centred on Burgos, Valladolid, and Toledo; and its leading exponents were first- or second-generation immigrants from France, Germany, and Flanders, such as Juan GUAS, Gil de SILOE, Simón de COLONIA, and Enrique EGAS. Especially characteristic of the style is the prominence given to heraldic motifs in the decoration. The Renaissance-Plateresque style was employed

throughout Spain and owed less to immigrant masters. Examples are the façades of the Universities of Salamanca (completed 1529) and Alcalá de Henares (1541–53, architect Rodrigo Gil de HONTAÑÓN) and the town hall at Seville (begun 1534, architect Diego de RIAÑO). The style was also used in Spanish America, e.g. at S. Domingo Cathedral (façade c. 1540) and in the main portal at Acolman (1560) in Mexico.

Plateresque tended to be used for smaller buildings, whereas for larger enterprises, such as the great cathedrals of the early 16th c., a relatively austere style was often preferred, either Gothic, as at Salamanca, or 'Roman', as at Granada, forecasting the extreme reaction against architectural ornament initiated in the second half of the 16th c. by Philip II and Juan de HERRERA.

478.

**PLEIN AIR** (French: open air). Term used for a painting which conveys the feeling of open air and atmosphere or, more usually, term for painting actually done in the open air instead of in the studio. Landscape painting in the open became reasonably convenient only after the invention of the collapsible tin TUBE, which was adopted by the colour merchants Winsor and Newton in 1841. Before this time painters' colours had been sold as powders and kept in bladders to be ground up and mixed with a suitable MEDIUM by the painter. The new tin tubes were portable and clean. They encouraged the use of slow-drying paints suitable for ALLA PRIMA painting. The thick, buttery character of the new paints was also adapted to a style of painting which favoured thick IMPASTO and the utilization of the brush stroke. Open air painting was further facilitated by the invention of a light and portable EASEL, an example of which was displayed at the Great EXHIBITION of 1851.

The expression '*plein air*' therefore implies a style of painting which emphasizes the impression of the open and of spontaneity and naturalness. On the other hand it also indicates an actual technique of painting, which involved more than working in the open direct from nature instead of the older practice of composing a finished picture in the studio from rough sketches done on the spot. The impression of naturalness and open air was much valued by the IMPRESSIONISTS but the actual technique of painting in the open became fashionable more gradually. It was never favoured by DEGAS and MANET was a late convert to it. Some of the earliest to adopt it were the painters of the BARBIZON SCHOOL.

**PLEYDENWURFF**, HANS (d. 1471). German painter of the School of Nuremberg (see GERMAN ART). His work is typical of the kind of painting produced in Nuremberg by the generation before WOLGEMUT. The springs of INTERNATIONAL GOTHIC were drying up and a new REALISM was beginning to come in from the

Netherlands. A large *Crucifixion* (Munich) is characteristic of his work.

**PLINY THE ELDER** (GAIUS PLINIUS SECUNDUS, A.D. 23 or 24–79). Roman encyclopedist, a writer of extraordinary industry and thirst for knowledge, who as a side-line to his official career produced among many other things the *Historia Naturalis* (Natural History), a comprehensive encyclopedia intended to embrace not only the whole of the natural sciences but also their application to the arts and crafts of civilized life. His method was to compile excerpts from previous writers and he was heavily indebted to earlier Roman authors such as Marcus Terentius Varro (116–27 B.C.). His work has been condemned as uncritical, unreliable, and superficial; it is of interest because of the amount of information it contains which would otherwise have been lost in oblivion. The chapters on the history of painting and sculpture (in Bks. xxxv and xxxvi) are especially interesting because earlier treatises on classical art have perished and Pliny is thought to have preserved (either directly or at second hand) critical and historical views from an earlier date and also reveals the estimation in which Greek artists were held at Rome in his time. Among the older writers thought to be represented in his compilation the most important are: Xenocrates of Sicyon, who wrote a critical history of Greek sculpture c. 280 B.C.; Duris of Samos (b. c. 340 B.C.), who wrote an anecdotal *Lives of Painters*; and Antigonus of Carystus, who may have combined the works of the two preceding writers with other material in a history of ancient art. Though difficult to assess in detail, the work of Pliny incorporates much useful information about the art and artists of antiquity.

**POCHOIR.** See STENCIL.

**PODIUM.** A continuous base or pedestal, especially the high base on which a ROMAN or RENAISSANCE building stands; also, the raised platform round the arena of a Roman AMPHITHEATRE.

**POELENBURG**, CORNELIS VAN (c. 1586–1667). One of the first generation of 17th-c. Dutch LANDSCAPE painters who worked in Rome. Like so many artists of his time who were born in Utrecht, he studied with Abraham BLOEMAERT. He was in Rome c. 1617–22, where he came under the spell of ELSHEIMER, RAPHAEL, and the ancients. He made small pictures in cool enamel-like colours of Arcadian landscapes populated with biblical or mythological personages. He frequently painted on copper. During his life he was popular with royalty and appreciated by the greatest artists of the time. He worked in Florence for the Grand Duke of Tuscany; in 1627 RUBENS visited him in Holland; and Charles I called him to England in 1637. He had several pupils and a large workshop.

**POELZIG,** HANS (1869–1936). German architect; one of the most original of the new generation which, following the lead of Peter BEHRENS, established MODERN ARCHITECTURE in Germany before the First World War. Among Poelzig's early works were a water-tower at Poznań (1912), a chemical works at Lauban (1912), and an office building at Breslau (1913) which is notable for the horizontal emphasis produced by the alternation of strips of wall and almost continuous fenestration, a motif first used in this building and later popularized by Erich MENDELSOHN and many others. Poelzig had close affinities with van de VELDE and his ART NOUVEAU movement, and some of his work has an unusual element of fantasy: notably his *Grosse Schauspielhaus* in Berlin (1919), which he converted from a circus into a theatre for Max Reinhardt. It had a DOMED ceiling consisting of concentric rings of stalactite forms, into which the triangular CAPITALS of the supporting COLUMNS merged and which served also to mask the source of artificial lighting. His office block for I.G.-Farben at Frankfurt-am-Main (1928–31) exemplifies a change to forthright monumentality.

**POINTILLISM.** A technique of painting which is described by Maitland Graves (*Color Fundamentals*, 1952, p. 39) as follows: 'Pointillism is the method whereby the chromatic light beams reflected by tiny, juxtaposed dots of paint . . . are additively mixed [see COLOUR] by the eye and fused into one solid colour. This fusion occurs only when the chromatic dots are too small to be resolved by the eye, or when they are viewed at a sufficient distance.' The method was developed systematically by SEURAT, first in his painting *La Grande Jatte*, where dots of pure PIGMENT of uniform size are superimposed on fundamental underlying painting in longer brush-strokes or *balayé*, and afterwards in *Les Poseuses* and later paintings as a fundamental structural technique. The use of a stippled technique in painting to secure additive mixture of colours was proposed by the theorists Charles Blanc (*Grammaire des arts du dessin*, 1867) and Ogden N. Rood (*Modern Chromatics*, 1879), whose writings were studied by Seurat. Rood referred to RUSKIN and also to Dr. Jean Mile, whose method of securing optical mixture of colours by a stippled technique he described as follows: 'Another method of mixing coloured light seems to have been first definitely contrived by Mile in 1839, though it had been in practical use by artists a long time previously. We refer to the custom of placing a quantity of small dots of two colours very near each other, and allowing them to be blended by the eye placed at the proper distance. . . . This method is the only practical one at the disposal of the artist whereby he can actually mix, not pigments, but masses of coloured light.'

In reference to Seurat's *La Grande Jatte* the critic Félix Fénéon spoke of 'peinture au point' ('Les Impressionnistes', *La Vogue*, June 1886) but Seurat himself and also SIGNAC preferred the word 'DIVISIONISM'. Seurat found anticipations of the method in many of the earlier masters, notably in WATTEAU, DELACROIX, MURILLO, and the IMPRESSIONISTS. Seurat's use of the method was defended under attack both as a means to achieve greater luminosity and as a means of securing more delicate control of hue, a means whereby the tonality could be slowly and carefully changed according to the representational effect desired by the artist.

1135.

**POINTING.** A method used by sculptors for mechanically transferring the proportions of a three-dimensional MODEL (usually of PLASTER) to a block of stone, or for copying. The principle of pointing is that if three points are fixed in space, it is possible to locate any other point in relation to them.

The sculptor first chooses three points on the model. They must be points from which it is possible to measure all other points easily: in a standing figure they might be the top of the head and two points at the foot of the base. With three pairs of callipers he measures the distances between these points on the model. He then transfers the measurements to the stone and makes three marks on it where the points come. This first step, on which everything else depends, requires experience because the points have to be fixed in such positions that the whole figure will be contained within the available stone. The rest of the process, however, is more or less mechanical. A fourth point on the model is chosen—say the navel. The distances on the model between this fourth point and the first three are taken with the callipers. All the callipers are then applied to the block in such a way that one end of each pair touches one of the three marks. The point sought is where the free ends of the callipers meet. Probably, however, they cannot be made to meet because the point sought is not on the surface of the block but somewhere inside it; so the stone in that region is chiselled or drilled away until they do meet. At that point another mark is made. The process can be repeated indefinitely, each successive point being found by reference to three others already established. So far it has been assumed for simplicity's sake that the stone figure is to be the same size as the model. Usually, of course, it is very much bigger, and each measurement that is taken has to be converted to the larger scale.

An elementary method of mechanical pointing was developed in the 1st c. B.C., when the copying of Greek statues for Roman PATRONS had become an industry, but it is probable that the copiers took rather few points.

According to PLINY the indirect method of stone-carving from a clay model began in the time of Alexander the Great (see PLASTER CASTS) but it is likely that during HELLENISTIC times sculptors used a simple method of measuring

by means of a plumb-line and a frame, not unlike that of ALBERTI.

Many methods have been developed over the centuries for making copies and enlargements; several methods of enlarging mentioned by Alberti, CELLINI, and VASARI are still in use. During the RENAISSANCE the practice grew up of employing masons to cut the stone statue using a model of plaster or TERRACOTTA; but it was not until the time of CANOVA in the early 19th c. that the task of pointing was rationalized by the perfection of a pointing machine. This device consists of an upright stand carrying movable arms, each arm having attached to it an adjustable measuring rod which shows the depth to which each point must be drilled. Sometimes hundreds and even thousands of points will be taken to ensure a meticulously exact copy. In the late 19th and early 20th c. most STONE SCULPTURE was produced by this indirect and mechanical

264. Method of measuring sculpture by means of a plumb-line and a frame. Engraving from *Della Statua* (1727) by Alberti

**265.** Pointing machine of the early 19th c. (Science Mus., London)

method. Modern sculptors increasingly reject it and prefer direct carving; they use MODELLING for terracotta and some metal sculpture.

**POLIDORO DA CARAVAGGIO** (*c.* 1500–43). Italian painter who owed his great fame to façade paintings imitating classical RELIEFS, which he executed in Rome. None of these has survived but engravings and drawings show his mastery of correct archaeological detail and his decorative skill. His FRESCO in the church of S. Silvestro al Quirinale in Rome, representing an episode from the life of St. Mary Magdalen, is considered a landmark in the history of LANDSCAPE PAINTING, foreshadowing the 'heroic landscapes' of CLAUDE and POUSSIN. Polidoro left Rome in 1527 after the sack of the city; he was murdered in Messina.

**266.** *Battle of the Naked Men.* Line engraving (*c.* 1470) by Antonio Pollaiuolo. In the centre portion of the engraving a pose is repeated from front and back view

**POLLAIUOLO,** ANTONIO (*c.* 1432–98) and PIERO (*c.* 1441 to before 1496). Brothers, Italian sculptors, painters, and artisans who jointly carried on a flourishing workshop business in Florence. Antonio was apparently primarily a goldsmith and worker in bronze, Piero primarily a painter. We know of several paintings wholly by Piero, e.g. three of the *Seven Virtues* (1469/70) in the UFFIZI. These figures are typical minor works of the period, elongated, fragile, and unconvincing, but chastely decorative and deriving mainly from Fra Filippo LIPPI. It has been impossible to isolate any painting wholly by Antonio, but certain pictures from the studio of the two brothers are so much better than Piero's independent work that Antonio's collaboration, at least, has usually been assumed. The most important of these pictures is the *Martyrdom of St. Sebastian* in the National Gallery, London, probably painted in 1475. The figures of the archers in the foreground reveal a mastery of the nude which can only be paralleled in certain bronzes undoubtedly by Antonio, e.g. the *Hercules and Antaeus* in the Bargello, Florence. Most historians credit him with two important contributions to the art of Florence, landscape interest and the searching analysis of the ANATOMY of the body in movement or under conditions of strain. Several vigorous and lively drawings by Antonio and at least one important engraving, the *Battle of the Naked Men*, reflect these preoccupations. He is said to have anticipated LEONARDO in dissecting corpses in order to study the anatomy of the body. His drawings in par-

ticular look forward to Leonardo's both in their style and in their exploratory function.

Antonio's two principal public works were the bronze TOMBS of Pope Sixtus IV (signed and dated 1493) and Pope Innocent VIII (*c.* 1495), both in St. Peter's, Rome. The latter contains the first sepulchral effigy to simulate the living man.

668, 2367.

**POLLOCK,** JACKSON (1912–56). American ABSTRACT EXPRESSIONIST painter. At the beginning of the 1930s he was painting under the influence of the movement towards a REALISTIC interpretation of the American scene and the regionalism of Thomas Benton (1889–     ) though even then with more vehemence of emotional expression than the rather commonplace NATURALISM of Benton. Towards the end of the 1930s he was influenced by the EXPRESSIONISM of the Mexican muralists OROZCO and SIQUEIROS and by the SURREALIST symbolism of MIRÓ. He also put to his own uses Surrealist theories of automatism, carrying unconventional techniques to extremes such as dripping paint on to huge canvases placed flat on the ground. He gave an important impetus to the principles of action painting with his aggressive spirit of revolt and his view that painting as an act was more important than the finished product. By repudiating traditional principles of composition and design he reduced his ABSTRACTS to a semblance of formlessness and chaos whose hidden

unity was imparted by the athletic and frenzied rhythms of the painting activity. Pollock became a leading celebrity both in the U.S.A. and abroad and was regarded both as a great innovator and the most representative figure among the younger school of post-war painters in the U.S.A. In 1951 he reduced his palette to black and white only. For two years before his death in a motor accident in 1956 he was inactive.

1965, 2277.

**POLYCHROME SCULPTURE.** There is reason to believe that a surprisingly large proportion of sculpture all over the world has been coloured. PIGMENTS, however, are fugitive over long periods of time and much of the sculpture which survives from distant times has either lost its colouring or retains only sufficient vestiges to show what once was there. The idea that sculpture should reveal the natural colour and appearance of the material from which it is made seems to have come to prominence during the RENAISSANCE. This concept may have been connected with the reverence which then was felt for classical antiquity, since the surviving MONUMENTS from the Greco-Roman world had for the most part lost their colours.

Most figures which have survived from the Palaeolithic Age retain traces of colouring matter—red-ochre and the like—and it seems reasonable to conclude that they were coloured as a rule. The same is true of the Neolithic period. It is believed that all or the great majority of EGYPTIAN sculpture, both RELIEF and sculpture in the round, was coloured. As in Egyptian painting, the colours were decorative or conventional rather than naturalistic: thus male figures were reddish brown, female figures light yellow. The Greeks also coloured their sculpture as well as their architecture, using conventional rather than realistic hues to differentiate planes or to distinguish various parts of the object (eyes, flesh, etc.). In the Archaic groups on the ACROPOLIS at Athens the colour used for bulls and horses, and even for beards, was blue. The head-dresses and costumes of the KORAI (Nat. Mus., Athens) were painted in different colours. The bronze *Charioteer of Delphi* (Delphi Mus.) has traces of silver in the fillet binding the hair and the eyes are inlaid with glass paste and enamel. PHIDIAS's huge statues *Zeus* and *Athena*, now lost, were constructed of gold and ivory (CHRYSELEPHANTINE), to stand in temples which themselves were brilliantly painted; and gilding can still be seen on the sandals of the MARBLE *Hermes* of PRAXITELES (Olympia Mus.). The writings of PLINY and Plutarch suggest that classical sculptors attached great importance to skilful painting, and the former describes techniques of preserving colour on statues by coating them with oil and VARNISH.

In the sculpture of HELLENISTIC and ROMAN times polychromy seems to have declined some-what in importance. The marble copies of Greek sculpture made for Roman PATRONS were mostly uncoloured, although such combinations as pink oriental ALABASTER, BASALT, and Luni marble in the colossal statue of a veiled goddess (Nat. Mus., Rome), the heightening by colour of the portrait of Augustus from Prima Porta (Vatican Mus.), and the painting of historical reliefs and SARCOPHAGI reveal the persistence of the taste for colour in sculpture.

The medieval processes of applying colour to sculpture are described in the writings of CENNINI. Stone figures, after being prepared by SIZING and covering with a mordant consisting largely of oil, were painted in TEMPERA, and some parts might then be adorned with gilding (see GOLD). Figures of wood were often bound with strips of linen to prevent cracking. Over this linen, or on the wood itself, GESSO was applied in a thick layer and carved afresh, then polished to a smooth surface to receive the tempera paint and gilding, and finally the whole was varnished. By these methods medieval carvers matched the brilliance of manuscript ILLUMINATION, using glowing colour and gilding to enhance the splendour of stone or wooden figures. Stone figures, such as the English effigies in PURBECK MARBLE, alabasters, and wooden sculptures were painted and gilded; even IVORIES were sometimes partly or completely tinted. Carved ALTARPIECES and RETABLES were coloured. While colour thus played an important role in medieval sculpture, particularly for free-standing statues and statuettes, the extent of its use in architectural STONE SCULPTURE is not known. Traces of colour found on the façade of the abbey of Conques, the TYMPANUM of the abbey of Vézelay, and the portal of NOTRE-DAME, Paris, as well as the extensive colour still visible on SLUTER's *Well of Moses* (Chartreuse de Champmol, Dijon), confirm its use in at least some major monuments. The most conspicuous change in the course of the Middle Ages was towards a gradual preference for more natural colours, a development which made heavy demands on skill and taste in adjusting the colours of nature to those required by the work. From the end of the 14th c. polychrome sculpture is found concurrently with uncoloured sculpture in natural stone, BRONZE, or wood. In Spain polychrome carving had a particular vogue.

Both conventional and ILLUSIONISTIC treatments of colour continued through the Renaissance; the former in the glazed TERRACOTTAS of Luca della ROBBIA, the latter in such a figure as DESIDERIO's painted wood *Magdalene* (Sta Trinità, Florence, c. 1467). From c. 1500 new factors began to tell in favour of monochrome sculpture. One was the excavation in Italy of classical statues which had either lost their original colouring or, being Roman copies, had never had any. Another was the dominance of MICHELANGELO, who abjured surface attractions in order to convey an idea by form alone. Nevertheless, colour continued to be used in various

ways from this time until the 19th c. Small objects were enriched by such colours as the enamels and gold of CELLINI's fabulous *Salt Cellar* (Vienna, 1543). The REALISM of wooden images in Spain and Portugal was enhanced by colour for such different effects as the graceful *Immaculate Conception* (J. MONTAÑÉS, Toledo Cathedral), the violent, decapitated *Head of St. John the Baptist* (J. A. Villabrille, San Juan de Dios, Granada, 18th c.) and the tableaux of life-sized figures wearing actual costumes in scenes from the *Passion of Christ* by F. Zarcillo (1707-81), in the Ermita de Jesús, Murcia. In the BAROQUE churches of Italy and Germany (Il Gesù, Rome; St. John, Munich) great splendour is achieved through the lavish use of colour uniting painting, sculpture, and architecture. Such a decorative unity is never more attractive than in the ROCOCO rooms of 18th-c. France and Germany, sparkling with silver and gilt and delicate hues. This iridescence was lost in the triumph of the NEO-CLASSICISTS, who preferred whiteness, believing that they were following the example of the Greeks. WINCKELMANN's theories about the importance of purity of form are demonstrated in CANOVA's sculpture with its uniform white tone as in his *Perseus* (Vatican Mus.) and *Pius VI* (St. Peter's, Rome). The attempts in the later 19th c. to revive polychromy appear somewhat forced and contrived, like KLINGER's portrayal of Beethoven (Leipzig Mus.) in different coloured marbles, onyx, and amber. The *Tinted Venus* of John GIBSON created a sensation at the Great EXHIBITION. Polychrome sculpture for architectural decoration seems to have been more successful; the serpentine benches of GAUDÍ's Park Güell, Barcelona (1900-14), are formed as sculptural shapes accented by a surface mosaic of broken FAIENCE.

Polychromy runs counter to the 20th-c. emphasis upon the aesthetic importance of the natural properties of material and coloured sculpture has been experimental rather than central. Eric GILL was one of the earliest to apply colour to parts of a stone figure. In a similar manner MARINI uses touches of colour in a natural and successful way to enliven the features of his *Portrait of Mme G.* (Zürich, 1945). Hans ARP first showed painted wooden ABSTRACT reliefs in 1917 and continued to use colour in his sculptures (*Two Heads*, Mus. of Modern Art, New York, 1929). ZADKINE did coloured wood sculptures from 1928 and many others have experimented with colour. In the period following the Second World War in particular the line of demarcation between two-dimensional painting and three-dimensional sculpture has become blurred; some of the techniques of colour used in modern painting have been applied in the domain of sculpture. The most original return to colour in sculpture, however, has been the use by GABO and PEVSNER of translucent plastic materials. The different hues of these materials enabled them to make colour an intrinsic feature of visibly three-dimensional constructions rather than a mere surface embellishment.

636.

**POLYCLITUS.** Greek architect, the younger of that name, who built the Tholos and THEATRE at Epidaurus (*c.* 350 B.C.).

**POLYCLITUS (POLYCLETUS) OF ARGOS OR SIKYON** (active *c.* 450-420 B.C.). The most famous Greek sculptor after PHIDIAS. According to the tradition he laid down a canon of ideal male beauty embodied in a system of mathematical proportions and exemplified in his statue of the *Doryphorus* (Spear Bearer). The only words which can with reasonable probability be attributed to Polyclitus himself are the statement: 'the beautiful comes about little by little, through many numbers'. The *locus classicus* on the canon of Polyclitus is a passage from Galen (*c.* A.D. 129-99): 'Chrysippus holds that beauty does not consist in the elements but in the symmetry of the parts, the proportion of one finger to another, of all the fingers to the hand ... in fine, of all the parts to all others as it is written in the canon of Polyclitus.' The *Doryphorus* is one of the most common examples of classical Greek IDEALIZING sculpture in all the art histories and sculptural handbooks. Copies also exist of a *Diadumenus* (a youth wreathing a band round his head) by Polyclitus. He usually worked in BRONZE but is known also to have executed a colossal statue of Hera in IVORY and gold for the Heraeum, a famous temple of Hera near Mycenae.

**POLYGNOTUS OF THASOS.** First of the great Greek painters, active chiefly in Athens in the mid 5th c. B.C. He painted decorations for the Stoa Poicile at Athens. PAUSANIAS gives a factual description of the paintings *The Sack of Troy* and *Odysseus in the Underworld* which he executed in the Lesche of the Cnidians at Delphi. From this and some abnormal red-figure vase-paintings of the time we can infer the general character of his style. The figures, which were still not shaded, were grouped at varying heights to indicate depth in space, and LANDSCAPE was economically suggested by outlined hillocks and a few conventional shrubs.

**POLYNESIAN ART.** The term 'Polynesia' covers a vast triangle of Pacific islands stretching from Hawaii in the north to New Zealand and Easter Island in the south and east. When first explored by Europeans in the 18th c. the islands were populated by brown-skinned peoples who possessed an active and virile tradition of carving in wood and stone. Of this art the rapacity of colonizers and the iconoclasm of Christian missionaries has left us only scattered traces. Today, apart from handicrafts intended for sale to tourists, Polynesian art scarcely survives outside the show-cases of ethnographic

museums. These collections, reflecting as they do the taste of 19th-c. European curio hunters, probably give a very unbalanced picture of the aesthetic interests of J. J. Rousseau's Noble Savage.

A museum show-case labelled 'Polynesian art' is likely to be filled with a variety of carved ceremonial clubs and objects of household furniture heavily decorated with repetitive geometrical designs. Draped at the back will be pieces of bark-cloth printed in attractive patterns reminiscent of mid 20th-c. wall-paper. There may also be shown examples of elaborate feather-work (Hawaii), finely woven mats (Samoa), a peculiar greenish POTTERY (Fiji), and carved jadeite pendants or *hei tiki* (New Zealand). Objectively considered all such items are the products of craftsmen rather than imaginative artists. Nevertheless there is evidence that the ancient Polynesian culture produced artists of highly original vision; that the more significant artists concerned themselves not with decorative surface carving but with sculpture in high RELIEF and in the round; and that in the early 19th c. even the smaller islands contained wooden and stone sculpture of ancestral deities in considerable numbers. To judge from surviving specimens, some of these works displayed great freedom of imaginative expression. Unfortunately the early missionaries regarded such things as obscene idols and had them destroyed wherever they could. Those that have been preserved are for the most part sexually mutilated. One of the most remarkable, the figure of the deity Tangaroa from Rurutu (Austral Islands), now in the British Museum, has been treated in this way but might perhaps never have reached its present haven at all if the collector had appreciated that the whole statue is an anthropomorphized phallus. Even in the emasculated form in which Polynesian art has come down to us, however, certain general characteristics seem reasonably clear. Carvings were produced as enduring valuables, not just as decorations for a single festive occasion or as objects of fancy dress; the artist had the conscious intention of producing a 'work of art'. He operated everywhere within a rigid set of local conventions; one can tell at a glance that an object originated in Hawaii, or Easter Island or New Zealand. But common to all these styles is a disciplined formality. The art of this whole region is strikingly lacking in the romantic emotionalism apparent in many of the products of neighbouring MELANESIA. Polynesian society likewise was formal and stiffly structured. There was often a proliferation of titular offices and an exaggerated consciousness of class distinctions. Although linguistic evidence suggests that all the Polynesians had a common historical origin of no great antiquity, communication between the different island groups was almost certainly infrequent and haphazard and the different local styles developed more or less independently of what went on elsewhere.

In Hawaii, from which little traditional work survives, the WOOD-CARVING style was strongly sculptural. As P. S. Wingert has said: 'Sharp angles and planes contrast with flowing curved surfaces to express the tension of a pose and the unity of the figure.' There was here no surface patterning, though elsewhere, except in Easter Island, surface decoration is usually prominent, at any rate in surviving work.

Characteristic of central and western Polynesian carving is a dense type of geometrical ornament with rectilinear cross-hatchings and circles predominating. The decoration of bark-cloth was also very elaborate. In Fiji the patterns were applied by a kind of printing technique. Fijian pottery is technically interesting but the forms are conventional and monotonous. Culturally Fiji is marginal to Polynesia and Melanesia, and while in general Fijian art resembles that of Polynesian Samoa, some Melanesian elements are also present.

Maori designs likewise are almost always completely covered with surface ornamentation but the general pattern is curvilinear. Although the characteristic motif is a geometrically precise double spiral, this is employed in such complex combinations that the more elaborate carvings often acquire the appearance of freely flowing line. The Maori seem to have felt strongly that surface ornament is an essential quality of beauty. In former times even the human face itself was completely covered with tattooed spirals. In some cases the dried skull, complete with its tattooed facial skin, was preserved after death as a cult object, and skulls of this type are sometimes to be seen in museum collections. The most

**267.** Figurehead of a Maori war canoe from Waitangi, New Zealand. Wood-carving with tattoo patterns

**268.** Carved wooden uprights in interior of Maori tribal meeting house, alternating with plaited panels. The carving shows characteristic curvilinear design below stylized heads. Kotorua, New Zealand

elaborate examples of Maori carving occur as decorations for ceremonial canoes and tribal meeting houses. For the latter the traditional styles have survived down to the present day, but modern work though technically competent appears lacking in vigour. Maori carving of small stone objects in jadeite and similar materials was technically very proficient but stereotyped. Textiles were also well developed. It may be noted that the Maori cloths were made by basketry techniques and made use of weaves which cannot be reproduced on a mechanical loom.

In the eastern corner of Polynesia, remote and isolated, Easter Island developed a style of its own. Wood was here a rarity and was carved with gem-like precision. The accuracy of drawing and the economy of materials are such as elsewhere one might find associated with IVORY-carving. The British Museum has particularly fine specimens. In contrast Easter Island stone-carving was monumental in character. The figures were constructed out of a soft easily worked TUFA. Some were as much as 60 ft. in length and weighed over 20 tons. They represent human figures and are carved according to a stereotyped design with strongly emphasized geometrical planes which is, nevertheless, extraordinarily expressive. Some of the figures originally had detachable cylindrical caps of red tufa. A relatively small unhatted specimen is to be seen on the terrace of the British Museum.

In their present condition most Polynesian objects are devoid of colour, but in the original context brightly coloured feathers and lavish red earth washes would have added considerable liveliness to their appearance.

It needs to be remembered that all pictorial themes in Polynesian art have been influenced by a variety of religious and mythological ideas of which we now have only vague indications. For example, the fact that the ancestor deities in Maori carving are commonly shown as having bird claws rather than hands is probably linked with the belief that the human soul at death assumes the form of a bird. But the finer details of such symbolism are now largely beyond recovery.

The external influences that bore upon the development of Polynesian art have long been a source of scholarly dispute. Linguistic evidence suggests that the Polynesian peoples entered the region from the west in the not very distant past. Yet direct relationships between the art styles of Polynesia and those of Asia are not at all easy to demonstrate. An earlier theory that Polynesian culture was heavily influenced by contacts or immigration from the Americas has been revived by a popular Norwegian explorer, Th. Heyerdahl, but has been rejected by most experts. On the other hand the view that the decorative styles of the Maori and of western Polynesia generally have been influenced by contact with the Melanesian region seems plausible, even if precise examples of this influence are hard to demonstrate. Many of the books published on South Pacific art since the Second World War (see OCEANIC ART) discuss the relation between the art forms and traditional social systems, religious beliefs, and mythologies and connect the relationship between art styles and techniques in various parts of Polynesia, Melanesia, and MICRONESIA with ethnological factors.

**POLYPTYCH.** Anything consisting of more than three leaves or panels folded or hinged together, as a picture or an ALTARPIECE.

**POMARANCIO,** IL. See RONCALLI, C.

**POMPEII.** Pompeii, Herculaneum, and Stabiae are the chief known centres of Campanian art (see ROMAN ART). The three towns were overwhelmed by the eruption of Vesuvius in A.D. 79 and to this circumstance is owed the survival of much painting from about the end of the 2nd c. B.C. until that date. These paintings are preponderantly murals from upper middle-class houses. They are thought, however, to provide fairly typical samples of southern Italian and Roman painting during the period which they cover, since the fashion of the time favoured mural painting rather than hanging detachable easel pictures. PLINY's statement that whereas classical GREEK painting was done on PANELS Roman painting was done on walls seems to be a reasonably correct generalization. Excavation has been almost continuous since 1748 and the impact made by the finds on various phases of European art has been considerable. During the

early period of recovery the custom was to detach the more striking paintings from the walls and transfer them to panels for display in a museum (most are in Naples Mus.). More recently attention has been given rather to their function as integral elements in a striking and virtually unique mode of interior decoration and methods have been found for preserving them *in situ*.

In accordance with a classification originated by Professor A. Mau at the end of the 19th c. four styles of Roman decorative mural painting are recognized during the period under survey and these are conventionally named the Four Pompeian Styles. It is generally thought that the First is the earliest and that the others were not strictly successive in time but that a good deal of overlap occurred. The First Style, sometimes called 'incrustation style', made no use of figurative painting and did not break through the wall plane, but the walls were painted to resemble facings of different coloured MARBLES. This style goes back to the late 3rd c. or early 2nd c. B.C. and examples have been found in the island of Delos. But in south Italy until *c.* 80 B.C. it was elaborated and diversified, the wall being divided horizontally into three zones and vertical divisions of painted pilasters cut across the horizontal divisions. The wall itself was given a new

plastic and chromatic importance in the production of a rich and decorated interior. In the Second Style the plane of the wall is caused ILLUSIONISTICALLY to recede by painting an architectural screen or columns which seem to stand out in front of it and cause it to lie back. At the same time the background of the wall plane itself is often broken through and caused to disappear by painting large PERSPECTIVE FRIEZES and LANDSCAPE or figure scenes. The wall section becomes as it were a window opening up into deep picture space in a manner which was not recovered until after the study of perspective which was one of the revolutionary features of the RENAISSANCE. Alternatively, as in the Villa of the Mysteries outside the Herculaneum gate at Pompeii, sequences of figural scenes stand out from a background of richly coloured monochrome panels on a narrow stage. The Third Style, which partially overlapped the Second, made less use of deep vistas and simulated recession but enriched the complication of architectural ornament with delicacy and fantasy. The walls were divided into brilliant monochrome panels, which might be individually decorated by small painted scenes, figures floating in space, or small pictures painted as if hanging or applied. Light, atmosphere, and space give way to a BAROQUE riot of

**269.** Wall decoration from the House of the Vettii, Pompeii

**270.** Fountain with mosaic decoration from the House of La Grande Fontana, Pompeii

decorative elaboration. It was mainly the Third Style which provided the material and inspiration for the various 'Pompeian' phases of 18th- and 19th-c. interior decoration and the long-continued taste for GROTESQUES. The so-called Fourth Style occurs most frequently since many houses at Pompeii were redecorated after the earthquake of A.D. 63. As in the Second Style the plane of the wall is again illusionistically dissolved into landscape and architectural vistas but certain features are retained from the Third Style in the division of the wall space into separate segments. But this style is more varied and difficult to characterize than the others, so that some experts have purported to distinguish at least four phases of this one style.

The Roman painters had not mastered the principles of scientific perspective with a single vanishing point and uniform source of light, but usually combined a 'plunging' perspective with a quasi-horizontal perspective and sometimes others as well. But they had obviously carried pictorial domestic decoration to a point that has rarely been surpassed and the effects they aimed at, whether scenographic or open landscape vistas or purely decorative ornament, were often achieved with a superb mastery which must be admired. The murals were combined with MOSAIC, painted ceilings, patios, swimming pools, gardens, to form a brilliantly conceived scheme of decoration in which different rooms were done in different styles with different colour schemes and real and artificial vistas were made to work together. It has been a matter of much controversy whether the Roman painting as exemplified at Pompeii was original or derivative PASTICHE from HELLENISTIC or classical Greek painting. It seems likely, however, that the alternatives have not been correctly put. There is every reason to suppose that some of the paintings, particularly small murals used to decorate wall panels of the Third Style in the manner of hanging easel pictures, were copies of earlier Greek originals. Furthermore many of the artists were of Greek origin and it may well be that some of the figural scenes, particularly those in the classicizing or Hellenistic style (see ROMAN ART for a discussion of the two painting styles), were modelled on earlier Greek themes or compositions, perhaps with the aid of 'copy books'. How close the parallel was cannot now be judged since no Greek work has survived. It is known that Roman and Italian painters were also at work and it is reasonably supposed that they were chiefly responsible for developing non-idyllic landscape and the robust and realistic GENRE which was less developed in the Hellenistic world. No hard-and-fast line of distinction can be drawn and in any case a distinction between Greek artists working for Italian patrons in an Italianate decorative scheme and Italian artists working with acquired Greek techniques is bound to be largely artificial. The most important factor is the originality of this Italian fashion of interior decoration, which fits in with the Roman tend-ency to construct for the sake of the interior rather than to concentrate primarily on exterior appearance as the Greeks had done. (See discussion of architecture in ROMAN ART.) There are no known Hellenistic precedents for the Second, Third, and Fourth Pompeian Styles and even the First transformed the Greek custom of painting walls to resemble marble facing into something new and unique.

**PONTE,** DA. See BASSANO.

**PONTIGNY.** This Cistercian abbey was founded in 1114, the second daughter of Cîteaux. The present church, begun in 1150, represents the second phase of Cistercian architecture. Although outside it still looks like a barn, the interior has a monumental dignity beyond the bare austerity of FONTENAY. This is due chiefly to its great ribbed VAULTS. The choir was altered c. 1170, and is even more distinctly GOTHIC in appearance. It foreshadows the complete assimilation of Cistercian architecture into the Gothic idiom, represented by Royaumont.

**PONTORMO,** JACOPO CARUCCI (1494–1557). Italian painter of the FLORENTINE SCHOOL. His early works, such as the *Visitation* (SS. Annunziata, Florence, 1514–16), were in the style of his master ANDREA DEL SARTO. Soon, however, a more personal style emerges, visible in the ALTARPIECE in S. Michele Visdomini, Florence (1518). He was one of the most sensitive of those artists who worked on the borderland between late CLASSICISM and early MANNERISM but his work manifests a nervous and almost hysterical temperament. The *Joseph in Egypt* (N.G., London, 1518–19) is crowded and confused; the statues in it seem more alive than the people and an architecturally impossible building is contrasted with a view of a purely German gatehouse. In 1519–20 Pontormo painted a lunette in the MEDICI villa at Poggio a Caiano in which an apparently idyllic scene reveals a strong undercurrent of neurosis. In the Certosa near Florence he decorated the cloisters with scenes of the PASSION (1522–5); here his personal Mannerism was enriched by suggestions from the prints of DÜRER. This influence, which VASARI firmly condemned in an otherwise sympathetic account of the artist, was completely discarded when in 1526–8 Pontormo painted a *Deposition*, an *Annunciation*, and some roundels in Sta Felicità, Florence. The *Deposition* is one of the chief monuments of early Florentine Mannerism. The figures are tightly grouped yet irrationally composed, in complicated postures yet frozen into immobility; the colours are bright but the total effect is one of disintegration. The influence of MICHELANGELO waxes and wanes in Pontormo's later work. Quite absent from the highly individual *Visitation* (Carmignano, Pieve, 1528–30), it utterly dominates his greatest commission, the decoration of the choir of S. Lorenzo, Florence, which occupied

him from 1545 until his death. (In 1738 these frescoes were whitewashed.) A large number of the artist's drawings remain (Uffizi, Louvre, etc.) and amongst them are several preparatory studies for the S. Lorenzo scheme. His subjects included the Flood and the Resurrection, represented by means of tight groups of swirling, over-developed nudes. Pontormo's diary for part of 1554–6 remains, giving a day-to-day account of his progress in his great undertaking. It also tells us much of the artist's character, melancholy and introspective, dismayed by the slightest illness. He was highly regarded for his portraits, in some of which he achieved a refreshing direct-ness and strength.

557, 2195, 2656.

**PONZIO,** FLAMINIO (*c.* 1560–1613). Italian architect, who worked mainly for Pope Paul V Borghese and the Borghese family. In Rome he built their chapel in Sta Maria Maggiore, a casino, and parts of their palace. His best known work is the severe façade of the Palazzo Sciarra-Colonna, Rome. His style, like that of Martino LUNGHI I, marks the transition from MANNERISM to early BAROQUE.

**POP ART.** Term coined by the English critic Lawrence Alloway for a movement which origin-ated with a group of friends who first called them-selves the Independence Group when they began to meet in the winter of 1954–5. In the words of Alloway: 'We discovered that we had in common a vernacular culture that persisted beyond any special interests or skills in art, architecture, design, or art-criticism that any of us might possess. The area of contact was mass-produced urban culture: movies, advertising, science fiction. We felt none of the dislike of commercial culture standard among most intel-lectuals, but accepted it as fact, discussed it in detail, and consumed it enthusiastically.' As it developed the movement came into more pro-nounced opposition to accepted aesthetic standards, as expressed for example in the writings of Clive BELL and Herbert Read, treating the arts as one form of communication among others. One of the spokesmen of the movement, David Syl-vester, quoted Roy LICHTENSTEIN's description of Pop Art as 'an involvement with what I think to be the most brazen characteristics of our cul-ture, things we hate, but which are also powerful in their improvement on us'. Sylvester added: 'British artists by and large take a far more romantic and optimistic view of Coke culture than Americans do. If this is so, the reason would clearly be that Coke culture has not yet completely taken Britain over and so exerts a more exotic fascina-tion for us.' It was a feature of Pop Art both in Britain and in the U.S.A. that it rejected any distinction between good and bad taste.

In the U.S.A. Pop Art was initially regarded as a reaction from ABSTRACT EXPRESSIONISM be-cause its exponents brought back figural imagery and made use of hard-edged, quasi-photographic

techniques. They were labelled NEO-DADAISTS because they used commonplace subjects (comic strips, soup-tins, highway signs) which had affinities with DUCHAMP's ready-mades of 1915–20. Their most immediate inspiration, however, was the work of Jasper JOHNS and Robert RAUSCHENBERG. Johns's paintings of flags, tar-gets, and numbers and his sculptures of ale cans, light bulbs and flashlights, and Rauschenberg's COLLAGES and 'combines' with Coke bottles, stuffed birds, and photographs from magazines and newspapers, opened a wide new range of subject matter. While often using similar sub-ject matter, the Pop Artists employed commercial techniques in preference to the painterly manner of Johns and Rauschenberg. Examples are Andy WARHOL's silkscreens of soup-tins, electric chairs, Marilyn Monroes, flowers; Roy Lichten-stein's paintings of comic strips; Tom Wessel-mann's (1931–  ) still lifes and Great American Nudes; James Rosenquist's (1933–  ) billboard paintings; and Robert Indiana's stencilled signs. Jim Dine (1935–  ) and Larry Rivers (1923–  ) both combined commonplace subjects with painterly qualities. The major Pop Art sculptors are: Claes OLDENBURG, whose subjects include ice cream cones and hamburgers; George Segal (1924–  ), whose plaster casts of figures are set in fragments of their environments; and Marisol Escobar (1930–  ), whose work includes groups of figures in geometric blocks of wood with realistic details drawn in pencil.

41, 1675.

**PÖPPELMANN,** MATTHAEUS DANIEL (1662–1736). German architect, who became chief architect to Augustus the Strong of Saxony, King of Poland. Augustus's chief architectural undertakings were the rebuilding of Old Dresden after the fire in 1685, and of his own Dresden palace after a fire in 1701. Pöppelmann's main contribution, besides TOWN-PLANNING designs, was the Zwinger, a 'Roman arena', as he called it, for fêtes and sports, formed by galleries and pavilions, combining the richness of the BAROQUE with ROCOCO gaiety.

**POPPY OIL.** An oil extracted from poppy seeds has been one of the most popular of the DRYING OILS used as a MEDIUM for OIL PAINTING. It is less viscous than LINSEED and WALNUT OIL and does not easily turn rancid. It is, however, slow drying. This turned out to be an advantage rather than a disadvantage when the method of ALLA PRIMA painting came into vogue about the middle of the 19th c. and for a time during the second half of that century poppy oil was much used by commercial colourmen.

**PORCELLIS** (PERCELLIS), JAN (*c.* 1584–1632). Artist who was born in Ghent and migrated to Holland, where he painted and etched seascapes. His favourite theme was a modest fishing-boat making its way through a choppy sea near the shore, and in 1624 he himself went to sea for some months. His

paintings mark the change in Dutch MARINE PAINTING from the strongly coloured pictures by painters like Hendrick Cornelisz Vroom (*c.* 1563–1640), with their emphasis upon the representation of ships, to monochromatic paintings which are essentially studies of sea, sky, and atmospheric effects. His remarkable achievement was recognized by his contemporaries, who praised him without reservation as the greatest marine painter of the day. Both REMBRANDT and Jan van de CAPPELLE collected his works. His son JULIUS, who died prematurely in 1645, was also a marine painter.

**PORCH** (see also PORTICO). Architectural term for a structure set in front of the door of a building to provide it with a covered approach. Porches vary in size and appearance very considerably and it is not always easy to distinguish where the building proper ends and the porch begins. Thus in what is probably the earliest known type of porch, that attached to the hall or *megaron* occupied by the earliest rulers of settlements in Asia Minor—e.g. Troy before 2000 B.C. and later in MYCENAEAN citadels such as Tiryns and Mycenae itself—the side walls of the royal hall were simply extended beyond the end wall in which the door was placed, and the roof brought forward to form a porch that was a kind of open vestibule. The *megaron* plan survived to become the typical TEMPLE plan of classical GREEK times, the porch or *pronaos* then being partially enclosed by one or more rows of COLUMNS. In one notable case, however, that of the ERECHTHEUM at Athens (*c.* 420 B.C.), which has a unique plan for a Greek temple, there are no less than three porches, one of the kind just described and two others which project from the side walls: one of these is the famous CARYATID Porch. The Greek type of porch survived into ROMAN architecture and even when the great CONCRETE structures of Imperial times were built, on a scale that dwarfed Greek temples (the PANTHEON), the traditional colonnaded porch was retained. By the time the first large Christian CHURCHES were built in Rome, however, low passages were being used to give access to the main doors (the BASILICA of Maxentius, *c.* A.D. 310), and this form was adopted for the churches as well. The covered passage was extended around an open courtyard, or ATRIUM, to which a covered doorway gave access at the far end.

During the early Middle Ages a new kind of porch developed in northern Europe—the so-called 'tower porch', in which the door of the church was approached through the lower storey of a tower-like construction at the west end. These tower porches often achieved considerable dimensions. Perhaps the best surviving example is that of St. Benoît-sur-Loire (11th c.). During this period the open atrium of the early Roman churches was occasionally repeated, but it was eventually built up to the full height of the church and roofed in, thus becoming a spacious NARTHEX or vestibule which might be regarded as a kind of internal porch. Another new development began during the 12th c., perhaps first in Lombardy, with the building out of small true porches over the doorways in the west fronts of cathedrals (Piacenza, Modena, Verona, etc.). These structures were supported by slender columns which rested on the backs of lions or dragons. In northern Europe similar projecting porches were adopted—e.g. at LAON and CHARTRES—to accentuate the dramatic effect of the great triple portals which opened on to the new GOTHIC interiors. At Chartres, on the transept façade, the porches were heavily encrusted with sculpture which amplified the encyclopedic programmes of the portals themselves. Later Gothic porches seldom achieved this sort of scale but the idea of the projecting porch continued in use right down to the 16th c. Some of the later ones are particularly rich in Gothic ornament—e.g. Louviers and ALBI. Sometimes polygonal forms were used. At St. Mary Redcliffe, Bristol, there is a hexagonal porch; while in Germany there are triangular examples at Erfurt and Regensburg. At St. Maclou, Rouen, the porch is half an irregular polygon. In England porches were usually placed on the side of church naves rather than at the west front. Perhaps the most impressive of them is at Cirencester, where there is an upper room big enough to serve later as a town hall.

During the Middle Ages church portals had certain liturgical and parochial uses which help to account for their great variety. With the RENAISSANCE, however, porches reverted to the function which they had served in classical architecture, namely to provide an imposing approach to the entrance of great buildings. As such they were subjected to more careful planning. In the 15th c. there were a few notable experiments in Italy, such as ALBERTI's deep recessed porch for S. Andrea, Mantua, and the enormous LOGGIA in front of Sta Maria della Grazie, Arezzo. Porches were not much favoured in church designs by the High Renaissance architects in the 16th c., but PALLADIO used colonnaded porticoes to impart a classical effect to some of his VILLAS (the Villa Rotonda, Vicenza) and under his influence they are to be found in certain English country houses.

In Post-Renaissance architecture the colonnaded portico occasionally assumed exaggerated proportions (the Superga, Turin); that of the Panthéon, Paris, was, however, more obviously inspired by the antique. With the Classical Revival of the 19th c. the Doric portico was brought back into favour. There were even deliberate copies of well known antique works, e.g. the caryatid porch of St. Pancras Church, London, which was taken from the Erechtheum.

**PORDENONE,** GIOVANNI ANTONIO DE SACCHIS (1483–1539). North Italian painter, born in Friuli. He was trained locally and in his earlier work betrays the influence of GIORGIONE. After *c.* 1616 he developed a predilection

for MICHELANGELO's monumental figures, which he made yet more violent through over-dramatic ILLUSIONISTIC tricks. This is seen particularly in his chief work, a series of frescoes in Cremona Cathedral (1520-2). Many of his works throughout his life retained the crude vitality and vigour of his early training but the preparatory drawings reveal skill and elegance. In his work in the choir of San Rocco (1528-9) Pordenone represents a type of MANNERIST reaction against TITIAN which in certain respects anticipated TINTORETTO.

872.

**PORPHYRY.** A hard volcanic stone, difficult to carve and polish, varying in colour from red to green. The porphyry used by the ancient sculptors was a very hard, durable stone of a deep purplish red and the only known source was at Mt. Porphyrites in Egypt. Purple was the royal colour of the Ptolemies and the quarries were a royal possession; the porphyry BUSTS, STELAE, SARCOPHAGI, and other works of sculpture that have survived from Ptolemaic times were made, it appears, only at the ruler's command or with his consent. When Cleopatra died (30 B.C.) Egypt became a Roman province and the Roman emperors took possession of the quarries and control of the stone, purple being the Imperial colour. Large numbers of Roman works in porphyry have been preserved—GEMS, vases, urns, sarcophagi, busts, and statues, some of the last having only the clothing in porphyry and the flesh parts in some other stone. The Eastern emperors in BYZANTIUM used porphyry, often despoiling Roman MONUMENTS to get it, as when columns were taken from Rome and set up in Sta Sophia. During the Italian RENAISSANCE this costly stone of the ancients (*pórfido rosso antico*) came again into favour, especially with the MEDICI, and some sculptors, such as the Florentine Francesco di Giovanni del Tadda Ferrucci (1497-1585), made a speciality of it.

The name 'porphyry' is now loosely used to cover several other hard igneous stones used for monumental sculpture.

**PORTA, BACCIO DELLA.** See BARTOLOMMEO, Fra.

**PORTA, GIACOMO DELLA** (*c.* 1537-1602). Italian architect, born in Rome and trained there under MICHELANGELO, although he was later much influenced by VIGNOLA and became one of the most successful exponents of the frigid, academic MANNERISM of the later 16th c. He completed several works by Michelangelo, including the Palazzo dei Conservatori on the Capitol, and, with Domenico FONTANA, the DOME of St. Peter's (1586-90): in both cases he made major alterations to Michelangelo's designs. After 1572 he completed the façade of Vignola's Gesù, again altering the design, and he used it as a model for several Roman churches of his own (Sta Maria dei Monti, 1580-1; S. Atanasio, 1580-3).

**PORTICO** (see also PORCH). Architectural term for a colonnade or range of COLUMNS with ROOFED projection along the side or before the entrance of a building. In classical architecture the type of portico was described according to the number of frontal columns, e.g. *tetrastyle* (4), *hexastyle* (6), *octastyle* (8), *decastyle* (10), *dodecastyle* (12). The term 'transverse portico' is used for an entrance with columns running parallel to the face of the building.

**PORTINARI, CANDIDO** (1903-62). Brazilian painter of Italian descent. Trained at the Rio de Janeiro School of Fine Arts, he won a scholarship in 1928 which enabled him to visit Europe. Among many decorative commissions executed in Brazil and the U.S.A. are his murals and AZULEJO designs for the Ministry of Education building at Rio (1936-45). He combines resonant colours with a delicate harmony of design in moods ranging from lyrical gaiety to poignant tragedy, e.g. his deeply moving series, *Retirantes* (1944), representing victims of drought in north-eastern Brazil.

1484.

**PORTLAND STONE.** A LIMESTONE which is quarried at Portland and Swanage, occurring also in France near Boulogne. It occurs in three beds. The topmost, called 'roach', is light buff in colour, coarse in texture, and will not take a good face or a sharp arris. It is therefore suitable for rough general building such as harbours and docks but unsuited for urban building. The 'whitbed' occurs beneath the roach and is a light dove colour, comparatively close-grained, somewhat granular in appearance, and will take a good arris and face. It is much used for building, particularly in London, and the better qualities have been used by modern sculptors. The lowest bed is called 'base bed', a lighter cream colour than whitbed, but it is less hard and does not weather so well in exposed positions. It takes a good arris and face. The weathering qualities of different kinds of Portland stone vary considerably. The Banqueting Hall at Whitehall and St. Paul's Cathedral have weathered well for 300 years, whereas some comparatively new Portland stone has decayed badly.

**PORTUGUESE ART.** Portugal won independence from the Spanish kingdom of León in 1143 since when the art of Portugal has owed comparatively little to Spanish inspiration; and although foreign influences have played an important role in Portuguese as in Spanish art, the duration and intensity of these influences have been markedly different in the two countries.

The few remains of prehistoric, ROMAN, VISIGOTHIC, and MOZARABIC art in Portugal belong to the art of the Peninsula as a whole (see SPANISH ART). Nor do the ROMANESQUE churches and cathedrals which survive from the formative years of Portuguese independence reveal dis-

tinctively national features. These 11th- and 12th-c. monuments in north and central Portugal, of which Coimbra Cathedral (1162-76) is the outstanding example, follow the same French precedents as do the slightly earlier Romanesque churches of north-western Spain. The late 12th-c. Templar church at Tomar and the Cathedral of Evora (begun 1186) are representative of the period of transition associated with the reconquest of central and southern Portugal from the Moors. Portugal had no large Moorish industrial centres comparable to Toledo or Seville, so MUDÉJAR influence was relatively slight in Portuguese medieval art. GOTHIC architecture is magnificently represented by the monasteries of Alcobaça and Batalha. The former was a Cistercian foundation and the church (1158-1222) retains certain Romanesque features, but the 14th-c. TOMBS of Inés de Castro (d. 1361) and King Peter (d. 1367) are masterpieces of Portuguese Gothic sculpture. These tombs and the monastery church of Batalha herald the evolution of specifically Portuguese styles in art and architecture.

There is no indication of a native school of medieval painting and Jan van EYCK's visit in 1428-9 seems to have left no traces. Apart from a few mural fragments the earliest surviving works are a series of panels attributed to Nuño GONÇALVES from the third quarter of the 15th c. The first half of the 16th c. was the era of the so-called Portuguese PRIMITIVES, prolific painters whose manner was largely dependent upon FLEMISH example. Active at Viseu in the north were Vasco Fernandes (c. 1475-1542) and Gaspar Vaz (c. 1490-1568); while to the Lisbon circle of court painters belonged Jorge Afonso (active 1508-40) and his pupils, initiators of Portuguese MANNERISM, Cristóvão de Figueiredo (active 1515-43), Garcia Fernandes (active 1514-65), and Gregório LOPES. Their work is distinguished by a REALISM not devoid of sentiment, exceptional skill in portraiture, and a predilection for brilliant colour schemes.

Parallel with these Luso-Flemish schools of painting there appeared in the early 16th c. the first indigenous style of architecture, known as MANUELINE, in which buildings of Gothic construction were overlaid and transformed by a new and original type of sculptural ornament. This was the epoch of the great maritime discoveries of the Portuguese, and their first overseas buildings were Manueline in style (see PORTUGUESE COLONIAL ART).

Although Andrea SANSOVINO had visited Portugal in the 1490s, the effective pioneer of RENAISSANCE art appears to have been the French decorative sculptor Chanterène, active in the early 16th c. Then during the reign of John III (1521-57) Italian influence began to penetrate every branch of Portuguese art. The painter Gregório Lopes, and the architect João de Castilho (active 1515-52) were transitional figures. More completely Italianate on the other hand were the MINIATURIST Francisco de HOL-

ANDA, the sculptor João de Ruão (active 1530-80), and also the architects Diogo de Torralva (1500-66), Afonso Alvares (active 1551-75), and Filippo TERZI, who employed a late Mannerist style which re-echoed in provincial versions throughout the 17th c., notably in several of the large churches built by the Jesuits and Benedictines.

The absence of any school of painters or sculptors in the late 16th or 17th c. may be partly explained by the fact that PATRONAGE of the Spanish crown (to which Portugal was politically united from 1580 to 1640) attracted to Madrid many gifted Portuguese artists such as the sculptor Manuel PEREIRA. Only in the sphere of the decorative arts were there signs of a more distinctive originality towards the end of the 17th c., manifested for example in TERRACOTTA religious statuary at Alcobaça (1669-87) and textiles, furniture, and metal-work incorporating INDIAN motifs. From this period also dates the development of the distinctively Portuguese blue-and-white AZULEJO and the first examples of the gilded BAROQUE and ROCOCO carved wood REREDOSES in Portuguese churches during the 18th c.

But it was not until the reign of John V (1706-50) that the Baroque style was fully acclimatized in Portugal. It was introduced by artists trained in Italy, the most prominent of whom was the Italianized German J. F. LUDOVICE, architect of the enormous palace-monastery of Mafra (1717-70). Both Italian and Portuguese artists participated in the decoration of Mafra, among the latter being the painter Francisco Vieira de Matos (1699-1783) called Vieira Lusitano and the sculptor MACHADO DE CASTRO. Meanwhile the Tuscan architect and painter NASONI had introduced a richly decorated late Baroque style to the provincial towns of the north, thereby stimulating the local builders to develop a form of Rococo architectural decoration of their own (c. 1760-80) which provides one of the most interesting chapters in the history of Portuguese art. The work of Jean Baptiste Robilleon (d. 1768) at the palace of Queluz (1747-60) and the Factory House (1786-90) built by the British consul John Whitehead, exemplify French Rococo and English NEO-CLASSICAL influences during the second half of the 18th c. The greatest architectural achievement of this period was, however, the reconstruction of Lisbon after the 1755 earthquake, a splendid example of 18th-c. TOWN-PLANNING drawn up under the direction of Eugenio dos Santos and executed in the mixture of Neo-Classical and Baroque known as the 'Pombaline' style after A. F. Pombal (active 1721-45).

About the turn of the century the most prominent painters were Francisco Vieira (1765-1805) and D. A. de SEQUEIRA. The latter was a master of European importance. During the rest of the 19th c., however, painting declined despite the technical proficiency of certain ROMANTIC painters such as the Viscount de

Meneses (1820–78) and Miguel Lupi (1826–83). With the exception of the ABSTRACT painter VIEIRA DA SILVA Portugal has contributed little to 20th-c. modern art movements.

174, 1536, 1550, 1615, 2054, 2389, 2390, 2391, 2393, 2807.

**PORTUGUESE COLONIAL ART.** The present colonial possessions of Portugal, which are mainly in Africa, represent what is historically their third empire. The first was in south and east Asia, the second in Brazil. The prosperity of the two earlier empires, at their height in the 16th and 18th centuries respectively, provided favourable conditions for the development of a flourishing colonial art, derived from that of Portugal but often displaying original variations.

The Portuguese reached India via the Cape in 1498 but their Asian empire began in 1510 with the capture of Goa, which became the metropolis of a chain of fortresses and trading-posts stretching from Mozambique in south-east Africa to Macao in China. The principal surviving monuments of the first Portuguese empire are on the west coast of India. They date from the 16th and 17th centuries and include several imposing fortresses and fortified cities, such as Diu, Damão, and Bassein, and also a number of ecclesiastical edifices. The finest of the latter are the churches of Old Goa, which provide an architectural sequence from MANUELINE (Rosario, 1543) through late RENAISSANCE or MANNERIST (Cathedral, 1562–1631; Bom Jesus, 1594) to BAROQUE (Divina Providencia, 1655–9). There also survive in these churches a number of carved wood REREDOSES, incorporating occasional Moslem and Hindu motifs in characteristically Portuguese designs. The comparative poverty of Goanese art and architecture since the 17th c. reflects the economic decline of Portuguese India.

It was not until the mid 17th c., after the Dutch had been expelled from Pernambuco (1654), that the importance of Brazil as a colonial possession began to be realized. The paintings of Frans POST record the rustic simplicity of early Brazilian buildings; no major work of architecture precedes the third quarter of the 17th c., when the Jesuit church (now cathedral) was built at Salvador da Bahia. This building is a characteristic example of the provincial Mannerist style which was then still current in Portugal and which continued in vogue well into the 18th c. in Brazil, where it is often termed the 'Jesuit style' although it was by no means exclusive to the Jesuits.

During the second quarter of the 18th c. certain Baroque elements (already freely employed in carved and gilded wood reredoses, church furniture, and painted ceilings) began to be used architecturally in the elevations of façades. But it was between the mid 18th c. and the end of Portuguese rule (1822) that colonial art and architecture in Brazil reached its peak

with features of Baroque, ROCOCO, and NEO-CLASSICAL character. Especially remarkable are the early Neo-Classical (Pombaline) churches of Rio de Janeiro and Belém do Pará and the late 18th-c. Rococo churches of Minas Gerais. The latter, enriched with the soapstone sculpture of António Francisco LISBOA and the decorative painting of Manuel da Costa Ataíde (1762–1837), achieve a lyrical elegance reminiscent of central European Rococo. The complete city of Ouro Preto, colonial capital and artistic centre of Minas, is scheduled as a national monument by the Brazilian government.

201, 847, 1536, 1677, 2389, 2518.

**POSADA,** JUAN GUADALUPE (1852–1913). Mexican GRAPHIC artist, born at Aguascalientes of peasant stock. After working as a school-teacher in León, he came to Mexico City in 1877, where he produced a series of political LITHOGRAPHS for the publisher Venegas Arroyo and did satirical illustrations for opposition newspapers. From 1890 he made his studio an open shop fronting the street and turned out sensational broadsheets and cheap cartoons which spread among the illiterate throughout the country. From an earlier artist, Santiago Hernandez, he took over the *calavera*, or skeleton WOODCUT, using the skull as an instrument of social satire and ridicule. Unlike the more self-conscious nativists of the revolutionary era his work had the vigour and spontaneous strength of genuinely popular art with the inborn Mexican taste for the more gruesome aspects of death. He was a pioneer of social REALISM and anticipated the CARICATURE of the revolutionary artists, many of whom were influenced by his work. He made a lasting impression on both OROZCO and RIVERA during their student days.

**POSNIK,** YAKOSLEV (16th c.). Russian architect from Pskov. He is mentioned—together with BARMA—as the architect of the Cathedral of the Blessed Basil at Moscow (1554–60). Nothing is known about the respective contributions of the two architects.

**POST,** FRANS (1612–80). Dutch painter and engraver who with Albert Eeckhout (d. 1663) and other artists painted LANDSCAPES and scenes of Indian and colonial life in the Dutch-occupied region of north-east Brazil during the governorship of Prince John Maurice of Nassau (1637–44).

**POSTER.** Posters were known to antiquity, but only in the form of public written communications. As a form of art their history does not begin until the second half of the 19th c. The improvement of GRAPHIC processes, notably of LITHOGRAPHY, led to this development, which finds its expression in designs by major artists for what is in essence an art of the people. Political propagandists discovered the compelling

power of the image in the First World War, and PICASSO's dove is an instance of art in the service of politics. But the poster is mainly, though not exclusively, commercial. It would be possible for this reason to consider it as part of commercial art. There is, however, a strong link between the development of the poster and the development of modern painting and typography. In the thousands of posters which since the late 19th c. have led an ephemeral existence on highways and in public places all over the world, and which are preserved in collections, most tendencies of modern art from ART NOUVEAU to TACHISME are evident. They are by turns representational, non-representational, FUNCTIONALIST or SURREALIST. ABSTRACT artists such as MONDRIAN have influenced layout and design.

France is the country where the designing of

posters has attracted the greatest number of artists. From the time of Jules Chéret (1836–1933) there have been those who considered the poster one of the media through which they might convey their ideas. Best known are: FORAIN, T. A. Steinlen (1859–1923), and, above all, TOULOUSE-LAUTREC, whilst in more recent times Picasso and MATISSE have made their contributions to this form of art.

In England the Beggarstaff Brothers, PRYDE and NICHOLSON, represent an early phase of development, whilst special mention may be made of Aubrey BEARDSLEY's work in the field. The character of early posters, especially in Great Britain, was largely decorative with special attention to broad effects which may derive from the influence of JAPANESE prints and which contribute to preserve a close unity between the pictorial and the typographical elements. (It

**271.** *Don Quixote.* Poster designed by the Beggarstaff Brothers for the play *Don Quixote* at the Lyceum, but not used. Black and brown paper cut out and pasted on white. (V. & A. Mus., 1895)

899

may be of interest to note that Japanese theatre posters were among the first to connect a picture with a printed communication.) A comparison of photographs of street hoardings made in 1863 with those made in 1899 shows that the former relied for their appeal upon bold type and carefully finished pictures, which were in fact large engravings of very poor quality. Those of the later period employed large areas of colour and made use of silhouetted forms clearly derived from Oriental sources.

English poster design in the 20th c. varies between the illustrative, as exemplified in railway posters, and the work of great merit done for Shell-Mex acting on the advice of Jack Beddington and for the London Transport Authority, who employed Frank Pick. The name which immediately comes to mind in this connection is that of E. McKnight Kauffer (1891–1954), but many others have devoted themselves to this field. Nevertheless, posters of aesthetic merit are a small fraction of the many which are obnoxious or indifferent artistically.

## POST-IMPRESSIONISM, POST-IMPRESSIONIST.
Term invented by Roger FRY and adopted by Clive BELL and others (see Preface to Clive Bell's *Art*, 1914) to denote the modern French masters—notably CÉZANNE, GAUGUIN, MATISSE—and the so-called movement with which they were associated. The term had a much wider and looser connotation than the French 'Néo-Impressionnisme' and was not applied specifically to the movement or techniques inaugurated by SEURAT. The first London Post-Impressionist exhibition, held at the Grafton Galleries in the autumn of 1910–11 and entitled *Manet and the Post-Impressionists*, contained only two port scenes by Seurat and five pictures by SIGNAC compared with 21 by Cézanne, 41 by Gauguin, and 22 by van GOGH. The second Post-Impressionist exhibition, in 1912, had nothing by Seurat or Signac but included PICASSO and BRAQUE, who had not been represented in the first.

In the Preface to the Catalogue of the second exhibition Roger Fry remarked that the distinguishing feature of the artists represented was 'the markedly Classic spirit of their work' and explained that they did not seek to imitate natural forms but to create form. Clive Bell in an essay on Post-Impressionism said: 'At this moment there are not half a dozen good painters alive who do not derive, to some extent, from Cézanne, and belong, in some sense, to the Post-Impressionist movement.'

1244.

## POT, HENDRIK GERRITSZ (c. 1585–1657).
Dutch portrait and GENRE painter who was probably a contemporary of Frans HALS in van MANDER's studio. In 1631 Pot painted Charles I in England; versions of this portrait are in Buckingham Palace and the Louvre.

## POTTER, PAULUS (1625–54).
Dutch painter and ETCHER of animals in landscapes, particularly herds of cows, horses, and sheep in the green pastures of Holland. W. Bode, a distinguished critic of Dutch painting, wrote that Potter was so much in tune with animals that his portraits of them are always free of anthropomorphism, and when he paints people he is guilty of zoomorphism. Potter's life-size painting *Young Bull* (Mauritshuis, 1647) is his most famous work. His detailed and precise manner of painting makes this colossal picture appear a trifle dry and laboured. He is at his best in small pictures; one of the most beautiful is the painting of phlegmatic cattle and sheep in the cool sunlight of *Early Morning* (Rijksmuseum, 1651). He was a precociously talented artist but even so his premature death at the age of 29 has made his paintings very rare.

1832.

## POTTERY.
The shaping and baking of clay vessels is among the oldest and most widely practised of all the crafts; and in quite early times potters already spent much ingenuity on making their wares stylish as well as practical. Even in the Neolithic stages of culture, when pots were often laboriously constructed from superimposed coils of clay, baked in open fires or sometimes merely dried in the sun, their shapes and simple incised or painted ornament were often of no little aesthetic merit. These elementary processes are still in use among

272. Potter at the wheel. Woodcut by Jost Amman from *Panoplia Omnium Artium* (1568), Hartmannus Schopperus

primitive races even today. With the invention of the wheel—a pivoted platform on which the pot is mechanically turned during the manipulation of the clay—it became possible to achieve forms of great refinement and variety. But the more advanced types of decoration, such as glazing and fine painting, and comparatively superior materials such as stoneware and porcelain were only perfected as a result of centuries of tradition and individual experiment. Above all progress in these fields was dependent on the extremely testing exigencies of the firing-kiln, imposing limitations which were reflected back upon every stage of the manufacture. For these reasons, therefore, the history of the ceramic art is bound up to an exceptional degree with considerations of technique.

TECHNIQUE. All pottery can conveniently be divided into three categories—earthenware, stoneware, and porcelain—according to its degree of hardness or special constitution. By far the commonest of these is earthenware, the ordinary pottery of all ages and still widely used for many purposes. It may require baking at temperatures in the region of 700 °C., or in the case of very soft wares even lower. When clay is fired to c. 1150 °C. or more it becomes vitrified—i.e. close grained and virtually non-porous—and forms the extremely durable material known as stoneware. Until modern times this was much more commonly produced in the Far East than in Europe. Porcelain is also a Chinese invention: hard, white, and translucent, and capable of the most delicate modelling, it is the most refined of all ceramic materials. Because of its particularly homogeneous composition the typical

Oriental porcelain is known as 'hard-paste'. No similar hard-paste porcelain was made in Europe until the 18th c., but its discovery was preceded by the development of various artificial porcelains, known as 'soft-pastes', which in many countries (e.g. England) remained long in use.

A most important aspect of the potter's craft is the use of glazes, which prevent seepage of liquids in the softer wares, impart a pleasing finish, and provide a medium for all kinds of decorative effects. A glaze is in effect a thin layer of glass caused to form over the clay body during the firing, and is composed generally of sand together with a fluxing agent such as lead or alkaline potash. The earliest earthenware glazes, those of ancient Egypt, were of the alkaline type and were tinted with metallic oxides. Similar glazes were again used in medieval times by the potters of Islam. Most Greek and Roman wares, on the other hand, received no more than a surface gloss, applied in the form of potash mixed with liquid clay, which by skilful control of the kiln atmosphere was made to yield red or black surfaces at will. But in most parts of the world, and particularly in Europe, the commonest earthenware glazes have been those fluxed with lead. Such lead glazes are comparatively soft, and liable to both 'crazing' and chemical decay in adverse climates. By the addition of mineral oxides they, too, can be tinted in many colours, although these run too freely to permit of precise designs unless some special expedient is adopted, such as a tin-glaze ground (see below).

For hard-paste porcelain a clear, felspathic glaze is generally the most suitable, and this fuses very closely indeed with the body material. Most

273. Stoking a potter's kiln. Terracotta plaque found at Corinth. (Louvre)

soft-paste porcelains, however, employ glazes fluxed with lead. For certain purposes—e.g. for figure models—the aesthetic qualities of unglazed porcelain (known as 'biscuit') have been exploited. Glazes of felspathic type combine well with stoneware bodies also, especially when (as often in China) these are of a semi-porcellanous nature; and many of the Sung potters' finest effects were obtained by mixing them with mineral oxides and skilfully varying the kiln temperature and atmosphere. From oxides of iron alone they were able to produce in this way not only red and brown tints (in a well ventilated, 'oxidizing' fire), but soft greens, blues, greys, and blacks as well (by means of a 'reduced', airless atmosphere). Only in recent times have European potters ventured on these testing techniques: their customary finish for stoneware has been salt glaze, whose tough, pebbled surface is induced by throwing salt into the kiln at the maximum temperature. Here, too, glaze has sometimes been entirely dispensed with, e.g. in the case of Wedgwood's tinted 'jasperwares'.

In addition to the use of glazes to create a play of light and colour upon its surface, pottery may be decorated by a wide range of manipulative techniques. Among these are the processes of carving, stamping, and inlaying designs in the clay before it is baked, as well as the more sophisticated use of moulds and applied work of all kinds. In the latter category falls the production of figurines and other models, which in many cases require casting and assembly from a number of separate moulds. Another device greatly favoured by small-scale 'peasant' potteries has been the use of variously coloured 'slips' (liquid washes of clay), which may be trailed or painted on in a variety of ways, or alternatively applied in successive layers through which designs are then scratched (*sgraffito*) to produce an effect of contrast.

By far the most widely practised of all ornamental techniques, however, has been that of painting. Much early, unglazed pottery was decorated in this way with simple earth PIGMENTS, fired or unfired, while slip painting occurs not infrequently on the more elementary glazed wares. Fine painting in bright mineral colours occurs first in ISLAMIC pottery, following the invention of a semi-absorbent white tin-oxide 'glaze' for use as a ground (*c.* 9th c.). The subsequent adoption of this in Spain and Italy made possible an immense production of painted pottery throughout Europe from RENAISSANCE times onwards. Painting on porcelain—a feature of Chinese ceramics since the 14th c.—has involved two distinct techniques. In the first of these, known as 'underglaze' or *grand feu* decoration, the designs are executed directly on the porcelain itself, and cobalt blue is virtually the only pigment which will stand up to the immense heat of the firing. But painting in a more extensive range of colours soon became possible with the use of 'overglaze' enamels: these are a form of coloured glass, powdered and mixed with liquid, which can be applied to the already glazed, fired porcelain and fused to it by firing at a low temperature (*petit feu*) in the so-called 'muffle-kiln'. Both underglaze and enamel painting were extensively employed on European porcelains, and they proved equally serviceable for many other types of wares. In the modern industrial era, however, most decoration is carried out by the mechanical processes of transfer-printing.

HISTORICAL OUTLINE. (*a*) *The Ancient World.* In early times pottery was shaped entirely by hand, and many centuries passed before the introduction of the wheel. That of predynastic Egypt (up to the 4th millennium B.C.), the earliest to have survived, is nevertheless often distinguished by great refinement of form and finish: it includes plain red or black wares, their surface burnished to a fine gloss, and buff wares with simple geometric or figure designs either incised or painted in earth pigments. Similar pottery also appeared under the civilizations of the Euphrates valley and is, indeed, typical of early societies throughout the eastern Mediterranean. Strangely enough the use of glaze, a technique discovered and perfected in Egypt by the 2nd millennium, was never widely adopted: it plays little part, for example, in the outstanding pottery of MINOAN Crete (3000–1200 B.C.). The later Athenian red and black figure wares represent the climax of a long development. Their somewhat stereotyped shapes were above all a vehicle for paintings of mythological and historical scenes which are not only superbly drawn, but constitute also an invaluable record of Greek customs and beliefs (see GREEK ART). By contrast the pottery of Imperial Rome stands at a much humbler level, and the ubiquitous red Samian ware (known also as *terra sigillata* or ARRETINE), with its rather meagre range of forms and reliance on stamped ornament, shows only too clearly the predominating influence of metal-work. In the outlying provinces of the empire, however, more vigorous traditions still survived, and much Romano-British or Gaulish pottery is shaped with real freedom and spirit. These wares often bear bold, rhythmic patterns carved in the clay, or trailed on in white slip. In Syria and Egypt, meanwhile, potters were perfecting the use of lead glazes, which were tinted in various colours; and thus introducing a technique of great significance for the future.

(*b*) *The Far and Near East.* For many centuries there was little or no interchange of ceramic skills and styles between Europe and the great civilizations of Asia. The brilliant achievements of the Chinese and their neighbours, especially in the field of glazed stoneware and porcelain, remained almost completely unknown, and it was scarcely until the opening of the direct sea route in the 16th c. that they began to exercise an influence. (See CHINESE ART, JAPANESE ART, KOREAN ART.)

But these wares were not without influence

on the Islamic pottery of the Near East. From the 9th to 16th c. Mesopotamia, Persia, Egypt, and Turkey all produced wares of uncommon originality and refinement, and these in turn embodied innovations in technique which were to revolutionize the practice of the art in Europe from late medieval times onwards.

(c) *Europe: the Middle Ages.* For centuries after the departure of the Romans the craft remained at a low ebb in the north. It was the introduction of the Egypto-Roman technique of lead glaze, in all probability transmitted through BYZANTIUM, which led to its gradual revival. But in England, as elsewhere, there are few remains of glazed pottery datable before the 13th c. Throughout medieval times pottery was little used at table, and excavated finds consist almost entirely of somewhat roughly made, imperfectly glazed jugs and pitchers. But these vessels are by no means lacking in sensibility: the earlier shapes are both slender and graceful, and, like the more capacious, rotund vessels developed during the 14th c., are glazed in various shades of green, yellow, or brown. Further decoration was often applied in the form of interlaced strips and rosettes of clay, and occasionally even beasts or human figures were represented. At the same time, stamped, inlaid tiles were made in quantity for the floors of monasteries and churches.

A similar pattern of development may be discerned in much of the medieval pottery made on the Continent. The chief exception was in the German Rhineland, where a highly distinctive manufacture of stoneware had already begun by the 15th c.

(d) *The Renaissance.* In many northern countries the manufacture of lead-glazed earthenware continued to predominate throughout the 16th c. and was greatly improved. Better glazes in brighter colours now became available, several often being applied to the one piece; while in search of more refined models for shape and design potters did not hesitate to borrow from more advanced arts, such as silver and RELIEF sculpture.

Among the more important potters in Germany, Austria, and Switzerland were the Hafner —the traditional makers of large, central-heating stoves covered with pottery tilework. In the 16th c. many of these stoves began to be covered with figure compositions in boldly cast relief illustrating biblical or historical events, and picked out in a variety of colours; while at Nuremberg, among other places, many handsome jugs and dishes were also made in the same style. In France Bernard Palissy achieved considerable renown by his manufacture of relief-decorated, polychrome lead-glazed earthenwares in the new Renaissance manner; he also produced some curious MONTAGES with plants and reptiles carefully modelled after nature. The so-called 'Henry II wares', made at St. Porchaire, are perhaps the rarest of all the ceramic oddities of this period: they include a variety of fantastic,

many-tiered salt-cellars, goblets, and other vessels made of white clay with stamped, coloured clay inlays.

In Tudor England the manufacture of neatly turned, leaf-green mugs and bowls bears witness to a somewhat more modest rise in the status of the craft. But in the case of important commissions—e.g. certain handsome cisterns bearing the arms of Henry VII—quite elaborate relief work was undertaken here also. Candlesticks and many-spouted 'puzzle-jugs' designed to confuse the drinker, as well as a slender, concave-sided beaker with several handles known as a 'tyg', were among the new shapes popularized at this time. A distinctive, glossy black-glazed ware found on certain monastic sites has been nicknamed 'Cistercian'. English potters retained their traditional fondness for applied decoration in the form of clay stamps and trailed slip designs—techniques which were even more extensively employed in the Stuart period.

But none of this activity was of such far-reaching importance as the contemporary development of painted pottery which took place in Spain and Italy. This was made possible by the adoption of the FAIENCE technique long practised by Islamic potters, in which the ware was first coated with a white tin-oxide glaze that not only showed up the designs to advantage but also preserved them during the firing. The Moorish craftsmen who brought the technique to Spain also introduced another Islamic invention—the shiny, metallic lustre pigment; and by the mid 15th c. their boldly painted LUSTRE POTTERY was already renowned throughout Europe (see HISPANO-MORESQUE POTTERY). This date likewise marks the beginning of the most illustrious phase of Italian MAIOLICA, in which subjects of great complexity were represented in a brilliant polychrome palette. In the 16th c. maiolica factories were established in many parts of Italy, and under the inspiration of the great Renaissance painters incidents from the Bible or from classical mythology were depicted often in brush-work of a high order.

By degrees the maiolica technique took root in various countries north of the Alps during the course of the century. To begin with the designs remained largely Italianate in character, but after 1600 a variety of more individual styles were developed. In France and Germany (and later in Scandinavia and Slavonic countries also) the painted wares were known as faience (French: *faïence*, German: *Fayence*, both derived from Italian *faenza*); and in Holland and England, as delftware. Their colourful appearance and neat finish may be said to have raised the art of pottery to an entirely new level; and it is worthy of remark, too, that from this time onwards the painter ranked almost equal in importance with the potter himself.

At Delft in Holland potters began *c.* 1625 to imitate the newly imported Chinese blue-and-white porcelain, making a thinner, more whitely glazed ware painted in blue only, and this Delft

style, in which Chinese shapes and designs mingled freely with those of native origin, was to exercise a considerable influence on potters throughout Europe until the end of the century. Particularly in France and Germany, however, there remained a strong partiality for poly-chrome-painted BAROQUE subjects; and these became merged in turn with the *famille verte* and other Oriental styles of the early 18th c. There was by this time an immense demand for table and ornamental wares of all kinds, and new factories appeared in many countries. The 18th-c. delftware of Holland and England was hardly of a standard to compete with the luxury porcelain industry now springing up in Europe, but not a few firms in France and Germany attempted to do so; by 1750 they were practising the ROCOCO style with some success, and borrow-ing also the porcelain-decorator's brilliant palette of overglaze enamel colours. They were still flourishing in 1770, although within 20 years they were virtually put out of business by the newer porcelain factories and the cheap, service-able English manufacture of 'cream-coloured earthenware'.

*(e) The Rise of Industrial Staffordshire.* As the makers of faience and porcelain rose to pro-minence during the 17th and 18th centuries, so in most countries the manufacture of the humbler lead-glazed wares sank into insignifi-cance. In England, however, it continued to flourish in Staffordshire throughout this period, and provided a basis for the large-scale industrial production that followed—this despite a size-able production of delftware, the introduction of stoneware after the German model, and a grow-ing native output of porcelain from *c.* 1744 onwards.

In 1700 the chief medium of Staffordshire potters was still the homely slipware, which provided a very sound training in clay and glaze techniques; but the growing popularity of im-ported porcelain for table use pointed the need for a much greater refinement in both material and potting. The first step in this direction was the introduction by the brothers J. P. and D. Elers, *c.* 1693-8, of unglazed red stoneware, a hard, thinly made ware with neat, stamped relief decoration, which remained a staple manu-facture for some 70 years. This was followed by other finely potted wares in which a light colour was obtained by using white clays imported from Devonshire. By adding calcined flint, it was found possible to fire these also to a state of considerable hardness; and Staffordshire potters therefore had at their command both cream-coloured earthenware (with lead glaze) and the even harder salt-glazed stoneware.

Undoubtedly a leading spirit in these innova-tions was John Astbury (1686-1743), whose neat, rustically designed tea wares are distin-guished by a highly decorative use of coloured clays. The style was further elaborated by the energetic Thomas Whieldon (1719-95), who added a variety of mottled glaze effects in soft

brown, green, yellow, grey, and blue. Many charming, freely modelled figures of animals, horsemen, musicians, etc., were produced at this time. The moulding not only of ornamental details, but of whole sections of vessels also, was greatly aided by the introduction *c.* 1740 of multiple PLASTER OF PARIS moulds cast from a master block—a notable step towards mass-production.

These somewhat provincial wares still com-peted with delftware and early English porcelain when in 1759 Josiah Wedgwood (1730-95) em-barked on his independent career. Wedgwood is best known today for his ornamental stone-wares, but it was undoubtedly the comparatively plain cream-coloured earthenware ('Queen's Ware') which established his reputation. With the completion in 1773 of a vast service for Catherine of Russia, painted in enamels with English views, his success became established on an international level. Immense quantities of this very practical 'creamware' were made by firms in Staffordshire, Leeds, and elsewhere from this time onwards, sometimes furnished with painted designs, verses, and initials, some-times with pierced or moulded work only. A few potters remained faithful to the Whieldon colour-glazing tradition, such as the Ralph Woods of Burslem, who made skilfully modelled figures of many kinds; but in the increasing pro-duction of cheap, serviceable tablewares cream-ware held sway. Various improved types were developed, such as Mason's 'ironstone china' containing porcelain ingredients (in 1813); indeed the former distinctions between earthen-ware, stoneware, and porcelain became in-creasingly blurred as the 19th c. progressed. Transfer-printing—practised in Liverpool work-shops since the 1750s—gradually replaced hand-painting for reasons of economy; decora-tion in pink or silver lustre, or moulded designs picked out in high-temperature colours, were for a time extremely popular. A somewhat severe style influenced by the French EMPIRE gave way *c.* 1825 to a mild Rococo revival which brought back relief scrollwork, applied flowers, etc., and much pretty, sentimental flower-painting (espe-cially on porcelain). This was followed by a series of increasingly tasteless revivals—GOTHIC, Renaissance, 'Moorish', 'Japanese'—until the end of the century.

231, 451, 538, 674, 980, 1097, 1236, 1355, 1358, 1359, 1360, 1361, 1362, 1363, 1555, 1556, 1557, 1558, 1595, 1750, 2160, 2161, 2162, 2164, 2419, 2676, 2746.

**POURBUS.** The name of three generations of Flemish artists who all distinguished themselves as portrait painters. PIETER (1510-84) was born in Gouda and settled *c.* 1540 in Bruges, where he became the pupil and son-in-law of Lancelot BLONDEEL. He worked in Bruges for the rest of his life as surveyor and cartographer as well as painter. His *Love Feast* (Wallace Coll.,

London) abounds in the kind of allegorical allusions which were common currency among the literati during the RENAISSANCE but which few people are able to decipher today. Pieter's son, FRANS the Elder (1545-81), was one of the chief pupils and a close follower of Frans FLORIS, the leading painter of Antwerp in the mid 16th c. The most famous member of the family is FRANS the Younger, who was in his day one of the principal court portraitists of Europe. He first worked for the court at Brussels, and from 1600 to 1609 was employed in Mantua by Vincenzo GONZAGA I. In 1609 he was called to Paris by Marie de Médicis and worked as her court painter until his death. His formal state portraits are notable for their exquisite and meticulous reproduction of the rich and elaborate costumes and jewellery of his royal patrons.

**POURTRAN.** See COLT.

**POUSSIN,** GASPARD. See DUGHET.

**POUSSIN,** NICOLAS (1593/4-1665). French painter. Although he worked most of his life in Rome, he is regarded as the founder of French CLASSICAL painting. His interest in painting was aroused by the visit to his home town, Les Andelys, in 1611 of Quentin Varin (c. 1570-1634), a minor painter in the late MANNERIST style, and in 1612 he settled in Paris. There he studied under various artists of the late Mannerist tradition, but was able to familiarize himself with Classical works in the form of RENAISSANCE pictures and engravings, particularly of RAPHAEL and his school, and ROMAN statuary and reliefs, in the royal collection. Between commissions of various kinds—the most notable being for work for the Luxembourg palace, with Philippe de CHAMPAIGNE (c. 1621) —he made two attempts to go to Rome. In Paris, c. 1623, he made the acquaintance of the poet Marino, who commissioned from him drawings to illustrate Ovid's *Metamorphoses* (Windsor). In 1623 he once more set out for Rome; travelling via Venice, he arrived early in 1624. Through Marino he came to the notice of Cardinal Francesco BARBERINI and his secretary Cassiano dal Pozzo, who became his patrons. His first Roman works show him to have been still dominated by the Mannerism of the mid 16th c. whilst also open to influences from various sources, so that no definable style was yet apparent. He worked for a time in the studio of DOMENICHINO and under the influence of Cassiano, who had a keen interest in antiquity, he studied Roman sculpture. With the predominance of these interests his manner began to shed the earlier Mannerist features and to evidence a Classical bent and a quality of restraint. This was the source of criticism in his most important work at this time, the ALTARPIECE *The Martyrdom of St. Erasmus*, commissioned by Cardinal Barberini for St. Peter's (Vatican Pinacoteca, 1628). But he was never at home with the new

BAROQUE tendencies which were the prevailing enthusiasm at Rome and his most personal work during this period is the *Inspiration of the Poet* (Louvre, 1628/9), Classical in design but VENETIAN in colouring.

In 1629-30 Poussin passed through a crisis, perhaps as a result of illness, which changed the direction of his work. Abandoning the competition for public commissions and rivalry with the current Baroque, he gave himself up to his dominating passion for the ANTIQUE and during the next ten years brought to maturity the manner which has become recognized as peculiarly his own creation. Instead of religious subjects he painted themes from ancient MYTHO-LOGY seen through the eyes of Ovid or Tasso, which he treated in a PASTORAL and poetic mood. Until about 1633 the influence of TITIAN was paramount. During the latter part of the 1630s he turned to Old Testament and historical subjects which afforded scope for more elaborate pageantry (*The Worship of the Golden Calf*, N.G., London, c. 1635; *Rape of the Sabines*, Louvre, and a slightly later version in the Metropolitan Museum, New York). In the paintings of these years the influence of Titian waned and he moved towards a more austere Classicism which echoed the later Raphael and GIULIO ROMANO. He was preoccupied with the depiction of emotion by the gestures, pose, and facial expression of his figures, and pondered a literary and psychological conception of painting which he elaborated in a letter sent to his friend Fréart de Chantelou with the picture *The Gathering of the Manna* (Louvre, 1639). His views on the rendering of the emotions were taken up and formalized in the doctrines of the Académie. From this period came also the first series of the *Seven Sacraments*, painted for Cassiano dal Pozzo (N.G., Washington, and Belvoir Castle, 1639-40), and the *Dance of Time* (Wallace Coll.).

His reputation was very high by the end of the 1630s and in 1640 he succumbed to strong pressure and returned to Paris. Louis XIII's aside on receiving him—'Voilà Vouet bien attrapé'—gives the tone of this visit, which was ruined by jealousy and intrigue. He was commissioned to superintend the decoration of the Grande Galerie of the LOUVRE, to paint altarpieces, and to design frontispieces for the royal press. But he was most at home with smaller canvases painted at leisure and the work he executed during this Paris visit is not up to his usual standard. In September 1642 he set out again for Rome, and remained there for the rest of his life.

The most important outcome of the visit for Poussin was that he had come into contact with the intellectual bourgeoisie of Paris, the public of Corneille and Descartes, who not only patronized him for the remainder of his life but also caused a revolution in his outlook which enabled him to become the most typical and complete embodiment in the visual arts of French 17th-c. rationalism. As a result his painting between

1643 and 1653 was considered in his own day to be his finest achievement and is still recognized as the purest exemplification of the Classical spirit. The emphasis is on clarity of conception, moral solemnity, and obedience to rule. This new solemnity and the rational economy of the means of expression are apparent in the second series of the *Seven Sacraments*, and the *Eucharist*, painted for Fréart de Chantelou (Earl of Elles- mere Coll. on loan to N.G., Edinburgh, 1644-8). Poussin also made it his endeavour to achieve a rational unity of mood in each picture and developed a theory of *modes* (later taken up by the Académie) akin to the current theory of musical 'modes' supposed to be derived from antiquity. According to this theory the subject of the picture and the emotional situations depicted dictate the appropriate treatment, which can be worked out rationally and consistently according to principles expressible in language. He formulated what became the central doc- trines of the Classicism taught in the ACADEMIES. Painting must deal with the most noble and serious human situations and must present them in a typical and orderly manner according to the principles of reason. The typical and general is to be preferred to the particular and trivial sensuous allures, such as glowing colours, are to be eschewed. Painting should appeal to the mind not to the eye.

During the second half of the 1640s Poussin displayed a new interest in LANDSCAPE, applying to animate and inanimate nature the principles of quasi-mathematical lucidity and order which he sought elsewhere. He achieved an impression of monumental simplicity and calm. Examples are *Landscape with Diogenes* (Louvre), two land- scapes illustrating the story of Phocion (Earl of Plymouth Coll., Ludlow, and Earl of Derby Coll., Knowsley), and *Orpheus and Eurydice* (Louvre). The *Self Portrait* (Louvre, 1650), showing the artist half-length against a series of overlapping vertical planes created by picture frames and wall, is also typical of this period.

By 1650 Poussin had achieved European fame and his position in the world of art was unique. Between 1653 and his death in 1665 his style underwent yet a further development. Psycho- logical expression, even if rationally controlled, was underplayed and his compositions took on a timeless allegorical quality. A motionless solem- nity took the place of action and gesture and his pictures became symbols of eternal truths instead of representations of historical events. In some of the works nature takes on a new wildness and grandeur contrasting with the impassive calm of the human figures. Examples of this period are: *Landscape with Orion* (Met. Mus., New York) and *Apollo and Daphne* (Louvre). His figure-subjects, such as the late *Holy Family* paintings (e.g. that in the Hermitage, *c*. 1655), are marked by a timeless stillness and a superhuman grandeur. In his late series of *The Seasons* (Louvre, 1660-4) he combined the descriptive idea with biblical references; thus Winter is

represented by the *Deluge*. The cold rationalism of his earlier works was left behind, and a poetical, imaginative approach took its place.

In the later 17th c. Poussin's name was used in the Académie to give support to those who believed in the superior importance of design in painting (Poussinistes) in opposition to that of RUBENS, who stood for the importance of colour- ing. Although the Rubensistes won the day, Poussin continued to be the inspiration of classically minded artists right into the early 19th c. In the ROMANTIC era his reputation dropped. In England he early awoke the admira- tion of the Earl of Shaftesbury and was respected throughout the 18th c., though not always care- fully distinguished from his brother-in-law Gaspard DUGHET, also known as Poussin. Hazlitt praised him as a 'painter of ideas', but RUSKIN condemned him as lacking in sensibility, mentally degraded, and 'untrue'. CÉZANNE and other modern French artists have drawn inspiration from the Classicist tradition which he in- augurated.

311, 934, 935, 1423, 2140.

**POUTRAIN.** See COLT.

**POWERS,** HIRAM (1805-73). American sculptor. He acquired a facility in MODELLING

**274.** *The Greek Slave*. Marble sculpture by Hiram Powers, exhibited at the Great Exhibition of 1851. Print from *Baxter's Gems of the Great Exhibition* (1854) by George Baxter

by making wax models and automatic figures in the Western Museum of Cincinnati and later became adept at turning out slick statues in Carrara MARBLE for the homes and gardens of the wealthy. In 1837 he established himself in Florence. He made BUSTS and statues of a number of prominent men, including Jackson, Longfellow, and General Sheridan. His best known work was *The Greek Slave*, which was praised at the Great EXHIBITION of 1851 and was for a time one of the most talked about statues of the 19th c.

**POYNTER,** SIR EDWARD JOHN (1836–1919). English painter, one of the last upholders of the Classical academic tradition in England. He was a fine draughtsman, but his importance lay chiefly in his ability as a teacher and administrator. He became Director of the NATIONAL GALLERY in 1894, and President of the ROYAL ACADEMY in 1896.

**POZZO,** ANDREA (1642–1709). Italian painter, a leading exponent of the BAROQUE style of ILLUSIONIST ceiling decoration in Rome, where he worked for the Jesuits, notably on the nave vault of S. Ignazio. After 1702 he was in Vienna, where he decorated the Jesuit Church, the University Church, and the Liechtenstein Garden Palace. His textbook on PERSPECTIVE for painters and architects, *Perspectiva Pictorum*

*et Architectorum* (1693–1700), was translated into many languages. His vertiginous and daring use of decorative TROMPE-L'ŒIL had an effect on the development of SOLIMENA and TIEPOLO.

**PRADO,** MADRID. The Prado was founded in 1818 by Ferdinand VII of Spain, seconded by Queen Isabella of Braganza, as the national Museum of Fine Art. It was opened to the public in 1819. After projects by Joseph Buonaparte and Ferdinand himself to establish a picture gallery in the Buenavista Palace had come to nothing, the gallery was finally housed in the large building, perhaps the most important example of Spanish NEO-CLASSICAL architecture, which Charles III had had constructed by the architect Juan de VILLANUEVA on the Prado Avenue. Completed before 1808, it had been intended for a Museum of Natural Science but had never served that purpose. Its resistance to drastic changes of temperature and its relative humidity have helped to keep the pictures in a good state of preservation.

The major part of the collection derives from the royal collections made in the course of three centuries by the Habsburg and Bourbon kings of Spain, who were some of the most discriminating and lavish patrons in Europe. The Prado itself is one of the most prized museums among art lovers in the world, less for its allround comprehensiveness than for unequalled

275. Clarendon House, Piccadilly. Designed by Sir Roger Pratt

and irreplaceable treasures in certain fields. It is relatively weak in works of the British School and has few Dutch paintings. But it contains almost all the important works of VELAZQUEZ, the most complete representation of El GRECO, the fullest representation of GOYA throughout his development, and is among the richest of all museums in works by Hieronymus BOSCH, TITIAN, and PATENIER. It has superb collections of TINTORETTO, VERONESE, RUBENS, and van DYCK and splendid examples of the MASTER OF FLÉMALLE, Rogier van der WEYDEN, BRUEGEL, RAPHAEL, and MANTEGNA. It has fine pictures by RIBERA, MURILLO, and ZURBARÁN. These are but the highlights of a collection which is unique of its kind.

**PRANDTAUER** (PRANDAUER), JAKOB (1660–1726). Austrian architect, the leading builder of monasteries at a time when political circumstances and an upsurge of artistic vitality combined to bring about Austria's most splendid period of architecture. His best known buildings are the monastery at Melk (1702–38) and that of St. Florian at Linz (from 1708 on). In these ebullient interpretations of the Italian BAROQUE style one may see the counterparts of the palaces and villas of imperial Vienna; to them, especially those designed by HILDEBRANDT, Prandtauer owed much of his architectural charm.

1246.

**PRATT,** SIR ROGER (1620–85). English architect. He trained himself by the study of RENAISSANCE architecture during a six years' tour of the Continent, and on his return in 1649 assisted a relative in the building of Coleshill House, Berks. (destroyed 1952). Inigo JONES and John WEBB were also concerned with it; and in many ways Pratt's architecture continues that of Jones. His most influential building was the short-lived Clarendon House, Piccadilly (1664–7; demolished 1683). He advised on the repair of Old St. Paul's, and was one of the Commissioners for the rebuilding of the City of London after the Great Fire.

**PRAXITELES.** Athenian sculptor of the mid 4th c. B.C., perhaps the son of CEPHISODOTUS. He and PHIDIAS were in ancient esteem the two greatest Greek sculptors. He worked most successfully in MARBLE. The calm, even indolent sensuousness of his style is not conveyed by the copies of his *Sauroctonus* or his *Cnidian Aphrodite*, the first important female nude, but irradiates the marble *Hermes* at Olympia. Doubts whether this is original or an unusually fine copy cannot be settled on the present evidence. A female head in Boston is an original from his school.

**PRE-COLUMBIAN ARTS OF THE ANDES.** Those arts indigenous to the Ameri-

cas, prior to the discovery of the continent, are usually referred to as 'Pre-Columbian'. Recognition of their aesthetic importance has come only in the 20th c., although they exercised a curiosity appeal almost from the beginning.

The whole western side of South America is dominated by the Andes, the most extensive orographical system in the world, which sweep north and south for 4,000 miles from the eastern end of the Isthmus of Panama to the Magellan Straits. The area generally designated the central Andean region runs from the Atacama desert in northern Chile to the rugged country of Ecuador. This area was the seat of the highest development of civilization in terms of indigenous culture and has been the most intensively studied of all archaeological areas in South America. At the time of the Spanish Conquest the cultures of the central Andean region had to some extent been brought to a unified pattern by the influences of the Inca Empire, which extended from the southern borders of Colombia, through Ecuador, Peru, Bolivia, north-west Argentina, and south to the river Maule in Chile. To the north the Chibcha culture flourished in the western Cordillera of Columbia and to the south an Araucanian culture in Chile. It is apt to be forgotten that the Inca dominated the central Andes for only a short period of some 200 years and that they were preceded by a long period of cultural development. Monochrome decorated POTTERY and a peculiar type of modelled female figurines have been discovered on the coast of Ecuador from a time between 3000 and 2500 B.C. Sophisticated designs on textiles and on small carved objects found in Peru go back to c. 2500 B.C. The splendid artistic and cultural development which lends a unique interest to the pre-history of this region took place from c. 1000 B.C. to c. A.D. 800, before the Inca domination. Although craftsmanship in many spheres—textiles, stonemasonry, ceramic, metal-work—was developed to a pitch which has been considered unrivalled in any other part of the world, iron was unknown to South American cultures and bronze remained the chief utility metal until the arrival of the Europeans in the mid 16th c. Writing was unknown and the history of Andean art is hampered by the lack of any written history of the civilizations and peoples. Precise dating is made difficult by the absence of any fixed dates which can be independently established. Andean archaeologists have therefore divided the history into periods, which are set out below.

Topographically the region is divided into three major zones.

1. COASTAL ZONE. A narrow strip of desert or semi-desert between the Pacific Ocean and the Cordilleras of the Andes. Human occupation was restricted to a number of valleys watered and fertilized by rivers which run down from the high mountains to the sea. For the purposes of archaeological study these are conveniently

**Map 5.** PRE-COLUMBIAN ARTS OF THE ANDES

divided into three groups (see Map 5). On the *North Coast* the most important centres are the valleys of Chicama, Huarmey, Moche, and Viru, near the modern Trujillo. The *Central Coast* group includes those of Paramonga, Chancay, and Rimac and Pachacamac in the vicinity of the modern Lima. The *South Coast* section includes the culturally and artistically important valleys of Paracas (Pisco), Nazca, and Ica.

A large part of the surviving artistic material from the early cultures of Peru comes from burials in the coastal zone, where the dry, sandy conditions have favoured preservation.

2. HIGHLAND ZONE. Much of the mountain terrain of Peru and Bolivia is uninhabitable because of high altitudes and the barrenness of the soil. Population has clustered in the high valleys and intermontane plateaux where pasturage and subsistence agriculture is possible. There are six major fertility basins hemmed

between the mountain ranges and for archaeological purposes these are customarily divided into three regions: (i) *northern highlands*, comprising Cajamarca, the Chavín section of the river Marañon, the Callejón de Huaylas, through which flows the river Huaraz, and Huamachuco; (ii) *central highlands*, comprising Huánuco, the river Mantaro basin east of Lima, and the Cuzco basin, the seat of the Inca Empire; (iii) *southern highlands*, comprising chiefly the regions of Puno and Tiahuanaco adjacent to Lake Titicaca (12,500 ft. above sea level) although subsidiary centres are known further south on the Bolivian Altiplano and in the eastern Cordillera of Bolivia.

3. MONTAÑA ZONE. The eastern slopes of the Andes and high tropical valleys or Yungas which merge into tropical rain forest. This region has been little explored archaeologically and climatic conditions are not favourable for the preservation

of art objects. It is generally believed that the typical Andean civilizations did not penetrate deeply into the Amazonian forest regions, although these undoubtedly had their own still little known arts of feather-work, wood and bark manufactures, and ceramics. It is sometimes thought that the tropical forest cultures may have had an important influence particularly on the early development of Andean cultures in such fields as religious beliefs, ICONOGRAPHY, design, and industrial techniques.

The nature of the central Andean terrain encouraged the segregation of the population into geographically isolated pockets, which despite a basic cultural pattern developed strongly marked and persistent local traditions of style and techniques. Superimposed on these regional subdivisions, however, are so-called 'horizon' styles which at various periods in the history spread

**276.** Design of semi-stylized fantastic head. Double spout and bridge jar, Paracas Cavernas. (Miss Kemper Coll., London)

more or less widely over the area under the influence of trade, religious beliefs, or political domination. Six such horizon styles are generally recognized.

(a) *Chavín Horizon* had its centre at the religious site of Chavín de Huántar in the northern highlands and spread along the northern (where its characteristic manifestation was the Cupisnique type), central, and southern coastal regions. It is distinguished by stone carving, a highly stylized feline motif, and a characteristic design of 'stirrup' pottery.

(b) *White-on-red Horizon* is characterized by relatively simple, mainly geometric decoration executed by a positive technique of brush-painting in white on red clay ceramics. It followed the Chavín and spread widely in the northern highland and north and central coastal regions.

(c) *Negative Horizon* is marked by a technique of negative painting for the decoration

of ceramics and occurs in the northern highlands and throughout the coastal belt south into Chile.

(d) *Tiahuanaco Horizon* is composed of a complex of iconographic and stylistic features with characteristic formalizations of design, which are found in stone-carving, ceramic and textile decoration, and in other media. The style originated at Tiahuanaco on the (then) shores of Lake Titicaca in the Bolivian Altiplano, where its most typical expression is the RELIEF carving on the Gateway of the Sun. Thence it spread to the southern coastal region of Peru and throughout the central Andes. It is the first horizon which can be regarded as genuinely pan-Andean.

(e) *Black-white-red Horizon*, sometimes called Coastal Tiahuanaco, is a breakdown of the design motifs of the Tiahuanaco ceramic painting into geometrical units which spread over all the Peruvian coast and into the northern highlands.

(f) *Inca Horizon*. Like the Tiahuanacan horizon this was a complex of many features and spread throughout the central Andes, following the political domination of the Inca. Its main features are a somewhat mechanical but finely executed polychrome design of geometrical elements, the distinctive shape of the aryballoid jar with conical base, a shallow plate with a bird handle, a pitcher with wide ribbon loop handle, ceremonial stone llamas, and generally a characteristic adaptation of earlier designs.

The historical periods mentioned above are difficult to date and classify and there is no universally agreed nomenclature. The following names and divisions are, however, generally recognized. In the table on p. 911 they are set out with approximate dating and with an indication of the cultural centres in the various regions which are of chief interest to the art historian for their local styles.

1. FORMATIVE PERIODS. These comprised (i) a *Pre-Agricultural* period (c. 8000 to c. 3000/2500 B.C.); (ii) *Early Agricultural* period (c. 3000 B.C. to c. 1200 B.C.); (iii) *Cultist* period (c. 1200 to c. 400 B.C.). As in ancient Meso-America (see PRE-COLUMBIAN ARTS OF MEXICO AND CENTRAL AMERICA) the Andean culture was based on the domestication of plants (beans, potatoes, squash, quinoa, chilli pepper, coca, etc., and from about the middle of the period, maize) and animals (llama, alpaca, guinea-pig or cavy, and the dog). The early peoples lived in small communities dependent on primitive farming and fishing. Among many bone and shell objects which have been found are textile fragments with sophisticated designs of snakes or fish.

The Cultist period is so named because it is thought to have been dominated by a religious iconography emanating from the site of Chavín de Huántar and a religion which seems to have included worship of the jaguar and was perhaps connected with the introduction of maize. It was the period of the Chavín-Cupisnique horizon style and the combination of the snake and feline motifs which persisted through many later horizons of Peruvian art. As a broad generaliza-

| circa | Period | Northern Coast | Central Coast | Southern Coast | Northern Highlands | Central Highlands | Southern Highlands |
|---|---|---|---|---|---|---|---|
| 1200 BC | Cultist | Cupisnique | | | Chavín | | |
| 400 BC | Experimenters | Salinar Gallinazo | Early Chancay | Paracas | Huaraz | Huaylas | Early Tiahuanaco |
| 100 AD | Master Craftsmen | Mochica | | Nazca | Requay | Huarmey Huacho | Classical Tiahuanaco |
| 900 AD | Expansionist | | Coastal Tiahuanaco Pachacamac | Coastal Tiahuanaco Later Nazca | | Chanca | Late Tiahuanaco La Paz |
| 1200 AD | City Builders | Chimu | Later Chancay | Ica | | Early Inca | |
| 1440 AD | Imperialist | | | | | Inca | |

PERIODS AND HORIZONS OF PRE-COLUMBIAN ART

tion the finer Andean art comes from the earlier periods particularly as regards structural or formal qualities, and this is true of the Chavín-Cupisnique ceramics, which have a grandeur and a feeling as if wrought in stone. The lines are at once heavy and flowing, giving a sense of massiveness, and there is a fine feeling for balance between spout and body. The spout rises organically from the stirrup and the stirrup from the body in contrast with the more mechanical joining of the later Mochica and Chimu styles.

2. EXPERIMENTAL PERIOD, dated from c. 500 B.C. to about the beginning of the Christian era, was so named because of the emergence of many new techniques and local styles. In the southern coastal region the cultures known as Paracas Cavernas and Paracas Necropolis produced pottery and textiles which cannot be surpassed by anything else in the Americas. From the former come ceramics characterized by great purity of form with thin, regular, but subtly graded walls which invite the touch. The pots are decorated with thick resin PIGMENTS applied after firing in incised designs either of geometrical patterns or of semi-stylized fantastic figures or heads vaguely reminiscent of Chavín iconographic elements. In some ways they foreshadowed Nazca shapes and designs but they have a classical restraint which contrasts with the garrulous luxuriousness of fancy that developed in the later styles. The commonest colours are deep red and amber yellow, but as many as five colours may occur on one vessel. The technique gives a rich, lacquer-like, cloisonné effect. Pottery of a similar kind, though recognizably distinct, has been found in graves at Ocucaje in the nearby Ica valley. Paracas Necropolis has furnished some of the most magnificent textiles that the world has seen, elaborate and richly designed with stylized figures of gods and fantastic iconography of animals and monsters. The pottery is finely made, usually monochrome and decorated with incised ornament of restrained and beautiful design.

The Experimental period was also characterized by widely spread white-on-red horizon style, found among other places at Salinar and Chancay on the northern and central coastal areas and at Huaraz in the northern highlands. The early Gallinazo pottery from the northern coast already displayed a negative horizon style which developed in the following period at Recuay and elsewhere. From the same period may come highly individualistic pottery with vigorous semi-naturalistic figures discovered at Ayabaca in the extreme north of Peru more recently than the more familiar cultural types.

During the Experimental period also the great centre of Tiahuanaco on the Bolivian Altiplano is thought to have come into being, perhaps between A.D. 300 and 500. Its finely cut megalithic stone architecture and elaborately engraved stone sculptures imply technical skills and a degree of social organization higher than anything hitherto evidenced in the central Andean region.

3. MASTER CRAFTSMEN PERIOD sometimes called FLORESCENT is dated usually from about the beginning of the Christian era until c. A.D. 900. It covers the centuries in which craftsmanship became most accomplished and ambitious; engineering, architecture, agricultural techniques of irrigation and terracing, road and bridge building, and other social crafts probably made their greatest progress during the same time. The best known ceramic styles are the Mochica from the north central coast and Nazca from the southern coast. The former is naturalistic, of great vitality and enormous representational range. MODELLING, incision, appliqué, painting, and pressed relief are all used. The body of the pot was often modelled to represent natural objects, scenes, or

animals and the Mochica portrait jars have been considered to be at their best among the world's finest portrait sculpture. A distinctive style of brush-painted drawing reaches a very high level of draughtsmanship. The Nazca was the finest of all polychrome painted pottery. Modelling was of secondary importance and not of high excellence. The ware is fine grained, thin, metallic, and highly polished. It is painted in from three to eight colours, including a bluish grey or violet which may have faded with time. The feeling for colour contrasts was extremely individual and bold juxtapositions of hue are often used with surprising effect. Twenty-five basic shapes have been distinguished but the variations within each are many. The decoration was stylized and fantastic with a richly exuberant iconography which cannot now be interpreted. The flowing lines and the phantasmagoria of hybrid and monstrous figures have been likened to certain developments of CHINESE ART. From the neighbouring valley of Ica comes pottery of a similar technique but more restrained design which often has a surprisingly modern beauty that makes it unmistakable. The most interesting pottery from the highlands in this period is that of Recuay in the Callejón de Huaylas. There is a rich variety of forms—12 basic types have been distinguished—and the pottery is often negative painted in two or three colours. Like the Mochica it is naturalistic, although easily distinguished in style.

4. EXPANSIONIST PERIOD. From c. A.D. 900 to c. 1200 the classic Tiahuanaco style culminated and the influence of Tiahuanaco shapes and iconographical stylizations spread throughout the central Andes, modifying but not supplanting or suppressing the regional traditions. The black-white-red horizon style began during this period in the northern coastal area and continued elsewhere during the following period.

5. URBANIST PERIOD. About A.D. 1200 began the period of well organized communities controlling large areas and centred on important cities built usually of adobe. The most important of these was the kingdom of Chimu, whose capital Chanchan on the northern coast was a city extending some six miles and its ruins are still impressive outside the modern town of Trujillo. Large quantities of pottery from Chimu have survived and may be seen in museums throughout the world. It continued the naturalistic tradition of the Mochica, but the direct vision of Mochica REALISM tends to degenerate into stereotyped convention and animals and birds are often so conventionalized as to be unidentifiable. Though technical skill survived, the spontaneity of the earlier culture had disappeared. There was no portraiture. Modelled black ware produced in a reducing kiln and burnished and monochrome red are characteristic of the culture. As with the Mochica the stirrup spout was ubiquitous. Whistling jars were also common, as were vessels with a double spout connected by a bridge but without a whistling device. There

was greater reliance on moulds for standardization and mass production.

It was during this period also that the first stages of the expanding Inca power were laid at Cuzco in the central Highlands.

6. THE IMPERIALIST PERIOD is the name given by archaeologists to the time from the conquest of the coastal kingdoms by the expanding Inca power about 1450 until the defeat of the Inca by the Spanish in 1532. The Inca, who have been referred to as the Romans of South America, were a people with a genius for administration and public works. Their empire was founded on rigid bureaucratic control and coincided with an unprecedented efflorescence of engineering, agricultural, and building programmes. In the sphere of art they showed little originality, were somewhat unimaginative and pedestrian, but were well able to make the most fruitful eclectic use of the technical skills and craftsmen's traditions which survived among the peoples whom they brought under their domination.

Despite the numerous regional styles and the inter-regional horizon styles which spread through the area from period to period, most historians claim that central Andean art had an over-all cultural unity which recognizably distinguishes it from the art of other parts of the Americas. Though some critics have found it less spectacular than the art of ancient Mexico and central America, it had a quality of urbanity and quiet assurance, a recurrent visual humour or confident objectivity, which evidences a civilization at home with its environment, material and spiritual, in marked contrast with the often sadistic and self-torturing terrors of the Mexican in face of the imagined ruthlessness of the supernatural forces. The technical achievements of the Andean peoples have nowhere been surpassed but it would be an elementary blunder of taste to regard their superb craftsmanship as a manifestation of technique rather than aesthetic gifts. The art of the central Andes is for mature and cultivated appreciation; the miracle is that despite the lack of significant intercultural contacts with the Western hemisphere it nevertheless appeals to the best aesthetic judgement of today.

ARCHITECTURE. In the coastal area, where stone was scarce, building was mainly of adobe and has largely perished. In the highlands stone architecture was developed to a pitch of technical excellence which still astounds. The earliest large-scale building activities are associated with the Chavín culture and the most important remains are at the religious centre of Chavín de Huántar in the northern highlands. The buildings, constructed of large, stone-faced platforms, contained several floors of interior galleries and rooms. The massive walls are decorated with low relief and carved tenoned stone heads. A stylized feline and snake design predominates. The architectural remains at Tiahuanaco on the borders of Lake Titicaca in the Bolivian

A. Shaped stones at Machu Picchu

C. Doorway at Ollantaytambo

B. Irregular fitted masonry in the Callejón de Santo,
Cuzco

D. Irregular shaped masonry at Ollantaytambo

E. Irregular fitted masonry with megalithic blocks at the Inca fortress of Sacsahuaman

F. Polished and squared masonry, remains of the Temple of the Sun, Cuzco, where now stands the church of Santo Domingo

G. Freestone masonry fitted to natural rock formation at Machu Picchu

**277.** INCA MASONRY (*continued*)

highlands are even more impressive. They are characterized by the use of enormous SAND-STONE and BASALT blocks worked to a smooth finish and fitted together with astonishing accuracy, although some weighed more than 100 tons. On the whole the masonry and construction of the Tiahuanaco architecture was the most skilled and complex of the central Andes and surpasses anything found in Mexico or Central America.

Somewhat later than the Chavín horizon adobe architecture developed in the coastal areas on an impressive scale. Large pyramidal structures, probably religious in their purpose, formed of tens of millions of rectangular adobe bricks, were made by the Mochica. The first urban building is attributed to the Chimu culture. The population centre of Chanchan, covering almost eight square miles, consists of numerous compounds which are enclosed by high clay-plastered and STUCCO-decorated walls. Each compound is dominated by a stepped pyramid and has rows of houses, reservoirs, and gardens.

The Inca were the town-planners *par excellence* of South America and far in advance of European town-planning at the same date. They used the gridiron system of streets converging round a central plaza with secondary plazas arranged according to the geography of the site. The main avenues were wide and spacious, the secondary streets narrower. The main public buildings were located in the central plaza or on the main avenues; they included a temple, a governmental residence and a large public building used as a storehouse, an inn for travellers and guests, and a hall for public meetings. In many towns the Inca built their palaces. Water was brought down the middle of the main streets and care was always taken to distribute it through the town. The towns were generally undefended but a strongly walled fortress was built on a neighbouring hill as may still be seen at Ollantaytambo in the valley of the Urubamba. The urban genius of the Inca is the more remarkable in that no hint of any similar gift can be discerned in the Aymara or Quechua Indian settlements of the highlands, ancient or modern. From the earliest pre-Inca vestiges right through to the present day Indian settlements have nowhere shown evidence of planned design, but proliferate at random and grow up higgledy-piggledy as house is added to house in a purely haphazard way. The organizing genius of the Inca was also manifest in their system of roads throughout their extensive empire, their systematic schemes of agricultural irrigation and terracing, their hanging bridges, and so on. Most remarkable of their achievements was the megalithic architecture for which they have become famous. They built both with large squared and faced rectilinear stone blocks and also in a 'polygonal' style in which large irregularly shaped stones are faced in accordance with their natural contours and fitted together with minute exactness. Examples of the latter may

be seen at Machu Picchu and the fortress of Sacsahuaman; the classical examples of the former are in Cuzco itself. Although the Inca did not surpass the craftsmanship of Tiahuanaco in stone masonry, their building was more extensive and systematic. Its strength was proved once again in the earthquake which hit Cuzco in 1950, when the Inca building showed itself better able to stand up than the later Spanish architecture.

STONE CARVING. Stone sculpture was practically restricted to the highlands and was for pretty obvious reasons either architectural or religious in character. The Chavín horizon style is best seen in stone carvings both in the round and in relief which emphasize a feline deity figure with characteristic stylizations and symbolic iconographical devices. There are also human and demoniacal figures and the condor, snake, and other animals are depicted or combined in elaborate conventionalized patterns. There is a preference for curvilinear lines but the effect is massive and strong. Far from being naturalistic or pictorial, the sculpture is stylized, conventionalized, and symbolical. A near-contemporary but stylistically distinct type of dynamic and naturalistic relief carving has been found at the Serro Sechín site in the Casma valley. The sculpture at Tiahuanaco includes both naturalistic figures in the round and conventionalized relief carvings. The former, usually considered to represent the earliest stone carving at the site, is best exemplified by two kneeling statues, now outside the church at Tiahuanaco village, with prominent cheek bones, jutting jaws and flaring lips, headbands decorated with curvilinear designs. The features, still extraordinarily impressive, are difficult to fit in with anything else in Andean culture. The classic style is represented by monolithic pillars and anthropomorphic figures decorated by often elaborate stylized relief carving. The typical example is the symbolic carved frieze of the Gateway of the Sun, which is one of the archaeological wonders of America. It is cut from a single block of Andesite, about 10 ft. long and $12\frac{1}{2}$ ft. wide and is estimated to weigh about 10 tons. The frieze carving in a geometrical style represents a central figure flanked by 48 smaller rectangular figures and is the purest example of the typical Tiahuanaco horizon style.

Architectural sculpture was little used if at all by the Inca, although there is evidence of their skill in stone-cutting for the purpose of baths, water conduits, boundary marks, etc.

POTTERY. In the absence of iron and many other utility materials which are taken for granted today, pottery in the ancient Andean civilizations was adapted to a very wide range of practical functions. One of its principal uses was for the preparation, serving, and storage of food and drink. It was also used for ceremonial purposes and was buried with the dead as mortuary gifts. Most, though not all, the pottery which

**278**  PRE-COLUMBIAN PERUVIAN POTTERY SHAPES

A. Stirrup spout pot (Cupisnique)  B. Stirrup spout pot in form of human figure with death's head or skull (Mochica)  C. Keru (Tiahuanaco)  D. Double spout and bridge jar with trophy heads and fantastic figure design (Nazca)  E. Spout and bridge whistling jar with figure of bird (Chimu)  F. Aryballus (Inca)

has survived in museums and private collections was recovered from burials. This was probably more elaborate and finely made but was of the same general character as the pottery in everyday use. Few peoples of antiquity have left such an abundance and variety of pottery as the ancient Peruvians. It has been one of the principal guides to archaeologists in drawing up a scheme of the various peoples and cultures. It has been suggested, though this is not certain, that potters were mainly women. The high quality of the work is shown not only by the sculptural Mochica, which includes some of the most sensitive modelled portraiture in the world, or the immense variety of its representational NATURAL-ISM, later taken over by the Chimu, but by the excellence of the paste, polish, colour, and design of many different cultures from Paracas to the Ica and Nazca. From the earliest Cupisnique and Paracas there is an ambitiousness of form with nearly closed bodies, curved and tubular stirrup spouts, bridges, and handles, figures in modelled relief, which betrays a sure mastery of technique. A large number of different tech-niques were perfected at an early date. The wheel was unknown in Pre-Columbian America and none of the pottery shows the mechanical precision of wheel-made wares. In the early work there is a subtle sensibility in the model-ling which communicates to it a high aesthetic quality. A keen eye for natural form, character-istic modes of simplification, a feeling for three-dimensional sculptural quality are revealed by the relatively crude animal ceramics of the central highlands. The purpose of much of this pottery seems to have been decorative rather than immediately utilitarian.

Some of the most characteristic shapes are the stirrup-spout pot (from Chavín to Chimu), the spout and bridge or double spout and bridge jar (from Paracas to Chimu), the whistling jar (mainly Mochica and Chimu), the keru (Tiahuan-aco and Inca), and the ARYBALLUS (Chimu and Inca).

TEXTILES. The peoples of the central Andean region had perfected cotton and wool spinning to an amazing degree from an early date. The modern highland Indian woman still spins as she walks or engages in other activities and representations on early pottery show that this was the case in ancient times also. Textiles of extraordinarily fine weave were produced on elementary hand looms and in addition they had the imagination, ingenuity, and technical proficiency to develop many simple and complex weave-variants. Designs and colour combina-tions exhibit a confident sense of artistry which never fails to arouse admiration. Materials were cotton and wool from the llama, vicuña, and alpaca; the sheep was unknown before the Conquest. Natural vegetable and mineral dyes were used. Many of the colours have survived with astonishing brilliance, blues and greens less well than others. The typical design patterns and iconographical structures noticed in the

ceramic paintings have their analogues in the textiles. The standard techniques included damask weaving, tapestry weave (sometimes so fine from the central coast as to appear like painted cloths), brocades, and embroideries. Patterns were sometimes inwoven and sometimes applied after weaving. The latter include painted or stamped designs, embroidery tassels, fringes, etc. Equally interesting from an aesthetic point of view are the bold abstract or stylized designs which have the quality of abstract paintings and the infinitely delicate many-coloured figure patterns. Some of the finest of all in colour, design, and weaving technique are those from Paracas Necropolis and the more gay Mochica run them a close second. In some there is a quality of pawky humour and a confident urbanity of visual assurance which bespeaks a people of refined and sophisticated civilization who had come to terms with their world.

METALLURGY. America before the Conquest did not acquire the use of iron. Bronze was introduced about A.D. 1000 and the Spanish conquerors were shocked to find that it was more highly prized by the Inca as being more useful than gold. It is thought that the origin of metallurgy in the Americas was in Columbia or the northern coastal area of Peru probably in the Cultist period, c. 700 B.C., and one of its earliest forms was gold repoussé work. It spread throughout the region and pieces have been found, for example, from the earliest periods of the Tiahuanaco horizon. Andean gold and plati-num work reached such technical and artistic heights that it has astounded modern metal-lurgists and art connoisseurs. Gold was panned from the streams which brought it down from the mountains in the form of dust and crude nuggets. Silver, copper, and tin were mined from pure veins and the extent to which smelting was used in the early periods is not certain. Casting was done by the *cire-perdue* method (see BRONZE SCULPTURE). Several processes of gilding were known (*mise-en-couleur*, etc.). The most frequently used alloy was the mixture of copper and gold known as *tumbaga*. Chimu smiths excelled in the production of silver and gold cups and gold masks, while Inca goldsmiths con-centrated on gold and silver filigree jewellery. Gold under the Inca became a special preroga-tive of the nobility.

84, 240, 241, 284, 460, 629, 749, 1190, 1477, 1530, 1533, 1623, 1628, 1693, 1791, 1812, 2326, 2557, 2685, 2695, 2696, 2774, 2775.

**PRE-COLUMBIAN ARTS OF MEXICO AND CENTRAL AMERICA.** At the time of the Spanish Conquest of the Americas (1520-42), the great indigenous civilizations were those of the Aztec in Mexico, the Maya in Yucatan, Southern Mexico, and Guatemala; and the Inca in Peru and Bolivia. All of them had been preceded by other cultures which we know today through native legends, ILLUMINATED

MANUSCRIPTS (*codices*), Spanish Colonial documents, and archaeological research.

Pre-Columbian Mexico and Central America can be divided into seven regions, with distinctive artistic styles, which comprise what is generally referred to today as the Meso-American culture area:

1. NORTHERN MEXICO (no cultures with important Pre-Columbian artistic development).

2. CENTRAL PLATEAU (Teotihuacan, Toltec, Aztec).

3. WEST COAST (Tarascan).

4. GULF COAST (Olmec, Totonac, Huaxtec).

5. VALLEY OF OAXACA (Zapotec, Mixtec).

6. NORTHERN MAYA AREA (Yucatan Maya, Tropical Rain Forest or Lowland Maya).

7. SOUTHERN MAYA AREA (Highland Maya, Pacific Coastal Maya).

The development of the Pre-Columbian arts in Meso-America can be traced through the following four major periods:

1. PALAEO-INDIAN (20,000–2000 B.C.). Primitive hunters and food gatherers. No important artistic development.

2. PRE-CLASSICAL (2000 B.C.–A.D. 200). Domestication of food plants (maize, black-beans, chilli pepper, etc.) and cotton; beginning of plastic arts in form of monochrome pottery and megalithic stone sculpture; jade carving; beginning of religious symbolism, temple and burial mound building, and homogeneous settlements.

3. CLASSICAL (A.D. 200–900). The rise, culmination, and decline of theocratic city states, characterized by monumental architecture, sculpture, wall FRESCOES, carved stone STELAE, elaborate polychrome pottery vessels, and intricate calendrical computations and recordings.

4. POST-CLASSICAL (A.D. 900-1520). Walled, fortified, and hill-top cities, characterized by the rise of secular warrior and merchant classes, bureaucracy; first Toltec and then Aztec imperialism and colonialism; development of metallurgy, money economy (based on cacao beans), codex writing.

GENERAL CHARACTERISTICS OF PRE-COLUMBIAN ARTS. The highest quality is found in the plastic and GRAPHIC ARTS. The prehistoric artists of Meso-America showed sensitive feeling for their material whether it was LIMESTONE, volcanic stone, serpentine, jade, bone, shell, wood, or clay. In general, the Pre-Columbian arts of Mexico and Central America were closely associated with religious beliefs and rituals. Unlike South America there was virtually no portrait statuary or painting. Although the aesthetic feeling in stone sculptures and mural and pottery paintings has sufficient in common with Western art for us to be able to appreciate and enjoy it today, the human physical types represented were often very different. Artificially flattened foreheads, crossed eyes, and receding chins seem to have been considered attributes of beauty among prehistoric Mayan and Mexican Indians. The grotesque and terrifying also played an important role in Pre-Columbian art, while REALISM was almost entirely submerged by religious symbolism.

ARCHITECTURE. The enclosure of space played little part in Pre-Columbian Meso-American sacred architecture. Such space enclosures as existed were only in form of superstructures built on the tops of massive truncated PYRAMIDS. The ancient Meso-Americans had no true cities. Domestic architecture was on the simplest possible scale, consisting of square or oval thatched-roof huts with wattle-and-daub walls often constructed on low earthen platforms and scattered haphazardly around the ceremonial centres. The fabulous archaeological sites with their architectural wonders were, in actuality, centres for religious pilgrimage and administration. Many of the temple mounds were immense (some as much as 200 ft. in height) and were visible from great distances. They were constructed around central plazas where the populace of the surrounding district congregated to watch religious dramas enacted on the elevated platforms and steep temple stairways. The small temple enclosures were constructed to house nothing but the stone or pottery images of the gods. After the fall of the theocracy, however, at the end of the Late Classical period, there was an increase in both urbanization and secularization. Numerous and more spacious stone buildings were erected to house the increasing numbers of bureaucrats, warriors, and wealthy merchants who constituted the new nobility.

Meso-American architects were restricted by two major limitations—the lack of metal tools and their ignorance of the true, or keystone, ARCH. The latter made it impossible for them to span a wide space, although there were no limits placed on the length of the building. The false or CORBELLED arch, with its vertical thrust, was especially typical of Maya architecture. COLUMNS (round or square) were used only rarely and mostly during the Post-Classical period. Many architectural structures were enlarged, added to, and built over in such a way that an excavation may reveal as many as eight superimposed buildings. This periodic rebuilding is thought to have been prompted either by the commencement of new ceremonial cycles (probably 52 years), or by a desire on the part of the priestly, ruling class to keep their subjects constantly occupied.

STONE SCULPTURE. Most of the stone sculpture decorated buildings. Structural elements such as columns and lintels were frequently carved to represent human or mythical figures, and façades were commonly decorated with anthropomorphic or zoomorphic forms in high or low RELIEF friezes.

In general Mexican sculptures are plain and massive, though the East Coast Mexican (Totonac) and Lowland Maya plastic art has a tendency to over-elaboration of surface, and curvilinear lines. This perhaps shows the

**279.** Corbelled arch from The 'House of the Governor' at Uxmal, Yucatan

influence of environment on the development of the arts, the overwhelming display of plastic richness of the Mayas and Totonacs reflecting the dense tropical rain forest as opposed to the flat, more geometrically structured tablelands of the Mexican plateau.

Stone sculpture reached its height among the lowland and rain forest Maya during the Classical period at such places as Copan (Honduras); Quirigua, Tikal, Uaxactun, Piedras Negras, and Yaxchilán (Guatemala); and Palenque (Mexico). Temples were richly decorated with relief carvings. Monumental stone sculpture in the round was also primarily architectural, consisting of masterfully carved, vertically tenoned human or animal heads (serpents, parrots, jaguars, etc.). Intricately carved LIMESTONE stelae 20 to 30 ft. tall were erected in the paved courts of the many ceremonial centres, to mark the passing of time (probably every five years) and/or the coming to power of new priest-rulers. Most stelae are carved with low relief representations of priest-rulers performing various secular and sacred duties. On the sides and back are carved glyphs and calendrical inscriptions. At the end of the Classical period (c. A.D. 850) the Lowland Maya abandoned their ceremonial centres and stelae carving, along with all other artistic activities, came to an abrupt end.

Post-Classical Maya sculpture is most notable in Yucatan, where the Toltec or Mexican artistic influence was strongly felt. Characteristic of the period are reclining *Chac Mool* figures, jade and shell inlaid jaguar thrones, columns ending in serpent heads, and standard bearers. They have a rigid, static appearance with none of the vitality of line and gentleness of facial expression of the Classical Maya style.

Colossal human heads of BASALT, many of them 8 ft. in height with a circumference of 20 ft. and weighing as much as 15 tons, have been found at the archaeological sites of La Venta and Tres Zapotes on the Mexican Gulf coast (today's central Veracruz), a semi-tropical area inhabited during Pre-Classical and Classical times by a gifted and little-known group, the Olmec. The heads have a strangely negroid appearance with heavy everted lips. They seem to combine human with feline features and have been called the Olmec 'baby faces'. The Olmec area has also yielded carved stone stelae (different in style and glyph forms from those of the Maya), carved stone altars and columns, and MOSAIC floors representing stylized jaguar heads. Many of the sculptures were originally painted. Most common are bearded men with decidedly aquiline noses, dwarfs, hunchbacks, jaguars, and smiling infants. The Olmec style influenced an area far

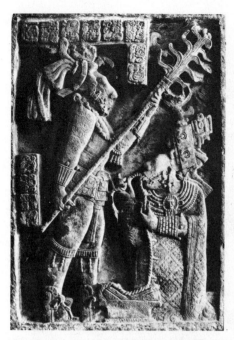

280. Relief carvings from Maya ceremonial centre at Yaxchilán, Guatemala. A. Penitent kneeling before a priest and mutilating his tongue by passing a rope of thorns through it. A calendrical inscription gives a date which probably occurred in the year A.D. 709

B. Worshipper kneeling before a double headed serpent deity. The inscription gives a date which probably occurred in the year A.D. 681

beyond its geographical boundaries. Its characteristic elements of simplicity, vigour, realism, and monumentality penetrated throughout ancient Meso-America, reaching probably as far south as Peru.

The finest non-architectural stone sculptures in Mexico are those found in the so-called Totonac area of northern Veracruz. These Classical stone yokes, flat stone heads (sometimes referred to erroneously as 'axes'), and palmate stones are delicately and skilfully carved and show a decided feeling for ABSTRACT forms. It is generally accepted that these objects were used in pre-game ceremonies in connection with the Pre-Columbian competitive rubber-ball games or were worn on the hips of the ball-players during the game itself.

During the Post-Classical period the best stone sculptures in Mexico were produced by the Toltecs and, later, by the Aztecs. Largely architectural in nature, they consisted of tall anthropomorphic columns representing warriors, calendar stones, carved lintels, carved façades, and low relief friezes. Sculpture in the round was grim, powerful, and massive. The Aztecs were little concerned with art except in its religious connotation and in the realistic carving of small animal figures (grasshoppers, dogs, etc.).

CLAY SCULPTURE AND POTTERY. In both the Mexican and Maya areas there was an amazing versatility in the methods of MODELLING clay, ranging from bowls and incised and carved effigy vessels to toylike figurines, effigy whistles, life-size clay statues, and incense burners. Ceramic objects were used for domestic, ceremonial, and funerary purposes.

Most of the Pre-Classical pottery is simple in form and monochromatic (highly polished red or black ware). The so-called archaic figurines and effigy whistles are hand modelled, and are usually small, solid, realistic, and frequently represent large-hipped pregnant women. They may represent fertility figures or earth goddesses. The finest Pre-Classical figurines come from the Valley of Mexico (in particular Tlatilco) and the central Maya highlands (Kaminaljuyu and Las Charcas).

At the end of the Pre-Classical and during the Classical period the liveliest and most varied clay figurines and effigy vessels were made by the Tarascan Indians of the west coast of Mexico. They reflect the secular aspects of life among the common people (like the Greek TANAGRA figurines), in contrast to much of Pre-Columbian art which is preoccupied with religious and supernatural representations. The hand-modelled Tarascan figurines represent a lively variety of

positions and activities. Warriors, acrobats, ball-players, children, pole climbers, funeral processions, and groups of dancers were represented with a forceful, realistic, and humorous style.

Also in the Classical period the solid, hand-made figurines and effigy whistles produced by the Yucatan Maya (especially on the Island of Jaina) are outstanding for their beauty and elegant though ornate decoration. Most commonly represented are priests, priestesses, and warriors in elaborate ceremonial attire with delicately painted head-dresses and vestments in blue, green, and red.

During the late Classical period the Lowland Maya of the northern Guatemala rain forest and the Alta Verapaz area inaugurated the production of mould-made figurines and effigy whistles representing dancers, ball-players, and priestly officials; while in the Valley of Mexico, particularly at the site of Teotihuacan, the potters excelled in the manufacture of small delicate hand-made but mould-decorated figurines, many with movable arms and legs. The contemporary Zapotec and Maya effigy funerary urns and incense burners are highly stylized, ornately sculptured vessels, almost architectural in spirit.

In northern Veracruz peculiar mould-made figurines and effigy whistles were produced which today are known as the 'Totonac smiling head' figurines. They were made with broad, artificially flattened heads (fronto-occipital deformation), slanted eyes, and an enigmatic mysterious smile. These Classical period Totonac figurines may have their origin in the earlier Olmec 'baby faces'.

PAINTING. Meso-American paintings are known from decorated pottery vases, monumental wall frescoes, and illuminated manuscripts called 'codices'. The most striking impression made by most of the paintings is dislike of empty spaces (*horror vacui*) and an emphasis on colour over line.

Polychrome pottery painting is a Classical period characteristic found especially in the Lowland Maya area, where human and bird figures dominate in an ingenious blending of abstract and realistic design. Especially noteworthy are the beautifully painted vessels and vases from Uaxactun, Tikal, Piedras Negras, Holmul, Copan, and various semi-tropical sites in the Department of Alta Verapaz, with their representations of dancers, priests, mythological beings, and animal forms. During the same period in Teotihuacan, Mexico, and in the Maya highlands of southern Mexico and Guatemala, multicoloured STUCCO or fresco decorated cylindrical tripod vases were made. The stucco decoration was applied by ingenious paint cloisonné technique after the vessel was fired.

The Pre-Columbian art of painting culminated during the Classical period in the monumental frescoes which decorated the interior walls of many temple structures. It reached its height in the Lowland Maya area and at Teotihuacan in Mexico, the most magnificent murals being preserved in a small temple at Bonampak in the midst of the dense rain forest of eastern Chiapas, Mexico. Painted on damp plaster in true fresco style, the Bonampak murals demonstrate how far Maya graphic art could go when not limited by the size of clay vessels. The interior walls of three rooms are covered with nearly life-size figures of priests and warriors. Ceremonies, processions, scenes of battle and raids on neighbouring settlements, dances of victory and sacrifice, and the presentation and torturing of captives are vividly reproduced. Joy and fear are expressed by dynamic action and posture rather than by facial expression. Colourful costumes and ceremonial paraphernalia contribute to the effect of magnificent splendour. Recession in depth is indicated by overlapping figures (in the battle and dance scenes). Figures face each other when engaged in conversation or gossip (in the procession and courtly scenes). Many of the figures (the dancers, musicians, and warriors especially) wear grotesque masks, or hold weapons or musical instruments. A most striking effect is achieved by the skilful use of contrasting and rich colours (red, green, white, blue, and purple) against dark browns and blacks or black and brown against yellow and blue backgrounds.

The frescoes of the Post-Classical period, inferior in design and execution to those of the Classical period, represent the expansion of the Toltec and Mixteca-Puebla cultures. They have been found at Tenayuca, Tizatlan, Tamuin, Cholula, Malinalco, Tula, Mitla, and Monte Alban in Mexico; and at Chichen Itza and Tulum in the Yucatan Maya area.

Since none of the existing Maya, Mixtec, or Aztec picture books or codices goes back earlier than A.D. 1000, it is safe to assume that the Pre-Columbian MINIATURE art had its origin in the great art of mural painting or in its humbler counterpart, vessel painting. The miniatures were painted on deerskin PARCHMENT or on bark paper dressed with white chalk. They seem to have adopted and even systematized the story-telling (both historical and mythological) function of the painted pottery and murals using an accordion-like folded surface to reveal in a systematic and continuous story their traditional tribal histories and lengthy ceremonial calendar. The Mixtec and Aztec codices are primarily historical and genealogical in content, while the three extant Maya codices (Dresden, Paris, Tro-Cortesianus) contain divinatory and calendrical information.

METALLURGY. Compared to South America, metal-work in Pre-Columbian Meso-America was a late development. Except for a few early gold pieces found at Copan, Honduras, which probably had been obtained in trade from Costa Rica, metallurgy in Mexico and the Maya area does not seem to antedate A.D. 700. Gold, silver, copper, tin, and LEAD were used either in a relatively pure state or in various alloys. *Tumbaga* was an alloy of gold and copper. Copper was

**281.** Page from the *Codex Zouche-Nuttal*. The scene may represent the creation of the Mixtec people. Pre-Columbian Mixtec pictographic codex painted on deer-skin parchment. (B.M.)

also alloyed with tin and lead. The technical processes known and used were those of repoussé, hammering, casting, soldering, gilding, moulding, inlaying, and plating. The *cire-perdue* casting process (see BRONZE SCULPTURE) was known, but was probably introduced from Peru; clay, stone, or charcoal moulds were used. The *mise-en-couleur* technique was also known and used for gilding. Gold filigree jewellery was made in many areas, but the Mixtecs of the Oaxaca region in Mexico were the leading masters of the technique. The repoussé gold plaques from Chichen Itza, which represent scenes of the Itza conquest of Yucatan, also have considerable artistic value.

THE LESSER ARTS. The Pre-Columbian inhabitants of Central America also excelled in bone-, shell-, and wood-carving. Bone was worked to produce or decorate trophy heads, miniature masks, flutes, and spatulae. Bracelets, earrings, pendants, trumpets, and inlaid ornaments were made from carved shell. Wood was carved to make figurines, decorative lintels, vessels, weapons, slit drums (*teponatzli*), and skin-covered drums (*huehuetl*). Lapidary art reached a high artistic level in the carving of jade to produce figurines and votive axes (Olmec and Maya), masks (Teotihuacan), and pendants, earplugs, necklaces (Maya). Much as in the

Orient, the often translucent green jade had symbolic meaning: the Aztec name for jade (*chalchihuitl*—'precious green stone') carried an association with green grass and emphasized the colour which was symbolic of life itself. To the peoples of Meso-America jade was more precious than gold or silver.

The Pre-Columbian craftsmen also worked with obsidian and flint (monkey effigy vessels, masks, and blades of various and intriguing shapes); rock crystal (Aztec human skulls, cups); and ALABASTER (carved vases from the Ulua Valley of Honduras and monkey effigy vessels from Mexico). Turquoise was used in mosaics together with jade, shell, red coral, and other materials. Small turquoise mosaics were glued in bases of wood, bone, or stone to form masks, ceremonial shields, weapons, and sacrificial knife handles.

Other applied arts were feather-work (headdresses, cloaks, fans, shields), lacquered gourds (produced by the paint cloisonné technique in what today are the states of Sinaloa, Guerrero, and Michoacan in Mexico), basketry, leatherwork, and textiles (made with the use of the primitive backstrap hand loom). They cannot be compared for quality, however, with the crafts in South America and south-western North America.

See also PRE-COLUMBIAN ARTS OF THE ANDES; INDIAN ARTS OF NORTH AMERICA.

460, 646, 749, 1477, 1533, 1692, 1693, 2203, 2534, 2535, 2670, 2685, 2710, 2774, 2850, 2851.

**PREDA** or PREDIS, AMBROGIO DA (c. 1455–c. 1517). Italian painter and ILLUMINA-TOR of Milan, appointed court painter to the SFORZA in 1482. He is chiefly remembered for his association, together with his elder half-brother EVANGELISTA PREDA, with LEONARDO DA VINCI in the 1483 contract for an ALTARPIECE to which *The Virgin of the Rocks* and its wings (N.G., London) are thought to have belonged. The wings, depicting ANGELS with musical instruments, are presumed to be by Ambrogio or Evangelista Preda. A portrait of Maximilian I (Vienna) is signed by Preda and dated 1502; the supposed portrait of Francesco di Bartolomeo Archinto (N.G., London, 1494) is probably from his hand. He was very much under the influence of Leonardo and combines his manner with the spirit of the quattrocento.

**PREDELLA** (Italian: 'kneeling-stool'). An altar-step, and hence a picture on the vertical fall of this. The word is also applied to a raised shelf at the back of an altar, or to a picture on the front of such a shelf; and, loosely, to any subsidiary picture forming an appendage to a larger one, especially a small painting or series of paintings beneath an ALTARPIECE.

2380.

**PRE-RAPHAELITE MOVEMENT.** The name adopted in 1848 by a group of young English painters, the nucleus of which was formed by John Everett MILLAIS, William Hol-man HUNT, and Dante Gabriel ROSSETTI (to whom, son of an Italian ex-revolutionary, the sealing of the group into a secret Brotherhood was due). The other four initial brethren were J. Collinson (1825?–81), the sculptor T. WOOL-NER, and the art critics W. M. Rossetti and F. G. Stephens. Ford Madox BROWN was closely allied with them, though not at any time a mem-ber of the Brotherhood. The members of the group were linked by a certain revolutionary fervour, which in Holman Hunt particularly manifested itself in a form of social REALISM, and by a determined reaction from the emptiness of the stereotyped medievalism occurring in current historical painting and from the meaninglessness of academic 'subject' painting as exemplified for example by Daniel MACLISE. The movement had a strong literary flavour from the start: they were roused to lyrical excitement by Keats and Tennyson and many of the members were them-selves poets as well as painters. The name 'Pre-Raphaelite' was chosen after they had been looking over Lasinio's engravings (published in 1828) of the frescoes by Benozzo GOZZOLI for the Campo Santo at Pisa. No very precise meaning seems to have been attached to it, though in its implied challenge to the then paramount authority of RAPHAEL it was in keep-ing both with their revolutionary spirit and their romantic if uninformed medievalism.

The initials PRB were first used on Hunt's picture *Girlhood of Mary Virgin*, exhibited in 1849, and were adopted by the other members of the Brotherhood. When their meaning became known in 1850 the group were subjected to violent criticism and abuse. Dickens led the attack in *Household Words*, calling Millais's *Christ in the House of His Parents* (Tate Gal.) 'mean, odious, revolting and repulsive'. He was outraged by the implied rejection of Raphael, who was identified with the doctrine that beauty is an essential element of art, and he regarded the claim to go behind Raphael as an anti-progressive reversion to primitivism and ugliness. The Pre-Raphaelites were, however, defended by RUSKIN (who made it clear that he held no sympathy for their 'Chartist' doctrines) on the somewhat two-edged ground that they were copying nature and *not* the quattrocento. In the next three years both Millais and Hunt did some of their best work and won considerable recognition.

Besides their revolutionary aspirations to bring a new moral (and literary) seriousness to painting, to study directly from nature in dis-regard of arbitrary rules, and to develop a new ICONOGRAPHY to express new ideas, the Pre-Raphaelites had certain technical devices in common. Chief of these were the decorative use of flat expanses of bright colour with a par-ticular luminosity gained by painting on a wet white GROUND, meticulous accumulation of indi-vidual detail, the study of outdoor motifs on the spot, and a kind of poetic symbolism which when generalized led to artificiality. It is indeed ironic that the group which set themselves to oppose artificiality and challenged fake sentimentality in the name of honesty has been judged by history to have created a new artificiality of escapism. But their best works were raised by intensity of conviction and genuineness of poetic vision into the class of masterpieces.

Basically, however, the individual members had little in common as artists, and as a group they were never united in a clear theoretical doctrine. After about 1853 the group as a group dissolved. Millais became the typical academic success. Rossetti found greater affinities with BURNE-JONES and William MORRIS, after being associated with them in painting the frescoes of the Oxford Union in 1857. Holman Hunt remained most faithful to the earlier doctrines of the group. But the style they had created caught the fancy and was perpetuated by a number of inferior imitators.

182, 988, 1387, 1388, 1406.

**PRESTON,** MARGARET (1883–1963). Aus-tralian painter who studied first at the Melbourne National Gallery School and later in Munich and

Paris. Influenced by the modern movement, in her work and writing after the early 1920s she was a pioneer in adapting the colour and decorative motifs of AUSTRALIAN ABORIGINAL ART to contemporary landscape and still life.

**PRETE GENOVESE**, IL. See STROZZI, B.

**PRETI**, MATTIA, also called IL CAVALIERE CALABRESE (1613–99). Prolific Neapolitan painter of the late BAROQUE period, whose works are to be found in Modena, Rome, Naples, and Malta. During the first half of his busy career he travelled widely. His easel paintings have a basis of REALISM perhaps deriving from CARAVAGGIO, but enriched by a sense of colour and movement typical of the VENETIAN tradition and the early works of GUERCINO. In fresco painting LANFRANCO was his model, and in fact he succeeded Lanfranco in the fresco decoration of S. Andrea della Valle (1650–1). Between 1650 and 1656 he was in Naples, and from 1661 until his death he lived and worked in Malta, decorating the Cathedral of Valletta. He became a Knight of the Order of the Hospital of St. John of Jerusalem in 1642.

**PRICE**, SIR UVEDALE (1747–1829). English landed gentleman and writer on the PICTURESQUE. His *Essay on the Picturesque* (1794–8) remains one of the principal monuments of the picturesque doctrine. He combined practical taste with theoretical speculation and laid out his Herefordshire estate, Foxley, on picturesque principles.

**PRIEUR**, BARTHÉLEMY (d. 1611). French sculptor, a follower of PILON, who represented the classicizing tendency of the second MANNERIST School of FONTAINEBLEAU. He is best known for his sculptures for the tomb of Constable Montmorency (Louvre), the architectural portions of which were designed by BULLANT. A bust of Christophe de Thou in the Louvre is also ascribed to him.

**PRIMARY COLOURS.** See COLOUR.

**PRIMATICCIO**, FRANCESCO (1504–70). Italian painter, architect, and decorator, mainly active in France. He worked first under GIULIO ROMANO in Mantua. From 1532 he worked at FONTAINEBLEAU with ROSSO on the decoration of the Gallery of Francis I (c. 1535). He also decorated other rooms, e.g. the Salon de la Duchesse d'Étampes (finished 1543), the Salle de Bal (1550–6), and the Galerie d'Ulysse (finished 1570), and with Rosso provided the main impetus for the distinctive French type of MANNERISM known as that of the First FONTAINEBLEAU School. On Henry II's death (1559) he replaced DELORME as chief architect. He was probably responsible for the design of the Valois Chapel at SAINT-DENIS and the Aile de la Belle Cheminée, Fontainebleau (1568). His decorative paintings, which pioneered the new preference for classical MYTHOLOGY in place of religious themes, tempered the wilder Mannerism of Giulio Romano and PARMIGIANINO to the more sophisticated elegance of French taste. His combination of painting with STUCCO ornament in sumptuous decorative schemes was an original contribution introducing new elaborative possibilities which were exploited to the full.

**PRIMING.** A term which is sometimes confused with GROUND. Properly, however, a priming is a thin layer applied on top of the ground to make it more suitable to receive PAINT. For example, if the ground is too absorbent the priming may make it less so, or the priming may supply a tint. The Italian word IMPRIMATURA was commonly used in this sense as when VASARI recommends laying over the GESSO ground a pigmented mixture which will assist the drying of the paint and adds that 'many call this the *imprimatura*'.

**PRIMITIVE.** The term 'primitive' has become current in the literature of the arts with three different meanings and confusion between them has been a frequent cause of misunderstanding.

1. Towards the end of the 19th c. it became fashionable to apply the term 'primitive' to peoples outside the direct influence of the great centres of civilization on the mistaken 'evolutionist' assumption that their life patterns represented cultural phases through which the great civilizations had progressed. Hence the art products of such peoples as the African Negroes south of the Sahara, the Eskimos, and the inhabitants of the Pacific islands came to be referred to as 'primitive art'. As later it became evident that these cultures were not necessarily in either a formative or degenerate stage but had achieved maturity within a system of social organization and technology different from western European civilization, the term 'primitive' was recognized to be inappropriate though agreement as to an alternative nomenclature was not reached. It has similarly become evident that the term 'primitive art' as a term denoting the art products of primitive peoples carries no implications of aesthetic or technical inferiority and no implication that it belongs to an earlier or fumbling stage of development towards a greater artistic maturity. Neither does the use of the term imply any diffusionist assumption that art manifestations called 'primitive' in this context are merely a backwash from imperfectly apprehended and poorly imitated art activities of the higher cultures.

Recognition of the maturity of the finest primitive art within its own cultural traditions, and an appreciation of its often superb quality by some imperfectly understood aesthetic standards, grew up at the turn of the century as available examples of primitive art began to attract the attention of some of the leaders of modern movements in European art. In 1897 the BENIN incident brought this art to the knowledge of Europe and GAUGUIN's work in Tahiti attracted attention

to another aspect of the primitive. The Paris Exhibition of 1900 used native motifs as decoration for some of the pavilions. Ethnological museums began to collect primitive art and artefacts, and in the early 1900s the artists of the German BRÜCKE studied South Sea carvings in the Dresden museum. The Gauguin memorial exhibition of 1905 made clear the wealth of native motifs which had been incorporated into his painting. Some years later VLAMINCK began to collect African carvings, PICASSO and BRAQUE were excited about the masks in the Trocadéro ethnological collection. When the BLAUE REITER EXPRESSIONISTS published their manifesto in 1912 reproductions of primitive masks and carvings were included as a matter of course.

2. Within the European context art historians and CONNOISSEURS have used the term 'primitive' for early phases within the historical development of painting or sculpture in the various European countries, a usage which carried the implication, now believed to be false, that these earlier artists were attempting unsuccessfully to achieve—particularly in the field of NATURALISTIC or ILLUSIONISTIC representation—what was achieved by the artists of the so-called mature periods. From the middle of the 19th c. it was applied to the art of western Europe during the period before the RENAISSANCE, an art which was then considered 'primitive' because it pre-dated scientific PERSPECTIVE and ANATOMY. Interest in the early ITALIAN painters was shown as far back as the middle of the 18th c. by men like Ferdinando Hugford, a monk of Italian descent, and Thomas PATCH the engraver. Seroux d'Agincourt, settling in Rome, conceived the idea of doing for the 'centuries of barbarism' what WINCKELMANN had done for the Golden Age of classical art. The result of his inquiries into the art of CIMABUE, GIOTTO, etc., was published in parts, beginning in 1810. It was Artaud de Montor, however, in 1843 who described his collection of early Italian painters as Peintres primitifs. In the handbook to the Manchester exhibition of Old Masters (1857), W. Y. Ottley—who had worked for d'Agincourt—was referred to as having formed 'a very authentic collection of primitive works'. The interest of the PRE-RAPHAELITES and the Prince Consort's collection of 'primitives' drew the attention of a wider public to the pre-Renaissance masters. In 1902 the term was used to describe the famous exhibition in Bruges of early Netherlandish pictures (Les Primitifs flamands). This use of the term is still regular with art historians, connoisseurs, and museum or gallery curators. But it has become a descriptive and not an evaluative term and no longer carries an implication that the 'primitive' represents an infantile stage in a process of maturation.

3. 'Primitive' is also applied by ART DEALERS, connoisseurs, and historians to artists, recent or not, who have not received—or not absorbed—professional training but paint in a way alien to the academic, traditional, or avant-garde manner

of their day and who display a highly idiosyncratic naivety in their interpretation and treatment of their subject matter. Examples of such artists are Henri ROUSSEAU and more recently Grandma MOSES. In this sense of the word and this sense only it does carry an implication of a lack at least of traditional techniques and this is accompanied by a not always justified assumption that the deficient technique is compensated for by spontaneous charm. By a judicious use of the term 'primitive' dealers can sometimes sell the works of anonymous AMATEURS for more than they are worth.

8, 316, 1077, 2748, 2910.

**PRINTS.** 1. METHODS AND TECHNIQUES. Prints are made by a great variety of processes which are briefly classified here, and described more fully, with something of their history, in separate articles. These processes, or GRAPHIC techniques, fall into four main groups.

(a) *Relief Methods.* In these, the parts of the wood block or metal plate which are to print black are left in relief and the remainder is cut away. The block is then rolled over with a stiff printing ink and, as the pressure required for printing is not great, impressions can be taken in an ordinary printing-press or even by hand.

The principal relief methods are WOODCUT, WOOD-ENGRAVING, and LINOCUT. To these we may add certain techniques such as METAL CUT, MANIÈRE CRIBLÉE, and RELIEF ETCHING, in which metal plates are ENGRAVED and printed like woodcuts.

(b) *Intaglio Methods.* In intaglio printing the principle is the reverse of that which operates in the relief methods, for the surface of the plate does not print, the ink being held only in the engraved furrows. The lines of the design are incised in a plate of copper or zinc; ink is rubbed into these lines and the surface of the metal wiped clean with a series of rags. A sheet of damp paper is laid on the plate, together with two or three thicknesses of felt blanket, and the whole run through a copper-plate press. This press, which consists of a bed-plate passing between two rollers, applies heavy pressure to the plate; the paper, backed by the blankets, is forced into the lines and picks up the ink that is in them, thus receiving an impression of the entire design.

The various ways in which the design may be incised in the metal plate constitute the different intaglio techniques. These techniques are: LINE ENGRAVING, in which the design is engraved on the metal plate with a BURIN; DRYPOINT, where the lines are drawn by scratching the plate with a strong steel needle; ETCHING, SOFT-GROUND ETCHING, and AQUATINT, where the designs are bitten into the plate by means of acid. In addition there are the defunct, or nearly defunct, reproductive processes of MEZZOTINT, STIPPLE, and CRAYON MANNER. Certain of the intaglio methods —mezzotint, aquatint, and stipple—have as their aim the production of a continuous tone; these are called the 'tone processes', though tonal

effects may also be obtained by soft-ground etching and crayon manner. The various intaglio processes are frequently used in combination with one another on the same plate. Once the principle is grasped that they are simply different ways of incising or marking a copper plate so that it will hold ink in intaglio printing, this combination of methods will not be difficult to understand.

(c) *Surface or Planographic Methods.* These are LITHOGRAPHY and its variants. Lithographs are neither incised nor raised in relief, but are printed from a perfectly flat slab of limestone or from prepared metal plates. The process utilizes the antipathy of grease and water to separate areas which receive and areas which reject the printing ink.

(d) *Stencil Methods.* The principle involved here is simply that of cutting a hole in a protecting sheet and brushing colour through the hole on to a surface beneath. Stencils have long been used for colouring prints in quantity and for fabric printing. The principal modern development is the SILK-SCREEN print or 'serigraph'.

We may add two processes which cannot be classified with the rest, namely, the MONOTYPE, and the GLASS PRINT or *cliché verre*, which is related to photography. COLOUR PRINTS, which can be produced by almost all the graphic techniques here listed, and process REPRODUCTION, both manual and photo-mechanized, are discussed in separate articles.

Prints made by the main graphic processes have special characteristics by which they may be distinguished from one another. Thus intaglio prints will show a plate-mark where the edge of the plate has been impressed into the dampened paper, though many old etchings and engravings lack this feature because it was formerly the custom of print collectors to cut down their prints inside the plate-mark. Relief prints and lithographs have no plate-mark, since in their case the paper is not moulded to the shape of the plate during printing. A related characteristic of intaglio prints is the fact that the black lines are raised a little in relief; their projection may be felt by passing a finger lightly over the surface of the printing paper. This is because in printing the damp paper is forced into the hollows of the plate and receives their impression in the manner of a mould. Correspondingly in woodcuts the black parts are slightly sunken, but this only happens when excessive pressure has been used in printing. Intaglio prints, especially etchings and line engravings, frequently show a faint grey tone over the whole print which is caused by a thin film of ink left on the surface of the metal plate when it was wiped and which establishes a certain relationship of tone and quality between the lines and the blank areas, whereas in a woodcut there is an absolute contrast between the black of the printed areas and the white of the paper.

An ability to distinguish the various techniques

**282.** Printing from copper plates. Engraving from *Nova Reperta & Alia* by Jan van der Straet, called Stradanus (c. 1530–1605)

is, of course, essential to a real appreciation of prints, and comes from an understanding of the basic principles by which each is produced along with continuous study of the prints themselves. Very generally, one might say that woodcutting and wood-engraving and, more recently, lithography have been the more popular and utilitarian arts, while intaglio prints have enjoyed the favour of collectors as articles of rarity and value. Within the early decades of the 20th c., however, such distinctions have effectively lost their meaning; for since the advent of the photomechanical processes all the manual techniques of print-making are used solely as means of original expression and as such are judged without prejudice for their aesthetic qualities alone.

(*e*) *Mixed Methods of Engraving*. It is somewhat misleading to think of the various graphic methods as separate arts, because it is extremely common to find two or more combined in a single print. This is particularly true of the intaglio methods, some of which were originally devised not as new processes but as adjuncts to old ones. During the 17th and 18th centuries it was normal practice to work the same plate with etching and line engraving, and in modern times ABSTRACT artists (especially S. W. Hayter and his school) have tried out the possibilities of combining burin lines with every kind of bitten texture. Etchers since REMBRANDT's day have often reinforced their plates with drypoint. Aquatint has been more frequently used in combination than by itself. Crayon manner and stipple were so essentially part of the same process that their results can scarcely be distinguished. Many reproductive prints of the late 18th and 19th centuries, particularly portraits, are interesting if baffling mixtures of several methods.

Nor are these combinations confined to the intaglio processes. The Baxter prints of the 19th c. were taken from intaglio plates and woodengraved blocks; and 20th-c. artists have made colour prints by combining wood-engraving with woodcut or linocut, or even occasionally woodcut with lithography.

2. IMPRESSIONS AND EDITIONS. The number of good impressions that may be taken from blocks, stones, or plates varies greatly and depends on several factors. In general woodblocks are pretty durable and with careful handling will yield hundreds or even thousands of good prints. This is also the case with lithographs, and in this medium the quality of impressions may even improve with repeated printing. As for the intaglio methods the possible number of perfect prints depends on the process used, though all copper plates eventually suffer from the extremely heavy pressure to which they are submitted during printing. Drypoint plates are particularly fragile, sometimes giving only about 20 good impressions before the BURR is worn down. Most line engravings and deeply bitten etchings will yield hundreds of good impressions, though the shallower lines will gradually print fainter and may ultimately disappear. The

modern practice, if the intention is to give longer life to a fragile plate, is to steel-face it; a drypoint reinforced by this means would then yield about a hundred good prints.

During the early centuries of print-making a strictly utilitarian attitude prevailed towards the number of prints to be taken. Printing was simply a means of duplicating an image; therefore the more good prints that could be taken the better, and engraving was done in such a way that the block or plate would yield a large trade edition. With the appearance, roughly in the time of Rembrandt, of the painter-etcher, who usually worked his own plates in the fragile medium of etching combined with drypoint, the situation gradually changed; utility began to be replaced by aesthetic considerations and also rarity from the COLLECTORS' point of view—for early impressions, before the plate was worn, were often better than late ones. The idea arose of the 'Fine Print' or 'Artist's Print', issued in a strictly limited edition in order to enhance its value. Since the mid 19th c. it has become the custom for most artists to issue their prints, whether etchings, woodcuts, or lithographs, in these restricted editions, with each copy signed and numbered; the number is written like a fraction, e.g. '7/100' indicating the seventh print of an edition of 100 copies (though the artist does not necessarily number his prints in the order in which they are made). The plate is usually defaced after the edition has been printed in order to reinforce the rarity value and to prevent unauthorized prints of inferior quality being taken subsequently.

3. PROOFS AND STATES. A proof is an impression taken by an engraver from his plate or block in order to see how his work is proceeding and decide what corrections or additions to make. 'Counterproofs' or 'offset proofs' are made by impressing a sheet of paper against a proof that is still wet so as to produce an image the same way round as the original design on the plate. The term 'artist's proof', often written in pencil alongside the artist's signature on the printed sheet, should mean a proof taken by the artist, outside the numbered edition referred to above, and reserved for his own reference; but the phrase is sometimes misused.

Corrections on a metal plate are made by smoothing away the faulty lines with scraper and burnisher and hammering or 'knocking up' the plate from the back until the surface is level. On a wood-block correction can only be done by drilling out the area in question and plugging with a fresh piece of wood. The slightest alteration to a plate or block after a proof has been taken results, for the collector, in a 'change of state'—a state being a particular stage in the development of the work. When different states are compared they often provide an enlightening history of the growth of the artist's idea and his method of working. Early states, though often aesthetically inferior to later ones, are eagerly sought after by collectors and may command

uniquely high prices simply because of their rarity.

4. INSCRIPTIONS. Many old prints, particularly etchings and engravings of views, portraits, battles, and so forth were issued with dedications, descriptions, and other lettering added to the picture or incorporated in its decorative surround. This lettering was frequently engraved by another engraver after the subject itself had been finished and proofed. Proofs made before the application of the lettering are known as *avant la lettre* proofs; they constitute for the collector a rare and valuable state and consequently command high prices.

Various Latin formulas, often abbreviated, are found beneath old reproductive prints indicating the name of the engraver, the artist who made the original design, and sometimes the publisher or printer. Thus *incidit* or *sculpsit* indicates the engraver, *delineavit* or *pinxit* the artist who drew or painted the original, and so on. Sometimes additional notes or sketches, called *remarques*, are found in the lower margins of intaglio prints. 'Remarque proofs' were sometimes issued in the 19th c., supposedly having a special value as rarities.

The uses to which prints have been put and the forms they have taken are very numerous. Broadsheets, song sheets, playing-cards, holy pictures, maps, CARICATURES are only a few. But their history was at the beginning inseparable from that of book illustration. Certain of the processes—wood-engraving, for instance—are more obviously suited to this purpose than others, but all the print techniques have made their contributions to the art of the book. It is probably not too much to say that in France during the 20th c., for example, the continued publication of magnificent 'éditions de luxe' with original engravings by the finest of contemporary artists is more than anything else responsible for the maintenance of that country's tradition of fine engraving.

A very high proportion of the finest prints has always been made not by professional engravers but by painters and sculptors. Most of the greatest artists of the last three or four centuries have made at least a few prints, and for some masters engravings have formed an important part of their total work. One need only instance MANTEGNA and DÜRER in line engraving, Rembrandt and GOYA in etching, TOULOUSE-LAUTREC and BONNARD in lithography, GAUGUIN and MAILLOL in woodcut. In the 20th c. all the leading artists have been prominent also in this field —PICASSO, MATISSE, BRAQUE, Juan GRIS, KLEE, MASSON, BISSIÈRE, to name but a few. Only the movements called 'Action Painting' or ABSTRACT EXPRESSIONISM in some of their manifestations have seemed antipathetic to the meticulousness and deliberation which go with the various techniques of the print.

293, 418, 427, 714, 1136, 1279, 1324, 1326, 1328, 1412, 2148, 2836, 2944, 2964.

**PRIVATE PRESSES.** Printing presses usually operated by hand on non-commercial lines by private individuals with freedom to experiment in the production of books distinguished for their typography, illustration, format, and binding. In a general sense private presses are almost as old as printing itself. The astronomer and mathematician Regiomontanus maintained a press at Nuremberg (1471) to publish his own writings. Caxton's *Recuyell of the Historyes of Troye* (1474), the first book printed in English, was printed at the command of, and financed by, Margaret Duchess of Burgundy. Best known of these individual ventures by princes, scholars, and dilettantes was the Strawberry Hill Press, founded at Twickenham by Horace WALPOLE in 1757.

The private press movement of more recent times was initiated by William MORRIS, whose KELMSCOTT PRESS provided both the impetus and the model for the revival of interest in typography and book production around 1900. Morris had been anticipated by Dr. Charles Daniel, later Provost of Worcester College, Oxford, whose family press, first established at Frome in 1845, was active intermittently at Oxford from 1874 to 1906. To the Daniel Press was due the credit for the revival of Fell types in 1876, but its influence was local and unrecognized until Morris established the vogue for private presses. Although aims and accomplishment varied considerably in the different presses set up after his death, some emphasizing typography and layout to the exclusion of illustration, the movement as a whole was characterized

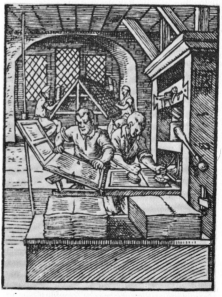

283. Book Printing. Woodcut by Jost Amman from *Panoplia Omnium Artium* (1568), Hartmannus Schopperus

**284.** Printing press (*c.* 1700) of the type used by Caxton. (Science Mus., London)

by (1) an interest in type design shown in the use by individual presses of types produced specially for them; (2) an interest in illustration; (3) the appeal to bibliophiles implicit in the production of limited editions of finely printed and carefully designed books and the stimulus given to commercial printing.

The Kelmscott Press was followed in England by the DOVES, ASHENDENE, ESSEX HOUSE, ERAGNY, and VALE presses; in Germany by the Janus, Bremer (1911–32), and Cranach (1913–33) presses; and in the United States by the Village (founded 1903), Merrymount (1893–1953), and Riverside presses. The English private presses had the credit of stimulating a revival of wood-engraving for illustration, a development continued after the First World War by the GOLDEN COCKEREL, NONESUCH, and

other presses. The decline of the movement, already apparent in the 1930s, was completed by the Second World War. Improved standards in commercial printing and the high cost of the books, which were usually printed in limited editions for subscribers only, were among the reasons which made the private press an anachronism by the mid 20th c.

1370, 2178, 2664.

**PROOFS.** See PRINTS.

**PROPHETS.** As deliverers of God's message and representatives of the old law the prophets were considered to be a prefiguration of the APOSTLES; the four major prophets—Isaiah, Jeremiah, Ezekiel, and, later, DANIEL—were thought to prefigure the EVANGELISTS (CHARTRES window, four prophets with four Evangelists on their shoulders) (see also TYPOLOGICAL BIBLICAL ILLUSTRATION). In Western art they are usually represented holding a phylactery or roll inscribed with their name or a verse from their prophetical writings. Only in BYZANTINE ART are their heads ornamented with AUREOLES.

Isolated representations of the prophets appeared very early in EARLY CHRISTIAN ART, in catacomb painting, and on SARCOPHAGI (*Isaiah's prophecy of the Virgin birth*, Catacomb of Priscilla). Book illustrations often included scenes from the lives of the prophets (Jeremiah's vision of Isaiah in Cosmas Indicopleustes *Topography*, Vatican, 6th c.; *Homilies of Gregory of Nazianzus*, Bib. nat., Paris, *c.* 886; prayer of Isaiah, *Paris Psalter*, Bib. nat., Paris, 10th c.). Groups of prophets were represented in Byzantine churches, often in MOSAIC, in the PENDENTIVES of domes and along the arcades of naves (stucco reliefs, Orthodox Baptistery, Ravenna, mid 15th c.; doors of S. Paolo fuori le Mura, Rome, 1070; S. Angelo in Formis, second half 11th c.; Cappella Palatina, Palermo, 12th c.). In ROMANESQUE and GOTHIC cathedrals the prophets as figures of the old law, sometimes in the attitude of disputing, were part of the elaborate decoration of the portals or west façades (Modena, Parma, BOURGES, Chartres, Strasbourg, Bamberg). At AMIENS Cathedral 13th-c. reliefs illustrate actions, visions, and prophecies of each of the prophets. The lives of the prophets were illustrated in STAINED GLASS at Chartres, REIMS, and Bourges.

On ALTARPIECES, PREDELLAS, and the wings of POLYPTYCHS the prophets, signifying the old law, often flank the central figures of the VIRGIN and Child (DUCCIO, Siena). Six prophets announcing the death of CHRIST surround the cross on the 15th-c. *Puits de Moïse* at Dijon, by Claus SLUTER.

The prophets occur in schemes of fresco painting—by CAVALLINI, 1308, Sta Maria Donna Regina, Naples; at Orvieto they form part of the *Last Judgement* begun in 1447 by Fra ANGELICO. From the 15th c. onwards they were associated with the SIBYLS and were sometimes represented with them (PERUGINO, Cambio, Perugia; PIN-

TORRICCHIO, Appartamento Borgia, Vatican; MICHELANGELO, Sistine Chapel, Vatican).

**PROPORTION.** The idea of proportion derives from that of ratio, which is the simple quantitative comparison between two things of the same kind. In its most general sense proportion is the measure of relative quantity; in its mathematical sense it is a similitude or equivalence of two or more ratios. True proportion therefore necessarily involves at least three terms. Several types of mathematical proportion are distinguished, the best known of which are geometric, arithmetic, and harmonic proportion. All types have the essential characteristic that each successive ratio is linked to the next by a constant ratio which is common to the whole sequence (called the analogical invariant). Thus a mathematical proportion exemplifies the principle of unity amongst a variety of ratios by virtue of a constant ratio which makes them all analogous.

When associated with ideas of beauty 'proportion' usually refers to a harmonic relationship among the parts and between any part and the whole of an object, such as a building or a body. It has often been linked with the notion of cosmic harmony. Thus when LEONARDO wrote that the beauty of a beautiful face consists in 'the divine proportionality in the composition of its members' (*Trat.* 32), he was thinking in terms of a universal harmony of which proportion in particular things is an intellectually apprehensible reflection. This sort of view was general, though not unopposed or alone in the field, until it gave way to a more subjective conception in the 17th and 18th centuries. Thus Plotinus, for example, said that: 'Practically everybody asserts that visible beauty is produced by symmetry of the parts towards each other and towards the whole' (*Enneads*, 1, 6). He himself, however, refutes this view on the ground that if beauty consists in the proportion of the parts, the simple parts of a beautiful object cannot themselves be beautiful; and this he is not prepared to accept. Furthermore he argues that the idea of proportion cannot be extended to moral and intellectual beauty. Aquinas names 'due proportion or harmony' as one of the three ingredients necessary to beauty. And the cosmic or theological extension given to the mathematical idea of proportion is evident in the following scholastic definition of the Trinity as 'Three Persons co-ordinate in a marvellous harmony, the Son being the image of the Father and the Holy Ghost the link between them' (Ulrich Engelbert, *De Pulchro*). ALBERTI, who believed that beauty depended on a rational order, nevertheless admitted that 'there are some who . . . say that men are guided by a variety of opinions in the judgement of beauty . . . and that the forms of structures must vary according to every man's particular taste'. DÜRER, who worked out more systems of proportion than any other great artist, tells how in his youth he heard of a canon of ideal human proportion from Jacopo

de' BARBARI and from this and VITRUVIUS set himself to work out the ideal canon.

Evidence of the change from an objective idea of mathematical beauty to a subjective notion of beauty based upon feeling and sentiment is to be found, for example, in *The Principles of Painting* by DE PILES (Eng. trans. 1743), where he writes: 'But according to general opinion there is no definition of the beautiful: Beauty they say is nothing real; everyone judges of it according to his own taste, and 'tis nothing but what pleases.' BURKE prefaces his detailed attack on the 'proportion' theory of beauty by *defining* beauty (in contrast to the intellectualist notions which had been general until his time) as the quality or qualities in things which cause 'that satisfaction which arises to the mind upon contemplating anything beautiful'. He rejects proportion as the source of beauty on the ground that it is 'a creature of the understanding, rather than a primary cause acting on the senses and imagination'. A new idea of beauty, based on feeling and the senses, has been substituted in his definitions. Though the subjective conception of beauty has prevailed, the idea that the cause of the special sort of satisfaction which a beautiful thing imparts may reside in its proportions has still not finally disappeared.

The origin of theory of proportion is traditionally ascribed to the Pythagorean philosophers of the 6th c. B.C., who saw in the tuning of the musical scales 'the unity of variety and the agreement of opposites'. The Pythagoreans are said to have been the first to make the famous experiment which showed that if a resonant string is stopped at half its length and sounded, it produces a note an octave higher than that given off by the whole string, that two-thirds of the string gives the fifth and three-quarters the fourth. Thus the principal aural consonances were shown to be linked with the first four numbers and the three main intervals to be expressible by the three types of proportion or 'means' known to them, viz. the arithmetic (in which each term is greater than its predecessor by the same amount, as 1:2:3:4), the geometric (which they called proportion *par excellence* and which is an equivalence of two or more ratios, as 1:2::2:4), and the more subtle harmonic proportion (in which three terms are so related that the two extremes are separated from the mean by the same fraction of their own quantity, as 6:8:12).

The Pythagoreans, conceiving numbers spatially (e.g. 4 as the square, 3 as the triangle, etc.), believed number to be the origin of all things and that forms, or the heavenly shapes and essences of things, are numbers or ratios of numbers. They were not, however, able to cope with incommensurable relationships, such as that of the diagonal to the side of the square, and it was Plato who, in the cosmological system developed in the *Timaeus*, succeeded by his theory of the Five Regular Solids in incorporating the irrationals into the ultimate elements of which the cosmos is constructed. For although an infinite

**Fig. 75.** Plato's Five Regular Solids

number of regular polygons may be postulated in the two-dimensional plane, only five regular figures exist in three-dimensional space. These were called by Plato the most perfect bodies and he invested them with cosmological significance. The first four solids, tetrahedron, etc., formed the 'atoms' of the four elements, fire, water, earth, and air. God fashioned them out of primordial chaos 'by form and number' and 'made them as far as possible the fairest and best'. The fifth solid (the solid composed of 12 regular pentagons which subsequently acquired heavenly connotations) gave form to the cosmos: 'There was yet a fifth combination which God used in the delineation of the heavens.' In order to unite these different elements into one harmonious whole God used proportion, for 'the fairest bond is that which makes the most complete fusion of itself and the things which it combines; and proportion is best adapted to effect such a union'. Thus 'the body of the world was created, and it was harmonized by proportion, and therefore has the spirit of friendship'. But before making the visible and tangible world in this way God created the 'world soul'. First out of the indivisible and the divisible (symbolized by the Pythagoreans by the first two integers) he created an essence. 'When he had mingled them with the essence and out of the three made one, he then divided the whole into as many portions as was fitting' according to the proportions of the Pythagorean Tetractys and Diatonic scale. Thus 'the soul partakes of reason and harmony'.

The influence of Plato's cosmological myth continued into the Middle Ages mainly through

# PROPORTION

**Fig. 76.** The Pythagorean Tetractys

Roman writers (Cicero, Seneca, Boethius) or through Byzantine and Arab sources. Most medieval libraries of any standing possessed a copy of Chalcidius's Latin version of the *Timaeus* made about A.D. 350 (which however stops at the section on the geometrical figures). Another work of great importance for theory of proportion, as for mathematics in general, was Euclid's *Elements*, which appeared shortly after Plato's death and was a product of his school. It first became accessible to the West through a Latin translation made in the 12th c. and it is sometimes supposed that this is reflected in the geometrical designs of GOTHIC cathedrals. In the systems of proportion which arose during the RENAISSANCE Pythagoras and Plato are constantly quoted as authorities, and the persistence of the Platonic habit of thought may be seen even in Kepler (1571-1630), the founder of modern astronomy. Kepler wrote: 'Nature loves these proportions in everything which is capable of proportion, so does the human understanding love them which is the image of the Creator. . . .' Moreover the

**Fig. 77.** Kepler's solar system based on an arrangement of the five Platonic solids. From his *Mysterium cosmographicum* (1596)

association of proportion with mathematics was kept alive by the place held by theory of music in the *quadrivium* of LIBERAL ARTS throughout the Middle Ages, which received a new impetus from the humanist movement of the Renaissance. The analogy between musical harmony and proportion in the visual arts was assumed on a philosophical and mystical level as in the following words of Alberti (*De re aedificatoria*): 'the same numbers, by means of which the agreement of sounds affects our ears with delight, are the very same which please our eyes and mind. And therefore we shall borrow all our rules for the finishing our proportions from musicians, who are the greatest masters of this sort of numbers.' The fusion of the practical with the metaphysical was assisted by new discoveries in PERSPECTIVE, which showed that Pythagoreo-Platonic harmonies exist in optical space. By the early 16th c. proportionality had become a catchword. As PANOFSKY has said: 'The proportions of the human body were praised as a visual realization of musical harmony, they were reduced to general arithmetical or geometrical principles . . . they were connected with various classical gods.' FILARETE, Luca Pacioli (see GOLDEN SECTION), and LOMAZZO were among the many who discussed proportion in this spirit.

SYSTEMS OF PROPORTION IN ARCHITECTURE. Already the Neolithic monuments show a geometrical conception in their design (e.g. the three concentric enclosures round an altar at Stonehenge). But perhaps the earliest authentic systems of proportion grew from the ancient Egyptian tradition of 'cording the temple', which involved the use of a knotted rope marked off in 12 units for the purpose of making a right-angle triangle of $3 \times 4 \times 5$. It was a simple matter to extend and adapt this method to the elevation and the design in general. Early records of the *harpedonaptai*, or cord-stretchers, go back to the 3rd millennium B.C. A similar practice is described in the Hindu *Sulvasutras* of the 6th c. B.C. or earlier (the word means 'rules of the cord'), which treat of the construction of sacrificial altars. M. Cantor says that the Egyptian rope-stretching operation dates back possibly to the 1st Dynasty.

At some time during the 6th or 7th c. the Greeks obtained from ancient Egypt knowledge of this manner of correlating elements of design. In their hands it was highly perfected into an abstract science. But the secret of its artistic application has completely disappeared. Apart from the monuments themselves we have very little documentation on the systems of proportion used by Greek architects and sculptors of the archaic and classical periods. It is generally assumed that they derived the proportions of their temples from the geometrical figures and that they preferred those rectangles whose sides are in the ratio of $1 : \sqrt{2}$, $1 : \sqrt{3}$, and $1 : \sqrt{5}$, whereas Roman design was often based on a simple and practical modular system. But this is no more than an inference from the buildings themselves.

Fig. 78. The Root Rectangles

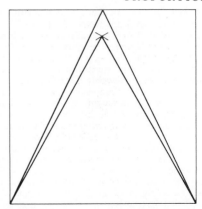

Fig. 79. Proportion *Ad Quadratum* and *Ad Triangulum*

Though analyses of great architecture almost always suggest some geometrical scheme and scholars show unlimited patience and resource in attempting to identify particular systems, it is never quite certain that the order which their studies reveal is not merely a by-product of some anterior system which they have missed. Everything that has been written about proportion in Greek architecture is open to this doubt.

There is unfortunately no document which gives us any facts about classical systems of proportion until the treatise on architecture written late in the 1st c. B.C. by the Roman architect Vitruvius. He must have known Greek sources, for he gives much information about Greek methods and theories of the HELLENISTIC period, but often in a confused form. The chapter on the building of TEMPLES (*De architectura*, III. i) describes the MODULE system of proportion. The module is the diameter of the COLUMN at its base (sometimes he says it is half the diameter). It is a unit, and multiples or fractions of this unit determine the size and placing of each member of the building. Vitruvius demands that the parts of a building should be proportionate to the whole in the same way as the parts of the body were supposed to be in nature. In his famous account of the well-made man who spreadeagled fits exactly into a circle and with feet together and arms extended fits into a square, he says: 'Therefore if Nature has planned the human body so that the numbers correspond in their proportions to its complete configuration, the ancients seem to have had reason in determining that in execution of their works they should observe an exact adjustment of the several members to the general pattern of the plan.'

It is unlikely that any elaborate mathematical theories were connected with Romanesque or early Gothic architecture. The buildings suggest simple regular figures as key figures to the proportions: especially the square and the equilateral triangle. These gained especial authority from the tradition deriving from Plato and Euclid. Our knowledge of drawings or plans used in masons' lodges is very scanty, but it seems likely that simple arithmetical rules were in use, not only because the latter had certain magical powers ascribed to them but also for their practical usefulness in carrying out a design without the advantage of a yardstick. Medieval cathedrals

have been exhaustively examined and measured by such scholars as VIOLLET-LE-DUC and F. M. Lund (*Ad Quadratum*). There is overwhelming evidence that many medieval churches were built either *ad triangulum* or *ad quadratum*. In the case of Milan Cathedral we have not only contemporary drawings but also full reports of discussions of the council meetings in 1392 which a French and a German architect attended as consultants. It was deliberated whether the nave 'ought to rise according to the square or the triangle', and the decision was that it should rise 'up to the triangular figure and no further'. Clearly it was considered necessary that some established geometrical order should be followed; no one suggested that the proportions should be arbitrary. P. Frankl believes (*The Secret of the Medieval Masons*) that the proportion was used as a practical device to compensate for lack of a yard-stick. Nevertheless there could be a relation of the method as a whole with some principle of aesthetic.

The theoretical interest of the Renaissance in proportion has already been mentioned. BRUNELLESCHI, DONATELLO, and Alberti took measurements from classical buildings and statues in the hope of finding that rational basis for beautiful forms which they believed the ancients to have possessed, and it has been demonstrated that the buildings of Brunelleschi and Alberti are planned with classical systems of proportion in mind. The façade of Brunelleschi's Pazzi Chapel, for example, appears to be based on the 'root' rectangles $\sqrt{2}$, $\sqrt{3}$, $\sqrt{5}$. But Alberti, like most later Renaissance architects, had a preference for commensurable ratios: the proportions used in the façade of Sta Maria Novella are $1:2:4$. BRAMANTE followed the precepts of Alberti and after Bramante PALLADIO, who developed Alberti's system into an elaborate scale of visual harmony. Vitruvius was looked to as *maestro e guida* by these Renaissance architects and much was read into his obscure text. Palladio's buildings and writings exercised a good deal of

influence in northern Europe, particularly in England through Inigo JONES. Sir Henry Wotton's *Elements of Architecture* (1624) stressed the importance of harmonic proportions.

NEO-CLASSICAL architects of the late 18th and 19th centuries were content to copy antique forms and paid curiously little attention to traditional systems of proportion. More recently architects have again sought for a rationale. The most notable product of this revival of interest was LE CORBUSIER's *Modulor*, a scale of measurements (in the form of a tape) composed of units intended to be related to one another in a pleasing way. It may be used for choosing the proportions of a design and it ensures that all the parts shall be harmoniously related. (The objection has been raised that such an infinity of lengths is sanctioned that the *Modulor* allows you to design almost exactly as you please.) The divisions of the *Modulor* are derived from the Golden Section, which Le Corbusier found in the measurements of the human body. But although Le Corbusier returned to a Platonic theory of proportion, his *Modulor* did not pretend to the metaphysical implications of the old systems. By taking man in his environment instead of universals as his starting-point, Le Corbusier accepted the shift from absolute to relative standards which began to become general in the 18th c.

CANONS OF PROPORTION. The object of a canon of human (or animal) proportions is to establish an ideal of a beautiful body whether in nature or in artistic reproduction. The aesthetic assumption implicit in the use of such canons in classical antiquity, diametrically opposed to the aesthetic outlook of the 20th c., is that by exactly reproducing the proportions of a beautiful living body and transferring them to stone or bronze (with some compensation in certain cases for distortions of optical perspective) the artist will produce a beautiful work of art. This assumption is present even in Isaiah (xliv. 13): 'The carpenter stretcheth out his rule; he marketh it [the image] out with a line; he fitteth it with planes and he marketh it out with the compass, and maketh it after the figure of a man according to the beauty of a man.'

The first canons of which we have any exact knowledge are those of EGYPTIAN ART. Effigies, which were to be dwelling-places for the spirits of the dead, had to be made according to certain proportions. Their purpose was purely constructional. All the craftsman needed to know was the mechanical rules governing the relationship between the grid and the human body, i.e. in which squares the different parts of the body were fixed. Diodorus Siculus describes how two sculptors using the Egyptian method were able to work on separate parts of the same statue, one in Samos and one in Ephesus, and nevertheless secure that the parts fitted so perfectly when brought together that they seemed to have been made by one man.

The influence of the Egyptian method is probably to be seen in archaic Greek sculpture, but in the 5th c. B.C., when statues began to show organic movement, the Egyptian system would no longer suffice. The Greeks had a natural bias towards mathematical modes of thought and it is traditionally maintained that they evolved various canons of proportion. The purpose of these must have been simply to provide a scale of the comparative measurements of a normal or a beautiful figure, to be used as a point of departure for the innumerable variations produced by movement. This being so, it is impossible to gain exact information about the Greek canons by measuring the works themselves. We can only infer their general nature from the references in ancient literature. In a key passage Galen describes the so-called canon of POLYCLITUS: 'Chrysippus . . . holds that beauty does not consist in the elements but in the harmonious proportion of the parts, the proportion of one finger to the other, of all the fingers to the rest of the hand, . . . in fine, of all parts to all others, as it is written in the canon of Polyclitus.' Unfortunately the interpretation of this passage is obscure. Some have taken it to mean that the proportions of the body (or statue) were expressed in terms of a module which was itself a part of the body (this interpretation is given for example by Panofsky). This accords with Vitruvius, the only ancient writer who has recorded actual data regarding ideal proportions of the human body. He formulates them as common fractions of the length of the figure: e.g. the face from hairline to chin is one-tenth of the total height. But a module expressed in terms of a part of the figure has no more aesthetic significance than a module expressed in terms of inches or centimetres or than the Egyptian grill, and the adjustments made by the Greeks for movement would have been made by eye and were not inherent in the canon. On the other hand the language of Chrysippus is consistent with the view that the canon was a true proportion, i.e. a relation among ratios, and laid down a common or similar relation of parts to parts and to the whole. Such a canon might have aesthetic significance, as ancient writers asserted, as helping to ensure an organic unity among the parts and in the whole.

As the Roman empire declined the classical ideal of naturalistic beauty was abandoned. Late pagan and EARLY CHRISTIAN ART adapted classical models to easily recognizable images whose symbolic function was best served by schematic formulas. But even in this flat and schematic art some simple rule of thumb was useful. Two such schemes are known, the Byzantine and the Gothic. Of the two the Byzantine was nearer to the classical tradition, for it broadly recognized the articulation of the limbs and their relative proportions in nature. Details of it are recorded in the *Painter's Manual of Mount Athos*, which has come down in an 18th-c. edition, and similar proportions are given in the *Book of Art* of Cennino CENNINI deriving from the Byzantine

tradition. The Byzantine canon was not an aid to the appreciation of human proportions, but rather a simple practical routine in which the proportions of nature had been modified to fit into a scale of measurements. Simple units were multiplied, such as the length of the nose (for the head) or the length of the face (for the whole figure). This system is easily traceable in heads done in the Byzantine tradition. The frontal view of a head with its halo was proportioned by means of three circles having a common centre at the root of the nose. The innermost circle, with a radius of one nose-length, gave the tip of the nose and the top of the forehead; the next circle, with a radius of two nose-lengths, gave the outline of the hair; and the outermost circle, with three nose-lengths, gave the outline of the halo. Obviously the representation of foreshortening or natural movement would be restricted by such a method.

The Gothic system was not concerned with relative measurements, and it practically ignored the structure of the body, limiting itself almost exclusively to determining the outlines and the directions of movement. A unique record of it has been handed down in the notebooks of the French architect Villard d'HONNECOURT, whose sketch book (written between 1243 and 1251) provided the artist with handy geometrical aids 'pour légèrement ouvrier', such as would help him to draw animal and human heads and figures. Villard's system is not a modular system

**Fig. 80.** Byzantine scheme of proportion for representing head with halo

**Fig. 81.** Rule-of-thumb precepts of proportion from the sketch book of Villard d'Honnecourt

or even metrical: the measurements are to be supplied by the artist to suit the task in hand. The late Gothic artists of the 14th and 15th centuries seem to have rejected constructional aids altogether. The trend was towards movement and NATURALISM, and they relied more and more on observation and personal judgement.

The intense interest in proportion during the Renaissance led many artists of the 15th and 16th centuries to devise canons for the figure. In Florence the artists of the new movement, led by Brunelleschi, saw themselves as the heirs of classical antiquity and sought to rival it not so much by direct imitation of antique remains as by an attempt to understand the principles underlying the classical ideal. With this purpose in view they made measurements of ancient statues in Rome, and in their search for a rational basis for beautiful forms they applied the same scientific method to living models. The first notable canon was the product of Alberti's ingenious system of measurement which he called *Exempeda*. He divided the whole length of the figure into 600 *minuta*. This gave him an accurate and practical scale for making and recording measurements, and his canon, recorded in his treatise on sculpture (1464), was the result of measuring a considerable number of persons. Leonardo produced tables and analyses of equine as well as human forms. He also broke entirely new ground by investigating the ANATOMICAL processes by which the dimensions of the body are altered in movement. Both he and PIERO DELLA FRANCESCA studied proportion in relation to perspective. Dürer, the first artist in the north to take up these studies, was obsessed throughout his life by the search for ideal proportion. He not only prepared a treatise on human proportions but produced more systems than any other great artist; indeed he carried his interest so far beyond the bounds of artistic usefulness that his researches, like some of Leonardo's, may rather be seen as the beginnings of such sciences as anthropometry and biometry.

Though the High Renaissance exploited the classical canons in one way or another, it was inherent in the precepts of MANNERISM to disregard them. Nevertheless the ACADEMIES, from the late 16th c. onwards, taught canons of proportion, together with perspective, as part of the discipline of DRAWING. Books of engravings for the edification of students were published which not only reproduced all the most famous classical statues but also gave a careful analysis of their proportions. Their purpose was to familiarize the young artist with correctly drawn figures so that he would no longer need to construct them mathematically. Thus REYNOLDS could write: 'I am confident the works of ancient sculpture were produced, not by measuring but in consequence of that correctness of eye which they had acquired by long habit.' With ROMANTICISM the artist's individual conception rather than a universal ideal became the subject of the work

of art, and therefore systems of any kind were looked upon with abhorrence as obstructions to the creative urge. Nevertheless vestiges of the traditional canons survived: students of drawing were still taught to relate forms—for instance the size of hands to that of heads—and many of the books on 'how to draw' give rudimentary rules of proportion.

In modern times some artists and aestheticians have revived an interest in mathematical principles of proportion which were neglected through the Romantic period. Experimentalists, following Fechner, have tried to find empirically the proportions in simple shapes (such as a visiting-card) which are most generally pleasing. Artists have usually adopted a different approach, seeking to apply proportion directly to the construction of a picture rather than to the natural objects to be reproduced in the work of art. Interest in principles and theories of proportion has not been restricted to ABSTRACT artists such as KANDINSKY or MONDRIAN but has been shown by many others, as for example CHIRICO and the ORPHISTS. It is no longer generally believed that anything of use to the creative artist is likely to result from investigations into historical theories of proportion apart from a reaffirmation of the general principles of design expressed in terms of unity, variety, and balance. But it is accepted that 'a sense of proportion'—in some meaning of the term—is one of the artist's most important assets. On the other hand much work on the mathematical aspects of organic forms, and forms in crystallography and molecular physics, has stimulated a widespread interest in new sorts of analogy between artistic form and the natural forms in which the modern scientist is interested with common features of proportion in both.

With regard to the practical utility of systems of proportion in architecture a debate was held at the R.I.B.A. on 18 June 1957 on the motion 'that Systems of Proportion make a good design easier and a bad design more difficult'. The motion was lost by 60 votes against to 48 votes in favour.

730, 1026, 1027, 1410, 1411, 2429, 2857, 2877.

**PROPYLAEA.** The monumental entrance at the west of the ACROPOLIS of Athens, built 437-432 B.C. by MNESICLES. It consists of two Doric PORCHES at different levels, with a pierced wall between and Ionic COLUMNS (see ORDERS OF ARCHITECTURE) lining the road through. The awkward junction of the two roofs is visible only at a distance. Wings, projecting in front, flank the porches, but were not completed: at the south-west an ingenious sham optically balances the *pinakotheke* (picture gallery or store) across the way. The Franks in the 13th c. converted the Propylaea into a keep, and in the 17th c. the Turks used it as a magazine (which exploded) and afterwards for a bath.

**PROTO-RENAISSANCE.** This term was used by Jakob Burckhardt to characterize those elements in Italian architecture which show the closest links with CLASSICAL antiquity. He quoted the BASILICAL form and the use of COLUMNS in such buildings as the cathedral at Civita Castellana or S. Miniato and the Baptistery at Florence as evidence of the desire to use revived ANTIQUE forms before the RENAISSANCE proper.

Erwin PANOFSKY also refers to a movement commonly—though somewhat loosely—referred to as the 'proto-Renaissance of the twelfth century' (*Renaissance and Renascences*, vol. i, p. 55). He describes it as a classicizing movement which began in the latter part of the 11th c., reached its climax in the 12th, and continued into the 13th c. It was a 'Mediterranean phenomenon, arising in Southern France, Italy and Spain'. Nicola PISANO is regarded as the highest point in this early revival of Classicism and his influence extended through the trecento and into the early Renaissance proper.

**PROUT,** SAMUEL (1783-1852). English painter best known for his WATER-COLOUR views of PICTURESQUE buildings and streets in Normandy. He worked for a time with John Britton (1771-1857) on the *Beauties of England and Wales* (1801-15) and from 1830 the *Landscape Annuals* of Robert Jennings were illustrated by engravings after his work. He was an important popularizer of picturesque LANDSCAPE and helped to build up the English ROMANTIC image of the Continent. His work was greatly admired by RUSKIN.

**PROVOST,** JAN (c. 1465-1529). Flemish painter born at Mons. In 1493 he was made a master of the Antwerp Guild, but in the next year he moved to Bruges, where he spent the rest of his life. Nothing ascribed to him is signed, but a *Last Judgement* (Bruges) is attested as his work by documents. The attributed works show that he followed the lead of Quentin MASSYS and brought the Antwerp style to Bruges, where the 15th-c. tradition was being carried on by Gerard DAVID. In 1521 Provost met and entertained DÜRER, who is reputed to have drawn his portrait.

926.

**PRUD'HON,** PIERRE-PAUL (1758-1823). French painter of the Revolution and First Empire. He was trained at the Dijon Academy and went to Rome in 1784, where he was a friend of CANOVA and formed his style on a blend of LEONARDO and CORREGGIO. He returned to Paris in 1787 but did not attract attention until his picture *Justice and Divine Vengeance pursuing Crime*, which was exhibited at the Salon of 1808 and for which he received the Legion of Honour. He was a favourite of both empresses, Josephine (*Empress Josephine*, Louvre) and Marie Louise, and designed the decorations for the

bridal suite of the latter. His friendship with Talleyrand enabled him to remain in favour even after the fall of Napoleon and in 1816 he was made a member of the Institut. He painted an *Assumption* for the Tuileries chapel in 1816 (Met. Mus., New York) and *Christ on the Cross* (Louvre) in 1822.

Prud'hon belongs both to the 18th and to the 19th centuries. His work bridges the period from DAVID's *Oath of the Horatii* to GÉRICAULT's *Raft of Medusa*. In his elegance, his grace, and his exquisite fancy he is akin to the epoch of Louis XVI and David referred to him slightingly as 'the BOUCHER of his time'. But his deep personal feeling aligns him with the ROMANTICS. GROS said of him: 'He will bestride the two centuries with his seven league boots.' Among his best known pictures are *The Rape of Psyche* (Louvre) and *Venus and Adonis* (Wallace Coll., London), for the latter of which the empress Marie Louise, whose drawing master he was, is said to have been the model.

1131, 1199.

**PRYDE,** JAMES FERRIER (1866-1941). English painter and designer, born at St. Andrews, who studied at the Royal Scottish Academy and in Paris. He designed posters for Henry Irving in collaboration with his brother-in-law Sir William NICHOLSON, under the name 'The Beggarstaffs'. His paintings, which are chiefly of architecture and interiors, with figures dwarfed by their surroundings, express the sinister mystery of buildings and the insignificance of man set amid dramatic voids.

**PSALTER.** The earliest extant Psalter is a 3rd-c. A.D. Greek PAPYRUS Roll from Egypt (B.M.). No illustrated Psalter of the EARLY CHRISTIAN period has survived, though these may well have existed. Illustrated BYZANTINE Psalters fall into two categories: the one, whose origin is perhaps connected with the Cathedral of Sta Sophia at Constantinople, is adorned with small marginal illustrations (*Chludov Psalter*, Hist. Mus., Moscow, c. 900; B.M., Add. 19352, dated 1066); the second is the more sumptuous 'aristocratic' Psalter, of which the most famous example is that in Paris (Bib. nat., gr. 139, mid 10th c.) containing 14 full-page MINIATURES of the life of DAVID and other Old Testament scenes.

In the Latin West the distinction must be made between the biblical and the liturgical Psalter. The former consisted simply of the Psalms without any additions. The liturgical Psalter, which was much more common, was divided into eight sections in accordance with the Benedictine rule that monks must recite the Psalms in full every week (the extra section is for Vespers). The Psalms were generally preceded by a Calendar and followed by various hymns and prayers and by a litany of saints. Both types were illustrated in a number of ways. In one group of biblical Psalters the text is illustrated

in a literal fashion by oblong drawings extending across the page (*Utrecht Psalter*, Univ. Lib., Utrecht, 9th c.; Trinity College, Cambridge, *c.* 1147). In liturgical Psalters full-page miniatures often appeared after the Calendar (which was itself frequently illustrated), before the actual Psalms. At first these were single pictures of David with or without his choir or of CHRIST (Faculty of Medicine, Montpellier; B.M., Cotton, Vesp. A. I; both 8th c.). In England in the 11th and 12th centuries these preparatory pictures were expanded into long series of Old and New Testament scenes (B.M., Cotton, Tib. C. VI, *c.* 1050; *St. Albans Psalter*, Hildesheim Cathedral, *c.* 1120), which became even fuller and were adopted abroad in the 13th and 14th centuries. The eight sections of the Psalter text itself were usually headed by a historiated initial (Psalms 1, 26, 38, 52, 68, 80, 97, 104 of the Vulgate). This scheme originated in England in the 12th c. (*Shaftesbury Psalter*, B.M., Lansdowne 383, *c.* 1140–50) and became almost universal from the 13th c.

The great popularity and copious illustration of the Psalter make it the most important illuminated book from the 11th to the 14th centuries. (See also ILLUMINATED MANUSCRIPTS.)

**PSYCHIATRIC ART.** INTRODUCTION. This article has been entitled 'psychiatric art' in preference to 'psychotic art' because it is intended to deal with the art not only of patients suffering from psychotic illnesses but also of those suffering from psychoneurotic and other abnormal conditions, and to consider it in relation to the art of normal persons and in the light of diagnosis and psychotherapy. For these reasons a wider term than 'psychotic' was needed.

There are two major dimensions of variability to be taken into account at the start. The first is the degree of normality of the patient or artist, and the second is the aesthetic quality of his art product. The two dimensions are not correlated, that is to say it is not true that good works of art are produced only by normal artists or that all art products of abnormal artists are bad. It may be true, however, that more good works of art are produced by normal than by abnormal artists.

There is, of course, the additional difficulty of the definition of the abnormal, which cannot be dealt with fully here. An abnormal person, however, is not necessarily an undesirable or useless member of society. This depends on the kind and degree of his abnormality, and the extent to which he adjusts himself. Abnormality may be said to have two main aspects. Firstly there is the purely statistical sense, in which the less frequent is the more abnormal, and secondly there is the functional sense, in which that which is less well adjusted or more disturbed is more abnormal.

PSYCHOTIC ART. Psychotic art includes the art products of patients in mental hospitals who are suffering from psychotic illnesses. A number of persons who are essentially psychotic in minor ways, however, may not be in mental hospitals, either because they have adapted themselves reasonably well to an ordinary life or because they are not disturbed enough to justify entry into a hospital. Some of these may be artists. Indeed artistic work may well be one of the activities taken up by mildly or potentially psychotic people, which enables them to adapt themselves to everyday life or to keep their conditions from developing seriously, and they may produce either good or bad art.

The psychotic condition most concerned with art is undoubtedly schizophrenia, or in mild cases a schizoid personality pattern. Manic-depressive and other conditions are also important. The reason why the schizophrenic or schizoid type of disturbance is most frequently associated with art productions is probably not far to seek. To a great extent the mental and emotional regressions involved are to the earliest levels of infancy. At these stages language is undeveloped and the contents of consciousness tend to include many bizarre and often fragmentary and strangely assorted visual images, which form the main substance of schizophrenic art. These bizarre, fragmentary, and strangely combined mental images are often of parts of the mother's body, particularly the breasts and eyes. Some paintings may show the same object, such as a face, as if seen from more than one aspect at the same time, or be more conceptual, showing the contents of the body as if it were transparent or an eye floating in space. Fragments and parts may be combined in fantastic ways, and reality relationships depending on shadows, perspective, and support from the ground may be dispensed with, albeit the final art product may be excellent, because artistic quality does not depend on the kind of material used or its realistic appearance, but on the harmony of organization created.

The art of depressive patients is often less bizarre and more realistic, and the colouring may be less garish or vivid, or even be dimmed almost to greys, blues, and violets. In the art of depressives we are dealing with material from less infantile levels in the regression due to illness, and the expressive content may be more coherent. Instead of seeing fragmentary images of the mother's body re-combined into a more or less presentable work of art, we see more recognizable themes such as a person drowning. Needless to say there is no sharp dividing line, and the schizoid and melancholic types of art are often found combined in the same pictures. On the whole, however, while schizophrenic art tends to remain puzzling, incomprehensible, and often rather frightening to such persons as normal artists, melancholic art may be more widely appreciated and almost certainly forms a considerable part of accepted religious painting.

ART RELATED TO OTHER ABNORMAL STATES. Psychoneurotics are not generally found in mental hospitals because they retain insight into their illnesses, tending to regard themselves as

unwell or abnormal, and to seek help, while they are not unable to maintain ordinary relationships although as invalids. They will, however, be found in outpatient clinics, and in those hospital wards in which there is provision for their treatment by psychotherapeutic or other methods.

Many of them show considerable interest in drawing, painting, and other artistic activities, but their products do not tend to be bizarre and unrelated, like those of the schizophrenic, and often remain bright and cheerful in content and expression, unlike those of melancholics. These paintings may represent clearly the patient's predominant obsessions, compulsions, phobias, and anxieties. A patient who suffered from an intense anxiety neurosis produced many paintings, in the first of which there was a woman's head, serene, blissful, and aloof, and red waves flowed from it down towards the lower left-hand side. The sky was black with white birds flying across it. The woman was his mother. The red waves were his repressed sexual wishes causing anxiety. The black sky was his state of mind, and the birds were celestial influences which would help him. During the course of analytical treatment the mother's face changed into the sun, as a symbol of life irradiating everything and dissipating all obscurity, and his anxiety neurosis disappeared.

A hysterical patient might produce a picture full of gay and flamboyant objects but lacking in poise and balance, whereas when she was well again the very same objects could appear in an integrated and harmonious picture. Perhaps the anxious and phobic patients will show the very themes and objects which are associated with their fears. The delinquent will show in his art the aggressive impulses which he tends uncontrollably to express in his anti-social behaviour, or to dissociate himself by appearing as if blameless while others commit a robbery.

A similar tendency may be found in the work of many patients who have physical illnesses, as shown clearly by Miss Joyce H. Laing in her work on the art of tuberculosis patients. There was a strong tendency to represent a blood-red sky or ramifying tubes like blood-vessels and bronchioles in the lung tissues.

Dr. Istvan Hardi of Budapest has studied drawings of the human figure made by 150 alcoholic outpatients during the course of treatment. In one case, before apomorphine treatment and cure, the human figure was drawn only partly. Later the deficient arms were completed, the attitude became more purposeful, and, at the end, a man appeared fully elaborated in all details. Many other significant points emerged.

ART AS A MEANS OF DIAGNOSIS. Clearly there are two ways in which art products can be used for diagnosis. One is that particular characteristics, qualities, or features should be known by prior research to be most frequently found in the work of patients with certain mental or physical symptoms, so that when they are found a syndrome or disease can be diagnosed or pre-dicted. The other lies in the detailed analysis and interpretation of the painting, with all its subsidiary themes and features, in relation to whatever is known about the patient in other ways, so that the use of the painting is an important link, or series of links, in our understanding of his case and all the emotional influences and environmental events and factors which contributed to it. The first is the method of the objective diagnostician who seeks precise data or evidence to help him to fix a useful label. The second is the method which places more emphasis on the detailed information which leads to psychotherapy, because it evolves into a thorough grasp by the therapist of all the factors in the case and its development. This helps him to evoke insight and readjustment in the patient. Both methods of diagnosis are required in an adequate approach.

A first approximation towards a list of diagnostic features within the ambit of the former method was worked out at the Ross Clinic, Aberdeen, by Miss Joyce H. Laing, Art Therapist there, as follows. Groups of patients diagnostically selected by a consultant were asked to paint series of pictures with free choice of subject matter. All patients used the same size of paper and range of colours.

(a) Psychoses: *Schizophrenia.* Fragmentation; abstraction (two dimensions); bizarre ideation; grotesque humour; unrealistic colour; and, in addition, incongruity of relationships, excessive stylization, and intermingled writing and hieroglyphic-like symbols.

*Endogenous or psychotic depression.* Dearth of ideas; one subject only is depicted, rather like isolating one word in a sentence; objects are mundane, such as a cup, bowl, or handbag; human beings are never portrayed; colours are bright and crude, with reasonable relevance to the object.

*Dementia.* Difficulties in using space, important parts of the picture being crammed into one corner; outlines are of a broken or spidery nature, colour merely confuses the picture, revealing difficulty in controlling the consistency of paint; pictures convey a sense of confusion and patchiness.

(b) Psychoneuroses. Pictures in this category are so individual that it is difficult to give more than a general reference to the following states:

*Hysteria.* Bright prime colours; pattern making; lack of control of paints; childish choice of subjects.

*Obsessional neurosis.* Symmetry determines choice of subject; clear, exact, over-meticulous detail in mediocre pictures.

*Neurotic depression.* Colours are sombre and low in tone; use of symbolic language to express emotion, e.g. black clouds, lone trees, barren landscapes, suicidal scenes.

*Psychopaths.* Subconscious identification of self in the choice of subjects, e.g. birds of prey, cowboys, criminals, racing drivers, and so on; often show skilled draughtsmanship. Since these

diagnostic categories and others in psychiatry are not necessarily exclusive, paintings of patients may show a mixture of characteristics and for this reason, if for no other, they are of value to the diagnostician. These diagnostic features show a close relationship with the distinctive nature of various psychotic and other disturbances mentioned in the previous paragraphs.

'FOUND' AND 'TRANSITIONAL' OBJECTS. Two important conceptions which show the relationship between works of art, good or bad, normal or abnormal, to the unconscious have been put forward by psychoanalysts. Fairbairn gave us the concept of the 'found object', and Winnicott that of the 'transitional object'.

A found object is any object which excites interest in the sense that it seems to resemble, or may require a very slight alteration to make it resemble, something familiar. Essentially the concept covers all such objects as bits of paper, wood, stone, or even representations of such objects which are used in a work of art or appear in it. Found objects give a clear indication of relationships with the unconscious because the motivation which makes such objects interesting arises from the deeper levels of the mind, and such objects are therefore the meeting points of conscious and unconscious interests.

Transitional objects are those objects to which early infantile interests are transferred as an intermediate stage in development before a full interest in the outside world emerges. The very earliest interests are usually centred upon the mother's body and other objects of immediate contact in infancy, and the transitional objects are substitutes for these. The infant will cling to them, exhibit dependence on them and imbue them with life and companionship for itself, until they are discarded in normal development because infantile dependences are abandoned and sublimation increases rapidly during childhood. Many transitional objects, however, tend to be retained, and form the basis of the unconscious side of an interest in all sorts of artistic objects and themes, however apparently abstract, and even in the canvas and paints themselves in many cases.

THE 'ART WORK'. Fairbairn made another very important contribution to the study of art from a psychological point of view. He showed that in art, just as in dreams, there are involuntary mental functions which lead to the disguise of deep unconscious meanings. The four functions explained by Freud which operate thus in dreams, and which he called the 'dream work', are: symbolic transformation, displacement of affect, condensation, and secondary elaboration. These functions protect the conscious ego from direct awareness of the primary unconscious meanings of the dreams, and make them consciously acceptable. Symbolic transformation ensures that primary sexual and aggressive images should take forms which are sufficiently different to offer disguise, but near enough to be unconsciously gratifying. Displacement of affect changes the emotional pattern so that sexual and aggressive emotions apply to unexpected objects in ways which hide their direction of meaning. Condensation combines images and emotions from various themes, contents, and levels of the unconscious so that confusion is produced, because several unconscious ideas or impulses are expressed at the same time. Secondary elaboration is the changing of apparent meaning and content during the process of awakening, so that the direct unconscious expression is lost in time for acceptance by waking consciousness.

Fairbairn showed that in art similar functions operate, and called them the 'art work'. They are widely varied in their force of application in different schools of art. In classical art the unconscious themes have generally been subject to profound transformation by such processes, which also operate in myth, fairy-tale, legend, and religious themes. ABSTRACT ART is also subject to powerful transforming influences due to the art work—since these are the very influences which make it abstract. In much modern art, however, especially that of the SURREALIST school, the unconscious is laid bare to a very considerable degree. Since the conscious mind may recoil from the directness of this form of expression, such art often seems unintelligible or requires special interpretation to dispel the anxiety it tends to excite.

ART AND THE UNCONSCIOUS. One of the most distinct marks of psychotic art, and of other abnormal art to a lesser degree, is that the art work is relinquished or relaxed in it, and the unconscious is expressed more or less directly. Hence it has been called Expressionistic art. There is a parallel between much modern art, which dispenses with the art work to a great extent, and CHILD ART, which uses it little, on the one hand, and psychotic and abnormal art on the other hand. It is often thought that psychotic, and other abnormal and child art, must be inferior to the work of modern artists of repute, and, since these artists have training, technique, and outstanding ability behind them, this is frequently true.

Just as the art of expert artists who exploit conscious themes is generally better than that of beginners and amateurs, so is that art of experts who exploit unconscious themes generally better than that of psychotics, neurotics, and children who also exploit such themes. Whether conscious or unconscious themes are exploited is not the criterion, and an expert would not be likely to produce a mere PASTICHE of consciously employed unconscious themes, if it were effective art, because any themes which he could use effectively in art must be themes of profound import for his personality. If, therefore, we return to the theories of the art work, we must see that, since conscious themes are always those which have been most subjected to its transformations, the unconscious is always the fundamental source of inspiration in art.

While it may be true, as many writers, such as

Naumann, have said, that the greatness of a work of art depends on the degree to which the artist has been gripped by the unconscious archetypes in its inspiration, we must add that its greatness also depends on the degree and success with which he has grappled with the unconscious in its execution. Thus great art is more than the unconscious breaking through, on the one hand, and more than the conscious manipulation of materials or contents, whether concrete or abstract, on the other. It is at the meeting points of the two, and transcends both in the event. In view of what has been said about the relationship of art and the unconscious, and the influence of the art work, the major dimension of variability is that of good versus bad art, while the second and third dimensions are those of conscious versus unconscious art, and of normal versus psychotic or otherwise abnormal art. The position of a given work of art would be determined by its measurements in all three dimensions.

ART AND PSYCHOTHERAPY. In psychotherapy art is rightly becoming more and more fully recognized as a valuable means of treatment. Sometimes it seems to be only an adjunct and often it is simply a form of occupation, while at other times it is a powerful instrument for expression of morbid stresses and conflicts in the patient, and for insight leading to their resolution. There are several ways in which these therapeutic functions of painting, sculpture, and other forms of art may have their effect. Firstly, while words provide the main forms of symbolic expression of the unconscious and the repressed conflicts associated with it in psychotherapy, expression through painting and sculpture may reinforce their use and be a means of expression through more concrete and permanent objects, which can be shown to the therapist and other people. Secondly, working on paintings often helps the patient to bring into consciousness and give expression to memories and fantasies which he could not put into words, either because of lack of verbal skill, verbal inhibition, or, more often, because visual and tactile experience precedes the use of language in infancy, and painting may penetrate further into the unconscious. This is particularly true in psychotics, and most especially in schizophrenics. Thirdly, to make the painting gives the patient's ego some control over the disturbing fantasies. Hallucinations may be turned into pictures which can be pinned up on the wall and shown to other people, with some such remark as: 'This is the face which used to come and terrify me.' Fourthly, if the paintings can be discussed with a psychotherapist, he can use his skill to help the patient to understand their unconscious meanings. Indeed, even if there is very little overt analysis, they form a language and means of communication of their own which does not necessarily have to be translated into words to have therapeutic value.

In art therapy it is important that the patient should be encouraged to express himself, but not be made to feel that he must try to produce good art. While the AESTHETIC quality of his work may well improve both with practice and as a result of the resolution of his conflicts, good aesthetic quality is not at all necessary to its therapeutic value and some of the crudest art products may be the most helpful, because their very crudity is itself an expression of conflict and stress. If a series of 20 or more paintings is made during an illness, it shows characteristic changes towards integration, harmony, and objectivity as the patient's condition improves.

CONCLUSION. In conclusion it is clear that psychotic and other kinds of abnormal art are not necessarily inferior to normal art, and, indeed, that the source of inspiration of all art is essentially in the unconscious, whether the final products are much affected by the transformations due to the 'art work', as in normal classical, Impressionistic, and abstract art, or little affected, as in psychiatric art, child art, and Expressionistic and Surrealist art. The trained expert artist has more ability, is more skilful, and is more often successful in bringing his inspiration to an aesthetically satisfactory outcome, whether he uses unconscious themes directly or not.

In addition, in the course of the 20th c. art has come to be more and more widely accepted as a mode of expression in hospital patients and those undergoing psychological treatment. It is a valuable aid to diagnosis and leads to insight and understanding which are advantages to psychotherapy.

701, 1313, 1528, 1843, 1912, 1913, 1922, 2075, 2078, 2210, 2211, 2418, 2424, 2773.

**PTOLEMAIC ART.** See EGYPTIAN ART.

**PUBLIC WORKS OF ART PROJECT.** A relief project organized by the Federal Government of the U.S.A. in 1933 with the twofold aim of providing work relief for artists who had suffered from the depression and of encouraging works of art for the decoration of public buildings. In 1934 the second part of the programme was transferred from the relief department to a new section of Fine Arts established in the Treasury Department under the painter Edward Bruce (1879-1943), while the assistance programme was transferred to a Federal Arts Project in the Works Progress Administration under Holger Cahill, a collector of American Folk Art. By June 1934 some 3,600 artists had produced nearly 16,000 works under the auspices of the Public Works of Art Project and by July 1943 the Treasury Department had commissioned 1,216 murals. With few exceptions these murals did not rise above a level of mediocre illustration. Some attention was attracted by those of Henry Varnum Poor (1879-1946) for the Pennsylvania State University representing *The Story of the Land Grant College* (1940) and by those of Frank Mechau (1903-46), while Ben SHAHN's mural at the community centre, Roosevelt, New Jersey, had the quality of his gift for social commentary.

**PUCELLE,** JEHAN (*c.* 1300–*c.* 1355). French MINIATURE painter. He was the master of an ILLUMINATOR's workshop and an artist of some renown in Paris during the 1320s, when he designed the Great Seal for the Confraternity of S. Jacques-aux-Pèlerins, supervised and played a large part in the decoration of the *Belleville Breviary* (Bib. nat., Paris), and shared in the illustration of the *Billyng Bible* (Bib. nat.). About the same time his masterpiece, the *Hours of Jeanne d'Évreux* (Met. Mus., New York), was the result of a royal commission. Principles and ICONOGRAPHY deriving from the early Italian RENAISSANCE make this work a landmark in the development of French painting. Pucelle must have gained his knowledge of ITALIAN ART in Italy, but he had a genius for enriching his style from a variety of sources, and the disposition of the numerous DROLLERIES in the *Hours of Jeanne d'Évreux* shows that he must also have been familiar with Flemish developments. It was the synthesis of these two elements, allowing for an increasing penetration of NATURALISTIC representation into traditional iconography, which formed the basis for Pucelle's subsequent development. The attribution of Pucelle's later works is on stylistic evidence only; but the survival of a number of closely interrelated royal manuscripts makes it clear that he continued to enjoy court patronage, and his large workshop dominated Parisian painting during the first half of the 14th c. The *Hours of Yolande of Flanders,*

**285.** Tailpiece from *Contrasts . . .* (1836) by A. W. N. Pugin

executed not earlier than 1353, is among the latest of the works which show signs of Pucelle's personal control. (See also INTERNATIONAL GOTHIC.)

1863.

**PUGET,** PIERRE (1620-94). French sculptor. He was born in Marseilles but worked much in Italy and assisted Pietro da CORTONA in the decoration of the PITTI Palace. He was an artist of great originality and the most important representative of the Roman BAROQUE style which penetrated to France during the closing decades of the 17th c. His work was not in keeping with the Classicist ideals of COLBERT and LEBRUN and he was given no part in the works at VERSAILLES until after the former's death in 1683. During this time he established a reputation for himself in Genoa (*St. Sebastian*, Sta Maria di Carignano, Genoa, 1661-5) and from 1667 worked at Toulon and Marseilles (Door of the Town Hall, Toulon). His most remarkable works were *Milo of Crotona* (Louvre) and a relief carving *Alexander and Diogenes* (Louvre) and in these he may be regarded as the founder of a distinctively French Baroque.

**PUGIN,** AUGUSTUS WELBY NORTHMORE (1812-52). English architect, who was also a designer of furniture, silver, textiles, STAINED GLASS, and jewellery. His chief importance is as propagandist of the GOTHIC REVIVAL largely responsible for transforming it from a semi-literary vogue into a movement which, through the passionate sense of mission of its advocates, swept over the whole of English architecture. Its first impetus was given by Pugin's book, *Contrasts* (1836), in which he upheld the Christian virtues of medieval architecture, contrasting it with the capriciously used RENAISSANCE styles then prevailing.

Pugin was the son of the French artist AUGUSTE-CHARLES PUGIN (1762-1832) and when a young man designed scenery and theatrical machinery at Drury Lane theatre. He was converted to Roman Catholicism in 1835. His architectural ideas were founded on the need for truthfulness in construction, and he combined a profound knowledge of the Middle Ages with great fertility and resource as a designer. His work was not always as convincing in practice as in theory, but his enthusiasm and his output were enormous. His qualities can be seen in his furniture and decorations for BARRY's Houses of

**286.** A. Private House. B. Shop. 'The consistent principles of old domestick architecture applied to modern street buildings.' Engraving from *An Apology for the Revival of Christian Architecture in England* (1843) by A. W. N. Pugin

Parliament. Other works are his own house, St. Marie's Grange, Salisbury (1841), Scarisbrick Hall at Ormskirk (1837 onwards), a spiky Gothic mansion, St. George's Roman Catholic Cathedral, Southwark (1845, destroyed by bombing, 1941), and St. Augustine's, Ramsgate (1846), a flint-and-stone church with a house for his own occupation alongside it. His main writings were: *Contrasts; or, a Parallel between the Noble Edifices of the Fourteenth and Fifteenth Centuries, and Similar Buildings of the Present Day; shewing the Present Decay of Taste* (1836). In this book he put forward a new conception of the Middle Ages not as a romantic ideal but as exemplifying a model of social structure by which present society must be reformed. Sir Kenneth Clark has written that the plates 'contain the germs of Christian Socialism and St. George's Guild'; *The True Principles of Pointed or Christian Architecture* (1841) based on lectures delivered as Professor of Architecture and Ecclesiastical Antiquities at Oscott College; *An Apology for the Revival of Christian Architecture in England* (1843); *Glossary of Ecclesiastical Ornament and Costume* (1844).

**PULPIT.** Term in Christian church architecture for a raised platform for the preacher, surrounded by a parapet and reached by steps or stairs. Early Christian churches had no pulpits other than the AMBOS. In the later Middle Ages, when services regularly included sermons, the pulpit came into use distinct from the ambo, and was usually set on the north side of the nave. That of S. Ambrogio, Milan, reconstructed in the 11th c. from parts of slightly earlier date, is among the oldest examples. Many 12th-c. Italian pulpits survive. These are generally rectangular, and decorated in Apulia and the Abruzzi with carvings of the EVANGELIST symbols, often combined with COSMATI work. The splendid series of sculptured polygonal pulpits of the PISANI (baptistery and cathedral, Pisa; Siena Cathedral; S. Andrea, Pistoia) date from c. 1260 to c. 1310 and have Gospel scenes in high RELIEF on the panels, often with standing figures between or grouped round the base. Other GOTHIC or early RENAISSANCE pulpits are attached to one of the nave PIERS, frequently with a canopy which serves as a sounding board. Those in the north seldom have sculptured panels, and are often of wood. The tradition of stone pulpits continued in Italy, however, and received a new impetus from the activities of the Friars, who laid great stress on preaching. Franciscan pulpits by BENEDETTO DA MAIANO (Sta Croce, Florence) display scenes from the life of St. Francis, while DONATELLO was employed to decorate the pulpit on the outside of the cathedral at Prato (for sermons were sometimes preached to great crowds in the open air) and also provided two remarkable pulpits in S. Lorenzo, Florence, with reliefs of PASSION scenes. In ISLAMIC ART during the Middle Ages pulpits (*mimbars*) in MOSQUES were of wood, elaborately inlaid (V. & A. Mus.).

They were rectangular in plan, surmounted by a canopy, and access was by a straight flight of steps. In the West the Counter-Reformation led to a renewed emphasis on the pulpit, since the new militant Orders, notably the Jesuits, laid great stress on preaching. Examples from the 17th and 18th centuries follow the general trend of BAROQUE and ROCOCO decorative styles but a special development took place in Flanders, where lavishly sculptured wooden pulpits combining trees and figures and a wide sounding board with flying ANGELS were made for many churches (Ste Gudule, Brussels; Antwerp Cathedral). Elaborate pulpits, carved and gilt, and enriched with figure sculpture in STUCCO, also appear in the Rococo churches of southern Germany (Ottobeuren). Preaching was of paramount importance in the Reformed churches, indeed in the Lutheran churches of Holland the pulpit rather than the aisle was the dominant feature of the interior. Such pulpits were always of wood and were of course without religious imagery, though their English counterparts, especially in WREN's churches, have decorative carving.

**PURBECK MARBLE.** A hard, greyish-brown, shelly LIMESTONE from the royal quarries in the Isle of Purbeck, Dorset. It is the nearest approximation to a true MARBLE quarried in England, can be cut to moderately fine detail, and polishes to a darkish hue. By about the middle of the 12th c. Purbeck marble began to come into use for architectural details, COLUMNS, etc., gradually replacing the more costly foreign stones previously used. In the 13th c. Purbeck marble FONTS began to supersede the black marble fonts imported from Tournai and column bases, shafts, and CAPITALS were increasingly made of this material. It seems to have come into use for tombs and tomb effigies before the middle of the 12th c. and through the 13th c. was very popular for this purpose (*Knights* of the London Temple Church, c. 1200; *Bishop Henry Marshall*, Exeter, 1210; *Archbishop Walter Gray*, York, 1255–60; *Bishop Giles of Bridport*, Salisbury, 1264; *Bishop Peter of Aquablanca*, Hereford, 1279). Shrine bases of Purbeck marble survive at Oxford (1289) and at St. Albans (1305). The last known date of a tomb effigy in Purbeck marble is that of a knight in Dodford church (1305).

Because of its compact nature Purbeck marble could be carved into fine detail and given a high finish, which made it particularly suitable for tomb and effigy sculpture. It is likely that roughly shaped blocks were sent from the quarries to cathedral workshops to be finished there. The increasing use of painted GESSO as a finish on the more easily carved FREESTONE (e.g. for the Eleanor Crosses set up by Edward I) gradually brought the funerary trade in Purbeck marble to a finish and it went out of fashion early in the 14th c. It has been conjectured that another reason for this may have

been that the elaborate decoration, painting, and gilding done by the workers in Purbeck marble obscured the material so that the less expensive freestone seemed as good to clients.

**PURISM, PURIST.** The manifesto of Purism was the book *After Cubism*, written in 1918 by the painter Amédée OZENFANT and the architect and painter Édouard Jeanneret (better known as LE CORBUSIER). They protested against the 'destruction of the object' by CUBISM and sought to restore representational reference to natural things reduced to purified outline, stressing the impersonal machine-like quality of objects. Purist ideas, which were developed in the magazine *L'Esprit nouveau* (1920–5), were more influential in architecture and DESIGN than in painting.

**PUTTO** (Italian: 'little boy'). The term can be applied to any little boy, or, by extension, to any child—pagan, human, or divine. It is usually reserved for the type of child, often but not invariably winged, developed from the Greek god of love Eros, or the corresponding Latin PERSONIFICATIONS, Amor and Cupido. The *putto* has been a frequent motif of decorative art since classical antiquity; the natural charm of childhood has secured his entry into the boudoir and the church, and blurred the distinction between Amores and Cherubim (SEE ANGELS).

**PUVIS DE CHAVANNES,** PIERRE (1824–98). Foremost French mural painter of the second half of the 19th c. He created a style of monumental decorative painting with flat FRESCO colours, simplified forms, and an etiolated rhythmic line. His paintings, done on canvas and then affixed to the walls, favoured the evocation of a somewhat anaemic idealization of antiquity or allegorical representations of abstract themes. He was admired by Sérusier for his pale 'aesthetic' colour and poetic atmosphere and by SEURAT for his composition in simple areas of flat colour which respected the plan of the wall. GAUGUIN and TOULOUSE-LAUTREC were also among his admirers and during his lifetime he was universally respected even by artists of very different aims and outlook from his own. In 1890 he founded with RODIN and other secessionists the Société nationale des Beaux-Arts. His best known works are murals for the Hôtel de Ville, Paris, and the Sorbonne and *Ste Geneviève veillant sur la ville endormie* (1898) for the Panthéon. Notable also are the painting *Le Bois Sacré cher aux Arts et aux Muses* (Palais des Arts, Lyon, 1883–4) and decorations for the Boston Library (1893–5). A memorial exhibition of his works was included in the Salon d'Automne of 1904.

1800, 1831.

**PYLON.** A Greek word for gateway, applied to the type of entrance characteristic of Egyptian temples from the New Kingdom (see EGYPTIAN ART). It consisted of a doorway flanked by two large towers of masonry with slightly inclined faces framed by torus MOULDINGS and a cavetto CORNICE. Most of the towers incorporated staircases and some had small chambers built within; grooves in the front originally held flagstaffs, and the surface was often covered with RELIEFS. Before such pylons there might stand OBELISKS, colossal statues, and SPHINXES.

**PYNACKER,** ADAM (1622–73). Dutch LANDSCAPE painter who was Jan BOTH's pupil. He probably spent three years in Italy. Graceful birches, reeds, and thistles, streaked with a silvery light, frequently figure in the foreground of his Italianate landscapes.

**PYNAS,** JAN (1583/4–1631). Dutch painter and ETCHER who visited Rome early in the 17th c. and there came under the influence of ELSHEIMER and LASTMAN. One of his best pictures is the *Raising of Lazarus* (Johnson Coll., Philadelphia, 1615), which shows him as an important precursor of REMBRANDT.

**PYRAMID.** The true Egyptian pyramid is a massive stone (or brick) structure on a square base, with sides sloping to an apex, which incorporates or covers passages and a burial chamber. Pyramids were the TOMBS of royalty, and the form was probably connected with the idea of the ascent of the dead pharaoh to the sky. It seems to have originated from the heap of sand or rubble placed over early graves, the first MASTABA tombs and the step-pyramids of the 3rd Dynasty being intermediate stages in this development. The classic pyramids of the Old Kingdom generally had a funerary temple on the east side with a causeway leading to another nearer to the river, and were surrounded by mastabas of the nobility. Their interiors were undecorated until the 5th Dynasty, when the 'Pyramid Texts' first appeared. The main pyramid field lies along the desert edge west of the Nile from Abu Roash to Hawara, important groups being those at Giza (of Khufu (Cheops), Khafrē, and Menkaurē), Abusir, Sakkara, and Dahshur. In all there are remains of about 70 pyramids in Egypt and the Sudan.

There are also pyramids in Central America, but they have little in common with those of Egypt, being the stepped bases upon which temples stood, and rarely used for burials. (See PRE-COLUMBIAN ARTS OF MEXICO AND CENTRAL AMERICA.) Remains of pyramids also survive from the Mochica and Chimu cultures of Peru. (See PRE-COLUMBIAN ARTS OF THE ANDES.)

805, 1576.

**PYTHAGORAS.** Greek sculptor of the 5th c. B.C., who emigrated from Samos to Rhegium in Italy. He worked in BRONZE and according to later tradition was noted for his REALISM and

for his attention to symmetry. PLINY says—at least exaggerating—that Pythagoras was the first sculptor to aim at rhythm and PROPORTION in the pose of his figures and to render the sinews and veins and that he represented hair on the head more meticulously than previous sculptors. His work is unknown.

**PYTHIUS?** (the name is uncertain). Greek architect who was noted for rigid rules of PROPORTION and built the MAUSOLEUM and the Ionic temple of Athena at Priene (c. 340 B.C.).

**PYXIS** (pl. *pyxides*). A covered cylindrical box, in classical times made of box-wood (Gk. *pyxos*: box-tree, whence the name), but later of metal or ivory. Originally a toilet box, or a container for jewels or incense, the pyxis was adopted by the Church as early as the 4th c. to hold relics or the reserved Host. Since a section of elephant tusk lends itself to this form when hollowed out and closed at one end with an ivory disk, most Early Christian pyxides were of this material (see IVORIES).

A 4th-c. pyxis in the British Museum carved with PASTORAL subjects and a 6th-c. example in New York (Met. Mus.) with Bacchic figures indicate that the secular use of this type of box continued throughout the EARLY CHRISTIAN period. However, the celebrated pyxis in Berlin (Staatl. Mus., Berlin), which has been attributed to Antioch in the 4th c., represents CHRIST teaching and ABRAHAM's Sacrifice, and was probably made to contain the Host. Another in the British Museum, made in 6th-c. Egypt, represents the martyrdom and veneration of St. Menas, and was therefore presumably a reliquary of this saint.

It is not surprising that such a characteristic ivory product should reappear in the secular art of Moslem Spain and Sicily from the 10th c. to the 14th. These examples are either carved in flat conventional patterns of foliage and animals (V. & A. Mus.), or have been merely painted (Met. Mus., New York).

As a result of the Crusades, both Early Christian and Moslem pyxides found their way into Western churches in the 12th c., and were used to hold relics or the Host. But there were few attempts to copy them, since the small enamelled copper pyxides with conical covers produced in Limoges, so popular throughout the 13th and 14th centuries, were already beginning to take their place.

# Q

**QUARENGHI, GIACOMO** (1744-1817). Italian architect. He studied painting, first at Bergamo where he was born and later in Rome under MENGS. But he was so impressed by PALLADIO that he abandoned painting for architecture. In 1779 he went to Russia at the invitation of Catherine II, became court architect, and practised in St. Petersburg and Moscow until his death. His main works are the 'English Palace' in Peterhof (1781-9); the Theatre (1782-5) and the 'Raphael Loggias' (1788) of the HERMITAGE; the Academy of Sciences, Leningrad (1783-7); and the Alexander Palace at Tsarskoe (now Detskoe) Selo (completed in 1796). Although nearly all his executed buildings are on Russian soil, Quarenghi acquired international fame as one of the leading architects of the NEO-CLASSICAL movement. Engravings of his buildings helped to spread his reputation and he designed palaces and interior decorations for patrons in Germany, Austria, and England.

**QUAST,** PIETER JANSZ (1606-47). Dutch painter of peasant GENRE in the manner of BROUWER and Adriaen van OSTADE. Some of his drawings on PARCHMENT of rotund, CARICATURE-like figures were probably sold as finished pictures to be used as amusing and cheap decorations for taverns and homes. Similar sheets hang in many of the interiors painted by 17th-c. Dutch artists.

**QUEEN ANNE STYLE.** A term which should be restricted to works produced in England between 1702 and 1714, but which is constantly wrongly applied both to red-brick houses and their decoration built at any time between c. 1660 and c. 1720, as also to modern imitations and period revivals. It is valid for furniture and silver made in the reign of Queen Anne, graciously designed with rich curved forms, but solid as well as elegant.

**QUEEN'S BEASTS.** Popular name for the decorative sculptures of the 10 beasts acting as supporters of the shields bearing the Royal Arms. These were made by James Woodford, R.A. (1893- ), under guidance from Sir George Bellew, Garter King of Arms, and set up in front of the Annexe to Westminster Abbey

on the occasion of the Coronation of Elizabeth II. Supporters first appear in the reign of Richard II.

**QUELLIN** (or QUELLINUS), THE ELDER, ARTUS (1609-68). The chief representative of Flemish BAROQUE sculpture. He was born in Antwerp and was a pupil of François DUQUESNOY in Rome, where he came under the influence of BERNINI. He was back in Antwerp *c*. 1640. Quellin stayed in Amsterdam from *c*. 1650 to 1664 while he was in charge of providing the sumptuous sculpture for the Town Hall designed by Jacob van CAMPEN. The high quality of his portrait BUSTS can be seen in the Rijksmuseum.

ARTUS II QUELLIN (1625-1700), his cousin, was a sculptor. ARNOLD (ARTUS III) QUELLIN, the Younger (1653-86), son of Artus II, was also a sculptor, though less skilled. He came to England about 1678, and soon obtained commissions, the most important being for the TOMB of Thomas Thynne (Westminster Abbey, 1682). By 1684 he was working with Grinling GIBBONS, and was almost certainly responsible for the design of some of his better figures, including a *Charles II* (destroyed) for the Royal Exchange.

1925.

**QUERCIA**, JACOPO DELLA (JACOPO DI PIETRO D'ANGELO) (*c*. 1374-1438). Italian sculptor, a native of Siena and a contemporary of GHIBERTI and DONATELLO. He is first heard of as unsuccessfully competing for the BAPTISTERY doors at Florence in 1401. His first surviving work is the TOMB of Ilaria del Carretto, wife of the ruler of Lucca, Paolo Guinigi (cathedral, Lucca, *c*. 1406), which was eulogized by RUSKIN. It shows a curious juxtaposition of GOTHIC effigy and RENAISSANCE PUTTI and SWAGS round the sides of the coffin. The two styles are more happily blended in his *Fonte Gaia* (commissioned 1409, completed 1419), now in the Siena Museum. The fountain is surrounded by a low wall decorated with figures in relief which combine Gothic rhythms in the drapery with a classic energy and assurance. Between 1417 and 1431 he worked together with Donatello and Ghiberti on reliefs for the Baptistery at Siena.

In 1425 Quercia received the commission for his last great work, the reliefs on the portal of S. Petronio, Bologna, with scenes from Genesis and the NATIVITY of Christ. The figures—usually only three to a relief, in contrast to the crowded panels of Ghiberti—have a directness and strength which won the admiration of MICHELANGELO, who visited Bologna in 1494. Several of the motifs are to be found, reinterpreted, on the Sistine ceiling.

269, 1240.

**QUESNEL.** French family of painters the best known of whom were: (1) PIERRE (d. *c*. 1547), who was introduced by Marie de Guise to the Scottish court where he is said to have painted the *Portrait of Mary Queen of Scots* (Lady Lee Coll.), and (2) his son FRANÇOIS (1543-1619), who was born in Edinburgh but worked mainly in France as a portrait painter, carrying on the tradition of the CLOUETS into the 17th c. (*Mary Ann Waltham*, Earl Spencer Coll., 1572).

# R

**RAEBURN**, SIR HENRY (1756-1823). Portrait painter, born in Edinburgh. On leaving school he was apprenticed to a goldsmith. He began his career as a MINIATURIST, but apart from the fact that he worked for a short time in the studio of the Edinburgh painter David Martin (1737-98) he appears to have been largely self-taught as a painter in oils. His work from the first was vigorous, and when he went to Italy in 1785 his style was already formed. From 1787, when he set up a studio in George St., he was the leading portrait painter of Edinburgh and of Scotland. He exhibited at the ROYAL ACADEMY only occasionally, but was elected A.R.A. in 1812, and R.A. in 1815. In 1822, on the occasion of George IV's visit to Edinburgh, he was knighted and in 1823 he was appointed His Majesty's LIMNER for Scotland. Raeburn made no drawings for his portraits and no preliminary sketch on the canvas. He painted directly and boldly with strong shadows, and at times achieved arresting impressions of character type, (*John Wauchope* and *Colonel Hollistair Macdonnel of Glengarry*, N.G., Edinburgh). At other times his work was careless. Since he had all the sitters he needed in Scotland, there was no need for him to compete with LAWRENCE and HOPPNER in London, and in the history of British portraiture he is an isolated and perhaps underrated figure.

**RAEDECKER**, JOHN (1885-1956). Dutch sculptor whose works are represented in all the principal collections of Holland. He and the

architect J. J. P. Oud did the national MONUMENT on the Dam, the main square of Amsterdam.

**RAIBOLONI,** FRANCESCO. See FRANCIA.

**RAILWAY ARCHITECTURE.** The age of railway building in Britain reached its climax in the 1840s, and thus immediately followed the age of experimental engineering. Many of the architects and engineers of the Industrial Revolution, for whom the railways' predecessors, the canals, had been a principal proving-ground, were still active. They and their disciples were responsible for many noble bridges, viaducts, and other railway works. But when the railways wanted to impress the public at their more important stations they turned to established architects to put a fashionable period façade on the relatively reticent structures of the engineers, e.g. HARDWICK's Greek Revival work at Euston; Sir Gilbert SCOTT's GOTHIC pile at St. Pancras alongside King's Cross, where by contrast Lewis Cubitt's nobly simple train-sheds were allowed to retain the character of engineering unadorned; the fine CLASSICAL station façades at Newcastle on Tyne by John Dobson; those at Huddersfield by J. P. Pritchett; and the ROMANTIC Tudor composition at Temple Meads, Bristol. Dublin is outstanding for the high architectural quality of its railway termini, now going out of use. Less important railway stations were mostly designed in groups as each stretch of line was built. With

their widely spreading roofs and romantically composed buildings, an attempt perhaps to soften the impact of the railways on the countryside, they have—especially the smaller wayside stations—a charm of character that belies their enterprising use of iron construction. They have generally a Gothic or Italianate flavour. The best and most original of the railway-station architects, whose names are little known because they worked anonymously and almost exclusively in this field, were David Mocatta (1806-82), a pupil of SOANE, and Francis Thompson of Derby.

As railways spread from Britain over Europe and America their architecture followed British models, though without the romantic charm of the English country stations. Hittorf's Gare du Nord in Paris (1861) was notable, as were more recent American stations with great halls modelled on ancient Roman baths, the best being the Pennsylvania station in New York (1906).

Modern architects have had few opportunities to design railway stations, but there are notable ones at Helsinki by Eliel SAARINEN (designed in 1905 but not completed until 1914) and at Stuttgart by Paul BONATZ (1928). The station at Rome, completed in 1950 by a group of six Italian architects, is one of the most important buildings of the post-war era. In London the stations for the underground railway system, designed in the 1920s and 1930s mostly by Adams, Holden and Pearson under the inspira-

**287.**   Entrance Arch to Euston Station in Greek Doric Order, designed by Philip Hardwick (1847). Engraving by T. H. Shepherd

**288.** Façade of King's Cross Station in 1881. Designed by Lewis Cubitt. From oil painting hanging in the station

tion of Frank Pick, did much to familiarize the British public with the idea of a rational, reticent but at the same time homely modern type of building.

165, 1811.

**RAIMONDI,** MARCANTONIO (*c.* 1480–*c.* 1534). Italian engraver. He went to Venice *c.* 1506 and was there excited by DÜRER's woodcuts, some of which he copied. From 1510 he engraved many of RAPHAEL's paintings and specially executed designs (*Judgement of Paris* and *Dido*) and also some by GIULIO ROMANO. His works were often copied on MAIOLICA dishes and contributed much to the spread of RENAISSANCE motifs throughout Europe. (See also REPRODUCTION.)

**RAINALDI,** CARLO (1611–91). Italian architect, son of the architect GIROLAMO RAINALDI, with whom he worked in Rome and north Italy. In 1652/3 he began, possibly in collaboration with his father, the church of Sta Agnese in the Piazza Navona which was later completed and much altered by BORROMINI. His most important church was Sta Maria in Campitelli, Rome (founded 1662), where the plan is based on connected Greek crosses, neither truly central-planned nor completely longitudinal. From 1662 to 1667 he worked on the twin churches of Sta Maria di Monte Santo and Sta Maria de' Miracoli, where the Corso and two other streets debouch into the Piazza del Popolo.

The design was completed (1671–9) by BERNINI and Carlo FONTANA. In 1665 Rainaldi completed both the façade of MADERNA's S. Andrea della Valle and the Capitoline Palace, a replica of MICHELANGELO's Conservatori Palace on the Capitol.

**RAJPUT PAINTING.** Previous to the advent of the Moghul emperors there had existed in northern India a style of painting, not necessarily in MINIATURE, of which we know only a little from isolated indications. Under the influence of ISLAMIC modes this style adapted itself to the Persian album-leaf format, and at the courts of Rajput feudatories of the Moghuls developed into a specifically Hindu art form. Its subject matter was drawn from Hindu legend, chiefly from the highly erotic histories of the cowherd god Krishna, and from the closely related romantic themes of music and song, especially the so-called Ragas and Raginis. It is worth remarking that some of the most accomplished artists bore Moslem names.

This art laid far less stress on technical perfection than did Moghul painting (see ISLAMIC ART IN INDIA). In the earlier stages colours were employed for the sake of their intrinsic beauty and brilliance, and the drawing was generally summary and strongly formalized with little or no attempt at portraiture. Pictures were composed of associated conceptual elements, without any attempt to achieve illusionistic three-dimensional picture-space.

The chief centre of this art during the first half of the 17th c. was Udaipur, in Mewar. Here its main characteristics were laid down, and the artists sought to express intense emotions directly through sheer intensity of colour—the red of passion appears very frequently. As the century wore on and as other centres, notably Bundi, took up the Udaipur style there was a development in the direction of increased expressiveness of drawing and more variegated texture without loss of intensity of colour. Flowering trees, the dresses of women, and skies were treated with more and more variety. During the later 17th and the early 18th centuries the artists of this style became capable of extended compositions and refined orchestration of their brilliant colours, often using gold.

In the second half of the 17th c. the Udaipur style found its way to the distant Punjab hill-state of Basohli. Here a superb and idiosyncratic style developed, characterized by a farouche expression. The faces are dominated by enormous eyes, and to the colour palette of Udaipur are added acid lemons, greens, and pinks. Around the silhouettes of the figures the ground is often darkened, and the jewellery is represented by thick blobs of colour. These devices give to the figure an effect of relief and intense physical reality. This style persisted into the 18th c. with steadily declining vigour. During the 18th c. also the influence of Delhi painting was felt in many Rajput centres and combined with earlier Rajput traditions to produce paintings in various extremely individual manners. These painters became especially fond of the enamel-like colours (achieved by burnishing) and the competent, almost realistic treatment of LANDSCAPE and trees with some indication of three-dimensional picture-space. Bundi in Rajasthan and later Jodhpur and Kotah benefited in this way. In the Punjab hills, however, in the state of Guler in the mid 18th c. a style derived from Basohli was strongly influenced by sophisticated Delhi art to produce a very characteristic suave and feminine style which was transplanted fully fledged to Garhwal and to Kangra c. 1770. From the Garhwal comes a group of miniatures of especial beauty, where green landscapes and water are dominated by great swirling spiral lines. The special quality of Kangra painting—which remained vital well into the 19th c.—was the enamelled tranquillity of its figures seen amidst fronded landscapes. Other states in the Punjab hills—Kulu, Jammu, Chamba, for example—also supported artists working in analogous styles on similar material.

Especial mention must be made of Kishangarh, where between 1740 and 1785 were painted a large number of Krishna miniatures, some highly elaborate and of large format, which are among the most beautiful works of art of the world. The feminine figures of extravagantly slender proportions have vastly elongated, curved eyes. Forests filled with birds and animals and sunset skies are treated with great delight, and the fineness of brush-work was never excelled in Rajput art.

69, 616, 1062, 2207.

**RAMSAY,** ALLAN (1713–84). Portrait painter, son of Allan Ramsay the poet, born in Edinburgh. He studied in London under Hans Hysing (1678–1752/3), a Swede, in Rome under Francesco Fernandi Imperiali, and in Naples under SOLIMENA, and when in 1739 he settled in London he brought a cosmopolitan air to British portrait painting. His portraits of women have a decidedly French grace (*The Artist's Wife*, N.G., Edinburgh, 1754/5). In 1760 he was appointed Painter-in-Ordinary to George III. He travelled considerably. His literary productions, e.g. *Dialogue on Taste* (1754), gained him success in intellectual circles, and Hume and Rousseau were among his sitters. He ceased to paint after an accident in 1773. Ramsay was the most considerable portrait painter of the generation between those of HUDSON and HIGHMORE and has been called a link between the portraiture of HOGARTH and GAINSBOROUGH and was the Scottish counterpart of REYNOLDS.

2498.

**RAPHAEL,** properly RAFFAELLO SANZIO (1483–1520). One of the most famous painters of the High RENAISSANCE, born in Urbino, where the court of Federico of MONTEFELTRO Italian culture had found one of its most distinguished settings. Raphael's father, Giovanni SANTI, was a provincial painter, working in the Umbrian manner of the time, more remembered for a long poem containing information about contemporary artists than for his own paintings. He died in 1494, when Raphael was 11 years old. The boy early came under the influence of PERUGINO, and may have worked in his studio. His *Coronation of the Virgin* (Vatican Gal., 1502-3), the *Crucifixion* (N.G., London, 1503), and the *Marriage of the Virgin* (Brera, 1504) are in the style of Perugino, though already, particularly in the drawings associated with the first of these works, there is a sureness of touch, a power of suggesting the volumes that his line encloses, which Perugino never equalled. Raphael was, however, singularly open to new impressions and when he visited Florence c. 1504 he speedily assimilated much that was new in the art of LEONARDO DA VINCI and MICHELANGELO. In 1508, though he was only 25 years old, his reputation was sufficiently established for him to be summoned to Rome by Pope Julius II and entrusted with the frescoes for one of the papal rooms in the Vatican, the Stanza della Segnatura. He continued to work in Rome till his death in 1520.

To the Florentine period belong many of his best known versions of the VIRGIN and Child. Constantly reproduced, often in unsuitable materials, they have at times seemed too familiar,

his theme. The HALOES are lightly marked, the setting an open meadow or, as in the *Madonna del Granduca* (Pitti, Florence), a dark background from which the figures emerge with a luminous quality. The Virgin, the CHRIST Child, the young Baptist, the aged Joseph, and Elizabeth are his main subjects, and he only used the elaborate grouping of saints round the Madonna in one or two of his more formal ALTARPIECES. It was the family group that interested him, and he paints them as splendid, healthy human beings, but with a serenity of expression, a sense of some deep inner integrity, that removes any doubt as to the holiness of the subject. In Rome, probably in 1512, he painted his greatest altarpiece, the *Sistine Madonna* (Dresden Gal.). Here Mother and Child appear among the clouds, still triumphantly and splendidly human, but transcending the earthly conditions in which he had earlier represented them. It is the final vision which crowns his long meditation on the doctrine of the Incarnation, of the Word becoming flesh. At the time of his death he was working on another great altarpiece, similar in theme, the *Transfiguration* (Vatican Gal.), the moment in the manhood of Christ when His divinity shone through His mortal form.

It was, however, in the frescoes in the papal apartments in the Vatican that his genius reached its widest expression. The Stanza della Segnatura is based on a complex theological programme of the relationship between classical learning and the Christian revelation. On one

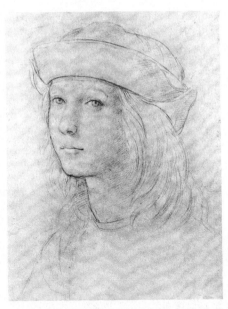

**289.** Self-Portrait. Pen-and-ink drawing by Raphael. (Ashmolean Mus., *c.* 1497)

too easily acceptable to rouse interest or enthusiasm, but this is the penalty of their own completeness of statement. Raphael uses few emblems to indicate the supernatural content of

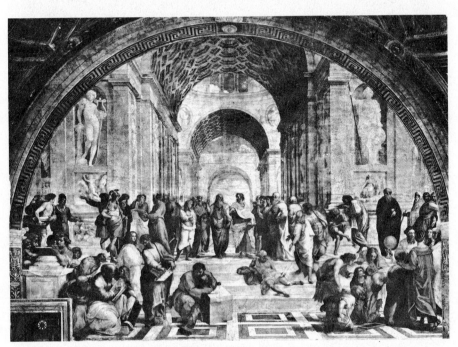

**290.** *The School of Athens.* Fresco from Stanza della Segnatura. By Raphael. (Vatican, *c.* 1509)

wall are shown the ancient philosophers, led by Plato and Aristotle, enclosed in a great architectural setting, a masterpiece of PERSPECTIVE drawing: opposite, the doctors of the church adore the Sacrament, while above the TRINITY is surrounded by the saints and martyrs, and ANGELS appear, as in the *Sistine Madonna*, vaguely among the clouds. Here the setting is a wide open space. They are works which in power of representation have never been surpassed and which have had a profound influence on European art. After its completion in 1511 Raphael was entrusted with three other apartments, in the first of which he painted the *Mass of Bolsena*, where he builds up his design with a new richness of colour. His undertakings were now so numerous that many pupils and assistants

had to be employed and if the planning of the design comes from him, much of the execution is by lesser hands, among them that of a talented youth, GIULIO ROMANO, whose liking for bronze, metallic tints, and over-emphatic contrast of light and shade modified, not altogether happily, the tradition of Raphael's achievement. From this later period date Raphael's designs for tapestries to be hung in the Sistine Chapel. These were brought to England by Charles I to serve as CARTOONS for his tapestry works at Mortlake and when Cromwell dispersed the Royal Collection the cartoons were retained and are now loaned by the Crown to the Victoria and Albert Museum. Comparatively little of the work can be from Raphael's own hand but they must have been done under his close supervision;

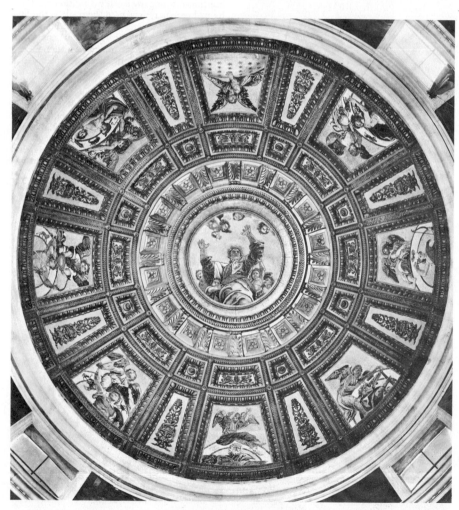

**291.** Mosaic of the cupola in the Chigi chapel. Designed (1515) by Raphael for the church of Sta Maria del Popolo, Rome. Executed (1516) by Luigi da Pace

and the *Miraculous Draught of Fishes* and the *Charge to St. Peter* are amongst the noblest of his designs. Wonderfully well preserved, and carefully restored in 1966, the cartoons are the most important large-scale work of the Italian Renaissance outside Italy. In addition to the tapestries Raphael supervised various other great decorative schemes in Rome: the Villa Farnesina with its ceiling showing the story of Psyche and a wall fresco, *Galatea* (1511-12), which is from Raphael's own hand at its most expert; the Chigi Chapel in Sta Maria del Popolo, where he designed the MOSAICS (1516) and the marble figure of JONAH; the majestic rendering of the SIBYLS in Sta Maria della Pace (1514) and the ceiling and wall ARABESQUES of the Vatican Loggie, which left a permanent imprint on European interior decoration.

Raphael also painted many portraits. He moved almost as an equal in the intellectual circles of Rome and has left in portraits such as those of Baldassare Castiglione (*c.* 1515), and of his patrons, Julius II (N.G., London, *c.* 1511), which TITIAN copied in the version in the Pitti Palace, and Leo X (1518), a remarkable record of Italian humanism. In his last years he was employed in architecture and in a survey of ancient Rome, but so many activities exhausted his strength and he died at the age of 37. During his lifetime many of his designs were engraved by Marcantonio RAIMONDI, and through this medium his influence was widely spread. He became 'the divine painter', the model of all ACADEMIES, and today we can only approach him through a long tradition, in which Raphaelesque forms and motifs have been used with a steady diminution of their values. His NATURALISM and his religious feeling have both been at a discount in much 20th-c. criticism. But his place is secure: in the technical ability to render rounded forms on a two-dimensional surface he remains an unrivalled executant, and he used his great formal sensibility to create memorable symbols of the basic doctrines of the Christian Church.

475, 875, 1082, 1973, 2138.

**RASTRELLI,** BARTOLOMEO FRANCESCO (1700-71). Architect, son of the Italian sculptor BARTOLOMEO CARLO RASTRELLI (1670-1744). He went to Russia in 1715 with his father and, apart from some travels in western Europe, spent the rest of his life there, becoming the leading architect, and from 1736 onwards held the post of chief architect at the imperial court. His palaces are highly personal interpretations of current French and Italian styles (Winter Palace, 1754-62; Peterhof; Tsarskoe Selo). His ecclesiastical buildings are a very original and successful attempt to harmonize traditional Russian church architecture with the exuberance of the Italian BAROQUE (Smolny Cathedral, Leningrad). Many of his designs remained on paper; a very large collection of his drawings exists in the ALBERTINA in Vienna.

**RATGEB,** JÖRG (1480-1526). Painter, active in south-west Germany. His largest surviving work, an ALTARPIECE now in the Stuttgart Museum (1514-17), is for all its crudities a telling document of the religious unrest of the age.

**RAUCH,** CHRISTIAN DANIEL (1777-1857). German sculptor. During his studies in Rome he came under the influence of CANOVA and THORWALDSEN, but their cold CLASSICISM was enlivened in his work by a closer study of nature, particularly noticeable in his portraits. He is best known for his equestrian MONUMENT of Frederick the Great in Berlin, and for his BUSTS of prominent contemporaries such as GOETHE and KANT.

**RAUSCHENBERG,** ROBERT (1925- ). American artist, born in Port Arthur, Texas. He studied at the Kansas City Art Institute, the Académie Julien in Paris, Black Mountain College in North Carolina, and the Art Students' League in New York. His earliest works include boxes filled with objects, blueprints, black paintings and white paintings. His characteristic COLLAGE style began with a series of 'red paintings' in which he used textiles of various designs and textures, rusty metal, electric lights, mirrors, reproductions of Old Masters, and newspaper and magazine illustrations, combined with paint (*Charlene*, 1954). In 1955 he broadened the range of his imagery and presented it in a more depersonalized manner to refer to the multiplicity and flux of the contemporary urban environment (*Rebus*, 1955). In 1955 he also did his first 'combines' where large three-dimensional objects are incorporated into collages. Examples are *Monogram* (1955-9), with a stuffed goat and rubber tyre and *Odalisque* (1955-8), with a pillow, electric lights, and a stuffed bird. He also used Coke bottles, fragments of clothing, electric fans and radios.

From 1962 he employed the technical device of silk-screening, which facilitated changes of scale and repetition of imagery. Rauschenberg was interested in combining art with new technological developments; he was active in forming E.A.T. (Experiments in Art and Technology), an organization to help artists and engineers work together. In his most recent work, the spectator is active in controlling the arrangement or visibility of the images. He did choreography and participated in dance-theatre pieces, and from 1955 he designed costumes and sets for Merce Cunningham's dances.

**RAVESTEYN,** JAN ANTHONISZ VAN (*c.* 1570-1657). Dutch portrait painter active in court circles in The Hague, who adopted the style of MIEREVELT.

**RAVY**, JEAN (d. 1344). Parisian architect who worked with Pierre de CHELLES on the apsidal chapels of NOTRE-DAME, and succeeded him as master mason in 1318. Together they completed the chapels (by 1320), replaced the flying BUTTRESSES of the CHEVET, and enlarged the tribune windows—all of which gave the east end of the cathedral its RAYONNANT character. Ravy also began the sculptured reliefs of the choir-screen. They were completed after his death by his nephew and successor as master mason, JEAN LE BOUTELLIER.

**RAYONISM.** An ABSTRACT movement in painting launched in Russia in 1911–12 by Mikhail Larionov (1881–1964) and Natalya Goncharova (1881–1962) after lectures given in Moscow by the FUTURIST MARINETTI. The theory was that a rayonist painting should appear to float outside time and space in some fourth dimension. This was to be achieved by projecting lines or rays of parallel or contrasting colour into space, representing lines of force and attraction. The movement was an important step in the direction of abstractionism.

**RAYONNANT STYLE.** Architectural term. The subdivisions of French GOTHIC architecture are still generally known by the terms invented by the early 19th-c. antiquarian, Arcisse de Caumont. They were derived from what is perhaps the most readily classifiable feature of medieval churches, namely the shape of their windows, and the kind of TRACERY used to fill them. Rayonnant (which was applied to the late 13th and 14th centuries) came after simple lancets and before the highly distinctive FLAMBOYANT; and it can be recognized by the presence of numerous mullions combined with elaborate geometrical patterns based on circles or arcs of circles. The most characteristic of all Rayonnant windows are the great roses, e.g. of the transepts of NOTRE-DAME, Paris.

But actually far more was involved in the new style—a whole system of forms and a complete change of intention on the part of the architects. After *c.* 1250 they gradually lost interest in the art of distributing great masses of masonry and shaping space; instead they concentrated on producing a rich and elegant visual impression. A long series of structural experiments came to an end. Structure became stereotyped, and henceforth decoration was all-important. The chief elements of this decoration were tracery, which was not confined to windows, and finely cut MOULDINGS. Wholesale use of these produced effects which made the relatively undressed surfaces of CHARTRES look archaic and uncouth. But as these fine effects needed more light windows became larger, sometimes occupying almost the whole wall surface, and the colours of the glass changed from the deep rich tones of the Chartres and BOURGES windows to a predominant GRISAILLE which admitted more light and silhou-

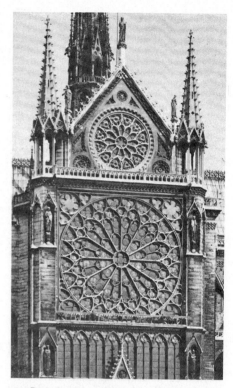

**292.** Rose window in north transept, Notre-Dame, Paris (1258)

etted the tracery (see STAINED GLASS). The logic of structure mattered less. Members were no longer kept rigidly separate; mouldings and ribs merged into their supports; CAPITALS were broken up and gradually disappeared. All of this foreshadowed the 'illogical' architecture of late Gothic. The change of outlook which Rayonnant represents was perhaps the most important event in the history of Gothic architecture. It was possible only because plenty of highly skilled masons were available, trained in the cathedral lodges. The style began in the Paris region with the works of Pierre de MONTREUIL and his associates and spread with the extension of the French royal domain throughout France, to Troyes, Normandy, and Toulouse. But it also spread beyond France, to Flanders and Germany. Even English PERPENDICULAR has affinities with it. Rayonnant is in fact the only Gothic style of architecture that can properly be called international.

**REALISM.** As a term of art history, criticism, and art theory 'realistic' has had many meanings, which writers who have employed it have often failed to keep distinct. (1) In the vaguest and most general sense the term is often applied to works which instead of choosing conventionally

beautiful subjects depict ugly things or at least scenes from the life of the poorer classes. Thus painters like COURBET would be called 'realists' because they depicted low life or the activities of the common man or CARAVAGGIO would be called a 'realist' because he painted St. Matthew with dirty feet. (2) In a more specific sense 'realistic' can be used as the opposite of 'ABSTRACT' in one meaning of the latter word. Thus the apples of CÉZANNE are more abstract and less realistic than those of CHARDIN or ZURBARÁN, and Zurbarán is less realistic than Jan van HUYSUM. (3) Again 'realistic' may be used as an opposite not of 'abstract' but of 'distorted' (see DISTORTION). Much of the painting of, for example, DALI would be called realistic in the sense that it is the reverse of abstract, being painted with an almost PRE-RAPHAELITE meticulousness to detail, but it is not realistic in so far as the objects are represented as distorted from their appearance in natural life. This meaning is very close to one meaning attached to 'NATURALISM', i.e. aspiring to be like natural objects. Its extreme is TROMPE L'ŒIL, where the artist makes it his object to deceive the observer into thinking that his painting is not a painting but the real thing depicted. (4) In practice, however, the term 'realistic' when associated with 'naturalistic' is often applied as the opposite of STYLIZATION. Thus the Greek naturalistic sculpture of the classical period is often said to be more realistic than the more stylized sculpture of the archaic period. (5) Contrasting with the preceding usage is that where 'realistic' is the opposite of 'IDEALIZED'. Aristotle says that the painter POLYGNOTUS depicted men as better than they are and Pauson worse, while Dionysus made them like. In the language of contemporary criticism one might say that Dionysus was a realist and Pauson a CARICATURIST. In this sense TITIAN's portraits idealized Charles V, and COPLEY was a realist. (6) There is, however, a rather different sense of 'idealize' for which 'realistic' is also used as an opposite. In this sense Greek classical sculpture rarely produced a recognizable portrait of an individual human being but instead a generalized type. (The 'villain' can be generalized in this sense as well as the god or hero.) According to this terminology Greek sculpture is said to be idealized and Roman to be realistic. In this sense 'realistic' is almost the equivalent of 'individualized'. The extreme of realism in this sense combined with sense (2) is the style of portraiture called VERISM, in which every idiosyncrasy of the sitter to the last wrinkle and pimple is faithfully reproduced.

The term 'social realism' has been used to describe 19th- and 20th-c. painting and sculpture which is realistic in sense (2) and has a specifically political or social content. Courbet's painting *Stonebreakers* (1850, formerly at Dresden, now destroyed) was one of the earliest 'social realist' pictures, but most of Courbet's work, though realist in sense (2), carried no social message and did not belong to the category 'social realism'. The term has also sometimes been extended to paintings such as those of OROZCO and SIQUEIROS, which carry a strong social implication although they may not be realist in sense (2) but to some extent abstract. The term came into general use after 1945, at first chiefly in connection with the Italian painter GUTTOSO and his followers.

The term 'social realism' is distinguished from 'socialist realism', the latter being reserved for the kinds of social realism which are from time to time approved by adherents of Marxist AESTHETIC views in Soviet Russia or elsewhere.

Still another use of 'realism'—sometimes 'New Realism'—arose among painters and *littérateurs* who started a new vogue in reaction from ABSTRACT EXPRESSIONISM. In this context the term has been very widely used of a variety of aesthetic styles, both abstract and ultra-representational, so that it is not easy to put a precise meaning to it. It has, however, in many circles come to signify adherence to the typically 20th-c. aesthetic creed that a work of art ought to be a thing added to the world of things rather than merely a reflection of things that already exist. When a work of art is called 'realistic' in this context the meaning intended is that the work is not merely ILLUSIONISTIC in the sense of being a representation (although it may be that) but draws the spectator into an invented realm of meanings not unlike, or related in some way to, that of his everyday life.

**REDMAN**, HENRY (active 1495–d. 1528). Master mason of Westminster Abbey from 1515 in succession to his father, THOMAS REDMAN I of Westminster. He was the designer of the tower and chancel of St. Margaret's, Westminster, of Cardinal Wolsey's palaces at York Place and Hampton Court (all 1515/16), and of Wolsey's college (now Christ Church) at Oxford (1525). He was also joint architect with William VERTUE of Lupton's Tower in Eton College (1516) and the cloister of St. Stephen's Chapel in Westminster Palace (c. 1526).

**REDON**, ODILON (1840–1916). French painter, lithographer, and etcher. He was born at Bordeaux and spent his childhood in the Landes. His father was of French peasant stock, his mother a Creole. He was taught by J. L. GÉRÔME and later by the engraver Rodolphe Bresdin (1825–85). He was introduced to LITHOGRAPHY by FANTIN-LATOUR and produced nearly 200 lithographs of dream-like scenes populated by weird amoeboid creatures, including a series entitled *Dans le Rêve* (1879), *À Edgar Poe* (1882), *Hommage à Goya* (1885), and *L'Apocalypse de Saint Jean* (1899). He was taken up by the SYMBOLISTS and was a friend of J.-K. Huysmans and Mallarmé. In 1884 he

was President of the Société des Artistes Indé-
pendants founded by SEURAT and SIGNAC, and
exhibited with them in successive years. In
1898 he abandoned ETCHING and turned to
PASTELS and poetic oils, studies of flowers,
dreaming heads, etc. In 1904 he was given a
room in the Salon d'Automne and in 1924 the
Museum of Modern Art, New York, had a large

show of his work. SURREALIST artists regarded
him as one of the precursors of their move-
ment.

127, 1822, 1936, 2201, 2202.

**RÉGENCE ORNAMENT.** See LAUB- UND
BANDELWERK.

**293.** Design for ornamental panel. Engraving (*c.* 1693) by Jean Bérain

**RÉGENCE STYLE.** Not to be confused with the English REGENCY STYLE, this is a style of decoration which flourished in France c. 1705-30. The name is taken from the Regency of Philip of Orleans (1715-23). The style bridged the transition from the late 17th to the 18th c. It corresponds with a reaction in life and manners from the period of political gloom and social austerity which followed the Revocation of the Edict of Nantes (1685) and lasted until the end of the reign of Louis XIV; in art Régence was a reaction from the GRAND MANNER of Louis XIV and the dying splendour of VERSAILLES and the beginning of boudoir art with its new note of lightness and elegance. One of the pioneers of the change was Jean BÉRAIN, who towards the end of the 17th c. with Claude AUDRAN inaugurated a new decorative style which took its inspiration from the RENAISSANCE theme of *grotteschi*. A BAROQUE ebullience manifested itself with more freedom and fantasy in the minor arts of metal-work, furniture, and pottery than in the major arts of painting and sculpture and the term 'Régence' came to be applied to the more lavish and fantastic flights of the ROCOCO, such as the fountains of Gilles-Marie OPPENORD and the CARTOUCHES of Bernard Toro (1671-1731). For general purposes of art history the term is now rarely used except as a sub-class of Rococo, but it lingers on as an expression of the sales rooms and auctioneers' catalogues.

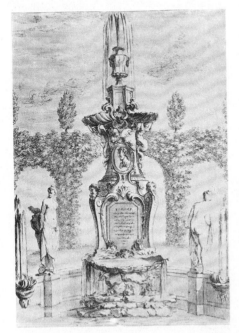

**294.** Design for a fountain. Engraving by Gabriel Huquier from *Livre de différents fragments pour des fontaines par Gilles-Marie Oppenord* (1888)

**REGENCY STYLE.** A term properly applicable to ENGLISH ART during the time when George IV was Prince Regent (1811-20) but also used for that of his reign (1820-30). Although this was a period of great variety, the most characteristic decoration and furniture is marked by extreme elegance, and a refinement and often an attenuation of CLASSICAL forms.

2088.

**REGNAULT, GUILLAUME.** One of the sculptors of the Loire Valley School active in the early 16th c. He worked with Michel COLOMBE on the MONUMENT of Francis II of Brittany at Nantes (1502-7), and later with Jean JUSTE at Tours on that of the children of Charles VIII (1506). He was one of the men who developed the RENAISSANCE style in France.

**REICHENAU SCHOOL.** The term was used by art historians under the belief that among the Ottonian monasteries producing ILLUMINATED MANUSCRIPTS (see OTTONIAN ART) that on the island of Reichenau in Lake Constance was the most important. Later research, however, tended to the conclusion during the 1960s that this claim for Reichenau was unsupported by external evidence or by any contemporary reference to the existence of monastic illuminators or even of scribal activity there during its period of supposed pre-eminence (c. 965-1025) although there are references to such artistic work at other monasteries such as Magdeburg and Hildesheim. Hence the tentative view was put forward that Trier rather than Reichenau may have been the main centre of the school of illumination which used to be known as the Reichenau School. However that may be, the illuminators did not freely invent new cycles of illustrations for GOSPEL books and liturgical texts but, as their surviving work unmistakably shows, must have used models of widely varying types which nevertheless all had one thing in common: the heritage of CLASSICAL art. Thus the *Gero Codex* (Darmstadt), written before 969, is a partial copy of a CAROLINGIAN Gospel book, whilst the famous Gospel book commissioned c. 980 by Archbishop Egbert of Trier (Stadtbibliothek, Trier) must have been done after a (now lost) Roman model of the 4th or 5th c. The individual scenes of its extensive New Testament cycle are simply framed; the treatment of the figures, composition, use of colour, and especially the atmospheric rendering of the background strongly suggest a Roman origin. But the scriptorium must also have owned early BYZANTINE Gospel books or Carolingian copies. In this kind of book the individual scenes are arranged in rows or registers very much in the manner of present-day 'strip cartoons', giving a continuous narrative when read one after the other. The Gospel book written for Otto II or Otto III (Aachen) is arranged in this way. At the height of its powers the school evolved an individual

style with distinguishable features of its own, exemplified in the *Bamberg Apocalypse* (*c.* 1000) and the *Gospel Book of Otho III* (Munich). In these manuscripts the figures, for the most part depicted against a plain gold ground, are elongated with ecstatic faces and expressive gestures; the EVANGELISTS resemble divinely inspired prophets. Their inspiration may have been in the apocalyptic mood which prevailed at the end of the first millennium.

752.

**REIDY,** ALFONSO EDUARDO (1909–63). Brazilian architect and TOWN-PLANNER of British descent. He graduated in architecture at Rio de Janeiro in 1930 and in 1932 became chief architect of the Federal District municipality. He collaborated with Lúcio COSTA, NIEMEYER, MOREIRA, and others on the Ministry of Education building at Rio de Janeiro (1937–43). Best known of his independent works is the Pedregulho housing estate for municipal employees in the S. Cristóvao suburb of Rio de Janeiro (1948–50).

**REILLY,** SIR CHARLES (1874–1948). English teacher of architecture to whose enthusiasm and ready support of new ideas much of the progress made by English architecture during the 1920s and 1930s was due. He was Professor of Architecture at Liverpool University from 1904 to 1933 and several of his students, including Maxwell FRY and W. G. Holford (1907–   ), became the leading modern architects of the next generation. Reilly was instrumental in persuading Lord Leverhulme to found at Liverpool the first chair of Civic Design at any British university.

**REIMS,** CATHEDRAL OF NOTRE-DAME. One of the finest examples of French classical GOTHIC construction. The present church at Reims was begun in 1211; the designer was probably Jean d'ORBAIS. The interior is similar to that of CHARTRES, but is higher and in proportion narrower, so that the vertical emphasis is stronger. The forms have a greater complexity than at Chartres. Bar TRACERY appears for the first time in windows, and the leaf foliage of the later nave CAPITALS and the inside wall of the west front captures the rich profusion of nature itself. Altogether sculpture plays a more important part in the design at Reims than in any other Gothic cathedral. It is deliberately used to eliminate the last vestiges of flat wall surface, and in conjunction with the wholesale use of gables, CROCKETS, and FINIALS it creates the impression of a tremendous congestion of forms which far exceeds anything at LAON and anticipates the characteristic effects of prickly solids set against voids typical of later Gothic architecture. This is particularly true of the west front, which was redesigned, no doubt to avoid the mistakes of Amiens. All the elements of the

classic design of NOTRE-DAME, Paris, reappear, but elongated and transformed in a manner which points unmistakably toward Master Erwin's design for Strasbourg. Yet the Gothic of Reims never lapses into the emaciated elegance of pure RAYONNANT. The architecture and sculpture share a quality of solidity and robust energy which is peculiar to Reims and make it one of the most distinguished of all Gothic buildings. So vast was the programme of sculpture that masons were attracted to Reims from many different regions, and the workshop became an international centre for the exchange of artistic ideas. The sculpture at first displayed a remarkable variety of styles. Some of the earliest figures have the profuse draperies of Mosan metal-work. Others, including the famous *Visitation* group, seem to have been directly inspired by classical models. Still others have the flat, passive draperies of Amiens. These date from *c.* 1220–35. When a distinct Reims style finally emerges, towards 1250, the figures have complete freedom of movement, echoed by the draperies in broad and powerful folds. They are animated by a warm humanity that finds expression in a smile, common alike to the ubiquitous ANGELS and the delightful Frenchman in the centre portal who masquerades as

**295.** Absidal chapel at Reims Cathedral. Pen-and-ink drawings by Villard d'Honnecourt. A. Exterior elevation

295B. Interior. (Bib. nat., Paris, *c.* 1235)

The Reims workshop was by far the most influential in France during the 13th c., but the further development of its style took place not in France but in Germany and Italy (see MASTER OF NAUMBURG and G. PISANO). Henceforth the development of medieval sculpture was independent of architecture, and the rupture marked the end of French predominance. Reims suffered badly during the First World War, but was restored with meticulous care.

2759.

**REIMS SCHOOL.** CAROLINGIAN school of manuscript ILLUMINATION and IVORIES. Its earliest and most important work is the famous *Utrecht Psalter* containing many pen-drawings in a lively and expressive style (produced under Archbishop Ebbo, 816-35). The *Psalter* influenced English drawing of the 11th and 12th centuries, and a copy of it made in Canterbury is in the British Museum. There are also a number of Bibles and prayer-books, some of them commissioned by Charles the Bald, which combine characteristics of the Reims style with elements

St. Joseph. With this humanity went an interest in nature exemplified in the foliage of the capitals, an aspect of Reims sculpture that was echoed as far away as Southwell in England and Naumburg in Germany, as well as all over France.

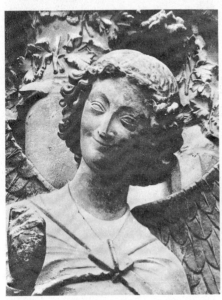

296. Smiling angel from left portal of west façade of Reims Cathedral (*c.* 1260)

297. The Psalmist between an angel and a devil. Detail from an 11th-c. English copy from Canterbury of the *Utrecht Psalter*. (B.M.)

from the ADA and TOURS SCHOOLS. Consequently it has not so far been possible to ascertain where these have been produced. But in addition to Reims Corbie and Saint-Denis have been suggested. The very richly illustrated Bible in S. Paolo fuori le Mura at Rome, and the somewhat earlier *Codex Aureus* in Munich, represent the style at its best. The ivory cover of the latter MS. belongs to a group named after Liuthard, the scribe of this codex, which has stylistic affinities with the *Utrecht Psalter.* Similar characteristics appear also in some goldsmith's work, e.g. the gold cover of the *Codex Aureus* and a book-cover from Lindau in the Morgan Library, New York. (See also CAROLINGIAN ART.)

**RELIEF** (RELIEVO). Term for a work of sculpture in which the forms stand out from a plane or curved surface and the dimension of depth is reduced beyond other dimensions. It differs from engraving, as, for example, the Neolithic rock carvings of the Sahara where the outlines are marked out by incised contour lines. A relief is, on the contrary, genuinely in three dimensions though the degree of depth is less than that of the other dimensions.

The word is derived from the Italian *rilievo*, from *rilievare*, to raise. *Alto rilievo*, or high relief, is used when the scale of projection (the dimension of depth) is half or more than half the other dimension. The term is sometimes incorrectly applied to architectural sculpture carved fully in the round (i.e. where the dimension of depth is equal to other dimensions), but the figures are cut off midway or attached to an architectural background. Such sculpture is not properly relief carving (e.g. the figures of gods and giants on the Great Altar of Zeus at PERGAMUM). *Mezzo rilievo* is used when the dimension of depth is roughly half the scale of the other two dimensions. *Basso rilievo*, low relief or bas-relief, is used when the scale of projection is very much less than that of the other dimensions and there is no undercutting at all. The term 'intaglio' is used when the design is incised and sunk beneath the surface of the block and is moulded in reverse. It is not really a form of relief but the reverse of relief. A peculiar type of low relief was sometimes used by the Egyptians (called

**298.** Marble panel from base of the Column of Antoninus Pius, Rome. The scene depicts a parade of infantry and cavalry. Late classical relief

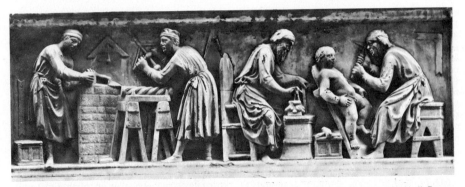

**299.** Predella carved in low relief, below the sculptured group *I Quattro Santi Coronati* by Nanni di Banco. Church of Or San Michele, Florence. The scene depicts artists and craftsmen at work, bricklaying, drilling, measuring, and carving

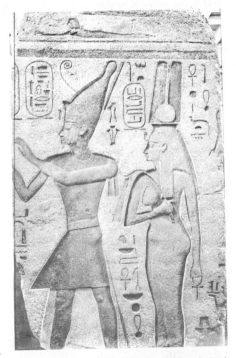

**300.** Egyptian granite coelanaglyphic relief from Bubastis (12th dynasty). The figures are those of Osorkon II and his wife, Karama. (B.M.)

high reliefs made by the Sumerians by hammering sheets of copper over wooden cores and the famous BRONZE doors made by GHIBERTI for the Baptistery at Florence.

**RELIEF ETCHING.** A method of ETCHING plates for RELIEF printing (ordinary etching being in intaglio). The design is drawn on the plate in an acid-resisting VARNISH. The plate is then immersed in acid, which eats away the unprotected parts so that the design stands out in relief and PRINTS can be taken in the same way as from a WOODCUT block. The method dates from the 18th c., but was little used except by BLAKE, who called it 'woodcut on copper'.

Recently, the relief etching process has been revived and combined with intaglio printing by S. W. HAYTER and Joan MIRÓ. Plates, deeply etched as described and sometimes with AQUATINT GROUNDS laid in the etched portions, are printed in two colours by inking the hollowed areas with one colour as for intaglio printing and by rolling up the relief portions with a second colour. The plate is then passed through a copper-plate press, the result being a two-colour print partly in relief and partly in intaglio.

**RELIGIOUS ORDERS.** In the 4th c. A.D. religious communities and communal life sprang up spontaneously in Egypt, Palestine, Syria, Cyprus, and even in Ireland. The needs of the monks found various architectural expression. In Egypt they lived in caves, the walls of which were often decorated with paintings; in Ireland each monk inhabited a small stone-built cell which differed little from a layman's cabin. At Qalaat Seman in Syria may still be seen a splendid stone church and monastery built round the column of St. Simeon Stylites, notable for its conventual buildings round a cloister, its cruciform church, and its subsidiary chapels, the plan of which later entered the west European tradition of monastic building.

Monasticism in the West seems to derive from St. Athanasius's visit to Rome in 340. St. Martin founded Ligugé *c.* 360 and Tours a little later,

*coelanaglyphic*) in which the surface of the block is allowed to remain as background and the figures are carved with positive projections (not negative as in the case of true intaglio) within deeply incised outlines, never projecting beyond the surface. The name *rilievo stiacciato* (also *schiacciato*) is given to a form of very low relief practised in the 15th c. especially by DONATELLO and DESIDERIO DA SETTIGNANO.

Reliefs may be executed in WOOD or in metal as well as STONE. Contrasting examples are the

and St. Cassian, a Provençal who had visited Egypt, established his Rule at Marseilles *c.* 410. St. Benedict of Nursia, not long before his death in 343, drew up a code which transformed the idea of monastic life into that of a highly organized community. In 817, under authority from Charlemagne, Benedict of Aniane imposed this reform on the Frankish dominions. An ideal plan for a monastery preserved at St. Gall shows the Carolingian church plan with an APSE at each end and raised sanctuary (see also CAROLINGIAN ART).

The Benedictine houses were independent, but since they had the same needs they followed the same general plan, with a CHAPTER HOUSE, refectory, and common dormitories round a cloister which adjoined the apsidal church.

In the 11th c. a reform was instituted in the foundation of the Order of CLUNY. Cluny itself had been founded in 910. Many abbeys were reformed by its abbots, and various small priories were founded and given to Cluny. Under Hugh of Semur (Abbot 1049-1109) these were bound together into a centralized Order, each daughter-house depending directly on the mother abbey. The Cluniacs were skilled in ILLUMINATION, and decorated their churches richly with sculpture and painting of subjects related to those of their manuscript paintings. Many of their churches had TYMPANA carved with the figure of CHRIST in Glory. The plans of the churches tended to follow those of the successive churches at Cluny itself.

The next Benedictine reform, the Cistercian, arose in the monastery of Cîteaux which was founded in 1098. It owed its inspiration to the puritanical Stephen Harding of Sherborne and its organization to St. Bernard of Clairvaux. It adopted the principle of daughter-houses, each of which could have its own children *ad infinitum*. It was opposed to Cluny in many ways, especially in its severer attitude to art. No gold and little colour was used in Cistercian illumination, no figure sculpture in its churches. The only representation of a figure permitted was a crucifix of painted wood. A characteristic Cistercian architectural style was developed, based on the simplest Burgundian architecture of Bernard's day (PONTIGNY; FONTENAY). It proved, however, capable of magnificent development. Though in England Cistercian churches nearly always had flat east ends, in France and Italy this was not invariable. The Cistercians' living quarters were more impressive than the Cluniacs'; among other peculiarities they usually had a night-stair from the dormitory to the church and a warming-room off the cloister.

Other monastic creations of the 11th c. reverted to the eremitic tradition. Several contemplative Orders were founded, among them the Carthusians in 1084. Each monk had his own chamber or little house and lived in solitude except for the services in the church and meals (usually eaten in silence) in the refectory. The contribution of the contemplative Orders to art consisted chiefly in a demand for small devotional pictures for each solitary cell of which instances survive from the Chartreuse de Champmol near Dijon. Their cloisters were in the 16th and 17th centuries often painted with scenes of the life of their founder St. Bruno.

The 13th c. was the apogee of the Cistercians; few Orders escaped their influence either in organization or in architecture. It was strongly felt in the Military Orders of the Temple (founded *c.* 1118), who followed the Benedictine Rule, substituting perpetual exile and holy war till death for enclosure in the cloister. For their first church they inherited the mosque of the Dome of the Rock at Jerusalem, and they followed its octagonal plan on an infinitesimal scale in many of their European chapels; for others they adopted the circular plan of the church of the Holy Sepulchre at Jerusalem.

The 13th c. also saw a considerable development of the Augustinian Rule, both for priests living in a small community to serve a church and for nursing sisters and priests working in the world. They did not usually make vows of poverty and their possessions approximated to secular standards. The Augustinians' churches were usually aisleless. The White Canons, or Premonstratensians, founded by St. Norbert in 1119, followed a stricter rule, and came strongly under the influence of Cîteaux in spirit and in architecture.

As the monastic Orders tended to decline, so the Orders of Friars rose. The Church gave recognition to the Franciscans in 1217 and to the Dominicans in 1219; the Carmelites came to Europe in 1245. The friar, like the monk, took vows of poverty, chastity, and obedience, but he was not bound to a communal life within a monastery but allotted to a province in which he was to evangelize and, above all, to preach. The development of the great preaching churches of the 14th and 15th centuries (see GOTHIC) was primarily due to the needs of the friars; and to them, too, was in some measure due the creation of a popular Christian ICONOGRAPHY in the 15th c. The Friars produced several painters, especially in Italy, of whom Fra ANGELICO is the most famous. Many of the painted crucifixes of the 14th c. were due to their patronage or their influence.

In the 16th c. the Benedictine houses began to be grouped into great Congregations, such as the Cassinese in Italy, the Congregation of St. Maur and St. Vannes in France, and the two Congregations of Spanish Benedictines. In the 17th c. a Cistercian reform was instituted at La Trappe. The characteristic post-Reformation Orders were, however, destined to work in the world rather than in the cloister. They were the Orders of Clerks Regular who are primarily priests and afterwards men bound to a particular training and way of life. The Theatines (founded in 1524), the Barnabites (1533), and other smaller Orders of the kind were followed in 1540 by the Society of Jesus, whose members make profes-

sion of poverty in common. Like the Friars they have by their preaching had a considerable influence on the subjects of religious art; and since the architecture of their churches had to be approved by the heads of the Order, they have characteristics in common which are sometimes said to constitute a Jesuit style. Its BAROQUE splendour may be studied from the Gesù in Rome to the churches of Central and Southern America. They developed a characteristic iconography of the Saints of their Order, notably St. Francis Xavier and St. Ignatius Loyola; a picture of the Circumcision often hung over the high altar in their churches.

The great medieval Orders all included houses of women living under their rule, though the women Franciscans and Dominicans were enclosed. Nuns, however, could not form a part of the 16th-c. societies of priests. Several Orders for women only were founded at this time, notably the Ursulines and Visitandines, whose work lay in education. Their chapels presented many elegant variations of a central DOMED plan; those of the Visitandines were notable for elaborate façades. Their high altars were usually adorned by a picture of the Visitation.

## REMBRANDT HARMENSZ VAN RIJN

(1606–69). The greatest painter of the DUTCH School. He was born at Leiden, where he studied at a Latin school and was enrolled for a few months at Leiden University. He left the University c. 1620 to study painting under the mediocre painter Jacob van SWANENBURGH, with whom he worked for three years. More decisive for his development were six months spent with Pieter LASTMAN c. 1624 at Amsterdam. The glossy paint surfaces and the vivid greens, yellows, and violets in the pictures Rembrandt did shortly after he set up as an independent artist in Leiden c. 1625 (*The Angel and the Prophet Balaam*, Musée Cognacq-Jay, 1626), show Lastman's influence quite clearly. But what was even more important, Lastman probably inspired Rembrandt to turn his hand to historical painting. The bulk of pictures he did in Leiden, where he worked until c. 1631/2, are on religious or allegorical themes. This was an unusual choice for a young man in 17th-c. Holland where most artists specialized in painting the people or things around them. And he continued to paint biblical and historical subjects through every phase of his career. The origin of other themes which became favourites in his maturity can be traced to the early Leiden years. His interest in old people and picturesque types is in evidence from the moment he picked up his brushes. The extraordinary series of self-portraits—almost 100 are known—also began in the Leiden years. In youth Rembrandt studied physiognomy to learn how facial expressions could express different kinds of emotions, and the results were incorporated into his more ambitious compositions. His contemporaries were soon impressed by his achievement in this

field. As early as 1630 Constantin Huygens wrote a glowing account of Rembrandt's *Judas Returning the Pieces of Silver* (Lady Normanby Coll., London, 1629) because Judas's facial expression and gestures successfully portrayed remorse and anguish, and he already predicted that the Leiden miller's son would one day surpass both the ancients and the Italian RENAISSANCE masters. The Leiden pictures, which are mostly small in scale and meticulously finished, show how quickly he acquired a mastery of CHIAROSCURO and spatial effects for heightening the drama of a picture (*The Presentation in the Temple*, Mauritshuis, 1631), and how keen his interest was from the very beginning in exploiting the full potentialities of oil paint. Patches of heavy IMPASTO and experiments with the butt end of the brush in wet paint are by no means exceptional in his early work.

When Rembrandt moved to Amsterdam c. 1631/2 he was an accomplished artist, and he spent the rest of his life there; his reputation immediately assured by the *Anatomy Lesson of Dr. Tulp* (Mauritshuis, 1632). The new vitality he brought to this traditional subject impressed all Amsterdam, and for a decade he was the city's leading portraitist. Examples of his commissioned portraits during these years are to be found in most major museums. He continued to paint religious pictures: the most important commission he received during the 1630s was from the Stadtholder Prince Frederick Henry of Orange for five pictures depicting scenes of the *Passion* (Pinakothek, Munich). These were done in the High BAROQUE style which appealed to Rembrandt and his patrons at this time. He himself wrote, in one of his rare statements about his work, that he used emphatic gestures and movements to convey 'the greatest inner emotion'. The most sensational picture in this style is his life-size *Blinding of Samson* (Frankfurt, 1636), which he gave to the friendly critic Huygens.

Rembrandt's early success enabled him to collect works of art on a rather grand scale. In 1639 he moved to a pretentious house in Amsterdam where he lived with Saskia van Uylenburch, whom he had married in 1634. Three of their children died in infancy; Titus (1641–68), the fourth, survived. Saskia died in 1642, soon after Titus was born. In the year of her death Rembrandt painted his most famous picture, *The Night Watch* (Rijksmuseum). His most spectacular innovation in this group portrait was to subordinate the individuals to the action of the group, which is shown getting ready to march— not, however, to a night watch. The picture's popular title was first used c. 1800, when it was so overlaid with discoloured varnish that it looked like a night scene. When this was stripped off after the Second World War journalists named it 'The Day Watch'. The correct title was *The Corporalship of Captain Banning Cocq's Civic Guards*. There is a legend to the effect that when the Amsterdam Guards who commissioned

the picture saw it, they were shocked; they did not pay to be depicted as dim bits of animated shade. They demanded that Rembrandt make radical changes in the picture, paint a new one or refund their money. Rembrandt, the story continues, refused to change a stroke. He knew he had created a masterpiece. A scandal followed. The picture was eventually cut down and hung upon some obscure wall and Rembrandt soon fell into obscurity and died friendless and penniless. There is not a scrap of evidence to support this story, though it is frequently repeated by romantic biographers who like to believe that an innovator in the arts is always misunderstood by his public. But to the contrary, there is no doubt that *The Night Watch* was an unorthodox solution to the problem of the group portrait; yet available evidence indicates that the picture was well received. Rembrandt was also well paid for it; his fee came to about 1,600 guilders. Moreover, he continued to receive important commissions. During the 1640s he executed expensive religious pictures for the Stadtholder Frederick Henry; in 1655 and again in 1661 the burgomasters of Amsterdam asked him to make paintings for their new Town Hall. He also continued to receive important portrait commissions. One of the greatest, the portrait of the burgomaster Jan Six (Six Coll., Amsterdam), was painted in 1654. His group portrait *The Syndics of the Drapers Guild* (Rijksmuseum) was done in 1662. Before he died in 1669 his works were known from Poland to Sicily; his fame was international. But it would be wrong to assume that he had the same kind of popularity during the last decades of his life that he had enjoyed during the 1630s. There was a change in the appreciation of his work, but it was not caused by *The Night Watch*. It resulted from an important shift in emphasis which occurred early in the 1640s when he became more interested in portraying inner life and character than the outward appearance and actions of his subjects. Then, as now, this theme was neither fashionable nor popular. A small group continued to follow his work with keen interest; from others he commanded respect, if not understanding.

During the 1640s Rembrandt gradually abandoned the more explosive and extravagant aspects of Baroque art and sought ways of making colour, chiaroscuro, and atmospheric effects express tenderness and compassion (*The Holy Family*, Hermitage, 1645). Perhaps the warmth and sympathy which permeates works of this period are connected in some way with the death of Saskia. About this time he also made direct studies from nature in which the mood of a scene is dominant. Few 17th-c. Dutch artists have matched the beautiful LANDSCAPE drawings and ETCHINGS (*The Three Trees*, 1643) Rembrandt did during these years.

Hendrijke Stoffels entered his household c. 1645 and became his devoted mistress; their daughter Cornelis was born in 1654. In 1656 Rembrandt was forced to petition for a *cessio*

*bonorum*, the most honourable way of declaring bankruptcy. His house and effects were sold by auction in 1657 and 1658. Loss of patronage and the money he spent on his collection help to account for his insolvency, as also does the fact that he began to paint more and more for himself. As far as we know large religious pictures like *Bathsheba* (Louvre, 1654) and *Jacob Blessing the Sons of Joseph* (Cassel, 1656) were not commissioned works but were painted on his own initiative—an unusual thing in those days. Rembrandt's etchings of biblical themes, on the other hand, always had wide appeal. The high price paid c. 1700 for his etching known as *The Hundred Guilder Print* (c. 1649), which represents scenes described in Matthew xix, accounts for the print's popular name. In 1660 Rembrandt became the employee of an art firm established by Hendrijke and Titus to protect him from his creditors. The following year he was commissioned to paint a night scene depicting the *Conspiracy of Claudius Civilis*, the one-eyed Batavian who led a revolt against the Romans in A.D. 69, considered as a type of William the Silent who led the Dutch revolt against the Spanish. The completed painting was the most monumental historical picture ever painted in Holland. For reasons which historians still debate in part removed from the Town Hall and never mounted again. Only a fragment of it is extant (Nationalmuseum, Stockholm).

Rembrandt's last years brought additional tragedy. Hendrijke died in 1663, Titus in 1668. But difficulties did not impair Rembrandt's power. On the contrary, they seemed to deepen his insight and human understanding. Some of the most majestic works ever painted were executed a year or two before his death. There is no parallel in the history of painting for the psychological penetration or the phosphorescent colour harmonies of scarlet and gold in the *Jewish Bride* (Rijksmuseum, c. 1669) and *The Return of the Prodigal Son* (Hermitage, c. 1669).

The many sides of Rembrandt's genius can only be grasped when one becomes familiar with his prodigious output: over 600 paintings, about 300 etchings, and almost 2,000 drawings can be attributed to him. For long academic critics objected to the lack of decorum and the vulgar types he depicted and for long he was regarded as crude and 'Gothic'; yet his treatment of light was generally considered exemplary. A few discerning writers, such as BALDINUCCI in the 17th c. and DE PILES in the early 18th c., rated him highly. English and French CONNOISSEURS of the 18th c. often paid high prices for his works and even REYNOLDS modelled one of his self-portraits on those of Rembrandt. In 1851 DELACROIX uttered the 'heresy' that one day Rembrandt might be rated higher than RAPHAEL; his prophecy came true within 50 years.

Rembrandt had pupils in his studio from the beginning until the end of his career. They include DOU, FLINCK, BOL, BACKER, C. FABRITIUS, P. KONINCK, HOOGSTRATEN, MAES,

EECKHOUT, and de GELDER. And through them something of his original contributions passed into the tradition of Dutch painters, though often his pupils later abandoned his exacting standards for a more facile popularity.

235, 565, 968, 1283, 1896, 2306, 2750, 2869.

**RENAISSANCE.** The word generally applied to the intellectual movement that began in Italy in the 14th c. and culminated in the 16th. Its exact application, however, has been the subject of much discussion for the last hundred years, and this being so a brief history of the term must be given. The metaphor of a 'rebirth' actually goes back to the 15th c. when it was used to describe the revival of classical learning. It was also applied to a revival of the arts, and it was in the famous *Lives* of VASARI (1550) that the idea of such a revival was systematically developed. Vasari saw the history of art in Italy from GIOTTO to MICHELANGELO as a continuous progress which he compared to the process of organic growth. His view dominated the conception of ART HISTORY up to recent times when the idea of progress came under fire. The extension of the meaning of the term from a movement in art and letters to a period of time began in the 18th c. and was given final currency when Michelet called a section of his history of France

**301.** Title page to *Le Vite de' piu eccellenti Pittori, Scultori, e Architettori* (1568), Second edition, Florence, by Giorgio Vasari

*La Renaissance* (1855). RUSKIN had used the expression 'The Renaissance period' in his *Stones of Venice* in 1851. A few years later, in 1860, Jakob Burckhardt described 'the Civilization of the Renaissance in Italy' as an organic entity. To him 'the discovery of the world and of man' was due to a new upsurge of the human spirit rather than a revival of classical letters. The leading representatives of this 19th-c. conception in England are John Addington Symonds and Walter PATER.

This wide definition of the term made it particularly difficult to indicate the limits of the period. If the 'discovery of the world' was taken to mean progress towards 'NATURALISM' in art, such tendencies might be detected in the 13th-c. FRENCH ART usually described as GOTHIC. If the 'discovery of man' was taken as the touchstone, such thoroughly medieval figures as St. Francis of Assisi might be hailed as the harbingers of the new age. These and similar inconsistencies in delimiting the period under discussion have prompted 20th-c. historians to re-examine the whole concept.

For the sake of greater precision it is here proposed to describe as 'Renaissance' in art such aspects as manifest a deliberate imitation of classical patterns or a conscious return to classical standards of value. Such an interpretation would be in accord with the original usage of the term *rinascita*. When it first gained currency among the humanist followers and admirers of Petrarch it implied an imitation of classical Latin style and a boundless admiration for all relics of classical antiquity. Petrarch (1304–74) had collected Roman imperial coins, Poggio Bracciolini (1380–1459) classical sculpture as well as manuscripts; and it was in this atmosphere at the beginning of the 15th c. that the revival of classical art became the ambition of a group of FLORENTINE artists.

ARCHITECTURE. The most momentous effect of this new enthusiasm was the invention of a style of building by the Florentine architect BRUNELLESCHI, who discarded all Gothic detail and modelled his forms on buildings that he considered Roman. His COLUMNS, PILASTERS, CAPITALS, and MOULDINGS reintroduced the vocabulary of classical architecture. Contemporaries referred to this new mode of building as the *maniera all'antica* and contrasted it with the Gothic, which they believed to have been introduced into Italy by the northern barbarians. The new ideas were codified and exemplified by ALBERTI in his *De re aedificatoria*, the canonical book of the new style—VITRUVIUS's 10 books on architecture rewritten for the modern age. In a sense the 'Five Orders' (see ORDERS OF ARCHITECTURE) and other rules laid down by Alberti have dominated European architecture since that day. (For this reason the term 'Renaissance' is often used by architects for all post-medieval buildings in this idiom. Historians of art, on the other hand, have preferred to limit the use of the term to the architecture of the Renaissance period

**302.** Portico of the Foundling Hospital, Florence, designed (1419) by Brunelleschi

proper, that is to the end of the 16th c.) Various centres apart from Florence contributed to the development of the style in the 15th c. Alberti himself designed buildings for Rome, Rimini, and Mantua; his follower Antonio ROSSELLINO rebuilt the town of Pienza for Pope Pius II, and the Dalmatian LAURANA designed the Ducal Palace of Urbino, the most magnificent example of domestic architecture during this period. In Milan, at the court of the SFORZA, FILARETE introduced a somewhat bizarre version of the Renaissance style in the Ospedale Maggiore. Venice characteristically modified the style to harmonize with her own version of Gothic (Sta Maria dei Miracoli, *c.* 1480).

One of the main problems which engaged the mind of early Renaissance architects was the question of church design, for here the adaptation of Roman forms proved most difficult. Brunelleschi reverted to the early Christian BASILICA (S. Lorenzo and S. Spirito, Florence), but Alberti experimented with entirely novel plans. Departing from the longitudinal ground-plan, he tried to evolve his plans from the square and the circle which the Platonic tradition considered the most perfect forms and therefore the most suited to reflect divine perfection. Designs for centrally planned churches preoccupied artists such as FRANCESCO DI GIORGIO, LEONARDO, and Giuliano da SANGALLO, whose Sta Maria delle Carceri at Prato, a DOME over a Greek cross, exemplifies the 15th-c. ideal of a church.

It was therefore inevitable that when Pope Julius II decided to rebuild the principal church of Christendom his architect, BRAMANTE, should advocate a central plan. Bramante of Urbino,

**303.** Interior of the Pazzi chapel, Sta Croce, Florence, designed (*c.* 1429–30) by Brunelleschi

**304.** The Tempio or church of S. Pietro in Montorio, Rome, designed (1502) by Bramante

who had worked in Milan, is generally considered to represent Renaissance architecture at its purest; his designs for S. Pietro in Montorio and for the Belvedere were considered 'classic' by later generations. The monumental grandeur of Bramante's designs is characteristic of the ambition of the High Renaissance to match not only the style but also the scale of imperial Rome. Michelangelo's transformation of the Capitol and the crowning CUPOLA that he added to St. Peter's reflect this spirit, but at the same time he introduced wilful and even capricious variants of the classical canon (Porta Pia, Rome; Laurentian Library, Florence). In the second half of the 16th c. these two tendencies existed side by side. The architects who deliberately broke from orthodox Classicism for the sake of surprise effects are more conveniently treated under the heading of MANNERISM. Among those who adhered to a stricter interpretation of the Vitruvian rules SAMMICHELE and VIGNOLA may be mentioned, but it was PALLADIO who evolved the most harmonious and consistent system of building in the Renaissance style. His buildings in Vicenza and Venice and his books were for a long time invested with the same authority as classical antiquity.

The penetration of the *maniera all'antica* into northern Europe happened fitfully and comparatively late. The fashion, for such it was, only gained hold where the new learning was taken up—principally, that is, at the courts of princes and in the centres of international commerce. The French kings gained first-hand acquaintance with the Renaissance through the invasions of Italy that began in 1494 and resulted in the French domination of Milan. Francis I (reigned 1515-47) was anxious to obtain the

**305.** Façade of the Château of Chambord. Pen-and-ink drawing by Jacques Androuet Ducerceau. Engraved in *Les plus excellents bastiments de France* (1576)

services of Italian architects such as Leonardo and the early 16th c. saw the erection of several châteaux such as Blois and Chambord where Italian ornaments and classical Orders were grafted on to fundamentally Gothic structures. In the Netherlands Margaret of Austria imitated this fashion when she commissioned François BLONDEL to decorate her palace at Bruges. In Germany it was the emperor Maximilian (d. 1519) who wished to be modern though he lacked the money to make his grand schemes come true. His creditors, the bankers Fugger of Augsburg, commissioned Italian artists to build their family chapel. Later in the century (c. 1540) the Dukes of Bavaria sent to Mantua for patterns before building their residence at Landshut. Individual Renaissance forms were transmitted through engravings and pattern-books and by the middle of the 16th c. they began to replace Gothic detail all over northern Europe. England held out longest despite the fact that Henry VIII, like his rivals on the Continent, followed the fashion and employed Italian and Italianate workmen at Hampton Court and elsewhere. It was not until Inigo JONES brought back the pure Renaissance style from Italy in the 17th c. that the hybrid forms Tudor Gothic and JACOBEAN were finally outmoded. The PLATERESQUE which flourished in Spain in the 16th c. is another hybrid style, exemplified in the portal of Salamanca University (1525-30).

SCULPTURE. Whilst the dependence on classical models and rules makes it comparatively easy to characterize Renaissance architecture, Renaissance sculpture is less easily defined. Vasari saw the beginnings of it in Nicola PISANO because he had borrowed motifs from classical SARCO-PHAGI. But we know that Gothic sculptors also borrowed motifs from classical statuary, as for example at REIMS, and we now see that there is in fact so much in common between the art of the Pisani and that of their northern contemporaries that we classify their style as proto-Renaissance rather than Renaissance proper. Moreover Italian sculpture of the 14th c. remains Gothic. It is only in the early 15th c. that we can see a reflection of Renaissance taste in sculpture. DONATELLO was not content with the copying of individual classical motifs but aimed at a revival of the spirit of classical sculpture whose glory had been extolled by the ancient authors. His David (Bargello) was the first monumental free-standing nude in BRONZE since classical antiquity, just as his Gattamelata (Padua) was a deliberate revival of the classical EQUESTRIAN MONUMENT. Less complex minor artists, such as the engaging MINO DA FIESOLE, also reveal their conscious acceptance of the new ideals. The collecting of classical sculpture, particularly GEMS and small bronzes, by such patrons as Lorenzo de' MEDICI, created a demand for statuettes and RELIEFS all'antica, which was satisfied by masters such as POLLAIUOLO and BERTOLDO in Florence, and Antico, Moderno, and RICCIO in northern Italy.

The fact that Michelangelo grew up in the atmosphere of Lorenzo's household must be remembered as one of the formative influences on the greatest of Renaissance sculptors. In his youth he entered into deliberate rivalry with the ancients. The objects of his emulation were no longer small bronzes but monumental marbles, many of which only became known c. 1500 (LAOCOON, APOLLO BELVEDERE). One of his early sculptures, a sleeping Cupid (now lost), was actually sold as antique. The way in which Michelangelo entered into the spirit of classical sculpture can be seen from his Bacchus (Bargello). In his later works, such as the Dying Slaves for the TOMB of Pope Julius II (Louvre), we can feel his ambition to challenge the most famous works of antiquity and to surpass them in the treatment of anatomy and the expression of emotion. At the end of his life, however, Michelangelo turned away from the ideals of classical sculpture and from the Renaissance itself.

The last phase of Italian Renaissance sculpture is represented by the striking personality of Benvenuto CELLINI, whose Perseus (Loggia dei Lanzi, Florence), created as a counterpart to Donatello's Judith, exemplifies a trend towards virtuosity and elegance. These Mannerist tendencies became almost excessive in the vast œuvre of Giovanni BOLOGNA.

Renaissance sculpture was carried to northern Europe by travelling Italian artists. TORRIGIANO, Michelangelo's fellow pupil and enemy, was called to England by Henry VIII and executed the tomb of Henry VII (Westminster Abbey) between 1512 and 1518. Cellini came to France in 1540 to work at the court of Francis I and his style decisively influenced the leading Renaissance sculptor of France, GOUJON. In Germany the lead in the Renaissance movement was taken by sculptors in Nuremberg and Augsburg, who maintained close contact with Italy. In the former town the workshop of Peter VISCHER adapted north Italian small bronzes to its own purposes, particularly in the decorative figures of the Sebaldus Tomb, Nuremberg. A German master, Conrad MEIT, carried Renaissance ideas to the Netherlands, where he worked at the court of Margaret of Austria.

PAINTING. Although the Renaissance style in architecture can be defined by reference to classical prototypes and Renaissance sculpture can at least be characterized through its rivalry with ancient monuments, the problem of defining what constitutes Renaissance painting is considerably more complex. For the painting of the period originally developed without the support of classical models, since no Roman wall-paintings were available as patterns until the very end of the 15th c. The works of such famous masters as APELLES and ZEUXIS were known only through literary records, but PLINY's descriptions of them influenced the painters as well as patrons and critics. From classical authors the Renaissance public learned to expect of painting a high degree of fidelity to nature and

a search for the perfect form. But these influences hardly made themselves felt before the 15th c., and it is customary to date the beginning of Renaissance painting much earlier, to the time, that is, when Italian painting first turned away from the HIERATIC symbolism of the BYZANTINE tradition. This momentous change in the aims of art was attributed by subsequent centuries to one person—Giotto. 'I am the man through whom the extinct art of painting lived once more', as Poliziano makes him say in his epigram (1485) on Giotto's monument in the cathedral of Florence. According to this tradition there was only one forerunner of Giotto, namely CIMABUE, who owed his position at the source of the great renewal of painting to the fact that Dante had mentioned his fame as preceding that of Giotto. Modern research has confirmed the decisive role of Giotto in the establishment of naturalistic tradition in Florence, though the question of the roots of the 'new style' which aimed at the ILLUSION of three-dimensional reality is less susceptible of a clear-cut answer. It is probable that not Florence but Rome was the birth-place of these tendencies.

The development of the tradition headed by Giotto appears to us still in the light in which it appeared to its first historian, Vasari, in 1550. He saw the development of painting since Giotto as a continuous progress towards the ideals of classical art, reaching its fulfilment in the work of Michelangelo. This progress he envisaged in three well-defined stages. The first, corresponding roughly to the 14th c., included the consolidation of Giotto's achievement in Florence and Siena in the works of painters such as SIMONE MARTINI, Ambrogio LOREN-ZETTI, or Andrea ORCAGNA. It is well to remember, however, that what Vasari calls the 'first manner' of Renaissance painting coincides in time with Gothic architecture and sculpture in Europe. It will not be surprising, therefore, that within the European rather than the Italian context an artist such as Simone Martini appears as a promoter of the INTERNATIONAL GOTHIC style. The decisive break that established the primacy of Italy in painting occurred when what Vasari calls the 'second manner' was introduced by MASACCIO c. 1425. The date is significant for it coincides with the inauguration by Brunelleschi of the Renaissance style of building and with Donatello's first Renaissance sculptures. Masaccio owes his special place in art history to his application of scientific PERSPECTIVE, an invention due to the mathematical genius of Brunelleschi. The consequences of this invention for the AESTHETICS of Renaissance painting are incalculable: the picture-frame could be conceived in Alberti's words as 'a window' through which the spectator looks into the little world created by the artist. Painting thus became a rational pursuit with definite problems and demonstrable solutions. The standards of scientific accuracy which were introduced demanded a close study of three-dimensional

forms. The study of the PROPORTION and structure of the human body led artists to anatomical research and systematic DRAWING from the nude MODEL. This concentration on problems of structure gives to the paintings of Masaccio's followers in Florence and elsewhere, such as UCCELLO, CASTAGNO, PIERO DELLA FRANCESCA, and MANTEGNA, their sculptural, statuesque quality.

Painting of this kind was particularly apt to approximate to classical sculpture and reliefs: Mantegna's FRESCOES seem populated by Roman statues. When he painted the *Story of St. James* (Eremitani, Padua) he took care to dress his actors in classical armour and place them against a background of Roman architecture; later in his life he reconstructed with archaeological accuracy the *Triumph of Caesar* (Hampton Court). Such works, which helped to recover the lost world of classical antiquity, were bound to appeal to the humanists, who in their turn praised the painters as the equals of Apelles. Thus it happened that in the second half of the 15th c. painting reflected another essential aspect of the Renaissance, the enthusiasm for classical subject matter: the *Metamorphoses* of Ovid appeared illustrated on CASSONI, and BOTTICELLI round about 1480 painted the first monumental MYTHOLOGICAL pictures, the *Primavera* and the *Birth of Venus*.

Hand in hand with this re-creation of the classical world went the discovery of the poetry of nature. Here it was Venice which gave the lead. The LANDSCAPE backgrounds of Giovanni BELLINI's paintings reflect the mood of the scenes represented. How far his mastery of light and atmosphere was due to the technical means which he owed to ANTONELLO DA MESSINA, who practised the FLEMISH mixed technique of OIL and TEMPERA painting, is undecided. What matters is the fact that his work laid the foundations for Venetian supremacy in colour.

The mastery of accurate and proportionate representation and the recovery of classical beauty characterize what Vasari calls the 'third manner', known to us as the High Renaissance—the age of the great names, Leonardo, Michelangelo, RAPHAEL, and TITIAN. In the art of these masters later centuries saw the fulfilment of all the ideals that painters had pursued since Giotto: Vasari points out that the perfect mastery of means achieved in this period led to an ease of manner and a graceful harmony that stand in marked contrast to the strained efforts of preceding generations. The harsh sculptural outline gave way to the mellow modelling (SFUMATO) of Leonardo, the rigid symmetry of PERUGINO to the balanced variety of Raphael's pyramidal compositions; the artist no longer felt obliged to adhere slavishly to his model but saw himself as a quasi-divine creator. Within this new conception there is room for Michelangelo's heroic images on the Sistine ceiling as well as for GIORGIONE's transfigured PASTORALS.

Renaissance critics saw the achievements of the painters of their time in terms of *disegno* and *colore*, Drawing and Colour. The TUSCAN tradition of rational design and firm outline culminated in Michelangelo and his followers such as BRONZINO, SALVIATI, and Vasari, who founded the Accademia del Disegno, the first of the ACADEMIES of art. In the work of these Florentine academicians over-emphasis on complexity of posture and the mastery of muscular nudes led to Mannerism with its disruption of Renaissance harmony. The perfection of colour was attributed to the Venetians and in particular to Titian, whose fame rivalled that of Michelangelo. His north Italian contemporaries CORREGGIO and VERONESE shared with him the radiance of colour and an interest in light effects that presaged the BAROQUE. The younger artists in the north, like those in Tuscany, can no longer be referred to as Renaissance painters. In the art of PARMIGIANINO and TINTORETTO the tendencies now usually described as Mannerism predominate.

North of the Alps painting developed independently of the Italian Renaissance movement throughout the 15th c. There were indeed Italian influences, such as that of Mantegna on the Austrian Michael PACHER, but they were exceptions. The acceptance of Renaissance ideals as such was due to the conscious effort of a handful of men; above all to DÜRER, who saw it as his mission to transplant the arts 'reborn' in Italy on to GERMAN soil. He visited Italy twice with the aim of acquiring the 'secrets' of the Italian masters, that is the mathematical principles of perspective and proportion; and he struggled all his life both in his theoretical writings and in his art to fathom the mystery of classical beauty. Nevertheless, the number of Dürer's works that conform to pure Renaissance standards is perhaps limited: among his paintings those that come to mind are the Munich *Self-Portrait* with its solemn frontality, the *Adoration of the Trinity* (Vienna) with its symmetrical grouping of masses, and the *Four Apostles* (Munich) with their echoes of Bellini. More superficial Renaissance tendencies can be discerned in the mythological nudes of CRANACH, who worked in Saxony at the court of Frederick the Wise, or in the Italianate portraits of BURGK-MAIR, whose patrons were the internationally minded merchants of Augsburg. Whether the landscapes of the so-called Danube School, and in particular of ALTDORFER, owe their existence to Renaissance impulses is an open question. The figure of HOLBEIN the Younger, on the other hand, clearly belongs to the Renaissance tradition. He came to maturity in Basel, the centre of the humanist publishing trade, he was a friend of Erasmus and Thomas More, and he brought the taste for Renaissance art to England. Not only his portraits but also his designs for pageantry and jewellery are conceived in the Renaissance tradition.

The Netherlands with their strong Gothic tradition were slow to accept the Renaissance and at first they only assimilated it through the medium of Dürer's prints. LUCAS VAN LEYDEN best represents this phase. In the work of Quentin MASSYS we find the direct influence of Leonardo's art both in his types and in his treatment. But only when the Flemings travelled to Italy did they experience the full impact of the Renaissance: GOSSAERT tried somewhat ostentatiously to emulate classical statuary and the more sensitive Jan van SCOREL absorbed something of southern poise and serenity.

The later imitators of Italian painting, such as HEEMSKERCK and the FLORIS brothers, belong to Mannerism rather than the Renaissance. The same is true of painting in France. PRIMATICCIO and ROSSO, who were called to Fontainebleau by Francis I, represent the Mannerist phase no less than does Cellini, and the School of FONTAINE-BLEAU cannot therefore be said to represent pure Renaissance ideals, nor can the courtly portrait style of the CLOUET family.

These distinctions reflect once more the elusiveness of the term 'Renaissance', particularly in its application to the north. While in the field of literature and thought we are used to speaking of the Renaissance in Elizabethan England, few historians of art would now consider such painters as HILLIARD or EWORTH as representatives of Renaissance style. Like their French contemporaries, they embody rigid courtly ideals far removed from the wide sympathies and intellectual adventure from which the Renaissance had originally sprung in Florence.

23, 48, 55, 170, 234, 246, 441, 442, 531, 532, 534, 565, 634, 771, 921, 978, 996, 1083, 1085, 1089, 1114, 1218, 1270, 1739, 1900, 2018, 2309, 2611, 2699, 2714, 2834, 2906, 2922, 2927.

**RENI,** GUIDO (1575-1642). Italian painter of the generation immediately following the CAR-RACCI. He began his training under CALVAERT, and was influenced by Ludovico Carracci. When he went to Rome in 1600 he remained independent of the two strongest artistic currents there, represented by CARAVAGGIO and Annibale Carracci, and became one of the earliest exponents of a sophisticated Classicism not common in Rome until later in the century. The *Crucifixion of St. Peter* (Vatican, 1603) is a refined, balanced version of the subject so startlingly treated by Caravaggio not long before. Among his many FRESCO decorations is the *Aurora* on the ceiling of the Casino Ludovisi (1613), a graceful composition with none of the emphatic leanings to MICHELANGELO so characteristic of Annibale Caracci's work. Reni's tendency to idealize his figures after the models of neo-HELLENISTIC sculpture is particularly apparent in the *Massacre of the Innocents* (Bologna, 1611). In 1614 he returned to Bologna, which he left only to visit Naples in 1622 and Rome in 1625. He continued

to paint works of lucid design with a tendency towards a lighter range of hues.

Reni's latest style, exemplified in several works in the Capitoline Museum in Rome, tends towards greatly simplified designs almost of the nature of sketches, thinly painted in very pale colours. The superficially structureless appearance of these works was exaggerated by his followers into insipid charm and the numerous flaccid copies of his religious works prevented the appreciation of his real stature until well on into the 20th c.

1058.

**RENOIR,** PIERRE AUGUSTE (1841–1919). French IMPRESSIONIST painter, born at Limoges. He went to work at the age of 13 as a painter in a porcelain factory at Paris and, whether or not on account of this early training, his work always retained something of the facile decorative technique of the 18th c. and the charm of BOUCHER's colouring. After working at painting blinds, he entered the studio of Marc Charles Gabriel Gleyre (1806–74) in 1862 and there formed a lasting friendship with MONET, SISLEY, and BAZILLE. He painted with them in the BARBIZON district and became a leading member of the group of Impressionists who met at the Café Guerbois. He exhibited at four of the Impressionist exhibitions in the years 1874–82. He also exhibited at the Salon during the same period, notably *La Esmeralda* (which he later destroyed) in 1864 and his portraits *Mlle Samary*

**306.** Portrait of Renoir. Lithograph (1905) by Forain

(Moscow) and *Mme Charpentier et ses enfants* (Met. Mus., New York) in 1879. Renoir was perhaps the most individual of the Impressionists. He was responsible for the introduction into the Impressionist technique of the so-called 'rainbow palette' restricted to pure tones at maximum intensity with the elimination of black and also for a more thoroughgoing use of DIVISIONISM (derived from WATTEAU) and the subordination of outline. The human figure played a larger part in his painting than in that of his colleagues and he delighted in the intrinsic charm of lovely women, children, flowers, and beautiful scenes. He looked on the beauties of the world with fresh eyes and sought to combine the enchantment of natural loveliness with the luscious allure of PIGMENT. Nowhere in his LANDSCAPE is there a suggestion of sadness or melancholy.

During the 1880s he drew away somewhat from the rest of the Impressionists. After a successful one-man exhibition by the dealer Durand-Ruel in 1883, he began to paint in a more classical manner as though impelled by a new creative urge towards the magnificent maturity of his final years. The outstanding work from this period is *Les grandes baigneuses* (Philadelphia, 1885–7). In the years 1904–19 Renoir, already a world-famous master, lived in the south of France, chiefly at Cagnes and Magagnosc, and although crippled by rheumatoid arthritis, painted ceaselessly and achieved the most original of his masterpieces (*Les grandes laveuses*, 1912; *Le jugement de Paris*, c. 1914; *Les femmes aux chapeaux*, c. 1910). During the same period he also modelled sculpture with the aid of assistants, usually Richard Guino, a pupil of MAILLOL. The best known pieces are a large *Vénus* and *Femme allaitant son enfant* (a bronze of the latter is in the Tate Gal.).

Renoir was represented by 10 paintings in the exhibition of French Impressionist Pictures held at the Grafton Galleries, London, in 1905. In 1933 a retrospective exhibition of 126 pictures from all his periods was held at the Musée de l'Orangerie, Paris. The largest collection of representative pictures by Renoir is that of the Barnes Foundation, Merion, U.S.A.

224, 784, 900, 1123, 1210, 1815, 2212, 2272, 2772.

**RENWICK,** JAMES (1792–1863). American architect and one of the leading figures of the GOTHIC REVIVAL IN NORTH AMERICA. He is known for his design for the Smithsonian Institute in Washington (1846), but his most famous work was St. Patrick's Cathedral in New York (1850–79). Designed with archaeological exactitude in a French Gothic style (compare Saint-Ouen, Rouen), this building reveals Renwick as an ECLECTIC. In this respect he was also a leader, for he was an initiator of both the LOMBARD ROMANESQUE and the SECOND EMPIRE STYLES IN THE U.S.A.

**REPIN,** ILYA (1844-1930). Russian painter. He received his first training from a provincial ICON painter, but later studied at the St. Petersburg Academy. He joined the 'Wanderers' (*Peredvizhniki*), an influential association of young painters in revolt against the Academy, inspired with ideas of bringing art to the people, who formed the REALIST movement in Russia. His *Volga Boatmen* (Russian Mus., Leningrad), exhibited in Vienna in 1873, made him internationally famous. From then on he was regarded as the leading Russian painter. Of his later works two became particularly popular: *Ivan the Terrible with the Body of his Son* (Moscow, 1885), and *Cossacks defying the Sultan* (Leningrad, replica at Moscow, 1891). His *They did not expect him* (1884), showing the unexpected return of a political exile from Siberia, expresses a deeply felt social theme. Repin was also an outstanding portrait painter (*Trubetskoi*, Galleria d'arte moderna, Rome, 1908). His various portraits of Tolstoy have often been reproduced. From 1893 Repin taught at the St. Petersburg Academy. He was a fine painter and colourist, but what chiefly appealed to his contemporaries was the exciting subject matter of his pictures. The generation of the 1890s objected to his paintings as 'anecdotal' or 'melodramatic', calling them 'painted leading articles'. With the introduction of a 'socialist realism' in 1932 Repin has been established as the model and inspiration for the Soviet painter.

**REPOUSSOIR** (French). The use of a strongly defined figure or object in the foreground of a picture in order to 'push back', give depth to, and enhance the principal scene or episode.

**REPRODUCTION.** Neither the ancient world nor the Middle Ages knew how to reproduce an image exactly, if one excludes seal impressions, MEDALS, and PLASTER CASTS. Two-dimensional reproduction begins as far as Europe is concerned with the first essay in woodcutting and intaglio engraving on metal in the 15th c. The multiplication of exact copies of a single design, which has become a continuing need of civilized man, was the original purpose behind the invention of all the traditional manual techniques of engraving and their modern descendants the photo-mechanical processes. Wherever such repetition of design is the basic intention in making a print we employ the term 'reproductive engraving' as distinct from 'creative engraving'. It is a characteristic of such work that the engraver is seldom the author of the original design but a craftsman whose sole occupation is the reproduction of the designs of others. This article is concerned with the general character and development of reproductive engraving, with its cultural and artistic implications and, briefly, with modern photo-mechanical methods. For detailed information about the various techniques of manual engraving which have been used for reproductive purposes, the reader is referred to the articles on the techniques themselves (LINE ENGRAVING, WOODCUT, etc.) and to that on PRINTS, where they are enumerated.

Until the RENAISSANCE progress in most of the sciences and practical arts was gravely hampered by the absence of textbooks and treatises with reliable illustrations and diagrams. All illustrations had to be copied by hand, and the accuracy of the pictorial representation of an object is invariably lost when it is copied by one artist from work by another. The woodcuts of the 15th c. were a significant advance in this respect, for they did at least ensure that once the block had been cut all the printed copies would be identical in some respects at least. The vital function performed by the printed picture in spreading practical knowledge is attested by the publication of great numbers of illustrated books on the military arts, PERSPECTIVE, handwriting, anatomy, botany, zoology, and numerous other sciences, together with maps and charts, pattern-books for metalsmiths, reference books of designs for architects, and so forth. Much of the early reproductive woodcutting was what is called 'facsimile' woodcutting, that is to say the drawing was made on the block by the artist and the white spaces were then cut away by the woodcutter. So long as the designs were fairly simple the cutters were able to preserve with considerable success the qualities of the artist's drawing and the finished print could reasonably be called a 'facsimile'. But by the middle of the 16th c. elaborate pictures and illustrations had become fashionable and the woodcut was unable to meet the complicated demands made on it. From then until the 19th c. the history of reproductive engraving is that of the intaglio techniques on metal.

The decisive advantages of line engraving on copper over woodcut were that fine and elaborate work could be more easily engraved and, above all, more accurately printed. It was, however, more expensive, slower to print, and less able to yield large editions, because the plates, which must be carefully wiped by hand for each impression, tend to deteriorate with repeated printing and require in any case a special press giving heavier pressure than that used for letterpress, so that it is impossible to print text and illustrations together. These factors caused the illustrated book to become again something of a luxury, as it had been in the Middle Ages.

Perhaps the greatest name in reproductive line engraving is that of Marcantonio RAIMONDI, who made many remarkable prints after paintings and designs by RAPHAEL and whose influence on the whole history of European engraving has been enormous. Marcantonio's achievement consisted in developing a standardized method of rendering solid form by means of a network of intersecting engraved lines. Examination of the modelling of any human torso, with its swellings and hollows, in an engraving by Marcantonio will show what is meant. Other engravers adopted this method until it became a universal

**307.** *St. Cecilia.* Engraving by Marcantonio Raimondi after a painting (*c.* 1516) by Raphael

public who obtained their knowledge of works of art from such sources could only do so at several removes. What they saw was the work of three successive hands: an engraving, stylized in a particular manner, made from a drawing which was itself a translation from the original work. Such a print would give an idea of the composition and grouping and also of the ICONOGRAPHY, but little more. The texture, quality, and surface of the original would not be shown, nor would those traces of the master's hand which we nowadays value so highly—the painter's IMPASTO or the sculptor's characteristics in carving or MODELLING. Engravings of this kind, all bearing a certain likeness to one another as engravings but bearing a rather distant resemblance to their originals, were current in Europe until well into the 19th c. and from them countless artists, scholars, and men of taste must have formed their judgements on works of art, a fact which should be borne in mind by anyone studying the artistic taste and scholarship of those times.

Many other processes of reproductive copperplate engraving were developed during the 17th and 18th centuries. ETCHING, used either in such a way as to resemble line engraving or in conjunction with it, became widespread during the 17th c. MEZZOTINT, an entirely tonal process, provided an alternative to the line engraver's formalized network of lines and was a good method for rendering the rich darkness of 18th-c. portraits. AQUATINT became in the 18th and early 19th centuries the standard process for reproducing water-colour washes, while the CRAYON MANNER, STIPPLE, and SOFT-GROUND ETCHING were used, sometimes with remarkable effectiveness, to imitate the effects of soft drawing media, such as pencil or crayon. As reproduction, however, they all suffered from the same disadvantage. They were all indirect, that is to say they all required the intervention of the specialized reproductive engraver and his draughtsman, and the truthfulness of the reproduction was strongly affected by their personality and style. Such was the situation in the year 1800.

By 1900 all this had changed, owing to a remarkable series of inventions. Although the greatest part of 19th-c. reproduction was done by WOOD ENGRAVING, the developments of real significance were the discovery of LITHOGRAPHY in 1798 and of photography between 1825 and 1840. Lithography, though it was still a manual process at this period, is important in the history of reproduction because it cut out the intermediate stage. The design could be made by the original artist on the stone and a print taken directly from his lines; thus the 'drawing' and 'engraving' were one action. The introduction of photography, particularly Fox Talbot's 'Calotype' method whereby a number of prints could be taken from a single negative, had even more startling consequences. Reproductions could now be prepared with a minimum of human intervention, though some years of experiment

system which can be recognized in the numberless reproductions of antique sculptures and of paintings of mythological and religious subjects that were made all over Europe during the 16th, 17th, and 18th centuries.

The consequences of this widespread reproduction of works of art were twofold. In the first place the transmission of artistic ideas was greatly accelerated, and the Renaissance, MANNERIST, and BAROQUE styles of design and their variations were carried into all parts of Europe and propagated quickly and persuasively in a way that had been unknown in previous centuries. The second consequence derives from the character and methods of production of the engravings themselves. As the demand increased, production inevitably became commercialized and specialized, and large engraving establishments came into being, like those of the print publishers Lafreri in Italy and Cock in the Netherlands or that established by RUBENS for the reproduction of his own works. Under this system there intervened, between the painter or sculptor of the original work and the engraver working in the standardized manner, a draughtsman whose task it was to redraw the original in terms suitable for the engraver to work from. It follows that the

were needed before the photographic processes and those of engraving and printing were finally linked together.

The procedures on photo-engraving and photo-lithography which together make up what is known as 'photographic reproduction' are complex and not easily described in words, though they are based on simple principles. The principles only will be mentioned here. Broadly speaking the processes all derive from one or other of the old hand-engraving methods and can, like them, be classified as relief, intaglio, or surface processes (see PRINTS). 'Line blocks', for example, which were first used commercially in the 1870s, are used for the reproduction of line drawings when these are printed by the relief process. The original drawing is photographed on to a sensitized zinc plate which has been so treated that the lines of the design, when the plate is immersed in acid, are left in relief, while the remainder of the surface of the metal is etched away. It will be noticed that the process is a direct descendant of RELIEF ETCHING, the method employed by William BLAKE for engraving his *Songs of Innocence and Experience*.

The most widespread of the photo-mechanical methods is, however, the 'half-tone' process, introduced during the last years of the 19th c. and used for the reproduction of tonal originals such as wash drawings, paintings, and photographs. The process involves translating the continuous tone of the original into a relief printing surface of small separate raised dots. The first step is to photograph the subject through a glass screen ruled with minute lines intersecting at right angles. This produces a negative in which the subject appears in the form of concentrations of large and small dots corresponding with the light and dark tones. The negative is photographically printed on to a sensitized copper plate which is then etched with acid in the same way as a line block, and the result is a printing surface consisting of raised dots—large dots where the plate is to print dark, and small ones for the light areas. Half-tone reproductions vary in quality with the coarseness or fineness of the screen, a factor which is related to the characteristics of the paper to be used. Thus newspaper photographs are reproduced with a very coarse screen, but fine-screen half-tones need to be printed on specially coated hard and glossy papers.

The other processes may be more briefly mentioned. 'Photogravure' is an intaglio method (see PRINTS) and resembles a mezzotint made by photographic and chemical means. Among its qualities are softness and richness in rendering continuous tone. 'Photolithography' and 'offset photolithography' are, as their names imply, photographic adaptations of the principles of lithography and therefore come into the category of surface prints. For rendering tonal originals they employ a half-tone screen, but among other advantages do not need to be printed on coated papers. For tonal reproductions of the highest class 'collotype' is used. This also is a surface process, the photographic image being transferred to a specially prepared glass plate covered with gelatine which accepts printing ink in proportion to the amounts of moisture retained by different areas of the design. It may be used for printing on hand-made papers and reproduces with great fidelity, without a mechanical screen, the most delicate gradations of tone.

These processes can all be adapted to printing in colour according to the principles used in the traditional techniques of hand engraving (see COLOUR PRINTS). In colour half-tone reproduction, for example, three or four half-tone blocks are prepared, one for each of the colours chosen as 'primary' (now usually magenta, primrose yellow, and a greenish blue) and a fourth for black if an extra degree of strength in the tones is required. The blocks, carefully registered so that they will exactly coincide, are then printed successively on to the same sheet of paper. The negatives required for making each of the colour blocks are obtained by photographing the original through a series of filters, each of which allows only one of the primary colours to pass into the camera at a time.

By now it is possible to reproduce almost anything after a fashion. Success depends not only on the craftsman, whose skill and judgement still count for much, but also on the nature of the original. The ideal subject is small, for to reduce the size of a work of art is to alter something of its character. Woodcuts can be reproduced almost to the point of deception; facsimiles of etchings can satisfy the eye if not the sense of touch. Medieval MINIATURES, with their flat areas of unbroken colour, are excellent subjects for colour reproduction. Oil paintings often reproduce passably well if they were painted ALLA PRIMA, for photography can render even brush-strokes and the minute shadows cast by a heavy impasto; consequently IMPRESSIONIST paintings fare better than most. But pictures which consist of GLAZES—that is, thin layers of translucent paint—present a problem which technology has not yet solved: hence reproductions of Rubens never satisfy. None the less even picture postcards, often unreliable as to tone and colour, give far more information about their originals than did the manual engravings of former times. This very fact is the reason why many people who have to do with original works of art regard reproduction as a necessary evil at best. The more convincing a reproduction is, they say, the more it misleads. Objects made of canvas and paint, of silks or precious metals, cannot be 'reproduced' in any other material. Even if the scale is right, the texture can never be. No technical skill can cause the light which falls on a sheet of inked paper to behave in the same way as that which falls on a canvas coated with oil paint. For such reasons the monochrome photograph, which does not

attempt to counterfeit its original, is more acceptable to CONNOISSEURS than the colour print, which tells much more about its original but in the nature of things cannot tell it truthfully.

So widely published are reproductions that almost anyone can, without leaving home, gain some notion of the arts of other times and places. This has had important consequences for the arts themselves, for artistic scholarship, and for the taste and cultural education of the public.

In the arts it has led to ECLECTICISM. Combined with other causes it has contributed to the lack of coherence of contemporary art as a whole. Young artists, no longer trained as a matter of course in a certain traditional style, are introduced by photographic reproductions to the work of remote cultures. Such acquaintance is invigorating, but it may also be superficial, for though a European may appreciate the formal elements in, say, an Aztec or Polynesian carving and even incorporate some of them into his own production, he can never experience the religious and other impulses which originally brought about the creation of those works.

Scholarship has gained much but it has also lost something. The range and outlook of ART HISTORIANS have certainly been widened and a far greater precision of thought is possible than in the days of manual engravings. The work of comparison, classification, and attribution has been made immeasurably easier. The modern scholar, when he wishes to communicate his arguments in print, is able to support them with visual evidence. On the other hand he is tempted to rely upon illustrated books and photographs instead of examining actual works of art. And because reproductions tend to flatten out great works and lesser works to the same level of achievement, he may be less ready than his predecessors were to appreciate quality. In one sense he may even be less well equipped than they, for he has not been under the same compulsion to train his visual memory.

As for the general public, there is no doubt that many people have been helped by reproductions to form a genuine taste for the arts that might otherwise never have been formed at all: the youth who buys a colour print of van GOGH's *Sunflowers* may grow into the man who collects original works. It is also true that the range of aesthetic experience available to us is far wider than it was for our ancestors. But the experience may be less profound. Multiplication of the great works has cheapened them. We may be immune from supposing that when we have seen a reproduction we have seen the work. None the less, when we say that a reproduction is 'just like' the original, we imply that it offers the same experience; and because it does offer a small part of that experience, it blunts the edge of our appreciation beforehand and cheats us of surprise, so that when we visit the Louvre and see the *Mona Lisa* something of the picture's originality and strangeness is no longer perceptible.

673.

**REPTON,** HUMPHRY (1752–1818). English landscape gardener (see GARDENS AS AN ART FORM). Between the unsuccessful ventures which occupied him as a young man Repton made a serious study of plant life and garden design. In 1788 he set up as a landscape gardener and was soon the acknowledged leader of his profession. His early work for the Duke of Portland at Welbeck Abbey, Notts., made his name, and thereafter he produced over 400 'Red Books'. These were the albums he prepared after surveying an estate in which his proposals were set out in detail with water-colour drawings of the chief views in both their existing and their 'improved' states. 'Capability' BROWN was his acknowledged master and Repton, who had keen practical intelligence, defended Brown's methods in his *Sketches and Hints on Landscape Gardening* (1795) against the criticisms of Richard Payne KNIGHT and Uvedale PRICE, the intellectual champions of the PICTURESQUE. Repton's reconstructions were less sweeping than Brown's and latterly he swung back to regular bedding and straight paths close to the house; but his parks were carefully informal, as Brown's were.

Repton thought of himself as an ECLECTIC inheriting the best of the modern style in landscape gardening from Brown and combining this with the best of the older style to form a modern renaissance. In his *Observations on the Theory and Practice of Landscape Gardening* (1803) he wrote: 'I do not profess to follow either LE NOTRE or Brown, but, selecting beauties from the style of each, to adopt so much of the grandeur of the former as may accord with a palace, and so much of the grace of the latter as may call forth the charms of natural landscape.' Repton also developed an architectural side to his practice; he embattled and rendered with cement many comely red-brick houses and designed some new ones. About 1795 he joined forces with John NASH, a fruitful partnership for both men which, however, ended in misunderstanding in 1803.

In architecture Repton used 'picturesque' as a term of praise rather than opprobrium and he favoured irregularity of plan and elevation and intricacy of ornamentation. He advocated GOTHIC in preference to 'Grecian', but Elizabethan Gothic rather than 'castle or abbey' Gothic. His *Theory and Practice* included in the title the words *Including Some Remarks on Grecian and Gothic Architecture*. In 1808 he dedicated to the Prince of Wales *Designs for the Pavilion at Brighton*, in which work was included *An Inquiry into the Changes in Architecture, as It Relates to Palaces and Houses in England; including the Castle and Abbey Gothic, the Mixed Style of Gothic, the Grecian and Modern Styles: with Some Remarks on the Introduction of Indian Architecture*. His *Fragments on the Theory and*

*Practice of Landscape Gardening* (1816) included *Some Remarks on Grecian and Gothic Architecture*.

The park at Cobham, Kent, is a fine early example of a Repton landscape, but his most complete creation is Sheringham Hall, Norfolk, and its surroundings (1812). Repton's activity was lessened by a carriage accident in 1811 but he continued to design and write, his last book appearing in 1816. His sons, JOHN ADEY REPTON, F.S.A., and GEORGE STANLEY REPTON, collaborated in the *Designs for Brighton Pavilion* and the *Fragments*.

**REREDOS.** See ALTARPIECE.

**RESIN.** Secretion from trees and plants used as a constituent of VARNISH. The resins used by painters in the past are not always easy to identify but they include both soft resins from living trees, such as MASTIC, DAMMAR, SANDARAC, Canada balsam, Venice TURPENTINE, and hard fossil resins, such as COPAL and AMBER. Synthetic vinyl resins are used mainly for industrial purposes but have sometimes been used by modern painters.

**RESTORATION OF PAINTINGS.** See CONSERVATION AND RESTORATION OF PAINTINGS.

**RESURRECTION** (Matt. xxviii; Mark xvi; Luke xxiv; John xx). According to the Gospels the Resurrection of Christ passed unseen, even by the watching soldiers, who only became aware of it on Easter morning when the angel announced it to the women come to anoint the body. Thus

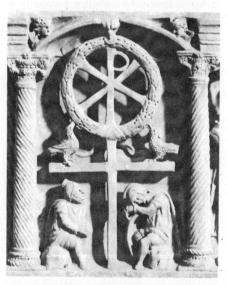

**308.** The Sacred Monogram enclosed in a wreath, symbolizing the Resurrection. Sarcophagus from the Catacomb of Domitilla. (Lateran Mus., Rome, 4th c.)

the earliest pictures are confined to the events of Easter morning, as in the 3rd-c. FRESCOES from the baptistery at Dura Europos, Syria (Damascus Mus.), which show only the women approaching the sepulchre. In later scenes the stupefied soldiers are depicted also (IVORY relief, B.M., early 5th c.), and usually the angel sits at the door of the tomb (ivory, Trivulzio Coll., Castell' Sforzesco, Milan, early 5th c.). The same rendering of the Resurrection persists in ivories and book illustrations of the CAROLINGIAN and OTTONIAN periods. On SARCOPHAGI of the 4th c. (Lateran Mus., Rome) the Resurrection is represented in symbolical form; the SACRED MONOGRAM enclosed in a triumphal wreath stands on a cross, and the only figures present are the two watching soldiers below. Only once in the EARLY CHRISTIAN period, on an ivory of the early 5th c. in Munich, does Christ appear in connection with the events on Easter morning, and even here He is not really part of the scene but is drawn up into heaven by the hand of God above, while the women, as on the Trivulzio ivory, approach the angel at the door of the empty tomb.

The first attempt at showing Christ rising from the tomb occurs in a small compartment on the page of an Ottonian Gospel book (Staatsbib., Munich, c. 1000), where He stands in an open sarcophagus with the cross staff in one hand. But the idea of showing Christ's bodily resuscitation did not gain general acceptance until the 12th c. It appears in the *Ratmann Missal* of the mid 12th c. (Cathedral Treasury, Hildesheim), where Christ steps firmly over the front of the sarcophagus, leaning on a cross staff with flag attached; this banner cross, sign of His triumph over death, became characteristic of Resurrection scenes from this time onwards. NICOLAS OF VERDUN in the late 12th c. devised a more idealized version of the subject as part of his altar-frontal at Klosterneuburg, near Vienna, in which Christ rises swiftly up with a majestic movement, His gaze fixed on the sky.

In Italy, where the Resurrection was first portrayed in the 14th c., the moment of Christ's awakening was rarely shown. Usually He stands suspended in the sky above the tomb and its sleeping guards, as in GIOTTO's medallion in the Accademia, Florence, and in the 14th-c. paintings of the Spanish Chapel, Florence. In some versions (PIERO DELLA FRANCESCA's fresco at San Sepolcro) He stands triumphantly with one foot on the edge of the tomb; in others (GHIBERTI's relief on the north door of the Baptistery, Florence) He stands on top of the sarcophagus. In the north a more realistic style was usually preferred, as in a picture by MASTER FRANCKE (Kunsthalle, Hamburg, 1424) which shows an awkward figure climbing over the back. But from the 16th c. Giotto's idealized conception became general, combined often with REALISM of detail as in GRÜNEWALD's ALTARPIECE at Isenheim and BRUEGHEL's engraving in the British Museum. Even more dramatic is

the rendering by TINTORETTO, in the Scuola di San Rocco, Venice, where Christ, freed from the stone by the angel, flies up in a blaze of light to heaven. REMBRANDT, however, treated the theme in a strictly realistic manner, depicting Christ still in His funeral bands and rising painfully up inside the sarcophagus (Pinakothek, Munich, 1639).

In all these versions of the Resurrection the watching soldiers are shown, usually from two to six in number, either stupefied 'as dead' (Matt. xxviii. 4) or staring in fear. The women tend to disappear once Christ Himself is introduced, but they are still included in some of the Italian versions (Spanish Chapel, Florence, and Fra ANGELICO's fresco in S. Marco, Florence). Their visit to the sepulchre survived as a separate scene up to the time of RUBENS (Czernin Gal., Vienna) and after. It was especially common in the Eastern Church, where the resuscitation of Christ was not portrayed.

**RETABLE.** 'A shelf or ledge (on which ornaments may be placed), or a frame enclosing decorated panels, above the back of an altar' (*S.O.E.D.*). The word may also be used for a painted or carved ALTARPIECE, consisting of one or more fixed panels, not hinged like a TRIPTYCH.

**RETHEL,** ALFRED (1816–59). German painter. He was trained at the Düsseldorf Academy and under a minor NAZARENE painter in Frankfurt. His principal work, a cycle of frescoes from the life of Charlemagne (Town Hall, Aachen, 1847–52), was once much admired as a great achievement of heroic history painting; today these frescoes seem hollow and theatrical. The 1848 Revolution inspired Rethel to do a series of highly original and moving WOODCUTS in the tradition of the late medieval DANCE OF DEATH (*Auch ein Totentanz*, 1849).

**RETOUCHING VARNISH.** See VARNISH.

**RETROUSSAGE.** A term used in engraving for the technique of placing a fine muslin cloth over a warm engraved plate that has already been inked, and then removing it, thereby drawing out a little of the INK and spreading it over the edges of the lines. It produces a soft effect in printing.

**RETZSCH,** FRIEDRICH AUGUST MORITZ (1779–1857). German engraver. Working in a mixture of Classicist and ROMANTIC styles, he translated old and modern literary themes into visual narratives of bourgeois sentimentality. He became widely known in Germany and England through his many engraved cycles, notable GOETHE's *Faust* and the *Gallery of Shakespeare*.

**REVETT,** NICHOLAS (1720–1804). English architect, whose career was closely linked with that of James STUART. He studied painting in Rome, where he met Stuart and Gavin HAMIL-

TON. In 1748 they decided to go to Athens, but only Stuart and Revett actually went, first to Venice (1750) and then via Pola to Greece (1751–3). In Athens Revett made the measured drawings for their *Antiquities*, the first volume of which appeared in 1762, after Stuart had bought out Revett. Revett was in Asia Minor 1764–6 and made the drawings for the Society of DILETTANTI's *Antiquities of Ionia* (2 vols., 1769–97). His few buildings include the PORTICO at Trafalgar House and Ayot St. Lawrence Church (1788), both copied from the Temple of Apollo at Delos.

**REYMERSWAELE, VAN.** See MARINUS.

**REYNOLDS,** SIR JOSHUA (1723–92). English painter, first President of the ROYAL ACADEMY, the most important artist of his day, and perhaps the most important figure in the history of English painting. He established a tradition of portraiture in the GRAND MANNER, expressed most fully the whole range of the English 18th-c. aesthetic outlook, and did more than any other man to raise the status of the artist to a new level of dignity in England.

Reynolds was born at Plympton in Devonshire, where his father, a former Fellow of Balliol College, Oxford, was headmaster of the Grammar School, and he was brought up in an atmosphere of learning. He studied painting in London under HUDSON 1740–3, but set up independently in Devon as a local portraitist before his apprenticeship was up. In 1749 he obtained a passage to the Mediterranean and spent the years 1750–2 in Italy in intensive study of RAPHAEL, CORREGGIO, TITIAN, and MICHELANGELO, with a few important weeks in Venice on his way home. In 1753 he settled in London, determined to make a show and emulate the success of KNELLER (who died in the year of his birth). He has been called an *arriviste*, a humbug, and a snob. R. H. Wilenski goes so far as to say that 'no English artist of his eminence is so unattractive as a personality'. But whatever element of truth is in this judgement, it is certainly but one side of the picture. He moved in the circle of Dr. Johnson, Goldsmith, Garrick, and by his profound conviction of the dignity of the artist's calling and his deliberate cult of learning and classical allusion he did much to increase the prestige of art in England. By the sixties he had out-distanced his only serious rivals, RAMSAY and COTES, and on the foundation of the Royal Academy in 1768 he was the obvious choice for President, being knighted the following year. For the next 20 years, until his blindness in 1789, his authority in the Academy was paramount and his *Discourses* delivered over that period have become the classical expression of the academic doctrine of the Grand Manner, the doctrine of the rational IDEAL as against the incipient ROMANTICISM inherent in the new emphasis on feeling, sentiment, emotion as the basis of aesthetic judgement.

In the *Discourses* there are present many

critical tenets which had elsewhere been argued only separately and taken together they comprise, in the words of Walter Jackson Bate, 'perhaps the most representative single embodiment in English of 18th-century aesthetic principles'. In true NEO-CLASSICAL tradition Reynolds regarded taste not as a matter of sensibility and feeling but as the 'power of distinguishing right and wrong' in the arts and taught that the most important requisite in forming a 'just taste' is to have recourse to 'reason and philosophy'. He held that the primary principle and 'standard' of taste is the imitation of nature, but by this he meant generalized or universal nature, the *ethos* or ideal type, not the particular: 'to paint particulars is not to paint nature, it is only to paint circumstances'. It was one basis of his famous theory of the Grand Manner—a view which was the counterpart in art theory of Dr. Johnson's theory of poetry—that 'the whole beauty and grandeur of art consists in being able to get above all singular forms, local customs, particularities, and details of every kind'. The other basis was derived from his classical doctrine that the end and object of art is ethical improvement. Hence the great artist must aspire always to the noble and sublime subject matter and eschew what is mean and ignoble. For both these reasons he deprecated the DUTCH SCHOOL, whose REALISM was based on truth to details and who admitted the mean and commonplace, preferring the 'ideal' attitude of the great Italian masters of the RENAISSANCE. In typical Neo-Classical manner Reynolds laid great emphasis on obedience to the 'Rules of Art, as established by the practice of the great masters'—a doctrine which was violently attacked by BLAKE. While not denying the freedom of individual genius, his main burden was always on the use of the great as models and he held that the practice of art had steadily deteriorated since Michelangelo. More than any other he advocated the 18th-c. ideal of sublimity.

Reynolds's own work had a genuine creative versatility which to some extent belied his theories. He established a new school of English portraiture which combined the dignity of the Grand Manner with a genuine sensitiveness to the personality of his subjects, sometimes achieving the simplicity and directness of a masterpiece and at others a bravura swagger which belongs to the BAROQUE. In 1781 he visited Holland and Flanders and from then until 1789 his work displayed an additional warmth of feeling which may be attributed to the effect of RUBENS. Owing to defective technical procedures many of his pictures cracked and faded even in his lifetime and many are now in so deplorable a state of preservation that it is difficult to judge the original effect of the colours.

Reynolds was buried with imposing ceremonies in St. Paul's Cathedral. His effect upon the history of English painting has been even far beyond the intrinsic quality of his output.

1134, 1317, 1852, 1955, 2230, 2801.

**RHOECUS.** Greek artist of Samos, joint architect with THEODORUS of an enormous TEMPLE to Hera at Samos (*c.* 560 B.C.). An uncertain tradition connects him with the origin of brass founding.

**RIAÑO,** DIEGO (d. 1534). Spanish architect who was the leading exponent of the RENAISSANCE-PLATERESQUE style in southern Spain. He was cathedral architect at Seville from 1523 and designed the elaborately decorated Seville Town Hall (built 1534-72).

**RIBALTA,** FRANCISCO (1565-1628). Spanish painter. He was probably trained at the ESCORIAL and his earlier paintings, MANNERIST in character, show the influence of Juan Fernández de NAVARRETE. By 1599 he was settled in Valencia and there gradually changed his style. His mature work was typical of the Spanish BAROQUE, e.g. *The Vision of Father Simeon* (N.G., London, 1612) and two paintings executed for the Capuchins *c.* 1620, the *Vision of St. Francis* (Prado) and *St. Francis embracing Christ* (Valencia Mus.). His son JUAN (*c.* 1597-1628) was also an able painter in the CARAVAGGIO manner.

692, 835.

**RIBERA,** JOSÉ (JUSEPE) DE (1591-1652). Spanish painter, born at Jativa, near Valencia. He was stated by Aciscolo PALOMINO (*Museo Pictórico*, 1724) to have been a pupil of RIBALTA, but this is regarded as doubtful and Ribalta's influence is not apparent in his work. He visited Italy and worked in Parma shortly after 1610, was in Rome *c.* 1613/14 when CARAVAGGIO was the rage, and in 1616 settled in Naples, still at that time a Spanish possession, where he at once became fashionable and remained for the rest of his life. Owing to his small stature he gained the sobriquet Il Spagnoletto.

Ribera's earliest known works are ETCHINGS (1621-4) of saints, GROTESQUES, etc., which became very popular and were often copied (GOYA's *Duchess of Alba reflecting on Death*). The earliest surviving dated painting is the *Drunken Silenus* (Naples, 1626). Ribera's early paintings were TENEBRIST, with dramatic CHIAROSCURO though the drawing of faces and figures was sharply etched, but the influence of Caravaggio has been exaggerated. In painterly technique he followed rather the loose and expressive brush-stroke of TITIAN. His *penchant* for martyrdoms and the realistic depiction of torture has also been overplayed since he obtained a reputation reflected in Byron's line: 'Il Spagnoletto tainted his brush with all the blood of all the Sainted' (*Don Juan*, xiii. 71). He painted martyrdoms, e.g. *Martyrdom of St. Bartholomew* (Prado, 1624) and *Martyrdom of St. Andrew* (Budapest, 1628), but not more frequently than the taste of the day warranted and certainly not more than other artists of the period (POUSSIN's *Martyrdom of St. Erasmus*, 1627). Ribera was

particularly notable for his power of individuation, his feeling for individual humanity, and his expression of character in contrast with the idealization of type which was the MANNERIST heritage from the RENAISSANCE. In the pictures of penitent saints and some of the ecstasies (*St. Paul the Hermit*, *St. Mary of Egypt*, Prado; *St. Agnes*, Dresden), in the *St. Peter* (Prado, *c.* 1631–2), the *St. Jerome* (Prado, 1644), the *St. Joseph and the Budding Rod* (Met. Mus., New York, *c.* 1635) he combines microscopic attention to detail with monumentality of form and expressive brush-work to emphasize the humanity and inner character of his subjects. He laid the foundation of that respect for the dignity of the individual which was so important a feature of SPANISH ART from VELAZQUEZ to Goya. This feature of his work is evident also in the secular subjects, such as *The Laughing Girl with Tambourine* (private coll., London, 1637) and *Laughing Drinker with Bottle* (Prince Carlos de Borbón Coll., Madrid, 1638). He was the first to breach the traditional Spanish dislike for MYTHOLOGICAL themes and his *Death of Adonis* (Museo Nazionale, Rome, 1637) and his *Apollo and Marsyas* (Brussels, 1637) are not only the finest but almost the only Spanish mythological paintings of the 17th c. He also broadened the BAROQUE repertory by his series of philosophers depicted as beggars or vagabonds (*Archimedes*, Prado, 1630), done to flout the humanistic pedantry of the Academies and heralding the anti-classical pictures of Velazquez.

In his mature work, from about the middle 1630s, Ribera's tenebrist palette lightened. With less chiaroscuro, softer and broader modelling, and more luminous shadows he conveyed the effect of an impalpable enveloping atmosphere and the penetration of a third dimension which in his most masterly paintings became as it were a spiritualized apotheosis of light and air. This may be seen in such paintings as *St. Anthony with the Child Christ* (Academy, Madrid, *c.* 1636), *Trinity* (Prado, 1636–7), *St. Jerome* (Prado, 1644), and *The Mystic Marriage of St. Catherine* (Met. Mus., New York, 1648). In *The Communion of the Apostles* (S. Martino, Naples), done in the year of his death, he painted a picture of atmosphere and light whose real theme is the personal, inner life of the characters.

Ribera's complete mastery of conception enabled him to introduce a rapid and sensitive brush-stroke and the ALLA PRIMA technique (wet into wet) with a DIVISIONIST and almost IMPRESSIONIST manipulation. It was carried on by Velazquez, from whom it was inherited by MANET and the 'virtuoso brush-stroke' school of which the most facile exponent was SARGENT. Ribera enjoyed the widest European reputation of any Spanish painter in the 17th and 18th centuries. While his REALISM had its influence on south Italian schools, he stands at the beginning of a long development in Spanish painting which he enriched by his painterly techniques, his scrupulous draughtsmanship, his power of

characterization, and the spiritual quality of his work.

2683.

**RIBERA,** PEDRO DE (*c.* 1683–1742). Spanish architect and sculptor, town architect of Madrid from 1726 onwards. Surviving works are the Toledo bridge (designed 1719), the church of Montserrat (1720), and the Hospicio Provincial (begun 1722). The main doorway of the Hospicio Provincial is characteristic of the CHURRIGUERESQUE style. A striking example of Ribera's versatility is the magnificent tower of the new cathedral at Salamanca, which he designed in Neo-GOTHIC style.

**RICCI,** J. A., and F. See RIZI.

**RICCI,** SEBASTIANO (1659–1734). Italian decorative painter, one of the principal figures in the revival of VENETIAN decorative painting which culminated in TIEPOLO. He was born at Belluno, and was trained first in Venice, where he was influenced by VERONESE, and then in Bologna; and he supplemented his training by studying the BAROQUE decorations of Pietro da CORTONA in Rome. His travels then included a two-year stay in Vienna (1701–3). He went with his nephew Marco to England *c.* 1712, where he subsequently went in for the competition for the decoration of St. Paul's dome, which was given to THORNHILL. Little of Sebastiano's decorative work in England survives except the *Resurrection* in the apse of the Chelsea Hospital Chapel and some large but damaged canvases on the staircase at Burlington House. On his way back to Venice he stayed in Paris and was made a member of the French Académie in 1716. For the last 17 years of his life he worked principally in Venice. There Joseph Smith (see also CANALETTO) commissioned from him, *c.* 1725, a series of religious paintings in which Marco collaborated. Nearly 30 of these are now in the English Royal Collection, having been bought from Smith in 1762. One very large canvas (nearly 9 ft. by 20 ft.) of *The Magdalen Anointing Christ's Feet* hangs at Hampton Court and shows the extent of Sebastiano's debt to Veronese and to FRENCH ART.

Sebastiano Ricci was not in the first rank of great creative artists, but his extensive pictorial culture drawn from Venice, Bologna, Rome, and France, his gift for vivid fresh colouring, and his skill as a decorator make it clear that the story of 18th-c. Venetian painting begins with him. It was under Sebastiano's influence that Tiepolo moved towards his latest and most mature style.

MARCO RICCI (1676–1729), nephew of the foregoing, was also born in Belluno and travelled extensively. In 1708 he was taken to England with PELLEGRINI by the Earl of Manchester, and among other work was employed in painting scenery for the opera. Thus the visit to England with his uncle was his second. He

returned to Venice finally in 1716, where he later collaborated with Sebastiano in the religious pictures painted for Smith. For the same patron he painted over 40 landscapes, which are now also in the Royal Collection. Marco Ricci inaugurated the 18th-c. school of LANDSCAPE PAINTING in Venice, he himself owing something to the Neapolitan School and MAGNASCO.

**RICCIO,** ANDREA BRIOSCO, called IL RICCIO (1470-1532). Italian sculptor, who was born in Trento but lived and worked in and around Padua, where he was trained by one of DONATELLO's assistants. His fame rests on his BRONZES, though he also used TERRACOTTA. His masterpiece is the great bronze Easter candle-stick in the Santo at Padua (1507-16), which with its relief scenes of classically draped figures, its SATYRS, SPHINXES, and decorative conceits, is one of the most sumptuous and elaborate examples of decorative bronze casting. He also did RELIEFS in the same church, and there are reliefs by him in the Louvre. Riccio treated Christian themes in the style of classical mythology. Even the least inspired bronzes by Riccio's hand (as against the many versions turned out by his workshop and his rivals) are of exceptional technical brilliance, and the working of their surfaces is of outstanding beauty.

2099.

**RICHARDSON,** HENRY HOBSON (1838-86). United States architect who is considered the father of MODERN ARCHITECTURE in that country. He studied in Paris at the École des Beaux-Arts and under Henri Labrouste (1801-75), returning to the States in 1865. He was in many ways the American equivalent of William MORRIS or Philip WEBB and did much to free American building from the trivialities of anti-quarian fashion. He employed period styles, especially a robust ROMANESQUE, but not in a directly imitative way. He used massively model-led stone walling and semicircular ARCADING to produce vigorous geometrical compositions, pre-paring the ground for the pioneer work of Louis SULLIVAN and leaving some impression on the later CHICAGO SCHOOL. Richardson's master-piece was the Marshall Field store in Chicago (1885-7), since demolished.

1336.

**RICHARDSON,** JONATHAN (1665-1745). English portrait painter, a pupil of John RILEY. He adapted his style to the prevailing taste for KNELLER. With Kneller he founded the St. Martin's Lane Academy, which preceded the R.A. Schools, and after Kneller's death he was one of his most competent successors. The portrait of George Vertue (N.P.G., London) is a good example of his work. Richardson is re-membered today for his writings rather than his paintings. His essay in AESTHETIC criticism, *The Theory of Painting* (1715), had a great influence

on the young REYNOLDS. His other writings include *An Essay on the Whole Art of Criticism as it relates to Painting* (1719), and *An Account of Some of the Statues, Bas-Reliefs, Drawings, and Pictures in Italy* (1722), the latter being extensively used as a guide-book by young Englishmen making the GRAND TOUR. He formed a celebrated collection of Old Master drawings. His son, also JONATHAN (1694-1771), also a painter, collaborated in the tourist's guide and also wrote on CONNOISSEURSHIP, being one of the first to maintain that connoisseurship and taste should be regarded as an essential part of the education of an English gentleman.

**RICHIER,** LIGIER (c. 1500-67). French sculptor of Lorraine, the most famous of a family of sculptors. His carved group for the EASTER SEPULCHRE in the church of S. Étienne at S. Mihiel (1553) combines GOTHIC NATURALISM with Italianate treatment of draperies. A recum-bent effigy of Philippe de Gueldres, Duchess of Lorraine (now in the church of the Cordeliers, Nancy), is also attributed to him. In this and in the skeleton on the tomb of René de Châlons (now in the church of S. Pierre at Bar-le-Duc) a grim naturalism bordering on the macabre predominates over Italianate elements. Richier became a convert to Protestantism and died a religious refugee in Geneva.

**RICHMOND,** GEORGE (1809-96). English painter and a member of BLAKE's circle, into which he was introduced by FUSELI. He copied Blake's mannerisms but had nothing of Blake's spirit. He later became a fashionable portrait painter with the monotonous charm which attends a facile success. He was responsible for repainting the faces of the 36 figures which sur-vived on the late GOTHIC Southwold ROOD-SCREEN.

**RICHMOND,** JAMES CROWE (1822-98). Painter, born in London. He had little training in art, but was educated at University College, London, and practised as a civil engineer before migrating to New Zealand in 1850. Despite his deep involvement in the political and admini-strative life of the colony, he painted indus-triously and spent a long period of retirement mainly in his studio. His WATER-COLOUR LAND-SCAPES (National Art Gal., Wellington) are less ambitious than those of his friend John GULLY, but more vigorous and more varied.

DOROTHY KATE (1861-1935), painter, born in Auckland, New Zealand, was a daughter of the foregoing. Taken on a continental GRAND TOUR by her father, she studied at the Slade School of Art, London, and after further Euro-pean travels established herself in Wellington as teacher and painter. Her numerous landscapes and STILL-LIFE paintings (National Art Gal., Wellington) are products of a sensitive, cultivated talent, but, in the words of her friend Frances HODGKINS, are lacking in 'fire and originality'.

**RICHTER,** ADRIAN LUDWIG (1803–84). German painter. After studying at the Dresden Academy he lived between 1823 and 1826 in Rome, where he was in close touch with the NAZARENES. After a short period as drawing-master at the Meissen porcelain manufactory he became professor of painting in Dresden. His many paintings and WOODCUT illustrations—often for children's books—may be called 'romantic' in the popular sense of the word. The pleasures of the countryside, moods of landscape, fairy-tales, and the more idyllic incidents of sacred and legendary art were his favourite subjects. His autobiography, *Lebenserinnerungen eines deutschen Malers* (1885), is not only a charming piece of writing but also an important source for the ideas of German ROMANTICISM.

2252.

**RICKETTS,** CHARLES (1866–1931). English painter, designer, sculptor, and writer on art. While a youth he met SHANNON, who became his lifelong friend. Trained as an illustrator, he founded in 1896 the VALE PRESS, for which he designed founts, initials, borders, and illustrations in the tradition of William MORRIS. But after 1904 he turned instead to painting, modelling, and theatrical design. He was a notable CONNOISSEUR and collector.

**RICKMAN,** THOMAS (1776–1841). English architect. Throughout his early years as a doctor and in an insurance office Rickman developed a taste for drawing and a passionate interest in medieval archaeology; this led to the publication in 1817 of his *Attempt to Discriminate the Styles of English Architecture from the Conquest to the Reformation.* His new terminology for English medieval buildings (NORMAN, EARLY ENGLISH, DECORATED, and PERPENDICULAR) found general acceptance and, although still much criticized, is too widely understood to be abandoned now (see GOTHIC). The book had an enormous sale and brought him a very large architectural practice. He built six churches in Birmingham, four in Liverpool, and some 40 more mainly in the midlands and north of England. The majority were in a thin Perpendicular style with extensive use of cast iron for support. He also built a number of houses and public buildings. His best known work is the New Court of St. John's College, Cambridge (1827–31), which he carried out with his partner, Henry Hutchinson. (See also GOTHIC REVIVAL.)

2258.

**RICO,** MARTIN (1835–1908). Spanish landscape painter. He studied first under Federico MADRAZO at the Madrid Academy, but settled in France in 1862, where he was influenced by the landscape painting of DAUBIGNY and the BARBIZON SCHOOL. After 1870 his style changed under the influence of ROSALES and FORTUNY.

**RIDOLFI,** CARLO (1594–1658). Italian painter, ETCHER, and ART HISTORIAN. He wrote a *Life of Tintoretto* in 1642. His *Marvels of the Painter's Art* (1648) provides, with the work of Boschini, the most valuable source of information about 17th-c. VENETIAN art. Ridolfi's own painting was negligible.

2261.

**RIETVELD,** GERRIT THOMAS (1888–1965). Dutch designer and architect who was a member of the De STIJL group. An armchair which he made in 1917 was the first piece of furniture constructed according to the group's principles of design, and the Schröder house in Utrecht (1924) was the first realization of their architectural ideas.

**RIGAUD Y ROS,** HYACINTHE (1649–1743). French painter, the friend and rival of LARGIL-LIÈRE. He was the outstanding court painter at the end of the reign of Louis XIV and retained his popularity through the Regency and under Louis XV. He originated the tradition of the court portrait in painting, as COYSEVOX did in sculpture, where the aim is less to depict individual character than the rank and condition of the sitter by nobility of attitude and expressiveness of gesture in an age when deportment and attitude were in fact symbols of rank to a far greater extent than they now are. His famous portrait of Louis XIV, painted in 1701, created the image of royal majesty with all its attributes. Louis XIV so admired this portrait that, although he had intended it as a present to Philip V of Spain, he kept it himself. Although he creates social types, Rigaud often achieves a quality of truth in his portraits (*Cardinal de Bouillon,* Musée Rigaud, Perpignan; *Bolingbroke,* N.P.G., London; *Financier Montmartel,* Cherbourg). In his unofficial portraits he was influenced by REMBRANDT (*Marie Serre,* Louvre), and he has been called the 'van DYCK' of French painting.

**RIJKSMUSEUM,** Amsterdam. The Dutch national collection had its origin in the Royal Museum erected by Louis Napoleon as King, of Holland in 1808. The prime mover was Johan Meerman, appointed Director-General of Arts and Sciences in 1807. To this was transferred the collection of the National Art Gallery, established in The Hague in 1800 as the first public gallery in the Netherlands. The city of Amsterdam also transferred to it seven large canvases, including REMBRANDT's *The Night Watch* and *The Governors of the Cloth Guild.* The idea of the Royal Museum was both to assemble Netherlands paintings of national importance and also to stimulate contemporary art. In 1815 the collection was transferred to the Trippenhuis, where it was opened in 1817 as the Rijksmuseum. Owing to the inadequacy of the accommodation provided by the Trippenhuis for the growing collection a Commission to

Prepare the Establishment of an Art Museum was set up in 1862, but it was not until 1885 that the new Rijksmuseum was inaugurated. From this time acquisitions reflected the dual aims of the foundation though to the younger generation the aesthetic value of a picture tended to be more important than its historic interest. A new appreciation of the Dutch PRIMITIVES gradually arose. In 1922 Schmidt Degener, formerly of the Boymans Museum at Rotterdam, became Director of the Rijksmuseum, modernized the display, and began the acquisition of foreign works of art. After the Second World War the Foundation for Netherlands Art-Possessions succeeded in recovering a considerable quantity of looted art works, particularly from private collections, and many of the national museums, including the Rijksmuseum, were enriched by long-term loans of this material. The collection continued to benefit from purchases and although its most outstanding possessions are the VERMEERS, the Rembrandts, and the primitives, it has many more treasures which rank it among the other important national collections.

**RILEY,** JOHN (1646–91). English portrait painter, who founded a small school of native English portraiture in the interval between the death of LELY and the domination of KNELLER. He is stated to have been a pupil in his youth of SOEST and FULLER and he taught Jonathan RICHARDSON. His extant work all belongs to the period after 1681. His forte was the painting of heads, in which he displayed a sensitive observation of character, a reticent and unassuming sincerity of presentation, and a certain vein of melancholy. His best works have a well-bred delicacy and directness which is typical of the English way of portraiture. His larger canvases betray weakness of composition and inequality between the face and the rest of the picture. In them he often collaborated with Johann Baptist Closterman (1656–1713), who came to England c. 1681. Riley was appointed Principal Painter, together with Kneller, to the court of William and Mary.

**RIMMER,** WILLIAM (1816–79). American sculptor. He was born in Liverpool, but his family emigrated in the same year and finally settled in Boston. When Rimmer was 15 he displayed a facility for carving in GYPSUM; the only extant example of his work in this material is a figure entitled *Despair*. Between 1830 and 1848 he taught himself ANATOMY, medicine, painting, and sculpture. At a time when the vogue for CLASSICISM prevailed, Rimmer was producing strong figures showing exaggerated anatomy, the most famous of which is the *Falling Gladiator* (Boston Mus. of Fine Arts, 1861). His symbolical drawings have been compared to BLAKE. He is best remembered, however, as a teacher. He wrote two books, *Elements of Design* (1864) and *Art Anatomy* (1877), and for four years was director of a school of design in New York.

**RINEHART,** WILLIAM HENRY (1835–74). American sculptor. While still on his father's farm in Maryland he became an assistant carver in a local quarry. He moved to Baltimore in 1844 and for 11 years worked in a marble yard and attended art classes at night. At last, in 1855, he was able to go to Rome where he remained for the rest of his brief career except for visits to London, Paris, and his native country. Like other American NEO-CLASSICAL sculptors in Rome he received commissions for a standardized type of nude which was largely derived from prototypes by Italian contemporary stone-carvers (*Clytie*, Baltimore, 1872). But there is also a NATURALISTIC quality in his work which anticipates the style of the period following the Civil War. This is apparent in some of his portraits, such as that of Chief Justice Taney (1869), in the doors for the Senate and the House of Representatives in Washington (1861), and in the *Indian and Pioneer* group (1857) for the clock in the House of Representatives.

Rinehart left his collection of casts and models to trustees, who later transferred them to the Peabody Institute in Baltimore. He also left his estate to promote the appreciation of sculpture among Americans and to assist young men in the study of art.

2347.

**RIPLEY,** THOMAS (1683–1758). English architect. Ripley was a Yorkshireman who went to London and in 1705 became a freeman of the Carpenters' Company. Through the influence of Sir Robert Walpole he obtained a number of official posts of rapidly increasing importance and in 1726 was made Comptroller of Works in succession to VANBRUGH. His old Admiralty building (1723–6) was a poor and badly proportioned example of architectural incompetence in imitation of WREN's style, but in completing Colen CAMPBELL's design for Walpole's mansion at Houghton, Norfolk (1722–30), he learnt PALLADIANISM. Wolterton, Norfolk (1724–30), which he built for Sir Robert's brother Horatio, was a well planned and finely constructed house in the fashionable style of the time.

**RITSEMA,** COBA (JACOBA) (1876–1962). One of the seven Dutch women who painted in the IMPRESSIONIST tradition and were called the *Amsterdamsche Joffers* (The Spinsters of Amsterdam). Her pictures of flowers, interiors, and portraits show the influence of BREITNER.

**RIVERA,** DIEGO (1886–1957). Mexican painter, the most flamboyant and for some time the most highly reputed figure in modern MEXICAN revolutionary art. Born in Guanajuato, he spent the years 1907–21 mainly in Europe and became familiar with the advanced techniques of modern European art. During the Obregón regime he was one of the leaders in the movement for a popular mural art and survived the over-

throw of that regime, continuing to make murals for the Ministry of Education (1923-9), the Agricultural School, Chapingo (1923-7), the National Palace (1929-35), the Ministry of Health (1929), the Palace of Cortez at Cuernavaca (1929-30), and the National Palace of Fine Arts, Mexico City (1934). During the 1930s he fell out of favour with the left wing owing to his espousal of the Trotsky cause and did murals in the U.S.A. (California School of Fine Arts, San Francisco, 1931; Detroit Institute of Arts, 1932; Independent Labour Institute, New York, 1934). In 1936 he did portable panels in the Hotel Reforma but this was his last important commission in Mexico until 1943, when he made decorations for the Institute of Cardiology. This was followed by a series of important works, including murals in the National Palace and Hotel del Prado. In 1952 he completed a mural 50 square metres in area painted in polyesterine on canvas which was entitled *The Nightmare of War and the Dream of Peace*. It was intended for inclusion in a large exhibition arranged by the Mexican Government for the Paris Museum of Modern Art and the Stockholm Museum but it was withheld because of its tendentious character. In 1954 Rivera was readmitted into the Mexican Communist party and in 1955 he revisited the Soviet Union.

Rivera was a complex and sophisticated artist who deliberately abandoned the advanced contemporary techniques which he had learnt in Europe in order to create an 'art for the people' suited to the political situation in post-revolutionary Mexico. The decorative and expository character of his narrative murals, his large simple forms and bold areas of colour which contributed to his widespread popularity, lack the intensely EXPRESSIONIST character of OROZCO and the dynamic force and sculpturally overwhelming vigour of SIQUEIROS. His work is more consciously didactic, less forcefully creative, than that of the other two outstanding muralist painters of Mexico.

2269, 2270, 2443, 2926.

**RIZI** or **RICCI**. The name of two Spanish painters, sons of ANTONIO RICCI, a Bolognese artist who had settled in Spain. The elder, JUAN ANDRÉS (1600-81), a Benedictine monk, worked mainly for monasteries of his order in Castile, showing at times a certain affinity of spirit with ZURBARÁN. He was an outstanding portrait painter and author of an interesting manuscript treatise, *Tratado de la Pintura Sabia* (published 1930).

His brother FRANCISCO (1608-85) was appointed Painter to the King in 1656. Renowned for his mastery of PERSPECTIVE, he was chief designer for the royal theatre at the Buen Retiro Palace, Madrid.

**ROBBIA**, DELLA. A family of Italian sculptors of the FLORENTINE SCHOOL. LUCA (1400-82) was the senior and had the reputation in his time of being a leader of the modern movement comparable to GHIBERTI and DONATELLO in sculpture and MASACCIO in painting. His first recorded undertaking, a Singing Gallery for Florence Cathedral (1431-8), is a work of considerable accomplishment and originality, antedating by a year or so the Singing Gallery by Donatello which used to hang opposite. The decoration consists of marble reliefs with ANGELS and boys and girls singing, dancing, and making music. Though based on ANTIQUE prototypes these figures lack the dramatic and heroic grandeur of Donatello but make up for it in energetic and cheerful humanity. None of his subsequent work was equal to this in quality, and in his later years he tended to repeat himself. But he was responsible for one very popular invention—the half-length Madonna in glazed white terracotta on a blue ground. The novelty of these Madonnas lay not only in the medium employed but also in their sentiment. Luca gave the Madonna and Child theme (see VIRGIN) not only charm but humanity and was the first to exploit the sentimental aspect of maternal feeling in this subject. It was a popular innovation carrying forward into RENAISSANCE art a new human feeling which found expression in popular carols and religious lyrics in many countries during the 15th c.

The profitable business which Luca founded was carried on by his nephew ANDREA (1435-1525), and later by Andrea's five sons, of whom GIOVANNI (1469-after 1529) was the most important. The famous roundels of infants on the façade of the Foundling Hospital in Florence (1463-6) were probably made by Andrea. In course of time the artists' *atelier* of Luca became a potters' workshop-industry.

2102.

**ROBERT,** HUBERT (1733-1808). French LANDSCAPE painter. With Horace VERNET and Louis Gabriel MOREAU he satisfied the vogue for idealized landscape which was one aspect of ROCOCO artificiality. He spent 12 years in Italy, where he worked with PIRANESI and PANINI. In 1761 he travelled to south Italy and Sicily with FRAGONARD. He made a vast quantity of drawings, on which he based his pictures after his return to Paris in 1766. His particular interest was in RUINS and he was the first to make them the main theme of a picture rather than to use them as picturesque accessories as Salvator ROSA and Panini (*The Temple of Jupiter at Rome, Triumphal Arch at Orange, Maison Carrée at Nîmes* are examples in the Louvre). He was imprisoned during the Revolution, smuggled in paints, and while in prison painted *Taking Prisoners by Torchlight from St. Pélagie to St. Lazare*. He owed his life to an accident whereby another person of the same name was guillotined in his stead. Under Louis XVI he became Keeper of the King's Pictures and one of the

first curators of the LOUVRE. He supervised the construction of the French idea of an English park in the gardens of VERSAILLES (Grotto of Les Bains d'Apollon, to which GIRARDON's group *Apollo Tended by Nymphs* was transferred).

1601, 1950.

**ROBERTI,** ERCOLE DE' (*c.* 1450–96). Italian painter of the School of FERRARA. As a young man he collaborated with COSSA, notably in the frescoes of the OCCUPATIONS OF THE MONTHS at the Schifanoia Palace, the ALTAR-PIECE of S. Lazzaro (formerly Berlin, now destroyed), Ferrara, and also in Cossa's *Griffoni Altarpiece* at Bologna (*c.* 1476). The only picture certainly his is the altarpiece with a *Madonna Enthroned with Saints* (1480) painted for Sta Maria in Porto at Ravenna and now in the Brera, Milan. His reputation now established, Ercole was court painter to the Bentivoglio and from this period probably come two portraits, of Giovanni II and his wife Ginevra, now in the National Gallery, Washington. In 1486 Ercole returned to Ferrara and succeeded TURA as court painter to the ESTE. From this period come the *Harvest of the Manna* (N.G., London) and the *Pietà* (Liverpool) and *Way of the Cross* (Dresden) from a predella painted for S. Giovanni in Monte, Bologna.

Roberti inherited the tradition of the Ferrarese painters Tura and Cossa with their precise line and metallic colours against elaborately fanciful ornamentation. He developed this manner with great originality and in his more mature period combined it with 'modernistic' tendencies of Giovanni BELLINI and PIERO DELLA FRANCESCA towards a more balanced synthesis of tone and more open conception of space. All his work has exceptional intensity of feeling and a dynamic quality which is peculiarly his own. He stands out as one of the greatest artists of Ferrara.

Roberti has sometimes been confused with Ercole di Giulio Cesare de' Grandi, a painter who is said to have died in 1531 but by whom no pictures are known.

1943, 2373.

**ROBERTS,** DAVID (1796–1864). Scottish travel artist. He began as a scene painter in the Glasgow and Edinburgh theatres. He specialized in architectural paintings, both in oils and in WATER-COLOURS, of subjects of picturesque decay, rich in historical and exotic overtones. An R.A. by 1841, he became very popular and his work was widely known in lithographic reproductions. His chief interest now lies in the SKETCHES made on his extensive travels to Spain and Morocco (1832–3) and to Egypt and Palestine (1838–9), which anticipated those of Edward LEAR.

145.

**ROBERTS,** TOM (1856–1931). The founder of the first truly Australian school of painting.

Born in England, he arrived in Melbourne at the age of 12 and began to train as a photographer while studying art at night at the Carlton School of Design under the Swiss artist Louis Buvelot (1814–88). In 1875 Roberts joined the National Gallery School at Melbourne and in 1881 left for England to study at the ROYAL ACADEMY, where he came under the influence of the art of BASTIEN-LEPAGE. In 1883 during a walking tour of Spain he acquired some knowledge of IMPRESSIONISM from the painters Barrau (1848–1913) and CASAS Y CARLÓ. When he returned to Melbourne in 1885 he gathered several other painters about him and founded what came to be known as the HEIDELBERG SCHOOL. His major works were painted during the years that followed. In 1901, however, he left for England, not returning permanently until 1923. Roberts was essentially a portraitist and GENRE painter. His finest paintings deal with aspects of pastoral life: *Bailed Up* (N.G., Sydney, 1895), the last of the great paintings, celebrates the hazards of the pioneering era. Roberts's sensitive vision of the Australian bush and his realistic grasp of Australian country life began the growth of an indigenous school of AUSTRALIAN ART.

**ROBUSTI,** JACOPO. See TINTORETTO.

**ROCAILLE.** In its original meaning from the mid 16th c. onwards the word denotes fancy rock-work and shell-work for fountains and grottoes. It is ascribed only this meaning even in the second (1759) edition of the *Dictionnaire portatif des beaux-arts* of the Abbé Lacombe. But from about 1730 it began to acquire a wider connotation, being applied to the bolder and more extravagant flights of the ROCOCO style. Indeed, it preceded the word 'Rococo' itself as an indication of style. It was used by Victor Hugo as a general term for the style we now call Rococo and this usage has often been adopted by French ART HISTORIANS who have disliked the implications associated until recently with 'Rococo'.

**ROCK-CRYSTAL.** Rock-crystal, which is silicon dioxide, commonly known as quartz, was popularly believed as late as the 16th c. to be ice frozen by intense cold. Its pure transparency commended it to Oriental hard-stone carvers, and to Western GEM engravers, who found it particularly suitable for intaglios. Crystals are in fact not carved, but ground by an abrasive powder applied by a metal wheel or drill.

The Romans of imperial times put a high value on bowls of carved crystal, but little has survived beyond fragments of these, counters, beads, and plain though delicately worked cosmetic bottles.

The so-called 'Fatimid' crystals, made in Egypt from the 9th to 12th centuries and culminating under the Fatimid dynasty, are characterized by a delicate relief decoration based on the palmette and often including stylized animals.

There is a ewer in the Victoria and Albert Museum which is a masterpiece of this art. A number of faceted bowls, jugs, and mazers have been variously described as 'Fatimid, 12th c.' or 'European 14th-15th c.'; certainly, like other early ISLAMIC crystals, many found their way to Europe and were mounted and extensively used by the Church.

Crystal-carving continued in Europe after the fall of the Roman Empire, but nothing of importance was produced until the CAROLINGIAN Renaissance in the 9th c., when crystal intaglios were skilfully engraved—mostly with Crucifixion scenes, though they include the magnificent *Crystal of Lothair* (B.M.) with the story of SUSANNA. Cups and vases of semi-precious stones were highly prized in the Middle Ages. A guild of crystal workers existed in Paris as early as the 13th c., and later court workshops flourished in Bohemia, Germany, and Burgundy.

In the RENAISSANCE Italy took the lead in all branches of gem engraving. Artists such as Valerio Belli, called Il Vicentino (1468-1546), and Giovanni dei Bernardi (1496-1553) engraved intaglio plaques to be set in caskets or elaborate church ornaments. The production of crystal vessels increased enormously; these were highly ornate, both in shape and in their engraved decoration of foliage or figure subjects, and mounted in gold and enamel. Milan was the centre of this art and the birthplace of most of its practitioners; the Saracchi family had a prolific workshop in Milan, and the Miseroni family worked for the Habsburgs in Prague.

Crystal vessels enjoyed great popularity in 17th-c. Germany and engraved crystal, like engraved glass, was widely produced there till the mid 18th c. There had always been affinities between crystal and glass; one finds mills at several German courts for working both materials, and Franz Gondelach (1663?-after 1716) at Cassel was one of the greatest craftsmen of his time in either medium.

With the change in taste in favour of greater lightness, and with advances in the manufacture of glass, crystal ceased to have any independent artistic significance.

**ROCKER.** The tool used to roughen the plate in MEZZOTINT.

**ROCOCO.** A term in ART HISTORY for that phase of primarily decorative art and ornamentation characteristic of the reign of LOUIS XV, which emerged in France *c.* 1700 and dominated Europe until it was superseded by the CLASSICAL revival which took place in the later decades of the century. The word—perhaps derived on the analogy of *barocco* from ROCAILLE—is said by M.-E.-J. Delécluze to have originated in 1796-7 as artists' studio argot to designate the taste fashionable under Louis XV. It was used in a similar sense as a term of derision by Stendhal in 1828 (*Promenades dans Rome*, i. 244). It was absent from the 1835 edition of the dictionary of

the French Academy but was defined in the supplement of 1842 as follows: 'Rococo se dit trivialement du genre d'ornement, de style et de dessin qui appartient à l'école du regne de Louis XV et du commencement de Louis XVI. . . . Il se dit en général de tout ce qui est vieux et hors de mode dans les arts, la littérature, le costume, les manières, etc.' It is mentioned in English as a new slang word in 1836 and was defined by the *Oxford English Dictionary* as applied to furniture and architecture: 'Having the characteristics of Louis Quatorze or Louis Quinze workmanship, such as conventional shell- and scrollwork and meaningless decoration; excessively or tastelessly florid or ornate.' The word was first used as a formal term of art history from the middle of the 19th c. in Germany, where those followers

**309.** Design for chimney piece and mirror at Marly. Engraving from *Livre de cheminées executées à Marly* (1699) by Pierre Lepautre

of Burckhardt who tried to establish a rhythmic periodicity for the phases of artistic development applied it to the closing and therefore decadent period of any phase. With more recent changes in aesthetic taste the term has become respectable and is now used by art historians generally in an objective sense without implied belittlement to designate an artistic and decorative style which has a certain coherence and consistency. The concern for colourfully fragile decoration, for trivial instead of significant subjects, for pastoral poetry in art, and sculpture in minute rather than colossal scales gave it a readily identifiable character. It had certain affinities with the HELLENISTIC reaction after *c.* 150 B.C. (called by Wilhelm Klein the 'Hellenistic rococo') from the PERGAMENE SCHOOL. Its chief historian, Fiske Kimball, has called it 'an art essentially French in its grace, its gaiety and its gentleness, one of the most delightful flowerings of artistic creative genius'.

In the early period of the emergence of Rococo (1699–1715) the vital creative impetus for a new phase of interior style was given by Pierre Lepautre (*c.* 1648–1716) who, on his appointment in 1699 as Dessinateur in the Bâtiments, transformed, at Marly, the flat space-filling ARABESQUES of BÉRAIN by transposing

them into the architectural framework itself and so brought into being the essential scheme which was to prevail in the mature Rococo of Louis XV. Its most striking feature was a transformation of the traditional BAROQUE plasticity, where forms spring out of the mass, into a delicate play on the surface with surrounding and interlacing bands and scrolls, tectonic feeling subordinated to a sense of airy emptiness as a background for ornamental arabesque. Lepautre's characteristic style may also be seen in the Chapel at VERSAILLES and the choir of NOTRE-DAME. Credit must also be given to the architect Germain BOFFRAND, though little of his work has survived either in the original or in engravings, while in the painted decoration of surfaces leadership was taken by Claude III AUDRAN. After the death of Lepautre in 1716 the leading exponents of the new style were the decorative sculptor François-Antoine VASSÉ (1681–1736), who became the chief standby of de COTTE, and Gilles-Marie OPPENORD, who had to unlearn what he had learned in Italy before he was able to fit into the dominant fashion. Both Vassé and Oppenord carried on the essential scheme of Lepautre, emphasizing height by linear surface treatment and modifying the tectonic frame by progressively freer curvature of arabesque

310. Antechamber of L'Œil de Bœuf, Versailles, designed by Pierre Lepautre

elements. Both employed a minor use of asymmetry in balancing opposing elements.

From the years 1730–5 came a second phase of the Rococo, later called the *genre pittoresque* and characterized by the increased use of asymmetry in decoration. It was inaugurated in interiors by Nicolas PINEAU after his return from Russia in 1727 and by Juste-Aurèle MEISSONNIER, primarily in his silver-work. Jacques-François BLONDEL in his *Cours d'architecture* (1771) associates the painter Jacques de Lajoue (1686–1761) with Meissonier and Pineau as 'inventor' of the *genre pittoresque* and mentions as immediate 'imitators' the carver and jeweller Jean Mondon and the engraver Jean François de CUVILLIÈS. The painter to whom the epithet 'Rococo' has most often been loosely applied is, perhaps, WATTEAU, and in his rejection of the *grand sujet* and his fanciful and curvacious rhythms he does to some extent fit into the movement. Yet it is in BOUCHER, who besides his tireless activity as a painter and designer of tapestry occupied himself both with engraving and as an independent designer of suites of ornament, that we may find epitomized most typically the full spirit of the mature Rococo.

The decline of Rococo in France preceded the NEO-CLASSICAL revival. The attacks of Charles-Nicolas COCHIN about the middle of the century and of Jacques-François Blondin, whose *Architecture françoise* appeared 1752–6, were directed against the extravagances and extremes of the *genre pittoresque* and advocated not an imitation of classical antiquity but a return to the 'good taste' of the preceding century. Cochin himself mentions as a decisive influence in the change of taste the return to Paris in 1742 of the architect Jean-Laurent Legeay. Thus although the *genre pittoresque* came to an end with the death of Pineau, Rococo continued in a more conservative form under the designer Ange-Jacques GABRIEL, who succeeded his father as Premier Architecte in 1742, the craftsman Jacques Verberckt (1704–71), and, after 1755, the carver Antoine Rousseau. There was no sharp break until near the close of the reign of Louis XV. It was, indeed, the advent of Classicism which brought the ROCOCO to a close, as a new taste emerged under the influence of a more serious interest in the ANTIQUE. Paintings of Roman RUINS were made popular by PANINI and PIRANESI began to issue his engravings in 1748. The results of excavations at Herculaneum and POMPEII were published by Cochin and Bellicard in 1754 and the six-volume *Recueil d'antiquités* of Count CAYLUS appeared 1752–5. Yet the *coup de grâce* was given by the English Classical revival under Robert ADAM, which began to have an effect in France about 1770 and triumphed with the accession of Louis XVI in 1774. The Revolution brought with it a new civic and puritanical fervour which condemned the light-heartedness of the previous decades on moral as well as artistic grounds.

From Paris the Rococo was disseminated by

**311.** *Leda.* Engraving in Rococo style designed by Boucher

French artists working abroad and by engraved publications of French designs. It spread to Germany, Austria, Russia, Spain, and northern Italy (TIEPOLO, LONGHI, GUARDI). In England only it had little vogue except in furniture. In each country it took on a national character and in addition many local variants may be distinguished. Most intensive study has been given to the manifestations of Rococo in Germany and Austria. But Rococo came to Germany late, the main flow of influence following after it had been abandoned in France. In the German Rococo fantasy was more unbridled and discipline less. Moreover the Rococo in Germany met a still vital and active Baroque interest in spatial and plastic variety, resulting in a successful and highly characteristic hybrid. As a result of this, because the German Rococo was something very different from the French original in spirit and in its formal developments, German art historians, such as Gottfried Semper and August Schmarsow, have usually gone astray in analysing the 'essence' of the Rococo as a set of features

which belong to the German hybrid rather than to the pure French stylistic movement.

193, 202, 273, 401, 1476, 1495, 2199, 2430.

**RODIN,** AUGUSTE (1840–1917). The most celebrated sculptor of the French ROMANTIC School. Born at Paris, he studied under the Classicist master Horace Lecoq de Boisbaudran, 1854–7. Having failed in the entrance competition for the École des Beaux-Arts, he worked as an ornamental mason while attending classes by the sculptor BARYE. From 1864 to 1870 he worked in the studio of A. E. Carrier-Belleuse (1824–87), whom he assisted in 1871 on the decoration of the Brussels Bourse de Commerce. In 1864 his *L'Homme au Nez Cassé* was rejected by the SALON. He went to Italy in 1875, where he saw the works of MICHELANGELO (he later wrote to BOURDELLE: 'Michelangelo freed me from academicism') and conceived an admiration for Pierre PUGET. In 1878 he exhibited his first major work, *The Age of Bronze*, which caused a sensation since the novel MODELLING was so life-like that he was even accused of having cast it directly from the living model. The masterly REALISM of this work and his love of movement were revealed also in the *Walking Man* and a study for *St. John the Baptist Preaching* which followed. From 1879 to 1882 he worked in the Sèvres porcelain factory, executed a statue of D'Alembert for the Hôtel de Ville, Paris, and began the huge *Gates of Hell* (commissioned 1880 and still unfinished 20 years later) for the Musée des Arts Décoratifs. The regular design, inspired by GHIBERTI's *Paradise Gate* for the Florence Baptistery, was broken into a wild Romantic chaos of twisted and anguished figures with reminiscences of the *Last Judgement* of the Sistine Chapel, Gustav DORÉ's illustrations for the *Divine Comedy*, and BLAKE's engravings. Many of the nearly 200 figures formed the basis of some of his most famous independent sculptures: *The Thinker*; *The Kiss*; *La Belle Heaulmière*; *Fugit Amor*; etc. In 1884 he was commissioned by the town of Calais to produce a monument in honour of the liberation when it was besieged by the English in the 14th c. His group *The Burghers of Calais*, completed in 1886, was not erected until 1895 and then not according to his design. A replica bought by the British Government was erected by Rodin in 1913 in the Victoria Tower Gardens, London. In 1889 he was commissioned by the town of Nancy to do a monument to CLAUDE Lorraine and in 1898 his monument to President Sarmiento was unveiled in Buenos Aires.

During the 1890s he was commissioned to produce monuments to Victor Hugo and Balzac. The first version of the *Hugo* monument, intended for the Panthéon, was not considered suitable (now in the Musée Rodin and a bronze version has been set up in the avenue Victor-Hugo) and a second version commissioned in 1891 was not completed. The *Balzac*, perhaps his most mature work, aroused great controversy and was rejected by the Société des Gens de Lettres. Cast in bronze it was unveiled in 1939 by DESPIAU and MAILLOL at the juncture of the boulevard Montparnasse and the boulevard Raspail. By the turn of the century Rodin's reputation was international and established despite the controversy which embroiled so much of his work. He did a large number of portraits of eminent personalities, including: PUVIS DE CHAVANNES, Clemenceau, Bernard Shaw, BAUDELAIRE, Gustav Mahler, César Franck, Nijinsky, Pope Benedict XV. The volume of his GRAPHIC work was enormous. In 1916 he made a gift to the nation of the works still in his possession and they are now housed in the Musée Rodin in Paris.

Rodin was a Romantic sculptor with a preference for modelling and for the expression of character and movement. Many of the creations of his last years were inspired by the dance. He welcomed literary and symbolic significance and was to this extent out of keeping with the conception of 'pure' sculpture which predominated in the 20th c. Yet despite its Romantic and literary character his work was genuine research into the problems of three-dimensional spatial composition and to this extent in line with contemporary trends. His skill and craftsmanship were exemplary. His influence on many of the next generation of artists was profound and among his assistants were numbered Bourdelle, Despiau, and Maillol.

233, 525, 553, 734, 816, 969, 1003, 1589, 1702, 1797, 2285, 2596, 2787.

**RODRÍGUEZ,** VENTURA (1717–85). Spanish architect. In his early work, such as the Church of San Marcos, Madrid (1749–53), he used elliptical and circular plans of Italian BAROQUE derivation. From 1750 he was employed to refashion Francisco HERRERA's 17th-c. Church of El Pilar at Saragossa, where he built the oval-shaped Virgin's chapel, focal point of the interior. But he was also one of the first Spanish exponents of NEO-CLASSICISM, and provided Pamplona Cathedral with a Corinthian PORTICO façade (1783) in severely classical taste. Some of his best designs were never realized, but he had many followers and, as director of architecture at the Academy of San Fernando from its foundation in 1752, and as town architect of Madrid from 1764, he exercised a powerful influence throughout Spain.

**ROELAS,** JUAN DE LAS (c. 1558–1625). Spanish painter, who became a priest (sometime before 1602) and painted for churches and religious houses in and around Seville. He was the greatest of Sevillian painters, although his work is little known outside Andalusia. Less MANNERIST than TINTORETTO, he has been likened to VERONESE for his painterly qualities

and complex yet harmonious composition. Among his finest works are considered to be: the *Circumcision* (University Church, Seville, *c.* 1606), the *Martyrdom of St. Andrew* (Seville Mus., 1609-13), and the *Pentecost* (Seville, 1615).

**ROGERS,** JOHN (1829-1904). American sculptor. Trained as a machinist in New England and Chicago and completely self-taught as an artist, he became the most popular sculptor of sentimental subjects in the United States. *One More Shot* and *The Town Pump* are characteristic titles of his 'Rogers groups', the best known of which was *Slave Auction* (1859). He also executed works of a stronger character such as the EQUESTRIAN STATUE *Major-General Reynolds* (1883) in front of the City Hall in Philadelphia.

2503.

**ROGERS,** WILLIAM (active *c.* 1589-1605). The best of English-born 16th-c. engravers, famous for his allegorical portraits of Queen Elizabeth. He also engraved title-pages (e.g. for Camden's *Britannia*, 1600, and Gerard's *Herbal*, 1597).

**ROHLFS,** CHRISTIAN (1849-1938). German painter. He taught from 1900 to 1903 at the Weimar Academy and through Henri van de VELDE became familiar with contemporary French art. Later he was employed by Karl Osthaus, a patron of modern art, at the Folkwangschule in Hagen. Rohlfs's style developed from NATURALISM through IMPRESSIONISM to a forceful and unreflective EXPRESSIONISM. His favourite themes were visionary views of old German towns, colourful LANDSCAPES, and flower pieces.

2767.

**ROLDÁN,** PEDRO (1624-1700). Spanish sculptor. He studied with Pedro de MENA in Granada under the latter's father, Alonso de Mena. By 1656 he had settled at Seville, and from 1664 to 1672 was director of sculpture at the Academy there. In 1670-5 he executed the REREDOS for the high altar of the church of the Hospital de la Caridad. This BAROQUE masterpiece, representing the Entombment, was POLYCHROMED by VALDÉS LEAL. Roldán's daughter, LUISA (*c.* 1656-1704), was also a sculptor, principally active at Cadiz and Madrid.

**ROLFSEN,** ALF (1895- ). Norwegian painter, notable for his murals, which owed something to CUBISM. In the crematorium of Oslo (1933-7) he has unified the vault and the scenes on the walls into a single impressive composition of lines and spaces.

**ROMAN ART.** The overriding importance of the Roman contribution in the broad history of western European art is common ground among art historians. The recurrent 'classical revivals'

which have been described from their different points of view in such studies as Erwin PANOFSKY's *Renaissance and Renascences in Western Art* (1960), Benjamin Rowland's *The Classical Tradition in Western Art* (1963), and Cornelius Vermeule's *European Art and the Classical Past* (1964)—the constant glance over the shoulder to check direction and seek fresh impetus from a common source—have all been centred upon Rome. Even the 18th-c. NEO-CLASSICISM, ushered in and propagated by the antiquarian enthusiasms of the Comte de CAYLUS and by that strangely wrong-headed theorist WINCKELMANN, admired its classical GREEK ART through the uneven mirror of Roman reproductions or indirectly by way of the regional art of southern Italy. It was not until the ELGIN MARBLES became publicly available in the British Museum that the original Greek sculpture of the classical period made a significant impact. Its impact was indeed so great that not until the 20s and 30s of the 20th c. did it begin to be seen in perspective. But the impact it had on creative artistic production, as distinct from criticism and historical interpretation, had no great importance in altering the main trends which had already been established. Against this broad canvas of European artistic evolution to treat Roman art as a mere autumnal phase of the HELLENISTIC Greek tradition must be regarded, in the words of Sir Mortimer Wheeler, as a 'traditional misunderstanding of major issues', while the word 'decadence'—which has also been used—loses any clear significance in the context.

Yet the term 'Roman art' has not an unambiguous connotation. At least three different senses must be distinguished as set out by Professor J. M. C. Toynbee in her book *The Art of the Romans*. We may designate by it the art of the Roman people in the narrow sense, the original inhabitants of Rome and those directly descended from them. In this sense it seems that, as Professor Toynbee says, this people was 'not naturally endowed with creative artistic genius'. There was, perhaps, no 'Roman art' in the sense that there is a Latin literature created primarily by Romans or by writers of foreign stock who had become in a definable sense Romanized. Even so, we must not overlook that, as Sir Mortimer Wheeler reminds us, 'creative Roman art and architecture, with vague or trivial exceptions, are anonymous'. We do not know who the artists were who designed and carved the ARA PACIS, the ARCH OF CONSTANTINE, TRAJAN's COLUMN, Hadrian's PANTHEON, and many more. Yet it does seem plausible to suppose that the contribution of the Romans themselves was chiefly as patrons in guiding by their interests and tastes the foreign artists—mainly Greeks—whom they employed. A second sense of the term arises when 'Roman art' is applied to the 'art of Italy as gradually absorbed by Rome and ultimately united under her hegemony'. Most historians agree that this was a real thing, true as it may be that from the earliest times ETRUSCAN ART

exercised a strong moulding influence whose effects survive in much of the Roman art of the later Republic and Empire, and large as the debt was to Hellenistic Greek craftsmen and entrenched modes of representation. This is the Roman art which, together with the many Roman copies or PASTICHES of Greek originals, provided a continuous source of iconographic types and forms for classicizing trends in European art. Finally 'Roman art' can mean the art current in the Roman Empire, from the late 1st c. B.C. until what is known as the Late ANTIQUE period (c. A.D. 300–500) gave place to BYZANTINE and to BARBARIAN ART. In the central Mediterranean area—what may properly be called the Greco-Roman world—it was up to a point a conscious and indeed inevitable continuation of the Greek tradition, executed often by Greek artists working to satisfy Roman purposes and tastes (including of course the cultivated Hellenizing taste). In the more outlying regions, from southern Scotland to Mesopotamia and from the Sahara to Spain and beyond the Rhine, as the Hellenistic tradition was usually weaker so local styles and themes were more predominant. The extent to which the exuberant multifariousness of local thematic, stylistic, and technical traditions came to manifest under the aegis of Rome identifiable common features adequate to justify the designation 'Roman art' as a general descriptive term is a question which remains open to subjective interpretation. It can be held that the term 'Roman art' is an abstraction if it is applied to cover all the art produced in the Roman Empire and a misnomer if it is understood to designate more than an epoch. Other historians have pointed to certain concepts, such as the idea of cosmopolitanism, a sense for the importance of the individual, a feeling for the aesthetic value of the monumental and the colossal, which they believe brought some measure of identifiable unity to the art produced within the orbit of Rome. In the later centuries of the Empire these concepts merged and interacted with others which were contributed by the Christian religion.

As regards the relation of Roman to Greek art it may be useful to quote the refreshingly conservative and unemphatic statement of Professor Toynbee. She says: 'If Rome had not become, from the second century BC onwards, the guardian and ruler of the homelands of Hellenistic art, she would never have produced the great imperial art that she has bequeathed to us. Nevertheless, the converse is also true. Rome had a very definite role of her own to play in the evolution of ancient art; and again we would suggest that, if Greek artists had not been provided by the Romans with a new setting and centre, new subjects, new patrons, a new purpose and dignity, and a new sense of art as a service both in public and in private life, Hellenistic art, having achieved the apotheosis of technical perfection and having run through the gamut of

**312.** Church of Sta Maria degli Angeli, Rome. Formerly central hall of the Baths of Diocletian. Engraving from *Vedute di Roma* (1748–78) by Piranesi

313. Pont du Gard, Nîmes (c. A.D. 14)

314. Maison Carrée, Nîmes (c. 16 B.C.)

its fresh ideas, might have perished from aimlessness and inanition by the end of the first century BC.' The innovations which have been attributed to Rome will be mentioned later in this article in connection with the separate arts.

1. ARCHITECTURE. Architecture at Rome was in origin Etruscan. As power and prosperity increased the Etruscan element was overlaid but never absorbed by Hellenistic features. Rome itself fostered or initiated certain trends which culminating in the great architectural achievements of the Empire made them a recurrent model for centuries to come. The following broad traits may be regarded as symptomatic of the characteristics of style which, in later ages at any rate, came to be regarded as specifically Roman. (i) Compared with classical Greek, Roman architecture gave more importance to the secular and utilitarian. Whereas the ERECHTHEUM on the ACROPOLIS at Athens or the Temple of Zeus at Olympia could be instanced as exemplary manifestations of Greek artistic building, in illustration of the special bent of the Roman genius one might well point to the Baths of Diocletian (now Sta Maria degli Angeli, Rome, as converted by MICHELANGELO in 1563) or the three-tiered Pont du Gard near Nîmes (c. A.D. 14). Under the aegis of Rome constructional energy was to a greater extent than before directed towards the practical and utilitarian—though not by any means exclusively, as witness the peculiar Roman taste for the TRIUMPHAL ARCH. (ii) Roman monumental and public architecture gave far more attention than the Greek had done to interior. Greek architecture was a kind of sculpture made to be seen from outside, Roman a development of engineering constructed for men's use. Whereas the Greek temple was, typically, conceived as a background for procession and ceremonial, the Roman BASILICA led on to the Christian CHURCH, a building designed to house the ritual and the congregation of worshippers. The change in spirit has been described epigrammatically as one from pageantry to personality. (iii) The Romans pre-eminently in the classical world understood and exploited the aesthetic values of grandeur and magnificence in sheer size. While the tendency towards the colossal can be dated to Hellenistic times, the technical expertise of the Romans enabled them to carry it further and under them alone it became a dominant feature. Such things as the temple at Baalbek (second half of 2nd c. A.D.) and the COLOSSEUM at Rome (end of 1st c. A.D.) reveal a new sense of scope and magnitude.

The distinctive character of Roman architecture was already immanent in the 2nd c. B.C., when new technical developments were making possible the satisfaction of newly emerging needs and preparing the way for a structural revolution. The needs were for emphatic façades (inherited from the Etruscans), spacious interiors, and grandiose symmetrical groupings. The technical innovations derived from an increasingly effective exploitation of CONCRETE, brickwork, and veneering. The discovery in the 2nd c. B.C. of an efficient concrete made practicable the general use of the ARCH which with its corollaries the VAULT and the DOME allowed the roofing of wide spans (where the Greeks had made shift with a multitude of internal COLUMNS) and a more economical construction for big walls and platforms. The Colosseum is a standing example of structural economy. By the 2nd c. A.D., as the structural possibilities of concrete had been mastered, the Roman feeling for decoration became freer and more exuberant. The Romans drew on the Hellenistic repertory, particularly its less austere forms such as the Corinthian CAPITAL (see ORDERS of ARCHITECTURE) and scroll, added new combinations (among them, from the time of Augustus, the MODILLION applied to CORNICES), sought opulence of effect by the use of coloured MARBLES and GRANITES, and increasingly omitted part or all of the FLUTING of columns. To the Romans is attributed the Composite Order, a combination of features from the Ionic and the Corinthian, which was first identified by ALBERTI c. 1450 and figured by SERLIO as the fifth and most elaborate of the Orders. The Romans gave a base to the Greek Doric Order and their use of the Ionic is distinguished by VOLUTED capitals and DENTILS in the cornice. Some influence of the primitive and massive Tuscan Order can also be found in Roman building.

In early Rome the more solid structures had been built of large blocks of soft local TUFAS and from the 2nd c. B.C. they were increasingly faced or reinforced by the finer and harder TRAVERTINE. As has been said, the most important Roman innovation in building material was concrete. It was poured *in situ* and at first was faced with small irregular stones (*opus incertum*), then from the latter part of the 1st c. A.D. with roughly pyramidal stones (*opus reticulatum*) or with triangular tiles or bricks, the points set inwards. For greater stability bonding courses of tiles were added to *opus reticulatum*. Normally, at least on important buildings, exterior walls were STUCCOED or faced with stone or slabs of marble and the interior stuccoed or veneered. Exposed brickwork began in Rome on some modest structures in the later 2nd c. A.D. In other parts of the Empire masonry continued to be used to a greater extent than in central Italy.

(a) *Temples.* The most traditional of Roman buildings were the temples, Etruscan in their basic plan. They stood on a high platform usually approached only by a central stairway from the front and were composed of a deep colonnaded porch and a *cella* of equal width. Unlike the Greek temple, the back was unimportant and might be masked by an adjacent wall. Differences from the Etruscan model were a PERISTYLE simulated by engaged half-columns or PILASTERS on the sides and back of the *cella*. Inside, from the early 1st c. B.C., the back wall was often ennobled by a half-domed

APSE, which did not project on the outside. With the relaxation of decorative tradition in the 2nd c. A.D. an arch was sometimes used in the centre of the columned façade, either breaking or deflecting the ENTABLATURE. The most complete surviving example of Roman temple architecture from the Augustan age, with columns of the Corinthian Order, is the Maison Carrée at Nîmes (c. 16 B.C.). Two examples of circular temples, both probably from the 1st c. B.C., are the one by the Tiber in Rome, now the Church of Sta Maria del Sole, and the so-called Temple of Vesta at Tivoli, which was used by Sir John SOANE as model for the façade of the Bank of England. Outstanding among circular temples and one of the greatest architectural interiors of all time is the Pantheon (c. A.D. 126).

(b) *Baths*. The public baths (or THERMAE) were centres of social life in the Roman world. Besides hot, warm, and cold saloons, and sometimes an open-air swimming bath attached, sweat baths and steam baths, the larger buildings had accommodation for physical and intellectual diversion. The baths in particular favoured the Roman bent for large and ornately decorated interiors. From the later 1st c. A.D. they contained a great central hall with a roof of intersecting vaults, buttressed by aisles. Grouped around the hall and affording long colonnaded vistas were other rooms, varied by apses and niches. Columns, ARCHITRAVES, and superposed

Orders added to the sumptuous decoration, arranged the more freely because functionally unnecessary. The great Roman baths were supreme examples of Roman engineering skill, made possible only by innovations of building technique. (The earliest surviving example of the Roman conical dome is in the *frigidarium* of the Stabian Baths at POMPEII from the 2nd c B.C.) Their importance in the development of architecture for the systematic adaptation of structural plan to function has been widely recognized.

(c) *Theatres and Amphitheatres*. Roman theatre architecture is discussed in the article on THEATRE, and little need be added here. The Roman theatre differed in principle from the Greek in that whereas the latter was conceived as an open-air structure, the Roman theatre was in principle enclosed, the audience being shut off from the outside by high walls and often covered in by an awning. The typical structure, evolved in the late 1st c. B.C., had a semicircular auditorium, often built up from level ground by arches and vaults and united with the stage building. The high back wall of the stage (*scenae frons*) was the main centre of decorative interest. It was often fussily adorned with tiers of colonnaded niches set with statuary and in the 2nd c. A.D. might be further enlivened by such devices as projecting pairs of columns complete with entablature and in the top storey straight, curved,

**315.** The Colosseum, Rome (A.D. 80)

and interrupted PEDIMENTS. The first stone theatre in Rome was built by Pompey in 55 B.C.

The AMPHITHEATRE was a more specifically Roman creation. It was usually oval in shape. The earliest permanent structure known is that at Pompeii (c. 80 B.C.). The earliest stone amphitheatre in Rome was built in the time of Augustus. The greatest amphitheatre, and perhaps the greatest monument of architectural engineering, from antiquity was the Colosseum. Under the Empire amphitheatres became an important feature of Romanization, less so in the Hellenized provinces of the Near East, and by their sturdy upstanding presence and ingenious use of vaulting were a potent influence on later architecture. There are good examples surviving at Nîmes and Arles.

(*d*) *Forum and Basilica.* In Roman as in Greek times the market place (see GREEK ART) was the civic centre, law court, and market. The Greek *agora*, which was irregularly supplied with colonnaded shelters (STOAE), developed through the more regular Hellenistic *agora* into the Roman FORUM, which in imperial times became more symmetrical, either square or a narrowish rectangle enclosed with colonnades and with perhaps a monumental entry at one end and a temple at the other. The basilica, functioning as town hall and court of justice, was a sort of enclosed extension to the forum. Its origins and development into the Christian ecclesiastical basilica are discussed in the separate article. The basilica as a normal adjunct to the market place was an essentially Roman innovation, going back to the 2nd c. B.C. when the Basilica Porcia was added to the Roman Forum by the elder Cato (184 B.C.) and a little later the Basilica Aemilia. The most magnificent which partially survives is the Basilica Nova (finished *c.* A.D. 313), whose nave had three heavy cross-vaults rising to 114 ft.

(*e*) *Triumphal Arch.* The triumphal arch was a specifically Roman invention, in its simplest form a vault framed by rectangular PIERS, which usually stood isolated spanning a street. Unlike most Roman architecture it had no utilitarian function. Yet the practical bent of the Roman temperament was still reflected in these arches. They were erected usually in honour of the head of the state, in commemoration of notable victories and usually bore relief sculpture and inscriptions recording contemporary history. They became a symbol of empire and it is perhaps not too fanciful to note the appropriateness of converting into a non-utilitarian symbol the technical device of construction which had made possible Roman bridges and aqueducts and the expansion in the size of interiors which was the most typical feature of Roman building. The commemorative arch began in Rome in the 2nd c. B.C. It usually had a single opening as in the surviving Arch of Titus at Rome (*c.* A.D. 81). Sometimes imperial arches had three spans as in an Augustan arch of 18 B.C. and the Arch of Constantine (A.D. 312–15). The TRIUMPHAL ARCH

is discussed more fully in its historical setting in the special article. Here one need note only that the Marble Arch and the Arc de Triomphe do not stand alone; the Roman triumphal arch became a heritage and a model to all countries.

(*f*) *Domestic Architecture.* The basic Italian type of dwelling-house consisted of rooms grouped on a symmetrical plan round a central hall or open court, which became the ATRIUM— as in upper-class houses at Pompeii *c.* 300 B.C.— with central rainwater tank. Often columns were added around the tank or a colonnaded court at the rear. There were at most two storeys, the upper with windows and sometimes with balconies, the lower more or less blank to the street unless it contained shops (not internally connected with the house). Roofs were pitched and tiled. In late Republican Rome and from the 1st c. A.D. in Ostia (where extensive ruins survive), as ground became more valuable and the concentration of population increased, tenement blocks running to some five storeys became common. These usually occupied one city block or *insula*, the apartments being entered from a central court or by stairs between ground-floor shops looking on to the street. Usually constructed of unfaced brick or concrete, they were plainly functional in appearance (though examples of decorative balconies have been found) and utilitarian in plan. Owing to danger of fire and collapse their height was restricted by Augustus to 70 ft. and reduced by Trajan to 60 ft.

The country house, if not a Roman invention, at any rate became a characteristic feature of the Roman way of life. Its popularity represents an aspect of the distinctively Roman fondness for landscape and the countryside. Such houses were not limited to Italy but spread over most of the Empire to the ultimate fringes of Roman Britain. They were particularly frequent in Gaul and Britain, where they sometimes reached the size of small villages with cottages of retainers clustered round the main mansion. The growth of the country house and its influence on later architectural development is discussed in the article on VILLAS.

The large country house merged into the imperial country palace, of which an outstanding example is Hadrian's Villa near Tivoli with its great colonnaded courtyard known as the Piazza d'Oro and other striking and unusual structures. In this architectural type the Roman bent for sometimes tasteless extravagance ran riot. Nero's country palace built in Rome itself, the Golden House, was a byword of luxurious ostentation in its own day (A.D. 64–68). It was demolished to make way for the public baths built by Titus and Trajan (A.D. 104). The most important of imperial palaces in architectural history is the Palace of DIOCLETIAN (*c.* A.D. 300), whose remains still contain the central portion of the town of Split.

(*g*) *Town-Planning.* The Roman contribution to TOWN-PLANNING is important both for original

features it introduced and because it established a type which lasted through the Middle Ages, both in Roman foundations and in many new towns (e.g. Oxford) built on the Roman model. A few things may here be added to what is said in the special article on town-planning.

The Romans perpetuated the Hellenistic chequerboard type of town plan, deriving it perhaps from the similar Greek model which influenced the planning of Etruscan cities built in plains and the cities of south Italy from the 5th c. B.C. The Romans gave to it a military twist, basing their idea of town-planning on two main axes set at right angles, on which were aligned geometrical oblong blocks. These axes were referred to as the *decumanus* and the *cardo*, with the forum (or headquarters block) fronting their intersection. A good example of the typical Roman planned town at various stages of its development is afforded by the port of Ostia. A splendid example of a burgeoning Roman town is provided by Leptis Magna on the coast of Tripolitania, with a nuclear chequerboard formation built in the time of Augustus and later divergent but generally rectilinear enlargements. In the Near East, particularly, the broad axial streets were often flanked by colonnades which sometimes carried memorial statuary.

2. SCULPTURE. Roman sculpture divides broadly into portraiture and RELIEF. For their free-standing sculpture the Romans used almost always Greek originals or copies and contributed little or nothing to the types and techniques which were perfected in the Hellenistic age. Yet their practice of pillaging and copying Greek statuary, whatever its immediate motives, bespoke an attitude towards them as art objects to be used primarily for admiration and adornment divorced from the setting for which they were designed originally. This new attitude signals the birth of CONNOISSEURSHIP in the Western world. It is an outlook which never quite disappeared and lies at the base of modern interest in ART HISTORY, COLLECTING, MUSEUMS, and preservation.

Realistic portraiture has often been regarded as the characteristic contribution of Roman sculpture. In fact both the idealizing and the realistic type of portrait were introduced to Rome from Greek sources in the 2nd and early 1st centuries B.C. and although statues have not survived from the early Republican period, the existence of contrasting styles of representation can be observed from coin portraiture. Under Augustus there emerged a fusion of the individualized portrait type with the Hellenistic BAROQUE style to create a picturesque and romanticized but recognizable 'image' in the modern manner. Yet it was the Roman taste for prosaic, factual recording which fostered a development from Hellenistic naturalism to the minute and meticulous REALISM which in art history goes by the name of VERISM. How much this tendency owed to the factuality of the Etruscan portrait tradition, or the extent to which it was favoured by the custom in Roman aristocratic families to preserve life-like *imagines* of ancestors, is a matter of speculation. But whatever its origin it was this specifically Roman inclination which allowed the classical Greek ideal of abstract and typical beauty to give way to a recording of individual peculiarities in the manner of the DEATH MASK. In Veristic portraiture, in contrast to the Greek tradition, the body was subordinated to the face and often followed some stock type from the existing repertory. An extreme example is a naked Venus surmounted by the head of a forbidding Roman matron coiffured in the bloated fashion of the late 1st c. A.D. (e.g. the *Venus Capitolina*, Capitoline Mus., Rome). Heads of statues were readily exchanged either to celebrate the change of a regime or for reasons of economy. In general the best Veristic works are BUSTS, a form of sculpture canonized if not invented by the Romans. Late Republican busts stop at the base of the neck; but by a gradual extension the whole chest was included by the late 2nd c. A.D.

The realistic and idealizing modes of portraiture continued side by side or in alternation during the Empire, although the effects of the descriptive Veristic style did not disappear until the late 3rd c. A.D. The vogue tended to be set by individual emperors. Claudius favoured a return to the Greek form of realistic portrait; Nero reverted to a more exuberantly modelled early Hellenistic idealism. Vespasian encouraged a dry, uncompromising realism, which persisted till Hadrian. Hadrian began the custom, which lasted until Constantine the Great, of the bearded portrait and in his time also began in large-scale sculpture the practice of incising the iris of the eye and drilling the pupil. Technical ability, taken over from Hellenistic craftsmen, was at first high, at least in the more conscientious workshops, though in the 2nd c. A.D. there was an increasing and franker use of the time-saving drill and highly polished surfaces were more admired. In the 3rd c. standards began to deteriorate and, although fine portraits were still done, the puerility of some of the official statuary c. A.D. 300 was succeeded by the factitious grandeur of imperial portraits which neglected MODELLING, PROPORTIONS, and ANATOMY to express through huge upturned eyes the impersonal, monolithic majesty of God's vicegerent on earth. This HIERATIC style and the increasing incompetence of much private portraiture was the end of the classical Roman portrait tradition. Yet while it lasted it created an unequalled array of masterly physiognomic studies.

The two most important classes of Roman relief sculpture were commemorative historical MONUMENTS and funerary relief carving. In both they contributed an emphasis and a bias which were the equivalent of innovation.

The Greeks preferred to represent even contemporary events under the guise of mythology whereas the matter-of-fact bent of the Romans

favoured the documentary rendering of actual happenings. In their commemorative sculpture if they did not invent—it had been practised by the ASSYRIANS and was found in some Hellenistic schools—they at any rate made peculiarly their own and gave a new shape to the convention of 'continuous narrative' recording. In this convention successive incidents of a continuous event—a battle or a campaign, for instance—are pictured anecdotally in a sequence of merging scenes something after the manner of a strip cartoon. Yet the Greek mythologizing convention was too firmly established to be shaken off entirely and Roman historical sculpture became a curious blend of realistic depiction with allegorical figures and PERSONIFICATIONS—an

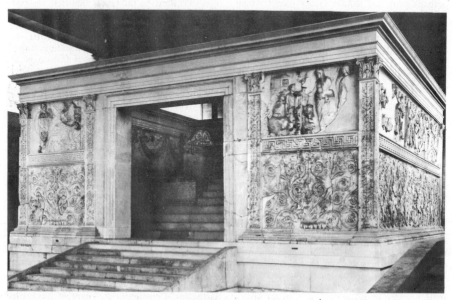

**316.** Ara Pacis, Rome. A. Reconstruction

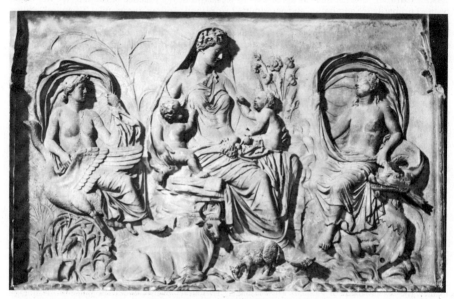

B. Detail from frieze with personification of Tellus or Italia

incongruous amalgamation which has had lasting reverberations throughout European commemorative sculpture.

The earliest important monument surviving in this syncretizing style is the Ara Pacis at Rome, founded by Augustus in 13 B.C. and completed in 9 B.C. The reliefs represent processions of the Emperor and his family and of Roman civil and religious dignitaries at the foundation of the altar. The former are done in the Hellenistic manner of recognizable portraiture and although in disposition and placement there is a reminiscence of a Panathenaic pageant in both processions, heightened by the classical treatment of DRAPERY, the aloof dignity and the realism of the faces seems characteristically Roman. Wholly Roman too are such touches of realistic human incident as the woman who hushes a young married couple with a finger to her lips and the child who wishing to be picked up grabs the toga of the man beside him. Combined with these, symbolical figures of Tellus or Italia and a legendary scene of Aeneas are in the Greek idealizing manner. The impression of depth is obtained by shallower cutting of background figures with competent attention to PERSPECTIVE.

In the reliefs on either side of the passage-way of the Arch of Titus personifications of Victory, Virtue, and Honour are combined with realistic portrayal of the human participants. The imperial processions are represented in a way which approximates to pictorial illusion of a continuous movement as if seen by a spectator from a window. In contrast, reliefs from the late 1st c. A.D. depicting the departure of Domitian to war and the arrival back of Vespasian in A.D. 70 are statically rendered with the figures modelled against a flat background and without pictorial illusion of movement. Allegorical figures are again combined with human portraiture. The 'continuous narrative' style is most fully realized in the winding ribbons of reliefs which spiral up Trajan's Column. It is a prosaic, factual record of the Dacian wars in a sequence of interlocking scenes notable for the accuracy and verisimilitude of realistic detail. Vertical perspective is combined with horizontal in filling each band with a tapestry-like design embracing the maximum amount of incident. Depth is indicated by a lavish employment of architectural and scenic background. The disproportionate scale of the figures causes the action to stand out prominently from the background. Although the modelling and disposition of individual figures and groups reveals no lack of sculptural competence, the over-all design disregards the classic canons of COMPOSITION. It is the first mature, and one of the most complete, examples of that 'documentary' style of visual recording which had a long and complicated history through the Middle Ages. The impression made on the observer that he is gazing upon a dramatic action of epic proportions is overwhelming. Another FRIEZE of Trajan's wars survives mainly in four panels which were incorporated in the Arch of Constantine. The style is similar though the figures are in higher relief and more plastically rendered.

The relief spirals on the Column of Marcus Aurelius, erected in the Campus Martius to commemorate his campaigns against the northern barbarians, follow the continuous narrative style of Trajan's Column, but although scene succeeds scene without break there is less transition or movement from scene to scene and the frieze gives rather the impression of a sequence of stills. Unity of design is sometimes broken up into superimposed zones of parallel horizontal scenes. On the Marcus Column the relief is higher and the major figures are modelled almost completely in the round with the back flattened and attached to the background. (See RELIEF on this technique.) There, as contrasted with Trajan's Column, began an increasing tendency to introduce frontal presentation in order to give a hieratic aspect to the principal figures and to rivet attention upon them while emphasizing their god-like removal from ordinary mortals. The Emperor is raised on a podium high above the assembled crowds and looks straight out into the eyes of the spectator, not in the direction of the people he is addressing. (See further FRONTALITY.) Differences in size are also used to emphasize importance. Both these tendencies culminate in the Arch of Constantine, which combines a classically static and centralized style of design with a more niggling manner of friezes which has affinities with the carving on SARCOPHAGI.

From about the end of the 5th c. B.C. cremation was the general rule in Rome until in the 2nd c. A.D. it began to be superseded by inhumation, which during the latter part of the 3rd c. spread from Rome and Italy to more distant parts of the Empire. In the early period STELAE or gravestone pillars marking cremation burials carried portrait busts; in early imperial times some stelae combined carved reliefs, depicting for the most part lively GENRE scenes from everyday life and allegorical groups or incident. Larger and more elaborate funerary structures, sometimes called MAUSOLEA, were also decorated lavishly with relief carving, both realistically descriptive genre exemplifying the Roman *penchant* for artistic representation of the prosaic details of daily life and also MYTHOLOGICAL and allegorical scenes. Some had TERRACOTTA relief panels on their façades. Reliefs also decorated TOMBS, including the house-tombs such as were found near Ostia and under St. Peter's in Rome. Another and perhaps the most interesting category of funerary reliefs is the decoration of sarcophagi and a fuller account of this is given in the relevant article.

One of the more interesting features of much funerary decoration, in particular the decoration of sarcophagi, is the extensive use of floral ornament, conventionalized animals, urns, garlands, etc. Apart from this the most striking

trait is the delight in vigorous if homely detail. The technique is very various. Sometimes careless and naïve, at its best it is competent stonemasons' workmanship within a familiar convention rather than a creative style. The subject takes precedence over any aesthetic considerations. Yet this popular sculpture of the later Empire had an important bearing on EARLY CHRISTIAN ART and through that on some currents of ROMANESQUE and later medieval styles.

3. PAINTING. Roman painting is known chiefly from mural paintings from the late Republican and early Imperial times which have been recovered in the south Italian towns of Pompeii, Herculaneum, and Stabiae buried beneath the ashes of Vesuvius in A.D. 79. Some wall-paintings have been rediscovered at Rome and Ostia since the Renaissance but though interesting in showing parallel trends, they are few and usually have less intrinsic importance. When the south Italian discoveries were first made about the time of the Neo-Classical revival they aroused extravagant enthusiasm and gave rise for a time to a so-called 'Pompeian' style of decoration. Later opinion of the paintings declined and they were studied chiefly for their iconographical and archaeological implications, being treated as a derivative and decadent phase of Hellenistic art. There is no positive evidence for the extreme view that the pictures were copies and pastiches of classical Greek or Hellenistic masterpieces. No comparable painting has survived from east of Italy before Imperial times and literary descriptions of famous paintings of antiquity are not sufficiently precise to enable positive identifications to be made. Many of the motifs and much of the ICONOGRAPHY is demonstrably Hellenistic and those paintings which are signed show that Greek painters were employed in Italy and Rome, and there is nothing in our knowledge which conflicts with the use of copy-books based on Hellenistic traditions. But the compositions and the treatment may well be an expression of contemporary taste. Criticism in the 20th c. was more alive to the intrinsic aesthetic qualities of this painting and by 1950 the extremist view had been abandoned by most art historians. In fact the paintings reveal a similar sort of amalgam as was found in Roman relief sculpture between a classicizing taste and a new interest in LANDSCAPE, genre, and popular scenes of daily life which seems typical of the Roman spirit in art. Even stock mythological themes and standardized iconography are often treated on realistic lines and ceremonies, natural scenes, and incidents of everyday life are depicted with a spontaneous realism which overrides the canons of academic tradition. Something has been said in the article on GREEK ART about Roman and Italian painting regarded as a final phase of the Greek tradition. Here something will be added about its main characteristics as precursor of major trends in Christian and later pagan art. Although not one of the major manifestations of the world's creative art, this work has importance in the general history of European painting both as the only surviving examples from antiquity and as a herald of things to come.

The so-called Four Pompeian Styles which extend from the 2nd c. B.C. to the end of the 2nd c. A.D. are discussed in the article on POMPEII. Pre-Roman painting in Campania from the end of the 5th to the 3rd c. B.C. is known only from a few examples of funerary painting. There are examples in the National Museum at Naples from tombs in Rubi, Paestum, and Cumae. The emphasis is on drawing and colours are laid on flat within well-defined contours. The influence of Etruscan funerary painting combines with Hellenistic and on perhaps too slight evidence some critics have seen in them the expression of a characteristic 'Italiot' manner. The few examples of mural painting which have survived from Rome come from wealthy aristocratic houses and therefore no doubt represent a specific Hellenizing taste. From the much-damaged House of Livia, the private residence of Augustus, there survives one painting in a poor state of preservation illustrating the story of Argus and Io. Certain similarities have been noticed in the posture (though not the disposition) of the figures with a Pompeian picture *Perseus Freeing Andromeda* (House of the Dioscurides; now in Naples) and it has been conjectured that both may be derived from an original by the Greek artist NICIAS, though on no stronger ground than that this 4th-c. painter was credited in antiquity with 'originating' such romantic mythological themes. Belonging to the Second Pompeian Style are paintings from the Villa Farnesina now in the Museo delle Terme, Rome. Also from the age of Augustus is the famous *Aldobrandini Wedding* (now in the Vatican Library), which was discovered c. 1605 and has had greater direct influence than any one other Roman painting, being copied by, among others, van DYCK, RUBENS, Pietro da CORTONA, and POUSSIN. The 'Odyssey Landscapes', found in 1848 in a house on the Esquiline Hill and now in the Vatican Library, are discussed below. From apartment houses at Ostia survive examples of middle-class interior decoration, most notably with walls painted in bright panels of red or yellow and small pictures painted as if framed on to the panels. Two mythological Ostian wall-paintings survive from the Severan period.

We know something about the Greek and Hellenistic painters in the way of literary anecdote and their prestige rating, although their works have not survived; on the other hand there is a fairly considerable body of painting from Roman times although we know virtually nothing about the artists who executed it. If we consider it for what it is, the most interesting features for the modern student of European art—and they are very interesting features indeed—are the treatment of nature, of genre, and of STILL LIFE.

According to a statement of PLINY (*Nat. Hist.*

**317.** Scene from the *Odyssey*. Wall-painting from a house in the Via Graziosa, Rome. (Vatican Mus., 1st c. A.D.)

xxxv. 116), a Roman painter of the time of Augustus, variously known as Ludius, Studius, and Tadius, first popularized the vogue for landscape and genre scenes in mural decorations of country villas. The surviving murals, mostly from town houses, exhibit two distinct styles of landscape. Pictures in the classicizing manner often use poetic and idealized landscapes as a background for mythological scenes, introducing romantically jagged crags, crooked trees, rustic temples, and other bucolic appurtenances which may well have been stock furniture taken over from Hellenistic painting. (Examples from Pompeii are: *Jason Appearing before Peleas*; *Hercules, Deianira, and the Centaur Nessus*; and *Cupid Punished*, all now in the Nat. Mus., Naples.) In other paintings, however, landscape is no longer background to anecdote or story but the main theme of the picture and figures, if they occur, serve merely the purpose of enlivening the landscape. Examples are a landscape from the Villa of Agrippa Postumus, near Pompeii, a harbour scene from Stabiae, a *Sacred Landscape* with rustic temples from Pompeii (all in the Nat. Mus., Naples). Such pictures exactly illustrate the innovation attributed by Pliny to Ludius. Such pictorial use of landscape as a primary theme is the more surprising because in the history of later European art landscape as an independent genre did not emerge until the 16th c. (see LANDSCAPE). Their technique also differs

from that of the classicizing style. It has been called IMPRESSIONISTIC and the pictures have in common with Impressionist technique a certain rapid and sketchy manner of execution, an emphasis on atmospheric effect and the dissolution of contours with suggestion of forms by interplay of contrasting tonal values and effective use of light and shade. There is in many of the paintings of this type a masterly use of plunging, not quite bird's-eye, perspective combined with the device, common to some CHINESE landscape painting, of beginning the scene at the spectator's feet instead of at accommodation distance; and this, together with an ample depth of picture-space, seems to bring the spectator right into the scene depicted which he simultaneously observes from above. As murals these landscapes are ILLUSIONISTIC. They no longer seem to decorate the walls to which they were applied but dissolve the walls away and create the impression (mentioned by Pliny) as if the spectator within the room were looking out through a window upon a landscape scene. These various features are all well exemplified by the now famous 'Odyssey Landscapes', in which scenes from Books X and XI of the *Odyssey* are shown in a panoramic landscape, depicted in a manner between the romantic-idyllic and the realistic, with free play to fantasy but always subordinating the incident to the landscape. The spectator within the room would seem to be really looking out upon scenes

taking place in the middle distance within a slightly unreal and poeticized landscape.

The predilection for paintings of gardens (such as the shallowly painted garden scenes from the House of Livia) appears to link up with the taste for landscape gardening (*opus topiarium*) mentioned among others by VITRUVIUS and the pictorial delight in nature finds expression in fruit trees and flowering shrubs, flowers, birds, snakes, and other animals, vividly observed and painted as objects of interest in themselves not as decorative incidentals to narrative scenes. Such miniature naturalistic tableaux (e.g. a heron confronting a cobra) are at one remove only from the still life proper, into which birds, rabbits, snakes, hens, etc., are frequently introduced. The Romans were certainly not the inventors of the still·life. No still lifes remain from the classical Greek or Hellenistic periods but from the scanty literary allusions it might appear that the Greeks were interested in still life mainly as a means of demonstrating the painter's virtuosity in illusionistic realism or else in the special type of *xenia* (see STILL LIFE). The still lifes from the Roman period have a surprisingly modern air. Despite the Roman taste for Verism in portraiture, the still lifes do not display that superfluous attention to meticulous detail which makes tedious so much of the second-rate FLEMISH and DUTCH ART. There is a real feeling for the presence of the object, an unemphatic grasp of essential form, a freshness of vision, and sometimes unusual and complex compositional balance which make them, after the finest portraiture, the nearest thing to great pictorial art which has survived from Roman antiquity (*Bowl of Fruit and Amphora* and *Still Life with Eggs and Game* from the House of Julia Felix, Pompeii; *Still Life with Bird* and *Still Life with Peaches and Glass Jar* from Herculaneum: all now in Nat. Mus., Naples).

By the accident of survival portrait painting is poorly represented from Italy. The famous mummy portraits are discussed elsewhere (see MUMMY PORTRAITS and EGYPTIAN ART). An example of academic idealized portraiture is a painting of a young girl holding stylus and writing tablets (from Pompeii, now in the Nat. Mus., Naples). Instances of more robust and individualized middle-class portrayal, reminiscent of the Egyptian technique of representation, are portraits from the House of the Terentii, thought to be Terentius Neo and his wife, and a mosaic portrait of a lady with vividly characterized features. From the 4th c. also survive a series of technically exquisite miniature portraits in gold leaf on glass, combining refinement with extremely realistic depiction of individual characteristics. The mode of Verism, so prominent in portrait sculpture, does not obtrude in the portrait painting that survives.

In genre also a contrast of two styles may be noticed. On the one hand there are charming, aristocratic, but unexciting genre scenes in the classicizing Hellenistic manner, such as a beautifully drawn monochrome scene of *Knuckle-Bone Players* from Herculaneum and a *Gynaeceum Scene, Music Lesson*, and others from the Triclinium of the Imperial Villa, Pompeii. On the other hand are brilliantly, sometimes humorously observed incidents from the popular quotidian life of the towns, market scenes, shops and taverns, street scenes, and many from the comic stage. An outstanding example is a representation of a Baker's Shop from Pompeii. The popularity of this type of subject is evidenced by the fact that they were also rendered in MOSAIC, e.g. a scene of *Street Musicians* signed by 'Dioskourides of Samos', from the Villa of Cicero, Pompeii. These pictures are in line with the Roman taste for homely, realistic recording of detail which was noticed even in the historical relief sculptures. The hint of satire or burlesque puts them in the great tradition of social CARICATURE which HOGARTH and DAUMIER carried on in a later age. Occasionally burlesque spills over into fantasy, as in the *Pygmies' Hunt* and *Judgement of Solomon* from Pompeii (Nat. Mus., Naples).

35, 108, 208, 1241, 1402, 1578, 1741, 1853, 2137, 2279, 2439, 2553, 2574, 2677, 2678, 2859.

**ROMANELLI,** GIOVANNI FRANCESCO (*c.* 1610–62). Italian painter of large fresco decorations who was active mainly in Rome and Paris as protégé of the BARBERINI family. He was a pupil of Pietro da CORTONA but his own style, which is seen at its best in the Sala di Carlo Magno in the Vatican, was more restrained and classical. In Paris he worked on the decoration of the Palais Mazarin and the LOUVRE.

**ROMANESQUE.** Term used in ART HISTORY for the first of the two great international styles of medieval western European art and architecture. Its formative stages are complex and, on account of the destruction, decay, and alteration of so many of its monuments, difficult to trace; but it is generally agreed that it emerged as a mature style at about the middle of the 11th c. and prevailed until the close of the 12th. GOTHIC, the second style, evolved from Romanesque during the latter half of the 12th c. and eventually supplanted it.

The dominant art of the Middle Ages was architecture, and 'Romanesque', like 'Gothic', is primarily an architectural term which has been extended to the other arts of the period. It first came into use in the early 19th c. as a descriptive term (analogous to 'Romance' in the classification of languages) for all the derivatives of Roman architecture that developed in the West between the collapse of the Roman Empire and the beginning of Gothic (*c.* A.D. 500–1200). But as knowledge of the period grew and its complexity was appreciated historians found it expedient to distinguish the major style of the 11th and 12th centuries from earlier minor styles

and to confine the term 'Romanesque' to it. The architecture of the renaissance initiated by Charlemagne is often referred to as 'Carolingian Romanesque', but it is usually treated as a distinct stylistic unit (see CAROLINGIAN ART). The name 'First Romanesque' has been given to an international provincial style of building, formerly known as 'Lombard', which originated in north Italy during the 9th c. and spread across much of south-western Europe and into the valleys of the Rhine and Rhône, where it contributed to the development of the mature style. This First Romanesque style together with the art of Germany under the Ottonian emperors (see OTTONIAN ART) and certain late 10th- and early 11th-c. developments in France are sometimes called collectively 'Early Romanesque'. English Romanesque is known as NORMAN.

Romanesque artists drew upon the motifs and qualities of ROMAN, BYZANTINE, BARBARIAN, and Carolingian art and welded them into a new unified style which, in spite of considerable regional differences, was a truly international one. The energy, inspiration, and wealth needed to create the style came from the Church, especially the monasteries. Many great monastic Orders, including the Cluniac, Cistercian, and Carthusian, were founded in the 10th and 11th centuries and expanded rapidly, building hundreds of churches all over Europe. At one time CLUNY alone controlled about 1,450 houses (see RELIGIOUS ORDERS), the remains of 325 of which still exist. The liturgical needs of these monasteries set new building problems and provided the functional basis for the growth of a new kind of architecture. But the particular direction their solution to these problems took—its new way of articulating space, the orderly grouping of its elements—cannot be explained solely in functional terms. Aesthetic considerations and the urge to create architectural symbols expressive of the monastic Christian view of the world also played their part. Some historians see in the style a reflection of the hierarchic social structure of feudalism.

It is in the figurative arts that the Romanesque concern with transcendental values is most apparent. They contain little of the NATURALISM and humanistic warmth of classical or later Gothic art. The forms of nature are freely translated into linear and sculptural designs which are sometimes majestically calm and severe and at others are agitated by a visionary excitement which can become almost delirious. Because of its expressionistic DISTORTION and stylization of natural form, Romanesque art, like many other great non-naturalistic styles of the past, has had to wait for the revolution in sensibility brought about by the development of modern art in order to be widely appreciated.

ARCHITECTURE. Romanesque architecture resulted largely from the contact of Lombard First Romanesque building, which preserved something of the Roman tradition of vaulting, with the late Carolingian traditions of Germany and France. In Germany this was made possible by the revival of the arts under the Ottonian emperors. In France the main early developments occurred in Burgundy where they received their impulse from the monastic centre of Cluny. The Cluniac Abbot William of Volpiano, who was personally responsible for the earliest known large vaulted church of S. Benigne at Dijon (1001-18), came from Lombardy and employed Lombard masons. Although Early Romanesque developed in Germany into a powerful and independent mature style, it is the traditions of Burgundy and central and northern France (and hence England also) which were historically more fruitful and eventually developed into Gothic.

In spite of its massiveness mature Romanesque architecture is spatial rather than sculptural and depends for its effect on a complex arrangement of clearly defined but interrelated groups of elements. To grasp the significance of Romanesque as a style it is necessary to know something of the development and progressive integration of these elements.

Changes that were to become typical features of the east ends of the greater Romanesque churches were necessary for three practical reasons: to provide more chapels containing altars for the increasing number of priests required by their Order to say daily Mass; to give processions of pilgrims access to the relics of saints which were housed in the churches; and to provide space in which the monks could conduct services in privacy. These architectural problems were solved (probably for the first time at St. Martin's at Tours in 918) by extending the apsidal end of a fundamentally BASILICAN structure and equipping it with radiating chapels and an AMBULATORY which enclosed the sanctuary. At Cluny II (981) a different plan was adopted in which the aisles continued past the transept and terminated in chapels on either side of the main APSE. These became the two main plans of the greater Romanesque churches. The radial plan was adopted in the important and influential group of five large churches built during the second half of the 11th c. on the pilgrim route to the shrine of St. James at Santiago de Compostela. Three of these first great monuments of the mature international style have survived— Santiago itself, S. Sernin at Toulouse, and Ste Foi at Conques (see PILGRIMAGE CHURCHES).

Although narrow masonry VAULTS were common in the aisles and crypts of early churches, the vaulting of the much wider naves of greater churches was the major structural challenge for Romanesque architects. Stone vaulting was desirable for fire prevention (disastrous fires were common in churches with wooden ROOFS), for its permanence, for completing the monumental effect of the interior, and, particularly among the Cluniacs, for the excellent acoustics it provided for chanting. The two main forms of Romanesque vaulting were the semicircular tunnel vault and intersecting groin vault. The

**318.** Modena Cathedral, façade (12th c.)

**319.** Church of S. Miniato, Florence, façade (12th c.)

enormous weight and outward thrust of these stone vaults account for much of the characteristic heaviness of Romanesque. They had to be supported by massive stone walls and PIERS, and buttressed by the vaults of GALLERIES built over the aisles. Windows had to be kept small in order not to weaken the walls.

An important step in the vertical development of medieval architecture was taken by the architects of a group of early Norman churches, including Jumièges (1037–66) and Mont-St.-Michel (1024–84), when they applied shafts (engaged COLUMNS) to the piers of the main ARCADE and continued them up the walls and across the nave as diaphragm ARCHES supporting a wooden roof. This had the effect of dividing

the main space of the church into a series of square bays. These vertical shafts were later combined with stone vaulting and continued across the nave as arches following the curve of the vault. The beautiful church of S.-Etienne at Nevers (1083–97) is the oldest surviving building which displays all the characteristics of the mature style—a high tunnel-vaulted nave divided into bays, a transept, an apse with radiating chapels and ambulatory, a main arcade of semicircular arches, a gallery above the aisles, and a CLERESTORY. The external masses of a typical Romanesque church clearly reflect its interior shape and are made more imposing by the addition of a large tower at the crossing and twin smaller towers at the west end.

320. Durham Cathedral, nave (11th c.)

The Romanesque style, with regional variations, spread west to Portugal and was carried as far east as the Holy Land by the Crusaders. Its influence was felt, via Sweden, as far north as Finland. Among the most important monuments of the rich and varied Italian Romanesque are the Cathedral of Pisa, S. Ambrogio at Milan, Modena Cathedral, and S. Miniato at Florence, in whose elegant façade the first faint breath of the RENAISSANCE can already be felt. In the churches of the German Rhenish School (Speyer, Mainz, Worms, and Maria Laach) the spatial design of the great Ottonian church of St. Michael at Hildesheim, with its double chancels and transepts and wealth of towers, was further developed, notably by the addition of fine vaulting. The greatest achievements of the Norman Romanesque style were in England. They include the cathedrals at Winchester, Ely, Peterborough, Norwich, and Durham. The earliest known examples of rib vaulting occur at Durham (begun 1093).

The only secular Romanesque buildings of any importance are the castles and keeps, of which an excellent and almost intact example is the Tower of London.

SCULPTURE. The growth of Romanesque architecture was accompanied by a remarkable efflorescence of monumental sculpture, which had been almost dormant in Europe for 600 years. Most of it is RELIEF sculpture in stone, subordinate to the architecture and confined

321. Tympanum at Vézelay (12th c.). The carving depicts the Apocalyptic Vision

**322.** Sculptured capital (*c.* 1178) from Autun Cathedral. The scene represents a hanged man tormented by devils

and England (Kilpeck, Herefordshire), the barbarian tradition dominates; at others, as in Provence (S.-Trophime at Arles) and parts of Italy, where the remains of Roman sculpture abounded, the main influence was classical.

One of the most powerfully expressive and formally inventive traditions of stone relief sculpture existed in Languedoc and Burgundy where, under Cluniac patronage, it reached its zenith in the tympanum of MOISSAC and the tympana and capitals of AUTUN and VÉZELAY. It has been possible to trace the 10 years' work at Autun (1125–35) of the sculptor GISLEBERTUS. In his work, as in other monuments of this school, the forms of plants, animals, and human figures are treated with the utmost freedom and woven into vigorous, complex designs which enliven without destroying the shapes they decorate. The transcendental and didactic role of the frightening apocalyptic tympana, with their majestic central images of Christ, is clearly shown by the inscriptions on that at Autun, one of which reads: 'Here let fear strike those whom earthly error binds, for their fate is shown by the horror of these figures.'

within frameworks provided by the structural parts of the church—CAPITALS, TYMPANA, MOULDINGS, etc. There are, however, many surviving examples of free-standing sculpture in wood and metal. The finest works of Romanesque sculpture are original conceptions of a high order. Their most characteristic traits arise from the fusion of the geometric decoration of the settled and converted barbarian tribes with the remnants of the classical figurative tradition. Sometimes, as in northern France

St. Bernard of Clairvaux regarded sculpture as a distraction for his meditating monks, fearing that they would find it 'more delightful to read the marbles than the manuscripts'; consequently, Cistercian churches, unlike those of the art-loving Cluniacs, are plain and austere.

Romanesque sculptors in Germany excelled in metal sculpture. As early as 1015 Ottonian bronze founders produced the technically and

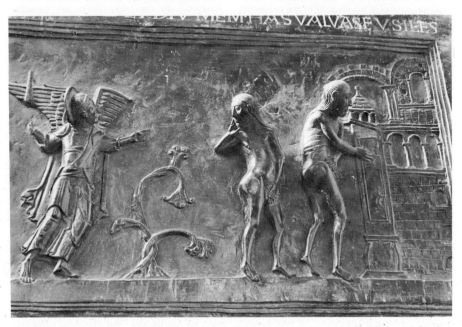

**323.** Detail from bronze doors at Hildesheim Cathedral. The scene depicts the expulsion of Adam and Eve from Paradise

artistically superb gates for St. Michael's at Hildesheim, and the tradition was continued in the gates at Novgorod in Russia and Gnesen in Poland, both of which were made in Germany. Among the best known works of German sculpture in the round are the metal-clad wood-carved Imad Madonna, the 5-ft. high bronze candle-bearing figure from Erfut, the POLYCHROMED wooden LECTERN from Freudenstadt with its four CARYATID figures, and the energetic bronze lion which Henry the Lion had erected in 1166 in the market place at Brunswick as a memorial to himself—the first such free-standing secular memorial sculpture in the West.

Other fine work was produced in Spain, especially the two 12th-c. portals at Santiago de Compostela. The best known Italian works are the late 12th-c. ones at Parma associated with the name of Benedetto ANTELAMI. Interesting examples of Romanesque sculpture occur in many parts of England, especially at Lincoln, Chichester, Ely, Malmesbury, and Kilpeck, but they are inferior to the best continental work.

PAINTING. It is difficult to realize in their present state that the interiors of Romanesque churches were once colourful. The paint has worn off the sculptures and the mural paintings, which were as abundant and widespread as carvings, have nearly all perished. Enough paintings survive, however, to give some idea of their general qualities.

Romanesque FRESCO and DISTEMPER painting followed directly on the Carolingian and Ottonian traditions. In Italy, where Byzantine influence was strong, it led directly to the beginning of Renaissance painting in the duecento (GIOTTO, CIMABUE, CAVALLINI), while in northern Europe it developed into Gothic. Generally speaking the paintings are flat, linear, weightless, shadowless, and highly STYLIZED. They illustrate scenes from the Bible and the lives of the saints with the utmost directness and simplicity, excluding everything from the setting that is not relevant. The Romanesque love of ornament is apparent in the richly patterned clothes of many of the figures and in the decorative borders that frame the pictures.

Some of the best surviving French paintings are at S.-SAVIN-SUR-GARTEMPE, Tavant, Brinay, and Berzé-la-Ville. Many of the finest examples of the justifiably renowned Catalan School of painting have been transferred from their churches (e.g. S. Clemente at Tahull) to the museum at Barcelona. These are powerful paintings with strong contours and rich, glowing colours. The paintings at S. Clemente in Rome are generally considered to be the best Italian examples.

THE MINOR ARTS. Book ILLUMINATION, IVORY-carving, precious metal-work, enamelling, STAINED GLASS, and textiles flourished throughout the period. One of the greatest schools of illumination existed in England, at Winchester, Canterbury, and St. Albans. Its masterpiece is the *Winchester Bible* (c. 1160–70). And what is perhaps the most celebrated of all textiles—the 231-ft. long embroidered BAYEUX TAPESTRY, with its lively scenes of the Norman Conquest of England—was made in England for Bishop Odo of Bayeux, the brother of William the Conqueror.

50, 62, 115, 214, 216, 298, 326, 457, 554, 555, 556, 661, 731, 733, 839, 885, 886, 959, 981, 1122, 1573, 1743, 2134, 2257, 2363, 2372, 2433, 2601, 2602, 2871.

**ROMAN SCHOOL.** From the 6th to the middle of the 15th c. the most powerful and richly adorned city of the West was steadily degraded. The myth of the Eternal City might strengthen its hold on popular imagination, but Rome itself, pillaged by barbarians and disfigured by the strongholds of factions, crumbled yet further into ruin. Only the CAROLINGIANS, associated with popes such as Hadrian I (722–95), Leo III (795–816), and Paschal I (817–24), rebuilt its walls and holy places. In the 12th c., however, after the ravages of the Normans and at the height of the struggle between the papacy and the empire, an effort was made to restore BASILICAS such as Sta Maria in Trastevere and S. Clemente. From these labours sprang a school of architect-decorators, the COSMATI, and, during the second half of the 13th c., a school of painter-mosaicists (TORRITI, CAVALLINI) who gave some hint of a return to the grandeur of antiquity. But Roman art produced nothing of note until the papacy returned from its exile in Avignon. In the quattrocento the humanist popes Nicholas V (1447–55) and Pius II (1458–64) made TOWN-PLANNING their chief concern, but it was not until Sixtus IV's pontificate (1471–84) that a modern street-plan began to take shape round the Castel S. Angelo. The architects and decorators were Tuscans or Lombards, the painters Umbrians and Florentines. We owe to them the Palazzo Venezia (begun 1455), the FRESCOES on the walls of the Sistine Chapel, and a few monumental TOMBS.

The real rise of Roman art began during the pontificate of Julius II (1503–13), when an educated and discriminating society, the men whom we see in RAPHAEL's portraits, felt a new enthusiasm for the excavation and preservation of ancient monuments and texts. Artists came from all over Italy to confront tasks of unprecedented magnitude. At the Vatican BRAMANTE was able to subordinate site to architecture. His design for the new St. Peter's, a domed building of central plan, was meant to reveal the deep significance which was believed to lie in harmony of PROPORTION. This ideal harmony appeared also in Raphael's frescoes at the Vatican (the *Stanze*). Raphael's decorative works and his VILLAS show the same equilibrium in their felicitous setting and in the adaptation of each building to its site and function. MICHELANGELO painted the ceiling of the Sistine Chapel

and designed his first project for the tomb of Julius II at the time when the beauty of his art was still purely sculptural. These works defined a new phase in style and dominated the development of the whole century. The new style became even clearer under Leo X (1513-21): the Church of S. Biagio at Montepulciano, by Antonio da SANGALLO the Elder, may be seen as the perfect expression of Roman CLASSICISM in architecture. But these successes had an unhappy counterpart: Roman art was afflicted by a kind of sclerosis, a pompous academicism which soon appeared in the work of Raphael's pupils and Michelangelo's imitators.

The Sack of Rome in 1527 dispersed the artists and so helped the new conventions to spread. In the 1540s Michelangelo created a final monumental design for the Capitol and the DOME of St. Peter's. But meanwhile MANNERISM had appeared, with its over-learned decorators and its architects who alternated between luxurious effects (Villa Giulia) and severity (the Gesù; S. Luigi dei Francesi). Yet this period also saw the creation of those sumptuously laid-out gardens which were the prelude to the grand designs of the BAROQUE.

Early in the 17th c. two important schools of painting appeared. There was on the one hand the powerful NATURALISM of CARAVAGGIO, who decorated chapels in several Roman churches. The other comprised the clear and idealized academic style of the CARRACCI. Its birthplace was Bologna but Rome was its chosen home, and the Carracci, DOMENICHINO, Guido RENI, and ALBANI all worked there. The Salone in the Palazzo Farnese is the outstanding achievement of this School. Rome was also the centre of the type of GENRE painting known as *bambocciate* (see LAER).

Splendour reappeared in Roman art at the time when the Counter-Reformation had triumphed in Europe. During the pontificates of Urban VIII (1623-44), Innocent X (1644-55), and Alexander VII (1655-67), great feats of urban design were undertaken such as the piazza in front of St. Peter's and the vast works, both religious and secular, that we owe to the theatrical imagination of BERNINI and the skill of Pietro da CORTONA and BORROMINI. They were accompanied by immense decorations in TROMPE L'ŒIL where Andrea POZZO could show his virtuosity (ceiling in S. Ignazio).

Roman Baroque was denounced in the 18th c. by the exponents of NEO-CLASSICISM, who favoured a clarity of style and purity of form derived from the ANTIQUE. Once again Rome was the capital of the arts where the doctrinaires of Germany, England, and France came for edification. The city had been a centre of LANDSCAPE painting since POUSSIN's residence there, and had contributed something new to that art—the painted and engraved *vedute* (city views) by PANINI, an artist from Bologna, PIRANESI from Venice, and the Frenchman Hubert ROBERT. But although Napoleon had grandiose projects

for the city and foreign artists continued to visit it, the Roman School ceased in the 19th c. to be an artistic force of any consequence.

313, 921, 1234.

**ROMAN STONE.** See ISTRIAN STONE.

## ROMANTICISM IN THE VISUAL ARTS.
In the visual arts Romanticism is easier to detect than to define. It shows itself both in the artist's choice of subject and in his attitude to that subject. It reflects the general tenor of feeling at a certain time, and may so cut across the autonomous technical development of the art form as to impede it. While it is everywhere important as a part of the history of taste, it is not always clearly a part of the history of art. But the techniques developed by the more important artists in their efforts to validate the Romantic attitude exercised a profound AESTHETIC influence on the course of style in the 19th c.

In contemporary usage the term 'Romantic' is treated as one that may be applied to art objects or movements throughout the history of art; but the term itself emerged in the language of art criticism during the 18th c., and developed its full implications very gradually. By the end of the 19th c. it could be almost a term of abuse, and certainly in the visual arts it was not a part of the main stream after 1850. The word derives from the Romances of the Middle Ages, that is to say the stories and legends invented in the languages deriving from Latin, and it thus suggests what is imaginative and IDEAL after the pattern of medieval chivalry. Romanticism was most commonly regarded in late 18th-c. art as an opposition to the CLASSICAL; and while this is perhaps the simplest way to approach its character, it must be remembered that in the broad analysis of the styles of world art both the classical and the Romantic incorporate the *ideal* rather than the *real*, and that both are types of NATURALISTIC painting and sculpture. Diagrammatically this may be shown as follows:

Both Classicism and Romanticism are here seen as modes of the Ideal, the selection, the 'stepping up' of the possible or usual, the reorganization of environment. It is precisely because of the closeness of classical and Romantic art forms that they afford such interesting and obvious points of contrast and comparison. Both are chosen instead of everyday life. Both

embrace concepts of nobility, grandeur, virtue, and superiority. But where the classical seems a possible ideal which will adapt man to his society and mould that society into an orderly setting for him, the Romantic envisages the unattainable, beyond the limits of society and human adaptability. The classical view of a possible society becomes politics; the Romantic view becomes poetry. The classical hero accepts the fate over which he has no control and triumphs nobly in this acquiescence, otherwise he would not be a hero. The Romantic hero pits himself against a hostile environment and at no time comes to terms with it even if he reaches his goal, otherwise he would not be Romantic. The symbols of Classicism could be the colonnade and the cornucopia; the symbols of Romanticism are the RUIN and the wreath.

It has been suggested that the emergence of the Romantic attitude can first be discerned in England as early as the first quarter of the 18th c. There is no precisely definable 'history' of Romanticism. The Romantic sentiment had a vogue for about a hundred years and it was a characteristic of that vogue that it could encompass a fairly wide sphere. Some historians talk of the 'Pre-Romanticism' of the 18th c. as compared with the full-bodied Romanticism of the early 19th. What seems to have happened is that man's image of the past took on a more poignant nostalgia which increased in potency as the present increasingly revealed its shortcomings. In this distanced view no one style may be said to have triumphed altogether over another, and to this extent there is a certain historical sequence. At first it was the life and art of the ancients that captured the imagination and later a conviction of the superiority of the Middle Ages led, almost as an end event, to the GOTHIC REVIVAL. But it was not nearly so clear-cut as this.

In the first place it must be remembered that Romanticism represents an attitude of mind and involves the expression of an idea that tends to have a verbal rather than a visual origin. In this context a ruined temple is more significant than a new one because it is more suggestive of the passage of time and a human frailty which nevertheless enhances the meaning of spiritual and emotional qualities. What is broken or partial can never be classical in the true meaning of the concept because the classical object is whole and coherent, not fragmentary. A view that finds a ruined temple beautiful is a Romantic view, though the temple may once have been a classical masterpiece. The expansion of the middle classes in England and France, the isolation of the intelligentsia in Germany, led to a wistfulness for what was past, or what was distant and exotic, in preference to the industrial emphasis; it was a reaction to the disappearance of aristocratic grace, a sign of escapism from intolerably widespread corruption.

While the Romantic attitude may be seen everywhere as an indirect protest against the inadequacy of social conditions, its alliance with one or other specific set of political tenets can by no means be clearly asserted; though it does tend to represent middle-class attitudes rather than those either of the aristocracy or of the proletariat, it permeates in one form or another the whole of society. It was only the aristocracy in England that could afford the conceit of Roman and medieval 'ruins' in their gardens—could afford indeed to have extensive estates at all.

It is in fact in landscape gardening among the gentry that the Romantic attitude may first be observed in England. Though the formal garden along with the formal house had become the norm by the time of Inigo JONES and WREN, the late medieval had not entirely died out in the hands of local craftsmen and builders even by the beginning of the 18th c.—though an indication that it was seen as belonging to the past occurs in the first use of the term 'GOTHIC' by the middle of the century. It was in the quest for what was regarded as the PICTURESQUE that the formal garden gradually lost its popularity. By the middle of the 18th c. the garden had become, through the influence of such men as Batty LANGLEY and William KENT, a deliberate reconstruction of the chance effects of nature. As early as 1728 Batty Langley had published his *New Principles of Gardening; or the laying out and planting Parterres, Groves, Wildernesses, Labyrinths, Avenues, Parks, etc.* William Kent, though one of the keystones of the PALLADIAN group, designed a Gothic garden building for Queen Caroline in 1735, in spite of having to his credit a large number of more or less Roman temples. The picturesque style was in the first instance probably meant to reproduce in the round the quality found in such classical painters as POUSSIN, though it was soon influenced by current writers like Pope, Dyer, and Mallet, who were themselves stimulated by some of the more suggestively brooding aspects of Melancholy that had appeared earlier in Spenser and Milton. Ivy-covered ruins, deserted graveyards, hooting owls, and cold moonlight invoked a visual setting which stimulated landscape gardeners and architects to the contriving of bizarre and weird effects. Here ruined temples were helpful, but it was soon realized that 'Gothick' shapes were more effective and often more readily available. In any case at this time a 'classical' style, whether a conscious revival or (as in England) a deliberate importation, did not necessarily bear all the marks of its original. It is almost impossible to classify any architect of the 18th c. in England as a deviser of solely classical buildings. The example of Kent has been quoted, but later in the century that apparent diehard of the classical tradition, Sir William CHAMBERS, provides a characteristic example of prevailing taste. His Albany in Piccadilly, his Casino in Dublin, even Somerset House, are classical in every pedantic sense, but the intention behind, for example, Charlemont's Casino is Romantic, while the 'ruined' arch and Pagoda

at Kew together with his writing on landscape gardening show him to have had as much Romanticism in his attitudes as any of his contemporaries. Perhaps the extreme example of Romanticism in building was Fonthill Abbey, built for William BECKFORD by WYATT at the turn of the century, and supposed to be medieval in character. Only the dreams of a millionaire could have given rise at all to this impractical and grotesque fabric; the tower was inadequately constructed and collapsed after only a few years, leaving a real ruin to be part of the Romantic legacy. If the picturesque is a Pre-Romantic, then the Gothic Revival must be regarded as a Post-Romantic phase in England; but it is difficult to find a strict dividing line between the three stages of taste. Romantic elements in the arts may be sharply contrasted with the genuinely classical, but it should be borne in mind that all deliberate revivalism savours of Romanticism, and that themes and motifs taken from the ancients do not in themselves result in a classical œuvre. Truly classical art had been produced during the RENAISSANCE, especially in Italy, because it was stimulated by a conviction of the formal and intellectual superiority of the environment of the ancients, and of the barbarism of the Middle Ages. Though the intentions of the Greeks and Romans may sometimes have been misinterpreted, this was largely owing to the imperfections of historical research and not, as in the 18th and 19th centuries, to a wistful longing for Utopias.

While we can point to numerous classical buildings in England from the time of Inigo Jones onward, it is not so easy to find examples of the purely classical in painting or sculpture, upon which the great Italian styles of the 15th, 16th, and 17th centuries had little direct influence. Superficial elements brought to England by minor artists or infiltrated by way of the FRENCH and DUTCH Schools can of course be detected everywhere, but produced no art of importance. Romantic art in England was not the result of a reaction from the classical, for there was no classical art to stimulate such a reaction. Rather it was the projection of a taste, largely literary in origin, upon a conveniently complaisant medium. REYNOLDS, for all his sturdy awareness of the character of the GRAND MANNER, was by no means a classical traditionalist in his painting. The MYTHOLOGICAL associations which he allowed to invade some of his works were far more Romantic in effect than classical. GAINSBOROUGH was even less of a classicist. And these are the two foremost painters of the 18th c. Elements of Romanticism are clearly discernible in BLAKE and FUSELI, the first avowedly, the second in spite of protest, both illustrators of literary and poetic ideas. The one distinguished Romantic English painter is TURNER, who removed his themes from a purely literary context by a masterly use of paint. His diffused canvases—differing in that respect from almost all other Romantic paintings—are merely heightened in their Romanticism by this device, which removes them from practical reality into the essential dream-world of the genre.

The simplicity and lack of intellectualism in Turner allowed him to give adequate expression to his vision. More often a too conscious intention to record complicated spiritual and emotional experiences strangled the pictorial techniques of the painter. An interesting contrast to Turner in this respect may be seen in his contemporary FRIEDRICH, a leading figure among GERMAN Romantic painters. The German Romantics, deriving their outlook as they did from writers and philosophers, were concerned with ideas and feelings whose expression was most readily achieved by verbal means: painters were moved to explain their works volubly. Frequently an enthusiastic description of the intentions of a painting is more evocative than the painting itself. Friedrich reads in the infinity of nature both the infinity and hopelessness and also the nobility of human yearning. A painter like P. O. Runge (1777-1810), in his *Four Phases of the Day*, attempted, with the inevitable result of bathos, to suggest subtle meanings in man's relation to the universal Purpose. Everywhere the pathetic fallacy was invoked, and to this end only an academic and indeed highly photographic technique sufficed. Unless the stormy sky and deserted hills are trapped and held by the picture frame with sufficient verisimilitude the reference will be lost. This imperative need for precise recording is to a greater or lesser extent a feature of all art which is Romantic in intention, since the associative element is so important. It may be thought that small reform groups like the NAZARENES, who between 1809 and 1820 protested their identification with earlier styles of art both German and Italian, may have done something to restore a more formal, painterly, or plastic approach to painting in Germany. They were, however, so circumscribed by the consciousness of their religious and moral aims that they failed to recognize important qualities in the works they so much admired, and fell back, in the manner of ECLECTICS, on superficially derivative productions. It was perhaps not entirely chance that led to the formation of a similar sort of group in England in 1848. The PRE-RAPHAELITE Brotherhood saw themselves as the rediscoverers of the uncorrupted naturalism of ITALIAN ART of the 15th c. but their ignorance of the true nature of the works of that time again resulted in a kind of travesty and placed them unmistakably in the ranks of the Romantics.

Romantic painting is generally considered to have achieved its purest development in France. Perhaps it made its first appearance in the ROCOCO of WATTEAU; and if we can accept this, then Romanticism was earlier in France than in England. Certainly the pastoral dream of Watteau and other court painters reflects the escape-idyll characteristic of a certain kind of Romanticism, though in France it always remained different

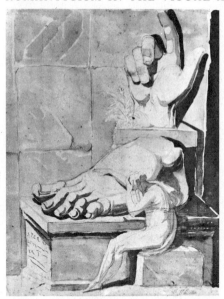

**324.** The artist overwhelmed by the magnitude of antique fragments. Wash drawing by Henry Fuseli. (Kunsthaus, Zürich, 1778-9)

from the English desire for vicarious terrors and excitements and from the German *Weltschmerz*. Painting has a longer and more varied history in France than in England. Poussin had represented a properly classical stream of BAROQUE, and the REALIST School from CHARDIN onwards was never negligible. Yet if we carefully scrutinize the work of DAVID, by common consent father of French Classicism, we cannot help but question this traditional classification. Classical art never portrays human emotion: neither in subject nor in treatment are the *Murdered Marat* or *Napoleon Crossing the St. Bernard Pass* classical. David is in fact in these something between a realist and a Romanticist, and much the same quality is shown in the *Oath of the Horatii*, though the theme is taken from ancient literature. Without the bias of their traditionally accepted roles it is difficult to distinguish between David and GÉRICAULT, who clearly derives from his school, though this means rather that David was not truly classical than that Géricault was not mainly Romantic. The Classicism of INGRES is less disputable. He was a pupil of David and although his themes were less frequently of an ancient origin than those of his master, his manner of painting had that substance and serenity essential to the genre and rare indeed at the turn of the 19th c. It is rather a realistic than a Romantic emphasis that distinguishes him from earlier Classicism, a sometimes embarrassing preoccupation with the rendering of textures that modifies what would otherwise be an immaculate classical distancing and generalization of his subject. It

is in contrast to painting of this kind that the character of Romanticism may be most clearly demonstrated, and of course its greatest contemporary exponent in this respect was DELACROIX. He was nearly 20 years younger than Ingres and his opposition to the older painter resulted rather from this—that he represented a new generation in painting—than from a simple choice between Classicism and Romanticism. Delacroix's importance, and he was undoubtedly the most important of all Romantic artists, is that he was the only painter to develop a technique that would enable the Romantic theme to achieve a valid aesthetic expression. The only other painter of whom this might with justification have been said was perhaps Turner, though his was a somewhat different case. The strength of Delacroix as a painter lies in the fact that he did not develop a specifically Romantic style—there is in fact no such thing, there is only a Romantic attitude. He welded the Romantic point of view on to a style which would accommodate it. This manner of painting was the easy and fluent result of a development that may have originated in Venice and was passed on through both Rococo and realist manifestations of the Baroque. RUBENS, REMBRANDT, Watteau, and Chardin all partook of it to some extent; it was still to flow on by way of COROT and MANET to the IMPRESSIONISTS. It is a painter's technique which is not limited by subject so long as that subject is a valid one for painting. It was this that Delacroix opposed to the formal architecture of Classicism, and it was this that both crowned and ended the Romantic movement in France. Romanticism persisted in various forms until the end of the century, but was never anything but derivative or sentimental or both.

Looking back from our vantage point of more than a hundred years we can see that in fact Romanticism never was a part of the mainstream of development in the visual arts. Its proper sphere seems to have been a literary one and with perhaps two exceptions it never produced a distinguished artist. One of these, as has been said, is Delacroix, though his distinction lies not so much in his having been a Romantic as in his having managed to surmount this fact. The other is Turner. The latter was considerably older than Delacroix and does not represent the new generation of painting, though this is a point of contention. It is not without significance that the English painter who most influenced the course of painting in France was CONSTABLE, not Turner. This was inevitable once it is accepted that the mainstream of art from the 17th to the 19th century was a realistic one. If we compare Turner's *Rain, Steam and Speed* with MONET's *Gare St. Lazare*, we shall see at once the basic difference. The mists that veil Turner's canvases represent not the optical but the imaginative limitations of the spectator. This is not, as it was later to be with the Impressionists, actuality translated into a system of opacity and luminosity of paint, but the shimmer of the

unattainable. Perhaps Turner was the only truly Romantic painter of any standing because he used his paint to enhance his Romantic vision, not to justify it. This is probably what RUSKIN—another great Romantic—so much admired, and why at the same time he could not come to terms with WHISTLER, who used paint as the Impressionists used it, to integrate the surface of the canvas and provide aesthetic distance.

If painting found it impossible to represent the exiled soul, the stirring moment, the unattainable ideal, and to satisfy the desire for vicarious, thrilling, and delicious horror, without a descent into the theatrical and the sentimental, it may be imagined that there was little possibility for sculptural offerings to the Romantic temperament. Sculpture is by its material nature, particularly those traditional materials of stone and bronze which were used in the 18th and 19th centuries, bulky, static, and actual. Any attempt to introduce ethereality or suggestion or evanescence produces something in the nature rather of theatrical paraphernalia than sober art. Themes remained those of antiquity, and a Romantic desire for PERSONIFICATION or the display of emotion resulted in the comic or the sentimental. Whether in Italy, Germany, England, or France, there is scarcely an 18th-c. piece of sculpture acceptable to contemporary taste. Robust classical idealism as well as Renaissance and Baroque energy were transformed by the processes of repetition and misunderstanding into sentimentality and posturing, and more often than not a saccharine pornography.

The technical developments which infused so much new vigour into painting in the 19th c. had no parallel in sculpture before the time of RODIN, whose work represents very well the struggle between the potency of realism and the constricting tentacles of Romanticism, from whose more shallow sentimentalities he never completely escaped in his marbles, but which were triumphantly overthrown in his forward-pointing masterpieces of bronze.

As has been said, there is a tendency in current writing to treat Romanticism as a manner that may appear at any time in the visual arts, and in some cases to extend the meaning of the term to include contemporary emotional and Expressionistic styles. This extension of meaning renders the term virtually useless as a definition. It must be emphasized that while Romanticism can be regarded as a kind of EXPRESSIONISM, by no means all Expressionism is Romantic—just as all Romanticism is not necessarily sentimental although the sentimental in the visual arts tends to arise out of a Romantic vision. It may reasonably be suggested that the quality or manner of outlook which was to be recognized as Romanticism in the 18th and 19th centuries had appeared from time to time at earlier periods. The works of ALTDORFER, GIORGIONE, and LEONARDO have an obviously Romantic vein. In the 20th c. it may be suggested that the SURREALISTS showed an

excitement in the irrational which in its literary and intellectual origins may be classified with, if not as, Romanticism. The same may be said with reservations about a painter of fantasy such as CHAGALL, but certainly not about van GOGH except perhaps in his very early paintings before he met the Impressionists. The Romantic ideal may stem from, and often appears to merge with, the Classical ideal; but in spite of its often photographically naturalistic detail and its predilection for historical themes, it is never preoccupied with actuality and appears to approach realism only of the more emotional kind.

Romanticism involves attitudes and ideas, and in philosophy and literature reached a maturity that can be equated with the beginnings of contemporary consciousness. Its importance in expanding poetic awareness beyond the formality of the Classical framework has no parallel in the visual arts, and this fact must be faced. There is scope both for the irrational and the fantastic in representational painting; but it is obvious that the further one proceeds from the extremes of representation in painting to the more tangible and solid forms of sculpture and architecture, the less able the medium becomes to carry the subtleties that lie behind the finest achievements of the Romantic imagination.

932, 2092, 2486.

**ROMBOUTS,** THEODOOR (1597–1637). Flemish narrative and GENRE painter, whose career is similar to that of Gerard SEGHERS. Born at Antwerp, where he was a pupil of JANSSENS, Rombouts went to Italy c. 1616, where he worked until c. 1625. He painted genre and religious subjects with strong CHIAROSCURO effects in a thoroughgoing CARAVAGGESQUE style (*The Five Senses*, Ghent), and later treated Classicist compositions with the same dramatic contrasts of lighting. In common with so many artists he later inclined towards the style of RUBENS. His *Allegory of Justice*, which is now in the museum at Ghent, was originally an important commission for the Town Hall, where it is said to have been admired by Rubens. Other examples of his work are at Antwerp, Madrid, Vienna, and Paris.

**ROME,** CAPITOLINE MUSEUM. The municipal museum of Roman antiquities (see ROME, Museo Nazionale), situated in the Palazzo Nuovo and the Palazzo dei Conservatori on the Capitoline Hill. It is the oldest civic collection, having been begun in 1471 by Pope Sixtus IV; but it is connected with a still older tradition, which persisted throughout the Middle Ages in Rome, of preserving in or near public buildings or palaces ANTIQUE statues saved from the barbarian invasions.

The Palazzo dei Conservatori stood next to the Palazzo dei Denatori, which was built on the ruins of the old Roman Tabularium, or state archives: Sixtus was consciously reviving the

traditional symbol of Republican Rome when he gave the antique bronzes from the Lateran Palace to the Conservators of the city. The collection grew rapidly at the end of the 15th and in the first half of the 16th centuries, becoming the storehouse for the many sculptures excavated in Rome throughout that period, except for the choicest, which the popes kept for the Cortile del Belvedere in the Vatican. Even during the Counter-Reformation it was enriched by many antique sculptures, then considered too profane to be kept in the papal palace (1566). The greater part of the museum's collections, however, was acquired in the 18th c., the second great period of excavations, notably by the gift of the superb collection of Cardinal ALBANI, presented by Pope Clement XII in 1733. Its contents have overflowed into the Lateran Palace, and also include a large collection of Christian antiquities.

The imposing aspect of the Capitoline, intended to recall though not to imitate its ancient glory, is due to MICHELANGELO, who designed the layout of the square. He transferred thither the bronze statue of the emperor Marcus Aurelius from the precincts of the Lateran and designed (but did not execute) the three palaces, though the final design for the Palazzo dei Senatori was that of Giacomo della PORTA.

325. Self-Portrait. Oil by George Romney. (N.P.G., London, 1782)

**ROME,** MUSEO NAZIONALE (Museo delle Terme di Diocletiano). A foundation of the Italian State (1889), where are preserved the antiquities excavated within the city of Rome. The museum has a collection of great importance, which includes the frescoes from the Villa Livia and the famous 17th-c. Ludovisi collection, acquired entire in 1901, and is unsurpassed for its Roman SARCOPHAGI. It occupies some of the remaining buildings of the Baths of DIOCLETIAN, as well as the cloisters of a 16th-c. monastery within their precincts. Since this setting almost precludes systematic arrangement of the exhibits, a decorative scheme has been adopted.

**ROMNEY,** GEORGE (1734-1802). English portrait painter, the son of a builder and cabinet-maker at Dalton-in-Furness. He studied under provincial painters at Kendal and York, and settled in London in 1762. He travelled in Italy, 1773-5. Romney is best known to the general public by facile portraits of women and children and by his many studies of Lady Hamilton, whom he delighted to portray in various historical roles. These are not, however, his best work. His visit to Italy at a time when the NEO-CLASSICAL movement was gaining ground made a lasting impression on him and some of his portrait groups, e.g. *The Gower Children* (Duke of Sutherland Coll., 1776), are composed with classical statuary in mind, particularly in the treatment of the DRAPERIES. He painted a number of impressive male portraits, e.g. *Richard Cumberland* (N.P.G., London, *c.* 1776), and some fashionable groups of great elegance, e.g. *Sir Christopher and Lady Sykes*

(Sledmere, 1786). His output was large, but he never exhibited at the ROYAL ACADEMY. Though the huge prices his portraits fetched between the two World Wars were out of all proportion to their quality, later his work was rated below its true worth.

Romney was of an imaginative, introspective, and nervous temperament. He was attracted to literary circles and William Hayley and William Cowper were among his friends. He had aspirations to literary subjects in the GRAND MANNER, and painted for BOYDELL's Shakespeare Gallery. His sepia drawings, mostly designs for literary and historical subjects which he never carried out, were once highly prized; there is a large collection of them in the Fitzwilliam Museum, Cambridge. His aspirations were in advance of his achievement but he had some importance as a Neo-Classical link to FLAXMAN.

2792.

**RONCALLI,** CRISTOFORO, also called IL POMARANCIO (after his birthplace near Volterra) (1552-1626). Italian painter who executed many fresco decorations in the Vatican and the Quirinal Palace between *c.* 1590 and 1610. He remained in the late MANNERIST tradition to the end of his life. His unbiased, commonsense views on art, however, known from a lecture he gave to the Academy of St. Luke in 1594, commended him to Vicenzo GIUSTINIANI, one of the most enlightened patrons of his time. Roncalli became his artistic adviser and accompanied him on his famous journey to Germany, Holland, England, and France in 1606.

**ROOD-SCREEN.** Term in Christian CHURCH architecture. The rood-screen of medieval churches was a combination of two elements: a closure which marked off the region of the altar from the part of the church assigned to the laity (i.e. the nave) and a beam across the entrance to the altar space on which stood an image of CHRIST on the Cross (the rood proper). This was turned towards the nave and was often accompanied by the VIRGIN and St. John. The primary function of a screen was to exclude profane persons from the immediate vicinity of the altar, where Mass was celebrated and in or beneath which the relics were housed. At first no attempt was made to prevent laymen seeing what went on at the altar. The earliest screens, such as the six spiral COLUMNS which were already standing in Old St. Peter's at Rome by A.D. 600, or the primitive form of the BYZANTINE ICONOSTASIS in which columns were joined by a low parapet and a beam overhead (e.g. Torcello), must have allowed a fairly uninterrupted view of the proceedings in the sanctuary. The decisive change came in the wake of the reform of the 10th and 11th centuries, when the Church became acutely conscious of the need to distinguish between clergy and laity, especially in monastic churches which were used by both. Screens now became solid walls across the church separating off the nave, which had its own altar for the laity. The rood served as a kind of reredos for this altar, often richly decorated with sculpture (e.g. Vezzolano, late 12th c.). When this happened, however, the character of the screen changed. It became a symbol of the frontier between the temporal and spiritual worlds, and the rood now took its place as the essential link between the two: a visible proclamation of Christ's sacrifice which won for sinful men the possibility of eternal life. A very rich ICONOGRAPHY developed around rood-screens during the 13th c., especially in Germany. Thus at Mainz the rood was raised directly over the lay altar, with the figure of ADAM interposed between them. The lay altar was particularly associated with the Mass for the Dead, death being regarded as the fruit of Adam's sin. Medieval beliefs about Golgotha and the Church of the Holy Sepulchre at Jerusalem were woven into an elaborate programme. At Naumburg the rood was brought down and set in the doorway of the screen across the west choir, which was a kind of memorial chapel to the dead benefactors of the cathedral. In the late Middle Ages the screens themselves to which the roods were attached were very elaborate throughout Europe. York and Canterbury in England are every bit as ornate in their own way as those at Albi or La Madeleine, Troyes, in France, or Halberstadt in Germany. Even more complicated is the wooden screen at Chester Cathedral (end of 14th c.), which is a continuation of the fretted tracery and pinnacles of the adjacent CHOIR STALLS. Wooden screens were an English speciality in the late Middle Ages. A splendid series, mainly of the 15th c., still survives in English parish churches. They are of the open type because there was no nave altar. The lower panels were often painted with images of saints (e.g. Ranworth, Norfolk).

Rood-screens survived into the 16th c., and in Belgium at least some impressive examples were built in the new RENAISSANCE style (e.g. Tournai Cathedral). Subsequently, however, they went out of fashion and many of the best medieval examples were destroyed in the 18th c. so that we know them, if at all, only as dismembered fragments.

**ROOF.** Architectural term applied very broadly to the covering of a building primarily intended to make it weatherproof. Many materials have been used for roofing, e.g. straw, thatch, mud, wooden shingles, TERRACOTTA, tiles, MARBLE, slate, sheet lead, etc. The conditions under which any material is effective vary considerably. For instance straw thatch requires a very steep pitch for it to drain well, whereas lead can be laid almost horizontally. Considerations of this kind make the roof one of the fundamental factors in determining architectural design. Thus straw cannot easily be used to cover very wide buildings, and we can understand why Greek TEMPLES, for instance, did not begin to acquire their broad rectangular shapes and their low-pitched PEDIMENTS until tiles were introduced, possibly in the 7th c. B.C. Another case where a change of roof pitch contributed to the making of a style occurred in English PERPENDICULAR, where roofs were practically flat. In the 17th and 18th centuries roofs of different pitch were sometimes grouped together for the sake of visual effect (e.g. in French châteaux) and from this it was only a short step to the kind called MANSARD, in which there is more than one pitch to the same roof.

The roof is what transforms an enclosure into an interior, although where ceilings and VAULTS are used it cannot be seen from within. But there have been many buildings in which the roof has contributed to the internal aesthetic effect. Perhaps the most outstanding examples are to be found in medieval churches and halls. Several principles were used, each creating its own structural problems, and we often find in the most ambitious buildings (e.g. Westminster Hall) more than one principle employed in the same design. The most satisfactory arrangement for large buildings involved the use of trusses in which horizontal tie-beams resolved the thrust developed by the inclined roof members. The well known hammer-beam roofs, which are a distinctive feature of English medieval architecture, were a variation of the tie-beam principle; instead of a continuous truss at the base of the roof short beams extend out from the walls and are supported from below (hammer-beams) and the centre-piece has, as it were, been elevated by the introduction of verticals resting on the hammers. In Westminster Hall (1394) this hammer-beam method is combined with wooden

ARCHES that provide additional bracing and the whole structure is embellished with delicate open panelling, reminiscent of contemporary stonemasons' work. Later, in Elizabethan times, two rows of hammer-beams were sometimes used (e.g. the Hall of the Middle Temple).

The success of timber roofs in England was so great that it took the place of stone vaulting in all but the very largest churches, but elsewhere in Europe church roofs tended to be purely utilitarian structures concealed by stone vaults.

**ROOF BOSS.** See BOSS.

**ROOKER,** MICHAEL ANGELO (1743–1801). English painter, scene designer, and book illustrator, who took lessons from Paul SANDBY. From 1788 he travelled extensively in the southern and midland counties and was one of the most assiduous topographers of his time (see TOPOGRAPHICAL ART).

**ROPS,** FÉLICIEN (1833–98). Belgian PRINT-maker and painter who spent the greater part of his life in France. He was one of the most skilled ETCHERS of his time. His illustrations for *Le Vice suprême* by Péladan, *Les Diaboliques* by d'Aure-ville, and frontispieces for poems by Mallarmé are excellent examples both of his technical ability and of his curious imagination, which frequently skirted the morbid, perverse, and erotic.

155, 844, 2083, 2173, 2174.

**RORITZER.** Family of German architects of the 15th and early 16th centuries who were in charge of work at Regensburg Cathedral and also worked in Munich (Frauenkirche), Nuremberg (S. Lorenzkirche), and Vienna (Stefansdom). The most interesting of them was MATHÄUS (d. c. 1492) whose little book *Von der Fialen Gerechtigkeit* is one of the rare documentary sources affording us an insight into the actual methods of designing used in late GOTHIC masons' lodges.

**ROSA,** SALVATOR (1615–73). Italian painter, born near Naples, and a pupil of Aniello FALCONE, whose BATTLE-PIECES he imitated. In 1635, encouraged by LANFRANCO, he went to Rome and for the next few years was alternately in Naples and Rome, where he made his name as a painter, poet, actor, and musician. In 1640, partly to escape the anger of BERNINI, whom he had satirized, he moved to Florence, where he worked for the MEDICI. After 1649 he remained in Rome until his death. Rosa introduced a new type of LANDSCAPE representing wild and savage scenes boldly handled, which were particularly esteemed in England by admirers of the PICTUR-ESQUE in the late 18th c. and in the 19th c. he was regarded as the exemplar of a ROMANTIC artist. His attempts to rival the painters of Rome after c. 1650 in large religious and historical composi-

tions were less successful. He took up ETCHING c. 1660, and proved himself an able and original etcher.

503.

**ROSALES Y MARTÍNEZ,** EDUARDO (1836–73). Spanish painter. He was trained in the Academy at Madrid under Federico MADRAZO. From 1857 he lived mainly in Rome and he became the director of the Spanish school established there. He was one of the leading painters of his time to show an appreciation of contemporary painting in France, and affinities with both DEGAS and MANET have been claimed for his work.

**ROSICRUCIANS.** An esoteric order of artists organized in close contact with the SYMBOLIST movement in 1888 under the name 'Ordre de la Rose-Croix du Temple et du Graal'. In 1891 it was joined by Jan TOOROP, Odilon REDON, Émile Bernard (1868–1941), Ferdinand HODLER, and others. According to the catalogue of an exhibition organized in 1892 by Péladan the objects were 'to destroy REALISM and to bring art closer to Catholic ideas, to mysticism, to legend, myth, allegory, and dreams'.

**ROSLIN,** ALEXANDER (1718–93). Swedish portrait painter, who left his country in 1745, visited Bayreuth and Italy, and finally settled in Paris in 1752. There he rapidly attained success, becoming a member of the Académie in 1753. He was particularly esteemed for his skilful rendering of garments and DRAPERIES. His portraits show psychological insight as well as technical proficiency. He seems to have observed his rich and complacent sitters with a certain cool cynicism which explicitly reflects the situation of the bourgeois under the *ancien régime*.

**ROSSELLI,** COSIMO (1439–1507). A competent but uninspired FLORENTINE artist, a pupil of Benozzo GOZZOLI. Among his own pupils were Fra BARTOLOMMEO and PIERO DI COSIMO. There is an *Annunciation* by him in the Louvre (1473) and extant frescoes in the cloister of the Annunziata and the Church of S. Ambrosius, Florence. He was commissioned out of his class in 1481 to paint frescoes for the Sistine Chapel along with BOTTICELLI and GHIRLANDAIO.

**ROSSELLINO,** BERNARDO (1409–64), Florentine sculptor and architect, and AN-TONIO (1427–79), his brother, also a sculptor. Bernardo began his career as a sculptor when Florentine sculpture had been brought to its highest point by GHIBERTI, DONATELLO, and MICHELOZZO, and the principles of RENAISSANCE Classicism had been established by BRUNEL-LESCHI. We know of several purely architectural works by Bernardo (e.g. the Town Hall and two palaces in Pienza, designed in the 1460s) and

several purely sculptural ones (e.g. the terra-cotta *Annunciation* in the cathedral and the *Madonna della Misericordia* relief in the Hospital at Arezzo, 1433-5). His chief work combined both arts—the TOMB of the great humanist and Chancellor of the Florentine Republic, Leonardo Bruni, in Sta Croce, Florence (1444-50). The work retains Donatello's classical grace of line without his ruggedness, and the figure of the dead man has been called one of the most beautiful mortuary effigies extant. Bernardo placed the effigy, which lies on a bier over the coffin, within the frame of a niche derived from the entrance to the choir of Brunelleschi's Old Sacristy in S. Lorenzo. The result is a design of the utmost economy and poise. This work became the type of the niche tomb for the next century.

Antonio also developed the linear grace of Donatello and the flowing pictorial devices of Ghiberti. But he was an artist of some stature in his own right. In keeping with the spirit of the third quarter of the century his work was more elaborate and sophisticated than Bernardo's. He was also more concerned with movement. A comparison of the Bruni Tomb with Antonio's tomb of the Cardinal Prince of Portugal in S. Miniato al Monte, Florence (1461-6), brings out the change in style and feeling. The decorative adjuncts although individually exquisite do not fit together into a coherent design. This tomb was admired by Antonio Piccolomini, who in consequence commissioned a replica for the Church of Monte Oliveto, Naples, in memory of his wife, Maria of Aragon (d. 1470). Antonio executed several reliefs and statuettes of the Madonna and Child, one of which is in the Victoria and Albert Museum. These continue, but with more grace and liveliness, the tradition created by Luca della ROBBIA of stressing the naturalness and humanity of the VIRGIN.

2100.

## ROSSETTI, DANTE GABRIEL (1828-82).

English-born painter and poet of Italian descent who with Holman HUNT and John Everett MILLAIS formed the PRE-RAPHAELITE Brotherhood in 1848. He was taught drawing by COTMAN but early discovered a bent for painting in two-dimensional patterns of vivid colour. After an unsuccessful attempt to learn the secret of colour as a vehicle for the expression of emotion from Ford Madox BROWN, he left him for Holman Hunt under whose guidance he painted *The Girlhood of Mary Virgin* at the age of 21. His first fully independent work was *Ecce Ancilla Domini* (N.G., London, 1850). At this time he met Elizabeth Siddal, whom he encouraged also to paint and whom he married in 1860. (His portrait of her is in the Tate Gallery.) She posed also for Hunt and Millais and her curious beauty haunted the Pre-Raphaelites till the end of the century. Some of Rossetti's best work was done under the inspiration of his feeling for Elizabeth Siddal. His subjects were

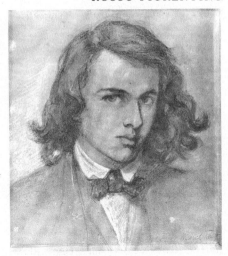

326. Self-Portrait. Pencil drawing by Dante Gabriel Rossetti. (N.P.G., London, 1847)

taken from Dante and from a world of medieval romance which alike in his painting and his poetry he transformed into a universe of imaginative reality. Yet at this time there was often a real intensity of experience to which the pictorial image gave symbolic expression (*Arthur's Tomb*, Tate Gal.). After the death of his wife from laudanum in 1862 much of the intensity of realized experience departed and he became a mechanical maker of pictures, except for those done under the impulse of his new passion for Mrs. Morris. He became an addict of chloral and a recluse. Perhaps the last work which reflected his former intensity was his painting of his wife as *Beata Beatrix* in 1863 (Tate Gal.).

Although a member of the Pre-Raphaelite Brotherhood, Rossetti had little in common with the aims and principles of the rest. His contribution was personal. His medievalism had little of the socialistic roots which inspired MORRIS and his work had little in common with Millais or Hunt. He had many superficial imitators but the only one of account was BURNE-JONES, who had something of Rossetti's ROMANTIC escapism even when he had passed from the influence of Rossetti to that of BOTTICELLI and MANTEGNA.

759, 1772.

## ROSSO FIORENTINO, GIOVANNI BAT-TISTA (1494-1540). Italian painter who with PONTORMO worked under ANDREA DEL SARTO. He was active in Florence 1513-23 and afterwards in Rome. The exaggeration of dramatic intensity in his works of these years belongs to the early history of Italian MANNERISM (*Moses Defending the Daughters of Jethro*, Uffizi, c. 1523). He was brought to France in 1530 by Francis I, and with PRIMATICCIO at FONTAINEBLEAU became

one of the founders of French Mannerism (see School of FONTAINEBLEAU). The exact shares of Rosso and Primaticcio in the designing and decoration of Fontainebleau are not known, nor their respective contributions towards the creation of the new style which emerged. Rosso's main work at Fontainebleau was the decoration of the Galerie François I in the Italian style, though adapted to the requirements of the French courtly taste of the time. Despite influences of MICHELANGELO and Andrea del Sarto his own painting seems to have achieved some originality of style, as is attested by the *Pietà* executed for the Constable Anne de Montmorency (Louvre). His important influence on French painting and decorative arts was enhanced by the many engravings which were made from his designs.

169.

**ROTHKO,** MARK (1903-70). American ABSTRACT EXPRESSIONIST painter; born in Russia. In 1913 he came to the U.S.A. and studied at Yale. During the mid 1920s he was a student of Max WEBER in New York; in 1937-8 he painted for the Works Progress Administration. He moved toward abstraction chiefly under the influence of SURREALISM during the 1940s. About 1950 he began to mature his characteristic idiom: large rectangular bands of colour (often layers of thin washes of different hues) arranged parallel to each other, usually in a vertical format. The edges of these shapes are softly uneven, giving them a hazy, pulsating quality as if they were suspended and floating on the canvas. The overall effect of these often enormous canvases is one of calmness and contemplation, as opposed to the frenzied energy of the Action Painters, such as DE KOONING and POLLOCK. In 1948 he founded a school with Baziotes, Newman, and MOTHERWELL, based on the search for the most simple means to express universal truths. He influenced many contemporary painters, especially those aiming at expression through large, luminous fields of colour.

**ROTTENHAMMER,** JOHANN (1564-1625). German painter. As a young man he lived for several years in Rome, where he was in close contact with Paul BRIL. He specialized in MYTHOLOGICAL subjects but paid much attention to the LANDSCAPE backgrounds. His pictures were usually on a small scale and he liked to paint on copper plates.

**ROTTMANN,** CARL (1797-1850). German painter. He studied at the Munich Academy and travelled extensively in Italy and Greece. He is best known for his Greek and Italian landscapes commissioned by King Ludwig I of Bavaria and painted in fresco on the walls of the *Hofgarten* cloisters in Munich. His panoramic views combine heroic grandeur with accurate observation and an interest in Mediterranean light.

**ROUAULT,** GEORGES (1871-1958). French painter and engraver. In his youth he was apprenticed to a glass painter and assisted in the restoration of medieval STAINED GLASS. In 1892 he became a fellow pupil of MATISSE and MARQUET under Gustave MOREAU at the École des Beaux-Arts. He painted religious pictures and unsuccessfully submitted for the Prix de Rome in 1893 *Samson tournant la meule* and in 1895 *Le Christ mort pleuré par les Saintes Femmes* (Grenobles). About 1898 he underwent a psychological crisis and although he continued to associate with the group of artists around Matisse who were later known as FAUVES, he did not adopt their brilliant colours but painted clowns, prostitutes, outcasts, judges in sombre but glowing tones with emphatic outlines. From 1906 began his association with the dealer Vollard, for whom during the years 1914-20 he engraved illustrations to a number of books (*Les Réincarnations du Père Ubu*; *Le Cirque*; *Les Fleurs du Mal*; *Miserere et Guerre*). During the 1930s his work began to be exhibited abroad, including an exhibition of his engravings at the Museum of Modern Art, New York (1938). From *c.* 1940 he devoted himself to religious art, making use of the strong simplifications, deep and powerful colouring, and the emphatic black outline which had become characteristic of his style. In 1945 he was given a large retrospective exhibition at the Museum of Modern Art, New York, which included the windows he designed for the church at Assy, and also a retrospective exhibition at the Kunsthaus, Munich. A final retrospective was arranged at the Musée Nationale d'Art Moderne, Paris, in 1952.

Rouault's very personal style has been thought to be reminiscent in its glowing colours and strong outlines of the stained glass on which he worked as a youth. He was the most individual and the most powerful artist of the French EXPRESSIONISTS.

102, 638, 1021, 2523, 2738.

**ROUBILIAC,** LOUIS FRANÇOIS (*c.* 1705-62). Sculptor, born in Lyon. He probably had some training in Saxony under Balthazar PERMOSER, and more in France under Nicolas COUSTOU. He settled in England before 1735, and had worked for Henry CHEERE when he made his name with the statue of Handel for Vauxhall Gardens (now V. & A. Mus.). This was a lively ROCOCO invention of very high quality, at once informal and topical, and an excellent portrait. During the following years Roubiliac was to show himself a brilliant maker of BUSTS, fitting his designs to the character of his sitters. Many show the head sharply turned (*William Hogarth*, N.P.G., London), and in all he stresses small forms and rippling movement, which is very different from the broader treatment of his contemporary, Michael RYSBRACK. He was especially successful with portraits of old and ugly men (*Dr. Martin Folkes*, Wilton

**327.** *Misrere mei, Deus, secundum magnam misericordiam tuam.* First illustration to the *Miserere et Guerre* (1916–27). Photo-engraved plate reworked with a variety of engraving techniques by Georges Rouault

House, 1749) and in his series of busts at Trinity College, Cambridge, showed a remarkable gift for producing lively portraits of men long dead. His TOMB sculpture, which may be well studied at Westminster Abbey, brings a new note of drama and of symmetrical design to England,

notable examples being General Hargrave (1757) rising from his tomb, Lady Elizabeth Nightingale (1761) being struck by the spear of Death emerging from his prison, and Handel (1761) conducting a celestial orchestra. These are, however, slightly less successful than his busts or his

328. Self-Portrait. Marble bust by Louis François Roubiliac. (N.P.G., London, c. 1760)

smaller monuments, partly because the small forms which he loved are unimpressive in large-scale sculpture. His masterpiece is perhaps the statue of Newton (1755) at Trinity College, Cambridge.

834.

**ROUEN,** CATHEDRAL OF NOTRE-DAME. The old cathedral was burnt in 1200, and presumably Jean d'Andeli, master-in-charge in 1206, was responsible for the new design. It is an ECLECTIC building. The tower arrangement follows that of LAON; the transept façades those of CHARTRES; while the west front has projecting towers connected by a screen in the English manner. Four storeys were originally intended but the tribunes were abandoned in the course of construction, leaving a curious makeshift arrangement in the aisles. The building was virtually completed by 1260, but a series of later additions were made and it is for these that the cathedral is mainly famous. The RAYONNANT transept façades date from c. 1280; the beautiful Lady Chapel from 1302-20; the west front with its open FLAMBOYANT texture and rows of statues from c. 1370; and the Tour de Beurre from between 1485 and 1507. The picturesque qualities of Rouen Cathedral attracted many 19th-c. painters, notably MONET, who made a number of paintings representing the façade in different conditions of light.

**ROUEN,** S. MACLOU. This church, begun in 1434, may be taken as representative of

FLAMBOYANT architecture. The interior is restrained, all the most striking effects being concentrated outside, where the Flamboyant TRACERY produces an over-all impression of extra-ordinary grace and fragility, as though the masons had set themselves to emulate the virtuosity of finely wrought metal-work. The delicacy of the carving, however, is contrasted with the dramatic shadows of its porch, a late GOTHIC effect which, as in the case of Ulm, seems to have been inspired ultimately by the porches of S. Urbain, Troyes.

**ROULETTE.** An ENGRAVING tool having at one end a toothed wheel, used for making dotted lines or tonal areas on copper plates. Together with its variants the matting wheel and the chalk roll it was evolved in the 18th c. for making engravings in the CRAYON MANNER and the other tonal processes.

**ROUSSEAU,** ÉTIENNE-PIERRE-THÉO-DORE (1812-67). French LANDSCAPE painter, the central figure though not the greatest painter of the BARBIZON SCHOOL. After receiving a pre-dominantly classical training he visited the mountains of Auvergne in 1830 and began to paint landscapes direct from nature in the open air. He had a picture accepted by the SALON when he was 19 but was subsequently refused consistently until 1848. In 1836 and 1837 two of his finest early landscapes, *Descente des Vaches* (The Hague) and *Avenue of Chestnut Trees* (Louvre), were refused. From 1836 he worked regularly in the Forest of Fontainebleau, speci-alizing in wooded scenes (*Edge of a Forest—Sunset*, Salon 1850-1, Louvre). About 1846 he settled in the village of Barbizon, where he was a close friend of MILLET and DIAZ. He was influenced largely by RUYSDAEL and from about 1863 became interested in Japanese WOODCUTS. After about 1850 the subjective, ROMANTIC elements in his earlier works gave way to an almost scientific objectivity and his interest in the rendering of atmospheric effects predomi-nated (*Farm in the Landes*, Salon 1859).

755.

**ROUSSEAU,** HENRI (1844-1910). French painter, known as LE DOUANIER ROUS-SEAU. At the age of 18 he did his military service as a saxophonist in a military band and claimed to have seen service in Mexico, although this is unconfirmed. In 1866 he obtained a minor post in the *octroi* department of Customs and Excise on the outskirts of Paris. He apparently took up painting as a spare-time hobby c. 1884 and on his retirement in 1885 set up as an amateur painter in order to supplement his pension. He has gone down to history not only as the greatest of untaught modern PRIMITIVES but also for the naïvety and ingenuousness of his character. In 1886 he was introduced by

SIGNAC to the Société des Artistes Indépendants and exhibited at the Salon des INDÉPENDANTS regularly from that time. He was in contact with GAUGUIN, PISSARRO, SEURAT, and other leading artists of the day and his work was admired by RENOIR, REDON, and TOULOUSE-LAUTREC. Among men of letters Alfred Jarry, Rémy de Gourmont, and the critic Gustave Coquiot appreciated his work. About 1905 he began to engage the attention of Guillaume APOLLINAIRE and artists of PICASSO's circle, who used to visit him in his rooms. When visited by Picasso he is recorded to have said to him: 'We are the two greatest artists of our age—you in the Egyptian manner, I in the modern.' In view of the increasing reputation which Le Douanier has enjoyed in art criticism the assessment does not seem quite so ridiculous at the middle of the 20th c. as it did at the time it was made. In 1908 Picasso gave a banquet, half serious half burlesque, in Rousseau's honour.

Rousseau's ambition was to paint in the academic way. He admired the works of such traditionalist painters as Adolphe William Bouguereau (1825-1905) and Jean-Léon GÉRÔME. He was admired by the greatest artists of his day for a quality of directness which they found also in the art of primitive peoples. At a time when popular art had lost the last remnants of its vitality Rousseau brought it to new heights, and he contributed an element to 20th-c. sophisticated art which is unique to himself. His influence has been surprisingly wide and may be seen in many trends of modern art movements.

179, 368, 2058, 2376, 2698, 2720, 2959.

**ROWLANDSON,** THOMAS (1756-1827). Most talented draughtsman of English 18th-19th-c. social satirists and CARICATURISTS. He went to the Académie Royale school in Paris at the age of 16 and to the R.A. Schools when he was 19. He began to specialize in the *tableau de modes* or humorous comment on the social scene about 1780 and in 1784 exhibited his elaborate promenade scene *Vauxhall Gardens*. His talent for exuberant and flowing line had affinities with the French ROCOCO of FRAGONARD and the *tableaux de modes* of Baudouin (1723-69), but his rollicking humour and delicate tonal effects

**329.** *The Rivals.* Water-colour drawing (*c.* 1812) by Thomas Rowlandson. (Private Coll., Boston Public Library, U.S.A.)

were distinctively English. His repertory of themes was inexhaustible and his *œuvre* has been termed the English equivalent of Balzac's *Comédie humaine*. In the general history of art he is a link between the *estampes galantes* of French 18th c. and the REALISTIC social commentary of DAUMIER and Constantin GUYS. He was a friend of George MORLAND and travelled about England and also in France, Germany, and the Low Countries making rapid and brilliantly illuminating sketches of country life. In addition he produced series of illustrative drawings for the publishers Fores (*Comforts of Bath*, 1798) and Ackermann (*The Miseries of Life*, 1808, and *The Tours of Dr. Syntax*, 1812-20). A different side to his character found expression in drawings exaggerating in pictorial terms the bestiality and depravity of the human animal (*Cobbler's Cure for a Scolding Wife*). Rowlandson's *World in Miniature*, 40 etched plates with characteristic groups of figures 'for the illustration of landscape scenery', published in 1861, is now a collectors' piece and is vastly superior to similar volumes prepared by his companion IBBETSON.

1974.

## ROYAL ACADEMY OF ARTS IN LONDON, THE.

Although the Royal Academy arrived late, its Instrument of Foundation being signed by George III on 10 December 1768, it had its precursors. In 1636 Charles I, himself a notable COLLECTOR, founded the Museum Minervae for instruction in the arts, sciences, and other gentlemanly accomplishments and this short-lived venture is usually considered to have been the first attempt to form a national ACADEMY of Art. According to William Sandby's history of the Royal Academy (1862) it was foreshadowed by a scheme put forward by John Evelyn, the diarist, in *Sculptura* (1662), a book on engraving. This scheme has not survived. The first private academy of drawing and painting was opened by KNELLER in 1711. Kneller was succeeded as Governor by THORNHILL in 1716. In 1720 Thornhill formed his own academy, which was not a success, and in 1735 Kneller's foundation, transferred to St. Martin's Lane, was re-established by HOGARTH. In 1755 the St. Martin's Lane Academy approached the Society of DILETTANTI with a scheme for a Royal Academy which should provide for both annual exhibitions and schools of training for students. But the project came to nothing because the artists were unable to accept the conditions made by the Society which would have given the latter control of the management. A similar cause of disagreement prevented smooth co-operation between the Society of Arts (which became the Royal Society of Arts in 1908), formed in 1754 for 'the encouragement of arts, manufactures and commerce in Great Britain', and the Society of Artists, which staged successful annual exhibitions and was incorporated by Royal Charter in 1765 as The Incorporated Society of Artists of Great Britain.

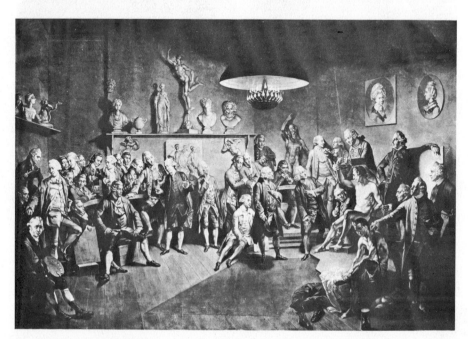

330. *The Royal Academy.* A gathering of members in the Life Room of the Royal Academy in London. Mezzotint (1772) by R. Earlom after a painting *The Academicians of the Royal Academy* by J. Zoffany

The immediate impetus to the formation of the Royal Academy was provided by a struggle between the architects James PAINE and Sir William CHAMBERS for control of the Incorporated Society of Artists. Sir William Chambers put up a proposal to the king for a national Academy and the royal approval was given. Membership was limited to 40 Academicians, who must be artists by profession, and 36 were named in the Instrument of Foundation. The Royal Academy came into being through royal PATRONAGE at the instigation of a group of leading artists, whose motive was to raise the status of their profession by establishing a sound system of training and expert judgement in the arts and to arrange for the free EXHIBITION of works which attain an appropriate standard of excellence. Behind this conception was the desire to foster a national school of art and to encourage appreciation and interest in the public based on recognized canons of good taste. The Instrument of Foundation provided for setting up Schools of Design; Professorships of Anatomy, Architecture, Painting, and Perspective and Geometry; an annual exhibition of paintings, sculpture, and designs, open to all artists of distinguished merit; and a library of books on architecture, sculpture, painting, and all the sciences relating thereto, also of prints of bas-reliefs, vases, trophies, ornaments, dresses, ancient and modern customs and ceremonies, instruments of war and arts, utensils of sacrifice, and all other things useful to students in the arts. It was also provided that after the first 36 members named in the Instrument each Academician should deposit a sample work with the Academy on admission. These form a permanent collection housed in the Diploma Gallery. In 1769 a new class of Associates was instituted, from whom the number of Academicians was recruited. At first 20, the number of Associates was raised to 30 in 1876.

The Royal Academy first functioned in Pall Mall. The Schools and the Exhibition were transferred to the Somerset Palace in 1780, shared with the NATIONAL GALLERY its premises in Trafalgar Square 1837-68, and moved to the present site of Burlington House in 1867. The first President of the Royal Academy was Sir Joshua REYNOLDS, who held the office until his death in 1792. His famous *Discourses*, delivered over a period of 20 years, laid down the basic conception of the Academy as a body of professional men which, 'besides furnishing able men to direct the student', was to form 'a repository for the great examples of the Art'. The latter function was important since until the foundation of the National Gallery in 1824 there was no public collection of masterpieces available to students and schools. Reynolds was followed by Benjamin WEST, who was President from 1792 until 1820 (except in 1805-6).

Regarding itself as the main depository of national tradition in the arts and the safeguard of sound standards of professional competence in execution, the Royal Academy, in common with other official establishments, has been cautious of innovation and slow to lend the seal of its approval to experimental novelty. The conservatism which is inherent in the conception of such an organization is attended by special dangers in the field of fine art, where at any rate since the age of ROMANTICISM creative originality has come to be regarded as a necessary quality of great work. During the latter decades of the 19th c. the reputation of the Academy sank very low and it began to be regarded as the bulwark of orthodox mediocrity in opposition to creative and progressive art. Other organizations, such as the NEW ENGLISH ART CLUB, and later the LONDON GROUP, were formed to accommodate progressive trends. From the 1930s its policy has become more liberal and the conflict between official 'Academy' art and creative art has narrowed. But something of the opinion from the late 19th c. continued during the 20th c. and the function of the Academy at its inception to provide exhibitions of the best contemporary work from year to year has not survived the competitive claims of the commercial galleries and of such bodies as The ARTS COUNCIL OF GREAT BRITAIN.

1340, 1396, 1549.

## RUBENS, SIR PETER PAUL (1577-1640).
Flemish artist, who was one of the greatest painters of his age. He was born at Siegen in Westphalia, the son of Jan Rubens, a protestant lawyer from Antwerp who played a notorious part in the life of Anna of Saxony, Princess of Orange. Rubens's masters were three mediocre painters of Antwerp, Tobias Verhaecht (1561-1631), Adam van NOORT, and Otto van VEEN, none of whom could teach him more than the local tradition. On the other hand he acquired a thorough knowledge of the classics, his Latin was sound, and he was a master of the major European languages. His correspondence, which must have been voluminous, reveals his activities as a scholar, antiquarian, business man, and above all as a diplomat.

In 1598 Rubens became a Master of the Antwerp Guild of St. Luke. Two years later he went to Italy, and it was there that he reached full artistic maturity. He lived in Rome until 1602. In 1603, on behalf of Vincenzo GONZAGA, Duke of Mantua, he went to Spain, where he painted the equestrian portrait of the Duke of Lerma (Coll. Conde Valdelagrana, Madrid, 1603) and made copies after TITIAN. In 1604 he returned to Italy, first to Mantua, where he stayed for another year in the service of Gonzaga, and then to Genoa and Rome (1605-8). His principal works during this second Italian visit were portraits of the Genoese patricians and the ALTARPIECE of Sta Maria Nuova in Rome. These were decisive years, for his study of the ANTIQUE and the careful copies he made of MICHELANGELO's sculpture and frescoes and of the paintings of Titian, TINTORETTO, and CORREGGIO were to affect much of his later work.

In 1608 Rubens returned home. Antwerp at this time had lost its position as a powerful international centre of trade, but it had become instead the cultural headquarters of the Counter-Reformation in Flanders—a Flanders dominated by Spain. It had many artists of note and its moneyed classes, with the Church and the court of Brussels, furnished patrons. This was a setting ready to receive a leader, and with his social background and his standing as an artist Rubens was able to fulfil this role. In 1609 he was appointed painter to the Archduke Albert of Austria and his wife the Infanta Isabella, the Viceroys for the King of Spain. In the same year he married Isabella Brant. The portrait of the artist and his young wife (Munich, 1609) reveals something of the intimate side of his life; his public activity is attested by an astonishing series of commissions during the years 1609-21. They included TRIPTYCHS for Antwerp Cathedral; *The Miraculous Draught of Fishes* for the church at Malines; the designs for the tapestries of the *History of Decius Mus*, to which van DYCK, who was a member of his workshop, contributed (Liechenstein Coll., Vaduz); altarpieces and sketches for 39 ceiling paintings for the Jesuit church at Antwerp. The church was destroyed by fire in 1718 and all the ceiling paintings were lost but various of the small oil sketches for this monumental project are at the Vienna Academy and in museums at Oxford, Dulwich, and Buffalo, U.S.A. In 1622 Rubens published *Palazzi di Genova*, an architectural pattern-book of plans and façades to show his countrymen how to replace what he termed their 'barbaric or GOTHIC' style of architecture with one that conformed 'to rules of the ancient Greeks and Romans'. The house he built for himself in Antwerp helped to popularize the style. In 1622 Rubens also visited Paris, having been commissioned to paint a series on the *Life of Maria de' Medici* for the Palais du Luxembourg (now in the Louvre). This glorification of the Queen marks a high-point of BAROQUE decorative painting. In 1626, a year after completing the Medici series, he painted the altarpiece of the *Assumption* in Antwerp Cathedral, with its reminiscences of Titian. About this time he made designs (now at the Boymans–Van Beuningen Mus., Rotterdam, and in Detroit) for the *Achilles Tapestries*, and the astounding *Triumph of the Eucharist Tapestries*. A complete set of the latter is in the Convento de las Carmelitas Descalzas at Madrid.

Rubens was now recognized as the leading artist of his day. Moreover he was becoming a power in the diplomatic world. He wrote: 'I regard all the world as my country, and I believe I should be very welcome everywhere.' He did not exaggerate. When he went to Spain on a political mission in 1628 he completely charmed Philip IV, who ordered portraits and other works from him. By the time of his death more than 100 of his pictures were in Spanish palaces. In 1629, still in the dual role of diplomat and painter,

he was sent to London, where Charles I knighted him. On this visit, though primarily occupied with political affairs, he found time to paint the *Peace and War* (N.G., London) and the *St. George* (H.M. the Queen), which he set in a dream-like transposition of a Thames landscape. He also painted portraits and did much of the preliminary work for the ceiling of Inigo JONES's Banqueting Hall in Whitehall.

Isabella Brant had died in 1626 and Rubens felt her loss keenly. He wrote to a friend: 'I have no pretensions about ever attaining a stoic equanimity . . . I do not believe that one can be equally indifferent to all things in this world.' In 1630, on his return to Antwerp, Rubens married the 16-year-old Hélène Fourment. She was the epitome of all Rubensian models and appears in his late works not only in portraits but in the guise of various saints and deities.

The last 10 years of Rubens's life saw a further deployment of his astonishing powers. Apart from the Whitehall ceiling (completed in 1634), there were the paintings for the royal palace of Buen Retiro, near Madrid, and the altarpiece of *St. Ildefons*, Vienna, with its portraits of the Archduke and the Infanta (Kunsthist. Mus., Vienna). At the same time he was doing works of a more intimate nature: *The Garden of Love* (Prado, 1630-4) and large landscapes like those in the National Gallery, London, and the Wallace Collection. In these he summed up the achievements of a century of LANDSCAPE PAINTING and showed himself the heir to Pieter BRUEGEL.

Rubens's genius encompassed every branch of painting and engaged every faculty. Modern taste tends to admire the finished works less than the oil sketches, the sketches less than the DRAWINGS, regarding draughtsmanship as the basis of his greatness. He came to draw with the brush as with a CHALK rapidly, with an immediate, flawless accuracy which enabled him on a larger scale to make uninterrupted sweeping strokes of exceptional length and power. The assurance and vibrancy of his strokes brings his compositions to life even when they are traditional and static, as in the *Self-Portrait with his Wife under a Honeysuckle Bower*. The special quality of his draughtsmanship can best be seen in the chalk and PEN drawings, but is also very striking in his preparatory oil sketches such as the preparatory sketch (Louvre, 1610) for one of his most famous altarpieces, *The Elevation of the Cross*, which, 15 ft. in height, dominates the centre of Antwerp Cathedral. Because of this facility Rubens was able to put his ideas down in the freshness of inspiration, and apart from providing countless sketches for his workshop to fulfil so many commissions himself. Speed was essential and Rubens certainly possessed it; it is recorded that on one occasion the portrait of a family was painted in two days (*The Earl of Arundel, Wife and Son*, Munich). The other keystone of his genius was the luminosity of his colour, which was influenced by Titian and

Tintoretto but inspired by the earlier Flemish tradition. His manner of juxtaposing primary and complementary colours anticipated French 19th-c. development. Today outside Belgium his great religious paintings are often seen in museums, where their true significance is lost. When a painting is restored to a place of worship, as happened recently in England with the *Adoration of the Magi* at King's College Chapel, Cambridge, his grandeur is more easily understood. It is generally admitted that the great decorative paintings are not 'original works' in the modern sense, for Rubens's method was to leave his assistants to carry on alone between the initial sketch and his own finishing touches. But this was sufficient for his contemporaries. The music of Rubens's art, the sequence of colour upon colour, is certainly more pronounced in the sketches; but this was of no great importance for the men of his time. What they enjoyed was the reality of Rubens's creations, the vitality he could impart to the world of myth and history, to the symbolism of secular and religious power. Sketches like those for the *Life of Maria de' Medici* (Munich), for all their attractiveness, give only a glimpse of the intellectual and literary enjoyment that the finished works afford.

In this outline much great work by Rubens has been passed over—thronged compositions like the *Battle of the Amazons* and the *Fall of the Damned* (both at Munich), and thousands of sketches and drawings, which include designs for silver-work and engravings, title-pages and frontispieces for his friend Moretus, the Antwerp printer, and visual directives for sculptors and architects. Rubens left his mark on Antwerp as no one has before or since. He was, as his fellow diplomatist Dudley Carleton expressed it, 'the Prince of Painters and fine gentlemen'. The battle of the Poussinistes and the Rubensistes (see POUSSIN) in which DE PILES played the part of Rubens's advocate, illustrates the breadth of his influence; the work of WATTEAU, FRAGONARD, and DELACROIX, its depth.

440, 1285, 1968, 2299, 2336.

**RUBLEV, ANDREI** (1360?–*c.* 1430). Considered to be the greatest Russian religious painter, although comparatively little is known about his life or works. The 600th anniversary of his birth was celebrated by Soviet Russia in 1960, but there is some evidence that he may have been born a decade later. He was a monk in the monastery of Troitsky-Sergieva and also spent some years in the monastery of Andronnikov. In 1405 he worked as assistant to THEOPHANES in the Cathedral of the Annunciation in the Kremlin at Moscow and three ICONS on the ICONOSTASIS (those of the NATIVITY, the BAPTISM, and the TRANSFIGURATION) have been attributed to him on stylistic grounds. He also executed murals and icons together with Daniil Cherni in the Cathedral of the Dormition at Vladimir (*c.* 1408) and at Moscow (*c.* 1425), but so far it has not been possible to distinguish his share. In 1422 he returned to Troitsky-Sergieva and there, according to the tradition, decorated the Cathedral of the Trinity and executed his masterpiece, the icon of the Old Testament Trinity, which symbolizes the TRINITY through representations of ABRAHAM's three ANGELS (now in the Tretyakov Gal., Moscow). Though Rublev has been regarded as a pupil of Theophanes, the other-worldly lyrical simplicity of his linear style seems to owe little or nothing to the painterly and dramatic manner of the latter and to represent rather a break with the BYZANTINE tradition inaugurated by Theophanes.

1591.

**RUBRICATION.** The painting, usually in red, of initial letters, catchwords, and section headings in ILLUMINATED manuscripts and early printed books; first practised in the papyrus rolls of the Egyptian BOOK OF THE DEAD.

**RUDE, FRANÇOIS** (1784–1855). French sculptor, a lifelong admirer of the ANTIQUE who in practice was too much influenced by the ROMANTIC tendencies of his time to remain strictly in conformity with the Classical ideal. He excelled in capturing and dramatizing a fleeting and characteristic pose, gesture, or expression rather than in producing an ideal generalized image (*Joan of Arc*, Louvre, 1852; *Marshal Ney*, Place de l'Observatoire, Paris, 1853). His most famous and perhaps his finest work is the high relief on the Arc de Triomphe: *Departure of the Volunteers in 1792*, popularly known as *The Marseillaise* (1833–6).

904.

**RUFFO, MARCO.** See SOLARIO, Pietro Antonio.

**RUINS.** Artistic interest in ruins for their own sake is a relatively new thing in human history and specifically a feature of the ROMANTIC age. Through the greater part of human history buildings which had fallen into decay were freely rebuilt, neglected, or cannibalized for other building and their destruction was not checked either by nostalgic respect for antiquity or by a regard for the PICTURESQUE appearance of the ruins themselves. Before the Romantic love of ruins for their own sake, however, there existed from early RENAISSANCE times onwards an exaggerated respect for Roman ruins, particularly in Italy, as the relics and visible signs of the perfection which had been achieved once for all in antiquity. The phrase *Roma quanta fuit ipsa ruina docet* ('from the ruin we learn the greatness that was Rome') occurs in a guidebook by Albertini in 1510 as well as on a drawing by HEEMSKERCK and as a motto on the title-page of several of SERLIO's books of architecture. A similar attitude pervades a *Report on Ancient*

*Rome* presented to Pope Leo X by a member of RAPHAEL's circle: 'the little that remains of the ancient mother of glory and of the Italian name, witness of the divine spirits whose memory even today creates and moves us to virtue—spirits still alive among us—should not be altogether wiped out by the depredations of the evil and the ignorant.' This attitude towards ruins surviving from classical antiquity found pictorial expression in landscape art, particularly the landscapes of CLAUDE and Salvator ROSA, both of whom had a vogue and exercised an important influence on the development of the picturesque style in England. The earliest of the specialized ruin painters was PANINI, who created a new kind of *vedute* often based on real ruins accurately delineated but placed in a fantastic setting. The greatest of those who made a speciality of ruins was PIRANESI, who anticipated the Romantic feeling for their picturesque quality but combined this with the exactness of a trained architect and the enthusiasm of an amateur archaeologist and a partisan of the Romans against the Greeks. Hubert ROBERT introduced to France the Romantic style of ruin-painting of which Panini and Piranesi were masters. But he lacked what WALPOLE describes as the 'sublime dreams' of Piranesi.

The enthusiasm for GOTHIC ruins came later as one of the precursors of the Romantic outlook. One of its most extravagant manifestations was the vogue for artificial ruins in landscape gardening during the GOTHIC REVIVAL. The earliest of these sham ruins was probably the one erected by Sanderson MILLER at Edgehill, but the craze soon became general and spread from England to the Continent. A nostalgic affection for ruins in their natural setting as an enhancement to natural scenic beauty has remained a feature of Western aesthetic outlook.

**RUISDAEL,** JACOB VAN (1628/9–82). The greatest and most versatile of all Dutch painters of LANDSCAPE in the 17th c. He was born in Haarlem, traditionally called the home of Dutch landscape painting, where he probably received training from his father ISAAC and his uncle Salomon van RUYSDAEL and certainly knew the works of the local painter Cornelis Vroom (1591–1661). In 1657 he took up residence in Amsterdam and later, in 1676, he apparently qualified as a doctor at Caen in Normandy and practised medicine at Amsterdam. He seems to have been an isolated and melancholy personality, wholly immersed in his work.

Artistically Ruisdael was precocious. His early talent is apparent from the fine colour and effective contrasts of light and shadow in the carefully executed views of white dunes, hedges, and the woods, painted before he was 20. He was a bachelor and made a comfortable living; the story that he died a pauper in an insane asylum is based upon a mistaken identity. Like all great landscape painters he was sensitive to the effects of light and space, and had a personal vision which informed his paintings, drawings, and ETCHINGS. For him man was insignificant beside the majesty and power of nature, to which he gave expression in his heroic trees in ancient forests, his torrents and waterfalls, and his vast fields of golden grain. Always nature is paramount in his paintings. Picturesque crowds of skaters and tobogganists have no place in his winter scenes; only one or two pedestrians brave the cold and never distract attention from the grey sky, the crisp atmosphere, and the dead

331. *A river shore with fishermen.* Ink and brush drawing by Jacob van Ruisdael. (B.M., 1648)

trees. The theme of growth and decay received its finest expression in *The Jewish Cemetery* (one version in Dresden, another in the Detroit Institute of Arts), where tombstones and elegiac RUINS, symbols of man's transitory and ephemeral existence, are contrasted with nature's power of renewal. GOETHE responded to this mood in his meditation on *Ruisdael als Dichter*. When Ruisdael found inspiration in the work of another artist, as he did in Allart van EVERDINGEN'S paintings of waterfalls, he created something new and personal out of the borrowed motif. His landscapes of Holland have no parallel. His views of Haarlem seen from a high dune capture the silent movement of the clouds across the great plain. His masterpiece, *The Windmill at Wijk* (Rijksmuseum), is a symbol of the Dutch countryside to the entire world.

Ruisdael had many followers, the most distinguished of whom, HOBBEMA, was his pupil.

2305.

**RUNCIMAN,** ALEXANDER (1736-85) and JOHN (1744-68). Scottish painters, brothers, of Edinburgh who painted religious, literary, and historical subjects in a manner which anticipated the ROMANTIC movement of the early 19th c. John, the more brilliantly gifted, died young during a sojourn by both brothers in Italy. His masterpiece, *King Lear in the Storm* (N.G., Edinburgh), has freshness and originality with nothing of the staginess of most 18th-c. Shakespearian pictures. Alexander's major work, the decoration of Penicuik House with romantically treated subjects from Ossian and the history of Scotland, has been destroyed; some of its compositions survive in a series of spirited ETCHINGS he based on them.

**RUPERT,** PRINCE (1619-82). Nephew of Charles I, an active dilettante of science and the arts. He was an amateur ETCHER and introduced to England MEZZOTINT engraving, which he may have learnt from the inventor Ludwig von SIEGEN. He demonstrated the technique to Evelyn, by whom it was publicized in his *Sculptura* (1662) under the auspices of the Royal Society. His prime interest was in techniques, not only of engraving but of staining and painting MARBLE.

**RUSH,** WILLIAM (1756-1833). American sculptor. He was typical of the self-taught, somewhat naïve artists of the early years of the Republic—the artist in transition from craftsman to sculptor. Apprenticed to a wood-carver, he progressed from ships' figureheads to freestanding figures, such as the *Nymph of the Schuylkill* (1812), a work which almost perished through exposure to the elements in Fairmount Park, Philadelphia, and was only preserved when it was belatedly cast in bronze. EAKINS was attracted by the simplified NATURALISM of Rush's work and called him 'one of the earliest and one of the best American sculptors'.

1762.

**RUSIÑOL Y PRATS,** SANTIAGO (1861-1931). Spanish painter, poet, and writer on art. Trained first in Barcelona and influenced by the art of his friend Ramón CASAS, he continued his studies in Paris. He was among the more prominent 19th-c. Spanish painters who worked in the international style which had its centre in Paris.

**RUSKIN,** JOHN (1819-1900). English critic and art theorist, considered the most influential in his time. John Stuart Mill said of him that apart from his own group Ruskin was the only original English thinker of his day.

Ruskin belonged to the ROMANTIC School in his conception of the artist as an inspired prophet and teacher. Greatness of art, he thought, is 'the expression of a mind of a God-made man'. In *Modern Painters* (1843-60), which was largely devoted to the defence and elucidation of TURNER, he acknowledged in particular his debt to Carlyle. In 1851 he came forward as a champion of the PRE-RAPHAELITES. In 1849 he published *Seven Lamps of Architecture*, and *Stones of Venice* in 1851-3. Like PUGIN he advocated a revival of the GOTHIC style, though he differed from Pugin in his theory of ornament. His rejection of the CLASSICAL tradition followed from his assumption that art and architecture should mirror man's wonder and delight before the visual creation of God and that this demanded a freely inspired and NATURALISTIC style to which he felt that Gothic alone was really suited. He saw ornament as an aid to contemplation of the wonders of divinely inspired Nature and introduced a highly personal scale of expressive value in ornament based on representation of natural forms. He praised the Gothic for its 'noble hold of nature' and for the 'careful distinction of species, and richness of delicate and undisturbed organisation, which characterise the Gothic design'.

Although Ruskin's worship of beauty for its own sake brought him into affinity with the advocates of 'art for art's sake' (see AESTHETICISM), his strong interest in social reform and ever-increasing concern with economic and political questions during the second half of his life kept him from accepting a doctrine of the autonomy of the arts in divorce from questions of social morality. His eloquence in linking art with the daily life of the workman had affinities with the views of William MORRIS and his insistence on regarding the state of the arts as a 'visible sign of national virtue' and his constant emphasis on their moral function have sometimes been regarded as a conspicuous instance of the 'moral fallacy' in aesthetics and criticism. In 1854 Ruskin began teaching in F. D. Maurice's Working Men's College while writing and

lecturing widely on a variety of subjects including political economy. In 1870 he was appointed Slade Professor at Oxford and founded the Drawing School there. The following year he began the monthly publication of *Fors Clavigera* as an organ for his views on social and educational reform and founded the unsuccessful St. George's Guild for the revival of the hand-made linen industry. His interest in social reform also coloured his most popular works *Sesame and Lilies* (1865) and *The Crown of Wild Olive* (1866). Ruskin set himself obstinately and short-sightedly against the effects of the Industrial Revolution in supplanting the older craftsmanship and opposed the efforts of Henry Cole, Matthew Digby Wyatt, Owen Jones, Richard Redgrave, and others to raise the standard of design in industry and to institute schools for the application of good principles of design to mass production. His opposition was grounded in his dislike of the commercial motives which prompted the movement and in *Fors Clavigera* he wrote (Letter 79, 8 July 1877): 'the Professorship of Sir Henry Cole at Kensington has corrupted the system of art-teaching all over England into a state of abortion and falsehood from which it will take twenty years to recover.' Ruskin extolled loving truth as the essential motive of art. 'The greatest thing a human being ever does in this world is to *see* something, and tell what it *saw* in a plain way.'

566, 840, 2348, 2349, 2350, 2351.

**RUSSELL,** JOHN (1745–1806). English pastellist, a pupil of Francis COTES who appears to have set up independently in London by 1767. He had a large practice and was generally held the first man of the time for 'crayons'. He became A.R.A. in 1772, R.A. in 1788, and Crayon Painter to the Prince of Wales in 1785. He used bolder colours than other contemporary PASTEL painters and blended them by gently rubbing in with the finger. He published a valuable technical treatise, *Elements of Painting with Crayons* (1772).

2352, 2899.

**RUSSIAN ART.** As distinct from art on Russian soil, Russian art began about A.D. 1000 with the Christianization of the country. Neither the ANIMAL STYLE of the Scythian nomads nor the art of the Greek colonies on the Black Sea could contribute to it in any way, as both these civilizations had been dead for centuries. The new Russian state received its architecture and its painting together with its religion from Byzantium. The ornamental art of the pagan Slavonic tribes may have lingered on for some time in FOLK ART, but the art of medieval Russia was almost exclusively ecclesiastical and belonged to the wider sphere of BYZANTINE ART. The contribution of the early Scandinavian settlers—the Varangians—appears to have been as insignificant as that of the Slavs themselves.

The outstanding monument from the 11th c. is the Cathedral of Sta Sophia at Kiev, a Byzantine building with 13 CUPOLAS and (originally) nine aisles. Built by Greek workmen, it was later considerably altered and restored. The MOSAICS and FRESCOES of the interior are likewise the work of Greek artists. The frescoes which adorn the walls of the winding staircases, by which cathedral and palace were originally connected, contain portrait groups, hunting and circus scenes; they give us an idea of the otherwise lost secular art of the Byzantine court.

The first artists working in Russia appear to have come from Constantinople, but they were very soon replaced by native ones. This does not mean that medieval Russian art ever lost contact with that of the Byzantine capital: though it has a distinct physiognomy of its own, it nevertheless followed step by step the changing styles of its parent. How much the Byzantine provinces contributed to Russian art is a much discussed but unsolved question; most probably the influence of Bulgaria (whence the Russians received their liturgy), Asia Minor, and the Caucasus was very slight.

On a number of buildings dating from the 12th c. there appear motifs taken over from the ROMANESQUE art of western Europe, but this influence is limited to minor details and does not affect the predominantly Byzantine character of Russian architecture. Romanesque and Armenian influences have been adduced in turn to account for the rich sculptured decoration of the church of St. Demetrius at Vladimir; neither the one nor the other, however, offers a cogent explanation for the strikingly original style of these sculptures.

The Mongol invasion first brought southern Russia (1224) and shortly afterwards northern Russia (1238) under foreign domination. The Mongols were conquerors and destroyers without a civilization of their own. To connect with them those Oriental elements which are to be found in Russian art is therefore erroneous.

Only the dukedom of Novgorod remained independent or semi-independent, and became the centre of Russian cultural life. Here we meet in the second half of the 14th c. a great artistic personality, the first whose name we know: THEOPHANES THE GREEK. Theophanes—in Russian 'Feofan Grek'—represents the last great period of Byzantine art, the revival of HELLENISTIC painting under the Palaeologans. His frescoes in the church of the Transfiguration at Novgorod (1378) exemplify his highly individual style; they are powerful and dramatic compositions with expressive figures, executed in broad, nervous brush-strokes. The Blessed Andrei RUBLEV was perhaps Feofan's pupil. His frequently copied *Trinity* (Tretyakov Gal., Moscow, c. 1410) became the most popular of all Russian ICONS. Rublev gave up the almost 'Impressionistic' Neo-Hellenism of his teacher; his works were conceived in a linear style dominated by long, flowing curves.

The second period of Russian art begins with the 15th c. The Tartars were driven from Russian soil and the whole country was united under the leadership of the Grand Dukes of Moscow. After the fall of Constantinople (1453) Russian political ideology evolved the slogan 'Moscow the Third Rome'; 'All Russia' was the spiritual heir of the Byzantine Empire. Henceforth Russian art was no longer a province of Byzantine art but its legitimate successor; Moscow became its artistic centre.

Italian architects were called to Russia to help with the monumental buildings to be erected on the Kremlin, the citadel of Moscow. They had to compromise with the traditional style of Russian church architecture. In the Cathedral of the Assumption (1474-9), built by the Bolognese Aristotele FIORAVANTI, the Italian elements play a subordinate part; it is a Russian church with the typical bulbous DOMES and an interior that makes no concession to foreign taste. Alevizo Friasin (ALEVIZ), the architect of the Cathedral of St. Michael the Archangel (1505-9), had to combine a typically north Italian RENAISSANCE façade with the traditional bulbous domes. Only in a secular building was the style of the Italian Renaissance allowed free play: the Granovitaya Palata (the 'Faceted Palace') in the Kremlin (by Marco Ruffo and Pietro SOLARIO, 1487-91) really looks like a north Italian palace of the quattrocento.

In general, however, the influence of the Italian Renaissance was very small and during the 16th and 17th centuries we see for the only time the flourishing of a style which is truly Russian. Russian art was then no longer a dependent province of Byzantium, nor had it yet become an integral part of European culture. The Cathedral of the Blessed Basil on the Red Square of Moscow (by POSNIK and BARMA, 1554-60) is the most exemplary achievement of purely Russian art. To many Western critics this dream-like phantasmagoria appeared an oddity contradicting all the rules of CLASSICAL architecture. To unprejudiced eyes it is a unique creation. Comparisons with ISLAMIC or INDIAN architecture, or with the—later—western BAROQUE, only help to stress its originality. It determined the style of Russian architecture for about 100 years (the 'Moscow Baroque'). Its influence can even be discerned in the typically popular Russian art of the wooden churches.

In painting the traditional Byzantine subjects yielded to a new didactic ICONOGRAPHY. Intricate allegories were rendered in a popular narrative style. The icons of the so-called Stroganov School (17th c.) show a miniature-like technique and a hitherto unheard-of brilliance and intensity of colour. In the 18th c. the art of icon painting became, after a last flowering, a mere industry for the production of devotional images. Vain attempts were made in the 19th c. to revive a traditional art which was by then completely dead.

Traditional church art had no place in a country which had broken with its Byzantine past. Peter the Great (reigned 1689-1725) transformed Russia into a European country. Moscow, the traditional capital, and St. Petersburg, the new one (begun in 1703 and laid out on a purely Western plan), represent two different worlds. In the 18th c. all outstanding works of art created in Russia were the work of foreigners who had been called there—e.g. FALCONET's masterpiece, the EQUESTRIAN STATUE of Peter the Great (1752-82) and the imperial palaces built by Bartolomeo Francesco RASTRELLI (Winter Palace; Peterhof; Tsarskoe Selo). In 1757 an ACADEMY of arts was founded for the training of Russian artists.

From the late 18th c. onwards Russian artists took part in all the successive movements of European art. But while the great writers led by Pushkin brought Russia into the van of European literature, the figurative arts did not produce a personality of a stature comparable to the giants of her literature until the 20th c. Mention should, however, be made of the NEO-CLASSICAL architect Andreyan ZAKHAROV (Admiralty Building, St. Petersburg, begun 1805) and of Vladimir SHERWOOD, an architect of English descent who imbued the retrospective architecture of his day with both a Russian and a personal spirit (Historical Mus., Moscow, 1874-83). The delightful GENRE scenes of Pavel FEODOTOV have been called painted counterparts of Gogol's comedies. An artist of stature was Ilya REPIN, the 'Russian Courbet' who, like COURBET, combined strong social tendencies with a brilliant pictorial technique. He was the most outstanding representative of the 'Wanderer' movement, an attempt to popularize art and bring the artist in touch with the people. Socialist REALISM is modelled on this movement. Repin won European fame with his *Volga Boatmen* (1870) and with *Tolstoy at the Plough*. To the ageing TOLSTOY's circle of friends belonged his illustrator, the painter Leonid PASTERNAK, and the sculptor Prince Paul TRUBETSKOY.

That turbulent and tragic individualist Mikhail Vrubel (1856-1910), whose decorations for the monastery of St. Cyril at Kiev shocked by their originality, has only more recently become known to the West. He is the first powerful personality to emerge in the figurative arts in Russia since the Muscovite period. Above all he was a brilliant draughtsman; his work pointed the way to CUBISM and FUTURISM, and in this way prepared the merging of Russian art with the mainstream of the European movements which was to flower in SUPREMATISM and CONSTRUCTIVISM, when for the first time the Russians emerged as leaders of the European *avant-garde*.

The Russian Modernist movement produced no great artist although Alexander BENOIS and Sergei Diaghilev were highly influential in the development of Russian art of the 20th c. The *World of Art* (MIR ISKUSSTVA) society and

magazine were their most notable early activity which then gave rise directly to the 'Ballet Russe', which had its first season in Paris in 1909. This enterprise brought together all the outstanding Russian artists of the day in painting and music. Among them were Leon BAKST and Matislav Dubuzhinsky (1875-1957), who taught Marc CHAGALL. In 1914 Diaghilev invited Natalya Goncharova (1881-1962) to design décors for his ballet and her settings for *Coq d'Or* and *Firebird* made an impact which was lasting in its effects. Like Goncharova, Mikhail Larinov (1881-1964) was at this time searching for a new style which could combine the new aesthetic achievements of the West with inspiration from native Russian folk art. He was responsible for the 'Golden Fleece' exhibition of 1908, in which Russian *avant-garde* painters were hung side by side with French IMPRESSIONISTS, and this was followed in 1910 by the 'Knave of Diamonds' exhibition and later the 'Donkey's Tail' exhibition, in which KANDINSKY, JAWLENSKY, and MALEVICH took part. During this period he together with Goncharova was working out the new RAYONIST style. Like most Russian movements, Rayonism was metaphysical in inspiration, the attempt to penetrate to the essence of an object leading to the concept of rays emanating from objects and linking one object with another in a haze of colour where two sets of rays meet. Rayonism was important also as one of the influences which led Malevich to evolve his Suprematist theories. Suprematism and Constructivism, evolved by Vladimir TATLIN with followers such as Alexander Rodchenko (1891-1956), were artistic movements of European significance which laid the basis of the international 'FUNCTIONALIST' style of design and architecture which is now accepted throughout the world.

Russia has produced great figures in 20th-c. art, some of whom, however, have done their main work outside their native country: such are Kandinsky, ARCHIPENKO, Chagall, Jawlensky, SOUTINE, ZADKINE, and others. After the communist revolution an experimental *avant-garde* survived for a few years in Russia itself, but after the death of Lenin and the end of the more liberal administration of Lunacharsky by the early 1930s it had to give way to an art of political propaganda based on academic painting and sculpture of the 19th-c. 'socialist realism'.

38, 101, 242, 437, 464, 852, 865, 1139, 1227, 1251, 1351, 1518, 1592, 1695, 1928, 2236, 2238, 2240, 2241, 2313, 2337, 2777, 2838.

**RUSTICATION.** Architectural term for masonry or imitation masonry where the joints between the stones are deliberately emphasized or where the stones are left rough or worked in such a way as to exaggerate the textural effect of the surface and give an impression of rustic simplicity. A good example of light rustication exists in the court and exterior façades of the Luxembourg Palace by Salomon de BROSSE

332. Elevation of the Palais du Luxembourg, indicating rustication. Designed by Solomon de Brosse. Engraving from *Cours d'Architecture* (1771-7), Vol. II by François Blondel

(1615). Rustication was used by Italian RENAISSANCE architects as a method of imparting grandeur to the *palazzi* of the merchant princes by emphasizing the massiveness of the stones.

**RUYSCH**, RACHEL (1664-1750). Dutch painter of flower pieces and STILL LIFES, who was probably the most distinguished Dutch female artist. She was a pupil of Willem van Aelst (1627-83) and the most important flower painter in the 18th c. after the great van HUYSUM. From 1701 to 1708 she worked in The Hague, and from 1708 to 1716 in Dusseldorf as court painter to the Elector Palatine. Her richly devised bouquets were painted in delicate colours with meticulous detail, and their artistry and craftsmanship are worthy of the finest tradition of Dutch flower painting. There are examples in many European museums, but major pictures are rarely available to private collectors.

1130.

**RUYSDAEL**, SALOMON VAN (c. 1600-70). Among the best known and most prolific of Dutch LANDSCAPE painters. He was born at Haarlem, where he lived throughout his life, and began painting under the influence of Esaias van de VELDE. His early works in the 1620s and 1630s were painted in the same monochrome style as those of Jan van GOYEN, and it is sometimes difficult to differentiate between the work of the two artists. Ruysdael, however, introduced strong colour to his palette, and his mature landscapes are characterized by broad, sweeping strokes with strong greens in the foliage and blues in the sky. His compositions often include a river or estuary, relying on a diagonal as their axis, and like van Goyen he repeated similar scenes many times during a long and productive career. His work is represented in

most museums and in many private collections. The use of a 'y' in the spelling of his name distinguishes him from his celebrated nephew, Jacob van RUISDAEL.

2549.

**RYBACK,** ISSACHAR (1897–1934). Russian painter. He was born in Elisabethgrad of Jewish parentage and a background of chassidic mysticism pervaded his work. He was trained at Kiev (1911–16), after which he did decorative work while studying at Moscow (1918–19). He went to Berlin in 1921, where he exhibited with the Berlin SEZESSION. After spending a year in Russia (1925) he finally settled in Paris in 1926. Ryback was a sensitive and lyrical painter of flower pieces, animals, and portraits. But like his fellow countryman CHAGALL the sustenance of his painting derived from memories of the Jewish background amid which he spent his early years. This is particularly apparent in his GRAPHIC work such as the Album of DRYPOINTS entitled *Shadows of the Past*. The critic Waldemar George called him 'a visionary of the Ghetto who transforms rags and tatters into brocades'. Ryback visited England in 1933 and held a private exhibition of his work at Cambridge. He was already suffering from the spinal disease which carried him off prematurely two years later. In 1964 a Ryback Museum was opened in Israel to house his remaining works donated by his widow.

**RYDER,** ALBERT PINKHAM (1847–1917). American painter, regarded as one of the most distinguished artists of the subjective and imaginative trend in U.S. art. Born at New Bedford, Massachusetts, he lived and worked most of his life as a solitary and dreamer in New York. Although he studied with the ROMANTIC painter and engraver William E. Marshall (1837–1906) and for a short time at the National Academy of Design, his methods and approach were largely self-taught. His most productive years were 1880–1900. His pictures reflect a rich inner life, with a haunting love of the sea, and a constant search to express the ineffable. He himself is quoted as saying: 'Have you ever seen an inch worm crawl up a leaf or twig, and then clinging to the very end, revolve in the air, feeling for something to reach something? That's like me.

I am trying to find something out there beyond the place on which I have a footing.' This imaginative quality and eloquent expression of the mysteriousness of things is expressed typically in such pictures as *The Tempest* (Detroit Institute of Arts) and *The Temple of the Mind* (Albright-Knox Art Gal., Buffalo, N.Y., *c.* 1888).

1938.

**RYEPIN.** See REPIN.

**RYSBRACK,** JOHN MICHAEL (1694–1770). Sculptor, rarely used the name John. He was a member of an Antwerp family of artists, and settled in England about 1720, having been trained in Antwerp under Michel Vervoort (or van der Voort, 1667–1737), a sculptor who had moved away from the extreme BAROQUE which had dominated his country since the age of RUBENS. Rysbrack's style, with its deep undercutting, was throughout his life to show Baroque influence, though he was also interested in the ANTIQUE. Since he never visited Rome, his imitation of the antique is always less slavish than that of his rival, Peter SCHEEMAKERS. Several of his first MONUMENTS in England, such as that of Matthew Prior (Westminster Abbey, 1723), were designed by the architect James GIBBS, but he also found favour with Lord BURLINGTON, the leader of the PALLADIAN fashion in architecture, and made statues of Inigo JONES and PALLADIO for the Gardens of Chiswick House. He built up an extensive practice as a maker of BUSTS, his sitters including Sir Robert Walpole (1738), Alexander Pope (1730), and Sir Hans Sloane (*c.* 1737). His portraits are usually quiet and frontal, and he was willing to use either antique or contemporary dress. He was also a notable TOMB sculptor, his best known commissions being those of Sir Isaac Newton (Westminster Abbey, 1731) and the Duke of Marlborough (Blenheim Palace Chapel, 1732), both designed by William KENT. His EQUESTRIAN STATUE of William III (Bristol, 1735) is the finest of its kind made in England in the 18th c. Although his leading position was challenged about 1740 by Peter Scheemakers and Louis François ROUBILIAC, he continued to get many orders, for his vigorous work was greatly to the taste of English patrons.

2815.

# S

**SAARINEN,** ELIEL (1873-1950). Finnish architect, who emigrated in mid-career to America. He first became known outside Finland for his Finnish Pavilion at the Paris Exhibition of 1900, in which he collaborated with Herman Gesellius and Armas Lindgren, with whom he entered into partnership in 1896. Though a member of the DEUTSCHER WERKBUND as early as 1913, he had little to do with the central European movements out of which MODERN ARCHITECTURE developed. His originality and basic affinity with the spirit of early modernism were revealed in his design (1904) for the railway station at Helsingfors (built 1910-14). In spite of certain ROMANTIC southern Germanic characteristics it was a pioneer building unique in RAILWAY ARCHITECTURE of the time, freely and asymmetrically planned in an age still dominated by academic formality, personal and sensitive in style in an age of insensitive period revivalism.

Saarinen first visited America in 1923 after winning second prize in the competition for the Tribune Tower at Chicago (see SKYSCRAPER), and soon afterwards settled there, practising from 1937 in partnership with his son EERO SAARINEN (1910-61) and teaching. His American works include buildings at Cranbrook, Michigan, and the Kleinhans Music Hall, Buffalo (1938), notable for its successful acoustics. He also built a number of churches, of which the Lutheran Church at Minneapolis (1949-50) is typical. His work retained its vitality but became progressively more dependent on stylistic mannerisms.

Eero Saarinen has designed some original and widely imitated furniture and a large factory for General Motors (1950), one of the outstanding examples of American industrial architecture in the severer style which owes much to MIES VAN DER ROHE.

542, 2364, 2365, 2631.

**SACCHETTI,** GIOVANNI BATTISTA (1700-64). Italian BAROQUE architect. A follower of JUVARRA at Turin, he was invited after Juvarra's death (1735) to Madrid where he designed and built the royal palace (begun 1738). He also built to a design of Juvarra the centre of the palace of San Ildefonso near Segovia, called La Granja.

**SACCHI,** ANDREA (1599-1661). Italian painter. The pupil of ALBANI and master of MARATTA, he was the leading representative of the CLASSICAL tradition in Roman painting in the mid 17th c. (see ROMAN SCHOOL). He was a profound admirer of RAPHAEL, and in his best work emulated the spiritual unity of Raphael's compositions and his portrayal of individual emotions. In the Academy of St. Luke he supported the classical theories against Pietro da CORTONA's arguments for the BAROQUE method. His ceiling fresco *Divine Wisdom* (c. 1629-33) in the Palazzo Barberini, though not itself a successful composition, initiated a new type of allegorical decoration. He painted ALTARPIECES for St. Peter's and directed the redecoration of the Lateran Baptistery. His *Vision of St. Romuald* is in the Vatican Gallery.

**SACRA CONVERSAZIONE.** See VIRGIN.

**SACRA FAMIGLIA.** See HOLY FAMILY.

**SACRAMENTARY.** See MISSAL.

**SACRED MONOGRAM.** At first an esoteric monogram for CHRIST, the Sacred Monogram has become universally accepted as a sign of the Christian faith in religious art. In its earlier forms it was constructed from a combination either of the Greek letters chi and rho, the first two letters of the Greek word Χριστός, or of the Greek letters iota and chi, the initial letters of Ἰησοῦς Χριστός. The latter are the first two letters of the Greek word for 'fish' (ἰχθύς), which also stood as a symbol of the faith because it gives the initial letters of the Greek phrase Ἰησοῦς Χριστός, Θεοῦ Υἱός, Σωτήρ (Jesus Christ, Son of God, Saviour). The monogram was closely associated with the sign of the Cross and sometimes the Cross was introduced into the monogram itself. The monogram was sometimes enclosed in a circle or a wreath and there is a suggestion, which falls short of proof, that some of its forms were influenced by the popular Mithraic sun-wheel. On 4th-c. SARCOPHAGI (e.g. Lateran Mus., Rome) surrounded by a triumphal wreath the monogram may symbolize the RESURRECTION of Christ. Sometimes it is set in the NIMBUS of Christ (5th-c. MOSAIC at S. Aquilino, Milan) and in a medallion it is supported by ANGELS in the ceiling mosaic of the Archbishop's chapel at Ravenna. It is marked on the orb carried by Christ in the 11th-c. golden altar-front from Basel in the Cluny Museum, Paris. Sometimes the monogram was combined with the first and last letters of the Greek alphabet, alpha and omega, signifying the beginning and the end

| a | b | c | d |

**Fig. 82.** SACRED MONOGRAMS
a. Greek letters chi and rho; b. Greek letters iota and chi; c. and d. the monogram combined with the cross

with an allusion to Revelation i. 8; xxi. 6; xxii. 13. The conjunction occurs together with peacocks, vine, and DOVES on the 5th-c. sarcophagus of Theodore, S. Apollinare in Classe, Ravenna. A modern example of the chi-rho monogram with peacocks (symbolizing resurrection and immortality) is a headstone designed by the Duke of Wellington in Brookwood Cemetery near Woking.

The use of the monogram became general after the vision of Constantine (A.D. 312) and after Christianity was officially recognized (A.D. 330) it was introduced on the Labarum, the military standard of the Roman army. For about a century it was very frequent on coins, TOMBS, seals, etc., after which it was rarely used in the West although it continued to be general in the East and appeared on military standards until the 8th c. It is found on the shield of one of Justinian's bodyguard in his mosaics at S. Vitale, Ravenna.

Another form of the monogram was the letters iota, eta, sigma, IHS or IHC, being the first two and the last letters of the Greek name Jesus. The earliest known instance of the former version is on a coin of Basil I dated A.D. 867. The latter occurs in 6th-c. manuscripts. The contemporary sign is an amalgamation of the IHS with a cross. This version began to supersede the chi-rho monogram in the 12th c. As its use spread in Latin-speaking countries, the middle letter was read as an aitch by confusion with the Latin alphabet (in Greek it is an eta or long E), and various interpretations were applied to it. The meaning *Jesus Hominum Salvator* (Jesus Saviour of Men) was supposed to have been revealed in a vision to S. Bernadino of Siena, and after the foundation of the Society of Jesus in 1540 the Jesuits attached to it such meanings as *In hoc salus* (In this is safety) or *Iesu Humilis Societas* (Humble Society of Jesus) or *In hoc signo* (In this sign *sc.* thou shalt conquer). The sign was closely associated with the Triumph of the Name of Jesus, which has an important place in the ceiling paintings of many BAROQUE churches (BACICCIA, the Gesù, Rome, late 17th c.). In El GRECO's *Dream of Philip II* this monogram, shining in the sky, is adored by the king himself and by all mankind.

**SAENREDAM,** PIETER JANSZ (1597–1665). Called the first portrait painter of Dutch church interiors. Before his time most architectural painters represented imaginary buildings, but the subjects of Saenredam's pictures can be identified. Most of them are views of the great whitewashed GOTHIC churches of Haarlem and Utrecht; he also made pictures of buildings in his birthplace, Assendelft, and in Amsterdam, Alkmaar, 's Hertogenbosch, and Rhenen. His drawings, which are inscribed with the exact hour and day they were made, were primarily studies for his paintings, which are delicately coloured and have a distinctive light tonality. He was particularly sensitive to colour, light, and to the vast space created by the great VAULTS and PIERS of the churches.

2606.

**SAFTLEVEN,** CORNELIS (1607–81) and HERMAN (1609–85). The best known members of a Dutch family of artists. Cornelis painted GENRE scenes of peasants and satirical pictures of animals dressed and· acting like theologians and jurists; the influence of BROUWER and TENIERS can be seen in these works. He also did LANDSCAPES with sheep and cattle grazing. His brother Herman gained a considerable reputation for TOPOGRAPHICAL drawings and small, highly finished panoramic views of the Moselle and Rhine.

**SAGREDO,** DIEGO DE. Sixteenth-century Spanish writer on architecture. His *Medidas del Romano*, a romantic VITRUVIAN commentary illustrated with WOODCUTS, was first published at Toledo in 1526 (French edition, *Raison d'architecture*, 1530). Theorist of the Renaissance-PLATERESQUE, Sagredo propagated a return to the Roman or ANTIQUE style, and rejected mixtures of Roman with the GOTHIC or 'modern' style.

**SAGRERA,** GUILLERMO (active first half 15th c.). Spanish architect and sculptor. He was one of the 12 leading architects called together in 1416 to report on the construction of

the projected nave for Gerona Cathedral. In 1422 he carved statues of St. Peter and St. Paul for the south door of Palma Cathedral, Majorca. He designed, built, and executed sculptured decoration for the merchants' exchange at Palma (begun 1426), prototype of the great exchange at Valencia (1482-98). In 1449 he left Palma for Naples, where he was employed by Alfonso V of Aragon on the Castel Nuovo and built the village of Coridola.

**SAINT-AUBIN.** Family name of four French brothers, draughtsmen, and designers in the ROCOCO manner. The eldest, CHARLES-GERMAIN (1721-86), worked on embroidery designs, wrote a treatise on embroidery, and was patronized by the ladies of the court. GABRIEL-JACQUES (1724-80) was the best known of the four and an ETCHER of some distinction who satisfied the public taste for anecdotal depiction of daily life in its most elegant and appealing aspects. His views of picture sales and the Salons are valuable documents for the art historian (*An Auction*, Bayonne; *Salon of 1765*, Louvre). LOUIS-MICHEL (1731-79), less talented, was attached to the Sèvres factory. AUGUSTIN, the youngest (1736-1807), was a draughtsman of considerable charm (*Young Lady*, Albertina) but lacked the *brio* of Gabriel. He had a large output as an engraver of the works of BOUCHER, GREUZE, FRAGONARD, and C.-N. COCHIN.

678.

**SAINT-DENIS.** An ancient Benedictine abbey which had close associations with the French monarchy. The existing church was begun by Abbot SUGER in 1129. Although it was based on earlier experiments, the lightness of structure and the sure handling of the ribbed VAULTS in the AMBULATORY and chapels have made the choir famous as the first in the long succession of great GOTHIC buildings. Equally important is the west front with its triple portal, also built by Suger. He brought artists from many lands to Saint-Denis, and the abbey became one of the focal points of 12th-c. ecclesiastical architecture and ornament. The sculptures of the west front, though still ROMANESQUE in style, have the rich ICONOGRAPHY which was developed in the later Gothic cathedral portals. The STAINED GLASS and the rich accumulation of jewellery and treasure were notable in their day. The west front was dedicated in 1140, and the choir in 1144. The rest, left unfinished at Suger's death in 1151, was completed during the 13th c. The upper parts of Suger's choir were remodelled after 1231, and the nave and transepts were built by Pierre de MONTREUIL (*c.* 1240). This later work is as famous as Suger's, being one of the starting-points of RAYONNANT architecture, which introduced a new lightness and poise into the High Gothic tradition. The glazed TRIFORIUM and the rose windows of the transepts had widespread influence. Saint-Denis suffered heavily during the Revolution and 19th-c. restorations.

897.

**SAINTES-CHAPELLES.** Sumptuously decorated chapels modelled on the Sainte-Chapelle in Paris, which was begun by St. Louis after 1239 to house relics brought from Constantinople and finished in 1248. Like the old chapel of the palace which it replaced, it had an upper and a lower floor. It was probably designed by Pierre de MONTREUIL, and set a fashion for opulently decorated 'glasshouse' churches which deeply influenced RAYONNANT architecture. Though heavily restored in the 19th c., the Paris Sainte-Chapelle still gives the rich impression of a medieval shrine. Other Saintes-Chapelles were built by members of the French royal family when fragments of the original relics were occasionally given to them, or when they wished to honour relics of St. Louis himself after his canonization. The Duke of Berry built no less than three, of which Riom (1382) survives. Another surviving example is in the royal castle of Vincennes. These generally followed the same plan as at Paris, although variations were sometimes introduced, e.g. at Châteaudun where the smaller chapel is over the larger.

**SAINT-GAUDENS,** AUGUSTUS (1848-1907). American sculptor. Born in Dublin of a French father and an Irish mother, Saint-Gaudens was brought to America in infancy. He began his career as a cameo-cutter in New York, and during his six-year apprenticeship in this art he also studied DRAWING. There followed three years in Paris and three in Rome. After his return to America in 1878 he received his first important commission, that for the *Admiral Farragut Monument* in New York. This work, largely done in Paris, was well received when it was exhibited in the Paris Salon of 1880. By 1885 Saint-Gaudens had achieved a recognized position of prominence among American sculptors and retained this throughout his life. His work combined simplicity and good taste with technical refinement of finish. His *Lincoln Memorial* (1887) in Chicago established a type of American MONUMENT which was also exemplified in his *The Puritan* (Springfield, Mass., 1887), *Shaw Memorial* (Boston, 1897), and *Sherman* (New York, 1903). His studio in the Cornish Hills of New Hampshire houses a Memorial Collection of casts of his works. He is represented in the permanent collections of many public galleries of the U.S.A. and is considered one of the more important figures in American 19th-c. art.

**SAINT-GILLES-DU-GARD.** A Benedictine abbey which was associated with CLUNY in the 12th c. It had a violent history, suffering especially in the 17th-c. wars of religion and the Revolution. Only the crypt and the lower

part of the west front remain from the medieval church. The latter includes the three portals for which Saint-Gilles is famous. Miraculously they have escaped serious damage and present one of the finest displays of ROMANESQUE sculpture extant. Their date is controversial. They have been assigned to all periods from the late 11th to the early 13th centuries. What is undisputed is the CLASSICAL inspiration of the design and style. Together with the sculpture of Arles and Valence that of Saint-Gilles evidences the activity in Provence of a group of sculptors interested in the remains of late ROMAN ART. Their influence was considerable, more especially in Lombardy and more remotely in south Germany.

**SAINT-ROMAIN,** JEAN DE. French sculptor who was in charge of the workshop which produced the statues for the staircase at the LOUVRE, designed by Raymond du TEMPLE (c. 1365). The figure of Charles V still survives and is a penetrating REALISTIC study of the king's personality.

**SAINT-SAVIN-SUR-GARTEMPE.** This Poitevin abbey church was begun before 1050 and enlarged towards 1100. Like several churches in that district, it has no CLERESTORY and the aisles are almost as high as the nave. Thus it approximates to the HALL CHURCH form. Saint-Savin is famous for its ROMANESQUE wall-paintings, the most extensive and best preserved in France. There are four distinct cycles: APOCALYPTIC scenes in the PORCH; PASSION scenes in the tribune above; legends of the local saints in the crypt, and most splendid of all no less than 30 Old Testament scenes on the nave barrel vault. In style they differ completely from the CLUNIAC paintings of Berzé-la-Ville. They owe nothing to MOSAIC, and though they show affinities with manuscript ILLUMINATIONS their freedom of execution and the imaginative power and vigour of the forms place them in the authentic tradition of monumental wall-painting. Their dating is controversial, but the greater part seems to belong to the 12th c.

**STA SOPHIA.** See BYZANTINE ART.

**SALLINEN,** TYKO (1879-1951). Finnish painter, whose explosive EXPRESSIONIST paintings with harsh wooden brush-strokes depict the life of the undeveloped areas from which he came. Their distortions are sometimes grotesque, but some of the larger groups, e.g. *The Hikulites* (1918) and *Peasants Dancing* (1917-20), are imbued with a deeply felt sympathy for the poor. No other artist has caught so well the character of the Finnish LANDSCAPE as Sallinen did in his later paintings.

**SALOMÓNICA.** Spanish and Portuguese term for a COLUMN, usually of the Corinthian Order (see ORDERS OF ARCHITECTURE), with a spirally twisted shaft. The name derives from a Roman example preserved in St. Peter's, Rome, which according to legend came from Solomon's temple. VIGNOLA gave rules for the proportions of twisted columns in his *Five Orders*; and BERNINI used them for the BALDACHIN (1624-33) in St. Peter's. Gilded, painted, and decorated with vines, birds, and other motifs, *salomónicas* were used extensively for REREDOSES and façades by architects such as José de CHURRIGUERA during the first phase of Iberian BAROQUE (c. 1680-c. 1720) and continued popular in the Spanish and Portuguese colonies as late as c. 1740.

**SALON.** Name given to the exhibitions of members of the French Royal ACADEMY of Painting and Sculpture founded in the 17th c. by COLBERT and LEBRUN. The name derived from the fact that exhibitions were held in the Salon d'Apollon in the LOUVRE. From 1737 to the Revolution they were two yearly and afterwards annual. As these were the only public exhibitions in Paris the official academic art obtained through them a stranglehold on publicity. Protests from creative artists who were refused entry reached such proportions that in 1863 Napoleon III ordered a special Salon des Refusés for those who were rejected. In 1881 the Salon was reorganized as the Société des Artistes français with a jury elected from each previous year's exhibitors. It nevertheless still remained hostile to new and creative artists.

**SALON DU CHAMPS-DE-MARS.** See NATIONALE, Salon de la.

**SALVIATI,** FRANCESCO DE' ROSSI (1510-53). Italian painter. After instruction from ANDREA DEL SARTO in Florence he came to Rome (c. 1530) and entered the service of Cardinal Salviati, whose name he adopted. He achieved early fame with his fresco of the *Visitation* (S. Giovanni Decollato, 1538). In 1539 he travelled to Venice, probably visiting Parma on the way since his subsequent works owe much to the example of PARMIGIANINO both in colour and in the treatment of figures. In 1544-8 he decorated the Sala dell'Udienza in the Palazzo Vecchio in Florence (then the MEDICI residence) with the story of Furius Camillus—a scheme which in complexity and ambition surpassed the decorative fresco cycles of the ROMAN SCHOOL. In 1554 he went to France, but with his customary restlessness did not settle there, returning to Rome the next year. The chief work of his last years is a set of decorative frescoes commemorating the achievements of the FARNESE family (Palazzo Farnese, Rome). This does not rival his FLORENTINE decorations in grandiloquence but is of special interest as an extreme example of MANNERIST pictorial equivocation, for Salviati causes figures painted as though part of a tapestry to come into contact with figures depicted realistically, deliberately confusing different

levels of reality with piquant effect. Salviati also made designs for tapestries and was particularly noted for his portraits, which were Florentine in their direct characterization but north Italian in their richness of colour.

**SAMBIN,** HUGUES (1515/20–1601/2). French architect and wood-carver, who worked in Burgundy. His work was the finest expression of French provincial architecture during the second half of the 16th c. notable for its development of RUSTICATION and its fanciful use of high relief carving. Sambin built the Palais de Justice at Besançon (1581) and produced *Œuvre de la diversité des termes, dont on se sert en architecture* (1572), profusely illustrated with fanciful engravings of CARYATIDES.

**SAMMICHELE** (1484–1559). Italian architect and military engineer, born in Verona. In Rome (*c.* 1500) he probably worked with BRAMANTE and Antonio da SANGALLO II, remaining in the Papal State until just after the Sack of Rome (1527), when he returned home and became military engineer to the Venetian State (*c.* 1530), working in Crete, Corfu, and other Venetian territories, as well as in Verona where his works were much admired by GOETHE. Of his palaces there the Pompei (now a museum) and the Canossa, both of the early 1530s, are enriched versions of Bramante's 'House of Raphael'. The Palazzo Bevilacqua (before 1538) repeats the type but abandons Bramante's strict symmetry and repetition of parts in favour of more complicated alternating rhythms—i.e. it is a MANNERIST building. The Cappella Pellegrini, Verona, is a combination of the PANTHEON, Rome, with the Mannerist elements of the Bevilacqua. Sammichele also built two palaces in Venice, the Corner-Mocenigo (*c.* 1543) and the Grimani on the Grand Canal (*c.* 1556), adaptations of the traditional Venetian type with centrally massed windows but again containing Mannerist elements.

**SÁNCHEZ COELLO,** ALONSO (*c.* 1531–88). Spanish painter of Portuguese parentage. He studied in Brussels and there made the acquaintance of Anthonis MOR VAN DASHORST, whom he succeeded in 1571 as court painter to Philip II, and whose style in formal court portraiture he continued with distinction. Some of his best portraits are at Buckingham Palace.

**SÁNCHEZ COTÁN,** JUAN (1561–1627). Spanish painter, born near Toledo and trained by the Toledo painter of STILL LIFE Blas de Prado (*c.* 1545–*c.* 1592). He painted still lifes of food and vegetables of the kind known in Spain as *bodegones* and his feeling for the geometrical organization of space and volume anticipates the 'magic' REALISM of ZURBARÁN (*Bodegon with Cabbage*, San Diego, California). In 1604 he became a Carthusian monk and painted religious pictures at Granada and Seville, where he was in contact with ROELAS. In 1615–17 he painted for the Carthusian monastery of Granada a set of pictures illustrating the Life of St. Bruno and the history of the Order.

**SANDARAC.** A soft RESIN used in the preparation of VARNISHES. It becomes darker and redder with age and for that reason the soft resin MASTIC is usually preferred.

**SANDBY,** PAUL (1725/6–1809). English TOPOGRAPHICAL artist, for no good reason called 'the father of WATER-COLOUR art'. He and his brother THOMAS (1721–98) worked at the Military Drawing Office of the Tower of London and were engaged as draughtsmen on the survey of the Highlands of Scotland after the rebellion of 1745. In 1751 Paul went to live with his brother at Windsor Park where Thomas held the position of Deputy Ranger. Their work is often indistinguishable in subject, but Paul was the better artist. While Thomas specialized in architectural drawings, Paul was more versatile and his work includes lively figure subjects as well as an extensive range of LANDSCAPE PAINTING. In his later work he often used body-colour, as in *The Terrace at Windsor Castle looking West* (V. & A. Mus., London, 1800) and he seems to have been the first to experiment with the AQUATINT process in England. He was singled out by GAINSBOROUGH as the only contemporary English landscape artist who painted 'real views from nature' instead of artificial PICTURESQUE compositions. He joined the attack on HOGARTH for his *Analysis of Beauty* and in an ETCHING *The Author run Mad* represented him in a lunatic asylum with a MAHLSTICK formed as his 'line of beauty'. The Victoria and Albert Museum has a varied collection of Sandby's aquatints, and also of his etchings, both separate prints and 74 in a bound volume. His etchings have bluff directness of observation which anticipates BEWICK.

**SAND-PAINTING.** The term 'sand-painting' has many synonyms: dry painting, ground painting, sand mosaic, sand altar, earth picture, etc. Although sand-painting occurs infrequently throughout the world, it has an interesting distribution. In the Americas it has been practised among the Navajo, Pueblo, and Zuni Indians of the south-western U.S.A., by the San Carlos Apaches (Arizona) and Jicarilla Apaches (New Mexico), and by various California Indian tribes (the Luiseño, Fernandeño, Gabrileño, Cupeño, Cahuilla, and Diegueño). It has been reported among such Plains Indian tribes as the Cheyenne, Arapaho, Blackfoot, Dakota, Sioux, and Ponka, especially in connection with the sacred Sun-dance ceremonies and the ceremonial transference of medicine bundles. It has also been reported among the Mandalas of Tibet, the Japanese and Hindus, and among some of the Australian aborigines. The widely scattered distribution of this art may suggest a common Asiatic origin.

By the beginning of the 20th c. sand-painting had died out among California tribes and the Plains Indians but it continues to be an important ritual among the Navajos and to a lesser degree among the Indians of the Hopi Pueblos. The sand-paintings of the Navajo Indians of New Mexico and Arizona inspire unqualified admiration and are among the most interesting of the aboriginal American arts. The Navajos, however, regard the sand-paintings not as an artistic expression but as the vital core of a powerful magic performance connected with their healing ceremonies. To begin the ceremony clean yellow-white sand is carried in blankets into the

medicine lodge or *hogan*. It is spread over the dirt floor in an even layer from 1 to 3 in. thick and over an area of about 10 ft. square. The medicine man, or healer, believing himself to be divinely inspired, determines the design according to the nature of the illness. First the sand is smoothed with the long sword-like wooden batten sticks used in weaving. The medicine man and his assistants (4–12 in number) work from the centre outward, sitting cross-legged or crouching on their heels. Before them are their five bark trays of coloured sand. The medicine man takes a handful of the required colour and lets a fine stream of coloured

**333.** Sand-painting executed by a Navajo Indian for the Horniman Museum, London, in 1966

sand run between thumb and forefinger. The design proceeds in accordance with the order of precedence of the cardinal points: east, south, west, north. Loose sand particles are blown off before the trickling starts. If a mistake is made, it is covered with background sand and the entire design is re-drawn. Contrary to common belief the drawing is not always or entirely freehand. Long lines may be drawn with the aid of a taut string, and spacing may be measured off with the palm of the hand or a portion of the arm. The colours employed are black, the colour of the north and denoting male (powdered CHARCOAL mixed with ground SANDSTONE); white for east; red for sunshine; yellow for west (ground sandstone mixed with GYPSUM, natural ochres, and mineral earth); and blue for south denoting female (charcoal and white sand). More recently brown has been introduced and also a sparkling pink made by concocting red, white, and a shiny mineral, probably specular hematite or mica particles. Represented in the paintings are highly conventionalized figures of the male and female gods of the Navajo and Pueblo pantheon, divine ceremonies, clouds, stars, rainbows, lightning, mountains, plants, animals, and mythical scenes. The bodies of the deities are elongated, slim, with square (female) or round (male) heads and short angular legs and arms.

There are about 17 major healing ceremonies among the Navajos, with from 5 to 25 paintings for each ceremony. Songs are chanted and prayers murmured as the patient is introduced into the painting and sits down in the middle of it, facing east towards the only doorway of the *hogan*. As the sand touches him in the prescribed ritual he is believed to come into physical contact with the different gods. The sand is believed to absorb the illness so that the gods can enter the sick or injured body. Upon completion of the ceremony the painting is systematically destroyed by the medicine man before sunset and the sand is collected in blankets. It is carried out of the lodge and deposited in a deserted place lest its magic harm someone. The sand-painting ceremony, the chants and prayers, are repeated or intensified until the patient recovers or dies. In some cases coloured sand may be replaced by pollens (corn-yellow and flower-red), cornmeal (white), charcoal (black), and larkspur blossoms (blue).

Theoretically the design and composition of the sand-paintings follow rigid rules. But since they are destroyed after each ceremony no models or guides exist and the designs are carried in the minds of the medicine men from one winter to the next, the usual time for healing ceremonies. It is to be expected that inconsequential changes in the pictures do occur from year to year. See also INDIAN ARTS OF NORTH AMERICA.

**SANDRART,** JOACHIM VON (1606–88). German artist and writer. After studying engraving and painting he travelled in Italy 1627–35 and then set up as an artist in Nuremberg. He is chiefly remembered for his *Teutsche Akademie der Edlen Bau-, Bild- und Mahlerey-Künste* (1675), the first part of which is an introduction to the arts of architecture, painting, and sculpture put together largely from material taken from VASARI, PALLADIO, SERLIO, and van MANDER. The second part, consisting of biographies of artists, contains in addition to much material borrowed from previous writers also original material and in particular information about the German artists CRANACH, SCHONGAUER, etc. The third part contains information about art collections and a study of ICONOGRAPHY. Sandrart was the first to apply the name GRÜNEWALD to Mathis Neithart. It is also noteworthy that he included in his book a chapter on Far Eastern art.

**SANDSTONE.** A consolidated rock composed of sand grains welded together by calcareous material acting as cement, the solid masses being sufficiently hard to serve as building stones. Sandstones vary in colour depending on the nature of the sand and of the cementing matter. Ferruginous sandstones range in hue from grey or yellow to brown or red while those containing glauconite are greenish in tone. The warm colours of the stone and the fact that it is readily workable have enhanced its popularity for building and sculpture, although some varieties are insufficiently resistant to weather and atmosphere. Sandstones are widely distributed and local variants differ considerably in their qualities and appearance. The 'Old Red Sandstone' of Herefordshire and Breconshire is dark red in tone, while the 'New Red Sandstone' of Devon is of a lighter, brighter shade. Medieval builders made much use of these red sandstones of England (e.g. Chester and Lichfield Cathedrals). The Normans used a soft sandstone from Surrey, somewhat greyish in appearance, instead of imported CAEN STONE. (This stone can be seen in the Tower of London, at Westminster Cathedral, and in many old City churches.) Hollington Stone, a red sandstone quarried in Staffordshire, was used in Hereford Cathedral and in the new Cathedral of Coventry. A Nottingham sandstone, Red Mansfield, was used by Sir Gilbert SCOTT for part of St. Pancras station. Another richly glowing sandstone, characteristic of western Germany, was used in Cologne Cathedral. The Egyptians used sandstones from very early times both for carving and for building. In the East the red sandstone of Mathura, north India, was used for figure sculpture on Jain and Buddhist STUPA balustrades (1st–6th c. A.D.).

**SANGALLO.** Family of FLORENTINE architects consisting of: GIULIANO DA SANGALLO (*c.* 1443–1516), architect and sculptor in wood; ANTONIO DA SANGALLO the Elder (1455–1534), younger brother and pupil

of the foregoing; and ANTONIO DA SAN-GALLO the Younger (1483-1546), nephew of the two foregoing. Giuliano spent several years in Rome and visited France in 1496, but he was essentially a follower of BRUNELLESCHI. His little church of Sta Maria delle Carceri, Prato (begun 1484/5), is based on ALBERTI's S. Sebastiano, Mantua, in plan but is otherwise very close to Brunelleschi's Pazzi Chapel, Florence; and his Sacristy in Brunelleschi's S. Spirito, Florence, is in Brunelleschi's style. The Palazzo Gondi, Florence (begun 1490), is also based on Brunelleschi and on MICHELOZZO's Palazzo Medici, but has the soft decorative quality of the later quattrocento. Sangallo's importance as a transitional figure bridging the passage from the quattrocento to the High RENAISSANCE is particularly apparent from his projects for St. Peter's, where he succeeded BRAMANTE in 1514-15, and by his designs for the façade of Brunelleschi's S. Lorenzo in Florence (1516). An ardent student of the ANTIQUE, he seems to have acted as a friend and mentor to MICHELANGELO.

Antonio da Sangallo the Elder has been regarded as a minor Bramante. His masterpiece, S. Biagio at Montepulciano (c. 1518-29), is a centrally planned church developed from Giuliano's Sta Maria delle Carceri, Prato, but is more massive and CLASSICAL.

Antonio da Sangallo the Younger was trained by his uncles and was working for Bramante in Rome by c. 1503. His first work was probably Sta Maria di Loreto, Rome (c. 1507), which was much altered by del DUCA. Sangallo worked mainly for the FARNESE family, especially Cardinal Farnese, later Pope Paul III, for whom he began the VILLA at Caprarola and the huge Farnese Palace in Rome (c. 1513), which was completed and altered by Michelangelo. From 1516 to 1546 he was nominally in charge of the building of St. Peter's, but he built little there and most of what he did build was altered by Michelangelo (1546-64). An elaborate model of Sangallo's project preserved in St. Peter's Museum does not inspire regrets. The main influence on Sangallo was Bramante, as may be seen in the Banco di S. Spirito, Rome, and to a lesser extent in the Farnese Palace.

**SANGUINE.** Red or flesh-coloured crayon. (See CHALKS AND CRAYONS.)

**SANO DI PIETRO,** properly ANSANO DI PIETRO DI MENCIO (1406-81). Italian painter, the head of what may well have been the largest workshop in Siena during the 15th c. Producing ALTARPIECES in a popular version of SASSETTA's style, this workshop was the main source of supply for the village churches around the city.

**SANSOVINO,** ANDREA (probably 1460-1529). Italian sculptor and architect, named after his birthplace near Monte San Savino, his real name being CONTUCCI. He was trained under

Antonio POLLAIUOLO and called himself a Florentine, but although Florence contains much of his sculpture his fame rests on what he did elsewhere. In Rome the companion tombs of Cardinals SFORZA and Basso (Sta Maria del Popolo, between 1505 and 1509) and the group of *The Virgin and Child with St. Anne* (S. Agostino, 1512) display classical grace combined with human tenderness.

Sansovino spent much of the period 1513-27 in Loreto in charge of the sculpture (and for part of the time the architecture also) of the shrine of the Holy House. His own reliefs there are crowded and more painterly than sculptural, with a rather primitive handling of the planes. His architecture can be seen at his birthplace and at Jesi. Unfortunately no work can be identified from his visits to Portugal between 1491 and 1501.

1390.

**SANSOVINO,** JACOPO TATTI (c. 1486-1570). Italian architect and sculptor, born in Florence. Trained as a sculptor under Andrea SANSOVINO, after whom he was called, he went to Rome and joined the BRAMANTE circle (1505/6). At the Sack of Rome (1527) he fled to Venice, where he became city architect in 1529. He began S. Francesco della Vigna in 1534 (the façade is by PALLADIO), but his chief works were all begun c. 1537. These are the Library of St. Mark, with the adjoining Mint (Zecca) and the Loggia of the Campanile, and the Palazzo Corner on the Grand Canal. The Library is based on the antique THEATRE of Marcellus in Rome and uses a form of the so-called 'Palladian motive': it was much admired by Palladio, who adapted the design in his Basilica, Vicenza. The long, low façade harmonizes with the Doge's Palace opposite, although entirely different in style, and the Zecca and Loggia are admirable foils to it. The Palazzo Corner is the first truly CLASSICAL solution, based on Bramante's 'House of Raphael', to the special problems of Venetian palace-design. Sansovino's best known statues are the *Mars* and *Neptune* on the Scala de' Giganti of the Doge's Palace. His richly classical style, hardly affected by MANNERISM, parallels that of his friend TITIAN.

FRANCESCO (1521-86), the son of Jacopo, lived and died in Venice. He was a scholar of diversified rather than profound interests. He dabbled in humanist philosophy and in history. Of greater interest today are his TOPOGRAPHICAL studies. In 1576 he published the *Portraits of the most noble and famous Cities in Italy*. It contains a summary of the history of the principal Italian cities with descriptions of their public and private buildings, their noble families and famous men. His *Description of Venice, most noble and unique City*, 1581, is the first attempt to give a systematic account of a city's artistic heritage. It is rich in information, but lacking in accuracy.

1769, 2826.

**SANTAYANA,** GEORGE (1863–1952). American aesthetician, humanist, and poet. His views on art are expressed in *The Sense of Beauty* (1896) and *The Life of Reason* (1905–6) and had an important influence on theory of art and taste in the early 20th c. Santayana refused to consider theory of art or AESTHETICS except as part of an over-all theory of values embracing rational living, happiness, and freedom. He included theories of art within theory of morals and on this basis developed them with exceptional sensitivity and wide learning. In his retrospective *Apologia pro Mente Sua* (1940) he wrote: 'Nor has my love of the beautiful ever found its chief sustenance in the arts. . . . If ever I have been captivated it has been by beautiful places, beautiful manners, and beautiful institutions.' He discriminated aesthetic from moral values by restricting the latter to negation and instrumentality. While basing value upon pleasure, he discriminated aesthetic pleasure from other pleasures as that in which the organs of perception are 'transparent' and do not intercept attention but 'carry it directly to some external object'. Thus aesthetic value is defined as pleasure which partakes of the act of 'objectification', i.e. the 'transformation of an element of sensation into the quality of a thing'.

1891.

**SANT' ELIA,** ANTONIO (1888–1916). Italian architect, who was associated with the FUTURIST group. Inspired by the idea of a new city of the future, he made many imaginative drawings of TOWN-PLANNING projects and tall city buildings linked by elevated roadways at different levels which were possibly influenced by Otto WAGNER's designs for subways and suburban railways in Vienna. Some of these were exhibited in 1914 by the Nuove Tendenze group under the grandiose title *Città Nuova* and Sant'Elia wrote a manifesto for the catalogue in which he argued for a new architecture jettisoning the past and freeing men from the bonds of convention and tradition. Sant'Elia was killed in the First World War at the age of 28. His own architecture had little in common with the manifestations of MODERN ARCHITECTURE elsewhere, although it

**334.** Pen-and-ink drawing by Antonio Sant'Elia. From *La Città Nuova* series. (Museo Civico, Como, 1914)

**335.** *Stazione Aeroplani.* Pen-and-ink drawing by Antonio Sant'Elia. From the series of sketches for the rebuilding of Milan Central Station. (Museo Civico, Como, 1912)

had some affinities with Russian CONSTRUCTIV-ISM. But his ideas were ahead of their time and uncannily foreshadowed much that became articulate to the leaders of the modern movement only a decade later.

**SANTERRE,** JEAN-BAPTISTE (1651–1717). French painter, known in his day chiefly for his allegorical portraits. He also painted religious pictures in a nascent ROCOCO style which caused some scandal by their use of provocative nudes in a manner which foreshadowed BOUCHER and FRAGONARD (*St. Theresa* painted for the Versailles Chapel, now lost; *Susanna*, Louvre, 1704).

**SANTI,** GIOVANNI (*c.* 1431/40–1494). Father of the Italian painter RAPHAEL, he worked for the court of Urbino both as painter and as writer. He composed a verse chronicle in 23 books recounting the exploits of the dukes of Urbino and dedicated it to the young Duke Guidobaldo MONTEFELTRO. This work is interesting to us because it includes incidental comments on the reputations of contemporary artists. There is a *Madonna* by him at Urbino and an *Annunciation* in the Brera, Milan.

**SANTVOORT,** DIRCK DIRCKSZ (1610/11–1680). Dutch portrait painter, great-grandson of Pieter AERTSEN. He was old-fashioned and in the middle of the century he was still painting in the style of the generation before him. He enjoyed great popularity and made a large fortune as an artist. His portraits of children had a particular appeal.

**SARACENI,** CARLO (*c.* 1585–1620). Venetian painter, who spent his short but important working life in Rome. Two great contemporary artists influenced him profoundly, CARAVAGGIO and ELSHEIMER. The influence of Elsheimer is seen particularly in his small luminous LANDSCAPES on copper with their rich effects of dark green boscage. Nine of these with MYTHOLOGICAL scenes are at Naples. Saraceni also worked with TASSI and LANFRANCO on decorative FRESCOES in the Quirinal Palace. Towards the end of his life he painted a number of large ALTARPIECES for Roman churches. The homely facial types in his work are unmistakable. His liking for turbans, tasselled fringes, stringy drapery folds, and his richly IMPASTED paint may have influenced Dutch artists in Rome such as LASTMAN and PYNAS, and through them REMBRANDT.

**SARCOPHAGUS.** The name given in classical antiquity to a stone or TERRACOTTA coffin. According to PLINY the name ( = flesh-devouring) was derived from the custom of making or lining coffins with a slate stone found in Asia Minor which had the property of consuming the corpse. From early HELLENISTIC times until the end of the early Christian period sarcophagi constitute one of the most important surviving sources for our knowledge of funerary sculpture in antiquity. Elaborately carved and vividly coloured MARBLE sarcophagi come mainly from the eastern Hellenistic kingdoms from the mid 4th c. B.C. onwards. RELIEFS were carved on all four sides, representing either whole FRIEZES of continuous scenes or rows of single figures in architectural

336. *Alexander Sarcophagus.* From the royal cemetery at Sidon in Phoenicia. (Istanbul Mus., late 4th c. B.C.)

settings. They were often decorated with elaborate MOULDINGS and had heavy gabled lids. Notable examples dating from the latter part of the 4th c. were found at the royal cemetery at Sidon in Phoenicia, the best known of which is the *Alexander Sarcophagus* in which the colours are unusually well preserved. This type of sarcophagus continued in use throughout the eastern provinces during the Roman Empire and is known as the 'Greek' type in contrast with the 'Roman' type later developed in the west with carving on three sides only.

Stone, ALABASTER, and terracotta sarcophagi were in use for upper-class burials in Etruria from the 5th to the 1st c. B.C. They were sometimes carved with reliefs on one side only and they originated the peculiar feature of a recumbent effigy of the dead upon the lid. The practice was later adopted by the Romans and sometimes used in EARLY CHRISTIAN ART. It was the latest ETRUSCAN stone sarcophagi which provided the Italian and other western European masons in later centuries with the prototypes for funerary effigies and GISANTS. The Etruscan recumbent effigy was used tellingly as a theme by PIRANESI. Recumbent figures on the lids of sarcophagi are not found in the Greek type before imperial times and then only probably under Italian influence.

In Rome cremation was the general rule from the 5th c. B.C. until the end of the 1st or the beginning of the 2nd c. A.D. and only a few exceptional examples of sarcophagi for inhumation are known. The earliest is that of L. Cornelius Scipio Barbatus, consul in 298 B.C. and great-grandfather of Scipio Africanus. From the time of Trajan onwards inhumation increasingly took the place of cremation in Rome and Italy and by the middle of the 3rd c. A.D. had spread to the more distant provinces. The many examples of carved sarcophagi which have survived are now the main source of our knowledge of the changes and development in sculptural style and technique in private and unofficial MONUMENTS from this time until the end of paganism under Constantine and onwards in Early Christian art through the 3rd, 4th, and 5th centuries.

The so-called 'Attic' sarcophagi originated on the mainland of Greece and were largely exported to the west during the 2nd and 3rd centuries A.D. They are carved on all four sides, either with MYTHOLOGICAL scenes or with garlands and SWAGS, and have elaborately gabled lids or else lids carved in the form of funerary couches on which rest effigies of the dead. Many were exported in a rough carved state and finished on the spot by Attic craftsmen. (There are many examples of Attic sarcophagi in the museums of Athens and Salonika.) Greek types of sarcophagi were also exported to Rome and the west from workshops in Asia Minor. (A notable example is a marble column sarcophagus now in the Palazzo Pubblico, Melfi.)

Christian sarcophagi in the 3rd c. displayed no stylistic difference from the pagan and were presumably made by the same craftsmen in the workshops of Rome and Italy. Biblical themes held to be types of the RESURRECTION and Redemption (e.g. the story of JONAH) occasionally appear and sometimes figures which have been doubtfully thought to represent the Good Shepherd or the Christian Orans. In the 4th c. biblical scenes became general and Christian sarcophagi followed the style of the pagan continuous narrative design. In both there was a tendency to sacrifice design and PROPORTION to the desire to include a maximum of incident, sometimes in two superimposed tiers, and a typically niggling and crowded 'sarcophagus' style developed which at most displayed a certain lively vigour of REALISM in particular incidents. In the 4th c. also there came into fashion a so-called 'column' sarcophagus, based on the

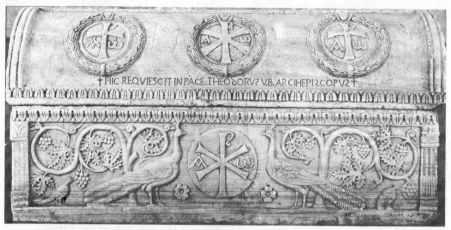

337. Sarcophagus of Archbishop Theodore. (S. Apollinare in Classe, Ravenna, 5th c.). The design includes the Sacred Monogram

Asiatic type, in which single figures or groups between colonnettes are worked in higher relief and in a more classically statuesque manner. A revival of the classical Greek tradition is evident in Christian 5th-c. sarcophagi represented particularly at Ravenna.

**SARGENT,** JOHN SINGER (1856–1925). Painter, born in Boston and educated in Europe. He studied painting at the Florence Academy and in Paris under Carolus Duran (1838–1917), a painter of portraits. In 1884 he settled in Chelsea and became internationally famous as a fashionable society portraitist. In technique he followed the tradition of VELAZQUEZ and MANET, the technique of the virtuoso brush-stroke, painting directly with loaded brush and utilizing instead of concealing the brushmarks. But though adept, he was more superficial in his effects than they. Despite his immense popularity his work was deprecated by artists and critics in his day. Roger FRY described it in *Transformations* (1926) as 'applied art', an application of technical skill for social purposes. Sargent painted the social mask without attempting to pierce behind it and in the opinion of some had no interest in aesthetic qualities. Describing his painting of *The Sitwell Family*, Osbert Sitwell said that he held up a mirror to the rich so that 'looking at his portraits, they understood at last *how* rich they really were'. Anthony Bertram summed up this view as follows: 'All that was wrong with Sargent was that he gave his sitters no souls and his pictures no pictorial meaning. His pictures have a similar relation to art that skilful juggling has to great acting.' Others have held that at his best Sargent not only brought back to British portraiture a vital and lavish elegance which had been lost since LAWRENCE but on occasions a sardonic projection of character which was new to that tradition. It has also been said that his portraits are the precise faces described in the novels of Henry James.

Sargent was for a time a member of the NEW ENGLISH ART CLUB. He exhibited at the ROYAL ACADEMY from 1882, became A.R.A. in 1895 and R.A. in 1897. After 1910 he did much LANDSCAPE PAINTING and there are war pictures in the Imperial War Museum. In 1926 Lord Duveen built a Sargent room at the Tate and in this were hung among others his portraits of the Wertheimer family, which were bequeathed to the nation in 1922.

529.

**SARRAZIN,** JACQUES (1588–1660). The most important figure in FRENCH sculpture of the middle 17th c. In Rome (1610–28) he collaborated with VOUET and DOMENICHINO for Cardinal Aldobrandini and developed affinities with a group of classicizing artists who preceded the rise of BAROQUE, including Giacomo della PORTA, Pietro BERNINI, and François DUQUESNOY. On his return to Paris he designed the grotto at Wideville and its STUCCO decoration, working in his Roman manner. He used a more personal style in the decoration of LEMERCIER's Pavillon de l'Horloge at the LOUVRE (1636), where his CARYATIDES set the tone of French CLASSICISM in sculpture. His last work was the monument for Henry II of Bourbon in the church of S. Paul-et-S. Louis (1648–63), which was reconstructed and moved to Chantilly in the 19th c. The relief panels based on the *Triumphs* of Petrarch and the *Virtues* which surround the tomb display an individual mixture of Classicism and Baroque which dominated the sculptural style of VERSAILLES for the next two decades. Most of the French sculptors of the next generation passed through Sarrazin's studio.

743.

**SASSETTA,** STEFANO DI GIOVANNI (*c.* 1392/1400–1450). Italian painter and perhaps the most original artist of 15th-c. Siena. While keeping alive the religious ideals of the trecento masters and the poetic feeling of the end of the Middle Ages, he made his own use of the idiom of INTERNATIONAL GOTHIC decorative style and of contemporary FLORENTINE movements, combining them into a personal and coherent manner expressive of his own mystical imagination. His first recorded work is an ALTARPIECE (now broken up and distributed) for the Arte della Lana Chapel (1423–6). His *Madonna of the Snow* (completed 1432 and now in the Contini Coll., Florence) forms a link between the medieval *Maestà* and the RENAISSANCE *Sacra Conversazione* (see VIRGIN). His talent found its most lyrical expression in the smaller panels of an altarpiece completed in 1444 for the church of S. Francesco at Borgo San Sepolcro. Seven of these panels, illustrating the legend of St. Francis, are now in the National Gallery, London, and one in the Musée Condé, Chantilly. In them Sassetta combined an almost 19th-c. ROMANTICISM with reminiscence of late medieval devotionalism which make them a unique expression of the SIENESE SCHOOL.

487, 2123.

**SATURATION.** See COLOUR.

**SATYRS.** Attendants of the god Dionysus in Greek popular mythology, spirits of the woods and hills, especially connected with the idea of fertility. The Arcadian Satyrs were represented as goat-footed with horns and tail, the Anatolian Satyrs with the ears, feet, and tail of a horse. In painting and vase-painting the satyr appears in the 7th c. B.C., in sculpture rarely before the HELLENISTIC period. The Romans identified the satyrs with the Fauni, spirits of the countryside.

**SAVERY,** ROELANDT (*c.* 1576–1639). Prolific Flemish painter and ETCHER of LANDSCAPES, animals, and STILL LIFE. He was born at Courtrai

in Flanders but spent a considerable part of his career abroad, first in Amsterdam as a pupil of his brother JACQUES, who died there in 1602. He is thought to have visited France and worked for Henry IV, and *c.* 1604 he travelled to Prague to work for Rudolf II. The various native and imported animals in the Emperor's menagerie were favourite subjects with him and animals are included in many of his MYTHO-LOGICAL scenes. His individual studies of animals were among the first of their kind in Holland. He drew the now extinct dodo from life. In Rudolf's employ he travelled through the Alps and the Tyrol from *c.* 1606 to 1608, painting and drawing landscape views of considerable quality, with steely and brilliant blues as the most characteristic feature. From 1612 to 1616, with a visit to Amsterdam in 1613, he was based in Vienna, employed by the emperor Matthias, and in 1619 settled in Utrecht, where he also became prominent. In 1626 he was chosen to present a gift of his own paintings to Amalia van Solms, wife of Prince Frederick Henry, on behalf of the city of Utrecht. His rare flower paintings are sometimes of outstanding quality, and with BOSSCHAERT he was an influential Flemish exponent of this genre in Holland. His work is represented in most European museums; examples of his wooded, mountainous landscapes are to be seen in Vienna, animal groups in the National Gallery, London, and at Hampton Court, and his flower paintings in the Victoria and Albert Museum, London, at Utrecht, and at Copenhagen. Gillis d'HONDECOETER (1580–1638) was a pupil of Savery's in Holland.

**SAVOLDO,** GIOVANNI GIROLAMO (*c.* 1480–*c.* 1548). Italian painter, born in Brescia. He trained in Florence and worked chiefly in Venice although much of his career remains obscure. His output was apparently small and he stood somewhat apart from the main Venetian tradition. His work was sometimes inspired by TITIAN, another native of Brescia. In the *Transfiguration* (Uffizi) he shows a liking for unusual effects of lighting together with a sentimentality which is the religious counterpart of CORREGGIO at his most coquettish. In other paintings he displays a meticulous attention to details of texture and materials (*Mary Magdalene*, N.G., London). His *Gaston de Foix* (Louvre) uses the device of the double mirror reflection to illustrate the then popular comparison between painting and sculpture. He was a minor and lyrical talent.

353.

**SCAGLIOLA.** Imitation MARBLE, a compound of marble fragments, PLASTER OF PARIS, colouring matter, and glue. Known in classical antiquity, the secret of its manufacture was rediscovered in north Italy in the 17th c. and used there for intricate coloured inlay work. In the late 18th c. English architects such as ADAM and WYATT, who had little access to true marbles, used it for surfacing COLUMNS when they were working in the Roman manner.

**SCAMOZZI,** VINCENZO (1552–1616). Italian architect and theorist. He completed several buildings by PALLADIO including La Rotonda and the Teatro Olimpico, Vicenza (1583/4), but his chief original work is the Procuratie Nuove, Venice (*c.* 1584 onwards), based on Palladio and on SANSOVINO's adjoining Library. His treatise *L'idea dell'architettura universale* (Venice, 1615), in which he opposes the BAROQUE conceptions, was widely read and translated.

**SCANDINAVIAN ART.** The history of the arts in Scandinavia begins with rock pictures from the end of the Ice Age (see STONE AGE ART IN EUROPE). They are attributed to hunting and fishing peoples who as the ice retreated from southern Europe went north in pursuit of the herds and carried with them a late Magdalenian style of rock engravings. These rock carvings have not the fine aesthetic quality of the best Palaeolithic cave paintings, but are free and lively linear representations of animals and men, and unlike the Palaeolithic art generally they sometimes appear to be anecdotal. They sometimes include what are apparently graphic signs. These rock engravings continued into the Bronze Age and are sometimes overlaid by Bronze Age engravings (e.g. at Bardal, Norway). The Bronze Age engravings are more frequent in the south, particularly in the districts between Oslo and Göteborg. They represent a wide diversity of human activities—ships, sleds, wagons, men on horseback, battle scenes, ploughing, grazing, weapons, etc. They are more schematic than earlier rock art, a rectangle or hour-glass standing for a human TORSO with a rough circle for the head, two lines for legs and so on, like the drawing of young children. Artistically they have been described as the 'babble of children' compared with the Palaeolithic art. Their motivation is a matter of speculation. Sometimes representations of circles and spirals have been thought to indicate sun-worship and the carvings have been assumed to be religious or magical in their purpose; but this remains uncertain. Many weapons and utensils of bronze have survived from the Bronze Age with characteristic ornament of precise concentric circles, spirals, elementary interlock, and wavy lines which indicates the development of a decorative art of a higher order. A remarkable example is an engraved bronze sun disc drawn by a chariot and horse of forged bronze which was found at Trundholm, Denmark, and is dated *c.* 1000 B.C. (Copenhagen Mus.). Also found in Denmark were some huge bronze wind instruments which evidence considerable technical mastery.

This time of artistic activity was followed from *c.* 500 B.C. by a period of general decline, which may possibly have been due to climatic changes. The rare finds from the following centuries consist for the most part of imported goods, e.g. the

Fig. 83. Animal head post from the Oseberg ship burial. Drawing after a photograph. (Viking Ship Mus., Oslo, 9th c.)

338. Detail of decoration from the opening words of The Gospel according to St. Mark. *Book of Kells*. (Trinity College, Dublin, 8th c.)

unique silver kettle found at Gundestrup, Denmark. But *c.* A.D. 400 there emerged an important ornamental art with abstract animal motifs based on continental patterns. This decorative style appears in its purest form on arms found at Valsgärde and Vendel not far from Stockholm (8th c.). About the same time also there was an intense efflorescence of artistic activity centring on the island of Gotland, whose stone STELAE with lively figurative scenes in RELIEF, originally coloured, are among the most interesting monuments of European art in the 8th c.

The period from *c.* 800 to *c.* 1050—called the 'Viking Age'—is the period of the Scandinavians' great expansion, which began not in piracy but

339. Borgund Stave church, Norway (mid 11th c.)

Fig. 84. Jelling stone. (Jelling, Jutland, *c.* A.D. 980). Figure of Christ. Drawing after a photograph

in trade. Towards the beginning of the period they acquired a virtual monopoly of the trade between Russia and western Europe, particularly the trade in precious metals from the East. They were thus wide open to outside influences and these are reflected in the various foreign impacts upon the changing fashions of ornamentation. Thus the WOOD-CARVINGS found at Oseberg give evidence of contacts with CAROLINGIAN ART of

the 9th c. and the lacework patterns (surely once painted) or the Danish Jelling stones (Jelling, Jutland, 10th c.) have affinities with Irish manuscript ILLUMINATION. But the characteristic animal decoration persisted even after Christianity reached Scandinavia and into the 11th c., when it appears on the runic stones (often signed with the makers' names) which are found in the neighbourhood of Lake Mälar in Sweden and in the richly carved doorways of wooden churches in Norway. These wooden churches (e.g. Urnes and Borgund) belonging to the ROMANESQUE period with their complicated construction are some of the most interesting examples of Scandinavian art. Churches of stone, however, were built in large numbers during the 11th and 12th centuries, especially in south Sweden and Denmark. (It is a noteworthy fact that over ninetenths of Denmark's many medieval churches belong to this early period.) Cathedrals also were built, such as Ribe in Denmark with its grand DOME, and Lund in Sweden, the archiepiscopal church of the see of Denmark and the most influential of all—both built on German models (e.g. Speyer). But these great undertakings should not overshadow the multitude of parish churches where the Romanesque forms were adapted to a more domestic need. The wall-paintings in these churches, like the magnificent ALTARPIECES in gilded copper which were presumably made in Jutland, followed continental schemes. But in the sculptured portals and FONTS one may find, alongside the entwining vines and fabulous beasts of the Romanesque style, the animal lacework of the ancient Scandinavian tradition. The best sculptors came from the island of Gotland, a more or less independent province which since the 10th c. had appropriated the leadership in the Baltic trade and had gradually attained considerable prosperity. More than 90 medieval churches on Gotland bear witness to the intense artistic activity there, which even spread to the mainland and lasted into the GOTHIC age.

The outstanding buildings of the Gothic period were the cathedrals of Roskilde and Uppsala, built chiefly of brick but on FRENCH models, and those of Linköping and Trondheim (Nidaros), both of which, but particularly the latter, were offshoots of the English style of Lincoln. Of special interest is the pure and austere style which was advocated by the Swedish saint, Birgitta (Bridget), for her abbey at Vadstena (erected c. 1380-1430), a style which was to be followed in the other Brigittine monasteries of the Baltic countries. The type of plan was peculiar to this Order but went back to the principles of the Cistercians, who a long while before had exercised a wholesome influence on Scandinavian ecclesiastical architecture, as particularly at Alvastra (begun 1143) in the neighbourhood of Vadstena itself.

The wooden images and the paintings of the Gothic period show, as one would expect, some German influence, but also one that is clearly French; and in Norway and northern Sweden one can discern reflections of English work. But in the 15th c. works of art began to be imported from Germany in great numbers, particularly from Lübeck, which had taken over from Gotland the control of the Baltic trade and become the foremost art centre of the Baltic. This German influence was so overwhelming that Scandinavian work could hardly be distinguished from German and it lasted until the 16th c. when the German workshops met with strong competition from Brussels and Antwerp. It must be borne in mind too that during this time the leading citizens of the Scandinavian seaports were German-speaking Germans. Outstanding examples of this art are Bernt Notke's carved and painted altarpiece at Aarhus, Claus BERG's at Odense, and Notke's principal work, the great free-standing group of St. George at Stockholm. The painted decorations on the walls of late Gothic churches were likewise German in conception, particularly in the larger towns of the south such as Malmö and Aarhus. But more interesting are the many painted ceilings of the country churches which are so well preserved throughout Scandinavia, the best perhaps being those round Stockholm and Uppsala and in the coastal districts of Finland.

The RENAISSANCE coincided with a change in the position of the arts in Scandinavia as elsewhere in Europe. Until then artistic activity had generally been devoted to the Church, though commissions had also come from secular PATRONS such as the powerful Hvide family of Denmark. The effect of the Renaissance and the Reformation (c. 1530) with decline of the ecclesiastical power was to channel artistic activity into glorification of the prestige of kings and princes and their courts. To this end the Danish and Swedish kings imported from the Netherlands and Germany architects, sculptors, portrait painters, weavers, and other artists and craftsmen. In Denmark especially, during the reigns of Frederick II (1559-88) and Christian IV (1588-1648), the secularization of the arts ushered in a burst of intense creative activity. The most important undertakings were the castle of Kronborg (c. 1570-90) at Helsingør, whose name has been made famous by Hamlet, and those of Frederiksborg (c. 1560-1620) and Rosenborg, all three in the 'Netherlandish Renaissance' style. The leading architects were Hans van Stenwinkel and his two sons, who all took part in the building of the Exchange in Copenhagen and the church of Kristianstad in Scania—this last being one of the most beautiful Protestant churches of this period. In Denmark and in Scania (which was Danish until 1645) the nobility erected a number of splendid mansions. In Sweden the kings' chief artistic concern was to turn their ancient strongholds at Stockholm and Kalmar into fashionable residences, but several new castles were also erected such as the beautiful one at Vadstena (1545-1620).

The Thirty Years War (1618-48) gave Sweden

**340.** Kronborg Castle, Helsingør (c. 1570-90)

a period of prosperity which lasted until the end of the century. Queen Christina (r. 1632-54) sent for skilled artists from abroad, including the portrait-painter Sebastien BOURDON. It was at this time that the Old Town of Stockholm acquired its richly carved doorways and its House of Nobility, the finest Swedish example of the Dutch PALLADIAN style. Among the architects who served the court and the nobility were Nicodemus TESSIN and his son, who exerted a profound influence on the artistic development of Sweden with their Franco-Italian background. Together they created the castle of Drottningholm (1662-1700). The greatest achievement of the son, however, was the rebuilding of the castle of Stockholm (1690-1708; 1727-53). In plan it resembled an immense palazzo of Rome; but its stark walls and straight profiles reflect also the spirit of Charles XII, who took a personal interest in it, insisting on purity of design and imposing restraint upon sculptural decoration.

In Norway, which from 1380 until 1814 was a Danish province, there was no such tendency towards princely magnificence. But during the 17th c. along the western coastal districts, there was an outstanding development in wood-carving, an art in which the Norwegians had excelled since pagan times. The profuse BARO-QUE ACANTHUS designs which adorn the altars and PULPITS of the churches in Norway are almost all from this period. One of the leading masters was Anders (Andrew) Smith, an immigrant from Scotland.

When the ROCOCO style reached Norway it acquired a certain domestic character, a rustic intimacy quite different from the reserved and lofty dignity of Swedish Rococo. For that tendency towards exaggerated movement which the Rococo was apt to show when it strayed outside France was foreign to the Swedes. And in Sweden, as in France, the step from Rococo to NEO-CLASSICISM was not a long one. Perhaps it is no accident that several Swedish artists were

highly esteemed in Paris, like ROSLIN the portrait painter, Lafrensen (1737-1807) (Lavrëince), the painter of *fêtes galantes*, and HALL the MINIA-TURIST. This was the period of Gustavus III, in whose reign (1771-92), corresponding closely to that of Louis XVI, the arts greatly flourished. It was also the time of the bohemian poet Carl Michael Bellman, close friend of the sculptor SERGEL and of the painter MARTIN.

Compared with the Rococo of France and Sweden that of the Danes displays a more intimate and friendly character. Even where the pattern was French, as in the octagonal Amalienborg Square in Copenhagen by N. Eigtved (1701-54), the final design became genuinely Danish, though the splendid EQUESTRIAN STATUE which stands in the middle of that square is by a Frenchman, J. F. Saly (1717-76). Among the portrait painters were that strange artist PILO (who, however, was born and trained in Sweden), and a little later JUEL. Juel's portraits combine intimacy with objectivity, qualities to which the next generation was to bring a sterner note of CLASSICISM.

The break with the Rococo grace of the 18th c. was introduced by the sculptor THORWALDSEN, who was for many years a leading personality in Rome and had greater international prestige than any other Scandinavian artist. The lucid and harmonious, perhaps over-studied, forms which he introduced may appear somewhat anaemic by reason of their unrelieved whiteness; but they were brought to life in painting by the Danes of the first EMPIRE period. This was the Golden Age of Danish painting. Among its qualities is a charming REALISM which is yet so tranquil that it can still be called classical. The initiator was ECKERSBERG, a pupil of J. L. DAVID and a kind of Scandinavian equivalent of INGRES. He was followed by KØBKE and Jørgen Roed (1808-88), who were also realists, by Constantin Hansen (1804-80), who was a purer Classicist, and by the more literary painter W. N. Marstrand (1810-73)—all of them contemporaries of Hans Andersen. Nor should one forget the background of this art, the sober Danish architecture of the time and the furniture with its graceful inlay.

In Finland, which from 1809 until 1917 was a Russian province, Neo-Classicism assumed a quite different character. But this more pompous version of the First Empire style, which still gives to parts of Helsinki a special atmosphere, properly belongs to RUSSIAN ART.

In the middle of the 19th c. Scandinavian painters gravitated to Düsseldorf, a place more congenial than Paris to artists who wanted to express their patriotic emotion in landscapes and GENRE scenes from national folklore tradition. The exception were the Danes, who preferred to study at their excellent Academy in Copenhagen or to visit Rome as they had always done. At this time of ROMANTIC nationalism attention centres on the Norwegians. TIDEMAND, the painter of folk-tales, attained a reputation at

Düsseldorf; so also did H. F. Gude (1825-1903), painter of the Norwegian fjords, who however was a somewhat theatrical artist compared with the profounder interpretation of his predecessor, DAHL.

The national characteristics which distinguish the several Scandinavian countries became more pronounced. Norway, more than the rest, inclined to the emotional and pathetic. The time of Ibsen and Grieg was also the time of Christian KROHG, a painter preoccupied with social questions, and of WERENSKIOLD, who caught the atmosphere of the Norwegian countryside and gave reality to its folk-tales. This emotional quality of Norwegian art was to have influence abroad through the impressive SYMBOLISM of MUNCH, whose paintings were one of the starting-points of German EXPRESSIONISM. To the same generation belonged VIGELAND, who was inspired by RODIN and a sculptor of genius even though he succumbed to the temptation to give way to that exaggerated emotionalism which has become the mark of monumental Norwegian art of today. There is more mural painting in modern Norway than in any other country except Mexico. The principal commissions have fallen to SÖRENSEN, an Expressionistic follower of Werenskiold, and to Per KROHG, a brilliant and humorous raconteur who was trained in Paris. The results may be seen in the profusely decorated Town Hall of Oslo. There, too, Aage Storstein (1900- ) has attracted attention, a younger painter who owes something to PICASSO. It is characteristic of Norwegian art that there are hardly any purely ABSTRACT painters. The only important exception is Rolf Nesch (1893- ) who is a German immigrant.

In Finland, too, representational art had developed on nationalistic lines. It is true that the art of EDELFELT, one of Finland's best known landscape painters, is international and Parisian rather than Finnish. But a purely national style was launched in the 1890s by GALLEN-KALLELA's interpretations of the *Kalevala* legends. In this new Finnish style the colours were more oppressive than in the Norwegian and it was more linear in conception, being based partly on the old traditions of Finnish textile design. Highly original in this Finnish manner, and better adapted to the conditions of easel painting, are the Expressionist peasant scenes of SALLINEN. In sculpture, the rustic wooden reliefs of Hannes Autere (1888-1967) are important, as also the very different work of AALTONEN with its heavy forms and plastic velvety modelling. As a contrast to these masculine trends in Finnish art, there is the subtle colouring of the painter Helene SCHJERFBECK.

In Sweden the painting and sculpture of our time have shown a good deal of variety. Among the numerous Swedish painters who formed their style in Paris in the 1880s, JOSEPHSON held the leading place, a gifted colourist and an artist of deep feeling, one of the most pathetic figures in Scandinavian art. In the next decade Carl

LARSSON, reacting against the current mysticism, began to work out a bright and graceful linear style, particularly in charming interior scenes which have become popular symbols of a happy Sweden. A contemporary of Larsson was the IMPRESSIONIST painter and ETCHER ZORN; part of his brilliant reputation was made in the United States, like that of MILLES, the sculptor. During the 1920s there arose a strong movement towards the primitive and the naïve, which lasted until the middle of the century; one of its exponents is the sculptor HJORTH. But this trend was gradually counterbalanced by an increasing intellectualism which led primarily in the direction of the abstract.

In Denmark the modern era begins in the 1880s with the vital realism of KRØYER. More contemplative were the quiet interior scenes of HAMMERSHØI, who gave a deeper poetical feeling to the Classicism of Eckersberg. The only other connection that 20th-c. Danish painting shows with its brilliant First Empire florescence is a certain healthy realism and contact with everyday life. The passion for experiment and for strongly dynamic effects displayed by the Symbolist WILLUMSEN foreshadowed much of what has been created in Denmark during the 20th c. The FAUVES in Paris had their counterparts among Danish painters, GIERSING being the most outstanding. It is clear now that during the first 30 years of this century the most independent and vital painting in Scandinavia was being done in Denmark. There, besides Giersing, were ISAKSON (actually a Swede) and the unsentimental CUBIST LUNDSTRØM. More recently a fairly homogeneous group of abstract painters has appeared, younger men who have applied continental theories with freedom and vigour in a typically Danish way.

But perhaps the greatest contribution of Scandinavia has been to architecture and the APPLIED ARTS, and this has had genuinely international importance. The most valuable expression of ART NOUVEAU in Scandinavia was in the early buildings of the Finnish architect SAARINEN. The building which has had most influence abroad is the Town Hall of Stockholm by ÖSTBERG—already something of a classic—in which Romanticism is strengthened by a monumental silhouette and exquisite workmanship. The FUNCTIONAL movement, of which the Stockholm Fair of 1930 was the first important manifestation in Scandinavia, was manifested most convincingly in the buildings of the Swedes ASPLUND, MARKELIUS, and Sigurd Lewerentz (1885- ), the Danes Kay Fisker (1893-1965) and Arne Jacobsen (1902-71), and the Finn AALTO, who like Saarinen achieved a high reputation in the United States. The Scandinavian architects have won their international fame primarily by taking the lead with socially adapted urban dwellings, by the adaptation of form to function and to materials—as in the suburban settlements of Copenhagen and Stockholm—and by their novel organization of architectural space.

The same social sense has controlled the design of furniture and household utensils. The hand-made furniture of Denmark is specially interesting, thanks to its admirable workmanship—indeed in that country all craft-work, especially silver, bookbinding, and POTTERY, is of high quality and appeals to the aesthetic sense by virtue of the charming inventiveness which the Danes often show. But industrial furniture production has gone further in Sweden and Finland—e.g. the moulded plywood furniture designed by Aalto. In glass-making, again, the Swedish factories of Orrefors and Kosta have long been famous, but subsequently some of the Finnish factories, such as Iittala and Notsjö, rose to the same level. In ceramics Denmark preserves a fine tradition at the Royal Porcelain Factory (founded 1775) and the factory of Bing and Gröndahl, both at Copenhagen. In Sweden the counterparts of these are the ceramic industries of Gustavsberg and old Rörstrand and in Finland the huge Arabia Factory at Helsinki.

17, 37, 298, 810, 877, 1235, 1330, 1474, 1481, 1579, 1646, 1669, 1919, 1945, 1966, 1982, 2042, 2244, 2301, 2477, 2478, 2507, 2904.

**SCARAB.** The commonest of EGYPTIAN amulets, made in the form of a sacred beetle (chiefly *scarabaeus sacer*) and associated with ideas of spontaneous generation and renewal of life, as well as with the solar deity Khepri. Scarabs became popular from the end of the 3rd millennium B.C., and innumerable examples of varied materials—glazed steatite, FAIENCE, semi-precious stones—have been found in TOMBS and elsewhere. Some bear the owner's name and were used as seals, but most have decorative designs, messages of good luck or words of power, including royal CARTOUCHES. Large green stone scarabs which served as substitutes for the dead man's heart are often inscribed with spell 30B of the BOOK OF THE DEAD, and there are some commemorative pieces which record notable events. Scarabs spread throughout the Near East and the Mediterranean world and were reproduced in many centres during the 1st millennium B.C.

1926.

**SCARSELLINO** or SCARSELLA, IPPO-LITO (1551-1620). Italian painter, draughtsman, engraver, and MINIATURIST of the FERRARESE SCHOOL, active in various parts of north Italy. He was trained in Bologna and Venice, where he was influenced by the work of VERONESE and BASSANO. He was a prolific and unequal painter, and is seen at his best in the *Nativity* (Brera) and in some charming smaller works such as the *Flight into Egypt* (Dresden).

**SCAUPER.** See SCORPER.

**SCHADOW,** JOHANN GOTTFRIED (1764-1850). German sculptor. He travelled in Italy,

1785-7, and in 1788 he settled in Berlin, where he became head of the Academy in 1816. Schadow was a sensitive portraitist (*Goethe, Kant, The Princesses Luise and Frederika of Prussia*, 1795-7). His work was in the NEO-CLASSICAL style but retained a vestige of BAROQUE liveliness (tomb of Graf von der Mark, Berlin; quadriga on the Brandenburg Gate, Berlin).

**SCHAFFNER,** JACOB (1478/9-1546/9). German painter from Ulm. His work reflects the struggle of German tradition with the Italian RENAISSANCE. His use of motifs taken over from LEONARDO makes it likely that he visited Italy. In his later years, when the Reformation put an end to commissions for ALTARPIECES, he had to turn to portraiture.

**SCHALKEN,** GODFRIED (1643-1703). Dutch painter of biblical, allegorical, and anecdotal subjects. HOOGSTRATEN was his first teacher, DOU his second. He followed Dou's style closely, but his paintings have a smoother, glossier finish. He frequently painted scenes illuminated by candle-light and these works, which have a red glow, were immensely popular. He used this light even for painting William III, King of England and Prince of Orange. WAL-POLE, who informs us that Schalken was in England twice, wrote that he would put his model in a dark room with a candle and himself sit in the light, looking into the room through a peep-hole.

**SCHEDONI,** BARTOLOMEO (*c.* 1570-1615). North Italian painter, born near Modena but active almost exclusively in Parma, where he was already in the service of the FARNESE family by 1597. He was trained in the local MANNERISM of Modena, but in Parma came under the pervading influence of CORREGGIO and later he was affected by the BAROQUE movements of Rome. Many of his works remain, particularly in the Pinacothecas of Naples and Parma; they have an attractive charm but miss greatness.

**SCHEEMAKERS,** PETER (1691-1781). Sculptor, son of a BAROQUE sculptor of Antwerp. He settled in England before 1720, having probably already been to Rome. He and his compatriot Laurent Delvaux (1695-1778) completed unfinished work by another Fleming, Pierre Denis Plumier (d. 1721), built up a practice as TOMB-makers, and both went to Rome *c.* 1728. Scheemakers, whose admiration for antiquity was profound, returned about 1730 bringing a number of casts of famous ANTIQUE statues, some of which he subsequently copied as garden figures. He quickly became a rival to Michael RYSBRACK both as a BUST- and a tomb-maker, undercutting the latter's prices, but his work is less lively. In 1740, however, he gained a great success with the *Shakespeare* MONUMENT (Westminster Abbey), designed by William KENT, which is more Baroque in character than

most of his work. Thereafter he received many commissions and controlled a large studio with many assistants. He was perhaps the most prolific of mid 18th-c. sculptors, his signed works ranging from small tablets to large monuments with many figures, the majority being based on classical patterns; but though competent, he is seldom imaginative. He returned to Antwerp in 1771, but his son THOMAS (1740-1808) remained in England, making a number of monuments, several of which were designed by the architect 'Athenian' STUART. His brother, HENRY, also worked in England from c. 1726 to c. 1738, apparently mainly in partnership with Henry CHEERE.

**SCHEFFER,** ARY (1795-1858). Dutch painter, engraver, and book illustrator, who made a name in Paris during the reign of Louis Philippe. His sentimental pictures of classical subjects and of scenes from the works of GOETHE and Byron had a vogue throughout Europe and America during the 19th c.

**SCHELFHOUT,** ANDREAS (1787-1870). Dutch LANDSCAPE painter who was a forerunner of the HAGUE SCHOOL. He is best known for carefully depicted winter scenes reminiscent of those made by 17th-c. Dutch artists. He also painted seascapes and was an accomplished WATER-COLOURIST; and it was these aspects of his work which impressed JONGKIND, his most famous pupil.

**SCHIAVONE.** ANDREA MELDOLLA (1522-64). North Italian painter of religious and secular subjects and portraits. Adopting the rich colours of TITIAN, he combined them with the elegant MANNERIST figures of PARMIGIANINO, whose style he imitated also in his engravings and ETCHINGS. TINTORETTO had a high regard for Schiavone's use of colour and was influenced by him in his early works.

**SCHILDERSBENT** (Dutch: 'band of painters'). A fraternal organization founded in 1623 by a group of Netherlandish artists living in Rome for social intercourse and mutual assistance. One of its early leaders was Pieter van LAER. The society had no written laws and no fixed programme. Its members called themselves *Bentvueghels* or 'birds of a flock'. Today they would be called Bohemians. In 1720 the Schildersbent was dissolved and prohibited by papal decree because of its Bacchic irregularities.

**SCHINKEL,** KARL FRIEDRICH (1781-1841). German architect, mainly active in Berlin. He trained under Friedrich GILLY and his first buildings, the Neue Wache (1816), a theatre (Schauspielhaus, 1818-21), and the Altes Museum (1822-8), combine a pure Greek taste with the plain utilitarian character of FRENCH revolutionary architecture. His essays in GOTHIC REVIVAL (Werderkirche, Berlin, 1829) were in-fluenced by English models, some of which he had seen during a journey in 1826. In his most advanced buildings—the Academy of Architecture (1832-5), designs for a store (1827), and a library (1835)—he attempted a purely FUNCTIONAL style, free from historical associations. Schinkel edited folios of patterns for craftsmen and manufacturers and was fully aware of the new tasks of industrial DESIGN. He was also a fine painter of ROMANTIC landscapes and a stage director of note (Mozart's *Magic Flute*, 1815).

**SCHJERFBECK,** HELENE (1862-1946). Finnish painter of interiors and figures. She attracted attention during the 90s as a sensitive colourist. Later, living a solitary life and almost forgotten, she continued to work on similar subjects with increasing simplification. These later compositions, with their soft outlines and carefully combined colours, are among the most refined examples of Finnish art.

**SCHLAUN,** JOHANN CONRAD (1695-1773). German architect, active in Westphalia. Influenced by BORROMINI and south German design, he worked in a BAROQUE style tempered by French CLASSICISM. His masterpiece is the church of St. Clement on a corner site in Münster (1732). He had a special fondness for the combination of brick and stone dressings, which he used in this church, in his own Münster house (1752), and in his Münster Palace (1767).

2213.

**SCHLEMMER,** OSKAR (1888-1943). German painter and stage designer. He was trained at Stuttgart under Adolf Hölzel (1853-1934) and from 1920 to 1929 taught at the BAUHAUS, where he became head of the department of theatrical design. He did much work for the theatre, including the CONSTRUCTIVIST *Triadic Ballet* to music by Hindemith. As director of the sculpture workshop he experimented with space-construction in plastic reliefs. In his painting he tried to translate the fugitive movements of dance into the static medium and by a strict grouping of human figures to create an irrational space reflecting the existential states rather than the emotional moods of man. His reaction from EXPRESSIONISM shared something with the French PURISTS and something with the Constructivists. He said: 'Particularly in works of art that spring from the imaginative faculty and the mysticism of our souls, without the help of external subject matter or content, strict regularity is absolutely indispensable.' His latest pictures were small WATER-COLOUR variations of the view by night of lighted windows across the way from his studio at Wupperthal.

1312.

**SCHLÜTER,** ANDREAS (1662-1714). German architect and sculptor, active in Berlin. He built for Frederick I part of the royal palace in

Berlin (1698–1707), endowing it with Roman grandeur. The same pomp appears in his sculpture, e.g. the EQUESTRIAN STATUE of the Great Elector (1696–1700), but in his own house in Berlin (1711–12), where he combined the two arts, he achieved a highly sophisticated synthesis of Italian BAROQUE and French CLASSICISM.

**SCHMIDT-ROTTLUFF,** KARL (1884–    ). German painter and founder member of the Dresden BRÜCKE. The influence of the FAUVES, CUBISM, and PRIMITIVE art is present in his figure paintings and landscapes. His technique was simple and bold and best suited to the GRAPHIC ARTS and in particular the WOODCUT, in which Schmidt-Rottluff did his best work.

1165.

**SCHNORR VON CAROLSFELD,** JULIUS (1794–1872). German painter. After studying at the Vienna Academy he joined the NAZARENES in Rome (1817–25) and with them painted frescoes in the Villa of Prince Massimo. In Munich he worked for Ludwig I, painting mainly frescoes in the royal palace. As head of the Dresden Academy from 1846 onwards, Schnorr exercised a considerable influence in Germany as a representative of Nazarene ideals. His Bible illustrations were popular in their day and were also published in England (*Schnorr's Bible Pictures*, 1860).

**SCHÖNFELDT,** JOHANN HEINRICH (1609–82). German painter and ETCHER. He worked as a young man in Rome and Naples, where he was influenced by some of the followers of CARAVAGGIO. Later he fell under the spell of POUSSIN. His principal works are to be found in some of the churches in Salzburg. There is also a painting by him at Hampton Court (*The Sarmatians at the Tomb of Ovid*).

**SCHONGAUER,** MARTIN (*c.* 1430–91). German painter and engraver. He came from an Augsburg family of artists but settled in Colmar, Alsace. In his day he was perhaps the most famous artist in Germany; it was in his workshop that the young DÜRER hoped to study, but when he arrived in Colmar in 1492 the master was already dead. Schongauer has sometimes been called a pupil of Rogier van der WEYDEN, for though he never met the Flemish painter he must have studied his works closely and drawings after Rogier by his hand survive. Curiously enough these belonged at one time to Dürer. Schongauer's mature paintings (*Madonna in the Rose Garden*, St. Martin's, Colmar, dated on the back 1473) are more lyrical than Flemish painting; they show less interest in REALISM and a certain amount of GOTHIC insistence on line. But at all times Schongauer's fame rested chiefly on his many engravings, which were among the first truly artistic renderings of popular religious imagery. His Madonnas, PASSION scenes, etc.,

were not, like earlier ones, meant for inserting in missals or prayer-books, but are works of art in their own right. They were widely dispersed and served as models for many other artists. That Schongauer himself valued these engravings is clear, for he invariably initialled them.

194, 426, 881, 2920.

**SCHOOTEN,** FLORIS VAN (active first half of 17th c.). Dutch painter of Haarlem who was prolific in STILL LIFES of laid out buffets and simple breakfast tables. His style was influenced by his more original contemporaries, HEDA and CLAESZ.

**SCHOUMAN,** AERT (1710–92). Versatile Dutch artist who did everything from painting wall-paper to engraving glass. His best works are his delicate WATER-COLOURS of birds and animals.

**SCHWIND,** MORITZ VON (1804–71). Austrian painter, trained in Vienna and in Munich under CORNELIUS. Schwind represents the tail end of German ROMANTICISM. In his many FRESCO decorations fairy-tales and homely legends take the place of more heroic subjects. His WOODCUTS, many of them for the *Fliegende Blätter* (a humorous Munich periodical), are the work of an accomplished and witty draughtsman. In his young days Schwind had been friendly with Schubert and late in his own life he immortalized Schubert's Vienna circle in a number of drawings.

**SCHWITTERS,** KURT (1887–1948). German artist. He studied at the Dresden Academy, came under the influence of KANDINSKY in 1918, and later was a member of the German DADAIST group. In 1920 he invented MERZ, a variety of Dada, and from 1923 edited the magazine *Merz*. He emigrated to Norway in 1937 and after the German invasion of 1940 fled to England, where he passed the rest of his life. He made pictures by a COLLAGE technique from odds and ends such as tram-tickets, cigarette cards, scraps of old newspaper, etc. and constructions which he called *Merzbau* from bits of wood, scrap metal, etc.

**SCOPAS OF PAROS.** One of the most celebrated Greek sculptors, active in the mid 4th c. B.C. He collaborated on the reconstruction of the TEMPLE of Athena at Tegea and on the MAUSOLEUM. But though much of the sculpture from them has been found, Scopas's own share cannot be determined with certainty. It is generally presumed that his style was marked by dramatic vigour of expression, looking forward to the emotionalism of HELLENISTIC sculpture. It can be judged from surviving copies of such things as his *Dancing Maenads* or *Meleager*. The vivid portrayal of Bacchic frenzy in his *Bacchante* of Parian MARBLE is described in the *Greek Anthology* (ix. 774) and by CALLISTRATUS.

**SCOREL,** JAN VAN (1495–1562). The first Netherlandish artist to bring the ideals of the Italian RENAISSANCE to the area we today call Holland. He was born in Schoorel near Alkmaar. After studying with three other teachers he went in 1516 to work with GOSSAERT, who was then in Utrecht. Possibly encouraged by Gossaert, who had already visited Italy, Scorel set out in 1519 on a tour which was to determine the course of his entire career. Stopping at Speyer, Strasbourg, Basel, and Nuremberg, he eventually reached Venice, where he joined a group of pilgrims and sailed to Cyprus, Rhodes, Crete, and on to Jerusalem. He returned to Venice the following year and finally made his way to Rome, where he found favour with Pope Adrian VI—a native of Utrecht. By 1524 Scorel was back in Utrecht, where he spent the rest of his life. His countrymen immediately ranked him as one of their leading artists, and he had contact with the courts of France, Spain, and Sweden. He was extremely productive and possessed the proverbial versatility of Renaissance men.

Most of Scorel's great ALTARPIECES have been lost or destroyed, but enough of his work survives to show how he had studied classical sculpture and the works of RAPHAEL and MICHELANGELO while he lived in Rome. His treatment of LANDSCAPE and portraiture reveals that he was impressed by the Venetian masters GIORGIONE and PALMA VECCHIO. Unlike many other Netherlandish masters his works are no mere jumble of Renaissance motifs. The *Presentation in the Temple* (Vienna) is set in a BRAMANTESQUE building and the PROPORTION, movement, and DRAPERY of the figures indicate that he understood what his Italian contemporaries were trying to achieve. On the other hand his interest in atmospheric effects, in the play of light and shadow, and his fine landscape drawings are part of his Netherlandish heritage. The degree to which he was able to synthesize northern and southern elements in his figure compositions varies but the quality of his portraits is uniformly high. A fine example is the *Portrait of Agatha Schoonhoven* (Doria Pamphili Gal., Rome, 1529). The *Jerusalem Pilgrims* (Utrecht and Haarlem Museums) are the starting-point for that unique branch of DUTCH painting, group portraiture, which culminates in the works of Frans HALS and REMBRANDT.

Scorel made a powerful impression in Holland and his influence can be detected in the work of Maarten van HEEMSKERCK and Antonio Moro (MOR VAN DASHORST).

926, 1367.

**SCORPER** (SCAUPER). A tool used in WOOD-ENGRAVING for clearing away large areas of the block or for engraving broad lines. Its cutting section is usually rounded, occasionally square.

**SCOTLAND,** NATIONAL GALLERY OF, EDINBURGH. The National Gallery of Scotland was opened to the public on 22 March 1859 in the building by W. H. Playfair (1789–1857) which it shared with the Royal Scottish Academy. The collection originally comprised 331 pictures, most of which came from three sources: (1) the collection built up over 30 years by the Royal Institution for the Encouragement of the Fine Arts of Scotland; (2) a collection bequeathed to Edinburgh University in 1835 by Sir James Erskine of Torrie composed chiefly of Italian and Netherlandish works; and (3) pictures contributed by the Royal Scottish Academy, consisting of a few Old Masters but mainly works by 18th- and 19th-c. Scottish artists. In 1882 the Scottish National Portrait Gallery was established in Queen Street and Scottish historical portraits were removed there. But overcrowding was still a problem and congestion continued even after separate accommodation was found in 1912 for the Academy at the old Royal Institution. In 1946 the Department of Prints and Drawings was moved to 17 Ainslie Place, where laboratories for restoration and preservation had been set up. Until the passing of a National Galleries of Scotland Act in 1906 the Gallery had no funds from which to purchase new acquisitions and the collection has always relied to a large extent on gifts and bequests. Among the most important has been 31 splendid paintings from the Bridgewater House collection, deposited by the Earl of Ellesmere on extended loan in 1946.

**SCOTT,** SIR GEORGE GILBERT (1811–78). English architect. The busiest of all the GOTHIC REVIVAL architects, according to Goodhart-Rendel 'during a working career of forty years, [he] built or interfered with nearly five hundred churches, thirty-nine cathedrals and minsters, twenty-five universities and colleges, and many other buildings besides'. He was a knowledgeable and respectable designer, but not a religious enthusiast like his contemporary PUGIN, and he has been much criticized for his drastic restoration work in many English cathedrals. He studied and imitated French and German, as well as English GOTHIC models. Following his famous contest with Palmerston in 1858 about his design for the Foreign Office Building, which brought the 'battle of the styles' to a climax, he was compelled to alter his Gothic design to a CLASSICAL one. Other buildings by Gilbert Scott are St. Pancras Station (1860) and the Albert Memorial (1862–72).

Several of Scott's descendants became period-revival architects, the best known being his grandson SIR GILES SCOTT (1880–1960). The latter achieved fame young by winning the competition for Liverpool Cathedral at the age of 23. It is Gothic in style, the first portion to be built, the Lady Chapel, having the most vigour and originality. In his new building for the Bodleian Library, Oxford (1942), Scott introduced a fashion for small-stone rubble walling into a city previously noted for the dignity of

its smooth ashlar. In the rebuilt Commons Chamber, Westminster (1950), he used a decorative late-Gothic veneer to encase the elaborate new mechanical installations. As consulting architect for a number of industrial buildings (e.g. Battersea and Bankside power stations) and the new Waterloo Bridge, Scott did little more than embellish the work of the engineers responsible for the designs.

**SCOTT,** SAMUEL (1702?-1772). English MARINE and TOPOGRAPHICAL painter and ETCHER. He was working in London by the late 1720s when he painted in the manner of the brothers van de VELDE. In 1731-2 he collaborated with George LAMBERT in a series of views of the East India Company's settlements (Commonwealth Relations Office). He was later greatly influenced by CANALETTO (who was in England c. 1746-55) and in particular his views of the Thames and its bridges, which often include small figures, owe much to Canaletto's example. He settled in Bath c. 1766, and died there. There are pictures of his in the Tate Gallery, the Maritime Museum, London, and the Guildhall.

**SCOTT,** WILLIAM (1913- ). Painter of mixed Scottish and Irish descent, born at Greenock on the Firth of Clyde. He was trained at the Belfast College of Art and from 1931 to 1934 at the Academy Schools, where he won prizes for both sculpture and painting. His early work consisted of figural studies under the influence of or showing interest in CÉZANNE and BONNARD. After an interval during the war years he said of his work in the latter half of the 1940s: 'I picked up from the tradition of painting in France that I felt most kinship with—the STILL LIFE tradition of CHARDIN and BRAQUE, leading to a certain kind of ABSTRACTION which comes directly from that tradition.' His work continued to be mainly based on still life with increasing abstraction though with a new conception of space from c. 1951. Scott was elected a member of the LONDON GROUP in 1949, was invited in 1951 by the ARTS COUNCIL to do a large picture for the Festival of Britain, and in 1958 had a retrospective exhibition at the Venice Biennale. He was awarded first prize in the British Painting Section at the second John Moore's Liverpool Exhibition and was awarded the International Critics Purchase prize at the sixth São Paulo Biennale. In 1955 he wrote: 'I should like to combine a sensual eroticism with a starkness which will be instinctive and uncontrived.'

**SCOTTISH ART.** It was not till the 13th c. that Scotland emerged as a unified nation to which Pictish, Celtic, Norse, Anglo-Saxon, and Norman elements had all made their contributions. Throughout the late Middle Ages remoteness from the main centres of European civilization and an almost perpetual state of war created conditions in which the arts could scarcely be expected to take root. There is little distinctively

341. Pictish carved stone slab from Burghead, Morayshire. (B.M., 7th c.)

Scottish architecture before the 16th and 17th centuries; painting of any quality was to come still later. It would none the less be wrong in the context of Scottish art to ignore completely or to dismiss as irrelevant even the earliest artistic products of northern Britain. They have at different times, and with varying emphasis, been part of the inherited consciousness of later Scottish artists.

Before the medieval period the art of the area which is now Scotland falls into three main divisions, which in the course of time became more and more intermingled. In the north, from the Forth to Orkney, the Picts evolved a linear style of incised and RELIEF stone carvings, some geometrical and others using animal forms. At their best, such as the bull on the 7th-c. slab from Burghead, these possess great vitality and a masterly yet economical sense of pattern. A different artistic tradition, one shared with Ireland, was nourished from the 7th c. onwards in St. Columba's Celtic monastery on Iona. CELTIC ART received more from Scotland than is usually acknowledged, and some of its finest examples, including a part at least of the *Book of Kells*, were executed on Scottish soil. It was carried from Iona by Columba's missionaries and inspired the art of English Northumbria, the boundaries of which reached north to the Forth. This Anglo-Celtic style, which from its beginning absorbed certain Pictish motifs, produced, in the *Book of Durrow* and the *Lindisfarne Gospels*, two of the greatest achievements of early British art. It became, as it were, a synthesis of the art of the emergent Scottish nation.

A Celtic-inspired style remained dominant till well into the 11th c. Indeed in the West Highlands it lingered on in isolation up to the eve of the Reformation, and some of the remarkable carved stone crosses of this twilight era possess a vitality never equalled in later Scottish

342. View of Stirling Castle. Engraving (1770) from drawing by Thomas Hearne

sculpture. In areas more accessible from the south NORMAN influence reached Scotland shortly after the Conquest and for the next 400 years or so the art of the greater part of the country followed, in a modest and somewhat provincial fashion, the same course as England's. Norman architecture is widespread, with work of high quality as far north as St. Magnus Cathedral in Orkney; and the GOTHIC which succeeded it, though at times achieving real merit as in Glasgow's 13th-c. cathedral, was for the most part an importation.

The RENAISSANCE was slow in reaching Scotland but when it did it took on a recognizedly Scottish character. Towards the end of the Middle Ages relationships with France and the Netherlands had become at least as strong as with England. Scottish artists began to look in more than one direction for their examples and to adapt varying foreign ideas and styles to local requirements. In the first half of the 16th c. a complete break with the past appears in the architecture and far from unsophisticated decoration of the palace at Stirling Castle and of Falkland Palace, both products of royal PATRONAGE and very directly inspired by France. At the same time a plainer vernacular architecture, the so-called 'Scotch Baronial', arose to meet the needs and tastes of the great landowners rather than the court. Though its parentage was largely French, Netherlandish influences and the traditional form of the Scots medieval 'peel' tower

also contributed to its distinctive characteristics. In the later 16th and earlier 17th centuries castles in this very individual style were built throughout the country. They vary in plan but all possess common stylistic ingredients: a vertical emphasis austere at the base and breaking in the upper storeys into a complex of CORBELLED turrets, crow-stepped gables, and often elaborately decorated dormer windows.

The almost total separation of Scottish and English architecture did not disappear in the years following the Union of the Crowns in 1603. A change, however, did occur. In the work of William Wallace (d. 1631), most notably Heriot's Hospital in Edinburgh, begun in 1628, the irregular and semi-fortified appearance of the vernacular castles is replaced by an orthodox Renaissance plan and more open and generously decorated lower storeys. This new style retained for a time some of the features of its immediate predecessor, but it owed considerably more to Netherlandish example. Wallace had capable successors who were responsible for a few mansions and large public buildings and much urban architecture of a more modest kind. It was not till the latter part of the century that Sir William Bruce (d. 1710) brought the tradition of WREN to Scotland and closed for a long time the division between the Scottish and English styles.

Eighteenth-century Scotland, the Scotland of Hume and Adam Smith, was self-consciously cosmopolitan. It supplied Russia with the archi-

**343.** *Design of the South Front of the New Building for the University of Edinburgh*, by Robert Adam. Engraving (1791)

tect Charles CAMERON and England with Colen CAMPBELL and James GIBBS; and it received only a lesser share of the work of Robert ADAM. Adam's father, William Adam, had been the most able of the Scottish architects of the generation after Sir William Bruce, to whose borrowings from Wren he added others from VANBRUGH and the PALLADIANS. The son's elegant NEO-CLASSICAL style was enthusiastically received in Scotland; one of his very last works, the design for Charlotte Square, did much to establish a standard for the rest of the New Town of Edinburgh.

There had been Scottish painters of a kind in the late 17th and early 18th centuries. It was not, however, till the 1740s when Allan RAMSAY, after an apprenticeship in London and Rome, began his career as a graceful and sophisticated portraitist, that Scotland produced a painter of European status. Ramsay spent most of his life in London; a younger contemporary, Gavin HAMILTON, established himself in Rome, where he became something of an artistic institution,

dealing in Old Masters and classical sculpture and painting history pictures which anticipate, in kind if not in performance, the art of Jacques-Louis DAVID. It was also in Rome that the brothers Alexander and John RUNCIMAN developed as sensitive and original painters of themes from Shakespeare and romantic literature. In 1752 an ambitious, if naïve, attempt was made by the Glasgow University printer, Robert Foulis, to establish a native ACADEMY of art; the venture failed but in David ALLAN it produced a painter of talent whose domestic GENRE pictures were the first of a long-lived and distinctively Scottish succession.

By the early 19th c. Scotland had become a comparatively prosperous country whose painters and architects could usually find work to keep them at home. Out of somewhat modest beginnings an academy of art, and the prestige that went with it, was established in Edinburgh. RAEBURN dominated the scene with his shrewdly observed portraits of local society into which, if the occasion demanded, he could infuse a

**344.** Design for the Royal High School, Edinburgh. Water-colour drawing by Thomas Hamilton. (Royal Scottish Academy)

ROMANTICISM akin to Sir Walter Scott's. The other major painter of the period, WILKIE, moved early to London where, after making himself the unrivalled master of genre, he developed a style more nearly related to French than English Romanticism. Both Raeburn and Wilkie had numerous followers; there were also lesser artists of originality, such as Andrew Geddes (1783-1844) in portraiture, John Thomson (1758-1840) of Duddingston in LANDSCAPE, and David Scott (1806-49) in Romantic subject painting.

The New Town being built in Raeburn's Edinburgh was largely inspired by Adam's ECLECTIC Neo-Classical style and the severer Neo-Greek propounded by 'Athenian' STUART. Its architects included men of real merit, among them Archibald Elliot (1761-1823), W. H. Playfair (1789-1857), and Thomas HAMILTON. Hamilton's Royal High School (1825-9), with a central block modelled on the THESEUM at Athens and general grouping derived from the PROPYLAEA, is one of the most dogmatically Greek buildings in Britain. In Glasgow a similar Classical style, of which David Hamilton's (1763-1843) Royal Exchange (1829-30) is a good specimen, long remained unchallenged. The most individual of Glasgow's mid-Victorian architects was Alexander THOMSON, nicknamed 'Greek' Thomson, who developed the Neo-Greek in a scholarly but highly original fashion and on occasion added to it an element of fantasy —as though the architectural imaginings of John MARTIN were translated into stone. Throughout the age of the GOTHIC REVIVAL Glasgow architects such as Thomson, Charles Wilson (1809-82), J. T. Rochead (1814-78), John Honeyman (1831-1914), and others remained almost perversely faithful to the classical and Renaissance tradition, though this stylistic conservatism did not inhibit some of them, notably the elder John Baird (1798-1859), from becoming pioneers in the use of new techniques and new materials such as iron. There was no shortage of painters or collectors in Victorian Scotland. In many ways they differed from their English counterparts. PRE-RAPHAELITISM, for example, gained no wide popularity: William McTaggart (1835-1910), an able if sometimes overrhetorical landscape painter, began in this style but soon developed a looser quasi-IMPRESSIONIST technique. In the 80s a group of Glasgow artists, to be called the Glasgow School, drawing inspiration from BARBIZON and from WHISTLER, made a protest against established fashion. They achieved recognition at home and abroad, but the early promise suggested by works such as George Henry's (1859-1943) Galloway Landscape (Glasgow, 1889), which in many ways paralleled what GAUGUIN was doing at Pont-Aven, was to remain unfulfilled. It was, none the less, in the milieu of Glasgow patronage, the Glasgow School, and 'Greek' Thomson that an artist of genius, Charles Rennie MACKINTOSH, was to emerge.

Mackintosh was one of the great pioneers of MODERN ARCHITECTURE. He was also the leader of a group of designers whose contribution to ART NOUVEAU was of European significance. His 'Glasgow style' shared many of the characteristics of art nouveau but its adaptations from Celtic and Pictish art—not unlike those of an Edinburgh group who illustrated Sir Patrick GEDDES's periodical Evergreen—gave it a peculiarly national flavour. Scottish elements are no less present in Mackintosh's architecture, where there is often a vertical emphasis which can trace its descent from the vernacular castles of the 16th c.

By 1914 Mackintosh had virtually ceased to practise, and with his departure all that was adventurous seems to have left Scottish architecture. In recent years—with Sir Basil Spence (1907- ), Sir Robert Matthew (1906- ), and a number of others in Edinburgh and Glasgow— there has been an awakening. But contemporary Scotland still waits for something as brilliant and as original as Mackintosh's School of Art.

In the earlier 20th c. painters still continued to be drawn by the magnet of Paris. The three aptly known 'Scottish Colourists', J. D. FERGUS-SON, S. J. Peploe (1871-1935), and Leslie Hunter (1879-1931), who in the years preceding the First World War were closely associated with the FAUVES, all lived in France for varying periods. In the succeeding generation William Gillies (1898- ), painter of atmospheric landscape, and John Maxwell (1905-62), whose fantasies have in them something akin to REDON and something of CHAGALL, were both pupils of Parisian masters. In the post-1945 period French ties have become looser: the works of Joan Eardley (1921-63) and Robin Philipson (1916- ) seem to belong to a wilder, more northern world; and the painter Alan DAVIE and the sculptor Edouardo Paolozzi (1924- ), both London based, are full members of the international fraternity of New York, London, and Paris. The question as to whether the future belongs to the nationals or the cosmopolitans is by no means a uniquely Scottish one: there is, however, much talent among the artists working in both idioms.

419, 504, 671, 672, 871, 1275.

**SCRAPER.** A tool, normally in the form of a three-bladed knife, used by ENGRAVERS and ETCHERS for removing the BURR from engraved lines or for making corrections by smoothing or scraping the surface of the copper plate. A similar instrument is used in MEZZOTINT for scraping those areas of the roughened plate which are to print light, and also in LITHOGRAPHY.

**SCROTES** or STRETES, GUILLIM (active c. 1537-53). One Scrotes, a Netherlander, was Court Painter to Mary of Hungary, Regent of the Netherlands, in 1537 and appears in the service of Henry VIII in 1546. Full-length portraits of the Earl of Surrey (Knole, 1546) and of Edward VI (Hampton Court, c. 1550) are linked

with his name. These are very competent, in the international MANNERIST courtly style.

**SCRUFFING.** See SCUMBLE.

**SCULPTURE.** See BRONZE SCULPTURE, STONE SCULPTURE.

**SCUMBLE.** Painters' term for an upper layer of paint used to modify the colour of the surface to which it is applied, but unlike a GLAZE the PIGMENT is opaque. A scumble must therefore either be thin enough to allow some light to penetrate through to the under surface or it must be applied irregularly—dragged or scruffed—in such a way that small areas of the under colour show through. By scumbling it is possible to produce effects—such as 'optical greys'—which cannot be obtained by direct painting.

**SEBASTIÁN DE ALMONACID,** called EL MAESTRO SEBASTIÁN (active last quarter 15th c.). Spanish late GOTHIC sculptor who worked on the main reredos of Toledo Cathedral. To him and his School are credited the TOMBS of Alvaro de Luna and his wife (1489) in Toledo Cathedral and several other sculptured tombs in Castile such as the tomb of Cardinal Alfonso Carrillo de Acuña (d. 1482) in the main church of Alcalá de Henares, which are among the masterpieces of Hispano-Flemish sculpture.

**SEBASTIANO DEL PIOMBO,** properly SEBASTIANO LUCIANI (c. 1485-1547). Italian painter, who trained in the studio of Giovanni BELLINI but soon turned from the established art of his master to the revolutionary manner of GIORGIONE. In 1511 he moved to Rome and remained there for the rest of his life except for a visit to Venice in 1528-9. In 1531 he received the official position in the papal mint which gave him his cognomen, and in the years that followed he added little to his artistic work.

The paintings of his Venetian years were dominated by the style of Giorgione, but the half-figure picture of *Salome* (N.G., London, 1510), for example, has a statuesque vigour which is in contrast to Giorgione's romantic gentleness and to the sensuous quality of PALMA. His first Roman commissions were for MYTHOLOGICAL FRESCOES in the Villa Farnese (1511), painted in competition with RAPHAEL, PERUZZI, and SODOMA in a medium of which he had no experience. Contemporaries condemned the composition whilst admiring his richness of colour. Sebastiano soon, however, established himself as a portraitist and became pre-eminent as such after Raphael's death. The *Portrait of a Young Woman* (Uffizi, 1512) shows how he adapted the Venetian half-figure type to this use. The *Portrait of a Young Man* (Uffizi, 1514) is exceptional in that it shows Sebastiano's momentary return to the CHIAROSCURO of Venice.

Sebastiano's way to more extensive commissions was barred by Raphael and his School.

He therefore turned away from his former friend and allied himself with MICHELANGELO, who befriended and guided him until the 1530s, recommending him to people of influence, supplying occasional sketches, etc. Among the first-fruits of this partnership was the large *Raising of Lazarus* (N.G., London, 1516-18), painted in competition with Raphael's *Transfiguration*. Drawings by Michelangelo for the figure of Lazarus are in the British Museum and the powerful figure of CHRIST was presumably also conceived by him; Sebastiano's setting for them is barely able to contain them. He was more successful in the wall-painting of the *Flagellation* (Borghini Chapel, S. Pietro in Montorio, Rome, 1516-24) where his architectural setting and secondary figures firmly support the nude Christ. In his *Holy Family with a Donor* (N.G., London, 1517-18) the influence of Michelangelo is most completely and happily assimilated. His chief work of this period is the great *Pietà* (Viterbo, c. 1520-5) for which again, according to VASARI, Michelangelo provided a design.

Michelangelo had no interest in portraiture, and in this field Sebastiano was able to complement the work of his master. In 1526 he painted two portraits, *Andrea Doria* (Palazzo Doria, Rome) and *Clemente VII* (Mus. Naz., Naples), which mark the climax of his achievement in this genre.

**SECCO** (Italian: dry). The term used in the later Middle Ages and the RENAISSANCE for wall-painting done on plaster which had fully dried, as distinct from true FRESCO which was painted on fresh, wet plaster. The colours were either TEMPERA, or PIGMENTS ground in some MEDIUM such as lime-water; if lime-water was used, the plaster had to be damped before painting, a method which was described by THEOPHILUS and which was popular in northern Europe and in Spain. Often the finishing touches to a true fresco would be painted al secco. Such additions may be seen in the series of paintings by Fra ANGELICO in the Convent of S. Marco, Florence. Colours painted al secco are less permanent than those of true fresco, especially the whites and blues: in the S. Marco series, for instance, the sky behind the *Christ on the Cross* should probably be blue, but now shows only the red underpainting.

Nowadays 'secco painting' may mean any kind of wall-painting other than true fresco.

**SECONDARY COLOURS.** See COLOUR.

**SECOND EMPIRE STYLE IN THE U.S.A.** After the Civil War the dominating influence in AMERICAN architecture was the style of the French Second Empire. Characterized by multiple MANSARD ROOFS (therefore sometimes known as the Mansard style), high PEDIMENTED dormers, and a lush application of French RENAISSANCE detail, it appeared in every form of secular building in America from post offices and city

345. State, War, and Navy Department Building, Washington (1871-5)

halls (for which it was the official style) to city dwellings and summer cottages. Although fundamentally a masonry style, it was frequently executed in wood. The first prominent architect to employ it seems to have been RENWICK. The Charity Hospital in New York (1858-61, now Welfare Island) and Vassar College (1860) were his two most important early forays in the style. The State, War, and Navy Department Building in Washington (1871-5) designed by Alfred B. Mullett is one of the most impressive examples still extant.

**SECTION D'OR.** See ORPHISM.

**SEDILIA.** Term in Christian church architecture for stone seats on the south side of the sanctuary, used by officiating priests. They are usually three in number but sometimes four (Durham) or five (Southwell). Sedilia were in use in England by the 12th c. and many late medieval examples survive, usually recessed in the thickness of the wall and surmounted by carved CANOPIES. They are rarely found in other European countries, where movable chairs were favoured.

**SEGALL,** LASAR (1890-1957). Russian-born EXPRESSIONIST painter and sculptor resident from 1923 at São Paulo, Brazil, where he exercised a formative influence on younger painters of the modern school.

158.

**SEGANTINI,** GIOVANNI (1858-99). Italian painter of Alpine scenery. Although largely self-taught, he evolved a method akin to the DIVISIONISM of the NEO-IMPRESSIONISTS for representing the mountain light. In later life, from c. 1890, he often painted weirdly symbolic and mystical pictures (*The Bad Mothers*, Walker Art Gal., Liverpool). There is a Segantini museum at St. Moritz.

430, 2445, 2756.

**SEGHERS,** DANIEL (1590-1661). The leading Flemish flower painter of the generation after Jan BRUEGHEL. Born at Antwerp and taken as a child to Holland, where he was brought up as a Protestant by his Dutch mother, he returned to Antwerp only when the Twelve Years Truce was signed in 1609. There he became the pupil of Jan Brueghel and joined the Guild in 1611. He not only returned to Catholicism, but joined the Jesuit Order in 1614. The words 'Society of Jesus' usually follow his signature. In 1625 he made a two-year stay with the Order in Rome, before settling finally in Antwerp. The monastery records, which still survive, give an account of his considerable fame and the distinguished persons who visited him—among them Ferdinand, Governor of the Netherlands, Archduke Leopold-William, and in 1649 the future Charles II of England. His works could not be sold like those of an ordinary artist, and they were presented as gifts by the monastery.

Seghers's work consists mainly of garlands or SWAGS of flowers, often painted around a Madonna and Child or a Pietà by another artist. He collaborated with his friend RUBENS in this way. Much rarer are his bouquets of flowers in a glass vase, where brilliant colours stand out

against a dark background. Among Seghers's followers Jan van Thielen (1618-67) was notable, and certainly Jan Davidsz de HEEM was influenced by the distinguished painter-priest's achievements.

**SEGHERS,** GERARD (1591-1651). Flemish narrative and portrait painter. Born at Antwerp, where he became a pupil of JANSSENS and a master in 1608, Seghers travelled to Rome and thence to Madrid, where he worked for Philip III. After his return to Antwerp in 1620 he continued working in the CARAVAGGESQUE manner he had acquired in Italy, but by 1630 he had abandoned it and followed the style of RUBENS, for whom he worked on several projects. He was a very successful artist, enjoying considerable Spanish patronage, but his best work was done for churches in Antwerp and Ghent. Excellent examples are *The Assumption of the Virgin* (Grenoble, 1629) and *The Adoration of the Magi* (Notre-Dame, Bruges, 1630).

**SEGHERS** (SEGERS), HERCULES PIE-TERSZ (1589/90-c. 1635). A highly original and important Dutch etcher and painter of LAND-SCAPES, active in his native Haarlem and in Amsterdam. He was a pupil of Gillis van CONINXLOO in Amsterdam, and purchased prints and paintings at the sale of his master's possessions after his death in 1607. Recorded in Amsterdam from 1614 onwards, he also stayed briefly in Utrecht and the last record is of his living in The Hague (1633). Some of his paintings suggest contact with Flanders, and a lost view of Brussels belonged to the painter van de CAPELLE.

Very little personal record exists of Seghers and he is to a large extent a mysterious and intriguing figure, but his importance and influence in the early 17th-c. Dutch landscape painting is undeniable. The majority of his extant work consists of ETCHINGS and the fact that he also painted landscapes was only discovered in 1871, when the art historian Bode attributed to him the landscape in the Uffizi called *The Great Mountain View*, which had previously been attributed to REMBRANDT. Less than 15 paintings by him are known today, although as contemporary documents show he certainly painted more. None of his extant work is signed and the chronology therefore is very difficult. He painted almost exclusively mountainous scenes, fantastic or Romantic in conception but realistic and advanced in the treatment of light and atmosphere. The mood of his visionary paintings is one of grandeur and spiritual unrest, only comparable to that of Rembrandt and RUISDAEL. Seghers certainly influenced Rembrandt, who admired him sufficiently to own eight of his paintings. His influence is equally apparent in the work of KONINCK. Although there is some indication in Seghers's works of the influence of older masters such as de MOMPER and Coninxloo, they are most striking in their originality.

Because of the realistic Alpine detail and above all the sense of atmosphere in his mountain panoramas, it is supposed despite lack of documentary evidence that he journeyed through the Alps at some period. The advanced REALISM of paintings like the two *Views of Rhenen* (Berlin), with their low horizon and fine AERIAL PER-SPECTIVE, influenced both Romantic and realistic Dutch landscape at its formative period. In his etchings he experimented with different techniques and methods of making COLOUR PRINTS on paper and linen. The influence of the Danube School may perhaps be seen in some etchings. In both his etchings and his paintings one is struck by the force and pathos of his landscapes, their desolation and dramatic evocation of the all-powerful forces of nature where man plays little or no part. His few figures are dwarfed by the landscape and the mountains.

In 1678 HOOGSTRATEN wrote a highly coloured account of his unhappy career, his desperate experiments with etchings, and his eventual poverty and drunkenness, adding that he was killed by falling downstairs when intoxicated. There is evidence of poverty at the end of his life, but the remainder of the account is fanciful, simply adding to the mystery of this strange artist. The best collection of his etchings is in the Print Room at Amsterdam, and major examples of his paintings are at Berlin, Rotterdam, Florence, Amsterdam. The National Gallery, London, has a painting catalogued as 'style of Seghers'. Both paintings and etchings are excessively rare, and many wrong attributions have been made. An indication of the rarity of his etchings is given by the fact that a single etching was sold at auction in the 1960s for £12,000.

589, 2543.

**SEISENEGGER,** JACOB (1505-67). Austrian, Court Painter to the Habsburgs. In 1532 he painted a full-length portrait of Charles V which served as a model for the much more famous one by TITIAN (Prado).

**SELF-PORTRAIT.** At all times the self-portrait has had to serve two simple ends: an artist is always his own cheapest model and, further, his own likeness is an ideal means of self-immortalization, a kind of MONUMENT which he sets up to himself. Yet between a self-portrait by RUBENS, where he shows himself in all his nobleman's finery, and one of van GOGH's provocatively proletarian self-portrayals there is a world of difference. Any artist when making his own likeness is much more personally involved than when treating any other subject. He will not only attempt to render his physical appearance, but will represent himself in such a manner as he wants to be seen.

The first recorded self-portrait seems to have been a proud confession of skill and artistry: PLINY tells us (*Nat. Hist.* xxxiv. 83) that the

6th-c. Samian architect and sculptor THEO-DORUS cast his own portrait in bronze, holding a file in his right hand and in his left an example of his craft as a GEM engraver: a four-horse chariot marvellously executed and so small that a fly, made with it, covered the whole thing. This may only be a legend, but the type of self-portrait, showing an artist with examples of his work or actually at work, has persisted up to our day.

If an artist includes his own person amongst a crowd of figures, such a self-portrait assumes the role of a pictorial signature. Among the train of the Magi in Benozzo GOZZOLI's frescoes in the chapel of the Palazzo Riccardi, Florence, we see a man with a high cap, inscribed *Opus Benotii*. Self-portraits of this kind are not peculiar to the RENAISSANCE: they may have existed in ancient Egypt and in Greece. We are told that PHIDIAS included his own picture among the warriors fighting the Amazons on the relief adorning the shield of the *Athena Parthenos*; Hubert and Jan van EYCK, MASACCIO, RAPHAEL, and many others are all supposed to be hiding somewhere in their large compositions. It is highly questionable whether such identifications are always correct; many may have been invented by guides to satisfy a curious public wanting to know what the artist of a famous picture really looked like.

The pictorial signature can take yet another form. On the fine frontispiece of his *Historia Anglorum* (B.M.) we see Matthew PARIS, who was also a painter of note, kneeling before the VIRGIN. Riquinus, the Master of the 12th-c. bronze doors of Novgorod Cathedral, signed his work with his own picture and so did GHIBERTI in the 15th c. when he made his two sets of doors for the Baptistery in Florence. Peter PARLER, the 14th-c. architect of St. Vitus's Cathedral in Prague, added his own to the royal portraits in the triforium. The most charming of such 'signatures' is perhaps that of Anton Pilgram (early 16th c.) at the foot of the pulpit in St. Stephen's, Vienna.

DÜRER seems to have been the first artist who used the self-portrait for entirely different and much more personal ends. Like his Italian colleagues and his patrons he wanted to be a gentleman (Prado). He studies the expression on his own face (drawing, Lwów), or demonstrates with the help of his own head rules of beauty and harmony (Munich). With REMBRANDT the self-portrait was an even more absorbing psychological and artistic task. We still have about 60 painted self-portraits by him and some 20 engravings. The master's biography is revealed by this moving series of self-revelations. Youthful swagger, maturity and serenity, senile decay —they were all recorded with a splendid detachment.

Once artists had become self-conscious in their portrayals they often enough used their likenesses demonstratively to assert their position: the finest example of a type which persisted from the 16th to the 19th c. is perhaps VELAZQUEZ's *Las Meninas*, where the painter presents himself working in a stiff and formidable court-dress. Similarly since the age of ROMANTICISM artists have used self-portraits to show to the world that they are different from ordinary human beings. They dress differently, they are often slovenly or Bohemian, and they are not ashamed to appear in such a fashion. COURBET gives us fine examples. Among artists of the 20th c. this type of 'confession' has taken yet another form: one of the FAUVES paid tribute to the PRIMITIVE art which had inspired him by painting himself looking like some African chieftain, and the SURREALISTS bared their souls and placed the paraphernalia of the analyst's consulting room in their self-portraits.

**SENEFELDER, ALOYS** (1771-1834). German commercial artist who in 1796 accidentally discovered LITHOGRAPHY. In 1808 *The Prayer Book of Maximilian I*, originally published in 1575 with DÜRER's marginal drawings, was reproduced by Senefelder with the drawings on lithographic stone by Strixner after Dürer. Senefelder soon realized the possibilities of lithography for REPRODUCTION and wrote of them in his *Complete Course of Lithography* (Munich, 1818).

**SENS, WILLIAM OF** (active 1174-80). French master mason, apparently trained somewhere in the province of Reims (? Valenciennes), selected from among other foreign and English candidates for the rebuilding of the choir of Canterbury Cathedral after the fire of 1174. He was the first to transplant a developed French GOTHIC style to England. In 1178, when the choir proper apart from the VAULT was finished, he was disabled by a fall from the scaffolding; the work was continued by WILLIAM THE ENGLISHMAN.

**SEQUEIRA, DOMINGOS ANTÓNIO DE** (1768-1837) Portuguese painter. He studied at Rome 1788-95 and in 1802 he was appointed first court painter. He was a prolific painter of religious and historical compositions as well as portraits, e.g. *The Count of Farrobo* (Lisbon Mus., 1813) and *Dr. Neves* (Ashmolean Mus., Oxford, 1825). After 1823 he lived in Paris and Rome.

The silver table service presented by the Regent of Portugal to the Duke of Wellington (Apsley House, London, 1812-16) was designed by Sequeira.

2394.

**SERGEL, JOHAN TOBIAS** (1740-1814). Swedish sculptor, who combined the grace of the ROCOCO with a NEO-CLASSICAL heroic quality; particularly in some of his reliefs he came close to the pagan spirit of antiquity. In Rome he executed his first masterpiece, a recumbent

*Faun* (1769-70). He was summoned home in 1779, and was soon overwhelmed with commissions. The most important of these was the bronze statue *Gustavus III* (Stockholm, 1790-1808), to which he gave the pose of the APOLLO BELVEDERE in graceful allusion to the king's artistic and literary interests. He also created numerous medallions which are sketchily NATURALISTIC in the treatment of features but have a CLASSICAL simplicity. His many pen-drawings and CARICATURES are valuable documents of the time. In these he hits off the milieu in which he moved in Stockholm with figures such as those of the painter Elias MARTIN, King Gustavus III, and the poet Carl Michael Bellman. Sometimes too he introduces his own features, and these drawings are perhaps the most humorous and disrespectful of all.

**SERIGRAPHY.** See SILK-SCREEN PRINTING.

**SERLIO,** SEBASTIANO (1475-1564). Italian architect and architectural theorist. He started as a painter of PERSPECTIVE in Pesaro and from 1514 studied architecture and antiquarianism under PERUZZI. In 1527 he went to Venice and in 1537 and 1540 published there the fourth and third books of a comprehensive treatise on architecture, the latter of which caused Francis I of France to appoint him painter and architect to the court in 1541. In France he built very little, although Ancy-le-Franc was probably designed by him and exercised considerable influence on the château type of building. He

**346.** Rustic doorway. Illustration from *Libro Extraordinario* (Venice, 1551) by Sebastiano Serlio

published the first and second books of the treatise in 1545 and the fifth in 1547. On being superseded at FONTAINEBLEAU by DELORME he went to Lyon, where he wrote a sixth book (rediscovered in 1925) and a seventh book (published posthumously in 1575) of his treatise. This was intended to be a guide to AMATEURS rather than a professional treatise like the later works of VIGNOLA and PALLADIO and became widely popular, being used as a pattern-book all over Europe. It was translated into English in 1611 under the title *The Entire Works of Architecture and Perspective.* Serlio also published in 1551 a short book on portals, *Libro Extraordinario,* and its rustic doorways had a wide vogue.

**SERRA,** JAIME (d. *c.* 1399) and PEDRO (d. between 1404 and 1409). Spanish painters, brothers, who worked for the court of Aragon and were active in Barcelona during the second half of the 14th c. The first documented work by Jaime is an ALTARPIECE (1361) now in the Saragossa Museum. A POLYPTYCH from the Monastery of Sigena, panels from which are now in the Barcelona Museum, is also attributed to him. Attributed to Pedro are the *Virgin of Tobed,* dedicated by Henry II of Castile, whose portrait appears, and altarpieces at San Cugat del Vallés, at Manresa Cathedral (1394) and a *St. Peter* painted about 1400 and now in Barcelona Museum. Both brothers were influenced by the style of Siena.

**SERVAES,** ALBERT (1883- ). Belgian EXPRESSIONIST painter of religious subjects whose works were found offensive by the Roman Catholic Church for exceeding the bounds of permissible ugliness; *Stations of the Cross* and an ALTARPIECE he made for a cloister near Antwerp were removed. His works can be seen at the Museum of Modern Art at Brussels and in the Municipal Museums of Amsterdam and The Hague.

**SERVANDONI,** JEAN-NICOLAS (1695-1766). Italian architect and decorator who settled in Paris in 1724. He designed stage scenery for the Opera and festivities of great BAROQUE splendour, not only in Paris but in London (1749), Vienna (1760), and elsewhere. He also painted views of RUINS in the manner of PANINI. His plan for the façade of S. Sulpice, Paris (1732), heralded a veer of taste towards NEO-CLASSICISM.

**SEURAT,** GEORGES (1859-91). French painter, the founder of NEO-IMPRESSIONISM. Seurat enrolled at the École des Beaux-Arts in 1878 and worked under Henri Lehmann, an academic artist and a pupil of INGRES, until 1879. From some of his early work he appears to have shared his teacher's admiration for Ingres. After his year of military service Seurat returned to Paris in 1881 and worked independently. From the time when he started painting, in 1876, until

1884 Seurat experimented in a variety of styles, but gradually turned for inspiration more and more to painters in the colourist tradition, DELACROIX, the BARBIZON SCHOOL, and the IMPRESSIONISTS. Among contemporary artists he was chiefly attracted by PUVIS DE CHAVANNES. In the same period began his interest in scientific theories of COLOUR vision and colour combination and he became familiar, directly or indirectly, with the writings of Maxwell, Chevreul, Charles Blanc, O. N. Rood, Thomas COUTURE, David Sutter, and others. He found that the principles of scientific colour mixture by the 'additive' method of juxtaposing colours to be combined through the seeing eye had been to some extent anticipated empirically by the Impressionists and by COROT, but he set himself to systematize the method by discovering scientifically based formulas for *peinture optique* (optical painting), as he called his own system. His first major painting, *Une Baignade, Asnières* (Tate Gal., London), was done in 1883-4, rejected by the Salon in 1884, but exhibited by the Groupe des Artistes Indépendants. The picture used a subject which had been a favourite with the Impressionists—Parisians on the banks of the Seine—but it differed from the Impressionist style of painting not only because of the more systematic use of PALETTE and technique but more fundamentally by its monumental character and carefully planned composition from preparatory studies.

In 1884 Seurat met SIGNAC and Henri-Edmond Cross (1856-1910), who also exhibited pictures with the Groupe des Artistes Indépendants, and these artists collaborated with him in developing the method of DIVISIONISM which was exemplified in Seurat's next major painting *Un Dimanche d'été à la Grande-Jatte* (Art Institute, Chicago), exhibited at the last Impressionist Exhibition in 1886. It was Seurat's aim by means of the scientific division of colour and optical mixture ensured by a POINTILLIST technique to obtain the highest degree of luminosity and brilliance and thus to approximate to the scintillating, vibratory quality of light as perceived in nature. His friend, the critic Félix Fénéon, said: 'The tones are decomposed into their constituent elements: they are then presented in a mixture where their respective proportions are, one may say, variable from millimetre to millimetre; thus specific gradations of hues, supple modelling, and the most delicate colourations are obtained.' In his subsequent paintings the method was perfected and such pictures as *Honfleur, un soir, embouchure de la Seine* (Mus. of Modern Art, New York, 1886) show the Pointillist technique being used as a dominant structural element rather than superimposed on a technique of short horizontal brush-strokes.

After 1887 Seurat became increasingly concerned with the problem of expressing specific emotions through pictorial means and under the influence of the aesthetician Charles Henry he tried to systematize the academic theory of emotional expression by formal means which goes back to POUSSIN's theory of 'modes'. Major pictures painted during this period were *Le Chahut* (Rijksmuseum Kröller-Müller, Otterlo, 1889-90), *Parade* (New York, 1887-8), and *Cirque* (Louvre, 1890-1).

640, 645, 1298, 1354, 1697, 2219, 2356, 2449.

**SEVEN,** GROUP OF. The name given in 1920 to a group of painters who, coming together about 1913, inaugurated a nationalistic movement in CANADIAN painting. Their style is characterized by the powerful rhythms and brilliant colours of the northern Canadian landscape. Beginning in Toronto, they extended their painting ground first to northern Ontario, then east to Quebec, Nova Scotia, etc., and west to the Rocky Mountains and the west coast, and finally to the Arctic Circle. The group disbanded in 1933 and merged with the Canadian Group of Painters founded in that year.

The original seven were A. Y. Jackson (1882- ), Lawren Harris (1885- ), Arthur Lismer (1885- ), F. H. Varley (1881- ), J. E. H. MACDONALD, Franklin Carmichael (1890-1945), and Franz Johnston (1888-1949). Johnston resigned after several years and others joined at later dates: A. J. Casson (1898- ), Edwin H. Holgate (1892- ), and L. L. Fitz-Gerald (1890-1956); there were eight members when the group disbanded.

**SEVERINI,** GINO (1883-1966). Italian painter, born at Cortona. In 1901 he was in Rome and there met BOCCIONI, later the chief theoretician of the FUTURIST movement, and BALLA, from whom he took lessons. From 1906 he was in Paris and became a member of the CUBIST group of BRAQUE, PICASSO, APOLLINAIRE, and Max Jacob. Severini himself, however, was never fully absorbed in Cubist theories but developed certain aspects of the work of SEURAT and concerned himself primarily with the problem of conveying a sense of movement and action by breaking up his picture space into contrasting and interacting rhythms. He painted in vivid semi-geometrical patches of pure COLOUR, though not in the POINTILLIST manner, and may have helped to influence the Cubists to reintroduce colour into their own work. His most famous pictures during the years 1909-11 were *Le Boulevard* (Estorick Coll., London) and *La Danse du Pan -Pan à Monico.* In 1910 he was a signatory of the Futurist Manifesto and he brought several of the Futurists, including Boccioni and CARRÀ, into contact with the Paris Cubists.

From 1915 he devoted himself to studies of PROPORTION in the attempt to find a path from the too personal and individual art of the day towards a more objective and CLASSICAL art which would none the less take account of the contributions of modern AESTHETIC movements. In 1922 he executed frescoes for the Palazzo

Montegufoni, near Florence, and from that time turned his interest to mural painting and MOSAIC, finding many commissions not only in Italy but also in Switzerland and France.

**SEZESSION.** During the last decade of the 19th c. many of the more advanced German artists found it impossible to exhibit their works through the traditionally minded organizations. Hence they 'seceded', founded their own associations, and organized exhibitions. The first of these groups came together in Munich in 1892, its leading members being Franz von Stuck (1863-1928) (later a teacher of KANDINSKY) and Wilhelm Trübner (1851-1917). The *Berliner Sezession*, led by Max LIEBERMANN, was founded in 1899 and its exhibitions soon became a forum for European *avant-garde* painters. When in 1910 a number of young painters were rejected by the Sezession—among them members of Die BRÜCKE—they started the *Neue Sezession*. The Vienna Sezession, founded by Gustav KLIMT in 1897, was concerned with the APPLIED ARTS and architecture as much as with painting. The exhibitions of this group and its periodical *Ver Sacrum* did much to spread the *Jugendstil*, the German variant of ART NOUVEAU.

**SEZESSIONSTIL.** See ART NOUVEAU.

**SFORZA DYNASTY.** The effective rulers of Milan from 1450, when the *condottiere* FRANCESCO seized power, until the end of the century when his son LODOVICO (*Il Moro*)—the third to succeed him—called the French into Italy and Milanese independence came to an end. During that time they were lavish PATRONS of the arts, carrying on the building of Milan Cathedral and the Certosa of Pavia, founding the castle that bears their name, and many churches and palaces. The atmosphere of Lodovico's court was essentially Aristotelian and lacked the literary, humanist element that characterized MEDICI patronage. Among the artists he employed were the sculptors Amadeo (1477-1522) and Mantegazza, the painters FOPPA, BERGOGNONE, and Butinone (active 1484-1507), the architect BRAMANTE, and—above all—LEONARDO DA VINCI, who not only painted *The Last Supper* for him, but was employed on commissions ranging from military engineering to costumes for court masques.

**SFUMATO** (from Italian *fumo*: smoke). The achievement of smooth and imperceptible transitions between areas of COLOUR 'like smoke dissolving in the air' (BALDINUCCI, 1681). The capacity to mellow the over-precise and harsh outlines characteristic of the earlier quattrocento masters was, according to VASARI, a distinguishing mark of the perfect manner of painting ushered in by LEONARDO DA VINCI and GIORGIONE.

**SGRAFFITO.** See GRAFFITO.

**SHADE.** See COLOUR.

**SHAHN,** BEN (1898-1969). American artist and draughtsman, born in Kaunas. He came to the U.S.A. in 1906 and worked as a LITHOGRAPHER until 1930. He had a keen eye for social types and his art had something of the CARICATURIST's harsh irony for social predicaments. In 1932 he did a series of 23 GOUACHES on the trial of Sacco and Vanzetti (Mus. of Modern Art, New York). In 1933 he worked with Diego RIVERA on murals for the Rockefeller Center and from 1933 to 1938 worked as photographer for Farm Security Administration. His gift for vivid and pungent pictorial statement led him to a poetically heightened POSTER art. In 1947-8 he was awarded retrospective exhibitions at the Museum of Modern Art and at the Institute of Modern Art, Boston. His later work revealed a warmer poetry and feeling for the individual lost in the melancholy solitude of the modern city (*Willis Avenue Bridge*, Mus. of Modern Art, New York, 1940) and his STILL LIFES have acquired an imaginative impact which places them in the first rank of contemporary work (*Composition with Clarinets and Tin Horn*, Detroit Institute of Arts, 1951). He obtained awards at the International Exhibition of São Paulo in 1953 and at the Venice Biennale of 1954, the Temple Gold Medal of the Pennsylvania Academy of Fine Arts in 1956 and the Medal of the American Institute of Graphic Art in 1958.

2520.

**SHANNON,** CHARLES HAZELWOOD (1863-1937). English LITHOGRAPHER and painter, a lifelong friend of Charles RICKETTS. Shannon edited the *Dial*, of which five numbers appeared between 1889 and 1897. Painting began to take first place with him from 1897, his portraits and figure compositions being indebted to the Old Masters, especially TITIAN.

**SHARAKU** (d. 1801). Japanese COLOUR PRINT artist whose output was limited to portraits of actors. Nothing is known of his life and training except that he was a Nō actor and he worked as an artist for only 10 months (1794-5). His prints were not popular with the general public of his day, who looked for decoration rather than discernment. Their strong and extravagant draughtsmanship, psychological penetration, and perverse simplifications are admired in the West for their qualities of CARICATURE (*Mitsugoro II*, Mus. of Fine Arts, Boston). Now extremely rare, his prints are among the most highly prized of the UKIYO-E.

**SHAW,** RICHARD NORMAN (1831-1912). English architect, who became the dominant architectural personality in the last decades of the 19th c., he was famous for his picturesque country houses (mostly Tudor in character) in which he revived the use of traditional local

materials and introduced an informality of style which led the escape from academicism. His later houses, such as Bryanston, Dorset (1890), were in a more monumental CLASSIC style. In his numerous town houses he was the first to revive earlier styles, such as QUEEN ANNE, FLEMISH RENAISSANCE, and JACOBEAN, which then became fashionable. Shaw was trained in STREET's office and practised at first with William Eden Nesfield (1835–88). He was partly responsible for the pioneer garden suburb of Bedford Park (1878) and designed the first big block of flats in London, Albert Hall Mansions (1879).

302.

**SHAWABTI,** SHABTI, USHABTI. Different forms of the name given by the Egyptians to the figures of wood, stone, FAIENCE, and clay which were placed in TOMBS, often in very large numbers, to do agricultural work on behalf of the deceased in the after-life (see EGYPTIAN ART). First appearing in the Middle Kingdom in place of the older servant statues, *shawabtis* became common during the New Kingdom and were produced in great quantities thereafter, notably in the Saïte period (664–525 B.C.). The figures are usually mummiform, with a hoe in each hand and a basket on the back, but there are also 'overseers' wearing a long garment and carrying a whip, and others dressed as in life. Most bear the name and titles of the deceased, and the larger and more elaborate are inscribed with the sixth spell of the BOOK OF THE DEAD.

**SHEE,** SIR MARTIN ARCHER (1769–1850). Painter, born in Dublin. He practised first in Dublin, and from 1788 in London. His mature portrait style lies between the bravura of LAWRENCE and the precision of WEST (*William IV*, N.P.G., London). Elected P.R.A. in 1830, he guided it through a difficult period. His *Rhymes on Art* (1805), urging the claims of art on national support, enjoyed a considerable popularity.

2475.

**SHÊN CHOU** (1427–1509). One of the most famous and successful of Chinese calligraphers, poets, and painters in INK; typical of the *wên-jên* painters or *literati* (see CHINESE ART). He was a most prolific and versatile artist. Most of his works are in the style of one or other of the Four Great Landscape Masters of the Yuan Dynasty, but the most important are those landscapes into which he, perhaps for the first time, introduced bold, intimate GENRE scenes. In these his abbreviated brush-work seems to foretell the great INDIVIDUALISTS of the 17th and 18th centuries. Shên Chou founded a School centred on Kiangsu Province.

**SHERWOOD** (SHERVUD), VLADIMIR (1832–97). Russian architect and painter of English descent. He was the architect of the

Historical Museum at Moscow, an outstanding monument of the retrospective movement in 19th-c. Russian architecture.

**SHIELD OF DAVID** (Hebrew *Magen David*). A cabbalistic symbol consisting of two triangles superimposed. Since the 18th c. it has superseded the MENORAH as the symbol of Judaism.

**SHIH-TAO.** See TAO CHI.

**SHUBIN,** FEDOT (1740–1805). Russian sculptor. Shubin began his career at Archangel as a carver in bone. At the age of 19 he went to St. Petersburg, where he studied at the Imperial Academy under its French Director Gillet. He studied in Paris under PIGALLE, travelled in Italy (Turin, Bologna, Rome), and studied for a short while in London under NOLLEKENS (1773). Shubin is best known for his expressive portrait BUSTS in marble (*Potemkin*, 1791; *Paul I*, 1800), and is regarded as the most talented Russian sculptor of the 18th c.

**SHUNSHŌ,** KATSUKAWA (1726–92). JAPANESE COLOUR PRINT (UKIYO-E) master and painter. He was one of the early designers of SURI-MONO. Together with Mamoru Buncho (active 1764–90) he introduced *c.* 1765 a new type of recognizably realistic actor portraits and he was responsible for the large type of portrait heads which became the fashion in the last quarter of the century. In the polychrome (*nishiki-e*) style *The Hundred Poets and their Poems in Brocade* (1775) are considered his best work and are among the finest of their kind. Shunshō had a great influence on *ukiyo-e* artists of a younger generation such as KIYONAGA, UTAMARO, SHARAKU, Toyohiro (1774–1829) and especially HOKUSAI, his direct pupil.

As a painter Shunshō excelled as colourist and designer and was considered one of the foremost in the second half of the 18th c. He rarely made prints of beautiful women but as painter he won fame for his representations of female beauty. He also introduced elaborate LANDSCAPE backgrounds in his GENRE paintings.

**SHUTE,** JOHN (d. 1563). Author of *The First and Chief Groundes of Architecture* (1563) in which he describes himself as 'painter and architecte' and says that he was sent to Italy in 1550 by the Duke of Northumberland. His book contains reasonably competent engravings of the five ORDERS, with a preface and descriptions. It was the first published English architectural work, and the only one of the 16th c.; further editions appeared in 1579, 1584, and 1587. No building designed by him is known.

**SIAMESE ART.** See THAILAND.

**SIBERECHTS,** JAN (1627–1703). Flemish LANDSCAPE painter born at Antwerp and well known in England. His early works are very

similar to the Dutch Italianate masters, such as Karel DUJARDIN, and it is probable that he went to Italy briefly before joining the Antwerp Guild in 1648. He later developed a style of considerable grandeur quite different from the decorative kind of landscape painting current among his contemporaries. His palette was characterized by powerful blues. In about 1672 Siberechts was taken by the second Duke of Buckingham to England, where he worked for several aristocratic patrons, painting views of country houses in a simple, rather archaic manner. His rare WATER-COLOURS are particularly fine.

888.

**SIBYL.** A prophetess, of classical origin; a woman young or old, possessed with the spirit of Apollo and thus able to foresee the future. Traditionally associated with any place inhabited by an oracle, the nine more important sibyls were those of Libya, Persia, Delphi, Cimmeria, Eritrea, Samos, Cumae, the Hellespont, and the Tiber. Supposed in the Middle Ages to be the writers of a collection of Jewish and Christian prophetical texts called the Sibylline Oracles, they were thus associated with the PROPHETS and often portrayed with them in Christian art. The six sibyls on the corners of Giovanni PISANO's pulpits in Pisa and Pistoia wear long hooded robes and carry scrolls like the prophets. They held a special fascination for artists of the RENAISSANCE, as can be seen from MICHELANGELO's sibyls on the ceiling of the Sistine Chapel. They rarely appear in isolated scenes; but the Tiburtina, who was famous as the prophetess of CHRIST, is sometimes shown with the emperor Augustus, pointing to the Madonna and Child appearing in the sky (J. van EYCK, Ypres; B. PERUZZI, Fontegiusta Church, Siena, 1528).

**SICCATIVE.** A substance which is added to a paint to make it 'dry' (i.e. set hard) more quickly (see PAINT).

**SICKERT,** WALTER RICHARD (1860–1942). English artist born at Munich of mixed Danish and Irish descent. After a short period on the stage he studied art at the Slade School under Alphonse LEGROS and then in WHISTLER's studio. In 1883 he worked in Paris with DEGAS, sharing his interest in theatre and adopting from him the method of painting from drawings, memory, or photographs instead of on the spot like the PLEIN AIR school. In 1895 he was painting in Venice. He then worked in Dieppe from 1900 to 1905, when he returned to England and from that time became the main link between FRENCH and ENGLISH ART. His studio in Fitzroy Street, Bloomsbury, was a centre for a group of artists who later formed the nucleus of the CAMDEN TOWN GROUP and the LONDON GROUP. Sickert joined the NEW ENGLISH ART CLUB in 1888, was A.R.A. in 1924 and R.A. in 1934 but resigned in 1935. He taught at Westminster Art School until 1918, when he was succeeded by his pupil and follower Walter Bayes (1869–1956). Sickert was a highly articulate artist, though not systematic in the expression of his views, and much of his writing was published posthumously in *A Free House* (1947).

Sickert took the elements of his style from many sources, which he dominated for the creation of a highly personal *œuvre*. From Whistler he derived his characteristic method of painting in a narrow range of low tones, but in place of Whistler's delicacy he sought to achieve a special effect of richness by subtle gradation. Within this self-imposed restriction he painted a wealth of colour into drab and dingy scenes. At various periods he experimented with the IMPRESSIONIST palette and he shared with the Impressionists their concern for structure and their gift for design. But his attitude to his subject was more intensely personal and he aimed at the impression of surprised intimacy, representing those he painted as if caught 'through the keyhole' in unsuspecting privacy. He avoided fashionable good taste and the conventionally picturesque, eliciting rare beauty from the sordid and lending enchantment to the commonplace and dull. In his ETCHINGS particularly he continued the tradition of HOGARTH and ROWLANDSON, seizing on all that was most characteristic in the quotidian scene and depicting the pathetic and the ridiculous with a penetrating but unmalicious eye.

**SIEGEN,** LUDWIG VON (1609–after 1676). A German military officer of Dutch origin who probably invented the technique of MEZZOTINT. Only a handful of his PRINTS is extant. The earliest one, a portrait of the Landgravine Amelia Elizabeth of Bohemia, dated 1642, was sent by Siegen to the Landgrave with a letter stating that the invention was his.

**SIENESE SCHOOL.** The special character of Sienese art crystallized and matured in the course of the 14th c. It was an ideal of all-pervading charm. The Sienese artists had an assured gift for extracting from the BYZANTINE and GOTHIC trends that reached them whatever accorded with that ideal. The peculiarly poetic quality of Sienese art may be associated with the lively, picturesque, and tender piety practised by mystical saints such as St. Catherine and St. Bernardino.

The Abbey of S. Galgano near Siena is perhaps the first important Italian work which has fully assimilated the Gothic style. Its builders were brought into the city to alter the old ROMANESQUE cathedral, and they transformed it into an enormous and splendid edifice with a façade begun by Giovanni PISANO. The Palazzo Pubblico, the ordered plan of the great public square (the Campo), the palaces and gates of the city, and several churches built at the same period (end of 13th and beginning of 14th c.) still give Siena its character.

Great Sienese painting begins with DUCCIO DI BUONINSEGNA, who paradoxically countered the decorative Gothic style by deepening the colour and strengthening the sinewy energy of the best Byzantine art. His pupil SIMONE MARTINI, a friend of Petrarch, evolved an art of elegant ornament, full of tenderness; and this style, being easier to imitate, had a following. The FRESCOES in the Palazzo Pubblico, where Simone worked, were continued by Pietro LORENZETTI, an artist of power who was in touch with the GIOTTESQUES of Florence. In the work of Pietro's brother Ambrogio we first meet that mixture of decorative fantasy, brilliant use of colour, and minute observation which was to characterize the INTERNATIONAL GOTHIC of the end of the 14th c., the style in which the Sienese played such an illustrious part.

Religious painting, compounded of gentle sentiment and charm, flourished throughout the 15th c. Its exponents were LORENZO MONACO, the master of Fra ANGELICO, SASSETTA, whose delicate use of line was coarsened by SANO DI PIETRO, the unknown painter of the spacious and elegant Osservanza ALTARPIECE (1436), Pietro Lorenzetti, and his pupils NEROCCIO DEI LANDI and FRANCESCO DI GIORGIO. In MATTEO DI GIOVANNI we can discern the violent NATURAL-ISM of the FLORENTINES, and in Benvenuto di Giovanni (1436–c. 1518) a sharpness typical of the north.

POLYCHROMED wooden sculpture, a speciality of Siena, was never more than a craft, but the MARBLE sculpture of Jacopo della QUERCIA carried on the powerful tradition of the Pisani. In the second half of the 15th c. Francesco di Giorgio, who was a man of many arts and a theorist, managed to combine Gothic tension with the Classical forms of Florence.

Cinquecento art reached Siena in the guise of SODOMA's rather decadent imitation of LEO-NARDO, and this was adopted by BECCAFUMI and led in the direction of MANNERISM.

1817, 2124, 2384.

**SIGNAC,** PAUL (1863–1935). French NEO-IMPRESSIONIST painter. After beginning in the IMPRESSIONIST manner, he met SEURAT in 1884 and became an ardent disciple of his views and method. He helped to found the Société des Artistes Indépendants in the same year. In 1908 he became its President. After the death of Seurat in 1891 he became the acknowledged leader of the Neo-Impressionist group, although his own work had a liveliness and spontaneity not altogether in keeping with the theory. In 1899 he published D'Eugène Delacroix au néo-impressionnisme, which was long regarded as the definitive and authoritative work on the School. The book was, however, more in the nature of a manifesto in defence of the movement than an objectively accurate history, and it reflected changes which had taken place in Signac's own style since 1890 towards greater brilliance of colour and ABSTRACTION at the expense of verisi-militude with an underplaying of the scientific aspects of Seurat's teaching and practice.

644.

**SIGNIFICANT FORM.** Term introduced into AESTHETICS and art criticism by Clive BELL in his book *Art* (1914). Bell wrote in the chapter 'The Aesthetic Hypothesis': 'The starting-point for all systems of aesthetics must be the personal experience of a peculiar emotion. The objects which provoke this emotion we call works of art. . . . This emotion is called the aesthetic emotion; and if we can discover some quality common and peculiar to all the objects that provoke it, we shall have solved what I take to be the central problem of aesthetics. We shall have discovered the essential quality in a work of art, the quality that distinguishes works of art from all other classes of objects.' Bell thought that on the basis of experience he could eliminate nar-rative, representational, or symbolic features and trace the common quality in all objects of visual art which stir aesthetic emotions to 'lines and colours combined in a particular way, certain forms and relations of forms'. This quality was what he called 'significant form'. The term entered into critical vocabulary with no very clear or concrete meaning and became a catchword particularly among exponents of formal criticism. Philosophers and aestheticians, however, re-sponded more critically than the critics and for the most part repudiated Bell's theory, some on the ground that there is in experience no peculiar 'aesthetic emotion' special to the appreciation of art and others on the ground that the theory is either tautologous or circular. Since the mid century there were signs of a reaction in its favour, exemplified by a group of commemorative essays by Miss R. Meager, Mr. R. K. Elliott, and Mr. H. Osborne, published in *The British Journal of Aesthetics*, vol. 5, no. 2 (April 1965). Typical is the statement by Miss Meager: 'I think nevertheless that we need to have a notion of a peculiar and genuine aesthetic emotion, about which we can be mistaken but which when it occurs is a proper basis for appreciation and judgement of art.' On this basis Bell's theory of significant form may be regarded as 'philo-sophically respectable'.

**SIGNORELLI,** LUCA (1441?–1523). Italian painter. He was a citizen of Cortona, but also worked in Arezzo, Florence, Rome, Perugia, and Orvieto. According to VASARI he was a pupil of PIERO DELLA FRANCESCA. He did not exploit Piero's new open treatment of space, however, but rather his sculptural rendering of figures and to this he brought an interest in the representa-tion of action, which put him in line with the contemporary FLORENTINE SCHOOL of POL-LAIUOLO and VERROCCHIO. Like most TUSCAN artists of the late 15th c., Signorelli tried to get as much movement as possible into his composi-

tions, but his figures are rounder, heavier, with emphasis on muscular development. In his early *Flagellation* (Milan, *c.* 1475) the animation of the figures was enhanced by strong oblique lighting. Sometimes his work is pervaded by an ease and lassitude reminiscent of PERUGINO, as in the so-called *School of Pan* (*c.* 1490) formerly in Berlin, destroyed in the Second World War, which seemed to represent a cycle of unrequited loves. But his masterpiece is a work of extreme, even brutal, vigour. This is the FRESCO series in Orvieto Cathedral with scenes of *The End of the World* and *The Last Judgement* (1499–1504), in which Signorelli displayed a mastery of the nude in a wide variety of poses only surpassed at that time by MICHELANGELO. But his powerful REALISM and somewhat forced use of the GROTESQUE differentiate him from Michelangelo.

789, 2374.

**SILHOUETTE.** (From Étienne de Silhouette, French politician and amateur maker of paper cut-outs, 1709–67.) All forms of monochrome painting, dark against light or vice versa, bounded by a sharp outline, are designated by this term. The method is found in many periods of art from the silhouettes of hands in Palaeolithic cave paintings, in EGYPTIAN ART, and on GREEK vases. But the great vogue of silhouette portraits (more often known in England as 'shades') came between 1750 and 1850. Silhouettists offered the quickest and cheapest method of portraiture (their art has been called 'the poor man's MINIATURE'), and their popularity was fostered by the NEO-CLASSICAL taste and given intellectual prestige by J. C. Lavater's *Essays on Physiognomy*, which were held in great respect throughout Europe, notably by GOETHE, and which relied on silhouettes for the exposition of their theme. Of miniature size (often reduced by mechanical processes) the earlier ones in England (*c.* 1780–1800) were usually painted in black on white plaster or card; the most subtle practitioner was John Miers. The usual format was a head profile, but the range extended even to CONVERSATION PIECES. After 1800 a greater variety of techniques was developed and silhouettes cut out freehand from paper became especially popular in the hands of the French VIRTUOSO, A. Edouart, who worked mainly in England but also in America. The strength of the silhouette was, however, vitiated by the introduction of colour, gilding, and fancy backgrounds; its death-blow, like that of the miniature, was dealt by the popularization of PHOTOGRAPHY about 1850, and the art survived only as a curiosity on fair-grounds and piers, although interesting experiments, such as L. Reiniger's animated silhouette cartoon films, made in the 1930s, have been attempted.

1413.

**SILK-SCREEN PRINTING** or **SERIGRAPHY.** A modern development of STENCIL printing. A cut stencil is attached to a silk screen of fine mesh which has been stretched on a wooden frame, and the colour is forced through the unmasked areas of the screen on to the paper beneath by means of a squeegee. This method is an improvement on the simple stencil where, for example, a letter O required connecting pieces to prevent the centre from falling out—a problem which does not arise if the stencil is supported by the silk mesh. By a further improvement in the process the cut stencil is dispensed with altogether, its equivalent being painted directly on to the screen with opaque glue or VARNISH.

The process has been widely used for commercial textile printing but in the 1930s was developed, particularly in the United States, as an artists' medium for making PRINTS in broad masses of brilliant and opaque colour.

**SILOE, DE.** The name of two artists, father and son, whose work respectively represents the end of the GOTHIC and the beginning of the RENAISSANCE style in Spain.

GIL (active *c.* 1483–1500), sculptor, is described in a contemporary document as 'de Vrliones' (Orleans). He designed four great reredoses for churches at Valladolid and Burgos, and the tombs of John II and Isabella and of Prince Alfonso (1489–93) for the monastery of Miraflores, Burgos. His style shows both MUDÉJAR and FLEMISH influences. Gil de Siloe was the last great exponent of Gothic sculpture in Spain, but his influence was cut short by the advent of Renaissance fashions.

DIEGO (*c.* 1495–1563), architect and sculptor, visited Italy, working at Naples *c.* 1515. His

347. *The Artist's children.* Silhouette (1828) by Auguste Edouart

first recorded work in Spain, the *Escalera Dorada* (gilded stairway) of Burgos Cathedral (1519-23), proves that he had learnt much from contemporary Italian work. In 1528 he succeeded Enrique EGAS as architect of Granada Cathedral, erecting a great domed church with ribbed VAULTS and Corinthian ORDER on Enrique's Gothic foundations. He adapted the plan with great ingenuity, constructing his DOME over the sanctuary APSE, inspired, it has been suggested, by the Anastasis of the Holy Sepulchre at Jerusalem. His choice of style was criticized, but he defended himself successfully at court. The cathedral was opened for worship in 1561. The plan of rectangular nave combined with circular domed sanctuary recurs in his design for the church of El Salvador at Ubeda (1536) built by Andrés VANDELVIRA. He is also credited with designs for the cathedrals of Málaga and Guadix (1549).

1086.

**SILVER POINT.** See METAL POINT.

**SILVESTRE,** ISRAËL (1621-91). Member of a French family of etchers, settled mainly at Nancy and active from the 16th to the 18th c. He became drawing-master to the Dauphin. His ETCHINGS of architectural works and of ceremonies and fêtes are valuable for the historical information they give.

**SIMONE MARTINI** (*c.* 1285-1344). One of the most distinguished painters of Siena. He was probably trained in DUCCIO's circle, and he developed further the decorative use of outline and sophisticated patterning of colour which were the marks of Duccio's work. The main features of his style are present in his earliest surviving work, the large mural of *The Virgin in Majesty* (1315; reworked 1321) in Siena Town Hall: the sumptuous materials and the aloofness of the Madonna from the BYZANTINE style of the older generation; decorative line, gesture, and expression informed by the gracious GOTHIC fashion that was now current in Siena; while in presenting the heavenly company as a tableau on an earthly stage and using the foreshortened CANOPY to create the illusion of depth, he satisfied the awakening desire for more lifelike effects. In 1317 Simone was in Naples, where he executed for Robert of Anjou a painting (Museo di Capodimonte, Naples) showing his elder brother St. Louis of Toulouse, newly canonized, resigning his crown to him. The PREDELLA scenes of this altarpiece contain the boldest compositions in PERSPECTIVE that had been produced up to that date. The ALTARPIECES which Simone painted in 1320 for churches in Pisa and Orvieto (Museo Civico, Pisa, and Cathedral Mus., Orvieto) suggest the participation of his assistant Lippo MEMMI, whose sister he married. To commemorate a victory in 1328 the Sienese commune employed Simone to portray, on the wall opposite his *Virgin in Majesty*, the commander Guidoriccio da Fogliano riding between the captured fortresses of Montemassi and Sassoforte. This FRESCO is the earliest surviving example of a commemorative equestrian portrait. In the Lower Church of S. Francesco at Assisi Simone also painted at an uncertain date frescoes illustrating scenes from the life of St. Martin.

Perhaps Simone's finest work is the *Annunciation* of 1333 (Uffizi), which is generally regarded as the epitome of his style though in fact it also bears the signature of Lippo Memmi, who was probably responsible for the saints at the side. It is an exquisite ARABESQUE of a VIRTUOSO. The line is a marvel of sharpness and elegance, all gentle swirls for the ANGEL and shrill angles for the VIRGIN—a blend of etiolated grace and sweet sentiment.

Apparently Simone's rich and gracious style fulfilled the Gothic ideal for the French. In 1340/1 he went to Avignon to serve the papal court, where he painted the *Christ Reproved by his Parents* (Walker Art Gal., Liverpool, 1342) and the frontispiece to Petrarch's copy of Virgil (Ambrosiana Lib., Milan). Simone's style and his very compositions were taken over by illuminators from France and Flanders and generations of Italian PANEL and fresco painters copied him too.

**SINGERIES.** The conceit of *babouineries*—figures of monkeys aping human occupations and sports—goes back to medieval manuscript decorations. But the word *singeries* is usually restricted to a particular phase of CHINOISERIE during the French RÉGENCE period. The 18th-c. *singeries* go back to Jean BÉRAIN, who first hit on the idea *c.* 1695 of replacing the CLASSICAL fauns and statues and RENAISSANCE GROTESQUES by figures of monkeys. But the origin of the *singerie* as a distinct genre is usually attributed to Claude AUDRAN, who in 1709 painted an arbour with monkeys seated at table for the Château de Marly. Later WATTEAU, who had worked under Audran at Marly, painted *Les Singes-Peintres* for the Regent as a pendant to BRUEGEL's *La Musique des chats*. The fantasy was further developed by Christophe Huet (d. 1759) in his *Grande Singerie* painted in the Château de Chantilly (*c.* 1735) and for the Hôtel de Rohan (1745). In these paintings mandarins and monkeys are so mingled that it is often difficult to tell which an individual figure represents. While the monkeys of Bérain, Audran, and Watteau were attired as fashionable if mischievous Parisians, in the third decade of the 18th c. they began to appear in Chinese robes and to ape the airs of the mandarin. Other exponents of the style were Claude GILLOT and Jean OPPENORD.

**SINHALESE ART.** See CEYLONESE ART.

**SINOPIA.** A red ochre used in FRESCO painting.

**SIQUEIROS,** DAVID ALFARO (1896-    ).
Mexican painter. Born in Chihuahua, he came
to Mexico City in 1907. In 1911 he began to
study at the Academy and became a member
of the student circle which sought its inspira-
tion from Dr. Atl, became involved in the
student strike of that year and student plots
against the dictator Huerto, and at the age of
15 joined the Constitutionalist army. In 1914
he was a staff officer in the Carranza army and
during these years acquired his profound
understanding for the Mexican peasantry and
the extreme socialistic revolutionary views
which dominated his life. In 1919 he was sent
to Paris by the Government to train as an artist

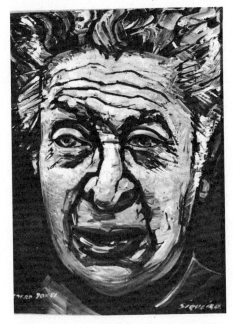

**348.** Self-Portrait. Painting by D. A. Siqueiros. (Private
Coll., 1961)

and there met RIVERA. In 1921 he issued from
Barcelona his famous Manifesto (see MEXICAN
ART (modern)) and returning to Mexico in 1922
he took a leading part in the artistic revival
fostered by the Obregón regime. He was active in
organizing the Syndicate of Technical Workers,
Painters and Sculptors and was partly respon-
sible for drafting its Manifesto which set forth
the idealistic aims of the revolutionary artists:
'our own aesthetic aim is to socialize artistic
expression, to destroy bourgeois indivi-
dualism. . . . We proclaim that this being the
moment of social transition from a decrepit to
a new order, the makers of beauty must invest
their greatest efforts in the aim of materialising
an art valuable to the people, and our supreme
object in art, which today is an expression for
individual pleasure, is to create beauty for

all, beauty that enlightens and stirs to struggle.'
During this time he also helped to found *El
Machete*, a paper designed to emphasize the
social role of mural painting.

His murals in the National Preparatory School,
painted 1922-4, already showed a mature grasp
of sculptural solidity, a feeling for architectural
space and an understanding for the spirit of
Aztec sculpture different in kind from the more
superficial MANNERISM of Rivera. During the
years following the closure of the Preparatory
School project Siqueiros worked first at decora-
tions for the University and State Capitol build-
ings in Guadalajara but devoted most of his
energies to the Labour movement. In 1929 as
delegate of the Mexican unions to the Continental
Workers Congress at Montevideo he was arrested
in Buenos Aires and expelled from the Argentine.
The following year he was imprisoned in Mexico
for participation in violent May Day demonstra-
tions. During this time and while living at Taxco
in 1931 (where he met and was influenced by the
Soviet film director Sergei Eisenstein) he pub-
lished a series of WOODCUTS and produced easel
paintings whose monumental tragedy sums up
the sorrow of the Mexican peasantry on a new
level of artistic simplicity (*Proletarian Mother*).

Throughout the 30s Siqueiros was energetic
both inside Mexico and abroad in socialist and
political activities, becoming in 1934 President
of the militant League against War and Fascism
and carrying on in 1935 a public controversy
with Rivera about the nature of revolutionary
painting. He experimented with the use of syn-
thetic lacquer paints and modern techniques of
paint spraying and in 1936 founded the Siqueiros
Experimental Workshop in New York. In 1937
he went to Spain as a pictorial propagandist and
saw active service with the Loyalist forces. Back
in Mexico in 1939 he headed a team of artists who
executed the pyroxilin murals called *The Trial
of Fascism* for the Electrical Workers Union. The
Neo-Realist theories exemplified in this painting
were developed with still more vigorous and
masterly effect in a series of enormous murals
during the 40s, among the most important of
which were the *Liberation of Chile* (259 sq.
metres) at the Escuela México in Chillán (1942),
the *New Democracy* executed for the Palacio de
Bellas Artes in Mexico City (1945), and *Patricians
and Patricides* (360 sq. metres) for the Old
Customs Building (begun 1946). He was also
doing a great deal of easel painting—completing
about 70 pictures for a show in 1947—and though
he himself insisted that they were subordinate to
his murals, they proved a major factor contribut-
ing to his international fame as an artist.

Since the 1930s Siqueiros enjoyed constantly
higher recognition as a master and by the 1950s
he was the acknowledged leader of the artistic
left in Mexico, and the country's most illus-
trious artist both as a muralist and as an easel
painter. He is the most individualist of Mexican
artists and the most spectacular personality of
the movement. In contrast with the sense of

disillusionment and foreboding which was sometimes featured in OROZCO's work, that of Siqueiros always expressed the dynamic urge to struggle. If he shows less of profundity than Orozco's philosophical conceptions, he surpasses him in fiery impetuosity. The seal was set on his international standing at the Venice Biennale of 1950, where he was awarded the prize donated by the Museum of São Paulo in Brazil, the leading honours going to the veteran Henri MATISSE.

2644.

**SIRÉN,** OSVALD (1879–1966). Born at Helsinki, Osvald Sirén was Professor of Fine Arts at Stockholm University 1908–25 and Keeper of Painting and Sculpture at the National Museum of Stockholm 1928–45. After beginning as a historian of ITALIAN ART, Professor Sirén turned to CHINESE ART. He travelled extensively in China, explored and photographed the treasures of the Palace Museum, Peking, and private collections, surveyed the sculptures and murals of the Buddhist cave temples, and published definitive studies of most aspects of Chinese art. He published his four-volume *Chinese Sculpture from the Fifth to the Fourteenth Century* in 1924, a four-volume *History of Early Chinese Art* in 1929–30, a *History of Early Chinese Painting* in 1933, and *History of Later Chinese Painting* in 1938. His monumental seven-volume *Chinese Painting, Leading Masters and Principles* (1956–8) is the most important source for reference on the subject. Not only was Professor Sirén the outstanding authority of his time on Chinese art, but the treasures of Chinese painting and sculpture which he brought back made the Stockholm Museum of Far Eastern Antiquities the most important collection of Chinese art in Europe.

**SISLEY,** ALFRED (1839–99). Painter, born in Paris of English parents. In 1826 he entered the studio of Marc Charles Gabriel Gleyre (1806–74) and there met RENOIR, MONET, and BAZILLE. He became a member of the IMPRESSIONIST group and painted Impressionist pictures throughout his life. His range was restricted to LANDSCAPE and he was concerned chiefly to represent the mood of atmosphere and weather (*Effet de neige*, 1874). His sense of colour and tonal values owed much to Monet and like Monet he adopted the 'rainbow palette' of Renoir, but he did not like Monet dissolve his colours into a luminous mist. He exhibited at the Salon des Refusés in 1863, had landscapes accepted by the Salon in 1866 and refused in 1867. He contributed to four Impressionist exhibitions between 1874 and 1886 and was given a successful one-man show by the dealer Durand-Ruel in 1883. In the retrospective section of the Exposition Centennale at the Exposition Universelle of 1900 he was represented by eight landscapes.

After the family business failed in 1871 Sisley lived in straitened circumstances but during the later years of his life his pictures came into favour with the CONNOISSEURS and he sold for reasonable prices.

770, 1001.

**SIZE.** Term used in painting for gelatine or highly purified glue, but the word is sometimes used for any glue. CENNINI mentions the preparation of size from PARCHMENT waste by soaking it in water and heating it. It is used for filling the porous surface of wooden PANELS or CANVASES to provide a suitable foundation for the PAINTING or PRIMING (see GROUND). It is also used as a MEDIUM in certain WATER-COLOUR techniques (see GOUACHE).

**SKETCH.** 'A rough drawing or delineation of something, giving the outlines or prominent features without the detail, especially one intended to serve as the basis of a more finished picture, or to be used in its composition . . .' (*O.E.D.*). This was the original meaning of the word; not until the latter part of the 18th c. did it acquire the additional sense of 'a drawing or painting of a slight or unpretentious nature'. In the 18th c. the cult of the PICTURESQUE, especially as fostered by William GILPIN, led to appreciation of the sketch because of its spontaneous and 'unfinished' character, which stimulated the play of imagination. In the 20th c. also considerable attention has been paid to the aesthetic aspects of the unfinished or *non finito*. It should be noticed that in the former, or dictionary, sense 'sketch' is equivalent to MODELLO but in the latter it is in contrast. The 'unfinished' sketch is aesthetically complete in itself and is not regarded as a preliminary or a model for a more finished picture.

**SKYSCRAPER.** A popular architectural term for a many-storeyed building, especially the type of office building that dominates Manhattan Island, New York, and the centres of other large American cities. Skyscrapers were first built because of the high cost of land in congested urban areas and subsequently also for their prestige value even when they were not economical. They were made possible technically by the development of STEEL-frame construction and the invention of the electric lift.

Leroy S. Buffington, a Minneapolis architect, designed the first skyscraper in 1880, but the first one actually erected was the Home Insurance Building in Chicago, a 10-storey structure designed by William Le Baron Jenney and completed in 1885. This was followed by others in Chicago, which became the home of an inventive and prolific school of architect-engineers (see CHICAGO SCHOOL). William Le Baron Jenney's Leiter Building (1889) was the first to express its frame construction externally; but in most of the early skyscrapers the frame was used merely to support an outer disguise in some fashionable

period style. Louis SULLIVAN, however, experimented successfully with new forms based on the natural rhythms and the cellular character of skeleton structures. Sullivan's example was largely ignored as skyscrapers came into fashion. The 60-storey Woolworth Building in New York (architect, Cass Gilbert, 1913) was rich in Neo-GOTHIC trimmings, and the first prize in the competition for the Tribune Tower in Chicago, held in 1922, was awarded to Raymond Hood for another Gothic design.

One of the first buildings to recapture Sullivan's forthrightness and add to it something of the sleekness of 20th-c. technological AESTHETIC was the Philadelphia Savings Building by Howe and Lescaze (1929). The highest skyscraper is the Empire State Building, New York (102 storeys), by Shreve, Lamb, and Harman (1931). The Rockefeller Center, New York, designed by a number of architects and completed in 1933, is a group of skyscrapers conceived as a whole.

The most distinguished skyscrapers of the mid 20th c., also in New York, include the United Nations Secretariat Building (1951) by Wallace Harrison (working as leader of an international team of architects) and Lever House (by Skidmore, Owings, and Merrill, 1952) in which frame construction is used to raise the whole building on *pilotis* allowing the ground to flow beneath it. Both buildings exemplify the unarticulated, diagrammatic type of structure which relies for its aesthetic effect on the scale and rhythm of structural frame and glass in-filling.

Interesting European adaptations of the skyscraper idea may be seen in the Pirelli Building and the Torre Velasca at Milan and the Phoenix-Rheinrohr Building, Düsseldorf. The S.A.S. Building, Copenhagen, comprises a long, low block surmounted by a 22-storey skyscraper whose external form brings the influence of Lever House to evidence.

The invention of the mechanical lift dates from about the same time as frame construction, for James BOGARDUS proposed a steam passenger elevator for the New York World's Fair in 1853. In the same year Elisha Graves Otis displayed the first efficient elevator with a safety device, and he installed one in a New York department store in 1857. The first lift in Europe was built at the Paris Exhibition of 1867. It was operated hydraulically. The electric lift did not come till near the end of the century. The economic height of a skyscraper is limited by the fact that beyond a certain point so many lifts are required to serve the offices or flats that they occupy too large a proportion of the floor-space.

**SLEVOGT,** MAX (1868-1932). German painter and GRAPHIC artist. He was born in Bavaria and studied in Munich with visits to Paris, Italy, and Holland. His paintings were at first in a sombre NATURALIST style akin to that of LEIBL, but from 1900 onwards they became increasingly dramatic and colourful. Slevogt

may be considered one of the first EXPRESSIONISTS, but he inherited something of the Bavarian BAROQUE tradition. His later work, especially the large decorative schemes at Cladow (1912), Newkastel (1924 and 1929), Bremen (1927), and Ludwigshafen (1932), is characterized by loose handling of paint, bold effects of light, and restless movement of forms. Slevogt did much graphic work, including illustrations for Fennimore Cooper's *Mocassin Hunters* (1909) and Mozart's *Magic Flute* (1918-19).

2496.

**SLOAN,** JOHN (1871-1951). American painter, born in Lockhaven, Philadelphia. He learned painting from Robert HENRI during the late 1890s while working as an illustrator for the Philadelphia *Press* and *Enquirer*. After 1904 he settled permanently in New York, where while continuing to work as illustrator he kept a painter's eye alert for themes of human interest on the Lower East Side, the Bowery, and in West Greenwich Village (*The Haymarket*, 1907, *The Wake of the Ferry*, 1907). He was one of the original members of The EIGHT and influential in promoting modern realism in the U.S.A. He taught at the Art Students' League and became its director in 1931, but he was not accepted by many of the social realists of the 1930s because he refused to incorporate what he called 'socialist propaganda' into his art.

**SLODTZ.** Family of French sculptors, designers, and decorators in the ROCOCO manner, originating from Antwerp. They were SÉBASTIEN (1655-1726) and his three sons: SÉBASTIEN-ANTOINE (1695-1754), PAUL-AMBROISE (1702-58), and RENÉ-MICHEL called Michel-Ange (1705-64). All three sons succeeded MEISSONIER at the Menus Plaisirs and all three had talent in portrait BUSTS. Michel-Ange also made catafalques (TOMBS of the archbishops of Vienne and of Languet de Gergy at S. Sulpice) and was later championed by COCHIN against BOUCHARDON.

**SLUTER,** CLAUS (d. 1406). Sculptor, probably of Dutch origin though Mainz is mentioned in one document. He worked for Duke Philip the Bold of Burgundy on the Charterhouse at Champmol, near Dijon, where he succeeded MARVILLE as master in 1389. Sluter was responsible for the execution of most of the great programme of sculpture, including the portal and the Calvary of which the base, known as the *Puits de Moïse*, survives. He also designed the Duke's tomb, though most of the latter was executed by his nephew, Claus de WERVE. Sluter turned away from the INTERNATIONAL GOTHIC style of his time, and introduced an unprecedented REALISM into sculpture. The statues of the Champmol portal form a three-dimensional tableau in which the figures enter into relations with one another; there is no

question of their being merely decorative or subordinate to the discipline of the architecture. To find antecedents for this sort of thing one must look back to the MASTER OF NAUMBURG's *Crucifixion* group (mid 13th c.). But Sluter's style was individual throughout. His DRAPERIES have an amplitude which endows his figures with monumental dignity, and the vigorous involutions of their folds often suggest deep spiritual agitation. In fact he transformed GOTHIC drapery conventions into a highly personal means of expression. Some of the *Mourners* for the Duke's tomb are completely enveloped in their voluminous cowls, so that they are in effect nothing else but drapery. As character studies the PROPHETS of the *Puits de Moïse* can only be matched by those of DONATELLO, which they preceded by nearly 20 years. But perhaps the work which leaves the deepest impression of Sluter's spiritual intensity is a head and TORSO of *Christ*, a fragment from the *Calvary*, which remains supremely evocative despite its present mutilated state. When we see this we can the more readily understand why Sluter chose to retire to the Monastery of S. Étienne at Dijon in 1404.

The complete realism at which Sluter aimed required that his figures should be painted, and this was done by MALOUEL among others. He undoubtedly exercised a profound influence on early FLEMISH painters such as the MASTER OF FLÉMALLE and Jan van EYCK, both of whom are known to have painted statues and whose PANELS contain figures painted in the colour of stone to represent statues.

697, 1664, 2688.

**SLUYTERS,** JAN (JOHANNES CAROLUS BERNARDUS) (1881-1957). One of the leading representatives of POST-IMPRESSIONISM in Holland. His early works show the influence of van GOGH and BREITNER, and of TOULOUSE-LAUTREC and MATISSE. Like many other 20th-c. painters he also experimented with CUBISM. He finally worked out a lively personal style of colourful EXPRESSIONISM which is best seen in his pictures of nudes—he had a predilection for painting nude children, portraits, and STILL LIFES. His works are represented in the principal museums of Holland.

1705.

**SMART,** JOHN (1741?-1811). One of the most technically skilled British MINIATURE painters, he was Vice-President of the Society of Artists in 1778 and exhibited at the ROYAL ACADEMY from 1794. His output was large. He worked mainly in London but was in India 1785-*c.* 1796.

902.

**SMET,** GUSTAVE DE (1877-1943). Belgian painter who was one of the main figures in the creation of Belgian EXPRESSIONISM after the First World War. Towards the close of his life his lyrical quality found expression in a series of beautiful LANDSCAPES. His works may be seen in Antwerp and Brussels.

1563, 2157.

**SMIBERT,** JOHN (1688-1751). Scottish-born painter who settled in New England at the age of 41. He had lived and studied painting in Italy and practised successfully in London as a portrait painter. He was a competent though uninspired exponent of the decorative BAROQUE style, though after he settled in America his work showed some tendency towards a blunter and more REALISTIC manner. He brought with him a small collection of art, including copies of pictures by RAPHAEL, van DYCK, POUSSIN, etc., and opened a shop where he sold English engravings from the works of well known artists. His own paintings and his gallery of copies and engravings became the corner-stone of the New England Colonial portrait style.

892.

**SMIRKE,** SIR ROBERT (1781-1867). English architect. He was the son of a Royal Academician, was a pupil of Sir John SOANE, and also worked with John NASH. He toured Greece, Italy, and Sicily (1801-5) and returned to acquire a large practice, to share with Soane and Nash the position of architect to the Board of Works, and to become Surveyor to the Inner Temple, for which he built the library (destroyed 1941) and hall. His work was competent, NEO-CLASSICAL, and dull. His best known design is the BRITISH MUSEUM, begun in 1823 and completed by his younger brother SYDNEY (1798-1877). He also made the General Post Office (1824-9), which was altered by the addition of an attic storey in 1874 and demolished in 1913, and Covent Garden Theatre (1808-9, burnt down in 1856).

**SMITH,** DAVID (1906-65). American sculptor; he studied at the Art Students' League after having worked in factories assembling metal parts. His initial interest was painting. Explaining his transition to sculpture, he wrote: 'The painting developed into raised levels from the canvas. Gradually the canvas was the base and the painting was a sculpture.' During the late 1940s he began making welded steel constructions with a suggestion of SURREALISM. His works grew more and more linear, becoming rod and wire 'drawings-in-space' (*Hudson River Landscape*, 1951). During the 1950s Smith did series of constructions based on the human figure, such as *Tank Totem*. His work during the 1960s became increasingly geometric and less whimsically organic. For example in the *Cubi* series he arranged three-dimensional geometric volumes of stainless steel in a monumental, dynamic balance. Smith's sculpture is related to the work of the ABSTRACT EXPRESSIONIST painters.

**SMITH, FRANCIS, OF WARWICK** (1672–1738). English mason and architect, who with his brother WILLIAM (1661–1724) had a large business in the Midlands, sometimes carrying out the designs of other architects, but capable of producing dignified work in a modified BAROQUE manner on their own account. Among such buildings are Stoneleigh Abbey, Warwickshire (1714–26), and the Court House, Warwick (1725–30). They also probably designed churches, among other places at Whitchurch, Shropshire, and Burton-on-Trent.

**SMITH, JOHN RAPHAEL** (1752–1812). English painter, MINIATURIST, and engraver, was born at Derby and came to London c. 1767. He adopted engraving as his profession and produced a number of fine MEZZOTINTS, of which some of the best were after portraits by REYNOLDS and GAINSBOROUGH. He also published engravings, and at one time employed GIRTIN and TURNER to colour prints.

**SMITH, JOHN 'WARWICK'** (1749–1831). English LANDSCAPE painter. He travelled in Italy and Switzerland from 1776 to 1781 under the protection of the second Earl of Warwick. He later settled in London and made many sketching tours in Wales. His WATER-COLOUR paintings were marked by an exceptional fullness and range of colour for the time. The introduction of the grey GROUND technique has been attributed to him.

**SMITH, SIR MATTHEW ARNOLD BRACY** (1879–1959). English painter of nudes, STILL LIFE, and LANDSCAPE. He studied at the Slade School and afterwards for a short time in Paris under MATISSE during the FAUVIST period. He began exhibiting with the LONDON GROUP after the First World War. His output up to the early 20s was small and he had his first one-man show at the Mayor Gallery in 1926. In his later work the Fauvist influence of DERAIN and Othon Friesz (1879–1949) matured into a personal style with a richer and more splendid orchestration of colour and an opulent fluency of line. Much of his life up to 1940 was spent in France, where he enjoyed a high reputation among English painters.

1290.

**SMITS, JAKOB** (1855–1928). Dutch-Belgian painter. He spent the greater part of his life in the Campine, a bleak, primitive region near Antwerp, and painted LANDSCAPES and biblical scenes which he set in the surroundings which he knew and loved. He also made portraits which show the influence of REMBRANDT's use of CHIAROSCURO.

1208.

**SMYTHSON** or **SMITHSON, ROBERT** (c. 1536–1614). English architect. He is first heard of as the chief mason at Longleat, Wiltshire, 1567–80. From 1580 he settled at Wollaton, Nottinghamshire, where he died and is described on his tombstone as 'Architect and Surveyor unto the most worthy house of Wollaton and divers others of great account'. Many plans and drawings by him are now at the R.I.B.A., and on their and other evidence he can be shown to have designed Hardwick Hall,

**349.** Longleat, Wiltshire

**350.** Worksop Manor, Nottinghamshire. Pen-and-ink drawing with wash (18th c.) by Samuel Buck. (Bodl. Lib., Oxford)

Derbyshire, Burton Agnes, Yorkshire, and the vanished Worksop Manor, Nottinghamshire. A further group of northern and midland houses can be attributed to him on mainly stylistic grounds, notably Barlborough, Derbyshire, Wootton Lodge, Staffordshire, and Fountains Hall, Yorkshire.

His son JOHN (d. 1643) entered the service of Sir Charles Cavendish about 1612, and remained in his employment and that of his son, William, later Duke of Newcastle, until his death. For them he designed the riding-school (1622–3) and other buildings at Welbeck Abbey, Nottinghamshire, and between 1612 and 1634 the majority of the buildings at Bolsover Castle, Derbyshire. Many of his plans and drawings are at the R.I.B.A., London, including interesting records of a journey to London in 1618.

**SNYDERS,** FRANS (1579–1657). Flemish painter of animals, hunting scenes, and STILL LIFE. He was born in Antwerp, where he studied with Pieter BRUEGHEL the Younger and Hendrick van Balen (1575–1632). While still a young man he went to Italy, returning to Antwerp in 1609. Here he entered the studio of RUBENS, who had also recently returned from Italy. Their relationship was friendly and lasted until Rubens died in 1640, having made Snyders executor of his will. The friendship had artistic consequences. Snyders's early work is in the tradition of the Brueghel school of flower and fruit painters, but from Rubens he gained new freedom of power and an exuberance of colour which enabled him to infuse BAROQUE vitality and movement into a type of painting which is by nature static. In his large cornucopian still lifes cats attack the fish and poultry, dogs bark and snort over the game, monkeys throw fruit, parrots chatter and shriek. The paintings of fighting wild animals and the hunting scenes have even greater exuberance. His rare drawings of animals and birds always capture their characteristic movements. Snyders painted animals, fruits, and flowers in Rubens's pictures, and Rubens painted figures in his. He later worked out the same kind of reciprocal arrangement with JORDAENS, and collaborated with his brother-in-law Cornelis de VOS, van DYCK, and Abraham JANSSENS.

**SOANE,** SIR JOHN (1753–1837). The last great English architect before the Victorian age of revivals. He was not an orthodox 18th-c. Classicist but devised an unmistakably individual style based partly on his intense interest in structure and partly on his search for perfection in the use of the basic geometrical elements of architecture. These were relieved only by a restrained surface treatment of incised lines, grooves, and panels. He produced Classical architecture without copying CLASSICAL detail.

Soane was the son of a Reading stonemason, and was first a pupil of George DANCE and then of Henry HOLLAND. He was given a travelling scholarship by George III and spent three years in Italy and Greece, returning in 1780. In 1788 he won the competition for a new Bank of England. This building (1795–1827) is his most important work, but the effect of its low windowless façade with recesses ornamented with Corinthian COLUMNS has been destroyed by a clumsy superstructure added in 1925. Some of

351. The Bank of England. Drawing showing on the right St. Bartholomew's by the Exchange (*c.* 1836)

the fine interior halls have, however, been preserved. Soane was Professor at the ROYAL ACADEMY from 1806 onwards, and in 1815 was made, with NASH and SMIRKE, joint architect to the Board of Works. Among other buildings he designed Pitzhanger Manor, Ealing (1802), and the Dulwich Art Gallery (1811-14).

Soane married a rich wife and amassed a great collection of pictures and antiques which he displayed in the house he designed for himself in Lincoln's Inn Fields, London. He left it and his collection to the nation, and it is now Sir John Soane's Museum.

337, 338, 2575, 2591.

**SOAPSTONE,** also called STEATITE. A variety of talc, a very soft smooth stone superficially like MARBLE in appearance but with a soapy texture. It will take a smooth polish, and is so easily worked that it may even be carved with a knife. Its colour is a dull greenish or bluish grey or sometimes brown. It is vulnerable to dampness in the atmosphere and will only serve for indoor sculpture. It has been used, especially for more decorative and less permanent sculpture, in most parts of the world—in Egypt, Europe, China and Japan, in AFRICAN TRIBAL ART, and by American Indians and Eskimos. Soapstone carvings are sometimes sold to the unwary as JADE.

Soapstone was included as an ingredient in the soft-paste porcelain first manufactured at a factory founded at Bristol in 1750 and moved to Worcester in 1752.

352. Design for the interior of the Bank of England. Pen-and-ink drawing by Sir John Soane (Sir John Soane's Mus.)

**SOCIAL REALISM.** See REALISM.

**SODOMA,** GIOVANNI ANTONIO BAZZI (1477-1549). Painter born at Vercelli in northern Italy but who worked chiefly in and around Siena. His first dated works are the frescoes in Sta Anna in Camprena, Pienza (1503-4), and those in Monteoliveto Maggiore (1505-8), in which his Piedmontese training fused with the UMBRIAN style of PINTORICCHIO and SIGNORELLI. Another formative influence upon him was that

353. Elevations of the front of the Bank of England next to Threadneedle Street. Pen-and-ink drawings by Sir John Soane. (Sir John Soane's Mus.)

of LEONARDO, seen both in the SFUMATO technique and in borrowed arrangements and postures. Sodoma worked in Rome 1508–10, painting frescoes of the story of Alexander and Roxana in the Villa Farnese. The influence of RAPHAEL in these and later works combined with a taste for beautiful features and gestures to produce an attractive, decorative style which sometimes borders on sentimentality. His most admired work is the fresco cycle of *The Life of St. Catherine* (S. Domenico, Siena, 1526), particularly the scene of the saint receiving the stigmata, set in one of Sodoma's gentle, poetic landscapes. In his time Sodoma was considered the leading artist in Siena but later critics have come to rank BECCAFUMI above him.

677.

**SOEST,** GERARD (*c.* 1600–81). Portrait painter born in Holland, who worked in London from some time before 1649. His portraits have a Dutch gravity in the depiction of character and a REALISM which dispensed with flattery and superficial elegance and was at odds with the fashionable taste of the Restoration court. He is distinguished for his lucent silvery colours transfused with the warm tones of a brown UNDERPAINT and for his highly personal treatment of DRAPERY with strongly emphasized patterns of light and shadow. Good examples of his work are *Lady Margaret Hay* (*c.* 1670) and *Sir Richard Rainsford* (Lincoln's Inn, 1678). His colouring and his manner of treatment influenced many native Stuart portrait painters.

135.

**SOFT-GROUND ETCHING.** The peculiarity of this technique is that it can be made to render textures. When it was invented late in the 18th c. it was employed for imitating crayon or PENCIL lines. The traditional method was as follows. A copper plate was covered all over with a waxy RESINOUS mixture, somewhat like the ordinary ETCHING ground but much softer and sticky enough to adhere to anything pressed into it. Over this ground was laid a sheet of PAPER on which the artist drew with a pencil. Wherever the lines ran the ground stuck to the back of the paper, so that when it was lifted the wax immediately underneath the lines came away with it, while the rest remained in place. The plate was then immersed in acid, which bit into the metal along the lines. Finally it was cleaned and inked and PRINTS were taken from it by the copper-plate press. The printed lines were granulous, coarse, or fine according to the texture of the paper used for the drawing: thus if the paper had been smooth, the lines resembled pencil, but if rough, they were more like chalk. Soft-ground etchings bear a strong likeness to prints in the CRAYON MANNER, but are generally a little softer and less regular. Although the technique was used in the late 18th and early 19th centuries chiefly for REPRODUCTION, a number of excellent original soft-ground etchings were produced by GAINSBOROUGH, COTMAN, and GIRTIN. Gainsborough in particular, in his landscape prints, combined the soft-ground line most effectively with AQUATINT in a manner resembling spontaneous drawing in pencil and WASH.

Modern artists have used the process for very different purposes and in so doing have altered it. The paper pressed into the ground has been dispensed with and the drawing made directly through the ground with a wooden STYLUS. Without the paper the artist dare not rest his hand on the surface, so he must draw boldly and freely; moreover, since the soft ground is easily applied with a roller, he can obliterate failures merely by rolling up his plate with fresh ground. Both these factors ensure that spontaneity of touch is preserved in the final print.

So much for linear work. But soft-ground etching has also come into use for making various tones and textures in ABSTRACT or semi-abstract prints. A plate, frequently one which has already been worked with etched or BURIN-engraved lines, is covered with a soft ground into which is pressed tissue paper—often crumpled—or textile material. The areas to be left untextured are then painted out with acid-resisting VARNISH and the plate bitten in a clean-biting acid called DUTCH MORDANT. Nor are paper and fabric the only substances that may be used; the textures of leaves, feathers, wood grain, and so forth, or even the artist's finger-prints, may all be bitten into the plate.

**SOLARIO,** ANDREA (active 1493-1515/20). North Italian painter. His style was that of Lombardy, showing the influence of FOPPA and LEONARDO, with occasional suggestions of Rome and of the northern RENAISSANCE (as may be seen in the *Madonna with a Green Cushion*, Louvre, 1507). His technical skill inspired the best north Italians of the younger generation such as LUINI and Gaudenzio FERRARI.

**SOLARIO,** PIETRO ANTONIO (c. 1450-93). Italian architect and sculptor. He was active in Milan and from 1490 onwards in Russia, where he designed some of the fortification towers of Moscow. With Marco Ruffo, an Italian architect otherwise unknown, he built the 'Faceted Palace' (*Granovitaya Palata*) in the Kremlin, remarkable as a work in pure Italian RENAISSANCE style on Russian soil (1487-91).

**SOLIMENA,** FRANCESCO, also called L'ABATE CICCIO (1657-1747). Italian painter, whose long and extremely productive life spans the whole period of the late BAROQUE in Naples, where he painted frescoes in many of the greatest churches. His work in the Gesù Nuovo (1725) is a dramatically lit and vigorous re-statement of RAPHAEL's fresco *Heliodorus* in the Vatican. His decorations are overloaded with architectural adjuncts and agitated figures, but his firmly designed compositions, vigorous draughtsmanship, and rich colouring make them clear to read and exciting. The sketches for his frescoes are usually done in oil on canvas and have been much admired. LANFRANCO, GIORDANO, PRETI, and MARATTA all helped to form Solimena's style. He in his turn was a celebrated teacher whose influence was international. CONCA and Allan RAMSAY studied under him (1737), and his work in S. Paolo Maggiore was copied by FRAGONARD.

**SOLIS,** VIRGIL (1514-62). German engraver and DESIGNER working in Nuremberg. He was extremely prolific of patterns for the APPLIED ARTS. He was also a popular Bible illustrator.

**SOMER,** PAUL VAN (c. 1577-1622). Portrait painter from Antwerp who settled in London in 1616 and worked for King James's Court (*Queen Anne of Denmark*, Windsor, 1617) in a style close to that of MYTENS but less forceful. Both he and Mytens were able to supply the more imposing and vital type of portrait in the Dutch manner which corresponded to the taste of court circles.

**SONDERGOTIK.** This name was proposed by K. Gerstenberg in 1913 to indicate the distinct character of later GERMAN GOTHIC architecture. The style inaugurated by the choir of the Kreuzkirche at Gmund (1351) and the tower of Freiburg Münster persisted in Saxony until c. 1550. It is characterized by elaborate VAULT patterns, complicated and often fantastic TRACERY, and brilliant exploitation of the visual properties of the HALL CHURCH form, with which it is usually associated. There are several outstanding examples among the churches of Nuremberg. Gerstenberg regarded the style as an expression in architecture of the mystical and irrational tendencies of the German character, and a counterpart to English PERPENDICULAR and French FLAMBOYANT. Later research, however, has tended to play down the differences between the various late Gothic styles and to give more prominence to affinities between them. There seems to be a definite relation between some English lierne vaults and those of *Sondergotik*, and between some French and German PORCHES and tracery. The origins of late Gothic architecture are too complex to be explained wholly in terms of national characteristics, but use has given a certain convenience to Gerstenberg's term.

1019.

**SÖRENSEN,** HENRIK (1882-1962). Norwegian painter who carried on the nationalistic tradition of WERENSKIOLD in his own EXPRESSIONIST and colourful style. There is a note of mysticism even in his LANDSCAPES, which have had some influence on younger Norwegian painters. Some of his political allegories reveal strong social feelings, and his later religious and symbolic compositions are also highly emotional —for example, the mural paintings at Geneva (finished 1939), and that in the new Town Hall at Oslo (begun 1950). The latter is one of the largest mural paintings in existence. Sörensen has also done some remarkable book illustrations (Björnson's *Peasant Tales*, 1929, and a collection of Norwegian folk tales, 1936).

**SOTATSU,** NONOMURA (d. 1643). Japanese artist who collaborated with Honnami KŌETSU and was regarded as joint founder with him of the KŌRIN SCHOOL. Little is known about his biography, though he is known to have

restored the Sutras of the Taira family in 1602 and to have copied the scrolls of the *Tales of Saigyo* in 1630. Like Kōetsu he stood for the revival of native Japanese traditions and worked towards the closer unification of painting with Japanese literature. He copied ancient paintings and several times made screens illustrating incidents from the *Tale of Genji*. He painted delicate bird and flower pieces in a technique known as *tarashikomi*, obtaining a particularly soft effect by applying rich colours over a wet colour UNDERPAINTING (three panels of *Poppies* in the Mus. of Fine Arts, Boston). He was noted for his gracefulness, fantasy, and lively NATURALISM.

**SOTTO IN SU** (Italian: from below upwards). The ILLUSIONIST representation of figures on a ceiling, so that they appear foreshortened. MANTEGNA's *Camera degli sposi* in Mantua, GIULIO ROMANO's *Sala di Psiche*, and COR-REGGIO's cupolas in Parma are famous early examples of this 'frog perspective', which was often adopted by the Italian ceiling painters of the 17th c.

**SOUFFLOT,** JACQUES-GERMAIN (1713–80). French architect. After several journeys to Rome, where he acquired a taste for the ANTIQUE, he made himself a name through his lectures and buildings in Lyon, notably the Hôtel-Dieu (1740) and the Exchange (1747). In 1755 Marigny, Director of the Bâtiments du Roi, brought him to Paris as Surveyor of Works. In this capacity he was instrumental in introducing the new CLASSICISM, in plans for reconstructing Paris, in the Place Royale at Reims, and most notably in the rebuilding of the Church of Ste-Geneviève (now the PANTHÉON), Paris, which Laugier, a preacher of the new Classicism, hailed as 'le premier modèle de la parfaite architecture'.

2064.

**SOUILLAC.** The church of Ste-Marie of Souillac (restored in 1932) contains some of the finest and most interesting fragments of ROMAN-ESQUE sculpture. The early 12th-c. portal has been destroyed, but several important sculptural pieces remain. The TYMPANUM seems to have been one of the first to be carved with the story of the VIRGIN, for a surviving fragment illustrates one of her miracles. The figure of Isaiah on the doorway is justly famous for its powerful writhing movement, and the *trumeau* is the best known instance of a complex design of birds and beasts intertwined and biting one another. Its meaning has been much discussed, but it is fairly certain that it was a stone version of a kind of decoration used to embellish capital letters in some 11th- and 12th-c. manuscripts.

**SOUTH AFRICAN ART.** Cape Dutch architecture of the 18th c. derived directly from the domestic architecture of 17th-c. Holland, modified only by considerations of climate and local materials. Both town and country houses, simply designed with whitewash on plastered walls, their weathered woodwork and setting against mountain and blue sky, may well be thought the most satisfactory and significant works of art that South Africa has produced.

LANDSCAPE has always been central to South African painting, not only because the first artists to work in the country were 'reporters' whose main object was to illustrate the topography, fauna, and flora of a new land, but because the early stages in the development of settler art coincided with an efflorescence of enthusiasm in Europe for an intensive development of skills in representing the objective world including an intensification of interest in landscape.

Although Netherlands painting was at its highest peak when the Dutch settled the Cape in 1652, this was not reflected in a local school of Colonial painting such as grew up, for example, in North America. Serious TOPOGRAPHY began only in the latter part of the 18th c. after the visit of Samuel Daniel (1775–1811), whose colour plates *African Scenery and Animals*, although still record rather than art, encouraged others to look at the actual scene rather than the legend and led to the prolific work of Thomas Baines (1820–75), who came to South Africa in 1842. Baines worked for the *Illustrated London News*, had the distinction of meeting Livingstone, and was the first artist to paint the Victoria Falls. The first South African painter of any importance is by general consent Hugo Naudé (1869–1941), who was trained at the Slade School in London and afterwards at Munich. His style bears the stamp of English IMPRESSIONISM of the 1890s and he describes the world around him in the free and unimpassioned manner then in vogue, thinking in paint rather than in terms of form. His portrait studies on the other hand show the careful skill of the school which produced Augustus JOHN. Contemporary with Naudé was the self-trained painter J. E. A. Volschenk (1853–1936), a meticulously descriptive portrayer of reflections of rivers, dust from cartwheels, contours of leaves, without the personal vision which marks an artist of distinction. Of greater significance was Pieter Wenning (1874–1921), a Dutchman who came to South Africa in 1905 and began to be known as an artist during the First World War. He painted landscapes in a style between JONGKIND and BOUDIN which owed little to Impressionism but which became more intimately invested with the atmosphere of the scenes he portrayed than were those of Naudé. His work was therefore particularly evocative for South Africans and after his premature death acquired the character of collectors' pieces and eventually became among the most sought after in the country. He set a fashion for subject matter and approach to the younger painters of the Cape which had not entirely been superseded by the middle of the 20th c. Contemporary also with Naudé, but bringing a mature north

354. *An Explorer's Camp.* Engraving by T. Baines and J. J. Crew

European style even earlier in its origins than that of Wenning, was the Hollander Frans Oerder (1867-1944), a war artist for the Kruger government who for almost a generation represented the trained professional painter in the Transvaal. Anton van Wouw (1862-1945), also a Hollander, who settled in the Transvaal in 1890, was a sculptor of smooth REALISTIC BRONZES mainly of the Bantu people and made the huge realistic Paul Kruger monument in Pretoria. Twenty years younger than Oerder was Hendrik Pierneef (1886-1957), who more than any other artist swung eyes to the north. Without formal instruction, he was concerned all his life to show what for him was the central character of each kind of tree, animal, or plant, and with penetrating vision was alert to the individual physiognomy of the different parts of the country. Between the two wars he established himself as the painter of South Africa *par excellence*. He travelled to Europe in 1930 and evolved a personal form of CUBISM which enabled him to give that stamp to his descriptions of South African topography which has remained uniquely his own. A commission for murals in South Africa House, London, took him again overseas and on his return the mural panels he painted for the Johannesburg railway station crown his contribution to the art of South Africa. His later painting was more directly descriptive and consequently less of a personal comment.

The Cape, however, remained the artistic centre of South Africa until the Second World War. EXPRESSIONISM was brought to South Africa by Irma STERN and Maggie Laubser (1886- ), both of whom were trained in Germany. Irma Stern in particular remained an important influence in South African art since the 1920s and was instrumental in encouraging a more emotional spirit beside the dispassionate painterly methods inherited from the French Impressionists. In addition there continued to be popular a purely descriptive, topographical type of painting which specialized in typically South African subjects—Cape farmhouses, Karoo sunsets, ox-wagons, etc.—rendered in a purely academic manner. Besides Pierneef perhaps only Adolph Jentsch (1888- ) combined a surprised delight in the vagaries of the subject with a confident style based on current European traditions. In spite of his German origins he remained more of an Impressionist than an Expressionist but employed this observant and painterly style to record the characteristic tawny and unyielding landscapes of South West Africa in a manner far more credible than painters of eastern South Africa have achieved. Most of the serious professional painters, however, were so identified with European styles that they either ignored or deliberately avoided the more insistent South African or exotic aspects of their environment.

Meanwhile there was emerging a younger generation of painters, also consisting partly of settlers and partly of indigenous artists, most of whom made their impact after the Second World

War. One of the most distinguished of the immigrants was Wolf Kibel (1903-38), who came to South Africa in 1928 and did street and figure scenes in a Jewish manner reminiscent of SOUTINE. His great sensitivity was recognized only after his death. Of the South Africans born in the first decade of the 20th c. one of the first to attract notice was Gregoire Boonzaaier (1909-   ), who returned to South Africa in 1938 after training in London. His sprightly and robust version of the free descriptive manner which had already been identified with painting at the Cape rapidly became popular. With the end of the war a new kind of vision seems to have been born in South Africa, of which Cecil Higgs (1906-   ) was one of the most distinguished exponents. Her long period of study in London and Paris had endowed her with a fluent 'Intimist' style which she deployed more and more to the communication of an original experience of the visual world. The new manner took hold even more firmly in Pretoria, where Walter Battiss (1906-   ) had come as an art master in the years immediately preceding the war. His formal training had been entirely South African and although he had travelled widely, his style showed almost nothing of foreign influence, being based on an intimate sympathy for the Bushman rock paintings (see AFRICAN PREHISTORIC ART). His canvases look as if they were painted in bright sunlight and probably more than any other artist he showed younger painters how the vitality and flicker of the radiant South African countryside may be reflected by the hand of her artists. Here at last a quality that was purely South African controlled the style, which was both imaginative and unaffected, a combination of bright descriptive narrative and sensuous, joyful pigment. A similar South African quality infused the work of his younger contemporary Alexis Preller, who was born and spent most of his life in Pretoria. Though he refused to identify himself with any school, his work showed a highly organized personal fantasy playing on themes and symbols suggestively South African in a vaguely SURREALIST way and executed with punctilious and impeccable craftsmanship. A still younger painter who devoted himself almost exclusively to landscape was Gordon Vorster and his subtle descriptions of herds and deserts, rocks and plains, seem to signify a final stage in the long development of South African landscape, while in the work of Anna Vorster of the Transvaal and Erik Laubscher of the Cape the objective world became almost completely ABSTRACT in its expression.

With no indigenous stimulus the story of sculpture in South Africa begins with settler artists, first of whom was Anton van Wouw, who came to the country in 1890 as a man of 30 trained in the conservative traditions of the Rotterdam Academy. The first hint of a 20th-c. idiom was brought by Moses Kottler, who came to the country in 1915. Working most frequently in WOOD—the main sculptural medium of Africa

—he became known for his evocative and poignant figure studies. The first generation of 20th-c. sculptors were foreign born. Lippy Lipshitz (1903-   ), who came to South Africa from Lithuania at the age of five, was the first to train locally, and after further study in Paris under BOURDELLE became one of the most distinguished sculptors of South Africa, using a largely Expressionist symbolism and working a great deal in wood. The tendencies to abstraction and to Expressionism were carried on by a number of other foreign-born artists, among whom one of the strongest talents to make itself felt in the Transvaal was that of the Italian-born Edouardo Villa (1920-   ), who settled in 1947 and produced strenuous abstractions in various materials including welded metals, deriving sometimes from South African plant forms. Sculptors of this generation born in South Africa included Coert Steynberg, known for his monumental portraiture, the more intimate portraitist Rhona Stern, and Willem de Sanderes Hendrikz, whose death in 1959 deprived the art world of the Transvaal of one of its most colourful personalities.

31, 365, 366, 1109, 2047.

**SOUTINE,** CHAÏM (1894-1943). Painter, born in Lithuania, who after studying at Vilno came to Paris and was one of the painters from eastern Europe who gave a special character to the School of PARIS. He was a friend of MODIGLIANI, who introduced him to the patron Zborowski and the latter made it possible for him to paint at Céret in 1919 and at Cagnes in 1925. Soutine was an undisciplined and tragic character with a phobia against exhibiting his work. His talent was nevertheless recognized and he had important influence in the U.S.A. during the 1930s. Soutine belongs to the French EXPRESSIONIST school represented also by CHAGALL and in the U.S.A. by the Armenian Arshile Gorky (1904-48).

501, 896.

**SPAGNUOLO,** LO. See CRESPI, Giuseppe Maria.

**SPANDREL.** Architectural term for the triangular space between the curves of adjacent ARCHES or the two triangular areas with curved hypotenuses which remain adjacent to the haunches of the arch when it is set in a rectangular frame. The shape does not readily lend itself to decorative exploitation, if only because it is generally seen with its natural axis canted to one side. This gives it an unstable appearance and the only kind of subject for which it is suitable, other than ABSTRACT patterns, is the human figure in certain postures. It is not surprising that winged figures have been particularly favoured by artists who have had to fill spandrel shapes. Winged Victories occur in this position on Roman TRIUMPHAL ARCHES, and in the Middle

Ages we find ANGELS with spreading wings in the spandrels of the SAINTE-CHAPELLE in Paris, at Westminster Abbey, Lincoln Cathedral, etc.

In RENAISSANCE painting groups of figures were often skilfully arranged to fit neatly into this shape. The best known examples are probably those which MICHELANGELO used in the triangular spaces over the windows of the Sistine Chapel; although here the term 'spandrel' is used loosely for triangular areas with curved sides. Less sensitive artists, however, have at all times filled spandrels without reference to their peculiar shape.

**SPANISH ART.** I. PREHISTORIC. Spain was one of the main centres of Palaeolithic cave art in Europe from Aurignacian to Magdalenian times. (See STONE AGE ART IN EUROPE.) Since the dramatic discovery of ALTAMIRA in 1879 many other stations of rock painting and engraving have come to light in northern Spain, including El Castillo (1903), Hornos (1903), and La Pasiega (1911). Centres of Ice Age art in Spain extend southwards as far as Andalusia and among the sites found are Pindal (1908) and Peña de Candamo (1914) in Asturias, Los Casares (1934) near Guadalajara in Old Castile, and La Pileta (1911) near Málaga in Andalusia. These belong to a Franco-Cantabrian style of late Palaeolithic art which was widely distributed over western Europe and is not distinctively Spanish. To a later period, possibly after the termination of the Ice Age, are usually assigned the stylistically distinct paintings in rock shelters of eastern Spain with well known sites in the provinces of Teruel, Lérida, Albacete, Castellón, and Valencia. The later, pictographic art of the Neolithic period is found principally in the province of Andalusia, though examples occur also in Jaén, Almería, Cádiz, and even as far as La Mancha and Estremadura. From Asturias comes the curious anthropomorphic patterned figure of Peña Tú.

But it is not appropriate to speak of a Spanish art in the prehistoric period. The Palaeolithic and the Neolithic remains indicate widespread art styles which covered Spain as well as other European areas but without special features identifiable as Spanish. The same may be said of the period from about the 9th to the 3rd c. B.C., during which Phoenicians, Greeks, and Carthaginians successively established colonies in the Peninsula. Among the objects which have survived from these centuries particular interest attaches to the painted vases from Liria, Valencia, and the painted female BUST found at Elche (now in the Prado), probably native Iberian work of the 5th c. B.C.

2. ROMAN. During the six centuries of Roman occupation (218 B.C.–A.D. 414) Spain was the scene of extensive building of bridges, aqueducts, THEATRES, VILLAS, TEMPLES, etc., as elsewhere in the Roman Empire. With the exception of the isolated town of Mérida founded by the emperor Augustus as capital of the province of Lusitania, where extensive Roman ruins survive, most of the Roman towns and MONUMENTS in Spain were destroyed when they were used as quarries for later building and only a few TOMBS and TRIUMPHAL ARCHES survive. A few fragments of Roman mural painting have been found and several MOSAICS, notably one depicting the triumph of Bacchus discovered at Saragossa in 1910 (now in the Museo Archeológico Nacional) and one from Catalonia representing a chariot race (Museo de Arte de Cataluña, Barcelona). The evidence does not establish that Spanish ROMAN ART displayed any distinctive regional characteristics as in certain other parts of the Empire.

3. VISIGOTHS AND ISLAM. In 414 the Peninsula was overrun from the north by the Visigoths and in 711 from the south by the Arabs.

The Visigoths contributed nothing to the development of a distinctive Spanish art (see VISIGOTHIC) but did something to preserve the preceding Roman traditions in a crude and clumsy way. The Moslem civilization in Spain did indeed establish a brilliant artistic expression with distinct regional characteristics. But it belongs none the less within the tradition of ISLAMIC ART and is discussed under that head.

4. ASTURIAN: MOZARABIC: ROMANESQUE: MUDÉJAR. A local and ephemeral efflorescence of non-Islamic art occurred during the 8th and 9th centuries in the little kingdom of Asturias, which successfully resisted the Moorish invasion and established a pocket of Christian resistance. Its court aspired in a humble and provincial way to carry on the prestige of the Visigothic regime and established connections with other centres of Christian culture in the West, the Carolingian court, Normandy, and Rome. It is not certain how much Asturian painting and architecture owed to submerged local traditions, how much to the employment of foreign craftsmen (see ASTURIAN).

The beginnings of a genuine Spanish national art are usually traced to the MOZARABIC style which was developed by the Spanish Christians who kept alive the traditional culture of Spain under Moorish domination. It was brought to the northern regions of León and Castile by migrations from southern Spain in the 9th and 10th centuries and there formed, in the words of Henri Focillon, 'the earliest amalgam, the first harmonization, of Islamic and Western culture'. Its influence can be traced in Basse-Auvergne, in a sculpture of Notre-Dame at Le Puy, in Le Velay, and as far as the middle Loire. In Spain for a while it constituted a barrier against the early ROMANESQUE and might have survived as the basis of a genuine national style had it not become submerged in the 11th c. by elements imported from France. From the settling of the CLUNIAC monks at San Juan de la Peña in 1025 Spain became one of the most active spheres of Cluniac operations and Spanish CHURCH architecture, though still coloured by local feeling, bears witness to the stream of Romanesque

influence which from the reign of Alfonso VI (1072–1109) spread irresistibly over the whole of Christian Spain. The church at Palencia, rebuilt early in the 11th c. by a Frenchman, combined Asturian features with a Romanesque APSE. Romanesque features are prominent in the great Benedictine abbey of Ripoll (begun 1020), in the royal church of San Isidoro at León (begun 1054), and elsewhere in northern Spain. The church of Santiago de Compostela reflected the style of the French PILGRIMAGE CHURCHES; the half-barrel VAULTS of Auvergne reappear in the cathedral of Lugo. As Spain became the main sphere of Christian crusade the influence of France became paramount.

Yet the prestige of Islam was not easily shaken off. The Islamic culture under the Cordoban Emirate and Caliphate (755–1008) had far surpassed in brilliance that of Christian Europe and the great mosque of Córdoba (786–990) was the most important architectural monument constructed in western Europe since the Roman Empire. It was natural, therefore, that as the Christians successively recaptured cities such as Toledo (1058), Saragossa (1118), and Seville (1248), they made use of artisans and craftsmen trained in the Islamic traditions. These originated a style known as MUDÉJAR, which in the 14th and 15th centuries was very strongly Moorish in its decorative features and only

355. Horseshoe and scalloped arches from the Great Mosque, Córdoba (786–990)

slowly adapted itself to the GOTHIC. Thus the mudéjar extensions to the ALCÁZAR of Seville built for Peter I of Castile in the 14th c. bear many close analogies to the ALHAMBRA, which was built at about the same time for the Moorish sultans of Granada. Through the mudéjar the Moslem artistic inheritance persisted in Spain and Portugal long after the political power of the Moors had come to an end. An instance is the lasting popularity of the glazed polychrome tile or AZULEJO as a decorative wall facing. (See also HISPANO-MORESQUE POTTERY.)

5. GOTHIC, HISPANO-FLEMISH, PLATERESQUE. Owing both to geographical isolation and to historical circumstance Spanish life and culture early took on a pronounced regional character which has persisted in some measure into the present century. But it is as easy to exaggerate as to underplay the independence of the regional schools in art. There was constant interaction between the kingdoms and the activity of many of the more prominent artists, both Spanish and foreign, was inter-regional. The different centres perpetuated local tastes and traditions in work done within the framework of wider European styles which affected Spain from the 13th to the 16th c. and out of the union of many influences there gradually evolved, first in the Hispano-FLEMISH and then in the phases of PLATERESQUE, a type of art which reflects a distinguishable Spanish character. The formative effect of a Spanish spirit can be detected even when outside influences were strong.

In the second half of the 12th c. the foundation of a number of Cistercian abbeys south of the Pyrenees helped to acclimatize the TRANSITIONAL style of early French Gothic, to which type belong the cathedrals of Sigüenza and Tarragona and the old cathedral of Salamanca. The Franco-Gothic influence persisted in the 13th c. with the construction of the great cathedrals of Burgos, León, and Toledo, in which both architecture and sculpture reflect the inspiration of REIMS and AMIENS. During the 13th c. Franco-Gothic traits became gradually more prominent in painting also, although there was no abrupt breach with the older Romanesque traditions. French influence showed itself in the development of STAINED GLASS and book illustration. Alfonso X of Castile was an enthusiastic bibliophil and made his court a notable centre of skilled ILLUMINATORS. His collection included fine codices on chess and astronomy, while the illuminated codices of the *Cantigas*, poems in honour of the Virgin, were for the 13th c. what the *Beatos* (see MOZARABIC) had been for the 10th and 11th.

In the 14th c. an active regional school developed in the Spanish Levant in fairly close contact with new ITALIAN modes of Gothic, especially the Schools of SIENA and FLORENCE, both direct and through the papal court at Avignon. The impact of the Italian style is apparent in the work of Ferrer BASSA, a contemporary of GIOTTO and the outstanding figure of the early Catalan

School, though his work was often imbued with a more dramatic and expressive REALISM which was to become typical of Spain (FRESCOES in the Monastery of Sta María de Pedralbes, Barcelona, c. 1345). His contemporary at Barcelona, the MINIATURIST Ramón Destorrents, was teacher of the brothers Jaime and Pedro SERRA, who dominated the second half of the century. Italian influence may have been fortified by the presence in Spain during the latter part of the century of Fra ANGELICO and the Florentine painter Gerard di Jacopo Starnina (c. 1354–1409), to the latter of whom paintings in the cathedral of Toledo have sometimes been attributed.

The close cultural contacts between southern Spain and Italy continued throughout most of the 15th c. The kings of Aragon ruled the Balearic Islands, Sardinia, and Sicily (which seceded in 1458) and in 1442 Alfonso V added Naples to his domains. Vigorous trade with southern Italy and the Levant as well as direct commercial contacts with the towns of northern Italy encouraged artistic interchange. Flemish realism, whose impact in central Spain led to the emergence in the second half of the century of the Hispano-Flemish style, was foreign to the decorative traditions so strongly rooted in the south and either did not acclimatize itself there or, with some exceptions, its influence penetrated indirectly by way of Naples.

In the Catalan School the tradition created by the brothers Serra was tempered by the more animated narrative interest and lively colour of Luis BORRASÁ, in whose studio many of the next generation of painters were trained (ALTARPIECE of Sta Clara, Mus. of Vich, c. 1415; *St. Peter walking on the Water* from the altarpiece of St. Peter, Church of Sta María, Tarrasa, 1411). The talented painter, miniaturist, and designer of stained glass Bernardo MARTORELL combined a gift for NATURALISTIC observation with a Gothic archaism in his landscapes and backgrounds and the stylized poses of his figures (*Marriage of Cana* from the *Transfiguration* altarpiece, Barcelona Cathedral, c. 1447; panels of *St. George*, Louvre and Art Institute, Chicago, c. 1438). He is said to have introduced the gilded STUCCO RELIEFS which were later used to excess in this School. Lúis DALMAU, who worked in Valencia and Barcelona, visited Bruges 1431–6, the earliest recorded contact of a Spanish painter with the Flemish School.

The leader of the Valencian School, Jaime BAÇO, known as Master Jacomart, visited Naples in the train of Alfonso V and developed a style which combined a certain naturalism with a continuation of Italian Gothic features. His style was carried on in a rather more mannered and decorative fashion by his pupil Juan Rexach and by Rodrigo de Osona, whose only authenticated work, a *Crucifixion* in the Church of S. Nicolás, Valencia, seems to show a maturer concept of spatial composition. In Tarragona the work of Ramón de Mur was informed by a

similar predilection for 14th-c. Gothic and in Lérida Jaime Ferrer the Elder, whose work has recently been identified, followed in the path of the brothers Serra and Borrasá. Jaime HUGUET of Tarragona was the most original artist of the Catalan School at the mid century and worked in Barcelona c. 1448–92, while at the turn of the century Bartolomé BERMEJO, perhaps the greatest painter of the age, was working in Catalonia and Aragon.

In 1479 the marriage of Isabella of Castile with Ferdinand of Aragon united the two rival kingdoms and created a strong centralized power. Their authority was supported by the creation in 1480 of the office of the Inquisition and by 1492 they had completed the reconquest of Spain from the Moors. In all the arts, but most particularly in the arts of painting, architecture, and architectural sculpture, the influence and PATRONAGE of their court was of paramount importance. The active commercial relations of the kingdoms of Castile and León during most of the 15th c. with the Low Countries favoured cultural contacts and encouraged a taste for Flemish realistic painting of the Schools of Brussels and Bruges. Paintings of Flemish artists were imported in large numbers and the Queen herself possessed a notable collection. She appointed the Fleming JUAN DE FLANDES and the Frenchman Juan GUAS her court painter and architect respectively.

In central Spain Flemish naturalism did not encounter a deeply engrained local tradition as in the south and during the second half of the century there emerged a composite style of Spanish realistic painting known as Hispano-Flemish or Hispano-Flamencan. Much has sometimes been made in this connection of a diplomatic visit of Jan van EYCK to the Peninsula between 1427 and 1429, but apart from a commissioned portrait of Isabel of Portugal there is no record of work by him from this period and in later developments the style of Rogier van der WEYDEN and Robert Campin (MASTER OF FLÉMALLE) proved more congenial to the Spanish temperament. The influence of the latter may be seen in the Buitrago altarpiece of Jorge INGLÉS (c. 1450) and the *Annunciation* of Pedro de Córdoba (Córdoba Cathedral, 1475). Central Spanish painting was no mere inferior imitation of Flemish but coalescing with the long tradition of Moorish and mudéjar arabesque style gave birth to something new. A combination of monumental and decorative quality so characteristic of much later Spanish painting is found in Fernando GALLEGO, the most representative and perhaps the finest artist of this School, from whose work a large part of the production of Castile, León, Valencia, Burgos, Ávila, and Toledo more or less directly derives in the last third of the 15th c.

An age which saw the unification of Spain, the conquest of Granada (1492), and the discovery of America was a period of pride and ostentation which in the second half of the century found expression in magnificent architectural projects characterized by a lavish profusion of surface decoration in a style which fused late Gothic with mudéjar and, later, Italian RENAISSANCE features in an overwhelming riot of display which has nowhere else been equalled in Western art. The term 'Plateresque' is somewhat vaguely used by art historians of the various phases of this style whose chief common characteristic was an exuberance of surface relief ornament covering large areas without organic relation to underlying structure. It was also at this time that the medieval Castilian tradition of POLYCHROME wood sculpture culminated in the enormous reredoses such as those of the cathedrals of Toledo (1498–1504) and Seville (1482–1525), which combine Gothic design with some Renaissance detail.

Owing to the enthusiastic support given by the Queen the earlier phase of Plateresque is often given the name 'Isabelline'. In co-operation with anonymous craftsmen working in the mudéjar tradition foreign architects and sculptors played a large part in the evolution of this building style throughout central Spain, finding visible expression for the spirit of their adopted country. Juan Guas was master of works at Toledo and Segovia Cathedrals and built the magnificent Infantado Palace at Guadalajara. The Rhenish family Juan and Simón de COLONIA were working at Burgos. During the first half of the 16th c. the Gothic basis of the lavishly ornamented Plateresque building gradually gave way to a greater accretion of Italianate and Renaissance features. The brothers EGAS succeeded Guas at Toledo and the sculptor FORMENT worked both in a Gothic and an Italianate manner. Others who worked in the Renaissance Plateresque manner were Diego de SILOE, who succeeded Enrique Egas at Granada Cathedral, COVARRUBIAS, who succeeded Egas at Toledo, VILLALPANDO, translator of SERLIO, and sculptors such as Bartolomé ORDÓÑEZ and VIGARNY. Meanwhile, at the same time as this resounding fusion of Gothic and Renaissance styles with native decorative traditions and sometimes prompted by the same artists, there were 'purist' movements demanding either an uncontaminated Gothic or an 'antique' Roman style emancipated from Gothic elements. The former was represented by the Castilian Gothic cathedrals of Segovia, begun by Juan Gil de HONTAÑÓN, and the new cathedral at Salamanca, and a would-be Renaissance purism was represented by the transitional MANNERIST architecture of the so-called 'Granadine Renaissance' exemplified by Siloe's cathedral and Pedro MACHUCA's palace for Charles V.

By the middle of the 16th c. Italian Mannerism had a firm foothold in Spain, with its leading exponents among the sculptors, several of whom had visited Italy. The most original were Alonso BERRUGUETE and JUAN DE JUNI, whose carved wood reredoses were elaborately gilded and

**356.** Principal façade of the University of Salamanca (*c.* 1520–30). Plateresque design embodying Italianate motifs within a Gothic frame

painted by a technique called ESTOFADO. Among the pioneer Mannerist painters were the Fleming Pedro de CAMPANIA (Kempeneer) and the Spaniard Luis de Vargas (1506–68), both of whom worked in Seville. To the next generation of Mannerists belong the sculptor Gaspar BECERRA and the painter Juan de Juanes (*c.* 1523–79), son of Vicente Juan MACIP.

The story of Spanish art during the reign of Philip II (1556–98) is centred about his great

building enterprises, the monastery-palace El ESCORIAL, an austere structure in late Mannerist style planned by Juan Bautista de TOLEDO and largely executed by Juan de HERRERA under the close personal supervision of the King. Very many artists, including Italians, were employed on its decoration but neither the popular MORALES nor El GRECO participated since their work did not conform to Philip's taste. Philip was also the first Spanish monarch to employ court portraitists. As a result of his encouragement the Dutch artist Anthonis MOR VAN DASHORST and the Portuguese SÁNCHEZ COELLO

effective means of propagating the ideals of the Counter-Reformation. The dominant note was naturalism, associated in painting with a special interest in the representation of sculpturesque, three-dimensional form with dramatic emphasis on contrasts of light and shade which suggests influence from the School of CARAVAGGIO. A forerunner in this dramatic use of CHIAROSCURO shade effects, known in Spain as TENEBRISMO, was the Mannerist Juan Fernández de NAVARRETE, one of the few Spanish painters employed at the Escorial. But the effective initiators of the new Spanish naturalistic style were the generation of

357. The Escorial. External façade and angle towers

founded the tradition of Spanish court portraiture subsequently inherited by VELAZQUEZ—the first purely secular development in the history of Spanish painting.

Between the Mannerism of the late 16th c. and the full BAROQUE of the late 17th c. Spain produced no great architects. In keeping with the general conservatism of the times architectural development was discouraged by the official approval which the Herreran style continued to enjoy. But this same period was a Golden Age for religious painting and sculpture, which enjoyed an efflorescence reflecting the importance given to these arts as the most

artists born in the 1560s, of whom the most important were the painter RIBALTA in Valencia, the sculptor Gregorio FERNÁNDEZ and the painter MAYNO in Castile, and the sculptor MONTANÉS and painters ROELAS and PACHECO at Seville. The interest of this generation of artists in depicting nature also inspired a new type of STILL LIFE known as *bodegon* of which SÁNCHEZ COTÁN was a pioneer.

The next generation, born in the 1590s or early 1600s, included the great masters Velazquez, José de RIBERA, and ZURBARÁN and also the distinguished sculptor and architect CANO, while among lesser artists were the religious

painter of Italian descent, Juan RIZI and the Portuguese sculptor PEREIRA. With these masters Spanish art reached its zenith. Their successors of the following generation, born around the year 1620, were brought up in the same tradition of naturalistic representation, but developed away from it in an increasingly Baroque direction. Among them were the Sevillian religious painters MURILLO and VALDÉS LEAL, the painter-architect Francisco HERRERA the Younger, and the sculptors Pedro ROLDÁN and MENA. After them artistic originality declined. Claudio COELLO was the last of the important Spanish 17th-c. painters.

A change took place in the development of Spanish art about the middle of the 18th c. The strongly regional character of the various districts—although still more pronounced in Spain than in most other European countries—had been gradually devitalized during the 17th c. by the growing preponderance of Madrid as a cultural and economic centre. Decrease in ecclesiastical patronage with a consequent increase in the influence of the court tended in the same direction. The foundation of ACADEMIES and schools of art in the principal cities during the 18th c. had a still stronger effect of weakening local traditions by spreading the ruling European fashion of NEO-CLASSICISM evenly through the country and thus cut at the root of what had in the past given Spanish art such variety and vitality. During the reign of Charles III (1759-88) the decoration of the great Baroque palace at Madrid (begun in 1738 by the Italian architect SACCHETTI) became a focus for secular artistic activity and a means of imposing centralized taste comparable to the effect of the Escorial for religious art two centuries earlier. The work was put mainly in charge of the Italian Giambattista TIEPOLO and the German MENGS with the result that the influence of the latter in particular permeated Spanish painting for more than a generation. It is apparent in some of the early work of GOYA and in the output of Francisco BAYEU and Vicente LÓPEZ Y PORTAÑA. In architecture the change-over from Baroque to Neo-Classical was brought about by the academic architect Ventura RODRÍGUEZ and by Juan de VILLANUEVA, the most important architect of Neo-Classicism in Spain. Representative of Neo-Classicism in sculpture were Manuel Álvarez (1727-97) and Francisco Gutiérres (1727-82), while the last 18th-c. Spanish sculptor of distinction was the Valencian TOLSÁ, active mainly in Mexico.

Goya was one of those great individual masters who transcended the trends and teachings of his day, while lacking successors of sufficient calibre to found a school. During the 19th c. Spanish ROMANTIC art, though often it displayed considerable technical proficiency, remained too hide-bound within the cramping framework of academicism to produce much that could claim general European interest. The work of the MADRAZO family was typical of official painting in this period. The portraits of Antonio María ESQUIVEL are evidence of the growing importance of middle-class patronage in the arts, while in the third quarter of the century the Belgian HAES founded a flourishing school of LANDSCAPE PAINTING. Among the Romantics Eduardo ROSALES and FORTUNY, both of whom died young, achieved some recognition beyond the borders of Spain.

At the turn of the century there was a 'modernist' movement at Barcelona strongly coloured by ART NOUVEAU, of which the chief figures were the architect GAUDÍ—whose fantastic genius later came into its own—and the painter NONELL. During the 20th c. Spain contributed a number of artists to the School of PARIS, whose importance in modern AESTHETIC trends has been great. Besides PICASSO, there were Juan GRIS, Francisco Borès (1898-    ), the SURREALISTS Oscar Domínguez (1904-58), Salvador DALI, and Joan MIRÓ, and the sculptors Mateo Hernández and Apeles Fenosa (1899-    ). Since the Second World War a younger school of ABSTRACT or semiabstract painters has arisen with certain nationally Spanish characteristics. From a multiplicity of artists one may cite Antonio Tapies and Luis Sáez.

19, 55, 80, 266, 354, 355, 545, 546, 547, 959, 962, 973, 992, 993, 995, 1086, 1087, 1089, 1090, 1091, 1191, 1201, 1202, 1213, 1252, 1289, 1302, 1536, 1546, 1550, 1551, 1689, 1699, 2089, 2134, 2165, 2166, 2170, 2309, 2382, 2452, 2632, 2667, 2668, 2669, 2832, 2833, 2834, 2871.

**SPANISH COLONIAL ART.** From the first half of the 16th c. until early in the 19th c. the Spanish crown possessed a colonial empire comprising the greater part of the western hemisphere. It was organized under the Viceroyalties of New Spain (Mexico), Lima (Peru and highland Bolivia), and (from 1776) La Plata with Audiencia at Buenos Aires. As colonists the Spanish were not agriculturalists like the Anglo-Saxon settlers in North America but exploiters, who set up an aristocratic model of society with an economy based on the exportation of a small number of specialized products and the exploitation of indigenous labour. They therefore did not exterminate the indigenous populations but preserved them as a reservoir of suppressed labour. Few women accompanied the Spanish immigrants, and a large *mestizo* class arose from the union of the Spanish with the indigenous peoples. In the second generation there arose a further distinction between the *Peninsulares* (immigrants who were born in Spain) and the *Creoles* (unmixed whites born in the colony). The Spanish colonists were city builders who tried in all things to reproduce in the colonies the conditions they had known in metropolitan Spain. They were destructive of native arts and culture, importing into the colonies the architecture and art current in Europe. Nevertheless the employment of *mestizo* and Indian craftsmen in the workshops set up by immigrant European

artists led in the course of time to some syncretism with native traditions of design and representation and to the emergence of local or 'mixed' styles. (See MESTIZO STYLE.)

PAINTING. Apart from the few minor European artists who settled in the colonies painting in Spanish America was for the most part derivative from devotional religious prints from the Netherlands, Italy, and France. Mexican painting in the first half of the 17th c. was dominated by the Sevillian painter Alonso Vázquez (c. 1564–1608), who went to Mexico City in 1603 (*St. Michael casting out the Devil*, Academía de San Carlos, Mexico), and by his Mexican-born follower Luis Juárez (c. 1585–c. 1645) and the Spaniard Baltasar de Echave Orio (c. 1548–1620), who settled in Mexico c. 1580. The latter's son, Baltasar de Echave Ibía (c. 1585–c. 1645), and grandson, Baltasar de Echave Rioja (1632–82), were both important in the development of Mexican painting. The most proficient and exuberant artist of the late MANNERIST BAROQUE was Cristóbal de VILLALPANDO. From the late 1630s onwards Spanish American painting fell massively under the influence of ZURBARÁN. He was the one Spanish painter of note who sent his works extensively to the colonies and he was widely copied and imitated throughout Central America, Peru, and Bolivia.

In Spanish South America the main artistic centres were Cuzco, the Bolivian capital Sucre, and the 'silver city' of Potosí. At Cuzco a largely anonymous but quite distinctive style emerged soon after the Conquest (from c. 1560) and evolved slowly through the 17th and 18th centuries until well into the 19th c., spreading with variants throughout the Central Andean region as the basis of popular painting. Almost unknown to traditional art histories, it was one of the most interesting examples of a sophisticated FOLK ART, interpreting European concepts (religious themes, portraiture, pictures for the craftsmen's guilds, etc.) with a wealth of rather flat decorative pattern in bright colour and gold incorporating flowers and birds in a manner deriving from the pre-Spanish tradition. Of the foreign artists who worked in Peru mention must be made of the Italian Jesuit Bernardo Bitti (1548–c. 1610), whose example was influential in Bolivia, Peru, and Ecuador through the 17th and into the 18th c. The one major artist to be born in the Viceroyalty was Melchor Pérez HOLGUÍN, who dominated the Schools of Sucre and Potosí.

ARCHITECTURE. In the first years of colonization architecture other than ephemeral building was for the most part religious or military and few examples of civil or domestic architecture have survived from the earlier period. In the 16th c. the type of Spanish Peninsular architecture, which spread first to the island of Hispaniola and rather later to the Mexican mainland, was controlled by PLATERESQUE architects. Examples of their work are the cathedral of San Domingo (now Ciudad Trujillo), begun

c. 1520, and the first Mexican monasteries, such as the Franciscan convent of Huejotzingo (1544–71) with a lofty crennellated GOTHIC church in front of which is a quadrangular forecourt for open-air worship with pyramidical chapels (*posas*) at the corners. In the churches of the Viceroyalty of Peru Gothic features survived unusually late and pointed ARCHES were being used at Lima Cathedral in 1604, while rib VAULTING remained the rule at Cuzco until the mid 17th c. The most imposing monuments of the century 1560–1660 are the great cathedrals of Mexico and Peru designed by the itinerant Spanish architects ARCINIEGA and Francisco BECERRA in the Mannerist tradition then current in Spain. The most striking of the architectural achievements in colonial Latin America belonged to the Baroque. Outstanding examples of the early Baroque period (late 17th c.) are churches at Puebla and Oaxaca in Mexico, Bogatá and Tunja in Ecuador, and at Cuzco in Peru. Even more spectacular are the High Baroque and CHURRIGUERESQUE buildings of the 18th c. at Mexico City and elsewhere by Lorenzo Rodriguez (1704–74) and Francisco Antonio GUERRERO Y TORRES. Resplendent for their decorations of AZULEJOS, churches in this style were widely disseminated not only in Mexico but in Central America at Antigua in Guatemala, León in Nicaragua, and throughout South America as far as Córdoba in Argentina. A special style known as the 'Cuzco style' (not to be confused with the Cuzco School of painting) began in Peru after the earthquake of 1650, and was influential in the rebuilding at Lima after the earthquake of 1746 (Franciscan church, 1657–74; church of the Desamparados, 1669–72). Typical examples of the style are S. Pedro at Cuzco, the Belén Church at Cuzco, and the parish church at San Sebastián outside Cuzco. Provincial examples are the village churches at Lampa, Ayaviri, and Asillo on the Altiplano.

SCULPTURE. Spanish colonial sculpture makes little claim on the historian of art. Free-standing sculpture consisted chiefly of POLYCHROME religious figures more noteworthy for their devotional than their aesthetic appeal. Famous as objects of pilgrimage are the black *Christ of Esquipulas* (1595) by the Guatemalan sculptor Quirio Cataño (d. 1622), the Spanish-style *Virgen de la Natividad* (1686) by an Indian Juan Tomás Tuyru Tupac at the Almudena, Lima, and the still more popular 'Indian' *Virgen de la Candelaria* at Copacabana, Bolivia, by an Indian, Tito Yupanqui. Their artistic value is subordinated to their religious purpose. Throughout the colonial era there was a profusion of sculptured altars, CHOIR STALLS, PULPITS, etc., whose regional and stylistic variations make fascinating study; but they belong rather to the field of decoration than to that of independent art and, beautiful as they often are, they do not display trends or achievements of general importance. Most interesting is the RELIEF sculpture of architectural decoration, which over certain areas and periods mani-

fested an intimate fusion of native with European traditions to form an autonomous stylistic synthesis. In Mexico the *tequitqui* manner (see MESTIZO STYLE) is seen to advantage at the chapel of Tlalmanalco. In the highlands of the Central Andes from Arequipa to Potosí, for some hundred years after *c.* 1650, there prevailed a highly characteristic manner of flat relief stone carving which elaborated a synthesis of Christian motifs with native pre-Spanish ICONO-GRAPHY in flattish patterns reminiscent of pre-Inca textiles or, as at Potosí and San Juan de Juli, of carved wooden panels. Towards the end of the colonial period the high Baroque and ROCOCO decorative styles gave place to a severer mode which reflected European NEO-CLASSICISM.

52, 133, 431, 472, 629, 630, 688, 1534, 1535, 1536, 1914, 1927, 1997, 1998, 2278, 2528, 2672, 2727, 2835, 2855.

**SPECULUM HUMANAE SALVATIONIS.** This medieval textbook of Christian typology demonstrates how the Incarnation and PASSION of Our Lord (antitype) had been prefigured in the Old Testament, Jewish legend, and secular history (type); e.g. 'As Moses lifted up the serpent in the wilderness, even so must the Son of Man be lifted up', John iii. 14. (See TYPOLOGICAL BIBLICAL ILLUSTRATION.)

A Dominican friar, Ludolph of Saxony, probably wrote the first *Speculum* at Strassburg in 1324. Nearly 300 copies of the manuscript are known, a large majority of which are without pictures. Most of the illustrated copies are German or Flemish. The *Speculum* is written in irregular rhyming Latin verse, the complete version comprising 4,924 lines and 192 subjects, usually in sets of four. The main text has 42 or 45 chapters of 100 lines, each explaining four histories with three types to every antitype. A French prose version was made in 1448 by Jean Mielot, canon of Lille, and it was later translated into German, Dutch, English, and Czech; the *Speculum* had no great vogue in Italy.

The illustrated *Speculum* is normally arranged so that on opening the book there are four pictures at the head of the page—the antitype on the left and the types on the right. Eight introductory pictures of the Fall of the ANGELS, Creation and Fall of Man, and the Deluge precede the types and antitypes. In the third chapter New Testament history is introduced by illustrations of the Conception and Birth of the VIRGIN and followed by the Infancy and Passion of CHRIST to the Ascension and Pentecost; then the after-life and death of the Virgin, her intercession for mankind, Christ's mediation with the Father, the LAST JUDGEMENT, the pains of hell and the bliss of heaven. The work ends with three additional chapters of 208 lines, illustrating the Seven Hours of the Passion, the Seven Sorrows and the Seven Joys of Mary.

Its extensive influence and popularity can be judged from the fact that it was issued as a BLOCK BOOK, and used in STAINED GLASS, tapestry, sculpture, and painting throughout western Europe.

**SPENCER, SIR STANLEY** (1891-1959). English painter, born at the village of Cookham in Berkshire of an organist and musician. He studied at the Slade School 1909-12. He was a religious painter with a highly personal manner not bound to tradition or ecclesiasticism. He represented biblical stories and scenes from the Gospels in the everyday environment of Cookham. His LANDSCAPES were in a vein of quiet REALISM which had affinities with the PRE-RAPHAELITE style, but in his religious paintings he developed an individualistic manner of DIS-TORTION and emphasis. His religious paintings gave rise to considerable controversy both for this reason and because he depicted sacred incidents in the setting of a familiar environment (*The Visitation*; *Christ carrying the Cross*, Tate Gal.). He served in the First World War, part of the time in Macedonia, and the impact of this experience upon him is shown in his picture *The Resurrection: Cookham* (Tate Gal.) and chiefly in the series of decorative murals for the War Memorial Chapel at Burghclere in Hampshire (1926-34). It has been asserted that his deep religious faith was undermined during the war years and that the character of his later painting was affected in consequence. On the other hand some of the most well known religious paintings were done after the end of the war. Spencer was elected A.R.A. in 1934 but resigned in 1935 when two of his pictures were rejected. Outstanding among his later work is a series entitled *Resurrection: Port Glasgow* (1945-50), the large central panel of which is in the Tate Gallery.

His younger brother GILBERT SPENCER (1892-    ) also began with imaginative religious paintings but later concentrated on landscape (e.g. *A Cotswold Farm*, Tate Gal.). He painted decorations for the extension of Balliol College, Oxford.

**SPHINX.** The Greek name for a compound creature with human head and lion's body, a type which may have originated in Egypt, where the sphinx was generally male—often the likeness of the reigning pharaoh. The most famous and one of the earliest, evidently the work of Khafrē (Chephren) (*c.* 2550 B.C.), is the great sphinx at Giza, hewn from the solid rock and completed with masonry. It is 240 ft. long and 66 ft. high, and the face is 13½ ft. across. Couchant sphinxes occur frequently in architectural contexts, sometimes flanking the approaches to a temple PYLON, as at KARNAK. Sphinxes are also common in the art of the Near East, notably in Anatolia, north Syria, and Phoenicia; they may be either male or female and are most often winged. They appear too in the Mediterranean world, whence they will have passed to mainland Greece, the classical Greek sphinx being female,

**358.** Sphinx found at Spata, Attica. (Nat. Mus., Athens, late 6th c. B.C.)

with wings and human bust, the type of the Oedipus legend.

2921.

**SPINELLO ARETINO** (active 1373–1410). Italian painter, born at Arezzo, and probably trained in Florence. He was the most popular narrative painter of his time and undertook large fresco cycles all over Tuscany. He was a quick worker: within 1387 he completed the fresco cycles of St. Benedict for the sacristy of S. Miniato, Florence, and of St. Catherine of Alexandria for the Alberti family's oratory near Florence. He contributed to the loggia of the Campo Santo at Pisa the frescoes of the legend of St. Ephesus, now ruined. His last series was the cycle devoted to the Sienese pope Alexander III in Siena Town Hall (1408–10). Spinello was a facile technician who borrowed stock scenes and characters from great masters, both FLORENTINE and SIENESE. His sharp realistic detail and his neat calligraphic arrangements show the late 14th-c. nostalgia for the passing GOTHIC style.

**SPITZWEG,** KARL (1808–85). German painter, who lived in Munich. In his small narrative GENRE paintings he immortalized the German Philistine and small-town bourgeois. His luminous LANDSCAPES owed a good deal to French contemporaries and a visit to Paris in 1851.

**SPRANGER,** BARTHOLOMEUS (1546–1611). Flemish painter born and trained in Antwerp, where he came under the influence of Frans FLORIS. Spranger travelled widely in Italy and France before he finally settled in Prague in 1581 at the court of the emperor Rudolf II. There he became a leading figure in the later MANNERIST movement. His paintings exhibit extremely formalized 'spiral' compositions and reflect the work of CORREGGIO and his School (*Hercules and Omphale*, Vienna). Spranger met van MANDER in Rome and through him his style was carried to Haarlem, where it became a formative influence in the Haarlem Academy.

**SPRINGER,** CORNELIUS (1817–91). Dutch painter of views of old Dutch towns done in a precise manner and looking like renderings of actual sites, though most of them are made up of fragments taken from different places.

**SQUARCIONE,** FRANCESCO (1394–c. 1468). Tailor, painter, and probably an ART DEALER who was active in Padua in the middle years of the 15th c. Traditionally he has been seen as a centre of the new interest in ancient art, and as in some way the founder of the 'Paduan School' or 'Paduan style'. These are rather vague terms which are used sometimes of painters who, like MANTEGNA, Giorgio SCHIAVONE, and Marco ZOPPO, were trained at Padua at this time, sometimes more widely of a group of characteristics which recur in some of them: usually, a harsh awareness of plastic values, a violent and slightly tendentious use of linear PERSPECTIVE, a taste for classical architecture and other ANTIQUE accessories. But what Squarcione's part really was in all this is uncertain. A Paduan writer of 1560 patriotically described him as a famous and benevolent master, giving instruction to his many pupils, having a large collection of antique sculpture and paintings gathered on youthful journeys through Greece and Italy. More recent documentary research, on the other hand, gives a picture of a tailor who, turning painter in his middle thirties, was for many years discreditably involved in a series of lawsuits with resentful pupils who, like Mantegna, Schiavone, and Zoppo, had broken their apprenticeships with him. No traces of his supposed collection remain; and the only two paintings firmly associated with his shop—a POLYPTYCH in a retarded TRANSITIONAL style (Padua), and a half-length *Virgin and Child* derivative in character (Staatl. Mus., Berlin)—show little of the 'Paduan' character, and seem in any case to be from two different hands.

It is certainly likely that something of the antiquarian erudition of the university town of Padua rubbed off on the young men who spent time in Squarcione's workshop, but there does not seem much to suggest that Squarcione himself played any very positive part in this. As things stand it seems more reasonable to see the sources of the 'Paduan style' elsewhere: in the activity in the Veneto of Florentines like CASTAGNO, UCCELLO, and DONATELLO, for instance, or in the archaeological interests of

Jacopo BELLINI, Mantegna's father-in-law, and not least in the character of Mantegna himself.

**SQUINCH.** Architectural term for an ARCH built diagonally across the corner of a square building to support an octagonal spire or circular DOME. There is some reason to believe that the squinch was first employed in Persia to solve the problem of fitting a circular dome on a square structure (see PERSIAN ART).

**STAINED GLASS.** Glass-painting is the term commonly used of the art by which windows are filled with 'stained glass'. As a rule such windows are built up of panels, not too big for convenience in handling, composed of pieces of glass either dyed in its substance or superficially coloured, set together in a framework usually of lead, to form decorative or pictorial designs. The art began in the service of the Christian Church and is of BYZANTINE origin, but in its most characteristic development and its highest achievements it is essentially an art of Western Christendom, practised most splendidly in the west and north of Europe. Its early history is traceable only by inference: the oldest surviving remnants show an art already nearly perfect, with a technique which has endured in principle to the present day, developed or modified only in inessential details.

Stained glass as usually understood may be said to have come into existence when it occurred to some now forgotten craftsman to employ flexible strips of lead as a support for the pieces of coloured glass in a window; this made it unnecessary to cut them in simple geometric shapes as it had been when the designer had at his disposal only a rigid framework of stone or wood, such as was employed by early Byzantine builders. The lead framework is analogous to, and was doubtless prompted by, the strips of metal used in jewellery by goldsmiths, from Roman times onwards, as a setting for stones arranged in patterns or for *cloisonné* enamel-work.

From the earliest stage of which we have any evidence stained glass as we have described it was employed not only for geometrical or other purely decorative patterns but also for pictorial designs. The most ancient examples also show that besides glass and lead a third element—PIGMENT—is almost invariably present in a stained-glass window; this, however, is not indispensable—colourless windows in which a linear pattern is effected solely by manipulation of the leads can be seen in early Cistercian churches in France, and modern artists have composed figure-subjects in colours by ingenious use of glass and leads alone.

The broad outlines of ordinary stained-glass technique may be briefly described. A design is first drawn on a small scale; from this a CARTOON is made to the actual size of the window on paper (in earlier times a white-washed board or table was used). In this cartoon the lines to be fol-

lowed by the 'leads' are heavily drawn in black, whilst the various colours of the glass to be employed are indicated in writing. Pieces of 'pot-metal', as the glass is called by glaziers—whether plain white or stained with colouring oxides in the making—are then cut to the required outlines out of large sheets. This is done by breaking off a piece approximately the requisite size with the help of a heated iron instrument; the piece is then laid over the cartoon and the exact outline required traced with pigment over

Vitripictor. Der Glasmaler.

A Rte renidentes operosus inuro colores,
    Et vigil illustro vitra labore meo.
Nobilis effigie Ducis, historiaq; vetusta
Conspicitur nostra picta fenestra manu.

Nam quod imaginib. sunt templa referr... ae. oris,
Clara nec Heroum tot monumenta iacent.
Id mihi pracipuè laudabile duco, bonumq;
Hoc opus officij glorior esse mei.
Quippe repræsento speculum velut arma virosq;
Factaq; magnorum nobilitata Ducum.
                                                      Vitria-

**359.** The Glass-painter. Woodcut by Jost Amman from *Panoplia Omnium Artium* (1568), Hartmannus Schopperus

the underlying lines. To reduce it to this outline the piece of glass is finally nibbled by means of a 'grosing iron'—a tool cut along one edge with notches of various gauges; the invention of a diamond cutter in the 16th c. made it possible to do this much less laboriously and with greater accuracy.

The pieces of glass, now cut to shape, are ready for painting, an almost invariable accessory for rendering details such as features of

a face, folds of drapery, or foliage; the painter follows the lines of the cartoon over which the glass is again laid for this purpose. The pigment is a black or dark brown enamel which needs firing at a low temperature in a 'muffle' to fix it on the surface of the glass. When this operation has been completed the pieces of glass are once more assembled over the cartoon and fixed in the leads; these are strips of lead, cast—or (from the 16th c. onwards) moulded in a hand-mill or 'lead-vice'—with flanges forming a groove on each side to clinch the edge of the pieces of glass.

All stained-glass windows of any size are made up of separate panels held in place by iron bars ('saddle bars') to which they are attached by means of lead ribbons or, in modern times, copper wires soldered to the leads. In the very large windows of the 12th and 13th centuries (Canterbury, CHARTRES, SENS) the space is divided up by a framework of iron ('armature') which serves not only as a support against wind pressure for the leaded panels but also to accentuate the main outlines of the general design of the window.

Such was the technique of glass-painting in practice in the 12th c. The refinements introduced as time went on will be noticed in their place; their effect in general was to make the art easier for the practitioner, but often at the expense of aesthetic quality. Many of the changes made possible an ever nearer approach to pictorialism and the imitation of painting in FRESCO or OILS on an opaque GROUND. In the process of change the peculiar character of the art came to be ignored: the artists forgot that light itself, transmitted through a coloured material, is its primary MEDIUM; in their efforts to simulate the mass and solidity of natural forms they cast away the distinctive virtues of an essentially two-dimensional art.

Five windows in Augsburg Cathedral, each with a standing figure about life-size, are probably the oldest glass-paintings in existence other than fragments; their date is disputed—some authorities place it about 1050-60, others not before 1100-50. The earliest considerable remnants of stained glass in France are some windows (much restored) at SAINT-DENIS, near Paris; they belong to the work carried out under Abbot SUGER between 1144 and 1151 precisely. Slightly later are the great west window and a Madonna—*Notre Dame de la Belle Verrière*—embodied in a 13th-c. window of the choir at Chartres Cathedral. Small windows, now in museums, from Neuwiller, Alsace, and Flums, Switzerland, also belong to approximately the same period. In England there is 12th-c. glass at York and Canterbury.

Though windows surviving from the earliest GOTHIC period are but a fraction of what once existed, we can say that the Île de France with Saint-Denis as its artistic nucleus, was the centre of a school of glass-painting spreading its influence all over northern France and other regions west of the Rhine and even into England; these countries form a single artistic province, in which a general uniformity of window design with only minor local variations lasts well into the 14th c.

Windows of the early Gothic period until about 1250 are commonly strong in COLOUR, with a dominance of blue (the usual colour for the background), red, golden yellow, and green; accessories are violet, brown, a pinkish hue used especially for rendering flesh, and a horny white usually bluish or greenish in tone. The separate pieces of glass are small; the effect is of a vibrant MOSAIC of intense translucent colour. The only exception is the so-called GRISAILLE pattern windows devised as a measure of austerity by the Cistercian Order and afterwards adopted where low costs were necessary; in these coloured glass is introduced sparingly, if at all. The best example of such glass is in the Cistercian abbey church of Altenberg, near Cologne (c. 1300), glazed throughout except in the west window with *grisaille*. The most important in England —grisaille combined with bands or 'medallions' of colour—are at York Minster (the *Five Sisters* window) and at Salisbury.

The red ('ruby') glass used in glass-painting is peculiar in being in two layers—a 'flash' or thin film of red (from copper) fused on the surface of a thicker sheet of white. Black enamel is used for painting details and in mass where reduction of brilliance is requisite. A technique effectively employed in the 13th c. is that of scratching details such as DRAPERY patterns, hair, and especially the Lombardic lettering of inscriptions, through a solid mass of pigment so as to be seen as if in white or colour on a black ground. With the improvement in quality of the glass itself in the 14th c. and later it became the custom to graduate its translucency by skilful stippling of a film or smear of the black pigment.

Most early windows are pictorial. Like sculpture and wall-painting, they not only enrich the architecture but also served to illustrate the spoken word, whether the incidents of Bible history and the stories of the saints or the teachings of theology. In their completest development they are arranged in an ordered scheme such as that of which there are remnants at Canterbury.

Windows at this early stage can mostly be grouped in two main classes. In one the window is divided by an 'armature'—in itself an element of high value in the design—into a number of small compartments of geometrical form (medallions), containing successive or related incidents of a story or symbolic theme, set against a patterned background within a decorative outer border, usually of foliage (Chartres, Canterbury, Sens, Lyon). Such an arrangement of window space is unsuitable where the window is set at a distance away from the level of vision. Here a second type was needed: CLERESTORY windows were as a rule filled with a single standing figure, usually set in the semblance of an architectural niche (as at Augsburg and, magnificently, at

Chartres and BOURGES), or with two such figures in compartments one above the other. Of this latter kind the choir clerestory windows of Canterbury illustrating the descent of CHRIST from ADAM are an example. A CRUCIFIXION window at Poitiers of intense emotional power shows a masterly combination of medallion and large-figure types. A theme well suited to medallion windows is the TREE OF JESSE, adopted also by manuscript ILLUMINATORS and for wall- and ceiling-paintings; here the royal lineage of Christ from Jesse onwards is summarized, with reference also to the PROPHETS who foretold his coming. This theme appears first at Saint-Denis, with a figure of Abbot Suger introduced as donor; it was repeated in many other churches, among them York Minster (where there is a solitary panel closely resembling those of Saint-Denis) and Canterbury. As the 13th c. advanced the medallion windows declined in quality; the foliage borders became steadily narrower and more meagre, backgrounds were reduced to a tedious trellis, and figure-drawing lost its vigour. In the Sainte-Chapelle, Paris (1248), superbly beautiful though it is in its brilliant colouring and unity of general effect, this falling off in the quality of window design is clearly perceptible. An air of sterility characterizes most French stained glass in the second half of the 13th c.; from this stagnation it was rescued by the architectural revolution which was now approaching consummation (see GOTHIC ART).

The tendency in church building which followed the perfection of the Gothic vaulting-system was more and more to eliminate, as no longer structurally needful, the walls between the PIERS supporting the VAULTS. This made possible a vast increase in the width of windows and the problem of supporting so much glass was solved towards 1250 by introducing stone mullions and TRACERY, sub-dividing a single window where previously one or several smaller round-headed or lancet windows had been inserted in the solid masonry of the wall. A greater display of glass-painting thus became possible. Architectural construction and window design influenced one another reciprocally; better lighting and splendour of translucent colour became the occasion of structural refinement. The panels of glass were now held in place not by a decorative iron armature but horizontally by 'saddle-bars' of iron and vertically by the mullions. The greater area made available for the glass-painter was divided into narrower compartments unsuited to the earlier system of medallion design. Pictorial panels were to a large extent discarded in favour of the single figure standing in a niche. Niches with pinnacled and CROCKETTED CANOPIES of ever-increasing height were a useful expedient for filling the space: here we have a sign of the growing influence of the architect on the design of stained glass for his windows. The area below the canopied figures was often occupied by heraldry, or a small figure of a DONOR, or a panel depicting some incident relevant to the personage standing above. These architectural settings were treated, as yet, in a purely conventional manner and in two dimensions. A groundwork of trellis pattern in *grisaille* with spots or bands of colour was often adopted to reduce costs. Each light of the window was enclosed by a narrow border of foliage—often a vine—or composed of an initial letter, a crown, a heraldic badge, or other simple motif repeated at intervals, with strips of plain colour between; in large windows (S. Ouen, Rouen; York Minster) small human figures, animals, or birds sometimes enliven the border in this manner. A change in the character of foliage design is noticeable: leaves were no longer of a nondescript conventional kind but NATURALISTIC—vine, ivy, oak (with acorns), etc.

All these changes were greatly facilitated by a technical innovation first adopted, almost certainly in Paris, about 1310. It was discovered that chloride of silver applied to the surface of the glass and fired at a low temperature would produce a superficial yellow stain ranging from a pale brassy hue to a deep gold or amber, as desired. This 'silver-yellow' stain made it possible to depict a crowned head, or a gold-embroidered white robe, on a single piece of glass where two pieces, of white and yellow pot-metal, separated by a lead had previously been required; similarly, at a later stage this stain was used to make one pane of blue glass serve for sky and trees or grass. A change in general tonality is also observable as the 14th c. advanced; intermediate tones—tawny brown, murrey, olive green—tended to find favour instead of the earlier dominant primaries, ruby, blue, and golden yellow. In England York Minster, in France Évreux, best illustrate the change in layout and colour. The windows of Merton College Chapel, Oxford, set up not later than 1310, represent a type of window in which canopied figures in colour combine with a trellis or vine groundwork, for the most part in *grisaille*. Comparable designs appear at Rouen a little later, now enriched with yellow stain. A minor change during the 14th c. is the substitution of Gothic black-letter for Lombardic lettering in inscriptions.

The windows of central and southern Germany, Austria, and Switzerland followed in several regional schools a course of development of their own, quite distinct from that of French glass and its derivatives. From about the middle of the 13th c. canopied niches and simple medallions gave place to compartments with all manner of fantastic outlines such as squares, lozenges, or (for figures) upright rectangles, with simple or multiple curved lobes excrescent from their sides. The field remaining above and below the compartments was occupied by foliate and other DIAPERS of endless variety, often elaborately coloured, and in a class known as *Tapetenfenster* ('carpet windows') patterns of this kind took the place of *grisaille*. After 1300, foliage became naturalistic in Germany also. The range of

colours in German early Gothic windows was apt to be more varied than in French glass, with a larger proportion of violet, tawny, and brownish green (Naumburg Cathedral and St. Cunibert, Cologne). In Sweden a school of glass-painting grew up in the 13th c. largely under German influence, of which there are considerable remnants in Gotland.

Signs were already apparent in the middle of the 14th c. of the approach of a radical change in the character of design. In England the arrival of the PERPENDICULAR style of architecture, with its immense windows divided by mullions and transoms into a multiplicity of small lights in which the disproportion between height and width was lessened, gave new opportunities to the glass-painter. Soaring canopies were replaced by a more restrained type, showing a steady trend away from two-dimensionalism towards architectural REALISM; this was in general accompanied by the use for the canopies of only white glass, as a rule enriched with details in yellow stain. At the same time PERSPECTIVE began to appear. Thus ribbed vaulting is represented under the canopies housing figures in the east window of Gloucester Cathedral (c. 1350). This window displays another characteristic which gradually spread to many other churches in England—a restriction of the colour-scheme to little besides blue, ruby, white, and silver-yellow, giving an effect of great serenity. The large proportion of white glass, now so much improved in quality as to be almost colourless, provided the light increasingly needful for appreciation of the growing richness of interior carvings and furniture. Similar developments were taking place in France, where vast windows were subdivided by numerous mullions and FLAMBOYANT tracery.

In central Europe Italian influences, deriving from GIOTTO and communicated through ILLUMINATED MANUSCRIPTS and fresco painting, can be detected in a perspective treatment of canopies and other architectural settings of the figures and scenes represented (Königsfelden in Switzerland, St. Stephen's, Vienna). Though there was for a time no marked departure from two-dimensionalism, the trend everywhere was towards imitation in stained glass of the realism attained in other branches of the painter's art.

The content of church windows also underwent steady modification from the growing custom of introducing either portrait figures of the donors (of which Saint-Denis offers a rare instance as early as the 12th c.) or their shields of arms. Such figures steadily increased in scale, until in the 16th c. the donors were represented as large as the patron saints, by whom they were often accompanied, or as the participants in the incidents from sacred story depicted in the window. They were shown as if themselves onlookers or even actors in biblical scenes. The less obtrusive feature of heraldry gave opportunities for decorative design highly suitable to glass as a medium. As early as the 13th c.

escutcheons of superb effectiveness are to be found in France (Chartres) and in England (Westminster Abbey). Portraits and heraldry alike illustrate developments of technique which greatly facilitated the craftsmen's work.

The black pigment and silver-yellow stain were supplemented by the invention of new colours painted on the surface of the glass and fired, like the black, in a muffle. The black itself was used in stippled and shaded masses to give projection to figures and perspective to architectural settings; these came to have the appearance no longer of mere canopied niches, but of vast edifices sometimes, as notably as Ste Gudule, Brussels, and Liége (second quarter of 16th c.), filling much more of the window-space than the figures. The first new pigment—a brownish red (known by the name of a glass-painter, Jean COUSIN, to whom its discovery was mistakenly attributed)—helped to give verisimilitude to the complexion of a face where formerly the painters had to be content with pink or white pot-metal. This colour is akin to yellow-stain in the manner of its application. It first appeared about 1490, in Paris. It was followed by vitreous enamel colours, first blue (S. Patrice, Rouen, 1540), then violet and green. These latter are seen to perfection in the small heraldic panels which enjoyed immense popularity in Switzerland.

The heraldic glass-painters were helped also in rendering complicated charges in small shields by another technical refinement. This was the process of abrasion, first appearing, as at S. Ouen, Rouen, and Cologne Cathedral, in the second quarter of the 14th c. Used first with ruby glass and later extended to other colours, it consists in grinding away a coloured flash to reveal the underlying white. It was very serviceable not only in heraldry but also for such details as patterns on drapery. It was superseded in the 18th c. by the much easier process of ETCHING away the coloured film with hydrofluoric acid.

Pictures, as we have seen, were a main part of the glass-painter's output from the earliest stages of the art of which we have evidence; but the depiction of figures and actions must not be confused with pictorialism, by which the later artists strove to give an appearance of realism to their paintings. In pursuit of this aim they were at last driven to adopt expedients which stultified the very purpose of a window. The process begins with the development of perspective, already mentioned. A stage further, still within the legitimate boundaries of the art, was reached when the mullions, which restricted the designer to narrow and awkward vertical spaces, were disregarded and a subject such as the Annunciation or the Crucifixion was made continuous through two or more adjacent lights of a mullioned window. This procedure, seen in rudimentary form in the 14th c. (Évreux and elsewhere), culminated in the superb compositions, with their perfect balance of luminous colour, of such artists as the Le Prince family of Beauvais. At

the beginning of the 16th c. RENAISSANCE accessories began everywhere to creep into designs which were still essentially Gothic in feeling and technique. Soon, however, the influence of GRAPHIC ART, and especially of engravings after RAPHAEL, had its effect, and it became the ambition of glass-painters to achieve the highest possible degree of realism in representation. The obstacles presented by the medium were overcome by ever-increasing use of black pigment to produce CHIAROSCURO, and of enamels to give local colour; at the same time the traditional Gothic accompaniments (canopies, etc.) were completely discarded, and the whole area of a window was treated as a single field for a picture. This stage is seen in England in the later windows of King's College Chapel, Cambridge. Paris and provincial France offer countless examples of the transformation; its faults and such meagre virtues as it could achieve are apparent, above all, in the vast narrative windows of St. James, Gouda, in Holland (1555-1603). Pot-metal and its accompanying irregular leads were more and more discarded; their place was taken by monotonous rectangular panes with painting in enamel colours, often dingy in effect, showing a deplorable tendency to peel off with the passage of time. In Germany the colour qualities peculiar to early medieval glass were long maintained; the glass-paintings also bear the stamp of late Gothic GERMAN ART in general, with their powerful colour and their distinctive tracery often simulating leafy branches and twigs. In south Germany the leading glass-painter late in the 15th c. was Hans Wild, whose style was influenced by SCHONGAUER (Ulm, Nuremberg). The glass of the Cologne region was closely akin to that of the Netherlands; from about 1510 it began to acquire Renaissance idioms whilst preserving an essentially medieval spirit.

England followed a conservative course of its own. The established system of single figures and subjects in small canopied compartments was maintained, and a limited scheme of colour, with much white glass, was usual. The type is seen in the great east window of York Minster, dated 1408, with its multiplicity of small panels, the work of John Thornton of Coventry, and later windows of the choir; Ludlow, Cirencester, and Great Malvern also provide characteristic examples of the 15th c. Continental influences and Renaissance fashions were beginning to take effect, as in the Cambridge windows already mentioned, when the Reformation put an end for a time to glass-painting on the grand scale. In England, as everywhere north of the Alps, from the 15th c. onwards glass-painting, which began as an art of the Church, was increasingly adopted, especially in the form of heraldry, for secular buildings.

Stained glass never won universal acceptance in Italy, where it took on a character of its own. The earliest substantial remains, dating from the late 13th and 14th centuries under German influences, are at Assisi. The development may be followed in Florence (the Duomo and other churches), Venice, Milan, and Arezzo. Notable are the 15th-c. windows, already in the spirit of the Renaissance, from designs by Lorenzo GHIBERTI and others; the *occhio* or large round window undivided by tracery is a feature peculiar to Italy. Spain has early windows of the French medallion type at León Cathedral and magnificent late Gothic and early Renaissance glass under Netherlandish and Rhenish inspiration and largely designed by foreigners (Burgos, Toledo).

In the 18th c. glass-painting became virtually extinct, except in England. Here there had been a rebirth in early Stuart times at the hands of FLEMISH artists such as the brothers van Ling (working chiefly at Oxford); from this grew a tradition fostered by ROMANTICISM and kept alive, though in a manner which was the very negation of stained-glass principles, by a succession of practitioners of the enamel-painting technique such as William Peckitt of York (1731-95), until the GOTHIC REVIVAL presented new opportunities. About 1828 English glass-painters carried the reborn art to Paris. But the efforts of the revivalists were hopelessly baffled, as their insipid plagiarisms of medieval work bear witness, by glass entirely unsuitable in quality. Deliverance came from the researches in the 1840s of the amateur Charles Winston (1814-64). A more sympathetic material was developed, but slavish fidelity to archaistic designs, by no means extinct even at the present day, threatened artistic stagnation. Rescue from this disappointing situation was brought when William MORRIS turned his attention to stained glass. From 1861 onwards, his associates Philip WEBB and the PRE-RAPHAELITE painters provided him with designs which soon broke wholly away from medieval formulas and culminated in such original embodiments of sound stained-glass technique as Edward BURNE-JONES's windows at Birmingham Cathedral (1887). Though later developments in Great Britain have shown a reactionary tendency, the pioneering work of these artists may justly be claimed as the beginning of the immense advance in glass-painting which has taken place abroad in the present century, notably in France, Germany, and Holland. Among artists of standing who have designed windows may be named MATISSE, ROUAULT, SCHMIDT-ROTTLUFF, THORN PRIKKER, and VIGELAND.

77, 139, 876, 1609, 1764, 2163, 2190, 2231, 2852, 2929.

**STANDING FIGURE SCULPTURE.** See CONTRAPPOSTO.

**STANTONS, THE, OF HOLBORN.** A family of mason sculptors with a large workshop managed successively by THOMAS (1610-74), his nephew WILLIAM (1639-1705), and the latter's son EDWARD (1681-1734). They were

much patronized by the lesser aristocracy and the professional classes, and their signed MONUMENTS are widespread in England. These range from relatively simple tablets to elaborate TOMBS with several figures. Their designs are usually conservative, but William (who was also a mason) and Edward were competent sculptors.

**STARK,** JAMES (1794-1859). English LANDSCAPE painter, born at Norwich and a pupil of CROME. He was a member of the Norwich Society of Artists from 1812 and he exhibited intermittently in London from 1814. He worked in Norwich 1818-30, then in London till 1840 when he settled at Windsor. He was a competent, painstaking, and unoriginal follower of Crome. He published *Scenery of the Rivers of Norfolk* (1827-34), engravings from his work by various hands with text by J. W. Robberds. His work may best be studied at the Castle Museum, Norwich.

**STATES.** See PRINTS.

**STEATITE.** See SOAPSTONE.

**STEEL CONSTRUCTION.** The economical industrial production of steel by the Bessemer process, invented in 1856, made possible the structural use of steel for building. It was first used in the 1880s by the CHICAGO SCHOOL of architects and in France for EXHIBITION ARCHITECTURE. The first steel-frame English building was the Ritz Hotel, Piccadilly, built by Merves and Davis in 1906.

The use of steel-frame construction, which in America has generally been preferred to the CONCRETE frame, made possible the development of the SKYSCRAPER.

**STEEN,** JAN (c. 1626-79). Dutch painter of Leiden best known for his animated scenes of taverns and popular feasts. In the Netherlands a 'Jan Steen household' has become an epithet for an untidy house. But Steen, one of the most prolific Dutch artists (nearly 900 paintings have been ascribed to him), has many other facets. In fact with the exception of REMBRANDT—who seems to be an exception to every generalization made about Dutch artists—he was the most versatile. He painted portraits, historical and mythological subjects, and made more than 60 religious paintings. The animals, birds, and STILL LIFES in his pictures are as fine as those painted by any of his contemporaries, and no one surpassed him as a painter of children.

His masters were probably Nicolas Knupfer (1603-60) and Jan van GOYEN, who became his father-in-law. The influence of the latter can be seen in the LANDSCAPE backgrounds which are so important in his early pictures. The impact of Frans HALS, Adriaen van OSTADE, de HOOCH, DOU—again, apparently every important Dutch master except Rembrandt—can also be seen in

his work at different periods of his career; but he was able to adopt the subjects or techniques of other artists without losing his own artistic personality. Steen lived at various times in Leiden, The Hague, Delft, Warmond, and Haarlem. He was in the last city from c. 1660 to 1670 and it was there that his popular pictures of *St. Nicholas' Feast* (Amsterdam) and *As the Old Sing, the Young Pipe* (The Hague) were painted. His many different versions of these subjects reveal the versatility of his inventive powers. Those made during this period are relatively large in scale and broadly painted; the dominant hues are salmon-red, rose, pale yellow, and blue-green. At this time Steen must have had close contact with theatrical companies. He used stock types from the repertory of the Italian Commedia dell'Arte (e.g. the doctor in *The Doctor's Visit*, Amsterdam), and he depicted Dutch amateur actors (*The Rhetoricians*, Worcester, Mass.). Steen is well represented at the National Gallery, London, where his whole development from the early picture *The Game of Skittles*, which shows the lyrical effect of evening summer light playing through the foliage of slender trees, to the late *Music on the Terrace*, which approaches the ROCOCO world of WATTEAU, can be studied.

1788.

**STEENWYCK,** VAN. HENDRICK VAN STEENWYCK the Elder (c. 1550-after 1600) and his son HENDRICK the Younger (1580-before 1650) were Netherlandish painters of architectural views. The father, who was probably a pupil of Vredeman de VRIES, is credited with developing the church interior as a special branch of painting. Both father and son painted small pictures of real and imaginary GOTHIC churches. There are typical examples of Hendrick the Younger's work in the National Gallery, London.

**STEER,** PHILIP WILSON (1860-1942). English painter, son of a portrait painter PHILIP STEER. He was first trained at the Gloucester School of Art and studied in Paris at the Académie Julien and subsequently at the École des Beaux-Arts (1882-5). Throughout his life he was a keen admirer of TURNER. The impact of the IMPRESSIONISTS on his work began not during his studies in Paris but from London exhibitions of their works during the latter part of the 1880s. He was a founder member of the NEW ENGLISH ART CLUB and in 1892 George Moore wrote of his exhibition 'it is admitted that Mr. Steer takes a foremost place in what is known as the modern movement'. He was assistant teacher of painting at the Slade School 1893-1930. A retrospective exhibition of his work was given at the TATE GALLERY in 1929. He gave up painting in 1935 owing to failing eyesight. Excellent pen-portraits of Steer have been given by George Moore in *Conversations in*

*Ebury Street* and by Sir William Rothenstein in *Men and Memories.*

In LANDSCAPE PAINTING Steer has been judged the greatest English artist of his generation, carrying on the English NATURALISTIC tradition of GAINSBOROUGH, CONSTABLE, and Turner but enriching it with the atmospheric qualities exploited by the Impressionists. In figure painting he stood at the opposite pole from SICKERT, treating his subjects with the same detachment as landscape. His work is characterized by unrivalled magic of light and spaciousness and by its great beauty of colour and pattern and its subtlety of tonal design. He was a 'pure' painter, whose work is entirely devoid of literary comment. He is well represented at the Tate Gallery.

1405, 1715.

**STEFANO DA ZEVIO** or STEFANO DI GIOVANNI DA VERONA (*c.* 1375–after 1438). Italian painter of the Veronese School, the most faithful Italian exponent of the stylistic current called INTERNATIONAL GOTHIC, which flowed through Verona into Italy from northern Europe at the end of the 14th and the beginning of the 15th centuries. The chief pictorial symbol of the style was the VIRGIN seated in an enclosed garden, of which there is an exquisite example by Stefano in the City Museum, Verona. His principal late work is *The Adoration of the Magi* (Brera, 1435).

**STELE.** A Greek word now used principally of a stone (or TERRACOTTA) slab that marks a grave or displays an official INSCRIPTION. Grave stelae were sometimes plain, but by the 6th c. B.C. were often carved or painted. The earliest were long and narrow, surmounted by a palmette or seated SPHINX and decorated with an IDEAL figure, standing and in profile, to represent the dead. In the 5th c. B.C. a squarer gabled slab offered room for relatives too, and the poses were more open. The Archaic figures are gay, the classical resigned, till in the 4th c. emotion intrudes. Original grave stelae are numerous, but their quality varies.

**STELLA,** JACQUES (1596–1657). French painter and engraver born at Lyon. He went to Florence (*c.* 1619), where he was patronized by Cosimo II de' MEDICI and made engravings of his festivities. From 1623 he spent many years in Rome and became a friend and imitator of POUSSIN, returning to France in 1634.

**STENCIL.** Duplicating a design by means of a stencil is one of the oldest and simplest of the GRAPHIC methods, the principle being merely that of cutting holes in a piece of card or metal and brushing colour through the hole on to a sheet of paper beneath. Until the SILK SCREEN was devised only simple shapes could be printed by the stencil technique; yet from the aesthetic

point of view its very simplicity and sharpness of outline may become major virtues, and the process has a long history both for fabric printing and for the colouring of prints, especially WOOD-CUTS (see COLOUR PRINTS AND COLOURED PRINTS).

In France, where it is called *pochoir*, stencilling has been much employed in book illustration. A notable English example of this use was in Paul NASH's illustrations to Sir Thomas Browne's *Urne Buriall* (1932), where it is combined with collotype.

**STEREOCHROMY.** The Victorian name for WATER-GLASS PAINTING.

**STERN,** IRMA (1894–1966). South African painter, born at Schweitzer-Reneke in the Transvaal. She studied at the BAUHAUS (Weimar) and in Berlin. She was active from 1916 and is perhaps the South African artist best known in Europe. She travelled widely and exhibited both in group and in one-man shows in Berlin, Paris, Brussels, Amsterdam, London. She is represented in many collections in South Africa and in Europe.

**STEVENS,** ALFRED (1818–75). English sculptor born at Blandford in Dorset, the son of a house-painter. With the assistance of the Rector of Blandford Stevens was sent to study in Italy when he was 15. There he spent nine years, and in 1841 was employed by THOR-WALDSEN in Rome until they both left Italy in 1842. In 1845 he was appointed to teach architectural drawing, PERSPECTIVE, and MODEL-LING in the Board of Trade's School of Design. He resigned his post two years later but had already exercised a considerable influence on the younger English artists. In 1850 he was appointed chief artist to a firm of bronze- and metal-workers in Sheffield, H. E. Hoole & Co., and his designs secured the firm first place in the Great Exhibition of 1851. On his return to London in 1852 he designed, among other things, the vases and lions on the railings in front of the BRITISH MUSEUM. In 1856 he went in for the competition for the Wellington Monument to be erected under one of the great arches of St. Paul's Cathedral at a cost of £20,000. His design was placed sixth and he was awarded a premium of £100. Subsequently, however, the commission was given to him, though £6,000 was deducted from the expenditure originally intended for the purpose of compensating the other artists. Stevens devoted most of the rest of his life to this grand MONUMENT, which was to be his masterpiece, and died before it was finished. It stood for many years in a small side chapel, where its magnificent BRONZE groups *Valour and Cowardice* and *Truth and Falsehood* were hidden from view. The equestrian group, which Stevens had intended should be placed on top, was abandoned and he left only a rough model. In 1892 through the efforts of Lord LEIGHTON the monument was moved to the position originally

intended for it; and in 1912 the equestrian group was carried out by John Tweed (active *c.* 1894-1950).

Stevens's art was noted for its purity of line and revival of composition in the grand manner of the High RENAISSANCE. He worked in all media, silver, bronze, MARBLE, porcelain, making mantlepieces—a fine one from the dining-room of Dorchester House is now in the TATE GALLERY—and church furniture. He was also a painter, though he destroyed much of his work because it did not satisfy him. His unexecuted designs (many of them now in the Tate Gal.) included schemes for the decoration of the interior of the dome of St. Paul's Cathedral and the Reading Room at the British Museum. Among the few portraits that survive is *Mrs. Leonard Collman* (Tate Gal.).

78, 2674, 2675.

**STEVENS,** ALFRED-ÉMILE-LÉOPOLD-VICTOR (1823-1906). Belgian painter of female portraits, GENRE pictures, and coastal and MARINE scenes. After an early training with Navez (1787-1869) in Brussels he visited Paris in 1844 and there spent the major part of his life. He specialized in depicting fashionable ladies in an interior or as single figures, painting with a very subtle palette and meticulous though not wearisome detail, which earned him the title 'The TERBORCH of France'. His coast scenes with boats and figures were done in a freer style, comparable to JONGKIND and BOUDIN. Stevens was extremely successful in his lifetime, respected by the young IMPRESSIONISTS, who admired his obvious merits. His influence on WHISTLER was apparent but his closest friend was probably MANET, to whom he introduced the dealer Durand-Ruel. In 1900 he achieved the distinction of a one-man exhibition at the École des Beaux-Arts, Paris, the first one-man show accorded to a living artist. Stevens has been surprisingly little known in England, considering his rating in Belgium, France, and the United States.

**STIFTER,** ADALBERT (1805-85). Austrian poet and painter. As an artist he was self-taught. His pretty and colourful Austrian LANDSCAPES may be compared to COROT's in their lyrical interpretation of scenery.

**STIJL,** DE. Dutch art periodical founded by Theo van DOESBURG in 1917 in collaboration with Piet MONDRIAN and edited by him until 1928. A final number was published in 1932 by Mme van Doesburg in memory of her husband. At the outset the periodical was devoted to the principles of NEO-PLASTICISM associated in Holland with Mondrian's name. But in 1924 van Doesburg welcomed DADAISTS such as ARP, SCHWITTERS, and François Kupka (1871-1957) as contributors and with Arp and Schwitters, and Tzara edited a Dadaist supplement under the name of *Mecano*. Mondrian ceased to contribute to *De Stijl* after 1924 and in 1926 van Doesburg published the manifesto of a splinter movement which he called ELEMENTARISM. Despite this lack of cohesion *De Stijl* was probably the most influential on artistic ideas and performance among the many *avant-garde* publications in Europe between the two wars.

The name is also applied to the group of artists and architects who were associated with the periodical and to the movement in architectural style which they inaugurated. Besides van Doesburg and Mondrian the painters included Vilmos Huszar (1884-1960), Georges Vantongerloo (1886-1965), who was also a sculptor, and Bart van der LECK. These and most others reached ABSTRACTION by generalizing forms from natural representation and were thus differentiated from Mondrian, who constructed his paintings *ab initio* from non-figurative geometrical elements.

The architects in the group included OUD, RIETVELD, Robert van't Hoff (1887- ), and Jan Wils (1891- ). They favoured a CUBIST design which emphasized smooth surfaces and austere lines and they conceived the enclosed spaces as opening out on all sides into the infinite space of the environment. Like Mondrian they restricted themselves to primary colours and used colour not as decoration but as an ancillary to special definition. The architectural style of De Stijl and in particular its new concept of space had great influence on the German movement NEUE SACHLICHKEIT, with which it is sometimes confused.

1419, 1420.

**STILE LIBERTY.** See ART NOUVEAU.

**STILL LIFE.** A painting of inanimate objects such as fruit, flowers, or utensils, usually arranged on a table. The term derives from the Dutch *still-leven*, which did not come into use before the middle of the 17th c. and denotes simply a motionless (*still*) aspect of nature (*leven*). Paradoxically, therefore, it means exactly the same as the French term *nature morte*, which dates from the 18th c. The painting of such inanimate objects for their own sake and for the display of the painter's skill presupposes an attitude to the art of painting that is by no means universal in the history of art. It existed only sporadically in 4th-c. Greece, as when ZEUXIS painted grapes and Pyreicus (according to PLINY) obtained great glory and high prices by painting not only low GENRE pieces but also 'foodstuff'. The admirable pieces of still life surviving in POMPEIAN murals and in ROMAN MOSAICS make one mourn the loss of the GREEK originals. According to VITRUVIUS (VI. vii. 4) painters called pictures of eatables *xenia* from the custom of sending gifts of foodstuffs to foreign visitors. Descriptions of *xenia* are included in the *Imagines* of PHILOSTRATUS. They seem to have had the features of genuine still lifes.

There was no room for the still life proper within the context of Christian medieval art, but during the same centuries the painters of the Far East developed the most subtle understanding for the hidden life of plants, birds, and insects. Some of these approximate in subject to the Western conventions of still life, but the motif here never becomes a mere pretext for the solution of pictorial problems (see CHINESE ART).

The re-emergence of still life in Western art is linked with the revival of the classical ideals of ILLUSIONISTIC NATURALISM. When Boccaccio praised GIOTTO for his skill in rendering any object so as to deceive the sight he was using the naïve language of classical criticism and it has been asserted that the TROMPE L'ŒIL niches in Giotto's Arena Chapel or T. GADDI's similar recesses with ecclesiastical implements are the first still lifes of Western art. Neither these, however, nor the books and implements frequently displayed on quattrocento marquetry work were yet emancipated from a larger decorative and EMBLEMATIC context. The meticulous naturalism of the Netherlandish masters such as van EYCK and Rogier van der WEYDEN was much admired for its own sake and in particular their skill in rendering light and texture contributed to their fame north and south of the Alps. But though this style of painting demanded from the artist the sort of detailed study which belongs to still life, such studies were not made or sold for their own sake. Neither DÜRER's famous water-colours nor Giovanni da UDINE's studies of fruit or birds (made in preparation for decorative GROTESQUES) can therefore be classed as still lifes. Whether or not Jacopo de' BARBARI's panel in Munich with a dead partridge and a pair of gauntlets (1504) was such a study, a cover for a portrait, or the first still life, remains a matter for speculation.

The rise of the still life as an independent category of art is certainly connected with that emancipation of 'specialists' in the Netherlands of the RENAISSANCE which secured the survival of painting after the crisis of the Reformation. Ecclesiastical PATRONAGE had all but ceased and the COLLECTOR and ART DEALER provided the main source of income for the artist. Among the specialists in portrait, genre, and LANDSCAPE there were some who liked to display their skill in the rendering of inanimate objects. Thus Pieter AERTSEN and Joachim BUECKELAER represented such biblical scenes as CHRIST in the house of Martha piling up food and kitchenware in the foreground—a fashion that also found imitators among such Italian MANNERISTS as PASSAROTTI. Round about 1600 the 'banquet piece', a meal on a table, was a frequent collector's item.

The new degree of REALISM introduced at that time by CARAVAGGIO in Rome was quickly absorbed into this tradition and a number of Italians and Spaniards painted such *bodegones* ('shop-pieces'), mostly in sombre tones.

But the development of the typical still life took place mainly in the Netherlands. The workshop of RUBENS in Antwerp favoured specialization and J. BRUEGHEL painted flowers while SNYDERS concentrated on trophies of the hunt. In 17th-c. Holland the simpler motifs of still-life painters tend to reflect the different ethos of a Protestant society. Some of them preserved an emblematic meaning reminding the spectator of the vanity of earthly pleasures (the skull, the watch, the hour glass, the smoking pipe), perhaps as a convenient pretext for the display of sensuous riches. Different towns favoured different motifs: the university town of Leiden liked books and skulls, The Hague with its rich market preferred BEYEREN's fish, wealthy Haarlem the 'breakfast' pieces of Willem Claesz HEDA and Pieter CLAESZ, and Catholic Utrecht, the home of many Belgian refugees, continued the FLEMISH tradition of flower painting. Amsterdam, of course, was dominated by the genius of REMBRANDT, whose occasional excursions into still life took such unexpected forms as his famous carcass of an ox in the Louvre. Willem KALF, perhaps, came nearest to understanding the pictorial problems posed by Rembrandt's art. (See DUTCH ART.)

In France, and wherever the ACADEMIC creed held sway, still life was considered the lowest form of art. Some French 17th-c. masters, especially outside Paris, achieved great skill and charm in *trompe l'œil* exercises but it needed the independence and sensitivity of CHARDIN in the 18th c. to elevate the still life into a major art form of monumental quality. Still life never found much favour in Germany or England during the 18th or 19th centuries and in the United States it remained confined to the more simple aspects of *trompe l'œil* (PETO, HARNETT).

The relatively low estimate of still life, encouraged in England by REYNOLDS, could only be overcome through the spread of the doctrine of ART FOR ART'S SAKE with its slogan that 'a well painted turnip is better than a badly painted Madonna'. COROT, COURBET, and MANET broke down the distinction between a study and a picture for exhibition. The still lifes in their *œuvre*, though not very numerous, claim the same status as any other work. IMPRESSIONISTS such as MONET and RENOIR still relied on the sensuous appeal of sparkling textures, while CÉZANNE, the greatest master of the still life, turns simple motifs such as his famous apples into MASTERPIECES of formal organization. Thanks to his influence the still life became the chosen demonstration ground of new movements from FAUVISM to CUBISM and beyond.

Still life came finally into its own with the new AESTHETIC attitude of 20th-c. art which regards a picture not (or not primarily) as a visual anecdote or the reproduction of something in nature outside itself but as the creation of a new disposition of shapes and appearances. There has been a deliberate attempt to play down the

literary and anecdotal element and the interest of the subject, relying solely on the pictorial construct. For this reason still life has become the most characteristic genre of 20th-c. art movements and even where subject is introduced (e.g. landscape, portraiture, war painting) it has often been treated in the manner of a still life. This tendency must not be confused with the SURREALIST impulse to represent a dream reality by exploiting the disturbing quality of incongruous juxtapositions and particular distortions of space nor yet with the occasional attempt to suggest a transcendental or quasi-metaphysical reality by the depiction of a commonplace object. (An example of the former is MAGRITTE's picture of old boots with real toes, *The Red Model*, 1935, and of the latter van GOGH's well known picture of two old shoes which has been elaborately expounded by the philosopher Heidegger.) The Cubist reduction of the portrait to a quasi-still life may therefore be taken as typical.

853, 2555.

**STIMMER.** Swiss family of painters and engravers, of whom the most well known was TOBIAS (1539-84). He decorated the astronomical clock in Strasbourg Cathedral and was repeatedly employed in grand Italianate schemes of exterior or interior decoration in FRESCO (Haus zum Ritter, Schaffhausen; Old Castle, Baden-Baden). He was also a prolific book illustrator.

**STIPPLE ENGRAVING.** A method of engraving in tone, much used in the late 18th and early 19th centuries for the reproduction of DRAWINGS, but now extinct. It differed little from the CRAYON MANNER and was generally used in conjunction with it.

In principle stipple is merely an element in LINE ENGRAVING, for dotting the surface of a copper plate with short flicks of the BURIN has always been one of the line-engraver's ways of producing a tone. Stipple engraving as practised in the 18th c. was, however, a combination of the line-engraver's technique with ETCHING. The plate was first covered with an etching ground and the design laid in with dotted lines, as if for a print in the crayon manner. After biting, the engraver cleared away the ground and proceeded to build up his tones by means of a multiplicity of dots engraved with a special burin. The work was frequently completed with ROULETTES and sometimes with engraved lines.

Stipple engravings are characterized by softness and delicately graded tones and bear a certain resemblance to modern half-tone REPRODUCTIONS in that the shaded areas are rendered by concentrations of small dots running into one another. Like the crayon manner PRINTS they were frequently printed in red and sometimes in colours, the plate being coloured by hand between each printing.

The use of stipple was almost entirely confined to England, where Francesco BARTOLOZZI made a great reputation with prints after fancy subjects by Angelica KAUFMANN and G. B. CIPRIANI. Other notable stipple engravers were William Ryland (1732?-83), who after serving as engraver to George III was hanged for forging a banknote, and John Raphael SMITH. Crayon manner and stipple were both rendered obsolete early in the 19th c. by the introduction of LITHOGRAPHY, though the use of stippled textures is still an integral part of the technique of line engraving.

**STODDART,** MARGARET OLROG (1865-1934). Painter, born in Canterbury, New Zealand, and trained at the Canterbury College School of Art, Christchurch. During an interlude in Europe her work was hung by the ROYAL ACADEMY and continental societies, but failing to achieve more solid distinction, she returned to Christchurch, where she won a deserved reputation as a painter of LANDSCAPES and flower pieces (Robert McDougall Art Gal., Christchurch).

**STONE,** NICHOLAS (1583-1647). Sculptor and mason, the son of a Devonshire quarryman. He was trained in England, but in 1606 went as a journeyman to the Amsterdam workshop of Hendrik de KEYSER, whose daughter he married. On his return to London in 1613 he quickly built up a good practice as a TOMB-maker, his effigies being more NATURALISTIC than those of his older contemporaries. His early work, cut presumably chiefly by his own hand, is sensitively modelled, as on the tomb of Lady Carey (Stowe-Nine-Churches, Northants., 1617), and proves him to be the most accomplished English sculptor of his time. He was also responsible for the introduction of new ideas: the MONUMENT to Francis Holles (d. 1622; Westminster Abbey) has the first English example of a figure in Roman armour, and that to Dr. John Donne (St. Paul's Cathedral, 1631, re-erected after the Great Fire of 1666) shows, by the owner's direction, the great preacher and poet standing erect in his shroud.

In 1619 Stone became Master Mason for Inigo JONES's Banqueting House at Whitehall, and in 1632 Master Mason to the Crown. His contact with the court gave him a knowledge of the ANTIQUE sculpture in Charles I's collection and his work after *c.* 1630 shows a change in style, marked by an attempt to imitate antique DRAPERY (Lyttelton Monument, Magdalen College, Oxford, 1634). His large workshop produced monuments of many types—plain tablets in an architectural frame, which include those to Edmund Spenser (1620) and Isaac Casaubon (1634), both in Westminster Abbey, BUST monuments, tombs with kneeling and reclining figures, and a little work in imitation of the antique, such as the bust of Apollo (1640) at Kirby Hall, Northants. He also carried out important work as a mason, including the PORTICO of St. Paul's Cathedral, designed by Inigo Jones, and

Goldsmiths' Hall, London (destroyed). Much information about the organization of a sculptor's workshop can be gained from his *Note-Book* and *Account-Book* (Sir John Soane's Mus.). His practice was carried on after his death by his younger son, JOHN (1620-67).

**STONE AGE ART IN EUROPE.** It is supposed that the earliest manifestations of artistic impulse occurred when a new race, *homo sapiens,* superseded the Mousterian types of man in Europe. The earliest known works of art date from the Upper Palaeolithic period (Upper Old Stone Age), which began some 30,000 years ago during the last great glaciation and ended about 10,000 B.C. They are associated with an advanced hunting and food-gathering culture practised by men whose weapons and implements were of stone, wood, or bone. Similar cultures with characteristically similar phases of art have occurred at different periods in other parts of the world. Among the Bushmen of South Africa, for example, the Early Stone Age culture and art were practised until recent times, while among the Australian aborigines they still somewhat precariously survive. These

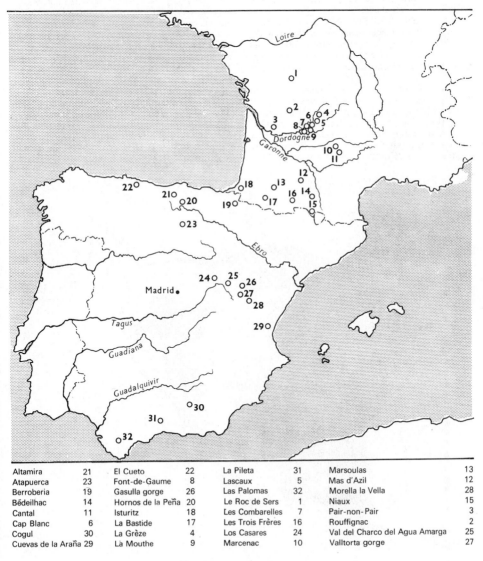

| | | | | | | | | |
|---|---|---|---|---|---|---|---|---|
| Altamira | 21 | El Cueto | 22 | La Pileta | 31 | Marsoulas | | 13 |
| Atapuerca | 23 | Font-de-Gaume | 8 | Lascaux | 5 | Mas d'Azil | | 12 |
| Berroberia | 19 | Gasulla gorge | 26 | Las Palomas | 32 | Morella la Vella | | 28 |
| Bédeilhac | 14 | Hornos de la Peña | 20 | Le Roc de Sers | 1 | Niaux | | 15 |
| Cantal | 11 | Isturitz | 18 | Les Combarelles | 7 | Pair-non-Pair | | 3 |
| Cap Blanc | 6 | La Bastide | 17 | Les Trois Frères | 16 | Rouffignac | | 2 |
| Cogul | 30 | La Grèze | 4 | Los Casares | 24 | Val del Charco del Agua Amarga | | 25 |
| Cuevas de la Araña | 29 | Là Mouthe | 9 | Marcenac | 10 | Valltorta gorge | | 27 |

**Map 6.** STONE AGE ART IN EUROPE

artistic cycles are discussed under AFRICAN PREHISTORIC ART and AUSTRALIAN ABORIGINAL ART. The present article deals with European Stone Age art.

I. PALAEOLITHIC. In Europe there were three Palaeolithic (Old Stone Age) cultures, the Aurignacian, the Solutrean, and the Magdalenian. One would therefore expect three distinct cycles of art. Actually the Solutreans came as intruders into the Aurignacian world and eventually disappeared or were absorbed, and very little art is found during Solutrean times. What there was may have been the product of the autochthonous Aurignacian population. We are left, then, with the Aurignacian art cycle and that of the Magdalenians.

The art objects fall into two groups: decorated or ornamental objects, usually small, found in the prehistoric homes associated with the stone and bone industries of the period, and engravings and paintings found on the walls and ceilings of caves.

Examples of 'home art' are found throughout Upper Palaeolithic times both in western and in central European sites, but they vary in style in the two regions, being much more conventionalized in the latter. Sculptures, RELIEFS, silhouettes in bone, and engravings all occur. Paintings are extremely rare, probably because humic acids

in the soil tend to be destructive. It used to be averred that sculpture preceded LINE ENGRAVING but this is not strictly true. It is a fact that at the beginning of an art cycle sculpture in the round is commoner than line engraving, but the latter always occurs. Perhaps the most characteristic sculptured objects in the Aurignacian cycle are the so-called Venuses, little STONE and IVORY statuettes of women, often pregnant. Generally they are considerably STYLIZED in treatment. For the most part they date to the late Aurignacian, and they are found as far apart as at Brassempoùy in western France and on Lake Baikal in Asiatic U.S.S.R. Besides these, simple outline engravings of early Aurignacian date have been found at Hornos de la Peña (near Santander, northern Spain); and of upper Aurignacian date there are some more sophisticated drawings on pebbles at Labattut in the Dordogne, where an attempt at foreshortening is introduced and the lines are frequently hatched. At this site the head, neck, and dorsal line of a painted stag on a block of rock has also survived.

Among the few known Solutrean works of art there are some sculptured animals on large blocks of stone forming a revetment at Le Roc de Sers (Charente); and a few examples found in the northern Pyrenees at Isturitz have been attributed to this period. But in Magdalenian times

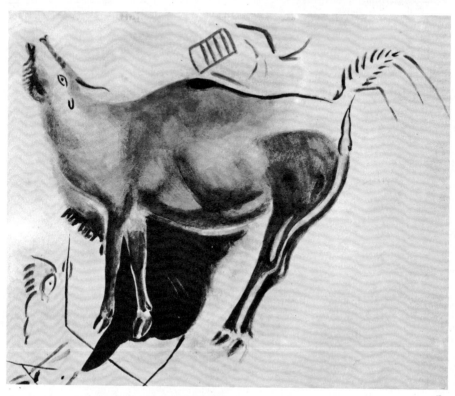

**360.** Pregnant Bison. After a cave-drawing at Altamira

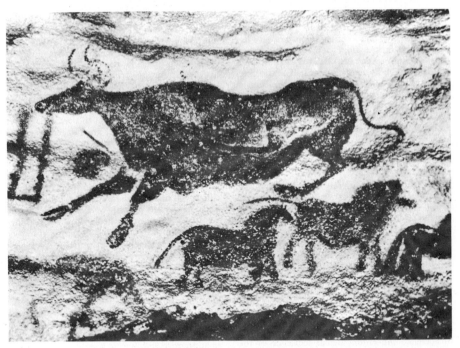

361. Bull and Horses, Lascaux

this home art reached its apogee. Lovely sculptures and engravings of high artistic merit have been collected. A little carved horse's head from Mas d'Azil (eastern Pyrenees) and a fine engraving on a piece of sandy LIMESTONE of a reindeer turning its head over its shoulder may be cited. In one instance there is an engraving on a piece of bone some 4 in. long representing a herd of reindeer; fairly complete figures of the animals in front and behind with in between a mere forest of antlers give a real impression of a numberless herd. Towards the end of Magdalenian times degeneration began to set in and there was a great increase of conventionalization and pattern, but right to the end this sensitive home art remains an astounding phenomenon. We may be faced with the childhood of art, but not with the art of CHILDREN.

The central European home art is not quite like that of western Europe nor are the industries exactly similar, though cultures comparable to middle and upper Aurignacian occur and Venuses are not uncommon. The engravings and some of the sculptures are very stylized, and no painting has survived.

The first example of home art was discovered as long ago as 1834 at Chaffaud, a site in the Vienne, France. At the time it was considered to be CELTIC. But the true antiquity of the home art is guaranteed when art objects are found with industrial objects in levels often sealed in and in stratigraphical sequences which can be dated with reasonable certainty.

The first example of cave art was found by chance at ALTAMIRA in north Spain as early as 1879. There a magnificent frieze of polychrome figures of animals was seen on the low roof of the vestibule. At first the scientific world was unwilling to credit them with great antiquity and it was only after the discovery in 1895 of the paintings and engravings in the cave of La Mouthe, near LES EYZIES in the Dordogne, that convincing proofs of the Palaeolithic age of this cave art were produced.

The oldest examples of cave art are thought to be representations of hands, outlined in red and black against the background of rock. The cave art also comprises engravings, paintings, and relief modellings of animals, many of them now extinct or no longer living in western Europe, as well as signs and geometric figures which we cannot interpret with certainty. Its distribution is fairly narrowly confined to three regions in France and Spain; but as it depends on the existence of suitable caves, and these only occur in limestone country, the significance of this distribution is not clear. In France it is found in the departments of the Dordogne and Corrèze as far east as the Rhône; it is found in the central Pyrenees; and it is found in northern Spain, north of the Cordillera Cantabrica. A few other examples are known elsewhere in Spain (Los Casares, Guadalajara) and a somewhat anomalous group has been found in the extreme south (La Pileta, Málaga). One or two engravings of similar kind have been found in a cave in the

heel of Italy (Romanelli), and others in a small cave on the island of Levanzo off the north-west coast of Sicily; and another important site has been found on the slope of Monte Pellegrino, near Palermo. Some of the caves are vast; that of Niaux in the Pyrenees is over half a mile long. The cave of Rouffignac, which had been a tourist attraction for more than a century, extends for six miles: here in 1956 was discovered an astonishingly large and fine collection of drawings dating from Aurignacian times to early Magdalenian. Some of the individual pictures are as much as 6 ft. 6 in. in length. The famous picture gallery at LASCAUX is 33 yds. in length by 11 yds. wide.

The paintings are differentiated into a number of different styles and as they frequently overlap or are superimposed, it is possible to hazard a scheme of relative dating. Four so-called phases have been discriminated such that the different styles which belong to each phase are found sometimes over and sometimes under one another, but the order of the phases when superpositions occur is always constant. An interesting characteristic of the 'Perigordian' phase is the 'twisted perspective', which gives a frontal view of antlers or horns of cervidae and bovidae although the remainder of the body is depicted in profile. It has been a task of the prehistorian to correlate the chronological sequence of the phases with the various Upper Palaeolithic cultures found in the prehistoric homes and revealed by the industrial artefacts.

The authenticity of Stone Age cave paintings has often been disputed in the past. Those at Altamira were dismissed as forgeries at the Congress of Anthropology and Prehistoric Archaeology held at Lisbon in 1880 and had to wait 16 years for recognition. The discoveries at Lascaux (1940) and at Rouffignac (1956) were the subject of long debate. Finds can be authenticated in a number of ways. In some cases evidence of antiquity is provided by the formation of sinter deposit. More exact dating can be given where deposit of rubbish has raised the floor of the cave and partly covered the paintings: where the strata of the deposit contain bones of Ice Age animals or relics of prehistoric human industries they serve to date the murals they had screened (Pair-non-Pair, La Grèze, Cap Blanc, etc.). At La Mouthe the entrance to the cave in the rear, where the paintings and engravings are situated, had been completely blocked by deposits in the vestibule containing embedded samples of Magdalenian industries so that since Magdalenian times nobody could have got through to the murals. Sometimes the paintings themselves bear evidence of authenticity, when they represent animals (reindeer, mammoths, rhinoceroses, musk-oxen, bison, and saiga antelopes—the last only at Les Combarelles) which either became extinct or no longer inhabited Europe after the Ice Age. Sometimes they are partially masked by stalactite and although stalactite can form fairly quickly, its presence rules out any

suggestion of modern forgery. Occasionally, too, a peculiar style on the murals is matched by an engraving in similar style in home art and since the latter is datable by the industry in conjunction with which it occurs, the style of the mural can also be dated.

The paints used were ochres and manganese oxides, CHARCOAL and iron carbonate, which give various shades of red and yellow as well as black. Soot was also employed, but this is more fugitive than the others. (White, greens, and blues are not found and violet is instanced only at Altamira.) It would seem that the PIGMENT bases, which are of common occurrence, were collected and then ground to powder and kept in hollow bones plugged up at one end. The powdered colour was mixed with fat, which for the purpose must have been melted, or with other binding MEDIUMS, and then applied to the walls, sometimes with a BRUSH, sometimes with a stump or even with the fingers, twigs, feathers, or leaves. Sometimes the powdered pigment seems to have been blown on to a presumably greased wall-surface to produce a negative or stencilled impression, e.g. the human hands at Castillo, Gargas, and elsewhere, where the shape of the hands is blank, the colour being all round the fingers. A practical demonstration made it evident to the writer that the artist must have had an apprentice with him to keep the fat warm and mix the colours. This is interesting, because the changes of phases took place at the same time over wide areas, and the art seems to have been the work not of chance individuals, but of trained artists who had been taught their job.

Engravings were cut by means of flint BURINS, examples of which have survived in large numbers. Deeper reliefs were probably pecked out by means of heavy picks and then finished by the use of an abrasive.

The caves are natural formations and were not used as habitations. The murals are usually located in remote places to which daylight does not penetrate and are often difficult to view even by artificial light. Thus at Altamira, where the height is no more than 6 or 7 ft., the paintings can best be seen by lying down on the floor. It is certain that artificial lighting was used, though problems of accessibility and method remain unanswered. A few cupel-shaped stone lamps have been found with residues of a fatty substance (e.g. La Mouthe) and scorched slabs of SANDSTONE coated with a carbonized mass (e.g. Trois Frères). It has also been conjectured that a skull full of fat with a moss wick was used as a torch. These facts seem to rule out the idea that any AESTHETIC motive of decoration or artistic self-expression accounted for the murals. Their significance and purpose remain an intractable problem for the prehistorians.

It is most generally held that they were magical in intention and connected with rituals designed to ensure either, on the one hand, the success of the hunt or, on the other hand, the fertility or seasonal return of the animals to

which men's lives in the early Stone Age were so closely linked. The high aesthetic quality of much of the work, the development of stylistic phases, and the gradual perfection of representational techniques seem to tell against this theory, however, since in general it is found that for the purposes of sympathetic magic neither artistic excellence nor any great representational verisimilitude are held to be necessary. Certain prehistorians have suggested as an alternative and perhaps more plausible view that we ought to interpret the Palaeolithic European cave art on the analogy of the more recent Stone Age art of the African Bushmen and the Australian aborigines. It is known that in their case mural painting has as its object to give expression to a cosmic mythology of the sort which is embodied in the symbolical cosmological folk-tales in which so many primitive peoples delight. Such an explanation for the European Palaeolithic cave art would not exclude the view that these art stations were also sacred places of the tribe and possibly connected with initiation or other rituals. Even today many of the caves are frightening and awe-inspiring places. The silence is absolute, the darkness can be felt. They may well have been served by a priesthood who were depositories of tradition and ministers of a cult. At the cave of Trois Frères in the Pyrenees there is a painted and engraved figure which may be a representation of the priest-sorcerer masked with the antlers of a stag, the face of an owl, and the tail of a horse.

Two further matters deserve mention. Preservation of the paintings is possible only when the air humidity is very constant. The chief cause of destruction is the sweating of the walls resulting from slowly percolating water. Unless this has been considerable, the fat with which the colours were mixed prevents any etching of the walls where the paintings occur. During the First World War at Bédeilhac, a cave in the Pyrenees near Tarascon-sur-Ariège, a small gallery which in ancient times had been masked by a little landslide was discovered near the entrance. It was full of paintings. Within six months they had disappeared. Weathering had etched the walls and destroyed the art. After surviving several millennia the rock-shelter paintings of eastern Spain have almost disappeared in a few decades because they are damped and sprinkled by sight-seers in order to bring out the colours. Where light penetrates lichens grow on the rock and mosses and algae if there is damp. Such vegetation may help to destroy the paintings. Even where the surface is dry oxidization of the rock-face will change the colour of the surface and may dull the colour of the pigments. Ground-water, on the other hand, may percolate through fissures in the rock and deposit calcareous layers of sinter on the walls, which help to preserve the paintings.

The rock paintings are also useful for reconstructing the appearance of some extinct animals. Attempts to reconstruct from surviving bones

have not been always plausible. In the case of the woolly rhinoceros, for example, a frankly fantastic animal was evolved. At Font-de-Gaume a painting of a woolly rhinoceros occurs high up on the wall in a narrow fissure at the end of the cave. About 1907, when bitumen was being dug near Lwów in Poland, a complete woolly rhinoceros was discovered which had apparently fallen into one of the natural pits of bitumen and salt which occur in the district and had been preserved as it were 'in pickle'. The brown hair had been partly burnt off, but otherwise the animal was complete. Her appearance is quite different from the reconstructions which had been made from bones found in prehistoric homes, but is almost exactly that of the drawing by late Aurignacian man at Font-de-Gaume. Where we can still check, the keen eye of these artists for characteristic shape and pose and movement is unsurpassed in the history of animal art and bears witness to the intimate knowledge they had of the animal world as well as their graphic skill. It has been thought that the relative scarcity of human figures in the Palaeolithic cave art, and the greater degree of schematization where human scenes occur, may reflect a common superstition of early man against having his likeness depicted.

2. MESOLITHIC. The Mesolithic (Middle Stone Age), commencing about the end of the geological Pleistocene period, was a transitional stage between the Palaeolithic and the Neolithic (Late Stone Age) and in Europe dated c. 10,000/8000–c. 3000 B.C. In this period the dog was domesticated, fishing and catching birds supplemented large game hunting, and stone implements became smaller (microliths). Several sub-cultures are recognized, such as the Azilian of western Europe (named from the Mas d'Azil, Ariège), the Maglemosian extending from the North Sea to the Baltic, the Capsian of North Africa, and the Natufian found in Syria and Palestine.

Not much art of Mesolithic date is known. Perhaps a painted barbed line covering the last Palaeolithic drawings at Marsoulas in the Pyrenees dates to this period, and the Azilian painted pebbles must not be forgotten. These consist of flat river pebbles covered on one side with dots and lines and occasionally more complicated figures in reddish pigment. Their age is certain; the reason for making them is entirely unknown. Engravings on bones have been found in Maglemosian and Kitchen Midden sites in Denmark. The former consist mostly of geometric patterns, though one or two examples of animal figures occur, and in one case conventionalized human beings seem to be intended. Two techniques can be observed, an earlier style of engraving and a later where the line consists of a series of little pock-marks such as must have been made with a small bow-drill. Very little art occurs in the Kitchen Middens, but a few geometric patterns have been noted. The origin of this rather peculiar art is obscure. Perhaps it

is derived in part, as indeed may be these cultures themselves, from the rather different Upper Palaeolithic civilization of central Europe already referred to.

At sites in Scandinavia a rock art occurs which may owe something to this Mesolithic art from further south. For the most part, as far as the very hard surfaces of the rock allow, it is reasonably NATURALISTIC. But certain peculiarities can be noticed, and at least three different styles forming a chronological sequence determined. The earliest of these is genuinely naturalistic. In the second style the line of an animal's hind leg is frequently drawn right up through the body to the line of the back. The last style is more geometric in character. Whether the rock engravings on Lake Onega (U.S.S.R.) belong to this time or are more recent is a matter of doubt. Here, besides animals, a number of figures of ships can be seen.

In Palestine in a cave at Mount Carmel there was found a Mesolithic culture called Natufian. Among the tools unearthed was a sickle haft, probably intended for use in reaping wild grain, the end of which was beautifully carved into the head of a young deer. There was also a rather crude figure in calcite of a human head.

By far the most interesting of this group, and perhaps the most vigorous of all prehistoric European art, are the paintings (there are few engravings) in the rock shelters of eastern Spain in the rocky hinterland of the coastal region from the Pyrenees to the Sierra Nevada. These occur not in deep caves but in natural shallow niches or beneath overhanging ledges of rock. Although they have been known for some centuries to the local inhabitants, by whom the sites are sometimes regarded with superstition as sacred, they did not attract the attention of scholars, until the first decade of the 20th c. By the middle of the century more than 50 sites had been described.

The paintings are usually in monochrome and are small, individual figures being rarely more than 6 to 8 in. Animals are represented naturalistically with fine powers of observation; human figures, which occur frequently, are much more schematic but convey a lively impression of movement. What is rare in Palaeolithic cave art, human and animal figures are combined scenically depicting hunting (Agua Amarga, Teruel; Cueva de los Caballos, Valltorta gorge) or warlike (Cueva Remigia, Gasulla gorge; Morella la Vella, Castellón) episodes. Subjects include honeygatherers (Cuevas de la Araña, Valencia), insects (spider surrounded by flies, Cingle de la Mola Remigia, Castellón), and therianthropic figures. The dating of this art is peculiarly difficult. There are no comparable and datable objects of home or industrial art; they do not occur in caves, which can be dated by strata of detritus; and the fauna depicted give little guide to date. Some prehistorians, including H. Breuil, date them to the end of the Ice Age. But many Spanish scholars regard them as Mesolithic or early Neolithic. M. Almagro in 1954 stated that they date from a post-glacial period, being produced by Mesolithic hunters but with affinities at one end to Ice Age Perigordian culture and at the other considerable overlap with Neolithic. The style of the eastern Spanish rock paintings is individualistic and markedly at variance with other European Stone Age art. On stylistic grounds affinities have been suggested with South African rock art. But no link through north African Capsian or through Saharan art has been established and chronologically there is no serious scientific foundation for such a connection.

3. NEOLITHIC. The Neolithic Age is marked by a change-over (perhaps the most important revolution in human history) from a hunting and food-gathering economy to nomadic pastoralism or primitive farming with fixed agricultural settlements. It saw the domestication of animals (pigs, sheep, goats, cattle) and the cultivation of food-crops. From this period date the crafts of POTTERY, weaving, baking, and polished stone implements. It began in Europe c. 3000 to 1800 B.C. or as early as 5000 B.C. in the eastern Mediterranean area and the Middle East. Neolithic art is discussed under BARBARIAN ART IN EUROPE and outside Europe in articles relating to the several areas of developing civilizations (EGYPT, MESOPOTAMIA, etc.). The present article touches upon certain general characteristics only. Though we find much of interest in the field of APPLIED ART, there is nothing aesthetically comparable to Ice Age cave painting.

Pottery, which was an innovation of Neolithic times, lends itself to decoration and because of its remarkable powers of survival has become the most important art-form for the prehistorian. We can roughly divide Neolithic Europe into an eastern, a northern, and a western region. Pottery belonging to the eastern (Danubian) region was often beautifully decorated with incised flowing patterns. The well made Danubian I pots with their spiral-meander decoration are objects of great beauty. Later on other forms of decoration appeared, and filtering into central Europe from the east we also find painting. The lovely pots found at such places as Cucuteni in Romania, with their finely flowing patterns, are a source of wonder, if one were to assume that primitive stages of civilization necessarily involve primitive powers of design. In the northern region the decoration is more geometric, largely consisting of closely packed zigzags; but again the final results are often of considerable artistic merit. The western area yields pottery with less interesting decoration and the pots themselves are not nearly so well shaped or manufactured.

The other most characteristic feature of New Stone Age art is its megalithic building and monumental structures such as the OBELISKS, or menhirs, the cromlechs, and the dolmens.

150, 394, 395, 1142, 1332, 2383, 2697, 2907.

Statuarius. Der Bildhauwer.

EFfigies veterum Pario de marmore Regum
Sculpo, vel ex ligno temporis acta mei.
Olim multa dedit sculptoribus æra vetustas,
Præmia cùm nostri magna tulêre chori.

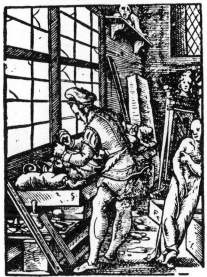

Quando Deûm nitidas statuis decorauimus ædes,
Pinximus & vani templa vetusta Iouis.
Nunc ea posteritas violenter diruit, ipsi
Reddere debebat quæ meliora Deo.
Praxiteles nostræ statuarius optimus artis,
Millibus è multis, quot viguere, fuit.

D 4        Merca-.

**362.** The Sculptor. Woodcut by Jost Amman from *Panoplia Omnium Artium* (1568), Hartmannus Schopperus

**STONE SCULPTURE.** There are basically two methods of approach to stone carving, which are known as *indirect* and *direct* carving respectively. In indirect carving the sculpture is first made in some other material—usually a PLASTER CAST taken from a clay model (see MODELLING)—and this is transferred more or less mechanically into stone by POINTING. Where the indirect method is used the actual cutting of the stone may be done by artisan carvers or workshop assistants and need not be done by the artist himself.

The indirect method of stone sculpture is not to be confused with the practice of making a small preliminary figure in clay, wax, or a comparable material as a general guide to the sculptor cutting his stone block. According to PLINY this practice originated among the Greeks in the late 4th c. B.C. and soon became general. Centuries later the same method was described by CELLINI and VASARI and used by MICHELANGELO. (Their contemporary LEONARDO described a

method which more nearly approximates indirect carving with pointing.) The obvious advantage of the method based on preliminary studies is that certain problems of form or formal relationships can be worked out more easily and economically in clay than in stone and the use of a three-dimensional statement of a sculptor's general idea can save much wastage and time.

Since indirect carving conflicts with contemporary ideas almost all creative artists today use the direct method or *taille directe*. They argue that modelling and carving are different activities in fact and principle. Modelling is a process of building up form in an ideally structureless material while carving is a matter of thinning away in accordance with the structure of a given material—stone or WOOD—and so releasing a shape which is imaginatively conceived as pre-existent in the block of uncarved material. For this reason it is sometimes asserted that the original shape of a block should never be completely destroyed and should remain as a background in terms of which the finished figure is seen. Adrian Stokes has said: 'Carving is an articulation of something that already exists in the block. The carving should never, in any profound imaginative sense, be entirely freed from its matrix.' The preference for direct carving is in keeping with the importance which contemporary AESTHETIC thought assigns to respecting the physical properties of any medium. This attitude rejects as dishonest painting or otherwise concealing any material by giving it an artificial surface. One typical statement of this 20th-c. attitude is worth quoting: 'It is not desirable to make exact models in clay, because the sort of thing which can be easily and suitably constructed in clay may not be, and generally is not suitable for carving in stone. . . . Modelling is a process of addition; whereas carving is a process of subtraction. The proper modelling of clay results in certain spareness and tenseness of form and any desired amount of "freedom" or detachment of parts. The proper carving of stone results in a certain roundness and solidity of form with no detachment of parts. Consequently a model made to the full size of the proposed carving would be, if modelled in a manner natural to clay, more of a hindrance than a help to the carver. The finished work is not a piece of carving but a stone imitation of a clay model' (Eric GILL, *An Essay on Stone Cutting*, 1924). The classic statement of the sculptor's imaginative conception of an idea existing in the stone to be released by the hand of the sculptor is found in Michelangelo's 15th Sonnet:

Non ha l'ottimo artista alcun concetto
Ch'un marmo solo in se non circonscriva
Col suo soverchio, e solo a quello arriva
La man, che ubbidisce all'intelletto.

(The greatest artist has no conception which a single block of marble does not potentially contain within its mass, and only a hand obedient to the mind can penetrate to this image.)

Direct carving is then a process of releasing superfluous material from a block to reveal the shape the artist has conceived as latent within the block. The way in which an artist releases this image depends on his own imaginary conception. If he conceives the form as a set of profiles fitting within the block, he will proceed in one way; if he conceives the form fully in the round from the beginning, his approach will necessarily differ.

**Fig. 85.** SCULPTOR'S TOOLS
a. Flat chisel  b. Claw  c. Claw  d. Point  e. Boucharde with section of striking face  f. Pick  g. Mallet

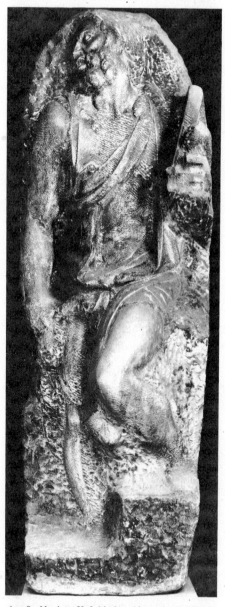

**363.** *St. Matthew.* Unfinished marble carving by Michelangelo. (Accademia, Florence, *c.* 1506)

The Egyptians followed the first approach since they wanted to reproduce what they held to be the objective reality of natural objects as distinct from their momentary appearances. They therefore conceived the figures in rigidly distinct aspects: frontal elevation, lateral elevation, and ground plan. They marked these aspects on the corresponding faces of the block and thinned down each face independently to its required shape. Modern sculptors, who normally conceive their figures fully in the round, work the block all round from the outset, carving off layers of superfluous stone until the figure stands revealed. Michelangelo preferred to work from the front to the back of the block, progressing steadily towards the rear plane. His method may be seen in the unfinished *Slaves* and in the *St. Matthew* (Accademia, Florence). The choice between methods of carving depends upon a sculptor's initial idea and his feeling for the nature of the material with which he works. A sculptor's response to the particular stone will inevitably be revealed in the quality of his carving.

The tools and techniques of stone carving have varied comparatively little over long periods of time. The first major shaping of the block may be done by sawing off large pieces at angles to give the general shape required for the figure to be carved. The major roughing down to the shape of the figure is done by means of a 'pick' or

a 'point' (pointed chisel), which chips off large irregularly shaped pieces of stone. The pick was used in the prehistoric Sahara cave carvings to mark out the engraved outlines; these were afterwards smoothed with abrasive to a level U or V groove. In the great periods of sculpture carvers have used the point until a very late stage of carving because the jagged, roughly curved shapes which emerge with each blow are to some extent determined by the structure of the material and enable the sculptor to feel that he is in contact with the 'living stone'. After this he will resort to the 'claw', a broad chisel with teeth, or to the boucharde, a hammer with parallel rows of teeth which may be regarded as a multiple pick. The latter is inclined to stun or bruise the stone, leaving dull marks which show through the final polish and for this reason is rarely used when the work approaches the final surface. At this stage the surface is worked with 'flat chisels' of various shapes and dimensions. These chisels leave marks which the sculptor smooths away with rasps or abrasives to the extent he judges best for the final surface. For deep cavities or recesses and to facilitate undercutting in general drills may be used. The use of drills is particularly important in NATURALISTIC sculpture or where cast shadows are desired to help the definition of form in the final work (e.g. in HELLENISTIC Greece). Polishing is a distinct technique which varies with the kind of stone employed.

The Greeks used most of the tools in use today —the point, the boucharde, claw chisels and flat chisels, drills, rasps, gouges, and abrasives. Most of them were familiar also to the early Egyptians. Where very hard stones were carved in ages before iron tools were known greater use was made of abrasive techniques and by drilling with the aid of a wet abrasive. Stone blocks were split during quarrying and afterwards by packing holes with wood which was then wetted to cause it to expand. But the full story of early techniques of working hard stones such as the GRANITES or the Andesite cut so accurately by the Incas and their predecessors is not known.

**STOPPING-OUT VARNISH.** An acid-resisting varnish which is used in ETCHING, AQUATINT, and similar processes.

**STOSS, VEIT** (c. 1450-1533). German sculptor and WOOD-CARVER. His earliest and most characteristic work is the gigantic ALTARPIECE carved between 1477 and 1489 for St. Mary's church in Cracow. Deriving from the REALISM of Nicolaus GERHAERT, Stoss's art was still more dramatic and monumental. The central shrine displays the *Death* and *Assumption of the Virgin* with the vividness of a medieval mystery play. All the figures are carved in the round and some of them are well over life size. But even small figures such as the boxwood *Madonna* in the Victoria and Albert Museum can give some idea of Stoss's powerful manner. He is little con-

cerned with the anatomy and correct proportion of the human body but gets his effects through a rich display of DRAPERIES, thereby allowing for a bold pattern of light and shade. He puts strong emphasis on gesture and exaggerates facial expression. In all this Stoss was a typical late GOTHIC artist. VASARI admired this virtuosity and called the *St. Roch* (SS. Annunziata, Florence) 'a miracle of carving'.

Stoss settled in Nuremberg in 1489 but his career was periodically interrupted because he forged a document and was involved for years in criminal proceedings. His last important work, a carved altarpiece for Bamberg (after 1520), while maintaining the monumentality of his earlier style, is perhaps less dramatic. He sometimes abandoned the use of a POLYCHROME finish, but this seems almost his only concession to the AESTHETIC principles of the RENAISSANCE.

**STOTHARD, THOMAS** (1755-1834). English painter and book illustrator. He entered the R.A. Schools in 1777, becoming A.R.A. in 1791, R.A. in 1794, and was Librarian at the ROYAL ACADEMY 1814-34. His output of small narrative pieces in a sentimentalized CLASSICAL manner was large, and he also did occasional more ambitious works, e.g. the decoration of the staircase at Burghley House (begun 1794), the cupola of the upper hall of the Advocates' Library, Edinburgh (1822). He won the competition for the design of the Wellington Shield in 1814.

**STRAPWORK.** Ornament resembling INTER-LACING or pierced rolled straps of leather. First developed by ROSSO and his school at FONTAINE-BLEAU in the 1530s, it spread rapidly to Flanders and from there, by means of engraved pattern books and refugee craftsmen, to England. It was profusely used in Elizabethan and JACOBEAN decoration.

**STREET, GEORGE EDMUND** (1824-81). English ecclesiastical architect, one of the leading figures, along with BUTTERFIELD and Gilbert SCOTT, at the height of the GOTHIC REVIVAL. He collected in his office a number of brilliant younger men, most of whom, however, rather than following in his footsteps reacted against his somewhat rigid outlook. Norman SHAW and Philip WEBB were his assistants, and William MORRIS a pupil. Among Street's many churches the best known is St. James the Less, Westminster (1861). His largest building, the Law Courts (1874-82), was the last great public building in the Gothic style.

2569.

**STREETER, ROBERT** (1624-79). English mural painter, appointed Serjeant-Painter, 1663. He also painted LANDSCAPE (*Boscobel House*, Royal Coll.), allegorical pictures, decorations, and portraits (*Sir Francis Prujean*, Royal College of Physicians). Most of his mural decoration

has perished. His most important surviving work is the allegorical painted ceiling, *The Triumph of Truth and the Arts* (1668-9) in the Sheldonian Theatre, Oxford, the most ambitious BAROQUE composition by an English artist.

**STREETON,** ARTHUR (1867-1943). The most important LANDSCAPE painter of the Australian HEIDELBERG SCHOOL. Between 1898 and 1924 he spent most of his time abroad—from 1916 to 1918 as an official war artist with the Australian forces in France. His landscapes, painted with a square brush technique and featuring dominant notes of gold and blue, gave the lead to a popular school of Australian landscape.

**STRETCHER.** The wooden frame or chassis on which a CANVAS is stretched and fixed. In the early days of OIL-PAINTING the stretcher was removed when the painting was complete. By the early 19th c. wedges or keys were used to tighten the canvas yet further; and later in the century came the present-day stretcher with mitred corners which allow the framework to be slightly extended.

**STRICKLAND,** WILLIAM (1787-1854). American craftsman, painter, engraver, engineer, and architect, one of the original founders, in 1836, of the American Institute of Architects, with Thomas U. Walter (1804-87) and A. J. DAVIS. Like Robert MILLS, he was a pupil of LATROBE. His most famous work, executed during the last years of his life, is the State Capitol in Nashville, Tennessee. Large in conception, practical in plan, and refined in PROPORTION and detail, it is altogether characteristic of his sensitive and ingenious interpretation of the NEO-CLASSICAL style.

1042.

**STRIGEL,** BERNHARD (c. 1460-1528). German painter. He was a pupil of ZEITBLOM and worked in Memmingen, near Ulm. He painted a number of ALTARPIECES (Germanisches Mus., Nuremberg), but did his best work in portraiture (*Emperor Maximilian*). His style is transitional between late GOTHIC and RENAISSANCE.

**STROZZI,** BERNARDO called IL PRETE GENOVESE (1581-1644). Leading painter of the Genoese School at the beginning of the 17th c. He entered the Capuchin Order, becoming a priest in 1610. His most characteristic style developed after he had removed to Venice in 1631, under the impact of the work of FETI and Johann LISS. With them he helped to keep alive the tradition of painting in Venice at a time when native talent was at a low ebb, and to prepare for the revival in the 18th c.

**STUART,** GILBERT (1755-1828). American portrait painter, considered to be the creator of a distinctive American style of CLASSICAL portraiture. His talent showed itself early and he was befriended by the Scottish painter Cosmo Alexander (active in Newport c. 1765-72), with whom he returned to Edinburgh. On the death of Alexander within the year Stuart was left stranded and worked his way back to America. He went to London in 1775 with an introduction to Benjamin WEST and after painting for some years in his studio went into practice on his own and won success as a portrait painter. Among others he did portraits of Benjamin West, REYNOLDS, GAINSBOROUGH, and COPLEY. He practised as a portrait painter in Ireland from 1788 to 1792, when he returned to America. In 1794 he went to Philadelphia with the avowed intention of painting George Washington and 124 paintings of Washington by him are listed. The *Vaughan Washington* (N.G., Washington, 1795) exemplifies his search for the permanent and timeless and his repudiation of the accidental in the detached Classical style which he made his own. He also painted from life a full-length *Lansdowne* portrait of Washington (Earl of Rosebery Coll., London, 1796) and the unfinished *Athenaeum* head (Mus. of Fine Arts, Boston, 1796), of which he made more than 70 copies. When he used accessories or gestures it was to erect the individual into the type. In 1803 he moved to Washington and in 1805 to Boston. He is reputed to have painted more than 1,000 portraits, remaining within the narrow limits of his strictly Classical style until after 1820, when during the last eight years of his life he made some concessions to the prevailing ROMANTICISM. With Copley, Stuart is usually considered the greatest of American portrait painters.

883, 1873, 1884, 2028, 2873.

**STUART,** JAMES 'ATHENIAN' (1713-88). English architect and forerunner of the Greek Revival, who began as a fan painter. He went to Rome, where he made a name as a CONNOISSEUR, and in 1748 he, REVETT, and others discussed the idea of publishing measured drawings of Athenian antiquities, since the superiority of GREEK over ROMAN architecture was then being tentatively mooted (and vehemently opposed, e.g. by PIRANESI). A prospectus was issued, support obtained, and he and Revett spent 1751-3 in Greece (where Stuart was nearly murdered by the Turks) making measured drawings and views of Athenian buildings. The first volume of their *Antiquities of Athens* appeared only in 1762, after Stuart had bought out Revett; the second volume, with the more important buildings, appeared in 1789, published by Stuart's widow; a third volume came out in 1795 and in 1816 and 1830 supplementary material appeared. The 19th-c. volumes were part of the Greek Revival which Stuart was supposed to have initiated as a counterbalance to the 'corrupt taste' of ADAM: in fact the early volumes had no such intention

**364.** Portrait of George Stubbs. Pencil drawing (1794) by George Dance. (R.A., London)

and WINCKELMANN expressed disappointment with the first. Stuart was a lazy man, incapable of true NEO-CLASSICAL fervour, and so dilatory that his architectural practice suffered greatly and he was never a serious rival to the Adam brothers. His major work, Mrs. Montagu's house in Portman Square (c. 1775), was destroyed in 1940 and his finest surviving work is the chapel of Greenwich Hospital (1779-88), although much of it was executed by his assistant at Greenwich, where he was Surveyor from 1758.

**STUBBS,** GEORGE (1724-1806). English animal painter and ETCHER. He was born at Liverpool of a prosperous currier, and came into contact at the age of 16 with Hamlet Winstanley (1698-1756), an engraver employed in copying Old Masters at Lord Derby's gallery at Knowsley Hall. But he had no regular training and was an almost entirely self-taught artist. He worked as a portrait painter at Leeds and studied human and animal ANATOMY at York. He settled in London in 1759, after a journey to Italy and Morocco, and in 1766 published his *Anatomy of the Horse*, for which he engraved his own plates. The book represented 10 years of preparation and 18 months of drawing from dissected horses. It won international fame and has retained its reputation for accuracy and beauty among both veterinarians and animal painters. The plates occupy a unique position in the history of English etching. It has been said that 'subtle forms and modelled curves and planes in a skeleton were to George Stubbs what a symphony is to a musi-

cian'. The *Anatomy* has been prized by animal painters generally, including A. J. MUNNINGS, and the drawings for it were treasured by LANDSEER.

The publication put Stubbs in the way of a successful career as a horse painter. His 'portraits' of horses with their owners or grooms were in great demand, as also were his CONVERSATION PIECES in which the family were grouped in and around a carriage and pair. In his heyday he commanded higher prices than REYNOLDS from the same buyers. He was more than an animal and sporting artist with unusual accuracy of observation. He had a genuine feeling for form and for spatial organization (*Phaeton and Pair*, N.G., London). He sometimes appears as a GENRE painter of English rural life and some of his subject pieces anticipate the ROMANTICISM of the next generation, such as *Gentleman holding his Horse* (Tate Gal.) and *Horse frightened by Lion* (Walker Gal., Liverpool), a theme which was suggested to him by an incident during his return from Italy. He also tried his hand at painting in enamel on earthenware and panels of his were fired by Wedgwood (*Warren Hastings on his Arab Horse*, Memorial Hall, Calcutta).

1678.

**STUCCO.** In the strict sense sculptural stucco is dehydrated lime (calcium carbonate) mixed with finely pulverized MARBLE dust and glue and sometimes reinforced with hair. This mixture is weather resisting, and can be coloured. Many

**365.** Detail of the stucco decoration from the Baths of Pompeii (1st c. A.D.)

kinds of plastering are often commercially called stucco, but stucco is a different substance from plaster (which is calcium sulphate). Stucco is specially suitable for the ornamental decoration of walls—whether outside or inside—and ceilings. In order to give the stucco a hold on a wooden wall or ceiling reeds are nailed to the surface beforehand, providing a 'key'. As the mixture is comparatively slow in setting the *stuccatore* has time for the free MODELLING of even complicated shapes. Recurring ornament can be cast beforehand from moulds and affixed to the wall so as to take its place in the general design.

Some of the early Egyptian PYRAMIDS contain stucco work still intact. HELLENISTIC and late ROMAN interiors—at POMPEII, for instance, and in the catacombs—provide fine examples of stucco design. Brilliantly coloured stucco was used from at least the 3rd to the 5th c. A.D. in Hadda, Afghanistan, as figures, RELIEFS, and architectural decorations for the many monasteries of this site in the Greco-Buddhist style of Gandharan art. During the RENAISSANCE the Italians became the acknowledged experts in the art and carried it all over Europe. The interior decoration of FONTAINEBLEAU by the Italian artists PRIMATICCIO and ROSSO followed the model set by RAPHAEL and GIULIO ROMANO in the Vatican *loggie* in their effective use of stucco in combination with painting. White stucco ornamentation, often representing ANGELS, is

European BAROQUE churches such as Diessen, Vierzehnheiligen, and the cloister church of Ottobeuren. The lightness of stucco was used to great effect by the Italian sculptor Giacomo Serpotta (1656–1732) for his decorations in Sicily. In a typical example, the Oratory of S. Lorenzo, Palermo, full-size figures, smaller figures, and intricately shaped reliefs are all of white stucco, freely combined in a graceful and attractive way.

By adding large quantities of glue and colour to the stucco mixture the *stuccatori* were able to produce a material which could take a high polish and assume the appearance of marble. This material was extensively used for interior decoration during the 18th c. and is difficult to distinguish from real marble except that it is warmer to the touch. The ROCOCO style of 18th-c. France and the ADAM style in England demonstrate the varied effects possible from the skilful use of stucco decoration.

**STUDIO.** 1. Although the term may be applied to any artist's work-place, it normally suggests a large room with ample sources of light, usually facing north. This is already mentioned in VITRUVIUS (VI. iv): '. . . the picture galleries, the weaving-rooms of the embroiderers, the studios [*officinae pictorum*] of painters should have a north aspect, so that in the steady light the colours in their work may remain of unimpaired quality.' This idea was taken up by LEONARDO,

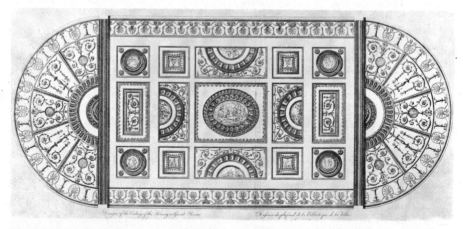

**366.** *Design of the ceiling of the Library or Great Room at Kenwood* (1767). Engraving from *The Works in Architecture of Robert and James Adam* (1822)

frequent in churches (Sta Maria del Popolo, S. Andrea al Quirinale, Rome) and designs often derived from models used in ancient ROMAN ART decorate a number of secular buildings (Villa Madama, Villa Giulia, Villa Doria) in Rome.

From the 17th c. onwards the *stuccatori* worked in teams under a leader and the virtuosity of these craftsmen in combining figures with ornamental work may be seen in central

who stipulated that 'the light for drawing from nature should come from the north, in order that it may not vary'. He advocated a small room as he found that it disciplined the mind, whilst a large one tended to distract it.

In the Middle Ages and the RENAISSANCE studios were normally inside private dwellings. We still know today in which street and even in which house the studios of some artists were situated. MASACCIO had his next to the Badia

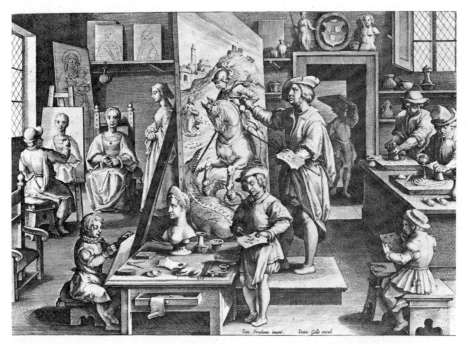

**367.** Painter's studio. Engraving (*c.* 1550) designed by J. van der Straet called Johannes Stradanus

Church in Florence, in a part of a shop; GHI-BERTI's after 1450, was opposite Sta Maria Nuova, and BENEDETTO DA MAIANO had no less than three studios, one for woodwork, one for marble, and a third in his house. Such studios differed little from the rooms and halls used by merchants, being usually situated on the ground floor, well lit, and with large doors facing the street so that they could serve as work-rooms and sale-rooms at the same time. Modern building techniques have led to a new type of studio-design, with top lights of large glass panes usually facing north; more recently a south light which can be dimmed has been favoured.

2. Since the Renaissance the term 'studio' has also signified the artist and his assistants, and the busier an artist was the larger would his 'studio' be (cf. RUBENS). By the 19th c. this term had expanded to mean 'a school', and artists who were already established sometimes entered a famous studio to gain further experience: thus MANET was in the studio of COUTURE at intervals for six years.

'Studio work' as a critical term signifies a work which is believed to have been executed in the studio of a known artist according to his design and more or less under his supervision, but largely and often wholly by the hands of assistants (see also WORKSHOP). It implies some participation by the master himself, whereas 'school work', for instance, implies none. After the death of a master the members of his studio have often taken over the completion of a work

(e.g. the High Altar in Sta Maria Novella, Florence, by GHIRLANDAIO's brothers and assistants).

The expression 'studio work' or 'studio picture' can also carry the quite different meaning of a picture which has been executed indoors and not directly from nature. Until the BARBI-ZON SCHOOL, who advocated PLEIN AIR painting, indoor composition from SKETCHES was the normal method of LANDSCAPE PAINTING.

**STUMP,** also called TORTILLON. A short tapered stick usually of cork or tightly rolled leather or PAPER, used to soften the edges of a DRAWING or spread the CHALK, crayon, or PENCIL in shading. It was used in 18th-c. France, especially for drawings in MINIATURE, and it was also advocated by 19th-c. academic teachers for large-scale drawings from casts and MODELS, chalk powder being spread laboriously over the paper and rubbed to imitate the modelling. Its use declined in the 20th c.

**STUPA.** The stupa originates in ancient INDIAN burial ceremonies and it was in essence a burial mound or tumulus. The most ancient stupas are very plain, hemispherical or sometimes square in plan, made of unbaked bricks. They were often surrounded by a railing serving to keep off evil spirits. In earliest times they contained sacred relics which were objects of reverence and became a focus for devotion. Gradually the stupa itself acquired symbolic value as an

emblem of Buddhist truth, of the *Parinirvana* or extinction of selfhood; stupas without relics (i.e. cenotaphs) were built, particularly at places important in the Buddhist legend, and miniature stupas were dedicated at the great shrines.

Architecturally the stupas became more ornate, developing into a tall, domed or bell-shaped structure raised on plinths and crowned with an ornamental spire based on the form of tiers of honorific umbrellas. Sculptural decoration was added. The railing was transformed into a screen composed of sculptural RELIEFS and gateways became very elaborate. The Gandharan stupa built by the great ruler Kamishka (c. A.D. 14) at Shah-ji-ki-Dheri was crowned with stupendous tiers of umbrellas which, rather than the DOME beneath, are thought so to have impressed Chinese visitors that the Chinese pagoda was invented in imitation of the spire of the stupa alone. Stupas continued to be built all over the Buddhist world right down to modern times in all sizes from miniatures to the monsters of northern India which reached a height of 200 to 400 ft. and the colossal pagodas of Mandalay and Bangkok.

In the early centuries of the Christian era the stupa was also used in the Jain religion as an object of reverence and devotion, but among the Jains the custom did not last long and in general the stupa is associated with Buddhism.

**STURM, DER** (The Assault). Name of a magazine and an art gallery in Berlin, both founded and owned by Herwarth Walden (1878-1941). The gallery ran until 1924 and the magazine from 1910 to 1932. Through them Walden, an enthusiastic supporter of the *avant-garde*, assisted in introducing FUTURISM to Germany in 1912 and publicized the EXPRESSIONISM of the BLAUE REITER group, making them an international clearing house of ideas. In 1912 he also published five essays by the modernistic architect Adolf LOOS.

2785.

**STYLIZED, STYLIZATION.** Terms applied to types of art or ornament which are based on the representation of natural objects but depart from exact representation or NATURALISM in favour of conventional schematization, linear rhythm, simplification, or stereotyped forms.

**STYLUS** or STYLE. A pointed metal instrument, usually of iron, essentially the same as the METAL-POINT but intended only to impress the GROUND, not to mark it. Originally used in classical times for writing on wax tablets, it later served many other purposes: to incise the ornament on gold grounds, rule the lines for a manuscript, or trace the outlines of a composition from the CARTOON on to the plaster in FRESCO painting or engraving. It was much used for the PERSPECTIVE lines, and other lines of measurement and guidance, in architectural drawings, and for squaring up compositions. Nowadays the clear erasable line of the lead PENCIL is preferred for most purposes.

**SUARDI, BARTOLOMEO.** See BRAMANTINO.

**SUBLEYRAS, PIERRE** (1699-1749). French religious painter who worked mainly in Rome from 1728 and continued the academic traditions of the 17th c. with a particular elegance of technique (*Mass of St. Basil*, Sta Maria degli Angeli, Rome). Like Pompeo BATONI, in some of his work he foreshadowed the NEO-CLASSICAL reaction.

**SUBLIMITY.** The term 'the sublime' came into general use in the 18th c. to denote a new AESTHETIC concept held distinct from, and sometimes contrasted with, the beautiful. It was first prevalent in literary theory as a translation of the key concept 'elevation' of Longinus's treatise *Peri Hupsous*, which combined the notions greatness of conception, elevation of diction, and emotional intensity. Boileau, whose French translation of Longinus (1674) was largely responsible for the popularity in England and in France both of the treatise and of the term, interpreted the sublime in his Preface as 'the extraordinary, the surprising and the marvellous in discourse'. From the literary sphere the term was extended to a wider range of aesthetic reactions, for which ADDISON and Hume had preferred the term 'greatness', and in especial the new sensibility for the wild, awe-inspiring, and stupendous aspects of natural scenery.

The outstanding work on the concept of the sublime in English was BURKE's *Philosophical Enquiry into the Origin of our Ideas of the Sublime and Beautiful* (1757). In keeping with the current practice in his time Burke understood the sublime as a general mode of aesthetic experience found in literature but also far more widely. He did, however (and for this he was ridiculed by Richard Payne KNIGHT), restrict its nature more systematically than any of his predecessors to the emotion of terror: 'terror', he says, 'is in all cases whatsoever, either more openly or latently, the ruling principle of the sublime.' His work is important for being one of the first to realize (in contrast with the emphasis on clarity and precision during the Age of Enlightenment) the power of suggestiveness to stimulate imagination. Speaking of painting he says that 'a judicious obscurity in some things contributes to the effect of the picture', because in art as in nature 'dark, confused, uncertain images have a greater power on the fancy to form the grander passions than those which are more clear and determinate'. Burke's *Enquiry* was one of the sources for KANT in his *Critique of Judgement* (1790), which contains the classical exposition of the notion of sublimity in philosophical writing. Kant contrasts the beautiful, which inheres in form, with

the sublime which attaches to objects devoid of form in so far as they immediately involve, or by their presence provoke, an impression of limitlessness—such as storms at sea, lightning, mountains, waterfalls. 'But the most important and vital distinction between the sublime and the beautiful is certainly this: that if, as is allowable, we here confine our attention in the first instance to the sublime in Objects of nature (that of art being always restricted by conditions of an agreement with nature), we observe that whereas natural beauty (such as is self-subsisting) conveys a finality in its form making the object appear, as it were, preadapted to our judgement, so that it thus forms of itself an object of our delight, that which, without our indulging in any refinements of thought, but, simply in our apprehension of it, excites the feeling of the sublime, may appear, indeed, in point of form to contravene the ends of our power of judgement, to be ill-adapted to our faculty of presentation, and to be, as it were, an outrage on the imagination, and yet it is judged all the more sublime on that account.'

The growing feeling for the wild, grand, and terrifying aspects of nature later to be embraced in the concept of the sublime were expressed by Addison, John Dennis, and Shaftesbury and were given a wider vogue by the tremendous popularity of Thomson's *The Seasons*. Salvator ROSA was the painter most favoured by the CONNOISSEURS of the sublime in nature. But the writers mainly responsible for introducing the concept of the sublime into the literature of painting were Roger DE PILES in France and Jonathan Edwards in England. The following quotation from De Piles shows his indebtedness to Boileau: 'in Painting there must be something Great and Extraordinary to surprise, please and instruct, which is what we call the *grand Gusto*. 'Tis by this that ordinary things are made beautiful and the beautiful sublime and wonderful; for in Painting, the *grand Gusto*, the Sublime and the Marvellous are one and the same thing' (*Art of Painting*, Eng. trans., 1706). RICHARDSON made a careful study of the concept of the sublime in literature and in the second edition of *An Essay on the Theory of Painting* (1725) he applied it to painting. His notion of the sublime is close to Longinus. He defines it generally as 'the most Excellent of what is Excellent, as the Excellent is the Best of what is Good', and applied to painting he says that it is 'the Greatest, and most Beautiful Ideas, whether Corporeal, or not, convey'd to us the most Advantageously'. He held that these ideas were conveyed by Grace and Greatness 'whether from the Attitude, or Air, of the Whole, or the Head only'. INVENTION, expression, and COMPOSITION contributed to sublimity. It was in a sense such as this, rather than because of an addiction to the extraordinary, the terrible, or the marvellous, that MICHELANGELO and above all RAPHAEL were generally held at this time to be the two exemplarily sublime painters and

historical painting and portraiture were considered the typically sublime genres. Richardson himself instanced the MANNERIST Federico ZUCCARO and REMBRANDT as typically sublime painters but in this respect was out of line with the taste of his time, which regarded the detailed minuteness of Dutch painting and its preference for everyday subject matter as contrary to the principles of sublimity.

REYNOLDS discussed the Sublime in his last *Discourse*, delivered in Burke's presence in 1790. He claimed that the figures of God and the SIBYLS in the Sistine Chapel excited the same sensations as 'the most sublime passages of Homer'. 'The Sublime in painting, as in poetry, so overpowers, and takes possession of the whole mind, that no room is left for attention to minute criticism. The little elegancies of art, in the presence of these great ideas thus greatly expressed, lose all their value, and are, for the instant at least, felt to be unworthy of our notice. The correct judgement, the purity of taste which characterize Raffaelle, the exquisite grace of CORREGGIO and Parmigianino, all disappear before them.' The vogue of the Sublime was closely allied with the cult for the PICTURESQUE in nature and led on to the ROMANTIC Movement and more particularly the attitude to nature in the 'Gothic' novels of Mrs. Radcliffe and such paintings as John MARTIN's *Fall of Babylon* (1819).

**SUDARIUM.** See VERNICLE.

**SUGAR AQUATINT.** See AQUATINT.

**SUGER** (1081-1151). As Abbot of the 'royal' abbey of SAINT-DENIS from 1122 until his death, Suger was responsible for the reformation of the monastery and the rebuilding of the abbey. He was the trusted adviser of Louis VI and Regent during the latter's absence on the Second Crusade. Suger's two ambitions, which he managed to reconcile in his own mind, were to strengthen the power of the Royal House of France (for which he is sometimes called the father of the French monarchy) and to achieve the aggrandizement of the abbey of Saint-Denis. Owing to certain revolutionary features his reconstruction and redecoration of the abbey was an important landmark in the emergence of French GOTHIC. Suger's autobiographical account of the reconstruction is a rare document for the insight it gives into the religious philosophy of the PATRONS of the great Gothic ecclesiastical buildings. Unlike St. Bernard, his constant critic, Suger was, in the words of PANOFSKY, 'frankly in love with splendour and beauty in every conceivable form: it might be said that his response to ecclesiastical ceremonial was largely aesthetic'. His conception of the magnificence of church architecture, decoration, and treasure was anagogic: through the splendour and brilliance of material treasure, the soaring architecture, and the effulgence of material light men were led

away from the material to an appreciation of the spiritual glories of the divine Being.

**SUIBOKU** (Japanese: ink painting). Style of black INK painting on white silk or PAPER which was practised throughout Japan, chiefly by Buddhist priests, during the 14th–17th centuries. It was directly inspired by CHINESE painting of the Sung and Yüan periods—MA YÜAN, Hsia Kuei, and MU CH'I being the Chinese masters who influenced the JAPANESE most strongly. The essentials of *suiboku* were bold composition in the Chinese style, strength of brush-work, and nuance in the tone of the ink. The most favoured subjects were LANDSCAPES, flowers, and birds, or priests and sages, portrayed usually on hanging scrolls or screens.

In its early development *suiboku* was impregnated with the austere simplicity of Zen Buddhism and attempted to express, both in landscape and in figural compositions, the meditative, intuitive, simple-hearted, and other-worldly philosophy of that sect. By the end of the 15th c. the Zen simplicity and economy of statement had receded and later *suiboku* were virtuoso exercises in black and white exploiting the technical possibilities of the medium. The 15th-c. works with their expressive brush-work were still close to the Chinese model, but the later exponents of the style developed an angular, jagged brush-stroke which, though often powerful, tended to be clever rather than profound. The compositions were striking in their design but somewhat empty; subtlety and suggestion gave way to the obvious and dramatic. In the late 16th to early 17th c. the movement split into three Schools—Hasegawa, Soga, and Unkoku—and died out c. 1670.

Biographical detail of the many artists who adopted this style is generally lacking. Josetsu (active 1393–1411), a priest of Shōkokuji, was believed to be the founder of the style. Geiami (1431–85) and Sōami (d. 1525) belong to its maturity. Another priest, Shūbun (first half of 15th c.), pupil of Josetsu, was himself regarded as the outstanding teacher of his time. Sesshū (1419–1506), perhaps a pupil of Shūbun, was considered the greatest of the 15th-c. artists and his School spread over most of Japan and was carried on by the individualistic painter Sesson (c. 1504–89).

**SUKENOBU,** NISHIKAWA (1671–1715). Japanese painter and illustrator of Kyoto. He was also active in COLOUR PRINTS (UKIYO-E) of the elaborate polychrome type known as *nishiki-e* and was said to be one of the few masters of the colour print who excelled as a painter. As an illustrator he made his speciality animated and graceful compositions of women and domestic scenes.

**SULLIVAN,** LOUIS (1856–1924). One of America's greatest architects and the first to design large commercial buildings which instead of recalling the architecture of past periods were a direct expression of their metal-frame structure and its function to provide large uninterrupted floor areas and admit ample light to the interior. He developed an ORGANIC theory of architecture relying for aesthetical effect on PROPORTION and strength of line.

He worked for Frank Furness (1839–1912) in 1873, spent a few months in 1874 at the École des Beaux-Arts, Paris, and may have worked for William Le Baron Jenney (1832–1907), a pioneer in the use of the STEEL frame for multi-storey buildings. His mature work, much of which was done in partnership (1881–95) with Dankmar Adler (1844–1900), represents the culmination of the achievements of the CHICAGO SCHOOL of architects.

Sullivan's principal buildings were the Wainwright building, St. Louis (1890–1), the Prudential building, Buffalo (1894–5), the Bayard building, New York (1897–8), and the remodelling of the Carson, Pirie, Scott department store, Chicago (1899–1904). His *Kindergarten Chats*, published in 1901–2, expounded his philosophy to the younger generation of architects, among whom was Frank Lloyd WRIGHT, Sullivan's pupil and his successor as the American prophet of 'organic' architecture, a term first publicized in Sullivan's book.

Sullivan originated the famous cliché 'Form follows function' (see FUNCTIONALISM) but his own building was not rigorously functional in character. After 1895, when for a time he designed façades for buildings designed by others, his interest in elaborate ornament was a more prominent feature of his work, as exemplified in his Farmers and Merchants Union Bank, Columbus (1919). His rambling and turgid book *The Autobiography of an Idea* (1923) still contains flashes of insight.

459, 1879.

**SULLY,** THOMAS (1783–1872). English-born painter who lived and worked in the United States and was regarded as the leading portrait painter of his day. During a visit to England 1809–10 he was impressed by Sir Thomas LAWRENCE and he has been regarded as the Lawrence of America, the creator of a ROMANTIC portraiture of mood and elegant sweetness. He was a rapid and industrious painter, and there are some 2,000 portraits besides MINIATURES and more than 500 subject and historical pictures listed to his name. In 1837 he visited London to paint Queen Victoria for the St. George Society of Philadelphia and another portrait of the Queen from his brush is in the Wallace Collection. His masterpiece is considered to be the portrait *Col. Thomas Handasyd Perkins* (The Boston Athenaeum, 1831–2). Of his subject paintings the best known is perhaps *Washington Crossing the Delaware* (Mus. of Fine Arts, Boston, 1819). He was for 15 years a Director of the Pennsylvania Academy of Fine Arts. But after c. 1830 his work was weakened by the

genteel sentimentality which became increasingly prominent in American painting towards the middle of the 19th c.

**SUMERIAN ART.** See BABYLONIAN ART.

**SUPPORT.** The CANVAS, wooden PANEL, PAPER, or other solid substance on which a painting is executed; technically distinguishable, as a rule, from the GROUND.

**SUPREMATISM.** An ABSTRACT movement launched in Russia by Casimir MALEVICH in 1913, maintaining that painting should be constructed only from the geometrical elements the rectangle, circle, triangle, and cross. As a paradigm for the movement Malevich exhibited a black square on a white ground. In 1915, with the aid of the poet Mayakovsky, Malevich published a manifesto explaining the principles of the movement, later translated into German under the title *Die gegenstandlose Welt*. In 1919 he exhibited in Moscow his famous 'white on white' paintings. The white square on a white ground (Mus. of Modern Art, New York) was supposed to have carried Suprematism to its ultimate logical conclusion.

**SURI-MONO.** Miniature Japanese COLOUR PRINTS or UKIYO-E designed, often by AMATEURS, to commemorate a special occasion such as the New Year, a birth, a marriage, or a change of name. They were elaborately printed on special PAPER, often goffered with gold or silver dust, and were inscribed with a poem contributed by some popular literary figure. The aim was charm and a variety of devices was used to underscore the symbolism. The poet-artist Kubo Shunman (1757–1820) devoted himself in later life to the *suri-mono*. SHUNSŌ, UTAMARO, TOYOKUNI, HOKUSAI and his pupils were among the more famous professional designers who practised this branch of miniature colour printing.

**SURREALISM.** A movement in art and literature which took over some of the attitudes of DADAISM within the framework of a more positive creed. Although like Dadaism and FUTURISM it claimed to be a way of life rather than a new artistic style, it became the most widely disseminated and controversial aesthetic movement between the First and Second World Wars. Basically Surrealism sought to explore the frontiers of experience and to broaden the logical and matter-of-fact view of reality by fusing it with instinctual, subconscious, and dream experience in order to achieve an absolute or 'super' reality. In the words of André BRETON, its purpose was 'to resolve the previously contradictory conditions of dream and reality into an absolute reality, a super-reality'. Within this general aim it combined a large number of different and not altogether coherent doctrines and techniques, the most characteristic of which

were the various attempts to breach the dominance of reason and conscious control by methods designed to release primitive urges and imagery. At one stage Breton defined Surrealism as: 'purely psychic automatism through which we undertake to express, in words, writing, or any other activity, the actual functioning of thought, thoughts dictated apart from any control by reason and any aesthetic or moral consideration. Surrealism rests upon belief in the higher reality of specific forms of associations, previously neglected, in the omnipotence of dreams, and in the disinterested play of thinking.'

One manifestation of the movement was a new interest in the fantastic and GROTESQUE aspects of such artists as BOSCH, ARCIMBOLDI, PIRANESI, GOYA, ROPS and closer contemporaries such as REDON, CHIRICO, and CHAGALL were welcomed as forerunners for similar qualities. Freud's theories of the unconscious were exploited and various techniques of automatism were cultivated in order to breach the control of reason and release the submerged impulses and imagery. Poets practised automatic writing and a kind of visual equivalent of this was attempted by some painters, notably MIRÓ, ARP, MASSON, ERNST, in techniques ranging from FROTTAGE to the REALISTIC reproduction of dreams. Since the complex techniques of painting and sculpture are unfavourable to pure automatism and require at least some measure of conscious direction emphasis was laid on the OBJET TROUVÉ and on dream. Surrealist paintings differed at their most characteristic from dream paintings of the past by their greater success in conveying the peculiar emotional quality of dreams by their

368. *Vendredi. Élément: La Vue. Exemple: L'intérieur de la vue.* Engraving from *Une Semaine de Bonté ou Les Sept Éléments Capitaux (Troisième Poème Visible)*, (1934) by Max Ernst

reproduction of dream space (e.g. in the works of Yves TANGUY) and the suggestive juxtaposition of logically unconnected objects. The Surrealists also took over the methods of the Dadaists Marcel DUCHAMP and Francis PICABIA, exhibiting objects lifted out of their normal setting so as to appear functionless or elaborately constructed objects with no function. The method of illogical juxtaposition was developed particularly by DALI and MAGRITTE in conjunction with a photographic technique akin to the meticulous style of the PRE-RAPHAELITES or to that of late 19th-c. academic painting in order to give an illusion of objective reality to constructs of fantasy, whose disturbing impression was heightened by the contrast between the realistic treatment and the unreal subject. Dali, Man Ray (1890-   ), Hans Bellmer (1902-   ), and others also developed the technique of multiple and ambiguous images intended to evoke obscure subconscious associations.

The AESTHETICS of the movement were developed by the French poets André Breton, Paul Éluard, and Paul Reverdy. Breton was the chief theorist and mainly responsible for the Surrealist manifestos of 1924 and 1929. In 1928 he published *Le Surréalisme et la Peinture*. In 1926 the Surrealists founded their Galerie Surréaliste and important Surrealist exhibitions were held in London in 1936 and in Paris in 1947. Although the enthusiasm for Surrealism diminished after the 1930s, the movement did not disappear but persisted to a minor extent after the Second World War. Its significance in 20th-c. aesthetics lies chiefly in its resurrection of the marvellous and exotic at a time when interest in these was in abeyance and the emphasis which it placed on poetic content when in CUBISM and various forms of ABSTRACT and IMPRESSIONIST painting subject matter counted for little and formal considerations were given predominance.

387, 388, 389, 390, 494, 1905, 2193, 2784.

**SURVAGE.** See CUBISM.

**SUSANNA.** In EARLY CHRISTIAN ART Susanna was a symbol of the saved soul. She was represented in the attitude of prayer between the elders in the Catacomb of Priscilla, Rome (2nd c.); in the IVORY relief of the Lipsanotheca in Brescia (*c.* 370); and as a LAMB between two wolves in the Catacomb of Praetexta, Rome (4th c.). The whole story occurs on a 4th-c. SARCOPHAGUS in San Feliú, Gerona, and on the Lothair crystal (B.M., 9th c.).

Susanna in her chastity was seen as a prefiguration (see TYPOLOGICAL BIBLICAL ILLUSTRATION) of the VIRGIN and the story of her acquittal was also used during the Middle Ages to illustrate the concept of Justice. After the RENAISSANCE the bath scene, with its erotic connotations, was preferred (e.g. PINTORICCHIO, fresco in the

Appartamento Borgia, Vatican, 1494; ALTDORFER, Munich, 1528; RUBENS, Munich, 1635— Susanna crouches at the edge of a fountain; REMBRANDT, The Hague, 1637). The scene was often rendered in the 19th c. and was set as the subject for the *Prix de Rome* in 1957.

**SUTHERLAND,   GRAHAM   (1903-   ).** English painter. After abandoning a career as a railway engineer he studied at the Goldsmiths' College School of Art and until *c.* 1930 made a living as an ETCHER, working with enthusiasm in the ROMANTIC and visionary tradition of Samuel PALMER. During the 1930s he took to painting and from 1933 to 1939 worked chiefly on pictures which he described as imaginative paraphrases of the Pembrokeshire landscape. During the war years he was employed as an official war artist to record the effects of bombing and his work matured as he wrestled with the problems of finding a visual surrogate for the devastation and the destruction of man-made things. Writing of Sutherland's pictures of ruined and shattered buildings, the critic Eric Newton said: 'they have a bold, crucified poignancy that gives the war a new meaning.' His first portrait was *Somerset Maugham* (1949); he also did *Beaverbrook* (1951) and *Churchill*. In 1951 he executed a large exhibition canvas evocative of the Origins of the World. In 1952 he had a retrospective exhibition at the Venice Biennale and in 1953 retrospective exhibitions at the Tate Gallery, London, and in Amsterdam, Zürich, and Boston. He made his mark in religious painting with the *Crucifixion* commissioned for St. Matthew's, Northampton, in 1944, which was followed by the still more famous tapestry for Coventry Cathedral and the *Crucifixion* for St. Aidan's, East Acton. He was awarded the Order of Merit in 1960.

**SU TUNG-P'O** (1036-1101). A Chinese poet of the Sung dynasty who was also famous for his calligraphy and paintings of bamboo, arts which he said he learned from Wen T'ung (d. 1079). Examples are extremely rare. In later generations many *wên-jên* painters (see CHINESE ART) took him as their model. Su Tung-p'o was also a writer on art theory. Like many of the *literati* Sung painters, he held that the painter must by meditation so immerse himself in the essence of the bamboo or other subject as to become identified with it.

1668.

**SWAG.** Any representation of a festoon of flowers or DRAPERY, e.g. in carving or painting.

**SWANENBURGH,** JACOB ISAACSZ VAN (1571-1638). Dutch painter of Leiden whose rare works include both architectural views of Italy, where he lived for about 15 years, and pictures of hell and the witches' sabbath. He has

the distinction of being the first teacher of REMBRANDT.

**SWART VAN GRONINGEN, JAN** (*c.* 1500– after 1553). Netherlandish painter, book illustrator (he made 73 of the 97 WOODCUTS for the Dutch Bible published by W. Vostermann, Antwerp, 1528), and designer of STAINED-GLASS windows. He probably worked in Antwerp and Gouda and travelled to Italy. His works show that he was familiar with those of DÜRER, HOLBEIN, SCOREL, and other northern artists who were impressed by Italian RENAISSANCE art. He had a predilection for showing people wearing high hats, turbans, and other odd head gear.

**SWEERTS,** MICHIEL (1624 – *c.* 1664). Painter who was born in Brussels and worked in Rome 1643–56, where he came into contact with Pieter van LAER's friends, the *Bamboccianti*, and like them painted scenes of Roman street-life. He also painted portraits, scenes of popular life illustrating the Christian virtues, and scenes from the lives of artists. *The Painter's Studio* in the Rijksmuseum gives a good idea of studio practices in Rome *c.* 1650. Sweerts's GENRE paintings are distinguished from those of the other *Bamboccianti* by the quiet, melancholy dignity of the figures and their silvery-violet tonality. He has been called 'The Dutch LE NAIN'. In 1656 he was back in Brussels and *c.* 1658/60 in Amsterdam. In 1661 he joined a missionary group which set sail for the Orient, but in the following year the bishop in charge dismissed him at Tabriz. There is evidence that Sweerts was active again as a painter along the south-west coast of the Bay of Bengal in 1663 and it is reported that he died in Goa.

**SYMBOLISM.** A loosely organized movement or attitude common to certain painters and sculptors from *c.* 1885 in close connection with the Symbolist movement in French poetry. It came as a reaction from the aims of IMPRESSION-ISM and still more from the principles of REALISM as formulated by COURBET: 'Painting is an essentially concrete art and can consist only of the representation of things both real and existing. . . . An abstract object does not belong to the domain of painting.' In direct opposition to this idea of painting the poet Jean Moréas published a Symbolist Manifesto in the *Figaro* of 18 September 1886, in which it was stated that the essential principle of art is 'to clothe the idea in sensuous form'. The aim of Symbolism was to resolve the conflict between the material and the spiritual world. As the Symbolist poets regarded poetic language primarily as symbolic expression of inner life, so they demanded of the painters that they should give visual expression to the mystical and the occult. The basis of the Symbolic position was formulated by the critic Albert Aurier, an enthusiastic member of the group of GAUGUIN's supporters, in an article published in the *Mercure de France* in March 1891. He there affirmed that 'the work of art must be (1) *ideaed* (*idéiste*) since its sole ideal will be the expression of the idea; (2) *symbolist*, since it will express this idea in forms; (3) *synthetic*, since it will present these forms, these signs, in a mode of comprehension that is general; (4) *subjective*, since the object it depicts will never be considered just as an object but as the sign of an idea perceived by the subject; (5) (as a consequence) *decorative*, for decorative painting proper . . . is nothing else than a manifestation of an art which is at once subjective, synthetic, symbolist and ideaed'.

The word 'synthetic' was sometimes used to distinguish the art movement from the Symbolist movement in poetry and it was also used of the work of the NABIS, which was very closely related to one part at least of the Symbolist movement. Indeed the Nabis were regarded as Symbolists by Maurice DENIS, the theorist of the movement, who wrote in *Cézanne as Symbolist* (1907): 'Symbolism was not originally a mystical or idealistic movement. It was begun by LANDSCAPE and STILL-LIFE painters, and not by painters of the soul. It did however imply a belief in the correspondence between external forms and subjective states. Instead of evoking our state of mind by means of the subject represented, it is the work itself that should transmit the initial sensation and perpetuate the emotion. Every work of art is a transposition, an impassioned equivalent, a caricature of some sensation experienced or, more usually, a psychological fact.'

The outlook of Symbolism and Symbolist art was propagated in a large number of periodicals. In 1886 began the *Pléiade*, the *Décadent*, *Vogue*, and the *Symboliste*. The *Mercure de France* was founded in 1890 and the *Revue Blanche* in 1891. The artists recognized as chiefly representative of the Symbolist attitude were PUVIS DE CHAVAN-NES, who believed that 'for each clear idea there is a pictorial thought which translates it', Odilon REDON, called by Maurice Denis 'the Mallarmé of painting' and who stated that his goal was 'to transform human emotions into ARABESQUES', Gustave MOREAU, who was the teacher of MATISSE, ROUAULT, and others of the FAUVES, the 'French PRE-RAPHAELITE', and Eugène CAR-RIÈRE with his dreamlike, literary monochromes.

The Symbolists did not create a new pictorial style but were ECLECTICS or individualists, more interested in the expression of poetic ideas, in the occult, or in religious dilettantism than in artistic form.

1697, 2739.

**SYN.** The name of a group of painters formed in 1964 in south-western Germany and of a magazine in German and English. The aims of the group are stated as follows: 'SYN (Greek for together) reveals the possibilities of an

integral art beyond the strictures of Formalism (Concrete Art, Optical Art, Hard-Edge painting) or Informalism (EXPRESSIONISM, TACHISME, Action Painting), and based on pure plastic principles.' Among the members were Bernd Berner (1930– ) and Rolf-Gunter Dienst (1939– ). Another member of the group, Klaus Jürgen-Fischer, has said (1966) that the paintings of the group 'depict a new realm of organised freedom'.

**SYNAGOGUE.** The synagogue as an institution dates back probably to the 6th c. B.C., but the earliest literary and epigraphic evidences do not go beyond the 3rd c. B.C. and the first substantial remains are of Palestinian synagogues of the 3rd–6th centuries A.D., mainly in Galilee. These are built in the provincial Roman style, some in BASILICA form: sculptured decorative features include masks, birds, and animals, and there were sometimes (e.g. at Beth Alpha, 6th c.) MOSAIC floors depicting biblical scenes. The 3rd-c. wall-paintings of the synagogue of Dura Europos (on the Euphrates) were probably not exceptional. In the Middle Ages the small size of the Jewish communities, and fear of Gentile jealousy, coupled with the intimate and instructional nature of Jewish worship, kept the synagogue, generally speaking, small and unostentatious. The only necessary feature apart from a reading-desk or platform was a receptacle ('Ark') for the Scrolls of the Pentateuch, which while sometimes an architectural feature in the form of APSE or niche, might be merely a cupboard-like addition. A separate section (later a gallery) was reserved for the women worshippers. Architecturally, the synagogue was in the style of the environment: ROMANESQUE or GOTHIC in Germany, etc. (Worms, 11th c., Prague, 14th c.), MOZARABIC or MUDÉJAR in Spain (Cordova, 14th c., Toledo, 12th and 14th centuries). A new architectural tradition, somewhat in the style of Protestant meeting-houses, began with the age of emancipation in northern Europe (Amsterdam, 1675; Bevis Marks, London, 1701; Great Synagogue, London, 1790). A characteristic type worth mentioning were the pagoda-like wooden synagogues of Poland as well as the fortified stone synagogues, sometimes decorated with interior frescoes, all in the style of eastern European FOLK ART. A deplorable retrogression in the 19th c., when Mauresque styles were unimaginatively imitated in inappropriate media, was succeeded by a 20th-c. revival, largely under the influence of American 'Reform' Judaism. In this, the former intimate tradition was superseded by grandiose forms in which the women's gallery tends to be abandoned, and reading-desk and Ark converge in an altar-like combination at which the Rabbi officiates rather than teaches.

1696, 2582.

**SYNCHROMISM.** A movement, based on pure-colour abstraction, founded in 1913 by the American painters Stanton Macdonald-Wright (1890– ) and Morgan Russell (1886–1953). These two artists were in Paris, 1912–13, where they saw the work of the ORPHISTS, Robert DELAUNAY and Frank Kupka. Although Macdonald-Wright and Russell worked in different styles, both painted with brightly coloured, segmented disc-like forms. Their colour theories went back to the NEO-IMPRESSIONISTS, and the theoreticians Chevreul and Rood. Arthur Burdett Frost, Jr. (1851–1928) and Patrick Henry Bruce (1881–1937) were also associated with this movement. Both had been students of MATISSE and both worked with shapes and volumes of pure colour. Frost especially helped to spread the ideas of the Synchromists in America. This was the first American movement with a formulated doctrine and manifesto.

**SYNTHETISM.** See SYMBOLISM.

**SYRIAN ART.** Knowledge of the early phases of Syrian art is very incomplete. Isolated sites, referred to in the entry on HITTITE ART, prove a high degree of culture in north Syria in the early Chalcolithic period (4th millennium B.C.: Sakçagözü, Tell Halaf). Evidence exists of Syrian contacts with Mesopotamia in the Jemdet Nasr period (late 4th millennium: Carchemish, Brak in the River Habur region, and other sites). Notable is the existence in the middle 3rd millennium of a quasi-Sumerian style in stone sculptures, yet in some cases depicting men of distinctive racial type with large noses (Brak, Jebelet el-Beida). Syrian art of the 3rd millennium is little known, as excavated sites hitherto have produced few works of art of that period save POTTERY (except at Mari: see below). But it may be deduced that a developed native art already existed in the north and west with its own traditions for representing gods, men, animals, and monsters. From the end of the 3rd millennium we have a fine though headless statue from Sefiré. From reflections in EGYPTIAN ART of the Middle Kingdom from contemporary Syrian art it seems likely that in it SPHINXES, griffons, chimaeras, and other demons were already well known as familiar features.

In the early 2nd millennium a potent Semitic Amorite centre of art and commerce, yet under considerable Sumerian and Babylonian influence, existed on the middle Euphrates at Mari. In the palace of Zimrilim were impressive FRESCO-paintings, while the entrance of a temple was protected by a series of magnificent sheet bronze figures of life-size lions with inlaid eyes, perhaps the start of a tradition of placing lions in doorways which survived through Hittite art to be revived from Eastern sources in ROMANESQUE churches of Provence. As Syria, like Palestine, is an open landbridge between continents crossed by roads north to south and east to west, the definition of artistic schools is difficult. The influence of the north Syrian Hurrian people has, however, been claimed by

some in the art of the 2nd millennium B.C. The architecture of the period is very little known, but the *bit-hilani*, a type of building developed by the Hittites, and temple palaces ornamented with CARYATID figures and RELIEFS in basalt or limestone, often alternated in contrasting colours, are already found at Atchana, block-like yet expressive. A fair example of the curious provincial yet lively style is the inscribed statue in the round showing Idrimi King of Atchana (now in the B.M.).

In the 2nd millennium a very characteristic Syrian medium of art borrowed from Mesopotamia was the cylinder-seal for sealing cuneiform tablets. Syria was open to foreign settlers and imports on the coast, e.g. at Ras Shamra; but by the Hittites' occupation of the country from 1375 to 1200 B.C. Hittite taste became influential in several departments of art, especially in architecture. The protecting power of the Hittites collapsed in 1200 B.C., but the principal centres in the north (Carchemish, Malatya, Tell Halaf, Zinjirli, Sakça-gözü, Tell Taiyanat, and Hama in the south and others) either continued, or now appeared, as productive cultural centres,

maintaining a late Hittite tradition far into the 1st millennium B.C. Yet in combination with the Hittite tradition, an ancient native tradition with its own formulas for depicting animals and men is likewise found surviving, especially in IVORY carvings from Nimrud (Assyria), probably carried off from Hamath or other places as booty by Assyrian kings. But all, or almost all, independent styles of local art in Syria were extinguished when the Assyrian armies destroyed the Syrian cities piecemeal during the 9th–7th centuries B.C.

358, 2314, 2934, 2935.

**SYRLIN**, JÖRG (d. *c.* 1490). German (Swabian) wood-carver. His magnificent CHOIR STALLS in Ulm Cathedral (*c.* 1475) are one of the greatest works of German late GOTHIC carving. Although taken from stock imagery, the figures of PROPHETS and SIBYLS at the bench-ends were no longer distinguished merely by attributes or inscriptions. Each face expresses a strongly individual personality, whose spiritual force proclaims its message.

2764.

# T

**TACCA**, PIETRO (1577–1640). FLORENTINE sculptor in BRONZE, the pupil and follower of Giovanni da BOLOGNA. After the latter's death he completed a number of his works and succeeded him as sculptor to the Grand Dukes of Tuscany. His works for the MEDICI include the four *Slaves* (1615–24) at the foot of BANDINELLI's statue of Ferdinand I at Leghorn, the GROTESQUE fountains in the Piazza della SS. Annunziata, Florence, and the statues of Ferdinand I and Cosimo II in the Chapel of the Princes, S. Lorenzo, Florence. His last work was the EQUESTRIAN STATUE of Philip IV of Spain for the Plaza de Oriente, Madrid, in which the King is shown on a rearing horse. This pose, which was to become a standard type for BAROQUE statues of monarchs, was imposed on the artist, having been already used in pictures of the King by RUBENS and VELAZQUEZ. But the smooth, generalized treatment of the work shows that Tacca remained essentially a MANNERIST sculptor.

**TACHISME**. Term coined in 1952 by the critic Michel Tapié (from the French *tache*) to designate paintings made up of irregular dabs or splotches of colour which at first sight appear to have no constructive idea but to be arranged capriciously by random chance. This technique differs from BLOT painting from LEONARDO to

the SURREALISTS, where the chance blot or blemish is used to stimulate the imagination or the unconscious in the creation of formal compositions. The Tachiste painter accepts the patch of colour as an element in its own right, regarding it as an emotional projection, and aims to create the impression in the finished painting as if the dabs of colour had been thrown on to the canvas at haphazard. The movement had affinities with the AESTHETIC of American Action Painting in that it strove to be completely spontaneous and instinctive, excluding deliberation and formal planning. It did not try to represent or to express, but to *be* a dramatic or emotional state of mind. It was called by Tapié the 'other art' to emphasize its complete break with all aesthetic values and techniques prior to 1950 and it has been regarded as the culmination of those tendencies in post-war art which oppose the ideal of spontaneous 'formlessness' to traditional form. The new aesthetic of Tachisme claimed to be equally in revolt from ABSTRACT ART as it had been up to then and from the art of NATURALISTIC representation. Its idea was expressed by Jean Atlan in 1953: 'I believe that there is a common source for the painter and the dancer, this common source is a certain manner of living rhythms. . . . For me a picture cannot be the result of a preconceived idea, the role of chance

(*aventure*) is too important in it and indeed it is this role of chance which is ultimately decisive in creation. At the beginning there is a rhythm which tends to unfold itself: it is the perception of this rhythm that is fundamental and it is in its development that the vital quality of the work depends.' Camille Bryen wrote in 1955: 'Painting is first a creation and then a revelation; it is no longer a definition or a signification, still less an expression.'

Besides Atlan and Bryen, artists of this school have been: Georges Mathieu, François Arnal, Jean Fautrier, and Robert Lapoujade. The German Wols (Alfred Otto Wolfgang Schülze) and the Canadian Jean-Paul Riopelle (who in 1940 founded in Montreal the group called Les AUTOMATISTES) had affinities with it.

**TACTILE VALUES.** Term introduced into art criticism by Bernard BERENSON in his *Florentine Painters of the Renaissance* (1896). He says that since sight alone gives us no vivid sense of three-dimensional solidity, we acquire that sense in infancy by means of touch 'helped on by muscular sensations of movement'. We make touch together with kinaesthetic imagery our test of reality. 'Every time our eyes recognize reality we are, as a matter of fact, giving tactile values to retinal impressions. Now, painting is an art which aims at giving an abiding impression of artistic reality with only two dimensions. The painter must, therefore, do consciously what we all do unconsciously—construct his third dimension. And he can accomplish his task only as we accomplish ours, by giving tactile values to retinal impressions. His first business, therefore, is to rouse the tactile sense, for I must have the illusion of being able to touch a figure, I must have the illusion of varying muscular sensations inside my palm and fingers corresponding to the various projections of this figure, before I shall take it for granted as real, and let it affect me lastingly. It follows that the essential in the art of painting—as distinguished from the art of colouring, I beg the reader to observe—is somehow to stimulate our consciousness of tactile values, so that the picture shall have at least as much power as the object represented, to appeal to our tactile imagination.' Berenson goes on to say that GIOTTO was the first master since classical antiquity whose painting had this power.

Berenson's description of FLORENTINE painting in terms of tactile values remains a classic of Renaissance criticism although the psychological theories on which it is based have been largely superseded. But his elevation of tactile values into a general requisite of all painting must be rejected as an example of the fallacy into which many critics have fallen of wishing to impose their own interests and likings universally. Berenson was notoriously incapable of appreciating those schools of modern—and ancient—art which subordinate tactile values to other qualities of pictorial design.

**TAI CHIN** (active *c.* 1446). Chinese painter. He was a professional at a time when AMATEUR painting predominated (cf. SHÊN CHOU), and his work was thus not appreciated until some time after his death. He is credited with founding a Chekiang School, later followers of which aimed at combining the T'ang and Sung modes. A scroll of river scenes in the Freer Gallery, Washington, is attributed to him.

**TAINE, HIPPOLYTE** (1828–93). French historian and critic, the best-known exponent of positivism in 19th-c. aesthetics. In *Philosophie de l'art* (1881) he declared: 'My sole duty is to offer you facts and show how these facts are produced' and he described ART HISTORY as a sort of applied botany: 'Just as there is a physical temperature which by its variations determines the appearance of this or that species of plants, so there is a moral temperature which by its variations determines the appearance of this or that kind of art.' He defended the view that a work of art is the product of its environment and nothing else and that it can be fully explained by environmental factors. Taine was professor of aesthetics and art history at the Ecole des Beaux-Arts in Paris and had wide influence.

**TALENTI,** FRANCESCO (d. 1369 or later). FLORENTINE architect first recorded at Orvieto in 1325 (cf. MAITANI). Soon after 1343 he was working on the CAMPANILE of Florence Cathedral, and in 1357 he redesigned the plan and façade of the Cathedral, begun by ARNOLFO DI CAMBIO, but his façade was destroyed in the 16th c.

**TALMAN,** WILLIAM (1650–1719). English architect, who played a large part in the development of the BAROQUE house in England. At Chatsworth (1686–96), though hampered by the necessity for the gradual rebuilding of an older house, his design, with giant PILASTERS below a straight balustrade, shows a knowledge of continental Baroque, probably through engravings, and the chapel, painted by LAGUERRE and decorated with sculpture by CIBBER, is one of the most typically Baroque of English interiors. Dyrham Park, Glos. (1698), a more modest house, also has a feeling for mass, and his transformation of the courtyard of Drayton, Northants., has exceptionally rich surface treatment. Talman made designs for Castle Howard, Welbeck, and Buckingham House, but quarrelled with his patrons before they were executed and the commissions passed to others. In 1689 he became Comptroller of the Office of Works and enjoyed the favour of William III, but was bitterly jealous of WREN, and was dismissed in favour of VANBRUGH in 1702.

His son JOHN was in Rome with William

KENT in 1710 and became a collector of architectural and antiquarian drawings, some of which he later sold to Lord BURLINGTON, others being in the Victoria and Albert Museum. In 1717 he became the first Director of the Society of Antiquaries.

**TAMAYO,** RUFINO (1899– ). Mexican painter, born at Oaxaca of native blood. He taught in the open-air art schools launched by José Vasconcelos (see MEXICAN ART, modern) and was deeply influenced by the AESTHETICS of popular Mexican art. During the Callas regime which followed that of Obregón he was a leader in the revival of easel painting and came out openly in opposition to the aesthetic creed of the revolutionary mural painters who set greater store by the message and theme of a picture than its plastic qualities. In 1933 he did frescoes for the National Conservatory of Music, Mexico City, but he did not identify himself with the revolutionary movement of 'art for the people' and his reputation was higher abroad than in Mexico itself. In 1938 he moved to New York and was influenced by the PICASSO exhibition of 1939. In 1943 he did an ABSTRACT mural at Smith College and thereafter turned towards a more violent and emotive form of ABSTRACT EXPRESSIONISM. His work in a highly individual style had achieved a world reputation by the 1950s.

1078.

**TANAGRA STATUETTES.** A class of carefully moulded and painted TERRACOTTA figurines mostly of the 3rd c. B.C. Many were made and found at Tanagra in Boeotia. The favourite subjects were draped women of cabinet elegance. The lusher Tanagras are usually modern FORGERIES.

1506.

**TANGUY,** YVES (1900–55). French painter. Originally a merchant seaman, he was impelled to take up painting after seeing a picture by CHIRICO and in 1925 joined the SURREALIST group. In 1939 he emigrated to the U.S.A., became an American citizen, and lived in the United States for the rest of his life. His paintings, half marine and half lunar landscapes in which amorphous nameless objects proliferate in a spectral dream-space, exert a magical appeal not explicable in rational terms. His pictures of this type are among the finest examples of the Surrealist ambition to create a spontaneous visual imagery of the subconscious. During his American period he moved in the direction of Classical form under the influence of Florentine MANNERISM and is best described as a Neo-ROMANTIC.

2525.

**T'ANG YIN** (1470–1523). Chinese academic painter of LANDSCAPES and figures, known especially for his richly coloured, delicate outline paintings of women. He began as a pupil of Chou Ch'en but later developed a broader style based on the great Yüan masters. He was also associated with SHÊN CHOU and is sometimes assigned to the Wu School (see CHINESE ART). His great popularity has resulted in countless FORGERIES and copies, and he is one of the few Chinese painters who are well known in the West.

**TAO CHI** or SHIH-TAO (1667–1714). Chinese painter, calligraphist, poet, and writer on the theory of painting. He lived in troubled times and was related to the Ming royal house; when the dynasty fell in 1644 he became a monk, devoting himself to travel and the arts. Tao Chi claimed attachment to some of the Old Masters like NI TSAN but his work is self-consciously free from many of the old canons and has an unmistakable originality. Its essentials are unusual compositions, a self-assured spontaneity, a contemplative appreciation of the moods of landscape which may be due to the influence of Zen Buddhism, and an unhesitating execution with bold and even eccentric brush-work. As one of the early INDIVIDUALISTS, Tao Chi, together with men like CHU TA and K'un Tsan, inspired some of the most vital and independent artists of the Ch'ing dynasty. His work, much admired in China and in the West, has often been forged. A fine representative album is in the Museum of Fine Arts, Boston.

**TASSI,** AGOSTINO, properly AGOSTINO BUONAMICI (c. 1580–1644). Italian painter, one of the organizers of the great schemes of decoration in Rome. Unlike most of the Roman artists of the early BAROQUE period, he was native-born. He was trained in the Florentine studio of Giulio Parigi (d. 1635), where he learned the methods and PERSPECTIVE techniques necessary for elaborate stage presentations (opera came to birth in Florence at the grand-ducal court soon after 1600). He was busy in Rome from 1610 until his death, although he was affected by arthritis in his later years. The novelty of Tassi's schemes lay in their feigned architectural settings, e.g. in the reception hall of the Quirinal Palace, where Chinese and other figures appear to look down on the people in the hall. Tassi was responsible for the feigned architecture of both rooms in GUERCINO's striking decorations at the Casino Ludovisi (1621–3). BRIL and ELSHEIMER were strong influences on his painting, particularly in the beautiful frieze of 20 sea and coast scenes in the Palazzo Doria-Pamphili, and all three artists played a role in the formation of CLAUDE's LANDSCAPE style. Claude entered Tassi's service as a pastry-cook some time before 1619, and for centuries Tassi was remembered because he taught Claude to paint, his significance as a decorative painter being forgotten.

**TATE GALLERY,** LONDON. The conception of the Tate Gallery arose from growing

dissatisfaction during the 19th c. with the inadequate representation of English schools of painting in the NATIONAL GALLERY and the need felt for a collection which would do for British painting what the Luxembourg did for French. The purchases made under the CHANTREY Bequest of 1840, which had envisaged the formation of a separate national collection of British art, and the Sheepshanks gift of 233 British paintings in 1857 were housed in the VICTORIA AND ALBERT MUSEUM. The Robert Vernon gift in 1847 of 157 paintings and a group of sculpture, and also the TURNER Bequest in 1856 of 282 paintings in oil and over 19,000 water-colours, were housed in the National Gallery but could not be properly displayed owing to lack of space. Discontent came to a head when in 1890 Mr. Henry Tate offered his collection of modern British paintings to the nation and the offer was supported by *The Times*, which demanded 'a really representative and choice collection of our art gathered together in some great central gallery'.

After many difficulties the Tate Gallery was opened at Millbank in 1897. It contained the Chantrey purchases, 18 paintings presented by G. F. WATTS, the Tate collection of 67 pictures, and 96 paintings by British artists born after 1790. A collection of works by Alfred STEVENS was added and in 1910 the Turner Bequest was transferred to a new wing financed by Sir Joseph Duveen. The Tate Gallery on formation was not, however, an independent gallery of British art as had been envisaged by Henry Tate. It was subordinate to the National Gallery and it was only intended for modern British art. One of the principal difficulties attending its formation had been the fear that it would come under the control of the ROYAL ACADEMY, which was at this time at its lowest ebb; this to some extent happened, since purchases from the Chantrey Bequest were for long a main source of regular additions and these were determined by the Academy. The Curzon Committee, reporting in 1915, recommended that the Tate should be converted from a Gallery of Modern British Art to a Gallery of British Art, that a Gallery of Modern Foreign Art should be formed in connection with the Tate, and that the administration of the Tate should be separate from that of the National Gallery. The idea was that Britain should have two National Galleries. Supreme masterpieces of British art would continue to be hung in the National Gallery at Trafalgar Square alongside masterpieces from other countries, but the history and evolution of indigenous art would be seen at the Tate and the Tate would also be responsible for a national collection of modern foreign art. In 1923 Samuel COURTAULD created a fund for the purchase of modern French paintings as a result of which the Tate within a few years became one of the finest collections in this line. In 1937 its functions were extended to modern sculpture, both British and foreign. The Gallery was formally reopened in February 1949 after damage and flooding during the war, but from 1946 it began a continuous series of exhibitions, some arranged by the Gallery itself and some by other bodies, such as the ARTS COUNCIL. Those arranged by the Tate have been mainly retrospective exhibitions of British painters, and have included Matthew SMITH, Stanley SPENCER, Wyndham LEWIS, Edward WADSWORTH, Francis BACON, Ivon HITCHENS. In 1955 the National Gallery and Tate Gallery Bill came into force, making the Tate fully independent with provision for transfers between the two galleries.

**TATLIN,** VLADIMIR (1885–1953). Russian painter, designer, maker of ABSTRACT constructions and founder of CONSTRUCTIVISM. Born in Kharkov, he attended painting classes at the Moscow School of Painting, Sculpture, and Architecture (1909–11) and until 1914 combined painting with the life of a merchant sailor. He was influenced by ICON painting and by PICASSO's analytical CUBISM, deriving from the latter the basis for his first Constructions (1913–14), entirely abstract combinations of materials such as wood, metal of various kinds, and glass. Angled Constructions, free-suspended works, date from 1915–16. In 1919–20 he built a tower of wood and glass called *Monument to the 3rd International*. With the crystallization of the Constructivist movement in 1922 he went into industrial design, working on furniture, ceramics, and theatrical design. He spent most of his later years designing a wooden glider based on insect forms.

**TATTI,** JACOPO. See SANSOVINO, J. T.

**TAYLOR,** SIR ROBERT (1714–88). English architect, son of an important London mason-sculptor, and apprenticed to Henry CHEERE. In 1743, after a short visit to Rome, he set up as a sculptor and gained some important commissions of which the Mansion House pediment was the most ambitious; but after about 10 years he turned to architecture. He soon built up a very large practice and held a number of official appointments, of which the surveyorship to the Bank of England was the most productive though his extensive work there has been largely obliterated. His work was PALLADIAN in mass and outline and in its use of finely detailed RUSTICATION, though his interior use of fluted COLUMNS, plaques, and trailing ornament shows the lightening of touch which became more usual as the century advanced. Harleyford Manor, Bucks. (1756), and Ely House, Dover Street, London (1772), are good examples of Taylor's work on a modest scale. Stone Buildings, Lincoln's Inn (1774), is in the GRAND MANNER.

Taylor had many interests in the City of London and was knighted when he became a Sheriff in 1782. He left a large sum to found a school of modern languages at Oxford, where the Taylorian Institute is named after him.

**TEMPERA.** The term has borne various meanings in connection with painting. Medieval writers used it in a wide sense for any colours ground in water and kneaded into a paste with organic GUMS or glues, but particularly applied it to SIZE painting (see GOUACHE) and PIGMENTS mixed or 'tempered' with egg. CENNINI used the word almost as an equivalent of MEDIUM and spoke of both size and oil tempera. VASARI also applied it to all mixtures of pigments, including those bound with oil or VARNISH. The name was, therefore, applicable to almost all methods except true FRESCO. In modern terminology it generally implies painting with an emulsion—a turbid mixture of oily and watery elements—thinned with water and with pigments made into a paste with water. Emulsions are 'natural' (e.g. egg or milk of figs), 'artificial' (e.g. solutions of CASEIN and glue, or various gums and varnishes), or 'saponified' (fatty oil, wax, or soap emulsified by the addition of alkalis). The most important historically is egg tempera and the word 'tempera' has come to be chiefly associated with that technique. Strictly, however, the white of egg or GLAIR is not an emulsion and for this reason those who regard the presence of an emulsion as a criterion of tempera do not classify this medium as tempera painting.

The process of painting with egg-yolk was described by Cennini in the early 15th c. It was used chiefly for painting executed on wood PANELS. The panel was first prepared with a GROUND and PRIMING. The whole design was then drawn in with CHARCOAL, the excess charcoal was dusted away, and the outlines and parts of the shading were painted with a WATERCOLOUR. If the background was to be in gold, its outlines were incised in the GESSO ground, and some of the contours of the design were incised also. Any gilding was completed first; next came the painting of the DRAPERY, architecture, and other parts. The flesh parts were painted last and often had an UNDERPAINTING of the green earth pigment called *terre verte*. Other parts too might be underpainted in order to enhance or subdue the colour. A few local colours only were used—one colour for flesh, and two or three for the different draperies etc.—and, as in fresco, each was prepared in three different tones by adding varying quantities of white. The darker parts of the flesh might be shaded in *verdaccio*, a mixture of ochre and black, and a pure white might be used for the highlights.

The grinding of the pigments in egg-yolk was of course done beforehand. The yellowness of the egg had little effect on the colours, though Cennini says that town hens produce the palest and best yolks, and adds that darker yolks will do for the flesh colour of 'old people, or such, who are darker in colouring'. Indeed pale yolks are still preferred today.

The method demanded not only knowledge of the materials, but also great certainty of purpose. The paint was not easy to handle, and the colours were few and difficult to blend. So the variety and subtlety that were so often attained depended on a slow building-up process, in which each stage—ground, underpainting, and various layers of semi-transparent paint—would have a calculated effect upon the next. Tempera has more luminosity and depth than fresco, but its range of colour and tone is limited and it cannot achieve the close imitation of natural effects that is attainable in OIL PAINTING. Since tempera refracts the light very little, the colours are clearer and more vivid than in oil painting.

Tempera painting appeared in Europe in the 12th or early 13th c. From that time it was the most important technique for panel painting until the 15th c., when it began to give way to oil painting. It suited the HIERATIC style of medieval painting, but it was also used by most of the great, and minor, masters from BERLINGHIERI and DUCCIO to MICHELANGELO and RAPHAEL. After being neglected for about 400 years, tempera painting has had a limited revival in the present century.

**TEMPESTA,** ANTONIO (1555–1630). FLORENTINE painter, engraver, and ETCHER, who is chiefly remembered for his hunting scenes and BATTLE-PIECES. The vocabulary of decorative art, particularly tapestries, was greatly enriched by his widely diffused etchings and engravings. Tempesta was trained in Florence under Stradanus and assisted VASARI on the vast mural schemes in the Palazzo Vecchio, but spent nearly all his adult working life in Rome, occupied with decorative work in the Vatican and other Roman palaces and at the villas of Caprarola and Tivoli. The Borghese Gallery has small paintings by him on stone, copper, and PARCHMENT.

**TEMPLE,** RAYMOND DU. The leading Paris mason of the second half of the 14th c., his position analogous to that of YEVELE in England and Peter PARLER in Germany. He was the king's mason, and in some sense the head of the masons' guild. His most famous achievement was the external staircase which he built in the LOUVRE for Charles V. This became a popular feature in French houses, e.g. the Hôtel de Cluny in Paris, and the House of Jacques Cœur at Bourges. He also designed the Collège de Beauvais, founded in 1387 as part of Paris University. At the same time he was master mason at NOTRE-DAME, where he succeeded Bouteiller in 1363. He was still there at the beginning of the 15th c.

**TEMPLES,** GREEK AND ROMAN. To the Greeks and Romans the centre of worship was the altar in the open air. The temple served essentially to house the image of the god and also valuable offerings and equipment. Usually it faced east towards the altar. Early Greek temples were mostly simple, narrow chapels, apsidal or rectangular, entered through the short east wall. The nascent architecture of the mid 7th c. B.C.

devoted itself principally to the temple and, since the functional requirements were very simple, aesthetic effects could become paramount. The basic temple (*cella*) was at that time a rectangular room with low-pitched roof. It might be elaborated in various ways—with a PORCH at the front, a second (often false) porch at the back, and a surrounding colonnade. To judge by siting, the three-quarter view was considered of first importance. As regards decoration and certain details of plan there were two principal systems, the Doric and the Ionic (see ORDERS OF ARCHITECTURE). For further embellishment sculpture might be added. The Doric style normally permitted free statues at the six corners of the roof (ACROTERIA), more or less free statuary in the gables (PEDIMENTS), and high RELIEF on the METOPES. In the Ionic there might be low relief on the FRIEZE. The elaborate type of Roman temple, derived from the ETRUSCAN, differed principally in these respects: the structure, with three *cellae* side by side, was designed for an emphatically frontal view and so was set on a high platform, had a deep porch with steps only at the front, and did not require a colonnade on the sides and back. But there were, of course, simpler and also hybrid Roman temples.

**TEN, THE.** The name taken by a group of American artists, who exhibited together in 1895 and whose painting was somewhat distantly influenced by French IMPRESSIONISM. Several of them studied at the Académie Julien in Paris. They were Frank W. Benson (1862-1951); Joseph R. De Camp (1858-1923); T. W. Dewing (1851-1938); Childe Hassam (1859-1935); Willard L. Metcalf (1858-1925); Robert Reid (1862-1929); Edward E. Simmons (1852-1931); Edmund C. Tarbell (1862-1938); J. H. Twachtman (1853-1902); J. Alden Weir (1852-1919). On the death of Twachtman his place was taken by W. M. Chase (1849-1916). Hassam worked in a high colour scheme and often achieved a bright, sparkling clarity as emphatic and exhilarating as a brass band on a sunny day. Twachtman, under the influence of French painting, developed a cool, silvery colour and in his interest in light and atmosphere had close affinities with American quietism. His shimmering, evanescent glimpses of nature, which seem wholly surface, have been ranked among the finest examples of American LANDSCAPE (*Sailing in the Mist*, Pennsylvania Academy of the Fine Arts, Philadelphia). He is supposed to have been the first American artist to employ blue shadows. Dewing has sometimes been considered the most original of the group and is noted particularly for his small, sensitive, and poetic pictures of women in dim interiors (*Lady in Green and Grey*, Art Inst., Chicago; *Girl at Desk*, Met. Mus., New York; *A Musician*, Luxembourg Mus., Paris).

**TENEBRISMO.** Term in Spanish painting for an emphatic use of CHIAROSCURO to achieve effects of dramatic NATURALISM reminiscent of the style initiated by CARAVAGGIO. One of the earliest artists to adopt this style was Juan Fernández de NAVARRETE, known as El Muto.

The name 'tenebristi' was also used of early 17th-c. Italian painters, chiefly in Naples, who were much under the influence of Caravaggio.

**TENIERS.** The Flemish painter DAVID TENIERS the Elder (1582-1649) is a shadowy figure and there is no firm basis for the numerous pictures ascribed to him. His famous son, DAVID TENIERS the Younger (1610-90), is said to have been his pupil. David the Younger's early biblical pictures show the influence of his father-in-law Jan BRUEGHEL and Frans FRANCKEN II. His peasant pictures are derived from BROUWER, but he never captured Brouwer's vigour or tension. David the Younger's finest paintings were made during the 1640s. They are characterized by a silvery PALETTE and are exquisite in their delicacy and refinement. In 1645 he became Dean of the Antwerp Guild of Painters. Soon afterwards he was summoned to Brussels, where he was appointed court painter to Archduke Leopold Wilhelm of Austria, Governor of the Austrian Netherlands. He was also made custodian of the Archduke's art collection. Teniers was an unusual curator. He not only compiled a first-rate catalogue of the Archduke's pictures but he also made paintings of the galleries in which the works of art were installed, and painted small copies of some of the pictures (examples of the latter are in the Wallace Coll., London, and the N.G., Dublin). The copies he made after the works of other masters—he had a predilection for copying VENETIAN RENAISSANCE pictures—left no mark on his own work. About 2,000 paintings have been attributed to Teniers; he was productive, but not to that extent. His GENRE pictures had a special charm for the aristocracy of the 17th and 18th centuries, and his pupils and followers continued to supply the demand after his death. There are 20 examples of his genre painting in the National Gallery, London.

**TENNIEL,** SIR JOHN (1820-1914). English draughtsman, known chiefly for his illustrations to Lewis Carroll's *Alice* books, and his cartoons in *Punch*, which ran for 50 years (1851-1901). His ingenious and prolific fancy was served by a draughtsmanship whose angular awkwardness, at least for *Alice*, created an enduring image. 1856.

**TEQUITQUI STYLE.** See MESTIZO.

**TERBORCH** (TER BORCH), GERARD THE YOUNGER (1617-81). Dutch painter and draughtsman of interiors and small portraits. One of the most precocious artists who ever lived—his earliest dated drawing (Rijksmuseum, Amsterdam) is from 1625—Terborch

studied with his father, GERARD the Elder, and Pieter de MOLYN. Unlike most of the great Dutch artists of his time he travelled much. In 1635 he was in London, and from c. 1636 to 1640 he was in Italy, where he painted an eerie GOYA-like night scene of *A Procession of Flagellants* (Rotterdam). From Italy he probably went to Spain and then to Flanders. In 1648 he was in Germany, where he painted the principal Dutch 17th-c. historical picture, *The Oath of the Peace Treaty between the Dutch and Spanish at Munster* (N.G., London, 1648), a group portrait of the signatories to the Treaty of Westphalia, which gave the Dutch independence from the Spanish and ended the Eighty Years War. In 1654 he finally settled in Deventer, where he won both professional and social success.

Terborch ranks with the finest Dutch masters who specialized in small pictures. His portraits, which are sometimes painted on copper, are notable for their depth of expression in a restrained PALETTE of greys, blacks, and blues. He is best known for his scenes of elegant society. The so-called *Parental Admonition* (versions in Amsterdam and Berlin) shows his ability to render textures, particularly satin. (It is significant of Terborch's unvaryingly solemn decorum that the true theme of this picture is a man making a proposition to a courtesan. The popular title originated in an 18th-c. mistake.)

1193.

**TERBRUGGHEN,** HENDRICK (1588–1629). In the reappraisal of CARAVAGGIO which took place in 20th-c. criticism students of the BAROQUE have been agreed that one of the most poetic and sensitive of his followers was the Dutch painter Terbrugghen, who had been neglected by the 18th- and 19th-c. collectors and historians. But their discovery had been made before. When RUBENS visited Utrecht in 1627 he is reported to have said: 'Travelling through the Netherlands and looking for a painter, I found but one, namely Henricus Ter Brugghen.' Hendrick's career was short. He was in Italy 1604–14, and there became familiar with the work of Caravaggio's circle. By 1616 he was back in Utrecht, where he and HONTHORST (who returned from Italy in 1620) became the leaders of the Caravaggism associated with the Utrecht School. Terbrugghen's light, delicate colours anticipated by a generation the tonality of VERMEER and other great painters of the Delft School. The two paintings of *A Flute Player* (Cassel) show what heights he could achieve in GENRE; *Jacob and Laban* (N.G., London, 1627) is one of the most original of his religious pictures.

1941.

**TERRACOTTA** (Italian: baked earth). Clay baked to become hard and compact. Figures and architectural ornaments have been made of it since very early times and it is to these, rather

than POTTERY vessels, that the word 'terracotta' usually refers. Clay is, of course, found all over the world in many different colours and qualities. Coloured clay is commoner than white. The presence of certain chemicals, such as iron oxide, affects the colour of the baked product, so terracotta works are not necessarily of the reddish or tan colour that is normally associated with the word. Firing may produce a wide range of colour from light buff to deep red or black. The hardness and strength of the baked clay vary according to the temperature at which it has been fired. During the firing the clay shrinks by about one-tenth of its volume, sometimes more, sometimes less, according to its quality and the amount of moisture.

Clay MODELLING, essentially a simple and primitive process, is described in another article. Certain precautions have to be taken if a clay model is to be fired. It must contain no air-bubbles because they would expand during the firing and cause it to crack. Very small objects can be modelled solid, but large ones must be made hollow, again to avoid the danger of cracking. One method of preparing a hollow figure is to model a solid one, then cut it into pieces when the clay has half hardened, scrape out the clay from inside, and stick the pieces together again with diluted clay, known as 'slip'. This can be done even when the model has been built round an ARMATURE, as the armature, which would cause cracking if it were left in, can be severed and pulled out in sections. Many medieval terracotta figures were made in this way and modern sculptors make use of the same technique. Another method of preparing a hollow model is to build it up gradually in rings or coils, a technique related to one method of pottery-making.

Figures modelled by either of these methods go straight to the kiln. But if several replicas of the same piece of work are desired, recourse must be had to the more complicated process of casting from a mould. The negative mould may be of plaster or may itself be of terracotta and is made from the clay model. It may be all in one piece for a RELIEF without any undercutting, or in two or more pieces for a figure in the round. It is also possible to model the mould concavely, but such modelling in reverse is difficult and is seldom done except when very simple architectural ornament is being prepared. By whichever method the mould has been made, it is fired in the kiln. When it is cool, thin layers of soft clay are pressed into it. The mould is then removed, revealing a hollow clay form which, as soon as any seams caused by the meeting of the piece-moulds have been retouched, is ready for firing. The mould can be used again for numerous replicas.

An alternative method of casting is to make piece-moulds of plaster (see PLASTER CASTS). They are fitted together and the hollow is filled with slip. The plaster sucks away the moisture from the slip, which settles into the mould as

hardened clay. The slip in the middle, which is still liquid, is poured out; then the plaster mould is removed and the hollow clay figure is re-touched and fired. Figures with protruding limbs can be cast in parts—arms, legs, trunk—and stuck together with slip before firing. This is the same method as that used for porcelain figures. Here again, the same mould can be used repeatedly.

Tiles, an important terracotta product, can be pressed out from moulds in the same way as figures, but they have to be reinforced at the back with strips of clay to prevent them from warping in the kiln. The clay can be coloured in various ways. A coloured slip can be applied on top, during or after modelling. If a shiny surface is wanted, a coloured GLAZE may be applied after firing and the object fired a second time. Glazing imparts greater resistance to weather and is particularly useful for tiles when they are to be used as architectural decoration (see ISLAMIC ART, AZULEJO).

Terracotta sculpture goes back to the invention of pottery techniques in the Neolithic ages (see STONE AGE ART IN EUROPE). Many terracotta figurines survive from the Stone Age, predynastic Egypt, ancient Crete, PRE-COLUMBIAN South America, and the early Oriental civilizations. In China during the T'ang dynasty (A.D. 618–906), the climax of a long tradition of terracotta tomb statuettes, so much wealth was spent on funerals that it became necessary to regulate the number of statuettes given to the dead according to his rank in life. The figures were painted over a slip, or covered by a monochrome or multi-coloured glaze; the typical mixture of three glaze colours was brown, cream, and green. The Greeks made much use of terracotta in their early wooden architecture for a richly decorated sheathing of the CORNICE, for roof tiles, and, later, for ornaments such as ACROTERIA and antefixes (see GREEK ART). The charming little Greek figurines known as TANAGRA STATUETTES were mass-produced from moulds (specimens of which still exist); some were representations of everyday life, others copies of famous statues, a popular version of a great art. Most of them were originally covered with a white slip and coloured, but this has usually flaked off. Terracotta was also popular in ancient Italy; the light wooden and brick temples of Etruria were given an elaborate decorative facing in terracotta and early ETRUSCAN sculpture included both small objects buried in tomb-chambers and impressive life-size figures such as the *Apollo* from Veii (Villa Giulia Mus., Rome). Terracotta was also much used by the Romans.

During the Middle Ages a scarcity of stone in the flat plains of northern Germany and the Low Countries encouraged the use of brick for building and terracotta for architectural ornament, but terracotta sculpture declined. In the RENAISSANCE it not only flourished again for BOZZETTI (sculptors' sketches) but it was also a favourite medium for images, plaques, wall-tombs, and the like, as a substitute for the more costly MARBLE and BRONZE, made attractive and durable by glazing and colouring. The innovation of applying white and coloured enamels to terracotta sculpture, using known techniques of glazing, was first made by Luca della ROBBIA in the early 1440s as a form of architectural decoration and then used for free-standing figures and reliefs.

The 18th-c. figurines of PIGALLE, CLODION, and HOUDON, small in scale, delicate and light in conception, are really clay sketches preserved by being fired and hence validly retain the freshness, spontaneity, and immediacy of clay modelling. Terracotta has been an accepted medium of all modern sculptors who have practised modelling. Terracottas by MAILLOL, DESPIAU, Frank DOBSON, EPSTEIN, and many others are valued products of contemporary sculpture.

**TERTIARY COLOURS.** See COLOUR.

**TERZI,** FILIPPO (1520–97). Italian architect and engineer who worked for the kings of Portugal from 1577. The late MANNERIST style of his buildings (e.g. church of S. Vicente de Fora, Lisbon, begun 1582) exercised an influence over subsequent architecture in Portugal comparable to that of Juan de HERRERA in Spain.

**TESSIN.** Swedish architects, father and son. NICODEMUS TESSIN the Elder (1615–81) was an immigrant from Stralsund, Germany, who in 1661 became architectural superviser of Stockholm. The most important among his numerous buildings in the town and province of Stockholm was the castle of Drottningholm (begun 1662, continued by the son), the interior of which was in the French taste. Some of his later works (e.g. the Old National Bank, Stockholm) have Italian features, perhaps owing to the influence of his son, NICODEMUS the Younger (1654-1728), who during the 1670s studied in Rome. The main enterprise of the younger Tessin was the erection of the castle of Stockholm (1690, finished 1754). The exterior was that of an Italian palace, but some of its detail and the whole of the interior were in the French taste. Tessin, like LEBRUN in France, was in charge of a large staff of artist-craftsmen, many of which were Frenchmen, and designed much of their work. The influence he thus exerted upon the development of Swedish art and architecture was immense. Besides the royal castle he built an exquisite palazzo for himself, with a charming little garden (1696-1700). The son of Tessin the Younger, CARL GUSTAV TESSIN (1695-1770), was one of the greatest collectors of the time. The famous Dutch and French collections of the National Museum of Stockholm were in large part assembled by him.

**TESTA,** PIETRO, called IL LUCCHESINO (1611-50). Italian painter and engraver active

in Rome. He worked with DOMENICHINO until 1629, and then for a time with Pietro da CORTONA. He studied ancient sculpture and was employed by Nicolas POUSSIN's patron Cassiano dal POZZO to make antiquarian drawings. His paintings are rare and he is better known as an ETCHER than as a painter.

**THAILAND, ART OF.** The states of Indo-china first emerged into the light of history during the early centuries of the Christian era when the blocking of the northern trade routes by movements of the nomadic peoples stimulated trade with India. Both Hinduism and Buddhism gained a foothold during this period. What is now Thailand was then part of the kingdom of Funan. Little or nothing is known, however, about the artistic developments in the area until the establishment in central Thailand of the Mon-Dvaravati kingdom which was closely connected with the Mon kingdom of Burma with its main centre at Thaton. (See BURMESE ART.) The Mon confederation did not extend south into the Malay peninsula, which was controlled from the 8th c. to the 13th c. by the Shrivijaya empire of Sumatra. During the 11th c. the expanding Khmer kingdom annexed both central Thailand and the northern part of the Malay peninsula; the Dvaravati capital Lavo was renamed Lopburi. In the 13th c. Thai peoples established the kingdom of Sukhodaya in central Thailand and in the 14th c. a separate wave of Thai invaders penetrated further south to U Thong with their capital at Ayudhya. Ayudhya gradually obtained supremacy over Sukhodaya and extended its influence over the Malay peninsula. During this period it was one of the most important cities of Asia until it was sacked by the Burmese in 1767 and the capital was transferred to Bangkok. The northern part of Thailand remained partially independent until it was annexed by Burma in the 16th c. to be joined with Thailand in the 19th c.

From the above historical summary it will be apparent that there was neither political nor racial or religious homogeneity over the area which is now Thailand, and in discussing the art of the region it is customary to do so under regional styles which correspond only in a rough and general way with political vicissitudes during the centuries under consideration. The following classification is that adopted in the catalogue of the exhibition *The Arts of Thailand* arranged by the Arts Council of Great Britain in the Victoria and Albert Museum in 1964.

| | | |
|---|---|---|
| Dvaravati style | Central Thailand | 6th–11th c. |
| Shrivijaya style | Malay peninsula | 8th–13th c. |
| Khmer-Lopburi style | Central and eastern Thailand | 11th–15th c. |
| Chieng Sen or Northern style | North Thailand | 12th (?)–20th c. |
| Sukhodaya style | Mainly central Thailand | 13th–15th c. |
| U Thong style | Central Thailand | 13th (?)–15th c. |
| Ayudhya style | Central Thailand | 15th–18th c. |
| Bangkok style | Central Thailand | late 18th c.–present day |

DVARAVATI STYLE. The Dvaravati kingdom had its capital at Nakhon Pathom (Nagara Patham) in addition to the Mon centre of Thaton in what is now Burma. No architectural structure remains from this period apart from a few STUPA bases and vestiges. There survive sparse fragments of STUCCO RELIEFS which were used to decorate these bases (some are in the Bangkok Mus.). They usually represented scenes from the life of the Buddha. Sculpture consisted mainly of statues of the Buddha in stone, bronze, or more often stucco. These belong to the Hinayana School of Buddhism and seem to indicate that the Mon people of Thailand were converted to Buddhism before the spread of Mahayana. The carving has a sureness and mature accomplishment which seem to indicate a previous tradition, perhaps in materials which have perished. The influence of Gupta (see INDIAN ART) style is apparent, but the Dvaravati style is not purely derivative. There are also regional features of iconography and *mudras* (see BUDDHIST ICONOGRAPHY) and the Mon facial type is preserved. In a cave sanctuary at Tham Rusi there are two gigantic Buddha figures in this style, one seated and the other standing, from the 6th to the 7th c.

SHRIVIJAYA STYLE. The Shrivijaya kingdom with its capital at Palembang in Sumatra, known to the Chinese as Chi-Li-Fo-Che, began to expand towards the end of the 7th c. and beginning of the 8th c. with the decline of the kingdom of Funan. The Chinese pilgrim Yi-Tsing, who visited Palembang in the latter part of the 7th c., says that it held more than a thousand Buddhist monks and was the seat of a flourishing university. The kingdom gained control over the greater part of the Malay peninsula and penetrated parts of Java. The surviving art consists mostly of bronzes and perhaps because climatic conditions in Sumatra are unfavourable to survival, these come chiefly from Malaya. The fact that the copper alloy does not contain tin, although tin is common in Malaya and copper unknown, may indicate that they were imported there from Sumatra. The images belong to Mahayana Buddhism and are related to the Pala style (see INDIAN ART). There are elaborately decorated representations of the Bodhisattva Avalokiteshvara (Lokeshvara), some of which are among the finest bronzes found in Thailand (now in Nat. Mus., Bangkok).

KHMER-LOPBURI STYLE. From c. A.D. 1000 until c. 1220 central Thailand was dominated by the Khmer people of Cambodia, who made their capital at Lopburi (formerly Lavo). The sculpture, although predominantly Khmer in style, was modified by the Dvaravati style of the indigenous Mon people and may have been made partly by native craftsmen. It is usually treated as a regional style of KHMER art and is known as

the Khmer-Lopburi style. As in Cambodia (see CAMBODIA, art of) the Khmer introduced a fusion of Hinduism and Buddhism, which may have been coloured by local ancestor worship. The kings were revered as divine, conceived as incarnations of one of the Bodhisattvas or a Hindu deity such as Shiva or Vishnu and their consorts as Lakshmi or Paravati. Thus the sculptures combined the characteristics of human portraits and divine images. The emphasis is on the heads and torsos, the faces are square with lips and eyebrows clearly marked (being worked in the bronze after casting).

The craftsmen of this period also made well cast bronze images and utensils for household or ceremonial use. The small images retained close affinities with the carving style and it has been thought that (as with Greek bronze statues) the cores from which the moulds were made for the *cire-perdue* casting method may have been carved rather than moulded.

The Khmer were great builders and there are examples of their architecture, now ruined, throughout Thailand. The most important monument of the period is at Pimai (early 13th c.), near Khorat. Two temples at Lopburi, one with three laterite towers (*prangs*) each with four PORCHES (Phra Prang, Sam Yot), are typical of Khmer work in the 11th-12th centuries. The most northerly sanctuary is the Vat Chao-Chao at Sawankalok. Khmer architecture in Thailand was almost indistinguishable, apart from sculpture and decoration, from contemporary building style in Cambodia.

Both in architecture and in sculpture the Khmer style established itself firmly in Thailand and remained the basis of development for several centuries after the Khmer were superseded by the Thai.

THAI STYLES. About 1220 Thai peoples from Yunnan, who had been peacefully infiltrating for a long time, established small kingdoms in Thailand and by the end of the 13th c. these had combined into a unified state with its capital at Sukhodaya, superseding the Khmer. They adopted Hinayana Buddhism from the native Mon peoples, with whom they intermingled. In their art forms they combined conventions from the Khmer and from Burma into a vital and confident style of their own. The Thai brought with them CHINESE ceramic techniques, including that of CELADON, and produced quantities of stoneware of excellent quality. Five regional styles are distinguished which go by the general name of *Sangkalok*. The most distinguished production came from kilns at Sawankalok (Thuriang Ko Noi) near Sukhodaya; it was made for export and has been found as far afield as the Philippines, Borneo, and the Near East. Though originally derived from the Chinese, characteristic Thai glazes and styles of brush-work in the decoration developed. The body is usually grey under the glaze, reddish where exposed. The glazes resemble slightly watered celadons with an interesting range of colour overtones; a clear dark brown is used, often for painted decoration in a manner reminiscent of Chinese Tzu Chou, sometimes—especially in early examples—as an over-all glaze. Glazes are usually crazed. Vertical striations, panelled ornament, and foliated parts, e.g. lips and lids, sometimes occur.

CHIENG SEN STYLE. During the Sukhodaya period of central Thailand northern Thailand was an independent state with its capital at Chieng Sen. The architecture shows certain characteristics of the native Mon styles with Khmer and Sukhodaya influences in the decoration. One of the most important monuments is the Chedi Si Liem (*c.* 1300) near the capital. The Chedi has five recessed storeys with terraces, pagodas on the corners, and on each side three niches containing standing Buddhas. The base is adorned with lions on the corners and a projecting niche on each side with a seated Buddha. Interesting also is the Vat Chedi Chet Yot (also called Vat Bodharam) at Chieng Sen, built probably in the mid 15th c. and partly modelled on the Mahabodhi Temple at Pagan (see BURMESE ART). The surviving sculpture consists chiefly of bronze figures of the Buddha somewhat stiffer and more angular than the Sukhodaya style. The faces are rounder, the nose straighter and heavier, and the eyes are slit in almond shapes. The arms are long, reaching almost to the knees and in some cases the Buddha wears the royal *mukuta* (diadem).

In the 16th c. northern Thailand was conquered by Burma and annexed. The artistic production was merged with that of the conqueror until its return to Thailand in the 19th c.

SUKHODAYA STYLE. Combining the native Dvaravati tradition with elements from Khmer and new influences of Sinhalese Buddhism, the Thai of the Sukhodaya kingdom evolved a type of Buddha image peculiar to Siam. In the words of Sherman E. Lee: 'The influences disappear as if exorcised by fire and the resulting diamond-sharp configuration recalls the abstraction of geometry. . . . at the moment of perfect balance in the fourteenth century the result seems a perfect expression of Hinayana simplicity and asceticism.' The masculinity and squareness of the Khmer type is softened and idealized into an almost feminine cast. The long, oval faces with full cheeks have fine, regular features. The distinctive nose is long, slightly hooked with drooping tip and fine bridge. The eyebrows are highly arched, the eyelids formed of wavy lines rising towards the outer corners and the eyes look downwards with a half-closed mystic expression. The lips are pressed tightly together and the mouth clearly incised. The hair is represented in tight formalized curls coming to a point above the centre of the forehead and surmounted by a flame-like emblem rising from the centre of the head and symbolizing the emanation of spiritual fire. The type spread rapidly over the whole country and has remained the ideal to this day. A unique creation of Sukhodaya Thai art was the 'walking Buddha' which embodies a vision of the

Buddha as an idealized super-Being gliding with superhuman ease and lissomness, for the first time sculptured in the round.

U THONG AND AYUDHYA STYLES. About the middle of the 14th c. a separate group of Thai peoples established a southern kingdom at U Thong in the lower Menam basin and made their chief city at Ayudhya. They introduced a transitional style stemming from Khmer. Four groups of Buddha type are distinguished in U Thong art from the 13th to the 15th c. showing affinities with Dvaravati and Khmer and tending towards an established Thai type. A national Thai style emerged gradually from the U Thong styles after the incorporation of Sukhodaya into the southern kingdom and is usually referred to as the Ayudhya style. Enormous production of bronzes gradually led to deterioration of technique and uninspired repetitive output of over-decorated conventionalized stereotypes.

BANGKOK STYLE. After the sack of Ayudhya by the Burmese in 1767 a distinctive style of art grew up around the new capital of Bangkok. It was characterized by decorative fantasy and superficial embroidery on the trends already apparent in the older Ayudhya art. Mural painting became popular but was pleasantly decorative rather than the outcome of any deep inspiration. The taste in this as in the bronzes and architecture turned shallow and showy, given to exaggeration and superficiality, and easily degenerated into an art for tourist trade.

85, 333, 334, 348, 373, 399, 576, 780, 919, 1157, 1633, 1634, 2033, 2034.

**THANGKA.** See TIBETAN ART.

**THEATRE.** The theatres of ancient Greece and Rome are known to us in some detail from two main sources: the remains of a very large number—some hundreds—of actual buildings, and the information given by VITRUVIUS and Pollux (2nd c. A.D.) and other writers, especially the playwrights themselves in such things as stage directions and internal evidence. The ruins of theatres extend from the south of England to Dura Europos and some of them were certainly known in the Middle Ages and RENAISSANCE—e.g. the theatre at Orange and that of Marcellus in Rome. The most important literary evidence is the very full description given by Vitruvius (Book V, chapters iii–ix) of the Greek and Roman types. The exact differences between these are still debated, but their main features are sufficiently clear. The earliest Greek theatres were at least partly cut out of the hillside for acoustic reasons: audibility was evidently an important consideration, and Vitruvius says that the purpose of a theatre was for 'seeing plays or festivals of the immortal gods', which is sufficient to distinguish the theatre from the AMPHITHEATRE devoted solely to less edifying spectacles, where audibility was unnecessary. Two of the best preserved of the Greek theatres, at

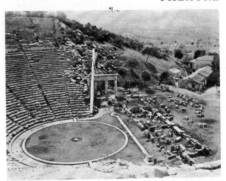

369. Theatre at Epidaurus (? 4th c. B.C.)

Delphi (c. 160 B.C.) and Epidaurus (?4th c. B.C.), make clear the basic difference between the Greek and Roman types, namely the shape of the acting area. The action took place in the *orchestra*, completely circular at Epidaurus and more than half a circle at Delphi, surrounded for most of its circumference by the steeply rising tiers of seats. The rest of the circumference— the open end of the horseshoe at Delphi—was taken up by the *skene*, a wood-covered structure from which the actors entered and to which they retired. What we would regard as the stage was a relatively high and narrow shelf between the *orchestra* and the *skene*. Every major city had a theatre, the first stone-built one being at Athens (4th c. B.C.), with a capacity estimated at 27,500. This was presumably in order to accommodate the large crowds attending the Dionysiac festivals for which the theatres were originally built.

The Roman theatre is fully described by Vitruvius (v. 6) and differs from its Greek prototype mainly in the shape of the *orchestra*, which was always semicircular, and in the fact that the *orchestra* was filled with seats for Senators and other great persons instead of being used for the action: the consequence of this was that the actors had necessarily to have a raised stage running across the diameter of the semicircle. The Roman stage was therefore only a few feet above ground level but was much deeper than its Greek equivalent, since all the action had to take place on it. Behind it was the *scenae frons*, a three-storey building rising to the same height as the highest tier of seats. The oldest known Roman theatre, the Small Theatre at Pompeii of c. 80 B.C., was actually roofed, but the larger ones had only a cantilevered roof over the stage proper, evidently intended as a sounding-board. The first stone-built Roman theatre was Pompey's (55 B.C.), but by far the most important and influential was the Theatre of Marcellus, in Rome, built by Augustus (13 B.C.). This was largely built over during the Middle Ages but was sufficiently well known in the early 16th c. to serve as an example to PERUZZI, SERLIO, and above all PALLADIO. The Roman theatre at

Orange in France is the best preserved in Europe and was certainly also known to Renaissance architects since there are drawings of it by Giuliano da SANGALLO, who was in the south of France in 1494.

During the whole of the Middle Ages no permanent stone theatre was built and all dramatic performances took place in temporary settings in or near a church. As in the earliest Greek plays the art of drama in the Middle Ages was essentially a function of religion and the Easter plays required no more than a Sepulchre. The development of the Mystery plays led to two innovations, the use of 'mansions' or little booths to indicate locality and the practice of mounting the plays as a series of tableaux which could be put on carts and moved around the town as a pageant. This was popular in England, where the Guilds presented the plays and it was possible for each to have its own cart processing round the town.

With the revival of interest in Greek and Latin literature and architecture it was inevitable that someone would wish to perform classical drama in its own setting and equally inevitable that this should first take place in Italy. There were performances of comedies in the 15th c. but the first major attempt to reconstruct the antique theatre (apart from the paper reconstructions made in editions of Vitruvius) was made by Palladio at the very end of his life, for the Accademia Olimpica in Vicenza. He had built theatres in the 1560s for individual performances and his illustrations to Barbaro's Vitruvius (1556) had prepared him for the task of recreating an ancient theatre for its original purpose. The result was a masterpiece, with beautifully arranged PERSPECTIVE settings carried out by SCAMOZZI (whose own theatre at Sabbioneta continues the tradition). These illustrate Vitruvius's description of the *scenae frons*, which had three entrances. The central or royal door was used only by the leading characters and the two on either side were for subsidiary characters; in what we would call the wings, at either side of the stage, were the *paraskenia* which were traditionally understood to be used by messengers from the Forum or near by, or by messengers from abroad on the other side. Vitruvius also describes scenery, naming three types of setting—Tragic, Comic, and Satyric—for each type of play. Stage scenery was revived in modern times by Peruzzi and the designs were spread all over Europe by the plates in the book of his pupil Serlio, but Palladio concentrated on a fixed architectural decoration corresponding to the *scenae frons*.

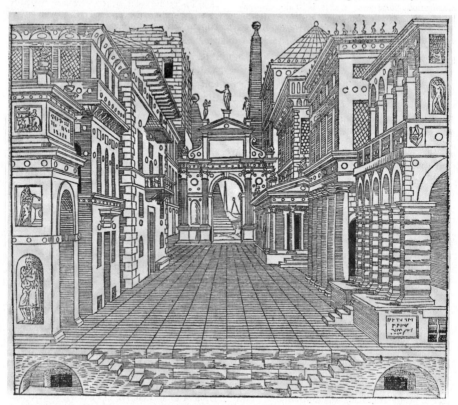

370. Scenery for *Tragedy*. *Libro d'Architettura* Bk. 2, *Di Perspettiva* (1545) by Sebastiano Serlio

Modern theatres do not in fact descend from the Teatro Olimpico, since they are based on the ideas of separating the world of the stage from that of the audience by means of the proscenium arch, the use of illusionistic scenery which can be changed frequently, and the abandonment of Palladio's revival of the semicircular auditorium (*cavea*) in favour of the horseshoe or rectangle. All these features can be found in Italy in the mid 16th c. (e.g. in the work of BUONTALENTI) and thus precede the Teatro Olimpico. The important Teatro Farnese at Parma (1618-19) by Aleotti (1546-1636) had the first permanent proscenium arch and a U-shaped auditorium, later to be developed into an ovoid or horseshoe shape in such celebrated Italian theatres as the Teatro alla Scala, Milan, or the San Carlo in Naples.

The first theatre in England was built in 1576 and both Shakespeare's 'Globe' as well as the 'Swan' (of which a drawing exists) seem to have been distant descendants of the classical theatre with a 'tiring house' (*scenae frons*), a raised stage, and a roughly circular bank of seats. With Inigo JONES the English theatre caught up with the latest Italian developments in illusionist scenery and stagecraft: his numerous masque designs show that he used the proscenium arch as well as a great variety of movable scenes, but he never built a permanent theatre. Sir Christopher

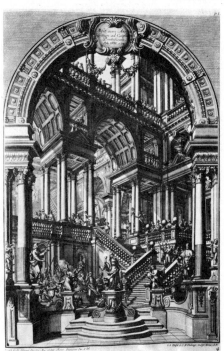

**372.** Engraving from *Architettura e Prospettive . . .* (1790), showing a design for a theatrical setting by Giuseppe Galli-Bibiena

several theatres, of which one, at Bayreuth, survives. The great growth of the new art of opera in the 17th and 18th centuries led to renewed study of acoustics and during the 18th and 19th centuries scores of theatres and opera houses sprang up all over the world, often built by architects specializing in such work. Some of the more notable ones, not so far mentioned, are those at VERSAILLES (by A.-J. GABRIEL), Besançon (by C.-N. LEDOUX), and Bordeaux (by V. Louis), together with Covent Garden in London and GARNIER's Opéra in Paris and the more recent ones in Bayreuth and Salzburg.

**THEED, WILLIAM** (1804-91). English sculptor, the son of a painter and sculptor of the same name. He trained under E. H. BAILY and at the R.A. Schools. In 1826 he went to Rome and worked under THORWALDSEN and GIBSON. He returned to London in 1848 and became one of the most distinguished and prolific of the Victorian sculptors. His portrait BUSTS included *Queen Victoria* (1861), *The Prince Consort, Sir W. Peel, Sir F. Goldsmith* (Lincoln's Inn), *W. Tite* (The London Institution). He made statues for Osborne, Windsor Castle, and Balmoral (*The Prince Consort*). Statues by him also include *Henry Hallam* (St. Paul's Cathedral), *Sir J. Mackintosh* (Westminster Abbey), *Edmund*

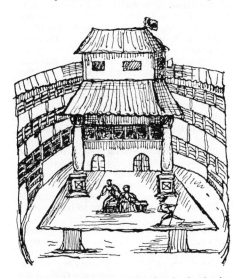

**371.** The Swan Theatre *c.* 1600, after the drawing by Johannes de Witt in Arend van Duchell's commonplace-book

WREN's Sheldonian Theatre was not intended for the performance of plays, but it was the first Roman type theatre to be built in England for over a thousand years.

Illusionistic decoration and effects were carried to their apogee in the 17th and 18th centuries, most notably by the BIBIENA family. They built

*Burke* (St. Stephen's Hall), *The Bard* (Mansion House). He carved low reliefs of historical subjects for St. George's Chapel, Windsor and for the Palace of Westminster, and the colossal group of *Africa* for the Albert Memorial.

**THEODORUS OF PHOCAEA.** Greek architect who probably built the Tholos at Delphi (early 4th c. B.C.). This circular building had an outer Doric colonnade and engaged Corinthian COLUMNS inside.

**THEODORUS OF SAMOS.** Greek architect and according to one tradition the son of RHOECUS, jointly with whom he built the famous TEMPLE of Hera at Samos (*c.* 560 B.C.). He was also joint architect of the Artemisium at Ephesus and built the Skias (Assembly Hall) at Sparta. He is said to have invented a lathe for turning COLUMNS and, like many later architects, to have published a book on his work.

**THEOPHANES THE GREEK** (in Russian FEOFAN GREK; *c.* 1370–*c.* 1405). BYZANTINE painter, active mainly in Russia. His early works in Constantinople and the Crimea are lost, and the first extant work is a cycle of FRESCOES in the church of the Transfiguration at Novgorod which dates from 1378. These frescoes, which were rediscovered between 1910 and 1940, are one of the outstanding monuments of Russian medieval art. Theophanes brought the style of late Byzantine painting to Russia but adapted himself also to the native Russian School and evolved a highly personal manner of modelling his figures in light and shade with masterly, almost IMPRESSIONISTIC, brush-strokes and an interestingly individualistic PALETTE. The wall-paintings in the church of the Dormition at Volotovo, near Novgorod, and in the church of St. Theodore Stratilates in Novgorod itself, are in a similar style. They have often been attributed to Theophanes, but are now regarded as the work of anonymous artists of the Novgorod School painting under his influence (*c.* 1380). Theophanes executed paintings at Moscow between 1395 and 1405, but none of these survives except some ICONS from the Cathedral of the Annunciation on the Kremlin, which were painted with the help of Russian assistants and are poorly preserved. According to a contemporary source Theophanes was also famous as a book-ILLUMINATOR. No signed or documented work in this field is known by him, but recently an attempt has been made to attribute to him a few manuscripts which were illuminated at Moscow in the late 14th c. and are distinguished by their highly original and REALISTIC initials. Theophanes made a great impression on the Novgorodian and Moscow Schools of painting in the 15th c.

**THEOPHILUS.** The author of a treatise on medieval Christian arts and crafts entitled *De Diversis Artibus*. The work has been variously dated from the 9th to the 13th c. C. R. Dodwell, who translated and edited it in 1961, assigns it to a date between A.D. 1110 and 1140. Little or nothing is known with certainty about the writer, but internal evidence suggests that he was a German Benedictine monk and priest, an educated person conversant with scholastic philosophy and also a practising craftsman whose primary interest lay in metal-work. He has sometimes been identified with Roger of Helmarshausen. His book is the most important source of information on medieval arts and techniques and is unusual for its time in its references to the artist's attitude to his work. Dodwell states that: 'Nowhere in the Middle Ages is there so full and sincere an account by an artist of his own conceptions and ideals, and not until the time of CELLINI does one find so close a study of the relationship between the artist and his work.'

**THERMAE.** The name given by the Romans from the 1st c. B.C. to buildings which combined public baths with the facilities of a Greek *gymnasium*. They included hot, warm, and cold baths, steam baths, and rest rooms; open and closed colonnades for conversation and fore-gathering; and like the Greek *gymnasia* facilities for sport, exercise, discussion, and instruction. They constituted the social rendezvous of Roman society. During the Empire the thermae became very luxurious and they gave an important impetus to ROMAN architecture in the organized planning of spacious and splendid interiors and the ingenious adaptation of functional engineering to the orderly planning of structure. They have been described as 'triumphs of interior perspective' and they exhibited some of the boldest developments of Roman VAULTING. The earliest surviving example of a Roman concrete DOME is in the *frigidarium* of the Stabian Baths at POMPEII (2nd c. B.C.). The requirement for a lavish and varied assemblage of interiors united into an over-all harmony by vaulted and colonnaded vistas and elaborate decorative ornament within the discipline of a systematized function called for an exercise of creative imagination which had a lasting effect on architectural planning.

The earliest thermae at Rome were built by Agrippa (25–12 B.C.). The general type of more highly symmetrical structure followed by later architects was probably established by the Baths of Nero (A.D. 62). Of the surviving remains the most interesting are the Baths of Diocletian (A.D. 302), the *tepidarium* of which was converted by MICHELANGELO and VANVITELLI into the church of Sta Maria degli Angeli in 1563, and the Baths of Caracalla (A.D. 211–17), finished by Alexander Severus. The main building block measured 750 by 380 ft. and lay to the north of a walled enclosure about 20 ft. high and measuring about 1,080 ft. in each direction. The circular domes over two octagonal halls display the most

successful Roman use of PENDENTIVES and the dome above the *calidarium*, about 115 ft. across, resting on eight PIERS, is the first important example of the use of hollow pots to reduce the weight. Outside Rome one of the largest and most elaborate surviving examples is the Hadrianic thermae (A.D. 126-7) at the colony of Leptis Magna on the coast of Tripolitania. In Great Britain an example of a Roman private bath survives at Caerwent and relics of London baths have been found in the City and the Strand.

**THESEUM.** Doric TEMPLE of Hephaestus and Athena (or perhaps Theseus) which stood above the Agora at Athens. Built *c.* 449-444 B.C., probably by the same architect as the temples of Poseidon at Sunium, Ares in Athens, and Nemesis at Rhamnus, it later became the church of St. George and though the interior was gutted remains the best preserved temple in Greece.

**THOMA,** HANS (1839-1924). German painter. His early LANDSCAPES—usually scenes from his native Black Forest—show the influence of COURBET and the BARBIZON SCHOOL. Later, under the impact of BOECKLIN, he turned to more formalized compositions and his subjects were often unpleasantly symbolic. The largest collection of his works is in the Karlsruhe Gallery.

**THOMON,** THOMAS DE (1754-1813). French architect active in Russia, where he was court architect to Alexander I. His main work is the Stock Exchange at St. Petersburg (1805-16), a Doric building of austere forms which was inspired by the Temple of Poseidon at Paestum.

**THOMSON,** ALEXANDER (1817-75). Glasgow architect known as 'Greek' Thomson. He designed in a very personal Greek manner inspired mainly by SCHINKEL, LEDOUX, T. HAMILTON, and H. L. ELMES; his work after 1858 contains Egyptian and other antique Eastern elements and is remarkable for its 'early modern' approach to fenestration and structure. Surviving buildings are chiefly churches (Caledonia Road, 1856-7, St. Vincent Street, 1858-9), commercial buildings (Buck's Head, 1849-63; Egyptian Halls, 1871), terraces (Walmer Crescent, 1857, Moray Place, 1859, Great Western Terrace, 1869), and villas (Holmwood, Cathcart, 1857) in Glasgow.

**THOMSON,** TOM (1877-1917). Canadian LANDSCAPE PAINTER. Born at Claremont, Ontario, he grew up near Owen Sound and worked first as a machine-shop apprentice before going to business school. About 1901 he travelled west and worked as a photo-engraver in Seattle, where he probably began to sketch. In Toronto, where he came in 1905, he·again worked at photo-engraving and about 1910 he met J. E. H. MAC-DONALD and began to make landscape sketches. His first camping and sketching trip to northern

Ontario was in 1912, and in the following year he met A. Y. Jackson (1882-    ), who influenced his colour and design. This began his painting career, but it lasted only four years, for he was mysteriously drowned in Algonquin Park in 1917. His many small sketches of the wooded northern Ontario country are mainly of spring and autumn, and from them he painted a few canvases (*Spring Ice*, N.G., Ottawa, 1916). See also CANADIAN ART.

**THORÉ,** THÉOPHILE, pseudonym of W. BÜRGER (1807-69). Originally a political journalist who took an active part in the Revolution of 1830 and had to live in exile from 1849 to 1860. Except for these years, he published an admirable account of the French SALON from 1832 to 1868, and was amongst the first to acclaim MILLET, COURBET, DAUMIER, RENOIR, and MANET and to see the weakness of Delaroche (1797-1856) and MEISSONIER. His ideas were those of the first generation of REALISTS who believed that the new art had a duty to work for the betterment of human conditions, and he criticized Manet for giving as much interest to a slipper as to the human head. He was a pioneer of factual ART HISTORY and produced memorable studies on CARAVAGGIO, VELAZQUEZ, the LE NAINS, CHARDIN, REMBRANDT, and VERMEER, whom he rediscovered.

2642.

**THORNHILL,** SIR JAMES (1675-1734). English decorative painter in the European BAROQUE manner. He was influenced by the style of VERRIO and LAGUERRE but his work was not inferior to theirs. He was the only British painter of his day to understand and successfully to emulate the European formulas for wall and ceiling painting and was the only native English painter who could challenge on their own ground the many foreign decorative painters then at work in England. In 1707 he was working at Chatsworth with Laguerre. He worked at All Souls, Oxford, Hampton Court (Queen Anne's bedroom), Blenheim, and St. Paul's, where he painted the GRISAILLE panels inside the DOME. His greatest achievement was the Painted Hall at Greenwich Hospital, on which he worked intermittently from 1708 to 1727. He was appointed History Painter to George I in 1718 and Serjeant Painter in 1720, was knighted in 1722 and elected Member of Parliament in the same year. In 1723 he was made a Fellow of the Royal Society and he was Master of the Painter-Stainers' Company. He started an academy in London at which HOGARTH was a pupil and from which he eloped with Thornhill's daughter.

**THORN PRIKKER,** JOHAN (1869-1923). Dutch SYMBOLIST artist, who designed large murals, MOSAICS, and STAINED GLASS for churches and public buildings. After 1904 he worked and taught in Germany. The church of Neuss and

the Folkwang-Museum at Hagen have windows designed by him.

**THORPE,** JOHN (*c.* 1563-1655). English architect, who came of a family of stonemasons established at Kingscliff, Northants. In 1570, when still a child, he laid the foundation stone of Kirkby Hall, Northants., where his father was perhaps master mason. He was Clerk of the Royal Works from 1584 to 1601, then set up as an independent land-surveyor, in which capacity he was much employed by the Government. On the strength of a book of his plans and drawings, now in Sir John Soane's Museum, London, Thorpe used to be considered the architect of most major Elizabethan and Jacobean houses. But many of these were built before or soon after his birth, and his plans are probably mostly surveys rather than his own designs; some, however, seem to be the latter, though there is no documentary evidence for a single building. His book is the most valuable document relating to Elizabethan architecture which survives.

**THORWALDSEN,** BERTEL (1768-1884). Danish sculptor, who became one of the leaders of the international NEO-CLASSICAL movement. As the son of an Icelandic wood-carver in Copenhagen he grew up in straitened circumstances and was late in achieving the independence necessary for the free development of his art. After five years at the Copenhagen Academy, he reached Rome at last in 1797 on 3 March, a day which he henceforth considered as his birthday. In his approach to the ANTIQUE his principal guides were the German painter CARSTENS and the Danish archaeologist Zoëga. His first successful work was the statue *Jason* (1802-3), which appeared as a practical demonstration of the new CLASSICISM which purported to go back to the Greek instead of to Rome. Commissions streamed in and Thorwaldsen was soon the central figure in the circle of Classicists at Rome, being ranked next only to CANOVA. He was respected not only as an artist and an interpreter of the classical past, but also as an antiquarian authority, and it was natural that the restoration and partial reconstruction of the Aeginetan marbles at Munich should be entrusted to him (1816-17). Overwhelmed with commissions, he gradually enlarged his staff until in 1820 he had 40 assistants in his Roman workshop. In that year, when visiting Copenhagen, he began planning the decoration of the newly built church of Our Lady with marble statues and reliefs, a scheme which was to be his principal task for several years. The *Christ* and the *St. Paul* were carved entirely by his hand; the other figures were copied by his assistants from his models. He also worked on the great TOMB of Pius VII at St. Peter's in Rome (1824-31). In 1838 he returned finally to Denmark, a celebrity whose authority in the arts was sovereign. In Copenhagen a museum was built for him (1839-48), itself a remarkable piece of neo-

antique architecture, the courtyard of which was to contain his tomb.

Thorwaldsen aimed at reviving the sublimity of Greek sculpture, but he never went to Greece and (in common with his time) bestowed his admiration on late HELLENISTIC or Roman copies. Compared with Canova he is cool and calculating; his sculptures are more logically worked out, but they lack Canova's sensitive surfaces. Characteristically, it was only for portraits that Thorwaldsen used living models; in the rest of his work his only guide was his conception of the antique. His numerous portrait BUSTS (e.g. that of Byron, one cast in the Thorwaldsen Mus., Copenhagen, 1817) reveal a clear but not profound observation. Even in portraiture he would combine the individual with an antique prototype—so, for instance, he used the EQUESTRIAN STATUE of Marcus Aurelius for his bronze *Poniatowski Monument* in Warsaw (1826-7; destroyed 1944, and replaced by a copy). It is perhaps the more peaceful and idyllic works, such as *The Three Graces* (one version in the Thorwaldsen Mus., Copenhagen, 1817-19), that most truly express Thorwaldsen's artistic personality. His *Christ* is one of the most popular works of ecclesiastical art of the 19th c., and indeed it is this statue, rather than any of his antique compositions, that best conveys the significance of his art. According to the taste of the time critics have either praised his work for its nobility and Classical calm or dismissed it as insipid and empty.

**THREE HOLY CHILDREN.** The story of Shadrach, Meshach, and Abed-nego in the furnace (Dan. iii. 12-20) was seen, like the story of SUSANNA, as an example of the grace of God protecting the elect. The ANGEL who walked with them in the fire was a symbol of CHRIST descending into limbo to deliver the just. The scene was first represented in the catacomb of Priscilla in Rome (early 3rd c.). The three Hebrews were also celebrated as a prefiguration (see TYPOLOGICAL BIBLICAL ILLUSTRATION) of the three Magi, and on a 4th-c. SARCOPHAGUS (Louvre) they are even dressed as Persians. The scene recurs throughout the Middle Ages (13th-c. portal of the VIRGIN at LAON Cathedral), but after the 16th c. it ceased to be a usual topic of representation.

**THULDEN,** THEODOR VAN (1606-69). Flemish painter, a pupil and collaborator of RUBENS, who worked in his home town of 's Hertogenbosch and in Antwerp, Paris, and The Hague. Although like most contemporary painters of historical and religious themes he followed in the footsteps of Rubens, he did succeed in working out a personal idiom. His reputation has suffered because his name has been given to the work of many third- and fourth-rate followers and copyists of Rubens. He was also an engraver and designed tapestry CARTOONS.

**THYRSUS.** A staff or spear tipped with an ornament like a pine-cone, and sometimes wreathed with ivy or vine branches; borne by Dionysus (Bacchus) and his votaries. It became a stock symbol and accessory of pictorial representations of Bacchanalian revelries in the classicizing tradition.

**TIBALDI,** PELLEGRINO (1527–96). Italian painter, sculptor, and architect. After completing his early training at Emilia he went to Rome (1549–53), where he came into contact with Daniele da VOLTERRA and conceived an admiration for MICHELANGELO's work which lasted through his life. It is seen for example in the decoration of two rooms in Bologna University (c. 1553). His later life was devoted chiefly to architecture, much of it under the patronage of Charles Borromeo: e.g. the Seminary at Pavia (1564), the church of S. Fedele in Milan (1569), and the court of the Archbishop's Palace there (1570), as well as architectural and rich sculptural additions to Milan Cathedral (1567–76). Tibaldi's architectural style owed much to VIGNOLA and SAMMICHELE, and was competent without originality. In 1587 he went to Madrid to superintend building operations at the ESCORIAL and did sculpture and paintings for its decoration. The 46 large FRESCOES show the MANNERIST inclination to break down forms into quasi-geometrical decorative shapes. He returned to Milan in the year of his death.

**TIBETAN ART.** Nearly all Tibetan works of art were religious and served the elaborate cult and ritual of Lamaism. The Tibetans had originally practised a form of Shamanism but in the first half of the 7th c. A.D. Buddhism in the purer, Hinayana form entered the country from India. By the 8th c. it had given place to the more elaborate Mahayana form of Buddhism with its galaxy of deities and complicated ritual, which in Tibet reached its most intricate systematization of imagery and ICONOLOGY, even making some concessions to a native shamanistic cult called Bon-po (or Ponpo). The fusion was incomplete and some Ponpo ritual and art persisted into the 20th c., although little is known about it. Lamaism originated with the Indian preacher Padonasambhava (c. A.D. 750), who fused and transformed Ponpo and Mahayana cults and created the sect of the 'Red Cap' monks. In 975 a new sect of 'White Cap' monks was founded by the teacher Tilopu, and was strengthened by an influx of refugee monks from Chinese persecution. These were followed by artists and craftsmen from Khotan, who brought with them the styles and iconography of the Khotanese School of Buddhist painting which centred round the monasteries of Dandan-Uilik, Rawak, and Endere. In the 15th c. the Yellow sect of Lamaism was founded by Tsong-kha-pa (d. 1419). Lamaism was not restricted to Tibet but became the ruling creed in those barren and desolate regions of Asia which alone could provide a solitude vast, calm, and inaccessible enough to nourish its intense spirituality and mysticism.

Through the area dominated by Lamaism there were variations in art style. In the west and south Indian and Nepalese influence was stronger and Chinese in the north and east. There were also sectarian differences. In style and subject matter the works of the Red sects differed considerably from those of the Yellow. The difference was primarily a psychological one. In the works of the Yellow sect the demonic forces were dominated by and subordinated to the ultimate serenity of spiritual contemplation while the Red Cap monks depicted them in their naked, undisciplined, and compelling fury. The first aimed at inspiring awe, the second at a paralysing dread and horror. The two can also be distinguished by their literary sources and by the dress of the monks, who usually appear somewhere in a picture as subordinate figures. The influence of the Yellow sect predominated in central Tibet and Mongolia, but other parts of the Lamaist world remained untouched by its reforms.

Works of art in the Western sense were unknown in Tibet, which belonged to a world in which magic was supreme. All art was sacred art, every work designed as an object of religious devotion or a basis for meditation, or prized as a source of miraculous power. So that his work should be efficacious an artist had to be physically, morally, and ritually pure. Paintings were consecrated by lamas, and at the back they generally carried a formula, such as *om āh hūm*, and sometimes the imprint of the hand of a 'living Buddha'. Sculptures contained magical formulas sealed up in cavities. All works were anonymous. In a very few cases inscriptions give an indication of the date, but in general there are few clues which allow us to date the works or to form a clear notion of the various schools of monks and wandering artists who produced them. Little scope was given to the individual imagination of the artist. Divinities were depicted according to definite rules found in manuals called *Sādhanas* ('Invocations'), which specify the appearance of each divinity, his attributes, colours, garments, ornaments, posture, and attendants, while other handbooks give the measurements and proportions to be observed. Craftsmanship, of course, varied greatly, and some works show more genius, vigour, and accomplishment than others. Mere mechanical reproduction, which one might have expected, has usually been avoided, but there has been a steady decline in skill since c. 1800.

The study of Tibetan art is handicapped not only by ignorance as to when and where the artists worked, but also by the size and complexity of the Lamaist pantheon, of which no comprehensive survey has ever been attempted. The pantheon is chiefly derived from the Tantric Buddhism of India as it developed between the 8th and 11th centuries, but many local deities,

**373.** Systematic painting of the Tibetan system of iconography.

mountain-gods, water-gods, demons, and devils were added in Tibet and Mongolia. Buddhas, male and female, Bodhisattvas, tutelary deities (*yi-dam*); a host of lesser divinities such as the 'Defenders of the Law' (*dhar mapāla*), fairies (*dakinis*), demons, witches, serpent-gods, local spirits; and, finally, the teachers of the Law—the doctors of the Indian Church—the 18 great Arhats, the 84 great magicians, and prominent members of the indigenous hierarchy, saints such as the celebrated ascetic Milarepa, the Sakya *panditas* who were predecessors of the Dalai Lamas, *Hutuktus* (Mongol: 'great incarnations'), and Dalai and Tashi Lamas, who would be regarded as incarnations of divinities. The images of Tibetan dignitaries generally represent types, but there are a few portraits.

PAINTINGS. These were of two kinds, wall-paintings and *thangkas*. Professor G. Tucci has photographed and described very fine wall-paintings in western Tibet dating back to the 10th c., and some are much older though often altered by later restorations. A *thangka* is a painted or embroidered banner which was hung in temples or on family altars or carried by lamas in religious processions. *Thangkas* were first made in the 10th c., but the overwhelming majority of those now known date from the 17th c. onwards. They usually depict a deity surrounded by a retinue, or by scenes from his, or her, life or legend. Other *thangkas* represent magical circles (*mandalas*) which are means of invoking, or conjuring up, a deity. Their style has been subjected to many influences, such as INDIAN ART of the Pala dynasty of Bengal (*c.* A.D. 730-11th c.) transmitted through Nepal, Indian and PERSIAN miniatures, Chinese painting, etc. Nevertheless they are characteristically Tibetan, and could not easily be taken for something else. They are often of great beauty, vivid and striking, with clean colouring, balanced and harmonious arrangement, monumental in character despite a passion for minute detail.

SCULPTURE. Buddhist sculpture was widely practised in Tibet and almost all possible materials were used: metal, STONE, WOOD, IVORY, clay, and even butter. There is a tradition that sculpture was introduced in the 7th c. by the two wives of King Srong Tsan Gampo, one Chinese and the other from Nepal. Both Chinese and Indian influences contributed to the distinctive Tibetan style, which combines the serene aloofness characteristic of most Buddhist sculpture with linear vitality and an Indian elegance.

ARCHITECTURE. Tibetan architecture included monastic buildings, palaces, some fine TOMBS, and countless STUPAS. Monasteries were built on the Indian pattern of the 10th c. Although the structure of the buildings was affected by the need to keep out snow and cold, their sites, materials, and arrangement were largely determined by magical considerations. A building had to fit in with the lines of magical force pervading a given terrain, and it had to reproduce in miniature the structure of the universe in Buddhist cosmology. A certain unearthly charm has resulted from this mode of thought.

MINOR ARTS. Large wooden book-covers give an opportunity for fine carvings, and the books themselves for fine calligraphy and for WOODCUT illustrations. In Tibet as in China calligraphy was regarded as a fine art almost on a par with painting. In imitation of Indian usage graceful clay votive tablets were cast in metal moulds, and fine craftmanship went to the production of the countless ritual objects of the Lamaist cult—musical instruments, amulets and amulet boxes, cups and bowls, vases and butter-lamps, bells and gongs, ornamental thunderbolts (*vajra*) for holding in the hand or decorating altars, and magical daggers (*phur-bu*), reliquaries, and praying-wheels, not to mention aprons made of human bones, and the robes and masks used in religious dances and mystery plays. Though ephemeral, no less careful craftsmanship was lavished on the sculptures of coloured butter which were made once a year and then destroyed, and on the *mandalas* of coloured sand which were set up for a particular ceremony. The household implements used by laymen, such as jugs, teapots, etc., and the jewellery worn by both men and women were often decorated with religious symbols.

1105, 1106, 1158, 1386, 1443, 2442, 2689, 2690.

373. Key to illustration
A. The Herukas, embraced by terrible dakinis
B. The peaceful Buddhas and dakinis and Bodhisattvas
C. The six Buddhas presiding over the six realms of existence
D. The five Knowledge-holders
E. Vajvadhara, who appears twice (sometimes Vaivocana)
F. Vajvasattva, the remotest and all-embracing Truth
G. The Guardians of the Directions

**TIDEMAND**, ADOLPH (1814-76). Norwegian painter, who from 1837 onwards was mainly active in Germany. He became a leading figure among the painters of Düsseldorf, producing idyllic and often rather sentimental peasant scenes in the romantic setting of Norway, based on sketches made there. His group of *The Haugians* (a Norwegian sect), which is unusually dramatic for Tidemand, is regarded as his chief work (Düsseldorf, 1848; a replica of 1852 is in Oslo).

**TIEPOLO,** GIOVANNI BATTISTA or GIAMBATTISTA (1696–1770). The most brilliant and sought-after Italian painter of his period. His work sums up the splendours of Italian decorative painting, and with him the tradition which had begun with GIOTTO is brought to an end. Although he painted numerous easel pictures, his fame rests on his many FRESCO decorations. He revived the glories of the VENETIAN SCHOOL, e.g. of VERONESE and TINTORETTO, and enriched them with the experience of the Roman and Neapolitan BAROQUE and the new PERSPECTIVE techniques of theatre decoration. Tiepolo is unsurpassed in his bold handling of fresco and with all his facility there is nothing shallow in the details of his conceptions. His deep pictorial culture was drawn from a wide variety of sources, including RUBENS, REMBRANDT, and DÜRER.

In 1719 he married Cecilia Guardi, sister of Francesco GUARDI. After making his name in Venice with some works in the 'dark' manner of PIAZZETTA, he carried out fresco cycles in Udine (1726), Milan (1731), and Bergamo (1732). In the Udine frescoes he broke away from the dark tonality of his earliest work and established the clear, sunny palette which became one of his foremost characteristics. Between 1741 and 1750 Tiepolo was active mainly in Venice, where his chief work is the decoration of the Palazzo Labia (1745). Assisted by his expert in perspective, Gerolamo Mengozzi-Colonna, Tiepolo created a sumptuous scheme which embraces the entire space of the Gran Salone. On the walls there are two scenes from the life of Cleopatra, a favourite theme of his, and in the *Embarkation* it seems as if Antony and Cleopatra were actually stepping down into the room.

The next decade represents the peak of Tiepolo's career. He was called to Würzburg in 1750 by the Prince Archbishop to decorate the Kaisersaal and the grand staircase of his palace, and this work is the MASTERPIECE of his maturity. Rich STUCCO work combines with a decoration that is always firmly and coherently related to the architectural setting. In 1757 Tiepolo and his son decorated a series of rooms in the Villa Valmarana near Vicenza, the father painting scenes from Homer, Virgil, Ariosto, and Tasso. These rooms give perhaps the most immediate experience of Tiepolo's qualities: grandeur, rich and glowing colour, and fancifulness warmed by humanity in the narrative. His work has the light-heartedness of the ROCOCO without the suggestiveness of BOUCHER. His last large-scale work in Italy was the ceiling of the ballroom in the Villa Pisani at Strà. While there he was called by Charles III to Madrid, where he spent the last eight years of his life. The ceiling of the throne room in the royal palace was his principal commission. Intrigue and jealousy embittered these last years in Madrid, and the final blow was dealt when his seven ALTARPIECES for the church of S. Pascal at Aranjuez were displaced by seven canvases done by the champion of NEO-CLASSIC-ISM, MENGS. Even if this was actuated by personal motives, it was none the less significant of the general trend in taste. But this trend was brief, and GOYA's art, which marks the decisive beginning of the modern age, derived much inspiration from Tiepolo. Goya was especially indebted to Tiepolo's graphic work, particularly in the famous series of ETCHINGS, *Capricci* and *Scherzi di Fantasia*.

GIANDOMENICO TIEPOLO (1727–1804), son of the foregoing, began to assist his father c. 1745 and accompanied him to Madrid. He was so faithful to his father's work that it is sometimes impossible to say exactly where he has collaborated. In his independent work he has a clearly defined style with a marked bias towards GENRE and CARICATURE, e.g. at the Villa Valmarana. His outlines are dark and his colouring is in a lower key than his father's. He is famous for his engravings and etchings, especially the 22 variations on the theme of the *Flight into Egypt* (1753).

663, 1864, 1865, 2469.

**TINO DI CAMAINO** (c. 1285–1337). SIENESE sculptor, active in Pisa, Florence, and Naples. Although he was associated with Giovanni PISANO's circle at Siena and Pisa until 1315, his manner remained aloof from theirs. He was a MONUMENT-maker rather than a story-teller or grand tragedian. The figures of his incompletely preserved TOMB of the emperor Henry VII in the Campo Santo, Pisa, are calm and reserved; their block-like massiveness recalls the ROMANESQUE. He was chief of the cathedral works at Siena between 1319 and 1320, but none of his work on the cathedral survives. He made the tomb of Cardinal Petroni and somewhat later the tombs of Antonio Bishop Aliotti (Sta Maria - Novella, Florence) and Bishop Orso (Florence Cathedral). The last monument is a seated effigy, a type probably invented by Tino. From 1324 until his death he was in Naples, carving tabernacled tombs for the Angevin court (e.g. for Queen Mary of Hungary in Sta Maria in Donnaregina and for the Duke of Calabria in Sta Chiara) and served as an architect during the rebuilding of the great monastery of S. Martino. In Naples Tino is known to have been in touch with GIOTTO, who was court painter there at the time, and with the Sienese painter Pietro LORENZETTI. He somewhat modified his own rigorous style in the direction of the more decorative grace of the INTERNATIONAL GOTHIC which was in vogue, but none the less his influence was significant as one of the TUSCAN artists who carried the new northern developments to the southern parts of Italy.

488, 2713.

**TINT.** See COLOUR.

**TINTORETTO,** JACOPO ROBUSTI (1518–94). VENETIAN painter. His nickname derives from his father's profession of dyer (*tintore*).

Little beyond the bare outlines is known of his life. VASARI is not very informative about him, and our chief source of information is the life written by the Venetian RIDOLFI in 1642, which is frequently inaccurate. The only certain fact about his early training is that he did work for a very short time, possibly only a few days, in TITIAN's studio. The style of his immature works suggests that he may also have studied SCHIAVONE, Paris BORDONE, or BONIFAZIO. As a man he was totally unlike Titian and attracted a different kind of PATRON—middle-class rather than aristocratic. He spent almost all of his life in Venice, working much for religious confraternities. He appears to have been unpopular because he was unscrupulous in procuring commissions and ready to undercut his competitors.

By 1539 he was sufficiently mature to be established independently, painting pictures composed in a traditional Venetian manner with the figures strung out parallel to the picture plane and unlinked by any strong movement or variation in the arrangement (*Moses Striking the Rock*, Frankfurt). The first dated works are the *Last Supper*, and the *Miracle of the Slave* (Accademia, Venice), in which many of the qualities of his maturity begin to be distinguishable. The latter shows the most marked advance in its daring yet coherent composition: the body of the slave lies projecting right into the picture, the bystanders form a wide semicircle round it, and St. Mark swoops from the sky in sharp foreshortening. The obvious derivation of some of the figures from MICHELANGELO's Sistine ceiling may indicate that Tintoretto had paid a visit to Rome, although he could have got them from drawings or engravings. The painting is an example of Tintoretto's practice as described by Boschini, of making small wax models which he arranged on a stage and experimented on with spotlights for effects of light and shade and composition. This method of composing is the key to many of his later paintings with their startling conception of enclosed space (*The Finding of the Body of St. Mark*, Brera, 1562), and explains the frequent repetition in his works of the same figures seen from different angles.

From c. 1550 the influence of Titian is increasingly apparent (*Cain and Abel*, Accademia, Venice); so too is the religious intensity of the FLORENTINE MANNERISTS, particularly of Daniele da VOLTERRA, whose *Deposition* inspired so many artists of this period. Tintoretto's religious paintings were fraught with the mystery of a deeply felt personal experience, the individual figures becoming more and more subservient to the total effect of mood and composition. His MYTHOLOGICAL compositions retained a more buoyant tone, nearer to the spirit of Titian's work. *Susanna and the Elders* (Vienna, c. 1556) is bathed in the soft glow of light reflected from the water, and its richness is enhanced by the beautiful line of the naked body set against dark foliage: a voluptuousness which was never quite absent from paintings of similar intention throughout

his life (*Bacchus and Ariadne*, Ducal Palace, Venice, 1578).

From 1565 until 1587 Tintoretto was working on a great series of sacred paintings for the Scuola di San Rocco. The complicated system, starting in the upper hall, was probably not conceived by Tintoretto himself, but he interpreted it with a vividness and economy of colour and detail which gives a miraculous cohesion to the whole scheme. This cycle of large canvases representing the life of CHRIST, though darkened by time, is one of the great monuments of Italian painting, comparable in rank to the Sistine Chapel or RAPHAEL's *Stanze*. Its personal conception of the sacred story overwhelmed RUSKIN, who devoted eloquent pages to it. The unorthodox rough brush-work incurred the censure of Vasari, but later generations recognized it as a means of heightening the drama and tension. In his treatment of light and shade and even in his introduction of northern elements of costume Tintoretto never shrank from the bizarre, though in all his greatest works he kept in duly subordinate.

Throughout his life Tintoretto painted numerous portraits. At their best they are direct statements of character and have a dignity reminiscent of Titian (*Vincenzo Morosini*, N.G., London). But some tend to dullness and may be the product of his large workshop. His son, DOMENICO (1562–1635), became his foreman and is said to have painted many portraits, although none can be attributed to him with certainty. The later paintings can thus be divided into those which are largely studio productions on the one hand and the visionary inspirations from Tintoretto's own hand on the other. An example of the latter is *The Martyrdom of St. Catherine* (Accademia), one of a series on her life: an explosive composition, unrestrained by REALISM, in which the main elements are the great wheels and the cascade of light that falls on the saint. *The Last Supper* (S. Giorgio Maggiore, Venice) is the culmination of a lifetime's development of this subject, from the traditional frontal representation to this startling diagonally viewed composition lit by the flickering glow of a rush lamp and the radiance of Christ. Tintoretto's ability to bring the spectator right into the action of a painting by his choice of unusual viewpoints or a tilted angle of vision here reaches its extreme of daring. He foreshadows the work of El GRECO, which drew importantly from him.

Tintoretto's genius can only be appreciated fully in Venice, where almost all his important paintings remain.

1930, 2095, 2645.

**TINT TOOL.** A type of BURIN used in WOOD ENGRAVING for cutting lines of even thickness. These lines, set close together and parallel to one another, form the grey tones or 'tints' so characteristic of 19th-c. reproductive wood engraving.

**TISCHBEIN.** Family of German 18th-c. painters. The best known of them, JOHANN HEINRICH WILHELM TISCHBEIN (1751–1829), was a friend of GOETHE's and painted the famous portrait of the poet *Goethe in the Roman Campagna* (Goethemuseum, Frankfurt, 1786).

**TISI,** BENVENUTO. See GAROFALO.

**TISSOT,** JAMES (1836–1902). French painter and ETCHER. After making an auspicious start in Paris as a painter of elegant society, especially women, in the manner of the Belgian artist Alfred STEVENS, Tissot became involved in the Commune and had to take refuge in London 1871–82. There his paintings of the demi-monde were again successful; he also painted many scenes along the Thames, inspired perhaps by WHISTLER. During the latter part of his life in France he became very religious, and devoted many years to illustrating the Bible.

1586.

**TITIAN** (TIZIANO VECELLIO) (c. 1487–1576). Italian painter, who dominated VENETIAN art during its greatest period. Like GIORGIONE and SEBASTIANO DEL PIOMBO, he received the more important part of his early training in the studio of Giovanni BELLINI; then, like Sebastiano, he came under the spell of the ROMANTIC manner of Giorgione. Titian's earliest known work, the *Votive Picture of Jacopo Pesaro* (Antwerp Mus., c. 1506), hints at both Bellini and Giorgione. His relationship with the latter must have been a close one: in 1506–8 he assisted him with the external FRESCO decoration of the Fondaco dei Tedeschi, and after Giorgione's early death in 1510 it fell to Titian to complete a number of his unfinished paintings.

Titian's first great commission was for three frescoes in Padua (Scuola del Santo, 1511), noble and dignified paintings suggesting an almost central Italian firmness and monumentality. When he returned to Venice, Giorgione having died and Sebastiano gone to Rome, the aged Bellini alone stood between him and supremacy, and that only until 1516 when Bellini died and Titian became official painter to the Republic. Meanwhile he was gradually winning free from the stylistic domination of Giorgione and developing a manner of his own. The latest and finest expression of Titian's work in the Giorgione manner was the *Three Ages of Man* (Earl of Ellesmere Loan, N.G., Edinburgh) of c. 1515, by which time Titian had already given evidence of his personal style elsewhere: in the ALTARPIECE of *St. Mark with Four Saints* (Sta Maria della Salute, Venice, c. 1511). There he had aimed at a grandeur based on reality quite opposed to Giorgione's poetic visions, and it was again the realistic aspects that he emphasized in a group of female half-figure pictures painted in the years 1512–15, outstanding amongst which are the *Woman at her Toilet* (Louvre) and the *Flora* (Uffizi). Something of a fusion between

Titian's worldliness and Giorgione's poetry is seen in the enigmatic allegory known as *Sacred and Profane Love* (Villa Borghese, Rome, c. 1516). This work inaugurated a brilliant period in Titian's creative career during which he produced splendid religious, MYTHOLOGICAL, and portrait paintings, original in conception and vivid with colour and movement. A series of great altarpieces opens with the *Assumption* (Sta Maria dei Frari, Venice, 1516–18), which in the soaring movement of the VIRGIN, rising from the tempestuous group of APOSTLES towards the hovering figure of GOD THE FATHER, contradicts the stable basis of quattrocento and High RENAISSANCE composition and heralds the BAROQUE. The strong, simple colours used here, and the artist's evident pleasure in the silhouetting of dark forms against a light background, reappear throughout the work of this period. There followed the *Resurrection* altarpiece (SS. Nazaro e Celso, Brescia, 1518–22), with its MICHELANGELESQUE study of a male nude in the figure of St. Sebastian, the altarpiece of the *Madonna and Saints with a Donor* (Ancona, 1520), in part based on RAPHAEL but dominated by Titian's dramatic vigour, the *Pesaro Family* altarpiece (Sta Maria dei Frari, Venice, 1519–26), a bold diagonal composition of great magnificence in which architectural motifs are used to enhance the drama of the scene, and finally the altarpiece of *St. Peter Martyr* (now destroyed but known to us from several copies and engravings), where trees and figures together form a violent centrifugal composition suited to the action. These large works, following closely one upon the other, in no way drained Titian's energies. Between 1518 and 1523 he painted three mythological pictures for Alfonso d'ESTE—the *Worship of Venus*, the *Bacchanal* (both in the Prado) and the *Bacchus and Ariadne* (N.G., London)—using techniques of colour and movement similar to those of the religious paintings. Outstanding amongst the portraits of these years is the familiar *Man with a Glove* (Louvre, c. 1520).

About 1530, the year in which his wife died, a change in Titian's manner becomes apparent. The vivacity of former years gave way to a more restrained and meditative art. He now began to use related rather than contrasting colours in juxtaposition, yellows and pale shades rather than the primary blues and reds which shouldered each other through his previous work. In composition too he became less adventurous and used schemes which, compared with his immediately preceding works, appear almost archaic. Thus his large *Presentation of the Virgin* (Accademia, Venice, 1534–8) makes use of the relief-like FRIEZE composition dear to the quattrocento, without movement or dramatic accent; the figures no longer dominate the canvas through their size or activity but share it in harmony with architecture, landscape, and STILL LIFE. Thus also his idyllic scene of nymphs, SATYRS, and hunters, known as the *Prado Venus* (Louvre, c. 1535–40), is divided into two contrasting

balancing halves with little suggestion of movement.

During the 1530s Titian's fame spread throughout Europe. In 1530 he first met the emperor Charles V and in 1533 he painted a portrait of him (Prado) based on a portrait by the German SEISENEGGER. By making seemingly slight alterations Titian endowed the portrait with imperial dignity, and the result was so appreciated that Charles appointed him court painter and knighted him. At the same time his works were increasingly sought after by Italian princes; for instance he painted portraits of the Duke of Urbino and his Duchess (Uffizi, 1536-8) and for the Duke's son the *Venus of Urbino* (Uffizi, c. 1538), choosing for the nude figure a pose almost identical with that of Giorgione's *Dresden Venus* but substituting a direct sensual appeal for Giorgione's idyllic remoteness.

Early in the 1540s Titian came under the influence of central and north Italian MANNERISM, with results clearly visible in his paintings. In the *Ecce Homo* (Vienna, 1543) his earlier vigour was once more in evidence, but it was now a vigour expressed in crowds and uncomfortable movement and shimmering colours. In the three large ceiling canvases (*Cain and Abel, Sacrifice of Isaac*, and *David and Goliath, c.* 1543-4) in Sta Maria della Salute, Venice, his energy finds outlet in terms of physical violence, and moreover the action is projected at the spectator from above his head. Then, as though to bring himself more fully within the milieu of central Italy, Titian made his first and only journey to Rome (1545-6). There he was deeply impressed not only by modern works such as Michelangelo's *Last Judgement*, but also by the remains of antiquity. His own paintings during this visit aroused much interest, his *Danaë* (Mus. Naz., Naples) being praised for its handling and colour and (according to VASARI) criticized for its inexact drawing by Michelangelo. Titian also painted in Rome a portrait *Pope Paul III and his Nephews* (Mus. Naz., Naples) which was left unfinished, perhaps because the picture was too revealing of the sitters' characters. The decade closed with further imperial commissions. In 1548 the Emperor summoned Titian to Augsburg, where he painted both a formal equestrian portrait (*Charles V at the Battle of Mühlberg*, Prado) and a more intimate one showing him seated in an armchair (Munich). At the same time Titian painted portraits of other personages at the Augsburg congress. He travelled to Augsburg again in 1550 and this time painted portraits of the Crown Prince Philip, future King of Spain, henceforth one of his most eager patrons.

Titian's last commission from Charles V was for the picture *La Gloria* (Prado, 1554), in which the Emperor and his dead wife, surrounded by the saints in heaven, are presented to the TRINITY. For Philip II he painted a series of erotic subjects: in 1554 the *Danaë*, the *Venus and Adonis* (both in the Prado), and the *Perseus and Andromeda* (Wallace Coll., London), and in

1559-60 the *Rape of Europa* (Isabella Stewart Gardner Mus., Boston) and *Diana and Actaeon* (Earl of Harewood, Harewood House). Titian referred to these pictures as *poesie*, and they are indeed highly poetic visions of distant worlds quite different from the sensual realities of his earlier mythological paintings.

During the last 20 years of his life Titian's personal works, as opposed to those which busy assistants produced under his supervision and with his intervention, showed an increasing looseness in the handling and a sensitive merging of colours which makes them more and more immaterial. Autumnal tones reflected the artist's meditative spirit. About the same time his interest in new pictorial conceptions waned. About 1550-5 he had painted a powerful *Martyrdom of St. Lawrence* (Gesuiti, Venice), which had affinities with Mannerism in the types and movements of the figures. In 1564-7 he repeated the picture (Escorial), but now the light, which had played a dramatic part in the first version, became the chief feature, creating and dissolving forms. Similarly, having painted a *Crowning with Thorns* (Louvre, c. 1542) he used the same conception for another version c. 1570 (Munich) but fundamentally changed the character of the picture. The masterpiece of his last years is the *Shepherd and Nymph* (Vienna, c. 1570), a loosely composed idyll in which forms and figures are dissolved into a mosaic of colour and light. Titian's career closed with the painting of the *Pietà* (Accademia, Venice, 1573-6), intended for his own tomb and finished after his death by PALMA GIOVANE.

Titian's influence on later artists has been profound. There can have been few painters in oils who have not, directly or indirectly, owed much to his example. His greatness as an artist, it appears, was not matched by his character. Like his friend Aretino, he would do anything for money. The story that he reached the age of 99 is untrue, being based on Titian's false claims for the purpose of extracting money from the King of Spain.

2007, 2646, 2712.

**TOBEY, MARK** (1890- ). American painter. He moved to the north-west in 1923 and is one of the group of painters who gave pictorial expression to the states of Washington and Oregon. He was in France, Greece, and the Near East in 1925-7 and lived in England 1931-8, where he was for a time resident artist at Dartington Hall. In 1934 he visited Shanghai and Japan and studied CHINESE calligraphy. In 1935 he developed his characteristic 'white writing' style, painting the first pictures in this manner at Dartington Hall. It is a personal kind of calligraphic brush-writing in bewildering movement of white overlying dimly discerned suggestions of colour beneath. Like the Zen artists Tobey considered the calligraphic brush-stroke as a 'symbol of the spirit'. Representational

themes in the earlier pictures of this style (*Broadway*, Met. Mus., New York, 1937; *San Francisco Street*, Detroit Institute of Arts, 1941) had often disappeared from the later ones (*Tropicalism*, Willard Gal., New York, 1948). He had exhibitions at the Institute of Contemporary Arts, London, and the Art Institute of Chicago in 1955, won the National Award in the International Exhibition at the Guggenheim Museum in 1956, held a one-man show and won the International Prize at the Venice Biennale of 1958 and was given retrospective exhibitions at Seattle Art Museum in 1959 and at the Musée des Arts Decoratifs, Paris, in 1961. In 1961 he took the First Prize at the Carnegie International Exhibition, Pittsburgh.

2420, 2447.

**TOCQUÉ,** LOUIS (1696–1772). French painter, pupil and son-in-law of NATTIER. He painted at the courts of Russia, Sweden, and Denmark (1756–9), and in 1750 wrote an important discourse on the art of portraiture. His portrait of the queen, Maria Leszczyńska, was commissioned in 1738 (Louvre). He was a practitioner of the fashionable mode of allegorical society portraits, but his non-official portraits have a more forthright vigour and REALISM (*Mme Danger Embroidering*, Louvre).

**TOLEDO,** JUAN BAUTISTA DE (d. 1567). Spanish architect. He is said to have assisted MICHELANGELO at St. Peter's, Rome, and later worked as viceregal architect at Naples. He was recalled to Spain by Philip II in 1559 to direct the royal works at Madrid. He designed the ESCORIAL and began it in 1563, but his assistant and successor Juan de HERRERA was mainly responsible for the construction. Despite extensive modifications by Philip II and Herrera, the basic design and the academic MANNERIST style of the building, which influenced subsequent Spanish architecture, may be attributed to Toledo.

**TOLSÁ,** MANUEL (1757–1816). Spanish sculptor and architect, trained in Valencia and active from 1791 in Mexico, where he was director of sculpture at the Academy of S. Carlos (founded 1783) and the central figure in the NEO-CLASSICAL reaction against the extravagances of Mexican CHURRIGUERESQUE. His best known works are the bronze EQUESTRIAN STATUE of Charles IV (1803) and the School of Mines (1797–1813) in Mexico City.

36.

**TOLSTOY,** LEV NIKOLAYEVICH (1828–1910). Russian novelist. He wrote *What is Art?* in 1896, considerably later than his most famous novels and partly under the influence of his religious conversion. In it he stigmatizes as decadent all art of restricted appeal and argues that art is justifiable only if it communicates universal human emotions of a high moral and religious character. In his theory of art beauty is incidental and the criterion is effectiveness to humanize and implant broadly religious sentiments.

**TOMBS.** The tomb occupies an important place in the history of art. In some cultures tombs have been fashioned as splendid works of art or have attracted for their adornment in the honouring of the dead the finest artistic performance of their time; changes in tomb design are thus very revealing in the history of taste. During other periods, when the tomb itself has held little of artistic merit, the widespread custom of burying objects of daily life with the dead has contributed much to our heritage of ART MOBILIER from the past in addition to the light thrown on ancient life and manners. To give but one example, the very great majority of all art objects which have survived from PRE-COLUMBIAN times in the Andes were recovered from burials. Tombs and burial MONUMENTS fall roughly into two very general categories, those whose primary purpose was to provide a home for the spirits of the dead and those which were designed primarily as monuments to honour and preserve the memory of the dead. The style of tomb is related to its function and the function depends upon the prevailing beliefs about a future life. It is supposed that burial customs of many different peoples over large periods of time were influenced by the widely disseminated belief that the spirit of the departed remained sentient in the region of the tomb for as long as the body survived and that it acquired supernatural powers to affect the living. The attitude of the living to the dead was a mixture of respect, affection, and fear. The tomb was constructed either as a home for the departed spirit or as a prison to keep it from wandering and with the body were buried favourite objects of daily life to enable the departed to enjoy the spiritual life and remain contented within the tomb. Tombs made in connection with this type of belief typically care little for external adornment but may be rich in interior decoration and contents. This type of burial had its extreme manifestation in ancient Egypt, where the tomb and its furnishings were believed not only to provide for the future life but to ensure it. Emphasis was upon size and permanence and adornment was for the eyes of the dead alone. The opposite type belongs to cultures where, as in the case of the ancient Hebrews, belief in a future life was absent or weak and where, as with the Greeks, correct burial was regarded as a *release* rather than a preservation of the departed. Thus monumental tomb architecture was not practised in mainland Greece in the CLASSICAL period and the STELE, or funeral monument, envisaged the preservation of the memory not the spirit of the departed. Stelae were sometimes but not invariably erected at the place of burial. The Christian belief in an extra-mundane future existence has afforded occasion

for tombs and burials whose primary purpose was commemoration but there has remained a close if somewhat illogical sentimental link with the physical relics and the place of burial.

The megalithic chamber tombs, known as dolmens, cromlechs, etc., constructed in the main between 2000 and 1500 B.C., are of interest as the earliest surviving architectural monuments of northern and western Europe. They are either excavated in the rock or built up on the surface. They were walled by a combination of upright stones and dry masonry and the roof was formed either by a large megalithic slab resting directly on the walls or by the technique of CORBELLING. The true ARCH or DOME is not found in these prehistoric collective tombs, although it was known in ancient Mesopotamia as early as *c.* 3000 B.C. and true domes exist in the royal tombs of Ur. But the principle of the true arch held in position by keystones was not introduced in Europe until Roman times. Examples of corbel-roofed surface megalithic tombs are at New Grange in Ireland and Maes Howe in the Orkneys. The *tholos* tombs of Mycenae and the Aegean (see MYCENAEAN ART) are conceived to be functionally akin to the chamber tombs of western Europe, but they differ from the megalithic tombs by their use of chisel-cut and saw-dressed stonework.

Admired by the Greeks as one of the seven wonders of the world, the MAUSOLEUM of Halicarnassus was perhaps the most famous tomb of antiquity and gave its name to the whole genre of magnificent memorial tombs. Erected for the Carian dynast Mausolus by his widow Artemisia (*c.* 350 B.C.), it was built by Greek architects and sculptors in a monumental style of structure which had no precedent in metropolitan Greece. From Asia Minor also came the sculptured stone coffin or SARCOPHAGUS, which had a long history of use by the Romans, and in the EARLY CHRISTIAN and BARBARIAN periods. A fine series of sarcophagi running from the middle of the 5th to the late 4th c. B.C. was found at Sidon (Istanbul Mus.). The Sarcophagus of Mourners (mid 4th c.) represents a TEMPLE with graceful figures of mourning women set between the COLUMNS, while the most magnificent, the so-called ALEXANDER Sarcophagus, has continuous FRIEZES of BATTLE and hunting scenes. The sarcophagus became again the usual form of burial in the 2nd c. A.D. when inhumation began to replace the earlier Roman custom of cremation. Many hundreds of these remain, especially from the Hadrianic period, both from Rome and from outlying provinces of the Roman Empire. Some show complex battle RELIEFS, others more lyrical subjects, Nereids and Bacchic scenes, others more sedate with rows of standing figures each in a niche. The Bacchic themes with PUTTI were particularly influential with the revival of classical interest at the RENAISSANCE.

In contrast to classical Greece the early Etruscan tombs betray a belief in the survival of the departed in some way linked with the mortal remains. Hence the tendency to give the tomb the shape and layout of a house and to furnish it with the appurtenances of life. The tomb paintings provide our primary source for examples of painting in pre-Roman antiquity and the sculptures and furnishings our fundamental data on the development of artistic forms and on the various aspects of everyday life. (See ETRUSCAN ART.) The Etruscans also used the sarcophagus with a characteristic feature of the effigy of the deceased, or of husband and wife, reclining on the lid. This feature too had a long and complex history in Christian mortuary art. The Romans took over and developed Etruscan forms, although their tombs were generally set above ground rather than excavated and the reminiscence of domestic architecture was reduced to a small PEDIMENTED structure (tombs on the Via Appia, Rome). There occur also stelae with portrait BUSTS in high relief or standing figures. Small sepulchral altars have also survived in large numbers, some of them decorated with the heads of sacrificial bulls or rams at the corners and festoons of laurel, and these too were a source for the repertory of antique decorative motifs elaborated in the Renaissance.

The largest tombs in Rome, however, were the great circular mausoleums erected by the emperors Augustus and Hadrian as burial chambers for the imperial family. Both are impressive masonry structures and both were originally surmounted by a tumulus of earth laid out as a garden and carrying a statue of the emperor. The sculpture has disappeared, and the mausoleum of Hadrian, used as a papal castle for many centuries and now known as the Castel S. Angelo, has been much altered; but its size makes it one of the landmarks of Rome. The Romans also evolved a new type of monument, the sculptured column, erected in Rome over the chambers containing the ashes of the emperors Trajan and Marcus Aurelius. These were not much imitated, but in later ages a memorial column, generally with a relief on the base only, became a recognized form of monument. They also took from Egypt the PYRAMID form, the best known Roman variant being the Pyramid of Cestius, Rome, much loved by ROMANTIC LANDSCAPE PAINTERS.

In the religion of Christianity emphasis was less on death than on survival and the dominant theme was the hope of resurrection depending not, as in most other ancient cultures, on the magical properties of the tomb but on redemption through Christ. The catacomb burials were decorated with symbols of faith and salvation. With the official recognition of Christianity in the 4th c. the sarcophagus form of burial became current with Christian figural subjects in place of pagan. Two remarkable tombs, both at Ravenna, bear witness to the survival of classical ideas. The Mausoleum of Galla Placidia (*c.* 450), wife of the emperor Constantine III, is a small cruciform building containing three mutilated sarcophagi, the walls being entirely covered with

MOSAICS Christian in theme but classical in style. The later Mausoleum of Theodoric the Goth (c. 525) is a massive circular building of stone, once surrounded by a colonnade and roofed by a monolith in the form of a shallow dome. It provides remarkable evidence of the impact of Rome on the barbarian peoples and of their skill in imitation.

The early Middle Ages did not produce important tombs or monuments, though the Anglo-Saxon crosses may have been sepulchral. It was not, however, until the late ROMANESQUE period, when burials began to take place inside CHURCHES, that the tomb itself regained importance. Two types prevailed: the tomb slab laid on the church floor and some form of sarcophagus. A few early medieval tombs show the deceased as in life. Among these are the sarcophagus of a nun, Doña Sancha (d. 1095), at Jaca, Spain, with reliefs on the sides, including one of the deceased seated with companions, and the champlevé enamel slab of Geoffrey Plantagenet (Le Mans Mus., c. 1160), who stands sword in hand. An effigy showing the figure dead or sleeping was far more usual. Effigies were sometimes set on the top of a plain or sculptured sarcophagus, and by the end of the 13th c. CANOPIES were added above the tombs of the great and the sarcophagus surrounded by small figures of mourners, termed 'Weepers' (though they seldom weep), and later by ANGELS holding heraldic shields. The 'Weeper' theme reached its climax in the dramatic work of Claus SLUTER at Dijon (c. 1404–11), from which developed a rare type with the effigy on a bier-like slab resting on the shoulders of Weepers (Philippe Pot, Louvre, c. 1494), an idea which reappeared in the 16th and early 17th centuries in Flanders and England, when the bier was supported by armed warriors or VIRTUES.

Stone was the most usual material in northern Europe, though metal effigies, such as the beautiful Henry III by William TOREL (1291–2) at Westminster, were also made, and in England other materials were used, such as dark PURBECK MARBLE (13th c.) or soft ALABASTER (14th and 15th centuries). Another use of metal was the monumental BRASS made in England and Germany. In France a shrine-like type was developed, now best represented by the tomb of S. Étienne at Aubazine (mid 13th c.), with an effigy lying within an ARCADE carrying a gabled ROOF with figural scenes on its sloping sides. In southern France a few wall-tombs survive (S. Nazaire, Carcassonne) with standing figures under canopies above a sarcophagus with Weepers, while the flat slab with a figure incised upon it persisted in France till the late Middle Ages.

In the 15th c. a morbid preoccupation with death led to the development of the GISANT, a macabre skeleton sometimes depicted with the flesh rotting on the bones, which was placed within arcades with the slab and effigy above. One of the earliest examples was the tomb of Bishop Fleming (c. 1430) at Lincoln. More

rarely the effigy itself was shown as a mouldering corpse. Portraiture began to appear on tombs in the late 14th c. (Richard II, Westminster Abbey).

In Italy tombs followed a slightly different pattern, for they were almost always attached to a wall and not free-standing as in the north. The dead man lies on a draped bier, often with a two-tiered sarcophagus decorated with COSMATI work below and usually a canopy above. Many such tombs of the late 13th and early 14th centuries exist in Roman churches, while ARNOLFO DI CAMBIO, in the tomb of Cardinal de Braye (Orvieto, 1282), added the motif of two figures drawing back curtains above the effigy, a device which was repeated in Siena, Florence, Venice, and Naples, and persisted until the 15th c. In some cases (Sta Chiara, Naples; Sta Croce, Florence) the sarcophagus was carried on the shoulders of Virtues, and in Pisa (Saltarelli tomb, Sta Caterina, c. 1343) a shrine-like canopy above enclosed standing figures of the Virgin and attendants. Except in the neighbourhood of Rome, the Cosmati work on the sarcophagus was replaced by reliefs, usually of biblical themes. In north Italy medieval despots were occasionally commemorated by striking tombs, erected outside the church, with the sarcophagus raised on colonnettes and surmounted by an EQUESTRIAN figure (Barnabo Visconti, Mus. Archeologico, Milan, 1370; the Scaliger tombs, Verona, 1330 onwards). Such representations of the departed as in life were rare in the Middle Ages, and even in 15th-c. Florence the Renaissance at first brought no change. One notable tomb at Lucca (Ilaria del Carretto by Jacopo della QUERCIA, c. 1406) revived the antique sarcophagus form with PUTTI carrying garlands at the sides and a most beautiful effigy on the lid; but the major FLORENTINE artists from DONATELLO and ROSSELLINO onwards were content to develop a Renaissance form of the traditional wall-tomb with the deceased lying on a bier within a niche. VERROCCHIO broke new ground with his MEDICI tomb (Sacristy of S. Lorenzo, 1472) which has no effigy and no Christian symbolism; but the first major innovation was that of Antonio POLLAIUOLO, who in his tomb of Innocent VIII (St. Peter's, Rome, 1492) represented the Pope both seated as in life and lying peacefully in death.

In the 16th c., both north and south of the Alps, an increasing interest in the living person, sometimes shown in a portrait, even if often IDEALIZED, accompanied a decline in Christian symbolism. French royal tombs from Louis XII (Saint-Denis, c. 1515) onwards have kneeling figures on an arcaded base, which encloses an effigy or gisant, and allegorical figures standing or seated at the corners. The reclining figure supported on one elbow appeared in France and Spain, and by the end of the century in England also. Bust monuments set in a roundel, the shoulders cut by the frame, were a sign of the interest in the individual natural to Protestant England, but the great majority of English 16th- or early 17th-c. tombs, made after c. 1580 by

refugees from the Netherlands, retained the recumbent effigy. A highly original and most impressive tomb is that of the emperor Maximilian I at Innsbruck, made between 1502 and 1584, with its huge empty sarcophagus surrounded by 24 standing figures of real or supposed ancestors. The most notable of all 16th-c. tombs, however, are MICHELANGELO's Medici tombs in S. Lorenzo, Florence (1521–34), with their splendid seated figures of the two Dukes and allegories reclining on the curved tops of the sarcophagi below. Tombs in both Rome and Venice were imposing architectural structures set against the wall, with seated and standing figures, often allegorical, but showed no notable changes of theme.

The BAROQUE age brought many innovations. In Catholic countries after the Counter-Reformation, the stress was upon death as a release from troubles, and the dramatic aspects of death were emphasized. Papal tombs of the early 17th c. were still fairly traditional, the seated pope giving the blessing above two life-sized allegorical figures. But by 1671 BERNINI's dramatic *Alexander VII* shows Death emerging from his prison and striking at the kneeling pope absorbed in prayer. The architectural frame of earlier ages disappeared in the 17th c.; interest was concentrated on the figures, and richly coloured marbles were used to create a decorative background. Many forms of Italian Baroque tomb survive, a particularly compelling type being that of the half-length portrait figure (Bernini's *Fonseca*, S. Lorenzo in Lucina, Rome, 1668–75) yearning ecstatically for death. The theme of Death bearing away a medallion portrait of the deceased also appeared first in Italy; but the 'Death in action' theme was even further developed in the north, especially in Flanders. The culminating expression of the Italian Baroque was perhaps the sepulchral chapel of the Cornaro family in Sta Maria della Vittoria, Rome, where Bernini set living members of the family in balconies watching the Ecstasy of St. Teresa, and no sarcophagus was shown.

Such French tombs as have survived are very varied, but many represent the deceased alive or in the act of dying. Marshal Turenne (Les Invalides) dies in the arms of Victory; Cardinal Mazarin (Louvre) kneels above attendant Virtues; Cardinal Richelieu (Sorbonne) dies on his bier surrounded by mourning Allegories. The theme of resurrection is implied, and often specifically stated, by angels pointing to Heaven or flying down with crowns of glory, but biblical figures do not appear. In Flanders, however, where the kneeling theme was much used, the deceased often gazes at a group of the VIRGIN and Child. Innumerable smaller monuments, many including a bust or using the mourning *putti* theme, were also made all over Europe in the 17th c. and continue in the 18th c.

The dramatic character of mortuary sculpture grew less in the 18th c. Specifically Christian themes became rare and great use was made of allegory. In England in particular the allusion was generally classical; the deceased persons stand or recline in classical dress against a pyramidal background, attended by PERSONIFICATIONS of their qualities. Some English tombs were more dramatic, notably those by Louis François ROUBILIAC: the dead man rises from his tomb and Time falls before Eternity (*Hargrave*, Westminster Abbey, 1757) or Death with his dart attacks the swooning wife (*Nightingale*, Westminster Abbey, 1761). Similar themes used in France, especially in the temporary catafalques put up at state funerals. But perhaps more impressive, because less theatrical, is PIGALLE's tomb of Marshal Saxe (Strasbourg, 1753–76), where the Marshal in full regimentals descends a flight of steps to the open tomb.

The NEO-CLASSICAL movement of the second half of the century was reflected in the taste for tomb design. CANOVA still made considerable use of allegory in his *Clement XIII* (St. Peter's, 1792), but the design is static and without the Baroque agitation. The theme of mourning came into vogue, and numbers of Neo-Classical monuments show a female figure in high relief against a plain ground, mourning over an urn or a broken column bearing a medallion portrait of the deceased. Pyramidal compositions built up of figures disappeared, and the form of the Greek stele, rectangular with a pedimented top, was revived. The Neo-Classical innovations did not always sit easily with the conventions of the sepulchral monument. Such examples of Classicism as nude representations of the heroes of the Peninsular War being greeted by Victories (St. Paul's Cathedral) have a somewhat ludicrous air to modern eyes. The smaller reliefs of FLAXMAN have suffered by becoming the model for 19th-c. monumental masons working without artistic talent for patrons lacking in artistic taste. More impressive are the NATURALISTIC monuments of the mid 19th c., consisting of a seated or standing figure alone as in life; though these, too, become stereotyped, for even the better 19th-c. sculptors left the cutting of the marble to assistants. In America the *Lincoln Memorial* at Gettysburg combines impressively the concepts of the temple and the tomb, for the President is buried in a great Doric temple which contains a seated statue of Lincoln as in life.

Burial in churches, except on special occasions, became increasingly rare; large cemeteries were laid out on the outskirts of towns (Kensal Green and Highgate), and were filled in the late 19th c. by tasteless angels from masons' yards, and by elaborate and often distasteful funeral furniture. The tomb proper, where it exists, turned back to types created in the Middle Ages. The war memorial alone has been thought fit for a more lavish display of sculpture, in which the use of allegory was not infrequently revived, but the result has seldom been inspiring.

665.

**TOMÉ,** NARCISO (*c.* 1690–1742). Spanish architect, sculptor, and painter who was a leading representative of the CHURRIGUERESQUE style. He is first recorded in 1715 working with others of his family on the façade of Valladolid University. In 1721 he was appointed architect to Toledo Cathedral, where he executed the *Transparente* (completed 1732), a sacramental chapel without walls which he made into an elaborate exercise in BAROQUE ILLUSIONISM and dramatic lighting, combining the arts of architecture, sculpture, and painting.

**TONDO.** An easel painting or RELIEF carving of circular shape.

**TONE.** See COLOUR.

**TONKS,** HENRY (1862–1937). English artist and draughtsman. He first studied medicine and became a Fellow of the Royal College of Surgeons in 1888. He studied art at the Westminster School under Frederick Brown (1851–1941) and became his assistant at the Slade, where he succeeded Brown as Slade Professor in 1918. He had considerable influence as a teacher, contributing to the so-called Slade style which fell into disrepute during the 30s. He was a member of the NEW ENGLISH ART CLUB from 1895 and an exhibition of his work was given at the Tate Gallery in 1936. He bequeathed a collection of his own drawings to the Slade. He was one of the dominant personalities in the world of art in England during the first half of the 20th c.

**TOOROP,** JAN THEODOOR (1858–1928). Dutch artist, born in Java, whose highly formalized manner introduced an exotic element into Dutch painting. His work belongs to the SYMBOLISM of the late 19th c. After experimenting with a great variety of techniques he found his proper medium in drawings and paintings which have the character of drawings. He was first inspired by the socialism of his day and during a trip to England 1884–6 he was in contact with William MORRIS. After 1895 Roman Catholicism was his chief source of inspiration and during the last decades of his life he mainly depicted religious subjects. Two works illustrate both his change in technique and his conversion: his POINTILLIST painting *After the Strike* (Kröller-Müller Mus., Otterlo, *c.* 1887) and the black chalk drawing *O Grave Where is Thy Victory?* (W. J. R. Dreesmann Coll., Amsterdam, 1892). The drawing, with its flowing lines and disembodied figures, was the type that had a great influence on Dutch ART NOUVEAU. Toorop's prolific output includes book illustrations, designs for STAINED GLASS, and POSTERS; his influence extended to Glasgow, where it is visible in the works of C. R. MACKINTOSH.

CHARLEY (Annie Caroline Pontifex) (1891–1955) was the daughter of the foregoing. The brutal REALISM of her over life-size portraits is the opposite of her father's refined AESTHETICISM, but like him she focused attention upon the large, sombre eyes of the people she painted.

1512, 2109.

**TOPOGRAPHICAL ART.** Term for pictorial and graphic art which is concerned with the depiction of places, especially towns, buildings, RUINS, and natural prospects. It may be distinguished from LANDSCAPE, into which at times it merges, by the fact that topographical art is closer to a craft whose object is to supply information whereas landscape is a branch of fine art which exists primarily for AESTHETIC enjoyment. It is not considered a blemish in landscape if it does not render its subject with exactness; but inaccuracy may be a fault in topographical art. No precise line can be drawn between the two. For topographical art frequently incorporates an element of invention, such as typical vegetation or characteristic inhabitants, in providing a place with an appropriate setting.

The desire to depict places graphically was associated in the ancient world with mapping and the commemoration of military campaigns. One of the earliest maps known illustrates a military campaign of Sargon of Akkad (*c.* 2400 B.C.); and the well known Stele of his great-grandson Naram-Sin (2334–2297 B.C.), one of the first works of art in which hills and trees are used as indications of a specific terrain, commemorates a military campaign of Sargon's grandson. Egyptians, Assyrians, and Romans also incorporated topographical features into RELIEF sculpture designed to celebrate military victories, a use continued in the Middle Ages in such works as the BAYEUX TAPESTRY (*c.* 1077), where the geography of the Conquest is rendered by means of rudimentary landscape features.

While landscape features remain inevitably generalized, the topographical portrayal of individual landmarks takes its starting-point from the rendering of architectural features. We find famous TEMPLES schematically but recognizably rendered on Greek coins and on Roman ceremonial reliefs; and we find allusions to individual buildings on medieval seals. With the onset of REALISM in art these schematic forms are gradually rendered more naturalistically. The background to one of the *St. Francis Legends* at Assisi (*c.* 1300) unmistakably, though still rather fancifully, shows the façade of the Minerva Temple of Assisi, and similar views of landmarks showing, for instance, the Baptistery of Florence or the Ducal Palace of Venice or the Tower of London as an indication of a locality become more frequent in the art of the trecento and early quattrocento. The new realism of northern 15th-c. art made possible the portrayal of the castles of the Duke of Berry in the *Très Riches Heures* by the brothers LIMBURG (1416) as well as views of Paris in the background of religious scenes by FOUQUET. During the same period Konrad WITZ (1444) placed the incident of

CHRIST walking on the waves in the topographical setting of Lake Geneva with Mont Salève in the background. In modern times Stanley SPENCER, perhaps with somewhat artificial archaism, has represented Gospel scenes in the environment of the English village Cookham.

The invention of printing was soon exploited to spread information about cities and countries, the pioneer work being E. Reuwich's WOODCUTS to Breydenbach's *Peregrinations* (Mainz, 1486), illustrating a pilgrimage to Jerusalem. By contrast the illustrations to the *Nuremberg Chronicle* by Hartmann Schedel (1493) show that the public did not expect or demand much topographical accuracy. The same blocks with a generalized city view were often used to illustrate towns as different as Damascus and Ferrara. Yet the same decades also saw the production of ambitious and fairly accurate views of Florence (the chain plan) and the magnificent bird's-eye view of Venice attributed to BARBARI and published by Kolb in 1500 on four large woodcut sheets. RENAISSANCE Venice also produced masterpieces of topographical paintings in the background of Gentile BELLINI's pictures while the great painters of central Italy seemed to spurn topographical accuracy.

The situation is different in the north where DÜRER in the realistic tradition portrayed with minute fidelity cities and sites he had encountered during his journeys to Italy and to the Netherlands, although even these gems of topographical art were intended as private mementoes rather than as pictures in their own right. The independent art of landscape painting took its origin not from the study of individual views but from the assemblage of PICTURESQUE PANORAMAS such as we know them from PATENIER and BRUEGEL. The latter's view of Naples harbour was hardly painted on the spot.

The second half of the 16th c. witnessed the spread of a fashion for decorative *vedute* in which northern masters such as Paul BRIL specialized. The Galleria Geografica in the Vatican (*c.* 1580) with its city views and maps is the best known example. Other 'specialists' from the Netherlands, such as Joerg Hoefnagel, worked mainly for large publishing firms such as Braun and F. Hogenberg, who published many volumes of city views between 1573 and 1598. To the topographer and historian these views often present considerable problems because their naturalistic idiom and wealth of circumstantial detail make them look more reliable than they are. Local historians and antiquarians who have tried to locate and reconstruct particular buildings such as the Globe Theatre on the ground of such views have often found that these artists relied a good deal on stereotypes and on their own imagination.

The spread of interest in foreign countries and foreign nations is reflected in the copious output of engravers such as Théodore de Bry (1528-98) of Frankfurt and his son-in-law Matthaeus MERIAN. Although the views with which de Bry and his sons illustrated their great work *Collectiones Peregrinatum in Indiam Orientalem et Indiam Occidentalem* (1590-1634) blended much fancy with little fact, they do serve to show how quickly exotic geography became the province of the topographical artist. Matthaeus Merian founded the great series of German town-books entitled *Topographia Germanica*. Wenceslaus HOLLAR, who probably studied under Merian, not only engraved a great number of very fine views of English life and scenery in the 17th c., but also designed plates of coins, medals, heraldic and historical subjects, drew the fauna and flora of distant lands, and provided plans and views of the fortress and naval base at Tangier for Charles I. His survey of English towns and buildings was carried on by Leonard Knyff (1650-1722), Jan SIBERECHTS, and Francis PLACE.

During the second half of the 17th c. an increasing interest in 'IDEAL' nature and the picturesque led to a more sensitive and atmospheric style of painting among topographers and encouraged the reproduction of natural views. In France the work of Israel SILVESTRE is among the most sensitive of the time, and in England the fine views of Windsor by Jan Vorstermans (1643?-1699?) may be noted. It was in 18th-c. Venice, however, that topographers first became fully aware of the visual charm of atmospheric NATURALISM. The works of CANALETTO and GUARDI were bought in large measure by English gentlemen of wealth and fashion engaged upon the Grand Tour of Europe. They vary from faithful delineations of actual scenes to CAPRICCI, in which buildings are incongruously juxtaposed or placed in impossible settings; in one of Canaletto's drawings the dome of St. Peter's rises above the Doge's Palace, in another Eton Chapel opens upon a Venetian lagoon. Such mingling of reality and fancy, typical of the visual wit of the ROCOCO, is also to be found in the romanticized and dramatic topography of PIRANESI.

The English WATER-COLOUR painters had affinities with topographical art and many of them did topographical work either as pot-boilers or more seriously.

But the more prosaic need of travellers for accurate views was catered for by specialists such as Jakob Phillipp HACKERT, whose life was written by GOETHE, and by Johann Christoph Kniep (1748-1825), who accompanied both Goethe and Richard Payne KNIGHT on their travels through Italy, fulfilling the function which a camera would fulfil now. The same increasing demand also led to the rise of topographical views of Alpine scenery in Switzerland (Johann Heinrich Meyer, 1755-1829) and in Austria.

It was in England, however, that the tension between 'ideal' landscape and topographical accuracy was overcome. GAINSBOROUGH, in a famous letter, still declined to paint a 'real view' and that assiduous traveller in search of the

picturesque, the Reverend William GILPIN, pitied the artist who had to submit to vulgar taste and copy nature where her 'lines run falsely'. In the art of Richard WILSON, Thomas GIRTIN, and J. W. M. TURNER admiration for the picturesque formula often struggled with their sensitive response to an actual scene but in their circles the word 'mappy' was still a term of opprobrium. It needed the new humility before nature exemplified by John CONSTABLE to bridge that gulf and to ennoble an actual unembellished view. But with the increasing interest in the transient effects of light and atmosphere the brief union between topography and fine art began to dissolve again.

Meanwhile the widespread interest in medieval buildings made possible the work of such men as Samuel PROUT, whose elaborate and meticulous drawings John RUSKIN so much admired, and the discovery and penetration of distant lands stimulated the demand for accurate depictions of exotic scenery and the accurate rendering of such regions became a point of honour among travelling artists. By the 1830s European artists had worked or were working in the most distant regions of the world, their views frequently finding publication in the handsome colour books of the time. The beginnings of AUSTRALIAN, CANADIAN, NEW ZEALAND, and SOUTH AFRICAN ART and AMERICAN ART OF THE UNITED STATES lie very largely in the field of the topographical. But with the invention of PHOTOGRAPHY the need for topographical draughtsmen gradually declined. During the 20th c., despite the fine work of some artists like Sir Muirhead BONE, topographical art has steadily declined in volume and quality. In the work of some war artists, however, as in Richard Eurich's (1903- ) *Withdrawal from Dunkirk* (1940), it has continued to perform its ancient function of commemoration.

**TOPOLSKI,** FELIKS (1907- ). British painter and draughtsman, who was born in Poland and studied at the Warsaw Academy of Art. He settled in England in 1935 and became a British subject in 1947. He was a war artist 1940-5 and made an unusually prolific draughtsman's record both on the home front and abroad, with the British Navy in the Arctic and Mediterranean and also in the Middle East, China, Burma, Italy, and Germany. His large painting *The East*, done soon after the War, is in the national collection of India at New Delhi. *Cavalcade of the Commonwealth* (60 ft. by 20 ft.) was commissioned in 1951 for the Festival of Britain and later placed in the Victoria Memorial Hall, Singapore. His mural of *The Coronation of Elizabeth II* (100 ft. by 4 ft.) is in Buckingham Palace. He has devoted himself to portraiture in an original style and a series of 20 portraits of English writers was commissioned for the University of Texas, 1961-2. From 1953 he published *Topolski's Chronicle*, a

draughtsman's impressions of contemporary incident in many countries and he has used these drawings made in the course of constant travels as the basis for large-scale paintings. He belongs to no school, but developed a vigorous personal style of swirling line and grandiose conception. He stands out among 20th-c. artists for his virtuosity as a draughtsman and his panoramic vision, consistently exploiting the recording function of the artist-draughtsman.

2665, 2666.

**TOREL,** WILLIAM. London goldsmith, active in the time of Edward I, for whom he made in 1291 three life-size gilt-BRONZE effigies: one of Henry III and two of Queen Eleanor. The one of Queen Eleanor at Lincoln has been lost, but the others survive in Westminster Abbey. The idea was probably suggested by the series in Saint-Denis made for St. Louis of France (1263). Although they were the first large-scale figures to be cast in England, Torel produced works of the highest quality and originality.

**TORRENTIUS,** JOHANNES (1589-1644). Dutch painter whose name before he translated it into Latin was JAN VAN DER BEECK. He specialized in STILL LIFES and bawdy GENRE scenes and was a very different character from the usual workman-like Dutch painter of the 17th c. In 1627 he was tried in Haarlem for heresy (the authorities charged him with being the leader of the Rosicrucian sect) and immorality. He was tortured and then sentenced to be burned alive, but the sentence was commuted to 20 years' imprisonment. Thanks to the intervention of Charles I he was pardoned in 1630 and permitted to go to England. He returned to Amsterdam c. 1641. It is ironical that the only picture which can be attributed to him with certainty—a still life (Rijksmuseum, 1614) which was once in the collection of Charles I—is an EMBLEM on temperance. It was probably painted with the aid of a CAMERA OBSCURA.

**TORRES-GARCÍA,** JOAQUIN (1874-1949). Uruguayan painter. Resident from 1891 in Spain, he studied art at Barcelona (1892-6), worked with GAUDÍ on STAINED GLASS for the cathedral of Palma, Majorca (1905), and undertook several decorative commissions for churches and public buildings in Barcelona. After a visit to New York (1920-2) he settled in Paris (1924-32) and there developed a symbolic, severely geometrical, two-dimensional CONSTRUCTIVIST style. He founded the review *Cercle et Carré* in conjunction with Michel Seuphor. In 1934 he returned to Uruguay, where he opened an art school. His decorative works in Montevideo include a Constructivist park monument and mural paintings. In 1944 he published *Universalismo constructivo*, which was subtitled 'A

contribution to the unification of art and culture in America'.

**TORRIGIANO,** PIETRO (1472–1528). FLORENTINE sculptor, notorious for having broken the nose of his fellow student MICHELANGELO. Quitting Florence, he wandered round Italy, producing no work of importance, and serving as a soldier. He visited the Netherlands, and *c.* 1511 he came to England. Here in 1512 he was commissioned to make the TOMB of Henry VII and his wife Elizabeth in Westminster Abbey. With the aid of death masks he cast two fine recumbent figures which, with the PUTTI and saints and figures in the surrounding grille, are England's greatest memorial of the Italian RENAISSANCE. Also in the Abbey is his earlier tomb of Margaret, Countess of Richmond, and a medallion of Sir Thomas Lovell. An altar commissioned 1517 was destroyed in 1641. The museum of the Public Record Office contains his tomb of Dr. John Yonge (1516).

Torrigiano left England for Spain (1520?), abandoning his projected tomb for Henry VIII. The museum at Seville contains two painted terracottas by his hand: the *S. Jerome Kneeling in Penitence,* a work which has been greatly admired, and a *Virgin and Child.* Imprisoned by the Inquisition, Torrigiano starved himself to death.

**TORRITI.** Italian painter and mosaicist, a contemporary of the Roman painter CAVALLINI, who is known only from two signed MOSAICS commissioned by Pope Nicholas IV for the APSES of S. Giovanni in Laterano (1291, restored in 1884) and Sta Maria Maggiore (1295), Rome. The restored mosaic in S. Giovanni in Laterano shows the influence of an original EARLY CHRISTIAN composition, being centred round a BUST of CHRIST and a jewelled cross from the foot of which flow the four rivers of Paradise with the VIRGIN and saints standing on either side and the kneeling figure of Pope Nicholas himself. Torriti's style can better be assessed from the less restored mosaic in Sta Maria Maggiore, which also contains ANTIQUE elements, such as the green ACANTHUS which twines round the central panel of the *Coronation of the Virgin* (cf. 12th-c. apse mosaic in Sta Maria in Trastevere, Rome), while the scenes from the life of the Virgin in the lower FRIEZE are mainly BYZANTINE in treatment. But he was clearly influenced in his choice of colour by the pale delicate harmonies and silvery lights of the 5th-c. mosaic on the TRIUMPHAL ARCH of the same church. The sense of colour and sureness of line give us an idea of Torriti's qualities as a painter in spite of the lack of paintings bearing his name; and a small series of FRESCOES in the Upper Church of S. Francesco, Assisi (lunettes of Christ, the Virgin, and saints in the nave VAULT near the transept), have been attributed to him on stylistic grounds.

**TORSO.** A statue without head or limbs; or the trunk considered independently of the head and limbs. The word, which is Italian, comes ultimately from the Greek *thyrsos,* a plant-stem. Some of the classical sculptures discovered during the RENAISSANCE were found to have lost their extremities but achieved great fame in this mutilated state; an example is the BELVEDERE TORSO, which influenced MICHELANGELO. Renaissance sculptors liked to make reconstructions of them, supplying the missing parts, for the idea that a representation of the central part of the human body could have an AESTHETIC value on its own did not become general until the 19th c. Many of RODIN's works seem to exploit the idea that incomplete forms can stimulate the imagination more than those which are fully defined, and he used the torso for a kind of ROMANTIC effect of *non finito.* MAILLOL, on the other hand, chose the torso as a highly concentrated sculptural form, one which considered as form and not as representation is a thing complete in itself. The torso has played a large part in modern sculpture. The distortions which it allows have been turned to account by EXPRESSIONISTS like LEHMBRUCK, but it has been used to still finer effect by sculptors such as DESPIAU, Frank DOBSON, Leon Underwood (1890– ), Maurice Lambert, Henry MOORE, and many others.

**TORTILLON.** See STUMP.

**TOSA SCHOOL.** A School of JAPANESE painting which took its name from the Tosa family, many of whom (including some adopted members) served as heads of the Court Bureau of Painting from the 15th to the 19th c. Although the name 'Tosa' first appears *c.* 1407, it is Tosa Mitsunobu (1434–1525) who is considered the real founder of the School. Like the KANŌ family School it claimed to follow the 15th-c. masters. But while the Kanō School carried on the traditions of painting which had come to Japan from China, the Tosa School favoured themes and motifs which derived from the native traditions of old Japan. Though they used the YAMATO-E technique, there was a gradual loss of vitality and invention and the brush-work became less expressive. Influences from the northern CHINESE School are evident but these were often mechanically incorporated. The School enjoyed a revival in the early Tokugawa period with Tosa Mitsuoki (1617–91) and Tosa art rose again to importance. But by the 18th c. the Tosa style retained little of its early vigour or promise.

**TOTEM-POLES.** The art of monumental WOOD-CARVING reached its apex among the native inhabitants of North America in the so-called totem-poles. Contrary to popular belief totem-poles were only produced by a limited number of tribes, who made their home along the Pacific coast from southern Alaska to southern British Columbia and the state of Washington. These tribes (Tlingit, Kwakiutl, Haida, Tsimshian, Bella Coola, and Nootka) depended for their

livelihood on fishing, primarily for salmon. They acquired a marked talent for wood-working, especially with cedar, which won them the name 'salmon and cedar people'.

Totem-poles vary in height from 10 to 90 ft. They are cedar pillars richly carved with symbolic figures of mythological beings, monsters, animals, birds, and fishes, seated one on top of another. Although these figures illustrate tribal myths as well as clan affiliations, they cannot be regarded as true totems. The primary purpose of these displays of totem animals seems to have been to enhance prestige and to inspire awe, jealousy, and respect rather than religious reverence. They may be compared to the heraldic crests displayed in some European homes to impress visitors with the aristocratic ancestry of their hosts. Totem-poles also represented a considerable accumulation of wealth since they cost a fortune to erect. Famous wood-carvers were hired and entertained with lavish feasts during the many months necessary for the completion of the pole. Often special feasts, called *potlatches*, were given to celebrate the dedication. A large force of men was necessary to install the pole with ropes, wooden props, and log levers in holes 6 ft. in depth.

Totem-poles were used as house poles, either inside the house or at the oval front door. They were also used as grave posts or 'grave fathers', in which case the body of the deceased was placed in a receptacle fixed upon them, or as memorial columns erected in commemoration of the deceased. The popular usage of the term 'totem-pole' refers more specifically to the tall memorial columns, which were entirely covered with legendary and genealogical motifs. The concept of the totem-pole goes back into prehistory. The first European explorer to record them was Captain Cook, who visited the area in 1778. But there is reason to suppose that the totem-pole evolved from its funerary function to a heraldic one only during the 19th c. By this time the introduction of European steel tools (knives, adzes, axes, chisels) replaced the jade and stone blades of earlier days, making possible easier and finer workmanship.

Additional totem symbols could be acquired by Indians of wealth in various ways—purchase, exchange, warfare, and marriage. The more totems a person had the greater was his family's prestige. In order to accommodate these additional heraldic symbols the poles tended to increase in height. As in European heraldry, totem design has symmetry, severity, and angularity. Most of the totem figures (whales, ravens, frogs, etc.) are recognizable although conventionalized; they are depicted in a mode of highly stylized naturalism. In the early period only the eyes and ears were painted, usually black, red, bluish green, and white. Colour in the 18th and 19th centuries was used for emphasis only. It is a relatively modern innovation for totem-poles to be painted all over in bright non-naturalistic colours. Ship's paint, obtained from

**374.** Totem pole from the Haida Indian village of Kayang, Queen Charlotte Island, British Columbia. (B.M.)

whaling vessels, became especially popular. It is now common to see a red bear, a yellow frog, or a yellow raven.

While at the end of the 19th c. some 600 poles were estimated to be standing, by the middle of the 20th c. there were no more than 200, and this only owing to the salvage project of the U.S. and Canadian Forest Service. Totem-pole carving had ceased to be a spontaneous and living art by the 20th c.

**TOULOUSE,** S. SERNIN. See PILGRIMAGE CHURCHES.

**TOULOUSE-LAUTREC,** HENRI DE (1864–1901). French painter and draughtsman, son of the nobleman Count Alphonse de Toulouse-Lautrec Monfa. He was a delicate child and as a result of falls when he was 14 and 15 years of age he became permanently deformed. He showed an early talent for drawing and was encouraged by his uncle, Count Charles de Toulouse-Lautrec, an AMATEUR painter, and by two family friends, the deaf and dumb sporting artist René Princeteau and another sporting painter John Lewis Brown. In 1882 he became a pupil of the academic portrait painter Joseph Florentin Léon Bonnat (1833–1922) and in 1883 entered the school of Fernand Cormon (1845–1924), an academic painter of religious pictures and imaginary scenes from the life of primitive man. At the age of 21, in 1885, he was given a financial competence and set up in a studio of his own at Montmartre. He also began to draw for the illustrated journals. He met van GOGH at Cormon's school in 1886 and came into con-

376. *Oscar Wilde.* Water-colour drawing (1895) by Toulouse-Lautrec

tact with IMPRESSIONIST and POST-IMPRESSION-IST painters. From the age of 15 until he was 24 he painted mainly sporting subjects. From *c.* 1888 he began to illustrate the theatres, music-halls, cafés, and low life of Paris. He collected the etchings of GOYA and his painting came much under the influence of DEGAS. From this period come *La Fille à l'accroche-cœur* (1889) and *Au bal du Moulin de la Galette* (Art Inst., Chicago, 1889). In 1890 he began to frequent the Moulin Rouge and painted his first Moulin Rouge picture, *Au Moulin Rouge : La Danse; Dressage des nouvelles,* which was hung in the foyer of the cabaret. During the next decade he frequented, with his cousin Dr. Tapié de Céleyran, the bars and cabarets and began to produce his brilliant POSTERS and his drawings and paintings of singers, dancers, *entrepreneurs,* etc.: Aristide Bruant, La Goulue, Jane Avril, Yvette Gilbert, May Belfort, the female clown Cha-U-Kao, and many more. From 1894 onwards he produced a series of LITHOGRAPHS and paintings of his favourite performers in music-hall, cabaret, and circus. He was associated with the *Revue Blanche.* In 1895 he was in London and made a drawing of Oscar Wilde. He also became an *habitué* of the *maisons closes* of Paris and pro-duced a large number of drawings and paintings of the girls, whom he treated as his friends.

In 1888 he had come into contact with GAU-GUIN and began a continuing enthusiasm for JAPANESE COLOUR PRINTS. The influence of Gauguin's aesthetic of flat rhythmic patterning and calligraphic use of strong outline is observ-able in the painting *Au Cirque Fernando* (Art Inst., Chicago) done in that year. But it became

375. *La Goulue.* Lithograph (1894) by Toulouse-Lautrec

dominant chiefly in his famous posters and in the lithographs. Toulouse-Lautrec was keenly interested in lithography and was one of the most important influences in contemporary art towards rendering both lithography and the poster major art forms. Although they held reminiscences of ART NOUVEAU, his posters for the Moulin Rouge and other cabarets had permanent artistic value.

During his lifetime Toulouse-Lautrec held a one-man show at the Goupil Gallery, Paris, in 1893 and in London in 1898. Despite some praise from critics neither show was a success. In 1922 the Lautrec family presented some 600 of his works to the town of Albi, where the Musée Lautrec was created to house them.

16, 369, 782, 1245, 1432, 1453, 1456, 1457, 1554, 1566, 1726, 2061, 2671.

**TOURNUS, S. PHILIBERT** (10th and 11th centuries). The church, one of the most imposing monuments of early ROMANESQUE architecture in France, is the composite result of several building campaigns. The dating is controversial. The NARTHEX with its upper storey belongs to a type that goes back to CAROLINGIAN sources. The AMBULATORY with its three radiating chapels is one of the earliest surviving examples. But the most interesting feature of the church is the nave. A monumental ARCADE is surmounted by transverse barrel-VAULTS—an arrangement which permits the opening of CLERESTORY windows without incurring the structural risks of groin vaulting. The effect is novel and imposing, and the scheme was later incorporated into the general formula of early Cistercian architecture. Outside, Tournus is dominated by two monolithic towers, and its western massif has the characteristic bands of the first Romanesque style.

**TOURS SCHOOL.** Term applied to products of the CAROLINGIAN scriptorium of the Abbey of S. Martin at Tours. It had its beginnings before Charlemagne's time; Alcuin (abbot, 796–804) reformed it, and it reached its prime under Lothar (d. 855) and Charles the Bald (d. 877). Its chief products were Bibles containing Alcuin's revised Vulgate illustrated with MINIATURES from an Old Testament cycle, pictures of the EVANGELISTS, and a *Maiestas Domini*. The miniatures were partly derived from a Roman Bible of the 5th c., now lost. Two of the most important of these Bibles are the *Alcuin Bible* (B.M.) and the Bible made for Charles the Bald (Bib. nat., Paris).

**TOWN, ITHIEL** (1784–1844). Senior partner in the architectural firm of Town and DAVIS and a leading architect of the ROMANTIC movement in America. He was also a prominent engineer and invented the Town lattice truss, a structural device which made possible many of the covered bridges of New England. He began his archi-

tectural career in the FEDERAL STYLE as exemplified by his Center Church in New Haven (1812). His next church, however, Trinity in New Haven (1814), was one of the first important applications of the GOTHIC style in America. But his most accomplished work was done in the GREEK mode. He and Davis together designed the Connecticut State Capitol (New Haven, 1827–31) for which the PARTHENON served as the basic model. A more individual and energetic use of the Greek style, however, is found in their North Carolina State Capitol, Raleigh (1833–40). Town's Sachem's Wood in New Haven (1828) was one of the purest and most graceful applications of the Doric mode to the domestic building of the period.

**TOWNE, FRANCIS** (1739/40–1816). English WATER-COLOUR painter, who lived chiefly in London but maintained a lifelong connection with Exeter. He seems to have been an AMATEUR and his work was little known to his contemporaries. A tour in Wales in 1777 was followed in 1780 by a visit to Italy from which he returned in 1781 through Switzerland with John 'Warwick' SMITH. In 1786 he visited the Lake District. His method of painting in flat WASHES over a brown pen-and-ink outline was employed with a severe economy of means and represents the culmination of the 18th-c. 'tinted drawing' style of water-colour. He brought new life to the stereotyped PICTURESQUE tradition of landscape and he had an eye for specific architectonic structure and geometrical planes which gives his work an affinity with such 20th-c. work as that of John NASH. His drawings combine imaginative force with severe linear pattern, and his poetic response to the mass and grandeur of a glacier or a Roman RUIN can be seen in *The Source of the Arveiron* (V. & A. Mus.), or *The Baths of Caracalla* (B.M.).

**TOWN-PLANNING.** Town-planning is one of the most ancient of the practical arts and excavations made in 1965 at Chatal Hüyük in south Turkey revealed clear evidence of definite site planning and layout as far back as c. 7000 B.C. Throughout history town-planning has been dominated by utilitarian rather than aesthetic considerations and its place among the arts remains precarious. It has been discussed by philosophers in the past mainly in connection with theories of political economy (Plato, Isidore of Seville, Hrabanus Maurus, Thomas More) and when it has been mentioned by architectural theorists (VITRUVIUS, ALBERTI) they have been concerned almost exclusively with the practical aspects.

Aristotle (*Politics* 1267 b 22) attributed the origin of regular town-planning to the sophist HIPPODAMUS of Miletus, who planned Piraeus, the port town of Athens, and may also have directed the planning of Thurii (443 B.C.) and Rhodes (408 B.C.). It is thought, however, that the 'gridiron' system of building existed before

this (see GREEK ART). Regular planning has also been claimed for Mohenjo-Daro and Harappa (see INDUS VALLEY ART) and for towns of ancient Babylonia.

The gridiron scheme became the predominant feature of HELLENISTIC towns, although there were exceptions, most notably, perhaps, Pergamum as it was rebuilt by the Attalid kings with their palaces and public buildings grouped on the massive hill of the acropolis in a 'seemingly endless series of terraces and colonnades reaching up and away into the heavens'. It was revived in medieval Europe and from then on became predominant. It was used in colonial town-planning and was adopted generally for the expanding towns of the 19th c.

It is usually accepted that Roman towns were laid out on the model of the Roman camp as described, for example, by the historian Polybius (vi. 27) in the middle of the 2nd c. B.C.; and that the typical Roman town (though not Rome itself) consisted of two intersecting streets dividing the square plan into four roughly equal parts. In north Africa and the eastern provinces of the Empire the Roman was often combined with the Greek plan, to form large, regularly planned towns traversed by wide colonnaded streets punctuated by ARCHES (Timgad, Palmyra, Baalbeck). The Roman system survived through the Middle Ages both in Roman towns (Chichester) and in some new ones constructed to the same model (Oxford). In France there was also prevalent a radial type of plan concentric round some dominating feature, the cathedral or castle.

Alberti was the first to discuss town-planning from an aesthetic point of view, though he restricted himself to occasional features and made no suggestions for the general layout. RENAISSANCE plans for complete towns concentrated on the mathematical or symbolical aspects of a geometrical diagram rather than the aesthetic appearance of the finished town. One of the most influential was that of the architect and writer FILARETE, which was used for entire towns (Grammichele, Palma Nuovo) and for single regions within a town, was incorporated into different types of plan (e.g. L'Enfant's Washington and WREN's plan for the City of London) or for systematizations within an existing town (the Piazza del Popolo scheme in Rome). From Filarete's text and the illustrations to his treatise it seems probable that he regarded his geometrical scheme as symbolizing the universe. To what extent later planners who used it as a model were influenced by these considerations is not certain, although LEDOUX still discussed cosmological questions in his large work on architecture published in 1804. It is characteristic generally of town plans from the 15th to the 18th centuries—FRANCESCO DI GIORGIO, Maggi, Cataneo, SCAMOZZI, DÜRER, etc.—that they are conceived as patterns only and make no attempt to organize the town into an aesthetic unit.

The history of French town-planning during the 19th c. is dominated by the name of Haussmann, who was in charge of the reconstruction of Paris under Napoleon I (see FRENCH ART). The ideas behind his policy have been described as 'the classical (i.e. Cartesian) aesthetic of straight line and vista, plus a certain practical idea unrelated to circulation but concerned with police strategy, rendering barricades, popular insurrection and street warfare impossible'. The primary concerns were social and strategic. In England and Scotland during the 18th c., instead of the axial planning characteristic of continental cities unostentatious squares and crescents were built round private gardens and a close connection was sought between architecture and landscape, as in Bath and Edinburgh where semicircular terraces lay open towards the country. But with these the tradition ended and the next 150 years were an era of heartless and meaningless industrial towns and suburbs, until towards the end of the 19th c. Ebenezer Howard introduced the idea of the GARDEN CITY. Until the introduction of town-planning legislation the uncontrolled proliferation of industrialism, suburbanization, and ribbon development progressively destroyed the amenities of town and countryside. A succession of Acts of Parliament passed in Great Britain during the 20th c. culminated in a comprehensive Town and Country Planning Act of 1947, which gave local authorities powers to control the use of land and the siting and design of buildings, together with powers of compulsory acquisition where it seemed desirable to develop land in the public interest.

England was already so densely built up in the industrialized areas by the time that town-planning was taken at all seriously that in practice it has been largely concerned with rebuilding within existing cities or planning additions to them. New opportunities were given by the planned dissemination of industry for social and economic reasons and by the idea of dormitory towns. In general the trend has been towards PICTURESQUE principles of planning as cultivated by the 18th-c. landscape gardeners, with emphasis on the informal and irregular and the exploitation of the existing characteristics of a site. Considerable influence has been exerted by the pioneer Garden Cities, Letchworth and Welwyn. In the U.S.A., owing to the rapid recent growth of population and the greater number of recent settlements, more towns have been planned mostly with a simple gridiron pattern. There are several satellite towns designed on Garden City principles (Greenbelt, Maryland) and Frank Lloyd WRIGHT was responsible for an early project for a decentralized model city called Broadacres.

The newly developing countries of South America have provided unusual opportunities for town-planning. Notable examples are Citade des Motores near Rio de Janeiro (projected pop. 25,000, designed 1944 by Paul Lester Wiener and José Sert), planned for aircraft production under the sponsorship of the Brazilian Government;

and the university town of Tucuman in northern Argentina. Brasilia, planned from the beginning as a new capital city, is a case of its own (see BRAZILIAN ART).

There have been contributions to the theory of town-planning in the form of projects for ideal towns. The Linear City (*ciudad lineal*) projected by the Spaniard Arturo Soria y Mata in 1882 was based on the idea that the conditions of modern life and movement point to an elongated pattern of building along the main line of communication. The population of his city was to be 30,000. A smaller settlement on these lines was actually built near Madrid, and in 1930 a somewhat similar Linear City was planned at Stalingrad. Another noteworthy project was Tony GARNIER's *Cité Industrielle*, exhibited and published in 1917. Of more practical importance have been LE CORBUSIER's various projects, especially his *ville contemporaine* (pop. 3 million) exhibited at Paris in 1922, a kind of vertical Garden City of isolated tall buildings set in green parkland and raised on *pilotis* communicating by elevated motorways, and his *ville radieuse*, submitted in 1933 in an international competition for re-planning Nedre Normalm, Stockholm.

126, 998, 2947.

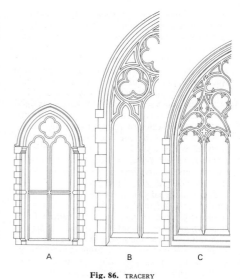

**Fig. 86.** TRACERY

A. Plate tracery (Early English). B. Bar tracery with trefoil cusps (Early English). C. Curvilinear tracery with mullions (Decorated)

**TOYOKUNI,** UTAGAWA (1769-1825). Japanese colour print (UKIYO-E) master and prolific book-illustrator. He was the real head of the Utagawa School, the most fertile of all groups of Japanese print designers. He often adjusted his work to the demands of the popular market and much of it is in the style of other and generally greater masters such as SHARAKU and particularly his great rival UTAMARO. After the retirement of Sharaku he was supreme as a designer of actor prints and the set *Yakusha Butai Sugatae* (Stage Representations of Actors), 1794-6, shows him at his best. At its finest his work had 'a broad and simple rhythm brought out with complete felicity'; at its worst it was cheap and melodramatic. With Toyokuni the great period of the *ukiyo-e* came to an end, though his School continued through the greater part of the 19th c.

**TRACERY.** Architectural term applied first and foremost to decorative stone-work set in window openings. Its use is one of the most characteristic features of medieval architecture after *c.* 1200 and its variations or absence have been used to classify the several styles of GOTHIC architecture (see EARLY ENGLISH, DECORATED, PERPENDICULAR, FLAMBOYANT, and RAYONNANT).

Two basic kinds of tracery are distinguished, known respectively as 'bar' and 'plate'. Bar tracery developed in northern France at the end of the 12th and beginning of the 13th centuries. Originally architects were satisfied with one window in each bay length of the aisles and CLERESTORY, but with the demand for more light

377. Rose-window from the west façade of Chartres Cathedral. Pen-and-ink drawing (*c.* 1235) by Villard d'Honnecourt. (Bib. nat., Paris)

several openings were grouped together and the stone-work between them was reduced to thin strips (e.g. S. Remi, Reims). From this it was but a short step to the invention of bar tracery proper, in which thin strips of stone are placed inside an enlarged window opening. This step seems to have been taken at REIMS Cathedral (c. 1211), where it was noted by Villard d' HONNECOURT. At first the lancet shape was retained, but very soon it gave way to a broader ARCH with several strips of tracery called 'mullions' in the lower part and the patterning confined to the head of the window.

Plate tracery also belongs to the period c. 1200, and is best illustrated by the first great rose windows (e.g. at LAON and CHARTRES), in which patterns are formed by perforating large expanses of flat stone. The amount of stone left is much greater, and plate tracery went out of fashion as bar tracery developed. The intricate designs of the latter provided Gothic masons with their best opportunities for displaying their skill as craftsmen, and the tendency for tracery to become more and more intricate, and to be applied more and more extensively not only to windows but to walls and voids as well persisted down to the end of the Middle Ages in almost every part of Europe except Italy.

**TRAJAN'S COLUMN.** A cylindrical COLUMN of Parian MARBLE 100 Roman ft. high (c. 125 ft. with pedestal) erected in the Roman FORUM in A.D. 113 to celebrate Trajan's victories in Dacia (Romania). The statue of Trajan which surmounted the column was later replaced by St. Peter. Round the shaft winds spirally a FRIEZE of relief sculpture, about a metre wide and 215 yds. long with 23 revolutions, depicting the two campaigns. The combination of spiral bands and figurative scenes was so far as is known an innovation. The reliefs are exemplary of Roman prosaic and matter-of-fact documentary recording and are considered the classic example of the 'continuous narrative' style where individual episodes are converted into a unified running sequence of interlocking scenes. (See ROMAN ART.) The Syrian Greek architect APOLLODORUS OF DAMASCUS, who was responsible for the architectural complex of which the column was the central feature, presumably supervised the design. But the pedestrian REALISM of much of the carving and the meticulous inclusion of detail seem typically Roman. The whole historical panorama creates an impression of epic grandeur.

The inscription is an outstanding instance of classical lettering and has served as a model for much subsequent inscription. (See INSCRIPTIONS, Greek and Roman.)

**TRANSFIGURATION, THE** (Matt. xvii. 1-13; Mark ix. 2-13; Luke ix. 28-36). CHRIST in glory, flanked by MOSES and Elijah, and witnessed by the APOSTLES Peter, James, and John, had become a common theme of BYZANTINE ART

before A.D. 1000. Christ stood on the central of three summits. He was usually depicted alone in a MANDORLA with light radiating from Him; sometimes the young unbearded Moses and the elderly bearded Elijah were included in one large HALO (*Homilies of St. Gregory Nazianzenus*, Bib. nat., Paris, c. 886). The three Apostles were shown in the foreground in attitudes of amazement and fear, St. Peter frequently raising his hand to speak (12th-c. MOSAIC, Cappella Palatina, Palermo). Sixth-century illustrations of the scene are found in a mosaic at the monastery of St. Catherine on Mt. Sinai, in a symbolical representation in the APSE mosaic of S. Apollinare in Classe, Ravenna, and in the Syrian *Rabula Gospels* (Laurentian Lib., Florence).

Although it occurred earlier (DUCCIO, N.G., London, 1308-11; GHIBERTI, Baptistery, Florence), the scene only became popular in Western art after 1457 when the feast of the Transfiguration was universally celebrated. Moses and Elijah were usually represented without marked difference in their ages, the Apostles were given less strained attitudes than in Byzantine art, and other figures were occasionally included (Fra ANGELICO, S. Marco, Florence, with the VIRGIN and St. Dominic).

At the RENAISSANCE the Byzantine configuration was changed. The three figures were grouped centrally on the summit of one mount and Christ's hand was sometimes raised in a gesture of blessing (G. BELLINI, Mus. Correr, Venice; Mus. Naz., Naples; H. HOLBEIN the Elder, church of St. Catherine, Augsburg). The tradition begun in 11th-c. Byzantine art of depicting Christ floating above the summit of the mountain was developed, first in a STYLIZED manner (PERUGINO, Collegio del Cambio, Perugia) and later more freely so that the figures of Christ and the PROPHETS appear to be flying (RAPHAEL, Vatican, c. 1518; RUBENS, Nancy, 1604-6—the group of Apostles and the family with the epileptic boy in the foreground await Christ's return from the mountain).

**TRANSITIONAL STYLE.** As one style gives way to another there is usually an intermediate phase when some characteristics of both are present in the same works. The transformation of ROMANESQUE into GOTHIC architecture continued over such a long period in various countries that a distinct stylistic term 'Transitional' is sometimes used to cover work or periods which prominently manifest the features of both. This usage was more plausible in the mid 19th c., when the term was introduced, than it is now. At that time the defining criterion of Romanesque (or NORMAN) was the use of round ARCHES, and of Gothic pointed arches; Transitional buildings were simply those in which round and pointed arches appeared together. But now it is recognized that much more was involved in the Gothic style than the replacement of one kind of arch by another. What exactly the change meant differed from region to region, for there was no single and

uniform kind of Gothic appearing everywhere. We can, however, distinguish between on the one hand the primary transition, which took place in the Île-de-France (*c.* 1135–60) and was in fact the formative period of the new Gothic style which manifested itself at SAINT-DENIS, SENS, NOYON, LAON, etc., and on the other hand the various reactions which this new Gothic evoked elsewhere. It is clear that hardly anyone outside France grasped what basically the French were trying to do, although they were prepared to borrow isolated Gothic features which caught their fancy and handle them according to their inherited traditions.

In England and Spain the Cistercian Order helped to make the pointed arch familiar, and at Roche, Yorkshire (1160s), and La Olivia, Navarre (early 13th c.), there are wall shafts and ribbed VAULTS which create a superficially Gothic appearance. In Germany and Italy, however, the Cistercians had less influence. In the latter the impact of French Gothic was always weak and spasmodic and the transition was in fact never completed. After 1200 the Germans became increasingly interested in French Gothic, and during the first half of the 13th c. they systematically studied French achievements. Though their first essays, e.g. Limburg an der Lahn (1226), were clumsy and heavy, eventually they produced at Cologne Cathedral (1248) a perfect High Gothic design. But the most extended, and in some ways the most interesting, transition took place in England. During the 12th c. the leading Norman architects were preoccupied with the application of ornament to their buildings and they saw Gothic not as an alternative method of construction (which is what the French were trying to make it) but as an alternative kind of decoration. Hence the reluctance of the English to abandon the Norman thick-wall method of construction even when they adopted the ribbed vaults, and their constant preoccupation with what might seem to be superficialities, such as the multiplication of ornamental shafts and elaboration of arch MOULDINGS and PIER profiles. Even ribbed vaults were not always considered essential in England, especially in the north where there developed at the end of the 12th and the beginning of the 13th centuries a very characteristic local Transitional style which eventually merged into EARLY ENGLISH (Byland, Ripon, Hexham, and Tynemouth). In the west country a similar development must have led from the nave of Malmesbury (1160s) to Wells Cathedral (before 1190). In England the transition terminated in a purely insular version of the Gothic style and in this respect England resembles Italy rather than Germany and Spain.

Elsewhere—for instance in Scandinavia and eastern Europe—the transition to Gothic was often further complicated by the wayward ideas of English or German intermediaries and Transitional buildings were still built towards the end of the 13th c.

**TRAVERTINE.** A LIMESTONE of almost pure calcium carbonate derived from the calcareous deposits of the Italian rivers at Tivoli (hence the original name *tivertino*), Fiano, Civitavecchia, etc. Varying in colour from pale buff to orange pink, it is sometimes porous. Since this modest stone attracted the attention of the emperor Augustus, who made generous use of the *lapis tiburtinus* in reconstructing Rome (COLOSSEUM, Theatre of Marcellus), it has been continually used in more recent times (colonnade of St. Peter's).

**TRAVESTY.** When used as a term of art criticism 'travesty' is burlesque or ludicrous imitation of a serious work of art or the deflation or lowering of elevated subject matter. In classical antiquity the Olympian gods and heroes were travestied in the Satyr plays and on south Italian vases representing heroic personages as comic yokels. POMPEIAN paintings in which pygmies enact the story of Troy or dogs the flight of Aeneas belong to the same genre. There are often elements of travesty in medieval DROLLERIES and misericords where animals play the part of men. During the great period of the RENAISSANCE respect for DECORUM was not favourable to travesty. Ultimately it was the disregard of decorum by Dutch 17th-c. artists that provoked HOGARTH to a travesty of the *Death of Dido* 'in the ridiculous manner of REMBRANDT'. The supreme master of travesty in the 19th c. was DAUMIER in such works as his *Mœurs antiques*. In the 20th c. repudiation of the pompous and pretentious, the academic and the established convention, has been so general that whole movements such as DADA have been pervaded by a spirit of travesty. DUCHAMP's *Mona Lisa* with a moustache is a case in point, as also within the field of SURREALISM René MAGRITTE's parodies of DAVID's *Madame Récamier* and MANET's *Le Balcon*.

**TREE OF JESSE, THE.** The genealogical tree of CHRIST (illustrating Matt. i. 1–17), usually represented by the recumbent figure of Jesse with a tree rising from his body (Isa. xi. 1–3). The imagery is derived from the interpretation of the *virga Iesse* as the VIRGIN. The trunk is formed by the ancestors of Christ, the Virgin, and Christ Himself, who is often surrounded by seven DOVES symbolizing the Seven Gifts of the Spirit. The PROPHETS, as spiritual ancestors of Christ, are, as a rule, placed on either side of the main trunk. Virgil and the SIBYL and groups of classical philosophers are sometimes included. The earliest known representation of the Tree of Jesse occurs in the late 11th c. (*Codex Vysehradensis*, University Lib., Prague). In the 12th c. it was turned into a genealogical table and the introduction of a line of kings ascending from Jesse obscured its tree-like appearance. Simplified versions of it sometimes showed DAVID alone, or David and Solomon, as the ancestors of the Virgin (Portico de la Gloria,

Santiago de Compostela, 12th c.). The much restored window at SAINT-DENIS (1144) and its copy at CHARTRES (1150) are early examples of the more complex Tree of Jesse showing several kings, the Virgin, Christ, the doves, and prophets on either side. The ceiling painting at St. Michael's, Hildesheim (*c.* 1200), contains medallions with the 42 ancestors of Christ enumerated by St. Matthew. With the growing cult of the Virgin in the 14th c. the figure of Christ at the top of the tree was replaced by the Virgin holding the Christ child in her arms (Puerta de los Leones, Toledo Cathedral, 16th c.), a form which survived into the 17th c.

**TRIFORIUM.** Term in Christian CHURCH architecture for a passage with ARCADE opening on to a nave and a wall behind, corresponding to the rafters of an aisle or gallery ROOF.

**TRIGLYPH.** Term in classical architecture. Vertical surfaces in the FRIEZE of the Doric Order (see ORDERS OF ARCHITECTURE) projecting over each COLUMN and between every two columns, decorated with two sunk vertical channels in the middle and two half-channels at the edges. Between the triglyphs are the METOPES. The system is thought to derive from an earlier method of timber construction.

**TRINITY.** Owing to its highly conceptual character the Christian doctrine of the Trinity, three Persons and one God, is difficult to translate into pictorial form. Indeed any concrete image must involve heresy; only by purely schematic signs can the pitfalls be avoided. A number of such abstract symbols for the Trinity were in fact invented or adapted: for instance the triangle, three interlaced circles, three circles within one large circle, the trefoil, three half moons within one circle, and so on. In spite of the inherent dogmatic difficulties the Trinity, central dogma of the Christian Church, was depicted in a great variety of combinations of symbolic and figurative forms. Some of these configurations stress the similarity of the three Persons, neglecting the unity; others emphasize the unity disregarding the likeness. For each Person in the Godhead one symbol became customary: the Hand from above, usually from amidst clouds, for GOD THE FATHER; the LAMB, sacrificial animal *par excellence*, for CHRIST; and the DOVE for the HOLY SPIRIT. These three symbols were hardly ever combined into one image, but one or two were used in combination with a human figure or figures for either Christ or God the Father or both. The following are the main contexts in which the Trinity was represented:

(i) The BAPTISM OF CHRIST (Matt. iii. 16–17) is the main event in the New Testament where the Trinity appears manifest: the heavens open above Christ, the Spirit descends in the form of the Dove and the voice of God the Father, pictured by the Hand from above, is heard

(IVORY book cover, Munich Staatsbib., 10th c.; VERROCCHIO and LEONARDO, *Baptism*, Uffizi).

(ii) Of incidents in the Old Testament interpreted as prefiguring the Trinity, most prominent was the visit of three men to ABRAHAM at Mamre (Gen. xviii). By their number they implied the Trinity; they were rendered as three identical ANGELS (MOSAIC in St. Mark's, Venice, *c.* 1125; GHIBERTI's door at the Baptistery, Florence, *c.* 1425–40). In Eastern, especially in RUSSIAN, art these three angels were isolated from the scene with Abraham and came to represent the Trinity as such (ICON by Andrei RUBLEV, *c.* 1400).

(iii) Ps. cx. 1: 'The Lord said unto my Lord, Sit thou at my right hand' was illustrated by God the Father and the Son sitting on a bench or throne next to each other—Christ usually distinguished by the cross nimbus—and between them the Dove of the Holy Spirit. This image, first used as text illustration, was later often employed on ALTARPIECES (TITIAN, *Gloria*, Prado, 1554).

(iv) Gen. i. 26: 'Let us make man in our image' was understood as a revelation of the Trinity and accordingly sometimes represented as such (Herrad of Landsberg's *Hortus deliciarum*, 1181; Brussels tapestries, *c.* 1500).

Regardless of the special context in which the Trinity appears, different types can be distinguished and preferences for certain types at certain epochs can be traced. The representation of the Trinity as three men of identical size and features (Christ is sometimes distinguished by a cross nimbus, the Father by a triple crown) became very popular towards the end of the Middle Ages, especially in representations of the Coronation of the Virgin (English alabaster reliefs in the V. & A. Mus., 15th c.). The three-headed Trinity, inspired by similar pagan images, was an attempt to fuse the three men into one, either by three heads on one body or by a three-faced figure (English PSALTER, St. John's College, Cambridge, 13th c.). By an ingenious grouping together a BYZANTINE image achieved oneness at the cost of similarity: God the Father sits enthroned and holds Christ, grown up but small, in his lap; Christ holds the Dove of the Holy Spirit between his hands or the Dove flies between the two, uniting their heads (Österreichische Nationalbib., Vienna, 12th c.; STAINED-GLASS window, Universitätsmuseum, Marburg, *c.* 1275). This type was formed in imitation of the Virgin with the Christ Child on her knees. In the 14th c. a variation of great originality was invented in Naples, where the image of the double-headed pagan god Janus was adapted to represent God-Christ — God, the old one, with a long beard, Christ, the young one, beardless—the body depicted with large wings to designate the Holy Spirit (*Hamilton Bible*, Print Room, Berlin).

In the best known and most widely distributed representation of the Trinity God sitting (or half figure) supports in front of Him (or sometimes

to the right) Christ on the cross, the Dove hovering above or between them. This may have been derived from the Byzantine type of God the Father with Christ in His lap (MASACCIO, *Trinity*, Sta Maria Novella, Florence, 1427/8). Later on in the Middle Ages Christ on the Cross was replaced by the Man of Sorrows: Christ crowned with thorns and showing His wounds is supported by God the Father, resting against His knees, with the Dove either sitting on Christ's shoulder or flying between the two (wing of an altar by the MASTER OF FLÉMALLE, Frankfurt, 15th c.). Later still, during the 17th and 18th centuries, the Man of Sorrows and God the Father, both full figures, are around the globe of the world in front of which the Dove is hovering, Christ carrying an enormous cross (TIEPOLO, *Trinity*, N.G., Washington).

**TRIPTYCH.** 'A picture or carving (or set of three such) in three compartments side by side, the lateral ones being usually subordinate, and hinged so as to fold over the central one' (*O.E.D.*). Like the DIPTYCH, this form lent itself to the making of portable religious images, whose delicate inner surfaces were protected by the outer leaves. Such images of CHRIST and the saints cut in relief in IVORY were made by BYZANTINE artists from an early time and large wooden triptychs both carved and painted were a common form of GOTHIC ALTARPIECE.

**TRISTÁN,** LUIS (*c.* 1586–1624). Spanish painter. From 1603 to 1607 he was working for El GRECO at Toledo, and many of his compositions are based on those of El Greco. Among his finest works are the ALTARPIECES for the church at Yepes (1616) and the *Adoration of the Shepherds* (Fitzwilliam Mus., Cambridge, 1620).

**TRIUMPH.** Roman triumphs were processional entries into Rome granted as an honour to victorious generals and under the Empire confined to the emperors themselves. Triumphs of Roman emperors were frequently commemorated in permanent form on TRIUMPHAL ARCHES, the Arch of Titus erected to commemorate the destruction of Jerusalem by Titus (A.D. 70) being among the most famous. The idea of the triumph appealed to the imagination of medieval poets, who sometimes described PERSONIFICATIONS, such as the Church triumphing over its opponents. The form was taken up first by Dante in the *Paradiso*, then by Petrarch in an influential cycle *I Trionfi*, the incidents of which were frequently illustrated in 15th-c. art on marriage chests, PRINTS, and tapestries.

With the renewed interest in classical lore the triumphs of ancient emperors were often represented on CASSONE paintings, partly no doubt because of the opportunities the theme offered for display, though an element of Christian humility was added by representing prominently the slave who had to remind the triumphant general of the evanescence of human glory. A more archaeological approach is evident in the great series of CARTOONS by MANTEGNA (Hampton Court) carefully modelled on ancient descriptions. Subsequently the theme of the triumph was frequently used for its didactic possibilities in tapestries and on façade paintings (GIULIO ROMANO's *Triumph of Scipio Africanus*). The most ambitious of these compositions was DÜRER's *Triumph of Maximilian*, which was published as a series of WOODCUTS.

The allegorical and MYTHOLOGICAL triumph is exemplified in Mantegna's *Triumph of Virtue* (Louvre) and in HOLBEIN's *Triumph of Riches and Poverty*. What these scenes have in common is the grouping of a retinue round the triumphal chariot, without much narrative content. A good many mythological pictures were cast in this form in the 17th c., representing the triumph of Silenus, Flora, or Bacchus. The subject also lent itself to application on medals and satirical prints.

The theme of the triumph carried with it the glamour of ancient Rome and with its exotic interest of rich accoutrements and strange animals was readily popular in a society where ceremonials, ritual, and pageantry were still part of public life and policy. It offered the artist unusual opportunities for complex and colourful compositions with crowd scenes and movement, suitable for a wide and shallow format such as a FRIEZE or a cassone panel. It was, moreover, a useful way to dramatize an abstract quality or personification. Enthroned in a chariot with enemies to spurn and champions to patronize, even the least interesting concept could acquire a certain visual interest and animation. It was, indeed, the very facility of the device which helped in course of time to sap its potential. For when, in the 17th c., it was attempted in a style in which lateral movement was not at home, rhetorical gesture and facial expression became substitutes for more truly formal animation (JOUVENET, *Triumph of Justice*, Grenoble). Just as the word 'triumph' was beginning to lose contact with the idea of a procession, the representation lost its sense of movement. So when TIEPOLO briefly and brilliantly revived the motif in the 18th c., it was by drawing on the source, the glamour and movement of the Roman imperial triumph.

**TRIUMPHAL ARCH.** A type of architectural MONUMENT originated by the Romans, by whom it was erected to commemorate a victory. In Imperial times it was restricted to the emperors themselves. It was sometimes known as *Fornix Fabii* from the arch erected by Quintus Fabius Maximus and PLINY (xxxiii. 27) records two put up in 196 B.C. by L. Stertinius. The triumphal arch combined the Roman ARCH with the Greek COLUMN. On top of their architectural base triumphal arches carried statuary in BRONZE. It usually represented the emperor standing in a triumphal chariot pulled by at least four horses or even by elephants, as can still be seen on

ancient coins. The base almost always contained one or three arches and was decorated with columns or half columns (usually of the Corinthian Order), an ARCHITRAVE and an attic, blind windows, and often niches for additional statuary. Scenes of BATTLE and TRIUMPH, public acts of the emperor, and representations of trophies in RELIEF appeared in frames which were let into the walls of the structure. In the quoins of the arches Victories were shown blowing trumpets and holding wreaths of laurel, and a dedicatory INSCRIPTION was placed on the attic. Triumphal arches were usually put up so that they straddled a street. Thus the statue of the person honoured appeared to be receiving the greetings and the homage of processions coming along the road and to tower over the traffic of the world. A procession in the act of passing under a triumphal arch is shown in a finely worked relief on the Arch of Titus.

The number of triumphal arches surviving in the territory of the former Roman Empire is 125. In Rome itself there remain extant the Arch of Titus erected after his death to commemorate

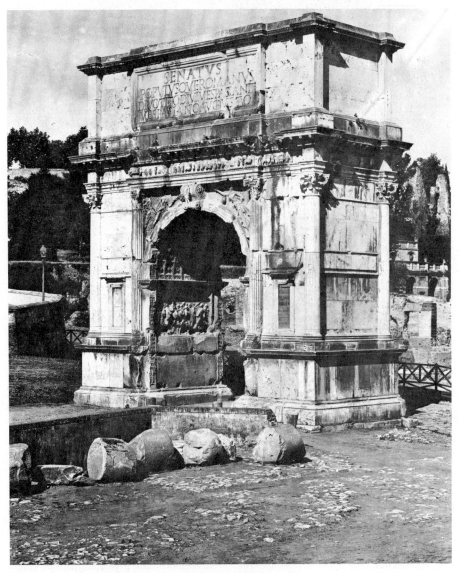

**378.** Arch of Titus, Rome (1st c. A.D.)

379. Triumphal Arch of the emperor Maximilian. Woodcut (1515) by Albrecht Dürer

the conquest of Judaea, the Arch of Septimius Severus erected in A.D. 203 to commemorate his victories over the Parthians, the ARCH OF CONSTANTINE erected after A.D. 311 and incorporating parts of the Arch of Trajan, which was destroyed at the time.

Triumphal arches were not erected during the Middle Ages, but the term 'triumphal arch' was employed for the western crossing arch in the Christian BASILICA. It is possible that the term owed its origin to the practice of placing an image of CHRIST in Majesty on the uppermost part of such arches. In the RENAISSANCE images of triumphal arches were frequently used to recall the grandeur of Rome and to demonstrate a connection between the modern and the antique world. They appear in many paintings, such as *The Triumph of Caesar* by MANTEGNA and *The Execution of St. Sebastian* by POLLAIUOLO. On occasion temporary triumphal arches were erected to celebrate the entry of a new or a victorious ruler, as, for example, an elaborate structure built in Rome at the expense of the banker Agostino Chigi upon the election of Leo X which was adorned with living figures representing Olympian deities. The memory of many temporary triumphal arches is preserved in laborious descriptions and engravings. A curious related document is DÜRER's representation of a fictitious triumphal arch to celebrate an imaginary triumph of the emperor Maximilian. A number of oil paintings by RUBENS which formed a part of a temporary arch designed by him for the entry of the Archduke Ferdinand into Antwerp still survives. Frequently temporary triumphal arches were constructed in connection with the presentation of fireworks at public festivities such as royal weddings.

The relatively few permanent arches which were built during the Renaissance and the 17th c. nearly always had an immediately practical function as entry gates into courtyards and cities. The earliest is the arch at the entrance to the Castelnuovo in Naples, which was erected for Alfonso I of Arragon in 1443. The most spectacular, perhaps, are the triumphal gates of Paris, which proclaim the victories of Louis XIV.

The noblest application of the Roman triumphal arch was made by the architects of the Renaissance who used its form, its proportions, and its historical significance to impart an air of dignity to the façades of their monumental buildings. Indeed the style of Renaissance architecture was to some extent fixed by this invention. The first to use it were BRUNELLESCHI in the Pazzi Chapel in Florence and ALBERTI in the Tempio Malatestiano in Rimini. In a variety of often impressive transformations it continued to be used as long as the academic tradition was respected. The study of Roman triumphal arches was considered an essential requisite in the education of the ARCHITECT until the early 20th c.

In the 18th and early 19th centuries triumphal arches were used as occasional focal points in city planning. One of their most eminent advocates was Sir John SOANE. The person to whom modern triumphal arches were dedicated *par excellence* was Napoleon, whose architects elegantly and faithfully imitated classical models. The *Arc du Carrousel* in Paris was built especially to accommodate a team of four antique horses from the façade of St. Mark's in Venice, which Napoleon had removed to Paris together with other Italian loot. Among the arches honouring victors over Napoleon is *Wellington Arch* in London (1846), which was originally topped by a statue of the Duke of Wellington in modern dress on horseback. Perhaps the best known of triumphal arches is the *Arc de Triomphe de l'Étoile*, built from designs by Jean-François Chalgrin (1739-1811).

In the course of the later 19th and the early 20th centuries triumphal arches were erected in a somewhat monotonous fashion. Since they were often intended to serve as monuments to express a nation's sense of relief at the end of a war, their decoration was difficult to reconcile with the idea of the personal triumph for which this particular type of monument had been perfected. Many carry allegorical sculpture on top, and traffic ordinarily is guided around them rather than through them. In several instances (Paris, Vienna) existing triumphal arches or gateways were converted into tombs of the 'unknown soldier'.

**TROMPE L'ŒIL.** A painting whose main criterion of success is its ability to deceive the eye as to the material reality of the objects represented: therefore an artefact rather than a work of art. It may at the same time have a decorative purpose. The term is sometimes applied in a derogatory sense to highly skilful paintings which lack artistic interest. The authentic *trompe l'œil* is essentially a picture of shallow depth, since it is restricted in subject matter to surfaces that lie in or near the picture plane, such as a letter pinned on a board, postage stamps or playing-cards, or low relief sculpture. The eyes easily detect the absence of parallax in representations of objects of greater depth. Nevertheless, the deception can be worked for these too if the *trompe l'œil* is situated where it can only be seen from an appreciable distance and from one point of view. (See also ILLUSIONISM.)

Anecdotes of almost miraculous feats of *trompe l'œil* by which some of the most famous painters of the past are said to have tricked and astonished their contemporaries are typical of NATURALISTIC periods such as classical GREEK ART and the Italian RENAISSANCE. Examples are the story preserved by PLINY about the contest in which ZEUXIS painted a bunch of grapes so realistically that the birds flew down to pick them, whereupon PARRHASIUS painted a curtain which his competitor tried to lift; in the same vein VASARI records in evidence of GIOTTO's precocity that as a boy he painted a fly on the nose of a figure on which his master CIMABUE was employed.

**TROOST, CORNELIUS** (1697-1750). Dutch painter and PRINT-maker. He made his name early with a lively group portrait of the Amsterdam *Inspectors of the Collegium Medicum* (Rijksmuseum, 1724) and continued to enjoy success as a formal portraitist and painter of CONVERSATION PIECES. He is best known for his pictures of actors in famous roles and for his witty GENRE scenes. His most famous work—made in his favourite technique of PASTEL and WATER-COLOUR —is a series of five pictures entitled *NELRI* (The Hague, 1740); the name is derived from the first letters of the Latin inscriptions which accompany the five views of the activities of a group of men during the night of a reunion. Troost is frequently compared to his contemporary HOGARTH, and the two artists do indeed have much in common. There is, however, one important difference: unlike Hogarth, Troost is a humorist without an ulterior motive; he never attempted to teach or preach.

**TROOSTWIJCK, WOUTER JOHANNES VAN** (1782-1810). Dutch artist whose early death cut off a promising career. His motto was 'observe nature'. His painting of the *Raampoortje* at Amsterdam (Rijksmuseum, 1809), a view of Amsterdam in the winter, shows that he observed nature with the eyes of the 17th-c. Dutch masters. ·

**TROPHY.** In early Greece memorials of victory took the form of the arms and armour of an enemy displayed on the branches of an oak tree lopped so as to resemble a human figure; these were consecrated within a shrine. Later trophies,

such as those set up after the victories over the Persians at Marathon and Salamis, consisted of COLUMNS or towers on high bases or mounds, embellished with sculpture and containing decorative groups of bronze armour. In HELLENISTIC times the motif of the armour began to appear as a decoration carved on the building itself. Throughout the ROMAN era trophies, often on a huge scale, were erected as symbols of conquest and often incorporated a mound over the fallen; enormous collections of captured arms were made both within public memorials and by private families.

In the RENAISSANCE the armour motif was freely used on RELIEFS, especially on TOMB-sculpture, and the term has since applied to any ornamental arrangement of weapons, banners, and armour.

**TROY**, JEAN-FRANÇOIS DE (1679-1752). Member of a French family of historical painters and tapestry designers. Fashionable painter of religious, MYTHOLOGICAL, and GENRE subjects, who reflects the somewhat frivolous taste of his times (*The Bath of Bathsheba*, Angers, 1727). His genre scenes (*La Lecture de Molière*, private coll.; *Oyster Feast*, Musée Condé, Chantilly; *The Alarm*, V. & A. Mus.) are among the best of those which rode on the wave of WATTEAU's success. He did designs for tapestry and collaborated with BOUCHER (1734) in the decoration of a room for the queen at VERSAILLES. His masterpiece was a group of pictures on *The Story of Esther* painted when he was Director of the French Academy at Rome.

**TRUBETSKOY**, PRINCE PAVEL (1866-1938). Russian sculptor, who was born at Intra and died at Suna (both Lake Maggiore). Son of Prince Pyotr Trubetskoy and an American mother, Trubetskoy grew up in Italy. From 1897 to 1906 he lived in Russia, and afterwards in Paris, the United States, and Italy. He was a friend of TOLSTOY, whom he portrayed. Trubetskoy formed his style under the influence of RODIN. His best works are the IMPRESSIONISTIC portraits and statuettes of animals from the early years of the century. The concessions to the then fashionable ART NOUVEAU style gave these features a pleasant period charm. The conventional monumental works from his later years are responsible for the oblivion into which his name has fallen.

**TRUMEAU.** Architectural term. A section of wall or a pillar between two openings; in particular a central mullion supporting the TYMPANUM of a doorway.

**TSOU I-KUEI** (1686-1772). Chinese court painter highly favoured by the Ch'ien-lung Emperor (1736-96). He is particularly known for his flower paintings in which the inspiration is derived from YÜN SHOU-P'ING. In much of his work the influence of Western colouring is apparent. Perhaps his best works are his few LANDSCAPES, which were uninfluenced by the West and succeed in preserving something of the atmosphere of the Yuan landscape masters.

**TUBE.** The soft-metal tube might be taken as a symbol of the effect which the Industrial Revolution has had on the painter's craft. Until about the middle of the 19th c. the OIL PAINTER ground his own PIGMENTS in his studio to the consistency he liked best, and kept them in pots, or, if he preferred something less bulky, in little skin bags like those shown in CHARDIN's sketch of *The Painter's Tools* (Princeton University). But early in the 19th c. it was possible to buy prepared PAINTS in little bladders, and at about the same time metal cylinders began to be made which were emptied by means of a piston and could be refilled at the colourman's shop. These devices were superseded by the collapsible screw-capped tube not long after it appeared on the market in the 1830s. The preparation of paints now passed from the studio to the factory and the painter lost part of his character as craftsman. Moreover a less fluid consistency had to be given to oil paints to make them suitable for packing in tubes, and other ingredients had to be added during manufacture in order to ensure that the pigments would stay suspended in the oil. Consequently manufactured paints do not flow from the BRUSH as those of the Old Masters used to do and a stiffer, shorter brush is needed for handling them or a DILUENT must be used. The tube, therefore, has caused an unnoticed revolution in painting technique. Furthermore the availability of ready-made paints in tubes made the practice of painting out of doors in oils much easier and also encouraged artists to work with a much wider range of colours instead of mixing the smaller number with whose tempering they were familiar.

**TUBY**, JEAN-BAPTISTE (1635-1700). French sculptor. He worked chiefly under LEBRUN at VERSAILLES, where he executed some of the sculpture for LE NÔTRE's gardens, basing many of his groups, e.g. those of the *Bassin d'Apollon*, on Roman BAROQUE paintings (*Saône*, Versailles).

**TUFA.** A term commonly used to describe rocks of varying nature, such as those of porous LIMESTONE, easily sawn and worked and therefore suitable for building. The Romans used a tufa for facing buildings, as it hardens on exposure to air. Friable SANDSTONE is also sometimes known as tufa.

**TUNG CH'I-CH'ANG** (1555-1636). Chinese painter, calligrapher, and art theorist, who was the leading authority on art in his own day and whose theories of painting became doctrine for the more traditional *wên-jên* painters of the following 200 years (see CHINESE ART). With Mo Shih-lung (d. 1587) he was responsible for

classifying Chinese painting into 'Northern' and 'Southern' Schools, giving the name 'Southern School' to the so-called Wu School of Su-Chou and providing for it a theoretical basis supported by a constructed tradition supposedly going back to the T'ang period. He regarded closeness to nature as unimportant and advocated representation by means of rigid symbols which could be converted into formulas from the works of the Old Masters instead of direct impression of natural objects. He set particular store by the 'Four Great Landscape Masters' of the Yüan dynasty, NI TSAN, HUANG KUNG-WANG, WU CHÊN, and WANG MÊNG. In his own painting he carried to an extreme the tendency to schematization which derived largely from Ni Tsan and which may be seen in the works of Hung-yen (1610–63). His style was ECLECTIC and combined the elasticity of the wet ink technique with the dry BRUSH texture. The canonization of schematized formulas led to a style of painting which lacked real feeling for nature.

**TURA,** COSMÈ (c. 1430–95). Italian painter, the first major artist of the FERRARESE SCHOOL. His sculptural figure style was derived in the first place from MANTEGNA, though its tortuous, metallic quality was a product of Tura's own feverish imagination. He also acquired a feeling for monumentality from PIERO DELLA FRANCESCA, who was painting in Ferrara c. 1449.

Three important paintings by Tura are in the National Gallery, London: an *Allegorical Figure*, which belongs to his early period when he loaded his compositions with spiky forms, a *Madonna Enthroned with Angels*, which is the central PANEL from a dismembered ALTARPIECE, and a *St. Jerome* from his last active years, when his nervous energy impelled him towards a style which appears in retrospect to anticipate 20th-c. EXPRESSIONISM.

272, 2343.

**TURBID MEDIUM.** Any substance which scatters light throughout its volume, as muddy water does, may be described as a 'turbid medium'. By extension the phrase is used to describe PAINTS or other colorants which diffuse the light in this way. It belongs to COLOUR science rather than to painter's terminology.

The degree of turbidity can be assessed scientifically by the amount of light scattered. There is a continuous series of turbidities from opaque white to clear, all of which are white and do not contain grey; they are exemplified by successive dilution of milk with water. AERIAL PERSPECTIVE is an imitation of the turbidity of the atmosphere.

**TURNER,** JOSEPH MALLORD WILLIAM (1775–1851). English painter and the most original genius in LANDSCAPE PAINTING during the 19th c. He was born in London, probably at 21 Maiden Lane, Covent Garden, of a provincial barber and wig maker. He showed early talent for drawing but matured slowly. During his teens he obtained various employment as a colourist and copyist. He was returned after a brief trial by the TOPOGRAPHICAL and PERSPECTIVE draughtsman Thomas Malton with the assurance that he would never be any good. Together with GIRTIN he worked for the engraver J. R. SMITH and both were employed by Dr. Monro and his neighbour in the Adelphi, the collector John Henderson. At this period Turner copied PIRANESI, SANDBY, DAYES, COZENS, and CANALETTO. He was admitted to the R.A. Schools in 1789 and exhibited his first WATER-COLOUR at the Academy in 1790. From 1792 he began the practice of sketching tours, making topographical drawings of PICTURESQUE and architectural subjects, views, and landscape, which he was able to sell to engravers or later work up into water-colours. At this time his work was more accurate but less personal and inventive than that of Girtin and though there were intimations of his later interest in atmospheric space and the phenomena of light, it was not until he was 24 that he broke through towards genuine artistic originality (*Norham Castle*, 1799). He first exhibited oils at the Academy in 1796 (*Fishermen at Sea*) and in 1797 (*Moonlight at Millbank*, Tate Gal.). Both were influenced by the Dutch 17th-c. tradition of MARINE PAINTING. He was made A.R.A. in 1799 at the age of 24 and R.A. in 1802. He was made Professor of Perspective at the Academy in 1807 and became Deputy President in 1845.

In 1802 Turner made his first journey to the Continent, visiting Paris like so many other painters to see the pictures looted by Napoleon, which were then on exhibition, and travelling through France to Switzerland. His next trip was in 1817; he visited Italy two years later and thereafter made periodic trips until 1845. The mountains and lakes of Switzerland and the haunting beauty of Venice were to provide him with the subjects for some of his most original compositions. He continued throughout life his habit of making rapid shorthand pencil jottings which he used later as reminders for imaginative compositions of atmospheric and scenic effects.

The Dutch influence in Turner's work soon gave way to that of WILSON and CLAUDE, but already in the early 1800s he was recognized to be introducing a new and revolutionary approach to landscape. Besides his attention to luminosity and atmosphere his painting became increasingly ROMANTIC in its dramatic subject matter and sense of movement, culminating in the powerful *Shipwreck* (Tate Gal., 1805). His work was attacked by Sir George BEAUMONT and the Classicists for its lack of formal organization, but was defended by Sir Thomas LAWRENCE. During these years he was also exhibiting pictures in a more conventional manner and was still working for engravers. From 1807 to 1819 he published the 70 plates of his famous *Liber Studiorum* conceived in emulation of Claude's

*Liber Veritatis.* From 1805 also he used frequently to make oil sketches of the Thames scenery near London. Between 1814 and 1826 he made a great many drawings, some of which were published in Cooke's *Picturesque Views of the Southern Coast of England* and elsewhere, the result of systematic tours in England and abroad studying the effects of landscape. Between 1827 and 1830 he made drawings for the collection of engravings *Ports of England* and for an illustrated edition of Roger's *Italy*. He was now at the height of his success. Though his work was still controversial and violently attacked by some, he had many patrons and defenders and there were those who regarded him as the outstanding genius of the day. The 1830s were a period of transition leading up to the more abstract conceptions of his last years. It was during the 30s also that Turner was 'discovered' by the young RUSKIN, who in the first volume of *Modern Painters*, published in 1843, was by that time one of his few articulate champions. Turner became more and more of a recluse and died in the year of the Great EXHIBITION under an assumed name in a Chiswick lodging-house. He left to the nation some 300 paintings and more than 20,000 drawings and water-colour sketches, which are now mainly in the Tate Gallery.

Turner's approach to the great masters of the past was not analytical like that of REYNOLDS but intuitive, but he achieved an unusually wide and intimate penetration into their values and their aims. 'He tried to make his art a synthesis of all European painting and at the same time a synthesis of his own visual and spiritual experience.' He made entirely new advances in the expression of atmospheric space and luminosity through colour. But his great originality lay not only in those features in which he anticipated and inspired the IMPRESSIONISTS. He went further than the Impressionists in his abstract organization of the phenomena of luminosity and he went further than any Romantic before him in the dramatic symbolization of the elements conceived as abstract forces. If he is not the greatest of English landscape artists, he is certainly the greatest of English Romantics and colourists.

870.

**TURPENTINE.** Crude turpentine is a RESINOUS liquid exuded from various species of pine. The 'spirits of turpentine' used in painting is distilled from this, and is the usual DILUENT, or thinner, for oil PAINT and the spirit VARNISH. There is no definite evidence that it was used before the 16th c. Some painters in the 20th c. use petrol instead.

**TUSCAN SCHOOL.** A collective name for the Schools of Florence (FLORENTINE SCHOOL), Siena (SIENESE SCHOOL), Pisa, Lucca, and Arezzo.

352, 2372.

**TUTANKHAMŪN'S TOMB.** The discovery of the TOMB of Tutankhamūn (*c.* 1350 B.C.) by Howard Carter in 1922 was perhaps the greatest archaeological sensation of the 20th c. and attracted unparalleled interest the world over. The contents of the tomb, the only burial of an Egyptian pharaoh to be found almost intact, are now in the Cairo Museum, and provide a unique spectacle of the wealth that accompanied a dead king at the height of Egypt's prosperity. Not all the objects were, however, made for Tutankhamūn, some at least having been intended for his predecessor Smenkhkarē. The burial-chamber was almost filled by a gilded wooden shrine enclosing three others, and within these was a quartzite SARCOPHAGUS. This in turn contained three mummiform coffins, one of gilded wood, the second inlaid, and the innermost of solid gold. In the last lay the mummy, adorned with jewellery and with its head covered by a gold portrait mask. In an adjacent chamber was a gilded shrine protected by exquisite figures of four goddesses and containing the canopic chest with miniature gold coffins for the viscera. Also in the tomb were two life-size statues of the king, his throne, beds, chairs and stools, stands, chests and boxes, baskets, vases, jewellery, and other items, many showing the influence of AMARNA ART. Technically these objects represent the highest level of achievement reached by the Egyptians, but fall short of some earlier work in quality of design. A taste for ostentatious brilliance and elaboration, particularly evident in the vases and jewellery, makes much of the treasure seem rather vulgar.

496, 908.

**TWACHTMAN,** J. H. See TEN.

**TYMPANUM** (Greek: 'drum'). Term in classical architecture for a stone or masonry enclosed by the ARCH of a doorway, usually resting on a LINTEL; occasionally tympana are found over windows or even within decorative ARCADES on walls. The word can also be applied to the triangle enclosed by a classical PEDIMENT. The tympanum has no structural function and its chief purpose is decorative. There are some completely plain tympana, however, which exist solely to fill in the head of an arch in order to provide a rectangular opening for a door (Porta di Stabia, Pompeii).

The shapes of tympana depend on the forms of the arches which enclose them. Thus from classical times until the end of the ROMANESQUE period they were semicircular while GOTHIC tympana were pointed. In Moslem art the usual forms of tympana were horse-shoe and OGEE, while in Indian temples tympana, when they were used, had a complex curvilinear form.

The variety of materials and techniques used in the decoration of tympana has been very great. Sometimes the decorative effect was achieved by putting together small stones which

had been cut into various geometrical shapes (Restigné, 11th c.). Occasionally two or more different kinds of stone were used in order to obtain a coloured effect (Fiesole, 12th c.). Not infrequently tympana were painted (BYZANTINE painting of St. Michael on the tympanum at S. Angelo in Formis, near Capua, 11th c.) or decorated with a MOSAIC (BALDOVINETTI's mosaic over the south doorway of Pisa Cathedral, before 1467). STUCCO RELIEFS on tympana were common in Moslem buildings. Another technique favoured by Moslem artists was the geometric inlay of glazed TERRACOTTA. Some Italian RENAISSANCE artists used glazed terracotta for their sculptures, among which were some tympana decorated with figure subjects (tympanum by Luca della ROBBIA over south sacristy doorway of Florence Cathedral, 1442-5).

The tympanum most frequently found, however, particularly in Western art, is made up of one or more pieces of carved stone. When and where in Christian art tympana were first carved is not at all clear. Some examples in Armenia may be as early as the 7th c. (Ateni, Djvari), while no Western tympanum can be dated earlier than the late 11th c. But by about 1100 the practice of carving tympana had spread throughout western Europe.

The subjects used in the decoration of tympana during the Romanesque period range from purely decorative, abstract patterns, through an infinite variety of GROTESQUE and FOLIAGE designs to religious symbols and scenes. Among the religious narrative subjects those taken directly from the Old and New Testaments were the most popular while the patron saint of a church was also a favourite subject. Some of the most important Romanesque tympana had CHRIST in Majesty surrounded by the symbols of the EVANGELISTS as the principal subject (CLUNY Abbey, c. 1130). The LAST JUDGEMENT was another of the apocalyptic themes which had considerable popularity: AUTUN, MOISSAC, Conques, and Beaulieu are some of the most famous examples of this.

At CHARTRES the three tympana of the west front (c. 1150) are no longer semicircular but slightly pointed. The arches enclosing the lateral doorways have a smaller span than the central one but are of the same height. Consequently the areas enclosed by the lateral arches have much more elongated proportions. In order that the tympanum should retain its traditional proportion of 2:1 base to height, it became necessary to add a narrow strip or register between the tympanum and the lintel. By the 13th c. the arches in Gothic architecture had become much more sharply pointed than they were at Chartres and therefore it was necessary to add more and more registers. The lintel lost its original visual meaning as the horizontal support of the tympanum, for the actual tympanum, with the exception of its uppermost part, had the appearance of several lintels placed one above the other. The tympanum of the Sixtus Doorway at REIMS Cathedral has, for instance, four such registers and so has the tympanum of the south transept at AMIENS Cathedral.

All these changes had a profound influence on the style of sculpture decorating these tympana. With the introduction of registers it was possible to carve long narrative scenes in continuous

**380.** *The Nymph of Fontainebleau.* Bronze tympanum by Benvenuto Cellini. (Louvre)

narrow strips. The scale of the carvings became much smaller than the average Romanesque tympana and the whole character of the sculpture lost its former clarity and monumentality, gaining instead an over-all picturesque effect. To the subjects already popular in the 12th c., such as the Last Judgement, were now added the PASSION of Our Lord, numerous scenes from the life of the VIRGIN and the stories of the saints.

The subsequent development of the Gothic tympanum saw the appearance of several new types. One of these consisted of blind TRACERY, imitating Gothic windows, with figures placed in the trefoils and quatrefoils formed by the tracery (S. Urbain, Troyes, Sens Cathedral, south-east PORCH at Lincoln Cathedral). The tympanum of S. Lorenz at Nuremberg (late 14th c.) illustrates well the contrast between Romanesque and Gothic types. Instead of the former proportions of 2:1 base to height, it has 2:3. The design of the tympanum consists of five registers of unequal height, with arcades and reliefs on panels interrupting the horizontal frames of the registers. The logical decoration of the earlier tympana was thus completely destroyed. At the close of the Gothic period tympana were often replaced by real window tracery with glass, by niches with statues, or some other device.

Italian Renaissance artists occasionally used painted and carved semicircular tympana for which, however, they had no classical prototypes. They are characterized by great simplicity of composition. Benvenuto CELLINI's bronze tympanum on the gate of the Château d'Anet, now replaced by a cast, is an exception both in its size and its material. BAROQUE and ROCOCO art did not favour the use of the tympanum, for its well-defined form was contrary to the spirit of those styles. When tympana were used, however, they were given fanciful shapes as in the west doorway

19th c. imitations of medieval tympana came into use. Restorations of medieval churches at that time also gave an opportunity for such imitations (Sir George Gilbert SCOTT's tympana on the north transept of Westminster Abbey).

**TYPOGRAPHY.** This term properly describes the art of printing with movable types. The art was preceded by the production of WOODCUTS and the consequent development of the BLOCK BOOK. It is not exactly known where, when, or by whom printing with movable types was first invented; the discovery is attributed by 15th-c. authorities to Johann Gutenberg of Mainz, though Laurens Janszoon Coster of Haarlem has also been credited with it. There is in any case little doubt that the art was established c. 1440-50. The earliest existing piece of printing is an *Indulgence*, printed at Mainz in 1454 and granted by Pope Nicholas V to such as should contribute towards the expense of the war against the Turks. There are two contemporary editions of this *Indulgence*, one consisting of 31, the other of 32 lines. Three names are connected with these pieces of printing: Johann Gutenberg, Johann Fust, and Peter Schoeffer. These men were closely associated with the early stages in the development of typography. The first printed edition of the Bible was issued at Mainz before August 1456. The exact share which Gutenberg, Fust, and Schoeffer each had in its production is not known, but it is sometimes assumed to have been printed by Gutenberg and is called the *Gutenberg Bible*. It is known also as the *Mazarin Bible*, because the copy which first attracted attention was found in the library of Cardinal Mazarin and it is also, more correctly, known as the *Forty-two line Bible*, from the number of lines in a column of its page. A copy of the book inscribed by Heinrich

**381.** Excerpt from the *Gutenberg Bible*

of the Frauenkirche, Munich, by Ignaz GÜNTHER, where a wooden door and tympanum are inserted into a Gothic arch.

Carved or stucco tympana reappeared during the NEO-CLASSICAL period of the 18th and early 19th centuries (the Petit Trianon, VERSAILLES). With the revival of historical styles during the

Cremer, Vicar of St. Stephen's Church, Mainz, is in the Bibliothèque nationale, Paris. Shortly after this another Bible was begun in a larger type, which is now known as the *Thirty-six line Bible*. It has been suggested that Fust and Schoeffer were responsible for the *Forty-two line Bible*, while the *Thirty-six line* edition was the work of

Gutenberg alone. By 1457, however, Gutenberg had given up printing and had become a pensioner of the Archbishop of Mainz. In that year Fust and Schoeffer brought out a famous PSALTER, the first printed book to contain the names of its printers and the date of printing. The design and execution of this fine book shows that by this time typography had advanced far beyond the experimental stage.

Very soon the art of printing spread to Cologne, where Ulrich Zell set up a press in 1466, to Strasbourg, Bamberg, Augsburg, and Nuremberg, where the most prolific printer was Anton Koberger. The invention found its way also to Italy, where two Germans, Conrad Sweynheym and Arnold Pannartz, set up a press in 1465, first in the Benedictine monastery at Subiaco and two years later in Rome. During the 15th c. more printers worked in Venice than in any other town. The most notable of them were Nicolas Jenson, noted for the beauty of his roman letter; Erhard Ratdolt, who printed mathematical and astronomical works adorned with ornamental borders; Bonetus Locatellus; and Aldus Manutius of world-wide fame (see ALDINE PRESS). By 1500 presses were established in more than 70 different towns south of the Alps. German craftsmen also carried typography to France, where the chief centres were Paris, Lyon, and Rouen. In Holland Haarlem, the reputed scene of Coster's operations, produced no printer until 10 years after a press had been started at Utrecht in 1473. The most important centres in the following years in the Netherlands were Deventer, Louvain, and Bruges, where William Caxton worked in partnership with Colard Mansion for two or three years before introducing typography to England. In conjunction with Colard Mansion Caxton printed at Bruges (1475-6) the first book in the English language, the *Recuyell of the Historyes of Troye*, which he had himself translated. In 1476 Caxton set up the first English press at the sign of the Red Pale hard by Westminster Abbey. Most of Caxton's books have a literary character; they include many volumes of poetry, romance, and fable. He was succeeded at Westminster by Wynkyn de Worde. Meanwhile Theodoric Rood, a Cologne printer, was working in Oxford (1478-85) and an unknown typographer, called the Schoolmaster Printer, printed eight books at St. Albans (1479-86). Law books were printed in London by John Lettou and William de Machlinia after 1480. Richard Pynson was also working in London as king's printer (c. 1490-1530). He printed law books and official documents, but also *The Canterbury Tales*, the English version of Brant's *Ship of Fools*, and Froissart's *Chronicles*.

These early printed books of the 15th c. are known as *incunabula* and closely resemble manuscripts, but by 1500 typography had almost freed itself from the influence of the manuscript. The medieval appearance of 15th-c. printed books was changed by Aldus Manutius and the 16th-c.

Paris typographers. Clear, finely cut types, well arranged press work, 'sober and tasteful decoration'—harmonizing with the type page—less crowded and more shapely than the Aldine books were those of Simon de Colines. As distinct from most *incunabula* the 16th-c. book generally has a title-page on which is displayed the name of its author and the address of the bookseller by whom it is published. The date is usually given also, though this is sometimes relegated to the colophon. By this time the name of the printer was often distinct from that of the publisher. Pagination, headlines, lists of contents or chapters are commonly found. The most striking innovation of the 16th c., however, was the introduction of small compact type, which replaced the use of type which imitated script and reduced books to convenient and portable dimensions.

The 16th-c. typography is dominated by the remarkable succession of scholar printers, such as Aldus in Venice, Froben in Basel, Badius, the Estiennes and Simon de Colines in Paris, and Plantin in Antwerp, who by their learning and their personality made the printing press an aid to the progress and expansion of culture. The list of English printers of this time contains no names equal to those of the great continental typographers. Richard Grafton and Edward Whitchurch printed several issues of the *Book of Common Prayer* in the reign of Edward VI. Richard Jugge issued in 1568 the first edition of the *Bishops' Bible*, containing excellent copperplate portraits. The outstanding name from a purely typographical point of view is that of John Day, who worked (1546-84) under the patronage of Archbishop Parker. Day had several new founts of type cut and issued the first book printed in Anglo-Saxon characters, Aelfric's *Paschal Homily*. The Stationers' Company was incorporated in 1557; under its charter no one was permitted to print anything for sale unless he was a member of the Company. Among the influential members of the Company during the last half of the century were Christopher Barker, who as Queen's printer was much occupied with the printing of Bibles, and whose son Robert printed the Royal or Authorized Version of the Bible in 1611; William Ponsonby, who published Sidney's *Arcadia* and the first three books of the *Faerie Queene* in 1590. Edward Blount issued in 1603 Florio's translation of Montaigne's *Essays*, published several of Marlowe's works, and was one of four partners in the publication of the First Folio *Shakespeare* (1623). By 1570-80 roman type had come into general use in England, displacing the old black letter for everything except Bibles and law books. Italic was also used to some extent, but it never acquired the vogue in England which it enjoyed on the Continent. Throughout the 16th c. the title-page was commonly ornamented by borders of various kinds, architectural and ARABESQUE decorations predominating.

In the 17th c. on the Continent there was a fashion for books of diminutive size, which

reached its zenith in the duodecimo volumes issued by the family of Elzevirs in Leiden, Amsterdam, and other centres. The Elzevirs were quite unlike the great scholar printers of the 16th c. who themselves edited and revised the texts they printed. Instead they were intelligent businessmen, who produced books which aimed at textual and typographical excellence; to ensure accuracy they employed scholars to edit their publications. Among prominent rivals of the Elzevirs were Jean Maire and Frans Hache of Leiden, Jean Jansson, Abraham Wolfgang, and Jean Blaeu in Amsterdam. Jean Blaeu's printing office was furnished with nine presses, each presided over by one of the Muses. In England the main occupation of the presses during the Civil War was the printing of pamphlets, but Sir Thomas Browne's *Religio Medici* appeared in 1642 and Humphrey Moseley published Milton's collected poems in 1645 as well as works by Crashaw, Suckling, and Herrick. Brian Walton's *Polyglot Bible*, containing the text of the scriptures in nine languages, was printed by Thomas Roycroft in six folio volumes 1654-7.

In the 18th c. the art of printing began to assume the aspect it wears today. The habit of reading was no longer limited to the learned. Periodicals appeared, *The Tatler* (1709-11) and *The Spectator* (1711-12), followed by many imitators; the novel began to assume its ever increasing importance in the production of books. During this period there was greater variety in the sizes of books. For about 200 years the sizes for books had been folio ($12 \times 7\frac{1}{2}$ in.), quarto ($7\frac{1}{2} \times 6$ in.), and octavo (about 6 in. high). Now the folio, though still used for illustrated TOPOGRAPHICAL works, was superseded by the quarto, which had become a most imposing volume about $10 \times 8$ in., and a large duodecimo ($7 \times 4$ in.) came into use.

At the beginning of the century the best type used came from Holland, but in England there were signs of improvement in typography. An example had already been set by the Oxford University Press, where Dr. John Fell had established a type foundry in 1667. In 1722 William Caslon designed for the printer William Bowyer a new and handsome fount of roman and italic letter which was first used for the folio edition of Selden's works (1726). Until *c.* 1900 Caslon's types were used in almost every attempt at fine printing.

This line is set in Caslon type

John Baskerville of Birmingham, originally a cutter of monumental inscriptions, turned his attention to type designing and in 1757 issued his first book, a quarto edition of Virgil. He became printer to the University of Cambridge and published in 1760 his chief work, a folio Bible. Baskerville is celebrated not only for the beauty of his type but for his choice of PAPER and quality of INK.

This line is set in Baskerville type

Other 18th-c. typographers of importance were Bodoni of Parma and the Didots of Paris. The Foulis Press of Glasgow produced work which rivalled that of the 16th-c. scholar printers.

In the 19th c. two innovations, the steam printing machine and the paper-making machine, revolutionized the art of printing; and the output of printed matter was further enormously increased by the process of stereotyping. Cheap magazines, series of volumes issued in uniform style, and illustrated annuals were features among the publications of the century. From a purely typographical point of view the products of the first part of the period are not interesting apart from their period flavour. The printers Thomas Bensley and William Bulmer, however, deserve mention; the latter printed BOYDELL's *Shakespeare* (1791-1802). Their books show the new fashion of type which set in at the end of the 18th c. and soon excluded every other model. It was a letter known as 'modern face', somewhat in the style of that used by the Bodoni Press. A special form of it, exaggerating the thick strokes, was called 'fat face'. A break in this fashion was made by the Chiswick Press; and William Pickering, the publisher of the series known as the Diamond Classics, revived the use of Caslon letter in 1844. Interest in the artistic aspect of typography was now awakened. The Chiswick Press revived the use of ornamental initial letters. Great impetus was given to a renaissance of printing as an art and the design of new types by many PRIVATE PRESSES, chief among which were the KELMSCOTT and the DOVES, the VALE, the ASHENDENE, and ERAGNY Presses and in more recent times the NONESUCH and GOLDEN COCKEREL Presses. In America the Grolier Club and the De Vinne and Merrymount Presses were influential. These presses were able to lavish more care on their books than was generally possible in the conditions under which machine-printed books were produced.

New types in France generally adhere closely to traditional roman models. In Germany the 20th c. has witnessed a more self-conscious revival in printing, and a bold attempt to break away from the tradition of *Fraktur* or German type. Among outstanding designers of type in recent times may be mentioned Eric GILL, the author of *Gill Sans* and *Perpetua*, Imre Reiner, the designer of *Corvinus*, and Berthold Wolfe, from whom comes *Albertus*. Today the art of printing is no longer as in its beginnings the product of one person; it is a synthesis of the work of three distinct persons, the artist who designs the type, the typographer who designs the layout of the piece of printing, and the printer who now all too often only carries out instructions, though there are notable exceptions as in the work issued from the Curwen Press, where printer and typographer were combined in the same person. The word 'typography', owing to this division, is sometimes applied in a limited sense to the designer of layout.

**TYPOLOGICAL BIBLICAL ILLUSTRA-
TION.** In Early Christian theology and exegesis personages and incidents of the Old Testament were regarded as mystical fore-runners and symbolically predictive of persons or incidents realized in the New Testament. In biblical illustration it became the custom for the figures or scenes of the Old Testament to be juxtaposed with or subordinated to the person or scene in the New Testament which each was thought to prefigure in order to demonstrate visually that the promise of the Old Testament was fulfilled in the New Testament. In such cases the Old Testament picture was called 'type' and the New Testament picture (which was prefigured by it) was called the 'antitype'.

The earliest 'typological' illustrations symbolized the doctrines of sin and redemption (JONAH as type of the Good Shepherd, catacomb of Callixtus, Rome, early 3rd c.). Similar scenes occur in the Christian FRESCOES at Dura Europos (c. 232). The *Dittochaeon*, a series of poetic inscriptions for a scheme of church decoration to represent an equal number of scenes from the Old Testament and the New Testament as type and antitype, was compiled by Prudentius in the 4th c. The subjects are developed in the Lipsanotheca at Brescia (c. 370) and on the wooden doors of Sta Sabina, Rome (c. 430), where miracle scenes are added.

From the early Middle Ages typological illustration had considerable vogue in England and France and by the 14th c. it had spread to most of northern Europe, though it never became popular in Italy or Spain. Bede (673-735) relates that pictures explaining the concordance of the Old Testament and New Testament were brought from Rome in A.D. 684 by Benedict Biscop, Abbot of Wearmouth, to adorn the abbey church. During the 12th c. typological scenes were illustrated in the choir at Peterborough and at Worcester Priory, only records of which survive. In the 12th c. also enamelled work showing types and antitypes became common in England and France (Malmesbury Ciborium, Pierpont Morgan Lib., New York; Kennet Ciborium, on loan to V. & A. Mus.). The portable altar of NICOLAS OF VERDUN at Klosterneuburg (1181) illustrates in detail prefigurations of the New Testament by the Old Testament. Typological scenes appear only rarely in monumental sculpture (13th-c. portal at LAON Cathedral). Types and antitypes were illustrated in STAINED-GLASS windows at SAINT-DENIS (1144), at CHARTRES, and at BOURGES. At Canterbury 12 typological windows were introduced in the 13th c.

Late medieval German typological compilations played an important part in book illustration. The two most frequently copied were the

382. Detail of an enamel from the Klosterneuburg Altarpiece (1181) by Nicolas of Verdun. The Holy Sea on Twelve Oxen was a prefiguration of the Baptism of Christ. The twelve oxen symbolize the twelve apostles. (Klosterneuburg Abbey)

BIBLIA PAUPERUM (c. 1300), and the SPECULUM HUMANAE SALVATIONIS (c. 1324). Types from the *Speculum* often occur in BOOKS OF HOURS. The *Bible moralisée*, although chiefly interpretative, includes types. Through the influence of the illustrated books the traditional typological method of biblical illustration was continued both in northern Europe and in Italy on tapestries, ALTARPIECES, and easel pictures (15th-c. tapestries at La Chaise-Dieu; van EYCK, *Adoration of the Lamb*, Ghent, 1432; PERUZZI, Cappella Ponzetti, Sta Maria della Pace, Rome). After the 16th c. typological scenes became rarer but isolated examples can still be found (HUBER, *Crucifixion and Brazen Serpent*, Kunsthist. Mus., Vienna).

**TYTGAT,** EDGAR (EDGARD) (1879-1957). Belgian artist whose works were an EXPRESSIONIST version of Flemish popular art. His WOODCUTS especially are typical examples of modern sophisticated naïveté. He worked in London during the First World War as a book illustrator. He is represented in museums of modern art in Belgium, Holland, and Germany.
2288.

# U

**UCCELLO,** PAOLO, properly PAOLO DI DONO (1397-1475). Florentine painter, MOSAICIST, and craftsman. He was noted for his preoccupation with geometry and PERSPECTIVE, which VASARI criticized as excessive. Modern criticism, beginning with RUSKIN, has tended to endorse this verdict, if more temperately. In fact it is partly Uccello's original application of perspective which gives him his place among the great names of the Italian 15th c. His development appears as a progressive effort to throw off the INTERNATIONAL GOTHIC style and devices which he inherited from his training in the GHIBERTI workshop (1407-15) and in Venice, and to reach a synthesis of the decorative and the realistic possibilities of the new weapons of perspective and ANATOMY already forged by BRUNELLESCHI, DONATELLO, and MASACCIO. The effort failed in its purpose, but a major document in the attempt is the magnificent fresco of *The Flood* (Sta Maria Novella, Florence, *c.* 1450), in which both the structural mechanism of the composition and the figure style show him at his best. The three panels of the *Rout of St. Romano* (London, Paris, and Florence) date from five years later. Geometrical configurations underlie many of the silhouettes in these pictures, but they also betray a different type of inspiration: the northern tapestries already perhaps in the possession of the MEDICI, who patronized Uccello on this occasion. These two factors combine to give the effect of abstract patterning often noticed in these famous BATTLE-PIECES. This effect is almost absent, however, from the very late *Hunt* in the Ashmolean Museum, Oxford, and we have to look carefully before we notice the science underlying this charmingly romantic composition. Uccello was primarily a decorative painter who by the use of geometrical construction and an outstanding natural feeling for abstract pictorial design achieved a plastic quality hardly equalled in his time.

46, 485, 2115.

**UDEN,** LUCAS VAN (1595-1672/3). Flemish painter who assisted RUBENS with his LANDSCAPE backgrounds. As an independent artist he painted the hilly countryside of Flanders and Brabant in glowing yellows, blues, and reds; David TENIERS the Younger frequently painted the figures in his landscapes. Uden also did ETCHINGS.

**UDHE,** WILHELM (1874-1947). German collector and CONNOISSEUR. After studying at Munich and Florence, he settled in Paris in 1904. In 1905 he was buying pictures by PICASSO and BRAQUE at a time when these artists were practically unknown and in 1906 he was one of the first to discover the Douanier ROUSSEAU. He published a monograph on Rousseau and in 1912 organized the first retrospective exhibition of his works. In 1908 he organized an exhibition of the IMPRESSIONISTS at Basel and Zürich. He had a particular interest in the modern PRIMITIVES and published a work on Rousseau, Vivin (1861-1936), Bombois (1883- ), Bauchant (1873-1958), and Séraphine (1864-1934). After his death a room in the Musée d'Art Moderne in Paris was devoted to the works of the '20th-c. primitives' and named after him.

**UDINE,** GIOVANNI DA (1487-1564). Italian painter, decorative artist, and architect. Born at Udine, he entered RAPHAEL's workshop in Rome and was put in charge of the two chief decorative undertakings of the Raphael School, the Vatican Loggie (1517-19) and the Villa Madama (1520). Inspired by archaeological discoveries in Rome such as the ancient GROTESQUES in the Baths of Titus, he evolved a light and graceful decorative style in STUCCO and FRESCO. Later he returned to Udine, where he worked both as decorator and architect, in 1552 being made responsible for all public architectural undertakings there. His decorative style, propagated throughout Italy by the activity of his colleagues, was imitated all over Europe by 18th-c. NEO-CLASSICAL designers.

**UFFIZI,** FLORENCE. The chief public gallery of Italian paintings in Florence. The nucleus of the collection derives from the collections of the MEDICI family and the Uffizi Palace, on the upper floor of which it is now housed, was built by VASARI in 1560-74 for Cosimo I, Grand Duke of Tuscany. The Loggia and the Tribune were built by Bernardo BUONTALENTI and decorated by Bernardino Poccetti (1548-1612). In 1565 Vasari built the corridor over the Ponte Vecchio connecting the Uffizi with the PITTI Palace and now containing a famous collection of SELF-PORTRAITS, begun by Duke Cosimo III (1642-1723). The Gallery was enlarged by Ferdinando II (reigned 1621-70). In 1762 the West Gallery was restored after a fire. It was damaged in the Second World War and the subsequent rearrangement and redecoration are said to some extent to have changed its original character. Serious flooding occurred in 1967.

PATRONAGE of the arts and CONNOISSEURSHIP were traditional in the Medici family, and their

collections embraced not only ancient classical sculpture but contemporary Italian and some foreign painting. The treasures of the Medici Palace on the Via Larga, assembled mainly by Cosimo the Elder (1389-1464) and Lorenzo the Magnificent (1449-92), were dispersed on the several banishments of the Medici and only partially recovered by Cosimo I (1519-74). Cosimo continued the family tradition and formed the famous collection known as the Medici *guardaroba*. The collection, now housed in the Uffizi Palace, was increased by Ferdinando I and Ferdinando II and in the latter reign received the additions of collections from collateral branches of the family, notably those of Bianca Cappello, of the della Rovere family, and of Cardinal Carlo de' Medici. Cosimo III added the collection of 17th-c. Dutch paintings and inherited from his uncle Cardinal Leopoldo the latter's collection which included self-portraits of artists, a large collection of drawings, and Italian 15th- and 17th-c. paintings. Of the Lorraines, who succeeded the Medicis, Pietro Leopoldo in particular increased the collection by classical sculptures from the Gaddi collection and by 100 self-portraits and began the concentration into the public collection of art treasures still scattered among the Medici palaces and public offices. Though not all the treasures were recovered which were lost during the period of French domination, the collection continued to grow and was subjected to radical reorganization in the 19th c. Much of the new archaeological material was placed in the Archaeological Museum in the Palazzo della Crocetta, while the medieval and RENAISSANCE sculpture and the rich collection of APPLIED ART was transferred to the BARGELLO. The Uffizi collection on the other hand was enriched by early Italian paintings resulting from suppressions of churches and monasteries and confiscations of religious property. In 1919 the Gallery of the Academy of Fine Arts became a subsidiary of the Uffizi. Thus the Uffizi acquired its present character of a gallery illustrating primarily the development of Italian painting from the 13th to the 18th c.

**UGO DA CARPI** (*c*. 1480 or earlier–after 1525). Italian painter and wood engraver. In 1516 he requested from the Venetian senate a patent for his method 'of making from woodcuts PRINTS that seem as though painted'. This method, known as the CHIAROSCURO WOODCUT, had been evolved in Germany some years before Ugo's first dated print. It consisted of the overprinting of two or more blocks in varying tones of one colour to achieve a three-dimensional effect. Ugo's discovery of the technique may have been independent of German example, and his prints certainly achieve their pictorial effect better than the Germans'. They are often based on designs by RAPHAEL and PARMIGIANINO.

**UGOLINO DA SIENA** or DI NERIO (active 1317-27). Sienese painter. His only authenti-

cated work, a high ALTARPIECE for Sta Croce, Florence, was dispersed during the last century. Some fragments are in the National Gallery, London; the *Betrayal* and *Deposition* from the PREDELLA are borrowed from DUCCIO's *Maestà*, but they have the delicate charm of an ILLUMINATED MANUSCRIPT. Ugolino's style, which in Siena was merely old-fashioned, must have been something of an anachronism in the Florence of GIOTTO's day.

**UHDE,** FRIEDRICH (1848-1911). German painter. Trained in academic history painting, he later became a convert to IMPRESSIONISM and was instrumental in introducing Impressionist painting in Germany. He is chiefly known for his New Testament paintings in which, like Stanley SPENCER, he represented New Testament scenes in contemporary settings.

**UKIYO-E.** A movement of Japanese GENRE painting which emerged during the Tokugawa period of the 16th and 17th centuries to satisfy popular taste, in particular among the artisan and trading classes. The earliest pictures of this class were panoramic scenes of contemporary city life painted by masters of the TOSA and KANŌ SCHOOLS but often unsigned. Favourite subjects were theatre scenes, which began to appear along with the development of the popular *Kabuki* theatre in the 17th c., circus and juggling scenes, portraits of actors in well-known roles, and paintings of prostitutes and bathhouse girls. Credit for originating the movement has been assigned to the Tosa master Iwasa Matabei (1578-1650), also known as Shoi or Katsumochi, but no pictures in this style are known by his hand and the attribution may be due to a confusion with a popular artist of similar name. The movement seems to have arisen spontaneously in response to a new demand and to have been started by no one artist or group. The word *ukiyo-e* is usually rendered 'pictures of the floating world' and may have reference either to the popular clientele or to the favourite subject matter of the genre and its attachment to ever shifting fashions.

The second phase of the movement was closely associated with the art of the popular PRINT and was essentially a plebeian taste, despised by the upper and cultivated classes. It has come to be regarded, however, as one of the most typical manifestations of the Japanese artistic genius and has been described as 'the fullest and most characteristic expression ever given to the temper of the Japanese people'.

As early as the 12th c. coloured prints were made on fan-shaped leaves and inscribed with Buddhist texts. By the 14th c. long scrolls in black and white were being made by this method. Although these are sometimes considered by the Japanese as predecessors of the *ukiyo-e*, they had little or nothing in common with the social function or the characteristic themes of the latter movement. The origin of the true *ukiyo-e* print

383. Making colour prints. Japanese woodcut (1857) by Utagawa Kunisada (1785/6–1864). (B.M.)

is attributed to Hishikawa Moronobu (c. 1625–c. 1695), who may have begun as an embroidery designer and who attained enormous popularity by his designs for WOODCUT illustrations of popular literature. The subject matter of the early *ukiyo-e* prints reflects the amusements of the common people and their interests. Those of Moronobu included warrior pictures from legend and history, a type which became enormously popular in the work of Kuniyoshi and others during the 19th c. Apart from these the most popular subjects were theatre scenes and favourite actors, sports, domestic scenes, well known courtesans, and the life of the bordel. With the exception of SHARAKU almost all the 600 to 700 artists in the movement produced pornographic prints, known as *shun-ga* or 'spring pictures'.

Until the introduction of colour printing c. 1740 the prints were done from black outline blocks and coloured by hand. Such prints were known as *tan-e* when the dominant tone was vermilion (*tan*) and *beni-e* when it was a rose-red derived from saffron. The true COLOUR PRINT, which originated c. 1740, was called *benizuri-e* and the full polychrome print, in which 20 or 30 blocks might be used, dated from c. 1765 and was called *nishiki-e* or 'brocade-like pictures'. The subject matter was also extended to include flowers, birds, animals, and LANDSCAPE.

At its best the craftsmanship was superb and the control of effect achieved in the complex and difficult technique was no less astonishing than the ingenuity displayed in its application. The artist's outline design was first cut by an engraver on a block from which the printer took a number of proofs. The artist then painted each proof with a different colour—red parts on one proof, blue on another, and so on—and with these proofs as a guide the colour blocks were cut and submitted to the printer for inspection. The printer was responsible for applying the colours to the blocks in the right gradation of tone—a most difficult operation involving great skill in

interpretation. *Ukiyo-e* at its finest owed much to the harmony between designer, engraver, and printer and their sympathetic understanding of one another's functions. Its freshness was due to its freedom from restrictive canons, a freedom which allowed the artists to take new and vital themes and treat them with boldness and originality; its refinement derived from a brilliant sense of line and colour together with impeccable workmanship. The product of all this taste and skill was sold at a price equivalent to a fraction of a penny.

The movement had a long and intricate development, from the 'primitive' like Moronobu through the whole range of book illustration and portraiture to the landscape masterpieces of HOKUSAI and HIROSHIGE. Lowered standards of taste, exhaustion of theme, repetitiveness, coarse drawing, poor workmanship, and increased costs of production were symptoms and causes of a decline after the middle of the 19th c. Though colour prints have continued to be produced in Japan, few of the 20th-c. artists have worked successfully in the older manner of the *ukiyo-e*.

The enormous output of two centuries of popular art was ignored by Japanese collectors. Appreciation began with European enthusiasts, to whom the flat decorative colour and expressive pattern came as a revelation. Japanese prints first came to Europe in the 19th c. via Holland, and made an impression by their novelty. Their artistic quality was already recognized by the IMPRESSIONISTS, and since that time their impact on many contemporary movements—NABIS, POST-IMPRESSIONISTS, ART NOUVEAU—and many individual artists has been appreciable.

The study of *ukiyo-e* is complicated by copies, FORGERIES, re-cut blocks, rivalries between artists working in similar styles, and studio works signed with the names of the founders of the various schools. The most comprehensive Western collections are those of the BOSTON MUSEUM OF FINE ARTS, the BRITISH MUSEUM, and the Musée Cernuschi, Paris.

(See also entries on MASONOBU, HARUNOBU, UTAMARO, KIYONAGA, SHARAKU, HOKUSAI, HIROSHIGE, SHUNSHO, TOYOKUNI, KORYŪSAI, SUKENOBU.)

282, 948, 1320, 1321, 1835, 2558, 2567.

**UMBRIAN SCHOOL.** Umbria, a mountainous district in the heart of Italy, traversed by the Tiber, is the land of St. Francis of Assisi and it is customary to speak of the 'sweetness' or 'softness' of Umbrian art. It was a country of builders. ROMANESQUE architecture took firm hold there (cathedrals of Spoleto, Todi, Narni, and Assisi, all close to the Lombard or TUSCAN style). It was also a busy highway, for the principal road from Rome to Ancona passed through its principal cities. A new impetus was given to the arts by the Franciscan movement (see RELIGIOUS ORDERS). The BASILICA of St. Francis at Assisi (1228–53), consisting of two churches one above the other, with side-chapels, a vestibule, and adjoining cloisters, was ornamented with FRESCOES whose execution provided the training for the finest painters of Florence, Rome, and Siena. The Basilica was imitated throughout Umbria, at Gualdo, Terni, Narni, and Perugia.

Around 1300 secular architecture made great advances and gave to the medieval towns of the region—Todi, Gubbio, Perugia, and Orvieto—the character which they still possess. At Orvieto the cathedral was begun in 1290 and in the 14th c. was given its remarkable façade, which the Sienese MAITANI began in delicate RELIEF. In the 15th c. Perugia was dominant, not owing to its architecture (the only buildings of note were the Oratory of S. Bernardino and the Porta S. Pietro) but to its school of painting. Domenico VENEZIANO and Fra ANGELICO had worked in the neighbourhood; their example, and that of LIPPI and GOZZOLI, gave rise to the flowery graceful style of Benedetto Bonfigli (c. 1420–96) and Caporali (active 1472–99), and then, under PIERO DELLA FRANCESCA's influence, to the art of the greatest Perugian masters, PERUGINO and PINTORICCHIO. Perugino developed a harmonious, light, broadly composed kind of painting, but it lacked depth and vigour and degenerated into routine. Yet such was its success that it affected the FLORENTINE and ROMAN SCHOOLS and, through FRANCIA's agency, the BOLOGNESE. RAPHAEL was Perugino's pupil and collaborated with him in the Cambio at Perugia in 1500, assimilating the best of his art. Pintoricchio, who went to Rome (Appartamento Borgia, Vatican) and Siena, derived from Perugino a decorative art, many-coloured and sumptuous. SIGNORELLI, a powerful painter in the Tuscan tradition and a virile draughtsman, created his MASTERPIECE at Orvieto (Chapel of S. Brizio), but could not prevail against the current of the 'soft' style. When the papacy annexed Perugia in 1540, the Umbrian School had ceased to count.

**UNDERPAINTING.** Painters' term for the preliminary layers of PAINT which are subsequently covered by GLAZES, SCUMBLES, or solid IMPASTO. Until the late 19th c., when ALLA PRIMA painting became general, most paintings were built up in a series of layers. In TEMPERA painting, after the design had been drawn on the GROUND, the system of light and shade was indicated by a WASH of terre verte (green earth colour), over which the other colours were laid, light at first, to be strengthened and enriched by subsequent layers if required. This green underpainting is often to be seen in 14th-c. paintings, especially in the shadows of the flesh (Pietà, Fogg Art Mus., Cambridge, Mass., 14th-c. SIENESE SCHOOL). Unfinished paintings allow the technique to be studied most clearly (Holy Family, attributed to Pierino del VAGA, Courtauld Inst.).

In OIL PAINTING different neutral colours were used for the monochrome underpainting, which might be painted over a coloured IMPRIMATURA. In the 15th and early 16th centuries many Italian painters may have followed the Flemish practice of using tempera for the underpainting; in MICHELANGELO's unfinished Entombment (N.G., London, c. 1495) the main masses of light and shade are indicated in terre verte and the standing figure on the left has the robe painted in tempera. The Venetians are said to have used tempera for their underpainting. HALS seems to have made his first painting in a cool monochrome on a darkish, warm ground. In the 18th c. almost all English painters followed the method of KNELLER, painting a first lay-in to provide the half-tones, over which the lights, shadows, and local colours were applied by glazes, scumbles, or solid paint, and the highlights put in last, often with a considerable impasto. By combining the underpainting with the subsequent layers, e.g. a warm transparent colour over a green to produce a grey, a rich and glowing effect was obtained.

In the 19th c. the main design of the painting was usually put in in a colour scheme similar to that planned for the finished work, though each colour might be more subdued and perhaps in a higher key, while extreme darks and lights would be avoided. This provided a basis for one or more applications of opaque paint so that the underpainting was obscured.

In the 18th and 19th centuries WATER-COLOURS were often built up in a series of flat washes. The earlier layers were usually in monochrome, the lights being reserved and the darks intensified by additional washes. Transparent tints were added to create local colour.

**UNITED STATES OF AMERICA.** See AMERICAN ART OF THE UNITED STATES.

**UNIT ONE.** A group of English artists formed in 1933. The 11 artists were: Barbara HEP-WORTH; Henry MOORE; John Armstrong (1893- ); John Bigge (Sir John Selby-Bigge,

1892-    ); Edward Burra (1905-    ); Tristram
Hillier (1905-    ); Paul NASH; Ben NICHOLSON;
Edward WADSWORTH; Wells Coates (1895-1958);
Colin Lucas (1906-    ). They were not unified
by any common doctrine or style but claimed to
express a 'truly contemporary spirit' in art and
were stated by Herbert Read, who wrote the
Introduction to the book *Unit One* published in
1934, to be united by 'a new awareness of the real
purpose or function of the arts' which was inter-
national in its extent. The group held one
exhibition, in 1933.

2192.

**UPJOHN**, RICHARD (1803-78). One of the
most popular and productive American archi-
tects of the mid 19th c. His work is ECLECTIC and
bears the stamp of an ardent ROMANTICISM.
His best known building, Trinity Church in
New York (1841-6), established his reputation
as a master of the GOTHIC REVIVAL, but he seems
to have been equally facile in other medieval
styles. His unexecuted design for Harvard
College Chapel (1846) was one of the first
examples of the LOMBARD ROMANESQUE style in
America. Of the two houses he built for Edward
King in Newport, the first (1838) was Gothic
and the second (1845-7) ITALIAN VILLA STYLE.

**USHAKOV**, SEMEN (1626-86). Russian
ICON painter active at Moscow. Ushakov com-
bined the traditional style of the Russian icon
painters with REALISTIC details derived from
western European painting. He also designed
engravings for book illustration (Psalter, 1680,
etc.). His modest achievements were greatly
overrated when in the 19th c. the Slavophils
rediscovered traditional RUSSIAN ART forms.

**UTAMARO**, KITAGAWA (1753-1806). One
of the best known and most prolific of the
Japanese masters of the COLOUR PRINT (UKIYO-E).
He first emerged to prominence in this field

*c.* 1790 during the last years of KIYONAGA's
activity. But his early work *Insects* (1788) broke
new ground by bringing into the ambit of the
colour print the keen observation of Japanese
NATURALISTIC painting and anticipated the bird
and flower prints of HOKUSAI and HIROSHIGE.
He was chiefly famous for his depiction of
womanhood, both portraits of famous beauties
and elegantly designed GENRE pieces of women's
occupations and amusements (*Catching Fire-
flies*, Mus. of Fine Arts, Boston). His scenes of
women of the licensed quarters have wit and
insight and beneath the elegance of his design
was a gift for catching character and mood.
Towards the end of his life his draughtsman-
ship suffered from over-production and his
reputation has further suffered from contempo-
rary FORGERIES and inferior work from artists of
his studio.

1322.

**UTRILLO**, MAURICE (1883-1955). French
painter, son of Suzanne VALADON. He became
a confirmed alcoholic at an early age and from
*c.* 1912 spent long periods in hospitals or in-
stitutions. He began to paint under constraint
from his mother, who hoped that this would
have remedial value. His first pictures of Pari-
sian streets were painted in 1902 and until *c.* 1908
he painted townscapes in an IMPRESSIONIST
manner. Between 1904 and 1908 he painted in
Montmartre and in Montmagny, a northern sub-
urb of Paris, and this is known as his 'Mont-
magny' period. The years 1909-14 are known
as his 'white' period from the predominance
of white in his paintings. From 1910 some of
his work shows a personal adaptation of CUBIST
aesthetic. His work was very unequal but at
its best had the magnificence of a great master,
and many of the unpretentious street scenes
have a beauty of composition which has rarely
been equalled in their kind.

633, 641, 727, 1014, 1175.

# V

**VAENIUS**. See VEEN, Otto van.

**VAGA**, PIERINO DEL (1500-47). Italian
painter, who after training in his native Florence
went to Rome to work with GIULIO ROMANO and
others under RAPHAEL on the Vatican Loggie, in
stucco as well as paint. From 1527 to *c.* 1540 he
was in Genoa decorating the Palazzo Doria.
Back in Rome he worked on decorative schemes
in the Vatican and the Castel S. Angelo with a
large body of assistants. He made rich use of

motifs such as masks and SWAGS, combining
sculpture with elegant MANNERIST painting. He
also painted a number of devotional pictures,
basically in the Raphael manner.

**VAILLANT**, WALLERANT (1623-77).
French painter of portraits, GENRE, and STILL
LIFES. He was born in Lille and settled in
Amsterdam. He was among the first to make
MEZZOTINTS, of which more than 200 are attri-
buted to him, for the most part REPRODUCTIONS

of the work of other artists. He probably learned the secret of the new art from Prince RUPERT, whom he met at Frankfurt at the coronation of Leopold I in 1658.

**VALADON,** MARIE-CLÉMENTINE (called SUZANNE) (1865-1938). French painter. After having worked as an acrobat in a circus she became a model and the reigning beauty of Montmartre. She posed for RENOIR, PUVIS DE CHAVANNES, and TOULOUSE-LAUTREC. Toulouse-Lautrec brought her drawings to the attention of DEGAS, who encouraged her to develop her artistic talent. Without formal tuition, she admitted owing something to the techniques of GAUGUIN and the Pont-Aven group. A child of the people, she has been compared with the writer Colette for her sharpness of eye and avidity for life. Her painting was naïve and unsophisticated, revealing a fresh and personal vision. At the age of 18 she became the mother of UTRILLO.

1418, 2564.

**VALDÉS LEAL,** JUAN DE (1622-90). The last great BAROQUE religious painter in Andalusia. Son of a Portuguese father, from 1656 he was established at Seville, where he joined with MURILLO in founding an ACADEMY of painting (1660). He remained at Seville for the rest of his life, executing paintings for the churches and religious houses of the neighbourhood, such as the series of *The Life of St. Jerome* (1657 onwards: three in Seville Mus.) and the series of single figures of Hieronymite monks (two in the Prado). The special characteristics of his style are intense feeling for movement and dramatic use of colour. His feverish excitability, often spilling over into the grotesque, was at the opposite pole from the sentimentality of Murillo. His most remarkable works are two large *Allegories of Death* commissioned in 1672 in the Hospital de la Caridad, Seville, which illustrate the latent medievalism of Spanish taste. The two DONORS portrayed in his *Immaculate Conception* (N.G., London, 1661) demonstrate his ability as a portrait painter. Among his followers was the Mexican architect Cristóbal de Villalpando.

262, 2680.

**VALENTIN,** MOÏSE (c. 1591/4-1632). French artist of Italian descent who painted in the CARAVAGGESQUE manner. The greater part of his working life was spent in Rome. His only documented work, *The Martyrdom of SS. Processus and Martinian* (Vatican, 1629/30), was a pendant to POUSSIN's *Martyrdom of St. Erasmus* in St. Peter's. He is best known for GENRE scenes of card-sharpers, soldiers, and gypsies, such as *Soldiers and Musicians* (Strasbourg), *The Fortune-Teller* (Fitzwilliam Mus., Cambridge).

**VALE PRESS.** A private publishing concern founded in 1896 in London by Charles RICKETTS and W. L. Hacon. The Vale books were printed at the Ballantyne Press in three special types, 'Vale', 'Avon', and 'King's'. They were designed by Ricketts, who was also responsible for most of the WOODCUT illustration and decoration. Forty-five titles were issued, the most notable production being *The Works of Shakespeare*, for which the 'Avon' type was designed, published 1900-3 in 39 volumes. The press ceased in 1904.

**VALKENBORCH** (VALKENBORGH). Family of Flemish LANDSCAPE and GENRE painters whose important members were LUCAS (c. 1535-97) and his younger brother MARTEN (1535-1612). Lucas joined the Malines Guild in 1560 and was in Antwerp in 1565, whence he fled to Aix-la-Chapelle to avoid persecution as he was a Protestant. He worked for Archduke Matthias and accompanied him to Luiz before settling in Frankfurt in 1593. Marten fled with his brother and returned to Antwerp before going to Frankfurt, Venice, and Rome. Both worked in the BRUEGEL tradition, and both favoured the subject of the *Tower of Babel* (examples by Lucas at Munich and Paris, by Marten at Dresden). They also painted series of *The Seasons*, and their winter scenes are especially notable.

**VANBRUGH,** SIR JOHN (1664-1726). English architect and playwright, one of the chief exponents of the BAROQUE in England. He was the grandson of a Flemish refugee merchant, but his mother came from the English aristocracy. Little is known of his early life, part of which was devoted to soldiering, but it is known that he visited France and was imprisoned in 1690 as a spy. In 1697 he produced his two most famous comedies, *The Relapse* or *Virtue in Danger* and *The Provok'd Wife*. He soon became a leading spirit in the KITCAT CLUB, where he made influential friends.

Suddenly in 1699 he appeared as an architect, taking over from William TALMAN the commission for the Earl of Carlisle's great new Yorkshire house, Castle Howard. By 1700 Nicholas HAWKSMOOR was working with him and though it is clear that Carlisle, and indeed all his contemporaries, regarded Vanbrugh as the creator of the house, the part played by Hawksmoor must have been considerable. The two men worked in unbroken friendship till Vanbrugh's death. They designed jointly the Clarendon Building, Oxford.

Castle Howard, a great spreading house round three courts, is Baroque in its sense of display and feeling for dramatic climax, since the whole group of buildings rises to the major accent of the central DOME (damaged by fire, 1940). The plan, with side blocks linked to the main pile by quadrant ARCADES, probably owes something to WREN's early design for Greenwich; but there are many innovations, notably the great stone hall under the painted dome almost like a French Baroque church. Carlisle's friendship presumably obtained for Vanbrugh

the post of Comptroller at the Office of Works in 1702, which he was to hold, except for a short interval, until his death. He also held a post at Greenwich Hospital after 1703, becoming Surveyor on Wren's retirement in 1716, but little if anything there is of his design. He was knighted by George I in 1714.

His connection with the Office of Works brought him his most important commission, the designing of Blenheim Palace (1705-20), the gift of the grateful nation to the victorious Duke of Marlborough. Here Vanbrugh, again working with Hawksmoor, deliberately attempted heroic architecture, echoing the military glory of the owner. More massive than Castle Howard, with four angle towers instead of a central dome, and with a far stronger use of projection and recession, Blenheim is a highly original creation; and the occasional clumsiness of detail and abrupt movement from part to part gives it a peculiar, uncouth grandeur.

Massive strength reappears in Vanbrugh's later, smaller country houses, built without Hawksmoor. Of these, Seaton Delaval, Northumberland (c. 1720-8), is the most impressive, for it combines a mature handling of Classical detail with a feeling for medieval castle architecture. This taste, unusual at the time, is again displayed in his own house, Vanbrugh Castle, one of a group which he built near Greenwich. In its asymmetry of plan and elevation it looks forward to the PICTURESQUE phase of the later 18th c. The same can be said of the informal gardens he created at Castle Howard, and of his desire to retain the RUINS of Woodstock Manor as a pleasing object to be viewed from the windows of Blenheim. His portrait by Jonathan RICHARDSON is at the College of Arms (1725), and he was painted by KNELLER as a member of the Kitcat Club.

2866, 2867.

**VANDELVIRA,** ANDRÉS (1509-75). Spanish architect, pupil of Diego de SILOE and the last exponent of the style, associated with MACHUCA and Siloe, known as the Granadine RENAISSANCE. He is credited with the design of Jaén Cathedral (c. 1548), which influenced the plans of 16th-c. cathedrals designed by ARCINI-EGA in Mexico and by Francisco BECERRA in Peru. His last work was the Santiago Hospital church at Ubeda (1562-75).

**VANDERBANK,** JOHN (c. 1694-1739). Portrait painter, son of PETER VANDERBANK (1649-97), who came to England from Paris. He had a considerable practice in London in the years immediately succeeding the death of KNELLER. His work was competent and undistinguished and is seen at its best in *Queen Caroline* (Goodwood) and *Sir Isaac Newton* (Royal Society, London). With Louis Chéron (1655-1725), a French painter, he founded a short-lived ACADEMY in London in 1720.

**VAN DER VELDEN,** PETRUS (1834-1913). Painter, born at Rotterdam, Holland. First apprenticed to a firm of lithographers, he took up painting at the age of 30 and won a minor reputation as a follower of the MARIS brothers and Joseph ISRAELS. Migrating to New Zealand in 1890, he settled in Christchurch, where he taught and profoundly influenced a whole generation of painters. He is well represented in New Zealand by Dutch GENRE scenes (Robert McDougall Art Gal., Christchurch) and local LANDSCAPES, of which the most notable is *A Waterfall in the Otira Gorge* (Public Art Gal., Dunedin).

**VAN DYCK.** See DYCK.

**VAN GOGH.** See GOGH.

**VANNUCCI,** PIETRO. See PERUGINO.

**VAN SOMER.** See SOMER.

**VANVITELLI,** LUIGI (1700-73). Italian architect, son of the TOPOGRAPHICAL painter van WITTEL (1653-1736). He studied in Rome and altered (1746-50) Sta Maria degli Angeli, the church made by MICHELANGELO from the Baths of Diocletian. In 1751 he began the enormous palace at Caserta for the king of Naples in emulation of, and influenced by, VERSAILLES.

**VARLEY,** JOHN (1778-1842). English LANDSCAPE painter, one of the foundation members of the Old Water Colour Society and perhaps the most influential teacher of his day. His pupils included LINNELL, PALMER, Holman HUNT, and David Cox. He was a protégé of Dr. Monro and later a member of BLAKE's circle. He represents the transition between TOPOGRAPHICAL drawing and WATER-COLOUR PAINTING. His style is somewhat too deliberate in the search for effects but his book *Landscape Design* (1816) was a valuable manual on water-colour composition. A younger brother, CORNELIUS (1781-1873), was also an accomplished though lesser water-colourist.

**VARNISH.** A solution of RESIN used chiefly in painting either as a protective coat over the PAINT or as a MEDIUM. *Oil varnishes* are made by dissolving resins—usually AMBER, COPAL, or SANDARAC—in fixed oils such as LINSEED. They have been used since the Middle Ages and the method is described by CENNINI. *Ethereal varnishes* are usually made from MASTIC or DAMMAR dissolved in essential oil of TURPENTINE or petroleum. They are very quick drying and cannot be safely applied until the paint is thoroughly dry. *Albumen varnishes*, usually made from white of egg, have been used as a temporary varnish intended to be removed before the final varnish was applied about a year after completion of the painting. *Spirit varnishes* originated in the Far East and were not introduced into Europe until the 16th or 17th c., becoming popular in the 18th c. They are chiefly used as FIXATIVES for WATER-COLOUR or TEMPERA paintings but have a solvent action on

oils. Waxes, chiefly bleached beeswax or paraffin wax, have been used to give a matt protective coat in place of resin varnishes and so-called 'wax varnishes' are sold by colour merchants for this purpose.

Ideally varnish used as a protective coating should be colourless, transparent, without effect on the colours of the paint, and easily removed if it deteriorates. Varnishes have seldom possessed these qualities. Most varnishes penetrate the paint layers to some extent, darkening the colours by making the pigment more translucent. When direct painting became popular (see ALLA PRIMA) a final coat of varnish was often relied upon to give a spurious unity of surface when the paint had dried irregularly and the textures of the various parts result from accident rather than design. For this purpose also some artists used a tinted varnish in the manner of a GLAZE. Some artists (e.g. SARGENT) made a practice of covering the painting with a re-touching varnish in order to provide a more homogeneous surface for further additions. Most varnishes have deteriorated and darkened with age, very many have modified the colours of the paint beneath, and in consequence it is not often possible to recover with any high degree of certainty the original appearance of Old Master paintings. The removal of old and impacted varnishes is a difficult and sometimes impossible task without damage to the paint layers and revarnishing to restore the appearance intended by the artist is never an easy or straightforward matter. When varnish has been used in the medium or when a coloured varnish has been applied as a final glaze the difficulties of restoration are multiplied (see CONSERVATION AND RESTORATION OF PAINTINGS).

There is evidence from medieval recipes that the use of varnish as a medium preceded the development of OIL PAINTING proper and some authorities have thought that this was a basis of van EYCK's method. A description by VASARI of the method of BALDOVINETTI shows that the practice was known to Florentine painters of the 15th c. It used to be thought, and may be the case, that the darkening of REMBRANDT's pictures is partly due to his use of varnish media. Oil varnishes tend to be coloured and to darken and their use as media is necessarily attended with risk. In the 18th and 19th centuries *mastic varnish* was mixed with linseed oil to form a jelly-like substance called MEGILP. This was used as a painting medium and imparted a rich 'buttery' quality to the colour with which it was mixed. It was discovered, however, that pictures painted with this medium are liable to crack, blister, and turn brown and its use has been discontinued. Pictures painted with megilp are difficult to clean as the solvent which removes the varnish also dissolves the mastic in the paint.

**VASARI,** GIORGIO (1511–74). Italian painter, architect, and biographer. He was born in Arezzo and received his first lessons in drawing from Luca SIGNORELLI, the cousin of his grandfather. In 1524 he went to Florence under the patronage of Cardinal Silvio Passerini and began his formal training with ANDREA DEL SARTO and Baccio BANDINELLI. At this time he briefly met MICHELANGELO, whom he later idolized. After his period of apprenticeship he worked successfully as a painter mainly in Florence and Rome. In 1555 he was appointed by Duke Cosimo de' Medici architect for the Palazzo Vecchio, Florence, and in 1563 he founded in Florence the Accademia del Disegno. As an artist Vasari's reputation has declined since his own day, but with the revival of interest in MANNERISM in the 20th c. he began to be taken somewhat more seriously. His talents were mainly as a decorator and impresario. His principal architectural works are the Palazzo dei Cavalieri, Pisa, the UFFIZI and the tomb of Michelangelo in Sta Croce, Florence, and the Loggie in Arezzo. His principal paintings are the frescoes in the Palazzo Vecchio, Florence, representing the history of Florence and the Medici, frescoes in the Sala Regia, Vatican, painted for Pope Pius V, and the so-called '100-days fresco' in the Sala della Cancelleria, Palazzo San Giorgio, Rome. There are also paintings in his own house at Arezzo, which is now a Vasari museum.

Vasari is best known for his *Lives of the most excellent Painters, Sculptors and Architects*, which was published first in 1550 and again in an enlarged edition in 1568. In virtue of this work Vasari was described by L. D. Ettlinger in his Inaugural Lecture (1961) as 'the first art historian worthy of the title'. The *Lives* has been translated many times and was described by Peter and Linda Murray as 'perhaps the most important book on the history of art ever written'. Vasari wrote with a definite philosophy of art and art history. He believed that art is in the first instance imitation of nature and that progress in painting consists of the perfecting of the means of representation. He accepted the belief of Italian humanism that these had been taken to a high level of perfection in classical antiquity, that art had passed through a period of decline in the Middle Ages, and that it was revived and set once more on its true path by GIOTTO. The main theme of the *Lives* was to set forth the revival of the true art in Tuscany by Giotto and CIMABUE, its steady progress at the hands of such artists as GHIBERTI, BRUNELLESCHI, and DONATELLO, and its culmination with Michelangelo, LEONARDO, and RAPHAEL, living artists in whom the progress had finally reached the 'summit of perfection'. In the first edition the climax was reached in Michelangelo, whose biography was the only life of a living artist. Although Vasari's accuracy has often been impugned on particular points, the *Lives* remains one of the most important sources for the period which it covers and is also an invaluable document for the outlook on aesthetics and art history which prevailed in the early Mannerist period.

484, 2338.

**VATICAN MUSEUMS.** These comprise the enormous collections of antiquities and works of art accumulated by the papacy since the beginning of the 15th c. As the leaders of the Christian Church the popes were continually showered with gifts; as political rulers they were, paradoxically, chief guardians of the remains of pagan Rome until Italy was unified in 1870. The Vatican collections are now among the largest and most important in the world.

When the pope returned to Rome in 1420 after the exile in Avignon and the subsequent Schism, papal prestige was at a low ebb. The lead given by the Florentines in the embellishment of their city inspired the popes to similar activity; the greatest Florentine artists were already studying ANTIQUE remains in Rome: many were commissioned in the service of the Church (e.g. FILARETE, bronze doors for St. Peter's) and soon the popes became veritable humanist princes (Pius II, Martin V) COLLECTING and commissioning for the love of art itself. In 1476 Sixtus IV built the Vatican Library and commissioned FRESCOES for his (Sistine) chapel. Julius II, greatest of the RENAISSANCE popes (1503-13), had the ceiling of the Sistine Chapel decorated by MICHELANGELO and his library and audience rooms (the Stanze) by RAPHAEL, there commemorating without modesty his own glorious career. When the first ancient statues began to be excavated he acquired some of the finest—the LAOCOON and the APOLLO BELVEDERE in 1503 and the *Venus* (before 1506), already well known from classical literature. They were placed in the courtyard of the Belvedere, a VILLA at the end of the Vatican gardens, specially rebuilt by BRAMANTE as a garden of antiquities in the prevailing Roman fashion. The history of the Cortile del Belvedere is an interesting commentary on the history of the papacy itself.

The Sack of Rome (1527) by the troops of the emperor Charles V ended this humanistic interest. Excavations continued (the FORUM, the first Etruscan sites) and Michelangelo painted the *Last Judgement* in the Sistine Chapel; but the Counter-Reformation inaugurated a long period of indifference and of hostility to the pagan works of art in the Vatican. The statues of the Belvedere were hidden behind wooden doors for 200 years; many of the antiquities were presented by Pius V to the Roman people and placed in the Capitoline palace.

With the classical revival in the 18th c. and the renewed interest in archaeology Rome became once more the cultural centre of the world. The popes shone again among the greatest excavators and collectors, and were instrumental in preventing the most valuable treasures from leaving Rome. The most prominent was Clement XI, who as Cardinal ALBANI had built up a number of vast collections of his own. The collections suddenly grew enormous and a period of organization began. The Museo Pio-Clementino was built around the Belvedere treasures and opened to the public in 1773. The Cortile lost its character of a garden: the trees were cut down and some of the statues were distributed to provide focal points for the new collections. The Museo Cristiano had been opened in 1753 by Benedict XIV; it contained mainly objects found in the Catacombs. The Museo Profano, partly to be dispersed during the Napoleonic era, harboured ancient GEMS and BRONZES. Both these museums are now in the Palace of the Lateran. Pius VII closed in Bramante's gallery connecting the Belvedere with the Vatican proper, and filled it with antiquities (Museo Chiaramonte). He also built the Braccio Nuovo (1817-21) parallel with the library which Sixtus V had erected across the Belvedere garden at the end of the 16th c. The Museo Gregoriano-Etrusco, which Gregory XVI opened in 1836, was filled with Etruscan finds from papal lands. Gregory also founded the Museo Egizio, partly from gifts brought by missionaries. A cabinet of coins was organized which contained one of the best collections of its kind. The Galleria Lapidaria (begun by Clement XIV and Pius VI, added to by Pius VII) is the most famous collection of pagan INSCRIPTIONS in the world. To this great complex of MUSEUMS was added in the present century the Pinacoteca or picture gallery, a haphazard agglomeration which, however, included some very considerable works (e.g. Raphael's *Transfiguration*). It was assembled (1909) by Pius X from the paintings scattered for centuries in the various papal palaces and from the old Pinacoteca, where works of art taken by Napoleon from churches and convents in church lands had been deposited.

The entire collections were declared indivisible and inalienable in 1871.

594.

**VAULT.** Architectural term applied to the construction of ROOFS by means of ARCHES. When timber was available horizontal beams from wall to wall provided the easiest and most serviceable form of roofing, and in early times alternative methods tended to be invented only in places where timber was scarce. It is therefore not surprising that the first forms of vaulting appeared in ancient Mesopotamia, where mud brick was the only suitable building material. Among the Greeks arches of any kind were little used until the HELLENISTIC period, when they were probably encountered in Mesopotamia and incorporated into the architecture of the Seleucid and Ptolemaic kingdoms. The fact that Heron of Alexandria wrote a special treatise on vaulting implies that there was at least some interest in the technical problems involved during the 1st c. A.D. Heron's work is lost, but it apparently influenced the practice of imperial Roman architects down to the time of Justinian (6th c. A.D.). From the end of the 1st c. onwards there appeared at Rome a series of immense vaulted buildings in which many of the possible kinds of vaulting were explored. The basic form of

Roman vault was the 'tunnel' or 'barrel' vault, which is in effect a continuous half cylinder of masonry. When two such barrel vaults are made to intersect at right angles the intersections are defined by two characteristic diagonal groins and the result is accordingly known as a 'groined' vault. Another variation of the barrel vault is the DOME, which can be thought of as a barrel vault with a rotating span. All these types were used by the Romans, who handled them with great audacity. Spans of 85 ft. were not unknown in rectangular buildings and heights of over 150 ft. were attained. These achievements were made possible by the Roman technique of building with CONCRETE, which was poured over a skin of thin bricks. Such vaults were extremely solid and durable, for example the dome of the PANTHEON, and the groined vaults of the Baths of Diocletian are still substantially intact despite earthquakes. The dome of Sta Sophia at Constantinople was the highest of all. It was over 180 ft. high and carried on PENDENTIVES at the corners to effect the transition between the square bay and the circular dome. The chief drawback to imperial Roman vaults was their weight, which made them only suitable for the most monumental buildings. When concrete went out of use lighter materials such as brick or TERRACOTTA tubes (e.g. at Sta Sophia and Ravenna, 5th and 6th centuries) were adopted for a time, but after the middle of the 6th c. the technical skill required to construct large vaults no longer existed in western Europe.

During the Middle Ages the construction of small barrel and groined vaults probably never entirely ceased, although they were confined to crypts, side aisles, etc. But medieval architects did not make a serious effort to recover the art of large vault construction until the 11th c. The first essays were made in southern Europe and the starting-point was the continuous barrel vault. This type of vault was used at first only over the choirs of CHURCHES, but later (e.g. the PILGRIMAGE CHURCHES) the nave was also used in the same way. The difficulty about continuous barrel vaults was that they needed massive and unbroken supports, and this made it dangerous to place them immediately over walls pierced by CLERESTORY windows. Occasionally this was done successfully (S.-Étienne, Nevers) but medieval architects soon began to seek other solutions. One curious experiment was the series of transverse barrel vaults at TOURNUS, but this was not repeated.

It is curious that masons were singularly reluctant to exploit the Roman groined vaults. They were used occasionally in the early 12th c. (e.g. Speyer, Mainz, and VÉZELAY), but in the medium of cut stone and in the context of medieval church design groined vaults proved difficult to handle. The solution which was eventually adopted almost everywhere in medieval Europe was the 'ribbed' vault. In appearance ribbed vaults resemble groined vaults in comprising a number of surfaces which meet at clearly defined edges. The edges themselves are masked or emphasized by the addition of stone arches known as ribs. The fundamental difference, however, lies in the geometry of their design. In a true groined vault, the surfaces are the primary consideration and the groins are simply a by-product. Over a square compartment the groins assume a smooth elliptical curve, but over rectangular compartments they follow more or less irregular lines. With a ribbed vault the ribs themselves are the starting-point. They are simply arches based on regular curves. The system of ribs could therefore be designed without considering the intervening surfaces, which could simply be filled in later. The advantages of ribbed vaults were considerably increased by the adoption of the pointed arch, in which there is no fixed relation between the span and height. Ribbed vaults could easily be adapted to the various bay forms of medieval church design, and they were perhaps the decisive constructional factor in the development of the GOTHIC style. The earliest known medieval ribbed vaults were made in Lombardy and at Durham (c. 1100), but it was in northern France that they were systematically exploited and the principal rib patterns, i.e. sexpartite for double bays and quadripartite for single bays, were evolved. The spectacular forms of external support known as flying BUTTRESSES were also developed there. The earliest ribbed vaults were comparatively simple in appearance, but during the later Middle Ages there was a strong tendency—especially in England and Germany—to introduce purely decorative additional ribs. Large arcs spanning most of the vault, but additional to the main diagonals, were known as *tiercerons*, and short sections starting from one rib and finishing on another were known as 'liernes'. In the final stages of Gothic architecture, e.g. English PERPENDICULAR and German SONDERGOTIK, the ribs became little more than TRACERY patterns on arched ceilings.

With the RENAISSANCE ribbed vaulting was repudiated along with other aspects of the Gothic style. Roman-type vaults (i.e. the barrel and more especially the dome) came back into favour. No constructional innovations were made, however, until the 19th c., when iron and STEEL replaced masonry to cover the enormous spans required for public halls and RAILWAY stations. A more radical innovation has taken place in the 20th c. with the application of new techniques in reinforced concrete construction to the special problems of vaulting.

879.

**VECCHIETTA** (LORENZO DI PIETRO) called CASTIGLIONE DI VAL D'ORCIA (c. 1412–80). Italian painter, sculptor, and architect of the SIENESE SCHOOL, who appears to have been trained by SASSETTA but also to have come under the influence of contemporary FLORENTINE art. Consequently his large-scale paintings

have a monumentality rare in the Sienese quattrocento. His surviving sculptures, all dating from the last 20 years of his life, reflect the example of DONATELLO, who visited Siena in 1457; and Donatello's influence may also account for the strength and plasticity of Vecchietta's later paintings, such as the *St. Catherine* in the Town Hall, Siena, and the *Assumption* in Pienza Cathedral, both dating from 1461/2. Vecchietta's individuality found its most attractive expression in work of quite a different kind: the illuminated codex of the *Divina Commedia* now in the British Museum, of which the illustrations to the *Inferno* and *Purgatorio* are by him, reveals a narrative gift second only to Sassetta's in Sienese painting.

2752.

**VEEN**, OTTO VAN, called VAENIUS (1556-1629). Flemish painter born in Leiden. From *c.* 1575 to *c.* 1580 he was in Italy, where he was a pupil of Federigo ZUCCARO. After his return to the Netherlands, where he was active mainly in Antwerp and Brussels, his work continued under the impression made upon him by the Italian MANNERISM. It was in Vaenius's studio that RUBENS received his final training.

**VEHICLE.** The liquid in which PIGMENT is suspended; the 'carrier'. The word can be applied to either the MEDIUM or the DILUENT, or to a mixture of both; thus the vehicle of OIL PAINTING might be either LINSEED OIL, or TURPENTINE, or both together (see PAINT).

**VELAZQUEZ.** DIEGO RODRÍGUEZ DE SILVA Y VELASQUEZ (1599-1660). Spanish painter, born at Seville, where he lived until he was 24. From 1610 to 1616 he was apprenticed to Francisco PACHECO, whose daughter he married and from whom he acquired a sound technique and a knowledge of the Italian and northern RENAISSANCE masters. Velazquez was, however, extremely precocious and by his 18th year it was he who was influencing his master. Pacheco's religious style was Italianate, dry, and academic; Velazquez revitalized it by re-submitting it to nature, and in works like *The Immaculate Conception* (N.G., London, *c.* 1619) and *The Adoration of the Magi* (Prado, Madrid, 1619) he developed a NATURALISTIC religious art in which the figures are portraits rather than IDEAL types and light, realistically observed but brilliant and mysterious, acts as a spiritual catalyst on the scene. These pictures are painted on a warm GROUND in the VENETIAN manner and in their strong CHIAROSCURO as well as their REALISM show the influence of CARAVAGGIO or his followers. The supple but clotted brush-work is, however, Velazquez's own.

Contemporary with these religious works were a series of *bodegones*, paintings of everyday subjects combined with STILL LIFE objects and sometimes a religious scene in the background, a type that ultimately derives from the boisterous

GENRE scenes of the Flemings AERTSEN and BUECKELAER but which had not long before become popular in Spain. In such paintings as *The Old Woman cooking Eggs* (N.G., Edinburgh, 1618) and *The Water-Carrier* (Apsley House, London) Velazquez gave this kind of subject a new seriousness and dignity. Each object is treated as of value in itself. The shape, substance, and texture of things is explored with a dispassionate realism which extends also to the figures, and the composition as a whole has a coherence and monumentality which had previously been anticipated only by SÁNCHEZ COTÁN. The *Christ in the House of Martha* (N.G., London) combines the *bodegon* with the religious theme.

In 1622 Velazquez paid a short visit to Madrid and in the following year returned there permanently at the invitation of the First Minister, the Count-Duke Oliváres, to become court painter to Philip IV. His gifts as a portrait painter had already been shown at Seville in portraits, e.g. the priest *Cristóbal Suárez de Ribera* (San Hermenegilde, Seville), which have something of the sharpness and dryness of his master Pacheco but also show his own dispassionate realism and fluid handling of paint. His mission as a court painter was to humanize the stiff and formal tradition of Spanish court portraiture derived from MOR VAN DASHORST and COELLO. To this end he set his models in more natural poses, gave them greater life and character, and eliminated unnecessary accessories. He drew inspiration from the portraits of TITIAN in the Royal Collection but went further than his model in the direction of naturalness and simplicity. His court portraiture is thus the antithesis of the idealized BAROQUE court portraiture of RUBENS and BERNINI, who developed the Renaissance tradition in the opposite direction. Typical of this period are the full-length portraits *Oliváres* (São Paulo, 1624) and *Infante Don Carlos* (Prado, 1626), and the bust portrait *Philip IV in Armour* (Prado, 1626-8).

Also in this period Velazquez painted for the King his first mythology, *The Topers* (Prado, *c.* 1629), in which a MYTHOLOGICAL scene, with Bacchus crowned amongst his crew, is treated as a contemporary genre subject set in the mountains near Madrid and painted with a realism that owes much to the influence of RIBERA. Despite the fact that the figures were painted directly from life, the composition is very carefully worked out—a combination of elements from Titian's Prado *Bacchanal* and an engraving after a similar subject by GOLTZIUS—and this marriage of genre-like realism with an intellectual approach to composition based on the study of the great Renaissance masters remained characteristic of Velazquez throughout his life.

In 1629 he paid his first visit to Italy, making his way to Rome via Genoa, Venice, and Loreto, and there he was able to study both contemporary ROMAN painting and the work of the great

Renaissance masters. The tonality of his paintings became increasingly cool and silvery, the strong chiaroscuro contrasts of his early work disappeared, and the brush-work became loose and impressionistic. The *Philip IV in Brown and Silver* (N.G., London) was followed in the mid 1630s by the portraits of the King, the Infante Ferdinand, and the infant Prince Carlos as a huntsman (Prado)—royal portraits of startling intimacy, in which the neutral browns and greens of the hunting dresses are set against the silvery LANDSCAPE of the sierras, the all-over cool tonality and sparkling brush-work binding foreground and background together in an atmospheric unity. Also in this manner is a series of equestrian portraits, e.g. of Oliváres, Philip IV, and Don Carlos, in which Velazquez played his own variations on a familiar Baroque theme. But in comparison with Rubens's equestrian portrait of Philip IV produced some years earlier Velazquez's portrait of the King is characteristically direct and lacking in bombast. The same directness is found in his less official portraits of dwarfs and court characters, which display pathos, humour, and human understanding. In some, such as the dwarf with an enormous dog (Prado), he seems to be gently mocking at the official type of Baroque portraiture with its pompous poses and accessories, while in all these portraits, official and unofficial alike, there is the same aesthetic perfection of arrangement.

He continued during this period to paint religious pictures (*The Crucifixion*, Prado), and made a decisive contribution to the painting of contemporary history with his *Surrender of Breda*, one of a series of BATTLE-PIECES painted for the Hall of the Realms in the Buen Retiro Palace. The composition is, once again, highly organized but the sense of great events is conveyed without rhetoric and no earlier picture of a contemporary historical event had seemed so convincing. In this, as in much else, he anticipated the 19th c.

Between 1649 and 1651 Velazquez paid a second visit to Italy in order to purchase paintings and antiques for the Royal Collection. His portrait of Innocent X (Doria Gal., Rome), painted in Rome, shows the Pope seated and is in the tradition of RAPHAEL's *Julius II* and Titian's *Paul III*. Similarly the *Rokeby Venus* (N.G., London), his only nude, which was also probably painted in Rome, is in the tradition of GIORGIONE and Titian. Yet in its extreme freshness and lack of idealization it seems to belong as much to the 19th as to the 17th c. and this is equally true of his two small and silvery paintings of the Medici Gardens.

Velazquez's last portraits of the royal family, painted after his return to Madrid, are mostly of the Queen and of the royal children and are now almost all in Vienna. The brush-work had become increasingly sparkling and free, and within the silvery tonality there is a new brightness of colour, ranging from the blue-green, scarlet, and silver of the *Infanta Margherita* (c. 1653) to the

orange and silver of the same sitter in the portrait of 1660, a late work completed by MAZO. A late portrait of the King is in the National Gallery, London.

Two large-scale late works, *Las Meninas* (*The Maids of Honour*) and *Las Hilanderas* (*The Spinners*), both in the Prado, sum up Velazquez's aims and achievements in portraiture and mythology respectively. The latter can be understood at several levels: the background scene represents the myth of Arachne, who was turned by Minerva into a spider, but it is set in a contemporary tapestry works with a copy of Titian's *Rape of Europa* on the wall and seems to be acted as a play before the ladies of the court. In the foreground three weavers, entirely contemporary in type and costume, are arranged in poses derived from the *Ignudi* on Michelangelo's Sistine ceiling and represent the Fates. By this complex interplay between humble and heroic, modern and mythological, Velazquez dissolves the traditional distinction between ideal and genre art. In *Las Meninas* the Infanta and her attendants are shown watching a sitting for a double portrait of the King and Queen. Inevitably not present in the picture, the royal couple are reflected in a mirror in the background, while on the left-hand side the painter himself is shown at work. Apparently spontaneous but in the highest degree worked out, it is both Velazquez's most complex essay in portraiture and itself expressive of the high claims he made for the dignity of his art. The picture made a strong impression on PICASSO, who saw it at the age of 15, and in 1957 he painted 44 variations upon its theme.

238, 1461, 1688, 1803, 2681.

**VELDE,** VAN DE. During the 17th c. there were talented Dutchmen named van de Velde engaged in painting and the GRAPHIC ARTS. Estimates vary as to the precise number, but there is a consensus on the importance and achievement of the six named in this entry.

ESAIAS (c. 1591-1630) was one of the founders of the Dutch School of realistic LANDSCAPE PAINTING, a pupil of Gillis van CONINXLOO. By 1615 he had already painted landscapes which got away from the panoramic effect and high point of view of his MANNERIST predecessors. The *Winter Scene* (1623) in the National Gallery, London, exemplifies his fresh brush-work and directness of vision, and heralds the subsequent accomplishment of his pupil Jan van GOYEN and of Salomon van RUYSDAEL. One of his best known paintings is *The Ferry* of 1622 at Amsterdam.

JAN II (1593-1641) his cousin, chiefly made prints and drawings of landscapes and GENRE scenes. He also did ETCHINGS and engravings after the work of other artists. His own early graphic works show the influence of Esaias.

JAN JANSZ the Haarlem STILL-LIFE painter (1619/20-after 1662) was the son of Jan II. He

painted *ontbijt* pictures—that is, pictures of breakfast dishes or snacks—in the monochromatic style of Pieter CLAESZ. His pictures had a quietly poetic quality of unpretentiousness and made much use of commonplace objects such as playing-cards, burning coals, smokers' accessories, nuts, and shells.

WILLEM I, WILLEM II, and ADRIAEN VAN DE VELDE were Dutch painters who belonged to a different family from those mentioned above. Both Willems were born in Leiden, but Adriaen in Amsterdam, where all of them spent parts of their careers.

WILLEM I (1611–93) was the son of a naval captain, his brother was a skipper of merchant vessels, and he himself spent part of his youth as a sailor before devoting himself to the drawing and painting of ships. His pictures, which are frequently GRISAILLES, contain faithful and detailed portraits of ships. Historians use them as a source of exact knowledge on build and rig and for information about naval battles and manœuvres. Willem always gives a better account of ships than of the sea. He was for a time an official artist for the Dutch fleet. In 1672, when Holland was at war with England, he went to London and entered the service of Charles II; why he left his country at a critical moment in its fortunes remains a mystery.

WILLEM II (1633–1707), his son, is generally considered one of Holland's greatest MARINE PAINTERS. He was the pupil of his father and Simon de VLIEGER. His work is distinguished from his father's by its more assured painterly qualities, which were recognized during his own lifetime. Like his father he left Amsterdam for England in 1672 and in 1674 Charles II gave them a yearly retaining fee of £100 each; the father received his 'for taking and making draughts of seafights' and the son 'for putting the said draughts into colours for our own particular use'. To this day the finest collections of Willem II's work are in England, particularly at Buckingham Palace, Hampton Court, and the National Maritime Museum at Greenwich. Both are also well represented in Amsterdam. They did not switch their allegiance to England completely; both subsequently painted pictures of naval battles for the Dutch as well as the English market. Willem II was able to endow a ship with the same stylish, elegant qualities that Dutch portrait painters of his time gave to their sitters. He is at his finest when he shows a ship in a calm sea. His works are outstanding for their sensitive interpretation of light, atmosphere, wind conditions, and even the time of the day.

ADRIAEN (1636–72), Willem II's younger brother, was as gifted and more versatile. His father and Jan WIJNANTS were his teachers. Sunny, open landscapes make up the bulk of his work, but he also painted biblical pictures, the beaches of Holland, genre and winter scenes, portraits, and animals. He was extremely productive; during his short career he did more than 400 paintings. He also did exceptionally fine etchings of landscapes with cattle and often painted the figures into the landscapes of his fellow artists.

1004, 2281, 2487.

VELDE, HENRI VAN DE (1863–1957). Leader of the revolutionary movement in architecture and the decorative arts that arose in Belgium during the last decade of the 19th c. Though he was the principal founder of the ART NOUVEAU movement in that country and his furniture designs of the 1890s have the flowing lines and the ornaments abstracted from vegetable forms that identify the *art nouveau* style, his work has a more enduring significance than that alone would indicate. His starting-point was the same: a revolt against the facile ECLECTICISM that dominated architecture in the late 19th c. and obscured its proper values; but van de Velde's special mission was more than stylistic; it was to purify the practical arts and establish new values based on, among other things, the disciplines imposed by new techniques.

Van de Velde's first work of architecture was the house he built for his own occupation in 1896 at Uccle, a suburb of Brussels, and his interest in furniture design arose partly from the difficulty he found in equipping it to his taste. William MORRIS had had the same experience and, indeed, van de Velde was deeply influenced by the English ARTS AND CRAFTS MOVEMENT founded by Morris. Others whose influence he acknowledged were Gottfried Semper and VIOLLET-LE-DUC, and the aesthetic theories of Theodor Lipps.

In 1896 and 1897 van de Velde designed interiors for exhibitions at Paris and Dresden, which attracted the attention of the historian Meier-Gräfe and which were popularized by the dealer S. Bing. But his most lasting influence was exerted in Germany, where he lived and worked from 1901 to 1914, designing among other things the interior of the Folkwang Museum at Hagen. He was given the task by the enlightened Duke of Sachsen-Weimar-Eisenach of 'raising the artistic level of design' in the duchy. There he set up workshops, and the success of their products at Leipzig trade fairs encouraged him to found, in 1907, the Weimar School of Arts and Crafts, one of the first institutions of its kind. His immediate successor there was Walter GROPIUS, in whose hands it developed into the celebrated BAUHAUS.

Van de Velde, who was also one of the founders of the DEUTSCHER WERKBUND, was a prolific writer and lecturer on architecture and AESTHETICS as well as the designer of many buildings in Belgium and Germany. In Belgium he founded the École Nationale Supérieure d'Architecture et des Arts Décoratifs (1926) and was its principal until 1935.

In Holland he designed the Kröller-Müller Museum at Otterlo (1937–54). He remained an

active designer up to the age of 80, when he retired to live in Switzerland. The main expression of his views is in *Formules de la Beauté architectonique moderne* (Weimar, 1917), republished under the title *Formules d'une Esthétique moderne* (Brussels, 1923).

2630.

**VELLERT,** DIRK (active 1511-44). Flemish artist who was made a master of the guild of St. Luke in Antwerp in 1511, where he was chiefly active as a glass painter. His signed and dated designs for glass roundels are included in many public collections of drawings. His panes, which are richly ornamented with garlands, masks, vases, and other classical motifs, were exported to Germany, Spain, and some can be seen in King's College Chapel, Cambridge. He also made engravings, ETCHINGS, and WOODCUTS, which owe a good deal to DÜRER and LUCAS VAN LEYDEN. His PRINTS, like his other works, usually bear his monogram with a star, and almost all his engravings bear the day of the month as well as the year.

**VENETIAN SCHOOL.** Venice was founded in the 5th c. as a colony of Ravenna, and her interests lay eastward in the Balkans. The city grew great under the auspices of Byzantium, and Venetian art, dominated by EARLY CHRISTIAN forms, was to perpetuate those forms within the tradition of ITALIAN ART itself. The BASILICA of St. Mark, built in the 11th c. and inspired by a church in Constantinople, has all the characteristics of this origin, not least in the arrangement of the rich MOSAICS, on which work was done as late as the 17th c.

For a long time the workshops of St. Mark's took the place of a school of painting. Paolo Veneziano, who died *c.* 1360, was untouched by the revolution which GIOTTO represented. At last GENTILE DA FABRIANO, who came to Venice in 1408, brought GOTHIC painting in its newest guise—rich, precious, delicate, and decorative, easily blended with an east European style. From the end of the 14th c. architecture took the same line: FLAMBOYANT Gothic was combined with richly coloured unrealistic BYZANTINE decoration to produce, among other works, the new façade of St. Mark's (1419), the Palace of the Doges (façade on the water, end of 14th c.; on the Piazzetta, 1424-42), and the Ca' d'Oro (1421-40).

RENAISSANCE forms were introduced late, and then by strangers, mostly Lombards (Foscari Arch in the Doges' Palace). Pietro LOMBARDO's church of Sta Maria dei Miracoli, all in panels of coloured MARBLE, shows what happened to Renaissance forms in Venice. More significant and more radical was the elaboration to which the Venetians subjected the severe sculptural painting of MANTEGNA. The VIVARINI and Carlo CRIVELLI turned it into a brilliant, enamelled, precious art; but this route was a blind alley.

The BELLINI family took a different course. Jacopo, the father, still belonged to the Gothic painting of Verona; and Gentile, who visited Constantinople, composed luminous narrative pictures (his style was carried on into the 16th c. by CARPACCIO, who is sometimes close to the Flemings). It is to Giovanni Bellini, the most gifted, who learned from Mantegna's art and from ANTONELLO DA MESSINA, that we owe that concord of figure with LANDSCAPE, of light with space, which was henceforward to distinguish Venetian painting. Above all it was he who, in his late works, established the predominance of colour as an element of composition—a feature which is characteristically Venetian and was much discussed by 16th-c. critics such as Dolce and VASARI.

The years just before 1500 saw the formation of a cultivated society of musicians, learned printers (Aldus Manutius), poets, and intellectuals (Pietro Bembo), thanks to which Venetian art was able to develop fully as a great and new style. The Republic, politically weakened but more brilliant than ever, became a refuge for men of independent mind. Jacopo SANSOVINO, arriving from Rome in 1527, began replanning the Piazza S. Marco, and turned it into a forecourt to the Basilica. But the leading art was painting. GIORGIONE, by temperament a colourist, contributed a new feeling for subdued expressive tones, light, and atmospheric effect. TITIAN, who owed much to him, was more robust. At first he favoured a rather formal balance, then achieved a monumental grandeur with a kind of pagan sanity which delighted RUBENS; and after a troubled and dramatic period reached the style of his old age, moving and serene. To his contemporaries he was inimitable whether in portrait or landscape, the master of warm colour and dense atmosphere. Titian and Giorgione were followed by numerous painters, each of whom adopted some small part of the masters' territory. SEBASTIANO DEL PIOMBO took Venetian art to Rome. Only LOTTO, obstinately persisting in the cold style of the quattrocento, held aloof and missed success.

Half-way through the 16th c. CLASSICISM began to flourish in Venetian architecture. PALLADIO, archaeologist and theorist as well as architect, retained what was rational in the classical world's ideas of harmonious PROPORTION (façade of S. Andrea della Vigna; Church of the Redentore). In painting TINTORETTO took from MANNERISM nothing but its formal elements, to use them in the service of his dramatic sense and his extraordinary talent for *mise en scène*. Jacopo BASSANO found in the 'pastoral' night-piece a formula which was used by succeeding generations. VERONESE, tireless in invention, clear-toned and sumptuous, introduced a new dramatic element into the Venetian tradition and so led on to TIEPOLO.

In BAROQUE architecture Venice had a place of its own. The church of Sta Maria della Salute,

by LONGHENA, is a brilliant flourish of the local art, besides being an original creation.

The great painters of the 18th c. specialized in the decoration of ceilings. First came PIAZZETTA; then G. B. Tiepolo, a miraculous VIRTUOSO, striking and imaginative, who scatters swirling figures and delicate or brilliant colours across a seemingly infinite space in the most romantic decorations ever devised. The Venice of this ROCOCO period is preserved for us in the GENRE scenes of Pietro LONGHI, but is far more vivid in Francesco GUARDI's astonishingly painted views (see TOPOGRAPHICAL ART). The luminous townscapes of CANALETTO remind us how much the painting of atmosphere owes to Venetian example. But NEO-CLASSICISM was fatal to the Venetian tradition, and Venice itself was separated from the rest of Italy from 1815 to 1866.

754, 2005, 2006, 2020, 2721.

**VENNE, ADRIAEN PIETERSZ VAN DE** (1589–1662). Dutch painter of portraits, LANDSCAPES, GENRE, and historical pictures. Early in his career he painted scenes of crowded markets and village fairs. These colourful and entertaining works show his debt to Jan BRUEGHEL's circle. Later he restricted his palette to greys and browns and more sombre subjects, such as beggars, cripples, and thieves or did illustrations for moralistic proverbs.

**VENUS OF MILO.** This half-naked MARBLE Aphrodite, the best known of all ancient statues, was found in Melos in 1820 and is now a treasure of the LOUVRE. Deriving her head from the later 5th c. B.C., her nudity from the 4th c., and her spiral, omnifacial posture from the HELLENISTIC, she is a harmonious creation of the CLASSICISM of *c.* 100 B.C.

**VERHULST, ROMBOUT** (1624–98). Flemish sculptor who worked in Holland. He was the most important assistant to Artus QUELLIN, supervisor of the sculptural decoration made for the Town Hall in Amsterdam. Verhulst finally settled in The Hague (1663) and became famous for his portrait BUSTS and TOMBS. His magnificent MONUMENT to de Ruyter, Admiral of the Dutch Fleet, is in the New Church at Amsterdam.

1956.

**VERISM.** An extreme form of REALISM, in which the artist makes it his aim to reproduce with rigid truthfulness the exact appearance of his subject and repudiates IDEALIZATION and all imaginative interpretation. The term has been applied, for example, to the most realistic ROMAN portrait sculpture. It has also been applied to that form of SURREALISM which claims to reproduce hallucination in exact and unselective detail. Veristic Surrealism has concentrated on illustrating the images which result from dreams and from psychic injury.

**VERMEER, JAN (JOHANNES)** (1632–75). Dutch painter born in Delft, where he died at the age of 43. He was the son of a silk merchant who was also an art dealer and tavern keeper. In 1653 Vermeer married and entered the Guild, and two years later on the death of his father took over his business activities. Through these he tried to support his ever-growing family (he left a widow and 11 children) in the face of constant debt and there is no evidence of his having sold any of his own paintings. Otherwise few documented facts are known about his life or work, so that modern scholarship is based on speculative suggestions and the evidence of the paintings themselves. Of these about 36 are known today. The earliest dated one is 1656 (*The Procuress*, Dresden), although the undated *Christ in the House of Martha* (N.G., Edinburgh) and the *Diana and her Companions* (The Hague) are generally thought to be a few years earlier. The latter two are unlike the remainder of his work in that they are of religious and MYTHOLOGICAL subjects and their style of brush-work is different. The remainder of the paintings are simple GENRE pictures, often with a single figure (his wife as the model), or views of streets and towns. Some have allegorical titles. The majority show one or two figures in a room lit from the onlooker's left, engaged in domestic or recreational tasks. The predominant colours are yellow, blue, and grey, and the compositions have an abstract simplicity which confers on them a power of impact out of relation to their small size. Such are the *Lacemaker* (Paris), *Woman with a Water Jug* (New York), and, with a more elaborate setting, *Lady and Gentleman at the Virginals* (Royal Coll., London). The National Gallery, London, has two paintings of *A Woman at the Virginals*. Two outstanding works on a larger scale than usual are the *View of Delft* (The Hague) and *The Painter's Studio* (Vienna).

Not the least puzzling aspect of Vermeer's story is the apparent lack of output. The Delft magazine explosion of 1654 may have destroyed many early works; but even allowing for severe losses then, there nevertheless survive today not more than an average of three pictures for every two years of the remaining 20 years of his life. He certainly did not live from his own painting, and it is assumed that he worked very slowly, or painted only in his spare time. But if this were so, it is difficult to explain the perfection and the facility which are such outstanding features of his work. Although there is no record of his having travelled outside Delft except to The Hague, his early work at Edinburgh strongly suggests knowledge of the Utrecht School and TERBRUGGHEN in particular. The work of Carel FABRITIUS has affinities in some respects with Vermeer's style, and he may have provided a link between REMBRANDT and Vermeer. At his death Vermeer owned three paintings by Fabritius 20 years after the latter's death in the Delft explosion. But whatever influences might be

traced in his work, Vermeer remains an isolated phenomenon in art history, and raises many apparently insoluble mysteries. Certainly no other artist has enjoyed so dramatic a change from obscurity to fame. Virtually unknown, or mistaken for other artists of the same name or for Pieter de HOOCH, until the later 19th c., Vermeer was as neglected after his death as he had apparently been in his lifetime. In 1866 Burger-Thoré published articles about him but 10 years later FROMENTIN neglected him save for a few lines. In 1879 van GOGH wrote an enthusiastic letter about the *Woman in Blue Reading a Letter* (Amsterdam). But not until the 1880s did general interest begin to be aroused, though even so at a sale in The Hague early in that decade the now famous *Girl with a Pearl Earring* (The Hague) was bought for the equivalent of five shillings.

1071, 1116, 2605.

**VERMEER VAN HAARLEM.** Four painters of this family, members of successive generations, were called Jan Vermeer van Haarlem. The titles of Elder and Younger have become attached to the second and third, very little being known about the other two.

JAN the Elder (1628–91) made panoramic landscapes of the dunes and ships around Haarlem. During the 19th c. he was confused with the great Jan VERMEER van Delft, but the name is the only thing they have in common. Jacob van RUISDAEL and Philips de KONINCK have more affinity with his work, but he was a less powerful artist than either of these.

His son JAN, called the Younger (1656–1705), was a pupil of his father and of Nicolaes BERCHEM. He also was a landscape painter. He spent some time in Italy and most of his pictures are idyllic views of the south.

**VERMEYEN,** JAN CORNELISZ (c. 1500–59). Netherlandish painter of religious subjects and portraits, also designer for tapestries and engravings. He was born near Haarlem but travelled in the courts of Margaret of Austria (1525–9), Mary of Hungary (1530), and Charles V, with whom he visited Tunis in 1535. He may have studied under GOSSAERT, but his style shows closer connections with that of his friend Jan SCOREL. For many years the *Portrait of Evrard de la Marck* (Pannwitz Coll., Heemstede) was attributed to Scorel, but now it is generally accepted as Vermeyen's and is held to show his lively forthright style. Also a considerable number of his engravings survive.

**VERNET.** Family of French painters. CLAUDE-JOSEPH VERNET (1714–89), himself son of a decorative painter of Avignon, was together with Hubert ROBERT a leading exponent of the new school of landscape which satisfied an artificial and sentimentalizing taste in reaction from the boudoir ROCOCO of the salon. He worked in Rome 1733–53 and there studied MARINE PAINTING. He was impressed by the PICTURESQUE and dramatic qualities of Salvator ROSA's work and he also knew the English landscape painter WILSON. From Italy he sent pictures to the SALON and he was (wrongly) hailed by DIDEROT as a greater artist than CLAUDE. He had a certain gift for catching the Italian light and a feeling for broad, calm expanses (*An Italian Landscape*, Dulwich; *Castle of St. Angelo*, N.G., London). On returning to Paris in 1753 he was elected a member of the Académie and commissioned by Louis XV to paint a series of the sea-ports of France. The 16 which he did are in the Louvre.

ANTOINE-CHARLES HORACE, known as 'CARLE' (1758–1835), son of the foregoing, showed early precocity as an artist. He trained under Nicolas-Bernard LÉPICIÉ, Secretary of the Académie, and at Rome. His earlier work showed a keen eye for naturalistic detail. After the Revolution he painted large BATTLE-PIECES, which were admired by Napoleon (*The Battle of Marengo*; *Morning of Austerlitz*; both at Versailles). He was official painter to Louis XVIII, for whom he did racing and hunting scenes.

ÉMILE-JEAN-HORACE VERNET (1789–1863), son of the foregoing, was a painter primarily of battle-pieces and is one of the most forceful and lively of French military painters. He worked with great rapidity and his work has fidelity of detail but lacks composition and plan. A portrait of Napoleon and five battle-pieces by him are in the National Gallery, London.

**VERNICLE** (*Sudarium*). A cloth impressed with an image of CHRIST's face. A legend, which first appeared in the 6th–7th c., relates that a pious woman possessed an image of Christ on a cloth which miraculously cured the emperor Tiberius of a fatal disease. This woman was later revered as St. Veronica. The legend gained currency in the West in this form, but in the 13th c. a new version appeared: Veronica accompanied Christ on the road to Calvary and gave him the cloth to dry his face, which left an imprint on it.

A picture of Christ's face on a cloth was revered as a true image (hence the medieval derivation of the name Veronica from *vera icon*) in Rome from the early Middle Ages, and in 1292 Boniface VIII had it displayed in St. Peter's for veneration during Holy Week. This image, probably the work of a BYZANTINE artist, portrayed the dead Christ with closed eyes. Subsequently the vernicle was represented in paintings. In these Christ is shown with His eyes open, in accordance with the later version of the legend. Generally the face conforms to the type of Christ current in the art of the time. The vernicle is most commonly shown as being carried by St. Veronica. It was a very popular subject in painting from the 15th to the 17th c. Outstanding examples are MEMLING's painting in the N.G., Washington, and DÜRER's woodcut.

**VERONESE,** PAOLO CALIARI (*c.* 1528–88). Italian painter, born at Verona. His father was a sculptor but he was trained in the studio of a local painter, Antonio Badile, and there learnt the use of the cool silvery colours and soft yellows which persisted in all his work. By about 1553 he had established himself in Venice and was already popular. His style was compounded of elements drawn from TITIAN, from DÜRER and from PARMIGIANINO, whose PRINTS he copied, on the basis of the native tradition of Verona. His first big commission was for decorations in the church and sacristy of S. Sebastiano, Venice (*c.* 1555). Three large ovals tell the story of Esther and Ahasuerus, vigorously depicted with an astonishing virtuosity in foreshortening which already betrays his interest in the MANNERISM of PORDENONE. In the evolution of his personal style, however, he avoided the more extreme Mannerist extravagances then in fashion; he was including architecture as an important feature in his compositions and making playful use of subsidiary figures or spectators peering round or over balconies.

RIDOLFI says that Veronese visited Rome in 1560 but if so it left little mark on his work. During the 1560s he decorated some of the villas belonging to the Venetian nobility on the mainland. The Villa Maser is a triumph of collaboration between an architect (PALLADIO), a sculptor (VITTORIA), and the painter, who together brought into being an ideally harmonious setting for a life of cultured ease. The paintings extend the architecture of the rooms, leading the eye into idyllic views of landscape and figures, or surprising it with servants appearing laden with viands through non-existent doors. The intention was to re-create the environment of the patricians of ancient Rome.

From this time onwards Veronese was inundated with commissions and with the help of a large WORKSHOP, including three of his sons and his brother, his output was enormous. *The Marriage Feast at Cana* for the refectory of S. Giorgio Maggiore (Louvre, 1562) is the first of a series of large religious feast-scenes with all the sensuous charm and pompous grandeur of a court function. The clear silvery tones of the Classical architecture provide a stage-set in which to place an assembly of people and the whole scene is suitably enlivened by spectators, dogs, fools, and musicians. As decoration these paintings are unsurpassed. Unfortunately their religious themes were not always felt to be sufficiently respected, and in 1573 Veronese was summoned before the Inquisition on a charge of irreverence in his painting of the *Feast in the House of Levi* (Accademia, Venice). Many of these innumerable religious paintings have compositions taken from Titian, as in the case of the *Marriage of St. Catherine* (Sta Caterina, Venice), which is based on the Pesaro ALTARPIECE. *The Family of Darius before Alexander* (N.G., London, *c.* 1570) is a splendid painting showing all Veronese's virtuosity of style and composition. It is said to

contain portraits of the Pisani family, and indeed many of his paintings contain portraits of himself and his friends.

From 1577 onwards Veronese was largely engaged in redecorating a room in the ducal palace in Venice after a fire, producing a great series of decorative canvases that culminated in the magnificent ceiling painting *The Triumph of Venice* (*c.* 1585), a model to the BAROQUE. Veronese was only about 10 years younger than TINTORETTO and each master influenced the other in some degree. This is especially noticeable in those allegorical subjects where the mood of the two was closest (e.g. the four allegories in the N.G., London, and also *The Crucifixion*, Louvre). The clear, light-toned colours and stately personages of TIEPOLO, as well as his more playful incidents, owe much to Veronese.

Veronese's achievement is not in his emotional impact on the beholder. He is rather the supreme decorator, who enhances the style and enjoyment of living without attempting to move us more fundamentally. The Venetian tradition of gay festive paintings of pageantry and splendour culminates in him.

1976, 2004.

**VERRIO,** ANTONIO (1630–1707). Italian decorative painter who first made a name in France and came to England in 1671. He received many commissions from the Crown and spent a great part of his time working at Whitehall Palace, Windsor Castle, and later at Hampton Court. He also worked at Chatsworth and Burghley House. In 1684 he was appointed 'Chief and First Painter to the King'. His great reputation in this country has not stood the test of time.

**VERROCCHIO,** ANDREA DEL. ANDREA DI MICHELE DI FRANCESCO CIONI (*c.* 1435–88). Italian sculptor and painter of the FLORENTINE SCHOOL, who studied as a goldsmith and was apparently also a pupil of DONATELLO. The universality of his talent foreshadows that of LEONARDO. He had the characteristic preoccupations of the second half of the century—elaboration and movement. He exercised his virtuosity as a metal-worker in the ARABESQUES on the bronze coffin of Piero and Giovanni de' MEDICI in S. Lorenzo, Florence (1472). His concern with the rendering of movement—not, as was usual in the late 15th c., in two dimensions, but in three—is seen in, for example, the *Boy with a Dolphin* in the court of the Palazzo Vecchio (*c.* 1480). This little bronze presents an interesting and changing pattern of interlocking curves from every viewpoint. Another peculiarity of Verrocchio's art was the tendency of his figures to separate out into two contrasting types—the tough old warrior and the epicene youth. The famous EQUESTRIAN STATUE of the *condottiere* Bartolomeo Colleoni (1479–88) in Venice is an example of the first type: the nude

bronze *David* (before 1476) in the Bargello, Florence, illustrates the second. The contrast was one of the many conceptions originating in Verrocchio's WORKSHOP which fascinated his most distinguished pupil, Leonardo da Vinci. The workshop was the largest in Florence during the second half of the century, and many other artists were trained there. The painting *The Madonna and Child with Two Angels* in the National Gallery, London, is one of its productions. Authentic paintings by Verrocchio himself are very rare.

669, 2098.

**VERSAILLES.** The Royal Palace of Versailles originated from a hunting lodge begun by Louis XIII about 1624, a relatively small slate-roofed building of brick and stone. Its plan was uncomplicated: a central rectangular block framed by wings which were linked at their extremities

accordance with designs by André LE NÔTRE and in their elaborate formalism and the orderliness with which they were adapted to the site became a notable example of the spirit of rationalism which dominated French culture at this time. The geometrical patterns and symmetry of plan created a background for sculpture and pieces of decorative architecture. The gardens and courts were the scene of courtly fêtes and celebrations, such as the *Plaisirs de l'Île Enchantée* (1664), and the ballet comedies in which Molière and Lully collaborated with other artists.

In 1669 Louis embarked on more radical and grandiose reconstruction from plans designed by Le Vau. For sentimental reasons he resisted COLBERT's idea of demolishing the existing château and instead completely enveloped it on three sides, leaving only the original façade on to the Cour de Marbre intact. From the gardens the central block of the new building presented an enormous expanse of 25 bays, the middle 11

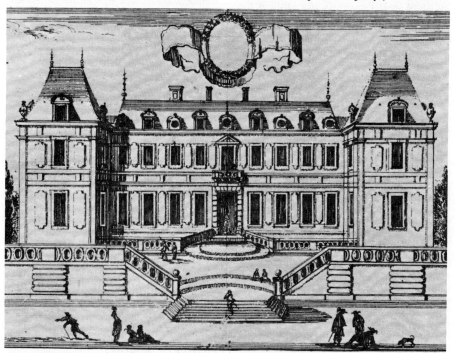

**384.** *Veuë du Chasteau Royale de versaille, ou le Roy se va souvent divertir a la chasse.* Engraving by Israel Silvestre. View of the palace as it was during the reign of Louis XIII (*c.* 1624)

by a low covered ARCADE, such as is found at the Luxembourg. The enclosed court and part of the inner façades still remain as the present Cour de Marbre.

Three reconstructions were undertaken by Louis XIV. The first in 1661, when soon after coming to power he had the existing château enlarged by the addition of two service wings in the forecourt and decorative additions by LE VAU. The original gardens were transformed in

bays on the first floor lying back behind a terrace and an arcaded ground floor forming a massive basement. The design combines grandeur of scale with a feeling for Classical principles. At the same time the interiors were decorated with great splendour under the direction of LEBRUN in a new style which adapted methods and devices current in Italian BAROQUE. Most spectacular was the Ambassadors' Staircase, which was constructed in 1671 to designs of Le Vau by

his assistant François Dorbay and decorated by Lebrun, combining real architectural virtuosities with ILLUSIONISTIC PERSPECTIVES in the paintings and carrying opulence and allegorical splendours to an extreme. Examples of these decorations, though somewhat modified from their original form, may still be seen in the Salons de Vénus and de Diane.

The third rebuilding of Louis XIV was begun in 1678 under the direction of Jules Hardouin-MANSART, the great-nephew of François MANSART. It was on a far more colossal scale than anything previously contemplated and was disastrous to the spirit of Le Vau's structure. On the garden side Mansart replaced Le Vau's terrace over the ground floor by a gallery, uniting the two wings in a straight line. He added wings, set slightly back, to the north and south of the central block, bringing the total extension of the façade to 550 yards. The Galerie des Glaces and two salons adjoining it—the Salon de la Guerre and Salon de la Paix—were also added at this time and were brilliantly decorated by Mansart and Lebrun. The sculptor COYSEVOX contributed an element of pure Baroque.

Mansart also built the stables (1679–86), replaced Le Vau's Orangerie by a larger building (1681–6), and built the present Grand Trianon in place of Le Vau's Trianon de Porcelaine. In 1689 he began work on a chapel which was to be worthy of the new Versailles, but work was interrupted by war and not resumed until 1699. It was completed in 1703 and the interior decoration, which includes an illusionist frescoed ceiling by Antoine COYPEL, was finished by 1710. The exuberant exterior decoration of the chapel strikes a different note from the rest of Mansart's work at Versailles. Mansart was succeeded by his assistant and brother-in-law de COTTE in 1708, and under the latter's direction there was added the Salon d'Hercule with a ceiling painted by François LEMOYNE in the nascent ROCOCO style then becoming popular.

Finally in 1742 Louis XV accepted a plan by the then Chief Architect Ange-Jacques GABRIEL for a complete renovation and reconstruction. But owing to lack of funds the project was not carried through. Gabriel added the Salle de l'Opéra (1768) to the north wing and destroyed Le Vau's right wing over the entrance where the famous Ambassadors' Staircase was situated, erecting the present building in its place. He also supervised interior decorations, including those by Jacques Verberckt (1704–71) and Antoine Rousseau in the Cabinet du Conseil (1755). His masterpiece was the Petit Trianon, built in 1763 for Mme du Barry. Marie-Antoinette and Louis XVI were responsible for further decoration in a style approximating to the NEOCLASSIC which has been compared with that of Robert ADAM, particularly the Cabinet Doré (1783) and the Hameau, a charmingly fragile pastoral creation conceived by Richard Mique (1728–94) under the inspiration of J.-J. Rousseau.

More than any other single monument Versailles embodies the whole spirit of the French monarchy and the courtly culture for which it stood. Its active life terminated and its *raison d'être* was gone when in October 1789 the Paris revolutionaries forced the king to leave for the city.

**VERSTER** (VAN WULVERHORST), FLORIS (HENDRIK) (1861–1927). Dutch artist chiefly known for small STILL LIFES of very modest objects. He brought the precision and devotion of the great 17th-c. Dutch still-life painters to his pictures of tin cans, glass jars, and eggs in a wooden bowl.

**VERTUE, GEORGE** (1684–1756). English engraver. He collected notes for a *History of the Arts in England* which are one of the main sources of information on artists and collections in Britain in the 17th c. They were used by Horace WALPOLE as a basis for his *Anecdotes of Painting in England* (1761–71) and have been published separately by the Walpole Society (6 vols., 1929–52). He engraved many portraits after KNELLER and from 1723 to 1751 he was responsible for the design of the *Oxford Almanack*.

**VERTUE, ROBERT** (active 1475–d. 1506) and **WILLIAM** (active 1501–d. 1527). English builders, sons of Adam Vertue (a mason of Westminster Abbey), who became King's Master Masons in 1487 and 1510 respectively. They were joint master masons for the rebuilding of Bath Abbey and almost certainly also for Henry VII's Chapel in Westminster Abbey (both c. 1501), Robert presumably providing the designs. In 1506 William was working on the vaulting of St. George's Chapel, Windsor Castle. He subsequently designed Corpus Christi College, Oxford (1512), St. Peter ad Vincula in the Tower of London (1512), Lupton's Tower in Eton College (1516), and the cloister of St. Stephen's Chapel in Westminster Palace (c. 1526), the last two in conjunction with Henry REDMAN. In 1520 he took a prominent part in the preparations for the Field of the Cloth of Gold.

**VESICA PISCIS.** See MANDORLA.

**VETH, JAN** (1864–1925). Dutch painter who excelled in portraits. He was one of the leading figures in the Dutch art world of his time and had great influence as professor of ART HISTORY at the University of Amsterdam and as a critic and writer on art. His *Rembrandts Leven en Kunst* (2nd edn., 1941) is one of the most perceptive books written on REMBRANDT.

1384.

**VÉZELAY, ABBEY OF THE MAGDALEN.** This Cluniac abbey was the centre of an important pilgrimage. The dating of the present

building is controversial. The nave was probably begun after a fire in 1120, and finished soon after 1132. The NARTHEX was added between then and 1150. Vézelay has a two-storey elevation and has the earliest surviving main groin VAULT in France. The result is a balanced clarity which is directly opposed to the monumental splendour of CLUNY. Much of its interest lies in the numerous carved CAPITALS, and its three great sculptured portals, technically perhaps the most accomplished of the Burgundian series (Cluny, AUTUN, etc.), although the style lacks the awe-inspiring integrity of Autun. The present GOTHIC choir dates from after 1170. The whole church was saved from ruin and thoroughly restored in the 19th c. by VIOLLET-LE-DUC.

**VICTORIA AND ALBERT MUSEUM.** The conception of the Victoria and Albert Museum as a MUSEUM for FINE and APPLIED ART of all countries, styles, and periods goes back to the recommendations of the Select Committee of 1835 'that the opening of public galleries for the people should, as much as possible, be encouraged'. It belonged to the context of ideas which prevailed over the second half of the 19th c. which led to the formation of Government Schools of DESIGN and ultimately to the Great EXHIBITION of 1851, namely that in the general interest the fine arts should be taught and studied irrespective of style or period in order that they might be applied to industry with a view to rendering the manufactures of Great Britain more competitive in the world markets. (See APPLIED ART and ART EDUCATION.) In 1852 a Department of Practical Art (changed in 1853 to 'Science and Art') was established under the Board of Trade to administer the government art schools and to establish museums 'by which all classes might be induced to investigate those common principles of taste which may be traced in the works of excellence of all ages'. In 1852 also a Museum of Manufactures under Sir Henry Cole was opened on the first floor of Marlborough House with the dual objects of 'the improvement of public taste in Design' and 'the application of fine art to objects of utility'. The nucleus of the collection consisted of objects of applied art bought from the Great Exhibition with the aid of a Treasury grant of £5,000 and collections from the Government School of Design (now the Royal College of Art).

In 1857 the Museum (now renamed 'Museum of Ornamental Art'), linked with an Art Library, was moved to the present site in South Kensington as part of the Prince Consort's plans to set up there a cultural centre of museums and colleges. The Museum was opened by Queen Victoria on 22 June 1857. The present building was begun in 1899, designed by Sir Aston Webb (1849–1930), and the name of the Museum was changed to 'The Victoria and Albert Museum' at the ceremony of laying the foundation-stone by

Queen Victoria. The new buildings were opened by King Edward VII on 26 June 1909. At this time the Museum became a purely art museum and the scientific collections were assigned to a separate Science Museum.

The Museum includes the National Art Library, the national collections of post-classical sculpture (excluding modern), of British MINIATURES, of WATER-COLOURS, and of English silversmiths' work; also the national lantern slide loan collection. Its ceramics collections are among the most important in the world.

**VIEIRA DA SILVA,** MARIA HELENA (1908– ). Portuguese ABSTRACT painter and engraver. She studied in Paris from 1927 and settled there. In 1930 she married the Hungarian abstract painter Arpad Szenes (1900– ). She was for a time a pupil of Roger BISSIÈRE. She moved to Brazil in 1939, and returned to Paris in 1947. Since 1946 she has exhibited frequently in New York, Paris, and London; and her work is represented in the principal modern art museums of Europe and America.

2693.

**VIEN,** COMTE JOSEPH-MARIE (1716–1809). French historical painter, who is now remembered chiefly as a teacher of DAVID and a pioneer of the NEO-CLASSICAL style. His visit to Rome (1743–50) coincided with excavations at Herculaneum and POMPEII and his support of the ideas of WINCKELMANN won him the patronage of Count CAYLUS (*Apotheosis of Winckelmann*, Langes, 1768). His own interpretation of the new Classicism consisted of prim but sentimentalized anecdote or allegory with pseudo-Greek trappings (*La Marchande d'Amours*, Fontainebleau; copies from a Roman painting discovered at Grignano in 1759). On his return from Italy he was accepted into the Académie on the strength of his painting *Daedalus and Icarus*. In 1776 he became director of the French Academy at Rome. He was made a senator by Napoleon after the Revolution and was buried in the PANTHÉON.

**VIGARNY** or BIGUERNY, FELIPE (d. 1543). Sculptor from Langres who was active in Spain from 1498. In that year he contracted to carve the relief *Christ Bearing the Cross* for the enclosure round the high altar of Burgos Cathedral, executed in a style which combined FLEMISH-BURGUNDIAN with Italian RENAISSANCE features. Vigarny was a prolific if uneven sculptor. His skill as a MEDALLIST is demonstrated by his portrait head of Cardinal Cisneros (Madrid University) probably dating from before 1517. In 1519 he signed a partnership agreement with Alonso BERRUGUETE: and his colleague's MANNERIST influence is apparent in the REREDOS which he carved for the Chapel Royal at Granada (1520–1). In 1539 he was engaged at Toledo

Cathedral, together with Berruguete, upon the carving of the upper part of the CHOIR STALLS. He also collaborated with Diego de SILOE. In SAGREDO's *Medidas del Romano* (1526) Vigarny's rule of PROPORTION for the human figure is cited and his Renaissance versatility applauded.

**VIGÉE-LEBRUN, MARIE-LOUISE ÉLISABETH** (1755-1842). One of two popular French women portrait painters, the other being Mme Adélaïde Labille-Guiard (1749-1803). She studied under VERNET and GREUZE. She was a friend of Marie-Antoinette, whom she is said to have painted 25 times (*Marie-Antoinette in Satin Dress with Rose*, Versailles), and she maintained a famous Salon in Paris. On the outbreak of the Revolution she left France (1789), travelling in Italy, Russia (1795-1800), Austria, Germany, and England (1802-5), returning to Paris in 1805. In most countries she had great success as a portraitist (*Lady Hamilton as Sybil* and *Bacchante*, Naples). Her most widely known painting is *The Artist and her Daughter* (Louvre), a one-time favourite steel engraving. She was a woman of wit and charm and her memoirs give a lively picture of the Europe of her day as well as an account of her own works (*Souvenirs de Mme Vigée-Lebrun*, Paris, 1835-7).

1272, 1600.

**VIGELAND**, GUSTAV (1869-1943). Norwegian sculptor. Stylistically evolving from RODIN, he carried romantic REALISM to the extreme limit. He is known for his *Park of Sculpture* at Frogner, Oslo, begun in 1905 and left uncompleted at his death, the most stupendous undertaking in granite that exists in the world. The unrestrained emotivity of theme, the representation of trees which in their romantic *non finito* outdo Rodin at his most Rodinesque, the monolithic depiction of unrestrained emotionalism and indeed the whole megalomaniac conception are out of line with the main currents of 20th-c. AESTHETIC. Vigeland has also done a number of portraits, including a bronze statue *Camilla Collete* (in the *Park*, near the Royal Palace), and perhaps these early works will stand out as his best.

**VIGNETTE.** An ornamental design in a book, especially at the beginning or end of a chapter; usually small, and having the edges shaded off.

**VIGNOLA**, GIACOMO BAROZZI DA (1507-73). Italian architect. After some years in Bologna and in France, where he was probably influenced by SERLIO, Vignola became architect to Pope Julius III and built the Villa Giulia (1551-5) with VASARI and AMMANATI. He also completed the huge Villa Farnese at Caprarola, near Viterbo, begun by A. da SANGALLO the Younger and PERUZZI. Here the influence of BRAMANTE is clear.

His most important churches are in Rome.

S. Andrea in Via Flaminia (1554) was the first church to have an oval DOME, though over a rectangular plan. In Sta Anna dei Palafrenieri (begun 1572-3) the oval dome is expressed on the plan as well—the essential step to BAROQUE types. Il Gesù, the mother-church of the Jesuits, was begun in 1568, but altered by Giacomo della PORTA. This enormously influential church has a Latin cross plan, perhaps influenced by MICHELANGELO, but is based on ALBERTI's church of S. Andrea, Mantua. Here the nave is broadened and the dome area increased, in accordance with Counter-Reformation ideas and the new importance attached to preaching.

The influence of Bramante and the academic tendencies of later MANNERISM can be seen in Vignola's works and especially in his standard treatise on the ORDERS, *Regola delli cinque Ordini d'Architettura* (1562/3).

**VIGNON**, CLAUDE (1593-1670). French painter and picture dealer, born at Tours. He studied in Rome (*c.* 1616-24), where he was influenced by ELSHEIMER and the followers of CARAVAGGIO. His later work has striking affinities with the early REMBRANDT, with whom he was acquainted (*Esther before Ahasuerus*, Louvre, 1624). He became a foundation member of the Académie, but his style has more in common with European MANNERISM than with the French CLASSICISM. His son, also named CLAUDE, was employed in the decoration of the *Grands Appartements* at VERSAILLES under the direction of LEBRUN (1671-81).

**VIKING ART.** See SCANDINAVIAN ART.

**VILLA.** The Romans were familiar with the idea of the villa as a country house to which the owner could retire from the cares of office (as Cicero did to his Tusculum) but which was also a self-supporting property. Many examples are known from all over Europe and there is also a complete exposition of the pleasures of country life and a description of two splendid villas in the *Letters* of Pliny the Younger. The *villa urbana* was generally a country house of retirement near the city corresponding to the *villa suburbana* of the Italian RENAISSANCE, which was often a palatial building just outside a town suitable for spending the day but usually without bedrooms (the finest example is the Palazzo del Tè, at Mantua). The *villa rustica* was akin to a farm, being planned around the stables and necessary buildings. The great Roman villas had a large series of smallish rooms, normally arranged as suites for summer and winter use, set round one or more courts and interconnected by cloisters for the family to walk in. Not too far away were the farm and the quarters of the farmer and upper servants; further off was the *ergastulum* for the slaves who worked the farm.

The rural villa or country house existed as far

afield as Wales. In Gaul especially country villas sometimes covered 40 acres or more and with their attendant cottages almost resembled villages. They are described in the writings of the 5th-c. poet Sidonius Apollinaris (*c.* A.D. 430–83). In contrast to the *villa rustica* the urban villa tended to approximate the magnificence of a palace, endeavouring to combine the comfort of a town house with the amenities of the countryside. Of this sort were the villa near Piazza Armerina in Sicily, built probably for the Emperor Maximian in the late 3rd c., and in Gaul the 4th-c. villa at Welschbillig, near Trier. The tendency to extravagant magnificence reached its culmination in the famous Hadrian's Villa near Tivoli and the Golden House of Nero (A.D. 64–8), which by A.D. 104 had been supplanted by the baths which Titus and Trajan built on the site.

With the revival of sophisticated country life in Italy in the 14th c. came the desire to revive the classical villa and the theory was expounded among others by ALBERTI. The most important of all Italian villas were those in the Veneto built for wealthy Venetian families by PALLADIO and his pupils, almost all of which were practical farms. The great Roman examples derive mainly from VIGNOLA's Villa Giulia and his Villa Farnese at Caprarola and are less family properties than show-pieces built by Cardinals, chiefly in the BAROQUE period and at Tivoli and Frascati. Palladio's combination of geometrical beauty, classical antiquity, and practical farming was to prove a decisive influence in the evolution of the English country house in the early 18th c. under the aegis of CAMPBELL and BURLINGTON.

**VILLALPANDO,** FRANCISCO CORRAL DE (d. 1561). Spanish architect and metalworker, member of a family of Palencian artists noted for their decorative work in plaster. He was responsible for the gilded and silver-plated chancel screen of Toledo Cathedral (dated 1548), designed in the Renaissance-PLATERESQUE style. Appointed royal architect in 1553, he built the great staircase of the ALCÁZAR at Toledo. He translated into Spanish the third and fourth Books of SERLIO's *Architecture*, first published at Toledo in 1552.

**VILLANUEVA,** CARLOS RAÚL (1900– ). Venezuelan architect, born in England and

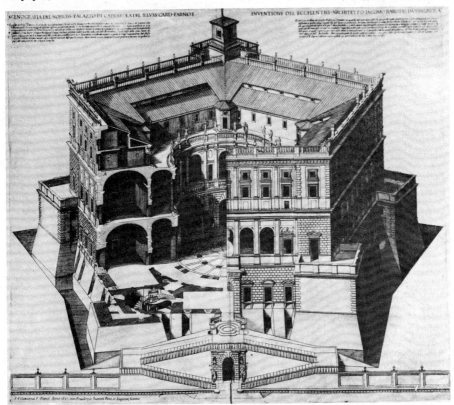

**385.** Elevation and section of the Villa Farnese, Caprarola. *Alcune Opere d'Architettura di Jacomo Barotio da Vignola,* Rome (1617). Begun *c.* 1520 by Antonio da Sangallo the younger and Peruzzi, continued by Vignola from 1559 till his death in 1573

trained at the École des Beaux-Arts, Paris. He was a dynamic personality who did more than any other to inspire the spread of MODERN ARCHITECTURE in Venezuela. His own forceful sense of design is expressed typically in exposed CONCRETE and a daring use of polychromy. Among the finest examples of his work are the Olympic Stadium (1950-1) and the Aula Magna and Plaza Cubierta (1952-3) for the University City of Caracas. He also made vital contributions to the large housing projects which accompanied the rapid growth of Caracas.

1850.

**VILLANUEVA,** JUAN DE (1739-1811). Spanish architect, son of a CHURRIGUERESQUE sculptor of the same name who worked on the ·altar of Coria Cathedral. His brother, DIEGO, became a convert to Classical rationalism in 1760 and published in 1766 a volume of essays, *Papeles Criticos*, attacking Churrigueresque and ROCOCO decoration. Partly under his influence Juan became the chief Spanish architect in the NEO-CLASSICAL manner. He was in Italy 1759-65 as a scholar of the Academy of San Fernando. In 1771 he was appointed architect to the three sons of Charles III and built for them two town houses and a large building in the HERRERAN style for their households. He also did work in 1770 for the cathedral of Burgo de Osma. His personal style appeared first in three *casitas* which he built (1773 and 1784) for the princes in the grounds of the ESCORIAL and at El Pardo. From 1774 he was Professor and from 1792 Director-General of the Academy of San Fernando. In 1798 he became royal architect. From 1785 to 1787 he was designing the PRADO, his greatest achievement. In 1789 he built the Oratory of the Caballero de Gracia in Madrid and in 1791 designed the rebuilding of the Plaza Major. His last important building was the Madrid Observatory (1790).

547.

**VILLES NEUVES.** A number of new towns were founded in France from the mid 12th to the mid 14th c. either near a castle or as a centre for undeveloped land. In 1344 their creation by anyone but the king was banned. They were uniformly planned with two wide streets north to south and east to west intersecting at a market square in the middle, and the four blocks thus formed were variously broken up by lesser streets. They were usually walled, with four fortified gates. Good surviving examples are Villeneuve-sur-Yonne (1163); Cordes, Tarn (1222); Aigues-Mortes (1272); Castelnau de Montratier and Vianne (1284); Monpazier (founded by Edward I of England, 1284); Villeneuve-lès-Avignon (1292); and Villeneuve-sur-Lot. At Créon the central square (occupying about one-tenth of the whole area) was surrounded by linked ARCADES, a pattern which still survives at Monpazier and Montauban.

**VINCKBOONS,** DAVID (1576-c. 1632). Painter, born at Mechelen (Malines) in Flanders. His family migrated to Holland before he was 10 years old and he spent his life working in Amsterdam. Judging from the number of PRINTS made after his paintings and drawings we can conclude that he was one of the most popular artists of his time. Vinckboons is a transitional master, midway between the decorative and imaginative MANNERIST style and the REALISTIC mode of 17th-c. Dutch LANDSCAPE and GENRE painting. His early genre pictures depicting village festivals reveal the influence of Pieter BRUEGEL and Vinckboons is credited with introducing into Holland some aspects of Bruegel's mood and some of his motifs. It has been asserted that Vinckboon's works can always be identified by the presence of a finch (*vinck*) in a tree (*boom*), but the painstaking student usually finds that the bird has flown.

**VIOLLET-LE-DUC,** EUGÈNE EMMANUEL (1814-79). French architect, engineer, and archaeologist who made one of the first comprehensive studies of medieval architecture, and propounded an influential theory about the characteristic forms of the GOTHIC style. He regarded Gothic primarily as the solution of an engineering problem posed by the use of pointed ARCHES in ribbed VAULTS. These created thrusts at certain fixed points which were neutralized by the counterthrusts of flying BUTTRESSES. His arguments, developed in his *Dictionnaire raisonné de l'architecture française* (1858-75), were sustained by an unrivalled knowledge of the buildings, many of which he restored. Though his conclusions have not survived modern criticism, they contain some measure of the truth, and he deserves credit for having brought the study of medieval architecture out of the ROMANTIC twilight. While we may deplore the thoroughness of some of his restorations, e.g. the Château of Compiègne, he undoubtedly saved some buildings, such as VÉZELAY, from complete ruin.

**VIRGIN.** I. DEVOTIONAL TYPES. The types of the Virgin in the ICONOGRAPHY of the Eastern Church were very many (16 are enumerated in the *Manual of Christian Iconography* of Denys of Fourna) and only the main ones can be discussed here. The group of the Virgin and Child was of special importance in EARLY CHRISTIAN ART (Catacomb of Priscilla, Rome, 3rd c.) not —or not primarily—because it symbolized a sentimental idea of motherhood, but because it was a concrete symbol of the reality of the central Christian doctrine of the Incarnation. The main point of the doctrinal controversies which rent the Church during the first five centuries was how to define the place of CHRIST within the TRINITY and to affirm the equal reality of the two Natures of Godhead and Manhood united in His one Person. The epithet *Theotokos* (she who gave birth to God), which

was used of the Virgin by Origen, Eusebius, and Athanasius, implied that the man Jesus in His human career combined equally the nature of God with His human nature and gained particular importance as a test of doctrinal orthodoxy after it was attacked by the Nestorians in the 5th c. Its use as a title on BYZANTINE images of the Virgin had this significance.

The Virgin was believed to have special powers of intercession and was often represented seated on the throne and cushion of Byzantine royalty. The earliest known instance of her occupying the place of honour in the centre of the APSE is in a 6th-c. MOSAIC at Parenzo. After the Iconoclast controversy of the 7th and 8th centuries this became general, and gradually her role of Intercessor gave place to that of Queen. In the West she was often shown enthroned with the Child on her lap after the famous *Nikopeia* (Bringer of Victory) of miraculous origin brought to St. Mark's in Venice in 1204 by the Doge Dandolo. In this type she sometimes wears the crown and royal robes (7th-c. fresco in Sta Maria Antiqua, Rome; early 12th-c. relief, York Minster), but usually the cloak and hood (6th-c. mosaic S. Apollinare, Ravenna; 9th-c. mosaic, Sta Maria in Dominica, Rome). The *Nikopeia* inspired the Italian *Maestà* or Madonna enthroned with angels (CIMABUE, Uffizi, 13th c.; SIMONE MARTINI, fresco, Town Hall, Siena, 14th c.).

Another influential Byzantine ICON, the *Hodegetria* (Guide or Instructress), was brought into the church of the Hodegos, Constantinople, in the 5th c. from Jerusalem. It was supposed to have been painted by St. Luke, as were many other pictures of the Virgin standing with Christ on her left arm, a type followed in both East and West (7th-8th-c. mosaic, Kitium, Cyprus; 10th-11th-c. Byzantine ivory statuette, V. & A. Mus.; 12th-c. mosaic, Torcello, Venice). A later version of the *Hodegetria* shows her suckling the Child, a group which originally pointed to the full humanity of Christ's Incarnation, though in the Middle Ages it was the mystical significance of the Virgin's motherhood which obtained increasing prominence (12th-c. façade mosaic, Sta Maria in Trastevere, Rome).

Another Byzantine icon shows the Virgin with arms raised outwards in supplication like a Roman *orant* (known to the Greek Church as *Blacherniotissa* after the miraculous icon of this name in the Church of the Blachernes in Constantinople). The praying Virgin (without her child) figured in mosaics in Rome of the 7th and 8th centuries (S. Venanzio in Laterano; Oratory of Pope John VII—now in S. Marco, Florence), and remained popular in the later Middle Ages, when she sometimes bears the Child in a medallion on her breast (12th- and 13th-c. marble reliefs, St. Mark's, Venice; 12th-c. mosaic, Cefalù, Sicily). It emphasized the Virgin's powers of intercession and was popular where a cult persisted. The same intercessory role was emphasized by the *Deesis* (Greek: *Entreaty*),

where she appears with St. JOHN THE BAPTIST, one at either side of Christ's throne, their hands raised in prayer (Harbeville ivory triptych, Louvre, 10th c.). This group figures in the LAST JUDGEMENT from the 11th c. in East and West (Byzantine Gospel book, Bib. nat., Paris; 12th-c. mosaic, Torcello; south central door, Chartres, 13th c.).

The solemn Byzantine iconic types of the Virgin had a varied history in medieval Europe: while religious painters in Russia and the Balkans remained faithful to the traditional forms of the Orthodox Church, in Italy and the West a more independent spirit prevailed and devotion to the Virgin was expressed, as in the preaching of St. Francis and his followers, by an attempt to evoke the human beauty and tenderness of her presence. GIOTTO and his successors transformed the Greek types and gave to Mother and Child ever more natural and varied gestures and expressions. The 14th-c. Sienese painters A. and P. LORENZETTI had a particular preference for simple and vivacious studies of the Virgin and Child, with or without attendant ANGELS, set against the traditional gold ground. In the 14th and 15th centuries this theme was taken up all over Europe and during this period the gold was replaced by REALISTIC settings: a garden or *Hortus Clusus* symbolizing her virginity (LOCHNER, *Virgin in the Rose-bower*, Wallraf-Richartz Mus., Cologne, 15th c.; STEFANO DA ZEVIO, Verona, 15th c.). Sometimes the group was depicted in a LANDSCAPE (Filippo LIPPI, Uffizi; MANTEGNA, *Virgin of the Stone-cutters*, Uffizi); or a formalized interior (C. CRIVELLI, N.G., London; pictures by Giovanni BELLINI and V. CARPACCIO, Accademia, Venice). RAPHAEL perfected the classical type of the Madonna and Child (*Madonna del Granduca*, Pitti Palace, Florence); and painters of the later RENAISSANCE concentrated increasingly on the domestic or sentimental possibilities of the group (see HOLY FAMILY). For medieval sculptors, too, the Virgin was a favourite theme, usually shown standing with the Child on her arm (Giovanni PISANO, Cappella della Spina, Pisa; Scrovegni Chapel, Padua). Madonnas of varying degrees of refinement or crudeness stand at countless street corners and wayside shrines in Roman Catholic Europe.

The Virgin and Child were often accompanied by saints, and from the 15th c. these groups were formed into an increasingly articulate composition, the *Sacra Conversazione*. The *Sacra Conversazione* differed in its more formal and solemn grouping from the *Sacra Famiglia* where the Virgin is accompanied by her biblical and apocryphal relatives (see HOLY FAMILY). A favourite variation on the *Sacra Conversazione* in Italian painting was the symbolic marriage of St. Catherine to Christ, in which she is shown kneeling before the Madonna and receiving the ring from the hand of the Child (G. DAVID, N.G., London, 15th c.; TINTORETTO, Palazzo Ducale, Venice). Some of the most impressive

examples of the *Sacra Conversazione* were painted in thanksgiving for victory (Mantegna, *Madonna of Victory*, Louvre, late 15th c.). In TITIAN's *Pesaro Madonna* (Frari Church, Venice, 1559) Jacopo Pesaro offers his standard in gratitude for his sea victory against the Turks. Recovery from illness or the plague also inspired votive Madonnas, such as that painted by HOL-BEIN for the Burgomaster of Basel (Darmstadt Mus.), or the *Paliotto del Voto* prepared by Guido RENI as the standard for a procession of thanksgiving after the cessation of the plague in Bologna in 1630.

The Virgin's role as Patron and Protector is clearly shown in the *Mater Misericordiae* or Madonna of Mercy, in which she holds her cloak over a group of sheltering worshippers. An early example by DUCCIO shows her protecting three Dominican friars (Accademia, Siena). Later examples depict a mixed crowd of suffering humanity beneath her mantle (PIERO DELLA FRANCESCA, San Sepolcro; CHARONTON, Musée Condé, 15th c.). *The Virgin of Mercy* was adopted as patron by the Dominicans, and a further type, the *Virgin of the Rose-crown* (sheltering members of the Brotherhood), was evolved by their dependent order, the Rose-crown Brotherhood, in Cologne about 1450 (triptych, St. Andrew's Church, Cologne). DÜRER's group, *The Rosenkranzfest* (Prague), shows yet another variation on this theme, the *Madonna of the Rosary*, which developed soon after 1500.

The doctrine of the perpetual virginity of the Mother of God was later amplified by the doctrine of her immaculate conception by her mother St. Anne. In the West from about 1200 the belief was expressed in a triple group showing the Virgin and Child seated on the knees of St. Anne (13th-c. window, Chartres). Here the figure of St. Anne necessarily exceeds that of the Virgin in size and importance, and few versions were able to overcome this disadvantage (Luca di Tomme, Siena Gal., 14th c.; Girolamo dai Libri, N.G., London, 16th c.). Some show the Virgin and Child seated one on either side of St. Anne (15th-c. reliquary from Naumburg, Cluny Mus., Paris); others show the pair in her arms (Q. MASSYS, wing of an ALTARPIECE, Munich). MASACCIO painted the Virgin fully grown seated with St. Anne at her shoulder (Accademia, Florence). In another grouping St. Anne and the Virgin sit side by side with the Child between them (Holbein the Elder, Augsburg Gal.; FRANCIA, N.G., London). Only LEONARDO DA VINCI succeeded in evolving a natural yet unified grouping of St. Anne, her daughter, and the two children (painting, Louvre; cartoon, N.G., London. See HOLY FAMILY).

The Roman Catholic doctrine of the Immaculate Conception was officially proclaimed by Pope Paul V in the early 17th c. and gave rise at once to a new type of the *Immacolata*; a young girl supported in the heavens by a crescent moon and crowned by stars or by a radiant HALO (fresco

by Guido Reni in Paul V's chapel in the Palazzo del Quirinale, Rome; VELAZQUEZ, N.G., London).

A devotional type of the suffering Virgin, the *Pietà*, shows her bearing the dead Christ on her knees. This scene grew naturally out of the *Deposition* (see PASSION CYCLE). There is an early 14th-c. example of a carving in Naumberg Cathedral, and a famous *Pietà*, from the School of Avignon (Louvre, mid 15th c.). It became popular also in Italy (Giovanni Bellini, Accademia, Venice). The composition offered problems of size and PROPORTION which were brilliantly solved by MICHELANGELO in his marble group in St. Peter's, Rome. For the sake of realism, painters sometimes preferred to place the dead Christ on the ground at the feet of the mourning Virgin (Petrus CHRISTUS, Met. Mus., New York, 15th c.; SEBASTIANO DEL PIOMBO, Viterbo). The ROMANTIC treatment of the theme is exemplified by the *Pietà* of DELACROIX. A related scene, the mourning of Christ, shows the Virgin and St. John weeping over His dead body, usually in its grave (CRANACH, altarpiece, Freiburg im Breisgau Cathedral; Giovanni Bellini, Brera).

With the decline of religious painting in the 17th and 18th centuries the Virgin lost importance as an artistic theme, but recent works have again found inspiration in the group of Mother and Child (EPSTEIN, Cavendish Square, London; Henry MOORE, seated *Madonna and Child*, St. Matthew's Church, Northampton).

2. SCENES FROM THE LIFE OF THE VIRGIN. Also a favourite theme of Christian art, incidents illustrating the life of the Virgin had a partly didactic purpose. For example the story of her parents Joachim and Anne, taken from the *Protevangelium of James*, was connected with the doctrine of her immaculate conception; and the scenes from her presentation in the Temple to the nativity and childhood of Christ (*Protevangelium* and *Pseudo-Matthew*) illustrated the Incarnation. Her death and assumption were shown in a series of scenes based on an early Greek narrative poem, and are also described, together with certain of her miracles and apparitions, in the *Golden Legend* of Jacopo di Voragine (late 13th c.).

Sometimes the life of the Virgin has been illustrated more or less completely in series of episodes. The late 11th-c. mosaics of the Catholicon at Daphni, Athens, include only the chief incidents, the prayers of her parents, her birth, presentation, and death. Her life is fully illustrated in the two 12th-c. manuscripts of *The Homilies of the monk James* (Bib. nat., Paris; Vatican, Rome. The mosaics of St. Saviour in Chora, Constantinople (early 14th c.), also present an extended series of scenes from her childhood and upbringing in the Temple. In the West the first and most complete cycle of the life of the Virgin is contained in the frescoes of Giotto in the Scrovegni Chapel, Padua (after 1304). Dürer likewise began his woodcuts of the

life of Mary (1510) with episodes from the story of Joachim and Anne.

The return of Joachim and his meeting with Anne at the Golden Gate became a scene of particular importance since it represents the moment of the immaculate conception of the Virgin; and it is shown in the *Menologion of Basil II* (976-1025) on the feast of the Immaculate Conception (8 Dec.). It was also a favourite of Western painters (Bartolomeo VIVARINI, Sta Maria Formosa, Venice), often forming the prelude to the Nativity of the Virgin (Taddeo GADDI, Baroncelli Chapel, Sta Croce, Florence). The presentation of Mary at the Temple when still a child is another favourite scene (Titian, Accademia, Venice), as is the choice of her husband, and her marriage to Joseph (Raphael, *Sposalizio*, Brera); in these scenes Joseph is often painted as a youth, and not as the old man described in the Gospels.

One of the earliest and most popular scenes from the life of the Virgin is the *Annunciation*. Among the mosaics in the TRIUMPHAL ARCH of Sta Maria Maggiore, Rome (5th c.), Gabriel flies down towards Mary, who is sitting wearing the purple thread which had been given to her in the Temple (8th-c. frescoes, Castelseprio, near Varese). In a few early versions Mary is shown drawing water from the spring as the angel approaches, as recounted in the apocryphal gospels (5th-c. ivory diptych, Cathedral Treasury, Milan). But more often she is seated, with the angel poised before her (6th-c. mosaic, Parenzo Basilica, Yugoslavia; 11th-c. Catholicon of Daphni, Athens). Later versions more usually show her reading or at prayer with the angel kneeling before her, and with the HOLY SPIRIT descending towards Mary in the form of a DOVE (A. Lorenzetti, Siena Gal.; Simone Martini, Uffizi; PISANELLO, fresco in S. Fermo, Verona). The Annunciation was painted by Leonardo and by most of the great artists of the Renaissance. From early Byzantine times to the PRE-RAPHAEL-ITES, Gabriel carries a lily to signify the purity of the Virgin. (The lily also denoted purity in ancient Greece, where it was fabled to have sprung from the milk of the goddess Hera.)

According to the Gospel of St. Luke soon after the Annunciation Mary visited her cousin Elizabeth, mother of St. John Baptist, and the embrace of the two women is often shown in the *Visitation* (GHIRLANDAIO, Louvre). It may also form part of a series, together with the Annunciation, Joseph's doubts, and the Nativity, as in the 8th-c. frescoes at Castelseprio, near Varese. The Visitation and the Nativity are shown together on a panel of N. PISANO's pulpit in Pisa Baptistery.

The death of the Virgin was an important theme in Byzantine painting. She was shown lying on a couch surrounded by the mourning APOSTLES and by a crowd of angels, while Christ carries her soul (a swaddled child) in His arms (frescoes, Sopocani, Yugoslavia, *c.* 1260; St. Saviour in Chora, Constantinople, early 14th c.).

This composition was adopted by Western artists (mid 13th-c. relief of south door, Strasbourg Cathedral; ORCAGNA tabernacle; Veit STOSS, carved altarpiece, Church of Our Lady, Cracow, 15th c.). The theme of her Assumption was of Western origin, and is first found as a separate scene in the 14th c. Orcagna's relief shows her carried in a MANDORLA by four angels, while the Apostles watch below; and Titian elaborated this composition for his *Assumption* in the Frari Church in Venice (1518).

The final glorification of the Virgin is portrayed in her *Coronation by Christ in Heaven*, an imaginary scene first developed in north-west France (12th-c. relief, Senlis Cathedral; *Portrait de la Vierge*, Bourges, 13th c.; south transept, Strasbourg Cathedral, 13th c.). It was taken over by Italian artists in the 13th c., and sometimes forms the centre of a series of scenes from her life (TORRITI, apse mosaic, Sta Maria Maggiore, Rome). Dürer, in his woodcuts of the life of the Virgin, shows her being crowned by the Trinity (1510).

Scenes from the life of Christ and the Virgin form a series of late medieval origin known as the *Seven Joys* and the *Seven Sorrows* of the Virgin. Among the *Joys* are Christ's RESURRECTION, and the Assumption and Coronation of the Virgin (Veit Stoss, carved altarpiece, Cracow; van EYCK, Colonna Gal., Rome). The *Sorrows* include the FLIGHT INTO EGYPT, the CRUCIFIXION, and the Entombment of Christ (van Eyck, Colonna Gal., Rome).

Miracles performed by the Virgin after her death are recorded in *The Golden Legend* and other texts, and form the subject of medieval carvings and STAINED-GLASS windows. Particularly popular were the story of the converted Jewish boy saved by her from his father's punishment, and of Theophilus, a priest whom she miraculously saved from a pact with the Devil (reliefs on north door and north wall, NOTRE-DAME, Paris; windows, Le Mans, Beauvais, and LAON cathedrals, 13th-14th centuries).

**VIRGIN AND CHILD.** See VIRGIN; HOLY FAMILY.

**VIRTU, VIRTUOSO.** The Italian word *virtù* (Latin *virtus*, 'excellence') signified a taste for art works or curios, and a love of the FINE ARTS. It was closely akin in meaning to CONNOISSEUR-SHIP. It became current in Italy through Castiglione's *Il Cortegiano* (1528), translated in 1561 into English as *The Courtier*, in which *virtù* is specified as one of the qualifications of the ideal courtier. Its currency in English was largely due to LOMAZZO's *Trattato dell'arte de la pittura* (1584), translated by Richard Haydocke in 1598. Horace WALPOLE refers (1746) to 'my books, my virtu and my other follies and amusements'. A 'piece of *virtu*' meant a curio, and this usage is still current in sale-room language.

Similarly 'virtuoso' was originally used of a specialist or COLLECTOR of art objects or

connoisseur. Henry Peacham in *The Compleat Gentleman* (1634) comments on those who can distinguish copies of antiquities from originals: 'Sure am I that he that will travell must both heed them and understand them, if he desire to bee thought ingenious, and to bee welcome to the owners. . . . Such as are skilled in them, are by the Italians tearmed *virtuosi* as if others that either neglect or despise them were idiots or rakehels.' But by the middle of the 17th c. the term was most frequently applied to people interested in the sciences ('a virtuoso of the Royal Society'). William Roscoe of Liverpool (1753–1831) was a virtuoso in both senses, for he not only assembled a magnificent collection of paintings of early Italian and Flemish masters, but wrote with great knowledge on botanical subjects, as well as the standard history of Lorenzo de' MEDICI and his times.

Virtuoso also meant a professional artist, and the 'Society of Virtuosi', founded in 1689, was composed of 'gentleman painters, sculptors and architects' (see VERTUE's *Notebooks*).

In modern usage it denotes a person who excels in technique and is applied primarily in music but also by analogy in the visual arts to an artist of outstanding technical ability sometimes with an implication that powers of invention are defective.

**VIRTUES AND VICES.** Personified virtues and vices are the stock-in-trade of classical poetry and illustration. One of the most famous descriptions of a classical painting, Lucian's account of the *Calumny* of APELLES, includes them, as did the popular theme of the choice of Hercules. Individual virtues attributed to a ruler were sometimes added to his portrait, e.g. the *Liberalitas Augusti* on the reverse of Roman coins. With the rise of Christianity and the emphasis on the ethical teachings of art the Battle between Virtues and Vices, as described in a famous poem by Prudentius (*Psychomachia*), was frequently illustrated. Many illustrated manuscripts of this poem and its imitations survive. The Virtues and Vices are included in the great didactic cycle of Herrad of Landsberg, the *Hortus Deliciarum* (12th c.), and appear on the PORCHES of French cathedrals (Paris, AMIENS) and on the DADO of the Scrovegni Chapel, Padua, by GIOTTO. Moral theology had systematized their numbers, the most frequent list comprising the three theological virtues (Faith, Hope, and Charity) and the four cardinal virtues (Prudence, Justice, Temperance, and Fortitude). Their opposites were the seven deadly sins. Secular literature appropriated the device, particularly in the lore of chivalry where the Lady's and the Lover's Virtues and Vices multiply and complicate the contest. Illustrations of the *Roman de la Rose* and on IVORY caskets provide examples. The moral and erotic traditions are fused in Petrarch's *Trionfi*, where chastity triumphs over love and death over chastity. In the RENAISSANCE Virtues and Vices were frequently identified with the classical

gods, Minerva, for instance, standing for Prudence. In this transformation the gods were sometimes represented engaging in battles which though not recorded by any classical author were in keeping with the tradition of the *Psychomachia*. The most famous examples are MANTEGNA's and PERUGINO's elaborate allegories painted for the Studiolo of Isabella d'ESTE (now in the Louvre) where chaste Diana and prudent Minerva fight lascivious Venus and her attendant Cupid. The motif of the struggle suited the taste of 16th-c. sculptors such as Baccio BANDINELLI and many BAROQUE decorations elaborate the cosmic strife between Virtues and Vices until it resembles the defeat of the rebel ANGELS (RUBENS, Whitehall Ceiling). In the 18th c. the picture sermon came down to earth with the didactic but humorous cycles of HOGARTH. The PERSONIFICATIONS survive but are frequently travestied in the satirical PRINTS and CARTOONS of the 18th and 19th centuries.

**VISCHER.** Nuremberg family of sculptors and bronze-founders. The most important members were: PETER the Elder (*c.* 1460–1529), HERMANN the Younger (1486–1517), PETER the Younger (1487–1528), HANS (*c.* 1489–1550), and GEORG (1520–92).

The outstanding work of the Vischer WORKSHOP is the spectacular bronze shrine over the SARCOPHAGUS of the patron saint of the *Sebalduskirche* in Nuremberg. The first design by Peter the Elder (Academy, Vienna) dates from 1488 and shows an elaborate, richly decorated BALDACCHINO of three bays, rising over the sarcophagus. Actual work began only in 1508 and was carried on till 1519. Through journeys of the younger generation the workshop had by that time gained a good deal of knowledge of Italian bronzes and in particular the work of north Italian sculptors. Thus the Sebaldus TOMB became a fascinating mixture of GOTHIC and RENAISSANCE styles. The CANOPY remained Gothic as also the main figures of the APOSTLES standing before the supports; but both the base and the baldacchino were inhabited by biblical, MYTHOLOGICAL, and decorative figures conceived in a genuine Renaissance spirit.

The workshop also contributed a number of figures to the tomb of the emperor Maximilian in Innsbruck. The Apollo fountain in the courtyard of the Nuremberg Town Hall, dated 1532, is usually attributed to Hans Vischer. The youthful figure of the god was copied from an Italian engraving and shows real appreciation of the formal problems which exercised Renaissance artists. It was, incidentally, the first freestanding nude north of the Alps.

Georg, a son of Hans, seems to have specialized in small decorative bronzes such as ink-wells (Ashmolean Mus., Oxford).

1821.

**VISIGOTHIC.** Term in ART HISTORY for the style of architecture and ornament current in the

Iberian peninsula during the rule of the Visigoths (5th–8th centuries). From this period there has survived a number of small churches which follow in a primitive manner the example of late ROMAN work and also reveal certain BYZANTINE influences. Their rough execution reflects the incomplete understanding by Visigoth craftsmen of the models which they were imitating. Examples are S. Pedro de Balsemão near Lamego (Portugal) and S. Juan de Baños near Palencia (Spain). The latter was built by King Recceswinth in 661. Its Roman features include a three-aisled BASILICAN plan, nave ARCADES supported on monolithic COLUMNS with simplified Corinthian CAPITALS (see ORDERS OF ARCHITECTURE), and an external colonnade. Also of Roman origin is the slightly flattened horseshoe shape of the ARCHES and of the chancel tunnel VAULT.

Visigothic goldsmiths' work is represented by a magnificent series of jewelled gold crowns and crosses (Archaeological Mus., Madrid) which have Byzantine features in their design. (See MIGRATION PERIOD ART.) The famous *Ashburnham Pentateuch* (Bib. nat., Paris) has been thought to be Visigothic work.

**VISITATION.** See VIRGIN.

**VITRUVIUS BRITANNICUS.** The title given by Colen CAMPBELL to his three folio volumes (1715, 1717, and 1725), each containing 100 engraved plates of English buildings of the 17th and early 18th centuries, with short notes on them in English and French. Campbell's taste is clearly indicated by the reference to VITRUVIUS in the title and also in the Introduction, where he castigates Italian BAROQUE architecture as 'licentious' and praises that of PALLADIO and Inigo JONES. He includes many of his own designs in the Palladian manner, but also some by WREN and VANBRUGH in a more Baroque style. The work is an important source-book for English 17th-c. building, though some of the attributions are incorrect; and while the somewhat dull engravings are on the whole accurate, Campbell was occasionally unable to resist the temptation to 'improve' the original building.

Two additional volumes were published in 1767 and 1771 respectively by John Wolfe and James GANDON; and the *New Vitruvius Britannicus* (2 vols., 1802, 1808) compiled by George Richardson contains later examples of English PALLADIANISM.

**VITRUVIUS POLLIO.** Roman architect who held an official position in connection with the rebuilding of Rome by Augustus and who wrote, probably before 27 B.C., a treatise *De Architectura* which is the only technical handbook of its kind to have survived from antiquity. The treatise in 10 books dealt with architecture and building in general, with sites, materials, the construction of TEMPLES, THEATRES, dwelling-houses, and VILLAS;

it also covered TOWN-PLANNING, decoration, water supply, machines, sundials, and water-clocks. It embodied the theoretical and practical know-how of the GREEK tradition in its day and rapidly became a standard work. It was referred to by PLINY and remained in vogue up to Sidonius Apollinaris in the 5th c., being temporarily eclipsed only when BYZANTINE architectural styles and techniques imposed themselves in the 6th c. During the Middle Ages the text survived in monastic libraries (it was taken by Ceolfrid to the scriptorium of Jarrow) and became the basis of the 'Roman style' of building. Christian architects followed the BASILICA of Vitruvius rather than his instructions for the pagan temples. Later the Benedictines carried a knowledge of Vitruvius from England to the kingdom of Charlemagne and to Germany. He had an important influence on the architectural school of Charlemagne and thus on the development of GOTHIC.

Reflections of Vitruvius's remarks on PROPORTION appear in Villard d'HONNECOURT and Cennino CENNINI, and with the new enthusiasm for classical antiquity which characterized 15th-c. humanism his doctrines of proportion and his descriptions of the ORDERS became authoritative for best practice. There were editions by Sulpitius (Rome, 1486), by Fra GIOCONDO (Florence, 1522), by Laet (Amsterdam, 1649), and by PERRAULT (Paris, 1673). He was translated into Italian by Barbaro (Venice, 1567) and into French by Perrault (1673) and by Choisy (1909). There are English translations by Gwilt (1826), by Morgan (1914), and by Granger (1931). Many architectural theorists who hoped through Vitruvius to apply the architectural principles of antiquity in their own practice have left commentaries and interpretations. Among them are SERLIO, *Architettura* (1559–62); VIGNOLA, *Regola delli cinque Ordini d'Architettura* (1562/3); PALLADIO, *I quattro Libri dell' Architettura* (1570); De BROSSE, *Reigle générale* (1619); Le Clerc, *Architecture* (1714). Inigo JONES and Christopher WREN also wrote commentaries and notes on Vitruvius.

Vitruvius incorporated in his treatise the practical know-how of an architect's studio in his day. He either did not understand or signally failed to explain the theoretical basis of his precepts or their background of Greek theories of proportion, etc. It was not his primary purpose to write a theoretical basis to the aesthetics of architecture. In consequence his words, being authoritative for ancient theory because there are no others, have allowed ample opportunity for speculation and interpretation. Even where their authority was most unquestioned his meaning was seldom clear.

**VITTORIA, ALESSANDRO** (1525–1608). Italian sculptor, who was born at Trent but lived from 1543 in Venice, where he was the pupil of Jacopo SANSOVINO. He worked extensively in the Palazzo Ducale both before and after the fire of

1577, executing, for example, the stuccoed ceiling of the Scala d'Oro (1555-9) and three statues in the Sala delle Quattri Porte (1587). In the PALLADIAN Villa Barbaro at Maser his STUCCOES are combined with FRESCOES by VERONESE. He was the leading monumental sculptor in Venice after Sansavino's death, continuing the latter's style but giving it a more MANNERIST character. Examples are in the Frari, S. Zacheria, S. Francesco della Vigna, and many other churches in Venice and the Veneto. He also produced small elongated bronze figures of great elegance and realistic portrait-busts of Venetian personalities of which there are examples in the Ca' d'Oro and the Seminario Patriacale, Venice, and in Berlin.

510.

**VIVARINI.** Family of Italian painters of the VENETIAN SCHOOL. ANTONIO (c. 1415-76/84) seldom worked independently. He collaborated first with his brother-in-law, Giovanni d'Alemagna (active 1441-1449/50), and secondly with his own younger brother BARTOLOMEO (c. 1432-c. 1499). Their pictures usually took the form of large-scale POLYPTYCHS with stiff, archaic figures and very elaborate carved and gilded frames in the GOTHIC tradition. Bartolomeo's independent works date from the 1460s onwards. He continued to paint polyptychs, but modernized his style to some extent by imitating MANTEGNA.

ALVISE (c. 1445-1503/5), son of Antonio, was trained by his uncle, but later adopted the manner of Giovanni BELLINI. None of the three had much originality. But they well illustrate the general level of 15th-c. painting; and Antonio's work fairly represents the native painting of Venice before the advent of Giovanni Bellini.

**VLAMINCK,** MAURICE DE (1876-1958). French painter. He began life as a racing cyclist and violinist, painting in his spare time virtually without instruction. Indeed he delighted to inveigh against all forms of academic training and boasted that he had never set foot inside the LOUVRE. In 1901-2 he shared a studio with DERAIN at Chatou and founded with him the so-called 'Dalou School' which was one of the precursors of FAUVISM. He and Derain were excited by the 1901 exhibition of van GOGH and as active members of the Fauves painted in exuberant colours with pure PIGMENTS squeezed straight from the tube. Though their pictures remained representational, they contributed to the contemporary trend to free colour from the shackles of representation. From 1908 to 1915 Vlaminck sought to achieve volume and a more solid basis of composition from a study of CÉZANNE. He remained uninfluenced by CUBISM, repudiating its intellectualism and from c. 1915 evolved a personal style of vehement though essentially French EXPRESSIONISM, combining his Fauvist exuberance with the maturer qualities of construction which he had acquired.

1008, 2055, 2454, 2763.

**VLIEGER,** SIMON DE (c. 1600-53). Dutch MARINE and LANDSCAPE painter, active in Delft and Amsterdam. His primary importance is as a marine artist and he developed a monochrome style in the 1630s, based on Jan PORCELLIS, which influenced van de CAPPELLE and Willem van de VELDE the younger. The silvery grey tones in his best work are finely modulated in a subtle and harmonious way.

**VLIET,** HENDRICK CORNELISZ VAN (1611/12-75). Dutch painter who worked in Delft. During the first years of his career he did portraits and GENRE scenes. About 1650 he began to paint architectural views. He is known principally for his pictures of church interiors, almost all of them views of the old church or new church at Delft.

**VOLTERRA,** DANIELE RICCIARELLI DA (1509-66). Italian painter and sculptor of the MANNERIST period. He was born in Volterra and was trained there by SODOMA. He moved to Rome in or before 1541, where his first commissioned work was a FRESCO FRIEZE in the Palazzo Massimi depicting the story of Fabius Maximus—firmly composed scenes with finely drawn and disposed nudes. He was in close personal touch with MICHELANGELO but was too individual and too intelligent to join the crowd of followers who aped the master. His finest surviving work is the one remnant of his decorations in the Cappella Orsini in SS. Trinità dei Monti: the *Deposition* (1541), a powerful and moving representation, based compositionally on ROSSO FIORENTINO's famous painting of the same subject in Volterra. This was one of the most admired works of its generation in Rome.

Daniele wavered for many years between painting and sculpture, completing little of either. His sculpture includes, however, the famous bronze BUST of Michelangelo (best examples in the Casa Buonarroti, Florence, and the Louvre), made shortly after the latter's death.

**VOLTO SANTO** (Italian: 'Sacred Face'). A large wooden crucifix in Lucca Cathedral, on which CHRIST is shown fully robed. According to an early medieval tradition this crucifix was an actual portrait of Christ made by the disciple Nicodemus. It was said to have been in Lucca from the 8th c., but there is a suggestion that the present *Volto Santo* is a 13th-c. copy of an 8th-c. original. The commercial importance of Lucca in the Middle Ages helps to explain the appearance of a considerable number of 12th-15th-c. copies of the *Volto Santo* in nearly every country in Europe.

**VOLUTES.** Term in classical architecture for the coiled ends of an element introduced between

the ABACUS and the OVOLO (or sometimes springing directly from the ovolo) in an Ionic capital. The term was later extended to any curvilinear ornament particularly on CAPITALS and consoles.

**VORTICISM.** An English art movement which arose out of The Rebel Art Centre formed by Wyndham LEWIS in 1913. With him were associated NEVINSON, William Roberts (1895-      ), Frederick Etchells (1886-      ), and WADSWORTH. Its sculptor was GAUDIER-BRZESCA and its philosopher T. E. Hulme. The organ of the group was the journal *Blast* of which two numbers only appeared, in 1914, edited by Wyndham Lewis. The literary contributors included Ezra Pound, T. S. Eliot, Richard Aldington, Ford Maddox Hueffer, Rebecca West. The movement was stimulated partly by exhibitions of Italian FUTURISM in 1912-13 and the personal appearance in London of MARINETTI. The name 'Vorticism' was taken from a statement of BOCCIONI that all artistic creation must originate in a state of emotional vortex. The aim was stated to be 'to establish what we consider to be characteristic in the consciousness and form content of our time: then to dig to the durable simplicity by which that can be most grandly and distinctly expressed'. A Vorticist exhibition was held in 1915 at which there was manifested a tendency to simplify into angular, machine-like forms. Owing to wartime conditions the movement did not persist. An attempt to revive it in 1920 as Group X proved abortive.

**VOS,** CORNELIS DE (1584?-1651). Flemish painter who specialized in straightforward portraits of the burghers of Antwerp. One of his finest works is the portrait of his family (1621) in Brussels. His sympathetic treatment of his own two children in this painting is characteristic of his portraits of young people. His brother PAUL DE VOS (*c.* 1596-1678) painted hunting scenes and STILL LIFES in the style of Frans SNYDERS, who was the brother-in-law of the Vos brothers. In 1637 all three helped RUBENS execute pictures for the Torre de la Parada, Philip IV's hunting-lodge near Madrid.

1150.

**VOS,** MARTIN DE (*c.* 1531-1603). Flemish painter who was a pupil of Frans FLORIS. In 1552 he went to Italy and studied in Rome, in Florence, and with TINTORETTO in Venice. By 1558 he was back in Antwerp, and after the death of Floris in 1570 he became the leading Italianate artist in that city. His ALTARPIECES, usually designed upon vertical compositions, create a strong illusion of space and are peopled by elegant personages with slender, elongated bodies. His historical compositions make a curious contrast with his rare and more successful portraits of self-conscious Flemish burghers against a plain background (*Antoine Anselme and his Family*, Brussels, 1577).

**VOUET,** SIMON (1590-1649). The most important influence in French painting in the first half of the 17th c. He had already established a name as a portrait painter when he visited England at the age of 14. He spent the years 1613-27 in Italy and achieved considerable reputation, being made President of the Roman Academy of St. Luke in 1624. His early work in Italy was much influenced by CARAVAGGIO, but he later developed an eclectic style in the early BAROQUE manner tempered by a superficial Classicism reflecting certain aspects of GUIDO and DOMENICHINO. This compromise style proved exactly to the taste of a French public brought up in the MANNERIST tradition and seeking something new but unprepared for the dramatic naturalism of the Caravaggesque or the full emotionalism of the Baroque. Besides religious and allegorical PANELS (e.g. *The Presentation*, Louvre, 1641; *Allegory of Peace*, Chatsworth, *c.* 1648) he was employed on many important decorative schemes, at first in conjunction with Jacques SARRAZIN, and introduced new methods of illusionist decoration, founding a tradition which dominated French decorative painting for a century. His most important work in this field was done for Marie de Médicis in the Luxembourg, for Richelieu in the Palais Royal and at the Hôtel Séguier.

Vouet's talent was brilliant and superficial rather than profound and his influence depended on his having hit upon a style which accorded with the taste of the day. He introduced into French painting a tradition of solid competence and most of the next generation of artists passed through his studio, including LEBRUN, LE SUEUR, and MIGNARD.

657.

**VOYSEY,** CHARLES ANNESLEY (1857-1941). English domestic architect and designer of furniture, textiles, wallpapers, and the like. The simple small houses he built in England between 1888 and *c.* 1908 were a revelation after the fussiness and fancifulness of late Victorian period-revival architecture. Their influence was widely felt in Europe, largely as a result of the writings of their German admirer Muthesius (*Die englische Baukunst der Gegenwart*, Leipzig, 1900; *Das englische Haus*, Berlin, 1904), and the group of architects, of whom Voysey was the most important (including also MACKMURDO, MACKINTOSH, ASHBEE, Ernest Newton, and Baillie Scott (1865-1945)), laid a considerable part of the foundations on which the modern architects of the 20th c. built.

Though in the direct line of succession to those of William MORRIS and Philip WEBB, Voysey's houses were in one sense a return to the rural vernacular, using natural materials and solid construction, the latter emphasized by low roof-lines, battered walls, and heavy BUTTRESSES. They were simple and unaffected, relying on the dignity of plain surfaces and the simple geometry of chimneys and gables. Their planning was

informal. Voysey was one of the first in modern times to design buildings from within outwards, instead of beginning with a preconceived idea of their external appearance. He was not an innovator structurally; in fact his houses are the prototype of the small suburban house of today; it was his integrity and the simplicity and freshness of his approach to design, at a time when these were rare in architecture, rather than any technical originality that made his work such an inspiration to others. Voysey was as active and interested in furniture and textile design as he was in architecture and his interiors had a personality of their own. He played a leading part in the various movements which fostered a new approach to design, becoming Master, for example, of the Art Workers' Guild in 1924. But he remained at the same time an individualist, mistrusting all forms of planning and academic teaching.

**VREL,** JACOBUS (active 1654–62). Dutch painter, distinguished for his fresh and naïve vision in his interiors and townscapes of Holland. Today he would be called a PRIMITIVE in the stylistic sense. Very little is known about his life. He probably worked in Haarlem and Delft and may have belonged to the circle of De HOOCH. His pictures are very rare; some were once attributed to Jan VERMEER van Delft.

**VRELANT,** WILLEM (d. 1481?). Dutch-Flemish miniaturist. He was born at Utrecht, but lived and died at Bruges, where he was the friend and neighbour of MEMLING. His best known work is *The Mirror of Humility*, made for Philip the Good, which later came into the possession of Margaret of York, Duchess of Burgundy (Bib. municipale, Valenciennes).

**VRIENDT,** DE. See FLORIS.

**VRIES,** ADRIAEN DE (c. 1546–1626). Sculptor who was born at The Hague but became Italian in everything but name. He received his training in Florence from Giovanni da BOLOGNA, a Fleming by birth, at that time the principal MANNERIST sculptor in Italy. De Vries's sleek, elegant bronzes are based upon his teacher's models, but he took greater interest in the play of shimmering light over the surface of his figures.

He worked in Rome and Prague, and made fountains for Augsburg (1598, 1602) and Copenhagen (1617). The figures made for the fountain in Copenhagen were taken by the Swedes as war booty in 1660 and are now in the Palace of Drottningholm near Stockholm. None of De Vries's commissions came from Holland.

1569.

**VRIES,** HANS VREDEMAN DE (1527–after 1604). Designer of architectural and ornamental pattern books, painter, and architect, who was born in Friesland and worked in Germany, Prague, Antwerp, Amsterdam, and The Hague. The pattern books by De Vries that contain decorative ornaments, cartouches, and GROTESQUES are similar to those designed by Cornelis FLORIS. His many books containing PERSPECTIVE studies of fanciful palaces, courts, gardens, furniture, and illusionistic walls and ceilings are more original. A good example of the latter is *Perspective*, published in two parts (1604 and 1605) in Leiden. De Vries meant his published works to be handbooks for students and artists, and some of his designs were used as a basis for architectural paintings. His contemporary van MANDER gave high praise to his illusionistic paintings.

**VUILLARD,** ÉDOUARD (1868–1940). French painter and lithographer. In 1888 under the influence of SÉRUSIER he became a member of the NABIS together with his friends DENIS and BONNARD, with whom he shared a studio in 1891, K.-X. Roussel (afterwards his brother-in-law), and other companions of the Académie Julien. He painted intimate interiors and scenes from Montmartre, immortalizing the tiny square, Vintimille. His sensitive patterning of flattish colours owed something to GAUGUIN and something to PUVIS DE CHAVANNES, yet created a small but distinctive manner of his own. He was made a member of the Institut in 1937. In 1938 he did the decorations *Allégorie de la Paix* for the Palais des Nations at Geneva and had a retrospective exhibition at the Musée des Arts décoratifs, Paris. Since his death some critics have claimed a profound abstract significance for his quiet but serious interiors.

2268, 2292, 2377.

# W

**WADSWORTH,** EDWARD (1889-1949). English artist. Born at Cleckheaton, Yorkshire, he studied at the Bradford Art School and from 1910 at the Slade School. He was associated with Wyndham LEWIS in the VORTICIST group and he worked for a short time with Roger FRY at the OMEGA WORKSHOPS. He was a member of the NEW ENGLISH ART CLUB from 1921 and also of the LONDON GROUP. In 1933 he exhibited with UNIT ONE. He executed the decorations for the *Queen Mary*. His work combined a romantic love of the sea with ABSTRACT machine-like precision, or with clear-cut and precise shapes which sometimes exhibited a SURREALIST temper. He was one of the few artists of his time who painted largely in TEMPERA.

**WAGNER,** OTTO (1841-1918). Professor of Architecture at the Academy of Vienna from 1894 and one of the architects—BERLAGE in Holland and RICHARDSON in America were others —who made possible, each in his own country, the breakaway from 19th-c. period-revival architecture. Wagner was a pupil of Gottfried Semper (1803-79), and though his buildings display many traditional elements, his use of materials was revolutionary, especially his use of light non-weight-bearing MARBLE slabs as walls, secured within a frankly exposed iron frame, in the Karlsplatz station of the Vienna subway (1894). This and his Savings Bank building in Vienna (1904-6) have some affinity with the work of French engineers such as EIFFEL. Its glass and iron vault, and its interior lined with marble slabs, were treated with an honesty and simplicity rare at that time. Another unusually advanced design was his Steinhof church near Vienna (1906).

In his Inaugural Lecture *Moderne Architektur* (1894) Wagner put forward the AESTHETIC position that architecture must base itself on contemporary social requirements and seek adequate forms in which to express them, eschewing superfluous and irrelevant ornament and abandoning inappropriate period revival. He may be regarded as the founder and master of the Vienna School of architectural thought. Among his pupils were Josef HOFFMANN, a founder of the WIENER WERKSTÄTTEN, and Josef OLBRICH, who opened the SEZESSION gallery in 1898. Adolf LOOS, who attacked the Sezession, based his repudiation of ornament partly on the teaching of Wagner.

1706.

**WALDMÜLLER,** FERDINAND (1793-1865). Austrian painter. His LANDSCAPES and GENRE scenes were characterized by a meticulous, almost photographic REALISM; in consequence he was repeatedly in conflict with current academic art theories. The Prince Consort invited him to exhibit at Buckingham Palace in 1857, encouraging the English nobility to buy his works and himself acquiring two pictures for Osborne House.

1155.

**WALES,** NATIONAL MUSEUM OF, CARDIFF. Founded in 1912, as a repository of Welsh culture. The chief concern has been to acquire examples of the work of Welsh painters, pictures illustrating Welsh scenery and customs, and portraits of eminent Welsh men and women. But it also took over pictures of a more varied character from the Cardiff Museum and benefited from the Gwendoline Davies Bequest (1951), one of the earliest and most important collections of late 19th-c. FRENCH ART in Britain. The collection also contains a small but distinguished group of Old Masters.

**WALKER,** DAME ETHEL (1861-1951). English painter, trained at the Slade School and one of the leading figures in the NEW ENGLISH ART CLUB from 1900. She began by painting figures in sombrely lit interiors; her later pictures were portraits, flower pictures, seascapes, and idyllic figure compositions in paler and brighter colours. Her decorative style is exemplified by the large *Nausicaa* in the Tate Gallery and her precise and unaffected nude drawings are prized by connoisseurs. She is represented in many provincial galleries.

**WALKER,** FREDERICK (1840-75). English illustrator and painter. Apprenticed in 1858 to J. W. Whymper (1813-1903), a wood-engraver, he drew, 1859-66, for *Good Words*, *Once a Week*, and *The Cornhill Magazine*, then gave up illustration for painting in OIL and WATER-COLOUR. His scenes of peasants in a LANDSCAPE, treated with grace and pathos, had considerable influence in England.

**WALKER,** HORATIO (1858-1938). Canadian painter of LANDSCAPE and peasant GENRE. He was born at Listowel, Ontario, and studied painting to some extent in Toronto and New York before settling permanently on the Île

d'Orléans near Quebec in 1880. To help him paint the life of the people, he visited Europe and studied the work of the BARBIZON SCHOOL. Like theirs, his paintings are full of the poetry of toil, and in fact he was seriously considered by one American critic to have out-Barbizoned Barbizon by his dramatic compositions and flaring colours. His work was highly prized in the United States in the early years of the 20th century. (See also CANADIAN ART.)

**WALKER,** ROBERT (1605?–after 1660). English portrait painter of indifferent talent and little originality. He was associated with Cromwell and was a favourite portrait painter of the Parliamentarians. His heads have a certain austere directness but are incongruously attached to figures derived from van DYCK. This incongruity is apparent in his portrait of Cromwell (N.P.G., London, 1649). His most personal works are said to be the *Self-Portrait* (Ashmolean Mus., Oxford, and Belvoir) and *John Evelyn* (Christ Church, Oxford, 1648).

**WALLACE COLLECTION,** LONDON. The collection was built up by the Seymour-Conway family, Earls and later Marquesses of Hertford, and was bequeathed to the nation by Lady Wallace, who died in 1897. It is the largest of the 19th-c. private collections to be preserved intact. The collection was begun by the first Marquess, Francis Seymour-Conway (1719–94), a nephew of Sir Robert Walpole, and the foundation of the present collection of English portraiture was laid by the second Marquess (1743–1822). The third Marquess, Francis Charles Seymour-Conway (1777–1842), a brilliant wit and social figure, who married the wealthy daughter of the Marchesa Fagnani, bought for the Prince Regent and laid the basis of the collection as we know it. Their son, the fourth Marquess, Richard Seymour-Conway (1800–70), was a recluse and an eccentric, living mainly in Paris, whose chief interest was in COLLECTING, and helped by his natural son Sir Richard Wallace he transformed the collection into one of the finest and most varied private collections that has ever been formed. His originality was shown in his purchase of French 18th-c. art, which was at that time under eclipse. He also bought many of the splendid 18th-c. English portraits which are now the pride of the collection.

The collection was inherited by Sir Richard Wallace in 1871 and the greater part of the collection moved to Hertford House in Manchester Square, London. Part of this was exhibited in the Bethnal Green Museum, 1872–5, where it is said to have been visited by 5 million people. Part perished by fire in 1874. Towards the end of his life Wallace made preliminary moves towards presenting the collection to the British Nation and the greater part of it was so bequeathed by his widow, formerly Mlle Julie Amélie Charlotte Castelnau, who died in 1897. The lease and freehold of Hertford House were bought by the Government and the collection was formally opened as a national museum in 1900 by King Edward VII, then Prince of Wales.

The fine representation of French 18th-c. paintings, in particular WATTEAU, LANCRET, BOUCHER, and FRAGONARD, at the Wallace Gallery in the setting of the furniture and decoration for which they were intended, to some extent compensates for the weakness of the NATIONAL GALLERY, London, in this period.

**WALLOT,** PAUL (1841–1912). German architect, who in 1882 won the competition for the design of the Berlin Reichstagsgebäude (built 1884–94), an 'overpoweringly monumental Neo-BAROQUE project recalling VANBRUGH more than BERNINI or SCHLÜTER' as it is described by H. R. Hitchcock in *Architecture: Nineteenth and Twentieth Centuries* (1958).

**WALNUT OIL.** One of the earliest oils used in PAINTING, and perhaps the commonest MEDIUM in the early days of OIL PAINTING. It dries more slowly than LINSEED OIL but has less tendency to turn yellow. It is best suited for use with 'lakes' but is little used today.

**WALPOLE,** HORACE (1717–97). English collector and CONNOISSEUR, fourth son of Sir Robert Walpole, he became in 1791 fourth Earl of Orford. In 1739–41 he made the GRAND TOUR, travelling in France and Italy with the poet Gray. His own literary fame rests on his Letters and on the 'gothic' story *The Castle of Otranto* (1764). In the history of taste he was important for his house at Twickenham, Strawberry Hill, the chief example of the prevalent fashion for GOTHIC REVIVAL. Although Walpole led the way by introducing archaeological research in the revival, he adapted his medieval models in accordance with the taste of the time for ROCOCO Gothic. Walpole's main influence on the movement was probably to give social and aristocratic *cachet* to a fashion in taste which might otherwise have remained a foible of the few eccentrics. Sir Kenneth Clark has said of Strawberry Hill: 'Bad art flourishes in every epoch, but art may be healthily or unhealthily bad, and Strawberry was bad in a peculiarly ominous way. Walpole's taste seems to have found satisfaction in just those things which were to bring about the collapse of architecture in the nineteenth century. He introduced a Romantic style, and instead of using his borrowed forms freely, as the Renaissance used classical forms, he insisted on copying them. If his Gothic shows a little more style than Gilbert Scott's, it is because he was an incompetent copyist, and a little 18th-c. feeling crept into his medievalism. Worse still, he seems to have been instinctively opposed to anything made of its right material, and Strawberry is full of new devices to render craftsmanship unnecessary—new wallpaper which was stamped to imitate stucco work, and new artificial stone which allowed the architect to order his detail

wholesale. Nothing in that house was simple, natural, and solid; nowhere had the workman followed his own bent. Instead of good workmanship he introduced the quaint—a word which covers everything silly and unnecessary in style. Walpole killed craftsmanship: it was reserved for later Gothic revivalists to resurrect it.' (*The Gothic Revival.*)

Walpole made at Strawberry Hill a collection of objects of VIRTU and established there a printing-press from which he issued *Anecdotes of Painting in England*, a free adaptation of material from George VERTUE's notebooks, and the *Catalogue of Engravers in England* (1763).

1660.

**WALTON,** HENRY (1746-1813). English painter, a pupil of ZOFFANY. He invested anecdotal painting with 18th-c. elegance but is remembered for a small number of GENRE pictures which are the only examples of British painting that bear comparison both in spirit and in quality with the work of CHARDIN. The best known are *Girl Plucking a Turkey* (N.G., London) and *The Cherry Barrow* (Sitwell Coll.).

**WANDELALTAR.** See ALTARPIECE.

**WANG.** The 'Four Wangs' were WANG SHIH-MIN (1592-1680), WANG CHIEN (1598-1680), WANG HUI (1632-1720), and WANG YÜAN-CH'I (1642-1715). These prolific Chinese LANDSCAPE masters, the most famous painters of the late Ming–early Ch'ing period, were typical *wên-jên*—that is, literary men who took to painting as AMATEURS (see CHINESE ART). Their work, the last flowering of the traditional style, is opposed to that of the INDIVIDUALISTS. They were followers of TUNG CH'I-CH'ANG and their inspiration was ultimately derived from the 'Four Great Landscape Masters' of the Yüan dynasty (HUANG KUNG-WANG, WANG MÊNG, NI TSAN, and WU CHÊN). Their approach to landscape, however, though still IDEALISTIC, was more direct and intimate and their well-mannered, somewhat unemotional landscapes laid the emphasis on refinement of composition and polished brush-work. Wang Yüan-ch'i was the editor of the K'ang-hsi Emperor's great *Encyclopaedia of Painting and Calligraphy*. Wang Hui (often called Wang Shih-ku), the best known of the four, was perhaps also the most original, his brush being more spontaneous and his compositions more open to new influences such as Western PERSPECTIVE and individualist brush-work.

**WANG MÊNG** (1308-85). Chinese LANDSCAPE painter, the last of the 14th-c. *wên-jên* painters, youngest of the 'Four Great Landscape Masters' of the Yüan dynasty. (See CHINESE ART.) In contrast with the Southern Sung School he had a tendency to fill the whole surface of the picture with brush-strokes. His influence on *wên-jên*

painting of the 15th-19th centuries was particularly strong.

**WANG WEI** (698-759). One of the most famous early Chinese painters, renowned for his contribution to the development of pure LANDSCAPE PAINTING. This can now only be judged from a few stone engravings and paraphrases by later masters and it is not possible now to form any secure idea of his painting. He seems, however, to have been a key figure in the movement linking landscape painting with the poetry of nature and poetic mood. He is said to have been a pioneer in monochrome INK painting, though this is not verified. Later historians made him the founder of the so-called Southern School and the model for the retired, unworldly, poet-painters of subsequent times.

**WARBURG,** ABY (1866-1929). German historian of art who founded at Hamburg the library that was transferred to England in 1933 and now bears his name as an Institute of the University of London. His main field of study was the art of the FLORENTINE quattrocento during the period of transition from late medieval GOTHIC taste to the CLASSICAL style of the High RENAISSANCE. The description of this change in terms of formal categories such as Wölfflin propagated appeared to him inadequate, and he searched the archives and memoirs of the period for evidence of the taste and preoccupations of the artists and their PATRONS. The picture that emerged was far removed from the idyllic springtime envisaged by Victorian travellers. In particular Warburg was impressed by the hold that religious loyalties and astrological superstition retained on the minds of Renaissance merchants and princes, indicating that the subject matter of the paintings they commissioned was no mere pretext for the display of artistic fancies. Warburg aimed at understanding every work of art in terms of a tradition modified by the psychological needs of the moment. The changing forms of the classical gods and astrological symbols testified to the tenacity of such traditions and their continued vitality in various guises. These transformations of the classical heritage, therefore, became the favoured field of study for his followers.

**WARD,** JAMES (1769-1859). English animal painter. He was apprenticed to the engraver J. R. SMITH and until about the end of the century painted mainly GENRE and anecdotal pictures in the manner of his brother-in-law George MORLAND. He was appointed 'painter and MEZZOTINTER' to the Prince of Wales in 1794, elected A.R.A. in 1807 and R.A. in 1811. He specialized in animal painting, often representing prize cattle. His *Bulls Fighting* (V. & A. Mus.) was painted *c.* 1804 after seeing RUBENS's landscape *The Château de Steen*. His *Fighting Horses* (1806), a theme which appeared repeatedly through his life, represents a wild and ROMANTIC element in his animal pictures which

was an inspiration to GÉRICAULT and the French Romantic School. In his landscapes he often achieved a poetic quality and a sense of that grandeur which in the 18th c. was known as the sublime (*Gordale Scar, Yorkshire*, Tate Gal., *c.* 1815) and his dramatic use of light and shade has been likened to some of the characteristic effects of TURNER. His canvases were often very large and between 1815 and 1821 he worked on a huge allegorical composition commemorating Waterloo. From about 1830 until his death he lived in retirement in the country.

1187.

**WARD,** JOHN QUINCY ADAMS (1830–1910). American sculptor. For seven years he was apprenticed in New York to Henry Kirke Brown (1814–86), who had studied sculpture for five years in Italy, and had installed one of the first BRONZE foundries in America. Ward assisted Brown with his *Washington*, the first bronze EQUESTRIAN STATUE ever achieved in the United States, and this experience helped him to solve satisfactorily the problem of rider and horse in his own statue of General Thomas (1878) in Washington. *Indian Hunter* (1864), an early work, is typical of the rather prosaic sculpture which Ward produced for parks and other public commissions throughout a long and prolific life. His work had a solid Mid-Western NATURALISM and never became flashy or superficial. He was elected President of the National Academy of Design in 1802 and was the first President of the National Sculpture Society.

11.

**WARE,** ISAAC (1700?–66). English architect, thought to have been a chimney-boy whose natural talent for architectural drawing brought him to the notice of Lord BURLINGTON, who undoubtedly forwarded his career. He built competently in the English PALLADIAN manner and held a number of posts at the Board of Works, but most of his buildings were for private clients. Chesterfield House, London (1748–9), his most celebrated work, which incorporated a noble staircase with Corinthian screens from Pannons House, Edgware, was demolished in 1934. Wrotham Park, Middlesex (1754), with an Ionic PORTICO approached by curving stairs, designed by Ware for Admiral Byng, still presents an imposing exterior, though the interior work has gone. Ware also built several smaller houses in London but he was probably most renowned in his own day for his edition of PALLADIO (1738), in which the plates follow the original designs more closely than do those of LEONI's 1715 edition; and for his *Complete Body of Architecture* (1756), which was designed for the use of patron and builder alike.

**WARHOL,** ANDY (1930?– ). One of the better known American POP ARTISTS, whose work was in line with current developments in mass media. One of his particular characteristics was his use of familiar objects, such as Campbell's soup tins, in deliberate contradiction of traditional concepts of beauty. He used the SILK SCREEN with the machine-like precision of industrial art, his originality lying in his selection of subjects.

**WASH.** Technical term for a layer of diluted INK or transparent WATER-COLOUR spread evenly over a broad area so as to show no BRUSH-marks. Washes of Indian ink or BISTRE are frequently used for the shadows or the modelling of a DRAWING.

CENNINI gives various instructions for reinforcing a PEN drawing with the brush. This seems to have been a kind of spotting technique, very deliberate, but during the RENAISSANCE the brush-work gradually loosened. Although the north Italian artists of the 15th c. hatched their drawings meticulously with fine vertical lines, POLLAIUOLO, BOTTICELLI, and LEONARDO used much freer methods, suggesting forms and shadows by the shape and depth of the wash. In the 16th c. we find, apparently as a discipline, the practice of preparing the wash in two tones and using both concurrently, the one being sometimes shaded into the other (e.g. the drawings of VERONESE). By the 17th c. REMBRANDT, ELSHEIMER, CLAUDE Lorraine, and POUSSIN were using washes very freely, each in his own way, obtaining their effects as much by PAINTING as by drawing.

In the TOPOGRAPHICAL drawings of the 18th c. the wash was merely an adjunct to the pen line, as it still is in architectural drawing (hence the term 'water-colour drawing'). The earlier watercolourists even into the 19th c. built up their pictures in an orderly and systematic way of thin superimposed washes, imitating the GLAZES of the oil painter. A grey, blue, or brown wash of varying depth was first laid in over all passages except the highlights, and various colours were then superimposed in a series of thin washes from light to dark, building up towards the final depth and colour required. One advantage of this technique was that it was admirably suited for reproduction in LITHOGRAPHY or AQUATINT. The method was expounded in many 19th-c. books on SKETCHING and was perfected by COZENS, after whom the use of direct colour was increasingly practised and the importance of the underlying drawing diminished.

**WASTELL,** JOHN (active 1495–1515?). English builder, thought to have been master mason of the abbey of Bury St. Edmunds from 1490 in succession to Simon Clerk (active 1445–*c.* 1489), with whom he had collaborated in the rebuilding of Saffron Walden church (1485) and whose work at King's College, Cambridge, he continued. He is documented as the author of the vaulting of King's College Chapel, with assistance from William VERTUE from 1512, and of the Angel Tower of Canterbury Cathedral

(1494). Attributions are numerous. St. James's (now the cathedral) at Bury St. Edmunds (1503), the nave of Lavenham church (1495–1515), and the retrochoir of the abbey church (now the cathedral) of Peterborough (c. 1500) are the most important.

**WASTE MOULD.** See PLASTER CASTS.

**WATER-COLOUR PAINTING.** In its broadest sense this term denotes painting done in PIGMENTS bound with a MEDIUM (generally GUM arabic) which is soluble in water. Its use has been widespread and extends over many centuries. It includes the papyrus rolls of ancient Egypt, the paintings on silk and rice-PAPER of the Orient, and (combined with an egg medium) the decorations of European ILLUMINATED MANUSCRIPTS of the Middle Ages. In a more specific sense water-colour proper differs from other kinds of painting with water as a medium, such as GOUACHE, TEMPERA, and MINIATURE, by the fact that lighter tones are not obtained by adding white pigment but by thinning with water so that the light is given by the paper or other support showing more strongly through the thinner layers of paint.

Monochrome washes, generally in brown BISTRE or the lower-toned sepia (which was made from the 'ink' of the cuttle-fish), were used by European artists, notably in the 17th c. on pen drawings, for figure and LANDSCAPE compositions, and both CLAUDE and REMBRANDT achieved remarkable effects of light by this method. Many landscape drawings by minor Dutch artists in this technique are surprisingly successful in the impression they give of space, recession, and atmosphere, these being easier to obtain in monochrome than in full colour.

The use of full colour was, indeed, exceedingly rare in water-colour before the late 18th c., though it was used by DÜRER for a charming series of landscape drawings made on his journey to Italy in 1495, and also by van DYCK in a group of landscape studies (mainly in the B.M.) done perhaps in England. The chief development of water-colour painting took place in 18th-c. and early 19th-c. England. The use of the medium on the Continent has been rare, though in France it was occasionally used, for figure scenes rather than landscape, strengthened with gouache or BODY-colour (i.e. pigment mixed with white), and a few Swiss artists, notably Philipp HACKERT, a friend of GOETHE's who worked in Rome in the late 18th c., used fairly full colour and may have had some influence on English painters.

English water-colour painting was at first primarily TOPOGRAPHICAL or archaeological and grew out of the Dutch monochrome tradition, taking over the effects of light and atmosphere, which are as natural to the English climate as to the Dutch, though with a gradually increasing use of a restricted range of colour added over the monochrome ground (see TOPOGRAPHICAL ART). This phase reached its climax after the middle of

the 18th c. with the work of Paul SANDBY, which went beyond the tinted drawing where the outline was first completed in pencil or ink, for he drew in water-colour with the BRUSH and often reinforced his effects with the addition of body-colour. Topography continued to be the main interest of a host of English water-colour painters, such as Thomas HEARNE, Michael Angelo ROOKER, and Thomas Malton, who supplied drawings for engraved books of the antiquities and scenery of Great Britain. But the drawings of social life by Edward DAYES and, with a more humourous twist, those of Thomas ROWLANDSON, reveal another use of the popular medium. Both in the 18th c. and in the 19th c. proficiency in water-colour was also considered an elegant accomplishment for young ladies.

The lure of Italy, on the other hand, reinforced by the visit of CANALETTO to England, led English artists in water-colours as well as their contemporaries in oils to a more formal, IDEALIZED type of composition, influenced chiefly by Claude and Gaspard DUGHET. Alexander COZENS, some of whose Italian compositions in monochrome have great distinction, was only the first of many artists, among them William Taverner, William Pars (1742–82), and Francis TOWNE, to visit Rome and paint views of the Campagna for the English market, or on their return to see the English countryside through Italian eyes.

Alexander's son, John Robert COZENS, played a more important role; for his poetic renderings of mountain scenery, delicately tinted and filled with an admiration for the grandeur of nature, were to have a profound influence on the art of the two great masters of the end of the century, GIRTIN and TURNER. The former's early death in 1802 cut short a career of great achievement, during which a break had been made with the monochrome tradition, and the coloured medium used freely and directly, generally on rough white paper, with no UNDERPAINTING, so that the white surface was left bare, or slightly tinted, for the lights. Turner was to build on this technique for another fifty years, achieving a brilliance and luminosity of colour which rivals his work in oils. The new freedom was further exploited by CONSTABLE, and this fresh approach, so closely bound up with the ROMANTIC spirit, was to change the entire character of water-colour painting. Having heightened their PALETTE, artists were also to increase their range, and figure subjects by BONINGTON, Muller, and Lewis compete with landscape with or without figures by COTMAN and David COX, and with architectural subjects with figures by Samuel PROUT. Indeed almost the full range of English painting outside the portrait could now be shown in water-colours, and its use for exhibition pictures was confirmed by the founding of the Old Water-Colour Society in 1804. Some foreign artists of the Romantic movement, notably Carl Föhr, found water-colour a sympathetic vehicle, and its quick-drying quality is especially suited to

SKETCHES, particularly those done in the open air.

The medium was much used in England in the early years of the 20th c. (Wilson STEER, John and Paul NASH) and continued to be used in the second half of the century (Graham SUTHERLAND, John PIPER). From the time of the NEO-IMPRESSIONISTS it became more popular—though still a subsidiary technique—on the Continent and was used by such artists as CÉZANNE, SIGNAC, and DUNOYER DE SEGONZAC, and later in the gay beach scenes of DUFY.

278, 454, 2893.

**WATER-GLASS PAINTING.** A method of mural painting. The PIGMENTS are mixed with plain water and painted on the plaster, which is then coated with a solution of water-glass (potassium or sodium silicate). When the water-glass dries it leaves a thin film which seals the painting. As water-glass is strongly alkaline it can only be used with certain pigments. Potassium silicate was first made commercially as a painting MEDIUM in 1825. Some of the mural paintings in the House of Lords were executed in it, because it was thought that they would be proof against the damp and dirty atmosphere of London, but they deteriorated within 10 years. Afterwards, in the 1880s, Adolf Keim of Munich improved the process, which he called *Mineralmalerei*, 'mineral painting'. The Victorian name was 'stereochromy'.

**WATERHOUSE,** ALFRED (1830–1905). Successful late Victorian architect, who worked in picturesque mixtures of many styles, from Eaton Hall, Cheshire (1867), which imitates a French 16th-c. château, to the striped-brick ROMANESQUE of the Natural History Museum, South Kensington (1879). His son PAUL (1861–1924) also became a well known architect.

**WATSON,** HOMER (1855–1936). Canadian LANDSCAPE painter, born at Doon, near Kitchener, Ontario. Watson was mainly self-taught, though he had some connection with the Hudson River School (of New York) in its later phases and with CLAUSEN in England. His early style was straightforward in its rendering of the cleared farmsteads of the peaceful Grand River valley in Ontario. Later he emulated the BARBIZON painters, CONSTABLE, and the IMPRESSIONISTS with decreasing success. Most of his life was spent at his native village, where he died.

**WATTEAU,** JEAN-ANTOINE (1684–1721). Now considered to be, with CHARDIN, most important of the pre-Revolutionary French 18th-c. painters. He was born at Valenciennes, which had passed to France from the Spanish Netherlands only six years before his birth, and it may have been for this reason rather than for any characteristic of his paintings that he was known during his lifetime as 'le peintre Flamand'.

He came to Paris in 1702 and from 1703 to 1708 he worked with GILLOT, who stimulated his interest in theatrical costume and scenes from daily life. In 1708 he joined Claude AUDRAN, Keeper of the Luxembourg Palace, and thus had access to the RUBENS Marie de Médicis decorations. At this time he designed the lost Chinese ARABESQUES for the Château de la Muette and painted easel pictures in the style of WOUWERMAN. He came to the notice of the CONNOISSEUR Pierre Crozat, and access to his collection of FLEMISH and ITALIAN paintings, particularly the VENETIANS, became a formative influence on his painting style. In 1717 he submitted the Diploma picture *L'Embarquement pour l'Île de Cythère* (Louvre), his finest and most characteristic work, and owing to the difficulty of fitting him into recognized categories was received as 'peintre de fêtes galantes', being the first to bear this title. Watteau suffered from consumption and in 1719 went to England to consult the famous Dr. Mead, but the London winter proved too much for him and he returned to Paris, where he died the following year.

Watteau is historically important in that he delivered French painting from the yoke of Italianate academicism and created a truly 'Parisian' style, blending aspects of Rubens and VERONESE, which set the tone for the 18th c. until the NEO-CLASSICISM of DAVID. But his own work has an underlying melancholy which saves the apparent frivolity of the themes from superficiality and beside the poetic gravity of his art the work of others seems trivial. His reputation suffered eclipse with the Revolution but he was rescued from obscurity by the de GONCOURTS and by Walter PATER, who said of him: 'He was always a seeker after something in the world that is there in no satisfying measure, or not at all.'

In fact, two artists exist side by side in Watteau. The first is a straightforward GENRE painter in the tradition of TENIERS and is responsible for joyous little scenes such as *La Marmotte* (Leningrad) painted in Valenciennes. The second is the ultra-sophisticated, hypersensitive organizer of FÊTES CHAMPÊTRES in which exquisitely dressed figures are frozen in attitudes of pleasure like flies in amber (*Les Champs Elysées*, Wallace Coll., London). There are signs that had he lived Watteau would have achieved a synthesis of the two styles. His last important work, a shop sign painted for the picture dealer Gersaint and known as *L'Enseigne de Gersaint* (Berlin, 1719) is a superb scene of life in a fashionable Paris shop and combines sharpness of observation with delicacy of handling to a degree not always apparent in his lighter works.

He was careless in matters of material technique and many of his paintings are in a poor state of preservation in consequence. He was casual in introducing his figures from his repertory of drawings rather than from life and haphazard in the use of studio properties. But this seemed the less important as he was creating an

unreal and imaginative world of release. As a colourist Watteau was outstanding and he has been credited with being the first to use systematically the method of DIVISIONISM, whereby colours are juxtaposed on the canvas and mingled by the eye instead of by mixing PIGMENTS on the PALETTE—the method which was carried further by DELACROIX and which SEURAT and the NEO-IMPRESSIONISTS reduced to a science.

13, 680, 990, 1899, 2032.

**WATTS,** GEORGE FREDERICK (1817-1904). English painter and sculptor. He trained with W. BEHNES and in the R.A. Schools; in 1843 he won a prize in the competition for the decoration of Westminster Hall, and went to Italy. Returning in 1847, he established a solid reputation in intellectual circles and was elected R.A. in 1867, but popular fame came late, from 1880 on. Thereafter the most revered figure in British art, he was one of the first holders of the Order of Merit, 1902. His first marriage, with Ellen Terry in 1864, was not a success and in 1886 he married again. His style was early influenced by ETTY, but the ELGIN MARBLES, the VENETIANS, and MICHELANGELO were his avowed exemplars; contemporary revolutionary techniques such as those of the PRE-RAPHAELITES and of the IMPRESSIONISTS did not interest him; his own art was a vehicle for his moral purpose: 'to affect the mind seriously by nobility of line and colour'. His allegories (*Hope*, Tate Gal.), once immensely popular but often diluted by vague content, have lasted less well than the great series of portraits (*Gladstone, Tennyson, J. S. Mill*, etc., N.P.G., London). His attempts to revive FRESCO painting were marred by defective technique. A cast of the colossal *Physical Energy*, perhaps his finest statue, forms the central feature of the Cecil Rhodes Memorial, Cape Town, and another is in Kensington Gardens, London. His former house at Compton, near Guildford, is now the Watts Gallery, devoted to his work.

526, 2808.

**WAX CASTING.** See BRONZE SCULPTURE.

**WAX MODELLING.** See MODELLING.

**WAX PAINTING.** See ENCAUSTIC PAINTING.

**WEBB,** JOHN (1611-72). English architect, trained by Inigo JONES, whose niece he married. Many of Jones's designs, including those for the rebuilding of Whitehall Palace, are drawn by Webb, and he acted as Jones's deputy early in the Civil War. At the Restoration he failed to obtain the Surveyorship, which was given to the poet, Sir John Denham; but in 1663 he designed a palace at Greenwich, of which only King Charles's Block was built. This, which formed the starting-point of WREN's Greenwich Hospital, is a mature work, more massive than any

building by Jones, and making accomplished use of a giant ORDER. He worked at several country houses, including Lamport Hall, Northants., and also continued Jones's work as a stage designer.

**WEBB,** PHILIP SPEAKMAN (1831-1915). English architect who was one of the pioneers of the late 19th-c. breakaway from rigid academic styles. He was assistant to STREET in Oxford, where he met William MORRIS. He designed furniture with Morris and BURNE-JONES (1858-9) and was architect of Red House, Bexley Heath, Kent (1859), which Morris built for his own occupation on his marriage to Jane Burden. It is one of the first examples of that return to a simple vernacular domestic architecture using materials without artifice, which was followed up later in the work of VOYSEY and others. Webb worked with the firm of Morris, Marshall, Faulkner & Co., designing furniture, metal-work, jewellery, etc. He designed several other, and larger, country houses.

1649.

**WEBBER,** JOHN (1750-93). English painter of Swiss origin, who accompanied Captain Cook as draughtsman on his third voyage to the South Seas. He visited Switzerland and Italy and made a number of views of English scenery.

**WEBER,** MAX (1881-1961). Painter, born in Russia. He came to the U.S.A. in 1891 and studied at the Pratt Institute, Brooklyn, 1898-1900. Weber's work more than that of any other American painter synthesized the latest developments in European art at the beginning of the 20th c. In Paris, 1905-8, he was influenced by FAUVISM (he studied with MATISSE in 1908) and the early CUBISM of PICASSO and BRAQUE. He was also interested in primitive and Oriental art. His show at Stieglitz's 291 Gallery in 1911 had a hostile reception by the Press because of its radical abstraction. *The Chinese Restaurant* (1915), a combination of decorative patterns in Cubist-Futurist arrangement, reveals his synthesis of the various movements of modern art at its best. After 1917 his work became more naturalistic. During the 1940s he painted scenes with rabbis and Jewish scholars—mystical, religious recollections of his Russian childhood. Weber wrote *Cubist Poems* (1914) and *Primitives* (1926).

**WEENIX,** JAN (1640-1719), of Amsterdam. Dutch painter of STILL LIFES and LANDSCAPES. He was a pupil of his father, JAN BAPTIST WEENIX, and like his uncle Gysbert d'HONDECOETER he had a predilection for painting hunting trophies (usually including a dead hare). From 1702 to 1712 he worked at Düsseldorf, where he painted a series of huge hunting still lifes for Bensberg Castle, one of which is now in the Alte Pinakothek, Munich. His landscapes

mostly depict the countryside and seaports of Italy.

**WEIDITZ,** HANS (before 1500–c. 1536). German designer of WOODCUTS and prolific book illustrator. After being trained in the workshop of BURGKMAIR at Augsburg he illustrated many sacred, classical, humanist, and scientific texts and designed a large number of devotional PRINTS. His illustrations are remarkable for their acute observation and masterly technique. At a time when DÜRER's influence was all-pervasive Weiditz maintained his own very personal style.

**WEINBRENNER,** FRIEDRICH (1766–1826). German architect, active in Karlsruhe. Weinbrenner had the good fortune to be allowed to build almost a whole town during a period of relative prosperity. He drew on PALLADIAN and NEO-CLASSICAL elements, but he transformed the monumentality inherent in both into a more homely and bourgeois manner. The rational 18th-c. fan-shaped plan of the town, with the Grand-Ducal castle at the centre, blended well with Weinbrenner's straightforward and austere style. Before the heavy destruction during the Second World War the town was one of the most harmonious in Germany.

**WEISSENBRUCH,** HENDRIK JOHANNES (J. H.) (1824–1903). Dutch LANDSCAPE and MARINE PAINTER, prominent in the HAGUE SCHOOL. He signed his pictures 'J. H. Weissenbruch' and should not be confused with his nephew JOHANNES (JAN) WEISSENBRUCH (1822–80), who painted carefully executed views of towns. Hendrik Johannes Weissenbruch was a pupil of A. SCHELFHOUT and in his early works followed his teacher's precise manner. More characteristic are his pictures done with large, broad strokes. Exquisite blues and silvery greys distinguish them from those made by less inspired members of the Hague School.

**WÊN CHÊNG-MING** (1470–1567?). One of the many Chinese men of letters who practised painting for their own pleasure and became known as *wên-jên* (see CHINESE ART). He was a pupil of SHÊN CHOU, and a central figure in the revolutionary Wu School of Su-chou in the middle Ming period, combining the expressive effects of the wet INK and dry brush techniques. His works, which are particularly appreciated by the Chinese themselves, had great influence on subsequent generations of painters. Many of them are preserved, mostly landscapes in typical *wên-jên* style.

**WERENSKIOLD,** ERIK (1855–1938). Painter who during the 80s and 90s was one of the leading personalities in Norwegian art. He developed a harsh REALISTIC style of his own, which was influential through its unsentimental

yet affectionate approach to the Norwegian landscape. He did portraits of Ibsen and Björnson. But his finest works are perhaps his book illustrations: *Norwegian Folk Tales* (1878–87), *Snorre Tales* (1899), and a novel by J. Lie (1903).

2597.

**WERFF,** ADRIAEN VAN DER (1659–1722). Dutch painter who learned the precise and careful finish of the Leiden painters from Eglon van der NEER. He used this technique for portraits, biblical, MYTHOLOGICAL, and historical subjects and GENRE. But unlike earlier masters of the Leiden School he brought his pictures into conformity with the standards set by the French Académie which, established in Paris in 1648, had given its authority to taste in aristocratic circles of northern Europe. His elegant figures complied with the new standards of CLASSICAL beauty; their refined poses were in the Classical and RENAISSANCE tradition as revived by the Académie; and all his paintings had a decorative quality enhanced by their enamel-like surface. He enjoyed international success and made an enormous fortune, being particularly popular with the royal houses in Germany.

**WERVE,** CLAUS DE (d. 1439). The nephew of SLUTER, with whom he worked from 1396 and whom he succeeded in 1404 as chief sculptor to the Duke of Burgundy. It was Werve who carried out most of Sluter's design for the tomb of Duke Philip the Bold at Dijon, finished in 1410. He was then commissioned to produce a similar tomb for Duke John the Fearless, but died before it was begun. The work passed first to HUERTA and then to MOITURIER. Werve's style was modelled very closely on that of Sluter.

**WEST,** BENJAMIN (1738–1820). American painter, born in Pennsylvania on what is now the campus of Swarthmore College, of Quaker parentage. He displayed even as a child an unusual talent for DRAWING and there is a tradition that he was first introduced to colours by an Indian chief. He learnt something of painting technique from the English AMATEUR painter William Williams, who was active in Philadelphia 1746–7, and from the Swedish artist Gustavus Hesselius (1682–1755), who settled in America in 1711. But at the age of 22 West left America for Europe, becoming the prototype of the American expatriate artist. He spent three years studying in Italy, chiefly in Rome where he enjoyed considerable social success, and settled in London in 1763. Here he soon won for himself a position of prominence, becoming historical painter to George III and succeeding REYNOLDS as President of the ROYAL ACADEMY in 1792. His studio became a centre for American painters visiting London for experience and training and his collection was open to students as a gallery.

West had the happy knack of being always at the head of fashion. Arriving in Europe in the midst of the CLASSICAL revival, he was with Gavin HAMILTON the first to paint large historical canvases in the NEO-CLASSICAL style. His *Agrippina with the Ashes of Germanicus* (Yale Gal., 1767) brought him to the notice of George III, who ordered a painting *Regulus returning to Carthage* (1769). His *The Death of Wolfe* (1771) broke with the conventions of Neo-Classicism by depicting his figures in the dress of the time and the success of the picture caused something of a revolution in taste. It was followed by another picture drawn from the history of his own country, *William Penn's Treaty with the Indians* (Independence Hall, Philadelphia, 1772). Some years later he was painting in the proto-ROMANTIC style, representing fantastic and melodramatic subjects with dramatic effects of light and shade, and by 1800 this had become the predominant mood of his work. One of the earliest pictures in this style was his *Saul and the Witch of Endor* (Wadsworth Atheneum, Hartford, 1777). His enormous *King Lear* (Boston Mus. of Fine Arts, 1788) has all the rather artificial turmoil of early Romantic melodrama. His *Death on a Pale Horse* (1802) has been hailed as a forerunner of DELACROIX's *Death of Sardanapalus* (1827), one of the pictures which established the French Romantic Movement, and in 1817 he painted another picture of the same name 25 ft. long by 15 ft. high (Pennsylvania Academy of Fine Arts). His *Christ Healing the Sick* (1816) was sent as a gift to the Pennsylvania Hospital but a special gallery had to be built to receive it since there was no space in the Hospital large enough for it. West was also a forerunner of the Romantic style in portraiture (*Franklin Drawing Electricity from the Sky*, c. 1805). He did many paintings for the State Rooms at Windsor Castle and spent 30 years on a set of gigantic canvases representing *The Progress of Revealed Religion* (formerly in the Royal Chapel of George III, since lost).

West was the first American painter to achieve international reputation and in his own day his work was very highly considered. His fame as an artist has not survived and his importance is now judged to be historical in the main.

837, 963, 1414.

**WESTALL,** RICHARD (1765–1836). English GENRE painter, perhaps best known today for his VIGNETTE illustrations to contemporary poetry. He studied at the R.A. Schools, and his painting is typical of the work of a second-class artist of the generation which was trained in the 18th-c. tradition and lived to adapt itself to the ROMANTICISM of the new century. He was a contributor to the BOYDELL Gallery and his *Ecce Homo* (Langham Place) is an example of the late 18th-c. revival of large religious paintings. He was at his best in PASTORAL scenes, e.g. *Peasants Sheltering* (Downton Castle).

**WESTMACOTT,** SIR RICHARD (1775–1856). English sculptor, the son of a sculptor of the same name, trained first under his father and then in Rome under CANOVA. He returned to London in 1797 and soon had a very large practice, second only to CHANTREY, much of his work in the NEO-CLASSICAL manner being of high quality. Among his best known works are the fine tomb of Charles James Fox (Westminster Abbey, 1807) and the *Achilles* statue in Hyde Park. He became R.A. in 1811 and was Professor of Sculpture at the ROYAL ACADEMY from 1827 till 1854.

His son RICHARD WESTMACOTT, R.A., F.R.S. (1799–1872), also had a very considerable practice though not as large as his father's. His best works are his portrait BUSTS, though he is also known for his sculpture on the PEDIMENT of the Royal Exchange. He was Professor of Sculpture at the Royal Academy from 1857 till 1867, though he virtually ceased to practise as a sculptor in 1855, and he was a well-known writer and lecturer on art.

**WEYDEN,** ROGIER VAN DER (c. 1400–64). The leading Flemish painter of the mid 15th c. Nothing is known of his early years, but in 1427 a certain Rogelet de la Pâture entered the WORKSHOP of Robert Campin at Tournai and left as Maistre Rogier in 1432. It is generally accepted that this is Rogier van der Weyden. In 1435 he was appointed official painter to the city of Brussels, where he spent most of his working life apart from a visit to Italy in 1450. No works are actually signed or dated by Rogier although some are datable. To establish a chronology of his work it must be accepted that his master was Robert Campin and that this artist was identical with the MASTER OF FLÉMALLE. The whole problem is based on stylistic analysis. The *Deposition* (Prado) is a major work and later documents ascribe it unequivocally to Rogier. The use of a plain gold ground and the very scale of the picture compare with the *Crucified Thief* fragment (Frankfurt) by the Master of Flémalle, but the *Deposition* has a dramatic force to which the earlier artist could only aspire. The work is undated but a copy was made in 1443 and it is possible that this is a work of the 1430s. Connections with the Master of Flémalle can also be seen in the *Miraflores Altarpiece* (Berlin), where the attitude of CHRIST appearing to His Mother is close to the *St. John* in the Werle wings of 1438; yet the arrangement of the scenes set beneath painted architecture is a brilliant and influential innovation by Rogier. Jan van EYCK's influence can also be detected in Rogier's work, particularly in the *St. Luke Painting the Virgin* (Boston, Mass.). The linear rhythms of the Prado *Deposition* are echoed in the *Triptych of the Crucifixion* (Vienna), where the poignancy is heightened by fluttering calligraphic DRAPERIES.

In the Jubilee Year of 1450 Rogier went to Italy and he may have worked for Italian patrons.

The *Frankfurt Altarpiece* of the *Madonna with Four Saints* bears the arms of the MEDICI family and the composition is a *Sacra Conversazione* in the Italian tradition (see VIRGIN). Also the *Entombment* (Uffizi) has strong ICONOGRAPHIC connections with the art of Fra ANGELICO.

Rogier's mature style, dating from after his return from Italy, can be seen in paintings like the *St. Columba Altarpiece* (Munich) and the *Bladelin Triptych* (Berlin). Unlike Jan van Eyck he seems to have had a large workshop with many assistants and pupils, and many of his compositions are known in several versions. His influence was strong and widespread; in his own lifetime his paintings were sent all over Europe, to Spain, France, Italy, and Germany, and he was the creator of certain definite types of paintings. Dieric BOUTS was strongly influenced by him and Rogier's *Last Judgement* at Beaune was the prototype for MEMLING's *Altarpiece* at Danzig. His portraits influenced Netherlandish portraiture until the end of the 15th c.

215, 736, 926.

**WHEATLEY, FRANCIS** (1747–1801). English painter. Perhaps a pupil of ZOFFANY, he was a versatile artist who first practised in London as a painter of small whole-length portraits and CONVERSATION PIECES. He was in Dublin 1779–83/4, but returned to London and began to specialize in scenes of rural and domestic life, imparting a certain 18th-c. elegance to a genre in which HOGARTH had excelled, and exploiting a facility for popular moral sentiment. Engravings of his *Cries of London* (1795) had a great sale and it is by these that he is generally remembered. He occasionally chose more lofty subjects, e.g. *Mr. Howard offering Relief to Prisoners* (Earl of Harrowby Coll.). He became A.R.A. in 1790 and R.A. in 1791.

2275.

**WHISTLER, JAMES ABBOTT MCNEILL** (1834–1903). American-born, French-educated, and (mainly) English-domiciled painter and etcher. His training as an artist began indirectly when, after his discharge from West Point Military Academy for 'deficiency in chemistry', he learnt ETCHING as a U.S. navy cartographer. In 1855 he went to Paris, where he studied intermittently under Marc Charles Gabriel Gleyre (1806–74), made copies in the Louvre, acquired a lasting admiration for VELAZQUEZ, and became a devotee of the cult of the JAPANESE PRINT and, in general, Oriental art and decoration. Through his friend FANTIN-LATOUR he met COURBET whose REALISM inspired much of his early work. He settled in London in 1859 and eagerly disseminated the enthusiasms he had acquired in Paris; he had immediate success, both with his paintings and with his etchings. During the 1860s he became increasingly dissatisfied with his dependence on Courbet and attempted to free himself from it. His *Symphony*

in *White No. 1: The White Girl* of 1862 (N.G., Washington) shows a relationship to ROSSETTI, a friend of his early years in England; in *La Princesse du Pays de la Porcelaine* of 1863–4 (Freer Gal., Washington) this PRE-RAPHAELITISM is overlaid with Oriental detail; and in a number of subsequent works the figures and poses become less Japanese and more like those of Greek TERRACOTTA statuettes. The experiments of his early years found their fulfilment in his work of the 1870s. The Thames *Nocturnes* distil the Japanese and realist elements into a harmonious relationship of tone and colour; and the portrait 'Arrangements', such as *The Artist's Mother*, of 1872 (Louvre), translate Velazquez into the language of the 19th c. and at the same time foreshadow something of the geometrical formalism of the 20th.

No less original was his work as a decorative artist, notably in the Peacock Room (1876–7) for F. R. Leyland (now reconstructed in Freer Gal., Washington), where attenuated decorative patterning anticipated much in the ART NOUVEAU style of the 1890s.

In 1877 RUSKIN denounced his *Nocturne in Black and Gold: The Falling Rocket*, accusing him of 'flinging a pot of paint in the public's face'; and the farthing's damages with no costs awarded in the consequent libel action left him bankrupt. After a year (1879–80) devoted mostly to making etchings and PASTELS in Venice he returned to London, which, apart from the years 1893–6 when he lived in Paris, remained his base for the rest of his life. He continued to paint large-scale portrait arrangements but the *Nocturnes* were largely replaced by intimate little seascapes, landscapes, townscapes, and interiors in oil and WATER-COLOUR. Whistler's friends were many and wide-ranging: in France they included MANET, DEGAS, MONET (whose work he brought for exhibition in England), and TOULOUSE-LAUTREC; and in England Albert Moore and (until they quarrelled) his pupil, SICKERT. But despite these many contacts he chose to work in artistic isolation, turning from the realism and the embryonic IMPRESSIONISM of the early 1860s to an intuitive kind of SYMBOLISM in which subject matter was largely eliminated and titles took on a musical or abstract form. The Butterfly symbol, which in the mid 60s he substituted for his signature, is highly appropriate not only to his art but to his character. A dandy, a wit, and an inveterate controversialist, he conducted a series of campaigns against the public and critics in the form of pamphlets, annotated exhibition catalogues, and letters to the Press. His aesthetic creed, which had affinities with the AESTHETICISM of the 'art for art's sake' movement, is presented in *Ten O'Clock*, a lecture first delivered in 1885; and this, and much else on art and society, was republished in *The Gentle Art of Making Enemies* (1890).

94, 750, 785, 802, 1149, 1587, 1826, 2052, 2594, 2595, 2809, 2810.

**WHISTLER,** REX JOHN (1905-44). English artist, who studied at the Slade School and at Rome. He developed a personal decorative style in a modern ROCOCO manner which could charm but not disturb. He illustrated the Cresset Press edition of *Gulliver's Travels* and is known for his mural decorations in the refreshment room of the TATE GALLERY.

**WHITE,** ETHELBERT (1891-    ). English painter, engraver, and POSTER designer. He studied at St. John's Wood Art School and was a member of the NEW ENGLISH ART CLUB. He was the most successful and original of those artists who remained indifferent to French influences (although his mother was a French woman) and made it his ambition to continue the English WATER-COLOUR and LANDSCAPE tradition, basing himself on a study of COTMAN. His work was decorative and occasionally MANNERED but he was not to be dismissed by Clive BELL's contemptuous epithet 'native hedgerow artists'.

**WIENER WERKSTÄTTEN.** An organization of DESIGNERS and craftsmen established at Vienna in 1903 by HOFFMAN and MOSER under the impact of the social and AESTHETIC teaching of William MORRIS. It was here that the interior decoration and furnishings for buildings such as Hoffman's Pürkersdorf Sanatorium were produced in a Viennese version of the ART NOUVEAU style of C. R. MACKINTOSH.

**WIERTZ,** ANTOINE (1806-65). Belgian artist who said that he painted his portraits for bread and his religious and historical compositions for honour. He refused to sell the latter, believing that they surpassed the masterpieces of RUBENS, RAPHAEL, and MICHELANGELO. They are indeed very large, but uneven in quality. The fantastic, macabre, and erotic features of some of them mark Wiertz as one of those eccentrics of the imagination to whom the SURREALISTS later looked back. The Belgian Government built him a studio in Brussels in 1850, which is now the Wiertz Museum.

321, 2878.

**WIJNANTS,** JAN (*c.* 1630/5-84). Dutch painter of Haarlem, who died in Amsterdam. He was purely a landscape painter and never painted the figures in his own pictures, but had them done usually by WOUWERMAN and J. Lingelbach (1622-74) or by Adriaen van de VELDE. Most of his paintings are in a yellowish-brown tone and represent the sandy slopes of dunes with trees and clouded skies. His smaller pictures (mostly on PANEL) had great appeal.

**WILDENS,** JAN (*c.* 1584-1653). Flemish LANDSCAPE painter born at Antwerp, where he became a master in 1604. He made a prolonged stay in Italy in the second decade of the century and returned in 1618 to Antwerp, where he became a member of the RUBENS entourage. His early work followed the style of the GRIMMERS, but his contact with Paul BRIL in Italy and the influence of Rubens induced him to change to very decorative landscapes, modelling his foregrounds with fluent strokes in the Rubens manner. He contributed landscape backgrounds for Rubens and for many artists in his circle and took part in pageant decorations. In his later work he assimilated something of the spacious DUTCH concept of landscape but was only partially successful. Examples are at Amsterdam, Antwerp, and Vienna. One of his best known works is the *Winter Landscape with a Hunter* (Dresden, 1624).

**WILIGELMO** (active *c.* 1100). Founder of an Italian school of ROMANESQUE sculpture radiating from Modena Cathedral (begun 1099), on the reliefs for which he is recorded as working. Nothing is known of his origins, but his style is more or less related to contemporary or earlier work in Languedoc and Apulia. Within the context of Romanesque art it is markedly CLASSICAL and owes much to antique SARCOPHAGI. Closely related work in his manner but probably not by him is at S. Silvestro, Nonantola, and Cremona Cathedral. The *Genesis* reliefs and *Prophets* on the façade at Modena are generally considered the touchstone for his personal style.

**WILKIE,** SIR DAVID (1785-1841). Scottish painter. He was trained in Edinburgh and then at the R.A. Schools in London. With his first exhibit at the R.A. (1806), a painting of village life, unpretentious, charming, and unidealized, his success was immediate. His work before 1825 is mainly on a small scale, influenced both in technique and in subject matter by the great 17th-c. DUTCH and FLEMISH REALISTS, especially TENIERS and OSTADE, but more pointedly anecdotal, with a unique vivacious elegance of drawing (*The Village Festival*, Tate Gal., 1811). In 1825-8 he was abroad, and his style was revolutionized by SPANISH painting; he turned to larger work, to historical subjects and portraits, but on a life-size scale his elegance becomes diffuse, and also his later work has suffered from unsound technique. But he could at times invest ceremonial subjects with a remarkable humanity (*Queen Victoria's First Council*, Royal Coll.). He was appointed Painter-in-Ordinary to George IV in 1830, and knighted in 1836. He died at sea off Malta.

Wilkie's success did much to establish the popularity of the ENGLISH 19th-c. School of anecdotal or 'subject' painting. The esteem in which he was held could have been possible only in an age which looked first to the 'story' of a painting and the moral lesson it contained. In his *Last Judgement* (1853), painted 12 years after Wilkie's death, John MARTIN put Wilkie along with MICHELANGELO, LEONARDO, RAPHAEL,

RUBENS, and DÜRER among his leading painters. John Brown, no mean critic for his time, writing in *Horae Subsecivae* (1858-61) of Wilkie's painting *Distraining for Rent*, concludes: 'We are inclined to rank HOGARTH and Wilkie as the most thoughtful of British Painters, and two of the greatest of all painters.'

670.

**WILKINS, WILLIAM** (1778-1839). English REGENCY architect and GREEK Revivalist; author of books on Greek architecture. As a young man he toured Greece, Italy, and Asia Minor and on

of ambitious undertakings: Winchester College (1382), New College, Oxford (1379), and later in his own cathedral of Winchester, where the nave was completed at his expense after his death.

**WILLIAM THE ENGLISHMAN** (active 1174-1214). Master mason of Canterbury Cathedral from 1179 in succession to William of SENS, he erected the Trinity Chapel and Corona. Though both were his work, in the general plan he must to a greater or lesser extent have followed his predecessor's designs for the east end. He

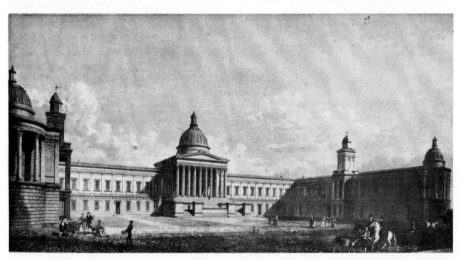

386. *The University of London* (now University College), by William Wilkins

his return was given the commission of adding to Downing College, Cambridge, in the Greek style (1804). His other principal works are Haileybury College (1806); St. George's Hospital, Hyde Park Corner (1827); London University (now University College, 1828); and the NATIONAL GALLERY, London (1832-8), in the design of which he was made to incorporate the COLUMNS from the recently demolished Carlton House; and the Nelson Column on the sands at Gorleston, Great Yarmouth. Wilkins succeeded SOANE as Professor of Architecture at the ROYAL ACADEMY.

**WILLIAM OF SENS.** See SENS.

**WILLIAM OF WYKEHAM** (1324-1404). One of the most lavish PATRONS of English medieval architecture, Wykeham rose in the service of Edward III from obscure beginnings to the office of Chancellor. He was also Bishop of Winchester. In 1356 he became Clerk of the Royal Works, which gave him charge of important building operations, e.g. at Windsor and Queenborough Castles. The taste for architecture which he then acquired found an outlet after his fall from power in 1376 in a series

was apparently trained somewhere in the province of Reims (or perhaps at Laon) and was in touch with the most recent French developments.

**WILLUMSEN, JENS FERDINAND** (1863-1958). Danish painter and sculptor. In 1890 he was in touch with GAUGUIN and also came under the influence of Max KLINGER; and it was then that he arrived at his peculiar SYMBOLIST manner of pictorial expression, and his choice of weird subject matter. He loved to render strong sunlight and glaring lamplight and his colours were inclined to be overpowering. A characteristic work is his dynamic painting *Supper* (1918); sharp yellow, greenish, and violet hues and its distortions recall El GRECO, on whom Willumsen wrote a long treatise (1927). His largest sculptural undertaking was the *Great Relief* (1893-1927) with gigantic symbolic figures in different MARBLES, partly gilded. He was also an architect and a potter. The monumental qualities of his art are also striking in his large, beautiful lithographs.

**WILSON, RICHARD** (1714-82). British landscape painter, born in Wales. He studied in London under Thomas Wright, an indifferent

portrait painter, and achieved success as a portrait painter himself before he set out for Italy towards the end of 1752. He did not return to England until 1756. He had spent his time partly in Venice but largely in Rome, whence he had also visited Naples, and during these years he abandoned portraiture almost entirely. He was profoundly influenced by the painting of CLAUDE and by the natural surroundings of Rome where Claude had worked—the Campagna, the Alban Hills, Tivoli, and the gardens of some of the villas overlooking the city. Here he found subject matter suited both to his own taste and to that of his patrons, who were for the most part English noblemen, for whom he made CHALK and CHARCOAL drawings as well as paintings.

Wilson was made a foundation member of the ROYAL ACADEMY and in 1776 he became its librarian. His temperament, however, was difficult and his career after his return from Italy was not uniformly successful. He painted many splendid views of English country houses in their setting of park and woodland, but he also repeated his Italian compositions in a sometimes careless manner. It is often difficult to distinguish a work of his later years from that of his pupils and on this account his reputation has suffered. Wilson should be judged by such masterpieces as *The Vale of Narni* (Brinsley Ford Coll., London), *Snowdon* (Walker Art Gal., Liverpool), *Oke-hampton Castle* (Birmingham), and *Tabley House* (Lord Ashton of Hyde Coll.). Many of his finest works are still in private collections.

WOOTTON and LAMBERT established a tradition of LANDSCAPE PAINTING in England as distinct from TOPOGRAPHICAL painting, but it was Wilson who first interpreted the English scene in terms of Claude and Classical COMPOSITION. Although he worked in the PICTURESQUE NEO-CLASSICAL style, he was fundamentally an original artist and his last work shows a natural inclination to embody the direct experience of nature and mood. REYNOLDS showed discernment in describing his landscapes as 'near common nature' and his enrichments of the picturesque style made him appreciated by such later artists as COTMAN, CROME, CONSTABLE, and TURNER.

453, 606, 894.

**WILTON,** JOSEPH (1722–1803). English sculptor, the son of a manufacturer of ornamental plaster. He was trained first under Laurent Delvaux (1695–1778) in Brabant and secondly under J.-B. PIGALLE in Paris. He was in Italy from 1747 till 1755. On his return to London he rapidly became successful, carved the state coach (still in use) for the coronation of George III, and was then appointed sculptor to the King. His early portrait BUSTS in the antique manner (*Lord Chesterfield*, B.M., 1757) are of high quality, but in his MONUMENTS, of which that of General Wolfe (Westminster Abbey, 1772) is the most famous, he seems to hesitate between admiration for the antique and for French ROCOCO. He was an intimate friend of the architect Sir William CHAMBERS, with whom he often collaborated, was one of the original members of the ROYAL ACADEMY, and Keeper of the R.A. from 1790 till his death. His talents were considerable, but he gave much time to social life, lived extravagantly, and gave little attention to artistic work.

**WINCKELMANN,** JOHANN JOACHIM (1717–68). German ART HISTORIAN and archaeologist. He impressed contemporaries and later generations as much through his romantic life-story as by his teaching. Born of a poor cobbler, he early developed a fervent love for classical antiquity and ancient art. After holding some lowly positions as a schoolmaster and tutor he managed to reach Rome in 1755, where he became librarian to the famous collector Cardinal ALBANI and soon established himself as a scholar and antiquarian of European fame. In 1768 he was murdered in Trieste, perhaps for the sake of some gold coins he had shown to a fellow guest at his inn.

Winckelmann's first small book already embodied his creed and established his renown. *Gedanken über die Nachahmung der griechischen Werke in der Malerei und Bildhauerkunst* was published from Dresden in 1755, shortly before Winckelmann left for Rome. J. H. FUSELI published an English translation in 1765 under the title: *Reflections on the Painting and Sculpture of the Greeks*. In this essay Winckelmann took up the 17th-c. theory of the Classical standards of all true art. Unlike his predecessors, however, he did not simply point to 'the ancients' or their RENAISSANCE followers. He saw the Classical ideal as the product of the Greek genius, and became the first historian to draw a sharp distinction between GREEK ART and its ROMAN copies. In recommending imitation of the ancients he himself—unlike some of his followers—did not think of cold copying. He wished for a re-creation of the Greek spirit and his often quoted description of classical art as embodying '*edle Einfalt und stille Grösse*' (noble simplicity and calm grandeur) applied to AESTHETICS as well as to ethics.

Winckelmann elaborated his ideas in *Geschichte der Kunst des Altertums* (1764), a book which in some respects laid the foundations of modern methods of ART HISTORY. He was also one of the leading figures of the NEO-CLASSICAL movement. The style of artists such as MENGS, CANOVA, and THORWALDSEN owed much to the stimulus of his doctrines. Moreover his interpretation of classical antiquity and his praise of serene 'Apolline' beauty determined education, particularly in Germany, right into the 20th c. One of the most sensitive appreciations of Winckelmann's place in the classical tradition is to be found in Walter PATER's *The Renaissance* (1873).

1266, 1462.

**WINDE, CAPTAIN WILLIAM** (d. 1722). Architect, born in Holland of an English Royalist family. Returning to England after the Restoration, he became a soldier and a military architect. While still in the army he completed the house at Hampstead Marshall (destroyed 1718) begun for the Earl of Craven by Sir Balthasar Gerbier, and he may have designed Ashdown House, Berks., for the same PATRON. He later worked at Combe Abbey, Warwickshire, and other country houses (all now destroyed), carrying on the manner of Sir Roger PRATT and Hugh MAY. His most important building was Buckingham House (1703, partly incorporated in the present palace), a commission taken over from William TALMAN.

**WINGED ALTAR.** See ALTARPIECE.

**WINTERHALTER, FRANZ XAVIER** (1806–73). German artist and international court-painter. He studied mainly in Munich as an engraver. After beginning to paint portraits, he made his reputation in Paris in 1834 under the PATRONAGE of Queen Marie-Amélie; thereafter he painted royalty with great success—the Orleans family of France, and then Napoleon III, the emperor Francis Joseph, and Queen Victoria. His work (e.g. *Queen Victoria and her Family*, Windsor Castle) still has a clear-cut, waxen, decorative charm, but is remembered rather as a reflection of the high society that he portrayed than as creative art.

**WISSING, WILLEM** (1655–87). Portrait painter, who was born at Amsterdam and studied at The Hague under Arnoldus van RAVESTEYN and Willem Doudijns (1630–97). He entered LELY's studio in London in 1676, and in 1680, on Lely's death, took over much of his fashionable practice. He was a competent painter but his style was coarser, more flaccid than Lely's. He was sent to Holland by James II in 1685 to paint Princess Mary and William III. His surviving work includes *Charles II* (Windsor Castle), *Princess Anne* (N.P.G., Edinburgh, *c.* 1685), and portraits of Lord Burghley and William Cecil, sons of the Earl of Exeter (Burghley).

**WIT, JACOB DE** (1695–1754). Dutch painter who was trained at Antwerp but spent most of his life in his native city of Amsterdam. He was the outstanding ceiling painter in Holland during the 18th c. As with other Rococo decorators the general tonality of his pictures is blond and he had a predilection for PASTEL colours. One of his principal ceilings has been installed in the room where POTTER's *Bull* is exhibited at the Mauritshuis, The Hague. De Wit gave his name ('Witje') to a kind of decorative painting in GRISAILLE which gives the illusion of a marble RELIEF and is meant to be set over a chimney-piece or a door.

**WITTE, EMANUEL DE** (1617–92). Dutch painter of architectural views, GENRE scenes, and portraits. He must have spent his formative years in Delft, but sometime after 1654 settled in Amsterdam. He ranks with the great Dutch masters who could make the commonplace poetic. In his hands a portrait of a patron making a purchase at a fishmarket became a poignant encounter. His pictures of real, or more frequently imaginary, church interiors were the best in his day. They frequently contain small genre scenes, but the major action in them is the dramatic play of light and shadow in the lofty interiors.

**WITZ, KONRAD** (*c.* 1400–44/7). German painter, born in Rottweil, Swabia, but working mainly in what is now Switzerland. Witz is best represented in the museums of Basel and Geneva, which between them have panels from at least three large ALTARPIECES. He must have been fully conversant with the art of his contemporary Jan van EYCK. In place of the soft lines and lyrical qualities of INTERNATIONAL GOTHIC we find in Witz's early work heavy, almost stumpy figures whose ample DRAPERY emphasizes their angular solidity in harsh and deliberate contrast to the PERSPECTIVE depth of the picture. His last work, *Christ Walking on the Waters* (Geneva), is one of the finest of all German LANDSCAPE PAINTINGS. His loving attention to details as minute as the bubbles on the water never detracts from the conception of the whole scene —the shores of Lake Geneva bathed in the light of the summer sun.

970.

**WOLFE, EDWARD** (1899–  ). Painter, born in Johannesburg. He went to England in 1917 and was trained at the Slade. He worked with the OMEGA WORKSHOPS. He was associated with the LONDON GROUP and exhibited widely in London, Paris, New York, Naples, Johannesburg, etc.

**WOLGEMUT, MICHAEL** (1434–1519). German painter and woodcutter of the School of Nuremberg. As a painter Wolgemut followed the predominant Netherlandish fashion (High Altar in Zwickau, Saxony, 1479). More important and much more original was his work in WOODCUT, particularly for book illustration. His large and very active WORKSHOP produced, amongst many other books, Hartman Schedel's *Weltchronik* (1493), the most enterprising attempt of its time at combining letterpress with woodcut illustration. Hitherto woodcuts had often been embellished by ILLUMINATION, but Wolgemut tried to refine the technique of wood-cut so that it could achieve its own proper effects without hand painting. But perhaps his chief claim to fame is that in his workshop the boy DÜRER learned the technique of painting and designing for woodcut.

**WONDJINA.** See AUSTRALIAN ABORIGINAL ART.

**WOOD,** CHRISTOPHER (1901–30). English painter. To influences from the modern French school, particularly MATISSE, he brought an entirely personal freshness and naïvety of vision. Though sensitive and charming, his work is slight but contained promise of more important achievements had his life not been cut short.

**WOOD,** GRANT (1892–1942). American painter. He grew up in Cedar Rapids, Iowa, where he worked as a craftsman in metal, attending night classes at the Art Institute, Chicago. During the early 1920s he went to Europe and studied for a short while at the Académie Julien, Paris. He returned to Cedar Rapids in 1924 and in 1927 obtained a commission for STAINED-GLASS memorial windows. In 1928 he went to Munich to supervise their manufacture and under the influence of early GERMAN and FLEMISH painting which he saw there abandoned his earlier IMPRESSIONIST style and began to paint in the meticulous, sharply detailed manner for which he is chiefly known. Adapting this style to the depiction of the plain people and ordinary subjects of Iowa, he gained a reputation as an interpreter of the American national scene (*American Gothic* and *Stone City*, Art Inst. of Chicago, 1930). In 1932–3 he was a founder of the Stone City art colony. His landscapes were more controversial than his figure painting. By some they have been accused of rather trivial STYLIZATION, but others have claimed that besides being delightful patterns they are more faithful to actuality than might be supposed by those unfamiliar with the Iowa countryside.

982.

**WOOD,** JOHN, OF BATH (1704–54). English architect, an important figure in the spread of the PALLADIAN movement and in the development of English TOWN-PLANNING. He gained some experience of the latter in 1725–7 through work on Cavendish Square and perhaps also Grosvenor Square, London, and before he returned to Bath in 1727 he had produced a plan for the development of that fashionable spa. This included a square (Queen Square, 1729–36) and also schemes for a circus and a FORUM. The latter was never completed, but the circus, a monumental conception like a miniature COLOSSEUM turned inside-out, surrounded by town houses having three storeys of superimposed ORDERS, was begun in 1754 and completed by his son. He also built a large Palladian house, Prior Park (1735–48, since altered), for Ralph Allen, a leading citizen whose quarries had provided the stone for the building of the town.

Wood's work in Bath was continued by his son, JOHN WOOD II (1728–81), whose major contribution was the development of Royal Crescent (1767–75), a half-ellipse of uniform houses treated with an Ionic Order on a noble scale, an idea which was to be imitated in Buxton, London, and Brighton. He also designed the New Assembly Rooms (1769–71, internally destroyed by bombing in 1942 and restored), a skilful and charming example of Palladian planning.

**WOOD-CARVING.** Wood has been an almost universal medium of sculpture for at least 5,000 years. Earlier than that there is little direct evidence owing to difficulties of preservation. As an organic substance wood has a shorter life than STONE and ceramic materials. It has been used for both RELIEF carving and for free-standing sculpture. Wood has also been extensively used for architecture, architectural decoration, cult objects, and furniture designed to complement architecture.

Wood is comparatively light, fibrous, reasonably compact, and durable. It usually has a distinct structure, largely determined by conditions of growth, and a pronounced grain. The very many species of timber which have been used for sculpture are divided generally into hard woods and soft woods, the hard woods usually being more close grained than soft woods and taking a higher polish. The tendency of modern sculpture is to set great importance on retaining in the finished work a suggestion of the natural growth forms of the tree and on using the grain and natural irregularities for aesthetic effects. This had less importance in the past when most wood sculptures were painted or gilded or otherwise decorated in ways which concealed the actual material. There is, however, some evidence from surviving examples of wood sculpture that artists have always felt an instinctive delight in fashioning wood in accordance with its natural structure and form. This is particularly apparent in such places as the Easter Islands, where the only wood available and suited for sculpture was twisted and gnarled shrub roots. The contorted shapes of these roots were ingeniously adapted to figure carvings. This artistic adaptation of organic form to the finished product is also found in other early civilizations where no distinction was felt between FINE ARTS and useful arts. Modern artists seem to be returning to this early approach in their belief that the best form for any carved object is that suggested by the actual material, whether stone or wood.

Knowledge of the different properties of various kinds of wood, their preparation, manipulation, working, and preservation belong equally to the utilitarian wood-worker and the sculptor. The essential equipment for wood-carving is very simple indeed and may be no more than an adze and a knife, as in AFRICAN TRIBAL ART. Modern tools comprise basically a fairly complicated array of chisels, gouges, and drills. Files and abrasives are used for surface smoothing and polishing. In medieval and BAROQUE WORKSHOPS the work was divided between carpenters, who prepared the wood and roughed out the shape of the intended figure with saws, and carvers who took over from there. The

carving was then passed on to plasterers, painters, and gilders. In surviving 17th-c. contracts every detail is specified as to the types of wood to be used and the colours, and the artist guarantees that no cracks will appear afterwards.

Wood statues, originally coated with STUCCO and painted, are known from the 5th–6th Dynasties of ancient Egypt (*Head* from Saqqara, Cairo Mus., *c.* 2350 B.C.; statue of functionary, called *Sheik el Beled*, Cairo Mus.). From China a wood and leather Griffon-Dragon head from Pazyryk dates from the 6th–5th c. B.C. (Hermitage) and lacquered wood figures from the late Chou period have been found at Ch'ang-Sha (*Birds and Snakes*, Cleveland Mus. of Art). In Indonesia from the Neolithic Age fine stone adzes have been found which could only have been used for delicate carving of wood. Wood was scarce in Mesopotamia and the Near East: Phoenician objects of carved ebony and boxwood are known, but wood seems to have been little used for sculpture. Wooden sculptural figures have survived from early PRE-COLUMBIAN times in the Andean area, usually coloured, sometimes with human hair attached or covered with brilliant feather cloaks and copper or gold adornments. There are literary records of wooden cult objects, called XOANA from the Late Geometric GREEK period. But these are thought to have been small roughly shaped aniconic pillars on which garments or adornments were hung and not sculpture in any real sense. They seem not to have been an early stage in the tradition of Greek stone carving, for as Rhys Carpenter has said: 'Technically the tradition of monumental sculpture cannot be derived from *xoana* or any other form of wood-carving.' No early wood statues have survived from Greece except a few statuettes from a waterlogged temple site at Samos.

The history of wood-carving in Christian ecclesiastical sculpture is a long and elaborate story which cannot be included here. Of decorative wood-carvers Grinling GIBBONS stands out among all others. Many modern sculptors have used wood as a material among others; few, if any, have concentrated exclusively on it. In the German EXPRESSIONIST mode Ernst BARLACH stands out for his use of wood. Among those who have contributed most originally to the aesthetic applications of wood-carving techniques in the 20th c. are ARCHIPENKO, Leon Underwood (1890–    ), Henry MOORE, and the Nigerian sculptor Ben Enwonwu (1921–    ).

**WOODCUT.** This is the oldest technique for making PRINTS, and its principles are very simple. The artist draws his design on the smooth, flat surface of a block of wood and then cuts away, with knife and gouges, the parts which are to be white in the print, leaving the design standing up in RELIEF. After INKING the surface of the block, he places upon it a sheet of PAPER. Finally by applying pressure to the back of the paper, either by hand or in a press, he transfers to the sheet an impression in reverse of his original design.

Woodcuts thus come into the category of relief prints and differ basically from ETCHINGS and LINE ENGRAVINGS, which are printed from the grooves incised in the plate (see PRINTS). The characteristics of woodcut are boldness, simplicity, and ruggedness of line, all of which derive from the nature of the wood itself and the simple tools with which it is cut. Almost any wood of medium softness will serve for wood-cutting, but pear, cherry, and sycamore are among those most frequently used. The blocks are sawn along the length of the tree and smoothly planed; consequently, the lines of the design have to be cut through the fibres of the wood with a sharp knife, and this obliges the artist to keep his design simple and imposes on the print its characteristic angular quality. Subtlety, however, is not unattainable, and though the virtues of the early woodcuts are chiefly those of bold drawing and forceful cutting, modern designers have achieved surprising results by exploiting the surface qualities of the wood. Led by Paul GAUGUIN, some have scored and scratched the surface of the block with sandpaper and other unconventional tools, thus imparting to the print a variety of silvery tones and mysterious textures,

**387.** Frontispiece to *Nave Nave Fenua*. Woodcut (1892) by Paul Gauguin

**388.** *Salome-Paraphrase.* Woodcut (1898) by Edvard Munch

earliest dated woodcut that we possess appeared in a book known as the *Diamond Sutra*, a Buddhist scripture printed in China in A.D. 868. The knowledge of paper-making, on which the GRAPHIC ARTS as we know them depend, did not reach Europe from the East until much later, and we may assume that the art of woodcutting in the West, for the purpose of taking paper prints, dates approximately from the beginning of the 15th c. It developed steadily during the next 100 years, in Germany, in Italy, and finally in France, taking three main forms: religious pictures, playing-cards, and book illustrations. The first extant European cuts are from the first quarter of the 15th c. They are religious pictures, probably distributed at pilgrimage centres, depicting Our Lady and the saints in simple linear design, and apparently printed by hand pressure. Woodcut playing-cards also appear in the first half of the 15th c., sometimes hand coloured, and it is interesting to note how the angular formalized shapes of this early period have influenced the entire subsequent course of playing-card design. The practice of cutting a simple inscription as part of the woodcut, which is found on many of the religious prints of that time, at once established the essential connection between word and image which is so characteristic of the art, and also led directly to the BLOCK BOOKS of the 15th c., where each page was printed from a single block on which was cut both text and illustration. However, printed book illustration as we know it was made possible when Gutenberg invented printing with movable type, between 1440 and 1460. By 1470 woodcut illustrations, already common in Germany, were beginning to appear in Italian books.

This early period appears in retrospect to have been the Golden Age of the woodcut. The virtues of the northern woodcut style were expressive vigour of line, narrative force, and a sense of decoration. In Italy comparatively few single-sheet prints were issued, but the illustrated books, of which the *Hypnerotomachia Poliphili* (Aldus, Venice, 1499) is the most celebrated, were one of the great achievements of the RENAISSANCE. The Italian style is calmer and more noble than the northern; there is purity of drawing and design, an interesting use of decorative borders and solid black areas, and above all a feeling of complete unity with the accompanying type.

At this time the various stages of the process—designing, cutting, printing, and at some periods even the transfer of the artist's drawing to the block—were each carried out by different individuals, mostly anonymous except for the celebrated book-printers. The 16th c. saw a considerable increase in the technical skill of the cutters, and a change in basic aims and intentions. The old direct linear style was gradually abandoned in favour of facsimile reproductions of sophisticated and academic designs by famous painters like DÜRER, HOLBEIN, and CRANACH. But in the effort to render the complicated

while others, following the example of Edvard MUNCH, have used the wood-grain itself, lightly inked and carefully printed, to add interest to the solid areas of their designs.

The history and practice of woodcutting have always been closely connected with the art of the book. Since the impression is taken from the relief surface of the block, which can be made the same thickness as the standard height of type, the medium is inherently suitable for book illustration. The engraved blocks may be locked with the movable type in the press so that text and illustration are inked and printed together. This procedure is much cheaper and simpler than illustrating with copperplate engravings, which have to be printed in a different press and on separate sheets, and bound into the book afterwards.

The colour woodcut is usually made by cutting a separate block for each colour and printing the blocks successively on the same sheet of paper. More information about the practice and history of this art will be found in the articles on COLOUR-PRINTS, CHIAROSCURO WOODCUT, and UKIYO-E (Japanese colour woodcuts).

The origins of woodcut are obscure, for the medium is very ancient. Stamps cut on wood for fabric printing dating from the 5th c. A.D. have been found in the Middle East, and there is evidence of their use in still older times. The

three-dimensional draughtsmanship of the High Renaissance much of the characteristic urgency and graphic quality of woodcut was lost. Indeed as a reproductive medium woodcut was bound to fail. The cross-hatching, for example, which the taste of the times demanded, could be rendered easily enough by the line engraver, who had only to make intersecting strokes with his BURIN, but the woodcutter was condemned to the laborious and inartistic task of cutting out row upon row of lozenges, working with relatively clumsy tools upon a somewhat recalcitrant surface. A further cause of discouragement among 16th-c. wood-cutters was that their finer work was all too frequently spoiled in the printing by the unsuitable papers and uncertain inking methods in use at that time. Not until the end of the 18th c., when the technique of burin engraving on wood was developed (see WOOD ENGRAVING), did the relief print again challenge the intaglio process for public favour.

None the less many fine designs were cut in the 16th c. With Dürer woodcutting became the vehicle for elaborate three-dimensional composi-tions in the High Renaissance style, and began to partake of the characteristics of painting. Other notable works of the period are the strange and imaginative visions of Hans BALDUNG, the Landsknechts of Urs GRAF, still strongly imbued with the GOTHIC spirit, and Niccolò Boldrini's (1510–after 1566) interpretations of the works of TITIAN. During the 17th and 18th centuries woodcut was used solely for popular jobbing work—broadsheets, printers' decorations, and so forth. Europe knew nothing of the magnificent

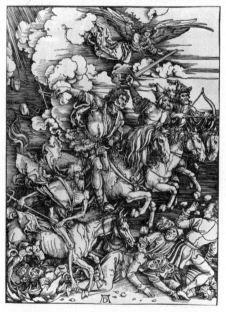

**389.** *The Four Riders of the Apocalypse.* Woodcut (1498) by Albrecht Dürer

prints of the Japanese, and only J.-M. Papillon, who published a famous treatise on the art in 1766, is worthy of mention. In the mid 19th c. reproductive wood engraving flourished, but the cutting of side-grain blocks was virtually a for-gotten art. The revival of woodcut at the end of the 19th c. was due to painters like Gauguin, Munch, and Félix Vallotton (1865–1925), who saw once again its possibilities as a means of original expression; for now that REPRODUCTION was taken over by the process camera, all kinds of hand engraving could make a fresh start. A return was made to the simplicity and directness of the 15th c., with the difference that the modern artists learned the craft themselves and cut their own designs on wood, both for book illustration and for free prints. Rich and forceful illustrations were cut by DERAIN and DUFY before the First World War, and the sculptor MAILLOL, taking as his models the Italian books of the Renaissance, succeeded with designs of a truly Classical spirit in achieving again a wonderful balance between type and illustration. The German EXPRESSION-ISTS found the woodcut particularly suited to their needs, and KIRCHNER, Franz MARC, and others made many prints of disturbing force and originality. The medium has been widely used by both European and American artists designing in an ABSTRACT EXPRESSIONIST style, especially in colour.

275, 1629, 2209, 2297, 2319.

**WOOD ENGRAVING.** The process of en-graving on wood for the purpose of taking PRINTS derives from the WOODCUT, but the method of working, the conception of the design, and the effects produced all tend to be different. As in woodcut the printing is done from the surface of the block, and the parts that are not to be printed are cut away. The wood used is a hardwood, generally box, sawn across the grain and very highly polished. The medium is often referred to as 'end-grain' engraving (French *bois de bout*), as distinct from 'side-grain' woodcutting (*bois de fil*). The design is engraved with the BURIN, as used by the copper-plate engraver, and with various other tools of different section, which are pushed through the wood, making white lines against a background of black. This white line is characteristic: the artist sees his print as a design in white on black, or as a three-dimensional black space in which he reveals or illuminates a little more of his subject each time he engraves a stroke. Other qualities of the process, all deriving from the hard, even surface of the material, are its accuracy, its suitability for achieving delicate modelling and fine tones by means of lines set close together, and the possibility of engraving curved lines unhampered by the fibres of the wood. These characteristics tend to dispose the medium towards NATURALISM and REPRODUCTION, as its later history confirms.

Although it is necessary, in order to explain the

process, to emphasize the differences between wood engraving and woodcut, in practice it is not always easy to tell which method produced a given print. It is possible to engrave an end-grain block in such a way that the resulting print resembles a black-line woodcut; conversely, one frequently sees prints cut on soft wood which have many of the characteristics of an engraving. These ambiguities have to be accepted, and it is significant that the French, though they have different names for the two techniques, tend to minimize the distinction by referring to both simply as *gravure sur bois*.

Though not the inventor of wood engraving, Thomas BEWICK of Newcastle-upon-Tyne was the first fully to exploit its possibilities. Trained as a metal engraver, Bewick developed his method of burin engraving on end-grain wood till he succeeded in producing works which for subtlety of rendering, delicacy, and quality of detail could rival the copperplate engravings which were then universally employed for book illustrations of quality.

Other artists to use the process at this time included William BLAKE, whose celebrated illustrations for Thornton's *Virgil* date from 1821, and Edward CALVERT. In the event, however, wood engraving developed during the 19th c. not on creative but on purely reproductive lines, for a number of reasons. Bewick and his Newcastle School, which included his brother John Bewick (1760–95), Luke Clennell (1781–1840), William Harvey (1796–1866), and others, not only restored prestige to the relief techniques by the quality of their work, but also—owing to the fact that wood blocks can be printed with type in a single operation—demonstrated the cheapness and convenience of their art as a medium for illustration. Furthermore, it was obvious that Bewick's technique of engraving delicate tonal variations with fine white lines could be applied to the reproduction of shaded areas in DRAWINGS. These factors, combined with advances in printing and PAPER-making, brought about a great increase in the production of inexpensive illustrated literature of all kinds, and by the 1840s reproductive wood engraving was a skilled and flourishing profession in England and on the Continent. As with all large-scale enterprises, the tendency was towards specialization, and the engraver seldom made his own designs. Most of the celebrated illustrators of the 19th c.—TENNIEL, KEENE, DORÉ, MENZEL, and others—would make their drawing, often in PENCIL, on the wood block, which would then be sent to the engraver's shop, where the drawing, complete with elaborate cross-hatching and tonal effects, would be faithfully engraved in facsimile. The most celebrated of these reproductive engravers in England were the Dalziel brothers and John Swain. The famous weeklies of the mid-Victorian period, *Punch*, *The Illustrated London News*, *The Ladies' Home Journal*, and many others, together with every variety of illustrated book, bear witness to this remarkable partner-ship between designer and engraver. Before 1870 photographs were being developed on to the surface of wood blocks, and the engravers soon mastered the technique of rendering continuous photographic tones by means of very fine parallel lines engraved with multiple tools; but the introduction of the photo-mechanical processes of reproduction in the 1880s at once changed the situation. The cheapness and accuracy of the new methods were impossible to deny, and though in the last 15 years of the 19th c. the wood engravers developed their art to an extraordinary degree of skill and subtlety in competition with the half-tone block, they were inevitably superseded. This final phase of reproductive wood engraving can best be studied in the work of the American Timothy Cole (1852–1931), whose engravings after celebrated paintings represent the ultimate achievement of the engraver in translating a tonal original into a printing surface of black and white lines.

By 1920, however, the medium was showing signs of revival in a different form. Artists, reverting to the practice of Bewick, taught themselves the craft and began engraving their own designs, both for book illustrations and for prints on separate sheets. Ignoring the elaborate reproductive techniques of the previous century, they conceived their prints in terms of the white line, and developed their designs by direct, free strokes of the burin.

275, 1629, 1630, 2209, 2297.

**390.** *Dead Willow Herb.* Wood engraving (1953) by John Farleigh

**WOOLLETT**, WILLIAM (1735-85). English draughtsman and LINE ENGRAVER, born at Maidstone. He studied in London under John Tinney (d. 1761) and at the St. Martin's Lane Academy. His earliest work was TOPOGRAPHICAL. In 1760 he engraved CLAUDE's *Temple of Apollo* for BOYDELL, and he established his reputation in 1761 with WILSON's *Niobe*. His greatest success was *The Death of Wolfe* after WEST (1776), for which he was given the title Historical Engraver to His Majesty. He was for some years secretary to the Incorporated Society of Artists. Woollett was the first English engraver whose work had a considerable market on the Continent.

**WOOLNER**, THOMAS (1825-92). English sculptor and poet, who was apprenticed at the age of 12 to W. BEHNES and in 1842 joined the R.A. Schools. He met Dante Gabriel ROSSETTI in 1847 and became one of the original PRE-RAPHAELITES. In spite of some excellent work at this date he made little money and so sailed for the Australian gold-fields in 1852, his departure inspiring Ford Madox BROWN's picture *The Last of England* (Birmingham). He returned to England in 1854, finally making his name with his BUST of Tennyson in 1857. The original of this is in the Library of Trinity College, Cambridge, but there are copies in Westminster Abbey, the National Portrait Gallery, and elsewhere. He also did among many others: *R. E. Ellis*, *Rev. C. Trotter*, *Dr. Whewell* for Trinity College, Cambridge, *Cardinal Newman* (Keble College, Oxford), *Canon Kingsley* (Westminster Abbey), *W. E. Gladstone* (Guildhall), *Queen Victoria* (Town Hall, Birmingham), *Rev. J. Henslow* (Fitzwilliam Mus., Cambridge).

2936.

**WOOTTON**, JOHN (d. 1756). English LANDSCAPE and sporting painter. He studied under Jan Wyck (1652-1700) in London and later spent some time in Rome, where he was greatly impressed by the work of CLAUDE and DUGHET. He specialized in horse subjects, but his main contribution to British painting was the introduction of the CLASSICAL landscape of the Dughet type. There are important decorative paintings by him at Longleat and Althorp, and a hunting picture in the Tate Gallery.

**WORKSHOP**. Paintings are sometimes described as being from the 'workshop' of a master to indicate that they are not by his own hand. The implication is that there is a recognizable distinction between the 'autograph' work of a painter and that of his assistants and apprentices. There is, of course, some warrant for this assumption. In many 15th- and 16th-c. contracts the master pledges himself to execute the main panel of an ALTARPIECE himself, while he is free to let other members of the workshop execute decorative parts or the PREDELLA. Nevertheless the rigid division between work by the artist's own hand and that by his helpers which is often made in discussions on authenticity is more appropriate to the 19th-c. idea of artistic individuality than it is to earlier master-craftsmen. The organization of a workshop aimed at smooth teamwork in which the leading spirit might intervene at any stage. We know from the letters of RUBENS to Sir Dudley Carleton that even if the master had put in only the finishing touches to a painting, he still regarded it as his own. The same must have been true of RAPHAEL and many other successful masters of the past. Portraitists such as KNELLER and REYNOLDS employed a team of assistants to paint the accessories and DRAPERIES in their portraits. It was the decline of the ideal of craftsmanship which made it inconceivable to critics that a work of art could ever be the product of a team. Yet we have seen in our time that such organized collaboration has had happy results in architecture, industrial DESIGN, and the cinema; Walt Disney's animated cartoons come to mind as a supreme example of workshop procedure, in which the results are always unmistakable 'Disney'.

**WORPSWEDE**. Name of a north German village near Bremen. After 1895 it became the centre for a group of realistic LANDSCAPE painters —Otto Modersohn (1865-1943), Fritz Overbeck (1869-1909), Heinrich Vogeler (1872-1942) —who settled there, following the example of the BARBIZON group. Rainer Maria Rilke, who through his wife the sculptress Clara Westhoff (1878-1954) had connections with the group, wrote a monograph entitled *Worpswede* (1903).

**WOTTON**, SIR HENRY (1568-1639). Diplomat and poet, English Ambassador in Venice 1604-24, who immediately on his return published *The Elements of Architecture*, the first English treatise to be based on High RENAISSANCE architectural theory.

2509.

**WOUTERS**, RIK (1882-1916). Belgian painter and sculptor whose great talents reached incomplete development owing to his early death in the First World War. Affinities have been traced between his painting and that of RENOIR, BONNARD, and the FAUVES, but he retained a distinctively FLEMISH character. His work was notable for its vitality and ebullience. His bronze nude *Mad Virgin* (1912) was inspired by one of Isadora Duncan's dances.

713, 2938.

**WOUWERMAN**, PHILIPS (1619-68). Dutch painter of Haarlem, known chiefly for his views of hilly country with horses (usually including a white one), riders, BATTLES, and hunting scenes. He was the son and brother of painters and appears to have been a pupil of Frans HALS. Little is known about his life except that he made

a journey to Hamburg and probably travelled with the Dutch army in the battlefields towards the end of the Eighty Years War against Spain. His work shows that he had a more than superficial knowledge of Italian and French buildings but there is no proof that he ever went to those countries. Wouwerman's pictures possess a delicate harmony of colouring and composition. The sky is clear and nearly white, the folds of the landscape are outlined against it, and in the foreground the figures of men and horses stand out in clear relief. The elegance of his style is matched by the elegance of the palaces, even the RUINS, which are depicted in his paintings. Wouwerman collaborated with Jacob van RUISDAEL and Jan WIJNANTS and painted the figures in many of their landscapes. He made a fortune during his lifetime, and during the 18th c. his works continued to fetch high prices.

**WREN, SIR CHRISTOPHER** (1632–1723). English architect and scientist, son of the Royalist Dean of Windsor. He early showed great promise as a scientist, holding Chairs of Astronomy first at Gresham College, London, and then at Oxford before he was 30. He was a foundation member of the Royal Society (1660) and its President in 1680. His interest in science persisted after he had abandoned it for architecture; his most intimate friends were scientists, and his training in scientific experiment profoundly affected the character of his architecture.

He first approached architecture as an AMATEUR, building Pembroke College Chapel, Cambridge (1663), for his uncle, Bishop Mat-thew Wren. The Sheldonian Theatre, Oxford (1663–9), gave him greater scope, and was much admired by his contemporaries. Though the exterior is immature in handling, the interior is remarkable in its solution of the problem of roofing a span of 70 ft. without supports from the ground.

In 1664–5 Wren, still a scientist, paid his only visit to the Continent, staying for some months in Paris, where he met BERNINI and saw many buildings in the neighbourhood. Before he went, he had been consulted, with others, about the repair of Old St. Paul's Cathedral, then in a dangerous state, and made a long report on it when he returned. In September 1666 the cathedral and a large part of the City of London were destroyed by the Great Fire, and new opportunities opened to Wren. He quickly produced an ideal TOWN PLAN, with open spaces ringed by radiating streets, but the cost of execution would have been great and the citizens rebuilt their houses on the old foundations, though timber building was forbidden. Wren was, however, to be concerned with the rebuilding of 51 of the City churches and with St. Paul's Cathedral. Through his work at the Royal Society he had gained the favour of King Charles II, and in 1669 was appointed Surveyor-General to the Crown, when he relinquished his Chair at Oxford. In 1673 he was knighted.

The City churches, largely built between 1670 and 1686, are outstanding examples of the flexibility and ingenuity of Wren's mind. The sites were often irregular, building had to be quick and cheap and the requirements of Anglican

391. Interior of the Church of St. Stephen Walbrook. Early 18th-c. engraving

worship fulfilled. Wren later defined one of his main objectives: 'that all should hear the service, and both see and hear the preacher'. Naturally in the 17th c. the CLASSICAL rather than the GOTHIC style was used, but there was little suitable precedent for church building in this manner since the Catholic churches of the Continent could not set a pattern. Wren produced endless variants, some with aisles and some without, with different arrangements of supports and ROOF, sometimes drawing his inspiration from the BASILICA described by the ancient Roman architect VITRUVIUS (St. Bride, Fleet Street), sometimes using Dutch models (St. Anne and St. Agnes, destroyed 1941; St. Mary-at-Hill). A few of the churches had DOMES (St. Mary Abchurch; St. Mildred, Bread Street, destroyed 1941), the finest of all being St. Stephen Walbrook, a most ingenious building,

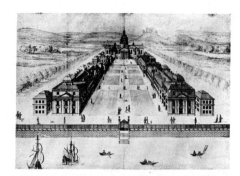

393. Pen-and-ink and wash drawing by Christopher Wren. Original perspective design for Greenwich Hospital

392. South front of St. Paul's Cathedral. Pen-and-ink and wash drawing known as *The Warrant Design* (1675) by Christopher Wren. (All Souls College Lib., Oxford)

with fine plaster work in the coffered dome. Since many of the churches were hemmed in by other buildings, Wren spent little money on lavish exteriors, but he adorned them, sometimes long after the building was finished, with steeples of extraordinary variety. Sharply pointed lead spires (St. Martin, Ludgate), small open CUPOLAS (St. Magnus the Martyr), stone steeples with a ring of COLUMNS round a central core (St. Stephen Walbrook; St. James, Garlick Hill), or stone steeples of many storeys (St. Mary-le-Bow; St. Bride, Fleet Street) are still, as he himself described them, 'an ornament to the town'.

St. Paul's was many years in building. Two preliminary models survive in the cathedral (one fragmentary), the second showing a dome over a Greek cross, said to be Wren's favourite. The executed design was a compromise between the architect's desire for a centrally planned church with a great central space, and the wish of the clergy for the traditional Latin cross type with a long nave. Innumerable devices are employed to support the great weight of the dome, the most notable being the use of false walls in the upper storey of nave and choir, which act as

BUTTRESSES, and the insertion of a cone between the inner and the outer dome which carries the stone LANTERN. The cathedral was begun in 1675 and not finished till about 1710. Few comparable buildings are the work of a single architect, and in the design of the west towers and the dome (both evolved after 1700) Wren shows a mastery of form combined with an ingenuity of construction which proclaims them as his masterpiece.

Throughout the time he was working in the City he was also creating other buildings. The Library of Trinity College, Cambridge (1676), is perhaps his most refined design; at Chelsea Hospital (begun 1683) and Winchester Palace (1683, now destroyed) he experimented on a larger scale with linked blocks of buildings marked by accents in the form of cupolas or giant PORTICOES. Since money was a consideration, at Chelsea and later at Kensington and Hampton Court Palaces he was to show that dignity could be achieved with brick, varied with small areas of stone. At the last, he first devised a grander scheme, surmounted by a dome, but it, and his remarkable plan for the layout of the Whitehall and Westminster areas after the Whitehall fire of 1698, were never carried out. In his last great civil building, Greenwich Hospital (begun 1696), he was also compelled to compromise. He had hoped to create a complex of blocks running back from the river, flanking narrowing courts and reaching a grand climax in a dome. Instead he was forced to leave a vista open for Inigo JONES's Queen's House, beautiful in itself but too small and low to dominate the whole. Two fine small domes, nearer the river, were introduced, and the long colonnades behind them lead gently back to the Queen's House.

Throughout his life Wren's architecture was marked by his ability to find ingenious solutions to the problems set him. He borrowed motifs freely from Italy, France, and Holland, but adjusted them to his own purposes. His later work, notably at St. Paul's and Greenwich, shows an interest in three-dimensional form and a feeling for large-scale work which brings it nearer to the BAROQUE; but the patrons for whom he worked, and the rational background of the

Royal Society, gave to his designs a restraint which cannot be termed Baroque.

2448, 2590, 2814.

**WRIGHT, FRANK LLOYD** (1869-1959). Considered to be the greatest of North American architects and sometimes described as 'the most influential architect of his time'. After early apprenticeship in practical building and a few months with the Chicago architect Lyman Silsbee, Wright worked for SULLIVAN's firm from 1888 to 1893. He was employed on the designs for the Chicago Auditorium and the Transportation Building at the Chicago Fair of 1893. During this time he did much of the firm's domestic building and also designed houses on his own account. His most important buildings were his own house at Oak Park, a severer and more coherently organized structure in the 'shingled cottage' style of Silsbee (1890), and the Charnley house (1891), classically 'modern' in a symmetrical, geometric style which was still regarded as advanced 20 years later. The Winslow house which he built at River Forest in 1893 was remarkable for containing the germ of the 'Prairie' houses which revolutionized American domestic architecture during the first decade of the 20th c. with their expanding horizontal planes, their interlocking volumes, and visual merging of interior with the surrounding landscape. The Robie house, finished in 1908, has come to be considered the most influential house of its era. Wright's urban building during the same decade included the Larkin Building at Buffalo (1904), possibly the most widely admired American building of its time, and Unity Church at Oak Park (1906), which was the prototype of many later experiments in functional CUBISM and one of the inspirations of the Dutch De STIJL movement. By 1910 Wright was one of the most prominent architects of the U.S.A. and his work had been introduced to Europe by Kuno Franke and BERLAGE and through the Wasmuth publications of his works (1910 and 1911), the second of which had a foreword by ASHBEE.

In his lecture *The Art and Craft of the Machine* (first delivered 1901, several times revised and amplified), Wright took his stand on the principle that art in an industrial civilization must come to terms with the machine by dominating it and adapting it to artistic purposes: he repudiated the belief that the 'machine look' is an inevitable or desirable result of machine fabrication. To the ideal of teamwork which was later to become a dogma with GROPIUS and others he opposed in advance a theory of 'democratic' architecture whose central notion was 'unity through individual creativeness'. He interpreted the theoretical FUNCTIONALISM of Sullivan in a manner opposed to the later functionalist doctrine that beauty inevitably results from the expression in appearance of structure and function, but agreed that beautiful form can only be created after functional expression has been satisfied.

Through his 'Prairie house' period, from the time when his fancy had been caught by the Japanese Pavilion at the 1893 exhibition, Wright had had a liking for Japanese decoration. He first visited Japan in 1905. Again in 1915 he was commissioned to build the new Imperial Hotel in Tokyo and remained in Japan until 1921 for this purpose. His ornate and fanciful building, with decoration reminiscent of the Mayan, was an entirely novel sectionalized structure with floor slabs balanced over central pin-supports in order to minimize the effects of earthquake shock, and did in fact survive the great earthquake of 1923. On his return to the States he carried further his earlier interest in reinforced CONCRETE, experimenting with the decorative use of concrete blocks patterned in cast relief which at Midway Gardens (1914; since destroyed) he had combined with sculpture. More importantly he developed a new idea of the plastic potentialities of concrete in continuous structure used both as structure and as enclosing skin, deriving its strength and fluidity from 'organic' forms of nature. During the 1920s also Wright applied his ORGANIC concept to working out a prototype design for a SKYSCRAPER on the idea of a tree, whose only support was a central trunk containing lifts and services, with floor slabs cantilevered out from it like branches and the exterior skin simply a sheath of glass and metal. He was not able to put these ideas into effect until the Johnson Wax tower (1950) and the Price tower at Bartlesville, Ohio (1953-6).

Wright took a keen and lasting interest in creative pedagogy and his original training methods were a force in the formation of the younger generation of architects in the CHICAGO SCHOOL. The Oak Park Studio (1895) remained a unique *atelier*, until it was disbanded in 1909, for the opportunities and inspiration it afforded an informal body of pupils and assistants, who included Walter Burley GRIFFIN, later the winner of the international competition for the city of Canberra plan. The methods adopted by Wright at Oak Park formed the basis for his later training activities at Taliesin (1911; rebuilt after fires in 1914 and again in 1925) and at Taliesin West, near Phoenix, Arizona, from 1938. The Taliesin Fellowship, founded by Wright in 1929 when in financial difficulties, has been called one of the most extraordinary schools of architecture in the modern world. Pupils came from all parts of the world to work and train under Wright at Taliesin.

In Taliesin West itself the colourful, romantic aspect of Wright's domestic building found its culminating expression. Outstanding also among his buildings during the 1930s were the Kaufmann house (1936), dramatically cantilevered over a natural waterfall, and the Johnson Wax administrative building, a rounded structure based on the circular module. Both these buildings developed his principles of structural plasticity and spatial continuity. His modernization of the Prairie house in the 1930s laid a

foundation for a new development of American domestic architecture in the 1940s and 1950s. During the war years Wright elaborated his circle pattern into a three-dimensional spiral in a number of projects, which later bore fruit in the Morris store, San Francisco (1948), and the Guggenheim Museum, New York, which was completed in 1959 shortly after his death.

Wright's views are to be found expressed in *An Autobiography* (1943), in *Genius and Mobocracy* (1949), his biography of Sullivan, and in his latest work *A Testament* (1957).

1337, 2440, 2939, 2940, 2941, 2942, 2943, 2962.

**WRIGHT,** JOHN MICHAEL (1617-1700). English portrait painter, born in London but stated to have been apprenticed to the Scottish portrait painter George JAMESON in 1636. In 1662 he was referred to by John Evelyn as a Scotsman. He worked in Rome at the Accademia di S. Luca and later travelled to Flanders, returning to England *c.* 1656. His style was provincial and inferior to that of LELY, but he achieved a moderate success, particularly with Catholic patrons. In 1670 he was commissioned to paint a series of full-length portraits of the judges appointed to deal with the legal problems resulting from the rebuilding after the fire and two of these survive in the Guildhall. His *Colonel John Russell* (Ham House, 1659) has been called 'one of the most honest English portraits of the century'.

**WRIGHT,** JOSEPH (1734-97). English painter, who was born at Derby and studied in London under HUDSON. He settled in Derby as a portrait painter in 1758. He was in Italy 1774-6, and on his return moved from Derby to Bath, hoping to succeed to the practice of GAINSBOROUGH, who had left Bath for London; but his expectations were not realized, and he returned to Derby in 1779. He exhibited at the ROYAL ACADEMY from 1778 and became A.R.A. in 1781. He later refused election as R.A.

From *c.* 1765 Wright made important experiments in painting unusual effects of light, particularly moonlight and candlelight, such as *The Orrery* (Derby, 1766) and *The Experiment with the Air Pump* (Tate Gal., 1768), and he painted a number of carefully finished pictures of Vesuvius in eruption. He also painted LANDSCAPE studies of Dovedale. His work is characterized by REALISM and integrity, combined with a quiet poetry, and foreshadows some aspects of the ROMANTIC movement. A representative collection is in the Art Gallery, Derby.

232, 1942.

**WU CHÊN** (1280-1354). Chinese painter, one of the 'Four Great Landscape Masters' of the Yüan dynasty and famous also for his paintings of bamboo, one of which, *Bamboos in the Wind*, is in the Museum of Fine Arts, Boston. Like HUANG KUNG-WANG, WANG MÊNG, and NI

TSAN, he derived his inspiration from the 10th-c. landscape masters Tung Yüan and Chu-jan (see CHINESE ART). Wu Chên was a master of 'INK play', and defined the attitude of the cultivated AMATEUR as follows: 'The activity of brush-play is practised by the literatus outside his official and literary activity; it is the result of a momentary inspiration.' He stated the characteristic Chinese doctrine that when the artist has completely identified himself with his subject the activity of painting is automatic: 'When I begin painting I am in a state of unconsciousness; I suddenly forget that I am holding a brush in my hand.'

**WU LI** (1632-1720). One of the *wên-jên*, Chinese men of letters who became AMATEUR painters (see CHINESE ART). In later life he was a Christian convert and is even said to have visited Europe. Little, if any, Western influence can be detected in his works, which are generally broad, detailed LANDSCAPES in typical *wên-jên* style (see WANG), but occasionally in smaller and bolder compositions his brush-work shows influences of the INDIVIDUALIST painters such as CHU TA.

**WU TAO-TZU** (*c.* 700-*c.* 760). The most famous Chinese painter of antiquity. No originals of his work exist but there is a large number of copies and later paraphrases. Most valuable perhaps are rubbings of stone copies in relief, which show his gift for combining monumentality with deep Buddhist religious feeling. He is said to have executed 300 wall-paintings in Lo-yang, the T'ang dynasty capital, and his famous nirvana and Kuanyin compositions formed the models for many similar works in later times. According to legend he was the father of figure painting, the originator of the monochromatic calligraphic style of bamboo painting known as *mo chu*, and the inventor of a method of printing silk used by the T'ang artists and called *sêng chüan*.

**WYATT,** JAMES (1746-1813). English architect. He was the son of an architect and studied in Italy for six years (1762-*c.* 1768). Soon after his return to England he was fortunate enough to gain the commission for the Pantheon in Oxford Street, London, a building intended as a 'Winter Ranelagh' or fashionable assembly rooms. The building, completed in 1772, burnt in 1792, and demolished in 1937, was an extremely skilful cross between the PANTHEON in Rome and Sta Sophia in Constantinople and brought immediate fame to the architect. He was elected A.R.A. in 1772, R.A. in 1785, and was temporarily President in 1805; and he succeeded CHAMBERS as Surveyor-General in 1796. In spite of his fame and position his erratic and unbusinesslike ways exasperated many clients. According to his own account, he had to conform to the prevailing ADAM taste at the beginning of his career and Heaton Hall, near Manchester

(1772), and the interior of Heveningham, Suffolk (1788–99), show his skill in that idiom. Later he developed a CLASSICAL style (e.g. the library of Oriel College, Oxford, 1788; the Canterbury Gate, Christ Church, Oxford, 1778) simultaneously with his better-known 'GOTHICK' manner, the best examples of which were Fonthill and Ashridge. Fonthill was built for William BECKFORD, the eccentric author of *Vathek*, between 1796 and 1807 when the whole gorgeous fantasy collapsed. Ashridge, Hertfordshire (1808–13), was less fantastic and furnished an example for the Gothic country houses of the 19th c. Both these houses show considerable knowledge of Gothic detail and construction, which Wyatt learned from his restorations of the great cathedrals: these included Westminster Abbey, Salisbury, and Durham and earned him the name of 'The Destroyer'. It is true that he treated these venerable buildings in a most arbitrary manner, but he also did a great deal of urgent repair work.

Other architect members of the family included Wyatt's nephew and pupil Jeffry, later SIR JEFFRY WYATVILLE (1766–1840), who was chiefly responsible for the present form of Windsor Castle. SIR MATTHEW DIGBY WYATT (1820–77) was a distant relative.

682, 2069.

**WYNFORD,** WILLIAM (active 1360–1403). A mason of Windsor Castle, promoted master mason *c.* 1364 in succession to John Sponlee (active 1350–d. *c.* 1382) by WILLIAM OF WYKEHAM, then clerk of the works at Windsor. Under Wykeham's aegis he was subsequently master mason of Wells Cathedral (western towers) from 1365, of New College, Oxford, from 1380, of Winchester College from 1387, and of Winchester Cathedral from 1394. The designs in all these cases were apparently his and related to Sponlee's work (surviving much altered in the present royal apartments) at Windsor.

# X

**XOANON.** There are literary references to early cult figures of wood in the late Geometric GREEK period. These were called *xoana* or *bretea*. They are thought to have been very crudely shaped poles, probably portable, on which garments and decorations were hung. It is doubtful whether they were shaped as naturalistic figures and scholars do not believe that the tradition of monumental STONE SCULPTURE was derived technically or otherwise from them. These *xoana* have not survived.

# Y

**YAMATO-E.** A School of painting in Japan which was considered to embody the Japanese native tradition and to exhibit a purely national style. Its most typical expression was in scroll paintings (*emakimono*) some 10 to 15 in. high and 30 ft. or more in length. Scroll painting with Buddhist themes was introduced to Japan from China in the 8th c. During the Heian period and still more in Kamakura art (see JAPANESE ART) secular subjects predominated and this School of painting found its distinctive character in illustrating popular or literary stories, romances, biographies, historical themes, etc. Whereas the Chinese used the scroll painting largely for unfolding landscape, the Japanese adapted it to the quasi-narrative depiction of human incident. The art of the horizontal scroll painting came to prominence with the development of Japanese literature and culminated in the 12th and 13th centuries. The oldest surviving examples from the Heian period are the scrolls illustrating the *Tale of Genji*, attributed to Fujiwara no Taka-

yoshi (active first half of 12th c.). The scroll of *The Adventures of Kibi in China* (late 12th c.) is in the Museum of Fine Arts, Boston.

The handscroll was to be viewed in sections adapted to the hold and the composition was devised in accordance with this and with the flow of the narrative. Sometimes scenes to be viewed successively were interspersed with calligraphic text. Sometimes the connection was visual and this together with the long, narrow space often led to original and exciting devices of DESIGN.

These *emakimono* were often executed in thin BRUSH-lines and flat colours at once soft and brilliant. NATURALISTIC and ornamental effects were skilfully united and the whole effect combined gravity and refinement of line with lively presentation of incident. Many of the scrolls display humour, keen psychological observation, and a gift for rapid and dramatic narrative. The typical Japanese fondness for nature and movement is manifest in the earlier scrolls, but there

was a loss of spontaneity when in the Ashikaga period (1392–1568) the style was adopted by the TOSA SCHOOL and made excessively decorative. Subsequently the artists seem to have lost their powers of invention in this style and in so far as it was not ousted by the 'INK painting' style from China (see SUIBOKU) it became conventional and uninteresting.

**YÁÑEZ DE LA ALMEDINA,** FERNANDO (active 1506–26). Spanish painter. In 1507–9 he collaborated with Fernando de Llanos (active 1506–25) to paint 12 panels of the life of the VIRGIN for the main ALTARPIECE, Valencia Cathedral. From the style of these paintings it is inferred that the 'Fernando spagnuolo' who was working in 1505 with LEONARDO DA VINCI on the *Battle of Anghiari* was either Yáñez or Llanos. In 1513 they separated, and Yáñez (the more gifted of the two) is last recorded in 1526 working on the altarpiece of Cuenca Cathedral.

**YEN LI-PÊN** (d. 673). Chinese artist, court painter to the T'ang emperor T'ai-tsung, who painted chiefly historical and Buddhist subjects. He did mainly wall-paintings, which have disappeared. But at least half the scroll *Portraits of the Emperors* in the Boston Museum seems to be authentic. From this we can see that his style was in a REALISTIC genre in which the pomp, elegance, and ceremonial of the age are depicted in fine outlines, rich, solid colours, and stately, sweeping but somewhat static poses (see CHINESE ART).

**YEVELE,** HENRY (active 1353-1400). English builder, master mason to Edward III (from 1360) and Richard II. All his directly documented works except the TOMBS of Cardinal Langham and Richard II (both in Westminster Abbey and commissioned in 1395) have disappeared, and apart from these his surviving work consists of more or less probable attributions. The principal monuments are the naves of Westminster Abbey (rather dubious) and Canterbury Cathedral (dubious), the remodelled hall of Westminster Palace (fairly certain), and the west gate of the city of Canterbury (rather dubious). He has been assigned every building of note in the home counties erected during his tenure of office as well as the Neville Screen in Durham Cathedral, which is known to have been carved in

London. The bulk of this work is fairly homogeneous, workmanlike rather than distinguished in design, with a high proportion of plain wall to window and using straightforward types of early PERPENDICULAR TRACERY. The real merit of Westminster Hall lies, moreover, in the roof, the credit for which is due to the carpenter Hugh Herland; the nave of Westminster Abbey is principally noteworthy for the self-effacement with which it is assimilated to the 13th-c. work; and the extremely successful nave of Canterbury, combining exceptionally lofty aisles with a panelled and plastic treatment of the wall surface, differs so much from all the rest as to suggest another architect. The last, however, may well be the only surviving building in which Yevele had a free enough hand to show his true ability.

1262.

**YSENBRANDT,** ADRIAEN (d. 1551). Flemish painter, apparently a productive artist, though a rather nebulous figure. The pictures now associated with him were once attributed to the anonymous Master of the Seven Sorrows of the Virgin and to Jan MOSTAERT, but G. Hulin de Loo (*Catalogue Critique, Exposition*, Bruges, 1902) switched the ascriptions to Ysenbrandt. He was made a master in Bruges in 1510, and worked and died there. He is also said to have been Gerard DAVID's pupil. Most of the paintings ascribed to him (*Mary Magdalene in a Landscape*, N.G., London) are derivative upon David. *The Adoration of the Magi* (City Art Gal., Birmingham) is in part a copy of MEMLING's *Epiphany* in the Prado and a lost work by Hugo van der GOES.

926.

**YÜN SHOU-P'ING** (1663–90). Chinese landscape and flower painter generally grouped with the Four Wangs (see WANG) and WU LI. His landscape style is less detailed and somewhat freer than that of the Wangs, his brush-work more alive, and his approach a compromise between the Sung style and the freer and more intimate manner of landscape that was characteristic of the INDIVIDUALISTS. His flower paintings, for which he is best known, are a synthesis of Sung grace and Ming objectivity with an element of individuality.

# Z

**ZADKINE,** OSSIP (1890–1967). Sculptor, born at Smolensk, Russia. He studied at the London Polytechnic in 1907 and in 1909 settled in Paris and worked for a few months at the École des Beaux-Arts, taking French nationality in 1921. He went through a CUBIST period from 1915 but developed a highly individual style with lyrical and BAROQUE features which transcend and supersede the restraints of Cubism. In 1950 he was awarded the Prize for Sculpture at the Venice Biennale and in 1953 was commissioned to make the memorial monument to those killed by German bombing which stands at the harbour entrance of Rotterdam. It is a large bronze statue called *The Destroyed City*. He was given a retrospective exhibition in 1958 at the Maison de la Pensée, Paris. The lyrical fantasy of Zadkine's work unites with a special gift for exploiting the qualities of metal and a highly individual reversal of the roles of masses and voids in his sculptural groups.

1232, 1441.

**ZAKHAROV,** ANDREYAN (1761–1811). The leading NEO-CLASSICAL architect in Russia. He was born in St. Petersburg, where he studied at the Academy of Fine Arts. The Admiralty Building in St. Petersburg (begun in 1805, completed after his death by Andrey Voronykhin (1759–1814)) is his chief work. A drawing of his for the ICONOSTASIS of a monastery at Gatchina is remarkable for the introduction of neo-GOTHIC art forms into RUSSIAN church decoration.

**ZAMPIERI,** DOMENICO. See DOMENICHINO.

**ZEITBLOM,** BARTEL (*c.* 1460–*c.* 1520). German painter who worked in the Ulm region and supplied a number of Swabian towns with large ALTARPIECES. His late-GOTHIC lyricism endeared him to the ROMANTICS, and the 19th c. liked to call him a 'German PERUGINO' or even more incongruously a 'German LEONARDO'.

**ZEUXIS** (latter 5th c. B.C.). One of the great Greek painters, born at Heraclea in south Italy. He specialized in PANEL pictures rather than murals like POLYGNOTUS. He perfected APOLLODORUS's use of shading. There are many anecdotes about his verisimilitude. He also painted in a kind of GRISAILLE. LUCIAN describes a family group of centaurs, said to have been copied from a lost original by Zeuxis.

**ZIGGURAT.** The name given in the ancient Babylonian language (Akkadian) to the towers of brickwork which rose over all the great temples of Babylonia and Assyria (see BABYLONIAN ART, ASSYRIAN ART). They were enormous masses of mud-brick, sometimes having an outer facing of burnt-brick, and were constructed as piles of flattened cubes each smaller than the one below. Occasionally there were as many as seven of these storeys, and at the top was a small temple built of blue enamelled bricks, imitating the colour of the sky. Within was an image of the god, dwelling thus in heaven but accessible from the earth, for the towers were ascended by flights of steps or by an encircling ramp. Best preserved of these towers is the ziggurat of Ur, but the most famous was the 'tower of Babel' at Babylon, of which nothing but the foundations are now to be seen.

2037.

**ZILLE,** HEINRICH (1858–1929). German etcher, lithographer, and draughtsman. Zille's vivid renderings of the Berlin proletariat are an unequalled record of social life. Inspired by genuine sympathy they are humanitarian rather than political in character.

**ZIMMERMANN,** DOMINIKUS (1685–1766). German ecclesiastical architect. In the churches of Steinhausen (1727) and Wies (1745) he created a ROCOCO equivalent of the GOTHIC HALL CHURCH—airy and spacious, of great architectural purity.

**ZOFFANY,** JOHANN (1734/5–1810). Painter, born at Frankfurt-am-Main. He studied at Ratisbon under Martin Speer (1702–65), a pupil of SOLIMENA, then after some years spent travelling in Austria and Italy he came to England *c.* 1758, where he first found employment as a decorator of clock-faces. An introduction to Garrick led to his painting scenes from the contemporary theatre, e.g. *The Clandestine Marriage* (Garrick Club, London), which brought him immediate success. He was elected R.A. in 1769. In 1770 he was in Italy with a commission from Queen Charlotte to paint *The Tribune of the Uffizi* (Windsor Castle), and he went on to Vienna, where he made full-length portraits of members of the imperial family. He was in India 1783–9.

The bulk of Zoffany's work consists of CONVERSATION PIECES in the manner of HOGARTH, crowded with figures, lively in spirit, and highly

skilled in the painting of detail. His paintings are valuable to the historian and antiquary as records of features and costume, but are for the most part of indifferent artistic merit. His full-length portraits (*Mrs. Oswald*, N.G., London), are, however, sometimes of unexpectedly high quality.

1753, 1842.

**ZOPPO,** MARCO (*c.* 1432–*c.* 1478). Italian painter, who was trained in the WORKSHOP of SQUARCIONE at Padua. In 1455 he left to work in Venice and Bologna. He well represents the general level of late 15th-c. painting in northern Italy. Two of his works are in the National Gallery, London.

**ZORN,** ANDERS (1860–1920). Swedish painter and etcher. On his travels during the 1880s, which included visits to London, Paris, Spain, Algiers, and Istanbul, he proved himself to be a brilliant WATER-COLOURIST, his manner becoming gradually more IMPRESSIONISTIC. In 1888 he turned to painting in oil, and at about the same time moved to Paris. In portraits, in Parisian street scenes, and in views of the surroundings of his home at Mora in Dalecarlia, his swift and elegant Impressionistic technique found its fullest scope, although he became known chiefly for his pictures with bathing peasant girls. After 1896 when he settled at Mora his work tended to mere virtuosity. As a successful portraitist in a manner which came to resemble SARGENT's, Zorn made several tours in the United States. But his best work was probably his ETCHINGS, done in a technique of more or less parallel lines across the plate, which was the counterpart of his rapid manner of painting. Here again, it is the earlier works from the 1890s that have been judged the finest.

110, 111, 330.

**ZUCCARELLI,** FRANCESCO (1702–88). Italian painter. Although Tuscan by birth, he was associated with the VENETIAN SCHOOL of PASTORAL LANDSCAPE PAINTING, derived from Marco RICCI. From his arrival in Venice in 1732 he was, like CANALETTO, patronized by Joseph Smith, and through his pastoral landscapes and city views achieved popularity and exerted great influence in England. When Richard WILSON (still primarily a portrait painter) visited Venice in 1751 he painted Zuccarelli's portrait and it was partly Zuccarelli's encouragement which induced him to turn his attention to landscape. Between 1751 and 1771 Zuccarelli spent nearly 17 years in England, where his facile and PICTURESQUE talent suited the taste of George III and ensured his popularity. He was made a foundation member of the ROYAL ACADEMY in 1768, and on his return to Venice he became President of the Venetian Academy. There are examples of his work in the National Gallery, London, and at Windsor Palace.

**ZUCCARO,** TADDEO (1529–66) and FEDERICO (1543–1609). Italian painters from the neighbourhood of Urbino, who dominated Roman painting in the later 16th c.

Taddeo had early contact with the art of Parma, and his first important commission in Rome, where he settled in 1551, shows CORREGGIO's influence. This was the decoration of the Cappella Mattei in Sta Maria della Consolazione, finished in 1556. Out of a fusion of the GRAND MANNER of RAPHAEL and the power and movement of MICHELANGELO with north Italian colour and line, Taddeo created a harmonious manner of history painting which soon became popular. He employed many assistants and trained his younger brother, Federico, to work beside him. Among the brothers' chief commissions were those from the FARNESE family for decorative schemes in their palace in Rome and their villa at Caprarola.

Federico worked for a while in Venice, where he painted the fresco of *Barbarossa Kissing the Foot of the Pope* in the Doge's Palace, but he returned to Rome in 1566, in which year Taddeo died and Federico took over his studio and commissions, continuing the work at Caprarola and also the decoration of the Sala Regia in the Vatican (begun by Taddeo in 1561). In 1573/4 he travelled via Lorraine and Holland to England, where he is said to have painted portraits of the Queen and many courtiers, although only two drawings in the British Museum portraying Elizabeth and Leicester can safely be attributed to him. After more work in Venice, Loreto, and Rome, he was invited to the ESCORIAL by Philip II of Spain, where he painted a number of ALTARPIECES (1585–8). Back in Rome he was elected the first President of the new Academy of St. Luke, founded in 1593, to which he later gave his house as headquarters. Like many of his contemporaries he believed that correct theory would produce good works of art and himself wrote *L'Idea de' Pittori, Scultori ed Architetti*, 1607.

The ECLECTIC style created by Taddeo and continued by his brother, though not of the highest artistic merit, had a wide international influence.

**ZULOAGA,** IGNACIO (1870–1945). Spanish painter, born at Eibar in the Basque country, son of PLACIDO ZULOAGA, a well known goldsmith and metal-worker of an old Basque family of armourers. As a youth he studied in Paris, where he was influenced by the works of MANET and was on friendly terms with RODIN, GAUGUIN, DEGAS, Mallarmé, and the Spanish painter RUSIÑOL. He later visited Toledo, studied artists of the FLORENTINE quattrocento and also learnt much from the works of GOYA and VELAZQUEZ. He painted for preference Spanish scenes, bull-fighters, gypsies, brigands, as well as portraits and figure studies. There is a Zuloaga museum in Madrid.

263, 1548.

**ZURBARÁN,** FRANCISCO (1598-1664). Spanish painter. He was born in Estremadura and by 1614 was at Seville. In 1628 he became official painter to the town, and remained there, with occasional breaks, for the next 30 years. Like his contemporary VELAZQUEZ he was influenced indirectly or directly by the paintings of CARAVAGGIO, and by the realistic figure sculpture of MONTAÑÉS. In 1629-30 he executed two narrative series of scenes from the lives of St. Bonaventura (two in the Louvre) and of St. Peter Nolasco (two in the Prado); his *St. Hugh of Grenoble visiting the Refectory* (Seville Mus.) is probably slightly later. These paintings reveal the principal characteristics of his style, a serene yet profound REALISM and mastery of sculpturesque form combined with simplicity of COMPOSITION and colour.

In 1634 he was employed by Philip IV on the one important secular commission of his life, 10 paintings, *The Labours of Hercules*, and a large historical picture, *The Defence of Cadiz*, designed for the Buen Retiro Palace (now in the Prado). During the years 1637-9 he was painting various works for the Carthusian monastery at Jerez, among them the large pictures now in the museum at Grenoble, which include *The Adoration of the Shepherds*, dated 1638 and signed 'Regis Pictor'. To the same period (1638-9) belongs a further series of large paintings, including *The Temptation of St. Jerome*, which he executed for the Hieronymite monastery at Guadalupe.

The most characteristic of Zurbarán's works are the single figures of monks and saints in meditation or prayer, most of which seem to have been executed in the 1630s. Many of these monumental figures are conceived in great series, such as *The Members of the Mercedarian Order* (Academy, Madrid), or *The Twelve Apostles* (several series; Lisbon, Guatemala, and Lima), or *The Carthusian Saints* (Cadiz Mus.). But there are single pictures of the same kind. He painted 14 versions of *St. Francis* (two in the N.G., London) and a number of virgin saints. Zurbarán also excelled as a painter of LANDSCAPE backgrounds and of contemplative STILL LIFES.

Towards the end of his career his work lost something of its power and monumental simplicity under the influence of MURILLO's more popular and less ascetic art. About 1658 he moved to Madrid, and died there six years later.

In Spain Zurbarán was eclipsed during his lifetime by Murillo, but he exercised some influence on the colonial painters of Spanish America through the many works which he exported there. The secularization of the Spanish monasteries in 1835 made his work known throughout Europe; and among other painters COURBET, MANET, and PICASSO have paid tribute to him.

2110, 2531.

# BIBLIOGRAPHY

## I. DICTIONARIES, ENCYCLOPEDIAS, GENERAL HISTORIES, AND BIBLIOGRAPHICAL WORKS

ATKINSON, T. D. *A glossary of terms used in English architecture*, 1946 (1906)

BAZIN, G. R. M. *A concise history of art*, 1958

BRYAN, M. *Bryan's dictionary of painters and engravers*, 5 vols., 1919-21 (1816)

CHAMBERLIN, M. W. *Guide to art reference books*, Chicago, 1959

CHANCELLOR, E. B. *The lives of the British architects from William of Wykeham to Sir William Chambers*, 1909

— *The lives of the British sculptors and those who have worked in England from the earliest days to Sir Francis Chantrey*, 1911

CHENEY, S. *A new world history of art*, New York, 1956

CHRISTENSEN, E. O. *The history of Western art*, 1959

COLVIN, H. M. *Biographical dictionary of English architects, 1660-1840*, 1954

DELTEIL, L. *Le Peintre-graveur illustré*, 30 vols., 1906-30

FAURE, É. *History of art*, 5 vols., 1921-30 (1909)

FLEMING, J. and others. *The Penguin dictionary of architecture*, 1966

GOMBRICH, E. H. *The story of art*, 1966 (1950)

GRANT, M. H. *A dictionary of British etchers*, 1952

— *A dictionary of British landscape painters*, 1952

— *A dictionary of British sculptors*, 1953

GRINTEN, E. F. VAN DER. *Enquiries into the history of art-historical writing*, Venlo, 1952

GUNNIS, R. *Dictionary of British sculptors, 1660-1851*, 1953

HARVEY, J. H. *English mediaeval architects: a biographical dictionary down to 1550*, 1954

HATJE, G. (ed.). *Encyclopaedia of modern architecture*, 1963

— (ed.). *The styles of European art*, 1965

HAUSER, A. *The social history of art*, 4 vols., 1962 (1951)

HOLT, E. G. (ed.). *Literary sources of art history: an anthology of texts from Theophilus to Goethe*, Princeton, 1947

JANSON, H. W. and D. J. *A history of art*, 1962

LUCAS, E. L. *The Harvard list of books on art*, Cambridge, Mass., 1952

MAILLARD, R. (ed.). *A dictionary of modern sculpture*, 1962

MALRAUX, A. *Le Musée imaginaire de la sculpture mondiale*, 3 vols., 1952-4

MURRAY, P. and L. *A dictionary of art and artists*, 1965 (1959)

O'DWYER, J. and LE MAGE, R. *A glossary of art terms*, 1950

PALLOTTINO, M. (ed.). *Encyclopedia of world art*, New York, 1959-

RÉAU, L. *Encyclopédie de l'art. Les arts plastiques*, 1951

ROWLAND, B. *The classical tradition in Western art*, Cambridge, Mass., 1963

THIEME, U. and BECKER, F. (edd.). *Allgemeines Lexicon der bildenden Künstler*, Leipzig, 1907-50

VOLLMER, H. (ed.). *Allgemeines Lexicon der bildenden Künstler des XX. Jahrhunderts*, Leipzig, 1953

WARE, D. *A short dictionary of British architects*, 1967

WATELET, C. H. and LÉVESQUE, P. C. *Dictionnaire des arts de peinture, sculpture et gravure*, 1792

WÖLFFLIN, H. *Principles of art history*, 1932

## II. THEORY AND CRITICISM

ALISON, A. *Essays on the nature and principles of taste*, 1790

ARNHEIM, R. *Art and visual perception: a psychology of the creative eye*, 1956

— *Toward a psychology of art*, Berkeley, 1966

BATE, W. J. *From Classic to Romantic: premises of taste in eighteenth century England*, Cambridge, Mass., 1946

BAYER, R. *L'Esthétique mondiale au XXᵉ siècle*, 1961

— *Histoire de l'esthétique*, 1961

BEARDSLEY, M. C. *Aesthetics from Classical Greece to the present: a short history*, New York, 1966

— *Aesthetics. Problems in the philosophy of criticism*, New York, 1958

BELL, C. *Art*, 1914

BIEDERMAN, C. *Art as the evolution of visual knowledge*, 1948

BIRKHOFF, G. D. *Aesthetic measure*, Cambridge, Mass., 1933

BLANSHARD, F. M. B. *Retreat from likeness in the theory of painting*, New York, 1949

BLUNT, SIR A. F. *Artistic theory in Italy, 1450–1600*, 1940

BOSANQUET, B. *A history of aesthetic*, New York, 1957 (1892)

BRUYNE, E. DE. *L'Esthétique du Moyen Âge*, Louvain, 1947

— *Études d'esthétique médiévale*, 3 vols., Brugge, 1946

BURKE, E. *A philosophical enquiry into the origins of our ideas of the sublime and beautiful*, 1757

CARRITT, E. F. (ed.). *Philosophies of beauty*, 1931

— *The theory of beauty*, 1962 (1914)

CHAMBERS, F. P. *The history of taste*, New York, 1932

CLARK, SIR K. M. *The nude. A study of ideal art*, 1956

COLLINGWOOD, R. G. *The principles of art*, 1938

COOMARASWAMY, A. K. *The transformation of nature in art*, Cambridge, Mass., 1934

CROCE, B. *Aesthetic*, 1922 (1909)

DE, S. K. *Sanskrit poetics as a study of aesthetics*, Berkeley and Los Angeles, 1963

DEWEY, J. *Art as experience*, 1934

DIDEROT, D. *Essai sur la peinture*, 1765

EHRENZWEIG, A. *The psycho-analysis of artistic vision and hearing*, 1953

FOCILLON, H. *The life of forms in art*, New York, 1948 (New Haven, 1942)

GAUSS, C. E. *The aesthetic theories of French artists, 1855 to the present*, Baltimore, 1949

GILBERT, K. and KUHN, H. *A history of esthetics*, 1956 (New York, 1939)

GILSON, É. *Painting and reality*, 1957

GOLDWATER, R. J. and TREVES, M. *Artists on art*, New York, 1945

GOMBRICH, E. H. *Art and illusion*, 1960

— *Meditations on a hobby horse, and other essays on the theory of art*, 1963

HOFSTADTER, A. and KUHNS, R. (edd.). *Philosophies of art and beauty. Selected readings in aesthetics from Plato to Heidegger*, New York, 1964

HOME, H. *Elements of criticism*, 3 vols., 1762

HUYGHE, R. *Art and the spirit of man*, 1962

KANDINSKY, W. *Concerning the spiritual in art*, New York, 1947

KANT, I. *The critique of judgement*, trans. by J. C. Meredith, 1952 (1790)

— *Observations on the feeling of the beautiful and sublime*, trans. by J. T. Goldthwait, Berkeley, 1960 (1764)

KROEBER, A. L. *Style and civilizations*. Berkeley, 1963 (Ithaca, N.Y., 1957)

LANGER, S. K. *Feeling and form*, 1953

— (ed.). *Reflections on art*, New York, 1961 (Baltimore, 1958)

MAHON, D. *Studies in seicento art and theory*, 1947

MALRAUX, A. *The metamorphosis of the gods*, 1960

— *The voices of silence*, 1954 (1951)

MONK, S. H. *The sublime: a study of critical theories in XVIII century England*, New York, 1935

MUMFORD, L. *Art and technics*, 1952

NEEDHAM, H. A. *Le Développement de l'esthétique sociologique en France et en Angleterre au XIXᵉ siècle*, 1926

OSBORNE, H. *Theory of beauty: an introduction to aesthetics*, 1952

PAALEN, W. *Form and sense*, New York, 1945

PANOFSKY, E. *Galileo as a critic of the arts*, The Hague, 1954

PHILLIPSON, M. H. (ed.). *Aesthetics today*, New York, 1961

RASMUSSEN, S. E. *Experiencing architecture*, 1960

READ, SIR H. E. *The forms of things unknown*, 1960

— *Icon and idea*, 1955

— *The philosophy of modern art*, 1952

SAKANISHI, S. *The spirit of the brush*, 1939

SANTAYANA, G. *The life of reason*, 5 vols., 1905–6

— *The sense of beauty: being the outlines of aesthetic theory*, 1896

SESONSKE, A. (ed.). *What is art? Aesthetic theory from Plato to Tolstoi*. New York, 1965

SIRÉN, O. *The Chinese on the art of painting*, New York, 1963 (1936)

SPARSHOTT, F. E. *The structure of aesthetics*, 1963

STOKES, A. *The invitation in art*, 1965

— *Painting and the inner world*, 1963

— *Three essays on the painting of our time*, 1961

STOLNITZ, J. *Aesthetics and philosophy of art criticism*, Boston, 1960

TAINE, H. *Philosophie de l'art*, 1881 (1865)

TOLSTOY, L. N. *What is art?*, trans. by A. Maude, 1898

VALENTINE, C. W. *The experimental psychology of beauty*, 1962

VENTURI, L. *History of art criticism*, New York, 1936

VERMEULE, C. C. *European art and the classical past*, Cambridge, Mass., 1964

WALPOLE, H. *Anecdotes of painting in England*, 4 vols., 1762–71

WHITE, J. *The birth and rebirth of pictorial space*, 1967 (1957)

WIND, E. *Art and anarchy*, 1963

## III. GENERAL WORKS ON THE NINETEENTH AND TWENTIETH CENTURIES

BOWNESS, A. *Modern sculpture*, 1965

BRION, M. and others. *Art since 1945*, 1958

CASSON, S. *Some modern sculptors*, 1929

CASSOU, J. *Panorama des arts plastiques contemporains*, 1960

CHENEY, S. *The story of modern art*, 1958 (1941)

CHRIST, Y. *L'Art au XIXᵉ siècle*, 2 vols., 1961–2

CRAVEN, T. *Modern art: the men, the movements, the meaning*, 1935

# BIBLIOGRAPHY

FOCILLON, H. *La Peinture aux XIX^e et XX^e siècles. Du réalisme à nos jours*, 1928

FRANCASTEL, P. *Nouveau dessin, nouvelle peinture*, 1946

GERTZ, U. *Plastik der Gegenwart*, 2 vols., Berlin, 1953–64

GIEDION-WELCKER, C. *Contemporary sculpture*, 1961 (1956)

GRÜNIGEN, B. VON. *Vom Impressionismus zum Tachismus*, Basel, 1964

HAFTMANN, W. *Painting in the twentieth century*, 2 vols., 1965 (1960)

HAMMACHER, A. M. *Modern English sculpture*, 1967

HERBERT, R. L. (ed.). *Modern artists on art*, 1964

HOLT, E. G. (ed.). *From the Classicists to the Impressionists. A documentary history of art and architecture in the 19th century*, 1966

HUYGHE, R. *Histoire de l'art contemporain. La peinture*, 1935

LANGUI, É. *Fifty years of modern art*, 1959

MACCOLL, D. S. *Nineteenth century art*, 1902

MARYON, H. *Modern sculpture : its methods and ideals*, 1933

MYERS, B. S. *Modern art in the making*, New York, 1950

OZENFANT, A. *Foundations of modern art*, 1931

PACH, W. *The classical tradition in modern art*, New York, 1959

PLATZ, G. A. *Die Baukunst der neusten Zeit*, Berlin, 1927

RAMSDEN, E. H. *Sculpture : theme and variations*, 1953

RAYNAŁ, M. *History of modern painting*, 1949

READ, SIR H. E. *Art now. An introduction to the theory of modern painting and sculpture*, 1960 (1933)

— *A concise history of modern sculpture*, 1964

RITCHIE, A. C. *The new decade*, New York, 1955

SELZ, J. *Modern sculpture*, 1963

SEUPHOR, M. *The sculpture of this century*, 1960

TRIER, E. *Form and space, the sculpture of the twentieth century*, 1961

USHENKO, A. P. *Dynamics of art*, Bloomington, 1953

WILENSKI, R. H. *The meaning of modern sculpture*, 1932

— *The modern movement in art*, 1935 (1927)

## IV. MATERIALS AND TECHNIQUES

ANDERSON, M. D. *The medieval carver*, 1935

DAVEY, N. *A history of building materials*, 1961

DOERNER, M. *The materials of the artist and their use in painting, with notes on the techniques of the Old Masters*, New York, 1949 (1935)

HERBERTS, K. *The complete book of artists' techniques*, 1958

JAGGER, S. *Modelling and sculpture in the making*, 1933

LAMB, L. *Preparation for painting. The purpose and materials of the artist*, 1954

MAYER, R. *The artist's handbook of materials and techniques*, 1951

MEILACH, D. and SEIDEN, D. *Direct metal sculpture*, 1966

MILLS, J. F. *Studio and art-room techniques*, 1965

MILLS, J. W. *The technique of sculpture*, 1965

RICH, J. C. *The materials and methods of sculpture*, New York, 1947

THOMPSON, D. V. *The materials of medieval painting*, 1936

TOLNAI, K. *History and technique of Old Master drawings*, New York, 1943

## V. SELECTIVE LIST OF WORKS ON SPECIFIC SUBJECTS

*(Numbers at the end of articles refer to items in this list)*

1. AALTO, A. *Alvar Aalto*, 1963
2. ABBOTT, W. *The theory and practice of perspective*, 1950
3. ABDUL-HAK, S. *Sculpture des porches du transept de la cathédrale de Chartres*, 1943
4. ÅBERG, N. F. *The Occident and the Orient in the art of the seventh century*, 3 vols., Stockholm, 1943–7
5. ABIZANDA Y BROTO, M. *Damián Forment, el escultor de la corona de Aragón*, Barcelona, 1942
6. ACHARYA, PRASANNA KUMAR. *An encyclopaedia of Hindu architecture*, 1946 (1927)
7. ACKERMAN, J. S. *The architecture of Michelangelo*, 2 vols., 1961
8. ADAM, L. *Primitive art*, 1954 (1940)
9. ADAM, R. and J. *The works in architecture of Robert and James Adam, Esquires*, 3 vols., 1778–1822
10. ADAM, S. *The technique of Greek sculpture in the archaic and classical periods*, 1966
11. ADAMS, A. V. *John Quincy Adams Ward, an appreciation*, New York, 1912
12. ADDELSHAW, G. W. O. and ETCHELLS, F. *The architectural setting of Anglican worship*, 1948
13. ADHÉMAR, H. *Watteau: sa vie, son œuvre*, 1950
14. ADHÉMAR, J. *Graphic art of the 18th century*, 1964 (1963)
15. — *Honoré Daumier*, 1954
16. — (ed.). *Toulouse-Lautrec: his complete lithographs and drypoints*, 1965 (1962)
17. AHLBERG, C. A. H. *Swedish architecture of the twentieth century*, 1925
18. AINAUD DE LASARTE, J. *Jaime Huguet*, Madrid, 1955
19. AINAUD DE LASARTE, J. and others. *La Ciudad de Barcelona*, 2 vols., Madrid, 1947
20. AKIYAMA, TERUKAZU. *Japanese painting*, Lausanne, 1961

21. AKURGAL, E. *The art of the Hittites*, 1962 (1961)
22. ALAUX, J. P. *Académie de France à Rome*, 1933
23. ALAZARD, J. *L'Art italien au XVᵉ siècle*, 1951
24. — *Ingres et l'ingrisme*, 1950
25. ALBERTI, LEON BATTISTA. *De pictura (On painting)*, Basel, 1540; New Haven, 1956
26. ALDRED, C. *The development of ancient Egyptian art from 3200 to 1315 B.C.*, 1952
27. — *The Egyptians*, 1961
28. ALEAUME, J. *La Perspective speculative et pratique*, 1643
29. ALEXANDER, B. *England's wealthiest son. A study of William Beckford*, 1962
30. ALEXANDER, C. *Arretine relief ware* (Corpus vasorum antiquorum), Cambridge, Mass., 1943
31. ALEXANDER, F. L. *Art in South Africa: painting, sculpture and graphic work since 1900*, Cape Town, 1962
32. ALKEN, H. *The art and practice of etching*, 1849
33. ALLEN, J. R. *Celtic art in pagan and Christian times*, 1912 (1904)
34. ALLESCH, J. VON. *Michael Pacher*, Leipzig, 1931
35. ALLSOPP, B. *A history of classical architecture*, 1965
36. ALMELA Y VIVES, F. and IGUAL ÚBEDA, A. *El arquitecto y escultor valenciano Manuel Tolsá, 1757–1816*, Valencia, 1950
37. ALNAES, E. and others. *Norwegian architecture throughout the ages*, Oslo, 1950
38. ALPATOV, M. V. *Russian impact on art*, New York, 1950
39. ALTENA, J. Q. VAN REGTEREN. *The drawings of Jacques de Gheyn*, Amsterdam, 1936
40. ALTHERR, A. (ed.). *New Swiss architecture*, 1965
41. AMAYA, M. *Pop as art: a study of the new super realism*, 1965
42. AMORY, M. B. *The domestic and artistic life of John Singleton Copley, R.A., with notices of his works*, Boston, 1882
43. ANAND, M. R. *The Hindu view of art*. Introductory essay on art and reality by Eric Gill, 1933
44. ANANOFF, A. *L'œuvre dessinée de Jean-Honoré Fragonard, 1732–1806*. Catalogue raisonné, 1961
45. ANATI, E. *Camonica Valley*, 1964 (1960)
46. ANCONA, P. D'. *Paolo Uccello*, 1960
47. ANDERSON, W. *Descriptive and historical catalogue of a collection of Japanese and Chinese paintings in the British Museum*, 1886
48. ANDERSON, W. J. *The architecture of the Renaissance in Italy*, 1927 (1896)
49. ANDREWS, K. *The Nazarenes: a brotherhood of German painters in Rome*, 1964
50. ANFRAY, M. *L'Architecture normande: son influence dans le nord de la France aux XIᵉ et XIIᵉ siècles*, 1939
51. ANGOULVENT, M. *Berthe Morisot*, 1933

52. ANGULO, A. and others. *Historia del arte Hispano-Americano*, 3 vols., Barcelona, 1945–56
53. ANGULO IÑIGUEZ, D. *Alejo Fernández*, Seville, 1946
54. — *Juan de Borgoña*, Madrid, 1954
55. — *La Mitología y el arte español del Renacimiento*, Madrid, 1952
56. — *Pedro de Campaña*, Seville, 1951
57. ANGYAL, A. *Die slawische Barockwelt*, Leipzig, 1961
58. ANTAL, F. *Florentine painting and its social background, XIV and early XV centuries*, 1948
59. — *Fuseli studies*, 1956
60. — *Hogarth and his place in European art*, 1962
61. ANTHONY, E. W. *A history of mosaics*, Boston, 1935
62. — *Romanesque frescoes*, Princeton, 1951
63. APOLLINAIRE, G. *Chroniques d'art (1902–1918)*, ed. by L. C. Breunig, 1960
64. — *Les Mamelles de Tirésias*, 1946
65. — *Les Peintres cubistes: méditations esthétiques*, Geneva, 1950 (1913)
66. APOLLONIO, U. *Mario Marini, sculptor*, 1958
67. ARBERRY, A. J. (ed.). *The legacy of Persia*, 1953
68. ARCHER, W. G. *India and modern art*, 1959
69. — *Paintings of the Sikhs*, 1967
70. — (ed.). *Central Indian painting*, 1958
71. — (ed.). *Indian painting*, 1956
72. ARCHIPENKO, A. and others. *Archipenko: fifty creative years, 1908–1958*, New York, 1960
73. ARGAN, G. C. *Botticelli*, New York, 1957
74. — *Marcel Breuer: disegno industriale e architettura*, Milan, 1957
75. — *Pier Luigi Nervi*, Milan, 1955
76. ARIAS, P. E. *A history of Greek vase painting*, 1962
77. ARMITAGE, E. L. *Stained glass*, 1959
78. ARMSTRONG, W. *Alfred Stevens: a biographical study*, 1881
79. ARNASON, H. H. *Calder*, 1967
80. *Ars Hispaniae. Historia universal del arte hispánico*, 19 vols., Madrid, 1947–66
81. ARTS AND CRAFTS EXHIBITION SOCIETY, THE. *Arts and crafts essays*, by members of the Arts and Crafts Exhibition Society, 1893
82. ARTS COUNCIL OF GREAT BRITAIN, THE. Exhibition Catalogue. *Alberto Giacometti; sculpture, paintings, drawings, 1913–65*, 1965
83. — *The almost complete works of Marcel Duchamp*, 1966
84. — *Ancient Peruvian art*, 1962
85. — *The arts of Thailand*, 1964
86. — *Austrian painting and sculpture, 1900–1960*, 1960
87. — *Brazilian art today*, 1965
88. — *Claude Monet*, 1957
89. — *An exhibition of national art treasures of Korea*, 1961
90. — *5000 years of Egyptian art*, 1962
91. — *Gauguin and the Pont-Aven group*, 1966
92. — *Gerard David*, 1949

93. ARTS COUNCIL OF GREAT BRITAIN, THE. Exhibition Catalogue. *The graphic work of Edvard Munch, 1863–1944,* 1964

94. — *James McNeill Whistler,* 1960

95. — *Kokoschka: a retrospective exhibition of paintings, drawings, lithographs, stage designs, and books,* 1962

96. — *Lovis Corinth,* 1959

97. — *Max Beckmann, 1884–1950,* 1965

98. — *Max Ernst,* 1961

99. — *Painters of the Brucke,* 1964

100. — *Picasso: sculpture, ceramics, graphic work,* 1967

101. — *A retrospective exhibition of paintings and designs for the theatre: Larionov and Goncharova,* 1961

102. — *Rouault: an exhibition of paintings, drawings and documents,* 1966

103. — *Trends in contemporary Dutch art,* 1958

104. — *Wilhelm Lehmbruck, 1881–1919: sculpture, paintings, drawings, etchings,* 1957

105. ASHBEE, C. R. *The private press: a study in idealism, to which is added a bibliography of the Essex House Press,* 1908

106. — *Should we stop teaching art?,* 1911

107. — (ed.). *Transactions of the Guild and School of Handicraft,* vol. i, 1890

108. ASHBY, T. *The architecture of ancient Rome,* 1927

109. ASHTON, SIR A. L. B. and GRAY, B. *Chinese art,* 1935

110. ASPLUND, K. *Anders Zorn: his life and work,* 1921

111. — *Zorn's engraved work: a descriptive catalogue,* 2 vols., Stockholm, 1920

112. AUBERT, M. *L'Architecture cistercienne en France,* 2 vols., 1947 (1943)

113. — *La Cathédrale Notre-Dame de Paris,* 1950 (1909)

114. — *High Gothic art,* 1964

115. — (ed.). *L'Art roman en France,* 1961

116. AUBERT, M. and others. *Le Vitrail français,* 1958

117. AUBOYER, J. *Arts et styles de l'Inde,* 1951

118. AUERBACH, E. *Nicholas Hilliard,* 1961

119. — *Tudor artists,* 1954

120. AVERMAETE, R. *James Ensor,* 1952 (Antwerp, 1947)

121. BABELON, E. *La Gravure en pierres fines. Camées et intailles,* 1900 (1894)

122. BABELON, J. F. L. *Germain Pilon,* 1927

123. — *La Médaille et les médailleurs,* 1927

124. BACCI, M. *Piero di Cosimo,* Milan, 1966

125. BACHHOFER, L. *Early Indian sculpture,* 2 vols., 1929

126. BACON, E. N. *Design of cities,* 1967

127. BACOU, R. *Odilon Redon,* 2 vols., Geneva, 1956

128. BADHAM, H. E. *A study of Australian art,* Sydney, 1949

129. BADT, K. *The art of Cézanne,* 1965 (1956)

130. — *Eugène Delacroix drawings,* 1946

131. — *John Constable's clouds,* 1950

132. BAIN, G. *The methods of construction of Celtic art,* 1951

133. BAIRD, J. A. *The churches of Mexico, 1530–1810,* Berkeley, 1962

134. BAKER, C. H. COLLINS. *Crome,* 1921

135. — *Lely and the Stuart portrait painters,* 1912

136. — *Pieter de Hooch,* 1925

137. BAKER, C. H. COLLINS and CONSTABLE, W. G. *English painting of the sixteenth and seventeenth centuries,* 1930

138. BAKER, C. H. COLLINS and JAMES, M. R. *British painting,* 1933

139. BAKER, J. *English stained glass,* 1960

140. BALDASS, L. VON. *Hans Memling,* Vienna, 1942

141. — *Hieronymus Bosch,* 1960 (Vienna, 1943)

142. — *Jan van Eyck,* 1952

143. — *Joos van Clive, der Meister des Todes Mariä,* Vienna, 1925

144. BALDINUCCI, F. *Vita di Bernini (The life of Bernini),* Florence, 1682 (University Park, 1966)

145. BALLANTINE, J. *The life of David Roberts, R.A.,* 1866

146. BALLO, G. *Boccioni: la vita e l'opera,* Milan, 1964

147. — *Modern Italian painting from futurism to the present day,* 1958

148. BALSTON, T. *John Martin 1789–1854, his life and works,* 1947

149. BALTRUŠAITIS, J. *Anamorphoses, ou perspectives curieuses,* 1955

150. BANDI, H. G. and others. *The art of the Stone Age: forty thousands years of rock art,* 1961

151. BANERJEA, J. N. *The development of Hindu iconography,* Calcutta, 1956 (1941)

152. BANGE, E. F. *Die deutschen Bronzestatuetten des 16. Jahrhunderts,* Berlin, 1949

153. BANHAM, R. *Theory and design in the first Machine Age,* 1960

154. BARAMKI, D. C. *Phoenicia and the Phoenicians,* Beirut, 1961

155. BARBEY D'AUREVILLY, J. A. *Les Diaboliques,* 1947 (1891)

156. BARBIER, C. P. *William Gilpin: his drawings, teaching, and theory of the picturesque,* 1963

157. BARBIERI, F. *Tutta l'architettura di Michelangelo,* Milan, 1964

158. BARDI, P. M. *Lasar Segall,* São Paulo, 1952

159. BARKER, V. *American painting: history and interpretation,* New York, 1950

160. BARLACH, E. *Ernst Barlach, ein selbsterzähltes Leben,* Munich, 1948

161. — *Frühe und späte Briefe,* Hamburg, 1962

162. — *Plastik,* Munich, 1959

163. — *Taschenbuch-Zeichnungen,* Leipzig, 1955

164. — *Zeichnungen,* Munich, 1961

165. BARMAN, C. A. *An introduction to railway architecture,* 1950

166. BARNES, A. C. and DE MAZIA, V. *The art of Henri Matisse,* 1933

167. BARNETT, R. D. *Assyrian palace reliefs and their influence on the sculptures of Babylonia and Persia,* 1960

168. BARNETT, R. D. and WISEMAN, D. J. *Fifty masterpieces of ancient Near Eastern art in the Department of Western Asiatic Antiquities, British Museum*, 1960

169. BAROCCHI, P. *Il Rosso Fiorentino*, Rome, 1950

170. BARON, H. *The crisis of the early Italian Renaissance*, 2 vols., Princeton, 1966 (1955)

171. BARR, A. H. *Cubism and abstract art*, New York, 1966 (1936)

172. — *Picasso : fifty years of his art*, New York, 1966 (1946)

173. — *Matisse : his art and his public*, New York, 1966 (1951)

174. BARREIRA, J. *Arte portuguesa*, 3 vols., Lisbon, 1948-54

175. BARRETT, D. and GRAY, B. *Painting of India*, Lausanne, 1963

176. BARROW, T. T. *The life and work of the Maori carver*, Wellington, New Zealand, 1963

177. BARRY, A. *The life and works of Sir Charles Barry*, 1867

178. BASEL, KUNSTMUSEUM. *Die Maler Familie Holbein in Basel* (Exhibition catalogue), Basel, 1960

179. BASLER, A. *Henri Rousseau*, 1929

180. BASTELAER, R. VAN. *Les Estampes de Pieter Bruegel l'Ancien*, Brussels, 1908

181. BATAILLE, G. *Manet*, Lausanne and New York, 1955

182. BATE, P. *The English pre-Raphaelite painters : their associates and successors*, 1901 (1899)

183. BATTARBEE, R. E. *Modern Australian aboriginal art*, Sydney, 1951

184. BATTELLI, G. *Lodovico Cardi, detto Il Cigoli*, Florence, 1922

185. BATTEN, M. I. *The architecture of Dr. R. Hooke, F.R.S.* (Walpole Society, vol. XXV), 1937

186. BATTISS, W. W. *The artists of the rocks*, Pretoria, 1948

187. BATTISTI, E. *Cimabue*, Milan, 1963

188. — *Rinascimento e barocco*, Turin, 1960

189. BAUCH, K. *Der Magdalenen-Altar des Lucas Moser zu Tiefenbronn*, Bremen, 1940

190. BAUDELAIRE, C. *L'Art romantique*, 1931 (1899)

191. — *Le Peintre de la vie moderne (The painter of modern life)*, 1863 (1964)

192. BAUER, F. *Caspar David Friedrich : ein Maler der Romantik*, Stuttgart, 1961

193. BAUER, H. *Der Himmel im Rokoko : das Fresko im deutschen Kirchenraum des 18. Jahrhunderts*, Regensburg, 1965

194. BAUM, J. *Martin Schongauer*, Vienna, 1948

195. BAUR, J. I. H. *Charles Burchfield*, New York, 1956

196. — *Revolution and tradition in modern American art*, Cambridge, Mass., 1951

197. — (ed.). *New art in America*, 1957

198. BAYER, H. (ed.). *The Bauhaus 1919-1928*, 1968

199. BAYLEY, F. W. *Five colonial artists of New England : Joseph Badger, Joseph Blackburn, John Singleton Copley, Robert Feke, John Smibert*, Boston, 1929

200. — *The life and works of John Singleton Copley*, Boston, 1915

201. BAZIN, G. R. M. *L'Architecture religieuse baroque au Brésil*, São Paulo, 2 vols., 1956-8

202. — *Baroque and rococo*, 1964

203. — *Corot*, 1951

204. — *Impressionist paintings in the Louvre*, 1958

205. BEAZLEY, SIR J. D. *Attic red-figure vase-painters*, 3 vols., 1963 (Tübingen, 1925)

206. — *Etruscan vase-painting*, 1947

207. BEAZLEY, SIR J. D. and ASHMOLE, B. *Greek sculpture and painting to the end of the Hellenistic period*, 1932

208. BECATTI, G. *L'arte romana*, Milan, 1962

209. BECKETT, R. B. *Hogarth*, 1949

210. — *John Constable and the Fishers*, 1952

211. — *Lely*, 1951

212. BECKWITH, J. *The art of Constantinople : an introduction to Byzantine art, 330-1453*, 1961

213. — *Coptic sculpture, 300-1300*, 1963.

214. *Early medieval art : Carolingian, Ottonian, Romanesque*, 1964

215. BEENKEN, H. *Rogier van der Weyden*, Munich, 1951

216. — *Romanische Skulptur in Deutschland*, Leipzig, 1924

217. BEER, J. *Albrecht Dürer als Maler*, Königstein im Taunus, 1953

218. BEERBOHM, SIR H. M. *The poets' corner*, 1943 (1904)

219. BEGUIN, S. *L'École de Fontainebleau*, 1960

220. BEGUIN, S. and others. *A dictionary of Italian painting*, 1965

221. BEHR, H. *Der Malerfürst Franz von Lenbach und seine Zeit*, Munich, 1960

222. BEHRENDT, W. C. *Modern building*, 1938

223. BELL, C. *An account of French painting*, 1931

224. — *Auguste Renoir : Les Parapluies*, 1945

225. — *Enjoying pictures*, 1934

226. BELL, SIR C. *The anatomy and philosophy of expression, as connected with the fine arts*, 1877 (1806)

227. BELL, C. F. *Annals of Thomas Banks*, 1938

228. BELL, Q. C. S. *Roger Fry*, 1964

229. — *The schools of design*, 1963

230. — *Victorian artists*, 1967

231. BEMROSE, G. J. V. *Nineteenth century English pottery and porcelain*, 1952

232. BEMROSE, W. *The life and works of Joseph Wright, A.R.A.*, 1885

233. BÉNÉDITE, L. *Rodin*, 1926

234. BENESCH, O. *The art of the Renaissance in Northern Europe : its relation to the contemporary spiritual and intellectual movements*, Cambridge, Mass., 1965 (1945)

235. — *The drawings of Rembrandt*, 6 vols., 1954-7

236. — *Edvard Munch*, 1960

237. BENESCH, O. *Der Maler Albrecht Altdorfer*, Vienna, 1939
238. BENÉT, R. *Velázquez*, Barcelona, 1950
239. BENJAMIN, R. L. *Eugène Boudin*, New York, 1937
240. BENNETT, W. C. *Ancient arts of the Andes*, New York, 1954
241. BENNETT, W. C. and BIRD, J. *Andean culture history*, 1965 (New York, 1949)
242. BENOIS, A. *The Russian school of painting*, 1919 (New York and St. Petersburg, 1916)
243. BENOIST, L. *La Sculpture française*, 1963 (1945)
244. BERENSON, B. *The drawings of the Florentine painters*, 2 vols., 1903
245. — *The Florentine painters of the Renaissance*, New York, 1896
246. — *The Italian painters of the Renaissance*, 1952 (1930)
247. — *Lorenzo Lotto*, 1956 (New York, 1895)
248. — *Three essays in method*, 1927
249. BERGER, J. *Renato Guttuso*, Dresden, 1957
250. — *The success and failure of Picasso*, 1965
251. BERGER, K. *French master drawings of the nineteenth century*, 1950
252. — *Géricault and his work*, Lawrence, Kansas, 1955
253. BERGHE, L. VANDEN. *Archéologie de l'Iran ancien*, Leiden, 1959
254. BERGSTRÖM, I. *Dutch still-life painting in the seventeenth century*, 1956
255. BERMAN, E. DAVIDSON. *Thomas Jefferson among the arts*, New York, 1947
256. BERMEJO, E. *Juan de Flandes*, Madrid, 1962
257. BERNDT, R. M. (ed.). *Australian aboriginal art*, 1964
258. BERNET KEMPERS, A. J. *Ancient Indonesian art*, Cambridge, Mass., 1959
259. BERTINI, A. *Botticelli*, Milan, 1953
260. BERUETE Y MORET, A. DE. *Goya as portrait painter*, 1922
261. — *The school of Madrid*, 1909
262. — *Valdés Leal*, Madrid, 1911
263. BERYES, I. DE. *Ignacio Zuloaga, o una Manera de Ver a España*, Barcelona, 1944
264. BESSON, G. *Dufy*, 1953
265. BEUCKEN, J. DE. *Un Portrait de Cézanne*, 1955
266. BEVAN, B. *History of Spanish architecture*, 1938
267. BHARATHA IYER, K. *Indian art, a short introduction*, Bombay, 1958
268. BHATTACHARYYA, B. *The Indian Buddhist iconography*, Calcutta, 1958 (1924)
269. BIAGI, L. *Jacopo della Quercia*, Florence, 1946
270. BIANCONI, P. *All the paintings of Piero della Francesca*, 1962
271. — *Tutta la pittura del Correggio*, Milan, 1953
272. — *Tutta la pittura di Cosmè Tura*, Milan, 1963
273. BIERMANN, C. W. G. *Deutsches Barock und Rokoko: herausgegeben im Anschluss an die Jahrhundert-Ausstellung deutscher Kunst, 1650-1800*, 2 vols., Leipzig, 1914
274. — *Der Zeichner Lovis Corinth*, Dresden, 1924
275. BIGGS, J. R. *Woodcuts: wood-engravings, linocuts and prints by related methods of relief print making*, 1958
276. BINDING, R. G. *Vom Leben der Plastik inhalt und Schönheit des Werkes von Georg Kolbe*, Berlin, 1932
277. BINYON, R. L. *The drawings and engravings of William Blake*, 1922
278. — *English water-colours*, 1944 (1933)
279. — *Flight of the dragon: an essay on the theory and practice of art in China and Japan, based on original sources*, 1911
280. — *Painting in the Far East*, 1934 (1908)
281. BINYON, R. L. and ARNOLD, T. W. *The court painters of the Grand Moguls*, 1921
282. BINYON, R. L. and SEXTON, J. J. O'BRIEN. *Japanese colour-prints*, 1960 (1923)
283. BINYON, R. L. and others. *Persian miniature painting, including a critical and descriptive catalogue of the miniatures exhibited at Burlington House, January, 1931*, 1933.
284. BIRD, J. and BELLINGER, L. *Paracas fabrics and Nuzca needlework, 3rd century B.C.- 3rd century A.D.*, Washington, 1954
285. BITTNER, H. (ed.). *George Grosz*, 1965 (1960)
286. — (ed.). *Kaethe Kollwitz: drawings*, New York, 1959
287. BIZARDEL, Y. *American painters in Paris*, New York, 1960
288. BLACK, M. (ed.). *Exhibition design*, 1950
289. BLACK, R. *Old and new Australian aboriginal art*, Sydney, 1964
290. BLACKBURN, H. G. *Randolph Caldecott*, 1886
291. BLAKE, P. *Marcel Breuer: architect and designer*, New York, 1949
292. — *The master builders*, 1960
293. BLANC, C. *The grammar of painting and engraving*, New York, 1874 (1867)
294. BLANCHE, J. E. *Manet*, 1925
295. BLASER, W. *Mies van der Rohe: the art of structure*, 1965
296. BLAUENSTEINER, K. *Georg Raphael Donner*, Vienna, 1947
297. BLIJSTRA, R. *Nederlandse stedebouw na 1900*, Amsterdam, 1964
298. BLINDHEIM, M. E. *Norwegian romanesque decorative sculpture, 1090-1210*, 1965
299. BLOCH, R. *Etruscan art*, 1966
300. BLOCH, V. *Georges de la Tour*, Milan, 1953 (Amsterdam, 1950)
301. BLOMFIELD, SIR R. T. *The formal garden in England*, 1892
302. — *Richard Norman Shaw, R.A., architect*, 1940
303. BLONDEL, J. F. *Architecture françoise*, 4 vols., 1752-6

304. BLUM, A. S. *Abraham Bosse et la société française au dix-septième siècle*, 1924

305. — *L'Œuvre gravée d'Abraham Bosse*, 1924

306. BLUM, A. S. and LAUER, P. *La Miniature française aux XVᵉ et XVIᵉ siècles*, 1930

307. BLUNT, SIR A. F. *Art and architecture in France, 1500–1700*, 1953

308. — *The art of William Blake*, 1959

309. — *The drawings of G. B. Castiglione and Stefano della Bella in the collection of Her Majesty the Queen at Windsor Castle*, 1954

310. — *François Mansart and the origins of French classical architecture*, 1941

311. — *The paintings of Nicolas Poussin: a critical catalogue*, 1966

312. — *Philibert de l'Orme*, 1958

313. BLUNT, SIR A. F. and COOKE, H. L. *The Roman drawings of XVII & XVIII centuries in the collection of Her Majesty the Queen at Windsor Castle*, 1960.

314. BLUNT, SIR A. F. and POOL, P. *Picasso, the formative years, a study of his sources*, 1962

315. BOARDMAN, J. *Greek art*, 1964

316. BOAS, F. *Primitive art*, Oslo, 1927

317. BOAS, G. *The hieroglyphics of Horapollo*, New York, 1950

318. BOASE, T. S. R. (ed.). *The Oxford history of English art*, 11 vols., 1949–

　Vol. II. *English Art 871–1100*, by D. Talbot Rice, 1952

　　III. *English Art 1100–1216*, by T. S. R. Boase, 1953

　　IV. *English Art 1216–1307*, by P. Brieger, 1957

　　V. *English Art 1307–1461*, by J. Evans, 1949

　　VII. *English Art 1553–1625*, by E. Mercer, 1962

　　VIII. *English Art 1625–1714*, by M. D. Whinney and D. Millar, 1957

　　X. *English Art 1800–1870*, by T. S. R. Boase, 1959

319. BOCCIONI, U. *Pittura, scultura futuriste*, Milan, 1914

320. BOCCIONI, U. and others. *Manifesto of the Futurist painters*, Milan, 1910

321. BODART, R. *Antoine Wiertz*, Antwerp, 1949

322. BODE, W. VON. *Adriaen Brouwer, sein Leben und seine Werke*, Berlin, 1924

323. —— *Great masters of Dutch and Flemish painting*, 1909

324. BØE, A. *From Gothic revival to functional form: a study in Victorian theories of design*, Oslo, 1957

325. BOECK, W. and SABARTÉS, J. *Picasso*, 1955

326. BOECKLER, A. *Abendländische Miniaturen bis zum Ausgang der romanischen Zeit*, Berlin, 1930

327. — *Deutsche Buchmalerei der Gotik*, Königstein im Taunus, 1959

328. — *Deutsche Buchmalerei vorgotischer Zeit*, Königstein im Taunus, 1952

329. BOESIGER, W. and GIRSBERGER, H. *Le Corbusier, 1910–1960*, 1960

330. BOETHIUS, G. A. *Zorn, Swedish painter and world traveller*, New York, 1961

331. BOGGS, J. S. *Portraits by Degas*, Berkeley, 1962

332. BOINET, A. *La Miniature carolingienne*, 1913

333. BOISSELIER, J. *La Statuaire khmère et son évolution*, Saigon, 1955

334. — *Tendances de l'art khmèr*, 1956.

335. BOL, L. J. *The Bosschaert dynasty, painters of flowers and fruit*, 1960

336. BOLTON, A. T. *The architecture of Robert and James Adam (1758–1794)*, 2 vols., 1922

337. — *The works of Sir John Soane*, 1924

338. — (ed.). *The portrait of Sir John Soane, R.A., 1753–1837, set forth in letters from his friends*, 1927

339. BOND, F. *Fonts and font-covers*, 1908

340. — *Gothic architecture in England*, 1905

341. — *An introduction to English church architecture from the eleventh to the sixteenth century*, 2 vols., 1913

342. BONNEFOY, Y. *Miró*, 1967 (1964)

343. BONSER, W. *An Anglo-Saxon and Celtic bibliography. 450–1087*, 1957

344. BONY, J. *French cathedrals*, 1951

345. BONYTHON, K. *Modern Australian painting and sculpture: a survey of Australian art from 1950–1960*, Adelaide, 1960

346. BOOZ, P. *Der Baumeister der Gotik*, Munich, 1956

347. BORENIUS, T. and TRISTRAM, E. *English medieval painting*, Florence, 1927

348. BORIBAL BURIBHANDH, L. *Images of the Buddha*, Bangkok, 1952

349. BORINSKI, K. *Die Antike in Poetik und Kunsttheorie vom Ausgang des klassischen Altertums bis auf Goethe und Wilhelm von Humboldt*, Leipzig, 1914–24

350. BOROVKA, G. *Scythian art*, 1928

351. BORRADAILE, V. and R. *The student's Cennini*, 1942

352. BORSOOK, E. *The mural painters of Tuscany, from Cimabue to A. del Sarto*, 1960

353. BOSCHETTO, A. *Giovan Gerolamo Savoldo*, Milan, 1963

354. BOSCH GIMPERA, P. *Los celtas y la civilización céltica en la Península Ibérica*, Madrid, 1921

355. — *Two Celtic waves in Spain*, 1940

356. BOSSE, A. *Manière universelle de M. Desargues pour pratiquer la perspective*, 1648

357. BOSSERT, H. T. *Altanatolien*, Berlin, 1942

358. — *Altsyrien*, Tübingen, 1951

359. — *The art of ancient Crete*, 1937

360. BOSWELL, P. *George Bellows*, New York, 1942

361. BOTHMER, B. V. *Egyptian sculpture of the Late Period, 700 B.C. to A.D. 100* (Catalogue of the Brooklyn Museum), New York, 1960

362. BOTTARI, S. *Correggio*, Milan, 1961

363. BOTTINEAU, Y. *L'Art d'Ange-Jacques Gabriel à Fontainebleau, 1735-1774*, 1962
364. BOUDAILLE, G. *Gauguin*, 1964
365. BOUMAN, A. C. *Kuns en kunwaardering*, Pretoria, 1942
366. — *Kuns in Suid-Afrika*, Pretoria, 1935
367. BOURET, J. *Degas*, 1965
368. — *Henri Rousseau*, 1961
369. — *Toulouse-Lautrec*, 1964
370. BOURKE, J. W. P. *Baroque churches of central Europe*, 1962 (1958)
371. BOUVIER, M. *Aristide Maillol*, Lausanne, 1945
372. BOWIE, T. *The drawings of Hokusai*, Bloomington, 1964
373. — (ed.). *The arts of Thailand*, Bloomington, 1960
374. BOYD, A. K. H. *Chinese architecture and town planning, 1500 B.C.-A.D. 1911*, 1962
375. BOYD, R. G. P. *Australia's home*, Melbourne, 1952
376. BOYDELL, J. *Suggestions towards forming a plan for the encouragement, improvement and benefit of the arts and manufactures in this country on a commercial basis*, 1801
377. BOYDELL, J. and J. *A collection of prints from pictures painted for the purpose of illustrating Shakespeare by the artists of Great Britain*, 1805 (1803)
378. BOYS, T. S. *Original views of London as it is*, 2 vols., 1954-5 (1842)
379. — *Picturesque architecture in Paris, Ghent, Antwerp, Rouen, etc.*, 1839
380. BRADLEY, J. W. *The life and works of Georgio Giulio Clovio, miniaturist, with notices of his contemporaries, and of the art of book decoration in the sixteenth century*, 1891
381. BRANDI, C. *Duccio*, Florence, 1951
382. — *Giovanni di Paolo*, Florence, 1947
383. BRANNER, R. *Burgundian gothic architecture*, 1960
384. BRAQUE, G. *Georges Braque: his graphic work*, 1962
385. BRAUN, H. S. *An introduction to English mediaeval architecture*, 1951
386. BRÉHIER, L. *L'Art chrétien*, 1928 (1918)
387. BRETON, A. *Manifeste du surréalisme*, 1924
388. — *Second Manifeste du surréalisme*, 1930
389. — *Le Surréalisme et la peinture*, 1965 (1928)
390. — *What is surrealism?* 1936
391. BREUER, M. *Marcel Breuer: buildings and projects, 1921-1961*, 1962
392. — *Sun and shadow, the philosophy of an architect*, 1956
393. BREUIL, H. *Les Roches peintes du Tassili-n-Ajjer*, 1954
394. BREUIL, H. and OBERMAIER, H. *The cave of Altamira at Santillana del Mar*, Madrid, 1935
395. BREUIL, H. and WINDELS, F. *Quatre Cents Siècles d'art pariétal*, Montignac, 1952

396. BRIDENBAUGH, C. *Peter Harrison, first American architect*, Chapel Hill, N. Carolina, 1949
397. BRIGANTI, G. *Italian mannerism*, 1962
398. — *Pietro da Cortona o della pittura barocca*, Florence, 1962
399. BRIGGS, L. P. *The ancient Khmer empire*, Philadelphia, 1951
400. BRINCKMANN, A. E. *Barockskulptur*, 4 vols., Frankfurt, 1923-55
401. — *Die Baukunst des 17. und 18. Jahrhunderts*, 2 vols., Berlin, 1915-19
402. BRION, M. *Art abstrait*, 1956
403. — *Georges Braque*, 1960
404. — *German painting*, 1959
405. — *Kandinsky*, 1961
406. — *Marc Chagall*, 1960
407. BRION-GUERRY, L. *Philibert de l'Orme*, Milan, 1955
408. BRONSTEIN, L. *Altichiero, l'artiste et son œuvre*, 1932
409. BROULHIET, G. *Meindert Hobbema, 1638-1709*, 1938
410. BROWN, M. W. *American painting from the Armory Show to the depression*, Princeton, 1955
411. BROWN, P. *Indian architecture: Buddhist and Hindu periods*, Bombay, 1947 (1942)
412. — *Indian architecture: the Islamic period*, Bombay, 1952 (1942)
413. — *Indian painting*, 1918
414. — *Indian painting under the Moguls, A.D. 1550 to A.D. 1750*, 1924
415. BROWSE, L. *Degas' dancers*, 1949
416. BRUCE-MITFORD, R. L. S. *The Sutton Hoo ship burial*, 1947
417. BRUNNER-TRAUT, E. *Die altägyptischen Scherbenbilder*, Wiesbaden, 1956
418. BRUNSDON, J. *The technique of etching and engraving*, 1965
419. BRYDALL, R. *Art in Scotland: its origin and progress*, 1889
420. BUCHANAN, D. W. *The growth of Canadian painting*, 1950
421. — (ed.). *Canadian painters*, 1945
422. BUCHHEIM, L.-G. *Der Blaue Reiter und die 'Neue Künstlervereinigung München'*, Feldafing, 1959
423. — *Graphik des deutschen Expressionismus*, Feldafing, 1959
424. — *Die Künstlergemeinschaft Brücke*, Dresden, 1957
425. BUCHNER, E. *Das deutsche Bildnis der Spätgotik und der frühen Dürerzeit*, Berlin, 1953
426. — *Martin Schongauer als Maler*, Berlin, 1941
427. BUCKLAND-WRIGHT, J. *Etching and engraving*, 1953
428. BUCKLE, R. *Jacob Epstein, sculptor*, 1963
429. BUDGE, E. A. T. W. (ed.). *The Book of the Dead: the chapters of coming forth by day*, 1898
430. BUDIGNA, L. *Giovanni Segantini*, Milan, 1962

431. BUENOS AIRES, CENTRO DE ARTE VISUALES DEL INSTITUTO TORCUATO DI TELLA. *Arte Virreinal. Oleos y Tallas del Virreinato del Perú* (Exhibition catalogue), Buenos Aires, 1966

432. BÜHLER, A. and others. *Oceania and Australia : the art of the South Seas*, 1962

433. BUHOT, J. *Histoire des arts du Japon*, Vanoest, 1949

434. BULTMANN, B. *Oskar Kokoschka*, 1961 (1959)

435. BÜNEMANN, H. *Franz Marc : Zeichnungen-Aquarelle*, Munich, 1948

436. BUNIM, M. *Space in medieval painting and the forerunners of perspective*, New York, 1940

437. BUNT, C. G. E. *Russian art*, 1946

438. BURCHARD, J. *The voice of the phoenix : postwar architecture in Germany*, Cambridge, Mass., 1966

439. BURCHARD, J. and BUSH-BROWN, A. *The architecture of America : a social and cultural history*, 1967

440. BURCHARD, L. and D'HULST, R.-A. *Rubens drawings.* 2 vols., Brussels, 1963

441. BURCKHARDT, J. C. *The civilization of the Renaissance in Italy*, 1950 (Stuttgart, 1868)

442. BURGER, F. and others. *Die deutsche Malerei vom ausgehenden Mittelalter bis zum Ende der Renaissance*, 3 vols., Berlin, 1919–20

443. BURKE, G. L. *The making of Dutch towns, development from the tenth to the seventeenth centuries*, 1956

444. BURKE, J. and CALDWELL, C. *Hogarth : the complete engravings*, 1968

445. BURKHARD, A. *Matthias Grünewald*, Cambridge, Mass., 1936

446. BURNE-JONES, G. *Memorials of Edward Burne-Jones*, 2 vols., 1904

447. BURNHAM, R. W. and others. *Color : a guide to basic facts and concepts*, New York, 1963

448. BURROUGHS, A. *Limners and likenesses*, Cambridge, Mass., 1936

449. BURSSENS, G. *Floris Jespers*, Antwerp, 1956

450. BURT, SIR C. L. *Mental and scholastic tests*, 1921

451. BURTON, W. and HOBSON, R. L. *Handbook of marks on pottery and porcelain*, 1928

452. BURTY, P. (ed.). *Lettres de Eugène Delacroix (1815 à 1863)*, 1878

453. BURY, A. *Richard Wilson, the grand classic*, 1947

454. — *Two centuries of British water-colour painting*, 1950

455. — *Shadow of Eros : a biographical and critical study of the life and works of Sir Alfred Gilbert*, 1952

456. BUSCAROLI, R. *Melozzo e il melozzismo*, Bologna, 1955

457. BUSCH, H. *Germania romanica : die hohe Kunst der romanischen Epoche im mittleren Europa*, Vienna, 1963

458. BUSCHIAZZO, M. J. *Bibliografia de arte colonial argentino*, Buenos Aires, 1947

459. BUSH-BROWN, A. *Louis Sullivan*, New York, 1960

460. BUSHNELL, G. H. S. *Ancient arts of the Americas*, 1965

461. BUTLER, A. J. *The ancient Coptic churches of Egypt*, 2 vols., 1884

462. BUTLER, A. S. G. and others. *The architecture of Sir Edwin Lutyens*, 3 vols., 1950

463. BUTLER, H. *Early churches in Syria*, Princeton, 1929

464. BUXTON, D. R. *Russian mediaeval architecture*, 1934

465. BYRON, R. and RICE, D. TALBOT. *The birth of Western painting*, 1930

466. CABANNE, P. *Edgar Degas*, 1958

467. CAFFIN, C. H. *American masters of painting*, 1903

468. — *The story of American painting*, 1908

469. CAHILL, J. *Chinese painting*, New York, 1960

470. CAIGER-SMITH, A. *English medieval mural paintings*, 1963

471. CALDER, A. *An autobiography with pictures*, 1967 (New York, 1966)

472. CALI, F. *The art of the conquistadors*, 1961 (1960)

473. CALVERT, S. *A memoir of Edward Calvert, artist*, 1893

474. CAMERON, G. G. *History of early Iran*, Chicago, 1936

475. CAMESASCA, E. (ed.). *All the paintings of Raphael*, 4 vols., 1963 (Milan, 1956)

476. CAMO, P. *Maillol mon ami*, Lausanne, 1950

477. — *Raoul Dufy, l'enchanteur*, Lausanne, 1947

478. CAMÓN AZNAR, J. *La Arquitectura plateresca*, 2 vols., Madrid, 1945

479. — *Domenico Greco*, 2 vols., Madrid, 1950

480. CAMPBELL, C. *Vitruvius Britannicus*, 3 vols., 1715–25

481. CAMPBELL, D. M. *Java : past and present*, 2 vols., 1915

482. CANUTI, F. *Il Perugino*, 2 vols., Siena, 1931

483. CARDELLINI, I. *Desiderio da Settignano*, Milan, 1962

484. CARDEN, R. W. *The life of Giorgio Vasari : a study of the later Renaissance in Italy*, 1910

485. CARLI, E. *All the paintings of Paolo Uccello*, 1963

486. — *Il pulpito di Siena*, Bergamo, 1943

487. — *Sassetta e il Maestro dell'Osservanza*, Milan, 1957

488. — *Tino di Camaino, scultore*, Florence, 1934

489. CARLS, C. D. *Ernst Barlach : das plastische, graphische und dichterische Werk*, Berlin, 1954

490. CARPENTER, R. *Greek art : a study of the formal evolution of style*, Philadelphia, 1962

491. — *Greek sculpture*, Chicago, 1960

492. CARR, M. E. *Growing pains, autobiography*, Toronto, 1946

493. CARR, M. E. *Klee Wyck*, 1941
494. CARROUGES, M. *André Breton et les données fondamentales du surréalisme*, 1950
495. CARTER, D. O. *The symbol of the beast : the animal-style art of Eurasia*, New York, 1957
496. CARTER, H. and MACE, A. C. *The tomb of Tut-ankh-Amen, discovered by the late Earl of Carnarvon and Howard Carter*, 3 vols., 1923-33
497. CASSON, S. *The technique of early Greek sculpture*, 1933
498. CASSOU, J. *Chagall*, 1965
499. — *French drawing of the XX century*, 1955
500. — *Raoul Dufy, poète et artisan*, Geneva, 1946
501. CASTAING, M. and LEYMARIE, J. *Soutine*, 1965
502. CASTELFRANCO, G. *Donatello*, 1965
503. CATTANEO, I. *Salvator Rosa*, Milan, 1929
504. CAW, J. L. *Scottish painting past and present, 1620-1908*, 1908
505. CELLINI, B. *The life of Benvenuto Cellini, written by himself*, trans. by J. A. Symonds, 1949
506. CENIVAL, J. L. DE. *Living architecture : Egyptian*, 1965
507. CENNINI, CENNINO. *Il libro dell'arte (The craftsman's handbook)*, ed. and trans. by D. V. Thompson, *c*. 1400 (2 vols., New Haven, 1932-3)
508. CERONI, A. *Amedeo Modigliani : dessins et sculptures*, Milan, 1965
509. — *Amedeo Modigliani, peintre*, Milan, 1958
510. CESSI, F. *Alessandro Vittoria, architetto e stuccatore (1525-1608)*, Trento, 1961
511. CETTO, A. M. *Watercolours by Albrecht Dürer*, 1954
512. CETTO, M. L. *Modern architecture in Mexico*, 1961
513. CÉZANNE, P. *Letters*, ed. by J. Rewald, trans. by M. Kay, 1941
514. CHABRUN, J. F. *Goya*, 1965
515. CHADWICK, G. F. *The works of Sir Joseph Paxton*, 1961
516. CHAMBERLAIN, A. B. *Hans Holbein the younger*, 2 vols., 1913
517. CHAMBERS, SIR W. *Designs of Chinese buildings, furniture, dresses, machines, and utensils*, 1757
518. — *A dissertation on oriental gardening*, 1772
519. — *A treatise on civil architecture*, 1791 (1759)
520. CHAMOT, M. *Painting in England, from Hogarth to Whistler*, 1939
521. CHAMPFLEURY, J. H. *Histoire de la caricature antique*, 1867 (1865)
522. — *Histoire de la caricature au Moyen Âge et sous la Renaissance*, 1875 (1870)
523. — *Histoire de la caricature moderne*, 1885 (1865)
524. — *Histoire de l'imagerie populaire*, 1869
525. CHAMPIGNEULLE, B. *Rodin*, 1967
526. CHAPMAN, R. *The laurel and the thorn : a study of G. F. Watts*, 1945
527. CHARENSOL, G. *Degas*, 1959

528. CHARPIER, J. *Lam*, 1960
529. CHARTERIS, SIR E. E. *John Sargent*, 1927
530. CHASSÉ, C. *Les Nabis et leur temps*, 1960
531. CHASTEL, A. *The age of humanism : Europe 1480-1530*, 1963
532. — *The golden age of the Renaissance. Italy, 1460-1500*, 1965
533. — *Italian art*, 2 vols., 1963
534. — *The studios and styles of the Renaissance. Italy 1460-1500*, 1967
535. — (ed.). *The genius of Leonardo da Vinci*, New York, 1961
536. CHASTILLON, C. *Topographie françoise*, 1641
537. CHAULEUR, S. *Histoire des Coptes d'Égypte*, 1960
538. CHAVAGNAC, X. DE and GROLLIER, G. A. DE. *Histoire des manufactures françaises de porcelaine*, 1906
539. CHENEY, S. *Expressionism in art*, New York, 1948 (1934)
540. CHESNEAU, E. *Le Statuaire J.-B. Carpeaux*, 1880
541. CHEVREUL, M. E. *The laws of contrast of colour and their applications to the arts and manufactures*, 1882 (1839)
542. CHRIST-JANER, A. W. *Eliel Saarinen*, Chicago, 1948
543. — *George Caleb Bingham of Missouri : the story of an artist*, New York, 1940
544. CHRISTOPHE, L. *Constantin Meunier*, Antwerp, 1947
545. CHUECA GOITIA, F. *La catedral nueva de Salamanca*, 1951
546. — *Historia de la arquitectura española edad antigua y edad media*, Madrid, 1965
547. CHUECA GOITIA, F. and MIGUEL, C. DE. *La vida y las obras del arquitecto Juan de Villanueva*, Madrid, 1949
548. CIPRIANI, R. *Tutta la pittura del Mantegna*, Milan, 1956
549. CIRICI PELLICER, A. *Miró y la imaginación*, Barcelona, 1949
550. — *Picasso antes de Picasso (Picasso avant Picasso)*, Barcelona, 1946 (Geneva, 1950)
551. CIRLOT, J. E. *El arte de Gaudí*, Barcelona, 1950
552. CLADEL, J. *Aristide Maillol : sa vie, son œuvre, ses idées*, 1937
553. — *Rodin*, 1953 (1908)
554. CLAPHAM, A. W. *English romanesque architecture after the Conquest*, 1934
555. — *English romanesque architecture before the Conquest*, 1930
556. — *Romanesque architecture in England*, 1950
557. CLAPP, F. M. *Jacopo Carucci da Pontormo, his life and work*, 1916
558. CLARK, J. M. *The Dance of Death, by Hans Holbein*, 1947
559. — *The Dance of Death in the Middle Ages and the Renaissance*, 1950
560. CLARK, SIR K. M. *A catalogue of the drawings of Leonardo da Vinci in the collection of His Majesty the King at Windsor Castle*, 2 vols., 1935

561. CLARK, SIR K. M. *A failure of nerve. Italian painting 1520-1535*, 1967
562. — *The Gothic revival*, 1950 (1928)
563. — *Leonardo da Vinci: an account of his development as an artist*, 1952 (1939)
564. — *Piero della Francesca*, 1951
565. — *Rembrandt and the Italian Renaissance*, 1966
566. — (ed.). *Ruskin today*, 1964
567. CLARK, SIR K. M. and others (edd.). *Sidney Nolan*, 1961
568. CLARKE, S. and ENGELBACH, R. *Ancient Egyptian masonry: the building craft*, 1930
569. CLAUS, H. *Karel Appel, painter*, 1963
570. CLAY, R. M. *Julius Caesar Ibbetson, 1759-1817*, 1948
571. CLÉMENT, C. *Géricault*, 1867
572. CLÉMENT-CARPEAUX, L. *La Vérité sur l'œuvre et la vie de J.-B. Carpeaux, 1827-1875*, 2 vols., 1934-5
573. CLEMENTS, R. J. *Michelangelo's theory of art*, New York, 1961
574. CLIFFORD, D. and T. *John Crome*, 1968
575. COCTEAU, J. *Modigliani*, 1950
576. COEDÈS, G. *Les Collections archéologiques du Musée national de Bangkok*, 1928
577. COFFIN, D. R. *The villa d'Este at Tivoli*, Princeton, 1960
578. COGNIAT, R. *Chagall*, New York, 1965
579. — *Dufy décorateur*, Geneva, 1957
580. — *Hommage à Bourdelle*, 1961
581. — *Raoul Dufy*, New York, 1962
582. COHN, W. *Chinese painting*, 1951 (1948)
583. COLDING, T. H. *Aspects of miniature painting*, Copenhagen, 1953
584. COLETTI, L. *All the paintings of Giorgione*, 1961
585. COLIN, P. *La Peinture belge depuis 1830*, Brussels, 1930
586. — *Van Gogh*, 1926
587. COLLINGWOOD, W. G. *Northumbrian crosses of the pre-Norman age*, 1927
588. COLLINS, G. R. *Antonio Gaudí*, 1960
589. COLLINS, L. C. *Hercules Seghers*, Chicago, 1953
590. COLLINS, P. *Changing ideals in modern architecture, 1750-1950*, 1965
591. COLLINS, W. WILKIE. *Memoirs of the life of William Collins, Esq., R.A.*, 1848
592. COLLON-GAVAERT, S. *L'Orfèvrerie mosane au Moyen Âge*, Brussels, 1943
593. COLMJON, G. *The Hague school: the renewal of Dutch painting since the middle of the nineteenth century*, Rijswijk, 1951
594. COLONNA, G. and DONATI, M. *Musei vaticani*, Novara, 1962
595. COLVIN, S. *The drawings of Flaxman in the gallery of University College, London*, 1876
596. COMANDUCCI, A. M. *Dizionario illustrato dei pittori, disegnatori e incisori italiani, moderni e contemporanei*, 4 vols., Milan, 1962
597. COMBE, J. *Jheronimus Bosch*, 1946

598. COMO, U. DA. *Girolamo Muziano, 1528-1592 : note e documenti*, Bergamo, 1930
599. CONANT, K. J. *Carolingian and romanesque architecture, 800 to 1200*, 1959
600. CONDIT, C. W. *The rise of the skyscraper*, Chicago, 1952
601. CONDIVI, A. *Vita di Michelagnolo Buonarroti (The life of Michael Angelo Buonarroti)*, trans. by C. Holroyd, Rome, 1553 (1911, 1903)
602. CONSTABLE, J. *John Constable's correspondence*, ed. by R. B. Beckett, 1962
603. — *The letters of John Constable, R.A. to C. R. Leslie, 1826-1837*, ed. by P. Holmes, 1931
604. CONSTABLE, W. G. *Canaletto: Giovanni Antonio Canal, 1697-1768*, 1962
605. — *John Flaxman, 1755-1826*, 1927
606. — *Richard Wilson*, 1953
607. CONWAY, W. M. *Literary remains of Albrecht Dürer*, 1889
608. COOK, R. M. *Greek painted pottery*, 1960
609. COOK, SIR T. A. *The curves of life*, 1914
610. COOMARASWAMY, A. K. *Catalogue of the Indian collections in the Museum of Fine Arts, Boston*, 5 vols., Cambridge, Mass., 1923-30
611. — *The dance of Siva*, New York, 1918
612. — *Elements of Buddhist iconography*, Cambridge, Mass., 1935
613. — *History of Indian and Indonesian art*, 1927
614. — *Indian drawings*, 1910-12
615. — *Medieval Sinhalese art*, 1908
616. — *Rajput painting*, 1916
617. COONEY, J. D. *Late Egyptian and Coptic art*, New York, 1953
618. COOPER, D. *Fernand Léger et le nouvel espace*, 1949
619. — *Georges Braque, paintings, 1909-1947*, 1948
620. — *Pastels by Edgar Dégas*, Basel and New York, 1954
621. COOR, G. M. *Neroccio de' Landi, 1447-1500*, Princeton, 1961
622. COPLEY, J. S. *Letters and papers of John Singleton Copley and Henry Pelham, 1739-1776*, ed. by C. F. Adams and others (Collections of the Massachusetts Historical Society, vol. 71), Boston, 1914
623. COQUIOT, G. *Dégas*, 1924
624. — *Paul Cézanne*, 1919
625. COQUIS, A. *Corot et la critique contemporaine*, 1960
626. CORBETT, P. E. *The sculpture of the Parthenon*, 1959
627. COROT, J. B. C. and others. *Corot: raconté par lui-même et par ses amis*, 2 vols., Geneva, 1946
628. COSSÍO, M. B. *El Greco*, 2 vols., Buenos Aires and Mexico, 1944 (Madrid, 1908)
629. COSSÍO DEL POMAR, F. *Arte del Perú precolombino*, Mexico and Buenos Aires, 1949

630. Cossío del Pomar, F. *Pintura Colonial: Escuela Cuzqueña*, Cuzco, 1928

631. Costantini, V. *Pittura italiana contemporanea dalla fine dell'800 ad oggi*, Milan, 1934

632. Coudenhove-Erthal, E. *Carlo Fontana und die Architektur des römischen Spätbarocks*, Vienna, 1930

633. Coughlan, R. *The wine of genius: a life of Maurice Utrillo*, 1952

634. Coulton, G. G. *Art and the Reformation*, 1928

635. Courajod, L. C. J. *Histoire de l'enseignement des arts du dessin au XVIIIe siècle*, 1874

636. — *La Polychromie dans la statuaire du Moyen Âge et de la Renaissance*, 1888

637. Courthion, P. *Bonnard, peintre du merveilleux*, Lausanne, 1946

638. — *Georges Rouault*, 1962

639. — *Raoul Dufy*, Geneva, 1951

640. — *Seurat*, 1967

641. — *Utrillo*, Lausanne, 1948

642. —(ed.). *Courbet: raconté par lui-même et par ses amis*, Geneva, 1948

643. Courthion, P. and Cailler, P. (edd.). *Portrait of Manet by himself and his contemporaries*, 1960

644. Cousturier, L. *P. Signac*, 1922

645. — *Seurat*, 1921

646. Covarrubias, M. *Indian art of Mexico and Central America*, New York, 1957

647. — *Island of Bali*, New York, 1937

648. Cowles, F. *The case of Salvador Dali*, 1959

649. Cox, D. *A treatise on landscape painting and effect in water colours*, 1922 (1841)

650. Cox, Sir G. T. *David Cox*, 1947

651. Cox, T. *Jehan Foucquet, native of Tours*, 1931

652. Cox-Johnson, A. L. *John Bacon, R.A. 1740-1799*, 1961

653. Cozens, A. *A new method of assisting the invention in drawing original compositions of landscape*, 1952 (1785)

654. Crane, W. *The bases of design*, 1898

655. — *William Morris to Whistler*, 1911

656. Crane, W. and Day, L. F. *Moot points*, 1903

657. Crelly, W. R. *The painting of Simon Vouet*, New Haven, 1962

658. Cresson, M. F. *The life of Daniel Chester French*, Cambridge, Mass., 1947

659. Creswell, K. A. C. *A bibliography of the architecture, arts and crafts of Islam*, 1961

660. — *The Muslim architecture of Egypt*, 2 vols., 1952-9

661. Crichton, G. H. *Romanesque sculpture in Italy*, 1954

662. Crichton, G. H. and E. R. *Nicola Pisano and the revival of sculpture in Italy*, 1938

663. Crivellato, V. *Tiepolo*, 1962

664. Croce, B. *An autobiography*, trans. by R. G. Collingwood, 1927

665. Crossley, F. H. *English church monuments A.D. 1150-1550: an introduction to the study of tombs and effigies of the mediaeval period*, 1921

666. Crouse, R. *Mr. Currier and Mr. Ives, a note on their life and times*, New York, 1930

667. Crozet, R. *La Vie artistique en France au XVIIe siècle, 1598-1661: les artistes et la société*, 1954

668. Cruttwell, M. A. W. *Antonio Pollaiuolo*, 1907

669. — *Verrocchio*, 1904

670. Cunningham, A. *The life of Sir David Wilkie*, 1843

671. Cursiter, S. *Scottish art*, 1949

672. — *Scottish art to the close of the nineteenth century*, 1949

673. Curwen, H. *Processes of graphic reproduction in printing*, 1934

674. Cushion, J. P. and Honey, W. B. *Handbook of pottery and porcelain marks*, 1965 (1956)

675. Cust, Sir L. H. *Anthony van Dyk*, 1900

676. Cust, Sir L. H. and Colvin, S. *History of the Society of Dilettanti*, 1898

677. Cust, R. H. H. *Giovanni Antonio Bazzi, hitherto usually styled 'Sodoma': the man and the painter, 1477-1549*, 1906

678. Dacier, É. *Gabriel de Saint-Aubin, peintre, dessinateur et graveur, 1724-1780*, 2 vols., 1929-31

679. — *La Gravure française*, 1946

680. Dacier, É. and others. *Jean de Jullienne et les graveurs de Watteau au XVIIIe siècle*, 1921-9

681. Daix, P. *Picasso*, 1965

682. Dale, A. *James Wyatt, architect, 1746-1813*, 1936

683. Dali, S. *Diary of a genius*. Foreword and notes by M. Déon, 1966

684. — *On modern art: the cuckolds of antiquated modern art*, New York, 1957

685. — *The secret life of Salvador Dali*, 1961 (1948)

686. Dalton, O. M. *Byzantine art and archaeology*, 1911

687. — *East Christian art: a survey of the monuments*, 1925

688. Damaz, P. F. *Art in Latin American architecture*, New York, 1963

689. Danielsson, B. *Gauguin in the South Seas*, 1965

690. Dannatt, T. *Modern architecture in Britain*, 1959

691. Dantzig, M. M. van. *Vincent? A new method of identifying the artist and his work and of unmasking the forger and his products*, Amsterdam, 1953

692. Darby, D. F. *Francisco Ribalta and his school*, Cambridge, Mass., 1938

693. Dark, P. *Benin art*, 1960

694. Darwin, Sir Charles R. *The expression of the emotions in man and animals*, 1872

695. DAULTE, F. *Frédéric Bazille et son temps*, Geneva, 1952
696. DAVENPORT, C. *Mezzotints*, 1904
697. DAVID, H. *Claus Sluter*, 1951
698. DAVIES, G. S. *Ghirlandaio*, 1908
699. DAVIS, F. *Victorian patrons of the arts*, 1963
700. DAVIS, T. *The architecture of John Nash*, 1960
701. DAX, E. C. *Experimental studies in psychiatric art*, 1953
702. DAY, L. F. *The art of William Morris*, 1899
703. DAYES, E. *The works of the late Edward Dayes*, 1805
704. DEBRUNNER, H. *Der Zürcher Maler Hans Leu im Spiegel von Bild und Schrift*, Zürich, 1941
705. DEGAS, H. G. E. *Letters*, ed. by M. Guerin, trans. by M. Kay, 1947
706. DE GRADA, R. *Boccioni : il mito del moderno*, Milan, 1962
707. DEHIO, G. G. *Geschichte der deutschen Kunst*, Leipzig, 1919-34
708. DEKNATEL, F. B. *Edvard Munch*, 1950
709. DELACROIX, F. V. E. *Journal*, ed. by A. Joubin, 1932
710. DELAISSÉ, L. M. J. *La Miniature flamande à l'époque de Philippe le Bon*, Milan, 1956
711. DELBANCO, G. *Der Maler Abraham Bloemaert, 1564-1651*, Strassburg, 1928
712. DELECLUZE, É. J. *Louis David, son école et son temps*, 1855
713. DELEN, A. J. J. *Rik Wouters*, Antwerp, 1948
714. DELTEIL, L. *Manuel de l'amateur d'estampes des XIX<sup>e</sup> et XX<sup>e</sup> siècles, 1801-1924*, 1925
715. DE MARÉ, E. S. *Gunnar Asplund : a great modern architect*, 1955
716. DEMARGNE, P. *Aegean art : the origins of Greek art*, 1964
717. DEMUS, O. *Byzantine mosaic decoration*, 1948
718. DENIS, M. *Histoire de l'art religieux*, 1939
719. — *Nouvelles Théories sur l'art moderne, sur l'art sacré, 1914-1921*, 1922
720. — *Théories, 1890-1910 : du symbolisme et de Gauguin vers un nouvel ordre classique*, 1912
721. DENIS, V. *All the paintings of Jan van Eyck*, 1961
722. — *All the paintings of Pieter Bruegel*, 1961
723. DENUCÉ, J. (ed.). *Letters and documents concerning Jan Breugel I and II*, Antwerp, 1934
724. DE PAOR, M. and L. *Early Christian Ireland*, 1958
725. DE PILES, R. *Cours de peinture par principes*, 1708
726. — *Dialogue sur le coloris*, 1673
727. DE POLNAY, P. *The world of Maurice Utrillo*, 1967
728. DERAIN, A. *Lettres à Vlaminck*, 1955
729. DESARGUES, G. *Méthode universelle*, 1636
730. DE SAUSMAREZ, M. *Basic design : the dynamics of visual form*, 1964

731. DESCHAMPS, P. *French sculpture of the Romanesque period, eleventh and twelfth centuries*, 1930
732. DESCHAMPS, P. and THIBOUT, M. *La Peinture murale en France au début de l'époque gothique, 1180-1380*, 1963
733. DESCHAMPS, P. and THIBOUT, M. *La Peinture murale en France : le haut Moyen Âge et l'époque romane*, 1951
734. DESCHARNES, R. and CHABRUN, J. *Auguste Rodin*, 1967
735. DESTRÉE, JOSEPH. *Hugo van der Goes*, 1914
736. DESTRÉE, JULES. *Roger de la Pasture, van der Weyden*, 1930
737. DEVENDRA, D. T. *Classical Sinhalese sculpture, c. 300 B.C. to A.D. 1000*, 1958
738. DEVIGNE, M. *De la parenté d'inspiration des artistes flamands du XVII<sup>e</sup> et du XVIII<sup>e</sup> siècle. Laurent Delvaux et ses élèves*, Brussels, 1928
739. DE WALD, E. T. *Pietro Lorenzetti*, Cambridge, Mass., 1930
740. DEYDIER, H. *Contribution à l'étude de l'art du Gandhâra*, 1950
741. DIEHL, G. *Henri Matisse*, 1954
742. DIEZ, E. and DEMUS, O. *Byzantine mosaics in Greece : Hosios Lucas and Daphni*, Cambridge, Mass., 1931
743. DIGARD, M. *Jacques Sarrazin*, 1934
744. DIMAND, M. S. *A handbook of Muhammadan art*, New York, 1958 (1930)
745. DIMIER, L. *L'Art français*, 1965
746. — *Histoire de la peinture de portrait en France au XVI<sup>e</sup> siècle*, 3 vols., 1924-6
747. — *Les Peintres français du XVIII<sup>e</sup> siècle*, 2 vols., 1928-30
748. DINSMOOR, W. B. *The architecture of ancient Greece*, 1927
749. DISSELHOFF, H.-D. and LINNÉ, S. *Ancient America, the civilisations of the New World*, 1961
750. DODGSON, C. *The etchings of James McNeill Whistler*, 1922
751. DODWELL, C. R. *The Canterbury school of illumination, 1066-1200*, 1954
752. DODWELL, C. R. and TURNER, D. H. *Reichenau reconsidered : a re-assessment of the place of Reichenau in Ottonian art*, 1965
753. DONY, E. *François Duquesnoy, 1594-1643 : sa vie et ses œuvres*, Rome, 1922
754. DONZELLI, C. *I pittori veneti del Settecento*, Florence, 1957
755. DORBEC, P. *Théodore Rousseau*, 1910
756. DORIVAL, B. *Les Étapes de la peinture française contemporaine*, 3 vols., 1943-6
757. DORNER, A. *Meister Bertram von Minden*, Berlin, 1937
758. DORTA, MARCO E. *Fuentes para la historia del arte hispanoamericano*, Seville, 1951
759. DOUGHTY, O. *A Victorian romantic. Dante Gabriel Rosetti*, 1949
760. DOUGLAS, F. and D'HARNONCOURT, R. *Indian art of the United States*, New York, 1948 (1941)

761. DOUGLAS, R. L. *Piero di Cosimo*, Chicago, 1946
762. DOWD, D. L. *Pageant-master of the Republic. Jacques-Louis David and the French Revolution*, Lincoln, Nebraska, 1948
763. DOWNES, K. *Hawksmoor*, 1959
764. DREXLER, A. *The architecture of Japan*, New York, 1955
765. DREYFOUS, M. *Dalou: sa vie et son œuvre*, 1903
766. DRYSDALE, G. R. *Paintings*, Sydney, 1951
767. DUBE-HEYNIG, A. *Kirchner: graphic work*, 1966
768. DU BOIS, G. P. *William J. Glackens*, New York, 1931
769. DUCHENNE, G. B. *Mécanisme de la physionomie humaine, ou analyse électrophysiologique de l'expression des passions*, 1862
770. DU COLOMBIER, P. *Alfred Sisley in the Musée du Louvre*, 1947
771. — *L'Art Renaissance en France*, 1945
772. — *Jean Goujon*, 1949
773. — *Le Style Henri IV-Louis XIII*, 1944
774. DUFRESNOY, C. A. *De arte graphica. The art of painting*, 1695
775. DUNCAN, D. D. *Picasso's Picassos*, 1961
776. — *The private world of Pablo Picasso*, New York, 1958
777. DUNLAP, W. *A history of the rise and progress of the arts of design in the United States*, 3 vols., Boston, 1918 (New York, 1834)
778. DUPONT, J. and GNUDI, C. *Gothic painting*, Geneva, 1954
779. DUPONT, P. *Archéologie mône de Dvārati*, 1959
780. — *La Statuaire préangkorienne*, Ascona, 1955
781. DÜRER, A. *Underweyssung der Messung*, Nuremberg, 1525
782. DURET, T. *Lautrec*, 1920
783. — *Manet and the French Impressionists*, 1910
784. — *Renoir*, New York, 1937
785. — *Whistler*, 1917
786. DURRIEU, P. (Count). *Les Antiquités judaïques et le peintre Jean Foucquet*, 1907
787. — *La Miniature flamande au temps de la Cour de Bourgogne, 1415-1530*, 1921
788. DUSSAUD, R. *L'Art phénicien du IIe millénaire*, 1949
789. DUSSLER, L. *Signorelli: des Meisters Gemälde*, Stuttgart, 1927
790. DUTHUIT, G. *La Sculpture copte: statues—bas-reliefs — masques*, 1931
791. DUTTON, G. *Russell Drysdale*, 1965
792. DUTTON, R. *The English garden*, 1950 (1937)
793. EARLAND, A. *John Opie and his circle*, 1911
794. EARP, T. W. *French painting*, 1945
795. EASTLAKE, SIR C. L. *Contributions to the literature of the fine arts*, 2 series, 1848, 1870

796. EASTLAKE, SIR C. L. *A history of the Gothic revival*, 1871
797. — *Materials for a history of oil painting*, 2 vols., 1847-69
798. EASTLAKE, E. (ed.). *Life of John Gibson, R.A., sculptor*, 1870
799. EATES, M. (ed.). *Paul Nash, paintings, drawings and illustrations*, 1948
800. ECKARDT, A. *A history of Korean art*, 1929
801. ECKARDT, W. VON. *Eric Mendelsohn*, 1960
802. EDDY, A. J. *Recollections and impressions of James A. McNeill Whistler*, 1903
803. EDE, H. S. *A life of Gaudier-Brzeska*, 1930
804. EDGELL, G. H. *The American architecture of to-day*, 1928
805. EDWARDS, I. E. S. *The pyramids of Egypt*, 1961 (1947)
806. EDWARDS, K. *The English secular cathedrals in the Middle Ages*, 1949
807. EINSTEIN, C. *Georges Braque*, 1934
808. EISLER, M. *Josef Israëls*, 1924
809. ELAM, C. H. (ed.). *The Peale family: three generations of American artists*, Detroit, 1967
810. ELDJÁRN, K. *Icelandic art*, 1961
811. ELGAR, F. *Mondrian*, 1968
812. — *Picasso, a study of his work*, 1956
813. — *Van Gogh, a study of his life and work*, 1958
814. ELIOT, SIR C. N. E. *Japanese Buddhism*, 1935
815. ELLIS, M. H. *Francis Greenway: his life and times*, Sydney, 1949
816. ELSEN, A. E. (ed.). *Auguste Rodin: readings on his life and work*, Englewood Cliffs, N.J., 1965
817. ENG, H. *The psychology of child and youth drawing, from the ninth to the twenty-fourth year*, 1957
818. — *The psychology of children's drawings from the first stroke to the coloured drawing*, 1931
819. ENGEL, E. P. *Anton Mauve (1838-1888)*, Utrecht, 1967
820. ENGELBACH, R. *The problem of the obelisks, from a study of the unfinished obelisk at Aswan*, 1923
821. ENSOR, J. *Les Écrits de James Ensor*, Brussels, 1921
822. EPSTEIN, J. *Epstein: an autobiography*, 1955 (1940)
823. — *The sculptor speaks. Jacob Epstein to Arnold L. Haskell; a series of conversations on art*, 1931
824. ERNST, M. *Beyond painting, and other writings by the artist and his friends*, New York, 1948
825. ERPEL, F. (ed.). *Van Gogh self-portraits*, 1964
826. ESCHOLIER, R. *Daumier, peintre et lithographe*, 1923
827. — *Delacroix: peintre, graveur, écrivain*, 3 vols., 1926-9
828. — *Matisse, from the life*, 1960

829. ESCHOLIER, R. *La Peinture française au XIXᵉ siècle*, 2 vols., 1941–3
830. — *La Peinture française, XXᵉ siècle*, 1937
831. ESDAILE, K. A. *English church monuments, 1510–1840*, 1946
832. — *English monumental sculpture since the Renaissance*, 1927
833. — *John Bushnell, sculptor* (Walpole Society, vols. xv, xxi), 1927, 1933
834. — *The life and works of Louis François Roubiliac*, 1928
835. ESPRESATI, C. G. *Ribalta*, Barcelona, 1948
836. EVANS, SIR A. J. *The Palace of Minos*, 7 parts, 1921–36
837. EVANS, G. *Benjamin West and the taste of his times*, Carbondale, 1959
838. EVANS, J. *Art in Mediaeval France, 987–1498*, 1948
839. — *Cluniac art of the Romanesque period*, 1950
840. — *John Ruskin*, 1954
841. — *Monastic architecture in France, from the Renaissance to the Revolution*, 1964
842. EVANS, M. *Frances Hodgkins*, 1948
843. EVANS, R. M. *An introduction to color*, New York, 1948
844. EXSTEENS, M. *Félicien Rops, peintre*, Brussels, 1933
845. FABER, H. *Caius Gabriel Cibber, 1630–1700*, 1926
846. FAGAN, B. M. *Southern Africa during the Iron Age*, 1965
847. FAGG, W. B. *Afro-Portuguese ivories*, 1959
848. — *Nigerian Images*, 1963
849. — *The sculpture of Africa*, 1958
850. — *Tribes and forms in African art*, 1965
851. FAGG, W. B. and PLASS, M. *African sculpture: an anthology*, 1964
852. FARBMAN, M. (ed.). *Masterpieces of Russian painting*, 1930
853. FARÉ, M. *La Nature morte en France*, 1962
854. FARR, D. L. A. *William Etty*, 1958
855. FECHTER, P. *Ernst Barlach*, Gütersloh, 1957
856. — *Der Expressionismus*, Munich, 1919
857. FÉLIBIEN, A. *Entretiens sur les vies et sur les ouvrages des plus excellens peintres anciens et modernes*, 4 vols., 1705 (1666–88)
858. — *Mémoires pour servir à l'histoire des maisons royalles et bastimens de France*, 1874
859. FENOLLOSA, E. F. *Epochs of Chinese and Japanese art*, 2 vols., 1912
860. FERGUSON, G. W. *Signs and symbols in Christian art*, 1955 (New York, 1954)
861. FERGUSSON, J. *History of the modern styles of architecture*, 1862
862. FERGUSSON, J. and others. *History of Indian and Eastern architecture*, 1910 (1876)
863. FERNÁNDEZ, J. *Mexican art*, 1965
864. FEULNER, A. *Skulptur und Malerei des 18. Jahrhunderts in Deutschland*, Potsdam, 1929
865. FIALA, V. *Russian painting of the 18th and 19th centuries*, 1956
866. FIERENS, P. *James Ensor*, 1943
867. — *Les Le Nain*, 1933
868. FIGGIS, D. *The paintings of William Blake*, 1925
869. FILARETE, A. A. *Treatise on architecture*, trans. by J. R. Spenser (includes facsimile of the Magliabecchiana manuscript in the Biblioteca Nazionale, Florence), New Haven, 1965
870. FINBERG, A. J. *The life of J. M. W. Turner, R.A.*, 1961 (1939)
871. FINLAY, I. *Art in Scotland*, 1948
872. FIOCCO, G. *Giovanni Antonio Pordenone*, Padua, 1943 (Udine, 1939)
873. — *Giovanni Bellini*, 1960
874. FIRPO, L. *La città ideale del Filarete*, Turin, 1954
875. FISCHEL, O. *Raphaels Zeichnungen*, 2 vols., 1948 (Strassburg, 1896)
876. FISCHER, J. L. *Handbuch der Glasmalerei*, Leipzig, 1937
877. FISKER, K. and YERBURY, F. R. (edd.). *Modern Danish architecture*, 1927
878. FITCH, J. M. *Walter Gropius*, 1960
879. FITCHEN, J. *The construction of Gothic cathedrals: a study of medieval vault erection*, 1961
880. FLAXMAN, J. *Lectures on sculpture*, 1838 (1829)
881. FLECHSIG, E. *Martin Schongauer*, Strassburg, 1951
882. FLEMING, J. *Robert Adam and his circle, in Edinburgh and Rome*, 1962
883. FLEXNER, J. T. *Gilbert Stuart: a great life in brief*, New York, 1955
884. — *John Singleton Copley*, Boston, 1948
885. FOCILLON, H. *L'Art des sculpteurs romans*, 1931
886. — *The art of the West in the Middle Ages*, 2 vols., 1963
887. — *Giovanni-Battista Piranesi, 1720–1778*, 1918
888. FOKKER, T. H. *Jan Siberechts, peintre de la paysanne flamande*, Brussels, 1931
889. FONTAINAS, A. *L'Art belge depuis 1830*, 1925
890. FONTAINE, A. *Académiciens d'autrefois*, 1914
891. — *Les Doctrines d'art en France*, 1909
892. FOOTE, H. W. *John Smibert, painter; with a descriptive catalogue of portraits, and notes on the work of Nathaniel Smibert*, Cambridge, Mass., 1950
893. — *Robert Feke, colonial portrait painter*, Cambridge, Mass., 1930
894. FORD, B. (ed.). *The drawings of Richard Wilson*, 1951
895. FORDHAM, M. *The life of childhood*, 1944
896. FORGE, A. *Soutine*, 1965
897. FORMIGÉ, J. *L'Abbaye royale de Saint-Denis*, 1960
898. FÖRSTER, O. H. *Bramante*, Vienna, 1956
899. — (ed.). *Stefan Lochner, ein Maler zu Köln*, Bonn, 1952 (Frankfurt, 1938)
900. FOSCA, F. *Renoir: his life and work*, 1961

# BIBLIOGRAPHY

901. FOSKETT, D. *British portrait miniatures*, 1963
902. — *John Smart the man and his miniatures*, 1964
903. FOUCHET, M.-P. *Bissière*, 1955
904. FOURCAUD, L. DE. *François Rude, sculpteur : ses œuvres et son temps (1784–1855)*, 1904
905. FOURREAU, A. *Berthe Morisot*, 1925
906. FOX, SIR C. F. *Pattern and purpose : a survey of early Celtic art in Britain*, 1958
907. FOX, H. M. *André le Nôtre, garden architect to kings*, 1962
908. FOX, P. *Tutankhamun's treasure*, 1951
909. FRANCASTEL, P. *Art et technique aux XIX^e et XX^e siècles*, 1956
910. — *Girardon : biographie et catalogue critiques*, 1928
911. — *Le Style Empire, du Directoire à la Restauration*, 1944
912. FRANCOVICH, G. DE. *Benedetto Antelami architetto e scultore e l'arte del suo tempo*, 2 vols., Milan and Florence, 1952
913. FRANKFORT, H. *The art and architecture of the ancient Orient*, 1954
914. — *Cylinder seals : a documentary essay on the art and religion of the ancient Near East*, 1939
915. — (ed.). *The mural painting of El-'Amarneh*, 1929
916. FRANKL, P. *Gothic architecture*, 1962
917. — *The Gothic : literary sources and interpretations through eight centuries*, Princeton, 1960
918. FRANSOLET, M. *François du Quesnoy, sculpteur d'Urbain VIII, 1597–1643*, Brussels, 1942
919. FRÉDÉRIC, L. *The temples and sculpture of southeast Asia*, 1965
920. FREEDBERG, S. J. *Andrea del Sarto*, Cambridge, Mass., 1963
921. — *Painting of the High Renaissance in Rome and Florence*, 2 vols., Cambridge, Mass., 1961
922. — *Parmigianino : his works in painting*, Cambridge, Mass., 1950
923. FREISE, K. *Pieter Lastman : sein Leben und seine Kunst*, Leipzig, 1911
924. FREUD, S. *Leonardo da Vinci*, trans. by A. A. Brill, 1922 (New York, 1916)
925. FRIDLANDER, E. D. *Matthew Maris*, 1921
926. FRIEDLÄNDER, M. J. *Die altniederländische Malerei*, 14 vols., Berlin, 1924–37
    Vol. I. *Die van Eyck. Petrus Christus*, 1924
    II. *Rogier van der Weyden und der Meister von Flémalle*, 1924
    III. *Dierick Bouts und Joos van Gent*, 1925
    IV. *Hugo van der Goes*, 1926
    V. *Geertgen van Haarlem und Hieronymus Bosch*, 1927
    VI. *Memling und Gerard David*, 1928
    VII. *Quentin Massys*, 1929
    VIII. *Jan Gossart. Bernart van Orley*, 1930
    IX. *Joos van Cleve. Jan Provost. Joachim Patenier*, 1931

Vol. X. *Lucas van Leyden und andere holländische Meister seiner Zeit*, 1932
    XI. *Die Antwerpener Manieristen Adriaen Ysenbrant*, 1933
    XII. *Pieter Coeck. Jan van Scorel*, 1935
    XIII. *Anthonis Mor und seine Zeitgenossen*, 1936
    XIV. *Pieter Bruegel*, 1937
927. — *Early Netherlandish painting*, Leiden, 1967–
928. — *Early Netherlandish painting from Van Eyck to Bruegel*, 1956
929. — *Landscape, portrait, still-life, their origin and development*, 1949
930. — *On art and connoisseurship*, 1942
931. FRIEDLÄNDER, W. *Caravaggio studies*, Princeton, 1955
932. — *David to Delacroix*, Cambridge, Mass., 1952
933. — *Mannerism and anti-mannerism in Italian painting*, New York, 1957
934. — *Nicolas Poussin : a new approach*, 1966
935. — (ed.). *The drawings of Nicolas Poussin*, 1939–
936. FRIEDRICH, C. J. *The age of the baroque, 1610–1660*, New York, 1952
937. FROMENTIN, E. S. A. *The masters of past time*, 1948 (1913)
938. FROTHINGHAM, A. W. *Lustreware of Spain*, New York, 1951
939. FROVA, A. *L'arte etrusca*, Milan, 1957
940. FRY, E. F. *Cubism*, 1966
941. FRY, R. E. *Cézanne : a study of his development*, 1952 (1927)
942. — *Last lectures*, 1939
943. — *Henri-Matisse*, 1930
944. — *Reflections on British painting*, 1934
945. — *Transformations*, 1926
946. — *Vision and design*, 1920
947. — (ed.). *Records of journeys to Venice and the Low Countries*, Boston, 1913
948. FUJIKAKE, SHIDZUYA. *Japanese wood-block prints*, Tokyo, 1938
949. FURNESS, S. M. M. *Georges de la Tour of Lorraine, 1593–1652*, 1949
950. FURST, H. E. A. *Chardin and his times*, 1907
951. FURTWÄNGLER, A. *Die antiken Gemmen*, 3 vols., Leipzig, 1900
952. FURUMARK, A. *The chronology of Mycenaean pottery*, Stockholm, 1941
953. — *The Mycenaean pottery. Analysis and classification*, Stockholm, 1941
954. FUSELI, H. *Lectures on painting delivered at the Royal Academy*, 1801–20
955. GABELENTZ, H. VON DER. *Fra Bartolommeo und die Florentiner Renaissance*, 2 vols., Leipzig, 1922
956. GACHET, P. *Deux Amis des impressionnistes : le docteur Gachet et Murer*, 1957
957. GADD, C. J. *The stones of Assyria*, 1936
958. GAEDERTZ, T. *Adrian van Ostade : sein Leben und seine Kunst*, Lübeck, 1869
959. GAILLARD, G. *Les Débuts de la sculpture romane espagnole*, 1938

960. GALIFRET, Y. (ed.). *Mechanisms of colour discrimination*, 1960
961. GALL, E. *Karolingische und ottonische Kirchen*, Magdeburg, 1930
962. GALLEGO Y BURÍN, A. *El barroco granadino*, Granada, 1956
963. GALT, J. *The progress of genius; or authentic memoirs of the early life of Benjamin West*, 1832
964. GANAY, E. DE. *André le Nostre*, 1962
965. GANDON, J. *The life of James Gandon*, Dublin, 1846
966. GANGOLY, O. C. *Critical catalogue of miniature paintings in the Baroda Museum*, Baroda, 1961
967. — *South Indian bronzes*, Calcutta, 1915
968. GANTNER, J. *Rembrandt und die Verwandlung klassischer Formen*, Berne, 1964
969. — *Rodin und Michelangelo*, Vienna, 1953
970. — *Konrad Witz*, Vienna, 1943
971. GANZ, P. L. *The drawings of Henry Fuseli*, 1949
972. — *The paintings of Hans Holbein*, 1950
973. GARCÍA CHICO, E. (ed.). *Documentos para el estudio del arte en Castilla*, 8 vols., Valladolid, 1940-6
974. GARDNER, A. *English medieval sculpture*, 1951 (1935)
975. — *Medieval sculpture in France*, 1931
976. GARDNER, J. E. G. *The painters of the school of Ferrara*, 1911
977. GARDNER, S. *A guide to English gothic architecture*, 1922
978. GARIN, E. *Il Rinascimento italiano*, Milan, 1941
979. GARLICK, K. *Sir Thomas Lawrence*, 1954
980. GARNER, F. H. *English delftware*, 1948
981. GARRISON, E. B. *Italian romanesque panel painting*, Florence, 1949
982. GARWOOD, D. *Artist in Iowa: a life of Grant Wood*, New York, 1944
983. GASSIER, P. *Goya*, New York, 1955
984. GAUGUIN, P. *The intimate journals of Paul Gauguin*, 1930 (1923)
985. — *The letters of Paul Gauguin to Georges Daniel de Monfreid*, 1923
986. — *Letters to his wife and friends*, 1948
987. — *Noa, Noa*, 1924
988. GAUNT, W. *The Pre-Raphaelite tragedy*, 1942
989. GAUTHIER, M. *Le Corbusier, ou l'architecture au service de l'homme*, 1944
990. — *Watteau*, 1959
991. GAYA-NUÑO, J. A. *Claudio Coello*, Madrid, 1957
992. — *Historia del arte español*, Madrid, 1946
993. — *Historia y guía de los museos de España*, Madrid, 1955
994. — *Luis de Morales*, Madrid, 1961
995. — *La Pintura española fuera de España. (Historia y catálogo)*, Madrid, 1958
996. GÉBELIN, F. *Les Châteaux de la Renaissance*, 1927
997. GEBHART, H. *Gemmen und Kameen*, Berlin, 1925

998. GEDDES, SIR P. *City development*, 1904
999. GEFFROY, G. *Claude Monet: sa vie, son temps, son œuvre*, 1922
1000. — *Constantin Guys, l'historien du Second Empire*, 1920
1001. — *Sisley*, 1927 (1923)
1002. GEIGER, B. *Magnasco*, Bergamo, 1949
1003. GEISSBUHLER, E. C. *Rodin: later drawings. With interpretations by Antoine Bourdelle*, 1964
1004. GELDER, J. G. VAN. *Jan van de Velde, 1593-1641*, The Hague, 1933
1005. GELDZAHLER, H. *American painting in the twentieth century*, New York, 1965
1006. GELÉE, C. *Liber Veritatis; or a collection of prints after the original designs of Claude le Lorrain, executed by Richard Earlom*, 3 vols., 1777-1819
1007. GENET, J. *Alberto Giacometti*, Zürich, 1962
1008. GENEVOIX, M. *Vlaminck*, 1954
1009. GEORGE, E. *The life and death of Benjamin Robert Haydon, 1786-1846*, 1967 (1948)
1010. GEORGE, M. D. *Hogarth to Cruickshank: social change in graphic satire*, 1967
1011. GEORGE, W. *Aristide Maillol*, 1965
1012. — *Chirico: avec des fragments littéraires de l'artiste*, 1928
1013. — *Despiau*, Cologne and Berlin, 1954
1014. — *Utrillo*, 1960
1015. GERKE, F. *Christus in der spätantiken Plastik*, Mainz, 1948
1016. GERNSHEIM, H. and A. *The history of photography*, 1955
1017. GERSON, H. *Philips Koninck*, Berlin, 1936
1018. GERSON, H. and TER KUILE, E. H. *Art and architecture in Belgium, 1600 to 1800*, 1960
1019. GERSTENBERG, K. G. (ed.). *Deutsche Sondergotik*, Munich, 1913
1020. — (ed.). *Hans Multscher*, Leipzig, 1928
1021. GETLEIN, F. and G. *Georges Rouault's Miserere*, Milwaukee, 1964
1022. GEYMÜLLER, H. VON. *Les Du Cerceau, leur vie et leur œuvre*, 1887
1023. GHIRSHMAN, R. *Iran: from the earliest times to the Islamic conquest*, 1954
1024. — *Iran: Parthians and Sassanians*, 1962
1025. — *Persia from the origins to Alexander the Great*, 1964
1026. GHYKA, M. *Essai sur le rhythme*, 1938
1027. — *Esthétique des proportions dans la nature et dans les arts*, 1927
1028. — *A practical handbook of geometrical composition and design*, 1952
1029. GIBBS-SMITH, C. H. *The Great Exhibition of 1851*, 1950
1030. GIBSON, F. *The art of Henri Fantin-Latour: his life and work*, 1924
1031. GIBSON, W. P. *Barbara Hepworth, sculptress*, 1946
1032. GIEDION, S. *A decade of contemporary architecture*, New York, 1954 (1951)
1033. — *The eternal present*, 2 vols., 1962
1034. — *Space, time and architecture*, 1962 (1941)

1035. GIEDION, S. *Walter Gropius; work and teamwork*, 1954

1036. GIEDION-WELCKER, C. *Constantin Brancusi*, Stuttgart and Basel, 1958

1037. — *Jean Arp*, 1957

1038. — *Paul Klee*, 1952

1039. GIEURE, M. *Initiation à l'œuvre de Picasso*, 1951

1040. GILCHRIST, A. *The life of William Blake*, by R. Todd, 1942 (1863)

1041. — *The life of William Etty*, 1855

1042. GILCHRIST, A. A. *William Strickland, architect and engineer, 1788-1854*, Philadelphia, 1950

1043. GIL FILLOL, L. *Mariano Fortuny : su vida, su obra, su arte*, Barcelona, 1952

1044. GILPIN, W. *Observations relative chiefly to picturesque beauty*, 1786

1045. GIOSEFFI, D. *Perspectiva artificialis*, Trieste, 1957

1046. GIRTIN, T. and LOSHAK, D. *The art of Thomas Girtin*, 1954

1047. GISCHIA, L. and MAZENOD, L. *Les Arts primitifs français*, 1953

1048. GISCHIA, L. and VÉDRÈS, N. *La Sculpture en France depuis Rodin*, 1945

1049. GLAIZE, M. *Les Monuments du Groupe d'Angkor*, Saigon, 1944

1050. GLASER, C. *Les Peintres primitifs allemands, du milieu du XIVᵉ siècle à la fin du XVᵉ*, 1931

1051. — *Die altdeutsche Malerei*, Munich, 1924

1052. GLEESON, J. T. *William Dobell*, 1964

1053. GLEIZES, A. and METZINGER, J. *Cubism*, 1913

1054. GLÜCK, G. *Pieter Bruegel the elder*, 1951 (1937)

1055. — *Van Dyck*, Berlin and Stuttgart, 1931

1056. — *Bruegels Gemälde*, Vienna, 1951 (1932)

1057. GNUDI, C. *Giotto*, 1959

1058. — *Guido Reni*, Florence, 1955

1059. — *Morandi*, Florence, 1946

1060. GOBIN, M. *Daumier, sculpteur, 1808-1879*, Geneva, 1952

1061. GOETZ, H. *India : five thousand years of Indian art*, 1959

1062. — *The Kachhwala school of Rajput painting (Bulletin of the Baroda State Museum and Picture Gallery, IV)*, Baroda, 1944

1063. GOETZE, A. *Kleinasien*, Munich, 1933

1064. GOGH, V. W. VAN. *The complete letters of Vincent van Gogh*, 3 vols., 1958

1065. GOLDBLATT, M. H. *Deux Grand Maîtres français : le Maître de Moulins identifié, Jean Perréal*, 1961

1066. GOLDSCHEIDER, C. *Laurens*, Cologne and Berlin, 1958

1067. GOLDSCHEIDER, L. *El Greco*, 1938

1068. — *Etruscan sculpture*, 1941

1069. — *Ghiberti*, 1949

1070. — *Leonardo da Vinci : life and work, paintings and drawings*, 1943

1071. — *Jan Vermeer, the paintings*, 1958

1072. — *Michelangelo drawings*, 1966 (1951)

1073. GOLDSCHEIDER, L. *Michelangelo : paintings, sculptures, architecture*, 1953

1074. GOLDSCHMIDT, A. *German illumination*, 2 vols., New York and Florence, 1928

1075. GOLDSCHMIDT, A. and WEITZMANN, K. *Die byzantinischen Elfenbeinskulpturen des X.-XIII. Jahrhunderts*, 2 vols., Berlin, 1930-4

1076. GOLDWATER, R. J. *Bambara sculpture from the Western Sudan*, New York, 1960

1077. — *Primitivism in modern painting*, 1938

1078. — *Rufino Tamayo*, New York, 1947

1079. — *Lipchitz*, Cologne and Berlin, 1954

1080. — *Paul Gauguin*, 1957

1081. GOLZIO, V. *Lorenzo Monaco : l'unificazione della tradizione senese con la fiorentina e il gotico*, Rome, 1931

1082. — *Raffaello : nei documenti nelle testimonianze dei contemporanei, e nella letteratura del suo secolo*, Vatican City, 1936

1083. — *Seicento e Settecento*, 2 vols., Turin, 1960

1084. GOMBOSI, G. *Palma Vecchio*, Berlin and Stuttgart, 1937

1085. GOMBRICH, E. H. *Norm and form : studies in the art of the Renaissance*, 1966

1086. GÓMEZ-MORENO, M. *Las águilas del Renacimiento español : Bartolomé Ordóñez, Diego Silóee, Pedro Machuca, Alonzo Berruguete*, Madrid, 1941

1087. — *Catálogo monumental de España : inventario general de los monumentos históricos y artísticos de la nación*, Madrid, 1915-

1088. — *El Greco*, Barcelona, 1943

1089. — *La escultura del Renacimiento en España*, Florence and Barcelona, 1931

1090. — *The Golden Age of Spanish sculpture*, 1965

1091. GÓMEZ-MORENO, M. E. *Breve historia de la escultura española*, Madrid, 1951 (1935)

1092. — *Gregorio Fernández*, Madrid, 1953

1093. GOMPERTZ, G. ST. M. *Korean celadon, and other wares of the Koryŏ period*, 1963

1094. GONCOURT, E. H. DE. *L'Art japonais du XVIIIᵉ siècle*, 2 vols., 1891-6

1095. GONCOURT, E. H. DE and J. DE. *French XVIII century painters*, 1948 (1859-75)

1096. GONCOURT, E. H. DE and J. DE. *Gavarni : l'homme et l'œuvre*, 1873

1097. GONZÁLEZ MARTÍ, M. *Cerámica española*, Buenos Aires and Barcelona, 1933

1098. GOODHART-RENDEL, H. S. *English architecture since the Regency*, 1953

1099. — *Nicholas Hawksmoor*, 1924

1100. GOODRICH, L. *Thomas Eakins : his life and work*, New York, 1933

1101. — *Winslow Homer*, New York, 1959 (1945)

1102. GOODRICH, L. and BAUR, J. I. H. *American art of the twentieth century*, 1962

1103. GOODWIN, P. L. *Brazil builds : architecture new and old, 1652-1942*, New York, 1943

1104. GORDON, A. E. and J. S. *Album of dated Latin inscriptions*, 3 vols., Berkeley, 1958-65

1105. GORDON, A. K. *The iconography of Tibetan Lamaism*, New York, 1939

1106. — *Tibetan religious art*, New York, 1952

1107. GORDON, J. *Modern French painters*, 1923

1108. GORDON, T. C. *David Allan of Alloa, 1744-96 : the Scottish Hogarth*, 1951

1109. GORDON-BROWN, A. *Pictorial art in South Africa, during three centuries to 1875*, 1952

1110. GORISSEN, F. *B. C. Koekkoek, 1803-1862*, Düsseldorf, 1962

1111. GOSEBRUCH, M. *Nolde, Aquarelle und Zeichnungen*, Munich, 1958

1112. GOTCH, J. A. *Inigo Jones*, 1928

1113. GOUGH, M. *The early Christians*, 1961

1114. GOULD, C. *An introduction to Italian Renaissance painting*, 1957

1115. GOWANS, A. *Looking at architecture in Canada*, Toronto, 1958

1116. GOWING, L. *Vermeer*, 1952

1117. GRABAR, A. *The beginnings of Christian art : 200-395 A.D.*, 1967

1118. — *Byzantine painting*, Geneva, 1953

1119. — *Christian iconography*, 1968

1120. GRABAR, A. and CHATZIDAKIS, M. *Greece : Byzantine mosaics*, 1960

1121. GRABAR, A. and NORDENFALK, C. *Early medieval painting from the fourth to the eleventh century*, Lausanne, 1957

1122. GRABAR, A. and NORDENFALK, C. *Romanesque painting from the eleventh to the thirteenth century*, New York, 1958

1123. GRABER, H. *Auguste Renoir*, Basel, 1943

1124. — *Edgar Dégas*, Basel, 1942

1125. — *Eduard Manet*, Basel, 1939

1126. — *Paul Gauguin*, Basel, 1939

1127. GRAETZ, H. R. *The symbolic language of Vincent van Gogh*, 1963

1128. GRANT, M. H. *Chronological history of the old English landscape painters—in oil—from the XVIth century to the XIXth century*, 3 vols., 1926-46

1129. — *Jan van Huysum, 1682-1749*, 1954

1130. — *Rachel Ruysch, 1664-1750*, 1956

1131. GRAPPE, G. P. P. Prud'hon, 1958

1132. GRASSI, L. *All the sculptures of Donatello*, 2 vols., 1964 (Milan, 1958)

1133. — *Tutta la pittura di Gentile da Fabriano*, Milan, 1953

1134. GRAVES, A. and CRONIN, W. V. *A history of the works of Sir Joshua Reynolds*, 4 vols., 1899-1901

1135. GRAVES, M. *Color fundamentals*, New York, 1952

1136. GRAY, B. *The English print*, 1937

1137. — *Early Chinese pottery and porcelain*, 1953

1138. — *Persian painting*, 1930

1139. GRAY, CAMILLA. *The great experiment : Russian art, 1863-1922*, 1962

1140. GRAY, CHRISTOPHER. *Sculpture and ceramics of Paul Gauguin*, Baltimore, 1963

1141. GRAZIOSI, P. *L'arte rupestre della Libia*, Naples, 1942

1142. — *Palaeolithic art*, New York, 1960

1143. GRÉARD, V. C. O. *Meissonier : his life and his art*, 1897

1144. GREAVES, M. *Regency patron : Sir George Beaumont*, 1966

1145. GREEN, C. *Sutton Hoo : the excavation of a royal ship-burial*, 1963

1146. GREEN, D. B. *Grinling Gibbons, his work as carver and statuary, 1648-1721*, 1964

1147. GREEN, J. H. *A catalogue and description of the whole of the works of the celebrated Jacques Callot*, 1804

1148. GREENBERG, C. *Joan Miró*, New York, 1948

1149. GREGORY, H. V. *The world of James McNeill Whistler*, 1961 (New York, 1959)

1150. GREINDL, E. *Corneille de Vos : portraitiste flamand 1584-1654*, Brussels, 1944

1151. GRIFFITS, T. E. *The rudiments of lithography*, 1956

1152. GRIGSON, G. E. H. *Samuel Palmer : the visionary years*, 1947

1153. GRILLI, E. *Golden screen paintings of Japan*, 1961

1154. GRIMSCHITZ, B. *Das Belvedere in Wien*, Vienna, 1946

1155. — *Ferdinand Georg Waldmüller : Leben und Werk*, Vienna, 1943

1156. — *Johann Lucas von Hildebrandts, Künstlerische Entwicklung bis zum Jahre 1725*, Vienna, 1922

1157. GRISWOLD, A. B. *Dated Buddha images of northern Siam*, Ascona, 1957

1158. GRISWOLD, A. B. and others. *Burma, Korea, Tibet*, 1964

1159. GRIVOT, D. VON and ZARNECKI, G. *Gislebertus, sculptor of Autun*, 1961 (Clairvaux-les-Lacs, 1960)

1160. GROCE, G. C. and WALLACE, D. H. *The New-York Historical Society's dictionary of artists in America, 1564-1860*, New Haven, 1957

1161. GRODECKI, L. *Au seuil de l'art roman : l'architecture ottonienne*, 1958

1162. — *Ivoires français*, 1947

1163. GROHMANN, W. *The art of Henry Moore*, 1960

1164. — *E. L. Kirchner*, 1961

1165. — *Karl Schmidt-Rottluff*, Stuttgart, 1956

1166. — *Paul Klee*, 1958 (1954)

1167. — *Wassily Kandinsky, life and work*, 1959

1168. — (ed.). *Paul Klee, drawings*, 1960

1169. GRONAU, H. D. *Andrea Orcagna und Nardo di Cione*, Berlin, 1937

1170. GRONAU, G. *Correggio : des Meisters Gemälde*, Stuttgart, 1907

1171. GROOT, C. HOFSTEDE DE. *A catalogue raisonné of the works of the most eminent Dutch painters of the seventeenth century*, 1907

1172. — *Quellenstudien zur holländischen Kunstgeschichte*, 15 vols., The Hague, 1893-1928

# BIBLIOGRAPHY

1173. GROPIUS, W. *The new architecture and the Bauhaus*, 1935

1174. — *Scope of total architecture*, New York, 1955

1175. GROS, G. J. *Maurice Utrillo, sa légende*, Lausanne, 1947

1176. GROSLIER, B. P. *Angkor, hommes et pierres*, 1956

1177. — *Indo China: art in the melting-pot of races*, 1962

1178. GROSSMAN, F. G. *Bruegel: the paintings*, 1966 (1955)

1179. GROSZ, G. *Ecce homo*, New York, 1965

1180. — *A little Yes and a big No: the autobiography of George Grosz*, New York, 1946

1181. — *A post-war museum*, 1931

1182. GROTE, L. *Deutsche Kunst im zwanzigsten Jahrhundert*, Munich, 1954

1183. GROUSSET, R. *La Chine et son art*, 1951

1184. — *L'Inde*, 1961 (1930)

1185. GROUSSET, R. and AUBOYER, J. *De l'Inde au Cambodge et à Java*, Monaco, 1950

1186. GRÖZINGER, W. *Scribbling, drawing, and painting*, 1955

1187. GRUNDY, C. R. *James Ward, R.A.: his life and works*, 1909

1188. GRUYER, G. *Fra Bartolommeo della Porta et Mariotto Albertinelli*, 1886

1189. GSELL, P. *Millet*, 1928

1190. GUAMAN POMA DE AYALA, F. *Nueva corónica y buen gobierno*, (codex péruvien illustré), 1936

1191. GUDIOL RICART, J. M. *The arts of Spain*, 1964

1192. — *Bernardo Martorell*, Madrid, 1959

1193. GUDLAUGSSON, S. J. *Gerard ter Borch*, 2 vols., The Hague, 1959

1194. GUÉRIN, M. *J.-L. Forain, lithographe*, 1910

1195. — *L'Œuvre gravée de Gauguin*, 2 vols., 1927

1196. GUERZONI, S. *Ferdinand Hodler: sa vie, son œuvre, son enseignement. Souvenirs personnels*, Geneva, 1957

1197. GUIART, J. *The arts of the South Pacific*, 1963

1198. GUICHARD-MEILI, J. *Matisse*, 1967

1199. GUIFFREY, J. *L'Œuvre de Pierre-Paul Prud'hon*, 1924

1200. GUILLAUME, P. and MUNRO, T. *Primitive Negro sculpture*, 1926

1201. GUINARD, P. and BATICLE, J. *Histoire de la peinture espagnole du XIIe au XIXe siècle*, 1950

1202. GULLÓN, R. *De Goya al arte abstracto*, Madrid, 1952

1203. GUPTE, R. S. *The iconography of the Buddhist sculptures, caves, of Ellora*, Aurangabad, 1964

1204. GURNEY, O. R. *The Hittites*, 1952

1205. GUTHEIM, F. *Alvar Aalto*, New York, 1960

1206. HAAB, A. *Mexican graphic art*, 1957

1207. HAESAERTS, P. *Histoire de la peinture moderne en Flandre*, Brussels, 1960

1208. HAESAERTS, P. *Jacob Smits*, Antwerp, 1948

1209. — *James Ensor*, 1957

1210. — *Renoir, sculptor*, New York, 1947

1211. HAFTMANN, W. *Emil Nolde*, 1959

1212. — *The mind and work of Paul Klee*, 1967 (1954)

1213. HAGEN, O. F. L. *Patterns and principles of Spanish art*, Madison, Wis., 1943 (1936)

1214. HAGEN-DEMPF, F. *Der Zentralbaugedanke bei Johann Michael Fischer*, Munich, 1954

1215. HAGSTRUM, J. H. *William Blake: poet and painter*, Chicago, 1964

1216. HAHN, O. *André Masson*, 1965

1217. HAKE, H. M. *Francis Place, engraver and draughtsman* (Walpole Society, vol. x), 1922

1218. HALE, J. R. *England and the Italian Renaissance*, 1954

1219. HALÉVY, D. *My friend Degas*, 1966

1220. HALFPENNY, W. *Magnum in parvo*, 1722

1221. HALFPENNY, W. and J. *Chinese and Gothic architecture properly ornamented*, 1752

1222. HALFPENNY, W. and J. *Rural architecture in the Chinese taste*, 1750-2

1223. HALL, C. (ed.). *Constantin Guys*, 1945

1224. HALL, D. *Henry Moore: the life and work of a great sculptor*, 1966

1225. HALLAYS, A. *Les Perrault*, 1926

1226. HAMBRIDGE, J. *Dynamic symmetry: the Greek vase*, New Haven, 1924

1227. HAMILTON, G. H. *The art and architecture of Russia*, 1954

1228. — *Manet and his critics*, New Haven, 1954

1229. HAMLIN, T. F. *Benjamin Henry Latrobe*, New York, 1955

1230. — (ed.). *Forms and functions of twentieth-century architecture*, 4 vols., New York, 1952

1231. HAMMACHER, A. M. *Jacques Lipchitz, his sculpture*, 1961

1232. — *Zadkine*, Cologne and Berlin, 1954

1233. HANDLEY-READ, C. (ed.). *The art of Wyndham Lewis*, 1951

1234. HANFMANN, G. M. A. *Roman art*, 1964

1235. HANNOVER, E. *Danish art in the nineteenth century*, 1922

1236. — *Pottery & porcelain*, 1925

1237. HANSFORD, S. H. *Chinese jade carving*, 1950

1238. — *A glossary of Chinese art and archaeology*, 1954

1239. — (ed.). *The Seligman collection of oriental art*, 2 vols., 1957-64

1240. HANSON, A. C. *Jacopo della Quercia's Fonte Gaia*, 1965

1241. HANSON, J. A. *Roman theater-temples*, Princeton, 1959

1242. HANSON, L. *Mountain of victory: a biography of Paul Cézanne*, 1960

1243. HANSON, L. and E. *The noble savage: a life of Paul Gauguin*, 1954

1244. HANSON, L. and E. *The Post-Impressionists: Cézanne, Gauguin, Van Gogh*, 1963
1245. HANSON, L. and E. *The tragic life of Toulouse-Lautrec, 1864-1901*, 1956
1246. HANTSCH, H. *Jakob Prandtauer, der Klosterarchitekt des österreichischen Barock*, Vienna, 1926
1247. HARDCASTLE, E. *Wine and walnuts*, 1823
1248. HARDEN, D. B. *The Phoenicians*, 1962
1249. HARDIE, M. *John Pettie, R.A., H.R.S.A.*, 1908
1250. HARDWICK, T. *A memoir of the life of Sir William Chambers*, 1825
1251. HARE, R. *The art and artists of Russia*, 1965
1252. HARRIS, E. *Spanish painting*, 1938
1253. HARRIS, J. R. *Egyptian art*, 1966
1254. HARRIS, T. *Goya's engravings and lithographs*, 2 vols., 1964
1255. HARTLAUB, G. F. *Gustave Doré*, Leipzig, 1924
1256. HARTT, F. *Giulio Romano*, 2 vols., New Haven, 1958
1257. — *Michelangelo*, 1965
1258. — *Sandro Botticelli*, New York, 1954
1259. HARVEY, G. E. *History of Burma from the earliest times to 10 March 1824*, 1925
1260. HARVEY, J. H. *Gothic England: a survey of national culture, 1300-1550*, 1948 (1947)
1261. — *The Gothic world, 1100-1600*, 1950
1262. — *Henry Yevele, c. 1320 to 1400*, 1944
1263. — *An introduction to Tudor architecture*, 1949
1264. HASELOFF, A. E. G. *Pre-romanesque sculpture in Italy*, Florence, 1930
1265. HASKELL, F. *Patrons and painters: a study in the relations between Italian art and society in the age of the Baroque*, 1963
1266. HATFIELD, H. C. *Winckelmann and his German critics, 1755-1781*, New York, 1943
1267. HATTON, J. *The life and work of Alfred Gilbert*, 1903
1268. HAUSENSTEIN, W. *Vom Genie des Barock*, Munich, 1956
1269. HAUSER, A. *Mannerism*, 2 vols., 1965
1270. HAUTECŒUR, L. *Histoire de l'architecture classique en France*, 1963- (7 vols., 1943-57)
1271. — *Louis David*, 1954
1272. — *Madame Vigée-Lebrun: étude critique*, 1914
1273. HAVELL, E. B. *The art heritage of India*, Bombay, 1964
1274. — *A handbook of Indian art*, 1920
1275. HAY, G. *The architecture of Scottish Post-Reformation churches, 1560-1843*, 1957
1276. HAYDON, B. R. *Lectures on painting and design*, 2 vols., 1844-6
1277. — *Life of Benjamin Robert Haydon, from his autobiography and journals*, ed. by T. Taylor, 3 vols., 1853
1278. HAYDON, B. R. *Thoughts on the relative value of fresco and oil painting, as applied to the architectural decorations of the Houses of Parliament*, 1842
1279. HAYTER, S. W. *About prints*, 1962
1280. — *New ways of gravure*, 1966 (1949)
1281. HEATH, A. *Abstract painting*, 1953
1282. HECKE, P. G. VAN. *Frits van den Berghe*, Antwerp, 1948
1283. HECKSCHER, W. S. *Rembrandt's anatomy of dr. Nicolaas Tulp*, New York, 1958
1284. HEDICKE, R. *Cornelis Floris und die Floris-Dekoration*, Berlin, 1913
1285. HELD, J. S. (ed.). *Rubens: selected drawings*, 2 vols., 1959
1286. HEMPEL, E. *Baroque art and architecture in central Europe*, 1965
1287. — *Das Werk Michael Pachers*, Vienna, 1943 (1931)
1288. HENDERSON, P. P. *William Morris, his life and friends*, 1967
1289. HENDY, SIR P. *Spanish painting*, 1946
1290. — *Matthew Smith*, 1944
1291. HENDY, SIR P. and GOLDSCHEIDER, L. *Giovanni Bellini*, 1945
1292. HENNUS, M. F. *Johan Barthold Jongkind*, Amsterdam, 1945
1293. HENRY, F. *Art irlandais*, Dublin, 1954
1294. — *Irish art during the Viking invasions, 800-1020 A.D.*, 1967
1295. — *Irish art in the early Christian period*, 1965 (1940)
1296. HENZE, A. *La Tourette, the Le Corbusier monastery*, 1966
1297. HEPWORTH, B. *Carvings and drawings*, 1952
1298. HERBERT, R. L. *Seurat's drawings*, 1965
1299. HERKOMER, SIR H. VON. *The Herkomers*, 2 vols., 1910-11
1300. HERMAN, M. *The early Australian architects and their work*, Sydney, 1954
1301. HERNÁNDEZ-DÍAZ, J. *Juan Martinez Montañés*, Seville, 1949
1302. HERNÁNDEZ-DÍAZ, J. and others. *Catálogo arqueológico y artistico de la provincia de Sevilla*, 4 vols., Seville, 1939-55
1303. HERVEY, M. F. S. *The life, correspondence and collections of Thomas Howard, Earl of Arundel*, 1921
1304. HERZFELD, E. E. *Archaeological history of Iran*, 1935
1305. — *Iran in the ancient east*, 1941
1306. HESS, H. *Lyonel Feininger*, 1961
1307. HETHERINGTON, J. A. *Australian painters: forty profiles*, 1964
1308. HEVESI, L. *Österreichische Kunst in neunzehnten Jahrhundert*, Leipzig, 1903
1309. HEYDENREICH, L. H. *Leonardo da Vinci*, 2 vols., New York, 1954
1310. HEYER, P. (ed.). *Architects on architecture: new directions in America*, 1967
1311. HIBBARD, H. *Bernini*, 1965
1312. HILDEBRANDT, H. *Oskar Schlemmer*, Munich, 1952
1313. HILL, A. K. G. *Art versus illness*, 1945

1314. HILL, D. *Mr. Gillray the caricaturist*, 1965

1315. HILL, SIR G. F. *A corpus of Italian medals of the Renaissance before Cellini*, 2 vols., 1930

1316. — *Medals of the Renaissance*, 1920

1317. HILLES, F. W. *The literary career of Sir Joshua Reynolds*, 1936

1318. HILLIER, J. R. *Hokusai drawings*, 1966

1319. — *Hokusai: paintings, drawings and woodcuts*, 1955

1320. — *Japanese masters of the colour print: a great heritage of oriental art*, 1954

1321. — *The Japanese print: a new approach*, 1960

1322. — *Utamaro, colour prints and paintings*, 1961

1323. HIND, A. M. *Catalogue of the drawings of Claude Lorrain preserved in the Department of Prints and Drawings in the British Museum*, 1926

1324. — *Engraving in England in the sixteenth & seventeenth centuries*, 2 parts, 1952, 1955

1325. — *Giovanni Battista Piranesi*, 1922

1326. — *A history of engraving and etching*, 1923 (1908)

1327. — *An introduction to a history of woodcut*, 2 vols., 1935

1328. — *The processes and schools of engraving*, 1952 (1914)

1329. HINKS, R. *Carolingian art*, 1935

1330. HIORT, E. *Contemporary Danish architecture*, Copenhagen, 1949

1331. HIPPLE, W. J. *The beautiful, the sublime, and the picturesque in eighteenth-century British aesthetic theory*, Carbondale, 1951

1332. HIRN, Y. *The origins of art*, 1900

1333. HIRSCHMANN, O. *Hendrick Goltzius*, Leipzig, 1920

1334. HITCHCOCK, H. R. *American architectural books: a list of books, portfolios and pamphlets on architecture and related subjects, published in America before 1895*, Minneapolis, 1962 (1946)

1335. — *Architecture: nineteenth and twentieth centuries*, 1963 (1958)

1336. — *The architecture of H. H. Richardson and his times*, New York, 1936

1337. — *In the nature of materials. 1887–1941. The buildings of Frank Lloyd Wright*, New York, 1942

1338. HITCHCOCK, H. R. and DREXLER, A. (edd.). *Built in U.S.A.: post-war architecture*, New York, 1952

1339. HOBHOUSE, C. *1851 and the Crystal Palace*, 1950 (1937)

1340. HODGSON, J. E. and EATON, SIR F. A. *The Royal Academy and its members, 1768–1830*, 1905

1341. HODIN, J. P. *Barbara Hepworth*, 1961

1342. — *Chadwick*, 1961

1343. — *Edvard Munch: Nordens genius*, Stockholm, 1948

1344. — *Oskar Kokoschka: the artist and his time*, 1966

1345. HOFBAUER, I. (ed.). *George Grosz*, introduced by John Dos Passos, ed. by Imre Hofbauer, 1948

1346. HOFF, A. *Wilhelm Lehmbruck: seine Sendung und sein Werk*, Berlin, 1961 (1936)

1347. HOFFMAN, E. *Kokoschka: life and work*, 1947

1348. HOGARTH, D. G. *Hittite seals*, 1920

1349. HOGARTH, W. *The analysis of beauty*, ed. by J. Burke, 1955 (1753)

1350. HOLLAND, J. *Memorials of Sir Francis Chantrey*, 1851

1351. HOLME, C. G. (ed.). *Art in the U.S.S.R.*, 1935

1352. HOLMES, SIR C. J. *Constable and his influence on landscape painting*, 1902

1353. HOLST, N. VON. *Creators, collectors and connoisseurs*, 1967

1354. HOMER, W. I. *Seurat and the science of painting*, Cambridge, Mass., 1964

1355. HONEY, W. B. *The art of the potter*, 1946

1356. — *The ceramic art of China and other countries of the Far East*, 1945

1357. — *Corean pottery*, 1947

1358. — *Dresden china*, 1954 (1934)

1359. — *English pottery and porcelain*, 1949 (1933)

1360. — *European ceramic art*, 2 vols., 1949–52

1361. — *French porcelain of the 18th century*, 1950

1362. — *German porcelain*, 1947

1363. — *Old English porcelain*, 1948 (1928)

1364. HONNECOURT, V. D'. *Album de Villard de Honnecourt*, 1906

1365. — *Kritische Gesamtausgabe des Bauhüttenbuches*, Vienna, 1935

1366. HONOUR, H. *Chinoiserie: the vision of Cathay*, 1961

1367. HOOGEWERF, G. J. *Jan van Scorel*, The Hague, 1923

1368. HOPE, H. R. *Georges Braque*, New York, 1949

1369. — *The sculpture of Jacques Lipchitz*, New York, 1954

1370. HORNBY, C. H. ST. JOHN. *A descriptive bibliography of the books printed at the Ashendene Press*, 1935

1371. HORODISCH, A. *Picasso as a book artist*, 1962

1372. HOUBRAKEN, A. *De Groote Schouburgh der Nederlantsche konstschilders en schilderessen*, Maastricht, 1943–53 (Amsterdam, 1718–21)

1373. HOWARD, E. *Garden cities of to-morrow*, 1902 (1898)

1374. HOWELL, A. R. *Frances Hodgkins, four vital years*, 1951

1375. HSIEH HO. *Some T'ang and pre-T'ang texts on Chinese painting*, trans. and annotated by W. R. B. Acker, Leiden, 1954

1376. HUARD, P. (ed.). *Léonard de Vinci, dessins scientifiques et techniques*, 1962

1377. HUBERT, G. *Gothic France*, Neuchâtel, 1960

1378. HUBERT, J. L'Architecture religieuse du haut Moyen Âge en France, 1952
1379. — L'Art pré-roman, 1938
1380. HUDSON, D. Charles Keene, 1947
1381. HUEBNER, F. M. Die neue Malerei in Holland, Leipzig, 1921
1382. HUEFFER, F. M. Ford Madox Brown, 1896
1383. HUGNET, G. L'Aventure Dada (1916–1922), 1957
1384. HUIZINGA, J. Leven en Werk van Jan Veth, Haarlem, 1927
1385. HUMBERT, A. Louis David, peintre et conventionnel, 1948 (1936)
1386. HUMMEL, S. Geschichte der tibetischen Kunst, Leipzig, 1953
1387. HUNT, J. D. The Pre-Raphaelite imagination, 1968
1388. HUNT, W. H. Pre-Raphaelitism and the Pre-Raphaelite Brotherhood, 1913 (1905)
1389. HUNTER, S. Mondrian, 1872–1944, 1959
1390. HUNTLEY, G. H. Andrea Sansovino, sculptor and architect of the Italian Renaissance, Cambridge, Mass., 1935
1391. HÜRLIMANN, M. and MEYER, P. English cathedrals, 1950
1392. HUSSEY, C. English gardens and landscapes, 1700–1750, 1967
1393. — The life of Sir Edwin Lutyens, 1950
1394. — The picturesque, 1927
1395. HUTCHESON, F. An inquiry into the original of our ideas of beauty and virtue, 1753 (1725)
1396. HUTCHISON, S. C. The history of the Royal Academy 1768–1968, 1968
1397. HUTTON, E. The Cosmati: the Roman marble workers of the XIIth and XIIIth centuries, 1950
1398. HUXTABLE, A. L. Pier Luigi Nervi, 1960
1399. HUYGHE, R. Delacroix, 1963
1400. — La Peinture française du XIVme au XVIIme siècle, 1937
1401. IKÉUCHI, HIROSHI. T'ung-kon, English résumé by J. Harada, Tokyo, 1938–
1402. INAN, J. and ROSENBAUM, E. Roman and early Byzantine portrait sculpture in Asia Minor, 1966
1403. INGERSOLL-SMOUSE, F. Pater, biographie et catalogue critiques, 1928
1404. INVERARITY, R. B. Art of the Northwest Coast Indians, Berkeley and Los Angeles, 1950
1405. IRONSIDE, R. Wilson Steer, 1943
1406. IRONSIDE, R. and GERE, J. Pre-Raphaelite painters, 1948
1407. IRWIN, D. English neoclassical art, 1966
1408. ITTEN, J. The art of color, New York, 1961
1409. IVANOFF, P. Indonésie, archipel des dieux, 1962
1410. IVERSEN, E. Canon and proportions in Egyptian art, 1955
1411. IVINS, W. M. Art & geometry, Cambridge, Mass., 1946
1412. — Prints and visual communication, 1953
1413. JACKSON, E. N. Silhouette, 1938

1414. JACKSON, H. E. Benjamin West, his life and work, Philadelphia, 1900
1415. JACKSON, T. G. Reason in architecture, 1906
1416. JACOBSTHAL, P. Early Celtic art, 2 vols., 1944
1417. JACOBUS, J. M. Twentieth-century architecture: the middle years, 1940–65, 1966
1418. JACOMETTI, N. Suzanne Valadon, Geneva, 1947
1419. JAFFÉ, H. L. C. De Stijl, 1919–1931: the Dutch contribution to modern art, 1957 (Amsterdam, 1956)
1420. — (ed.). De Stijl, 1968
1421. JALOUX, E. Johann-Heinrich Füssli, Geneva, 1942
1422. JAMES, M. R. (ed.). The Bestiary, 1928
1423. JAMOT, P. Connaissance de Poussin, 1948
1424. — Corot, 1936
1425. — Dunoyer de Segonzac, 1929
1426. — Georges de La Tour, 1948 (1942)
1427. JAMOT, P. and WILDENSTEIN, G. Manet, 2 vols., 1932
1428. JANATA, A. Korean painting, 1964
1429. JANSON, H. W. (ed.). The sculpture of Donatello, Princeton, 1963 (1957)
1430. JANTZEN, H. Deutsche Bildhauer des XIII. Jahrhunderts, Leipzig, 1925
1431. — Ottonische Kunst, Munich, 1947
1432. JEDLICKA, G. Henri de Toulouse-Lautrec, 1961
1433. JELLICOE, G. A. Studies in landscape design, 2 vols., 1960–6
1434. JENKINS, L. and MILLS, B. The art of making mosaics, Princeton, 1957
1435. JENYNS, S. Chinese archaic jades in the British Museum, 1951
1436. — Later Chinese porcelain: the Ch'ing dynasty, 1644–1912, 1951
1437. — Ming pottery and porcelain, 1953
1438. JERROLD, B. Life of Gustave Doré, 1969 (1891)
1439. JETTMAR, K. Art of the Steppes, 1967
1440. JIANOU, I. Brancusi, 1963
1441. — Zadkine, 1964
1442. JAINOU, T. and DUFET, M. Bourdelle, 1965
1443. JISL, L. Tibetan art, 1960
1444. JOEDICKE, J. A history of modern architecture, 1959
1445. JOHNSON, L. F. Delacroix, New York, 1963
1446. JOHNSON, P. C. Mies Van der Rohe, New York, 1947
1447. — Machine art, New York, 1934
1448. JONES, C. Architecture today and tomorrow, New York, 1961
1449. JONES, G. Sir Francis Chantrey, 1849
1450. JONES, J. R. The man who loved the sun: the life of Vincent van Gogh, 1966
1451. JORDAN, R. F. Victorian architecture, 1966
1452. JOURDAIN, F. Marquet, 1948
1453. JOURDAIN, F. and ADHÉMAR, J. Toulouse-Lautrec, 1952

1454. JOURDAIN, M. *The work of William Kent,* 1948
1455. JOUVEAU-DUBREUIL, G. *Iconography of Southern India,* 1937
1456. JOYANT, M. *Henri de Toulouse-Lautrec, 1864-1901,* 1926
1457. JULIEN, E. *Les Affiches de Toulouse-Lautrec,* 1950
1458. JULLIAN, R. *Caravage,* 1961
1459. — *L'Éveil de la sculpture italienne,* 1945-
1460. JULLIEN, A. *Fantin-Latour: sa vie et ses amitiés,* 1908
1461. JUSTI, C. *Diego Velazquez and his times,* 1889
1462. — *Winckelmann: sein Leben, seine Werke und seine Zeitgenossen,* 3 vols., Cologne, 1956 (Leipzig, 1866-72)
1463. KAEMMERER, L. *Chodowiecki,* Bielefeld and Leipzig, 1897
1464. KAFTAL, G. *Iconography of the saints in Tuscan painting,* Florence, 1952
1465. — *Saints in Italian art,* 1952-
1466. KAHN, G. *Fantin-Latour,* 1927
1467. KAHNWEILER, D. H. *Juan Gris, his life and work,* 1947
1468. KANE, P. *Wanderings of an artist among the Indians of North America,* 1859
1469. KAR, C. *Indian metal sculpture,* 1952
1470. KARLINGER, H. *Die Kunst der Gotik,* Berlin, 1934
1471. KATZ, D. *The world of colour,* 1935
1472. KAUFMANN, E. *Architecture in the age of reason,* Cambridge, Mass., 1955
1473. — *Three Revolutionary architects: Boullée, Ledoux, and Lequeu,* Philadelphia, 1952
1474. KAVLI, G. *Norwegian architecture past and present,* 1958
1475. KAYSER, W. *The grotesque in art and literature,* Bloomington, 1963
1476. KELEMEN, P. *Baroque and rococo in Latin America,* New York, 1951
1477. — *Medieval American art: a survey,* New York, 1956 (1943)
1478. KELLER-DORIAN, G. *Antoine Coysevox,* 2 vols., 1920
1479. KENDON, F. *Mural paintings in English churches during the middle ages,* 1923
1480. KENDRICK, SIR T. D. *Anglo-Saxon art to A.D. 900,* 1938
1481. — *Late Saxon and Viking art,* 1949
1482. KENNA, V. E. G. *Cretan seals,* 1960
1483. KENNEDY, R. W. *Alesso Baldovinetti: a critical and historical study,* New Haven, 1938
1484. KENT, R. *Portinari: his life and art,* Chicago, 1940
1485. KEYNES, SIR G. L. *A bibliography of William Blake,* New York, 1921
1486. — *Blake studies,* 1949
1487. KEYSER, C. E. *A list of Norman tympana and lintels,* 1927 (1904)
1488. KIDDER, J. E. *Early Japanese art,* 1964
1489. — *Japan before Buddhism,* 1959
1490. KIDSON, P. *Sculpture at Chartres,* 1958
1491. KIELLAND, E. C. *Geometry in Egyptian art,* 1955
1492. KILBRACKEN, LORD. *Van Meegeren, a case history,* 1967
1493. KIM, C. and W.-Y. *The arts of Korea,* 1966
1494. KIM, C. and GOMPERTZ, G. ST. G. M. (edd.). *The ceramic art of Korea,* 1961
1495. KIMBALL, S. F. *The creation of the rococo,* Philadelphia, 1943
1496. — *Mr. Samuel McIntire, carver, the architect of Salem,* Portland, 1940
1497. — *Thomas Jefferson, architect,* Boston, 1916
1498. KING, G. G. *Mudéjar,* 1927
1499. KIRKER, H. and J. *Bulfinch's Boston, 1787-1817,* New York, 1964
1500. KITSON, S. D. *The life of John Sell Cotman,* 1937
1501. KITZINGER, E. *Early medieval art in the British Museum,* 1955 (1940)
1502. KLEE, P. *The diaries of Paul Klee, 1898-1918,* 1965
1503. — *On modern art,* 1948
1504. — *Pedagogical sketchbook,* 1953
1505. — *The thinking eye. The notebooks of Paul Klee,* 1961
1506. KLEINER, G. *Tanagrafiguren: Untersuchungen zur hellenistischen Kunst und Geschichte,* Berlin, 1942
1507. KLINGENDER, F. D. *Art and the Industrial Revolution,* 1947
1508. — *Goya in the democratic tradition,* 1948
1509. — *Hogarth and English caricature,* 1943
1510. KNAPPE, K. A. (ed.). *Dürer: the complete engravings, etchings and woodcuts,* 1965
1511. KNIGHT, R. P. *An analytical inquiry into the principles of taste,* 1808 (1805)
1512. KNIPPING, J. B. *Jan Toorop,* Amsterdam, 1947
1513. KNOWLES, J. *The life and writings of Henry Fuseli,* 1831
1514. KOCH, C. *Die Zeichnungen Hans Baldung Griens,* Berlin, 1941
1515. KOEHLER, W. R. W. *Die karolingischen miniaturen,* Berlin, 1930-
1516. KOKOSCHKA, O. *Oskar Kokoschka: watercolours, drawings, writings,* 1962
1517. — *Schriften 1907-1955,* Munich, 1956
1518. KONDAKOV, N. P. *The Russian icon,* 1927
1519. KONODY, P. G. *The art of Walter Crane,* 1902
1520. KORNERUP, A. and WANSCHER, J. H. *Methuen handbook of colour,* 1967 (1963)
1521. KOSTOF, S. K. *The orthodox baptistery of Ravenna,* New Haven, 1965
1522. KRAMER, S. N. *The Sumerians, their history, culture and character,* Chicago, 1963
1523. KRAMRISCH, S. *Indian sculpture,* Calcutta, 1933
1524. — *A survey of painting in the Deccan,* 1937
1525. — (ed.). *The art of India,* 1965 (1954)
1526. KRAUTHEIMER, R. *Early Christian and Byzantine architecture,* 1965

1527. KRAUTHEIMER, R. and KRAUTHEIMER-HESS, T. *Lorenzo Ghiberti*, Princeton, 1956

1528. KRIS, E. *Psychoanalytic explorations in art*, 1953 (New York, 1952)

1529. KRISTELLER, P. *Andrea Mantegna*, 1901

1530. KROEBER, A. L. *The Uhle pottery collections from Moche and the Uhle pottery collections from Supe*, Berkeley, 1925

1531. KROM, N. J. *Barabudur, archaeological description*, 2 vols., The Hague, 1927

1532. KRUMBHAAR, E. B. *Isaac Cruikshank*, Philadelphia, 1966

1533. KUBLER, G. *The art and architecture of ancient America: The Mexican, Maya and Andean peoples*, 1962

1534. — *Mexican architecture of the sixteenth century*, 2 vols., New Haven, 1948

1535. — *The religious architecture of New Mexico*, Colorado Springs, 1940

1536. KUBLER, G. and SORIA, M. *Art and architecture in Spain and Portugal and their American dominions, 1500–1800*, 1959

1537. KÜHNEL, P. E. *Islamic art and architecture*, 1966

1538. KULTERMANN, U. *New architecture in Africa*, 1963

1539. — *New Japanese architecture*, 1960

1540. KUNSTLER, C. *L'Art au XIXᵉ siècle en France, 1815–1870*, 1954

1541. KURTZ, L. P. *The Dance of Death and the macabre spirit in European literature*, New York, 1934

1542. LABAREE, B. W. (ed.). *Samuel McIntire: a bicentennial symposium*, Salem, 1957

1543. LABORDE, L. DE. *Les Comptes des Bâtiments du Roi, 1528–1571*, 1877–80

1544. LACY, A. D. *Greek pottery in the Bronze Age*, 1967

1545. LA FAILLE, J. B. DE. *Vincent van Gogh*, 1939 (1928)

1546. LAFUENTE FERRARI, E. *Breve historia de la pintura española*, Madrid, 1946 (1934)

1547. — *Los Desastres de la Guerra de Goya*, Barcelona, 1952

1548. — *La vida y el arte de Ignacio Zuloaga*, San Sebastián, 1950

1549. LAMB, W. R. M. *The Royal Academy: a short history of its foundations and development to the present day*, 1951 (1935)

1550. LAMBERT, É. *L'Art en Espagne et au Portugal*, 1945

1551. — *L'Art gothique en Espagne, au XIIᵉ et XIIIᵉ siècles*, 1931

1552. LAMBOTTE, SIR P. *Henri Evenepoel*, Brussels, 1908

1553. LAMI, S. *Dictionnaire des sculpteurs de l'école française*, 8 vols., 1898–1921

1554. LANDOLT, H. *Henri de Toulouse-Lautrec: drawings and sketches in colour*, 1955

1555. LANE, A. *Early Islamic pottery: Mesopotamia, Egypt and Persia*, 1947

1556. — *Greek pottery*, 1948

1557. — *Italian porcelain*, 1954

1558. LANE, A. *Later Islamic pottery: Persia, Syria, Egypt and Turkey*, 1957

1559. LANGE, K. and HIRMER, M. *Egypt: architecture, sculpture, painting in three thousand years*, 1961 (1956)

1560. LANGLEY, B. *New principles of gardening*, 1728

1561. LANGLEY, B. and T. *Ancient architecture, restored and improved . . . in the Gothick mode*, 1742

1562. LANGUI, É. *Constant Permeke*, Antwerp, 1947

1563. — *Gust de Smet. De mensch en zijn werk*, Brussels, 1945

1564. — *Marino Marini*, Cologne and Berlin, 1954

1565. LANKHEIT, K. (ed.). *Franz Marc: watercolours, drawings, writings*, 1960

1566. LAPPARENT, P. DE. *Toulouse-Lautrec*, 1928

1567. LARKIN, O. W. *Daumier, man of his time*, 1967

1568. LARREA, J. *Guernica*, New York, 1947

1569. LARSSON, L. O. *Adrian de Vries, 1545–1626*, Vienna, 1967

1570. LA SOUCHÈRE, D. DE. *Picasso in Antibes*, 1960

1571. LASSAIGNE, J. *Goya*, 1948

1572. LASTEYRIE DU SAILLANT, R. C. DE. *L'Architecture religieuse en France à l'époque gothique*, 2 vols., 1926–7

1573. — *L'Architecture religieuse en France à l'époque romane*, 1929 (1912)

1574. LATHOM, X. *Claude Monet*, 1931

1575. LAUDE, J. *La Peinture française (1905–1914) et 'l'art nègre'*, 2 vols., 1968

1576. LAUER, J. P. *Le Problème des pyramides d'Égypte*, 1952 (1948)

1577. LAUFER, B. (ed.). *Dokumente der indischen Kunst*, Leipzig, 1913

1578. LAURIE, A. P. *Greek and Roman methods of painting*, 1910

1579. LAURIN, C. and others. *Scandinavian art*, New York, 1922

1580. LAUTS, J. *Carpaccio: paintings and drawings*, 1962

1581. — *Antonello da Messina*, Vienna, 1940

1582. — *Domenico Ghirlandajo*, Vienna, 1943

1583. LAVALLEYE, J. *Juste de Gand*, Louvain, 1936

1584. LAVATER, J. K. *The whole works of Lavater on physiognomy*, trans. by G. Grenville, 1800?

1585. LAVEDAN, P. *French architecture*, 1956

1586. LAVER, J. *'Vulgar Society.' The romantic career of James Tissot, 1836–1902*, 1936

1587. — *Whistler*, 1930

1588. LAWRENCE, A. W. *Greek architecture*, 1957

1589. LAWTON, F. *The life and work of Auguste Rodin*, 1906

1590. LAYARD, G. S. *Life and letters of Charles Samuel Keene*, 1892

1591. LAZAREV, V. N. *Andrei Rublev*, Moscow, 1960

1592. LAZAREV, V. N. *Old Russian murals & mosaics, from the xi. to the xvi. century*, 1966

1593. LAZZARONI, M. and MUÑOZ, A. *Filarete, scultore e architetto del secolo XV*, Rome, 1908

1594. LEACH, B. *Kenzan and his tradition*, 1966

1595. — *A potter's book*, 1945 (1940)

1596. LEAR, E. *The book of nonsense*, 1846

1597. LEBEL, R. and others. *Marcel Duchamp*, 1959

1598. LE BLOND, A. J. B. *The theory and practice of gardening*, 1728 (1712)

1599. LE BRUN, C. *A method to learn to design the passions, proposed in a conference on their general and particular expression*, trans. by J. Williams, 1734

1600. LEBRUN, M. L. E. V. *The memoirs of Mme Élisabeth Louise Vigée-le Brun, 1755–1789*, trans. by G. Shelley, 1926

1601. LECLÈRE, T. *Hubert Robert et les paysagistes français du XVIII⁰ siècle*, 1926

1602. LECOQ DE BOISBAUDRAN, H. *Lettres à un jeune professeur*, 1876

1603. LE CORBUSIER. *The city of to-morrow and its planning*, 1929

1604. — *Le Corbusier et Pierre Jeanneret : œuvre complète de 1910-* , Zürich, 1946-

1605. — *The Modulor*, 1954

1606. — *Modulor 2, 1955*, 1958

1607. — *My work*, 1960

1608. — *Towards a new architecture*, 1946 (1927)

1609. LE COUTEUR, J. D. *English mediaeval painted glass*, 1926

1610. LEEDS, E. T. *Celtic ornament in the British Isles down to A.D. 700*, 1933

1611. LEENHARDT, M. *Arts of the Oceanic peoples*, 1950

1612. LEES-MILNE, J. *The age of Adam*, 1947

1613. — *The age of Inigo Jones*, 1953

1614. — *Baroque in Italy*, 1959

1615. — *Baroque in Spain and Portugal and its antecedents*, 1960

1616. — *Tudor Renaissance*, 1951

1617. LEFRANÇOIS-PILLION, L. *L'Art du XIV⁰ siècle en France*, 1954

1618. LÉGER, C. *Courbet*, 1929

1619. LEGRAIN, G. A. *Les Temples de Karnak*, Brussels, 1929

1620. LEGRAND, F. C. and SLUYS, F. *Arcimboldo et les arcimboldesques*, 1955

1621. LEGROS, A. *A catalogue of paintings, drawings, etchings and lithographs by Professor Alphonse Legros, 1837–1911, from the collection of Frank E. Bliss, Esq.*, 1922

1622. LEHMANN, E. *Der frühe deutsche Kirchenbau*, Berlin, 1938

1623. LEHMANN, H. *L'Art précolombien*, 1960

1624. LEHMANN-HARTLEBEN, K. *Thomas Jefferson, American humanist*, New York, 1947

1625. LEHMANN-HAUPT, H. *The terrible Gustave Doré*, New York, 1943

1626. LEHMBRUCK, W. *Zeichnungen und Radierungen*, Munich, 1955

1627. LEICESTER MUSEUM. *Sir George Beaumont and his circle* (Exhibition catalogue), 1953

1628. LEICHT, H. *Pre-Inca art and culture*, 1960

1629. LEIGHTON, C. *Wood-engravings and woodcuts*, 1932

1630. — *Wood engravings of the 1930's*, 1936

1631. LEIRIS, M. and LIMBOUR, G. *André Masson and his universe*, 1948

1632. LEITH, J. A. *The idea of art as propaganda in France, 1750–1799*, Toronto, 1965

1633. LE MAY, R. *A concise history of Buddhist art in Siam*, 1938

1634. — *The culture of South-East Asia: the heritage of India*, 1954

1635. LEMOISNE, P. A. *Degas et son œuvre*, 4 vols., 1949

1636. — *Eugène Lami, 1800–1890*, 1912

1637. LEMONNIER, C. *L'École belge de peinture, 1830–1905*, Brussels, 1906

1638. LE MUET, P. *Maniere de bien bastir pour toutes sortes de personnes*, 1647 (1623)

1639. LEONARDO DA VINCI. *The literary works of Leonardo da Vinci*, compiled and ed. from the original manuscripts by J. P. Richter, 2 vols., 1939 (1883)

1640. — *On painting. A lost book*, ed. by C. Pedretti, Berkeley, California, 1964

1641. — *Treatise on painting (Codex Urbinas Latinus 1270)*, trans. and annotated by A. P. McMahon, 2 vols., Princeton, 1956

1642. LEROQUAIS, V. *Les Livres d'heures. Manuscrits de la Bibliothèque nationale*, 3 vols. and Suppl., 1927-43

1643. LEROY, A. P. A. *Maurice Quentin de la Tour et la société française du XVIII⁰ siècle*, 1953

1644. LE ROY, G. *James Ensor*, Brussels and Paris, 1922

1645. LESLIE, C. R. *Memoirs of the life of John Constable*, ed. J. Mayne, 1951

1646. LESPINASSE, P. *Les Artistes suédois en France au XVIII⁰ siècle*, 1929

1647. LESSING, G. E. *Laocoon*, trans. by Sir R. Phillimore, 1905 (1766)

1648. LETHABY, W. R. *Form in civilization*, 1938 (1922)

1649. — *Philip Webb and his work*, 1935

1650. — *The study and practice of artistic crafts*, 1901

1651. LETHÈVE, J. *Impressionnistes et Symbolistes devant la presse*, 1959

1652. LEUZINGER, E. *Africa, the art of the Negro peoples*, 1962

1653. LEVEY, M. *Dürer*, 1964

1654. — *The German school* (National Gallery Catalogue), 1959

1655. — *Painting in eighteenth-century Venice*, 1959

1656. LEVI, D. *Antioch mosaic pavements*, 2 vols., Princeton, 1947

1657. LEVY, M. M. *Gaudier-Brzeska drawings and sculpture*, 1965

1658. LEWIS, A. B. *Carved and painted designs from New Guinea*, Chicago, 1931
1659. LEWIS, D. *Constantin Brancusi*, 1957
1660. LEWIS, W. S. *Horace Walpole*, 1961
1661. LEYMARIE, J. *André Derain ou le retour à l'ontologie*, Geneva, 1948
1662. — *Van Gogh*, 1951
1663. LEYMARIE, J. and others. *Henri Matisse*, Berkeley, 1966
1664. LEIBREICH, A. *Claus Sluter*, Brussels, 1936
1665. LIEURE, J. *Jacques Callot*, 5 vols., 1924-9
1666. LILIENFELD, K. *Arent de Gelder, sein Leben und seine Kunst*, The Hague, 1914
1667. LIMOUSIN, R. *Jean Bourdichon, peintre et enlumineur : son atelier et son école*, Lyon, 1954
1668. LIN, YU-T'ANG. *The gay genius : the life and times of Su Tungpo*, 1948 (New York, 1947)
1669. LINDBLOM, A. *La Peinture gothique en Suède et en Norvège*, 1916
1670. LINDSAY, J. *Death of the hero : French painting from David to Delacroix*, 1960
1671. LINFERT, C. (ed.). *Hieronymus Bosch : the paintings*, 1959
1672. LINTON, R. and WINGERT, P. S. *Arts of the South Seas*, New York, 1946
1673. LIORÉ, A. and CAILLER, P. *Catalogue de l'œuvre gravé de Dunoyer de Segonzac*, 1958-
1674. LIPMAN, J. *What is American in American art*, New York, 1963
1675. LIPPARD, L. R. (ed.). *Pop art*, 1967
1676. LITTLE, B. *The life and works of James Gibbs*, 1955
1677. LIVERMORE, H. V. (ed.). *Portugal and Brazil : an introduction*, 1953
1678. LIVERPOOL, WALKER ART GALLERY. *George Stubbs, 1724-1806* (Exhibition catalogue), 1951
1679. LLOYD, S. H. F. *The art of the ancient Near East*, 1961
1680. — *Early Anatolia*, 1956
1681. LOCQUIN, J. *La Peinture d'histoire en France de 1747 à 1785*, 1912
1682. LOMAZZO, G. P. *Trattato dell'arte de la pittura*, Milan, 1584
1683. LONG, B. S. *British miniaturists*, 1929
1684. LONGHI, R. *Piero della Francesca*, 1930
1685. LONGHURST, M. H. *English ivories*, 1926
1686. LOOSLI, C. A. *Ferdinand Hodler*, 4 vols., Berne, 1921-4
1687. LÓPEZ-REY, J. *Goya's Caprichos : beauty, reason and caricature*, 2 vols., Princeton, 1953
1688. — *Velázquez : a catalogue raisonné of his œuvre*, 1963
1689. LÓPEZ SERRANO, M. *Bibliografía de arte español y americano, 1936-40*, Madrid, 1942
1690. L'ORANGE, H. P. and NORDHAGEN, P. J. *Mosaics*, 1966
1691. LORENZ, P. (ed.). *Bourdelle, sculptures et dessins*, 1947

1692. LOTHROP, S. K. *Treasures of ancient America : the arts of the Pre-Columbian civilizations from Mexico to Peru*, 1964
1693. LOTHROP, S. K. and others. *Essays in Pre-Columbian art and archaeology*, Cambridge, Mass., 1961
1694. LOUKOMSKI, G. K. *Charles Cameron, 1740-1812*, 1943
1695. — *History of modern Russian painting*, 1945
1696. — *Jewish art in European synagogues, from the middle ages to the eighteenth century*, 1947
1697. LÖVGREN, S. *The genesis of modernism : Seurat, Gauguin, van Gogh and French symbolism in the 1880's*, Stockholm, 1959
1698. LOW, D. *British cartoonists, caricaturists and comic artists*, 1942
1699. LOZOYA, J. DE C. *Historia del arte hispánico*, 5 vols., Barcelona, 1931-49
1700. LUCAS, A. *Ancient Egyptian materials and industries*, 1962 (1926)
1701. LUCKHURST, K. W. *The story of exhibitions*, 1951
1702. LUDOVICI, A. M. *Personal reminiscences of Auguste Rodin*, 1926
1703. LULLIES, R. and HIRMER, M. *Greek sculpture*, 1957
1704. LUND, F. M. *Ad quadratum : a study of the geometrical bases of classic and medieval religious architecture*, 1921
1705. LUNS, H. *Jan Sluijters, 1941?*
1706. LUX, J. A. *Otto Wagner : eine Monographie*, Munich, 1914
1707. LYNCH, J. *Metal sculpture, new forms, new techniques*, 1957
1708. LYNTON, N. *Klee*, 1964
1709. MABILLE DE PONCHEVILLE, A. *Philippe de Champagne*, 1938
1710. MCALLISTER, I. *Alfred Gilbert*, 1929
1711. MCBURNEY, C. B. M. *The Stone Age of northern Africa*, 1960
1712. MCCALLUM, I. *Architecture USA*, 1959
1713. MACCARTHY, F. D. *Australian aboriginal decorative art*, Sydney, 1938
1714. MCCAUSLAND, E. *George Inness, an American landscape painter, 1825-1894*, New York, 1946
1715. MACCOLL, D. S. *Life, work and setting of Philip Wilson Steer*, 1945
1716. MCCOMB, A. K. *Agnolo Bronzino : his life and works*, Cambridge, Mass., 1928
1717. — *The baroque painters of Italy*, Cambridge, Mass., 1934
1718. MCCORMICK, E. H. *Letters and art in New Zealand, 1940*, 1940
1719. — *Works of Frances Hodgkins in New Zealand*, Auckland, 1954
1720. MCCUNE, E. *The arts of Korea, an illustrated history*, Tokyo, 1962
1721. MCDERMOTT, J. F. *George Caleb Bingham, river portraitist*, Norman, Oklahoma, 1959
1722. MACDONALD, W. L. *Early Christian and Byzantine architecture*, 1962

1723. MACGIBBON, D. *Jean Bourdichon, a court painter of the fifteenth century*, 1933

1724. MACK, G. *Gustave Courbet*, 1951

1725. — *Paul Cézanne*, 1935

1726. — *Toulouse-Lautrec*, 1938

1727. MACKAIL, J. W. *The life of William Morris*, 1899

1728. MACKAY, E. *Early Indus civilizations*, 1948

1729. MCKAY, W. and ROBERTS, W. *John Hoppner, R.A.*, 1909-14

1730. MACKE, A. *Aquarelle : Nachwort von Wolfgang Macke*, Munich, 1958

1731. — *44 Zeichnungen aus den Skizzenbüchern*, Munich, 1959

1732. MCKINNEY, R. *Thomas Eakins*, New York, 1942

1733. MACKLIN, H. W. *The brasses of England*, 1907

1734. MACLAGAN, SIR E. R. D. *Catalogue of Italian plaquettes*, 1924

1735. MACORLAN, P. *Courbet*, 1951

1736. MADSEN, S. T. *Art Nouveau*, 1967

1737. MADURELL MARIMÓN, J. M. *El pintor Lluís Borrassá : su vida, su tiempo, sus seguidores y sus obras*, 3 vols., Barcelona, 1950-9

1738. MAGNÉE, R. M. H. (ed.). *Willem M. Dudok*, Amsterdam, 1954

1739. MAGNUSON, T. *Studies in Roman quattrocento architecture*, Stockholm, 1958

1740. MAISON, K. E. *Daumier drawings*, 1960

1741. MAIRUI, A. *Roman painting*, Geneva, 1953

1742. MÂLE, É. *L'Art religieux de la fin du Moyen Âge en France*, 1931 (1908)

1743. — *L'Art religieux du XIIᵉ siècle en France*, 1928 (1922)

1744. — *La Fin du paganisme en Gaule et les plus anciennes basiliques chrétiennes*, 1950

1745. — *The Gothic image : religious art in France of the thirteenth century*, 1961 (1913)

1746. — *Religious art, from the twelfth to the eighteenth century*, 1949

1747. MALEVICH, K. *Die gegenstandslose Welt*, Munich, 1928

1748. MALLOWAN, M. E. L. *Early Mesopotamia and Iran*, 1965

1749. MANDER, C. VAN. *Het schilder-boeck*, Haarlem, 1604

1750. MANKOWITZ, W. and HAGGAR, R. G. *The concise encyclopedia of English pottery and porcelain*, 1957

1751. MANNERS, LADY V. *Matthew William Peters, R.A.*, 1913

1752. MANNERS, LADY V. and WILLIAMSON, G. C. *Angelica Kauffmann, R.A.: her life and her works*, 1924

1753. MANNERS, LADY V. and WILLIAMSON, G. C. *John Zoffany, R.A.: his life and works*, 1920

1754. MANSON, J. B. *The life and work of Edgar Degas*, 1927

1755. MANSUELLI, G. A. *Etruria and early Rome*, 1966

1756. MANZÙ, G. *Das Salzburger Domtor : Entwürfe und Ausführung*, Salzburg, 1959

1757. — *Studio per un ritratto*, Florence, 1956

1758. MARANGONI, M. *Guercino*, Milan, 1959

1759. MARASH, J. G. *Henri Monnier, chronicler of the bourgeoisie*, 1951

1760. MARCAIS, G. *L'Art de l'Islam*, 1946

1761. — *L'Art musulman*, 1962

1762. MARCEAU, H. *William Rush, 1756-1833, the first native American sculptor*, Philadelphia, 1937

1763. MARCHAL, H. *Les Temples d'Angkor*, 1955 (1928)

1764. MARCHINI, G. *Italian stained glass windows*, 1957

1765. MARCHIORI, G. *Arp*, 1964

1766. — *Modern French sculpture*, 1964

1767. — *Scultura italiana moderna*, Venice, 1953

1768. MARCKS, G. *Gerhard Marcks Tierplastik : mit einem Geleitwort des Künstlers*, Wiesbaden, 1954

1769. MARIACHER, G. *Il Sansovino*, Milan, 1962

1770. MARIANI, V. *Arnolfo di Cambio*, Rome, 1943

1771. MARIETTE, J. *L'Architecture française*, 3 vols., 1927-9 (1727)

1772. MARILLIER, H. C. *Dante Gabriel Rossetti*, 1899

1773. MARINATOS, S. *Crete and Mycenae*, 1960

1774. MARINI, M. *Graphic work and paintings*, 1960

1775. MARIUS, G. H. *Dutch painting in the nineteenth century*, 1908

1776. MARIUS, G. H. and MARTIN, W. *Johannes Bosboom*, The Hague, 1907

1777. MARLE, R. VAN. *The development of the Italian schools of painting*, 19 vols., The Hague, 1923-38

1778. MARLIER, G. *Anthonis Mor van Dashorst —Antonio Moro*, Brussels, 1934

1779. MARQUET, M. *Marquet*, 1951

1780. MARQUET, M. and others. *Marquet : vie et portrait de Marquet*, Lausanne, 1953

1781. MARSHALL, J. and DRYSDALE, G. R. *Journey among men*, 1962

1782. MARSHALL, SIR J. H. *The Buddhist art of Gandhāra*, 1960

1783. — *Mohenjo-Daro and the Indus civilization*, 1931

1784. MARTIN, J. R. *The Farnese Gallery*, Princeton, 1965

1785. MARTIN, K. (ed.). *Manet : water-colours and pastels*, 1959

1786. MARTIN, M. W. *Futurist art and theory*, 1968

1787. Martin, W. *Gérard Dou*, 1911

1788. — *Jan Steen*, Amsterdam, 1954

1789. MARTINDALE, A. *Gothic art*, 1967

1790. MASON, E. C. *The mind of Henry Fuseli*, 1951

1791. MASON, J. A. *The ancient civilizations of Peru*, 1957

1792. MATĚJČEK, A. and PEŠINA, J. *Czech Gothic painting, 1350-1450*, Prague, 1950

1793. MATHER, F. J. *The Isaac Master : a reconstruction of the work of Gaddo Gaddi*, Princeton, 1932

1794. MATHEW, G. *Byzantine aesthetics*, 1963

1795. MATHEY, F. *The world of the Impressionists*, 1961

1796. MATZ, F. *Crete and early Greece : the prelude to Greek art*, 1962

1797. MAUCLAIR, C. *Auguste Rodin : the man, his ideas, his works*, 1905

1798. — *Claude Monet*, 1925

1799. — *Jean-Baptiste Greuze*, 1905

1800. — *Puvis de Chavannes*, 1928

1801. MAULDE-LA-CLAVIÈRE, M. A. R. DE. *Jean Perréal, dit Jean de Paris*, 1896

1802. MAUROIS, A. *J.-L. David*, 1948

1803. MAYER, A. L. *Velázquez : a catalogue raisonné of the pictures and drawings*, 1936

1804. MAYER, L. A. *Islamic architects and their works*, Geneva, 1956

1805. — *Islamic metalworkers and their works*, Geneva, 1959

1806. — *Islamic woodcarvers and their works*, Geneva, 1958

1807. MAYNE, J. *Thomas Girtin*, 1949

1808. MAYOR, A. H. *Giovanni Battista Piranesi*, New York, 1952

1809. MEAUZÉ, P. *African art*, 1968

1810. MEEKS, C. L. V. *Italian architecture, 1750-1914*, New Haven, 1966

1811. — *The railroad station*, New York, 1956

1812. MEGGERS, B. J. *Ecuador*, 1966

1813. MEIER-GRAEFE, A. J. *Cézanne*, 1927

1814. — *Degas*, 1923

1815. — *Renoir*, Leipzig, 1929

1816. — *Vincent van Gogh : a biographical study*, 2 vols., 1922

1817. MEISS, M. *Painting in Florence and Siena after the Black Death*, Princeton, 1951

1818. MEKHITARIAN, A. *Egyptian painting*, Geneva, 1954

1819. MELCHER, E. *The life and times of Henry Monnier 1799-1877*, Cambridge, Mass., 1950

1820. MELCHIORI, G. *Michelangelo nel Settecento inglese : un capitolo di storia del gusto in Inghilterra*, Rome, 1950

1821. MELLER, S. *Peter Vischer der Ältere und seine Werkstatt*, Leipzig, 1925

1822. MELLERIO, A. *Odilon Redon : peintre, dessinateur et graveur*, 1923

1823. MELLQUIST, J. *The emergence of an American art*, New York, 1942

1824. MELVILLE, R. (ed.). *Ned Kelly. 27 paintings by Sidney Nolan*, 1964

1825. MENDELSOHN, E. *Three lectures on architecture*, Berkeley and Los Angeles, 1944

1826. MENPES, M. *Whistler as I knew him*, 1904

1827. MESNIL, J. *Masaccio et les débuts de la Renaissance*, The Hague, 1927

1828. MESSER, T. M. *The emergent decade*, 1966

1829. MEYER, F. *Marc Chagall*, 1964

1830. — (ed.). *Marc Chagall : the graphic work*, 1957

1831. MICHEL, A. *Puvis de Chavannes*, 1912

1832. MICHEL, E. *Paul Potter*, 1907

1833. MICHELETTI, E. *Masolino da Panicale*, Milan, 1959

1834. MICHELIS, P. A. *An aesthetic approach to Byzantine art*, 1955

1835. MICHENER, J. A. *Japanese prints from the early masters to the modern*, Rutland, Vermont, 1959

1836. MIERAS, J. P. *Na-oorlogse bouwkunst in Nederland*, Amsterdam and Antwerp, 1955

1837. MIERAS, J. P. and YERBURY, F. R. (edd.). *Dutch architecture of the XXth century*, 1926

1838. MIGEON, G. *Manuel d'art musulman : arts plastiques et industriels*, 1927 (1908)

1839. MILLAIS, J. G. *The life and letters of Sir John Everett Millais*, 1899

1840. MILLAR, E. G. *English illuminated manuscripts from the Xth to the XIIIth century*, 1926

1841. — *English illuminated manuscripts of the XIVth and XVth centuries*, 1928

1842. MILLAR, O. *Zoffany and his Tribuna*, 1967

1843. MILNER, M. *On not being able to paint*, 1957 (1950)

1844. MINDLIN, H. E. *Modern architecture in Brazil*, 1956

1845. MINNS, SIR E. H. *The art of the northern nomads*, 1942

1846. — *Scythians and Greeks*, 1913

1847. MODESTI, R. *Pittura italiana contemporanea*, Milan, 1958

1848. MODIGLIANI, J. *Modigliani : man and myth*, 1959

1849. MOHOLY-NAGY, L. *The new vision*, New York, 1947 (1932)

1850. MOHOLY-NAGY, S. *Carlos Raul Villanueva and the architecture of Venezuela*, 1964

1851. — *Moholy-Nagy : experiment in totality*, New York, 1950

1852. MOLLY, F. *Sir Joshua and his circle*, 2 vols., 1906

1853. MOMIGLIANO, A. (ed.). *The conflict between paganism and Christianity in the fourth century*, 1963

1854. MONDRIAN, P. *Le Néoplasticisme*, 1921

1855. — *Plastic art and pure plastic art 1937, and other essays, 1941-1943*, New York, 1945

1856. MONKHOUSE, C. *The life and works of Sir John Tenniel*, 1901

1857. MONOD, F. and HAUTECŒUR, L. *Les Dessins de Greuze, conservés à l'Académie des Beaux-Arts de Saint-Pétersbourg*, 1922

1858. MOORE, G. *Modern painting*, 1898 (1893)

1859. MOORE, H. *Henry Moore on sculpture : a collection of the sculptor's writings and spoken words*, 1966

1860. — *Sculpture and drawings, 1921-1948*, 1957 (1944)

1861. MOORE, H. *Sculpture and drawings, 1949–1954,* 1965 (1955)

1862. MOORE, W. *The story of Australian art,* 2 vols., Sydney, 1934

1863. MORAND, K. *Jean Pucelle,* 1962

1864. MORASSI, A. *A complete catalogue of the paintings of G. B. Tiepolo,* 1962

1865. — *G. B. Tiepolo, his life and work,* 1955

1866. MOREAU-NÉLATON, A. É. A. *Les Clouet et leurs émules,* 3 vols., 1924

1867. — *Jongkind raconté par lui-même,* 1918

1868. — *Manet raconté par lui-même,* 2 vols., 1926

1869. — *Millet raconté par lui-même,* 3 vols., 1921

1870. MOREAU-VAUTHIER, C. *Gérome, peintre et sculpteur,* 1905

1871. MOREY, C. R. *Early Christian art,* Princeton, 1953 (1942)

1872. MORGAN, C. H. *The life of Michelangelo,* 1960

1873. MORGAN, J. H. *Gilbert Stuart and his pupils,* New York, 1939

1874. MORICE, C. *Paul Gauguin,* 1917

1875. MORISANI, O. *Michelozzo architetto,* Turin, 1951

1876. MORISOT, B. *The correspondence of Berthe Morisot with her family and friends,* ed. by D. Rouart, 1959 (1957)

1877. MORRIS, W. *Architecture, industry and wealth,* 1902

1878. — *Art and socialism,* 1884

1879. MORRISON, H. *Louis Sullivan, prophet of modern architecture,* New York, 1935

1880. MOSCHINI, V. *Canaletto,* Milan, 1955

1881. — *Disegni di Jacopo Bellini,* Bergamo, 1943

1882. — *Francesco Guardi,* Milan, 1952

1883. — *Pietro Longhi,* Milan, 1956

1884. MOUNT, C. M. *Gilbert Stuart: a biography,* New York, 1964

1885. MUKERJEE, R. *The flowering of Indian art: the growth and spread of a civilization,* 1964

1886. MULLER, J.-É. *Fauvism,* 1967

1887. MÜLLER, T. *Sculpture in the Netherlands, Germany, France, and Spain, 1400 to 1500,* 1966

1888. MUMFORD, L. *The brown decades: a study of the arts in America, 1865–1895,* New York, 1931

1889. — *Roots of contemporary American architecture,* New York, 1952

1890. — *Technics and civilization,* 1934

1891. MUNSON, T. *The essential wisdom of George Santayana,* New York, 1962

1892. MUNSTERBERG, H. *The arts of Japan,* New York, 1957

1893. — *The landscape painting of China and Japan,* Rutland, 1955

1894. — *A short history of Chinese art,* 1954 (Michigan, 1949)

1895. MÜNZ, L. *Bruegel: the drawings,* 1961

1896. — *Rembrandt's etchings,* 2 vols., 1952

1897. MÜNZ, L. and KÜNSTLER, G. *Adolf Loos, pioneer of modern architecture,* 1966

1898. MURRAY, L. *The late Renaissance and mannerism,* 1967

1899. MURRAY, P. *Watteau, 1684–1721,* 1948

1900. MURRAY, P. and L. *The art of the Renaissance,* 1963

1901. MUS, P. *Barabuḍur,* Hanoi, 1935

1902. MUSSAT, A. *Le Style gothique de l'Ouest de la France xiie–xiiie siècles,* 1963

1903. MYERS, B. S. *Expressionism: a generation in revolt,* 1957

1904. — *Mexican painting in our time,* New York, 1956

1905. NADEAU, M. *The history of Surrealism,* New York, 1965

1906. NAGEL, O. *Käthe Kollwitz,* Dresden, 1963

1907. NAGERA, H. *Vincent van Gogh, a psychological study,* 1967

1908. NAMÉNYI, E. *The essence of Jewish art,* New York, 1960

1909. NASH, P. *Outline: an autobiography, and other writings,* 1949

1910. NATANSON, J. *Early Christian ivories,* 1953

1911. NAUMANN, R. *Architektur Kleinasiens,* Tübingen, 1955

1912. NAUMBURG, M. *Psychoneurotic art: its function in psychotherapy,* New York, 1953

1913. — *Schizophrenic art: its meaning in psychotherapy,* New York, 1950

1914. NAVARRO, J. *Religious architecture in Quito,* New York, 1945

1915. NEILSON, K. B. *Filippino Lippi,* Cambridge, Mass., 1938

1916. NEMITZ, F. *Deutsche Malerei der Gegenwart,* Munich, 1948

1917. NERVI, P. L. *New structures,* 1963

1918. — *The works of Pier Luigi Nervi,* 1957

1919. NEUENSCHWANDER, E. and C. *Finnish architecture and Alvar Aalto,* New York, 1954

1920. NEUHAUS, E. *The history and ideals of American art,* Stanford, California, 1931

1921. NEUMANN, E. *The archetypal world of Henry Moore,* 1959

1922. — *Art and the creative unconscious: four essays,* 1959

1923. NEUMEYER, A. *Cézanne: drawings,* New York, 1958

1924. NEURDENBURG, E. *Hendrick de Keyser, beeldhouwer en bouwmeester van Amsterdam,* Amsterdam, 1930

1925. — *De zeventiende eeuwsche beeldhouwkunst in de noordelijke Nederlanden,* Amsterdam, 1948

1926. NEWBERRY, P. E. *Egyptian antiquities. Scarabs: an introduction to the study of Egyptian seals and signet rings,* Liverpool, 1906

1927. NEWCOMB, R. *Spanish-colonial architecture in the United States,* New York, 1937

1928. NEWMARCH, R. *The Russian arts,* 1916

1929. NEWTON, D. *Art styles of the Papuan Gulf,* New York, 1961

1930. NEWTON, E. *Jacopo Tintoretto*, 1951
1931. NEWTON, R. H. *Town and Davis, architects*, New York, 1942
1932. NEW YORK, MUSEUM OF MODERN ART. Exhibition catalogue. *Alberto Giacometti*. With an introduction by Peter Selz and an autobiographical statement by the artist, New York, 1965
1933. — *German art of the twentieth century*, New York, 1957
1934. — *The last works of Henri Matisse*, New York, 1961
1935. — *Max Ernst*, New York, 1961
1936. — *Odilon Redon, Gustave Moreau, Rodolphe Bresdin*, New York, 1961
1937. — *Robert Motherwell*. With selections from the artist's writings, New York, 1965
1938. NEW YORK, WHITNEY MUSEUM of AMERICAN ART. *Albert P. Ryder centenary exhibition catalogue*, New York, 1947
1939. NICCO FASOLA, G. *La Fontana di Perugia*, Rome, 1951
1940. NICHOLSON, A. *Cimabue : a critical study*, Princeton, 1932
1941. NICOLSON, B. *Hendrick Terbrugghen*, 1958
1942. — *Joseph Wright of Derby*, 1968
1943. — *The painters of Ferrara : Cosmè Tura, Francesco del Cossa, Ercole de' Roberti and others*, 1950
1944. NIHĀRA-RAÑJANA, R. *Brahmanical gods in Burma : a chapter of Indian art and iconography*, Calcutta, 1932
1945. NISSER, W. *Michael Dahl and the contemporary Swedish school of painting in England*, Uppsala, 1927
1946. NOBLE, J. V. *The techniques of painted Attic pottery*, New York, 1965
1947. NOBEL, L. L. *The Course of Empire, Voyage of Life, and other pictures of Thomas Cole, N.A.*, New York, 1853
1948. NOLDE, E. *Südsee-Skizzen*, Munich, 1961
1949. NOLHAC, P. DE. *François Boucher, premier peintre du roi, 1703-1770*, 1907
1950. — *Hubert Robert, 1733-1808*, 1910
1951. — *J.-M. Nattier, peintre de la cour de Louis XV*, 1905
1952. NOMA, S. *The arts of Japan, ancient and medieval*, Tokyo, 1966
1953. NORDENFALK, C. A. J. *The life and work of van Gogh*, 1953
1954. NORGATE, E. *Miniatura : or the art of limning*, 1919
1955. NORTHCOTE, J. *The life of Sir Joshua Reynolds*, 2 vols., 1813-18.
1956. NOTTEN, M. VAN. *Rombout Verhulst, beeldhouwer, 1624-1698*, The Hague, 1907
1957. NOVOTNY, F. *Hundert Jahre österreichische Landschaftsmalerei*, Vienna, 1948
1958. OAKESHOTT, W. *The artists of the Winchester Bible*, 1945
1959. — *The mosaics of Rome, from the third to the fourteenth centuries*, 1967

1960. OAKESHOTT, W. *The sequence of English medieval art*, 1950
1961. O'DRISCOLL, W. J. *Memoir of Daniel Maclise*, 1871
1962. OERTEL, R. *Fra Filippo Lippi*, Vienna, 1942
1963. OETTINGER, K. and KNAPPE, K.-A. *Hans Baldung Grien und Albrecht Dürer in Nürnberg*, Nuremberg, 1963
1964. OFFNER, R. *A critical and historical corpus of Florentine painting. The fourteenth century*, 13 vols., New York, 1930-67
1965. O'HARA, F. *Jackson Pollock*, New York, 1959
1966. OKKONEN, O. *L'Art finlandais aux XIXe et XXe siècles*, Helsinki, 1938
1967. — *Wäinö Aaltonen*, Stockholm, 1941
1968. OLDENBOURG, R. *Peter Paul Rubens*, Munich and Berlin, 1922
1969. — *Thomas de Keysers Tätigkeit als Maler*, Leipzig, 1911
1970. OLSEN, H. *Federico Barocci : a critical study in Italian Cinquecento painting*, Stockholm, 1955
1971. OPPÉ, A. P. *Alexander & John Robert Cozens*, 1952
1972. — *The drawings of William Hogarth*, 1948
1973. — *Raphael*, 1906
1974. — *Thomas Rowlandson : his drawings and water-colours*, 1923
1975. ORLANDI, S. *Beato Angelico : monografia storica della vita e delle opere*, Florence, 1964
1976. ORLIAC, A. *Veronese*, 1948
1977. ORSINI, G. N. G. *Benedetto Croce, philosopher of art and literary critic*, Carbondale, 1961
1978. ORUETA Y DUARTE, R. DE. *Berruguete y su obra*, Madrid, 1917
1979. OSBORN, F. J. *Green belt cities : the British contribution*, 1946
1980. OSGOOD, C. B. *The Koreans and their culture*, New York, 1951
1981. OSLEY, A. S. (ed.). *Calligraphy and palaeography : essays presented to A. Fairbank*, 1965
1982. ØSTBY, L. *Modern Norwegian painting*, Oslo, 1949
1983. OSTEN, G. VON DER. *Lovis Corinth*, Munich, 1955
1984. OSTWALD, H. *Das Liebermann-Buch*, Berlin, 1930
1985. OTTAWA, NATIONAL GALLERY OF CANADA. *Emily Carr, her paintings and sketches* (Exhibition catalogue), Toronto, 1945
1986. OTTINO DELLA CHIESA, A. *Bernardino Luini*, Novara, 1956
1987. OURSEL, C. *La Miniature du XIIe siècle à l'Abbaye de Cîteaux, d'après les manuscrits de la Bibliothèque de Dijon*, Dijon, 1926
1988. OZINGA, M. D. *Daniel Marot*, Amsterdam, 1938
1989. OZZOLA, L. *Gian Paolo Pannini pittore*, Turin, 1921

1990. PAATZ, W. *Süddeutsche Schnitzaltäre der Spätgotik, 1465-1500*, Heidelberg, 1963

1991. PAATZ, W. and E. *Die Kirchen von Florenz : ein kunstgeschichtliches Handbuch*, 6 vols., Frankfurt, 1940-54

1992. PACCHIONI, A. *Giacomo Manzù*, Milan, 1948

1993. PACCHIONI, G. *Carlo Carrà : painter*, Milan, 1959

1994. PÄCHT, O. *The Master of Mary of Burgundy*, 1948

1995. PACIOLI, L. *Divina proportione*, Venice, 1509

1996. PAGANI, C. *Architettura italiana oggi. Italy's architecture today*, Milan, 1955

1997. PAGANO, J. L. *El arte de los Argentinos*, 3 vols., Buenos Aires, 1937-40

1998. — *Historia del arte argentino*, Buenos Aires, 1944

1999. PAINE, R. T. and SOPER, A. C. *The art and architecture of Japan*, 1955

2000. PALLADIO, A. *I quattro libri dell'architettura (The four books of A. Palladio's architecture)*, trans. by I. Ware, Venice, 1570 (London, 1738)

2001. PALLOTTINO, M. *The Etruscans*, 1955

2002. — *La Peinture étrusque*, Geneva, 1952

2003. PALLUCCHINI, R. *Giovanni Bellini*, 1965

2004. — *Gli affreschi di Paolo Veronese e Maser*, Bergamo, 1939

2005. — *La pittura veneziana del Cinquecento*, 2 vols., Novara, 1944

2006. — *La pittura veneziana del Settecento*, Bologna, 1951

2007. — *Tiziano*, 2 vols., Bologna, 1953-4

2008. PALMER, L. R. *Myceneans and Minoans*, 1965 (1961)

2009. PANOFSKY, E. *Classical mythology in mediaeval art*, New York, 1933

2010. — *Early Netherlandish painting : its origins and character*, 2 vols., Cambridge, Mass., 1953

2011. — *Gothic architecture and scholasticism*, Latrobe, 1951

2012. — *Hercules am Scheidewege und andere antike Bildstoffe in der neueren Kunst*, Leipzig, 1930

2013. — *Idea*, Berlin, 1960 (1924)

2014. — *The life and art of Albrecht Dürer*, Princeton, 1955 (1943)

2015. — *Meaning in the visual arts*, New York, 1955

2016. — *Die Perspektive als 'symbolische Form'*, Leipzig, 1927

2017. — *Renaissance and Renascences in Western art*, Uppsala, 1960

2018. — *Studies in iconology : humanistic theories in the art of the Renaissance*, New York, 1939

2019. PANOFSKY, E. and SAXL, F. *Dürers 'Melencolia. I.'*, Leipzig, 1923

2020. PAOLETTI, P. *L'architettura e la scultura del Rinascimento in Venezia*, Venice, 1893

2021. PAPADAKI, S. *The work of Oscar Niemeyer*, New York, 1950

2022. — (ed.). *Le Corbusier, architect, painter, writer*, New York, 1948

2023. PARENT, P. *L'Architecture des Pays-Bas méridionaux aux XVI$^e$, XVII$^e$ et XVIII$^e$ siècles*, 1926

2024. PARIS, BIBLIOTHÈQUE NATIONALE. *Les Manuscrits à peintures en France du VII$^e$ au XII$^e$ siècle* (Exhibition catalogue), 1954

2025. PARIS, MUSÉE DE L'ORANGERIE. *David. Exposition en l'honneur du deuxième centenaire de sa naissance* (Exhibition catalogue), 1948

2026. PARIS, MUSÉE DES ARTS DÉCORATIFS. *L'Art ancien en Tchécoslovaquie* (Exhibition catalogue), 1957

2027. PARIS, MUSÉE DU LOUVRE. *Théodore Chassériau, 1819-1856* (Exhibition catalogue), 1957

2028. PARK, L. *Gilbert Stuart : an illustrated descriptive list of his works*, 4 vols., New York, 1926

2029. PARKER, B. N. and WHEELER, A. B. *John Singleton Copley, American portraits in oil, pastel and miniature, with biographical sketches*, Boston, 1938

2030. PARKER, SIR K. T. *The drawings of Antonio Canaletto, in the collection of His Majesty the King at Windsor Castle*, 1948

2031. — *The drawings of Hans Holbein in the collection of His Majesty the King at Windsor Castle*, 1945

2032. PARKER, SIR K. T. and MATHEY, J. *Antoine Watteau : catalogue complet de son œuvre dessiné*, 1957

2033. PARMENTIER, H. *L'Art khmèr classique*, 2 vols., 1939

2034. — *L'Art khmèr primitif*, 2 vols., 1927

2035. PARROT, A. *Nineveh and Babylon*, 1961

2036. — *Sumer*, 1960

2037. — *Ziggurats et tour de Babel*, 1949

2038. PASTOUREAU, H. *Albert Dürer : dessins*, 1963

2039. PATER, W. H. *Studies in the history of the Renaissance*, 1873

2040. PAULHAN, J. *Braque le patron*, 1946

2041. PAULME, D. *African sculpture*, 1962

2042. PAULSSON, T. *Scandinavian architecture*, 1958

2043. PAUTY, E. *Bois sculptés d'églises coptes : époque fatimide*, Cairo, 1930

2044. PAVIÈRE, S. H. *The Devis family of painters*, 1950

2045. PAYRÓ, J. E. *Veintidós pintores*, Buenos Aires, 1944

2046. PEACOCK, C. *John Constable, the man and his work*, 1965

2047. PEARSE, G. E. *Eighteenth century architecture in South Africa*, 1933

2048. PEDRETTI, C. *A chronology of Leonardo da Vinci's architectural studies after 1500*, Geneva, 1962

2049. PEISCH, M. L. *The Chicago School of architecture*, 1964

2050. PÈLERIN, J. *De artificiali perspectiva*, Toul, 1505

2051. PENDLEBURY, J. D. S. *Tell el-Amarna*, 1935

2052. PENNELL, E. R. and J. *The life of James McNeill Whistler*, 1908

2053. PENROSE, F. C. *An investigation of the principles of Athenian architecture*, 1888 (1851)

2054. PÉREZ-EMBID, F. *El mudejarismo en la arquitectura portuguesa de la época manuelina*, Seville, 1944

2055. PERLS, K. G. *Vlaminck*, New York, 1941

2056. PERRAULT, C. *Ordonnances des cinq espèces de collones selon la méthode des anciens. (A treatise of the five orders of columns in architecture)*, trans. by J. James, 1708 (1683)

2057. PERRUCHOT, H. *Cézanne*, 1961

2058. — *Le Douanier Rousseau*, 1957

2059. — *Gauguin*, 1963

2060. — *Manet*, 1962

2061. — *Toulouse-Lautrec*, 1960

2062. PETERS, H. T. *Currier & Ives. Printmakers to the American people*, New York, 1942

2063. PETITJEAN, C. and WICKERT, C. *Catalogue de l'œuvre gravé de Robert Nanteuil*, 1925

2064. PETZET, M. *Soufflots Sainte-Geneviève, und der französische Kirchenbau des 18. Jahrhunderts*, Berlin, 1961

2065. PEVSNER, N. B. L. *Academies of art past and present*, 1940

2066. — *The buildings of England*, 1951–

2067. — *An enquiry into industrial art in England*, 1937

2068. — *High Victorian design*, 1951

2069. — *Matthew Digby Wyatt*, 1950

2070. — *An outline of European architecture*, 1951 (1942)

2071. — *Pioneers of modern design*, 1960

2072. PEVSNER, N. B. L. and GRAUTOFF, O. *Barockmalerei in den romanischen Ländern*, Berlin, 1928

2073. PEVSNER, N. B. L. and MEIER, M. *Grünewald*, 1958

2074. PHILIPP, F. *Arthur Boyd*, 1967

2075. PHILIPSON, M. H. *Outline of a Jungian aesthetics*, Evanston, Illinois, 1963

2076. PHILLIPS, D. and others. *Arthur B. Davies: essays on the man and his art*, Cambridge, Mass., 1924

2077. PHILLIPS, E. D. *The royal hordes: nomad peoples of the Steppes*, 1965

2078. PHILLIPS, W. (ed.). *Art and psychoanalysis*, New York, 1963

2079. PHYTHIAN, J. E. *Jozef Israëls*, 1912

2080. PICA, A. *Recent Italian architecture*, Milan, 1959

2081. PICABIA, F. *Poèmes et dessins de la fille née sans mère*, Lausanne, 1918

2082. PIEL, F. *Die Ornament-Grotteske in der italienischen Renaissance*, Berlin, 1962

2083. PIÉRARD, L. *Félicien Rops*, Antwerp, 1949

2084. — *La Vie tragique de Vincent Van Gogh*, Brussels, 1946

2085. PIERRON, S. *Les Mostaert*, Brussels, 1912

2086. PIGGOTT, S. *Prehistoric India to 1000 B.C.*, 1950

2087. PIGLER, A. *Georg Raphael Donner*, Vienna, 1929

2088. PILCHER, D. E. *The Regency style 1800–1830*, 1947

2089. PILLEMENT, G. *La Sculpture baroque espagnole*, 1945

2090. PINDER, W. *Deutscher Barock*, Leipzig, 1924

2091. PIPER, D. *Catalogue of seventeenth-century portraits in the National Portrait Gallery, 1625–1714*, 1963

2092. PIPER, J. *British romantic artists*, 1942

2093. PISSARRO, C. *Letters to his son Lucien*, ed. by J. Rewald, 1944

2094. PITTALUGA, M. *Filippo Lippi*, Florence, 1949

2095. — *Il Tintoretto*, Bologna, 1925

2096. PITT-RIVERS, A. H. L. *Antique works of art from Benin*, 1900

2097. PLACE, C. A. *Charles Bulfinch, architect and citizen*, Boston, 1925

2098. PLANISCIG, L. *Andrea del Verrocchio*, Vienna, 1941

2099. — *Andrea Riccio*, 1927

2100. — *Bernardo und Antonio Rossellino*, Vienna, 1942

2101. — *Desiderio da Settignano*, Vienna, 1942

2102. — *Luca della Robbia*, Vienna, 1940

2103. PLAUT, J. S. (ed.). *Oskar Kokoschka*, 1948

2104. PLENDERLEITH, H. J. *The conservation of antiquities and works of art*, 1956

2105. PLON, E. *Benvenuto Cellini: recherches sur sa vie, sur son œuvre et sur les pièces qui lui sont attribuées*, 1883

2106. — *Les Maîtres italiens au service de la Maison d'Autriche*, 1887

2107. POBÉ, M. *The art of Roman Gaul: a thousand years of Celtic art and culture*, 1961

2108. POINTER, A. *Die Werke des florentinischen Bildhauers, Agostino d'Antonio di Duccio*, Strassburg, 1909

2109. POLAK, B. H. *Het fin-de-siècle in de Nederlandse schilderkunst*, The Hague, 1955

2110. POMPEY, F. *Zurbarán: su vida y sus obras*, Madrid, 1948

2111. POOL, P. *Degas*, New York, 1963

2112. — *Impressionism*, 1967

2113. POOLE, R. L. *Edward Pierce, the sculptor* (Walpole Society, vol. xi), 1923

2114. POPE, A. U. and ACKERMAN, P. *A survey of Persian art from prehistoric times to the present*, 6 vols., 1938–9

2115. POPE-HENNESSY, J. W. *The complete works of Paolo Uccello*, 1950

2116. POPE-HENNESSY, J. W. *The drawings of Domenichino in the collection of His Majesty the King at Windsor Castle,* 1948

2117. *Fra Angelico,* 1952

2118. — *Giovanni di Paolo, 1403–1483,* 1937

2119. — *An introduction to Italian sculpture,* 5 vols., 1955–63

2120. — *Italian Gothic sculpture in the Victoria & Albert Museum,* 1952

2121. — *A lecture on Nicholas Hilliard,* 1949

2122. — *The portrait in the Renaissance,* 1967

2123. — *Sassetta,* 1939

2124. — *Sienese quattrocento painting,* 1947

2125. — *The Virgin and Child by Agostino di Duccio,* 1952

2126. POPHAM, A. E. *Correggio's drawings,* 1957

2127. — *The drawings of Leonardo da Vinci,* 1946

2128. — *The drawings of Parmigianino,* 1953

2129. POPHAM, A. E. and POUNCEY, P. *Italian drawings in the Department of Prints and Drawings in the British Museum. The fourteenth and fifteenth centuries,* 2 vols., 1950

2130. POPHAM, A. E. and WILDE, J. *The Italian drawings of the XV and XVI centuries in the collection of His Majesty the King at Windsor Castle,* 1949

2131. PORCHER, J. *French miniatures from illuminated manuscripts,* 1960

2132. PORTER, A. K. *Lombard architecture,* 4 vols., 1915–17.

2133. — *Romanesque sculpture of the pilgrimage roads,* 10 vols., Boston, 1923

2134. — *Spanish Romanesque sculpture,* 2 vols., 1928

2135. PORTER, F. *Thomas Eakins,* New York, 1959

2136. POSSE, H. *Lucas Cranach d. Ä.,* Vienna, 1942

2137. POULSEN, V. *Les Portraits romains,* Copenhagen, 1962–

2138. POUNCEY, P. M. R. and GERE, J. A. *Italian drawings in the British Museum. Raphael and his circle,* 2 vols., 1962

2139. POUND, E. *Gaudier-Brzeska, a memoir. Including the published writings of the sculptor and a selection from his letters,* 1939 (1916)

2140. POUSSIN, N. *Lettres et propos sur l'art,* ed. by A. F. Blunt, 1964

2141. POWELL, N. *The drawings of Henry Fuseli,* 1951

2142. — *From Baroque to Rococo: an introduction to Austrian and German architecture from 1580–1790,* 1959

2143. POZZO, A. *Perspectiva pictorum et architectorum. (Rules and examples of perspective proper for painters and architects),* 2 parts, 1693–1700 (1707)

2144. PRADEL, P. *Michel Colombe: le dernier imagier gothique,* 1953

2145. PRAZ, M. *Gusto neoclassico,* Naples, 1959 (1940)

2146. PRESTON, L. *Sea and river painters of the Netherlands in the seventeenth century,* 1937

2147. PRICE, SIR U. *An essay on the picturesque as compared with the sublime and the beautiful,* 2 vols., 1796–8 (1794)

2148. PRIDEAUX, S. T. *Aquatint engravings,* 1909

2149. PRIEST, A. *Chinese sculpture in the Metropolitan Museum of Art, New York,* New York, 1943

2150. PRINGLE, J. D. *Australian painting today,* 1963

2151. PRIOR, E. S. *A history of Gothic art in England,* 1900

2152. PRIOR, E. S. and GARDNER, A. *An account of medieval figure-sculpture in England,* 1912

2153. PROCACCI, U. *All the paintings of Masaccio,* 1962

2154. PROPERT, J. L. *A history of miniature art,* 1887

2155. PROWN, J. D. *John Singleton Copley,* 2 vols., Cambridge, Mass., 1966

2156. PURDOM, C. B. *The building of satellite towns,* 1949 (1925)

2157. PUYVELDE, L. VAN. *Gustave de Smet,* Antwerp, 1949

2158. — *Jordaens,* Brussels, 1953

2159. PYE, D. *The nature of design,* 1964

2160. RACKHAM, B. *Catalogue of the Glaisher Collection of pottery & porcelain in the Fitzwilliam Museum, Cambridge,* 2 vols., 1935

2161. — *Early Netherlands maiolica,* 1926

2162. — *Mediaeval English pottery,* 1948

2163. — *A guide to the collections of stained glass in the Victoria and Albert Museum,* 1936

2164. RACKHAM, B. and READ, H. *English pottery,* 1924

2165. RÁFOLS, J. F. *El arte romántico en España,* Barcelona, 1954

2166. — *Diccionario biográfico de artistas de Cataluña,* 3 vols., Barcelona, 1951–4

2167. RAFTERY, J. (ed.). *Christian art in ancient Ireland,* Dublin, 1941

2168. RAGON, M. *L'Aventure de l'art abstrait,* 1956

2169. — *Dubuffet,* New York, 1959

2170. RAHLVES, F. *Cathedrals and monasteries of Spain,* 1966

2171. RAINES, R. *Marcellus Laroon,* 1967

2172. RAMBACH, P. and GOLISH, V. DE. *The golden age of Indian art: Vth–XIIIth century,* 1955

2173. RAMIRO, E. *Catalogue descriptif et analytique de l'œuvre gravé de Félicien Rops,* 1887

2174. — *Félicien Rops,* 1905

2175. RAMSAY, J. *American potters and pottery,* New York, 1939

2176. RANDALL, L. M. C. *Images in the margins of Gothic manuscripts,* Berkeley, 1966

2177. RANKE, H. *The art of ancient Egypt,* 1936

2178. RANSOM, W. *Private presses and their books,* 1929

2179. RASMO, N. *Der Multscher-Altar in Sterzing*, 1963
2180. RASMUSSEN, H. *Printmaking with monotype*, 1961
2181. RAVAL, M. and MOREUX, J.-C. *Claude-Nicolas Ledoux, 1756–1806*, 1945
2182. RAVE, P. O. (ed.). *Karl Blechen*, Berlin, 1940
2183. RAWSON, P. S. *The art of Southeast Asia*, 1967
2184. — *Indian painting*, 1961
2185. — *Indian sculpture*, 1966
2186. RAYNAL, M. *Modern French painters*, 1929
2187. — *Picasso*, New York, 1953
2188. READ, SIR H. E. *Art and industry*, 1953 (1934)
2189. — *Education through art*, 1943
2190. — *English stained glass*, 1926
2191. — *Henry Moore: a study of his life and work*, 1965
2192. — *Unit I. The modern movement in English architecture, painting and sculpture*, 1934
2193. — (ed.). *Surrealism*, 1936
2194. READE, B. E. (ed.). *Beardsley*, 1967
2195. REARICK, J. C. *The drawings of Pontormo*, 2 vols., Cambridge, Mass., 1964
2196. RÉAU, L. *Étienne-Maurice Falconet*, 2 vols., 1922
2197. — *Fragonard*, 1938
2198. — *Histoire de l'expansion de l'art français moderne*, 4 vols., 1924–33
2199. — *Histoire de la peinture française au XVIIIe siècle*, 2 vols., 1925–6
2200. — *Houdon: sa vie et son œuvre*, 2 vols., 1964
2201. REDON, O. *A soi-même. Journal, 1867–1915. Notes sur la vie, l'art et les artistes*, 1922
2202. — *Lettres 1878–1916*, 1923
2203. REED, A. M. *The ancient past of Mexico*, 1966
2204. — *The Mexican muralists*, New York, 1960
2205. — *Orozco*, New York, 1956
2206. REIFENBERG, B. and HAUSENSTEIN, W. *Max Beckmann*, Munich, 1949
2207. REIFF, R. (ed.). *Indian miniatures. The Rajput painters*, Rutland, Vermont, 1959
2208. REILLY, SIR C. H. *McKim, Mead, & White*, 1924
2209. REINER, I. *Woodcut, wood engraving*, 1947
2210. REITMAN, F. *Insanity, art, and culture*, 1954
2211. — *Psychotic art*, 1950
2212. RENOIR, J. *Renoir, my father*, 1962
2213. RENSING, T. *Johann Conrad Schlaun: Leben und Werk des westfälischen Barockbaumeisters*, Munich, 1954 (Dortmund, 1936)
2214. REPTON, H. *Fragments on the theory and practice of landscape gardening*, 1816
2215. — *Observations on the theory and practice of landscape gardening*, 1803
2216. — *Sketches and hints on landscape gardening*, 1794

2217. REUTHER, H. *Die Kirchenbauten Balthasar Neumanns*, Berlin, 1960
2218. REWALD, J. *Camille Pissarro*, 1963
2219. — *Georges Seurat*, New York, 1946
2220. — *Giacomo Manzù*, 1967
2221. — *The history of Impressionism*, New York, 1961 (1949)
2222. — *Maillol*, 1939
2223. — *The ordeal of Paul Cézanne*, 1950
2224. — *Paul Gauguin, 1848–1903*, 1954
2225. — *Pierre Bonnard*, New York, 1948
2226. — (ed.). *Degas: works in sculpture, a complete catalogue*, 1957
2227. — (ed.). *The woodcuts of Aristide Maillol: a complete catalogue*, New York, 1943
2228. REYNOLDS, G. *English portrait miniatures*, 1952
2229. — *Painters of the Victorian scene*, 1953
2230. REYNOLDS, SIR J. *The complete works*, 3 vols., 1824
2231. REYNTIENS, P. *The technique of stained glass*, 1967
2232. RHEIMS, M. *The age of art nouveau*, 1966
2233. RICCI, C. *Antonio Allegri da Correggio: his life, his friends, and his time*, 1895
2234. RICE, D. TALBOT. *The art of Byzantium*, 1959
2235. — *Art of the Byzantine era*, 1963
2236. — *Russian icons*, 1947
2237. — (ed.). *Byzantine wall paintings*, 1968
2238. — (ed.). *Russian art*, 1935
2239. RICE, T. TALBOT. *Ancient arts of Central Asia*, 1965
2240. — *A concise history of Russian art*, 1963
2241. — *Russian art*, 1949
2242. — *The Seljuks in Asia Minor*, 1961
2243. — *The Scythians*, 1957
2244. RICHARDS, J. M. *A guide to Finnish architecture*, 1966
2245. — *An introduction to modern architecture*, 1956 (1938)
2246. RICHARDSON, E. *The Etruscans, their art and civilization*, Chicago, 1964
2247. RICHARDSON, E. P. *Painting in America: the story of 450 years*, 1956
2248. — *Washington Allston*, Chicago, 1948
2249. RICHARDSON, J. *Edouard Manet: paintings and drawings*, 1958
2250. — *Pablo Picasso: watercolours and gouaches*, 1964
2251. RICHER, P. *Anatomie artistique*, 1890
2252. RICHTER, A. L. *Lebenserinnerungen eines deutschen Malers*, Dachau, 1918 (Frankfurt, 1885)
2253. RICHTER, G. M. *Giorgio da Castelfranco, called Giorgione*, Chicago, 1937
2254. RICHTER, G. M. A. *A handbook of Greek art*, 1959
2255. — *The sculpture and sculptors of the Greeks*, New Haven, 1950 (1929)
2256. RICHTER, H. *Dada: art and anti-art*, 1965
2257. RICKERT, M. *Painting in Britain in the Middle Ages*, 1965 (1954)

# BIBLIOGRAPHY

2258. RICKMAN, T. *An attempt to discriminate the styles of English architecture from the Conquest to the Reformation*, 1881 (1817)

2259. RIDDER, A. DE. *Constant Permeke, 1887–1952*, Brussels, 1953

2260. — *Oscar Jespers*, Antwerp, 1948

2261. RIDOLFI, C. *Le maraviglie dell'arte, overo le vite degl'illustri pittori Veneti*, Venice, 1648

2262. RIETH, A. *Gerhard Marcks*, Recklinghausen, 1959

2263. RIIS, P. J. *An introduction to Etruscan art*, Copenhagen, 1953

2264. RING, G. *A century of French painting, 1400–1500*, 1949

2265. RINTELEN, F. *Giotto und die Giotto-Apokryphen*, Munich, 1923 (1912)

2266. RIPLEY, E. *Picasso: a biography*, 1959

2267. RITCHIE, A. C. *Charles Demuth*, New York, 1950

2268. — *Édouard Vuillard*, New York, 1954

2269. RIVERA, D. *Portrait of America*. With an explanatory text by Bertram D. Wolfe, New York, 1934

2270. — *Portrait of Mexico*. Text by Bertram D. Wolfe, 1937

2271. RIVIÈRE, G. *Le Maître Paul Cézanne*, 1923

2272. — *Renoir et ses amis*, 1921

2273. RIVOIRA, G. *Lombardic architecture, its origin, development and derivatives*, 2 vols., 1933 (1910)

2274. ROBAUT, A. and MOREAU-NÉLATON, É. *L'Œuvre de Corot*. With Supplements, 4 vols., 1905–56

2275. ROBERTS, W. *Francis Wheatley, R.A.*, 1906

2276. — *Sir William Beechey, R.A.*, 1907

2277. ROBERTSON, B. *Jackson Pollock*, 1960

2278. ROBERTSON, D. *Mexican manuscript painting of the early colonial period*, New Haven, 1959

2279. ROBERTSON, D. S. *A handbook of Greek and Roman architecture*, 1943 (1929)

2280. ROBIDA, M. *Le Salon Charpentier et les impressionnistes*, 1958

2281. ROBINSON, M. S. *Van de Velde drawings in the National Maritime Museum, Greenwich*, 1958

2282. ROBINSON, W. *The wild garden*, 1895 (1870)

2283. ROBSON-SCOTT, W. D. *The literary background of the Gothic revival in Germany*, 1965

2284. ROCHEBLAVE, S. *French painting in the XVIIIth century*, 1937

2285. RODIN, A. *On art and artists*, 1958 (1912)

2286. ROE, A. S. *Blake's illustrations to the Divine Comedy*, Princeton, 1953

2287. ROE, F. G. *Sea painters of Britain*, 1947–

2288. ROELANTS, M. *Edgard Tytgat*, Antwerp, 1948

2289. ROETHEL, H. K. *Moderne deutsche Malerei*, Berlin, 1957

2290. ROGER-MARX, C. *French original engravings from Manet to the present time*, 1939

2291. ROGER-MARX, C. *Graphic art of the nineteenth century*, 1963

2292. — *Vuillard, his life and work*, 1946

2293. ROGERS, E. N. *Auguste Perret*, Milan, 1955

2294. ROGERS, M. R. *Carl Milles: an interpretation of his work*, New Haven, 1940

2295. RÖMPLER, K. *Der deutsche Impressionismus: die Hauptmeister in der Malerei*, Dresden, 1958

2296. ROOD, O. N. *Modern chromatics*, 1879

2297. ROOKE, N. *Woodcuts and wood engravings*, 1926

2298. ROOSES, M. *Jacob Jordaens: his life and work*, 1908

2299. — *L'Œuvre de P. P. Rubens*, 5 vols., Antwerp, 1886–92

2300. — (ed.). *Dutch painters of the nineteenth century*, 4 vols., 1898–1901

2301. ROOSVAL, J. *Swedish art*, Princeton, 1932

2302. ROSCOE, S. *Thomas Bewick: a bibliography raisonné of editions of the General History of Quadrupeds* [etc.], 1953

2303. ROSE, J. *The drawings of John Leech*, 1950

2304. ROSENAU, H. *The painter Jacques-Louis David*, 1948

2305. ROSENBERG, J. *Jacob van Ruisdael*, Berlin, 1928

2306. — *Rembrandt*, 1964 (Cambridge, Mass., 1948)

2307. — *Die Zeichungen Lucas Cranachs d. Ä.*, Berlin, 1960

2308. ROSENBERG, J. and others. *Dutch art and architecture, 1600 to 1800*, 1966

2309. ROSENTHAL, E. E. *The cathedral of Granada*, Princeton, 1961

2310. ROSENTHAL, L. *Manet: aquafortiste et lithographe*, 1925

2311. ROSS, D. W. *The painter's palette*, Boston and New York, 1919

2312. ROSS, R. B. *Aubrey Beardsley*, 1908

2313. ROSTOVTZEFF, M. I. *The Animal Style in South Russia and China*, Princeton, 1929

2314. — *Caravan cities*, 1932

2315. — *Dura-Europos and its art*, 1938

2316. — *Iranians and Greeks in South Russia*, 1922

2317. ROTH, C. (ed.). *Jewish art: an illustrated history*, 1961

2318. ROTHENSTEIN, SIR J. K. M. *An introduction to English painting*, 1965 (1933)

2319. ROTHENSTEIN, M. *Linocuts and woodcuts, and related ways of print-making*, 1962

2320. RÖTHLISBERGER, M. *Claude Lorrain: the paintings*, 2 vols., 1961

2321. ROUART, D. *Claude Monet*, New York, 1958

2322. — *Manet*, 1960

2323. ROUMA, G. *Le Langage graphique de l'enfant*, Brussels, 1912

2324. ROURKE, C. M. *Audubon*, 1936

2325. ROUX, G. *Ancient Iraq*, 1964

2326. ROWE, J. H. *Chavin art: an inquiry into its form and meaning*, New York, 1962

2327. ROWLAND, B. *The art and architecture of India*, 1956 (1953)

2328. — *The Harvard outline and reading lists for Oriental art*, Cambridge, Mass., 1952

2329. ROWLAND, D. B. *Mannerism—style and mood*, New Haven, 1964

2330. ROWLEY, G. *Ambrogio Lorenzetti*, 2 vols., Princeton, 1958

2331. — *Principles of Chinese painting*, Princeton, 1947

2332. ROY, C. *Maillol vivant*, Geneva, 1947

2333. ROYAL ACADEMY OF ARTS, THE. Exhibition catalogue. *The art of India and Pakistan*, 1950

2334. — *Leonardo da Vinci. Quincentenary exhibition*, 1952

2335. — *Works by Holbein and other Masters of the 16th and 17th centuries*, 1950

2336. RUBENS, SIR P. P. *The letters of Peter Paul Rubens*, ed. by R. S. Magurn, Cambridge, Mass., 1955

2337. RUBISSOV, H. *The art of Russia*, New York, 1946

2338. RUD, E. *Vasari's life and lives. The first art historian*, 1963

2339. RUDENKO, S. I. *The culture of the Huns and the Barrows of Noin Ula* [in Russian], Moscow, 1962

2340. — *The art of the Scythians of the Altai* [in Russian], Moscow, 1949

2341. RUHEMANN, H. *The cleaning of paintings*, 1968

2342. RUHMER, E. *Cranach*, 1963

2343. — (ed.). *Tura: paintings and drawings*, 1958

2344. RUIZ CABRIADA, A. *Aportación a una bibliografia de Goya*, Madrid, 1946

2345. RUIZ DE ARCAUTE, A. *Juan de Herrera, arquitecto de Felipe II*, Madrid, 1936

2346. RUPRICH-ROBERT, V. *L'Architecture normande aux XIe et XIIe siècles en Normandie et en Angleterre*, 1884

2347. RUSK, W. S. *William Henry Rinehart, sculptor*, Baltimore, 1939

2348. RUSKIN, J. *Modern painters*, 5 vols., 1846–60 (1843)

2349. — *Sesame and Lilies*, 1865

2350. — *The seven lamps of architecture*, 1849

2351. — *The stones of Venice*, 3 vols., 1851–3

2352. RUSSELL, J. *Elements of painting with crayons*, 1772

2353. RUSSELL, J. *Francis Bacon*, 1964

2354. — *Georges Braque*, 1959

2355. — *Max Ernst, life and work*, 1967

2356. — *Seurat*, 1965

2357. RUSSOLI, F. *All the sculpture of Michelangelo*, 1963

2358. — *Modigliani*, 1959

2359. — (ed.). *Marino Marini: paintings and drawings*, 1965

2360. RUTTER, F. *El Greco, 1541–1614*, 1930

2361. RUTTER, J. *Delineations of Fonthill and its abbey*, 1823

2362. RYERSON, E. *The Netsuke of Japan*, 1958

2363. SAALMAN, H. *Medieval architecture, European architecture, 600–1200*, 1962

2364. SAARINEN, E. *The City*, New York, 1943

2365. — *Search for form*, New York, 1948

2366. SABARTÉS, J. *Picasso: documents iconographiques*, Geneva, 1954

2367. SABATINI, A. *Antonio e Piero del Pollaiolo*, Florence, 1944

2368. ST. CLAIR, W. *Lord Elgin and the Marbles*, 1967

2369. SALAMAN, M. C. *Modern masters of etching: Alphonse Legros*, 1926

2370. — *Modern masters of etching: J. L. Forain*, 1925

2371. SALMI, M. *Andrea del Castagno*, Novara, 1961

2372. — *L'architettura romanica in Toscana*, Milan, 1927

2373. — *Ercole de' Roberti*, Milan, 1960

2374. — *Luca Signorelli*, Novara, 1953

2375. — *Italian miniatures*, 1957

2376. SALMON, A. *Henri Rousseau*, 1963

2377. SALOMON, J. *Auprès de Vuillard*, 1953

2378. SALVINI, R. *All the paintings of Botticelli*, 1965

2379. — *All the paintings of Giotto*, 1963

2380. SALVINI, R. and TRAVERSO, T. *The Predella from the XIIIth to the XVIth centuries*, 1960

2381. SAMBRICIO, V. DE. *Francisco Bayeu*, Madrid, 1955

2382. SÁNCHEZ CANTÓN, F. J. (ed.). *Fuentes literarias para la historia de arte español*, 5 vols., Madrid, 1923–41

2383. SANDARS, N. K. *Prehistoric art in Europe*, 1968

2384. SANDBERG VAVALÀ, E. *Sienese studies: the development of the school of painting of Siena*, Florence, 1953

2385. SANDBLAD, N. G. *Manet: three studies in artistic conception*, Lund, 1954

2386. SANDFORD, C. and RUTTER, O. *Pertelote*, 1943

2387. SAN LAZZARO, G. D. *Klee: a study of his life and work*, 1957

2388. SANOUILLET, M. *Picabia*, 1964

2389. SANTOS, L. R. *Enciclopédia portuguesa e brasileira*, Lisbon, 1950

2390. SANTOS, R. DOS. *L'Art portugais; architecture — sculpture — peinture*, 1938

2391. — *O estilo manuelino*, Lisbon, 1952

2392. — *Nuño Gonçalves*, 1955

2393. — *Oito séculos de arte portuguesa: historia e espirito*, Lisbon, 1964

2394. — *Sequeira y Goya*, Madrid, 1929

2395. SARTORIS, A. *Encyclopédie de l'architecture nouvelle*, Milan, 1948–

2396. SAUNDERS, E. D. *Mudrá, a study of symbolic gestures in Japanese Buddhist sculpture*, New York, 1960

2397. SAUNDERS, O. E. *English illumination*, 2 vols., Florence and Paris, 1928

2398. — *A history of English art in the Middle Ages*, 1932

2399. SAUNIER, C. *Louis Barye*, 1926

2400. SAVAGE, G. *A concise history of bronzes*, 1968

2401. SAWITZKY, W. *Ralph Earl, 1751–1801*, Worcester, Mass., 1945

2402. SAXL, F. *English sculptures of the twelfth century*, 1954

2403. — (ed.). *Classical antiquity in Renaissance painting*, 1938

2404. SAXL, F. and WITTKOWER, R. *British art and the Mediterranean*, 1948

2405. SCHAEFER, H. *Von ägyptischer Kunst*, Leipzig, 1930 (1919)

2406. SCHAPIRO, M. *Vincent van Gogh*, 1951 (New York, 1950)

2407. SCHARF, A. *Filippino Lippi*, Vienna, 1935

2408. SCHÉFER, G. *Moreau le Jeune, 1741–1814*, 1915

2409. SCHEFFLER, K. *Deutsche Maler und Zeichner im neunzehnten Jahrhundert*, Leipzig, 1911

2410. — *Max Liebermann*, Wiesbaden, 1953

2411. SCHEFOLD, K. *Myth and legend in early Greek art*, 1966

2412. SCHELTEMA, J. F. *Monumental Java*, 1912

2413. SCHIAFFINO, E. *La pintura y la escultura en Argentina, 1783–1894*, Buenos Aires, 1933

2414. SCHIEFLER, G. *Emil Nolde : das graphische Werk*, Cologne, 1966

2415. SCHILLING, E. (ed.). *Drawings by the Holbein family*, New York, 1955 (1937)

2416. SCHLENOFF, N. (ed.). *Ingres : cahiers littéraires inédits*, 1956

2417. — *Ingres, ses sources littéraires*, 1956

2418. SCHMIDT, G. and others. *Though this be madness*, 1961

2419. SCHMIDT, R. *Porcelain as an art and as a mirror of fashion*, 1932

2420. SCHMIED, W. (ed.). *Mark Tobey*, 1966

2421. SCHMITZ, C. A. *Oceanic sculpture : sculpture of Melanesia*, 1962

2422. — *Wantoat : art and religion of the northeast New Guinea Papuans*, The Hague, 1963

2423. SCHMUTZLER, R. *Art nouveau*, 1964

2424. SCHNEIDER, D. E. *The psychoanalyst and the artist*, New York, 1950

2425. SCHNEIDER, H. *Jan Lievens, sein Leben und seine Werke*, Haarlem, 1932

2426. SCHNEIDER, M. F. *Arnold Böcklin : ein Maler aus dem Geiste der Musik*, Basel, 1943

2427. SCHNIER, J. *Sculpture in modern America*, 1948

2428. SCHOENE, W. *Dieric Bouts und seine Schule*, Berlin, 1938

2429. SCHOLFIELD, P. H. *The theory of proportion in architecture*, 1958

2430. SCHÖNBERGER, A. and SOEHNER, H. *The age of Rococo*, 1960

2431. SCHÖNBERGER, G. (ed.). *The drawings of Mathis Gothart Nithart called Grünewald*, New York, 1948

2432. SCHOTT, R. *Michelangelo*, 1963

2433. SCHRAMM, P. E. and MÜTHERICH, F. *Denkmale der deutschen Könige und Kaiser, 768–1250*, Munich, 1962

2434. SCHUBRING, P. *Cassoni : Truhen und Truhenbilder der italienischen Frührenaissance*, Leipzig, 1923

2435. SCHUMANN, W. *Käthe Kollwitz*, Gütersloh, 1953

2436. SCHURITZ, H. *Die Perspektive in der Kunst Albrecht Dürers*, Frankfurt, 1919

2437. SCHWAB, A. T. *James Gibbons Huneker : critic of the seven arts*, Stanford, California, 1963

2438. SCHWEMMER, W. *Adam Krafft*, Nuremberg, 1958

2439. SCRANTON, R. L. *Aesthetic aspects of ancient art*, Chicago, 1964

2440. SCULLY, V. *Frank Lloyd Wright*, 1960

2441. SÉAILLES, G. *Eugène Carrière : essai de biographie psychologique*, 1911

2442. SECKEL, D. *The art of Buddhism*, 1964

2443. SECKER, H. F. *Diego Rivera*, Dresden, 1957

2444. SEDLMAYR, H. *Johann Bernhard Fischer von Erlach*, Vienna, 1956

2445. SEGANTINI, G. *Giovanni Segantini*, Zürich, 1949

2446. SEITZ, W. C. *Claude Monet*, 1960

2447. — *Mark Tobey*, New York, 1962

2448. SEKLER, E. *Wren and his place in European architecture*, 1956

2449. SELIGMAN, G. *The drawings of Georges Seurat*, New York, 1947

2450. SELLERS, C. C. *Charles Willson Peale*, 2 vols., Philadelphia, 1947

2451. — *Portraits and miniatures by Charles Willson Peale*, Philadelphia, 1952

2452. SELVA, J. *El arte en España durante los Austrias*, Barcelona, 1943

2453. SELZ, J. *Matisse*, New York, 1964

2454. — *Vlaminck*, New York, 1963

2455. SELZ, P. *Emil Nolde*, New York, 1963

2456. — *German Expressionist painting*, Berkeley, 1957

2457. — *The work of Jean Dubuffet*, New York, 1962

2458. SELZ, P. and CONSTANTINE, M. (edd.). *Art Nouveau : art and design at the turn of the century*, New York, 1960

2459. SENSIER, A. *Jean-François Millet*, Boston, 1881

2460. SERRA, L. *Domenico Zampieri, detto Il Domenichino*, Rome, 1909

2461. SÉRULLAZ, M. *French Impressionists*, 1963

2462. SEUPHOR, M. *Abstract painting from Kandinsky to the present*, 1963

2463. — *A dictionary of abstract painting*, 1958

2464. — *Piet Mondrian, life and work*, 1957 (New York, 1956)

2465. SEYMOUR, C. *Notre-Dame of Noyon in the twelfth century*, New Haven, 1939

2466. — *Sculpture in Italy, 1400–1500*, 1966

2467. SHARP, D. *Modern architecture and expressionism*, 1966

# BIBLIOGRAPHY

2468. SHATTUCK, R. *The banquet years: the arts in France 1885-1918*, 1959

2469. SHAW, J. B. L. *The drawings of Domenico Tiepolo*, 1962

2470. — *The drawings of Francesco Guardi*, 1951

2471. SHAW-SPARROW, W. *British sporting artists from Barlow to Herring*, New York, 1922

2472. — *John Lavery and his work*, 1911

2473. SHEARMAN, J. K. G. *Andrea del Sarto*, 2 vols., 1965

2474. — *Mannerism*, 1967

2475. SHEE, M. A. *Memoir of Sir Martin Archer Shee*, 2 vols., 1860

2476. SHERMAN, F. F. *Early American painting*, 1932

2477. SHETELIG, H. *Classical impulses in Scandinavian art from the Migration period to the Viking Age*, Oslo, 1949

2478. — (ed.). *Viking antiquities in Great Britain and Ireland*, 6 parts, Oslo, 1940-54

2479. SHETELIG, H. and FALK, H. *Scandinavian archaeology*, 1937

2480. SHIICHI, TAJIMA. *Masterpieces selected from the Kôrin School, with biographical sketches of the artists of the School and some critical descriptions*, Tokyo, 1903-5

2481. SHIRLEY, A. *The rainbow: a portrait of John Constable*, 1949

2482. SHORT, F. *British mezzotints*, 1925

2483. SIEVERS, J. *Pieter Aertsen*, Leipzig, 1908

2484. SIGNAC, P. *D'Eugène Delacroix au néo-impressionnisme*, 1899

2485. — *Jongkind*, 1927

2486. SIMCHES, O. *Le Romantisme et le goût esthétique du XVIII<sup>e</sup> siècle*, 1964

2487. SIMON, A. *Ian van de Velde, 1593-1641/2*, Essen, 1962

2488. SIMSON, O. VON. *The Gothic cathedral*, 1956

2489. SINIBALDI, G. *I Lorenzetti*, Siena, 1933

2490. SIRÉN, O. *Chinese painting*, 7 vols., 1956-8

2491. — *Chinese sculpture from the fifth to the fourteenth century*, 4 vols., 1925

2492. — *A history of early Chinese art*, 4 vols., 1929-30

2493. — *A history of early Chinese painting*, 2 vols., 1933

2494. — *A history of later Chinese painting*, 2 vols., 1938

2495. SKELTON, R. A. *Decorative printed maps of the 15th to 18th centuries*, 1952

2496. SLEVOGT, M. *The Magic Flute, marginal sketches to Mozart's manuscript*, 1926

2497. SLOANE, J. C. *French painting between the past and the present*, Princeton, 1951

2498. SMART, A. *The life and art of Allan Ramsay*, 1952

2499. SMITH, A. R. (ed.). *Gavarni in London*, 1849

2500. SMITH, B. W. *Australian painting, 1788-1960*, 1962

2501. — *European vision and the South Pacific, 1768-1850: a study in the history of art and ideas*, 1960

2502. SMITH, B. W. *Place, taste and tradition: a study of Australian art since 1788*, Sydney, 1945

2503. SMITH, C. *Rogers groups, thought and wrought by John Rogers*, Boston, 1934

2504. SMITH, C. B. *Builders in the sun: five Mexican architects*, New York, 1967

2505. SMITH, G. E. K. *Italy builds*, 1955

2506. — *The new architecture of Europe*, Cleveland, 1961

2507. — *Sweden builds*, 1957 (1950)

2508. — SMITH, J. T. *Nollekens and his times*, ed. by W. Whitten, 2 vols., 1920 (1828)

2509. SMITH, L. P. *The life and letters of Sir Henry Wotton*, 2 vols., 1907

2510. SMITH, R. C. *Drawing from memory and mind picturing*, 1921

2511. SMITH, S. *Early history of Assyria to 1000 B.C.*, 1928

2512. SMITH, S. U. (ed.). *The art of William Dobell*, Sydney, 1946

2513. — *Present day art in Australia*, Sydney, 1949

2514. SMITH, V. A. *A history of fine art in India and Ceylon*, 1962 (1911)

2515. SMITH, W. S. *The art and architecture of ancient Egypt*, 1958

2516. — *A history of Egyptian sculpture and painting in the Old Kingdom*, Boston, 1950 (1946)

2517. — *Interconnections in the ancient Near East: a study of the relationships between the arts of Egypt, the Aegean, and western Asia*, New Haven, 1965

2518. SOARES LEITE, S. *Artes e oficios dos Jesuitas no Brasil, 1549-1760*, Lisbon, Rio de Janeiro, 1953

2519. SOBY, J. T. *Arp*, New York, 1958

2520. — *Ben Shahn: his graphic art*, New York, 1957

2521. — *Giorgio de Chirico*, New York, 1955

2522. — *Juan Gris*, New York, 1958

2523. — *Georges Rouault: paintings and prints*, New York, 1945

2524. — *Salvador Dali*, New York, 1941

2525. — *Yves Tanguy*, New York, 1955

2526. SOBY, J. T. and BARR, A. H. *Twentieth century Italian art*, 1949

2527. SOBY, J. T. and MILLER, D. C. *Romantic painting in America*, New York, 1943

2528. SOLÁ, M. *Historia del arte hispano-americano*, Barcelona, 1935

2529. SOMARÉ, E. *La pittura italiana del l'ottocento*, Novara, 1944

2530. SOPER, A. C. *The evolution of Buddhist architecture in Japan*, Princeton, 1942

2531. SORIA, M. S. *The paintings of Zurbarán*, 1953

2532. SOSSONS, J. P. *Les Primitifs flamands de Bruges*, Brussels, 1966

2533. SOTRIFFER, K. *Modern Austrian art: a concise history*, 1965

2534. SOUSTELLE, J. E. *Arts of ancient Mexico*, 1967

2535. SOUSTELLE, J. E., *The daily life of the Aztecs, on the eve of the Spanish conquest*, 1961

2536. SPAAK, C. *Paul Delvaux*, Antwerp, 1948

2537. SPAHN, A. *Palma Vecchio*, Leipzig, 1932

2538. SPARKES, J. C. L. *Schools of art*, 1884

2539. — *Flaxman's classical outlines*. 1879

2540. SPARLING, H. H. *The Kelmscott Press and William Morris, master-craftsman*, 1924

2541. SPEAIGHT, R. *The life of Eric Gill*, 1966

2542. SPELEERS, L. *Les Figurines funéraires Égyptiennes*, Brussels, 1923

2543. SPRINGER, J. *Die Radierungen des Herkules Seghers*, Berlin, 1910–12

2544. STADLER, F. *Hans von Kulmbach*, Vienna, 1936

2545. STANGE, A. *Deutsche Malerei der Gotik*, 11 vols., Berlin, 1934–61

2546. — *Der Hausbuchmeister*, Baden-Baden, 1958

2547. STÄUBLI, W. *Brasilia*, 1966

2548. STECHOW, W. *Dutch landscape painting of the seventeenth century*, 1966

2549. — *Salomon van Ruysdael*, Berlin, 1938

2550. STEIN, G. *Picasso*, 1938

2551. STEINBART, K. *Johann Liss*, Vienna, 1946

2552. — *Masaccio*, Vienna, 1948

2553. STENICO, A. *Roman and Etruscan painting*, 1963

2554. STERLING, C. *Great French painting in the Hermitage*, 1958

2555. — *La Nature morte de l'antiquité à nos jours*, 1952

2556. — *La Peinture française : les primitifs*, 1938

2557. STEWARD, J. H. (ed.). *Handbook of South American Indians*, 6 vols., Washington, 1946–50

2558. STEWART, B. *Subjects portrayed in Japanese colour-prints*, 1922 (1920)

2559. STEWART, V. *45 contemporary Mexican artists*, Stanford, California, 1951

2560. STOKES, A. *Stones of Rimini*, 1934

2561. STOKES, M. *Early Christian architecture in Ireland*, 1878

2562. STOLL, R. *Architecture and sculpture in early Britain*, 1967

2563. STONE, L. *Sculpture in Britain : the Middle Ages*, 1955

2564. STORM, J. *The Valadon story : the life of Suzanne Valadon*, 1959

2565. STORY, A. T. *The life of John Linnell*, 1892

2566. STOW, G. W. *Rock-paintings in South Africa*, 1930

2567. STRANGE, E. F. *Japanese colour prints*, 1931 (1904)

2568. STRAUSS, G. *Käthe Kollwitz*, Dresden, 1950

2569. STREET, A. E. *Memoir of George Edmund Street, R.A., 1824–1881*, 1888

2570. STREICHHAN, A. *Knobelsdorff und das friderizianische Rokoko*, Magdeburg, 1932

2571. STRIBLING, M. L. *Mosaic techniques*, 1966

2572. STROBL, A. *Gustav Klimt : Zeichnungen und Gemälde*, Salzburg, 1962

2573. STROMMENGER, E. and HIRMER, M. *The art of Mesopotamia*, 1964

2574. STRONG, D. E. *Roman imperial sculpture*, 1961

2575. STROUD, D. *The architecture of Sir John Soane*, 1961

2576. — *Capability Brown*, 1950

2577. — *Henry Holland, 1745–1806*, 1950

2578. STRZYGOWSKI, J. *Early church art in northern Europe*, 1928

2579. STUTCHBURY, H. E. *The architecture of Colen Campbell*, 1968

2580. STUTTERHEIM, W. F. *Studies in Indonesian archaeology*, The Hague, 1956

2581. SUIDA, W. E. *Bramante pittore e il Bramantino*, Milan, 1953

2582. SUKENIK, E. L. *Ancient synagogues in Palestine and Greece*, 1934

2583. SULLIVAN, M. *The birth of landscape painting in China*, 1962

2584. — *A short history of Chinese art*, 1967

2585. SULLY, J. *Studies of childhood*, 1903 (1895)

2586. SUMMERSON, SIR J. N. *Architecture in Britain 1530 to 1830*, 1963 (1953)

2587. — *Georgian London*, 1962 (1945)

2588. — *Inigo Jones*, 1966

2589. — *John Nash, architect to King George IV*, 1935

2590. — *Sir Christopher Wren*, 1953

2591. — *Sir John Soane, 1753–1837*, 1952

2592. SUTTON, D. *American painting*, 1948

2593. — *André Derain*, 1959

2594. — *James McNeill Whistler : paintings, etchings, pastels and water colours*, 1966

2595. — *Nocturne : the art of James McNeill Whistler*, 1963

2596. — *Triumphant satyr : the world of Auguste Rodin*, 1966

2597. SVEDFELT, T. *Erik Werenskiold*, Oslo, 1947

2598. SWANN, P. C. *Art of China, Korea and Japan*, 1963

2599. — *An introduction to the arts of Japan*, 1958

2600. SWARUP, S. *The arts and crafts of India and Pakistan*, Bombay, 1957

2601. SWARZENSKI, H. P. *Moments of Romanesque art, the art of church treasures in North-Western Europe*, 1967 (1954)

2602. — (ed.). *Early Medieval illumination*, 1951

2603. SWIFT, E. H. *Hagia Sophia*, New York, 1940

2604. SWILLENS, P. T. A. *Jacob van Campen, schilder en bouwmeester*, Assen, 1961

2605. — *Johannes Vermeer, painter of Delft, 1632–1675*, Utrecht, 1950

2606. — *Pieter Janszoon Saenredam*, Amsterdam, 1935

2607. SWINDLER, M. H. *Ancient painting from the earliest times to the period of Christian art*, New Haven, 1929

2608. SYDOW, E. VON. *Afrikanische Plastik*, Berlin, 1954

2609. SYMONDS, J. A. *The life of Michelangelo Buonarroti*, 2 vols., 1892

2610. SYMONS, A. J. A. and others. *The None-such century*, 1936
2611. SYPHER, W. *Four stages of Renaissance style : transformations in art and literature, 1400-1700*, New York, 1955
2612. SZE, MAI-MAI. *The Tao of painting*, 1957
2613. TABARANT, A. *Manet et ses œuvres*, 1947
2614. — *Le Peintre Caillebotte et sa collection*, 1921
2615. — *Pissarro*, 1925
2616. TAFT, L. *The history of American sculpture*, New York, 1930 (1903)
2617. TAÏCHUNG, NATIONAL PALACE MUSEUM. *Three hundred masterpieces of Chinese painting in the Palace Museum*, 6 vols., Tokyo, 1959
2618. TALLMADGE, T. E. *The story of architecture in America*, 1936 (New York, 1927)
2619. TAMMS, F. (ed.). *Paul Bonatz : Arbeiten aus den Jahren 1907 bis 1937*, Stuttgart, 1937
2620. TAMMUZ, B. and WYKES-JOYCE, M. (edd.). *Art in Israel*, 1966
2621. TANGE, K. *Katsura : tradition and creation in Japanese architecture*, New Haven, 1960
2622. TANNENBAUM, L. *James Ensor*, New York, 1951
2623. TAPIÉ, V. L. *The age of grandeur : Baroque and Classicism in Europe*, 1960
2624. TATE GALLERY, THE. *Canadian painting 1939-1963* (Exhibition catalogue), 1964
2625. TAYLOR, BASIL. *Animal painting in England from Barlow to Landseer*, 1955
2626. TAYLOR, BROOK. *Linear perspective*, 1715
2627. TAYLOR, F. H. *The taste of angels : a history of art collecting from Rameses to Napoleon*, 1949
2628. TAYLOR, J. C. *Futurism*, New York, 1961
2629. TEAGUE, W. D. *Design this day : the technique of order in the machine age*, New York, 1940
2630. TEIRLINCK, H. *Henry Van de Velde*, Brussels, 1959
2631. TEMKO, A. *Eero Saarinen*, 1962
2632. TEMPLE, A. G. *Modern Spanish painting*, 1908
2633. TESTELIN, H. *Sentimens des plus habiles peintres sur la pratique de la peinture et sculpture*, 1680
2634. THAPAR, D. R. *Icons in bronze : an introduction to Indian metal images*, Bombay, 1961
2635. THEURIET, A. *Jules Bastien-Lepage and his art*, 1892
2636. THOMAS, E. J. *The life of Buddha as legend and history*, 1927
2637. THOMAS, H. *The drawings of Giovanni Battista Piranesi*, 1954
2638. THOMSON, A. *A handbook of anatomy for art students*, 1930 (1896)
2639. THOMSON, B. L. *Jean François Millet, 1814-1875*, 1927

2640. THOMSON, D. C. *The Barbizon School of painters : Corot, Rousseau, Diaz, Millet, Daubigny, etc.*, 1890
2641. — *The life and works of Thomas Bewick*, 1882
2642. THORÉ, T. *Salons de T. Thoré, 1844-1848*, 1868
2643. THORNTON, A. *Fifty years of the New English Art Club, 1886-1935*, 1935
2644. TIBOL, R. *Siqueiros, introductor de realidades*, Mexico, 1961
2645. TIETZE, H. *Tintoretto : the paintings and drawings*, 1948
2646. — *Titian : the paintings and drawings*, 1950 (1936)
2647. TIETZE-CONRAT, E. (ed.). *Mantegna : paintings, drawings, engravings*, 1955
2648. TIGLER, P. *Die Architekturtheorie des Filarete*, Berlin, 1963
2649. TIMMERS, J. J. M. *Gérard Lairesse*, Amsterdam, 1942
2650. TINTELNOT, H. *Die barocke Freskomalerei in Deutschland*, Munich, 1951
2651. TINTORI, L. and BORSOOK, E. *Giotto : the Peruzzi chapel*, New York, 1965
2652. TINTORI, L. and MEISS, M. *The painting of the life of St. Francis in Assisi, with notes on the Arena Chapel*, New York, 1962
2653. TIPPING, H. A. *Grinling Gibbons and the woodwork of his age, 1648-1720*, 1914
2654. TISCHNER, H. *Oceanic art*, 1954
2655. TODA, K. *Japanese scroll painting*, Chicago, 1935
2656. TOESCA, E. B. *Il Pontormo*, Rome, 1943
2657. TOESCA, I. *Andrea e Nino Pisani*, Florence, 1950
2658. TOESCA, P. *Pietro Cavallini*, 1960
2659. TOLNAI, K. *The drawings of Pieter Bruegel the Elder*, 1952
2660. — *Hieronymus Bosch*, Basel, 1937
2661. — *Le Maître de Flémalle et les frères van Eyck*, Brussels, 1939
2662. — *Michelangelo*, 5 vols., Princeton, 1943-1960
2663. — *Pierre Bruegel l'Ancien*, 2 vols., Brussels, 1935
2664. TOMKINSON, G. S. *A select bibliography of the principal modern presses, public and private, in Great Britain and Ireland*, 1928
2665. TOPOLSKI, F. *Britain in peace and war*, 1941
2666. — *88 pictures*, 1951
2667. TORMO Y MONZÓ, E. *Jacomart y el arte hispano-flamenco cuatrocentista*, Madrid, 1913
2668. — *Pintura, escultura y arquitectura en España*, Madrid, 1949
2669. TORRES BALBÁS, L. and others. *Resumen histórico del urbanismo en España*, Madrid, 1954
2670. TOSCANO, S. *Arte pre-colombino de México y de la América Central*, Mexico, 1952 (1944)

2671. TOULOUSE-LAUTREC, H. DE. *Dessins de Toulouse-Lautrec*, Lausanne, 1959

2672. TOUSSAINT, M. *Colonial art in Mexico*, 1968

2673. TOVELL, R. M. *Flemish artists of the Valois courts*, Toronto, 1950

2674. TOWNDROW, K. R. *Alfred Stevens: a biography with new material*, 1939

2675. — *The works of Alfred Stevens, sculptor, painter, designer, in the Tate Gallery*, 1950

2676. TOWNER, D. C. *English cream-coloured earthenware*, 1957

2677. TOYNBEE, J. M. C. *Art in Britain under the Romans*, 1964

2678. — *The art of the Romans*, 1965

2679. TRALBAUT, M. E. *Van Gogh: a pictorial biography*, 1959

2680. TRAPIER, E. DU GUÉ. *Valdés Leal, Spanish Baroque painter*, New York, 1960

2681. — *Velazquez*, New York, 1948

2682. — *Luis de Morales and Leonardesque influences in Spain*, New York, 1953

2683. — *Ribera*, New York, 1952

2684. TRIER, E. *The sculpture of Marino Marini*, 1961

2685. TRIMBORN, H. VON. *Das alte Amerika*, Stuttgart, 1959

2686. TRISTRAM, E. W. *English medieval wall painting*, 4 vols., 1944–55

2687. TRIVAS, N. S. *The paintings of Frans Hals*, New York, 1941

2688. TROESCHER, G. *Claus Sluter und die burgundische Plastik um die Wende des XIV. Jahrhunderts*, Freiburg im Breisgau, 1932

2689. TUCCI, G. *The theory and practice of the mandala, with special reference to the modern psychology of the subconscious*, 1961

2690. — *Tibetan painted scrolls*, 3 vols., Rome, 1949

2691. TUCKERMAN, H. T. *Book of the artists: American artist life*, 1867

2692. TUER, A. W. *Bartolozzi and his works*, 1885 (1882)

2693. TURIN, GALLERIA CIVICA D'ARTE MODERNA. *Vieira da Silva.* (Exhibition catalogue), Turin, 1964

2694. TURNER, A. R. *The vision of landscape in Renaissance Italy*, Princeton, 1966

2695. UBBELOHDE-DOERING, H. *The art of ancient Peru*, 1952

2696. — *Kunst im Reiche der Inka. El arte en el imperio de los Incas*, Barcelona, 1952

2697. UCKO, P. J. and ROSENFELD, A. *Palaeolithic cave art*, 1967

2698. UHDE, W. *Henri Rousseau*, Lausanne, 1948

2699. ULLMAN, B. L. *Studies in the Italian Renaissance*, Rome, 1955

2700. UNDERWOOD, E. G. *A short history of English painting*, 1933

2701. — *A short history of English sculpture*, 1933

2702. UNDERWOOD, L. *Bronzes of West Africa*, 1949

2703. — *Figures in wood of West Africa*, 1947

2704. — *Masks of West Africa*, 1948

2705. UNDERWOOD, P. A. *The Kariye Djami*, 3 vols., 1967

2706. URBAN, M. *Emil Nolde: flowers and animals—watercolours and drawings*, 1966

2707. UTRECHT, CENTRAAL MUSEUM. *Moderne Braziliaanse kunst* (Exhibition catalogue), Utrecht, 1960

2708. VACCARINO, P. *Nanni*, Florence, 1950

2709. VAILLANT, A. *Bonnard*, 1966

2710. VAILLANT, G. C. *The Aztecs of Mexico*, 1950

2711. — *Indian arts of North America*, 1939

2712. VALCANOVER, F. *All the paintings of Titian*, 1965

2713. VALENTINER, W. R. *Tino di Camaino, a Sienese sculptor of the fourteenth century*, 1935

2714. — *Studies of Italian Renaissance sculpture*, 1950

2715. — (ed.). *Frans Hals*, Stuttgart, 1923 (1921)

2716. — (ed.). *Nicolaes Maes*, Stuttgart, 1924

2717. — (ed.). *Pieter de Hooch*, Stuttgart, 1930

2718. VALLANCE, A. *Art in England during the Elizabethan and Stuart periods*, 1908

2719. VALLENTIN, A. *Picasso*, 1963

2720. VALLIER, D. *Henri Rousseau*, 1964

2721. VALSECCHI, M. *Venetian painting*, 1962

2722. VAN DIEREN, B. *Epstein*, 1920

2723. VANDIER, J. *Egyptian sculpture*, 1951

2724. — *Manuel d'archéologie égyptienne*, 1952–

2725. VAN FALKE, O. *Das rheinische Steinzeug*, 2 vols., Berlin, 1908

2726. VANZYPE, G. *L'Art belge du XIX<sup>e</sup> siècle*, 1923

2727. VARGAS UGARTE, R. *Ensayo de diccionario de artifices coloniales de la América Meridional*, 2 vols., Lima, 1947–55

2728. VAUGHAN, M. *Derain*, New York, 1941

2729. VAUXCELLES, L. *Le Fauvisme*, Geneva, 1958

2730. VELÁZQUEZ CHÁVEZ, A. *Contemporary Mexican artists*, New York, 1937

2731. VENICE, PALAZZO GRASSI. *Mostra dei Guardi* (Exhibition catalogue), Venice, 1965

2732. VENTURI, A. *Giovanni Pisano: his life and work*, 1928

2733. — *Storia dell'arte italiana*, Milan, 1901–

2734. VENTURI, L. *Les Archives de l'Impressionnisme*, 2 vols., 1939

2735. — *Cézanne: son art — son œuvre*, 2 vols., 1936

2736. — *Chagall: biographical and critical study*, New York, 1956

2737. — *Four steps towards modern art: Giorgione, Caravaggio, Manet, Cézanne*, 1956

2738. — *Georges Rouault*, 1948

2739. — *Impressionists and symbolists*, New York, 1950

2740. VENTURI, L. *Italian painters of today*, New York, 1959

2741. — *Paul Cézanne : water colours*, 1943

2742. VERDET, A. *Faunes et nymphes de Pablo Picasso*, Geneva, 1952

2743. — *Georges Braque le solitaire*, 1959

2744. — *Prestiges de Matisse*, 1952

2745. VERLET, P. *Le Style Louis XV*, 1945

2746. VERLET, P. and others. *Sèvres*, 1953

2747. VERNEUIL, P. *L'Art à Java : les temples de la période classique indo-javanaise*, 1927

2748. VERWORN, M. *Zur Psychologie de primitiven Kunst*, Jena, 1917

2749. VERZONE, P. *L'architettura religiosa dell'alto Medio Evo nell'Italia settentrionale*, Milan, 1942

2750. VETH, J. *Rembrandt's leven en kunst*, Amsterdam, 1941 (1906)

2751. VIEYRA, M. *Hittite art, 2300-750 B.C.*, 1955

2752. VIGNI, G. *Lorenzo di Pietro, detto Il Vecchietta*, Florence, 1938

2753. — *Tutta la pittura di Antonello da Messina*, Milan, 1952

2754. VIGNOLA, G. B. *Le due regole della prospettiva pratica*, Rome, 1583

2755. VILÍMKOVÁ, M. *Egyptian art*, 1962

2756. VILLARI, L. *Giovanni Segantini*, 1901

2757. VILLIERS, G. H. *Hans Holbein the younger : The Ambassadors, in the National Gallery*, London, 1947

2758. VIOLLET-LE-DUC, E. E. *Dictionnaire raisonné de l'architecture française du XIᵉ au XVIᵉ siècle*, 10 vols., 1858-68

2759. VITRY, P. *La Cathédrale de Reims : architecture et sculpture*, 2 vols., 1915-19

2760. — *French sculpture during the reign of Saint Louis, 1226-1270*, Florence and New York, 1938

2761. — *Michel Colombe et la sculpture française de son temps*, 1901

2762. — *La Sculpture française classique de Jean Goujon à Rodin*, 1934

2763. VLAMINCK, M. DE. *Paysages et personnages*, 1953

2764. VÖGE, W. *Jörg Syrlin der Ältere und seine Bildwerke*, Berlin, 1950

2765. — *Niclas Hagnower, der Meister des Isenheimer Hochaltars und seine Frühwerke*, Freiburg, 1931

2766. VOGEL, J. P. *Buddhist art in India, Ceylon and Java*, 1936

2767. VOGT, P. *Christian Rohlfs*, Cologne, 1967 (1956)

2768. VOLBACH, W. F. and HIRMER, M. *Early Christian art*, 1961

2769. VOLLARD, A. *Degas : an intimate portrait*, 1928

2770. — *En écoutant Cézanne, Degas, Renoir*, 1938

2771. — *Paul Cézanne : his life and art*, 1924

2772. — *La Vie et l'œuvre de Pierre-Auguste Renoir*, 1919

2773. VOLMAT, R. *L'Art psychopathologique*, 1956

2774. VON HAGEN, V. W. *The ancient sun kingdoms of the Americas : Aztec, Maya, Inca*, 1962

2775. — *Realm of the Incas*, New York, 1961 (1957)

2776. VOSS, H. *Die Malerei des Barock in Rom*, Berlin, 1925

2777. VOYCE, A. *The Moscow Kremlin : its history, architecture and art treasures*, 1955

2778. VRIESEN, G. (ed.). *August Macke*, Stuttgart, 1957 (1953)

2779. VRIESEN, G. and IMDAHL, M. *Robert Delaunay — Licht und Farbe*, Cologne, 1967

2780. WAAL, H. VAN DE. *Jan van Goyen*, Amsterdam, 1941

2781. WACKENRODER, W. H. *Herzensergiessungen eines kunstliebenden Klosterbruders*, 1948 (1797)

2782. WAENTIG, H. *Wirtschaft und Kunst*, Jena, 1909

2783. WAGNER, F. A. *Indonesia : the art of an island group*, 1959

2784. WALDBERG, P. *Surrealism*, 1965

2785. WALDEN, N. and SCHREYER, L. *Der Sturm : ein Erinnerungsbuch an Herwarth Walden und die Künstler aus dem Sturmkreis*, Baden-Baden, 1954

2786. WALDMANN, E. *Albrecht Altdorfer*, 1923

2787. — *Auguste Rodin*, Vienna, 1948 (1945)

2788. — *Édouard Manet*, Berlin, 1923

2789. — *Der Maler Adolph Menzel*, Vienna, 1941

2790. WALKER, R. A. *The best of Beardsley*, 1967 (1948)

2791. WALPOLE, H. *A catalogue of engravers who have been born or resided in England*, 1763

2792. WARD, T. H. and ROBERTS, W. *Romney : a biographical and critical essay, with a catalogue raisonné of his works*, 2 vols., 1904

2793. WARE, I. *A complete body of architecture adorned with plans and elevations from original designs*, 1756

2794. WARNER, L. *The enduring art of Japan*, Cambridge, Mass., 1952

2795. — *Japanese sculpture of the Suike period*, New Haven, 1923

2796. — *Japanese sculpture of the Tempyō period*, Cambridge, Mass., 1964 (1959)

2797. WARNER, O. *An introduction to British marine painting*, 1948

2798. WATERHOUSE, E. K. *Baroque painting in Rome, the seventeenth century*, 1937

2799. — *Gainsborough*, 1958

2800. — *Painting in Britain, 1530 to 1790*, 1962 (1954)

2801. — *Reynolds*, 1941

2802. WATKINSON, R. *William Morris as designer*, 1967

2803. WATSON, B. *The life of Thomas Patch* (Walpole Society, vol. xxviii), 1940

2804. WATSON, F. *Mary Cassatt*, New York, 1932

2805. WATSON, F. J. B. *Canaletto*, 1950

2806. WATSON, W. *Sculpture of Japan from the fifth to the fifteenth century*, 1959

2807. WATSON, W. C. *Portuguese architecture*, 1908

2808. WATTS, M. S. *George Frederic Watts*, 1912

2809. WAY, T. R. *Memories of James McNeill Whistler the artist*, 1912

2810. WAY, T. R. and DENNIS, G. R. *The art of James McNeill Whistler: an appreciation*, 1903

2811. WEALE, W. H. J. *Hubert and John Van Eyck: their life and work*, 1907

2812. WEBB, G. F. *Architecture in Britain: the Middle Ages*, 1965 (1956)

2813. — *Gothic architecture in England*, 1951

2814. — *Wren*, 1937

2815. WEBB, M. I. *Michael Rysbrack sculptor*, 1954

2816. WEBER, H. *Walter Gropius und das Faguswerk*, Munich, 1961

2817. WEBER, W. *A history of lithography*, 1966

2818. WEBSTER, J. C. *The Labors of the Months in antique and mediaeval art*, Princeton, 1938

2819. WEBSTER, T. B. L. *Hellenistic art*, 1967

2820. — *Hellenistic poetry and art*, 1964

2821. 'WEEGEE'. *Creative photography*, 1964

2822. WEEKES, C. P. *Camille: a study of Claude Monet*, 1962

2823. WEIGELT, C. H. *Duccio di Buoninsegna*, Leipzig, 1911

2824. WEIGERT, H. *Geschichte der deutschen Kunst*, Berlin, 1942

2825. WEIGERT, R. A. *Jean I Berain, dessinateur de la Chambre et du Cabinet du roi, 1640–1711*, 2 vols., 1937

2826. WEIHRAUCH, H. R. *Studien zum bildnerischen Werke des Jacopo Sansovino*, Strassburg, 1935

2827. WEILER, C. *Alexej Jawlensky*, Cologne, 1959

2828. WEINBERGER, M. *Michelangelo, the sculptor*, 2 vols., 1967

2829. — *Wolfgang Huber*, Leipzig, 1930

2830. WEISBACH, W. *Der Barock als Kunst der Gegenreformation*, Berlin, 1921

2831. — *Französische Malerei des XVII. Jahrhunderts*, Berlin, 1932

2832. — *Die Kunst des Barock in Italien, Frankreich, Deutschland und Spanien*, Berlin, 1924

2833. — *Spanish Baroque art*, Cambridge, 1941

2834. WEISE, G. *Die spanischen Hallenkirchen der Spätgotik und der Renaissance*, Tübingen, 1953

2835. WEISMANN, E. W. *Mexico in sculpture 1521–1821*, Cambridge, Mass., 1950

2836. WEITENKAMPT, F. *How to appreciate prints*, 1930 (New York, 1908)

2837. WEITZMANN, K. *Greek mythology in Byzantine Art*, Princeton, 1951

2838. WEITZMANN, K. and others. *Icons from south eastern Europe and Sinai*, 1968

2839. WEIXLGAERTNER, A. *Grünewald*, Vienna, 1962

2840. WEIZSAECKER, H. *Adam Elsheimer, der Maler von Frankfurt*, Berlin, 1936–

2841. WELCKER, C. J. *Hendrik Avercamp en Barent Avercamp*, Zwolle, 1933

2842. WELLER, A. S. *Art USA now*, 2 vols., Lucerne, 1962

2843. — *Francesco di Giorgio, 1439–1501*, Chicago, 1943

2844. WERNER, A. *Amedeo Modigliani*, 1967

2845. — *Ernst Barlach*, New York, 1966

2846. — *Modigliani the sculptor*, 1965 (1962)

2847. WERTHEIMER, O. *Nicolaus Gerhaert: seine Kunst und seine Wirkung*, Berlin, 1929

2848. WESCHER, P. *Jean Fouquet and his time*, 1947

2849. WESSEL, K. *Coptic art*, 1965

2850. WESTHEIM, P. *Ideas fundamentales del arte pre-hispánico en México*, Mexico, 1957

2851. — *The sculpture of ancient Mexico*, New York, 1963

2852. WESTLAKE, N. H. T. *A history of design in painted glass*, 4 vols., 1879–94

2853. WESTPHAL, D. *Bonifazio Veronese*, Munich, 1931

2854. WETHEY, H. E. *Alonso Cano: painter, sculptor, architect*, Princeton, 1955

2855. — *Colonial architecture and sculpture in Peru*, Cambridge, Mass., 1949

2856. — *El Greco and his school*, 2 vols., Princeton, 1962

2857. WEYL, H. *Symmetry*, Princeton, 1952

2858. WHATELY, T. *Observations on modern gardening*, 1770

2859. WHEELER, SIR R. E. M. *Roman art and architecture*, 1964

2860. — *Civilizations of the Indus Valley and beyond*, 1966

2861. WHIFFEN, M. *Elizabethan and Jacobean architecture*, 1952

2862. — *Thomas Archer*, 1950

2863. WHINNEY, M. D. *Early Flemish painting*, 1968

2864. — *Sculpture in Britain, 1530 to 1830*, 1964

2865. WHINNEY, M. D. and GUNNIS, R. *The collection of models by John Flaxman R.A. at University College, London*, 1967

2866. WHISTLER, L. *The imagination of Vanbrugh and his fellow artists*, 1954

2867. — *Sir John Vanbrugh, architect and dramatist*, 1938

2868. WHITE, C. *The flower drawings of Jan van Huysum*, 1964

2869. — *Rembrandt and his world*, 1964

2870. WHITE, J. *Art and architecture in Italy, 1250 to 1400*, 1966

2871. WHITEHILL, W. M. *Spanish Romanesque architecture of the eleventh century*, 1941

2872. WHITLEY, W. T. *Artists and their friends in England, 1700–99*, 2 vols., 1928

2873. — *Gilbert Stuart*, Cambridge, Mass., 1932

2874. — *Thomas Gainsborough*, 1915

2875. WHITTICK, A. *Eric Mendelsohn*, 1956 (1940)

2876. WHITTICK, A. *European architecture in the twentieth century*, 1950–

2877. WHYTE, L. L. (ed.). *Aspects of form*, 1951

2878. WIERTZ, A. J. *La Correspondance d'Antoine Wiertz*, Brussels and Rome, 1953

2879. WIGHT, F. S. *Milestones of American painting in our century*, 1949

2880. WILDE, J. *Italian drawings in the Department of Prints and Drawings in the British Museum: Michelangelo and his studio*, 1953

2881. WILDENSTEIN, G. *Chardin: biographie et catalogue critiques*, 1933

2882. — *Gauguin, sa vie, son œuvre*, 1958

2883. — *Ingres*, 1956 (1954)

2884. — *Lancret: biographie et catalogue critiques*, 1924

2885. — *The paintings of Fragonard*, 1960

2886. WILENSKI, R. H. *The meaning of modern sculpture*, 1932

2887. — *Modern French painters*, 1954 (1940)

2888. WILLCOX, A. R. *The rock art of South Africa*, Johannesburg, 1963

2889. WILLETT, F. *Ife in the history of West African sculpture*, 1967

2890. WILLETTS, R. F. *Ancient Crete: a social history from early times until the Roman occupation*, 1965

2891. WILLETTS, W. *Foundations of Chinese art from neolithic pottery to modern architecture*, 1965 (1958)

2892. WILLIAMS, D. E. *The life and correspondence of Sir Thomas Lawrence*, 2 vols., 1831

2893. WILLIAMS, I. A. *Early English watercolours*, 1952

2894. WILLIAMS, W. C. *John Marin*, Berkeley and Los Angeles, 1956

2895. WILLIAMSON, G. C. *Bernadino Luini*, 1899

2896. — *George Morland*, 1904

2897. — *The history of portrait miniatures*, 2 vols., 1904

2898. — *John Downman, A.R.A.*, 1907

2899. — *John Russell, R.A.*, 1894

2900. — *Richard Cosway, R.A.*, 1905 (1897)

2901. WILLICH, H. and ZUCKER, P. *Die Baukunst der Renaissance in Italien*, Potsdam, 1930

2902. WILLIS, F. C. *Die niederländische Marinemalerei*, Leipzig, 1911

2903. WILLUMSEN, J. F. *La Jeunesse du peintre El Greco*, 2 vols., 1927

2904. WILSON, D. M. and KLINDT-JENSEN, O. *Viking art*, 1966

2905. WILSON, M. *The life of William Blake*, 1948 (1927)

2906. WIND, E. *Pagan mysteries in the Renaissance*, 1967 (1958)

2907. WINDELS, F. *The Lascaux cave paintings*, 1949

2908. WINGERT, P. S. *American Indian sculpture: a study of the Northwest Coast*, New York, 1949

2909. WINGERT, P. S. *Art of the South Pacific Islands*, 1953

2910. — *Primitive art: its traditions and styles*, New York, 1962

2911. — *The sculpture of Negro Africa*, New York, 1950

2912. WINGLER, H. M. *Introduction to Kokoschka*, 1958

2913. — *Oskar Kokoschka, the work of the painter*, 1958

2914. WINKLER, F. *Hans von Kulmbach: Leben und Werk eines fränkischen Künstlers der Dürerzeit*, Kulmbach, 1959

2915. — *Die Zeichnungen Albrecht Dürers*, 4 vols., Berlin, 1936–9

2916. WINSTEDT, R. O. (ed.). *Indian art*, 1966 (1947)

2917. WINTER, C. *Elizabethan miniatures*, 1943

2918. WINZINGER, F. *Albrecht Altdorfer: Graphik*, Munich, 1963

2919. — *Albrecht Altdorfer: Zeichnungen*, Munich, 1952

2920. — *Die Zeichnungen Martin Schongauers*, Berlin, 1962

2921. WIT, C. DE. *Le Rôle et le sens du lion dans l'Égypte ancien*, Leiden, 1951

2922. WITTKOWER, R. *Architectural principles in the age of humanism*, 1952 (1949)

2923. — *Art and architecture in Italy, 1600–1750*, 1965 (1958)

2924. — *The drawings of the Carracci in the collection of Her Majesty the Queen at Windsor Castle*, 1952

2925. — *Gian Lorenzo Bernini, the sculptor of the Roman Baroque*, 1966 (1955)

2926. WOLFE, B. D. *The fabulous life of Diego Rivera*, New York, 1963

2927. WOLFFLIN, H. *Classic art, an introduction to the Italian Renaissance*, 1952

2928. WOODALL, M. *Thomas Gainsborough: his life and work*, 1949

2929. WOODFORDE, C. *English stained and painted glass*, 1954

2930. WOODHEAD, A. G. *The study of Greek inscriptions*, 1959

2931. WOODWARD, J. *Tudor and Stuart drawings*, 1951

2932. WOOLF, V. *Roger Fry*, 1940

2933. WOOLLEY, SIR C. L. *Excavations at Ur*, 1954

2934. — *A forgotten kingdom. Being a record of the results obtained from the excavation of two mounds, Atchana and Al Mina, in the Turkish Hatay*, 1953

2935. — *Mesopotamia and the Middle East*, 1961

2936. WOOLNER, A. *Thomas Woolner, R.A., sculptor and poet: his life in letters*, 1917

2937. WORRINGER, W. R. *Abstraction and empathy*, 1953

2938. WOUTERS, R. *Sculptures et dessins*, Brussels, 1947

2939. WRIGHT, F. L. *An autobiography*, New York, 1943 (1932)

2940. — *Drawings for a living architecture*, New York, 1959

2941. WRIGHT, F. L. *Genius and mobocracy*, New York, 1949

2942. — *A testament*, New York, 1957

2943. — *Writings and buildings*. Selected by Edgar Kaufmann and Ben Raeburn, New York, 1960

2944. WRIGHT, J. B. *Etching and engraving*, 1953

2945. WULF, O. *Altchristliche und byzantinische Kunst*, 2 vols., Berlin, 1914–16

2946. WÜRTENBERGER, F. *Mannerism*, 1963

2947. WYCHERLEY, R. E. *How the Greeks built cities*, 1962 (1949)

2948. YASHIRO, Y. *Two thousand years of Japanese art*, 1958

2949. YAZDANI, G. S. (ed.). *Ajanta. The colour and monochrome reproductions of the Ajanta frescoes based on photography*, 4 parts, 1930–55

2950. YERBURY, F. R. *Modern Dutch buildings*, 1931

2951. YOUNG, J. L. *Mosaics: principles and practice*, New York, 1963

2952. ZACHARIAS, T. *Joseph Emmanuel Fischer von Erlach*, Vienna, 1960

2953. ZACHWATOWICZ, J. *Polish architecture*, Warsaw, 1967

2954. ZAMPETTI, P. *Carlo Crivelli*, Milan, 1961

2955. ZARNECKI, G. *English Romanesque sculpture, 1066–1140*, 1951

2956. — *Later English Romanesque sculpture, 1140–1210*, 1953

2957. ZERVOS, C. *L'Art de la Crète, néolithique et minoenne*, 1956

2958. — *Constantin Brancusi: sculptures, peintures, fresques, dessins*, 1957

2959. — *Rousseau*, 1927

2960. ZEVI, B. *Erik Gunnar Asplund*, Milan, 1948

2961. — *Storia dell'architettura moderna*, Turin, 1955 (1950)

2962. ZEVI, B. and KAUFMANN, E. F. *Lloyd Wright's Fallingwater*, Milan, 1965 (1963)

2963. ZIESENISS, C. O. *Les Aquarelles de Barye*, 1954

2964. ZIGROSSER, C. (ed.). *Prints, 13 illustrated essays on the art of the print*, 1963

2965. ZIMMER, H. *The art of Indian Asia*, 2 vols., New York, 1955

2966. — *Myths and symbols in Indian art and civilization*, Washington, 1946

2967. ZIMMERMANN, E. H. *Vorkarolingische Miniaturen*, Berlin, 1916

2968. ZIMMERN, H. *L. Alma-Tadema*, 1886

2969. ZWEIG, S. and others. *Frans Masereel*, Dresden, 1959